WHO'S WHO IN ART

33RD EDITION

i

WHO'S WHO
IN ART

33rd EDITION

WHO'S WHO IN ART

33RD EDITION

Biographies of leading Men and Women
in the World of Art in Britain today:
Artists, Sculptors, Designers, Architects, Critics,
Writers, Lecturers, Curators and Photographers.

Charles Baile de Laperrière
Editor

Lynda Murray
Assistant Editor

Tara Underwood
Editorial Assistant

Hilmarton Manor Press
2008

Hilmarton Manor Press
Calne
Wiltshire SN11 8SB
Great Britain

ISBN 978 0 904722 42 0

Distributed exclusively in the United States of America, its Possessions,
Canada and Mexico, by:
The Gale Group Inc.
27500 Drake Road, Farmington Hills,
Michigan 48331 - 3535 U.S.A.

Typeset by TR Training Services
15 Court Close, Portishead, North Somerset, BS20 6UX
Printed in Great Britain by
The Cromwell Press, Trowbridge, Wiltshire, BA14 0XB

WHO'S WHO IN ART

33RD EDITION

To
Colombe

ACKNOWLEDGEMENTS

Again my first thanks must be to Lynda Murray, my Assistant Editor, for her continuous dedication to this bi-annual publication, updating over 3,000 entries and editing the entries of over 500 new names.

Tara Underwood for her technical skill on the computer and general assistance in dealing with the production of the book.

I also gratefully acknowledge my debt to the officers of the academies, societies, groups, artists clubs and galleries for their continuous co-operation, as well as the numerous individuals who have helped us in this edition, many of them artists themselves.

For the errors and omissions I take full responsibility and I would like to take the opportunity to apologise to those I have inadvertently erroneously recorded, may they rest assured that all corrections notified to me will be included in the next edition.

Charles Baile de Laperrière

31st January 2008

EDITOR'S NOTES

In compiling Who's Who In Art it is my aim to produce a comprehensive list of biographical details of living artists of any nationality, active or being represented in the United Kingdom or Ireland today, as well as leading personalities in British Contemporary Art.

Who's Who In Art embraces exponents of all forms of painting, drawing, graphic art and sculpture in their widest forms and any mediums, as well eminent photographers.

This edition now also has two new indexes. An Index of over 1,000 Alphabetically Indexed Artists' Websites, and another of over 700 Modern and Contemporary Art Gallery Websites. This will enable the reader to access several thousand illustrated works of artists listed in the book, as well as an innumerable quantity of works recorded on the galleries websites.

The omission of well-known names is most regrettable, but we are limited to those artists who wish their names to appear. The entries are free and merit is the only criterion.

If, by any chance, there are artists of repute who have never been approached, I can only apologise for the oversight and hope, if they should read these editor's notes, they will inform us of the omission so that they may appear in the next edition of Who's Who In Art, which will be published in 2010.

All the entries in the last edition have been submitted to the individuals concerned and any corrections or additions notified have been incorporated in the present edition.

We have approached numerous artists and many new names appear for the first time. We always welcome applicants and names of artists recommended by others.

CONTENTS

Who's Who In Art
Editions

1st	1927	18th	1977
2nd	1929	19th	1980
3rd	1934	20th	1982
4th	1948	21st	1984
5th	1950	22nd	1986
6th	1952	23rd	1988
7th	1954	24th	1990
8th	1956	25th	1992
9th	1958	26th	1994
10th	1960	27th	1996
11th	1962	28th	1998
12th	1964	29th	2000
13th	1966	30th	2002
14th	1968	31st	2004
15th	1970	32nd	2006
16th	1972	33rd	2008
17th	1974		

WHO'S WHO IN ART

NOTES

AN APPEAL

TO

ARTISTS

AND

AGENTS

Applications for inclusion in *Who's Who in Art* are always sympathetically considered.

If you know of an artist who you think should be included an entry form will be sent on request. Entries are free and there is no obligation whatsoever to purchase a copy of the book on publication. Merit is the only criterion for inclusion.

Any information that should be added to existing entries should be sent to the Editor immediately.

Who's Who in Art is revised every two years

NOTES

NOTES

NOTES

BENEZIT
DICTIONARY OF ARTISTS
1ST ENGLISH EDITION

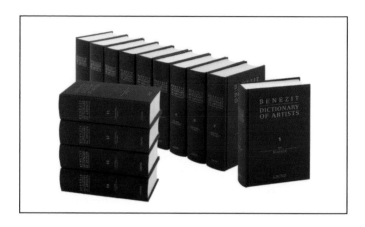

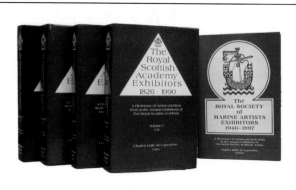

THE ROYAL SCOTTISH
ACADEMY EXHIBITORS 1826-1990

A complete dictionary of all the artists who exhibited at The Royal Scottish Academy
Annual Exhibitions and recording all their works of art.
THE FOLLOWING INFORMATION, COLLECTED FROM THE OFFICIAL
ANNUAL CATALOGUE, IS GIVEN FOR EACH ARTIST (WHEN AVAILABLE).
SURNAME CHRISTIAN NAME(S) STYLE DATE OF BIRTH & DEATH
MEDIUM: PAINTER: MINIATURIST: SCULPTOR: ENGRAVER: OR
ARCHITECT
ADDRESS(ES) YEAR(S) EXHIBITING, EXHIBIT(S): CATALOGUE no.
TITLE OF WORKS AS IT APPEARS IN THE OFFICIAL CATALOGUE-MEDIA.
CHRONOLOGICAL LIST OF PRESIDENTS & OFFICIALS OF THE ACADEMY.
ALPHA LIST OF ALL MEMBERS WITH DATE OF ELECTION.
Cloth bound. 230 x 150 mm. Each volume - 500 pages (approx.)

The set 4 volume 2000 pages. ISBN 0 904722 24 4 **£200.00**

THE ROYAL SOCIETY OF
MARINE ARTISTS EXHIBITORS 1946-1997

The Royal Society of Marine Artists Exhibitors 1946 - 1997 is a complete dictionary
of all the artists who exhibited at the Royal Society of Marine Artists Annual
Exhibition, and records all their work.

FOREWORD by the Countess Mountbatten of Burma
INTRODUCTION by Mark R. Myers, President
The following information, collated from the annual catalogues, is given for each
artist (when available):
SURNAME MAIDEN/MARRIED NAME(S) CHRISTIAN NAME(S) IN FULL
STYLE - DISCIPLINE - ADDRESS(ES) YEARS EXHIBITING
EXHIBIT(S) CATALOGUE NUMBER(S)
TITLE OF WORK AS IT APPEARS IN THE OFFICIAL CATALOGUE
MEDIUM – PRICE CHRONOLOGICAL LIST OF PATRONS, PRESIDENTS
AND OFFICIALS OF THE SOCIETY. ALPHA LIST OF ALL MEMBERS DATES
OF MEMBERSHIP INDEX OF ALL SHIP NAMES

Cloth Bound 230 x 135 mm. 450 Pages ISBN 0 904722 31 7 **£50.00**

THE NEW ENGLISH
ART CLUB EXHIBITORS
1886-2001

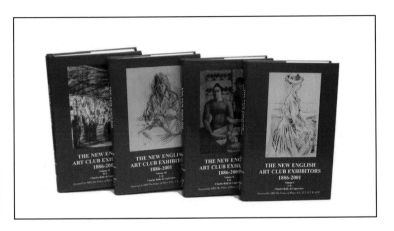

THE NEW ENGLISH ART CLUB EXHIBITORS 1886-2001 in
4 volumes, is the complete dictionary of all the artists who exhibited at the New
English Art Club Exhibitions and a record of all their works of art.

FOREWORD by HRH The Prince of Wales, K.G., K.T., G.C.B., O.M.
INTRODUCTION by Ken Howard RA President
The following information, collated from the official annual catalogues, is given for
each artist (when available).
SURNAME - CHRISTIAN NAME
STYLE
MEDIUM: PAINTER, SCULPTOR, ENGRAVER, (the term "engraver" has been used
in this work to describe not only engravers but etchers, lithographers etc).
ADDRESS(ES)
YEAR(S) EXHIBITING
EXHIBIT(S): CATALOGUE No.(s)
TITLE OF WORK AS IT APPEARS IN THE OFFICIAL CATALOGUE MEDIA. -
PRICE
CHRONOLOGICAL LIST OF OFFICIALS OF THE CLUB.
ALPHABETICAL LIST OF ALL MEMBERS OF THE N.E.A.C. WITH DATE OF
ELECTION

The Set 4 Volumes, 1600 pages **£200**

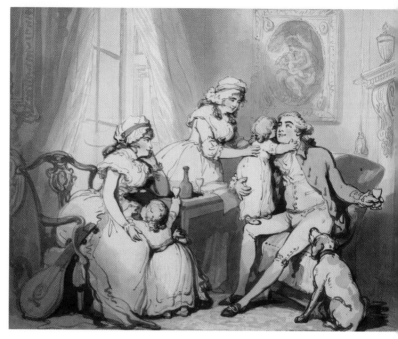

Thomas Rowlandson The Happy Family Pen & black ink and watercolou
(1756-1827) over pencil 248 X 306mm

Illustration Courtesy of Lowell Libson Ltd., London

ANTHONY LAW

INDEPENDENT CONTRACT PUBLISHER TO THE INTERNATIONAL
FINE ART AND ANTIQUES TRADE
UK AGENT FOR THE DUBAI ART AND ANTIQUES FAIR

ARTPRESS ADVISERS LTD

10 STRATHMORE CLOSE CATERHAM SURREY CR3 5EQ UK
TEL: +44 (O) 1883 348082 FAX: +44 (O) 1883 344772
EMAIL: ANTHONYJLAW@HOTMAIL.COM

CREATING A SPLASH

THE ST IVES SOCIETY OF ARTISTS
THE FIRST 25 YEARS
1927-1952

David Tovey

PART I

The most complete historical and biographical dictionary on the St Ives Society of Artists.

History of the Foundation of the Society
– The Touring Exhibitions of the 1930's
 – The War Years
– The Touring Exhibitions of the 1940's
– The Split of 1949.

Stylistic trends – Media and subject matter.

Women Artists within the Society.

Limited Edition
Hardback, 298mm x 210mm, 344 Pages
88 Colour Illustrations
230 Black and White Illustrations

Price £55.00
ISBN 0 904722 38 4

PART II

Detailed Biographical dictionary, profusely illustrated, of all members of the Society during the period covered, divided into:

A – members included in the 2003/4 Touring Exhibition, with commentary on exhibits.
B– other prominent members.
C - short-term and lesser known members.

Appendices

List of Works
- Brighton and Stoke, 1932 Touring Exhibition
- National Museum of Wales, Cardiff, 1947
- Festival of Britain, 1951
- The Mackelvie Collection at Auckland Art Gallery

Bibliography – Index

ROYAL ACADEMY

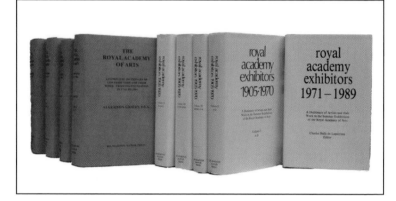

ROYAL ACADEMY OF ART
1769 – 1904
A. Graves

A complete dictionary of all artists who exhibited, giving chronologically the list of their exhibits, as well as the address of their Studio(s).

Cloth Bound 225 x 145 mm 3,348 pages The set 8 volume bound in 4 volumes

ISBN 0 904722 18 X **£350**

ROYAL ACADEMY EXHIBITORS
1905 – 1970

A complete dictionary of the 20,000 Artists who exhibited, giving chronologically the list of all their 100,000 exhibits, as well as the address of their Studio(s).

This is the continuation of A. Graves' "Royal Academy of Art 1769 – 1904".

Cloth Bound 230 x 135 mm

1, 857 pages The set 4 volumes ISBN 0 904722 13 9 **£200**

ROYAL ACADEMY EXHIBITORS
1971 – 1989
Charles Baile de Laperrière

ROYAL ACADEMY EXHIBITORS 1971 – 1989 brings the work started by A. Graves to the present day. ROYAL ACADEMY EXHIBITORS 1971 – 1989 is the complete dictionary of all the 5,500 artists who exhibited at the Royal Academy Summer Exhibitions and records all their 25,000 works of art.

Cloth Bound 230 x 135 mm ISBN 0 904722 19 8 **£50**

THE SOCIETY OF
WOMEN ARTISTS EXHIBITORS 1855-1996

The Society of Women Artists Exhibitors 1855 - 1996 in 4 volumes is the complete dictionary of all the artists who exhibited at The Society of Women Artists Annual Exhibitions and recording all their works of art.

FOREWORD by Her Royal Highness Princess Michael of Kent
INTRODUCTION by Professor Barbara Tate, President
The following information, collated from the official annual catalogues, is given for each artist (when available):
SURNAME MAIDEN/MARRIED NAME(S) CHRISTIAN NAME(S) IN FULL
STYLE - DISCIPLINE - ADDRESS(ES) YEAR(S) EXHIBITING
EXHIBIT(S): CATALOGUE No(s) TITLE OF WORK AS IT APPEARS IN THE OFFICIAL CATALOGUE MEDIUM - PRICE
CHRONOLOGICAL LIST OF PRESIDENTS & OFFICIALS OF THE SOCIETY.
ALPHABETICAL LIST OF ALL MEMBERS WITH DATE OF MEMBERSHIP.
76,000 WORKS EXHIBITED BY OVER 11,500 ARTISTS

Cloth Bound 230 x 135 mm. Each Volume 400 pages (approx.)
The set of 4 volumes ISBN 0 904722 30 9 **£200.00**

DICTIONARY OF
BRITISH ARTISTS WORKING 1900-1950
Grant M Waters

The standard work on the period giving biographies of over 6,500 Artists.

2 Volume Set ISBN 0 902010 05 0 **£69.00**
Volume 1 only, The Text A biographical dictionary of more than 5,500 British artists active between 1990 and 1950 ISBN 0 904722 37 6 **£49.00**
Volume 2 only, The Plates Over 1,000 further biographical entries. Also extensive record of the various exhibition societies ISBN 0 902010 06 9 **£25.00**

ROYAL HIBERNIAN ACADEMY OF ARTS

Index of Exhibitors
1826 - 1979
Ann M. Stewart

A complete dictionary of all artists who exhibited from the first annual exhibition in Dublin in 1826. Chronological lists of exhibits with titles and, when available, original prices: addresses of studios. Over 55,000 works recorded from 7,000 artists. This work is complementary to Royal Academy Exhibitors, as a large number of artists also exhibited at the R.H.A.

Summary history of the R.H.A. by C. de Courcy

Cloth Bound 299 x 150 mm 336 pages The Set 3 Volumes £120

ISBN 0 9510610 0 3

MANTON Publishing
52 Upper Grand Canal Street, Dublin 4, Eire
Tel/Fax 00 353 1 667 1785

THE ROYAL GLASGOW INSTITUTE OF THE FINE ARTS

1861-1989

A Dictionary of Exhibitors at the Annual Exhibitions of the
The Royal Glasgow Institute of the Fine Arts
In four volumes

Compiled by Roger Billcliffe

Over 10,000 artists, engravers, sculptors and architects have shown at the Glasgow Institute. This series of volumes lists each of their exhibits - over 100,000 in all - in a dictionary format. Entries are arranged by the exhibitor's name with full details of changes of address, title, medium and, where available, price.

Cloth bound 215 x 155 mm Each volume 400 pages (approx)
The set of four volumes £200 ISBN 0-9515945-0-8

Published by Woodend Press
134 Blythswood Street
Glasgow
G2 4EL

AIMS AND ACTIVITIES OF ACADEMIES, GROUPS, SOCIETIES, ETC.

Armed Forces Art Society

Annual Exhibition in Mall Galleries, London. Anyone of any rank who is serving or has served in the Armed Forces (including Reserve Forces and cadets) is entitled to apply to become an Associate of the Society; spouses and widows/widowers of such may also apply for Associateship. The Committee considers applications from eligible personnel. Applicants are accepted if their work is deemed to be of the requisite standard. Once accepted for membership applicants are eligible to submit works for selection for the exhibition.

Chairman: Major General The Revd. Morgan Llewelyn, CB, OBE, DL., Llangattock Court, Llangattock, Crickhowell, Powys, NP8 1PH *Membership Secretary:* Colonel Edward Cowan, OBE , Pond Farm, Musbury Lane, Marnhull, Dorset, DT10 1JP *Exhibition Secretary:* Squadron Leader Martin Balshaw, 70 Eider Avenue, Lyneham, Chippenham, Wiltshire, SN15 4QG

The Association of Illustrators (AOI)

Established in 1973 the AOI works to advance and protect illustrators' rights, promoting good practice throughout the profession. As the only body to represent illustrators and campaign for their rights in the UK, the AOI has successfully increased the standing of illustration as a profession and improved the commercial and ethical conditions of employment for illustrators. One of the results of its work is improved quality of professional business practice for graduating illustrators, hence better results for companies who commission illustration for promotional reasons. The AOI is run by administrative staff, responsible to a Council of Management. The Chairman is Michael Bramman. The AOI publishes a bi-monthly magazine, the Journal, and organizes various events throughout the year covering the full range of diverse issues that concern illustrators today.

For more information please contact the AOI at *Address:* 2nd Floor, Back Building, 150 Curtain Road, London EC2A 3AR *Tel:* 020 7613 4328 *Fax:* 020 7613 4417 *Email:* info@theaoi.com *Website:* www.theaoi.com.

British Society of Painters

(In Oils, Pastel and Acrylics) (1987)

Formed to promote the very best in works of art in these media. Society formed of Hon. Fellows, Fellows and Members, in a very short time has become a leading Society in the field with twelve Fellows and fifty members; promoting all that is best in traditional values, allowing artists in any media to compete unrestricted in open exhibition - showing their works alongside those of the Fellows and Members - with the opportunity of being selected for Membership. (Membership on merit - restricted by selection). Major Prize "The Old Masters Award", presented annually. Also many other prestigious prizes. Exhibitions bi-annually, Spring and Autumn at the Kings Hall/Winter Gardens Complex, Ilkley, West Yorkshire - central geographical position, equi-distant from Scotland, the South, the West Country and the East Coast. Applications for exhibition to the Director.

Hon. Fellows: David Shepherd, O.B.E., F.R.S.A., Terence Cuneo, O.B.E., Rowland Hilder, P.P.R.I., R.S.M.A., O.B.E. The First International *Hon. Fellow:* The late Pietro Annigoni. *Secretary:* Margaret Simpson, 13 Manor Orchards, Knaresborough, North Yorkshire, HG5 0BW *Tel:* 01423 540603 *Email:* info@britpaint.co.uk

The British Watercolour Society

Only the second major Art Society to leave London; formerly The Royal Water-colour Society Art Club, reverted its title to that of The British Watercolour Society (1911) which became defunct in 1961. The aims of The Society are to promote all that is best in the traditional values of watercolours, allowing watercolourists to compete in unrestricted open exhibition, showing their works alongside those of the Members and Associate Members - membership restricted by selection. Several thousands of pounds in prizes annually - two Exhibitions per year, Summer and Christmas, at The Kings Hall/Winter Gardens Complex, Ilkley, West Yorkshire - central geographical position equi-distant from Scotland, the South, the West Country and the East Coast. Applications to The Director.

Hon. Members: Sir Robin Philipson, R.S., P.P.R.S.A., R.S.W., Rowland Hilder, P.P.R.I., R.S.M.A., O.B.E., Edith Hilder, W. J. L. Baillie, R.S.A., P.R.S.W., W. Heaton-Cooper, R.I. *President:* Kenneth Emsley, M.A. (Cantab), L.L.M., F.R.S.A. *Secretary:* Margaret Simpson. *Director:* Leslie Simpson, F.R.S.A., 13 Manor Orchards, Knaresborough, North Yorkshire, HG5 0BW. *Tel:* 01423 540603 *Email:* info@britpaint.co.uk

The Cartoonists Club of Great Britain

Since its inaugural meeting at The Feathers Pub, Tudor St, London on Friday 1st of April 1960, The Cartoonists' Club of Great Britain has evolved into one of the largest cartoonist's organisations in the world, with a membership of over 200 full and part time Cartoonists in the United Kingdom (and further afield).

Our membership reflects the specialisations within the profession, all aspects of the business being severally represented, from single gags to strips, Caricature and Cartoon illustration. Prominently featured in our constitution are our objectives as an organisation with emphasis on encouraging good social contacts between cartoonists, (who for the most part lead rather more solitary professional lives than most) and to promote the art of the Cartoon.

Many of the great names from the British cartoon fraternity have passed through our portals during the last 43 years and all have contributed something to the organisation. We have collectively been responsible for organising very many local, nationwide and international Cartoon events, from exhibitions and competitions to charitable fund raising events or indeed demonstrating the art of the Cartoon to enthusiastic youngsters at road shows and public exhibitions. Cartooning has fantastic appeal to a wide section of the great British public with a high level of interest and curiosity with the mirth you would expect to be evident at a Cartoon event.

The organisational structure of the Club is fairly informal. The Committee, of 15 members, including The Chairman, Secretary, Treasurer and Projects Officer, meets once a month to conduct our various affairs. We publish internally a monthly newsletter 'The Jester'. The Club also publishes a complete members handbook usually every four years or so and also manages a permanent body of framed Cartoon work on general theme, called 'The Cartoonists' Exhibition'. This exhibition is

available for various Club events such as link-ups with other arts organisations and galleries or as a fund raising exhibition at charity auctions.
Chairman: Graham Fowell *Treasurer:* Jill Kearney *Secretary:* Richard Tomes
Address: 29 Ulverley Crescent, Olton, Solihull, W Midlands B29 8BJ *Email enquiries:* r.tomes@virgin.net *Website:* www.ccgb.org.uk

The Chartered Society of Designers

Founded in 1930, CSD is the professional body for designers. It is the world's largest chartered body of professional designers and is unique in representing designers in all disciplines.
CSD is governed by Royal Charter and as such its members are obliged to practice to the highest professional standards. The Society is also a registered charity and adheres to best practice as a membership organization.
Membership is only awarded to qualified designers who must also prove their professional capability during an admission assessment. If a designer has MCSDTM or FCSDTM after their name you can be assured of a professional service.
The Society exists to promote concern for the sound principles of design in all areas in which design considerations apply, to further design practice and encourage the study of design techniques for the benefit of the community. In doing so, it seeks to secure and promote a professional body of designers and regulate and control their practice for the benefit of industry and the public.
With 3000+ members in 34 countries around the world, CSD offers a truly diverse and inclusive base of professional designers, each committed to operating to the highest professional standards in whichever field or country they practice.
Address: 1 Cedar Court, Royal Oak Yard, Bermondsey Street, London SE1 3GA
Tel: 020 7357 8088. *Fax:* 020 7407 9878. *Email:* csd@csd.org.uk
Website: www.csd.org.uk

Chelsea Art Society

Exhibition held annually at The Main Hall, Chelsea Old Town Hall, Kings Rd., London SW3.
President: Julian Barrow. *Vice-President:* Ann Marvolean. *Hon. Secretary:* Heather Wills-Sandford. *Hon. Treasurer:* Francis Howard. *Council:* Roger Dellar RI PS, John J. Petts, Anne Wright, Katherine Yates, Michael Alford, Marysia Jaczynska, Janet Treloar ARWS, Alex Wheeler, Christine E.Ellis, Alison Pullen, Ian Wright. *Address:* Hon.Secretary, 50 Bowerdean St., London SW6 3TW. *Tel:* 020 7731 3121.

The Cheltenham Group of Artists

The Cheltenham Group was founded in 1920 with the aim of bringing together local professional artists from a wide range of disciplines. The group comprises members of all ages working in both contemporary as well as traditional media representing current art directions. The group has never drawn up a formal manifesto: indeed it is a characteristic of the exhibitions that works are widely varied in style, approach and technique.
A regular programme of members' exhibitions is held together with a bi-annual open exhibition. Prizes are awarded for works of special merit in a variety of categories.
Hon.Secretary: Helen Benson. *Address:* 15 The Barracks, Parkend, Lydney, Glos, GL15 4HR. *Tel:* 01594 562114 *Email:* helen.benson524@btinternet.com

The Colour Group

Founded in 1940 as an interdisciplinary society aiming to bring together those interested in all aspects of colour. Monthly public lectures (October to May) provide a forum for information on colour in the arts and sciences. Admission is usually free. Members receive a regular newsletter. An elected committee administers the biennial Newton Medal and Turner Medal and the William David Wright and David Palmer financial awards. Membership (available online) currently comprises 200 scientists, artists and other interested persons.

Address: The Hon.Secretary, The Colour Group (Great Britain), c/o Applied Vision Research Centre, City University, Northampton Square, London EC1V 0HB. *Website:* www.colour.org.uk

The East Anglian Group of Marine Artists

In 1979 six amateur and professional marine painters met at the famous "Butt and Oyster" pub at Pin Mill on the banks of the River Orwell, Suffolk. Inspired by the surroundings and a shared enthusiasm for depicting the maritime scene, the East Anglian Group of Marine Artists was brought into being. Soon others were invited to join, amongst them being some well-known and highly regarded artists with a leaning towards East Coast subject matter. An inaugural exhibition was held in Ipswich early the following year, since when the group has moved from strength to strength with a steady improvement in standards and diversity.

Candidate members exhibit with the group before being considered for full membership at the annual general meeting. The group has a maximum of 25 full members.

A major exhibition is held twice a year, including a biennial show at the Mall Galleries in London. Although the over-riding theme is work depicting the East Anglian maritime scene, some members stray to other parts of the world from time to time with equally good effect.

President: Ian Houston Chairman: Anthony Osler, 01379 688121 *Secretary:* Trevor Sowden, 10 Harefield, Long Melford, Sudbury, Suffolk, CO10 9DE tel: 01787 313539 *Email:* tbsowden@btinternet.com

Federation of British Artists

The Federation of British Artists (FBA) is a registered charity established in 1961 which operates the Mall Galleries. Through its continuous programme of exhibitions, the FBA provides a focal point for contemporary, mainly figurative art by living artists working in the UK. It aims to promote and encourage the study and practice of the visual arts by showcasing contemporary works in different media and different subjects, and its exhibitions attract both well-established artists and emerging talent.

The FBA is home to eight of this country's most prestigious art societies, each of which exhibits annually at the Mall Galleries, and includes: the Pastel Society, the New English Art Club, the Royal Society of British Artists, the Royal Institute of Painters in Watercolours, the Royal Institute of Oil Painters, the Royal Society of Portrait Painters, the Royal Society of Marine Artists, and the Society of Wildlife Artists. In 2008 the Mall Galleries launched the £25,000 Threadneedle Figurative Prize as well as the FBA Selectors' Choice. The Galleries also host several of the UK's premier open art competitions, including the Kaupthing Singer and Friedlander/ Sunday Times Watercolour Exhibition, and the ING Discerning Eye. The FBA receives no public funding, and is entirely reliant for its income on sponsorship, sales

commissions and membership fees. It places great importance on its educational activities, which include an art education programme for children considered at risk, a 'Living Art' primary schools programme in the London Borough of Brent, and 'Art Break', a regular series of lunchtime workshops promoting a healthy work-life balance, for adults working in the local area.

Director: Lewis McNaught *Chairman:* Lord Lyell of Markyate *Address:* 17 Carlton House Terr., London SW1Y 5BD *Tel:* 020 7930 6844

Free Painters and Sculptors (F.P.S.)

This FPS was founded in 1952 when painter members of the ICA formed an individual group devoted to the principle of a 'free association of painters for mutual assistance, without regard to style, with no theory held in common, but believing in vital experiment and friendship'. Initially known as the Free Painters Group, the name was changed in the mid-Sixties to the Free Painters and Sculptors to include sculptors who had become an integral part of the Group.

In 1972 the FPS opened the Loggia Gallery in Buckingham Gate where exhibitions of members' work were held. Group shows were also sent to galleries out of London. Giving up our gallery, in 2000 we moved with SPANA to new premises. From there we send out pictures from our Reserve Collection to galleries in London and around the country.

Membership is £30 annually and Student Membership £15. Persons interested in the visual arts are welcomed and applications will be submitted to the Executive Committee. Full membership is awarded to practising artists whose work is of the required standard. The Free Painters and Sculptors is an Incorporated body and is registered as an Educational Charity.

Chairman: Penelope MacEwan. *Secretary:* Owen Legg. *Address:* 14 John Street, London WC1N 2EB. *Tel:* 0207 828 5963. *Website:* www.piczo.com/FreePaintersAndSculptors

Glasgow Art Club

This Club was formed in 1867 to advance the cause of and stimulate interest in art in all its branches by means of exhibitions of works of art, life classes, the acquisition of Publications on art, lectures on art subjects, and by such other means as the Council may decide from time to time. Consequently, the Club's Membership comprises painters, sculptors, architects and others involved in creative work as Artist Members and ladies and gentlemen interested in art as Lay Members. To be admitted to Artist membership, candidates must submit examples of their work for the approval of the Artist Members. Painters, sculptors and members pay on admission an entry fee

Secretary: David Watson, CA, Gillespie & Anderson, 147 Bath St., Glasgow G2 4SN. *Tel:* 0141 248 4884. *Fax:* 0141 248 5630. *Email:* david.watson@gillespieandanderson.co.uk

Guild of Aviåtion Artists

The Guild of Aviation Artists, a specially authorised Friendly Society founded in 1971, incorporates the Society of Aviation Artists, which held its first exhibition in 1954 at London's Guildhall. However, by 1958, a number of professional members had become somewhat disenchanted with the Society and turned their attention to a small social club catering for light flying and gliding enthusiasts called the Kronfeld Club, which was keen to put on an exhibition of aviation art at its Victoria premises. So it

was that top professionals like Wootton, Turner and Young hung their work alongside artists who actually flew the aeroplanes.

It is the same today, and from these small beginnings, the Guild now has over 450 members including a number of "Friends" who are mostly artists as well. An annual open exhibition, held at The Mall Galleries and entitled 'Aviation Paintings of the Year', is sponsored by, amongst others, BAE Systems, Rolls-Royce and Messier-Dowty. It attracts a prize of £1,000, sponsored by BAE Systems, for the artist of what is judged to be the best exhibit.

Other exhibitions are organized to commemorate many of the important events in our aviation history and members' work continues to be sought by historians, publishers and collectors alike. Their paintings are hanging in service messes and clubs, museums, galleries and aviation offices throughout the world.

President: Michael Turner FGAvA (President). *Founder President:* The Late Frank Wootton O.B.E. GAvA *Chairman:* Stephen Arch GAvA. *Treasurer:* Mrs Janet Latham. *Administrator/Secretary:* Mrs Susan Gardner. *Address:* Trenchard House, 85 Farnborough Road, Farnborough, Hants GU14 6TF *Tel:* 01252 513123 *Fax:* 01252 510505 *Email:* admin@gava.org.uk

Hesketh Hubbard Art Society

Founded as RBA Art Club under the auspices of the Royal Society of British Artists. Members meet on Monday or Friday evenings to draw from the model throughout the year. New members admitted any Monday or Friday after a folio of work is inspected. No tuition unless specially requested. The Mall Galleries, The Mall, SW1.

President: Simon Whittle. *Hon.Secretary:* Frances Tipton. *Address:* 17 Carlton House Terr., London SW1Y 5BD. *Tel:* 020 7930 6844.

The Hilliard Society of Miniaturists

Society founded in 1982 by Sue Burton and miniaturist Rosalind Pierson. Worldwide membership of around 300 artists, sculptors, and Patrons of miniature art. Full exhibiting artists entitled to use HS (HSF - Founder Member). Charter Member of the World Federation of Miniaturists.

Annual Wells exhibition held in June. AGM/awards luncheon, demonstrations. Occasional visits organised to specialist collections etc. Two excellent social and technically informative newsletters annually. Work accepted and returned by post, worldwide. This friendly society supports and encourages artists, whilst promoting miniature art internationally.

Enquiries: The Secretary, Priory Lodge, Priory Road, Wells, Somerset BA5 1SR *Tel/Fax:* 01749 674472 *Email:* hilliardsociety@talk21.com *Website:* www.art-in-miniature.org (*Office hours:* Tuesday/Wednesday 9.30am-3pm).

The International Guild of Artists

Now exclusively restricted to 20 leading artists as Hon. Fellows and Fellows of the Society. Ultimate aim of the Guild to act as adviser to the British Watercolour Society, Society of Miniaturists, British Society of Painters, Yorkshire Artists Exhibition. The four major National Societies annually on show at The Kings Hall/Winter Gardens Complex, Ilkley, West Yorkshire.

Principal: I.G.A., 13 Manor Orchards, Knaresborough, North Yorkshire, HG5 0BW *Tel:* 01423 540603 *Email:* info@britpaint.co.uk

WHO'S WHO IN ART

Ipswich Art Society

Ipswich Art Society, founded in 1874, put on its 130th Annual Open Exhibition in 2007. There have been held, also, the Anna Airy Award Exhibition for young artists aged 16-25, and separate exhibitions of work of full members and of Friends of the Society. Annual Open Exhibition May/ June.

President: Ken Cuthbert. *Chair:* Barbara Norman *Secretary:* Rosie Rooke *Address:* 41 Spring Road, Ipswich IP4 2RU. *Website:* www.ipswich-art-society.org.uk

The London Group

Founded in 1913 by an amalgamation of the Camden Town Group and the English Vorticists, the London Group is composed of working artists, has a written constitution, annually elected officers, working committees and a selection committee. There are usually between 90 and 100 members and an annual fee is charged. The group organises an exhibition each year and, when finances allow, invites non-member artists to submit work through open submission. The group has no permanent exhibition venue and rents gallery space in London, most recently the Menier Chocolate Factory and Bankside gallery.

The London Group aims to support contemporary artists from diverse backgrounds working in a wide range of media. Throughout its' lifetime the London Group has given artists a platform to show work to the public without the constraints of commercial, establishment and curatorial censorship. Approaching its' centenary, the London Group has an exciting programme of events planned for the future supported by an energetic, enthusiastic and committed membership. Previous members have included Walter Sickert, Wyndham-Lewis, Vanessa Bell, Henry Moore, David Hockney and Paula Rego.

Address: The London Group, PO Box 61045, London SE1 8RN *President:* Susan Haire *Website:* www.thelondongroup.com *Email:* enquiries@thelondongroup.com

The Master Carvers' Association

The Master Carvers' Association, founded in 1897, is the only Association for professional wood and stone carvers. Originally constituted as an employers association to enable national negotiations with the emerging unions, today the Association has transformed into a forum for professional wood and stone carvers.

The objects of the Association are the promotion, protection and interests of the wood and stone carving trades, and of the Association's members in particular.

There are three categories of membership, Member, Honorary Member and Associate Member. The Committee elects candidates for membership. More detailed information, including a history and the criterion for membership can be found on the website.

Hon.Secretary: Paul Ferguson, Unit 20, 21 Wren Street, London WC1X 0HF *Tel:* 020 7278 8759 *Fax:* 020 7278 8759 *Email:* info@mastercarvers.co.uk *Website:* www.mastercarvers.co.uk

Medical Art Society

The Medical Art Society was founded in 1935 by a distinguished group of 'doctor-artists' who liked to draw, paint or sculpt at leisure. It has continued ever since as an independent society supported by its members, currently about 300, through their subscriptions (£12 annually) and partly by a bequest from the late Baron ver Heyden de Lancey. Administrative support is provided by the Royal Society of Medicine's Academic Department. Membership is open to any doctor, dentist or vet whether qualified, student or retired. A number of events are arranged each year by and for members and their painting friends. Besides painting days and weekends there are life drawing sessions, lectures and painting holidays abroad. The highlight of the year is the Annual Exhibition.

President: Dr Jane Jackson *Address:* c/o Academic Department, Royal Society of Medicine, 1 Wimpole Street, London W1G 0AE *Tel:* 020 7290 3948

The National Acrylic Painters' Association

This Association, founded in 1985, is for all practising artists and painters, who wish to explore the potential of the acrylic medium. A person is elected into full membership. It is recognised that acrylic painting is but a medium amongst others, yet that as a painting substance it has a flexibility that renders it extremely versatile.

Founder and Director: Kenneth J. Hodgson. *President:* Alwyn Crawshaw. *Vice-President:* Vacant. The Association's patrons are: Dr. Sally A. Bulgin, Mark Golden - USA, Dr Catherine Marcangeli - France, and The Master of the Fine Art Trade Guild. In 1995 the Association established an American Division known as NAPA USA, this has now become ISAP. Membership of either organization has mutual membership possibilities. NAPA also has members in Brazil and European countries.

Further information and details of membership obtainable from: Website www.art-arena.com/napa or the Membership Secretary, National Acrylic Painters' Association, 134 Rake Lane, Wallasey, Wirral, Merseyside, CH45 1JW.

National Society of Painters, Sculptors and Printmakers

The National Society was formed in 1930 to escape rigid traditionalism by allowing Member Artists to exhibit a diversity of the best of creative art with full freedom of expression. The objects of the Society are to advance the awareness of the public by promoting, demonstrating or teaching painting, sculpture and printmaking and to hold an annual exhibition in London (and secondary exhibitions from time to time) of the work of artists of every creed and outlook representing all aspects under one roof without prejudice or favour to anyone.

Membership is in two categories: Members (NS) and Associate Members (AMNS). Members are elected on merit from among those Associates who have had at least two works selected for the annual exhibition for three years. Application information may be requested from the Hon. Secretary. A Newsletter is sent to Members and Associates twice a year.

President: Michael Clifford Leman. Hon. *Secretary:* Gwen Spencer. *Address:* 122 Copse Hill, Wimbledon, London SW20 0NL.

Nature in Art

NATURE IN ART is a museum of fine, decorative and applied art inspired by nature. It opened to the public in May 1988 and in June 1988 HRH Princess Alexandra

attended a celebration of the opening. Nature in Art is the first of its kind anywhere in the world. It is housed in a fine, early Georgian mansion set in its own grounds and is owned and managed by Nature in Art Trust, registered charity 1000553. Nature in Art is readily accessible from M5 (J11 and 11A) and the centre of Gloucester (both 10 minutes by car). The entrance is on A38 in Twigworth, one mile North of A40. Art inspired by nature, from all periods and parts of the world in any medium, including works by living artists, is included in the permanent collection.

All aspects of nature are included (but domestic, farm and sporting animals etc. are excluded). Temporary exhibitions are held regularly and the permanent collection on show is regularly changed. Nature in Art was twice "specially commended" in the National Heritage Museum of the Year Awards. The museum is fully registered.

Facilities include free car parking, meals and light refreshments all day, library and reference collection of slides and other information, children's play area, shop, studios and nature garden with open air sculptures.The museum is fully accessible to wheelchair users. Different artists are in residence February/November and courses and demonstrations on a wide range of art techniques are arranged. A new conference/education centre opened in 1994. Open Tuesday-Sunday and Bank Holidays 10am-5pm. Closed other Mondays, (except by special arrangement when the facilities of Wallsworth Hall can be privately hired), and on Dec. 24, 25 and 26.

Patron: H.R.H. Princess Alexandra. *President:* Lady Scott. Chairman: Dr David H.Trapnell *Director:* Simon H. Trapnell. *Address:* Wallsworth Hall, Twigworth, Gloucester GL2 9PA. *Tel:* 01452 731422. *Fax:* 01452 730937. *Website:* www.nature-in-art.org.uk

Nature in Art Trust

Established as a Registered Charity (No. 1000553) in 1982, the Trust owns and manages Nature in Art. This centre has been created to exhibit, study and teach fine, decorative and applied art inspired by nature in all media from all national origins and all historical periods depicting any living (or previously living) wild thing. The facilities of Nature in Art are described under that title.

Friends of the Trust receive a regular Newsletter, Nature in Art, free admission to all regular activities of the Society, use of the library etc. Individual and gallery membership (for commercial and institutional galleries) is available. Further details from the Membership Secretary, Nature in Art (q.v.).

Patron: H.R.H. Princess Alexandra. *President:* Lady Scott. Director: Simon H. Trapnell. *Address:* Wallsworth Hall, Twigworth, Gloucester GL2 9PA. *Tel:* 01452 731422. *Fax:* 01452 730937. www.nature-in-art.org.uk

New English Art Club

The New English Art Club was founded in 1886. Its origin was a wave of foreign influence in the person of a number of students who had worked in the Parisian schools. The New English Art Club came into existence as a protest against a false concept of tradition, and it stands today against an equally false rejection of tradition. The annual exhibition is held in the Mall Galleries, The Mall, SW1, when the work of non-members is considered for display, November/December.

President: Tom Coates RWS, RP, PPRBA, PPPS, RWA. *Hon. Treasurer:* David Corsellis. *Keeper:* Charlotte Halliday, RWS. *Assistant Keeper:* Bob Brown. *Address:* 17 Carlton House Terr., London SW1Y 5BD. *Tel:* 020 7930 6844.

WHO'S WHO IN ART

Newlyn Art Gallery

Newlyn Art Gallery plays an important role in the South-West as one of the leading venues for contemporary art. The programme reflects current U.K. and international art practice and includes regular shows from locally-based artists. As an educational charity Newlyn Art Gallery aims to promote and encourage greater understanding and enjoyment of contemporary art. Throughout the year we present nine major exhibitions and associated educational events.

Director: Elizabeth Knowles. *Education Officer:* Esen Kaya. *Address:* Newlyn, Penzance, Cornwall TR18 5PZ. *Tel:* 01736 363715. *Fax:* 01736 331578.

Pastel Society

Founded 1898. Annual exhibition open to all artists who work in any 'dry" medium, i.e. pastel, pencil, charcoal, chalk, conté, sanguine, etc., at The Mall Galleries, The Mall, SW1, usually March.

President: Moira Huntly. *Vice-President:* Victor Ambrus. *Hon.Secretary:* Brian Gallagher. *Hon.Treasurer:* Mark Leach. *Archivist:* Barbara Stewart. *Address:* 17 Carlton House Terrace, London SW1Y 5BD. *Tel:* 020 7930 6844. *Fax:* 020 7839 7830 *Website:* www.thepastelsociety.org.uk

Penwith Society

The Penwith Society was founded in 1949 by a group of notable contemporary artists in St Ives and its seasonal exhibitions became a national show place for contemporary work. The Society has an elected membership limited to fifty, and an unlimited associated membership. Its aims are to encourage practicing artists and craftworkers in Cornwall and to further public interest in the arts. To this end four members' exhibitions are held a year, also selected artists and exhibitions from both inside and outside the area.The gallery has charity status. It is a unique complex of buildings, including public galleries, book shop, artist's studios and the Print Workshop, with facilities for silkscreen, etching and relief printing and dark room. Eleven studios and two cottages complete this remarkable arts and crafts complex. Open all year, Tuesday to Saturday, 10.00-1.00 and 2.30-5.00.

Curator: Kathleen Watkins *Address:* Back Road West, St Ives, Cornwall. *Tel:* 01736 795579

Royal Academy of Arts

The Royal Academy was founded in 1768 under the patronage of George III, as a society for the promotion of the arts of design. Sir Joshua Reynolds was the first President. Since that date it has fulfilled this role through promotion of the work of living artists with an unbroken series of Summer Exhibitions, held annually since 1769. It provides post-graduate training for 60 students in the Royal Academy Schools, which were established at the foundation.

The Academy continues to administer trust funds for the benefit of artists and for the promotion of the visual arts, and has a distinguished Collection and Research Library, and an Archive. Loan exhibitions, of great international importance, date from the 1870s. The Royal Academy receives no direct Government subsidy. It is an independent, self-supporting institution, under the patronage of the Crown, and its activities are directed by its Members (Painters, Engravers, Sculptors and Architects) who serve in rotation on the Council. The President is elected annually.

The Royal Academy is supported by sponsorship, through the subscriptions of its 90,000 Friends, it's Patrons and Benefactors, its Corporate Members, an active fundraising programme, retail sales of art books and specially commissioned works and a fine art framing service.
President: Sir Nicholas Grimshaw, C.B.E. *Keeper:* Professor Maurice Cockrill. *Secretary and Chief Executive:* Dr. Charles Saumarez Smith *Treasurer:* Professor Paul Huxley. *Address:* Burlington House, Piccadilly, London W1J 0BD. *Tel:* 020 7300 8000. *Website:* www.royalacademy.org.uk

Royal Birmingham Society of Artists

The Royal Birmingham Society of Artists is a non-profit-making society, with its own spacious exhibition galleries in the Jewellery Quarter of Birmingham, close to St. Paul's Square which is an active restaurant/cultural centre. The gallery has a craft area featuring the work of local craftsmen, a cafe, and two further exhibition galleries. These galleries are available for hire for exhibitions and evening meetings, when not in use by the Society - the programme for which is published early each year. Schedules for the three Open Exhibitions may be obtained from the Secretary by sending a stamped addressed envelope six weeks before the sending in day. A Prize Exhibition is held annually with a top prize of £1000 for Painting, donated to the RBSA, and many other prizes for sculpture, ceramics, etc. that are specially donated by Birmingham industries.

The Society also holds a Members and Associates Exhibition in the Autumn, as well as numerous other exhibitions throughout the year. There is also a flourishing Friends of the R.B.S.A., who hold two Exhibitions per year at the Gallery.

For details apply to the Hon. Secretary, The Royal Birmingham Society of Artists, 4 Brook St., St. Paul's, Birmingham B3 1SA. *Tel:* 0121 236 4353.

Royal Cambrian Academy of Art

The Royal Cambrian Academy of Art was founded in 1881, and granted its Royal Charter in 1882. The Headquarters have been in Conwy since 1886. In 1993 the Academy moved from Plas Mawr to its new purpose built Gallery, where Exhibitions are held throughout the year. The main Exhibition is the Annual Summer Exhibition, and there is also an Open Exhibition held biannually. Forms for this exhibition and membership of the Academy, may be obtained from the Gallery.
President: Maurice Cockrill RA *Vice-President:* Dr. Ivor Davies. *Hon. Secretary:* Tim Pugh. *Hon. Treasurer:* Tom Jones. *Curator:* Gill Bird. *Address:* Crown Lane, Conwy LL32 8AN.
Gallery open 11am-5pm daily except Monday, Sunday 1pm-4.30pm. *Tel/Fax:* 01492-593413. *Email:* rca@rcaconwy.org *Website:* www.rcaconwy.org

Royal Glasgow Institute of the Fine Arts

This Institute was founded in 1861 and has now over 1,100 Members. Its object is "to promote a taste for art generally and more specifically to encourage contemporary art, to further the diffusion of artistic and aesthetic knowledge and to aid the study, advancement and development of art in its application." Towards the attainment of this object, the Institute holds open annual exhibitions in The Mitchell, Glasgow, and shows approximately 350 works in all mediums. The RGI Kelly Gallery is available for hire. The Membership fee is an initial payment of £35, Annual subscription £25, Corporate Members Scheme £117.50.

Secretary: Mrs. Lesley Nicholl *Address:* 5 Oswald St., Glasgow G1 4QR. *Tel:* 0141 248 7411. *Fax:* 0141 221 0417. *Email:* rgi@robbferguson.co.uk *Website:* www.rgiscotland.co.uk

Royal Hibernian Academy

The Academy was incorporated by Charter of King George IV in 1823 with the intention of encouraging the fine arts in Ireland by giving Irish artists the opportunity of exhibiting their works annually. It was reorganized under a new Charter in 1861 and enlarged to thirty Constituent Members, and up to the present time has consistently fulfilled its original aims. The Academy has encouraged and developed art in Ireland since its foundation. It has given the Irish artist his status; and the present position of Irish Art can be said to be the outcome of the encouragement it has afforded to Irish men and women of talent and the part it has taken in art affairs generally in the country. There is hardly an Irish artist of note living or dead who has not been a member of the Academy or who has not benefited in one way or another by its activities.

President: Stephen McKenna RHA. *Secretary:* James Hanley RHA. *Treasurer:* James English RHA. *Keeper:* Martin Gale RHA. *Address:* 15 Ely Place, Dublin 2.

Royal Institute of Oil Painters

Founded in 1883 as the Institute of Painters in Oil Colours. The annual exhibition, which is open to all artists, subject to selection, is held in the Mall Galleries, The Mall, SW1.

President: Denis Syrett. *Vice-President:* Peter Wileman. *Hon. Secretary:* Brian Roxby. *Hon. Treasurer:* Pat Syrett. *Address:* 17 Carlton House Terr., London SW1Y 5BD. *Tel:* 020 7930 6844.

The Royal Institute of Painters in Watercolours

Formed in 1831 as the "New Society of Painters in Water-colours," a title which was afterwards changed to the "Institute of Painters in Water-colours." Shortly after the opening of the 1884 Exhibition the command of Queen Victoria was received that the Society should henceforth be called "The Royal Institute of Water-colours." The honour of a diploma under the Royal Sign Manual was given to the members on August 29, 1884, by virtue of which they rank as Esquires. Members are limited to 100. Annual Open Exhibition, March, at The Mall Galleries, The Mall, SW1.

President: Ronald Maddox, Hon. RWS, FCSD, Hon. RBA *Vice-President:* Peter Folkes, RWA *Secretary:* Terry McKivragan Exhibitions *Secretary:* Tony Hunt *Address:* 17 Carlton House Terr., London SW1Y 5BD. *Tel:* 020 7930 6844. *Website:* www.mallgalleries.org.uk

Royal Scottish Academy

The Royal Scottish Academy maintains a unique position in Scotland as an independently funded institution lead by eminent artists and architects whose purpose is to promote and support the creation, understanding and enjoyment of the visual arts through exhibitions and related educational events. The RSA also develops scholarships, awards and residencies for artists living and working in Scotland and has an historic collection of important artworks and an extensive archive of related material chronicling art and architecture in Scotland over the last 180 years.

Admission to most exhibitions is free. Office hours are Monday to Friday 9.30am-5pm. For exhibition hours, please contact the RSA Office or RSA website.

President: Ian McKenzie Smith, O.B.E., DA, RSA, PRSW, FRSA, FSS, FMA, FSAScot., LL.D. *Secretary:* Bill Scott, RSA, DA, FRBS *Treasurer:* Isi Metzstein, O.B.E., RSA, MA, ARIAS *Librarian:* Peter Collins, *R.S.A. Librarian:* Alastair R Ross, RSA, RGI, FRBS, DA, HFRIAS, D.Arts *Programme Director:* Colin R Greenslade *Academy Co-ordinator:* Pauline Costigane *Address:* The Mound, Edinburgh, EH2 2EL. *Tel:* 0131 225 6671. *Fax:* 0131 220 6016. *Website:* www.royalscottishacademy.org *Email:* info@royalscottishacademy.org

Royal Scottish Society of Painters in Watercolour

This Society was founded in 1878, and in 1888 Queen Victoria conferred on it the title "Royal." In its first Exhibition twenty-five artists showed their works; today there are 119 exhibiting Members. The object of the Society is to encourage and develop the art of painting in watercolour and the appreciation of this art, and toward the attainment of that object exhibitions of watercolour painting are held annually. While these are normally held in Edinburgh, they have on occasion been held in Glasgow, Aberdeen, Dundee and Perth. Candidates for Membership must be sponsored by Members of the Society, and must submit works for the consideration of the Members at an election meeting. The entrance fee is £45 and the annual subscription £45.

President: John Inglis RSW *Secretary:* Mrs Lesley Nicholl *Address:* 5 Oswald St, Glasgow G1 4QR. *Tel:* 0141 248 7411. *Fax:* 0141 221 0417. *Email:* rsw@robbferguson.co.uk *Website:* www.thersw.org.uk

Royal Society of British Artists

This Society was founded in 1823, incorporated by Royal Charter in 1847 and constituted a Royal Society in 1887. Membership is limited to 200. Annual exhibition held each year, when the work of non-members is admitted after selection at The Mall Galleries, The Mall, SW1.

President: Cav. Romeo di Girolamo. *Hon. Secretary:* Judith Gardner. *Hon. Treasurer:* Colin Gardner. Keeper: Alfred Daniels. *Address:* 17 Carlton House Terr., London SW1Y 5BD. *Tel:* 020 7930 6844.

Royal Society of British Sculptors

The Royal Society of British Sculptors (RBS) is a membership society for professional sculptors, founded in 1904. It is a registered charity which exists to 'promote and advance the art of sculpture', to ensure the continued widespread debate on contemporary sculpture and to promote the pursuit of excellence in the artform. We provide services to subscribing members by offering advice on all technical, aesthetic and legal matters concerning the production of sculpture, which assists artists in producing excellent work and ensures that both artist and client can achieve the best results. We advocate good and fair practice in the commissioning and exhibition of work, and offer guidelines for both artists and clients to help ensure this is achieved. We actively encourage the exchange of ideas by organising workshops, lectures and exhibitions and are involved in projects which ensure the continued improvement in sculpture education. The RBS has over 500 professional members throughout the UK and internationally, from world acclaimed names like Sir Anthony Caro and Richard

Serra. It also offers membership for recent sculpture graduates and less established artists, providing advice on the way to establishing professional practice.

The RBS houses a comprehensive resource centre and library for contemporary sculpture which contains visuals and information about all members of the RBS. Via an easy-to-use slide library, the best of contemporary sculpture is accessible to all for commissioning, exhibiting or research purposes. The RBS extends an invitation to anyone wanting to obtain a work of sculpture, source a particular artist or learn more about the artform to use the slide library. The RBS can also offer a consultancy service for large scale public commissions, providing advice and expertise from the selection of an artist right through to safe installation and the PR activities surrounding an unveiling. The Society is run by a Council of elected sculptors. Membership of the RBS is by application (submit 10 slides and an up-to-date CV). The Council meets every three months to review the applications and membership when the work submitted is of a sufficiently professional criteria.

Criteria for membership: Any practicing professional sculptor over the age of 21 may apply by submitting:

(1) An up-to-date CV (to include name, address, phone/fax number).

(2) 10 images

(3) Typed slide list detailing title of work, dimensions and material.

(4) A cheque for £23.50 to cover our administration costs.

President: Prof. Brian Falconbridge *Vice President:* Helaine Blumenfeld *Treasurer:* Johannes Von Stumm *Address:* 108 Old Brompton Rd., S. Kensington, London SW7 3RA. *Tel:* 020 7373 5554. *Fax:* 020 7370 3721. *Email:* info@rbs.org.uk

Royal Society of Marine Artists

Founded 1939, following a major exhibition entitled "Sea Power" under the patronage of King George V and opened by Winston Churchill. First exhibition was not until 1946 owing to the war. Initially known as The Society of Marine Artists, the right to use the title "Royal" was granted by H M The Queen in 1966.

Membership in two categories: Artist Members and Lay Members. Before election, Artist Members must demonstrate the consistently high standard of their work, which must essentially be maritime in nature. Lay Membership is open to anyone who has an interest in marine art and who wishes to support the aims of the Society. An Open exhibition is held annually at The Mall Galleries, London in late October.

President: Geoff Hunt. *Vice-President:* David Howell. Hon. *Secretary:* Elizabeth Smith. *Hon. Treasurer:* Alan Runagall. *Address:* 17 Carlton House Terr., London SW1Y 5BD. *Tel:* 020 7930 6844.

Royal Society of Miniature Painters, Sculptors and Gravers

This Society was founded in 1896 and its aim is to promote the fine art of miniature painting or any allied craft. The annual exhibition is held in London at the Mall Galleries. The Gold Bowl Award was established in 1985 and is one of the highest accolades for miniature art in the world. Non-members may submit work. Membership is by selection after establishing a consistently high standard of work. (ARMS - Associate Member, RMS - Full Member).

President: Elizabeth R.Meek PPSWA HS FRSA. For further information contact the *Executive Secretary:* Phyllis Rennell, 3 Briar Walk, London SW15 6UD *Tel:* 020 8785 2338

WHO'S WHO IN ART

Royal Society of Painter-Printmakers

The Royal Society of Painter-Printmakers was founded in 1880. The Society was granted a Royal Charter in 1911. Eminent Past-Presidents have been Sir F. Seymour Haden, Sir Frank Short, Malcolm Osborne and Robert Austin. All the well-known printmakers have exhibited with the Society, whose annual exhibition caters for and encourages all forms of printmaking. An election of Associates is held annually. As part of its aim to promote a knowledge and understanding of original printmaking, the Society organises courses, talks and tours.

President: Hilary Paynter. *Secretary:* Anthony Dyson. *Address:* Bankside Gallery, 48 Hopton St., London SE1 9JH. *Tel:* 020 7928 7521. *Fax:* 020 7928 2820.

Royal Society of Portrait Painters

This Society was founded in 1891 and has for its object the promotion of the fine art of portrait painting. The annual exhibition is held during April/May in The Mall Galleries, The Mall, SW1 and non members may submit work in any medium, except miniatures or sculpture, to the Selection Committee.

President: Andrew Festing. *Hon. Secretary:* Andrew James *Vice-President:* Sue Ryder. *Hon. Treasurer:* Richard Foster RP *Address:* 17 Carlton House Terr., London SW1Y 5BD. *Tel:* 01932 562368.

Royal Ulster Academy of Arts

President: Carol Graham, PRUA *Hon. Secretary:* Amanda Croft *Treasurer:* Barbara Killen

All correspondence to: *Secretary:* Kay McKelvey, 57 Ballycoan Road, Belfast BT8 8LL

Royal Watercolour Society

The Royal Water-Colour Society, which is next in seniority to the Royal Academy, was founded in 1804. It has numbered amongst its distinguished Members John Varley, Peter de Wint, David Cox, John Sell Cotman, Samuel Prout, Samuel Palmer, Ambrose McEvoy and D. Y. Cameron to mention but a few. Two exhibitions are held annually - in the spring and autumn. These exhibitions are confined to the works of Members. An annual exhibition open to all water-colour painters is held in the summer. There is an annual election of Associates. As part of its educational remit, the Society organises courses, talks, tours and other events on the subject of water-colour.

President:.Richard Sorrell *Hon.Secretary:* Trevor Frankland RWS RE RBA HonRI *Secretary:* to be appointed *Address:* Bankside Gallery, 48 Hopton St., Blackfriars, London SE1 9JH. *Tel:* 020 7928 7521. *Fax:* 020 7928 2820.

Royal West of England Academy

The Academy was founded in 1844. Election to Membership (R.W.A.) is by postal ballot. The Academy is an independent, self-supporting institution, founded to assist professional artists, sculptors and architects, through exhibitions and other activities. Regular and varied exhibitions are shown at its galleries. An Open Exhibition is held every autumn; open sculpture, painting and print exhibitions are held triennially; information may be obtained from the office.

WHO'S WHO IN ART

President: Derek Balmer, Hon. D ART, Hon. RA, PRWA *Address:* Queen's Rd., Clifton, Bristol BS8 1PX. *Tel:* 0117 973 5129. *Fax:* 0117 923 7874. *Website:* www.rwa.org.uk *Email:* info@rwa.org.uk

St. Ives Society of Artists

Holds Spring, Summer and Autumn Members' Shows in the Main Gallery in the Mariners Church, St.Ives, Cornwall. There are also 3 invited exhibitions, a September Festival Open and a Life Open during the year.

More information about all the exhibitions will appear on the website which is www.stisa.co.uk

President: Lord St. Leven. Chairman: Nicola Tilley Administrator: April Brooks. *Address:* Norway Square, St Ives, Cornwall TR26 1NA. *Tel:* 01736 795582. *Email:* gallery@stisa.co.uk

Scottish Artists' Benevolent Association

This Association was formed in 1889, and gives assistance to distressed deserving artists, their widows and dependants. Each year it disburses over £10,000. Life Membership (£25) is open to all. Subscriptions and donations should be sent to the Secretary Mrs Lesley Nicholl *Address:* Second Floor, 5 Oswald St, Glasgow G1 4QR. *Tel:* 0141 248 7411. *Fax:* 0141 248 0417.

Society of Botanical Artists

The Society of Botanical Artists is an International Society, founded in 1985.

Holds an open exhibition at Westminster Central Hall, Storey's Gate, London SW1H 9NH each year April/May with other exhibitions of members' work. Combines art and science and strives to enhance botanical art by proper promotion. Newsletter and Social meetings for members.

President: Margaret Stevens. Enquiries to Executive *Secretary:* Mrs. Pamela Henderson, 1 Knapp Cottages, Wyke, Gillingham, Dorset SP8 4NQ. *Tel:* 01747 825718.

Society of Designer Craftsmen

The Society of Designer Craftsmen was founded in 1888 as The Arts and Crafts Exhibition Society with Walter Crane and William Morris among its most prominent members, each of whom was to serve as President. Its aim is to strengthen the professional standards and status of designer-makers in Great Britain and to stimulate public awareness by bringing works of fine craftsmanship before the public through major comprehensive exhibitions and specialised displays. In 1960 the Society assumed its present title as representative of the largest body of independent professional crafts practitioners in Britain. It lays great emphasis on helping young graduates at the outset of their careers by arranging assessments of their work and offering Licentiateship of the Society (L.S.D.C.) to those whose work is of a high standard. Among its other activities, the society mounts an annual exhibition of work by selected fellows, members and licentiates.

Applications for election as Members (M.S.D.C.) are considered on a regular basis throughout the year by a Selection Committee, which meets to examine the individual craft pieces submitted. Fellowship of the Society (F.S.D.C.) may be awarded by a

majority vote of the Fellows on Council. Annual subscriptions: Fellows, £60; Members, £60; Licentiates, £32.50; Associates, £30.
Hon. Secretary: Miranda Falkner, M.S.D.C. *Address:* 24 Rivington St., London EC2A 3DU. *Tel:* 020 7739 3663. *Website:* www.societyofdesignercraftsmen.org.uk *Email:* info@societyofdesignercraftsmen.org.uk

Society of Equestrian Artists

Founded in 1978/79, the Society of Equestrian Artists exists to encourage the study of equine art and, by mutual assistance between members, to promote a standard of excellence in its practice worthy of the subject's importance in British artistic traditions. Membership comprises Associate and Full Members, who have attained a consistently high standard in their work, as well as Friends, who may be artist or non-artist. Annual Exhibitions, normally early Autumn at a major central London venue.
President: The Lord Oaksey, O.B.E. *Vice-Presidents:* Air Vice-Marshal Norman E. Hoad, C.V.O., C.B.E., A.F.C., John N.Thompson, Group Captain Philip Gibson O.B.E. *Chairman:* Mrs Anthony Lyle Skyrme. *Treasurer:* John Campbell. *Secretary:* Mrs Margaret Curtis, 75 Codrington Hill, Forest Hill, London SE23 1LR. *Tel:* 0208 690 9681.

The Society of Graphic Fine Art- The Drawing Society

(formerly: The Society of Graphic Artists)
Founded in 1919. The Society exists with the purpose of promoting drawing skills by means of exhibitions for both Members and Non-Members work. Suitable artwork will be drawings in any medium, any original form of printmaking, watercolours and acrylic with evidence of additional drawing, but no oils.
President: Roger Lewis SGFA, UKCPS 020 8655 0221 *Vice-Presidents:* Jo Hall SGFA, AOI , Angela Williams, SGFA, Keith M Kennedy, SGFA, RAS Cert.. *Hon. Treasurer:*Margaret Eggleton, SGFA, SWA, SBA. *Hon. Secretary:* Richard Banham, Hon.SGFA *Contact:* www.sgfa.org.uk

Society of Miniaturists

(founded London, May 1895)
The oldest Miniature Society in existence and the first major Society to leave London - its main aim is to promote the traditional, ancient and precise art of miniature painting that goes back many centuries. The Society holds two Exhibitions per year, Summer and Christmas, at The Kings Hall/Winter Gardens, Ilkley, West Yorkshire - a central geographical position equi-distant from the South, Scotland, West Country and the East Coast. A major prize is presented at each Exhibition for the best miniature. Non-members can exhibit alongside Members work - applications to the Director.
President: Kenneth Emsley, M.A. (Cantab), L.L.M., F.R.S.A. *Secretary:* Margaret Simpson. *Director:* Leslie Simpson, F.R.S.A., 13 Manor Orchards, Knaresborough, North Yorkshire, HG5 0BW *Tel:* 01423 540603 *Email:* info@britpaint.co.uk

Society of Portrait Sculptors

The Society of Portrait Sculptors was founded in 1953. It is a registered charity established to promote the art of portrait sculpture, encourage the highest standards, challenge preconceptions and stimulate interest in this timeless yet contemporary art

WHO'S WHO IN ART

form. This is done primarily through the Society's annual open exhibition held in May at The Gallery in Cork Street W1.
President: Nigel Boonham FRBS *Vice-President:* Etienne Millner FRBS. *Hon. Secretary & Treasurer:* David Houchin. *Address:* Farm Place, Isfield, Near Uckfield, East Sussex TN22 5TY. *Tel:* 01825 750485. *Website:* http://www.portrait-sculpture.org/ *Email:* sps@portrait-sculpture.org

Society of Scottish Artists

The S.S.A. was founded in 1891 to represent the adventurous spirit in Scottish art. Today the S.S.A. has over 500 members throughout Britain of which 150 are elected Professional members. Associate and Ordinary membership is also available by payment of an annual subscription. The main focus of the Society is its Annual Exhibition which traditionally takes place in the Royal Scottish Academy in Edinburgh in the Autumn. Submission of work is open to both members and non members, who undergo the same selection procedures, ensuring that each Annual Exhibition is unique, challenging and innovative.
For details about the Annual Exhibition (available from September) or about membership, contact the Secretary.
President: Kate Downie. *Secretary:* Joanne Soroka, 18 Clarence St., Edinburgh EH3 5AF. *Tel:* 0131 220 3977. *Email:* ssa@soroka.plus.com *Website:* www.s-s-a.org

Society of Wildlife Artists

Founded in 1964, the Society of Wildlife Artists is a registered charity that seeks to generate an appreciation of and delight in the natural world through all forms of fine art based on or representing the world's wildlife. Through exhibitions and publications of fine art, the Society aims to further an awareness of the importance of conservation in order to maintain the variety of the world's ecosystems and its wildlife. The Society also supports and promotes art based objectives of other conservation and wildlife charities.
Through Bursary schemes, (sponsored by Capmark Europe), the Society is able to help young artists keen to develop their knowledge and skills in wildlife art.
The focus of the Society's work is the annual exhibition featuring all media, held in September/October at the Mall Galleries, London. Included with the work of members from the UK and abroad is that of successful Bursary applicants, as well as a selection of work from non-members. The Annual Exhibition of the SWLA is the foremost event in the British wildlife art calendar.
President: Andrew Stock. *Hon. Vice-Presidents:* Bruce Pearson, Robert Gillmor and Keith Shackleton. *Hon. Secretary:* Jill Moger. *Address:*17 Carlton House Terr., London SW1Y 5BD. *Tel:* 020 7930 6844. *Website:* www.swla.co.uk

Society of Women Artists

This Society was founded in 1855 for the encouragement of women painters and sculptors, etc. The Annual Exhibition at the Mall Galleries runs in June and is open to all women artists.
Patron: Princess Michael of Kent. *President:* Barbara Penketh Simpson RMS FRSA. *Vice-Presidents:* Christine Birchall and Belinda Tong. *Hon. Secretary:* Debby Faulkner-Stevens RMS *Executive Secretary:* Pamela Henderson, 1 Knapp Cottages, Wyke, Gillingham, Dorset SP8 4NQ. *Tel:* 01747 825718. *Website:* www.society-women-artists.org.uk

WHO'S WHO IN ART

The Society of Wood Engravers

The S.W.E. was founded in 1920 by a group of artists which included Philip Hagreen, Robert Gibbings, Lucien Pissarro, Gwen Raverat and Eric Gill; it thrived until World War II and continued in the altered context after it. After a decade in which there were no exhibitions, it was re-formed in the 1980s, with its first new exhibition in 1984 and has steadily built an international reputation for excellence. It now tours its annual exhibition to several venues; organizes regular additional exhibitions; publishes a newsletter for members and subscribers six times a year; and is an international contact-point for all interested in the subject. The Society also administers The Rawlinson Bequest, through which grants are made to students of wood engraving. Subscription is open to anyone, artist, collector or simple enthusiast. Exhibitions are open to all forms of relief printmaking. Sending-in days are usually in the summer. The work of members and non-members alike is subject to selection. Membership: applications are considered from those who have had their work hung in at least three different exhibitions organized by the Society. Applicants are required to submit a portfolio of work and are elected on merit. Details of all the above are obtainable from the Secretary.

Chairman: Peter Lawrence. *Secretary:* Geraldine Waddington, 3 West Street, Oundle, Northants PE8 4EJ.

Ulster Society of Women Artists

The Ulster Society of Women Artists was founded in 1957 by Gladys MacCabe, M.B.E., well-known Artist and Writer. The Society was formed at a time when many women painted on their own without recognition or support for their creative skill. Nowadays there is more opportunity for women to progress in the openness that did not exist in 1957. The Society continues to grow with over 100 members at present, including 34 Diploma holders and 70 Prospective members seeking full membership. The Ulster Society of Women artists has a strict policy for membership selection. When full membership is achieved, it is a mark of distinction for a high level of skill accomplished in any medium. The Society always welcomes new members. Those interested in joining may submit work to the Election Committee. For further details about the Society, contact The Hon. *Secretary:* Dr Margaret Mathews, 61 Gobbins Rd, Islandmagee, Larne BT40 3TY. *Tel:* 02890 353404

President: Barbara Ellison. *Vice-President:* Doris Houston. *Secretary:* Dr Margaret Mathews, 61 Gobbins Rd, Islandmagee, Larne BT40 3TB *Tel:* 02893 353404 *Assistant Secretary:* Georgina Lilley, 8 Church Rd, Jordanstown, Carrickfergus BT37 0PJ *Tel:* 02890 862011 *Treasurer:* Lucy McCleane, 1 Hillside Dr., Stranmillis, Belfast BT5 6HR *Tel:* 02890 592700. *Assistant Treasurer:* Margaret Brand, 'Ardleevan', 178 Upper Malone Rd, Belfast BT17 9JZ *Tel:* 02890 611723.

United Society of Artists

Founded in 1921, the Society aims to exhibit work of professional quality primarily in London but also elsewhere in Britain and in any media. New Members and Associate Members are selected based on work submitted. At least one Open Exhibition is held each year. Artists who are not members of the Society may submit works for exhibition in accordance with the Society's current regulations. Members or Associate Members can submit up to 6 pictures, and shall have specific rights to have their work hung relating to the number of works submitted.

WHO'S WHO IN ART

President: Spate Huntermann *Vice-President:* Ann Whitehead *Secretary:* Anthony Goss, 37 Harvard Court, Honeybourne Road, London NW6 1HL *Website:* www.united-artists.org.uk

The Wapping Group of Artists

The Wapping Group of Artists is a muster of painters dedicated to painting from nature in company with one another on Wednesdays throughout the summer months. The founding membership was drawn from the Langham Sketching Club - their chosen subject London's river. Following the 39/45 war, the founders, meeting in the Prospect of Whitby Public House at Wapping in 1946, decided to paint the Thames from the Pool of London down the dozen reaches to the estuary.

The 21 original members decided on a limited membership of 25 and this is still so. The first president was Jack Merriott. Annual exhibitions were first at the P.L.A. building on Tower Hill, later at the Royal Exchange, followed by 21 years at St. Botolphs Church, Aldgate. Since 2002 the Group has held its annual exhibition at the Mall Galleries in February of each year. The river has changed amazingly but today's members still have the same love of painting and the same enthusiasm for their subject. The Group is now in its 61st year, and in 2006 Seafarer Books in conjunction with Sheridan House published a new hardback, full colour book entitled 'The Wapping Group of Artists -Sixty years of painting the Thames'.

President: Bert Wright PPRSMA. *Hon. Secretary:* Alan Runagall, R.S.M.A., 7 Albany Rd., Rayleigh, Essex, SS6 8TE.

Yorkshire Artists Exhibition

Now recognised as the largest event of its kind in Great Britain, with between 1,000 and 1,500 paintings by over 200 artists on show, bi-annually. Exhibitions Spring and Autumn at The Kings Hall/Winter Gardens Complex, Ilkley, West Yorkshire. The Exhibitions attract leading artists from all over Britain and abroad. Established over ten years, it is well supported by the art-buying public and commercial galleries, etc. Application for entry to: The Director. Hon. Patron: David Shepherd, F.R.S.A., O.B.E. *Director:* Leslie Simpson, F.R.S.A., 13 Manor Orchards, Knaresborough, North Yorkshire, HG5 0BW *Tel:* 01423 540603 *Email:* info@britpaint.co.uk

COMPETITIONS AND ART PRIZES

Beck's Futures

Beck's Futures, the result of an ongoing collaboration between the Institute of Contemporary Arts and Beck's is the UK's most generous and ambitious art award, worth £65,000. It is now established as a major exhibition and annual event that identifies, supports and showcases the most promising contemporary artists working in Britain today. The Beck's Futures Awards were created in 2000 to provide support for the work of a new generation of British artists at a critical point in their careers.

Unlike other art awards, Beck's Futures provides all the short-listed artists with an opportunity to create new works for exhibition at the ICA, as well as with financial awards intended to support their ongoing practice. Building on its now firmly established reputation in Scotland, Beck's Futures will tour to the CCA: Centre for Contemporary Art, Glasgow, after closing at the ICA.

Nominated artists could be of any age and work in any media and should be based in the UK. Details of the short-listed artists were announced in mid-December. The Beck's Futures Student Prize For Film and Video will be held alongside the main awards, showcasing the best work in moving image media by students attending film and art schools throughout the UK.

For further information about Beck's Futures, visit their website www.becksfutures.co.uk

The Discerning Eye Exhibition

The Discerning Eye is a show of small works independently selected by six prominent figures from different areas of the art world including two artists, two collectors and two critics. Awards: ING Purchase prize of £3,000; The Discerning Eye Chairman's Purchase prize £1,000, Meynell Fenton prize £1,000, Crispin Odey Prize £1,000, Penrose Purchase prize £1,500, Humphreys prize £750, and seven Regional Entry prizes £200 each. Maximum dimensions: 2D - 20" x 20" (including the frame), 3D - 20" x 20" x 20" (including the plinth/stand). Receiving Day dates (London): September 2006 - to be confirmed.

Exhibition opens to the public: at Mall Galleries, November, 10-5, including weekends. For general information and regional receiving days please contact: The Discerning Eye Exhibition, Parker Harris, PO Box 279, Esher, Surrey, KT10 8YZ 01372 462190 de@parkerharris.co.uk

Parker Harris

Founded in 1990, Parker Harris Partnership specialise in the organisation, administration, promotion, press, and public relations of visual art exhibitions, competitions, and events. Parker Harris also act as consultants in visual arts and sponsorship matters, and project manage public art commissions. The partners are Emma Parker and Penny Harris.

Parker Harris have organised such open exhibitions as the Jerwood Painting Prize and The Hunting Art Prizes. They are currently behind the organisation of the long running ING Discerning Eye exhibition, the Kaupthing Singer and Friedlander / The Sunday Times Watercolour Competition, and the Jerwood Sculpture Prize and Jerwood Contemporary Painters exhibition.

www.parkerharris.co.uk Parker Harris Partnership, PO Box 279, Esher, Surrey, KT10 8YZ. 01372 462190 info@parkerharris.co.uk

The ING Discerning Eye Exhibition

The ING Discerning Eye is a show of small works independently selected by six prominent figures from different areas of the art world including two artists, two collectors and two critics. Each curate their own section, inviting well known artists to exhibit alongside lesser known artists selected from the open competition. Previous selectors have included HRH The Prince of Wales, Sir Peter Blake, and Davina McCall. Prizes awarded in a range of categories. Maximum dimensions: 2D - 20" x 20" (including the frame), 3D - 20" x 20" x 20" (including the plinth/stand). Receiving dates nationwide August / September annually. Launched 1990.

2008 exhibition opens to the public at Mall Galleries, November 13 - 23, including weekends. For details please send a stamped addressed envelope to: The ING Discerning Eye Exhibition, Parker Harris, PO Box 279, Esher, Surrey, KT10 8YZ 01372 462190 de@parkerharris.co.uk

The Garrick / Milne Prize

The Garrick/Milne Prize was launched in 2000 in memory of the Garrick Club's generous benefactor A.A. Milne to actively encourage the art of theatrical painting and portraiture. It heralds an intermingling of the arts as painters become involved with theatres and actors.

For details please send a stamped addressed envelope to: Parker Harris Partnership, PO Box 279, Esher, Surrey, KT10 8YZ. *Website:* www.parkerharris.co.uk/comps/GMP.html *Email:* info@parkerharris.co.uk

Kaupthing Singer & Friedlander/Sunday Times Watercolour Competition

Annual competition with prizes totaling £30,000, promoting and celebrating the diversity and beauty of the frequently undervalued medium of watercolour. Abstract, figurative, and landscape pieces in any water soluble medium are considered from nationwide submission. First prize £15,000. Other awards include 2nd Prize £6,000, three 3rd Prizes £2,000, and a Young Artist's Prize of £2,000. Works must have been carried out in the last three years and not previously exhibited. Receiving dates nationwide in June annually. 2008 exhibition 10 - 20 September at the Mall Galleries. For details, please send a stamped addressed envelope to: Kaupthing Singer & Friedlander/Sunday Times Watercolour Competition, Parker Harris, PO Box 279, Esher, Surrey, KT10 8YZ. Information and forms for downloading can be found on the website: www.parkerharris.co.uk *Email:* KSF@parkerharris.co.uk

Jerwood Sculpture Prize

Biennial £25,000 commissioning prize to give strong support and encouragement to emerging talent within the medium of outdoor sculpture. A short list of approximately eight artists will be chosen, and awarded £1,000 to develop their proposals and produce a maquette for exhibition. The winner will receive the £25,000 commission to produce a large scale sculpture for the Jerwood Sculpture Park. Application forms for entry into the Jerwood Sculpture Prize 2008 will be available from April 2008. Deadline August 2008, exhibition 2009.

WHO'S WHO IN ART

For details please send a stamped addressed envelope to Jerwood Sculpture Prize, PO Box 279, Esher, Surrey KT10 8YZ tel (01372) 462190 fax (01372) 460032 *Email:* JSP@parkerharris.co.uk *Website:* www.jerwoodvisualarts.org

Jerwood Contemporary Painters exhibition

Vibrant exhibition of thirty emerging artists who have all graduated since 2000. Artists are invited to exhibit; there is no open submission process. Each artist exhibits one selected piece and receives £1,000, not as a 'prize' but as a participation fee. It is unusual for any group show or prize to reward all showing artists but this fee is an important part of nurturing serious support for artists at an important turning point in their careers. The 2008 selection panel consists of Stephen Farthing as chair and Anita Taylor and Jason Brooks accompanying.

Exhibition runs 9 April - 18 May 2008, Jerwood Space, 171 Union Street, London SE1 0LN (Nearest tube: London Waterloo) *Tel:* 020 7654 0171, Monday - Friday, 10am - 5pm, Saturday & Sunday, 10am - 3pm, Admission Free. *Press & event information:* 01372 462190, www.jerwoodvisualarts.org jcp@parkerharris.co.uk. Tour dates TBC

EAC Over 60s Art Awards

Annual open competition for amateur artists over the age of 60 living in the UK. Created by the Elderly Accommodation Counsel, this competition celebrates the talent and creativity of older artists. Around 120 artists are selected for exhibition in the prestigious Mall Galleries, and prizes are awarded in a range of categories. Closing date: in May annually. The 2008 exhibition will run at the Mall Galleries 8 - 12 July. For details please send a stamped addressed envelope to: Art Awards, PO Box 279, Esher, Surrey KT10 8YZ tel (01372) 462190 fax (01372) 460032 *Email:* EAC@parkerharris.co.uk *Website:* www.artawards.eac.org.uk

Lynn Painter-Stainers Prize

Annual prize encouraging creative representational painting and promoting the skill of draughtsmanship. Total prize money: £22,500. First prize is £15,000 and an engraved gold medal. Open to artists born or resident in the UK. Receiving dates nationwide August / September annually with the exhibition taking place in Autumn / Winter. Launched 2005.

For details please send a stamped addressed envelope to: Lynn Painter-Stainers Prize, PO Box 279, Esher, Surrey KT10 8YZ tel (01372) 462190 fax (01372) 460032 *Email:* lps@parkerharris.co.uk *Website:* www.painter-stainers.org www.parkerharris.co.uk

The David Gluck Discerning Eye Bursary

Artists are invited to submit up to 6 slides or digital images of their work, along with a current CV and written statement (max. 300 words), detailing how they would spend this £1,000 bursary. Applications should be sent to: DE Bursary c/o Parker Harris Partnership, 15 Church Street, Esher, Surrey, KT10 8QS (Please include a SAE if you would like your slides returned) T: 01372 462190 E: de@parkerharris.co.uk Closing date: October annually.

The Tiranti Prize for Young Portrait Sculptors

For details of this prize and entry requirements, contact: Alec Tiranti Limited, 70 High Street, Theale, Reading RG7 5AR, or see www.tiranti.co.uk.

WHO'S WHO IN ART

NOTES

NOTES

NOTES

NOTES

NOTES

NOTES

NOTES

ARTISTS' WEBSITES

AARONS, Andrew
www.andrewaarons.com
ADAIR, Hilary
www.hilaryadair.co.uk
ADAMSON, Crawfurd
www.crawfurdadamson.com
AHMAD, Sophie Maryum
www.rainbirdfineart.com
AIRD, Philippe Leigh
www.PhilippeAird.com; www.phoenix-gallery.co.uk
ALDOUS, Veronica
www.aldousart.co.uk
ALEXANDER, Gregory
www.gregory-alexander.com
ALEXANDER, Naomi
www.axisartists.org/artistsid/8735
ALFORD, Michael
www.michaelalford.co.uk
ALLEN, Martin John
www.martinjallen.com
ALLUM, Avis Elizabeth
www.avisallum.com
ALSOP, William
www.alsoparchitects.com
ALTENBURGER, Ekkehard
www.altenburger.org.uk
ANDERSON, Jennifer
www.jennifer-anderson.co.uk
ANGELINI, Cristiana
www.theinternetartshop.com
ANTONIOU, Andrew
www.antoniou.com.au
ARCHER, Nicholas Lloyd
www.nicholasarcher.com
ARMITAGE, Sandra Wall
www.watercolourflowers.co.uk
ARNOLD, Phyllis Anne
www.portraits-miniaturesandsilhouettes.com
ARNUP, Sally
www.sallyarnup.co.uk
ASH, Lucy
www.lucyash.com

ASHMAN, Malcolm Paul
www.malcolmashman.co.uk

ASQUITH, Rosalind Lucy
www.rosasquith.com

ASTBURY, Paul
www.paul-astbury.com

ATKIN, Ann Fawssett
www.ann-fawssett-atkin.co.uk

ATKIN, Ron
www.artwanted.com/RjjA

ATKINS, David Alexander
www.david-atkins.com

ATKINSON, Shelagh
www.axisweb.org/artist/shelaghatkinson

AUSTIN, Michael J
www.jonathancooper.co.uk

AVELLINO, Alessia E.R.
www.st-art.biz

BACKHOUSE, David John
www.davidbackhousesculptures.com

BAILEY, Liz
www.lizbailey.org.uk

BAILEY, Susanna
www.susannabailey.com

BAINES, Valerie
www.valeriebaines.com

BAKER, Alexandra Clare
www.alixbaker.com

BAKER, Christopher William
www.christopherwbaker.com

BALDWIN, Martyn John
www.martynbaldwin.com

BALKWILL, Raymond James
www.raybalkwill.co.uk

BANEY, Ralph R.
www.ralphandverabaney.com

BANNING, Paul
www.paulbanning.com, www.paulbanning.co.uk

BANNISTER, Geoffrey Ernest John
www.geoffbannisterartist.com

BARANOFF, Elena
www.elenabaranoff.com

BARBER KENNEDY, Mat
www.matbarberkennedy.com

BARKER, Allen
www.arcart.org.uk

BARLOW, Bohuslav
www.bohuslav.co.uk

BARNES-MELLISH, Glynis Lily
www.barnesmellish.com

BARÓN, Maite
www.tessabaron.co.uk

BARRATT, Mary H.
axis database

BARROW, Julian
www.julianbarrow.com

BARTLETT, Paul Thomas
www.netsibition.com/paulbartlett

BASSINGTHWAIGHTE, Paul
www.basspaul.co.uk

BATEMAN, Robert McLellan
www.robertbateman.ca

BATES, Andrea Maria
www.andreabates.co.uk

BATT, Deborah Jane
www.deborah-batt.com

BATTYE, Martin
www.targetfollow.com

BAUMFORTH, David John
www.davidbaumforth.com

BAWTREE, John Andrew
www.johnbawtree.com

BAYS, Jill
www.jillbays.com

BEALE, Gillian
www.gillianbeale.co.uk

BEARD, Peter Fraser
www.peterbeard.co.uk

BEATON, Rosemary
www.rosemarybeaton.co.uk

BEAUMONT, Sarah Elizabeth
www.sarahbeaumont.com

BECKFORD, Laurence
www.beckfordartworks.co.uk

BEER, David
www.penhavengallery.co.uk

BEERBAUM, Frederik
www.beerbaumart.com

BEESLEY, Mark
www.remaginations.com or axisweb.org/artist/markbeesley
BEGARAT, Eugène
Eugene Begarat
BELDERSON, John Walter (Rev.)
www.beldersonart.com
BELLAMY, David
www.davidbellamy.co.uk
BELLWOOD, Colin
www.NuMasters.com ; www.londonart.co.uk
BELYI, Peter
www.peterbelyi.com
BENNETT, Margaret Ann
www.margaretannbennett.co.uk
BENSON, Dawn Mary
www.barwellgallery.co.uk
BERESFORD-WILLIAMS, Mary E.
axis
BERG, Adrian
www.adrianberg.co.uk
BERNSTEIN, Carol
www.carolbernstein.co.uk
BERRY, Peter Leslie
www.peterberry.org.uk
BETOWSKI, Noel Jan
www.betowski.com
BEVAN, Oliver
www.oliverbevan.com
BEVIS, Michael John Vaughan
www.artservegallery.com
BEWICK, Pauline
www.paulinebewick.com
BINNS, David
www.swla.co.uk
BIRO, Val (B. S.)
www.valbiro.co.uk
BISHOP, William Henry
www.bishopmarineart.com
BISSELL, Lauren Hayes
www.lhbissell.com
BLACK, Simon
www. thomascormanarts.com
BLACKBURN, David
www.hartgallery.co.uk

BLACKWOOD, Simon Anthony James
www.simonblackwood.com
BLAKE, Marie Dora
www.marieblake.com
BLAKER, Michael
www.michael-blaker.co.uk
BLANE, Frances Aviva
www.ecartspace.com
BLEASDALE, Marcus
marcusbleasdale.com
BLIK, Maurice
www.mauriceblik.com
BOLAN, Sean Edward
www.grimeshouse.co.uk
BOLTON, Richard Marston
www.richardbolton.com
BOND, Jane
www.TheRp.co.uk
BOTTOMLEY, Eric
www.eb-prints.co.uk
BOULTON, Janet
www.janetboulton.co.uk
BOUSFIELD, Neil
www.inkyfingerspress.com
BOWEN-MORRIS, Nigel Vaughan
www.nigelbowen-morris.com
BOWMAN, Day
www.daybowman.com
BOWYER, Francis David
www.bowyerfineart.co.uk
BOYES, Judy Virginia
www.judyboyes.co.uk
BOYT, Judy
www.judyboyt.com
BRADSHAW, Elizabeth Anne Makin
www.lizmakinbradshaw.co.uk
BRAIN, Ann/Annie (Philippa)
www.annbrain.co.uk
BRAMLEY, Victor
www.st.ivessociety of artists.com
BRANSBURY, Allan Harry
www.allanbransbury.com
BRASON, Paul
www.paulbrason.co.uk

BRASSEY, Barbara, Lady
www.room4art.com

BRASSINGTON, Alan Francis
www.alanbrassington.com

BREWSTER, Martyn Robert
www.martynbrewster.com

BRIDGE, Eoghan
www.lindablackstone.com

BRIDGES, Ann Elizabeth
www.ann-bridges.com

BRIERTON, Irene Annette
www.irenebrierton.co.uk

BRINDLEY, Robert Edward
www.robertbrindley.com

BRISTOL, Sophy
www.panterandhall.com

BRODERICK, Laurence John
www.laurencebroderick.co.uk

BROOKES, Gerry
www.gerrybrookes.com

BROWN, Bob
www.bobaugurbrown.co.uk

BROWN, Diana Elizabeth
www.swla.co.uk

BROWN, John Robert
www.johnbrown-sculptor.co.uk

BROWN, Keith
www.homepage.ntlworld.com/cyberform

BROWN, Peter Edward Mackenzie
www.Peterbrownneac.com

BROWN, Philip
www.iconpress.co.uk

BROWN, Ralph
www.ralphbrown.co.uk

BROWN, William McClure
www.william-brown.com

BROWNE, Piers
www.piersbrowne.com

BRYCE , Gordon
www.gordonbryce.co.uk

BUHLER, Michael Robert
www.michaelbuhler.org

BURBRIDGE, Claire-Chantal Emma
www.claireburbridge.com

BURGESS, Brenda Jean
www.brendaburgessarts.co.uk

BURGESS, Peter
www.rasalumni.org

BURKE, Christopher Paul
www.chrisburke.org.uk

BURKETT, Norman, Hittersay
www.burkett.nl

BURR, Lesley Jane
www.lesleyburr.co.uk

BURTON, David
http://davidburton.mysite.wanadoo-members.co.uk

BUSBY, John P.
www.thelandgallery.com, www.wildlifeartgallery.com

BUTT, Jennifer Gillian
www.jennybutt.com

BUTTERFIELD, Sarah Harriet Anne
www.sarahbutterfield.co.uk

BUTTERWORTH, John Russell
www.jbutterworth.co.uk

BUXTON, Jennifer
www.tigertigerburningbrightly.com

BYROM, Gillie Hoyte
www.enamelportraitminiatures.co.uk

CAHILL, John
www.tenbyharbourgallery.co.uk

CAIN, Judith
www.judithcain.co.uk

CAINS, Gerald Albert
www.rwa.org.uk

CALLAND, Ruth Elaine
www.transitiongallery.co.uk

CALVER, Michael
www.axisweb.org/artist/michaelcalver

CAMERON, Zoe Rebecca
www.zoecameron.co.uk

CAMPBELL, Christopher
www.st-art.biz

CAMPBELL, Huw Phillip
www.zap-art.f2s.com

CARNIE, Andrew John
www.andrewcarnie.co.uk

CARO, Sir Anthony
www.anthonycaro.org

CARR, David James
www.davidcarr.me.uk
CARTER, Beth Arabella
www.bethcarter.co.uk
CARTER, Mary Elizabeth
www.marycarter.co.uk
CARUANA, Gabriel
http://www.zorin.com/gabriel/
CASE, David Charles
www.davidcasefineart.com
CASTLE, James Munro
www.jamescastle.co.uk
CHAFFIN, Roy
http://www.roychaffin.com
CHAITOW, Michael
www.michaelchaitow.com
CHANCE, Sula
www.sulaartist.co.uk
CHANCELLOR, Deborah Ann
www.ameliaessex.co.uk
CHAPLIN, Michael James
www.mikechaplin.com
CHAPMAN, John Lewis
www.johnchapman.co.uk
CHEFFINS, Valma Maud
axis
CHESTERMAN, Merlyn
www.twohartonmanor.co.uk
CHEUNG, Gordon
www.gordoncheung.com
CHIRINO, Marta
www.martachirino.com
CHURCHILL, Robert Bruce
www.robchurchill.com
CLARKE, Graham Arthur
www.grahamclarke.co.uk
CLARKE, Granville Daniel
www.granvilledclarke.com
CLARKE, Jonathan
www.jonathanclarke.co.uk
CLAY, Andie Joy
www.andieclay.com
CLAYTON, Inge
www.ingeclayton.com

CLEMENTS, Patricia Kathleen
www.patriciaclementsart.com

CLINE, Penelope
www.penelopecline.homestead.com

CLOAKE, Beatrice Pierrette Denise
www.beatricecloake.co.uk

CLOSSICK, Peter
www.thelondongroup.com/artists/clossick.html

CLYNE, Thora
www.catpawtraits.co.uk

COATES, Penny
www.pecoates.com

COBLEY, David Hugh
www.davidcobley.co.uk

COBURN, Ivor Basil
watercoloursivorcoburn.com

COCKRILL, Maurice
www.cockrill.co.uk

COHEN, Bernard
Flowers East Gallery

COLE, Barbara Evelyn (B.E.)
RBS

COLLINS, Clive Hugh Austin
www.clivecollinscartoons.com

COLLINS, Marjorie
www.marjoriecollins.com

COMBES, Richard A.
www.dukeriesartgallery.com

CONNER, Angela
www.angelaconner.co.uk

CONNOLLY, Anthony
www.anthonyconnolly.co.uk

COODE, Caroline Ann
www.coodec.freeserve.co.uk

COOK, Jennifer Martin
www.jennycook.net.

COOK, Katrina
www.katrinacook.co.uk

COOMBE, Nick
www.coombearchitecture.com

COOPER, Eileen
www.eileencooper.co.uk

COOPER, Julian
www.artspacegallery.co.uk/www.heatoncooper.co.uk

COPPINGER, Sioban
www.siobancoppinger.co.uk
CORBETT, Lily Gloria
www.theartofcreativity.co.uk
CORBETT, Peter George
www.axisweb.org/artist/petercorbett
CORNELL, David
www.davidcornell.com
CORSELLIS, Jane
www.newenglishartclub.co.uk
COULOURIS, Mary Louise
www.artmlc.co.uk
COUSINS, Timothy
www.anderssonhall.com
COX, Julian Charles
www.julian-cox-sculpture.co.uk
CRAIG-McFEELY, Joanna
www.botanicalillustration.co.uk
CRAWFORD, Alistair
www.alistaircrawford.co.uk
CRAWFORD, Susan L.
www.slcrawford.com
CRAWSHAW, Donna
www.donnacrawshaw.co.uk
CRESWELL, Alexander Charles Justin
www.alexandercreswell.com
CROFT, Paul John
www.spgw.co.uk http://users.aber.ac.uk/puc/paulcroft/open.htm
CROOK, P. J.
www.pjcrook.com
CROSS, Richard Henry
www.richardcrossgallery.com
CROSTHWAITE, Sally
www.sallycrosthwaite.co.uk
CROWE, Victoria Elizabeth
www.victoriacrowe.com
CROZIER, William
www.williamcrozier.com
CRYER, Ian David
www.iancryer.com
CULVER, Cheryl Vivien
www.cherylculverpaintings.com
CURMANO, Billy X.
www.billycurmano.com

CURRY, Denis Victor
www.humanpoweredwing.co.uk

D'ARCY HUGHES, Ann
brightonprintmaking.co.uk

DALRYMPLE, Neil
www.neildalrymple.com

DAMINATO, Vanda
www.daminatoarte.eu

DANIELS, Harvey
www.harveydaniels.com

DANIELS, Jason
www.jasedaniels.com

DANNATT, George
www.georgedannatt.com

DARBISHIRE, Stephen John
www.stephen-darbishire.com

DARTON WATKINS, Christopher
www.dartonwatkins.com

DAVID-COHEN, Yael
www.yaeldc.co.uk

DAVIDSON, Anne
www.ajdsculptors.co.uk

DAVIDSON , Philomena
www.davidsonarts.com

DAVIS, Cynthia
www.cynthiadavis.co.uk

DAVIS, James Spence
www.meadowsfineart.com

DAVIS, Jason Pyper
www.jasonpyperdavis.com

DAVISON, Martin
www.martindavisonart.com

DAWSON, Susan Shepherd
www.stivessocietyofartists.com

de LACY, Ellie
www.elliedelacy.co.uk

DEAN, Graham
www.grahamdean.com

DEARNLEY, Benjamin Chad
www.bcdsculpture.co.uk

DELLAR, Roger
www.rogerdellar.com

DEMSTEADER, Mark
www.panterandhall.com

DENTON, Kenneth Raymond
www.dentonuk.net
DESMET, Anne Julie
www.annedesmet.com
DEVEREAUX, Jacqueline
www.watercolour-online.co.uk
DEVEREUX, Glenis
www.glenisdevereux.xom
DI GIROLAMO, Megan Ann
www.megan-di-girolamo.co.uk/megan htm
DI GIROLAMO, Selina Maria
www.myspace.com/selinadigirolamorba
DICKENS, Mark
www.markdickens.net
DIGGLE, Philip
www.philipdiggle.com
DITZ,
www.aappl.com
DMOCH, Paul
http://www.artmajeur.com/aquarelliste
DODDS, James
www.jamesdodds.co.uk
DONALD, George M.
www.royalscottishacademy.org
DONALDSON, Antony
www.antonydonaldson.com
DOREY, Russell Peter
www.russelldorey.co.uk
DRAPER, Matthew John
www.matthewdraper.net
DRING, Melissa Jane
www.totallyessential.com
DRURY, Christopher
www.chrisdrury.co.uk
DU TOIT, Susanne
www.susannedutoit.com
DUFFIN, Stuart
www.stuartduffin.com
DUFFY, Terry
www.terryduffy.info
DUFORT, Antony
www.antonydufort.com
DUKES, Robert Laurence
www.browseanddarby.co.uk

DULEY, Helen Elizabeth
 http://helen.duley.googlepages.com
DUMITRIU, Anna
 www.annadumitriu.com
DUNCAN, Jean
 www.jeanduncan.freeuk.com
DUNCAN MEYER, Mary Elizabeth Anne
 http://www.intune.co.uk/Meyer.Duncan
DUNN, Philip
 www.windowgallery.co.uk
DUNSEATH, Chris
 www.axisweb.org/artist/chrisdunseath
EASTOP, Geoffrey Frank
 www.bsgart.com
EATWELL, David
 www.gallery-modern-art.com
EDWARDS, Alan C.L.
 www.alan-edwards-artist.com
EDWARDS, C.C.G.
 www.ccgedwards.com
EDWARDS, John
 www.johnedwards-artist.com
EDWARDS, John Colin
 www.johnedwardsrp.com
EDWARDS, Peter Douglas
 www.peteredwards.net
EDWARDS, Sylvia
 www.sylviaedwards.com
ELKINS, Bridgette Mary
 www.westdean/reclamation.org
ELLIOTT, Paul
 www.blacksmithonline.co.uk
ELLIS, Belinda Anne
 www.belindaellis.myzen.co.uk, www.belindaellis.co.uk
ELLIS, Edwina
 www.edwinaellis.co.uk
ELLIS, Ian
 www.radley.org.uk/ian%27s%20web%20page/ian's%20web%20page.html
ELLIS, Sean
 www.theofficelondon.com
ELPIDA,
 www.realartfirst.com
ELSTEIN, Cecile
 www.cecileelstein.com

ELWELL, Brian
www.phoenixgallery.co.uk/ www.brianelwell.co.uk

ELWES, Luke
www.lukeelwes.com

EMANUEL, John
www.johnemanuel.co.uk

ENGLERT, Béatrice
www.beatrice-englert.com

ERLAND, Sukey
www.sukeyerland.me.uk

EVANS, Tony
www.turnerfinearts.com

FAIRCLOUGH, Michael
www.michaelfairclough.co.uk

FALCIDIA, Paulette
www.falcidia-art.co.uk

FALLSHAW, Daniel
www.artofcreation.co.uk

FARMAR, Francis Edmund
www.francisfarmar.com

FARTHING, Stephen
www.stephenfarthing.com

FEIJOO, Fernando
www.fernandofeijoo.com

FERGUSON, George
www.acanthusfm.co.uk

FERGUSON, Paul
www.paulferguson.co.uk

FERGUSON, Shaun
www.shaunferguson.co.uk

FERRUZZI, Roberto
www.robertoferruzzi.com

FILIPE, Paulo Duarte
www.pauloduartefilipe.blogspot.com

FINCH, Michael
www.mickfinch.com

FINDLAY, Denise
www.denisefindlay.com

FINER, Stephen
www.stephenfiner.com

FINLATOR, Hannah Verena
www.fairfields.demon.co.uk/onlinegallery/hannah.html

FIRMSTONE, David James
www.davidfirmstone.com

FISHER, John Edward
 www.franciskylegallery.com
FLEMING-WILLIAMS, Julia Elizabeth Catherine
 www.rooths.co.uk
FLÖCKINGER, Gerda
 www.mobilia-gallery.com/artjewel.html
FLOWER, Rosina
 www.rosinaflower.co.uk
FOLAN, Andrew
 www.andrewfolan.com
FONTAINE, Fleur
 www.artmadness.co.uk
FORBES, Ronald
 www.ronald-forbes.com
FORBES COLE, Joy
 www.aarti.co.uk
FORD, Noel
 www.fordcartoon.com
FORD, Peter Anthony
 www.peterford.org.uk
FOSTER, Christine
 www.lilacarts.co.uk
FOSTER, Richard Francis
 www.richardfoster.co.uk
FOUNTAIN, Desmond Hale
 www.desmondfountain.com
FOX, Jane Amber
 www.janefoxartist.com ; www.rbs.org.uk
FOX, Karrie
 www.karriefox.co.uk
FOX, Peter
 www.axisartists.co.uk/ cornishcollective.com/silverwellfineart.com
FOX OCKINGA, Fyne Marianne
 www.mariannefoxockinga.co.uk
FRAME, Mary Elizabeth Bruce
 www.maryframepaintings.co.uk
FRANKLAND, Eric Trevor
 www.trevorfrankland.co.uk
FREEMAN, Lily
 www.happypaintings.co.uk
FREEMAN, Michael John
 www.mikefreeman.uk8.net (& links)
FREER, Roy
 www.royfreer.co.uk

FREW, Hilary
www.hilaryfrew.com
FRÖHLICH-WIENER, Irene
www.breakingart.com.//:irene
FRONTZ, Leslie Robinson
www.frontzstudio.com
FROST, Anthony
www.galleryonline.org.uk
FULLER, Martin Elliott
www.martinfuller.net
FURR, Christian Peter
www.christianfurr.com
GABAY, Laurie, L.
www.lauriegabay.co.uk
GAGE, Anthea Dominique Juliet
www.antheagage.co.uk
GAINSFORD, Sylvia Petula
www.SylviaPGainsford.com
GALE, Jeremy
www.jeremygale.co.uk
GALLOWAY, Richard Andrew
www.RichardGalloway.co.uk
GARDINER, Vanessa
www.hartgallery.co.uk
GARDNER, Reginald Stephen
www.rsgardner.co.uk/com
GASKELL, Eric
www.egdesign.co.uk
GATTEAUX, Marcel
www.caeltgallery.com
GELDART, William
www.geldartgallery.com
GEORGE, David
www.sculptor.freeserve.co.uk
GERAGHTY, Paul Leo
www.stivespainter.com
GIBBONS, John
www.johngibbons.org.uk
GIBBS, Mavis
www.mavisgibbs.co.uk
GIBBS, Stephen Roy
www.londonart.co.uk
GIBSON, Jane Barr
www.cornerwaysart.co.uk

GIBSON-WATT, Marcia Susan
www.gibsonwatt.com
GIFFORD, Andrew John
www.jmlondon.com
GILBERT, Dennis
www.dennisgilbert.net
GILBERT, George
www.georgegilbertrsw.co.uk
GILBERT, Rowena Justine
www.rowenagilbert.com
GILBERT, Terence John
www.terencegilbert.com
GILLESPIE, Sarah
www.sarahgillespie.co.uk
GILLET, Francois Marie Marcel
www.francois-gillet.com
GILLICK, James Balthazar Patrick
www.gillick-artist.com
GILMOUR, Judith
www.judithgilmour.com
GLASS, Margaret
www.margaretglass.com
GLASSBOROW, Stephen
www.galleryperutz.com
GLASSFORD, Susan Hilary
www.meadowbankfarm.co.uk
GODDARD, Juliette Ingrid
www.cosalondon.com
GOLDBART, Sarah Rachel
www.create.ltd.uk
GOOD, Trudy
www.belgraviagallery.com
GOODFELLOW, Peter George
www.lostgallery.co.uk
GOODMAN, Sheila
www.sgart.co.uk
GOOSEN, Frederik Johannes (Frits)
www.fritsgoosen.nl
GOUGH, Paul James
www.amd.uwe.ac.uk/vortex/
GOUGH, Piers
www.czwgarchitects.co.uk
GRAA JENSEN, Lisa
www.lisagraajensen.com

GRADIDGE, Daphne
www.jonathancooper.co.uk

GRAHAM, David
www.davidgraham-rp.com

GRAINGER, Chris Rowan
www.rowangrainger.com

GRANT, Marianne
www.swissart.ch/marianne-grant

GRANVILLE-EDMUNDS, Peter Donald
www.artistspace.net

GREEN, Alfred Rozelaar
new site coming soon

GREEN, Anthony
www.anthonygreenra.com

GREEN, Gerald
www.ggarts.demon.co.uk

GREEN, Lorna
www.lornagreen.com

GREENSLADE, Suzanne Lyon
www.suzannegreenslade.com

GREENWELL, Patricia K.
www.tate-it-aint.co.uk

GREENWOOD, Philip John
www.philgreenwood.info

GRENVILLE, Hugo Gerard
www.hugogrenville.com

GREY, Jenni
www.designerbookbinders.org.uk

GRICE, David
www.artbydavidgrice.com

GRIFFITH, David Lloyd
www.davidlloydGriffith.co.uk

GRIFFITHS, David
www.david-griffiths.co.uk

GROVES, John Michael
www.johngroves.org

GUDGEON, Simon David
www.simongudgeon.com

GUNN, Linda Sue
www.lindagunn.com

HAGGER, Henry
camdenprintmakers.co.uk

HALL, Christopher Compton
www.christopherhall-painter.com

HALL, Dennis Henry
www.parrotpress.co.uk
HALLIDAY, Colin Thomas
www.st-art.biz
HALLOWES, Veda Nanette
www.vedahallowes.co.uk
HALSBY, Miranda
www.halsby.com
HAMILTON, Susie
www.paulstolper.com
HANLEY, James
www.jameshanley.net
HANSCOMB, Brian
www.brianhanscomb.co.uk
HANSELAAR, Marcelle
www.marcellehanselaar.com
HARBON, Jan
www.janharbon.com
HARDIMAN, Patsy Christine
www.LondonArt.co.uk
HARDING, Alexis
www.mummeryschnelle.com
HARDMAN, Paul Ritson
www.hartoons.co.uk
HARDY, Robert
www.roberthardyartist.co.uk
HARING, Noël
www.surreyartists.co.uk
HARLEY, Alexandra
www.alexandraharley.co.uk
HARMAN, Alice
www.cow-shed-studio.com
HARPER, Alison
www.harperart.com
HARRIS, Jennifer Joy
www.axisartists.org.uk www.rwa.org.uk
HARRISSON, Tim
www.timharrisson.co.uk
HART-DAVIES, Christina Ann
www.christinahartdavies.co.uk
HARTILL, Brenda
www.brendahartill.com
HARVEY, Patricia
www.patframes.co.uk

HASTAIRE, Claude
www.hastaire.com
HASTE, Kendra
www.kendrahaste.co.uk
HASTINGS, Gerard
www.modernbritishart.co.uk
HAUGHTON, Patrick
www.axisweb.org/artist/patrickhaughton
HAWKES, Justin Sheridan
www.justinhawkes.com
HAY, Ian
www.members.aol.com/ianhaygallery
HAYES, Georgia
www.georgiahayes.com
HAYWARD, Timothy John
www.jonathancooper.co.uk
HAZZARD, Charles Walker
www.charleswalkerhazzard.com
HEATHCOTE, Peregrine
www.peregrineheathcote.com
HELD, Julie
www.julieheld.com
HEMMANT, Lynette
www.lynettehemmant.com
HERBST, Günther Daniel
www.sod-and-willems
HERIZ-SMITH, Bridget
www.bridgetheriz.co.uk
HERON, Susanna
www.susannaheron.com
HICKS, June Rhodes
www.trevescanstudio.com
HICKS-JENKINS, Clive
www.hicks-jenkins.com
HIGGINSON, Clifford Edward
www.cliffhigginson.freeuk.com
HILLHOUSE, David
www.davidhillhouse.com
HILLS, Jonathan Graham
www.smartshillstudios.co.uk
HIPPE , Susan Kerstin
www.absolutearts.com/portfolio/s/susanhippe
HITCHENS, John
www.johnhitchens.com

HOCKIN, Julie
www.hockinandroberts.com
HODDER, Monroe
www.monroehodder.com
HOLCH, Eric Sanford
www.ericholch.com
HOLD, William Ashley
www.artincornwall.com
HOLDEN, John
www.numasters.com
HOLMES, Clyde
www.clydeholmes.force9.co.uk
HOOD, Andrew David
www.andrewhoodgallery.com
HOPKINSON, Sian Carolyn
www.artnet.com/rvalls.html
HORNER, Michael Julian Alistair
www.galleryonthenet.com
HOUGH, Liz
www.art-on-line.co.uk
HOWARD, Ghislaine Marianne
www.ghislainehoward.com
HOWARD, Ken
www.kenhoward.co.uk
HOWARTH, Derek
www.derekhowarth.co.uk
HOWELL, David
www.davidhowell.co.uk
HOWELLS, Suzanne
www.suehowells.com
HUFTON, Susan Mary
www.calligraphyanddesign.com
HUGH-JONES , Philip Morrell
www.janewatt.net
HUGHES, Christine
www.christinehughesimages.co.uk
HUMPHREYS, Ian
www.cunnamore.com; www.hallwardgallery.com;
www.anthonyhepworthfineart.com
HUNT, Georgina
www.thelondongroup.com/artists/hunt.html
HUNTER, Alexis
www.alexishunter.co.uk
HUNTER, Christa
www.christahunter.com

HUNTER, Elizabeth
www.ecrhunter.com
HUNTER, Janet Claire (Jan)
www.janhunter.com
HUXLEY, Jonathan
www.jonathanhuxley.co.uk
I'ANSON, Mari
www.mari-artist.co.uk
IBBOTSON, Pam
www.pamibbotson.co.uk
INGLIS, Catherine Elizabeth
www.cath-inglis.btinternet.co.uk
IRVIN, Magnus
www.magnusirvin.co.uk
ISOM, Graham Michael
www.grahamisom.co.uk
JACKLIN, Bill
www.bjacklin.com
JACKSON, Ashley
www.ashley-jackson.co.uk
JACKSON, Kurt Dominic
www.kurtjackson.co.uk
JACKSON, (Penelope) Mary
www.newenglishartclub.co.uk
JAFAR, Abu
www.abujafar.com
JAFFE, Ilona Lola Langdorf
www.todres.fsnet.co.uk
JAKOBER, Ben
www.jakobervu.com
JAMES, Nicholas Philip
www.philipjamestudio.ndo.co.uk
JAMES, Roderick Morris
www.jamesfineart.co.uk
JEFFREY, Jill
www.jilljeffrey.com
JELBERT, Rebecca
www.rebeccajelbert.co.uk
JELBERT, Wendy
www.wendyjelbert.co.uk
JELLEY, Susan Jane
www.suejelley.co.uk
JELLICOE, Colin
www.colinjellicoe.co.uk

JENKINS, Lawrence Fifield
www.lawrencejenkins.co.uk
JENNISON, Robert William
www.rwa.org.uk
JERVIS, Sharon
www.sharonjervis.com
JIANG HUANG, Limin
www.limin.com
JOEL, Alan Alfred
www.joelpaintings.com
JOEL, Judy
www.judyjoel.com
JOHNS, Phil
www.philjohns.com
JOHNSON, Annette
www.annettejohnson.co.uk
JOHNSON, Ben
www.benjohnsonartist.com
JOHNSON, Carl
www.numasters.com
JOHNSON, (William) Holly
www.hollyjohnson.com
JONCZYK, Prof. Dr. Leon
www.academia-polona-artium.de
JONES, Lucilla Teresa
www.artistlucillajones.co.uk
JONES, Malcolm
http://www.chisenhale.co.uk/jones.html
JONES, Philip Charles
www.philip-jones.co.uk
JONES, Robert William
www.firstlightgallery.co.uk
JONES, Royston
www.pacificstream.info
JONES, Steven
www.stevenjonesart.freeuk.com
JONES, Yvonne
www.yvonnejones.net
JONSSON, Lars Ossian
www.larsjonsson.se
JORDAN, Maureen Ann
www.maureenjordan.com
JOYCE, Paula
www.paulajoycefsba.com

JUILLERAT, Paul
www.hotairdesign.com
KALKHOF, Peter Heinz
www.annelyfineart.co.uk/Gallery-Artists
KALMAR, Janos
www.janoskalmar.com
KANDER, Nadav
www.nadavkander.com
KANTARIS, Rachael Anna
www.kantaris.com
KAPLAN, Krystyna
www.kaplan.4me.pl
KARPINSKI, Christine Dauray
www.pinneygallery.com
KAVANAGH, Paul
www.paul-kavanagh.co.uk
KEABLE, Karen S J
www.ksjkeable.co.uk
KEELEY, Simon Phillip
www.simonkeeley.com
KELLY, Brendan
www.brendankellyartist.co.uk
KELLY, Marty
www.blueleafgallery.com
KELLY, Victor Charles
www.victorkelly.co.uk
KELSEY, Robert
www.rkelsey.com
KELSO, James Philip
www.kelsopaintings.com
KENNEDY, Keith Manning
www.sgfa.org.uk
KENNEDY, Michael Peter
www.michaelkennedy.org
KENNISH, Jenny
www.jkennish.com
KERMAN, Lesley Frances
www.lesleykerman.co.uk
KERR, Janette
janette2.kerr@uwe.ac.uk
KEY, Geoffrey
www.geoffreykey.com
KIANUSH-WALLACE, Katy
http://www.art-arena.com

KIKI, John
 www.johnkiki.co.uk
KIMBLE, Grace
 www.gracesart.co.uk
KINAHAN, Lady Coralie
 www.coralie-kinahan.com
KING, Mary
 www.maryking.co.uk
KING, Robert
 www.robertking.co.uk
KINTGEN, Yanne
 www.kintgen.com
KIRK, Robert Joseph
 www.robertkirk.co.uk
KISSEL, Gernot
 www.veraandkisselart.co.uk
KITZLEN ,
 www.kitzlen.com
KLEIN, Anita
 www.anitaklein.com
KNEALE, William, Henry (Bill)
 www.billkneale.co.uk
KNIGHT, Geraldine
 www.geraldineknight.com
KNOX, Liz
 www.lizknox.com
KOCH, C.-Clarissa
 www.c-clarissakoch.com
KORALEK, Paul George
 www.abk.co.uk
KOWAL POST, Christine
 www.christinekowalpost.com
KUBECKI-PEARCE, Terence Peter
 www.terrykubecki.co.uk
KURTZ, Peter Felix Magnus von
 www.fetishfoto.co.uk
LAING, Gerald
 www.geraldlaing.com
LAKEY, Antony William Albert
 www.myspace.com/Antony_Lakey
LANDERS, Linda Anne
 www.lindalanders.co.uk
LANE, Jason
 www.jasonlane.org.uk

LANGFORD, Martin James
www.martinlangford.com
LAST, Bob
www.thepastelsociety.org.uk
LAST, Joanne
www.joannelast.co.uk
LATHAM, Rebecca
www.lathamstudios.com
LAUBIN, Carl David
www.carllaubin.com
LAUCHLAN, Anya
www.Rolland-Fine-Art.com
LAWRENCE, Peter Alfred
the-art-works.co.uk
LAWRENCE, Tory
www.torylawrence.com
LAWSON, Sonia
www.sonialawson.co.uk
LAZAROV, Peter Petkov
www.lazarov.nl
LE BROCQUY, Louis
www.le-brocquy.com
LE BRUN, Christopher Mark
www.christopherlebrun.co.uk
LE MARCHANT, Sir Francis
www.francislemarchant.com
LEACH, Mark Alan
www.markleach.net
LEE, Sidney Edward
www.StIvesSocietyofArtists.com
LEES, Caroline
www.caroline-lees.com
LEESON, Geoffrey Glynne
www.wobblybridge.co.uk
LEMAIRE, Angela Jacqueline
www.angelalemaire.co.uk
LENNON, Stephen
www.stephenlennon.co.uk
LESTER, James Richard
www.james-lester.com
LETTS, John Barry
www.lettssculptures.co.uk
LEVEE, John
google my name

LEVERITT, Thomas Michael James
www.leveritt.com
LEWIS, Ann
www.annlewis.co.uk
LEWIS, Jane
www.janelewisartist.com
LEWIS, Roger, Leslie
www.sgfa.org.uk
LEWIS, Sanchia
www.sanchialewis.co.uk
LEWTHWAITE, Paul Frank
www.paullewthwaite.com
LEYSHON-JONES, Steffan
www.urbandecoy.co.uk
LIDZEY, John
www.johnlidzey.co.uk
LIGHTFOOT, Katharine Lucy
www.lightfootart.com
LIJN, Liliane
www.lilianelijn.com
LIMBREY, John Nigel Stephens
www.fossewayartists.com
LIN, Hsiao-Mei
www.hmlin.co.uk
LINDSLEY, Kathleen Margaret
www.kathleenlindsley.co.uk
LIPTON, Laurie
www.laurielipton.com
LLOYD-JONES, Pamela
www.pamelalloydjones.com
LLYWELYN HALL, Dan
www.danllywelynhall.co.uk
LOCKHART, David
RSW Lockhart
LOGAN, Andrew
www.andrewlogan.com
LOKEN, Julia
www.loken.co.uk
LONG , Gary Nigel
www.garylongart.com
LOVELL, Margaret
www.margaretlovell.co.uk
LOWE, Peter
www.peterllowe.plus.com

LUKE, John
www.johnlukepaintings.com

LUKIC, Jelena
www.homunculus.co.uk/jelena/

LUMLEY, Thomas Henry
www.thomaslumley.com

LYDBURY, Jane Sarah
www.janelydbury.com

LYDIATE, Avril Ann
www.avrillydiate.co.uk

LYFORD, Rosina
www.rosinalyford.com

LYNCH, James
www.james-lynch.co.uk

LYNCH , Kate Mary
www.katelynch.co.uk

MACALPINE, Jean
www.jeanmacalpine.com

MACARA, Andrew
www.picasaweb.google.com/andrewmacara

MACARTHUR, Susan
www.susanmacarthur.co.uk

MACCORMAC, Sir Richard Cornelius
www.mjparchitects.co.uk

MACDONALD, Alan
www.alanmacdonald.net

MACDONALD, Allan Sween
www.allanmacdonald.co.uk

MacEWEN, Penelope
www.FreepaintersandSculptors.co.uk

MACKAY, Jane Elizabeth
http://www.soundingart.com

MacLENNAN, Alastair MacKay
http://www.vads.ahds.ac.uk/collections/maclennan

MADDISON, Robert
www.maddisonstudios.com

MAHON, Phyllis Josephine
www.jolls.co.uk

MALCOLM, Bronwen
www.bronwenmalcolm.com

MALENOIR, Mary
www.malenoir.co.uk

MALI, Yashwant
www.Maliart2000.co.uk

MALLIN-DAVIES, Joanna
 www.mallin-davies.com
MALTMAN, Philip John
 www.numasters.com; www.maybole.org/photogalleries
MANNES-ABBOTT, Sheila
 www.botanicalartist.co.uk
MANNING, Julia
 www.juliamanning.co.uk
MARKEY, Danny
 www.redfern-gallery.com
MARLIN, Brigid
 www.brigidmarlin.com
MARTIN, Barry John
 www.barrymartin.co.uk
MARTIN, Blandine
 www.blandinemartin.com
MARTIN, Mary Grace
 www.marymartin.eu
MARTIN, Misty
 www.mistymartin.com
MARTINEAU, Luke
 www.panterandhall.co.uk
MARTINEAU, Luke
 www.lukemartineau.com
MATHEWS, Binny
 www.hereasel.com
MATTHEWS, Les
 www.lesmatthews.co.uk
MATTHEWS, Sally
 www.sallymatthews.co.uk
MAUGY, Sandrine
 www.sandrinemaugy.com
MAY, Elsie D.
 www.elsiemay.com
MAY, Joanna
 www.joannamay.com
MAYES, Emerson
 www.emersonmayes.co.uk
McADAM CLARK, Caroline
 www.mcadamclark.com
McADAM FREUD, Jane
 www.janemcadamfreud.com
McCANN, Brian
 www.numasters.com; www.tate.org.uk/liverpool;
 www.kingston.ac.uk/picker/fellowships

McCARTER, Keith
www.keith-mccarter.com

McCARTHY, Peter
www.pmcart.co.uk

McCARTNEY, Jamie
www.jamiemccartney.com

McCOMBS, John
www.johnmccombs.co.uk

McCOY, Josie
www.josiemccoy.co.uk

McCULLOCH, Ian
www.s-s-a.org/html/featart/mcculloc/index.htm

McCURRY, Steve
www.stevemccurry.com

McDOWELL, Phyllis Ann Graham
www.phyllismcdowell.com

McEWAN, Angus Maywood
www.angusmcewan.com

McFADYEN, Jock
www.jockmcfadyen.com

McGOOKIN, Colin Trevor
www.colinmcgookin.com

McGREGOR, Lynn Barbara
www.lynnmcgreagor.co.uk

McGUIGAN, Bernard
www.bernard-mcguigan.co.uk

McKEAN, Lorne (Miss)
www.polosculpture.co.uk

McKECHNIE, Christine
www.christinemckechnie.co.uk

McKELLAR, Robert
www.robert-mckellar.com

McKENNA, John Anthony
www.johnmckenna.co.uk

McKENZIE, Mo
www.mckenziepictures.co.uk

McKIVRAGAN, Terrence Bernard
www.terrymckivragan.co.uk

McLACHLAN, Edward Rolland
www.edmclachlan.co.uk

McLEAN, Mary
www.paintingsinminiature.com

McMULLEN, Sue
www.suemcmullen.com

McNAUGHTON, Rachel Patricia
www.artbyrachel.co.uk/ www.minigalleryworld.com/Rachel_McNaughton

McWILLIAMS, Simon
www.simonmcwilliams.com

MEDWAY, Sarah
www.medwayart.com

MEEK, Elizabeth R.
www.elizabethmeek.com

MEISELAS, Susan C.
www.susanmeiselas.com

MELVIN, Johanna Helga
www.johannamelvin.com

MENDOZA, Edwin
www.mendoart.co.uk

MENDOZA, June
www.junemendoza.co.uk

MENZIES, Gordon William
www.ionagallery.com

MICAH, Lisa
www.LisaMicah.com

MICHAEL, Colin
www.londonart.co.uk

MIDGLEY, Julia
www.juliamidgley.co.uk

MIERS, Christopher John Penrose
www.christopher-miers.co.uk

MILLER, Colin James
www.colin-miller.co.uk

MILLER, Shannon
www.shanmiller.com

MILLINGTON, Terence
www.terencemillington.net

MILLMORE, Mark Alexander
www.eyelidproductions.co.uk

MILLNER, Etienne Henry de la Fargue
www.portrait-sculpture.org Etienne Millner

MILLS, Glynis
www.equestrianartists.co.uk

MILLS, Teresa Ann
www.teresamills.com

MILNE, Judith Erica
www.miart.org.uk

MITCHELL, Janet Elizabeth
www.artspaces.co.uk

MONROE, Chuck
www.monroe-art.com
MONTAGUE, Lucile Christine
www.axisartists.org.uk
MOORE, Cleland Randolph
www.clelandmoore.co.uk
MOORE, Gabrielle Kaye
www.gabymoore.co.uk
MOORE, Sally
www.artwales.com
MORAN, Carolyne Sandra Anne
www.carolynemoran.com
MORETON, Nicolas
www.nicholasmoreton.com
MOREY de MORAND, C.
www.cmoreydemorand.co.uk
MORGAN, Dr. Michael
www.marinehouseatbeer.co.uk
MORGAN, Mark Andrew
www.artcatz.biz
MORLEY, John
www.johnmorley.info
MORREAU, Jacqueline Carol
www.morreaux.co.uk
MORRIS, Elizabeth
www.elizabethmorrisprints.co.uk
MORRIS, Mali
www.malimorris.co.uk
MORROCCO, Jack Bernard
www.jackmorrocco.com
MORSE, Colin Benjamin Scale
www.bestofruralwales.co.uk / www.welshpictures.co.uk
MORTON, Gina
www.ga-morton.co.uk
MOTT, Miranda J M
www.mjmott.co.uk
MOXLEY, Susan
www.susanmoxley.co.uk
MUIR, Jane
www.artworkersguild.org
MULROY, Alison
www.alisonmulroy.com
MUNDY, William Percy
www.billmundy.co.uk

MURPHY, Richard
 www.richardmurphyarchitects.com
MUSGRAVE, Olivia Mirabel
 www.jmlondon.com
MUSGRAVE, Sally Ann
 www.kapiljariwalagallery.co.uk
MYERS, Chris
 www.chrismyersart.com
NASH, Elizabeth
 www.elizabethnash.co.uk
NASON, Kristine
 www.axisweb.org/artist/kristinenason
NEAL, Trevor
 www.trevorneal.co.uk
NEILAND, Brendan
 www.brendanneiland.com
NESBITT, Mark Alexander
 www.autografix.com
NEWBERRY, Angela
 www.angela-newberry.co.uk
NEWNHAM (CHILES), Annie
 www.annienewnham.co.uk
NEWSOME, Peter Martin
 www.peter.newsome.com
NICE, Derek Vernon
 www.dereknice.com
NICHOLLS, Paul Edward
 www.paulnichollsartwork.com
NICKOLLS, Deborah
 www.deborahnickolls.com
NOAKES, Michael
 www.michael-noakes.co.uk
NOBLE, Guy
 www.guynoble.com
NOBLE, Jean
 www.jeannoble.com
NORRIS, David
 www.davidnorris.co.uk
NORRIS, Linda
 www.linda-norris.com
NOYES, Margot
 www.thesuffolkgroup.co.uk
O'CARROLL, John Patrick
 www.johnocarroll.co.uk

O'DONOGHUE, Declan
www.sffurniture.co.uk

O'HARA, D. Patrick
www.oharasculpture.com

O'REILLY, Oran
www.oranoreilly.co.uk

OLIN, Leon
www.LeonOlin.com

OLINER, Sheila
http://www.org/artist/sheilaoliner

OOZEERALLY, Barbara
www.barbaraoozeerally.co.uk

ORR, Chris
www.chrisorr-ra.com

ORWIN, Carol
www.orwinsculptures.com

OSBORNE, Roy
www.coloracademy.co.uk

OTTEY, Piers Ronald Edward Campbell
www.piersottey.co.uk

OWEN, Glynis
www.glynisowensculptor.co.uk

PACKHAM, John Leslie (Les)
www.lespackham.co.uk

PALMER, Joan Dowthwaite
www.joanpalmer.com

PALMER, Juliette
www.the-rba.org.uk

PANCHAL, Shanti
www.shantipanchal.com

PANKHURST, Alvin Ernest
www.alvinpankhurst.com

PANNETT, Denis Richard Dalton
www.denispannett.co.uk

PAPADOPOLOUS, George
www.yorgosglass.com

PARFITT, David Granville
www.newenglishartclub.co.uk

PARKER, Gill
www.gillparker.com

PARKIN, Ione
www.ioneparkin.co.uk

PARR, Martin
www.martinparr.com

PASKETT, David
 www.davidpaskett.co.uk
PATTERSON, Janet
 www.janetpatterson.co.uk
PATTON, Marcus
 www.operahat.co.uk
PAUL, Sylvia
 www.sylviapaul.com
PAVEY, Don
 www.coloracademy.co.uk
PAVITT, Diane
 included in art-in-miniature.org
PAVLENKO, Sergei
 www.spavlenko.demon.co.uk
PAYNE, Tom
 www.st-art.biz
PEARSON, Bruce Edward
 www.brucepearson.net
PEGLITSIS, Nicolas
 www.nicolaspeglitsis.com
PERKINS, Marion
 www.soc-botanical-artists.org
PERRIN, Sally Jane
 www.soc-botanical-artists.org
PERRY , Robert
 www.robertperry-artist.co.uk
PERRY, Simon Peter George
 www.peterperry.com
PESKETT, Tessa
 www.theorangetreegalerie.com
PETHERS, Ian Peter Andrew
 www.glenrockstudio.co.uk
PETLEY, Roy
 www.petleyfineart.com
PEVERALL, Adrienne
 www.penwithprintmakers.co.uk
PHILLIPS, Rex
 www.rex-phillips.co.uk
PHILLIPS, Tom
 www.tomphillips.co.uk
PHIPPS, Jemma Louise Rose
 www.jemmaphipps.com
PICHÉ, Roland
 www.rolandpiche.com

PICK, Wayne Erich
www.st-art.biz
PICKERING, J. Robin H.
www.robinpickering.co.uk
PIERCY, Rob
www.robpiercy.com
PIERSE, Simon
www.simonpierse.co.uk
PIESOWOCKI, Leon
www.leonpiesowocki.net
PIKE, Jonathan
www.jonathanpike-paintings.blogspot.com
PIMLOTT, Geoffrey
www.geoffrey@pimlott.info
PINSKY, Michael
www.michaelpinsky.com
PLATT, Theo
www.theoplatt.com
PLOWMAN, Christopher Charles
www.chrisplowman.co.uk
POCOCK, Heather
www.franciskylegallery.com
POLAINE, Peter David
www.polaine.com/peter
POOLE, Greg
http://homepage.virgin.net/greg.poole
POOLE, Jonathan
www.jonathanpoole.co.uk
POOLEY, Vanessa
www.vanessapooley.com
PORTELLI, Guy Anthony
www.portelli.sculptor.co.uk
POVER, Lesley
www.lesleypover.com ; www.bronze-icous.com
POVEY, Edward
www.edwardpovey.com
PRAED, Michael
www.michaelpraed.co.uk
PREST, Kathy
www.kathyprest.co.uk
PRICE, Christopher Francis
www.BibaBook.com
PRICE, Trevor
www.trevorprice.co.uk

PROWSE, Alexander Reginald
www.alexprowse.com
PUGH, Tim
www.timpugh.co.uk
PULLAN, Tessa
www.tessapullen.co.uk
PURSER, Keith
www.jc-art.com
PYBUS, Michelle Christine
www.mpybusfinearts.co.uk
PYE, Chris
www.chrispye-woodcarving.com
PYE, William
www.williampye.com
PYNE, Kenneth John
www.kenpyne.com
PYTEL, Walenty
www.wyebridge.com
QUIGLEY, Vlad
www.vladquigley.com
QUINN, Mary P.
www.maryquinnsculptor.com
RAE, Barbara
www.barbararae.com
RAE, Robin
www.robinraepaintings.co.uk
RAMSBOTHAM, Meredith
www.meredithramsbotham.com
RANDALL, Carl
www.carlrandall.com
RANDALL-PAGE, Peter
www.peterrandall-page.com
RANK-BROADLEY, Ian
www.ianrank-broadley.co.uk
READING, Peter William
www.peter-reading.com
REDEMER, Roberta
www.bracknellartgallery.org.uk
REDFERN, June
www.juneredfern.com
REDINGTON, Simon
www.kamikazepress.com
REIS, Klari
www.klarireis.com

RELTON, Maxine
www.maxinerelton.com

REMFRY, David
www.davidremfry.com

REYNOLDS, Michael
see website of Royal Portrait Society; also Gallery Vieleers:www.vieleers.nl

RHYS-JAMES, Shani
look under Shani Rhys-James

RICH, Andrea
andrearich.com

RICH, Graham Denton
www.faslondon.com

RICHARD, Gabriel-Georges
www.artotheque-valdeloire.com

RICHARDSON, Ilana
www.ilana-richardson.com

RICHARDSON, Ray
www.rayrichardson.co.uk

RICHMOND, Miles Peter
www.milesrichmond.co.uk

RIGGS, Clive
www.saa.co.uk/art/cliveriggs

RITCHIE, Ian
www.ianritchiearchitects.co.uk

ROBERTS, Richard Travers
www.richardrobertsbronzes.com

ROBINSON, Barbara
www.barbararobinsonpaintings.com

ROBINSON, Kay
www.chester.gov.uk

ROBINSON, Wayne
www.waynejrobinson.com

RODULFO, Peter
www.peterrodulfo.com

ROGERS, Carol Ann
www.hvaf.org.uk/gallery/rogers or www.saa.co.uk/art/rogers

ROGERS, John Rowland
www.johnrogersartist.co.uk

ROSE, Tim Simon
www.timrose.co.uk

ROSS, Annie
www.annieross.com

ROSS, John
www.axisweb.org/artist/johnross

ROSS, Michèlle
 http:.mysite.wanadoo-members.co.uk/MichelleRoss
ROWLAND, Dawn
 www.dawnrowland.com/ www.dawnrowland.co.uk
ROWSELL, Joyce
 www.spring-grove-gallery.com
RUBIRA, Sue (Susan Debra)
 www.suerubira.co.uk
RUDD, Bob
 www.bobrudd.com
RUDDUCK, Ron
 www.rbs.org.uk/ www.sculpturesales.fsnet.co.uk
RUDDY, Austin
 c/o www.art-connections.org.uk
RUNAYKER, Irene
 www.irenerunayker.com
RUSHMER, Gordon
 www.gordonrushmer.com
RUSPOLI, Francesco Mario Robert
 www.francesco-ruspoli.com
RUSSELL, Caroline
 www.russellsculptures.com
RUSSELL, Christine Gillian
 www.art-christinerussell.co.uk
RUTHERFORD, Iain
 www.iainrutherford.com
RUTT, Loraine
 www.st-art.biz
SADDINGTON, Donald William
 www.donsaddington.co.uk
SAMUEL, Alison
 www.silverwellfineart.com
SAMUELSON, Becky
 www.beckysamuelsonfinearts.co.uk
SANDERS, Rosanne Diana
 www.rosiesanders.com
SANFORD, Sheila
 www.sheila-sanford.com
SANIN, Fanny
 www.lablaa.org/blaavirtual/todaslasartes/sanin/indice.htm
 www.colarte.com/colarte/conspintores.asp?idartista=525
 www.latincollector.com/artists/index.php?lang=en
SANN, Tin Tin
 www.tin-tin-sann.narod.ru

SCHETNEV, Leonid
www.cultinfo.ru/schetnev
SCHILDERMAN, Pamela
www.pamelaschilderman.com
SCHLEE, Nick
www.nickschlee.co.uk
SCHOFIELD, David Owain
www.david-schofield.com
SCOTT, Celia Maxwell
www.celiascott.com
SCOTT, Jac
www.jacscott.com
SCOTT, Richard Ridsdale
www.thesuffolkgroup.co.uk
SCOTT-TAGGART, Elizabeth Mary Josephine
www.elizabethscotttaggart.co.uk
SCOULLER, Kim
www.kimscouller.com
SCOULLER, Lara
www.larascouller.com
SCULLARD, Susan Diane
www.suescullard.co.uk
SEAGER, Harry Abram
www.harryseagersculptor.com
SEE-PAYNTON, Colin Frank
www.see-paynton.co.uk
SEELEY, Eric Charles
www.rasalumni.org
SEGELMAN, Frances Rosaline
www.segelman.com
SEGRAVE, Lydia
www.lydiasegrave.com
SEIJO, Armando
www.st-art.biz
SELBIE, Rosy
www.selbie.co.uk
SENFT, Nadin
Axis Leeds Univ. - www.axisartists.org.uk
SENIOR, Bryan
www.axisweb.org/artist/bryansenior
SERGEANT, Emma
www.emmasergeant.com
SEWARD RELFE, Elizabeth Anne Harvey (Liz)
www.sewardart.co.uk

SEWELL, Peggy Joan Kearton
 www.croydonartsociety.org.uk
SEXTON, Anthony John
 www.jsexton.eu
SHAKESPEARE, Francesca
 www.francescashakespeare.com
SHARP, Elizabeth
 www.stantongraphics.co.uk
SHAW, Andrew Stuart Dunlap
 www.oio.nu
SHAW, Tim
 www.timshawsculptor.com
SHEARD , Rosalind Elizabeth Allaway
 www.londonart.co.uk
SHELLIM, Maurice Arthur
 www.mauriceshellim.me.uk
SHEPHERD, Eve
 www.eveshepherd.com
SHEPHERD, Gerald
 www.ionistart.com/ www.ionistart.co.uk
SHIELDS, Christopher Ronald
 www.chris-shields.com
SHIELDS, Mark
 www.grosvenorgallery.com
SHIRLEY, Rachel
 www.rachelsgallery.fsnet.co.uk
SHIRLEY SMITH , Richard Francis
 www.richardshirleysmith.co.uk
SHOA, Nahem
 http://www.nahemshoa.co.uk
SHORT, Susan
 www.southbank-printmakers.com
SHOWELL, Billy
 www.billyshowell.co.uk
SHUTT, David Richard Walter
 www.shuttpaintings.com
SIDOLI, Dawn Frances
 RWA & NEAC
SIEVEWRIGHT, Dionne Lesley
 www.dionesievewright.co.uk
SIMMONDS, Jackie
 www.jackiesimmond.co.uk
SIMPSON, Leslie
 www.britpaint.co.uk/www.britpaint.com

SIMS, Anna
www.annasims.co.uk

SINNOTT, Kevin
kevinsinnott.co.uk

SLATER, Paul
www.paulslaterbugle.com

SLOAN, Victor
www.victorsloan.co.uk

SLOGA, Alison
www.alisonsloga.com

SMITH, Barry Edward Jervis
www.barryejsmithart.co.uk

SMITH, Graham
www.art.abelgratis.co.uk

SMITH, Peter Macdonald
www.petermacdonaldsmith.co.uk

SMITH, Richard Michael
www.richardsmith.gallery.btinternet.co.uk

SMITH, Rita
www.ritasmith.org.uk

SMITH, Ronald F
gallery websites

SMITH, Simon
www.simonsmith.plus.com

SOREL, Agathe
www.agathesorel.co.uk

SORRELL, Julia
www.juliasorrell.i12.com

SORRELL, Richard
www.richardsorrell.co.uk

SOUBIRAN-HALL, Alix
www.alixsoubiran-hall.com

SPARE, Richard, John
www.richardspare-kayspare.com

SPELLER, Michael Phillip
www.spellersculptures.com

SPENCER, Liam David
www.liamspencer-art.co.uk

ST. JOHN ROSSE, Nicholas David
www.nstjohnrosse.com

STANDEN, Peter
www.edinburghetchings.com

STAUVERS, Feliks
www.feliksstauvers.co.uk

STEADMAN, Ralph Idris
www.ralphsteadman.com
STEELE-PERKINS, Christopher Horace
www.chrissteeleperkins.com
STEPHENSON, Christine Frances
www.paintingsofplants.com
STEPHENSON, Jack
www.portraitsfromlife.co.uk
STEWART, Hannah
www.hannahstewartsculpture.co.uk
STEWART, Laurie Leon
www.artonlinelimited.com
STILLMAN, John
www.johnstillman.co.uk
STOCK, Andrew Nicholas
www.andrewstock.co.uk
STOCKWELL, Susan
www.susanstockwell.co.uk
STODDART, Tom
www.tomstoddart.com
STOKER,, Richard,
www.richardstoker.co.uk
STONES, Anthony
www.sculptor.co.nz
STRAFFORD, Judy
www.judystrafford.co.uk
STRANG, Michael
www.michaelstrang.com
STRANGELOVE, Nikolas Alexander
www.studiostrangelove.com
STREVENS, Bridget Julia
www.bridgetstrevens.com
STUBBS, Michael
www.michaelstubbs.org
STUBLEY, Trevor Hugh
www.trevorstubleygallery.co.uk
STUMMEL, Henning Friedrich
www.henningstummelarchitects.co.uk
STYLES, (Elizabeth) Caroline
www.carolinestyles.com
SULLIVAN, Benjamin Christian
www.benjaminsullivan.com
SUTTON, Jilly Bazeley
www.jillysutton.com

SWALE, Suzan Georgina
www.thelondongroup.com
SWAN, Ann
www.annswan.co.uk
SWANBOROUGH, Patsy & Janet
www.rosehillstudio.co.uk
SWEENEY, Kevin Michael
www.abstractsculptures.co.uk
SWETCHARNIK, Sara Morris
www.swetcharnik.com
SWETCHARNIK, William Norton
www.swetcharnik.com
SYKES, Barbara
www.barbarasykes.com
SYKES, Sandy
www.sandysykes.co.uk
SYMINGTON, Christy Mary
www.christysymington.com
SYVERSON, Judith
www.MontanaProfessionalArtistsAssoc.com
TAHERIAN, Christine
www.society-women-artists.org.uk
TAIT, Wendy Ann
www.wendytait.com
TAKEDA, Fumiko
http://homepage1.nifty.com/miuraarts
TANDY, Bonita Marilyn
www.theinternetartshop.com
TANG, George
www.georgetang.com.hk
TARRANT, Olwen
www.olwentarrant.co.uk
TAYLOR, Alan
www.supercovers.co.uk
TAYLOR, Alan
www.paintingstore.net
TAYLOR, Krista Louise
www.kristataylor.com
TAYLOR, Martin
www.martintaylor.org
TAYLOR, Michael Ryan
www.mrtaylor.co.uk
TAYLOR, Sean
www.softday.ie

TAYLOR, Wendy Ann
www.wendytaylorsculpture.co.uk
THOMAS,, Glynn David Laurie,
www.glynnthomas.com
THOMSON, Harry Ross
www.rosstoons.com
THORESBY, Valerie Cecilia
www.valeriethoresby.co.uk
THORNTON, Pat
www.patthornton.net
THORPE, Hilary
www.hilarythorpe.co.uk
THURGOOD, Gwyneth
www.micro-art.co.uk
THURSBY, Peter
www.peterthursbysculptor.co.uk
THYNN, Alexander (7th Marquess of Bath)
www.lordbath.co.uk
TIDNAM, Nicholas Rye
www.tidnam.com
TIERNEY, Sadie
www.sadietierney.co.uk
TILLYER, William
www.jacobsongallery.com/ www.tillyer.com
TIMMIS, Rosemarie
www.rosemarietimmis.co.uk
TINGLE, Michael
www.miketinglepaintings.com
TOLSTOY, Carolinda
www.carolinda-tolstoy.co.uk
TOOP, Bill
www.billtoop.com
TOWSEY, Mary
www.marytowsey.com
TRATT, Richard
www.richardtratt.co.uk
TRAYHORNE, Rex
www.rextrayhorne.co.uk
TREANOR, Frances
www.francestreanor.com
TRELOAR, Janet Quintrell
www.janetqtreloar.com
TROTH, Miriam
www.axisweb.org/artist/miriamtroth

TUBB, Stephen
www.tubbart.co.uk
TURNBULL, Andrew
www.akturnbull.com
TURNER, Anthony Hugh
www.anthonyturner.net
TURNER, Cyril B.
http://miniaturepaintings.mysite.orange.co.uk
TURNER, Jacquie
www.jacquieturner.com
TURPIN, Louis
www.louisturpin.com
TUTE, George William
www.georgetute.com
TUTTIETT, Dora
www.dorat.yourprivatespace.com/ www.axisartists.org.uk
TYLER, Carol
www.axisweb.org/artist/caroltyler
UNDERWOOD, George
www.georgeunderwood.com
UNWIN, Bren
www.brenunwin.com
UPTON, Mark Lundy
www.markupton.com
URQUHART, Anne
www.nonsafety.co.uk/pauk.html
VAHEY, Lorna
www.hastingsarts.net
VALENTINE-DAINES, Sherree E.
www.parklanefinearts.co.uk
VANDER HEUL, Yvonne Christine
www.drawingwaterworks.net
VARELA, Armando
www.armandovarela.net
VEALE, Anthony McKenzie
www.tonyveale.com
VIEIRA DA SILVA DALL'ORTO, Lucy
www.lucydalorto.kit.net
VISOCCHI, Michael
www.michaelvisocchi.com
VOGEL, Paul, Sidney
www.paulvogel.com
VON STROPP,
www.outsiderart.co.uk

VON STUMM, Johannes
www.vonstumm.com
VOROBYEV, Alexander
www.alexandervorobyev.com
WADDELL, Heather
www.hwlondonartandartistsguide.com
WADDINGTON, Geri
www.geraldinewaddington.com
WADE, Jonathan Armigel
www.jonathanwade.co.uk
WALDRON, Dylan Thomas
www.dylanwaldronartist.co.uk
WALKER, Edward Donald
www.edwalkermarine.com
WALLER, Jonathan Neil
www.geocites.com/jonathanwalleruk
WALTER, Stephen
www.stephenwalter.net
WALTERS, Kate
www.katewalters.co.uk
WANG, Elizabeth
www.radiantlight.org.uk
WANLESS, Tom
www.t.b.wanless.btinternet.co.uk
WARD, Eric Thomas
www.ericward.org
WARD, Michael Lawrence
www.pbase.com/deadlinearts/mikeward
WARREN, Michael John
www.mikewarren.co.uk
WARREN, Vaughan
www.thepenzanceartgallery.com
WATSON, Thomas Jude (Tomas)
www.jillgeorgegallery.co.uk
WAUTERS, Jef
www.jefwauters.be
WEBB, Sarah Ann
www.sarahwebb.com
WEBSTER, John Morrison
www.johnwebster.org.uk
WELLS, Peter
www.onetimepress.com
WELTON, Peter
www.peterwelton.com

WESTON, David J.
www.artisticactivities.co.uk

WHISHAW, Anthony
www.anthonywishaw.com

WHITAKER, Vivien
www.vivenwhitaker.co.uk

WHITE, Lucy Annette
www.cornwallhumanists.org.uk

WHITE, Philippa
www.chelseaartsociety.org.uk

WHITE, Robert Edward
www.robertwhite.info

WHITEHEAD, Steve
www.panterandhall.com

WHITTAKER, Lucianna
www.luciannawhittaker.com

WHITTEN, Jonathan Philip
www.stkewpottery.co.uk

WHITTLE, Janet
www.janetwhittle.co.uk

WHITTON, Judi
www.watercolour.co.uk

WIGGINS, Toby
www.tobywiggins.co.uk

WILLIAMS, Alex
www.alexwilliams.net

WILLIAMS, Glynn
www.glynnwilliams.co.uk

WILLIAMS, Graham Richard
www.grahamwilliams.co.uk

WILLIAMS, Jacqueline E. E.
www.jacquelinewilliams.co.uk

WILLIAMS, John
www.freeformphoto.co.uk

WILLIAMS, Simon
www.swillustrations.com

WILLIAMS-ELLIS, Bronwyn Mary
www.handmade-tiles.co.uk

WILLIAMS-ELLIS, David Hugo Martyn
www.DWE.com

WILLIS, Lucy
www.lucywillis.com

WILSON, Arthur
www.arthurwilson.co.uk

WILSON, David
www.david-wilson.net
WILSON, Douglas
www.oddyart.com
WILSON, Susan Ahipara
www.susanwilsonartist.com
WINNER, Tolleck
www.tolleck.com/ www.tolleckwinner.com
WINTER, Faith
www.FaithWinter.co.uk
WISE, Gillian
www.gillianwise.com
WNEK-WEBB, Ewa
www.wnek-webb.co.uk
WOOD, Andy
www.andywoodgallery.com
WOOD, Christopher Malcolm Fayrer
www.christopherwood.co.uk
WOOD, Juliet Anne
www.julietwood.co.uk
WOODFINE, Sarah
www.daniellearnaud.com
WOODROW, Bill (William Robert)
www.billwoodrow.com
WOODS, Michael John
www.michaelwoods.me.uk
WOODWARD, Justine
http://www.starhub.net.sq/jascough
WOUDA, Marjan Petra
www.marjanwouda.co.uk
WRAITH, Robert
www.robbiewraith.com
WRIGHT, Bert
www.bertwright.com
WRIGHT, David
www.davidwright-artist.co.uk
WRIGHT, Liz
www.wrightfineart.co.uk
WRIGHT, Roy
www.henryboxergallery.com
WRIGHT, Stuart Pearson R.
www.thesaveloyfactory.com
WYNNE, Althea
www.althea-wynne-sculptor.com

YALLUP, Pat
www.patyallup.com
YATES, Alan
www.alanyates-sculpture.com
YOUNG, Emily
www.emilyyoung.com
YOUNSON, Sydna
www.younson.com
ZACRON,
www.zacron.com
ZENIN, Eugene
www.zenin.dk
ZIZOLA, Francesco
www.zizola.com
ZWOLINSKA-BRZESKI, Teresa
www.theartshopper.com

GALLERY WEBSITES

LONDON

A&D GALLERY
www.a-and-d.co.uk
ABBOTT & HOLDER
www.abbottandholder.co.uk
AC GALLERY
www.acgallerylondon.com
ACKERMANN & JOHNSON
www.artnet.com/ackermann-johnson.html
ADAM GALLERY
www.adamgallery.com
ADRIAN SASSOON
www.adriansassoon.com
ADVANCED GRAPHICS LONDON
www.advancedgraphics.co.uk
AFFORDABLE ART FAIR
www.affordableartfair.com
AGNEW'S GALLERY
www.agnewsgallery.co.uk
AINSCOUGH CONTEMPORARY ART
www.acag.co.uk
THE AIR GALLERY
www.farishams.com
ALAN CRISTEA GALLERY
www.alancristea.com
ALBEMARLE GALLERY
www.albemarlegallery.com
ALBION
www.albion-gallery.com
ALEXANDRE POLLAZZON LTD.
www.alex-pollazzon.com
ALEXIA GOETHE GALLERY
www.alexiagoethegallery.com
ALISON JACQUES GALLERY
www.allisonjacquesgallery.com
ALLA BULYANSKAYA GALLERY
www.allabulgallery.com
ALMA ENTERPRISES
www.almaenterprises.com
ANDREW MUMMERY GALLERY
www.andrewmummery.com

ANNE FAGGIONATO
www.annefaggionato.com
ANNELY JUDA FINE ART
www.annelyjudafineart.co.uk
ANTHONY REYNOLDS GALLERY
www.anthonyreynolds.com
THE APPROACH
www.theapproach.com
APT
www.aptstudios.org
ARCHEUS
www.archeus.co.uk
ARCHITECTURAL ASSOCIATION
www.aaschool.ac.uk
ARISTAO
www.aristao.co.uk
ARTANDPHOTOGRAPHS LTD
www.artandphotographs.com
ARTANGEL
www.artangel.org.uk
ART FIRST
www.artfirst.co.uk
ART LAB
www.artlab-gallery.co.uk
ART LONDON
www.artlondon.net
ART PILGRIM LONDON
www.artpilgrim.co.uk
ART SPACE GALLERY
www.artspacegallery.com
THE ARTS GALLERY
www.arts.ac.uk
ARTHESTER
www.arthester.co.uk
THE ARTHOUSE GALLERY
www.lewishamarthouse.co.uk
THE ART MOVEMENT
www.art-movement.com
ASHWIN STREET
www.ashwinstreet.com
ASSOCIATES
www.associategallery.co.uk
ATLAS GALLERY
www.atlasgallery.com

ATRIUM GALLERY PRICEWATERHOUSECOOPERS
 www.dicksonrussell.co.uk
AUGUST ART
 www.augustart.co.uk
AUSTIN/DESMOND FINE ART
 www.austindesmond.com
BANKSIDE GALLERY
 www.banksidegallery.com
BARBARA BEHAN
 www.barbarabehan.com
BARBICAN ART GALLERY & THE CURVE
 www.barbican.org.uk/artgallery
BARRETT MARSDEN GALLERY
 www.bmgallery.co.uk
VON BARTHA GALLERY
 www.vonbartha.com
BEACONSFIELD
 www.beaconsfield.ltd.uk
BEARDSMORE GALLERY
 www.beardsmoregallery.com
BEARSPACE
 www.thebear.tv/bearspace
BEAUX ARTS
 www.beauxartslondon.co.uk
BELGRAVE GALLERY
 www.belgravegallery.com
BELGRAVIA GALLERY
 www.belgraviagallery.com
BEN BROWN FINE ARTS
 www.benbrownfinearts.com
BEN URI GALLERY
 www.benuri.org.uk
BERNARD JACOBSON GALLERY
 www.jacobsongallery.com
BERTRAM
 www.bertramenterprises.co.uk
BEVERLEY KNOWLES FINE ART
 www.beverleyknowles.com
BHAVAN CENTRE ART GALLERY
 www.bhavan.net
BISCHOFF/WEISS
 www.bischoffweiss.com
BLOOMBERG SPACE
 www.bloomberg.net

BLOW DE LA BARRA
www.blowdelabarra.com
BOUNDARY GALLERY
www.boundarygallery.com
BOURLET FINE ART FRAME MAKERS
www.bourlet.co.uk
BROADBENT
www.broadbentgallery.com
BROWSE & DARBY
www.browseanddarby.co.uk
BYARD ART
www.byardart.co.uk
CADOGAN CONTEMPORARY
www.artcad.co.uk
CAFÉ GALLERY
www.cafegalleryprojects.org
CAMDEN ARTS CENTRE
www.camdenartscentre.org
CAMPBELL'S ART GALLERY
www.campbellsart.co.uk
CAROLINE HODGKINSON
www.hodgkinsonart.com
CAROLINE WISEMAN
www.carolinewiseman.com
THE CATTO GALLERY
www.catto.co.uk
CELIA PURCELL CONTEMPORARY
www.celiapurcell.com
THE CHAMBERS GALLERY
www.thechambersgallery.com
CHARLOTTE STREET GALLERY
www.r-h-g.co.uk
CHELSEA SPACE
www.chelsea.arts.ac.uk
CHISENHALE GALLERY
www.chisenhale.org.uk
CITY & GUILDS OF LONDON ART SCHOOL
www.cityandguildsartschool.ac.uk
CLAPHAM ART GALLERY
www.claphamartgallery.com
COLEMAN PROJECT SPACE
www.colemanprojects.org.uk
COLLYER BRISTOW GALLERY
www.collyerbristow.com

COLOMB ART GALLERY
www.colomb-art.co.uk
CONNAUGHT BROWN
www.connaughtbrown.co.uk
CONTEMPORARY APPLIED ARTS
www.caa.org.uk
CONTEMPORARY ART SOCIETY
www.contempart.org.uk
CORVI-MORA
www.corvi-mora.com
COSA
www.cosalondon.com
COUNTER
www.countergallery.com
THE COURT GALLERY
www.courtgallery.com
CRANE KALMAN GALLERY LTD
www.cranekalman.com
CREATIVE PICTURE FRAMING
www.creativepictureframing.co.uk
CUBITT GALLERY
www.cubittartists.org.uk
CURWEN & NEW ACADEMY GALLERY
www.curwengallery.com
THE CYNTHIA CORBETT GALLERY
www.thecynthiacorbettgallery.com
DAIWA FOUNDATION JAPAN HOUSE
www.dajf.org.uk
DANIEL KATZ LTD.
www.katz.co.uk
DANIELLE ARNAUD
www.daniellearnaud.com
DANUSHA FINE ARTS
www.danusha-fine-arts.co.uk
DAVID RISLEY GALLERY
www.davidrisleygallery.com
DEBLON ART GALLERY
www.deblon.co.uk
DEBUT ART LTD & THE CONINGSBY GALLERY
www.coningsbygallery.com/@Web_Address:www.debutart.com
DESIGN MUSEUM
www.designmuseum.org
DICKSMITH GALLERY
www.dicksmithgallery.co.uk

DILSTON GROVE
www.cafegalleryprojects.org
DOMINIC GUERRINI FINE ART
www.dominicguerrini.co.uk
DOMOBAAL
www.domobaal.com
DOROTHÉE SCHMID ART CONSULTING
www.dorotheeschmid.com
THE DRAWING GALLERY
www.thedrawinggallery.com
THE DRAWING ROOM
www.drawingroom.org.uk
DULWICH PICTURE GALLERY
www.dulwichpicturegallery.org.uk
DUNCAN R MILLER FINE ART
www.duncanmiller.com
DURLACHER FINE ART
www.durlacherfineart.com
THE EAGLE GALLERY
www.emmahilleagle.com
EAST WEST GALLERY
www.eastwestgallery.co.uk
THE ECONOMIST PLAZA
www.contempart.org.uk
ELEVEN
www.elevenfineart.com
EMILY TSINGOU GALLERY
www.emilytsingougallery.com
THE EMPIRE
www.theempirestudios.co.uk
ENGLAND & CO.
www.englandgallery.com
ESTORICK COLLECTION OF MODERN ITALIAN ART
www.estorickcollection.com
FAGGIONATO FINE ARTS
www.faggionato.com
FAIRFAX GALLERY
www.fairfaxgallery,com
FA PROJECTS
www.faprojects.com
F-ART
www.f-art.uk.com
FIELDGATE GALLERY
www.fieldgategallery.com

FINE ART COMMISSIONS
www.fineartcommissions.com
FIUMANO FINE ART
www.fiumanofineart.com
FLACA
www.flaca.co.uk
THE FLEMING COLLECTION
www.flemingcollection.co.uk
FLOWERS CENTRAL
www.flowerseast.com
FLOWERS EAST / FLOWERS GRAPHIC
www.flowerseast.com
FLYING COLOURS GALLERY
www.flyingcoloursgallery.com
FORTESCUE AVENUE/JONATHANVINER
www.fortescueavenue.com
FOSS FINE ART
www.fossfineart.com
491 GALLERY
www.artphilogallery.com
FOUR SQUARE FINE ARTS
www.foursquarearts.co.uk
FRANCIS KYLE GALLERY
www.franciskylegallery.com
FRED
www.fred-london.com
FRITH STREET GALLERY
www.frithstreetgallery.com
FROST & REED
www.frostandreed.com
GAGLIARDI GALLERY
www.gagliardi.org
GALERIE BESSON
www.galeriebesson.co.uk
THE GALLERIA
www.safinearts.com
THE GALLERY
www.lomaart.co.uk
GALLERY 5
www.natashakumar.co.uk
GALLERY 12
www.gallery12.info
GALLERY 19
www.gallery19.com

GALLERY 27
www.njcox.com/www.sandrabell.com
GALLERY 286
www.gallery286.com
GALLERY 320
www.gallery320.co.uk
GALLERY FIFTYTHREE
www.galleryfiftythree.com
GALLERY IN CORK STREET
www.artborderline.com
GALLERY K
www.gallery-k.co.uk
GALLERY KALEIDOSCOPE
www.gallerykaleidoscope.com
GALLERY PANGOLIN
www.gallery-pangolin.com
GALLERY RICHMOND
www.galleryrichmond.com
GASWORKS
www.gasworks.org.uk
GIMPEL FILS
www.gimpelfils.com
GOETHE-INSTITUT / HUGO'S
www.goethe.de/london
GORDON REECE GALLERY
www.gordonreecegalleries.com
GRAPEVINE IN LONDON III
www.grapevinegallery.co.uk
GREENGRASSI
www.greengrassi.com
GREENWICH PRINTMAKERS GALLERY
www.greenwich-printmakers.org.uk
GROSVENOR GALLERY
www.grosvenorgallery.com
GUILDHALL ART GALLERY
www.guildhall-art-gallery.org.uk
GX GALLERY
www.gxgallery.com
HACKELBURY FINE ART LTD
www.hackelbury.co.uk
HACKNEY FORGE
www.hackneyforge.com
HALES GALLERY
www.halesgallery.com

HAMILTONS GALLERY
 www.hamiltonsgallery.com
HANG:UPS
 www.hangupslondon.com
HANINA GALLERY
 www.haninafinearts.com
HARLEQUIN GALLERY
 www.studio-pots.com
HARTGALLERY LONDON
 www.hartgallery.co.uk
HAUNCH OF VENISON LONDON
 www.haunchofvenison.com
HAUSER & WIRTH GALLERY LONDON
 www.hauserwirth.com
HAY HILL GALLERY
 www.hayhill.com/www.sirin.co.uk
HAYWARD GALLERY
 www.hayward.org.uk
HENRY SOTHERAN LTD.
 www.sotherans.co.uk/prints
HERALD STREET
 www.heraldst.com
HIGHGATE FINE ART
 www.oddyart.com
HIGHGATE GALLERY
 www.hlsi.net
HOLLYBUSH GARDENS
 www.hollybushgardens.co.uk
HOLLYWOOD ROAD GALLERY
 www.hollywoodroadgallery.com
HOOPERS GALLERY
 www.hoopersgallery.co.uk
HOTEL
 www.generalhotel.org
HOULDSWORTH
 www.houldsworth.co.uk
IAP FINE ART
 www.iapfineart.com
IBID PROJECTS
 www.ibidprojects.com
ICA (INSTITUTE OF CONTEMPORARY ARTS)
 www.ica.org.uk
I-CABIN
 www.i-cabin.co.uk

IMPERIAL WAR MUSEUM
www.iwm.org.uk

INGO FINCKE GALLERY
www.ingofincke.com

IRAN HERITAGE FOUNDATION
www.iranheritage.org

JAGGEDART
www.jaggedart.com

JAMES HYMAN FINE ART
www.jameshymanfineart.com

JAMES KINMONT FINE ART
www.kfineart.co.uk

JEREMY HAMMICK
www.jeremyhammick.co.uk

JERWOOD SPACE
www.wimbledonarts.ac.uk

JILL GEORGE GALLERY
www.jillgeorgegallery.co.uk

JIQ JAQ GALLERY
www.jiqjaq.com

JOANNA BIRD POTTERY
www.joannabirdpottery.com

JOHN BLOXHAM GALLERY
www.johnbloxham.com

JOHN IDDON FINE ART
www.johniddonfineart.com

JOHN MARTIN LONDON
www.jmlondon.com

JOHN MITCHELL FINE PAINTINGS
www.johnmitchell.net

JOHNNY VAN HAEFTEN GALLERY
www.johnnyvanhaeften.com

JONATHAN CLARK
www.jonathanclarkfineart.com

JONATHAN COOPER
www.jonathancooper.co.uk

THE JONATHAN WYLDER GALLERY
www.jonathanwylder.com

KATE MACGARRY
www.katemacgarry.com

KINGS ROAD GALLERY
www.kingsroadartgallery.com

THE KOWALSKY GALLERY at DACS
www.dacs.org.uk

LA GALERIE LONDON
 www.lagalerielondon.co.uk
LAURA BARTLETT GALLERY
 www.laurabartlettgallery.com
LENA BOYLE FINE ART
 www.lenaboyle.com
THE LENNOX GALLERY
 www.lennoxgallery.co.uk
LINDA BLACKSTONE GALLERY
 www.lindablackstone.com
LIMEHOUSE GALLERY
 www.limehousegallery.co.uk
LISSON GALLERY
 www.lisson.co.uk
LLEWELYN ALEXANDER GALLERY
 www.LlewelynAlexander.com
LONDON GALLERY WEST
 www.wmin.ac.uk
LONDON PRINTWORKS TRUST
 www.londonprintworks.com
LONDONPRINTSTUDIO GALLERY
 www.londonprintstudio.org.uk
LONG & RYLE
 www.longandryle.com
LOUIS T. BLOUIN INSTITUTE
 www.ltbfoundation.org
LOUNGE
 www.lounge-gallery.com
LUCY B CAMPBELL FINE ART
 www.lucybcampbell.com
McHARDY COOMBS SCULPTURE GALLERY
 www.mchardy-sculpture.com
MACLEAN FINE ART
 www.macleanfineart.com
MADDER ROSE
 www.madderrosegallery.com
THE MALL GALLERIES
 www.mallgalleries.org.uk
MANYA IGEL FINE ARTS
 www.manyaigelfinearts.com
MARK BARROW FINE ART
 www.markbarrowfineart.co.uk
MARK GALLERY
 www.markgallery.co.uk

MARK JASON GALLERY
www.markjasongallery.com
MARLBOROUGH FINE ART
www.marlboroughfineart.com
MARTYN GREGORY
www.martyngregory.com
MATHAF GALLERY
www.mathafgallery.com
MATTHEW BOWN GALLERY
www.matthewbown.com
MATT'S GALLERY
www.mattsgallery.org
MAUREEN PALEY
www.maureenpaley.com
MAX WIGRAM GALLERY
www.maxwigram.com
THE MAYOR GALLERY
www.artnet.com/mayor.html
MEDICI GALLERY
www.medicigallery.com
MENIER CHOCOLATE FACTORY
www.edgarmodern.com
MERRIFIELD STUDIOS
www.tommerrifield.co.uk
MESSUM'S
www.messums.com
THE METAL GALLERY
www.themetalgallery.com
MICHAEL HOPPEN GALLERY
www.michaelhoppengallery.com
THE MILLINERY WORKS
www.millineryworks.co.uk
MODERN ART
www.stuartshavemodernart.com
MODERN BRITISH ARTISTS
www.modernbritishartists.co.uk
MOONBOW JAKES GALLERY
www.axisweb.org.uk/artist/jonathanpolkest
MORLEY GALLERY
www.morleycollege.ac.uk
MOT
www.motinternational.org
MUMFORD FINE ART
www.mumfordfineart.net

NAHWHAL INUIT ART GALLERY
www.narwhalgallery.com
www.niaef.com
THE NATIONAL GALLERY
www.nationalgallery.org.uk
NATIONAL MARITIME MUSEUM
www.nmm.ac.uk
NEW GRAFTON GALLERY
www.newgrafton.com
NINE CLARENDON CROSS GALLERY
www.nineclarendoncross.co.uk
93
www.ninetythree.co.uk
THE NOBLE SAGE ART GALLERY
www.thenoblesage.com
NOLIA'S GALLERY
www.fotolog.com/alexion555/
NORTHCOTE GALLERY
www.northcotegallery.com
NOVAS GALLERY, CAMDEN
www.novas.org
THE NUNNERY
www.nunnerygallery.com
OCTOBER GALLERY
www.octobergallery.co.uk
OLIVER CONTEMPORARY
www.oliverart.co.uk
ONE IN THE OTHER
www.oneintheother.com
108 ROSEBERY AVE
www.windowsoneoeight.com
OPERA GALLERY LONDON
www.operagallery.com
OSBORNE SAMUEL
www.osbornesamuel.com
OSBORNE STUDIO GALLERY
www.osg.uk.com
PAINTBOX FINE ART
www.paintboxfineart.com
PANTER & HALL
www.panterandhall.com
PARADE
www.maureenpaley.com
PARASOL UNIT FOUNDATION FOR CONTEMPORARY ART
www.parasol-unit.org

PATRICK HEIDE CONTEMPORARY ART
www.patrickheide.com
PAUL STOLPER
www.paulstolper.com
PEACE AND COLOUR GALLERY
www.peaceandcolour.info
PEER
www.peeruk.org
PESCALI & SPROVIERI
www.sprovieri.com
PETER NAHUM AT THE LEICESTER GALLERIES
www.leicestergalleries.com
PHOTOFUSION
www.photofusion.org
THE PHOTOGRAPHERS' GALLERY
www.photonet.org.uk
PIANO NOBILE FINE PAINTINGS
www.piano-nobile.com
THE PICCADILLY GALLERY
www.piccadillygall.demon.co.uk
PIERS FEETHAM GALLERY
www.piersfeethamgallery.com
PLATFORM FOR ART
www.tfl.gov.uk/pfa
PLUS ONE GALLERY
www.plusonegallery.com
PM GALLERY & HOUSE
www.ealing.gov.uk/pmgalleryandhouse
POLLOCK FINE ART
www.pollockfineart.com
PORTAL GALLERY
www.portal-gallery.com
PORTLAND GALLERY
www.portlandgallery.com
POUSSIN
www.poussin-gallery.com
PROJECT 133
www.confusionproject.net
PUMP HOUSE GALLERY
www.wandsworth.gov.uk/gallery
PURDY HICKS GALLERY
www.purdyhicks.com
PYMS GALLERY
www.pymsgallery.com

QUANTUM CONTEMPORARY ART
 www.quantumart.co.uk
THE RAILINGS GALLERY
 www.railings-gallery.com
RAINBIRD FINE ART
 www.rainbirdfineart.com
RAQUELLE AZRAN VIETNAMESE FINE ART
 www.artnet.com/razran.html
RAW SPACE
 www.wadadaw.com
REBECCA HOSSACK GALLERY
 www.r-h-g.co.uk
REDFERN GALLERY
 www.redfern-gallery.com
THE RELIANCE
 www.thereliance.co.uk
RICHARD NAGY
 www.richardnagy.com
RIFLEMAKER
 www.riflemaker.org
RITTER/ZAMET
 www.ritterzamet.com
R.K.BURT & COMPANY LTD.
 www.kess.me.uk
ROCKET
 www.rocketgallery.com
ROKEBY
 www.rokebygallery.com
ROLLO CONTEMPORARY ART
 www.rolloart.com
ROMAN BLACK GALLERY
 www.romanblackgallery.com
RONA GALLERY
 www.ronagallery.com
ROSSI & ROSSI Ltd
 www.rossirossi.com
ROSY WILDE
 www.rosywilde.blogspot.com
THE ROWLEY GALLERY
 www.rowleygallery.co.uk
ROYAL ACADEMY OF ARTS
 www.royalacademy.org
ROYAL ACADEMY SCHOOLS GALLERY
 www.RASchoolsGalleryHornsey.com

ROYAL OVERSEAS LEAGUE
www.roslarts.co.uk
THE RUSSELL GALLERY
www.russell-gallery.com
SAATCHI GALLERY
www.saatchi-gallery.com
SADIE COLES HQ
www.sadiecoles.com
SALON RUSSE
www.salonrusse.com
ROBERT SANDELSON
www.robertsandelson.com
SARAH MYERSCOUGH FINE ART
www.sarahmyerscough.com
SARTORIAL CONTEMPORARY ART
www.sartorialart.com
SARTORIAL CONTEMPORARY ART & NOMOREGREY
www.sartorialart.com
SE1 GALLERY
www.se1gallery.com
SERPENTINE GALLERY
www.serpentinegallery.org
SESAME
www.sesameart.com
SHADES & WOOD ART GALLERY
www.shadesandwood.co.uk
SHERIDAN RUSSELL GALLERY
www.sheridanrussellgallery.com
SIEFF
www.sieffgallery.com
SIGNAL GALLERY
www.signalgallery.com
SIMON LEE
www.simonleegallery.com
SKYLARK GALLERIES:Artist-Run
www.skylarkgallery.com
SOUTHBANK PRINTMAKERS
www.southbank-printmakers.com
SOUTH LONDON GALLERY
www.southlondongallery.org
SOVIET CARPET & ART GALLERIES
www.russian-art.co.uk
SPACE
www.spacestudios.org.uk

STANDPOINT GALLERY
www.standpointlondon.co.uk
STANLEY PICKER GALLERY
www.kingston.ac.uk/picker
STEPHEN FRIEDMAN GALLERY
www.stephenfriedman.com
STERN PISSARRO GALLERY
www.pissarro.net
STOPPENBACH & DELESTRE
www.artfrancais.com
STORE
www.storegallery.co.uk
THE STRANG PRINT ROOM
www.art.museum.ucl.ac.uk
STRUCTURE AND FUNCTION STUDIO/GALLERY
www.s-and-f.co.uk
THE STUDIO
www.clareinskip.com
THE STUDIO GLASS GALLERY
www.studioglass.co.uk
STUDIO 1.1
www.studio1-1.co.uk
STUDIO VOLTAIRE
www.studiovoltaire.org
THE SURGERY
www.surgery123.org
SUTTON LANE
www.suttonlane.com
SW1 GALLERY
www.sw1gallery.co.uk
TADEMA GALLERY
www.tademagallery.com
TAG FINE ARTS
www.tagfinearts.com
TANYA BAXTER CONTEMPORARY
www.kingsroadartgallery.com
TATE BRITAIN
www.tate.org.uk
TATE MODERN
www.tate.org.uk
THACKERAY GALLERY
www.thackeraygallery.com
THEOBALD JENNINGS
www.theobaldjennings.com

THIRTEEN LANGTON STREET GALLERY
www.thirteenlangtonstreet.com
THOMAS DANE GALLERY
www.thomasdane.com
THOMPSON'S GALLERY
www.thompsonsgallery.co.uk
TIMOTHY TAYLOR GALLERY
www.timothytaylorgallery.com
TONI HEATH GALLERY
www.toniheath.com
TRACEY McNEE FINE ART
www.traceymcnee.com
TRANSITION GALLERY
www.transitiongallery.co.uk
TRICYCLE GALLERY
www.tricycle.co.uk
TURF
www.stephaniecarltonsmith.co.uk
20 RIVINGTON STREET
www.fosterart.net
20/21 BRITISH ART FAIR
www.britishartfair.co.uk
UNION
www.union-gallery.com
VALIANT ART GALLERY
www.mongolianartgallery.com
VESTRY HOUSE MUSEUM
www.e17arttrail.co.uk
VICTOR ARWAS GALLERY
www.victorarwas.com
VICTORIA AND ALBERT MUSEUM
www.vam.ac.uk
VICTORIA MIRO GALLERY
www.victoria-miro.com
VILMA GOLD GALLERY
www.vilmagold.com
VINESPACE
www.vinespace.net
WADDINGTON GALLERIES
www.waddington-galleries.com
THE WALK
www.walkgallery.com
WATERHOUSE & DODD
www.modbritart.com

WEBBS ROAD FINE ART
www.thewebbsgallery.co.uk
WHITE CUBE
www.whitecube.com
WHITECHAPEL
www.whitechapel.org
WHITECHAPEL PROJECT SPACE
www.whitechapelprojectspace.org.uk
WHITECROSS GALLERY
www.whitecrossgallery.com
WHITE SPACE GALLERY
www.whitespacegallery.co.uk
WHITFORD FINE ART
www.whitfordfineart.com
WILKINSON GALLERY
www.wilkinsongallery.com
WIMBLEDON ART STUDIOS
www.wimbledonartstudios.co.uk
WIMBLEDON COLLEGE OF ART
www.wimbledon.arts.ac.uk
WOLSELEY FINE ARTS/ MVAC
www.wolseleyfinearts.com
WOOLFF GALLERY
www.woolffgallery.co.uk
W/S FINE ART LTD/ANDREW WYLD
www.andrewwyld.com
THE WYLDER GALLERY
www.thewyldergallery.com
ZEST GALLERY
www.zestgallery.com
ZIZI GALLERY
www.davidlilford.com

PROVINCIAL GALLERIES-ENGLAND

BATH

ADAM GALLERY
www.adamgallery.com
ANTHONY HEPWORTH FINE ART DEALERS LTD
www.anthonyhepworth.com
BEAUX ARTS BATH
www.beauxartsbath.co.uk
CHAPEL ROW GALLERY
www.chapelrowgallery.com
EDGAR MODERN INTERNATIONAL ART
www.edgarmodern.com
THE HOLBURNE MUSEUM OF ART
www.bath.ac.uk/holburne
MAUGER MODERN ART
www.maugermodern.com
ONE TWO FIVE GALLERY
www.carolewaller.co.uk
QUEST GALLERY
www.questgallery.co.uk
ROSTRA & ROOKSMOOR GALLERY
www.rostragallery.co.uk
VICTORIA ART GALLERY
www.victoriagal.org.uk
THE WHITE ROOM GALLERY
www.thewhiteroomgallery.com

BEDFORDSHIRE

EAGLE GALLERY
www.eaglegalleryartists.co.uk

BERKSHIRE

THE CONTEMPORARY FINE ART GALLERY ETON
www.cfag.co.uk
MODERN ARTISTS GALLERY
www.modernartistsgallery.com

BIRMINGHAM

IKON GALLERY
www.ikon-gallery.co.uk
INTERNATIONAL PROJECT SPACE
www.internationalprojectspace.org

MAC
 www.macarts.co.uk

BRISTOL

ARCHITECTURE CENTRE, BRISTOL
 www.architecturecentre.co.uk
ARNOLFINI
 www.arnolfini.org.uk
INNOCENT FINE ART LTD.
 www.innocentfineart.co.uk
JEAN JONES GALLERY
 www.jeanjonesgallery.co.uk
OFF-CENTRE GALLERY
 offcentre@lineone.net
ROYAL WEST OF ENGLAND ACADEMY
 www.rwa.org.uk

BUCKINGHAMSHIRE

BUCKINGHAMSHIRE COUNTY MUSEUM & ART GALLERY
 www.buckscc.gov.uk/museum

CAMBRIDGESHIRE

ANGELA MELLOR GALLERY
 www.angelamellorgallery.com
BROUGHTON HOUSE GALLERY
 www.broughtonhousegallery.co.uk
BYARD ART
 www.byardart.co.uk
CAMBRIDGE BOOK & PRINT GALLERY
 www.cambridgeprints.com
EE FINE ART
 www.eefineart.com
KETTLE'S YARD GALLERY
 www.kettlesyard.co.uk
WYSING ARTS CENTRE
 www.wysingartscentre.org

CHESHIRE

CLARK ART LTD.
 www.clark-art.co.uk

CORNWALL

BESIDE THE WAVE
www.beside-the-wave.co.uk
CORNWALL CRAFTS ASSOCIATION
www.cornwallcrafts.co.uk
MID CORNWALL GALLERIES
www.midcornwallgalleries.co.uk
THE NET LOFT GALLERY
www.cornwall-art.co.uk
OUT OF PLACE GALLERY
www.outofplaceart.co.uk
PADSTOW CONTEMPORARY GALLERY
www.padstowgallery.com
PADSTOW STUDIO
www.padstowstudio.co.uk
THE SALT GALLERY
www.thesaltgallery.co.uk
SCHOOLHOUSE GALLERY, MORVAH
www.morvah.com
THE SQUARE GALLERY
www.thesquaregallery.co.uk
SUCH GALLERY
www.suchgallery.co.uk
TREGONY GALLERY
www.tregonygallery.co.uk
TRELISSICK GARDEN
www.paulvanstone.co.uk
WATERSIDE GALLERY
www.watersidegallery.co.uk
YEW TREE GALLERY
www.yewtreegallery.com

Newlyn:

BADCOCK'S GALLERIES LTD.
www.badcocksgallery.co.uk
NEWLYN ART GALLERY
www.newlynartgallery.co.uk

Penzance:

CORNWALL CONTEMPORARY
www.cornwallcontemporary.com
THE EXCHANGE
www.newlynartgallery.co.uk

GLASS HOUSE GALLERY
 www.glasshousegallery.co.uk
GOLDFISH CONTEMPORARY FINE ART
 www.goldfishfineart.co.uk
HILTON YOUNG
 www.hiltonyoung.com
LIGHTHOUSE GALLERY
 www.lighthouse-gallery.com
NEWLYN ART GALLERY
 www.newlynartgallery.co.uk
NEWLYN SCHOOL GALLERY
 www.newlynschoolgallery.com
PENLEE HOUSE GALLERY & MUSEUM
 www.penleehouse.org.uk
THE PENZANCE ART GALLERY
 www.thepenzanceartgallery.com
RAINYDAY GALLERY
 www.rainydaygallery.co.uk

Scilly Isles:

GALLERY TRESCO
 www.gallerytresco.co.uk

St.Ives:

ALEXANDRA DICKENS STUDIO
 www.alexandradickens.co.uk
ART SPACE GALLERY
 www.artspace-cornwall.co.uk
BELGRAVE GALLERY ST.IVES
 www.belgravegallery.com
THE NEW MILLENNIUM GALLERY
 www.newmillenniumgallery.co.uk
PENHAVEN GALLERY
 www.penhavengallery.co.uk
THE PILCHARD PALACE GALLERY
 www.pilchardpalace.co.uk
PORTHMINSTER GALLERY
 www.porthminstergallery.co.uk
ST IVES SOCIETY OF ARTISTS
 www.stisa.co.uk
TATE ST IVES
 www.tate.org.uk/stives
THE WILLS LANE GALLERY
 www.willslanegallery.co.uk

Truro:

ARTONOMY FINE ART
www.artonomy.co.uk
GLASS HOUSE GALLERY
www.glasshousegallery.co.uk
LANDER GALLERY
www.landergallery.co.uk
LEMON STREET GALLERY
www.lemonstreetgallery.co.uk
LIGHTHOUSE GALLERY
www.lighthouse-gallery.com

CUMBRIA

ABBOTT HALL ART GALLERY
www.abbotthall.org.uk
CASTLEGATE HOUSE GALLERY
www.castlegatehouse.co.uk

DERBY

TREGONING GALLERY
www.tregoningfineart.com

DEVON

AINSCOUGH CONTEMPORARY ART
www.acag.co.uk
THE BURTON ART GALLERY & MUSEUM
www.burtonartgallery.co.uk
DELAMORE GALLERY & SCULPTURE GARDEN
www.delamoregallery.com
MARINE HOUSE AT BEER
www.marinehouseatbeer.co.uk
SPACEX
www.spacex.co.uk
THE DEVON GUILD OF CRAFTSMEN
www.crafts.org.uk
WHITE SPACE
www.whitespaceart.com

Exeter:

POLKA DOT CONTEMPORARY GALLERY
www.polkadotgallery.com

THE TURNER GALLERY
 www.thebarnardturnergallery.co.uk

DORSET

ALPHA HOUSE GALLERY
 www.alpha-house.co.uk
THE ART STABLE
 www.theartstable.co.uk
PIERREPOINT GALLERY
 www.pierrepointgallery.co.uk
SHERBORNE HOUSE
 www.sherbornehouse.org.uk
SLADERS YARD
 www.sladersyard.co.uk

EAST SUSSEX

CHALK GALLERY
 www.chalkgallery.co.uk
DE LA WARR PAVILION
 www.dlwp.com
FOUR SQUARE FINE ARTS
 www.foursquarearts.co.uk
HQ GALLERY
 www.hqgallery.co.uk
THE INDEPENDENT PHOTOGRAPHERS GALLERY
 www.ipgbattle.com
THEBES GALLERY
 www.emmamason.co.uk

ESSEX

CHAPPEL GALLERIES
 www.chappelgalleries.co.uk
FIRSTSITE@THE MINORIES ART GALLERY
 www.firstsite.uk.net
GEEDON GALLERY
 www.geedongallery.co.uk
HEAD STREET GALLERY
 www.headstreetgallery.co.uk
NORTH HOUSE GALLERY
 www.northhousegallery.co.uk

GLOUCESTERSHIRE

ASHCROFT MODERN ART
www.ashcroftmodernart.com
ASTLEY HOUSE FINE ART
www.art-uk.com
CAMPDEN GALLERY
www.campdengallery.co.uk
GALLERY PANGOLIN
www.gallery-pangolin.com
JOHN DAVIES FINE PAINTINGS
www.the-john-davies-gallery.co.uk
JONATHAN POOLE
www.jonathanpoole.co.uk
MARTIN'S GALLERY
www.martinsgallery.co.uk
RUSKIN MILL GALLERY
www.joydeberker.com
WETPAINT GALLERY
www.contemporary-art-holdings.co.uk
THE WONDERWALL GALLERY
www.thewonderwallgallery.com

HAMPSHIRE

ASPEX
www.aspex.org.uk
COURCOUX & COURCOUX CONTEMPORARY ART Ltd.
www.courcoux.co.uk
JOHN HANSARD GALLERY
www.hansardgallery.org.uk
LACEWING FINE ART GALLERY & STUDIO
www.lacewing.co.uk
MILLAIS GALLERY, SOUTHAMPTON SOLENT UNIVERSITY
http://millais.solent.ac.uk
ON LINE GALLERY
www.online-gallery.co.uk
ROWLEY CONTEMPORARY ART
www.rowleycontemporaryart.com
THE SELBORNE GALLERY
www.hampshireartistscooperative.com
SMART GALLERY
www.smartgallery.org.uk

HARROGATE

THE GASCOIGNE GALLERY
www.thegascoignegallery.com
GODFREY & WATT
www.godfreyandwatt.co.uk
108 FINE ART
www.108fineart.com
WALKER GALLERIES CONTEMPORARY ART
www.walkerfineart.co.uk

HEREFORDSHIRE

FEATHERSTONE FINE ART
www.featherstonefineart.co.uk
GALLERY 54
www.gallery-54.com
MONNOW VALLEY ARTS CENTRE
www.monnowvalleyarts.org
WOLSELEY FINE ARTS
www.wolseleyfinearts.com

HERTFORDSHIRE

ARTSHED – WARE Ltd
www.artshed-ware.com
COURTYARD ARTS
www.courtyardarts.org.uk
UNIVERSITY OF HERTFORDSHIRE GALLERIES
www.herts.ac.uk/schools/art/uhgalleries

KENT

CASTLE ARTS
www.castlearts.co.uk
FRANCIS ILES GALLERY
www.francis-iles.com
LIBERTY GALLERY
www.liberty-gallery.com
THE METROPOLE GALLERIES
www.metropole.org.uk
WEST END HOUSE GALLERY
www.west-end-house-gallery.co.uk

LEEDS

HENRY MOORE INSTITUTE
www.henry-moore-fdn.co.uk

LINCOLNSHIRE

WOODBINE CONTEMPORARY ARTS
www.woodbinecontemporaryarts.co.uk

LIVERPOOL

BLUECOAT GALLERY
www.bluecoatartscentre.com
GREENLAND STREET
www.afoundation.org.uk
TATE LIVERPOOL
www.tate.org.uk/liverpool
UNIVERSITY OF LIVERPOOL ART GALLERY
www.liv.ac.uk/artgall

MANCHESTER

CASTLEFIELD GALLERY
www.castlefieldgallery.co.uk
CORNERHOUSE
www.cornerhouse.org
MANCHESTER ART GALLERY
www.manchestergalleries.org
TROUBADOUR GALLERY
www.troubadour-gallery.co.uk
RICHARD GOODALL GALLERY
www.richardgoodallgallery.com

MERSEYSIDE

LADY LEVER ART GALLERY
www.ladyleverartgallery.org.uk
VIEW TWO GALLERY
www.viewtwogallery.co.uk
WALKER ART GALLERY
www.thewalker.org.uk

MIDDLESEX

BELDAM GALLERY
www.brunel.ac.uk/artscentre

LINDA BLACKSTONE GALLERY
www.lindablackstone.com
OSTERLEY PARK HOUSE
www.nationaltrust.org.uk

MILTON KEYNES

MILTON KEYNES GALLERY
www.mk-g.org

NORFOLK

BIRCHAM GALLERY
www.birchamgallery.co.uk
BURNHAM GRAPEVINE
www.burnhamgrapevine.co.uk
DAVID CASE FINE ART
www.davidcasefineart.com
THE FORUM
www.makingfaces.org.uk
GRAPEVINE
www.grapevinegallery.co.uk
KING OF HEARTS
www.kingofhearts.org.uk
KING'S LYNN ARTS CENTRE
www.kingslynnarts.co.uk
NORWICH GALLERY
www.norwichgallery.co.uk
OUTPOST
www.norwichoutpost.org
ST.JUDE'S MODERN BRITISH
www.stjudesgallery.co.uk

NORTHAMPTONSHIRE

FERMYNWOODS CONTEMPORARY ART
www.fermynwoods.co.uk

NORTH YORKSHIRE

BIANCO NERO GALLERY
www.bianconero.co.uk
LUND GALLERY
www.bianconero.co.uk
YORKSHIRE SCULPTURE PARK
www.ysp.co.uk

NOTTINGHAMSHIRE

ANGEL ROW GALLERY
www.angelrowgallery.com

OXFORDSHIRE

BARRY KEENE GALLERY
www.barrykeenegallery.co.uk
BOHUN GALLERY
www.bohungallery.co.uk
BRIAN SINFIELD GALLERY
www.briansinfield.com
MODERN ART OXFORD
www.modernartoxford.org.uk
SIX CHAPEL ROW
www.sixchapelrow.com

RUTLAND

GOLDMARK GALLERY
www.goldmarkart.com
ORANGE STREET GALLERY
www.orangestreetgallery.com
SAMUEL ROBSON FINE ART
www.srfagallery.com

SHEFFIELD

SITE GALLERY
www.sitegallery.org

SCILLY ISLES

GALLERY TRESCO
www.gallerytresco.co.uk

SHROPSHIRE

TWENTY TWENTY
www.twenty-twenty.co.uk

SOMERSET/N. SOMERSET

ATKINSON GALLERY
www.atkinsongallery.co.uk
DORSEFRAME PICTURES
info@barns-grahamtrust.org.uk

THE LLOYD GILL GALLERY
www.thelloydgillgallery.com
REGENT GALLERY
www.regentgallery.co.uk
TOLLHOUSE GALLERY
www.clevedonpier.com

SUFFOLK

BURY ST.EDMUNDS ART GALLERY
www.burystedmundsartgallery.org
THE HUNTER GALLERY
www.thehuntergallery.com
LIME TREE GALLERY
www.limetreegallery.com
THE TOWN HALL GALLERIES – IPSWICH
www.townhallgalleries.org.uk
WILDWOOD GALLERY
www.wildwoodgallery.co.uk

SUNDERLAND

NORTHERN GALLERY FOR CONTEMPORARY ART
www.ngca.co.uk

SURREY

CCA GALLERIES
www.ccagalleries.com
CHALK HILL CONTEMPORARY ART
www.chalkhill.co.uk
FOYER/ JAMES HOCKEY GALLERIES
www.ucreative.ac.uk/galleries
GALLERY ONE
www.gallery-one.co.uk
GUILDFORD HOUSE GALLERY
www.guildfordhouse.co.uk
THE ROBERT PHILLIPS GALLERY
www.riverhousebarn.co.uk

WALSALL

NEW ART GALLERY WALSALL
www.artatwalsall.org.uk

WARWICKSHIRE

ART GALLERY AND MUSEUM
www.warwickdc.gov.uk
COMPTON VERNEY
www.comptonverney.org.uk
THE GALLERY UPSTAIRS
www.thegalleryupstairstorquil.co.uk
LEAMINGTON SPA ART GALLERY & MUSEUM
www.warwickdc.gov.uk/royalpumprooms
THE STOUR GALLERY
www.thestourgallery.co.uk

WEST MIDLANDS

THE BRITISH GLASS BIENNALE
www.ifg.org.uk
THE NEW ART GALLERY WALSALL
www.artatwalsall.org.uk

WEST SUSSEX

ASKEW ART
www.askewart.co.uk
CASS SCULPTURE FOUNDATION
www.sculpture.org.uk
THE MILL STUDIO
www.themillstudio.com
MONCRIEFF-BRAY GALLERY
www.moncrieff-bray.com
PALLANT HOUSE GALLERY
www.pallant.org.uk
THREE ROSES ART GALLERY
www.threerosesgallery.co.uk
ZIMMER STEWART GALLERY
www.zimmerstewart.co.uk

WILTSHIRE

THE CLARE INSKIP GALLERY
www.clareinskip.com
KATHARINE HOUSE GALLERY
www.katharinehousegallery.co.uk
MORGAN-BOYCE
www.morganboyce-gallery.co.uk
NEW ART CENTRE
www.sculpture.uk.com

WHO'S WHO IN ART

WHO'S WHO IN ART

WORCESTERSHIRE

THE GALLERY AT BEVERE
www.beverevivis.com
GREENSTAGE GALLERY
www.greenstagegallery.co.uk

YORK

KENTMERE HOUSE GALLERY
www.kentmerehouse.co.uk

PROVINCIAL GALLERIES-WALES

ANGLESEY

ORIEL TEGFRYN GALLERY
www.orieltegfryn.com
ORIEL YNYS MON
www.angleseyheritage.org.uk
UCHELDRE CENTRE
www.ucheldre.org

CARDIFF

THE ALBANY GALLERY
www.albanygallery.com
KOOYWOOD GALLERY
www.kooywoodgallery.com
MARTIN TINNEY GALLERY
www.artwales.com
ORIEL TRI
www.orieltri.co.uk
ORIEL WASHINGTON GALLERY
www.washingtongallery.co.uk
ST DAVID'S HALL FOYER GALLERIES
www.stdavidshallcardiff.co.uk
WASHINGTON GALLERY
www.washingtongallery.co.uk

CONWY

THE ROYAL CAMBRIAN ACADEMY
www.rcaconwy.org

DENBIGHSHIRE

Y CAPEL
kim.dewsbury@denbighshire.gov.uk

GWYNEDD

LLWYNGWRIL GALLERY
www.llwyngwril-gallery.co.uk
ORIEL PLAS GLYN-Y-WEDDW
www.oriel.org.uk

MONMOUTHSHIRE

THE ART SHOP
info@artshopandgallery.co.uk
DENISE YAPP CONTEMPORARY ART
www.deniseyapp.com

PEMBROKESHIRE

NANT Y COY ARTS
www.nantycoy.co.uk
WEST WALES ART CENTRE
www.westwalesartcentre.com

PENARTH

FFOTOGALLERY
www.ffotogallery.org

POWYS

ORIEL CONTEM PORARY ART
geoffevans@amserve.com
MoMA WALES
www.momawales.org.uk

SWANSEA

GLYNN VIVIAN ART GALLERY
www.glynnviviangallery.org

PROVINCIAL GALLERIES-SCOTLAND

ABERDEENSHIRE

THE CARBYART GALLERY
www.carbyart.co.uk
GALLERY HEINZEL
www.galleryheinzel.com
RIVERSIDE GALLERY
www.riversidegallery.com
TOLQUHON GALLERY
www.tolquhon-gallery.co.uk

ARGYLL & BUTE

JUNO DESIGN GALLERY
www.junogallery.com

DUMFRIES & GALLOWAY

HIGH ST GALLERY
www.highstgallery.co.uk

DUNDEE

DUNDEE CONTEMPORARY ARTS
www.dca.org.uk
THE KRYSZTYNA GALLERY
www.britishprintmakers.co.uk/matysiak

EAST LOTHIAN

STENTON GALLERY
www.stentongallery.com

EDINBURGH

AMBER ROOME CONTEMPORARY ART
www.amberroome.co.uk
ANTHONY WOODD GALLERY
www.anthonywoodd.com
ATTICSALT: contemporary art
www.atticsalt.co.uk
BOURNE FINE ART
www.bournefineart.com
CITY ART CENTRE
www.cac.org.uk

WHO'S WHO IN ART

DEAN GALLERY
www.nationalgalleries.org/summer
EDINBURGH SHOWROOM
www.scottishartpromotion.net
THE FRUITMARKET GALLERY
www.fruitmarket.co.uk
HANOVER FINE ARTS
www.hanoverfinearts.co.uk
INVERLEITH HOUSE, THE ROYAL BOTANIC GARDEN
www.rbge.org.uk
JAMIE PRIMROSE
www.jamieprimrose.com
LANDINGS GALLERY
www.roslarts.co.uk
THE LEITH GALLERY
www.the-leith-gallery.co.uk
NATIONAL GALLERY OF SCOTLAND
www.nationalgalleries.org
OPEN EYE GALLERY
www.openeyegallery.co.uk
RIVERSIDE GALLERY at the Dundas Street Gallery
www.riverside-gallery.com
ROYAL SCOTTISH ACADEMY
www.royalscottishacademy.org
ROYAL SCOTTISH ACADEMY BUILDING
www.thersw.org.uk
THE SCOTTISH GALLERY
www.scottish-gallery.co.uk
SCOTTISH NATIONAL GALLERY OF MODERN ART
www.nationalgalleries.org
SCOTTISH NATIONAL PORTRAIT GALLERY
www.nationalgalleries.org

FIFE

EAST NEUK OPEN STUDIOS EXHIBITION
www.eastneukopenstudios.org

GLASGOW

ART IN THE CITY
www.art-in-the-city.co.uk
BILLCLIFFE GALLERY
www.billcliffegallery.com
BONHAMS
gordonmcfarlan@bonhams.com

COMPASS GALLERY
www.compassgallery.co.uk
CYRIL GERBER FINE ART
www.gerberfineart.co.uk
EWAN MUNDY FINE ART
www.mundyfineart.com
GALLERY 23
www.artgallery23.co.uk
THE GATEHOUSE GALLERY
www.gatehousegallery.co.uk
HUNTERIAN ART GALLERY
www.hunterian.gla.ac.uk
JOHN GREEN FINE ART
www.fineartscotland.com
MANSFIELD PARK GALLERY
www.mansfieldparkgallery.com
ROGER BILLCLIFFE FINE ART
www.billcliffegallery.com
ROYAL GLASGOW INSTITUTE OF THE FINE ARTS
www.rgiscotland.co.uk

ISLE OF ARRAN

THE BURNSIDE
www.theburnside.com

PERTH & KINROSS

FRAMES CONTEMPORARY GALLERY
www.framesgallery.co.uk

SCOTTISH BORDERS

BROUGHTON GALLERY
www.broughtongallery.co.uk
PENNEL GALLERY
www.pennelgallery.co.uk

PROVINCIAL GALLERIES-IRELAND

DUBLIN

APOLLO GALLERY
 www.apollogallery.ie
DUBLIN CITY GALLERY THE HUGH LANE
 www.hughlane.ie
GREEN ON RED GALLERY
 www.greenonredgallery.com
THE IRISH MUSEUM OF MODERN ART
 www.imma.ie
KERLIN GALLERY
 www.kerlin.ie

NOTES

SOCIETY WEBSITES

Armed Forces Art Society
www.afas.org.uk

The Association of Illustrators
www.theaoi.com

Bath Area Network for Artists (BANA)
www.bana-arts.co.uk

Birmingham Artists
www.birminghamartists.com

British Society of Master Glass Painters
www.bsmgp.org.uk

British Society of Painters
www.britpaint.co.uk/society.html

The British Watercolour Society
www.britpaint.co.uk/society.html

Candid Arts Trust
www.candidarts.com

The Cartoonists Club of Great Britain
www.ccgb.org.uk

The Chartered Society of Designers
www.csd.org.uk

Chelsea Art Society
www.chelseaartsociety.org.uk

The Cheltenham Group of Artists
www.beehive/thisisgloucestershire.co.uk/default.asp

The Colour Group
www.colour.org.uk

Euroart Studios and Galleries
www.euroart.co.uk

Federation of British Artists
www.mallgalleries.org.uk

Figurative Artist Network (FAN)
www.steveyeates.co.uk

Free Painters and Sculptors
www.piczo.com/FreePaintersAndSculptors

Group 75
www.group75.co.uk

Guild of Aviation Artists
www.gava.org.uk

Guild of Glass Engravers
www.gge.org.uk

Hesketh Hubbard Art Society
www.mallgalleries.org.uk

The Hilliard Society of Minaturists
www.art-in-miniature.org

Independent Artists Network (IAN)
www.independentartists.org.uk

The International Guild of Artists
www.britpaint.co.uk/society

Ipswich Art Society
www.ipswich-art-society.org.uk

Ipswich Arts Association
www.ipswich-arts.org.uk

Learning Stone Portland Sculpture and Quarry Trust
www.learningstone.org

London Group
www.thelondongroup.com

Manchester Academy of Fine Arts
www.mafa.org.uk

Master Carvers' Association
www.mastercarvers.co.uk

Medical Art Society
www.rsm.ac.uk/social/art.php

Milton Keynes Society of Artists
www.MKSA.org.uk

The National Acrylic Painters Association
www.art-arena.com/napa/

National Association of Decorative and Fine Arts Societies (NADFAS)
www.nadfas.org.uk

National Association of Master Masons
www.namm.org.uk

National Society of Painters, Sculptors and Printmakers
www.ns.highgrovefinearts.co.uk

Nature in Art
www.nature-in-art.org.uk

New English Art Club
www.newenglishartclub.co.uk

Newlyn Art Gallery
www.newlynartgallery.co.uk

Newlyn Society of Artists
www.nsanewlyn.com

Nottingham Society of Artists (NSA)
www.nottinghamstudios.org

Nottingham Society of Artists Trust (NSAT)
www.nottinghamstudios.org

Pastel Society
www.thepastelsociety.org.uk

Penwith Society
www.cwic.cornwall.gov.uk/

Phoenix Arts Association
www.phoenixarts.org

Portrait Institute (USA)
www.jhsanden.com/institute

Printmakers Council
www.printmaker.co.uk/pmc

Queens Park Arts Centre
www.qpic.org

RAG
www.artistsandmakers.com/rag

Royal Academy of Arts
www.royalacademy.org.uk

Royal Birmingham Society of Artists
www.rbsa.org.uk

Royal Cambrian Academy of Art
www.rcaconwy.org

Royal Glasgow Institute of the Fine Arts
www.rgiscotland.co.uk

Royal Hibernian Academy
www.royalhibernianacademy.com

Royal Institute of British Architects
www.riba.org

Royal Institute of Oil Painters
www.mallgalleries.org.uk

The Royal Institute of Painters in Watercolour
www.mallgalleries.org.uk

Royal Scottish Academy
www.royalscottishacademy.org

Royal Scottish Society of Painters in Watercolour
www.thersw.org.uk

Royal Society of British Artists
www.the-rba.org.uk

Royal Society of British Sculptors
www.rbs.org.uk

Royal Society of Marine Artists
www.mallgalleries.org.uk

Royal Society of Miniature Painters, Sculptors and Gravers
www.royal-miniature-society.org.uk

Royal Society of Painter-Printmakers
www.banksidegallery.com

Royal Society of Portrait Painters
www.therp.co.uk

Royal Ulster Academy of Arts
www.ruaonline.com

Royal Watercolour Society
www.royalwatercoloursociety.co.uk

Royal West of England Academy
www.rwa.org.uk

St.Ives Society of Artists
www.stisa.co.uk

Scottish Sculpture Trust
www.scottishsculpturetrust.org

Society for All Artists (SAA)
www.saa.co.uk

Society of Botanical Artists
www.soc-botanical-artists.org

Society of Catholic Artists
www.catholicartists.co.uk

Society of Designer Craftsmen
www.societyofdesignercraftsmen.org.uk

Society of Equestrian Artists
www.equestrianartists.co.uk

Society of Floral Painters
www.socfp.net

Society of Graphic Fine Art
www.sgfa.org.uk

Society of Miniaturists
www.britpaint.co.uk/society

Society of Portrait Sculptors
www.portrait-sculpture.org/

Society of Scottish Artists
www.s-s-a.org

Society of Scribes and Illuminators
www.calligraphyonline.org/

Society of Wildlife Artists
www.swla.co.uk

Society of Women Artists
www.society-women-artists.org.uk

The Society of Wood Engravers
www.woodengravers.co.uk

Spike Island
www.spikeisland.org.uk

Suffolk Art Society
www.suffolkartsociety.org

Ulster Society of Women Artists
www.uswa.co.uk

UK Coloured Pencil Society
 www.ukcps.co.uk
United Society of Artists
 www.united-artists.org.uk
Visual Artists Ireland
 www.visualartists.ie
The Wapping Group of Artists
 www.wappinggroupofartists.info
Watercolour Society of Wales
 www.watercolourwales.co.uk
Yorkshire Artists Exhibition
 www.britpaint.co.uk/soc

NOTES

Who's Who in Art

A

AARON, Cheryl A., BFA, MFA (1972), DipAT (1982); Awards: Arts Council, London Art Board, Paul Hamlyn Trust, Scottish Arts, Docklands Development Trust. *Medium:* oil, prints, photography. *b:* USA. *Educ:* Art Students League, NYC; Tyler School of Fine Arts, Rome. *Studied:* Ohio University, Pratt Institute, Goldsmiths College, London University. *Exhib:* RA, Discerning Eye, National Theatre, Royal Festival Hall, Whitechapel Art Gallery, Curwen Gallery, Barbican, Camden Art Centre, Air Gallery, Hunting-Observer, Museum of London, Garrick-Milne, Christie's, Morley College, Gallery 24, New Academy Gallery, London;Collins Gallery, Glasgow;Cornerhouse,Manchester; Neatherbow, Edinburgh. *Works in collections:* V&A, Marks&Spencer, St.Thomas' Hospital, Chelsea & Westminster Hospital, LB of Hounslow, Hammersmith,TH; New York Public Library, Manchester City Arts, Gateshead, Suffolk CC, Paintings in Hospitals, London Guildhall. *Commissions:* Aldgate Subways Project, GUS. *Publications:* Cafe, Laundry. *Works Reproduced:* Sunday Times Magazine (1998), Evening Standard (1997) The Royal Court Theatre 'The World is a Text' (Prentice Hall), 'Belly Dancing' (Virago). *Signs work:* "Cheryl A.Aaron". *Address:* 44 Copperfield Rd, London E3 4RR.

AARONS, Andrew, NDD (1958), Postgrad.Dip. Printmaking (1991). *Medium:* painter/printmaker; video installations. *b:* London, 1 Feb 1939. *m:* Paula. one *s.* one *d. Educ:* Camberwell School of Art, Junior Dept. (1951-54). *Studied:* Camberwell School of Art (1954-58). *Exhib:* Germany, UK, Canada, USA, Australia. *Works in collections:* CBC Toronto; York University, Toronto; Barclays Bank; Bank of Mexico; Cambridge University; Sternberg Centre, London. *Commissions:* Bodilly Suite; Sporting Etchings: Serigraphs of Newmarket Life; Portraits; Landscapes and Mythology. *Publications:* Two Nations in a New Land; A History of Canadian Painting; Is this Art; Journal of Progressive Judaism: Jewish Quarterly; Kettles Yard Publication. *Principal Works:* Landscapes of Memory; Images of the Shoah; Landscapes of War. *Signs work:* "AARONS" followed by year. *Address:* 16 Huntingdon Rd., Cambridge CB3 0HH. *Email:* alaarons@gmail.com *Website:* www.andrewaarons.com

ABBASSY, Samira, BA (Hons) (1987). *Medium:* painter in oil on paper, canvas and board, gouache on paper, etchings. *b:* Ahwaz, Iran, 29 May 1965. *d of:* Naim and Sonya Abbassy. *m:* Guy Buckles. *Educ:* Hillview School for Girls, Tonbridge; West Kent College of FE. *Studied:* Maidstone College of Art and

Design, Canterbury College of Art. *Exhib:* Mercury Gallery, East West Gallery London, Joan Prats Gallery, NY. *Works in collections:* South East Arts, Leicestershire CC. *Publications:* book jackets: Landscape Painted with Tea by Milorid Pavich, The Ice Factory by Russell Lucas. *Clubs:* Rye Soc. of Artists. *Signs work:* "Samira Abbassy." *Address:* c/o Mercury Gallery, 26 Cork St., London W1X 1HB.

ABBOTT, Paul Philip John, BA (Hons) degree in painting (1986-1989); painter in oil and teacher; currently living and working in the USA. *b:* London, 1960. *m:* Audrey Pietre. one *s.* one *d. Studied:* Plymouth Foundation Course, WSCAD Farnham, Surrey under Richard Mann (1973-1978) and Robert Lenkiewicz (1979-1985). *Exhib:* 17 solo and 8 group exhibs. (1979-2002). *Works in collections:* Christian Marquant, Christopher and Dominique Brooks, and throughout Europe and USA. *Commissions:* Include - Kate Mortimer, Micky Burn, Donald Martin Betts, John Ingram, Asia Tanlaw. *Signs work:* "P. Abbott." *Address:* c/o Jonathan Cooper, Parkwalk Gallery, 20 Park Walk, London SW10 0AQ. *Email:* mail@jonathancooper.co.uk

ABE, Yuki, BA (Hons) Fine Art Painting, MA Fine Art. *Medium:* painter. *b:* Fukuoka, Japan, 4 Jun 1977. *d of:* Haruo and Kuniko Abe. *m:* Thomas Lamb. *Studied:* Wimbledon School of Art (1997-2000); Chelsea College of Art (2000-01); Fukuoka Asian Art Museum (2005). *Exhib:* Lexmark European Art Prize, Eyestorm Gallery, London (2003); British School at Rome (2002,03), Brecce, Rome, Italy (2003). *Address:* Rose Cottage, Belleau, Lincolnshire, LN13 0BW. *Email:* yukilamb@hotmail.com

ABELL, Roy, RBSA, ARCA (Silver Medal, Painting, First Class Hons. 1957); oils, water-colour, etching; Head of School of Painting, Birmingham College of Art; Course Director BA Fine Art, Birmingham Polytechnic (retd.). *Medium:* oil, watercolour. *b:* Birmingham, 21 Jan 1931. *s of:* Alfred Abell, engineer and Muriel. *m:* Mary Patricia. two *s.* one *d. Educ:* Waverley Grammar School, Birmingham (Jack Davis). *Studied:* Birmingham College of Art (1947-52, Harold Smith, Fleetwood-Walker); Royal College of Art (1954-57, Carel Weight, Ruskin Spear, John Minton). *Exhib:* Young Contemporaries, RA, John Moores; one-man exhbns.: National Museum of Wales, Ikon, Oriel (Cardiff), Thackeray (London), Tegfryn (Menai), Birmingham Centenary Artist 1989, Brian Sinfield, Burford; Artifex, Sutton Coldfield. *Works in collections:* National Museum of Wales, ACGB, Art Galleries of Birmingham, Bradford, Lichfield, Walsall, University of Wales, University of Central England. *Publications:* The Birmingham School – The Lavenham Press. *Recreations:* cricket: Moseley C.C.; Warwickshire C.C.Cc. *Signs work:* "Roy Abell." *Address:* 236 Green Lanes, Sutton Coldfield, Birmingham B73 5LX.

ABRAHAMS, Ivor, RA, FRBS, Sir Winston Churchill Fellow (1989); NDD Sculpture (Special Hons). *Medium:* sculpture and prints. *b:* Lancs., 10 Jan 1935. *m:* Evelyne. two (one decd.) *s. Educ:* Wigan Grammar School. *Studied:* St.

Martin's School of Art (under Frank Martin, Anthony Caro), Camberwell School of Art (Prof. Karel Vogel). *Represented by:* Mayor Gallery W1, and Bernard Jacobson Gallery, London W1. *Exhib:* One-man shows: Arnolfini Gallery, Bristol (1971), Aberdeen AG(1972), Mappin Gallery, Sheffield (1972), Ferens Gallery, Kingston upon Hull (1979), Warwick Arts Trust, London (1982); Kölnischer Kunstverein, Cologne (1973), Ikon Gallery, B'ham (1976), Yorkshire Sculpture Park, Wakefield (1984). *Works in collections:* ACGB; Bibliotheque National, Paris; British Council; Denver Museum, Colorado; Metropolitan Museum, NY; V & A; Wilhelm Lembruck Museum, Duisburg; Boymans Museum, Rotterdam, Tate Britain, etc. *Commissions:* Black Lion House, Whitechapel Rd., E1; 39 Chancery Lane with Brian Clark; Painshill Park, Cobham, Surrey, and Chelsea and Kensington Town Hall. *Publications:* E.A. Poe (1975), Oxford Gardens Sketchbook (1976). *Official Purchasers:* over 30 museums worldwide. *Works Reproduced:* numerous magazines, catalogues and books. *Recreations:* reading. *Clubs:* Chelsea Arts. *Signs work:* "Ivor Abrahams." *Address:* 18 Spezia Road, London NW10 4QJ. *Email:* ivor.abrahams@googlemail.com

ABRAHAMS, Ruth, NDD(Painting) (1955), Cert. RAS (1959), Leverhulme award; painter in oil and water-colour on canvas and paper; part-time lecturer, Loughborough College of Art. *b:* London, 11 Mar 1931. *d of:* S.B. Abrahams, importer. *m:* formerly to David Willetts. one *s. Educ:* Dagenham Grammar School, Essex. *Studied:* St. Martin's School of Art (1951-55, Frederick Gore, Bateson Mason), RA Schools (1955-59, Peter Greenham, RA). *Exhib:* Young Contemporaries, London Group, John Moores, RA, Middlesbrough Drawing Biennale (1980); work selected for Sunday Times water-colour competition (1990). *Works in collections:* Durham University, J. Walter Thompson. *Signs work:* "R.A." or "Ruth Abrahams." *Address:* Pear Tree Cottage, 1 Allington Rd., Sedgebrook, Grantham, Lincs.

ACKROYD, Jane V.M., BA (Hons.), MA, RCA (Sculpture); sculptor in mild steel. *b:* London, 25 Feb 1957. *d of:* John Ackroyd, M.A., Oxford. *m:* David Annesley, (divorced). one *s. Educ:* Godolphin and Latymer School, London. *Studied:* St. Martin's School of Art (1975-79, Adrian de Montford, David Annesley, Anthony Caro); RCA (1980-83, Philip King, Bryan Kneale). *Exhib:* International Garden Festival Liverpool (1984), Serpentine Gallery (1984), Anti-Thesis Angela Flowers Gallery (1986), RA Summer Exhbn. (1988, 1989, 1995, 1996, 1997, 1998, 2001); one-man shows Anderson O'Day (1988 and 1991), Worcester College, Oxford (1997), Kingsgate Gallery 2002 (one-man show). *Works in collections:* ACGB, Contemporary Arts Soc., Leics. Educ. Authority, London Docklands Development Corp. *Commissions:* 'Herring Gull' Limehouse, 'Moonlight Ramble' Haymarket London, and others. *Signs work:* "Jane Ackroyd." *Address:* 34, Winton Ave., London N11 2AT. *Email:* jane.ackroyd@virgin.net

ACKROYD, Norman, RA (1991); painter/etcher. *b:* Leeds, 26 Mar 1938. *s of:* Albert Ackroyd, master butcher. *Educ:* Cockburn High School, Leeds. *Studied:*

WHO'S WHO IN ART

RCA (1961-64). *Exhib:* extensively in Europe and USA. *Works in collections:* Tate Gallery, V&A, Museum of Modern Art, NY, National Galleries of Scotland, Canada, S. Africa, Norway, The Rijksmuseum and Stedelijk Amsterdam, The Albertina Vienna, Musee d'Art Historie Geneva, British Council, Leeds, Manchester, Sheffield, Hull, Glasgow, Aberdeen, Norwich, Preston, Bradford, Newcastle, and other city A.G's. *Publications:* Thirty minute film on etching for BBC, writing for Studio International. *Address:* 1 Morocco St., London SE1 3HB.

ADAIR: see PAVEY, Don,

ADAIR, Hilary, NDD (1963), ATC (1965), RE (1991); painter/printmaker in water-colour, acrylic, oil, etching, silkscreen. *b:* Sussex, 29 May 1943. *m:* Julian Marshall. two *s. Educ:* Chichester High School for Girls. *Studied:* Brighton College of Art (1960-61; 1964-66, J. Dickson), St. Martin's School of Art (1961-63, F. Gore, A. Reynolds). *Exhib:* British Council, RA, Sue Rankin Gallery, Jill Yakas Gallery Athens, RWA, Concourse Gallery, The Barbican, Bankside Gallery, Museum of Garden History, London, Mall Galleries. *Works in collections:* British Council, Gray's Library, Eastbourne, Lancs., Oldham and Stoke-on-Trent Educ. Authorities, Paintings in Hospitals, Royal Devon and Exeter Hospital, Ashmolean Museum, (RE.Collection) Macmillan/Heineman. *Commissions:* Hilton and Intercontinental Hotels, Athens, P&O's 'Aurora' four Edns. of etchings. *Publications:* The English Garden (Aug. '98) - Arts Review - The Athenian Magazine, The Artist, The Somerset Magazine. *Signs work:* "Hilary Adair" on prints, "Adair" on paintings. *Address:* Halse Cottage, Winsford, nr. Minehead, Som. TA24 7JE. *Email:* hilaryadair@halsecottage.fsnet.co.uk *Website:* www.hilaryadair.co.uk

ADAMS, Anna: see BUTT, Anna Theresa,

ADAMS, Ken Praveera, MA (1958), DipFA (1964), DipAT (1986); painter in oil and acrylic, sculptor in bronze and ceramic; formerly lecturer in sculpture at St. Martin's School of Art. *b:* Northumberland, 1 Sep1933. *s of:* Alan Adams. Grandson of Moses James Adams. *Educ:* Balliol College, Oxford. *Studied:* Slade School of Fine Art. *Exhib:* London, Suffolk, Amsterdam, Dusseldorf, Paris, New York, R.A. Summer Shows (intermittently). *Works in collections:* Museum Sztuki, Lodz, Poland, and private collections in Europe and USA. *Commissions:* Netherhall Gardens Gable, Wild Boar, etc. *Publications:* Leonardo Vol.12 (1979) Commentary on Sculptures. *Works Reproduced:* Leonardo (above). *Misc:* Figurative work veering to abstraction '60 to '65 and again '80 to '85. Also composes music. *Signs work:* "Ken Praveera Adams" or "K.P.A." or intermediate forms. *Address:* 19 Dartmouth Park Rd., London NW5 1SU. *Email:* kenadams33@wtsonline.co.uk

ADAMS, Marina, Dip LA Reading University 1962. Member Landscape Institute 1968; landscape architect in private practice: drawings in ink, water-colour, gouache, crayon. *b:* Athens, 27 Aug 1940. *d of:* Nicholas Haidopoulos and

Maria Stavropoulos. *m:* (1964) Robert John Adams, dissolved (1980). one *s.* one *d. Educ:* Pierce College, Athens. *Studied:* Reading University (1959-1962). *Exhib:* RA Summer Exhbn. (1987, 1988, 1989, 1990, 1992, 1993, 1994, 1998). *Signs work:* "Marina Adams." *Address:* 3 Pembroke Studios, Pembroke Gdns., London W8 6HX. *Email:* marinadams@dial.pipex.com

ADAMS, Sarah, BA (Hons 2:1) Fine Art (1984), MA (RCA) Fine Art Printmaking (1987). *Medium:* oil, watercolour. *b:* Wokingham, 27 Jun 1962. *d of:* Mr & Mrs H H G Adams. *Educ:* Falmouth School of Art (Foundation Course 1980-81). *Studied:* Gloucestershire College of Art and Technology (BA Hons 1981-84); Royal College of Art (MA Fine Art Printmaking 1984-87); University of Mysore (Folklore Studies, 1991-92). *Represented by:* Pierrepont Fine Art, 1 Folly Bridge, Oxford; Falle Fine Art, Halkett St, Jersey. *Exhib:* Hunting Art Prize Exhibition (2003); Beyond England, Royal College of Art (1996); solo shows: Falle Fine Art (1995, 1998, 2000, 2001, 2002); Ice House, Holland Park (1992, 1994); Coach House Gallery, Guernsey (2003). *Works in collections:* Royal College of Art, Crill Canavan, Cater Allen Bank, Bank of America, Ogier and Le Mesurier, Sedgewick Group, Count de Monteluce. *Commissions:* 'Paarl Rock', oil on linen (2003), Lord Lilford. *Publications:* Encyclopedia of Drawing Techniques, Ian Simpson, London 1987; Bv. Surfish, catalogue intro, Gallery 7, Bombay 1992; Sarah Adams: Land and Sea, monograph and text by Dr. Heather MacLennan (2000). *Principal Works:* Plemont series (1-3), Land and Sea series (1-4), Quarry series. *Clubs:* RCA Society; South West Academy of Fine and Applied Arts. *Address:* 41 Fore Street, Tregony, Truro, Cornwall TR2 5RW. *Email:* vivier@localdial.com

ADAMSON, Crawfurd, DA (1975); painter in oil and pastel. *b:* Edinburgh, 24 Mar 1953. *m:* Mary Phimister. one *s.* one *d. Educ:* Royal High School, Edinburgh. *Studied:* Duncan of Jordanstone College of Art (1971-76, Alberto Morrocco, David McLure, Jack Knox). *Exhib:* 12 one-man shows since 1984 (seven in London); group shows in UIK, USA, Spain, France, Japan, Monaco. *Works in collections:* Metropolitan Museum of Art, NY. *Publications:* exhibition catalogues (1991, 1995). *Signs work:* "Crawfurd Adamson." *Address:* 14 Seddlescombe Rd. Sth. St.Leonards-on-Sea TN38 0TA. *Email:* crawfurd@gmail.com *Website:* www.crawfurdadamson.com

AHMAD, Sophie Maryum, BA (Hons) Fine Art (Painting). *Medium:* oil. *b:* Essex, 24 Jun 1973. *m:* Glen Goodman. *Studied:* The Byam Shaw School of Art (1991-92); Central St.Martin's College of Art and Design (1993-96). *Represented by:* Rainbird Fine Art, London. *Exhib:* Christie's 'Art for Life' (2007), Rainbird Fine Art, London (2005-present), Artlounge Gallery, Birmingham (2004); Contemporary Art Society, Art Futures (1996, 2002, 2003), Affordable Art Fair, London (2003, 2004), Will's Art Warehouse, London (2004), The Hurlingham Club, London (2002), Sloane Graphics, London (1996, 1997, 2001, 2002). *Works in collections:* work held in private collections in the UK, India, Barbados, USA, Japan, including private collection of Raymond Kelvin, Founder and CEO of Ted

Baker. *Publications:* features in The Jackdaw, The Lady magazine, and Voyager magazine. *Signs work:* "S.M.Ahmed". *Address:* Flat 1, 3rd Floor, Northwood Hall, Hornsey Lane, London N6 5PH. *Email:* sophieahmad@blueyonder.co.uk *Website:* www.rainbirdfineart.com

AIERS, Pauleen Victoria, painter and printer in oil, pastel, charcoal, monoprint, collagraph. *b:* Inverness, 1926. *m:* David Aiers (decd.). one *s.* one *d. Educ:* West Heath School, Sevenoaks. *Studied:* Warsaw Beaux Arts (1947-48), Ju I. Hsiung, Philippines (1959-62), Morley College (1984-85), with Oliver Bevan, London (1984-89). *Exhib:* solo shows: Lionel Wendt Gallery, Colombo, Gallery 47 and Wine Gallery, London, National Museum of Fine Arts, Malta; two person: Hyde Park Gallery, London, Riverside Gallery, Richmond; others, Singapore Art Soc., Spirit of London, Royal Festival Hall, Camden Annual, Southwark Cathedral, Gallery 10, Flying Colours Gallery, International Arts Fair, Islington, Art for Sale, Thornton Bevan Arts. *Works in collections:* National Museum of Fine Arts, Malta. *Signs work:* "P.A." *Address:* 13 Harefield, Hinchley Wood, Surrey KT10 9TG. *Email:* pvaiers@waitrose.com

AINLEY, John Anthony, retired Head Teacher; Diploma in Child Development; MSc, Diploma in the Visual Arts; water colour painter. *b:* Sheffield, 1931. *m:* Ann. one: Mark *s.* one: Elizabeth *d. Works in collections:* Self portrait on display in Ruth Borchard's permanent collection of British Self-portraits at King's Place in King's Cross London. *Publications:* features in 'Face to Face: A Collection of 100 20th Century Self Portraits'. *Clubs:* Founder of Leatherhead Art Club. Convenor of "Surrey Painters". *Address:* Bridleside, 1A Yarm Ct. Rd., Leatherhead, Surrey KT22 8NY.

AINSCOW, George Frederick, Paris Salon gold and silver medallist (1980, 1981); textile designer, artist in water-colour and oil. *b:* Manchester, 10 Feb 1913. *s of:* George Ainscow, manufacturer and designer. *m:* (1) Margaret Shackleton (decd.). (2) Marjorie Standring. one *s.* one *d. Educ:* Derby St. School, Rochdale. *Studied:* Rochdale College of Art (1929-33, G.Wheeler, Principal). *Exhib:* RA, RI, RBA, NEAC, Preston AG, RWS Open; one man shows, Rochdale AG, Mall Galleries, Salford AG, Oldham AG. *Works in collections:* RAF Museum, Hendon, Bury AG, Rochdale A.G, work in private collections, textile designs in V & A and Whitworth Art Gallery, Manchester. *Signs work:* "G.F. Ainscow." *Address:* 4 Saxonholme Rd., Castleton, Rochdale, Lancs. OL11 2YA.

AIRD, Philippe Leigh, BA (Hons); 1st International Video Festival Award. *Medium:* oil. *b:* Manchester, 14 Jul 1961. *s of:* George & Joyce Aird. *Studied:* Salford College of Art; Chelsea School of Art; taught by L S Lowry and Harold Riley. *Represented by:* Farmilo Fiumano. *Exhib:* Sotheby's (Farmilo Fiumano); Affordable Art Fair; New York, Los Angeles, Glasgow, Stockport Art Gallery. *Works in collections:* MUFC players. *Commissions:* private. *Publications:* Phoenix Gallery brochure; book "Eye of the Beholder". *Works Reproduced:* Vortex Paintings. *Principal Works:* abstract. *Recreations:* tennis. *Signs work:*

'Philippe'. *Address:* Phoenix Studio, 17 Ellesmere St., Castlefield, Manchester M15 4JY. *Email:* phil19@btconnect.com *Website:* www.PhilippeAird.com; www.phoenix-gallery.co.uk

AITCHISON, Craigie, painter in oil. *b:* 13 Jan 1926. *Studied:* Slade School of Fine Art. *Commissions:* Four panels for Truro Cathedral. *Publications:* 'Art of Craigie Aitchison' by Gillian Williams. *Signs work:* "Craigie Aitchison." *Address:* c/o Royal Academy of Arts, Burlington House, London W1.

AIVALIOTIS, Sharon Firth, RE, BA (Hons.) (1979), Postgrad. Dip. (Printmaking) (1980); artist/printmaker in mezzotint, all intaglio processes and graphite; part-time lecturer, St. Martin's School of Art and Design. *b:* Trinidad, 12 Apr 1951. *m:* Stak Aivaliotis. *Studied:* St. Martin's School of Art (1975-79, Albert Herbert), Slade School of Fine Art (1979-80, Bartolomeo Dos Santos). *Exhib:* solo shows: Jill George Fine Art London since 1985; many mixed shows nationally and internationally. *Works in collections:* V&A, Library of Congress Washington DC, Whitworth Gallery Manchester, Ferens AG Hull. *Publications:* 'The Mezzotint: History and Technique' by Carol Wax (Thames and Hudson). *Signs work:* "Sharon Firth Aivaliotis" or "S. Aivaliotis." *Address:* 22 Brownlow Mews, London WC1N 2LA.

AL-ATTAR, Suad, BA Fine Art; PG Dip (Printmaking); awards: The CIB Award for Excellence (1999), Honorary Award, 1st International Biennial, Malta (1995), Gold Medal, International Biennial, Cairo, Egypt. *Medium:* oil, prints. *b:* Baghdad, Iraq. *d of:* Ali Sadq Al-Attar. three *d. Studied:* A.A.Calif. Polytechnic Univ., Baghdad Univ., Wimbledon School of Art & Central School of Art and Design, London. *Exhib:* solo: Green Art Gallery, Dubai (2006), Leighton House Museum, London (2006, 1997), Chelsea Art Club (2002, 2004), Westcliffe Gallery, Sheringham, Norfolk (2004), Albemarle Gallery, London (1999), Europ Gallery, Los Angeles (1990), Annex Gallery, London (1981), Gallery ALif, Washington DC (1985). Group: British Museum (2006), Women of the World, New York (2000), 230th Summer Exhbn., Royal Academy of Art (1998). *Works in collections:* British Museum, Gulbenkian Collection, Barcelona Museum of Modern Art, Amman, Jordan, Museum of Modern Art, Damascus, Museum of Modern Art, Kuwait, Indira Gandhi private collection, New Del Helhi, Conference Center, Qatar. *Commissions:* Paintings for the Holland Park 1998 Opera. *Publications:* 'Suad Al Attar' (large book of the artist's works), World Literature Project by McGraw-Hill of New York. *Official Purchasers:* The British Museum, Modern Art Museum, Baghdad. *Works Reproduced:* by Bridgman Art Library; Greeting card by UNICEF (1975, 1993). *Recreations:* travel. *Clubs:* Chelsea Art Club. *Signs work:* "SUAD AL ATTAR". *Address:* 18 Fitz James Avenue, London W14 0RP. *Email:* suadalattar@hotmail.co.uk

ALDOUS, Veronica, BA (Hons), Cert. Ed. *Medium:* watercolour, drawing, poetry, art criticism. *b:* Herts., 9 Jun 1962. *d of:* Vivienne & Basil Ripley-Duggan. *Educ:* St.Mary's Catholic School. *Studied:* Ravensbourne College of Art.

Represented by: Allied Artists. *Exhib:* Coningsby Gallery, London; Society for Art of the Imagination, Highgate; The Gentle Gallery; Avalon Gallery. *Works in collections:* private collections. *Commissions:* Inn on the Park Hotel, Hyatt Carlton Hotel, Maxwell's Restaurant. *Publications:* Quarto Book of Faeries, Quarto Book of Dragons and Mythical Beasts, HQ Quarterly, Urthona. *Principal Works:* Estella's Song; Mr. Wolfslick; Commuter; Seahenge. *Misc:* art lecturer Beechwood Centre; arts correspondent 'Urthona'. *Signs work:* 'Veronica Aldous'. *Address:* 7a Downscourt Road, Purley, Surrey CR8 1BE. *Email:* veronicaspaintbox@yahoo.co.uk *Website:* www.aldousart.co.uk

ALEXANDER, Elsie W. M., AMNS (1977); artist in oil on canvas; retired company director. *b:* Ware, Herts., 13 Feb 1912. *d of:* George Albert Barker, farmer. *m:* Herbert John Alexander, Ph.D. one *d. Educ:* Grammar School, Ware. *Studied:* pastel and abstract painting at Montclair State College, NJ (1958); graphic art with Hyman J. Warsager; also pupil of the late Victor Askew, ROI, FIAL(1972-73). *Exhib:* City of London (awarded vellum and freedom, Worshipful Co. of Painters and Stainers, freedom, City of London), Leicester, Chelsea, Cornwall, Norfolk; one-man show, Mill Hill (1971). First prize winner of She comp. (Chelsea, 1968). *Clubs:* Buckingham Art Soc., Wine Trade Art Soc. *Signs work:* "ALEXANDER." *Address:* 20 Parkside Drive, Edgware, Middx.

ALEXANDER, Gregory, RWS (1984), BA (1981); artist in water-colour and oil. *b:* Ramsgate, Kent, 14 May 1960. *s of:* Chris Alexander, ARE, ARCA. *m:* Francesca Rigoni. *Studied:* Canterbury College of Art (1976-78), W. Surrey College of Art (1978-81). *Represented by:* Catto Gallery, London NW3 1DP. *Exhib:* RWS, NEAC, RA Summer shows, and over 25 one-man exhbns. in England and Australia. *Works in collections:* RWS Diploma, ANZ Bank Melbourne, National Gallery of Australia. *Publications:* Kipling's The Jungle Book (Pavilion 1991), Tales from the African Plains (Pavilion 1994), Step by Step Water-colour Painting (Weidenfeld & Nicolson 1994). *Signs work:* "Gregory Alexander." *Address:* 1/73 Abbott St., Sandringham, Melbourne, Victoria 3191, Australia. *Email:* greg@gregory-alexander.com *Website:* www.gregory-alexander.com

ALEXANDER, Hazel, sculptor in bronze and cold cast bronze. *b:* Newcastle-on-Tyne, 1 Feb 1912. *d of:* Charles Zuckerman. *m:* John Alexander. one *s.* three *d. Educ:* Smarts College. *Studied:* Luton Art School (1936), Camden Inst. (1970 under Joan Armitage and Fred Kormis). *Exhib:* Mall Gallery, Ben Uri Gallery (The London Jewish Museum), Bristol Cathedral (Amnesty), St. Paul's Cathedral, Festival Hall, Discerning Eye. *Works in collections:* Cambridge University Library, All England Lawn Tennis Club (Members Lounge), Museum of Israel Defence Forces, King Solomon Hotel, Elat, Wimbledon Museum, Wolfson-Poznansky Home, London, Ben Uri Museum; private collections in England, France, Italy, Germany, U.S.A., Israel. *Commissions:* Wimbledon Lawn Tennis Club. *Official Purchasers:* All England Lawn Tennis Club-Wimbledon. *Signs*

work: "Hazel Alexander." *Address:* 34 West Heath Rd., Hampstead, London NW3 7UR.

ALEXANDER, Naomi, NDD (1959), ROI (1982); British Association of Paintings Conservators-Restorers; Council, ROI; Trustee for Paintings in Hospitals. *b:* 1938. *d of:* John and Hazel Alexander. one *d. Studied:* Hornsey College of Art (1954-59), Central School of Art (1961-63). *Exhib:* RA (1985-2006), Spink, Mercury Gallery, NEAC, RBA, ROI, RP, Fosse, David Messum, British municipal galleries, Richmond Gallery; one-man shows Ben Uri Gallery, Sheila Harrison, Sheridan Russell Gallery, Buxton Museum, Baker Tilly, the Temple Tolerence Centre, Vilnius, Lithuania, Lithuanian Embassy, London, LJCC London. *Works in collections:* V&A; Duke of Devonshire; Japanese Broadcasting; Salomon Bank, Tokyo; Sir Richard Storey; Katharine, Viscountess Macmillan; 2nd Royal Tank Regt.; Sultan of Oman; Paintings in Hospitals; Baker Tilly; Europos Parkas, Lithuania. *Publications:* Graves Encyclopedia of RA Exhbns., Artist and Illustrator, 'Once Upon a Time in Lithuania' (David Paul Books); Collins, Quorto publications. *Works Reproduced:* The Royal Academy, Arts Review, Observer, Tableaux, Galleries, etc. *Signs work:* "Naomi Alexander." *Address:* 6 Bishops Ave., London N2 0AN. *Email:* naomitalexander@hotmail.com *Website:* www.axisartists.org/artistsid/8735

ALEXANDER, Steven, BA, PhD. *Medium:* landscape and townscape in oils and watercolour. *b:* Margate, 9 Dec 1951. *s of:* Chris Alexander, ARE, ARCA. *m:* Ann. one *s.* one *d. Educ:* Simon Langton Grammar School, Canterbury. *Studied:* Kings College, London. *Exhib:* RA Summer Exhbn, RSMA, NEAC, RBA. *Works in collections:* many private collections in UK and Europe. *Works Reproduced:* Wapping Group of Artists website. *Recreations:* reading, travelling, writing. *Clubs:* Wapping Group of Artists. *Signs work:* 'STEVEN ALEXANDER'. *Address:* 16, Kings Ride, Camberley, Surrey, GU15 4HX.

ALEXANDRI, Sara, Dip. of Royal Academy of Fine Arts in Painting (Florence, Italy); art teacher; landscape, flower and figure painter in oil and water-colour; etcher. *b:* Kherson, Russia, 22 Oct 1913. *d of:* Schneior Alexandri, teacher. *m:* Michael Perkins. one *s. Educ:* High School, Palestine, and privately in Italy and Switzerland. *Studied:* Royal Inst. d'Arte, Florence, and Royal Academy of Fine Arts, Florence (1936-40, 1946-47). *Exhib:* RA, RBA, WIAC, RWA, Paris Salon, foreign and main provincial galleries. *Signs work:* "S. ALEXANDRI" or "S. Alexandri."

ALFORD, John, NDD, ATD, RBA, NEAC; painter in oil and water-colour; Director of Art, Shrewsbury School (retd. 1989). *b:* Tunbridge Wells, 14 Oct 1929. *s of:* Arthur William Alford. *m:* Jean. one *s.* two *d. Educ:* Reading School. *Studied:* Camberwell School of Art (1949-53, Gilbert Spencer, Richard Eurich, Bernard Dunstan). *Exhib:* RA, RWA, RBA, RSMA, NEAC; numerous one-man shows in England, S. Africa, France, Canada. *Works in collections:* At home and abroad, Reading A.G., Shropshire C.C. *Commissions:* several for the Royal Navy

and Royal Canadian Navy. *Signs work:* "John Alford." *Address:* 47 Porthill Rd., Shrewsbury, Shropshire SY3 8RN.

ALFORD, Michael, BA Hons; Agnes Reeve Memorial Prize; Green & Stone Prize; Lodi Mural Festival Prize. *Medium:* oil, acrylic, watercolour. *b:* Cookham, 15 Sep 1958. *s of:* Col.J.R.Alford. *m:* Makta Marie Maretich. one *d. Studied:* Durham University; Chelsea School of Art; Slade (part-time and extra mural). *Represented by:* Duncan Campbell. *Exhib:* Duncan Campbell; Royal Society of Oil Painters; Chatto Gallery; Kings Road Gallery; Collins & Hastie; Highgate Fine Art; Blackheath Gallery. *Works in collections:* San Francisco Museum of Modern Art (Fort Mason). *Commissions:* Chelsea Town Hall; Harold Lancer Corporation; Princess Ayse Osmanoglu. *Official Purchasers:* Hill & Knowlton. *Recreations:* painting, walking. *Clubs:* Chelsea Art Society. *Signs work:* 'MR' or 'M.Alford'. *Address:* 127 Trentham St., London SW18. *Email:* info@michaelalford.co.uk *Website:* www.michaelalford.co.uk

ALLBROOK, Colin, RI, ARSMA, SEA, SWAC; Awards: Excellence in Watercolour, RWA (twice); Cuneo Medal, SEA (twice); Royal Bath and West (twice). *Medium:* watercolour, oils. *b:* Barnet, 8 Mar 1954. *s of:* W.P.Allbrook. *m:* Christine. two *s.* two *d. Educ:* Ashmole Secondary Modern. *Studied:* evening classes: St.Martin's School of Art. *Exhib:* RI, RWS, RSMA, RWA, ROI, PS, SEA; Sunday Times Watercolour Competition; Lynn Painter Stainers Exhbn; Royal Bath & West; NRA Llewelyn Alexander. *Works in collections:* Daler Rownwy; Burton Art Gallery & Museum; Marquis of Salisbury. *Publications:* Colin Allbrook's North Devon (Halsgrove, 2002). *Works Reproduced:* by Sally Mitchel Fine Arts. *Signs work:* 'COLIN ALLBROOK'. *Address:* Hollycot, Umberleigh, North Devon, EX37 9AS. *Email:* colin@allbrook.fsbusiness.co.uk

ALLCOCK, Annette, painter in oil and gouache, greeting card designer, illustrator. *b:* Bromley, Kent, 28 Nov 1923. *d of:* John William Rookledge. *m:* James Allcock. one *s.* one *d. Educ:* various private schools. *Studied:* West of England College of Art (Stanley Spencer). *Exhib:* RA, RWA, Bath Contemporary Arts Fair. *Works in collections:* Japan. *Works Reproduced:* illustrating childrens books. *Signs work:* "Annette Allcock." *Address:* 22 South St., Corsham, Wilts. SN13 9HB.

ALLEN, Barbara, ARUA, BA(Hons.) Graphic Design, Ad.Dip.; John Ross Prize for Water-colour (RUA 1992); self employed artist in water-colour. *b:* Belfast, 5 Sep 1959. *m:* Paul Ferran. three *s. Studied:* University of Ulster, Belfast (1978-84, Terry Aston). *Exhib:* annually with RUA; solo shows: St. John's Art Centre, Listowel (1998), McGilloway Gallery, Derry (1998, 2004), Galleri Parken, Bergen, Norway (1993). *Works in collections:* The White House, Washington DC, Tele (Norwegian Telecom), BP Oil Europe, etc, and private collections throughout N.America and Europe. *Commissions:* N.I. Blood Transfusion Service, Bass Ireland Ltd., Royal Norwegian Embassy, London, etc. *Publications:* illustrates regular column with UK magazine 'Country Living';

illustrations for 'Irish Shores' and 'Uster Rambles' (Greystone Press). Residencies: The Florence Trust, Islington (1991); several residencies at Tyrone Guthrie Centre since 1983. *Official Purchasers:* University of Ulster. *Recreations:* beach walking. *Signs work:* "Barbara Allen." *Address:* 12 Newton Park, Four Winds, Belfast BT8 6LH.

ALLEN, David Frederick, CEngMICE (1970), RSMA (2006); Frank Herring Award (Pastel Society, 2002), Classic Boat magazine award (RSMA 2005), Conway Maritime Press Award (RSMA 2006); Draughtsman and Chartered Civil Engineer. *Medium:* pastel. *b:* Harrogate, 10 Mar 1945. *s of:* Nellie & George Frederick Allen. *m:* Diane. *Exhib:* Laing (1990-97), Walker Galleries (1995-2007), Pybus Fine Art (1998-2007), John Noott Galleries (2001-04), Pastel Society (1997, 98, 2002-05), Eton College, Royal Society of Marine Artists (1995-2007). *Works Reproduced:* A Celebration of Marine Art (Bounty Books), International Artist magazine, Leisure Painter magazine. *Recreations:* hill walking. *Clubs:* Fylingdales Group of Artists (elected 1998). *Signs work:* "David Allen". *Address:* 2 Almsford Road, Harrogate, North Yorkshire, HG2 8EQ. *Email:* davidallenart@tiscali.co.uk

ALLEN, Joe, BA Hons, RA Post-Graduate Diploma. *Medium:* oil. *b:* 23 Aug 1955, Airdrie, Scotland. *s of:* Annie Campbell & Laurence Allen. *Educ:* St.Margarets Secondary School, Airdrie, Scotland. *Studied:* Camberwell School of Arts and Crafts, St.Martin's School of Art, RA Schools, London. *Represented by:* Galerie ClaireFontaine, Luxembourg. *Exhib:* Luxembourg, Vienna, Munich, Cologne, Basel, Paris, all major art fairs in Europe and America since 1986; John Moors Liverpool exhbn, RA Summer Show, Burlington Fine Art Gallery, London W1; Museum Schloss Moyland, 10 Years Work, Germany. *Works in collections:* Dom Museum, Trier, Germany; Schloss Moyland, Germany. *Publications:* numerous magazines and newspapers in Europe. *Works Reproduced:* catalogues and many websites; major fully illustrated catalogue of the Last Ten Years Work published by Museum Schloss Moyland, Germany. *Principal Works:* series of large 10x9ft paintings produced over last ten years. *Recreations:* playing guitar and piano, writing, reading. *Clubs:* Reynolds Club. *Misc:* works are inspired by French Art History and European & American literature. *Signs work:* Joe Allen. *Address:* 31 Mansfield Rd, London E11 2JN.

ALLEN, Martin John, BSc (Hons) 1991 (Horticulture); Royal Horticultural Society Gold Medal (1999-Group, 1997, 1995); Society of Botanical Artists - Certificate of Botanical Merit (1998, 1996); Chelsea Physic Garden Florilegium Society - Emeritus Fellow. *Medium:* watercolour. *b:* Sunderland, 22 Jun 1970. *Studied:* Nottingham University (1988-91). *Exhib:* Gallery 27, Cork Street, London (2007); Hortus, London (2001); Royal Horticultural Society, London (1999, 1997, 1995); Society of Botanical Artists, London (1998, 1997, 1996); Harlow Carr Botanical Gardens, Harrogate (1995, 1994). *Works in collections:* Shirley Sherwood Collection. *Commissions:* Collectors' plate series (Autumn - 3 designs); Royal Horticultural Society Enterprises Ltd (1996-98). *Works*

Reproduced: Pulsatilla Vernalis, Flower Paintings from the Apothecaries Garden (2005). *Principal Works:* 'Seeing Potential' series. *Clubs:* Chelsea Physic Garden Florilegium Society, American Society of Botanical Artists. *Misc:* Consultant in native plant conservation and horticulture. *Signs work:* "M J ALLEN", "MARTIN J ALLEN", or "MARTIN ALLEN". *Address:* 4a Samaria Gardens, Middlesbrough, TS5 8DF. *Email:* paintings@martinjallen.com *Website:* www.martinjallen.com

ALLINSON, Sonya Madeleine, MFPS (1989). *Medium:* artist in oil, acrylic, gouache, collage, pen and wash. *b:* London. *d of:* Dr. Bertrand P. Allinson. *Studied:* St. Martin's School of Art (Fine Art course); Landscape scholarship from RA; RA Schools (3 Year Post-graduate course). *Exhib:* one-man shows: Federation of British Artists, Cheltenham General Hospital, Cheltenham Museum Cafe, Cirencester Workshops, Everyman, Axiom Centre for the Arts, Cheltenham, Sheffield; mixed: R.A., Leicester Galleries, R.B.A., New English, Tooth's, Heal's, Brighton, Fosse, Manor House, Delahaye, Loggia, R.W.A., Bloomsbury, Anderson, Waterman Fine Art, Masters Fine Art, Bath; Gloucester City A.G., Albany, Cardiff, Stroud House Gallery, Cheltenham Town Hall; 'Open Houses', Cheltenham; Martin's Gallery, Cheltenham. *Works in collections:* Britain, France, Holland, Israel, U.S.A., S. America. *Clubs:* Cheltenham Group, F.P.S., Reynolds Club (RASAA). *Signs work:* "Allinson" or "S.M. Allinson." *Address:* 13 Cleevemont, Evesham Rd., Cheltenham GL52 3JT.

ALLISON, Jane, 1st Class B.A. Hons. (1980), Slade Higher Dip. (1982); portrait painter in oil/pastel. *b:* Woking, 21 Mar 1959. *m:* John Tatchell Freeman. one *s. Educ:* Charterhouse. *Studied:* Chelsea School of Art (1977-80, Norman Blamey), Slade School of Fine Art (1980-82). *Exhib:* B.P. Portrait Award, Royal Library, Windsor Castle, St. Pancras Hospital, University of Surrey, Royal Society of Portrait Painters. *Works in collections:* Royal College of Surgeons, Edinburgh, University of Surrey, Royal Institute, Royal Library, Windsor Castle, Guys Hospital. *Commissions:* Sir George Edwards, O.M., F.R.S., Lord Robens, Lord Mishcon, Sir Christopher Collet, Prof. P.S. Boulter, Lord Nugent, etc. Court of Examiners, Royal College of Surgeons, London, Prof. Nairn Wilson, President of the General Dental Council, Baroness Susan Greenfield. *Signs work:* "Jane Allison." *Address:* 12 Sydney Rd., Guildford, Surrey GU1 3LJ. *Email:* jatatchell@aol.com

ALLUM, Avis Elizabeth, BA Hons (Textile Design, Leeds), PG Dip. Textile Art, ATC Goldsmiths College. *Medium:* (now) painting/drawing, figurative work. *b:* London, 27 Nov 1951. one *s. Studied:* Leeds University, Goldsmiths College, St.Ives School of Painting. *Exhib:* Mariners Gallery, St.Ives, St.Ives Society of Artists, Truro Museum, Helston Museum, Lizard Art Group. *Works in collections:* private. *Clubs:* St.Ives Society of Artists. *Misc:* costume designer. *Address:* Boderwennack Farm, Wendron, Helston, TR13 0NA. *Email:* avis@wendron.freeserve.co.uk *Website:* www.avisallum.com

ALSOP, Roger Fleetwood, SGFA (1991); painter in water-colour, crayon, oil. *b:* Skipton, 1946. *s of:* Alan Alsop, accountant. *Educ:* Queen's Boys' Sec. Mod., Wisbech. *Studied:* Cambridge School of Art (1966-72). *Exhib:* Amalgam Gallery, Barnes, Roy Miles Gallery, Zella Nine Gallery, Old Fire Engine House, Ely. *Commissions:* Medici Soc., Mercedes-Benz, Right Now magazine. *Signs work:* "Roger Alsop." *Address:* 4 St. John's Villas, London N19 3EG.

ALSOP, William, O.B.E. (2000), RA (2000), Dip-ING (1996), AA DIP(1973), ARB (1978), RIBA (1978); many prizes and awards from 1971 to present, including: Toronto Architecture and Urban Design Award (2005), AJ/Bovis Lend Lease Award for Architecture (2003,2004). *b:* 12 December 1947. *Exhib:* Many UK and overseas exhibitions since 1969, including MoMA New York (2005), Venice Biennale (2000, 2002, 2004), Urbis, Machester (2005), Sir John Soame Museum, London (2002). *Publications:* Selected publications: 'Supercity' (Urbis, 2004), 'Bruce McLean and Will Alsop' (Wiley Academy, 2002), 'Will Alsop, Book 1 (2001) & Book 2 (2002)(Laurence King Publishing). *Misc:* tutor of Sculpture, Central St.Martinbs College of Art & Design, London, for several years. *Address:* Parkgate Studio 41 Parkgate Road London SW11 4NP. *Website:* www.alsoparchitects.com

ALTENBURGER, Ekkehard, *Medium:* sculpture. *b:* Waldshut, Germany, 9 Nov 1966. *s of:* Peter Altenburger. one *s. Educ:* apprentice stonemason. *Studied:* Hochschule für Kuenste, Bremen (Dip-Akad); Edinburgh College of Art; Chelsea College of Art (MA). *Exhib:* 1996-Richard Demarco, Edinburgh; 1999 - Cambridge Darkroom Gallery; 1999 -Goethe Institute, London; 2000 -Kunsthalle Bremen (Germany); 2001 -Goethe Institute, Salvador, Brazil; 2001-Jerwood Sculpture Prize, London; 2002 -Le Confort Moderne, Poitier, France; 2002 -APT Gallery, London; 2005 -Sculpturespace Utica (USA). *Works in collections:* Jerwood Collection, Museu Municipal Caldas da Rahina, Poland; Bridcisso Sculpture Park (Italy); Eglisan Sculpture Trail (Swiss). *Commissions:* 2007 - Flühli, Switzerland; 2007/8 "Negative Fall" Westminster, London; 2007 - Maidstone, Kent; 2006 -Chelsea and Westminster Hospital; 2004- Brighton & Hove. *Publications:* 1997 -Schottland Bieder; 2001 -Jerwood Sculpture Prize; 2001 -Flash Art; 2002 -Corporate Mentality, by Alexandra Mir. *Signs work:* "E. Altenburger". *Address:* Apt-Studios, 6 Creekside, London SE8 4SA. *Email:* info@altenburger.org.uk *Website:* www.altenburger.org.uk

AMBRUS, Victor Gyozo Laszio, ARCA (1960), RE (1973), FRSA (1978); Prizes: R.A. Arts' Club Prize (1996) Summer Exhbn.; P.S. Prize (1995); Daler Rowney Prize; World Wildlife Prize (1994); Mall Galleries; Library Assoc., Kate Greenaway Gold Medal (1966 and 1975); book illustrator, graphic designer; visiting lecturer, Graphic Design. *b:* Budapest, 19 Aug 1935. *s of:* Gyozo Ambrus, Dipl. Eng. of Chemistry. *m:* Glenys Rosemary, A.R.C.A. two *s. Educ:* St. Imre Grammar School, Budapest. *Studied:* Hungarian Academy of Fine Art, Budapest; R.C.A., London. *Exhib:* R.A., R.E., Biennale: Bratislava; Bologna, Italy, Belgium, Japan, Belgrade, New York. *Works in collections:* University of

Southern Mississippi, U.S.A.; Library of Congress, U.S.A.; O.U.P., London. *Publications:* The Royal Navy, British Army, Royal Air Force, Merchant Navy, Three Poor Tailors, Brave Soldier Janos, The Little Cockerell, The Sultan's Bath, Hot Water for Boris, Country Wedding, Mishka, Horses in Battle, Under the Double Eagle, O.U.P.: Dracula (1980), Dracula's Bedtime Storybook (1982), and Blackbeard (1983) author and illustrator. *Signs work:* "V.G. Ambrus." *Address:* 52 Crooksbury Rd., Farnham, Surrey GU10 1QB.

AMERY, Shenda, ARBS (1984); sculptor in bronze; Council mem. RBS. *b:* England, 1937. *d of:* William Garrett. *m:* Sheikh Nezam Khazal. two *s. Educ:* Municipal College, Southend-on-Sea (chemistry). *Exhib:* R.A., Paris Salon, Mall Galleries, Locus Gallery, Osbourne Studio Gallery, Orangery, Holland Pk., Tehran, Iran, Dorman Museum, Middlesborough, Scottsdale, Ariz. *Commissions:* Portrait bust:John Major, Prime Minister, Baroness Thatcher, Prime Minister, Dr. Lee, President Roh Tae Woo,S. Korea, Baroness Betty Boothroyd, Cherie Booth Blair, Robin Cook, M.P., David Blunkett, M.P., Dame Felicity Lott, opera singer, King Hussein and Queen Noor of Jordan. *Clubs:* Arts. *Signs work:* "Shenda Amery." *Address:* 25a Edith Grove, London SW10 0LB.

ANDERSON, Douglas Hardinge, RP; portrait painter and wildlife artist in oils. *b:* 8 Aug 1934. *m:* Veronica née Markes. one *s.* two *d. Studied:* under Pietro Annigoni in Florence. *Exhib:* R.P., R.A. Paintings in private collections worldwide and National Gallery, Edinburgh. *Signs work:* "Douglas Anderson." *Address:* Luthy, Recess, Co.Galway Eire.

ANDERSON, James, BA; East of England art show Under-30 award (1993); printmaker, painter, writer, teacher. *b:* Cambridge, 3 Mar 1965. *Educ:* Worcester College, Oxford. *Studied:* Central School of Art and Design. *Represented by:* Eagle Gallery. *Exhib:* mixed and solo shows in Oxford, Bristol, London, Svendborg Denmark, Lvov Ukraine. *Works in collections:* Museum of History of Religion, Lvov, Ukraine. *Signs work:* "J.W. ANDERSON." *Address:* 18c Digby Cres., London N4 2HR.

ANDERSON, Jennifer, BA (Hons) Fine Art (painting), Duncan Jordanstone College of Art (Dundee); The Ewan Mitchel Painting Prize; The HSBC Management Investment Award for Artists under 35; The Arts Club Prize. *Medium:* painter in oil. *b:* Glasgow, 24 Oct 1975. *d of:* Anne Anderson (artist). *m:* Patrick Gorevan. *Studied:* Duncan of Jordanstone College of Art (Dundee). *Represented by:* Maclean Fine Art, 10 Neville St., London SW7 3AR. *Exhib:* 2 solo shows in Glasgow (The Gate House Gallery), two in London (McLean Fine Art), RSA, RGI, Royal Society of Portrait Painters, BP Portrait Award, The British Art Fair, The Noble and Grossart Painting Prize, The National Portrait Gallery. *Commissions:* portraits of Mervyn Rolfe, Lord Provost of Dundee, Dr. Ian Graham-Bryce, principal of Dundee University, Mr Wilson Sutherland, Acting Warden, New College, Oxford. *Signs work:* 'JA'. *Address:* 107 Hyndland

Rd, Glasgow, G12 9JD. *Email:* janderson@hotmail.com *Website:* www.jennifer-anderson.co.uk

ANDERSON, Wendy, MA; artist; visiting lecturer, Central/St. Martin's School of Art. *b:* Elgin, Scotland, 10 Feb 1961. *Studied:* Gray's School of Art (1979-83), Birmingham Polytechnic (1983-84). *Represented by:* Eagle Gallery. *Exhib:* 'British Art' Eritrea, Eagle Gallery; 'Self-Contained, The Field Institute, Dusseldorf. *Works in collections:* Arthur Andersen, The Economist, Warwickshire Museum. *Commissions:* Scottish Touring Exhbns. Consortium - Touring Exhbn. (1999-2002). *Publications:* 'Artists Now'; author: Education Guides for R.A. 'Sensation' and 'Joseph Beuys'. *Clubs:* London Group (member). *Address:* 19 Arrow Rd., London E3 3HE.

ANDERTON, Eileen, ARMS, SM, HS, FRSA; Gold Medal (1981) Accademia Italia delle Arti e del Lavoro, Gold plaque (1986) Premio d'Italia Targa Djoro; freelance artist in body-colour, water-colour, mixed media. *b:* Bradford, Yorks., 26 Apr 1924. *d of:* Sam Anderton, schoolmaster (art), M.R.S.T. *Educ:* Bradford Girls' Grammar School. *Studied:* Bradford Art School (1939-44) under John Greenwood and Vincent Lines. *Exhib:* Cartwright Hall, Bradford, Wakefield, Halifax, S.W.A., Royal Water-colour Soc. Gallery; one-man show at Bradford Library Gallery. *Works in collections:* Bradford University. *Clubs:* Bradford Arts. *Signs work:* "E. Anderton." *Address:* 4 Braybrook Ct., Keighley Rd., Bradford BD8 7BH.

ANDREW, Keith, RCA (1981); artist, painter/printmaker in water-colour, tempera, etching; elected VP Royal Cambrian Academy (1993). *b:* London, 26 Jan 1947. *s of:* John Albert Andrew, shopkeeper. *m:* Rosemary. two *s*. *Educ:* Picardy Secondary, Erith, Kent. *Studied:* Ravensbourne College of Art and Design (1963-67, Mike Tyzack, John Sturgess). *Exhib:* R.A. Summer Exhbn. (1981), Mostyn A.G., Llandudno, Oriel Cardiff (1982), Bangor A.G. (1982), Aberystwyth Arts Centre (1982), Williamson A.G., Birkenhead (1982), National Eisteddfod Swansea (1982) and Anglesey (1983), Oriel Mold (1983), Tegfryn Gallery, Anglesey (1983); group exhbn. 'Through Artists Eyes'. *Works in collections:* National Library of Wales, Contemporary Art Soc. for Wales, University of Wales, Amoco, Ocean Transport, British Gypsum, Milk Marketing Board. *Signs work:* "Keith Andrew." *Address:* Gwyndy Bach, Llandrygarn, Tynlon P.O., Holyhead, Anglesey LL65 3AJ, Wales.

ANDREWS, Carole, SBA; Founder Presidents Hon. Award SBA (1995); professional artist in water-colour; tutor for mid-Surrey Educ. *b:* Worcester Park, Surrey, 13 Jan 1940. *m:* Peter Leonard. two *d*. *Studied:* Sutton College of Liberal Arts (Philip Meninsky, Ken Bates). *Exhib:* Mall Galleries (1983-86), Westminster Central Hall (1986-2002), The Guildhall, London, Alexandra Palace, Turner A.G., Denver, U.S.A., Christie-Wild, Fifth Ave New York. Work in private collections. *Works Reproduced:* Limited edn. and volume prints, illustration for Coalport and

Wedgwood porcelain. *Signs work:* "Carole Andrews S.B.A." *Address:* 129 Chapel Way, Epsom Downs, Epsom, Surrey KT18 5TB.

ANDREWS, Marcia Tricker, life member IAA; painter in oils. *b:* London, 1923. *d of:* Walter James Tricker. *m:* Edward Andrews. one *s.* one *d. Educ:* St. Andrews; New City, London. *Exhib:* London and provinces; Mexico, France, Spain, U.S.A. *Works in collections:* University of Surrey; Medway Council Library Loan Service; private collections at home and abroad. *Signs work:* "M. ANDREWS," "M. Andrews" or "M.A." *Address:* 40 Robin Hood La., Walderslade, Chatham, Kent ME5 9LD.

ANDREWS, Pauline Ann, graphic artist and designer in Bournemouth. *b:* Bournemouth, 4 Mar 1968. *d of:* Graham Teasdill, museum and art gallery curator. *Educ:* Stourfield and Beaufort Schools, Bournemouth. *Misc:* Work includes book illustration, leaflet, poster, card and badge design and production in addition to normal commercial work. Also undertakes drawings and sketches as Fine art. *Address:* 99 Carbery Ave., Southbourne, Bournemouth BH6 3LP.

ANGEL, Marie, ARCA (1948); calligrapher, illustrator. *b:* 1923. *Educ:* Croydon School of Art (1940-45), R.C.A. Design School (1945-48). *Exhib:* R.A., S.S.I., and widely in U.S.A.; one-man shows: San Francisco (1967), Casa del Libro (1975). *Works in collections:* Harvard College Library, Hunt Botanical Library, Casa del Libro, San Francisco Library and V. & A. *Publications:* A Bestiary, A New Bestiary, Two Poems by Emily Dickinson, An Animated Alphabet (Harvard); illustrated: The Tale of The Faithful Dove, The Tale of Tuppenny by Beatrix Potter; Catscript, Cherub Cat, Angel Tiger; author: The Art of Calligraphy, Painting for Calligraphy. *Signs work:* "Marie Angel," "Angel" or "M.A." *Address:* Silver Ley, 33 Oakley Rd., Warlingham, Surrey CR6 9BE.

ANGELINI, Cristiana, DipFA (1955); Laing Exhbn First Prize for London and South-East (1990). *Medium:* oil, drawing, pastels. *b:* Italy, 6 Jun 1937. *d of:* Giovanni Poletti- Conte di Montecassiano. *m:* Alfred. three *d. Studied:* Carrara School of Art, and Florence (1951-54/5). *Represented by:* Harlequin Gallery, Greenwich. *Exhib:* RA Summer Show (1997, 1998); Mall Galleries (1976-77, 1988, 2002-05-07), several London Galleries, solo shows, the most recent being Hall Place and Gardens, Bexley Heritage Trust (2004); over 30 mixed shows since 1976. *Works in collections:* private collections UK, USA, Italy. *Commissions:* several still-life and portrait. *Publications:* The Guardian (1992); The Art of Drawing and Painting (Eagle Moss Ltd.), The Drawing and Painting Course (Amber Books, 1996); La Vie magazine (2000), Artists and Illustrators (2004), Woodhasterne UK Greeting Card 'Sunflowers', The Dictionary of Artists in Britain Since 1945 by David Buckman. *Works Reproduced:* 'Campagna Amica' Italy. *Principal Works:* 'Grape Pickers'(2004). *Recreations:* classical music, opera. *Misc:* 1989-92, part-time lecturer ILEA, 1985-2007 part-time lecturer Bexley College AE. *Signs work:* with monogram of 'CA', or 'Cristiana

Angelini'. *Address:* 12 Prior Street, Greenwich, London SE10 8SF. *Website:* www.theinternetartshop.com

ANGUS, Michael Graham, *Medium:* oil, watercolour, drawing. *b:* 1 Dec 1947, Kingston. *Studied:* Kingston School of Art. *Exhib:* RA; local exhibitions. *Works in collections:* private collections. *Address:* 27 St.Vincent Road, Walton on Thames, Surrey KT12 1PA.

ANNAND, David, sculptor in clay, bronze resin, bronze, mixed media; Awards: Royal Scottish Academy: Latimer (1976), Benno Schotz (1978), Ireland Alloys (1982); Sir Otto Beit medal, R.B.A. (1987). *b:* Insch, Aberdeenshire, 30 Jan 1948. *s of:* J.S. Annand, bank manager (decd.). *m:* Jean. one *s.* one *d. Educ:* Perth Academy. *Studied:* Duncan of Jordanstone College of Art, Dundee (Scott Sutherlands). *Exhib:* Royal Scottish Academy, Open Eye, Edinburgh, etc. *Works in collections:* throughout the world, including Edinburgh, Dundee, Perth, Canberra, Wisconsin, Hong Kong. *Commissions:* "Deer Leap" Dundee Technology Pk.; "Man Feeding Seagulls" Glasgow Gdn. Festival; "Grey Heron" Edinburgh Botanic Gdns.; "Cranes" British High Commission Hong Kong; "Naeday Sae Dark", Perth; "Civic Pride" four life-size lions on pillars of steel, Barnet, London. *Signs work:* "David A. Annand," a tiny frog on a lily leaf. *Address:* Pigscrave Cottage, The Wynd, Kilmany Cupar, Fife KY15 4PU.

ANNEAR, Jeremy, DAAD Scholarship, Germany; Atelierhaus Worpswede, Kreissparkasse, Bremen, Germany. *Medium:* oil, watercolour, mixed, print, construction. *b:* Exeter, 18 Feb 1949. *s of:* Ralph and Joyce Annear. *m:* Judy Buxton. two *s.* three *d. Studied:* Shebbear College, Exeter College of Art, Rolle College. *Exhib:* one person and mixed shows in Germany, UK, France, Holland and Australia. *Works in collections:* Lazard Bros, Ionian Trust, London University, Deutsch Bank. *Publications:* Catching the Wave by Tom Cross (Halsgrove Press, 2003); exhbns catalogues 1997, 98, 2000, 01, 02; Drawing Towards the End of the Century, NSA (1996); Innovators and Followers by Peter Davies (Bakehouse Publications 1994); Cat Essays by Norbert Lynton, John Russell Taylor, Rachel Barns. *Works Reproduced:* numerous. *Misc:* Artist/Director of Artsound.co.uk, working with contemporary classical musicians and the composer Jim Aitchison. *Address:* Chapel House, Garras, Helston, Cornwall, TR12 6LN. *Email:* jeremyannear@btinternet.com

ANNESLEY, David Robert Ewart, FRBS (1994); sculptor in welded steel; Senior lecturer, St. Martin's School of Art (1975-95). *Medium:* welded steel. *b:* London. *m:* divorced. two *s.* one *d. Studied:* St. Martin's School of Art (1958-62, Anthony Caro, Frank Martin). *Represented by:* Wilfred Cass. Sculpture at Goodwood. *Exhib:* Waddington (1966, 1968), Poindexter Gallery, N.Y. (1966, 1968), Anderson O'Day (1989). *Works in collections:* Tate Gallery, Arts Council, British Council, MoMA New York, etc. *Commissions:* Peterborough, Orton Centre, Royal Hampshire County Hospital. *Signs work:* "David Annesley." *Address:* 80 North View Rd., London N8 7LL.

ANSCHLEE: see SCHLEE, Anne H.,

ANSELMO, (Anselmo Francesconi), painter in oil, acrylic on canvas, drawing and etching, sculptor in clay for bronze; stone and wood. *b:* Lugo (Ravenna), Italy, 29 Jul 1921. *s of:* Cesare Francesconi. *m:* Margherita Francesconi. *Educ:* Lugo. *Studied:* Liceo Artistico, Ravenna; School of Fine Art, Bologna; Brera, Milan. *Represented by:* Montrasio Arte, Via Carlo Alberto 40, 20052 Monza, Italy. *Exhib:* one-man shows: Catherine Viviano, N.Y., Engelberths, Geneva, Galleria d'Eendt, Amsterdam, Musée d'Art et d'Histoire, Geneva, Fine Art Faculty, University of Teheran, Iran, Galleria Toninelli, Milan, Galleria Giulia, Rome, Bedford House Gallery, London, stained glass windows and murals for two churches - Canton de Friburg, Switzerland, Mussavi Art Center, N.Y., Fante di Spade, Milano, Museum of Bagnacavallo, Museum of Bulle, Switzerland, Palazzo Trisi - Lugo, Palazzo Corradini, Ravenna, Montrasio Arte, Monza, etc. *Works in collections:* Musée d'Art et d'Histoire, Geneva; Musée Cantonale de Lausanne; Cabinet delle Stampe, Castello Sforzesco, Milan; Museum of Fine Art, N.Y.; Museum of Fine Art, Buffalo. *Commissions:* stained glass windows mural for two churches, Canton de Fribourg, Switzerland. *Publications:* in different publications, personal catalogues and books. *Signs work:* "Anselmo." *Address:* Via Prina 15 20154 Milano Italy.

ANTONIOU, Andrew, RE; BA, MA Printmaking. *Medium:* etching, drawing, painting. *b:* London, 22 Jun 1951. *m:* Marilyn Puschak. *Studied:* Harrow School of Art, Central School of Art (MA), Winchester School of Art (BA). *Represented by:* Australian Galleries. *Exhib:* Bankside Gallery, London; Sydney, Melbourne, Canberra. *Works in collections:* Art Gallery of NSW; National Gallery of Australia; Ashmolean Museum, Oxford; Microsoft, USA; Canberra Museum, Australia; Larnaca Council, Cyprus. *Publications:* 'An Appreciation of Andrew Antoniou' by Rogar MacDonald (Australian Galleries Press). *Misc:* teaches renowned workshop 'Drawing on Yourself'. *Signs work:* 'A.Antoniou'. *Address:* 1 Buckland Street, Mollymook, NSW 2539, Australia. *Email:* ant51@aapt.net.au *Website:* www.antoniou.com.au

ANTONSEN, Sylvia, NDD (1957), ATD (1958). *Medium:* acrylic painting. *b:* Bournemouth, 30 Mar 1937. two *s.* one *d. Educ:* King Alfred School, Plou.Schleswig-Holstein, Germany. *Studied:* Bournemouth College of Art (1953-58). *Exhib:* mixed shows from 1993 onwards: Bow House Gallery, Barnet; Thompson's Galleries -Aldeburgh and London; Fountain Fine Art, Llandeilo; Beatrice Royal, Eastleigh; Open Eye, Edinburgh; Anthony Hepworth, Bath (solo show 1997); Cambridge Contemporary Art (solo show 2004); The Leith Gallery, Edinburgh; Red Rag Gallery (solo show 2007). *Works in collections:* private collection of Women's Art; Norwich Union Collection. *Commissions:* many. *Signs work:* "SYLVIA ANTONSEN". *Address:* 37 Dennis Road, East Moseley, Surrey, KT8 9EE. *Email:* antonsenpaintings@yahoo.co.uk

WHO'S WHO IN ART

ap RHYS PRYCE, Vivien Mary, FRBS; sculptor in modelling clay and wax for bronze. *b:* Woking, 1 Nov 1937. *d of:* Brig. M. H. Ap Rhys Pryce. *Educ:* Claremont School, Esher, Surrey. *Studied:* City and Guilds of London Art School. *Exhib:* R.A., R.W.A., Jonathan Poole Gallery, London, and various provincial galleries. *Works in collections:* National Gallery of New Zealand, Wellington, University of Exeter (water sculpture), Nymans Gdns., Handcross, Sussex (fountain). *Signs work:* Impress of signet ring (Lion's head). *Address:* 3 Leighton Home Farm Court, Wellhead Lane, Westbury, Wiltshire, BA13 3PT.

APPLEBY, Malcolm Arthur, Doctor of Letters, Honorary Degree from Heriot-Watt University, Edinburgh (2000). *Medium:* engraving, jewellery and medal metal work, sporting guns. *b:* Beckenham, Kent, 6 Jan 1946. *s of:* James William Appleby. *m:* Philippa Swann. one *d. Educ:* Beckenham School of Art, Ravensbourne College of Art and Design. *Studied:* (1961-68): Central School of Arts and Crafts, Sir John Cass School of Art, Royal College of Art. *Represented by:* own workshop. *Exhib:* 'Precious Statements', Goldsmiths' Hall, London (2006); 'Collect', V&A London (2004, 05, 06); 'Cutting Edge' 2007-08 (Royal Museum of Scotland, The Dick Institute, Gallery of Modern Art Glasgow, Aberdeen Art Gallery and Museum 2008). *Works in collections:* V&A, Royal Museum of Scvotland, Aberdeen Art Gallery & Museum, Goldsmiths' Compnay, Ashmolean Museum, Crafts Council, Birmingham Art Gallery, Perth Art Gallery & Museum etc. *Commissions:* selected commissions: 1969-engraves orb for Prince of Wales coronet (collaboration with Louis Osman for Goldsmiths' Company); 1971-77 -works on Chess Set (for Collingwood of Conduit Street); 1978 - Cup to commemorate 500th anniversary of the London Assay Office (for Goldsmiths' Company); 1985-Seal for Board of Trustees (V&A Museum); 1986 - Raven Gun for Tower of London (Royal Armouries); 1988 - Condiment Set for 10 Downing Street (the Silver Trust); 1989 - Standing Cup and Cover (National Museums of Scotland); 1994 - Charger - Cockerel Bowl (Goldsmiths' Company); 1999 - Sculptural table centrepiece for Bute Collection, for use by Scottish First Minister (Incorporation of Goldsmiths of the City of Edinburgh); pair of Tazzas (WS Society, Signet Library); white gold Millennium Casket (Goldsmiths' Company); 2000 - First Royal Medal (Royal Society of Edinburgh); 2005 - The Trafalgar Medal (Sim Comfort Associates, London); 2007 - Contributor to V&A'a 150th Anniversary Celebration Book. *Recreations:* enjoying myself. *Signs work:* "Malcolm Appleby". *Address:* Ault Beag, Grandtully, Perthshire, PH15 2QU.

ARCHER, Cyril James, RI; self taught artist in water-colour; retd. company director. *b:* London, 7 Aug 1928. *s of:* Walter James Archer. *m:* Betty. two *s. Educ:* West Ham Municipal College. *Exhib:* numerous galleries in London, south of England, also one-man shows. *Works in collections:* England, U.S.A., Canada, Middle and Far East, Japan. Limited Editions etc. *Commissions:* numerous. *Clubs:* Association of Sussex Artists. *Signs work:* "ARCHER." *Address:* 4 Willowbrook Way, Hassocks, W. Sussex BN6 8QD.

ARCHER, Nicholas Lloyd, RP; BA (Hons), Post Graduate Diploma (RA Schools); 1st Prize Hunting Art Prizes (2002). *Medium:* painting (oil on canvas), watercolour, drawing. *b:* Yorkshire, 30 Jun 1963. *s of:* Alec and Beryl Archer. *m:* Jenny Pockley. one *d. Educ:* Leeds Polytechnic (1983-85). *Studied:* RA Schools (1996-99). *Represented by:* Sarah Myerscough Fine Art, London. *Exhib:* Sarah Myerscough Fine Art (2001, 2002, 2004), Beaux Arts Bath (2004), Gibsone Jessop Gallery, Toronto, Canada (2005); Jerwood Drawing Prize (2003); BP Portrait Award, NPG(1998, 1999, 2002, 2004). *Works in collections:* London Business School. *Commissions:* The Mill Film Production Co.; many portrait commissions. *Publications:* 'Forever England' catalogue foreword-Martin Gayford. *Works Reproduced:* BP Portrait Award Catalogue (1999, 2002). *Signs work:* 'Archer'. *Address:* c/o Sarah Myerscough Fine Art 15-16 Brooks Mews, London W1K 4DS. *Email:* nicholas@archerart.fsnet.co.uk *Website:* www.nicholasarcher.com

ARCHER, Patricia Margaret Alice, PhD, Dip. FA, ATD, FMAA, Hon. FIMI; Head of Dept. of Medical Illustration, Guy's Hospital Medical School (1964-83). *b:* London. *d of:* Henry Patrick Archer. *Educ:* Convent Collegiate School, Sacred Heart of Mary, Chilton, Bucks. *Studied:* Ruskin School of Drawing, Slade School of Fine Art (1944-47), Inst. of Education, London (1947-48). *Exhib:* Medical Artists' Assoc., London (1952, 1964, 1970, 1989, 1993); one-man show, London Hospital (1955), Medical Picture Show, Science Museum (1978); "A Brush With Medicine", Barber-Surgeons' Hall, London (1993). *Publications:* illustrations for teaching the medical sciences. *Clubs:* Fellow, Medical Artists' Assoc., Hon. Sec. (1964-68), Chairman (1984-86) and (1990-93), Vice-Chairman (1986-1988) and (1993-1995), Archivist (1986-); Founder Associate, Inst. of Medical Illustrators (1968). *Signs work:* "ARCHER." *Address:* Rangemore, 30 Park Ave., Caterham, Surrey CR3 6AH.

ARDAGH, Elisabeth (now Mrs. Tredgett), elected Hon. Senior mem. ROI(1994); artist in oil, acrylic, gouache. *b:* Brighouse, Yorks., 26 Mar 1915. *m:* L.V. Ardagh (decd.). one *d. Educ:* Godolphin School, Salisbury. *Studied:* Farnham (1934-36, Otway McCannel), Chelsea Polytechnic (1936-37, sculpture under Henry Moore), Wimbledon (1937-39, painting under Gerald Cooper). *Exhib:* F.P.S., N.S., R.O.I., R.A. *Clubs:* Overseas. *Signs work:* "Ardagh." *Address:* 40 Orchard Ave., Chichester, W. Sussex PO19 3BG.

ARDIZZONE, Charlotte, NDD, Byam Shaw Dip.(1st), RWA, NEAC. *Medium:* oil. *b:* London, 24 Oct 1943. *d of:* David Ardizzone, solicitor. one *d. Educ:* Rye St. Antony School, Oxford. *Studied:* St.Martin's School of Art; Byam Shaw Art School under Maurice de Sausmarez. *Exhib:* one-man shows: Blond Fine Art, Bohun Gallery, Curwen Gallery, Drian Gallery, Sally Hunter Fine Art, Broughton House Gallery, Albemarle Gallery. *Works in collections:* National Gallery, Australia, National Gallery, Warsaw, Dublin University, Nuffield Foundation. *Clubs:* N.E.A.C., R.W.A. *Signs work:* "Charlotte Ardizzone," and

"CA" joined. *Address:* The Old School, Whinburgh, Norfolk NR19 1QR. *Email:* charlotteardizzone@hotmail.com

ARKLESS, Lesley Graham, BA Hons; painter/illustrator in oil, gouache, water-colour; MA Museums and Galleries in Education (1993); Head of Education, Design Museum, London. *b:* Northumberland, 30 Jan 1956. *d of:* Norman G. & Joyce G. Arkless. *m:* John M. Butterworth. two *s.* one *d. Educ:* Church High School for Girls, Newcastle-upon-Tyne. *Studied:* West Surrey College of Art and Design (1974-78). *Exhib:* Ash Barn Gallery, Petersfield, St. Edmund's Art Centre, Salisbury, National Museum of Wales, 'Pictures for Schools', Astoria Theatre, London, Le Havre Municipal Gallery, Sanderson's Gallery, London. *Publications:* author and illustrator: 'What Stanley Knew' (Andersen Press, London). *Signs work:* "LESLEY ARKLESS." *Address:* 2 Nun's Walk, Winchester, Hants.

ARLOTT, Norman Arthur, SWLA; freelance wildlife illustrator in water-colour, author. *b:* 15 Nov 1947. *s of:* R.W.A. Arlott. *m:* Marie Ellen. one *s.* two *d. Educ:* Stoneham Boys School. *Exhib:* Annual S.WL.A., London, widely in U.K., also U.S.A. *Publications:* over 100, including 'Norman Arlott's Bird Paintings', and many Commonwealth stamp issues, i.e. Bahamas, Jamaica, British Virgin Islands. *Signs work:* "Norman Arlott." *Address:* Hill House, School Rd., Tilney St. Lawrence, Norfolk PE34 4RB.

ARMFIELD, Diana M. (Mrs. Bernard Dunstan), ARA(1989), RA (1991), RCA(Wales), MCSD, Hon. PS, Hon.NEAC., RWA, RWS; painter, retired textile and wallpaper designer; taught at Central School, and Byam Shaw Art School. *b:* Ringwood, Hants, 1920. *d of:* Joseph Harold Armfield. *m:* Bernard Dunstan, R.A. three *s. Educ:* Bedales. *Studied:* Bournemouth Art School, Slade School, Central School. *Represented by:* Browse & Darby, London; Albany Gallery, Cardiff. *Exhib:* Festival of Britain; one-man shows, Browse and Darby, National Eisteddfod Wales, Albany Gall. Cardiff, U.S.A., W.Australia etc.; R.A. with book launch, Holland, R.A. Summer Exhbns. (1966-), Royal Cambrian Academy, Conwy. *Works in collections:* V. & A., R.W.A., Govt. picture collection, Contemporary Art Soc. (Wales), National Trust, Reuters, Yale Centre (British Art), Faringdon Collection, H.R.H. Prince of Wales, Lancaster City Gallery, Mercury Asset Management Collection, R.A. Diploma Collection, R.W.A. Talbot Collection. *Commissions:* H.R.H. Prince of Wales, Reuters, Contemporary Art Soc. for Wales, National Trust. *Publications:* The Art of Diana Armfield by Julian Halsby (David & Charles, 1995). Artist in Residence: Perth (1985), Jackson Hole, U.S.A. (1989). Mitchell Beazley - "Drawing', Mitchell Beazley -"Painting in Oils". *Recreations:* music, gardening. *Clubs:* Arts. *Signs work:* "D.M.A." *Address:* 10 High Park Rd., Kew, Richmond, Surrey TW9 4BH.

ARMITAGE, Ann Susan, BA Hons Fine Art Painting;Elizabeth Foundation for the Arts,Travel Grant; Art Newspaper Award;Northbrook College Award. *Medium:* oil, watercolour. *b:* Huddersfield, 10 Nov 1959. *Studied:* Grimsby

School of Art (foundation, 1984); Canterbury College of Art (1984-87). *Represented by:* Lynne Strover Gallery, Merriscourt Gallery, Wykesham Gallery, East West Gallery, Langham Fine Art. *Exhib:* regularly with above. Gallery Urd, Bergen, Norway (solo); RA Summer Exhbns 1998, 1999, 2003; Discerning Eye (1995, 2003); Chichester Open (2001, 2002); Mall Galleries-:RBA, NEAC, ROI, PS, Laing (2001); Singer & Friedlander (2001); Watercolour C21 RWS (1999, 2001); Royal Overseas League (1994); The Traveller, Wexas International (1995). *Works Reproduced:* Homes and Gardens magazine (May 1998); Art Review, Art for Under £1000 (1995). *Signs work:* "A.S.A." *Address:* Flat D, 6 Hardel Rise, London SW2 3DX.

ARMITAGE, Karen Marie, *Medium:* oil, watercolour, drawing, pastel. *b:* London. *m:* Mark Armitage. four *s. Studied:* Chelsea School of Art, Regent St.Polytechnic; 3 years portrait painting with Stanley Grimm (PPRP), Jason Bowyer. *Represented by:* William Paterson Gallery; Oliver Swann Gallery; Bridgeman Art Library since 1985. *Exhib:* RA, RP (portraits, first time aged 17), Chelsea Art Society, RI, ROI, RWS, NEAC. *Works in collections:* many originals and reproductions. The Bridgeman Art Library since 1985. *Commissions:* through Oliver Swann Gallery, Bridgeman Art Library, Patterson Gallery, Acorn Gallery in Billingshurst, W.Sussex. *Publications:* Bridgeman Art Library. *Works Reproduced:* over 60 by Bridgeman Art Library; Oliver Swann Gallery, Patterson Gallery. *Recreations:* travel and painting, fishing, dogs, riding. *Clubs:* Chelsea Arts Club; Dover St. Arts Club. *Misc:* Studio Painting in own studio - some teaching. *Signs work:* "Karen Armitage". *Address:* Hurst Farm House, Wisborough Green, W.Sussex RH14 0AH.

ARMITAGE, Paul, BA Fine Art, MFA Fine Art; Boise Travel Award. *Medium:* oil. *b:* Gillingham, Kent, 22 Mar 1953. *s of:* Roy Armitage. *Studied:* Gloucestershire College of Technology (BA), Reading University (MA). *Represented by:* Innocent Fine Art, Bristol. *Exhib:* generally in Cornwall and Oxfordshire; Affordable Art Fair (2001); Royal West of England Academy. *Works in collections:* Digital Computers. *Commissions:* Digital Computers. *Address:* Trevider Farm, St.Buryan, Penzance, Cornwall, TR19 6BP.

ARMITAGE, Sandra Wall, SBA; awards: People's Choice, SBA Annual Open Exhbn. (2006); Daler Rowney Award (Best Painting in Exhibition, SBA Annual Open (2006). *Medium:* water colour. *b:* 25 Sep 1943. *m:* Paul Armitage. two *d. Educ:* Cheadle Hulme School. *Studied:* Manchester College of Art (1960-64) (Post Grad 1964-65). *Exhib:* SBA Annual Open Exhbn, Central Hall, Westminster (1998-2007); Heal's Gallery (joint show, 1976-78); The Stable Gallery, Wandsworth (1978-79); Darlington Arts Centre (solo, 1980); Sevenoaks Wildlife Centre (1992-2000) & Florum (2002-2006). *Works in collections:* internationally. *Commissions:* Todan Co.Ltd., Japan (calendar 2006-07, 2007-08); Tiffany's NY (1992-96, commissioned on their behalf by Sybil Connolly, International Designer. *Publications:* illustrations for: 'Decoupage-Painted Furniture' by Rubena Gregg (David & Charles); 'Irish Hands' by Sybil Connolly

(Hearst); 'The Botanical Palette' (Harper Collins). *Official Purchasers:* Mr.K.Kowaguchi, President:Todan Co.Ltd., Japan (private collection). *Works Reproduced:* as calendars and greeting cards by Gordon Fraser Gallery, Hallmark Cards, Ling Design, Todan Co.Ltd., Japan. *Recreations:* gardening, Rotary International, Past President Luton Rotary Club (2006-07); currently Publicity Director SBA (2004-). *Clubs:* Leighton Buzzard Art Society. *Signs work:* 'SANDRA WALL ARMITAGE'. *Address:* Common Farm, Luton Road, Chalton, Bedfordshire, LU4 9UH. *Email:* sandra@watercolourflowers.co.uk *Website:* www.watercolourflowers.co.uk

ARN or ARNEAL: see NEAL, Arthur Richard,

ARNETT, Joe Anna, painter in oil. *b:* Texas. *d of:* John Gary Arnett. *m:* James D. Asher. *Educ:* Baylor University and University of Texas. *Studied:* Art Students' League, N.Y. (1979-83), University of Texas (1970-72). *Represented by:* Zaplin-Lampert Gallery, Santa Fe, New Mexico. *Exhib:* Gilcrease Museum, Albuquerque Museum, Artists of America, Denver (1988, 1995), Catto Gallery, London (1987-92), Zaplin-Lampert Gallery, Santa Fe, N.M., Art Asia (1994) Hong Kong, Prix de West, National Cowboy and Western Heritage Museum (1996-2003). *Works in collections:* Norwest Bank, Cobra Farms, REM Inc. *Publications:* Painting Sumptuous Vegetables, Fruits & Flowers in Oil. *Signs work:* "J.A. Arnett." *Address:* P.O. Box 8022, Santa Fe, New Mexico 87504-8022, U.S.A.

ARNOLD, Gordon C., RCA; artist in water-colour. *b:* Sheffield, 30 Mar 1910. *Studied:* Liverpool School of Art (Will Penn, ROI, RP, RCA, G. Wedgwood, RE). *Exhib:* one-man shows: Birkenhead A.G., Warrington A.G., Bootle A.G., Wrexham Library, Weaver Gallery, Weaverham, Pratts Hotel, Bath, etc. *Works in collections:* Williamson A.G., Birkenhead, Warrington A.G., Liverpool Corp. Library, etc. *Signs work:* "Gordon Arnold." *Address:* 58 Fairfield Terr., Newton Abbot, Devon TQ12 2LH.

ARNOLD, June, PS, FCSD; Intermediate NDD; DipAD 1st Class Hons (Interior Design); Dartmoor Artists Public Prize (1992, 1994, 1997); S.W. Academy Public Prize (2003); Pastel Society, Frank Herring and David Sinfield Fine Art Award (2004). *Medium:* pastels, oils, acrylics. *b:* Halifax, 6 Mar 1944. *d of:* James Oliver Sykes. *m:* Christopher George Arnold. *Educ:* Horsham High School. *Studied:* West Sussex College of Art; Kingston College of Art. *Represented by:* Marine House at Beer; Sarah Samuels Fine Paintings. *Exhib:* PS, SWA; Seymour Gallery, Totnes; Combe Farm Gallery, Dittisham; Wycombe Galleries, Stockbridge; Coves Quay Gallery, Salcombe; Marine House Gallery, Beer; Sarah Samuels Fine Paintings;. *Works in collections:* private collections. *Commissions:* interiors, portraits. *Works Reproduced:* Limited edition cards. *Principal Works:* interiors, figurative. *Recreations:* travel, gardening, music (Classical), current affairs. *Signs work:* 'June Arnold'. *Address:* 24 Old Manor

Close, Holne Close, Ashburton, Devon TQ13 7JF. *Email:* junearnold@tiscali.co.uk

ARNOLD, Phyllis Anne, RMS (1988), ARMS(1983), SM (1976-86), USWA(1982), PUSWA (1988-91), PUSM (1987-93), UWS (1984), HS (1985); Hunting Group finalist (1980, 1981, 1983), RMS Memorial Gold Bowl (1988); miniaturist. *Medium:* ink, gouache, acrylic and oils. *b:* Belfast, 1938. *d of:* David McDowell, engineer. *m:* Michael J. Arnold, C.Eng. two *s. Educ:* Victoria College, Wallace High School. *Studied:* self taught, entered Commercial Art Dept. Short Bros & Harland (1956-58). *Exhib:* S.M., R.M.S., R.A., U.S.W.A., H.S., U.W.S., R.U.A. *Works in collections:* Ulster Museum, Belfast. *Commissions:* Ulster Television, Coalport Porcelain. *Works Reproduced:* Felix Rosensteil Widow & Sons. *Signs work:* "P.A. ARNOLD". *Address:* Phyllis Arnold Studio, Deepwell House, Lowry Hill, Bangor, Co. Down, N. Ireland BT19 1BX. *Email:* artist@portraits-miniaturesandsilhouettes.com *Website:* www.portraits-miniaturesandsilhouettes.com

ARNOTT, Ian, DA (Edin); DipTP (Edin); RSA, RIBA, ARIAS; Civic Trust Awards (10); RIBA Award (1); EAA Awards (2); Saltire Society Awards (2); RSA Gold Medal for Architecture. *Medium:* architecture: design and planning. *b:* Galashiels, 7 May 1929. *s of:* Henry & Margaret Arnott. *m:* Stella. one *d. Educ:* Galashiels Academy. *Studied:* School of Architecture; School of Town Planning; Edinburgh College of Art. *Exhib:* Royal Scottish Academy, Edinburgh; RIBA, London; RIAS, Edinburgh; Association of Consultant Architects, London; Civic Trust, London. *Works in collections:* 'Timeline': Diploma work, Royal Scottish Academy. *Commissions:* bespoke houses, housing, schools, hospitals/health buildings, theatre/cultural/recreation, commercial/leisure, urban masterplanning. *Publications:* work published in many periodicals and books. *Principal Works:* Saltire Court, Edinburgh; AEG HQ, London; Edinburgh Park; An Carn. *Recreations:* painting, travelling, music. *Clubs:* New Club, Edinburgh. *Address:* The Rink, Gifford, East Lothian, EH41 4JD. *Email:* iana@therink.fsbusiness.co.uk

ARNUP, Sally, FRBS, ARCA (1954); sculptor in bronze. *b:* London, 15 Jul 1930. *d of:* L. Baynton-Williams. *m:* Mick Arnup, A.R.C.A. two *s.* two *d. Studied:* Kingston School of Art (1943-50, H. Parker), Camberwell School of Art (1951, Dr. Vogel), Royal College of Art (1952-55, John Skeaping). *Exhib:* Tryon Gallery (1973, 1976, 1981), U.S.A. (1977, 1980, 1986, 1987), Drobak Norway (1976), Wexford Festival (1974, 1978, 1982, 1986), York Festival (1969, 1976, 1978, 1980, 1984, 1988, 1992), Florence (1983), Edinburgh Festival (1988), Stamford Art Centre (1987, 1990), Holland & Holland (Paris, London 1994, 1995, 1997), Gainsborough's House, Suffolk (1998), Pyramid Gallery York ('01), Sabin Gallery London ('01, '04), Renishaw Hall Sheffield ('02), Blake Gallery York ('02, '05, '07), Sinfield Gallery, Oxon (1998, '03). *Works in collections:* H.M. The Queen, Burton Agnes, York A.G., Lord Halifax, Lord Middleton, York University. *Commissions:* Robert Fleming, Rowntree Trust, Hartrigg Oaks

(1999), Hartlepool (2007), Prince Philip, Duke of Edinburgh (2000). *Principal Works:* William Wilberforce (2007). *Signs work:* "ARNUP." *Address:* Studios Holtby, Panman Lane, York YO19 5UA. *Website:* www.sallyarnup.co.uk

ARRIDGE, Margaret Irene Chadwick, NS (1988), FSBA (1988), ARMS; artist in water-colour, pastel, oil, private teacher. *b:* Salisbury, Wilts., 13 Feb 1921. *d of:* Herbert Chadwick Arridge, A.C.A. *m:* I.M.C. Farquharson, M.A., F.I.A. one *s. Educ:* Croydon High School. *Studied:* Chelsea School of Art (Bernard Adams, Violet Butler, miniaturist). *Exhib:* R.A., Paris Salon, Mall Galleries; one-man shows Johannesburg. *Signs work:* "M. Arridge." *Address:* 5 Dudley Rd., Parkwood, Johannesburg 2193, South Africa.

ASCHAN, Marit Guinness, enamellist, painter and jeweller; President, Artist; Enamellers since foundation 1968. *b:* 28 January 1919. *d of:* H. S. H. Guinness. *m:* C. W. Aschan. one *s.* one *d. Educ:* Private, London. *Studied:* Munich, Florence, Paris, Central School of Arts and Crafts, London. *Exhib:* R.A., Leicester Galleries, Lincoln Center, N.Y., Worshipful Company of Goldsmiths, etc.; one-man shows, Beaux Arts, International Faculty of Arts, The Leicester Galleries, Roy Miles, Saga Gallery, London; The Minories, Colchester; Lilienfeld Gallery and Van Diemen-Lilienfeld Galleries, Bodley Gallery, N.Y.; Waldhorn Company Inc., New Orleans; Galerie J. Kraus, Paris; Inter Art Gallery, Caracas, Venezuela; Oslo Kunstforening, Galleri Galtung, Oslo; etc. *Works in collections:* V. & A., central enamel of Louis Osman Cross, Exeter Cathedral; Worshipful Company of Goldsmiths, London; Oppé Coll., Brooklyn Museum; New York University Art Coll.; Fordham University Art Coll.; Yale University A.G.; Nelson Gallery and Atkins Museum, Kansas; North Carolina State Museum of Art, Raleigh; Rochester A.G., N.Y.; University of Kansas Museum of Art, New Orleans Museum of Art; Parrish Art Museum, Southampton, N.Y.; Weatherspoon A.G., University of North Carolina; Finch College A.G.; The Housatonic Museum, Bridgeport, Connecticut; The Snite Museum of Notre Dame University; The Ian Woodner Family Collection, N.Y.; H.M.The Queen of Norway,The Royal Norwegian Embassy, London; Kunstindustrimuseet, Hans Rasmus Astrup Coll. Oslo, etc. *Publications:* Enamellist of Our Time (Graham Hughes), The Connoisseur (Jack Wood Palmer). *Works Reproduced:* 'Marit Guinness Aschan-Enamellist of Our Time' (Graham Hughes), The Connoisseur (Jack Wood Palmer). *Recreations:* travel. *Clubs:* Chelsea Arts. *Misc:* (studio) Moravian Close, 381 King's Rd., London SW10 6AF. *Signs work:* Marit Guinness Aschan. *Address:* 25 Chelsea Park Gdns., London SW3 6AF.

ASH, Lucy, BA (1977), BTechDist. (1995); painter in acrylic, digital artwork; designer; creative director of lucyash.com. *b:* London, 4 Feb 1955. *d of:* Michael and Dulcie Ash (nee Orme). *Educ:* Millfield School, Somerset. *Studied:* Central School of Art and Design, Camberwell School of Art and Crafts, South Thames College. *Exhib:* Heseltine Masco, Oztenzeki, Austin Desmond, London, Mokotoff, New York, On the Wall, London, RWA, Cork St. Fine Art, London. *Works in collections:* private Collections, Bluedoor Ltd. *Commissions:* Bluedoor

Ltd., Sony Radio Awards, Microsoft. *Publications:* 'A Taste of Astrology', pub. Alfred A Knopf, New York. (1988), written and illust.; 'The Astrological Cookbook', pub. Sainsbury (1993), written. *Recreations:* walking. *Clubs:* Chelsea Arts. *Misc:* Multimedia Digital Artwork. *Signs work:* "Ash." *Address:* Alfreston House, Middle Street, Petworth, W.Sussex GU28 0BE. *Email:* la@lucyash.com *Website:* www.lucyash.com

ASHBY, Derek Joseph, DA (Edin.); artist in oil painting and steel and aluminium; lecturer in drawing and painting, Gray's School of Art, Aberdeen. *b:* 24 Jun 1926. *s of:* Oswald Roy Ashby. *m:* Mairi Catriona. one *s.* one *d. Educ:* Oldham High School. *Studied:* Edinburgh College of Art (1948-51) under Gillies, Henderson, Blyth; RA Schools (1953-55) under Rushbury. *Exhib:* R.S.A., Aberdeen Artists, S.S.A. *Works in collections:* Scottish Arts Council. *Clubs:* A.A.S., S.S.A. *Signs work:* "Derek Ashby." *Address:* Old Invery, Auchattie, Banchory, Kincardineshire AB31 6PR.

ASHE, Faith: see WINTER, Faith,

ASHER, James, artist in water-colour, oil, lithograph. *b:* Butler, Missouri, 14 Apr 1944. *s of:* Glenn William Asher. *m:* Joe Anna Arnett. one *s.* one *d. Educ:* Central Missouri University. *Studied:* The Art Center College of Design, Los Angeles, Calif. *Exhib:* Catto Gallery, London, Zaplin-Lampert Gallery, Santa Fe, N.M., Artists of America, Denver (1991-1997), Gilcrease Museum, Royal Water-colour Soc., London (1992). *Works in collections:* Museum of Fine Arts, Santa Fe. *Publications:* Water-colour Magic (Summer, 1999). *Signs work:* "James Asher." *Address:* P.O. Box 8022, Santa Fe, New Mexico 87504-8022, U.S.A.

ASHMAN, Malcolm Paul, RBA, ROI. *Medium:* oil, watercolour, drawing. *b:* Bath, 14 Jul 1957. *Educ:* Keynsham Grammar School. *Studied:* Somerset College of Art. *Represented by:* Brian Sinfield Gallery, Oxon; Beaux Arts, Bath; Rowley Contemporary Art, Winchester. *Exhib:* RA Summer Exhbn, RWA Bristol, Mall Galleries, NEAC, ROI, RBA, Victoria Gallery, Bath. *Works in collections:* Wessex Collection, Longleat; Victoria Gallery, Bath. *Commissions:* Dragon's World publishers 1988-96. *Clubs:* Bath Society of Artists. *Signs work:* M.A. *Address:* Green Bank, Kipling Avenue, Bath BA2 4RD. *Email:* mail@malcolmashman.co.uk *Website:* www.malcolmashman.co.uk

ASHMAN, Margaret Christina Elizabeth, MA Oxon (Physics), Somerville College; MA Brighton (Printmaking and Professional Practice), BA Fine Art Hertfordshire; Julian Trevelyan Memorial Award 2004; University of Herts. Prizewinner 2003; University of Brighton mini print Competition 1st prize winner 2005. *Medium:* printmaking. *b:* Northampton, 19 Sept 1959. *d of:* Patricia and Donald McPhie. *m:* Kevin Ashman. one *s.* three *d. Studied:* University of Brighton in partnership with London Print Studio, University of Hertfordshire, University of Oxford (Somerville College). *Represented by:* Southbank Printmakers, Gabriels Wharf SE1. *Exhib:* Sofia Bulgaria (2005); Mall Galleries (originals) (2004, 2005); RA Summer Exhbn (2004); Southbank Printmakers;

Fovea Gallery(solo); The Candid Arts Trust; St.Alban's Cathedral; Cork Street; The Art of Love Competition, Obsidian Art Gallery; Radlett Art Centre (solo). *Works in collections:* Lovells, University of Hertfordshire. *Publications:* The Art of Love 2004. *Official Purchasers:* Lovells (Solicitors), University of Hertfordshire. *Principal Works:* Love Eternal, Always, Hide and Seek, Caught. *Signs work:* "Margaret Ashman". *Address:* 19 Northwick Park Rd, Harrow, Middlesex HA1 2NY. *Email:* margaret@artashamn.fsnet.co.uk

ASHMORE, Biba Victoria, DipAD; Awarded David Murray Studentship (1972) by RA. *Medium:* oil, watercolour, drawing. *b:* Trieste, 29 Nov 1952. *d of:* Mr NH&MrsGM Ashmore. *Educ:* The Town and Country School, London (1964-69). *Studied:* The Camden Arts Centre, London (1969-70), Camberwell School of Arts and Crafts (1970-74). *Exhib:* RA Summer Exhbn (1975, 1976, 1978, 1996, 1997); Mall Galleries (1973); London Group (1975); Llewelyn Alexander Gallery (2000); The Hunting Art Prizes at Royal College of Art (2001). *Works in collections:* private. *Commissions:* portrait. *Official Purchasers:* RA/Harrison Weir Fund (1978) for RA Collection. *Recreations:* visiting exhibitions, cooking. *Signs work:* "Biba Ashmore" or "B.Ashmore". *Address:* 134 Leander Road, London SW2 2LJ. *Email:* ashmorebiba@tiscali.co.uk

ASHMORE, Lady, Patricia, PS (1953); landscape and portrait painter in pastel, oil and water-colour. *b:* Horsham, 13 Jul 1929. *d of:* Admiral Sir Henry Buller. *m:* Vice Admiral Sir Peter Ashmore (decd). one *s.* three *d. Educ:* North Foreland Lodge. *Studied:* Chelsea Polytechnic (portrait painting with Sonia Mervyn). *Exhib:* Pastel Exhbn. (annually), Royal Portrait Painters (1949, 1950), Women Artists, Sussex Artists Assoc. (member and exhibitor), Kentish Artists Annual Exhbn. for Charities. *Commissions:* in Portraits or Landscape. *Signs work:* "Patricia Ashmore." *Address:* Netherdowns, Sundridge, Sevenoaks, Kent TN14 6AR.

ASQUITH, Rosalind Lucy, BA. *Medium:* cartoons/illustrations b & w and watercolour. *b:* Hove, Sussex. two *s. Studied:* Camberwell School of Art. *Represented by:* Rosemary Canter and Pat Kavanagh, PFD, Drury House, 34-43 Russell Street, WC2B 5HA. *Exhib:* Drill Hall, Cartoon Art Trust, The Gallery, Brighton Arts Centre, Battersea Arts Centre, numerous travelling exhbns. *Works in collections:* private houses. Murals: York Cathedral, Bath Hafebutsoth Museum, Qatar Museum, Phillips Museum Oslo. *Publications:* over sixty books, Guardian, Observer, Times, Time Out, City Limits, She, etc. *Works Reproduced:* see publications. *Signs work:* Ros Asquith. *Address:* 51 Muswell Avenue, London N10 2EH. *Email:* rosasquith@aol.com *Website:* www.rosasquith.com

ASTBURY, Paul, MA Hons RCA Dip AD; Awards: Arts Council 1977, Craft Council 1984, British Council 1997. *Medium:* oil, sculpture. *b:* Hough, Cheshire, 11 Dec 1945. *s of:* Elizabeth & John Thomas Astbury. *m:* Lesley. two *s.* one *d. Studied:* Stoke-on-Trent College of Art (1961-68); Royal College of Art (1968-71). *Exhib:* extensively in Britain and abroad, including Victoria & Albert

Museum, Whitworth Art Gallery, Manchester City Art Gallery, Yorkshire Sculpture Park, Museum of Modern Art Oxford, Barbican, London, Spacex Gallery, Exeter, Le Musee d'Art Contemporain de Dunkerque, Takenaka Corp Japan, Diorama Gallery London, Everson Museum NY, Shigoraki Museum, Japan, Ulster Museum Belfast, Für Angewandekunst, Vienna, Tiawan Arts Centre Taipei, Goreborg Museum Sweden, Musee Ariana Geneva, Grimmerhus Museum Denmark, Aberystwyth Arts Centre, Bradford City Art Gallery. *Works in collections:* V&A, Fine Art Museum Houston, USA, Ulster Museum, Shigaraki Museum, Japan, Southampton Museum & Art Gallery, Rohss Museum, Sweden, ILEA Collection, York Museums Trust, Aberystwyth Art Centre, Crafts Council Collection, Everson Museum NY, Arizona State Uni Art Museum, USA, North Western Arts Association, Portsmouth Museum and Art Gallery, Mint Museum USA etc.etc., plus many private collections. *Publications:* 'Images in Clay Sculpture' Charlotte Speight (Harper & Row 1983), 'The Potters Art' Garth Clark (Phaidon 1995), 'Sculptural Ceramics' Gregory, Ian (A&C Black 1992), 'Post Modern Ceramics' Mark Del Vecchio (Thames & Hudson 2002). *Works Reproduced:* 'Held under Wraps', 'Garden 1 & 2', 'Evacuated Boxes', 'Cup and Saucer', 'Mare', many others. *Principal Works:* 'Jacket' & 'Trousers', 'Held under Wraps', 'Tree in a Landscape', 'Robot eating Robot', 'Wendy House, Dragon & Machine' and others. *Recreations:* collecting: toys/advertising ephemera/badges/postcards; travelling to other countries to see specific works of Art which interest me. *Signs work:* "P.J.A", "PAUL ASTBURY" or "Astbury". *Address:* 62 Sedgeford Road, Shepherds Bush London W12 0NB. *Email:* pja_62@hotmail.com *Website:* www.paul-astbury.com

ATHERTON, Barry, NEAC, SSA; NDD, DA (Manc.) Dist. (1965), Leverhulme Scholarship (1965-66), RASCert. (1969); artist in mixed media; Lecturer in Fine Art, Glasgow School of Art. *b:* England, 1944. *m:* Linda. two *s. Studied:* Manchester College of Art and Design (Norman Adams), R.A. Schools (Edward Bawden). *Exhib:* solo shows: New Academy Gallery, London (1990, 1992, 1994, 1997, 1999, 2002), Mistral Galleries, London (1996), Art Gallery and Museum, Kelvingrove, Glasgow (2003) People's Palace, Glasgow (2007). *Works in collections:* Aberdeen A.G., University of Strathclyde, Glasgow Caledonian University, Paisley University, also private and corporate collections, in U.K., Europe and U.S.A. *Commissions:* University of Strathclyde, Glasgow Caledonian University, Paisley University, Alexon/Vogue, The Crown Estate Millennium Exhbn. *Publications:* 'Interview with the Artist', Pryle Behrman (Artline), 'Reflections in the Glass of History', Ray McKenzie. *Signs work:* no signature, identification on the back. *Address:* 235 Nithsdale Rd., Glasgow G41 5PY. *Email:* athertonart2005@yahoo.co.uk

ATKIN, Ann Fawssett, NDD Dip. Royal Academy of Arts. *Medium:* acrylic; clay. *b:* Lindfield, Sussex, 1937. *m:* Ron Atkin. two *s. Studied:* Brighton College of Art; Royal Academy Schools. *Exhib:* founded The Gnome Reserve, The Wild Flower Garden, The Pixie Kiln and The Gallery at West Purford in N. Devon; featured 65 times on TV and numerous times on radio and in newspapers,

magazines and books worldwide. Paintings in mixed and solo exhibitions, including annually the 'Artists Garden Exhibition', RHS Garden, Rosemoor. *Works in collections:* painting in the Dartington Hall Trust Collection; paintings and limited edition prints in private collections in the UK, Northern Ireland, Republic of Ireland, France, Guernsey, Switzerland, Denmark, Spain, Holland, Germany, Finland, Austria, Sweden, Dubai, Cyprus, South Africa, Australia, New Zealand, Canada and the USA. *Commissions:* many pottery landscape scenes with the people depicted as boy and girl pixies. *Publications:* Paintings (April 2007); Devon Today (May 2007). *Recreations:* gardening, birds. *Clubs:* The Reynolds Club. *Misc:* Prints of her ethereal landscape paintings discretely inhabited by fairies and/or gnomes selling daily from The Gallery, 50% to adults, 50% to children. *Signs work:* "Ann Atkin; Ann Fawssett, Ann Fawssett Atkin". *Address:* Wild Flower Studios, Abbots Bickington, N. Devon EX22 7LQ. *Email:* paintings@ann-fawssett-atkin.co.uk *Website:* www.ann-fawssett-atkin.co.uk

ATKIN, Ron, painter in water-colour and oil; Bronze and Silver medallist, RAS. *b:* Leics., 3 Feb 1938. *m:* Ann Fawssett-Atkin. two *s. Studied:* Loughborough College of Art (1954-57), RA Schools (1957-61). *Exhib:* regularly at R.A.; mixed shows: Roland, Browse and Delbanco. *Works in collections:* Lincoln College Oxford, Dartington Trust, Devon C.C. Schools Museum Service, Plymouth City Museum and A.G. Shortlisted for a Gulbenkian Printmakers award; featured in first and second edition of Dictionary of British Art Volume VI, 20th century painters and sculptors; also in Debrett's and Dictionary of Artists in Britain since 1945. *Publications:* 'A Trilogy' by R J J Atkin (ISBN 0-9538907-7-5 and 0-9538907-9-1). *Works Reproduced:* in above trilogy, and 160 on 'artwanted' website. *Recreations:* walking and observing a two-acre paradisiacal garden with two lakes. *Signs work:* "Ron Atkin." *Address:* Wild Flower Studios, Abbots Bickington, Devon EX22 7LQ. *Email:* wildflower.studios@gmail.com *Website:* www.artwanted.com/RjjA

ATKINS, David Alexander, BA (Hons.) Fine Art Painting 1st Class; lecturer in art; Course leader, Foundation Art and Design. *Medium:* artist in oil and watercolour. *b:* London, 20 Feb 1964. *m:* Jacqueline. three *d. Studied:* St. Martin's School of Art (1982-83), Winchester School of Art (1983-86). *Represented by:* Albemarle Gallery, London. *Exhib:* Discerning Eye, Alresford Gallery, Singer & Friedlander, Albemarle Gallery (2 solo); Fairfax Gallery, Chelsea; Albany Gallery, Cardiff; Beaux Arts, Bath; Stables Gallery, Ireland; Courcoux & Courcoux, Hampshire. *Works in collections:* Creasey Collection, Salisbury; Guildhall, Kingston, Surrey; Hampshire Council Collection. *Commissions:* four murals for GLC. *Publications:* The Public Catalogue Foundation, Hampshire. *Signs work:* 'David Atkins'. *Address:* 31 Monmouth Rd., Dorchester, Dorset DT1 2DE. *Email:* davidatkins@madasafish.com *Website:* www.david-atkins.com

ATKINS, Ray, DFA(Lond.); painter in 2D-oil, acrylic, drawing mediums, sculptor in 3D-clay, cement, wax. *b:* Exeter, 9 Jul 1937. one *s.* one (decd) *d.*

Studied: Bromley College of Art (1954-56, 1958-61), Slade School of Art (1961-64). *Represented by:* Art Space Gallery, 84 St. Peters St., London N1 8JS. email: artspacegallery@msn.com. *Exhib:* one-man shows: Whitechapel A.G. (1974), R.W.A. Bristol retrospective (1996), and many other one-man and group shows. *Works in collections:* B.M., British Council, Arts Council, South West Arts, Somerset C.C., and private collections Europe and America. *Publications:* 'Ray Atkins' R.W.A. (1996) ISBN No. 1899525 04 1; Ray Atkins – Paintings of the Figure, Truro (1999); 'Broken Ground' (2001); Ray Atkins-Paintings 2003 ISBN 09528502-5-7; Ray Atkins-Paintings 2005 ISBN 0-9549623-1-1. *Official Purchasers:* British Museum, British Council, Arts Council. *Signs work:* "Ray Atkins," 2D work is signed on the back. *Address:* 13 Holman Avenue, Camborne, Cornwall, TR14 7JQ. *Email:* ray99atkins@tiscali.co.uk

ATKINS, Rosalind Jane, SWE; Bachelor of Fine Art, Graduate Diploma of Fine Art. *Medium:* printmaking, wood engraving. *b:* Terang, Australia, 20 May 1957. two *s. Studied:* Royal Melbourne Institute of Technology University. *Represented by:* Australian Galleries, Melbourne and Sydney. *Exhib:* Australia, United Kingdom, USA. *Works in collections:* Australian National Gallery, Art Gallery of New South Wales, National Library, State Library of Victoria. *Publications:* 'Australian Prints', Art Gallery of NSW 1998, 'Women Engravers' Virago Press 1988. *Works Reproduced:* as above. *Clubs:* Society of Wood Engravers. *Address:* 2 Clive Street, Alphington, Victoria 3078, Australia. *Email:* rosatkins@iprimus.com.au

ATKINSON, Anthony, ARCA (1954); painter in oil; Dean, Colchester Inst. *b:* 1929. *s of:* Claude Atkinson. *m:* Joan Dawson. one *s.* one s- *d. Educ:* Wimbledon College. *Studied:* Royal College of Art. *Exhib:* R.A., Leicester Galleries R.W.S.; one-man: Minories, Colchester, Leighton House, London, Gainsborough's House, Sudbury, Mercury Theatre, Colchester, British Council, Kuwait, Coach-House Gallery, Guernsey, Highgate Fine Art, Chappel Gallery, John Russell, Ipswich. *Works in collections:* Essex Museum; Ernst & Young; Essex C.C.; Colchester Hospital, etc. *Works Reproduced:* Shell, London Transport, The Artist, Artist v Illustrators. *Clubs:* President Colchester Art Soc. *Signs work:* "ATKINSON." *Address:* Coach House, Great Horkesley, Colchester, Essex CO6 4AX.

ATKINSON, Eric Newton, NEAC, RCA; painter in oils and collage; Nat. Dipl. (1st hons., painting), RA Drawing Medal, Silver Medal for Painting; Dean, Faculty of Arts, Fanshawe College, London, Canada; Chairman, Fine Art, Leeds College of Art. *b:* W. Hartlepool, 23 Jul 1928. *s of:* James Atkinson. *m:* Muriel H. Ross. one *s.* one *d. Educ:* Dyke House, W. Hartlepool. *Studied:* W. Hartlepool College of Art and RA Schools. *Represented by:* Moore Gallery, Toronto; Thielsen Gallery, London, Ontario. *Exhib:* Redfern Gallery, Tate Gallery, Austin Hayes, York, Leeds Univ., Wakefield and Middlesbrough city galleries, Zwemmer Gallery, Corcoran Gallery, Rothman Gallery, Mendelson Gallery, Capponi Gallery, Pollock Gallery, Mendel Gallery, Carnegie Mellon, U.S.A., Tate, St. Ives, Wallace Gallery, Calgary. *Works in collections:* National Portrait

Gallery, Contemporary Art Soc., M. of W., Leeds, Leicester, Wakefield, Hereford and Kendal A.G., Leeds City A.G. Collection, McIntosh Gallery U.W.O., Government Art Collection, U.K.; V&A Collection. *Publications:* "The Incomplete Circle" Eric Atkinson, Art and Education, ed. David Lewis (Scolar Press,2000). *Signs work:* "Eric Atkinson." *Address:* 69 Paddock Green Cres., London N6J-3P6, Ontario, Canada. *Email:* murielatkinson@sympatico.ca

ATKINSON, Kim, MA (RCA) (1987); SWLA (1992); Young Bird Artist of the Year (1992), Royal Society for the Protection of Birds Art Award (2002). *Medium:* artist in water-colour, oil, printmaking, drawing. *b:* Bath, 1962. *d of:* Mr. & Mrs. A. Atkinson. *m:* Gwydion Morley. one *s. Studied:* Falmouth School of Art (Foundation); Cheltenham College of Art (BA Painting); Royal College of Art (MA Natural History Illustration). *Exhib:* Wales, England, Europe, America. *Publications:* Birds in Wales (Poyser, 1994) (illustrations); chapter in Water-colour Masterclass by Lawrence Wood (Collins, 1993), work included in Artists for Nature Foundation; publications resulting from projects in Poland, France, Spain, Ireland and India; Drawn to the Forest (2000, Wildlife Art Gallery), Modern Wildlife Painting (Pica Press, 1998); The Forgotten Forest (The Wildlife Art Gallery, 2004). *Recreations:* gardening, Natural History. *Misc:* subject matter primarily nature, esp.- birds, plants and insects within the landscape, both abroad and around her Welsh coastal home. *Signs work:* "Kim Atkinson." or "KA". *Address:* Ty'n Gamdda, Uwchmynydd, Pwllheli, Gwynedd LL53 8DA.

ATKINSON, Shelagh, HND Communication Studies (1988). *Medium:* work across the disciplines: printmaker, painter, photographer. *b:* 1959. *Studied:* Napier University, Edinburgh (1988); Leith School of Art, Edinburgh (2003/2004). *Exhib:* Glasgow, Sweden, Edinburgh, Japan, London, Bulgaria, Berlin. *Works in collections:* Scottish National Portrait Gallery, Edinburgh. *Commissions:* book cover Heirts Bluid, Chapman Publications, Scotland (1995), Circle the City, Community Project Edinburgh (1995/6), CD cover design Wee Dram Records (2004), various private. *Publications:* catalogues: Footsteps, Panzerhalle Berlin (1998), About Face Postcard series, Edinburgh (1999), Harlech Print Biennale, Wales (2000), Print Triennial, Kanagawa Yokohama (2001), Tidaholm Lithographic Symposium, Sweden (2002), Lessendra Print, Sofia, Bulgaria (2004/5). *Official Purchasers:* Scottish National Portrait Gallery, Edinburgh. *Recreations:* music, architecture, wine, eating, cooking and yoga. *Clubs:* Scottish Artists Union, Edinburgh Printmakers Studio, Glasgow Print Studio. *Address:* Robertson Cottage, Dolphinton, West Linton, Peebleshire, EH46 7AB. *Email:* atkinwood@onetel.com *Website:* www.axisweb.org/artist/shelaghatkinson

ATKINSON, Ted, DFA (Lond., 1952), RE (1988), FRBS, FRSA (1957), Slade Prize Winner (1952); sculptor; Head of Sculpture School, Coventry University (1968-83). *b:* Liverpool, 21 Mar 1929. *s of:* Edward Atkinson, musician. *Educ:* Oulton School, Liverpool. *Studied:* Liverpool College of Art and Slade School, Slade Post-graduate Scholar (1952-53). *Works in collections:* Arts Council, London, Ashmolean Museum, Oxford, Dallas Art Museum, Kunst Academie,

Dresden, Fitzwilliam Museum, Cambridge, Museum of Modern Art, N.Y., Seattle Art Museum, etc.; public sculptures in Coventry, Dusseldorf, Hamburg, Univ. Birmingham. *Misc:* One of six sculptors chosen to represent Britain at Expo 88 Brisbane. *Address:* 4 De Vere Pl., Wivenhoe, Essex CO7 9AX.

ATTREE, Jake (Jonathan), Dip.A.D. (Painting) (1972), R.A. Schools Post-Grad. Cert. (1977); Landseer prize, Creswick prize, David Murray Scholarship; painter. *b:* York, 13 Oct 1950. *s of:* Noel and Mary Attree. *m:* Lindsay Knight. *Educ:* Danesmead, York. *Studied:* York College of Art (1966-68), Liverpool College of Art (1969-72), R.A. Schools (1974-77). *Exhib:* regular one person and group shows include R.A. Summer Exhbn. (1975, 1985), Serpentine Summer (1982), Maastricht, Dortmund (1992), Leeds City A.G. (1993), Michael Richardson Contemporary Art, London, Dean Clough Halifax (1994), Hart Gallery, London (2003), Bruton Gallery (2003). *Works in collections:* Leeds City Council, City of Dortmund, Grays A.G. Hartlepool, Sheffield University, Nuffield Trust., Bradford Museums and Galleries. *Publications:* illustrated At This Time and The Purblind Man by John Holmes. *Misc:* Studio: Dean Clough, Halifax HX3 5AX. *Signs work:* usually unsigned, unless requested, then "J. Attree." *Address:* 33 Titus St., Saltaire, Shipley BD18 4LU. *Email:* Jake.Attree@ukgateway.net

AUERBACH, Frank Helmut, painter. *b:* Berlin, 29 Apr 1931. *Educ:* privately. *Studied:* St. Martin's School of Art; R.C.A. *Exhib:* one-man shows: Beaux-Arts Gallery (1956, 1959, 1961, 1962, 1963); Marlborough Fine Art (1965, 1967, 1971, 1974, 1983, 1987, 1990, 1997); Marlborough, N.Y. (1969, 1982, 1994); retrospective, Hayward Gallery (1978), Venice Biennale (1986) (joint winner Golden Lion), Hamburg (1986), Essen, Madrid (1987), Rijksmuseum Vincent Van Gogh, Amsterdam (1989), Yale Center for British Art, New Haven (1991), National Gallery, London (1995). *Works in collections:* Metropolitan Museum, N.Y.; Museum of Modern Art N.Y.; Los Angeles County Museum; National Gallery of Australia; B.M.; Tate Gallery, London; and many other museums; British Council; Arts Council; Contemporary Art Society, etc. *Address:* c/o Marlborough Fine Art Ltd., 6 Albemarle St., London W1X 4BY.

AUGUST, Lillias Anne, RI (2007); BA Hons (1978), CNAA (1979); Management council, Bury St. Edmunds Art Gallery, Suffolk (2000-2004); prizewinner, RI (2002, 2005). *Medium:* painter in watercolour. *b:* Gloucester, 5 May 1955; married. two *s. Studied:* Goldsmiths College, London (1973-1977), Birmingham Polytechnic (1977-1978). *Exhib:* Cloister Gallery, Bury St. Edmunds (1999, 2002, 2005); Hunter Gallery, Long Melford (2001-07); Singer & Friedlander Sunday Times Watercolour Exhib. (2001); Artworks, Rougham (2000-07); RI (2000-2008); Cross Country, Bury St. Edmunds Art Gallery (2001); Laing Exhibs. (1992, 1995, 1998 regional prizewinner, 2000); This Flat Earth, Firstsite, Colchester (2000); Old Fire Engine House, Ely (2000); RWS (1996, 2002), Art Auction East (2004/2005); Langham Fine Art (2006, 2007). *Works in collections:* Hylands House, Chelmsford; Manor House Museum, Bury

WHO'S WHO IN ART

St. Edmunds; St.Edmunds Cathedral, Bury St.Edmunds. *Commissions:* Chelmsford Borough Council; St Edmundsbury Borough Council, Suffolk; St. Bartholomew's Hospital, London; The National Trust; project artist, Suffolk Cathedral Millennium Project (2000-2005). *Publications:* Millennium Tower, St.Edmundsbury Cathedral (pub. 2005). *Signs work:* "Lillias August" or "LA." *Address:* West Barn, Golden Lane, Lawshall, Bury St. Edmunds, Suffolk IP29 4PS. *Email:* lilliasaugust@btinternet.com

AULD, John Leslie M., DABelfast, ARCA, NRD, FIAL; art teacher, designer-craftsman in goldsmiths' work; head, Art Dept., Municipal Tech. College, Londonderry (1940-46); Senior Lecturer, Glasgow School of Art (retd. 1979). *b:* Belfast, 21 Jan 1914. *s of:* Joseph Auld and Bertha (nee Lind). *m:* Doreen M. W. Auld (née Sproul). one *s. Educ:* Methodist College, Belfast. *Studied:* Belfast Coll. of Art (1931-35); Royal Coll. of Art (1935-39). *Exhib:* London, Brussels, Paris, New York, Stockholm, Arts Council, etc. *Works in collections:* Goldsmiths' Company, London; New York City Corpn.; University of Glasgow. *Commissions:* crozier: R.C. Bishopric Motherwell; font & ewer: Bearsden Parish Church; altar vases: Knightswood Parish Church, Glasgow. *Publications:* 'Your Jewellery'. *Signs work:* "J. L. AULD". *Address:* Flat 20, 41 Dundas Ct., East Kilbride G74 4AN.

AUSTIN, Michael J, *b:* London, 13 Sep 1959. one *s. Educ:* left school at 16. *Represented by:* Jonathan Copper, Park Walk Gallery, London. *Exhib:* solo shows: Park Walk Gallery (1996, '97, '99, 2000, '02, '03, '04, '05). *Works in collections:* Royal Collection. *Commissions:* Tour Artist H.R.H. The Prince of Wales (India/Oman Nov 2003). *Works Reproduced:* prints and posters, The Art Group, London. *Address:* 61 Manstow Road Exeter Devon EX1 2QA. *Email:* mail@jonathancooper.co.uk *Website:* www.jonathancooper.co.uk

AVATI, Mario, Prix de la Critique, Paris (1957), Gold Medal First International Prints Exhbn., Florence (1966), Prix du Lion's Club (1972), Grand Prix des Arts de la Ville de Paris (1981); painter/printmaker in mezzotint. *b:* Monaco, 27 May, 1921. *m:* Helen. *Educ:* College de Grasse, France. *Studied:* Ecole des Arts Decoratifs, Nice, Ecole des Beaux Arts, Paris. *Exhib:* one-man shows worldwide. *Works in collections:* museums in Europe, America, Asia, Oceania. *Publications:* 12 'Livres de Luxe' illustrated with original prints. *Works Reproduced:* in 'Mario Avati, L'Oeuvre Grave' by Roger Passeron. 7 volumes, 1947-2000 published by La Bibliotheque des Arts Lausanne, Switzerland. *Clubs:* Soc. Les Peintres-Graveurs Paris, La Jeune Gravure Contemporaine Paris, Royal Soc. of Painter-Printmakers, London. *Signs work:* "AVATI." *Address:* 12 Cite Vaneau, Paris, France F75007.

AVELLINO, Alessia E.R., BA (Hons) Drawing and Painting; Painter-Stainer bursary for Easel painting; Bruce Church Travel Scholarship. *Medium:* painter, drawer, charcoal and oil. *b:* Sofia, Bulgaria, 16 Sep 1972. *d of:* Antonio and Concita Avellino. *Studied:* Chelsea College of Art, Camberwell College.

33

Represented by: Start, 150 Columbia Road, London E2 7RG. *Exhib:* UK (London & Glasgow), USA (New York, Miami & Willan). *Works in collections:* BP, Yolles Engineers, ITV Television, Holman, Fenwick & Willan; private collections in the UK and USA. *Commissions:* Yolles Engineers, Canary Wharf. *Publications:* Artists Newsletter, Blueprint Magazine, The Times, Lloyd's List. *Signs work:* AER Avellino (A.E.R.A. on paintings). *Address:* c/o Eduardo Sant'Anna, Start, 150 Columbia Road, London E2 7RG. *Email:* art@st-art.biz *Website:* www.st-art.biz

AYERS, Duffy, senior art teacher, Denham Coll., Nr. Oxford (retired); artist in oil paint on board. *Medium:* painter in oil. *b:* Bucks., 19 Sep 1915. *d of:* William Fitzgerald. *m:* (1)Michael Rothenstein (one s., one d.)(2)Eric Ayers ARCA (decd.). *Educ:* private boarding schools, Sussex. *Studied:* Central School of Arts and Crafts, under William Roberts, Benard Meninsky and Maurice Kestleman. *Exhib:* Fry Art Gallery,Battersea Art Fair, Royal Academy, Chelsea Art Fair, Broughton House Gallery, Cambridge, Cricket Gallery, USA; Llewelyn Gallery, Cadogan Gallery, England & Co.Gallery London. *Works in collections:* private collections in UK and USA. *Commissions:* private portrait commissions. *Works Reproduced:* in many art magazines. *Principal Works:* mostly figures or still lifes. *Recreations:* painting and collecting from London markets. *Signs work:* "Duffy Ayers". *Address:* 4 Regent Sq., London WC1H 8HZ.

AYERS, Eric, A.R.C.A., M.S.I.A.; consultant designer. *b:* 12 Aug 1921. *s of:* Vivian Ayers. *m:* Duffy Rothenstein (née Fitzgerald). *Educ:* Balgowan Grammar School, Beckenham. *Studied:* The School of Photoengraving and Lithography, London, E.C.I, Beckenham School of Art, R.C.A. *Exhib:* Design in Business Printing Exhibition, Festival of Britain (Dome of Discovery); Milwaukee Library, Wisconsin (U.S.A.); C. of I.D. "100 Good Catalogues"; R.A. Summer Shows. *Works in collections:* Museum of Modern Art, N.Y., B.M. Dept. of Prints and Books, V. & A. Dept. of Prints and Books, O.U.P. Library. *Commissions:* Collaborated with David Hockney's artist's book 'Grimms Fairy Tales' (1969/1970), Henry Moore's artist's book 'W.H. Auden Poems' (1971/1972), Patrick Caulfield's artist's book 'The poems of Jules Laforge' (1972/1973), Claes Oldenburgh's Multiple, 'London Knees' 1966, etc. *Works Reproduced:* Graphis, Graphis Annual, Design Magazine. No. I42 1960. Article, "Do Posters Work?". *Misc:* Taught at London College of Printing, Senior Lecturer Camberwell School of Art, Graphic Arts Department (1972-1983), Fellow, Fine Art Dept., University of Newcastle, (1966-1967), Director and Art Director, since conception, of Editions Alecto (1963-1968). *Signs work:* "ERIC AYERS." *Address:* 4 Regent Sq., London WC1H 8HZ.

AYLES, Caroline, Chelsea Art Society Award. *Medium:* oil. *b:* Gartolharn, 2 May 1960. *d of:* Anne and Normile Baxter. one *s.* one *d. Educ:* Queensgate, Gordonstoun. *Studied:* South Thames College. *Represented by:* Portland Gallery. *Exhib:* RA Summer Exhbn, Art 2002, Art London (2003), Portland Gallery (2002, 2003, 2004, 2007), R. College of Art (2006). *Works in collections:* Palace

of Westminster. *Clubs:* Chelsea Arts Club, Soho House. *Signs work:* Caroline Ayles. *Address:* 28 Crescent Grove, London SW4 7AH. *Email:* caroline.ayles@btinternet.com

AYRES, Gillian, O.B.E., RA; Hon. Doctor Lit., University of London. *Medium:* painter. *b:* Barnes, London, 3 Feb 1930. two children. *Educ:* St. Paul's Girls' School. *Studied:* Camberwell School of Art. *Exhib:* group shows: Musée d'Art Moderne; Bienale de Paris, Paris (1959); Situation, London (1960-61); one-man shows, Gallery One (1956), Kasmin Gallery (1965-66, 1969), Knoedler London (1979, 1982, 1985, 1987), Knoedler New York (1985), R.A. British Art (1987), London, and Stuttgart, Germany. Awarded Japan International Art Promotion Association Award (1963), Gold Medal Triennale, India (1991). *Works in collections:* Tate Gallery, Museum of Modern Art, NY; Yale Center for Brit Art. *Publications:* 'Gillian Ayers' Mel Gooding (2001). *Misc:* taught at Bath Academy, St. Martin's; Head of Painting, Winchester School of Art (1978-). *Signs work:* "Gillian Ayres." *Address:* Tall Trees, Gooseham, nr. Bude, Cornwall.

B

BACK, Ken, Cert. RAS (dist.) (1967), NDD (1964); painter in oil and ink; part-time art lecturer. *b:* Guildford, 2 Apr 1944. *m:* Corinne Jones, artist (decd.). one *s.* one *d. Educ:* Astor School, Dover. *Studied:* Dover, Folkestone and Canterbury Colleges of Art (1959-64), R.A. Schools (1964-67, Peter Greenham, Charles Mahoney). *Exhib:* R.A., Piccadilly Gallery, Park Walk Gallery, London, Chappel Galleries, Colchester, etc. *Works in collections:* Europe and U.S.A. *Signs work:* "K.W. BACK" or "K.B." *Address:* White Cottage, Semere Green Lane, Dickleburgh, nr. Diss, Norfolk IP21 4NT.

BACKHOUSE, David John, RWA. FRBS, FRSA; sculptor in bronze and stone. *b:* Corsham, Wilts., 5 May 1941. *s of:* J. H. Backhouse. *m:* Sarah Barber. one *s.* two *d. Educ:* Lord Weymouth School, Warminster. *Studied:* West of England College of Art. *Exhib:* one-man shows: London, New York. *Works in collections:* RWA, British Steel Corp., Royal Opera House, Covent Garden, Morgan Crucible Co., Mercantile and General Reinsurance Co., Haslemere Estates, Telford Dev. Corp., City of Bristol, Tesco plc, J. Sainsbury plc., Standard Life, and private collections throughout Europe and in USA. *Misc:* Studio: Lullington Studio, Lullington, Frome, Som. BA11 2PW. *Signs work:* "Backhouse". *Address:* Lullington Studios Lullington, Frome, Somerset BA11 2PN. *Website:* www.davidbackhousesculptures.com

BAFFONI, Pier Luigi, N.S. (1975), R.O.I. (1979); artist in oil, water-colour and pastel. *b:* Turin, Italy, 11 Aug 1932. *s of:* Pierpaolo Baffoni, accountant. *m:* Mary Bainbridge. two *s. Educ:* College of the Missioni Consolata, Turin. *Studied:* College of Art, Turin (1954-58) under Luigi Guglielmino and privately from Alessandro Pomi of Venice. *Exhib:* one-man shows, Italy, Hertford, Cambridge, Bedford, Hitchin; mixed shows, Biennale of Castelfranco Veneto, Bologna, Mall

Galleries, London; Hawker Gallery, Amersham; Fosse Gallery, Stow-on-the-Wold. *Works in collections:* Montebelluna Town Hall, Bedfordshire Educ. Art Loan Service. *Publications:* included in "Modern Oil Impressionists" by Ron Ranson – David & Charles, (1992). *Signs work:* "P. L. Baffoni." *Address:* 140 Station Rd., Lower Stondon, Beds. SG16 6JH.

BAGHJIAN, Manouk, artist in water-colour, pastel, oil. *b:* Nicosia, Cyprus, 7 Jan 1929. married. *s of:* Aram and Mary Baghjian. one *s.* one *d. Educ:* Armenian High School, Cyprus. *Studied:* Richmond A.E.C. *Exhib:* Gulbenkian Hall Kensington, Clarendon Gallery Holland Pk., Chiswick Library, Pinacoteca Tossa de Mar, R.S.M.A. Mall Galleries (1989, 1990, 1991, 1994, 1995, 1996), B.B.C. Bush House, Hogarth Club W4, Hertford Art Soc. (1995), Chelsea Art Soc. (1995). *Works in collections:* 8 Turnham Green Terr., London W4. *Clubs:* Ealing Art, Richmond Art Soc. *Signs work:* "Manouk." *Address:* 213 Popes La., London W5 4NH.

BAILEY, Caroline, BA(Hons), MA, RSW; Awards: Daler Rowney RWS Open (1994), The Artist Award RWS Open (1997), Glasgow Arts Club Fellowship RSW (1999), NS Macfarlane Charitable Trust Award RSA (1999). Scottish Arts Club Award. *Medium:* artist in water-colour, gouache, acrylic. *b:* Chester, 5 Aug 1953. two *d. Educ:* St.Dominics High School. *Studied:* Manchester Polytechnic (1972-76). *Exhib:* John Noott Galleries Worcs., Broadway Modern Worcs., Panter and Hall, London, Walker Galleries Harrogate, Clifton Gallery Bristol, Colours Gallery Edinburgh, Manor House Gallery Oxon, also Open Exhbns. RSW, RSA, RWS, Ainscough Contemporary Art, London and Dartmouth, ClarkArt, Hale, Cheshire. *Works in collections:* Irish Management Inst., Maclay Murray & Spens, Edinburgh Fund Managers, Callscan Ltd. *Publications:* Landscape Drawing and Painting by Patricia Monohan. *Clubs:* R.S.W. *Signs work:* 'Caroline Bailey' (always in pencil). *Address:* Heathfields, Dunnockswood, Alsager, Stoke-on-Trent ST7 2XU.

BAILEY, Julian, BFA Oxon. (1985),RA Dip. (MA) (1988); Turner Gold Medal, RA Schools (1987); Landseer Scholarship (1988). *Medium:* oil and pastel. *b:* Cheshire, 8 Apr 1963. *s of:* Dudley Bailey, artist. *m:* Sophie Cullen, ceramist. two *s.* two *d. Educ:* Malvern College. *Studied:* Ruskin School of Art (1982-85), RA Schools (1985-88, Jane Dowling, Norman Blamey, RA). *Exhib:* R.A., New Grafton Gallery, Browse & Darby (1997 -2007. *Works in collections:* National Trust (F.F.A.), New College, Oxford, Warbergs, Reed Executive, H.R.H. the Prince of Wales, Dorchester County Council. *Recreations:* sailing. *Clubs:* Chelsea Arts. *Signs work:* "J.B." or "JULIAN BAILEY." *Address:* The Old Vicarage, Stinsford, Dorchester, Dorset DT2 8PS.

BAILEY, Liz, BA Hons Fine Art; BSc Hons Anthropology (UCL); shortlisted, Celeste Art Prize (2006). *Medium:* oil, photography, video. *b:* Herts., 19 Jan 1951. *m:* Ralph. two *s.* one *d. Studied:* Byam Shaw School of Fine Art (1998-2002); UCL (1981). *Exhib:* solo exhbn: Tricycle Gallery, London (2006); group:

RA Summer Exhbn (2004, 2005); Discerning Eye (2005); Vertigo Gallery (2003, 04, 05); Thompsons Gallery; Sarah Myerscough Fine Art; Menier Gallery;Business Design Centre; Century Gallery; Artsway Open (2006); Welsh Artist of the Year Exhbn, Cardiff (2007) etc. *Works in collections:* Esmee Fairbairn Foundation; The McGraw-Hill Companies Ltd; private collections. *Publications:* in RA Illustrated (2005); Celeste Art Prize catalogue (2006). *Works Reproduced:* reviews: a-n magazine (Nov 2006); solo exhibition 'On the Road' review by Roy Exley. *Misc:* residency at The Florence Trust Studios, Highbury, London N5 (Aug 2002-July 2003); lives and works in London and Welsh Borders. *Signs work:* 'Liz' and date. *Address:* 10 Grove Terrace, Highgate Road, London NW5 1PH. *Email:* liz@lizbailey.org.uk *Website:* www.lizbailey.org.uk

BAILEY, Susanna, BFA Hons, Slade Higher Diploma; Nancy Balfour Award; lecturer and writer. *Medium:* painting and printmaking (etching) - oil, acrylic, watercolour. *b:* Lusaka, Zambia, 12 Oct 1953. *d of:* Prof.D.K.Bailey. four *d. Educ:* USA, Britain, Eire. *Studied:* Slade School of Fine Art (1975-77). *Represented by:* Tracie Specia, Los Angeles. *Exhib:* Venice Gallery, Los Angeles; Beaux Arts, Bath; nationally and internationally. *Recreations:* walking, daydreaming. *Signs work:* "Susanna Bailey". *Address:* 2 Chapel Path, Colerne, Wiltshire, SN14 8DL. *Email:* mail@susannabailey.co.uk *Website:* www.susannabailey.com

BAILEY, Terence Robert, NDD (1958), ATD(1962), RBSA (1991); painter in oil; Senior lecturer, Northumberland CHE(1962-79). *b:* Wolverhampton, 21 Dec 1937. *m:* Kate (Valerie Ann Browning). three *s. Educ:* Wolverhampton Technical High School. *Studied:* Wolverhampton College of Art (1954-58), Bournemouth College of Art (1962). *Exhib:* Northern Painters (1966), Northern Art Exhbn. (1978), prize winner R.B.S.A. Open (1986), R.P., R.O.I., regularly at R.B.S.A.; several one-man shows. Winner in Alexon "Women on Canvas" portrait competition (1990). *Works in collections:* Northumberland C.C., Northern Arts, National Library of Wales, R.B.S.A.; many private collections. *Signs work:* "Terry Bailey." *Address:* Dovey Studio, Aberdyfi, Gwynedd LL35 0LW.

BAILLIE, William James Laidlaw, C.B.E.,P.P.R.S.A., P.P.R.S.W., R.G.I., H.R.A., H.R.H.A., H.R.W.A., H.B.W.S., H.F.R.B.S., H.R.U.A., H.S.S.A., D.Litt., D.A.Edin. (1950); painter in oil and water-colour; Past President, Royal Scottish Academy. *b:* Edinburgh, 19 Apr 1923. *s of:* James L. Baillie. *m:* Helen Baillie. one *s.* two *d. Educ:* Dunfermline High School, Fife. *Studied:* Edinburgh College of Art (1941-42); (War Service 1942-46) (1946-50, Gillies, Maxwell, Rosoman, Philipson, MacTaggart), Diploma (1950), Moray House Teaching College 1950-51. *Represented by:* many. *Exhib:* one-man shows: Edinburgh, Harrogate, Newcastle, Salisbury, London, etc. *Works in collections:* Aberdeen, Edinburgh, Glasgow, Fife, Perth, Kansas, U.S.A., Australia, Canada, Germany, Greece, Sweden, U.K., U.S.A., etc. *Commissions:* several private commissions. *Works Reproduced:* several, too many to report. *Recreations:* music and travel. *Clubs:*

Scottish Arts and New Club. *Signs work:* "W.J.L. Baillie." *Address:* 6a Esslemont Rd., Edinburgh EH16 5PX.

BAIN, Julia Mary, M.F.P.S. (1985), Mem. Chelsea Art Soc. (1984); Woodrow Award (1986); sculptor in terracotta, wax and bronze. *b:* London, 22 Jun 1930. *d of:* Guy Warrack, conductor and composer. *m:* 1st:David Bain, F.R.C.S.; 2nd Peter Cooke C.B.E. three *s.* one *d. Educ:* The Legat School of Russian Ballet. *Studied:* I.L.E.A. Chelsea/Westminster (1978-81), Sir John Cass College (1981-83). *Exhib:* F.B.A. (1983-89), R.B.A., S.W.A., N.S., F.P.S. Trends, Art of Living S.P.S., Chelsea Art Soc.; one-man shows, Windsor Festival (1981, 1986, 1989), Century Gallery, Datchet (1990, 1995), The Deanery, Windsor Castle (1993, 1995). Work in private collections. *Commissions:* The 'Tablet' Madonna - many portraits and others; The 'Woodrow Award'. *Recreations:* choral singing. *Signs work:* "J.B." *Address:* Oak Lodge, Maltmans Lane, Chalfont St.Peter, Gerrards Cross, Bucks SL9 8RP. *Email:* julia.cooke3@virgin.net

BAIN, Peter, painter in oil. *b:* London, 15 Dec 1927. *m:* Jennifer. four *s. Studied:* Bath Academy of Art. *Signs work:* "Bain." *Address:* Tiled Cottage, Old Bosham, Sussex PO18 8LS.

BAINES, Richard John Manwaring, M.A., PhD., ROI, RDS, NDD, ATD, V.P.ROI (1997), P.ROI(1998); painter, writer, lecturer, critic, broadcaster (radio & TV); previously Senior lecturer/Head of Academic Studies, London College of Fashion. *b:* Hastings, 1940. *s of:* John Manwaring Baines, B.Sc., F.S.A., F.M.A. *m:* Maureen Gregory. two *s.* one *d. Studied:* Regent St. Polytechnic, Goldsmiths' College, Birmingham Polytechnic. *Exhib:* R.O.I., R.B.A., N.S., R.E., Painter-Etchers, London and provinces; one-man exhbns. Hastings (1968, 1987). *Works in collections:* County Borough of Hastings, Manx Museum, London Inst. 'Genesis Triptych' in Fairlight Parish Church. *Commissions:* Royal Arms and mural restorations, All Saints Church, Hastings. *Publications:* Mainly design history. *Clubs:* East Sussex Arts (Past President). *Address:* Badgers End, Warren Rd., Fairlight, E. Sussex TN35 4AG.

BAINES, Valerie, A.R.M.S. (1985), founder-member of S.B.A. (1988), F.L.S. (1991), V.P.S.B.A. (1996); Botanical artist, miniature painter and natural history illustrator. *Medium:* watercolour, oil. *b:* Romford, 1935. *m:* Brian Norman. one *s. Educ:* Roxeth Mead School, Harrow on the Hill; Royal College of Music, London. *Studied:* Harrow Art School. *Exhib:* RMS, RHS, The Royal Academy, Society of Botanical Artists, Westminster Galleries, Mall Galleries, Alpine Gallery, Medici Gallery, 7th Exhbn. of International Botanical Art, Carnegie Mellon University, Pittsburgh, U.S.A., Memorial University, Botanic Gardens, Newfoundland, Canada, Le Jardin des Cinq Sens, Yvoire, France. *Works in collections:* Carnegie Mellon University Botanical Library, Pittsburgh, U.S.A., Port Lympne, Kent; many private collections world-wide, including U.K., America, India, South Africa, Canada and France. *Commissions:* Oil paintings of houses. Water-colour interiors, flowers, gardens etc. 14 gorilla portraits for John

Aspinall 1988/9. *Publications:* The Naturalist's Garden by John Feltwell (Ebury Press, 1987), Botanical Diary (St. Michael, 1989), The Story of Silk, J. Feltwell (Allen Sutton 1990), The Big Book (Collins, 1991), Meadows, J. Feltwell (Allen Sutton 1992), Glorious Butterflies, (Butterfly Conservation 1993), Gardens and Butterflies Calendar (Butterfly Conservation 1998), Mindful of Butterflies, Bernard S. Jackson (The Book Guild 1999), A2 poster for Watch (Wildlife Trusts 2000). *Works Reproduced:* Arte y Botanica. Seleccion de Illustraciones de 'The Society of Botanical Artists' (Caja Madrid Obra Social 2001); The Art of Botanical Painting, Margaret Stevens VPSBA (2004); The Botanical Palette, Margaret Stevens PSBA 2007. *Recreations:* music, gardening. *Misc:* biographical articles in 'The Artist' Nov 1983, 'Kent Life' 1999, 'Magnet' 2007. Butterfly Garden Design, Juniper Hall, FSC Dorking, Surrey. *Signs work:* "V.B.", "Valerie Baines" and "V. BAINES." *Address:* 26 Crittle's Court Wadhurst E.Sussex TN5 6BY. *Website:* www.valeriebaines.com

BAKER, Alexandra Clare, FRSA; PCAFAS; several prizes at exhibition; Chairman Armed Forces Art Society (2002-07). *Medium:* most media. *b:* Southborough 26 Jan 1947. *d of:* Field Marshal Sir Geoffrey and Lady Baker. *m:* Brigadier Thomas Bremridge. two *s. Educ:* PNEU School, Burgess Hill; Windsor Girls School, Germany. *Studied:* Sir John Cass, Tower Hill, London. *Exhib:* Many galleries at home and abroad including Mall Galleries, Malcolm Innes Gallery, Christie's, Wykeham Gallery, Al Muntasir Gallery Oman. *Works in collections:* Series for HM Sultan Qaboos, Oman; many museums; corporate and private collections. *Commissions:* official military, corporate and private; Royal presentations. *Publications:* Specialist journals; artwork for books. *Official Purchasers:* numerous. *Works Reproduced:* numerous. *Principal Works:* landscape, architectural, figurative, marine, military. *Recreations:* skiing, walking, reading. *Clubs:* several Art Societies. *Signs work:* AB (monogram). *Address:* The Orchards, Forton, Andover SP11 6NN. *Email:* art@alixbaker.com *Website:* www.alixbaker.com

BAKER, Christopher William, B.A.Hons. (Fine Art, 1978), P.G.C.E. (1981), R.B.A. (1981); printmaker, oil on canvas, dramatic landscape paintings; Tutor, West Dean College; David Murray Landscape Scholarship, Royal Academy; Laing Painting Prize Winner; major Award British Arts Council; Wolfers-O'Neill Foundation; Canadian Arts Council:Banff Centre for the Arts. *Medium:* oils, watercolour, printmaking. *b:* Essex, 27 May 1956. *s of:* Mrs.M.Sugden, Capt.D.S.Baker. *Educ:* Kingham Hill School, Oxon. *Studied:* West Surrey College of Art and Design (1974-75, M. Fairclough), Glos. College of Art and Design (1975-78, Prof. D. L. Carpanini), Exeter University. *Represented by:* The New Grafton. *Exhib:* Royal Academy, R.W.A., R.B.A., Mall Galleries, Phoenix Gallery, Highgate, Burstow Gallery, Brighton College; Wyckeham Gallery, Stockbridge; Portsmouth Museum of Art; Pallant House Gallery, Chichester; Petworth House Gallery; Oslo Museum of Art, Brighton Museum. *Works in collections:* Coventry Adult Educ., Oundle School, West Dean College, The Royal Mint (London). *Commissions:* The Royal Mint, No1 London Bridge, Hon.

Nicholas Soames, Edward James Foundation. *Official Purchasers:* Art Contact, London. *Works Reproduced:* The Artist, Quattro Publications; Encyclopedia of Oil Painting; Encyclopedia of Watercolours; Perspective for Artists; The Watercolour Palette; Oil Painters Masterclass. *Principal Works:* 'Ultimate Thule', 'Terra Incognita'. *Clubs:* Chelsea Arts Club. *Misc:* Research Expedition-Antarctica 2003; Canadian High Arctic 1997; 2000 Banff Centre for the Arts. *Signs work:* "Christopher Baker." *Address:* 110 Fitzalan Rd., Arundel, W. Sussex BN18 9JY. *Website:* www.christopherwbaker.com

BAKERE, Ronald Duncan, M.A., F.R.S.A. *Medium:* sculptor in metal and ceramic. *b:* Lanark, Scotland, 7 Sep 1935. *m:* (1) Dr. Jane Earthy. (2) Macaria Saducos. three *s.* one *d. Educ:* Norwich School, Christ Church, Oxford. *Studied:* Putney School of Art, Sir John Cass Dept. of Art at London Guildhall University. *Exhib:* Arts Club, Dover St., Brixton A.G.; South Thames College, etc. *Commissions:* private. *Clubs:* sometime Chairman Brixton Art Gallery, Sussex Arts Club, London Flotilla. *Address:* 11B Sussex Heights, St. Margaret's Place, Brighton BN1 2FQ.

BALDWIN, Arthur Mervyn, NDD(1955), Rome Scholarship, Sculpture, 1960; sculptor in metals and synthetics; self employed artist and restorer; 1978, retired defeated by lack of public appreciation - now restores antique watches for which service people happily pay. *b:* Immingham, Lincs., 1 Feb 1934. *s of:* William Henry Baldwin. *m:* Patrica Mary. two *s. Educ:* Humberstone Foundation School, Old Clee, Lincs. *Studied:* Grimsby School of Art, Leicester College of Art. *Works in collections:* National Museum of Wales, Arts Council (Wales); Städtischen Kunstammlungen, Ludwigshafen. *Signs work:* sculpture unsigned; drawings etc. signed "MERVYN BALDWIN." *Address:* 18 The Walk, Cardiff CF2 3AF.

BALDWIN, Gordon, O.B.E. (1992), NDD (1952), Central Dip. (1953); ceramist; Hon. Dr. RCA. *b:* Lincoln, 10 Nov 1932. *s of:* Lewis Nelson. *m:* Nancy Chandler. one *s.* two *d. Educ:* Lincoln School. *Studied:* Lincoln School of Art (1949-51, Toni Bartl), Central School of Art and Design (1951-53, Dora Billington). *Works in collections:* V. & A.; Southampton A.G.; Crafts Council; Leicester Educ. Authority; Usher Gallery, Lincoln; Abbots Hall, Keswick; Paisley A.G.: Boymans van Beuningen, Rotterdam; Bellrive Museum, Zurich; Penn. State University, U.S.A.; Gateshead A.G.; Swindon A.G.; Museum of Art, Melbourne; Museum of Art, Perth; Knukke-Heiste, Keramion, W. Germany; Octagon Centre, Idah., U.S.A. *Address:* Barrett Marsden Gallery 17-18 Grt. Sutton St., London EC1V 0DN.

BALDWIN, Martyn John, Dip.A.D.; BP Portrait Awards (Commended). *Medium:* painter in oil. *b:* Edgware, 18 May 1959. *m:* Christine Vivianne Baldwin. *Educ:* Downer Grammar School. *Studied:* Harrow School of Art (1979-83). *Exhib:* RA, NPG. *Works in collections:* Naughton Gallery, Belfast University. *Publications:* BP Portrait Award (1990-2001); National Portrait Gallery. *Works*

Reproduced: BP Portrait Award (1990-2001). *Signs work:* "M. Baldwin" or "BALDWIN." *Address:* Flat 3, 132 Headstone Rd., Harrow HA1 1PF. *Website:* www.martynbaldwin.com

BALDWIN, Nancy, painter. *b:* 3 Mar 1935. *d of:* Hayden Thomas Chandler. *m:* Gordon Baldwin. one *s.* two *d. Educ:* St. Joseph's Convent, Lincoln. *Studied:* Lincoln School of Art (1949-52, Toni Bartl), Central School of Art and Design (1952-54, Dora Billington). *Exhib:* Reading Gallery, Thames Gallery, Windsor, The Gallery, Eton College, Cross Keys Gallery, Beaconsfield, Salix, Windsor, Oxford Gallery, City Museum and Gallery, Stoke-on-Trent, Midland Group, Nottingham, Ikon, Birmingham, Holsworthy, London, Carmel College Gallery, Bohun Gallery, Henley, Ellingham Mill, Bungay, prize winner Midland View (1980), Lynne Strover Gallery, Cambridge, Barrett Marsden Gallery, London. *Works in collections:* Ashmolean Museum, Oxford and private collections in U.K., Italy, Switzerland, Belgium, Hong Kong, France, U.S.A. *Address:* Rylands House, Greathales St., Market Drayton TF9 1JN.

BALDWIN, Warren, DipAD (1971); Singer & Friedlander/Sunday Times Watercolour Competition (3rd prize 1990, 1992, 1st Prize 1995), The Hunting Art Prize (2nd 1995), The South West Academy of Art Annual Exhbn (1st 2000), The Prince of Wales Award for Portrait Drawing RSPP (2003). *Medium:* watercolour, drawing, prints. *b:* London, 7 Apr 1950. *m:* Wilhemina Croonenberghs. *Studied:* Wimbledon School of Art (1967-68), The London College of Printing (1968-71), but mainly self-taught, in self-imposed isolation 1971-81. *Exhib:* RA Summer Exhbn, Mall Galleries, RSPP, Discerning Eye, NEAC, The Jerwood Drawing Prize, National Portrait Gallery Portrait Awards, Offer Waterman & Co, Waterhouse & Dodd (Cork Street), RCA, Holburne Museum of Art Bath, many mixed shows since 1982. *Works in collections:* Singer & Friedlander, Beecroft Art Gallery, many private collections in UK and Europe. *Signs work:* 'Warren Baldwin' on reverse. *Address:* 2 Leaphill Road, Bournemouth, Dorset, BH7 6LU.

BALKWILL, Raymond James, SWAc (elected Academician of the South West Academy of Fine and Applied Art, 2006); painter in water-colour and pastel. *b:* Exeter, 7 Oct 1948. *m:* Jane. two *s. Studied:* Exeter College of Art. *Exhib:* Open shows including R.I., R.W.A., Bristol, South West Academy of Fine and Applied Arts. *Works in collections:* internationally. *Publications:* regular contributor of articles to 'The Artist'. Author of 4 books. 'Ray Balkwill's Exe Estuary', 'Watercolour Plus..', 'Coastal Landscapes', 'Painting Landscapes with Atmosphere'. *Clubs:* St. Ives Soc. of Artists. *Signs work:* " RAY BALKWILL." *Address:* 'Thistledown', Marley Rd., Exmouth, Devon EX8 4PP. *Email:* raybalkwill@raybalkwill.co.uk *Website:* www.raybalkwill.co.uk

BALL, Gerald, RCA (1979); painter in water-colour and tempera. *b:* Ashton-under-Lyne, 24 May 1948. *s of:* Robert Ball, musician. *m:* Ann Mumford. *Educ:* Hartshead Comprehensive. *Studied:* Ashton-under-Lyne CFE. *Exhib:* RWS, Richard Hagen, Ltd., RI, Manchester Academy, Agnews, Tegfryn Gallery, Bourne

Gallery, Catto Gallery, David Curzon Gallery, Walker Galleries, Crossing Gate Gallery, Brian Sinfield. *Works in collections:* Coleg Harlech. Work in many private collections worldwide. *Commissions:* numerous. *Signs work:* "GERRY BALL." *Address:* Old Golderwell, Golderfield, Pudleston, Leominster, Herefordshire HR6 0RG.

BALL, Robert, A.R.C.A. (1942), R.E. (1943), R.B.S.A. (1943), F.R.S.A. (1950), R.B.A. (1979), A.R.W.A. (1988); British Inst. Scholarship for Engraving (1937); teacher of painting, drawing and anatomy, Birmingham College of Art (1942); Princ. Stroud School of Arts and Crafts (Jan., 1953); teacher of painting, Glos. College of Art (1959-81); artist in oil, water-colour, drawing, etching, line-engraving, mezzotint, aquatint, and wood-engraving. *b:* Birmingham, 11 Jul 1918. *s of:* John William Ball, silversmith. *m:* Barbara Minchin. one *s.* two *d. Studied:* Birmingham Junior School of Art (1930-33), Birmingham College of Art (1933-40); R.C.A. (1940-42). *Exhib:* R.A., R.W.A., R.E., R.B.S.A., R.B.A. *Works in collections:* V. & A., Ashmolean, Gloucester, Dudley, Hunterian, Walsall, Cheltenham and Birmingham Museums. *Publications:* illustrated Cotswold Ballads by Mansell. *Signs work:* "Robert Ball." *Address:* Beth-shan, Kingsmead, Painswick, Glos. GL6 6US.

BALMER, Barbara, A.R.S.A. (1973), R.S.W. (1966), R.G.I. (1988); painter in oil and water-colour. *b:* B'ham, 23 Sep 1929. *m:* George Mackie, D.F.C., R.D.I., R.S.W. two *d. Studied:* Coventry School of Art; Edinburgh College of Art. *Exhib:* one-man shows: Demarco Gallery, Edinburgh (1965-70), Scottish Gallery, Edinburgh (1975, 1980, 1985, 1988), Posterngate Gallery, Hull (1983), Stirling Gallery (1976), Usher Gallery, Lincoln (1984); Retrospective '55-'95 Touring Exhbn. (1995-96). *Works in collections:* Glasgow Kelvingrove A.G., Edinburgh City Art Centre, Aberdeen A.G., Perth A.G., S.N.P.G., S.A.C., Usher Gall. Lincoln, Coventry Herbert A.G., Dundee McManus A.G., Leicester City Museum, Royal Bank of Scotland, Citibank, Stamford Museum. *Works Reproduced:* Many catalogues and Giclee prints. *Principal Works:* Large oil paintings of Tuscany/Umbria. *Signs work:* "Barbara Balmer." *Address:* 32 Broad St., Stamford, Lincs. PE9 1PJ.

BALMER, Derek Rigby, R.W.A.; painter in oil; President, Royal West of England Academy; R.A. (Hon.) Pro. Chancellor University of the West of England; Doctor of Arts (Hon) U.W.E. *b:* Bristol, 28 Dec 1934. *s of:* Geoffrey Johnson Balmer. *m:* Elizabeth Mary Rose. one *s.* one *d. Educ:* St. Gabriel's Convent, Waterloo House, Sefton Pk. *Studied:* West of England College of Art (Dennis Darch, Derek Crowe, Paul Feiler). *Represented by:* Anthony Hepworth Fine Art, Bath. *Exhib:* Arnolfini (four), New Art Centre, Leicester Gallery, R.W.A. Represented by Anthony Hepworth Fine Art Bath, and Gisela Van Beers London, Dutch Dealers: Smelik and Stokking The Hague and Amsterdam; recent one-man shows at Anthony Hepworth, London; Six Chapel Row, Bath, and Campden Gallery, Gloucestershire. Also RA Summer Show; Retrospective (1950-2007), Royal West of England Academy, Bristol 'Presidents Eye'. *Clubs:*

Chelsea Arts. *Signs work:* "Balmer" or "Derek Balmer." *Address:* Mulberry House 12 Avon Grove Sneyd Pk. Bristol 9 1PJ.

BANEY, Ralph R., F.R.B.S. (1984), M.F.A. (1973), Ph.D. (1980), Hon DLitt (2004), A.T.C. (1962), Who's Who in American Art (1973); Professor of Art; sculptor in wood, bronze, ceramic, fibreglass. *b:* Trinidad, 22 Sep 1929. *m:* Vera. one *s. Educ:* Naparima College, Trinidad. *Studied:* Brighton College of Art (1957-62, A.J.J. Ayres), University of Maryland, U.S.A. (1971-76, Ken Campbell). *Exhib:* Washington County Museum, O.A.S. Gallery, Washington D.C.; Sculpture House, N.Y.C.; Georgetown University. *Works in collections:* H.M. The Queen; Washington County Museum of Fine Arts, Hagerstown, Md.; Central Bank, Trinidad. *Commissions:* Sculpture for Sir Vidia Naipaul. *Clubs:* Sculptors Guild Inc. N.Y., Washington Sculptors Group. *Signs work:* "R. BANEY." *Address:* 5203 Talbot's Landing, Ellicott City, Md. 21043, USA. *Email:* baneyrr@yahoo.com *Website:* www.ralphandverabaney.com

BANKS, Brian, painter in acrylic, oil, mixed media. *b:* London, 21 Oct 1939. *s of:* William John Ralph. *m:* Christine, divorced 1974. two *s.* one *d. Educ:* Sir Walter St. John's Grammar School, London. *Studied:* St. Martin's (1956-57), Peter de Francia, Edward Middleditch, James Dring; privately with John Flavin, A.R.C.A. (1958). *Exhib:* one-man shows: Colin Jellicoe Gallery, Manchester; Ansdell Gallery, London; Zaydler Gallery, London; Fermoy Art Gallery, King's Lynn; Conway Hall, London; Leigh Gallery, London, (1984, 1985), Trinity Arts Centre, Tunbridge Wells. Represented by Leigh Gallery, Bloomsbury, London. *Works in collections:* Britain, Australia, France, U.S.A., Denmark. *Signs work:* "BANKS" (year). *Address:* 8 Ravenet Ct., Battersea Pk. Rd., London SW11 5HE.

BANKS, Claire Elinor, BA (Hons)1st Class, MFA; Alastair Salvesen Art Travelling Scholarship (administered through RSA) 1995; Rome Scholar in Painting, British School at Rome (1992-3), Anna Miller Trust Scholarship (2001). *Medium:* oil, watercolour, drawing. *b:* Edinburgh, 26 Mar 1967. *Educ:* Craigmount High School. *Studied:* Edinburgh College of Art (1985-91). *Represented by:* Open Eye Gallery, Edinburgh. *Exhib:* 11 solo exhbns in Scotland and Italy, including RSA, Open Eye Gallery Edinburgh, Florence(2), Cremona, Italy(1); many group exhbns including RSA and RSW. *Works in collections:* RSA Archive, City of Edinburgh Council, Paintings in Hospitals Scotland. *Official Purchasers:* RSA Archive, City of Edinburgh Council, Paintings in Hospitals Scotland. *Signs work:* Claire Banks (on reverse of work). *Address:* 2 Grosvenor Place, Main Street, St.Boswells, Roxburghshire, TD6 0AT. *Email:* cbjb@bosells.fsnet.co.uk

BANKS, Nancy, U.A., M.F.P.S.; sculptor in bronze, direct plaster, terracotta and mixed media. *d of:* the late W.J. Yates. *m:* John Banks, M.Eng., F.Eng. two *s. Educ:* Nutgrove, Rainhill, Lancs. *Studied:* Sir John Cass College of Art, and Eltham Art Institute. *Exhib:* Mall Galleries, R.B.A., U.A., N.S., R.M.S., S.W.A., S.P.S., Barbican, Bloomsbury, Guildhall, Alpine, Weighouse galleries, I.E.E.,

Blackheath, Usher, Lincs., Worthing Museum and A.G., M.A.S.-F. *Works in collections:* U.K., U.S.A., Japan, Spain. *Commissions:* several private; trophy for presentation to HMS Brave. *Clubs:* L.L.L.C. *Signs work:* "N. BANKS" or "Nancy Banks" depending on size of work. *Address:* B.1. Marine Gate, Brighton, E. Sussex BN2 5TQ.

BANNING, Paul, RI (2005), RSMA (2004); AROI (2006); N.D.D. (Hons.) Furniture Design (1956); painter in watercolour and oil, most subject matter; designed furniture in industry until 1986, now professional painter; Llewellyn Alexander Award, RI Exhibition (2002), RWS C21 Freshfields Prize (2000). *b:* Port of Spain, Trinidad, 1 Aug 1934. *m:* Margaret. three *s.* one *d. Educ:* Clifton College, Bristol. *Studied:* West of England College of Art, Bristol (1953-1957), taught drawing by Victor Passmore. *Exhib:* 24 solo exhibs. in U.K., Holland, Dubai, and group exhibs. in U.K., France, and U.S.A; NEAC, RA, Singer and Friedlander Watercolour Competition. *Works in collections:* Freshfields. *Publications:* articles for Artists, and Artists & Illustrators Magazine. *Clubs:* Member of Wapping Group of Artists, Chelsea Art Society, Armed Forces Art Society. *Signs work:* Now signs work "PB." *Address:* Woodlands Corner, Redlands Lane, Ewshot, Farnham, Surrey GU10 5AS. *Email:* paulbanning@uk2.net *Website:* www.paulbanning.com, www.paulbanning.co.uk

BANNISTER, Geoffrey Ernest John, served Royal Navy Minesweepers (1942-46); E.V.T. instructor in Commercial Art (Royal Navy, 1945-46). *Medium:* artist/designer, figure, scraper-board, water-colour, oils. *b:* Birmingham, 15 Jan 1924. *s of:* Henry J. Bannister. *m:* Beryl Parr Robinson, 1949 (deceased, 1966). one *s.* one *d.*; remarried, 1967, Susan Jennefer Peters, 2 *s. Educ:* St. Philip's Grammar School. Proprietor, Minster Print & Packaging. *Exhib:* Walsall Art Gallery; Worcester Cathedral. *Works in collections:* boardrooms, private homes. *Commissions:* chairpersons, directors, general public, portraits, animals, landscapes etc. *Clubs:* Catenian Assoc., Walsall Society of Artists. *Signs work:* "Geoff Bannister." *Address:* Crossways, 811 Sutton Rd., Aldridge, Walsall, W. Midlands WS9 0QJ. *Email:* geoff_bannister@hotmail.com *Website:* www.geoffbannisterartist.com

BARANOFF, Elena, RMS (1998); MFA in Miniatures; awards: Gold Memorial Bowl (Hon. Mention, 1997,1998, 2002); Mundy Sovereign Portrait Award (2005); First Historical & Mythical Award, Florida (2003); Mixed Media Award, Florida (second prize, 2004); Mixed Media Award, Colorado (First Place, 2002); portrait painter, icon painter, miniature painter, restorer, illustrator. *Medium:* specializes in centuries old technique of egg tempera. *b:* Ivanovo, Russia, 10 Aug 1960. *m:* divorced. one *d. Studied:* Palekh Art College, Palekh, Russia, under Boris Nemtinov, Michael Belousov, Victor Golov, Uriy Brovkin, Vitaliy Kotov (1977-82). *Represented by:* RMS. *Exhib:* Smithsonian, Washington DC, USA; Leepa-Rattner Museum, Florida; Gulf Coast Museum of Art, Florida; Westminster Gallery, London; Royal Automobile Club, London; Mall Galleries; The Millennium War & Peace Ball Auction, London; Chateau de Bernicourt,

France; World Exhbn of Miniature Art, Tasmania; Art Expo, New York, USA; El Dorado Gallery, Colorado Springs, USA; Light Opera Gallery, San Francisco, USA; Serendipity Gallery, Dallas, USA; Stardust Gallery, McLean, Virginia, USA; Leon Kaplan Gallery, NY, USA; Consulate General of Russian Federation, San Francisco, USA. *Works in collections:* private collections of: H.R.H.Prince of Wales, Count & Countess Andrei Tolstoy-Miloslavsky, Eveline Kirkland (art dealer, USA); other collections around the world. *Commissions:* Light Opera Gallery, San Francisco, USA; Serendipity Gallery, Dallas, USA; commissions from private collectors and companies worldwide, including bishops and archbishops of the Orthodox Church, USA. *Publications:* artworks were featured in: BBC World News; H.R.H. The Prince of Wales Official Website; PBS interview, Westminster Central Hall. *Works Reproduced:* artworks have been critically acclaimed in newspapers and magazines in USA and UK. *Signs work:* 'Elena Baranoff'. *Address:* 41 Sutter Street, PMB #1303, San Francisco, CA 94104, USA. *Email:* elena@elenabaranoff.com *Website:* www.elenabaranoff.com

BARANOWSKA, Janina, artist in oil. *b:* Poland, 28 Oct 1925. *d of:* Josef Zbaraszewski, officer in Polish Army. *m:* Maksymilian Baranowski. one *s. Educ:* In Poland, Middle East and Scotland. *Studied:* Borough Polytechnic under Prof. Bomberg (1947-50), School of Art at the Polish University of Stefan Batory in London (1951-54). *Exhib:* One-man shows: Drian Gallery, Grabowski Gallery, Raymond Duncan Galleries, Alwin Gallery, Grand Prix Rencontre Lyon, France, Det Lille Galleri, Norway, State Galleries in Krakow and Poznan, Poland, Royal Festival Hall, London, Dixon Gallery - University of London, Bloomsbury Gallery, Woburn Fine A.G., Polish Cultural Inst. Mixed exhib.: R.A., Burlington Gallery, Cassel Gallery, R.B.A. Galleries, New Vision Centre, Walker's Galleries, Whitechapel A.G., Edinburgh. *Publications:* Editor of Contemporary Polish Artists in G.B. (1983), Form and Colour (Congress of Polish Culture). *Clubs:* W.I.A.C., Group 49, I.A.L., I.A.A. - U.K. National Com., A.P.A. in G.B. (Chairman), N.S.P.S. (Mem.). *Signs work:* "Baranowska." *Address:* 20 Strathmore Rd., London SW19 8DB.

BARBER, Raymond, A.C.F.I., A.M.II.M., City and Guilds, London Inst. (1943), E.M.E.U. (1937), S.S.I.A. (1945); Course Tutor at Footwear Dept Wellingborough Technical College; Footwear Section Head (retd.). *b:* 30 Sep 1921. *m:* Eileen. *Educ:* Kettering Rd. Inst., Northampton, College of Technology, Northampton, Leicester College of Technology. *Exhib:* Walsall, London, in conjunction with "Leather, Footwear and Allied Industries" Export Corp., Ltd.; Quality Footwear Exhib., Seymour Hall, London. *Clubs:* N.C.T.S.A., N.G.C., N.S.M.E. *Signs work:* "Renny." *Address:* 10 Wantage Cl., Moulton, Northampton NN3 7UY.

BARBER KENNEDY, Mat, B.A.(Hons.) (1984), M.A. (1988), R.I. (1994); painter in mixed media collage using water based media, water-colour, acrylic, ink. *b:* Hornchurch, Essex, 7 Oct 1962. *m:* Sherry Kennedy. three *s. Educ:*

Coopers Company and Coborn School. *Studied:* Royal College of Art. *Represented by:* Shell House Gallery, Ledbury; Linda Blackstone Gallery, Pinner; E.S.Lawrence Gallery, Charleston S.C. & Aspen, Co. *Exhib:* annual Spring show at Mall Galleries, regular events at galleries in England and America. *Works in collections:* Chicago Public Library, Hertfordshire County Council. *Commissions:* The Marchday Group, Pollard Thomas & Edwards Architects. *Address:* 1706 1/2 S. Halsted St., Chicago, Illinois 60608, USA. *Email:* mbk@matbarberkennedy.com *Website:* www.matbarberkennedy.com

BARCLAY, Sir Colville, Bt.; M.A. *Medium:* painter in oil and water-colour. *b:* London, 7 May 1913. *s of:* Sir Colville Barclay, K.C.M.G. *m:* Rosamond Elliott. three *s. Educ:* Eton and Oxford. *Studied:* Ruskin School, Oxford. *Exhib:* R.B.A., R.A., London Group, Brighton and Bradford A.G. *Works in collections:* L.C.C. Schools, Arts Council, Bradford City Art Gallery. *Signs work:* "Barclay." *Address:* 23 High St., Broughton, Stockbridge, Hants. SO20 8AE.

BARKER, Allen, HND (1960); artist in acrylic paint; Personal tutor and Specialist lecturer, Central St.Martin's School of Art. *b:* Australia, 11 Mar 1937. *m:* Marilyn Norton-Harvey. one *s. Educ:* Lismore High School. *Studied:* art at National Art School, Sydney (1955-60); lithography at Central School of Art, London (1962). *Exhib:* one-man shows: University of Kent (1967), University of Essex (1968), Galerie Junge Generation, Vienna (1969), Lucy Milton Gallery, London (1971, 1973), Galerie Van Hulsen, Amsterdam (1972), Ferens A.G., Hull (1973), City A.G. Manchester (1973), Laing A.G., Newcastle-upon-Tyne (1973), Museum and City A.G., Leicester (1974), City Museum and A.G., Portsmouth (1974), Ikon Gallery, Birmingham (1974), Park Sq. Gallery, Leeds (1974), Kinsman Morrison Gallery, London (1975), Galerie Grafica, Tokyo (1976), I.C.A. (1976), Structured Theatre Co., Nuffield Theatre, Lancaster University (1976), Galerie Grafica, Nasaka (1977), Architectural Assoc., London (1977), Coracle Press, London (1978), Galleri Morner, Stockholm (1978), Gallery Pinc Studio, London (1996), 21st Century Gallery, London (1997), retrospective exhbn. Bonham's Fine Art, London (1998), Cambridge University (Sir Norman Foster Building, Faculty of Law, one-man show, 1998), Carpet designed by Barker produced and made by Mike Evans and showing in London (1999), ArcArt Gallery, London (2004, 2006). Documentation of all exhbns. held in the archives of the Tate Gallery, London (2005). *Works in collections:* Sheffield Museum and City A.G., Leicester Museum and City A.G., Manchester City A.G., Galerie Orez Mobile, Den Haag, Holland, AT and T, New York, Museum Boymans Van Beuningen, Rotterdam, Cambridge University, Sir Norman Foster Bldg., Faculty of Law; numerous work in private collections. *Publications:* Two-page colour article on Boreatton Workshop, Nippon Broadcast Publications, Japan (1992), The Australian Magazine, colour article and review by Jane Cornwell titled "London Bridges", (July 2000). *Misc:* Formed: Structured Theatre Co. (1976), Bassett Architectural Constructions and Designs (1984), Boreatton Bat Soc. of Fine Artists and Designers (1990). Travelling Visually - Boreatton Hall, Shrewsbury - Master Classes and Performance Workshops

(1991). *Signs work:* "Barker." *Address:* 14 Bassett Rd., London W10 6JJ. *Email:* mike@mikerole3.co.uk *Website:* www.arcart.org.uk

BARKER, Clive, sculptor in bronze and chrome. *b:* Luton, Beds., 29 Aug 1940. *s of:* F. Barker. *m:* Rose Bruen-divorced. two *s. Educ:* Beech Hill Secondary Modern. *Studied:* Luton College of Technology and Art (1957-59) under Clifford Barry, A.R.C.A. *Exhib:* Robert Fraser Gallery, Hanover Gallery, Musee d'Art Moderne, Museum of Modern Art, N.Y., Palais des Beaux-Arts, Palazzo Strozzi, etc. *Works in collections:* Arts Council of Gt. Britain, British Council, V. & A., Tate Gallery, etc. *Publications:* Pop Art Re-defined (Thames & Hudson), Image as Language (Penguin), Pop Art (Studio Vista), Art in Britain 1969-70 (Dent), Objekt Kunst (Dumont). *Signs work:* "Clive Barker." *Address:* 6 The Clocktower, Heath St., Hampstead, London NW3 6UD.

BARKER, Dale Devereux, R.E., B.A. (Hons.) (1984), H. Dip. F.A. (Slade) (1986); printmaker, public artist. *b:* Leicester, 4 Feb 1962. *m:* Rebecca Weaver. *Educ:* Alderman Newton's Grammar School, Leicester. *Studied:* Loughborough College of Art and Design, Leicester Polytechnic and Slade (Stanley Jones). *Exhib:* 26 solo exhbns. *Works in collections:* Tate Gallery, V. & A., Ashmolean, New York Public Library, Harvard University, Yale University, Columbia University. *Commissions:* Clifford Chance, British Rail, Lloyds Insurance, Taylor-Woodrow, Penguin Books, Colchester B.C., Wolverhampton B.C. *Publications:* Published own collaborative books with poets Martin Stannard (G.B.), Paul Violi (U.S.) and Kenneth Koch (U.S.). *Recreations:* competitive swimming. *Signs work:* "D.D. Barker." *Address:* The Bungalow, Capel Grove, Capel St. Mary, Ipswich, IP9 2JS. *Email:* dale.d.b.@talk21.com

BARKER, David, Dip. A.D. (1966), A.T.C. (1967), Hon. R.E. (1995), Prof. Lu Xun Academy of Fine Arts, China (1997); Senior lecturer/ research translator; Senior lecturer, University of Ulster, Prof., Lu Xun Academy of Fine Arts, Mem. International Exchange Com., China National Academy of Fine Arts; drawing/silk screen. *b:* Dorchester, 11 Jan 1945. *m:* Catherine Elizabeth (née Grover). one *s.* two *d. Educ:* University of London (1962-67), University of Leeds (1988). *Studied:* Goldsmiths' College, London. *Publications:* An English - Chinese Glossary of Printmaking Terms (1995), The Chinese Arts Academies Printmaking Exhibition (1993), The Techniques of the Chinese Print (in preparation), The Woodcuts of Zheng Shuang (1999), '30 Years of the Printmaking Workshop' (2001). *Signs work:* "David Barker." *Address:* University of Ulster, School of Art and Design, York St., Belfast BT15 1ED.

BARKER, Jill, B.A. (1982), S.G.F.A. (2001); M.A. (2004) Printmaking. *Medium:* wood engraving. *b:* Hong Kong, 21 May 1955. *d of:* Professor & Mrs D. Barker. *Educ:* Durham High School. *Studied:* Newcastle-upon-Tyne (1979-1982) under Ralph Sylvester; University of the West of England, Bristol (2002-2004). *Exhib:* national and international events. *Works in collections:* Princeton University, Graphic Arts Library, U.S.A.; Wood Engravers Network; Hutton-

Wilson Collection, and private. *Commissions:* privately undertaken. *Publications:* Alembic Private Press Guide (1984); Holy Sonnets by John Donne (Alembic Press 1986), Black Goddess (Chiron Press 1991); 'Time Beyond Time' by H.Todd (Sun on Earth Books, 2005); 'Works on Wood' (Chiron Press, 2001); 'Small Blocks' Vols 1,2,3,(Chiron Press, 2002). *Official Purchasers:* Taunton & Somerset NHS Trust (2005); Papyrus Ltd. (2005); Sedgemoor District Council (1997); Welsh Development Agency (1992). *Signs work:* "Jill Barker." *Address:* 7 Church House, Churchview, Evercreech, Somerset BA4 6HX.

BARKLAM, Harold, A.R.C.A. (1936); artist in oil, water-colour; art lecturer, Derby College of Art; art teacher, Lowestoft School of Art (1946-50). *b:* Tipton, Staffs., 14 Jan 1912. *s of:* George R. Barklam. *m:* Marjorie Hale. one *d. Educ:* Ryland Memorial School of Art, W. Bromwich, R.C.A. and College of Art, Birmingham. *Exhib:* Birmingham A.G., Derby A.G., Norwich Castle, Nottingham Castle. *Publications:* oil paintings of Dunster Castle, Hardwicke Hall, Serlby Hall, Berkeley Castle, Blithfield Hall, Ingestre Hall; mural paintings entitled "Children's Games" painted for Lady Bagot of Blithfield Hall. *Signs work:* "H. BARKLAM." *Address:* Royal Manor Nursing Care Home, 346 Uttoxeter New Rd., Derby DE22 3HS.

BARLOW, Bohuslav, Dip.A.D.(Hons.) (1970), SGFA; artist mainly in oil, some pastel. *b:* Bruntal, Czechoslovakia, 8 Jul 1947. *m:* Karen Barlow. one *s.* one *d. Educ:* St. Mary's Grammar School, Blackburn. *Studied:* Manchester (1966), Central School of Art, London (1967-70). *Exhib:* RA, RE, PS, International Contemporary Art Fairs. Work in many Northern municipal collections, Manchester Academy. *Works in collections:* Leeds City Council, Coopers & Lybrand, N.Rothschild, Royal Family of Saudi Arabia. *Commissions:* Four large murals for MEPC plc., Bronte Soc. *Publications:* Visual Alchemy - Bohuslav Barlow. *Works Reproduced:* www.penninegallery.co.uk. *Recreations:* running, on fell and road. *Clubs:* Manchester Academy. *Misc:* Opened own gallery in Todmorden 1997. *Signs work:* "B. Barlow." *Address:* Shade Studio, 58 Burnley Road, Todmorden, Lancs. OL14 5EY. *Email:* slavo@bohuslav.co.uk *Website:* www.bohuslav.co.uk

BARLOW, Gillian, B.A. (1970), M.A. (1971), P.G.C.E. (1972), R.H.S. Gold medal (1994, 1997, 1999). *Medium:* artist in water-colour on paper and vellum. *b:* Khartoum, Sudan, 10 Dec 1944. *Educ:* Ashford School for Girls, Kent; University of Sussex. *Studied:* Slade School (1962-63, Patrick George, John Aldridge). *Exhib:* solo shows: British Council, Bombay; Hudson View Gallery, N.Y.; Vassar College, N.Y.; Blond Fine Art, London; Spinks Fine Art, London; numerous mixed shows: Newhouse Galleries, NY; Millbrook Galleries, NY; Mall Galleries, London. *Works in collections:* Hunt Inst. of Botanical Documentation, Pittsburgh, U.S.A.; Vassar College, N.Y.; Lady Margaret Hall, Oxford; Boscobel Restoration, N.Y.; British Council, India; Shirley Sherwood Botanical Painting Collection, London; Royal Horticultural Soc. London; Chelsea Physic Garden, London; Royal Botanic Gardens, Kew, London. *Commissions:* numerous private

commissions. *Publications:* Plantsman, (1992, 1993); New Plantsman (1994, 1997); Curtis Botanical Magazine, Kew (since 1998 annually). *Signs work:* 'G.B.' and 'G.BARLOW'. *Address:* 33a Moreton Terr., London SW1V 2NS. *Email:* gillian@barlow52.freeserve.co.uk

BARNARD, Roger, B.A. Fine Art (1974); artist, participatory set-ups some include video; painting, drawing, photography, holography, writing. *b:* London, 4 Nov 1951. *s of:* E.C. and J.M. Barnard. *Educ:* Chichester High School for Boys. *Studied:* West Sussex College of Design (1970-71), North Staffs. Polytechnic (1971-74). *Exhib:* one-man shows, Tate Gallery, Air, Scottish Arts Council Gallery, Third Eye Centre, South Bank London, Truro, etc.; mixed shows, Tate, Serpentine, Hayward, Air, Holborn Underground Comp., Whitechapel, Arts Council of G.B. touring exhbn., Coventry, Chichester, Third Eye Centre, Osaka Triennale '90' (Painting), '91' (Print) Japan, etc. *Works in collections:* Royal Inst. of Cornwall County Coll., Contemporary Art Centre Osaka, Japan; private collections in U.K., U.S.A., France, Germany; U.C.H. London. *Commissions:* Organisations, incl. British Refugee Council, and private individuals. *Signs work:* paintings since 1970 unsigned, drawings dated, some signed "R. Barnard." *Address:* 151 Archway Rd., London N6 5BL.

BARNDT, Helen Grace, artist in sepia ink, oil, tempera. *b:* Santa Rosa, Calif., 1928. *Educ:* S.F. Academy of Art. *Exhib:* S.F. De Young Museum; Palace Legion of Honor, San Fransisco, Calif.; Museum of Nature & Science, Denver. *Works in collections:* Dr. J. Trenton Tully, Ronald M. Tully, Victor Hansen, Lori Koranski, Don Zimmerman. *Commissions:* Commissioned by: Dr. J. Trenton Tully, founder of the Metaphysical Research Society of Denver, Colorado (1968-92) for series of religious oil paintings, ceiling murals; paintings - Denver Museum of Natural History (1993-1998) - faux painting and murals exhibits, Denver Museum of Nature & Science (2000-). Geology: 'The Rifle Iron Meteorite' replicas for the Rifle Creek Museum, D. & F. Tower Bldgs. Ceiling Mural Designs; 'Astrology Signs' (2004); 'Dragons on Flight' (2005); 'I Paint Dogs' (2006); Tigers with "O" Dragon with "M" (2007). *Principal Works:* "Winter's Spring", "Egyptian Mummies", "Botswanna", "Tritians of Libia", "One Hundred and Forty Four Elements", illustrations, books. *Signs work:* "H. G. Barndt" and "H.G." *Address:* Apt 9, 940 E. 8th Ave., Denver, Colorado 80218 USA.

BARNES, Ann Margaret, B.Ed.(Hons.) (1973), M.F.P.S. (1974), A.M.N.S. (1978), F.R.S.A. (1995). *Medium:* artist in airbrush, acrylic and mixed media on botanical themes. *b:* London, 1951. *d of:* William Barnes, water-colour artist. *Educ:* Wimbledon County School for Girls; Stockwell College of Education, Bromley. *Exhib:* F.P.S., N.S., Soc. of Botanical Artists; one-man shows: London, Chiswick, Leatherhead, Henley, Croydon, Morden. *Signs work:* "A. Barnes." *Address:* 16 Mount Pleasant, Ewell, Epsom, Surrey KT17 1XE.

BARNES, Diane Stephanie, B.A.(Hons) 3-D design (Jewellery) Sheffield (1973), Leverhulme Travel Scholar (1973-74); printmaker in lino; demonstrator

(Art in Action); artist in residence (Nature in Art, various schools, stately homes); part-time teacher of multiply disabled young adults. *b:* London. *m:* Roger (jeweller). two *s. Studied:* Sheffield Polytechnic (1970-73). *Exhib:* many, nationally and internationally including Beatrice Royal, Bankside, Mall Galleries. *Works in collections:* Gallup, Royal Marsden Hospital, Provident Bldg. Soc., National Trust, Dewsbury Hospital. *Commissions:* Year 2000 calendar for New Internationalist, which won "Best International Food Calendar 2000" Award. *Misc:* Appeared recently on "Handmade" for Channel 4 T.V. *Address:* 8 Moor Park Mount, Leeds LS6 4BU.

BARNES-MELLISH, Glynis Lily, S.W.A.; B.A.Hons. Fine Art (1975), Advanced Combined Fine Art Dip. (1983); portrait painter in water-colour. *Medium:* watercolour. *b:* Bromley, Kent, 10 Jun 1953. *d of:* Alan John Mellish. one *d. Educ:* The William School, Letchworth. *Studied:* St. Albans School of Art (1971-72, 1981-83), W. Surrey College of Art and Design (1972-75). *Exhib:* annually R.I., S.W.A., P.S. *Works in collections:* Self portrait - Lee Valley University. *Publications:* The Artist, Hodder & Stoughton, Penguin Books; DK Publishing; Quarto Books. *Clubs:* Cambridge Drawing Soc. *Misc:* Limited Edition Prints (Solomon & Whitehead Ltd.). *Signs work:* "Mellish." *Address:* 44c High Street, Henlow, Bedfordshire, SG16 6AA. *Website:* www.barnesmellish.com

BARNETT, Rosemary, RASA, FRBS; Founder and Director Frink School of Sculpture; curator Jerwood Sculpture Park (2000-2004); sculptor. *Medium:* stone, clay. *b:* Kingston-on-Thames, Surrey, 12 Aug 1940. *m:* Nigel John Burfield Holmes. two *s.* two *d. Educ:* Queen's Gate, London. *Studied:* art at Kingston School of Art, Royal Academy Schools (Arnold Machin). *Exhib:* RA Gallery, 43 Great Russell St., 1, Finsbury Av., Mall Gallery, Royal West of England Academy, Art in Action, Oxford. *Commissions:* Royal Mint, London University, Household Cavalry, Coventry Cathedral, Shallowford House Ecumenical Retreat Centre, St.Thomas's Church, Hanwell; private commissions. *Recreations:* walking. *Clubs:* Reynolds Club, Royal Society British Sculptors. *Address:* 25 Brookfields Road, Ipstones, Staffordshire, ST10 2LY.

BARNETT HUGHES, Emyr, Certificate in Education (1971), Certificate in Carving and Guilding (1983). *Medium:* Wood. *b:* Pentredwr, Llangollen, Wales, 12 Dec 1949. *s of:* Trevor Lloyd Hughes. *m:* Rosemary Hughes. one *s.* one *d. Educ:* Trinity College, Carmarthen, South Wales. *Studied:* City and Guilds of London Art School. *Exhib:* Wood carving Exhibitions and Trade Fayres; Eisteddfodau. *Commissions:* Windsor Castle, House of Lords, Madam Tussauds, The College of Arms, local churches, Tom Ford - Ford's Shop in New York, St.Fagan's Museum of Welsh Life, Cardiff (St.Teilo's Church carvings) etc. *Principal Works:* Windsor Castle restoration. *Recreations:* sculpture. *Clubs:* Association of Master Carvers. *Signs work:* "EBHughes". *Address:* 1 Woodside Cottage, Payford Bridge, Redmarley, Glos., GL19 3HY.

BARNHAM, Nicholas, NDD (Norwich), ATD (Southampton). *Medium:* watercolour, drawing, prints. *b:* Walsingham, Norfolk, 12 Jan 1939. *m:* Linnea Birgitta. three *s.* eight *d. Studied:* Royal Masonic School 1947-56, Norwich School of Art 1956-60. *Represented by:* Baron Art, 17 Chapel Yard, Holt, Norfolk, NR25 6HG. *Exhib:* RA Summer Exhibitions (exhib. approx. 12 pictures); seven one-man shows at the Thackeray Gallery, Kensington; Union Society, Cambridge; The Old Fire Engine House, Ely; Gainsborough's House; Halesworth Gallery, DLI Museum & Arts Centre, Durham; Shetland Museum Gallery, Lerwick; Robert Colquhoun Memorial; also in Germany and Sweden. *Works in collections:* Richard Rodney Bennet, Christopher Hogwood, Ruth Lady Fermoy, Pamela Miles & Tim Pigott-Smith, Marks & Spencer, Cleo Lane & Johnny Dankworth, Government Art Collection, Shetland Islands Council etc. etc. *Commissions:* Somerville College, Oxford. *Official Purchasers:* Somerville College, Marks & Spencer, Sealink, British Rail. *Recreations:* messing about in boats. *Misc:* Taught at Cambridge School of Art 1969-79; Spends part of each year working in Unst, Shetland, painting and printing; Nominated for Associate Membership, RWS and Royal Society of Painters, Etchers and Gravers. *Signs work:* "Nicholas Barnham". *Address:* 70 Mill Road, Wells-next-the Sea, Norfolk, NR23 1DB.

BARÓN, Maite, B.A. Art and Design (Fashion), Interior Design, B.Tec PDC Interior Decorative Applications, B.Tec. PDC in Fine Art Management and Professional Practice; Teachers Training City & Guilds 7307, stages 1 & 2; teaching experience – interior design, photoshop and dreamweaver, papermaking and paper products, colour workshops, decorative paint finishes, decoupage, stencilling, drawing; designer, artist and printmaker in drypoint, collograph, etching, screen printing, acrylics, paper making, fibre art. *b:* Barcelona, Spain, 10 Jun 1965. *s of:* Joaquin Baron. *Studied:* International Centre of Art Studies Interart, Barcelona (1985-88), Art and Design School, Barcelona (1984-85), London Print Studio (1999), Kensington and Chelsea College (1999), W.A.E.S (1997-01), Central Saint Martin's College; NLP Coaching Certificate; NLP Master Practitioner. *Exhib:* R.B.A. and National Print Exhbn. at Mall Galleries, Falmouth Arts Centre; U.A. at Westminster Gallery; Walford Mill (Wimborne); New York Prestige Artists Debut (2000), Manhattan, N.Y., U.S.A.; The Laing Art Competition Exh. (2001); Saatchi & Saatchi, the Art Phoenix Art Auction for the Kosovo children; the Intrinsic Book, the Barbican Library, London; Open Biennale 1999, Whiteley's, London; Freshly Printed, Buckingham Galleries, Southwold, Suffolk; Impact at Spike Island Printmakers, Bristol; Royal Society of British Artists (1998), Mall Gallery, London; National Print Exhibition (1998 & 1999), Mall Gallery, London; The Laing Art Competition Exhibition (2001), The Mall Gallery, London, EWACC 2nd Group Exhbn., La Gallerie Espace City Garden, Paris (2002), Fresh Art, Business Design Centre, London (2002). *Works in collections:* private collections Barcelona, Madrid, Ireland. *Commissions:* available for private commissions in 'Healing' Art/Colour Psychology. *Publications:* Catalogues: 2001 The Laing Art Competition Exhbn., The Mall

Gallery London; 2000 National Print Exhibition, The Mall Gallery, London; 1999 United Society of Artists, 78th Annual Exhibition, Westminster Gallery, London; 1999 National Society of Painters, Sculptors and Printmakers, 66 Annual Exhibition, Whiteley's, London. *Clubs:* N.A.A., Printmakers' Council, Paperweight, Axis, N.A.P.A., N.S.A., A.U.A. *Address:* Flat 2, 46 Chiswick Lane, London W4 2JQ. *Email:* maite@tessabaron.demon.co.uk *Website:* www.tessabaron.co.uk

BARRATT, Mary H., B.A. (1969); part-time art lecturer. *Medium:* painter in oil. *b:* Annesley Woodhouse, Notts., 27 Mar 1948. *d of:* A.H. Fryer, head teacher. *m:* Michael Ian Barratt. *Studied:* Loughborough College of Art and Design (1966-69, Philip Thompson, Colin Saxton). *Represented by:* Elaine Heane (Worksop); Karen Sherwood (Sheffield). *Exhib:* 359 Gallery, Nottingham, Crucible Theatre, Sheffield, Rufford Country Pk., Ollerton, Merlin Gallery, Sheffield, Pierrepont Gallery Thoresby Park, Newark, The Rebecca Hossack Gallery, Southwell Minster. *Works in collections:* Nottingham University, Leicester Royal Infirmary, Wetherspoon Restaurant chain (5 national venues). *Commissions:* Wetherspoon Restaurant chain. *Publications:* Resurgence Journal. *Official Purchasers:* hospitals, universities. *Works Reproduced:* photographed and recorded by Alfred Rolfe (Halfway -Sheffield). *Clubs:* Worksop Cricket and Sports Club. *Misc:* work moving decisively towards a spiritual content. *Signs work:* "M. Barratt." *Address:* 7 Craigston Rd., Carlton-in-Lindrick, Worksop, Notts. S81 9NG. *Email:* jandmbarratt@hotmail.com *Website:* axis database

BARRETT, Priscilla, S.WL.A; freelance illustrator and wildlife artist in water-colour, pastels, pencil, pen and ink. *b:* S. Africa, 4 May 1944. *m:* Gabriel Horn. *Educ:* Universities of Cape Town and Stellenbosch. *Exhib:* solo exhbns. in Cambridge, also exhib. London, Brighton, Lavenham. *Publications:* Collins Field Guide - Mammals of Britain and Europe; European Mammals; Evolution and Behaviour; The Domestic Dog; Running with the Fox; The Wolf; A Year in the Life: Badger; A Year in the Life: Tiger; RSPCA Book of British Mammals; Ecotravellers Wildlife Guides to Costa Rica, Belize, Tropical Mexico, Ecuador; History of British Mammals. *Recreations:* Agility and riding. *Signs work:* "Priscilla Barrett." *Address:* Jack of Clubs, Lode, Cambridge CB5 9HE.

BARROW, Julian, President of the Chelsea Art Society since 1990. *Medium:* oil. *b:* Cumberland, 28 Aug 1939. *s of:* Erskine. *m:* Serena. two *d. Educ:* Harrow School. *Studied:* Royal West of England Academy; Signorina Simi, Florence. *Represented by:* Fine Art Society, London; W.M.Brady & Co., New York. *Exhib:* RA Summer Exhbn (over 25 times); London: Hazlitt, Gooden & Fox; Morton Morris & Co.; Leger Gallery; Fine Art Society; Indar Parischa Fine Arts; New York: Bodley Gallery; Coe Kerr Gallery; W.M.Brady & Co; Middle East: Kuwait, Jerusalem, Dubai, Jeddah, Muscat. *Works in collections:* H.M. The Queen; H.H. Prince of Wales; Grand Duke of Luxembourg; Sultan Qaboos of Oman; Sir Peter Moores. *Commissions:* Houses of Parliament; Grenadier Guards; Green Jackets. *Publications:* numerous catalogues. *Works Reproduced:* on cover of various

books. *Recreations:* travel. *Clubs:* Chelsea Arts Club. *Misc:* specialises in painting inside and outside of buildings throughout the world. *Signs work:* 'Julian Barrow'. *Address:* 33 Tite Street, London SW3 4JP. *Website:* www.julianbarrow.com

BARRY, Jo, RE; BA. *Medium:* watercolour, drawing, prints. *Educ:* Bexley Grammar School. *Studied:* Ravensbourne College of Art and Design. *Exhib:* Royal Academy Summer Show (since 1974); New Academy, London; Bankside Gallery, London; Montpellier Gallery, Stratford-upon-Avon; Gallery Nine, Bath; J&G Gallery, Chichester; H.C.Dickens (Oxfordshire); For Your Walls (Louth); Carmens Gallery, Maryland, USA; nuemrous galleries in New England, USA. *Signs work:* 'Jo Barry'. *Address:* Wing House, Hightown Hill, Ringwood, Hants BH24 3HG. *Email:* barry4lee@aol.com

BARTH, Eunice, painter in oil and acrylic in contemporary style. *b:* London, 1937. *m:* Philip Barth M.A. two *d. Educ:* Neyland House, Sevenoaks; Regent Polytechnic; local Quinton and Kynaston art classes. *Studied:* in England, France and Spain; principal teacher Chris Channing. *Exhib:* F.B.A., V.A. and local venues. *Works in collections:* Stoller Household and various private collections in England. *Clubs:* United Society of Artists. *Signs work:* "Eunice Barth." *Address:* 53 Charlbert Court, Macrennal St., St. Johns Wood, London NW8 7DB.

BARTLETT, Adrian, N.D.D. (1961), A.T.D. (1962); artist in painting, etching, lithography;. *b:* Twickenham, 31 Mar 1939. *m:* Victoria Bartlett. two *d. Educ:* Bedales School. *Studied:* Camberwell School of Art. *Exhib:* British Council, Athens (1985), Morley Gallery (1996), Walk Gallery (1999 and 2003), Piers Feetham Gallery 2007. *Works in collections:* B.M., Ashmolean, V. & A., Berlin Graphotek, etc. *Commissions:* mural for Anglo American (2000). *Publications:* Drawing and Painting the Landscape (Phaidon, 1982). *Clubs:* Chelsea Arts. *Address:* 132 Kennington Park Rd., London SE11 4DJ.

BARTLETT, Charles, P.P.R.W.S., R.E., A.R.C.A. *Medium:* artist in oil and water-colour, printmaker. *b:* Grimsby, 23 Sep 1921. *s of:* Charles Henry Bartlett. *m:* Olwen Jones. one *s. Educ:* Eastbourne Grammar School. *Studied:* Eastbourne School of Art, R.C.A. *Exhib:* solo; John Russell Gallery, Ipswich, (regular exhibitor), Hayletts Gallery, Maldon, Essex; two one-man shows in London; major Retrospective Exhbn. (1997), Bankside Gallery, London, Bohun Gallery, Henley-on-Thames (regular exhibitor). *Works in collections:* V. & A. Museum, National Gallery of S. Australia, Arts Council of Great Britain, Artothek, Dusseldorf, Albertina Collection, Vienna; numerous public and private collections in Britain and abroad. *Publications:* Monograph: Charles Bartlett, Painter and Printmaker; Starting in Watercolour, Watercolour Expert, The Complete Artist, Watercolour Masters. *Recreations:* music and sailing. *Signs work:* "Charles Bartlett." *Address:* St. Andrew's House, Fingringhoe, nr. Colchester, Essex CO5 7BG.

BARTLETT, Paul Thomas, RBSA (1997), RBA (1981); FE/AE Teaching Cert (UCE, 1987), RA Schools PG Cert./MA (1980), PG Dip. hist. art/design (UCE, 1990), BA Hons. Fine Art (Falmouth 1976). Major Prizes: NOT The Turner Prize 2004; Turner Gold Medal (RA Schools); Stowells Trophy national competition for Art Colleges; Royal Overseas League; Spirit of London; Mid Art; Hunting Group; Alexon Women on canvas; RBSA: Prize Show, & Open Drawing. Awards/Scholarships: Elizabeth Greenshield Foundation; David Murray. *Medium:* painter/draughtsman/printmaker/lecturer. *b:* B'ham, 7 Jul 1955. *s of:* H.T. Bartlett, designer. *Exhib:* RA, NPG, V&A ("Garden Exhibition" 1979), RBA, RBSA. *Commissions:* articles for 'Artist & Illustrator', 'Art of England', 'Leisure Painter' etc. *Works Reproduced:* Ian Hutchison, Quarto, Dorling Kindersley etc. *Signs work:* "Paul Bartlett" or " P.T.B." *Address:* 144 Wheelers Lane, Kings Heath, B'ham. B13 0SG. *Website:* www.netsibition.com/paulbartlett

BARTLETT, Victoria Anne, N.D.D. (1961), A.T.D.(1962). *Medium:* mixed media relief and 3D images, also paper and textile works. *b:* Caterham, 1940. *m:* Adrian Bartlett. two *d. Studied:* Camberwell School of Art, and Reading University (1957-62). *Exhib:* solo exhbns: The Egg & The Eye, Los Angeles; Van Doren Gallery, San Francisco; Gallerie Simoncini, Luxembourg. In London: Morley Gallery, Edward Totah Gallery, Camden Art Centre, Benjamin Rhodes Gallery, Peralta Pictures, Piers Feetham Gallery; group exhibitions in Britain, USA, Australia, France, Hungary, Poland and Luxembourg including The Chicago Art Fair 1995 with Browse & Darby, and the London Group since 1978. *Works in collections:* South Bend Regional Museum of Art, USA; Savaria Museum, Szombathley, Hungary; Chelsea and Westminster Hospital; Kroll International; Royal Marsden NHS Foundation Trust, and numerous private collections. *Signs work:* "Victoria Bartlett." *Address:* 132 Kennington Park Rd., London SE11 4DJ.

BARTOLO, Maria, painter in mixed media, including wax and varnish;. *b:* Cardiff, 7 Dec 1967. *d of:* N.A. Bartolo. *Educ:* Oaklands R.C. Comprehensive. *Studied:* City and Guilds of London Art School (Roger de Grey). *Exhib:* The Discerning Eye, Mall Galleries, Christie's, Sotheby's, R.A. Summer Show, Barbican. *Works in collections:* Art Council, De Beers. *Works Reproduced:* R.A. magazine, C.V. magazine, Evening Standard Newspaper (four edns.). Winner of Evening Standard prize. *Address:* 23a Milner Sq., London N1.

BARTON, Patricia: see MYNOTT, Patricia,

BARTON, Charlotte, Cecelia, Gillbe, BA Fine Art Painting. *Medium:* oil, watercolour, drawing, prints. *b:* Maidstone, Kent, 24 Aug 1964. *d of:* Robert & Moira. *Educ:* St.Mary's, Shaftesbury; Salisbury College of Technology. *Studied:* Kingston School of Fine Art. *Exhib:* group shows: Fisherton Mill Gallery, Salisbury (2005), Art for UK Youth, Mall Galleries (2004, 2005), The Gallery, Cork Street (2004), Oxford Brookes University (2002),Stanley Picker Gallery, Kingston University (2001), Edinburgh City Art Gallery (2001), The John Ruskin

Brantwood Museum (2001); touring group show 'Demarco70/2000/The Road to Meikle Seggie' (2001); solo shows: Michael Tippett Centre, Bath Spa University (2004), Hackney, London (2002). *Official Purchasers:* T.R.H. The Earl and Countess of Wessex. *Recreations:* horses, yoga, running. *Signs work:* 'Charlie Barton'. *Address:* Church House, Shrewton, Salisbury, Wilts. SP3 4BZ. *Email:* charliegbarton@aol.com

BASIA: see WATSON-GANDY, Basia,

BASKO, Maurice P. Duviella, Dip. Salon Automne, France; Prize, Figuratif Chateau of Senaud, France; painter in oil and water-colour, art researcher; restoration of paintings; art expert; Prize: France, USA. *b:* Biarritz, 30 Sept., 1921. *s of:* J.L. Duviella, contractor and art dealer. three *d. Educ:* Jules Ferry College, Biarritz. *Studied:* Academy Frochot, Paris. *Exhib:* Museum of Modern Art, Paris, Salon Automne, Salon Bosio, Grand Prix, Pont Aven, Salon Art Libre, Paris, Salon Versailles, France, Paris Gallery, N.Y., Galerie Colise, Paris, Fontainebleu Gallery, N.Y.; one-man shows: Paris, N.Y., Lyon, Mallorca, Vichy, Cannes, Biarritz. *Works in collections:* Guggenheim Museum, N.Y., Albertina Museum, Vienna, Museum of Modern Art, Miami, Public Library, N.Y.; Petit Palais, Geneve, and more than 400 works in private collections. *Publications:* 5000 Painter's Signatures (famous painters) all world, all periods. *Misc:* President of Biarritz Art Festival since 1991. *Signs work:* "BASKO" and sometimes "Duviella." *Address:* Résidence Arverna/Bloc C, 26 Ave. Lahouze, 64200 Biarritz, France.

BASSINGTHWAIGHTE, Paul, BA (Hons) Fine Art; Spirit of London (watercolour prize, 1981); Travel Award, Poland (2005). *Medium:* oil, watercolour, prints. *b:* London, 9 Mar 1963. *s of:* Lewin Bassingthwaighte, artist. *Studied:* Chelsea School of Art (1982-86), National Film and Television School (1986-90). *Represented by:* Quantum Contemporary Art, New Grafton Gallery. *Exhib:* RA, RWS, The London Group, Piccadilly Gallery, Flying Colours Gallery; Art'97, '98, '99, 2000, 2001; Art Expo New York, Lena Boyle, Bohun Gallery, Kato Gallery Tokyo, Ainscough Contemporary, Fish Gallery, Young Masters Atlanta, Christie's, Sotheby's, Bonhams, Thompsons Gallery. *Works in collections:* Leicestershire Museums Arts and Records Service, The Permanent Fine Art Collection and 'Artworks' Loan Scheme, Derek Jacobi, Clive Owen, Kathy Burke, Liza Tarbuck. *Commissions:* large painting for Elizabeth Acland. *Publications:* Dictionary of Artists in Britain Since 1945 (David Buckham), Art Review (Oct '99),The Hill Magazine (Sept '99), Illustrator of 'Le Provencal Diet' (2007). *Official Purchasers:* Leicestershire Museum and Art Gallery. *Works Reproduced:* Camden Graphics (2002). *Recreations:* travel. *Misc:* film/video, photography, graphic design/ illustration. *Signs work:* 'Paul Bassingthwaighte', on the reverse. *Address:* 22 Winscome Street, London N19 5DG. *Email:* pbassingthwaighte@yahoo.co.uk *Website:* www.basspaul.co.uk

BATCHELOR, Bernard Philip, R.W.S.; painter in water-colour and oil;. *b:* 29 May 1924. *Studied:* St. Martin's and City and Guilds of London Art schools gaining City and Guilds Painting medal and a David Murray Scholarship. Subject matter relates mainly to town or landscapes with figures, coastal scenes, etc. *Works in collections:* many in private collections here and abroad; also M.O.W., Museum of Richmond and Richmond Parish Charity Lands. Painting of H.M.S.Richmond presented to the ship by the Borough of Richmond and Twickenham; etching of Vauxhall bridge (1952) to D.C.M.S. *Signs work:* "B.P. BATCHELOR" or sometimes "B.P.B." *Address:* 50 Graemesdyke Ave., East Sheen, London SW14 7BJ.

BATCHELOR, Valerie, artist in water colour, acrylic and pastel;. *b:* 16 Mar., 1932. *m:* John. one *s. Studied:* Salisbury College of Art (1947-50). *Exhib:* solo shows: Salisbury Library (1990, 1993, 1996), Salisbury Playhouse (1991- 98), R.I. since 1985, R.W.A. since 1990. *Publications:* book illustrations including Collins Artists Manual. *Clubs:* N.A.P.A. *Address:* 'Tresses', Larkhill Rd., Durrington, Wilts. SP4 8DP.

BATEMAN, Robert McLellan, O.C., R.C.A., D.Litt., D.Sc., Ll.D., D.F.A., B.A.; artist in oil and acrylic. *b:* Toronto, 24 May, 1930. *s of:* J.W. Bateman, electrical engineer. *m:* Birgit Freybe Bateman. four *s.* one *d. Studied:* University of Toronto (1950-54). *Exhib:* major one-man shows in museums throughout Canada and U.S.A. incl. Smithsonian Institution, Washington D.C. (1987) and the Joslyn Fine Arts Museum, Nebraska (1986); Tryon Gallery, London (1975, 1977, 1979, 1985); Canadian Embassy, Tokyo (1992); Everard Read Gallery, Johannesburg, South Africa (2000); Gerald Peters Gallery, Santa Fe, NM (2004). *Works in collections:* the late Princess Grace of Monaco, H.R.H. Prince Philip, H.R.H. Prince Charles, H.R.H. Prince Bernhard, Hamilton Art Museum, Canada, Leigh Yawkey Woodson Art Museum, U.S.A. etc. *Commissions:* numerous. *Publications:* numerous articles, five major books and seven films on Robert Bateman. *Clubs:* Life membership in numerous clubs and conservation organizations. *Signs work:* "Robert Bateman." *Address:* Box 115, Fulford Harbour, Salt Spring Island B.C. Canada V8K 2P2. *Website:* www.robertbateman.ca

BATES, Andrea Maria, Elected member of Oxford Art Society (1974), elected member of Fosseway Artists, Cirencester (1981). *Medium:* pastel, oil. *b:* Budapest, Hungary, 11 May 1943. *d of:* Andrew J.A. Bartok. *m:* David N. Bates. two *s. Educ:* Paris, Montreal. *Studied:* Academy of Fine Arts, Vienna (1959-62). *Exhib:* solo: Oxford Playhouse (1969, 1984), Phyllis Court Club, Henley (1983), regular solo participant in Oxford Art Weeks since 1985, plus many others. Group: RBA (1980s), ROI (1981), Medici Gallery, Grafton Street (1984-1991), John Noott Gallery, Broadway (1997-2001), Rooksmoor Gallery, Bath (1998-2003), Pastel Society, Mall Galleries (1984, 2000, 2001, 2004-2007), Alexander Gallery, Clifton (1998-present), Carmel Gallery, Ottawa (2004-present). *Commissions:* Portrait of Eric Lane Burslem, Founder of BALPA (hangs in

boardroom of BALPA, Heathrow). *Works Reproduced:* illustrations: pen & ink in "The Story of Enstone" (Enstone Local History Circle, 1999); By the Rideau River, in "100 Ways to Paint Favourite Subjects, Vol. 1" (International Artist, 2004); 3 cards by Medici (1993); 2 cards by Hallmark UK (1998). *Recreations:* circle dancing, gardening. *Signs work:* "A Bates". *Address:* Hillside, Oxford Road, Enstone, Oxon, OX7 4NE. *Email:* info@andreabates.co.uk *Website:* www.andreabates.co.uk

BATES, Joan Elliott, DFA (Lond.) 1952; Awards: Laing Painting Competition 3rd prize, Laing Painting Competition 2nd prize, Cornelissen award. *Medium:* oil, watercolour, drawing, printmaking, gouache, ink, charcoal. *b:* Sheffield, 22 Jan 1930. *d of:* John Elliott, solicitor. *m:* John F. Bates. three *s. Studied:* Sheffield College of Art (1947-49), Slade School of Fine Art (1949-52, Prof. William Coldstream). *Exhib:* RA Summer Exhbns., NEAC, RWS, RBA, ROI, RI, RWA, RE, The Hunting Award, The Laing, Discerning Eye, and in numerous galleries in London and the provinces, including The New Grafton, Cadogan Contemporary, Bohun Gallery, Beaux Arts and New Ashgate Gallery. *Official Purchasers:* Paintings in Hospitals- one watercolour, one gouache; Government Art Collection -one oil. *Works Reproduced:* The Complete Drawing Course, Ian Simpson, Collins Artist's Manual, Collins Artist's Colour Manual, Quarto publications and others. *Signs work:* "J. Elliott" or "J.E." *Address:* 17 Marlow Mill, Mill Rd., Marlow, Bucks. SL7 1QD.

BATES, Patricia Jane, B.Ed. (Lond.) (1976), M.F.P.S. (1980); artist in oil, oil collage, mixed media, sculpture, printmaking;. *b:* Surbiton, 8 Jan 1927. *d of:* George and Elsie Simon (decd.). *m:* Martin Colin Bates. one *s.* one *d. Educ:* Priors Field, Godalming. *Studied:* Bartlett School of Architecture (1944-46), Epsom School of Art (1947-48), Byam Shaw (1952-53). *Exhib:* one-man shows: Loggia Gallery, London, Cranleigh Art Centre; mixed shows: Mall Galleries, London, Guildford, Westcott Gallery, Mill Gallery, Coverack, Cornwall. Work auctioned: East African Wildlife Soc. Kenya. *Works in collections:* England and many other countries. *Signs work:* "PAT BATES" or "PAT SIMON BATES." *Address:* Brackenhurst, Wonham Way, Gomshall, Guildford, Surrey GU5 9NZ. *Email:* patcobates@supanet.com

BATT, Deborah Jane, artist in acrylic, oil and water-colour;. *b:* London, 12 Dec 1966. *Exhib:* Extensively throughout the UK. *Works in collections:* both private and corporate collections in the U.K. and U.S. *Clubs:* Fine Art Trade Guild, National Acrylic Painter Association, National Society of Painters, Sculptors and Printmakers. *Signs work:* "D.J.B." *Address:* 45 The Terrace, Wokingham, Berks. RG40 1BP. *Email:* deborah.batt@virgin.net *Website:* www.deborah-batt.com

BATTERBURY, Helen Fiona, self taught artist in water-colour;. *b:* Stockton-on-Tees, 30 July, 1963. *m:* Paul Batterbury. two *s.* one *d. Educ:* Durrants School, Watford. *Exhib:* S.Eq.A., S.WL.A., S.W.A., Wildlife Art Soc., numerous mixed

exhbns.: Century Gallery, Thoresby Hall, Newport Gallery. *Commissions:* Commissioned as equestrian artist primarily. *Publications:* wrote and illustrated article The Horse in Watercolour for Leisure Painter magazine (Jan. 1997); paintings reproduced in many sporting magazines as promotions for exhbns. *Clubs:* S.W.A., Wildlife Art Soc. *Signs work:* "Fergusson." *Address:* Dunham House, Dunham-on-Trent, Notts. NG22 0TY.

BATTERSHILL, Norman James, R.B.A. (1973), R.O.I. (1976), P.S. (1976); R.O.I. Stanley Grimm award (1989); R.O.I. Awarded Cornelissen Prize for outstanding work (1999). *Medium:* landscape painter in oil, pastel, acrylic and water-colour. *b:* London, 23 Apr 1922. *s of:* Leslie Battershill, scenic artist. two *s.* three *d. Studied:* no formal art training. *Exhib:* R.A., R.B.A., R.O.I., N.E.A.C., P.S., etc., numerous one man shows etc. *Works in collections:* work in many private collections. *Commissions:* Ciba Geigy, Beechams, Post Office, Southern Gas. *Publications:* Light on the Landscape, Draw Trees, Drawing and Painting Skies, Draw Landscape, Draw Seascapes (Pitman Publishing), Working with Oils, Painting Flowers in Oils, Painting Landscapes in Oils, Drawing for Pleasure, Teach Yourself to Draw (Search Press Ltd., London; and Pentalic Corp. U.S.A.), Painting and Drawing Water (A. & C. Black Ltd., 1984), Learn to Paint Trees (Collins, 1990), Painting Gardens (Batsford 1994), Painting Landscapes in Oils (Batsford 1997). *Works Reproduced:* International Artist, The Leisure Painter, Pastel Artist International. *Signs work:* "Norman Battershill." *Address:* 'The Hollies' Burtonstreet, Marnhull, Dorset DT10 1PS.

BATTYE, Martin, BA, FRSA,2003 Watercolour Prize Eastern Open. *Medium:* oil, watercolour. *b:* Woddbridge, 30 Mar 1952. *m:* Hilary. four *d. Studied:* Sunderland School of Art. *Exhib:* RA Summer Exhbn; Eastern Open; 12 East Anglian Artists; King of Hearts, Norwich; Chappel Galleries, Colchester; Graham & Oldham, Ipswich; Warehouse, Lowestoft. *Works Reproduced:* cover painting-W.G.Sebald:A Critical Companion. *Misc:* Chairman, Kirton Healthcare Group Ltd. *Signs work:* Martin Battye. *Address:* Old Forge, Hempnall, Norwich NR15 2AD. *Email:* martinballye@kirtonhealthcare.co.uk *Website:* www.targetfollow.com

BAUMFORTH, David John, painter of contemporary northern seascapes and landscapes in watercolour, acrylic and oil. *b:* York, 21 Oct 1942. *m:* Jenny. two *d. Educ:* Nunthorpe Grammar School. *Studied:* self taught. *Represented by:* The Walker Galleries, Harrogate and Honiton; Brian Sinfield, Burford; The Alpha House Gallery, Sherborne. *Exhib:* R.W.S. open, R.A. Summer Exhib., Hunting Prizes, The Daily Mail, Not the Turner Prize, and many national galleries. *Works in collections:* various national and international collections. *Recreations:* Ferrari driver, motor sport. *Clubs:* F.O.C. *Misc:* 'Anyone who has an eye for art the deep passionate colour of Turner, the pure loving observations of Constable, must rejoice that our century has David Baumforth. This work is the real thing, wet with sea spray we can feel, fresh with gusts of wind, always mysterious, always beautiful, art to be cherished.' -Sister Wendy Beckett. *Signs work:* "D J

Baumforth." *Address:* Low Garth, Snainton, Scarborough, N. Yorks YO13 9AF. *Email:* baumforth@lowgarth.fsnet.co.uk *Website:* www.davidbaumforth.com

BAWTREE, John Andrew, D.Arch. (Kingston, 1977), A.R.B.A. (1982), R.B.A. (1984); Greenshield Foundation Award (1978, 1980); painter in oil on canvas;. *b:* Cheam, Surrey, 1 Nov 1952. *s of:* Harold Maurice Bawtree. *Educ:* Bradfield College, Berks. (1966-70). *Studied:* Kingston Polytechnic School of Architecture (1970-73, 1975-77). *Exhib:* R.A., R.B.A.; one-man: Cambridge, Oxford, Oman, Aldeburgh, Piers Feetham Gallery, London, Melitensia Gallery, Malta, British Embassy, Oman. *Works in collections:* Greenshield Foundation, Montreal, Foreign and Commonwealth Office, Muscat. *Commissions:* Chelsea Financial Services and Grindlays Bank. *Works Reproduced:* prints, cards, calendars. *Clubs:* Chelsea Arts. *Signs work:* "John Bawtree." *Address:* Pine View, Peasenhall, Suffolk IP17 2HZ. *Email:* john@bawtree.fsnet.co.uk *Website:* www.johnbawtree.com

BAXTER, Ann W., NDD(Hons.) (1955), SEA; winner, British Sporting Art Trust Sculpture Prize (1990), joint winner (1986, 1998, 2004) and President's Medal (1994); freelance sculptor in wood, stone and bronze;. *b:* Leeds, Nov 1934. *m:* W.L.J. Potts (decd.). one *s. Educ:* Leeds Girls' High School. *Studied:* Leeds College of Art (1950-55, Harry Phillips). *Exhib:* S.E.A. annually, Open exhbns.: Leeds City A.G., Cartwright Hall Bradford, Wakefield City A.G., and widely in U.K. in private and public galleries. *Works in collections:* York City A.G, and private collections in UK, USA, Europe and Australia. *Commissions:* presentation pieces for the SEA. *Misc:* breeds Arabian horses. *Signs work:* "A.W. Baxter." *Address:* Ivy Farm, Roecliffe, Boroughbridge, York YO51 9LY.

BAXTER, Denis Charles Trevor, RWA (2002); Royal Society of British Artists (2003), FRSA (1970), Mem. Printmakers Council (1981), NS (1987), President, NS (1989-2001), Society of Graphic Fine Art (2001); awarded the Gold Medal for Graphic Art at the 2nd Biennale Internazionale DellArte Contemporanea in Florence (1999), awarded the Gold Medal for Graphic Art presented by the Spanish Embassy at the Kyoto International Exchange Exhibition, Japan (1999); teacher, lecturer, artist. *Medium:* printmaking, oil and watercolours. *b:* Southsea, 1 Mar 1936. *m:* Diana M.Hawkins, NS, FRSA. *Educ:* Ryde School, I.O.W. *Studied:* Bournemouth and Poole College of Art (1964-65); Stockwell College, Bromley, Kent (1965-68), Bournemouth and Poole College of Art (1969-'74). *Exhib:* RA, RWA, RE, NEAC, PS, NS, UA., Organised the first EuroArt Touring exhbn in the UK at Christchurch, Dorset, before moving on to Ahrenshoop, Germany and Brussels. Organised for the Printmakers Council an exchange exhbn entitled 'Reflections' with printmakers from Landau, Germany. The Mini Print Internacional Barcelona, Spain; Galerie Meier, Arth am See, Switzerland. Euroart Touring Exhibition at La Defense, Paris, Barbizon and in Oosterbeck, Holland. *Works in collections:* Canada, France, Germany, Japan, Switzerland, U.K., U.S.A. *Publications:* Two articles published for inclusion in the catalogue for 'World Festival of Art on Paper' in Kranj, 2000. An article on

etching published in the 'Artist and Illustrator' magazine. *Official Purchasers:* work purchased by four Hampshire hospitals for display in various departments. *Clubs:* Chelsea Arts, Royal Over-Seas League. *Signs work:* "Denis Baxter" or "D.B." *Address:* Knightley House, Middle Road, Sway, Lymington, Hants SO41 6AT. *Email:* mail@the-rba.org.uk

BAYLY, Clifford John, RWS (1981), NDD(1950); painter in oils, acrylic, water-colour, illustrator, lecturer, writer. Five times prizewinner in national competitions (1992/93, 1996, 1997);. *b:* London, 1927. *s of:* Paul Bayly. *m:* Jean Oddell (decd. 2006). two *s.* one *d. Studied:* St. Martin's and Camberwell Schools of Art (Sir William Coldstream, Prof. Sir Lawrence Gowing). *Represented by:* Royal Watercolour Society, 48 Hopton St., London SE1. *Exhib:* R.A., R.W.S., various galleries in U.K., also Malta, Sydney, Melbourne and Adelaide, Australia and Perth, Western Australia; Broome Art Residency, Cable Beach Resort, Broome, Western Australia; Monsoon Art Gallery, Broome. *Works in collections:* H.R.H. Prince Charles, Westpac Bank, T.V. South, Tricentrol, London, Chevron U.K. *Commissions:* Winchester Hospital, many garden portraits- most recent for Midland Software, Nottingham; Oxford Colleges, Sheldonian Theatre, Oxford. *Publications:* children's educational books, books on painting and drawing techniques. *Works Reproduced:* Oxford University Press, Collins Junior Dictionary, 'Visions of Venice' by Michael Spender (David & Charles), The Glory of Watercolour (RWS), Search Press-various books. *Recreations:* travel, photography and found object sculpture. *Signs work:* "CLIFFORD BAYLY." *Address:* 50 Kitchener Street Trigg Western Australia 6029 Australia.

BAYNES, Pauline Diana, M.S.I.A.; designer and illustrator; Kate Greenaway Medal. *b:* 1922. widow of Fritz Gasch. *Studied:* Farnham School of Art and Slade. *Publications:* books illustrated include: A Treasury of French Tales, Farmer Giles of Ham and Tom Bombadil (Allen and Unwin), Arabian Nights and Fairy Tales of the British Isles (Blackie), seven Narnia Books by C. S. Lewis (Bles and Bodley Head), Sister Clare, Miracle Plays, St. George and the Dragon (Houghton Mifflin, U.S.A.), Dictionary of Chivalry (Longmans), Kate Greenaway Medal (1968), Companion to World Mythology (Kestrel Books, 1979). *Signs work:* "PAULINE BAYNES" - occasionally with a small bird. *Address:* Rock Barn Cottage, Dockenfield, nr. Farnham, Surrey GU10 4HH.

BAYS, Caroline, BA Hons Painting/Printmaking (2006), Higher Surrey Diploma -Communication Design (1982). *Medium:* oil, drawing, pastels. *b:* Weybridge, 26 Jul 1960. *d of:* Jill & Bernard Bays. *m:* Mr.A.Williams. *Studied:* Epsom School of Art and Design (1979-82), Roehampton University (2004-06). *Exhib:* Royal Society of Portrait Painters (1998-2007), The Pastel Society (1997-2007), NEAC (1998, 1999, 2005), The Discerning Eye, Mall Galleries (2005), The Hunting Prize, Royal College of Art (2002), The Garrick Milne Prize, Christie's (2000), Waterman Fine Art, London (1999-2000), Century Gallery, Henley (1999-2000), Fosse Gallery, Stow-on-the-Wold, Glos (2001-03). *Works in*

collections: private. *Signs work:* "Caroline Bays". *Address:* The Cottage, 8e Windsor St., Chertsey, KT16 8AS. *Email:* carolinebays@googlemail.com

BAYS, Jill, NDD(1951), BA (Open)(1985); artist in water-colour and oil, teacher;. *b:* Ambala, India, 24 Nov 1931. *d of:* W.C. Burton, R.A.F. (decd.). *m:* Bernard Bays (decd.). two *d. Educ:* Sir William Perkins', Chertsey. *Studied:* Guildford School of Art (1947-51). *Exhib:* R.I., S.WL.A., S.W.A., numerous shared exhbns. with husband and others. *Publications:* The Watercolourist's Garden (David and Charles, 1993), Flowers in the Landscape (David and Charles, 1995), Drawing Workbook (David and Charles, 1998), The Watercolourist's Nature Journal (David and Charles, 2001); Watercolour in a Weekend (Flowers) (David & Charles, 2004), The Flower Painters Essential Handbook (David & Charles, 2006). *Signs work:* "Jill Bays." *Address:* Bayswater, Hamm Ct., Weybridge, Surrey KT13 8YB. *Email:* jilleb@ic24.net *Website:* www.jillbays.com

BAZAINE, Jean, painter, Commandeur des Arts et Lettres (1980). *b:* Paris, 1904. *Educ:* L. ès L. *Exhib:* Galerie Carré and Maeght, Paris, retr. exhbn., Berne (1958), Eindhoven (1959), Hanover, Zürich, Oslo (1963), Paris (1965), Athènes, London, Edinburgh (1977), Oslo (1983), Maeght's Foundation (1987); repr. Biennele de Venice, São Paulo and Carnegie (member of the jury, 1952). *Works in collections:* most important museums in Europe and America. *Publications:* Notes sur la peinture d'aujourd'hui (ed. Seuil, Paris, 1948), Exercise de la peinture (ed. Seuil, 1973), Illustration de l'oeuvre de 12 poétes francais. Mombreux décors et costumes de théatre. *Misc:* Awards: Prix Blumethal (1939), Prix National des Arts (1964). Executed stained-glass windows for the church of Assy (1946), Saint Séverin, Paris (1966), Cathedrale St. Die (1986), Chapelle de la Madeleine Bretagne, Chapelle de Berlens Suisse, Chapelle St. Dominique paris; ceramic mural and windows at Audincourt (1951-54); ceramic mural at U.N.E.S.C.O. (1960); Maison de l'O.R.T.F., Paris (1963), Se'nat, Paris (1986), Subway 'Cluny' (1987). *Address:* 36 r. P. Brossolette, 92140 Clamart. France.

BEACH, John, RMS, AMPSGS, MASF; 'Masters Award 2000', Million Brushstrokes Exhbn; First Prize annual 'Lake Oswego Fesival of Art Exhbn', USA; the 'Manny Sullivan Memorial Award for Excellence' and overall 2nd, Miniature Painters Society of Washington DC (2004, Hon. mention 2001); Llewelyn Alexander Award in the Hilliard Society Exhbn (1998); Hon mentions: RMS (1999, 2000); Miniature Art Society of Florida Exhbn (2003). *Medium:* watercolour (miniaturist). *b:* Windsor, 7 Nov 1930. *m:* Marion. *Studied:* Kingstone School of Art (1945-47). *Exhib:* Westminster, London; Llewelyn Alexander; Mall Galleries; Hilliard Society, Bath; Tavistock; Gold Coast, Australia; in USA: Washington DC; Florida; Lake Oswego; Lexington Massachusetts; Bethlehem, PA; Portland, Oregon. *Works Reproduced:* greeting cards. *Recreations:* painting. *Signs work:* 'JOHN BEACH'. *Address:* Lyndale, 60 Coppermill Road, Wraysbury, Staines, Middx, TW19 5NS.

BEALE, Gillian, *Medium:* oil, watercolour, drawing, prints. *b:* Bridlington. one *s.* one *d. Studied:* Lincoln College of Art/Swarthmore Leeds; Hull University. *Exhib:* Usher Gallery Lincoln; Thirsby Hall; Neka Gallery Bali, Indonesia; Scorer Gallery Lincoln; Tatton Park, Patchings Gallery, Notts; NEC Birmingham; Ranby Hall, Lincoln Fine Art. *Works in collections:* France, Spain, Japan, Australia, etc. *Recreations:* travel, swimming. *Misc:* Art Tutor, Lincoln County Council. *Signs work:* "GILLIAN BEALE". *Address:* Paxhaven Studio, Doddington, Lincoln, LN6 4RS. *Website:* www.gillianbeale.co.uk

BEALE, Philippa Sally, B.A. (Hons.) 1969, M.Ed. (1970), M.F.A. (1985); sculptor, printmaker and video artist in casting, photoprint and video; P.L Central St. Martin's College of Art and Design. *b:* Winchester, Hants., 17 Jan 1946. *d of:* Joseph Vaux-Beale. *m:* David Troostwijk, A.R.C.A. (divorced); Christopher Plato m.2000. one *s. Studied:* University of Reading, Goldsmiths' College, London. *Exhib:* widely including: Akumulatory 2 Galleria, Poznan, Poland; Richard Demarco Gallery, Edinburgh; Flowers East, Acme Gallery, Gulbenkian Gallery, Inst. of Contemporary Art, London; The Third Eye, Glasgow; Arnolfini, Bristol; Blue Coat, Liverpool. Most recently at Danielle Arnaud and The Discerning Eye, Mall Galleries, London since 2000. Visions at Key, London, St. Sebastian, Chelsea Arts Club, Station of the Cross at St. Pancras Church, London. *Works in collections:* Tate Gallery Archive, National Art Archive, V. & A., Southampton A.G., Camden Council. *Commissions:* Southampton A.G. *Publications:* J. Moreau, The Sexual Imagination, edited by Harriet Gilbert (Jonathon Cape), Roszika Parker, Women's Images of Men, edited by S. Kent and J. Moreau (Pandora Press, Unwin Paperbacks), L. McQuiston, Graphic Agitations (Phaidon), D. Postle, The Mind Gymnasium (Gaia Books). *Works Reproduced:* in publications above, and 'Graphic Agitations' Liz McQuiston, Phaidon, 'outsidedge online magazine' 2002, London Group 90 years of visual arts' 2003. *Clubs:* President, London Group (1995-98). *Signs work:* "P.S.B." *Address:* 1 Burnt Ash Lane, Bromley BR1 4DJ.

BEALING, Nicola Janette, *Medium:* oil, prints. *b:* Hertford, 29 Oct 1963. two *s. Studied:* Byam Shaw School of Art, London. *Represented by:* Cadogan Contemporary, London; Lemon Street Gallery, Truro; Beaux Arts, Bath. *Exhib:* numerous solo and group shows including: Hunting Art Prizes, Discerning Eye, Mall Galleries (Invited Artist 2004); Beaux Arts, Bath; Wagner & Schortgen, Luxembourg; BP Portrait Award, NPG; RSBA; Belgrave Gallery, Cornwall; Waterman Fine Art; Cadogan Contemporary. *Works in collections:* Unilever; Deutsche Bank; Cliveden; Millfield School; Channel 4 TV; London International Brokers; Royal College of Paediatrics and Child Health. *Commissions:* 'Inside Art' Channel 4 (1996). *Official Purchasers:* The Jerwood Foundation. *Works Reproduced:* 'Artist & Illustrator Magazine' (Mar 2000); 10 Years of the BP Portrait Award (NPG, 2001). *Recreations:* travelling, eating. *Clubs:* Chelsea Arts, Newlyn Society of Artists. *Signs work:* 'NB'. *Address:* Lower Goonhusband, Debigna Lane, Helston, Cornwall TR12 7PP. *Email:* bryant.bealing@virgin.net

BEARD, Peter Fraser, BA (Hons), INAX Design Prize (1996), Pot D'Or Keramisto (2000), Silver Medal XVIII Biennial Vallauris, France. *Medium:* sculpture, ceramic, stone, bronze and glass. *b:* Southport, 5 Nov 1951. *Studied:* Ravensbourne College of Art, London. *Exhib:* taken part in over 100 group exhbns, and 45 solo shows since 1975 in many countries including Japan, Korea, Australia, USA, Europe, Canada, UK (inc.RA). *Works in collections:* Museum Ariana, Geneva; Stoke-on-Trent City Museum; Keramion Museum, Koln Museum and Neue Sammlung, Germany; INAX Corporation, Japan; University of Kansas, USA; Ichon World Ceramic Centre, Korea; Norwich Museum; Burnley City Art Gallery. *Publications:* author of 'Resist and Masking Techniques'. *Works Reproduced:* in numerous books and megazines since 1973. *Misc:* see website for details. *Signs work:* initials 'PFB', and symbol. *Address:* Tanners Cottage, Welsh Road, Leamington Spa CV32 7UB. *Email:* peter@peterbeard.co.uk *Website:* www.peterbeard.co.uk

BEATON, Rosemary, 1st Class BA Hons Degree and Postgraduate Studies; Winner of National Portrait Award (1984). *Medium:* stained glasss, oil, watercolour, drawing. *b:* Greenock, 6 Jul 1963. *d of:* Mary & Malcolm Beaton. *m:* Paul Doherty. one *s.* three *d. Studied:* Glasgow School of Art (1981-86). *Represented by:* Boundary Gallery, London. *Exhib:* Glasgow, London, Shetland, Maastricht, Amsterdam, Aachen, Kendal, Edinburgh, Dunfermline, Leicester, Stirling. *Works in collections:* The National Portrait Gallery, London; The British Broadcasting Corporation. *Commissions:* painter Sir Robin Day for NPG (1985); Stained Glass window (11m x 2.2m) Palisade Properties, Glasgow (2005). *Publications:* '20th Century Portraits', R.Gibson & H.Clerk; Many 'Images of a Queen', I.McFarlane. *Principal Works:* portrait of Sir Robin Day; The West End Window, Glasgow. *Signs work:* "Rosemary Beaton". *Address:* 17 Laighpark Ave, Bishopton, Renfrewshire, PA7 5BH. *Email:* rosemarybeaton1@yahoo.co.uk *Website:* www.rosemarybeaton.co.uk

BEAUMONT, Jeffrey (Jeff), *Medium:* watercolour (occasionally pen and ink, pencil). *b:* 15 Feb 1949. *s of:* Jack and Hilda Beaumont. *m:* Rose Anne. one *s.* one *d. Educ:* Holmfirth High School. *Exhib:* several solo exhbns. Holmfirth Civic Hall, also Holmfirth Artweek for past 20 years, Saddleworth Museum and Art Gallery, Buxton Museum and Art Gallery, Barnard Castle 92 venues), Lupton Square Gallery (Honley), etc. *Works in collections:* worldwide, including America, Canada, Finland, Spain, Australia, Borneo, etc. *Commissions:* considered upon request. *Publications:* several articles in Yorkshire Post, Huddersfield Examiner. *Works Reproduced:* limited edition prints of several Yorkshire scenes. *Recreations:* sport, particularly football (Huddersfield Town FC), long distance walking, outdoor photography. *Clubs:* Yorkshire Watercolour Society. *Address:* 5 Chaucer Close, Honley, Holmfirth, Huddersfield, W. Yorks, HD9 6EN.

BEAUMONT, Sarah Elizabeth, B.A. (Hons.) (1988), FRSA (2001), NS.(2000), NAPA (1997); Worshipful Guild of Painter Stainers Prize for Art; Pro

Art Prize for Contemporary Painting; Aya Broughton Prize (Commended). *Medium:* painter in oil and acrylic. *b:* London, 10 Sept., 1966. *Educ:* City of London School for Girls, EC1; University of Lancaster (1985-88). *Exhib:* R.A., S.W.A., N.S., NAPA; group shows include London: Westminster Gallery, The Atrium, Whiteley's, Mall Galleries, R.A, Barbican Arts Centre, Lamont Gallery, Art-Islington; The Mariners Gallery, St.Ives; Jersey Gallery, Osterley Park; Scott Gallery, Lancaster,and numerous galleries around the U.K. *Works in collections:* in USA, Canada, Australia, Europe. *Commissions:* various for public bldgs. including the Millfield Theatre, London. *Publications:* Dominatrixes (EPS). *Clubs:* Fine Art Trade Guild. *Signs work:* "S.E Beaumont." *Address:* P.O.Box 22894 The Hyde, London NW9 6ZE. *Email:* sarah@sarahbeaumont.com *Website:* www.sarahbeaumont.com

BECKER, Bill, BA (Hons) Psychology (Reading University 1971); BA (Hons) Fine Art (2000), MA Fine Art (2002)Lincolnshire and Humberside University; poet, qualified hypnotist and family therapist. *Medium:* oil on canvas. *b:* London, 1 Feb 1932. *m:* multi divorcee. two *s.* two *d. Educ:* Chichester High School, Army School of Physical Training. *Studied:* Bognor Regis (Teachers) Training College; Tavistock Institute of Human Relations. *Exhib:* RA Summer Exhbn (2004), Hull, Boston (Lincs), Barton-on-Humber. *Commissions:* do 'negotiated' art, where client and I negotiate a painting through interview/discussion. *Publications:* several poems published. *Principal Works:* landscape-mostly trees with dream-like mystical elements, and old age themes. *Recreations:* Romantic old fashioned music-mainly English and French late 19th-20th century. Romantic poetry. *Signs work:* "Bill Becker". *Address:* 30 Bargate, Grimsby, N E Lincs DN34 4SZ. *Email:* billbecker@btinternet.com

BECKER, Haidee, draughtsman, painter in oil. *b:* Los Angeles, Calif., 13 Jan 1950. *d of:* John Becker, writer. one *s.* one *d. Educ:* French Lycée. *Studied:* with Uli Nimptsch, R.A., Elizabeth Keys, Adrian Ryan. *Exhib:* R.P., H.A.C., R.A., Ben Uri Gallery (The London Jewish Museum), Roland, Browse & Delbanco, New Grafton, C.D. Soar & Son, Odette Gilbert Gallery, Timothy Tew Galerie, Atlanta, Georgia; Anne Berthoud, Redfern Gallery, Byard Art, Thomas Henry Fine Art Ltd., Bourne Fine Art, Fine Art Society, Angela Flowers. *Works in collections:* N.P.G. *Signs work:* "Becker." *Address:* 46 Glebe Pl., London SW3 5JE.

BECKER, Skadi, HS, SLm, MASF, RGA; awards: Chairman's Choice (SLm, 2005); Best in Show (SLm, 2006). *Medium:* watercolour on ivorine. *b:* Germany, 5 Aug 1937. *d of:* Maria Reiser. two *s.* one *d. Studied:* self-taught artist (miniatures). *Exhib:* RMS, HS, SLm, MASF, RGA, SAMAP, Llewelyn Alexander Gallery, World Exhibition of Miniature Art. *Works in collections:* Hilliard Society Travelling Exhibition. *Commissions:* portraits. *Signs work:* 's' (monogram). *Address:* 24 Ullswater Drive, Tilehurst, Reading, RG31 6RS. *Email:* skadibecker@virgin.net

BECKERLEY, Tracy, M.A. (1989), B.A.(Hons.) (1986), Higher Dip. in Visual Art (1987), Art Foundation Dip. (1983); artist in gouache, paper making, printmaking; visiting lecturer, Lincoln Art School and Brooks University; and psychotherapist;. *b:* Bournemouth, 10 Dec 1963. *Studied:* Harrow C.H.E. (1982-83, Brian Pummer), Gwent C.H.E. (1983-86, Roy Ascot), Oxford Polytechnic (1986-87, Ivor Robinson), Chelsea School (1988-89, Tim Mara). *Exhib:* Whitechapel Open (1994); mixed shows in East-West Gallery, Todd Gallery, Concourse Gallery Barbican, Flowers East, Overseas League House, Whitworth Gallery, Business Design Centre. *Signs work:* "Beck." *Address:* Suite 22, Sparkford House, Battersea Church Rd., London SW11 3NQ.

BECKFORD, Laurence, MCA. *b:* Exeter, 30 Mar 1961. *Address:* 7 Jury Road, Dulverton, Somerset, TA22 9DX. *Email:* l.beckford@tiscali.co.uk *Website:* www.beckfordartworks.co.uk

BEE, Sarah, PS; DipAD. *Medium:* mixed. *b:* Salisbury, 22 Sep 1951. one *s.* *Educ:* Gillingham Comprehensive, Dorset; Bournemouth Art School. *Studied:* Maidstone School of Art; Heatherley School of Fine Art. *Exhib:* PS, RI, NEAC; Hicks Gallery, Wimbledon; Orange Street Gallery, Uppingham; First View, Stourhead. *Works in collections:* internationally. *Commissions:* Pure Recruitment, The Strand, London. *Signs work:* 'Bee'. *Address:* 97 Geraldine Road, London SW18 2NJ. *Email:* sarahbee@hotmail.co.uk

BEECROFT, Glynis: see OWEN, Glynis,

BEER, David, National Teachers Certificate (main subject Ceramics, 1971); retired from teaching after 27 years in 1998. *Medium:* oil, pastel, acrylics. *b:* Whitstable, Kent, 13 Feb 1943. *s of:* Mr & Mrs H.T.Beer. one *s.* one *d. Studied:* Bishop Otter College, Chichester (teaching, ceramics); St.Ives School of Painting. *Exhib:* RWA, Penwith Society St.Ives, Walker Galleries; Gallery Upstairs, Henley-in-Arden, Warwickshire; Mid-Cornwall Galleries; Kendalls Fine Art, Cowes, Isle of Wight; Innocent Fine Art, Bristol; Thomas Henry Fine Art, Nantucket, USA; Walker Galleries, Harrogate; Penhaven Gallery, St.Ives (owned by David Beer himself); Webbs Road Gallery, London; Glasshouse Gallery, Penzance. *Works in collections:* many private collections, both in UK and abroad. *Commissions:* private commissions for life pictures. *Publications:* exhibition catalogues only. *Principal Works:* landscapes/seascapes in oil using palette knife; life drawings (nudes) using pastel and acrylic. *Recreations:* painting! walking the dog!. *Signs work:* David Beer. *Address:* Penhaven, 4 St.Peters Street, St.Ives, Cornwall, TR26 1NN. *Email:* beer@penhavengallery.co.uk *Website:* www.penhavengallery.co.uk

BEERBAUM, Frederik, *Medium:* oil, watercolour, drawing, mixed media. *b:* Hilversum, 29 Jun 1942. *m:* Mary N. Byrde. one *d. Studied:* Gerrit Rietveld Academy, Amsterdam (1969). *Represented by:* Ann's Art, Groningen; Art Centre, Amsterdam; Arnhem, Assen, Utrecht, SBK Leeuwarden, SBK Hengelo, SBK Enschede. *Exhib:* 24 Drawings, Arti et Amicitiae, Amsterdam, solo, 1995; At sea

everything is possible, Arts Centre, Zaanstad, Zaandem, solo, 1996; Arundel Festival, Arundel, West Sussex, England, 1997; Mirror Image, portraits, Arti et Amicitiae, Amsterdam, 1998; Drenthe by the Sea, Veere and Drents Museum, 1999; Millennium Exhibition Arts Centre (SBK), Amsterdam, solo, 2000; Where No Birds Sing, Town Hall, Aljezur, Portugal, 2003; The Hogeschool Untrecht, Faculty of Education, solo, 2003; The Observer Observed, Forteleza de Sagres, Portugal, 2004, 2005; Landscapes and city scenes of Amsterdam from the 70's and 80's, Jubilee Exhibition, SBK Amsterdam (50 years), Helmond, solo, 2005; Eros and Thanatos, 733 drawings, slide show, DVD, Arti et Amicitiae, Amsterdam, 2005. Solo exhibitions 2007: Artscentre SBK Amsterdam (three consecutive exhibitions "Frederick Beerbaum 65 Years Young"), Galerie 2 Haaksbergen, the Netherlands, Amsterdam Medisch Centrum "Vitrines Brummelcamp". *Works in collections:* Stedelijk Museum for Modern and Contemporary Art, Amsterdam; Hoge School, Utrecht; Ericsson, Holland; Dutch Petroleum Co., Photographic Atlas Amsterdam (2007), Brummelcamp AMC Business Collection (2007), etc. *Publications:* Works featured in newspapers and magazines; Exhibition catalogues; Book cover, children, Problems at School and Stress, 1991; Book cover and 24 drawings, Silent Terror, 1995; Book cover, Stress-Theoretical Aspects of Remedial Education, 1999; Book cover and 12 paintings commissioned by Hogeschool Utrecht for book - In the Teachers Mind, 2003; Dictionary of International Biography, IBC Cambridge, 2005/6; "Eros and Thanatos" 44 drawings (2002/03, pub. by Lulu.com in 2007). *Official Purchasers:* Stedelijk Museum for Modern and Contemporary Art, Amsterdam; Amsterdam Council; Arts Council Drenthe; NAM (Dutch Petroleum Company); Ericsson Holland, Enschede, Amsterdam; Slotervaart Hospital, Amsterdam; Het Groene Land Insurance, Lelystad; SBK in Amsterdam, Assen, Leeuwarden, Hilversum, Tillburg, Arnhem, Maastricht, Utrecht; Hogeschool Utrecht. *Clubs:* Arti et Amicitiae Amsterdam (since 1978); affiliations: The Arts Club, London, The Salmagundi Club, New York. *Signs work:* "F.Beerbaum". *Address:* C.P.1366 Azenha, 8670-115 Aljezur, Portugal. *Email:* frederikbeerbaum@yahoo.co.uk *Website:* www.beerbaumart.com

BEESLEY, Mark, Datec Diploma in Art and Design. *Medium:* oil, pastel, watercolour. *b:* England, 29 Jan 1953. *Educ:* Burton-on-Trent Grammar School. *Studied:* Nottingham University; Suffolk College, Ipswich. *Exhib:* Gallery 44, Aldeburgh (2002), The Halesworth Gallery (2004), Christchurch Mansion, Ipswich (2004), Peter Pears Gallery, Aldeburgh (2006). *Works in collections:* Suffolk County Council; private collections in UK and USA. *Publications:* article in 'Artist & Illustrators' magazine (October 2003); article in supplement to 'New Statesman' magazine (October 2005). *Works Reproduced:* "The Artist's Sketchbook" (Northlight Books, 2001). *Principal Works:* ongoing series of paintings inspired by wind turbines in the landscape. *Clubs:* Ipswich Art Society. *Signs work:* "HMB" (monogram) or "HMBEESLEY". *Address:* 45 Old Barrack Road, Woodbridge, Suffolk, IP12 4ET. *Email:* mark.beesley1@virgin.net *Website:* www.remaginations.com or axisweb.org/artist/markbeesley

BEESON, Jane, Arnolfini Open Competition prize winner, 1963. *Medium:* oil & PVA on canvas and hardboard. *b:* Weybridge, Surrey, 10 Apr 1930. *d of:* Sir Noel Bowater, Bt. *m:* Christopher Beeson. three *s.* one *d. Studied:* Kingston School of Art, Surrey (1949-51); Beaux Arts, Paris (1951-52), under Brianchon; Slade, London (1953). *Exhib:* John Moore's, Liverpool (1961), painting purchased by Ferens Art Gallery, Hull; Richard Demarco Gallery, Edinburgh purchased a painting for their permanent collection (1966); Rowan Gallery, London (1963); Graves Art Gallery, Sheffield (1963); Penwith, St. Ives (1964); Arnolfini, Bristol. 3 prizewinner exhibition (1964); one-woman show (1966); 7 paintings shown in St. Ives Artists exhbn at the RAMM, Exeter (2002). *Works in collections:* "Mauve and Yellow" bought by Director, Ferens Art Gallery, Hull, and in other private collections; also painting in Richard Demarco Gallery Collection, Edinburgh. "Winter I" bought by the Royal Albert Museum, Exeter (2002), "Still Life" bought by the Royal Albert Museum (2002) (both permanent collection). *Publications:* 4 novels, plays for theatre, radio and TV; 2 poetry collections & poems included in various anthologies. *Signs work:* "J. Beeson." *Address:* Ford Farm, Manaton, S. Devon TQ13 9XA. *Email:* jane.beeson@tesco.net

BEGARAT, Eugène, artiste peintre. *Medium:* peinture huile, gouache, dessin. *b:* Nice, France, 21 Jul 1944. *s of:* Grisot Pierre. *Educ:* ecole des Arts Decoratifs, Nice; Ecole des Beaux Arts, Paris (1968). *Represented by:* Galerie Mongius-Artprestige (France);Galerie Les Tournesols, Vichy (France); Galerie Dumoyer St.Paul (France). *Exhib:* Brennau Gallery, Carmel, USA; Bernard Chauchet, Londres; Galerie du chateau Anray (France). *Works in collections:* collections priveès. *Works Reproduced:* publicités. *Address:* 30 route de Lourmèou, 06140 Coursegoules, France. *Email:* grisot.jean-pierre@wanadoo.fr *Website:* Eugene Begarat

BEHAN, John, RHA, sculptor in metal. *b:* Dublin, 17 Nov 1938. *s of:* Simon and Margaret Behan. one *s.* one *d. Studied:* NCAD Dublin (1957-60), Ealing Art College London (1960-61), The Royal Academy, Oslo, Norway (1968). *Represented by:* Kenny's Art Gallery, Middle Street, Galway (contact:Tom Kenny). *Exhib:* all major Irish Exhibitions from 1960 onwards, including IELA, Royal Hibernian Academy, Independent Artists, Group 65, Ruing Ground Project 67, Western Artists. Also Project Gallery, The Taylor Gallery New York, Gordon Gallery Derry, Kenny Gallery Galway, Cork Arts Society, Wagner Gallery Aust. *Works in collections:* National Gallery of Ireland, Hugh Lane Municipal Gallery Dublin, Crawford Gallery Cork, Queen Beatrix of the Netherlands, HMH, Late Samuel Beckett. *Commissions:* 'Arrival' -UN Plaza, NYC; Famine Ship, Murnsk Co Mayo; Wings of the World- Shenzhen, China; Twin Spires, NUIG, Galway; Carlow 1798 Memorial 'The Tree of Liberty' Winged Man- Enrics Co Clare. *Publications:* catalogue, essays, notes by Seamus Heaney, Brian Friel, Poet of Structure by Hayden Murphy. *Official Purchasers:* Galwat Corporation, Dublin Corporation, NUIG Galway. *Works Reproduced:* numerous in Bronze Edition since 1970. *Principal Works:* in China, New York, Mayo-Ireland, Dublin.

Recreations: reading and travel. *Clubs:* Arts Club Dublin, Royal Hibernia Academy since 1990, Aosdana. *Address:* Chestnut Lane, Lower Dangan, Galway, Ireland.

BEILBY, Pauline Margaret, NDD(1950); portrait and equestrian sculptor in clay, textile designer, freelance; water-colour paintings. *b:* Bramcote, Notts., 21 Jun 1927. *d of:* Percy Goold Beilby. *m:* Keith David Barnes, lace manufacturer. two *s. Educ:* Nottingham Girls' High School. *Studied:* Nottingham College of Arts and Crafts under A. H. Rodway, A.R.C.A., F.R.S.A., principal. *Address:* Burleigh House, 15 Albemarle Rd., Woodthorpe, Notts. NG5 4FE. *Email:* paula77@supanet.com

BELCHER, William Leeder, NDD, DesRCA, FCIAD; freelance artist/designer/illustrator in textiles, graphics and painting. *Medium:* oil, watercolour, drawing. *b:* 2 Jun 1923. *s of:* Sidney Belcher. *m:* Colleen Belcher (Designer/ Painter). *Educ:* Hastings Grammar School. *Studied:* Worthing School of Art (1947-50), RCA (1950-54). *Exhib:* many group exhbns including RA, Gimpel Fils Gallery, AIA Gallery, Jane England Gallery. *Works in collections:* private collections. *Commissions:* illustrations for many publications including IBM, Unilever, Radio Times, The Observer, Punch, The Oldie, Design. *Publications:* The Designer, Art News, The Author, BBC TV2 etc. *Works Reproduced:* in magazines, newspapers and books. *Signs work:* 'William Belcher'. *Address:* 304 Kew Road, Kew Gardens, Surrey, TW9 3DU.

BELDERSON, John Walter (Rev.), B.Arch., BD (Natal and London); Yorkshire Watercolour Society (1981); Minister of United Reformed Church (1965-1998, ret.); watercolour tutor, N.Yorks C.Council (1990-98). *Medium:* watercolour, oils, acrylic. *b:* 27 Aug 1933. *s of:* John Henry Belderson O.B.E. *m:* Elizabeth. one *s.* two *d. Studied:* Hilton College, Natal; Univ. of Natal; London Univ (1947-64). *Exhib:* Y.W.Soc. exhbns.; annual solo (1987-) Yorkshire; South Africa (P.W.Storey prizewinner); USA - Windsor, Conn.; Germany-Stuttgart. *Works in collections:* various - UK, Germany, South Africa, USA. *Commissions:* 'Harrogate in Bloom' Committee, Cockridge Hospital, Leeds; mural - Halifax Churches Comm. Centre; 'Old and New Testament'- two glass enamel painted windows (Dacre Church). *Official Purchasers:* Leeds (West) United Hospitals. *Address:* 27 Grange Road, Dacre Banks, Harrogate, HG3 4HA. *Email:* belderson@onetel.com *Website:* www.beldersonart.com

BELL, Stanley Fraser, D.A. (Mural Design) Glasgow (1970); artist in mixed media reliefs and painted murals; former Senior Lecturer, Glasgow School of Art; former Chairman, Glasgow League of Artists;. *b:* Glasgow, 12 Jan 1928. *s of:* John Armour Bell. *m:* Catherine MacDonald. one *s. Studied:* Glasgow School of Art (1966-70). *Exhib:* Scottish Young Contemporaries (1969, 1970, 1971), The Clyde Group, Edinburgh (1971), John Player Bienalle 2 Touring Exhbn. (1971), 'With Murals in Mind' Acheson House, Edinburgh (1974), 'Un Certain Art Anglais' Paris, Brussels (1979); regular exhibitor in group exhbns. in Scotland

and elsewhere. *Works in collections:* large scale exterior murals in Glasgow. *Clubs:* Glasgow Art. *Signs work:* "Stan Bell." *Address:* 419 North Woodside Rd., Glasgow G20 6NN.

BELL, Trevor, Hon.RWA; Winner Paris Biennale 1958; Head of Painting Winchester School of Art 1966-70; Professor for Graduate Painting, Florida State University, USA, 1972-1996; awarded Professor Emeritus 1995. *Medium:* painter. *b:* Leeds, 18 Oct 1930. *m:* Harriet. *Exhib:* solo exhibitions: Waddington Gallery, London (1958, '60, '62, '64); Richard Demarco Gallery, Edinburgh (1970); New Millennium Gallery, St.Ives (2001, 2003, 2005, 2007); Gillian Jason, ART2003; Waterhouse & Dodd, London (2006); plus many others at home and in the US. *Works in collections:* Selected Public Collections: Laing Art Gallery, Newcastle; Leeds City Museum and Art Gallery; Museum of Art, Fort Lauderdale, Florida; Phoenix Art Museum, Arizona; Tate Gallery, London; Victoria and Albert Museum, London; Wakefield City Art Gallery; Whitworth Art Gallery, Manchester; numerous private collections in Europe, Canada and the United States. *Signs work:* "TREVOR BELL" (on rear). *Address:* Vellyndruchia, Tremethick Cross, Penzance, Cornwall, TR20 8TZ. *Email:* bellstudio@btinternet.com

BELLAMY, David, self taught artist in water-colour, writer. *b:* Pembroke, 15 Jun 1943. *s of:* Arthur and Edith Bellamy. *m:* Jenny Keal. one *d. Educ:* Narberth Grammar School. *Exhib:* Cleveland Gallery, Bath; Lincoln Joyce Fine Art, Gt. Bookham; Albany Gallery, Cardiff; Mathaf Gallery, and many others. *Works in collections:* Berol Ltd., Welsh Development Agency, and worldwide. *Publications:* written and illustrated: Wild Places of Britain; Painting in the Wild; Wild Coast of Britain; David Bellamy's Water-colour Landscape Course, Developing your Water-colours; Images of the South Wales Mines, Wilderness Artist; Learn to Paint Water-colour Landscapes; David Bellamy's Coastal Landscapes; David Bellamy's Pembrokeshire; Painting Wild Landscapes in Watercolour; also fine art prints. *Recreations:* mountaineering. *Clubs:* Societé des Peintres de Montagne. *Signs work:* "David Bellamy." *Address:* Maesmawr, Aberedw, Builth Wells, Powys LD2 3UL. *Website:* www.davidbellamy.co.uk

BELLANY, John, C.B.E. (1994), D.A. (Edin.), M.A. (Fine Arts), A.R.C.A., R.A., Hon. R.S.A.; artist in oil, water-colour, etching; Dr. Honoris Causa, Edinburgh University (1997), Dr. Lit., Heriot Watt University, elected Senior Fellow, Royal College of Art (1999); elected Senior Fellow, Edinburgh College of Art. *b:* Port Seton, Scotland, 18 Jun 1942. *s of:* Richard Bellany. *m:* Helen Bellany née Percy. two *s.* one *d. Educ:* Preston Lodge, Prestonpans, Scotland. *Studied:* Edinburgh College of Art (1960-65), R.C.A. (1965-68). *Exhib:* one-man shows in major galleries and museums throughout the world. *Works in collections:* National Galleries of Scotland, N.P.G., Tate Gallery, V. & A., M.O.M.A. (N.Y.), Metropolitan Museum (N.Y.), etc. *Commissions:* portraits of Ian Botham, Lord Renfrew, Peter Maxwell Davies, Sean Connery etc.; portraits in both National Portrait Gallery London and National Portrait Gallery of

Scotland Edinburgh. *Publications:* John Bellany - Retrospective (Scottish National Gallery of Modern Art), John Bellany by John McEwen (Mainstream), John Bellany as Printmaker by Prof. Duncan Macmillan. John Bellany Retrospective, National Portrait Gallery, London; John Bellany Retrospective, Kunsthalle, Hamburg, Kunsthalle, Dortmund, Germany, The John Bellany Odyssey, The Mitchell Library, Glasgow; John Bellany Nella Valle del Serchio, Italy. *Recreations:* travelling the world in search of beauty. *Clubs:* Chelsea Arts. *Signs work:* "John Bellany." *Address:* c/o Royal Academy of Arts, Piccadilly, London W1V 0DS.

BELLWOOD, Colin, Master of Arts. *Medium:* oil, collage. *b:* Castleford, Yorks, 1 Jul 1949. *s of:* Doreen & William. *Educ:* Castleford Grammar School. *Studied:* Leeds College of Art, Coventry College of Education, University of Leeds (1950-70). *Exhib:* Royal Academy Summer Exhibition (1989, 1992, 1997-2 works hung, 1998, 2000-2 works hung; one-man shows: The Coningsby Gallery, London (2003, 2007), The Dundas Gallery, Edinburgh (2005). *Works in collections:* works in private collections in London, New York, The Hague, and others in Europe and N.America. *Misc:* now works in his studio in Seville, Spain. *Signs work:* "COLIN B." *Address:* Viriato 14.4, Seville 41003 Spain. *Email:* colinbellwood@yahoo.com.au *Website:* www.NuMasters.com; www.londonart.co.uk

BELSEY, Hugh Graham, M.B.E. (2004); B.A. (1976), M.Litt. (1981); museum curator; Curator, Gainsborough's House (1981-2004), freelancing thereafter; Senior Research Fellow, Paul Mellon Centre for Study 'British Art ' London (2006 -). *b:* Hemel Hempstead, 15 May 1954. *s of:* Graham Miles Belsey, F.M.I.C.E. *Educ:* University of Manchester and The Barber Inst. of Fine Arts, Birmingham. *Publications:* articles for art periodicals and exhbn. catalogues. Gainsborough at Gainsborough's House; Thomas Gainsborough: A Country Life. *Address:* 7 Rae's Yard, Bury St.Edmunds, Suffolk IP33 3EY. *Email:* h.g.belsey@talk21.com

BELTON, Liam, R.H.A. (1993), A.R.H.A. (1991), A.N.C.A. (1971); painter in oil, keeper of Royal Hibernian Academy (1995);. *b:* Dublin, 1947. *m:* Sharon Lynch. two *s.* one *d. Educ:* Synge Street. *Studied:* National College of Art, Dublin (1966-72). *Exhib:* five one-man shows, various group shows throughout Ireland. *Works in collections:* Dept. of Labour, E.S.B., G.P.A., National Self-Portrait Collection, K.P.M.G., Craig Gardner, Sisks, Elm Park Hospital, An Post., A.I.B., O.P.W., Haverty Trust, Contemporary Arts Soc., Ulster Bank. *Misc:* Member of A.A.I. and S.S.I.; Board mem. N.S.P.C. and R.H.A. Gallagher Gallery. *Signs work:* "Liam Belton, R.H.A." *Address:* 18 Whitethorn Rd., Artane, Dublin 5, Ireland.

BELTRAN, Felix, B.A., B.Sc.; American Inst. of Graphic Arts, N.Y. (1961), Internationale Buchkunst Ausstellung, Leipzig (1971), Bienale Uzite Grafiky, Brno (1972), International Print Biennale, Listowel (1980); painter, printmaker,

illustrator; Titular Prof. Universidad Autónoma Metropolitana, México;. *b:* Havana, 23 June, 1938. *s of:* Joaquín Beltrán, industrial designer. *m:* Lassie Sobera. one *d. Educ:* Colegio Cubano Arturo Montori, Havana. *Studied:* School of Visual Arts, N.Y., American Art School, N.Y., New School, New York; Graphic Art Center of the Pratt Institute, New York. *Exhib:* Rousski Gallery, Sofia; Galerie Manes, Praha; Sala Ocre, Caracas; Galería Elisava, Barcelona. *Works in collections:* Museo de Arte Contemporaneo, Panamá; Brooklyn Museum, N.Y.; Museo de Bellas Artes, Caracas; Muzeum Sztuki, Lodz; National Museum, Stockholm; Museum Narodowe, Warsaw. *Publications:* Desde el Diseño (Havana, 1970), Artes Plásticas (Havana, 1982). *Clubs:* World Print Council, San Francisco, Print Club, Philadelphia, L'Accademia d'Europa, Parma, Assoc. Internationale des Arts Plastiques, Paris. *Address:* Apartado M-10733, México 06000 DF, México. *Email:* felixbeltran@att.net.mx

BELYI, Peter, MA Printmaking (2000); Birgit Skiold Prize, National Print Exhibition (2003); Gavin Graham Gallery Award, National Print Exhbn (2002); Outstanding Printmaking Award, St.Petersburg Print Biennale (2001), Galleries Magazine Award, National Print Exhbn (2000). *Medium:* oil, prints, conceptual (installation). *b:* St.Petersburgh, Russia, 21 Apr 1971. *m:* Joanna Rogers. two *d. Studied:* Camberwell College of Art (1998-2000); Academy of Applied Art Ceramics Dept., St.Petersburg (1990-92); Secondary Art School of the Academy of Arts, St.Petersburg (1982-89). *Exhib:* over 10 solo exhbns in UK and overseas since 1994; RA Summer Exhbn (2001, 2002, 2003, 2004, 2005), My Neighbourhood, Rossia 2, Moscow Biennale (2005); National Print Exhbn, Mall Galleries (2001, 2003), Discerning Eye (2001, 2003), 5th Open Print Exhbn, RWA (2000); over 20 group exhbns in UK and overseas since 1992. *Works in collections:* V&A Permanent Collection; Ashmoloean Museum, RE Diploma Exhbn. *Official Purchasers:* V&A. *Principal Works:* Installations: Dream of a Concierge, Dream of the Dictator, My Neighbourhood, White Project, series of large-scale woodcuts 2000-2005. *Signs work:* 'Peter Belyi'. *Address:* c/o 16 Dartmouth Row, Greenwich, London SE10 8AN. *Email:* pbelyi@hotmail.com *Website:* www.peterbelyi.com

BENDALL-BRUNELLO, Tiziana, B.A. Joint Hons. (Fine Art/Ceramics) 1994; 1st Prize Winner of 'Terra Piemonte' Prize for Ceramics (Castellamonte Museum, Italy, 2004). *Medium:* glass/ceramic artist in glass and porcelain. *b:* Turin, Italy, 8 Feb 1959. *m:* John Bendall-Brunello. *Studied:* Camberwell College of Art (1991-94). *Exhib:* Hayward, Sotheby's, Barbican, Bowes Museum, Kettles Yard, Cambridge; Kunstmuseum, Wolfsburg, Germany; National Glass Centre, C.C.A. Cambridge; Roger Billcliffe, Glasgow; Scottish Gallery, Edinburgh; The Bluecoat, Liverpool; Affordable Art Fair (London & New York), Glasgow Art Fair, Scotland; SOFA Exhbn, Chicago; Art 2000 -International Art Fair, San Francisco International Gift Fair, USA; Chelsea Crafts Fair, London; Castellamonte Museum, Italy, 1st Prize winner of 'Terra Piemonte'; Contemporary Applied Arts, London; Beatrice Royal Contemporary Art and Craft Gallery. *Address:* 33 Cowper Rd., Cambridge CB1 3SL.

BENGE, Bryan Neil, B.A. (Hons.) (1977), M.A. (1994); lecturer, conceptual artist; Hon.Sec., London Group (1995-);. *b:* Middlesex, 16 Jun 1953. *m:* Maria Wasley. *Studied:* Chelsea School of Art (1973), Kingston Polytechnic (1974-77), Kingston University (1992-94). *Exhib:* Young Contemporaries, R.A., American Council for the Arts, N.Y. (Liquitex in Excellence, prize winner 1993); London: Mall Galleries, Barbican Centre, Danielle Arnaud, Morley Gallery, Westminster, Bedford Hill, St. James, Tricycle, London Inst., Central St. Martin's; Europe: Pompidou Centre, Reichstag Germany, Sarajevo, Obala Gallery. *Works in collections:* Tate Gallery London Archives. *Clubs:* London Group. *Signs work:* "BRYAN BENGE." *Address:* 51 Bramble Walk, Epsom, Surrey KT18 7TB.

BENJAMIN, Norman: see IBRAM, Peter B.,

BENJAMINS, Paul, B.A. (1st Class Hons.), M.A. (R.C.A.); artist in oil and acrylic;. *b:* London, 18 Oct 1950. *m:* Jacqui. one *s.* one *d. Studied:* Camberwell School of Art (1969-73), R.C.A. (1973-75). *Exhib:* solo shows: Thumb Gallery, London (1984, 1986, 1987), Galerie Pascal Gabert, Paris (1989, 1991, 1994), Gallery Cafe Mandy, Bergenz, Austria (1990), Jill George Gallery, London (1991, 1994, 1996, 2000), Champagne Vranken, Epernay (1993), Galerie Wam, Caen (1995), Brighton University Gallery (1998); group shows: numerous including Brighton Polytechnic Gallery, John Moores W.A.G. Liverpool, Thumb Gallery, International Contemporary Art Fairs (London, Bath, Los Angeles), Galerie Pascal Gabert, Paris, Original Print Gallery, Dublin, etc. *Commissions:* Royal Princess, Rhombert Austria, Herouville-St.Clair, Normandy, France. *Address:* c/o Advanced Graphics London, B206 Faircharm Estate, 8-12 Creekside, London SE8 3AX.

BENNETT, Brian Theodore Norton, MA Oxon. (1954), ROI(1973), PROI (1987-94), NS(1985), Hon. UA(1985); landscape painter in oil; Director of Art, Berkhamsted School (1957-87), Governor, Federation of British Artists (1992-98);. *b:* Olney, Bucks., 1927. *s of:* Horace T. Bennett. *m:* Margrit Elizabeth Brenner. *Educ:* Magdalen College School, Oxford and Magdalen College, Oxford. *Studied:* Ruskin School of Art, Oxford (1950) part-time; Regent St. Polytechnic (1956) evening classes. *Exhib:* RA., RBA, ROI, RSMA, etc. *Publications:* Choir Stalls of Chester Cathedral (1965), Oil Painting with a Knife (1993), A Painter's Year; Twelve Months in the Chilterns (2001). *Official Purchasers:* Buckinghamshire County Museum, Berkhamsted Town Council. *Signs work:* "BRIAN BENNETT" on front. Signature on reverse. *Address:* 18 Upper Ashlyns Rd., Berkhamsted, Herts. HP4 3BW.

BENNETT, David Stuart, B.A. (Hons.) (1992), M.A. (R.C.A.) (1995), S.WL.A. (1992-present); artist in water-colour and oil;. *b:* Doncaster, 11 Dec 1969. *Studied:* Leeds Polytechnic (1989-92), Royal College of Art, London (1993-95). *Exhib:* one-man shows: England; mixed exhbns. America, Holland, Spain, France, Ireland. *Publications:* Artist for nature publications, Flight of Cranes to Extremadura; and Alaska`s Copper River Delta; Nick Hammond,

Modern Wildlife Painting; Robin Darcy Shilcock: Pintores de la Naturaleza. *Signs work:* "David Bennett." *Address:* 16 Pearl St., Harrogate HG1 4QW.

BENNETT, June, NDD, ATD; painter/jeweller in silver and gold;. *b:* Grange over Sands. *d of:* E. B. Steer. *m:* Michael Bennett. two *s. Educ:* Ulverston G.S. *Studied:* Lancaster and Leicester Colleges of Art. *Exhib:* Goldsmiths Hall, Midland Group Gallery, Nottingham, Park Square Gallery, Leeds, Mignon Gallery, Bath, Ashgate Gallery, Farnham; one-man shows, Castlegate House Gallery, Cockermouth (1988, 1989, 1991, 1993, 1994, 1999, 2001, 2003), The Beacon, Whitehaven (2004), Orange Street Gallery, Uppingham (2005), Stronach Gallery, Ireland (2005, 2007). *Works in collections:* Jewellery: Abbot Hall Gallery, Kendal, Shipley A.G.; Paintings: Carlisle Museum and A.G., Copeland C.C. House of Lords Coll. Painting full time from 1987. *Signs work:* "June Bennett," "J.B." and Sheffield Assay Office hallmark. *Address:* The Hollies, Port Carlisle, Cumbria CA7 5BU.

BENNETT, Margaret Ann, VAS (1997); RSW (2004); BA (Hons); The William Bowie Award (PAI Exhbn 2006); Langside College Watercolour Award (RGI, 2005); The Armour Award (RGI, 2006); Glasow Art Club Fellowship. *Medium:* mixed media. *b:* Belshill, 21 Apr 1968. *d of:* Thomas Gerrard Bennett. *Educ:* Uddington Grammar School. *Studied:* Glasgow School of Art (1987-91). *Exhib:* RGI; RSW; RSA; PAI; Lime Tree Gallery, Suffolk; London Art Fair, Battersea; Thompson's Marylebone, London; Broadway Modern, Worcestershire. *Works in collections:* Paintings in Hospitals. *Commissions:* numerous private. *Signs work:* 'Margaret Bennett'. *Address:* Flat 3/2, 27 Cartvale Road, Glasgow, G42 9TA. *Email:* margaretannbennett@hotmail.com *Website:* www.margaretannbennett.co.uk

BENNETT, Michael, NDD, ATD; painter in oils;. *b:* Windermere, 1934. *s of:* T. W. Bennett. *m:* June Steer. two *s. Educ:* Windermere Grammar School. *Studied:* Lancaster and Leicester Colleges of Art. *Exhib:* one-man shows: Park Square Gallery, Leeds, Mignon Gallery, Bath, Bluecoat Gallery, Liverpool, Ashgate Gallery, Farnham, Abbot Hall, Kendal, A.I.A. Gallery, London; Leeds, Birmingham, Hull and Lancaster Universities, Castlegate Gallery, Cockermouth, Broughton House Gallery, Cambridge, Orange Street Gallery, Uppingham, Stronach Gallery, Ireland. *Works in collections:* Abbot Hall Gallery, Wakefield City A.G., Lincolnshire Arts Assoc., John Player Collection, Leeds Educ. Authority, Kettle's Yard, Univ. of Cambridge and Northern Arts Assoc., House of Lords Collection. *Signs work:* "Bennett" and date. *Address:* The Hollies, Port Carlisle, Cumbria CA7 5BU.

BENNETT, Terence, NDD, FRSA, Yorkshire Television Fine Art Fellowship (1973-74); painter in oil on canvas and water-colour, teacher; Head of Fine Art, Thomas Rotherham College, Rotherham (1976-91); the Sidney Holgate Fellowship, University of Durham (2001);. *b:* Doncaster, 7 Nov 1935. *Studied:* Doncaster School of Art (Eric Platt, T.A. Anderson). *Exhib:* R.A., R.O.I.,

N.E.A.C., Drian Gallery, Travelling exhbn. Yorkshire, Lincolnshire, N.S., British Painting, Mall Galleries. *Works in collections:* Nuffield Foundation, Bank of England, Yorkshire Television, Yorkshire Arts Assoc., Leeds Educ. Authority, Halifax Bldg. Soc., Sheffield University, Cambridge University, Doncaster Borough Council, I.C.I. Ltd., Durham University. *Misc:* Prizes: Singer and Friedlander, Sunday Times Water-colour competition. *Signs work:* "Terence Bennett." *Address:* Rambler Cottage, 43 Main St., Sprotbrough, Doncaster, S. Yorks. DN5 7RH.

BENNETT, William, R.M.S.; freelance artist of miniature portraits, still life and marine paintings in water-colour and oil; Council mem. RMS. *b:* London, 21 Jun 1917. *s of:* Cecil Percy Bennett, merchant. *m:* Isabel Weaver. one *s.* one *d. Educ:* Heritage School. *Studied:* Sir John Cass College, London. *Exhib:* R.A., F.B.A. Gallery. *Works in collections:* H.M. The Queen Elizabeth II Collection, Balmoral Galleries, Geelong, Australia, Manyung Gallery, Mt. Eliza, Victoria, Australia. *Signs work:* monogram of initials - and "Wm. Bennett." *Address:* 11 St. Peter's Ct., Sidmouth, Devon EX10 8AR.

BENNEY, Prof. Adrian Gerald Sallis, C.B.E., R.D.I. (1971), Hon. M.A. (Leics., 1963), Des. R.C.A. (1954); goldsmith and silversmith; Professor of Silversmithing and Jewellery at Royal College of Art (1974-83);. *b:* Hull, 21 Apr 1930. *s of:* Ernest Alfred Sallis Benney, A.R.C.A. *m:* Janet Edwards. three *s.* one *d. Educ:* Brighton Grammar School. *Studied:* Brighton College of Art (1946-50); Royal College of Art (1951-54) under Prof. Robert Goodden. *Exhib:* most European countries and major US states. *Works in collections:* V. & A., etc. *Commissions:* R.D.I. Royal Warrants of Appointment to H.M. The Queen (1974), The Late Queen Elizabeth, The Queen Mother (1975), H.R.H. The Duke of Edinburgh (1975) and H.R.H. The Prince of Wales (1980), worked extensively for the late Princess of Wales. *Publications:* Gerald Benney 50 Years at the Bench by Graham Hughes (1998). *Official Purchasers:* H.M.Government, etc. *Works Reproduced:* many works reproduced by Sangalor Pewter, Kuala Lumpur. *Principal Works:* Altar Silver for Coventry Cathedral; Altar crosses for: St.Paul's Cathedral, Westminster Cathedral; main Altar cross for Dublin St.Patricks; 18ct Mace for H.M. The Queen from Members of Commonwealth. *Recreations:* landscape and other gardening; water and oil painting, mostly nudes and country buildings. *Signs work:* "Gerald Benney." *Address:* The Old Rectory, Cholderton, nr. Salisbury, Wilts. SP4 0DW.

BENSON, Dawn Mary, L.S.I.A. (1974), Surrey Dip. (1974) Graphic Design. *Medium:* Figurative Sculptor, producing work in Bronze and Bronze resin; Painter in various media. *b:* Montreal, Canada, 7 Dec 1952. nee Stephens. *m:* divorced. one *d. Educ:* Thames Valley Grammar School, Twickenham. *Studied:* Twickenham College (1970-74, Stan Smith and Osmund Caine), Sir John Cass p/t (1976-78), Richmond College p/t (1989-94). Working in graphic design business for 16 years. *Exhib:* London and rest of England. Galleries throughout England. *Works in collections:* U.S.A., N.Z., England and Europe. *Commissions:* portrait

sculptures in London, Amsterdam (also sold Sotheby's); paintings in N.Z. and U.S.A. Large commercial project for 8 sculptures for Expo 2000 in Hanover, and for Jordanian Embassy (as part of a team). Newnham Paddox Art Parks. *Principal Works:* sold in galleries. *Clubs:* West Oxfordshire Artists; Surrey Sculptors. *Signs work:* 'DMB', 'Dawn Benson', 'D.M.Benson' or 'D.Benson'. *Address:* 33 Barwell, Wantage, Oxfordshire OX12 9AZ. *Email:* dawnstephens@yahoo.com *Website:* www.barwellgallery.co.uk

BENTON, Graham, NDD (1964), ARBSA (1986); RBSA (2005); abstract painter/illustrator in oil, gouache, collage, charcoal, pastel; part-time art tutor; Former Sec. and Chairman Walsall Arts Council and Walsall Soc. of Artists; coordinator Walsall Artists Network; Associate mem. Penwith Soc. of Arts; Mem. NSEAD.; Member of Royal Birmingham Soc. of Artists. *b:* Birmingham, 24 Oct 1934. *s of:* Sidney Benton. *Studied:* Walsall School of Art (1952-56, George Willott, Angus Macauley), Wolverhampton College of Art (1962-64, John Finnie, Bernard Brett). *Exhib:* Stafford A.G., Lichfield A.G., Walsall A.G., Letchworth A.G., 273 Gallery, London, Keele University, Salthouse Gallery, St. Ives, Penlee House, Penzance, RBSA Galleries, Birmingham, Wednesbury A.G., Camborne School of Mines; Solihull A.G., Mid-art, Dudley, Staffordshire Open. *Works in collections:* Arthur Andersen, London; RBSA Gallery, Birmingham; Private Collections in England. *Signs work:* "(Graham) Benton". *Address:* 38 Upper Forster St., Walsall, W. Midlands, WS4 2AA.

BERESFORD-WILLIAMS, Mary E., BA Hons. Fine Art, Reading (1953 Class 1); Cert. Educ. (1954); painter, printmaker and photographer; Mem. Newlyn Society of Artists; Mem. Devon Guild of Craftsmen. South-West Arts Major Award (1978); Photographer in Residence, Television South-West (1986-87); First Prize (Purchase) Burton Gallery, Bideford Open Art Competition (1999);. *b:* London, 30 Apr 1931. *d of:* F. N. Elliott. *m:* David Beresford-Williams. one *s. Educ:* Watford Grammar School. *Studied:* painting: Reading University under Prof. J. A. Betts. *Exhib:* Galleries in London and the South-west; solo shows Burton Gallery, Bideford, Devon (1998), Torre Abbey, Torquay, Devon (2000), Greenway Garden Gallery, (NT), Brixham (2002), Devon Guild (Café)(2003, 2007). *Works in collections:* Paintings, photographs and prints in public and private collections. Prints in hospitals. Prints in hotels. *Commissions:* portraits, prints. *Publications:* 1973-1997 made many screen prints, sold in limited editions. 1988 book of photographs: A Portrait of TSW. Since 2000 has been making digital prints. *Official Purchasers:* Torre Abbey, Torquay; Burton Gallery, Bideford. *Principal Works:* 'Summer on the Dart', 'The Lesson', 'The Birthday Party'. *Recreations:* reading, travel. *Signs work:* "M. Beresford-Williams", "MBW.", or "M.B.Williams". *Address:* 11 Langdon Lane, Galmpton, Brixham, Devon TQ5 0PQ. *Email:* mary@beresfordw.freeserve.co.uk *Website:* axis

BERG, Adrian, R.A.; Gold medal, Florence Biennale (1973), major prize, Tolly Cobbold (1981), third prize, John Moores (1982); painter; First Prize, Royal

Watercolour Society's Open Exhibition (2001). *b:* London, 1929. *Educ:* Charterhouse; Caius College, Cambridge (M.A.); Trinity College, Dublin (H.Dip.Ed.). *Studied:* St. Martin's (1955-56), Chelsea (1956-58), R.C.A. (1958-61). *Exhib:* 5, Tooth's (1964-75); 3, Waddington Galleries (1978-83), Rochdale A.G. (1980), 7, Piccadilly Gallery (1985-2002), Serpentine Gallery, Walker A.G. (1986), Barbican Touring Exhbn. (1993-94), Royal Academy, 1992-94 watercolours (1999). *Works in collections:* Arts Council, British Council, B.M., European Parliament, Govt. Picture Coll., Hiroshima City Museum of Contemporary Art, Tate Gallery, Tokyo Metropolitan Art Museum. *Signs work:* "Adrian Berg." *Address:* c/o Royal Academy of Arts, Burlington House, Piccadilly, London, W1J 0BD. *Website:* www.adrianberg.co.uk

BERMANT, Judith Rose, NDD. *Medium:* watercolour, drawing, prints, sculpture. *b:* London, 12 May 1939. widowed. *d of:* Mr & Mrs F Weil. two *s.* two *d. Educ:* Avigdor Grammar School. *Studied:* St.Martins School of Art (1955-1958). *Exhib:* 12 solo exhbns; many group shows including RA Summer exhbns, Royal Festival Hall, Mall Galleries, RP, Camden Arts Centre, Bloomsbury Galleries, Barbican Centre, Belgrave Gallery, House of Commons, etc. *Commissions:* many portrait commissions including: Mrs.Ruth Winston-Fox (mother of Lord Robert Winston), Lord & Lady Levene's children, Lord Jakobovits, etc.; stained glass windows: Shomrei Hadath Synagogue. *Publications:* book covers: 'The Patriarch', 'Titch', 'Dancing Bear', 'Genesis', 'On the Other Hand' -biography of Lord Jakobovits. *Official Purchasers:* prints bought by Contemporary Arts Society for new BUPA HQ. *Signs work:* 'Judy Bermant'. *Address:* 18 Hill Rise, London NW11 6NA. *Email:* Judy@bermant.com

BERNARD, Mike, B.A. (Hons.) (1978), R.A.S.Dip. (1981), R.I. (1997); demonstrator of painting techniques to art societies; painter in mixed media, acrylics, oil, tutor;. *b:* Dover, 2 Aug 1957. *m:* Susan. one *s.* one *d. Studied:* West Surrey College of Art and Design (1975-78), R.A. Schools (1978-81). *Exhib:* R.A., N.E.A.C., R.I., numerous one-man and group exhbns. *Works in collections:* Government Art Collection, Legal and General Assurance, William Garfield Ltd., Crosby Doors. *Commissions:* several mural and large scale works. *Works Reproduced:* writer for art magazine. *Clubs:* Elected member of Royal Institute of Painters in Watercolour (R.I.). *Address:* Nutcombe Farm, Nutcombe Hill, Combe Martin, North Devon, EX34 0PQ.

BERNSTEIN, Carol, NDD, BA (Open University), Post Grad Diploma Goldsmiths; painter and printmaker. *Medium:* oil, watercolour, prints, mixed media work on paper. *b:* Surrey. *m:* Sidney Bernstein (architect). one *s.* one *d. Studied:* Kingston School of Art and Design (now Kingston University); Goldsmiths College. *Exhib:* solo shows: New Hall College Cambridge; Castle Theatre Wellingbrough; Modern Artists Gallery, Whitchurch; Butley Gallery, Butley; Boughton House Gallery, Cambridge; over 30 group shows including RA Summer Exhbn. *Works in collections:* New Hall College Cambridge. Many

private collections in UK, Europe and USA. *Recreations:* making and editing short films. *Address:* Barn Studios, 71a High Street, Titchmarsh NN14 3DF. *Email:* carber@btconnect.com *Website:* www.carolbernstein.co.uk

BERRISFORD, Peter, NDD, ATD; painter (oils, water-colours), lecturer: Arts Council, National Trust, NADFAS, Swans (Hellenic). *b:* Northampton, 11 Feb 1932. *s of:* Ernest Berrisford. *m:* Jacqueline. one *s*. *Studied:* Northampton, Chelsea College of Art (Diploma), Bournemouth Art College (Travelling Scholarship 1953), Graduate Southampton University (1954). *Exhib:* Bear Lane, Wildensteins, Piccadilly, Trafford, Leicester, Hahn Galleries, London, R.B.A., R.A., John Moore's,Melitensia Gallery, Malta. *Works in collections:* Hertfordshire, Hull, Surrey, Leicester, Sheffield, Northampton, Wales University, East Sussex C.C. *Commissions:* Lithographs: New York Book of Month Club, Curwen Studios. Paintings for B.B.C.'s 'The Clothes in the Wardrobe' and 'The House of Eliott' (filmed 1992 and 1993). *Works Reproduced:* 'Young Artists of Promise' (Studio, 1957), 'Dictionary of Artists who Painted Malta' ('SAID' 1988). *Signs work:* oils "Berrisford," water-colours "Peter Berrisford." *Address:* 73 Woodgate Rd., Eastbourne BN22 8PD.

BERRY, John, A.I.C.A., Soc. of Portrait Artists, U.S.; Portrait artist U.S. Gallery of Presidents; artist in oil and pastel;. *b:* London, 9 Jun 1920. *s of:* Grace and John Berry. *m:* Jessie. three *s*. two *d*. *Studied:* Hammersmith Art College; Royal Academy Schools. *Exhib:* Weighhouse one-man show; Patterson Gallery; Driffold Gallery, South West Gallery, Dallas, Texas. *Works in collections:* Imperial War Museum, Regimental H.Q. Tidsworth, Hants. *Works Reproduced:* Esso Tiger, Ladybird Books, covers for Corgi, Four Square, Panther, Penguin and Readers Digest. *Misc:* U.S. Contact: Bob Mallenfant, Southwest Gallery, 4500 Sigma, Dallas, Texas. 75244 U.S.A. *Signs work:* "19 Berry 98." *Address:* Dove Cottage, 1 Scropton Old Rd., Hatton, Derbyshire DE65 5DX.

BERRY, June, DFA Lond. (1948), RE(1986), RWS(1993), NEAC(1990), RWA (1993); artist in etching, oil and water-colour;. *b:* Melbourne, Derbyshire, 10 Aug 1924. *d of:* Edwin Reeve. *m:* John Berry. one *s*. two *d*. *Educ:* Boston Lincs. *Studied:* Slade School of Fine Art (1941-42, 1946-49). *Represented by:* Bankside Gallery, 48 Hopton St., London, SE1 9JH. *Exhib:* R.A., R.E., R.W.S., R.W.A., N.E.A.C., and in Germany and U.S.A. *Works in collections:* Victoria and Albert Museum, Ashmolean Museum Oxford, Royal West of England Academy, Graphotek, Berlin, National Museum of Wales, Kettering A.G., Oldham A.G., H.M. The Queen, The Government Art Collection. *Publications:* Limited Edn. Livre d'Artiste 'Passing Days' (1984). *Recreations:* gardens. *Signs work:* "June Berry." *Address:* 45 Chancery La., Beckenham, Kent BR3 6NR.

BERRY, Peter Leslie, NDD Sculpture, PGDip (Slade School), MA (Art Ed.), M.Soc.Sci.(Cultural Studies). *Medium:* mainly watercolour. *b:* Cheltenham, Glos, 11 Jul 1936. *s of:* E.L.Berry. one *s*. one *d*. *Educ:* Cheltenham Grammar School. *Studied:* Cheltenham College of Art, Slade School (1961-63), University of

Birmingham. *Exhib:* Ikon Gallery Birmingham (solo and mixed since 1966); Museum and Art Gallery, Cheltenham (group); Museum and Art Gallery, Kidderminster (group); Art Council Gallery Cambridge; Goethe Institute, Glasgow; Modern British Artists Gallery, London (solo, 2007). *Works in collections:* private collections. *Recreations:* music, sport, reading. *Misc:* Has studied and taught Yoga (Advanced Teaching Qualification); Lecturer in Art/Sculpture 1963-94. *Signs work:* "P L BERRY". *Address:* 31 Stanton Road, Sapcote, Leics., LE9 4FR. *Email:* p.l.berry@btinternet.com *Website:* www.peterberry.org.uk

BERRY-HART, David James, M.A.; painter, sculptor and writer; Awards: Arts Council (1975), West Midlands Arts Association (1978). *b:* Trinidad, 1940. *s of:* Ralph and Alice Berry-Hart. two *s.* two *d. Studied:* St. Martin's School of Art (1959-1961), City of Birmingham Polytechnic (1981-83). *Exhib:* one-man shows: A.I.A. Gallery, London (1969), Herbert A.G. Coventry (1970), Camden Arts Centre (1975), University of Warwick (1977), Imperial College (1979), Royal National College for the Blind (1979), Cannon Hill Park (1979), Whitefriars Coventry (1988), mid-Warwickshire College Gallery (1990), Worcester City A.G. (1991), Quaker Gallery, London (1994), Nuneaton A.G. (1996), Brewhouse Gallery, Taunton, (1999); group: Spectrum Central (1971), Art in Steel (1972), Gawthorpe Festival (1974), On the Town sculpture (1987), Cultural Connections (1995), Nottingham Trent University; with "The Firm" exhib. Hampshire (Touring) (1983-4), Carlisle A.G. (1984), Liverpool University (1985), Williamson A.G. (1986), Beecroft A.G. (1987), Chelmsford A.G. (1987), Nuneaton A.G. (1998). *Works in collections:* R.N.C.B. Imperial College. *Publications:* Midlands Arts Magazine, Spectrum Central Catalogue. *Address:* 156A Watling Street, Grendon, Atherstone, Warwickshire CV9 2PE.

BERRYMAN, Derek James, NDD (1951), Society of Lithographic Designers, Engravers and Process Workers, ATD (1955), B.Ed.(Hons.) (1977), FRSA (1960); artist in oil, water-colour, etching, lithography; Head of Art Dept., Prince Henry's Grammar School, Otley, Yorkshire (1957-1961), lecturer (retd.); London Guildhall Univ. Sir John Cass College, Leeds College of Art, Buckinghamshire C.H.E., Weston-super-Mare School of Art; Graphic Designer, Carlton Studio, London; Hydrographic Dept., Admiralty, London. *b:* Chingford, Essex, 1926. *s of:* James Berryman, B.A. Manchester. *m:* Irene Metzger, elder daughter of Peter Metzger, architect and lecturer, Tübingen University, Germany. one *s.* one *d. Educ:* Normanhurst School, Chingford, St Aubyn's School, Woodford, S.W. Essex Technical College. *Studied:* St. Martin's School of Art; Sir John Cass College; King's College, University of Durham; University of Bristol; also English Speaking Union Scholarship to Syracuse University, U.S.A. *Exhib:* RA, RBA, ROI, RWA, Scotland, Germany, USA, and provincial galleries in England. *Works in collections:* various USA, Germany and Britain. *Misc:* War service: 1944-48 initially R.A.F.V.R. Air Crew cadet (compulsorily transferred into Infantry); Gordon Highlanders (due to increased infantry casualites, prior to Reichswald battle and Rhine Crossing) and Indian Army. *Signs work:*

"Berryman" or initial "B" with date. *Address:* The Mill House, Wester Tillyrie, by Milnathort, Kinross-shire KY13 0RW.

BERTHOLD: see DUNNE, Berthold,

BEST, Irene, artist in acrylic;. *b:* Sunderland, 3 Jun 1937. *m:* Kenneth. one *s.* one *d. Educ:* New College, Durham. *Exhib:* Witham Hall Gallery, Barnard Castle; Westminster Gallery, London; Darlington A.G.; Durham A.G.; Bede Gallery, Jarrow; R.B.S.A. Gallery, Birmingham. *Clubs:* N.A.P.A., Soc. of Amateur Artists. *Address:* 10 Wilbore Croft, Aycliffe, Co. Durham DL5 6TF.

BEST, Ronald O'Neal, R.C.A., Dip. F.A., Post Dip.; teaches litho at Heatherley School of Fine Art, London; painter and printmaker;. *Medium:* oil, etcher, watercolour. *b:* London, 25 May 1957. *Educ:* Sladebrook High School, London. *Studied:* Byam Shaw School of Art; Croydon College of Art; R.C.A. London; Asst. to Winston Branch, painter. *Exhib:* R.O.I., N.E.A.C., P.S., S.G.A., Salon des National, Paris, Lynn Stern Young Artists, London, Eva Jekel Gallery, Twentieth Century British Art Fair, R.C.A. London, 1492-1992 Un Nouveau Regard sur les Caraibes, Paris, Art House, Amsterdam, President Portobello Group, Pall Mall Deposit Gallery, the Portobello Group, W11 Gallery, Gallery Cafe, Portobello Printmakers. Coordinator, Visual Arts Portobello Festival. Founded the Chelsea Painters and Printmakers (1999), manager, Notting Hill Fine Art Gallery, co-ordinator, Art for the Unemployed, Portobello Academy of Drawing. *Works in collections:* R.C.A., Croydon College, Grange Museum, London. *Commissions:* London Art Forms. *Clubs:* Portobello Group, Chelsea Painters and Printmakers, Portobello Printmakers. *Signs work:* "Ronald Best." *Address:* 19D St. Julian's Rd London NW6 7LA.

BETHELL, David, C.B.E., LL.D.(Leic.), D.Litt. (Lough), D.Ed. (U.W.E.), D.Des (Bournemouth), RWA, FRSA, NDD, ATD, FSAE, FCSD; graphic and typographic designer; Director, Leicester Polytechnic (1973-87); Chairman, CNAA Committee for Art and Design (1974-80); mem. Design Council (1980-88); Chairman, Design Council Educ. Advisory Com. (1981-88); Hong Kong University and Polytechnic Grants Com. (1982-92); Chairman, Hong Kong Council for Academic Accreditation (1990-92); Chairman, Education and Training Committee, Chartered Society of Designers (1987-90); Senior Vice-President, R.W.A. (1997); Chairman, Bursary Awards Com. Worshipful Company Framework Knitters (1994);. *b:* Bath, 7 Dec 1923. *s of:* Wm. Geo. Bethell. *m:* Margaret (decd.). one *s.* one *d. Educ:* King Edward's School, Bath. *Studied:* Gloucester College of Art (1946-48), West of England College of Art (1948-51). *Works in collections:* Gloucester and Stafford Art Galleries, R.W.A., and private collections in U.S.A. and Israel. *Publications:* A Case of Sorts, 120 Woodcuts & The Bard, An Industrious People. *Clubs:* Athenaeum. *Signs work:* "David Bethell." *Address:* 48 Holmfield Rd., Stoneygate, Leicester LE2 1SA.

BETLEYOUN, Clarence, *Medium:* oil, acrylic, watercolour, pastel, sculpture. *b:* Akron, Ohio, USA 25 May 1950. *Educ:* AA Macon State College, USA.

Studied: Chatov Studio, Burton Silverman, Mercer University, Wesleyan College. *Represented by:* Beverley McNeil Gallery, The Anderson Gallery, Seaside Gallery, USA. *Exhib:* Black Sheep Gallery, Hawarden Castle, Wales (2001); DLI Museum, Durham Gallery, England (2000); Cornell Museum, USA (2003); Painters Sculptors Society, Washington DC, USA (1997); The Artist Gallery, Seattle, Washington, USA; International Acrylic Association, Liverpool; California Watercolor Assn, San Francisco, USA; Int. Acrylic Assn. Show, The Artists Colony Gallery, LA, USA. *Works in collections:* King and Prince Resort, Macon State College; Cherokee Brick Company; Patton, Albertson & Miller; Wealth Management. *Publications:* The Telegraph News- article, and work reproduced, show catalogues. *Principal Works:* landscapes, wildlife, people, still-lifes. *Recreations:* plays classical guitar, astronomy, travelling. *Clubs:* National Acrylic Society, National Oil and Acrylic Society, International Acrylic Assn.; Allied Artist; Oil Painters of America. *Misc:* teaches weekly art classes in painting and sculpture, also teaches workshops in USA and international. *Signs work:* 'betleyoun' or 'CB'. *Address:* 786 Wimbish Road, Macon, GA 31210, USA. *Email:* cbetleyoun@aol.com

BETOWSKI, Noel Jan, B.A. Hons. Fine Art Painting (1976), Central School of Art Diploma (1976), A.T.C. London University (1977); John Constable Landscape Competition prize winner 1987 3rd, 1988 2nd. *Medium:* oil and mixed media on canvas. *b:* Essex, 11 Dec 1952. *m:* Pamela Jane Niblett. one *s. Educ:* St. Mary's R.C. School, Tilbury, Essex. *Studied:* Thurrock Technical College, Essex (1970-1972), Central School of Art and Design, London (1973-1976), London University, Inst. of Education (1976-1977). *Exhib:* widely, including: N.P.G. (1983), R.A. (1976, 1984), New Grafton Gallery, London, (exhibitor since 1982), Royal Festival Hall (1983,1984), Mercury Gallery, London (1984, 1985), Worcester City Art Gallery (Cornish & Contemporary 1985), Crane Kalman Gallery, London (1986), Camden Arts Centre, Walker Galleries (1996,1997, 2000, 2003), Highgate Fine Art (1997, 2000), Great Atlantic Galleries. *Works in collections:* numerous collections worldwide. *Commissions:* Kinlet Hall School, Bewdley, Worcs. (1987), Peters and May Shipping Company, Southampton (1992). *Publications:* Noel Betowski (1998), various gallery catalogues, CD albums, magazines. *Works Reproduced:* various. *Principal Works:* "Forsythia" (1982), "Offspring" (1986), "Lifeforce Triptych" (1993). *Signs work:* "Noel Betowski." *Address:* Tregonebris House, Sancreed, Penzance, Cornwall TR20 8RQ. *Email:* pam@betowski.fsnet.co.uk *Website:* www.betowski.com

BEVAN, Daniel Vaughan Gwillim, R.I., W.C.S.W.; artist in water-colour. *b:* Cardiff, 8 Jun 1921. *s of:* Daniel Thomas Bevan. *m:* Betty Eileen, divorced. one *d. Educ:* Willesden and Hendon Technical Colleges. *Signs work:* "Vaughan Bevan." *Address:* Bryn Glas, Garndolbenmaen, Gwynedd, LL51 9UX.

BEVAN, Oliver, A.R.C.A. (1964). *Medium:* principally oil, also pastel, lithography. *b:* Peterborough, 28 Mar 1941. *s of:* David Bevan, painter, photographer, garden designer. *m:* Patricia Thornton (artist). two *s.* three *d. Educ:*

Eton. *Studied:* R.C.A. (Carel Weight, Colin Hayes, Leonard Rosoman). *Represented by:* Galerie de l'Ancien Courrier, Montpellier, France. *Exhib:* Angela Flowers (1981), Odette Gilbert (1984), Gallery 10 (1991), "City/Two Views", Barbican (1986); exhib. in and curated "The Subjective City" touring exhbn. (1990-91), "Witnesses and Dreamers" touring (1993-94), "The Motor Show" touring (1996-97); solo "Urban Mirror" National Theatre (1997), Hunting Art Prizes, R.C.A. (2000, 2001), Galerie de l'Ancien Courrier, Montpellier, France (2005 - 2007). *Works in collections:* Contemporary Art Soc., Museum of London, Middlesbrough Art Gallery, Unilever, Sainsbury, Guildhall A.G. *Commissions:* four ptgs for B.A.A. Gatwick (1990), Art on the Underground (1993). *Publications:* "London in Paint" Mus. of London, Modern Paintings in the Guildhall Art Gallery. *Principal Works:* 'Westway Triptych' (Museum of London); 'Walk' Guildhall Art Gallery. *Signs work:* canvases signed on back "Oliver Bevan" - elongated vertical in "B"; works on paper "OB '87", etc. *Address:* 9 Rue Grande Bourgade, 30700 Uzès, France. *Email:* oliverb@oliverbevan.com *Website:* www.oliverbevan.com

BEVAN, Tony, Dip.A.D. (1974), H.D.F.A. (1976); painter in acrylic and oil;. *b:* Bradford, 1951. one *d. Studied:* Bradford College of Art (1968-71), Goldsmiths' College (1971-74), Slade School of Fine Art (1974-76). *Exhib:* I.C.A. London touring Britain (1980-87), Haus der Kunst Munich (1989), Kunsthalle Kiel (1988), Whitechapel A.G. (1993). *Works in collections:* Staats Galerie Moderner Kunst Munich, Kunsthalle Kiel, Metropolitan Museum of Art N.Y., Yale University, B.M., Theo Wormland Foundation Munich, British Council, Arts Council, M.O.M.A. (N.Y.), Toledo Museum, Ohio, Wolverhampton A.G. *Signs work:* "Bevan." *Address:* Studio 2, Acme Studios, 165 Childers St., London SE8 5JR.

BEVIS, Michael John Vaughan, Cert Ed., AIE, ARPS, FRSA, F.CollP., D.F.A. (Painting); educational art consultant; artist in oil, photographer. *b:* London, 11 Oct 1948. *s of:* the late Albert John Bevis, actor stage manager. *m:* Marie Janice Gair. two *d. Educ:* Clarks College (1960-65). *Studied:* Hornsey College of Art (Foundation, 1966-67), Walthamforest Technical College and School of Art (1967-70), Barking N.E.L.P. (1970-72), London University Inst. of Educ. (Associateship, 1980-81). *Represented by:* Work on file at: Art Search Ltd., Project Art Ltd., Contemporary Arts Project Ltd., The Antiques and Fine Art Location Agency. *Exhib:* one-man: Loggia Gallery, London (1980); group: Mall Gallery, London. *Works in collections:* gallery and private collections. *Publications:* associateship report 'Some Art activities in Prison'. *Misc:* Director of Artserve Limited, Gallery, Lockram Villas, 7 Collingwood Rd., Witham, Essex CM8 2DY; Director: Schoolserve Ltd., Services for Education Ltd. *Signs work:* "M.J.V. BEVIS." *Address:* 2 Bergen Ct., Maldon, Essex CM9 6UH. *Email:* m.jv.bevis@talk21.com *Website:* www.artservegallery.com

BEWICK, Pauline, R.H.A., Áosdana; awards: U.N. Poster (1981), Irish Life Arts (1990); artist in water-colour, tapestry, sculpture, etching, ceramic, etc.; a

member of Internat. Womans Forum (Ireland) etc. *b:* Northumberland, 1935. *d of:* Collateral descendant of Thomas Bewick. *m:* Dr. Patrick Melia, psychiatrist. two *d. Educ:* progressive schools. *Studied:* N.C.A.D., Dublin. *Represented by:* Solo Arte, www.soloarte.ie. *Exhib:* Taylor Gallery Dublin, Catto Gallery London, Odette Gilbert Gallery London, Guinness Hop Store, Irish Museums. *Works in collections:* in many public and private collections worldwide, including '7 Ages' Permanent Collection Works from 2-70, Waterford, Kerry Council. *Commissions:* latest: 'A Visual Translation - Midnight Court' (2007, The Merriman Co.). *Publications:* subject of Painting a Life by James White, former Director of the National Gallery of Ireland, (1985); author and illustrator, Ireland: An Artist's Year (Methuen, 1990); A Boy and a Dolphin (Granada, 1983); illustrated, Irish Tales and Sagas (1994); author and illustrator: The South Seas and a Box of Paints (Art Books Int. London, 1996); The Yellow Man (1996); Seven Ages (Arlen House Galway). *Works Reproduced:* in a number of publications including 'Ireland, an Artists Year' Methuen, 'The South Seas and a Box of Paints' Art Books International, 'Kelly Read's Bewick' Arlen House, 'Seven Ages' works from the life of P.Bewick (Arlen House, 2005). *Clubs:* Chelsea Arts, London; United Arts, Dublin. *Misc:* Documentary: A Painted Diary by David Shaw-Smith, R.T.E., Channel 4, Pompidou Centre Paris, Los Angeles and Chicago film festivals (1994). Two years spent painting and writing in Polynesia, resulting in a book (see above). *Address:* Treanmanagh, Glenbeigh, Co. Kerry, Ireland. *Website:* www.paulinebewick.com

BICKNELL, John, B.A.(Hons.) (1980), H.Dip.F.A.(Lond.) (1983), Slade prize (1983), Boise Scholarship (1983), Greater London Arts award (1986), John Moores prize (1987), Henry Moore Fellow, Leeds Polytechnic (1989-90); painter. *b:* Surrey, 1958. *s of:* Peter Bicknell. *m:* Christina Dorees. two *d. Educ:* Ottershaw School. *Studied:* W.S.C.A.D. (1975-77), N.E. London Polytechnic (1977-80), Slade School of Fine Art (1981-83). *Exhib:* numerous group shows, including John Moores, Whitechapel, Christie's, New Contemporaries, R.C.A., Miro Foundation, Barcelona, Monjuic, Girona, Cleveland International Drawing Biennale, Metathesis Touring Greece, Slow Burn Touring U.K.; one-man shows: Pomeroy Purdy Gallery, London. *Works in collections:* Nat. West, Reed International, Texaco. *Signs work:* "John Bicknell." *Address:* School of Art, Architecture and Design, Leeds Metropolitan University, Calverley St., Leeds LS1 3HE.

BICKNELL, Les, B.A. (Hons.); book artist, printmaking/sculpture; visiting lecturer, Camberwell College of Art;. *b:* Coventry, 4 Mar 1963. *s of:* Tony and Pauline Bicknell. *m:* Jayne Knight. two *s. Educ:* Binley Park Comprehensive. *Studied:* London College of Printing (1982-85). *Exhib:* over 20 one-man shows since 1985 including Maison du L.A.C., Domart-en-Pontenthieu, V. & A., Nigel Greenwoods. *Works in collections:* Tate Gallery, V. & A., Rijkmuseum, Bodleian Library, M.O.M.A., N.Y. Public Library. *Commissions:* Many bookworks, including Eastern Arts Board and Birmingham Libraries. *Publications:* edited:

Mapping Knowledge, The Book as Art, Beyond Reading. *Address:* Eva's Place, Sibton Green, Saxmundham, Suffolk IP17 2JX.

BIDDULPH, Elizabeth Mary, ROI(1952), Hon. senior mem. R.O.I. (1982), N.D.D. (1947), Hon.Cert.R.D.S. (1942); painter chiefly in oils, portraits, landscapes, still-life, flowers; judging panel, John Laing Painting Competition (1988); voluntary art teaching to small class of mentally ill patients from 2000, selling work privately. *b:* Port Elizabeth, S.A., 17 Jun 1927. *d of:* the late A. D. S. Dunn, Comdr. R.N. *m:* Nicholas Osborne John Biddulph. one *s. Educ:* Hamilton House School, Tunbridge Wells. *Studied:* Wimbledon School of Art (1944-47) under Gerald Cooper, A.R.C.A., Slade School of Fine Art (1949-51). *Exhib:* yearly at R.O.I.; one-man shows, Hornsey Library (1971), Barclays Bank, Egham (1977), Egham Library (1985), murals in shop, Virginia Water (1984). *Commissions:* portraits; repainted and designed ceiling panels for writer Ralph Dutton's home 1961-62 (original ones destroyed by fire). *Publications:* articles for Leisure Painter Magazine (1980-81, 1987). *Recreations:* playing the piano, gardening. *Clubs:* Egham & District Music Club. *Signs work:* "E. Biddulph." *Address:* 74 Clarence St., Egham, Surrey TW20 9QY.

BILL, Joan Ada, N.D.D., A.T.D., U.A.; painter in all media. *b:* Redcar, 14 Jun 1933. *m:* Frank Bill. one *s.* one *d. Educ:* Saltburn High School. *Studied:* Middlesborough Art College; Sheffield Art College, Sir John Cass. *Exhib:* U.A., R.I., Artists in Essex. *Works in collections:* private collections U.K. and abroad. *Commissions:* portraits in pastel and oils, landscapes. *Publications:* pen and ink illus. - Farmhouses in an English Landscape by Sir William Addison; Essex Countryside Books. *Signs work:* "JABILL.": "JOAN BILL". *Address:* 11 Egg Hall, Epping, Essex CM16 6SA.

BINNS, David, N.D.D. (1956), S.WL.A. (1968); R.S.P.B. Fine Art Award (1990, 1992, 1993, 1994); awarded Doctor of Letters, Bradford University (2000); freelance artist in water-colour, lino, scraperboard; teacher SP courses. *b:* Sutton-in-Craven, 30 Sep 1935. *s of:* Dan Binns, teacher and artist. *m:* Molly. one *s.* two *d. Educ:* Ermysted's Grammar School, Skipton. *Studied:* Skipton Art School (Dan Binns, J. C. Midgley), Leeds College of Art (Pulée). *Represented by:* self. *Exhib:* S.WL.A., R.I., H.C. Dickens, Bloxham, Oxfordshire, Manor House, Ilkley, Aquarious Gallery, Harrogate, Leigh Yawkey Woodson Museum, Wisconsin, U.S.A., Northern Exh'n wildlife art (Liverpool), NEWA (ABR). *Works in collections:* New Zealand, Australia, U.S.A., Canada, France, U.K. *Commissions:* Northumberland N.P., RSPB Country Artists, private commissions. *Works Reproduced:* Dalesman, childrens animal books, circular jigsaws, print by Soloman & Whitehead, Medici cards, R.S.P.B. calendar and cards, Yorkshire Journal, plate and beaker designs for Country Artists Ltd. *Recreations:* bird watching. *Clubs:* S.WL.A. *Signs work:* "David Binns." *Address:* Holmestead, 9 Boundary Ave., Sutton-in-Craven, Keighley, Yorks. BD20 8BL. *Email:* david@davidbinns.wanadoo.co.uk *Website:* www.swla.co.uk

BIRCH, David William, painter/printmaker in oil, water-colour and wood engraving; landscape and architectural subjects;. *b:* 28 Jan 1945. *s of:* May and Eric Birch, engineer/designer. *m:* Annabel Carey (artist and art tutor). one *s.* *Educ:* Wellesbourne School, Birmingham. *Studied:* mentors: water-colour - Kay Kinsman, wood engraving - William T. Rawlinson. *Represented by:* Christine Talbot-Cooper - International artists. *Exhib:* R.A., R.I., R.W.S., R.E., S.W.E., R.W.A.; solo exhibitions: Michael Tippitt, Bath; Gloucester City Art Gallery; Goldsmiths College, London; John Noott Gallery, Broadway, Ombersley Gallery, Worcester, Confederation Life, Bristol; Warwick Museum and Art Gallery; regular solo shows in towns and villages of the West of England. *Works in collections:* University of Bristol, Confederation Life Insurance Co., Gloucester City Art Gallery. *Signs work:* "David W. Birch." *Address:* Croftsbrook, Blind La., Chipping Campden, Glos. GL55 6ED. *Email:* talbotcooper@onetel.com

BIRCHALL, Christine Winifred, VPSWA. *Medium:* oil, pastel. *b:* Leics., 13 May 1950. *d of:* Mr&Mrs D J Birchall. *m:* Robert King. two *d. Studied:* taught to paint by my husband, Robert King RI, RSMA. *Represented by:* Kendalls Fine Art, Isle of Wight. *Exhib:* Alexander Gallery, Bristol; Obliqué Gallery, Honfleur, France; Peter Hedley Gallery, Dorset; The House of Bruar, Scotland. *Works Reproduced:* 'Roses by the Sea' -Artgroup for Laura Ashley - worldwide. *Recreations:* sport and keep-fit, walking. *Clubs:* Vice-President SWA. *Address:* 2 Coastguard Cottages, Lepe, Southampton SO45 1AD.

BIRNE, Max Sidney, F.F.P.S.; landscape and abstract painter in oil, water-colour and gouache;. *b:* London, 12 Jan 1927. *s of:* Joseph and Sophie Birne. *m:* Rosemarie Kesselman. one *s. Studied:* City Literary Inst., London; Harrow School of Art. *Exhib:* one-man shows: Burgh House, Hampstead, Lauderdale House Highgate, Mandel's Gallery Goodmayes, Margaret Fisher Gallery London, Tricycle Theatre London; group shows: Loggia Gallery, Chenil Gallery, Alpine Gallery, Mall Galleries, Barbican Arts Centre, Bloomsbury Gallery, Usher Museum Lincoln, Brighton Polytechnic A.G., R.S.B.A.G. Birmingham, Boxfield Gallery, Stevenage. *Signs work:* "BIRNE." *Address:* 82 Preston Rd., Wembley, Middx. HA9 8LA.

BIRO, Val (B. S.), illustrator, painter, author; assistant production manager, Sylvan Press production manager, John Lehmann, Ltd. (1945-53). *Medium:* b/w line, watercolour, gouache. *b:* Budapest, Hungary, 6 Oct 1921. *s of:* Dr. B. Biro, solicitor. *m:* (1) Vivien Woolley. one d. (2) Marie-Louise Ellaway. one *s.* one *d. Educ:* Cistercian School, Budapest. *Studied:* Central School of Arts, London. *Represented by:* David Schutte, Petersfield. *Exhib:* Budapest, London, Chichester, Bath, Ashmolean, Petworth House. *Works in collections:* V. & A. Museum, British Museum and private. *Commissions:* from numerous British and foreign publishers. *Publications:* Author of 36 titles in the Gumdrop Series; Hungarian Folk Tales, Rub-a-Dub-Dub and some 40 other books for children; illustrated some 400 books, incl. My Oxford Picture Word Book, Hans Andersen, Aesop's Fables, The Father Brown Stories, The Joking Wolf, American Start with

English, Bible Stories for Children, Grimms Fairy Talesetc. *Works Reproduced:* in all the above books, Radio Times, other periodicals. *Recreations:* vintage motoring. *Clubs:* Vintage Sports Car. *Misc:* Lecturer on Art and storytelling. *Signs work:* "Biro" or "Val Biro." *Address:* Bridge Cottage, Brook Ave., Bosham, W. Sussex PO18 8LQ. *Website:* www.valbiro.co.uk

BISHOP, Peter Anthony, DFA (Lond), ATC, MA, PhD. *Medium:* painter in acrylic and mixed media, printmaker, lecturer in Fine Art/History of Art. *b:* Pembroke, 21 May 1953. *Educ:* Society of Friends School, Sibford; Banbury School of Art (1971-72). *Studied:* Slade School (1972-75), Birmingham Institute of Art and Design (1992-95), Slade School (1996-98), School of Art Aberystwyth (1998-2001). *Represented by:* Kilvert Gallery, Clyro. *Exhib:* various group and solo exhbns including Amwell Gallery, London; RA; Laing Landscape; MoMA (Wales); Royal Camrian Academy; National Library of Wales. *Works in collections:* numerous public and private. *Publications:* "Vision and Revision: Mountain Scenery in Snowdonia 1750-1880" (University of Wales, Aberystwyth 2001). *Works Reproduced:* Arts Review, Miller's Picture Price Guide (1994), Royal Academy Illustrated (1998), 'Art for Amnesty' (2001). *Principal Works:* mountain landscape of North Wales with reference to it's visual history. *Address:* Old Furnace, Knowbury, Ludlow SY8 3JH. *Email:* peteranthonybishop@lineone.net

BISHOP, William Henry, self taught artist in water-colour and oil of seascapes and landscapes. *b:* Liss, Hants., 21 Jun 1942. *s of:* Henry Bernard Bishop. *m:* Helen Dunkerley. three *s. Educ:* King's School, Canterbury. *Represented by:* in America: Quester Gallery, Stonington, Connecticut 06378, and Quester Gallery, 279 Greenwich Ave., Greenwich CT 06830. *Exhib:* R.S.M.A., Armed Forces, Southampton Maritime Year; one-man show: Royal Exchange Gallery, London (1989). *Works in collections:* U.S.A., Australia, New Zealand, Oman, Singapore, Hong Kong, Falkland Islands, U.K., Gibraltar, Germany, South Africa. *Commissions:* R.N. Museum, Portsmouth, and Mary Rose Museum, Portsmouth; HMS. Warrior Museum, The Mathew Project, City of Bristol. *Publications:* Dictionary of Sea Painters (E.H.H. Archibald). *Principal Works:* On display in the Minnesota Marine Art Museum, USA, 40"x72" Battle of Trafalgar (oil on canvas). *Signs work:* "W. H. Bishop" and "William H. Bishop" in new millenium. *Address:* West Mill, Mill Lane, Langstone, Havant, Hants. PO9 1RX. *Email:* whhsbishop@hotmail.com *Website:* www.bishopmarineart.com

BISSELL, Lauren Hayes, AS, AFC; awards: Mary Scott-Kestin Cup (2004); Wildscape Artist of the Year (2002). *Medium:* watercolour and acrylic, wildlife art and fantasy subjects. *b:* Birmingham. *d of:* Ron Dorman. *m:* Lorne Bissell. one *s. Exhib:* Mall Galleries, London; The Canterbury Pilgrim, Canterbury; RBSA; Marwell Zoological Park, Winchester; Wells Town Hall; The Gallery, Ottery St.Mary; Mayfield Gallery, Bournemouth. *Works in collections:* private collections: Canada, USA, Belgium, New Zealand, UK. *Works Reproduced:* for a

WHO'S WHO IN ART

list of open edition prints see www.lhbissell.com. *Principal Works:* 'Sea Song', 'Girl with the Flaxen Hair', 'The Canterbury Tales' Collection. *Clubs:* Signature Member of 'Art for Conservation'. *Signs work:* 'L.B.', 'LHB', 'LAUREN HAYES BISSELL H.S., A.F.C.'. *Address:* 987a Wimborne Road, Moordown, Bournemouth, Dorset BH9 2BS. *Email:* lhbissell@cwctv.net *Website:* www.lhbissell.com

BIZON, Edna, S.W.A. (1987); artist in oil. *b:* 13 Aug 1929. *m:* Ken Bizon. *Educ:* Honor Oak School. *Studied:* St.Martin's School of Art (1943-44), Camberwell School of Art (1944-46, Lawrence Gowing, John Minton, Claude Rogers). *Exhib:* R.A. from 1974 to 1994; one-man shows: Thorndike, Leatherhead (1970, 1977), Augustine, Holt (1973), Munich, W.Germany (1982), O'Nians King St. Galleries (1987), Look of Helmsley (1988), King St. Galleries (1990), Llewellyn Alexander (1991, 1993, 1995, 1997, 1999, 2001, 2003, 2005), Guild of Norwich Painters (1993-2007). *Clubs:* Guild of Norwich Painters. *Signs work:* "Edna Bizon." *Address:* Drove End, West St., North Creake, Norfolk NR21 9LQ.

BLACK, Antonia Ninette Hudson, Fine Art Degree (Slade); RBSA (1996-2003); Birmingham Midland Inst. (1992); Singer & Friedlander/Sunday Times (2nd Prize-2003; 3rd Prize-2006), 3rd Prize (2001); Grand Prix Salon International de la Peinture (2003) A L'eau Trégastel, France; RBSA Prize (2003, 2006). *Medium:* watercolour, gouache. *b:* Perth, WA, 9 Jun 1938. *d of:* H & W Hudson Shaw. *m:* R A Jones. one *s.* one *d. Educ:* Sydney Church of England Girls Grammar School. *Studied:* National Art School, Sydney; Slade School of Fine Art, London. *Represented by:* Roman Black Gallery, London; Robin Gibson Gallery, Sydney; Brian Sinfield, Burford. *Exhib:* RWS, RA Summer Exhbn, Art League Washington DC, USA; The Australian Embassy, Washington DC; Robin Gibson Gallery, Sydney; Singer & Friedlander, RBSA, Roman Black Gallery; Gallery 9, Birmingham; Affordable Art Fair, London; RI; Mall Galleries; RWA; Salon International Trégastel, France; London Art Fair, Business Design Centre, Islington; Art London, Royal Hospital Chelsea; Brian Sinfield Gallery, Burford. *Works in collections:* Sydney, New York, London; Singer & Friedlander. *Commissions:* mosaic murals chevron, Hilton Hotel, Sydney; Beckford Silk, Worcs (silk scarves), National Trust (silk scarf); mural after Douanier Rousseau, France. *Official Purchasers:* Singer & Friedlander Bank, 'Uluru' Ayers Rock, Central Australia. *Works Reproduced:* La Tour de l'Abbaye de Hambye, France. *Recreations:* travel, yoga. *Clubs:* Vintage Sports Car Club (own 1923 Peugeot); UCL Women's Dining Club. *Misc:* teaching:Kingston & Richmond Adult Colleges, Torpedo Factory, Virginia USA, 'Brushworks' at home in Gloucestershire; Jack Beck House, Yorkshire; Blockley Art Soc. Glos., North Cotswold Art Soc. *Signs work:* Antonia Black. *Address:* The Old Rectory, Alderton, Glos GL20 8NR. *Email:* bjab@carsart.co.uk

BLACK, Ian, Art Teaching Diploma, Bristol University (1956), R.W.A. (1978); art teacher and artist in oil, acrylic, pen and ink; Head of Art, Bristol

Cathedral School; Hon. Sec. R.W.A.;. *b:* Bury St. Edmunds, 31 May 1929. *s of:* Frederick Black, chemist. *m:* Judith Rhiannon. *Educ:* Culford School, Bury St. Edmunds. *Studied:* Southampton College of Art (1949), Bath Academy of Art (1952-56) under William Scott, Martin Froy, Jack Smith, Terry Frost, Peter Lanyon. *Exhib:* five one-man shows, R.W.A., R.A., travelling exhibs. *Works in collections:* R.W.A., Walsall Educ. Centre, Bath University, N.Z. Government, St. Catherine's College, Oxford, Wadham College, Oxford, Oxford Corp., Clifton High School, Redland School, Dorset House, Oxford. *Signs work:* "IB" or "Ian Black." *Address:* Blakes Farm, Englishcombe, Bath BA2 9DT.

BLACK, Simon, BA Hons Wolverhampton (1981); Public Art Freeform (1998); First Prize Art Royal Free Project Royal Free Hospital (2001), prizewinner South Bank Picture Show (1989). *Medium:* painter in oils, also works in mixed media. *b:* Salford, 17 Mar 1958. *s of:* Reuben and Phyllis Black. *m:* Raina Sheridan. two *d. Educ:* Manchester, Wolverhampton. *Studied:* Stand Grammar School, Bury; Manchester Polytechnic, Wolverhampton Polytechnic. *Represented by:* self and Ruth Corman (Thomas Corman Arts). *Exhib:* many solo and group shows including: Art London 2003, Pivotal Art Glasgow, Irish Art Fair (2002), Woolf Gallery, London (2001), Mercury Gallery, Portal Gallery, RA (1998), Barbican, Merseyside Maritime Museum, Quay Arts Isle of Wight, South Hill Park Arts Centre, Bracknell, Trinity Arts Centre, Tunbridge Wells, Midland Art Centre Birmingham. *Works in collections:* Royal Free Hospital London, Financial Services Authority London, Office for Public Management London, Harbour Vest Partners London, Ben Uri Collection, etc. *Commissions:* Royal Free Hospital (6 paintings), Financial Services Authority, Ascott Mayfair, and a number of private commissions. *Publications:* include 'Galleries Magazine' Oct 2003, Paint it Black (Jewish Chronicle, 1999), Angels and Mechanics Catalogue (1996); 'Artists in the Ben Uri Collection' (1994). *Misc:* Director of 'Designer and Artists Copyright Society' (DACS), trustee of RIVA (Residencies in Visual Arts. *Address:* 11 Wellington Avenue, London N15 6AS. *Email:* siblack@onetel.net.co.uk *Website:* www. thomascormanarts.com

BLACKBURN, David, artist in pastel on paper. *b:* Huddersfield, 1939. *Studied:* Huddersfield School of Art (1955), Royal College of Art (1959-62, Kenneth Clark, patron and adviser). *Exhib:* solo shows include: Peter Bartlow Gallery, Chicago; Huddersfield A.G.; Kreis Unna, Germany; Charles Nodrum Gallery, Melbourne, Australia; Hart Gallery, London and Nottingham, Yale Centre for British Art. *Works in collections:* M.O.M.A. (N.Y.), British Council, Leeds City A.G., Queensland A.G.; Ashmolean Museum, Oxford; British Museum, London. *Publications:* 'David Blackburn and the Visionary Landscape Tradition' by Sasha Grishin, 'A Landscape Vision' by Malcolm Yorke (both Hart Gallery Publications).'David Blackburn: The Sublime Landscape' Charlotte Mullins. *Misc:* Lives and works in Huddersfield. *Signs work:* "David Blackburn." *Address:* c/o Hart Gallery, 113 Upper St., Islington, London N1 1QN. *Website:* www.hartgallery.co.uk

BLACKBURN, Keith, full time artist in oil and mixed media, and writer. *b:* Wakefield, Yorks., 2 Apr 1943. *Exhib:* Cornwall; one-man shows: Holland and England. *Works in collections:* private: Australia, England, USA. *Publications:* Between September (Book Guild, 1994), Lamentations of a Young Pig (Book Guild, 1997), Feathers for Laura (Book Guild 2000), designed own covers. *Works Reproduced:* prints of Cornwall (Cadgwith and Mullion). *Address:* c/o A.G Hoegen, Keizersgracht 42E, 1015 CR Amsterdam, Holland.

BLACKLOCK, George, Dip.A.D. (1974), M.F.A. (1976); painter in oil and wax on canvas; Senior lecturer in painting, Wimbledon School of Art;. *b:* Durham, 11 Apr 1952. one *s. Studied:* Stourbridge College of Art (1971-74, Barrie Cook), Reading University (1974-76, Terry Frost). *Works in collections:* A.C.G.B. *Signs work:* "George Blacklock." *Address:* 11-31 Oarsmen Rd., London N1.

BLACKMORE, Clive David, painter;. *b:* Kingston-on-Thames, 1940. *Studied:* Twickenham and Kingston Schools of Art. *Exhib:* The New Millenium Gallery, St.Ives, Cornwall; Lymne Strover Gallery, Cambridge; regularly in the West Country and London. *Signs work:* "Clive Blackmore." *Address:* Eastcliff Farm, Rinsey, Ashton, Helston, Cornwall TR13 9TS.

BLACKWOOD, Brian, F.R.I.B.A., F.R.S.A.; painter in watercolour, line, gouache, pastel and etcher. *b:* 4 Feb., 1926. *Educ:* Holmesdale School, Reigate (hons. cert. Royal Drawing Soc. 1935), Inverness High School. *Studied:* Tunbridge Wells School of Art, Chelsea College of Art. *Clubs:* Liveryman, Painter-Stainers Co., member Soc. of Architect Artists, Société Internationale des Artistes Chrétiens, Art Workers Guild. *Signs work:* "Brian Blackwood." *Address:* Ebony House, Whitney Drive, Stevenage SG1 4BL.

BLACKWOOD, Simon Anthony James, Dip.Ad. (1970); artist in oil and pastel. *b:* Chelmsford, 17 May 1948. *s of:* H.J. Blackwood, policeman. *m:* Laura C.M. Blackwood. one *d. Educ:* Gilberd School, Colchester. *Studied:* Colchester School of Art, Coventry School of Art (Anthony Atkinson, Don Foster). *Exhib:* Art and Mysticism (1975) I.C.A. London; one-man shows: Dundas Gallery 'Bus Stop' Series (1985), Netherbon Arts Centre 'Aquatic Light' Series (1986), Anthony Mould Ltd. London (1989), Michael Parkin Fine Art (1991, 1995), William Hardie Gallery Glasgow (1992), Brian Sinfield Gallery Burford (1992, 1994), Kusav, Istanbul (1994, 1995), Cynthia Bourne, London (1996); Art London (2004, 2005); Glasgow Art Fare (2005); Foss Fine Arts, London (2006). *Works in collections:* Flemings Collection, Nomura International, Sabanci Corporation. *Commissions:* accepted. *Signs work:* "S.A.J.B." or "S.B." *Address:* 10 & 11 Bourtree Terrace, Hawick, Roxburgh, Scotland TD9 9HN. *Email:* simonblackwood@btconnect.com *Website:* www.simonblackwood.com

BLAKE, Elisabeth, SFP (1997), SBA (2007); DipAD (Fine Art); SFP Presidents Award for Excellence (2007). *Medium:* watercolour. *b:* S.Devon, 3 May 1946. *Studied:* University of London, Goldsmiths College of Art. *Exhib:*

Mottisfont Rose Garden, Romsey; Sir Harold Hillier Arboretum, Romsey; Ventnor Botanic Gardens; Jersey; Salisbury (with SFP); SBA Open Exhbns, Central Hall Westminster; Portsmouth City Museum; Southampton City Art Gallery. *Recreations:* gardening. *Clubs:* RHS. *Signs work:* 'ELISABETH BLAKE'. *Address:* 3 Gardner Road, Titchfield, Fareham, Hants PO14 4EF. *Email:* en_blake@yahoo.co.uk

BLAKE, Marie Dora, A.S.G.F.A. (1994); N.D.D. (1958), A.T.C. (1959);. *Medium:* oil, acrylic, watercolour, pastel, printmaking. *b:* London, 12 Mar 1938. *d of:* Eric Blake. *m:* Charles Calcutt Smith. two *s.* one *d. Educ:* Richmond and E.Sheen Grammar School. *Studied:* Kingston-on-Thames School of Art (1954-58), London University Inst. of Educ. (1959). *Exhib:* N.E.A.C., R.O.I., R.S.M.A., S.W.A., D.F.N. Gallery New York., S.G.F.A. *Publications:* author – "You Can Paint Pastels" Harper Collins U.K., (2000); Watson Guptil, NY (2000); Editions Fleuris, Paris (2001); Artist & Illustrator Magazine (1996); regular contributor Leisure Painter Magazine (1998-2004). *Clubs:* S.W.A. '87-'97. *Signs work:* "Marie Blake." *Address:* Long Close, Clappentail La., Lyme Regis, Dorset DT7 3LZ. *Email:* marie@marieblake.com *Website:* www.marieblake.com

BLAKE, Naomi, F.R.B.S.; sculptor in bronze;. *b:* Czechoslovakia, 1924. one *s.* one *d. Studied:* Hornsey School of Art (1955-60). *Exhib:* Salon de Paris, R.B.S., City of Leicester Museum, R.A. International Art Fair, St. Paul's Cathedral, Barbican London, Exhbn. Gallery Swansea University. *Works in collections:* Leicester Arts Council, North London Collegiate, Oxford Synagogue, Jews College Hendon, Fitzroy Sq. London, Bristol Cathedral, Hebrew University Jerusalem, Leo Baeck College London, Tel Aviv University Israel, Yarnton Manor Oxford, Norwich Cathedral, Duai Abbey Reading, St. Botolph's Church Aldgate, St. Anthony's College, Oxford. *Publications:* contributor, Anthologies, Each in his Prison, The Bridge is Love, London Statues, The A.A. Book of London, Open Air Sculpture in Britain. *Signs work:* "N.B." *Address:* 41 Woodside Ave., London N10 3HY.

BLAKE, Pippa Jane, B.A. Hons. (1976); painter in oil and gouache;. *b:* Portsmouth, 6 Apr 1954. *m:* Sir Peter Blake. one *s.* one *d. Educ:* Downe House School, Berks. *Studied:* Camberwell School of Art (1972-76). *Exhib:* one-man shows: Sussex, London, Auckland, N.Z.; mixed shows: Sussex, Hampshire and London. *Works in collections:* in Gt. Britain, France, Switzerland and New Zealand. *Signs work:* "P. Blake" or P.B." *Address:* Longshore, 3 Western Parade, Emsworth, Hants. PO10 7HS.

BLAKE, Quentin, C.B.E., R.D.I., M.A., F.C.S.D.; illustrator and teacher; Head of Dept. of Illustration, Royal College of Art (1978-85), Visiting Professor (1988-), Appointed Children's Laureate (1999); Honorary Doctor of London Institute 2000; Honorary Doctor Royal College of Art 2001; Honorary Fellow Royal Academy 2001; Chevalier des Arts et des Lettres 2002; Hon D.Litt Cambridge University; Prizes: Maschler Prize 1991, Bologna Ragazzi Prize

1996. *b:* Sidcup, Kent, 16 Dec 1932. *Educ:* Downing College, Cambridge. *Studied:* part-time, Chelsea School of Art. *Exhib:* one-man shows, Workshop Gallery, Illustrators A.G.; retrospective of illustration work, National Theatre (1983); Chris Beetles' Gallery (1994, 1996, 2002). *Publications:* illustrated over two hundred children's books, also books for adults; Mr. Magnolia (Kate Greenaway medal 1981). *Signs work:* "Quentin Blake." *Address:* 30 Bramham Gdns., London SW5 0HF.

BLAKER, Michael, Senior Fellow(retd.) Royal Soc. Painter-Printmakers; Fellow (retd.) Royal West of England Academy. *Medium:* etcher. *b:* Hove, 19 Jan 1928. *m:* Catriona McTurk. *Educ:* Brighton Grammar School. *Studied:* Brighton College of Art. *Exhib:* R.A., R.E., R.W.A., R.P., etc., and galleries across the UK. *Works in collections:* Tate Gallery (drawing), V. & A. (etchings). *Publications:* The Autobiography of a Painter-Etcher (1986); M.B. Etchings (1985); A Beginner's Guide to Oil Painting (1994). Editor, Printmaker's Journal (1983-93). Contributor to Printmaking Today. Self-published (Prospect Lodge Publications): comic novellas: Out of Place Angel; An Architect Unleashed; Artists at Large, etc. *Recreations:* early jazz. *Address:* 122 Grange Rd., Ramsgate, Kent CT11 9PT. *Email:* catblake@freeuk.com *Website:* www.michael-blaker.co.uk

BLANDINO, Betty, Dip. A.E. (London). *Medium:* ceramics. *b:* London, 12 Sep 1927. *m:* Dr. G.O. Jones, C.B.E. (decd). *Studied:* Goldsmiths' College, London (painting/pottery). *Exhib:* Over 20 solo ceramic exhbns. since 1973 and many group exhbns at home and abroad. Works sold at Christie's, Phillip's and Bonham's auction houses. *Works in collections:* Victoria & Albert Museum, London; Fitzwilliam Museum, Cambridge; Welsh Arts Council; National Museum of Wales; Bristol Museum and Art Gallery; many city and county museums in UK and Europe. *Publications:* Coiled Pottery - Traditional and Contemporary Ways (Black/Chilton 1984); Revised edn. (1997) revised colour edition (2003). The Figure in Fired Clay (A. & C. Black 2001; Overlook Press, USA 2002). *Works Reproduced:* British Studio Ceramics (Paul Rice, 2002) and others. *Misc:* On Crafts Council Selected Index; President, Oxfordshire Craft Guild (1989-93); exhibiting member, Contemporary Applied Arts, London. *Signs work:* Two B's impressed back to back. *Address:* 12 Squitchey Lane, Summertown, Oxford OX2 7LB. *Email:* bettyablandino@onetel.com

BLANE, Frances Aviva, Higher Diploma Fine Art Post Grad; Award winner Jerwood Drawing. *Medium:* oil painting, drawing. *b:* London, 14 Sep 1964. *d of:* Sir Sigmund Sternberg. *Studied:* Chelsea School of Art; Byam Shaw School of Drawing; Slade Post Grad. UCL. *Exhib:* Curwen Gallery; Galerie Seitz & Partner, Berlin; Painting with John McLean, London (2000); Drawing with Basil Beattie, London (2001); London Architecture Biennale (2004); Usher Gallery; Jesus College Cambridge; Shillam & Smith (2006); Annely Juda Fine Art (2007); London Original Print Fair; Marlborough Fine Art (2006). *Works in collections:* London School of Economics; Sternberg Centre; Blindart; Jesus College, Cambridge; Usher Gallery, Lincoln. *Publications:* various catalogues, Times

Newspaper Calendar 2000. *Recreations:* playing chess, swimming, theatre, reading, walking. *Clubs:* MD America Art Alliance; International Fellowship for Visual Artists; Djerassi Institute California. *Address:* 2 Bell Moor, East Heath Road, London NW3 1DY. *Website:* www.ecartspace.com

BLASZKOWSKI, Martin, Bronze Medal, Brussels (1958), Grand Prize, Buenos Aires (1960), First Prize, Competition: "Homage to Peace" of the City of Buenos Aires (1986); painter in oil, sculptor in wood; lecturer at Tulane University, New Orleans, U.S.A. (1976);. *b:* Berlin, 1920 (Argentine citizenship since 1958). *Exhib:* Brussels, Biennale Venecia, Argentine, Chile, Tate Gallery, London, Bienale de São Paulo, Brazil. *Publications:* Leonardo, 2.223 (1969) Oxford, Sculpture International 2.26 (1968) Oxford, Sculpture International 3.28 (1970) London, Sculpture of this Century, Editions du Griffon, Neuchatel, Switzerland (1959), Dictionnaire de la Sculpture Moderne, Fernand Hazan, Paris (1970). *Signs work:* "BLASZKO." *Address:* Santa Fé 3786-11-A, Buenos Aires, Argentina.

BLEASDALE, Marcus, *b:* Kendal, 7 Mar 1968. *s of:* Helen Bleasdale. *Educ:* BA (Hons) Economics and Finance, University of Huddersfield. *Studied:* Photojournalism- College of Westminster; Postgraduate Diploma in Photojournalism. *Represented by:* Independent Photographers Group. *Individual Shows/Exhibitions:* Sunday Times Nikon Ian Parry Award Exhibition- Tom Blau Gallery; Children at War- Spitz Gallery, London. *Awards/Commissions:* Sunday Times Nikon Ian Parry Award 2000 (1st place); Marie Claire Young Photojournalist of the Year (2nd place); Picture of the Year Award (magazine feature). *Principal Published Pieces:* Sunday Times magazine, Telegraph magazine (Sat.), National Geographic, Marie Claire; Book awarded USA Photo District News Book of the Year 2002. *Publications: Monograph/Contributer:* One Hundred Years of Darkness (a book covering the Congo war). *Specialist Area:* gallery based; documentary; advertising. *Address:* Thomas Heftyes Gate 39a, Oslo, 0267, Norway. *Email:* marcus@marcusbleasdale.com *Website:* marcusbleasdale.com

BLIK, Maurice, ATC (1968), PPRBS (1997), FRSA (1999); sculptor in bronze. *b:* Amsterdam, 21 Apr 1939. *s of:* Barend Blik. one *s.* one *d. Educ:* Downer Grammar School. *Studied:* Hornsey College of Art (1956-60), University of London (1968-69). *Exhib:* Mall Galleries, Ben-Uri Gallery, Royal Academy, Art for Offices (London, UK), Cavalier Galleries (Conn.,USA), Museum Masters (New York), Irving Gallery (Palm Beach, USA), Blains Fine Art (London). *Works in collections:* Work in private and public collections. *Commissions:* East India Dock, London; J.P. Morgan, London; Donnington Valley, Newbury, UK; Middlesex University, London; Jersey Museum, Jersey, C.I.; Glako Smith Kline HQ, London; Vanderbilt University Hospital, Nashville, Tenn. USA; Regent Quarter, Kings Cross, London; Evacuees Memorial, London. *Clubs:* Chelsea Arts. *Address:* 501 Bunyan Court, Barbican, London EC2Y 8DH. *Email:* mauriceblik@yahoo.com *Website:* www.mauriceblik.com

BLISS, Ian Reynolds, N.D.D. (1954), A.T.D. (1955), R.I. (1992); artist in water-colour and wood engraving; social worker;. *b:* Derby, 2 Apr 1930. *m:* Jill Michelle Cheney. one *s.* three *d. Educ:* Repton. *Studied:* Leicester (1950-55). *Exhib:* R.A., R.I., Piccadilly Gallery, Nevill Gallery Canterbury, Alex Gerard Fine Arts, Fenny Lodge Gallery. *Signs work:* "IAN BLISS." *Address:* 10 Vicarage Lane, Wing, Leighton-Buzzard LU7 0NU.

BLISS, Rosalind, SWE; DA Edinburgh College of Art (1959). *Medium:* oil, gouache, wood engraving. *b:* London, 2 Sep 1937. *d of:* Douglas Percy Bliss and Phyllis Dodd. *Educ:* St.Bride's School, Helensburgh. *Studied:* Edinburgh College of Art (1955-59, mural painting). *Exhib:* RA, RSA, Glasgow Institute; Oxford Gallery; Derby City Museum and Art Gallery, etc. *Commissions:* murals, screens, book plates for various and private collectors. *Works Reproduced:* Engravers; Engraved Gardens; Modern British Bookplates. *Clubs:* Society of Wood Engravers; The Art Workers Guild. *Misc:* 'murals' painted on folding screens. *Signs work:* Rosalind Bliss. *Address:* Hillside Cottage, Windley, Nr Belper, Derbyshire, DE56 2LP.

BLOCH, Gunther, F.R.A.I.; 1st prize winner of first National Crafts Competition (1948); art master of L.C.C. schools since 1948; sculptor in wood, stone, clay and ivory. *b:* Dt. Krone, Germany, 24 Aug., 1916. widower. *s of:* Mendelsohn Bloch. one *s. Educ:* German Colleges; Leeds College of Art (John Frank Kavanagh); Regent St. Polytechnic; and in Germany under Gerhard Priedigkeit. *Exhib:* Berkeley Galleries, Cooling Galleries, Ben Uri Gallery (The London Jewish Museum), Leeds Art Gallery, Britain Can Make It. *Works in collections:* Denmark, France, Australia, New Zealand, U.K. *Commissions:* various. *Works Reproduced:* bronze. *Signs work:* "Gunther Bloch" or "G. Bloch." *Address:* 88 Camden Mews, London NW1 9BX.

BLOOMER, Paul, RA postgrad Dip., BA (Hons); artist, lecturer. *Medium:* woodcut, egg tempera. *b:* Dudley, 1966. two *d. Studied:* Royal Academy Schools. *Exhib:* Boundary Gallery, Walsall Gallery, Clode Gallery - RA Summer Show. *Works in collections:* Walsall, Dudley, Shetland Art Galleries. *Publications:* The Black Country Man (articles), various newspaper reviews. *Clubs:* RASAA. *Address:* Brake Cottage, Bigton, Shetland, ZE2 9JA. *Email:* paulbloomer@lineone.net

BLOXHAM, Judith Ann, B.Ed.Hons. (1985); artist, specialist in painting detailed silks, mainly ties. *b:* Workington, Cumbria, 28 Jan 1961. *d of:* Donald Bone. *m:* David Gerald Bloxham. one *s.* one *d. Educ:* Whitehaven Grammar School. *Studied:* Cumbria College of Art and Design, Carlisle, St. Martin's College, Lancaster. *Exhib:* R.S.M.A. 4th International Miniatures Exhbn., Toronto, Fitz Park Museum, Keswick, St. Martin's, Lancaster, Cumberland Pencil Museum, Keswick, Wild ties V. & A., Whale tail Nairobi. *Commissions:* Mural commissions in Carlisle City. Specialist tie commissions, including B.P. and Akito Racing. *Misc:* Work in private collections. *Signs work:* "J.A.B." or "J.A.

Bloxham." *Address:* 3 Boston Ave., Carlisle, Cumbria CA2 4DR. *Email:* judybloxham@hotmail.com

BOCKING, Helen, Harrow Dip. in Illustration (1976); artist in water-colour of wildlife, country sports, animal and equestrian portraits;. *b:* Gillingham, 4 June, 1954. *Educ:* Fort Pitt School, Kent. *Studied:* Goldsmiths' College (1972), Harrow School of Art (1973-76, Sam Marshall, Brian Liddel). *Exhib:* S.WL.A., R.S.P.B., B.F.S.S., Game Conservancy; various one-man shows. *Works in collections:* S. London A.G., and many private collections. *Signs work:* "H. Bocking." *Address:* 30 Town Dam Lane, Donington, nr. Spalding, Lincs. PE11 4TP.

BOLAN, Sean Edward, G.R.A.; artist in oil and water-colour of landscapes, architecture, historical transport and military subjects. *b:* Rowlands Castle, Hants., 25 May 1948. *s of:* Edward Bolan, Ex. C.Q.M.S., Grenadier Guards. *m:* Raina Marion. two *d. Educ:* Warblington Secondary Modern School, Havant, Hants. *Studied:* Portsmouth College of Art (1965-68). *Works in collections:* private, municipal, Science Museum, S. Kensington, Guards Museum, Grenadier Guards, National Railway Museum, Welsh Guards, Scots Guards and Grenadier Guards. *Works Reproduced:* Limited edition prints, book jackets and illustrations, greeting cards, CD covers, etc. *Signs work:* "Sean Bolan." *Address:* Drive Cottage, Campden House Estate, Chipping, Campden, Glos. GL55 6UP. *Website:* www.grimeshouse.co.uk

BOLTON, Janet Mary, SBA (1992); Dip.AD (1970), ATD; RHS Gold medallist (1994); teacher, artist in pastel and pencil specializing in botanical subjects; art teacher, Kingsmead Technology College, Hednesford, Staffs.;. *b:* 26 Sep 1947. *Educ:* Gravesend Girls' Grammar School. *Studied:* Bath Academy of Art (1968-70), Bristol University (1972). *Exhib:* R.H.S., S.B.A., Oxford University and numerous shows in Midlands. *Works in collections:* Oxford University and private collections worldwide. *Publications:* 'Fruits' design for Aynsley china 'Grande Tasse' range (1993). *Signs work:* "Janet M. Bolton," "J.M. Bolton" or "J.M.B." *Address:* 7 Raven Cl., Hednesford, Staffs. WS12 2LS.

BOLTON, Richard Marston, artist in water-colour. *Medium:* watercolour. *b:* Aberdeen, 28 Jun 1950. *m:* Margaret. two *s. Studied:* Shrewsbury School of Art. *Exhib:* Linda Blackstone Gallery, Pinner; Firenze Gallery, Taiwan; L'Bidi Gallery, Cambs; Royal Institute, London. *Works in collections:* St. Ives Museum. *Commissions:* Views of China and Tibet by Taiwanese collector. *Publications:* written and illustrated: Weathered Textures in Water-colour, and Weathered Textures, Workshop (Watson & Guptil), Texture and Detail in Water-colour, and Creative Drawing and Sketching (Batsford), Creative Watercolour Techniques, (Search Press), Painting Landscapes & Nature (Search Press). *Signs work:* "R.M. Bolton." *Address:* 532 Orari Station Road, RD 22, Geraldine, New Zealand. *Email:* richardmbolton@hotmail.com *Website:* www.richardbolton.com

BONADA, Cinzia, R.B.A.; Awarded first prize for Artistic Excellence (1997/1998) by Kensington/Chelsea Arts Council; painter in oil, pencil and pastel;. *b:* Jersey, C.I., 22 Apr 1938. *d of:* Carlile Boyd and Queenie Kitto. *m:* Johnny Bonada. one *s.* two *d. Educ:* Jersey Ladies College, Bush-Davies, Royal Ballet School. *Studied:* Richmond Adult College (1975-79, Charles Fowler) and with Peter Garrard (1982-87). *Exhib:* R.A., R.B.A., R.P., N.E.A.C., etc. Founder member of Small Paintings Group. *Works in collections:* Drapers' Hall, A.W.G., Lampeter University, Japan, New Zealand, Europe, U.S.A., Egypt, Australia, Jersey C.I., HSBC Holdings plc, London, Art Workers Guild. *Commissions:* Trevor Eldrid Past Master/Drapers' Hall, Sir John Hill, F.R.S., Chev. Stephen Weiss, Prof. W. Winklestein, Peter Barker, M.B.E., Valerie Guy, B.E.M., Prof. D. Cohn-Sherbok, A.P.Thantrey. *Publications:* 'Portraits' by Thomas Coates. *Signs work:* "Cinzia." *Address:* 9 Alexandra Rd., Twickenham, Middx. TW1 2HE.

BOND, Jane, R.P., N.E.A.C., City & Guilds School of Art, (Roger de Grey, Dip. F.A. 1981), R.A. Schools (Peter Greenham, Post Grad Dip. F.A. 1984); artist in oil, charcoal and pencil of portraits, still lives, interiors. Formerly theatre, film and T.V. designer;. *b:* Zimbabwe, 1 Apr 1939. *Educ:* Holy Trinity Convent, Bickley; Kinnaird Park School, Bromley, Kent. *Exhib:* R.A., N.E.A.C., Hayward Gall., National Theatre, Glyndebourne Opera House, etc. *Works in collections:* private: England, Europe and U.S.A. *Commissions:* Portraits including; the Rt.Hon.Baroness Boothroyd, Lord Ron Dearing, Sir Aaron Klug.Om, Dr. John Moses, Dean of St.Paul's Cathedral, The Rt. Hon. Baroness Perry of Southwark, Mrs. Vivienne Duffield. *Clubs:* Two Brydges. *Address:* 8 Ceylon Rd., London W14 0PY. *Website:* www.TheRp.co.uk

BOND, Marj, D.A. (Glas.), S.S.W.A. (1974), R.S.W. (1989), S.S.A. (1989); artist in oil, acrylic, etching. *b:* Paisley, Scotland. *d of:* Hubert McKechnie, organist and ships draughtsman. *m:* James A. Gray, architect. one *s.* two *d. Educ:* Paisley Grammar School. *Studied:* Glasgow School of Art (David Donaldson, Mary Armour, Benno Schotz). *Represented by:* Adam Gallery, London. *Exhib:* many one-man shows, R.S.A., S.S.A., R.S.W., Scottish Soc. of Woman Artists. *Works in collections:* Arts in Fife, Edinburgh University, Dunfermline Building Soc., Perth A.G., Priorscourt School, Paintings in Hospitals. *Commissions:* Paintings in Hospitals, Cunard Liners, Priors Court School, Mary Queen of Scots. *Publications:* Who's Who in Scotland, catalogues. *Official Purchasers:* Edinburgh University. *Clubs:* Scottish Art Club. *Signs work:* "Marj." *Address:* Eden Cottage, Old Town, Gateside, Fife KY14 5SL. *Email:* bondgray@aol.com

BONE, Charles, PPRI, ARCA, Hon FCA (Canada); FBI Award for Design; painter and designer; former Governor, Federation of British Artists (Mall Galleries); Past President, Royal Institute of Painters in Water-colour; Awarded Hunting Group Prize for a British water-colour (1984); artist in water-colour, oil, variety of mediums including ceramic and murals. *b:* Farnham, Surrey, 15 Sep 1926. *m:* Sheila Mitchell, FRBS, ARCA (decd). two *s. Studied:* Farnham School of Art; Royal College of Art. *Exhib:* 39 one-man, Spain, Holland, USA, Britain.

Works in collections: many mural paintings in public buildings and water-colours and oils in private collections, including members of the Royal Family. *Publications:* author, Charles Bone's Waverley; Foreword by H.R.H. Prince of Wales; author, The Authors Circle, Foreword by Sir John Gielgud; Cathedrals, foreword by Archbishop of Canterbury. *Clubs:* Chelsea Arts. *Signs work:* "BONE." *Address:* Winters Farm, Puttenham, nr. Guildford, Surrey GU3 1AR.

BONE, Ronald, Dip.A.D. (1972), M.A.(R.C.A.) (1976); painter and designer in acrylic and water-colour. *b:* Consett, Co. Durham, 22 Jun 1950. married. *s of:* George Bone. one *s.* one *d. Educ:* Consett Grammar School. *Studied:* Bath Academy of Art (1968-72), R.C.A. (1973-76). *Exhib:* R.A., R.W.A., C.C.A. Galleries, Linfield Galleries, John Noott, Broadway, Llewellyn Alexander. *Works in collections:* U.K., Europe and America. *Works Reproduced:* illustrations in various books from London publishing houses. Many T.V. programmes. *Signs work:* "BONE." *Address:* Manor Farm Cottage, Pump La., Bathford, Bath, Avon BA1 7RT.

BOOKLESS, Sarah Theresa, Diploma of Art (Fine Art)(1972); Maclaine Watters Medal, RSA, Edinburgh (1971); Hospitalfield Award, Arbroath (1971). *Medium:* oils/mixed media, watercolour, drawing, prints. *b:* Glasgow, 24 Oct 1950. *Educ:* Eastbank Academy (1962-68). *Studied:* Glasgow School of Art (1968-72); Jordanhill College of Education (1972-73). *Exhib:* Royal Academy, London; Royal Scottish Academy; Llewelyn Alexander; St.Raphael Gallery; Wykeham Gallery, Stockbridge; Trinity College, Dublin; Kelvingrove Art Galleries, Glasgow; Gold Gallery, Edinburgh; Iona House Gallery, Woodstock, Oxford. *Works in collections:* Riggs Bank, London; private collections throughout the UK. *Publications:* catalogue for the Spring Show 20th Anniversary (mixed show) Wykeham Gallery, Stockbridge, Hants. *Misc:* described as an expressive modern colourist, varied subject matter including landscapes, inspired by poetry, prose and music. Also strong visionary artist, paintings often heavy with symbolism. *Signs work:* 'S.Bookless', 'Sarah Bookless', or 'Sarah T. Bookless'. *Email:* thenewdawngallery@yahoo.com *Website:* www.hudsonmackay.com

BOOTH, Rosa-Maria, VPRMS, RMS (1999), HS(F) (1983), MASF (1984), Dip. Fashion (1970); 17 awards including 1st Place Drawing & Pastel (1983), and 1st Place Abstract (1984-88) MASFlorida; painter and miniaturist. *Medium:* oil, acrylic. *b:* Olot, Spain, 9 Nov 1947. *d of:* J.E.Parejo Alonso. *m:* Peter Charles Booth (decd.). *Educ:* Sagrado Corazón de Maria, Olot; Inst. Marti, Barcelona. *Studied:* privately and in Paris under Madeleine Scali; L'Escola Olotina, Spain (Emili Parejo, J.M. Agusti); Thurrock Technical College (M. Martin, K.Walch). *Exhib:* RA, RMS, HS, Mall Galleries, Barbican, Westminster Gallery, Llewellyn Alexander, N. Ireland, Spain, France, Sweden, Canada, USA and Australia. *Works in collections:* Work in private collections. *Publications:* works included in the Centenary Book of the RMS, and Artistas del Millennium Enciclopedia Europea; listed in the Dictionary of International Biography, and Great Women of the 21st

Century (ABI). *Recreations:* entertaining, studying works at galleries and museums, etc. *Signs work:* "ROSMAR." *Address:* 36 Windsor Ave., Grays, Essex RM16 2UB.

BORCHARDT, Karolina, M.F.P.S., A.P.A., Mem. International Professional Artist (UNESCO);. *b:* Minsk, Lit, 26 Jul 1913. *d of:* Julian Iwaszkiewicz, civil servant official. *m:* Karol. one *d. Educ:* Krakow, Poland. *Studied:* University of Stephen Batory in London. Diploma di Merito at Universita Delle Arti, Italy. *Exhib:* one-man shows, English Painters Art Group, London, Gallerie Internationale, New York, Richmond Gallery and Barrett Gallery, London; group shows, Barbican A.G., Bloomsbury Galleries, Mall Gallery, Weighouse Gallery, London, Salon des Nations, Paris, London Cassel Gallery, Loggia Gallery, New Vision Gallery, Centaur Gallery, and POSK Gallery, Germany Gallery P.R.O. Stuttgart, and many others. *Works in collections:* U.S.A., Poland, England, Spain and France. *Publications:* Karolina Borchardt, Introduction by Pierre Rouve, V.P. of World Art Critics Assoc. *Clubs:* F.P.S. *Misc:* Now a British subject and lives in London. First Polish woman air pilot. *Signs work:* "K. Borchardt." *Address:* 4 Somerset House, Somerset Rd., Wimbledon, London SW19.

BORKOWSKI, Elizabeth Irena, Dip.A.D., Prix de Rome, Feodora Gleichen award (1971) Sculpture; sculptor/painter in clay, bronze, water-colour, charcoal, pencil, art teacher;. *b:* Redhill, 7 May 1949. *Educ:* Ursuline High School, Brentwood. *Studied:* Camberwell School of Art and Crafts, British School at Rome (Brian Taylor, Paul de Moncheaux). *Exhib:* R.A. Summer Show (1973), Palazzo Barberini National Museum of Rome (1973), Chelsea School of Art Rome Scholars (1986), Chelsea Harbour (1993). Elected A.R.B.S. (1992). *Signs work:* "Lissa Borkowski." *Address:* 3 High Trees Rd., Reigate, Surrey RH2 7EH.

BORRIE: see HOPE HENDERSON, Eleanor,

BOSZIN, Endre, founded, Taurus Artists (1961), London; painter in oil and water-colour, sculptor in bronze; President, Sculptors Society of Canada (1971-73), (1979-83). *b:* Hungary, 1923. *s of:* Julius Boszin, merchant. *m:* Charlotte de Sarlay. one *s.* one *d. Studied:* Budapest, R.C.A. *Exhib:* London Group; Festival of Visual Art at Harrogate, Edinburgh Festival; Grabovsky, Crane Kalman, Chiltern, Woodstock; Piccadilly Galleries, London, Gallery Raymond Creuze, Paris; International Medal Exhbns.: Madrid, Cologne, Helsinki, Prague; Sculpture Biennale: Dante Centre, Ravenna; Palace of Art, Budapest. *Works in collections:* Budapest, National Museum of Hungarian Art, Ujpest, City Collection, B.M., Pennsylvania Univ. *Clubs:* Sculptors Soc. of Canada. *Address:* 39 Gilgorm Rd., Toronto, M5N 2M4, Canada.

BOTT, Dennis Adrian Roxby, Dip.A.D. (1972), Cert.Ed. (1973), A.R.W.S. (1981), R.W.S. (1983)A.W.G. (1989-2005); painter in water-colour and oil;. *b:* Chingford, 29 Apr 1948. *s of:* Frederick William Roxby Bott. *Educ:* Forest School, nr. Snaresbrook, London E17. *Studied:* Colchester School of Art (1967-69), Norwich School of Art (1969-72). *Exhib:* one-man shows, Ogle Gallery,

Eastbourne, Gallery 33, Billingshurst, The Grange, Rottingdean, Ogle Gallery, Cheltenham, Bourne Gallery, Reigate, Worthing Museum and A.G., Canon Gallery, Chichester, Ebury Galleries. *Works in collections:* Towner A.G., Eastbourne, Hove Museum, Brighton Museum. *Commissions:* Wardroom of H.M.Y.Britannia, National Trust. *Clubs:* Arts. *Signs work:* "Roxby Bott." *Address:* Maplewood, Cherry Tree Rd., Milford, Surrey GU8 5AX.

BOTTOMLEY, Eric, G.R.A. (1985); artist/illustrator in oil and gouache. *b:* Oldham, 14 Jul 1948. *s of:* Clifford Bottomley. *m:* Jeanette. *Educ:* N. Chadderton Secondary Modern. *Studied:* Oldham School of Art and Crafts. *Exhib:* Omell Gallery, Shell House Gallery, Ledbury. *Works in collections:* National Museum of Wales (Industrial and Maritime Museum). *Publications:* illustrated three books, Limited Edn. prints, calendars, greetings cards, magazines and posters. Book published Nov '02 'The Transport Art of Eric Bottomley G.R.A.'. *Works Reproduced:* 'Eric Bottomley Prints' - published to date: 42 fine art prints, 61 greeting cards, 24 postcards. *Recreations:* walking, folk/blues music, playing guitar, mandolin and singing. *Signs work:* "Eric Bottomley." *Address:* The Old Coach House, Much Marcle, Ledbury, Herefordshire HR8 2NL. *Email:* eb-prints@lineone.net *Website:* www.eb-prints.co.uk

BOULTON, Janet, painter, water-colour and paper relief, specialising in still life and landscape gardens. *b:* Wiltshire, 14 Sep 1936. *d of:* E.F. Boulton, farmer. *m:* Keith Baines, poet and translator. one *d. Studied:* Swindon and Camberwell Schools of Art (1953-58). *Exhib:* widely in mixed shows including Belfast Arts Council Open, Chichester National, London Group, R.A. Summer Exhbns., The Cairn Gallery, etc.; one-person shows: Mercury Gallery, 26 Cork St. W1, (1988, 1991, 1994, 1997); Redfern Gallery (2001, 2004). *Works in collections:* Southern Arts, Radcliffe Infirmary, John Radcliffe Hospital, I.O.W. Area Health Authority, National Gallery, Ottawa, John Radcliffe NHS Trust, Swindon Museum & Art Gallery. *Publications:* edited and transcribed, Paul Nash Letters to Mercia Oakley 1909-1918 (Fleece Press, 1991), Monograph, Mercury Graphics (1985-91), Homage to Andre Derain, collaboration with Ian Hamilton Finlay (Wild Hawthorn Press, 1998), Monograph, Two Gardens; Monograph, Paper Relief Works. *Misc:* Residencies: Lankmead Comprehensive, Abingdon (1980), Radcliffe Infirmary, Oxford (1986). *Address:* 64 Spring Rd., Abingdon OX14 1AN. *Email:* mail@janetboulton.co.uk *Website:* www.janetboulton.co.uk

BOURDON SMITH, Diana, R.W.A. (1990); painter in oil, water-colour, charcoal and mixed media;. *b:* 16 Dec 1933. *m:* Richard (decd.). four *d. Studied:* Kingston Art School. *Exhib:* R.A., N.E.A.C., R.W.A. *Works in collections:* Royal West of England Academy. *Signs work:* "D.M.B.S." *Address:* 19 Crescent La., Bath BA1 2PX.

BOURGUIGNON, Doris, (née Blair); A.R.C.A.; painter in acrylic, oil, water-colour and gouache. *Studied:* College of Art, Belfast; R.C.A., London; Wallace Harrison, N.Y.; Fernand Leger, Paris; Andre Lhote, Paris. *Exhib:* one-man and

group shows: Belfast, Galerie l'Angle Aigu, Brussels; Museum and A.G., Belfast. *Works in collections:* Museum and A.G., Belfast. *Publications:* illustrated Various Verses by John O'The North. *Signs work:* "Doris Bourguignon," "Doris V. Blair" on academic work. *Address:* 8a Gunter Grove, London SW10 0UJ.

BOURNE, D. Peter, D.A. (Glasgow), R.S.W. (1982); painter in oil, gouache, water-colour. *b:* Madras, India, 1 Nov 1931. *s of:* D.J. Bourne, B.A., M.I.C.E. *m:* Marjorie. two *s.* two *d. Educ:* Glasgow. *Studied:* Glasgow School of Art (1950-54, David Donaldson). *Exhib:* R.S.A. Edinburgh, R.G.I. Glasgow, R.S.W. Edinburgh. *Works in collections:* City Art (Edinburgh), Pictures for Schools (Edinburgh), paintings in hospitals. *Publications:* Dictionary of Scottish Painters - Paul Harris and Julian Halsby (Cannongate Publishing). *Signs work:* "Bourne." *Address:* Tressour Wood, Weem, Aberfeldy, Perthshire PH15 2LD.

BOURNE, Jean Susan, B.A.Hons. (1971), Dip.Mus.Stud. (1972), A.M.A. (1974), F.M.A. (1992); Museum curator; Curator, Towneley Hall Art Gallery and Museum, Burnley; President, North West Federation of Museums and Art Galleries (1993-94);. *b:* Rochdale, 23 Feb 1950. *d of:* Bernard Bourne. *Educ:* Queen Margaret's School, Escrick, Lancaster University, Manchester University. *Publications:* museum guides, exhbn. catalogues, articles on oak furniture. *Signs work:* 'J.Susan Bourne'. *Address:* 94 Higham Hall Rd., Higham, Lancs. BB12 9EY.

BOUSFIELD, Neil, BA (Hons) Animation (1990), MSc Computer Graphics (1997), MA Printmaking (2007) awarded with Distinction; Rebecca Smith Award (2007); awarded Rawlinson Bequest by SWE. *Medium:* engraving, illustration, prints. *b:* Middlesbrough, 18 Dec 1967. *Studied:* Cleveland College of Art and Design (1984-87), West Surrey College of Art and Design (1987-90), Teesside University (1996-97), University of the West of England (2003-07). *Exhib:* New Designers, London (2006), The Society of Wood Engravers Annual Exhbn (2006), exhibitions across the UK, and major Arts/Film Festivals worldwide (1991-98). *Works in collections:* V&A, British Library. *Principal Works:* "Downsized"(2005), "The Cycle" (2007), illustrated artist books. *Signs work:* "NEIL BOUSFIELD". *Address:* 23 Avenue Terrace, Stonehouse, Gloucestershire, GL10 3RE. *Email:* prints@inkyfingerspress.com *Website:* www.inkyfingerspress.com

BOWEN-MORRIS, Nigel Vaughan, MA (Oxon). *Medium:* oil, prints. *b:* Barmouth, Gwynedd, 17 Aug 1961. *Studied:* St.Catherine's College, Oxford. *Exhib:* RA (2002, 2006); MOMA Wales (solo, 2004); The Gallery in Cork Street (solo, 2002, 2003, 2005, 2006); Agora Gallery, Chelsea, New York (artist in residence, 2005); Art for Life, Christie's, London (group, 2002, 2003, 2004, 2005); Florence Biennale, Italy (2005). *Works in collections:* private collection: Florida USA, Australia, Scotland, England. *Publications:* Recent Works (2002). *Principal Works:* oil on canvas. *Recreations:* Natural History. *Clubs:* FRGS.

Signs work: 'Nigel Bowen-Morris'. *Address:* Panos 22, Athens, Greece 16671. *Email:* recentworks@hotmail.com *Website:* www.nigelbowen-morris.com

BOWER, Susan, B.Sc. (1973), M.Sc. (1974), P.G.C.E. (1976), R.O.I., R.B.A; naive painter in oil. *b:* Tadcaster, Yorkshire, 20 Mar 1953. *m:* Stephen Bower. one *s.* three *d. Educ:* Nottingham, Sussex and Leeds Universities. *Exhib:* R.O.I., R.B.A., N.E.A.C., R.I., R.W.S., R.A. Summer exhibitions. *Works in collections:* Three works in the 'Anthony Petullo Collection'. *Works Reproduced:* cover of 'Time Out'. *Signs work:* "BOWER." *Address:* Larchfield House, Church St., Barkston Ash, Tadcaster, N. Yorks. LS24 9PJ.

BOWEY, Olwyn, A.R.C.A., R.A.; painter in oil and gouache;. *b:* Stockton-on-Tees, Cleveland, 10 Feb. 1936. *Studied:* West Hartlepool School of Art, Royal College of Art. *Signs work:* "Olwyn Bowey". *Address:* 4 Peace Lane, Heyshott, Midhurst, Sussex GU29 0DF.

BOWMAN, Day, BA; B.Ed (Hons). *Medium:* oil, watercolour, drawing, prints. *m:* widowed. one *s. Educ:* St.Audries School, Somerset. *Studied:* Chelsea School of Art (1977-80); Institute of Education, London. *Represented by:* Art First, 9 Cork Street, London W1. *Exhib:* RA Summer Exhbn (2003); Contemporary Arts Society, London (2002), Royal West of England Open (2002/05); Sherborne House (2006); Art First London (2006); Bournemouth University Art Loan Collection (2006); Karin Sanders Fine Art, New York (2006); 'Coast' Open: Rhyl Arts Centre (2007); many solo and group shows since 1983, also touring shows Installations. *Works in collections:* St.Vincent and Grenadines Govt. Art Gallery; Bournemouth University Art Loan Collection; Hilton Hotel Group; Phillip Morris Inc; Actes Sud Publishing. *Publications:* many art magazines including RA Magazine; 2006: Galleries Magazine; Evolver Arts Magazine; '50 Wessex Artists'; 2007: The Southampton Press, New York. *Recreations:* travel, swimming, music, food. *Clubs:* Chelsea Arts Club. *Signs work:* 'Day Bowman'. *Address:* 76a King's Road, London SW3 4TZ. *Email:* day@daybowman.com *Website:* www.daybowman.com

BOWNESS, Sir Alan, Kt., C.B.E., M.A.; art historian; formerly Director, Henry Moore Foundation, Director of the Tate Gallery, and Professor of History of Art and Deputy Director, Courtauld Inst. of Art, University of London;. *b:* London, 11 Jan 1928. *s of:* George Bowness. *m:* Sarah Hepworth Nicholson. one *s.* one *d. Educ:* University College School; Downing College, Cambridge, and Courtauld Inst. of Art. *Publications:* William Scott: Paintings (Lund Humphries, 1964); Modern Sculpture (Studio Vista, 1965); Henry Moore: Complete Sculpture 1949-1986 (Five vols. Lund Humphries, 1965-1988); Alan Davie (Lund Humphries, 1968); Gauguin (Phaidon, 1971); Complete Sculpture of Barbara Hepworth 1960-70 (Lund Humphries, 1971); Modern European Art (Thames & Hudson, 1972); Ivon Hitchens (Lund Humphries, 1973); The Conditions of Success (Thames & Hudson, 1989); Bernard Meadows (Lund Humphries, 1994). *Address:* 91 Castelnau, London SW13 9EL.

BOWYER, Francis David, B.A. Hons. (1974), RWS (1991), PPRWS, NEAC (1993); artist in water-colour and oil; part time teacher. *b:* London, 20 May 1952. *s of:* William Bowyer, RA, RWS, NEAC, RP. *m:* Glynis Porter. one *s.* one *d. Educ:* St. Mark's School, London SW6. *Studied:* St. Martin's School of Art (1971-75, Ken Roberts, Ken Bale), Hammersmith School of Art (1976-77, Ruskin Spear). *Exhib:* RA Summer Exhbn., NEAC, RWS. *Works in collections:* Royal Watercolour Society, Diploma Collection; H.R.H. Prince of Wales Collection; Arts Club, Dover St, W1; Royal Collection. *Commissions:* National Grid (1993). *Publications:* Art of Drawing and Painting (1995). *Works Reproduced:* RWS Card Collection. *Recreations:* sport. *Signs work:* "Francis Bowyer." *Address:* 12 Gainsborough Rd., Chiswick, London W4 1NJ. *Email:* francis@bowyerfineart.co.uk *Website:* www.bowyerfineart.co.uk

BOWYER, Jason Richard, M.A., R.P, N.E.A.C., PS; Greenshield Foundation (1983), Daler-Rowney award R.A. Summer Exhbn. (1986), William Townesend scholarship (1987), 'Changing Faces' Award, RP Annual (2003); Regional award, Hunting Group Prizes, RCA (1999); Critics Prize, NEAC Annual, Mall Galleries; painter in oil and pastel, draughtsman; Founder, New English School of Drawing (1993). *b:* Chiswick, London, 4 Mar 1957. *s of:* William Bowyer, R.A. *m:* Claire Ireland(Bowyer). one *s. Educ:* Chiswick School. *Studied:* Camberwell School of Art (1975-79), R.A. Schools (1979-82). *Exhib:* R.A. (1980-85, 1992-01); one-man show New Grafton (1991, 1995, 1997, 2001), Cedar House Gallery (2004). *Works in collections:* Arts Club, Dover St.; Arthur Andersen, Warburgs; Royal Tank Regiment. *Commissions:* Royal Tank Regiment; Emmanuel School, Fulham FC. *Publications:* Starting Drawing (Bloomsbury Press, 1988). *Recreations:* football, cricket. *Signs work:* "J.R. Bowyer." or initials JRB. *Address:* Studio No.7, Kew Bridge Steam Museum, Green Dragon Lane, Brentford, Middx. TW8 0EN. *Email:* jasonbowyer@yahoo.co.uk

BOWYER, William, RA (1981), RWS, NEAC, RP; artist in oil paint, water-colour; Head of Fine Art, Maidstone College of Art (1970-81); Hon. sec. NEAC. *b:* Leek, Staffs., 25 May 1926. *s of:* Arthur Bowyer. *m:* Vera Mary. two *s.* one *d. Educ:* Burslem School of Art. *Studied:* RCA (Carel Weight, Ruskin Spear). *Exhib:* RA., NEAC, RWS, many galleries London and provinces. *Works in collections:* RA, RWS, NPG, Sheffield City AG, City of Stoke-on-Trent, many provincial, and private collections home and abroad. *Clubs:* Arts, Dover St. Arts. *Signs work:* "William Bowyer." *Address:* 12 Cleveland Ave., Chiswick, London W4 1SN.

BOYD, Graham, N.D.D., A.T.D. (1951); Head of Painting, University of Hertfordshire (1976-93);. *Medium:* painting, acrylics on canvas and paper. *b:* Bristol, 1928. *s of:* Herbert Leslie Boyd. *m:* Pauline Lilian. one *s.* one *d. Educ:* Watford Grammar School. *Studied:* Watford School of Art and London University. *Represented by:* Salt Gallery, Hayle, Cornwall, TR27 4DX. www.thesaltgallery.co.uk; Sandra Higgins www.sandrahiggins.com. *Exhib:* include London Group, R.A., John Moores, Belfast 68, Triangle Artists, N.Y.,

London and Barcelona, Atlantic Fusion: Lisbon, Madrid, London Docklands, Bristol; one-man shows: A.I.A. (1962, 1967), Molton Gallery (1963), Oxford Gallery (1969, 1971, 1982), University of Hertfordshire (1980, 1988, 1994-2001), Spacex 1983, Sandra Higgins Fine Arts (1991), Harriet Green (1997), deli Art, Smithfield (1999), Pilgrim Gallery, WC1 (2003), Salt Gallery, Hayle (2004, 2006), Bushey Museum (2004); Courtyard Gallery, Hertford (2007), NI Gallery (2007). *Works in collections:* Walker Gallery, Trinity College, Oxford,Triangle Trust, New York, City of Barcelona, Azores, University of Hertfordshire, B.M.W.Financial Services. *Publications:* 'Disruptive Tendencies' recent paintings by Graham Boyd, University of Hertfordshire. *Works Reproduced:* Aquarelle pictures. *Signs work:* "Graham Boyd" or "G. BOYD." *Address:* Blackapple, 54 Scatterdells Lane, Chipperfield, Herts. WD4 9EX. *Email:* blackapple@amserve.com

BOYD-BRENT, James, A.R.E. (1988), B.A.(Hons.) (1988), M.F.A. Univ. of Minnesota (1994); artist/printmaker in etching, woodcut, water-colour; Asst. Professor, University of Minnesota, Minn. U.S.A.;. *b:* Solihull, England, 10 Aug 1954. *m:* Mary. one *s. Educ:* Selborne College. *Studied:* Anglia Polytechnic (1984, Walter Hoyle), Central/St. Martin's School of Art (1985-88, Norman Ackroyd, Bernard Cheese, David Gluck), University of Minnesota (1991-94, Malcolm Myers). *Exhib:* U.K. and U.S.A. *Works in collections:* work in public and private collections in U.K. and U.S.A. *Publications:* "Here by Design" (pictorial survey of design) published by Goldstein Museum of Design, U.S.A. *Clubs:* A.R.E., Mem. Southern Graphic Council, U.S.A. *Signs work:* "James Boyd-Brent." *Address:* 2231 Scudder St., St. Anthony Park, St. Paul, MN 55108. USA. *Email:* jboydbre@umn.edu

BOYDEN, Ann, S.W.A.; portrait painter in oil, water-colour, pastel, teacher; art teacher for Adult Educ.;. *b:* London, 1 Jun 1931. *d of:* Dr. Anthony Beach Cowley and Mary Mabel Cowley. *m:* to the late Alan Boyden. three *s. Educ:* Godolphin School, Salisbury. *Studied:* Southern College of Art, Bournemouth (1948-52). *Exhib:* S.W.A. Nottingham Castle Gallery, Dillington House; solo shows: Ancaster Gallery, British Council, Brussels, Bath Literary society Gallery, Artists 303. *Clubs:* Dillington Water-colour Soc., Artists 303 Group. *Signs work:* "Ann F. Boyden." *Address:* Brambleside, 52, Beechwood Drive, Crewkerne, Som., TA18 7BY.

BOYDEN, John, BA(Lond), DipAGMS(Manc), AMA, Cert.Theol. (Wales); teacher at The Old Grammar School, Lewes (1991-2001); Curator, Hove Museum and Art Gallery, Sussex (1973-86); painter in oil and acrylic. *b:* Tunbridge Wells, 1942. *s of:* G J Boyden, MA, HMI. *m:* Christine Portsmouth. two *s. Studied:* Northbrook College, Worthing (foundation). *Exhib:* Brighton Festival (2001), Northbrook College (2003), Adur Festival (2007). *Signs work:* "John Boyden". *Address:* 3 Rosslyn Rd., Shoreham-by-Sea, W. Sussex BN43 6WL.

BOYES, Judy Virginia, S.W.A. (1984), B.W.S. (1985); self taught landscape painter in water-colour. *Medium:* watercolour. *b:* Alton, Hants., 1 Jul 1943. *d of:* S.D. Potter, art teacher. *m:* John Boyes. two *d. Educ:* Eggars Grammar School, Alton. *Exhib:* R.I., Mall Galleries, S.W.A., Westminster Gallery; one-man shows: Liverpool University, Atkinson A.G., Southport, Guildford House A.G., Forest Gallery, Guildford. *Publications:* front cover of Artist Magazine, features and articles on water-colour technique in Artist. *Signs work:* "Judy Boyes." *Address:* Crag House, Grasmere, Cumbria, LA22 9QA. *Email:* judy.boyes@btinternet.com *Website:* www.judyboyes.co.uk

BOYT, Judy, M.A., F.R.B.S., S.E.A.; awarded R.B.S. medal for Rebellion (1993); British Sporting Art Trust and Sladmore Awards. *Medium:* sculptor in bronze, resins, silver, steel. *b:* 7 Jun 1954. *Educ:* Oxford High School, West Oxon. Tech. College, Henry Box, Witney. *Studied:* Oxford, Wolverhampton and North Staffs. Universities. *Exhib:* U.K., U.S.A., Jersey, Switzerland, France, Saudi Arabia. *Works in collections:* Japan; East India House, London; The National Racing Museum, Newmarket; Cheltenham Racecourse; Princeton University, U.S.A.; Wildenstein, Kenya; H.M. The Queen, Dubai, U.A.E., H.H. The President of the United Arab Emirates, Sheikh Hamdan al Maktoum. *Commissions:* 'Rebellion' - Standard Life; Mitsubishi Motors Trophy, Badminton Horse Trials; Golden Miller, Cheltenham racecourse; 'Up to the Line' lifesize horse, Windsor; The Working Horse Monument – Liverpool, 'Stretton' lifesize equine,private client, Yorkshire; Epsom town centre 'Evocation of Speed' equestrian bronze celebrating the Derby Horse Race; 'Attraction' bronze, Duke of Roxburghe; 'JCB', Sir Anthony & Lady Bamford. *Works Reproduced:* Film: 'Going for Bronze', documentary on Judy Boyt Sculpting the Equestrian bronze 'Up to the Line', HTV; Book: 'The Alchemy of Bronze' -Tony Birks, illustrations of 'Rebellion'. *Signs work:* "Judy Boyt." *Address:* Westwood, Easterton Sands, Devizes, Wilts. SN10 4PY. *Email:* judy@judyboyt.com *Website:* www.judyboyt.com

BRADSHAW, Bronwen Jeanette, B.A.(Hons.) (1966), R.W.A. (1988); artist in etching, silkscreen, oil, tempera, musician, artists' books;. *b:* London, 7 Sep 1945. divorced. one *d. Educ:* Sutton High School G.P.D.S.T. *Studied:* University of London. *Exhib:* R.A., R.W.A., R.E., New Munich Gallery, many group shows in the South-West. *Works in collections:* R.W.A. *Clubs:* Spike Island Printmakers; Royal West of England Academy. *Signs work:* "Bronwen Bradshaw," "Bradshaw" or "B.B." *Address:* The Dove, Butleigh, Glastonbury, Som. BA6 8TL. *Email:* bronbradshaw@yahoo.com

BRADSHAW, Elizabeth Anne Makin, SWA (1997), LSIA; Surrey Diploma in Art and Design: Illustration and Typography First Class (Hon.);. *Medium:* oil, watercolour, etchings, prints. *b:* Bovingdon, 1 Jan 1953. *d of:* Maurice J.Makin BICC. *m:* Christopher Bradshaw. one *s.* two *d. Studied:* Twickenham College of Art and Design; LSIA (1970-74). *Exhib:* London, Camberley, Sunningdale, Wokingham, Reading, and across UK. *Works in collections:* Surrey Heath

Museum, Camberley. *Commissions:* private individuals; commissions include wildlife botanical, abstract, portraiture. *Clubs:* Camberley and Frimley Society of Arts, Sunningdale Art Society. *Misc:* an experimental printmaker skilled in the art of etchings and mezzotint. *Signs work:* 'E.A Makin Bradshaw', 'E.A.Bradshaw'. *Address:* 1 Abingdon Road, Sandhurst, Berks GU47 9RN. *Email:* liz@heatherbradshaw.co.uk *Website:* www.lizmakinbradshaw.co.uk

BRADSHAW, Peter, freelance artist in oils and gouache;. *b:* London, 23 Oct 1931. divorced. *s of:* Billing A. Bradshaw, telephonist. one *d. Educ:* Kingsthorpe Grove, Bective. *Studied:* Northampton School of Art (1945-47) under F. Courtney, E. Goodson. *Exhib:* United Artists, R.O.I., Northampton Town and County and local exhbns. *Works in collections:* various U.K., worldwide. *Commissions:* various private collections. *Publications:* Railway Art. *Works Reproduced:* various Christmas and greetings cards. *Signs work:* "P. Bradshaw" (cat and robin featured in work). *Address:* 4 Bective Rd., Northampton NN2 7TD.

BRAIN, Ann/Annie (Philippa), BA Fine Art; ATC London; Maltese Biennale Special Distinction Award (1995). *Medium:* oil. *b:* Coventry, 20 Feb 1944. *Educ:* Rugby High School for Girls. *Studied:* Coventry College of Art; London University Institute of Education. *Represented by:* Bridgeman Art Library. *Exhib:* RA (1986, 92, 93, 94, 96, 97, 2004, 06); Rugby Art Gallery and Museum (2 exhbns); Mall Galleries; Artifex, Sutton Coldfield; Maltese Biennale (1995); Cygnet Gallery, Toronto; Anna-Mei Chadwick, London; etc. *Works in collections:* Rugby Borough Council, private collections in UK, Europe and USA. *Commissions:* many private. *Official Purchasers:* Warwickshire C.C., Rugby B.C. *Works Reproduced:* various works reproduced as cards, etc. *Recreations:* walking, reading, music, gardening, meals with friends. *Clubs:* Leamington Studio Artists; The Tantalus Project; Rugby and District Art Society; Association of Midland Artists; Rugby Artists' Support Group. *Signs work:* 'AB'. *Address:* 8 Dun Cow Close, Brinklow, Warwickshire, CV23 0NZ. *Email:* annie@annbrain.co.uk *Website:* www.annbrain.co.uk

BRAMER, William, M.A., R.C.A. (1968), gold medal, R.C.A. (1968); printmaker, etcher; visiting lecturer, R.C.A., Kingston University, head of painting, University of Northumbria, fellow in creative arts, Trinity College, Cambridge (1970-1972). *b:* Nottingham, 14 May 1943. one *s. Educ:* Loughborough Grammar School. *Studied:* Nottingham College of Art (1960-1965), R.C.A. (1965-1968). *Exhib:* numerous exhibs. internationally, including galleries in Paris, Berne, Zurich, London, New York. *Works in collections:* Arts Council, Queen Elizabeth College, London University, Trinity College, Cambridge, Leicester Education Authority, R.C.A., I.B.M., and others. *Misc:* Studio and editions printed at Atelier Lacourière et Frèlaut, Paris; studio in St. Ives, Cornwall. *Signs work:* "William Bramer." *Address:* 11 Maryon Mews, Hampstead, London NW3 2PU.

BRAMLEY, Victor, painter in oil, watercolour and acrylic. *b:* Sheffield, 16 Nov 1933. *s of:* family name: Oliver. *m:* Jacque Moran. *Educ:* Firth Park Grammar School, Sheffield. *Studied:* self taught. *Exhib:* London, Exeter, Cornwall, Cumbria. *Works in collections:* many private collections. *Clubs:* senior member of St. Ives Society of Artists. *Misc:* Studio/Gallery: Chapel St. Arcade, Chapel St., Penzance, Cornwall. *Signs work:* "VICTOR BRAMLEY." *Address:* 13 St. Warren St., Penzance, Cornwall TR18 2DW. *Website:* www.st.ivessociety of artists.com

BRAND, Margaret Mary Madeleine, A.I.M.B.I. (1968), M.M.A.A. (1969); medical artist, figurative and expressionist painter in oil, water-colour and mixed media; founder associate of I.M.B.I.;. *b:* London, 1938. *Educ:* Stella Maris Convent, Devon. *Studied:* Reigate and Redhill School of Art; Post-grad. diploma in medical illustration, Guy's Hospital Medical School (1961); Deputy Head of Dept. of Medical Illustration, Guy's Hospital (1963-69). *Exhib:* R.A., R.M.S., London and provincial societies and galleries. *Works Reproduced:* illustrations in medical and scientific books and journals. *Signs work:* "M. Brand" or "M.B." *Address:* 'Whitecot', Doctors Lane, Chaldon, Surrey CR3 5AF.

BRAND, Paul Benedict, N.D.D., A.T.D., A.U.A.; artist in oil paint, acrylic, watercolour, mosaic, internet online axis;. *b:* Glasgow, 14 Oct 1916. *m:* Barbara Meriel Newman Brand. three *s.* two *d. Studied:* Sir John Cass, Heatherleys and Camberwell School of Art (1948-52). *Exhib:* one-man shows: Gallery Nees Morfes, Athens (1966), Gallery Sphinx, Amsterdam (1969), Gallery Siau, Amsterdam (1970), Portsmouth County Library, Haslemere Educ. Museum; N.E.A.C., F.B.A., R.O.I., R.B.A., U.A., Laing, National Trust, Whiteley's 'Guardian' show, 'Borderlands' Meudon-Paris Exchange show, etc. *Works in collections:* private: Greece, Holland, England, U.S.A. *Publications:* two/three guides (Skye, etc.). *Signs work:* "Paul Benedict", "Paul Benedict Brand" or "P.B.B." *Address:* Ladygate Bungalow, Ladygate Drive, Grayshott, Hindhead GU26 6DR.

BRANDEBOURG, Margaret, (previously listed as M. E. Winter); part-time teacher in adult educ. for I.L.E.A.;. *b:* Surbiton, Surrey, 28 Apr 1926. *d of:* Eric Brandebourg, solicitor. *m:* Deryck William Winter. two *s.* three *d. Educ:* Tiffin Girls' School. *Studied:* Kingston Art School and R.A. Schools. Since 1976 has worked in textiles. *Exhib:* British Crafts Centre, Seven Dials Gallery, etc. *Works in collections:* Private Collections. *Commissions:* in Portsmouth Museum. *Publications:* book on Seminole Patchwork (Batsford, 1987). Lectures and demonstrates on this subject. *Clubs:* Quilter's Guild (founder mem.). *Signs work:* Margaret Winter. *Address:* 3 Cedars Rd., Hampton Wick KT1 4BG.

BRANSBURY, Allan Harry, FRBS, Chartered FCIPD, NDD, ATC (Lond.); artist, designer. *b:* Jersey, 1942. married. *s of:* H. G. Bransbury. *m:* Susan Bransbury. two *s. Educ:* Victoria College, Jersey. *Studied:* West of England College of Art, Bristol, and the University of London Inst. of Educ., followed by

study-travel in Canada and U.S.A. *Exhib:* various galleries including Royal Scottish Academy (1990 and 1992). *Commissions:* in Jersey, England and Scotland. Artist in Residence, University of Sussex (1976). Principal of the London Borough of Bromley Centre for Arts and Crafts (1977-80). Resident in Scotland since 1980. *Signs work:* 'Allan Bransbury' (as per 21st Edition). *Address:* Burnside, Kilmuir, North Kessock, Inverness IV1 3ZG. *Email:* allan@allanbransbury.com *Website:* www.allanbransbury.com

BRANSCOMBE, Dianne Lois, RMS (1996), SWA (1994), ARMS (1993), HS (1991); Masters Award for Best Set of Larger Paintings (A.Milliem Brushstrokes Exhbn, Llewelyn Alexander Gallery, 1999); Best Set of Miniatures, RMS Exhbn. (2000); teacher. *Medium:* water-colour and oil. *b:* Norwich, 1 Oct 1949. *m:* Robert. two *d. Educ:* Norwich City College. *Studied:* Goldsmiths' College (1969-72). *Represented by:* Llewelyn Alexander Gallery, London; Tudor Gallery, Norwich; Westcliffe Gallery, Sheringham. *Exhib:* RMS, SWA, HS, RA Summer show, Mandell's Gallery Norwich, Llewellyn Alexander Gallery London; The Guild of Norwich Painters, and many mixed shows. *Works Reproduced:* International Artist Magazine (Aug/Sep 2004); book 'Wide Skies' by A.May & B.Watts; cards, Medici and Clover greetings. *Signs work:* "D.L. Branscombe." *Address:* Bangala, 27 The Green, Surlingham, Norfolk NR14 7AG.

BRASIER, Jenny, R.H.S. Gold medals: for pencil drawing (1982, 1989), for paintings in water-colour on vellum (1988, 1994), for paintings on paper (2000); botanical artist and illustrator in water-colour on vellum and paper;. *b:* Worcs., 9 Aug 1936. two *s. Educ:* Sir James Smith's Grammar School, Camelford; University of Nottingham, School of Agriculture. *Exhib:* R.B.G. Kew, R.H.S., S.B.A., V. & A., Natural History Museum, Hunt Inst. Pittsburgh, Smithsonian Inst. Washington, The Linnean Society, worldwide with The Shirley Sherwood Collection, etc. *Works in collections:* V. & A., Natural History Museum, Nature in Art, Hunt Inst. for Botanical Documentation, Carnegie-Mellon University Pittsburgh, The Shirley Sherwood Collection. *Commissions:* numerous. *Works Reproduced:* numerous, including The Cyclamen Society Journals, Hosta, the Flowering Foliage Plant, The Art of Botanical Illustration, etc. *Address:* Bridge Cottage, Camelford, Cornwall PL32 9TL.

BRASON, Paul, R.P. (1994); portrait painter in oil. *b:* London, 17 Jun 1952. two *s.* one *d. Educ:* King James I Grammar School, I.O.W. *Studied:* Camberwell College of Art (1970-74). *Exhib:* NPG, RP, RWA, RA. *Works in collections:* NPG, Royal Collection Windsor Castle, Government Art Collection, Eton College, Trinity and Balliol Colleges, Oxford; Duke of Westminster; Goodwood House; Lady Lever Art Gallery, Liverpool; Merton College; RAF; RAC Club; Grosvenor Museum, Chester; University of Wales; private collections: UK, USA, France, Italy. *Clubs:* Arts Club, Chelsea Arts Club. *Signs work:* "P.B." or "BRASON" and date. *Address:* Blakeley's House, Beechen Cliff, Bath, BA2 4QT. *Email:* paulb@paulbrason.co.uk *Website:* www.paulbrason.co.uk

BRASSEY, Barbara, Lady, RA Silver Medal. *Medium:* oil and gouache. *b:* King's Somborne, Hants, 19 Dec 1911. *m:* first m. to Col. Westmorland, one s.; second m. to the late Lord Brassey, one d. *Educ:* at home. *Studied:* Royal Academy- Walter Russell, Bernard Adams, Graham Sutherland. *Represented by:* John Stocks Gallery. Tel: 07748 631022. www.johnstocksgallery.co.uk. *Exhib:* Royal Portrait Society, Paris Salon, Tryon Gallery London. One-man shows: Walker Gallery, Bond St., Wibley Gallery, Cork St., Chicago and Austin, Texas USA, R.Bingley, Rutland. *Works in collections:* Centre for Liberty and Justice, Von Baden Prince Ludwig and Swingberg Castle, W.Germany. *Commissions:* Sir Paul Mallinson, Rosale Coopman (Musician), William Bryce (Texas), Lord Monkton of Breuchly, Claud Oliver (Leicester), Rev. Cadick, etc. *Recreations:* golf, fishing. *Clubs:* Reynolds Club. *Address:* 23 Bull Lane, Ketton, PE9 3TB. *Email:* charles@allelujah.freeserve.co.uk *Website:* www.room4art.com

BRASSINGTON, Alan Francis, *Medium:* oil, watercolour, drawing, sculpture. *b:* Zimbabwe, 18 Mar 1960. *s of:* Trevor Brassington. *m:* Lisa Jane Brassington. one *s.* one *d. Educ:* Ireland, Dublin. *Studied:* Glasgow School of Art. *Represented by:* David Alexanda. *Exhib:* Contemporary Art, Manchester; Maggy Kay Cheshire - Liverpool; LPC Manchester; Theo Waddington, London; Ian Peck, New York. *Works in collections:* Sony, Cartier, Saudi Arabian Royal Family. *Commissions:* Sony, Cartier, Duke of Devonshire. *Publications:* Daily Telegraph, Telegraph Magazine, Field, Country Life, Daily Mail, House & Garden. *Recreations:* old cars. *Signs work:* "A.BRASSINGTON". *Address:* 5 Edwards College, South Cerney, Cirencester, GL7 5TR. *Email:* alan.brassington@tiscali.co.uk *Website:* www.alanbrassington.com

BRAVEN, Angela, NDD; Qualified Art Therapist; taught at Chelsea Art School for 24 years, and Ravensbourn and Hastings Art School. *Medium:* oil, watercolour, drawing, prints. *b:* 2 Jul 1947. *d of:* Olive and Arthur Braven. *m:* Gus Cummings, RA. two *s.* one *d. Studied:* Hammersmith Art & Buildings. *Exhib:* RA; Angela Flowers Gallery; Battersea Arts Centre; Odette Gilbert Gallery, Cork Street (solo show); Easton Rooms, Rye; Hastings Museum (solo show); Coastlines-Kent Inst. of Art and Design; (Braven & Bratby) Terrace Gallery, Worthing; Invited artist for Exhibition organised by the Arts Trust, Mumbai. *Works in collections:* Everard Reid Gallery, Atlanta, USA; Hastings Museum; Mumbai, India. *Commissions:* two 15ft murals for the Conquest Hospital, Hastings. *Publications:* featured on BBC TV abroad in Britain. *Works Reproduced:* many watercolours for Athena Publications. *Recreations:* jazz blues, tango, reading, swimming in sea, gardens. *Clubs:* Chelsea Art Club. *Misc:* I paint landscapes, interiors, gardens, dreams and autobiographical paintings using strong colours, so a lot of work is sold abroad. *Signs work:* 'ABraven' or 'AB'. *Address:* Harpsichord House, Coburg Place, Hastings, TN34 3HY.

BRAZDA, Jan, abstract painter, sculptor, stained glass artist and stage designer. *b:* Rome, Vatican, 1917. *s of:* Oki Brazda, Czech portrait painter, Amelie Countess Posse, Swedish authoress. *Studied:* Academy of Fine Arts,

Prague, Prix de Rome, 1st Prize Triennale Milan, Gran Premio, Biennale, Venice. *Exhib:* National Museum, Stockholm, Leonardo da Vinci (1982), Centre International du Vitrail Chartres (1995); retrospective: Prins Eugen Waldemarsudde, Stockholm (1981). *Works in collections:* National Museum, Moderna Museet, Prins Eugen Waldemarsudde Stockholm, Röhsska Konstslöjdmuseum, Gothenburg, Skissernas Museum Lund University. *Commissions:* designed Thermal Bath "Giardini Poseidon", Ischia, Bay of Naples; executed stained glass windows, mosaics and bronzes Växjö Cathedral, Sankt Andreas Malmö, and other churches; scenery: Covent Gdn. London, Lyric Opera Chicago, Bayerische Staatsoper Munich, Royal Opera Stockholm, Bolshoi Moscow. *Address:* Rindögatan 44, S115 58 Stockholm, Sweden.

BRAZIER, Connie, Hon.R.S.W.A. (2001); artist in water-colour, and engraved glass; Glass Engraving Tutor (retd.), Sutton College of Liberal Arts;. *b:* Croydon. *d of:* Arthur Philip Guerrier, solicitor. *m:* Desmond Brazier. two *s.* *Educ:* Stamford High School for Girls, Lincs. *Studied:* Croydon School of Art (Reginald Marlow, Frederick Hinchliffe, Michael Cadman). *Exhib:* Europa Gallery, Sutton (1977, 1979, 1981, 1983, 1984), Whitehall, Cheam (1986), Fairfield Halls (shared) (1987), Civic Centre A.G., Tunbridge Wells (1987), Playhouse, Epsom (1991), R.I., R.M.S., S.B.A. Invited to exhibit in Paris and New York. *Clubs:* Lewes Art. *Address:* 27 Sadlers Way, Ringmer, Lewes, East Sussex BN8 5HG.

BREEDEN, Keith James, R.P. (1999); self taught painter and sculptor in oil, water-colour, pencil, wood and metal;. *b:* Cheshire, 25 Mar., 1956. *m:* Helen. one *s.* two *d. Exhib:* MoMA Wales, Hamiltons London, Arts Connection, Llanfyllin, RP at Mall Galleries, BP Awards, NPG, London. *Works in collections:* private collections internationally, RLC Bicester, Oundle School. *Commissions:* Maj. Gen. G.W. Field, C.B., O.B.E., Resident Governor H.M. Tower of London; Jack and Morley Richards, Ty Nant; Maj. G. Crook & Smuts; H. Lloyd, Q.C.; David McMurray. *Works Reproduced:* record sleeves for Pink Floyd, Fine Young Cannibals, ABC, The Cult, Scritti Politti, etc. *Address:* Fronheulog, Llanfihangel, Llanfyllin, Powys, Cymru SY22 5HZ.

BRENT, Isabelle, designer/painter/illustrator specialising in water-colour and gold leaf. *b:* Caversham, 17 Mar 1961. *d of:* Norman Edmund Brent. *Studied:* Loughborough College of Art and Design; further studies in France and Italy; Employed in academic research and study in the Dept. of Decorative Arts, Leicester Museums and Art Galleries. *Exhib:* RA, London and other provincial galleries in Britain; Paris, Tokyo, New York, Michigan and Indianapolis etc. *Works in collections:* private throughout the world. *Commissions:* Specially commissioned by the MCC- a commemorative print depicting the evolution and development of cricket at Lords. *Publications:* illustrated: The Christmas Story (8 foreign editions, miniature editions and 3 reprints), Noah's Ark, A Cat for all Seasons, Cameo Cats, A Christmas Record Book, An Alphabet of Animals, All Creatures Great and Small, The Complete Just So Stories (4 reprints, described as

'The Definitive edition of Kiplings' great work'), Fairy Tales of Oscar Wilde (3 reprints), Grimm's Fairy Tales, Fairy Tales of Hans Christian Andersen, The Little Mermaid and Other Fairy Tales, Christmas Fairy Tales, Celtic Fairy Tales, Cats Love Christmas Too, The Golden Bird, King Midas, Best Loved Poems, Noah and the Devil, In the House of Happiness, Fairy Tales of Hans Christian Andersen for the Readers Digest. The attention to detail in the books and the academic research behind each illustration sets the work apart from other artists. Also well-known in America since 1992 for sophisticated and beautifully designed complete ranges of stationery for Marcel Schurman Company, San Francisco. Gift wrap, tissue, bags, boxes, Christmas and greeting cards, books, etc. Much sought after for miniature paintings on vellum in antique gold lockets and antique frames. *Recreations:* lives with a dalmatian, cat and Belgium hare- all have the run of the house and garden and frequently appear in the books. Main interests are classical music, Egyptology, Saxon History and theatre. *Address:* Quarr Hill Cottage, LulworthRd., Wool, Dorset BH20 6BY.

BRETT, Simon, S.W.E., A.R.E. (1986); wood engraver; Chairman, S.W.E. (1986-92);. *b:* Windsor, 27 May 1943. *s of:* Antony Brett, hospital administrator. *m:* Juliet Wood. one d. *Educ:* Ampleforth College. *Studied:* St. Martin's School of Art (1960-64, as a painter; learned engraving from Clifford Webb). *Exhib:* S.W.E., R.E., R.A., and occasional one-man shows. *Works in collections:* The Royal Collection, Windsor Castle. *Commissions:* over forty books illustrated, mainly for Folio Society and Fine Print Publications. *Publications:* 'Wood Engraving-How to do it' (revised edition 2000), 'An Engraver's Globe' (2002); other books, essays and articles on wood engraving. *Signs work:* "Simon Brett." *Address:* 12 Blowhorn St., Marlborough, Wilts. SN8 1BT.

BREVANT, Grisot, BEPC; Artiste peintre. *Medium:* gouache, pastel, dessins, oils. *b:* Paris, France, 26 Sep 1947. *d of:* Pierre et Andrée Grisot. *m:* Patrick Girard. *Educ:* Ecole Freinet (Vence AM) et (Cannes AM) Lycée. *Studied:* Entreé a l'Ecole des Arts Decoratifs de Nice a 14ans avec dispense (4 ans) d'études examen et Diplôme (CAFAS), Zatkine (Sculpteur et Peintre). *Represented by:* France: Galerie 'Albane', Nantes; Galerie Le 'Sagittaire', Annecy; Galerie Cimaise, Besancon; Japan: Galerie Daimaru, Tokyo; London: Bernard Chauchet. *Exhib:* Paris: galeries: Guigné Universite, Carre d'Or; Province: Etats Unis (Cannes) Sagittaire (Annecy); Chifflet, Contemporaine, Cimaise (Besançon); Saluden (Brest) Mas d'Artigny (St.Paul de Vence). *Works in collections:* Galeries Etrangèrs: Daimaru (Tokyo), Lambertini (Rome), Atelier 5 (Amsterdam). *Commissions:* Collectionneurs: Privés (Munich, Paris, Buenos Aires), Fresques Commandeés par une Grande Banque Suisse. *Publications:* catalogues et plaquettes faites lors de plusieurs expositions. *Works Reproduced:* Télévision: 1995 Compte Rendu Exposition (Monaco) AM. *Principal Works:* Jeux de Lumière; Atmosphère d'Eté; Le Printemps. *Address:* 318 Route des Valettes Sud 06140 Tourettes sur Loup, France.

WHO'S WHO IN ART

BREWSTER, Martyn Robert, B.A. (1974), Post. Grad. Dip. in Printmaking (1975), A.T.C. (1978); Eastern Arts award (1977), British Council Award (1991); painter in oil and acrylic, drawings, printmaking;. *b:* Oxford, 24 Jan 1952. *s of:* Robert Brewster. *Educ:* Watford Boys' Grammar School. *Studied:* Herts. College of Art (1970-71), Brighton Polytechnic (1971-75), Brighton Art Teachers' Centre (1977-78). *Exhib:* one-man shows: Jill George Gallery London since 1988. *Works in collections:* Russell-Cotes A.G. and Museum, Dorset. Many public and private collections U.K. and abroad. *Publications:* Monograph on artist by Simon Olding (Scolar Press, 1997). *Signs work:* "Brewster" either on front or back of work with date. *Address:* 15 West Rd., Boscombe, Bournemouth, Dorset BH5 2AN. *Website:* www.martynbrewster.com

BRIDGE, Eoghan, 'Ireland Alloys Award' for Most Promising Young Artist (RSA, 1989). *Medium:* sculpture. *b:* Edinburgh, 1963. *s of:* Thomas James Joseph Bridge. *m:* Angela. two *s.* one *d. Studied:* Harrogate College of Art; Leeds Polytechnic. *Represented by:* Linda Blackstone. *Exhib:* Leith Gallery (2001-2004); Bohun Gallery, Henley-on-Thames (1999-2004); Cambridge Contemporary Art (1997-2004); Open Eye, Edinburgh (1990-2004); RSA (1989,90,92); AAF London (1999-2004); Mall Galleries, (1991); and extensively across UK. *Commissions:* public: designed and produced 'The Yorkshire Television Press Awards' (1988); Rutland Court 'Horse & Rider' bronze, Baillie Gifford, Rutland Court, Edinburgh; Silvermills 'Horse-Rider-Eagle', bronze, Silvermills Residential Dev., Edinburgh; 'Horse-Rider-Eagle', Prior's School, Newbury. *Signs work:* 'EOGHAN BRIDGE'. *Address:* c/o Linda Blackstone Gallery, r/o 13 High Street, Pinner HA5 5QQ. *Email:* linda@lindablackstone.com *Website:* www.lindablackstone.com

BRIDGE, Muriel Elisabeth Emily, (Mrs. Millie Taylor); N.D.D.; artist in mixed media, water-colour and oils;. *b:* Rome, 1934. *m:* John R. Taylor. one *s.* two *d. Studied:* (graphic design) at St. Martin's School of Art. Southampton College Certificate of Advanced Painting. *Exhib:* regularly with S.W.A. Westminster; R.I. exhbn. at Mall Galleries; Whiteleys, Queensway; One-man show: West Dean College. Locally: Brighton Museum, Portsmouth Museum, Bishops Palace Chichester, Centre of Arts Chichester. Paintings in private collections worldwide. *Commissions:* 8ft. mural for travel agents in Regents St.; Brochure cover for Chichester Festivities. *Publications:* Art in Nature. *Recreations:* travel. *Clubs:* Founder mem. New Park Artists. *Misc:* Winner of national art prize 1996. Head of Art Dept. at Grammar school for 17 yrs.; Art Lecturer, Chichester College. *Signs work:* "M. Bridge." *Address:* The Mews, 22 Victoria Rd., Chichester, W. Sussex PO19 4HY.

BRIDGES, Ann Elizabeth, B.A. (Hons.) Design (1st class Hons. 1999), R.Cam. A. (2000); monoprint (printmaker); artist in residence Chester Zoo (1999-2001); Arts Council Awards (2000, 2004, 2005, 2006). *Medium:* drawing, painting, printmaking. *b:* London, 27 Apr 1960. *d of:* Martin Matthews (goldsmith, watchcase maker) and Margaret Matthews. one *s.* two *d. Educ:*

Thomas Peacocke Comprehensive, Rye. *Studied:* Yale College, Wrexham (1995-6), North Wales College of Art and Design (North East Wales Institute) (1996-1999). *Exhib:* London, Wales (National Eisteddfod), U.K. and U.S.A. *Works in collections:* private collections, Art for Health (Glan Clwyd cancer unit), Paintings in Hospitals (Wales), Hilton Hotel, Prague. *Commissions:* Chester Zoo, Rowan Foods, Private Commissions. *Publications:* Debretts Guides to Etiquette (1999); Included in Monoprint Printmaking Handbook (2006); New York Arts annual catalogue (2006). *Official Purchasers:* paintings in hospitals. *Works Reproduced:* Indigoart Ltd. *Principal Works:* large images of Aquariums, 'Shoal'. *Recreations:* walking, theatre. *Clubs:* Arts Centre Group. *Misc:* Freedom of the City of London (1993). *Signs work:* "AB" or "Ann Bridges." *Address:* Dol Rhedyn, Llanfair Rd., Ruthin, Denbighshire LL15 1DA. *Email:* ann@bridgeprint,fsnet.co.uk *Website:* www.ann-bridges.com

BRIERTON, Irene Annette, SWA (1988), HS (1997); H.R.H. Princess Michael of Kent Watercolour Award, SWA (2004); Llewelyn Alexander Masters Award (2004) for a Most Outstanding set of 6 miniature paintings of birds in watercolour on paper; ARMS (2006). *Medium:* painter of wildlife in watercolour. *b:* Belper, 10 Dec 1948. *d of:* William Gibson, M.B.I.M. *m:* Robert Brierton. one *s.* one *d. Educ:* Burnham Grammar School, Bucks. *Exhib:* RI (1985-88), S.WL.A. (1985), SWA, Llewellyn Alexander (Fine Paintings) Ltd., London, RMS (1996-99, 2005, 2006), National Exhibition of Wildlife Art (NEWA, 2001-2007), Alexander Gallery, Bristol (2006-2007), British Birdwatching Fair (1996-2006). *Works Reproduced:* paintings by WWF as cards. *Recreations:* actively involved in wildlife conservation. *Misc:* Council Member: Derbyshire Wildlife Trust; Chair: Mid-Derbyshire Badger Group since 1990. *Signs work:* "Irene Brierton." *Address:* 17 St. Michael's Cl., Crich, Derbyshire DE4 5DN. *Email:* irene_brierton@btopenworld.com *Website:* www.irenebrierton.co.uk

BRIFFETT, Susan Joyce, painter of landscapes in pastels and murals and scenery in acrylic, and biblical-based work. *b:* London, 10 May 1960. *m:* Geoffrey Hewlett. two *s. Educ:* Kingsbury High School, London. *Exhib:* Stanmore Library, Harrow Art Centre and with U.A., Westminster Central Hall, London. *Commissions:* various, locally. *Clubs:* United Society of Artists, Society of Equestrian Artists. *Misc:* Briffett is the painting name of Mrs Susan J. Hewlett. *Signs work:* "S.J.BRIFFETT." *Address:* 39 Wemborough Rd., Stanmore, Middx. HA7 2EA.

BRIGHT, Madge, A.R.O.I. (1990); winner, R.O.I. award Cornellissen prize; self taught artist in oil and mixed media;. *b:* S. Africa, 15 Feb 1939. *m:* P.S. Johnson. three *s. Educ:* Chaplin Gwelo, Rhodesia. *Exhib:* R.O.I. Mall Galleries, S.B.A., Britain's Painters, Hertford-Century Gallery Henley-on-Thames, Iwano Gallery Osaka Japan, Noor Gallery Bahrein, Look Out Gallery Plettenberg Bay S. Africa, Llewellyn Alexander Fine Art. *Works in collections:* National Gallery Zimbabwe. *Clubs:* S.B.A., Hertford Art Soc., Five Women Artists Plus. *Signs*

work: "Madge Bright." *Address:* 1 Great Ash, Lubbock Rd., Chislehurst, Kent BR7 5JZ.

BRIGSTOCK, Jane Lena, A.R.E., B.A. Hons. (Painting) (1979), M.A. (Printmaking) (1980), British Institution Fund Printmakers award (1981); guest artist, California College of Art and Crafts (1981-82); painter in pastel, water-colour, printmaker; lecturer, Nene College, Northampton; Maidstone School of Art; Chelsea School of Art;. *b:* 28 Mar 1957. *d of:* Michael John Brigstock. *m:* Michael Addison. one *s.* two *d. Educ:* Wellingborough County High School for Girls. *Studied:* Maidstone School of Art, and Chelsea School of Art. *Exhib:* R.A., Cleveland Drawing Bienale, Royal Overseas League, Drew Gallery, Canterbury. *Works in collections:* Northampton C.C. *Misc:* Mem. Soc. of Painter-Printmakers. *Signs work:* "J.L. Brigstock." *Address:* 76 West Hill Rd., St. Leonards on Sea, E. Sussex TN38 0NE. *Email:* jane.brigstock@btinternet.com

BRINDLE, Sharon Elizabeth, BA Hons; BP Portrait Award (1997, Special Commendation). *b:* Staffs., 20 Dec 1958. *d of:* Danny Brindle. *Educ:* Haulay Park Comp., Rugely, Staffs. *Studied:* Camberwell School of Arts (1979-82). *Represented by:* Falle Fine Art, Jersey. *Exhib:* solo: Stephen Lacy Gallery, London (2003); Falle Fine Art, Jersey (1998); Portland Gallery, London (1992); Boundry Gallery, London (1992). *Works in collections:* Bill Hopkins. *Publications:* The Dictionary of Artists in Britain since 1942-David Buckram. *Works Reproduced:* Ron Bowen-Drawing Masterclass, p.133 (Ebury Press, 1992). *Signs work:* 'Sharon Brindle'. *Address:* 17 Ion Court, 280 Columbia Road, London E2 7RW. *Email:* brindle_sharon@yahoo.co.uk

BRINDLEY, Donald, A.R.C.A. Sculpture (1951), F.R.B.S. (1973); sculptor in clay, bronze, ceramics of portraiture, equestrian subjects; Consultant to Josiah Wedgwood & Sons, Royal Worcester Porcelain Co., and continental and American businesses;. *b:* Penkhull, Stoke-on-Trent, 22 Feb 1928. *s of:* Albert Brindley, pottery manager. one *s.* one *d. Educ:* Burslem College of Art. *Studied:* R.C.A. (1948-51, Profs. Frank Dobson and John Skeaping, R.A.). *Works in collections:* H.M. The Queen, the late Lord Mountbatten. *Signs work:* "D. BRINDLEY". *Address:* Fernlea, Leek Rd., Stockton Brook, Staffordshire Moorlands ST9 9NH.

BRINDLEY, Kate, BA; Director of Museums, Galleries and Archives; AMA. *b:* Sheffield, 27 May 1970. *Studied:* University of Leeds (1988-91, BA), University of Manchester (Diploma in Museum Studies). *Publications:* various on museums and visitor attractions. *Address:* City of Bristol Museum and Art Gallery, Queen's Road, Bristol, BS8 1RL.

BRINDLEY, Robert Edward, R.S.M.A. (1997); painter in water-colour, oil, pastel;. *b:* Burton on Trent, Staffs. 11 Feb 1949. *m:* Elizabeth Brindley (née Brooke). one *s.* one *d. Exhib:* Mall Galleries (R.S.M.A. and R.O.I.); Ferens Hull; Carrisbrooke Gallery; Mercer Gallery, Harrogate; Houses of Parliament. *Works in collections:* 'Royal Society of Marine Artists' Diploma Collection, National

Maritime Museum, Falmouth, Cornwall. *Commissions:* paintings for "Allied Breweries U.K. Ltd." Burton on Trent. *Publications:* illustrations for "Minewinding and Transport" (1988), 'Artist & Illustrator', 'The Artist', 'The Dalesman', Step by Step Demonstrations for:- "How to Paint Watercolour Landscapes", Readers Digest - ISBN 978- 0-276-44092-7. *Signs work:* "Robert Brindley." *Address:* Sundial Cottage, Sleights, Whitby, N. Yorks. YO22 5EQ. *Email:* mail@robertbrindley.com *Website:* www.robertbrindley.com

BRISCOE, Michael J., B.A. (Hons.), R.Cam.A.; artist in oil and acrylic on canvas. *b:* Colwyn Bay, 11 May 1960. *s of:* T.J. Briscoe. three *s.* one d. two s- *d. Educ:* Eirias High School. *Studied:* Wrexham College of Art (1978-79, David Cooper), Sheffield City Polytechnic (1979-82, Brian Peacock, Terry Lee). *Represented by:* Martin Tinney Gallery. *Exhib:* Sheffield National (1980), Stowells Trophy (prize winner), Wales '83 Travelling Exhbn., R.A. Summer Exhbn. (1983-85), Through Artists Eyes Mostyn A.G., Paris Salon des Nations (1984), Blackthorn Galleries, Birkenhead (1998), Quay Arts, Kingson upon Hull (1999); mixed shows, Piccadilly Gallery (1984-85), R.C.A. Conwy (2000), Martin Tinney Gallery. *Works in collections:* Welsh Contemporary Art Soc., MOMA Wales. *Misc:* Selling paintings in Holland, Germany in 1995. *Signs work:* "Mike Briscoe." *Address:* 81 Coed Coch Rd., Colwyn Bay, Clwyd LL29 9UW.

BRISTOL, Sophy, *Medium:* oil. *b:* Brighton, 1973. *m:* Harry Darrell-Brown. *Studied:* Surrey Institute of Fine Arts. *Represented by:* Panter and Hall, London. *Exhib:* worldwide. *Signs work:* 'Sophy Bristol'. *Address:* c/o Panter & Hall, 9 Shepherd Market, Mayfair, London W1J 7PF. *Email:* enquiries@panterandhall.com *Website:* www.panterandhall.com

BROAD, Ronald Arthur, freelance artist in oil and water-colour specialising in winter landscape and line drawing. *b:* Crookham, Berks., 2 Sep 1930. *s of:* A.B. Broad, farmer and landowner. *Educ:* Newbury Grammar School, St. Aidan's College (C. of E.), Birkenhead. *Studied:* tutored by George Bissill. *Exhib:* regularly at RA. *Clubs:* Hockley Golf. *Signs work:* "Ronald A. Broad." *Address:* Belmont, Orchard Rd., S. Wonston, Winchester, Hants. SO21 3EX.

BROBBEL, John Christopher, R.B.A., W.C.S.I., P.G.C.E., R.A.S. (Cert.); awards, R.A.S. silver medal for fig. drawing, David Murray studentship (1975-1976), British Inst. Fund award, Richard Jack prize, Landseer Scholar (1976-1977), Vincent Harris mural design prize, Painter Stainers bursary, Spirit of London prizewinner, R.U.A.William Connor award; teacher and author. *Medium:* oil. *b:* Hartlepool, 16 Dec 1950. *m:* Rosemary Stapleton. *Studied:* Byam Shaw School of Art, under Peter Garrard P.P.R.B.A., R.A. Schools, under Peter Greenham R.A. *Exhib:* R.A., R.H.A., R.U.A., R.B.A., N.E.A.C., Cleveland International Drawing Biennial; solo exhibs.: Kilcock Gallery, Kildare, Jorgensen Fine Art, Dublin, Grant Fine Art, N. Ireland; William Franks, Monkstown, Co.Dublin. *Works in collections:* Sir Brinsley Ford, O.P.W., Dublin, Masonic Museum, Dublin, Trinity College, Dublin, St. James's Hospital, Dublin.

Commissions: Masonic Museum, Dublin, Trinity College, Dublin. *Publications:* 'Drawing With Ink', and 'Pencil Drawing', F Warne, London (1981); articles, reviews for Artist magazine. *Official Purchasers:* Dept. Environment, N.Ireland. *Clubs:* United Arts, Dublin, Friends of National Gallery, Ireland. *Signs work:* "John C. Brobbel." *Address:* 14 Lansdowne Park, Ballsbridge, Dublin 4, Ireland.

BRODERICK, Laurence John, A.R.B.S., F.R.S.A.; N.D.D. *Medium:* bronze and stone, figurative esp. otter carvings and portrait heads. *b:* Bristol, 18 Jun 1935. *s of:* John Leonard Broderick. *m:* Ingrid. three *s. Educ:* St. Nichol's, Clifton, Bristol; Bembridge School, I.O.W. *Studied:* Regent St. Polytechnic (1952-57), Hammersmith School of Art (1964-65). *Exhib:* Century Galleries, Henley-on-Thames; Park St. Gallery, Bristol; Belgrave Gallery, London; Gallery 1667, Halifax, Canada; City of London Festival; Rue Paradis, Monte Carlo, Monaco; Manor Gallery, Royston; Printmakers Gallery, Inverness; Malcolm Innes Gallery, Edinburgh; Phoenix Gallery, Lavenham; Chester Arts Festival; Warrington Museum A.G.; since 1980 annual sculpture exhbn. Isle of Skye, The Gallery in Cork Street, London, The Air Gallery, Dover Street, London; mixed shows: Keats House, Hampstead; C.P.S., London; R.W.A., Bristol; R.A., London; R.B.A., London; Art London '91; Broxbourne Festival, Woburn Arts Festival (2005). *Works in collections:* Birmingham Museum and Art Gallery, other work mostly in private collections. *Commissions:* Crucifix, Christchurch, Hants.; Madonna of the Magnificat, Priory, Dunstable, Beds.; Elation, Mother and Child, The Otter, Cherrybank Gdns., Perth (Bell's); Teko - The Swimming Otter, The Otter Trust, Earsham, Suffolk; Leaping Salmon, Chester Business Park; Head of Philippe Chatrier (Pres. ITF), Queen's Club, London and Roland Gaross, Paris; Turtle, Prudential, London; Mother and Child, Leicester Royal Infirmary; Family of Otters, Powergen, Coventry; Trophies, International Tennis Federation, 'Goddess Athena and the Owl' 'Indian Elephant Calf', Royal Caribbean Cruise Line; "The Bull", Bullring, Birmingham. *Publications:* Life of Purcell (Chatto & Windus), Uncle Matts Mountain (Macmillan), Village life through the Ages (Evans), Soapstone Carving (Alec Tiranti), Everyday Life in Traditional Japan (illustrations). *Signs work:* "Laurence Broderick." *Address:* Thane Studios, 10 Vicarage Rd., Waresley, Cambridgeshire SG19 3DA. *Email:* info@laurencebroderick.co.uk *Website:* www.laurencebroderick.co.uk

BROGAN, Honor, B.A. (English and French), Dip.Ed. (1967 and 1968, Cardiff). *Medium:* charcoal, oil, water-colour, clay, pastel. *b:* Welshpool, 26 Jan 1946. *m:* Diarmuid Brogan (decd.). one *s. Educ:* Welshpool High School. *Studied:* Morley College (Peter Richmond and Alan Thornhill). *Exhib:* Artist in Residence, Lichfield Festival (1996, 2001); Celtic/Uzbek Exchange at Tashkent Artists Union (1995); RA Summer Exhbn (1997); Belgrave Hall Painters at Pump House, Battersea Park; BACF Royal Cambrian Academy (1999); Chelsea Arts Soc.; Sculpture for Rumania; GLC Peace Exhbn.; Not the Royal Academy; Albany, Cardiff (2000, 2002, 2005); Tabernacyl Machynlleth Summer Shows; Tenby Museum and Art Gallery (2007); Artist in Residence, Dore Abbey (2007). *Works in collections:* Slaughter and May Collection. *Recreations:* walking,

swimming, travelling. *Signs work:* "Honor Brogan," small works "H.B." *Address:* 12 Westover Rd., London SW18 2RG.

BRONDUM-NIELSEN, Birgitte, R.I., S.S.W.A.; Diplome d'Honneur, Vichy (1964); artist in water-colours; illustrator. *b:* Copenhagen, 1917. *d of:* Dr. E. Bocher. *m:* H. Brondum-Nielsen. *Educ:* Copenhagen. *Studied:* College of Arts and Crafts, Copenhagen. *Exhib:* group shows: R.A., R.S.A., S.S.A., R.S.W., Pitlochry Festival Theatre, Charlottenborg (Copenhagen), Salon International de Vichy, Brighton Art Gallery, Royal Glasgow Institute of Fine Arts, English-Speaking Union Galleries (Edinburgh), The Danish Cultural Inst. (Edinburgh), The Mall Galleries, London; one-man shows: Bristol, Stirling, Edinburgh (seven), Roskilde (Denmark), Edinburgh Festival, Copenhagen. *Works in collections:* Glasgow Art Gallery, the private collection of H.R.H. The Duke of Edinburgh. *Publications:* illustrations for songbooks for children (Danish), De Smaa Synger, (Bestseller of Danish Childrens' songbooks, publ. 1948); Fairytales from many Lands; Switzerland, etc. *Signs work:* "BITTE B-N." *Address:* Tuborgvej 15 S. 3, 2900 Hellerup, Denmark.

BROOK, Peter, R.B.A.; painter in oil. *b:* Holmfirth, Yorks., 6 Dec 1927. *s of:* Hildred Brook. *m:* Margaret. two *d. Studied:* Goldsmiths' College, London University. *Exhib:* one-man shows: Agnews (7), Anna-Mei Chadwick (3), New Grafton (7). *Works in collections:* in many public and private collections in this country, Switzerland, Yale Center for British Art, New Haven, U.S.A., South Africa and Australia. Yale Centre for British Art, USA. *Publications:* 'Peter Brook - The Pennine Landscape Painter', 'Peter Brook in the Pennines with Mary Sara', and 'Peter Brook in and out of the Pennines, Even', 'About Peter Brook' with Sir Tom Courtenay, 'Walking the Dog' with Penny Hartley, 'Peter Brook Abroad' by Penny Hartley, 'The A to Z of Peter Brook' by Stuart Archer. *Misc:* Painted: West Riding; Pennine Landscapes; Oxford Almanak, Cornwall; Hannah Hauxwell (40 pictures); Scotland; Bowland; Swaledale paintings at Gallery Muker, Swaledale. *Signs work:* "PETER BROOK." *Address:* 119 Woodhouse La., Brighouse, W. Yorks. HD6 3TP.

BROOKE, David, B.A.Hons. (1978), S.G.F.A. (1993), U.A. (1994), N.A.P.A. (1997); Society for Art of the Imagination (1998); artist in oil, acrylic, pen and ink; President Soc. of Graphic Fine Art;. *b:* Yeovil, 24 Nov 1956. *Studied:* Yeovil School of Art (1972-75), Hull College of Art (1975-78). *Exhib:* R.O.I., U.A., S.G.F.A., R.W.A., N.A.P.A., South West Academy, plus fourteen one-man shows and many mixed exhbns. in England. *Works in collections:* Longleat House, Wilts. *Clubs:* S.G.F.A., U.A., N.A.P.A., Society for Art of the Imagination. *Misc:* Administrator, Yeovil Arts Centre, 80 South Street, Yeovil, Som. BA20 1QH. *Signs work:* "D. Brooke" or "David Brooke." *Address:* 15a Severalls Park Ave. Crewkerne Som. TA18 8DW.

BROOKE, Geoffrey Arthur George, D.S.C., R.N. (retd.); oil painter;. *b:* Bath, 25 Apr 1920. *s of:* Capt. J. Brooke, D.S.C., R.N. (retd.). *m:* V.M. Brooke.

three *d. Educ:* R.N. College, Dartmouth. *Studied:* under Miss Sonia Mervyn, 28 Roland Gdns., SW7 (1949-50). *Exhib:* Army Art Soc. exhbns. *Signs work:* "G.A.G.B." *Address:* Beech House, Balcombe, Sussex RH17 6PS.

BROOKES, Gerry, BA Hons Fine Art; RGN; BTEC Company Director Qsand Ltd, Morecambe; SAA Professional; FPS London. *Medium:* mixed media. *b:* Redditch, Worcs, 1944. *d of:* Clifford & Marion Harris. *m:* divorced. one *s.* two *d. Educ:* Bridley Moor, Redditch. *Studied:* North East Worcestershire College (1982-84); Margaret St. Birmingham University (1984-87). *Represented by:* Qsand Arts, Morecambe. *Exhib:* Piece Hall Gallery, Halifax; Royal Hallamshire Hospital, Sheffield; Cleveland International Drawing Biennale, Middlesborough; Brighton Women's Exhbn, Pankhurst Centre, Manchester; Book Project: Bromham Mills, Beds.; Westbury Farm Studios, Milton Keynes; Genesis Gallery, Norfolk; USA 2000 (ongoing); St.Peters UCLA, Preston; Bentham Gallery; Gregson Arts Centre, Lancaster; Folly Gallery, Lancaster; Creative Consultants Gall, Manchester; Frederick Finelines, USA; Maiden Bridge, Lancaster; Mid-Penning Gallery, Burnley; Inner City Living, Preston; Bankside Gallery, London; Jersey Gallery, London; Artshed, Leicester; Art Interiors-Internet Gallery, Qsand Arts, Morecambe (ongoing). *Commissions:* The Mariners, Lancaster; Wichfield Mural, Morecambe; Crufts Winner; various portraits, mural signposts (Morecambe). *Publications:* Freshfield Advertising Campaign, Lancashire. *Official Purchasers:* Nashbrooks, USA; Queen Alexander Hospital, Redditch; private collections. *Works Reproduced:* Freshfield Ad Campaign (Pearce Group). *Recreations:* Qsand Arts Project, Morecambe. *Misc:* Lecturer in art: Lancaster and Morecambe College; Cumbria Adult Education; WEA Liverpool. *Signs work:* 'GMV BROOKES'. *Address:* 26a Lister Grove, Heysham, Lancs, LA3 2DF. *Email:* gerrybrookes26a@hotmail.co.uk *Website:* www.gerrybrookes.com

BROOKES, Malcolm John, A.T.D. (1964), R.B.S.A. (1974), R.C.A (1995); teacher, painter in gouache, oil and pastel;. *b:* Birmingham, 11 Jul 1943. *s of:* William Brookes, telephone engineer. *m:* Norma Turner. one *s.* one *d. Educ:* Moseley School of Art. *Studied:* Birmingham College of Art and Crafts (1959-64, Gilbert Mason). *Exhib:* R.B.S.A., Worcester A.G., Lichfield, Malvern, Stoke-on-Trent A.G., Dudley A.G., Icon Gallery, Birmingham, Royal West of England Academy, Mall Galleries, Royal Cambrian Academy. *Clubs:* R.B.S.A., R.Cam.A., Malvern Festival Artists. *Signs work:* "M.J. Brookes." *Address:* 3 Clive Rd., Bromsgrove, Worcs. B60 2AY.

BROOKS, Alan Spencer, HS, SLm, ARMS. *Medium:* dry watercolour/ goache on watercolour paper. *b:* Slough, 18 Oct 1960. *s of:* Dr.G.T.Brooks. *Exhib:* Mall Galleries (RMS); Adventureres Art Club, Hampstead Heath; Weald of Sussex Art Club (Burgess Hill), Adur Art Club (Shoreham-by-Sea). *Works in collections:* over 4000 paintings sold to general public. *Commissions:* accepts commissions of Landscape views of Sussex, and pet portraits in dry watercolour/gouache. *Publications:* RMS, HS, SLm catalogues. *Works Reproduced:* none. *Principal Works:* miniatures in dry watercolour/gouache.

WHO'S WHO IN ART

Clubs: Abur Art Club, WOSAC, Adventurers Art Club. *Signs work:* 'Alan S Brooks SLm, H.S., ARMS'. *Address:* The Dolphins, 40 Wykeham Way, Burgess Hill, RH15 0HF.

BROOKS, Brenda, self taught artist specialising in oil - beach scenes/seascapes;. *b:* London, 1932. *m:* William. two *d. Educ:* Middleton College, Purley, Surrey. *Exhib:* Mall Galleries, various solo and mixed shows in London and South East. *Works in collections:* NatWest, Paintings in Hospitals. *Commissions:* Brighton Museum, C.D. covers for Voiceprint. *Signs work:* "B.B." *Address:* The Pointed Gable, 35 West Parade, Worthing, Sussex BN11 5EF.

BROTHERSTON, Daphne, F.S.B.A.; R.H.S. Grenfell silver gilt medal (1996); artist specializing in flower drawing with water-colour tint, and botanical painting. *b:* 19 Apr 1920. *d of:* Eric A. Price, solicitor. *m:* Peter Brotherston, engineer. one *s.* one *d. Educ:* Sutton High School, G.P.D.S.T. *Studied:* Epsom A.E.C. *Exhib:* S.B.A. Westminster Hall, S.G.F.A. Knapp Gallery; three-man shows: Fairfield Halls, Hampton Court International Flower Show. *Works Reproduced:* wedding cards/Christmas cards (C.C.A. Stationery Ltd.). *Clubs:* S.B.A. *Signs work:* "Daphne Brotherston." *Address:* 8 Bushby Ave., Rustington, W. Sussex BN16 2BZ.

BROWN Robert Auger: see BROWN, Bob,

BROWN, Bob, (Robert Auger); N.D.D. (1956), N.E.A.C. (1964); painter in oil; Assistant Keeper, N.E.A.C. (1990-2007); Hon.Mem. NEAC (2001). *b:* London, 10 Feb 1936. *m:* Susan. two *s. Studied:* Croydon College of Art (Fred Dubury, Lionel Bulmer). *Exhib:* usual mixed and private. *Works in collections:* private/corporate. *Misc:* Full name is Robert Auger Brown but known as Bob Brown. *Signs work:* "Brown." *Address:* North Lodge, Hamstead Marshall, Newbury, Berks. RG20 0JD. *Email:* bob.augur@virgin.net *Website:* www.bobaugurbrown.co.uk

BROWN, Deborah, Prizes: 1970 First Prize Carroll Open Award, Irish Exhibition of Living Art, Dublin; 1970 Prize Open Painting Arts Council of N. Ireland; 1980 Sculpture Prize Eva Limerick. Included in ROSC Dublin 1984. *Medium:* sculptor in glass fibre, papier mache and bronze. *b:* Belfast, 1927. *d of:* Austin & Evelyn Brown. *Studied:* in Belfast, Dublin, Paris. Has travelled extensively, France, Germany, Italy, Canada and USA. *Exhib:* one-man shows and major group exhbns. in Ireland, Gt. Britain, France, Germany, Scandinavia, USA and Canada. *Works in collections:* in Ireland, Gt. Britain and USA. *Commissions:* 1965, by Ferranti Ltd., panels for their building at Hollinwood, Manchester; private and public major commissions in bronze. *Publications:* 'Deborah Brown, From Painting to Sculpture' ed. Hilary Pyle (Four Courts Press, Dublin). *Official Purchasers:* Irish Museum of Modern Art, Dublin; City Art Gallery, Dublin; Ulster Museum and Art Gallery, Belfast; Arts Council (Dublin and Belfast) Collections. *Principal Works:* Sheep on the Road (bronze); The Gate

(bronze); The Goat (bronze). *Signs work:* "Deborah Brown". *Address:* The Mall, Ramelton, Co.Donegal Eire.

BROWN, Diana Elizabeth, S.W.L.A. (1967); painter in pen and ink, oil and watercolour; wildlife and animal artist and illustrator, specialises in deer and British wild mammals. *b:* Cambridge, 16 Apr 1929. *m:* Ian Alcock. *Educ:* Perse, Cambridge. *Studied:* Tunbridge Wells School of Art, and in Denmark. *Exhib:* S.W.L.A., P.S. *Works in collections:* private collections worldwide. *Commissions:* various books, animal portraits, wildlife paintings. *Publications:* Wildlife, deerstalking and scientific books, magazines and newspapers. *Recreations:* watching the abundant wildlife surrounding her home. *Clubs:* S.W.L.A., friend S.E.A., U.D.A.S., A.A.A. *Signs work:* "Diana E Brown" and monogram of "DEB." *Address:* Shannel, Ballogie, Aboyne Aberdeenshire AB34 5DR. *Website:* www.swla.co.uk

BROWN, Doris, S.W.A. (1987); freelance landscape artist in water-colour and ink, tutor and lecturer;. *b:* Newcastle under Lyme, Staffs., 17 Apr 1933. *d of:* Cecil Brown. *Educ:* Burslem College of Art, Stoke-on-Trent. *Studied:* Burslem and Stoke Schools of Art and privately under Reginald G. Haggar, R.I., F.R.C.A. *Exhib:* R.I., B.W.S., S.W.A., and numerous one-man shows. *Works in collections:* Hanley Museum, Stoke-on-Trent and Newcastle Fine A.G., University of Keele; paintings in private collections in England, America, Italy, S. Africa. *Clubs:* President and tutor to: Newcastle Water-colour Soc., Blythe Bridge Water-colour Soc., Oulton Water-colour Soc. *Signs work:* "Doris Brown S.W.A." *Address:* 86 Dunbrobin St., Longton, Stoke-on-Trent, Staffs. ST3 4LL.

BROWN, John, DA, RSW; Royal Academy Landscape studentship; Royal Scottish Academy Macaline Walters Bronze Medal; Glasgow SA Post.Dip. Highly Commended; Cargill Travel Scholarship, RSA; Carnegie Travel Scholarship; RGI James Torrance Award; SSAC Arts Club Award; Scottish Provident Award; Heinzel Gallery Award; RSW Alexander Munro Award. *b:* Irvine, Scotland, 19 Oct 1945. *s of:* Alexander Brown. *m:* Elizabeth (decd). three *s. Educ:* Ardrossand Academy. *Studied:* GSA. *Represented by:* Duncan Miller Fine Arts; Scottish Gallery. *Exhib:* DMFA; Scottish Gallery; Green Gallery; Heinzel Gallery; John Davis, Richmond Hill, Thompsons, Stenton, Open Eye Gallery, Red Barn, London Art Fair, Glasgow Art Fair, 20/21 British Art Fair, RGI, RSW, Torvance Gallery, Moray House Chessel Gallery. *Works in collections:* Robert Fleming Holdings Ltd., Scottish Life Assurance Co. Ltd., Scottish Provident, John Menzies plc, Korean Embassy, Willie Art Gallery, University of Edinburgh, Kuwait Royal Family, Hugh Martin Partners, RBS. *Commissions:* portraits: Hugh McDiarmuid, Viscount Arbuthnot, Chenevix-Trench, British Steel Chairman, Royal Archers. *Official Purchasers:* Craigie College. *Works Reproduced:* A History of Scottish Art; Compendium of Scottish Art; Who's Who Scotland. *Principal Works:* 'Journey's End'. *Recreations:* gardening. *Signs work:* 'JOHN C. BROWN'. *Address:* 92 Trinity Road, Edinburgh, EH5 3JU.

BROWN, John Robert, formerly F.R.B.S.; sculptor in bronze and stone; formerly Head of Art, Hampstead Garden Suburb Inst.;. *b:* London, 7 Jul 1931. *s of:* Robert Brown. *m:* Pauline Brown. one *s.* one *d. Educ:* Queen Elizabeth's, Barnet. *Studied:* Hornsey School of Art, Hampstead Garden Suburb Inst. (Howard Bate, R.A.). *Works in collections:* Prudential Art Collection, Glaxosmith Kline Collection. *Commissions:* 'Joy of the Family', Priors Court School, Thatcham (2000); BBC People's Award Trophy (2000); 'Tête à Tête', Harpenden(2001); 2 sculptures for Central Middx. Hospital (2001), 2 sculptures for Crowne Plaza Hotel, Marlow (2003); 'Mother and Child' for St. John the Baptist, Chipping Barnet (2004); 2 Sculptures for Leconfield House, Curzon Street, London, W1 (2006). *Signs work:* "J.R. Brown." *Address:* The Bow House, 35 Wood St., Barnet EN5 4BE. *Email:* info@johnbrown-sculptor.co.uk *Website:* www.johnbrown-sculptor.co.uk

BROWN, Julian Seymour, A.T.D., N.D.D.; painter and graphic designer in water-colour, acrylic and oil;. *b:* Swansea, 3 July, 1934. *s of:* Grandson of Seymour Brown, A.T.C. *m:* Gillian Thomas. two *s.* two *d. Educ:* Swansea Grammar School. *Studied:* Swansea College of Art (1950-55, Howard Martin), University College of Wales (1955-56). *Exhib:* one-man shows: W.W.A.A. Gallery, Henry Thomas Gallery, Trapp Art Centre (1989, 1990, 1991), The Session House Gallery (1991, 1992, 1993, 1994, 1995, 1996, 1997, 1998, 1999, 2001, 2002), The Abulafia Gallery (1998); work exhib. throughout the Principality. Bridge Gallery (1999, 2002), Goscar Gallery (2002), Patio Galler (2002), Oriel Emrys Gallery (2001), work accepted for 'Welsh Artist of the Year' (2001, 2002). *Works in collections:* Dyfed C.C. *Signs work:* "Julian Brown." *Address:* Penyrallt, Alltycnap, Johnstown, Carmarthen, Carmarthenshire SA31 3QY.

BROWN, Keith, DipAD (First Class Hons), HDA, MA(RCA), Sir James Knott's Scholarship. *Medium:* Sculpture, Digital Sculpture, Computer Arts. *b:* Hexham, 29 Jan 1947. *m:* Jenny Brown. one *s.* two *d. Studied:* RCA; Cheltenham Fellow in Sculpture (1995/96); Junior Fellow in Sculpture Cardiff College of Art (1996/97). *Represented by:* CMTG, San Francisco, USA. *Exhib:* SigGraph 2004, Art Gallery USA; St@rt_up 'Moving Sculpture' Museum of New Zealand; RA Summer Exhbns (2002, 2003, 2005); ISEA 2002 Artworks, Nagoya, Japan; 'Made Known' UTS Australia; 'Digital Art Exhibition' ISIMD3 2005, Turkey. *Works in collections:* International Print Collection, Krakow, Poland; Icondata World Print 2006. *Commissions:* Sale Leisure Centre, Sale, Cheshire. *Publications:* Rapid Prototyping Casebook 'Sculpture for the New Millennium'. *Official Purchasers:* Trondheim Kunstforening Norway; Welsh Arts Council. *Works Reproduced:* 'Outdoor Sculpture in Britain' RA Illustrated 2003. *Clubs:* MAFA. *Misc:* Director of Art and Computing Technologies Miriad M/C Met.Uni.; founder and president, Fast-UK (Fine Art Sculptors and Technology in the UK). *Signs work:* 'J.K.Brown'. *Address:* 18 Westfield Road, Chorlton-cum-Hardy, Manchester M21 0SP. *Email:* cyberform@ntlworld.com *Website:* www.homepage.ntlworld.com/cyberform

BROWN, Lucy, M.A.(Hons.) Fine Art (1991); tutor; artist in mixed media installations and video. *b:* Herts., 4 Aug 1967. *Educ:* Haberdashers' Aske's School for Girls, Elstree. *Studied:* Edinburgh University and Edinburgh College of Art (1986-91). *Exhib:* S.S.A., group and solo shows in Scotland, U.K. and abroad. *Works in collections:* Edinburgh City Arts Centre, Glasgow Museums and Galleries. *Signs work:* "Lucy Brown" or not at all. *Address:* 48 Montrose Terr., Edinburgh EH7 5DL.

BROWN, Mary Rachel: see Marais.,

BROWN, Peter Edward Mackenzie, B.A. (Hons.) Fine Art (1990), P.G.C.E. (F.E.) 1993, N.E.A.C., P.S., R.O.I.; The Hunting Art Prize Drawing Prize (2005); Crossgate Gallery Purchase Prize (2005); Arts Club Award (2001, 2002), W. H. Patterson Memorial Award (N.E.A.C. 2000), Llewelyn Alexander Award (N.E.A.C. 1999), Winner, Bristol F.A. oil painting prize R.W.A. Open (1998), St. Cuthbert's Mill Award, R.B.A. Open (1997), P.S. non-members award (1996); artist in oil, pastel and charcoal. *b:* Reading, 28 Jul 1967. *m:* Lisa Maria. two *s.* two *d. Studied:* Bath C.H.E. (1986-87), Manchester Polytechnic (1987-90). *Represented by:* Messums, 8 Cork Street, London W1. *Exhib:* regularly with N.E.A.C. R.O.I., P.S., R.A.Summer Exhibition, Messums London, W.H. Patterson Fine Art Ltd. London, Victoria Art Gallery, Bath and Albany Gallery, Cardiff. *Works in collections:* National Library of Wales, Victoria A.G., Bath, Holburne Museum, Bath. *Signs work:* "Peter Brown" in handwriting. *Address:* 52 Combe Park, Bath BA1 3NH. *Email:* Peter@Peterbrownneac.com *Website:* www.Peterbrownneac.com

BROWN, Philip, A.M.G.P., former V.P.S.I.A.C., former V.P.S.C.A.; painter, stained glass artist, author, publisher;. *b:* London, 4 Nov 1925. *s of:* Leslie Norman Brown, M.A. *m:* Gounil Hallin. five *d. Educ:* St. Paul's School, London. *Studied:* Slade School of Fine Art, Ateliers d'Art Sacré, Paris. *Exhib:* one-man shows: London, Brighton, Oxford, Paris, Carmargue, Madrid, Malaga, Alicante, Sweden, Japan. *Commissions:* stained glass in St. John's Cathedral, Umtata, S.A., many churches in England. *Publications:* The Essentials of Drawing and Painting; Picture Making; A Painter in Spain; Never Mind Picasso, Create Your Own World; Pen Drawing and Art of Hatching; Pages from Our Life (with Gounil); nine local history books (Ratton Trilogy and Norman Trilogy) following doing 3 A1 Millennium Maps for Willingdon & Jeungton. *Signs work:* "Philip Brown." *Address:* 1 Huggetts La., Lower Willingdon, Eastbourne, E. Sussex BN22 0LZ. *Email:* iconpress@philipbrown.screaming.net *Website:* www.iconpress.co.uk

BROWN, Ralph, R.A. (1972); sculptor in bronze and marble, draughtsman;. *b:* Leeds, 24 Apr 1928. *s of:* W.W. Brown. *m:* Caroline Ann Clifton. two *s.* one *d. Educ:* Leeds Grammar School. *Studied:* Leeds College of Art, R.C.A. and in Paris, Italy and Greece. *Exhib:* frequent one man and group exhbns. in this country and abroad, since 1954. *Works in collections:* Tate Gallery, Rijksmuseum

Kroller-Muller, Arts Council, Gallery of N.S.W., Sydney, Stuyvesant Foundation, S.A., Contemporary Art Soc., Leeds City A.G., and many other provincial and foreign museums. *Commissions:* Harlow New Town, Jersey Zoo. *Publications:* Motif 8, Ralph Brown, Sculpture and Drawings, Leeds City Art Galleries. *Address:* Southanger Farm, Chalford, Glos. GL6 8HP. *Website:* www.ralphbrown.co.uk

BROWN, Stephen Edward, R.B.A (1998). *Medium:* oil. *b:* Chard, 20 Dec 1947. *m:* Kathleen Irene. one *s.* one *d. Studied:* Somerset College of Art (1969-71), and privately with Patrick Larking, R.P., R.O.I. *Exhib:* RWA, RBA, ROI, RA Summer Exhbn., Thompson's Gallery, Ainscough, Contemporary Art, Rowley Gallery Contemporary Art, all in London; Red Rag Gallery, Stow-on-the Wold. *Signs work:* "S.B." *Address:* Apple Orchard, 63 Woolbrook Road, Sidmouth, Devon EX10 9XB. *Email:* sebrba98@aol.com

BROWN, William McClure, *Medium:* painting, printmaking, 3-D - (ceramics, constructions, etc.). *b:* Sunnyside, Toronto, Canada, 11 Dec 1953. *Studied:* Toronto, Canada. *Represented by:* Eastwest Gallery, 8 Blenheim Cr, London, U.K. www.david@ew-art demon.co.uk. *Exhib:* Toronto, Lille, Prague, London, etc.; web: artcymru.co.uk. *Works in collections:* National Maritime Museum Greenwich, Plymouth City Museum, Peel Heritage Gallery Ontario, Newport, Gwent, City Museum, etc. *Publications:* written and illustrated: Contemporary Printmaking in Wales, Someone Stole a Bloater, Five Schools: Image and Word; The New Bestiary (Suel Publications, France); March in Welsh, Old Emulsion Customs (with Greenslade). *Clubs:* 56 Group, Welsh Group. *Misc:* address also: St.Stephens Church, Llangwyd, Y Sgwar, Glamorgan CF34 9TD. *Signs work:* "Wm. Brown." *Address:* (studio) 31 Newcastle Hill, Bridgend, Mid Glamorgan CF31 4EY. *Email:* williammcclurebrown@hotmail.com *Website:* www.william-brown.com

BROWNE, Piers, RA Schools Certificate (1975); John Blayer Portrait Prize (2nd)(1987). *Medium:* oil, prints, etchings. *b:* London, 8 Sep 1949. *m:* Charlotte (decd). one *s.* two *d. Educ:* Byam Shaw 1968-70. *Studied:* RA Schools 1972-75. *Represented by:* Blake Gallery, York; New Grafton Gallery, London; Godfrey & Watt, Harrogate. *Exhib:* over twenty pictures selected for RA Summer Shows; Munster, Germany; Malibu; Iceland, etc. *Works in collections:* Bark Julius Baer, Shore Capital, John Mortimer, Brian Tufano, H.R.H.Prince Charles, Elie Brihi, Edward Guinness C.V.O., Julie Andrews, Julie Christie etc. *Commissions:* latest, Christopher Andrew's houses, Richard Hall's portrait. *Publications:* A Shropshire Lad (1988); An Elegy in Arcady (1990); William Wordsworth: A Lakeland Anthology (joint winner of the WHSmith Illustrated Book of the Year '91); Wensleydale (1994); The Glorious Trees of Great Britain (2002); Songs for a Siren (2008). *Official Purchasers:* York City Art Gallery, Plymouth Art Gallery, V&A, British Museum. *Principal Works:* 'Return of the Boats':September in Whitby' (etching, 2004); Ancient Scots Pine:Rothiemurchas (oil). *Recreations:* planting vegetables, writing poetry, playing piano, enjoying

family, dog and donkeys, travelling. *Clubs:* donated money to CPRE and Conservation Foundation, and founder member of Greenpeace. *Signs work:* 'PIERS BROWNE'. *Address:* Heugh, Asurigg, Leyburn, N Yorks DL8 3JY. *Email:* piersbrowne@heugh-wensleydale.freeserve.co.uk *Website:* www.piersbrowne.com

BROWNELL, Raymond, M.B.E. (1998), BA (1989), DipTP(1977), Dip. Arch. (1959); painter in acrylic - geometrical abstracts derived from mathematics; main career in architecture and project management, now painting full time. *b:* Hobart, Tasmania, 27 Nov 1934. *Educ:* Friends' School, Hobart, Tasmania. *Studied:* Hobart Technical College (1953-1959), Edinburgh College of Art (1974-1977), Open University (1984-1989). *Exhib:* various group exhibs. in London and South-East and in France and Australia (1996-2003); solo exhib.: Green Man Gallery, Eastbourne (2001), Burstow Gallery, Brighton College (2002), George Street Gallery Brighton (2003, 2006), Crypt Gallery Seaford (2003), Great Expectations Gallery, Camberwell, London (2004, 2006). *Clubs:* associate, United Society of Artists. *Signs work:* "RB." *Address:* 32 St. Swithun's Terr., Lewes, E. Sussex BN7 1UJ. *Email:* r.brownell@ukonline.co.uk

BROWNING, Mary Helena, N.D.D. (1956), A.T.D. (1957), S.Eq.A. (1988); animal artist in pastel specializing in horses and dogs;. *b:* Watford, 15 Mar 1935. *Educ:* East Haddon Hall School, Northants. *Studied:* Southampton College of Art (1953-56), Leicester College of Art (1956-57). *Exhib:* S.Eq.A. (annually since 1985); awarded President's Medal (1991). *Works in collections:* Kennel Club Gallery. *Publications:* Coursing - The Pursuit of Game with Gazehounds (Standfast Press, 1976), Rebecca, the Lurcher. *Recreations:* riding, beekeeping. *Signs work:* "MARY BROWNING." *Address:* Parish House, Greatworth, Banbury, Oxon. OX17 2DX.

BROWSE, Lillian, C.B.E. (1998); founder partner of Roland, Browse & Delbanco, 19 Cork St. W1; editor and writer of books on art; Hon. Fellow, Courtauld Inst. of Art (1986); former ballet critic, Spectator; organized wartime loan exhbns. at National Gallery, London (1940-45); also exhbns. for C.E.M.A. and British Inst. of Adult Education;. *m:* S.H.Lines (decd.). *Educ:* Girl's High School (Barnato Park) Johannesburg, S.A. *Studied:* Ballet, Cechetti School Margaret Craske, London. *Publications:* Augustus John Drawings (Faber & Faber, 1941); Sickert (Faber & Faber, 1943); Degas Dancers (Faber & Faber 1949); general editor of Ariel Books on the Arts, published for the Shenval Press by Faber & Faber; William Nicholson (Rupert Hart-Davis, 1955); Sickert (Rupert Hart-Davis, May 1960); Forain - the Painter (Elek, 1978); 'Duchess of Cork Street - the Memoirs of an Art Dealer' (Giles de la Mare, 1999); contributed articles to Apollo and Burlington Magazines; Sunday Times, Country Life, etc. *Address:* 19 Cork St., London W1X 2LP.

BRUCE, George J. D., PPRP (1991-94); elected R.P. (1959), Hon. Sec. (1970-84), Vice President (1985-90); portrait painter and painter of landscapes, still life,

flowers etc. in oil; runs studios in London and Suffolk. *Medium:* oil and pencil. *b:* London, 28 Mar 1930. *Educ:* by my portrait sitters. *Studied:* Byam Shaw School of Drawing and Painting (Brian D. L. Thomas, O.B.E., Patrick Phillips, RP, Peter Greenham, RA). *Exhib:* Royal Society of Portrait Painters, RA, David Messum Galleries. Over the years has painted and exhibited many flower pieces, still lifes, landscapes, etc. in the U.K. and abroad. *Works in collections:* Scottish National Portrait Gallery; numerous private. *Commissions:* has painted many private and official portraits male and female for the Church, City institutes, Colleges and businesses. *Principal Works:* three official portraits of Archbishop Ramsey for the Church of England, and Speaker George Thomas for the House of Commons. *Recreations:* skiing, windsurfing. *Clubs:* Athenæum. *Signs work:* 'George J.D. Bruce'. *Address:* 6 Pembroke Walk, Kensington, London W8 6PQ.

BRUNSDON, John Reginald, A.R.C.A. (1958), R.E. (1995); full time artist in etching;. *b:* Cheltenham, 1933. *m:* Ibby. one *s.* four s-s. one s- *d. Educ:* Cheltenham Grammar School. *Studied:* Cheltenham College of Art (1949-53, R.S.G. Dent, K. Oliver), R.C.A. (Julian Trevelyan, Alastair Grant, Edwin Ladell). *Exhib:* one-man shows, England, U.S.A., Canada, Australia, Sweden, Belgium. *Works in collections:* Arts Council, Tate Gallery, British Council, V. & A. *Publications:* Technique of Etching and Engraving (Batsford, 1964). *Signs work:* "John Brunsdon." *Address:* Old Fire Station, Church St., Stradbroke, nr. Eye, Suffolk IP21 5HG.

BRUNSKILL, Ann, Assoc. of Royal Society of Painter Etchers (1969); painter and printmaker. *b:* London, 5 Jul 1923. *d of:* Hugh George Edmund Durnford, M.C. *m:* John Brunskill. three *s.* one *d. Educ:* Langford Grove School. *Studied:* Central School of Arts and Crafts, Chelsea College of Art. *Works in collections:* V. & A., Bibliothèque Nationale, University College, Oxford, South London Collection of Original Prints, Lib. of Congress, Washington, U.S.A., J. Lessing Rosenwald Alverthorpe Coll., U.S.A., Universities of Princeton, Yale, U.S.A., National Library of Australia, Canberra. *Signs work:* "Ann Brunskill" and "AB" with date on paintings. *Address:* Star & Garter Cottage, Egerton, Ashford, Kent TN27 9BE.

BRUNWIN, David Martin, MA, D.Phil.(Oxon); painter in water-colour and oil. *b:* Banbury, Oxon, 27 Nov 1939. *m:* Margaret. one *s.* one *d. Educ:* Oxford University. *Exhib:* RSMA, RI. *Publications:* pages in 'The Wapping Group of Artists -Sixty Years of Painting by the Thames' (Oct 2005), ISBN 0-9547062-5-0. *Clubs:* Wapping Group of Artists. *Signs work:* "David Brunwin" or "DMB." *Address:* 40 Snells Wood, Cokes Lane, Little Chalfont, HP7 9QT. *Email:* david@brunwin.com

BRYANS, Jeremy William, artist in water-colour (landscapes). *b:* Harrow, 7 Dec 1929. *m:* Rachel Jane. four *s. Exhib:* three independent exhbns., also with U.A. and other local artists. *Address:* 94 West Hill, Wembley Park, Middx. HA9 9RR.

BRYANT-DUNCAN, Enid Dena, (née Bond); artist in oils, scraper-board, water-colour; retired gallery owner and restorer. *b:* Gloucester, 19 Mar 1930. *m:* Terry Duncan. three *s. Educ:* Red Maids' School, Westbury-on-Trym, Bristol. *Studied:* Royal West of England Academy of Art. *Exhib:* St. Albans Gallery (1975), St. Albans Museum (1970), Paris, Salon de Nations (Jan. 1983), R.H.S. International Exhbn. (Mall Galleries, 1984), St. Albans Gallery (1987), Paris (1987), Galerie Salammbo, Paris (1988), St. Albans Abbey (1991), Luton Hoo Station House (1996, 1998), Artists Corner, Chepstow (1999), Newnham Art Exhbn. (2001), The Manse, Westbury-on-Severn (2002). *Works in collections:* St. Albans, South Africa, Canada, America, France. *Commissions:* mural in local church 'Healing Angel' (2004). *Publications:* True Ghost Stories (Hamilton). *Recreations:* gardening, patchwork, church. *Misc:* 3 TV appearances, radio, magazine articles, newspapers. *Signs work:* "D.B.", "Dena" or a snail. *Address:* The Manse, The Village, Westbury-on-Severn, Glos. GL14 1PA.

BRYCE, Gordon, ARSA (1976), RSA, RSW (1976); Diploma in Art; numerous awards since 1965 including Chalmers Bursary, RSA; Keith Prize, RSA (1965), 1st Prize Pernod Scottish Academy Competition (1967); Arts Council Awards (1968, 1971, 1980), Latimer Award, RSA (1969), May Marshall Brown Award (1977), Educational Institute of Scotland Award (1981), Shell Expo, Premier Award (1982), Sir William Gillies Travelling Scholarship (1984), Scottish Postal Board Award (1986). *b:* Edinburgh, 30 Jun 1943. *s of:* George and Annie Bryce. *m:* Hilary. three *s.* two *d. Studied:* Edinburgh College of Art under Sir Robin Philipson and Sir William Gillies (1965). Appointed lecturer in printmaking, Grays School of Art, Aberdeen; Head of Fine Art, Grays School (1986-1995). Currently painting full-time. *Exhib:* New 57 Gallery, Edinburgh Festival (1966, 68), Absalom Gallery, Bath Festival (1968), Richard Demarco Gallery (1971), University of Aberdeen (1972), McMurray Gallery, London (1977), Royal Edinburgh Hospital (1978), The Scottish Gallery, Edinburgh (1978, 83, 92, 96, 98), Edinburgh University (1984), Sue Rankin Gallery, London (1986-93), Grape Lane Gallery, York; Kingfisher Gallery, Edinburgh (1988), Macaulay Gallery, Stenton (1989, 94, 97), 1Ancrum Gallery, Ancrum (1989)The Rendezvous Gallery, Aberdeen (1990, 92, 96, 99), Bruton Gallery, Bath (1993), Jorgensen Fine Art, Dublin (1994, 99), Corrymella Scott Gallery, Newcastle upon Tyne (1994, 98, 2000), Thackeray Gallery, London (1995, 97, 99), Henshelwood Gallery, Newcastle upon Tyne (2003). *Works in collections:* private collections throughout Britain, Ireland, USA, Canada, Europe, Australia and the Far East; Public collections: Edinburgh: Scottish National Gallery of Modern Art, College of Art, University, etc.; Aberdeen: Art Gallery, University, Educational Trust, etc.; Perth Museum and Art Gallery, Hunterian Museum Glasgow, and throughout Britain. *Recreations:* fishing. *Address:* 2 Culter House Road, Milltimber, Aberdeen, AB13 0EN. *Website:* www.gordonbryce.co.uk

BRYCE, Hazel Virginia, (previously FOSTER); Diploma Foundation Studies Art and Design (2000); Winner, Pen Ink (Artists & Illustrators Magazine, 1996); mainly self-taught. *Medium:* drawing, prints, sculpture, specifically papier mâchè

sculpture. *b:* Henley-on-Thames. *d of:* Professor Bryce-Smith. one *s. Studied:* Reading College and School of Arts and Design (2000). *Exhib:* RA Summer Exhbn (1999); Beatrice Royal, Eastleigh, Natural World Exhbn (2000); Christie's 'Art for Life' (2001, 2002); Oxfordshire Open Art Weeks (2002, 2003). *Commissions:* Reading Museum (to make papier mâchè figures for Reading Rock Festival Exhbn, 2004). *Principal Works:* 'The Sea Horse' (papier mâchè). *Signs work:* 'H.Bryce' or 'Hazel Bryce'. *Address:* 7 Elm Court, Sonning Common, Reading RG4 9ND. *Email:* hazel@hazelbryce.wanadoo.co.uk

BRYCE, John Dunbar, SWE, BSc (Eng) in Engineering, GAvA, ARE. *Medium:* watercolour, wood engraving, aviation art. *b:* 17 Nov 1934. *m:* Ann Margaret. one *s.* one *d. Educ:* Glyn Grammar School 1946-53. *Studied:* Kings College London 1953-56 (Mechanical Engineering); self-taught in art. *Exhib:* Bankside Gallery, Mall Galleries, Guild Hall Winchester, Wapping Group of Artists, Guild of Aviation Artists. *Works in collections:* Science Museum, Museum of Flight Scotland, RAF Museum, Ashmolean Museum. *Commissions:* 'Thrust' World Land Speed Record. *Official Purchasers:* Rolls-Royce, British Aerospace, Messier-Dowty. *Clubs:* Farnham Art Society, Wapping Group of Artists, Society of Wood Engravers, Guild of Aviation Artists, Royal Society of Painter-Printmakers. *Address:* 37 Copse Ave, Weybourne, Farnham, Surrey, GU9 9EA.

BUCHANAN, Elspeth, D.A. (Edin.); painter in oil; mem. of Council of S.S.W.A. (1956-59), S.S.A.; Andrew Grant Scholarship to Edinburgh College of Art (1933-38), Andrew Grant Travelling Scholarship (1938-39). *b:* Bridge of Weir, 29 Nov 1915. *d of:* John & Oughtred Buchanan. *Educ:* St. George's School for Girls, Murrayfield, Edinburgh. *Studied:* Edinburgh College of Art (1933-38) under Wellington. *Exhib:* R.A., R.Scot.A., S.S.A., S.S.W.A., G.I., N.E.A.C.; first one-man show, Great King St. Gallery; by invitation Alton Gallery, London SW13 (1990-95), R.S.A. Gallery. *Works in collections:* 'Gutting the Fish- Kyle of Lochalsh', BP Exploration, 301 St. Vincent St., Glasgow; 'Highland River', Scottish National Trust exhbn., Glasgow. Sold many oil and water-colour paintings to private collectors. *Commissions:* War work from 1939: Cartographic draughtsman N.I.D (6) worked in Cambridge and Oxford. *Publications:* illustrated Land Air Ocean (Duckworth). *Clubs:* Soroptomist, Edinburgh. *Misc:* Recently a group of women artists donated paintings to Western General Hospital - sum raised by sale at auction was £30,000. *Signs work:* "Elspeth Buchanan." *Address:* St.Raphael's Residential Home, 6 Oswald Road, Edinburgh EH.

BUCK, Jon, MA, RWA, ARBS; sculptor in bronze. *b:* Bristol, 8 Sep 1951. *m:* Jane Buck. two *d. Studied:* Trent Polytechnic (1976-79), Manchester Polytechnic (1979-80), Fellow at Cheltenham College of Art and Design (1980-81). *Represented by:* Gallery Pangolin. *Commissions:* 1995: John St., Porthcawl 'Street Beacon'; New Plaza, Harlesden 'On Our Heads'; 1996: British Consulate General, Hong Kong 'New Age'; 1997: Merthyr Tydfil Library, Merthyr Tydfil 'Common Knowledge'; 1998: Deal Pier, Deal, Kent 'Embracing the

Sea';'Returning to Embrace', Canary Wharf, London; 2000: 'In the Swim' West Quay shopping centre, Southampton; 2001: 'Family' and 'Equilibrium' Milton Keynes General Hospital, Milton Keynes; 2002: 'Family', Paddington Central, London; 'Flat Out', University of Bristol, (2004); 'From Ship to Shore', Portishead Marina (2007). *Address:* Luther Cottage, 619 Wellsway, Bath BA2 2TY. *Email:* jondbuck@hotmail.com

BUCKMAN, David John, qualified teacher, history specialist; full-time journalist for over 40 years, since 1998 exclusively on art, writes frequently for The Independent. *b:* Ringmer, Sussex, 20 Jun 1936. *s of:* Ernest Perceval Buckman & Dorothy Buckman. one *s. Educ:* College of St. Mark and St. John, Chelsea (1957-59); Portsmouth Training College/Southampton University (1959-60). *Studied:* history. *Publications:* 'Dictionary of Artists in Britain since 1945'; contributed to Macmillan's 28-vol 'Dictionary of Art', and Brian McFarlane's 'The Encyclopedia of British Film'. Artists' monographs include J B Manson, Leonid Pasternak, Jonathan Clarke, Mary Griffiths, Martin Leman, Roderic Barrett, Katherine Hamilton, Glyn Morgan; 'Mixed Palette' a study of Frank Ward and Kathleen Walne; 'Charles Debenham's East Anglia'; biography of sculptor A.H.Gerrard; full-time journalist for over 40 years, writes frequently for The Independent. *Clubs:* The Critics' Circle. *Address:* 2 Ufton Grove, London N1 4HG. *Email:* d.buckman@ukonline.co.uk

BUCKMASTER, Ann Devereaux, M.S.I.A. (1951-80); freelance artist in pen;. *b:* London, 27 Mar 1924. *d of:* Arthur D. Buckmaster. *m:* the late Anthony Gilbert. *Educ:* Bromley High School. *Studied:* Beckenham School of Art, Bromley College of Art. Illustration and fashion drawing for magazines and advertising. *Signs work:* 'B'. *Address:* Kimbell House, Charlbury, Oxon. OX7 3QD.

BUDD, Rachel, R.C.A., B.F.A. (Hons.), M.F.A. (Hons.); painter in oil on canvas; part-time lecturer, Cheltenham College of Art and Design, and Central St. Martin's School of Art. *b:* Norwich, 6 Mar 1960. *d of:* David John Budd. *Studied:* University of Newcastle upon Tyne (1978-82, Prof. Rowntree), R.C.A. (1983-86, Peter de Francia). *Exhib:* one-man shows: Purdy Hicks (1991), '3 Ways' British Council travelling show, Hungary, Poland, Czechoslovakia (1990), Athena Art Awards (1987), London Group (1987), Lloyds Bldg. Art for the City (1987), R.A. Summer Exhbn. (1987), Contemporary Arts Soc. Market, Covent Gdn. (1987). *Works in collections:* County Nat.West. London, I.B.M., Contemporary Art Soc., Lloyds of London, Arthur Anderson Collection, I.C.I. *Address:* 67-71 Columbia Rd., London E2 7RG.

BUHLER, Michael Robert, A.R.C.A.; Rowney Award, Royal Academy (1984); artist in oil and acrylic;. *b:* London, 13 Jun 1940. *s of:* Robert Buhler, R.A. one *s.* one *d. Educ:* Bryanston School. *Studied:* Royal College of Art (1960-63, Carel Weight, Roger de Grey, Ruskin Spear, Colin Hayes). *Exhib:* Galeria Boitata, Porto Alegre, Brazil, Museo do Estado da Bahia, Brazil, Eastern Arts

Assoc., New Art Centre, R.A., England Gallery, Chappel Gallery. *Works in collections:* Liverpool University, Carlisle City A.G., B.M., Arts Council, R.A., D.O.E. *Commissions:* Posters for British Museum (1979); U.F.O. illustrations, Mary Evans Picture Library. *Publications:* Tin Toys 1945-1975 (Bergstrom and Boyle). *Clubs:* Chelsea Arts. *Misc:* "Abductees" animated film (1994). *Signs work:* "Michael Buhler." *Address:* 6 Cavell St., London E1 2HP. *Website:* www.michaelbuhler.org

BULBROOK, Kaija, SWA (Council); BA (Hons). *Medium:* pastel, acrylic, oil, charcoal, etching, aquatint, monoprints. *b:* London. *m:* Stephen. one *s.* one *d.* *Studied:* Kingston College of Art. *Represented by:* Red Leaf Gallery, Tunbridge Wells; Nick Hills. *Exhib:* Mall Galleries, London (PS, SWA); The Red Leaf Gallery, Tunbridge Wells; Bay Art Gallery, Margate; Picturecraft Gallery, Holt, Norfolk; various other venues in the S.E.of England. *Signs work:* 'Kaija Bulbrook'. *Address:* Rogley Farm, Cranbrook Road, Biddenden, TN27 8ET. *Email:* bulbrook@rogley.wanadoo.co.uk

BULGIN, Sally, B.A.(Hons.), M.A., Ph.D. (History of Art); painter in acrylic; Editor, The Artist magazine. *b:* Ashford, Kent, 8 Nov 1957. *d of:* Ernest Bulgin. *Educ:* Highworth School for Girls, Ashford. *Studied:* Reading University (1977-81, Terry Frost), Courtauld Inst., London (1981-91). *Exhib:* R.A. Dip Galleries, N.A.P.A., Clare College, Cambridge. Work in private collections. *Publications:* author of Acrylics Masterclass (1994); Oils Masterclass (1996); Lucy Willis: Light in Watercolour (1997), (all Harper Collins); Ken Howard: Inspired by Light (David & Charles, 1998); Consultant editor Collins Art Class (1999, Harper Collins). *Clubs:* Patron, National Assoc. of Painters in Acrylics; Hon. Vice-Pres., Royal Birmingham Soc. of Artists. *Signs work:* "Sally Bulgin." *Address:* Clougy House, Canterbury Road, Brabourne, Ashford, Kent, TN25 6QP.

BULL, Ann, SWA, ASEA. *Medium:* figurative painter in oils, pastels, acrylic and watercolour. *b:* Ealing, W.London, 22 Jul 1940. *s of:* Oliver Hamilton Bull, BA (Hons), Artist. *m:* Geoffrey William Bull, CEng, FRACS. one *s.* *Studied:* Ealing School of Art, National Portrait Gallery w/shop, London Sketchclub, Mary Ward Centre Holborn. *Exhib:* Mall Galleries, London with: RSMA, RP, PS, SWA, SEA, Art for Youth; Chelsea Arts Society; Webbs Gallery; Llewelyn Alexander; St.Ives Soc Artists; Carlyle Gallery; Fowey River Gallery; Gallery 12, Cheltenham; Long Curve Gallery, Glos; Wymore Assoc. Cincinnati, USA; Battersea Affordable Art Fairs, Chelsea Arts Fair, Neville Fine Art. Solo exhbn: Mariners Gallery, St.Ives. *Works in collections:* UK and internationally. *Commissions:* Earls Court Boat Show for Cosmos Int.; British Airways (Operation Happy Child); BA Publicity Open Days. *Publications:* 'Chelsea Morning' in Leisure Painter mag.; '100 Ways to Paint People' via International Artist; Millers Art Guide, Paintings 18th Century to Present (2005)

. *Principal Works:* figurative oils. *Clubs:* mem. Chelsea Art Soc. St.Ives Soc. of Artists; Fellow, Moseley Art Society. *Signs work:* 'Bull'. *Address:* The Cow

Barn, Trevithal Farm, Paul, Penzance, Cornwall, TR19 6UQ. *Email:* annesstudio@aol.com

BULLIVANT, Tina, B.A.Hons.; artist in water-colour, mixed media, oil;. *b:* Brighton, 25 May 1958. *m:* Clive Bullivant. one *s. Educ:* Lourdes Convent. *Studied:* Brighton University (1976-80, Luther Roberts, Robert Birch). *Exhib:* S.W.A Sussex Open, Guild of Sussex Artists Open Exhbn., many mixed exhbns. *Works in collections:* Crawley Arts Council. *Clubs:* Artists of the Weald. *Signs work:* "T. Bullivant, S.W.A." *Address:* 110 Streatfield Rd., Uckfield, E. Sussex TN22 2BQ.

BULLOCK, Hazel, M.F.P.S. (1970); painter in oil and acrylic. *Studied:* St. Martins School of Art, Sir John Cass School of Art (1962). *Exhib:* R.B.A., F.P.S., H.A.C., Browse and Darby, Whitechapel; one-man shows, Loggia Gallery (1973), Judd St. Gallery (1985), Phoenix Gallery, Highgate (1989), Phoenix Gallery, Lavenham (1989), dn Gallery New York (2000), Loggia Gallery, London (2001), mixed exhibitions. *Works in collections:* private collections in England and Spain. *Clubs:* Arts. *Signs work:* "H. Bullock." *Address:* 32 Devonshire Pl., London W1G 6JL.

BULLOCK, Jean, S.P.S. (1964); sculptor in clay cast in foundry bronze and polyester resins, occasionally wood and stone, printmaker;. *b:* Bristol, 27 Apr 1923. *Educ:* Bishopshalt, Haberdasher Askes, George Watsons Ladies College, Edinburgh. *Studied:* Watford School of Art (Guido Belmonte), Camberwell School of Art (Dr. Karl Vogel). *Exhib:* R.A., S.P.S., Singapore Art Soc., Art Exhbns. Bureau Travelling Exhbns., Zillah Bell Gallery Thirsk, etc. *Works in collections:* M. of D., Central Institute, NW1, South Norwood School, Tulse Hill; stained glass window, St. Giles, Lockton. *Signs work:* "JEAN BULLOCK." *Address:* Warren Lane House, Galphey, Ripon, N.Yorks HG4 3PB.

BUMPHREY, Nigel, schoolmaster, goldsmith, and furniture maker; Diocesan adviser to Diocese of Norwich for Church Plate; Freeman of the Worshipful Company of Goldsmiths & The City of London; Fellow of the Royal Society of Arts;. *b:* Norwich, 22 Feb 1928. *s of:* Herbert Bumphrey. *m:* Eileen. *Educ:* The City of Norwich School and Loughborough College (now Loughborough University). *Studied:* Central School of Arts and Crafts and Norwich Art School. *Exhib:* Norfolk Contemporary Crafts Soc., and others, Goldsmiths' Hall. Works mainly on commissions. *Works in collections:* Norwich City Collection. *Commissions:* Badges of office for various societies - British Association of Occupational Therapists, Travelling Club of Surgeons of Gt. Britain et al. *Clubs:* Royal Overseas League. *Address:* 28g Jessopp Rd., Norwich NR2 3QB.

BURBRIDGE, Claire-Chantal Emma, B.A. (Hons.) Fine Art and History of Art (Oxon.), M.A. Printmaking; fine artist in sculpture, printmaking and painting;. *b:* London, 14 Dec 1971. *m:* Joby Talbot (Composer). one *s. Studied:* Magdalen College, Oxford, Ruskin School of Fine Art (1990-93), Camberwell College (1993-95). *Represented by:* USA: Toomey Tourrell Gallery, San

Francisco; Davis and Cline Gallery, Ashland, Oregon. *Exhib:* Toomey Tourrell Gallery, San Francisco, USA; Davis and Cline Gallery, Ashland, Oregon, USA; Coram Gallery London, Mall Galleries, Collyer Bristow, RWA, St. John's College Oxford, M.W. Contemporary Art, Hanging Space London, Attendi London, etc. *Works in collections:* Ashmolean Museum, Oxford, Herts. C.C. Art Collection. *Address:* 16 Denman Rd., Peckham, London SE15 5NP. *Email:* claire-burbridge@hotmail.co.uk *Website:* www.claireburbridge.com

BURDEN, Daniel, A.R.C.A. (1955); painter in oil, pastel, chalks, lino, collage, ceramic. *b:* Paris, 20 Jan 1928. *s of:* William Burden. *m:* Sallie Turner. two *d. Educ:* Kilburn Grammar School, London. *Studied:* Willesden Art School (1949-52, Ivor Fox, James Neal, Francis Gower), R.C.A. (1952-55, John Minton, Rodrigo Moynihan, Ruskin Spear, Colin Hayes). *Exhib:* R.A., R.W.A., A.I.A., R.B.A., Drian Gallery, Mignon Gallery, David Durrant Gallery, London Group, N.E.A.C., Salon des Independants Bordeaux, various expos Aquitaine. *Works in collections:* Leicester University, Southend Museum, Walsall Educ. Development Centre, Avon Art and Design Loan Service, R.W.A. Collection. *Signs work:* "Burden." *Address:* Atelier Moulin A Vent, 47800 Moustier, France.

BURGESS, Brenda Jean, BA (Hons). *Medium:* oil, prints, sculpture. *b:* Merseyside, 3 May 1961. *d of:* Jean and David Pennington. *m:* Ian. two *s. Educ:* Astor of Hever. *Studied:* Kent Institute of Art & Design; University College, Christ Church, Canterbury. *Exhib:* Mall Galleries (2007); Marlowe Gallery, Canterbury (2004/05); Bentliff Gallery, Maidstone (2001/02); RA (2001); Johnnie's Art Warehouse, Whitstable (2000); Ayres Gallery, London (1997); Bowe House, Canterbury (1997); Gallery on the Green, Bearsted (1994/96). *Works in collections:* Alan Wisket (Deal), William Smith (Sussex), Delyss Byrd (Lenham), Annie Gardner (Otham), Jon Graham (Leeds), Paula Tresnan (Cranbrook), T.Scrivens (Weavering), V.White (Yalding), R.Hurst (Kent). *Commissions:* many portrait sculptures, including: Oliver, Georgie, Charlie, Jack, Harry, Toby, Sasha, Luke, Kathleen, Delyss, Alan Hurst, Alan Wisket, Ruby through Blue, Rainforest Girl. *Principal Works:* portrait sculptures/oil paintings. *Misc:* committed community artist working with Kent CC, Maidstone BC, Stately homes, museums, schools and adult groups providing quality art workshops; Leeds Castles artist/educator (2007). *Signs work:* 'Burgess'. *Address:* Downslee, Grove Green Road, Weavering Street, Maidstone, Kent, ME14 5JX. *Email:* brendaburgess@brendaburgessarts.co.uk *Website:* www.brendaburgessarts.co.uk

BURGESS, Howard John, ACII. *Medium:* oil. *b:* Kensington, 3 May 1954. *Educ:* Buckhurst Hill County High School. *Represented by:* Thompson's Gallery, Aldeburgh; The Russell Gallery, Putney; Coastline, Aldeburgh. *Exhib:* RA (1998, 2001, 2006), NEAC (2001), RSMA (2002), Thompson's Galleries, Guildhall Art Gallery, London. *Works in collections:* Epping Forest District Museum. *Commissions:* various private. *Recreations:* following cricket, painting. *Signs work:* 'HB'. *Address:* 37 Greenhill, High Road, Buckhurst Hill, IG9 5SH.

BURGESS, Peter, painter in oil and watercolour;. *b:* 1952. *m:* Catherine (decd. 2003). *Studied:* Wimbledon School of Art (1972-74), R.A. Schools (1974-77). *Exhib:* R.A., etc.; one-man shows: Thackeray Gallery, etc. *Works in collections:* Contemporary Art Soc., Derby City A.G., The Harborough Museum, Nottingham City Council, Leics. Educ. Authority, S. Derbyshire Health Authority, S. Nottingham College, Adam and Co., The Boots Co. plc.; many private collections in Britain, U.S.A. and Europe. *Signs work:* "Peter Burgess" on reverse of painting, "PB" (in box) on front. *Address:* 28 North Fen Road, Helpringham, Lincolnshire NG34 0RR. *Email:* peter.burgess99@btinternet.com *Website:* www.rasalumni.org

BURKE, Andrew, DA (Edin.), David Murray Landscape Studentship RA, London; Travelling Scholarship from Edinburgh School of Art (Summer 1970). *Medium:* acrylic. *b:* Glasgow, 7 Apr 1947. *Studied:* Carlisle College of Art and Design (1967-68); Edinburgh School of Art (1968-71); Post-Diploma in Drawing and Painting, (1971-72). *Exhib:* many group exhbns including RA Summer Exhbns, RSW; regular exhibitor RSA, RGI. *Works in collections:* H.R.H.The Duke of Edinburgh. *Signs work:* 'Andrew Burke'. *Address:* 82 Lennox Ave., Scotstoun, Glasgow G14 9HG.

BURKE, Christopher Paul, BA (Hons) 1st Graphic Design and Art History; Cartoonist of the Year 2000; Creative Circle Gold Medal. *Medium:* illustrator, caricaturist and cartoonist. *b:* London, 4 Oct 1955. *m:* Amanda Doran. two *s.* *Studied:* St.Martin's, London '74, Canterbury College of Art 75/8. *Exhib:* one man shows: Roughs Gallery (1984), Conningsby Gallery (2002); two-man show-David Austin Gallery (1993). *Works in collections:* V & A, London Transport Museum and many private collections. *Commissions:* Welsh National Opera, BBC, Marks and Spencer, Menhuin School, Tatler, Virgin, Vogue, Tesco, London Review of Books, Sony, Dawn French (theatre drawings). *Publications:* Dictionary of Twentieth Century British Cartoonists and Caricaturists; Dictionary of British Cartoonists and Caricaturists 1730-1980; The British Art of Illustration 1780-1993; regular contributor to The Times, FT, Punch, Radio Times, Sunday Times, Sunday Telegraph. *Works Reproduced:* Penguin, Pan, Guardian, Observer, Evening Standard, Economist, Sunday Telegraph, etc. *Principal Works:* over 80 murals for Ottakar's Bookshops and Christmas catalogues, posters and p.o.s.; Wine Cellar Off Licences and Parisa Wine Bars corporate identity, posters, catalogues. *Misc:* two children's books with Lenny Henry: Charlie and the Big Chill; Charlie Queen of the Desert; stamps for Barbados and Malaysia; animated TV ad for Irish Tourist Board. *Signs work:* Burke. *Address:* 54 St. James Road, Tunbridge Wells, Kent, TN1 2LB. *Email:* christopher.burke@btclick.com *Website:* www.chrisburke.org.uk

BURKE, Peter, sculptor using reclaimed materials;. *b:* London, 29 Feb 1944. *m:* Wendy. two *d. Educ:* Bristol Technical School and Rolls Royce Bristol. *Studied:* Bristol Polytechnic (1972). *Exhib:* one-man shows: Festival Gallery, and Cleveland Bridge Gallery Bath, New Art Centre London (1992), New Art Centre

Rochecourt (1993); mixed shows: London, Chicago, New Mexico, Berlin, Basel, Miami, Madrid, Zurich. *Works in collections:* Contemporary Art Soc. *Commissions:* Installation: Hat Hill Sculpture Foundation, Goodwood. *Publications:* Internet entry for sculpture at Goodwood: www.sculpture.org.uk. *Signs work:* "P. Burke," "PB." or not at all. *Address:* 9 Woolley Green, Bradford on Avon, Wilts. BA15 1TZ.

BURKETT, Norman, Hittersay, RA (1974), painter in oil and pastel, sculptor. *b:* Dublin, Ireland, 23 Sep 1942. three *s.* two *d. Studied:* at Royal Academy under Peter Greenham. *Exhib:* all over Holland. *Works in collections:* private. *Commissions:* Diverse councils, cities, institutions. *Clubs:* RASAA. *Address:* Stepelerveld 50, 2151 JN-Nieuw Vennep, Holland. *Email:* norman@burkett.nl *Website:* www.burkett.nl

BURMAN, Chila Kumari, B.F.A.(Hons.) (1982), M.F.A. (1984); mixed media artist, printmaker, photographer. *b:* Liverpool, 17 Jan 1963. *s of:* Bachan Singh Burman, ice cream vendor. *Studied:* Southport College of Art, B.A. Leeds Polytechnic (1st Class Hons. in Printmaking and M.F.A.), and Slade School of Fine Art, University College of London. *Exhib:* Internationally and nationally - widely, e.g New York, Canada, Cuba, India, S.Africa, Europe. *Works in collections:* V. & A., Arts Council of England, Birmingham City Museum and Art Gallery, Walsall Art Gallery, and private collections world-wide. *Publications:* Own monograph 'Beyond two Cultures' by Lynda Nead (Kala Press); contributed to Framing Feminism, Visibly Female, Women and Self - Portraiture by Francis Barzello (Thames & Hudson). Currently represented by the Andrew Mummery Gallery, London. *Signs work:* "C.K. Burman." *Address:* 20 Woodview Cl., Hermitage Rd., London N4 1DG.

BURN, Hilary, BSc.Hons. (Zoology) (1967), S.WL.A. (1983); freelance wildlife artist/illustrator in gouache, specialising in birds. *b:* Macclesfield, Ches., 8 Apr 1946. *d of:* Colin Barber, engineering draughtsman. *Educ:* Macclesfield High School, and University of Leeds. *Exhib:* S.WL.A. Annual, regularly with R.S.P.B., Wildfowl Trust, Wildlife A.G., Lavenham, Nature in Art, Glos. *Publications:* illustrated, R.S.P.B. Book of British Birds (1982); Wildfowl: An Identification Guide to the Ducks, Geese and Swans of the World (1987); Crows and Jays: An Identification Guide (1993); The Handbook of Bird Identification (1998); Handbook of the Birds of the World (1993-2007). *Clubs:* S.WL.A. *Signs work:* "Hilary Burn." *Address:* Huish Cleeve, Huish Champflower, Taunton, Som. TA4 2HA.

BURNLEY, Heather Wynne, FPS, SWA; Cert Ed. (Art & Drama). *Medium:* paint in oils, sculpt in clay which is cast in resin or bronze. *b:* Theydon Bois, Essex, 11 May 1937. *d of:* Bernard & Winifred Burnley. *Educ:* Upholland Grammar School, Wigan. *Studied:* Bath Academy of Art; L'Accademia delle Belle Arti, Florence. *Represented by:* FPS & SWA. *Exhib:* Hanley (Stoke-on-Trent), Stockport, Leek, London, Corwen (N.Wales), Llangollen. *Works in*

collections: Hanley Museum and Art Gallery. *Commissions:* 3 sculpture portraits, 1 portrait in oils. *Principal Works:* Sculpture Group in bronze: Sigeric Riding Mule at Glastonbury Abbey. *Signs work:* 'Heather Burnley, FPS, SWA'. *Address:* Pen-y-Foel Isaf, Gwyddelwern, Denbighshire, LL21 9DU. *Email:* burnleyh@tiscali.co.uk

BURNS, William, F.S.A.I., F.R.S.A.; artist in oil;. *b:* Sheffield, 1923. *m:* Betty Pauline. one *d. Studied:* Sheffield Art School and architecture at Sheffield University. *Exhib:* R.O.I.; Medici Galleries, Bond Street; John Campbell Galleries, Kensington; Walker Galleries, Harrogate. *Works in collections:* John Campbell Gallery London, Walker Galleries Harrogate, Yorks. *Signs work:* "William Burns." *Address:* 29 Newfield Cres., Dore, Sheffield S17 3DE. *Email:* williamburns@amserve.net

BURNS McKEON, Katherine Balfour Kinnear, D.A.(Edin.) 1950; Hong Kong Urban Council painting prize (1979), 1st prize (Painting) R.S.A., W.R.N.S. Art Competition (1945); 1st Prize, St. Raphael International Exhbn. (1990) and Grimaud (1994); artist in oil on canvas, muralist in mosaic, fresco. *b:* Edinburgh, 10 Oct 1925. *d of:* Joseph William Burns. *m:* Leonard J. McKeon (decd.2005). two *s.* one *d. Educ:* Trinity Academy, Edinburgh. *Studied:* Edinburgh College of Art (1946-50, William Gillies, Leonard Rosoman). *Exhib:* Arts Council, S.S.A., Edinburgh, East Africa, Aden, Fiji, Hong Kong, London, France, Australia. *Works in collections:* Museums: Imperial War London, Nairobi, Hong Kong, Macau, Grimaud. *Commissions:* High Court, Dar es Salaam; murals: City Bank, Fiji; Hong Kong Bank, Paris; mosaic: Queen Elizabeth Stadium, Hong Kong and Mosque Social Centre. *Publications:* Hong Kong Art 1970-80. Fus Art, France 1996. *Signs work:* "Kitty Burns." *Address:* Hameau de Sauve Clare, Flayosc 83780, France.

BURR, Lesley Jane, BA (Hons) MA (1997); 1991 1st Prize Laing Art Competition; 1994 Scottish Prize & National Commended Laing, 1997 Ruth Davidson Scholarship, 2002 SAC Visual Arts Development Grant. *Medium:* ceramics, oil, watercolour, drawing, prints. *b:* St.Bees, Cumbria, 15 Jan 1963. *m:* Fergus Murray, Town Planner. one *d. Studied:* Glasgow School of Art (Drawing & Painting, 1981-85); Duncan of Jordanstone, Dundee (Public Art and Design, 1985-87). *Represented by:* Compass Gallery, Cyril & Jill Gerber, Glasgow; Boundary Gallery, Agi Katz, London. *Exhib:* solo shows: 2006 House for an Art Lover, Glasgow, Glasgow Buddhist Centre; 2001: Glasgow Print Studio; 1998, 1996, 1995 Shetland Museum; 1996 Bonhoga Gallery Shetland; 1995 Compass Gallery. Selected shows: 2002,1997 "Glasgow Girls", Boundary Gallery, 1999 Tongues of Diamond (5 artists) Touring Show, 2005 RGI, 1997, 1996 Royal Academy Summer Show. *Works in collections:* Stirling Smith Art Gallery & Museum, The Shetland Museum, The Royal Jubilee Hospital Glasgow (9 works), St.Andrews College. *Commissions:* Faroe Islands Lithographic Workshop, Painted mural -Shetland Recreational Trust, hand-painted tiles, East Kilbride, Marine mosaics, Rutherglen Pool, Glasgow City Council. Two commissions for

interior of Jute Mills in painted tiles, Hillcrest Housing Association. *Principal Works:* Silent Bird series; Heart of an Island; Love series, with Glasgow Girls; Isle of Jura Landscapes, Moon Vision series. *Recreations:* walking, gardening, travel, practising Buddhist. *Clubs:* Veernorth, Shetland Elemental Arts, Argyll. *Misc:* Co-founder of Veernorth (Shetlands' first Visual Arts Group). Known as one of the 'Glasgow Girls'. Lecturer at Argyll College (present), Shetland College and Glasgow School of Art (1994-97). *Signs work:* "BURR". *Address:* 73 Argyll Street, Lochgilphead, Argyll, PA31 8NE. *Email:* lesleyburr@zetnet.co.uk *Website:* www.lesleyburr.co.uk

BURROUGH, Helen Mary (Mrs.), RWA; artist in oil, water-colour, sepia and wash. *b:* Ceylon, 17 Feb 1917. *d of:* Axel J. Austin Dickson. *m:* T. H. B. Burrough. two *s. Educ:* St. George's Ascot. *Studied:* Miss McMuns Studio, Park Walk, Chelsea (1937), Prof. Otte Skölds' Ateljé, Stockholm (1938-39). *Works in collections:* R.W.A. Bristol. *Clubs:* Royal Commonwealth Society. *Signs work:* "Helen." *Address:* The Old House, Frenchay, nr. Bristol BS16 1ND.

BURROWS, Geoffrey Norman, mem. East Anglian Group of Marine Artists. *Medium:* oil, watercolour. *b:* St. Faiths, Norfolk, 16 May 1934. *s of:* Alfred Norman Burrows, automobile engineer. *Educ:* The Paston Grammar School, N. Walsham, Norfolk. *Studied:* Norwich Technical College, full C&G Certificate in Telecommunications Engineering. *Exhib:* RA, RWA, RBA, ROI, RSMA, NEAC, RI, Paris Salon, various solo and mixed exhbns at home and on the continent. *Works in collections:* Atkinson AG, Southport; Norfolk CC; Norwich Union Insurance Co.; Post Office Archives; Zenith Corporate Communications. *Works Reproduced:* in 'Wide Skies- A Century of Painting and Painters in Norfolk'. *Clubs:* Norfolk and Norwich Art Circle; East Anglian Group of Marine Artists. *Signs work:* "Geoffrey Burrows". *Address:* 84 Crostwick La., Spixworth, Norwich NR10 3AF.

BURTON, Charles William, Hon. Doctor of Letters; painter in oil and water media. *b:* Treherbert, 17 Aug 1929. *m:* Rosemary (children from former marriage to Jean Francis). two *s.* one (decd.) *d. Studied:* Cardiff College of Art, Royal College of Art. *Represented by:* Martin Tinney. *Exhib:* one-man shows: British Council Brussels, Welsh Arts Council, Cardiff, Brecknock Museum, Martin Tinney Gallery. *Works in collections:* B.B.C. Wales, Welsh Arts Council, Contemporary Arts Soc. of Wales, D.O.E., National Museum of Wales, Newport Art Gallery, House of Lords, et alia. *Publications:* A Taste of the Belgian Provinces. *Address:* 12 Plymouth Rd., Penarth CF64 3DH.

BURTON, David, First Prize, Landscape painting, Nuneaton Festival of the Arts (1984). *Medium:* oil, acrylic, drawing, sculpture. *b:* Leicester, 13 Jan 1961. *s of:* Sheila & Arnold Burton. *Educ:* Mkt. Bosworth High School, Bosworth College, Leics. *Studied:* self-taught. *Exhib:* Nuneaton Museum and Art Gallery; Oddfellows Gallery of Contemporary Art, Kendal; Tenby Museum and Art Gallery; Pontypool Museum and Art Gallery; Scolton Manor Museum;

Llantarnam Grange Arts Centre, Cwmbran; Lyth Gallery; Washington Gallery, Penarth; Mariners Gallery, St.Ives, Cornwall. *Works in collections:* Tenby Museum and Art Gallery; Pontypool Museum and Art Gallery; Pembrokeshire County Council Art Collection; Prince Phillip Hospital, Llanelli; Pembrokeshire and Derwen Health Authority; Carmarthen Health Authority; Bloomfield Centre, Narberth; Nuneaton Museum and Art Gallery; many major works in museums and private collections. *Commissions:* Night Club Murals (1998); 'Homage to Van Goch' (private collector, 1997). *Publications:* 'From Now to Zero: The Work of David Burton' (2005)(Pembrokeshire County Museums). *Works Reproduced:* numerous in books, catalogues, posters, magazines. *Recreations:* art history, history, walking, reading. *Clubs:* NAPA full member. *Misc:* The David Burton Collection and Archive is housed at Scolton Manor Museum; Signature 'dB.R' (d and B joined), is an abbreviation of D.B.R. The 'R' is artists' mothers maiden name of Richardson. Only recent works (2005-) are signed in this way. *Signs work:* 'David Burton.R' or 'dBR', often signed on reverse of works. *Address:* Glan Preseli, Efailwen, Clynderwen, Pembs. SA66 7UY. *Email:* david@burton6838.fsworld.co.uk *Website:* http://davidburton.mysite.wanadoo-members.co.uk

BURTON, Philip John Kennedy, B.Sc. (1958), Ph.D. (1967), S.W.L.A.; painter in acrylic; retired scientific civil servant, British Museum (Natural History). *b:* London, 9 Jan 1936. *m:* Jennifer Mary. one *s.* one *d. Educ:* Finchley Catholic Grammar School, University College, London. *Exhib:* S.WL.A. *Publications:* Birds of the Western Palearctic, various field guides, Identification Guide to Raptors of the World. *Signs work:* "Philip Burton." *Address:* High Kelton, Doctors Commons Rd., Berkhamsted, Herts. HP4 3DW. *Email:* pjkburton@supanet.com

BURTONSHAW, Keith, Hon.B.W.S., U.A., N.S.; artist, teacher and demonstrator in water-colour and oils;. *Medium:* oils and watercolours. *b:* Beckenham, 25 Sep 1930. *Educ:* Beckenham and Penge County School. *Studied:* Beckenham School of Art. *Exhib:* R.I., R.S.M.A. *Works in collections:* over 5000 paintings sold in U.K. *Commissions:* a few. *Works Reproduced:* water-colour entitled 'Glencoe' reproduced on a Calendar of Contemporary Art by Allan & Bertram Ltd., Waltham Abbey, Essex. *Clubs:* London Sketch Club, Armed Forces Art Soc., Croydon Art Soc., Cantium Group of Artists, West Wickham Arts Assoc., Lewisham Soc. of Art., Bromley Art Soc. *Signs work:* "Keith Burtonshaw." or 'K.Burtonshaw.'. *Address:* 150 Beckenham Rd., Beckenham, Kent BR3 4RJ.

BUSBY, John P., R.S.A., R.S.W., S.WL.A.; lecturer, Edinburgh College of Art (1956-88);. *b:* Bradford, 2 Feb 1928. *s of:* Eric Busby, M.B.E. *m:* Joan. one *s.* two *d. Educ:* Ilkley Grammar School. *Studied:* Leeds Art College (1948-52), Edinburgh Art College (1952-54); Post Grad. (1954-55), major travel scholarship (1955-56). *Represented by:* The Land Gallery, Lockington; The Wildlife Art Gallery, Lavenham. *Works in collections:* S.A.C., Flemmings Bank, Bradford,

Glasgow and Wakefield A.G's., Yorks Arts Assoc.; many private collections including H.R.H. The Duke of Edinburgh. *Publications:* The Living Birds of Eric Ennion (Gollancz), Drawing Birds (R.S.P.B.), Birds in Mallorca (Helm), Nature Drawings (Arlequin), Land Marks and Sea Wings (The Wildlife Art Gallery, Lavenham), many illustrated books. *Recreations:* bird watching, music. *Signs work:* "John Busby." *Address:* Easter Haining, Ormiston Hall, Tranent, E. Lothian EH35 5NJ. *Website:* www.thelandgallery.com, www.wildlifeartgallery.com

BUSHE, Frederick, O.B.E. (1994); sculptor;. *b:* Coatbridge, Scotland, 1931. *Studied:* Glasgow School of Art (1949-53), University of Birmingham (1966-67). Elected R.S.A. (1986); Scottish Arts Council Awards (1971, 1973) and S.A.C. Major Bursary (1977-78). *Clubs:* Established Scottish Sculpture Workshop (1980) and Scottish Sculpture Open Exhbn. (1981). *Address:* Scottish Sculpture Workshop, 1 Main St., Lumsden, Aberdeenshire AB54 4JN.

BUSHELL, Dorothy, H.S., R.M.S., Mundy Sovereign award (1983), Hilliard Soc. awards for best portraits (1998, 1999); miniature portrait painter. *Medium:* watercolour, oils. *b:* Halifax, Yorks., 3 Feb 1922. *d of:* Donald Clifton. *m:* Philip Bushell. two *s.* one *d. Studied:* Halifax School of Art, Reigate School of Art. *Exhib:* R.A. (1974, 1983, 1984, 1989, 1990, 1991, 1997), Mall Galleries, Westminster Gallery, R.M.S. (1982-97, 2002). *Works in collections:* Comte et Comtesse de Martigny, Soc. of Apothecaries, London, The Royal Anglian Regiment. *Commissions:* 150. *Publications:* The Techniques of Painting Miniatures. *Works Reproduced:* R.M.S. book commemorating One Hundredth Anniversary. *Misc:* Several works sold at exhibitions. *Signs work:* "D. Bushell, 98". *Address:* 90 Fairdene Rd., Coulsdon, Surrey CR5 1RF.

BUSTIN, Jane, B.A. (Hons.) Fine Art; painter. *b:* Borehamwood, Herts., 11 May 1964. *m:* David Gryn. one *s. Educ:* Nicholas Hawksmoor School, Herts. *Studied:* Hertfordshire College of Art, Portsmouth Polytechnic. *Exhib:* solo exhibs.: John Jarves Gallery (1995), Eagle Gallery (1998/2000); group exhibs. include British Abstract Painting (2000), Flowers East, Chora - touring exhib. (1999). *Works in collections:* Unilever, British Land, United Overseas, DLA Solicitors, KIAD Canterbury, V. & A. Museum, Goldman Sachs. *Commissions:* private commissions. *Publications:* "And a Year Ago, I Commemorated a Missed Encounter..", collaboration with writer Andrew Renton, pub. E.M. Arts; catalogues: Nameless Grace, Eagle Gallery; Chora, by Sue Hubbard and Simon Morley; British Abstract Painting, by Mathew Collins. *Signs work:* "Jane Bustin." *Address:* 6 Mackeson Rd., London NW3 2LT. *Email:* janebustin@hotmail.com

BUTCHER, Sue, U.E.I. Cert. A.D. (1979); artist in acrylic and plant fibres;. *m:* Edward Butcher. two *s. Educ:* Penarth Grammar School. *Studied:* Hereford College of Art (1977-80). *Exhib:* regular exhibitor R.A. and West of England, winner, Sainsbury's National Touring Exhib. (1982-83), Japan (1987, 1993), S.W.A. (1987), various mixed and one-man shows. *Works in collections:* Tayor

Gallery, London, Hereford City A.G., Hereford Council Offices. *Publications:* poetry in various magazines. *Misc:* B.B.C. and I.T.V. television programmes (1990), radio broadcasts to U.S.A. and Canada. *Signs work:* "S. Butcher." *Address:* Litley Orchard, Gorsty La., Hereford HR1 1UN.

BUTLER, Anthony, R.C.A. (Cambrian, 1960), A.T.D. (1950); schoolmaster; artist in oil and gouache; head of art, Birkenhead School (retd.);. *b:* Liverpool, 1927. *s of:* George Butler. *m:* Jean. two *s.* one *d. Educ:* Liverpool Institute. *Studied:* Liverpool School of Art (1944-45, 1948-50) under Martin Bell, Alfred Wiffin, Alan Tankard. *Exhib:* R.A., New Burlington, Agnews, Northern Young Contemporaries. *Works in collections:* Walker Art Gallery, Liverpool; Whitworth Art Gallery, Manchester; Williamson Art Gallery, Birkenhead; and various county educational collections. *Commissions:* ceramic decoration commissioned by Dudley C.C. for new shopping precinct. *Official Purchasers:* Granada Television, Manchester. *Signs work:* "BUTLER." *Address:* Otthon, Tan Yr Eglwys, Henllan, nr. Denbigh, Denbighshire LL16 5BD.

BUTLER, Elizabeth A., RWS (1999), BA, MA (RCA). *Medium:* watercolour, prints. *b:* Brampton, Cumbria, 12 Jun 1948. *m:* Ingram Pinn. one *s. Studied:* Liverpool College of Art; RCA. *Represented by:* Francis Kyle Gallery, London since 1979. *Exhib:* Christie's, London (2004); Discerning Eye, Mall Galleries (2001, 2003); National Theatre (2001); Arts Club, London (1987), New York (1984). *Works in collections:* Government Art Collection; Abbot Hall Gallery, Kendal; Queen Mother's Art Collection, Windsor; Royal Watercolour Society Diploma Collection. *Commissions:* set of stamps commemorating British gardens for the Post Office (1983); series of paintings of Harewood House and grounds for Earl of Harewood. *Publications:* 'The Seasons' (William Collins, 1982); 'Watercolour Expert' (Cassells, 2004). *Principal Works:* landscape. *Misc:* taught at Colchester School of Art (1973-83); Camberwell School of Arts and Crafts (1982-92); Dulwich Picture Gallery continuously since 1988. *Signs work:* 'liz Butler' on reverse of painting, or 'LB' (with B inverted) on front. *Address:* 33 Alexandra Road, Chiswick, London W4 1AX. *Email:* lizbutler@pinn33.freeserve.co.uk

BUTLER, James, R.A. (1972), R.W.A. (1980), F.R.B.S. (1981); sculptor in bronze and stone;. *b:* Deptford, 25 Jul 1931. *s of:* Walter Arthur Butler. *m:* Angela Berry. five *d. Educ:* Maidstone Grammar School. *Studied:* Maidstone School of Art (1948-50); St. Martin's School of Art (1950-52). *Commissions:* Major commissions: portrait statue of President Kenyatta of Kenya, Nairobi; monument to Freedom Fighters of Zambia, Lusaka, Zambia; sculpture of The Burton Cooper, Burton-upon-Trent; memorial statue of Richard III, Castle Gardens, Leicester; statue of Field Marshal Earl Alexander of Tunis, Wellington Barracks, London; Dolphin fountain, Dolphin Sq., London; statue of John Wilkes, New Fetter La., London; bronze sculpture of the Leicester Seamstress, Hotel St., Leicester; statue of Thomas Cook, London Rd. Leicester; memorial statue to Reg Harris, N.C.C. Manchester; statue of Billy Wright, Wolverhampton; statue, James

Greathead, Cornhill, London; D-Day Memorial to Green Howards, Crépon, Normandy; statue of James Brindley, Coventry Canal Basin, Fleet Air Arm Memorial, Embankment, London, portrait statue Jack Walker, Blackburn Rovers F.C., bust of Robert Beldam, Corpus Christi College, Cambridge, Royal Seal of the Realm, statue of Stan Cullis, Wolverhampton F.C.; busts of Sir Frank Whittle, R.J.Mitchell, Roy Chadwick - RAF Club Piccadilly; cellist, harpist in music annexe Marlborough School. *Clubs:* Arts. *Signs work:* surname and year. *Address:* Valley Farm Studios, Radway, Warwicks. CV35 0UJ.

BUTLER, Richard Gerald Ernest, painter, graphic designer. *b:* Essex, 31 Dec 1921. *s of:* Major Gerald Butler, A.P.T.C. *m:* Mary Driscoll. three children. *Studied:* Salisbury School of Art. *Exhib:* R.A., Arts Council Touring Exhbns., etc., one-man shows: Walker Galleries. *Works Reproduced:* book illustration (Macmillan Educ.), mural designs (Fitzroy Robinson & Partners). *Signs work:* "Richard Butler." *Address:* 32 Denne Rd., Horsham, Sussex. RH12 1JF.

BUTLER, Vincent, sculptor, figurative, bronzes; mem. Royal Scottish Academy, Royal Glasgow Inst.;. *b:* Manchester, 1933. *m:* Camilla. two *s.* *Studied:* Academy of Fine Art, Milan. *Exhib:* numerous one-man shows in various parts of the country,. *Works in collections:* private collections in Britain, U.S.A., Germany, Italy, Israel, etc. *Publications:* Casting for Sculptors (A. & C. Black, 1997). *Clubs:* Scottish Arts. *Address:* 17 Dean Park Cres., Edinburgh EH4 1PH. *Email:* vincentbutler@msn.com

BUTT, Anna Theresa, NDD Painting (1945), NDD Sculpture (1950). *Medium:* watercolour, sculpture, mainly ceramic/terracotta. *b:* Richmond, Surrey, 9 Mar 1926. *d of:* George & Dorothy H. Butt. *m:* Norman Adams (decd). two *s.* *Educ:* private. *Studied:* Harrow School of Art (1939-46), Hornsey College of Art (1948-50). *Exhib:* RA Summer Exhbn (1986-2005); Linton Court Gallery, Settle; Goosewell, Menston; Haworth Art Gallery & Museum, Accrington; Third Eye Gallery, Glasgow; Peter Scott Gallery, Lancaster University; widely in north of England as Anna Adams. *Works in collections:* Abbot Hall, Kendal, W. Yorks. Educ. Com., Moorside Mills Museum, Rochdale Museum, and Herts. Many private collections. *Commissions:* 2 Angels for Habergham Parish Church, near Gawthorpe; Madonna, font and tabernacle panels for Our Lady of Lourdes, Milton Keynes. *Publications:* collections of poems under name A. Adams; R. Wren's "Animal Forms" Batsford; 5 books Peterloo. *Works Reproduced:* Woodmansterne cards; Blackwell's (postcard); RA Illustrated catalogue Summer Exhbn (1987, 1989), cover designs for own books. *Recreations:* conversation, walking. *Clubs:* Poetry Society. *Signs work:* 'Anna Butt', 'Anna Adams', 'AA' on sculptures. *Address:* 3 Grange Road, Lewes, East Sussex, BN7 1TR.

BUTT, Jennifer Gillian, Diploma in General Art and Design (merit), BTEC. *Medium:* acrylic. *b:* Sidcup, 13 Jun 1968. *d of:* Patricia Butt. *m:* partner: Paul. one *d. Educ:* Falmouth School of Art, Falmouth, Cornwall. *Studied:* National Diploma in Art and Design (Foundation). *Represented by:* Lander Gallery, Truro;

New Craftsman, St.Ives; Round House Gallery, Sennen Cove, Cornwall. *Exhib:* Royal West of England Academy, Bristol (RWA) 150th Autumn Selected Exhibition; group shows: Mid-Cornwall Galleries, St.Blazey, Truro Museum, Trebah Garden Gallery. *Commissions:* various private commissions throughout the UK; Sydney, Australia and New York. *Publications:* Wavelength (Surf magazine), West Briton, Inside Cornwall, Cornwall Arts. *Works Reproduced:* limited edition prints of 'Flooded Surface' and 'Trevaunance'; Oceans Edge, Sandpods and Lone Limpet. *Recreations:* surfing; walking and sketching along coastal footpaths. *Clubs:* Truro Art Society, Penzance Art Club. *Misc:* all my works are based on the beauty of the North Coast of Cornwall, with its surreal and serene ever changing images. *Address:* 2 Crown Terrace, Perranwell Station, Cornwall, TR3 7JZ. *Email:* jennybutt@postmaster.co.uk *Website:* www.jennybutt.com

BUTT, Laurence Arnold, B.A. (Hons.) Fine Art (1998); artist in oil acrylic,charcoal, and sculpture. *b:* London, 9 Sep 1954. *m:* Tatiana. three *s.* one *d. Studied:* Surrey Inst. of Art and Design, Farnham. *Exhib:* Whiteley's London, R.A., Brighton, Russia, New Masters London. *Works in collections:* Surrey Institute of Art & Design. *Commissions:* still life, portraits, abstract art, spiritual paintings, landscape and prints. *Works Reproduced:* R.A. Abstract. *Clubs:* Sussex Art Club. *Misc:* varied commissions welcomed. *Signs work:* "Laurence A. Butt." *Address:* 9 Southdown House, 2 Silverdale Lane, Eastbourne, E.Sussex BN20 7AL. *Email:* lauriebutt@aol.com

BUTTERFIELD, Sarah Harriet Anne, B.Soc.Sci. Architecture Edin. (1975) 'Magna cum Laude', Cert. Fine Art Ruskin School of Fine Art, Oxford (1978), Distinction; qualified as architect 1983; self employed as artist since 1986; Official Tour Artist, on Royal Tour by HRH Prince of Wales to Egypt, Saudi Arabia and India. Awards: Egerton Coghill Landscape prize (1977), Winsor and Newton award, Hunting Group Competition finalist, commendation Spectator Magazine Three Cities Competition, art reviewer, LBC Arts & Entertainment Sunday Program. *b:* London, 28 Aug 1953. *m:* David Willetts. one *s.* one *d. Exhib:* Judd St. Gallery, London (1987), Agnew's Young Contemporaries (1988), Richmond Gallery, Cork St. (1990), Roy Miles Gallery (1991); Discerning Eye (1997); dfn Gallery New York (2000); one-man show: Cadogan Contemporary (1991, 1994, 1997), 27 Cork St., London (2001), Albemarle Gallery, London (2005). *Works in collections:* British Airways: Terminal 4 Departure Lounge, Gatwick Airport; Jerry's Home Store, Chelsea, London; David Lloyd Slazenger Racquet Club; Trusthouse Forte Hotels in Yorkshire and Exeter; Wimbledon Lawn Tennis Museum; 'Davies', Gt. Newport St., London. Private collection of HRH Prince of Wales. *Recreations:* tennis, running, films, music. *Clubs:* mem., Equity. *Address:* 21 Ashchurch Grove, London W12 9BT. *Email:* sarah.butterfield@mac.com *Website:* www.sarahbutterfield.co.uk

BUTTERWORTH, John Malcolm, MA(Ed.), FRSA, NDD, ATD; artist in oils, water-colour, etching, silkscreen and lithography, paper; Fine Art Degree

Course Leader, Design Faculty, Southampton IHE (retd. from post 1997). *b:* Lancs., 16 Jul 1945. *s of:* Jonathan and Annie (Tilling) Butterworth. *m:* Lesley G. Arkless, B.A.Hons. two *s.* one *d. Educ:* Rochdale Technical School for Boys. *Studied:* Rochdale College of Art (1961-63), Newport College of Art (1965-66), Cardiff College of Art (1965-66), David Murray Scholarship (R.A.) 1965. *Exhib:* Wills Lane Gallery, St. Ives, University of Surrey, Southampton Civic A.G. (one-man shows), Pictures for Schools Exhbn., National Museum of Wales, Cardiff, Midsommergarten Gallery, Stockholm, Cleveland, Drawing Biennale, International Print Biennale, Monaco, "Outpost" Venice Biennale (1995). *Works in collections:* Bristol Educ. Authority, Kent Educ. Authority, Surrey University, Hampshire C.C. *Signs work:* normal signature for prints, "J.M.B." monogram for paintings. *Address:* 2 Nuns Walk, Winchester, Hants. SO23 7EE.

BUTTERWORTH, John Russell, BA (Hons)Fine Art, MA Painting; Northern Young Contemporaries Prizewinner (1985); travel scholarship at Winchester SOFA (awarded by Albert Irwin). *Medium:* oil, prints. *b:* Malvern, Worcs, 22 Feb 1962. *s of:* Janet Mathilde Leyen-Decker. *Educ:* Kelsey Park Boys School, Beckenham, Kent. *Studied:* Winchester School of Art (1980-83), Chelsea School of Art and Design (1983-84). *Represented by:* various galleries in Kent and London. *Exhib:* RA Summer Exhbn (1999, 2001), Beardsmore Gallery London 4 Artists (2001), Canterbury Museum and Gallery 'Passing Tales' (2000). *Works in collections:* private collections London, Kent, France, Kuala Lumpar, Winchester SOFA Collection. *Commissions:* 'Sartorial Art' for Maurice Sedwell Ltd., Savile Row London; 'Creative Vista' album sleeve Mr Ben Cooper. *Works Reproduced:* Poetry Review Magazine Vol92 No3 Autumn 2002. *Principal Works:* 'Seasalter', 'Falling Down' (The Descent). *Recreations:* keen club cricketer. *Clubs:* Whitstable CC, Contemporary Arts Group (Whitstable). *Misc:* 'making connection with the human spirit through art'. *Signs work:* John Butterworth. *Address:* 51a Cromwell Road, Whitstable, Kent, CT5 1NW. *Email:* john.butterworth@tinyworld.co.uk *Website:* www.jbutterworth.co.uk

BUXTON, Jennifer, HRMS (retd.), Hon.Sec.RMS (1980-87), Hilliard Soc.; portrait, animal and landscape painter in water-colour, silverpoint, pastel, oil, gouache and acrylic; first winner of RMS Gold Memorial Bowl Award for best miniature (1985). *Medium:* watercolour, pastel, carbon drawings, oil, acrylic and coloured pencils. *b:* Hornsey, 12 Apr 1937. *d of:* N. Pearson, company director. *m:* Captain Vic (RN). two *s. Educ:* Northfield School, Watford. *Studied:* Frobisher School of Animal Painting (1948-53, Marguerite Frobisher), Byam Shaw School of Art (1954-57, Dunstan, Phillips, Mahoney). *Exhib:* Watford, Manchester, Bath, Wells, Paris Salon, Kendal, Ulverston, Ilkley, Toronto, annually RMS London. *Commissions:* numerous. *Misc:* now painting wild tigers in India, selling prints, all profits to building a school in Indian village, tree-planting in India, protection of tigers and the forest. *Signs work:* "jb", "Jen Buxton" or "J. Buxton." *Address:* Windy Ash Barn, Ulverston, Cumbria LA12 7PB. *Email:* jen@windyashbarn.com *Website:* www.tigertigerburningbrightly.com

BUXTON, Judy, BA (Hons) Fine Art, RA Dip Fine Art; Nat West Art Prize finalist and prizewinner (1997), Cyril Sweet Award (1996), Gold Medal The Worshipful Company of Painter-Stainers, Royal Watercolour Award (1996), David Murray Travel Scholarship; Hunting Art Prize (2nd Prize). *Medium:* oil, watercolour. *b:* Sydney, 16 Dec 1961. *d of:* John and Leonore Buxton. *m:* Jeremy Annear. *Studied:* Falmouth College of Art (1987-90), Royal Academy of Art (1990-93). *Represented by:* New Millennium Gallery, St.Ives, Cornwall. *Exhib:* Hunting Art Prizes, RCA 98/99/00/02/03/04/05, New Millennium Gallery 1997-03, Messums 1998-03, Beaux Art Gallery Bath 2001, Newlyn Art Gallery 1994-03, Royal Academy Summer Exhbn. 91/92/93/98. *Works in collections:* Falmouth College of Art, Guinness Collection, Swiss Bank. *Commissions:* The Crystal Serenity. *Publications:* Catching the Wave by Tom Cross (Halsgrove Press 2003), Newlyn Society of Artists Members Book (NSA Pub. 2000), exhbn.cat. Messums (foreword by William Packer), exhbn. cat. New Millennium Gallery (2002), Nat West Art Prize catalogue, exhbn. catalogue New Millennium (2004, foreward by William Packer). *Works Reproduced:* Royal Overseas League cat. (1997), Drawing the Nude by Diana Constance (Apple Press 1994), London Underground poster campaign for RA Summer Exhbn (1993). *Recreations:* travel, piano. *Clubs:* Reynolds Club RA Alumni. *Misc:* Freedom of the City of London, Hon.Freeman of the Worshipful Company Painter Stainers. *Signs work:* J Buxton. *Address:* Chapel House, Garras, Helston, Cornwall, TR12 6LN.

BYROM, Gillie Hoyte, R.M.S., H.S., B.S.O.E., M.Ed. (Exeter), B.Ed. (Cambridge); portrait miniaturist working in vitreous enamel on copper or gold;. *b:* Ceylon, 5 Nov 1952. *m:* Peter Byrom, O.B.E. *Educ:* Llotja School, Barcelona. *Exhib:* numerous. *Works in collections:* Wimbledon Lawn Tennis Museum, Diploma Collection of R.M.S. *Publications:* The Royal Miniature Society 100 Years; The Techniques of Painting Miniatures; Macmillan Dictionary of Art: Limoges. *Clubs:* Royal Society of Miniature Painters, Sculptors and Gravers, Hilliard Society, British Soc. of Enamellers, Devon Guild of Craftsmen. *Address:* Barton House, Woodland, Ashburton, Devon TQ13 7LN. *Website:* www.enamelportraitminiatures.co.uk

C

CADENHEAD, William Collie Milne, D.A., cert.R.A.S., Bronze Medal R.A. Schools (1957), David Murray Landscape Scholarship (1957), elected prof. member S.S.A. (1969); painter in oil and pastels; lecturer in drawing and painting, Duncan of Jordanstone College of Art, Dundee. *b:* Aberdeen, 8 Oct 1934. *s of:* A. L. Cadenhead, L.D.S., R.C.S. Edin. *m:* Violet. *Educ:* Aberdeen Grammar School; Forfar Academy. *Studied:* Dundee College of Art (1951-55); post-diploma scholarship 1956; travelled Europe (1956); Hospitalfield Art College, Arbroath; R.A. Schools, London (1957-61). *Exhib:* R.S.A., S.S.A., R.S.W., Savage Gallery, Compass Gallery, Royal Overseas League, Edinburgh Festival (1968), etc., one-man shows, Woodstock Gallery (1980), The Scottish

Gallery (1981, 1983), Retrospective, Meffan Inst. (1992), Texas Touring Exhbn. (1996-97). *Works in collections:* H.M. Queen Elizabeth, The Queen Mother, Scottish Arts Council, (Stations of the Cross), St. Fergus, Forfar; Meffan Institute, Forfar; Steel Company of Wales, Dundee A.G., and private collections in U.K., Europe and U.S.A. *Signs work:* "Cadenhead." *Address:* The Rowans, Muir of Lownie, Forfar, Angus DD8 2LJ.

CADMAN, Michael Lawrence, RI (1970), ARCA (1944); Instructor: Epsom School of Art (1947-68), Croydon College of Art (1947-53). *Medium:* water-colour, acrylic, oil and pastel. *b:* Epsom, Surrey, 1920. *s of:* Alfred & Effie Cadman. *m:* decd. *Educ:* Glyn Grammar School, Epsom, Surrey. *Studied:* Wimbledon School of Art (1937-41), RCA, Landscape and Architecture (1941-44, under Gilbert Spencer); B of E art-exams (1939-41);. *Exhib:* RA, RI, RWS, RBA, ROI, eight one-man shows. *Works in collections:* galleries nationwide and collections worldwide. *Commissions:* Protexulate Ltd. (large mural) Esher (1966). *Publications:* Orange Cap - Red Cap ('Prints for Pleasure', Paul Hamlyn, 1968); four fine art prints (Cornish Harbours and Hedgerow themes, Pancrest Ltd., 1981). BBC TV (1947, 1964). 3 articles in 'Leisure Painter' (1977). Numerous calendar illustrations: "Artists' Britain", BP, Southern Gas, Allan and Bertram. *Works Reproduced:* 5 paintings (illustr.)(mainly harbour scenes); 'The Encyclopedia of Water-color Techniques' by Hazel Harrison (pub. running Press); 'Buildings' by Hazel Harrison (Quarto Publishing, WellFleet Press); 'Fiddleford Mill, Dorset' (Southern Gas). *Recreations:* Natural history subjects, collecting. *Clubs:* RI, St. Ives Soc. of Artists; formerly: Reigate Society of Artists. *Misc:* favourite subjects – jockeys, rooftops, cattle, architectural, plants, other rural subjects, plus some 300+ wild flower illustrations. *Signs work:* "Michael Cadman." *Address:* Ballard Glebe, The Glebe, Studland, Dorset BH19 3AS.

CAHILL, John, B.A. (Hons.) Fine Art (1976), M.A. Painting (1980); painter in oil and water-colour, printmaker, etcher; professional artist and gallery owner;. *b:* 19 Nov 1954. *m:* Gillian. one *d. Studied:* Portsmouth Polytechnic (1976), Royal College of Art (1980). *Exhib:* RA Summer Shows; one-man shows: Harris Museum, Preston, St. David's Hall, Cardiff. *Works in collections:* Lord Bath, Longleat House. *Commissions:* many private commissions. *Works Reproduced:* fine art prints, calendars, cards. *Address:* The Harbour Gallery, 1 St. Julian St., Tenby, Pembrokeshire SA70 7AY. *Email:* tenbyharbgallery@aol.com *Website:* www.tenbyharbourgallery.co.uk

CAIN, Judith, NDD, ATC; Harewood Award, Harewood Landscape Open (1995); 1st Prize, Laing Regional (1995); Major Prize Laing National (1995); Arts Council Award (2003), AHRB Award (2003). *Medium:* watercolour, acrylic. *b:* England, 10 May 1944. *Studied:* Leeds College of Art (1960-64); Goldsmiths College (1964-65). *Represented by:* Thackeray Gallery, London. *Exhib:* solo shows: regularly at Thackeray Gallery; Adam Gallery, Bath; Blackburn Museum & Art Gallery; Myles Meehan Gallery, Darlington; Royal Botanical Gardens, Kew; Leeds City Art Gallery, and many mixed shows including Zoersel Belgium

International Biennale (2002); Art Synthesis Road Show; various venues in Sweden; R.A Summer Show (2007). *Commissions:* NHS Trust: floor piece and ten paintings for new cancer hospital in Leeds. *Publications:* all publications include accompanying essays: 'Judith Cain, Enfolding Places' (2000); 'Judith Cain, Adam Gallery' (2001); 'Judith Cain "Being in Place" Landscapes of Central Asia (2003)'. *Works Reproduced:* on numerous occasions inc.:Art Review (1999), Gardens Illustrated (1999). *Clubs:* Chelsea Arts Club, London. *Signs work:* 'Judith Cain'. *Address:* 30 Grove Road, Headingley, Leeds LS6 4EE. *Email:* judith@gordoncain.demon.co.uk *Website:* www.judithcain.co.uk

CAINES, Ronald Arthur, National Diploma Design (Painting); ATD. *Medium:* oil. *b:* Bristol, 13 Dec 1938. *m:* Susan Caines. one *s.* two *d. Educ:* Bristol Cathedral School. *Studied:* West of England College of Art (1955-61). *Represented by:* Alpha House Gallery; Levent Gallery, London. *Exhib:* RA, RWA, Arnolfini (Bristol), Brighton Art Gallery, Chichester Open; solo exhbns: Alpha House Gallery, Sherbourne; Levent Gallery. *Works in collections:* West of England College of Art; Lord Gosford; Lord Rees; John Fortune; Ron Weldon. *Misc:* began playing saxophone at art school, founded East of Eden in 1967, performed in concerts throughout Europe. Later career as free jazz musician. *Signs work:* 'R.Caines.'. *Address:* 36 Titian Road, Hove, E.Sussex BN3 5QS.

CAINES, Susan Mary, RWA (1995); NDD painting, ATD. *Medium:* painter in oils. *b:* Bristol, 1 Feb 1935. *d of:* Bertie Weaver and Dorothy Shepstone. *m:* Ronald Caines. one *s.* two *d. Educ:* St. George's Grammar School. *Studied:* West of England College of Art, ATD awarded by Bristol University 1956. *Represented by:* Lena Boyle Fine Art, London; Ainscough Contemporary, London; Alpha House, Sherborne. *Exhib:* since 1989, including one-person shows annually since 1990. Royal Academy Summer Exhbn 1993-2003. One-person show Royal West of England Academy Galleries 1999. *Works in collections:* Royal West of England Academy, West of England College of Art, private collections. *Works Reproduced:* illustrated catalogues of RA and RWA. *Recreations:* travelling in Italy, photography, reading. *Address:* 36 Titian Rd, Hove, E.Sussex, BN3 5QS.

CAINS, F. Blanche, S.W.A., A.T.D. (1927); artist in water-colour, mixed media, fabric collage, embroidery; art teacher, Head of Dept. Grammar School (mixed). *b:* Bristol, 1905. *d of:* William Charles Cains, craftsman. *Educ:* St. George Grammar School, Bristol. *Studied:* West of England College of Art (1922-27) Princ. R. E. J. Bush, R.E. *Exhib:* R.A., R.I., R.W.A., S.W.A., various other galleries in London, Brighton, Bristol, etc. *Signs work:* "F.B. Cains." *Address:* 99 Summerhill Rd., St. George, Bristol BS5 8JT.

CAINS, Gerald Albert, N.D.D. (Painting S.L. 1953), A.T.D. (1957), A.R.W.A. (1971), elected R.W.A. (1978), A.D.A.E. (University of Wales, 1975); R.W.A. Finalist Hunting Group Prizes (1984). *Medium:* oil and water-colour;. *b:* Stubbington, Hants., 11 May 1932. *s of:* Albert George Cains. *m:* Ruth Lillian Blackburn. one *s.* one *d. Educ:* Gosport County Grammar School. *Studied:*

Southern College of Art, Portsmouth (1949-53). *Exhib:* mixed: R.A.; R.W.A.; R.O.I.; R.B.A.; Football and Fine Arts, London 53: Pics for Schools (Cardiff); Euro '96 London; Wessex Artists, Southampton 78 (2nd prize). Selected for Touring Exhbn. A.C.G.B., Art Federations Bureau, Millfield Open (2003, 04, 05); Discerning Eye, Mall Galleries (2003); "One Love - Football", Lowry Galelry, Salford, Manchester (2007). *Works in collections:* Lancashire Museum Service, R.W.A., Walsall Museum Service, Wessex Longleat House. *Commissions:* mural: Southmead Hospital, Bristol. *Works Reproduced:* in 'Acrylic School' Hazel Harrison (Readers digest), 'How to Paint and Draw' Hazel Harrison (Quarto), 'Oil Painters' Pocket Palette' Rosalind Cuthbert (Batsford), Complete Painter, Brian Gorst, Watson Guptill, NY; The Oil Painters Bible, Quarto 2005, Marglin-Scott. *Principal Works:* 'The Miner in his Garden', oil (Wessex Coll., Longleat House). *Clubs:* R.W.A., Bath Soc. of Artists. *Signs work:* "G. A. CAINS." *Address:* 1 Broadway Cottages, Broadway Lane, Clandown, Radstock, Somerset BA3 2XP. *Website:* www.rwa.org.uk

CALLAND, Ruth Elaine, MA, MSc; Awards: Arts Council (2007); Art 4 All (1998); Boise Travelling Scholarship (1987); Fellowship in Painting, Gloscat, Cheltenham (1987). *Medium:* Live Art, oil, drawing. *b:* Scunthorpe, 8 Apr 1963. *d of:* John & Christine. *m:* Jonathan Waller. two *d. Educ:* Lanchester Polytechnic (Coventry, 1982-85). *Studied:* Chelsea School of Art (1986-87); Birkbeck College (1986-87). *Represented by:* Transition Gallery, London. *Exhib:* Rational Rec, Bethnal Green (2007); Transition Gallery (2005, 2007); Hastings Museum & Art Gallery (2007); Three Colts, London (2006); The Residence, London (2006); Vestry House Museum, London (2005, 2006); The Foundry, London (2005); Temporary Contemporary, London (2005); Flowers East (2003); Derby Museum and Art Gallery (1998); Paton Gallery (1987, 1989); New Contemporaries, ICA (1986). *Works in collections:* Leicestershire Collection, Coventry University, British Gas Plc, Slade School of Art. *Commissions:* Hastings Museum and Art Gallery (2007), Transition Gallery (2007), Arty Magazine (commissioned drawings, issues 14, 17). *Misc:* also known as: Radmilla Click, Hepsibah, Countess Euphoria, Professor Timecreep, Dame Batlove. *Address:* 35 Campbell Road, Walthamstow, London E17 6RR. *Email:* ruth8@tinyworld.co.uk *Website:* www.transitiongallery.co.uk

CALLMAN, Jutta Gabrielle: see SAUNDERS, Jutta Gabrielle,

CALVER, Michael, BA (Hons) Fine Art (1971); Arts Council Grants (2003, 2005); Pollock Krasner Foundation Grant (2007). *Medium:* painter. *b:* Kent, 6 Apr 1942. *m:* Megan. by previous marriage-one *s.* two *d. Studied:* At.Martins (1958-59), East Ham Tech. (1967-68), Winchester School of Art (1968-71), Brighton Polytechnic (1971-72). *Represented by:* Wahle Contemporary Art. *Exhib:* solo shows: Wolf at the Door, Penzance (1987); Exeter and Devon Arts Centre (1996); University of Bath (1997); Black Swan Guild, Frome (1999); Exeter Phoenix (2004); Brewhouse, Taunton (2007). Group shows: RWA Bristol (1989, 90, 97, 99, 2000), William Desmond, Exeter (1991), Gordon Hepworth,

Exeter (1991, 1992), Newlyn Art Gallery (1997, 99, 2001, 03, 04), Campden Gallery, Glos (2005), Sherborne House (2006), Tokyo (2002), Bad Homburg (2005). Art Fairs: London, Bristol, Bath, Glasgow (1999-2005). *Works in collections:* private and corporate, UK/Japan/Dubai. *Clubs:* Member of Newlyn Society of Artists. *Signs work:* "M.CALVER". *Address:* 3 Twyford Place, Tiverton, Devon, EX16 6AP. *Website:* www.axisweb.org/artist/michaelcalver

CALVERT, Diana, N.E.A.C. (1979); artist in oil;. *b:* Capel, Surrey, 7 Oct 1941. *m:* Richard Martineau. *Educ:* Benenden School, Cranbrook, Kent. *Studied:* Byam Shaw (1959-63, Charles Mahoney). *Exhib:* R.A., R.P., R.B.A., N.E.A.C. *Signs work:* "D.C." *Address:* The Lawn, Walsham-le-Willows, Bury St. Edmunds, Suffolk IP31 3AW.

CALVOCORESSI, Richard, BA, MA; Director (since 2007) Henry Moore Foundation; Director, Scottish National Gallery of Modern Art, Edinburgh (1987-2007); research asst., Scottish National Gallery of Modern Art (1977-79); research asst., Modern Collection, Tate Gallery (1979-82), asst. keeper (1982-87); member, British Council's Visual Arts Advisory Committee (since 1991), chair (since 1999). *b:* 1951. *m:* Francesca Temple Roberts. one *s.* two *d. Educ:* Magdalen College, Oxford; Courtauld Inst. of Art, University of London. *Publications:* author, Magritte (1979, 1984, 1990, 1994, 1998, 2000), Lee Miller: Portraits from a Life (2002); exhbn. catalogues: Tinguely (1982), Reg Butler (1983), Cross Currents in Swiss Art (1985), Oskar Kokoschka 1886-1980 (1986), Early Works: Lucian Freud (1997), Le Miller Portraits (2005) and catalogue essays on Miró, Klee, Penck, Baselitz, Lüpertz, von Motesiczky, Gormley, Picabia, Gabrielle Keiller Collection etc.; various articles and reviews; co-curator, 'Vienna 1908-1918', 'Century City', Tate Modern, (January-April 2001). *Clubs:* Fellow of Royal Society of Arts (2000). *Address:* Henry Moore Foundation, Dane Tree House, Perry Green, Much Hadham, Herts, SG10 6EE.

CAMBRON, Ghislaine, Officier de l'Ordre de Léopold II (1990); artist, painter, ceramist; Directrice de L'Académie des Beaux-Arts de Molenbeek Saint-Jean (Brussels); Academie de Molenbeek, Brussels; Grand Prix de Belgique (1954), Grand Prix de Decoration (1955), Grand Prix de Belgique (1956), Prix de l'État Belge (1942), Distinction-Prix Europe Peinture (1962);. *b:* St. Amand-les-Eaux, 6 July, 1923 (France). *m:* Mariee. *Studied:* Académie de Bruxelles. *Works in collections:* Musée Art Moderne, Brussels, Centre Culturel, Uccle, Musée de Molenbeek, Timbres-Poste du Congo (Serie Masques). *Signs work:* "Cambron, Ghislaine." *Address:* Dréve Angevine, Domaine de la Motte, Bousval 1470, Brabant, Belgique.

CAMERON, Ronald, N.D.D. (1951); sculptor in bronze, terracotta, pewter and silver;. *b:* London, 8 Oct 1930. *m:* Dorothy. two *d. Educ:* Wilson's Grammar School. *Studied:* Camberwell School of Art (1947-51). *Exhib:* bronzes at Bruton Street Gallery, Mayfair, London; also galleries in Europe and N. America. *Signs work:* "R. Cameron." *Address:* 9 Morecambe St., London SE17 1DX.

CAMERON, Zoe Rebecca, BA Hons Degree in Fine Art. *Medium:* sculptor/painter in acrylic, oils. *b:* Havant, UK, 29 Jan 1959. *Educ:* Cranford House School, Moulsford, Oxon. *Studied:* Maidenhead Coll. of Art (Foundation), Glos. Coll. Art and Design 1977-80. *Represented by:* Goldfish Contemporary Fine Art, Penzance; Avalon Gallery, Marazion; Square Gallery, St.Mawes. *Exhib:* Newlyn Orion, Penzance; Spacer Gallery, Exeter; Tate Gallery, St.Ives; Cadogan Gallery, London; David Messum Gallery, London; Saltrum House, Plymouth. *Works in collections:* Longleat House, Warminster; Dolphin House, Barbican, Plymouth. *Commissions:* Tate Gallery St.Ives- mug design; Lord Bath-portrait; PLM Estates-paintings for lobby luxury apartments; private portrait commissions. *Publications:* 'Living on the Line' - catalogue, ARTNSA - catalogue, Tregony Gallery - catalogue, Goldfish Contemporary Fine Art catalogues. *Principal Works:* series: Mrs. Morris's Companions, Truth and Lies, Finding and Losing, Fragile Lives. *Clubs:* associate mem. Newlyn Orion Gallery. *Misc:* studied in Italy 1993, '97, '98. Studio Italy Florence 1994, taught at Venice Academy 2000 (painting), studied Malta 1995-6. Influences: psychic and medium. *Signs work:* "Z Cameron". *Address:* Bluebell Cottage, St.Martins Green, St.Martins, Helston, TR12 6BW. *Email:* zoe@zoecameron *Website:* www.zoecameron.co.uk

CAMP, Ann, A.R.C.A. (1946), F.S.S.I.; freelance calligrapher and lettering designer; lecturer at Digby Stuart College, Roehampton Institute; retd. from teaching (1990);. *b:* London, 1924. *d of:* Leonie Camp and Instructor Capt. John Camp, R.N. *Studied:* Hampstead Garden Suburb Inst. and R.C.A. *Works in collections:* loan collections of V. & A., L.C.C. and National Museum of Wales; Book 4, R.A.F. Book of Remembrance in St. Clement Dane's Church; lettering on stamps, murals, etc. *Publications:* Pen Lettering (first published 1958 by Dryad Press; republished by A. & C. Black, 1984). *Clubs:* Soc. of Scribes and Illuminators. *Signs work:* "Ann Camp." *Address:* 115 Bridge La., London NW11 9JT.

CAMP, Jeffery, R.A. (1984); artist; lecturer, Slade School. *Educ:* Edinburgh College of Art, D.A. (Edin.). *Exhib:* one-man, Galerie de Seine (1958), Beaux Arts Gallery (1959, 1961, 1963), New Art Centre (1968), Serpentine Gallery (1973), S. London A.G. (retrospective, 1973), Bradford City A.G. (1979), Browse and Darby (1984, 1993), Nigel Greenwood Gallery (1986, 1990); retrospective, Royal Albert Memorial Museum, Exeter, Royal Academy of Arts, London, Manchester City A.G., Laing A.G., Newcastle (1988-89); group shows: Hayward Annuals (1974, 1982, 1985), British Council Touring Exhbns. to China and Edinburgh (1982) and to India (1985), Chantrey Bicentenary, Tate Gallery (1981), Narrative Painting I.C.A., London Arts Council Touring, The Hard Won Image Tate Gallery (1984); Twining Gallery, N.Y. (selected by William Feaver 1985), Peter Moores Liverpool Exhbn. (selected by William Feaver 1986); Athena Art Awards, Barbican Centre, London (1987), Land: Sea: Air, Herbert Read Gallery, Canterbury and tour (1987), 'The Self Portrait' Artsite Gallery, Bath and tour (1987). *Publications:* Draw (1981). *Address:* 27 Stirling Rd., London SW9 9EF.

CAMPBELL, Alex, professional artist in acrylic paint; Adviser N.A.P.A.;. *b:* Dukinfield, Ches., 5 Apr 1936. *m:* Anne. one *s.* one *d. Educ:* Hyde County Grammar School, Ches. Worldwide private collections and commissions. *Address:* Wern Mill, Nannerch, Mold, Flints. CH7 5RH. *Email:* huwpc@hotmail.com

CAMPBELL, Christopher, *Medium:* oil. *b:* Birmingham, 26 Sep 1975. *Studied:* Leeds Metropolitan University, UK. *Represented by:* Start Space, London. *Exhib:* Start Space, Catto Contemporary, Leeds, Metropolitan Gallery, Paton Gallery, New Academy Gallery. *Works in collections:* Lodeveans Collection. *Publications:* 'Epoch', Christopher Campbell ISBN 978-0-948413-1-7. *Signs work:* "CHRISTOPHER CAMPBELL". *Address:* c/o Start Space, 150 Columbia Road, London E2 7RG. *Email:* contact@st-art.biz *Website:* www.st-art.biz

CAMPBELL, Huw Phillip, B.A. Graphic Art and Design (1977); artist/graphic designer in acrylic paint;. *b:* Madagascar, 27 Feb 1955. *Studied:* Newport College of Art (1974-77). *Exhib:* U.K. and U.S.A. with N.A.P.A. including: Westminster Gallery, London, and the first International Open Long Beach Arts Gallery, Calif.; 'Vital Art 1993', Atlantis Gallery, London, 'Lyrical Orientations', Beatrice Royal Contemporary A.G., Eastleigh, British Work House Gallery, Dallas, Tex., Clifton Arts Club annual Open, Bristol, Cheltenham Group of Artists Summer Open, Society for Art of Imagination, NAPA 2002 The Mariners Gallery St. Ives, The Tobacco Factory Bristol. *Clubs:* N.A.P.A., Design and Artists Copyright Soc. *Signs work:* "H.P.C." *Address:* Flat 3, 3 Priory Street, Monmouth, Monmouthshire NP25 3BR. *Email:* huwpc@hotmail.com *Website:* www.zap-art.f2s.com

CAMPBELL, James Alexander, ARCA (1964); ceramist and draughtsman in ceramic, charcoal, pastel; Crafts Council index of selected makers. *b:* Cawdor, Scotland, 1942. five *d. Educ:* Eton (1955-60)(Gordon Baldwin). *Studied:* RCA (1960-64 David Queensberry). *Exhib:* Oxford Gallery, Aberystwyth Arts Centre, The Stour Gallery, West Wales Arts Centre, Amalgam, London, Brewery Arts, etc. *Works in collections:* National Gallery of Victoria, Australia, Manchester City A.G., Dundee A.G., Aberdeen A.G., National Library of Wales, National Museum and Gallery of Wales. *Commissions:* Tokoname Inst. of Ceramic Art, Japan; illustrations for 'Cofio' ('Memory'), interactive CDR. *Publications:* Collector's History of English Pottery by Griselda Lewis, Painted Ceramics by Brenda Pegrum, The Potter's Dictionary of Shape and Form by Neal French. *Official Purchasers:* The National Trust. *Recreations:* music. *Signs work:* 'James Campbell' or 'Campbell'. *Address:* Ashleigh House, Manorbier, Tenby, Pembrokeshire SA70 7TD.

CAMPBELL, Joan Betty, R.M.S. (1980), S.W.A. (1975), Retd. Hon.R.M.S. (1995), H.R.S.W.A. (1994); artist in water-colour, oil and acrylic; teacher of miniature painting, private tuition;. *b:* London, 4 May 1923. *d of:* Joseph

Longhurst. *m:* Archie Campbell. one *d. Educ:* Loughton County High School for Girls, Essex. *Studied:* Ilford Evening Institute (mostly self-taught). *Exhib:* Westminster Galleries, Llewellyn Alexander Gallery, M.A.S.-F. (Florida), Paris Salon (1973, 1974), Bilan l'Art Contemporain of Paris (1978). *Commissions:* Franklin Mint 'Birds of the World' Miniature Porcelain Plates (1983) RSA. *Publications:* Art Editor, Hillingdon Writer. *Clubs:* Member U3A. *Signs work:* miniatures "J.B.C." or "JC" entwined; larger works "Joan Campbell." *Address:* 21, Cole Court, Reservoir Road, Kettering, Northants. NN16 9QN.

CAMPBELL, Lee, B.A. (Hons) Fine Art (1991), M.A. History and Theory of Art (1993); professional artist and lecturer, painter in oil, drawings in charcoal; first Artist-in-Residence, King's School, Canterbury (1994-95), Artist-in-Residence, St. Saviour's Church, Pimlico; Winner of Worshipful Co. of Painters Stainers Award (1993). *b:* New Zealand, 25 Feb 1951. *Studied:* Chelsea School of Art, Canterbury College of Art, University of Kent. *Exhib:* Solo show: Fairfax Gallery, Tunbridge Wells (1997); Albemarle Gallery, London (1997 gallery artist). *Works in collections:* U.S.A., Scandinavia, Australia. *Commissions:* mural: Space Science Dept., University of Kent. *Clubs:* F.P.S. (Hon. Sec.). *Signs work:* "Lee Campbell." *Address:* 212 Hood House, Dolphin Square, London SW1V 3NQ.

CAMPBELL, Raymond, self taught artist in oil and acrylic, known for still life subjects;. *b:* Morden, Surrey, 2 Apr 1956. *Educ:* Garth High, Morden. *Exhib:* R.A., etc. *Works in collections:* England, Germany, Austria, Australia. *Works Reproduced:* limited edn. prints. *Signs work:* "Raymond Campbell." *Address:* 63 Courtnay Rd., Woking, Surrey GU21 5HG.

CANNING, Neil, A.R.B.A. (1983); Paris Salon (1994) bronze medal; artist in mixed media and oils, screen printing. *b:* Enstone, Oxon., 28 Apr 1960. *s of:* Gerald Canning. *Educ:* Spendlove School, Charlbury, and Chipping Norton School. *Studied:* privately with Betty Bowman (1978-81). *Exhib:* numerous including: R.A. Summer Show (1981, 1983, 1984, 2000), N.P.G. (1987), Europart Geneva, London Contemporary Art Fair (1992-01), 20th Century Art Fair (1994-2000). *Works in collections:* H.M. Customs and Excise, Rolls Royce, Eagle Star, Smithkline Beecham, University of Wales, NatWest Bank, London Insurance Investment Trust, I.C.I., Paintings in Hospitals, Unilever. *Publications:* illustrated Skylighters (Methuen). *Clubs:* Oxford Art Soc. *Signs work:* "CANNING." *Address:* 'Restormel', 4 Pednolver Terrace, St.Ives, Cornwall TR26 2EL.

CANTER, Jean Mary, SGFA(1977); painter in gouache, water-colour, pencil and scraperboard; lecturer; tutor, Mid-Surrey Adult Educ (1972-2006).; past President S.G.F.A.; elected signature member UK Coloured Pencil Society (2005). *b:* Epsom, 18 Mar 1943. *d of:* Henry Canter (Major). *Educ:* Convent of the Sacred Heart, Epsom. *Studied:* Epsom School of Art (1956-61); Wimbledon School of Art (1961-63). *Exhib:* S.G.F.A., R.W.S., R.I., R.M.S., Llewelyn Alexander; Medici Gallery etc., S.G.F.A. Prizes: Frisk (1983, 1985); Rexel

(1984); Daler-Rowney (1990); Liquitex (1993, 1997); Winsor and Newton (1996); Acco-Rexel (1996); SGFA Theme (2006); UK CPS Faber-Castell 2006. *Works in collections:* Museum Collection, Ewell. *Works Reproduced:* Demonstrations for many art books (Quarto, and Eaglemoss); articles for "Artist's and Illustrator's" and "Painting World" magazines; greeting cards etc. *Clubs:* U.K.C.P.S., SGFA. *Signs work:* "JEAN CANTER." *Address:* 7 Cox Lane, Ewell, Epsom, Surrey KT19 9LR.

CAPRARA, Julia Rosemary, NDD, ATC Lond. (1961), MSDC, Hon. Exhibiting mem. 62 Group (1970); designer in embroidery, textile artist; co-principal, Opus School of Textile Arts. *b:* London, 27 Feb 1939. *d of:* John I. L. Jenkins. *m:* Alex. Caprara. one *s. Educ:* Perse School for Girls, Cambridge; Henrietta Barnett School, Hampstead. *Studied:* Hornsey College of Art (1955-61). *Exhib:* one-man show of Embroidery at Commonwealth Institute A.G.; 62 Group shows: Guildford House, National Museum of Wales, Congress House, Foyle's A.G., Australia, U.S.A., Japan. *Works in collections:* National Museum of Wales, Cardiff; Holocaust Museum, Israel; private collections. *Commissions:* Wall panel, City Technology College, Bradford, Braintree Art Collections; private commissions. *Publications:* The Magic of Embroidery (B.T. Batsford). *Signs work:* "Julia Caprara." *Address:* 20 Crown St., Harrow-on-the-Hill, Middx. HA2 0HR.

CARDEW, Sidney, R.S.M.A.; senior design engineer, Ford M.C. (retd.); self taught marine artist in water-colour and oil;. *b:* London, 1931. *m:* Eunice. one *s.* one *d. Educ:* S.E. Essex Technical College. *Exhib:* R.S.M.A., R.W.S., London galleries. Work in collections internationally. *Commissions:* Large marine water-colour for London offices. *Publications:* article on Wapping Group, Calendar 1992, Articles in Wapping Group of Artists, Watercolour Skies & Clouds Techniques, RSMA Book, Celebration of Marine Art. *Clubs:* Wapping Group, London Sketch, Essex Art, Chelsea Arts. *Signs work:* "Sidney Cardew." *Address:* 31 Tudor Ave., Gidea Park, Essex RM2 5LB.

CARDNELL, Delia, R.I. (2000); Awarded the Stokes-Roberts Bursary by the Worshipful Company of Painter Stainers (1995); R.I. Winsor & Newton Young Artist, 1st prize winner (1999); National Young Artist winner of the Laing Art Competition (1999); R.I. Frank Herring Award for Still Life(2000), voted onto the council of the Royal Institute of Painters in Water-colours, 2001; painter in water-colour. *b:* London, 14 Oct 1974. *Educ:* Francis Holland School (Clarence Gate), (1986-91); South Hampstead High School, (1991-93). *Exhib:* R.P., N.E.A.C., R.B.A., Laing Art Competition, Singer & Friedlander/ Sunday Times Watercolour Competition, S.W.A.; South West Academy of Fine and Applied Arts, Royal Water-colour Society, Royal Society of Portrait Painters and their 2001 exhibition of selected paintings held at the National Portrait Gallery (other galleries: Marine House at Beer; Linda Blackstone, Pinner; Shell House, Ledbury). *Signs work:* "Delia Cardnell." *Address:* 26 Ockendon Rd., Islington, London N1 3NP.

CAREY, Annabel, BA Hons, PGCE. *Medium:* acrylic, oil, watercolour, batik. *b:* 8 Mar 1953. *d of:* Pam and Eric Luke. *m:* David W.Birch (artist). two *s.* one *d. Studied:* Durham University, Nottingham University (1971-75). *Represented by:* Christine Talbot-Cooper -International Artists. *Exhib:* RWA; RWS; solo exhbns: Michael Tippett Centre, Bath; Goldsmiths College, London; Gloucester City Museum and Art Gallery; solo touring exhbns: 'Spirit of Stones', Marischal Museum, Aberdeen; Lotherton Hall, Leeds; Hereford Art Gallery; and Royal Cornwall Museum and Art Gallery, Truro (2003-06). *Works in collections:* Gloucester City Museum and Art Gallery. *Signs work:* 'A.Carey' or 'A' within larger 'C'. *Address:* Croftsbrook, Blind Lane, Chipping Campden, Glos GL55 6ED. *Email:* talbotcooper@onetel.com

CARLETON, Elyn, R.A.A., R.A.S., F.F.P.S.; creative artist, teacher and founder, Creator's A.G. (1980), Innovators (1988); Council and Publicity Officer, Ridley Art Soc. (1987-89); Council Mem. and Executive Officer, N.C.A.C. (1993-97), F.S.C.C.A.G. (1993 N.S.W.); IBC Certificate of Distinction Creative Arts (2004). *b:* Palmyra, W.A. *d of:* Alexander A. Oders and Constance E. Wakeman. *m:* Laurence. one *s.* two *d. Educ:* Australia. *Studied:* Wesley Penberthy, Melbourne (1968-69); Victoria University, Wellington, N.Z. (Paul Olds, 1970-74); Dr. Desiderius Orban, O.B.E., Sydney (1975-79). *Exhib:* N.Z. Academy (1973), Victoria University (1973), (In Mind) Eight Wellington Artists, N.Z. Academy (1974), other galleries N.Z. and Australia; U.K.: Mall Galleries, R.O.I., H.A.C., C.P.S., R.A.S., U.A., F.P.S., C.W.A.C., N.C.A.C., Bloomsbury Intaglio Crafts (Creative Images 1987), Richmond Antiquary (Two Hemispheres 1988), Chertsey Hall (Australian Paintings 1988-89), Bourne Hall (1989-99), Queensland House London (1990), Loggia (1991), Edith Grove (1993), Boxfield Stevenage (1994). *Works in collections:* B.H.P. Sydney, N.C.R. Dayton, Ohio, Queensland House London, Stevenage Council; private collections U.K., Europe, U.S.A., Singapore, N.Z., Australia. *Commissions:* B.H.P Sydney, others private. *Publications:* Creative Images, Art Yesterday, Today and Tomorrow, Art Appreciation, Hanging Exhibition, Constructive Criticism, Abstract Art, Developed Unique Creative Art Teaching Method (1980). *Works Reproduced:* Sunshine Gallery, London. *Signs work:* "Elyn Carleton." *Address:* 120 Kangaroo Valley Road Berry NSW 2535 Australia. *Email:* lecarlet@bigpond.net.au

CARLTON, Cedric Charles, N.D.D., A.T.D., F.R.S.A., (1953), U.A., (1992); painter in oil, pastel, graphite; art teacher (1950-79);. *b:* London, 16, Jul 1920. *m:* Unity Mary. one *s.* four *d. Studied:* Hornsey (1937-39), Chelsea (1946-49), London University Inst. Educ. (1949-50). *Exhib:* Galleries: R.A., London Group, S. London, Westminster, U.A., Mall Galleries, Business Design Centre, Llewellyn Alexander, Army Museum, Chelsea Town Hall, Dyers and Painters Hall, Newport Quay I.O.W., Platform Kent; Sussex: Autumn Art Show, Neal Centre, Michelham Priory, Newtown, Sussex Artists, Gardener Centre, Brighton, Tunbridge Wells Museum Gallery, Stables Hastings, Hastings Museum A.G., Slides on View S.E.A. *Works in collections:* England, Canada, U.S.A. *Commissions:* portrait, sculpture, mural, design. All. *Signs work:* "C. Carlton."

Address: Flat 1 Highland Mansions, 117 Pevensey Rd., St. Leonards-on-Sea, E. Sussex TN38 0LZ.

CARLTON, Unity Mary, artist in oil, pastel and pencil. *b:* London, 24 Jun 1918. *m:* Cedric Charles Carlton. one *s.* four *d. Studied:* Hornsey School of Art. *Exhib:* Warfe Gallery I.O.W., Stables Theatre Hastings, annually: Autumn Art Show Sussex, U.A. Westminster Gallery, A.F.A.S., National Army Museum, Michelham Priory, Sussex, and Chelsea Art Soc., Chequermead.Sx., Mall Gallery. *Signs work:* "U. CARLTON" or "Unity Carlton." *Address:* Flat 1 Highland Mansions, 117 Pevensey Rd., St. Leonards-on-Sea, E. Sussex TN38 0LZ.

CARNEY, William Davies, BA Hons; Charles Pears Award for Best Painting in RSMA Exhbn (2003). *Medium:* oil, watercolour, drawing. *b:* Stockton-on-Tees, 18 Aug 1943. *s of:* Walter Carney. one *s. Studied:* Hornsey School of Art, London (1976). *Represented by:* RSMA. *Exhib:* RA, ROI, NEAC, RBA, NEAC, RSMA, private galleries, Royal Navy venues, Herts. Art Society, Llewelyn Alexander Gallery, The Cut (London), Waterloo SE1 8UN. *Works in collections:* private collections in UK, USA, Yugoslavia, Canada. *Publications:* International Artists (Painting Still Life and Florals). *Principal Works:* oil painting 'Old Harry's Rock' (Charles Pears Award). *Recreations:* travel, history. *Clubs:* RSMA. *Signs work:* 'W.Carney, ARSMA'. *Address:* 75 Baker Street, Potters Bar, Herts EN6 2EX. *Email:* wdcarney@yahoo.com

CARNIE, Andrew John, B.A. (1982), R.C.A. (1986); painter, sculptor, photographer and new media artist;. *b:* 8 Jan 1957. *s of:* Dr. and Mrs. J.M. Carnie. *m:* Judith Mary Wallas. two *s.* one *d. Educ:* Lakes School, Windermere. *Studied:* Goldsmiths' School of Art, London, Royal College of Art, London. *Represented by:* SCICULT. *Exhib:* many mixed person shows including 'Head On' Science Museum, London; International Film Festival, Rotterdam; 'Disperse', Amnesty International HQ, London; Whitechapel Open, Mostyn Open, John Moores; and one-person shows including Girray Gallery, London, Flowers Gallery, London, Winchester Gallery, Bracknell Gallery, Plymouth Art Centre, Tram Gallery, London, and Columbus Gallery, Georgia, U.S.A., Millais Gallery, Southampton. *Works in collections:* Unilever London, Chase Manhattan Bank London, Coopers and Lybrand London, Kaempher Corp., Washington, U.S.A., Prudential Collection, London. *Commissions:* D.C. Dance Company., Arts Humanities Board, Wellcome Trust. *Publications:* Andrew Carnie (Winchester Gallery). ISBN 1 873451 45 8. *Signs work:* "ANDREW CARNIE" or not at all. *Address:* 5 Powell Rd., London E5 8DJ. *Email:* andrewcarnie@tram.ndo.co.uk *Website:* www.andrewcarnie.co.uk

CARO, Sir Anthony, C.B.E. (1969), Kt (1987), O.M. (2000); Chevalier des Arts et Lettres (1996), 8 Hon Doctorates, 6 Hon Degrees, 8 Hon Fellowships, 4 Hon Memberships; Senior RA (2004), Presented the keys to New York City (1976); Nobutaka Shikanai Prize (1991), Praemium Imperiale (1992), Lifetime

Achievement Award (1997), Cristobal Gabarron Award (2004), Julio Gonzalez Award (2005);sculptor, part-time teacher of sculpture St. Martin's School of Art (1953-81), Trustee Tate Gallery (1982-89), co-founder of Triangle Workshop, New York (1982);. *Medium:* Steel, Bronze, stoneware, paper, wood, silver, lead. etc. *b:* London, 8 Mar 1924. *s of:* Alfred & Mary Caro. *m:* Sheila Girling. two *s*. *Educ:* Charterhouse School and Christ's College, Cambridge. *Studied:* Regent St. Polytechnic and R.A. Schools. *Exhib:* hundreds of one-man shows worldwide in galleries and museums, most recently Seoul Museum of Art (2004), Kunsthalle Würth (2004), Iveagh Bequest, Kentwood (2004), Tate Brotain (2005), IVAM Valencia (2005). *Works in collections:* represented in almost 200 public collections and hundreds of private collections throughout the world. *Commissions:* include National Gallery Ledge Piece, Washington (1978), Sea Music, Poole (1991), Chant des Montagnes, Grenoble (1994), Palma Steps, Mallorca (1999). *Publications:* Dieter Blume: Catalogue Raisonne Vol 1-14 (1981-2007), over 100 exhibition catalogues and monographs, most recently Ian Barker: Anthony Caro, Quest for new Sculpture (Lund Humphries, 2004). *Works Reproduced:* www.anthonycaro.org. *Clubs:* RAC. *Address:* Barford Sculptures 38c Georgiana St., London NW1 0EB. *Email:* sculpture@barfordsculptures.org *Website:* www.anthonycaro.org

CARPANINI, David Lawrence, Prof., P.R.E. (1995-2003), Dip.A.D., M.A. (R.C.A.), A.T.C., Hon. R.B.S.A., R.C.A., R.W.A., R.E., N.E.A.C., Hon R.W.S.; painter, printmaker; British Inst. Awards Committee Sch. Engraving (1969);. *b:* Abergwynfi, Glam., 1946. *s of:* Lorenzo Carpanini. *m:* Jane Allen. one *s*. *Educ:* Glan Afan Grammar School, Port Talbot. *Studied:* Gloucestershire College of Art (1964-68), Royal College of Art (1968-71), University of Reading (1971-72). *Exhib:* R.A., R.B.A., R.W.A., R.E., N.E.A.C., Bankside Gallery, New Academy Gallery, Agnews, Piccadilly Gallery, Attic, Albany, Mostyn, Fosse and Brandler Galleries, Welsh Arts Council, etc. *Works in collections:* National Library and National Museum of Wales, Contemporary Art Society for Wales, Newport A.G., Glynn Vivian A.G., Dept. Environment, R.W.A., N.C.B., A.S.T.M.S., Glam., Glos., Clwyd., Avon, Yorks. Educ. Authorities, and private collections in U.K., U.S.A., Canada, Europe, Australia, etc. Television Films: C4 (1984), H.T.V. (1987, 1997, 1998). *Publications:* regular contributor to art periodicals. *Signs work:* "David L. Carpanini." *Address:* Fernlea, 145 Rugby Rd., Milverton, Leamington Spa, Warwickshire CV32 6DJ.

CARPANINI, Jane, DipAD, ATC, RWA, RWS, RCA; artist in water-colour and pencil;. *b:* Luton, 1949. *d of:* Derrick Stanley Allen. *m:* David L. Carpanini. one *s*. *Educ:* Bedford High School. *Studied:* Luton College of Art (1967-68), Brighton Polytechnic (1968-71), University of Reading (1971-72). *Exhib:* R.A., R.W.A., R.B.A., R.W.S., Bankside Gallery, Attic, New Academy Gallery, Fosse and Brandler Galleries, Welsh Arts Council, Mostyn, Albany, etc. Winner of Hunting Group prize Watercolour of the Year (1983). *Works in collections:* National Library and National Museum of Wales, Burnley Building Soc., etc., and private collections in U.K., U.S.A., Europe. TV films, H.T.V. (1997).

Publications: regular contributor to art periodicals, reproductions; cards, prints, calendars, catalogues, etc. *Signs work:* "Jane Carpanini." *Address:* Fernlea, 145 Rugby Rd., Milverton, Leamington Spa, Warwickshire CV32 6DJ.

CARR, David James, BA Fine Art; Slade School Painting prize, Steer prize, Nettleship prize, David Murray Landscape Scholarship, Boise Scholarship U.C.L.; painter and printmaker. *b:* Middlesbrough, 15 Mar 1944. *m:* Marie Wylan. one(from first marriage) *d. Educ:* Sir William Turners Grammar School, Coatham, Yorkshire. *Studied:* Slade School (1962-66), John Aldridge, Auerbach, Coldstream, Uglow). *Represented by:* London-Rowley Gallery, Adam Butler Fine Art, The Walk SE1; San Francisco, Calif.- Thomas Reynolds. *Exhib:* R.A., London Group, Cleveland Biennale, Laing, Hunting Group, Singer & Friedlander. *Works in collections:* London Heritage, Royal Free, Wesleys Chapel, Ford Motors, U.C.L., local authorities; private collections: U.K., U.S.A., Japan. *Commissions:* Wesley Chapel, London (millennial); Ford Motors. *Publications:* Introduction to Painting the Nude (Quarto). *Works Reproduced:* London Group Year Book 2003, www.thomasreynolds.com. *Clubs:* London Group. *Signs work:* "DAVID CARR." or 'David J.Carr.'. *Address:* 22 Minton Mews, London NW6 1XX. *Email:* artdcuk@yahoo.co.uk *Website:* www.davidcarr.me.uk

CARRICK, Desmond, R.H.A.; artist in sculpture, oil, water-colour and tempera, lithography, stained glass and ceramics; secretary, Royal Hibernian Academy of Arts (1971-1982). *b:* Dublin, 18 Dec 1928. *s of:* Henry Carrick. *m:* Deirdre Mellett. *Educ:* Synge St. School. *Studied:* Dublin National College of Art. *Exhib:* R.H.A., Oireachtas, Waterford, Dublin Painters, Water-colour Soc. of Ireland, Living Art, Irish Contemporary Painters organized by the Cultural Relations Com. of Ireland, English and Canadian Contemporary Painters; one-man shows: Dublin (15) 1953-1992, England (1) 1989. *Works in collections:* National Self-portrait collection, National Water-colour collection. *Address:* Studio, Woodtown, Rathfarnham, Co. Dublin 16. Eire.

CARRINGTON-SMITH, Lynette, DipAD, SBA, SM, SLM (RHS); three Silver Medals & the Silver Lindley (for Special Scientific Interest) for 3 collections of botanical paintings at RHS. *Medium:* watercolour. *b:* Bath, 9 Oct 1946. one *s.* one *d. Studied:* West of England College of Art (textiles). *Exhib:* Royal Horticultural Society, Westminster Hall (SBA), USA, Spain and France. *Commissions:* since move to Spain in 1998 - commissions for Mayor of Principality of Tivissa, and large private collection of still lifes for restauranteur and private commissions. *Publications:* illustrations for 'Nature Trail' (Catalunyan publications). *Works Reproduced:* greetings cards; produced by various companies and County Councils. *Clubs:* SBA. *Misc:* currently working on large collection of paintings for future exhibitions, on commissions and completing the 'Far East' Collection also writing and illustrating a book. *Signs work:* "L.C.K." or "Lynette Carrington-Kerslake" or "L.C.S." *Address:* Mas de Montbaix Cami de les Planes Romandra 43746 Tivissa, Tarragona Spain.

CARROLL, Leo, Chartered Civil Engineer, Academician Royal Cambrian Academy(1980); Member National Society of Painters, Sculptors & Printmakers (1974); award Paris Salon (1974). *Medium:* painter in oils, acrylics, watercolour, pastel. *b:* St.Helens, 30 Dec 1932. *m:* Dorothea. two *d. Studied:* self-taught. *Exhib:* Royal Cambrian Academy, RA, Manchester Academy of Arts, Royal Society of British Artists; National Society of Painters, Sculptors and Printmakers; regularly over 25 years with Royal Institute of Oil Painters. One-man exhbns in London, North Wales, Cheshire, Lancashire, Shropshire. *Works in collections:* work on regular show in commercial galleries Lancashire, North Wales, Yorkshire. *Commissions:* Concrete Society, and numerous private collections. Portraits/landscapes. *Official Purchasers:* Liverpool University. *Misc:* paintings convey the visual image without the intrusion of detailed drawing, using a personal colour interpretation with closeness in tone values. Subjects range from human figure and it's environment to abstract considerations of human feelings and situations. *Signs work:* 'CARROLL'. *Address:* Romany, Plough Lane, Christleton, Chester, CH3 7PT. *Email:* leo@leocarroll.plus.net

CARRON, William John, W.C.S.I. (1977); A.R.H.A. (1996); acrylic marine and landscape painter; tutor. *b:* Dublin, 28 July 1930. *m:* Barbara Warren, R.H.A. one *d. Educ:* Bolton Street School of Education and Technology. *Studied:* N.C.A.D., Dublin. *Exhib:* R.H.A. and W.S.I.; one-man shows in Dublin. *Works in collections:* R.H.A. and W.S.I. collections; Nat. self-portrait (Limerick University); private collections in Ireland, U.K. and U.S.A. *Publications:* 'A Painter in the West', (poems and pen and ink drawings), 'In Roundstone Church Yard', (poems and pen and ink drawings). *Clubs:* Royal Dublin Society. *Signs work:* "W. CARRON." *Address:* "Matakana", Grey's Lane, Howth, Co. Dublin, Eire.

CARRUTHERS, Derek William, Prof., (Emeritus), B.A.; artist in various media, mainly oil painting;. *b:* Penrith, Cumbria, 1935. *s of:* William Edward Carruthers. *m:* Eileen. one *s.* one *d. Educ:* Royal Grammar School, Lancaster. *Studied:* Durham University, King's College (now Newcastle University) (Victor Pasmore, Richard Hamilton, Lawrence Gowing). *Exhib:* John Moores Liverpool, 'Structure' Bradford Arts Festival, Midland View, Open Drawing Show, Cheltenham, etc. *Works in collections:* Northern Arts, Leics. Educ. Authority, Bradford A.G., Abbot Hall Gallery Kendal, Leicester University, etc. *Commissions:* Relief for Attenborough Building, Leicester University. *Publications:* Artisan (1979), Haunting Monuments (1985), Recent Paintings (1985-88), Figuring Art (2004). *Signs work:* "CARRUTHERS" and "Derek Carruthers." *Address:* The School House, Harston, nr. Grantham NG32 1PS. *Email:* derek@carruthers2000.freeserve.co.uk

CARSWELL, Fiona Charis, B.A. Hons. (1983); artist in water-colour, mixed media and book binding;. *b:* Scotland, 10 Mar 1960. *m:* Richard Hackett. one *s.* two *d. Educ:* Rugby High School. *Studied:* Oxford Polytechnic (1980-83, Ivor Robinson). *Exhib:* various exhbns. showing book work and paintings in London,

Brussels, Oxford and U.S.A. *Signs work:* "Fiona Charis Carswell" or "F.C.C." *Address:* Windrush Cottage, Fulbrook, Oxon. OX18 4BL.

CARTER, Albert Henry, B.Ed. Hons(1977); PVPRBA (twice); artist in water-colour, acrylic, etc.; former Director of Art, Oundle School. *b:* Trowbridge, Wilts., 22 Feb 1928. *s of:* Edward Guy Carter. *m:* Eunice Enfield. one *s.* three *d. Educ:* Trowbridge Boys' High School. *Studied:* St. Paul's College, Cheltenham (1973-77, Harold W. Sayer, ARCA). *Exhib:* RBA, RWS, RWA, and provincial galleries. *Works in collections:* American Embassy, and many private collections in UK, Canada, USA, Russia, Germany, Hong Kong, Australia, France, Argentina and New Zealand. *Commissions:* portraits -Oundle School. *Signs work:* "A. H. Carter." *Address:* Haydn Studio, 27 South Rd., Oundle, nr. Peterborough PE8 4BU.

CARTER, Alexander Peter, BA (1986), MA (1989); painter in oil and watercolour. *b:* Epsom, Surrey, 12 Sep 1951. *m:* Sorrel Scott-Carter. two *s. Educ:* Wellington College, Berks. *Studied:* art Camberwell (1983-86), Royal Academy (1986-89). *Exhib:* Highgate (1995), Plough Terrington (2000). *Clubs:* RASAA. *Address:* 26 Station Rd, Okehampton, Devon EX20 1EA.

CARTER, Bernard Thomas, Hon.R.E. (1975), N.D.D. (1950), A.T.D. (1951); artist in oil; former keeper in charge of Pictures and Conservation, National Maritime Museum, Greenwich (retd. 1977);. *b:* London, 6 Apr 1920. *m:* Eugenie Alexander, artist (decd.). one *s. Educ:* Haberdasher Aske's. *Studied:* Goldsmiths' College of Art. *Exhib:* one-man shows, Arthur Jeffress (1955), Portal Gallery (twelve); mixed, R.A., Arts Council, British Council, galleries in Europe and U.S.A. *Commissions:* numerous. *Publications:* Art for Young People (with Eugenie Alexander). Work shown on television (BBC and ITV). *Signs work:* "Carter." *Address:* Robin Hood Cottage, 1 Egmere Road, Lt. Walsingham, Norfolk, NR22 6BT.

CARTER, Beth Arabella, BA (Hons)Fine Art; award: 1st prize Northern Graduates Show (1995) Royal College of Art; Cyprus College of Art, Paphos. *Medium:* sculpture, bronze and fabric. *b:* Derbyshire, 25 Oct 1968. *d of:* Roy Carter. *Studied:* Sunderland University UK (1992-95), Bath College Further Education (1990-91), Academy Fine Arts Bulgaria (1991-92). *Represented by:* Badcocks Gallery, Newlyn, Cornwall. *Exhib:* Plus One Plus Two Galleries London, No6 Chapel Row Bath, Badcocks Gallery, Royal West of England Open Exhbn, Royal College of Art 'Northern Graduate Show' (1995) London, Willsart Warehouse, London. *Works in collections:* private collections UK, Cyprus, Bulgaria, Monte Carlo, Los Angeles (Keanu Reeves). *Commissions:* lifesize bronze, private commission (2002), numerous private; site specific installation 'Beauty and the Beast' Show (2006), National Trust, Stourhead, Wiltshire. *Publications:* DeCode Magazine, Guardian newspaper (2003). *Principal Works:* Minotaur Reading. *Signs work:* 'BC'. *Address:* 38 Chatsworth Rd, Bristol, BS4 3EY. *Email:* bethcarter@tantraweb.co.uk *Website:* www.bethcarter.co.uk

CARTER, Derek Ronald, SGFA, painter in black and white media, watercolour, pastel, acrylic and oil; cityscape artist. *b:* London, 1930. *m:* June. two *s.* one *d. Educ:* Clarks College, London. *Studied:* with Brian Gallagher PS (1990-1993), Slade Summer School (1991-1993) under Jo Volley. *Exhib:* ROI, Pastel Society, Society Graphic Fine Art, and various in South East England. *Works in collections:* private collections in UK and USA. *Signs work:* "CARTER." *Address:* 5 Park Lawn Rd., Weybridge, Surrey KT13 9EU.

CARTER, Joan Patricia, RMS(1986), SWA (1985); Gold medallist Paris Salon (1974), finalist Hunting Group prizes (1980), Hon. men. Gold Bowl RMS; freelance portrait painter, book illuminator, illustrator and calligrapher in water-colour, pastel, acrylic and silverpoint; writer;. *b:* Vancouver, B.C., Canada, 11 Mar 1923. *d of:* Major G.F.B. Willcox, R.A. (India), soldier and artist. *m:* Alan Henry Carter. two *s. Educ:* Lord Selkerk School, Vancouver, Canada;. *Studied:* CFE, Longbridge Rd., Ilford; Havering CFE, Hornchurch (A' level Art and Art History). *Exhib:* Schweinfurt, Germany, Paris Salon, R.A., numerous one-man shows etc., MAS-F. *Works in collections:* miniature portrait (1.5" x1") of Mrs. S. Lucas on gold bowl, RMS (1985). *Publications:* Uncle Bill and Aunt Ethel, Allergy Cooking (Ian Henry Pub.), Solo Cooking on a Shoe String (Ian Henry Pub.), Illuminated Calligraphy (Search Press), Illuminated Alphabet (Search Press), Illuminated Design (Search Press), Silverpoint (Search Press), numerous Remembrance books - thirteen in England, one Normandy, France, one Tristan da Cunha, various talks and broadcasts, and articles; art work for book cover (Fowler Wright). *Signs work:* art books: "Patricia Carter"; other books: "J.P. Carter". *Address:* 4 Osprey Close, Hoveton, Norwich, Norfolk NR12 8DR.

CARTER, Kenneth, NDD (Sculpture), ATD (1955), FRBS (1970), RWA (1995), Hon.D.Arts (Plymouth) 1997; sculptor in bronze and synthetic resins. *b:* Hull, 16 Jun 1928. *s of:* Walter Carter. two *s.* two *d. Educ:* Kingston High School, Hull. *Studied:* Hull and Leicester Colleges of Art (1944-46, 1948-50, 1954-55). *Exhib:* RA Summer Exhbn.; Woodstock Gallery, London; various mixed exhbns. London and provinces. *Works in collections:* Exeter Cathedral Chapter House: 15 life-size niches; Ferens A.G., Hull. *Publications:* 'Open Air Sculpture in Britain' by W.J. Strachan (1984); 'Images of Alban', by Eileen Roberts (1999). *Official Purchasers:* Hull Corporation; Dean & Chapter, Exeter Cathedral. *Recreations:* walking, reading. *Signs work:* "K. Carter." *Address:* Figgins Gallery, Church Rd., Lympstone, Devon EX8 5JT.

CARTER, Mary, *Medium:* Contemporary figurative artist working in oil, casein, and sometimes egg tempera, as well as linoleum block prints. *b:* Hartsdale, NY, 12 Apr 1931. *m:* Peter Gould, decd. one *s. Studied:* Art Students League of N.Y. with Reginald Marsh, Robert Beverly Hale and others. *Exhib:* group and solo shows at the Hudson Guild, Audubon Artists, National Academy of Design, Hartford Athaneum, Springfield Art Mus., Ball State U., Del Mar College, Women in the Arts at Borough President's Office, Lafayette Grill, Venezuelan Center. *Publications:* Art News (1955); Women in the Arts

(2005). *Works Reproduced:* Women in the Arts Newsletter (2005). *Recreations:* Lifetime member Art Students League of NY; member Women in The Arts Foundation. *Address:* 253 W. 16 St. New York, N.Y. 10011. USA. *Email:* mary.carter4@att.net

CARTER, Mary Elizabeth, MA, ARCA; painter in oil of miniatures, portraits, rural and domestic scenes; Princess of Wales Scholarship. *Medium:* Oil. *b:* London, 1947. *d of:* H.E. Carter. *m:* J. B. Hiscock, painter. two *s.* one *d. Educ:* Ursuline Convent, Wimbledon. *Studied:* Kingston School of Art, Royal College of Art (Carel Weight, Roger de Grey). *Exhib:* Zaydler Gallery, R.W.A., Llewellyn Alexander Gallery, Richard Hagen Gallery, Miniaturist for New Grafton Gallery, R.A. Summer Exhbn. since 1968, Hestercombe House. *Works in collections:* Southend-on-Sea Library, R.A., Camden Council. *Publications:* The Dog Who Knew Too Much. *Signs work:* "Mary E. Carter." *Address:* 2 Hodges Cottages, Hemyock, Cullompton, Devon EX15 3RW. *Email:* mary@marycarter.co.uk *Website:* www.marycarter.co.uk

CARTER, Rita Violet, (nee DUNNING); NDD (1964), ATD (1965), Cert. RAS (1968); previously art lecturer West Sussex Colleges, presently painter, poet, illustrator. *Medium:* painter in watercolour, acrylics, oil; Illustrations pen and ink. *b:* London, 3 Jun 1944. *m:* Derek. two *s.* three *d. Educ:* Ifield Grammar School. *Studied:* West Sussex College of Art & Crafts (1960-64), London University (1964-65), RA Schools (1965-68). *Exhib:* Surrey, Sussex, Midlands (Worcs. and Shropshire). *Works in collections:* America - EMI (Capital Records), various private in UK. *Commissions:* illustration, painting. *Publications:* anthologies- 'One for Jimmy', 'Along the Line', 'Trees at the World's Edge', 'Path to the Year's Height', 'Lodestones', 'A Brush With Words' Painting and Poetry book (2005). *Clubs:* Shropshire Border Poets, RASAA. *Misc:* involved with preparing poetry/painting exhbn. with Border Poets and RASAA/Reynolds Club at Martin's Gallery, Cheltenham, Glos, in Oct 2005. *Address:* 17 Bowling Green Close, Burford, Tenbury Wells, WR15 8RD. *Email:* atir_49@yahoo.co.uk

CARTER, Roy, *Medium:* sculpture. *b:* London, 11 Apr 1938. one *s.* two *d. Studied:* self-taught. *Exhib:* RA (2007), RWA (2006, 2007), Discerning Eye (2007). *Signs work:* "R.C." (with year). *Address:* The Chimneys, Dauntsey Lock, nr. Lyneham, Wiltshire, SN15 4HE. *Email:* roycarter10@btinternet.com

CARTWRIGHT, Richard Saint George, painter in pastel and oil. *b:* Epsom, Surrey, 30 Sep 1951. *Studied:* self taught. *Exhib:* solo shows every two years at John Martin, London and Adam Gallery, Bath. *Works in collections:* private collections. *Signs work:* "Richard Cartwright." *Address:* 9 Woolcot St., Redland, Bristol BS6 6QH. *Email:* rsgcartwright@hotmail.com

CARUANA, Gabriel, M.Q.R.; Awards: Medal of Merit, Republic of Malta (2000), Accademico di Merito, Acc. P. Vannucci, Perugia, Italy, Fulbright Scholar USA (2001), name in Path of Artists, Yorkshire Sculpture Park (2003); sculptor, painter, ceramist;. *b:* Malta, 7 Apr 1929. *s of:* Anthony. *m:* 1980 Mary Rose

Buttigieg. two *d. Exhib:* one-man shows: Malta, England, Italy, Switzerland, Germany, Holland, Brussels; participated in International Exhbn. of Ceramic Art (Faenza), Lincoln Centers, New York, World Bank, Washington D.C. U.S.A., Foresteria, Venice Bn. (1995), Commonwealth Institute London. *Works in collections:* Museum of Fine Arts, Valletta, Malta; Whitworth A.G., Manchester; City of Manchester A.G.; Museum of Ceramics, Faenza, Italy; Albert Einstein (1879-1955) International Academy Foundation, Delaware, U.S.A., Malta University Campus, Museum of Ceramics, Faenza, Deruta, and Cervara di Roma, Italy, Glasmalerei Peters, Paderborn; also several private collections. Artist of the Year, Malta (1985-86); 1988, town of Faenza hosts one-man show to honour 25 Years of Artistic Activity within the City. Founder and Hon. Director, Modern Art, Culture and Crafts Centre, The Old Mill, B'kara, Malta. Artist for Porta del Terzo Milleniua, Cervara di Roma, Open Air Modern Art Museum; 1999 Medal for Cultural Activities re modern art, by the Malta Government; elected Accademico di Merito at Accademia Pietro Vannucci, Perugia Italy. *Commissions:* Porta del Terzo Millenio, Cervara di Roma; Monument to Arvid Pardo, Univ. of Malta; hard stone sculpture in monument at Kalsersteinbruch, Austria (2003); bronze relief for Office of CIHEAM Paris (2003); high relief ceramic sculpture, for Power Station, Malta (1994). *Publications:* 'Gabriel Caruana Ceramics' by Richard England, photography Bonne Ten Kate (2002); 'Gabriel Caruana, A Bank of Valletta Exhibition' by Richard England, photography Peter Bartold Parnis (2001); 'The Other Side of Gabriel Caruana: photography Benne Ten Kate, essay by Victor Debattista (2005). *Principal Works:* Faenza, Italy, honours 25 years of artistic activity in the city with one-man show (1998). *Misc:* Artistically active since 1953. Studio: 37, Balzan Valley, Balzan, Malta. Founder Hon. Director Modern Art Culture and Crafts Centre, The Old Mill, B'Kara, Malta. *Signs work:* "Gabriel Caruana." *Address:* 37 Balzan Valley, Balzan, Malta BZN 0S. *Website:* http://www.zorin.com/gabriel/

CARVER, Margaret, R.M.S. (1995), S.W.A. (1997); artist in oil, pastel, water-colour, pencil; Chairperson, Gt.Yarmouth Soc. of Artists for 20 years;. *b:* Caister-on-Sea, 10 Sep 1941. *m:* Richard Carver. two *s. Educ:* Caister High School; Gt. Yarmouth C.F.E. *Studied:* evening classes and part-time courses. *Exhib:* Westminster Galleries with S.W.A. and R.M.S., Norwich, Gt. Yarmouth. World Exhibitions of Miniature Art in London, Tasmania and Washington D.C. *Works in collections:* Gt. Yarmouth and District. *Signs work:* "M. CARVER." *Address:* 3 Orchard Cl., Caister-on-Sea, Gt. Yarmouth, Norfolk NR30 5DS.

CARY, Caroline Anne, F.P.S.; Palet Prize for Mixed Media; Purchase Prize Painting Royal London Hospital. *Medium:* painter in acrylic and mixed media. *b:* 28 Jul 1940. *m:* Lucius Cary (divorced). one *s.* three (one decd.) *d. Educ:* Convent of the Sacred Heart, Woldingham. *Studied:* Camberwell and Chelsea Colleges of Art under Lawrence Gowing. *Represented by:* Claudia Wolfers, New Grafton Gallery. *Exhib:* mixed shows: Clarges Gallery, Jonathon Poole, Clark Fine Art, Gallery Zol, Bruton St. Gallery, Austin Desmond Fine Art, William Desmond Fine Art, Devon, etc.; solo exhibitions: London: Loggia Gallery, New Grafton

Gallery, Langton Gallery, Lord Leighton's Studio, Leighton House, Sue Rankin Gallery; Watatu Gallery, Nairobi, Century Gallery Henley, Galerie Souham, Paris, Z Gallery, N.Y., The Millinery Works, London; The Royal London Hospital - Sam Pease; Corporate Connoisseurs. *Works in collections:* private collections: R. Agnew, J. Agnew, K. Shapland, M. Fisher; public collections: The Royal London Hospital, Whitechapel, London. *Official Purchasers:* The Royal London Hospital, Whitechapel. *Recreations:* films, reading, walking. *Clubs:* Chelsea Arts. *Signs work:* "C.A.C." *Address:* The Studio, 14 Gunter Grove, London SW10 0UJ. *Email:* caroline@carocary.co.uk

CASDAGLI, Daphne Catherine, RE (1999), MA (RCA); Print -technician (1972-73), then visiting lecturer at the Byam Shaw School of Art (1973-84); lecturer for Foundation,Printmaking & Illustrative Arts at the City & Guilds of London Art School (1973-1998). *Medium:* oils, watercolour, printmaking. *b:* Cairo, 11 Dec 1946. *d of:* Emmanuel Casdagli. *Educ:* in Cairo, Paris and England. *Studied:* Beaux Arts de Versailles(1964-1965), Guildford and Farnham Schools of Art(1965-69), RCA under Prof. Carel Weight and Sir Roger de Grey (Masters degree, 1969-1972). *Exhib:* The British Council, Athens (1977, 1982); RA Summer Exhibition, RWS Open, Bankside Gallery, Mall Galleries, London; Jonleigh Gallery, Guildford; Chichester Centre of Arts. *Works in collections:* UK, Europe, America, Venezuela. *Commissions:* Murals for Greek restaurant; St. Quinterie Press portfolio. *Publications:* illustrations for books on techniques. *Signs work:* "D. Casdagli." *Address:* Newark Farmhouse Chichester Rd., West Wittering, W.Sussex, PO20 8QA.

CASE, David Charles, M.A. (1966), Hon. R.E.; publisher;. *b:* 18 Oct 1943. *m:* Anthea. two *d. Educ:* Oakham School, Oxford University. *Address:* The Old Rectory, Church Road, Brockdish, Norfolk IP21 4JJ. *Website:* www.davidcasefineart.com

CASSELDINE, Nigel, A.R.W.A. (1985), R.W.A. (1991), Brandler Painting prize (1988); artist/painter in oil on gesso/drawing; Council mem. R.W.A. (1990-93, 1996-98); Mem. A.O.I.;. *b:* Havering, Essex, 1947. *s of:* G.E. Casseldine and P.W.M. Lovesy. *m:* Jenny Partridge. one *s.* one *d. Educ:* N. Romford Comprehensive School. *Studied:* Camberwell and Sir John Cass Schools of Art (1966-68, part-time); studio assistant to F.V. Magrath (1969-72). *Exhib:* R.A., R.W.A., Bath Festival, Edinburgh Festival, Medici Gallery, Gloucester A.G. and Museum, Bruton Gallery, Penwith Galleries (St. Ives), etc. *Works in collections:* R.W.A., Cheltenham and Gloucester, Lord of Bath. *Publications:* 20th Century Painters and Sculptors by F. Spalding; Light by L. Willis. *Signs work:* "CASSELDINE" in red. *Address:* Romany Studio, Woodbridge Rd., Tunstall Woodbridge Suffolk IP12 2JE.

CASSON, Simon John, A.R.E. (1992), R.A.S.(M.A.) (1994), Central Printmaking Dip. (1990), B.A.(Hons.) Fine Art (1988); painter in oil, printmaker in etching;. *b:* York, 17 May, 1965. *Educ:* Rose Avenue School, Zambia,

Cumbria, Penistone Grammar School, Sheffield. *Studied:* Barnsley College of Art (1985), Exeter College of Art and Design (1985-87), Central St. Martin's (1988-90, Norman Ackroyd), Royal Academy of Arts (1991-94, Prof. Norman Adams). *Exhib:* Regular solo shows at Long & Ryle Gallery, London. *Works in collections:* Private collections home and abroad. *Address:* 87a Albion Rd., Stoke Newington, London N16 9PL.

CASTLE, James Munro, BA Hons (Sculpture); ARBS; 1971 Hampshire Scholarship for Fine Art; travelled to Turkey and Greece. *Medium:* sculptor: works in wood (often painted), also works in bronze, plaster etc. Exhibits drawings with sculpture. *b:* Aberdeen, 14 Dec 1946. *s of:* Johann Davidson Gauld & James Munro Castle. *m:* Susan Harrison. one *s.* one *d. Studied:* Ealing School of Art (1967-68); Winchester School of Art (1968-71); Royal College of Art (Foundry Course, 1980). *Represented by:* Compass Gallery, Glasgow. *Exhib:* selected one-man shows: Artspace Galleries, Aberdeen (1983); Crawford Centre, St.Andrews University (1984); Open Eye Gallery, Edinburgh (1985, 1989); Compass Gallery, Glasgow (1993, 2006); Pier Art Centre, Stromness, Orkney (1993); Bohun Gallery, Henley-on-Thames (2003); group exhibitions throughout UK and Germany since 1984; curated major exhibition of 20th Century Sculpture in Gloucester Cathedral and Malmesbury Abbey. *Works in collections:* Scottish Arts Council, Aberdeen Art Gallery, Malmesbury School, Aberdeen Central Library; private collections in the UK, Switzerland, France, Germany and the USA. *Publications:* 'James Castle -Sculpture and Drawing 1992' (Peacock Printmakers, Aberdeen). *Works Reproduced:* in various exhibition catalogues, both solo and group. *Recreations:* cycling. *Misc:* Senior Lecturer in Sculpture at the University of Gloucestershire, appointed 1988. *Signs work:* 'James Castle'. *Address:* 'Newlands', Kings Walk, Malmesbury, Wilts. SN16 9DB. *Email:* castleharrison@aol.com *Website:* www.jamescastle.co.uk

CASTLE, Roger Bernard, U.A. (1988); landscape marine artist in oil; council mem. U.A.;. *b:* Dartford, 30 Apr 1945. *m:* Brenda. two *s.* one *d. Educ:* Dartford. *Studied:* under the late William Walden, R.B.A. *Exhib:* R.A., R.O.I., N.E.A.C., R.B.A., U.A.; gallery artist at Century Gallery Henley, Roger Freen Fine A.G. Kent, Blackheath Gallery, F. Illes, Rochester. *Works in collections:* K.C.C. Ashford. *Misc:* studio: Hales Pl., High Halden, Kent. *Signs work:* "R.B. CASTLE." *Address:* 38 Harvey Road, Willesborough. Ashford, Kent TN24 0AG.

CATCHPOLE, Heather O., R.M.S., H.S.F., M.A.S.S.A.; National Dip. in commercial and Applied Art (1962). *Medium:* portrait and dog artist in pastel; miniatures in watercolour on ivorine. *b:* Winnipeg, Canada, 26 Aug 1942. *d of:* Kenneth Siddons Osler, M.A. *m:* Brian E. Catchpole, L.D.S. *Educ:* Durban Girls' High School. *Studied:* Natal School of Arts and Craft, RSA. *Exhib:* R.M.S., R.A., Hilliard Soc. M.A.S.F., M.A.S.S.A. *Works in collections:* Hilliard Soc. Permanent Collection. *Publications:* author/illustrator 'Heidi, Holly and other dogs'. In various books on techniques of miniature painting. *Misc:* 2001-2004 President of Hilliard Society of Miniaturists. *Signs work:* "Heather O. Catchpole," miniatures:

the letter O with H inside with the year underneath it. *Address:* Heelers, Fitzhead, Taunton, Som. TA4 3JW. *Email:* heather.catchpole@ukonline.co.uk

CATTRELL, Annie Katherine, B.A.(Hons.) Fine Art (1984), M.A. Fine Art (1985); artist in glass, paper and mixed media; lecturer, Sculpture Dept., Cheltenham School of Art;. *b:* 15 Feb 1962. *Studied:* Glasgow School of Art (1980-84, Sam Ainsley), University of Ulster (1984-85, Alistair MacLennan). *Exhib:* Collins Gallery Strathclyde University (1989), 369 Gallery 'Artist's Choice' (1990), Artist in Residence, Chessel Gallery (1991), Paperworks, Seagate Gallery (1992). *Works in collections:* S.A.C., MacManus A.G. and Museum Dundee, City Art Centre Edinburgh. *Publications:* reviews, Edinburgh Medicine vol.65, Alba (1991) Mar./Apr., etc. *Clubs:* Collective Gallery, Edinburgh. *Signs work:* "Annie Cattrell." *Address:* 10a Greenhill Park, Churchill, Edinburgh EH10 4DW.

CAUDWELL, Celia, N.D.D. (1995), S.W.A. (1993), S.B.A. (1994), A.U.A. (1994); artist in water-colour, oil, pen and ink, pottery/ceramics; gallery owner, mem. F.A.T.G.;. *b:* Ewell, Surrey, 11 Jul 1943. *m:* John Caudwell. two *s. Educ:* Upper Chine School, Shanklin, I.O.W. *Studied:* Winchester School of Art (1961-64), Goldsmiths' College School of Art (1964-65). *Exhib:* Ryde Library/Gallery I.O.W., Boldrewood Gallery, Southampton University, Seely Gallery, Newport I.O.W., Westminster Gallery, Mall Galleries, Omell Gallery, Laing Art Competition Winchester. *Publications:* A Brief History of Winkle Street I.O.W. *Signs work:* "Celia Caudwell." *Address:* Brookside Cottage, Winkle St., Calbourne, I.O.W. PO30 4JF.

CAULKIN, Martin, RI(1983), RBSA (1983); Royal Birmingham Society of Artists, Certificate of Merit 1(979); Hunting Group Art Prizes, Finalist (1983); Award for Outstanding Watercolour, Paper Mill (2001). *Medium:* watercolour, tempera, some oil. *b:* B'ham, 12 Feb 1945. *s of:* Howard Caulkin Grandson of F.E.H. Caulkin, Hon. RBSA. *m:* Anne Cherry, S.W.A. one *d. Educ:* Great Barr Comprehensive, Sutton Art College (1958-1961). *Studied:* B'ham College of Art (1962-65, Glyn Griffiths). *Exhib:* R.W.S., R.B.S.A., R.I., R.A. Summer Show, Singer and Friedlander water-colour exhbn., Shell House Gallery, Ledbury, Ombersley Galleries, Worcs., Montpellier Gallery, Cheltenham, Manor House Gallery, Chipping Norton, Bill Toop Gallery, Salisbury, Barn End Gallery, Solihull., Linda Blackstone Gallery, Pinner, London, Rona Gallery, London. *Publications:* Landscape in Watercolours (Studio Vista); Paintings from Photographs (Harper Collins); Contemporary British water Colour Artists (Shandong Fine Arts Publishing House). *Official Purchasers:* 1) 1978-82: Brunot Productions; Prints (Americana, Fantasy, Landscape. 12 in all); 2) International Artist: Magazine for Artists Oct/Nov 2001. *Works Reproduced:* signed limited edition prints: Evening, Ploughed Field, Misty Morning, Clearing the Ground, The Lodge, Autumn Evening. *Principal Works:* Landscape, some figurative. *Recreations:* reading, gardening, films. *Signs work:* "Martin Caulkin." *Address:* September Cottage, Naunton, Upton upon Severn, Worcester WR8 0PY.

WHO'S WHO IN ART

CAVACIUTI, Peter, painter on handmade paper from China, Korea, Japan and Nepal using Chinese ink and traditional pigments and has developed methods of mixing colours from 17th c. Chinese recipes;. *b:* London, 13 May 1952. *Studied:* seven years with Prof. Fei Cheng Wu, continued with Prof. Bao at the Central Academy of Art, Beijing. *Exhib:* Urasenke Foundation, Kyoto, Japan; Salon de l'Aquarelle de Belgique, Belgium; R.A. Summer Show, London; R.W.S.; S.G.F.A.; The Discerning Eye, London; Kettles Yard, Cambridge; recent solo shows: Daiwa Foundation, London (1999) and Galerie Leda Fletcher, Geneva (2001). Demonstrations include Kettle's Yard and the Victoria and Albert Museum. *Works in collections:* Urasenke Foundation; Clare Hall College, Cambridge. *Publications:* illustrated: 'Taoist Wisdom' by T. Freke (Godsfield Press, 1999), 'The Japanese Tea Ceremony' (Element Books, Ltd.); included in 'Dictionary of Painters in Britain since 1945' (1998). *Works Reproduced:* Millennium calendar for IKEA Ltd.; posters and cards, Art Group Ltd.; calendar for W.H.Smith Ltd. (2002). *Clubs:* Far Eastern Painting Soc., Kaetsu Chado Soc. *Address:* 2 Oxford Rd., Cambridge CB4 3PW.

CAVANAGH, John Bryan, couturier (retd. Sept. 1974). *b:* Belmullet, 28 Sep 1914. *s of:* Cyril Cavanagh. *Educ:* St. Paul's School. *Exhib:* Munich, 1954 (Gold Medal); designed Wedding Dress for H.R.H. Duchess of Kent (June, 1961); designed Wedding Dress for H.R.H. Princess Alexandra (April, 1963). *Works in collections:* V. & A., Museum of Costume, Bath. *Misc:* Trained: with Molyneux and Balmain in Paris. *Signs work:* "JOHN CAVANAGH." *Address:* Nazareth House, Hammersmith Rd., London W6 8DB.

CAYLEY, Jeanette Ann, MSc MB BS (London) FFFP, mem. Inst. Psychosex. Med. *Medium:* pen and ink, watercolour, acrylic, oil. *b:* Plymouth, 4 Sep 1947. *m:* Charles Cayley. three *s. Educ:* Middlesex Hospital and University College, London. *Studied:* Plymouth College of Art. *Exhib:* Medical Art Society (1970-2003), Chelsea and Westminster Hospital Gallery (one-woman show) (2002). *Signs work:* 'J A Cayley'. *Address:* Oakleigh Cottage, The Green, Leafield, OX29 9NP.

CECIL, Roger, artist in oil and oil pastel; David Murray Award (1966);. *b:* Abertillery, 18 Jul 1942. *Studied:* Newport College of Art. *Exhib:* Howard Roberts Gallery, Cardiff (1966), R.A. Summer Exhbn. (1987, 1989); one-man shows, New Academy Gallery, London (1988, 1989, 1991, 1993, 1995-97), Cleveland Drawing Biennale (1989). *Publications:* B.B.C. documentary The Gentle Rebel. *Signs work:* "Roger Cecil." *Address:* c/o The New Academy Gallery, 34 Windmill St., London W1P 1HH.

CERCI, Sharon L., FMAS, ARMS (1983); scrimshander scribing on ivory with ink, lecturer; heraldic artist and designer. *b:* Providence, RI., USA, 4 Jul 1942. *d of:* Ida Mae Chadwick Keith. two *s.* one *d. Educ:* Brockton High School. *Studied:* B.H.P. Art School (1963). *Exhib:* I.F.M.A.S., R.M.S., International Circle of Miniature Artists, Spencer Gallery, Dunedin Fine Art Center.

Commissions: Coat-of-Arms design: USCG cutter, Durable (1991), Dunedin Highland Games (1994), Ocala Scottish Games and Irish Feis (1996), Ye Mystic Krewe of Neptune, St. Petersburg, Fla. (1991), Neptunus Rex XIII, XIV, XV, XVI, XVII and XV111 (1991-97), Coat-of-Arms design with Expository entitled: The Trinity Arms d.b.a. the King's Crest (1993). *Publications:* author of 'Penning Generation Around the World'. *Signs work:* S within a C, "S.Cerci," "Sharon Cerci," "Cerci." *Address:* 1358 N. Lotus Drive, Dunedin, Florida, U.S.A.

CHAFFIN, Roy, Professional wildlife artist in acrylic. *b:* Nottingham, 22 Jan 1948. *m:* Dinah Louise. one *s.* two *d. Recreations:* flight simulator computer programming. *Clubs:* President Watford and Bushey Art Society. *Misc:* Founder of the PAWS (Paint a Wildlife Subject) Competition. Nominated as 'Creative Briton' (1999). *Signs work:* "Roy Chaffin". *Address:* Blackwood, 10 Nascot Wood Rd., Watford, Herts. WD17 4RS. *Website:* http://www.roychaffin.com

CHAITOW, Michael, BA Fine Art (Painting and Printmaking); Llewelyn-Smith Prize for Painting. *Medium:* oil, watercolour, drawing, prints. *b:* Herts., 3 Aug 1944. *s of:* Boris Chaitow. *Educ:* Lancing. *Studied:* Central St.Martins; Commonwealth Painting Scholarship, Baroda, India 1971-73. *Exhib:* British Art: New Directions, Puck Building New York (1982); Piccadilly Gallery, Cork Street, London (1987); First Cardiff Festival, St.David's Hall (1990); Merz Contemporary Art (1991); Art '97 London Contemporary Art Fair (1997). *Works in collections:* Dr.William Johnson (collector, Guernsey, 53 paintings). *Commissions:* St.John's Church, Hampstead Parish, London -memorial painting (2005). *Publications:* Arts Review (1979, 1984); Marxist Review (1991). *Official Purchasers:* cover:'Lifestream' by David Boadella (1987) (Routledge & Kegan Paul). *Works Reproduced:* 'Dawn I', 'Avenue of Trees', 'Cornfield-Ely'. *Signs work:* 'Michael Chaitow'. *Address:* 'Caersalem', Commercial Street, Abergwynfi SA13 3YH. *Email:* michaelchaitow@hotmail.com *Website:* www.michaelchaitow.com

CHALKER, Jack Bridger-, Hon.MA, ARCA, RWA, ASIA, Hon FMAA; painter in oils, illustrator, medical/surgical artist, illustrator in oil, gouache, pen and wash etc.; Consultant, Birmingham University (art and design); War artist with Australian Army, Bangkok (1945);. *b:* 10 Oct 1918. three *s.* one *d. Educ:* Alleyn's School, Dulwich. *Studied:* Goldsmiths' College (1936-39), RCA (1946-49). *Exhib:* RBA, RWA, RP, London galleries; mixed shows: London, Cheltenham; one-man shows: Dixon Gallery London, RWA, Australia, Japan (Peace Museum, Kyoto), Holland and Thailand. *Works in collections:* Cheltenham, Imperial War Museum London, Army Museum London,War Memorial Canberra, Australia, Holland, Japan and in many films UK, USA, Australia; Work in private collections, U.K. and Abroad. *Commissions:* Range of Portraits/ Landscapes. *Publications:* author and illustrator: Burma Railway Artist (Leo Cooper, 1944, and Viking O'Neil Australia); wide range of surgical/medical publications, UK, America and Australia. *Official Purchasers:* Army Museum, Imperial War Museum London, War Memorial Museum, Canberra, Australia.

Works Reproduced: In some 34 Books, Films etc. *Principal Works:* Millfield School, Army Museum London (Oil Paintings). *Recreations:* horse-riding, gliding. *Clubs:* Arts, Lansdowne. *Signs work:* "Jack Chalker." *Address:* Bleadney Mill, Bleadney, Wells, BA5 1PF. *Email:* chalker@ic24.net

CHALLINOR, Trevor, RWA (1992); Cheltenham Group (1964)-Hon.Sec.1980-85; NDD (Painting); Slade Dip FA UCL London; Leverhulme Research Award (1958/59); David Murray Award (1951); Cornelissen W/c Prize RWA (1987). *Medium:* watercolour, acrylic, oil. *b:* Edgebaston, B'ham, 17 Mar 1938. *s of:* Ralph Clifford & Jessie (Fryer). *m:* Patricia Christine (divorced). two *s.* one *d. Educ:* Moseley School of Art; Aston Tec. College, B'ham. *Studied:* Birmingham College of Art & Crafts (1954-58); Slade School UCL (1959-61). *Exhib:* RA Summer exhbns (1984/85/86/88); RWS (1984/85/86/90); RWA (1986-2002); Singer & Friedlander Watercolour exhbns (1986/88), many provincial galleries; group shows: Bristol, Cheltenham, Gloucester, Cardiff, France and Germany. *Works in collections:* various private and public collections in the UK and worldwide, including Cheltenham Museum Art Gallery, C&G Building Society Collection. *Works Reproduced:* RWS Watercolour catalogues; Annecy (France) catalogue. *Principal Works:* watercolour: interior/exterior, still life, landscape. *Recreations:* small boat sailing. *Signs work:* 'Challinor'. *Address:* 49b Ryeworth Road, Charlton Kings, Cheltenham, Glos. GL52 6LS.

CHAMBERLAIN, Trevor, R.O.I. (1972), R.S.M.A. (1970); Past President of the Wapping Group of Artists; Past President of Chelsea Art Society; Chris Beetles award, Winner at 1987 R.W.S. Exhbn. *Medium:* marine, town, figure and landscape painter in oil and water-colour. *b:* Hertford, 13 Dec 1933. *s of:* Frederick Joseph Chamberlain. *m:* Elaine Waterfield. one *s. Educ:* Ware Central School. *Exhib:* London and abroad, R.A. Summer Exhbns. *Works in collections:* Guildhall A.G., London, Hertford Museum, Government Art Collection, National Maritime Museum, Falmouth; Hertford Town Council. *Publications:* The Connoisseur, Studio International, Dictionary of Sea Painters, 20th Century Marine Painting, Water-colour Impressionists; Author of 'Oils', Trevor Chamberlain - A Personal View and 'England and Beyond'. *Official Purchasers:* GPO Headquarters, Taylor Woodrow, Hampshire Regiment, Winsor & Newton, Marks & Spencer. *Works Reproduced:* Royle Publications, BBC TV. *Recreations:* music, travelling. *Signs work:* "T. Chamberlain." *Address:* Braeside, 1 Goldings La., Waterford, Hertford, Herts. SG14 2PT.

CHAMBERS, Stephen Lyon, B.A.Hons., M.A., Rome Scholarship; painter in oil on canvas;. *b:* London, 20 Jul 1960. *m:* Denise de Coruova. two *s. Educ:* Holland Park Comprehensive. *Studied:* Winchester School of Art (1978-79), St. Martin's School of Art (1979-82), Chelsea School of Art (1982-83). *Exhib:* widely in Europe, U.S.A. and U.K. Represented by Flowers East, London. *Publications:* Strange Smoke by John Gillett; Paintings 1988-89 by Gerard Wilson; Felonies and Errors by Isabella Oulton. *Signs work:* paintings on canvas only signed on reverse. *Address:* 129 Offord Rd., London N1 1PH.

CHANCE, Sula, President's Award, NAPA National Exhibition 2002; President's Award, NAPA International Exhibition 2005. *Medium:* oils & acrylics on canvas. *b:* Trinidad. *Exhib:* Platform for Art, Piccadilly Circus 2002, NAPA International Exhibition, USA, 2003; 'Closing the Door', Jewish Museum, Camden (2005). *Works in collections:* private collections. *Misc:* her work is inspired by the Caribbean of her childhood, showing the colours and rhythms of Caribbean flora, fauna, and Carnival life; featured BBC1 TV(Jun 2003), featured BBC radio (July 2003), BBC London TV (2005). *Signs work:* 'sula'. *Address:* 9 Widley Gardens, Waterlooville, Hants, PO7 5RB. *Email:* sulaartist@aol.com *Website:* www.sulaartist.co.uk

CHANCELLOR, Deborah Ann, BA Hons Fashion Design with Marketing. *Medium:* acrylic. *b:* Coventry, 25 Jul 1966. *d of:* William Walsh. *m:* James. two *s. Educ:* University of East London 1985-89. *Commissions:* Corporate clients: Courvoisier, Perrier, London Clubs International (Ritz, Les Ambassadeurs), UBS, Sears Plc, Viyella Greeting Card publisher. Amelia Essex 'Vintage Collection'. *Recreations:* caring for my boys and dog, music and cooking. *Signs work:* "D.Chancellor". *Address:* 23 Colebrooke Avenue, Ealing, London W13 8SZ. *Email:* info@ameliaessex.co.uk *Website:* www.ameliaessex.co.uk

CHANDLER, Cynthia Ann, landscape and coastal scene painter in water-colour and oil and portrait painter in oil, pastel and water-colour. *b:* Isleworth, Middx., 1 Jan 1937. *d of:* Thomas Joseph Wilfred Elliott. *m:* Frank Chandler. two *s.* one *d. Educ:* Hampton High School. *Studied:* Twickenham School of Art (Mr. Duffy, Mr. Kane, Miss Palby). *Exhib:* U.A., P.S., and several Midland exhbns. *Works in collections:* Nuneaton Art Gallery (3). *Clubs:* President, Rugby and District Art Soc., Coventry and Warwickshire Soc. of Artists, Banbury and District Art Soc. *Signs work:* "Cynthia Chandler," "CYNTHIA CHANDLER." *Address:* 36 Dunsmore Ave., Rugby, Warwickshire CV22 5HD.

CHANG, Chien-Ying, RI, RWA. SWA; BA (1935); artist in water-colour. *b:* 27 Jun 1915. *d of:* Peh-Sung Chang. *m:* Cheng-Wu Fei, artist. *Educ:* National Central University, China, and Slade School of Fine Art. *Exhib:* R.A., R.I., R.B.A.; one-man shows at Leicester Gallery (1951, 1955, 1960). *Works in collections:* London University; St. John's College, Oxford; R.W.A., Bristol; Grave's Gallery, Sheffield; Derby Art Gallery. *Works Reproduced:* in Studio, Art News and Review, Future, Picture Post, La Revue Moderne, Kunst, etc. *Address:* 27 The Fountains, Ballards Lane, London N3 1NL.

CHANNING, Leslie Thomas, A.R.I.B.A. (1941), U.A. (1973), A.N.S.P.S. (1975); artist in water-colour; architect (retd.);. *b:* Weymouth, 24 Apr 1916. *s of:* Richard Channing, engineer. *m:* (1st) Florence Helen (decd.), (2nd) Audrey Joan (decd.). one *s.* one *d. Educ:* The Wandsworth School and Regent St. Polytechnic Evening Inst. School of Architecture (1934-39). *Exhib:* R.I., U.A., N.S.P.S., Thames Valley Arts Club, Richmond Art Soc. *Clubs:* U.A., N.S.P.S., Thames

Valley Arts, Richmond Art Soc. *Signs work:* "L. T. Channing." *Address:* 30 Fullerton Court, Udney Park Road, Teddington, Middx. TW11 9BF.

CHAPLIN, Michael James, N.D.D., R.E., R.W.S., F.R.S.A.; printmaker, water-colourist; Past Vice-Pres. Royal Soc. of Painter-Printmakers;. *b:* St. Neots, 19 Sept., 1943. *m:* Gay Lloyd. one *s.* one *d. Educ:* St. Albans Boys' Grammar School. *Studied:* Watford College of Art (1961-64), Brighton College of Art (1966-67), post-graduate. *Exhib:* R.W.S., R.A. Summer Shows, Tate Britain - Film on Turners Techniques. *Works in collections:* Ashmolean and Fitzwilliam museums; public and private collections worldwide, Royal Collections. *Commissions:* mural for Express Newspaper's boardroom; United Arab Shipping. *Publications:* regular contributor to Artist Magazine. Resident art expert on Channel 4 T.V. 'Water-colour Challenge'; "Mike Chaplin's Expressive Watercolours" published Oct. 2001, Harper Collins. *Signs work:* "Michael Chaplin, R.W.S." *Address:* Suffield, Orchard Drive, Weavering, Maidstone, Kent ME14 5JG. *Website:* www.mikechaplin.com

CHAPMAN, John Lewis, Matthew Brown Trophy; artist in water-colour, gouache, oil, acrylic. *b:* Blackburn, 11 Sep 1946. *Studied:* Blackburn Art College (James Dolby). *Exhib:* R.A. Summer Exhbn., Patersons, London, Lewis Textile, Blackburn, Haworth Art Gallery, Accrington, Jersey, Birmingham, Warrington, Newcastle, Harrods, London, Unicorn Gallery, Wilmslow; Art Decor, Whalley. *Works in collections:* Blackburn Art Gallery. *Publications:* "John Chapman's Lancashire" (pub. Halsgrove); International Artist magazine; 22 signed Limited Editions (published by Miss Carter Publications, Bolton). *Signs work:* "J.L. CHAPMAN." *Address:* 25 Silverwell St., Bolton BL1 1PP. *Email:* info@johnchapman.co.uk *Website:* www.johnchapman.co.uk

CHAPMAN, June Dianne, painter in oil;. *b:* Ruislip, 12 Jun 1939. *Educ:* St. Joan of Arc's Convent School, Rickmansworth. *Studied:* Camberwell School of Art (1955-56). *Exhib:* R.A., R.B.A., R.O.I., U.A., Blackheath Gallery, Edwin Pollard Gallery, Foyles A.G.; group show: Kingsmead Gallery; Lincoln Joyce Fine Art. *Recreations:* reading, thinking, music. *Signs work:* "J. Chapman" or "June Chapman." *Address:* 35D Lancaster Grove Belsize Park London NW3 4EX.

CHAPMAN, Mark, B.A. (Hons.) Fine Art: 1st Class (1982), M.A. Fine Art (1983); artist in water-colour, metal and wood construction; Teacher of Art: Sherbourne School for Girls, Dorset. *b:* Cuckfield, Sussex, 30 Jan 1958. *Studied:* Sunderland (1979-82), Birmingham (1982-83). *Exhib:* Leicestershire Schools Exhbn. (1983-90); Sculpture in the Garden, Deans Court, Wimborne (1991, 1993, 1995). *Signs work:* "M. Chapman." *Address:* Marnel Cottage, Church Lane, Osmington, Dorset DT3 6EW.

CHART, Helga, R.S.W. (1994), D.A. (Edin.) Post Grad.; artist in oil and mixed media; lecturer in art and design, Edinburgh's Telford College (retired). *b:* Edinburgh, 31 Aug 1944. *m:* H. Robertson. one *s. Educ:* Edinburgh. *Studied:*

Edinburgh College of Art (1962-66, Sir Robin Philipson, David Michie, John Houston). *Exhib:* mixed shows 1968-95; three solo shows Edinburgh; R.S.A., R.S.W., S.A.A.C., S.S.A. *Works in collections:* British Rail, IBM, Edinburgh schools, Pictures in Hospitals (Scotland). *Signs work:* "Helga Chart." *Address:* 19 Dalrymple Cres., Edinburgh EH9 2NX.

CHATER, A.J., ERAC Diploma in Print and Illustration; Cert. in Advertising; Cert. Education. *Medium:* prints. *b:* London, 21 April 1953. *Studied:* Southend College of Technology. *Exhib:* RA Summer Show (2002, 2004). Many mixed shows, 1st and 2nd International Alternative Photo Art, 3d International Photo Alternative; Waverley City Gallery, Melbourne, Australia. *Commissions:* painting and 100 prints for British Army. *Publications:* Alternative Photography, Art & Artists Edition One. *Misc:* involved with the invention and development of temperaprint. *Signs work:* 'A J Chater'. *Address:* 13 Winton Avenue, Westcliff-on-Sea, Essex SS0 7QU. *Email:* alex.chater@macunlimited.net

CHATTEN, Geoffrey, R.B.A. (1992); self taught painter of E. Anglian life and landscape, figures and marine subjects in oil;. *b:* Gorleston, Norfolk, 20 Sep 1938. *m:* Patricia Chatten. one *s.* one *d. Exhib:* R.A., R.B.A., R.O.I., Southwell Brown Gallery, Richmond, Surrey, John Noott Gallery, Broadway, Fosse Gallery, Fosse on the Wold, Waterman Gallery, London, Dassin Gallery, Los Angeles, Gt. Yarmouth Galleries. *Works in collections:* Maritime Trust, many private collections throughout Britain and overseas. *Publications:* Lydia Eva (Maritime Trust). *Clubs:* Hon. Member Gt. Yarmouth Society of Artists. *Signs work:* "Chatten." *Address:* 82 Suffield Rd., Gorleston, Great Yarmouth, Norfolk NR31 7AL.

CHATTERTON, George Edward, F.I.A.L.; Accademia Italia Gold Medal (1979), Prize of Italy Distinction (1980); artist, cartoonist and photographer. *b:* Kidderminster, 15 Jul 1911. *s of:* Benjamin Chatterton. *m:* Iris Betty Wilce. two *s. Educ:* Toronto. *Studied:* Kidderminster School of Art; photography at School of Photography, Farnborough. *Works Reproduced:* since 1932 in leading London and Dundee illustrated journals, including London Opinion, Daily Mirror, Daily Sketch, Weekly News, etc. R.A.F. Artist/Photographer (1938-50). Cartoon creations include "Chad" of "Wot, No-?" fame (1938), "Sheriff Shucks" (1948), "Leo CV" mascot of Lions Clubs, G.B. (1969), etc. *Address:* Canal Cottage, Ryeford, Stonehouse, Glos. GL10 2LG.

CHAUCHET, Claude, President of the UNAID (union nationale des architects d'interieur et décorateurs); President of firm Dekoras (1966). *Medium:* painting: oil, gouache; furniture design: glass, steel, wood, carpet and fabric design. *b:* St.Maurice, France, 21 May 1935. *m:* Irina Nano. two *s.* one *d. Educ:* studied painting with Pierre Grisot, ecole Boulle (1950), and ateliers Beaux Arts de Paris. *Represented by:* Bernard Chauchet. *Exhib:* furniture: 'Salon International du Meuble, Paris' (1969-75), Spring Fine Art and Antiques Fair, Olympia, London (Feb 2003), Affordable Art Fair London & NY (2003). *Works*

in collections: Centre Creation Industrial, Pavillon de Marsan, Musée Arts Décoratifs. *Publications:* Collection Connaissance des Arts 'Decoration' Hachette (1973)(table basse (low table) 1969, page 201, Appartment Mr.Boccaro, Dekoras p.25); l'oeil, Plaisirs de France, Maison et Jardin. *Clubs:* Art Connaissance, Tradition (ACT), UNAID. *Misc:* worked for Jansen as interior decorator and in 1966 founded his own decorating firm (Dekoras) under which he edited furniture and fabrics. *Address:* 50 bis rue Madeleine Michelis, 92200 Neuilly/Seine, France. *Email:* cchauchet@wanadoo.fr

CHEEK, Carl F., A.R.C.A.; portrait painter in oil, pastel and conté;. *b:* Karlshamn, Sweden, 7 Mar 1927. divorced. one *s.* two *d. Educ:* Clifton College. *Studied:* Chelsea School of Art, Royal College of Art. *Exhib:* one-man shows: London (2), Manchester (1); twice at John Moores, Liverpool. *Commissions:* Sir Clough William Ellis, Lord Eden, Lord Butterfield, Field Marshall Sir Nigel Bagnall, etc. Taught at several art schools: Heatherleys, Berkshire College of Art, Croydon College of Art, S.E. Essex School of Art. *Signs work:* "Carl Cheek." *Address:* Flat 2, 24 Ladbroke Gdns., London W11 2PY.

CHEESE, Bernard, RE (1988), ARCA (1950); printmaker in lithography and water-colour. *b:* London, 1925. *s of:* Gordon William Cheese, taxi driver. three *d. Educ:* Beckenham Grammar School. *Studied:* Beckenham School of Art (Edward Bawden), Royal College of Art (Edwin Ladell). *Exhib:* Bankside Gallery, Zwemmer Gallery (1965), R.A., John Russell Gallery, Ipswich, Thompson Gallery, Aldeburgh, Fry Gallery, Saffron Walden, Royal Academy, University of Wales. *Works in collections:* Library of Congress, Washington, Cincinnati Museum, N.Y. Public Library, Leeds Library, V. & A. (Print Room), Government Art Collection, University of Wales, Hunterian Museum Glasgow, Ashmolean Oxford,Fry Art Gallery, MoMA. *Publications:* illustrated many music books for A. & C. Black. *Signs work:* "Bernard Cheese." *Address:* 2 High St., Nayland, Colchester CO6 4JE.

CHEFFINS, Valma Maud, (nee Toplis); artist/printmaker in etching and aquatint; former teacher. *b:* Maidenhead, 18 Jun 1946. *d of:* Thomas Oldfield Jones Toplis. *m:* Frank Cheffins. *Educ:* Clark's College, Ilford; Beal Grammar School for Girls. *Studied:* St. Osyth's Training College (1964-67, Graham Eccles, Michael Kaye), Barking Technical College (1967-80, Harry Eccleston, O.B.E.). *Exhib:* Loggia Gallery, Bankside Gallery, R.E., The Barbican, International Print Triennial, Japan (2001), Country Living Magazine Fairs (2000-2005). *Works in collections:* Britain, America, Europe, Ireland, Australasia. *Commissions:* Architecture in France. *Official Purchasers:* Marks and Spencer. Professor Ken Howard RA. *Clubs:* Ilford Art Soc., Essex Art Club, Essex Craft Society, Essex Guild of Craftsmen. *Signs work:* "VALMA CHEFFINS." *Address:* 62 Chadville Gdns., Chadwell Heath, Romford, Essex RM6 5UA. *Email:* frank.cheffins@bt.internet.com *Website:* axis

CHERRY, Anne, M.A. (R.C.A.) (1973), S.W.A. (1987), A.R.B.S.A. (1990); Princess Michael of Kent Award for Best Work in Show (SWA, 2002); Royal Socity of Arts Travel Bursary 1970; Harris Tweed Award 1972 (Jean Muir). *Medium:* watercolour. *b:* Isle of Sheppey, 16 Oct 1948. *d of:* George William Cherry, M.A., M.Sc.(Oxon). *m:* Martin Caulkin, R.I., R.B.S.A. one *d. Educ:* John Willmott Grammar School. *Studied:* Sutton Art College (1967-68), B'ham College of Art (1968-71), R.C.A. (1971-73, Joanne Brogden, Zandra Rhodes). *Exhib:* R.B.S.A. Galleries, R.W.S., R.I., S.W.A., Shell House Gallery, Ledbury, Ombersley Galleries, Worcs., Montpellier Gallery, Cheltenham, Manor House Gallery, Chipping Norton, Neville Gallery, Canterbury, Linda Blackstone Gallery, Pinner, London; Birties of Worcester; Littleton Gallery, Malvern; Fine Art UK, Ledbury. *Commissions:* House portraits, gardens, portraits, landscapes. *Publications:* "Landscape in Watercolour", Patricia Monahan, (Studio Vista), Beginner's Guides. *Works Reproduced:* Brunot Productions- 'Femmes fatales':1- Long Distance; 2-Windswept; 3-The Temptress; 4-The Mirror; 5-Behind the Scenes; 6-Gale Force; 7-The Adjustment; 8-Stormy Weather. Also 'Ploughed Field,' 'Watermeadows,' 'Evening Pastures,' 'Woodman's Cottage'. Art Marketing. *Principal Works:* landscapes and still life. *Recreations:* gardening, music. *Clubs:* Society for the Protection of Ancient Buildings. *Misc:* interested in Vernacular architecture & saving ancient buildings. *Signs work:* "Anne Cherry." *Address:* September Cottage, Naunton, Upton upon Severn, Worcester WR8 0PY.

CHERRY, Norman, D.A., M.C.S.D., F.R.S.A.; designer - jeweller and silversmith, precious and non-precious metals; academic; Head, School of Jewellery, U.C.E. *b:* Airdrie, Lanarkshire, 2 Aug 1949. *m:* Kate Cherry, H.M.I. one *s. Studied:* Glasgow School of Art (1966-70, J. Leslie Auld). *Exhib:* various inc. Hipotesi, Barcelona; Facèré, Seattle; Sculpture to Wear, Los Angeles. *Works in collections:* Dundee Museums and A.G.'s, Tennessee Technological Univ., U.S.A. and Royal Museum of Scotland. *Publications:* various, including "Textile Techniques for Jewellers" by Arline Fisch (Lark Books). *Misc:* Churchill Fellow (1983). Although work is undertaken in various areas of jewellery and metalwork, a major preoccupation in recent years has been the weaving of metals. *Signs work:* Sponsors mark: N.C. inside lozenge struck on all precious metalwork and assayed and hallmarked @ Edinburgh. *Address:* School of Jewellery, Vittoria St., Birmingham B1 3PA.

CHESTERMAN, Merlyn, BA Hons in Fine Art, Dip.Ed. *Medium:* painting in different media, prints. *b:* London, 18 Jun 1949. *d of:* Prof.W.D. & Mrs Chesterman. one *s.* one *d. Educ:* King George V School, Hong Kong. *Studied:* Bath Academy of Art, Corsham, Wilts.; Bath University. *Exhib:* solo show: National Liberal Club, Whitehall, London; Group shows: Contemporary Hong Kong Biennials; Royal West of England Academy; Open Print, Bristol; SWE, Bankside, London; Royal Albert Museum, Exeter; Russell-Cotes Museum, Bournemouth; Manhattan Graphics, NY. *Works in collections:* City Hall Museum of Art Permanent Collection, Hong Kong; Princess Ashitashi Dorti, Bhutan; Lord & Lady Wilson of Tillyorn; Simon & Caroline Bowes Lyon. *Commissions:*

St.George's Field wall mural, Bideford (2007, with partner Rod Nelson), 6 Acoustic Panels for Pound Arts Centre, Corsham (2007, with partner Rod Nelson). *Publications:* illustrations for Twelve Hong Kong Walks (OUP). *Works Reproduced:* monoprint in 'Monoprinting' by J.Newell & D.Whittington (pub.A&C Black). *Recreations:* photography, travel. *Misc:* two residencies at St.Croix Watershed Research Station, Science Museum of Minnesota, USA; teaches short courses in woodcuts at West Dean College, Chichester, and runs printmaking courses in North Devon. *Signs work:* "MC". *Address:* 2 Harton Manor, The Square, Hartland, Devon, EX39 6BL. *Email:* merlyn@twohartonmanor.co.uk *Website:* www.twohartonmanor.co.uk

CHEUNG, Gordon, BA Fine Art Painting (1998), MA Fine Art Painting (2001); British Council International Arts Award (2003), Arts Council of England International Award (2003), Lexmark Painting Prize finalist (2003); John Moore's Painting Prize 24 (2006). *Medium:* paint, multimedia. *b:* Lambeth, London, 13 Sep 1975. *s of:* Lawrence Cheung. *m:* Rui Matsunaga. *Educ:* Central St.Martin's (CSM), Royal College of Art. *Exhib:* Nunnery Gallery, London (2003), John Hansard Gallery, Southampton (2003), Eyestorm Gallery, London (2003), British Art Show 6 (2005), Tour UK beginning at Baltic Centre of Contemporary Art. Solo show: 'Paradise Lost', Laing Art Gallery (2007); RA Summer Exhbn (2007). *Works in collections:* Museum of Senegallia, Italy; Royal College of Art, London; London Institute, London; Arizona State Museum, USA; Hirshhorn Museum, USA. *Signs work:* 'GORDON CHEUNG'. *Address:* 6 Beverley Hyrst, Addiscombe Road, Croydon, CR0 6SL. *Email:* gordon.cheung@lineone.net *Website:* www.gordoncheung.com

CHILD, Dennis, O.B.E. (1997, Science, Education, Psychology); BSc (London, 1962), M.Ed (Leeds, 1968), Ph.D.(Bradford, 1973), FBPs.S; FCST; retired but with title of Emeritus Professor of Educational Psychology, University of Leeds; author. *b:* Ulverston, England, 10 Jul 1932. *s of:* Ronald Wren Child. *m:* Eveline (nee Barton). one *s.* one *d. Publications:* Painters of the Northern Counties of England and Wales 2nd Ed. (2002, 1st Ed. 1994); The Yorkshire Union of Artists 1888-1922 (2001), articles about artists in journals. *Address:* School of Education, University of Leeds, Leeds, LS2 9JT.

CHILTON, Elizabeth Carlyle, Ruskin Cert. Fine Art and Design (1964-67); artist in oil, some etching and sculpture. *Medium:* oils, pen and ink, watercolours. *b:* Darlington, 1 Mar 1945. *d of:* E. R. Chilton, FRIBA, FTPI. *m:* R. G. Denning, D.Phil., Oxon. two *s. Educ:* Headington School for Girls, Oxford. *Studied:* Ruskin School, Oxford University, University of Illinois, U.S.A., Mem. of the Italian Academy. *Exhib:* R.A., Paris Salon, Oxford University Colleges, N.E.A.C., R.O.I., Southwark Cathedral. *Works in collections:* Town Hall, Whitchurch, Hants., Magdalen College, Oxford, Wadham College, Oxford. *Commissions:* private individuals. *Works Reproduced:* prints of Oxford Colleges. *Recreations:* gardening, walking. *Signs work:* "Chilton." *Address:* Purlin House, Toot Baldon, Oxford OX44 9NE. *Email:* denning_elizabeth@hotmail.com

CHIPP, Beverley, versatile artist in eclectic media including: photograpic, literary, graphic and 3D art; specialises in thought provoking pieces on many issues. Current work in oils has a surreal and visionary nature, focusing on cosmic phenomena. *b:* 1964. Yorkshire. Arts and crafts family. *Studied:* self-taught. *Exhib:* "It's a Fine Line" and "Angeltoad Landing", Lauderdale House (2001), "All Stars", Union Chapel, London (2001). "Diorama" and "The Wagon & Horses Show", The Establishment (2002). *Commissions:* specialising in non-profit organisations, charities and ethical companies. *Publications:* "Occasional Sights" curated by Anna Best, published by the Photographers Gallery; "Going to Court, Not War", an introduction to the International Court of Justice. Various poems in a number of anthologies published by Forward Press. *Clubs:* Member of The House of Wheat Art Collective. *Signs work:* "angeltoad." *Address:* 10 Chenies St. Chambers, 9 Chenies St., London WC1E 7ET. *Email:* angeltoad@aol.com

CHIPP, Terry, M.A. (1994); painter and mixed media constructor; artist and art education adviser, tutor to individuals and small groups. *b:* Yorkshire, 1949. *Studied:* Doncaster and Durham (1967-1971). *Exhib:* four solo exhibs. and many group exhibs., including Doncaster Artists, touring exhib. in Kentucky, U.S.A. *Works in collections:* private collections across U.K. and ten countries worldwide. *Commissions:* many private commissions for landscapes and house portraits. *Signs work:* "T CHIPP." *Address:* 250 Sprotbrough Rd., Doncaster, S. Yorks. DN5 8BY. *Email:* terry@chippco.co.uk

CHIRINO, Marta, OVSBA (1998); RHS Gold Medal (1999); BSc (1986). *Medium:* pencil on paper, and ink for scientific illustration. *b:* Madrid, 12 Jun 1963. *d of:* Martin Chirino & Margarita Argenta. *m:* Eduardo Rodriguez. two *d*. *Educ:* Nuestra Senora Santa Maria (Madrid). *Studied:* Universided Autonoma, Madrid; Universidad Complutense, Madrid. *Represented by:* Madrid: Galeria Bat; Galeria Pelayo 47; Canary Islands: Galeria Cuadro, Galeria Magda Lazaro. *Exhib:* solo: Galeria Magda Lazaro (Sta.Cruz de Tenerife); Galeria Delayo47, Madrid (2006); Museo Nestor, Gran Canaria (2006/7); group: annualy with SBA since 1998 except 3 yrs; Galeria Cuatrodiecisiete, Madrid (2003); Galeria Bat, Madrid (2006). *Works in collections:* Museo Postal y Telegrafico, Madrid. *Commissions:* Real Jardin Botanica de Madrid, and several other official institutions around Spain. *Publications:* Main publications -Scientific Illustrations for: Flora Iberica Vols V, VI, VII'; Flora Acuatica Castilla-La Mancha; Alimentos Sillestres Comunidad de Madrid; Marta Chirino: De Botanica (catalogue, 2007); Libro de Los Mojos (author Marta Chirino). *Works Reproduced:* all botanical drawings since 1987; commissions by the Botanical Gardens, Madrid; several aquatic plants posters, and pencil drawings in various catalogues and books. *Misc:* graphic designer. *Signs work:* 'CHIRINO ARGENTA'. *Address:* C/Reyesmagos 18 (9 Lz) 28009 Madrid, Spain. *Email:* martachirino@hotmail.com *Website:* www.martachirino.com

CHRISTIE, Janet Mary, D.A. (Edin.) (1961), F.S.B.A. (1986 resigned 1997); R.H.S. Silver medal (1982), Grenfell medal (1985); former founder mem. Soc. of Botanical Artists; painter in water-colour;. *Medium:* Watercolour. *b:* Kampala, Uganda, 12 Mar 1939. two *s.* one *d. Educ:* Cranley, Edinburgh. *Studied:* Edinburgh College of Art (1957-61, Robin Philipson, Gillies, John Maxwell, John Houston). *Exhib:* R.S.S.W., S.A.A.C., R.H.S., also various mixed exhbns.; solo shows: Norwich, London, and Edinburgh area; Royal Academy Summer Exhibition (2001, 2004, 2005, 2006), several RSA exhbns Edinburgh; several RGI exhbns, Glasgow. *Signs work:* "J.M.C." *Address:* Marbert, Springhill Rd., Peebles EH45 9ER.

CHRISTOPHER, Ann, R.A., F.R.B.S., R.W.A., B.A.; sculptor;. *b:* Watford, Herts., 4 Dec 1947. *d of:* Wm. Christopher. *m:* K. Cook. *Educ:* Watford Girls' Grammar School. *Studied:* Harrow School of Art (1965-66), West of England College of Art (1966-69). *Exhib:* Redfern Gallery, London; Ann Kendall Richards Inc., New York; R.A. *Works in collections:* Bristol City A.G., Contemporary Arts Soc., Chantrey Collection, London, Glynn Vivian A.G., Royal Academy. *Commissions:* 1997 Linklaters & Paines, London, 1998 Gt. Barrington, U.S.A., 2001 Port Marine, Bristol, 2002 Albi, France. *Publications:* Ann Christopher 'Sculpture 1969-89'. also 'Sculpture 1989-94. *Signs work:* "AC." *Address:* Stable Block, Hay St., Marshfield, Chippenham SN14 8PF.

CHUHAN, Jagjit (Ms.), D.F.A.(Lond.) (1977); artist in oil on canvas; lecturer, curator;. *b:* India, 10 Jan 1955. *Studied:* Slade School of Fine Art (1973-77). *Exhib:* solo shows: Ikon Gallery, B'ham (1987), Commonwealth Inst., London (1987), The Lowry, Manchester (2002), Watermans Arts Centre, London (2004); mixed shows: Barbican Centre, London (1988), Tate Gallery, Liverpool (1990-91), Galeria Civica, Marsala, Sicily (1991), Arnolfini, Bristol (1991). *Works in collections:* Arts Council Collection; North West Arts Board; Usher Gallery, Lincoln; Grosvenor Museum, Chester; Cartwright Hall, Bradford; Tameside Museum & AG. *Publications:* 'A Long Way from Home' (Lowry Press, 2002); Parampara Portraits (Shisha, 2004). *Address:* Liverpool Art School, John Moores University, 68 Hope St., Liverpool L1 9EB.

CHUIKOV, Valeriy, painter in oils on canvas. *b:* Zaporozhie, Ukraine, 27 Mar 1949. *s of:* Eugenie Chuikov. *m:* Elena Chuikov. one *s. Educ:* Kiev State Art Institute. *Studied:* Kiev Republican Special Art College, Kiev State Art Institute, Academy of Art, Moscow. *Represented by:* Garden of Eden Art Gallery. *Exhib:* Roy Miles Gallery, Alberti Gallery, Omell Gallery, New Grafton Gallery, The Leith Gallery, Blackheath Gallery, Gallery on the Green, Francis Iles, The Rochefort Gallery, Garden of Eden and others. *Works in collections:* National Ukrainian Art Museum, The Russian Ministry of Culture Collection, The State Art Collection of the Moscow Art Academy, British Embassy in Kiev. *Commissions:* for Archbishop of Ukraine Philaret, Chairman of FIFA Joseph Beatter. *Publications:* more than 30 sources including books, catalogues, albums, articles. *Works Reproduced:* by Rosenstiel's. *Principal Works:* portrait of Che

Guevara, Tragedy of Chile, Grand Prince Vladimir. *Clubs:* mem. Union of Artists of the Ukraine and USSR. *Signs work:* 4.B. (early works), V.Chuikov. *Address:* Flat 3, The Vale, Broadstairs, CT10 1RB. *Email:* e.chuikov@ntlworld.com

CHURCHILL, Martin, DA (Edin); DFA (Painting) Post Grad.; Guthrie Award RSA, Hunting Group Art Prize (1st Prize), Elizabeth Greenshields Award, Canada; BP Portrait Award (2nd Prize), Morrison Scottish Portrait Award Winner; David Cargill Award RGI. *Medium:* oil, drawing. *b:* Glasgow, 18 Nov 1954. *Educ:* Wick High School (1967-72). *Studied:* Edinburgh College of Art: DA (Edin) with Distinction (1976); Post Graduate Diploma In Fine Art (Painting) with Distinction (1977); Fellow in Painting, Gloucester College of Art (1981-82). *Represented by:* The Fine Art Society (London). *Exhib:* RA, RSA, RGI, NPG, RP, RCA (London), Mall Galleries, The Fine Art Society, Grosvenor Gallery London. *Works in collections:* The Fleming Wyfold Art Foundation, Deutsche Bank, IBM, BP International, Hove Art Gallery, City Art Centre Edinburgh, Hunterian Gallery, University of Glasgow, Scottish Arts Council,Scottish Life Assurance, Nuffield Foundation, Robert Fleming Holdings Ltd. *Commissions:* University of Edinburgh (print). *Publications:* FAS Now, 125 Yrs (1876-2001); A History of Scottish Art; The Fleming Collection. *Official Purchasers:* Scottish Arts Council; Hove Art Gallery; Huntarian Glasgow University; City Art Centre, Edinburgh; The Nuffield Foundation, Hospitals in Scotland. *Works Reproduced:* print of Edinburgh University to commemorate their 400th Anniversary. *Principal Works:* 'Palace Hotel (Edinburgh)'-Guthrie Prize (stolen 1981). *Recreations:* listening to classical music, making sculpture, photography. *Clubs:* Scottish Arts Club, Edinburgh. *Signs work:* 'Churchill'. *Address:* 69 Fillebrook Road, Leytonstone, London E11 4AU.

CHURCHILL, Robert Bruce, BA (Hons) Architecture; PGCE. *Medium:* oil, watercolour, drawing, prints, pastels, etchings, collage. *b:* Vancouver, BC, 22 May 1965. *s of:* Alexandra Churchill (Artist). *m:* Serena Churchill. one *s.* one *d. Educ:* Vancouver. *Studied:* University of British Columbia (Art History); Oxford Polytechnic (Architecture); University of Gloucestershire (PGCE). *Exhib:* RI; RWA; Museum of Oxfordshire; Cheltenham Art Gallery and Museum; The Foreign Press Assoc., London; The White Room Galleries (Leamington Spa and Bath); Brian Sinfield (Burford); also, works selected by the Emily Carr College of Art for touring exhbn. of British Columbia. *Works in collections:* private collections internationally. *Commissions:* The Royal Shakespeare Company, Stratford-upon-Avon; The Watermill Theatre, Newbury. *Recreations:* sleeping, travelling, drinking, music. *Clubs:* The Gloucestershire Printmaking Co-op. *Address:* Court Lodge, Overbury, nr.Tewkesbury, Glos. GL20 7PH. *Website:* www.robchurchill.com

CINZIA: see BONADA, Cinzia,

CIOBOTARU, Gillian Wise: see WISE, Gillian,

CIREFICE, Vittorio Antonio, FRSA (2005); Dip. Ad. Chelsea, Post Dip. RA Schools; painted professionally since leaving RA Schools. *Medium:* egg tempera, oil. *b:* Bangor, N.Wales, 19 Apr 1949. *s of:* Marco Cirefice. *m:* Heather Grills. two *d. Educ:* Holyhead Comprehensive. *Studied:* RA Schools under Peter Greenham (1971-74). *Represented by:* Emer Gallery, Belfast. *Exhib:* various. *Works in collections:* private collections including: John Hulme, MEP; Brindslie Ford (Courtauld Inst.); Mary McAleese (President Ireland); Public collections: National Gallery Wales (Cardiff), Down Civic Museum (Downpatric), Queen's Collection. *Commissions:* Stations of the Cross, for St.Bartolo Casalattico, Italy (2004). *Publications:* tv appearances- 'Songs of Praise', 'Awash with Colour', 'Fathom Line'. *Principal Works:* Gaelic sports, festivals and fairs. *Recreations:* the mountains. *Clubs:* RASAA. *Misc:* lives, works and exhibits exclusively in rural environments. *Signs work:* 'V Cirefice'. *Address:* Ballymagart Mill, Ballyardle Rd., Kilkeel, Co. Down, BT34 4JX. *Email:* cirefice@btopenworld.com

CLARISSE, Bernard-Francois, Agregé d'Arts Plastiques. *Medium:* painter in acrylics, pate a papier, and wood, sculpture in wood. *b:* Bois-Robert, 22 Feb 1946. *s of:* Raymond Clarisse and Marie Louise Ansart. three *d. Educ:* University of Paris X (Nanterre), licence Histoire d'Art, Maitrise Histoire de l'Art. *Studied:* University of Paris I (Sorbonne), licence, Capes, Agregation Arts Plastiques. *Represented by:* Samagra, rue Jacob, Paris; du Fleuve, rue de Seine, Paris; Res Rei, rue Haut Cite, Limoges; Duchoze, bvd de l'Yse, Rouen; Can Marc, Gerone. *Exhib:* solo exhbns.: Musées (Saintes, 1996, Boulogne sur Mer, 2000), Centres d'Art Contemporain (Rouen, 1990, Eymoutiers, 1998, St.Cyprien, 2001), Galeries (Samagra, 1995, '97; Res Rei, 1996, '99, 2000; Duchoze, 1997, 2000, '02; Can Marc 1999; Sarlat 2000; Du Fleuve 2003. Salons: Mai, Figuration Critique, Montrouge, Automne,Comparaisons, etc; over 67 group shows from 1987 to 2003; Espace Culturel Fibert, Lyon (2005); Musée de l'Eveche (2005). *Publications:* Catalogue Musée de Saintes (1996), Cimaise no. 235, and numerous press articles. *Works Reproduced:* numerous colour reproductions in articles, catalogues, etc. *Recreations:* visiting galleries and museums. *Signs work:* 'BClarisse'. *Address:* 4, rue de la Croix Rouge, 76780 Saint Lucien, France.

CLARK, Bruce Michael, M.A., D.A.E., Cert. Ed.; painter in oil. *b:* Bedfont, 17 Jul 1937. *s of:* William Clark, artist in water-colour. *m:* Jill Clark. two *s. Educ:* Strodes School. *Studied:* Bath Academy of Art, Corsham (1958-60) under Howard Hodgkin, Gwyther Irwin, William Crozier. *Represented by:* NuMasters.com. *Exhib:* eleven one-man shows including Chiltern Gallery, London; Compendium Galleries, Birmingham; Worcester City A.G.; One Off Gallery, Dover; Tabor Gallery, Canterbury; numerous group shows including Walker's Gallery; Woodstock Gallery; Kootenay Gallery, Canada; Festival de Provence, France; Minotaur Gallery, Toronto; Royal Academy, Rowley Gallery, London.; Cambridge Contemporary Arts, Rye Art Gallery; Stark Gallery, Canterbury. *Publications:* included in 'Dictionary of Artists in Britain since

1945'. *Signs work:* "Clark." *Address:* Mingladon, Manns Hill, Bossingham, Canterbury, Kent CT4 6ED.

CLARK, John M'Kenzie, D.A. (Dundee, 1950); N.D.D. (Painting) St. Martin's (1956); artist in oil, water-colour, ink; winner of Punch scholarship. *b:* Dundee, 29 Nov 1928. *s of:* James Clark, commercial artist. *Educ:* Harris Academy, Dundee. *Studied:* Dundee College of Art (1945-50), Norwich Art College (1950-51), Hospitalfield Art School (1953), St. Martin's Art School (1955-56). *Exhib:* R.A., R.S.A., R.S.W., S.S.A., R.G.I., United Soc. of Artists, one-man shows at Dundee, Edinburgh (1960). Mem. Royal Glasgow Institute of Fine Art. *Works in collections:* City of Dundee Permanent Collection (1961). *Works Reproduced:* in Glad Mag. *Signs work:* "J. M'KENZIE CLARK." *Address:* 2 Birchwood Pl., Dundee DD1 2AT.

CLARK, Kenneth Inman Carr, M.B.E. (1990), D.F.A. (Lond. 1948); artist in ceramics; partner with Ann Clark;. *Medium:* Ceramics. *b:* 31 Jul 1922. *s of:* Aubrey Clark. *m:* Ann Clark. one *s.* one *d. Educ:* Nelson College, N.Z. *Studied:* Slade School of Fine Art (1945-48) painting, Central School of Art and Design (1949) under Dora Billington, ceramics, and G. Harding-Green. *Exhib:* one-man shows, Piccadilly Gallery, Zwemmer Gallery, and many group shows in England and abroad. *Works in collections:* Wellington, N.Z., Auckland, N.Z., Japan. *Commissions:* Endless. *Publications:* Practical Pottery and Ceramics, Throwing for Beginners, The Potters Manual, The Tile. *Address:* Merton House, Vicarage Way, Ringmer, Lewes, E. Sussex BN8 5LA.

CLARK, Norman Alexander, R.W.S.; Royal Academy Schools Gold Medallist and Edward Stott Scholar in Historical Painting (1931), Armitage Bronze Medallist in Pictorial Design (1931), Landseer prize-winner in Mural Decoration (1932), Leverhulme Scholar (1935); painter in oil and water-colour. *b:* Ilford, Essex, 17 Feb 1913. *s of:* Hugh Alexander Clark. *m:* Constance Josephine Barnard. one *d. Educ:* Bancroft's School, Woodford. *Studied:* Central School, London (1929), R.A. Schools (1930-35). *Exhib:* RA, RWS. *Works in collections:* Harris Museum and Art Gallery, Preston, Lancs., Imperial War Museum, and in private collections. *Signs work:* "Norman Clark." *Address:* Mountfield, Brighton Rd., Hurstpierpoint, Sussex BN6.

CLARK, Peter Christian, Oxford University Certificate of Fine Art; professional painter of abstract paintings in oil, acrylic and gouache; hand-made prints and wallpaper, bas-relief constructions. *b:* Bradford, Yorks., 19 Apr 1950. *s of:* T. H. Clark, ACP, ARDS, FRSA. *Educ:* Clifton House School, Harrogate, H.M.S. Conway, Anglesey, N. Wales. *Studied:* Ruskin School of Drawing and Fine Art under Richard Naish, M.A. *Exhib:* mixed shows: Ashmolean Museum, Oxford, Museum of Modern Art, Oxford, Llewellyn Alexander Gallery, London. Private commissions. *Signs work:* "Peter Clark", "Christian Clark" and "P.C.C." *Address:* 40 Delancey St., London NW1 7RY.

CLARK, Thomas Humphrey, A.C.P., A.R.D.S.; artist in black and white, water-colour, traditional canal ware painter. *b:* Manchester, 30 Jan 1921. *s of:* Edwin George Clark. *m:* Betty Whitley Clark. two *s. Educ:* Leeds Grammar School. *Studied:* Bradford Regional College of Art under Frank Lyle, A.T.D., Fred C. Jones, A.T.D., R.B.A. *Exhib:* Royal Cambrian Academy. *Signs work:* "T. H. Clark". *Address:* Woodland Rise, Beemire, Windermere, Cumbria LA23 1DW.

CLARKE, Edward, RAS PG Dip, BA (Hons); figurative portrait and landscape artist painting in oils and drawing in charcoal; RA Schools Prizes for landscape and portraiture (1986). Antique Collector Magazine's Annual Prize for Figurative Painting and Drawing (1987); Wise Speke Prize for Best Drawing in 'Up Close and Personal' Exhibition, Hatton Gallery, Newcastle (2006). *b:* Hartlepool, 1962. *Educ:* Manor School, Hartlepool. *Studied:* Cleveland College of Art (1980-81), Sheffield Hallam University (1982-85), R.A. Schools (1985-88). *Exhib:* RA Summer Exhbn. and RA Dip. Galleries, London (1986, 1987, 1988), NPG, London (1988, 1991), Agnews, London (1990), Centro Modigliani Gallery, Florence (2002), Burlington Fine Arts, London (2005), Red Box Gallery, Newcastle (2007); Royal Society of Portrait Painters Exhibition, Mall Galleries, London (2007). *Works in collections:* various, including National Trust's Foundation for Art. *Clubs:* Royal Academy Schools Alumni Member. *Signs work:* "Edward Clarke." *Address:* 304 Catcote Rd., Hartlepool, Cleveland TS25 3EF.

CLARKE, Geoffrey, R.A., A.R.C.A.; artist and sculptor. *b:* 28 Nov 1924. *s of:* John Moulding Clarke and Janet Petts. *m:* 1947, Ethelwynne Tyrer. two *s. Educ:* Royal College of Art (Hons.). *Exhib:* one-man shows: Gimpel, Redfern, Taranman, Yorkshire Sculpture Park and Travelling Retrospective, Fine Art Society. *Works in collections:* (stained glass) Coventry and Lincoln Cathedrals, Taunton, Ipswich, Crownhill Plymouth; (sculpture) Coventry and Chichester Cathedrals; Cambridge (Churchill, Homerton, Newnham), Exeter, Liverpool, Newcastle, Manchester and Lancaster Universities; Bedford, Chichester and Winchester Colleges. Other Principal Work: Castrol House, Thorn Electric, Newcastle Civic Centre, Nottingham Playhouse, Culham Atomic Energy, Guard's Chapel, Birdcage Walk, Aldershot Landscape, St. Paul Minnesota, Majlis Abu Dhabi, York House, Warwick University. *Publications:* Symbols for Man by Peter Black. *Address:* Stowe Hill, Hartest, Bury St. Edmunds, Suffolk IP29 4EQ.

CLARKE, Graham Arthur, Hon.M.A. Kent Ambassador, A.R.C.A. Chevalier de la Confrerie du Cep Ardechois, Hon. Associate K.I.A.D., President CPRE (Kent); artist in etching and water-colour, author;. *b:* Chipping Norton, Oxon., 27 Feb 1941. *m:* Wendy. one *s.* three *d. Educ:* Beckenham Grammar School. *Studied:* Beckenham School of Art, R.C.A. *Exhib:* Wildenstein & Co., Bond St., London; Henie-Onstadt, Oslo. *Works in collections:* V. & A., British Museum, Tate Gallery, National Libs. Scotland, Ireland and Wales, Hiroshima Peace Museum, National Lib. Congress (U.S.A.). *Publications:* Graham Clarke's History of England, Graham Clarke's Grand Tour, Joe Carpenter and Son -

English Nativity, W. Shakespeare (Gent.) actual notte booke, The World of Graham Clarke (Japanese), A Norwegian Sketchbook, Graham Clarke's Kent 'Baitboxstew' – Graham Clarke's Cornwall; Octopolis to Halki, Vinerelles. *Signs work:* "Graham Clarke." *Address:* White Cottage, Green Lane, Boughton Monchelsea, Maidstone, Kent ME17 4LF. *Email:* info@grahamclarke.co.uk *Website:* www.grahamclarke.co.uk

CLARKE, Granville Daniel, F.R.S.A., Y.W.S. (1989-2005); professional artist in water-colour and pencil; lecturer/demonstrator combining art, poetry and music;. *b:* Keighley, Yorks., 26 Oct 1940. *Educ:* Cudworth, Secondary Modern School of Life. *Studied:* Barnsley School of Art (1955-60). City & Guilds 1st Class Hons. (1957), Full Tech. Cert. (1959). *Represented by:* Jacquie Evans Management, London 0208-699-1202. *Exhib:* numerous one-man exhbns. since 1977; Westminster Gallery, London, Salford A.G., Mercer Gallery Harrogate, Doncaster A.G., Sir William Russell Flint Gallery Guildford, Laing at Mall Galleries London, Barnsley to Bombay Round the World Exhbn., Cooper Gallery Barnsley. Permanent exhbn.: Cannon Hall, Cawthorne, Yorks; Royal Society of British Artists Exhbn., London (2000), Open College of the Arts (2005). *Commissions:* English Nature, P. & O. Cruise Lines, Mercedes Benz, Guardian Newspapers, Michael Stewart Fine Art, Yorkshire Electricity, Yorkshire Water, Michael Parkinson, Countess of Wharncliffe. *Publications:* 'Sketches and Expressions' (1991). Listed in: Millers Art Guide (2005), International Biographical Dictionary (2005). *Works Reproduced:* limited editions: 'Elements','Silkstone Images of Winter', 'Wharncliffe Crags in Autumn'. *Principal Works:* commissioned to commemorate UK's first motorway Toll as a Limited Edition Print (2004). *Recreations:* cricket. *Misc:* Produced and presented: Clarke Colours the Lowry Trail - Art TV (1993), Clarke Colours York - Art Video (1999). 36 national TV appearances Channel 4 artist in residence/commentator 'Water-colour Challenge' (1998).; Watercolour Workshop series (Granada Breeze, Satellite TV, 2000); only artist to paint around the world in 90 days; uniquely interprets the musical classics through his art in live performance. Professional musician/writer/performer with 'Foggy Dew-O' (1965-76); Director, Scarlet Songs Publishing; com.mem., Yorkshire Water-colour Soc. (1989-2005, Society recently folded); co-founder, Meadowlands; environmental artist: Sight Savers, Whale and Dolphin, The Countryside Commission, wild flower conservation; environmental education through The Arts, Kirklees, W. Yorks. (1992-97). Poet in Residence Theatre Partnerships 2003-4 for Arts Council, South Yorks. *Signs work:* "Granville D. Clarke". *Address:* Huskar Cottage Studio, Silkstone Common, nr. Barnsley, S.Yorks. S75 4RJ. *Email:* g.danny.clarke@virgin.net *Website:* www.granvilledclarke.com

CLARKE, Hilda Margery, BA (Hons.), FRSA; artist in oils and other media; Director, 'The First Gallery'. *b:* Manchester, 10 Jun 1926. *d of:* Frank Thompson. *m:* Geoffrey Clarke. two *s. Educ:* Eccles Secondary School. *Studied:* privately in Manchester (Master: L. S. Lowry) and Hamburg; Southampton Art College, Ruskin School Print Workshop, Oxford (Chris Orr, Norman Ackroyd); B.A.

Southampton. *Exhib:* John Martin, London; John Martin, Chelsea; Staarb Museum, Lymington; Tibb Lane, Manchester, Bettles Gallery, Ringwood; London Galleries: Camden Town, F.P.S., Buckingham Gate; Southampton City A.G, The Mall Galleries, London, New Ashgate, Farnham; one-man shows, Hamwic, Southampton, Westgate Gallery, Winchester, Southampton University; The First Gallery, Southampton, Turner Sims Concert Hall, Soton., Hiscock Gallery, Southsea, Ramsgate Library Gallery, Kent; Southampton City Art Gallery. *Works in collections:* Southampton University, Southern Arts, (RAB) St. Mary's Hospital, I.O.W., Felder Fine Art, London; Angela Hunt Collection Southampton; Angus Neill, Deal, Kent. *Recreations:* music, literature. *Signs work:* "H.M. Clarke." *Address:* The First Gallery, 1 Burnham Chase, Bitterne, Southampton SO18 5DG.

CLARKE, Jeff, R.E., N.D.D., Rome Scholarship (1956-58), British Inst. Fund Scholarship;. *b:* Brighton, 1935. *Studied:* Brighton College of Art (1952-56). *Represented by:* Elizabeth Harvey-Lee. *Exhib:* Oxford Bear Lane Gallery, Oxford Gallery, Museum of Modern Art Oxford, Christ Church Picture Gallery, R.E., R.A. Summer shows, National Print shows Mall Galleries, London. *Works in collections:* Ashmolean Museum, Universities of Oxford, Cambridge, Reading. Many private collections in Europe, U.S.A. and Australia. *Signs work:* "Jeff Clarke". *Address:* 17 Newton Rd., Oxford OX1 4PT.

CLARKE, Johnnie, *Medium:* oil, watercolour, drawing, prints, sculpture. *b:* Tanzania, 3 May 1940. *Studied:* Academie de la Grande Chaumière, Bideford, Camberwell. *Represented by:* Toby Clarke. *Exhib:* RA. *Commissions:* Wetherspoons Liverpool:sculpture. *Publications:* War Child Art Auction (Feb 2004) Christie's. *Misc:* BBC2 The Apprentices. *Signs work:* 'Clarke'. *Address:* High House, 1 Castle Hill, Dunster TA24 6SQ.

CLARKE, Jonathan, *Medium:* aluminium sculpture. *b:* Suffolk, 14 May 1961. *s of:* Geoffrey & Bill Clarke. *m:* Joanne. one *s. Educ:* Sudbury Upper School. *Studied:* studied under father. *Represented by:* Ron Howell, The Strand Gallery, Aldeburgh, Suffolk. *Exhib:* RA Summer Exhbn (1989, 91, 92, 95, 96, 98, 99); Chappel Galleries Essex; Strand Gallery Aldeburgh; Byard Art, Cambridge; Art London; Lena Boyle Fine Art; Metropolitan Museum, Tokyo; Belgrave Gallery, St.Ives; Open Eye, Edinburgh; Galeria Carezzonica, Venice; Pallant House, Chichester; Snape Maltings, Suffolk. *Works in collections:* Christchurch Mansions, Ipswich; Britten Pears Library, Aldeburgh. *Commissions:* 'The Way of Life', Ely Cathedral; 'Stations of the Cross' 'Emaaus', Southwell Minster; P&O Lines, Asda, Tesco; Notley Bird, Notley. *Publications:* 'Sea Legs' National Maritime Museum, Cornwall; Strand Gallery. *Principal Works:* 'The Way of Life' Ely Cathedral. *Signs work:* 'JC'. *Address:* Stowe Hill, Hartest, Bury St.Edmunds IP29 4EQ. *Email:* jc@jonathanclarke.co.uk *Website:* www.jonathanclarke.co.uk

CLARKE, Pat, Surrey Dip. (1969); artist in water-colour, oil, pastel; printmaker; Adult Education teacher, and special needs teacher (1970-80); since 1984, joint owner with husband of art gallery, Oriel y Odraig, Blaenau Ffestiniog, N. Wales;. *b:* Banstead. *d of:* Samuel Clarke. *m:* Peter Elliott. *Studied:* Reigate Art School (1966-69). *Exhib:* Loggia Gallery, Gallery of Modern Art, London, Hereford City A.G., Rhyl and Denbigh Arts Centres, etc; 45 one-woman shows. *Works in collections:* Hereford City A.G. *Publications:* To the Mountain (1994). *Works Reproduced:* 12 artists cards. *Clubs:* N.S., F.P.S., Royal Cambrian Academy, Conwy, Watercolour Soc. of Wales. *Signs work:* "Pat Clarke." *Address:* 4 Bryn Dinas, Rhiwbryfdir, Blaenau Ffestiniog, Gwynedd LL41 3NS.

CLARKE, Ronald Aquilla, BA (Hons). *Medium:* oil, drawing. *b:* Leicester, 17 Mar 1950. *Educ:* City Boys Grammar School, Leicester. *Studied:* University of East Anglia (UEA), 1968-71. *Exhib:* Native American Arts Movement (NAPCAM) Exhibitions at Nuneaton, Riversley Park, and elsewhere (1980s), Maddermarket Theatre and other venues in Norwich (1970s). *Publications:* Publshed art catalogues in capacity as an art historian (1970s-1980s). *Misc:* Resumed practice as artist in 2006 after a gap of twenty years. Currently preparing "Drawn to St.Ives". *Signs work:* "Ron Clarke"; also "R.Aquilla Clarke". *Address:* 18 David Road, Coventry, CV1 2BW.

CLARKE, Sheena Elizabeth Brough, NDD Illustration; Head of Art, St.Paul's Prep School, London (1968-2001); teaching in USA (1981-83). *Medium:* batik, wood engraving, acrylic, calligrapher. *b:* London, 15 Apr 1942. *Studied:* Winchester Art School (1958 -1962). *Exhib:* RA (1968, 1969(; RA British educational tour (1969-70); group and solo in UK, Southern Yemen, Kenya. *Works in collections:* in the USA. *Commissions:* private and commercial: book illustrations, portraits, calligraphy, murals. *Works Reproduced:* greeting cards; book jackets. *Principal Works:* illustrated two books by Don Pavey (2006). *Misc:* studio: 30 Wayside, Sheen, SW14 7LN. *Signs work:* Sheena Clarke. *Address:* 38a Dancer Road, Richmond, Surrey TW9 4LA. *Email:* sheena.c@virgin.net

CLARYSSE, Maggy, Dip. Brussels Academy of Art (1956); painter in oil, water-colour, pastels, silk-screen printing;. *b:* Brussels, 21 Oct 1937. married. one *s. Educ:* Convent Sacre Coeur, Brussels. *Studied:* Brussels Academy of Art. *Exhib:* numerous exhbns. in U.K., France, Belgium, Switzerland. *Works in collections:* Private collections in U.S.A., Japan, Australia, S. America, France, Germany, Belgium,Holland, Italy, Switzerland, Sweden. *Publications:* The Graphic Artist (1980). *Signs work:* "M. Clarysse." *Address:* 13 The Elms, Vine Rd., London SW13 0NF.

CLATWORTHY, Robert, R.A. (1973); sculptor; mem. Fine Art Panel of National Council for Diplomas in Art and Design (1961-71); head of Fine Art, Central School of Art and Design (1970-75);. *b:* 1 Jan 1928. *Studied:* West of England College of Art, Chelsea School of Art, The Slade. *Exhib:* Hanover

Gallery (1954, 1956), Waddington Galls. (1965), Holland Park Open Air Sculpture (1957), Battersea Park Open Air Sculpture (1960, 1963), Tate Gallery British Sculpture in the Sixties (1965), Basil Jacobs Gallery (1972), British Sculpture '72, Burlington House, Diploma Galleries R.A. (1977), Photographer's Gallery (1981). *Works in collections:* Arts Council, Contemporary Art Society, Tate Gallery, V. & A., G.L.C.; Monumental Horse and Rider installed at 1 Finsbury Ave., EC2. (1984); portrait of Dame Elisabeth Frink purchased by N.P.G. (1985). *Address:* 1a Park St., London SE1.

CLAUGHTON, Richard Bentley, F.R.B.S.; sculptor;. *b:* London, 1917. married. one *s. Educ:* Woodford House School, Kent. *Studied:* Slade School (1946-49). Public commissions in London and provinces; Australia; Nigeria. *Exhib:* in galleries and open-air exhbns. in London and provinces; Holland and Lisbon. *Works in collections:* in Britain; Canada; Iraq and U.S.A. *Misc:* Former Director of Sculpture Studies, Slade School, University College, London. *Address:* Telham Lodge, Telham Lane, Battle, E. Sussex TN33 0SN.

CLAY, Andie Joy, B.A. (Hons.) 1975; artist in mixed media, acrylic, pastel. *b:* Surrey, 13 Apr 1954. *m:* Dave Clay. *Studied:* London College of Printing, London (1971-75). *Exhib:* St.David's Hall, Cardiff; Art Matters Gallery, Tenby; De Putron Fine Art, London; Chelsea Art Fair; Laing; Originals Gallery, Stow on the Wold; Wexford Arts Centre, Ireland; National Botanic Garden of Wales; Oriel Plas Glyn y Weddw, N. Wales; West Wales Art Centre, Fishguard; Wales Drawing Biennale; Washington Gallery, Penarth; Moma Wales, Machynlleth; Albany Gallery, Cardiff; Ogilvy & Estill, Conway; RCA, Conway; RBSA B'ham; Oriel Ceri Richards, Swansea; The Brownston Gallery, Modbury. *Publications:* 'Paint! Landscapes (RotoVision)'. *Signs work:* "Andie Clay." *Address:* Porth, Blaenporth, Cardigan, Ceredigion SA43 2AP. *Email:* andie@andieclay.com *Website:* www.andieclay.com

CLAY, Elizabeth Hervey, S.B.A. (1998); botanical sculptures in liquid porcelain and alabaster, porcelain painter on bone china and porcelain;. *b:* Nakuru, Kenya, 24 Sep 1928. *m:* decd. two *s.* one *d. Educ:* Loreto Convent, Nairobi, Kenya, Rhodes University, Grahamstown, S.Africa. *Exhib:* S.B.A. *Works in collections:* various flower sculptures. Work in international and private collections. Collections available from Mrs Munro, Jubilee House, 70 Cadogan Palce, London SW1X 9AH. *Commissions:* various flower sculptures and painted porcelain. *Recreations:* bridge, gardening, travelling. *Clubs:* social member of the Cooden Beach Golf Club; Bexhill Art Society. *Signs work:* "Sally Clay, S.B.A." *Address:* 13 Chelsea Close, Bexhill on Sea, E.Sussex TN40 1SJ. *Email:* sallyclay@tiscali.com

CLAYDEN, Phillippa, BA Hons; RA Post-Graduate Diploma; Landseer Prize; Dorothy Morgan Prize. *Medium:* oil, watercolour, collage. *b:* London, 4 Aug 1955. *d of:* Pauline & Alan Clayden. *Studied:* Central School of Art and Design; RA School; City Literature Inst. *Represented by:* Boundary Gallery

(1989-2002). *Exhib:* RA, Whitechapel, Royal overseas League, Orangery, Southampton Art Gallery, ICA, Business Design Centre, Bilim Sanat Gallery, Plymouth Museum Gallery, Commonwealth Inst. *Works in collections:* TSB, Freshfields, various private. *Commissions:* various private. *Publications:* 3 catalogues for boundary gallery. *Works Reproduced:* in 'Landscape Painting' by Kimm Stevens. *Recreations:* walking, yoga, swimming. *Address:* 68 Woodland Rise, Muswell Hill, London N10 3UJ.

CLAYTON, Inge, FRSA. *Medium:* oil, watercolour, drawing, prints, sculpture, collage and assemblage. *b:* Salzburg, Austria. *d of:* Josef Fagerer. *m:* Anthony Clayton. one *s.* one *d. Educ:* Austria. *Studied:* Camden Arts Centre; Camden School of Art (largely self-taught). *Represented by:* Catto Gallery, Hampstead, London; Maurice Sternberg, Chicago, USA. *Exhib:* Affordable Art New York(2002), Art on Paper RCA(2003); solo: Ana Mei Chadwick Gallery, Boundary Gallery, St.Judes Gallery, Centaur Gallery, Enid Lawson Gallery, Zella Gallery, Proud Gallery, Blackheath Gallery, Maurice Sternberg Gallery(Chicago), The Orange Gallery (Rutland), Wiseman Gallery (Oxford), Adze Gallery(York), Metal Gallery(London) and many more. *Commissions:* Four Seasons Hotel, Jeremy Irons, Stephen Berkhoff. *Publications:* Jack Yates 'Collage'; Jack Yates 'Fragments'. *Works Reproduced:* Homage to Picasso 'Demoiselles d'Avignon' on glass painting filmed and edited. *Recreations:* classical music, film, walking (to Birmingham on Grand Union Canal). *Clubs:* Chelsea Arts Club, Fellow Royal Society of Art. *Misc:* biographical film 30 mins. (Japan); advisory artist in 'Young Gifted and Broke' featured in erotic documentary. *Signs work:* 'CLAYTON'. *Address:* 5 Randolph Ave., London W9 1BH. *Website:* www.ingeclayton.com

CLEGG, Margrit, BA Hons Fine Art, Postgraduate Diploma in Printmaking. *Medium:* mixed media painting and printmaking (etching). *b:* Bremen, Germany, 18 Oct 1941. *d of:* Walter Arno Oestmann. *m:* R.S.Clegg. one *s. Educ:* Oberschule Bremen, Germany. *Studied:* Wimbledon School of Art, London. *Exhib:* solo: New Millennium Gallery, St.Ives (2001-03); selected: RA, Morley Gallery, Westminster, Tate St.Ives, Newlyn Art Gallery, Penwith Art Gallery St.Ives, Printmakers Gallery St.Ives, Lemon Street Gallery Truro, Art-Fair London 2001-2005 (New Millennium Gallery). *Works in collections:* private collections in Britain, Germany, USA and Canada. *Publications:* 'Drawing Towards the End of the Century 1996' (Newlyn Art Gallery); 'Another View' Marion Whybrow (1996), 'ARTNSA' (Newlyn Artists Publications, 2001). *Signs work:* Margrit Clegg. *Address:* 6 Academy Flats, Academy Place, St.Ives, Cornwall, TR26 1LD.

CLEMENTS, Jeff, M.B.E. (2007); Hon Fellow MDE (Meister der Einbandkunst)(2007); N.D.D. (1955), Fellow Designer Bookbinders; artist in acrylic, fine bookbinder; partner with Katinka Keus, Restauratie atelier Meridiaan, Amsterdam; formerly Dean, Faculty of Art and Design, University of the West of England (-1988). *b:* Plymouth, 23 Feb 1934. two *s. Educ:* Devonport High School for Boys. *Studied:* Plymouth College of Art (1950-55), Central

School of Arts and Crafts (1956-57). *Exhib:* from 1955 Daily Express Young Artists to recent ones in the Netherlands, Estonia, UK. *Works in collections:* fine bindings in: Royal Library, V. & A., London; Royal Library, The Hague; The Museum of the Book, The Hague; Texas University; University of Indiana; Röhsska Museum, Sweden; The National Library of Estonia, Tallinn; The Keatley Trust; The John Paul Getty jr. Trust, The Rylands Library, Manchesteretc.; paintings in private collections: Nice, Geneva, London, Birmingham, Bristol, Exeter, Oxford, York, The Hague, Amsterdam, Washington D.C. *Publications:* Book Binding (Arco, 1963), Ambachtelijk Boekbinden (Gaade, 1991); articles in 'The New Bookbinder' etc. *Address:* Jan Luijkenstraat 38II, 1071 CR Amsterdam, Holland.

CLEMENTS, Patricia Kathleen, SWA (2006), ASWA (2005); NDD; St.Cuthberts Mill Award - winner Best Painting on Paper; Artist in Residence, Agora Gallery, New York, USA (2006-07). *Medium:* oil, pastel, prints. *b:* Epping, 19 May 1953. *d of:* John Dart. *Educ:* Midhurst Grammar School. *Studied:* Worthing College of Arts & Crafts; Central School, London (Life & Fine Art). *Exhib:* RA Summer Exhbn (1980-94); Llewelyn Alexander (1991); Brighton Lanes (1985); Battersea Webbs Gallery (2002, 2004); SWA (2003, 2004); Pastel Society, Mall Galleries (2003); Society of British Landscape (2004); Parkside Gallery, Sheen (2005); solo shows: Bartley Drew Gallery, Bloxham Gallery (2000). *Works in collections:* TUC Headquarters, Congress House, London; Art Directors, TV Times & Hello Magazines; private collections at home and abroad. *Works Reproduced:* Giglee Prints, Art Decaf. *Recreations:* interior design, outdoor sketching in South of France. *Address:* 2 Cornwall Road, Twickenham, Middx TW1 3LS. *Email:* 2003@patriciaclements.com *Website:* www.patriciaclementsart.com

CLIFTON, David James, A.R.C.A., M.A.; professor fine art; exhbn. artist, painter in water-colour and oil, mixed media. *b:* Derby, 10 Jul 1938. *s of:* S. J. Clifton. *Educ:* at private and public schools; sometime placed Truro's (Eton). *Studied:* Bournville School of Art (Ruskin Hall), Birmingham College of Art (1956-58), Royal College of Art (1958-61). *Exhib:* Bourneville, Birmingham, Young Contemporaries, Royal College of Art, and London shows. Possible retrospective hung at Tate: withdrawn. *Commissions:* private. *Publications:* Contemporary Situation; New Wave Writing; Poetry; Serious Matters; Existential Surreal Metaphysical Metaphor Ethic Image and Criterion. *Clubs:* Sometime: guest invitation National Liberal Club in London. *Signs work:* "D. J. Clifton." Ref: no third party agent. *Address:* Flat 8, 63 Fountain Rd., Edgbaston, Birmingham B17 8NP.

CLIFTON-BLIGH, Olivia, ARBS (2004); BA (Hons)(1993); sculptor in bronze, plaster and paper. *b:* Wroughton, 11 Oct 1971. *m:* Daniel Petkoff. one *s.* one *d. Educ:* Downe House, Berks. *Studied:* Goldsmiths' College, London University (1990-1993), Brighton Polytechnic (1989-1990). *Represented by:* King's Road Gallery, London. *Exhib:* solo and group exhibs., London and various

galleries in British Isles; R.A. Summer Exhib. (1996-1998), Artist in Residence, North Foreland Lodge (1997), Kings Road Gallery, London (2000-07), Merriscourt, Oxon (2000), Mythic Garden Arboretum, Devon (2002-06), Delamore Arts, Devon (2004-07), RBS Centenary Exhbn, Leicester (2005). *Works in collections:* Lord Bath's Wessex Collection. *Signs work:* "OLIVIA CLIFTON-BLIGH." *Address:* 2 Bull Mill, Crockerton, Warminster, Wilts. BA12 8AY.

CLINE, Penelope, Cert. of Art, Cert. of Printmaking; artist in oil and acrylic;. *b:* London, 27 Apr 1947. *d of:* Arthur Walters, Elizabeth W. *m:* Keith Richard Cline. one *s.* two (one decd.) *d. Educ:* Deepdene School. *Studied:* Brighton Polytechnic. *Exhib:* S.W.A. (1994-97), N.A.P.A. (1994-96, 1998-99), Brighton Open (1993, 1996), Chichester Open (1995); solo shows: Brighton Festival and local socs. annually. *Works in collections:* U.K., U.S.A. and S. Africa. *Publications:* contributed to 'Her Mind's Eye', 'Bonfire Magazine', 'Gator Springs Gazette', and 'The Writers' Muse', some book covers for Flame & Littoral Press and others. *Works Reproduced:* The Introduction. *Clubs:* N.A.P.A., Assoc. Sussex Artists. *Signs work:* "Penelope Cline" or "P. Cline." *Address:* 23 Brangwyn Drive, Westdene, Brighton BN1 8XB. *Email:* pennycline@hotmail.com *Website:* www.penelopecline.homestead.com

CLOAKE, Beatrice Pierrette Denise, NAPA. *Medium:* oil, watercolour, acrylic, pastel; landscape, still life, wildlife, portrait and design. *b:* Amiens, France, 21 Nov 1946. *d of:* Pierre Pasquier, artist. *m:* Burton Cloake. one *s.* two *d. Educ:* Amiens. *Studied:* under father. *Represented by:* DACS. *Exhib:* Westminster (1995); Black Sheep Gallery, Hawarden (NAPA, 2001); Nevill Gallery, Canterbury (NAPA, 2003); Henley Royal Regatta (Summer 2006). *Works in collections:* private and corporate. *Commissions:* Bank of Scotland Corporate, design Burns Night (2006, 2007); and private. *Works Reproduced:* prints by artist. *Clubs:* Portrait Society of America. *Signs work:* 'B.Cloake'. *Address:* 6 Alexandra Corniche, Hythe, Kent CT21 5RN. *Email:* beatrice_cloake@btinternet.com *Website:* www.beatricecloake.co.uk

CLORAN, Julian Thomas, NAPA. (1998); self taught artist in acrylic and felt-tip pens;. *Medium:* Acrylic. *b:* Brighton, 10 Mar 1967. *Educ:* self taught from eleven years old. *Studied:* home, briefly Ruskin College, Oxford, 1999. *Exhib:* numerous local and national shows since 1987, including Westminster Gallery, NAPA London show (1999), Fiveways Artists' Open Houses (2000), The Biscuit Factory, Hove (2001). *Commissions:* series of posters advertising exhbns., cabaret and other events for Brighton venues including 'One Off Gallery'. *Publications:* T'he Sage of Aquarius' (Authorhouse 2006) a novel. *Works Reproduced:* line drawings in small press magazines. *Clubs:* NAPA, Mensa. *Signs work:* "Julian Cloran." *Address:* 1 Treyford Close, Woodingdean, Brighton BN2 6NP. *Email:* artworker1@yahoo.com

CLOSSICK, Peter, B.B.S.I. (1969), B.A. (Hons.) Fine Art (1978), A.T.C. (1979); Elected London Group (1999). President London Group (2001-); artist in 2D painting and drawing, lecturer/fine art;. *Medium:* oil and water-colour. *b:* London, 18 May 1948. *s of:* Peter James Clossick & Edith Walker. *m:* Joyce. one *d. Educ:* Finchley Grammar School 1959-65. *Studied:* Leicester College of Art and Design (1966-69), Camberwell School of Art (1974-78, Antony Eyton, David Hepher, Gary Wragg), Goldsmiths' London University(1978-79). *Represented by:* Gallery Duncan Terrace, London. *Exhib:* John Moores, London Group, R.A., Whitechapel Open, P.S., R.O.I. and National Portrait Gallery -John Player Award, Cooling Gallery, Cork St., Gallery Duncan Terrace, London, Woodlands Art Gallery, London, Sweet Waters Gallery, London, Phoenix Gallery, London, Bow House Gallery, Herts., Pelter Sands, Bristol, The Solomon Gallery, London, Arti et Amicitiae, Amsterdam, Basle Miami, USA. *Works in collections:* Corpus Christi College, Oxford, Working Men's College, London; Greenwich Community College, Life Long Learning, UK; private and international. *Commissions:* John Byrt, Q.C., Trevor Aston, Oxford Fellow. *Publications:* The New Painting Course (Quarto plc). Painting Without a Brush (Studio Vista), The London Group - 90th Anniversary. *Official Purchasers:* Life Long Learning, UK;. *Works Reproduced:* The London Group 90th Anniversary ISBN 0-9545238-0-6. *Recreations:* reading and travel. *Signs work:* 'Peter Clossick'. *Address:* 358 Lee High Rd., Lee Green, London SE12 8RS. *Email:* j.clossick@ntlworld.com *Website:* www.thelondongroup.com/artists/clossick.html

CLOUDSLEY, J. Anne, M.C.S.P. (1935), L.C.A.D. (1975), Dip. B.S. Hons(1976); University of the Arts London; mem. London Group; artist in oil, mixed media, etcher, lithographer, photographer. *Medium:* oil, watercolour, printing. *b:* Reigate. Surrey, 20 Mar 1915. *m:* Prof. J. L. Cloudsley-Thompson. three *s. Educ:* U.C.H., London (1932-1935). *Studied:* Byam Shaw School of Fine Art (1972-1976), Goldsmiths College (1976-1977), under John Flavin, Bill Jacklin, Diana Armfield, Peter Gerrard. *Exhib:* Solo: R.G.S., S.O.A.S., Durham, Beyreuth, Stockholm, Heidelberg, Glasgow, Budapest, Ecology Centre, London Group; Brunei, S.O.A.S., R.A., Curwen, Barbican, National Theatre, Business Design Centre, Studio Voltaire, Woodlands, Cork St., The Mall (Discerning Eye), (Pastel Society), Bankside (RWS). *Works in collections:* Statoil (U.K.) Ltd. and many private. *Commissions:* U.C.L., design for Biological Council Medal. *Publications:* Women of Omdurman, Life, Love and the Cult of Virginity (Ethnographica, 1983, reprinted 1984, '87); book illustrations for Allen and Unwin, Foulis, Dent, Crowood Press, Springer. *Works Reproduced:* various journals. *Signs work:* "Anne Cloudsley." *Address:* 10 Battishill St., Islington, London N1 1TE.

CLOUGH, Carolyn Stafford: see STAFFORD, C. Carolyn,

CLOUGH, Pauline Susan, P.S. (1982); artist in pastel, acrylic and oil;. *b:* 16 Oct 1943. *d of:* Lesley J. Bird and Millie F. Bird. *m:* Peter Clough. one *s.* one *d. Educ:* Sharmans Cross High School. *Studied:* Bourneville School of Art,

Birmingham (Phyllis Devey). *Exhib:* R.A., R.I., P.S., S.W.A., R.B.S.A. and many provincial galleries. *Works in collections:* Hove Museum. *Clubs:* mem. Pastel Soc. *Signs work:* "P.S. Clough" and "Clough." *Address:* 'Sundown', 103 Allington Rd., Newick, Lewes, E. Sussex BN8 4NH.

CLUR, Elizabeth Mary, Teaching Diploma Witwatersrand School of Art (1941), & 4 years Chinese study; 1st Annual Award Best Painting on Show, Brush and Chisel Club; W.H. Coetzer Prize, Best in Show (1984). *Medium:* oil, watercolour, pastel, pen & ink, pencil. *b:* Benoni, 2 Oct 1920. *d of:* British parents C.E.Bailey (Cornwall), Daisy Roberts (Leeds). *m:* Leonard Clur, Engineer. one *s.* one *d. Educ:* Durban Girls College; Parktown Convent Joh'burg. *Studied:* art at Witwatersrand School of Art (1937-41) Johannesburg, S.Africa; chinese art privately under Prof. Fok (KAM). *Exhib:* two solo exhbns Vryburgher Hall Linden, Jhb, SA, Rosebank gallery. Many group exhbns. Joh'burg,Durban, and all over South Africa 1954-1998. Annually, Brush and Chisel Club Exhbns, SA Watercolour Society until 1998, In Full Flight (1990), Artists Under the Sun. *Works in collections:* Directors Collection Ltd. *Commissions:* paintings sold worldwide. *Publications:* name in The Collectors Guide to Art and Artists in South Africa (Oct 1998, SA Institute of Art and Artists); illustrated all work in 'South African Handbook Concrete Technology' by F.S.Fulton (1957); illustrations in Macmillan Anthology of Verse. *Official Purchasers:* Municipal Buildings, Transvaal Town. *Works Reproduced:* many calendars, 1980s and 1990s; illustrations for two books. *Recreations:* painting, world travel. *Clubs:* Brush and Chisel Club SA, SA Watercolour Society, Artists under the Sun Soc. *Misc:* teaching adults and children for 45 years, preparing many for entry into Schools of Art and art careers. *Signs work:* 'E.M.Clur'. *Address:* 7 Keepers Coombe, Crown Wood, Bracknell, Berks, RG12 0TN.

CLUR, Paddy June Gillian, BSc Hons (Zoology, Botany). *Medium:* pastels, watercolours, pencil. *b:* Johannesburg, SA, 1 Jun 1949. *d of:* Elizabeth Clur. *Educ:* Witwatersand University, Johannesburg. *Studied:* no formal training in art, but always interested in wildlife conservation. *Exhib:* Everard Read Gallery, Johannesburg, Natural History Exhibition (1995), annual exhbns at the Brush and Chisel Club of SA; The Directors Collections. *Works in collections:* private collections in UK and abroad. *Publications:* 'A Collectors Guide to Art and Artists in Southern Africa' (1998). *Recreations:* reading,travel, wildlife conservation. *Clubs:* Brush and Chisel Club of S.Africa; Associate mem. Artists Under the Sun. *Misc:* now living permanently in Britain. *Signs work:* 'P Clur'. *Address:* 7 Keepers Coombe, Bracknell, Berkshire, RG12 0TN.

CLUTTERBUCK, Jan, painter in water-colours; teacher of painting, Cassio College, Watford; Chairman, Women's International Art Club (1973-76);. *b:* Newton, Mass., 16 Jul 1919. *d of:* Sier Diefendorf, Greenwich, Conn. *m:* Jeremy R. H. Clutterbuck. one *s.* one *d. Educ:* Greenbrier College, West Virginia. *Studied:* self-taught; studied printmaking at Harrow School of Art. *Exhib:* R.A., N.S., American Embassy, Woburn Abbey. *Works in collections:* Gloucester

Education Committee, Coventry Education Committee. *Publications:* 'The Artist'. *Clubs:* W.I.A.C. *Signs work:* "Jan Clutterbuck." *Address:* Penthands House, Sarratt, Herts. WD3 6BL.

CLUTTON-BROCK, Eleanor, BA Hons. *Medium:* sculpture. *b:* 19 Jun 1946. *d of:* Alan Clutton-Brock, Slade Prof. of Fine Art, Cambridge. two *s. Studied:* Goldsmiths, London: pupil of Annie Wootton and Peter Rush. *Exhib:* RA Summer Exhbn (2002, 2003, 2004); RWA Autumn Exhbn (2004, 2005); 'David Remfrey Selects' at Bohun Gallery, Henley-on-Thames; mixed shows include Banbury Mill, Bampton, Stour Gallery, Shipton-on-Stour, Modern Art Oxford (2005). *Works in collections:* Linda Sutton, David Remfry, Lady Pilling, Bill Woodrow RA, Nicholas Mynheer, Briony & Andrew Lawson. *Commissions:* Dr.Marvin Weil: portrait sculpture. *Recreations:* writing fiction and reading, walking. *Signs work:* 'Eleanor Clutton-Brock'. *Address:* Stable End, Church Road, Northleigh, OX29 6TX. *Email:* eclepaper@hotmail.com

CLYNE, Thora, M.A.Hons. in Fine Art (1960); Special Prize (S.S.W.A., 1984); Anne Redpath Award (S.S.W.A., 1979); Andrew Grant postgrad. Scholarship and Travel Fellowship (1960-61); artist in oil, water-colour, pastel, pen and ink, lithography;. *b:* Wick, Caithness, 10 Nov 1937. *m:* G. Clemson, composer. *Educ:* Edinburgh University; Edinburgh College of Art (1955-61). *Exhib:* group shows: Morrison Portrait Competition, Royal Scottish Academy (1991, 1995, 1997); 'Homage to Senefelder', Edinburgh Printmakers Workshop (1996); SOFA (1997-2000, 2003); Inverness Open (1998, 2001, 2004); Cats and Other Animals, Hanover Fine Arts, Edinburgh, 2003, 2004; 4th International Lithographic Symposium, Tidaholm, 2002; 2nd Print Open, DCA, 2002; RGIFA, 2002; 'Challenge the Nail', Salon des Arts, London, 2005; Highlands, Views & Visions, Library, RSA (2007); Remix (100), Vilnius (2006). *Works in collections:* Edinburgh Corporation Schools, Ross & Cromarty Educ. Authority, First Scottish-American Trust Co., Ltd., Gillies Bequest, R.S.A. *Commissions:* Portraits of cats, landscapes. *Works Reproduced:* in "Stone Lithography" by Paul Croft. *Clubs:* member of www.creativeperthshire.org.uk. *Signs work:* "Thora Clyne." *Address:* Tillywhally Cottage, Milnathort, Kinross-shire KY13 0RN. *Email:* thora@catpawtraits.co.uk *Website:* www.catpawtraits.co.uk

COATE, Peter, RW.A., A.T.D., Chelsea Dip. (1950); painter in oil, water-colour, and teacher; Director, Mendip Painting Centre (1974-86);. *Medium:* oil and watercolour. *b:* Nailsea, Som., 9 Mar., 1926. *s of:* Redvers Coate, cidermaker. *m:* Margaret Bickerton (died 1978). Pamela Somerville (1980). one *s.* one *d. Educ:* Sherborne and New College, Oxford. *Studied:* Chelsea under Robert Medley, Claude Rogers and Ceri Richards. *Exhib:* London Group, RA, NEAC, SWLA, RWA, ROI, Bath Society of Artists; and many one-man shows in West Country galleries including The Patricia Wells Gallery, The Mignon Gallery, The Mall Gallery, The Ginger Gallery, Bristol Guild, The Court Gallery, and The Albany Gallery, Cardiff. *Works in collections:* R.W.A., Hertfordshire and Cumberland County Councils, Nuffield Foundation. *Misc:* Painter of wild

landscape, birds and old buildings, including many Somerset churches. Has made many painting excursions to Wales - Brecon Beacons, Pembrokeshire (Skokholm and St.Davids) and North Wales around Cader Idris and the Lleyn Peninsula, and to Tuscany. Made two invited visits to Cill Rialaig in Western Ireland. *Signs work:* "Peter Coate." *Address:* Orchard Lodge 2A Ash Lane Wells Somerset. *Website:* BA5 2LU

COATES, Penny, HS. *Medium:* watercolour/ mixed media. *b:* Norwich, 12 Mar 1938. *d of:* Harold & Myrtle Forder. *m:* David. one *s.* two *d. Educ:* Wombwell Technical College. *Studied:* with Elizabeth Woods, past curator, Grundy Museum, Lytham St.Annes; Janet Sheath, RMS, SWA. *Exhib:* Llewelyn Alexander Fine Paintings Ltd., HS, SWA, RMS. *Works in collections:* H.R.H.Princess Michael of Kent. *Commissions:* locally. *Principal Works:* The Royal Yacht Squadron; Cowes Waterfront; East Cowes Waterfront; Farringford Manor, IOW (the home fo Lord Tennyson). *Clubs:* West Wight Painting Circle; SAA. *Signs work:* 'Penny Coates'. *Address:* 27 Forest End, Camphill, Newport, Isle of Wight PO30 5PG. *Email:* coatesforestend@talktalk.net *Website:* www.pecoates.com

COATES, Thomas J., P.N.E.A.C., P.P.R.B.A., R.W.S., R.P.; awarded De Lazlo Medal, 1st and 3rd prizes in Sunday Times Water-colour Exhbns. (1988, 1989); Past President Pastel Society; R.W.A., membre de Honneur French Pastille., Hon. R.B.S.A., many other awards; painter of landscapes, townscapes and portraits in oil and water-colour;. *b:* 1941. *Studied:* Bournville and Birmingham Colleges of Art (1956-61), R.A. Schools (1961-64). *Exhib:* R.A., R.B.A., and many one-man shows including New Grafton Gallery, Cross Gate Gallery, Ky., U.S.A., W.H.Patterson, Mall Gallery, Alresford Gallery. *Works in collections:* H.M. The Queen. H.R.H.Prince of Wales. Many other private collectors. *Publications:* Creating a Self Portrait. *Recreations:* golf, walking the dog. *Clubs:* Dover Street Arts Club, Chelsea Arts Club, Hampshire Golf Club. *Address:* Bladon Studio, Hurstbourne Tarrant, Hants. SP11 0AH.

COBB, David, P.P.R.S.M.A., R.O.I.; self taught artist;. *b:* 13 May, 1921. *m:* Jean Main, Associate Fellow, Guild of Glass Engravers (died 1998). one *d. Educ:* Nautical College, Pangbourne. *Exhib:* R.O.I., R.S.M.A. *Works in collections:* National Maritime Museum, Royal Naval Museum, Fleet Air Arm Museum, Army Museum, Mersey Museum, Hull Museum. *Clubs:* Royal Cruising Club (Life mem.), Royal Yacht Squadron (Hon. painter). *Signs work:* "DAVID COBB." *Address:* Woodis, Setley, Brockenhurst, Hants. SO42 7UH.

COBLEY, David Hugh, R.P. (1997), R.W.A. (2001);; portrait and figure painter in oil, charcoal, pencil, pen;. *b:* Northampton, 27 June, 1954. *m:* Masami Minagawa. three *d. Studied:* Northampton and Liverpool. *Represented by:* Beaux Arts, Bath; Everard Read Gallery, Johannesburg. *Exhib:* R.A., B.P. Portrait Award, R.P., R.W.A., Hunting Art prizes, Discerning Eye, New English Art Club. *Works in collections:* throughout the U.K. and abroad. *Commissions:* English

National Ballet, Royal Engineers, Royal Marines, National Soc. for Epilepsy, Westminster Abbey, etc. *Works Reproduced:* in The Artist, Artists and Illustrators, International Artist, Art Class (Harper Collins) magazines. *Address:* 22 Linden Crescent, Lower Westwood, Bradford-on-Avon, Wilts. BA15 2AN. *Email:* mail@davidcobley.co.uk *Website:* www.davidcobley.co.uk

COBURN, Ivor Basil, DA.(1955), UWS, NDD (1956),WCSI, ARUA, FSBA; RHS six Gold and two Silver medals, two Grenfell; Royal Ulster Academy Gold medal (perpetual); artist in water-colour and oil. *b:* Belfast, 10 Apr 1934. *s of:* Alfred and Margaret Coburn. *m:* Patricia. one *s.* three *d. Educ:* Grosvenor High School, Belfast. *Studied:* Belfast College of Art, Leeds College of Art, and University. *Exhib:* one-man shows: Belfast, Dublin, Newcastle, Londonderry, Glasgow, London, Antwerp, Brussels, Paris, Annecy, Compiegne, Wexford Galway (2003), Dublin; group shows: London, Belfast, Brussels, Paris, Dublin, Rochester, Windsor. *Works in collections:* U.S.A., Canada, France, Belgium, Holland, Australia, New Zealand, Israel, Sweden, England, Ireland, Scotland, Wales, Germany. *Commissions:* self-portrait, National Collection Ireland. *Publications:* Flower Painting Techniques by Sue Burton. *Official Purchasers:* NUU (New University, Ulster), UCD (University College, Dublin), QUB (Queen's University, Belfast). *Works Reproduced:* limited edition Siamese Cats 'Watchful' ans 'Sleeping Ching', 2 paintings of Monet's Garden, 850 limited ed. black cat 'Malt'. *Clubs:* S.B.A. (Founder mem.)., UWS (Founder mem.). *Signs work:* "Ivor B. Coburn." *Address:* The Springs, 50 Megargy Rd., Magherafelt, Co. Londonderry BT45 5HP, N. Ireland. *Email:* ivorcob@hotmail.com *Website:* watercoloursivorcoburn.com

COCHRAN, Margi, C.L.W.A.C. (1976), R.M.S. (1987), M.A.A. (1989); artist in oil, pastel, water-colour and colour pencil;. *b:* Philadelphia, Pa., 30 Aug 1925. *m:* Arthur Oschwald, Jr. one *s.* one *d. Studied:* Philadelphia Museum School of Art (1945-47), Montclair Art Museum (1974-79). Teacher - private groups (1973-83). *Represented by:* J.M.Stringer -Gallery of Fine Art, Bernardsville, NJ 07924, U.S.A. *Exhib:* 16 solo shows; many group shows; many juried shows, many awards, N.J., N.Y.C., Fla., Ga., Wash. D.C. International solo exhbn. (1995), Kirkleatham Old Hall Museum, Redcar, England. *Works in collections:* M.A.S.-F., Kirkleatham Old Hall Museum, Redcar, Millburn-Shorthills Collection of noted N.J. artists in area, RMS Diploma Collection. *Publications:* American Impression of Staithes (1995). *Works Reproduced:* "Autumn Cowboy" - poster, Lajitas, Texas; "Staithes Bonnet" - postcard, N.Yorkshire, England. *Clubs:* C.L.W.A.C., R.M.S., M.A.A., M.A.S.-F., M.P.S.F.S. (Washington D.C.). *Signs work:* 'Margi Cochran'. *Address:* Box 483, Bernardsville, New Jersey 07924-0483, U.S.A. *Email:* emcoartist@aol.com

COCKER, Doug, D.A., A.R.S.A., F.R.B.S.; sculptor;. *b:* Alyth, Perthshire, 1945. *m:* Elizabeth. two *s.* one *d. Educ:* Blairgowrie High School. *Studied:* Duncan of Jordanstone, Dundee (1963-68). *Exhib:* R.S.A., Yorkshire Sculpture Pk., The British Art Show, Air Gallery London, Serpentine Gallery London,

Fruitmarket Gallery, Edinburgh, Third Eye Centre, Glasgow. *Works in collections:* Arts Council, Scottish Arts Council, Contemporary Art Soc., Kelvingrove A.G., Glasgow, Peterborough A.G., Greenshields Foundation, Montreal, Leicester University, Hunterian A.G., Glasgow, Essex C.C., Staffs. C.C., M.M.A. Sarajevo. *Signs work:* "DOUG COCKER." *Address:* Lundie Mill, Lundie, Angus DD2 5NW.

COCKRILL, Maurice, R.A. (1999); Elected Keeper of Royal Academy of Arts (2004). *Medium:* artist in oil on canvas and other media. *b:* England, 1936;. *s of:* William Cockrill and Edith Godfrey. three *s. Studied:* Wrexham School of Art and University of Reading (1960-64). *Exhib:* one-man shows: Edward Totah Gallery (1984, 1985), Kunstmuseum, Düsseldorf (1985), Bernard Jacobson Gallery (1987, 1988, 1990, 1992, 1994, 1995), Retrospective '1974-94' Walker A.G. (1995) (illus. cat.), Galerie Clivage, Paris (1995), Annandale Galleries, Sydney (1995), Galleri Clivage, Paris (1997), Galerie Helmut Pabst, Frankfurt (1997), Royal West of England Academy (1998), Purdy Hicks Gallery, London (1998), Archrs Fine Art, London (2002), Galerie Vidal-St.Phalle, Paris, 2003. Hillsboro Fine Art, Dublin 2005. Galerie Alders, St.Tropez, 2006. Cheltnham Museum,. 2007. *Works in collections:* A.C.G.B., Walker A.G., Unilever, B.M., Contemporary Art Soc., Centro Cultural Arte Contemporaneo, Polanco, Mexico, Kunstmuseum, Düsseldorf. *Publications:* monograph, authors, Marco Livingstone and Nic.Alfrey, pub. Merrett 2002. *Principal Works:* "Four Seasons", oil. Walker Art Gallery, Liverpool, 1991. "Divided #83", Royal Academy, diploma work, 2000. *Clubs:* Chelsea Arts, Dover Street Arts Club, Lansdowne Club. *Signs work:* full signature on back. *Address:* 78b Park Hall Rd., London SE21 8BW. *Email:* admin@cockrill.co.uk *Website:* www.cockrill.co.uk

CODNER, John, RWA.(1937); artist in oil, portrait, landscape, still lives, marine, etc.; asst. master, Sir John Cass School of Art (1947-51);. *b:* Beaconsfield, 1913. *m:* Rachael Notley. two *s. Studied:* Regent St. Polytechnic School of Art (1930-32, Harry Watson). *Exhib:* RA, RP, RWA, most provincial galleries etc. *Works in collections:* Office of Works, RWA, Bristol, Gloucester Essex Corps., London Universities, Inst. of Civil Engineers, City Livery Club, Bristol Masonic Hall, RCGP, many boardrooms and private collections, Belgium, Canada, Europe, America, UK, Far East, etc. *Clubs:* Arts Dover St., Bristol Savages. *Misc:* Served in H.M. Forces (1939-45) in R.E. in camouflage; Co-founder of CARE for the Mentally Handicapped with Peter Forbes (Slade). *Signs work:* "John Whitlock" until death of his father 1958, since then "John Codner." *Address:* 15 Cote House, Westbury-on-Trym, Bristol BS9 3UP.

CODNER, Stephen Milton, painter in oil, pastel, portrait, landscape, still life, etcher. *b:* Clevedon, Som., 1952. *s of:* John Codner, RWA. Grandson of Maurice Codner, RP, ROI. *m:* Carolyn Hamilton. three *d. Educ:* Bryanston School Dorset. *Studied:* Camberwell School of Art and Crafts, City and Guilds Art School. *Exhib:* RA. RP, RWA, 'Discerning Eye.'. *Signs work:* "S. M. CODNER" or "STEPHEN CODNER." *Address:* 23 Maplestead Rd., London SW2 3LY.

COHEN, Bernard, Slade Dip.; professional artist in painting and printmaking; Slade Professor and University of London Chair in Fine Art; Director of Slade School, U.C.L.; Emeritus Slade Professor (1988-2000), Fellow of University College, London. *b:* London, 28 Jul 1933. *s of:* Victor Cohen. *m:* Jean. one *s.* one *d. Studied:* Slade School of Fine Art (1951-54, Sir William Coldstream). *Exhib:* Gimpel Fils (1958, 1960), major retrospective: Hayward Gallery (1972 touring), Kasmin Gallery (1963-1967), Waddington Galleries (1972, 1974, 1977, 1979, 1981, 1990), Flowers East (1998), Flowers West, L.A. (1999), Tate Gallery (1976), drawing retrospective Ben Uri Gallery (1994), 'Artist in focus', Tate Gallery (1995), and major group exhbns. worldwide including British Pavilion Venice Biennale (1966). *Works in collections:* Arts Council, MoMA (NY), Tate Gallery, V&A, etc. *Publications:* major catalogues: Hayward Retrospective 1972 - Arts Council G.B., Waddington Galleries (1974-1990), Bernard Cohen, Paintings from the 90's - Flowers East Gallery, Flowers Central (2001); Paintings from the 60's - Flowers East Gallery (2007). *Signs work:* "Bernard Cohen" on works on paper only. *Address:* 80 Camberwell Grove, London SE5 8RF. *Email:* bwc44@hotmail.com *Website:* Flowers East Gallery

COHEN, Mary, artist in oil, pen and wash, water-colour. *b:* London, 21 Nov 1910. *d of:* Ernest M. Joseph, C.B.E., F.R.I.B.A., architect. *m:* Cdr. Kenneth Cohen, C.B., C.M.G., R.N. one *s.* one *d. Studied:* Florence, Slade under Prof. Tonks and Prof. Schwabe (1928-31), and Euston Road School. *Exhib:* Leicester Galleries Mixed Exhbns., R.A., R.B.A., N.E.A.C., London Group, Roland, Browse and Delbanco, New Grafton Gallery. *Works in collections:* National Trust, Whitworth, A.G. and private collections in Gt. Britain, France and U.S.A. *Signs work:* "Mary S. C." *Address:* 33 Bloomfield Terr., London SW1.

COKER, Norman, Richard, City & Guilds of London Inst. FETC (1974), FSBA (1986); art teacher Adult Educ. Centres; Founder mem. S.B.A. (Society of Botanical Artists); awarded the Founder President's Honour in the year 2000 and 2004; artist in oil, lecturer;. *b:* Grays, Essex, 27 Jan 1927. *m:* Doreen Anne. *Educ:* Park Secondary School, Grays. *Studied:* Thurrock Tech. College. *Exhib:* Nairobi, Kenya (wild life), The McEwan Gallery, Scotland (British Flower Painters), The Veryan Gallery, Cornwall, Singapore, London, Amsterdam, The Frinton Gallery; one-man show at Beecroft Gallery, Westcliff-on-Sea (1991). *Works in collections:* many private collections worldwide including H.R.H. The Princess Anne, The Princess Royal, an equestrian portrait of H.R.H. with her horse Doublet. *Commissions:* James Last (orchestra leader) a painting of the Royal Albert Hall. *Publications:* work included in "The Encyclopedia of Flower Painting Techniques" by Sue Burton (Quarto, 1997); work in print with Rosentiel's of Chelsea, Medici; 'Dictionary of International Biography 31st Ed.'; 'The Cambridge Blue Book' (International Biographical Centre, Cambridge, England); autobiography, 'A Brush with my Palette' published 2005. Copies in the National Published Archive, The Universities of Oxford, Cambridge, Trinity College Dublin, and the National Libraries of Scotland and Wales. *Works Reproduced:* Jason Productions, New Zealand; Paper Rose of Nottingham. *Signs work:*

"Norman R. Coker." *Address:* "Tensing", Muckingford Rd., Linford, Stanford-le-Hope, Essex SS17 0RF.

COLDWELL, Paul, BA Fine Art; Slade Higher Diploma; Professor of Fine Art, University of the Arts, London. *Medium:* drawing, prints, sculpture. *b:* London, 8 Nov 1952. *m:* Charlotte Hodes. one *s.* one *d.* *Studied:* Bristol Polytechnic (1972-75); Slade School of Fine Art (1975-77). *Represented by:* Eagle Gallery, London. *Exhib:* solo: Edinburgh Printmaker (2005); London Print Studio, Queen's Gallery-Delhi (2002); Arthouse, Dublin (1999); Freud Museum, London (1996); numerous group shows including biennales at Ljubljana, Macau, Cairo and New York. *Works in collections:* Tate Gallery, Arts Council of England, V&A, Imperial War Museum, MOMA New York, British Museum. *Publications:* Finding Spaces Between Shadows (2005, Camberwell Press). *Signs work:* 'PAUL COLDWELL'. *Address:* 86 Oakfield Road, London N4 4LB. *Email:* coldwell.hodes@blueyonder.co.uk

COLE, Barbara Evelyn (B.E.), ARBS (2003); BA (Hons) Sculpture; MA (Sculpture). *Medium:* drawing; sculpture (bronze, aluminium, stone). *b:* Newport, Gwent, 14 May 1952. *d of:* Jack and Sylvia Vickery. one: Andrew Cole *s.* *Educ:* Croesyceiliog Grammar School, Cwmbran. *Studied:* Trent Polytechnic, Rochdale College of Art, Sheffield Hallam University. *Represented by:* Wills Lane Gallery; Porthminster Gallery, St.Ives; Colin Jellicoe, Manchester. *Exhib:* RA (1994, 95, 98, 2000, 02, 06); Triennial Sculpture Exhbn. RWA (1999); Wales Drawing Biennale (1997/8, 1999/2000); Jerwood Drawing Prize (2004/5); Solo: Holden Gallery, Manchester (2000); B.E.Cole New Work, Chichester (2004); Group: Rural Central, LCF (2006). *Works in collections:* London College of Fashion; private collections UK, USA and Australia. *Commissions:* private (1994-2007). *Official Purchasers:* LCF, London. *Works Reproduced:* Royal Academy Illustrated, 2002; Jerwood Drawing Prize, 2004/5. *Principal Works:* Form (aluminium); Untitled (boulder)(aluminium). *Misc:* exhibits as B.E.Cole; Associate, Penwith Gallery, St.Ives. *Signs work:* 'B.C.'; 'B.E.C.'. *Address:* Meadowhead Farm, Lobden, Whitworth, Lancs., OL12 8XJ. *Email:* becole22@aol.com *Website:* RBS

COLEBORN, Deanne, A.R.C.A., R.E.; painter/etcher;. *b:* Worcs., 30 Dec., 1931. *m:* Keith. six *d.* *Studied:* R.C.A. *Exhib:* R.A., R.E. *Signs work:* "DEANNE." *Address:* Downe Hall Farm, Cudham Road, Orpington, Kent BR6 7LF.

COLEBORN, Keith, A.R.C.A., A.T.D., F.R.S.A.; until July 1976 principal, Ravensbourne College of Art and Crafts; regional art principal, N.W. Kent; principal, Bromley College of Art (1946-62); principal, Stourbridge School of Art (1937-40); principal, Wallasey School of Art (1940-46);. *b:* Portsmouth. *Address:* Downe Hall Farm, Cudham Road, Orpington, Kent BR6 7LF.

COLEMAN, Brian, Mem. Pastel Soc.; painter in water-colour; Art Director/Graphic Designer, advertising;. *b:* Cheam, Surrey, 3 Sept., 1935. *m:* Joan

Coleman. *Educ:* Stoneleigh Secondary Modern. *Exhib:* Kingsmead Gallery, Bookham, Surrey. *Signs work:* "Brian Coleman." *Address:* 2 Sheraton Drive, West Hill, Epsom, Surrey KT19 8JL.

COLEMAN, Christine, A.N.S.P.S., A.B. (University of Chicago, 1946) sculptor in stone, wood and cement;. *b:* Joliet, Illinois, U.S.A., 22 Dec., 1925. *Educ:* Mary Ward Centre, London (1986-). *Exhib:* group shows in London. *Signs work:* "COLEMAN." *Address:* 24 Ladbroke Gdns. London W11 2PY.

COLLES, Dorothy Margaret Tyas, portrait painter in pastel and oil, drawings in pencil and chalk. *b:* Cairo, 1917. *d of:* William Morris Colles. *Educ:* Parsons Mead, Ashtead. *Studied:* Epsom Art School; Westminster Art School; St. Martin's School of Art. *Exhib:* P.S., R.P., R.A. Work in private collections. *Commissions:* mainly private families. *Publications:* Portraying Children; Christian Symbols Ancient and Modern with Heather Child. *Signs work:* "COLLES." *Address:* 70 Heath Rd., Petersfield, Hants. GU31 4EJ.

COLLETT, Paula, B.A.(Hons.); public/community artist in textile/soft sculpture; workshop leader;. *b:* Wakefield, 16 July, 1969. *Educ:* Woodkirk High. *Studied:* Chelsea School of Art and Design (1989-92, Roger Hoare). *Exhib:* tree art: Oakwell Hall. *Works in collections:* Huddersfield Royal Infirmary, Airville Leisure Centre. *Signs work:* "P. Collett." *Address:* 11 Boldgrove St., Earlsheaton, Dewsbury, W. Yorks. WF12 8NA.

COLLINGBOURNE, Stephen, painter, sculptor; prize winner, R.S.A., and John Moores; Awards: Welsh Arts Council, Scottish Arts Council, Arts Council GB, British Council. *Medium:* sculpture, mainly in metal; mixed media mainly on paper (collage, printing, drawing, painting). *b:* Dartington, 15 Aug 1943. *s of:* J.C. and A.M. Collingbourne. *m:* Aileen Keith (artist). one *s.* one *d. Studied:* Dartington College of Art (1960-61); Bath Academy, Corsham (1961-64). *Exhib:* British Council, Malaya; Chapter, and Oriel, Cardiff; Camden Arts Centre, Zella 9, Fisher Gallery and Serpentine, London; Kettles Yard, Cambridge; MacRobert Arts Centre, Stirling; Third Eye Centre, Glasgow; City Art Centre and Talbot Rice, Edinburgh; Nykarleby, Kokkola and Helsinki, Finland. *Works in collections:* Leicester A.G., Devon, Leicestershire and Hertford Educ. Authorities, Edinburgh City Art Centre, Motherwell Council, Art in Hospitals. *Commissions:* Welsh Arts Council, Leicester University, Livingstone, Edinburgh. *Publications:* Drawing Comparisons (ISBN 0-9531180-0-2). *Works Reproduced:* 'Open Air Sculpture in Britain' by W J Strachan. *Principal Works:* '4Fold', Leicester University. *Signs work:* 'Stephen Collingbourne' or 'Collingbourne'. *Address:* Tofts, Blyth Bridge, West Linton, Peeblesshire EH46 7AJ.

COLLINGE, Robert Anthony, N.D.D. (1955), A.T.D. (1956), Blond Travelling Scholarship (1957), Slade Dip. (1959); artist in collage and construction; taught at: Canterbury College of Art (1961-63), London College of Printing (1962-63), Goldsmiths' School of Art (1963-96, working with Anton Ehrenzweig and Harry and Elma Thubron); mem. London Group; Vice President

London Group (2000-2001);. *b:* Cheshire, 28 July, 1934. *Educ:* King's School, Chester. *Studied:* Liverpool College of Art (1951-56), British School at Rome (1957), Slade School (1957-59). *Exhib:* Northern Young Artists; Five Painters, Sandon Studios, Liverpool; Young Contemporaries; Drian Gallery; Hope Hall Gallery, Liverpool; New Art Centre, London; London Group's 75th Anniversary Exhbn. R.C.A. (1988), Storey Inst., Lancaster, Invited Artists Exhbn. (1993), London Group's 80th Birthday Open Exhbn., Concourse Gallery, Barbican (1993), Joint exhbn. with Elma Thubron, Storey Inst., Lancaster (1994); London Group's Biennial Open Exhbn., Concourse Gallery, Barbican (1995), 'Musée Imaginaire' group exhbn. Museum of Installation, Deptford (1997); solo show: Woodlands Gallery, Blackheath (1995), The Walk Gallery, London (Mar. 2001), Stark Gallery, London (2001). *Works in collections:* Arts Council, Goldsmiths' College Gallery, Archive of the Museum of Installation; various private collections. *Publications:* in collaboration with Anton Ehrenzweig a booklet 'Towards a theory of Art Education (Goldsmiths' College, 1964). *Signs work:* "TONY COLLINGE." *Address:* 32 Prior St., Greenwich, London SE10 8SF.

COLLINGS, David, Dip. (1969), A.T.D. (1972); artist in oil on board, canvas; teacher of mentally handicapped. *b:* London, 1949. *s of:* Robert Collings. *Studied:* Redruth School of Art (1965-69), Berks. College of Education (1969-72). *Exhib:* widely in S.W. England, Brittany and Ireland. *Works in collections:* Contemporary Art Soc. *Clubs:* Newlyn Soc. of Artists. *Signs work:* "David Collings." *Address:* 3 Lyn Terr., Newlyn, Penzance, Cornwall.

COLLINS, Clive Hugh Austin, Awards: Romania, Knokke-Heist, Netherlands, Macedonia, Japan, Canada, Germany, UK. *Medium:* brush and pens, gouache, occasioanlly AppleMac. *b:* Weston-Super-Mare, Avon, 6 Feb 1942. *s of:* Greville and June Collins. *m:* Lynne; one s. & one d. by previous marriage. *Educ:* Shene Grammar School. *Studied:* Kingston Art College, England. *Exhib:* Cartoon Gallery, London (1993), The Barbican, London (1993), Zagreb, Croatia (1987). *Works in collections:* Museum of Cartoon Art, Basel; Cartoon Art Trust, GB. *Publications:* Dictionary of Twentieth Century Cartoonists and Caricaturists (ed. Mark Bryant); Handbook of Sailing and Watersports (Mondria), Montreal Catalogue of Cartoons, Funny Book of. . Sex, Motoring, Work; The Idiots Guide to Sex. *Works Reproduced:* Punch (1964-2003), Playboy (1972), current newspapers and magazines. *Recreations:* drawing, meeting friends, music and films. *Clubs:* Cartoonists' Club of GB, The British Cartoonists Association. *Signs work:* 'Clive Collins'. *Address:* Mead Cottage, 77 Woodfield Road, Hadleigh, Essex, SS7 2ES. *Email:* collinscartoons@aol.com *Website:* www.clivecollinscartoons.com

COLLINS, Marjorie, SWA (1994); BSc Design; Winsor & Newton Grand Prize Award 'The Artist' Celebration 2000 Competition; Assoc SBA (2007). *Medium:* painter in watercolour and acrylic. *b:* Chicago, USA, 24 Feb 1941. *m:* Michael Collins. one *s.* one *d. Studied:* Universiy of Michigan; Art Institute of Chicago. *Exhib:* RA Summer Exhbn, Hunting Prizes, Singer &

Friedlander/Sunday Times Watercolour Competition; ROI, RWS, RI; solo shows: Joy Horwich Gallery, Chicago; Barbican Centre, London; group shows: in London including Artmonsky Arts, Llewelyn Alexander etc., many others throughout the UK. *Works in collections:* in USA and UK. *Publications:* paintings featured in: Artists & Illustrators Magazine (1995); 'Painting Great Pictures from Photographs (1999); 'Inspiration to Paint' (2002); How Did You Paint That?-100 Ways to Paint Still Life (2004); Painting Light and Shadow (2004); Painters with Watercolours magazine (2004); Different Strokes (2007). *Works Reproduced:* 1987 painting selected for reproduction by HM Government Office of Arts and Libraries. *Recreations:* playing bridge. *Clubs:* Oxford Art Society. *Signs work:* 'M.Collins'. *Address:* 28 Hayward Road, Oxford OX2 8LW. *Email:* mac@marjoriecollins.com *Website:* www.marjoriecollins.com

COMBES, Richard A., ROI (2004); BA & BArch (Hons) in Architecture; MA Fine Art (Cum Laude), New York Academy of Art; Cornelissen Prize for Outstanding Work (ROI, 2003); Stanley Grimm Award (ROI, 2005) - Visitors Vote 1st & 2nd Prize; The Menena Joy Schwafe Memorial Award - Outstanding Painter (ROI, 2006). *Medium:* oil and charcoal. *b:* Manchester, 28 May 1963. *m:* Luna. *Educ:* Retford, N.Notts., England. *Studied:* University of Liverpool; New York Academy of Art. *Represented by:* Mike Levers; Dukeries Art Gallery. *Exhib:* RA Summer Exhbn (2006, 2007); ROI (2003-07); RP (2001-04); National Portrait Gallery, BP Awards (1996-2003); Harley Gallery, Welbeck, Notts (2005, 2008); Whittington Fine Art, Henley on Thames; permanent at Dukeries Art Gallery, Worksop;. *Works in collections:* Barbara Streisand, Jeffrey Epstein, Leslie Wexner, John Major (former PM). *Commissions:* portraits of: Sir Hugh Neill KCVO, C.B.E., Ex Lord Lieutenant of South Yorkshire, Master Cutler of Sheffield; Sir Andrew Buchanan, Lord Lieutenant of Nottinghamshire. *Recreations:* swimming, reading, old films. *Address:* Dukeries Art Gallery, 88 Gateford Rd., Worksop, N.Notts., S80 1TY. *Email:* mike@dukeriesartgallery.com; michael.levers@ansbronze.com *Website:* www.dukeriesartgallery.com

COMPSTON, Diana Mary, retired painter in oil. *b:* Brighton, 4 Dec 1919. *d of:* Dr. Frank Standish. *m:* Dr. Nigel Compston C.B.E., FRCP (decd.). two *s.* one *d. Educ:* Westcliff, Weston-super-Mare. *Studied:* Hampstead, Tunbridge Wells, and Farnham Colleges of Further Education. *Exhib:* R.O.I., S.W.A., Laing, Mall Galleries, Gallerie de Defense, private exhibs., East Grinstead, Tunbridge Wells, Winchester. *Works in collections:* Laing Calendar (2001), Royal College of Physicians, London. *Clubs:* Dunmow Art Club, Fry Art Gallery, Saffron Walden. *Signs work:* "D C" in red. *Address:* 6 Little Larchmount, Saffron Walden, Essex CB11 4EF.

CONLON, Elizabeth, self taught part-time painter in oil, water-colour, egg tempera and embroidery;. *b:* Dublin, 1938. *m:* Norman Rogers. one *s.* one *d. Exhib:* annually at S.B.A., R.S.M.A., R.O.I., etc. *Publications:* author and

illustrator: Learn to Paint Flower Portraits in Water-colour. *Address:* 61 Orchard Ave., Poole, Dorset BH14 8AH.

CONN, Roy, *Medium:* oil, gouache, mixed media, photography. *b:* London, 19 Jan 1931. *Educ:* Westminster College. *Studied:* early training Structural Engineering-mainly Self-taught as a painter. Elected member of Penwith Society in 1959. Moved to St.Ives Oct. 1958. *Exhib:* solo exhibitions at the Rowan Gallery, London and Arnolfini Gallery, Bristol. Numerous group exhbns and mixed shows including: London Group, New Vision Centre, John Moores, Liverpool, Bradford City Art Gallery, Penwith Gallery, Tate St.Ives, etc. *Works in collections:* public collections include: Contemporary Arts Society, Arts Council of Northern Ireland, V & A Museum, Cornwall Education Authority, The Ind Coope Collection. Work also in many private collections in UK and abroad. *Clubs:* Penwith Society of Arts, Country Club UK. *Signs work:* Roy Conn. *Address:* 1 Porthmeor Studios, Back Road West, St.Ives, Cornwall TR26 1NG.

CONNER, Angela, FRBS, American Inst. Architects Award; sculptor in stone, bronze, water, light, wind; competition winner, Economist Plaza, London, Aston University, de Gaulle, London, Cambridge, Lexington Airport, Kentucky etc. *b:* London, 1935. *m:* John Bulmer. one *d. Represented by:* Rebecca Townshend (Australia); Peggy Townsend (USA); A.Conner Ltd. (UK). *Exhib:* solo exhibs., Lincoln Center, N. Y., Browse and Darby, and Hirschl Gallery, Cork St., London, Friends of the Tate, etc.; group exhibs., Gimpel Fils Gallery, N. Y., R.A. Summer Show, V. & A. Museum, Temple Gardens, London, Carnegie Museum of Modern Art, Washington Museum, Sculpture by the Sea, Sydney, Australia, etc. *Works in collections:* Arts Council G.B., National Portrait Gallery, Pittsburgh Museum of Modern Art, Jewish Museum, N. Y., Musee de l'Armee, Paris, V.&A. Museum, House of Commons, National Trust, etc.; private collections, H.R.H. Prince of Wales, Paul Mellon, Dr. Roy Strong, Lucien Freud, President Chirac, John Major, Crown Prince of Saudi Arabia, Duke of Devonshire, Lord Sainsbury, Dame Drew Heinz, Gunter Sachs, Evelyn Rothschild, Mrs. Henry Ford, Lord Cranbourne, 10 Downing St., French Embassy, etc. *Commissions:* largest outdoor sculpture in Europe, Dublin; city centre pieces for Heinz Hall Plaza, Pittsburgh, U.S.A.; Horsham, Surrey, Chesterfield, Derbyshire; largest indoor sculpture, Lovells, London, Mobile Arch,Longleat, Wessex and some 100 others. Many bronze portraits- Tom Stoppard, Lucien Freud, Dame Janet Baker, John Betjeman, Lord Rothschild,Janus Arch, Longleat Estate.Portrait of H.M. The Queen, Prime Ministers, etc. *Works Reproduced:* various books and magazines in UK, Australia & USA. *Principal Works:* Largest outdoor sculpture in Europe, tallest indoor mobile in Europe, gold and silver water mobile for State dining table, Memorial to Victims of Yalta outside V & A, London, etc. *Recreations:* Breeding and showing Morgan horses, Equitation etc. *Signs work:* Conner. *Address:* George and Dragon Hall, Mary Pl., London W11 4PL. *Email:* angelaconner@which.net *Website:* www.angelaconner.co.uk

CONNOLLY, Anthony, BA Hons, ARP; Prince of Wales Award for Portrait Drawing (2004). *Medium:* oil, pencil. *b:* Huddersfield, 2 Jun 1957. *m:* Josephine Edmondson. four *s.* six *d. Educ:* St.Peter Claver College. *Studied:* Goldsmiths 1978-81. *Exhib:* selected exhibitions include: RP (199702007), Discerning Eye (2002); Garrick Milne Prize Exhbn (2003); RWA (2004); Artexpo, Antwerp (2005); GMAC, Paris (2006), Battersea Art Fair (2006); solo shows: Guggleton Gallery (1998, 2000, 2004), London Oratory (2001), Century House, Salisbury (2005). *Signs work:* 'Anthony Connolly'. *Address:* Old Bridzor, Wardour, Tisbury, Wiltshire, SP3 6RG. *Email:* mail@anthonyconnolly.co.uk *Website:* www.anthonyconnolly.co.uk

CONNON, William John, D.A. (1959), post-Dip. (1960); painter in oil, draughtsman; retd. lecturer in drawing and painting at Grays School of Art, Aberdeen;. *b:* Turriff, 11 Dec 1929. *m:* Margaret Reid Mair. one *s.* one *d. Educ:* Turriff Academy. *Studied:* Grays School of Art, Aberdeen, under R. Henderson Blyth, R.S.A., Ian Fleming, R.S.A.; Hospitalfield, Arbroath. *Exhib:* RSA, Society of Scottish Artists, Aberdeen Artists Society (est.1885), McBey printroom, Aberdeen Art Gallery, Artspace, Aberdeen, Scottish Gallery, Edinburgh, Roger Bilcliffe Gallery, Glasgow. *Works in collections:* Aberdeen A.G., Scottish Arts Council, City of Edinburgh Art Centre, Royal Scottish Academy (Muirhead Bequest Coll.), Duke of Edinburgh. *Signs work:* "wjconnon." *Address:* 8 Fonthill Rd., Aberdeen AB11 6UB.

CONSTABLE, Richard Golding, *Medium:* mixed media. *b:* Lewes, 8 Jun 1932. *s of:* Lt. Col. John Constable, R.A. *m:* Valerie Zelle. two *s.* four *d. Educ:* Marlborough College, Millfield School, Cambridge University. *Exhib:* London, Ipswich, Bath, Norwich, Lincoln, Woodbridge, Halesworth, Hereford, Spanish Biennale, Versailles, Singapore, W. Germany, Eire, Glasgow, New York, Cincinnati, Dubai, Al Ain, Abu Dhabi, Muscat. *Works in collections:* worldwide. *Signs work:* "R. Constable." *Address:* The Old Smithy, Hayne, Blackborough, East Devon EX15 2JD.

CONTRACTOR DORAB DADIBA, NS; sculptor; part-time instructor for creative wood carving and stone at several Adult Education Centres in Essex. Employed by the Government of India in Archaeological Dept. to restore the famous rockcut sculptures of India; Awards: Special Award for Wood Sculpture, Bombay State (1958, 1959); 'First Prize for miniature sculptures in chalkstick, also "Premier Award" with Triophy for most outstanding Exhibit, London (1969); 'Dennis Price Challenge Trophy' for the best wood sculpture, London (1970-77); many other awards from different Boroughs, London. *Medium:* wood, marble, and many other mediums. *b:* Bombay, 13 Feb 1929 Naturalised British Citizen. *s of:* Parsee Zoroastrian parents, Dadiba C.Contractor, violin and cello restorer. *Educ:* Dr.Antonio da Silva High School. *Studied:* Sir J.J. School of Art, Bombay, and obtained Government of India Diploma (1957). *Exhib:* group: Guggenheim Gallery, London (1970); joint: Romford (1972), Euro Arts and Crafts, B'ham (1976), Mall Gallery, London (1978-81), Le Salon des Nations a Paris (1983);

one-man shows: India House, London (1972), Woodstock Gallery, London (1975), Queen's Theatre, Hornchurch (1977), Central Library, Romford (1982), Kenneth More Theatre, Ilford (1988). *Works in collections:* H.R.H. Prince Philip, Duke of Edinburgh, H.M. The Queen, H.M. The Late Queen Mother, the late Dame Barbara Hepworth (St. Ives, Cornwall), the late Henry Moore; private and public collections worldwide. *Signs work:* "DORAB" or "D.C." *Address:* 10 Elizabeth House, Durham Avenue, Gidea Park, Romford RM2 6JU.

CONWAY, Bryan, S.Eq.A.; artist in oil and water-colour;. *b:* Derbyshire, 3 Jan 1932. married. four *s. Educ:* Becket School, Nottingham. *Studied:* Arthur Spooner's studio and Nottingham College of Art. *Exhib:* Christie's of London annually, and many provincial galleries. *Works Reproduced:* calendars British Coal, British Steel publications, numerous cards. *Signs work:* "Bryan Conway." *Address:* 14 Ellesmere Drive, Trowell, Nottingham NG9 3PH.

CONWAY, Jennifer Anne, R.M.S. (1979), S.M. (1981), Dip.B.C.P.E. (1957); painter and miniaturist in water-colour and oils;. *b:* Brecon, 6 Oct 1935. *d of:* Ernest Brookes. *m:* John F. Conway. one *s.* one *d. Educ:* Brecon Girls' Grammar School; Bedford College of Physical Education (1954-57). *Exhib:* R.A., Paris Salon, R.M.S., S.W.A., Mall Galleries, Westminster Gallery, Bankside Gallery, Woburn Abbey, Miniature Art Soc. Florida, Soc. of Miniature Painters, S and G, Washington, U.S.A.; solo shows: Brecknock Museum (1980, 1989, 1993, 1998), Lion House Gallery (1988), Sable & Hogg Gallery, Brecon (2001). *Works in collections:* Marchioness of Tavistock. *Works Reproduced:* Welsh Crafts, Brecon 900 commemorative plate Royal Doulton, greetings cards, post cards, series of prints 'Country Collection', 'Brecon Cathedral', 'Brecon Beacons'; illustrated book 'A Pocketful of Posies' by J. & J. Conway. *Signs work:* "Jennifer Conway". *Address:* Copper Beech, Maescelyn, Brecon, Powys, Wales LD3 7NL.

CONWAY, Valerie, Dip FA London University (Slade); PS (2003); French Govt. & British Council (Post-Graduate scholarship for one year, Paris). *Medium:* oil, watercolour, pastel. *b:* Malmesbury, 9 Jul 1923. one *d. Educ:* Fernhill Manor, Gloucester High School, and Rossholme, Weston-super-Mare. *Studied:* Gloucester College of Art, Slade, UCL, L'École de Beaux Arts Paris. *Represented by:* Pastel Society, Mall Galleries, FBA. *Exhib:* RA, RWS, Mall Galleries, Llewelyn Alexander, Pastel Society, Beaux Arts Paris. *Works in collections:* Imperial War Museum, UCL Collection, IBM, Bridgeman Fine Art Library. *Publications:* 'Introducing Enamelling' (Batsford). *Works Reproduced:* in Artist Magazine, Pastel Society, Mall Galleries, Design Centre-Haymarket. *Principal Works:* mural British Hospital, Paris, and Junior School for Herts. CC. *Signs work:* 'Conway'. *Address:* Park Studio, Wonersh, Surrey GU5 0PF.

CONWAY-SEYMOUR, Frances, R.W.A.; painter in oil, conté, water-colour, collage;. *b:* Bristol. married. *m:* Robert Hurdle; John Seymour. two *s.* two *d. Studied:* West of England College of Art, Bristol, under George Sweet, Robert Hurdle, Francis Hoyland, William Townsend. *Exhib:* England and France. *Works*

in collections: Lord Bath's collection of Wessex Painters at Longleat; Royal West of England Academy. *Recreations:* reading, travel. *Signs work:* 'Frances Conway-Seymour'. *Address:* 37 Cornwallis Cres., Clifton, Bristol BS8 4PH.

COODE, Caroline Ann, Dip AD (Printmaking). *Medium:* printmaker, lino and woodcut, collagraph, etching, wood engraving. *b:* Wimbledon, 26 Jul 1938. *d of:* Lt.Col. & Mrs. W.A.Peachell. *m:* Mark (divorced). five *s. Educ:* The Mount School, Mill Hill. *Studied:* Sir John Cass College of Art, Whitechapel (1984-88). *Exhib:* 4 solo; 1 two-man; 5 three-man; 1 four-man (2005/6); group shows in UK, Germany and Israel. *Works in collections:* Artspace, Richmond, Surrey; Council for the Arts, Hounslow, Middlesex; Kingston University, Surrey; Ministry of Education and Culture, Landau, Germany; Malone House, Belfast. *Commissions:* P & O 'Oriana'- 2 landscape collagraphs of 50 each. *Publications:* articles in 'Printmaking Today' and 'The Artist'. *Works Reproduced:* City Information Centre, Newcastle-upon-Tyne tourist leaflet, Hatton Gallery Bulletin, Newcastle-upon-Tyne. *Recreations:* gardening, DIY, theatre, classical music. *Misc:* organiser of 'Namaste' touring exhbn of British and Nepalese Artists (2000-02); Committee Member of Friends of the Hatton Gallery, Newcastle-upon-Tyne. *Signs work:* "Caroline Coode". *Address:* Top Flat, 74 St.George's Terrace, Newcastle-upon-Tyne, NE2 2DL. *Email:* caroline@coodec.freeserve.co.uk *Website:* www.coodec.freeserve.co.uk

COOK, Christian Manuel, N.D.D. (1965); artist in acrylic, gouache, pastel, water-colour, collage;. *b:* Grossenhain, Germany, 26 June, 1942. *s of:* Werner von Biel & Uschi Cook. one *s. Educ:* Kent College, Canterbury. *Studied:* Camberwell School of Art (Robert Medley, Frank Auerbach, Frank Bowling), London College of Printing. *Exhib:* Kingsgate Gallery, Hornsey Library (New Gallery), H.A.C. (Camden Arts Centre), City Literary Inst., Loggia Gallery. *Works in collections:* Westminster City Council and private collections. *Works Reproduced:* in "Drawing Matters" by Jane Stobart. *Signs work:* "C.M. Cook" or "Chris Cook". *Address:* 77 Cumbrian Gdns., London NW2 1EH. *Email:* chrismcook@btinternet.com

COOK, Ian David, R.I., R.S.W. (1978); Post. Grad. Fine Art, Glasgow; Hutcheson Drawing Prize, Cargill Travelling Scholarship to Spain/N. Africa, Arts Council Travel Award to Central Africa; RI Award (2000), Winsor & Newton Award, RI (2005); artist in oil, gouache, watercolour, acrylic; mixed media constructions. *b:* 1950. *s of:* the late William Cook, shipyard manager, and Margaret Falconer. *m:* Elaine. two *s.* one *d. Educ:* Camphill High School, Paisley. *Studied:* Glasgow (1969-72). *Exhib:* Royal Glasgow Concert Hall, (1996); major exhibition on hist./contemporary aspects of American West; Scottish Gallery ('80, '81); Scottish Contemp. shows, R.G.I., R.S.W.; various London galleries; Dublin; European and American venues; Edinburgh Festival; Circle Gallery, 2003. *Works in collections:* Trainload Freight, Lloyds Bank, BBC. *Commissions:* decor. work/ Stakis PLC, Crest Hotels, Continental Hotels. *Publications:* Dorling

Kindersley/ Watercolour Techniques series. *Signs work:* "Cook." *Address:* 3 Falside Rd., Paisley PA2 6JZ.

COOK, Jennifer Martin, NDD, ATD; painter; carved and painted wood. *b:* Preston, Lancs., 10 Nov 1942. *d of:* Jane and Albert J. Heathcote. *Educ:* Casterton School. *Studied:* Harris College, Preston (1960-65); Leicester College of Art (1965-66). *Exhib:* R.A. (1975, 1976, 1981, 1982, 1983); one-man shows: Mercury Gallery, London (1976, 1978), Leics. Museum and A.G. (1982), City Gallery, Leicester (1997); group shows: Yew Tree Gallery, Oxford Gallery, Gallery on the Green, Lexington, Mass., U.S.A., Shipley Art Gallery. *Works in collections:* Middlesbrough, Leics., Oxfordshire. *Signs work:* "Jenny Cook." *Address:* 17 Brookhouse Ave, Leicester LE2 0JE. *Email:* jenny-cook@ntlworld.com *Website:* www.jennycook.net.

COOK, Katrina, SWLA; MA (RCA) Natural History Illustration; BA (Hons) Fine Art; Birdwatch Artist of the Year Award: Category Winner 1996, Overall Winner 1997. *Medium:* large graphite drawings; drypoints; etchings. *b:* UK, 13 Oct 1965. *d of:* unknown Welsh and Italian. *Studied:* The Royal College of Art; University of Plymouth (Exeter College of Art and Design). *Exhib:* SWLA (1987-2005, annually); solo shows: Bonhoga Gallery, Shetland; Plumbline Gallery, St.Ives, Cornwall; Royal Albert Memorial Museum, Exeter; The Walter Rothschild Zoological Museum, Tring. *Works in collections:* Royal Albert Memorial Museum, Exeter; Nature in Art, Twigworth, Glos. *Commissions:* Aig an Oir Art Residency; Artist in Residence (on board artist) Oceanwide Expeditions. *Publications:* Author of 'Birds' (Quercus Publications, 2007); illustrated 'A Field Guide to the Smaller Birds of South East Asia' Robinson, Tuck & Schaefer (NHM/Malaysian Natural History Society publication, 1994). *Official Purchasers:* Kent Kingdon Trust, Royal Albert Memorial Museum, Exeter;. *Works Reproduced:* John Busby 'Drawing Birds' (2nd ed.); Nicholas Hammond 'Modern Wildlife Painting'; Katrina Cook 'Birds'. *Principal Works:* Albatross. *Recreations:* exploring landscapes, ornithology. *Clubs:* Society of Wildlife Artists. *Misc:* employed as Bird Curator at The Natural History Museum. *Signs work:* 'Katrina Cook'. *Address:* 36 Northern Road, Aylesbury, Bucks HP19 9QY. *Email:* k.cook@nhm.ac.uk *Website:* www.katrinacook.co.uk

COOK, Richard, Dip.A.D. (Painting), M.A.(R.C.A.) Painting; artist;. *b:* Cheltenham, 31 Oct 1947. *s of:* Richard Leonard Cook. *m:* Parton. one *s. Educ:* Salesian College, Oxford. *Studied:* St. Martin's School of Art (1966-70), R.C.A. (1970-73). *Exhib:* House Gallery, London (1981), Hayward Gallery, London (1976, 1980), Artists Market, London (1976-80), Serpentine Gallery, London (1987), Odette Gilbert Gallery, London (1989, 1991), Austin/Desmond (1995, 1997, 2000, 2003), "Luminous", Tate St. Ives (2001). *Works in collections:* B.M., Arts Council, Manchester City A.G., Deutsche Bank, Barclays Collection, Slaughter & May Collection, Tate Collection, London. *Publications:* "Luminous", Tate St. Ives catalogue. *Signs work:* "Richard Cook." *Address:* 13 North Corner, Newlyn, Penzance, Cornwall TR18 5JG.

COOK, Richard Peter, R.B.A., Dip.A.D. Maidstone (1971), Post Grad. Royal Academy Schools (1975), A.T.C. (1977), R.B.A. (1978), E.T. Greenshield Travelling Scholarship (1972), Richard Ford Spanish Scholarship (1981); landscape and portrait painter in oil, water-colour, gouache;. *Medium:* oils and watercolour. *b:* Grimsby, 27 Feb 1949. *s of:* R. P. and M. A. Cook. *m:* Christine. two *d. Educ:* Grimsby College of Art, Maidstone College of Art (1968-71), Royal Academy Schools (1972-75). *Exhib:* one-man show, R.A. Schools (1980); R.B.A. (1977-); R.A. Summer Shows (1975-81, 1983, 1993); Art in Action (1988-93); N.E.A.C.; Royal Portrait Soc.; N.P.G. in 1984 John Player Award Show; Singer & Friedlander Water-colour Exhbns. and commercial galleries. *Works in collections:* in U.K. and overseas. *Commissions:* Dame Beryl Paston Brown. Commis. by Homerton College, Cambs. *Signs work:* "Richard P. Cook." *Address:* 17 Windlesham Gdns., Brighton BN1 3AJ.

COOK, Stephen Thomas, BA (Hons); Art Teaching Certificate. *Medium:* oil, watercolour, pastel, drawing. *b:* Romford, 8 Aug 1952. *s of:* Edward & Angela Cook. *m:* Pauline Anne Cook. one *s. Educ:* The Campion School, Hornchurch (1963-70). *Studied:* Hornsey College of Art (1970-71); North East London Poly (1971-73); Institute of Education (1977-80); Goldsmiths College (1982-83) ATC. *Represented by:* Brandler Galleries, Brentwood, Essex. *Exhib:* Brandler Galleries; Beecroft Gallery, Westcliff-on-Sea; Society of Equestrian Artists, Christies; Equus Gallery, Newmarket; Heath Gallery, Ascot; Osborne Studio Gallery; Caxton Gallery, Frinton, Essex. *Works in collections:* numerous private collections throughout UK, also Dublin, Mebourne, Lexington, Santa Monica, Toulouse. *Commissions:* regular commissions, mainly horseracing paintings/pastels. *Works Reproduced:* Injured Jockeys Fund promotional material, range of catalogues. *Principal Works:* horseracing paintings/ pastels. *Recreations:* walking, reading, racing. *Misc:* taught in Adult Education for 25 years. Runs regular classes/workshops at Arts Centre in Hornchurch, Essex, and monthly one-day workshops in watercolour. *Signs work:* 'Cook'. *Address:* 7 Austral Drive, Hornchurch, Essex RM11 1JJ. *Email:* stevecook852@msn.com

COOKE, Jean, RA, NDD, RBA; painter; lecturer, Royal College (1965-74). *b:* London, 18 Feb 1927. *d of:* A. O. Cooke. *m:* John Bratby. three *s.* one *d. Educ:* Blackheath High School. *Studied:* Central School of Arts and Crafts, Goldsmiths' College of Arts, Camberwell School of Art, City and Guilds, Royal College. *Exhib:* one-man show: Farnham (1962, 1964, 1973), Establishment (1963), Leicester Gallery (1964), Bear Lane, Bladon Gallery (1966), Phoenix (1970), New Grafton (1971); mixed show: R.A., Zwemmer, London Group, R.B.A., Arts Council, Young Contemporaries, Royal College of Art, Upper Grosvenor, Arundel, Furneaux (1968), Agnew (1974). *Works in collections:* R.A., R.C.A., Tate. *Signs work:* "Jean E. Cooke." *Address:* 7 Hardy Rd., Blackheath, London SE3.

COOKE, Stanley, artist in oil and water-colour. *b:* Mansfield, Notts., 11 Jan 1913. *s of:* John Cooke. *m:* Anne M. Clayton (decd.). one *s. Educ:* King Edward

School, Mansfield. *Studied:* Mansfield School of Art (1924-32) and The Press Art School. *Exhib:* R.A., R.I., R.O.I., Britain in Water-colours exhbns., provinces; one-man shows at Drian Galleries, London and Mansfield Art Gallery. *Works in collections:* Quarry at Mansfield, Mansfield Art Gallery. *Works Reproduced:* in Apollo, Arts Review and greetings cards. *Address:* Broadlands, Grasmere Cl., Guildford GU1 2TG.

COOKSON, Dawn, R.B.S.A. (1974); artist of portraiture, still-life, flower and landscape paintings in oil, tempera, pastel and water-colour;. *b:* B'ham, 11 June, 1925. *Educ:* Westonbirt School, Glos. *Studied:* Birmingham College of Art (1943-48, B. Fleetwood-Walker, R.A.), Accademia di Perugia, Italy (1954-56), Nerina Simi Studio, Florence (1955-58), and under Pietro Annigoni, Florence (1958-68). *Exhib:* R.P., P.S., R.B.S.A., B'ham Water-colour Soc., Fosseway Glos. bi-annually; one-man shows: Lygon Arms and Dormy House, Broadway, Worcs. (1972-82-85), Guildhouse, Stanton, Glos. (1976-79), Reade's Gallery, Aldeburgh, Suffolk (1977). *Works in collections:* throughout G.B., Europe and Overseas. *Clubs:* V.P. Birmingham Water-colour Soc. *Signs work:* "Dawn Cookson." *Address:* Quiet Place, Lifford Gdns., Broadway, Worcs. WR12 7DA.

COOKSON, Delan, F.S.D.C., Gold Medal (Vallauris, 1974), Churchill Fellow (1966); Senior Lecturer in ceramics at Buckinghamshire College of Higher Education;. *b:* Torquay, 13 Sep 1937. *s of:* W. R. Cookson. *m:* Judith. two *s. Educ:* Bournemouth School. *Studied:* Bournemouth College of Art, Central School of Arts and Crafts. *Exhib:* Oxford Gallery, British Crafts Centre, Craftsman Potters Assoc., Design Centre, Midland Group Gallery, Whitworth Art Gallery, New Craftsman, St. Ives; one-man shows: Salix, Windsor, Bohun Gallery, Henley, Peter Scott Gallery, Lancaster and Galerie an Gross, St. Martin, Cologne. *Publications:* Ceramic Review, Studio Porcelain and Studio Ceramics by Peter Lane. *Clubs:* Cornwall Crafts Assoc., C.A.C. Index of Selected Members. *Address:* 3 King George Memorial Walk, Phillack, Hayle, Cornwall TR27 5AA. *Email:* delancookson@hotmail.com

COOMBE, Nick, MA, RCA, RIBA; RIBA Award (1997, 2004); D&AD Award (2004), RSA'Art for Architecture' Award (2001). *Medium:* architect and exhibition designer. *Studied:* Royal College of Art (1980-83). *Exhib:* RA (2004); RIBA (1997, 2000); RCA (1996); Mackintosh Museum, Glasgow (1990); Camden Arts Centre (1989). *Commissions:* 'The Heart' (Wellcome Collection), 'Posh' (The British Council); 'Abracadabra' (Tate Britain); 'This Was Tomorrow' (Barbican Arts Centre); 'Mixed Belongings', 'Beauty and the Beast', 'Out There', 'Solid Air', 'Approaching Content' (Crafts Council); 'Shift' (Arts Council England). *Publications:* works in The Guardian, The Independent, The Times, The Telegraph, Sunday Times, RIBA Journal, RSA Journal, etc. *Address:* The Tea Building, Shoreditch High Street, London E1 6JJ. *Email:* nick@coombearchitecture.com *Website:* www.coombearchitecture.com

COOMBS, Jill, 3 Gold Medals (R.H.S.); botanical illustrator in water-colour;. *b:* Horsham, 1935. *m:* Bernard Coombs. one *s.* one *d. Educ:* High School for Girls, Horsham. *Studied:* West Sussex College of Art (1952-55), botanical illustration under Mary Grierson at Flatford (1976-79). *Exhib:* Kew Gdns. Gallery, National Theatre, R.H.S., Broughton Gallery, Arundel Festival, Chelsea Physic Gdn., Carnegie-Mellon University U.S.A., Horsham Museum. *Works in collections:* U.S.A., Australia, Japan, U.K., Shirley Sherwood Collection, Kew, R.H.S., Chelsea Physic Gdn., Horsham Museum, Highgrove Florilegium. *Commissions:* Crabtree & Evelyn, Readers' Digest, R.H.S. Kew. *Publications:* illustrated: Plant Portraits by Beth Chatto (J.M. Dent), Herbs for Cooking and Health by C. Grey-Wilson (Collins). *Works Reproduced:* in: Country Life, Curtis Botanical Magazine, Flora Iraq, Flora Qatar, Flora Egypt, The Crocus, Flower Artists of Kew. *Recreations:* gardening, mountain walking. *Clubs:* American Society Botanical Artists. *Signs work:* "Jill Coombs." *Address:* Weald House, Handford Way, Plummers Plain, Horsham, W. Sussex RH13 6PD.

COOPER, Eileen, Dip. A.D., M.A., R.C.A., Elected R.A. (2001). artist in oil and works on paper, prints, ceramics;. *b:* Glossop, 10 Jun 1953. *m:* M. Southward. two *s. Studied:* Goldsmiths' College and R.C.A. (1971-77). *Exhib:* numerous solo and group shows, R.A. Summer Exhib. (2001). Recent solo shows: 'Time of Your Life', Art First, London (2005), Eileen Cooper 50, Art First, London (2003), Passions, New Work on Paper, Art First, London/ New York (2002), Raw Material, Dulwich Picture Gallery, London (2000), Raw Material II, Art First, London. *Works in collections:* Arts Council, British Council, Whitworth Art Gallery, Yale University, Kunsthalle, Nuremberg, New Hall, Cambridge, British Museum, V. & A. *Commissions:* 1982-Staircase Project, ICA, London; 1992-The Art, tlevision programme for BBC Education; 1994- Inside Art, channel 4 documentary; 1999- cover and illustrations for carol Ann Duffy's childrens' poetry book 'Meeting Midnight'. *Signs work:* "Eileen Cooper" on reverse. *Address:* Art First, 9 Cork St., London W1X 1PD. *Email:* eileen@eileencopper.co.uk *Website:* www.eileencooper.co.uk

COOPER, Emmanuel, PhD; potter stoneware and porcelain, writer and broadcaster; editor of Ceramic Review; member of Arts Council England, London; visiting Professor, Royal College of Art;. *b:* Derbyshire, 12 Dec 1938. *Educ:* Tupton Hall Grammar School, Derbyshire. *Studied:* Middlesex University (PhD). *Exhib:* Contemporary Applied Arts, London, many other one-man and mixed exhbns. here and abroad. *Works in collections:* V. & A., Royal Museums of Scotland. *Publications:* 10 Thousand Years of Pottery (British Museum Press); Bernard Leach: Life and Work (Yale University Press). *Recreations:* theatre, dance, South Coast. *Clubs:* Chelsea Arts Club. *Address:* 38 Chalcot Rd., London NW1 8LP. *Email:* emmanuelcooper@lineone.net

COOPER, Jessica, RWA (2007); BA Hons (Textiles/Fine Art); Foundation Course Diploma; Newlyn Society of Artists. *Medium:* painter. *b:* Bristol, 1967. *d of:* Mr & Mrs L E Cooper. *m:* Benjamin Yarwood. one *s.* one *d. Educ:* Penzance

Grammar School for Girls. *Studied:* Falmouth College of Art; Goldsmiths College, London. *Represented by:* The Hart Gallery, London; Martin Tinney Gallery, Cardiff. *Exhib:* RWA Bristol; Newlyn Art Gallery, Cornwall; Tate St.Ives; Sherborne House, Dorset; Badcocks Gallery, Cornwall; Edgarmodern Fine Art, Bath; The Stour Gallery, Warwickshire. *Works in collections:* Hypatia Trust, Cornwall; Slaughter & May, London; RWA Bristol. *Publications:* Tate Publishing; Halsgrove; Newlyn Society of Artists; Truran. *Signs work:* 'Jessica Cooper'. *Address:* 5 Calartha Terrace, Pendeen, Penzance, Cornwall TR19 7DX. *Email:* jessicacooper@blueearth.co.uk

COOPER, Josephine Mary, SM.(1974), RMS (1983), UA (1975), SWA(1988); Silver Medallist, Paris Salon (1974), Prix Rowland (1977); artist in oil and water-colour, also drypoint engravings and monotypes. *b:* Brighton, 8 Aug 1932. *d of:* Everard Frisby. *m:* Tom Cooper. one *s.* one *d. Studied:* St. Albans School of Art under Kathleen Pargiter; Mid-Herts. College of Further Education under Kenneth Haw; Hertfordshire College of Art and Design under Peter Jacques; Will Raymont, privately. *Exhib:* R.M.S., U.A., S.M., R.I., R.S.M.A., R.B.A., Laing, S.G.A., Britain in Water-colour, Bilan de l'Art Paris and Quebec, Liberty of London, Medici Gallery, R.A. Summer Exhbn. (1980-85); one-man shows throughout mid-Herts area, also Liberty of London. *Publications:* included in 20th Century Marine Paintings. *Clubs:* Welwyn Garden City Art, Hertford Art Soc. *Signs work:* "Jo Cooper" and "JMC" (miniatures dated). *Address:* 27 Parkfields, Welwyn Garden City, Herts. AL8 6EE.

COOPER, Julian, B.A.(Hons.) Fine Art; painter in oil, water-colour, pastel. *b:* Grasmere, 10 Jun 1947. *s of:* William Heaton Cooper, landscape painter. *m:* Linda. *Educ:* Heversham Grammar School. *Studied:* Lancaster Art College (1963-64), Goldsmiths' College (1964-69), Boise Travelling Scholarship (1969-70). *Represented by:* Art Space Gallery, 84 St. Peters St., London N1 8JS. *Exhib:* London Group, Serpentine Gallery, J.P.L. Fine Art, Paton Gallery, V. & A., Laing A.G., University of Durham, Flowers East, Art Space Gallery, Wordsworth Trust, Grasmere, Brewery Arts Centre, Kendal, Hartlepool Art Gallery, Wolverhampton Art Gallery, Tate Britain, Museo Nazionale della Montagna, Turin. *Works in collections:* A.C.G.B., Laing A.G., Bolton A.G., Lancaster University, Northern Arts, I.L.E.A., Abbot Hall A.G., Reuters, Unilever, Pentagram, Davy Offshore Modules, Ferguson Industrial Holdings, Bankers Trust, Air U.K., Mountain Heritage Trust, Brathay Hall Trust, Tullie House Museum, Carlisle; Museo Nazionale della Montagna, Turin. *Commissions:* County Hall, Durham, Theatre by the Lake, Keswick, Kendal Magistrates Court, Mountain Heritage Trust. *Official Purchasers:* Arts Council of England. *Works Reproduced:* book cover for Fleur Adcock's Under Loughrigg. "Mind Has Mountains" pub: Wordsworth Trust; 'Cliffs of Fall' (pub. ArtSpace Gallery); 'Pareti, Ghiacci, Precipici' (pub: Museo Nazionale della Montagna). *Recreations:* climbing, walking. *Clubs:* Chelsea Arts, Alpine Club. *Signs work:* "Julian Cooper." *Address:* Manor House 23 St. Helen's St.,

Cockermouth, Cumbria CA13 9HX. *Email:* juliancooper@talk1.com *Website:* www.artspacegallery.co.uk/www.heatoncooper.co.uk

COOPER, Paul Anthony, NDD (1951), FRBS (rtd.); Competition Winner, Oxford City Education Authority, Sponsered, and City of Westminster, London. *Medium:* sculptor in all traditional and modern materials including precious metals and stones. *b:* Wool, Dorset, 23 May 1923, 10th of 10 children. *s of:* John Thomas & Annie Cooper (Newbury, Berkshire). *Educ:* Poole School of Art (1938-40). Studies interrupted by 'Distinguished' war service. Royal Navy Commando. Initial landings: North Africa, Sicily, Italy and in Burma from Chittagon to Rangoon. LCI (l)'s 1941-August 1945. *Studied:* Employed by stone firm on Portland, memorial and decorative figure carving (1946-48); Goldsmiths' College, London (1948-51); Lincoln College studying pottery(1958); further studies of Art in many places of the world. Professional Sculptor working for over 50 years on commissioned sculpture. *Exhib:* Exhibitions strictly by invitation only. Royal Academy, Covent Garden London, Scone Palace Perth, Bexley House Gardens, RIBA Headquarters London, Liverpool Cathedral etc. *Works in collections:* Oxford City Educ. Authority, Lincoln Educ. Authority, and places open to the public at Hanover Square Gardens, Westminster, City of London, Thorpe Tilney, Lincoln and Denton, Grantham; private collections in this country and in Holland, Israel, USSR; ecclesiastical work including several crucifixes in churches in England, Westminster Abbey, Wales and the Falkland Islands. *Principal Works:* Westminster Abbey, stone relief; St.Andrew By The Wardrobe, 2 memorials 7'x5' in English Lime and Oak of William Shakespeare and John Dowland; Hanover Square, London, 6' bronze water-feature; Christchurch Cathedral, Falkland Islands, wood carving of St.John the Evangelist; several large sculptures in private collections including water-features. *Misc:* Resident Sculptor for the last 10 years at the Abbotsbury Swannery and Sub-Tropical Gardens in Dorset where further works may be seen. *Signs work:* "Paul Cooper." *Address:* Quarr Hill Cottage, Wool, Dorset. BH20 6BY.

COOPER, Philippa, Slade Diploma (1954). *Medium:* watercolour and oil, etcher. *b:* 30 Mar 1934. *d of:* Phyllis Bray/ John Cooper-artists. two *d. Educ:* Southampstead High School. *Studied:* Slade School, UCL, Gower St., London. *Exhib:* solo exhbn. Judd Street Gallery (1987, 1990); mixed shows: Young Contemporaries, A Family of Painters-3 Generations, Queen Mary College (1978, organised by artist), Sally Hunter Fine Art (1997), Collyer-Bristow Gallery (1997), Millinery Works, Chappel Gallery (2005). *Works in collections:* Strang Print Room, University College, London (etchings); John Weeks, Architect; Eric Phillips, and others. *Recreations:* looking at paintings, exploring landscapes. *Clubs:* Twentieth Century Society, Plantlife. *Signs work:* see attached. *Address:* 13 Denton House, Halton Road, Canonbury, London N1 2AE.

COOPER, William Alwin, R.W.A.(1973), Artist Chairman (1993-96), Sherborne School (1952-83), Lecturer, Bristol University Extra Mural Dept. (1983-86); artist in oil, water-colour and collage;. *b:* Merthyr Tydfil, 2 June,

1923. *m:* Dorothy Tustain, G.R.S.M. one *s.* two *d. Educ:* Westminster School, Corpus Christi College, Cambridge. *Exhib:* one-man shows: Drian Gallery (1971), Albany Gallery, Cardiff (1972), Hambledon Gallery, Blandford, Pentagon Gallery, Stoke on Trent (1977), St. John's, Smith Sq. (1986), Rona Gallery, R.W.A. (1988), Bloomsbury Workshop Gallery (1994); group shows include: R.A., N.E.A.C., UNESCO, New York; Westward TV Open (Prizewinner), South West Open (Prizewinner) 1991, Laing Open (Prizewinner) 1999. *Works in collections:* Royal West of England Academy, Bryanston School, Staffordshire Educ. Com., Welsh Development Corporation, Sherborne School and various public and private collections, Royal Brompton Hospital. *Publications:* illustration in History of Corpus Christi College, Cambridge; Book 'Why College' (Memoir). *Works Reproduced:* book covers, greetings cards, charity Christmas cards. *Signs work:* "Cooper." *Address:* Elizabeth House, Long St., Sherborne, Dorset DT9 3BZ.

COOTE, Michael Arnold, painter in oils, water-colour, acrylic, oil and soft pastel, charcoal, pencil; Freeman of the City of London (1977);. *b:* London, 18 Mar 1939. *m:* Anita Davies. two *s.* one *d. Studied:* mainly self taught; Sir John Cass (sculpture and life class). *Exhib:* P.S., R.O.I., Mall Galleries, Alpine Gallery, many provincial galleries including John Noott Gallery and Barry Keene Gallery, Henley on Thames. *Works in collections:* London, Bath, America, Germany, Italy. *Signs work:* "M Coote". *Address:* 1 Tadlows Cl., Upminster, Essex RM14 2BD.

COPELAND, Lawrence Gill, Cranbrook Medal, U.S. State Dept. Purchase Award, Y.S.C. First Prize, National Merit Award, Craftsmen, U.S.A.; designer in metal; prof., Art Dept., City College of City University of New York (retd.). *b:* Pittsburgh, Pa., USA, 12 Apr 1922. *s of:* Lloyd D. Copeland, college professor. *m:* Mary Cuteri. two *s.* one *d. Educ:* Ohio State Univ., Cranbrook Academy of Art, Univ. of Stockholm, Univ. of Paris. *Studied:* Stockholm (1947-48, Baron Erik Fleming), Paris (1948-49, Emeric Gomery). *Works in collections:* National Gallery, Washington, D.C. *Address:* 6364 Clearview Rd. Boulder Colorado 80303 USA.

COPPINGER, Sioban, B.A.Hons. (1977), A.R.B.S. (1991), F.R.B.S. (1995), F.R.S.A. (1999). *Medium:* sculptor in bronze, copper, silver, concrete. *b:* 20 May, 1955. *m:* Peter Penfold. *Educ:* New Hall School, Boreham, Essex. *Studied:* Bath Academy of Art (1975-77). *Exhib:* 2006: Morgan Boyce, Marlborough (Solo); Puthall Sculpture Park, Wiltshire; RWA Bristol; 2005: Watermill Theatre, Newbury, Berkshire (Solo); 2001: Art in Prospect, Ramsbury, Wiltshire; ArtParks International, Guernsey. *Works in collections:* British Rail Board: 'Tempus Fugit' (National Garden Festival Gateshead '90); 'The Jolly Fisherman', 'The Gardener and the Truant Lion' (Paul Temple Ltd); Nottinghamshire County Council: 'The Beeston Seat' (Broxtowe Borough Council); 'Man & Sheep on a Park Bench' (East Midlands Arts, Arts Council of Great Britain). *Commissions:* Work in public places: 'Mrs Hedges', Great Notley, Essex; 'Birmingham Man', Chamberlain Square, Birmingham; 'Elephant's Waterworks', Basingstoke

Hospital, Hants.; 'Tempus Fugit' (National Garden Festival Gateshead '90), Templecombe Station, Somerset; 'The Beeston Seat', Beeston, Notts.; The Gardener and the Truant Lion' (Chelsea Flower Show & National Garden Festival, 1986), Stoke Mandeville Rail Station, Bucks; 'Man & Sheep on a Park Bench', Rufford Country Park, Notts. *Signs work:* "S. Coppinger." *Address:* The Muse, 23 Oxford Road, Lambourn, Berkshire, RG17 8XS. *Email:* sioban@coppinger.fsnet.co.uk *Website:* www.siobancoppinger.co.uk

CORBETT, Lily Gloria, MA in Sacred and Traditional Art (The Princes School of Traditional Art). *Medium:* oil, watercolour, drawing, sculpture, egg tempera and gilding on gesso ground. *b:* Hampshire, 22 May 1945. *Studied:* The City Literary Inst. with Cecil Collins (1976-86); The Princes School of Traditional Art, London. *Exhib:* RA, Cheniel Galleries, London, Piers Feetham Gallery, Richard Philp Gallery, RCA, The Princes Foundation, 'Shakespeare and Islam' at Shakespeares Globe (2004), Timothy Hobart Fine Art. *Works in collections:* many private collections. *Commissions:* private. *Recreations:* singing Rabindranath Tagore songs and Indian ragas. *Clubs:* Chelsea Arts Club. *Misc:* I teach drawing and painting based on Cecil Collins' teaching, and also teach egg tempera, gilding, gesso and oil painting. *Signs work:* 'L.C.' or 'Lily Corbett'. *Address:* 8 Clapham Manor Street, London SW4 6DX. *Email:* lilycorbett@waitrose.com *Website:* www.theartofcreativity.co.uk

CORBETT, Peter George, B.A. Hons. (1974); artist in oil on canvas; awards: 2000 – Vincent Van Gogh Award, St. Lukas Academy, Memmelsdorf, Germany; 2000 – Albert Einstein International Academy Foundation, honour in recognition of outstanding achievements; 1998 – Merseyside Contemporary Artists Exhibition, Purchase Prize, Liverpool; 1993 – Honorary Professor, Académie des Sciences Humanie Universelles, Paris, France. 2000- Hon. Prof. Honoris Causa (Painting), St. Lukas Academy, Germany; 2000- International Peace Prize, United Cultural Convention, U.S.A.; 2002 -World Lifetime Achievement Award, American Biographical Institute, U.S.A.; 2004 -Lexmark European Art Prize (Northwest Regional Winner);. *b:* Rossett, N. Wales, 13 Apr., 1952. *s of:* John Hotchkins Corbett, G.P. *Educ:* Liverpool College. *Studied:* Liverpool College of Art and Design (1970-71, Maurice Cockrill), Manchester Regional College of Art and Design (1971-74, Brendan Neiland, Keith Godwin). *Exhib:* Centre Gallery (1979), Acorn Gallery, Liverpool (1985, 1988), Major Merseyside Artists, Liverpool (1988), Marie Curie Art (Open), Albert Dock, Liverpool (1988), Surreal Objects Exhbn. Tate Gallery, Liverpool (1989), Merkmal Gallery "Alternative 17" Liverpool (1991), Manchester Academy 136th Exhbn. (Open) 1995, The Three Month Gallery, Liverpool (1996), Academy of Arts, Liverpool (1997, 1999), Academy of Arts, Liverpool St. George's Hall (Open) 1998, Walker Art Gallery, Liverpool (internet auction), (1999), dfn Gallery, New York, U.S. (2000); one-man shows: Southport Arts Centre (1980), Liverpool Playhouse (1982), Pilgrim Gallery, Liverpool (1984), Royal Institution, Liverpool (1986), Church Gallery, London (1988), Anglican Cathedral (1988), Senate House Gallery, Liverpool University (1993), Atkinson Gallery, Southport (1995),

International Biennial of Visual Art, Liverpool 'A Journey of Revelation' (1999), Liverpool Biennial of Contemporary Art (1999); Life and Image Exhibition, Daily Post and Echo Building, Liverpool (2006), Roundhouse, London (Flowers East Gallery, 2006); Loop Gallery, Liverpool Hope University (2007), Artfinder Gallery, Liverpool (2007), Florence Biennale of Contemporary Art, Florence, Italy (2007); two-man shows: Liverpool University (1983, 1990), Acorn Gallery, Liverpool (1985), Royal Liver Bldg., Pier Head, Liverpool (1991), Hanover Gallery, Liverpool (1999), Bluecoat Arts Centre, Liverpool (2002, paintings and open studio), The University of Liverpool Art Gallery (2002, mixed), Agora Gallery, New York, U.S.A. Influences and Innovations (2002, mixed), Mall Galleries (Deisgn and Artists Copyright Society 20th Anniversary Exhbn, 2004); Senate House Gallery, University of Liverpool (1987-2002); Retrospective (One-man-Part of the Liverpool Biennial Independent, 2004); The Artcell Gallery, Barcelona (five-person, 2005); The Cornerstone Gallery, Hope University, Liverpool (mixed, 2005). *Works in collections:* Great Britain, America and Australia, Netherlands, West Germany. Founder Mem. Chair, Merseyside Visual Arts Festival (1989-90). International German Art Prize, St. Lukas Academy, Memmelsdorf, Germany (Painting and Poetry) Grand Diploma (1998). Public collections: Atkinson Gallery, Southport, The University of Liverpool Art Gallery, Hope University Liverpool. *Publications:* Merseyside Arts Directory (2000/1), Brit Art Directory (2001), dfn Gallery write up/photo, Merseyside Arts Magazine (2000), Prestige Debut Artists NY 2000 Exhibition, dfn Gallery catalogue (2000), Liverpool Biennial of Contemporary Art catalogue (1999), 'The Pool of Life' exhibition (one-man), Senate House, Liverpool University (1993), Merseyside Visual Arts Festival, catalogue (1990), Merkmal Gallery, Liverpool (1990, catalogue), Bluecoat Art centre catalogue (2002, photo of work), ArtNow Gallery Guide, New York, U.S.A. (April 2002), New York Arts Magazine Vol. 7, International Edition (2002), Gallery and Studio Magazine, Vol. 4, New York, U.S.A. (Feb/Mar 2002), DACS Catalogue, Mall Galleries (2004); Retrospective Painting Exhibition catalogue (1987-2002, University of Liverpool). *Recreations:* playing the piano, yoga, meditation. *Clubs:* Design and Artists Copyright Society, London (life member), Maison Internationale des Intellectuels, Paris, France (1994). *Misc:* Galleries www.designbank.org.uk/57, Silde libraries: Pompidou Centre, Paris, France; Museum of Modern Art, New York, U.S.A.; Guggenheim Museum, New York, U.S.A. *Address:* Flat 4, 7 Gambier Terr., Hope St., Liverpool L1 7BG. *Website:* www.axisweb.org/artist/petercorbett

CORETH, Mark Rudolf, self taught sculptor in bronze (wildlife);. *b:* London, 5 Sep 1958. *m:* Seonaid. one *s.* two *d. Educ:* Kenya, Herefordshire (St. Richards Prep.). Ampleforth College. *Represented by:* Sladmore Gallery, 32 Brutin Place, Berkeley Square, London W1J 6NW. *Exhib:* Sladmore Gallery, London W1. (1986, 1990, 1992, 1994, 1996, 1998, 2000, 2002), Galerie la Cymaise, Paris (1993, 1995, 1997, 1999, 2001), Sydney (1996), Geneva (1997), New York (1999, 2001). *Commissions:* life-size Cheetah Group, Dubai; Drinking

WHO'S WHO IN ART

fountains at Globe Theatre and National History Museum. *Recreations:* flying, shooting, fishing, riding, travel. *Address:* Stowell House, Sherborne, Dorset DT9 4PE. *Email:* markcoreth@tiscali.co.uk

CORNELL, David, FRSA (1970), FRBS (1971), VPSPS (1977), PSSMCE (1995); sculptor in bronze. *b:* Enfield, 18 Sep 1935. *s of:* Henry Arthur Cornell. *m:* Geraldine. four *s. Educ:* Essendene. *Studied:* Central School of Art, London and Harrow School of Art (1952-62, Friend, Fryer and Philip Turner) Engraving and Sculpture; Academy of Fine Art, University of Pennsylvania (1968-70, Robert Beverley Hale) Anatomy. *Exhib:* London: R.A., Mall Galleries, Guildhall, R.B.S. Hall Place, Pavlova Soc., Park Walk Galleries, Plazzotta Studio, Edith Grove Gallery, Harrods; Iberian Bronze Gallery, London and Dublin, Newmarket Gallery, Newmarket, Royal Fine Art, Tunbridge Wells, Armstrong-Davis Gallery, Arundel, Scone Palace Scotland, English Gallery, Beverly Hills, U.S.A., L.C.A. Chelsea, Royal West of England Academy, Bristol, Alwin Gallery, Tunbridge Wells, Wales Fine Art - Chepstow. *Works in collections:* Wellcome Foundation, London. Recent works include portrait of Princess Diana and Queen Mother. *Commissions:* Life-size: Sir Arthur Conan-Doyle, numerous coins for world mints, latest being first official Royal mint coin of Prince William. *Signs work:* "David Cornell." *Address:* Barcombe Manor, Innhams Wood, Crowborough, E. Sussex TN6 1TE. *Email:* davidcornell1@aol.com *Website:* www.davidcornell.com

CORNWELL, Arthur Bruce, S.G.F.A.dip.(1947); illustrator in gouache, oil, water-colour, indian ink;. *b:* Vancouver, B.C., 11 Feb 1920. *s of:* Arthur Redfern Cornwell. *m:* Peggy Brenda Huggins. one *s. Educ:* Palms Public School, and Page Military Academy, California. *Studied:* Art Centre School, Los Angeles, Regent St. Polytechnic, London, Heatherley's, London, Academy Julien, Paris. *Exhib:* R.A., N.E.A.C., S.M.A., S.G.F.A., Sunderland Gallery, Bolton Gallery. *Works in collections:* Diploma Gallery, R.A. Stott Bequest, R.A., The Coaster. *Publications:* The Ship's Crew. *Works Reproduced:* in Yachting Monthly, Macmillan teach-visuals. *Signs work:* 'CORNWELL'. *Address:* Westways, 132 Eastcote Rd., Ruislip, Middx. HA4 8DU.

CORSELLIS, Jane, NEAC, RWS, RCA; artist in oil, water-colour, etching, lithography. *b:* Oxford, 1940. two *s. Studied:* Byam Shaw School of Art (Maurice de Sausmarez, Bernard Dunstan RA, Peter Greenham RA). *Exhib:* R.A., R.B.A., N.E.A.C., R.W.A., R.W.S., R.C.A.; one-man shows: Hong Kong, Ottawa, Kuala Lumpur, Upstairs Gallery, R.A. London (1985, 1986), New Academy Gallery, London (1988, 1990, 1992, 1994, 1996, 1998, 2000, 2002, 2004), Hollis Taggart Gallery, N.Y. (1998), Messums London, 2006. *Works in collections:* Canada, U.S.A., Italy, France, Malaysia, Singapore and U.K. *Commissions:* Freshfields, Capital Club London. *Publications:* Painting Figures in Light; Jane Corsellis, A Personal View (David and Charles). Landscapes in Oils (APV Films Ltd.), Coastal Watercolours (APV Films Ltd.). *Clubs:* Chelsea Arts; Arts Club, Dover

St. *Signs work:* "Corsellis." *Address:* 8 Horbury Mews, London W11 3NL. *Website:* www.newenglishartclub.co.uk

COSMAN, Milein, Slade Diploma Fine Art; painter, graphic artist. *b:* Gotha. *d of:* Hugo Cosmann. *m:* Hans Keller. *Educ:* Düsseldorf; International School, Geneva. *Studied:* Slade School. *Exhib:* one man shows: Berkeley Galleries, Matthiesen, Molton Gallery, City of London Festival, Camden Arts Centre, Aldeburgh Festival, Stadtmuseum, Düsseldorf, Clare Hall Cambridge, Ambleside, Menuhin School, Dartington, Belgrave Gallery. *Works in collections:* e.g. N.P.G., R.C.M., V. & A., British Academy, Cardiff University, Britten-Pears Foundation, Clare Hall Cambridge, Stadtmuseum Dusseldorf, Lancaster University, Royal Free Hospital, McMaster University, Swarthmore College, Texas University. *Publications:* Musical Sketchbook (Bruno Cassirer, Faber & Faber, 1957), Stravinsky at Rehearsal (Dobson, 1962), Strawinsky Dirigiert (Ullstein, 1962), Stravinsky Seen and Heard (Toccata Press, 1982); books illustrated: Penguin Music Magazine, A Composer's Eleven (Cardus, Cape, 1975), etc. *Misc:* Work repro.: Radio Times and other national and foreign press, art and musical magazines. Series of Educational Programmes on Drawing for ITV. *Address:* 3 Frognal Gdns., Hampstead, London NW3.

COTTON, Alan, DLitt (Honorary Doctor of Letters, Univ. of Exeter); NDD, ATD(B'ham), FRSA, M.Ed.; painter in oil, water-colour and pastel; works on art films for television; Executive Com., Phoenix Arts Centre, Exeter; President Emeritus SWAc (South West Academy of Fine & Applied Arts). *b:* Redditch, 8 Oct., 1938. *m:* Patricia Esmé. two *s.* two *d. Educ:* Redditch County High School. *Studied:* Redditch School of Art, Bournville College of Art, B'ham College of Art, Universities of B'ham and Exeter (Research Fellow). *Represented by:* David Messum Galleries since 1983: annual exhibitions. *Exhib:* over 40 one-man shows in U.K., Canada, France and the U.S.A. including Hammer Galleries N.Y. (1993). *Works in collections:* City of Exeter A.G., City of Plymouth A.G., Carlton Television, Royal Marines, Lympstone, Universities of Southampton and Exeter, Quen Mary II. *Publications:* "Alan Cotton On a Knife Edge". Biography by Jenny Perry, pub. Halsgrove, 2003. *Clubs:* Dover St. Arts, Chelsea Arts Club, University of Exeter Staff Club. *Signs work:* "Alan Cotton." *Address:* Brockhill Studio, Colaton Raleigh, nr. Sidmouth, Devon EX10 0LH.

COUDRILLE, Jonathon Xavier, Childrens Book of the Year for 'Farmer Fisher' (1976). *Medium:* oil, drawing, prints, silversmithing, 60s, 70s. *b:* Landewednack, 20 Nov 1945. *s of:* Francis Coudrille. *m:* one decd; one divorced. one *s.* one *d. Studied:* everything of worth learned from private tutors. *Exhib:* RA, solo show at Inaugural Harrogate Festival; Albemarle St.,Hoxton; Boundary Road Clerkenwell; Public galleries: Penwith, St.Ives, The Byram, Newlyn Gallery, Salon des Arts, South-West Academy, The Walker (Liverpool Biennial); regular exhibitor in members & artist members shows at The Art Club. *Works in collections:* The Marquis of Bath, The Bank of Nova Scotia, Abel Herrero-Ducloux Esq., Diocese of Truro, permanent coll. Arts Club, etc. *Publications:* 'A

Beastly Collection' (1974); 'Farmer Fisher' (1&2, 1976, '77); 'Vulgar Frog' etc. *Official Purchasers:* Bank of Nova Scotia. *Works Reproduced:* wide selection of prints available in The New Cornish Academy. *Principal Works:* The Metathesis Series, The Biomorphic Series, The Fallen Angel Series, The Harbinger, 'And Was Made Man' (Crucifixion). *Recreations:* music (was professional for 25 years, work performed at Festival Hall, Barbican, etc., plus broadcasting. *Clubs:* The Arts Club, London; Penzance Arts Club. *Misc:* many of the works listed in the series' above are on display in the London Collection at San Carlo, 2 Highgate High Street N6. *Signs work:* early works (1950s/60s):'JXC'; (1970s/80s):'Jonathon Coudrille'; later oils with monogram, graphics 'Coudrille', usually franked with studio stamp. *Address:* Studio Golva, Cadgwith, Helston, Cornwall TR12 7LB. *Email:* jxc@ukf.net

COUGHLAN, Shirley Lyall, County Major Award - Essex County Council 1953; Intermediate Exam in Art 1951; National Diploma in Design 1953; Art Teachers Certificate 1954. *Medium:* printmaking, drawing and painting, ceramics, photography, textiles, collages. *b:* 26 Feb 1932. *d of:* Thomas Moody, author. *m:* Patrick James Coughlan (decd). *Educ:* Colchester County High for Girls, Colchester School of Art 1949-53. *Studied:* London University - Institute of Education 1953-54; taught by John O'Connor, Blair Hughes Stanton, Carel Weight, Hugh Cronyn, and others; courses at Wymondham and Loughborough. *Exhib:* Young Contemporaries Exhibitions (London & touring); Laing Exhibitions; 'Eastern Open', King's Lynn, 1999; 'Drawings for All', Gainsborough's House, Sudbury, Suffolk (2000, 2002); Leicester, King's Lynn, Colchester, Ipswich, Bury St.Edmunds; long-time Member and Exhibitor, Ipswich Art Society. *Works in collections:* Diana Quick, and various other private collections. *Works Reproduced:* original Christmas cards since 1948. *Recreations:* music, gardening, natural history, crosswords, collecting. *Clubs:* Suffolk Craft Society. *Misc:* spent 34 years in Art Education in Leicestershire, Norfolk and Suffolk. *Signs work:* "SLC" or "S.L.Coughlan". *Address:* 26 Warrington Road, Ipswich, Suffolk, IP1 3QU.

COULING, Paula, S.W.A. (1993); landscape painter in acrylic; no formal art training;. *b:* Birmingham. *d of:* James Frederick Rogers (decd.). *m:* Robert H. Couling. two *s. Exhib:* S.W.A. Westminster Gallery; solo shows: Christchurch. *Publications:* greetings cards by the Medici Soc. *Clubs:* Romsey Art Group, Hengist Group of Artists. *Signs work:* "Paula Couling." *Address:* 201 Salisbury Rd., Burton, Christchurch, Dorset BH23 7JT.

COULOURIS, Mary Louise, R.E. (2000), A.R.E. (1973); Dip. A.D. (London) (1961); Post Grad. Scholarship, Slade School (1962); French Government Scholarship (1963); Churchill Fellowship in U.S.A. and Mexico (1993); artist and printmaker; Artists Exchange, Athens for Glasgow Year of culture (1990). *Medium:* watercolour, oil, printmaking. *b:* New York, 17 July, 1939. *d of:* George Alexander Coulouris, actor. *m:* Gordon Wallace. one *s.* one *d. Educ:* Parliament Hill School, London, Chelsea School of Art. *Studied:* Slade School, London

University (1958-62) under Antony Gross; Ecole des Beaux Arts, Paris (1963-64); Atelier 17, Paris (1963-64) under William Hayter. *Represented by:* Bankside Gallery, London; William James Gallery, Athens. *Exhib:* R.A. (1966, 1971, 1972, 1973); one-man shows: London, Oxford, Paris, Aberdeen, Glasgow, Athens. Artists Exchange: Athens for Glasgow Year of Culture (1990). Sainsbury Wine Label Competition Winner (1997), Purdue University, U.S.A. (1999), Circle Gallery, Edinburgh (2003), Melina Mercouri Gallery, Greece (2005), Just Scottish, Edinburgh (2007), William James Gallery, Athens (2007). *Works in collections:* London Weekend TV, Bibliotheque Nationale, Paris, New York Public Library, Nuffield Trust, Trinity College, Oxford, Bank of Scotland, Edinburgh District Council, Hambros Bank, Sainsbury PLC, Scottish Natural Heritage, House of Lords, Graphothek, Berlin Museum. *Commissions:* Scottish Poetry Library 3 Carpets (1999); mural: British Rail (1985); print: British Healthcare Arts (1993), Tapestry, Yale College, Wrexham, N.Wales 2003. *Publications:* 'Techniques to Trigger the Mind' Printmaking Today Vol.7 No. 4 (1998). *Official Purchasers:* House of Lords. *Works Reproduced:* 2 wine labels for Sainsbury's - 60,000 bottles. *Principal Works:* Mural: Linlithgow Rail Station, 1985; Tapestry, Yale College, N. Wales. *Recreations:* cycling, reading. *Signs work:* "Mary Louise Coulouris." *Address:* 5 Strawberry Bank, Linlithgow, West Lothian EH49 6BJ. *Email:* strawberrybanks@yahoo.co.uk *Website:* www.artmlc.co.uk

COULSON, Nancy Diana, (née Hibbert); sculptor stone, alabaster, marble, clay, wood, bronze; subjects: animals, portrait heads in terracotta, clay for bronze;. *b:* Kenilworth, 6 Mar 1926. *d of:* J.P.M. Hibbert, M.C. *m:* Robert Coulson. two *s.* one *d. Educ:* Kingsley School. *Studied:* Leamington Spa, Chelsea Art School (1946-48), Chelmsford (Ivor Livi). *Exhib:* R.A., F.P.S., S.C.A., Vaughan College Leicester, Bury St. Edmunds, Aldeburgh, Chelmsford, Westcliff-on-Sea. *Works in collections:* Guy Harlings and Chapter House, Chelmsford; Mansion House, London; Broomfield Hospital; Lord St. John of Fawsley; Abe Lerner, N.Y.; Sir Alastair Stewart, Bt.; Baroness Platt of Writtle; Daniela Landschuetz; Munich; Mrs. Martin Read of Felsted; and others, St. John Baptist Church Loughton; St. Barnabas Church Woodford. *Commissions:* church sculpture: Madonna St. Barnabus; sundials: St. Mary Great Warley, and Broomfield Hospital, Chelmsford. *Principal Works:* 'The Human Condition' carved oak (2005); 'Great Seal' Chelmsford Cathedral Chapter House 45"dia.;Portrait heads of Bishop Neville Welch, Professor Emeritus Richard Gregory C.B.E., Mrs. Dawn Arthur, Herr Walter Carlein, Mayor of Baden-Baden, retd., Sir Alastair Stewart Bart, Bishop of Chelmsford, John Triello. *Recreations:* gardening, family and friends. *Signs work:* "N.C." *Address:* Medlars, Mounthill Ave., Chelmsford CM2 6DB.

COURTNELL, Louise, BA (Hons) Fine Art - Painting, studied under Robert Lenkiewicz 1987-94. Plymouth Foundation Course. *b:* Plymouth, 24 Apr 1963. *d of:* Derek and Lesley Courtnell. *Studied:* Bristol Polytechnic 1982-85. *Represented by:* independent. *Exhib:* National Portrait Gallery, BP Portrait Award

1991, '92, '93, '94, '97, '98, 2000, '0 Cooling Gallery, Cork Street - 'Brian Sewell's Choice', Mall Galleries - R.S. Portrait Painters and Discerning Eye. *Works in collections:* Royal Holloway College. *Official Purchasers:* Church in Wales, Feb 2002 (Dr. Rowan Williams, Archbishop of Wales). *Principal Works:* self-portraits -National Portrait Gallery, BP Portrait Award. *Misc:* specializes in portraiture in oils, laso landscape and still life. Teaches teachings of Robert Lenkiewicz. *Signs work:* l. Courtnell. *Address:* Vista Hermosa, Rame, Torpoint, PL10 1LG.

COUSENS, Ruth Margaret, F.S.A.I.; Medaille d'Or, Paris Salon (Tricentenaire 1973) T.C., Women of the Year Luncheon; artist in water-colour; art teacher of history, architecture and painting: St. George's Ramsgate, Maidstone Technical High, Sittingbourne Girls' Grammar, pupils of Wilmington Grammar Schools, St.Olaves' Boys' Grammar School, Orpington; Day Courses Director and Tutor 'The Architectural Heritage of Thanet Towns of Ramsgate, Broadstairs, Margate; Rutherford College School of Continuing Education, University of Kent at Canterbury; Founder-Project Director, Castle Trust Arts Centre, Ramsgate;. *b:* London, 1930. *d of:* Abbot Winstanley Upcher (Burke's Landed Gentry), Pioneer Missionary to Arabia, and Ruth Wingate, niece of Sir George Pirie, late Pres. Scottish R.A. *m:* Stanley G. Cousens. one *s. Educ:* St. George's Ramsgate, and Clarendon Malvern. *Studied:* Rolle College, Exeter (1948-50, E.T. Arnold). *Exhib:* Paris Salon, R.A., R.I., R.I.B.A., etc.; one-man shows, 'Regency Ramsgate', Townley House, Ramsgate (1973), Royal Museum, Canterbury (1978), Geneva (1985), Westend, London (1986); by invitation: 'La Femme Creatrice d'Art', Monte Carlo (1976) (Brit. rep.), 'British Artists', Paris (1979), Expo Quebec, Canada (1980). *Works in collections:* Thanet Council, Ramsgate Charter Trustees; private: Sir Robert Bellinger, Rt. Hon. Edward Heath, M.P. *Works Reproduced:* book jackets, retail postcards; booklet 'Regency Ramsgate'. *Signs work:* "R.M. COUSENS." *Address:* 17 Spencer Sq., Ramsgate, Kent.

COUSINS, Timothy, BA (Hons) Fine Art; PGCE (Art Teaching). *Medium:* oil, watercolour, acrylic and gouache. *b:* Weston-super-Mare, 29 Jul 1952. *s of:* Constance Chapman. *m:* Angie Cousins. two *d. Educ:* Christ's Hospital, Horsham, Sussex. *Studied:* Exeter College of Art and Design; Ravensbourne College of Art and Design. *Represented by:* Anderssonhall; Ginette Kentish. *Exhib:* solo exhbns: Colston Hall, Bristol (1977); Deli Art London (2000); two-person, with Germaine Dolan, Diorama Gallery, London (1998); numerous group shows at APT Gallery London; Belgrave Gallery, London; Belgrave Gallery, St.Ives; Huddersfield Art Gallery; Derby Museum and Art Gallery. *Works in collections:* Rowing Museum, Henley-on-Thames); Whitstable Museum and Art Gallery; Huddersfield Art Gallery; Goldsmiths' College, London; Lewisham College, London; London Borough of Greeenwich. *Commissions:* fourteen paintings for offices - The Easton Corporation. *Official Purchasers:* Goldsmiths College, London. *Works Reproduced:* 'Sharing a View' catalogues, and numerous others. *Principal Works:* 'Eltham Bus Stop'; 'Bandstand'. *Recreations:* playing

and watching cricket. *Signs work:* 'Timothy Cousins'. *Address:* 1 Chestnut Rise, Plumstead, London SE18 1RJ. *Email:* aandtcousins@aol.com *Website:* www.anderssonhall.com

COUTU, Jack, A.R.E., A.R.C.A.; printmaker and sculptor; etching and engraving on copper, miniature carving in boxwood and ivory; netsuke. *b:* Farnham, Surrey, 13 Sep 1924. *s of:* Herbert Coutu. *Educ:* Farnham Grammar School. *Studied:* Farnham School of Art (1947-51), R.C.A. (1951-54). *Exhib:* travelling exhibition of Netsuke and Prints (2004 & 2005). *Works in collections:* King Gustave of Sweden, Museum of Fine Art, Boston, Mass., Bradford City Art Gallery, V. & A., Arts Council of Great Britain, Government Art Collection. *Publications:* articles in "International Netsuke Society Journal" (1996). *Signs work:* "Coutu". *Address:* Bramblings, 22 Quennells Hill, Wrecclesham, Farnham, Surrey GU10 4NE.

COWAN, Judith, BA. Fine Art (1977), MA Sculpture (1978), Gulbenkian Rome Scholarship (1979); Henry Moore Bursary (1992). *b:* London, 8 Dec 1954. *Studied:* Sheffield Polytechnic (1974-77); Chelsea School of Art (1977-78). *Exhib:* solo exhbns. include:'from life', Museo Laboratorio di Arte Contemporanea, Rome (2005); 'present, passing' Angel Row Gallery, Nottingham (touring, 1999), 'Passages and Incidents', Kettles Yard Gallery, Cambridge(1996), 'Sex, Birth, Sex, Death', Stefania Miscetti, Rome (1995), 'Water rises' Camden Arts Centre (1993), 'a line of blue and a pool of red' Yorkshire Sculpture Park (1992), 'New Sculpture' Oriel Mostyn, Llandudno (1989-90) (touring). *Works in collections:* A.C.G.B., London Borough of Tower Hamlets, Leics. Educ. Authority, New Hall, Cambridge; Hechinger Collection. *Publications:* 'the capacity of things: from life, monograph, Gangemi Editore (2005) ISBN 88-492-0861-8. *Address:* 2a Culford Mews, London N1 4DX.

COWAN, Ralph Wolfe, A.P.S., A.A.A., A.S.A., P.I.; Royal Portrait Painter to: Sultan of Brunei (1984-), Monaco (1956, 1981), Morocco (1983), Malacanang Palace, Philippines (1982, 1983); portrait painter in oil;. *b:* Phoebus, Va., 16 Dec 1931. *s of:* Joseph Carl Cowan. *m:* Judith Page. two *s*. *Studied:* Art Students League (1949-50, Bouché and Frank Reilly). *Works in collections:* Royal Palace Brunei, Palace Monaco, Royal Palace Morocco, Malacanang Palace Philippines, Carter Presidential Center, Atlanta, Reagan Private Coll., Los Angeles, Graceland Coll., Memphis, Portsmouth Museum, Portsmouth Va., N.P.G. Wash. D.C. *Publications:* seven Johnny Mathis album covers; first book "A Personal Vision" collector plate of His Holiness Pope John Paul II. *Signs work:* "Ralph Wolfe Cowan." *Address:* 243 29th St. West. Palm Beach, FL 33407 U.S.A.

COWDY, Richard Davenport, NDD, ATC. *Medium:* bronze sculpture. *b:* London, 18 Sep 1937. *s of:* Bernard Cowdy. two *s*. two *d*. *Educ:* Alleyns Grammar School. *Studied:* Camberwell Art School. *Exhib:* London Group, RA, Marlborough Gallery, Burford Gallery, Dulwich Gallery. *Works in collections:* London Stock Exchange, Sydney, Paris, Amsterdam, Hong Kong. *Commissions:*

Sainsbury's Calne Shopping precinct (sheep bronze), Calne Precinct (pigs bronze), various portraits, John Bentley School Calne: bronze boy and girl, and abstract bronze for language college. *Official Purchasers:* Colmans Mustard Norwich (large bronze bull's head). *Recreations:* music. *Misc:* visiting lecturer at the Slade, London, Guildford Art School, Camberwell Art School. *Signs work:* R D Cowdy. *Address:* 18 Wood St., Calne, Wilts, SN11 0DA. *Email:* richardcowdy@onetel.com

COX, Julian Charles, ARBS (2006); Diploma in Sculpture Restoration; Post Grad Teaching Certificate. *Medium:* sculpture: wood, bronze, stone. *b:* 25 Jan 1961. *s of:* Ken & Audrey Cox. *m:* Jane. two *s.* one *d. Educ:* Colston's Boys School, Bristol. *Studied:* City & Guilds of London Art School (1983-86); University of London, Goldsmiths College (1988-89). *Represented by:* Jonathan Poole-Compton Cassey Gallery; Innocent Fine Art, Clifton, Bristol; Morgan-Boyce Fine Art, Marlborough. *Exhib:* RWA; C20th Art & Design Fair, London; 20/21 British Art Fair, London; Olympia Affordable Art Fairs; Art Ireland, Dublin; Art London. *Misc:* 1986-88-Sculpture Restorer (Plowden & Smith International Conservators). Now, part-time teacher of Design & Technology, and Art. *Signs work:* 'COX' ('O incised with barbed 'J'). *Address:* 14 Phoenix Grove, Westbury Park, Bristol BS6 7XY. *Email:* jcjacox@tesco.net *Website:* www.julian-cox-sculpture.co.uk

COX, Paul, BA (Hons) (1996), MA, RAS (1999); sculptor. *b:* Shoreham-by-Sea, 28 Jan 1975. *Educ:* Steyning Grammar School. *Studied:* BA- Winchester School of Art, MA- Royal Academy Schools. *Works in collections:* Gazely Properties, Surrey Institute of Art. *Commissions:* Gazely Properties, Surrey Institute of Art. *Clubs:* RASAA. *Address:* 426 South Coast Rd, Telscombe Cliffs, Peacehaven, E.Sussex, BN10 7BE.

COX, Stephen B., B.A.Hons., British Council Research Scholar, P.G.C.E. (Merit); artist, interior designer, teacher; director, 'Club Anglia' international summer school; taught art: Wellington College, Reading Grammar, Langley College; arts organiser, Hexagon Reading; founder, Regional Secretary Artists Union; production manager independent British films (1977-80); promoter pop groups/artists; fashion model photographer; sponsor, Manpower Services Commission YTS. *s of:* the late Bernard Cox. *Educ:* Grange and Kingwood Grammar Schools. *Studied:* Reading University; Researched: Bucharest Fine Arts University. *Exhib:* now average four one-man shows and group shows annually U.K. and Europe. *Works in collections:* U.K., Europe, U.S.A. *Commissions:* painting/sculpture England. *Works Reproduced:* many catalogues, radio, TV interviews U.K. and Europe. Council mem./Head of Westminster lobby: Design and Artists Copyright Soc. *Misc:* Events: produced/performed (as Nevetz) Germany, France, U.K., Romania.; (studio) Chalkpit Farm, Englefield, Berks. *Signs work:* "STEPHEN". *Address:* 60 Elmhurst Rd., Reading RG1 5HY.

COYNE, Douglas, Hon. F.R.C.A., N.D.D. (Illustration) (1950); painter in oil and water-colour;. *b:* Newark-on-Trent, 6 June, 1930. *m:* Dinah Wood. *Studied:* Newark School of Art (1944-48), Nottingham College of Art (1948-50). *Exhib:* one man shows: Chipping Campden (1988, 1990, 1993, 1998, 2000); mixed shows: with Oxford Art Soc. and Blockley Art Soc. *Works in collections:* Newark Museum. *Signs work:* "COYNE" (oils), "DOUGLAS COYNE" (water-colours). *Address:* Mill Cottage, Calf Lane, Chipping Campden, Glos. GL55 6JQ.

CRABBE, Richard Markham, A.R.C.A. (1951); painter; principal lecturer, Portsmouth Polytechnic Dept. of Fine Art (retd.); Prizewinner, Chichester Open (2003). *b:* Horley, Surrey, 1927. *s of:* Sydney Crabbe. *m:* Peggy Crabbe 1929 - 2005 (decd). two *s.* one *d. Studied:* Croydon School of Art and Royal College of Art. *Exhib:* RA (2004), Drumcroon, Wigan (1982), Galleri 17, Stockholm (1984), Portsmouth Museum (1995), Aspex Gallery, Portsmouth (1997), Chichester Open (2002, 2003, 2004, 2006). *Works in collections:* Portsmouth Museum, Wigan Educ. Com., Koenig Braures, Duisburg, Germany, Southern Arts Assoc., S.W. Handelsbanken, Artothek, Düsseldorf, Germany, Hampshire C.C., Russell Cotes Museum Bournemouth. *Commissions:* Portsmouth City Arts and Social Services, residency, community centres (1995). *Clubs:* Art Space Portsmouth. *Signs work:* "R. Crabbe." *Address:* 22 Andover Rd., Southsea PO4 9QG.

CRAIG-MARTIN, Michael, Millard Professor of Fine Art, Goldsmiths' College;. *b:* Ireland, 28 Aug., 1941. one *d. Studied:* Yale University (1961-66). *Signs work:* "Michael Craig-Martin." *Address:* c/o Waddington Galleries, 11 Cork St., London W1X 1PD.

CRAIG-McFEELY, Joanna, SBA, SFP, FCPGFS, ASBA; awards: Joyce Cummings Presentation Award (SBA, 2004); 6 RHS Medals, Bronze (1999), Silver Gilt (1999, 2002, 03, 06), Silver (2001). *Medium:* watercolour on paper and vellum. *b:* Beckenham, 2 May 1934. *d of:* Mona & Douglas Jenkins. *m:* Gerald Martin Craig-McFeely. two *s.* two *d. Educ:* Mayfield Convent; St.Mary's Hospital, Paddington. *Studied:* self-taught and master classes Jenny Phillips (Venice, 2001, 02, 04, 06). *Exhib:* SBA (1998-2005, 2007); SWA (200, 01, 04); American Society of Botanical Artists, New York (2005); Chelsea Physic Garden Florilegium Society, Munich (2002); RHS (1999, 2002-04, 2006). *Works in collections:* Chelsea Physic Garden Florilegium (5 works); Highgrove Florilegium (2 works); and internationally. *Works Reproduced:* in 'The Art of Botanical Painting' (2004); 'The Apothecaries Garden' (2005). *Principal Works:* botanical illustration. *Recreations:* skiing, silver smithing. *Misc:* State Registered Physiotherapist (retd.). *Signs work:* 'JCMcF'. *Address:* Tintern, Hillbrow Road, Liss, Hampshire, GU33 7QA. *Email:* craigassociates@beeb.net *Website:* www.botanicalillustration.co.uk

CRAIGMILE, Heather, UA; Mem. Chelsea Art Soc.; artist in oil and crayon. *b:* Birkenhead, 13 Sep 1925. *d of:* Major H.W.C. Craigmile, M.A.Cantab. *Educ:* Downe House, Cold Ash, Newbury, Berks. *Studied:* privately under Arnold

Mason, RA, Harold Workman, RBA, RCA, also at Chester Art School. *Exhib:* RBA, RCA, UA, Chelsea Art Soc., one man show every two or three years at Beddgelert in Snowdonia and more recently in Isle of Anglesey. Two in the Conwy valley in the last 18 months. *Works in collections:* paintings in several local public buildings. *Recreations:* Painting!. *Clubs:* Chelsea Arts Society. *Signs work:* "Heather Craigmile." *Address:* Trem-y-Dyffryn, Llanbedr, Conwy, Gwynedd LL32 8UN.

CRAMP, Jonathan David, A.T.D., R.W.S.; painter; Head of Art Dept., Fishguard C.S. School (1954-81);. *b:* Ninfield, Sussex, 29 Jan 1930. *s of:* David Cramp. *m:* Elizabeth (painter). one *d. Educ:* Huish Grammar School, Taunton, Bexhill Grammar School. *Studied:* Hastings School of Art (1946-51) (Vincent Lines). *Represented by:* Bankside Gallery. *Works in collections:* Arts Council of Wales, Contemporary Art Society for Wales, Pembrokeshire County Museum, Schools Service, National Museum of Wales, Shell Oil (U.K.) Ltd., National Grid Co., Cartrefle and Caerleon Colleges of Education, various education authorities, the Government Art Collection, Providence Museum, Rhode Island, U.S.A., British Steel, National Library of Wales. *Commissions:* Shell Oil (U.K.) Ltd, National Grid Co. *Address:* Heatherdene, Windy-Hall, Fishguard, Pembs. SA65 9DU.

CRAWFORD, Alistair, (Professor); D.A. (1966), A.T.C. (1968), M.C.S.D. (1973-86), M.S.T.D. (1977-97), Fellow, Printmakers Council (1978-93), Churchill Fellow (1982), F.R.P.S. (1991-98), R.C.A. (1994), Hon. R.E. (2000); Balsdon Senior Fellow, British School at Rome (1995-96); painter, printmaker, photographer, art historian and exhibition curator; writer, performer;. *b:* Fraserburgh, 25 Jan 1945. *Studied:* Glasgow School of Art (1962-66). *Exhib:* 45 solo, over 230 joint and selected exhibitions throughout Britain and abroad. recent solo exhibitions 'A Return to Wales, Retrospective 1974-2000' and 'New Paintings', National Library of Wales, 'Landscape Capriccios' University of Wales, Aberystwyth (2005), Martin Gallery, Cheltenham (2006), Denbighshire Arts Touring (2006). Various awards including Welsh Arts Council, British Council, British Academy, Gold Medal Fine Art, Royal National Eisteddfod of Wales (1985), Kraszna Krausz Award (1992); performance: 'An Evening with Eugenie Strong' (1996-) and 'Brief Exposure (2001-); curated exhibitions shown throughout Britain and Ireland, Austria, Italy, Sardinia, Switzerland, U.S.A. *Works in collections:* 441 works in public and corporate collections throughout Britain and USA. *Publications:* Over 130 publications including: John Thomas 1838-1905 photographer (1977); Mario Giacomelli (1983, 1985); Elio Ciol, Italia Black and White (1986); Carlo Bevilacqua (1986); Elio Ciol, Assisi (1991); George Chapman (1989); Will Roberts (1993); Kyffin Williams (1995); Alistair Crawford Collected Photographs (1995); The Welsh Lens (1997); Robert MacPherson 1814-72 (1999); Made of Wales (2000); Father P. P. Mackey (1851-1935) Photographer (2000); Mario Giacomelli (2001, 2002, 2005, 2006). Erich Lessing Reportage - Photography 1948-73 (2002, 2003, 2005); 'North By Northwest', Jersey Arts Centre (2006), 'Made from Wales', Brecknock Museum,

Brecon (2007); column: 'Brief Exposure' for Inscape Magazine 1999-. Numerous articles in U.K. and abroad. *Signs work:* "Crawford" followed by the year. *Address:* Brynawel, Comins Coch, Ceredigion SY23 3BD. *Email:* alc@aber.ac.uk *Website:* www.alistaircrawford.co.uk

CRAWFORD, John Gardiner, D.A., Post Dip., R.S.W., R.B.A., R.I.; painter in water-colour, acrylic; Awards: Gray's School of Art, First Prize for Painting (1962); Governor's Award for Painting, Hospitalfield College of Art (1963); Royal Scottish Academy, Bursary Award (1964); First Prize, Scottish Arts Council Open Exhbn. (1969); Scottish Arts Council, Bursary Award (1981); Hunting Award, First Prize for Water-colour (1982); R.I. Medal (1983); Hunting Award, Second Prize (1984). *b:* Fraserburgh, 1941. *s of:* John Gardiner Crawford, fisherman. *m:* Elspeth Younger. one *s.* one *d. Educ:* Fraserburgh Academy. *Studied:* Gray's School of Art, Aberdeen. *Exhib:* internationally. *Works in collections:* worldwide. *Signs work:* "CRAWFORD." *Address:* Dunedin, 34 Strachan St., Arbroath, Angus DD11 1UA.

CRAWFORD, Susan L., equestrian artist and portrait painter in oil;. *b:* Scotland, 11 May, 1941. *d of:* H.Com. WH Crawford and Mrs P.M. Crawford, neé McCosh. *m:* Jeremy Phipps. one *s.* one *d. Educ:* Priors Field, Godalming. *Studied:* Studio Simi, Florence (1968-70). *Exhib:* solo show at Tryon Gallery (2001); part of large shows at N.P.G., Royal Scottish Academy, Queen's Gallery, V. & A., R.A., National Gallery of Penang, R.P., National Horseracing Museum, Newmarket, Cross Gate Gallery, Kentucky U.S.A. *Works in collections:* H.M. The Queen, H.M. Queen Elizabeth the Queen Mother, H.R.H. The Prince of Wales, the late Paul Mellon, H.M. Sultan Qaabos of Oman, The Sultan of Brunei, Prince Khalid Abdulla, The Duke of Devonshire, Sir Arnold Weinstock, Kerry Packer, etc. *Commissions:* 21 Derby winners; Royal portraits. *Publications:* included in Stella Walker's 'Sporting Artist of the 20th Century', '100 Years of British Farming Livestock'; etc. *Works Reproduced:* Rosenstiels, Fine Art Publishers, 33-35 Markham St., Chelsea Green, London SW3 3NR. *Signs work:* "S.L. Crawford." *Address:* Hillstreet Farmhouse, Tisbury, Salisbury, Wilts. SP3 6PU. *Website:* www.slcrawford.com

CRAWSHAW, Alwyn, SEA, BWS, PNAPA, FRSA (1978), UA (Hon.) (2000); artist in acrylic, water-colour and oil; director (partner), Russell Artists Merchandising Ltd., Kingston-upon-Thames, Surrey (1957-80); Lecturer and demonstrator on acrylic, oil and water-colour painting for Daler-Rowney & Co., Ltd. Bracknell Berks.; President, National Acrylic Painters Assoc.; Founder, Soc.of Amateur Artists (1992). *b:* Mirfield, Yorks., 20 Sep 1934. *s of:* Fred Crawshaw. *m:* June Crawshaw. one *s.* two *d. Educ:* Hastings Grammar School for Boys. *Studied:* Hastings School of Art (1949-51) under Vincent Lines. *Exhib:* RBA; one-man shows: Harrods, St. Paul's Gallery, London, Marina Gallery, Weybridge, Barclay A.G., Chester, Guildford Galleries, Guildford, Mensing Gallery, Germany; joint exhbn. with June Crawshaw, St. Helier Gallery, Jersey, C.I. (1992), Patricia Wells Gallery, Bristol (1989) and Tokyo, Japan (1998, 2001).

Publications: Pub. by Harper Collins: Alwyn Crawshaw's Oil Painting Course (1992), A Brush with Art (1991), Alwyn Crawshaw Paints Oils (1992), Alwyn Crawshaw Paints on Holiday (1992), Alwyn Crawshaw's Acrylic Painting Course (1993), Alwyn Crawshaw's Watercolour Painting Course (1991), Crawshaw Paints Acrylics (1994), Crawshaw's Sketching and Drawing Course (1995); Crawshaw Paints Constable Country (1996); Alwyn and June Crawshaw's Outdoor Painting Course (1997); Learn to paint with Acrylic Colours (Collins); Learn to paint with Watercolours (Collins); Learn to paint landscapes (Collins); Learn to paint boats and harbours (Collins); Learn to Sketch (Collins); Learn to Paint Still Life (Collins); Learn to Paint Outdoors in Watercolour (Collins); Learn to Paint in Oils for the Beginner (Collins); The Artist at Work - Alwyn Crawshaw (Collins); Sketching with Alwyn Crawshaw (Collins); The Half-Hour Painter (Collins); "You Can Paint Watercolour" pub. 2000, Harper & Collins. Guest on BBC Radio, BBC T.V., Independent Radio, discussing painting techniques; guest on the 'Gay Byrne Radio Show' R.T.E. Ireland (Mar. 1991), T.S.W. television series 'A Brush with Art' by Alwyn Crawshaw, 12 half hour programmes, 'Crawshaw Paints in Oils', 8 half hour programmes, 'Crawshaw Paints on Holiday', 6 half hour programmes (1992), 'Crawshaw's Watercolour Studio' 8 half hour programmes (1993), 'Crawshaw Paints Acrylics', 8 half hour programmes (1994), 'Crawshaw's Sketching and Drawing Course', 10 half hour programmes (1995), 'Crawshaw Paints Constable Country' T.V. for Anglia and Channel 4, 6 half hour programmes. All TV series screened network by Channel 4, and screened by P.B.S. America from April 1993, and Japan. TV series – 8 half hour programmes "Crawshaw's Watercolour Cruise" (2000), 'You Can Paint Landscapes in Watercolour' pub. Harper Collins (2003); "Alwyn Crawshaw's Ultimate Painting Course" pub. Harper Collins (Sep.2006). *Signs work:* "ALWYN CRAWSHAW." *Address:* The Hollies, Stubb Rd., Hickling, Norwich NR12 0YS.

CRAWSHAW, Donna, S.W.A., S.E.A.; animals and landscape painter in acrylic and water-colour;. *Medium:* acrylic. *b:* Woking, Surrey, 16 Mar 1960. *d of:* Alwyn Crawshaw. *m:* Andrew G.L. Goolding (Fine Art Dealer). two *d.* *Studied:* West Surrey College of Art and Design. *Exhib:* Omell Galleries, London; Ascot, Forest Gallery Guildford; Mall Galleries and Westminster Hall (various); Clifton Gallery, Bristol; Grimes House Gallery, Cotswolds; Wellington Gallery, Ballymena; Cheng-Kim Loke Gallery, Slimbridge; Valley Art Gallery, N.Ireland; Tallantyre Gallery, Morpeth, Northumberland; Cotswold Galleries, Stow-on-the-Wold; Whibleys, Worthing; Kingfisher Gallery, Cowbridge. *Works Reproduced:* Country Fine Arts and Solomon & Whitebread - Fine Art Prints; Royal Worcester Porcelain by Bradford Exchange; greetings cards by various. *Signs work:* "Donna Crawshaw." *Address:* Rhiwe Farm, Llanddeusant, Llangadog, Carms. SA19 9SS. *Email:* donnacrawshaw@email.com *Website:* www.donnacrawshaw.co.uk

CRAWSHAW, June Eileen, B.W.S. (1987), S.W.A. (1988), N.A.P.A. (1997); artist in water-colour, oil and acrylics, potter in ceramics, porcelain;. *b:* Woking, Surrey, 20 Jun 1936. *d of:* Ernest Bridgman, mechanical engineer. *m:* Alwyn

Crawshaw. one *s.* two *d. Educ:* Kingfield Secondary School, Woking. *Studied:* painting under Alwyn Crawshaw, S.E.A., B.W.S., P.N.A.P.A., F.R.S.A. (1970-87); ceramics at Danefield College, Woking (1975-80, June Duckworth). *Exhib:* joint exhbns. with Alwyn Crawshaw, Donna Crawshaw, S.W.A., Godalming Galleries (1985), Yorkshire Artists (1987), Sidmouth Visual Arts Festival (1981-87), B.W.S. (1987), joint exhbn. with Alwyn Crawshaw Harrods (1986), S.W.A. Annual Exhbn., B.W.S. Annual Exhbn., joint exhbn. with Alwyn Crawshaw at The Patricia Wells Gallery, Bristol (1989), St. Helier Gallery, Jersey, C.I. (1992), and Tokyo, Japan (1998, 2001); teaches with Alwyn Crawshaw on painting courses every year since 1982. *Publications:* 'You can Paint Seashore in Watercolour' (Harper Collins, 2004), Watercolour Made Easy (Harper Collins, 1995); Alwyn and June Crawshaw's Outdoor Painting Course (1997). Featured in TV series: 'Crawshaw Paints on Holiday' Channel 4 (1992) and P.B.S. America (1993) and book of series; 'Crawshaw Paints Acrylics' Channel 4 (1994) P.B.S. America (1994) and book of series; 'Crawshaw's Sketching and Drawing Course' Channel 4 (1995) P.B.S. America and book of series. All three series in Japan. *Signs work:* "June Crawshaw" (paintings). *Address:* The Hollies, Stubb Rd., Hickling, Norwich NR12 0YS.

CRAXTON, John, RA; artist in oil, tempera, conté crayon. *b:* London, 3 Oct 1922. *s of:* Harold Craxton, O.B.E., pianist, composer, teacher. *Educ:* various private schools. *Studied:* Goldsmiths' College and Academie Julian. *Exhib:* Leicester Galleries, London Gallery, Galerie Gasser, Zürich, British Council, Athens, Retrospective, Whitechapel (1967), Christopher Hull Gallery (1982, 1985, 1987), Pallent Gallery (1998-99). *Works in collections:* Tate Gallery, City Art Gallery, Bristol, Manchester and Birmingham A.G., Melbourne A.G., British Council, Arts Council, Victoria and Albert Museum, Ministry of Works, British Museum. *Commissions:* Cottrell Memorial Tapestry, Stirling University. *Publications:* John Craxton, by Geoffrey Grigson, Horizon (1948), The Poet's Eye (1944: 16 lithographs), sets and costumes for Royal Ballet, Daphnis and Chlöe (1951), Apollo (1966). *Signs work:* "Craxton." *Address:* Moschon 1, Hania, Crete.

CREBER, Frank, BFA (1981), MFA (1987); artist in oil on canvas, watercolour, pen and ink. *b:* Amersham, Bucks., 12 Jan 1959. *m:* Marguerite. two *s. Studied:* Newcastle University (Roy Kitchen), Chelsea School of Art (Ian Stephenson). *Exhib:* Sue Williams, Portobello Rd. (1988, 1989, 1991), Barclays Bank Young Painters £10,000 competition, Henry Moore Gallery, RCA.London (awarded joint winner 1987), Paton Gallery, London (1990), Artist of the Day, Flowers East, London (1989). *Works in collections:* Unilever, Arthur Andersen & Co.,Art for Hospitals, Leics. Schools Coll., Stanhope Construction Ltd. *Address:* 49 Darnley Road, Hackney, London E9 6QH.

CREE, Alexander, D.A.(Edin.) 1950; painter in oil, pastel and water-colour;. *b:* 24 Feb 1929. *s of:* John Cree. *Educ:* Dunfermline High School. *Studied:* Edinburgh College of Art (1946-52), Post Graduate Scholarship (1950),

Travelling Scholarship (1951). *Exhib:* R.S.A., R.S.W., R.G.I.,Scottish Lyceum Club (1957), Demarco Gallery (1968, 1976), Loomshop Gallery (1969), Shed 50 (1974), Macaulay Gallery (1990), Solstice Gallery (1991), Westgate Gallery (1991), Open Eye Gallery (1993), Ewan Mundy Gallery, Broughton Gallery, Kingfisher Gallery, Gallery 41, Edinburgh Gallery, Colours Gallery, Peter Potter Gallery. *Works in collections:* Scottish Arts Council, Nuffield Foundation. *Publications:* The Dictionary of Scottish Painters 1600 to the Present. *Recreations:* gardening. *Signs work:* "A. Cree." *Address:* Sospiri, Braeheads, E. Linton, E. Lothian EH40 3DH, Scotland.

CREFFIELD, Dennis, *b:* London, 29 Jan 1931. *Educ:* Colfes Grammar School, London. *Studied:* Borough Polytechnic, London with David Bomberg (1948-51), Slade School of Fine Art, London (1957-61); Gregory Fellow in Painting at the University of Leeds (1964-68). *Exhib:* many mixed and one-man exhbns; A Retrospective Exhibition, Flowers East Gallery, London (2005). *Works in collections:* include: Tate Gallery, Contemporary Art Soc., National Trust, House of Commons, Arts Council of Gt. Britain, Government Art Collection, Imperial War Museum, The Contemporary Art Soc. *Commissions:* include: South Bank Board – Medieval English Cathedrals (1987); The National Trust Foundation for Art – Petworth (1990) and Orford Ness (1994); The House of Commons Fine Art Commission (1990). *Signs work:* Dennis Creffield. *Address:* 3/ 45 Marine Parade, Brighton BN2 1PE.

CREME, Benjamin, artist in oil. *b:* Glasgow, 1922. *s of:* Maurice Charles Creme. *m:* Phyllis Power. two *s.* one *d. Educ:* Queens Park, Glasgow. *Studied:* with Jankel Adler. *Exhib:* A.I.A., London Group, Carnegie International (1952), Whitechapel (1954), Arts Council (1974), I.C.A. (1979); one-man shows: Gallery Apollinaire (1952), St. George's Gallery (1955), Bryant M. Hale Gallery (1964), Dartington New Gallery (1977), Themes and Variations Gallery (1985), England & Co. (1988); group shows: South Molton Gallery, Gimpel Fils, Redfern, Roland Browse and Delbanco, Leger Gallery, Reid and LeFevre. *Works in collections:* Pembroke College, Oxford, V&A, BM. *Publications:* Cage Without Grievance (W.S. Graham, Parton Press, 1942). *Signs work:* "Creme." *Address:* P.O. Box 3677, London NW5 1RU.

CRESWELL, Alexander Charles Justin, artist in water-colour, author; Knight of the Order of Francis I (KFO). *b:* Helsinki, 14 Feb 1957. *m:* Mary Curtis Green. one *s.* two *d. Educ:* Winchester College. *Studied:* Byam Shaw School of Art (1976), W. Surrey College (1976-78). *Exhib:* Portland Gallery, London; Hirschl & Adler Galleries New York; John Martin of London, Spink & Son, Cadogan Gallery, New Academy London, also Europe, Hong Kong and S. Africa. *Works in collections:* Palace of Westminster, The Royal Collection, The Frick Museum, Forbes Collection. *Commissions:* Royal Collection, Royal Bank of Scotland, English Heritage, B.B.C., Duchy of Cornwall, HSBC Bank Middle East, H.M. The Queen; H.R.H. The Prince of Wales. *Publications:* The Silent Houses of Britain (1991), Out of the Ashes (1999). *Clubs:* INTBAU, A.W.G.,

Institute of Classical Architecture. *Signs work:* "Alexander Creswell." *Address:* Copse Hill, Ewhurst, Surrey GU6 7NN. *Website:* www.alexandercreswell.com

CREW, Rowan Alexander, A.R.B.A. (1987), R.B.A. (1988); self taught artist in water-colour, acrylic and oil;. *b:* Woodchurch, Kent, 31 Dec 1952. *s of:* Alfred Crew, teacher. *m:* Linda Bannister. three *d. Educ:* Homewood Secondary Modern. *Exhib:* R.I., R.B.A., R.O.I., N.E.A.C. *Works in collections:* K.C.C., and private collections. *Signs work:* "Rowan Crew." *Address:* Brook Farm House, Brook St., Woodchurch, Ashford, Kent TN26 3SP.

CRISFIELD CHAPMAN, June, D.A. (Glasgow) (1955); National Award - Garrick/Milne Competition (portrait). *Medium:* wood engraving, portraiture, illustration. *b:* Kent, 4 Jun 1934. *m:* William Woodside Chapman, D.A. two *s. Educ:* Kilmarnock Academy. *Studied:* Glasgow School of Art. *Exhib:* solo: National Theatre London, Shakespeare's Globe London, Glasgow City A.G. Kelvingrove,Palace of Westminster, Natural History Museum at Water Rothschild Museum, Chelsea Physic Garden, Royal Botanic Garden Edinburgh; group: Edinburgh International Festival, Royal Scottish Academy, Royal Society of Painter Printers' Opens, Chaucer/Caxton, Westminster Abbey. *Works in collections:* engravings-Glasgow City, Edinburgh City, Ashmolean Museum, Oxford, Fitzwilliam Museum Cambridge, Fleming Scottish, London; portraiture-Theatre Museum (V&A), Paisley Museum, William Morris Society, Royal Academy Dramatic Art, National Trust. *Commissions:* theatre portraits, illustrative engraving, theatre gouaches-'Tribute to Scottish Theatre', 'Entertainment' panel, private portraiture, engravings. *Publications:* engravings Folio Book Society's Shakespeare (1988), 'The Countryman' ('87-'98), illustration in Radio Times. *Official Purchasers:* Garrick Club, London, Flemings Bank, Glasgow Corporation, Faculty of Public Medicine, Aberdeen Hospital, Essex Education Authority, V&A, Morris Society. *Works Reproduced:* engravings Folio Book Society, The Countryman Magazine, Radio Times, Engravers' Globe. *Misc:* talks, demonstrations, including British Library, V. & A. Museum. *Signs work:* "CRISFIELD" or "CRISFIELD CHAPMAN." *Address:* 23 Smythe Rd., Billericay, Essex CM11 1SE.

CROFT, Ivor John, C.B.E., M.A. (Oxon. and Lond.); painter and former civil servant;. *b:* 6 Jan 1923. *s of:* Oswald Croft. *Educ:* Westminster School; Christ Church, Oxford; Institute of Education, University of London; London School of Economics. *Exhib:* group shows: various, 1958 onwards including Camden Arts Centre (Survey of Abstract Painters, 1967); John Player Open Exhbn. (1968, 1969); Covent Garden Gallery (Critical Discoveries, 1973); Lorient, Brittany (Festival Interceltique, 1993); Anthony Hepworth (2002/3);one-man shows: Gardner Centre for the Arts, University of Sussex (1970); University of Warwick (1971). *Works Reproduced:* Art and Artists, postcard. *Clubs:* Reform. *Signs work:* "John Croft" on back. *Address:* 15 Circus Mews, Bath BA1 2PW.

CROFT, Maria Danuta, Ministry of Education Arts & Crafts National Diploma in Design (1953); Diploma Painting and Printed Textile (Hand) (1955). *Medium:* palette knife work, oil, watercolour, drawing, prints, pen and ink. *b:* Poland, 15 Jun 1932. *d of:* Rafal Kornel Ryzenski, officer/teacher. *m:* Arthur Jack Croft, ex.RN. three s- *s.* two *d. Studied:* Plymouth College of Art (under Lewis Duckett, Mr.Pickup, Mr Herman). *Exhib:* Art Frame Gallery, Tavistock and Plymouth; Tavistock Town Hall Art Society; Liskeard, Cornwall; Holiday Inn, Plymouth; and across the West Country; winner of Best Painting in the Show 3 times with TGA Society. *Works in collections:* Baroness Thatcher (private collection); Tavistock Town Hall (Mayor's Parlour); private. *Commissions:* Polish Maritime Training Ship 'Jan Turlejski'; moorland ponies, dogs, portraits, etc. Works sold in US, Canada, Australia, Poland, Belgium, Germany, Spain, Ireland and UK, over 200 paintings. *Publications:* Leisure Painter. *Principal Works:* 'Baroness Thatcher, Iron Lady'; Town Criers; scenes of Moorlands. *Recreations:* flower display for exhibitions, shop windows, theatre scenery, floats. G&S make-up artist, Plymouth Society. *Clubs:* Tavistock Group of Artists. *Signs work:* 'Maria D.Ryzewska', 'Maria D.Skalski', 'Lynx', 'Lynx Skalski', 'Lynx Croft', 'M.D.Croft' or 'Maria Danuta Croft'. *Address:* Barley House, 2 Barley Market Street, Tavistock, Devon PL19 0JF.

CROFT, Paul John, ARE (2005), TMP; BA Hons Drawing & Painting (Printmaking), PGDip Drawing & Painting (Printmaking), PGCE (Art & Design); many awards including: Elizabeth Greenshields Foundation award (1992, 1994), Arts Council Awards (1997, 1998, 2005), AHRC award (2006); Lecturer in Fine Art Printmaking, Aberystwyth School of Art. *Medium:* printmaking - lithography. *b:* Belfast, 14 May 1963. *s of:* Richard Croft, PPRUA. *Studied:* Edinburgh College of Art (1981-86), University of Ulster, Belfast (1989-90), Tamarind Institute, University of New Mexico, USA (1994-96). *Exhib:* Selected exhibitions include: Bankside Gallery (2007); Wrexham Print International (2007); Contemporary Welsh Printmakers, Lahore, Karachi, Pakistan(2007); Prints of Wales, Kansas City (2007); RE Bankside Gallery (2006); Affordable Art Fair, Battersea (2006); Wales Drawing Biennale (2005); Stark Gallery, London (2005); Attic Gallery, Swansea (2004-07); Royal Ulster Academy, Belfast (2004); many others since 1998. *Works in collections:* The Royal Society of Painter Printmakers (2005), University of Wales, Aberystwyth (2000), The Allied Irish Bank Print Collection, Dublin (1999), Arts Council of Northern Ireland (1998). *Works Reproduced:* "Stone Lithography" (A&C Black, 2001); "Plate Lithography" (A&C Black, 2003); "Collecting Original Prints" Rosemary Simmons (A&C Black, 2005);and various articles and catalogues. *Recreations:* reading, travel. *Clubs:* Aberystwyth Printmakers. *Signs work:* (printers chop mark). *Address:* 10 Green Gardens, Trefechan, Aberystwyth, Ceredigion, SY23 1BB. *Email:* puc@aber.ac.uk *Website:* www.spgw.co.uk http://users.aber.ac.uk/puc/paulcroft/open.htm

CROFT, Richard John, RUA (1967); President, Royal Ulster Academy of Arts (1997-2000); Founder Member of Group 63; Print Fellowship Ulster

Polytechnic (1977); RUA Gold Medal (2000). *Medium:* artist in oils/print. *b:* London, 1935. *m:* Helen Kerr, R.U.A. one *s.* one *d. Studied:* Bromley, and Brighton Colleges of Art. *Exhib:* Ireland, England and abroad; retrospective exhbn. Queens University Belfast (2003), and Touring, Lisburn, Downpatrick, Armagh; RUA Belfast, RHA Dublin. *Works in collections:* public and private, N.I. Arts Council, Government of NI, Queen's University Belfast, Oxford University, London University, Irish Embassy Beijing, Ulster Television, National Self-Portrait Collection of Ireland etc. *Publications:* Mike Catto Art in Ulster 2 (1977), RUA Diploma Collection (2000). *Address:* The Lodge, 187 Main St., Dundrum, Co. Down N.I. BT33 0LY. *Email:* croftlodge@supanet.com

CROKER, Valerie, S.B.A. (1987), H.S. (1994) S.F.P. (2001);artist in water-colour, pen and ink;. *b:* Cardiff, 19 Aug 1931. one *s.* one *d. Educ:* Abbey School, Reading. *Studied:* Maidenhead Art School (1950), Reading University (1951-53, Prof. Betts). *Exhib:* S.WL.A., U.A.; solo shows: Henley, Bath, Wells, Winchester; and many other mixed shows in U.K. and abroad. *Publications:* illustrated: People and Places by J. H. B. Peel, Old Wives Tales by Eric Maple, The Secret Lore of Plants and Flowers by Eric Maple, Still Waters by Margaret Cornish. *Recreations:* conservation, gardening and crafts. *Misc:* Work used for cards, tableware, etc. *Signs work:* "Valerie Croker" or "V.C." *Address:* Jessamine Cottage, 7 Lower Rd., Edington, Westbury, Wilts. BA13 4QW.

CROOK, P. J., RWA (1993), MAFA; painter. *b:* Cheltenham, 28 Jun 1945. *d of:* Jack Hagland. *m:* Richard Parker Crook, painter. one *s.* one *d. Studied:* Gloucestershire College of Art (1960-65). *Represented by:* Robert Sandelson, London; Galerie Alain Blondel, Paris; Brian Sinfield, Burford; Theo Waddington, Dublin; Boca Raton, USA. *Exhib:* One Woman Show: City of Gloucester Museum and Art Gallery (2002), Morohashi Museum of Modern Art-Japan (2001), Ad Hoc Gallery, Buddle Arts Centre-Tyne and Wear (2001), Theo Waddington Fine Art, Boca Raton, Florida (2000), Theo Waddington Fine Art, London (1998), Robert Sandelson, London (1994-96, 1998, 2003), Galerie Alain Blondel Paris (1991, 1993, 1995, 1997, 1999, 2002), Royal West of England Academy (1997), Brian Sinfeld, Burford (1999), Brian Sinfeld, Compton Cassey (1997), Portal Gallery, London (1980-1994), 112 Greene Street, New York (1989), Cheltenham A.G. and Museums (1986); retrospective (1980-1996); Cheltenham A.G. and Museums; Oriel Gallery, Theatr Clwyd, Mold; Musée Paul Valery, Séte; Rye A.G.; group shows: Royal Academy of Arts (1978-83, 1985, 1987, 1988, 1990, 1991, 1994, 1995), Royal West of England Academy (since 1978) (first prize 1984; A.R.W.A 1988, R.W.A.1993), Royal Bath and West Open, (First prize 1978), World of Newspapers, Sotheby's, R.A. Prizewinner (1982), Cheltenham Group, Purchase prize (1983), First prize (1990), Tolly Cobbold/Eastern Arts Open (1985), Athena International Arts Awards Open (1985, 1987), Five Gloucestershire Artists, Cheltenham Festival (1985), John Player Portrait Award Exhbn., National Portrait Gallery (1986), Small Pictures, Salisbury, Prizewinner, (1986), British Figurative Painting Since 1945, British Council tour of the Far East (1988-89), Friends of Carel Weight, London (1991),

WHO'S WHO IN ART

South West Open, Special Commendation (1992), Contemporary Icons, Royal Albert Memorial Museum, Exeter (1992), The Gift of Life, London, Prizewinner (1993), Manchester Academy of Fine Arts (since 1993), Dept. of Transport Exhbn., London, Purchase prize (1993), Reclaiming the Madonna, Lincoln Museum and A.G. tour (1993-94), Murs Peints, Mairie de Paris (1995), Salon des Independants, Paris (1995), Die Kraft der Bilder, Realismus der Gegenwart, Berlin (1996), Contemporary British Painting, Toronto (1996), Women Beyond the Borders-London and San Fransisco (2000); Pictures of Innocence-Melton Carnegie Museum (2000-1); Mother and Child-Holburne Museum of Art, Bath (2001); Rugby Art Gallery and Museum (2002). *Works in collections:* Imperial War Museum; Dept. of Transport; Cheltenham A.G. and Museum; Allied Domecq plc; J.P. Morgan Inc; Ralli Institute, Geneva; University of Pennsylvania; London Business School; Cheltenham Racecourse; City of Paris; Canadian Museum of Animal Art,;Morohashi Museum of Modern Art-Japan;. *Publications:* P.J. Crook: Peintures (Editions Ramsay, Paris, 1993); P.J. Crook: A Retrospective (Cheltenham A.G and Museums, 1996); P.J.Crook (Artemesia Press, London, 2003); various gallery publications: see www.pjcrook.com. *Clubs:* Chelsea Arts, London. *Signs work:* "P.J. Crook." *Address:* The Old Police Station, 39 Priory La., Bishop's Cleeve, Cheltenham GL52 4JL. *Email:* pj@pjcrook.com *Website:* www.pjcrook.com

CROSS, Richard Henry, BA (Hons) 1980, P.G. Dip RAS 1984; lecturer Blackburn College. *Medium:* figurative painter. *b:* Derby, 19 Jan 1958. *m:* Sarah O'Regan. one *s.* one *d. Educ:* Heanor Grammar School, Derbyshire. *Studied:* Liverpool College of Art (1977-80), Royal Academy Schools (1981-84). Work influenced by Peter Greenham and Norman Blamey. *Exhib:* Northern Young Contemporaries (1981), Royal Overseas League (1984), National Portrait Gallery (1986), Royal Academy Summer Exhbn (1985, 86, 90, 91). *Works in collections:* many private collections. *Clubs:* RASAA (Reynolds Club). *Misc:* figurative painter producing work based on analytical drawing from direct observation. *Address:* 10 Fort St, Clitheroe, Lancs, BB7 1BY. *Email:* richardcross247@aol.com *Website:* www.richardcrossgallery.com

CROSS, Roy, R.S.M.A. (1977), S.A.A. (1952), G.Av.A. (1998); historical marine and aviation painter in gouache, acrylic and oils;. *b:* London, 23 Apr 1924. *m:* Rita May (decd.). one *s. Exhib:* Malcolm Henderson Gallery, St. James's, (1973); one-man shows: Börjessons Gallery, Gothenborg, Sweden, (1975 and 1977); Marine Arts Gallery, Salem, Massachusetts (1976, 1989, 1999, 2003). *Works in collections:* National Maritime Museum; Constitution Museum, Boston, U.S.A.; Peabody Museum, Salem, U.S.A. and U.k. *Publications:* many limited edition prints of marine pictures signed and numbered by the artist (1977-1999) published in Sweden (2), U.S.A. (7) and Britain (3), plus art prints by Franklin Mint, Rosenstiel's, plates by Hamilton Collection, etc. *Works Reproduced:* many periodicals (marine, aviation) and own books. Autobiographies: Celebration of Flight (2004), Celebration of Sail (2005). *Signs work:* "Roy Cross ©" and usually

dated. *Address:* Squirrels, 4 Hither Chantlers, Langton Green, Tunbridge Wells, Kent TN3 0BJ.

CROSS, Tom, N.D.D.(1953), Dip.(Lond.)(1956); painter in oil and gouache; Principal, Falmouth School of Art (1976-87); mem. London Group; Chairman, Penwith Soc. of Artists (1982-84);. *b:* Manchester, 3 Feb 1931. *s of:* Frederick Cross. *m:* Patricia. one *s. Studied:* The Slade School, Abbey Minor Scholarship, Rome, French Govt. Scholarship. *Represented by:* The Atlantic Gallery, Falmouth, Cornwall. *Exhib:* one-man shows, Penwith Galleries, Montpelier Studio, Charleston, S.C., British Embassy, Oman, The Gallery at Trebah, Cornwall, Chelsea Arts Club, The Atlantic Gallery, Falmouth. *Works in collections:* Welsh Arts Council, Contemporary Art Soc. for Wales, Leicester and Glamorgan Educ. Authorities, UAE, U.S.A. and Australia, private collections. *Publications:* The Shining Sands, Artists in Newlyn and St. Ives 1880-1930; Painting the Warmth of the Sun, St. Ives Artists 1939-75; 'Catching the Wave' Artists in Cornwall 1975-2000; Artists and Bohemians, a History of the Chelsea Arts Club; Helford, A River and some Seascapes - a personal history of the artist. *Clubs:* Chelsea Arts. *Signs work:* "Tom Cross." *Address:* Treviadas Wollas, High Cross, Constantine, Falmouth, Cornwall TR11 5RG. *Email:* tom.cross1@btinternet.com

CROSSLEY, Bob, painter, printmaker. *b:* Northwich, 30 Aug 1912. *s of:* Edwin. *m:* Marjorie. one *s.* two *d. Educ:* Heybrook School, Rochdale. *Studied:* Rochdale Art School. *Exhib:* 11 one-man shows: Crane Gallery, Manchester (1959), Reid Gallery, London (1960, 1964), Gallery Bique, Madrid (1965), Reid Gallery, Guildford (1966), Curwen Gallery, London (1972), Singers Fridden Division, Stevenage (1972), John Player & Sons, Nottingham (1972), Bristol Arts Centre (1980), Penwith Galleries, St. Ives (1987, 1999), also mixed shows at the Tate Gallery and Belgrave Gallery St. Ives (2000). Hillsboru Fine Art (Dublin); Major Retrospective Exhbn., Touchstone Gallery, Rochdale (2004), Katharine House Gallery (2006), Thompson's Marylebone (2006), Tate St.Ives, major painting borrowed from Rochdale Art Gallery (2007), Belgrade St.Ives, Special Selective Retrospective (2007). *Works in collections:* Contemporary Art Society, Rochdale A.G., Durban, A.G., S.A., Winnipeg A.G., College of Advanced Education, Port Elizabeth, S.A., Hereford A.G., Open University, Sommerfield College; Falmouth Art Gallery. *Commissions:* R.A.F. Museum, Hendon (The Nimrod). *Publications:* illustrated catalogues for all above exhibitions. *Clubs:* Newlyn Art Society, Penwith Art Society. *Signs work:* "Crossley." *Address:* Studio Annexe, Porthgwidden, St. Ives, Cornwall TR26 1PL.

CROSSLEY, Gordon, painter in oil; Retd. Senior lecturer in Art and Design, Barking College of Technology;. *b:* Surrey, 6 Dec 1929. *s of:* Fred Eric Crossley. *m:* Jo Glosby. one *s.* three *d. Educ:* Rutlish School, Merton. *Studied:* Wimbledon School of Art. *Exhib:* R.A., R.B.A., N.E.A.C., P.S., N.S., Madden Gallery; one-man shows, Phoenix Gallery (1984), Gainsborough Gallery, Beecroft Gallery, Thompson's Gallery Aldeburgh (Gallery Artist). *Works in collections:* Essex

Museum. *Misc:* gives painting demonstrations to Art Groups and Schools. *Address:* The Sanctuary, Sheering, nr. Bishop's Stortford, Herts. CM22 7LN.

CROSTHWAITE, Sally, SBA; RHS Gold medal (2001); botanical illustrator;. *Medium:* watercolour. *b:* Woking, Surrey, 14 Apr 1944. *m:* Patrick Crosthwaite. one *s.* two *d. Studied:* English Gardening School, Chelsea Physic Garden (Distinction, Diploma Course, Botanical illustration). *Exhib:* Malcolm Innes Gallery, London, S.B.A. Open, etc., also in Sweden, U.S.A. *Works in collections:* Carnegie Mellon University, USA, Chelsea Physic Garden, Kew. *Commissions:* numerous private in UK and USA. *Publications:* various illustrations in books. *Works Reproduced:* fruit and tulip designs on plates. Limoges dinner service. *Address:* Lynchmere Farmhouse, nr. Haslemere, Surrey GU27 3NG. *Email:* sallycrosthwaite@supanet.com *Website:* www.sallycrosthwaite.co.uk

CROUCH, Helga Ursula, Cert.A.D. (Dist.) (1962), Dip.A.D. (graphics) (1964), FSBA (1986), FLS (2001); RHS Silver-Gilt Medal, Certificate of Botanical Merit; botanical artist in water-colour. *b:* London, 18 Jan 1941. *d of:* Clifford L.B. Hubbard, F.I.A.L. *m:* Julian Terence Crouch M.I.L.T. one *d. Educ:* Willoughby H.S. High School, Sydney, Australia. *Studied:* Cardiff College of Art (1959-62, A.T. Kitson), Central School of Arts and Crafts (1962-64, P. Kitley). *Exhib:* mixed shows: Mall Galleries, Westminster Gallery, Linnean Soc., R.H.S., Hunt Inst. Botanical Documentation, Pittsburgh, Kew Gardens, The Discerning Eye, Old Fire Engine House, Ely, Ashmolean Museum, Oxford, Cambridge Drawing Society; solo shows: Dorking Hall, Cambridge Open Studio, Little Sampford, Jonathan Cooper Gallery, London. *Works in collections:* The Shirley Sherwood Collection of Contemporary Botanical Art, Mr. & Mrs. Peter Warne, Windlesham Arboretum, Surrey. *Publications:* Botanicus Publishing Limited, Talents Publishing, Kew Magazine, Harmony Prints Limited, John Parfitt, Arte y Botanica, The Art of Botanical Painting, Contemporary Botanical Artists, A New Flowering-1000 Years of Botanical Art. *Clubs:* Cambridge Open Studios, European Boxwood and Topiary Society, The Sampfords Society, Royal Watercolour Society, Cambridge Drawing Society. *Signs work:* "Helga Crouch" hidden in work. *Address:* The Mill House, Little Sampford, nr. Saffron Walden, Essex CB10 2QT. *Email:* juliancrouch@maximusaaircargo.co.uk

CROW, Kathleen Mary, R.O.I. (1988), N.S. (1983); painter in oil and water-colour;. *b:* Oxton, Notts., 4 Jun 1920. *d of:* Levi Hopkin, company director. *m:* John Richard Crow (decd.). one *s.* one *d. Educ:* Ackworth; Basel, Switzerland. *Studied:* Nottingham Polytechnic (1964-76 part-time, Ronald Thursby), Leicester (1976-82 part-time, Leslie Goodwin). *Exhib:* R.A. Summer Exhbns., R.W.A., R.O.I., R.I., N.S., Nottingham, Rufford, Leicester, Oakham. *Clubs:* Nottingham Soc. of Artists. *Address:* 2 Blind La., Oxton, Southwell, Notts. NG25 0SS.

CROWE, Maida, FFPS; sculptor in wood and stone. *b:* Axminster, 1915. *d of:* Stafford Heal, engineer. *m:* Jim Crowe. *Educ:* privately. *Studied:* City and Guilds of London (1957-62). *Exhib:* R.B.A., F.P.S., A.I.R., Barbican, Surrey,

Birmingham, Southampton, Lincoln and London Universities, etc.; open air, Berkeley Sq., and Brixton; one-man shows, Loggia Gallery, Cockpit Gallery, I.A.C., Bridport and Southwark Cathedral. *Publications:* First and Last - A Search for Meaning (Purzebrook Press, 1994). *Clubs:* F.P.S., I.C.A., N.F.T. *Signs work:* "MAIDA." *Address:* 906 Keyes House, Dolphin Sq., London SW1V 3NB.

CROWE, Victoria Elizabeth, O.B.E., RSA, RSW; NDD, MA(RCA). *Medium:* oil, watercolour, mixed media. *b:* 1945. *Studied:* Kingston College of Art (1961-65), R.C.A. (1965-68). *Represented by:* Scottish Gallery, Edinburgh; Thackeray Gallery, London. *Exhib:* R.A., R.S.A.; selected solo shows, Scottish Gallery, Edinburgh (1970, 1974, 1977, 1982, 1995, 1998, 2001, 2004, 2006), Thackeray, London (1983, 1985, 1987, 1989, 1991, 1994, 1999, 2001, 2003, 2005, 2007), Scottish National Portrait Gallery (2000) and Touring(2001). *Works in collections:* National Portrait Gallery London; Scottish National Portrait Gallery; Scottish National Gallery Modern Art; Glasgow Museums and Art Galleries; Danish National Portrait Gallery; City Art Centre, Edinburgh; ILEA; Edinburgh Education Authority; Universities of Aberdeen, Cambridge, Edinburgh, Heriot-Watt, Newcastle, Oxford; Royal Academy; Royal Scottish Academy; Royal College of Art. *Commissions:* Portrait Galleries of London and Scotland; Boots PLC; Royal College of Surgeons, Edinburgh; Royal College Physicians, Edinburgh; Dept. Neuro Science, Edinburgh University. *Publications:* 'Painted Insights' Victoria Crowe, pub. A.C.C. (2001); 'A Shepherd's Life' pub. National Galleries of Scotland (2000); 'On Reflection' pub. Thackeray Gall. (2005). *Signs work:* "Victoria Crowe." *Address:* The Bank House, Main St., W. Linton, Peeblesshire EH46 7EE. *Website:* www.victoriacrowe.com

CROWTHER, Michael, Welsh Arts Council Bursary (1977). *Medium:* oil, drawing. *b:* St.John's Chapel, Co.Durham, 9 May 1946. *m:* Celia Davies, jeweller. two *s. Studied:* Leeds College of Art (1964-68); retired as Head of Painting, University of Wales Institute Cardiff, 2006. *Represented by:* Martin Tinney Gallery, Cardiff. *Exhib:* Serpentine Gallery, London (1975); Twelve Brit Painters, Reyjavik, Iceland (1977); British Art Show (1979, 1980); Benjamin Rhodes Gallery, London (1987, 1988); 11th Paris Biennale (1980); Sara Hilden Museum, Tampere, Finland (1981); John Moores Exhbn. (1982, 1985); since 1995 Martin Tinney Gallery, Cardiff. *Works in collections:* National Museum of Wales, Arts Council of Great Britain, Welsh Arts Council, Contemporary Arts Society for Wales, Leicester Education Authority, Univ. of Newcastle-upon-Tyne, Southern Arts Assoc., Russell Coates Museum, Bournemouth. *Signs work:* "Michael Crowther" or "M.C." *Address:* 112 Kimberley Road, Cardiff, CF23 5DN.

CROZIER, Philip, MA (Fine Art), DipAD. *Medium:* oil. *b:* Kent, 26 Dec 1947. *s of:* Kathleen Crozier (artist). *m:* Jane. one *s.* three *d. Studied:* Bath Academy of Art, Corsham; Goldsmiths. *Represented by:* London Group. *Exhib:* Royal Academy, South Bank Centre, Kettle's Yard, Brighton Art Gallery,

Bankside Gallery, Cork Street Gallery, Sussex University, Camden Art Centre, South London Art Gallery etc. *Works in collections:* Goldsmiths Collection, East Sussex County Council, Private Collections UK/USA. *Works Reproduced:* "Oil Paintings in Public Collections in Sussex". *Clubs:* London Group. *Signs work:* "CROZIER". *Address:* Morven, High Street, Queen Camel, Somerset, BA22 7NQ. *Email:* pjkcrozier@hotmail.com

CROZIER, William, Premio Lissone, Milan (1960), Visiting Fellowship, New York Studio School (1979), Prof. Emeritus, Winchester School of Art (1987); Elected member, Aosdana (1991); The Gold medal for painting of The Oireachtas, Dublin (1994); Honorary Member, Royal Hibernian Academy (2001). *Medium:* painter in oil on canvas. *b:* Glasgow, 1930. *m:* Katharine Crouan. one *s.* one *d. Educ:* Marr College, Troon (1942-48). *Studied:* Glasgow School of Art (1949-53), David Donaldson, Mary and William Armour. *Represented by:* The Taylor Galleries, Dublin. *Exhib:* Drian Galleries London (1958-70); Arthur Tooth & Sons, London (1961-64); Serpentine Gallery, London (1978); Richard Demarco Gallery, Edinburgh (1965, 69, 83); Angela Flowers (1985, 2007); Bruton St. Gallery, London (1995, 96); Taylor Galleries, Dublin (1990, 1998, 2004). *Works in collections:* National Gallery of Australia; National Gallery of Canada; Museum of Modern Art, Copenhagen; Carnegie Museum of Art, Pittsburgh; Scottish National Gallery of Modern Art; City Art Gallery, Gdansk; National Museum of Art, Warsaw; V&A Museum; ACGB, London; IMMA, Dublin; Crawford Art Gallery, Cork, etc. etc. *Commissions:* BNP Paribas, London. *Publications:* "William Crozier" ed. Crouan, K., with essays by Kennedy, SB and Vann, P.208 pages (Lund Humphries, London 2007). *Official Purchasers:* Allied Irish Banks, Dublin; Office of Public Works, Dublin; Bank of Ireland; Credit Lyonnais, London; BP Plc; Arthur Anderson Plc; Merrill Lynch; Channel 4 TV. *Recreations:* Listening to jazz, reading Proust. *Clubs:* The Arts Club, London; The Chelsea Arts Club, London; The Groucho Club, London. *Signs work:* "CROZIER" lower left or right of canvas. *Address:* c/o The Taylor Galleries 16 Kildare Street Dublin 2. *Website:* www.williamcrozier.com

CRYAN, Clare, A.T.C., D.A.; artist specializing in water-colour; Tutor-in-Charge, The Blue Door Studio;. *b:* Dublin, 3 Nov 1935. *Educ:* Dominican Convent, Sion Hill. *Studied:* National College of Art, Dublin; Ulster College of Art, Belfast and with Kenneth Webb in The Irish School of Landscape Painting. *Represented by:* Kenny Gallery, Galway; James Gallery, Dublin. *Exhib:* R.H.A., R.U.A., N.S., Salon d'Automne, Festival International Paris, Osaka, Brussels, Luxembourg, Hong Kong. *Works in collections:* Killiney Castle, Dublin, H.M. Queen Beatrix of the Netherlands. *Recreations:* horse riding, cross country. *Clubs:* European Inst. of Water-colours. *Signs work:* "Clare Cryan." *Address:* The Blue Door Studio, 16 Prince of Wales Terr., Dublin 4. Ireland.

CRYER, Ian David, ROI; painter in oils, visual celebrator of all things English;. *b:* Bristol, 1959. *m:* Wendy Patricia. one *s.* one *d. Educ:* Ridings High School, Bristol. *Studied:* part-time Bristol Polytechnic (1978-82); and in

Kensington under Leonard Boden, R.P. (1978-81). *Exhib:* Bristol Art Centre (1976), P. Wells Gallery (1983), Linfield Galleries (1984, 1985), R.A., R.S.M.A., G.R.A., R.B.A., R.W.A., R.O.I., N.E.A.C., Hunting Group finalist (1990), Discerning Eye (1991), Cooling Gallery (1992), 1st International Art Biennial, Malta (1995), NRM York. *Works in collections:* many private collections including Price Waterhouse, Longleat House, Bass Museum, Burton-on-Trent, Wadworth & Co., Bristol Rovers F.C., EWS Railway Co., Crossrail, House of Lords, Royal Mail. *Clubs:* Royal Institute of Oil Painters. *Signs work:* "Ian Cryer." *Address:* 93 Bath Rd., Willsbridge, Bristol BS30 6ED. *Email:* ian.cryer@btinternet.com *Website:* www.iancryer.com

CUBA, Ivan, D.Litt.; professor extraordinary of art, proclaimed for distinguished service, Dictionary of International Biography, Vol. V (1968); elected The Temple of Arts, U.S.A. (1970); elected Fellow, Academy Leonardo da Vinci and Poet Laureate Award (1979); President, Temple of Art Academy, N.Z.; developed educational composite painting, segment painting and aluminium engravure, discovered colour-balancing by mathematics and weight changes in matter; decorations include 14 diplomas, sets of other letters and two gold medals, ten other. Awarded, International Poet Laureate (1995), India; International Man of Year (1995-97); Hall of Fame USA (1998), Achievements-Lox theory of Stars and Tannin theory of Arterioscierosis. *b:* Notts, UK, 15 Sep 1920. *Studied:* University of Auckland, N.Z. *Exhib:* U.K., U.S.A., N.Z. *Works in collections:* Series Composite Art: all the art forms in a single painting London 1955; several colour oil paintings titled 'A Preacher in a Market Place', painted on canvas 'Golden Sec-6'X4' The British Museum; National Library of Wales; University of Missouri USA; University of Pennsylvania USA; Military Museum National Park, New Zealand; Military Museum, Australia, War Paintings. Paul Tacorian Collection oil 'Steaming into Jackson USA'; Townly Hall Art Gallery, UK; Holt Collection York UK; National Gallery Australia Posters Paintings. Eisenhower Centre USA; Liverpool Library; Mexico City Art Gallery, Mexico; other private collections. *Publications:* author of 18 books including poetry. *Works Reproduced:* posters in various sizes Iol oil paintings on canvas National Gallery of Australia; Cuba World War II book of sketches of Greece; Book of Cuba's Castles UK (Don Buk NZ); Battle of Corinth. Monroe hangs with Mona Lisa Le Louvre, Paris (oil); In Memory of Paul Gaugin series 2; Nude Dinosaurs; Battle of El Alamein; Messerschmitts attack Kkalkic Greece 1941, etc. *Principal Works:* Monument to Monroe. *Recreations:* historian-war correspondent. *Clubs:* AAA, RSA. *Misc:* author of 'Battlefield'. *Address:* P.O. Box 5199, Wellesley St., Auckland, N.Z.

CULLEN, Patrick, N.E.A.C., artist in oil, watercolour, and pastel. *b:* 8 Aug., 1949. *m:* Sally. two *d. Studied:* Camberwell 1973 -1976. *Exhib:* The Thackeray Gallery, Kensington, London W8. *Works in collections:* R.A., Sheffield City Art Gallery. *Clubs:* New English Art Club and Pastel Society. *Signs work:* "Patrick Cullen." *Address:* 19, Mount Pleasant Cres., London N4 4HP.

CULLINAN, Edward, C.B.E., R.A., F.R.S.A.; architect, artist; has taught and lectured in Canada, U.S.A., Australia, N.Z., Norway, Malta, Japan, Eire, etc. and many places in England, Wales and Scotland; Founder and principal architect, Edward Cullinan Architects, authors of many modern bldgs. and receivers of many awards;. *b:* London, 17 Jul 1931. *m:* Rosalind. one *s.* two *d. Studied:* architecture: Architectural Assoc., Cambridge and Berkeley, Calif. *Publications:* Edward Cullinan Architects by Kenneth Powell (Academy Editions, 1995); Edward Cullinan, Architects (RIBA Publications, 1984); Ends, Middles, Beginnings (Black Dog, 2005). *Signs work:* "E.C." or "Edward Cullinan Architects." *Address:* The Wharf, Baldwin Terr., London N1 7RU.

CULVER, Cheryl Vivien, RBA(2003); PS(2004); Diploma in Art & Design, Fine Art; Willi Hoffman-Guth Award. *Medium:* pastel, oil. *b:* Almondsbury, nr.Bristol, 12 Jan 1947. *d of:* Frederick & Patricia Gould. *m:* John Culver. *Educ:* Thornbury Grammar School. *Studied:* Leicester Polytechnic/College of Art. *Exhib:* Pastel Society, Mall Galleries (2001, 02, 03, 04, 05); RBA (2001, 02, 03, 04, 05); Art in Action Exhbn, Waterperry, Oxon (2003, 05); Curzon Global Finance, Mayfair, London (2005); Russell Gallery (2005); galleries across UK. *Works in collections:* private collections UK and abroad. *Commissions:* private. *Publications:* article 'Artist Magazine' (Dec 2002). *Recreations:* walking. *Signs work:* 'Cheryl Culver'. *Address:* 9 Stone Cross Lees Sandwich Kent CT13 0BZ. *Email:* cherylvculver@aol.com *Website:* www.cherylculverpaintings.com

CUMBERLAND-BROWN, James Francis, R.S.H., A.R.M.S.; self taught miniature marine artist in scrimshaw (engraving) and pencil;. *b:* Finsbury, 12 Apr 1934. *m:* Tamara Robertson Provis. two *d. Educ:* Kingham Hill, Oxon. *Exhib:* R.M.S., H.S., Montelimar, France, and numerous private galleries throughout Australia; received Bidder and Bourne Award for most outstanding work in sculptors and gravers, R.M.S. (1996). *Works in collections:* National Maritime Museum, Australia; W.A. Maritime Museum; Murdock University; Museum of Fine Art, Geneva; McKenzie Gallery, Perth. *Signs work:* "J.F.C." *Address:* "Mira-Near", 16 Coldwells St., Bicton, W.A. 6157. USA.

CUMING, Fred, A.R.C.A., A.R.A. (1969), R.A. (1974), N.E.A.C., Hon. R.O.I., Hon. R.B.A.; D.Litt Kent University (2004). *Medium:* oil. *b:* London, 16 Feb., 1930. *m:* Audrey Lee. two *s. Studied:* Sidcup School of Art (1945-1949), R.C.A. (1951-1955) under John Minton, Carel Weight, Rodrigo Moynihan, Ruskin Spear, Colin Hayes, Robert Buhler. *Represented by:* John Thompson, London; Manya Igel, London; Sinfield, Burford, Oxon; Adam Gallery, Bath. *Exhib:* U.K., U.S.A., Argentina, Ireland and Europe. *Works in collections:* R.A., Canterbury, Scunthorpe, Preston, Eastbourne, Brighton, Hove, Salford, Monte Carlo, Worcester Coll., Oxford, St. John's Coll., Oxford, Lloyds of London, W.H.Smith, Farendon Trust, L.W.T., Nat. Trust Foundation for Art etc., also U.S.A. and South America. *Publications:* Figure in the Landscape, Unicorn Press; video, The Art of Fred Cuming R.A., R.A. collection. *Clubs:* Chelsea Art

Club, Dover Art Club. *Signs work:* "Cuming." *Address:* The Gables, Wittersham Rd., Iden, Rye, E. Sussex TN31 7UY.

CUMMINGS, Albert Arratoon Runciman, U.A. (1973), F.S.A. (Scot.)(1973); painter in tempera, oil and water-colour, book illustrator, picture restorer;. *b:* Edinburgh, 20 Aug 1936. *m:* Marjorie Laidlaw. one *s.* one *d. Educ:* Edinburgh. *Studied:* apprentice stage designer under William Grason, Edward Bowers, painting under Charles Napier, Robert Jardine. *Exhib:* U.A., Scottish Gallery, Fine Art Soc., Edinburgh Gallery, Open Eye Gallery. *Works in collections:* Leeds Educ. authorities, Edinburgh Hospital Board. *Publications:* Dictionary of Scottish Art and Arch (Pub. Antique Collectors Club). *Clubs:* Scottish Arts. *Address:* 4 School Rd., Aberlady, E. Lothian.

CUMMINGS, Ann, *Medium:* painter in oil, pastel and egg tempera. *b:* Edinburgh, 12 Dec 1945. *d of:* Alexander Cummings (engineer). *m:* Dr. Laurie Jacobs, B.Sc., M.B.Ch.B. three *s. Educ:* Stamford College (1989-91) and under Albert A.R. Cummings (1991-94). *Exhib:* Edinburgh, Glasgow, Dunkeld, Stamford, London, Eton and Peterborough. *Clubs:* Welland Art Soc. *Signs work:* "A.C." *Address:* Hollywell, 38 Church St., Werrington, Peterborough, Cambs. PE4 6QE.

CUMMINGS, George Reid, L. Bryne Waterman Award (1995) Boston, U.S.A. for work in preserving the history of the modern whaling industry, Lay Mem., Royal Soc. Marine Artists; artist in oil;. *b:* Edinburgh, 11 May 1932. *m:* Mabel A. one *s.* one *d. Studied:* studied the use of oil painting by Joan Renton, R.S.A. Edinburgh (1985). *Exhib:* R.S.M.A. (1988); permanent exhbns.: Kendall Whaling Museum, Sharon Boston, Massachusetts; Sandefjord Whaling Museum, Sandefjord, Norway; Tonsberg Maritime Museum, Tonsberg, Norway; Grytviken Whaling Museum, South Georgia, Falkland Islands; Chr. Salvesen plc., Edinburgh, Scotland. *Commissions:* from Sir Gerald Elliott, Past Chairman Chr. Salvesen plc., Sir Maxwell Harper Gow, and numerous private individuals worldwide. Specializes in recording accurate details of the modern whaling industry ships and general maritime art. Paintings are technically correct giving very accurate detail of the vessel painted for historic purposes. *Clubs:* Chairman Salvesen's ex Whalers Club, Edinburgh. *Signs work:* "George R. Cummings, Edinburgh" and year completed. *Address:* 19 Blackford Hill View, Edinburgh EH9 3HD.

CUMMINS, Gus, R.A. (1992); N.D.D. (1963), M.A. (R.C.A.)(1967); Henry Moore Prize (London Group, 1982), 'Spirit of London' (Second Prize, 1983), Daler-Rowney Prize (RA, 1987), Hunting Group (First Prize: Mall Galleries1990, R.C.A.1999), House and Garden Prize and Blackstone Award (RA, 1992), Royal Watercolour Society Prize (2001), Jack Goldhill Award for Sculpture (RA, 2005). *Medium:* oil, gouache, water-colour, sculpture. *b:* London, 28 Jan., 1943. *m:* Angela Braven, painter. two *s.* one *d. Educ:* Sutton and Wimbledon Art School and R.C.A. *Exhib:* extensively, seven solo shows since

1990. Widely throughout the UK and in Norway, Holland, United Arab Emirates, USA, Ireland. *Works in collections:* R.A., R.C.A., Contemporary Arts Soc., Towner Coll., Hastings Museum Coll., Hastings Library, Freshfields plc., F.T. Coll., House of Commons, A.T.Kearney (London & Chicago), National Trust, Costain plc, I.C.I. *Clubs:* Chelsea Arts, The Arts Club (Dover Street). *Signs work:* "Gus Cummins." *Address:* Harpsichord House, Cobourg Pl., Hastings, Sussex TN34 3HY.

CUNNINGHAM, Anne, Diploma's in the Art of Painted Finish (The Isabel O'Neill School, New York); painter in pastel and oil; fine furniture painter. one *s.* one *d. Educ:* Welwyn Garden City Grammar School. *Exhib:* solo exhibs., London, Paris, group exhibs., New York. *Clubs:* former member of Chappaqua Artists' Guild, New York State, and Chichester Art Society, W. Sussex. *Signs work:* "Anne Cunningham." *Address:* The Studio, La Cour de la Grange, Chemin Blandin 14640 Auberville, Calvados France. *Email:* anne@auberville.com

CURMANO, Billy X., MS (1977), BFA (1973); McKnight Interdisciplinary Art Fellow (1997); Hampton Award (2002); JPF Experimental Album Award (2006); "Billy Curmano Day" at New Orleans, St.Louis and Cape Girardeau; Honorary Citizen, Greenville and Natchez. *Medium:* intermedia artist. *b:* U.S.A., 1 Feb 1949. *Educ:* Art Students League, NYC; University of Wisconsin. *Exhib:* solo: New Orleans, Chapel Hill, Minneapolis, Milwaukee, La Crosse, Winona; Group shows: "Live Art", Gateshead, England (2005),"Natural Histories", Cleveland (2001), "Nature Art", Korea (1999), Artpool, Budapest, Hungary (1995), Vienna Graphikbiennale, Austria (1977), International Miniprint, Ourense, Spain (1993), Metronom, Barcelona, Spain (1981), "Mail Art" New Zealand (1976),Tyler National, Texas (1972), Graphics U.S.A., Chicago (1971); New York city Shows: Franklin Furnace (1987, 2006), Small Works(1986), Public Works(1984), # 18(1972), Paula Insel Annual(1972). *Works in collections:* Museum of Modern Art, NYC. *Publications:* "The Search for the Spiritual in Art", videorecording, (2000). *Signs work:* "Billy X. Curmano." *Address:* 27979 County Road 17, Witoka, Mn. 55987, U.S.A. *Email:* billyx@acegroup.cc *Website:* www.billycurmano.com

CURRY, Denis Victor, Dip.FA (Slade) painting (1950) sculpture (1951), RCA.(1992); artist/scientist. *Medium:* oil, water-colour, bronze, stone, kinetic. *b:* Newcastle-on-Tyne, 11 Nov 1918. *m:* Jennifer Coram. *Educ:* Durham Johnson School. *Studied:* Durham -Architecture(Kremer), Slade School of Fine Art (Schwabe, Coldstream). *Exhib:* London Group, R.A., R.W.A., Slade Bi-Centenary, Oriel, Cardiff, Residency - sculpture, St. David's (1991), R.Cam.A., Sculpture at Margam, National Eisteddfod (1994, 2003); many group and one-man shows U.K. and abroad. *Works in collections:* Pembrokeshire Museum and A.G., Tunnicliffe Museum, Anglesey, Chatsworth House, Contemporary Art Soc., Wales. *Commissions:* numerous public and private, inc. 2 x life-size bronze eagles, swans, horses, fig (Processional Cross). *Publications:* Poetry Wales, This Land is Our Land (B.M. Nat.Hist. 1989), Laying Out the Body (Seren 1992),

R.Ae.Soc. Symposium - Man-powered Aircraft Group (1975)(Elected Associate 1975); own publication: Denis Curry Painting Sculpture Images (1985). *Principal Works:* initiation of thrust with a prototype human-powered ornithopter-cf. website. *Recreations:* research- wing kinetics in nature; judo; chess. *Signs work:* "Denis Curry," "D. Curry", "D.C." or "D.V.Curry". *Address:* Fron, Llanycefn, Clynderwen, Pembrokeshire SA66 7XT. *Email:* curry2@totalserve.co.uk *Website:* www.humanpoweredwing.co.uk

CURSHAM, Juliet, S.Eq.A.; self taught sculptor in bronze of equestrian subjects, animals and figures; S.Eq.A Sculptor Award. *Medium:* Bronze, Silver, Gold. *b:* Nottingham, 23 Aug 1960. *d of:* J.C. and E.J.Cursham., niece of Diccon Swan, portrait painter. *m:* Edward Packe-Drury-Lowe. one *s.* one *d. Educ:* Ockbrook Girls' School, Derbyshire, Nottingham High School, Winkfield Place, Berks. *Represented by:* The Osbourne Gallery. *Exhib:* Les Hirondelles Gallery, Geneva; Van Dell Gallery, Palm Beach, Florida; Tryon Gallery, London; Compton Cassey Gallery, Gloucestershire; Osbourne Studio Gallery; Royal Hong Kong Jockey Club; Brandy Wine Polo Club, Pennsylvania; Newmarket Racecourse. *Works in collections:* Life-size horse and jockey for the Hong Kong Jockey Club at Happy Valley; collections in America, Japan, Brunei, Canada. *Commissions:* Dancing Brave, Generous, Venture to Cognac, Ryadian, Best Mate (with Jim Culloty), numerous polo pony studies and life size bronze of the stallion Monsun and life size horse and jockey in Beijing. *Recreations:* hunting, gardening, eventing, skiing, polo. *Signs work:* "Juliet Cursham." *Address:* Prestwold Hall, Loughborough, Leics. LE12 5SQ.

CURTIS, Anthony Ewart, Dip.A.E.(Lond.), R.W.A.; experimental and landscape artist; served R.N. (1946-48); Mail Marketing International Prize (RWA, 2002). *Medium:* watercolour, gouache (often combined), oils. *b:* Wakefield, 7 Jul 1928. *s of:* G. E. and G. L. Curtis née Provis. *m:* Joyce Isabel Yates. three *s.* one *d. Educ:* Kingswood Grammar School, Loughborough (1948-50); London University (1974-76). *Studied:* Bath Academy, Corsham (1950-51, Potworowski, Scott, Armitage, Lanyon, Wynter);. *Represented by:* Modern British Artists: 49 Chiltern St., Marylebone, London W1U 6LY. *Exhib:* (1952-): Redfern, Zwemmers, Daily Express Young Painters, London Group, R.W.A. (1952 to date), Arts Council Modern Stained Glass (1960-61), R.I. (1983), R.W.S. (1984), 'Migraine Images' at St. Martin-in-the-Fields (1993). One-man shows include Bear Lane, Oxford (1959), Reading (1961), Cookham (1964), R.W.A. (1995); ceramic sculpture: Scopas, Henley (1975), Century, Henley (1980), Recent and Retrospective Work, Bloomsbury Gallery, University of London (1987), Retrospective shows 'Recollections', Wooburn Festival (1992); Australian Works, Methuen Gallery, R.W.A. (1995), Art on Paper Fair, R.C.A. (Julian Lax, 2000-2004), British Art Fair (Julian Lax, 2001-2004), Bucks 21 Group (2001-3, later resigning); Modern British Artists (2006 to date). *Works in collections:* RWA, Bristol Educ. Com., sand-blasted screen, St. Andrew's, Hatter's Home, High Wycombe. *Works Reproduced:* Young Artists of Promise (1957); contributor: A Celebration of Bath Academy of Art at Corsham. *Clubs:*

FPS ('50's-70's-lapsed membership). *Misc:* Working visits to Australia (1988-89); Oregon, USA.(1990, 1993), S.Africa (1996, 2000, 2002). *Signs work:* "Anthony Curtis," ("AC" on small works). *Address:* Oak Tree House, 143 Heath End Rd., Flackwell Heath, High Wycombe HP10 9ES.

CURTIS, David Jan Gardiner, R.O.I. (1988), R.S.M.A. (1983); artist in oil and water-colour;. *b:* Doncaster, 15 Jun 1948. *s of:* Arthur Gardiner Curtis, writer. one *s. Educ:* Doncaster Grammar School. *Represented by:* Richard Hagen Ltd, Yew Tree House, Broadway, Worcs. *Exhib:* R.A., R.S.M.A., R.I., R.W.S., R.B.A., N.E.A.C. R.O.I., R.P. Singer Friedlander/Sunday Times water-colour competition 1st prizewinner (1992), 2nd prizewinner (1997). *Works in collections:* Doncaster Museum and A.G., Ferens Gallery, Hull, Sultanate of Oman, Rockefeller Institute, New York, Cusworth Hall Museum, Doncaster. *Commissions:* Include: H.M. Crown Commissioners, Cavalry & Guards Club, Piccadilly. *Publications:* author, A Light Touch - The Landscape in Oils and The Landscape in Water-colour - a Personal View and films of the same titles; also 'Light effects in Water-colour' (video) 1997. Author: 'Light and Mood in Watercolour' (2005) and DVD (same title) 2005. Author: 'Capturing the Moment in Oils' (2007) and film of the same title. *Signs work:* "D.J. Curtis." *Address:* Gibdyke House, Gibdyke, Misson, Doncaster, S. Yorks. DN10 6EL. *Email:* david@djcurtis.co.uk

CURTIS, Joyce, Dip.A.E.(Lond.); artist and children's book illustrator in water-colour, gouache, oil, pencil; former Organiser (S.Bucks.), Bucks. Art Week Visual Images Group;. *b:* Sulhamstead, 5 Aug 1934. *d of:* H.J. Yates. *m:* Anthony Curtis. three *s.* one *d. Educ:* Faringdon Grammar School; Post-grad. Dip., London (1985-86). *Studied:* Bath Academy of Art, Corsham (1952-54, Potworowski, Litz Pisk, Frost, Meadows, Armitage, Ellis). *Exhib:* solo shows, Dixon Gallery, University of London (1986), Corsham (1990), High Wycombe Museum (1993); three joint exhbns. with husband; mixed shows including R.W.A. *Publications:* contributor: A Celebration of Bath Academy of Art at Corsham. *Signs work:* "Joyce Curtis." *Address:* Oak Tree House, 143 Heath End Rd., Flackwell Heath, Bucks. HP10 9ES.

CURTIS, Roger, N.D.D. (1965), A.T.D. (1966); painter in oil, watercolour and acrylic; paints beaches, harbours and landscapes of the far South-West of Cornwall. *Medium:* oil, acrylic, watercolour. *b:* Birmingham, 9 Apr 1945. *m:* Christine. two *d. Educ:* George Dixon Grammar School. *Studied:* Birmingham College of Art and Design (1961-1965). *Exhib:* various group exhibs. including R.I., R.S.M.A and R.W.A.; currently at a number of small galleries in the West Country and London. *Works in collections:* private collections in Britain, U.S.A., Europe, Japan, New Zealand and Australia. *Clubs:* St. Ives Society of Artists. *Signs work:* "ROGER CURTIS". *Address:* 2 Coombe Vale, Newlyn, Cornwall TR18 5QU.

CUTHBERT, Rosalind, R.W.A. (1998); MA(RCA)(1977); painter-engraver in gouache, oils, mixed media and wood engraving;. *b:* Weston-super-Mare,

1951. *m:* David. one *d. Studied:* Central School of Art and Design (1971-74), R.C.A. (1974-77). *Exhib:* mainly in the South-West and London, also France and U.S.A. *Works in collections:* N.P.G., National Poetry Library, National Art Library (V. & A.), Contemporary Art Soc. *Commissions:* various portraits and other commissions. *Publications:* Founded Yellow Fox Press (1993). Publish handmade books of poetry and wood engravings: 'Islands' (1993), 'Birdsong and Water' (1994), 'Nature Studies' (1995), 'Bouncing Boy' (1999), 'HLEP!' (2001). *Clubs:* R.W.A., Fine Press Book Assoc. *Address:* Winscombe Farm Studio, Parsons Way, Winscombe, N. Somerset BS25 1BT. *Email:* roscuthbert@hotmail.com

CZERWINKE, Tadeusz, NDD (1957), ATC (1973), SPS (1976), DAE (1981); sculptor, carver, modeller and potter in stone, wood, perspex, bronze and terracotta; Head of Arts and Crafts Dept., Shoeburyness Comprehensive School. *b:* Poland, 19 May 1936. *s of:* Sylvester Czerwinke, industrial thermal design engineer. *m:* Ewa. one *s.* one *d. Educ:* St. Peter's Winchester. *Studied:* Winchester School of Arts and Crafts (1957, Norman Pierce, FRBS). *Exhib:* regularly at SPS, Mall Galleries, Federation of British Artists, APA in GB., Salon des Nations, Paris; one-man portrait sculpture exhbn. Posk Gallery (1987) and at the Polish Hearth, London. *Works in collections:* Church of Czestochowa, Huddersfield; Kosciuszko Museum, Rappersville, Switzerland; St. Peter's Hinkley, Leics.; Les Laurents, Dordogne, France; St. Catherine's Dock, London; Our Lady of Lourdes Convent, Kent; Town Hall, Monte Cassino, Italy; Parish Church, Devonia Rd., London; St. Sebastian & John the Baptist, Preston; Andrzej Bobola Church, London; Memorial, Eaton Pl., London; General Sikorski Museum, London; Memorial, Marshal J. Pilsudzki Inst., London; Posk (Centre of Polish Culture, London); Dom Narodowca, London; S. Michalowski, Shute House, nr. Honiton; sculptures and portraits in private collections in U.K. and overseas. *Signs work:* "Tad. Czerwinke." *Address:* 20 Whitehouse Way, Southgate, London N14 7LT.

CZIMBALMOS, Magdolna Paal, S.I. Museum, N.Y., Gold Med. (1958, 1960, 1962, 1963, 1966); personal letter from President J. F. Kennedy for portrait of Jacqueline Kennedy (1961); Italian Culture Award, N.Y. (1967); Szinyei Merse Gold Med., N.Y. (1971); several Silver Med. and Hon. Men.; artist in oil;. *b:* Esztergom, Hungary. *m:* Kalman Sz. Czimbalmos. one *d. Studied:* under Prof. A. Bayor pr. Art Sch. Esztergom, Hung., Radatz pr. Art Sch. Germ. *Exhib:* Paris, Germany, Monaco, Canada, U.S.A., Budapest (1982), Esztergom, Hungary (1985); several one-man and group shows. *Works in collections:* S.I. Museum, N.Y., International Inst., Detroit, Carnegie International Cent., N.Y., Bergstrom Art Cent., Ill., City Museum, Esztergom and Budapest, Hungary. *Clubs:* S.I. Museum, N.Y., World Fed. of Hung. Artists, International Soc. of Fine Artists, U.S.A. *Signs work:* "Magdolna Paal Czimbalmos". *Address:* 31 Bayview Pl., Ward Hill, Staten Island, New York, 10304. USA.

CZIMBALMOS, Szabo Kalman, Hung. Roy. Acad. Pr. (1933), S.I. Museum, N.Y., Pr. Gold Med. (1950, 1956, 1962, 1963, 1967), St. Stephen Gold Medal,

N.Y. (1971), several Silver Med. and Hon. Men.; M.F.A., painter-educator, Dir. Czimbalmos Pvt. Art Sch., N.Y.; owner, Czimbalmos Fine Art Studio, S.I., N.Y.; artist in oil, water-colour, tempera. *b:* Esztergom, Hungary, 1914. *s of:* Janos Czimbalmos. *m:* Magdolna Paal Bohatka. one *d. Studied:* Royal Academy of Fine Art, Budapest (1936) under Prof. J. Harahghy, E. Domanowsky; postgrad. Vienna, Munich, Paris, Rome. *Exhib:* Munchen, Paris, Monaco, Canada, U.S.A., Budapest (1982), Esztergom, Hungary (1985); several one-man and group shows. *Works in collections:* S.I. Museum, N.Y., S.I. Com. Coll. N.Y., Bergstrom Art Center, Ill., City Museum, Esztergom, Hung., etc.; murals in churches, convents and private inst., U.S.A. *Clubs:* Bavaryan Fine Art Soc., S.I. Museum, N.Y., World Fed. of Hung. Artists, International Soc. of Fine Artists, U.S.A. *Signs work:* "K. Sz. Czimbalmos". *Address:* 31 Bayview Pl., Ward Hill, Staten Island, New York, 10304. USA.

D

D'AGUILAR, Michael, gold, silver and bronze medals, Royal Drawing Soc., Armitage and silver medal, R.A. (1949); artist in oil and pastels;. *b:* London, 11 May, 1922. *Educ:* privately and in Spain, Italy and France. *Studied:* R.A. Schools under Henry Rushbury, R.A., Fleetwood-Walker, A.R.A., William Dring, R.A. (1948-53). *Exhib:* R.A., R.B.A., N.E.A.C., Irving Galleries, Gimpel Fils, Leicester Galleries, Young Contemporaries; one-man shows, Gimpel Fils, Irving Galleries, New Grafton Gallery, Bruton St. Gallery (annually), Redfern Gallery. *Publications:* work repro.: Artist, Studio, La Revue Moderne des Arts; articles in Diario de Tarragona. *Clubs:* Chelsea Arts, Arts Dover St., London Sketch, Reynolds. *Signs work:* "M. D'Aguilar." *Address:* Studio 4, Chelsea Farm House, Milmans Street, London SW10 0DW.

D'AGUILAR, Paul, artist in oil, water-colour; 1st prize for drawing at R.A. Schools (1949); gold, silver and bronze medals, R.D.S. *b:* London, 9 Sep 1927. *Educ:* privately in Spain, Italy and France. *Studied:* R.A. Schools (1948-53) and with Prof. Barblain (Siena). *Exhib:* R.A., Redfern, Young Contemporaries, Leicester Galleries, Daily Express Young Artists, R.B.A., N.E.A.C., Sindicato de Iniciativa (Spain), Irving Gallery (1952), Temple Gallery (1960), New Grafton, Canaletto (1971), Southwell Brown Gallery (1974), Langton Gallery (1973, 1976); Carlyle Gallery, Old Church St., Chelsea (April/May 2003). *Works in collections:* Lord Rothermere. *Works Reproduced:* in Artist, Studio, Collins Magazine, La Revue Moderne, Drawing Nudes (Studio Vista). *Clubs:* The Arts Club, 40 Dover Street. *Signs work:* "P. D'Aguilar." *Address:* 11 Sheen Gate Gdns., London SW14 7PD.

D'AMOUR, Viola, art nouveau co-collaborator with Vlad Quigley; model and ballerina. *Educ:* Charterhouse, Orpington College. *Exhib:* pop art nouveau portraits of Viola D'Amour, Vampyria, Damned U.S. tour Ad2000, The Big Draw, Vampire Viola, Shock/ Anglo-French Aubrey Beardsley centenary. *Publications:* Viola D'Amour, Viola D'Amour's Phantom Sword, Evlalie, Vampire Viola,

Varney the Vampyre, 21st. Century Ghouls, Viola and the Vampires, Crimson, Demeter, Betty and the Boobies; advertising, catwalk, films, T.V. *Signs work:* "Viola D'Amour." *Address:* c/o 276a Lower Addiscombe Rd., Croydon, Surrey CR0 7AE.

D'ANDREA-PETRANTONI, Laura, painter-sculptor, wood engraver, silkscreen printing. *Medium:* canvas, oil, acrylic, stone, iron, wood. *b:* Caltanssetta, Italy, 22 Sep 1940. *m:* Giovanni D'Andrea. *Educ:* Degree in Humanities, Grenoble University. *Studied:* xylography, calcography at Urbino Academy of Art in Italy; interpreting French and Italian. *Represented by:* Bernard Chauchet, 20 Brechin Place, London SW7 4ZA. *Exhib:* solo exhbns in London, Rome, Palermo, Catania, Vienna; European Parliament, Strasbourg; Solentuna Art Fair, Stockholm; Basilea Art Fair, Gand Art Fair. *Works in collections:* private collections in Rome, London, Milan, Palermo, Catania, Strasbourg. *Commissions:* Intertrust Bank, London; Bank of Lodi, Italy. *Publications:* Freshtields-Bruckhaus-Deringer catalogues; articles in newspapers inc. 'Republica' etc. *Official Purchasers:* from the Mayors of many Italian towns, several panes for Pompeii Museum; Round House Exhibition, London; University of Catania, Palermo. *Address:* Via Gregorio VII 490, Settimo 490, 00165 Rome, Italy. *Email:* laurandrea@virgilio.it

d'ARBELOFF, Natalie, painter, printmaker, book-artist, writer. *b:* Paris, 7 Aug 1929. divorced. *d of:* Alexandre d'Arbeloff, Prince (Russian). *Educ:* Marymount School, N.Y. *Studied:* Art Students' League, N.Y., Central School of Art, London. *Exhib:* numerous group shows; solo shows include: Museum Fine Arts, Colorado Springs, Camden Arts Centre, Victoria & Albert Museum, Rijksmuseum, Meermano-Westreenianum, The Hague. *Works in collections:* V. & A., Manchester Polytechnic Library, Library of Congress, Washington D.C., N.Y. Public Library, Harvard, Princeton, Newberry Library, Humanities Research Center, Austin, National Library, Australia, and many more. *Commissions:* murals: Asuncion, Paraguay and London. *Publications:* Creating in Collage (Studio Vista), An Artist's Workbook (Studio Vista), Designing with Natural Forms (Batsford), Livres d'Artiste (own NdA Press), Augustine's True Confession, The Augustine Adventures. *Address:* c/o Society of Design Craftsmen, 24 Rivington St., London EC2A 3DU.

D'ARCY HUGHES, Ann, NDD Graphic Design; Industrial Arts Scholarship, Coventry; Lucy Clayton Travelling Scholarship; Slade Fine Art Bk.Ass. Illustration Award 1st Prize (2004); lecturer in Printmaking University of Brighton. *Medium:* prints. *b:* Paignton, 19 May 1945. one *s.* one *d. Studied:* Lanchester College of Art, Coventry; Brighton School of Art; Atelier 17 Paris; assistant Anthony Gross for Slade School University of London for 4 years. *Works in collections:* University of London, University of Sussex, University of Brighton, Xerox, BBC. *Commissions:* 70-minute video for the Open College of Arts; Hay Management: Drawing for Westminster Hall Conference. *Publications:* University of Brighton: Technical booklet on Lithography to go

with Art Video. *Misc:* founder and co-director of Brighton Independent Printmaking (BIP) 5 yrs, a fine art, open access printmaking workshop. *Address:* 13 Hampstead Road, Brighton BN1 5NG. *Email:* bip@brightonprintmaking.co.uk *Website:* brightonprintmaking.co.uk

D'VATZ, Timur, Guinness Prize for 'First Time Exhibitor' at Royal Academy of Arts Summer Exhbn, London 1994; A.T.Kearney Prize- Degree Show Royal Academy of Arts 1996. *Medium:* painter in oil. *b:* Russia, 16 Apr 1968. *Educ:* Lycee in Tashkent. *Studied:* Republican College of Art, Tashkent, Uzbekistan (1983-87); Post-Grad Royal Academy Schools (1993-96), awarded Jack Goldhill Scholarship. *Exhib:* Cadogan Contemporary, London (2000, 2002); Bruton Street Gallery (2001), BP Portrait Award (2002), National Portrati Gallery, London, Aberdeen Art Gallery, Scotland (2002). *Works in collections:* Tretyakov National Gallery, Moscow: Guinness PLC, in private collections in UK, USA, Russia. *Commissions:* 1994- work commisssioned by Guinness PLC; private commissions. *Publications:* illsutrations for 'The Resurrection of the Body' by Maggie Hamand (Penguin Books Ltd.). *Works Reproduced:* by Senecio Editions. *Clubs:* Royal Academy Schools-Alumni Association (Reynolds Club). *Address:* 84 Galloway Road, London W12 0PJ. *Email:* timur.d'vatz@virgin.net

DACK, Richard, DipAD (Hons); BEd (Hons); ATD; Worshipful Company of Shipwrights Award; Maimeri Award. *Medium:* oil, prints. *b:* 27 Sep 1944. *Educ:* Lowestoft County Grammar School. *Studied:* Camberwell School of Art (1963-67); Reading University ('67-68); Sussex University (1974-75). *Represented by:* Coves Quay Gallery, Salcombe; Buckeham Galleries, Southwold. *Exhib:* RA, RSMA, RWA, NEAC, ROI, Llewelyn Alexander, Messums. *Works in collections:* Worshipful Company of Shipwrights; many private collections. *Commissions:* several undertaken privately. *Publications:* 'An Affair with the Sea': The Artist (Aug 2005). *Signs work:* 'R.Dack'. *Address:* 12 Mirbecks Close, Worlingham, Beccles NR34 7RS.

DACK, Tom, artist in water-colour, oils, gouache and line, specialises in marine, aviation and landscape; 'Classic Boat' Award, RSMA 2004 Open Exhbn. Mall Galleries, London. *b:* Newcastle Upon Tyne, 26 May 1933. *m:* Catherine. one *s.* one *d. Studied:* Newcastle College of Art and Industrial Design. *Exhib:* solo shows; Patricia Wells Gallery (Bristol), Oddfellows, Kendal, Darlington A.G., Trinity Maritime Centre, Newcastle, Bryam Gallery, Huddersfield, South Shields Art Gallery, Durham Light Infantry Museum and Gallery, Durham, Sally Port Gallery, Berwick-on-Tweed, Osborne Gallery, Corbridge on Tyne. Participated: 'Journal Open, Newcastle; RSMA Open Exhbn, Mall Galleries, London. *Works in collections:* South Shields Museum & Art Gallery. *Commissions:* Several private. *Recreations:* reading, classical music. *Signs work:* 'Tom Dack'. *Address:* 13 Selwyn Ave., Whitley Bay, Tyne & Wear NE25 9DH.

DAINES, Deirdre, NEAC; R.A. Silver medal, bronze medal and Greenshields Award, R.A. Cert., Eric Kennington prize for drawing, Winsor and Newton prize;

painter in oil drawing and pastel, mainly figure paintings; teacher; etchings, portrait commissions. *b:* Ware, 2 May 1950. *d of:* Laurie Daines. *Educ:* Tottenham High Grammar School. *Studied:* R.A. Schools (1970-73, Peter Greenham). *Exhib:* New Grafton, R.A. Summer Exhbn., R.P., Agnew's, Watermans, Petley Fine Art, Cork Street; one-man shows, Thos. Agnew (1988), Cale Art (1982), one-man show Royal Academy's School 1981. *Works in collections:* Guinness, Nuffield Trust, Pole Carew, Bonham Carter. *Commissions:* Studio 3, Muspole Workshops, Muspole St, Norwich. *Signs work:* "Daines." *Address:* 114, Desmond Drive Old Catton Norwich Norfolk.

DAKAKNI, Susan Marie Thérèse, PS (2003); Frank Herring Award, Pastel Society (2002); Hon. Mention for The Founder Presidents Honour (SBA, 2003). *Medium:* pastel and charcoal. *b:* Calcutta, India, 17 Sep 1934. *d of:* Leonard John & Rita Mary Quine. *m:* Matt Dakakni. one *s*. *Studied:* Regent Street Polytechnic (1951-53); Central School of Arts and Crafts (1953-55). *Exhib:* Pastel Society Annual; Society of Wildlife Artists; Society of Botanical Artists; Westminster Gallery; group exhbns abroad and locally in Surrey and Sussex. *Commissions:* private, portraiture. *Misc:* taught part-time-Lincoln School of Art; worked in a commercial art studio in London for a number of years. *Signs work:* 'S Dakakni'. *Address:* 'Carmel Cottage', 33 Church Street, Steyning, W.Sussex BN44 3YB.

DAKEYNE, Gabriel, Membre Associé des Artistes Français; artist in collage, pen and ink, water-colour, oil. *b:* Marske-by-the-sea, Yorkshire, 23 Feb 1916. *d of:* Rev. Cecil R. B. Dakeyne, Clerk in Holy Orders. *m:* Wing-Cdr. Jack Brain, Retd. two *d*. *Educ:* home. *Studied:* Swindon Art School, Press Art School, London, The Hague Holland. *Exhib:* R.A., Royal West of England Academy, Paris Salon, S.W.A., Graphic Artists, Flower Paintings, 9th Grand Prix de la Côte d'Azure Cannes, one-man show: St. Aldates, Oxford. *Works in collections:* Yes. *Works Reproduced:* in La Revue Moderne. *Recreations:* Lace Making. *Signs work:* 'Gabriel Dakeyne'. *Address:* Sadlers Cottage, Sadlers End, Sindlesham, Wokingham RG41 5AL.

DALBY, Claire, RWS, RE, SWE.; Vice-Pres. RWS (1994-98); E.T.Greenshields Schol. (1962), D.Murray Studentship (1966); Jill Smythies Prize for Botanical Illustration (1994); Royal Horticultural Soc. Gold Medal (1995); Shackleton Scholarship to paint Landscapes in Falkland Is. (2000); artist in water-colour drawing, wood-engraving and botanical illustration. *b:* St. Andrews, 20 Nov 1944. *d of:* Charles Longbotham, R.W.S. *m:* D. H. Dalby, Ph.D. *Educ:* Haberdashers' Aske's Girls' School Acton. *Studied:* City and Guilds of London Art School (1964-67). *Exhib:* R.A., R.W.S., R.E, S.W.E. regularly; one-man shows: Consort Gallery, Imperial College, London (1981, 1988), Natural History Museum (1982); Shetland Museum, Lerwick (1988, 1991, 1995), Vaila Fine Art Lerwick, Shetland (2000). Numerous group exhbns. in London and all over Britain - also Australia, Sweden & US. *Works in collections:* Fitzwilliam Museum, Cambridge; V & A Museum, London; many private collections in Britain and abroad. *Commissions:* four paintings of wild plants for Surrey C.C.'s

Norbury Park Project (1996), "Charity" rose for National Gardens Scheme (1997). *Publications:* "Claire Dalby's Picture Book" (Carr, Kettering 1989); Wallcharts:"Lichens ands Air Pollution", "Lichens on Rocky Seashores" (Natural History Museum, London, 1981, 1987); "Shetland Lichens" with D.H.Dalby (Shetland Heritage Publications, 2005). *Official Purchasers:* Ashmolean Museum, Oxford; Natural History Museum, London; National Museums and Galleries of Wales, Cardiff; Shetland Museum, Lerwick, Hunt Institute for Botanical Documentation, Pittsburgh, USA. *Works Reproduced:* 'Women Engravers' by P.Jaffé (Virago Press, London 1988); 'An Engravers Globe' by Simon Brett (Primrose Hill Press, London 2000); 'Voyages of Discovery' by Tony Rice (Scriptum Editions London 1999); 'The Watercolour Expert' (Cassell Illustrated, London 2004). *Signs work:* 'Claire Dalby'. *Address:* 2 West Park, Stanley, Perthshire PH1 4QU.

DALE, Tom, DA(1958), HRMS, HSF; artist in water-colour. *b:* Greenock, 23 Jun 1935. *m:* Myra. two *d. Studied:* Glasgow School of Art. *Works in collections:* private in Europe and N.America. *Signs work:* "Dale." *Address:* Woodbourne House, West Shepton, Shepton Mallet, Som. BA4 5UN.

DALE, William Scott Abell, M.A. (Toronto, 1946), Ph.D. (Harvard, 1955); Prof. Emeritus; Professor of Art History, University of Western Ontario (1967-87); Deputy Director, National Gallery of Canada (1961-67); director, Vancouver Art Gallery (1959-61); curator, Art Gallery of Toronto (1957-59); research curator, Nat. Gallery of Canada (1951-57); mem. College Art Assoc. of America, Medieval Academy of America, R.S.A.; research fellow, Dumbarton Oaks, Washington (1956-57). *b:* Toronto, 18 Sep 1921. *s of:* Prof. Ernest A. Dale, M.A. (Oxon). *m:* Jane Gordon Laidlaw. three *s. Educ:* University of Toronto Schools; Trinity College, Toronto; Harvard University. *Publications:* articles in: Apollo, Art Bulletin, British Museum Yearbook, Burlington Magazine, Canadian Art, Racar. *Clubs:* Arts & Letters, Toronto, Canada. *Address:* 1517 Gloucester Rd., London, Ont., N6G 2S5, Canada.

DALRYMPLE, Neil, Dip. A.D. (1971), A.T.C. (1972), S.W.L.A., F.B.A.; ceramic sculptor. *b:* 16 Jun 1949. one *s.* three *d. Educ:* Cardiff University (1971-1972), post grad. *Studied:* Loughborough College of Art and Design (1968-1971). *Represented by:* Compton Cassey Gallery, Withongton, Cheltenham, Glos. *Exhib:* Mall Galleries, Nigel Stacey Marks Fine Art Gallery, Perth, Henry Brett Gallery, Stow-on-the-Wold, Slimbridge Wildfowl and Wetlands Trust, Glos. *Works in collections:* Canada Art Bank, Greater Victoria Art Gallery, Nature in Art, Wallworth Hall. *Commissions:* numerous, incl. Salmon and Trout Assoc., Atlantic Salmon Trust, two life size salmon presented to Orri Vibusson by H.R.H. Prince Charles. *Clubs:* SWLA. *Signs work:* "Neil Dalrymple." *Address:* 20 Maes-y-Dre, Ruthin, Denbighshire LL15 1DB. *Website:* www.neildalrymple.com

DAMINATO, Vanda, Independent professional painter 1970; works include oil paintings, collages, fine prints, art ceramics, advertising posters for industry;

Accademico Accademia Arti Incisione, Pisa. *b:* Mezzolombardo, Italy, 1951. *d of:* Giovanni Daminato, officer. *Exhib:* Palazzo Grassi, Venezia; Galerie Internationale, N.Y.; Museo Leonardo da Vinci, Milano; Villa Olmo, Como; Palazzo della Gran Guardia, Verona; Museo Arte Moderna, Malta. Creator of the Image of the Groups: Maristel - Sirti - Pirelli "Telecom '91" 6 Exposition mondiale des télécommunications, Genève; Ambroveneto-La Centrale Fondi SPA; Fortezza de Basso, Biennale Internazionale Dell'Arte Contemporanea, Firenze; Shariah Art Museum, Artcard 2005. *Works in collections:* Goglio Luigi Milano SPA; Sarplast SPA; Feltrinelli Giangiacomo Editore; Meritalia SPA. *Signs work:* "DAMINATO." *Address:* Corso XXII Marzo 28, 20135 Milano, Italy. *Email:* daminato@daminatoart.eu *Website:* www.daminatoarte.eu

DANIELS, Alfred, RWS, RBA, ARCA; Prizes: Lord Mayor's Award 1966, Spirit of London 1979-80-81, De Lazio Medal. *b:* London, 8 Oct 1924. *s of:* Samuel Daniels. *m:* Margot Hamilton Hill ARCA. *Educ:* George Greens School. *Studied:* Woolwich Polytechnic, Royal College of Art. *Exhib:* R.A., Rona Gallery, Mall Gallery, Bankside Gallery, Manya Igel Fine Arts, Russel Gallery. *Works in collections:* Cambridgeshire Educ. Com., Leicester Educ. Com., Leeds University, Nottingham Museum, Guildhall Museum, Graves Gallery, Tate Gallery. *Commissions:* Hammersmith Town Hall, British Rail, O.U.P., St. Fergus Gas Terminal, Shell Oil, Glaxo, British Transport Training School, Wembley, Mercantile Credit Bank, London; triptych, St.Nicholas Church, Rotherfield, Greys, Henley. *Publications:* Drawing and Painting (1961), Drawing Made Simple (1963), Enjoying Acrylics (1975), Painting with Acrylics (1988). *Official Purchasers:* Nuffield Foundation; GLC. *Works Reproduced:* Studio International, The Artist, Art and Artists, R.A. Illustrated, Arts Review, Nuffield Foundation, The Times. *Recreations:* drawing. *Clubs:* Langham. *Misc:* elected Keeper of the RBA, 1992. *Signs work:* "Alfred Daniels." *Address:* 24 Esmond Rd., London W4 1JQ.

DANIELS, Harvey, Hon R.E.; NDD, DipFA (Lond), ATD; artist in all paints and media. *b:* London, 17 Jun 1936. *s of:* Charles S. Daniels, artist designer. *m:* Judy Stapleton. two *d. Studied:* Willesden School of Art; Slade School of Fine Art (Ceri Richards). *Exhib:* Solo exhibitions: U.K., U.S.A., Scandinavia, Germany, France. *Works in collections:* MoMA N.Y., V. & A., London, Towner Art Gallery, Metropolitan Museum, N.Y., Bergens Kunstforening, Norway, Grampian Hospitals Art Trust. *Commissions:* pathway/cycle way designed and made in aggregate commissioned Southampton City Council, 175 metres in length; customised a Gibson guitar for high profile 'Rock Couture' charity auction titled Cubist Cool. *Publications:* Summer Psalms 10 etchings by Harvey Daniels, poems by Pacernick. Drawings by Harvey Daniels, introduction by Dr. Michael Tucker. *Official Purchasers:* Marks and Spencer plc; King & McGaw plc (painting); Grampian Hospital Arts Trust (4 woodcuts); Fishburn Hedges, Trafalgar Square. *Misc:* also: 96 Chemin de la Caladette, 30350 Lezan, Franca. *Signs work:* "HARVEY DANIELS". *Address:* 2 Sillwood Hall, Montpelier Road,

Brighton, BN1 2LQ. *Email:* judy@harveydaniels.fsnet.co.uk *Website:* www.harveydaniels.com

DANIELS, Jason, BA Hons Animation; Award: South West Undergraduate of the Year (Royal Television Society). *Medium:* illustration, mixed media, drawings, prints, sculpture. *b:* UK. *Educ:* Helston Community College. *Studied:* Surrey Institute of Art & Design; Cornwall College. *Commissions:* "How to Become a Guitar Player from Hell", Jason Earls; "Kim Chi Flying Fish", D.W.Green; "Princess Crocodile", D.W.Green; "This City is Alive", Forrest Armstrong. *Publications:* The Swallows Tail - Cover Art; Bust Down the Door and Eat All the Chickens - Cover Art. *Recreations:* musician, wrestling cats. *Misc:* available for commissioned work. *Signs work:* "J.Daniels". *Email:* jason2019@hotmail.com *Website:* www.jasedaniels.com

DANNATT, George, lyrical abstract painter and constructivist,self-taught,; Chartered Surveyor and music critic. Honorary Member of The Critics' circle. Associate Penwith Society of Arts (1970), Member Newlyn Society of Artists (1973); Vice-President Arthur Bliss Society. *b:* Blackheath, London, Aug 1915. *s of:* G.H. Dannatt. *m:* Ann Dannatt, née Doncaster. *Educ:* Colfe's School; College of Estate Management (London University). *Studied:* in music, privately educated; in painting, autodidact. *Represented by:* Osborne Samuel, Bruton Street, London W1J 6QG. *Exhib:* Penwith & Newlyn (Cornwall), Schreiner (Basel, Switzerland), Artica (Cuxhaven, Germany), Parkin (London), New Ashgate (Farnham), Dorset County Museum, Reeds Wharf (London), Town Mill (Lyme Regis), Russell-Cotes (Bournemouth), Art Centre (Basel Art Fair), Osborne Samuel (London), Southampton City Art Gallery, Atrium Gallery (Bournemouth University). *Works in collections:* Galerie Artica and Stadt Bibliotek, Cuxhaven, Germany; RAF Museum, Hendon; Russell-Cotes Gallery; Dorset County Museum; University of Bournemouth, Southampton City Art Gallery. *Publications:* Copies of Dannatt's books and selections of his catalogues are held by the Kunstmuseum, Basel, the Witt Library, Courtauld Institute; The National Art Library; V&A Museum; The Bridgeman Art Library. *Official Purchasers:* Southampton City Art Gallery, Bournemouth University. *Works Reproduced:* on website. *Recreations:* reading, music and Italian studies. *Clubs:* The Savage, The Lansdowne. *Misc:* Established a Charitable Trust for the advancement of education in the visual arts. *Signs work:* 'George Dannatt', or 'GD' or monogram. *Address:* East Hatch, Tisbury, Wilts. SP3 6PH. *Website:* www.georgedannatt.com

DANVERS, Joan, I.A.A.; painter in oils, potter, calligrapher. *b:* Diss, Norfolk, 4 Feb 1919; married. *d of:* Frank W. Gotobed. one *s.* *Educ:* Diss Grammar School; Norfolk and Norwich Hospital, S.R.N. (1940). *Studied:* Chelmsford School of Art under Clifford Smith; Belstead House, Ipswich under Cavendish Morton, R.O.I., R.I.; calligraphy at Wensom Lodge under Mr. Webster, and at Belstead House with Gerald Mynott. Silver Palette award (1966) International Amateur Art Exhbn. *Clubs:* Writtle Art Group (until 1976), Norfolk and Norwich

WHO'S WHO IN ART

Art Circle. *Signs work:* "Joan Danvers". *Address:* Little Haven, Cromer Rd., W. Runton, Cromer, Norfolk.

DARBISHIRE, Stephen John, B.Ed. (1971), R.B.A. (1983); painter in oil, water-colour, pastel. *b:* Greenodd, Cumbria, 9 Dec 1940. *s of:* Dr. Stephen Bright Darbishire. *m:* Kerry Delius. two *d. Educ:* Ulverston Grammar School, Cumbria. *Studied:* Byam Shaw School of Art (1958-59). *Exhib:* R.A., R.B.A., R.P., R.I.O., N.E.A.C, Richard Hagen Gallery, Broadway. *Works Reproduced:* as limited editions, open editions, greetings cards, etc. *Signs work:* "Stephen J. Darbishire," "Darbishire". *Address:* Agnes Gill, Whinfell, Kendal, Cumbria LA8 9EJ. *Email:* stephen@stephen-darbishire.com *Website:* www.stephen-darbishire.com

DARBY, Philip, self taught artist in oil. *b:* Birmingham, 14 Jun 1938. *s of:* Wilfred Darby. *m:* Susan. two *s. Exhib:* Newlyn Orion, Penwith Soc., Galerie Artica, Cuxhaven, Germany, R.W.A., Polka.Gallery, Exeter. *Works in collections:* Open University. *Signs work:* "Phil Darby." *Address:* Prospect House, Trevegean, St. Just, Penzance, Cornwall TR19 7NX.

DARTON WATKINS, Christopher, M.A.(Oxon.) (1951); painter in oil, wax, collage and mixed media; British Open Painting Competition, Arnolfini Gallery Bristol (2nd Prize). *b:* Hants., 1928. *s of:* Ricard Watkins, sculptor. *m:* Torun. one *s. Educ:* Ampleforth College and Oxford. *Studied:* Ruskin School of Art, and privately. *Exhib:* Bear Lane Gallery, Oxford, Arnolfini Gallery, Bristol, Gallery Aix, Stockholm, Seifert-Binder Gallery, Munich, Alwin Gallery,London, Indar Pasricha Fine Art, Anthony Dawson Fine Art, Edwin Pollard Gallery, David Curzon Gallery, Gerard Peters Gallery, Santa Fe, Original A.G., Båstad, Sweden, Galleri Tersaeus, Stockholm Art & Form, Stockholm, Sweden. *Works in collections:* Linacre and Hertford Colleges, Oxford, Liverpool University, Royal Hospital, Chelsea, S.N.E.E., Lisbon, Soc. of Apothecaries, Stockholm, Svenska Handsbanken, Stockholm, Charterhouse Bank, London. *Commissions:* received a Pollock Krasner Foundation Award, N.Y., USA. *Clubs:* L'Association Internationale des Arts Plastiques, UNESCO. *Signs work:* "C. Darton Watkins." *Address:* No.1 Dawes Cottages Putney Bridge Road London SW15 2PR. *Website:* www.dartonwatkins.com

DARWIN, Thomas Gerard, F.R.B.S. (1978), B.Ed. (1976); sculptor in resins and metal powders. *b:* Standish, Lancs., 10 Jun 1928. *s of:* Thomas Darwin, coal miner. *m:* Marie Agnes (decd.), remarried Bridget. three *s.* two *d. Educ:* St. Peter's College, Freshfield. *Studied:* St. Mary's College, Strawberry Hill (1951-53, L. de C. Bucher, K.S.S., A.R.C.A.), Wigan School of Art (1955-57, Woffenden). *Exhib:* one-man show: Rural and Industries Bank, Perth, W.A.; numerous joint shows. *Works in collections:* Monument (Warrior and Maiden) Manzini, Swaziland; several religious works in churches and schools in England and Australia, busts in private collections and public places in Swaziland and Australia; a series of historic bronze reliefs and water feature for the Memorial Walk at Armdale

Memorial Hospital, Perth, Western Australia. *Signs work:* "G. Darwin." *Address:* Ezulwini, 34 Croyden Rd., Roleystone, W.A. 6111. USA.

DAVID-COHEN, Yael, BA. *Medium:* painting in mixed media on found fabric, printmaking, artists books. *b:* Jerusalem, 28 Apr 1942. *s of:* Joseph and Thea David. *m:* Dr.S.L.Cohen. three *d. Educ:* University of Tel Aviv. *Studied:* Tel Aviv School of Art; St.Martin's School of Art. *Exhib:* selected solo: Institute of Education, London (1982, 86, 87, 90), Jerusalem Theatre, Jerusalem, Israel (1992, 95), The Coningsby Gallery, London (1997, 2000, 02, 04), Galerie Le Cocon, Hamburg, Germany (2007); since 1983, group exhibitions worldwide. *Works in collections:* Victoria and Albert Museum, British Museum (prints), British Library, Museum of Art and Design New York, Museum of Fine Art Philadelphia. *Publications:* Book of Ruth (Limited Edition). *Official Purchasers:* Book of Ruth (Yale University, British Library, National Library of Israel, JTS New York, Hebrew Union College Cincinnatti). *Address:* 175 West Heath Road, London NW3 7TT. *Email:* kushi@dircon.co.uk *Website:* www.yaeldc.co.uk

DAVIDSON, Anne, D.A. (1959), A.R.B.S. (1988);. *Medium:* sculptor in bronze, resin bronze, fibreglass;. *b:* Glasgow, 3 Feb 1937. *d of:* William & Norah Ross. *m:* James G. Davidson. one *s.* three *d. Educ:* Convent of the Sacred Heart, Aberdeen. *Studied:* Gray's School of Art (1955-59, Leo Clegg). *Exhib:* Aberdeen Artists Soc., Institut Français, London, Posk Gallery, London, Coventry Cathedral, Dundee A.G., etc. *Works in collections:* public works in Edinburgh, Aberdeen and New York; portraits etc. in private collections. *Commissions:* St. Mary's Cathedral, Aberdeen; St. Mary's, Inverness; Corpus Christi, St. Helens; St. Michael's, Whitefield, Manchester; Christ the King, Liverpool; and other churches, schools, etc. *Signs work:* "Anne Davidson." *Address:* 15 Redmoss Pk., Aberdeen AB12 3JF. *Email:* ajdavidsonsculptors@btinternet.com *Website:* www.ajdsculptors.co.uk

DAVIDSON, Jennifer Ann, BA (Hons) Fine Art; won several 'Best Landscape' awards in National Competitions; finalist in Laing Art Competition. *Medium:* acrylic, pastel, mixed media. *b:* Stanmore, Middlesex, 2 Oct 1938. *d of:* Frank and Nora Nelson. one *d. Educ:* Grammar School, Stratford-on-Avon. *Studied:* Mid-Warwickshire School of Art (1954-57); University of the West of England (1992-95). *Exhib:* RA Summer Exhbn, RWA, Mall Galleries, Discerning Eye; Westminster Central Hall, Olympia; Business Design Centre, Islington; Rooksmoor Gallery, Bath; Templeton College, Oxford; John Noott, Broadway; The Norwegian Arts Centre, Cardiff; Black Swan, Frome, and many others. *Works in collections:* Japan, Spain, Moscow, Monaco, Portugal, many in the UK, also the Governor of the Bank of Jamaica. *Commissions:* private commissions undertaken. *Works Reproduced:* Giclée prints of most popular paintings available. *Principal Works:* paintings of The Ridgeway (Ancient track across England). *Recreations:* dogs and horses, walking, sewing and embroidery. *Clubs:* Bath Society of Artists, Clifton Arts Club, Clevedon Art Club, Friends of the RWA.

Address: Leighbrook House, Sutton Lane, Redhill, North Somerset BS40 5RL. *Email:* jenniferdavidson@leighbrook.wanadoo.co.uk

DAVIDSON, Philomena, PPRBS, RWA, FRSA; sculptor. *b:* Westminster, 1949. *d of:* Thomas Davidson, violinist. *m:* divorced. two *d. Educ:* Convent of Jesus and Mary, Willesden. *Studied:* sculpture: City and Guilds, London (1967-70, James Butler, R.A.), R.A. Schools (1970-73, Willi Soukop, R.A.). *Exhib:* R.A. Summer Show, R.W.A. Bristol, sculpture at Margam, Chelsea Harbour Sculpture (1993, 1996). April 1990 elected first woman President Royal Society of British Sculptors (1990-96), Managing Director, The Sculpture Company (1995-present day). *Works in collections:* life-size bronzes Queens Ct., Milton Keynes Shopping Centre; Lady Henry Somerset Memorial, Victoria Embankment Gdns., London; "Fairway" a large outdoor sculpture for Donnington Valley. Hotel and Golf course, Newbury, Berks. *Misc:* Managing Director, The Davidson Arts Partnership (1999-present day). *Address:* 34 Quainton St., London NW10 0BE. *Email:* phil@davidsonarts.com *Website:* www.davidsonarts.com

DAVIES, Anthony John, R.E. (1994); artist/printmaker in etching, lithography and silkscreen; currently visiting artist U Col., Wanganui, N.Z. *b:* Andover, Hants., 14 Jan., 1947. *s of:* Denzil & Ruth Davies. *m:* Andrea du Chatenier. one *s. Educ:* Andover Grammar School. *Studied:* Winchester School of Art (1966-70), R.C.A. (1970-73), Prix de Rome, engraving (1973-75). John Brinkley Fellow (1990-91). *Exhib:* over 72 one-man shows: U.K., U.S.A., S. Africa, N.Z.;12 two-man exhibitions; Represented U.K. at numerous overseas print biennales. *Works in collections:* U.K., U.S.A., Japan, Norway, Hungary, Poland, Russia, Bulgaria, New Zealand. *Publications:* numerous exhbn. catalogues, articles and reviews. Contact above address for further information. *Recreations:* owner 2 dalmatians- Ruby, Taa6-Henry. *Signs work:* "A.J. Davies." *Address:* 14 Alexander St., Kingsland, Auckland, N.Z.

DAVIES, Gareth, Hon. S.G.F.A.; artist in pencil, black ink, coloured pens. *b:* St. Asaph, N. Wales, 10 Feb., 1972. *Educ:* Gogarth School/TVEI Centre Gogarth. *Exhib:* S.G.F.A., Botanical Fine Art Soc. *Publications:* Heroes All: The Story of the R.N.L.I. by Alec Beilby. *Signs work:* "G.P. Davies." *Address:* Bryn Awelon, Pentywyn Rd., Deganwy, Gwynedd LL31 9TL.

DAVIES, Gordon Lionel, ARCA; artist. *b:* 14 Apr 1926. *Educ:* Sevenoaks School. *Studied:* Camberwell School of Art (1949-50), R.C.A. (1950-53). *Exhib:* R.A. Summer Exhbns. (1953-91); one-man shows: Wye College, Kent (1964, 1967), King St.Galleries (1973, 1975, 1977, 1979, 1983, 1985); retrospective at The Royal Museum and A.G., Canterbury, Sally Hunter Fine Art (1993, 1994, 1997). *Works in collections:* mural decorations at Challock Church, Kent, Wolfson College, Cambridge, Wye College, Kent, Braxted Park, Essex, Clerical and Medical Assurance Bldg., Bristol; shellwork decoration at Basildon House, Pangbourne for National Trust. *Publications:* botanical illustrations for House

and Garden magazine (1949-70); Working with Acrylics (Search Press). *Signs work:* "Gordon Davies." *Address:* South View, Hastingleigh, Ashford, Kent TN25 5HU.

DAVIES, Iris Mary, FSBA (1986), BSc (1949), Cambs. Cert. in Teaching (1950); artist in water-colour; retd. from teaching (1979). *b:* Shotley, Ipswich, 4 Oct 1919. *d of:* Frederick William Wheeler. *m:* David Maldwyn Davies, B.Sc., divorced (2003). one, decd. 2001, medical doctor *d. Educ:* University College of Wales, Aberystwyth, Cambridge University. *Studied:* Cambridge University and privately. *Exhib:* R.I. (1982-89), S.B.A. (1986-95), S.W.A. (1987-93). *Commissions:* Lings Designs, Paper House Group, Lubkowski, Medici. *Works Reproduced:* mostly work for greetings cards, calendars, etc. *Recreations:* gardening - paintings all of own flowers. *Misc:* all sales now from home studio due to age (84). *Signs work:* "Mary Davies." *Address:* High Trees, Minstead, Lyndhurst, Hants. SO43 7FX.

DAVIES, Ivor, N.D.D. (1956), A.T.D. (1957), Ph.D. (Edin.) (1975), V.P.R.C.A. (1993); artist/painter in oil, tempera, water-colour, gouache, crayon. *b:* Wales, 9 Nov 1935. *Studied:* Cardiff (1952-56) and Swansea (1956-57) Colleges of Art, Lausanne University, Edinburgh University. *Exhib:* over 50 one-man shows worldwide since 1963, also Multi-media Destruction in Art 1960's, including National Museum of Wales; retrospective Brno, Czech Republic (2006); 'Blast to Freeze' 20c British Art, Wolfsburg and Toulouse; 'Art and the Sixties', Tate (& Australia and NZ tour, 2004-2005). *Works in collections:* Deal Coll. Dallas, A.C.G.B., W.A.C., S.A.C.,National Museum of Wales, etc. *Publications:* articles on Modern Art History, others in Welsh language journals; illustrations: Spirit (1971), Rubaiyat (1981), Science and Art (1981), 'The Age of the Vanguards (in Italian, UTET, Turin, 2002), 'Discovering Welsh Art' (in Welsh, Univ. Wales, Cardiff, 1999). *Recreations:* languages. *Signs work:* "Ivor Davies." *Address:* 99 Windsor Rd., Penarth CF6 1JF.

DAVIES, Ogwyn, RCamA (1995), ATD(1952), NDD (Hons. Painting 1951); retd. schoolmaster; Welsh Arts Council Prize (1976), 1st Prize: The Land: S4C and Post Office Exhibition (1992); 1st Prize: Art West (Cardiganshire, Carmarthenshire, Pembrokeshire)(2003). *Medium:* painter in various media and ceramics. *b:* Swansea Valley, 29 Mar 1925. *m:* Beryl. one *s.* one *d. Studied:* Swansea School of Art (1947-52). *Exhib:* five one-man shows and many mixed shows. *Works in collections:* National Museum of Wales, National Library of Wales, Welsh Arts Council, Contemporary Art Soc. for Wales, Gwent C.C., Merthyr Borough, Wilts. C.C., City of Bath, University of Wales, Y Tabernacl, Machynlleth, University of Ohio, USA. *Publications:* three Welsh children's books, "Certain Welsh Artists", "Darllen Delweddau"; Radio Wales interviews; TV programmes: S4C., H.T.V., B.B.C. *Clubs:* Watercolour Society of Wales, Celf Cambria Arts. *Signs work:* "Ogwyn" above "Davies" and date. *Address:* Ty Hir, Llanio Rd., Tregaron, Ceredigion SY25 6PR.

DAVIS, Cynthia, self taught artist in oil;. *b:* Allahabad, India. *m:* Eric Bernard Davis. *Exhib:* St Ives Soc. of Artists, Mariners Gallery, Penwith Gallery. *Signs work:* "Cynthia Davis." *Address:* 1 Bay Villas, St. Ives Rd., Carbis Bay, St. Ives, Cornwall, TR26 2SX. *Email:* cynthia@stisa.co.uk *Website:* www.cynthiadavis.co.uk

DAVIS, Derek Maynard, FCPA; Artist in Residence, University of Sussex (1967); painter, potter; Hon. Mem. International Academy of Ceramics. *b:* London, 24 Feb 1926. *s of:* James A. Davis, craftsman. *m:* Ruth. one *s. Educ:* Emanuel School, Wandsworth. *Studied:* painting: Central School of Arts and Crafts, London, under Keith Vaughan, Robert Buhler. *Exhib:* Istanbul, Munich, Toronto, Zurich, Tokyo, Paris, Primavera (London and Cambridge). *Works in collections:* Paisley Museum, V. & A., Portsmouth Museum, Southampton Museum, Keramion, Frechen, Germany, University of Sussex, Bradford Museum, Garth Clark Collection, U.S.A., Contemporary Art Soc., Musee Ariana, Geneva, Switzerland. *Commissions:* Ceramic Floor Decorated, Highgate London. *Publications:* Derek Davis By Caroline Genders. *Official Purchasers:* D.O.E. *Recreations:* music. *Clubs:* I.A.C. *Signs work:* "D.M. Davis." *Address:* Duff House, 13 Maltravers St., Arundel, Sussex BN18 9AP.

DAVIS, James, L.I.F.A.; Freeman the Worshipful Company Painter-Stainers (1972); Freeman of the City of London (1973); sculptor, carver and restorer in stone, marble. *b:* London, 16 Jul 1926. *s of:* James E. Davis, engineer. *m:* Joan Davis. *Educ:* Eastbrook Boys School, Dagenham, Essex. *Studied:* Sir John Cass School of Art (1949-53) under Bainbridge Copnal. *Exhib:* Guildhall; Leighton House, Royal Exchange, Mall Galleries. *Works in collections:* Painters Hall, Chelsea and Kensington Town Hall, Community Centre, Shoeburyness, Barclay International, Gracechurch St., St. Nicholas Church, Elm Park, Essex, St. Nicholas Church, Canewdon, Essex, Hyde Park Corner, London W1, Town Centre, Chelmsford, Essex. *Signs work:* "J. Davis." *Address:* Studio Workshop, 39a West Rd., Shoeburyness, Essex SS3 9DR.

DAVIS, James Spence, DA, RSW; David Cargill Award, RGI; Reid Kerr Painting Award, PAI. *Medium:* oil, watercolour, drawing. *b:* Glasgow, 2 Jul 1944. *s of:* Hugh & Mary Davis. *m:* Doreen Elizabeth Davis. one *s.* one *d. Studied:* Glasgow School of Art (1963-67). *Represented by:* Eton Contemporary Fine Art; Red Rag Gallery; The Wren Gallery; Gatehouse Gallery; John Davies Gallery; Morningside Gallery. *Exhib:* Royal Glasgow Institute of the Fine Arts; The Royal Scottish Academy; The Royal Scottish Society of Painters in Watercolour; Paisley Art Institute. *Works in collections:* The Royal Collection, Holyrood Palace; Glasgow City Chambers; The Vatican; The Feisal Royal Family Collection; Arisaig Holdings, Singapore. *Commissions:* portrait commission for The Vatican, and many others. *Official Purchasers:* Duke of Edinburgh; Glasgow City; The Vatican. *Works Reproduced:* by Meadows Fine Art (www.meadowsfineart.com). *Principal Works:* portrait of Bishop of Paisley; 'Staffa' at Royal Glasgow Institute of Fine Arts (2005). *Clubs:* Glasgow Art Club.

Address: The Meadows, 25 Arran Crescent, Beith, Ayrshire, KA15 2DU. *Website:* www.meadowsfineart.com

DAVIS, Jason Pyper, BA (Hons) Fine Art; Mayfest Prize 1997; The Royal Glasgow Insititute Award 1998; 1st Prize, MacRobertson Open 2003; City of Glasgow Award 2003. *Medium:* jewellery, oil, drawing, sculpture. *b:* Paisley, 17 Feb 1973. *s of:* James & Doreen Davis. *m:* Denise Findlay. *Studied:* Glasgow School of Art (1992-96). *Represented by:* Morningside Gallery, Edinburgh; Contemporary Fine Art, Eton; Lime Tree Gallery, Suffolk; Arteries Gallery, Glasgow. *Works in collections:* Costley & Costley Hotels, Troon, Scotland; The City Chambers, Glasgow; Merk Finance, Glasgow; International Law Courts, The Hague, Amsterdam (Judges Chambers). *Commissions:* commissioned to produce a series of seven heads for Precious Records, Glasgow (1996). *Official Purchasers:* The City Chambers, Glasgow. *Signs work:* "PYPER". *Address:* 15 St.James Terrace, Lochwinnoch Road, Kilmacolm, Inverclyde, PA13 4HB. *Email:* jason@pyperdavis.co.uk *Website:* www.jasonpyperdavis.com

DAVIS, John Warren, M.C., A.T.D.; sculptor in wood, stone and metal. *b:* Christchurch, 24 Feb 1919. *s of:* Capt. J. Warren Davis, M.C. *m:* Evelyn Ann. three *s.* one *d. Educ:* Bedford School. *Studied:* Westminster School of Art (1937-39), under Bernard Meninsky and Mark Gertler; Brighton College of Art (1948-52), under James Woodford, R.A. *Works in collections:* Cardiff, Leeds, Southampton, New York, Arts Council, Contemporary Art Soc., London, Houston, Texas, Fogg Art Musem, Mass., U.S.A. *Address:* Northfields Farm, Eastergate, Chichester, Sussex PO20 6RX.

DAVIS, Kate, B.A. (1982), H.Dip. (1986), M.A. (Status) Oxon. (1992), Stanley Picker Fellow (1986-87), Whitechapel Young Artist of Year (1988), Sargant Fellow, British School of Rome (1998); subject-led sculpture, video, photography and drawing; sculpture tutor, Royal College of Art; Jerwood Drawing 1st Prize, 2001; Sydney Water Sculpture Prize, 2002. *b:* Chesham, Bucks., 23 Feb 1960. one *d. Studied:* Herts. College of Art and Design (1978-79), Falmouth School of Art (1979-82), Slade School of Fine Art (1983-86). *Represented by:* Fred (Ltd), London. *Exhib:* solo: Milch,Newlyn A.G., University Gallery, Fred (Ltd), London, Whitechapel A.G., group shows in Britain and abroad. Rhodes & Mann, Gutleut 15. *Works in collections:* National Sculpture Centre, Oronsko, Poland; British Land, Middlesborough Art Gallery., British Museum, Campbelltown Art Gallery, Sydney. *Commissions:* Economist Plaza. *Publications:* Kate Davis (Milch, 1997); as if (University of Essex, 2001) (Crossing-Closing) Gutleut Verlag 2002. *Signs work:* "K.A. DAVIS." *Address:* 56 Nelson Rd., London N8 9RT.

DAVIS, Michael Robert, N.D.D., M.A. (R.C.A.); artist in charcoal conté (drawing), lecturer; Principal Lecturer (Painting), Kent Inst. of Art and Design. *b:* Birmingham, 11 Sept., 1943. *m:* Susan Davis. one *d. Educ:* Birmingham College of Art (1959-64), Royal College of Art (1964-67). *Exhib:* R.A. Summer Exhbn.

since 1986, Hayward Annual (1982), 15 British Painters, British Council, Barcelona, 5 British Artists - de Grey, Davis, Hockney, Freud, Weight, Alabama U.S.A., Mike Davis (drawings El Palau Valencia), Cassian de Vere Cole, London. *Works in collections:* Arts Council, and private. *Publications:* Guardian Arts Review, Contemporary Arts Review Guardian, Times Arts Review, 5 British Artists Honouring England, Alabama Times, Panning for Gold - George Melly (1993), Andrew Lambirth review or show at Cassian de Vere Cole (1996). *Address:* 5 Elmers End Rd., London SE20 7ST.

DAVIS, Pamela, V.P.R.M.S. (1979), F.S.B.A. (1985), S.W.A. (1977), H.S.F. (1983); Awards: Gold Memorial Bowl (RMS 1991), Llewelyn Alexander Gallery (Subject Award 1993, Masters Award 1998-2003); miniaturist and flower painter. *Medium:* water-colour, acrylic, gouache. *b:* Molesey, 27 Aug 1927. *m:* Ronald. two *s. Educ:* Ashford County School. *Studied:* Twickenham School of Art (1942-45, Dorothy Parlbey). *Exhib:* Westminster Gallery, London: R.M.S., S.W.A., S.B.A.; Llewellyn Alexander Gallery, London; Linda Blackstone Gallery, Pinner. *Signs work:* "Pamela Davis." *Address:* Woodlands, Pond Copse Lane, Loxwood, W. Sussex RH14 0XF.

DAVIS, Robin, self taught painter in oil. *b:* Bournemouth, 28 Feb., 1925. one *s.* one *d. Educ:* St. Catherine's College, Oxford; Birkbeck College, London. *Exhib:* one-man shows: Woodstock Gallery, London (1960), New Vision Centre, London (1964), Aston University, B'ham (1965), Horizon Gallery, London (1988), Belgrave Gallery, London (1995), Bakehouse Gallery, Penzance (1996). *Signs work:* "Robin Davis." *Address:* 45 Trelissick Rd., Hayle, Penzance, Cornwall TR27 4HY.

DAVIS, Simon, HND Art and Design (1988); RBSA (2005), HonSec RBSA (2007). *Medium:* gouache, oil. *b:* Stratford-upon-Avon, 8 Jun 1968. *m:* Sarah. *Studied:* Mid-Warwickshire College of Art and Design (1984-86), Swindon School of Art and Design (1986-88). *Represented by:* Red Rag Gallery, Stow-on-the-Wold; Wonderwall, Cirencester. *Exhib:* Mall Galleries (2006, 2007), RBSA, Birmingham (2004 onwards), Clifton Gallery, Bristol (2004), Beaux Arts, Bath (2004). *Works in collections:* RBSA Permanent Collection. *Publications:* various collections of comic strip work worldwide. *Misc:* illustrates comic strips for British comic 2000AD since 1994. *Signs work:* "S B DAVIS". *Address:* Leasowes Cottage, Leasowes Road, Offenham, Worcs., WR11 8RQ. *Email:* simsal20@tiscali.co.uk

DAVISON, Martin, MA (1958); SGFA (2000). *Medium:* painter, designer and sculptor in all media. *b:* Birmingham, 19 Dec 1931. *s of:* Geoffrey and Molly Davison. *Educ:* King Edward's School, Birmingham. *Studied:* Ruskins Schools (Oxford) and St.Martin's (London) (part-time). *Exhib:* ROI, PS, SGFA, UA, Chelsea Art Society, Richmond Art Society, Society of Feline Artists, Llewelyn Alexander, Orleans House Gallery, Riverside Gallery (Richmond); one-man shows: Riverside Barn (Walton); Post Nostalgia Gallery (Teddington); Bumbles

Gallery (East Sheen); Orange Tree Theatre (Richmond). *Publications:* "Rubik's Magic Strategy Game" by Martin Davison. *Recreations:* playing jazz clarinet and piano. *Clubs:* 'The Galsworthy Group', 'Thames Painters'. *Signs work:* "M.DAVISON". *Address:* 89 Ashleigh Road, Mortlake, London SW14 8PY. *Email:* martin.mortlake@talktalk.net *Website:* www.martindavisonart.com

DAWSON, Patricia Vaughan, printmaker, sculptor and writer. *b:* Liverpool, 23 Jan 1925. *d of:* Theodore James Wright, army officer. *m:* James N. Dawson. one *s.* two *d. Educ:* Croham Hurst School. *Studied:* Croydon School of Art (1941-45) under Reginald Marlow and Ruskin Spear. *Exhib:* Bear Lane Gallery, RA, London Group, Pastel Soc., RSPA, Alchemy Gallery. *Works in collections:* BM, Bibliothèque Nationale, etchings in British Public Collections, Bowes, Exeter and Gloucester museums, Victoria Museum, Bath; Birmingham & Sheffield libraries Lending schemes. *Publications:* The Artist Looks at Life (a series of books and slides published by Visual Publications introducing art to children), La Lanterne des Morts - illustrated poem (Ram Press), The Kiln and The Forge Reliquaries, Wet Leaves - collections of poetry (Hub Editions). *Works Reproduced:* 'Wet Leaves' on cover of Poetry Collection; etchings and sculpture re novels by John Cowper Powys; Porius, The Brazen Head, Glastonbury Romance in Powys Review; La Lettre Powysienne. *Principal Works:* Powys Newslettre and website. *Signs work:* 'Patricia V. Dawson'. *Address:* Flat 1, 3 Albion Villas Rd., London SE26 4DB.

DAWSON, Peter, R.I., B.Ed.; painter in water-colour, oil; Adviser for Art and Design, Hertfordshire (1985-2005). *b:* Leeds, 19 Mar 1947. *s of:* William Henry Dawson, painter and policeman, and Mary Elizabeth Dawson. *m:* (1) Andrea Dixon. (2) Sarah Harrison. *Educ:* Roundhay School, Leeds. *Studied:* Bingley College of Educ. (1967-71). *Exhib:* R.I., Yorkshire Artists, Hitchin Museum, Luton A.G., October Gallery, San Francisco, Federation of Canadian Artists Gallery, Vancouver, Fry Art Museum, Seattle, Shell House Gallery, Attendi Gallery. *Works in collections:* Herts. Authority, Luton A.G., Winsor and Newton R.I. award (1999 and 2003). *Publications:* Co-author, Albania - A Guide and Illustrated Journal; prints and limited editions. *Signs work:* "P. Dawson" or "Peter Dawson." *Address:* Little Cokenach, Nuthampstead, Royston, Herts. SG8 8LS. *Email:* pddawson@hotmail.co.uk

DAWSON, Susan Shepherd, BA (Hons) fine art (painting); painter of landscapes and garden scenes in oil, watercolour, and charcoal drawings en plein air; also maker of silver jewellery. *b:* Ponteland, Northumberland, 18 Feb 1955. one *s.* two *d. Educ:* Church High School, Newcastle-upon-Tyne. *Studied:* Bath Lane School of Art, Newcastle, Liverpool Polytechnic. *Exhib:* St. Ives Society of Artists and various exhibs. in Cornwall. *Works in collections:* various collections in Europe and New Zealand. *Signs work:* "Sue Dawson." *Address:* c/o Westwood House Townsend, Hayle Cornwall TR27 6AQ. *Email:* suesdawson@hotmail.com *Website:* www.stivessocietyofartists.com

DAY, Daphne P.A., Prof., A.G.P.P. (1979); artist in oil and water-colour. *b:* London. *Educ:* private. *Studied:* Chelsea School of Art, St. Martin's Lane for stone-carving, Camberwell School of Art for bronze-casting. *Exhib:* Mall Galleries, Knapp Gallery, Art Connoisseur Gallery, Westminster Gallery and Lauderdale House; one-man show: Durban and Johannesburg (1954); Heraldic portrait of Sir Winston Churchill exhib. for 6 years at Blenheim Palace from 1967. *Signs work:* "Daphne Day." *Address:* 20 The Avenue, Bedford Pk., Chiswick, London W4 1HT.

DAY, Jane, B.Ed.(Hons.) (1989); smoke-fired ceramics; Subject Leader (ceramics), City of Bath College. *b:* Cambridge, 18 June, 1966. *Educ:* Bath College of Higher Educ., but largely self taught. *Commissions:* Selfridges, London (Smokefired Vessel Forms). *Publications:* Ceramic Review. *Principal Works:* smoke-fired vessel forms. *Recreations:* oil painting. *Address:* 38 Cossham Rd, St. George, Bristol BS5 8DL. *Email:* janecday@hotmail.com

DAY, Lucienne, R.D.I., A.R.C.A. (1940), F.C.S.D.; textile designer; Royal Designer for Industry (1962), (Master 1987-89); Hon. Doctor of Design, Southampton University (1995); Senior Fellow R.C.A.; Hon. Fellow R.I.B.A. *b:* Coulsdon, Surrey, 1917. *d of:* Felix Conradi. *m:* Robin Day. one d. *Educ:* Convent of Notre Dame di Sion, Worthing. *Studied:* Croydon School of Art (1934-37), Royal College of Art (1937-40). *Exhib:* London, Manchester, Zürich, Milan, Oslo, Toronto, New York, Tokyo, Kyoto, Gothenburg. *Works in collections:* V. & A., Whitworth A.G., University of Manchester, museums of Cranbrook, Michigan, Museum of Industrial Design Trondheim, Norway, Röhsska Konstslöjd Museum, Gothenburg, Sweden, Musee des Arts Decoratifs, Montreal, and Art Inst. of Chicago. *Signs work:* silk mosaic tapestries: "L." *Address:* 49 Cheyne Walk, Chelsea, London SW3 5LP

DAY, Robin, O.B.E., A.R.C.A., F.C.S.D., R.D.I.; designer. *b:* High Wycombe, Bucks., 1915. one d. *Studied:* High Wycombe School of Art and R.C.A. *Exhib:* Museum of Modern Art, New York, I.C.A., Triennale, Milan (1951), Copenhagen, Oslo, Stavanger, Bergen, Zürich, Canada. *Works in collections:* Museum of Modern Art, New York, Trondheim Industrial Art Museum, V. & A. *Works Reproduced:* many architectural and design publications here and abroad. *Clubs:* Alpine, Eagles Ski. *Address:* 49 Cheyne Walk, Chelsea, London SW3 5LP.

DAYKIN, Michael, M.A. (R.C.A.); artist, curator. *b:* Yorkshire, 1947. *Studied:* Watford School of Art (1970-71), St. Martin's School of Art (1971-74), R.C.A. (1974-77). *Exhib:* City University Gallery, Cleveland College of Art Gallery, XO Gallery, The Figure of Eight Gallery, Gallery K, Attache Gallery. *Works in collections:* Northern Arts, Brown and Wood, Musee d'Art Contemporaire, Skopje, Macedonia. *Commissions:* Benchmark Holdings, Quaglino's. *Signs work:* "Daykin." *Address:* 9 Lowder House, Wapping Lane, London E1W 2RJ.

DEAKIN, Liz, (née Boatswain); S.W.A.; artist in water-colour, gouache and acrylics of landscapes, flower painting, interiors, silk painting and murals; runs

painting courses and gives demonstrations to societies. *b:* Dorchester, 1929. marriage dissolved. two children. *Studied:* Poole School of Art, and with Edward Wessen. *Works in collections:* many private collections throughout the world, including the Royal Family. *Publications:* "Deakin's Dorset"; designs hotel brochures. *Signs work:* "Liz Deakin." *Address:* 3 Hunters Mead, Motcombe, Shaftesbury SP7 9QG.

DEAKINS, Sylvia, A.T.D. (1946), S.G.F.A. (1986), C.D.S. (1987); painter and illustrator in oil, gouache, pastel, ink, collage; Vice-Pres. Cambridge Drawing Soc. (1997). *b:* Eccleshill, W. Yorks., 18 Oct 1924. *d of:* A.N. Leeming. *m:* C.E. Deakins (decd.). one *s.* one *d. Educ:* Hendon County Grammar. *Studied:* Hornsey College of Art (1941-46, Douglas Percy Bliss, Russell Reeve, Francis Winter). *Exhib:* R.A., R.B.A., N.E.A.C., and numerous galleries in E. Anglia. *Publications:* illustrated many for O.U.P. Longmans, Ward Lock, including A Beginner's Bible (1958), and Listening to Children Talking (1976). *Signs work:* "Sylvia Deakins," or "S.D." *Address:* 1 Mill Lane, Gt. Dunmow, Essex CM6 1BG.

DEAKINS, Thomas William (Tom), B.A. (Hons.) (1980), A.T.C. (1982), Charles Spence Memorial prize (1977); painter in oil;. *b:* Barnet, 8 Dec 1957. *s of:* Cyril Deakins, ARE. *m:* Ann Logan. two *s. Educ:* Newport Grammar School, Essex. *Studied:* University of Newcastle upon Tyne (1976-80, Kenneth Rowntree, Derwent Wise). *Represented by:* Chappel Galleries, Colchester Road, Chappel, Essex. *Exhib:* R.A. Summer Shows since 1983, Medici Gallery (1989), William Hardy Glasgow (1991), Chappel Gallery, Colchester (1995, 2000, 2006), Bruton St. Gallery (1999), Royal Institute of Oil Painters since 2005. *Works in collections:* Hatton Gallery, University of Newcastle, Epping Forest District Museum, Beecroft A.G. Westcliff on Sea; The Gardens of Easton Lodge, nr.Dunmow, Essex, Chelmsford and Essex Museum. *Commissions:* "Sacred Grove" - large drawing on wood to commemorate 60th Anniversary of end of WWII, at the gardens of Easton Lodge. *Signs work:* "Tom Deakins". *Address:* 31 The Causeway, Gt. Dunmow, Essex CM6 2AA. *Email:* tom5.deakins@tesco.net

DEAN, Dorothy, SWA; artist in gouache, oil, pastel. *b:* 14 May 1920. *m:* K.W. Howard. one *s. Educ:* Bromley County School, Kent. *Studied:* Goldsmiths' School of Art (1936-39), Eastbourne Art School, Guildford (part-time post war). *Exhib:* R.I., R.O.I., R.B.A., R.P.S., P.S., numerous solo and shared exhbns. in London, S. England and Bedford, private galleries Hampshire. *Works in collections:* private collections: France, Germany, Switzerland and Canada. *Signs work:* "Dorothy Dean" and "D. Dean." *Address:* Ashley Cottage, Bentworth, Alton, Hants. GU34 5RH.

DEAN, Graham, BA Art & Design; Abbey Award, British School, Rome (1992), Trivanorum Art Centre, India (2000), International Fellowship at the Vermont Studio Centre, USA. *Medium:* watercolour on handmade indian paper, prints, acrylic on canvas. *b:* Birkenhead, Merseyside, 5 Dec 1951. *s of:* Mr & Mrs

L.L.Dean. *m:* Denise Dean. one *s.* one *d. Studied:* Laird School of Art, Birkenhead (1968-70); Bristol Poly, Faculty of Art and Design (1970-73). *Represented by:* Waterhouse & Dodd, 26 Cork Street, London and Galerie Frans Jacobs/ Judith Bouwknegt/ Amsterdam/ Paris. *Exhib:* solo: Balse Art Fair(1987), Austin Desmond Gallery (1988, 1991), 20th C Art, The Armoury New York (2004); semi-retrospective, Brighton Art Gallery and Museum (1996), and Williamson Museum and Art Gallery (1995). *Works in collections:* V&A Watercolour Coll.; Ferens Museum and Art Gallery, Hull; Williamson Museum and Art Gallery, Birkenhead; Ing Collection, Amsterdam; Body Shop International; Great Eastern Hotel, London; Forbes Foundation, New York; Arts Council GB. *Commissions:* The Great Eastern Hotel, London. *Publications:* 'Art Today', Phaidon; 'Self-Portrait'-Ebury; 'Pictures for the Sky' Phaidon. *Works Reproduced:* 'Foreign Correspondent' (1987); 'Compartments' (1974); 'Nightswimming' (2000). *Principal Works:* 'The Kiss' (1987); 'Foreign Correspondent' (1987); 'Compartments' (1974); 'Nightswimming' (2000). *Recreations:* tennis and supporting Liverpool Football Club. *Clubs:* I have made several short films and videos and collaborated on many projects from books to dance (set design and film). *Address:* 17 Norfolk Road, Brighton, East Sussex BN1 3AA. *Email:* graham.dean1@virgin.net *Website:* www.grahamdean.com

DEAN, Pauline Margaret, R.H.S. Gold medals (8); freelance botanical illustrator in water-colour, ink; nurse (retd.); tutor of Botanical Art Courses, R.H.S. Gdn. Wisley, Surrey for 11 years. *b:* Brighton, 20 Aug 1943. *m:* George. three *s.* one *d. Educ:* Brighton and Hove High School; no formal art training. *Exhib:* Kew Gdns. Gallery; R.H.S. shows Vincent Sq. London; Linnean Soc., London; Guildford House Gallery, Guildford; Chelsea Flower Show; Jardin Botanique, Geneva. *Works in collections:* Hunt Inst. for Botanical Illustration, Pittsburgh, U.S.A.; Linnean Soc. London; Lindley Library R.H.S. London; Chelsea Physic Garden, London; Shirley Sherwood Collection 'Contemporary Botanical Artists', Royal Botanic Gardens, Kew. *Publications:* 'Pauline Dean: Portfolio of a Botanical Artist' (pub. 2004, Botanical Publishing, ISBN 0-9548204-0-1); with other artists: various inc. Curtis' Botanical Magazine, R.H.S. New Dictionary of Gardening, The New Plantsman. *Signs work:* "P.M. Dean." *Address:* 27 Poltimore Rd., Guildford GU2 7PR. *Email:* Deanbotart@aol.com

DEAN, Ronald Herbert, R.S.M.A. (1970), F.C.I.I. (1965); self taught painter in water-colour and oil; Insurance broker. *b:* Farnborough, Hants., 1929. *s of:* Herbert Dean, B.E.M. *m:* Audrey Grace Payne. two *d. Educ:* Farnborough Grammar School. *Exhib:* R.S.M.A., R.I., R.B.A., Biarritz, Salem Or., U.S.A., National Maritime Museum. *Clubs:* President Tonbridge Art Group. *Signs work:* "RONALD DEAN" printed. *Address:* 8 Glebelands, Bidborough, Tunbridge Wells, Kent.

DEANE, Frederick, R.P. (1972); painter in oil, gouache, pastel. *b:* Manchester, 1924. *m:* Audrey Craig. two *s.* one *d. Studied:* Manchester College of Art (1940-43), R.A. Schools (1946-51, Philip Connard). Served with Para

Regt. 1st Airborne Div. (1943-45). Visiting tutor: Manchester College of Art (1952-60), City of London Polytechnic (1970-82). *Exhib:* R.A., R.P. *Works in collections:* Chatsworth; Oxford, Cambridge, Manchester, Rhodes, McGill and Kent Universities; Manchester City A.G. *Clubs:* Chelsea Arts. *Signs work:* "Deane." *Address:* Penrallt Goch, Llan Ffestiniog, Gwynedd LL41 4NS.

DEANE, Jasper, Cert.F.A. (Oxon.) (1971), M.A. (R.C.A.) (1978); PGCE Greenwich University (2001); artist in water-colour and oil. *b:* Ches., 15 Jul 1952. *Educ:* Bryanston School, Blandford. *Studied:* Ruskin School of Drawing (1969-71), R.C.A. (1975-78), Greenwich University (2000-2001). *Exhib:* numerous exhbns. of paintings, drawings and water-colours in London & Paris, including R.C.A., Cadogan Gallery and Royal Festival Hall; Man & Eve Gallery. *Works in collections:* many private collections including Peter O'Sullivan, Martin Mills, Fiona Spencer-Thomas, Julian Wilson, Brian Patten. *Commissions:* include paintings for Martin Mills and Dr.N.Keppe. *Publications:* includes work for the Folio Society and R.C.A.; 'Colour Research' pub. Man & Eve Gallery (2006). *Clubs:* Old Students Assoc. R.C.A., Chelsea Arts. *Signs work:* "J.D." or "Jasper Deane." *Address:* 13c St. Stephens Ave., London W12 8JB. *Email:* sjdeane@onetel.com

DEARDEN, Chris, N.D.D., A.R.U.A., U.W.S., W.C.S.I. (Ireland); painter in water-colour, art teacher; Council mem.: R.U.A., and U.W.S.;. *b:* Halifax, 27 Dec., 1941. two *d. Studied:* Huddersfield College of Art. *Exhib:* Mall Gallery, London (1991-1996), Royal Hibernian (1979-98), Royal Ulster (1978-99), Laings, Cavehill Gallery, Belfast, etc. *Works in collections:* B.B.C., U.T.V., D.O.E., Albert Reynolds (Irish Prime Minister), H.R.H. Prince Charles, National Trust, U.S.A. and Russia. *Commissions:* M.O.D., Palace Barracks, Belfast, B.B.C. *Signs work:* "Chris Dearden." *Address:* 4 Knockagh Terr., Greenisland, Co. Antrim, N.I. BT38 8RN.

DEARNLEY, Benjamin Chad, BA (Hons) Sculpture. *Medium:* sculpture. *b:* Salisbury, Wilts, 29 Feb 1964. *s of:* Dr.Christopher H & Bridget D. Dearnley. two *d. Studied:* Camberwell College of Arts (2003-2006). *Represented by:* The Belgravia Gallery, Mayfair, London. *Exhib:* Belgravia Gallery, London (2007), Jean Jones Gallery, Bristol (2007), The Steps Gallery, Bristol (2006), The Salon Gallery, London (2006), Queen Elizabeth Hall, London (2006), Freestyle Gallery, Truman Brewery, Brick Lane, London (2005), Clifton Arts Club 100th Exhibition (2006), Royal Academy of Music, York Gate Gallery (2006). *Works in collections:* portrait bust of 'Lionel Tertis (1876-1975)', York Gate Collection, Royal Academy of Music (bronze); bust of Dr.C.H.Dearnley, Royal School of Church Music, Salisbury. *Commissions:* 2006: Bronze portrait, 'Maisy', Gloucester; 2007: Bronze portrait, private commission, Bristol; 2007: Alabaster carving: private commission, Massa, Italy. *Official Purchasers:* Marble male torso; Marble head (Belgravia Gallery). *Clubs:* Clifton Arts Club. *Signs work:* "BCD" (as monogram). *Address:* 32 Woodgrove Road, Bristol, BS10 7RE. *Email:* bendearnley@hotmail.co.uk *Website:* www.bcdsculpture.co.uk

de BURGH, Lydia, R.U.A. (Hon.), U.W.S., U.W.A., Dip.Mem. Chelsea Art Soc. (1958-65); portrait, African wildlife and landscape painter in oil and water-colour; lecturer;. *b:* London, 3 Jul 1923. *d of:* Capt. Charles de Burgh, D.S.O., R.N. *Educ:* privately. *Studied:* under Sonya Mervyn, R.P. (1948-51), Byam Shaw School of Art (1952), Edward Wesson, R.I. *Exhib:* London, N. Ireland Office (1955), Boston, Vose Gallery (1957), R.P., R.B.A., R.G.I., R.U.A., Royal Birmingham, Wildlife Artists, etc.; retrospective exhbns. 1993 Down Museum, Belfast for 6 weeks. St. Patricks Museum, Downpatrick, Oct 2003; Government House, Hillsborough Castle (2006, 2007). *Works in collections:* (personal sittings) of H.M. The Queen and the Royal Family; numerous works in public and private collections. *Commissions:* portraits and landscape. *Publications:* autobiography, "Lydia's Story" (1991), further autobiog. "Another Way of Life" (1999). *Works Reproduced:* see Bridgeman Picture Library (numerous). *Recreations:* reading, travelling, garden. *Signs work:* "L. de Burgh, R.U.A." (or earlier works A.R.U.A.) now "H.R.U.A." *Address:* 4 Church Ct., Clough, Downpatrick, Co. Down, N. Ireland BT30 8QX.

de DENARO, Furio, Historian of Art, Artist, Printmaker, teacher at University of Trieste (from 1996), il Bisonte (from 1998), Institut of Art Trieste (1978-81, and from 1996), Scuola Liberadell Acquaforte, Trieste (from 2002); National Drawing Comp. Award (1973); Regione FVG (1982); Torinotortona Award (1991); Rotary Award (1992); Varese Award (2002). *Medium:* wood engraving, copper engraving, etching, drawing, watercolour. *b:* Trieste, 3 Sep 1956. *s of:* Fabio and Brunetta Bruno. *m:* Roberta Dittura. one *s. Studied:* Institut of Art Trieste (MA 1974, Art Degree 1976) Camden School of Art (1979-80), London Camberwell College of Art, (Summer 1989), il Bisonte, Florence (1988-90), BA (Hons) University of Trieste 1991). *Represented by:* il Bisonte, Firenze; Society of Wood Engravers. *Exhib:* Trieste, Monfalcone, Milano, Ortona, Pisa; Great Britain, Schwetzingen, New York, New Caanan, Toronto, Monchengladbach, Firenze, Venezia, Urbino, Genova. *Works in collections:* New York City Public Library; University Barcelona; Rijeka; Malbork Genova (Villacroce); Ortona; Firenze; Trieste (Museo Civico). *Commissions:* Comune di Varese, Ex Libris Museum, A.i. Ex Libris. *Publications:* Domenico Tempesti: i Discorsi Sopra l'Intaglio (Firenze 1994), Omaggioa Gabor Peterdi (Monfalcone 2004); portfolio: Presenze Incise a Trieste (1996); Ilsegno Inciso (2001); Ex Libris Biblioteca CMSATS (2005); Pinicchio Xilografico. *Works Reproduced:* Ex Libris (Milano 1991), Grafica d'Arte (Milano 1996), Encyclopedia Bio-Biblio Contemporary Ex Libris (Portugal 1996), An Engravers Globe (UK 2002) by Simon Brett, and many others. *Recreations:* judo, cycling and mountain biking. *Clubs:* il Bisonte, Society of Wood Engravers. *Misc:* Artistic Co-ordinator: Centro Culturale Tranquillo Marangoni. *Address:* salita di Gretta 33, 34136 Trieste, Italy. *Email:* furiodedenaro@libero.it

DEES, Stephanie, RSW (2004), BA (Hons); MFA/The Scottish Arts Club Award (RSW, 2007); Cuthbert Young Artist Prize (RGI, 2006); Alexander Graham Munro Travel Award (RSW, 2002); Scottish International Education

Trust Award (1998); Andrew Grant Bequest (ECA, 1997). *Medium:* acrylic/
mixed media. *b:* Hexham, 29 Mar 1974. *d of:* James & Angela Dees. *Educ:* North
Berwick High School. *Studied:* Edinburgh College of Art. *Represented by:*
Scottish Gallery; Lemon Street Gallery. *Exhib:* The Scottish Gallery, Edinburgh
since 1997; Lemon St. Gallery, Truro; Baillie Gallery, London; White Space
Gallery, Devon; Stenton Gallery, East. Lothian; Campden Gallery, Glos.;
Compass Gallery, Glasgow. *Works in collections:* Paintings in Hospitals,
Scotland; Chartered Surveyors of Scotland; Caledonian Hotel, Edinburgh;
Edinburgh College of Art; Bank of Scotland; Scottish Courage; Royal College of
Physicians. *Commissions:* many private. *Publications:* many brochures for solo
shows at Scottish Gallery and Lemon Street. *Official Purchasers:* Alastair
Salvesen, Eastern General Hospital. *Recreations:* RSW Council Member 2004-
07. *Clubs:* Scottish Arts Club. *Signs work:* 'Stephanie Dees'. *Address:* 20/6 Boat
Green, Edinburgh, EH3 5LW.

de FRANCIA, Peter L., painter, author; Principal, DFA, School of Art,
Goldsmiths' College, University of London; Professor, School of Painting,
R.C.A. London (1972-86);. *b:* Beaulieu, Alpes Maritimes, France, 25 Jan 1921. *s
of:* Ferdinand de Francia. married. *Studied:* Academy of Brussels, Slade School,
University of London. *Works in collections:* Museum of Modern Art, N.Y., Arts
Council of Gt. Britain, Tate Gallery, V. & A., British Museum, National Portrait
Gallery, London, National Gallery of Modern Art, Prague, Imperial War Museum,
Ashmolean Museum, Oxford; Scottish National Gallery of Modern Art,
Edinburgh; Pallant House Gallery, Chichester; Graves Art Gallery, Sheffield;
private collections in U.K., U.S.A., Europe and India. *Publications:* Léger: The
Great Parade (Cassell, 1969); Fernand Léger (Yale University Press,
London,1983); "Untitled" 49 drawings (Brondums Forlag, Copenhagen 1989);
Fables, 1990-2001 (Maruts Press, London, 2002). *Address:* 44 Surrey Sq.,
London SE17 2JX.

DE GOEDE, Julien Maximilien, painter/sculpture in mixed media. *b:*
Rotterdam, Holland, 20 May 1937. *s of:* Maximilien Julien de Goede, builder.
Educ: High School, Nijmegen, Holland. *Studied:* Academie voor Beeldende
Kunsten en Kunstnijverheid, Arnhem, Holland; Eindhoven School of Art,
Eindhoven, Holland; Julian Ashton and Orban Schools of Art, Sydney, Australia.
Exhib: private galleries in Australia and London; also, Serpentine Gallery,
Whitechapel Gallery, Museum of Modern Art Oxford, Aberdeen Art Gallery,
Riverside Studios, London, Glasgow Institute of Fine Art, Museum of Modern
Art, Belfast, Ireland. *Works in collections:* include: Arts Council of Great Britain;
Laing Art Gallery, Newcastle Upon Tyne; City Art Gallery, Bristol; Australian
National University; Museum Sztuki, Lodz, Poland; Deutsche Bank; Unilever;
Johnson & Johnson; U.S.A. De Beers. *Publications:* nearly all main newspapers
and Arts Magazines, G.B. *Signs work:* "Jules de Goede." *Address:* 71 Stepney
Green, London E1 3LE.

de GRANDMAISON, Constance, HS (2003), ARMS (2004); awards: winner Bidder & Bourne Award for Best Sculpture (2003). *Medium:* miniature portraits in relief - wax, metal, terra cotta. *b:* Canada. *m:* Nicolas. one *s. Studied:* self-taught, and various art and sculpture courses. *Exhib:* Mall Galleries, HS, RMS. *Works in collections:* D.Heathcote; E J Pyke bequest to V&A and Fitzwilliam College, Cambridge. *Commissions:* E.J.Pyke, D.Heathcote, Mrs E.Milling, C.James, and others. *Publications:* Biographical Dictionary of Wax Modellers (as Constance Sykes). *Signs work:* 'Constanza'. *Address:* 2604-1850 Cornox Street, Vancouver, BC V6G IR3, Canada. *Email:* burkinholdings@shaw.ca

DE LA COUR, Brian David, M.Des. RCA; works on paper in oil bar, acrylic, charcoal and pastel; brooches in steel, acrylic and paint. *b:* Bushey, Herts, 4 Apr 1946. *s of:* Alfred Cour. *m:* Dora. two *s. Educ:* Harrow School of Art. *Studied:* Royal College of Art. *Represented by:* Benjamin C. Hargreaves. *Exhib:* Group shows: The Gallery, London; Diorama, London; Logos Gallery, London; Gallery Fresh, London; Tom Blau Gallery, London; Mark Senior Gallery, London; Mall Galleries, London; Aspects Gallery, London; Contemporary Applied Arts, London; Wakefield Art Gallery, One Aldwych Hotel, London; Kunstgwebe Museum, Berlin; Stadt Museum, Munich; Shipley Art Gallery and Museum. *Publications:* Brit Art Directory. *Recreations:* photography, walking. *Address:* 60 Bonnersfield Lane, Harrow, Middlesex, HA1 2LE.

de LACY, Ellie, HS. *Medium:* gouache and watercolour. *b:* Walsall, 5 Nov 1966. *Studied:* self-taught. *Exhib:* HS. *Works in collections:* national and international. *Commissions:* national and international. *Works Reproduced:* miniature replicas of animal art by George Stubbs, John Wootton. *Principal Works:* equine, wildlife, and pet portraits in miniature. *Signs work:* 'E de LACY'. *Address:* Salehurst, Butchers Lane, Three Oaks, E.Sussex TN35 4NG. *Email:* ellie@elliedelacy.co.uk *Website:* www.elliedelacy.co.uk

de la FOUGÈRE, Lucette, ROI, RBA; painter in oil, water-colour and pastel. *b:* London, 4 Oct 1921. *Educ:* both in Touraine, France, and London. *Studied:* under Leopold Pascal ROI, RBA, NEAC and Krome Barratt, PPROI, RBA. *Exhib:* RA., Royal Institute of Oil Painters, Royal Society of British Artists, National Soc. of Painters, Printers and Engravers; French Institute, London; one-man show: Mall Galleries. *Works in collections:* The National Museum of Wales, Cardiff. *Recreations:* singing, gardening. *Clubs:* Chelsea Arts. *Signs work:* "FOUGÈRE." *Address:* The Studio, 20 Lower Common South, Putney, London SW15 1BP. *Email:* lucettefougere@yahoo.co.uk

DELAHAYE, Luc, Deutsche Börse Photography Prize; NIEPCE Award; Robert Capa Gold Medal; Oskar Barwack Award. *Medium:* photography. *b:* Tours (France), 8 Oct 1962. *m:* Diane Dufour. two *d. Works in collections:* J.Paul Getty Museum (LA), Centre George Pompidou (Paris), High Museum (Atlanta), LaSalle Bank (Chicago), Los Angeles County Museum of Art, Chrysler Museum (Virginia), ICP (New York), National Gallery of Canada, National Museum of

Photography (Denmark), etc. *Publications:* History (Chris Boot), Une Ville (Xavier Barral), Winterreise (Phaidon), L'Autre (Phaidon), Memo (Hazan), Portraits (Sommaire). *Individual Shows/Exhibitions:* USA, UK, Germany, France. *Awards/Commissions:* Niepce Award, Robert Capa Gold Medal, ICP Infinity Award, Oskar Barnack Award, etc. *Publications: Monograph/Contributer:* Une Ville (Xavier Barral, 2003); History (Chris Boot, 2003); Winterreise (Phaidon, 2000); L'Autre (Phaidon, 1999); Memo (Hazan, 1997); Portraits/1 (Sommaire, 1996). *Specialist Area:* documentary. *Signs work:* Luc Delahaye.

DELAHAYE, Muriel, D.A. (Manc.); teacher's certificate, University of Manchester; artist in oil on canvas, charcoal, pastel (figurative paintings, mainly local coastline, people on the beach, fishermen and folklore);. *b:* Lancs., 18 Feb., 1937. *Studied:* Regional College of Art, Manchester; Victoria College, Unversity of Manchester. *Exhib:* numerous including six solo shows; 1994 – 1st prize winner, Museum Modern Art, Wales; 2000 – 1st prize winner, 'Art West 2000 – Wales, Land and People'. *Works in collections:* Showcase Wales, Museum of Modern Art, Machynlleth, Wales, Paintings in Hospitals, Wales, Attic Gallery, Swansea, Wales. *Address:* 'Efailwen', High St., Borth, Ceredigion SY24 5JQ.

DELHANTY, Denys, A.T.D. (1949), R.W.A. (1963); artist in collage, oil, water-colour, gouache; past Hon. Sec. and council mem. R.W.A.; Head of Art, Cheltenham Ladies College (1951-64), Senior Lecturer, Rolle College, Exmouth and Gloucester (1964-81). *b:* Cardiff, 13 Oct 1925. *m:* Kate Ormrod. three *s.* one *d. Educ:* St. Illtyd's College, Cardiff. *Studied:* Cardiff College of Art (1942-44, 1947-50, Ceri Richards). *Exhib:* R.W.A., etc. *Works in collections:* R.W.A., Welsh Arts Council, Cheltenham A.G., National Gallery of Wales. *Publications:* articles in Leisure painter magazine. *Recreations:* gardening, collecting ceramics. *Clubs:* Fosseway Artists, Cheltenham Group, Royal West of England Academy. *Signs work:* "Denys Delhanty." *Address:* Combe House, Sheepscombe, Stroud, Glos. GL6 7RG.

DELHANTY, Kate Elisabeth, D.F.A. (Slade); artist in oil; artist mem. R.W.A.; taught art at Cheltenham Ladies College (1953-60). *b:* London, 8 Nov 1928. *d of:* Frank Ormrod, artist/lecturer. *m:* Denys Delhanty. three *s.* one *d. Educ:* Downe House, Newbury, Berks. *Studied:* Reading University, Slade School of Fine Art (1950-53, Prof. Coldstream). *Exhib:* R.A., Bristol (R.W.A.), Cheltenham A.G., Bristol Guild, etc. *Works in collections:* R.W.A., Cheltenham A.G. *Publications:* articles in Leisure Painter Magazine. *Clubs:* Fosseway Artists, Cheltenham Group. *Signs work:* "Kate Delhanty." *Address:* Combe House, Sheepscombe, Stroud, Glos. GL6 7RG.

DELLAR, Roger, PS, RI; self taught artist in all media;. *b:* St.Albans, 29 May 1949. *m:* Lynda Ann Dellar. one *s.* one *d. Exhib:* R.W.S., P.S., R.S.M.A., N.E.A.C., R.I., R.O.I., R.W.A., R.B.A., R.A., R.P. *Works in collections:* internationally, University of Surrey. *Commissions:* Sir Donald Limon, Clerk of

House of Commons. *Clubs:* Pastel Society (PS), Royal Institute of Painters in Watercolour (R.I.), Wapping Group of Artists, Langham Sketching Club, Chelsea Arts Society, Associate Royal Institute of Oil Painters (AROI). *Address:* Nutcombe Hill Cottage, Hindhead Rd., Hindhead, Surrey GU26 6AZ. *Email:* rogerdellar@btinternet.com *Website:* www.rogerdellar.com

DEMARCO, Richard, O.B.E., l'Ordre des Arts et Lettres de France, Cavaliere de la Reppublica d'Italia, Gold Order of Merit Republic of Poland, Hon. F.R.I.A.S., Hon.D.F.A. (A.C.A.), R.S.W., S.S.A., R.S.A.; water-colourist/printmaker in water-colour, gouache, pen and ink, screen printing, etching; Professor Emeritus of European Cultural Studies, Kingston University; Artistic Director, Demarco European Art Foundation; Hon. Royal Scottish Academician (HRSA). *b:* Edinburgh, 9 July, 1930. *m:* Anne Muckle. *Educ:* Holy Cross Academy, Edinburgh. *Studied:* Edinburgh College of Art (1949-54, Sir William Gillies, Sir William MacTaggart, Leonard Rosoman). *Exhib:* over sixty one-man shows including Third Eye Centre (Glasgow), Aberdeen Artspace, Editions Alecto Gallery (London), Octagon Gallery (Belfast). *Works in collections:* S.N.G.M.A., Dundee City A.G., V. & A., Aberdeen A.G., Hunterian Museum Glasgow, S.A.C., Edinburgh City A.G., Citibank, Chemical Bank, Bank of Scotland, Royal Bank of Scotland, Clydesdale Bank, H.R.H. Prince Philip, H.R.H. Prince Charles, The British Government Art Collection. *Publications:* The Road to Meikle Seggie - The Artist as Explorer, A Life in Pictures. *Recreations:* exploring 'The Road to Meikle Seggie' from Scotland to the Mediterranean. *Clubs:* hon. mem. Scottish Arts, hon. mem. Chelsea Arts. *Misc:* (office) Demarco European Art, New Parliament House, 5 Regent Road, Edinburgh EH7 5BL. *Signs work:* "Richard Demarco." *Address:* 23a Lennox St., Edinburgh EH4 1PY.

DEMEL, Richard, Ph.D. (1981), Art Diploma (1948), F.I.L.Incorp. Linguist, F.R.S.A.; retd. art master, writer; lecturer: Univ. of Padova and Venice; stained glass artist (transparent mosaic method inventor), painter, engraver;. *b:* Ustron, Poland, 21 Dec 1921. *s of:* Joseph (artist) and Anna (née Bieta). *m:* Anna Parisi. one *s.* one *d. Educ:* Andrychow and Biala-Bielsko. *Studied:* Accad. d. Belle Arti (1945-47), Rome, Polish Accad. Art Centre, Rome, London (1945-49); London University Slade School (1949); LCC Central School of Art (1949-51) B.A. Lang, Venice University; M.A. Lang, Polish University, London; asst. to J. Nuttgens (St. Etheldreda's Church windows); asst. lecturer to Prof. M. Bohusz-Szyszko. *Exhib:* 28 one-man and 150 collective; ITV film (1961), BBC TV on pupils' work (with Miró 1962); Polish TV Documentary (1992); designed and exec; H.C. Comu. S.Leonards O.S. (4); Rome (1); 5 mosaic windows: Cathedral, Padua; Duomo Cittadella (4); Codevigo Church (2) Italy. *Publications:* in 68 art encyclopaedias and art publications. Biographer of Sergiusz Piasecki. *Address:* Via S. Domenico 21-35030 Tencarola, Padova, Italy.

de MEO, P. (Pamela Synge), artist in oil and water-colour. *b:* London, 2 Sep 1920. *d of:* Dr. Boris Vinyk. *m:* Major Brian Synge. three *s. Educ:* Cheltenham

Ladies' College. *Studied:* St. Martin's College of Art, Chelsea School of Art, Heatherleys (1953). *Exhib:* R.A. (1988, 1994, 1996), Paris Salon, R.B.A. Galleries, Chelsea Artists, Bankside Gallery (G.B., U.S.S.R. Assoc., 1985), Mall Galleries, Bowmore Gallery, Halkin St., W1 (1989), Charity Exhbn. for Red Cross (1991), Gagliardi Gallery, Chelsea (1993), Patterson Gallery, Albemarle St. (1994), Chelsea Arts Soc. (1993, 1994, 1996, 1999, 2003), Britain-Russian Assoc. (1995); one-man show: Tradescant Trust Museum (1988); The Mall Galleries (1996); Arts Club (1994-1998); one man show at home address - June 19th; Chelsea Festival (1999, 2001-2003); 150th anniversary of the Heatherley School of Fine Art; Chelsea Art Exhibitions (1994-1999); Edith Grove Gallery (1995). *Commissions:* A portrait of the late Col. Oliver Berger - commissioned by his wife Lady Rose Berger. *Publications:* Belgravia magazine. *Works Reproduced:* In the Chelsea Festival magazine - A Russian Rose View & Flowers. *Recreations:* singing & dancing. *Clubs:* Dover St. Arts, Chelsea Arts. *Signs work:* "P. de Meo." *Address:* 4 Pembroke Close, Grosvenor Cres., London SW1X 7ET.

de MONCHAUX, Paul, Arts Council Major Award (1980); Purchase Award Contemporary Art Society (1982); The Northern Electric Environmental Award (1990); Civic Trust Award with Townshend Associates for design of Oozells Square, Birmingham (2000). *Medium:* sculpture. *b:* Montreal, 20 May 1934. *s of:* Emile de Monchaux. *m:* Ruth. one *s.* three *d. Studied:* Art Students League, New York (1952-54); Slade School of Fine Art (1955-58). *Exhib:* RA; ICA; Serpentine Gallery; John Moores Liverpool; Whitechapel gallery; Crafts Council Gallery, Camden Art Centre; London Group, Gateshead Garden Festival, Stoke Garden Festival etc. *Works in collections:* Lord Irvine of Lairg; Contemporary Art Society; Colchester District Hospital; BBC. *Commissions:* Euston Station (benches, 1990); 'Basilica', Coventry Crown Court (1991); Wilfred Owen Memorial, Shrewsbury (1993); Oozells Square, Birmingham (1998); 'Enclosure' West Park Southampton; Brunswick Square, Birmingham (2001)' 'Song' BBC Memorial to Winston Churchill (2005); 'Silence' memorial to WWII Jersey Slave Workers (2007). *Works Reproduced:* Arts Council 'Sculpture Show' (1983); Crafts Council 'The Furnished Landscape (1992); 'Brindley Place' Right Angle (pub.1999); 'Bänk in Park und Garten' Galerie Handwerk, Munich; 'Public:Art:Space' Public Art Commissions Agency; 'Art & Architecture'; 'Sunday Times'; 'Guardian'; 'Times'; 'Telegraph'; 'Daily Mail'; 'Daily Express'; 'Evening Standard'" 'The Art Newspaper'; Artscribe'; 'Sculpture'; 'Stone |Industries'; 'Independent'. *Misc:* lecturer Goldsmiths College (1960-65); Head of Sculpture and Head of Fine Art, Camberwell School of Art (1965-86). *Signs work:* 'Paul de Monchaux'. *Address:* 56 Manor Avenue, London SE4 1TE. *Email:* p.demonchaux@btinternet.com

DEMPSTER, Justin William, BA Hons (1995); East Sussex Travel Award (1996). *Medium:* oil, acrylic. *b:* Luton, 6 Dec 1972. *m:* Vanessa Meintjes. *Educ:* Icknield High School, Luton. *Studied:* University of Brighton. *Exhib:* RA Summer Exhbn (2004); Hunting Art Prizes, RCA (2002); Discerning Eye, Mall Galleries (2004); other mixed shows: Hall Gallery, Leonard Street, London

(1992); Mall Galleries (1994); East Sussex Arts Winners, Gardners Arts Centre, Sussex (1996). *Publications:* cover Hunting Art Prizes Catalogue (2002). *Works Reproduced:* 'Gorgewalk', advertisement for Hunting Art Prizes. *Signs work:* 'Justin Dempster'. *Address:* 23 Honeygate, Luton, Beds LU2 7EP.

DEMSTEADER, Mark, The Lyceum Prize; The Sidney Andrews Scholarship; The Public Eye Prize, The Affordable Art Fair. *Medium:* oil, watercolour, drawing. *b:* Manchester, 1963. *Studied:* Rochdale College, Oldham College; Slade School. *Represented by:* Panter & Hall, London. *Exhib:* Panter & Hall, London. *Signs work:* 'M.Demsteader'. *Address:* c/o Panter & Hall, 9 Shepherd Market, London W1J 7PF. *Email:* enquiries@panterandhall.com *Website:* www.panterandhall.com

DENISON, David, surrealist artist in acrylic and oil; tutor, Prison Staff College, Wakefield. *b:* Wakefield, 21 May 1939. *s of:* Ernest Denison. *m:* Linda. one *s.* two *d. Educ:* Snapethorpe Secondary Modern School, Wakefield. *Studied:* Doncaster College of Art (1972). *Exhib:* Wakefield, Skipton, London, Keighley, Bradford, Camden Arts Centre; one-man shows: Manor House Public A.G., Ilkley (1970, 1977), Goole Museum and A.G. (1971), Wakefield Museum and A.G. (1972, 1974), Leeds City Gallery (1973), Doncaster A.G. (1973), Arthur Koestler Exhbn. London (1977), Bradford Cartwright Hall (1980), Angela Flowers Gallery, Arts Council of Gt. Britain. *Works in collections:* Brighton Museum and A.G., Sir Roland Penrose Collection. *Publications:* illustrated The Battle of Wilderness Wood by R. Adams. *Signs work:* "D. Denison." *Address:* 58 Station Rd., Burley in Wharfedale, W. Yorks.

DENNING, Antony, C. & G. Dip. (1988); sculptor and carver in wood, stone, welded steel;. *b:* Berks., 1 Nov 1929. *m:* Mary Denning. three *s.* three *d. Educ:* Clayesmore. *Studied:* Horsham School of Art, Weymouth College (1985-86), City & Guilds Art School (1986-88). *Exhib:* Cumberland Lodge, Windsor (1965), Blythes, Edinburgh (1966), Hambledon, Blandford (1971), Nuffield, Southampton (1972), Museum, Dorchester (1977), Arts Centre, Salisbury (1979), Honiton Festival (1994), etc. *Works in collections:* Southampton University; private collections in U.K., Europe, U.S.A., Canada. *Commissions:* Fishmongers' Co., Grocers' Co., St. Peter's Boyatt Wood, All Saints' Wardour, St. Mary's School, Highgate School, and private commissions. *Publications:* The Craft of Woodcarving (Cassell, 1994), Woodcarving - Two Books in One (Sterling, U.S.A, 1999; Apple Press, U.K., 2000). *Clubs:* Soc. of Heraldic Arts. *Signs work:* "Antony Denning." *Address:* 42 Nettlecombe, Shaftesbury, Dorset SP7 8PR.

DENNIS, Christopher John, S.Lm., A.S.E.A.; artist in water-colour and oil of equestrian, countryside and dogs art, abstract and miniatures;. *b:* Derby, 10 Feb., 1946. three *s.* one *d. Educ:* Ushaw College. Taught by artist mother B.C. D'Oyly Aplin. *Exhib:* exhbns.: Chelsea, Mall Galleries, Alexander Llewellyn, Royal Miniature Soc., Society of Equestrian Artists, Hilliard Soc. *Works in collections:*

Queen's miniatures. *Commissions:* York Race Committee, Racecourse Association. *Address:* 10 Church Lane, Knaresborough, N.Yorks. HG5 9AR.

DENT, Ann, mem. Chelsea Art Society. *Medium:* oil, watercolour. *b:* Kensington, 30 Jul 1924. *d of:* Dr.John Yerbury Dent. *m:* widow. one *s.* two *d.* *Studied:* Coventry Art School; St.Martin's School of Art; Ecoles des Beaux Artes, Paris. *Exhib:* RA; National Portrait Gallery; Mall Galleries; Sunday Times Water Colour Exhibition (Mall Galleries, 2007 - by selection); Manchester Town Hall. *Works in collections:* National Portrait Gallery; Huntings Ltd; Leicester Art Gallery; Aldeburgh Festival Marland Gallery (1998). *Commissions:* portraiture and landscape commissions, at home and abroad; Laing Calendar 1983. *Official Purchasers:* National Art Collections Fund. *Works Reproduced:* by NPG. *Principal Works:* portrait of Sir Angus Johnson Wilson (NPG). *Recreations:* drawing, reading. *Misc:* appeared on Japanese TV in 1993. *Signs work:* 'Ann L.Dent'. *Address:* 12 Smith Street, Chelsea, London SW3 4EE.

DENTON, Kenneth Raymond, R.S.M.A., F.R.S.A., I.S.M.P.; landscape and marine artist in oil. *Medium:* oils. *b:* Chatham, 20 Aug 1932. *s of:* Stanley Charles Denton. *m:* Margaret Denton (decd.). three *s. Educ:* Troy Town School, Rochester. *Studied:* Rochester School of Art and Technical School, Medway College of Art for decorative design and painting, landscape painting with David Mead. *Exhib:* York, Rochester, London, Eastbourne, Thames Ditton, Stratford-on-Avon, Norwich, Los Angeles, Mystic, Vancouver, San Francisco, Pennsylvania, Washington D.C., Tunbridge Wells; 45 one-man shows, R.O.I., R.B.A., etc. *Works in collections:* world-wide. *Official Purchasers:* Financial Institutions, Banks, etc. *Works Reproduced:* hundreds: cards, calendars, prints, books, etc. Medici Soc., Royles, Artists Britain, Yachting Monthly, Yachting World, Connoisseur, Guild Prints. *Recreations:* music, classical piano. *Clubs:* R.S.M.A. *Signs work:* "Kenneth Denton." *Address:* Priory Farm Lodge, Sporle, Kings Lynn, Norfolk PE32 2DS. *Website:* www.dentonuk.net

DENTON, Raymond, NDD (1960); The Charles Pears Prize; winner of 'Best in Show' Prize 2004 St.Ives Society of Artists 1st Open Exhibition. *Medium:* oil, pastel. *b:* Lambeth, London, 4 Sep 1939. *m:* Anne. one *s.* one *d. Educ:* Leeds College of Art. *Studied:* book illustration. *Exhib:* Royal Academy, The Royal Society of Marine Artists, The Laing Art Exhbn, also Yorkshire Artists Exhbn Bradford, Cardiff, Penzance, Falmouth, St. Ives, Cheltenham, Fowey and many London galleries. *Publications:* Artist and Illustrators, Cornwall Today. *Clubs:* St. Ives Society of Artists, Penzance Arts Club. *Misc:* Featured on west country television. *Address:* Trebartha Place, 26 Fore Street, St. Erth, Cornwall TR27 6HT.

DENYER-BAKER, Pauline, Des RCA, RMS, HS, MASF, SLm; Intermediate NDD in Design; Silver Bowl RMS (World Exhibition of Miniatures, 1995); Best Traditional Portrait Miniature (MASF, 2001, 2007); Washington Award for Still Life (World Exhibition of Miniatures, 2004); Bell Award (HS, 2004). *Medium:* oil

and watercolour on ivorine, portraits in miniature. *b:* Hove, Sussex. *d of:* RCW Sheppard. *m:* Brian Denyer-Baker, ARCA. two *s. Educ:* Brighton and Hove High School. *Studied:* Brighton College of Art; Royal College of Art. *Represented by:* commissionaportrait.com. *Exhib:* RA Summer Exhbns (1989-2004); World Exhibition of Miniatures, Tasmania (1990); World Exhibition of Miniatures, London (1995). *Works in collections:* Europe, America, Canada, Australia, Austria, Japan, UK. *Commissions:* Earl of Buchan (2004); ten miniature portraits for Hancock family (2006). *Official Purchasers:* Earl of Buchan. *Works Reproduced:* 'Eye of the Artist', William Feaver (Observer, Jun 1993). *Recreations:* music, gardening, swimming. *Signs work:* 'Pauline Denyer-Baker Des R.C.A.'. *Address:* Pollards Farm Cottage, Ditchling Common, Burgess Hill, W.Sussex RH15 0SE. *Email:* longbarnart@imacdemic.com

de QUIN, Robert, N.D.D. (1950); sculptor working in welded metals mainly in abstract style; retd. art teacher; also print, etching, drawing. *b:* Namur, Belgium, 6 Jul 1927. *s of:* Col. Urbain de Quin. *m:* Diana. two *d. Educ:* Belgium and UK. *Studied:* Hornsey School of Art (1945-50). *Exhib:* several one-man shows including Mall Galleries (1972); numerous group shows including Berkeley Sq., London (1972), B.P. Oil sculpture, Festival Hall, London (1990), Dolphin Sq. sculpture, London (1993), Loggia Gallery, London. *Works in collections:* Britain, Belgium, S. Africa, U.S.A.; several commissioned works. *Clubs:* Fellow and Past Chairman, F.P.S. and Loggia Gallery, London. *Signs work:* "Robert de Quin." *Address:* 95 Fortis Green, London N2 9HU.

de SAULLES, Mary, A.R.I.B.A., (1948), A.A.dip (1947), F.C.S.D. (1959), F.R.S.A. (1981); architect and designer, interior, exhbn., display; deputy to chief officer of specialized design section, L.C.C. Architects' Dept. (1950-52); partnership with John Lunn, F.S.I.A. (1951-55); Industrial Designer, B.E.A. (1959); private practice (1960), interiors, exhbns., housing, etc. Conservation consultant. *b:* Westcliff-on-Sea, 1925. *m:* Patrick de Saulles, A.A.dip. (d. 1997). two *s. Studied:* architecture: Architectural Assoc. School of Architecture. *Publications:* The Book of Shrewsbury (Barracuda Books Ltd.). Designers in Britain, Nos. 4 and 5, Architectural Review. *Clubs:* Architectural Assoc. *Misc:.* *Signs work:* "Mary de Saulles." *Address:* Watergate House, St Mary's Water Lane, Shrewsbury SY1 2BX.

DESMET, Anne Julie, M.A.(Oxon.) (1986), R.E. (1991), Dip. (Advanced Printmaking & Design) (1988), Rome Scholar in Printmaking (1989-90); SWE; Editor of 'Printmaking Today'. *Medium:* wood engraving, linocut, collage. *b:* Liverpool, 14 June, 1964. *m:* Roy Willingham. one *s.* one *d. Educ:* Sacred Heart High School, Liverpool. *Studied:* Ruskin School of Drawing, Fine Art(1983-86), Central School of Art, Printmaking(1987-88). *Represented by:* Hart Gallery, London. *Exhib:* group shows: worldwide; selected solo shows U.K.: Hart Gallery, London (2004, 2006); Ashmolean Museum (1998, touring seven UK museums in 1999); Duncan Campbell Gallery (seven solo shows 1991-2002) Royal Overseas League (1992), Godfrey & Watt Gallery (1993, 1995); Ex Libris Museum

Moscow, Russia (1995). *Works in collections:* Ashmolean Museum, V. & A., Whitworth Gallery, National Art Library; H.M.The Queen, Ex Libris Museum, Moscow; museums in France, Finland, Brazil, Poland, Italy. *Commissions:* Sotheby's, British Museum, British Library, 'The Times'. *Publications:* co-author of 'Handmade Prints' (A&C Black, 2000); 'Anne Desmet: Towers and Transformations' (Ashmolean Museum publication 1998). *Signs work:* "Anne Desmet". *Address:* Hart Gallery, 113 Upper St. Islington London N1 1QN. *Email:* annedesmet@pt.cellopress.co.uk *Website:* www.annedesmet.com

DESOUTTER, Roger Charles, R.S.M.A.; painter in oil. *b:* London, 21 Mar 1923. *m:* Mary Elizabeth. one *s.* one *d. Educ:* Mill Hill School and Loughborough College. *Exhib:* R.S.M.A., Stacy-Marks Galleries, R.O.I., G.Av.A., Lloyds, Mystic Seaport, Forbes Gallery, New York, Marine Arts Gallery, Salem, Kirsten Gallery, Seattle. *Works in collections:* U.S. Mercantile Marine Academy. *Commissions:* Shipping Companies, Banks, Insurance Companies, Lloyds Agents. *Publications:* 20th Century British Marine Painting, Liners in Art, A Celebration of Marine Art; paintings reproduced as greeting cards, calendars and fine art prints. *Signs work:* "ROGER DESOUTTER." *Address:* Copshrews, Amersham Rd., Beaconsfield, Bucks, HP9 2UE.

DE STEMPEL, Sophie, Cristina, *Medium:* oil. *b:* Hythe, 31 Dec 1960. *m:* Sir Ian Holm. *Educ:* Sacred Heart Convent. *Studied:* City & Guild School of Art (1978-81);. *Represented by:* Camilla Davidson. *Exhib:* Rebecca Hossack Gallery (1997, 1999); Houldsworth Fine Art (1990, 92, 94). *Works in collections:* Nick Cave, Mathiaus Gorne, Bella Freud, Kay Saatchi, Gina Marcu, Mark Quinn. *Commissions:* Andre Navrozov, Hanah Rothchild, Mark I Domitilla Getty. *Publications:* for Tatler, Vogue. *Official Purchasers:* Barclays Bank. *Clubs:* none. *Misc:* Lucien Freud model (1980-91). *Signs work:* 'Sophie de Stempel'. *Address:* 46 Bassett Road, London W10 6JL.

DE SWARTE, Laurie Leon:see STEWART, Laurie,

de VERE COLE, Cassian, art dealer; Director, Cassian de Vere Cole Fine Art (since 1993) specialising in twentieth century British and Irish paintings and drawings, and international contemporary art; Previously: Christie's, London (1990-92), freelance London and New York (1988-90), Michael Parkin Gallery, London (1986-88). *b:* London, 17 Nov 1966. *s of:* Tristan de Vere Cole and Diana Crosby Cook. *Clubs:* Chelsea Arts, Garrick. *Address:* c/o Cassian de Vere Cole Fine Art 50 Elgin Cres., Notting Hill, London W11 2JJ.

DEVEREUX, Glenis, ARBS; CSD. *Medium:* sculpture. *d of:* Kathleen & John Michael Devereux. one *s. Educ:* Sacred Heart Grammar, Harrow. *Studied:* self-taught. *Commissions:* Royal Worcester; Franklin Mint; Spode; Danbury Mint. *Publications:* The Sculptor's Bible; Royal Worcester Figurines; Border Fine Art Figurines. *Principal Works:* figurative. *Signs work:* 'G DEVEREUX'. *Address:* Unit 6, 26 Holland Ct., Broadbeach Waters, Queensland 4218, Australia. *Email:* glenis@glenisdevereux.com *Website:* www.glenisdevereux.xom

DEVEREAUX, Jacqueline, SGFA; Patchings 2001 & 2002; Beaux Arts de Beziers, France. *Medium:* watercolour. *b:* London, 16 Mar 1948. *d of:* George Alexander Allen. *m:* Barry Devereux, photographer. one *d. Studied:* St.Albans Art School (Fine Art Printmaking). *Represented by:* Society of Graphic Fine Art. *Exhib:* Mall Galleries (RI, SWA); Bankside Gallery (RWS); Cork Street (SGFA); Menier Gallery (SGFA); Chelsea Art Society; Tore Gallery, Inverness; La Jolla, USA; Tokyo, Japan. *Works in collections:* Esso, London; College Paul Bert, Beziers, France. *Commissions:* BRL Hardy Wines, Adelaide; Oriel House Hotel, N.Wales; Posford Duvivier, Peterborough. *Publications:* "Watercolour Innovations" by Jackie Simmonds (Harper Collins); The Artist, Leisure Painter. *Recreations:* travel. *Signs work:* "J.B.DEVEREUX". *Address:* 5 rue St. Laurent, Magalas 34480, France. *Email:* jb.devereux@wanadoo.fr *Website:* www.watercolour-online.co.uk

DEVLIN, George, R.S.W. (1964); painter in oil, water-colour, etching and ceramics. *b:* Glasgow, 8 Sep 1937. *s of:* George Devlin. *Studied:* Glasgow School of Art (1955-60). *Exhib:* many one-man shows; Belfast Open 100, 2nd British Biennale of Drawing, Contemporary Scottish Painting (Arts Council), etc. *Works in collections:* H.M. The Queen, Scottish National Gallery of Modern Art, Arts Council, Aberdeen A.G., Essex County Council, Leicester and Strathclyde Universities, Edinburgh City Collection, Argyle County Council. *Publications:* illustrations for Scotsman and Maclellan Publishers. Designed set and costumes for new ballet by Walter Gore (1973) and presented by Scottish Ballet. *Signs work:* "Devlin." *Address:* Rosebank, 6 Falcon Terr. Lane, Glasgow G20 0AG.

DEWSBURY, Gerald, RCamA (2003); BA; landscape, architecture and natural history painter in oil and water-colour. *b:* Dartford, 11 Jan 1957. *s of:* John Russell Dewsbury, engineer. *m:* Kim Rolling. one *s.* one *d. Educ:* King Edward VI Grammar School, Retford. *Studied:* Falmouth School of Art (1977-80). *Exhib:* R.A., London; John Noott Gallery, Broadway; St. David's Hall, Cardiff; Theatr Clwyd, Mold; Alderley Gallery, Alderley Edge; Y Capel, Llangollen; The Hunter Gallery, Long Melford; plus numerous others. *Works in collections:* Stowells of Chelsea; Grosvenor Museum, Chester; Soc. for Contemporary Art in Wales; Tabernacle Museum of Modern Art, Wales,- Machynlleth; Sultan of Oman; plus numerous otherprivate collections. *Commissions:* regularly works to commission. *Signs work:* "Gerald Dewsbury" or "G.D." *Address:* Tyn-Y-Ffridd, Llangwm, nr. Corwen, Clwyd LL21 0RW.

DEXTER, James Henry, designer. *b:* 23 July 1912. *s of:* James Badby Dexter. *m:* Marjorie Ellen Gurr. *Educ:* Leicester College of Art. *Exhib:* N.E.A.C., R.A., London Group, various provincial galleries. *Works in collections:* Corporation of Leicester. *Signs work:* "James Dexter." *Address:* 52 Scraptoft Lane, Leicester LE5 1HU.

DICK, Colin, N.D.D. (1951); figurative painter in oil, water-colour, stoneware sculpture, retd. teacher; former Head of Art, Campion School, Royal Leamington

WHO'S WHO IN ART

Spa;. *b:* Epsom, Surrey, 28 Feb 1929. *m:* Delia D., M.A. one *s.* two *d. Educ:* Wennington School, and Leighton Park. *Studied:* St. Martin's (1947-1951, Frederick Gore, R.A., R.V. Pitchforth, R.A.). *Exhib:* 'Romanies, Fairs and local customs' Nuneaton Riversley Gallery (1995), Herbert A.G. Retrospective, Christchurch J.C.R. Oxford, Musée Boulogne sur Mer, Biarritz Galerie Municipal, 'Coventry between Bombing and Reconstruction' Herbert A.G. (1997), R.A. Summer Exhbns. (seven oil paintings). *Works in collections:* Herbert A.G. and Museum, Coventry (35 paintings). *Commissions:* Midland waterways and traditional gatherings commissions accepted, portraits of people of ephemeral lifestyles in unusual beautiful settings, multi-cultural musicians. *Works Reproduced:* 'Last of the Horsedrawn Narrowboats - Coventry Canal' Bridgeman Art archiveonline/Herbert Art Gallery section. *Recreations:* painting at horse fairs. *Clubs:* Umbrella for the Arts, Coventry. *Signs work:* "Colin Dick." *Address:* Stoke Green Studio, 98 Binley Rd., Stoke, Coventry CV3 1FR. *Email:* colindick@gmail.com

DICKENS, Alison Margaret, company director; painter in oil. *b:* London, 1917. *d of:* J.D. Jamieson, senior civil servant, Home Office. *m:* G.E.J. Dickens (decd.). one *s.* one *d. Educ:* Haberdasher Aske's Girls' School. *Studied:* Ealing Art School (Kenneth Procter). *Exhib:* R.A., N.S., R.P., S.W.A.; numerous one-man shows at own studio, E. Horsley, and Thorndike Theatre, Leatherhead. *Works in collections:* Japan. *Publications:* dust cover for Foyles. *Signs work:* "Alison M. Dickens". *Address:* Norrels Lodge North, Norrels Drive, E. Horsley, Surrey KT24 5DL.

DICKENS, Mark, Post-Grad Diploma (Italy), BA (Hons). *Medium:* painting, mixed media. *b:* London, 18 Jul 1963. *Studied:* 'Il Bisonte' School of Graphic Art, Florence, Italy (1988); Maryland Institute College of Art, Baltimore, USA (1984); Central School of Art and Design, London (1983). *Represented by:* Stephen Lacey Gallery, London. *Exhib:* 2003: 'Art London' Artfair, Chelsea, Stephen Lacey Gallery, London Group 90th Anniversary Show, Cork St., Artfair 2003, Islington. 2002: Gallery Artists, Stephen Lacey Gallery, International Arts Festival, Prague, Gallery Fine 2, Londond. *Works in collections:* Banca Toscana, Italy. *Commissions:* Kuwait Petroleum (Europe). *Works Reproduced:* Media Contacts- Quarterly 'Art London' (2003). *Clubs:* elected mem. 'London Group of Artists'. *Address:* Space Studios, 142 Vauxhall Street London SE11 5RH. *Email:* markdickens14@hotmail.com *Website:* www.markdickens.net

DICKER, Kate, Elected Member of Society of Wood Engravers; Associate Member of The Royal Society of Painter-Printmakers (2007); BA Hons (1979-80), Postgrad Dip: History of the Modern Period (1992-94); MA Fine Art Printmaking (2004). *Medium:* wood engraving, drawing in colour. *b:* Southsea, 15 Nov 1953. *d of:* Molly Dicker (painter and etcher, 1924-2000). *Studied:* Camberwell College of Art (John Lawrence), Winchester School of Art. *Exhib:* Southampton City Art Gallery (2004), Society of Wood Engravers, Royal Academy (1998), The Bankside Gallery, London; Portsmouth University (solo,

2007). *Works in collections:* Royal County Hospital, Winchester, Hampshire County Council, Winchester City Council, Kensington & Chelsea Borough Council, Hampshire County Council Archive & Museum Services. *Commissions:* illustrations for: Weald & Downland Open Air Museum Medieval Cookery Book by Maggie Black (1993); In the Valley of The Fireflies by Peter Hobday (1995); Tales from a Village School by Miss Read (1995). *Publications:* Articles: 'Artists' Books, Microbes and Mechanical Trolls'; 'Printmaking Today' (Nov 2000); 'Wood Engraving in Britain's Art Schools' Printmaking Today (Nov 1998), 'Metro Links from Rivers to the Sea' Printmaking Today (Autumn 2004). *Misc:* in 2002 awarded Southern Arts Colle Verde Residency, Italy. *Signs work:* "Kate Dicker". *Address:* 6 Rosewarne Court, Hyde St, Winchester, SO23 7HL. *Email:* kd-zappypod@talktalk.net

DICKERSON, John, M.F.A., (1968), Dr.R.C.A. (1974); artist and lecturer in painting, ceramics, mixed media sculpture, drawing; subject leader for studio art, Richmond International University, London;. *b:* Swaffham, Norfolk, 11 Oct 1939. *s of:* F.E. Dickerson, businessman. *m:* Mary Robert. one *s. Educ:* Hammond's School, Swaffham. *Studied:* Goldsmiths' College, Art Students' League, N.Y., Pratt Inst., N.Y. (1966-68), R.C.A. (1971-74). *Works in collections:* Japan, U.S.A., U.K., Taiwan, Malaysia, Sweden, Australia, Serbia, Hong Kong, Spain, Montenegro. *Publications:* author: Raku Handbook; Pottery Making - A Complete Guide; Aspects of Raku Ware; Pottery. *Signs work:* some ceramics and sculpture carry "JD" monogram; other works signed "John Dickerson." *Address:* 47 Creffield Rd., London W5 3RR. *Email:* dickerj@richmond.ac.uk

DICKS, Margo, S.G.F.A.; R.H.S. medallist for Botanical Painting (1989, 1991, 1994); sculptor, potter and painter in water-colour;. *b:* Coventry, 1925. *m:* Dr. David Dicks. two *d. Educ:* Clarence House School, Coventry, Italia Conti School, London. *Studied:* pottery with Cecil Baugh, Jamaica (1954-56), recently, sculpture with Nigel Konstam, Italy. *Exhib:* Mall and Westminster Galleries. *Clubs:* Arts. *Signs work:* "Margo Dicks" or "M.D." *Address:* Bradstones, Hewshott Lane, Liphook, Hants. GU30 7SU.

DICKSON, Evangeline Mary Lambart, BWS; artist in water-colour and other media; Cert. of Merit for Distinguished Service (International Biographical Centre). *b:* 31 Aug 1922. *d of:* Hugh A.L. Sladen. *m:* John Wanless Dickson, FRCS. one *s.* two *d. Educ:* Stover, Newton Abbot. *Studied:* under Anna Airy, RI, ROI, RE. *Exhib:* solo shows: E. Anglia, London, Ipswich B.C. Museums and Galleries, Salisbury and S. Wiltshire Museum, English Heritage (Framlingham Castle); group shows include Cambridge, Hertfordshire, Yorkshire, Scotland, Paris Salon, R.W.S. Open and R.I. exhbns. (London), Ipswich B.C. Museums and Galleries, Gainsborough's House, Sudbury, Suffolk. *Works in collections:* Sheffield City A.G's (Picture lending scheme, Graves A.G.), Ipswich B.C. Museums and Galleries. *Publications:* commissioned illustrations "In Search of Heathland", Lee Chadwick (Dobson Books Ltd.) and for Collins publishers; painting for W.S.Cowell Ltd. calendar for international distribution. *Clubs:*

B.W.S., Yorks., Ipswich Art Soc., Eight Plus One Group. *Misc:* At their request transparancies of six paintings sent to the Bridgeman Art Library, London. Art career entered in 1999 Dictionary of International Biograhy. *Signs work:* "E.M. Dickson". *Address:* Stow House, Westerfield, Ipswich, Suffolk IP6 9AJ.

DICKSON, James Marshall, D.A. (Edin., 1964), R.S.W. (1972); artist in ink, gouache, P.V.A.; Head of Art, Lochgelly Centre. *b:* Kirkcaldy, 31 Jul 1942. *s of:* James Dickson, driver. *Educ:* Beath High School. *Studied:* Edinburgh College of Art (1960-64, Stuart Barrie). *Exhib:* R.S.W. (Edin.), R.G.I. (Glasgow), Kirkcaldy A.G., Perth A.G., Loomshop Gallery. *Works in collections:* Banff County, Angus County, Aberdeen, Tayside, Leeds Educ. *Signs work:* "James Marshall Dickson, r.s.w." *Address:* 44 Main St., Lochgelly, Fife.

DICKSON, Jennifer, R.A., R.E., LL.D. (1988), C.M. (1995); printmaker and photographer;. *b:* Piet Retief, S. Africa, 17 Sept., 1936. *Studied:* Goldsmiths' College School of Art (University of London, 1954-59) and Atelier 17, Paris, under S. W. Hayter. *Works in collections:* V. & A.; National Gallery of Canada; Hermitage, Leningrad; Cleveland Art Institute, etc. *Publications:* 30 major suites of original prints. *Address:* 20 Osborne St., Ottawa, Ontario K1S 4Z9, Canada.

DIGGLE, Philip, painter in oil on canvas;. *b:* 30 Dec 1956. *s of:* Dedalus Diggle, B.A., M.A., Ph.D. *Educ:* Ancoats Manchester Grammar; Trinity College Oxford. *Exhib:* Bede Gallery, Jarrow, Warwick Arts Trust (1985), Angela Flowers Gallery (1986, 1987), Art Now, London (1986, 1987, 1988), Festival of the 10th Summer, Manchester (1986), Barcelona Workshop (1988), Flowers East (1989, 1991); one-man shows: Rochdale A.G. (1985), Angela Flowers Gallery (1985), Warwick Arts Trust (1985), Some Bizarre Gallery Piero(1988, 1989), Barbizon Gallery, Glasgow (1989, 1990, 1991), Barcelona Workshop (1989), Flowers East (1991); Granada/LWT (1988), B.B.C. Playbus (1990), Piroque NY,NY. *Works in collections:* Chase Manhattan Bank, NY, Rockerfeller Centre. For information see www.philipdiggle.com. *Works Reproduced:* Film: Philip Diggle (35 mins), released July 2003. *Address:* 498 Archway Rd., London N6 4NA. *Website:* www.philipdiggle.com

DI GIROLAMO, Megan Ann, FRBS, RBA, SPS; MA Ceramics (1987), ATC (Lond.) (1963), NDD (1962); awards: De Laszlo Medal (R.B.A.), 1996; Silver Medal (R.B.S.), 1997; Frink Sculpture School Award, 1999; Potclays Award, 2000; Scott Goodman Harris Award 2001; UBS Award 2004; ceramic sculptor – stoneware and raku, casting – bronze and resin; Artist in Residence, Astor College for the Arts. *b:* New Delhi, 13 Jan 1942. *d of:* Robert & Mavis Surdivall. *m:* Romeo di Girolamo PRBA. two *d. Educ:* Aylesbury Grammar School. *Studied:* High Wycombe College; Hornsey School of Art; South Glamorgan Institute of Higher Education. *Exhib:* The Mall Galleries Royal Society of British Artists (1987-2001), Royal Academy (1993, 1996, 2005), Royal West of England Academy (1996-7), Society of Portrait Sculptors (1999-2001), R.B.S. Summer Exhibition (2000), Albemarle Gallery London, The Gallery Manchester, Art in

Action, Waterperry. *Commissions:* Great Missenden Church (Dunford), Villa Scalabrini (Vatican), Harris – sculpture, Bennet – sculpture, Dr. Riley – Wendover Health Centre, Trilogy – St. Mary's Church, Aylesbury (Fairclough). *Publications:* features in "Modern British Sculpture" by Guy Portelli (2005). *Signs work:* 'Megan di Girolamo'. *Address:* Sandrocks Studio, Sandrocks Hill, Sedlescombe, Battle, E.Sussex TN33 0QR. *Email:* megan@di-girolamo.co.uk *Website:* www.megan-di-girolamo.co.uk/megan htm

DI GIROLAMO, Romeo, RBA, NDD; artist in oil; Bucks. Architectural Competition (1953, 1954); Bucks. Art Scholarship (1954-59); Granada Theatre National Painting Prize (1957); David Murray Travelling Scholarship awarded by R.A. (1959); formerly Head of Art Depts., Gt. Marlow Secondary, Slough Grammar for Boys, The Radcliffe Comprehensive; at present Head of Painting Dept., Amersham College of Further Education and School of Art (formerly High Wycombe School of Art); mem. of the Academic Board and Governor of the College. *b:* Civitella Casanova, Italy, 1939. *s of:* Paolo Emilio di Girolamo. *m:* Megan, A.T.C. *Educ:* Quainton and Waddesdon secondary schools. *Studied:* High Wycombe School of Art (1954-59). *Exhib:* RA, RBA, Art Bureau Travelling exhbns. and many one-man shows. *Works in collections:* private collections in many countries. *Signs work:* "Romeo di Girolamo." *Address:* Sandrocks Studio, Sandrocks Hill, Sedlescombe, Battle, E.Sussex TN33 0QR.

DI GIROLAMO, Selina Maria, RBA; BA Hons; Creating Reality Painting Prize (2005); St.Cuthbert Mill Award (2002); G.Vivas Award (2005); lecturer in drawing at Buckinghamshire University; member of South Coast Artists; Board member of The Arts Forum. *Medium:* mixed media, fabric and paint abstract landscapes. *b:* Bucks., 5 Sep 1969. *d of:* Romeo & Megan Di Girolamo. *m:* Mike Fairclough PGCE, FRBA. three *s. Studied:* Hornsey School of Art, Middx Univ. (fine art degree); Amersham College of Art;. *Exhib:* RBA, RI, Buckinghamshire County Museum, The Russell Gallery, The Century Gallery, The Chocolate Factory, Art in Action, The Red Rag Gallery, Brighton Festival, Henley Festival, The Arts Forum, SOCO (South Coast Artists). *Works in collections:* private collections throughout UK and in Switzerland, Italy, Australia, India, USA, Canada, France and Spain. *Commissions:* numerous commissions based on sacred landscapes around the world and pneuminous power of place. *Publications:* We-Moon Women's International Arts Journal, The Guardian, Mind, Body & Spirit. *Misc:* former Council Member RBA; former Chair of Education Committee Federation of British Artists; worked with BBC, Discovery Channel, Yorkshire Television and Channel4 making documentaries on themes recurrent in her work. *Signs work:* 'Selina Di Girolamo' (on back of work). *Address:* Bona Dea, Manchester Road, Ninfield, E.Sussex TN33 9JX. *Email:* selinadigirolamo@darkmother.co.uk *Website:* www.myspace.com/selinadigirolamorba

DINN, Catherine Margaret, BA (1979), MA (1980), Dip. Art Gallery and Museum Studies (1981); Curator, Falmouth Art Gallery (1981-92); freelance

writer and lecturer. *b:* Norfolk, 4 Sep 1957. *d of:* Dr. & Mrs. A.J. Dinn. *m:* Michael E. Richards. two *d. Educ:* Walthamstow Hall, Sevenoaks. *Studied:* History of Art and English, University of Nottingham (1976-79), Courtauld Inst. of Art (1979-80), University of Manchester (1980-81). *Publications:* Co-author (with David Wainwright) of biography of Henry Scott Tuke, R.A. (Sarema Press, 1989; reprinted 1991). *Address:* Boscolla, Florence Pl., Falmouth, Cornwall TR11 3NJ.

DI STEFANO, Arturo, M.A. Fine Art (1981); painter in oil on linen, woodcuts, etchings;. *b:* England, 25 Feb., 1955. *s of:* Salvatore and Nicolina Di Stefano. *m:* Jan Di Stefano. one *s. Studied:* Goldsmiths' College, University of London (1974-77, Jon Thompson), R.C.A. (1978-81, Peter de Francia). *Exhib:* Kettle's Yard, Cambridge (1988), Serpentine Gallery (1989), John Hansard Gallery (1989); one-man shows, Oxford O4 Gallery, Pomeroy Gallery, London (1987), Woodlands Gallery (1987), Fasolino Gallery, Turin (1987), Pomeroy Purdy Gallery, London (1989), Purdy Hicks (1991,1993,1996), Walker A.G. (1993). *Works in collections:* Unilever, Arthur Andersen, Museum of London, N.P.G. London, Government Art Collection, Walker A.G., L'pool, Barclays Bank, Leicester Museum, Harris Museum, Preston. *Commissions:* Portrait of Sir Richard Doll for National Portrait Gallery, London. *Publications:* The School of London: A Resurgence in Contemporary Painting (Alistair Hicks, Phaidon 1989); four catalogues: 1989, 1991, 1993, 1995. *Signs work:* "A. Di Stefano." *Address:* 92 Fairfoot Rd., Bow, London E3 4EH.

DITZ, professional photographer (info@aappl.com). *Medium:* acrylic. *b:* Vienna, Austria, 9 Oct 1945. *m:* Cameron Brown. one *d. Represented by:* The Bridgeman Art Library; london@bridgeman.co.uk; Artists and Photographers Press Ltd, info@aappl.com. *Exhib:* RA (1982, 84, 85, 89, 90, 91, 92, 93, 97, 2000, 2001); Hillside Gallery, London (1989 -97, 2003); Fosse Gallery, Stow-on-the-Wold (1985-88); Mall Galleries (1983, 84, 90); many more across UK and in France. *Publications:* 'A Collection of Cat's Tales' (pub.AAPPL, 2003); 'What is It? Photographs to Keep You Guessing' (pub.AAPPL, 2005). *Works Reproduced:* many worldwide. *Principal Works:* animal 'spreads'-single pictured comprising multiple images of animals. *Recreations:* riding, photography, gardening. *Signs work:* 'Ditz'. *Address:* Church Farm House Wisley Surrey GU23 6QL. *Email:* ditz@aappl.com *Website:* www.aappl.com

DMOCH, Paul, self taught artist in water-colour, architect; 3rd prize winner in The International Artist magazine competition (2002). *b:* Warsaw, 22 Sept.,1958. *m:* Grazyna. one *d. Studied:* Polytechnic of Warsaw (architecture). *Exhib:* R.I. (1997 winner Frank Herring award, 1998-99), R.B.A. (1997-98), N.E.A.C. (1997), Singer and Friedlander/Sunday Times Water-colour Competition (1996-00, '06), R.W.S. (1997, winner Daler-Rowney Premier and Saunders Waterford awards) (1999-00); Albermarle Gallery, London (2001). *Works in collections:* Vatican and private collections worldwide. *Signs work:* "PaDmoch". *Address:* 5

Cherry Close, South Wonston, Winchester, Hants. SO21 3HU. *Website:* http://www.artmajeur.com/aquarelliste

DOBSON, Mary: see THORNBERY, Mary,

DOCHERTY, Michael, RSA (2005); DA (Edin.) (1968), Post-Grad. Dip. (1969), ARSA (1984); artist in oil/acrylic on canvas/wood, ink/graphite on paper/card; lecturer, Edinburgh College of Art; senior lecturer/ course leader in painting, ex-Dean of Faculty, Heriot-Watt University. *Medium:* mixed media. *b:* Alloa, 28 Dec 1947. *s of:* George Docherty. *m:* Odette Dominique Vitse. one *s.* one *d. Educ:* St. Modan's High School, Stirling. *Studied:* Edinburgh College of Art (1964-68, 1968-69); Moray House Course 1969-70, Post-graduate course. *Exhib:* Richard Demarco Gallery, New 57 Gallery, Fruitmarket Gallery, French Inst., National Gallery of Modern Art, Fremantle Art Centre, Western Australia, R.S.A., R.S.W., Air, London, Fine Art Soc., France, Brazil, Hungary, Poland, Finland, USA, Spain, Germany, Latvia, Lithuania; Invited exhibitions: various venues. *Works in collections:* Contemporary Art Soc., Scottish National Gallery of Modern Art, Scottish Arts Council, Edinburgh College of Art, Royal Scottish Academy, City of Edinburgh Art Centre, National Library of Scotland. *Commissions:* various national and international. *Publications:* various. *Works Reproduced:* various surveys of contemporary art/ catalogues. *Signs work:* "Michael Docherty" on reverse. *Address:* 20 Howard Pl., Edinburgh EH3 5JY. *Email:* mike_doc@hotmail.com

DODD, Alan, N.D.D. (1963), Cert. R.A.S. (1966); painter, interior designer, muralist. *b:* Kennington, Ashford, Kent, 23 Nov 1942. *Studied:* Maidstone College of Art, Royal Academy Schools. *Exhib:* R.A. Bicentenary Exhibition (1968); one-man shows: New Grafton Gallery (July, 1969, Nov., 1970, Oct., 1972), 'Four English Painters' Galleria Estudio Cid, Madrid (Nov., 1970); Baroque & Gothick: architectural studies from the Grand Tour (The Georgian Group, Nov 2004); 'Pangea' Gallery, Yoxford, Suffolk: Grand Tour Paintings (Aug 2005). *Works in collections:* V. & A., Sir John Soane's Museum; also in private collections in England, U.S.A., Australia, Spain, Portugal. *Commissions:* V. & A.: The Painted Room (1986), Alexandra Palace: Murals (1988), Spencer House: Trompe l'oeil work (1990), Sir John Soane's Museum: re-created Pompeiian ceiling (1992), Home House: re-creation of three lost works by Zucchi (1998), set designs for Opera Omnibus: "Masked Ball" (2000), designed the Westminster Millennium Cross, memorial to the late Cardinal Hume (2000); Tusmore Park, Bicester: two large grisaille panels of classical figure groups for the rotunda of the new house (2004). *Misc:* alternative address: High Hall, Weston, Beccles, Suffolk NR34 8TF. *Signs work:* "Dodd" with date. *Address:* 295 Caledonian Rd., London N1 1EG.

DODDS, James, Doctor of the University of Essex: DU (Essex) 2007; Shipwright (1976), B.A. (1980), M.A. (1984); artist in oil and linocut;. *b:* Brightlingsea, 3 May 1957. *m:* Catherine. one *s.* one *d. Studied:* Colchester

School of Art (1976-77), Chelsea School of Art (1977-80), R.C.A. (1981-84). *Exhib:* Aldeburgh Festival (1984, 1990, 1995, 1998, 2000), Bircham Contemporary Arts, Norfolk (1988, 1989, 1992, 1998), Printworks, Colchester (1989, 1990, 1992), Chappel Galleries, Colchester (1989, 1990, 1994, 2005), Union of Artists, St. Petersburg (1997), Hitzacker, Germany (1997), R.A. Summer Show (1998, 1999, 2000). Touring show 'Shipshape': Colchester (2001), Whitstable and Herne Bay, Kent (2002), Black Swan, Somerset (2002), Quay Arts IoW (2002), Bowes Museum, Co.Durham (2002), National Maritime Museum Cornwall (2003), National Maritime Museum Greenwich (2003), Tide & Time Museum, Yarmouth (2004), Hartlepool (2005), Thurso and Wick, Scotland (2005), Messum's, London (2004, 2006, 2007). *Works in collections:* Britten-Pears Library, Ipswich and Horniman Museums, National Maritime Museum. *Commissions:* National Trust, Lloyds Register. *Publications:* Peter Grimes, The Wanderer, The Shipwright Trade, Wild Man Of Orford, Wild Man of Wivenhoe, Alphabet of Boats, Black Shuck, James Dodds paintings, ABC of Boat Bits, The Song of the Waterlily, Longshore Drift, "James Dodds and the Jardine Press". *Signs work:* "James Dodds" or "J.D." *Address:* Barnacle House, 20 St. John's Rd., Wivenhoe, Colchester, Essex CO7 9DR. *Email:* james@jamesdodds.co.uk *Website:* www.jamesdodds.co.uk

DOGGETT, Susan Marguerite, B.A. (Hons.); W.C.C. award for Contemporary Craft (1994); book artist and bookbinder in mixed media; Lecturer in book arts, Croydon College; M.A. (design by independent project);. *b:* Reading, 24 Sept., 1960. one *d. Educ:* Waingel's Copse School, Woodley, Reading. *Studied:* Oxford Brookes University and Brighton University. *Exhib:* Festival Hall London, Royal Library Copenhagen, Angel Row Gallery Nottingham, Crafts Council, London, American Crafts Museum, N.Y., Washington D.C. Centre for Book Arts Minnesota. *Works in collections:* Tom Phillips, private libraries U.S.A. *Commissions:* Booker Prize bindings (1996, 1998, 1999). *Publications:* 'Bookworks' (Apple Press, 1998). *Clubs:* Fellow of Designer Bookbinders. *Signs work:* "S.D." or "Sue Doggett." *Address:* 4 Lancaster Ct., Lancaster Ave., London SE27 9HU.

DOIG, Maxwell Kirkcaldy, BA (Hons) Fine Art, Post Grad Diploma Fine Art, Joseph Webb Drawing Prize, Laura Ashley Scholarship, Villiers David Prize. *Medium:* mixed media on canvas. *b:* Huddersfield, 21 Feb 1966. *s of:* David, Thomas Doig & June Doig. one *s. Educ:* Salendine Nook High School, Batley Art College, Manchester School of Art, Slade. *Studied:* drawing, painting, etching, lithography, life drawing, anatomy. *Represented by:* Albemarle Gallery, 49 Albemarle St, London. *Exhib:* Albemarle Gallery, Hart Gallery (one man and group shows); Christies, Ettinger Gallery New York (group); various London Art Fairs; touring exhbn: 'Painting and Drawings 87-97' Huddersfield AG, Harrogate AG, Wakefield AG and Salford AG. *Works in collections:* Prudential plc, Provident Financial Group, University of London, Mercer Gallery Harrogate, Huddersfield Art Gallery, Holman Fenwick & Willan; many private collections. *Official Purchasers:* Prudential plc (2003), Provident Financial Group (1991),

Huddersfield AG (1997). *Works Reproduced:* 'Paintings and Drawings 87-97' Exhibition catalogue, 'Villiers David' Prize Exhbn. Calatogue (1999), Albemarle Gallery Exhbn. Catalogue (2003). *Principal Works:* 'Self Portrait Drawing, A Textile Worker' (1996), 'Figure in a Boat' (2001), 'Teabreak' (2001), 'White Boat, Self Portrait' (2003). *Recreations:* collector of paintings and ceramics. *Signs work:* Maxwell Doig. *Address:* 1 Oak Road, Sale, Cheshire, M33 2FD.

DOKOTLIVER, Miriam, MA Fine Art & Design; BA Hons. *Medium:* mixed media, watercolour, oil. *b:* Ukraine, 20 Dec 1954. one *s.* one *d. Studied:* Glasgow School of Art; Gray's School of Art. *Exhib:* Mall Galleries; RSA; Compass Gallery, Glasgow; Roger Billcliffe, Glasgow; Jonathan Shore, New York; The Hanover Galleries, Liverpool; The Talbot Rise Gallery, Edinburgh; McLellean Galleries, Glasgow. *Works in collections:* Cameron Mackintosh, UK; Kan & Law Design Consultants, Hong Kong; Aberdeen Art Gallery & Museum; Conoco UK, Scotland; University of Aberdeen, Scotland. *Signs work:* 'Miriam Dokotliver', 'Dokotliver'. *Address:* 41 Kelvinside Gardens, Glasgow G20 6BQ. *Email:* dokotliver@yahoo.co.uk

DONALD, George M., D.A. (1967), A.T.C. (1969), M.Ed. (1980), R.S.A. (1993), R.S.W. (1976); artist in painting & printmaking; former lecturer in drawing and painting, Edinburgh College of Art; Summer School Director, Centre for Continuing Studies. *Medium:* Painting. *b:* Ootacamund, S. India, 12 Sep 1943. *Studied:* Edinburgh College of Art; Hornsey College of Art; Edinburgh University. *Represented by:* Open Eye Gallery, Edinburgh. *Exhib:* annually. *Works in collections:* V. & A., R.S.A., S.A.C., Aberdeen A.G., S.N.G.M.A., Hunterian Museum; and in public and private collections in U.K., U.S.A., Europe, Far East. *Commissions:* worldwide. *Signs work:* "George Donald." *Address:* Bankhead, By Duns, Berwickshire TD11 3QJ. *Email:* g.donald@care4free.net *Website:* www.royalscottishacademy.org

DONALDSON, Antony, Post Grad Scholarship in Fine Art (1962-3);Harkness Fellowship to USA (1966-68). *Medium:* oil, drawing, prints, sculpture. *b:* England, 2 Sep 1939. *s of:* John William Donaldson. *m:* Patricia Anne. two *s. Studied:* Slade School of Fine Art; London University. *Exhib:* Solo: first one-man show at the Mayor Rowan Gallery London followed by several other (1965-82, 1989, 2004)), Felicity Samuel Gallery, London, many overseas including Galerie Alain Blondel, Paris; Corcoran Gallery, Los Angeles; group exhbns: over thirty worldwide since 1958 inc. RA. *Works in collections:* Gulbenkian Foundation, Lisbon; Tate Gallery, London; Ulster Museum, N.Ireland; Walker AG, Liverpool, Arts Council GB, plus many UK and worldwide. *Commissions:* Park Hyatt, Tokyo; Victoria Mills, London; Tower Bridge Piazza; Anchor Court, London. *Works Reproduced:* 'Pop Art' Lucy Lippard (pub.Frederick Praeger, NY, 1966); 'Movements in Art since 1945', Edward Lucie-Smith (pub. Thames & Hudson 1969); 'Pop Art', Michael Compton (pub.Hamlyn, 1970); Art and the Sixties, This Was Tomorrow, ed. Chris Stephens and Katherine Stout (Tate Gallery, 2004), and numerous other publications. *Signs work:* 'Antony Donaldson'. *Address:* 91a

Pimlico Road, London SW1W 8PH. *Email:* info@antonydonaldson.com
Website: www.antonydonaldson.com

DONALDSON WALTERS, Sheila, FRSA; Council Member Chelsea Art Society; Royal Scholarship RCA (wartime); later calligrapher for Historical Section War Cabinet Offices. *b:* London, Oct 1920. *d of:* James Alexander Donaldson. *m:* Nigel Vincent Walters (decd). three *d. Educ:* Royal Masonic School. *Studied:* Bromley & Beckenham Art Schools, Chelsea and Royal College of Art; SIAD, BTEC, DATEC Committees. *Exhib:* Chelsea Art Society (1980-); Queen's University, Belfast. *Works in collections:* private collections in England, France, Portugal & USA; Imperial War Museum, London. *Commissions:* Designed 'Joseph's' first shop in Kings Road, Salon 33; Consultant designer for World Congress of Anaesthesiologists, London (1968). *Principal Works:* Education- encouragement of the arts as a lifetime occupation. *Recreations:* reading, listening to music, meeting friends. *Clubs:* Chelsea Arts Club SW3. *Signs work:* 'Sheila Donaldson Walters' or 'SDW'. *Address:* Studio 6, Chelsea Farmhouse Studios, Milmans Street, London SW10 0BY.

DONNE, Leonard David, N.D.D., A.T.D. (1951); artist in oil, water-colour and etching; Head of Art, Cheshunt School, retired 1984. *b:* Leicester, 19 June, 1926. *s of:* W. D. B. Donne, local government officer. *m:* Elizabeth Donne. one *s.* two *d. Educ:* Wyggeston School, Leicester. *Studied:* Leicester College of Art under D. P. Carrington. *Exhib:* one-man shows: Gordon Maynard Gallery (1974), Loggia Gallery (1973), Countesthorpe College (1976), Hitchin Museum (1977), Loggia Gallery (1984), Birmingham University (1992), Gateway Arts Centre, Shrewsbury (1998, 2003), Ludlow Assembly Rooms (2004), and various provincial and London galleries. *Works in collections:* Croft Castle (Herefordshire), private collections. *Clubs:* FPS. *Signs work:* "D.D." *Address:* 15 Church St., Leintwardine, Herefordshire SY7 0LD.

DOREY, Russell Peter, B.A. Hons. (Painting), Post.Grad.Dip. R.A. Schools. *Medium:* oil on canvas, pencil drawings. *b:* Chelmsford, Essex, 26 Mar 1961. one *s.* one *d. Educ:* Felsted School, Essex. *Studied:* Maidstone College of Art (1979-82, John Titchell, A.R.A.), R.A. School (1983-86, Norman Blamey, R.A.). *Represented by:* Curwen and New Academy Galleries, 34 Windmill Street, London W1T 2JR. *Exhib:* R.A. Summer Exhbns. (1985-86), Agnews Young Contemporaries (1988), Burlington Gallery; Spa Galleries, Tunbridge Wells; Curwen and New Academy Galleries. *Clubs:* RASAA. *Signs work:* "Russell Dorey." *Address:* 31 St. Thomas Rd., Hastings, E. Sussex TN34 3LG. *Email:* russelldorey@tiscali.co.uk *Website:* www.russelldorey.co.uk

DORMENT, Richard, B.A. (1968), M.A. (1969), M. Phil. (1975), Ph.D. (1975); art critic, Daily Telegraph; Hawthornden Prize for Art Criticism in Britain (1992); Critic of the Year, British Press Awards (2000). *b:* U.S.A., 15 Nov 1946. *m:* Harriet Waugh. one *s.* one (by a previous marriage) *d. Studied:* Princeton University (1964-68), Columbia University (1969-75). *Publications:* Alfred

Gilbert (1985); Alfred Gilbert, Sculptor and Goldsmith (exhbn. catalogue, R.A. London, 1986); British Painting in the Philadelphia Museum of Art, From the Seventeenth through the Nineteenth Century (1986). *Address:* Daily Telegraph, 1 Canada Square, Canary Wharf, London E14.

DOS SANTOS, Bartolomeu, Emeritus Prof. in Fine Art, University of London, Fellow (U.C.L.), R.E.; artist and printmaker, public art, ceramic tiles, etched stone; taught at Slade School of Art (1961-1996). *b:* Lisbon, 24 Aug., 1931. *Studied:* Lisbon Art School (1950-1956), Slade School, under Anthony Gross (1956-1958). *Exhib:* 87 solo exhibs. worldwide, retrospective, Gulbenkian Foundation, Lisbon (1989), Retrospective - The London Institute (2001). *Works in collections:* British Museum, V. & A., M.O.M.A., N. Y., Bibliotheque Nationale, Paris. *Commissions:* include, etched stone decoration for Entre Campos tube station, Lisbon, Nihonbashi station, Tokyo, Macau Museum. *Publications:* Pas Memorial, by J. Saramago, Koron Verlag, Zurich (1999). *Signs work:* "B Dos Santos." *Address:* 57 Talbot Rd., London N6 4QX.

DOUBLEDAY, John, sculptor. *Medium:* mainly sculpture cast in bronze - also works in two dimensions. *b:* Langford, Essex, 1947; three s. (one decd.). *s of:* G. V. Doubleday, farmer. *m:* Isobel J. C. Durie. *Educ:* Stowe. *Studied:* Goldsmiths' College (1965-68). *Exhib:* one-man shows in London, New York, Amsterdam, Cologne. *Works in collections:* include Mary and Child Christ (1980) Rochester Cathedral; Charlie Chaplin (1981) Leicester Square; Isambard Kingdom Brunel (1982) Bristol and Paddington; The Beatles (1984) Liverpool; Commando Memorial C.T.C.R.M. (1986); Sherlock Holmes (1991) Switzerland; Graham Gooch (1992) Chelmsford; J.B. Pflug (1994) Braith Mali Museum, Biberach, Nelson Mandela (1997) U.W.C. in Italy, U.K., U.S.A., Singapore; Gerald Durrell (1999) Jersey; Sherlock Holmes (1999) Baker St. Station, London; The Dorset Shepherd (2000) Dorchester.; 'Jimmy' Jabara (2004); USAF Academy, Colorado Springs, Nelson (2005); Gibraltar (Bicentennial Memorial); Battle of Maldon Monument, Essex (2006); Museums include: Ashmolean Museum, B.M., V. & A., and Tate. *Address:* Goat Lodge, Great Totham, Maldon, Essex CM9 8BX.

DOUGLAS, Brian David, NEAC, RBA; BA (Fine Art), RAS. *b:* 8 Jul 1948. *s of:* David Douglas. two s. *Educ:* Maidstone, RA Schools. *Studied:* RAS (1973). *Exhib:* RBA, NEAC, RA. *Works in collections:* Brinsley Smith. *Publications:* RBA; entry in 'Dictionary of International Biography' 32nd Edition (Nov 2005). *Works Reproduced:* RBA. *Recreations:* reading, music. *Clubs:* RBA, NEAC. *Signs work:* 'Brian Douglas'. *Address:* 26 Whitestone Drive, York, YO31 9HZ.

DOUGLAS, Jean Mary, Dip.A.E. (1979), S.B.A. (1991); artist in pastel and oil, school teacher (retd.). *b:* London, 26 Sep 1927. *d of:* Sidney and Margaret Elgie. *m:* Frank Douglas. two d. *Educ:* Loughton County High School and Teacher Training College, Portsmouth. *Studied:* London University Art Diploma (1976-79). *Exhib:* Royal Exchange, Guildhall, Mall Galleries, Central Hall Westminster, and mixed exhbns. E. Anglia, S. England and Wales, also Sweden

and Austria. *Publications:* Reproduction rights of paintings sold to Royle and Medici, etc. *Clubs:* Soc. of Floral Painters. *Signs work:* "J.M.D." *Address:* 'Crossways', Main Road, Westfield, E.Sussex, TN35 4QH.

DOUGLAS, Jon, F.R.B.S., F.R.S.A.; sculptor in foundered bronze and resin bonded bronze, decorative art designer;. *b:* London, 7 Mar., 1911. *m:* Doris Helen. two *s.* one *d. Educ:* University College School, Frognal, Hampstead; Bethany College, Goudhurst, Kent. *Studied:* Institute Quinche, Lausanne (1928-31). *Exhib:* Mall Galleries, Camden Art Centre, R.B.S. Work in permanent collections worldwide. *Signs work:* "Jon Douglas." *Address:* 47 Finchley La., Hendon, London NW4 1BY.

DOUGLAS-DOMMEN, Marguerite France, C.I.A.L.; artist in oil and water-colour;. *b:* 12 Jul 1918. *d of:* Edouard Dommen, Swiss engineer. *m:* John Haig Douglas (decd.). one *s.* three *d. Educ:* Cheltenham Ladies' College. *Studied:* Derby, Lausanne (1935) and R.A. Schools under Russell and Monnington (1936-39). *Exhib:* S.S.A., R.S.W., Ancona, Morpeth, Melrose, Aikwood Tower. *Works in collections:* various. *Works Reproduced:* illustrated three books of James Hogg's poetry. *Recreations:* singing and gardening. *Clubs:* Reynolds. *Signs work:* "M.F.D." *Address:* Craigsford, Earlston, Berwickshire TD4 6DJ.

DOVER, Peter Charles, B.A. (Hons.) Graphic Design (1984), M.A. (R.C.A.) Fine Art (1988), A.R.E (1995); printmaker, painter, maker in relief printmaking on paper, found objects and materials; also musician;. *b:* Merseyside, 10 Apr., 1954. *Educ:* Wallasey Grammar School. *Studied:* Wallasey College of Art (1980-81), Leeds Metropolitain University (1981-84), R.C.A. (1986-88, under the late Alistair Grant). *Works in collections:* Tate Gallery, Ashmolean, Dudley Museum, Plymouth Museum, London Hospital, St.Thomas's, Estonia National Museum. *Commissions:* I.T.U. Floor of Gt. Ormond Street Hospital for Sick Children, silkscreen mural 'The Sea' (1990-91). *Signs work:* "P.C. Dover" usually verso. *Address:* 8 Betts House, Betts St., London E1 8HN.

DOWDEN, Joe Francis, painter in watercolour. *b:* Wimbledon, London, 16 June, 1958. *m:* Ruth. *Exhib:* Singer & Friedlander, Sunday Times watercolour competition (1998, 2000), Laing art competition (1998, 1999, 2000), R.I. (1998), R.S.M.A. (1998), Chichester Open (1998), eleven solo exhibs., yearly exhib. in Surrey. *Publications:* Water in Watercolour (Search Press), Two in One Watercolour (David & Charles), regular articles for Artists & Illustrators magazine; videos: Make it Look Real, Volumes 1&2 (Teaching Art). *Signs work:* "Joe Francis Dowden." *Address:* 91 Downlands Ave., Worthing, W. Sussex BN14 9HF. *Email:* joedowden@yahoo.co.uk

DOWLING, Jane, B.A. (Oxon.) Hons. (1946), M.A. (Oxon.) (1977); painter, etcher, engraver; formerly tutor, Ruskin School, Oxford and for over 30 years at R.A. schools. *b:* Dec 1925. *d of:* Geoffrey Barrow Dowling, M.D., F.R.C.P. *m:* Peter Greenham, (decd.). one *s.* one *d. Educ:* St. Anne's College, Oxford. *Studied:* Slade and Ruskin; Byam Shaw; Central School (Gert Hermes). *Exhib:* New

Grafton Gallery, R.A. Summer Exhbn. since 1954; many mixed exhbns., Travelling Arts Council exhbn. with Peter Greenham (1984), 'The Glass of Vision' at Chichester Cathedral, 'The Long Perspective' Agnews (1987), 'A Personal Choice' Kings Lynn (1988), 'Art in Churches' Tewkesbury and Worcester (1991), small retrospective, Mompesson House, Salisbury (1992), Leighton House (2001) Tempera Society, Stations: The New Sacred Art, Bury St. Edmunds Art Gallery Trust, (Lent 2000), Chappell Gallery (2002), several prizes. *Works in collections:* H.R.H. The Prince of Wales, The late Sir Brian Ford, Judy Egerton, Nicholas Penny, Sir Richard Carew, Farringdon Trust Buscot House, Southampton City A.G., Ashmolean Museum and loans to Churchill Hospital and John Radcliffe Hospital. *Commissions:* small mural: Edwin Abby Mural Fund for the Oxford Oratory Church (1995). *Publications:* various articles. *Official Purchasers:* The Faringdon Trust; Lady Margaret Hall, Oxford, and see above. *Recreations:* drawing. *Clubs:* Oxford Union. *Signs work:* "J.D." *Address:* The Old Dairy, Charlton-on-Otmoor, nr. Islip, Oxon. OX5 2UQ.

DOWLING, Tom, artist in oil. *b:* Dublin, 23 Jun 1924. *s of:* G.B. Dowling, M.D., F.R.C.P., Consultant Dermatologist. *Educ:* Royal Naval College, Dartmouth. *Studied:* City & Guilds of London Art School (1963-67, Gilbert Spencer, Rodney Burn, Bernard Dunstan). *Exhib:* R.A., R.B.A., N.E.A.C., R.O.I., R.P., R.E., Richard Allen Gallery, New Grafton Gallery, Pictures for Schools exhbn. *Works Reproduced:* "Cowes Week". *Clubs:* Emsworth Sailing. *Signs work:* "TOM DOWLING" or "T.B.D." (on small paintings). *Address:* 31 Slipper Rd., Emsworth, Hants. PO10 8BS.

DOWNIE, Kate, D.A., Post Dip.F.A.; artist/lecturer in acrylic, collage, printmaking, photography; part-time tutor, Fine Art Dept., Edinburgh College of Art;. *b:* N. Carolina, USA, 7 June, 1958. *m:* Peter Clerke. one *d. Educ:* Ellon Academy, Aberdeenshire. *Studied:* Gray's School of Art, Aberdeen (1975-80, Alexander Fraser, Francis Walker). *Exhib:* Collins Gallery, Glasgow (1991), Talbot-Rice Gallery, University of Edinburgh (1992), Amsterdam, Brussels, Utrecht, Cardiff, Aberdeen. *Works in collections:* Aberdeen A.G., Aberdeen University, Edinburgh University, Kelvingrove A.G., Peoples Palace Glasgow, Allied Breweries, Cleveland A.G., S.A.C., B.B.C. Scotland. *Clubs:* Scottish Arts, Edinburgh. *Signs work:* "Kate Downie." *Address:* 5 SOuth Fort Street, Edinburgh EH6 4DL.

DOWSON, Katharine, The Prince of Wales Scholarship RCA, Granada Foundation Prize. *Medium:* sculpture. *b:* London, 20 Jun 1962. *m:* James Colville. two *s. Studied:* Heatherley School of Art (1984-85); Camberwell School of Art and Craft (1985-88); Royal College of Art (1989-92). *Exhib:* 'Spectacular Bodies', Hayward Gallery; 'Head On' Science Museum, London; 'Myriad' Whitworth Art Gallery, Manchester; and many group shows in UK and Korea, Brazil, Brussels, Barcelona, Singapore, USA. *Works in collections:* Arts Council; The Wellcome Trust; Ulster Museum; Aberdeen Art Gallery; Cultura Inglesa, Brazil; Institute of Neuroscience, Newcastle University. *Commissions:* 'Myriad'

for Cultura Inglesa, Brazil; British Centre, San Paulo, Brazil; Henry Wellcome Wing, Newcastle University, Wellcome Collection. *Publications:* 'Shark-infested Waters' Saatchi Collection; 'Myriad'; 'Spectacular Bodies'; 'Head On'. *Principal Works:* Myriad, Pia Mater, My Soul. *Clubs:* Chelsea Arts Club. *Signs work:* 'Katharine Dowson', 'K.Dowson'. *Address:* 9 Nevis Road, London SW17 7QL. *Email:* katharine.dowson@virgin.net

DOWSON, Sir Philip Manning, C.B.E., P.P.R.A., M.A., A.A.Dip., R.I.B.A., F.C.S.D., Hon. F.A.I.A., Hon. F.R.C.A.; architect; Founder architectural partner, Arup Associates, and a senior partner, Ove Arup Partnership (1969-90), Consultant (1990-), President, Royal Academy of Arts (1993-99); Royal Gold Medal for Architecture (1981). *b:* Johannesburg, 16 Aug 1924. *s of:* Robert Dowson. *m:* Sarah. one *s.* two *d. Educ:* Gresham's School, University College, Oxford University (1942-43), Clare College, Cambridge University (1947-50). *Studied:* Architectural Assoc. (1950-53, Arthur Korn, Ernesto Rogers, Edwardo Catalano). *Exhib:* Arup Associates: R.A. Summer Exhbns., R.I.B.A. Anthology of British Architecture (1981), Venice Biennale (1982), R.I.B.A. Architecture Now (1983), R.I.B.A. The Art of the Architect (1984). *Clubs:* Garrick. *Signs work:* "Philip Dowson." *Address:* Royal Academy of Arts, Piccadilly, London W1V 0DS.

DOYLE, John, M.B.E. (1994), R.W.S.; 3rd prize Singer & Friedlander; artist in water-colour and aquatint; past President, Royal Water-colour Soc. (1996-2000);. *b:* London, 15 Feb 1928. *s of:* Eric Doyle. *m:* Elizabeth. two *s.* two *d. Educ:* Sherborne School. *Studied:* Maidstone College of Art, part-time. *Exhib:* Canterbury Cathedral (1973, 1976), R.A., R.W.S., Spinks (1981, 1983, 1990), Catto Gallery, Hampstead (1989), exhibition to mark 1400th anniversary of Foundation of Cantebury Cathedral (1997), Chris Beetles Gallery (2002). *Works in collections:* The Vatican. *Publications:* An Artist's Journey down the Thames (Pavilion Books, 1989). *Clubs:* Garrick. *Signs work:* "J.D." on small works, "John Doyle" on large works either pencil or water-colour. *Address:* Church Farm, Warehorne, Ashford, Kent TN26 2LP.

DRAGER, Brett: see DRAGER, Bertha,

DRAGER, Bertha, artist in water-colour and oil; teacher of art, Washington Junior High School, Honolulu (1930-33); fashion: Okla. City University (1940), Cornell Extension, N.Y. (1962). *b:* Moorefield, W.Va., USA., 29 Dec 1905. *m:* John C. Drager. *Educ:* B.F.A. University, Okla. (1930), Art Students' League, N.Y. (1940), Traphagen School of Fashion, N.Y. (1941), Kokoschka's School, Salzburg (1960). *Exhib:* National, Manila, Philippines, Okla. Museum of Art, Crespi A.G., N.Y.C. (1960), Art's Place II Okla. City A.G. *Works in collections:* University of Okla. Museum of Art. *Publications:* author and illustrator, Hat Tactics (and film 'Hat Tactics'), 'Hat Patterns' and 'Hat Trimming'. *Signs work:* "BRETT DRAGER." *Address:* Quail Plaza Apts., Apt. 112, 11002 N.May Ave., Oklahoma City 73120, U.S.A.

DRAPER, Kenneth, M.A. (1969), R.A. (1992); sculptor and painter; Mark Rothko Memorial Scholarship (1971); Arts Council Major Award (1977). *b:* Killamarsh, Sheffield, 19 Feb 1944. one *s. Educ:* Killamarsh Secondary Modern. *Studied:* Chesterfield School of Art, Kingston College of Art and R.C.A. (Bryan Kneale,Elizabeth Frink). *Exhib:* one-man shows: Redfern Gallery, Royal Academy, Hart Gallery, Islington, Peter Bartlow Gallery, Chicago, Adelson Gallery, N.Y. *Works in collections:* A.C.G.B., Contemporary Arts Soc., Fitzwilliam Museum, Ashmolean Museum Courtauld Inst., Mappin Art Gallery, Sheffield, Usher Gallery Lincoln, Lloyds of London, International Bank of Japan, London, ICI London, McCrory Corporation NY USA. *Publications:* The Life and Art of Kenneth Draper by Roger Bertoud. *Signs work:* "Kenneth Draper." *Address:* Carrer Gran 55a, 07720 Es Castell, Menorca, Spain. *Email:* drapermacalpine@terra.es

DRAPER, Matthew John, BA (Hons) Fine Art. *Medium:* watercolour, drawing. *b:* Stone, Staffordshire, 21 Mar 1973. *s of:* Jean Draper. *Studied:* Walsall College of Art (1991-92), Falmouth School of Art and Design (1992-95). *Represented by:* Open Eye Gallery, Edinburgh; Beaux Arts, Bath; Lemon Street Gallery, Truro. *Exhib:* Open Eye Gallery (2000, 2002, 2004, 2006), Lemon Street Gallery (2005, 2007), Beaux Arts Bath (2004, 2006), Jerwood Drawing Prize (2006), Hunting Art Prize (2002, 2004), Royal Scottish Academy (2003, 2006), Royal Scottish Society of Painters in Watercolour (2001, 2002), Cheltenham Open Drawing (1999), Art Miami (2006), Chelsea Art Fair (2001, 2003), Art London (2003), Affordable Art Fair (2001, 2002, 2005), From Castle to Palace, City Art Centre, Edinburgh (2007), Royal Glasgow Institute (2002, 2006). *Works in collections:* City of Edinburgh, Glasgow Museum and Art Gallery, Bank of Scotland, Paintings in Hospitals Scotland. *Commissions:* The Calledonia Hotel, Edinburgh. *Publications:* "Nostalgia", Lemon Street Gallery (2005), "January Light" Lemon Street Gallery (2007). *Signs work:* "MATTHEW J. DRAPER". *Address:* 15/5 Chancelot Terrace, Edinburgh, EH6 4SS. *Email:* matt.draper@hotmail.co.uk *Website:* www.matthewdraper.net

DRING, Melissa Jane, B.Sc. (Hons.) (1989), I.A.I., P.S., F.B.I.Dip. (1988); police forensic artist, portrait painter in pastel and oil, freelance courtroom artist;. *b:* Winchester, 1 Apr 1944. *d of:* William Dring, RA RWS RP. *m:* Michael Little. two *s. Educ:* St. Swithun's, Winchester. *Studied:* Winchester School of Art, R.A. Schools. *Exhib:* R.A., R.P., R.B.A., P.S. *Works in collections:* Northampton Central Museum and A.G., Jane Austen Centre, Bath, Czech Embassy London, Northampton Guildhall. *Commissions:* portraits in private and public collections in oil and pastel; forensic art facial recreations for TV programmes on C4, BBC1, BBC4, ITV3, Open University. *Publications:* Pastel Artist International, The Artist, Jane Austen's Regency World; articles on forensic artwork in Police Review, and The Journal of Audiovisual Media in Medicine. *Principal Works:* New speculative likeness; a forensically researched portrait of Jane Austen, commissioned by the Jane Austen Centre, Bath, 2002. *Signs work:* "Melissa

Dring." *Address:* 10 St. George's Pl., Northampton NN2 6EP. *Email:* m.a.m.j.little@btinternet.com *Website:* www.totallyessential.com

DRLJACHA, Zorica, A.R.B.S.; awarded First Prize British Institute in Sculpture (1961), anatomy drawing competition (1962), Landseer Scholarship, first prize and silver medal (1963), Catherine Adeline Sparkes prize; sculptress in bronze, aluminium, resin, ciment fondu;. *b:* Yugoslavia, 14 Jul 1942. *d of:* Rajna and Ilija Drljacha, detective sergeant. *m:* Mladen. two *d. Educ:* Grammar school (Yugoslavia), Luton College of Technology. *Studied:* Goldsmiths' College under H. W. Parker, F.R.B.S., R. Jones, R.A.; R.A. Schools under C. Mahoney, R.A., Sir Arnold Machin, O.B.E., R.A., Sir Henry Rushbury, K.C.V.O., C.B.E. *Exhib:* R.A. summer exhbns., R.B.S., Alwyn, Chelsea, Forty Hall, Portrait Society, open-air Holland Park, Davies St., Ealing, Chiswick, etc. *Works in collections:* England, U.S.A., Yugoslavia, Germany, Italy, France. *Commissions:* figures for "Battle of Trafalgar" at Madame Tussauds (1966), Expo '67 (Canada). *Address:* 152 Sutton Ct. Rd., Chiswick, London W4 3HT.

DROUGHT, George James, RCamA; NDD Graphic Design (1960). *Medium:* watercolour, oil, etching. *b:* St.Helens, 14 Jun 1940. *s of:* Jane & Samuel Drought. *m:* Mary. one *s. Educ:* Liverpool College of Art, LCC Central School. *Exhib:* RA Summer Exhbn (twice), RI Painters in Watercolour, Royal Hibernian Academy, University of Liverpool, etc. *Works in collections:* Birkenhead Art Gallery, University of Liverpool Art Gallery, many private collections as small watercolours. *Commissions:* steady stream of private commissions. *Recreations:* walking. *Clubs:* Royal Cambrian Academy, Wirral Society of Arts. *Misc:* now working as self-employed artist. *Address:* 46 East Lancashire Road, St Helens, Merseyside, WA11 9AB.

DRURY, Christopher, Dip.A.D. (1970); Artists and Writers programme - Antarctica (2006-7); sculptor, land artist, works on paper, photography. *b:* Colombo, Ceylon, 8 Jun 1948. two *d. Educ:* Canford School. *Studied:* Camberwell School of Art (1966-70, Paul de Moncheaux, Brian Taylor). *Represented by:* Beaux Arts, London. *Exhib:* one-man shows: London, Los Angeles, Leeds, Dublin, Edinburgh, San Jose, San Francisco, De La Warr Pavilion, Bexhill, Mostyn Art Gallery, Wales; mixed shows: Europe, America and Japan. *Works in collections:* British Museum, C.A.S., Leeds City A.G., Whitworth A.G. Manchester, Henry A.G. Seattle, Towner A.G. Eastbourne, Cheltenham A.G., British Government Collection, Wellcome Trust, Vanderbilt University Fine Art Gallery, Nashville. *Commissions:* Site specific works and cloud chambers in Britain, Europe, America and Japan. *Publications:* Songs of the Earth-Thames & Hudson; Chris Drury 'Silent Spaces' - monograph Thames & Hudson. *Official Purchasers:* print collections: V & A, British Museum. Whitworth Art Gallery, Leeds City Art Gallery, Henry Art Gallery-Seattle, Vanderbilt Mus. of Art-Nashville, TN, S.E. Arts & Arts Council England collections. *Principal Works:* Medicine Wheel, Edge of Chaos, Cloud Chambers, Mushroom Works. *Signs*

work: "Chris Drury." *Address:* 18 Eastport La., Lewes, E. Sussex BN7 1TL. *Website:* www.chrisdrury.co.uk

DRY-PARKER, Linda Joan, BA (Hons) Fine Art, Post Graduate Printmaking; Alice Bales Award. *Medium:* oil, watercolour, drawing. *b:* Essex, 16 Jul 1951. *d of:* J.A.Dry-Parker. *m:* S.A.Glassborow. one *s.* one *d. Studied:* Kingston Poly-Newcastle upon Tyne; Brighton School of Art & Design. *Represented by:* Gallery Perutz (UK); Wentworth Gallery (Aus). *Exhib:* Art Asia (HK); Ronald Coles Gallery, Sydney (Aus); Port Jackson Fine Art (USA); L'Attitude Gallery, Boston (USA). *Works in collections:* Walt Disney (HK), Holmes A Court, Mandarion Hotel, Phillipines. *Commissions:* St.Vincents Hospital, Shangri La Hotels, Australian Cancer Council. *Signs work:* 'Linda Dry-Parker'. *Address:* Talycoed Court Lodge, Talycoed, Monmouth NP25 5HR. *Email:* glass@iinet.net.au

DUBERY, Fred, Hon NEAC, ARCA; painter in oil, illustrator; Prof. of Perspective, Royal Academy;. *b:* Croydon, 12 May 1926. *m:* Joanne Brogden. *Educ:* Whitgift School, Croydon. *Studied:* Croydon School of Art, and R.C.A. *Exhib:* RA Summer Show (regularly since the 1950s), Hunting Exhibition, Leicester Gallery, Rowland, Browse and Delbanco, R.A., N.E.A.C., New Grafton Gallery, Trafford Gallery, Markswood Gallery, Patterson Fine Arts, Waterman Fine Art, Alresford Gallery, David Messum Gallery (recently). *Works in collections:* Brighton City A.G., Huddersfield City A.G., Nuffield Foundation, Arts Club Dover St., Worcester College, Oxford, Warburg Inst., London University. *Publications:* Drawing Systems, Dubery and Willats (Studio Vista); Perspective and other Drawing Systems, Dubery and Willats (Herbert Press). *Clubs:* N.E.A.C. *Signs work:* "Fred Dubery." *Address:* Buxhall Lodge, Gt. Finborough, Stowmarket, Suffolk IP14 3AU.

DUCHIN, Edgar, M.A. (Oxon.), B.A. (O.U.); artist in oil and gouache; consultant solicitor; founder chairman, Solicitors Art Group. *b:* 3 Sep 1909. *s of:* Dr. Charles Duschinsky, historian. *m:* Betty Margaret Bates. two *s.* two *d. Educ:* St. Paul's School; Brasenose College, Oxford. *Exhib:* Margaret Fisher Gallery, Hesketh Hubbard Art Soc. (prize winner). *Works in collections:* Prof. Dr. Paul Hodin, Dr. M. Altmann, Mr Nigel Wray, Mrs Alice Schwabe. *Clubs:* Savile. *Signs work:* "Edgar Duchin." *Address:* 16 West Heath Drive, London NW11 7QH.

DUCKER, Catherine, B.A. (Hons.) Fine Art, R.W.S.; painter in water based and oil paints: subject focus is colour and abstracted forms from flowers and the natural landscape. *b:* Wallingford, 24 Apr 1973. *Studied:* Central St. Martin's (1990-91, 1992-96). *Exhib:* Contemporary Art Soc. (1996), Royal Water-colour Soc. (1997), Henley Festival (1997), Royal Academy Summer (2001), Singer and Frielander (2000/2001). *Works in collections:* private collections. *Commissions:* Henley Festival, and various private garden commissions. *Address:* Littlestoke Farm, Littlestoke, Wallingford, Oxon. OX10 6AX. *Email:* catherineducker@hotmail.com

DUDLEY NEILL, Anna, DFA (Lond., 1957), RI (1980); artist in water-colour and oil. *b:* Merton, London, 26 Jul 1935. *d of:* Arthur Leonard Dudley, flooring specialist. *m:* Michael A. Neill. two *s. Educ:* Tolworth Secondary School. *Studied:* Winchester School of Art (1950-54), Slade School of Fine Art (1954-57). *Exhib:* Deist, Belgium (1977, 1979), R.I., Cahors, France (1992). *Works in collections:* R.I. *Clubs:* R.I. *Signs work:* "Anna Dudley." *Address:* 15 Putney Heath Lane, London SW15 3JG.

DUFFIN, Stuart, R.E., R.S.A.; artist in etching, oils; Studio etcher, Glasgow Print Studio; active musician;. *b:* Windsor, 13 June 1959. *Studied:* Grays School of Art, Aberdeen (Dip.Fine Art Printmaking). *Represented by:* Glasgow Print Studio Gallery. *Exhib:* U.S.A., Europe, Israel, Russia, Japan, India. *Works in collections:* Scottish Arts Council, Jerusalem Foundation, Glasgow City Council, BBC, Glasgow University, Karkov Museum. Artist and writer with 'The Moors' multi-media projects. *Commissions:* "Last Supper" oil on canvas for Langside Parish Church, Glasgow. *Address:* 40 Cromarty Ave., Glasgow G43 2HG. *Email:* info@stuartduffin.com *Website:* www.stuartduffin.com

DUFFY, Stephen James, artist, potter, printmaker in linocuts, screen-print, lithography, water-colour, ceramics. *b:* Winchelsea Beach, E. Sussex, 5 Feb 1962. *s of:* James Duffy. *Educ:* Rye Comprehensive. *Exhib:* Rye Soc. of Artists, Fremantle Print Biennial, W.A., Farnham Maltings Gallery, Modern Print Gallery, Wirksworth, Ormond Rd. Printmakers, Grundy A.G., Blackpool, Rye A.G. Easton Rooms, U.A., various mixed exhbns. *Publications:* Rye Nature Reserve, Irish Folk Tales (to be published). *Clubs:* Printmakers Council, U.A., Rye Fishheads. *Address:* 88 New Winchelsea Rd., Rye, E. Sussex TN31 7TA.

DUFFY, Terry, B.A.Hons., M.A.; painter of abstract art in oils on canvas and board, also photography and glass; Chair: British Art and Design Assoc.; Founder: Arena Studios, Liverpool; Dean/Head of Faculty Art & Design, Liverpool (1986-91); 1992 British Council visiting Professor of Fine Art: Hungarian Academy, Budapest;. *b:* Liverpool, 25 Mar., 1948. *m:* Angela. one *s.* one *d. Studied:* Liverpool Art College (1972-75), Liverpool University (1995-97). *Exhib:* one-man shows: Acme London (1976), Air London (1981), Harris Preston (1984), Blom & Dorn, N.Y. (1984), Laing Newcastle (1989), Merkmal Liverpool (1993), New Millennium St. Ives (1997); group shows: New Contemporaries (1976), Sotheby's Fine Art prize Chester (1980), European Artists Stuttgart (1981), Contemporary Arts Soc. (1991-93), John Moores Liverpool (1991), Stroud House Gallery (1998), New Millennium Gallery, St. Ives (1996-2000), International Art Consultants, London (1998-2000), '340 Old Street' London 2003; Lemon Street Gallery, Truro (2005); Der Erste Stock, Berlin (2005); Loop Gallery, Liverpool (2005); Liverpool Cathedral (2007), Venice (2007). *Works in collections:* corporate and private collections in Europe and U.S.A., including Sainsbury, Bosch, Panasonic, B.B.C., A.O.N., Welsh National. *Commissions:* British Lottery "Glass Commission" Unity Theatre Liverpool. *Publications:* "Her Revealing Dress" illustrations, Quartet London (1986), cover Collins "Chopin"

concertos (1992), cover for Edmund White's "Travels in Gay America". *Works Reproduced:* "Lyrical Abstraction" I, II, III, IV, V (1999). *Principal Works:* "Victim, No Resurrection", R.S.Thomas Triptych, Monuments Project. *Misc:* Reviews, media coverage: Studio International, The Guardian, Time Out, Art Scene U.S.A., B.B.C. World News, Art Review, Art World U.S.A., The TUBE, The Independent, Granada T.V., B.B.C. T.V., Artists Newsletter, etc. *Signs work:* "TERRY DUFFY". *Address:* 6 The Kings Gap, Hoylake, CH47 1HE. *Email:* info@terryduffy.info *Website:* www.terryduffy.info

DUFORT, Antony, MA Fine Art (1975), Dip.A.D. (1974) Chelsea School of Art;. *Medium:* public sculptor, painter, printmaker, draughtsman, author, filmmaker. *b:* Belfast, 12 Jun 1948. *s of:* Timothy Nesbitt-Dufort, M.A. Grandson of Doris Travis (Dorothea de Halpert) painter, pupil of Sickert. *Educ:* Ampleforth College, New College Oxford. *Studied:* Central School of Art (1971) under Norman Ackroyd, Winchester School of Art (1971) under John Bellany, Chelsea School of Art (1972-74) under Norman Blamey, painting; Edinburgh School of Art (1974-75) under Dick Hart, printmaking. *Exhib:* RA, NEAC, RWS, RBA, ROI, RP; one-man shows: Leighton House Museum (1988), Maas Gallery (1990), Artbank Gallery, Glasgow (1994), Knöll Gallery, Basel (1994), Milne & Moller, London (1997). *Works in collections:* Permanent collection of The House of Commons, Marylebone Cricket Club, Nottinghamshire County Council, London Oratory School, Eton College, Oriel College, Ampleforth College, Forest of Dean District Council, Hard Rock Café Los Angeles, Brook's Club. *Commissions:* Pope John Paul 2 for the City of Caen, Normandy (2005/06); Baroness Thatcher (full length) for Members' Lobby of the House of Commons (2005/06); 'Testing for Gas', Miners' Tribute Sculpture for Nottinghamshire at Silverhill near Teversal (2004/05). Bust of Cardinal Hume for Ampleforth College (2002/03). 'Fast Bowler' for the MCC at Lord's Cricket Ground (2001/02). Tribute Sculpture for the Miners of the Forest of Dean Cinderford, Glos (1999/2000); Mother and Child, London Oratory School (1995/96). *Publications:* Ballet Steps, Practice to Performance. Clarkson N. Potter, NY and Methuen(1985), revised edition (1991), paperback edition, Hodder & Stoughton (1993). Awarded 'Best Book for Young Adults' (1985, 1991) by New York Public Library. *Signs work:* "Antony Dufort" or "Dufort." (with date). *Email:* antony@dufort.com *Website:* www.antonydufort.com

DUGDALE, Mary, Distinction (Main Subject Art)(Leeds), Dip. U.S.W.A., U.W.S.; painter in pastel, oil, water-colour; art teacher, Girls' Schools, Burnley; Past President, U.S.W.A., Com., U.W.S.;. *b:* Burnley, Lancs., 15 Jul 1921. *m:* Dr. N. Dugdale (decd.). *Educ:* Burnley High School for Girls. *Studied:* Burnley College of Art, Belfast College of Art, City of Leeds Training College (specialised Art). *Exhib:* Five solo exhbns., many group shows, R.U.A., Laing, London. *Works in collections:* Britain, Moscow Germany, Australia. *Commissions:* portraits of many public figures, including Lord Eames, Archbishop of Armagh (now retired). *Publications:* book cover for husband's last book (1997). *Recreations:* painting, gardening, walking. *Clubs:* local art.

Signs work: "M Dugdale". *Address:* Bell-Rotary House, 10-12 Kings Road, Belfast BT5 6JJ.

DUKES, Robert Laurence, Boise Travel Scholarship (1988); NPG Portrait Award (2006);. *Medium:* oil. *b:* Hull, 14 May 1965. *Studied:* Grimsby School of Art (foundation) 1981-84; Slade School of Art, 1984-88. *Represented by:* Browse and Darby, 19 Cork Street, London W1S 3LP. *Exhib:* RA Summer Exhbn (2000-07); Critic's Choice, Wales (ed. A Lambirth)(2006); one-man shows: Browse and Darby (2005, 2008). *Works Reproduced:* RA Illustrated 2004, 2006. *Misc:* Lecturer at National Gallery, teaches at Prince's Drawing School. *Address:* 72 Parkside Estate, Rutland Road, London E9 7JU. *Website:* www.browseanddarby.co.uk

DULEY, Helen Elizabeth, BA, ASGFA; painter of Australian Contemporary and Imaginative landscape, Eco-Art; awards: Artists & Illustrators (UK), Swan-Stabilo (Eur), Winsor & Newton (Eur), Paws (UK). *Medium:* oils, acrylics, pencil. Small and large works. *b:* Bairnsdale, Australia, 18 Sep 1949. *m:* John. one *s. Educ:* La Trobe University, Australia (1971); Monash University, Australia (2007):MVisArt. *Studied:* With the Miriwong (traditional Aboriginal group), Western Australia; Christchurch Art Centre (NZ) Residency; Slade; tutor, Morley College, London. *Exhib:* UA, SGFA, various galleries in London, Great Britain, Australia, and New Zealand (solo shows); Watling Galleries, Gold Coast and Brisbane, Australia (www.watlingart.com). *Works in collections:* nationally and internationally, Japan, Middle East, Australia, New Zealand, Brazil, Poland and Russia. *Commissions:* nationally and internationally. *Signs work:* "HD" or "H Duley." *Address:* 633 Beechmont Road, Lower Beechmont, Queensland 4211, Australia. *Email:* helen.duley@gmail.com *Website:* http://helen.duley.googlepages.com

DU MAURIER-LEBEK, Royston Edward, Foundation Studies Art & Design; BA (Hons) Fine Art Painting. *Medium:* oil, watercolour, collage, mail art, drawing, prints, sculpture. *b:* Stoke-on-Trent, 25 Oct 1954. *s of:* Edward& Dorothey. *Educ:* St.Marks CofE Primary School, Shelton; St.Peter's High School, Penkhull, S-o-T. *Studied:* Northbrook College Union Place, Worthing. *Exhib:* Ben Uri Gallery, Bloomsbury Theatre, ICA (Stonewall Exhbn), Battersea Contemporary Arts Fair, MoMA (Wales); many exhbitions in UK and worldwide. *Works in collections:* 1863 paintings in 84 hospitals, clinics, schools, HIV/Aids clinics 'Art for the Community' project. *Recreations:* collecting Poole pottery and antique silver. *Signs work:* 'Royston du Maurier' or 'Royston'. *Address:* 15 Norman Road St. Leonards-on-sea TN37 6NH. *Email:* roystondumaurier@hotmail.com

DUMITRIU, Anna, BA (Hons), MA Fine Art; Year of the Artist Award (2000), Brighton Festival Arts and Business Award (2001), Personal Development Award-Arts Council (2003), Project Development Grant-Arts Council (2003). *Medium:* mixed media painting, watercolour, printmaking, digital art, live art,

video, installation. *b:* Shoreham-by-Sea, 24 Mar 1969. *d of:* Alan and Joyce Presence. *m:* Dan Dumitriu. one *s. Studied:* University of Brighton (1990-6) studying Fine Art Painting; 2005 onwards PhD in Fine Art. *Represented by:* Phoenix Gallery, Brighton; Scicult.com. *Exhib:* Mariners Gallery, St.Ives; Salford Museum; Gracefield Arts Centre, Dumfries; Islington Museum; Two-Ten Gallery, London. Also: Japan, France, Cuba, Slovenia; Blue Moon Gallery, Tunbridge Wells; LA Centre for Digital Arts, Los Angeles USA; New York Hall of Science, USA; Arena Gallery, Liverpool. *Works in collections:* Science Museum; State Museum, Novorsibirsk, Siberia, Russia. *Commissions:* The Wellcome Trust, Brighton and Hove City Council. *Publications:* Computer Graphics Imaging and Vision 05 Catalogue (cover); SigGraph Catalogue (2004, 2005); article in Arts Business News 'Sci-Art in Motion' (Jun 2004); Aesthetica Magazine (2005); NoParadoxa (Jul 2007); AN Magazine (2007). *Principal Works:* Normal Flora Project, The Institute of Unnecessary Research. *Address:* Flat 6, The Deco Building, 3 Coombe Road, Brighton, BN2 4EQ. *Email:* annadumitriu@hotmail.com *Website:* www.annadumitriu.com

DUNBAR, Lennox, RSA (2005), ARSA (1990); artist in drawing, painting and printmaking; Lecturer in Charge of Printmaking, Grays School of Art, Aberdeen. *b:* Aberdeen, 17 May 1952. *s of:* Lennox Dunbar. *m:* Jan Storie. two *s.* one *d. Educ:* Aberdeen Grammar School. *Studied:* Grays School of Art, Aberdeen (1969-74). *Exhib:* New Scottish Prints (1983, N.Y. and touring U.S.A.), Bradford Print Biennale (1984), Cleveland Drawing Biennale (1989), Intergrafik, Berlin (1990), International Print Biennale Cracow Poland (2000), and many group exhbns. national and international. *Works in collections:* Aberdeen, Paisley, Middlesbrough A.Gs., Portland Museum, Oregon, U.S.A., B.B.C., Mobil Oil, Royal Scottish Academy, Contemporary Art Soc., H.R.H. Princess Royal; Chancellor of the Exchequer. *Signs work:* "Dunbar" or "L.R. Dunbar." *Address:* West Denmore, Auchnagatt, Ellon, Grampian AB41 8TP. *Email:* l.dunbar@rqu.ac.uk

DUNCAN, Clive Leigh, FRBS (1983), RBA (1984), SPS (2005); NDD (1966); sculptor; Principal lecturer and Head of Sculpture, London Guildhall University, Sir John Cass Faculty of Art (1973-93); President, Thomas Heatherly Educational Trust (1974-94);. *b:* London, 1944. *s of:* the late John Charles Duncan. *m:* Janet McQueen, painter. one *s.* one *d. Educ:* John Colet School, Wendover. *Studied:* High Wycombe College of Art (1961-64), Camberwell School of Art (1964-66 under Sidney Sheppard), City and Guilds School of Art (1966-68 under James Butler, R.A.). *Exhib:* R.A., R.B.A., Guildhall, London, G.I., Nicholas Treadwell, Portland Sculpture Pk., Playhouse Gallery, Harlow. *Works in collections:* Britain, inc. Reading Museum and Art Gallery; Spain, U.S.A. *Commissions:* Trafalgar Crown, Royal Mint; The Snowdrop Garden Figure, Child Bereavement Trust. *Signs work:* "DUNCAN." *Address:* Holme Cottage, Shiplake, Henley on Thames, Oxon. RG9 3JS.

DUNCAN, Jean, R.U.A., U.S.W., D.A. (Edin.) 1955, Advanced Dip. printmaking University of Ulster (1981); artist in painting, video and printmaking; Hon. Trustee, Seacourt Print Workshop; Tokyo International Mini-Print Triennial 2005-Jury Award. *b:* Edinburgh, 27 Dec., 1933. *m:* Roderick. two *s.* two *d. Studied:* Edinburgh College of Art (William Gillies, Leonard Rosoman), University of Ulster (David Barker). *Exhib:* solo shows: Guiness Gallery, Dublin, One Oxford St. Gallery, Belfast, Waterfront Hall, Belfast, Hillsboro Fine Art, Dublin. *Works in collections:* Arts Council of N.I., U.C.D. Dublin, U.T.V. Belfast, Northern Bank, A.I.B. Bank, Dept. of Arts, Culture and the Gaeltacht, Irish National Self-portrait collection, Office of Public Works, Dublin, Limerick University, Dundee City A.G., Queen's University, Belfast. *Principal Works:* 'Still Dancers' with composer Piers Hellawell; 'The Fly' with composer Deirdre McKay; 'a pale yellow sky' with Deidre McKay. *Signs work:* Jean Duncan. *Address:* 15 Rugby Court, Belfast, N.I. BT7 1PN. *Email:* jeaniduncan@hotmail.com *Website:* www.jeanduncan.freeuk.com

DUNCAN, Jeremy John, BA Hons Fine Art. *Medium:* oil. *b:* Exeter, 15 Sep 1964. *s of:* Mrs.C.E.Duncan. *Educ:* Exmouth School. *Studied:* Exeter College of Art and Design (1983-4); Gloucestershire College of Art and Design (1984-7). *Represented by:* Waterhouse & Dodd, 26 Cork Stret, London W1S 3ND www.modbritart.com. *Exhib:* RA Summer Exhbn (1996, 1997, 2004, 2005); Laing Landscape Competition (1994, 2000, 2002); ROI (1998, 1999), RWA (1990, 91, 95, 97, 98, 2000, 2001, 2002), Cheltenham Art Gallery, Gloucester Museum, Adam Gallery Bath, Brian Sinfield Burford, Waterhouse & Dodd (2005). *Works in collections:* Eagle Star Insurance (eleven watercolours), Taylor Woodrow (illustrated brochures to various properties, inc.HQ). *Commissions:* Thomas Cole Kinder, Sasha Waddell Associates, Les Routiers Guides, Westbury Homes, many private across UK. *Official Purchasers:* Scheringa Museum, Spanbroek, Holland. *Works Reproduced:* in 'Homes and Gardens', 'Country Homes and Interiors', 'The Complete Oil Painter' by Brian Gorst (Batsford, 2003); Italian Architectural Digest. *Principal Works:* London and New York series. *Recreations:* reading, coin collecting, visiting country houses. *Clubs:* Associate of the Society of Architectural Illustrators. *Misc:* lecturer in drawing and painting, Stroud College. *Signs work:* 'J Duncan'. *Address:* 6 Royal Parade, Bayshill Road, Cheltenham, GL50 3AY. *Email:* jeremyd5@aol.com

DUNCAN, Terence Edward, specialist in display service for museums and personal collections. *Medium:* artist in oil and water-colour. *b:* Harpenden, Herts., 17 Aug 1947. *m:* Mrs.E.D.Bryant-Duncan. three s- *s. Educ:* Manland Secondary Modern, Harpenden. *Studied:* St. Albans School of Art; Harpenden Art Centre. *Exhib:* St. Albans Gallery (1971), Amateur Artists' Exhbn., London (1967), Batchwood Hall, St. Albans. *Works in collections:* permanent collection Red Lion Inn, Westbury-on-Severn. *Publications:* article, Hertfordshire Countryside; woodwork projects Guild of Mastercraftsmen; Traditional Woodworking Tools (Eddington Press, 1989). Lecturing on: woodwork, Oaklands College, Harpenden (1993-97), picture framing, Oaklands College Hatfield Campus (1993-98),

antique furniture restoration, Stanmore College, Middx. (1996-98). *Misc:* Teaching own workshop. *Signs work:* "Terry" with date. *Address:* The Manse, The Village, Westbury-on-Severn, Gloucs. GL14 IPA.

DUNCAN MEYER, Mary Elizabeth Anne, ASGFA; Diploma in Figurative Sculpture (2006-06); fine art tutor; trained as printmaker and painter. *Medium:* watercolour, drawing, prints, sculpture. *b:* London, 27 Jun 1942. *d of:* Daphne Pearson Andrew. *m:* divorced. three *s.* one *d. Educ:* Queens Gate School. *Studied:* Regent St. Polytechnic, Central School of Art (1960-63); Beaux Arts, Paris. *Represented by:* Ian Irving (Agent). *Exhib:* RA (2000); Atrium Library, Cork St., London (1999), Workhouse Gallery (2000), Start Gallery (2003), Cromwell Hospital (2002); Edith Grove Gallery; Stephen Bartley Gallery; Fulham Society of Artists and Potters (2007); Chelsea and Werstminster Hospital (2007); Soc. Graphic Fine Arts (2007). *Works in collections:* Art in Hospitals; bronze sculpture Mother and Child, oil painting Majorca - Doctor Hamami, Head Consultant, Cromwell, and private collections. *Commissions:* Carnavalle Restaurant; portraits (pastel). *Works Reproduced:* Kew Gardens watercolour. *Recreations:* theatre, concerts, opera. *Clubs:* Chelsea Arts Club. *Signs work:* "Elizabeth Duncan Meyer." *Address:* 59 Britannia Rd., London SW6 2JR. *Email:* elizabeth.duncanmeyer@yahoo.com *Website:* http://www.intune.co.uk/Meyer.Duncan

DUNCE, Brian Redvers, P.S. (1992); painter and draughtsman in all media; assoc. senior lecturer, Middlesex University, Heatherley School of Fine Art, the Yehudi Menuhin Music School. *b:* Godalming, 29 Apr 1937. *m:* Veronica. one *d. Studied:* Guildford School of Art, Salisbury School of Art, Reading University, under Jack Rodway, John Kashdan, Peter Startup. *Exhib:* major galleries in U.K., France, Germany, Switzerland, U.S.A. *Works in collections:* Royal Brunei Collection, V.& A. Prints and Drawings, McColls, Price Waterhouse, English Trust. *Works Reproduced:* The Pastel Society 1898-2000. *Recreations:* walking, swimming. *Signs work:* "Brian Dunce." *Address:* The Studios, Wonersh Court, The Street, Wonersh, Guildford, Surrey GU5 0PG. *Email:* b.dunce@mdx.ac.uk

DUNHAM, Susan, Curator, Doll Museum of Oregon, Mem. UFDC, Mem. ODACA; artist, designer and doll maker in porcelain buisque; Owner, Dunham Arts, designer of artist original dolls. *b:* Portland, Oregon, 6 Aug 1943. *d of:* Alan Bowmen Cathey. *m:* Jack Dunham, Jr., DMD. two *s. Educ:* Grants Pass, Oregon High School. *Studied:* University of Oregon (1983-85, Paul Buckner). *Exhib:* U.F.D.C. National Doll Convention (1983), Convention of Dolls, Victoria, Australia (1985). *Works in collections:* Ruth Doll Museum, China; Favel Museum, Klamath Falls, Oregon; Doll Castle Museum, N.J.; Jimmy Carter Library Collection, Ga.; Yokohama Doll Museum, Japan. *Clubs:* Eugene Doll, O.D.A.C.A. *Signs work:* "SUSAN Dunham" hand printed. *Address:* 2460 Cal Young Road Eugene Oregon 97401-5155 USA.

DUNIGAN, Anthony Gordon, SWE; Diploma in Painting (City and Guilds of London Art School, 1974); David Murray Scholarship 1972 and 1974; Philip Connard Award (1973); Oppenheim-John Downes Memorial Trust Awards (2003, 2004). *Medium:* oil, watercolour, wood-engraving, lino-cut. *b:* Skegness, Lincs., 3 Aug 1946. *s of:* Albert & Dorothy Dunigan. *Educ:* George Mitchell School, Leyton, London E10. *Studied:* Hastings School of Art (1968-70), City and Guilds of London Art School (1971-74). *Exhib:* Royal Academy Business Art Galleries (1981); Ernst and Young Exhibitions, Cambridge (1993-94); Mall Galleries; The Moseley Gallery (1998); St.Edmundsbury Cathedral (2002); Fry Gallery, Saffron Walden (2002); annual touring shows with SWE. *Commissions:* many private commissions for paintings and engravings of domestic and church architecture. *Publications:* 'An Engraver's Globe' by Simon Brett (2002). *Clubs:* Society of Wood Engravers. *Misc:* elected to membership of Society of Wood-Engravers (2003). *Address:* 26 Whiting Road, Oulton, Lowestoft, Suffolk, NR32 3QA.

DUNLOP, Alison M., BA(Hons.) (1980), RSW (1990); Greenshield Foundation award (1982, 1986); painter in water-colour, oil; President, SAAC. *b:* Chatham, Ontario, Canada, 24 Mar 1958. *d of:* M.E. Dunlop (decd.). *m:* R.F. Hood. *Studied:* University of Western Ontario, London (1976-78), L'Ecole des Beaux-Arts, Besançon, France (1978-79), University of Guelph, Canada (1979-80), Edinburgh College of Art (1982-83). *Exhib:* Canadian Soc. of Painters in Water-colours, Gallerie Rochon, Toronto, R.S.W., S.A.A.C., Scottish Gallery, Thackeray Gallery, Kingfisher Gallery, Bruton Gallery. *Works in collections:* Canada, U.S.A., G.B. *Signs work:* "DUNLOP" and year. *Address:* Croft Cottage, Crichton, By Pathhead, Midlothian EH37 5UZ.

DUNN, Alfred, ARCA (1961), Hon FRCA; artist;. *b:* Wombwell, Yorks, 4 Oct 1937. *s of:* George Simeon Dunn. *m:* Maureen Angela Dunn. one *s.* one *d. Educ:* Wath-upon-Dearne Grammar School. *Studied:* Royal College of Art (1959-61). *Exhib:* Galerie Buchhandlung Claus Lincke, Dusseldorf (1976), Monika Beck Gallery, Hamburg (1976, 1993), Redfern Gallery, London (1965, 1966, 1969, 1971, 1975, 1978, 1983, 1993), L'Umo del Arte, Milan (1971), Atlantis Gallery (1982), Galarie Julia Philippi, Heidelberg (1994); Das Druckgraphisce work retrospective 70er bis 90er Jahre (1944). *Works in collections:* Manchester City A.G., Cadillac Co., Houston, General Hardware Manufacturing Co., New York, Monika Beck Gallery, Germany, L'Umo del Arte, Milan, Yorkshire Sculpture Park, V. & A., Arts Council, London. *Commissions:* Concourse - Macau Ferry Terminal, Hong Kong; Hotel Victoria, Hong Kong; 574nd Dorothy Weinstein, New York, U.S.A. *Signs work:* "Alf Dunn." *Address:* Little Moss Farm, Trawden, nr. Colne, Lancs. BB8 8PR.

DUNN, Anne, painter, all mediums;. *b:* London, 4 Sep 1929. *d of:* Sir James Dunn, Bt. *m:* (1) Michael Wishart, 1950. one s. (2) Rodrigo Moynihan, 1960. two: *s.* 1951 Francis Wishart (etcher); 1959 Daniel Moynihan (painter) *Studied:* Chelsea, Academie Julian, Paris. *Exhib:* one-man shows, Leicester Galleries (8); Redfern Gallery, London; Fischbach Gallery, N.Y.(8); Philadelphia; Ville de Paris

(2); Gallery 78, Federicton, Canada (2); many group shows worldwide, R.A. (1978-93), Dactyl Foundation New York (1999, 2001), Gallery 55, Mercer Street NY (2005)(5); Tibor de Nagy Gallery NY (2005). *Works in collections:* Arts Council, M. of W., Carlisle City A. G., Columbus Gallery of Fine Arts, U.S., Beaverbrook A.G., N.B., Financial Times Inc. G.B., Commerce Bankshares, Kansas City, Mo., Amerada Hess Corp. N.Y., Xerox Corp. N.Y., Chemical Bank N.Y., Bank of Nova Scotia, Canada, New Brunswick Provincial Art Bank, Canada, The Art Centre, University of New Brunswick, Canada. *Commissions:* numerous, portraits, book illustrations, book jackets. *Publications:* Editor, Art and Literature (1964-68). *Official Purchasers:* numerous. *Works Reproduced:* numerous. *Clubs:* W.I.A.C., Chelsea Arts. *Signs work:* "Anne Dunn." *Address:* Domaine de St. Esteve, Lambesc, B.D.R. 13410, France.

DUNN, Philip, Dip.A.D. (Fine Art) (1968), A.T.C. (1969); painter/printmaker in acrylic, oil, gouache, screenprinting; Mem. Fiveways Artists' Open House since 1990;. *b:* London, 26 May, 1945. *m:* Carole-Anne White. *Educ:* Chiswick Grammar School, London. *Studied:* Twickenham College of Technology (1964), Hornsey College of Art (1964-68), Brighton College of Art (1968-69). *Exhib:* many including London, N.Y., Brighton, Bath, Cheltenham, also twenty solo exhbns. since 1968. Exhib. exclusively through Window Gallery, Brighton since 1982. *Works in collections:* Brighton Centre. *Official Purchasers:* Brighton Health Care NHS Trust. *Works Reproduced:* many, all published by Window Gallery, mainly of Brighton and Hove seafront with or without deckchairs. *Recreations:* gardening. *Signs work:* "Philip Dunn." *Address:* c/o Window Gallery, 59 Ship St., Brighton, E. Sussex BN1 1AE. *Email:* windowgallery@btconnect.com *Website:* www.windowgallery.co.uk

DUNNE, Berthold, Mem. Water-colour Soc. of Ireland (1951); artist in water-colour. *b:* Dublin, 21 Sep 1924. *s of:* Michael D. Dunne. *m:* Barbara Kelly. two d. *Educ:* Christian Brothers Schools, Synge Street. *Studied:* National College of Art, Dublin, under John Keating, P.R.H.A., and Maurice MacGonigal, R.H.A. (1946-51). *Exhib:* R.H.A., Oireachtas Art Exhbn., Water-colour Soc. of Ireland., RHA Banquet exhbn., Case 99, Case 2000 and Case 2004 Lavit Gallery Cork. *Works in collections:* Self-portrait in the National Self-Portrait Collection; one painting in Water-colour Soc. of Ireland Coll.; University of Limerick; watercolour "Low Tide Howth" acquired by Office of Public Works, Dublin. *Signs work:* "Berthold". *Address:* Goa, 29 Shrewsbury Rd., Shankill, Co. Dublin, Eire.

DUNSEATH, Chris, FRBS; BA (Hons); HDipFA (Lond). *Medium:* sculpture in wood, stone and bronze, drawing, prints. *b:* Bangor, N.Ireland, 3 Mar 1949. *m:* Pip. one *s.* two *d. Studied:* Yeovil School of Art (67-68); Gloucestershire College of Art, Cheltenham (68-71); Slade School of Fine Art (71-73); Sculpture Fellow, Cardiff College of Art (73-74); Winston Churchill Travelling Fellowship for Sculpture (92). *Exhib:* London: New Art Centre, Barbican, Warwick Gallery, Serpentine Gallery, Butler's Wharf, Sotheby's Grosvenor Gallery, Flow Gallery,

RBS, Mall Galleries, Rollo Gallery. Regional: Oriel Cardiff, Parnham House, Ikon Birmingham, YSP, Oxford Gallery, Hannah Peschar, Phillips Gallery (Taunton), Brewery Arts (Cirencester), RWA, Met Office, Devon Guild, Botanic Gardens (Edinburgh). *Works in collections:* Arts Council England; Ackerman Foundation, NY, USA; McDermott Collection, Dallas, USA; Dame Stephanie Shirley; The Met Office; University of Leicester; Robert Redford, California, USA. *Commissions:* major bonze for West Bromwich, Sandwell; major bronze for The Waterfront, Dudley (for Richardson Developments). *Recreations:* pilot hot air balloon. *Signs work:* 'CD; CHRIS DUNSEATH; C.DUNSEATH'. *Address:* The Priory, High Street, Hinton St.George, Somerset, TA17 8SE. *Email:* CChrisDunseath@aol.com *Website:* www.axisweb.org/artist/chrisdunseath

DUNSTAN, (Andrew Harold) Bernard, R.A. (A.R.A. 1959: Trustee 1990-95), N.E.A.C., R.W.A. (President 1980-84). *Medium:* painter in oil and pastel. *b:* 19 Jan 1920. *s of:* the late Dr. A. E. Dunstan. *m:* Diana Armfield, R.A. three *s*. *Educ:* St. Paul's School. *Studied:* Byam Shaw School, Slade School of Fine Art. *Represented by:* Thos. Agnew & Sons, Bond St., London. *Exhib:* R.A., NEAC etc., one-man exhbns. at Roland Browse & Delbanco, Agnew's, etc. *Works in collections:* Bristol, Rochdale, Coventry, National Gallery of New Zealand, London Museum, National Portrait Gallery, Royal Collection, Contemporary Art Soc., Arts Council, etc. *Commissions:* many portrait commissions. *Publications:* Painting Methods of the Impressionists, The Paintings of Bernard Dunstan (1993), ed. Ruskin's Elements of Drawing, etc. *Clubs:* Arts. *Signs work:* "B.D." *Address:* 10 High Park. Rd., Kew, Richmond, Surrey TW9 4BH.

DURANTY, Charles Henry, artist in water-colour;. *b:* Romford, Essex, Feb 1918. *s of:* W. H. Duranty, M.C. *m:* Vivian Marguerite (decd). *Educ:* St. Lawrence College, Ramsgate Kent. *Exhib:* Leicester Galleries, Roland, Browse & Delbanco, New Grafton, Mercury, Heal's, Zwemmers, Medici, Thackeray Gallery, London; outside London: Ashgate, Farnham, Rye Art Gallery, Sussex, Brighton Art Gallery, Sussex, Guildford House and Reid's Gallery, Guildford, Westgate Gallery, Winchester, Phoenix Gallery, Lavenham, Blakesley Gallery, Northamptonshire; abroad: Johannesburg, S.A., Galerie Racines, Brussels. *Publications:* Audition (poetry). *Signs work:* "Charles Duranty." *Address:* Albury House, 6 Albury Road, Guildford, Surrey GU1 2BT.

DURBIN, Eleanor Mary, B.A. (Hons.) (1972), M.Phil. (1984); artist/teacher in painting in acrylic, gouache, water-colour, printmaking: etching, woodcut; Head of Art Dept., Guildford High School;. *b:* London, 11 June, 1949. *m:* Martin Henley. one *s*. one *d. Educ:* Twickenham County School, Middx. *Studied:* Hornsey College of Art (1967-68), Leeds University (1972) B.A. Hons., (1984) M. Phil. Fine Art. *Exhib:* Cleveland Drawing Biennale (1975, 1977); Chenil Galleries, Young British Printmakers (1978); Printmakers Council National Touring exhbn. (1979); R.W.S., Bankside Gallery, Contemporary Water-colours (1983); Tradescant Museum of Garden History (1986); National Print Exhbn.

Mall Galleries (1999, 2000). *Signs work:* "Eleanor Durbin." *Address:* 89 Park Rd., Teddington, Middx. TW11 0AW.

DURBIN, Leslie, C.B.E. (1976), L.V.O. (1943), Hon. LL.D. (Cambridge) 1963; silversmith; liveryman of Worshipful Company of Goldsmiths (1943);. *b:* Fulham, London, 21 Feb., 1913. *s of:* Harry Durbin. *m:* Phyllis Ginger, R.W.S. one *s.* one *d. Commissions:* Altar plate for Guildford Cathedral (1938); principal part in making Stalingrad Sword to Prof. R.M. Gleadowe's design (1943); R.A.F. (1941-1945); Regional variants of £ coin design (1983); Coventry Cathedral; Smithsonian Institution, Washington D.C.; St. George's Chapel, Windsor. *Misc:* Apprenticeship and journeyman with late Omar Ramsden (1929-1938). *Address:* 298 Kew Rd., Richmond, Surrey TW9 3DU.

DU TOIT, Susanne, BAFA (Pretoria, SA), MFA (Massachusetts, Boston USA). *Medium:* oil, etching. *b:* S. Africa, 5 Mar 1955. *d of:* Wes & Elise Boshoff. *m:* Pieter. two *s.* two *d. Studied:* University of Pretoria; Massachusetts College of Art, Boston USA. *Exhib:* RA; RWA; in England several galleries, many mixed shows; widely in S. Africa, USA, France. *Works in collections:* private collections internationally. *Signs work:* 'Susanne du Toit'. *Address:* Le Bosquet, Wellingtonia Ave., Crowthorne RG45 6AF. *Email:* susannedt@hotmail.com *Website:* www.susannedutoit.com

DUVAL, Dorothy Zinaida, UA (1962), FBA (1963-78); gold medal, Accademia Italia (1980); silver medal, Paris Salon (1959), art merit, Stock Exchange Art Soc., (1969, 1973, 1981, 1986); oil painter, teacher of art. *b:* Ipplepen, Newton Abbot, Devon, 26 Sep 1917. *d of:* Frederick William Hecht (decd.), mem. London Stock Exchange. *Educ:* Bedford Park High School. *Studied:* Slade School. *Exhib:* R.A., R.P., N.E.A.C., R.B.A., R.O.I., R.Scot.A., U.A., R.S.M.A. (1987, 1990), Paris Salon, Galerie Vallombreuse, Biarritz (1976) awarded Dip. of Merit (1986); one-man shows: Saffron Gallery, Saffron Waldon, Broadstairs Library (1978), Margate Library (1979), Westminster Gallery U.A. exhbn. annually (1962-97). *Works in collections:* Grenadier Guards, H.Q., (Harry Nicholls, V.C.). *Signs work:* "D. Z. Duval." *Address:* 166 Percy Ave., Kingsgate, Broadstairs, Kent CT10 3LF.

DYNEVOR, Lucy, (née Rothenstein); painter in oil and pastel, and formally conservator of works of art; Graduate Diploma, Garden Conservation. *b:* Sheffield, 1934. *d of:* Sir John Rothenstein. *m:* Lord Dynevor; (divorced), present husband Simon Carter. one *s.* three *d. Educ:* The Old Palace, Mayfield, Sussex. *Studied:* Ruskin School of Fine Art in Oxford and conservation of art with Dr. Helmuth Ruhemann; Architectural Assoc., London 1991-4. *Exhib:* one-man shows: University College of Swansea, New Grafton Gallery, London (1991); mixed shows include Crane Kalman Gallery (1995). *Works in collections:* UK, Canada, USA. *Clubs:* Chelsea Arts Club. *Signs work:* "L.D." or "Lucy Dynevor." *Address:* Higher Easthams House, Crewkerne, Somerset TA18 7QQ.

DYRENFORTH, Noel, artist in batik. *b:* London, 17 Jun 1936. *s of:* Harold and Rachel Dyrenforth. one *s. Educ:* St. Clement Danes, London; C.A.C. Bursary (1977); Craftsmen-in-residence Arts Victoria '78, Toorak State College; study/travel in U.S.A., Indonesia, India, China. *Studied:* Goldsmiths' College of Art, University of London, Central School of Art, London. *Exhib:* one-man shows: 1965-2003: Cambridge, London, Coventry, Bradford, Loughborough, Oxford, Nottingham, L.A. (U.S.A.), Lincoln, Hull, Halifax, Melbourne (Australia), Bremen and Cologne (Germany), Banbury, Tokyo & Kyoto (Japan), Indonesia, Guizhou University (China), Boston USA and over 130 mixed exhbns. *Works in collections:* V. & A., and six others. *Publications:* Batik with Noel Dyrenforth by J. Houston (Orbis Publications, London); The Technique of Batik by Noel Dyrenforth (Batsford Publishing Co. 1988), new paperback issue (1997), Batik- Modern Concepts and Techniques by Noel Dyrenforth (Batsford, London 2003), 'Art Textiles of Great Britain' (Telos Publications 2006). *Signs work:* 'NDyrenforth'. *Address:* 11 Shepherds Hill, Highgate, London N6 5QJ.

E

EADES, Patricia, HS. *Medium:* watercolour, pastels, oils. *b:* Esher, Surrey, 17 Mar 1936. *d of:* Mr & Mrs L R Randall. *m:* Edwin John Eades. one *d. Educ:* St.Joseph's Convent, East Molesey, Surrey. *Studied:* mainly self-taught. *Exhib:* HS, Wells; SWA; Llewelyn Alexander Gallery; Robin McInnes, Island Landscapes, IOW; various island exhibitions. *Publications:* IOW County Press calendar 2006. *Recreations:* reading, gardening. *Clubs:* Island Art Groups. *Signs work:* 'PE' (monogram), 'P.A.EADES', 'Patricia Eades'. *Address:* 'Serendip', Fine Lane, Shorwell, Isle of Wight PO30 3JY.

EALES, Elisabeth Jennifer, SWA; SFP(retd). *Medium:* watercolour. *b:* Exeter, Devon, 29 Dec 1934. *d of:* Mr & Mrs Richard Tadman. *m:* Paul Eales,LLB (solicitor). one *s.* one *d. Educ:* Clifton High School, Bristol. *Studied:* mainly self-taught; also attended SCOLA, Sutton, Surrey, Adult Education Classes. *Exhib:* Westminster Gallery, Mall Galleries; Le Mur Vivant Gallery, London; Sofiero Castle, Helsingborg, Sweden; SBA, and other galleries in UK. *Works in collections:* many private individuals in UK and abroad, including USA, Holland, Kenya, East Africa, New Zealand. *Commissions:* private commissions. *Recreations:* gardening, grandchildren and family, cooking, theatre and history of art. *Signs work:* 'EJE'. *Address:* Park Cottage, Park Road, Banstead, Surrey SM7 3DL.

EAMES, Angela, B.A.Hons., H.D.F.A., M.A.(Computing in Art and Design); artist/lecturer in drawing/electronic media;. *b:* Malmesbury, Wilts., 28 May, 1951. *m:* Bill Watson. *Educ:* Woking County Grammar School. *Studied:* Bath Academy of Art (1971-74, Michael Kidner), Slade School of Art (1974-76, Tess Jaray, Noel Forster), Middlesex University (1991-92, John Lansdown). *Exhib:* widely, including London, Berlin, Linz, Bratislava and the U.S.A. *Misc:* Work commissioned and in private collections. Lectures: Associate Senior Lecturer in

Computer Aided Studies, University of Wolverhampton. *Signs work:* "A. Eames." *Address:* 15 Chapter Rd., Kennington, London SE17 3ES.

EARLE, Donald Maurice, A.T.D., D.A.E., M.Phil., Ph.D., F.R.S.A.; artist; taught art in variety of secondary schools (1951-88);. *b:* Melksham, Wilts., 15 Aug 1928. *m:* Jennifer Mary Isaac. one *s.* one *d. Educ:* Trowbridge (Wilts.) Boys' High School. *Studied:* W. of England College of Art, Bristol (1944-47, 1949-51). *Exhib:* N.E.A.C., R.W.S., R.W.A., R.B.S.A., Eastern Arts, Artists in Essex, Colchester Art Soc., Gainsborough House Print Workshop, and one-man shows in public galleries. *Works in collections:* work in private and public collections in Britain and France. *Official Purchasers:* House of Lords. *Signs work:* "D. M. Earle." *Address:* 50 Maltese Rd., Chelmsford, Essex CM1 2PA.

EASTON, Arthur Frederick, Surrey Dip. (1964), R.O.I. (1979), N.S. (1980); Dip. of Merit for Painting, University of Arts, Italy (1982); Pres. Reigate Soc. of Artists; artist in oil and water-colour, art teacher. *b:* Horley, Surrey, 9 Feb 1939. *s of:* Frederick William Easton. *m:* Carolle. three *d. Studied:* Reigate School of Art and Design (1961-64). *Exhib:* R.A., R.O.I., R.B.A., N.S., R.P., N.E.A.C.; 20 one-man shows; 14 shared shows; 36 mixed shows. Prize winner Upper St. Gallery (1973), Hunting Art Prize exhbn. (1990), International Arts Fair, Olympia (1991). *Works in collections:* Museum of British Labour. *Works Reproduced:* in The Artist, Quarto Publishing, Leisure Painter; posters, Ikea of Sweden; greetings cards, Les Editions Arts et Images du Monde. *Clubs:* Reigate Soc. of Artists. *Signs work:* "A. Easton." *Address:* 4 Winfield Grove, Newdigate, Surrey RH5 5AZ.

EASTON, Bella, Postgraduate Diploma (2000), B.A. (Hons.) (1993), Fine Art painting; B.Tec. Nat. Dip. (1990) Art and Design; painting in oil, printmaker in etching and silkscreen;. *b:* Epsom, Surrey, 28 Dec, 1971. *m:* Daniel Wray. two *s. Studied:* Suffolk C.F.E. (1988-90), Winchester School of Art (1990-93), Fellowship in Printmaking, City & Guilds of London Art School (2000-02), Royal Academy of Art (1997-2000). *Exhib:* Panter & Hall, London (2002), Japan (2001), event; John Russell Gallery, Suffolk (2002), 4011/2 Open Studio (2001), Curwen Gallery, London (2001), Summer Show (2001, 2000, '99, '98), Thompson's Gallery, London ('99), N.E.A.L, London ('98, '97), Discerning' Eye, London ('98). *Works in collections:* M. & G. Ltd., R.W.A., Tesco's, San-Ei Gen F.F.I. (U.K.), B.M.W. (G.B.) Ltd., Rover Group. *Commissions:* Tesco's 'a bag for life'; Rover Group Motor Show. *Publications:* limited edition books: English Fish in Foreign Lands, Japan (2001), Alf'n'Betty, (1998), Royal Academy Summer Exhibition illustrated catalogue (2001), R.A. Magazine (June 2000 issue), Royal Academy greeting card published by Canns Down Press. *Misc:* Awards: Japan 2001 subsidy (2000), R.O.S.L. Arts travel scholarship (2001), MacFarlane Walker Trust (2000), David Murray Prize (2000), The Gen Foundation for research in Japan (2000), The Worshipful Company of Painters/Stainers ('97-'00), Lever Hulme Scholarship, ('97-'00), M&G Purchase

Prize, ('98), R.W.A. – Bursary, ('98), etc. *Signs work:* "Bella Easton." *Address:* 33 Jansen Walk, Battersea, London SW11 2AZ. *Email:* bella.easton@virgin.net

EASTON, David William, R.I. (1985), N.D.D. (1956), B.Ed. (1976); painter in water-colour, pastel, acrylics, gouache;. *b:* Leicester, 29 Aug 1935. *s of:* John Donald Easton. *m:* Shirley. two *s.* one *d. Educ:* Wyggeston School, Leicester. *Studied:* Leicester College of Art (1952-56). *Exhib:* R.A., P.S., R.I., and many galleries throughout the U.K. *Publications:* Watercolour Flowers (Batsford, 1993), and Watercolour Inspirations (Batsford, 1997), both re-issued in paperback (2001). *Signs work:* "David Easton." *Address:* 9 Evington La., Leicester, LE5 5PQ.

EASTON, Frances, 1st Class Dip. (Florence, 1960); painter of landscapes, nudes and still life in oil. *b:* Kenya. *d of:* Brig. G.L. Easton, M.C. (decd.). *m:* Keith Stainton. three s- *s.* three s- *d. Educ:* Wycombe Abbey. *Studied:* Accademia di Belle Arti, Florence (1957-60, Prof. Giovanni Colacicchi). *Exhib:* one-man shows: London, Paris, Rome, most F.B.A. socs., Paris Salon (1977), Laing Competition (1986), Venice - Treviso (award). *Works in collections:* U.K., France, Canada. *Commissions:* Kennedy Inst., London (Founder's portrait); Suffolk/W. Germany 'Twinning' landscape of Gainsborough's birthplace. *Clubs:* Hesketh Hubbard Art, Hurlingham, The Arts. *Signs work:* "Frances Easton (Stainton)." *Address:* 5 Chelsea Studios, 410 Fulham Rd., London SW6.

EASTON, Shirley, S.W.A. (1988-92), N.D.D. (1956), A.T.D. (1957); painter in water-colour and acrylic;. *b:* Leicester, 28 Apr 1935. *d of:* Herbert A. Swift. *m:* David Easton, R.I. two *s.* one *d. Educ:* Gateway Girls' School, Leicester. *Studied:* Leicester College of Art (1952-57, D.P. Carrington). *Exhib:* R.A. (1986), R.I. (1985-2001), S.W.A. (1988, 1990, 1991). *Signs work:* "Shirley Easton." *Address:* 9 Evington La., Leicester LE5 5PQ.

EASTON, Timothy, Heatherley's Scholarship, London (1966), Elizabeth Greenshields Memorial Award, Montreal (1973); Winston Churchill Travelling Fellowship (1996); painter in oil on canvas, sculptor in bronze. *b:* 26 Aug 1943. *s of:* Dendy Bryan Easton, MIHort., DHRU. *m:* Christine Darling. two *d. Educ:* Christ College, Brecon. *Studied:* Kingston School of Art (1960-64), Heatherley School of Art (1966-67). *Exhib:* Chicago, Kansas, Los Angeles, Washington, New York and various Art Expos in America between 1968 and 1987; London and provinces from 1970 onwards; Germany, Luxembourg and Jersey 1984-1987. *Works in collections:* Hereford City A.G. *Publications:* John Hedgecoe's Nude Photography (Ebury Press, 1984), Timothy Easton, Oil Painting Techniques (Batsford, 1997). *Signs work:* "Timothy Easton" or "Easton." *Address:* Bedfield Hall, Bedfield, Woodbridge, Suffolk IP13 7JJ.

EASTOP, Geoffrey Frank, N.D.D. (1951), A.T.D. (1952), F.S.D.C. (1979); lecturer, potter. *b:* London, 16 Jan 1921. *s of:* Charles Alfred Eastop. *m:* Patricia Haynes. three *s.* one *d. Educ:* St. Olave's Grammar School. *Studied:* Goldsmiths' College (1949-52); Academie Ranson, Paris (1952-53). *Exhib:* V. & A., London

(1983-95), Stuttgart (1982), Cologne (1983), International Ceramics, Holland (1990), Contemporary Ceramics, London (1991) (solo); Touring retrospective: Portsmouth City Museum, Newbury Museum, Holburne Museum, Bath (1992-93), Berkeley Sq. Gallery, London (1995, 1998-99, 2001, 2003); Osborne Samuel Gallery, London (2005, 2007). *Works in collections:* V. & A., National Museum of Wales, Fitzwilliam Museum, Cambridge, Southampton Museum A.G., Reading Museum, B'ham City Museum, Portsmouth City Museum. *Commissions:* Tiles mural incorporating Reading coat of Arms from a design by John Piper. Wall and floor tiles Robinson College, Cambridge and numerous others. *Publications:* 'The Hollow Vessel' (1980), 'Forty years of change in Studio Pottery' (1993), 'Geoffrey Eastop A Potter in Practice' (1999). *Clubs:* Craft Potters' Assoc. of Gt. Britain, Society of Designer Craftsmen Fellow. *Address:* The Old Post Office, Ecchinswell, Newbury, Berks. RG20 4TT. *Website:* www.bsgart.com

EATWELL, David, painter in oil, landscape, abstract and cubism. *b:* 1 Jun 1960. *Educ:* Hereford High School. *Exhib:* Lower Nupend Gallery, one man shows - Wood for the Trees, Lees (1996), Recent Paintings (1997, 1998), Recent Paintings - Christmas (1998), 5th Exhibition (1999). His paintings are on permanent exhibition at the Lower Nupend Gallery, 6' Exhibition 2000, 7' Exhibition 2002. *Signs work:* "DAVID EATWELL." *Address:* c/o Lower Nupend Gallery, Cradley, Nr. Malvern, Worcs. WR13 5NP. *Website:* www.gallery-modern-art.com

ECCLESTON, Harry Norman, O.B.E., P.P.R.E. (1975-89), Hon. R.B.S.A. (1989), R.W.A. (1991), P.R.E. (1975), R.W.S. (1975), R.E. (1961), A.R.E. (1948), A.R.C.A. (1950), A.T.D. (1947), A.R.W.S. (1964), Hon. N.E.A.C. (1996); Hon Dr. of Arts, University of Wolverhampton (2003); engraver in all processes; artist in oil and water-colour; artist designer at the Bank of England Printing Works (1958-83);. *b:* Bilston, Staffs., 21 Jan 1923. widower. *s of:* Harry Norman Eccleston. two *d. Educ:* Wednesbury County Commercial College. *Studied:* Birmingham College of Art (1939-42) and R.C.A. (1947-51). *Exhib:* R.E., R.W.S., N.E.A.C., R.B.S.A., etc. *Works in collections:* Ashmolean Museum, Bank of England Museum, Black Country Museum, Birmingham Museum, British Museum, Fitzwilliam Museum, Royal Collection, Windsor, V.& A. Theatre Museum. *Clubs:* Arts. *Signs work:* "H. N. Eccleston." *Address:* 110 Priory Rd., Harold Hill, Romford, Essex RM3 9AL.

ECCLESTON, Margaret, N.D.D. (1954), A.T.D. (1955), B.A. Hon. Ed. (1955); painter in oil, pastel and watercolour; retired from full time education, now giving private workshops, invited tutor at St. Ives School of Painting. *b:* Worcestershire, 30 Mar 1934. two *d. Educ:* Holy Trinity Convent, Kidderminster, Worcs. *Studied:* Birmingham College of Art, under Marion Mackay (textile design). Also studied textiles, painting and pottery. *Exhib:* recent exhibs. include - Contemporary Print Show, Barbican Centre, London; Mariners Gallery, St. Ives, Penhaven Gallery, The New Craftsman, Printmakers Gallery; St. Ives Soc. of Artists,:solo exhib. St. Ives 1999 & 2002, Gordes, Provence, France, 2000. *Works*

in collections: New York and Paris. *Commissions:* private in England, Guernsey and USA. *Publications:* History of Moseley, Birmingham, St. Ives Illustrated Diary 2004 & 2005, St. Ives Illustrated Diary St.Ives Publication. *Clubs:* Porthmeor Printmakers, St. Ives, Dartmouth Art Soc., St. Ives Soc. of Artists. *Signs work:* "Margaret Eccleston." *Address:* Chatwell House, 9 Tuckers Brook, Modbury, S.Devon PL1 0TX.

EDEN, Max Nigel Byron, N.D.D. (1950), A.T.D. (1951); painter in oil, acrylic, water-colour;. *b:* St. Helens, Lancs., 12 Nov 1923. *s of:* Isaac Eden. *m:* Valerie Currie. one *s.* one *d. Educ:* Cowley School, St. Helens (1928-41), Borough Rd. College, London (1942-43, 1947-48). *Studied:* Liverpool College of Art (1948-51), Ecole des Beaux Arts de Paris (1951-52), Copenhagen Academy (1954-55). *Exhib:* In France, Denmark, England, U.S.A., Canada and Spain. Retrospective, 50 works (6 Oct-25 Nov 2005, Liverpool University). *Works in collections:* Southport Atkinson Gallery; private collections: Leo and Jilly Cooper, also in Europe, U.K., U.S.A., and Canada. *Signs work:* "Eden." *Address:* 7 Baker's Lane Churchtown Southport Merseyside PR9 9RN. *Email:* max.eden@btinternet.com

EDGERTON, Charmian, B.A. (Hons.) (Graphic Design), S.B.A., S.W.A.; painter in pastel;. *b:* 16 Sept., 1944. *m:* Nick Edgerton, psychologist. one *d. Educ:* Hillcourt School, Dublin. *Studied:* Zurich Kunstgeverbe Schule (1961), Dublin (1962, K. McGonigal), Stoke-on-Trent Polytechnic (1967, graphic design/illustration). *Exhib:* Medici (1991), Alresford Gallery (1993), Gallery Artist of John Thompson Gallery and Alresford Gallery, Aldburgh and Albemarle St., assorted Opens, Barry Keene Gallery, Henley, Blackheath Gallery SE3, John Noott Gallery, Broadway, Pheasantry Fine Arts, Headcorn, Kent, 20th Century Gallery, Windsor, John Falle, Jersey. *Publications:* Pastel Painting, and Flowers and Plants Ed. Jenny Rodwell (Cassell, 1993); author, Learn to Draw Flowers (Harper Collins); regular contributor to Leisure Painter magazine, and demonstrator for Rowney's Pastels. *Signs work:* "Charmian" and "C.P.E." *Address:* 13 Camden Row, London SE3 0QA.

EDMONDS, Angela, B.A. Hons. Fine Art (1990), M.A. (1997); artist in mixed media drawing, assemblage, photoworks; part-time lecturer;. *b:* London, 26 Nov., 1946. *m:* Brian. one *s.* one *d. Educ:* Hendon County Grammar School. *Studied:* Watford College of Art (1985-86), University of Herts. (1986-90), Middlesex University (1995-97). *Exhib:* solo shows: Ten Year Retrospective, Attenborough Centre, Leicester (2004); Moor Park Mansion (1989), Flower Gallery, London (1991), Harlequin Centre (1992); 'Landmarks', Cyberaxis, curator (2000); The Bull Gallery, Barnet (2001), Hertford Museum (2001); two-person show: Knapp Gallery, London (1995); group shows: (1988) Camden Art Centre, Wexner Center, U.S.A., R.A.;: Ikon Gallery, B'ham, Conference Centre, Brighton (1991), Business Design Centre; (1994): Arts - Fife Touring; (1995): Leicester City Gallery, Kettles Yard, Cambridge; (1996): Stoke Newington Gallery; (1997): Contact Gallery, Norwich; (1999): Bilston Gallery, Osterley Park

(2001); Ferens Gallery, Hull, Margaret Harvey Gallery (2000), Mainzer Kunstpreiz (2001); The Place, Letchworth (2002); Essex University, Colchester (2005), The Courtyard, Hertford (2006); Faith House Gallery, Dorset (2007). *Works in collections:* Glaxo Plc., Aldenham School, Watford Museum, Capital & Counties Plc., Bushey Museum, Ruskin Museum, and many private collections. *Commissions:* 1989-92: drawings on site - The Harlequin Centre Development.

Prizes: 1989: 1st Prize 'Hertfordshire Open' touring, 'Hunting Group Art prizes' touring; 1992: 1st Prize 'Drawings for All' Gainsborough House, touring. *Publications:* awards: Paul Hamlyn 1997, Year of the Artist 2000. *Recreations:* dancing. *Signs work:* "Angela Edmonds" or not at all. *Address:* 102 Oaklands Ave., Oxhey, Watford, Herts. WD19 4LW.

EDWARDS, Alan C.L., B.A. (Hons.) (1982), P.G.C.E. (1983), A.T.D. (1983), M.Ed. (1990); painter/teacher; Chair N.A.P.A.;. *b:* 1947. *s of:* C.L. Edwards. *m:* Carmel Wood. two *s.* two *d. Studied:* Laird School of Art (1965-67), Liverpool Polytechnic (1979-83), Liverpool University (1986-90). *Exhib:* Royal Academy London (Stowells Trophy); Walker Art Gallery, Liverpool; Ainscough Gallery, Liverpool; Hanover Gallery, Liverpool; Williamson Art Gallery, Birkenhead; Black Sheep Gallery, North Wales; Theatre Clwyd, North Wales; Durham Museum and Art Gallery; RBSA Galleries, Birmingham; Westminster Gallery, London; Grosvenor Museum, Chester; Long Beach Arts, California, USA; The Mariners Gallery, St. Ives; Gold Gallery, Edinburgh. *Works in collections:* England, N.Z. and Ireland. *Publications:* Visual Resource Packs for Teachers, International Artist Oct/Nov 2001. *Signs work:* "Alan Edwards." *Address:* 6 Berwyn Boulevard, Bebington, Wirral, Merseyside CH63 5LR. *Email:* alan.edwards420@ntlworld.com *Website:* www.alan-edwards-artist.com

EDWARDS, Benjamin Ralph, C. & G. Dip. (1972), R.A.S. Cert. (1977), A.T.C. P/G Goldsmiths' College (1978); painter/etcher in black and white etching, drawing, charcoal and pencil, lecturer; painting tutor P/T City and Guilds Art School, London. *b:* London, 11 Dec 1950. *s of:* Eric Fredrick Edwards. *m:* Ylva. one *s. Educ:* St. Christopher School, Letchworth, Herts. *Studied:* pre college with Capt. P.J. Norton, D.S.O., R.N.; City and Guilds Art School (1968-72, Eric Morby), Atelier 17, Paris (1972-73, S.W. Hayter), R.A. Schools (1973-77, Roderick Barret). *Exhib:* R.A. Summer Exhbn. (1977 onwards), Kanagawa Prints, Okohama, Japan (1982-84), R.E. (1969-75). *Works in collections:* V. & A., Wellesley College Library, Mass., Newberry Library, Chicago, Bridwell Library, Dallas, Texas. *Publications:* illustrated, The Four Seasons at Parkgate Cottages (Parkgate Press), A Fox under my Bed (Macmillan). *Address:* The Parkgate Press, 7 Argyle Rd., N. Finchley, London N12 7NU.

EDWARDS, Brigid, B.Sc. (Hons.); artist in water-colour on vellum;. *b:* London, 16 Feb 1940. *m:* R.J. Edwards. *Educ:* Our Lady of Sion, London, University College, London. *Studied:* Central School of Art (1960-63). *Represented by:* Thomas Gibson Fine Art Ltd. *Exhib:* R.H.S., R.B.G. Kew, R.A.,

Thomas Gibson Fine Art, Beadleston, N.Y., S. H. Ervin, Sydney, Yasuda Kasai Museum of Art, Tokyo; National Gallery of Modern Art, Edinburgh; The Ashmolean Museum, Oxford. *Works in collections:* Hunt Inst., Carnegie Mellon University, Penn., R.B.G. Kew. *Publications:* illustrated: 'Primula' monograph (Batsford). *Signs work:* "Brigid Edwards" or not at all. *Address:* Tregeseal House St. Just Penzance Cornwall TR19 7PW.

EDWARDS, C.C.G., *Medium:* sepia, watercolours and silverpoint, drawing, prints, oil; new work on English oak panels and handmade paper. *b:* London, 3 May 1936. *m:* Georgina. two *s. Educ:* Sir George Monoux Grammar School, London. *Studied:* attached to studio of Thomas Kennedy, London, for ten years. *Exhib:* RA, Paris Salon, Royal Cambrian Academy, Royal Institute of Oil Painters, numerous galleries. *Works in collections:* private collections in USA, Canada, France, Germany and Australia. *Publications:* cover of Wessex Magazine and Dorset Magazine; La Revue Moderne, Paris. *Signs work:* 'Edwards'. *Address:* Burlton Cottage, Shillingstone, Dorset DT11 0SP. *Website:* www.ccgedwards.com

EDWARDS, Gareth, RWA, NSA, BA Hons Art History. *Medium:* painting and sculpture. *b:* Berkshire, 31 Mar 1960. *m:* Rachael Reeves. two *d. Educ:* Kennylands Boarding School, Berkshire. *Studied:* London University (Art History); Goldsmiths (ATC). *Represented by:* Hart Gallery, London; Caelum Gallery, New York. *Exhib:* RA; Campden Gallery; Hart Gallery; Lemon St. Gallery, Truro; Bird & Davis, London; RWA Bristol; Newlyn Art Gallery, Newlyn; NSA; National Maritime Museum, Falmouth; Caelum Gallery, New York, USA; Art Fairs: London, Miami, Geneva, Nimes. *Works in collections:* Falmouth Art Gallery; Dr John & Kit Hart Collection, Nottingham; international. *Commissions:* Holmes Place Fitness; Dr John & Kit Hart Collection, Nottingham; Anne O'Brien; Saatchi & Saatchi. *Publications:* 'Painting in St.Ives since 1960' by Peter Davis (St.Ives Press, 2007). *Works Reproduced:* in Cornwall Today, Inside Cornwall, Galleries mag, RA magazine. *Principal Works:* Luxe Eterna (Frankie & Jackson), Emotional Weather. *Recreations:* poetry, interior and garden design; collects contemporary ceramics. *Clubs:* Newlyn Society of Artists. *Misc:* runs 'Gareth Edwards Painting School'. *Signs work:* 'gareth edwards' or 'GARETH EDWARDS'. *Address:* 'Valley View', Lamorna Cove, Penzance, Cornwall TR19 6XN. *Email:* gaz.ed@talktalk.net

EDWARDS, John, A.R.B.S.; painter and sculptor; Head of Painting, Sculpture, St. Martin's School of Art (1980-88);. *b:* London, 3 Mar., 1938. *Studied:* Hornsey School of Art, Leeds University Inst., and L'Cambre Brussels. *Works in collections:* Arts Council, British Council, Belgian Government, C.A.S., C.N.A.A., Govt. Art Collection, Gulbenkian Foundation, Solomon R. Guggenheim Museum, N.Y.C. *Commissions:* Southampton University, Hackney Council, etc. Fellowships: British Council Scholarship Brussels, Winston Churchill Fellowship, Leverhulme Fellowship, London Arts Board, Pollock-Krasner Foundation Grant. *Signs work:* "John Edwards." *Address:* (studio) 52

Isledon Rd., London N7 7LD. *Email:* johnedwards. artist@btopenworld.com *Website:* www.johnedwards-artist.com

EDWARDS, John Colin, RP, Cert. RA Schools; Silver and Bronze Medallist R.A. Schools;Elizabeth T. Greenshield Art Foundation Award, Canada (1970, 1972); World Wildlife Fund Art Award (1986).portrait, nude painter in oil, pencil, chalk, etc.;. *b:* Kidderminster, 23 Aug 1940. *s of:* William Edwards. *m:* Patricia Rose, M.Sc. two *d. Educ:* Sladen School, Kidderminster (1951-53), Stourbridge Art School (1953-55). *Studied:* Pietro Annigoni in Florence; R.A. Schools;. *Exhib:* Tate Gallery, NPG, RA, RP, Windsor Castle, SWLA, Tryon, Malcolm Innes and Solent Galleries. *Works in collections:* H.M. The Queen; Baroness Thatcher, O.M.; Royal Collection, Windsor; Adjutant General's Corps; Royal College of Radiologists; The Law Society; Carpenters Company; Cambridge, Oxford, Aston, Leicester Universities, Tate Gallery, Ashmolean Musuem, etc. *Commissions:* Oxford University Press; Taylor Hackford; Edmund de Rothschild; Penelope Keith; Helen Mirren; The Hon. William Hague, MP; Institute of Civil Engineers; Lord Mar and Killie; Institute of Structural Engineers. *Publications:* Tate Gallery, Mitchell Beazley, Collins Publications, etc. *Official Purchasers:* Royal Collection Windsor; House of Commons; Tate Gallery; Sultanate of Oman. *Works Reproduced:* Mitchell Beazley, Paper House, Cosmopolitan, Tatler. *Principal Works:* H.M. The Queen; Baroness Thatcher, O.M.; William Hague, M.P. *Recreations:* classical music. *Signs work:* "John Edwards" and "Edwards." *Address:* Chesterville Gallery and Studio, 163 Chester Rd. North, Kidderminster, Worcs. DY10 1TP. *Email:* holbine@aol.com *Website:* www.johnedwardsrp.com

EDWARDS, Karen, BA Hons Fine Art. *Medium:* oil on canvas. *b:* London, 8 Jan 1961. *d of:* Douglas Roopnarine. *m:* Simon Edwards. *Studied:* University of Newcastle upon Tyne. *Represented by:* Cube Gallery, Bristol. *Address:* 6 Ninetree Hill, Cotham, Bristol BS1 3SG. *Email:* KarenEdward@blueyonder.co.uk

EDWARDS, Malcolm, RCA, B.Arch, RIBA. *Medium:* watercolour and mixed media. *b:* Liverpool, 24 Jan 1934. *m:* Elizabeth. *Educ:* Hawarden Grammar School. *Studied:* Liverpool University. *Exhib:* Pastel Society; RI; St.Davids Hall, Cardiff; Tegfryn Gallery, Menai Bridge; Hen Capel Gallery, Llangollen; John Davies Gallery, Stow on the Wold. *Works in collections:* National Library of Wales; Clwyd Fine Arts Trust; Contemporary Art Society for Wales; National Museum & Gallery of Wales; international. *Commissions:* Clwyd Fine Arts Trust. *Signs work:* "Malcolm Edwards". *Address:* Caeronwy, Rhosemor Road, Halkyn, Holywell, Flintshire, CH8 8DL. *Email:* malcolmedwards@mac.com

EDWARDS, Mary Elizabeth, *Medium:* mixed media, acrylic/pastel, oil. *b:* Coventry, 7 Mar 1943. *d of:* James and Hilda O'Nions. *m:* David Edwards. one *s.* two *d. Studied:* self taught. *Exhib:* RA Summer Exhbn; Herbert Art Gallery Open, Coventry; Llewelyn Alexander, London; RWA Bristol Open; St.David's Hall, Cardiff. *Clubs:* Wye Valley Art Society; Glos Society of Artists. *Misc:*

Committee Member Forest of Deam Open Studios, Art Trail. *Signs work:* 'M.E.'. *Address:* Lindor's Farm, St.Briavels, Lydney, Glos GL15 6RP.

EDWARDS, Peter Douglas, BA Hons Fine Art; BP Portrait Award First Prize (National Portrait Gallery). *Medium:* painter, oils. *b:* Chirk, 20 Nov 1955. *s of:* Harry William Edwards. *m:* Lesley Sutherland. three *s.* one *d. Educ:* Oswestry School (1964-74). *Studied:* Foundation Shrewsbury School of Art (1974-75), Cheltenham GCAD (1975-78). *Represented by:* Beadleston Gallery, New York, Britart.com. *Exhib:* one-man: Contemporary Poets, Natioanl Portrait Gallery exhbn and tour; widely UK and abroad. *Works in collections:* National Portrait Gallery, Metropolitan Museum New York, Ulster Museum, National Museum of Wales, National Museums and Galleries on Merseyside, Ferens Hull. *Commissions:* Sir Bobby Charlton (NPG, 1991), Sir Peter Middleton (Chairman of Barclays, 1994), Kazuo Ishiguro (NPG, 1994), Baroness Tessa Blackstone. *Official Purchasers:* NPG London, Liverpool Poets, Willy Russell, Seamus Heaney. *Works Reproduced:* Seamus Heaney, Sir Bobby Charlton. *Principal Works:* as above. *Recreations:* gardening, running. *Clubs:* Chelsea Arts Club. *Address:* 10 Upper Brook Street, Oswestry, Shropshire, SY11 2TB. *Email:* artyedwards@btinternet.com *Website:* www.peteredwards.net

EDWARDS, Sylvia, artist, printmaker, painter in water-colour, oil, acrylic;. *Medium:* watercolour. *b:* Boston, Mass. *d of:* Junius Griffiths Edwards, music impressario (decd.), and Sylvia E. Mailloux (decd.). *m:* Sadredin Golestaneh. one *s.* two *d. Educ:* Boston public schools. *Studied:* fine art at Massachusetts College of Art, Boston, Mass. (1956-60, Prof. Lawrence Kupferman), Boston Museum of Fine Arts. *Exhib:* consistently in one-woman and mixed shows and international art expositions; London: Berkeley Sq. Gallery, C.C.A. Gallery and Christopher Hull Gallery; Tokyo, Bankamura, Mitsukoshi Mihonbashi Branch; Osaka, Nii Gallery (1989); Alexandria, Egypt, Alexandria Museum of Fine Arts (1980); Mediterranean Biennale (1980); Munson Gallery, Chatham, Mass. (1992); Morehead Planetarium, Chapel Hill, N.C.; Natalie Knight Gallery, Johannesburg, S.A. (1991); Singapore, Art Base Gallery (sponsored by Citibank, 1989); Bankamura, Tokyo (1991); C.C.A. Gallery Oxford (1996); The Galleria, Boca Grande Florida (2000), CCA Gallery, London (2003); Grovesnor Gallery, London (2003); State of the Art Gallery, Sarasota, Fla (2007). *Works in collections:* Tate Gallery, London; Boston University Special Collections; Mugar Memorial Library; National Museum of Women in the Arts, Washington, D.C.; Alexandria Museum of Women in the Arts; Alexandria Governorate, Egypt; Cape Museum of Fine Arts, Dennis, Mass.; Midwest Museum of American Art, Elkhart, Indiana. *Publications:* 'The Nucleus' narrative book of drawings; 'The Undoing of the Square' 'Painters' Wild Workshop'; Sylvia Edwards 'Works on Hand Cast Paper'; work widely published by U.N.I.C.E.F., Coriander Studios and C.C.A. Galleries, London for limited editions in silkscreen, and the London Art Group for prints and Bruce McGaw graphics; numerous gallery handbooks and catalogues; articles and television talks 'Sylvia Edwards Talks with Mel Gooding'. Monograph "Sylvia Edwards" published London Pallas Athene (introduction by

Mel Gooding and David Elliot). *Clubs:* Chelsea Arts. *Signs work:* "Sylvia Edwards." *Address:* 14 Cadogan Sq., London SW1X 0JU. *Website:* www.sylviaedwards.com

EDWARDS, Yvonne Sylvia, S.B.A., C.B.M. (1997) and (2000); artist in water-colour; RHS Silver Medal. *b:* S. Australia, 28 Nov., 1942. *m:* Malcolm Edwards. two *s.* *Exhib:* S.B.A. since 1994. *Works in collections:* Shirley Sherwood. *Address:* Lodge Farm, Moot Lane, Dowton, Wilts. SP5 3LN. *Email:* yvonneedwards2005@tisacali.co.uk

EGGLETON, Margaret, SWA, SBA, SGFA (Hon. Treasurer). *Medium:* ink, watercolour, mixed media. *b:* Sale, Cheshire, 20 Feb 1943. *m:* Stuart. one *s.* one *d.* *Educ:* Sale Grammar School. *Studied:* Trent Park Teacher Training College (main subject Art). *Exhib:* RWS, RI, Mall Galleries, Cork Street. *Works in collections:* internationally. *Clubs:* Croydon Art Society. *Signs work:* 'M.EGGLETON'. *Address:* 82 Tabor Gardens, Cheam, Sutton, Surrey, SM3 8RY. *Email:* eggleton@waitrose.com

EICHLER, Richard W., Professor, holder of "Schiller-Preis" (1969); art writer and critic. *b:* Liebenau, Bohemia, 8 Aug., 1921. *s of:* Richard H. Eichler, printer. *m:* Elisabeth Eichler (née Mojr). one *s.* six *d.* *Educ:* Gymnasium at Reichenberg. *Studied:* Vienna, Munich (history of art). *Publications:* Könner-Künstler-Scharlatane (Munich, 1960; 7th ed., 1970), Künstler und Werke (Munich, 1962; 3rd ed., 1968), Der gesteuerte Kunstverfall (Munich, 1965; 3rd ed., 1968), Verhexte Muttersprache (1974), Wiederkehr des Schönen (Tübingen, 1984; 2nd ed. 1985), Unser Geistiges Erbe (1995), Baukultur gegen Formzerstörung (1999) and many papers. *Address:* Steinkirchner Strasse 16, D-81475 München, Germany.

EISELIN, Rolf, Architect SIA dipl.EPFZ, reg. arch. State of Illinois, U.S.A. and Switzerland; Architect with Skidmore, Owings & Merrill, Chicago (in team for U.S. Air Force Academy design). *b:* Zürich, 6 Nov 1925. *Exhib:* individual show, prints: San Francisco Museum of Modern Art; group shows: architecture: Univ. Zürich; sculpture: Oakland Art Museum; painting: Univ. California; prints: U.S. National Museum, Washington; photography: Musée d'histoire naturelle, Fribourg; Honour Medal, Nat. Exhbn., Jersey City Museum (prints) hon.mention, Photography USA 88, 89. *Works in collections:* San Francisco Museum of Modern Art, Graphik-Sammlung ETH Zürich. *Address:* Rés. La Côte 60, 1110 Morges, Switzerland.

ELFORD, Norman, N.D.D., A.T.D., G.R.A.; artist in oil, acrylic, alkyd;. *b:* Portsmouth, 6 July, 1931. *m:* Dorothy. one *s.* one *d.* *Educ:* Portsmouth Northern Grammar School. *Studied:* Southern Colleges of Art, Portsmouth (1947-51), Bournemouth (1951-52). *Exhib:* N.R.M. York; Hexagon, Reading; two one-man shows: Stroud Festival, Gloucs.; regular exhbns. G.R.A. Work in private collections. *Commissions:* designs for Royal Doulton and Spode Fine China plates; calendars and greetings cards, fine art marine prints. *Clubs:* G.R.A.,

President, Portsmouth & Hampshire Art Soc. *Signs work:* "NORMAN ELFORD." *Address:* 36 Torrington Rd., North End, Portsmouth PO2 0TP.

ELGAR, Juliet Jane, B.A. (Hons.) Art/Teaching; painter; arts crafts tutor in drawing and painting, now independent. *b:* Wiltshire, 18 Mar., 1942. three *s.* two *d. Educ:* La Retraite Convent, Salisbury, Wilts. *Studied:* Bath Academy of Art under J. Hoskin sculptor, H. Hodgekin and M. Hughes, painters. *Exhib:* Westminster Gallery, London, Arthouse, Richmond, Gallery at Dauntsey's School, Wilts. *Commissions:* various landscape, portrait and design. *Misc:* Would like to be commissioned in aid of environmental charities on 50/50 profit. *Signs work:* "Jane Elgar." *Address:* 22 St. Mary's Grove, Richmond, Surrey TW9 1UY. *Email:* j-elgar@hotmail.com

ELIAS, Ken, B.A. Hons. Fine Art (1969), M.A. Fine Art (1987), R.C.A.; painter in acrylic on paper; Royal Cambrian Academician;. *b:* Glynneath, West Glamorgan, 9 Nov 1944. *Studied:* Cardiff College of Art (1965-66, 1985-87), Newport College of Art (1966-69), University of Wales, Cardiff (1969-70). *Exhib:* regularly in solo and group shows in U.K. and abroad. *Works in collections:* National Museum of Wales, National Library of Wales, Arts Council of Wales, Contemporary Art Society for Wales, Newport Museum and Art Gallery, Bangor College Normal, Brecknock Museum & Art Gallery, University of Glamorgan, School of Art, University of Wales Aberystwyth, Editions Alecto and private collections U.K. and abroad. *Clubs:* Welsh Group, R.Cam.A. *Address:* 29 Park Ave., Glynneath, West Glamorgan SA11 5DP.

ELKINS, Bridgette Mary, Post Grad Dip. Painting and Drawing (2005). *Medium:* oil, acrylic, mixed media. *b:* Didsbury, 11 Jun 1937. *d of:* Wilfrid Morley. *m:* widow. two *d. Educ:* Haunton Hall, nr.Tamworth. *Studied:* with professional painters in Cyprus, Bermuda and England; Slade Summer School; West Dean College/Sussex University (2005). *Represented by:* Red Biddy Gallery, Shalford, Surrey. *Exhib:* RA Summer Exhbns; numerous open exhbns and group shows in UK and overseas, including: Mall Galleries and London Art Fairs (2008); St.Botolph's Club, Boston, Mass. USA; The Studio Gallery, Midhurst (2004); Reclamation, Post Graduate Show, West Dean College. *Works in collections:* CMC Head Office, California, USA; several private UK and European, Canadian and Australian collections. *Official Purchasers:* Cyprus Mines Corp.HQ, California, USA; Bermuda Govt. Premier's Office. *Recreations:* Visiting art galleries, overseas travel, horse racing, theatre. *Misc:* tour guide lecturer, Pallant House Gallery, Chichester. *Signs work:* 'BM Elkins' or 'BME' (on paper). Early work 'BM Jemal' or 'BMJ' (until Dec 1980). *Address:* Bex Mill House, Heyshott, nr.Midhurst, W.Sussex GU29 0DQ. *Email:* belkins@bexmill4.freeserve.co.uk *Website:* www.westdean/reclamation.org

ELLIOTT, J.: see BATES, Joan,

ELLIOTT, Mary E.: see BERESFORD-WILLIAMS, Mary E.,

ELLIOTT, Paul, FWCB (Fellow Worshipful Company of Blacksmiths); Award: WCB bronze medal. *Medium:* metal - artist blacksmith. *b:* Harrow, 10 Apr 1968. *s of:* J Barrow & R.Elliott. *m:* J.M.Elliott. two *d. Studied:* City & Guilds Blacksmithing and Engineering; COSIRA (Rural Development Commission). *Commissions:* of sculptures, arbours, bridges, pergola's, staircases, water features, benches etc. for public and private, including Harrow Park, Scottish Arts Council, Sainsbury's, City Livery Companies, National Theatre, London, Chelsea Show Gardens, National Trust, religious bodies, Flying Hill Estate, Hampshire, Chisenbury Priory, Exbury Estate. *Works Reproduced:* in Metal Design International (2005); regularly featured in BABA; Contemporary Ironwork (2006). *Recreations:* artist blacksmithing, sailing. *Address:* Hammer & Tongs, Bulbourne Forge, Tring, HP23 5QF. *Email:* info@blacksmithonline.co.uk *Website:* www.blacksmithonline.co.uk

ELLIOTT, Walter Albert, F.B.I.S., L.F.I.B.A., S.G.F.A., P.S., U.A.; artist in pastel, oil, water-colour, acrylic; mem. Academy of Italy, Pres. Ilfracombe Art Soc., mem. International Assoc. of Art. *b:* Wembley, 24 Oct 1936. *s of:* Albert Elliott. *m:* Beryl Jean (decd.). one *s.* one *d. Educ:* Pinner Grammar School; de Havilland Aero College. *Studied:* Hammersmith Polytechnic, Harrow College of Art. *Exhib:* annually: P.S., S.G.F.A., U.A. (Mall Galleries), Pilton Arts Exhbn., Ilfracombe Art Soc.; Burton Gallery, Bideford (1976), Salon de Paris (1984), Torbay Guild of Artists. Permanent exhbn. of artwork at the Elliott Gallery, Hillsview, Braunton, N. Devon. EX34 9NZ. *Works in collections:* 'The Ascent of Man' (N. Devon Atheneaum 1970-81); Europe, Geneva, Canada, Australia, U.S.A. *Publications:* articles, Spaceflight, British Interplanetary Soc. 'The Dream of Gotama', a recently published 320 page book written and illustrated by Walter A. Elliot (21 fine art illus.). *Principal Works:* Triptych- 'The Ascent of Man' Triptych -'Man a Share-Time Bubble', 'The Arising of Intelligence', 'Searching for the Temple of Man's Heart', 'The Caress', 'Easter Bonnet', 'Refugees', Little Deaf Girl Learning to Speak', 'Young Mankind on the Threshold', 'Einstein', 'Time Tried', 'Earth's Human Flowers', 'Compassion', The Lake of Venus', 'Human Symphony', 'Old George', 'Moonlight over Venice', 'Caftane Walk', 'Japanese Family', Japanese Tea Party', 'Enchanted Ballroom', 'Woolacombe Beach', 'Devonshire Walk', 'Amour Maternal', 'The Sea Captain', 'Peace', 'Homeless', 'The Drop is in the Ocean, the Ocean is in the Drop', 'The Eternal Artist', 'The Warrior', 'The Favourite Hat', 'The Healing', 'The Sermon', 'The Bluebird', 'Charleston', 'Two Little Clowns', 'Durham Cathedral', 'The Shepherdess'. *Signs work:* "Walter A. Elliott." *Address:* Sollake Studio, Warfield Villas, Ilfracombe, N. Devon EX34 9NZ. *Email:* artform222@aol.com

ELLIS, Belinda Anne, A for E Lottery Grant. *Medium:* acrylic, watercolour, drawing, oils. *b:* London, 16 Apr 1949. *m:* Colin Challenger. one *s.* two *d. Studied:* Sir John Cass College, London (1967-69); North East London Polytechnic (1969-72); St.Martin's School of Art (1972-73). *Exhib:* RA Summer Exhbn, Royal Festival Hall, Whitechapel Open, Air Gallery, Warwicks Arts Trust,

Woodlands Gallery, Harlech Biennale (1996), Banbury and Woodstock Museums, 'deliArt' Smithfield, Lab Gallery New York, Said Business School Oxford, Mall Galleries. *Works in collections:* Triangle Arts Association; L'Art en vie Collection, France; Vara Komum Concert Hall, Sweden. *Commissions:* murals at Polytechnic of Central London (1974). *Publications:* Women Artists Slide Library Journal (1987). *Works Reproduced:* RA Illustrated (2004); House and Garden (1982). *Misc:* Triangle Artists' Workshop, New York (1986); 'Art in Situ' Project, Drôme, France (2001, 2006). *Signs work:* 'Belinda Ellis' or 'B.Ellis'. *Address:* St.Mary's Lodge, Church Street, Bloxham, Oxon OX15 4ES. *Email:* belindaellis@macunlimited.net *Website:* www.belindaellis.myzen.co.uk, www.belindaellis.co.uk

ELLIS, Christine Elizabeth, A.D.B. (1960), A.O.I (1990); landscape and portrait artist in pencil, ink, water-colour and oil; illustrator; writer; Brian Sinfield Fine Art Award (2005). *b:* London, 10 Sep 1939. *Educ:* Sacred Heart High School. *Studied:* Maria Assumpta College, Kensington, Theatre Arts at Rose Bruford College, Kent, part-time at Regent St. Polytechnic, Richmond and Putney Schools of Art. *Exhib:* solo exhibition 1999 Buckingham Galleries, Southwold; mixed gallery exhbns. including R.I., R.B.A, Discerning Eye, Pastel Soc., S.W.A. and NEAC. *Works in collections:* life-size, paper based, sculpture at Bursledon Brickwork's Museum. *Commissions:* Cover illustrations 1997 Egon Ronay Guides. Landscapes and portraits: Martina Navratilova; All England Club, Wimbledon; Equitable Life, and for private individuals in many countries. Illustrations: St. George's; La Prairie; Keymer Tiles; Wates; Squires. *Publications:* illustrations for "Pull`s Ferry" (Norwich, 1998), B.B.C. short stories for children broadcast (1979-82). *Works Reproduced:* Limited edition prints: National Trust Enterprises Chartwell. *Clubs:* mem. CAS. *Signs work:* "C.E. Ellis." *Address:* North Cottage, 6 High St., Hampton on Thames, Middx. TW12 2SJ.

ELLIS, Edwina, R.E. (1987), S.W.E. (1984); M.A. Fine Art (2004), Hon M.A. Buckinghamshire Chilterns U.C. (2003); wood engraver. *Medium:* printmaking. *b:* Sydney, Australia, 14 May 1946. *m:* P.J.N. Ellis. *Educ:* Manly Girls, Sydney. *Studied:* John Ogburn, and National Art School, Sydney, University of Wales, Aberystwyth. *Represented by:* Godfrey & Watt. *Exhib:* R.A., R.E., Duncan Campbell (1988-97), Godfrey and Watt (1987-2001), N.S.W. State Library, Australia, Fine Art Soc., London, Ashmolean Museum, Redfern Gallery London, V&A (1994). *Works in collections:* V. & A., University Library of California, Australian National Library Canberra, Ashmolean Museum Oxford, Fitzwilliam Museum Cambridge, Art Gallery of N.S.W. Australia, London Transport Museum, Museum of London, NSW State Library, University of Wales, University of NSW. *Commissions:* London Transport: 'Art on London Transport' poster (1996); Royal Mint: design of new One Pound Coins (2003). *Publications:* Prigs Seven Virtuous Lady Gardeners (Smith Settle, 1997). *Official Purchasers:* Royal Mint, British Museum, Museum of London. *Works Reproduced:* 'Handmade Prints', 'Relief Printmaking', 'Printmaking for Beginners',

'Engravers Globe'. *Principal Works:* one pound coin designs. *Clubs:* Chelsea Arts. *Signs work:* "E.N. Ellis." *Address:* Rhyd Goch, Ystrad Meurig, Ceredigion SY25 6AJ. *Website:* www.edwinaellis.co.uk

ELLIS, Harold, draughtsman and artist in oil, water-colour, line;. *b:* Baildon, 10 Apr., 1917. *s of:* Frederick Ellis, rating officer. *m:* Margaret Lovatt. one *s.* one *d. Educ:* Bradford Grammar School. *Studied:* as apprentice in commercial art studio, Messrs. Field, Sons & Co., Lidget Green, Bradford (1933-39). *Exhib:* Bradford City A.G. *Works Reproduced:* cartoons, general anonymous commercial work. *Signs work:* "H. Ellis" or "ELLIS." *Address:* 5 Whitelands Cres., Baildon, Shipley, Yorks. BD17 6NN.

ELLIS, Ian, BA (Hons), Post Grad Painting, Royal Academy of Arts; awarded Landseer Scholarship whilst at RA; Director of Fine Art, Radley College, Oxfordshire. *Medium:* fine art mixed media. *b:* Manchester, 1961. *m:* Valerie. two *s. Educ:* Rochdale College of Art, Loughborough College of Art. *Studied:* Royal Academy of Art (Peter Greenham, Norman Blamey). *Exhib:* The Sewell Centre Gallery, Oxfordshire. *Works in collections:* public and private collections. *Publications:* Mentioned in Christopher Hiberts book 'Radley-No Ordinary Place'. *Clubs:* RASAA. *Address:* The Sewell Centre Gallery, Radley College, Oxfordshire, OX14 2HR. *Email:* ipe@radley.org.uk *Website:* www.radley.org.uk/ian%27s%20web%20page/ian's%20web%20page.html

ELLIS, John Colin, U.A. (1988), M.B.I.A.T. (1971), M.I.P.D. (1973); artist/architectural illustrator in water-colour, oil, acrylic; artist working mainly on architectural subjects, plus land and town scapes developing into abstract art; designer/illustrator within retail commercial and residential sectors;. *b:* Fleetwood, Lancs., 1945. *m:* Penny. one *s.* one *d. Educ:* Bailey Secondary, Fleetwood. *Studied:* Blackpool School of Art (1961-67). *Exhib:* one-man shows: N.Wales, Stamford, Peterborough, London. *Works Reproduced:* housing sale illustration and brochure design. *Clubs:* U.A. *Signs work:* "John C. Ellis." *Address:* The Gallery, Braceborough, Stamford, Lincs. PE9 4NT.

ELLIS, Katy, RI (2003), RBA (2007); BA Hons; John Kinross Scholarship (1995); Baker Tilly Prize (2004); Treg' Aquarelle: Watercolour and Gouache Award (2003),Gouache Award (2004), Le Prix Maimeri (2005). *Medium:* watercolour and gouache. *b:* Greenwich, 20 Feb 1973. *d of:* Shirley Felts. *Educ:* Haberdashers Askes Hatcham School for Girls (1984-1990). *Studied:* Blackheath School of Art (Foundation Course, 1990-91); Glasgow School of Fine Art (1991-95). *Exhib:* RWS Open (1992-2007); RI Open (1993-2007); Singer Friedlander/Sunday Times (2003, 2004); Scotlandart.com Gallery, Glasgow; Red Rag Gallery, Stow-on-the-Wold; The Sheen Gallery, Richmond; The Medici Gallery, London; Bell Fine Art, Winchester; Stark Gallery, London & Canterbury; Morninside Gallery, Edinburgh; Haddenham Gallery, Haddenham; The Old Fire Engine House, Ely; Baker Tilly offices, London. *Works in collections:* private collections, and ongoing exhbns at Scotlandart.com & The Old Fire Engine

House. *Commissions:* several private commissions. *Publications:* Premier Magazine (1996/97); 'Water' by Chris Mulhern (Acorn Book Co., 1996); 'Paint' by Betty Hosegood (RotoVision Pub., 1998); The Artist magazine (1998, 2005) etc. *Signs work:* 'Katy Ellis RI, RBA'. *Address:* 20 Fairycroft Road, Saffron Walden, Essex, CB10 1LZ. *Email:* elliskaty@hotmail.com

ELLIS, Noel, A.R.C.A. (1948); painter and printmaker. *b:* Plymouth, 25 Dec 1917. *s of:* George Ellis. *m:* Linda Zinger. *Educ:* Sutton High School, Plymouth. *Studied:* Plymouth School of Art, R.C.A. *Exhib:* R.A., R.O.I., R.B.A., N.E.A.C., London Group, Grundy A.G., Blackpool, Plymouth A.G., Works in public and private collections. *Signs work:* "Noel Ellis" (cursive script). *Address:* 95 Bennerley Rd., Battersea, London SW11 6DT.

ELLIS, Robert, O.N.Z.M. Officer of the N.Z. Order of Merit; Professor Emeritus, Auckland University. *b:* Northampton, 2 Apr 1929. *s of:* Frederick Ellis. *m:* Elizabeth. two *d. Studied:* Northampton School of Art (1943-47), R.C.A. (1949-52). *Exhib:* 50 one-man shows in N.Z., Australia and U.S.A.; group shows in Australia, Canada, Malaysia, India, Japan, England, U.S.A., Finland, Holland, France, Germany, Hungary, Switzerland, etc. *Works in collections:* all major N.Z. public collections, National Gallery of Australia, British Foreign Office, N.Z. Arts Council, etc. *Signs work:* "Robert Ellis." *Address:* 23 Berne Pl., Auckland 1310, New Zealand. *Email:* robellis@akc.quik.co.nz

ELLIS, Sean, *b:* Brighton, 24 Nov 1970. *Educ:* state. *Represented by:* The Office London. *Publications:* '365' -A Year in Fashion. *Individual Shows/Exhibitions:* Mercury Nudes Exhibitions, Roundhouse, Camden(1999); Korovamatic Nudes Private Exhibition, RSA, London (2000). *Awards/Commissions:* Brit Award for Best Music Video, All Saints- 'Never Ever' (1998). *Principal Published Pieces:* '365' A Year in Fashion, pub. Vision On (2003). *Publications: Monograph/Contributer:* Arena; The Face; Visionaire; V; Numero; Vogue (UK, US, Japan, France); Vogue Homme; Dazed and Confused; i-D; GQ; Vanity Fare; The New Yorker; Surface. *Specialist Area:* portraiture, fashion, advertising. *Additional Projects:* 'Left Turn' short film (2001), 'Cash Back' short film (2003). *Address:* The Chocolate Studios, Unit 18, 7 Shepherdess Place, London N1 7LJ. *Studio Address:* The Chocolate Studios, Unit 18, 7 Shepherdess Place, London N1 7LJ. *Email:* kayte@theofficelondon.com *Website:* www.theofficelondon.com

ELLIS, William John, F.R.S.A.; artist in oil, water-colour, crayon; author/artist;. *b:* Rhyl, 21 Sep 1944. *s of:* John Ellis. *m:* Gaynor Ellis. one *s.* one *d. Educ:* Glyndwr Secondary Modern, Rhyl. *Studied:* Glyndwr Secondary and later under Robert Evans Hughes R.A. *Exhib:* Rhyl Town Hall and Holywell Library. *Publications:* author of Seaside Entertainments 100 Years of Nostalgia; Rhyl in old Picture Postcards; Entertainment in Rhyl and N. Wales (published July 1997); 'The Spirit of Rhyl' (pub. Landmark Publishers, 2004). *Recreations:* jazz, collecting theatre memorabilia. *Clubs:* Clwydian Art Society, Clwyd Assoc.

for the Visual Arts, Mem. of Rhyl Liberty Players, Abergele Players, British Music Hall Soc., Manchester Music Hall Soc., Derbys. and Notts. Music Hall Soc. *Misc:* Has own music hall company 'The Spotlights'. *Signs work:* "B. Ellis." *Address:* 2a Carlisle Ave., Rhyl, Denbighshire, LL18 3UD. *Email:* rhylbillellis@yahoo.co.uk

ELLMAN, Daphne Ann, SWA, SFP(Society of Floral Painters); Winner, Isle of Wight Landscape Award (1999, 2005). *Medium:* acrylic and mixed media. *b:* Herne Bay, Kent, 20 Jul 1952. *d of:* Margaret & Ivor Lear. *m:* Mel Ellman. one d. *Educ:* Southport High School; Eastbourne High School. *Studied:* self-taught. *Exhib:* Mall Galleries; Westminster Hall; Clairmonte Gallery; First Floor Gallery, Romsey; Exbury; Sir Harold Hilliers Arboretum; Ventnor Botanic Garden; Burley, New Forest; Wight Light Gallery. *Works in collections:* The Wakeham Collection, and private collections internationally. *Publications:* Leisure Painter publications; 'Start with Art'; included in 'How to Create Textures in your Paintings' and '50 Years of the Undercliff'. *Works Reproduced:* through Libra Jones Associates Ltd., and Gillyprint Fine Art. *Clubs:* Romsey Art Group; Marwell Art Society. *Signs work:* 'D.E.'. *Address:* 3 Wollescote House, 37 Spring Hill, Ventnor, Isle of Wight, PO38 1PF. *Email:* ellmans@tiscali.co.uk

ELLWOOD, Derek, Laing Award, London; Barnes, Willis & Howard Award. *Medium:* ceramics, oil, watercolour, drawing, prints, sculpture. *b:* Rochdale, Lancs, 7 Feb 1931. *m:* Joan Ellwood. one s. *Studied:* Rochdale School of Art, Lancs.; Bath Academy of Art, Corsham, Wilts; tutors:Sir Terry Frost, William Scott, Peter Lanyon, Bryan Wynters, James Tower (ceramics). *Exhib:* RA Summer exhbns, Daily Express Young Artists; AIA Gallery, London; Redfern Gallery, London; Inst. of Contemporary Artists; ROI; Laing Exhbns, Mall Gallery; 'Discerning Eye'; NEAC; RP; Hunting Group; Garrick-Milne, Christie's, London; Crossgate Gallery, USA; Singer Friedlander/Sunday Times, London; Rowley Contemporary Art, Winchester. *Works in collections:* St.Georges, Hanover Square, London; private collections. *Commissions:* portraits; Rev.William T.Atkins; Sir Robin & Lady Saxby & family; Sir George Solti; Jean Muir; Quentin Crisp; Barbara Cartland. *Works Reproduced:* limited edition prints; bronze sculpture; fabric designs. *Recreations:* music. *Clubs:* Arts Club, Dover St., London; Chelsea Arts Club, London. *Signs work:* 'Ellwood', 'DEREK ELLWOOD' or 'ELLWOOD'. *Address:* 2 Warren Mews, London W1T 6AL. *Email:* derek.ellwood@gmail.com

ELMORE, Pat, R.B.A. (1996); sculptress in stone and wood, also portraits and ceramics;. *b:* Rugby, 10 Sept., 1937. *d of:* William Lomas. four s. two d. *Exhib:* solo shows, Bampton Arts Centre, Bedford Central Library, Swindon Links Library, Wantage Museum, The Stable Gallery at Green College Oxford; group shows: R.B.A., Mall Galleries, R.W.A., Cheltenham Art Soc., Syon Lodge London, Salammbo Galerie Paris, Gloucester Museum, Jersey (Village Gallery). *Works in collections:* Thamesdown Arts, Abingdon Town Council, The Church Army Exeter, Magdalen College Oxford. Permanent sculpture garden and gallery,

and ongoing sculpture tuition at Nutford Lodge. *Address:* Nutford Lodge, Longcot, nr. Faringdon, Oxon. SN7 7TL.

ELPIDA, (née Georgiou) B.A.Hons. (1986), M.A. (1990); artist in oil on canvas. *b:* London, 23 Sep 1958. *d of:* Lucas Georgiou (decd.). *m:* Herbert Capelle. two, Alesya and Luca *d. Educ:* St Marylebone School for Girls. *Studied:* St Martin's School of Art (1983-86), R.A. Schools (1987-90). *Exhib:* R.O.I. at Lloyd's, Royal Overseas League (prizewinner), 'New Generation' Bonham's, R.A. Summer Show (1991) (prizewinner, Guinness award), R.A. Premium Show (Winsor and Newton award), Berlin Academy of Art; one-man shows: Christopher Hull Gallery, Lynne Sterne Gallery, 'The Leicestershire Collection', Leicester, 'East End Open Studios', Acme Studios, London, Whitechapel Open. *Works in collections:* Unilever plc, Guinness Collection. *Signs work:* "Elpida." *Address:* 26 Ellesmere Rd., Chiswick, London W4 4QH. *Website:* www.realartfirst.com

ELSTEIN, Cecile, MA, FRSA (1997); NW Arts Bursary Award for Design for Inflatable Spaces (Manchester Design and Technology Workshop,1983); colour prize, 9th British International Print Biennale, for 'Noon Meeting' (1986). *Medium:* sculpture in bronze, ceramic, wood and rope. Printmaking with screenprint and monotype Video/DVD. *b:* Cape Town, S.Africa, 8 Feb 1938. *d of:* Michael Hoberman. *m:* Emeritus Professor Max Elstein. one (decd.) *s.* one *d. Educ:* Good Hope Seminary, Cape Town; Medical Laboratory Technology and Research at Groote Schuur Hospital, Cape Town. Before 1960 in South Africa; Sculpture self directed with Nel Kaye, Mitford Barberton, Lippy Lipschitz and Neville Lewis; 1961-69 in London; Hans Swartz - painting. Beatrice Lyssy - drawing; Catherine Yarrow - ceramics. *Studied:* Sculpture/printmaking, West Surrey College Art Design (1975-1977); Art as Environment, M.A. Manchester Metropolitan University (1996). *Represented by:* Wendy J Levy Contemporary Art Ltd. email: wendy@wendyjlevy-art.com. *Exhib:* nationally in UK; internationally: Brazil, France, Gibraltar, Hungary, Israel, Korea, Mexico, Singapore, Spain and USA. *Works in collections:* private collections in UK and abroad; public collections, e.g. Clare Hall Cambridge UK, Tufts Collection of Fine Prints, Massachusetts USA, The Whitworth Art Gallery, Manchester, UK. *Commissions:* portrait sculpture/sculpture for Landscape. *Publications:* Design for Physical Variety, EcoDesign, 111, (3); The Role of Empathy in Design Education 1996 (in library of the Centre for Accessible Environments London SE1 2NY); 'Together with Tangents' pub. 1998 The Newsletter of the Landscape and Art Network; 'Present' pub. 2003 Journal of the Landscape and Art Network; 'Tangents, a mindscape in a landscape' DVD and companion booklet pub. Mo Media with The Gerald Hoberman Collection (2003, ISBN 1-91973497-X). *Works Reproduced:* DVD 'Tangents, a mindscape in a landscape' containing two videos with companion booklet (2003); 'Exhibiting Gender' by Sarah Hyde (pub. Manchester University Press 1997 pgs. 31 and 81). *Principal Works:* Play sculpture for physically disabled children, Treloar School, Alton, Surrey; 'Together with Tangents' a temporary rope sculpture for Wimpole Hall Gardens,

Cambridgeshire; Designs for Plastic Inflatable Spaces, made for Manchester Art and Technology Workshop; 'Tangents, a mindscape in a landscape' DVD videos and companion booklet. Bronze portraits include: Pincas Lavon (politician), Professor David Millar, John Garfield (neurosurgeon), Michael Kennedy (author and music critic). *Recreations:* walking, music (opera). *Clubs:* Landscape and Art Network, M.A.F.A., P.M.S.A., F.R.S.A. *Misc:* video – collaborative project with Maureen Kendal. DVD-'Tangents, a mindscape in a landscape' (Cecile Elstein, Maureen Kendal). *Signs work:* 'Cecile Elstein'. *Address:* 25 Spath Rd., Didsbury, Manchester M20 2QT. *Email:* cecile@cecileelstein.com *Website:* www.cecileelstein.com

ELWELL, Brian, MA Fine Art; Post-Grad Diploma Printmaking; Chelsea Dip. Fine Art; National Dip. in Design. *Medium:* oil. *b:* Jersey, 18 Nov 1938. *s of:* Frank Elwell. *m:* Emma Greeley. three *s.* three *d. Studied:* Chelsea School of Art; Birmingham Polytechnic; Wimbledon School of Art. *Represented by:* Fusion Gallery, Bristol; Phoenix Gallery, Bath. *Exhib:* selected solo exhbns: Fusion Gallery, Bristol (2005); Rooksmoor Gallery, Bath (2003); Jelly Gallery, Reading (2001); Victoria Art Gallery, Bath (2000), Black Swan Guild, Frome (1996), etc.; selected group shows: Phoenix Gallery, Bath (2005), Fusion Gallery (2005); Grand Designs Live, London (2005); Hot Bath Gallery, Bath (2004); Leith Gallery, Edinburgh (2004); Red Rag Gallery, Stow (2004), etc.; Art Fairs across UK, including Affordable Art Fair (2000, 01, 03, 04). *Works in collections:* Marquis of Bath, David Messum, Southern Arts Assoc., Southampton University, Salisbury Dist. Hospital; Charles Pettiward; Linda Saunders; Brian Roper. *Signs work:* 'Elwell'. *Address:* 1 Tennyson Road, Bath, BA1 3BG. *Email:* info@phoenixgallery.co.uk *Website:* www.phoenixgallery.co.uk/ www.brianelwell.co.uk

ELWES, Luke, *Medium:* oil, watercolour, drawing, prints. *b:* London, 26 Jul 1961. *Studied:* Camberwell School of Art; Bristol University (BA); Birkbeck (MA). *Represented by:* Art First, Cork Street, London W1. *Exhib:* RA (1995, 1998, 2003, 2005, 2007); Art First, London and New York (1998, 2000, 2002, 2004, 2007); Broadbent, London (2004, 2005); Rebecca Hossack, London (1990, 1991, 1993, 1995); Galerie Vieille du Temple, Paris (1993, 2000); Galerie Cerbelli, Bergamo (2007). *Works in collections:* public and private in Europe and USA. *Commissions:* National Trust, Imperial College, Christie's, Bayer, Royal Military Academy, Worth Abbey. *Publications:* all publications listed on website. *Works Reproduced:* listed on website. *Clubs:* Chelsea Arts Club. *Signs work:* 'Luke Elwes'. *Address:* 23 Lawford Road, London NW5 2LH. *Email:* info@lukeelwes.com *Website:* www.lukeelwes.com

EMANUEL, John, *Medium:* ink and gouache; oils; mixed media; prints. *b:* Bury, Lancs., 13 Feb 1930. *s of:* John and Beatrice. one *d. Represented by:* Belgrave Gallery, St.Ives; Manya Igel Fine Art, London; Thompson Gallery, London; Stour Gallery, Shipston-on-Stour. *Exhib:* Gilbert Parr Gallery, London (1979); Montpelier Studio, London (1979-98); Beaux Arts, Bath (1988, 1992);

Artist Market Warehouse, London(1978); Hayward Annual, London (1982); Cleveland International Drawing Biennale (1979); TSW Open Touring Exhbn. (1984-5); Royal West of England Academy, Bristol (1992, 1995); Mall Galleries, London (2002); The Stour Gallery, Shipton on Stour (2003, 2005, 2007); Penwith Gallery St.Ives (2005). *Works in collections:* Cornwall County Council, Truro; Slaughter and May, London; Tesco plc.; Crown Courts, Truro; Evans & Shalev, Architects, London. *Commissions:* Tate St.Ives to make an etching for the opening of the gallery in 1993 as one of the Porthmeor Printmakers. *Publications:* Dictionary of Artists in Britain since 1945 (David Bucknan, 1998). *Works Reproduced:* 'Catching the Wave -Contemporary Art and Artists in Cornwall from 1975 to the Present Day' (Tom Cross, 2002). *Recreations:* walking. *Clubs:* Chelsea Arts Club, London; Penwith Society of Arts. *Misc:* moved to Cornwall 1964, lived in St.Ives since 1983. *Signs work:* John Emanuel. *Address:* 3 Fore St., St.Ives Cornwall TR26 1AB. *Email:* jhnemanuel@yahoo.co.uk *Website:* www.johnemanuel.co.uk

EMERY, Edwina, A.R.B.S. (1984); Freeman of Worshipful Company of Goldsmiths (1986); sculptor and designer in chalk, oil and acrylic; retained exclusively by Garrard, the Crown Jewellers, animalier, portrait and design since 1982;. *b:* Huntingdonshire, 10 May, 1942. divorced. two *s.* two *d. Educ:* Grammar School and privately. *Exhib:* permanently at Garrard, Regent St., Oscar and Peter Johnson Gallery. Work collected by Royalty and Heads of State worldwide, also private collectors. *Commissions:* include prestigious confidential commissions, also racing, polo, portraits Lester Piggott and Willie Shoemaker, many for industry and commerce. *Publications:* Commercial Art in Youth. *Clubs:* The Farmers, Whitehall Court. *Address:* Little Manor, Ibberton, Dorset DT11 0EN.

EMMERICH, Anita Jane, (née POLLOK); Keeper of the RMS Diploma Collection; International member and exhibitor: R.M.S., S.W.A., H.S.F.; miniature painter specializing in contemporary and historical portrait, profiles and silhouettes in oil on vellum or old ivory; RMS Group Award Winner (2004); the President's Special Commendation Award for all miniature paintings submitted, R.M.S. Exhibition, London (1998), the Master's Award for the Most Outstanding Set of Miniatures at The Llewellyn Alexander Gallery, London (1996, 2006), Judges Choice, G.M.A.S., Atlanta, U.S.A. (1997). Individual Member's Award Cerificate, W.F.M., Tasmania (2000), plus numerous awards U.K. and U.S.A.; donates and judges the 'Anita Emmerich Presentation Award'. *b:* London, 3 Feb 1938. *m:* W. M. Ernst. two *s. Educ:* Sydenham High School for Girls (G.P.D.S.T.), London. *Studied:* self taught miniature painter. *Exhib:* London, the South East, and various overseas galleries; England, Jersey, N. Ireland, France, Germany, U.S.A., Australia, Japan. *Works in collections:* Work in private collections, R.M.S.Diploma Collection, can be seen at the Llewellyn Alexander Gallery, London. *Commissions:* for collectors and private requests. *Publications:* 'R.M.S. 100 Years'. *Works Reproduced:* in Art Magazines. *Recreations:* Woodland garden preservation. *Misc:* 1993 Contemporary Art Consultant,

Diocese of Rochester Kent. Previously mem. of S.M., S.Lm., A.S.M.A. (Q). (T). (N.S.W.)., G.M.A.S., MASF, WFM, MPSGS, ASOFA. *Signs work:* 'AJE' (as monogram). *Address:* 'Fielder's Folly' Cherry Garden Lane Wye, Ashford, Kent TN25 5AR. *Email:* ernst.emmerich@which.net

EMSLEY, Kenneth, M.A. (Cantab.), LL.M. (Newcastle), A.C.I.S., F.R.Hist.S., F.R.S.A.; artist in water-colour, pen and ink, author, retd. lecturer, President, Soc. of Miniaturists, President, British Water-colour Soc.; former chairman, Bradford Arts Club;. *b:* Shipley, 7 Dec., 1921. *s of:* C.B. Emsley, chief designer, motor manufacturers. *m:* Nancy Audrey Slee, B.Sc., Dip. Ed. *Educ:* Loughborough College, St. John's College, Cambridge. *Studied:* various schools under Edward Wesson, Arnold Dransfield. *Exhib:* Mall and Bankside galleries, London, Florida, U.S.A., Cartwright Hall, Bradford. *Publications:* Northumbria, Tyneside, Historic Haworth Today, etc. *Clubs:* Bradford. *Signs work:* "K.E.", "K. EMSLEY.", or "KENNETH EMSLEY". *Address:* 34 Nab Wood Drive, Shipley, W. Yorks. BD18 4EL.

ENGLAND, Frederick John, N.D.D., A.T.C. (Lond.), I.A.G., M.F.P.S., Norwegian Scholarship (1960), Medaille d'Argent, Paris Salon (Gold Medal, 1975), Diploma d'Honneur, International Arts Guild, Monte Carlo; painter in oil, lithograph, etching, water-colour; ex-lecturer in painting and design at Leek School of Art; ex Pres. Soc. of Staffordshire Artists; director, England's Gallery, Leek;. *b:* Fulham, London, 5 Mar 1939. *s of:* Frederick Thomas England. *m:* Sheelagh Jane. *Educ:* Deacons School. *Studied:* Brighton College of Art and Crafts (1956) under Sallis Bonney, R.O.I., R.W.S., Charles Knight, R.O.I., R.W.S., R.T. Cowen, Principal; Hardanger Folkschule, Norway (1960) under Oddmund J. Aarhus; London University (1961) under Ronald Horton. *Exhib:* Paris Salon, Arts Council of N. Ireland, R.B.A., R.I. Summer and Winter Salon, R.B.S.A., Manchester Academy, Bradford Open Exhibition, Trends Free Painters and Sculptors, R.W.A., S.I.A. (travelling shows included). Open Exhibition Stafford, Society of Staffordshire Artists; one-man shows: Galerie Helian, Montreux, England's Gallery, Burlington Gallery, Buxton Schaffer Gallery, Market Drayton, Galerie für Zeitgenössische Kunst, Hamburg, Galerie Bernheim-Jeune, Paris, I.A.G. Monte Carlo, Zilina, Czechoslovakia, Octagon Gallery, Bolton, University of Keele, Gallerie Helion, Montreux, Holstebro, Denmark. *Works in collections:* Nicholson Institute, Goritz Coll., Fenning Coll., Geneva, City of Stoke-on-Trent Art Gallery. *Commissions:* R.Breeze murals, 'Homage to Monet', 'Homage to Hirsage' (30m x 8m). *Official Purchasers:* City of Stoke on Trent Museum and Art Gallery. *Works Reproduced:* Art of England. *Clubs:*; Past President Society of Staffordshire Artists (Hon Life Member). *Misc:* Reviewed work in La Revue Moderne, Les Journal des Jeunes, Boomerang (Paris Salon Edition of One Hundred Young European painters), Dictionnaire des Artists, Repertorium Artis, Dictionnaire International d'Art Contemporain. *Signs work:* "England." *Address:* Ball Haye House, 1 Ball Haye Terr., Leek, Staffs ST13 6AP. *Email:* englands.gallery@anstrad.co.uk

ENGLERT, Béatrice, *Medium:* pastel, oil painting. *b:* Paris, 22 Jul 1952. two *d. Studied:* School of Fine Arts, Paris. *Represented by:* Hooks Epstein Galleries, Houston, USA; Galerie Illeana Bourboulis Gallerie Paris, France. *Exhib:* Hooks Epstein Galleries (Houston), Galerie Ileana Bouboulis, Mac 2002, Chapelle St.Leonard, France; résidence á l'avant-rue, Paris (2007); Europ'Art, Geneva (2007); Biennale de Florence, Italy (2007). *Works in collections:* USA, United Kingdom, Ireland, Italy, Belgium, Portugal, France. *Publications:* illustrations in 'Assombrissement' (editions L'Amourier, poet: J P Chambon); in NUNC no12 (editions De Conlevour); in Nuée de Corbeaux dans la Bibliotheque, inks and engravings (editions L'Amourier, poet: J P Chambon). *Works Reproduced:* in 'Béatrice Englert' by Gerard Xuriguera (FVW editions). *Principal Works:* 'Mémoire/I', 'Waiting Room', 'Merry-go Round', 'Man' 'The Orators'. *Address:* 1 Villa Lambert, 78400 Chatou, France. *Email:* margolo@moos.fr *Website:* www.beatrice-englert.com

ENGLISH, Bill, NDD (First Class), Cert RAS, ATC; Head of Fine Art Derby 1964-67, Head of Fine Art Nottingham 1967-72, Principal Norwich School of Art 1972-88. *Medium:* paint, collage. *b:* 12 Dec 1931. *m:* Helen. two *s.* two *d. Educ:* Reed's School, Cobham, Surrey 1942-48. *Studied:* art Sunderland 1948-52, RAS 1952-56, Leeds 1956-57. *Exhib:* one-man shows in York (1964), Norwich (1979), Chelsea (1989), Ipswich (1990), Peralada (1992), Espolla (1998). *Works in collections:* private, UK and abroad. *Clubs:* Chelsea Arts Club (Chairman 1989), The Colony Rooms, RASAA. *Address:* 185 Newmarket Rd, Norwich, NR4 6AP.

ERLAND, Sukey, Lecturer 3D Studies; Royal Western Academy, John Brandler Award. *Medium:* sculpture (bronze, resin bronze, stoneware). *b:* Farnham, Surrey, Aug 1927. *d of:* Col. & Mrs. C.F.King DSO. MC. *m:* John Erland. three *s. Educ:* St.Nicholas, Fleet; Chatelard, Switzerland. *Studied:* Farnham School of Art; Chelsea School of Art with Willi Soukop. *Represented by:* Artparks International Garden Gallery, Broughton; Mythic Garden, Devon; First Sight Fine Art, Bath, Albany Gallery, Cardiff, Bowlish Contemporary Gallery, Shepton Mallet. *Exhib:* Broadway Modern, Cotswolds, Royal Academy, Royal West of England Academy, Society of Portrait Sculptors, Artists 303, Atkinson Gallery, Millfield Art Centre, East Lambrook Manor, Albany Gallery. *Works in collections:* in USA, Japan, Australia, Great Britain. *Commissions:* Brotherhood of Man, New York; Rover Motor Co. commissioned portrait of Ben Hervey Bathurst, many portrait commissions. *Publications:* featured in Somerset Magazine, Historic House Magazine. *Official Purchasers:* 'Pelicans' purchased by Bristol Zoo. *Principal Works:* figurative bronzes of people and animals. *Recreations:* gardening, riding. *Clubs:* Society of Portrait Sculptors, Artists 303. *Signs work:* 'SE'. *Address:* The Malthouse, Totterdown Lane, Pilton, Shepton Mallet, Som., BA4 4EA. *Website:* www.sukeyerland.me.uk

ESPLEY, Tom, NEAC; NDD, DFA London; 1st Prize 'Spirit of London' (1984). *Medium:* oil, watercolour, tempera, etc. *b:* 24 Jul 1931. *s of:* Mr. & Mrs. T.H.Espley. *m:* Maureen. two *s. Educ:* The Downs School and Bryanston.

Studied: Camberwell School of Art, Slade School, University College, London. *Represented by:* Gallery Duncan Terrace. *Exhib:* Mitsukoshi Tokyo, Hayward Annual 1982, Royal Academy (1965-96), NEAC since 1999. *Works in collections:* Guinness, Chase Manhattan Bank, Eagle Star, Jesus College Oxford, Ondaatje Collection, the late King Hussein of Jordan, Cheltenham And Gloucester Building Society. *Publications:* photographs for catalogue Bonnard Exhbn. Hayward Gallery (1994). *Official Purchasers:* British Rail, Full Sutton Prison. *Address:* 24 Duncan Terrace, London N1 8BZ.

EUSTACE, David Leonard, BA Fine Art, PGCE; RBA (2002). *Medium:* acrylic, oil. *b:* Birmingham, 8 Mar 1950. *Studied:* Sutton Coldfield School of Art, B'ham (1971-73); Exeter College of Art 1973-76; Leicester College (1976-77). *Represented by:* Rowley Gallery, London; Highgate Fine Art, London. *Exhib:* London solo shows: Rowley Gallery, Highgate Fine Art; New Grafton, Hutson Gallery; mixed: RA Summer Exhbns, RCA, Russell Gallery, Mall Galleries, Discerning Eye; other: Beaux Arts, Bath; Altantic Gallery, Plymouth; Burton Art Gallery, Bideford; Canada and USA. *Recreations:* musician. *Signs work:* Eustace. *Address:* 13 Melbourne Street, St.Leonards, Exeter EX2 4AU.

EUSTACE, Eric George, H.S. (1991), A.R.M.S. (1993); painter in water-colour and acrylic;. *b:* Dunstable, 14 Jan 1925. *m:* Edna Roberts. *Studied:* art at Luton College (1953-55). *Signs work:* "Eric G. Eustace." *Address:* 28 Buttercup Close, Dunstable, Beds. LU6 3LA.

EVANS, Bernard, N.D.D. (1954), A.T.D. (1955); artist in oil, water-colour, pastel; Tutor/Director, Mounts Bay Art Centre, Newlyn, Penzance; mem. NSA. *b:* Liverpool, 6 Jul 1929. *s of:* G. F. Evans. *m:* Audrey M. Evans. three *s.* two *d. Educ:* St. Francis Xavier's Grammar School, Liverpool. *Studied:* Liverpool College of Art, Camberwell School of Arts and Crafts (Martin Bloch, Richard Eurich, R.A.). *Exhib:* Darlington Nottingham, Lincoln, Newlyn, Penzance, London, Connaught Brown Gallery, London. *Publications:* Drawing Towards the End of a Century, Art NSA (pub. NSA Newlyn Gallery), 'Catching the Wave' Halsgrove Press. *Clubs:* Penzance Arts. *Signs work:* "Bernard Evans" or "B. Evans" or "B.E." *Address:* Trevatha, Faugan La., Newlyn, Penzance, Cornwall TR18 5DJ. *Email:* bernardev@madasafish.com

EVANS, Brenda Jean, B.A.Hons. (1976), R.A.S. (1979), S.W.A. (1986); artist in water-colour and oil painting. *b:* Birmingham, 6 Jun 1954. *d of:* Alfred John Evans. *Educ:* Aldridge Grammar School. *Studied:* Sutton Coldfield School of Art, Loughborough College of Art, R.A. Schools. *Exhib:* R.A. Summer Shows, Highgate Gallery, Tenterden, S.W.A., Grape Lane Gallery, York, Edinburgh, New Grafton Gallery, Business Art Galleries, Singer and Friedlander, Kentmere House Gallery. *Works in collections:* H.R.H. Princess Michael of Kent, Mr. and Mrs. Ronnie Corbett. *Works Reproduced:* Medici Cards, Canns Down Press, Ranelagh Press. *Recreations:* gardening. *Signs work:* "Brenda Evans." *Address:* 61a Beulah Rd., Walthamstow, London E17 9LG.

EVANS, David Arthur, NDD, ATD; Emlyn Roberts' Memorial Awards (3); Edith Lodwick Award CSC; Ken Etheridge Award CSC. *Medium:* watercolour, acrylic. *b:* Burry Port, Wales, 9 Aug 1932. *s of:* Mervyn James Evans & Adeline Jane Evans. *m:* Audrey. one *s.* one *d. Studied:* Llanelli School of Art; Swansea College of Art. *Exhib:* RA (1992, 1994, 2001, selected 1993, 1983); RWA (1990, 92, 93, 94, 96, 97, 98, 2000, 03, 04); RSMA (1993-2004, except 2002); RI (1993, 98, 99, 2000, 01, 02, 03, 04, 05); Waterman Fine Art, London; Llewelyn Fine Art, London; Chelsea Art Society; series of one-man exhbns in Cardiff, Camarthen, Llandeilo, Swansea, Lesneven (Brittany). *Works in collections:* Brandler Galleries, London; Peter Hedley Gallery, Dorset; National Library of Wales. *Commissions:* Royal British Legion, Burry Port. *Publications:* work included in 'Art School' Acrylics/Paint Landscapes (Winsor & Newton). *Official Purchasers:* National Library of Wales; Llanelli Town Council. *Works Reproduced:* RA; European Art '96; Paint Landscapes. *Principal Works:* marine paintings. *Recreations:* travelling abroad, and local history. *Clubs:* SWAS, CAS. *Signs work:* 'David Evans'. *Address:* 24 The Crescent, Burry Port, Camarthenshire SA16 0PP.

EVANS, David Pugh, ARCA (1965), RSW (1975), RSA (1989); artist in oil and acrylic. *b:* Abercarn, Gwent, 20 Nov 1942. *s of:* John David Charles Evans, lorry driver. *Educ:* Newbridge Grammar School, Gwent. *Studied:* Newport College of Art (1959-62, Thomas Rathmell), R.C.A. (1962-65, Prof. Carel Weight). *Exhib:* Fruit Market Gallery, Edinburgh, University of York, Mercury Gallery, London, Open Eye Gallery, Edinburgh. *Works in collections:* Carlisle A.G., S.A.C., Hunterian Museum, Glasgow, Glasgow A.G., Royal Scottish Academy, R.A., City A.G., Edinburgh, Aberdeen A.G., Scottish Television, Government Art Collection, Royal Bank of Scotland, Readers Digest, First National City Bank of Houston. *Signs work:* "D.P. Evans." *Address:* 17 Inverleith Gdns., Edinburgh EH3 5PS.

EVANS, Eurgain, N.D.D. (1958), R.A. Schools Cert. (1961); painter in oil and water-colour; retd. lecturer, Faculty of Art and Design, W. Glamorgan Inst. of Higher Educ., Swansea;. *b:* Betws y Coed, Gwynedd, 28 Mar 1936. *d of:* Tom Wern. *Educ:* Llanrwst Grammar School. *Studied:* Wrexham College of Art; R.A. Schools. *Exhib:* Pritchard Jones Hall, Bangor University Wales, London Welsh Assoc. Young Contemporaries, R.A., F.P.S., etc. *Works in collections:* National Museum of Wales, Aberystwyth, and many private collections. *Signs work:* "Eurgain." *Address:* 24 Masefield Way Parc Beck, Sketty Swansea, S. Wales SA2 9FF.

EVANS, Garth, sculptor and draughtsman. *b:* Cheadle, Ches., 23 Nov 1934. *s of:* Cyril John Evans. *m:* Leila Philip. one *s. Studied:* Regional College of Art, Manchester, and Slade School. *Works in collections:* Metropolitan Museum, N.Y.; Museum of Modern Art, N.Y.; Tate Gallery; V. & A.; Power Gallery of Contemporary Art, Sydney; Manchester City A.G.; Portsmouth City A.G.; Bristol City A.G.; Contemporary Arts Soc. of G.B. *Misc:* Lives and works in both London

and New York. *Signs work:* " Garth Evans." *Address:* 106 North 6th St., Brooklyn, N.Y.11211. USA.

EVANS, Margaret Fleming, DA, ATC, UA; portrait painter in oils and pastels, art tutor; teacher in adult education in Kent. *b:* Glasgow, 9 Apr 1952. *d of:* Thomas Carswell. *m:* Malcolm William Evans. one *s.* one *d. Educ:* Whitehill Senior Secondary School, Glasgow. *Studied:* Glasgow School of Art (1970-74, Dr. David Donaldson, R.P., A. Goudie, R.P., L. Morocco, J. Robertson, A.R.S.A.). *Exhib:* London and S.E. England. *Address:* Larasset, High Halden, Ashford, Kent. TN26 3TY.

EVANS, Marlene Elizabeth, S.W.A. (1990), A.B.W.S. (1987), A.Y.A. (1989); artist of botanical studies and landscapes in water-colour, ink, mixed media;. *b:* Barking, Essex, 17 Feb 1937. *d of:* J.B. Stringer, taxi business proprietor (decd.). *m:* Lyn Evans (decd.). one *s.* one *d. Educ:* Racecommon Rd. School, Barnsley. *Studied:* Barnsley School of Art (textile design, L.H.H. Glover, A.R.C.A., A.T.D., R. Skinner, A.T.D.). *Exhib:* one-man shows: Cawthorne S.Y. (1990), Ossett, W. Yorks. (1991), annually S.W.A. and B.W.S., also various mixed exhbns. *Works in collections:* private. *Recreations:* countryside, walking, etc. *Signs work:* "M.E. Evans." *Address:* 14 Spencer St., Barnsley, S. Yorks. S70 1QX.

EVANS, Ray, R.I., R.C.A.; painter, writer and illustrator. *b:* 1920. *s of:* Evan Price Evans. one *s.* one *d. Educ:* Altrincham Grammar School. *Studied:* Manchester College of Art (1946-48), Heatherleys under Iain Macnab (1948-50). *Exhib:* worldwide. *Works in collections:* Gulbenkian Foundation; Nat. Library of Wales; Winchester Guildhall Gallery and many private collections in Europe, Britain, U.S.A. and Canada. *Commissions:* Illustration work accepted. *Publications:* Many books written and illustrated for John Murray, Consumers Assoc., Harper Collins, Batsfords. Illustrated entry in new 20th Century Painters and Sculptors, pub. by Antique Collectors Club. *Address:* New House, Eversglade, Devizes Rd., Salisbury, Wilts. SP2 7LU.

EVANS, Tony, BA (Hons) Fine Art; Wirral Met Coll. Fellowship Award. *Medium:* unique sculptures and architectural panels, drawing. *b:* Liverpool, 19 Nov 1944. *s of:* John Evans (saddler), Alice Evans (kitchen maid). *m:* Brenda. one *s.* one *d. Educ:* De La Salle Grammar School (1955). *Studied:* Liverpool Community College (1997); Wirral Met College (1999). *Represented by:* 'Turner Fine Arts' Art Agency. *Exhib:* Williamson Art Gallery, Birkenhead (2000); Brindley Gallery, Runcorn (2004); Cork Street Gallery, London (2004); Mall Galleries, London (2003); Pacific Road Art Centre (1999); Angela McAlpine Gallery, Chester Racecourse (2005); Atkinson Art Gallery & Museum, Southport (2001); No.9 Gallery, Birmingham (2004); Sheridan Russell Gallery, London (2005); Turner Fine Art Show, travelling nationwide annually. *Works in collections:* Lever-Fabergé Collection, Port Sunlight, Wirral; life-size animal sculptures for No.9 Gallery, Sheridan Russell Gallery. Private clients nationwide and Far East. *Official Purchasers:* Atkinson Art Gallery, Southport; Delamere

Forestry Commission, Cheshire. *Signs work:* 'Tony Evans'. *Address:* 68 Norfolk Tower, Lodge Road, Birmingham B18 5PJ. *Email:* tony@tonyevanssculptures.com *Website:* www.turnerfinearts.com

EVELEIGH, John, Dip. F.A. (Lond.) (1951), F.R.S.A. (1965), elected Fellow (W,gong) (1988), D.C.A. (W,gong) (1991), Aust. W.C.I. (1991), S.W.L.A. (1995), Professorial Fellow James Cook (1992-1994); practicing artist using mixed media; Hon. Founder Arts Director, New Metropole Arts Centre (1961), Hon. Founder Arts Director, The Long Gallery University of Wollongong, Australia (1984); Hon.Director of the University of Wollongong Art Collection (acquiring 540 works 1985-91); Hon. Director of the James Cook Art Collection (acquiring 100 works 1992-94). *b:* London, 15 Dec 1926. *m:* Margaret. three:Aldous, Bernard & Christopher *s. Educ:* Clayesmore School, Dorset (1940-44). *Studied:* Canterbury College of Art (1944-45), The Slade - London University (1948-52), University of Wollongong (1986-90). *Exhib:* one-man shows include: Wildenstein, Piccadilly, South London, Nevill, Abbot Hall, Morley College, Posk, Drew & Marsh Galleries, Metropole Arts Centre (6), University of Wollongong and Perc Tucker - Australia. *Works in collections:* Camberwell, Herts. and Kent County Councils, Welsh Contemporary Arts Soc., Wollongong City Gallery, Wollongong University, James Cook University, Metropole Arts Centre. Private collections: Australia, Austria, China, South Africa, U.K., U.S.A. and Spain. *Commissions:* public and private, portrait, landscape and wildlife. *Works Reproduced:* books, magazines. Published 150 catalogues. *Misc:* Directed video art documentaries (Carel Weight/ Fred Cuming). *Signs work:* " John Eveleigh." *Address:* 4 Broadfield Rd., Folkestone, Kent CT20 2JT.

EVERSFIELD, Marika, NS; RAS; Winner, Kensington-Chelsea Arts Council. *Medium:* oil and pastel. *b:* Gyder, Hungary, 13 Oct 1914. *Educ:* VP Gymnasium, Jasik Almos Art School. *Studied:* Kunste Academie, Vienna; Accademia Belle Arte Perugia (Italy); Arour Segal Art College, London. *Exhib:* solo exhibitions: La Galleria, Italy;Leighton House, Wigmore Hall; selected group exhbns: Royal Society of Arts; New English Art Club; Archer Gallery; Alpine Gallery; BH.Corner Camden Arts Centre; Holland Gallery; Hyde Park Gallery; Example Art Gallery; Atrium Gallery; Orangery (FHP) Bankside Gallery; Artbank Gallery; 29th Gallery; Gallery Cork Street (W1); Ridley Art Society; BVS Munich, Germany; Westminster Arts Council. *Works in collections:* internationally. *Clubs:* National Society of Painters, Ridley. *Signs work:* "ME". *Address:* 4/137 Holland Park Avenue, London W11 4UT.

EWING, John, RAS Cert (1951), ATD (1954), DAE (1970), BA (Hons) OU (1977); retired art teacher. *b:* Paris, 29 Jul 1929. *m:* Barbara. one *s. Educ:* Hove County Grammar. *Studied:* Croydon and Malvern Art Schools, Royal Academy Schools. *Exhib:* Mall Galleries, Piccadilly Gallery, etc. *Works in collections:* various, mainly oils. *Clubs:* RASAA. *Address:* 44 Norfolk Ave Sanderstead, Surrey, CR2 8BP. *Email:* j.b.ewing@eggconnect.net

EYTON, Anthony John Plowden, R.A. (1986), R.W.S., R.W.A., R. Cam. A., Mem. London Group, N.D.D., Abbey Major Scholarship in Painting (1950); prize winner, John Moore's Exhbn. (1972), awarded Grocer's Co. Fellowship (1973), 1st prize, Second British International Drawing Biennale, Middlesbrough (1975), Charles Wollaston Award, R.A. (1981), British Painting 1952-77, R.A. (1977); artist in oil. *b:* Teddington, 17 May 1923. *s of:* Capt. John Eyton, I.C.S., author. three *d. Educ:* Twyford School (1932-37), Canford School (1937-41). *Studied:* Reading University (1941); Camberwell School of Arts and Crafts (1947-50). *Exhib:* London Group, R.A.; one-man shows: Browse and Darby (1981, 1985, 1987, 1990, 1993, 1996, 2000, 2005); Retrospective: South London A.G. (1980), King's Road Gallery (2002), Woodlands Art Gallery (2003). *Works in collections:* Arts Council, Tate Gallery, Imperial War Museum, Govt. Picture Collection, Plymouth A.G. *Publications:* "Eyton's Eye", "A life in Painting" by Jenny Perry RA Publications. *Recreations:* gardening. *Clubs:* Arts. *Address:* 166 Brixton Rd., London SW9 6AU.

F

FABER, Rodney George, self taught artist in water-colour and pen and ink drawing; mem. SGFA 1987-98. *b:* Liverpool, 8 Jun 1935. *s of:* Leslie Faber. *m:* Asne Wainer. *Educ:* Hasmonean Grammar School. *Exhib:* S.G.F.A. Annual exhbns. and mixed exhbns. in various galleries in London and the Home Counties. Commission and other works in numerous private collections both in U.K. and abroad. Rexel prizewinner S.G.F.A. (1992). *Signs work:* "FABER." *Address:* Studio: 37 Darwin Ct., Gloucester Ave., London NW1 7BG.

FAILES, Colin Michael, City & Guilds Dip. (Sculpture) (1972), Beckworth travel scholarship to Egypt (1972), Postgrad. (Sculpture) Cert. R.A. Schools, Silver medal (Sculpture) (1975), bronze medal (Sculpture) (1976);. *Medium:* mural artist and sculptor. *b:* Farnborough, Kent, 2 Oct 1948. *s of:* Ceril Walter Failes. *Educ:* Arle School, Cheltenham. *Studied:* City & Guilds of London Art School (1969-72, James Butler, R.A.), R.A. Schools (1973-76, Willi Soukop, R.A.). *Exhib:* R.A. Summer Exhbns. (1976, 1980, 1987, 1988). *Works in collections:* London, Monaco, Luxembourg. *Commissions:* murals: "Oriana" P. & O.; Vintners' Hall, City of London; Bridge Housing Assoc., London, Worshipful Company of Distillers, London, Claridge's Hotel, London. *Works Reproduced:* in "Painting Murals" (MacDonald Orbis), and "Murals" (New Holland). *Clubs:* R.A. Schools Alumni Association. *Signs work:* "COLIN FAILES" or "C.M. Failes." *Address:* 6 Elfindale Rd., London SE24 9NW. *Email:* Colin.Failes@btinternet.com

FAIRCLOTH, Shireen, Full School Srawing Certificate (1950); Intermediate Examination in Arts & Crafts (1953); City and Guilds Pattern Cutting & Dressmaking (1953). *Medium:* drawing, painting, sculpture. *b:* East Sheen, Surrey, 6 Jan 1936. *Educ:* St.Joseph's Convent, Sidcup, Kent. *Studied:* Sidcup School of Art (1951-53). Subsequently painting at Adult Education classes.

Exhib: one-man show 1984 - Torrington, North Devon, paintings of 'Tarka' country to co-incide with opening of film. Twice in Royal Academy Summer Show also mixed shows at Chenil Galleries, Chelsea Art Society & Fulham Art Society; 3 person show at 'Old Sorting Office Arts Centre', Barnes (2005). *Commissions:* private commissions for child and pet drawings, paintings of horses and prize farm animals. *Works Reproduced:* cover of a cookbook (lemon painting) (2006). *Recreations:* learning the flute (and to read music); swimming. *Misc:* worked as commercial artist 1966-1980 specialising in birds, animals and illustrations for encyclopedias; 'Halcyon Days' enamel boxes- flowers and birds. *Signs work:* 'SF'. *Address:* 42 Anselm Road, London SW6 1LJ.

FAIRCLOUGH, Michael, R.E. (1964), Rome Scholar in Engraving (1964-66), N.E.A.C. (1995); painter/printmaker; lecturer, Belfast College of Art (1962-64); West Surrey College of Art (1967-79);. *b:* Blackburn, 16 Sept 1940. *s of:* Wilfred Fairclough. *m:* Mary Malenoir. two *d. Studied:* Kingston School of Art (1957-61); British School at Rome, (1964-67); Atelier 17, Paris (1967). *Exhib:* one-man shows Henley-on-Thames, Farnham, Toronto, Auckland, Berkeley Square Gallery, London (2000), Osborne Samuel, London (2004). *Works in collections:* V. & A., Ashmolean, Usher Gallery, Bowes Museum, Royal Albert Museum, New York Public Library. *Commissions:* mural, Farnham Post Office (1970), Post Office 'National Trust' issue of five stamps (1981), Meteorological Office, Exeter (2004). *Official Purchasers:* Government Art Collection. *Signs work:* "Michael Fairclough." or MF. *Address:* Tilford Green Cottages, Tilford, Farnham, Surrey GU10 2BU. *Email:* info@michalfairclough.co.uk *Website:* www.michaelfairclough.co.uk

FAIRFAX-LUCY, Edmund, painter of interiors, still-life and landscapes in oil;. *b:* Oxford,1945. *Studied:* City & Guilds of London Art School, and R.A. Schools (1967-70) winning David Murray Travelling Scholarship (1966, 1967, 1969). *Exhib:* R.A. since 1967, New Grafton Gallery since 1971. *Works in collections:* Brinsley Ford. *Misc:* information on date painting commenced/ time of year, time of day and sometimes place inscribed on reverse of painting or frame. *Signs work:* work unsigned. *Address:* Charlecote Park, Warwick CV35 9EW.

FAIRGRIEVE, James Hanratty, D.A. (Edin.), R.S.W., R.S.A.; Gillies award, R.S.W. (1987); retd. lecturer, painter in acrylic. *b:* Prestonpans, E. Lothian, 17 Jun 1944. *s of:* Andrew D. G. Fairgrieve, ex-miner. *m:* Margaret Fairgrieve. two *s.* one *d. Educ:* Preston Lodge Senior Secondary School. *Studied:* Edinburgh College of Art. *Exhib:* Hawarth A.G. (1974), Triad Arts Centre (1974), Scottish Gallery (1974), Scottish Arts Club (1973), New 57 Gallery (1969, 1971); one-man shows: Edinburgh University (1975), Scottish Gallery (1978), Mercury Gallery, London (1980, 1982, 1987), Macauley Gallery (1983), Mercury Gallery, Edinburgh (1984), Stichell Gallery (1990), Fosse Gallery (1992), Pontevedra, Spain (1995), Roger Billcliffe (1997), Edinburgh City Art Centre (1998), Portland Gallery (1999), Albemarle Gallery (1999), Frank T.Sabin Gallery (2000), Fosse Gallery

(2000), Compass Gallery (2000), Noble-Gosshert prize exhibition (2001), Open Eye Gallery (2001), New Grafton Gallery (2002), Maclean Fine Art, London (2002), Origin Art Gallery (2002), Leith Gallery (2003), New Grafton Gallery, London (2003), Thompsons Gallery, London (2004), Medici Gallery, London (2004), Randolph Gallery (Edin)(2004), Gothenburg Preston Pans (2005), Maclean Fine Art, London (2005). *Works in collections:* Edinburgh Corp., Scottish Arts Council, National Bank of Chicago, Milngavie A.G., H.R.H. The Duke of Edinburgh, Argyll Schools, R.C.P., Perth A.G., Lord Moray, Leeds Schools. *Publications:* 'Eye in the Wind' - Edward Gage; 'Scottish Water-colour Painting' - Jack Firth; 'A Picture of Flemings' - B. Smith; 'Dictionary of Scottish Art and Architecture' - P. McEwan. *Recreations:* fly-fishing. *Signs work:* "J. Fairgrieve." *Address:* Burnbrae, Gordon, Berwickshire, Scotland TD3 6JU.

FAIRHURST, Miles Christopher, painter in oil; painter of East Anglian landscape in tradition of Edward Seago and Arnesby-Brown, and abstracts; former owner of Fairhurst Gallery, London. *b:* Norwich, 3 Dec 1955. *Educ:* Gresham's School, Holt, Norfolk. *Studied:* largely self taught; studied under father, Joseph Fairhurst and at University of Aix-en-Provence, France. *Exhib:* R.S.M.A., Mall Galleries, Park Grosvenor Galleries, London, Barnes Gallery, London, and various London and provincial galleries. *Works in collections:* private collections in U.K., U.S.A., Australia, New Zealand, Europe. *Commissions:* oil painting for T.V. commercial for Volkswagen (1987). *Publications:* illustrations for Millers Picture Price Guide (1994 onwards). *Works Reproduced:* dust jacket illustration for 'Gypsy Jib-A Romany Dictionary' by James Haywood (2003). *Signs work:* "M. Fairhurst." and 'MCF' on abstracts. *Address:* Turkey Hall, Metfield, Suffolk, IP20 0JX.

FAIRMAN, Sheila, R.M.S., S.W.A., F.S.B.A.; awarded R.M.S. Gold Bowl (1989), Hunting Group art prize, runner up (1982); Barbara Tate Award, SWA (2003); painter in oil and water-colour and miniaturist. *b:* Benfleet, Essex, 18 Aug 1924. *d of:* Harry Kingston Newman. *m:* Bernard Fairman, F.A.P.S.A. one *s.* *Studied:* Southend-on-Sea College of Art (1938-41). *Exhib:* R.A., R.M.S., R.S.M.A., R.P., R.I., R.O.I., S.W.A., S.B.A. *Works in collections:* Beecroft A.G., Southend-on-Sea. *Signs work:* "SHEILA FAIRMAN" or "S.F." *Address:* 39 Burnham Rd., Leigh-on-Sea, Essex SS9 2JT.

FAIRWEATHER, Dorothy, painter/etcher. *b:* 4 Aug 1915, married. *d of:* Benjamin Stewart, F.A.I. one *s.* *Educ:* privately. *Studied:* Folkestone School of Art (1930-34), Liverpool School of Art (1942-44). *Exhib:* leading London galleries including R.A., Barbican, Paris (1983-84), Germany (1989). *Works in collections:* Britain and abroad. President Soroptimist Club of Sevenoaks (1973-74, 1984-85). *Address:* Lanterns, 4 Cade La., Sevenoaks, Kent TN13 1QX.

FAKHOURY, Bushra, BA, MA, PhD (Lond.); sculptor in bronze, stone. *b:* Beirut, 1 Apr 1942. *d of:* Bachir Fakhoury, chemist. two *s.* *Educ:* St. Paul's, Wimbledon School of Art and Emanuel. *Studied:* Beirut University College,

American University of Beirut, University of London. *Exhib:* Bloomsbury Galleries (1986), Mall Galleries (1986), Jablonski Gallery (1987), Ashdown Gallery (1988), Kufa Gallery (1989). *Publications:* Art Education in Lebanon. *Address:* 57 Madrid Rd., Barnes, London SW13 9PQ.

FALCIDIA, Paulette, *Medium:* acrylic, oil pastels, carving, installation, assemblage. *b:* Monyash, 27 Aug 1946. *m:* divorcee. one *s.* one *d. Educ:* Highfield School for Girls (1958-63). *Studied:* Chesterfield College of Art (1963-65); self-taught, studied under: Nasing Das, Disangen, Rajistan, India (1996); Hillsborough College (2005-2007) Access Art & Design. *Exhib:* RA (2000); Dept. Psychiatry, Sheffield University (1996); S10 Gallery, Sheffield (1998); Haitch's Bakewell (1998); Rowland Gallery Sheffield (1997); Ranmoor Church, Sheffield (1997); Blue Moon Cafe, Sheffield; Park View, Sheffield; Sheffield Wednesday Conference Room. *Commissions:* Regional Engineering and Computing Technology (Rotherham). *Publications:* Telegraph and Star, Sheffield; Focus Magazine; Westside Magazine. *Official Purchasers:* Regional Engineering and Computing Technology (Rotherham). *Principal Works:* large body of work conceived by dredging the subconscious. *Recreations:* self-analysis through art. *Misc:* wood carving, finding inspiration from its natural form; art therapy for Stocksbridge Rehab Centre. *Signs work:* (drawing of eye) and RIS. *Address:* Cliffe House, Flat 4, 10 Whitworth Road, Ranmoor, Sheffield S10 3HD. *Website:* www.falcidia-art.co.uk

FALCONBRIDGE, Professor Brian, Dip. A.D. (Fine Art) (1973), H.D.F.A. (Slade) (1975), elected F.R.B.S. (1997), President of the Royal British Society of Sculptors; Professor of Visual Arts, Goldsmiths'; sculptor in bronze and wood. *b:* Fakenham, 1 May 1950. one *s.* one *d. Educ:* Fakenham Grammar School. *Studied:* Canterbury College of Art (1968-69), Goldsmiths' College School of Art (1970-73), Slade School of Fine Art (1973-75). *Exhib:* numerous mixed and solo exhbns. in UK, Europe and Far East. *Works in collections:* A.C.G.B., Contemporary Arts Soc., University of East Anglia, British Council and numerous private collections in U.K. and abroad. *Clubs:* Chelsea Arts. *Signs work:* "Brian Falconbridge." *Address:* c/o Royal British Society of Sculptors, 108 Old Brompton Road, South Kensington, London SW7 3RA.

FALLA, Kathleen M., F.F.P.S (1985); relief printmaker and sculptor in wood. *Medium:* woodcuts etc. *b:* Guernsey, C.I., 25 Jan 1924. *d of:* John Hocart Falla. *m:* Kenneth R. Masters. one *s.* one *d. Educ:* Ladies College, Guernsey. *Studied:* Guildford School of Art and Morley College, London. *Exhib:* solo shows: Lauragais, France, University of Surrey, Godalming Museum; shared shows: Loggia Gallery, Farnham Maltings; group shows: Barbican, West of England Academy, Brighton Polytechnic Gallery, Bloomsbury Galleries, Yvonne Arnaud Art, Guildford, etc. *Signs work:* "Kit Falla." or "KMF". *Address:* Old Barn Cottage, Church La., Witley, Surrey GU8 5PW.

FALLSHAW, Daniel, painter in oil and acrylic, also pastel, charcoal,pen & ink, and pencil, sculptor in various media; Former M.D. of Creative Media Communications design consultants;. *b:* London, 17 Nov 1946. *s of:* George James Fallshaw. *m:* Elizabeth. two *d. Educ:* Broxhill, Romford and privately. *Studied:* studied under Arnold Allerbach (1966-68) Portraiture and painting under Leonard Boden, F.R.S.A.; sculpture under Jack Gillespie and Edmund Holmes; graphic design at the London College of Printing under Leonard Cusdens and Don Smith. *Exhib:* Mall Galleries, N.S., U.A., numerous London and UK galleries nationwide. *Publications:* "Art of Creation – inspired images'. *Clubs:* Folkestone Art Soc., Canterbury Society of Art. *Signs work:* "Fallshaw" – sculpture "DF." *Address:* Woodside Cottage, Maydensole, Nr. West Langdon, Dover, Kent CT15 5HE. *Email:* daniel@fallshaw.freeserve.co.uk *Website:* www.artofcreation.co.uk

FARLEY, James Osmer, ARBS (1990), ANSS (1985); portrait and architectural sculptor in clay, wax, direct metal, steels, bronze, copper. *b:* Cleveland, Ohio, 10 Apr 1935. *s of:* Wayne B. Farley, mechanical process engineer. *m:* Gillian Lewin. one *d. Studied:* Pennsylvania Academy of Fine Art (1952-56, Walker Hancock, Harry Rosin, Andrew Wyeth), Chicago Art Inst. (1957-59, Edvard Chaisang). *Exhib:* Art and the Corporate Image (1981). *Works in collections:* Arizona: Bell Center, Sun City; City Hall, Glendale; Centennial Hall, Mesa; St. Luke's Hospital, Phoenix; Hanna Boys Center, Sonoma, Calif. *Clubs:* F. & A. Masonic Lodge. *Misc:* other address: 4718 E. Portland, Phoenix, AZ. 85008, U.S.A. *Signs work:* "James Farley." *Address:* 150 Scott Ellis Gdns., St. John's Wood, London NW8 9HG.

FARMAR, Francis Edmund, Diploma in Art and Design. *Medium:* painting in watercolour and oil. *b:* Cheam, Surrey, 8 May 1948. *s of:* Hugh Farmar. *m:* Jane Lamb. 1 s- *d. Educ:* Eton College. *Studied:* Simi Academy Florence, St.Martin's College of Art London, West of England College of Art Bristol. *Represented by:* Duncan Campbell Fine Art, London. *Exhib:* several solo and mixed exhibitions since 1990, including Chelsea Arts Club (1992), Coleherne Road, London (1996), Duncan Campbell (1997-2006), Angel Lane Gallery, Shaftesbury (2000, 01), John Noot Galleries, Broadway, Worcs (2001), RCA (2002), Wren Gallery, Burford (2004-5); The Gallery, Tresco (2005); Hankyu, Osaka, Japan (2005); Flying Colours Gallery, Edinburgh (2006). *Works in collections:* Duke of Devonshire; Marquis of Bath, Longleat; Drapers Company London; numerous private collections in UK, USA and Europe. *Commissions:* Unicef Christmas card (1998), and numerous private. *Publications:* Carlos Nadal. *Works Reproduced:* various national magazines. *Recreations:* cooking, gardening. *Clubs:* Chelsea Arts Club. *Signs work:* Francis Farmar. *Address:* The Old Rectory, Sedgehill, Shaftesbury, Dorset, SP7 9JH. *Email:* francis.farmar@btconnect.com *Website:* www.francisfarmar.com

FARQUHARSON, Alex, M.A. (Dist.) Arts Critic, B.A. English/Art Comb. Hons.; curator; Exhbn. Officer, Spacex Gallery, Exeter;. *b:* Chalfont St. Giles, 26

Sept., 1969. *Educ:* Exeter University, City University, London. *Studied:* Exeter College of Art and Design (now Plymouth University) (1988-91). *Publications:* numerous catalogue texts. *Address:* c/o Spacex Gallery, 45 Preston St., Exeter EX1 1DF.

FARQUHARSON, Andrew Charles, artist in water-colour. *b:* Johannesburg, S. Africa, 14 Dec 1959. *s of:* Margaret Irene Chadwick Arridge, NS, FSBA, ARMS. *Educ:* St. John's College, Johannesburg. *Studied:* under his mother. *Exhib:* group show Johannesburg. *Misc:* Lectured: University of Wales, Anglo Spanish Soc., Inst. of Spain. *Signs work:* "A.C. Farquharson." *Address:* 80b Naylor Rd., Peckham, London SE15.

FARR, Colleen, Des RCA. *Medium:* oil, watercolour, egg tempera. *b:* London, 24 Nov 1931. *d of:* D.H.Farr. *m:* William Belcher. *Studied:* Harrow School of Art, RCA. *Exhib:* RA Summer Exhbn, RWS Bankside Gallery, Mall Galleries: Society of Landscape Painters, Sunday Times Watercolour Competition. *Recreations:* gardening. *Signs work:* 'Colleen Farr'. *Address:* 304 Kew Road, Kew, Richmond Surrey TW9 3DU. *Email:* colleen.farr@virgin.net

FARR, Dennis Larry Ashwell, C.B.E., M.A., Hon.D.Litt., F.R.S.A., F.M.A.; Director, Courtauld Institute Galleries (1980-93); Director, Birmingham Museums and Art Gallery (1969-80); Senior Lecturer in Fine Art, University of Glasgow (1967-69); Curator, Paul Mellon Collection, Washington, D.C. (1964-66); Asst. Keeper, Tate Gallery, London (1954-64). *b:* 3 Apr 1929. *m:* Diana Pullein-Thompson, writer. one *s.* one *d. Educ:* Luton Grammar School. *Studied:* Courtauld Inst. of Art, University of London (1947-50). *Publications:* William Etty (1958), Catalogue of the Modern British School in the Tate Gallery (with M. Chamot and M. Butlin, 1964-65), English Art 1870-1940 (1978), Lynn Chadwick, Sculptor (with Eva Chadwick, 1990), etc. *Address:* Orchard Hill, Swan Barn Rd., Haslemere, Surrey GU27 2HY.

FARRELL, Alan Richard, painter in water-colour and oil, miniaturist and member of R.M.S., M.A.A., H.S., M.P.S.G.S. and M.A.S.F.; chartered engineer and member of Institution of Electrical Engineers; Has received several awards in U.K. and overseas including Best of Show in M.P.S.G.S. Washington DC, 1st in International category in Washington, Gold for best painting in any traditional medium in Ottawa and 1st in Watercolour (MASF, Florida). *b:* London, 17 May, 1932. married. two *d. Studied:* S.E. Essex Technical College and School of Art (1953-56). *Exhib:* R.A.,R.M.S., R.I., R.S.M.A., R.B.A., U.A., International Boat Show, Britain in Water-colours, and several international exhibitions overseas including Wolrd Exhibition in the Dillon Ripley Centre (Smithsonian Museum) Washington DC. *Signs work:* "ALAN FARRELL" printed bottom right or left-hand corner; paintings dated on reverse. *Address:* The White House, Whitesmith, nr. Lewes, E. Sussex BN8 6JD.

FARRELL, Anthony, N.D.D. (1965), R.A.Dip. (1968); artist in oil, etching. *b:* Epsom, 28 Mar 1945. *s of:* William Farrell. *m:* Sarah. one *s.* three *d. Educ:*

Belfairs High School. *Studied:* Camberwell School of Art (1963-65), R.A. Schools (1965-68). *Exhib:* R.A. Common Room, Minories, Colchester, R.A. Summer Exhbns., Serpentine Gallery, Christchurch Mansions, Ipswich, Gainsborough House, Sudbury, Arts Space, London. *Works in collections:* A.C.G.B., The Minories, Colchester, Epping Forest Museum, Manchester City A.G., Beecroft A.G., Westcliff-on-Sea, Borough of St. Edmundsbury and Suffolk C.C., Essex Health Authority, Ipswich Borough Council. *Clubs:* Royal Academy Alumni Association (Reynolds Club). *Signs work:* "Anthony Farrell." *Address:* 6 Avenue Rd., Leigh-on-Sea, Essex SS9 1AX. *Email:* ansfarrell@aol.com

FARRELL, Don, R.I. (1984), R.B.A. (1985), S.F.C.A.; R.I. medal (1984); Daler Rowney award R.B.A. Exhbn. (1992); painter in water-colour and mixed media. *b:* Vancouver, B.C., 3 Oct 1942. *m:* Margaret. two *s. Represented by:* Adam Gallery, 24 Cork Street, London. *Exhib:* RA Summer Exhbn (2004, 2005), R.I. (1984-01), R.B.A. (1983-01), Vancouver International Arts Fair (1998), 20/21 British Arts fair (2000, 2002), The Gallery in Cork St. (2000), London Contemporary Art Fair (2001, 2002, 2003, 2004), Adam Gallery, London (solo, 2002), Royal College of Art, London (2002, 2003), Works on Paper, The Park Avenue Armory, New York (2002, 2003). *Works in collections:* H.R.H. The Prince of Wales; private and corporate collections: Britain, Canada, U.S.A. and Europe. *Signs work:* "Don Farrell." and "FARRELL". *Address:* 521 Maquinna Place, Qualicum Beach, B.C., V9K 1B3., Canada.

FARROW, Kieron, B.A. (Hons.) Fine Art (1982); artist, painter and printmaker in oil, monoprints;. *b:* Barnsley, Yorks., 25 Aug., 1949. *m:* Megan Farrow. two *s. Studied:* Middlesex University. *Exhib:* group shows: Ikon Touring Exhbn. (1985, 1986), Present Prints, Royal Festival Hall London; one-man shows: Curwen Gallery (1999), Museum of Archaeology, Valletta, Malta (1985). *Works in collections:* J.P. Morgan, Wall St., N.Y.; Lake Point Tower, Chicago; Royal British Legion, Malta; Royal Borough of Kensington and Chelsea, London; Norwich Castle Museum; Scarborough A.G. *Address:* c/o Curwen Gallery, 4 Windmill St., London W1P 1HF.

FARTHING, Stephen, RA (1998); Emeritus Fellow St.Edmund Hall, University of Oxford(2000); Honorary Curator of Collections, Royal Academy of Arts (2000). *Medium:* painting and drawing. *b:* London, 16 Sep 1950. one *d. Studied:* St.Martins (1969-73); Royal College (1973-76); British School in Rome (1975). *Represented by:* Frost and Reed, London & New York. *Exhib:* Paris Biennale, France (1982); S.Paulo Biennale, Brazil (1989); Edward Totah Gallery (1985-1990); National Museum of Modern Art, Kyoto (1994); Chelsea Future Space, London (2006); Gus Fischer Gallery, Auckland, NZ (2007). *Works in collections:* Arts Council of England, British Council, British Museum. *Commissions:* Ashmolean; Government Art Collection fund; Walker Gallery, Liverpool; Otemar University, Japan. *Publications:* Intelligent Persons Guide to Modern Art (Duckworth, 2002); 1001 Paintings You Must See Before You Die (Cassell, 2006). *Works Reproduced:* on RA website. *Recreations:* watercolour

painting; tennis. *Clubs:* Chelsea Arts Club. *Signs work:* "STEPHEN FARTHING". *Address:* c/o The Royal Academy, Burlington House, London SW1. *Website:* www.stephenfarthing.com

FAULDS, James Alexander, D.A.; artist in water-colour and oil; art teacher. *b:* Glasgow, 15 Jan 1949. *s of:* Alexander Faulds. *Educ:* Knightswood Secondary School. *Studied:* Dundee College of Art (1968-72). *Exhib:* Dundee under 30's, R.S.A., S.S.A., Colquhoun Memorial, Group 81, Glasgow, Eden Court Gallery, Contemporary British Water-colours, Festival Theatre, Pitlochry, R.S.W., John Laing, London, Nürnberg, Germany. *Clubs:* Glasgow Art; founder mem., Group 81, Glasgow. *Address:* 3 Camphill Ave., Glasgow G41 3AV.

FAULKNER, Amanda, B.A.(Hons.) Fine Art (1982), M.A. Fine Art (1983); artist in charcoal and pastel on paper, acrylic on canvas, lithography and etching; Senior lecturer in Fine Art, Chelsea College of Art and Design, University of the Arts, London. *b:* Poole, 5 Dec 1953. *d of:* Richard Faulkner, B.Sc. & Gillian Hopkinson (née Park). one *s. Educ:* St. Anthony's, Leweston, Dorset, and Canford School, Dorset. *Studied:* Bournemouth College of Art (1978-79), Ravensbourne College of Art and Design (1979-82), Chelsea School of Art (1982-83). *Exhib:* regularly at Angela Flowers Gallery and Flowers East since 1983; and in U.K. and internationally. *Works in collections:* including A.C.G.B., Unilever plc, V. & A., Contemporary Art Soc., Whitworth A.G., Silkeborg Kunstmuseum, Denmark. *Signs work:* "Amanda Faulkner." *Address:* 131 Listria Pk., London N16 5SP. *Email:* amandafaulkner@blueyonder.co.uk

FAULKNER, Iain, BA Hons (Fine Art). *Medium:* oil. *b:* Glasgow, 28 Jul 1973. *s of:* John and Janet Faulkner. *m:* Laura. *Studied:* Glasgow School of Art (1991-96). *Represented by:* Albemarle Gallery, London. *Exhib:* Albemarle Gallery, London; Eleanor Ettinger Gallery (New York); Sammer Gallery (Spain). *Works in collections:* The Prudential; private collections in Europe, USA, Japan. *Commissions:* portraits commissioned by Glasgow Chambers of Commerce, Royal College of Pharmaceutical Medicine, St.Andrews Society, private collectors. *Signs work:* IF. *Address:* 7 Queensgate, Glasgow, G76 7HE.

FAULKNER, Robert Trevor, A.R.C.A. (1955), F.R.B.S.; figurative sculptures in bronze, terracotta and direct metal; specialist in polychrome metal wild-life and aeronautical subjects. *b:* 17 Sept 1929. *m:* Brenda Mabel (Flowers). one *d. Educ:* Penistone Grammar School. *Studied:* Sheffield School of Art (1946-50); R.C.A. (1952-55). *Represented by:* John Noott, Broadway, Worcs. *Exhib:* Moorland, Alwin (London), John Noott Galleries, Broadway, Worcs; Renishaw Art Group. *Works in collections:* Ulster Museum, Derbys.; Oxford and Lancs.Educ. Authorities; Pewterers Company, London, Sir Reresby Sitwell. *Commissions:* medals for Virginia Air and Space Museum; trophy, Royal Aero Club; medals for B.M.F.A., Golfing figures for Jack Spencer (Goldsmiths'); Samuel Fox & Co. (Steelworks) Sheffield; Molins Ltd.: WVEC (Virginia). *Publications:* Manual of Direct Metal Sculpture (Thames & Hudson, 1978).

Recreations: swimming, model engineering. *Clubs:* Sheffield S.M.EE.E. *Signs work:* "TREVOR FAULKNER" or "T.F." *Address:* 4 Birchitt Cl., Bradway, Sheffield S17 4QJ.

FAUST, Pat, artist in oil, water-colour, pastel, theatrical designs, murals. *Educ:* Culcheth Hall, Ches. *Studied:* Manchester Regional College of Art; Crescent Theatre, Birmingham. *Exhib:* R.G.I., Manchester Academy, Birmingham A.G., Sewerby Hall, Bridlington, Scarborough A.G. and Town Hall, Ferens A.G., Hull, Beverley, Cartwright Hall, Bradford, Pannett, Whitby, R.A., R.B.A., S.W.A., R.Cam.A., U.A.S., Leeds City A.G., Paris Salon, Gallery Vallombreuse Biarritz, Brye A.G., Glaisdale, City Gallery, Darlington, Francis Phillips Gallery, Sheffield, Northern Academy of Art, Harrogate A.G., Guildhall, York, Yorkshire Artist Biennal, City A.G. York, Yorkshire Pastel Soc., Haworth, Cliffe Castle Museum and A.G. Keighley, Yorks.; one-man shows: Marshalls, Scarborough, Hull University, Yorkshire Pastel Soc., Dewsbury A.G. and Museum, Scarborough Scene, Scarborough Art Gallery (2001); joint exhbn. March-May 1998 Sewerbury Hall, Bridlington, Walker Gallery, Harrogate. *Works in collections:* Scarborough A.G., Scarborough Town Hall, Menston Hospital and private collections. Official purchases: painting of Scarborough A.G. (hung R.A.) by Scarborough Corp. Winner shield best medium (1992) and award (1993, 1994) Sewerby Hall, Bridlington. *Clubs:* Leeds Fine Art, Scarborough Arts Soc. *Signs work:* "Pat Faust."

FAWLEY, Charlotte Audrey, N.D.D. Illustration (1957); painter/designer in oil, pastel, water-colour;. *b:* Blackpool, 6 Dec., 1934. *Educ:* Arnold High School, Blackpool. *Studied:* Blackpool School of Art (1953-57), Camden Arts Centre, London (1964-66, Aubrey Williams). *Exhib:* Royal Opera House, Covent Garden; Royal National Theatre, South Bank; Primrose Hill Gallery; Soar Gallery Kensington; Chelsea Arts Club; RAC Club, Pall Mall; Bafta, Piccadilly, etc. Work in collections internationally. *Commissions:* Design of backcloth and costumes for ballet 'Serpentime' for Royal Ballet tour Kenya (1996). BBC2 Series 'Making their Mark' (R. Foster) 6 artists on drawing in different mediums. BBC2 Newsnight - graphics for Falklands War (1981) and Gulf War CNN. *Publications:* illustrated: 'Thinking About God' (HarperCollins). *Clubs:* Chelsea Arts, BAFTA, Piccadilly, London. *Signs work:* "CHARLOTTE FAWLEY." *Address:* 56 Holley Rd., Wellington Court, London W3 7TS. *Email:* Acfawley@aol.com

FAWSSETT, Ann: see ATKIN, Ann,

FEASEY, Judith Mary, Cert. R.A.S. (1976), A.T.C. (1977); painter/etcher in oil on canvas, water-colour, etching. *b:* Southgate, 3 Sep 1945. *d of:* Cyril Feasey, mechanical engineer. *Educ:* St. Maurs Convent, Weybridge, Surrey. *Studied:* Guildford School of Art (1965-69), R.A. Schools (1973-76) Turner gold medal for landscape painting. *Exhib:* R.A. London and Scotland, G.L.C. Spirit of London; four-man show, Alfred East Gallery, Kettering, and Mall Galleries,

London, etc. *Signs work:* "J. Feasey" or "J.M.F." *Address:* 90 Webster Rd., London SE16 4DF.

FEDDEN, Mary, O.B.E.;R.A.; Slade Diploma of Fine Arts; teacher of painting at Royal Coll. of Art (1958-64); Yehudi Menuhin School (1965-70); President, Royal West of England Academy (1983-88); Hon. D.Litt. Bath Univ. *Medium:* oils. *b:* Bristol, 14 Aug., 1915. *d of:* Vincent Fedden. *m:* Julian Trevelyan (decd.). *Educ:* Badminton School, Bristol. *Studied:* Slade School of Art. *Exhib:* Leicester Gallery, Gimpel Fils, R.W.A., London Group; solo shows: Christopher Hull, Bohun Gallery (4), Redfern Gallery (6), New Grafton Gallery (6), Beaux Arts Gallery (3), Provincial Galleries and Royal West of England Academy, Royal Academy. *Works in collections:* H.M. The Queen, Prince Hassan of Jordan, Tate, Hull, Carlisle, Melbourne, National Gallery of N.Z., Bristol, Bath, Durham,York, Chichester. Official purchases: murals, Charing Cross Hospital, Contemporary Arts Soc., Yorkshire C.C., Leicestershire C.C., Hertfordshire C.C., Min. of Works, Orient Line, Bristol Educ. Com., Barnet Hospital, Cambridge Colleges of New Hall and Lucy Cavendish, City Art Galleries Reading, Bristol, York. *Signs work:* "Fedden." *Address:* Durham Wharf, Hammersmith Terr., London W6 9TS.

FEI, Cheng-Wu, painter; Prof. (1941-46), College of Fine Art, National Central University, China. *b:* China, 30 Dec 1914. *s of:* Mai-Chu Fei, poet, prof. of Chinese literature. *m:* Chien-Ying Chang, artist. *Studied:* National Central University, China (1930-34), Slade School of Fine Art (1947-50). *Exhib:* R.A., R.I., R.W.A., R.W.S., N.E.A.C.; one-man shows at Leicester Galleries. *Works in collections:* Royal West of England Academy, Universities' China Committee, Grave's Gallery, Sheffield, Derby A.G., etc. *Publications:* Brush Drawing in the Chinese Manner (Studio). *Works Reproduced:* in Studio, Art News & Review, La Revue Moderne, Kunst, etc. *Address:* 27 The Fountains, Ballards Lane, London N3 1NL.

FEIJOO, Fernando, RE Council Member; Gwen May Sudent Printmaker (2003); Winner, Design a Book of Fables (FPBA, 2004); BA (Illustration); MA (Printmaking). *Medium:* relief printing, lithography, screen printing. *b:* Cambridge, 26 Sep 1978. *Studied:* Maidstone; Winchester School of Art. *Represented by:* Vinson Gallery, USA; Eyestorm Gallery, London. *Exhib:* Bankside Gallery; MoMA Wales; Eyestorm Gallery; Vinson Gallery USA; Estonia Print Triennial; Fry Art Gallery, Saffron Walden. *Works in collections:* MoMA Wales; Ashmolean Museum, Oxford. *Commissions:* Dolphin Hotel (headboard design). *Publications:* Ambit, Printmaking Today. *Works Reproduced:* in biik published by FPBA. *Recreations:* sport, travelling. *Misc:* works at the Curwen Studio as Master Printer, and sessional lecturing at universities around the country. *Signs work:* 'Feijoo'. *Address:* 80 Union Lane, Cambridge, CB4 1QB. *Email:* feijoo@talk21.com *Website:* www.fernandofeijoo.com

FEILER, Paul, painter. *b:* 30 Apr 1918. *s of:* Prof. E. Feiler, M.D. *m:* Catharine Armitage. three *s.* two *d. Educ:* Canford School, Dorset. *Studied:* Slade School of Fine Art. *Exhib:* one-man shows since 1953; Redfern Gallery, Grosvenor Gallery, Warwick Arts Trust, Austin/Desmond, London, Tate Gallery, St. Ives, Hong Kong. *Works in collections:* Tate Gallery, Arts Council, British Council, Universities of London, Oxford, Cambridge, Warwick, Newcastle. Liverpool; galleries in England, U.S.A., France, Austria, Canada, New Zealand, Australia. *Address:* Kerris, nr. Penzance, Cornwall TR19 6UY.

FELCEY, Trevor, ARCA (MA); Lorne Award (1991). *Medium:* oil, drawing, prints. *b:* Sussex, 25 Aug 1945. *Studied:* Grimsby School of Art; Camberwell School of Art; RCA. *Represented by:* Chris Insoll (01872-580445). *Exhib:* many mixed shows. Principal one-person shows: Brunel University Gallery (1976); Ian Birksted Gallery, London (1982); Concourse Gallery, Byam Shaw School of Art (1993); Plough Arts Centre, Devon (1999); Galerie Hofmann and Kyrath Berlin (2001); Royal Albert Memorial Museum Exeter, Beldam Gallery Brunel University (2005). *Works in collections:* Chantrey Bequest (University of Liverpool Collection), Nuffield Foundation; Franklyn Memorial Collection, South Humberside; Leicester Education Authority; Brunel University Collection. *Signs work:* 'T.Felcey'. *Address:* Church House, Throwleigh, Devon EX20 2HU.

FELL, Michael Anthony, F.S.D.C., L.R.E.; painter/printmaker; former Head of Foundation, City & Guilds London; visiting tutor, Prince of Wales Inst., London;. *b:* London, 31 Jan., 1939. *s of:* Sir Anthony Fell. *m:* Maureen. two *s. Educ:* St. George's, Weybridge. *Studied:* St. Martin's, City & Guilds London. *Exhib:* Jordan Gallery (1972-84), Halesworth Gallery (1972-85), Mall Galleries, Clementi House Gallery (1991), Gallery Renata, Chicago, Belanthi Gallery, New York, Chappel Galleries, Essex (1993, 1999), Comteroux Perpignan (1993), Flaran, France (1996), Grosvenor Gallery, London (1996). *Works in collections:* B.M.; Arts Council; Victoria National Gallery University Melbourne, Australia; Churchill Library, Massachusetts; Michael Estorick Collection. *Clubs:* Asylum, Charlotte St. *Signs work:* "Michael Fell." *Address:* 17 Fonnereau Rd., Ipswich, Suffolk IP1 3JR.

FELLOWS, Elaine Helen, B.A.(Hons.) (1981), H.S. (1987), S.W.A. (1988), R.M.S. (1992), U.S.M. (1990); professional painter of portraits and still life in miniature in water-colour on vellum or ivorine. *b:* Walsall, 27 Nov 1959. one *s. Studied:* Walsall College of Art (1977), Wolverhampton Polytechnic (1978-81). *Exhib:* R.M.S. (Hon. mention 1989, 1991), S.W.A., Hilliard Soc. (Bell award 1990), Ulster Soc. of Miniaturists (Madam MacCarthy Mór Memorial Award 1991), Llewellyn Alexander Award (1993), Suzanne Lucas Award (1995), Llewellyn Alexander Gallery, Linda Blackstone Gallery, France, Hong Kong, U.S.A. *Works in collections:* G.B., U.S.A., France, Germany. *Publications:* The Techniques of Painting Miniatures; contributor to The Magic of Miniatures. *Signs work:* 'ehf'. *Address:* Bwlch House, Beguildy, Knighton, Powys LD7 1UG.

FENNER, Michael James, B.A. (Hons.), A.T.D. (Dist.); painter in acrylic, art teacher; Head of Art, West Kirby Grammar School for Girls;. *b:* Liverpool, 5 Jan, 1952. *m:* Alison. one *s.* two *d. Studied:* Laird School of Art, Newport College of Art. *Exhib:* group and one-man shows: Birkenhead, Liverpool, Durham., U.S.A., Ireland, London. *Works in collections:* Williamson A.G., Birkenhead, Dee Fine Art, private collections in Britain, Ireland and Europe. *Commissions:* portraits, England and Holland. *Publications:* magazine articles. *Clubs:* N.A.P.A. *Signs work:* "M.J. Fenner." *Address:* la Charlesville, Oxton, Birkenhead CH43 1TP.

FERGUSON, George, B.A., B.Arch., P.P.R.I.B.A., R.W.A., Hon. M.A. Univ. of Bristol; architect and ex-Hon. architect to R.W.A.; on R.I.B.A. council; Hon. Doctorate of Design, University of West of England (2003); President Royal Institute of British Architects (RIBA) (2003-05). *b:* Winchester, 22 Mar 1947. one *s.* two *d. Educ:* Wellington College. *Studied:* University of Bristol and R.W.A. *Exhib:* R.W.A. *Commissions:* various architectural. *Publications:* Races against Time (1984). *Address:* 18 Great George St., Bristol BS1 5RH. *Email:* george@acanthusfm.co.uk *Website:* www.acanthusfm.co.uk

FERGUSON, Malcolm Alastair Percy, RWA, DFA(Slade, Lond., 1950); religious landscape and portrait painter; visiting teacher. *b:* Blackwater, Hants., 19 Dec 1913. *s of:* Capt. P. F. H. Ferguson. *m:* Rosemary J.M. Holdsworth (decd.). one *s.* one *d. Educ:* Durham School, R.M.A., Sandhurst 1932. *Studied:* Portsmouth and Croydon Schools of Art (1935-38), Slade School (1939, 1948-51, under Schwabe, Coldstream Monnington). *Exhib:* R.A., N.E.A.C., R.P., R.W.A., R.B.A., Paris Salon, Nat. Gall. of Wales, Bradford City A.G., etc.; one-man shows: London, provinces and Port Elizabeth, S.A. *Works in collections:* Plymouth City A.G., R.W.A., Talbot Bequest Bristol, Somerset Museum Service. *Commissions:* Triptych, High Altar, St. Marks 12thC Lord Mayor's Chapel, Bristol (1992); 14 Stations of the Cross on oak in egg tempera and gold leaf (for Collegiate Church of St.Mary the Virgin, N.Petherton, Somerset, Easter 2006). *Official Purchasers:* Sponsored by Anglo American and De Beers, to paint 'True Fresco' (1982, 1985), domed apse, St. Cuthbert's, Transkei. 1985-89, four altar panels and 30 ft. choir balustrade in egg tempera St. Augustine's Church, Penhalonga, Zimbabwe; various portraits, Chairman Cecil Whiley of George. M. Whiley Ltd; Gold Beaters Ltd., etc. *Works Reproduced:* various magazines. *Recreations:* gardening, reading history, classical novels. *Signs work:* "Malcolm A.P. Ferguson." *Address:* 7 Mill St., North Petherton, Som. TA6 6LX.

FERGUSON, Mary, F.F.P.S.; painter in oil, charcoal, pen and wash;. *b:* 6 May 1919. *m:* E.A. Ferguson. two *s. Educ:* Friends School, Ackworth. *Studied:* The Gallery Schools, Melbourne, Australia (1953-55, Charles Bush), Reigate School of Art (1957-60, Denis Lucas, Walter Woodington). *Exhib:* one-man shows: London including Loggia Gallery, F.P.S.; mixed shows: London and provincial galleries. *Works in collections:* Australia, Canada, Mallorca, Hong Kong and U.K. *Clubs:* F.P.S., Reigate Soc. of Artists. *Signs work:* "Ferguson" or "MF" joined. *Address:* Bayhorne Lodge, 164 Balcombe Rd., Horley, Surrey RH6 9DS.

FERGUSON, Paul, ACR (Accredited Consefvator/Restorer); Member of the Mastercarvers' Association (Hon.Secretary 1992-present, President 1999-2002); Liveryman of the Worshipful Company of Turners; Freeman of the City of London; Established the Paul Ferguson Workshop, Fine Wood Carving & Guilding, 1978. *Medium:* wood/gold. *b:* London, 17 Oct 1950. *m:* Jessie Ferguson. one *s.* two *d. Studied:* Kingston College of Art. *Represented by:* Accredited Member of The Institute of Conservation. *Commissions:* Restoration or new commissions: Windsor Castle, Osborne House, Osterley Park, Lancaster House, Admiralty House, Palace of Westminster, Kensington Palace, Woburn Abbey, Renishaw Hall, Victoria & Albert Museum, National Portrait Gallery, The Wallace Collection, The Imperial War Museum, The Army Museum, Royal Academy, Goldsmiths Hall, Drapers Hall, Stationers Hall. *Clubs:* The Georgian Group, Folly Fellowship. *Address:* Workshop 20, 21 Wren Street, London WC1X 0HF. *Email:* pf@paulferguson.co.uk *Website:* www.paulferguson.co.uk

FERGUSON, Shaun, BA Hons; Post-Graduate Diploma; The Richard Ford Award (Spain Scholarship 1988); The Discerning Eye 'New Discovery Award' (1990). *Medium:* acrylic and oil. *b:* Crewe, 8 Aug 1963. *Studied:* Royal Academy of Arts (1985-88); Trent Polytechnic, Nottingham (1982-85); Chester College of F.E. (1981-82). *Represented by:* Fairfax Gallery. *Exhib:* various group and one-man shows at Fairfax Gallery in London, Tunbridge Wells and Burnham Market (1998-2007); Glasgow International Arts Fair (2006, 07); London Art Fair, Islington (2005, 2006); 'Art London' (2003, 2004); The Discerning Eye (1991, 92, 96, 2003); RA Summer Exhbn (1992, 2001); 'Aspects of Irish Art 1960-90'; Dublin Museum of Modern Art (1994); Henry Wyndham Fine Art, London (1990, 91); one-man show, Solomon Gallery, Dublin (1991). *Works in collections:* Durban Museum, S.Africa; Dublin Museum of Modern Art; Ulster Museum, N.Ireland; Lloyds Bank. *Clubs:* Reynolds Club. *Misc:* Fine Art lecturer, City College, Brighton. *Signs work:* 'S.M.FERGUSON'. *Address:* Flat 9, 33 Compton Avenue, Brighton, BN1 3PT. *Website:* www.shaunferguson.co.uk

FERGUSSON: see BATTERBURY, Helen Fiona,

FERRAN, Brian, B.A., D.B.A., H.R.H.A., H.R.U.A.; painter in acrylic and oil; artist and former chief executive of the Arts Council of N. Ireland. *b:* Derry, Ireland, 19 Oct 1940. *m:* Denise. one *s.* one *d. Studied:* Courtauld Inst., London University, Brera Academy, Milan, Queens University, Belfast. *Exhib:* regularly in Ireland, U.S.A., Switzerland and Mexico. *Works in collections:* Ulster Museum, Arts Council of N. Ireland, Arts Council of Republic of Ireland, Allied Irish Bank, Gordon Lambert Collection, Crawford Municipal Gallery, Cork. *Publications:* exhib. catalogues and Basil Blackshaw - painter, a monograph published 1995. *Signs work:* "Brian Ferran." *Address:* Goorey Rocks, Malin, Inishowen, Co.Donegal, Eire. *Email:* brian.ferran@aol.com

FERRIAN, Marie, sculptor in wood, terracotta, stone. *b:* Hummelstown, Pa., 1 Jan 1927. *d of:* Harry Reigle. *m:* George Ferrian. one *s. Educ:* STHS. *Studied:*

Corcoran School of Art (painting: 1945-47, Eugene Weisz; sculpture: 1963-65, Heinz Warneke). *Exhib:* St. Camillus, Women's National Bank, Firenze House, Corcoran Gallery, Art Barn (2). *Works in collections:* National Museum of Women in the Arts. *Publications:* three children's books; featured in American Craftsmen (1975). *Signs work:* "M.F." *Address:* 4230 Silverwood La., Beth, M.D. 20816, U.S.A.

FERRUZZI, Roberto, *Medium:* oil and tempera (gouache), drawing, prints, sculpture. *b:* Venice, 30 Jan 1927. *Studied:* Scuola D'Arte in Venice. *Represented by:* Ferruzzi Gallery, 727 Dorsoduro, Venice (opposite entrance to Peggy Guggenheim collection). *Works in collections:* several private. *Publications:* three books, information on website. *Works Reproduced:* 'Ferruzzi' A Retrospective Catalogue (1950-2000). *Signs work:* 'BOBO' or 'ROBERTO FERRUZZI'. *Address:* 727 Dorsoduro, 30123 Venezia, Italy. *Email:* info@robertoferruzzi.com *Website:* www.robertoferruzzi.com

FERRY, David Dawson, A.R.E. (2006); F.R.S.A.; B.A. (Hons.) (1979), H.D.F.A. (Lond.) (1981); printmaker/collagist; lecturer, Camberwell/Canterbury Art Schools; 1993, appointed Head of Printmaking, Winchester School of Art; 1996, appointed Head of Fine Art, University of Southampton; elected FRSA (2001); Winner of Pollock/Krasner Award, New York (2002), bronze medal, First International Artists Book Competition, Seoul, Korea (2005). *b:* Blackpool, 5 Feb 1957. *s of:* Brian Ferry. *Studied:* Blackpool College Tech. (1975-76), Camberwell School of Arts and Crafts (1976-79, Mario Dubsky, Agathe Sorell), Slade School of Fine Art (1979-81, Stanley Jones). *Exhib:* Contemporary Printmaking Air Gallery, R.A., S. London A.G., Ferens A.G., Hull, Offenbach, Germany, Paris 'Trace' Biennale; solo shows: first and second International Contemporary Art Fairs at Barbican A.G., London Olympia, 5 Contemporary Printmakers, National Museum of Wales British Tour, The Star Chamber, Herbert Read Gallery, Canterbury, Kent University, Drew Gallery Canterbury, Boundry Gallery, London, Photomontage exhbn. in Dresden, New York (2002) Roe & Moore Rare Books, London (2003), Berlin (2005), Seoul (2005), Chelsea Arts Club, London (2005), Laurence Graham, London (2006). *Works in collections:* Ashmolean Museum, Oxford; Grundy A.G., Blackpool, University College and St.Thomas Hospital, London, Maidstone A.G., Nuclear Electric, Marconi Instruments U.K., British Airways, Art Institute of Chicago, USA, University of Oxford, University of Southampton. *Commissions:* GEC, UK. *Publications:* author, Painting Without a Brush, U.K. (1991), U.S.A. (1992), France (1994); 'Aspects of our National Heritage', exhbn. catalogue (1999), 'From the Window Seat' (2002). *Works Reproduced:* Dictionary of Modern British Painters, Frances Spalding. *Clubs:* Chelsea Arts Club. *Misc:* Formed video production titled 'Lost Shoe Productions'. *Signs work:* "D.D. Ferry" or "D.D.F." *Address:* c/o Winchester School of Art, Hants. SO23 8DL. *Email:* df@soton.ac.uk

FESTING, Andrew Thomas, R.P. (1992);President, Royal Society of Portrait Painters (2002-); portrait painter in oil. *b:* Chalford, 30 Nov 1941. *m:* Virginia

Fyffe. one *d. Educ:* Ampleforth College. *Exhib:* R.P. *Works in collections:* National Gallery Dublin, Royal Coll., National Portrait Gallery, Palace of Westminster. *Signs work:* "A.T. Festing." *Address:* 3 Hillsleigh Rd., London W8 7LE.

FFYFFE, Terrance Michael, Winner, Discerning Eye (1995), Eastern Open (1997); artist, figurative painter of nudes, religious paintings and portraits in oil;. *b:* Melbourne, Australia, 21 Dec 1957. *Educ:* St.Joseph's College, Melbourne. *Studied:* Prahran College now Swineburne University (1975-77). *Represented by:* Andrew Lamont Gallery, London. *Exhib:* numerous selected exhbns. *Works in collections:* internationally, mainly UK, Australia and U.S.A.,. *Commissions:* private portrait and mural commissions. Commissioned by London Borough of Havering for Murals in Upminster and Gidea Paek Libraries. *Address:* c/o 51 Billet Lane Hornchurch, Essex RM11 1AX. *Email:* TerryFfyffe@aol.com

FIELD, Peter L., A.T.D., F.R.S.A.; artist, teacher and lecturer; Head of Faculty of Art and Design, City of Birmingham Polytechnic (retd. 1982). *b:* Winson, Glos., 7 Feb 1920. *s of:* W. W. Field. *m:* Cynthia G. Barry. two *d. Educ:* Rendcomb College. *Studied:* Cheltenham School of Art (1937-39) under A. Seaton-White, Goldsmiths' College School of Art (1946-49) under Clive Gardiner. *Exhib:* London and provincial exhbns. *Works in collections:* Swindon Art Gallery, Swindon Corporation. *Signs work:* "Peter L. Field." *Address:* 264 Mary Vale Rd., Bournville, Birmingham B30 1PJ.

FILIPE, Paulo Duarte, N.A.P.A.; writer and painter in acrylic. *b:* Portugal, 3 Sep 1962. one *d. Exhib:* Teatro Lethes, Faro, Portugal (1990); Galeria "O Arco", Faro, Portugal (1991); 2nd Forum, da A.M.I., Lisbon, Portugal (1997); I.P. 3, Faro, Portugal; Vilamoura Marinotel, Portugal (1998); Centro Cultural, Lagos, Portugal (1998); Black Sheep Gallery, Hawarden, N. Wales (1999); Westminster Gallery, London (1999); Art Show, Manchester; Art Centre, Los Angeles, U.S.A.; Galerie Not, London (1999), Art Expo, New York (2000), Limelight Gallery, London (2000), Conservatorio Regional do Algarve, Portugal (2004), Artists Gallery of Seattle, USA (2005), Gallerie Dina Brito, Olhao, Portugal (2005), Galeria Municipal Albufeira (2005); Galeria de Arte Samora Barros, Albufeira (2006); Galeriea de Arte Praça do Mar, Quarteira (2006). *Publications:* Art Guide '92, Art Guide 95/96, Contemporary Art Year Book 98, Art 2001.com Guide. *Clubs:* Bromley Art Society, NAPA, ISAP. *Misc:* For Paulo Duarte Filipe, painting never is nor has been an amorphous or even ambiguous act. His painting does not allow any distraction nor even the slightest hint of indifference. As if we were induced, for a time undefined, into a curious and bizarre hypnotic state. His phone no is 00351 966 303772. *Signs work:* "Paulo Duarte Filipe." *Address:* Apartado 970, 8000 Faro, Portugal. *Email:* pauloduartefilipe@hotmail.com *Website:* www.pauloduartefilipe.blogspot.com

FILIPOV, Stanislav Nikolov, The Society of Wood Engravers Prize for Outstanding Print from Overseas (70th Annual Exhibition). *b:* General Toshevo,

17 Aug 1969. *Studied:* University of Veliko Tarnovo, Bulgaria (1996). *Exhib:* Society of Wood Engravers, UK (since 2006). *Address:* Ul. 'Pirin Planina' 4A, Grad General Toshevo 9500, Oblast Dobritch, Bulgaria. *Email:* stanifil2005@abv.bg

FINCH, Michael, B.A.(Hons.) (1980), M.A.(R.C.A.) (1986); painter in mixed media; Senior tutor, Parsons School of Art, Paris. *b:* London, 6 Jul 1957. *s of:* Reginald Finch. *m:* Bridget Strevens. one d. *Studied:* Ravensbourne College of Art (1976-80, Brian Fielding), R.C.A. (1982-86, Peter de Francia). *Exhib:* one-man shows: City Museum, Peterborough (1983), Groucho Club (1987, 1988), Pomeroy Purdy (1990, 1992), Purdy Hicks (1994), Le Carré, Lille, Art et Patrimoine, Paris. *Works in collections:* Unilever, T.I. Group Coll., Deutsche Bank. *Publications:* Sodium Nights (1990), 'N17', Closer than You Think (1998). *Clubs:* Groucho. *Address:* 59 rue de Meaux, 60300 Senlis, France. *Email:* mick@mickfinch.com *Website:* www.mickfinch.com

FINCH, Patricia, FRBS, SWA, SPS, FSNAD, CPS, AWG, FRSA; sculptor. *b:* London, 1921. *d of:* W.M. Feldman, physician. two d. *Educ:* King's College, London, West London Hospital. International Grollo d'Oro Silver medal (1976), Silver cups (1981, 1983). *Exhib:* London, New York, Geneva, Glasgow, Venice, Malta, Le Touquet; mixed annual exhbns.: Mall Galleries, Westminster Galleries, R.A. Summer exhbn. (1979), FIDEM XIII British Museum, XXIV Budapest. Demonstrator, Tate Gallery Sculpture Course (1983). *Works in collections:* B.M. Coins and Medal Dept., Bank of England Museum: two busts, Royal Academy of Dancing, Musée Quentovic, Le Touquet, Museum of Fine Arts, Malta, Town Hall, Rhodes. Private collections: in U.K., various European countries, Canada, U.S.A., S. America, Japan, Australia, Nigeria. Over 140 portrait commissions carried out. Tutor, Hulton Studio for Visually Handicapped (1986-90). Demonstrator/lecturer portrait bust, Islington etc. Finalist L.D.D.C. (1988, 1989). Life-size figurative bronze Golders Hill Park unveiled 1991. *Commissions:* Goldsmiths' Hall London, Prime Warden Medal, silver (1996), Bronze bust Glenn Miller 11/2 life-size for Corn Exchange, Bedford (1994). 1997: Institute of Child Health, Gt. Ormond St. Hospital, bronze bust of their Chairman, Leolin Price, C.B.E. Q.C. Queens Club, London "SPARKS" Children's Medical Charity Real Tennis trophies for annual tournament. 1999: Shakespeare's Globe, London, bust of founder Sam Wanamaker. *Signs work:* "P. Finch." *Address:* 851 Finchley Rd., London NW11 8LY.

FINDLAY, Denise, BA (Hons) Fine Art (Drawing and Painting); Elizabeth Greenshields Award (1998, 2001, 2002), Kennox Prize (runner-up). *Medium:* oil, drawing, figurative painter. *b:* Glasgow, 14 Dec 1973. *d of:* Gordon & Vivien Findlay. *m:* Jason Pyper Davis. *Studied:* Glasgow School of Art (1992-96). *Represented by:* The Scottish Gallery; Lemon Street Gallery; Thompsons. *Exhib:* solo exhbns: The Scottish Gallery (1999, 2001, 2004); Portland Gallery (2003); Kennox Prize, Thompsons (2005); Lemonstreet Gallery (2006). *Works in collections:* H.R.H.The Prince of Wales; Picardy Television, Sir David Murray.

Commissions: Picardy Television; many private. *Publications:* catalogues for solo exhbns, article in 'Homes and Interiors Scotland' (1999, Issue 12). *Clubs:* The Glasgow Art Club. *Signs work:* 'FINDLAY'. *Address:* Flat 1/2, 15 St.James' Terrace, Lochwinnoch Road, Kilmacolm, Inverclyde, PA13 4HB. *Email:* info@denisefindlay.com *Website:* www.denisefindlay.com

FINDLAY, Sheila Anne Macfarlane, RWS, DA(Edin.), Post-Grad.(1950), Travelling Scholar (1951); artist and illustrator in water-colour and oil. *b:* Auchlishie, Kirriemuir. *d of:* William R. Findlay, farmer. *m:* Alfred Hackney, R.W.S., A.R.E., D.A.(Edin.). two *d. Educ:* Webster's Seminary. *Studied:* Edinburgh College of Art (1945-51) under John Maxwell, Penelope Beaton, Sir William MacTaggart, Leonard Rosoman. *Exhib:* R.A., R.W.S., Catto Gallery, R.A. Prizewinner (1993). *Works in collections:* Department of the Environment, MacFarlanes, Alan Howarth C.B.E. M.P. *Publications:* children's books illustrated for Faber & Faber, Adprint, Harrap, Odhams, Medici Soc. *Signs work:* "Sheila Findlay." *Address:* Barnside, Lodge La., Cobham, nr. Gravesend, Kent DA12 3BS.

FINEGOLD, Stephen M., B.A. (Hons.) 1st class, Postgrad. (Dip.); artist in oil, acrylic, pastel, collage, print; Artistic Director, F.C.A. Gallery. *b:* London, 17 Jun 1959. *m:* Josephine. two *s. Educ:* Beal Grammar School, Ilford. *Studied:* Bradford College, Central School. *Exhib:* London, Salisbury, Yorkshire. *Works in collections:* F.C.A. Gallery, U.K., Spain, France, Australia, South Africa, U.S.A. *Commissions:* private, CAB. *Misc:* also actor, director, writer. *Signs work:* "Finegold." *Address:* Chantry House, Warley Town Lane, Warley, Halifax, W. Yorks. HX2 7SA. *Email:* stephenfinegold@hotmail.com

FINER, Stephen, artist. *Medium:* oil. *b:* London, 27 Jan 1949. *Studied:* Ravensbourne College of Art (1966-70). *Exhib:* one-man shows: Four Vine Lane, London (1981, 1982, 1985), Anthony Reynolds Gallery (1986, 1988), Berkeley Sq. Gallery (1989), Bernard Jacobson Gallery (1992, 1995), Woodlands A.G. (1994), Agnew's (1998), 'About the Figure' Six Chapel Row, Bath (1999), Pallant House Gallery (2001), Charleston (2002), ArtSpace Gallery (2004); mixed shows: British Art 1940-1980, from the Arts Council Coll., Hayward Gallery (1980), Collazione Ingleze 2, Venice Biennale (1984), The Portrait Now, N.P.G. (1993), Men on Women (1997-98), '50 Contemporary Self-Portraits', Six Chapel Row, Bath (1999), 'British Art 1900-1998' Agnews (1998), 'Painting the Century 101 Portrait Masterpieces 1900-2000', N.P.G. (2000-01). *Works in collections:* A.C.G.B., British Council, Contemporary Arts Soc., Southport A.G., N.P.G. (David Bowie), Los Angeles County Museum of Art; Pallant House Gallery, Sussex. *Publications:* 'Painting the Century' etc. *Works Reproduced:* www.npg.org.uk, 'The Portrait Now' (Marlene Dietrich), 'Painting The Century' (David Bowie and Iman) etc. *Signs work:* "S.A. Finer" on reverse. *Address:* 20 Kipling St., London SE1 3RU. *Email:* londonpainting@tiscali.co.uk *Website:* www.stephenfiner.com

FINLATOR, Hannah Verena, BA (Hons); residency abroad. *Medium:* oil. *b:* North Carolina, 28 Nov 1977. *d of:* Wallace Finlator. *Educ:* BFA, MFA. *Studied:* Corcoran College of Art Mons.; Newcastle University. *Represented by:* Henshelwood Gallery. *Exhib:* Société Imaginaire, Germany; Hemicycle Gallery, Washington DC; Corcoran Museum, Washington DC; Center St.Arts, Virginia, USA; Hatton Gallery, Newcastle and across UK. *Works in collections:* Henshelwood Gallery, Newcastle; Andrew HEard (dir. Shipley Gallery, UK). *Commissions:* private. *Works Reproduced:* in gallery catalogues. *Signs work:* 'Hannah Finlator'. *Address:* 116 Bewick Ct., Princess Square, Newcastle-upon-Tyne NE1 8EZ. *Email:* hannahverena@yahoo.com *Website:* www.fairfields.demon.co.uk/onlinegallery/hannah.html

FIRMSTONE, David James, M.B.E., RWS; Vice-President RWS; NDD, ATD; Recent prizes: Hunting Art Prize, short listed for 1st prize (1993), Hunting Art Prize, prizewinner (1998, 1999, 2001), St. Helens Open, prizewinner (1994, 1995), Manchester Academy, painting prize (1996), Chichester Open, prizewinner (1998), Chester Open, 1st prize (1999), Laing Open, prizewinner (1999), RWS Bankside, Water-colour: Century 21: Daler Rowney 1st prize/The Artist Prize/The Ashdown Gallery prize, for best landscape (1999), Prizewinner Sunday Times/ Singer & Friedlander Watercolour (2006). *Medium:* landscape painter in water-colour, tempera, acrylic, oils and mixed media. *b:* Middlesbrough, 28 Apr 1943. *m:* Jean Gilbert-Firmstone. two *s. Studied:* Middlesbrough College of Art, Birmingham University. *Represented by:* James Huntington Whiteley. *Exhib:* Galleries 1995-99: The Piccadilly, Waterman Fine Art, Warrington Art, Manchester Art, Royal College Open, The Mall, British Art Show, Gallery 27, International Art Show, R.A; one-man show: Gallery 27, Cork Street April (2002,2004), RWS Gallery, Bankside, London, New Ashgate Gallery, Farnham, NEAC, 2005 Sunday Times Watercolour Invited Artist. *Works in collections:* The British Museum (The Grosvener Collection), Singer & Friedlander, Freshfields. *Commissions:* Est, est, est Restaurants: Chester, Alderley Edge, Edinburgh, Formby, Knutsford, Shrewsbury, Newcastle, Harrogate, Chiswick, Notting Hill Gate, Liverpool, Glasgow. *Publications:* 'Cheshire in Tuscany', 'Watercolour Expert'. *Official Purchasers:* Singer & Friedlander; Freshfields Bruckhaus & Deringer. *Works Reproduced:* Parker Harris. *Clubs:* Vice-President Royal Watercolour Society. *Signs work:* "David J. Firmstone," "David Firmstone," "D.Firmstone," "Firmstone." *Address:* West Barn, Horringford, Newport, Isle of Wight PO30 3AP. *Email:* firmy.gilby@virgin.net *Website:* www.davidfirmstone.com

FIRTH, Annette Rose, N.D.D., F.S.B.A.; botanical artist in water-colour; The Floral Artists of Corinium, in the Friends Meeting House, Cirencester. *b:* Portsmouth, 21 May, 1921. widow. *d of:* Admiral J.W.L. McClintock. two *d. Educ:* home and Lewes, Sussex. *Studied:* in Florence (1938-39, Aubrey Waterfield), Central School, London, Whiteland College, Putney (Mary Yules). *Exhib:* S.B.A. and S.W.A., Central Hall Westminster, R.H.S., Fossway Artists, Glos. Soc. of Botanical Illustrators. *Commissions:* various miniature portraits.

Publications: The Alphabet of Roses, and Mary's Flowers. *Recreations:* choral singing -alto. *Signs work:* "A.F." *Address:* 29 Coxwell St., Cirencester, Glos. GL7 2BQ.

FIRTH, Jack, Diploma of Art (Edinburgh) in Drawing and Painting (1939); RSW (1961). *b:* Edinburgh, 21 May 1917. *s of:* John Beaton Firth. *m:* Christine Firth. two *d. Educ:* George Heriot's School, Edinburgh. *Studied:* Edinburgh College of Art (1935-40); Moray House College of Education (1940). *Exhib:* since 1949: Society of Scottish Artists, Royal Scottish Academy, Royal Scottish Society of Painters in Water-colour, 19 solo exhbns. in Scotland. *Works in collections:* Aberdeen Art Gallery, Scottish National Portrait Gallery, Edinburgh City Art Centre, Educational Collections of Edinburgh, Dunbartonshire, Dundee, Banffshire, many corporate and private collections in UK and abroad, Scottish Arts Council. *Publications:* Author of 'Scottish Watercolour Painting' (Ramsay Head, 1979), James Cumming (Merkat Press/Scottish Gallery 1993). Many articles and reviews for 'Books in Scotland 1979-1999). *Works Reproduced:* numerous Press exhibition catalogues, etc. *Principal Works:* portrait of Sir Robin Philipson PRSW, in Scottish National Portrait Gallery. *Recreations:* art history, Scottish art history. *Clubs:* hon. mem. Scottish Arts Club, Edinburgh (President 1972-74), RSW. *Misc:* teacher of art (1946-1963), travelling lecturer for Scottish Arts Council/ lecturer in drawing, Edinburgh College of Art (1950-65), Art Adviser, Edinburgh Education Dept., later Lothian Region (1963-82), Hon. Pres.ident Scottish Artists Benevolent Association. *Signs work:* Jack Firth. *Address:* 37 Traquair Park West, Edinburgh.

FISHER, Don Mulready, M.C.S.D., M.F.P.S.; portrait and landscape painter in oil and gouache; TV film and theatre designer; writer. *b:* Finchley, 27 Apr 1923. *s of:* Capt. Henry Cecil Fisher, M.C., playwright, and Louisa Mary Maddock. *m:* Lyliane Guelfand (decd. 1992). one *s.* one *d. Educ:* Golders Hill School and Ravensfield College. *Studied:* Hampstead Garden Suburb Institute, Art Class (1940-41); St. Martin's School of Art under Ruskin Spear, R.A. (1943-46). *Exhib:* London Group, R.O.I., R.B.A., N.E.A.C., N.S., Berkeley Galleries, New Burlington Galleries, Piccadilly Gallery, Salon des Nations, Paris (1984), Trends (1984), Barbican Centre, Paris Salon (1985-87); one-man shows, Dowmunt Gallery (1980), Cork St. Fine Arts Gallery (1983). *Works in collections:* Britain, France, Sweden, Spain, Canada, Australia, Italy, Belgium, Poland. *Publications:* Designers in Britain Nos. 6 & 7. *Clubs:* Chelsea Arts. *Address:* 26 Rue Monsieur le Prince, 75006 Paris. France.

FISHER, Isabelle Diane Mulready, Diplomee Beaux Arts, Paris; stained glass artist. *b:* Hampstead, 10 Dec 1954. *d of:* Donald G. Mulready Fisher, g-g-g-s of William Mulready, R.A. and Lyliane Guelfand of Paris. one *s. Educ:* Lycee Français de Londres. *Studied:* Sir John Cass College (1973-74), Wimbledon School of Art (1974-77), Beaux Arts, Paris (1978-82, Allain, Master of stained glass). *Exhib:* U.F.P.S. Luxembourg Museum, Paris (1981), Chartres Stained Glass Museum (1982), Sacred Art, le Salon des Nations (1984), Homage to Joan

Miro Exhbn., Barcelona (1985). *Commissions:* window, 'Noah after the flood' l'Eglise de Ligny le-Ribaut, Loiret, France (1981); four windows, Hotel le Kern, Val d'Isere; six memorial windows for the St. Martin's Chapel (Benedictine Monastery) Monte Cassino, Italy (1989-91). *Address:* Rue de la Halle, Martel, Lot, 46.600 France.

FISHER, John Edward, BA Hons Fine Art; Fellow, Ravensbourne College of Communication. *Medium:* oil. *b:* Coventry, 7 Jul 1938. *s of:* Charles Sidney Fisher. *m:* Janet Mary Fisher. three *s. Educ:* Cheylesmore Secondary School; Coventry College of Art Junior Art Dept. *Studied:* Camberwell School of Arts and Crafts. *Represented by:* The Francis Kyle Gallery. *Exhib:* Group shows: The Italian Journey:Footsteps of J W Goethe (1987), Paradise is Here (1989), Mozart's Travels (Lincoln Centre, New York) and others. One-man shows (Francis Kyle Gallery) Villages and Valleys of the Ardeche (1988), Provence and Pamphylia (1989), Egypt and Italy (1991), Jordan and Italy (1993), Central Asia (1996), In Mongolia (1998), Writers' rooms (2002), Writers' rooms II (2006). *Works in collections:* many private collections thoughout Europe and USA. *Commissions:* portraits in America and Saudi Arabia; The Guardian; The Artist. *Publications:* The Lair of the Leopard books. *Works Reproduced:* Wrietr's Museums - i.e. Robert Graves museum. *Recreations:* fly fishing, clay pigeon shooting. *Clubs:* CPSA. *Signs work:* "John Fisher". *Address:* 88 Lee Road, Blackheath, London SE3 9DE. *Email:* j.fisher8@btinternet.com *Website:* www.franciskylegallery.com

FISHER, Reginald Stanley, S.G.F.A. (1991); artist in oil, line and wash, pencil; retd. technical graphics illustrator and designer; Com. mem. S.G.F.A., Assoc. mem. Armed Forces Art Soc.;. *b:* London, 9 Nov., 1926. *Studied:* weekend courses at Heatherley School S.E. Federation of Art Socs. (Carl Cheek, Patrick Larking, Alfred Noakes). *Exhib:* S.G.F.A., U.A., R.B.A., R.I. Summer Show, Wardour Gallery, S.E.F.A.S., Int. Amateur, Wembley Art Soc., Armed Forces Art Soc., Blickling Hall, Norfolk; two one-man shows, Wembley. *Commissions:* several private commissions. *Publications:* illustrated technical books for B.P. Oil. *Address:* 36 Aldbury Ave., Wembley, Middx. HA9 6EY.

FITZGERALD, Susan Margaret, B.A. (1978), M.A. (1988); full-time painter in water-colour and oil;. *b:* Linc., 8 Jan., 1946. *m:* Edward Michael Fitzgerald. two *s. Educ:* Boston Girls' Grammar School. *Studied:* York School of Art (1962-64), Sunderland College of Art (1964-67). *Exhib:* Chris Beetles Ltd., London; The Catto Gallery, London; World of Drawings and Water-colours, London; Adam Gallery, Bath; Bourne Gallery, Reigate; Medici Gallery, London; Nevill Gallery, Canterbury. *Commissions:* Medici Gallery, London, Nevill Gallery, Canterbury. *Misc:* Much time spent painting in France in her studio nr. Montpellier. Has lived/worked in Middle East and Far East. *Signs work:* "Sue Fitzgerald." *Address:* Paragon House, 3 Stone Rd., Broadstairs, Kent CT10 1DY.

FLATTELY, Alastair F., D.A. (Edin.) 1949, Andrew Grant Fellowship (Edin.) 1953, R.W.A. (1963); painter in oil and water-colour, draughtsman in black and white; Professor and retd. Head of Grays School of Art, Aberdeen. *b:* Inverness, 20 Nov 1922. *m:* Sheila Houghton. *Studied:* Edinburgh College of Art (1945-50, Sir William Gillies). *Exhib:* London: Wildensteins, Roland Browse & Delbanco; Edinburgh: Aitken Dotts; Aberdeen: Rendezvous Gallery; R.A., R.S.A., R.W.A., R.G.I., Edinburgh Festival (2003), Lyon & Turnbull Gallery, etc. *Works in collections:* H.R.H. Duke of Edinburgh, The late President Eisenhower, Aberdeen Hull, Cheltenham, Dundee and Glasgow A.G's, R.S.A., R.W.A., Nuffield Foundation, Fleming Holdings, Grampian TV and Shell; private collections: worldwide. *Commissions:* Special artist Illustrated London News in early fifties. *Signs work:* "Flattely." *Address:* Braeside, 5 Windy Ridge, Beaminster, Dorset DT8 3SP.

FLEMING, James Hugh, B.A.Hons. (1987); printmaker, painter, illustrator, lecturer, poet. *b:* Barrow in Furness. *s of:* James Arthur Fleming. *m:* Norma. one *s.* one *d. Studied:* Open University, Liverpool Polytechnic. *Exhib:* Acorn Gallery, Bluecoat Gallery, Hanover Gallery, Davey Gallery, Williamson A.G., Dee Fine Arts, Marie Curie Foundation, Merseyside Artists Touring Exhbn., Heffers, Oriel Mostyn, Cadaques Mini Print, Intaglio Mini Print, Manchester Academy, Humberside Printmaking Exhbn., Theatre Clwyd, Ruthin Craft Centre, Broekman A.G. *Clubs:* N.A.P.A., Wirral Soc. of Arts, A.B.W.S., Bluecoat Studio Printmakers' Group. *Signs work:* "Jim". *Address:* 19c Church Rd., West Kirby, Wirral, Merseyside L48 0RL.

FLEMING-WILLIAMS, Julia Elizabeth Catherine, Gilder. *Medium:* oil. *b:* Bournemouth, 10 Dec 1946. *d of:* Ian and Barbara Fleming-Williams. *m:* Edward Rooth. two *s.* one *d. Studied:* Farnham Art College; Hammersmith College of Art. *Represented by:* Rooths of Bradford-on-Avon. *Exhib:* RA, RWA, Chomé Gallery, Rooths Gallery, White Exmead. *Works in collections:* private. *Recreations:* keeping chickens. *Signs work:* 'JFW' (and date). *Address:* Mount Pleasant Farm, South Wraxall BA15 2SO. *Email:* jecr@rooths.co.uk *Website:* www.rooths.co.uk

FLEMMING, Anthony, First Class Hon Degree, Goldsmiths College, London. *Medium:* oil, watercolour, drawing, prints. *b:* London, 17 Apr 1936. *m:* Heather. three *d. Educ:* Frensham Heights. *Studied:* Goldsmiths College under Sam Rabin, Roberts Jones, Ken Martin, Rowland Hilder. *Exhib:* RI, RSMA, New Grafton, Duncan Campbell, Francis Iles, and in USA, Netherlands, France, Spain and Japan. *Works in collections:* Shell, BP, Woolwich BS, Bank of Bermuda, Shipowners Protection. *Commissions:* Shell, BP, Woolwich BS, Robotham Shipping, Shipowners Protection, Nat West Bank. *Recreations:* sailing. *Clubs:* MYC, Weald of Kent (President). *Signs work:* 'Anthony Flemming'. *Address:* Four Winds, Beechenlea Lane, Swanley Village, Kent BR8 7PR. *Email:* tonyflemming@msn.com

FLETCHER, Adelene, N.D.D. (1960), S.B.A. (1989); artist in water-colour. *b:* Stockport, 6 Aug 1940. *m:* A.J. Fletcher. one *s.* one *d. Educ:* Fylde Lodge High School. *Studied:* Stockport Art School (1956-58), Manchester Regional College of Art (1958-60). *Exhib:* R.I., R.W.S., S.B.A., and many mixed exhbns. *Publications:* author of books on flower painting, work is published in print, including limited editions. *Signs work:* "A. Fletcher." *Address:* 20 Alexandra Rd., Warlingham, Surrey CR6 9DU.

FLETCHER, Alistair Richard, B.A.Hons. (1985), R.E. (1985), British Inst. award (1983), Commendation Stowells Trophy (1984), Garton and Cook award (1985); teacher, artist in etching, drawing and painting. *b:* Gosforth, Northumberland, 25 Jan 1963. *s of:* Gordon Richard Fletcher, B.A.Hons. *m:* E.M. Fletcher. two *s.* two *d. Educ:* Henry Smith School, Hartlepool. *Studied:* Cleveland College of Art and Design (1981-82), Kingston Polytechnic (1982-85), Bretton Hall (1986-87). *Exhib:* R.E., Lowes Court Gallery, Egremont. *Signs work:* "Alistair R. Fletcher." *Address:* 8 John St., Moor Row, Cumbria CA24 3ZB.

FLETCHER-WATSON, James, R.I. (1952), R.B.A. (1957); painter in water-colour;. *b:* Coulsdon, Surrey, 25 July, 1913. *Educ:* Eastbourne College. *Studied:* R.A. School of Architecture (silver medal for design, 1936). *Exhib:* R.A., R.I., R.B.A., Paris Salon, Stockholm, Windrush Gallery (annually). *Publications:* British Railways carriage posters; written instruction book on watercolour painting (Batsford, 1982, second book 1985, third book 1988, fourth book 1993, fifth book 1997), third video painting instruction (1993). *Signs work:* "J. Fletcher-Watson." *Address:* Windrush House, Windrush, nr. Burford, Oxford OX18 4TU.

FLÖCKINGER, Gerda, C.B.E; Freeman of the Goldsmiths Company; Honorary Fellow, University of the Arts. *Medium:* precious metals, inks, monotypes, photography, enamels. *b:* Innsbruck, Austria, 8 Dec 1927. *d of:* Anna Frankl & Karl Flöckinger. *m:* divorced. *Studied:* St.Martin's School of Art (1945-50), Central School of Arts and Crafts (1950-52 (etching), 1952-56 (jewellery techniques)). *Represented by:* Electrum Gallery; Adrian Sassoon; Mobilia Gallery. *Exhib:* solo exhibitions: The Crafts Centre of Great Britain (1968), V&A (1979, 1986, 2006), Bristol City Art Gallery & Museum (1971), Dartington Cider Press Gallery (1977), Crafts Council shop at the V&A (to celebrate her CBE, 1991), Electrum Gallery (2007). Group exhibitions worldwide since 1961. *Works in collections:* Bristol City Museum & Art Gallery, The Crafts Council, Royal Scottish Museum, Edinburgh, Schmuckmuseum Pforzheim, Germany, V&A, Centre Georges Pompidou, Paris, France, The Goldsmiths' Company, Boston Museum of Fine Art, USA, and many private collections. *Publications:* included in many publications worldwide since 1963. *Recreations:* Hybridising Iris Germanica, fashion, Siamese cats, driving. *Clubs:* University of the Arts. *Signs work:* "GF" on gold disc /more important pieces: "GF" plus flower - both on separate discs (gold). *Address:* c/o Catherine Williams, The Crafts Council, 44a Pentonville Road, London N1 9BY. *Email:* gerdaline@btconnect.com *Website:* www.mobilia-gallery.com/artjewel.html

FLOWER, Rosina, M.F.P.S., S.A.F.; painter;. *b:* London. one *s.* one *d. Educ:* London and Headley. *Studied:* 1971-75, P.D. Dennis Syrett, Bassetsbury Manor (Tom Coates), Burleighfield House (Anne Bruce). *Exhib:* R.B.A., R.O.I., P.S., R.I., Britains Painters, Medici Gallery, Roy Miles Gallery, Waldorf Hotel, London; Originals Gallery, Glos.; Paris Salon, France; dfn Gallery, New York; solo shows: Loggia Gallery, Roy Miles Gallery, Talent Store, Marks & Spencers, London; Henley Management College, Oxon.; Boxfield Gallery, Stevenage. *Works in collections:* in hospitals and private collections in many countries around the world. *Works Reproduced:* greetings cards, limited edition prints. *Clubs:* F.P.S., B.A.S. *Signs work:* "Flower," "R. Flower" or "Rosi." *Address:* 132 Roberts Ride, Hazlemere, Bucks. HP15 7AN. *Email:* rosina@rosinaflower.co.uk *Website:* www.rosinaflower.co.uk

FLUDGATE, Robert, artist in oil, pen and ink, pastel; specialising in pictures inspired by music and musicians; lovers and flowers; still life, portraits; also writes plays, poems, short stories;. *b:* Islington, London, 18 Oct 1950. one *d. Educ:* Highbury Grove Grammar School. *Works in collections:* Channel Islands and London. *Signs work:* "Bob Fludgate," "R.E.G. Fludgate" or "R.E.G." *Address:* 7 Avenue Road, Ramsgate, Kent CT11 8ET.

FLYNN, Dianne Elizabeth, Dip. A.D. (1973), A.T.C. (1974); artist in oil, acrylic and water-colour; 1st Prize, Royal Overseas League. *b:* Yorkshire, 11 Oct 1939. *m:* Paul Hedley, painter. *Studied:* Manchester School of Art (1970-73), Leeds Polytechnic (1973-74). *Exhib:* Bourne Gallery, Reigate; Priory Gallery, Broadway; Walker Galleries, Harrogate; Galerie Chaye, Honfleur; MacConnal-Mason Gallery, London; Art Gallery Gérard, Wassenaar; Victorian Gallery, Dallas; Odon Wagner Gallery, Toronto; Thompson's Gallery, Aldeburgh & London; Wren Gallery, Burford; Gallery Joniskeit, Stuttgart. *Publications:* 'Portrait Drawing Techniques' (Batsford, 1979). *Signs work:* 'D.E.Flynn'. *Address:* 6 Powderham Cres., Exeter EX4 6DA.

FOLAN, Andrew, RHA; ANCAD, HDFA; Douglas Hyde Gold Medal (1984). *Medium:* digital media, prints, sculpture. *b:* Donegal, 1956. *s of:* Peter Colm Folan. *m:* Dr Roisin Kennedy PhD. one *s.* one *d. Educ:* Mount St.Joseph's College, Roscrea, Tipperary, Ireland. *Studied:* National College of Art and Design, Dublin; Slade School of Fine Art, London. *Represented by:* Royal Hibernian Academy, Dublin. *Exhib:* solo exhbns: Ashford Gallery, Dublin (2002); Triskel Arts Centre, Cork (2000); Original Print Gallery, Dublin (1995); Project Arts Centre, Dublin (1982). *Works in collections:* Irish Museum of Modern Art, Trinity College Dublin, University College Dublin, The Irish Arts Council. *Commissions:* The Royal Hospital, Belfast; The Central Bank of Ireland; Temple Bar Properties, Dublin; The Mater Hospital, Dublin. *Publications:* The Works series (Gandon Editions, 1991); Profile (Gandon, 2002). *Signs work:* 'Andrew Folan'. *Address:* 45 Lower Mount Pleasant Avenue, Ranelagh, Dublin 06 Ireland. *Email:* andrewfolan@eircom.net *Website:* www.andrewfolan.com

FOLKES, Peter Leonard, A.T.D., R.W.A., V.P.R.I., Hon. F.C.A., Hon U.A.; painter in oil, water-colour and acrylic; Lecturer. *b:* Beaminster, 3 Nov 1923. *s of:* Leonard Folkes. *m:* Muriel Giddings. two *s. Educ:* Sexey's School Bruton. *Studied:* West of England College of Art, Bristol (1940-42 and 1947-50). *Exhib:* R.A., R.W.A., R.I.; one-man shows: Crespi Gallery, New York (1965), University of Southampton (1965, 1973), Barzansky Gallery, New York (1967), Alwin Gallery, London (1970), Gainsboroughs' House Gallery, Sudbury (1977), R.W.A. Galleries, Bristol (1986), Guildhall Gallery, Winchester (2001). *Works in collections:* Arts Council of Great Britain; R.W.A.; Southampton Solent University; University of Southampton. *Commissions:* London Contemporary Art (2002). *Signs work:* "Folkes." *Address:* 61 Ethelburt Ave., Swaythling, Southampton, SO16 3DF.

FONTAINE, Fleur, S.A.I. (1998); writer, painter in oil;. *b:* Denmark, 25 May, 1941. *m:* John Warren (divorced). one *s.* one *d. Studied:* Hørsholm Højskole (1959-60, Helge Ernst) and Skoulunde Stage Art (Knud Hegelund), Sorø Ungdom Skole (1958-59), South France (1995-97 Pierre and Michel Mira). *Exhib:* The Mall Gallery, Orland House Gallery, Quaker Gallery, and others. *Works in collections:* throughout the world. *Commissions:* Euston Sq. Hotel. *Publications:* The Book of Life (1995). *Works Reproduced:* cards, booklets, teeshirts. *Clubs:* Danish Club (part of Dover St. Arts), Soc. for Arts of The Imagination. *Signs work:* "FLEUR' FONTAINE." *Address:* 6 Pointers Cottages, Wiggins Lane, Ham, Richmond, Surrey TW10 7HF. *Website:* www.artmadness.co.uk

FOORD, Susan Jane, BA (Hons) Fine Art (1983), RWA (1997); Granada Foundation Award, MAFA (1993). *Medium:* mixed media, oil/ watercolour/ acrylic/ pencil/pastel/household paint. *b:* London, 9 Jul 1945. two *s. Educ:* Manchester High School of Art (1958-60). *Studied:* Jacob Kramer College of Art, Leeds (1977-80), Leeds Metropolitan University (1980-83). *Represented by:* Adam Gallery, London & Bath. *Exhib:* solo: Adam Gallery (1998, 2000, 2001, 2003, 2005), RWA (1999); Offer Waterman & Co. Fine Art, London (1997); Old Town Hall, Havant, Hants (1993); mixed: include RA Summer Show (1993-2003, 2007), RWA Autumn Exhbn. (1993-2006), Gallery 7, Hong Kong (1994-97); Art International, New York; EuropArt, Palexpo, Geneva; Musee du Prieure, Harfleur, France; Northern Young Contemporaries (1981); Aspex Gallery, Portsmouth (1990); Dean Clough, Halifax; two-person shows: The Manor House, Ilkley; Bradford City Art Gallery & Museums. *Works in collections:* RA., Arts Club, RWA Bristol, Provident Financial, Talbots, Leicestershire Collection for Schools and Colleges; private collections UK, Europe, USA., Asia. *Signs work:* 'S.Foord' -earlier works 'Susan Foord' or 'S.J.Foord'. *Address:* 17 Downfield Rd., Clifton, Bristol BS8 2TJ. *Email:* sjfoord@hotmail.com

FORBES, Christine, ALAM (Hons); BA (Hons); Anthony Amies Award for Painting (2003). *Medium:* watercolour, drawing, acrylic and ink. *b:* 3 May 1951. *m:* Paul Martin. one *d. Educ:* private. *Studied:* Northbrook College, Worthing,

W.Sussex. *Represented by:* www.numasters.com. *Exhib:* RA Summer Exhbn (2004); Worthing Art Gallery (mixed, 2003, 2004); The Capitol, Horsham (solo, 2004); Chequer Mead, E.Grinstead (2004). *Works in collections:* Ms.Stephanie Morgan. *Commissions:* various private. *Address:* 48 Forest Road, Worthing, W.Sussex BN14 9LY. *Email:* forbesart@aol.com

FORBES, Ronald, mem. Royal Scottish Academy. *Medium:* painter. *b:* Perthshire, 22 Mar 1947. *m:* Sheena H.Bell. one *s.* two *d. Studied:* Edinburgh College of Art. *Represented by:* Sonia Zaks Gallery, Chicago. *Exhib:* solo exhbns in Scotland, England, Ireland, Netherlands, Australia, USA. *Works in collections:* museums of Cork, Dundee, Perth, Smith/Stirling, Hunterian/Glasgow, Narodowego/Gdansk, State Library Queensland; Royal Scottish Academy; Universities of Strathclyde, Dundee and Abertay Dundee. *Publications:* most recent: 'Ronald Forbes: Riddles and Puzzles' (2002) with essay by Dennis Adrian, and 'Ronald Forbes: (Mind) Games' with essay by Dr.Peter Hill (2005). *Misc:* visiting Professor at University of Abertay, Dundee. *Signs work:* forbes. *Address:* 13 Fort Street, Dundee, DD2 1BS, Scotland. *Email:* ronnieforbes@blueyonder.co.uk *Website:* www.ronald-forbes.com

FORBES COLE, Joy, N.D.D., Kingston (1958); landscape painter in oil; tutor in painting at Chiswick and Isleworth Polytechnics; Tutor Co-ordinator and founder member of Kew Studio. *Medium:* oil, watercolour and prints. *b:* London, 19 Dec 1934. *d of:* Frances Forbes Cole. *m:* Alban Clarke. *Educ:* Northlace School, Cheam. *Studied:* Sutton School of Art (1950-1953), Kingston College of Art (1956-1958) under Reginald Brill. *Exhib:* solo and group exhibs., London, Surrey, Hampshire and Kent. *Works in collections:* Lord Beaumont of Whitley, Dr. G.V. Planer. *Commissions:* C.I.B.A. (ARL) Ltd., G.V. Planer Ltd., Jermyn Industries. *Recreations:* music, reading, the countryside. *Clubs:* Richmond Art Society. *Signs work:* "J Forbes Cole." *Address:* Flat 1, 24 Lambert Ave., Richmond, Surrey TW9 4QR. *Website:* www.aarti.co.uk

FORD, Jenifer, VPNS, FRSA, Cert. Fine Art (University of Cape Town) (1953); portrait, landscape and still-life painter. *b:* Cape Town, 25 Jun 1934. *d of:* Richard Dekenah. *m:* His Hon. Judge Peter Ford. one *d. Educ:* Rustenburg School, Cape Town. *Studied:* Michaelis Art School and under Bernard Adams, R.P. *Exhib:* R.P., R.O.I., N.S., C.P.S., Arts Exhbn. Bureau, Painting South East (1975), Haus der Kunst, Munich (1988-89), Kunst in Giesing (1985-90), European Patent Office, Munich (1980-89), S.W.A.; solo shows in England and Germany. *Works in collections:* European Patent Office, Bayern Versicherung, Munich, Patents Appeal Court, Stockholm. *Signs work:* "Jenifer Ford." *Address:* 59 Lancaster Ave., Hadley Wood, Barnet EN4 0ER.

FORD, Mary, *Medium:* paintings, drawings, prints, collages. *b:* London, 7 Jun 1944. *d of:* Mary & Anthony Ford-Whitcome. one *s.* one *d. Studied:* Byam Shaw School of Art (1970-73); Royal Academy Schools (1973-76). *Represented by:* Wills Lane Gallery, St.Ives; Oliver Contemporary, London. *Exhib:* New

Contemporaries (1972); CCA Galleries London (1976/86); RA Summer Exhbn (1977/79); Pallant House, Chichester (1985); Easton Rooms, Rye Art Gallery (1986); Roy Miles, London (1994); Wills Lane Gallery, St.Ives (1995-2006); Falmouth Art Gallery (2004); Oliver Contemporary, London (2002-07); solo exhbns: Sadlers Wells Theatre (1975); Eastgate Gallery, Chichester (1983); Oliver Contemporary, London (2003). *Works in collections:* Tate, London; Slaughter and May Art Collection, London. *Commissions:* private and business. *Works Reproduced:* Tate Publishing. *Signs work:* 'Mary Ford' or 'MF' (monogram). *Address:* 69 Trevethan Road, Falmouth, Cornwall TR11 2AT. *Email:* maryford102@aol.com

FORD, Noel, Dog-Cartoonist of the Year-United Nations (Cartoonists Against Drug Abuse); Lindsay Awards (Australia); Yomiyori Shimbun (Japan). *Medium:* digital. *m:* Margaret. one *d. Educ:* Kegs Grammar School, Nuneaton. *Studied:* Birmingham College of Art (briefly). *Exhib:* many exhbns in UK, USA, Europe. *Works in collections:* Cartoon Arts Trust, and many more. *Commissions:* all work is commissioned. *Publications:* UK national newspapers and magazines, various USA and Europe. *Recreations:* films, playing guitar, reading. *Clubs:* British Cartoonists Assoc.,Cartoonists Club of GB, Professional Cartoonists' Organisation. *Misc:* professional cartoonist since 1975 (Feb). *Signs work:* Noel Ford. *Address:* Ty Rhyd, Ystrad Meurig, Ceredigion, SY25 6AX. *Email:* noel@fordcartoon.com *Website:* www.fordcartoon.com

FORD, Olga Gemes, MSIA graduated in arch. (Techn. University, Berlin); lecturer, The City of Leicester Polytechnic and School of Architecture; traveller and freelance photographer, works for distinguished art publishers here and abroad (Photographic Illustrations). *d of:* L. Gemes. *m:* Oliver E. Ford, B.Sc. (London), Ph.D. (Zürich), F.R.I.C. (decd.). *Educ:* Realschule, Vienna. *Studied:* architecture: Vienna, Dresden, Berlin, Paris; under Prof. Poelzig. *Exhib:* Britain Can Make It, Cotton Board, Manchester. *Works Reproduced:* in Architectural Review, L'Architecture d'Aujourd'hui, La Construction Moderne, Design, 46 Designers in Britain 2 and 4, Decoration, etc. *Signs work:* "OLGA GEMES FORD" or "OLGA FORD." *Address:* 12 Highgate Spinney, Crescent Rd., London N8 8AR.

FORD, Peter Anthony, Sen. Fellow R.E. (1990), V.P.R.W.A. (2007), R.W.A. (2000); artist, independent exhibition organiser and writer; co-proprietor of Off-centre Gallery, Bristol. Designer of bookplates (ex libris). *b:* 17 Apr 1937. one *s. Educ:* Hereford High School, St. Mary's College, Twickenham, Brighton College of Art, London University (Diploma in special education). *Studied:* Brighton College of Art (1960-1961) under Michael Chaplin R.E., R.W.S. (tutor in etching). *Exhib:* Create Centre Gallery, Bristol (2001), Daiwa Anglo-Japanese Foundation, London (2001), The New Gallery, RWA, Bristol (2007). *Works in collections:* Tate Gallery (Artists' Books Collection), Nat. Art Library, V. & A. Museum, Bibliotheque National, Paris, Ashmolean Museum, Oxford, Bristol City Museum; also public collections in Poland, Russia, Spain etc. *Publications:* A

Time of Transition - Contemporary Printmaking In Russia and Ukraine; articles in A.N. (Artists' Newsletter); Printmaking Today; Grapheion. *Clubs:* member of The Bookplate Society. *Signs work:* "Peter Ford." *Address:* Off-Centre Gallery, 13 Cotswold Rd., Bristol BS3 4NX. *Email:* offcentre@lineone.net *Website:* www.peterford.org.uk

FOREMAN, William, painter in oil on canvas;. *b:* London, 1939. *m:* Lesley. one *s.* two *d. Studied:* self taught, but encouraged by Scottish painter Angus McNab. *Exhib:* British Arts Council (1965), Galerie Daninos, Paris (1971); one-man shows: Richmond Gallery, London (1982-93), Bruton St. Gallery (1994-2003), Wally Findlay Galleries, New York, Chicago, Palm Beach (2000), permanent. *Works in collections:* private: U.K., Europe, U.S.A, Canada, Middle East, Far East and Singapore. *Publications:* William Foreman Paintings 20 Years in London, (published 2000). *Clubs:* Chelsea Arts Club. *Signs work:* "FOREMAN" lower right of canvas. *Address:* c/o Bruton St. Gallery, 28 Bruton St. London W1X 7DB.

FORREST, Martin Andrew, B.A. (Hons.), Dip. Hist. Art, F.S.A. (Scot.); artist in oil, art restorer, art historian, editor; Com. Mem. 'Galleries and Visual Arts Committee of the Saltire Soc.'. *b:* Musselburgh, E. Lothian, 7 Jan 1951. *m:* Helen Forbes. one *s.* one *d. Educ:* Musselburgh Grammar School. *Studied:* Wimbledon School of Art (Maggie Hambling and David Poole) and post graduate Birmingham Polytechnic. *Exhib:* Royal Scottish Academy, R.G.I., Open Eye Gallery Edinburgh, Kemplay and Robertson, Edinburgh. *Works in collections:* private: U.K., U.S.A., France. public: University of Surrey, Serres Castet, France. *Commissions:* private figure, landscape and portrait commissions. *Publications:* numerous publications and exhbn. catalogues; Introduction to 'The House that Jack Built' by Robert Burns; contributor to Grove's Dictionary of Art. *Address:* 10 Langtongate, Duns, Berwickshire, TD11 3AE.

FORRESTER, Denzil, BA Hons Fine Art, MA Fine Art; Korn Ferry International Award, RA Summer Show; Rome Scholarship; Harkness Fellowship. *Medium:* oil, drawing. *b:* Grenada, 12 Jan 1956. *Educ:* Stoke Newington Comprehensive, London. *Studied:* Hackney & Stoke Newington FE College, Central School of Art, Royal College of Art. *Exhib:* selected solo shows: Commonwealth Institute, London (1986); Limelight Club, New York (1987); 'Dub Transition' Touring Exhibition (1990-94); 'Farewell to Shadowland', 198 Gallery, London (1995) 'Memory and Images', Peterborough Museum & Art Gallery (1996); 'Two Decades of Painting' The Edward Wilmot Blyden Project (2002); The Cork Street Gallery, Mayfair (2008). *Works in collections:* Freshfields, London; Arts Council of Great Britain; Harris Museum & Art Gallery, Preston; Katie & Ian Walker, Atlanta, USA. *Publications:* 'Dub' (1990-94); Two Decades of Painting (2002). *Official Purchasers:* ACGB - Witch Doctor diptych (oil on canvas 304x396cm). *Works Reproduced:* Bag Bag (oil on canvas, 183x122cm). *Principal Works:* Funeral of Winston Rose (1982, oil on canvas

204x280cm). *Recreations:* travel. *Address:* 68 Woodland Rise, Muswell Hill, London N10 3UJ. *Email:* denzil@fsmail.net

FORTNUM, Peggy, book illustrator and designer. *b:* Harrow-on-the Hill, 23 Dec 1919. *d of:* Comdr. Arthur John Fortnum. *m:* Ralph Nuttall-Smith, painter and sculptor (decd.). two s- *s. Educ:* St. Margaret's, Harrow. *Studied:* Central School of Arts and Crafts. *Exhib:* V. & A., (children's books), Public Libraries (Britain and America), British Museum (children's book show), Regional Book Show, I.C.A., Minories Colchester, Central School of Art, London. *Works in collections:* The Dromkeen Collection of Australian Children's Literature. *Publications:* textile designs, magazines, illustrations for eighty books, which include The Happy Prince and Other Stories (Oscar Wilde), The Reluctant Dragon (Kenneth Grahame), A Bear Called Paddington, 12 Books (Michael Bond), Thursday's Child (Noel Streatfield), Robin (Catherine Storr), Little Pete Stories (Leila Berg), A Few Fair Days (Jane Gardam), Running Wild (Autobiography) (Chatto & Windus); drawings for television: Playschool, Jackanory. *Signs work:* "PEGGY FORTNUM" or "P.F." *Address:* 10 Hall Barn, West Mersea, Essex CO5 8SD.

FOSTER, Christine, SBA; painter in water-colour. *b:* Winsford, Ches., 16 Jul 1947. *m:* Stuart. *Exhib:* local and London. *Signs work:* C and F intertwined. *Address:* 133 Swanlow Lane, Over, Winsford, Ches. CW7 1JB. *Email:* fostatwins@aol.com *Website:* www.lilacarts.co.uk

FOSTER, Judith, N.D.D., A.R.C.A.; painter/printmaker in oil, water-colour, pastel, etching. *b:* 19 Oct 1937. *m:* Richard Pinkney. two *s. Educ:* Bath High School G.P.D.S.T. *Studied:* Ipswich School of Art (1955-59, Philip Fortin, Colin Moss), R.C.A. (1959-62, Carel Weight, Ruskin Spear, Ceri Richards), Abbey Minor Scholarship (1962). *Exhib:* one-man shows: Ipswich, Bath, Peterborough, Edinburgh, Northampton; group shows: U.K., Belgium, Finland, and R.A., R.C.A. *Works in collections:* local authority collections; private collections U.K., U.S.A., Europe. *Clubs:* Suffolk Group, Ipswich Art Soc., Bearing 0900. *Signs work:* "J. Foster" or initials on small works. *Address:* 10 The Street, Bramford, Ipswich, Suffolk IP8 4EA.

FOSTER, Lord Norman Robert (Foster of Thames Bank), Baron 1999 (Life Peer), Kt. 1990, O.M., RA, RDI Dip.Arch. (Manc.), M.Arch. (Yale), RIBA, FCSD, Hon. FAIA, Hon.BDA.; Chairman, Foster and Partners Ltd. *b:* Reddish, 1 June, 1935. *s of:* Robert Foster. four *s.* one *d. Educ:* Burnage Grammar School, Manchester. *Studied:* architecture: Manchester University School of Architecture and Dept. of Town and Country Planning, Yale University School of Architecture. *Exhib:* R.A., London, Paris, Bilbao, Barcelona, Seville, Tokyo, Florence, Nimes, Norwich, Manchester, Milan, New York, Zürich, München, Madrid, Hong Kong. *Works in collections:* Museum of Modern Art, N.Y., Centre Georges Pompidou, Paris. *Publications:* Norman Foster: Buildings and Projects Vols. 1, 2 & 3 (1990),

Vol. 4 (1996). *Address:* Foster and Partners, Riverside Three, 22 Hester Rd., London SW11 4AN.

FOSTER, Richard Francis, R.P.; Lord Mayor's award for London Views (1972); painter in oil. *b:* London, 6 Jun 1945. *s of:* William Foster, M.A. *m:* Sally Kay-Shuttleworth. one *s.* two *d. Educ:* Harrow and Trinity College, Oxford. *Studied:* Signorina Simi, Florence (1963-66), City and Guilds, London (1967-70). *Exhib:* R.A., R.P.; one-man shows, Jocelyn Feilding Gallery (1974), Spink & Son (1978, 1982, 1984, 1991, 1997); Portrait Retrospective " So Far" with Rafael Valls (1999), 'Further' with Partridge Fine Art (2003), 'Home and Away' with Indar Pasricha Gallery (2005). *Works in collections:* Royal Collection, National Portrait Gallery. *Clubs:* A.W.G., Chelsea Arts. *Misc:* Vice President R.P. (1991-1993), Hon Treasurer (2003-2006). *Signs work:* "Richard Foster." *Address:* 5a Clareville Grove, London SW7 5AU. *Website:* www.richardfoster.co.uk

FOUNTAIN, Desmond Hale, F.R.B.S. (1986), Pre-dip. (Stoke-on-Trent 1966), Dip.A.D. (Exeter), A.T.D./Cert.Ed. (Bristol 1970); sculptor, female nudes and life-size children, bronze editions of nine. *b:* Bermuda, 29 Dec 1946, divorced. *s of:* D.O.T. Fountain, accountant and Ruth Masters Fountain, artist. *m:* Egonora 'Luli'. one *s.* one *d. Educ:* Normanton College, Buxton, Derbys. *Exhib:* one-man shows (1980-96): Alwin Gallery, London; Coach House Gallery, Guernsey; Sally le Gallais, Jersey; Windjammer Gallery, Bermuda; Renaissance Gallery, Conn., U.S.A.; Cavalier Galleries, Conn., U.S.A.; The Sculpture Gallery, Bermuda; Falle Fine Art, Jersey; Bermuda National Gallery, The Desmond Fountain Gallery, newly opened in Hamilton, Bermuda; Royall Fine Art, Tunbridge Wells, Kent; Chasen Galleries, Richmond, Virginia, USA. *Works in collections:* throughout U.S.A., Canada and Europe, numerous hotels, banks, public sites, corporations and Bermuda National Gallery. Founded the vehicle for Bermuda National Gallery (1982). *Publications:* 'Desmond Fountain: Sculptor' ISBN 09531 07019. *Signs work:* "Desmond Fountain" or "Fountain." *Address:* P.O. Box FL317, Flatts FLBX, Bermuda. *Email:* sculpture@ibi.bm, desfountain@logic.bm *Website:* www.desmondfountain.com

FOWKES, David Reeve, BA. *b:* Eastbourne, 15 Dec 1919. *s of:* A. F. Reeve Fowkes. *m:* Lorna Fowkes (decd). one *s.* one *d. Educ:* Eastbourne Grammar School; Reading University (1938-40, 1946-48). *Exhib:* Scottish Gallery Edinburgh (1973, 1976, 1980), Aberdeen University (1974, 1983), Peter Potter, Haddington (1979), Manor House, Ilkley (1984), Stonegate Gallery, York (1984, 1985, 1988, 1990, 1993, 1995, 1997), Towner, Eastbourne (1985), York University (1987, 2002, 2004), Abbot Hall, Kendal (1989), Charlotte Lampard, London (1989), Dean Clough, Halifax (1999, 2004), Hull University (2003). *Works in collections:* H.M. The Queen, Aberdeen A.G., Angus County, Towner, Eastbourne, N. of Scot. College of Agriculture, Rowett Inst., Rowntree, Scottish Arts Council, York University. *Publications:* A Gunner's Journal (1990). *Signs work:* "FOWKES." *Address:* 75 Bishopthorpe Rd., York YO23 1NX.

FOWLER, Ronald George Francis, SGFA (1982); Mem. of Council (1985-94), Hon. Member (1999); printmaker in etching, aquatint, drypoint and wood engraving;. *b:* London, 15 Apr 1916. *s of:* George Edward Fowler. *m:* Elizabeth Jean Stewart. one *s.* two *d. Educ:* Strand School, London, and Birkbeck College, University of London. *Studied:* Glasgow School of Art, Warrington School of Art, and Chester C.F.E. *Exhib:* R.S.B.A., N.S.P.S., S.G.F.A., Mall Prints and numerous one-man shows in N.W. England. *Works in collections:* Buxton Museum and A.G., Derbyshire. *Signs work:* "FOWLER." *Address:* Yew Tree Cottage, Lower Whitley, Ches. WA4 4JD. *Email:* ffowler@postmaster.co.uk

FOX, Jane Amber, ARBS (2007); MA Sculpture, BA Fine Art, BSc.Psychology, nurse, midwife, health visitor; Awards: The Welsh Poetry Competition (Specially Commended) (2007); Oppenhein Downes Memorial Trust Award (2003); ACAVA Studio Award (2002); MA Scholarship, RCA, London (1999-2001); The Prankard Jones Memorial Prize, Slade School, UCL (1997); The Mannington Prize, The Slade, UCL (1996); Entry Scholarship, The Slade, UCL (1995); Third and First Painting Prize, The Gwynedd Open, Holyhead, Wales (1994, 93). *Medium:* oil, drawing, sculpture, writer/poet/filmmaker. *b:* Wales. one *s. Studied:* RCA (1999-2001), The Slade School of Fine Art, UCL (1995-99); University College Cardiff (1982-85). *Exhib:* 2007/2008: DACS-Politics Pays Back: Images of Political life in the UK and around the world; film showing of 'Where Now (An Eye for an Eye, and We're All Blind), Kowalsky Gallery, London; 2004: Raindance East Film Festival, Experimental Shorts, London; 2002: Experimentica, Chapter, Cardiff; 2002: Arcadia in the City, London. *Commissions:* 2000: Underground Movement, FeeringburyIX, Colchester; 1999: New Contemporaries on Tour, Liverpool Biennial and Beaconsfield Gallery, London. *Publications:* 2007: Conflict, Sex and Solar Plexus (published in Literary Pocketbook); 2006: White Rabbit (published in poetry anthology 'Routemasters and Mushrooms'); 2002: Arcadia in the City. *Principal Works:* Black Forms (1997); Forget your Perfect Offering (2000); Intimate Immensity (2001); Getting Ready, Never Ready, Ever Ready (2002), edited version (2004); Where Now (An Eye for an Eye and We're All Blind)(2006); Microscope (2007). *Misc:* Sports Diver (BSAC). *Email:* info@janefoxartist.com *Website:* www.janefoxartist.com; www.rbs.org.uk

FOX, Karrie, full membership NAPA. *Medium:* acrylic-semi abstract koi fish paintings. *b:* Eastbourne, 13 Feb 1951. *d of:* Mrs. Barbara Fletcher. *m:* Dr. Simon Fox. three *s.* one *d. Educ:* St. Austell Grammar School. *Studied:* Falmouth College of Art, Cornwall. *Represented by:* various galleries throughout the UK including Chase Art, Wadebridge, Wavelength Falmouth, Fisherton Mill, Salisbury. *Exhib:* regular exhibitor: National Acrylic Painters Association; Westminster Gallery; Falmouth Arts Centre. *Works in collections:* Toshio Sakai, Japan. *Works Reproduced:* in Koi Keepers (front cover), Koi Ponds and Gardens, Koi Carp Magazine; limited editions prints on fine art paper, Giclee prints on Canvas, greeting cards. *Recreations:* running, yoga, skiing. *Signs work:* karrie (lower case, on front of work), Karrie Fox on back of canvas. *Address:* Toll

Lowarn, Penelewey, Truro, Cornwall, TR. *Email:* studio@karriefox.co.uk *Website:* www.karriefox.co.uk

FOX, Peter, BA (Hons) Degree Fine Art. *Medium:* painting, printmaking, sculpture and assemblage. *b:* Kettering, 12 Apr 1952. *Educ:* Kettering School for Boys. *Studied:* Falmouth College of Arts 1979-82 under Francis Hewlett. Printmaking under Norman Ackroyd (Winchester). *Represented by:* Padstow Fine Art. *Exhib:* Oriel 31 Gallery, Powys; Yew Tree Gallery, Morvah; Newlyn Art Gallery (Critic's Choice - Joan Bakewell); Royal Cornwall Museum, Truro; England & Co., London; Mall Galleries, London; Provincetown, New England, USA; 'Insiders: Art and the Box' touring UK (Arts Council, England). *Works in collections:* Dartington Hall Trust, Schumacher College. *Publications:* ARTNSA (2002); 'St.Ives and Cornish Art 1975-2005' by Peter Davies (pub.2007). *Principal Works:* Petroglyphs - series of works utilising slate and oil painted panels, gouaches, woodcut prints. *Recreations:* Latin American Percussionist with Rumba Diablo and El Zumo Salsa Band. *Clubs:* Newlyn Society of Artists. *Signs work:* 'Peter Fox'. *Address:* Little Treskello, Plain an Gwarry, Penzance, Cornwall TR17 0DU. *Email:* peter.fox4@tesco.net *Website:* www.axisartists.co.uk/ cornishcollective.com/silverwellfineart.com

FOX OCKINGA, Fyne Marianne, *Medium:* watercolour, drawing, prints. *b:* Baarn (Netherlands), 6 Feb 1943. *d of:* M.H.Okkinga-Slingenberg. *m:* Robert Fox (journalist). one *s.* one *d. Educ:* MMS Hengelo (O) Netherlands. *Studied:* Bath Academy of Art, Corsham, Wilts (1960-63); Rijks-Akademic van Beeldende Kunsten, Amsterdam (1963-66). *Exhib:* from 1976 regularly in England and the Netherlands; RA Summer Exhbns; RA, Barbican; Royal Festival Hall; Geffrye Museum; CTRL Visitor's Centre St.Pancras; Mall Galleries; Open Studio shows and solo shows since 1994 every year in Islington; Galerie Van Heyningen, Den Haag; Netherlands 2006: Galerie Petit Amsterdam, Rosa Spier Huis Laren (NH), Galerie Den Andel Groningen; 2007: Galerie Visée Diepenheim, Galerie "Leesbibliotheek" Zutphen, Galerie Koopmans, Eernewoude. *Works in collections:* ABN-AMRO Bank; Pilkington Corporate Collection; McAlpine; many private collections. *Commissions:* Arsenal-Emirates Stadium 2004-2005 Scenes of Construction; since 2001 a historical record of the changes at King's Cross St.Pancras with a second sponsored exhbn. in the LCR Visitor's Centre (2005). *Publications:* illustrations for "Once More with Feeling", a book of classic hymns (Short Books, 2007). *Recreations:* music, vocal and instrumental (piano, recorder). *Signs work:* 'Marianne Fox Ockinga' or 'Marianne Ockinga'. *Address:* 6 Thornhill Square, London N1 1BQ. *Email:* rfox@beeb.net *Website:* www.mariannefoxockinga.co.uk

FRAME, Mary Elizabeth Bruce, BA Fine Art (Dunelm). *Medium:* oil, pastel, watercolour. *b:* Newcastle-upon-Tyne, 30 May 1936. *d of:* Thomas Bruce Frame. *m:* James Attree. from previous marriage, one *d. Educ:* Rutherford High School, Newcastle-upon-Tyne. *Studied:* King's College, Durham University (1954-58). *Exhib:* mixed exhibitions: Royal Institute of Painters in Watercolour; Pastel

Society; Royal West of England, Bristol; Fosseway Artists, Helios Group. one-man: Braemar, Ullapool, London, Durham. *Works in collections:* Westminster Council. Private collections in the UK, USA and Europe. *Commissions:* private. *Recreations:* drawing, travel, walking. *Signs work:* "MARY FRAME". *Address:* Fordhill Lodge, Temple Guiting, Cheltenham, Glos. GL54 5XU. *Email:* frameattree@btinternet.com *Website:* www.maryframepaintings.co.uk

FRAME, Roger Campbell Crosbie, C.A. (1973); Secretary of: R.S.W.; Chartered Accountant;. *b:* Glasgow, 7 June, 1949. two *s.* one *d. Educ:* Glasgow Academy. *Clubs:* Glasgow Art. *Address:* 29 Waterloo St., Glasgow G2 6BZ.

FRANC, Barbara, sculptor in wire. *b:* London, 27 Oct 1954. *m:* Philip Sindall. one *d. Studied:* Morley College of Art (John Bellany, Maggie Hambling). *Exhib:* Phillips International Auctioneers, Molesey Gallery, Roy Miles Gallery, Fitch's Ark, Usiskin Contemporary Art, Worthing Museum; Sculpture Prize, Chelsea Art Soc., Linley & Co., Pimlico. *Commissions:* d.p.ua advertising agency - 6' fish for their offices, group of birds for L.C.A. *Publications:* Garden Crafts by Geraldine Rudge, Country Living, Homes & Gardens, Painting World, Country Homes & Interiors magazines. *Clubs:* Nine Elms Group of Artists. *Signs work:* "Babara Franc." *Address:* 11 Queen's Gdns., Ealing, London W5 1SE. *Email:* barbara.franc@btinternet.com

FRANCESCONI, Anselmo: see ANSELMO (Anselmo Francesconi),

FRANCIS, Audrey Frances, R.I. (1994); painter in gouache, oil and acrylic. *b:* 5 Oct 1931. *d of:* Charles Hatton Short, architect. *m:* O.R. Francis. *Educ:* PND Malaya, MLC Perth, W.A., Girdlers School, Kent. *Studied:* Wimbledon School of Art (1948-52), Central School of Arts and Crafts (1953). *Exhib:* R.I., R.W.S. Open, N.E.A.C., and mixed exhbns. *Signs work:* "F. Francis." *Address:* Grove Cottage, Waldron, nr. Heathfield, E. Sussex TN21 0RB.

FRANCYN, (Dehn Fuller), FFPS, WIAC, NS; painter in oils and gouache. *b:* Portsmouth. *d of:* Walter Henry Fuller, lecturer. *m:* Curt Dehn. one *s.* one *d. Educ:* at home. *Exhib:* one-man shows: Paris, The Hague, Utrecht, Sydney, London; group shows: Free Painters and Sculptors, W.I.A.C., Hampstead Artists, N.S., etc. *Works in collections:* Holland, Germany, U.S.A., Australia. *Publications:* Poems, Man's Moment (U.S.A.), portfolio of folk-songs, collection of poems. *Clubs:* I.C.A., Hampstead Artist. *Address:* 6 Elsworthy Ct., Elsworthy Rd., London NW3.

FRANK, Dianne, ASBA. *Medium:* coloured pencil, watercolour, gouache, pencil. *b:* Vancouver, 11 Oct 1950. *m:* Robert C.Allen, FBA. one *s. Studied:* UBC (BA, 1994); self-taught artist. *Exhib:* SBA Annual Exhbns (2004, 2006, 2007); Oxford Artweeks (2003-07); Broad Face & St.Nicholas Church, Abingdon; University of Oxford, Dept. of Economics. *Signs work:* 'D.FRANK', 'D.F.', 'DIANNE FRANK'. *Address:* 9 Salisbury Crescent, Oxford, OX2 7TJ. *Email:* diannelfrank@hotmail.com

FRANKENTHALER, Helen, BA(1949); First Prize, Paris Biennale (1959); painter in oils, acrylic, on unsized cotton-duck. *b:* New York, 12 Dec 1928. *d of:* Alfred Frankenthaler, Supreme Court Justice. *m:* Stephen M. DuBrul. *Educ:* Bennington College, Vermont, (B.A.). *Exhib:* numerous throughout America including M.O.M.A. (N.Y.), Andre Emmerich N.Y., Guggenheim Museum N.Y., Knoedler Gallery N.Y., Neuberger Museum of Art, Purchase College, N.Y. (1999-2000); also France, Italy, Sweden, Canada, Korea, Japan, Spain, Germany, Singapore, etc. *Works in collections:* includes, N.Y.C.: Guggenheim Museum, M.O.M.A., Whitney Museum, Metropolitan Museum of Art; Washington D.C.: National Gallery of Art, Corcoran Gallery of Art, Hirshhorn Museum and Sculpture Garden, etc; also many museums and art galleries worldwide. *Publications:* Monographs and exhbn. catalogues; films and videos. *Address:* c/o Knoedler Gallery, 19 E. 70th St., New York, N.Y 10021. USA.

FRANKLAND, Eric Trevor, PPRWS, RE, RBA, Hon RI, mem. of The London Group and Art Workers Guild, Leverhulme Fund award, Landseer Scholarship, RA Silver Medal for Drawing; RBA Delaszlo Medal, etc. painter and printmaker; part-time lecturer, Hornsey College of Art and Middlesex University. President Royal Watercolour Society 2003-2006. *b:* Middlesbrough, 7 Jul 1931. *m:* Dorothy Southern, artist. *Studied:* Laird School of Art, Birkenhead; Royal Academy Schools, London. *Represented by:* Bankside Gallery, 48 Hopton Street, London SE1 9JH. *Exhib:* many solo shows. Assisted by Grant Aid from the Arts Council and other regional Arts organisations, also and most major group shows. *Works in collections:* Brimingham University, Middlesbrough Art Gallery, The Rank Xerox Organisation, The Shipley Art Gallery, Gateshead, The Royal Academy of Arts (A.Hugill Fund Purchase), Middlesex University, The Special Trustees of Hammersmith Hospital, The Scarborough Art Gallery Print Archive, Cleveland County Council, The Ashmolean Museum (R.E.Diploma Collection), The Williamson Art Gallery, Birkenhead, The Royal Collection, Windsor, The Royal Water-colour Society, Diploma Collection, Dover St. Arts Club. Private Collections: England, Italy and America. *Clubs:* Chelsea Arts, Dover St. Arts. *Misc:* Domestic landscape construction, "Summer River Bed Winter Flood Plain", show on television, four short films, Channel Four TV (1988), BSkyB TV (1990), London Weekend TV (1992), Carlton TV (1999). *Signs work:* "Trevor Frankland" on prints, "FRANKLAND" on other works, sometimes "T.F." *Address:* 13 Spencer Rd., London SW18 2SP. *Website:* www.trevorfrankland.co.uk

FRANKLIN, Annette Winifred, H.S.; artist in water-colour, oil, pastel, pen and ink, and gouache; miniature portraitist, Poole Pottery paintress (1945-50); C.S.A. *b:* 28 Jan 1932; Adopted from orphanage 1936. Blood father Lesley Rex Ferguson, blood mother Winifred E.Ballard. *m:* Stanley Franklin. *Educ:* St. James and Henry Harbin Schools, Poole. *Studied:* mainly self taught, some tuition - pottery painting: (John Adams, Ruth Pavley); oil painting: (Leonard and Margaret Boden). *Exhib:* R.M.S. & R.W.S. at Mall Galleries., Westminster Hall, Hilliard Society, Gatcombe Farm, Royal School of Needlework, Foyles London, College

of Fashion and Design, Wallsworth Hall. *Works in collections:* U.K., U.S.A., Australia, Bahrain, Abu Dhabi, N.Z., The Princess Royal & Capt. Mark Phillips. *Publications:* Quilting and Design by M. McNeal; articles for Poole Pottery Collectors Club and Hilliard Society Magazine. *Official Purchasers:* portraits in oil of Sir Peter Scott, Simon Combes (wildlife artist), Peter Scott (Glider Club Nypsfield), President of World Wide Helicopters (Mr Arnie Sumarlidison, USA), various commissions. *Works Reproduced:* painted own designs on vases and plaques, also on china and wooden boxes. *Principal Works:* The United Arab Emirates Emblem (for the Ruler of Sharja). *Recreations:* gold and silver embroidered on wild silk. *Clubs:* Fine Art Promotions, Poole Pottery Artist Collectors Club, Lansdown Art, Fosseway-Artist. *Address:* 'Sunnymead', 15 Marsh Lane, Leonard Stanley, nr. Stonehouse, Glos. GL10 3NJ.

FRANKLIN, Ellen, F.P.S.; Mem. Ben Uri Gallery (The London Jewish Museum); painter in oil;. *b:* Berlin, 18 Aug., 1919. *Studied:* Reiman School of Art, Berlin (1936-38), Morley College, London. *Exhib:* Gladstone Pk. Gables Gallery (1980, 1995, 1997), Loggia Gallery (1985, 1991), Trends (1987, 1989), Ben Uri Gallery (The London Jewish Museum)(1988, 1992), Cardiff (1988), Morley Gallery (1991, 1993, 1994, 1995, 1996, 1997). *Misc:* Work in private collections. *Signs work:* "E. Franklin." *Address:* 44 Beechcroft Gdns., Wembley, Middx. HA9 8EP.

FRASER, Donald Hamilton, R.A.; painter. *b:* London, 30 Jul 1929. *m:* Judith Wentworth-Sheilds, 1954. one *d. Studied:* St. Martin's School of Art, London (1949-52) and in Paris (French Gov. Scholarship). Tutor, Royal College of Art (1958-84); Hon. Fellow R.C.A. (1984); Hon. Curator, Royal Academy (1992); Trustee, Royal Academy (1993); Vice-Pres. Royal Overseas League since 1986; Vice-Pres. Artist's General Benevolent Inst.; mem. of Royal Fine Art Commission (1986-1999). *Exhib:* Over 70 individual exhbns. in Europe, N. America and Japan. Work in public collections throughout the world. *Publications:* 'Gauguin's Vision after the Sermon' (Cassell, 1968), 'Dancers' (Phaidon, 1988). *Clubs:* Arts. *Address:* c/o Royal Academy of Arts, London W1V 0DS.

FRASER, Elizabeth Bertha, Mem. Society of Portrait Sculptors; sculptor in wax, plaster, bronze, painter in oil. *b:* Teddington, London, 1914. *d of:* Arthur Marks, F.I.C., A.R.S.M., A.R.C.Sc., A.M.I.Mech.E. *m:* Lindley Maughton Fraser. *Studied:* Birmingham School of Art, Central School of Art, London, Westminster School of Art, London, Edinburgh College of Art. *Exhib:* R.A.; one-man shows, London and Edinburgh, Tour of Britain Sculptors Society, Society of Portrait Sculptors Yearly Exhbn., Edinburgh Younger Academy. *Commissions:* portrait heads. *Works Reproduced:* television talks, theatrical designs. *Clubs:* Chelsea Arts. *Signs work:* "Liz Fraser," "Elizabeth Scott-Fraser" or "Elizabeth Fraser." *Address:* The Studio, 7 Ridgway Gdns., London SW19 4SZ.

FREEMAN, Janet A., B.Ed. (Hons.), B.S.A.; painter in oil. *b:* Bedford, 5 Dec 1933. *m:* Richard Freeman. three *s.* one *d. Studied:* Goldsmiths' School of

Art,University of London; Bath Academy of Art, Bath Spa University. *Represented by:* Duncan Campbell Fine Art, London. *Exhib:* Duncan Campbell, London, Royal Academy Summer Exhibition, N.E.A.C. London, Millfield Open, R.W.A., Annual Bristol, School House Gallery Bath, Laing Open, Black Swan Guild Frome, Bath University, Ron Whittle Fine Art, Birmingham. *Works in collections:* Marquis of Bath, Leonard Mannaseh PPRWA. *Clubs:* Bath Soc. of Artists. *Signs work:* "J.A. Freeman." *Address:* 27 Northampton St., Bath BA1 2SW.

FREEMAN, Lily, F.P.S., B.A. Hons. (1978); painter in oil and water-colour; lectured on Modern Art, Univ. of 3rd Age for 15 years. *b:* Vienna, 7 Feb 1920, widow. *d of:* Hans Fischer. one *d. Educ:* Realgymnasium, Vienna. *Studied:* Vienna, Arthur Segal School, Hampstead (A. Segal, Marianne Segal). *Exhib:* N.Y. Expo (1985), Barbican (1982), Orangery, Holland Pk. (1979, 1981-85), Alicante, Spain (1983), Loggia Gallery (1978, 1982, 1984), Cockpit Theatre, Odeon Marble Arch, Hampstead Town Hall, New Art Theatre, Alpine Club, Hampstead Art Centre, Ben Uri Gallery (The London Jewish Museum), Royal Overseas League, Guildhall, London, Tradescant Trust, Leighton House, Burgh House. *Works in collections:* Dr. Lansky, Vienna. *Signs work:* "Freeman". *Address:* 65 Dunstan Rd., London NW11 8AE. *Website:* www.happypaintings.co.uk

FREEMAN, Michael John, NDD, ATD. *Medium:* oil, watercolour, drawing, prints. *b:* Swansea, 10 Apr 1936. *s of:* John Stanley Freeman. *Educ:* Bishop Gore Grammar School, Swansea (1947-55). *Studied:* Swansea School of Art (1955-58, Teaching Diploma). *Represented by:* Fountain Fine Art, Llandeilo; Crane Gallery, Swansea. *Exhib:* Welsh Group; MoMA Machynlleth; National Museum of Wales; The Bar Covent Museum, York (1993); Retrospective 1964-84: Glynn Vivian Art Gallery & Museum (1985), Queens Hall, Narbeth (2001); also organised 32 annual public student shows (extra-mural Uni & WEA) of paintings, drawings and prints (1971-2003). *Works in collections:* Welsh Arts Council; Glynn Vivian, Swansea; Bangor College, and numerous private collections in UK, Germany, Sweden, USA & Canada. *Commissions:* not accepted. *Publications:* Dictionary of British Artists since 1945. *Works Reproduced:* booklet covers on Marco Polo & Naxos CDs; in exhibition catalogues and reviews. *Principal Works:* Shipwrecks; the Book of the Crab; Canute. *Recreations:* music. *Clubs:* British Music Society (retd), Welsh Group. *Misc:* My best teacher was the composer Edmund Rubbra. *Signs work:* "FREEMAN" and date (e.g. FREEMAN '08) on verso. *Address:* 11 Walters Street, Manselton, Swansea, SA5 9PL. *Website:* www.mikefreeman.uk8.net (& links)

FREEMAN, Ralph, *Medium:* painting and construction. *b:* London, 15 Jan 1945. *m:* Catherine. two *d. Studied:* Harrow and St.Martin's Schools of Art (1961-65). *Represented by:* New Millennium Gallery, St.Ives. *Exhib:* Camden Arts Centre (1983), Louise Hallett Gallery (1988), Royal Cornwall Museum (1992), Stemberg Centre (1996), Tate St.Ives (1998), Gardner Arts Centre, University of

Sussex (1999), Freud Museum, London (2002), New Millennium Gallery, St.Ives(2003 & 2006). *Works in collections:* Yad Vashem Museum, Israel, Freud Museum, London, Falmouth Art Gallery. *Commissions:* 'Man, Spirit, Energy' Albion Project. *Publications:* Foundations & Fragments, Tate Gallery St.Ives, D Cohen Freud Museum, Foundations and Fragments by E. Davies; More Than the Message, M.Birf, New Millennium Gallery; The Book Show. *Clubs:* Penwith Society of Arts; Newlyn Society of Artists. *Signs work:* Freeman or RF. *Address:* 29 Bowling Green Terrace, St.Ives, Cornwall, TR26 1JS.

FREEMAN, Richard, M.Ed., RWA; Morris Singer Award, RWA (1997); sculptor in clay, plaster, bronze. *b:* Windsor, 12 Apr 1932. *m:* Janet Freeman. three *s.* one *d. Studied:* Bognor Regis Training College, Goldsmiths' College, London, Chelsea Art School, London, University of Bristol. *Exhib:* recent shows include McHardy Sculpture Co. London, Wills Lane Gallery St. Ives, Anthony Hepworth Fine Art Bath, School House Gallery Bath, R.W.A. Annual Bristol (1992-2005), Gumstool Gallery Tetbury, Wine St. Gallery, Devizes, etc. Work in collections internationally. *Clubs:* RWA. *Signs work:* "FREEMAN" or "R.F." *Address:* 27 Northampton St., Bath BA1 2SW.

FREER, Roy, N.D.D., A.T.D., R.O.I., R.I., N.E.A.C.; artist in oil and water-colour; art course tutor and organiser, demonstrator, lectures on appreciation of painting and drawing. *Medium:* oil and watercolour. *b:* Birmingham, 1938. *m:* Sally Freer. two *s. Studied:* Bournville School of Art, and Birmingham College of Art. *Represented by:* Federation of British Artists, Mall Galleries, London. *Exhib:* The Callo Gallery, London; Anna Mel Chadwick Gallery, London; The Ceddar House Gallery, Surrey; The Chappel Gallery, Essex. *Signs work:* "ROY FREER". *Address:* 5 Bridgefoot, Cross Street, Sudbury CO10 2DG. *Email:* royfreer@btinternet.com *Website:* www.royfreer.co.uk

FREETH, Peter, Dip. Fine Art Slade School (1960), A.R.A., (1990), R.A. (1992), R.E. (1991); printmaker in etching, aquatint, water-colour, teacher; Tutor of Etching, R.A. Schools, London; Awards: Prix de Rome, Engraving (1960), RA Summer Exhbn: Best Print (1986), Hunting Art Prizes: Drawing/Print Prize (2002, 2004). *b:* B'ham, 15 Apr 1938. *s of:* A.W. Freeth. *m:* Mariolina. two *s. Educ:* K.E.G.S. Aston, B'ham. *Studied:* Slade School of Fine Art (1956-60, Antony Gross, William Coldstream). *Exhib:* R.A., R.E., Christopher Mendez, London SW1, Bankside Gallery (2001), London SE1, Beardsmore Gallery, London NW5, City Gallery, EC3, Mary Kleinman Gallery, N1, Christchurch College Picture Gallery, Oxford (2005). *Works in collections:* V. & A., B.M., Arts Council, Fitzwilliam Cambs., Metropolitan Museum, N.Y., National Gallery, Washington, Ashmolean, Oxford, Govt. art collection. *Signs work:* "P. Freeth." *Address:* 83 Muswell Hill Rd., London N10 3HT.

FREUNDLICH, Grace Ruth, Travelling Fellowship, Scottish Arts Council (1979), Fellowship, Provincetown Workshop (1976); artist in acrylic, ink, oil, graphite; instructor; exhbn. com., Provincetown Art Assoc. and Museum. *b:* New

York, 6 May 1939. two *s. Educ:* University of Wisconsin, Madison (1964), art & art history; C.U.N.Y. (N.Y.); H.S. of Music & Art, N.Y.C. *Studied:* Hunter College Graduate School (Bob Swain), Provincetown Workshop (Leo Manso, Victor Candell). *Exhib:* Gallery Matrix, Provincetown (1993, 1994), Foundry Gallery, Washington, D.C. (1981), Demarco Gallery, Edinburgh (1980), Provincetown Workshop (1976), Provincetown Art Assoc. and Museum (1986-96); solo show, Roosevelt House of Hunter College, N.Y. (1975), Galerie Henri, Boston, Mass. (1961). *Works in collections:* University of Wisconsin, Hunter College, Histadrut, Israel, American Forum, National Press Bldg., Washington D.C.; and Ilana Soesman, Israel, Marion Namenwirth, St. Paul, Minn., A. & S. Hoffman, Jerusalem, Israel. *Commissions:* The Land meets the Sea, The Sea meets the Land, American Forum, Washington D.C. *Publications:* Precis, with Robert E. Miller on exhbns. at Gallery Matrix, Provincetown. *Clubs:* College Art Assoc., National Women in the Arts Museum, Washington, D.C. Provincetown Art Assoc. and Museum. *Misc:* Scottish Arts Council fellowship/travelling, through Richard Demarco. *Signs work:* "G.F." or "G. Freundlich." *Address:* 200 W. 93rd St. 4J, New York, N.Y. 10025 USA. *Email:* graciousf@earthlink.net

FREW, Hilary, F.R.B.S. (1960), R.B.A. (2000), Cert R.A.S., A.T.D., P.G.C.E.; Leverhume Award (1961); sculptor in Portland stone; design technology teacher (1979-1993), now freelance sculptor; Mem. Sec. R.A.S.A./Reynolds Club at Royal Academy. *b:* Essex, 30 Mar 1934. *m:* G.R. Bonye. one *s.* one *d. Educ:* convents in Buckingham, Felixstowe and Bedford, St. Andrews University. *Studied:* S.E. Essex School of Art (1954-1957), Royal Academy Schools (1957-1961)(under T.B.Huxley Jones, Maurice Lambert, and Arnold Machin.); Stockwell College (1972-1973), Goldsmith's College (1978-1979). *Exhib:* numerous group society exhibs. and garden galleries, London, USA, Italy. *Works in collections:* Bromley Educ. Authority and many private collections. *Commissions:* Harlow Town Park Paddling Pool. Many private commissions including portraits. *Recreations:* photography, sculpture, swimming. *Signs work:* "H F." *Address:* Dees Holt, Raggleswood, Chislehurst, Kent BR7 5NH. *Email:* info@hilaryfrew.com *Website:* www.hilaryfrew.com

FRIEDEBERGER, Klaus, painter;. *b:* Berlin, 1922. *m:* Julie. *Educ:* Quakerschool Eerde, Netherlands. *Studied:* E. Sydney Tech. College. *Exhib:* one-man shows: Belfast (1963); London 1963, 1986, 1990, Retrospective 1992, Works 1940-1970 (2007); group shows since 1944. Europe Prize, Ostende 1964 (Gold Medal), National Gallery of Australia, 'Surrealism' (1993), 'The Europeans' (1997). *Works in collections:* private: Australia, England, Europe, U.S.A. Official purchases: Mosman Art Prize 1949, National Gallery of Australia, British Museum, University of Wollongong. *Publications:* Encyclopedia of Australian Art, Arts Review, Art and Australia, Twenty Five Years Annely Juda Fine Art (London 1985), Surrealism (Canberra 1993), The Dictionary of Art /Grove Art Online (OUP), The Europeans (Canberra 1997), Dictionary of Artists in Britain since 1945. *Signs work:* "Friedeberger." *Address:* 16 Coleraine Rd., London SE3 7PQ.

FRÖHLICH-WIENER, Irene, sculptress in bronze, stone, wood, fibreglass, cement. *b:* Luzern, Switzerland, 26 Aug 1947. *d of:* Sigmund Wiener. *m:* Josef Fröhlich. two *d. Educ:* Kantons-Schule, Luzern (Matura), Institut Maïeutique (Art-therapy). *Studied:* Centre de la gravure Contemporaine, Geneva (1969), Marylebone Inst. (1973-74, carving under E. Mehmet), H.G.S. Inst. (John Brown), Sir John Cass School of Art (Clive Duncan). *Exhib:* R.B.A., Royal Festival Hall, Camden Art Centre, Woodstock Gallery, Smee Gallery, Norfolk, Ben Uri Gallery (The London Jewish Museum), Mall Galleries, Old Bull Art Centre, Draycott Gallery, Blenheim Gallery, Cecilia Coleman Gallery, October Gallery, dfn Gallery, U.S.A. (New York). *Works in collections:* Helmut Stern Collection, Michigan, McHardy Sculpture Co., London, Gold Art, Haifa. *Commissions:* Rank Xerox (1996) award. Hertsmere: Bushey Park (1998), 'Tree of Life' Finchley Synagogue (1999), Florida Parc, Lugano (2001). *Clubs:* H.V.A.F. and Royal Soc. of Sculptors, F.P.S. *Signs work:* "Irène." *Address:* Via Cassarinetta 2, CH 6900 Lugano, Switzerland. *Website:* www.breakingart.com.//:irene

FRONTZ, Leslie Robinson, SWA; SW; Award of Excellence, Ohio Watercolor Society; Shook Memorial Award, Southern Watercolour Society; H.R.H. Princess Michael of Kent Watercolour Award; Watercolour Award, Society of Women Artists. *Medium:* watercolour. *b:* Cleveland Ohio, 23 Aug 1950. *d of:* James & Mary Robinson. *Educ:* MFA. *Studied:* University of North Carolina at Greensboro under Walter Barker and Andy Martin. *Represented by:* USA: Ambleside Gallery; Heart of Living Gallery; Broadhurst Gallery. *Exhib:* SWA, London; Smithsonian Institution, Washington DC; Comer Museum of Art. *Works in collections:* St.Cuthberts Mill, Burlington Industries, Bethany College, Bureau of Land Management, Wachovia Bank, Germanton Gallery, USA. *Publications:* 'Painting for Impact', The Artists Magazine (1995); recognised in Who's Who in American Art and 'Who's Who in America'. *Clubs:* Southern Watercolor Society; Plein Air Carolina. *Signs work:* 'L.Frontz'. *Address:* 296 Peace Haven Drive, Lexington, N.Carolina 27292 USA. *Email:* hlfrontz@lexcominc.net *Website:* www.frontzstudio.com

FROST, Anthony, DFA (1973); South West Open Prizewinner; artist in acrylic paint on canvas. *b:* St. Ives, Cornwall, 4 May 1951. *s of:* Terry Frost, artist. *m:* Linda Macleod. two *s. Educ:* North Oxon. Technical College and School of Art, Banbury. *Studied:* Cardiff College of Art (1970-73). *Represented by:* Advanced Graphics London, The Somerville Gallery Plymouth, Beaux Arts London. *Exhib:* Four Young Artists, Penwith Gallery, St. Ives; John Moores, Liverpool; Public Hanging, St. Ives; Dangerous Diamonds, Hull; Anthony Frost - on Colour, Newlyn Gallery; "Viva Blues" Newlyn Gallery (1996), touring Birmingham, Darlington and London (1997); The Belgrave Gallery, London (1997); King's University, Cambridge (1998); Corporate Connoisseurs, London (1999); Jersey Arts Centre, Jersey (1999), Hilsboro Fine Art, Dublin (2001); Corporate Connoisseurs, London (2001); Advanced Graphics, London (2001); The Original Print Gallery, Dublin (2002), 'Big Colour in Space' Space Gallery Penzance

(2003), 'Zig Zag Wanderer' The Somerville Gallery, Plymouth (2004); 'Lunar Notes Neon Dreams' Advanced Graphics, London (2005). *Works in collections:* John Moores, Liverpool, Nuffield Trust, Contemporary Arts Soc., Cornwall C.C., Kasser Foundation, New York, Whitworth Gallery Manchester, The Bank of America, Canary Wharf London, Addenbrooks NHS Cambridge, Truro Museums and Art Galleries, Devon CC, Contemporary Irish Art Society, Limerick Museum and Art Gallery. *Commissions:* UNESCO Paris, CDC IXIS Bank of France, Mutuelle Générale Assurance corporation Paris, The Eden Project - planting design for fodder crops exhibit in the roofless biome. *Publications:* "Viva Blues", 'Zig Zag Wanderer'. *Clubs:* Subbuteo Football, Petangue, Boule. *Misc:* performance "The Fast and Bulbous" Show Painter, Poet Head to Head! - Anthony Frost and Phil Bowen. Also "The Stand Upslide Show"- Anthony Frost. *Signs work:* "Anthony Frost." *Address:* Rosemergy Cottage, Morvah, Penzance TR20 8YX. *Website:* www.galleryonline.org.uk

FROST, Michael John, L.L.C.M. (1947), B.A. English Hons. (1951), M.A. Politics (1969), A.F.A.S. *Medium:* oil, pastel and acrylic. *b:* Burton-on-Trent, 8 Apr 1930. *Educ:* Burton Technical High School, Leeds University, Lancaster University. *Studied:* Glasgow School of Art (1963-1966), more recently taught by Rod Williams, Victor Ambrus and Brian Gallagher. *Exhib:* PS, RWA, The Armed Forces Art Society; numerous art groups and societies. *Signs work:* "FROST." *Address:* 2 Bedford Ave., Frimley Green, Surrey GU16 6HP.

FROY, Martin, D.F.A. (1951); Emeritus Professor of Fine Art, Reading University. *b:* London, 9 Feb 1926. *Studied:* Slade School. Gregory Fellow in Painting, Leeds University (1951-54); Trustee, National Gallery (1972-79), Tate Gallery (1975-79); Fellow U.C.L. (1978). *Works in collections:* Tate Gallery, Museum of Modern Art, N.Y., Chicago Art Institute, Arts Council, Contemporary Art Society, Royal West of England Academy, Leeds University, Art Galleries of Bristol, Carlisle, Leeds, Reading, Southampton, Wakefield. *Commissions:* Artist Consultant for Arts Council to City Architect, Coventry (1953-58); mosaic decoration, Belgrade Theatre (1957-58); two murals in Concert Hall, Morley College (1958-59). *Address:* University of Reading, RG1 5AQ.

FRY, Minne, BA (1953); painter and printmaker in oil, water-colour, etching;. *b:* Johannesburg, 20 Dec 1933. *d of:* J.S. Zidel, MRCS, LRCP. *m:* Lionel Fry. one *s.* two *d. Educ:* University of the Witwatersrand. *Studied:* Central School of Art (1955, Cecil Collins, Denis Bowen, Mervyn Peake), Morley College (Adrian Bartlett, Frank Connelly). *Exhib:* New Vision Centre (1958), Camden Galleries (1989), Green Room (1995), Coningsby Gallery (2000), britart.com. *Works in collections:* C.A.S. *Clubs:* Printmakers Council, National Society of Painters & Sculptors. *Signs work:* "Minne Fry." *Address:* 16 Caroline Pl., London W2 4AN. *Email:* britart.com

FRYER, Katherine Mary, A.T.D. (1932); Princess of Wales Scholarship for wood engraving (1932), Hoffmann Wood (Leeds) gold medal for painting (1968);

1937-47 taught at Bath School (later Academy) of Art Corsham; lecturer in School of Painting, B'ham College of Art (retd.); Professor of Painting, Royal Birmingham Soc. of Artists. *Medium:* oil, watercolour, engraving on wood. *b:* Roundhay, Leeds, 26 Aug 1910. *d of:* John Edward Fryer. *Educ:* Roundhay High School, Leeds. *Studied:* Leeds College of Art (1926-32, E. Owen Jennings). *Exhib:* R.A., R.B.S.A., S.W.E., etc.; Retrospective, exhibition, Royal Birmingham Soc. of Artists, June 2000. *Works in collections:* R.A., B'ham Register Office, Leeds, Wakefield and Harrogate Art Galleries Permanent Collections and University of Birmingham; Royal Birmingham Society of Artists; private collections in Britain, Ireland and Canada. *Publications:* book of wood engravings "Before the War and Long Ago", published by Old Stile Press Llandogo. *Official Purchasers:* Royal Academy painting, University of Birmingham, Textiles by Messrs Heals. *Works Reproduced:* poster for GPO Savings promotion. *Principal Works:* figurative. *Signs work:* "K.M. Fryer" or "K. FRYER." *Address:* 47 Moor Pool Ave., Harborne, Birmingham B17 9HL.

FUEST, Robert, NDD (Illustration) High Merit; ATD; freelance designer and film director, UK and NY, Hollywood; lecturer London Film School. *Medium:* oil, mixed media. *b:* London, 30 Sep 1927. *m:* Jane. three *s.* one *d. Educ:* Wallngton County, Surrey. *Studied:* Wimbledon School of Art (1944); Hornsey School (1950). *Represented by:* Bell Fine Art, Winchester: sales@bell-fine-art.demon.co.uk; Rowley Gallery Contemporary Arts, 115 Kensington Church St. *Exhib:* RA (first exhbn 1951), RWA, NEAC, Mall Galleries etc. *Recreations:* music. *Signs work:* 'Fuest'. *Address:* Garage Cottages, Bridget's Lane, Marty Worthy, Winchester SO21 1AW.

FULLER, Martin Elliott, Discerning Eye Modern Painters Prize (1996); First Prize, Hunting Art Prizes (1987); Guggenheim-McKinley Scholarship (American Art Workshop Italy, 1964); Artist-in-residence Santa Fe, New Mexico (1991-2). *Medium:* oil, watercolour, drawing, prints. *b:* Leamington Spa, 9 Feb 1943. *s of:* Sidney Fuller. *m:* Margaret Rand. one *d. Studied:* Mid-Warks College of Art; Hornsey College of Art;. *Represented by:* Studio II, 2 Blenheim Gardens, London SW2. *Exhib:* over twenty solo exhbns inc.: Arnolfini, Bristol City Art Gallery, Camden Arts Centre; RZA Galerie, Dusseldorf; Austin Desmond Fine Art; Adam Gallery, Cork Street, London (2005); over twenty group exhbns inc: Redfern Gallery, Angela Flowers, Michael Parkin, V&A, Barbican Centre, National Theatre, Jonathan Clark Fine Art (with Edward Burra); Retrospective, Leamington Spa Art Gallery & Museum (curated by William Packer, 2001). *Works in collections:* Bristol City Art Gallery and Museum; Trinity College, Oxford; Unilever; Chelsea and Westminster Hospital; Railtrack; Bank of America; Leamington Spa Museum. *Commissions:* Waldorf Hotel, London; Radisson Hotel, Cork and Glasgow; Malmaison Hotel, London. *Publications:* numerous, inc. 'The Guardian', 'Arts Review', 'Spectator', 'Modern Painters', 'The Times', 'Ambit', 'Apollo'. *Works Reproduced:* Ambit, Erotic Review, Modern Painters, Arts Review, Observer etc. *Recreations:* modern opera, jazz, Wagner. *Clubs:* Garrick, Chelsea Arts, Groucho, Academy. *Misc:* BBC Radio 3,

'Private Passions' with Michael Berkeley. *Signs work:* 'Martin Fuller'. *Address:* Studio 2, Blenheim Studios, 29 Blenheim Gardens, London SW2 5EU. *Email:* martin@martinfuller.net *Website:* www.martinfuller.net

FULLER, Peter Frederic, RAI(1976),AAH(1976), FPS(1991); Whatman prize; painter in water-colour; art historian;. *b:* Ramsgate, 10 Apr., 1929. *s of:* Frederic Fuller, RAF. *m:* Rosemary Blaker. one d. *Educ:* John Hezlett School. *Studied:* Maidstone College of Art. *Exhib:* R.A., R.B.A., R.P.S., R.W.S. (Open), R.I., N.E.A.C., F.P.S., R.S.M.A., The Discerning Eye, K.C.C. 'Kent Artists', Britain in Water-colours, Towner A.G., E. Stacey-Marks Gallery Eastbourne, Arts Centre Folkestone, Arune Arts Centre Arundel, Roger Green Fine Art High Halden, Bakehouse Gallery Sevenoaks, Cloisters Gallery Canterbury, Leeds Castle, KCC County Gallery, Redleaf Gallery Tunbridge Wells, finalist in the Laing Art Competition. *Works in collections:* America, Australia, Canada, France, Germany. *Commissions:* for landscapes and portraits from various distinguished people including the former Bishop of Southwark. *Works Reproduced:* in "The Artist". *Recreations:* music and reading. *Clubs:* Royal Archaeological Institute. *Misc:* teacher of water-colour painting. *Signs work:* "Peter Fuller." *Address:* 29 Sandling La., Penenden Heath, Maidstone, Kent ME14 2HS.

FULLER, Violet, FFPS; artist in water-colour, oil, pastel. *b:* Tottenham, 26 Jul 1920. *d of:* Charles Fuller. *Studied:* Hornsey School of Art (1937-40) under Russell Reeve, R.B.A., A.R.E.; Stroud School of Art (1942-44) under Gwilym E. Jones, A.R.C.A. *Exhib:* Paris, R.A., R.I., R.B.A., N.E.A.C., W.I.A.C., Whitechapel A.G. (1967), 9 painters of East London, Bath Festival (1967), Brighton Festival (1988, 1989, 1991, 1993); one-man shows: Woodstock Gallery, London W1(1958, 1959, 1961, 1963, 1967, 1970), Old Bakehouse Gallery, Sevenoaks (1968, 1970), Hornsey Library (1968, 1973), New Gallery, Hornsey (1975), Forty Hall, Enfield (1974, 1984), Bruce Castle, Tottenham (1980), Loggia Gallery (1983, 1986, 1991), The Grange, Rottingdean (1997, 2000, 2003, 2006). *Works in collections:* London Borough of Haringey, London Borough of Enfield. *Clubs:* Soc. of Sussex Painters. *Signs work:* "VIOLET FULLER." *Address:* 1 Helena Rd., Woodingdean, Brighton, Sussex BN2 6BS.

FURLONG, Gillian, David Murray Landscape Prize (RA)(1968). *Medium:* oil. *b:* Kingston, Surrey, 1 May 1948. *d of:* Betty Ryder. *m:* Edward Dawson, NEAC (decd). one *s.* three *d. Studied:* Epsom School of Art (1965-67); Camberwell School of Arts and Crafts (1967-70). *Exhib:* RA Summer Exhbn (1972-74, 1978-85, '87-'89, 2001); Affordable Art Fair, Battersea (1999-2006);David Curzon (1996-2007); Discerning Eye (1997, '99, 2000, '02); Francis Iles (1998-2007); Lincoln Joyce Fine Art (1994-2007); Rowley Gallery (1996-2005); Russell Gallery, Putney (2004-07); 'Not the RA', Llewelyn Alexander (1997-2004, 2007); RBA (2007). *Works Reproduced:* 'Early Morning: Crete', Getty Images; 'Sunday Morning: Newlyn', Kunstverlag Weingarten; through Bridgeman Art Library. *Signs work:* 'GF'. *Address:* 7 Oaks Court, Oaks Close, Leatherhead KT22 7SJ.

FURNESS, Valerie Jane, NDD (Painting), ATD; taught at Falmouth College of Art; Head of Redmaids School Art Dept.; Senior Art Award, Wimbledon School of Art (now Wimbledon College of Art). *Medium:* mixed media/collage, oil, watercolour, drawing. *b:* Devon, 23 Aug 1931. *d of:* Paul Jacob Furness. one *s. Educ:* Barnstaple Girls Grammar School, Devon. *Studied:* Wimbledon School of Art; University of London. *Exhib:* Newlyn Art Gallery, Cornwall; Penwith Society of Art, St.Ives; Penlee Museum, Penzance; Oxford College & RWA, Bristol; Humanist Association, London; New Gallery, RWA Bristol (2-man show with Peter Morrell, 2007); Wills Lane Gallery, St.Ives; Quest Gallery, Bath. *Works in collections:* James & Louise Ronane, Islington; Mr & Mrs Rudman, Penzance; Mr & Mrs Stanley; Nina Zborwska ('Woman with Irises'), Painswick, and other private collections. *Commissions:* mural: Dawsons, Bristol; portraits including Prof. Richard Gregory. *Publications:* 'Morocco-Paintings and Poems' by Jane Furness & D.Enay; The Dictionary of Artists in Britain Since 1945; St.Ives Art Colony 1975-2007. *Official Purchasers:* Henry Gilbert ('The Red Chair'), Wills Lane Gallery. *Works Reproduced:* many Moroccan paintings and drawings. *Principal Works:* 'Woman with Irises' (oil); 'Girl Watching Wasps'; 'The Red Chair'. *Recreations:* literature, music, travel. *Clubs:* Penwith Society of Artists (1959-66). *Misc:* Works in Morocco every year. Studio in Bristol House. *Signs work:* "V J Furness". *Address:* 8 Camden Terrace, Clifton, Bristol BS8 4PU. *Email:* jane.furness@ukonline.co.uk

FURNIVAL, John P., A.R.C.A.; artist in pen and ink and mixed media; retd. lecturer, Bath Academy of Art; editor, Openings Press. *b:* London, 29 May, 1933. *m:* Astrid Furnival. two *s.* two *d. Studied:* Wimbledon College of Art; Royal College of Art. *Represented by:* England & Co. *Exhib:* Biennale des Jeunes, Paris; one-man show: Thumb Gallery, London; retrospective: Laing Gallery, Newcastle, Arnolfini, Bristol, plus various international exhbns. of visual and concrete poetry. *Works in collections:* Arts Council of Gt. Britain, Arnolfini Trust, Munich Pinakothek. *Publications:* The Bang Book (Jargon Press), The Lucidities (Turret Books). *Clubs:* Satie's Faction. *Misc:* address Apr-Oct: La Cardonie, Bio, 46500 Gramat, France. *Signs work:* "John Furnival." *Address:* 13 rue St. Leonard 14600 Honfleur France.

FURR, Christian Peter, BA Hons Fine Art; Elizabeth Greenshields award for Figurative Artists (1991); Association of Colleges Gold Award (2004). *Medium:* Oil on canvas, watercolours. *b:* Heswall, Wirral, 24 Sep 1966. *s of:* Peter and Angela. *m:* Emma. three, Colette, Daphne, Anika *d. Educ:* St. Anselms, Birkenhead. *Studied:* De Montfort University, Leicestershire. *Exhib:* NPG (1989, 1999), 'Love', Arndean Gallery, Cork Street (2004), RSPP, ROSL, Jak Gallery Hoxton, 'Venice' Roseby Gallery, Leics. *Works in collections:* GMC, RCGP, Royal College of Obstreticians and Gynaecologists, Royal College of Psychiatrists, Key West Symphony Orchestra. *Commissions:* inc. H.M.Queen Elizabeth (youngest artist to have officially painted Her Majesty to date, 1994), Cardinal Cormac Murphy O'Connor (2002), Tim Henman (2005)- Wimbledon Art commissioned by Robinsons. *Publications:* 'The Lost Art-The New Magic

Way to Paint and Draw' (John Blake Publishing, 2005); in The Times, Guardian, Art Review, Liverpool Echo, Evening Standard, Mail on Sunday. *Works Reproduced:* in 'How to Paint Oils', Dorling Kindersley. *Recreations:* fishing, yoga. *Clubs:* Chelsea Arts, Gerrys, Colony Rooms. *Misc:* tv appearances inc. Brush With Fame (ITV), 'artschool' (BBC2), 'Kept' (VH1), Celebrity Portrait Masterclass on 'Richard and Judy' (C4), Good Morning (BBC), Big Breakfast Millennium Show (C4). *Address:* 29 Broughton Avenue, Ham, Richmond-upon-Thames, Surrey, TW10 7TT. *Email:* studio@christianfurr.com *Website:* www.christianfurr.com

G

GABAY, Laurie, L., BA (Hons) English, BA (Hons) Fine Art. *Medium:* oils, acrylics, mixed media. *b:* Paris, 14 Dec 1963. *Studied:* Paris, finished BA year at Wycombe College (Bucks). *Exhib:* Battersea Art Fair, Affordable Art Fair, Henley, Teddington Art Fair, Danceworks, Sandelson Gallery Cork Street, Millennium Hotel, Knightsbridge; theatres and colleges in Bucks., and venues relating to my theme 'dance and movement' semi-abstract to abstract. *Address:* 9 Cantelowes Road, Camden Square, London NW1 9XP. *Email:* laurie_gabay@hotmail.com *Website:* www.lauriegabay.co.uk

GAGE, Anthea Dominique Juliet, SSA, RSW; The May Marshall Brown Award (2006); art teacher, artist in gouache and water-colour; part-time teacher, Royal High School, Edinburgh. *b:* Edinburgh, 21 Mar 1956. *d of:* Edward A. Gage, PPSSA, RSW. *m:* David Dunlop. *Educ:* John Watsons School, Stevenson's College of Educ. *Studied:* Edinburgh College of Art (Dip. 1974-78, Post. Dip. 1978-79, David Michie, George Donald). *Exhib:* annually at SSA, RSW; various mixed exhbns. *Publications:* Who's Who in Scotland. *Recreations:* singing, gardening. *Signs work:* "Anthea D.J. Gage." *Address:* 15 Craighouse Gdns., Edinburgh EH10 5LS. *Website:* www.antheagage.co.uk

GAINSFORD, Sylvia Petula, NDD, ATD; painting and illustrating. *Medium:* acrylic. *b:* 1942. *m:* Leon Olin. *Studied:* Royal Tunbridge Wells (1962, painting and wood engraving). *Exhib:* numerous. Permanent: Gallery One, Fishguard, Pembrokeshire, Wales. *Works in collections:* Webber Coll. Ontario, Kallis Foundation, Beverly Hills. *Commissions:* numerous, both private and civic. *Publications:* Food from the Countryside (Leon and Sylvia Olin); The Country Kitchen (Della Lutes); Just Like You and Me (Johnny Morris); Divination card designs, commissioned & published by A.G.Muller/ Urania are: Tarot of the Old Path (4th World best seller), Tarot of Northern Shadows & Kabbalah; Rune Vision with Anoua Books. *Works Reproduced:* Limited Edition Prints (Froghall Publications), Open Edition Prints (Buckingham Fine Art), Cards (Society Cards, Medici, Bishopsgate). *Misc:* T.V. Film on work & lifestyle. Divination card designs featured in Hollywood documentary film. *Signs work:* "Sylvia P. Gainsford." *Address:* Fron Haul, Rhos-y-Caerau, Goodwick,

Pembrokeshire SA64 0LB. *Email:* sylvia@abergwaun.com *Website:* www.SylviaPGainsford.com

GAIT, Judith, Bachelor of Fine Art, Lottery Award, arts projects with elderly benchmarked by Health Education Authority, MA. *Medium:* wall-hangings, mixed media drawings, paintings. *b:* Monroe, Michigan, 4 Dec 1948. two *s.* three *d. Educ:* California College of Arts and Crafts; Ruskin School of Drawing; University of California; Instituto Dante Alighieri, Florence. *Studied:* University of the West of England. *Exhib:* numerous craft-council galleries; Invited Guest Maker American Museum in Britain; Southwest Academy of Art; Invited guest maker Stroud Bienniale, Bankside Gallery, Gallery 286, Royal College of Pathologists. *Works in collections:* Paintings in Hospitals; Salisbury District Hospital; Bristol Care and Repair Housing Agency; Bristol Special Care Baby Unit. *Commissions:* numerous private commissions. *Official Purchasers:* Norton-Radstock Town Council, NHS Trusts. *Works Reproduced:* Encyclopedia of Quilting Techniques; Waistcoats; Patchwork Pocket Pallet. *Recreations:* visiting museums, walking. *Address:* St Mary's Cottage, Hemington, Bath, BA3 5XX. *Email:* judithgait@hotmail.com

GALE, Jeremy, BA (Hons) 1st (1984). *Medium:* mixed media, oil, drawing, prints. *b:* Congo, 24 Dec 1961. *s of:* J.W.L.Gale CBE, & Eunice Gale. *Studied:* Central School of Art and Design, London (1981-84), Scuola Lorenzo de Medici, Florence (1984). *Exhib:* RIBA Summer Exhibition (1985); The Julius Gottlieb Exhibition Centre, Oxon (1986); Cromwell Gallery, London (1988); The Lethaby Gallery, London (1990, 1993); Burgh House, London (1992); Manor Gallery, London (1997); Chequer Mead Art Gallery, Sussex (1998). *Signs work:* "Jeremy Gale". *Address:* The Studio, Flinders, Henfield Road, Upper Beeding, West Sussex BN44 3TF. *Email:* pjeremygale@hotmail.com *Website:* www.jeremygale.co.uk

GALE, Martin, A.N.C.A.D. (1973), R.H.A. (1996); Degree in Painting. *Medium:* oil, watercolour, drawing, prints. *b:* Worcester, 20 Mar 1949. *s of:* John and Joan Gale. two *s.* one *d. Educ:* Newbridge College, Co. Kildare. *Studied:* National College of Art and Design, Dublin. *Represented by:* Taylor Galleries, Kildare St., Dublin. *Exhib:* RHA (1990-2005); Martin Gale Retrospective, RHA Dublin and Ulster Museum Belfast (2004-05); numerous solo and group exhibs. in Ireland, group exhibs. in Britain and USA, alos XI Biennale de Paris (1980-1981); International Connection-'Sense of Ireland' Festival, London (1980); Images from Ireland, Brussels (1989); NCAD '250 Drawings 1746-1996'. *Works in collections:* Irish Museum of Modern Art; Arts Council of Ireland; European Parliament, Strasbourg; all major public and private collections in Ireland and Britain. *Commissions:* National Self Portrait Collection, European Parliament, Strasburg, E.S.B. Municipal Gallery, Waterford, and others. *Publications:* Exhib. catalogues, catalogue essays. Gandon Editions - Works 19, Martin Gale in conversation with Brian Fallon; Martin Gale-Work in Progress. *Official Purchasers:* Dept. of Finance & Personnel, Belfast; Crawford Municipal Gallery,

Cork; Office of Public Works; National Self-Portrait Collection. *Misc:* member of AOSDANA, member of Royal Hibernian Academy (RHA) (- presently keeper). *Signs work:* "Martin Gale." *Address:* Coughlanstown, Ballymore Eustace, Co. Kildare, Ireland. *Email:* martingale@oceanfree.net

GALE, Richard John, Dip. A.D. (1968), M.A. (R.C.A., 1973); artist in oil. *b:* Bristol, 8 Feb 1946. *s of:* C. L. Gale. *m:* Frances Joan. *Educ:* Weston-super-Mare Grammar School. *Studied:* Kingston upon Thames School of Art (1965-68), R.C.A. (1970-73). *Signs work:* "R. Gale." *Address:* 5 Hillside Rd., Clevedon, North Somerset.

GALES, Simon, B/Tec.Dip. (Dist.) (1985), B.A. (First Class Hons.) Fine Art (1988); painter in oil on linen or canvas;. *b:* 1964. *m:* Susanne. one *s. Studied:* Ipswich School of Art (1983-85), Goldsmiths' College, London (1985-88). *Exhib:* Christie's (1989), Jill George Gallery London and Los Angeles (1990), Christie's, S. Kensington (1991), Bruton St. Gallery (solo: 1999, 2001). *Works in collections:* London Underground Museum, Covent Gdn., Robert Holmes à Court Museum, Perth, Australia. *Signs work:* "SIMON GALES" on back of painting. *Address:* c/o Bruton St. Gallery, 28 Bruton St., London W1X 7DB.

GALLAGHER, Brian, artist in water-colour, pastel and pencil; Secretary and Council mem. Pastel Soc; tutor to painting courses. *b:* Chester, 31 May 1935. *s of:* Frederick Alexander Gallagher, musician. *m:* Rosemary June Webb. one *s. Studied:* Portsmouth College of Art, privately under Herbert Green. *Exhib:* P.S., S.WL.A., Porthill Gallery London, Anna-Mei Chadwick Gallery, London, R.B.S.A. Galleries, Birmingham, John Nevill Gallery, Canterbury, Cowleigh Gallery, Malvern, and many provincial galleries. *Works Reproduced:* contributor to art magazines. *Clubs:* London Sketch. *Signs work:* "Brian Gallagher." *Address:* 99 Gilmore Cres., Ashford, Middx. TW15 2DD.

GALLOWAY, Richard Andrew, BTEC Diploma Art Foundation; BA Hons Painting/Printmaking; MA Printmaking (RCA); Bazil Alkazzi Award RCA (2004); Augustus Martin Prize RCA (2004). *Medium:* drawing, prints, linocut. *b:* Kettering, 18 Jun 1980. *s of:* David Galloway. *Studied:* RCA; Northumbria University; Nene University. *Exhib:* Wyer Gallery, St.John's Hill (2006); 200 Art Fair (2005); 'The Great Unsigned', 47 Great Eastern Street (2005); The New Academy Gallery, London (2005); AAF Recent Graduates, Battersea (2004). *Works in collections:* Saatchi Collection, London; Ben Alkazzi Collection, London. *Publications:* Le Gun Magazine, RCA. *Signs work:* Richard Galloway. *Address:* 50c Elderfield Road, Hackney, London E5 0LF. *Email:* info@RichardGalloway.co.uk *Website:* www.RichardGalloway.co.uk

GALVANI, Patrick, painter in water-colour and oil, journalist, author. *b:* Bures, Suffolk, 11 Sep 1922. *s of:* Dino Galvani, actor and broadcaster. *m:* Madeleine. one *s. Educ:* University College School. *Studied:* U.C.S. and self-taught. *Exhib:* London, Florida and Spain, various galleries in UK. *Commissions:* various houses, landscapes, boats. *Clubs:* Ipswich Art. *Signs work:* "PATRICK

GALVANI." *Address:* 2 Grand Court, King Edwards Parade, Eastbourne, E.Sussex BN21 4BU. *Email:* patrick.galvani@googlemail.com

GAMBLE, Tom, R.W.S.; painter in oil and water-colour; Mem. A.W.G.; senior lecturer, Art and Design, Loughborough College of Art (1952-84); Freeman of City of London, Gold Medallist and Liveryman of the Worshipful Company of Painter/Stainers. *b:* Norton-on-Tees, 6 Feb 1924. married. *s of:* Thomas Gamble, engineer. one *s. Studied:* Constantine College, Middlesbrough. *Exhib:* R.A., R.W.S., Bankside Gallery London, Royal Festival Hall, Mall Galleries, Singer & Friedlander/Sunday Times Exhibitions; Hunting Group Prizes, Brian Sinfield, Milne & Moller, Woodgates Gallery, East Bergholt, Burlington Gallery, London; Leicester A.G., Middlesbrough A.G., Exposicion International de Acuarela Barcelona, American and Canadian Water-colour Socs., and various provincial galleries. *Works in collections:* H.M. Queen; Lloyds of London, University of Loughborough, Notts. C.C., Leics. C.C., Crathorne Collection, Worshipful Company of Painter/Stainers, Intelligence Corps HQ; private collections in Europe, U.S.A., Canada. *Works Reproduced:* 'Artists of Northumbria' (2005), 'Visions of Venice', 'The Story of Watercolour', 'Exposton Internacional de Acaurela', 'Old Watercolour Society's Club Vol.63', 'Watercolour Masters', 'Watercolour Expert'. *Clubs:* Arts. *Signs work:* "Tom Gamble." *Address:* 10 Blythe Green, East Perry, Huntingdon, Cambs. PE28 0BJ.

GAMLEN, Mary, ATD (Lond. 1936), Hon.UA; sculptor in wood and terracotta, painter in oil and water-colour. *b:* London, 1913. *d of:* Hugh Gamlen, Freeman of City of London and Liveryman of the Company of Goldsmiths. *m:* Alan Somerville Young (decd.). one *s.* two *d. Educ:* Student at Hornsey School of Art; on staff there (1937-1945). *Exhib:* R.A., R.B.A., N.E.A.C., R.W.S., Edinburgh R.A., Fermoy Gallery, Kings Lynn, Premises, Norwich, Mall Galleries. *Works in collections:* Museum of the Royal Marines (Lying-in-State of Sir Winston Churchill), Belize Cathedral (reredos), Norfolk (village signs), Holt Church (carving of St. Andrew), Thorpe Market Church (restoration work). *Signs work:* "GAMLEN" or "Mary Gamlen". *Address:* Ham House Pottery, Southrepps, Norwich, Norfolk NR11 8AH.

GANJEI, Parastoo, BA Graphic Design, Advance Cert. in Animation. *Medium:* acrylics, watercolour. *b:* Tehran, Iran, 1 May 1952. *Studied:* University of Decorative Arts (Graphic Design), Croydon College of Art and Design (Animation), Bournemouth and Poole University (Graphic Design). *Represented by:* NAPA; Allied Artists of America. *Exhib:* SWA, Winchester City Hall, Arlsford Gallery, Salisbury City Hall, Wetminster Gallery (London), The Beatrice Royal Gallery (Eastleigh), Black Sheep Gallery (Chester), Hawker Gallery (Amersham), Modern Artist Gallery (Berks). *Works in collections:* The Princess of Brunei. *Commissions:* private clients (USA, Asia, Europe). *Publications:* Leisure Painters Magazine, International Artist Magazine. *Works Reproduced:* Medici (London) greeting cards. *Misc:* still life painter mainly in acrylic, lots of

details, patterns, bold and beautiful colours. *Address:* 117 Lowther Road, Bournemouth, Dorset, BH8 8NP. *Email:* parastooganjei@aol.com

GANTER, Josephone, MA (Hons) Fine Art; John Kinross Scholarship (1988); Rome Scholarship in Printmaking (1989); Boise Scholarship (1994); Sir William Gillies Award (2005). *Medium:* printmaking, etching. *b:* Yorkshire, 12 Nov 1963. *Studied:* Edinburgh University. *Exhib:* Hart Gallery, London; Glasgow Print Studio Gallery; AIR Gallery, New York; Open Eye Gallery, Edinburgh. *Works in collections:* Edinburgh City Art Centre; Jane Vorhees Zimmerli Collection, Rutgers University, USA; New York Public Library; Museum of Fine Art, Antwerp; Hunterian Art Gallery and Museum, Glasgow. *Publications:* Talbot Rice Gallery, Edinburgh University - catalogue "Cardinal Glimpses". *Signs work:* "JO GANTER". *Address:* c/o The Royal Scottish Academy, The Mound, Edinburgh, EH2 2EL. *Email:* jo.ganter@virgin.net

GARDINER, Vanessa, B.A. (Hons.) (1982); Awards: South West Arts-Fine Art (1999, 2000), Arts Council South West-Fine Art (2003). *Medium:* painter in acrylic, on plywood/hardboard. *b:* Oxford, 7 Apr 1960. *d of:* Patrick Lancaster Gardiner. one *d. Studied:* Oxford Polytechnic (1978-79), Central School of Art and Design, London (1979-82, David Haughton). *Represented by:* Hart Gallery, 113 Upper Street, Islington, London N1 1QN. *Exhib:* solo shows Hart Gallery, London, (2001, 2003, 2005); Duncan Campbell, London (1991, 1992, 1996, 1998-twice), Gordon Hepworth, Exeter (1993), Mill Lane Gallery, Lyme Regis, Dorset (1997); recent group shows: Merriscourt Gallery, Oxfordshire (1999), Six Chapel Row, Bath (1999), Duncan Campbell London (2000), Alpha House Gallery, Sherborne (1999, 2002); Bournemouth Arts Loan (2002/2003) - Bournemouth University; Eigse Carlow Arts Festival, Ireland - Invited Artist; Art First, London - Starting a collection (2002 and 2003); Royal Academy Summer Exhibition (2003); The Town Mill Galleries, Lyme Regis (2005); Atrium Gallery, Bournemouth University (2006) solo show; Sherborne House (2007) 2 person show; Hart Gallery (2007) solo show. *Works in collections:* Bournemouth University. Carlow Art Collection, Carlow, Ireland; Ballinglen Arts Foundation Archive, Co.Mayo, Ireland. *Works Reproduced:* Modern Painters Magazine, Summer 1996 - review by Elizabeth James. 'Reinventing the Landscape: contemporary painters and Dorset' by Vivienne Light, Canterton Books; 'Landscape and Architecture' Hart Gallery catalogue (2005), text by Judith Bumpus; Hart Gallery catalogue (2007). *Misc:* Fellow, Ballinglen Arts Foundation, Co.Mayo, Ireland (2003), Artist in Residence (2007). *Signs work:* "Vanessa Gardiner." *Address:* Lilac Cottage, Fernhill, Charmouth, Dorset DT6 6BX. *Email:* vanessa.gardiner@tiscali.co.uk info@hartgallery.co.uk *Website:* www.hartgallery.co.uk

GARDNER, Annette, Diploma Di Merito, Universita Della Arti, Italy (1982); painter in oil; Principal and Teacher, Wood Tutorial College; Founder and Director, New End Gallery. *b:* 11 Jun 1920. *m:* C. J. Wood, M.A., (Cantab.), (decd.1972). one *s.* one *d. Studied:* Twickenham Art School (1952-54);

WHO'S WHO IN ART

Hampstead Garden Suburb Institute (1954-56) under Mr. Gower; St. Martin's (1960-63) under David Tindle. Other studios: principal teacher Walter Nessler. *Exhib:* Numerous group shows, private and travelling exhbns.; finalist, Woman's Journal Painting of the Year (1961). *Works in collections:* Australia, England, U.S.A., Israel, Hungary. *Clubs:* F.P.S., Ben Uri. *Signs work:* "A. Gardner." *Address:* The Studio, 18 Canons Drive, Edgware, Middx. HA8 7QS.

GARDNER, Judith Ann, RBA; B.A. Hons. Fine Art (1974); painter in oil; art tutor. *b:* Welling, Kent, 15 Apr 1952. *m:* Colin. two *d. Educ:* Maryville Convent, Welling, Kent. *Studied:* Maidstone College of Art under principal, William Bowyer R.A., tutor, Frederick Cuming R.A. (1970-1974). *Exhib:* R.A., R.B.A., N.E.A.C., R.O. I., R.S.M.A., and other galleries. *Works in collections:* private collections in U.K., U.S.A. and Australia. *Clubs:* member of R.B.A, Small Paintings Group. *Signs work:* "J Gardner." *Address:* 72 Gladstone Rd., Broadstairs, Kent CT10 2JD.

GARDNER, Peter Colville Horridge, R.O.I. (1977), A.T.D. (1951), F.R.S.A. (1969); artist in oil. *b:* London, 25 Oct 1921. *s of:* Ronald E. Gardner. *m:* Irene. *Educ:* St. Matthias C. of E. School, London SW5. *Studied:* Hammersmith School of Art (1935-38, 1946-50), London University Inst. of Educ. (1950-51). *Exhib:* R.A., R.B.A., R.O.I., N.E.A.C. *Works in collections:* Nuffield Foundation, York University. *Signs work:* "Peter Gardner." *Address:* 11 Pixmead Gdns., Shaftesbury, Dorset SP7 8BZ.

GARDNER, Reginald Stephen, *Medium:* oil. *b:* Prestwich, Bury, 24 Apr 1948. *s of:* Charles Everard Gardner. *m:* Beryl Claire Gardner. two *s. Studied:* Manchester High School of Art. *Represented by:* Dave Gunning, Todmorton Fine Art, Lancashire. *Exhib:* Chenil Gallery, London; Colin Jellicoe Gallery, Manchester (solo and mixed); National Theatre, London; Lincoln Gallery; Great House Gallery, Norwich; Turtle Creek, Texas, USA; Watermill, Hampshire; Preston Harris Museum & Art Gallery; Collect art.com; Clarke Art, Bond St., London. *Works in collections:* private, national and international, including USA, Belgium, Russia, Bermuda, New Zealand. *Publications:* "Northern School" (p.89), Peter Davies (Redcliffe Press). *Works Reproduced:* Wilson's calendar 1978. *Principal Works:* painted and sold over 2,000 works over 40 years. *Signs work:* "R.S.GARDNER" or "RSG". *Address:* 68 Sandyhill Road, Blackley, Manchester, M9 8GL. *Email:* reginald.gardner@btinternet.com *Website:* www.rsgardner.co.uk/com

GARDNER, Roseanne Serena, *Medium:* oil, sculpture, acrylic. *b:* Hong-Kong, 30 Jan 1948. *d of:* Mr&Mrs C.A.N.Walker. *m:* Anthony Corlett. *Educ:* St.James's, West Malvern. *Studied:* Sorbonne, Paris. *Exhib:* RA Summer Exhbn (2000); solo shows: Shepherd Market (2001), Playhouse Salisbury (2003); Chelsea Art Society (1997, '98, '99); Christies 'Art for Life' (2006, 2007). *Works in collections:* M.Etherington-Smith, Editor Arts Review. *Commissions:* for outdoor temple ceiling. *Publications:* 3 pages in Woman & Home (June 2001).

Works Reproduced: Bronze torso. *Principal Works:* La Dame aux Violettes, and lifesize self-portrait. *Recreations:* gardening. *Clubs:* Boodles. *Signs work:* "Roseanne". *Address:* Dunworth House Donhead St. Mary Shaftesbury Dorset SP7 9DQ. *Email:* antcorlett@tiscali.co.uk

GARFIT, William, RBA.; ILEA Dip with hon., Byam Shaw School Cert. with Distinction, R.A.S. Cert.; artist in oils, specialising in River Landscapes and pen and wash illustration work;. *b:* Cambridge, 9 Oct 1944. *m:* Georgina Joseph. one *s.* two *d. Educ:* Bradfield College. *Studied:* Cambridge School of Art (1963), Byam Shaw (1964-67), R.A. Schools (1967-70). *Exhib:* one-man shows, Waterhouse Gallery (1970, 1972, 1974), Mall Galleries (1976), Stacey Marks, Eastbourne (1978), Tryon and Moorland Gallery, London (1981, 1983, 1985, 1988, 1991), Holland & Holland Gallery (1994). *Publications:* illustrated, Dudley worst dog in the World, Amateur Keeper, Your Shoot, The Woods Belong to Me, The Fox and the Orchid, Prue's Country Kitchen, Cley Marsh and its Birds, The Game Shot, How the Heron got Long Legs, The Woodpigeon, author of Will's Shoot (1993, re-published 2005). *Signs work:* "William Garfit." *Address:* The Old Rectory, Harlton, Cambridge CB3 7ES.

GARLAND, Nicholas Withycombe, *Medium:* pen and ink, oil paint, woodcuts. *b:* London, 1 Sep 1935. *s of:* T O Garland and M Withycombe. *m:* Priscilla Roth. three *s.* one *d. Studied:* Slade School of Fine Art (painting and etching). *Exhib:* Fine Arts Society, Bond St.; Grosvenor Gallery. *Works in collections:* British Museum, V & A, Imperial War Museum. *Commissions:* A boxed set of Linocuts for Mark Birley of Annabel's Nightclub. *Signs work:* 'Nicholas Garland' or 'Garland'. *Address:* 12 Parkhill Road, London NW3 2YN.

GARMAN, Evelyn Daphne, NS (1980), SWA (1985); sculptor in clay, wax, bronze, resin bronze. *b:* Beaconsfield, 6 Apr 1913. *d of:* W. G. Wingate Morris, solicitor. *m:* R.C. Garman, artist. three *d. Educ:* Convent of the Holy Child Jesus, Sussex. *Studied:* London studio of A. Acheson, A.R.A. privately (1933-38). *Exhib:* S.W.A., N.S., S.P.S., Winchester, Andover, and two private shows with husband. *Works in collections:* Heads of Founders in Winsor and Newton Museum, Wealdstone, Harrow. *Clubs:* Cheltenham and Cotswold. *Signs work:* "E.D.G." or "D. GARMAN." *Address:* Ashburnham, 8 Charnwood Cl., Cheltenham, Glos. GL53 0HL.

GARRARD, Peter John, P.P.R.B.A., R.P., N.E.A.C., R.W.A.; painter in oil. *b:* 4 Jan 1929. *s of:* Col. W. V. Garrard, M.B.E., T.D. *m:* Patricia Marmoy. one *s.* two *d. Educ:* Magdalen College School, Brackley. *Studied:* Byam Shaw School of Drawing and Painting. *Works in collections:* public and private collections in England, America, Australia, Canada, Germany, etc. *Signs work:* "P.J.G." *Address:* 340 Westbourne Park Rd., London W11 1EQ.

GARRETT, Roger MacLean, artist in oil; University Lecturer; Senior Lecturer, University of Bristol;. *b:* Nairn, Scotland, 10 Feb., 1942. *m:* Bertha Garrett. one *s.* one *d. Exhib:* R.W.A. (1995, 1997, 1998), R.A. (1997, 1998),

School House Gallery, Bath (1997), R.B.S.A. (1998), Chichester, Open Exhbn. (1998). *Signs work:* "R.G." and "Roger Garrett." *Address:* 38 Holmes Grove, Henleaze, Bristol BS9 4EE.

GARTON, Michael, N.D.D. (1956), D.F.A. (1959), R.W.A. (2000); painter in oil; retired lecturer in painting. *b:* Reading, Berks., 5 June 1935. *m:* Antonia. one *s.* four *d. Educ:* Reading, Berks. *Studied:* Guildford (1950), Exeter (1956), Slade School (1959). *Exhib:* R.A. Summer Exhib. (1977, 1987, 1997), R.W.A. (1997-2001). *Works in collections:* private collections. RWA public collection. *Publications:* Landscape Research (1984), Art in Nature (1996). *Clubs:* Kenn Group of Artists. *Signs work:* "M Garton." *Address:* 5 Silver Terr., Exeter, Devon EX4 4JE.

GASKELL, Eric, ASGFA; BA (Hons) Fine Art; Backhouse Fine Art Prize. *Medium:* oil, acrylic. *b:* Wigan, 21 Oct 1957. *s of:* Eric Shurrock Williams. *m:* Susan. one *d. Studied:* Sunderland College of Art (1977-80); Wigan (1976-77). *Exhib:* Norwich Arts Centre (1980/1); Sunderland Arts Centre (1980/1); Alnwick (1981); Hull City Gallery (1981); Middleborough (1981); Luton (1989); AoI (1990); Pentagon Type Gallery (1992); Rugby Gallery (2000, 01, 02, 05); Rugby School Gallery (2001, 03); The Wonderwall, Cirencester (2004); SGFA (2003, 04); SGFA, London (2005.06); Montserrat, New York (2004);The Salon, New York (2005); Ghent Expo (2004); RBSA (2006). *Works in collections:* International private collections. *Publications:* International Artist (July 2003); Computer Arts Projects Guide (Feb 2007). *Recreations:* genealogy. *Signs work:* "E GASKELL' or "EG". *Address:* 6 Gold Avenue, Cawston, Rugby, CV22 7FB. *Email:* eric@agdesign.co.uk *Website:* www.egdesign.co.uk

GASSON, Barry, OBE, Professor, Dip.Arch, MS, MA, ARIAS, RIBA, RSA; awarded Royal Scottish Academy Gold Medal, Royal Academy Premier Award, Museum of the Year Award, Gold Medal 4th World Bienale of Architecture. *Medium:* architecture. *b:* Westcliffe-on-Sea, 27 Aug 1935. *s of:* Gladys and Stanley Gasson. *m:* Rosemary Gasson. one *s.* two *d. Studied:* Birmingham School of Architecture; Columbia University New York City. *Publications:* contributor to: John Julius Norwich 'The Burrell Collection' (1983). *Principal Works:* major work: architect for the galleries for the Burrell Collection, Glasgow (won in open competition and opened by HM the Queen, 1983). *Recreations:* biodynamic farming, photography. *Signs work:* "Barry Gasson". *Address:* Lagard, 82110 Bouloc, France. *Email:* gassonbarry@free.fr

GATHERER, Stuart Luke, MA in Fine Art. *Medium:* oil painting. *b:* Nocton Hall, 19 Aug 1971. *m:* Annabel Gatherer. *Studied:* Edinburgh University, Edinburgh College of Art. *Represented by:* Albemarle Gallery, 49 Albemarle Street, London W1S 4JR. *Exhib:* McEwan Gallery, Scotland (2000), Portland Gallery, London (1997), Eleanor Ettinger Gallery, New York (1999), Albemarle Gallery, London (esxclusive representation)(1998, 99, 01, 03). *Works in collections:* Standard Life. *Principal Works:* 'The Cutting Edge' 74x84in(2002);

'Danae's Consumption Party' 60x70in (2002), 'The Unveiling' 60x80in (2001), 'The Optimism of Contemporary Life' 56x72in (1999), 'Anatomy Lesson of the On-Line Doctor' 72x80in (2001). *Clubs:* Chelsea Arts Club. *Address:* Beacon Cottage, Eastnor, HR8 1EP.

GATTEAUX, Marcel, landscape and still-life artist in oil. *b:* Mitcham, Surrey, 1 Oct 1962. *Studied:* Camberwell School of Art (1980-81, Dick Lee, Sargy Mann); then studied restoration for a number of years before redirecting his attention to painting. *Exhib:* one-man shows, Caelt Gallery (1997-2005). *Works in collections:* Churchill Hotel, London; Cliveden and private collections in the U.K. and U.S.A. *Publications:* Millers Picture Price Guide. *Address:* 182 Westbourne Grove, London W11 2RH. *Email:* art@caeltgallery.com *Website:* www.caeltgallery.com

GEARY, Robert John, MSIA (1967); FCSD (1980, resigned 2007); FRSA (1981); Hon SGFA (1994); graphic artist and illustrator in ink, water-colour and drypoint. *b:* London, 15 Jan 1931. *s of:* Robert & Ada Florence Geary. *m:* Hazel Mair Plant. one *d. Studied:* Hammersmith School of Arts and Crafts (1945-48). *Exhib:* SGFA, Chelsea Art Society, RBA. *Works in collections:* work in private collections: The Saatchi Gallery, University of Kent, Museum of London. *Works Reproduced:* drawings in several children's books, The Folio Soc., humorous illustrations for: New Statesman, Punch (1978-81), The Oldie, The Sunday Telegraph, The Times Supplements, The Independent, Private Eye. *Clubs:* Armed Forces Art Society. *Signs work:* "Robert Geary" or "R.G." *Address:* 70 Felton Lea, Sidcup, Kent DA14 6BA.

GEDDES, Stewart John, M.A. Arts Criticism (1997), B.A. (Hons.) Fine Art (1983), R.W.A. (1996), M.Phil (Royal College of Art)(2007); preferred medium - acrylic; University tutor; Vice President, Royal West of England Academy 2002-2005. *b:* Maidstone, Kent, 4 Mar 1961. *s of:* Brian Malcolm Geddes. *m:* Juliet Simmons. two *s. Educ:* Maidstone School for Boys. *Studied:* Canterbury College of Art (1979-80, Eric Hurran), Bristol Polytechnic (1980-83, Alf Stockham), City University, London (1996-97, Professor Eric Moody); Royal College of Art (2004-07, John Stezaker). *Exhib:* R.A., R.W.A., Cadogan Contemporary, London; Jersey Arts Centre; Advanced Graphics, London; Hockney Gallery, RCA, London. *Works in collections:* House Of Commons, RWA Permanent Collection, Landmark Plc. *Publications:* Research RCA 2007. *Clubs:* Chelsea Arts Club. *Signs work:* "S.J. GEDDES" on back of work. *Address:* 49 Noyna Rd., Tooting Bec, London SW17 7PQ. *Email:* s.geddes1@ntlworld.com

GEDEN, Dennis John, D.Litt (Hons); painter. *b:* Ontario, Canada, 25 Apr., 1944. *m:* Sandie. *Studied:* Sir George Williams', Montreal. *Exhib:* exhibits internationally. *Works in collections:* Tate, London, MacLaren Art Centre, Barrie, Canada, Simon Fraser University, Vancouver, Canada, Anderson Collection, Buffalo, U.S.A., Government of Ontario Art Collection, Canada, Bibliotheque

Nationale, Paris. *Signs work:* "D Gedden." *Address:* c/o Redfern Gallery, 20 Cork St., London W1X 2HL. *Email:* gedensan@vianet.on.ca

GEE, Arthur, SWLA (1969-1999), NAPA (1993); painter/printmaker, book artist, wildlife and landscape; Cert. of Merit, University of Art, Salsomaggiore, Italy (1982); Purchase prizewinner (1990), Mini-print International, Barcelona; Finalist, Laing Competition (1991, 1994), Manchester/London; Artists award, N.A.P.A. Exhbn. B'ham (1993, 1997, 1998, 1999); NAPA Exhibition Award 'Best British Painting' (2004); Invited Member, Sefton Guild of Artists (1997); Founder Com. Mem. National Exhibition of Wildlife Art, Liverpool (1994); Millenium Artists Index (2001); Member - Warrington Visual Artists Forum 2000. *b:* Latchford, Warrington, 10 Jan., 1934. *s of:* George Arthur Gee & Mary Elizabeth (nee McAdams). *m:* Margaret Ray Robinson. one *s.* one *d. Educ:* Penketh and Sankey Sec. School, Warrington (1945-49). *Studied:* St. Helen's College of Art and Design (1983-84). *Exhib:* throughout UK and abroad, SWLA. annually (1965-1999), Mall Galleries, London (FBA).; exhibitions 2003 - National Exhibition of Wildlife Art, Liverpool; Pendle Heritage Centre, Barrowford, Lancashire; Atkinson Art Gallery, Southport; Pyramid Centre, Warrington; Exhibition and Residency, Nature in Art, Gloucester, Aug 2003, 2004, 2005; NAPA St.Ives, Cornwall (2004, 2005); NEWA Wirral (2004, 2005); Art in the Square, Liverpool (2004, 2005). *Works in collections:* Nature in Art, Gloucester (acrylic painting 'Mallard in the Sere Wood', 2004). *Commissions:* FBA and BASC, plus private commissions. *Publications:* Three poems illustrated in "Flights of Imagination" (Blandford Press, 1982). *Works Reproduced:* originator of The Green Man Press, producing Artists Books and handmade prints. *Recreations:* birdwatching, walking. *Signs work:* "Arthur Gee." *Address:* 31 Karen Cl., Burtonwood, Warrington, Ches. WA5 4LL.

GELDART, William, artist/illustrator in pencil, pen and ink, scraperboard, pen and wash, water-colour. *b:* Marple, Ches., 21 Mar 1936. *s of:* William Edmund Geldart. *m:* Anne Mary. one *s.* one *d. Educ:* Hyde Grammar School. *Studied:* Regional College, Manchester (1956-57). *Exhib:* R.A., Manchester Fine Arts, Chris Beetles and various others. *Works in collections:* worldwide. *Commissions:* Hallé Orchestra, Manchester International Airport, Ciba Geigy, I.C.I., Rolls Royce, C.J.S., I.C.L., Reynolds Chains, Manchester Grammar School, Chetham School of Music, Astra Zeneca, Hodder & Stoughton, Gallimard (Paris), and others. *Publications:* written and illustrated: Geldart's Cheshire; illustrated many books for leading publishers. *Address:* Geldart Gallery, Chelford Rd., Henbury, nr. Macclesfield, Ches. SK11 9PG. *Email:* william.geldart@virgin.net *Website:* www.geldartgallery.com

GELLER, William Jasper, F.R.S.A., Hon S.G.F.A.; designer; Past Pres., Soc. of Graphic Fine Artists. *Medium:* pen and ink. *b:* London, 21 Dec 1930. *s of:* Henry Geller, master butcher. *m:* widower. two *d. Educ:* Loughton School. *Studied:* City of London, Apprentice in Art, Central School, Regent Polytechnic (1947-52). *Exhib:* R.S.M.A. Annual show, S.G.F.A. Annual show, F.B.A. Touring

Exhbn. *Works in collections:* Port of London Authority and private collections. *Works Reproduced:* 20th Century British Marine Painting. *Recreations:* sailing. *Clubs:* Rotary International, Old Loughtonians H.C. *Signs work:* "William Geller." *Address:* 26 Wellington Road, Maldon, Essex CM9 6HL. *Email:* billgeller@wgeller.freeserve.co.uk

GENTLEMAN, David, RDI (1970); artist and designer: illustration, stamps, posters, etc. *Medium:* watercolour, lithography, wood engraving. *b:* London, 11 Mar 1930. *s of:* Tom & Winifred Gentleman. *m:* Susan (née) Evans. one *s.* three *d. Educ:* Hertford Grammar School. *Studied:* St. Albans School of Art (1947-48), R.C.A. (1950-53, Edward Bawden, John Nash). *Exhib:* solo exhbns. at Mercury Gallery, London (1970-2000), Fine Art Society (2004, 2007). *Works in collections:* BM, V&A, Tate Britain, Fitzwilliam Museum, National Maritime Museum, and in private collections. *Commissions:* Murals at Charing Cross Underground Station (1979). *Publications:* David Gentleman's Britain, - London, - Coastline, - Paris, - India, - Italy(1982-97); A Special Relationship (1987); Artwork (2002) and many illustrated. *Signs work:* "David Gentleman." *Address:* 25 Gloucester Cres., London NW1 7DL. *Email:* d@gentleman.demon.co.uk

GEORGE, Brian, R.B.A., F.R.S.A., M.Phil. (Loughborough), M.Ed. (Nottingham), Hons. B. Ed. (Loughborough); painter in oil and acrylic; hard edge abstracts based on decay, dereliction and Suffolk coast sea defences; part-time lecturer at Nottingham and Derby Universities. *b:* Ripley, Derbyshire, 7 Jun 1945. *m:* Joan (née Smith). *Educ:* Queen Elizabeth's Grammar School for Boys, Mansfield; Loughborough and Nottingham Universities; Cambridge Institute of Education. *Exhib:* R.B.A., R.O.I., Laing; exhibited one-man and with groups throughout Great Britain and Europe. *Works in collections:* Nottinghamshire Library Service, Heiligenhaus Civic Collection, Nottingham University and numerous private collections. *Clubs:* President, Mansfield Society of Artists. *Signs work:* "B GEORGE." *Address:* Westfield House, 251 Alfreton Rd., Blackwell, Alfreton, Derbyshire DE55 5JN. *Email:* beageart@aol.com

GEORGE, David, wood sculptor, mostly fine-finished for interior display, abstract, curvacious beautiful woods; walnut, yew, cherry, etc., copper water features, sculptures. *Medium:* wood. *b:* Winchester, 20 Feb 1952. *Educ:* Andover Grammar School, Salisbury College, Basingstoke College. *Studied:* botany, zoology, holistic therapist. *Exhib:* various shows, galleries, South England. *Commissions:* oak troll for Test Valley Borough Council, depicting "Billy Goats Gruff" story; 'Celtic Art' sculpture for Andover Museum. *Principal Works:* 'Spiritual Growth' on display T.V.B.C. H.Q., Andover. *Misc:* fully qualified holistic therapist, and acoustic guitarist. *Signs work:* Unsigned. *Address:* Little Park Studio, Little Park, Andover, Hants SP11 7AX. *Email:* davidgeorge@sculptor.freeserve.co.uk *Website:* www.sculptor.freeserve.co.uk

GEORGE, Patrick, artist. *b:* Manchester, 1923. *m:* 1st 1955 June Griffith (dissolved 1980); 2nd 1981 Susan Ward. four *d. Educ:* Edinburgh College of Art,

Camberwell School of Art; taught, Slade School, University College London (1949-88); Slade Professor (1985-88). *Exhib:* Gainsborough's House, Sudbury (1975); retrospective, Serpentine Gallery (1980); Browse and Darby. *Works in collections:* Arts Council, Tate Gallery, etc. *Recreations:* Veg Gardening. *Misc:* Dealers: Browse and Darby. *Signs work:* 'Patrick George'. *Address:* 33 Moreton Terr., London SW1 2NS.

GEORGIOU, Elpida: see ELPIDA,

GERAGHTY, Paul Leo, BA (Hons) Fine Art, ATC; Adrian Henri Memorial Award (2003, 2004, 2005), NAPA President's Award (2004); Fine Art Trade Guild Award (2005); Daler Rowney, Best British Painting (2006). *Medium:* acrylics. *b:* Warrington, 18 Jun 1954. *m:* Katrina. one *s*. *Educ:* Stockton Heath County Secondary School. *Studied:* North Staffordshire Polytechnic, Goldsmiths College, University of London. *Exhib:* St.Ives Library (2003), Mariners Gallery (2003), 'Out of the Blue', Marazion (2003), Williamson Gallery (2004), Gateway Gallery, Shrewsbury (2004), Cube3, University of Plymouth (2005), Falmouth Municipal Art Gallery (2004); Rathaus Stuttgart (2005), Mariners Gallery, St.Ives (2006), Waterside Gallery, St.Ives (2007). *Works in collections:* Inverliever Lodge Trust. *Clubs:* NAPA. *Signs work:* Paul Geraghty or P.G. *Address:* 2 Belmont Place, St.Ives, Cornwall, TR26 1DT. *Email:* pg@minerslamp.freeserve.co.uk *Website:* www.stivespainter.com

GERRIE, Pamela Margaret, BA Hons Fine Art Sculpture, PGCE; Special Entry to Kingston School of Art; President Cambridge University Pottery Society (1996); Arts Council Award(Nov 2000). *Medium:* sculpture, ceramics, fire. *b:* Chelsea, London, 1 Feb 1952. *d of:* Robert Gerrie and Margaret Alston. one *s*. one (and two s-) *d. Studied:* Kingston School of Art; K.O.T. Garnett College of Education. *Represented by:* Cambridge Computer, Ric Alston 01223 562128. *Exhib:* RA; galleries and shows Cambridge, London, Suffolk and Wales, Brockdish Sculpture Meadow, Norfolk. *Works in collections:* private collections Washington DC, USA, UK and Europe. *Commissions:* coldcut fire sculpture logos, Lee Scratch Perry Meltdown Festival, Royal Festival Halls (2003); Strawberry Fair Festival, Grand Finale Fire Sculpture (1998); British Red Cross Performance and Bodyart, Guildhall, London (1994); and many others. *Principal Works:* "Window", "Rules". *Recreations:* driving around in a camper van. *Misc:* TV-1996 Fire Sculpture construction, Wysing Arts Cambridge (ITV, Anglia); 1997 1st American/British Contemporary Sculpture Iron Pour (ITV, Suffolk). *Signs work:* "PMG" (earlier work as P.Smith). *Address:* c/o 8 Walpole Road, Cherry Hinton, Cambridge CB1 3TJ. *Email:* pamela-gerrie@hotmail.co.uk

GETHIN, Jackie, C.I.C., S.B.A.; artist in water-colour; mem. Soc. of Botanical Artists. *b:* Brikendon, Herts., 14 May 1949. *m:* Richard. three *d. Educ:* Effingham House School, Cooden, Sussex. *Studied:* Southampton College of Art, Bournemouth and Poole College of Art (Keith Rennison). *Exhib:* numerous mixed shows including S.B.A. *Works in collections:* Francis Iles, Rochester,

Beaulieu Fine Arts. *Works Reproduced:* by The Medici Society Ltd. *Recreations:* walking. *Signs work:* "Jackie Gethin." *Address:* Trotts Ash, Sole Street, nr. Gravesend, Kent DA12 3AY.

GIARDELLI, Arthur, M.B.E., M.A. (Oxon); President, 56 Group Wales; painter and sculptor in mixed media (wood, brass, burlap, oil, paper etc.) for wall panels, water-colour, and lecturer. *b:* London, 11 Apr., 1911. married. *s of:* Vincent Giardelli. *m:* Bim Giardelli. one *s.* one *d. Educ:* Alleyn's School, Dulwich, Hertford College, Oxford. *Studied:* Ruskin School of Art, Oxford. *Represented by:* England & Co., London; Pen y Fan Gallery, Brecon. *Exhib:* Amsterdam, Paris, Chicago, Washington, Bologna, Bratislava, London, New York, Cardiff, Edinburgh. *Works in collections:* Arts Council of Great Britain, Welsh Arts Council, National Museum of Wales, National Library of Wales, Museum of Modern Art, Dublin, National Gallery Slovakia, National Gallery Prague, Musée des Beaux Arts, Nantes, Estorick Collection, Grosvenor Gallery, London, Tate Gallery, England & Co. *Commissions:* wall panel: Argus Newspaper; door: Grosvenor Gallery, and Brook St. Gallery. *Works Reproduced:* The Delight of Painting (University College, Swansea); art magazines; Arthur Giardelli painting, constructions, relief sculptures; Conversations with Derek Shiel (publisher) SEREN. *Recreations:* music (viola). *Address:* Golden Plover Art Gallery, Warren, Pembroke SA71 5HR.

GIBB, Avril V.: see WATSON STEWART, (Lady) Avril Veronica,

GIBBONS, Jeff, BA (Hons.), MA; prizewinner John Moores (1995). *Medium:* oil, watercolour, drawing. *b:* London, 9 Nov 1962. *m:* Joanna Melvin. one *s.* one *d. Studied:* Ravensbourne (1980-1981), Middx. Polytechnic (1981-1984), London University (1989-1991). *Represented by:* Art Space Gallery, 81 St.Peters St., London N1 (Michael Richardson). *Exhib:* various exhibs including, Morley Gallery, London (1994), Bede Gallery, Jarrow (1996), John Moores (1995 - prizewinner & 1999), Natwest Gallery (1997 & 1998), Art Business Design Centre (1999-2001); RA Summer Exhbn (2002); selected solo shows: 2005: St.Giles, Cripplegate, Barbican; Art Space Gallery, London; Gloucester Cathedral; Emma Hill Fine Art, London (1999, 2001); Art Space Gallery & Project Space (2007). *Works Reproduced:* catalogues, John Moores (19 & 21), Natwest (1997 & 1998), British Library Report (2000-2001), RA Summer Show (2002). *Signs work:* "Jeff Gibbons." *Address:* 123 Evering Road, London N16 7BU. *Email:* gibbonsjef@gmail.com

GIBBONS, John, B.A. Hons. (Sculpture); Head of Sculpture, Winchester School of Art, elected Prof. (1995). *b:* Ireland, 1949. *Educ:* Ireland. *Studied:* sculpture: St. Martin's School of Art (1972-75, David Annesley, William Tucker). *Represented by:* Flowers East London; Taylor Galleries, Dublin. *Exhib:* solo exhibitions: International Arts Centre, London (1975), Project Gallery, Dublin (1979), Nicola Jacobs Gallery, London (1981), Triangle Center, N.Y.C. (1984), Serpentine Gallery (1986), John Hansard Gallery, Southampton University

(1986), Galerie Wentzel, Köln (1987), Madeleine Carter Fine Art, Boston, Mass. (1988), Flowers East (1990, 1992, 1994, 1997, 1999, 2003), Flowers Graphics, London (1996), Butler Gallery, The Castle, Kilkenny Ireland (1996), Whitworth A.G. Manchester (1997), Kettles Yard, Cambridge (1997), Lothbury Gallery, London (1998), Temple Bar Gallery, Dublin (1998), Crawford Municipal A.G., Cork (1998), Nograd History Museum, Salgotorjan, Hungary (1999), Endre Horvath Gallery, Balassagyarmat, Hungary (1999), The Napolean Garden, Holland Park, London (2002), Taylor Galleries, Dublin (1999, 2005), Flowers Central, London (2001, 2007), One Canada Square, Canary Wharf, London (2005), Canem Galeria, Castello, Spain (2006). *Works in collections:* A.C. England, Syracuse University, N.Y., Edmonton A.G., Alberta, Gulbenkian Foundation, Comino Foundation, Museum of Contemporary Art, Barcelona; Tate; The National Self-Portrait Collection, Univ. of Limerick, Ireland; Nograd History Museum, Salgotorjan, Hungary; Contemporary Arts Society, Dublin; The Whitworth Art Gallery, Manchester; The Czech Museum of Fine Arts; Sculpture at Goodwood; Contemporary Arts Society, London; Bank of Montreal. *Commissions:* sculpture at Goodwood. *Publications:* Gonzalez: A Legacy; Introduction to catalogue, South Bank Centre, Whitechapel. *Signs work:* "J.G." welded on. *Address:* 14 Almond Rd., London SE16 3LR. *Website:* www.johngibbons.org.uk

GIBBS, Mavis, SLm, HS. *Medium:* watercolours - miniatures (portraits, flowers, animals). *b:* London, 10 Aug 1939. *m:* George Gibbs. two d. *Studied:* self-taught. *Exhib:* SLm, Chichester (annually); HS, Bath (annually); World Exhibition of Miniatures (Tasmania, 2007). *Works in collections:* various private collections in USA, Japan, South Africa, UK. *Commissions:* via recommendation. *Clubs:* Willesborough Art Fellowship (Founder Member). *Signs work:* 'Mavis Gibbs' or 'MJG' (monogram). *Address:* 33 Cherry Glebe, Mersham, Ashford, Kent, TN25 6NL. *Email:* mavisgibbs@gznet.co.uk *Website:* www.mavisgibbs.co.uk

GIBBS, Stephen Roy, London Diploma in Design (LDAD, 1980); Cert Ed. (1996); BA Hons Education and Training (Greenwich, 1999). *Medium:* watercolour, drawing, prints, sculpture. *b:* Southend-on-Sea, 10 May 1957. *s of:* Roy Frederick Gibbs and Pauline Jean Gibbs (nee Fraser). *Educ:* Cecil Jones High School, Southend-on-Sea (1968-75). *Studied:* Southend College of Arts and Technology (Foundation, 1975-77); London College of Printing (1977-1980); South East Essex College (1994-99). *Represented by:* www.londonart.co.uk. *Exhib:* RA, RWA, Discerning Eye, Singer & Friedlander/Sunday Times Watercolour Competition, RI, Beecroft Art Gallery (Southend-on-Sea), Estuary Art Gallery (Leigh-on-Sea). *Works in collections:* Beecroft Art Gallery. *Commissions:* sculptures commissioned for charity Childline. *Publications:* featured on page 264 of 'Oil Paintings in Public Ownership in Essex', The Public Catalogue Foundation, ISBN 1-904931-15-4, first published 2006. *Official Purchasers:* Beecroft Art Gallery (paintings, permanent collection); many paintings and linocuts in private collections. *Works Reproduced:* in The Times,

The Echo (Basildon & Southend-on-Sea). *Principal Works:* linocuts, Seaside paintings, Topiary paintings. *Recreations:* photography, exhibitions, music. *Signs work:* 'Stephen Gibbs' or 'Stephen R.Gibbs' on earlier works. Now signs as 'S.G.', and in all cases followed by the year work was produced. *Address:* 11 Stanfield Road, Southend-on-Sea, Essex SS2 5DQ. *Email:* gibbsste@southend.ac.uk *Website:* www.londonart.co.uk

GIBBS, Timothy Francis, M.A. (Oxon., 1948), C.F.A. (Oxon, 1949); painter in oils, acrylic and water-colour; deputy Ruskin master (1974-80), Ruskin School, Head of Fine Art Oxford University (1976-80). *b:* Epping, Essex, 21 Aug 1923. *s of:* G. Y. Gibbs. *m:* Bridget Fry. one *s.* two *d. Educ:* Trinity College, Oxford (1946-48). *Studied:* Ruskin School (1947-49). *Exhib:* one-man shows: Piccadilly Gallery (1955), Leicester Galleries (1962, 1963, 1966, 1969), Ashmolean Museum (1981), Rockefeller Art Collection, New York (1986), Clarendon Gallery (1987, 1990), Cadogan Contemporary (1993), Gallery 28, Cork St. (1998), Fry Art Gallery, Saffron Walden (2004), Maison Jacob (2005). *Works in collections:* Government Art Collection, Atkinson A.G., Southport, Financial Times, Royal College of Music, Nottingham, Hertfordshire, Essex, Leicestershire Educ. Authority, Royal Borough of Kensington. *Commissions:* murals: Blue Lion Fenditton Cambridge (1958); Barclays Bank Guildford (1968). *Signs work:* "T. F. Gibbs." *Address:* 14 St.Edyths Road, Bristol BS9 2ES.

GIBILARO, Jason, painter in oil and acrylic;. *b:* London, 25 Aug., 1962. *Studied:* St. Martin's School of Art and Design (1980-81), Brighton School of Art and Design (1981-84). *Exhib:* R.A. Summer Show, Peterborough Museum and Gallery, Christopher Hull Gallery London. *Works in collections:* University of London Picture Club. *Commissions:* Hazard Evaluation Laboratory. *Address:* 62 Kemble House, Barrington Rd., London SW9 7EF.

GIBSON, Jane Barr, R.M.S., H.S.; B.A., artist in oil, pastel, water-colour of miniatures and larger works; Artist in Residence, Dorothy L. Sayers Soc. *b:* Smithton, Tasmania, 14 Sep 1954. *Studied:* Carlisle College of Art and Design, Norwich School of Art. *Exhib:* R.M.S. Westminster Gallery London, H.S. Wells, Medici Gallery London, Polak Gallery London, Malcolm Innes Gallery, London and Edinburgh, Samap, France (miniature soc.), Smithsonian Institute, Washington DC, Hobart & Burnie, Tasmania. *Works in collections:* Capitol Hill, Washington D.C. U.S.A. *Commissions:* "Lockerbie Remembered" (commissioned by Dumfries & Galloway Constabulary). *Publications:* illustrated: To Those Who Love - poetry book by Jo McNaught. *Works Reproduced:* by Hockin & Roberts Ltd. (Cornwall). *Address:* 'Cornerways', 7 Selkirk Rd., Kirkcudbright DG6 4BL. *Email:* jane@cornerwaysart.co.uk *Website:* www.cornerwaysart.co.uk

GIBSON, Veronica, B.A. (Hons.); painter in oil, private teacher;. *b:* St. Albans, Herts., 15 Apr., 1954. *Educ:* Loretto College. *Studied:* Hertfordshire College of Art (1972-73), Canterbury College of Art (1978-81, Thomas Watt,

D.A. Edin.). *Exhib:* R.A., N.E.A.C., R.O.I., R.W.A., Cardiff. *Works in collections:* S. Glamorgan; private: France and Sweden. *Address:* Ty Coed, Chapel St., Bedlinog, Mid Glamorgan CF46 6TS.

GIBSON-WATT, Marcia Susan, BA Graphic Design. *Medium:* acrylic and pastel. *b:* London, 12 Sep 1949. *d of:* Sir Roger Cary. *m:* Robin Gibson-Watt. three *s.* one *d. Educ:* St.Mary's Convent, Ascot. *Studied:* Studio Simi Florence (1966-67); Kingston Art College (1967-71). *Exhib:* RA Summer Exhbn (several times, most recent 2005); The Gallery in Cork Street (1999, 2001, 2004); Alpine Gallery, London (1986, 87); solo: Memphis Botanic Gardens, Tennessee, USA (2003), Fosse Gallery (2007). *Works in collections:* Terry Wogan, A Barbour, the late Sir Geraint Evans. *Commissions:* label for English and Californian Vineyard; Betty Parsons retirement present, presented at RA; Robin Price:Welsh Black Cattle. *Publications:* two privately published (Bluestone Books) prayer books: 'The Four Graces' and 'A.C.T.S. I'. *Principal Works:* 'Tea Pickers in Sri Lanka' Lumle village, Nepal (6'x4' gouache/pastel). *Recreations:* travel. *Clubs:* Chelsea Arts Club. *Address:* Gelligarn, Llanyre, Llandrindod Wells, Powys LD1 6EY. *Email:* robin.gibson1@btconnect.com *Website:* www.gibsonwatt.com

GIFFARD, Colin Carmichael, M.A. Cantab., Dip.Arch. London (A.R.I.B.A. 1947-57), R.W.A.; R.I.B.A. Schools Drawing Prize (1932), Rome finalist (Arch.) 1939; painter in oil, acrylic; lecturer, Bath Academy of Art, Sydney Place (1951-68);. *b:* London, 1915. *Educ:* Charterhouse, Clare College, Cambridge; University College, London. *Studied:* painting: Bath Academy of Art (1948-51). *Exhib:* R.A., R.W.A., London Group, Bristol City A.G., Salon des Nations, Paris; one-man shows, Woodstock Gallery, London (3). *Commissions:* murals in schools for Herts., Wigan Educ. Coms. *Misc:* Work purchased: R.W.A., Newton Park Coll., Bath, Bristol, Walsall Educ. Coms. *Address:* Little Mead, Freshford, Bath BA3 6DH.

GIFFORD, Andrew John, *Medium:* oil paint, also neon and all forms of artificial light. *b:* Sheffield, 26 Mar 1970. *s of:* John and Kay Gifford. *m:* Rosie. one *s. Educ:* Foundation, York Tech., first class BA Hons Newcastle University. *Studied:* Fine Art. *Represented by:* John Martin of London, 38 Albemarle Street, London W1X 3FB. *Exhib:* solo: Art London, Chelsea Barracks (2003), John Martin of London (2002); group(2000): 'Blue', The New Art Gallery, Walsall, French Paintings, Art 2000, BDC, Islington; (1997) Northern Lights, Fruit Market Gallery, Edinburgh. *Works in collections:* Walsall, New Art Gallery; Middlesborough Art Gallery. *Recreations:* 1996-97 part-time lecturer/ Newcastle and Aberdeen University. *Misc:* Documentaries: Date with an Artist BBC2 (1997); Don't Look Down, Scottish TV (1997). *Address:* Le Bourg, Fontaine, 24320, Dordogne, SW France. *Email:* rosieinfrance@hotmail.com *Website:* www.jmlondon.com

GILBERT, Dennis, N.E.A.C.; portrait and landscape painter; formerly senior lecturer, Chelsea School of Art; all conventional media (oil, watercolour, pastel).

b: London, 7 Jan 1922. *s of:* Gordon S. Gilbert. *m:* 1st Joan Musker; 2nd (2000) Ann Kodicek. three *s.* one *d. Educ:* Weston-super-Mare. *Studied:* St. Martin's School of Art (1946-51). *Exhib:* R.A., Paris Salon, R.P., R.B.A., N.E.A.C., Soc. of Landscape Painters, Browse & Darby, Leicester Galleries, Redfern, W.H. Patterson Fine Art, Thompsons Gallery, Duncan Miller and Zwemmer Galleries, etc.; one-man shows: F.B.A. Gallery (1968), Langton Gallery (1982), Gill Drey Gallery (1989), Highgate Fine Art (1997 and 2002), Piers Feetham Gallery (2002, 2005). *Clubs:* Arts, Chelsea Arts, London Sketch Club. *Signs work:* "Dennis Gilbert." *Address:* Top Studio, 11 Edith Gr., Chelsea, London SW10 0JZ. *Email:* dennis@dennisgilbert.net *Website:* www.dennisgilbert.net

GILBERT, George, R.S.W. (1973), D.A. (Glasgow) 1961, Post. Dip. (1962); Art Store award P.A.I. (1992); W.G. Gillies Award, R.S.W. (1993); RCPSG award, R.G.I. (2006); R.S.W. Council award (2007). *Medium:* water-colour, acrylic, pen and wash. *b:* Glasgow, 12 Sep 1939. *s of:* Samuel Gilbert, railwayman. *m:* Lesley. three *s. Educ:* Glasgow. *Studied:* Glasgow School of Art (1957-61): Guthrie Book Prize (portraiture). Art Store Award (P.A.L.) 1992; W. G. Gillies Award (.R.S.W.) 1993. *Exhib:* one-man shows: Kelly Gallery, Glasgow (1967), Byre Theatre, St. Andrews (1979), Loomshop Gallery, Lower Largo (1981, 1988, 1990), Torrance Gallery, Edinburgh (1991); several joint shows in Glasgow and Edinburgh; regular exhibitor at R.S.A., R.S.W., etc., also Commonwealth Arts Festival, Bath Art Fair, Cleveland International Drawing (90). One man shows: The Gatehouse Gallery, Glasgow (1996), The Open Eye Gallery, Edinburgh (1994), The Courtyard Gallery, Crail (1996, 1997), Pittenweem Arts Festival (2003, 2004, 2005). *Works in collections:* Nuffield Foundation, Fife Regional Council; Heritage collection, St. Monans; Royal College of Physicians & Surgeons, Glasgow; many private home and abroad. *Signs work:* "George Gilbert." *Address:* 41 Main St. Kilconquhar Fife KY9 1LG. *Email:* enquiry@georgegilbertrsw.co.uk *Website:* www.georgegilbertrsw.co.uk

GILBERT, John Stewart, Cert. Ed. (1955), Art teaching Cert. (1964); taught in Cheltenham, then Sheffield as Head of Art and Crafts Dept., Abbeydale Grange School; examiner A level Art (practical and Art history); silver medal Paris Salon (1965), first prize International Competition for Professional Artists Still Life in Oils (1999). *Medium:* painter in oil, watercolour, acrylic and pastel. *b:* 25 Apr 1933. *m:* Helena Rosemary. one *s.* one *d. Educ:* St. Paul's College Cheltenham under George W. Sayer 1953-55. *Studied:* Bournemouth and Poole College of Art under E.D'Arcy Lister 1963-64. *Exhib:* RA, Paris Salon, RWA, RI, ROI, RWS, BSP, etc. Various galleries in London, Yorkshire, Derbyshire and the Lake District. *Works in collections:* America, Sweden, Finland, Derbyshire County Council, Lady Wortley, Lord Ingoldsby. *Commissions:* court artist for YTV since 1992; Group portraits: Officers' Mess 2nd Battalion Royal Fusiliers;Leeds coroner's court, and other individuals. *Publications:* illustrations for Phasmid Society, entry in La Revue Moderne des arts et de la vie September 1963, entry Repertorium Artis 1969 (International Arts Guild) and Christmas cards. *Works Reproduced:* Rotherham City Centre (Going Home). *Recreations:* art, family,

gardening and music. *Clubs:* Associate of the Societe des Artistes Francais since 1966. Chairman, Yorkshire Watercolour Society, Hallam Art Group, Underbank Art Club. *Misc:* regular workshops in York Art Gallery in conjunction with major exhbns (Canaletto, Cox, Wilson-Steer and Dutch still-lifes), also workshops and talks for Art groups and Societies in the North of England. *Address:* 4 Oakbrook Rd, Sheffield, S11 7EA.

GILBERT, Rowena Justine, BA (Hons) Three Dimensional Crafts (2002): 'Best Up and Coming Local Artist Award 2002' (The Juicy Awards Brighton & Hove). *Medium:* painting, sculpture, ceramics. *b:* Taplow, Berkshire, 24 Nov 1979. *d of:* Terence Gilbert. *Educ:* 3D Crafts-University of Brighton (specialising in ceramics and plastics). *Studied:* Art and Design Foundation- Brighton College of Technology; A'levels (Fine Art, Fashion & Textiles, Design and Technology, Mathematics)Christs Hospital School, Horsham. *Exhib:* Hove Museum and Art Gallery, Lewes Contemporary Art Fair; Shangri-La Hotel, Dubai; The Alexander Gallery, Brighton; Blend Design, Brighton; Phoenix Arts Association, Brighton; Henley Royal Regatta, Steward's Enclosure, Henley-on-Thames; Blue Moon Gallery, Tunbridge Wells; Worthing Museum and Art Gallery; The London Art and Design Show; Belle Fine Arts, Winchester. *Address:* Unit 3, Level 5 (North), New England House, New England Street, Brighton, E.Sussex, BN1 4GH. *Email:* info@rowenagilbert.com *Website:* www.rowenagilbert.com

GILBERT, Terence John, SEA. *Medium:* oil, watercolour, pastel. *b:* London, 14 Oct 1946. *s of:* J.S.Gilbert. *m:* Pamela Gilbert. one *s.* one *d. Educ:* London. *Studied:* Camberwell Arts School, London. *Represented by:* Mathaf Gallery, W.H.Patterson, London. *Exhib:* Mathaf Gallery, London, Dubai, Jordan, Saudi Arabia, Oman, Society of Equestrian Artists, Osborne Studio Gallery, London (2004); one-man shows Bruton Street Gallery (1995-2002) London. *Works in collections:* former President Reagan, Charlton Heston, Sheikh Mohammed al Maktoum, Sir Peter O'Sullevan, Sultanate of Oman, J.P.MacManus, Frankie Dettori. *Commissions:* Royal Blackheath Golf Club, Racehorse Owners Association, Derby Winners Nashwan and Generous, Royal Palace of Jordan, British Airways, The Ashes at the Oval 2005, James D. Jameson. *Publications:* Punch Magazine, Golf Monthly, ES Magazine, exhibition catalogues. *Official Purchasers:* Royal Palace Amman, Jordan. *Works Reproduced:* limited editions of sport and landscapes. *Principal Works:* H.M. The Queen, and President Reagan riding at Windsor. *Signs work:* 'T.J.Gilbert'. *Address:* Wisteria Cottage, 27 Rushington Avenue, Maidenhead, Berks, SL6 1BY. *Email:* info@terencegilbert.com *Website:* www.terencegilbert.com

GILDEA, Paul Rudolph, B.A. Hons. Fine Art; artist in oil on canvas; part time tutor, Fulham and Chelsea A.E.I. *b:* London, 3 Jan 1956. *s of:* John Robert Denis Gildea, B.A. Hons. *Educ:* Dulwich College. *Studied:* Camberwell School of Arts and Crafts (1975-76), Middlesex Polytechnic (1976-79). *Exhib:* Serpentine Summer Show (1982), Whitechapel Open (1987), Riverside Open

(1987), R.A. Summer Show (1987). *Signs work:* "Gildea." *Address:* 41 Ballater Rd., Brixton, London SW2 5QS.

GILES, Peter Donovan, Ph.D. (Middx) (2000), N.D.D. (Special level Illustration) (1959), A.T.C. (Lond.) (1960), F.R.G.S.; painter, illustrator and sculptor; countertenor; teaches part-time, workshops. *Medium:* mixed. *b:* Perivale, Middx., 15 Feb 1939. *s of:* Donovan Eric Giles and Evelyn Mary Sherlock. *m:* Elizabeth Ann Broom. one *s.* one *d. Educ:* Castlehill College, Ealing. *Studied:* Ealing School of Art (1954-59), Hornsey College of Art (1959-60). *Exhib:* All Hallows on the Wall, EC2; provincial one-man shows; lecture tours, U.S.A. and Canada. *Works in collections:* Lichfield City A.G., War Memorial Ely Cathedral. *Commissions:* various. *Publications:* novels, non-fiction, cartoons, board games. *Signs work:* "Peter Giles." *Address:* Filmer House, Bridge, Canterbury, Kent CT4 5NB. *Email:* petergiles@filmer-house.co.uk

GILI, Katherine, FRBS; BA (1970); Advanced Dip. (1973); Elephant Trust Award; sculptor in steel. *b:* Oxford, 6 Apr 1948. *d of:* J.L. & E.H.Gili. *m:* Robert Persey. one *s. Studied:* Bath Academy of Art (1966-70), St Martin's School of Art (1971-73). *Exhib:* solo shows: Salander/O'Reilly NY, Serpentine Gallery; mixed shows: Tate Gallery, Hayward Gallery, Serpentine Gallery, RA, Conde Duque Centre Madrid, Battersea Park, Flowers East, New Art Centre Sculpture Park, Pride of the Valley Sculpture Park, Dumfries and Galloway. *Works in collections:* Arts Council of England, and private collections in Britain, Spain and U.S.A.; City of Lugano Switzerland; General Electric, U.S.A.; Railtrack; Cartwright Hall Museum, Bradford. *Publications:* numerous exhbn. catalogues, reviews, articles. *Clubs:* Anglo-Catalan Society. *Misc:* selector for New Contemporaries, Serpentine Summer Show, 'Have you Seen Sculpture from the Body' Tate Gallery. *Signs work:* some work signed. *Address:* 7 The Mall, Faversham, Kent, ME13 8JL. *Email:* katherine@persey.plus.com

GILLARD, Charles Richard, NDD (1961) (Illustration), Cert RAS (Painting)(1964), Leverhulme Scholarship (1964); part-time lecturer, senior lecturer, workshop director for drawing, London and University of Wales (1965-95). *Medium:* oil, egg tempera, drawing, prints. *b:* Southampton, UK, 11 Sep 1940. *Studied:* Southampton College of Art (1957-61), Royal Academy Schools (1961-64). *Exhib:* RA, Christie's etc. *Commissions:* private commissions for paintings, still lifes and portraits. *Publications:* London Parks 1976. *Clubs:* RASAA. *Signs work:* 'CRG', 'CRGillard'. *Address:* Flat 3, 1-3 Little Titchfield St, London W1W 7BU.

GILLESPIE, Michael Norman, A.R.B.S.; sculptor in bronze. *s of:* Reginald Gillespie. *m:* Lesley Todd. two *s.* one *d. Educ:* St. Paul's School. *Studied:* Hammersmith College of Art (1952-56). *Exhib:* nineteen plus mixed shows. *Works in collections:* Cambs. CC, Herts. CC. *Publications:* Studio Bronze

Casting (Batsford, 1969). *Signs work:* "M. Gillespie." *Address:* 53 Cottenham Rd., Histon, Cambridge CB4 9ES.

GILLESPIE, Sarah, BFA, MFA (Oxford); Egerton Coghill Award (1983); Elizabeth Greenshield International Award (1984). *Medium:* oil, watercolour, drawing. *b:* Winchester, 27 Jun 1963. *d of:* David Gillespie ARCA & Ann Gillespie ARCA. one *s.* one *d. Studied:* Atelier Neo-Medici, Paris (1981/1982), Ruskin School of Drawing and Fine Art, Oxford (Pem.Coll., 1982-85). *Represented by:* Waterhouse & Dodd, London. *Exhib:* solo: Ombersley Gallery, Worcs. (1997), New Street Gallery, Plymouth (2003), Waterhouse & Dodd (2005, 2007). Selected group shows (since 1982): Weir Gallery, Bath (1988), Gallery Revel, New York (1990), Cheltenham Open (1997), RWA Open (1999), Thompson's Gallery, Stow on the Wold (2001, 2002), Art London (2005), The London Art Fair (2006), Coombe Gallery, Dartmouth (2006). *Works in collections:* Merryl Lynch Bank, Rolls Royce, Victoria Gallery Bath, Government Offices (SW). *Publications:* "Sarah Gillespie. The Slapton Ley Project", White Lane Press (2007). *Official Purchasers:* Victoria Gallery, Bath; Government Offices (SW). *Signs work:* "GILLESPIE". *Address:* Clover Cottage, Blackawton, Totnes, Devon, TQ9 7BN. *Email:* studio@sarahgillespie.co.uk *Website:* www.sarahgillespie.co.uk

GILLET, Francois Marie Marcel, *b:* Balleroy, France, 24 Sep 1949. *Studied:* photography at Bournemouth & Poole College of Art (1968-71). *Represented by:* Annabelle Dalton: 07973 392625. *Individual Shows/Exhibitions:* Salon de la Photo, Paris (1983), Photopia, Tokyo (1983), Gallery il Milione, Milano (1986), Frovifors Pappersbruk, Sweden (1993), World Trade Centre, Stockholm (1993), Musee Francais de la Photographie, Bievres (1996), Exponera, Warehouse Photogallery, Malmo (1996). *Awards/Commissions:* advertising award: Gold Lion at Cannes for Silk Cut 'Can-Can' through Saatchi & Saatchi (1993). *Principal Published Pieces:* L'Album de Francois Gillet (Publicness, Paris, 1981), Pour Gourmets (Ceres Verlag I.M, GMBH Bielefeld 1991). *Publications: Monograph/Contributer:* Zoom (1975, 79, 81, 83), Photo Japan (1983), Creative Review (1982), Bat (1985), Italian Vogue (1986), Vanity Fair (1986), Direction (1987), Harpers & Queen (1987), Graphis (1990), Step-by-Step (1991), Archive (Luerzer Archive). *Specialist Area:* advertising, still life, food, portraiture, gallery, image bank on website. *Equipment Used:* 10x8 studio camera. *Address:* Box 262, 13302 Saltsjobaden, Sweden. *Email:* francois@francois-gillet.com *Website:* www.francois-gillet.com

GILLICK, James Balthazar Patrick, BA (Hons). *Medium:* painter in oil, drawings, drypoint, portraits, still lifes, figures. *b:* Kings Lynn, 8 Feb 1972. *m:* Miriam. two *s.* three *d. Educ:* Ratcliffe College, Wisbech Grammar School. *Studied:* C&GCHE. *Represented by:* Jonathan Cooper: Park Walk Gallery. *Exhib:* numerous exhibs., London and nationally. *Works in collections:* Baroness Thatcher. *Commissions:* portraits: Baroness Thatcher (1998), Rt. Rev. M. Couve de Murville, Archbishop of Birmingham (1999); His Holiness Pope John Paul II

(2004/05). *Signs work:* monogram - G bisected by J. *Address:* c/o Jonathan Cooper, Park Walk Gallery, 20 Park Walk, London SW10 0AQ. *Email:* mail@jonathancooper.co.uk *Website:* www.gillick-artist.com

GILLIMAN, Tricia, B.A. (Hons.) Fine Art, M.F.A. Fine Art; artist in oil on canvas; Senior lecturer, Central/St. Martin's School of Art, London Inst.;. *b:* 9 Nov., 1951. *m:* Alexander Ramsay. one *s. Studied:* Leeds University, Newcastle University. *Exhib:* Benjamin Rhodes (1985, 1987, 1993), Arnolfini (1985), Gardner Centre, Brighton (1993), Jill George (1997-99), John Moores (1983, 1985, 1989, 1991), etc. *Works in collections:* Contemporary Art Soc., Unilever PLC., New Hall Cambridge, University of Liverpool, Herbert A.G. Coventry, University of Leeds, Stanhope Properties Ltd., Television South West, The Stuyvesant Foundation. *Commissions:* B.B.C. Film: The Colour Eye: The Dynamics of Paint. *Address:* 149 Algernon Rd., London SE13 7AP.

GILLISON TODD, Margaret, M.C.S.P., Dip.Ed.Lond.; painter and illustrator; Keeper of Display, Grosvenor Museum, Chester (1966-77); Awards: Royal Horticultural Soc. (Silver Gilt and Silver Medals), Alpine Garden Soc. (Gold Medal). *b:* Warwick, 1916. *d of:* Douglas Gillison. *m:* Hugh Michael Todd. *Educ:* Howell's School, Denbigh. *Exhib:* R.Cam.A., N. Wales Group, S. Wales Group, S.E.A. Pictures for Schools, National Eisteddfod, Royal Horticultural Soc., Alpine Garden Soc., N.Wales Society of Fine Art, Clwydian Art Society. *Publications:* illustrations for "The Flora of Flintshire" by Goronwy Wynne (1993); A Histology of the Body Tissues, illustrated (E. & S. Livingston, Edinburgh); Louise Rayner (Grosvenor Museum, Chester). *Works Reproduced:* medical and botanical publications, etc. *Clubs:* Clwydian Art Society. *Signs work:* "MARGARET GILLISON," "MARGARET GILLISON TODD," or initials. *Address:* Pen-y-Llwyn, Llanarmon-yn-lâl, Mold, CH7 4QW.

GILLMOR, Robert, N.D.D. (1958), A.T.D. (1959); freelance illustrator, designer, painter in water-colour, black and white, lino-cut prints; Director Art and Craft, Leighton Park School (1959-65); President, S.WL.A.(1984-94), President, Reading Guild of Artists (1969-84). *b:* Reading, 6 Jul 1936. *s of:* Gerald Gillmor. *m:* Susan Norman, painter. one *s.* one *d. Educ:* Leighton Pk. School, Reading. *Studied:* School of Fine Art, Reading University (1954-59, Prof. J.A. Betts, William McCance, Frank Ormrod, Hugh Finney). *Exhib:* S.WL.A. *Works in collections:* Ulster Museum and A.G., Belfast, Reading Museum and A.G. *Publications:* 100 books illustrated. *Signs work:* "R.G." or "Robert Gillmor." *Address:* North Light, Hilltop, Cley, Norfolk NR25 7SE.

GILLMORE, Olwen Nina, S.W.A.; sculptor in clay and bronze;. *b:* Zimbabwe, 19 Mar., 1936. *d of:* John Henry Forsyth. *m:* Charles Gillmore. two *s.* three *d. Educ:* U.S.A. (1980-82), London Karin Jonzen (1983-90). *Exhib:* Chelsea; S.W.A. London; Chichester Cathedral; U.S.A.; Guernsey, C.I. *Commissions:* Chase Hospice Service for Children, Cotswold Wildlife Park; King Edward VII School, Whitley, Surrey; private commissions. *Signs work:* "Olwen."

Address: Sarnesfield, Lurgashall, Petworth, W. Sussex GU28 9EZ. *Email:* olwen.gillmore@tiscali.co.uk

GILMOUR, Albert Edward, artist in oil, pen and ink; sec., Gateshead Art Club (1950-51); retd. B.R. train driver. *b:* W. Hartlepool, 31 May 1923. *s of:* A. E. Gilmour. *m:* Elaine Bolton. one *s.* one *d. Educ:* Heworth and Felling Elementary Schools. *Studied:* courses at Gateshead Technical College, King's College, Newcastle. *Exhib:* Federation of Northern Arts Socs. Exhbns., Artists of the Northern Counties Exhbns., Artists of Durham Exhbn., Gateshead Art Club Exhbns. *Publications:* Locomotive Express, British Railways Magazine, N.E. Region. *Clubs:* Park Rd., and West End Group, Newcastle; Gateshead Art. *Signs work:* "GILMOUR." *Address:* 11 Limewood Grove, Woodlands Pk., North Gosforth, Newcastle upon Tyne NE13 6PU.

GILMOUR, Judith, D.A. (Glas.); ceramist in stoneware and porcelain thrown and assembled;. *b:* Edinburgh, 2 Oct., 1937. one *d. Studied:* Edinburgh College of Art, Glasgow School of Art. *Exhib:* Roger Billcliffe Glasgow, Scottish Gallery and Open Eye Gallery, Edinburgh, R.A. Summer Show, Crafts Council Contemporary Applied Arts. *Works in collections:* Royal Museum Edinburgh, Art Galleries Glasgow and Aberdeen, Wustum Museum Wisconsin, Graz Museum Austria. *Commissions:* wall panel: Diaspora Museum, Tel Aviv; entry hall: Canada Life Assurance Head Office. *Clubs:* Chelsea Arts. Selected makers Inex Crafts Council, Mem.: Contemporary Applied Arts, Assoc. of Applied Arts (Scotland). *Address:* 52 Bronsart Rd., London SW6 6AA. *Website:* www.judithgilmour.com

GIRVIN, Joy, B.A. Hons. Fine Art (1984), Post Grad. Dip. in Painting (1987); artist in oils and pastels; Art Tutor;. *b:* Herts, 15 Nov., 1961. *Educ:* University of Northumberland (1984), Royal Academy Schools of Art (1987). *Exhib:* regularly at Cadogan Contemporary Gallery, London. *Works in collections:* Barings Bank, National Trust Foundation for Art, Paintings in Hospitals, London Weekend T.V., Manchester City A.G., Exeter Museum and A.G. *Commissions:* Gardens, Italian landscape. *Clubs:* A.C.G and Sailing, member of Chisendale Studios. *Signs work:* " Joy Girvin." *Address:* 133a Friern Park, London N12 9LR.

GLANVILLE, Christopher, R.W.A.; David Murray Landscape Scholarship (1968, 1970); landscape painter in oil on canvas, oil on panel; Vice-President R.W.A. (1992-97). *b:* London, 10 Aug 1948. *s of:* Roy Glanville, RBA, RSMA, marine artist and illustrator. *m:* Zelda Glanville, potter and painter. one *s. Educ:* St. Clement Danes Grammar School, London. *Studied:* Heatherley School of Art (1965), Byam Shaw School of Art (1967-70, B. Dunstan, M. de Sausmarez), R.A. Schools (1970-73, P. Greenham). *Exhib:* R.A., R.W.A., Bruton Gallery, Kaplan Gallery, Woburn Abbey, N.E.A.C., Alresford Gallery, Sinfield Gallery, Wykeham Gallery, W.H.Patterson. *Works in collections:* R.W.A., Richmond Museum, Kingston Museum, MBNA Bank. *Publications:* Dictionary of British Artists

Since 1945; RA Exhibitors. *Clubs:* Arts Club. *Signs work:* "GLANVILLE." or "G." *Address:* Galveston, Giggs Hill Road, Thames Ditton, Surrey, KT7 0BT.

GLASS, Margaret, P.S., Membre Société des Pastellistes de France; landscape and marine artist. *Medium:* pastel and oil. *b:* Chesham, Bucks., 1950. *m:* Mr.Brian Smith. *Signs work:* "M.R.G." *Address:* Hill Cottage, Needham Road, Barking, Suffolk IP6 8HP. *Email:* margaret.glass@btinternet.com *Website:* www.margaretglass.com

GLASSBOROW, Stephen, BA (Hons) Fine Art; BA (Hon) Sculpture. *Medium:* sculpture. *b:* London, 10 Mar 1951. *s of:* Maurice Glassborow. *m:* Linda Dry-Parker. *Studied:* Brighton College of Art. *Represented by:* Gallery Perutz (UK); Wagner Gallery (Sydney, Australia). *Exhib:* Makers Mark Gallery, Sydney; Art International, Hong Kong; L'Attitude Gallery, Boston; Port Jackson Fine Art, Los Angeles. *Works in collections:* KPMG Sydney, Qantas, Bank of New Zealand, Walt Disney, McDonalds Group, Remy Martin. *Commissions:* Hasting City Council, Hilton Shanghai, Boston City Council, Apollo Group Singapore, Star City Casino. *Official Purchasers:* Whitehorse City Council, Victoria; Rochester City Council. *Signs work:* 'STEPHEN GLASSBOROW'. *Address:* Talycoed Court Lodge, Monmouth, NP25 5HR. *Email:* glass@iinet.net.au *Website:* www.galleryperutz.com

GLASSFORD, Susan Hilary, Diploma of Art. *Medium:* etching, engraving, oil, watercolour, drawing, prints. *b:* London, 11 Mar 1946. *d of:* grand-daughter of George Herbert Peet (artist). *m:* John Glassford. one *s.* one *d. Educ:* Queen Anne Grammar School for Girls, York. *Studied:* I.M.Marsh College, Liverpool (1964-7, teacher training); Cumbria Colloege of Art & Design (1980-3). *Exhib:* RA Summer Exhbn; RBA Mall Galleries; Laing Exhbn; various group exhbns since 1982. *Works in collections:* The British Embassy, Madrid. *Commissions:* private. *Publications:* The Lake Artist Society-A Centenary Celebration. *Principal Works:* landscape and travel subjects, painter and printmaker. *Recreations:* travel. *Clubs:* The Lake Artist Society (1992). *Misc:* shows work in own gallery. *Signs work:* 'Susan H Glassford' or 'SHGlassford'. *Address:* Meadowbank Farm, Curthwaite, Wigton, Cumbria CA7 8BG. *Email:* sueglassfordart@aol.com *Website:* www.meadowbankfarm.co.uk

GLAZEBROOK, Christina Fay, Hon.S.G.F.A. (1987); artist in pastel, watercolour; teacher of art for Herts. C.C., and Watford Borough Council. *b:* Watford, 1 Apr 1934. *d of:* George Cornish. *m:* Charles Michael Glazebrook. two *s. Educ:* Watford Technical College of Art. *Studied:* Cassio College, Watford (1976) and St. Alban's College of Art (1981). *Exhib:* P.S. (1980-81), Liberty's (1982), S.G.A. (1985, 1987), Herts. in the Making (1986-87), U.A. (1998), Mall Galleries, Knapp Gallery, London, and many one-man shows. *Signs work:* "Fay Glazebrook." *Address:* 10 Monkshood Cl., Highcliffe, Christchurch, Dorset BH23 4TS.

GLOECKLER, Raymond Louis, BS (1950), MS (1952); Emeritus Professor of Art University of Wisconsin-Madison. *Medium:* woodcut, wood engraving, oil. *b:* Portage, Wisconsin, 13 Dec 1928. *s of:* Louis and Florence Gloeckler. *m:* Joyce. two *s.* two *d. Studied:* University of Wisconsin, Madison (under Sessler). *Exhib:* nationally and internationally with over 100 awards. *Works in collections:* Butler Institute of American Art; Detroit Art Museum; Boston Museum of Fine Arts; Philadelphia Art Museum; Cincinnati Art Museum; Smithsonion Institution. *Publications:* 'The Engravers Cut: Raymond Gloeckler (Primrose Academy, Bicester, England 2001), An Engravers Globe: Wood Engraving Worldwide in the Twenty First Century by Simon Brett (Primrose Hill Press, London,2002); Progressive Printmaking: Wisconsin Artists and the Print Renaissance by Colescott and Hove (Univ. of Wisconsin Press, 1999). *Recreations:* bicycling, curling and yoga. *Address:* 305 Riverview Court, Portage, Wisconsin 53901, USA.

GOAMAN, Michael, banknote and stamp designers; stained glass. *b:* East Grinstead, 14 Feb 1921. *s of:* John F. Goaman. *m:* Sylvia Priestley (decd). three *d. Studied:* Reading University (1938-39); London Central School of Arts and Crafts (1946-48). *Works Reproduced:* UK and widely overseas. *Address:* Pilgrims Furzley, Bramshaw Lyndhurst, Hants. SO43 7JL.

GODDARD, Juliette Ingrid, BA (Hons) Fine Art, Middlesex University; MA (RCA) Fine Art Printmaking at the Royal College of Art; Henry Moore Bursary RCA. *Medium:* acrylics, ceramics, drawing, prints, sculpture. *b:* Kent, 13 Mar 1959. *d of:* Peter Goddard. *m:* Charles Scott. *Educ:* Magna Carta Secondary School; Ashford Sixth Form College. *Studied:* Epsom School of Art and Design. *Represented by:* Cosa London (Gallery). *Exhib:* RA Summer Exhbn; Crafts Council, London; Christie's; Swiss Embassy, London; Basel, Switzerland; Chateau de Penthes, Geneva; Chapter Arts Centre, Wales; Aberystwyth University, Wales; Fifty Years of Printmaking-Australian Touring Exhbn; Hot off the Press - Ceramic and Print. *Works in collections:* Switzerland: Davidoff/Lang & Partners, Basel; Kecskemet: International Ceramic Collection, Budapest; Crawley Museum Collection; private swiss collections and collectors. *Commissions:* Davidoff for Lang & Partners Architects. *Publications:* books: 'Printed Clay', 'Ceramic & Print' (A&C Blacks), 'Potters Guide to the Ceramic Surface'; '100 Years of the Royal College of Art'; magazines: Ceramic Review - UK, Ceramic Technical, Ceramic Monthly; 'Allegemeines kunstlerlexikon' (world biography). *Works Reproduced:* catalogues for solo exhbns; in '100 Years of the Royal College of Art', 'Printmaking at the Royal College of Art' catalogue. *Recreations:* music, sports, skiing, travel. *Clubs:* RCA Society, London; Le Club Francais -Swiss Club. *Signs work:* 'Juliette Goddard'. *Address:* 9 Dingle Close, West Green, West Sussex RH11 7NG. *Email:* juliette13_uk@yahoo.com *Website:* www.cosalondon.com

GOELL, Abby Jane, B.A., M.F.A.; Sen. Mem., Appraiser's Ass'n. of America. *Medium:* artist in oil, acrylic, lithography, assemblage, silk-screen,

collage;. *b:* U.S.A. one *s. Educ:* Syracuse Univ.; Columbia Univ. (M.F.A. 1965); Art Students' League, N.Y. (Life Mem.). *Studied:* Pratt Graphic Arts Centre, N.Y.C., Attingham Adult College, Shropshire, U.K. *Exhib:* Childe Hassam Purchase Exhbn. N.Y.C. (1977), Amer. Acad. and Inst. of Arts and Letters (1977), U.S. Dept. of State, Havana (1979-82), many invitational shows in U.S. *Works in collections:* MoMA (NY), Grafisches Kabinet, Munich, Chase Manhatten Bank, NY, Atlantic-Richfield Oil Co., Sloane-Kettering Memorial Center, NY, NY Public Library Print Coll., Neuberger Mus., Purchase N.Y. Smith College, Yale Univ. Art Gallery, Princeton Univ. Art Collection; Grey Art Gallery, NYU; Newark Public Library, NJ; Zimmerli Museum, NJ; Vassar College Museum, NY. *Publications:* editor, English Silver 1675-1825 Ensko & Wenham rev. ed. 1980 (Arcadia Press). *Recreations:* literature, foreign travel, opera. *Misc:* Founder/Publisher Arcadia Press, NY (1980); listed: E. Benezit Dictionnaire, 1999, Who's Who in America 2007, Who's Who in American Art and other biographical dictionaries of U.S. and abroad. *Signs work:* "Goell" and date. *Address:* 37 Washington Square West, New York, N.Y. 10011-9181, U.S.A. *Email:* abbygoell@earthlink.net

GOGOLIUK, Gennadii, Maud Hutchinson Gemmel Prize, RSA (2001). *Medium:* oils. *b:* Russia, 25 Mar 1960. *s of:* Vladimir Gogoliuk. *m:* Rose France. two *s.* three *d. Educ:* St.Petersburg Academy of Arts. *Studied:* Faculty of Painting, Studio of Moeseenko. *Represented by:* John Martin of London. *Exhib:* Russia, Finland, Germany, Denmark (1990-95), Scottish Society of Artists (2000), Royal Scottish Academy (2001, 2003); solo shows: John Martin of London (2000, 01, 03). *Publications:* Exhbn. catalogues: Stubnitz (1993) Manege Biennial Exhbn, St.Petersburg (1994), John Martin of London solo show (2001), 'On the Edge of Things' John Martin of London (2003). *Recreations:* writing the eternal book with Pan Pesochnyi. *Signs work:* Gogoliuk. *Address:* 32 Sciennes Rd, Edinburgh, EH9 1NT.

GOLDBACHER, Fiona C., water-colourist, sculptress in marble. *b:* London, 1935. *d of:* Donald Robertson. *m:* Rodolfo Goldbacher. one *s.* one *d. Educ:* Iona College, N.Z. *Studied:* under Ruth Liezman. *Exhib:* Chiba Museum,Tokyo; Tanja Flandria, Morocco; Blackheath, Bow House, Heiffer, Thompsons, Gagliardi Galleries, London; Turtle Gallery, Sussex. *Works in collections:* Sanyu Art Japan, Blackheath, Gagliardi, Thompsons Galleries, London, John Noott, Broadway, Cotswolds, Turtle Gallery, Sussex. *Works Reproduced:* various cards and prints. *Misc:* other address: 43 via Borgo 2, Strettoia (Lucca), Tuscany. *Signs work:* "Fiona C. Goldbacher." *Address:* 14 Edmunds Walk, London N2 0HU.

GOLDBART, Sarah Rachel, BA (Hons). *Medium:* painter in acrylics. *b:* Watford, Herts, 26 Jul 1964. *d of:* Leonard and Sheila Goldbart. *Studied:* Middlesex Polytechnic (Foundation Course); Loughborough College of Art and Design (Degree). *Represented by:* Michael Wood Fine Art Gallery, Plymouth;The Square Gallery, St.Mawes,Cornwall. *Exhib:* Lander Gallery, Truro; Mariners Gallery, St.Ives; Lennox Gallery, London; London Contemporary Art Gallery,

London; Smiths Gallery, London; Stark Gallery, London; New Gallery, Birmingham; Falmouth Art Gallery, Cornwall. *Works in collections:* IBM, Sir William Mather, Countess of St.Germans, The Lithuanian Embassy, The Ukrainian Embassy. *Commissions:* P & O Developments, J.D.Wetherspoon, Stakis Hotels, Radisson Edwardian Hotels, Architects and Interior Designers; private commissions. *Publications:* Gallery West Catalogue, 'Optimum Light' (A Celebration of Works Old and New). *Works Reproduced:* limited edition Giclee prints. *Principal Works:* semi-abstract still life/ portraits/abstract. *Address:* The Old Custom House, 53 Chapel Stree, Penzance, Cornwall, TR18 4AF. *Email:* create.sarah@virgin.net *Website:* www.create.ltd.uk

GOLDSMITH, Patricia, NDD (1950), ATD (1951), Post Graduate RA Schools (1951). *Medium:* painter in oil and watercolour, monotypes, drypoint etchings and collagraph. *b:* Hove, Sussex, 27 Mar 1929. *d of:* Mr & Mrs R.H.Kerley. *m:* Colin. one *s.* four *d. Educ:* Brighton and Hove High School. *Studied:* Brighton (1947-51), RA (1951-55). *Exhib:* Sussex Artists, Royal Portrait Society, RA, RWA, Marlborough Artists, S.West Academy of Fine Art. *Clubs:* RASAA (Reynolds Club, Old RA Schools Alumni). *Address:* 15 Hyde Lane, Marlborough, Wilts, SN8 1JL. *Email:* colingol@colingal.demon.co.uk

GOLPHIN, Janet, R.W.S. (1992), V.P.R.W.S. (1998), R.B.A. (1993); artist in water-colour, oils, mixed media;. *b:* Pontefract, 7 Nov., 1950. one *s. Exhib:* Bankside Gallery, London, Medici Soc., London, Thompsons Gallery, London, Mall Galleries, Richmond Hill Gallery, Richmond, Surrey, R.A. Summer Exhbn., Manor House Gallery, Chipping Norton, Oxon, Ashdown Gallery, Haywards Heath, Albany Gallery Cardiff. *Works in collections:* H.M. The Queen, Provident Financial, Brodsnorth Hall, M. Doncaster, Johnson and Johnson, John Lewis Partnership. *Commissions:* John Lewis Partnership. *Clubs:* R.W.S., R.B.A., Manchester Academy of Fine Art, Leeds Fine Art. *Signs work:* "Janet Golphin." *Address:* 6 Orchard View, Darrington, W. Yorkshire WF8 3AZ.

GOOCH, Wendy, HS. *Medium:* watercolour, oils, acrylic. *b:* Gorleston-on-Sea, Norfolk, 7 Sep 1939. *d of:* Mr & Mrs Cyril Frederick Allen. *m:* Paul Bernard Gooch. *Educ:* Gt.Yarmouth Technical High School. *Studied:* self-taught artist in all media and sizes. *Exhib:* HS, Wells; Mall Galleries, London; RMS, Westminster Galleries, London; Crome Gallery, Norwich. *Works in collections:* private collections in UK, USA and New zealand. *Commissions:* pet portraits in various mediums. *Principal Works:* wild and domestic animals, countryside, marine. *Recreations:* music, drama, walking. *Clubs:* Gt.Yarmouth Gilbert and Sullivan Society, Norwich Gilbert and Sullivan Society, RSPB. *Signs work:* 'W.G.' (miniatures), 'W.Gooch' (others). *Address:* 3 Robinson Road, Scole, Diss, Norfolk IP21 4EF.

GOOD, Trudy, self taught. *Medium:* oil, watercolour, drawing. *b:* Farnborough, Hants, 30 Aug 1967. *Educ:* Farnborough Sixth Form College. *Studied:* Winchester School of Art. *Represented by:* Belgravia Gallery, Mayfair.

Exhib: one-man shows: Belgravia Gallery, Llewelyn Alexander Gallery, Bell Fine Art Winchester, Desmoulin Gallery. *Works in collections:* Lenny Goodman (judge on Strictly Ballroom), and many other private collections. *Commissions:* commissioned to draw the Collection of Lindka Cierach, fashion designer, for London Fashion Week. *Works Reproduced:* posters by 'The Art Group', limited edition prints of the 'Ballroom Series'. *Principal Works:* figurative, specialising in pastel and charcoal. *Signs work:* 'TMG'. *Address:* c/o Belgravia Gallery, 45 Albemarle Street, Mayfair, London W1S 4JL. *Email:* trudy2socksgood@tesco.net *Website:* www.belgraviagallery.com

GOODALL, Oscar Ronald, R.S.W.; Dip. & PD, Dundee College of Art. Lectured for Scottish Arts Council, Chairman of Scottish Advisers in Art and Design, Adviser in Art/Design Central Region Scotland. Lectured for Extra-Mural Depts. of Dundee,St. Andrews and Stirling Universities, Art Education St.Lucia. *Medium:* oil, water-colour, acrylic, pastel; abstract landscape, drawings, pastels. *b:* S.Australia, 30 Jun 1924. *m:* Janet M.Goodall (née Wylie) DA (Glas.). *Educ:* Perth Academy. *Studied:* Dundee Col. of Art, Hospitalfield, Arbroath. *Exhib:* The Major Scottish Exhibitions, RSA, RSW, SSA, Scottish Gallery, Colours & 41 Galleries, Edin. etc.etc. British Council and Arts Council, The Scottish Gallery, Eduardo Alessandro Studios, The Wren Gallery, The Green Gallery. *Works in collections:* Perth Art Gallery, Dundee Art Gallery, Scottish Arts Council. *Official Purchasers:* Scottish Arts Council, Dundee and Perth Art Galleries. *Works Reproduced:* 'Golden River', 'Bridge Over the 'Earn', 'Fragments'. *Recreations:* fishing, gardening, good company, travel, talking, looking. *Misc:* co-founder of 'The Dollar Summer School', Civic Trust member. *Signs work:* Goodall. *Address:* 27 Drummond St., Muthill, Perthshire, PH5 2AN.

GOODAY, Leslie, O.B.E., R.I., F.R.I.B.A., F.C.S.D., F.R.S.A.; painter in acrylic and collage; architect and designer. *b:* Croydon, 1921. *m:* Poppy. *Educ:* Stanley Technical Trade School. *Studied:* Articled to P.A. Robson F.R.I.B.A. *Exhib:* Expo '70 Japan, B.N.F.L. Nuclear visitors centre, Cumbria, British Golf Museum, St. Andrews, Scotland, and numerous solo and group exhibs. in galleries, London and countrywide. *Publications:* The Artist. *Works Reproduced:* greeting cards by Woodmansterne. *Clubs:* Chelsea Art Society. *Signs work:* "L. Gooday." *Address:* 5 River Bank, Hampton Court, Surrey KT8 9BH.

GOODE, Mervyn, landscape painter best known for his oil paintings of the English countryside – featuring mainly the landscape close to his main home in Hampshire, as well as seascapes/estuary subjects inspired by the landscape close to his second home in South Devon, and also known for his landscapes produced from his travels in the South of France;. *b:* 1948. *m:* Stephanie. *Educ:* Gloucestershire College of Art. *Exhib:* has exhib. widely through the U.K. and also in the U.S.A.; one-man exhbns.: Highton Gallery, EC4 (1970), Alpine Gallery, W1 (1970, 1971), King St. Galleries, SW1 (1974), Furneaux Gallery, SW19 (1975), Southwell Brown Gallery (1976, 1984), Fraser Carver Gallery (1977), Reid Gallery (1978, 1981, 1983, 1985, 1987, 1989, 1991, 1993), Windsor

and Eton Fine Arts (1978, 1980), Century Gallery (1982, 1984, 1985), David Messum (1982), Medici Gallery, W1 (1983, 1985, 1990), H.C. Dickins, W1 (1987, 1989), Arun Art Centre (1987), Bennet Galleries, U.S.A. (1988), Bourne Gallery (1992, 1994, 1995, 1996, 1998), David Messum W1 (1993, 1994), John Noott (1995, 1997), Nevill Gallery (1998), Jerram Gallery (1999); mixed exhbns.: Medici Gallery, W1; H.C. Dickins, W1; Mall Galleries (R.O.I.); Royal Academy Business Art Galleries, W1; Southampton A.G.; Bruton Gallery, Somerset; Southwell Brown Gallery, Richmond; Bourne Gallery, Reigate; David Curzon Gallery, London SW19; Century Galleries - Hartley Wintney and Henley-on-Thames; Nevill Gallery, Canterbury; Omell Galleries - London W1 and Ascot; Kingsmead Gallery, Bookham; Wykeham Gallery, Stockbridge; H.C. Dickins, Bloxham; David Messum, Cork St. W1; Burlington Paintings, W1; John Noott, Broadway, Worcs.; Ashgate Gallery, Farnham; Jerram Gallery, Salisbury; D'Art Gallery, Dartmouth; Walker Gallery, Honiton; Alexander Gallery, Bristol; W.H. Patterson, London, W1. *Works in collections:* private collections in U.K. and world-wide. *Commissions:* not accepted. *Works Reproduced:* by the Medici Society, Kingsmead Publications, Bucentaur Gallery, Royle, Rosenstiel's, Almanac Gallery and Country Cards; in numerous periodicals and books; on ITV and BBC TV, etc. *Signs work:* "Mervyn Goode." *Address:* Lane Copse, Hawkley, Hants. GU33 6NS.

GOODFELLOW, Peter George, 2nd Class Honours, Central School of Art, London. *Medium:* collage, oil, watercolour, prints. *b:* Middlesbrough, 14 Jun 1950. *s of:* Tommy & Joan Goodfellow. *m:* Jean. *Educ:* Bede Hall Grammar School, Billingham. *Studied:* Middlesbrough College of Art, Central School of Art, London. *Exhib:* V&A, Duncan Miller, Osbourne, Lennox (London); Open Eye, Edinburgh; Art from Scotland (New York, USA); Riverside, Lost, Duff House (N.E.Scotland); Iona House (Oxfordshire); Biscuit Factory (Newcastle); Tracey McNee (Glasgow); Leith Gallery (Edinburgh). *Works in collections:* Conoco, Cidel Bank, Saab-Scania, BTelecom, Penguin, Saatchi & Saatchi, Qantas, V&A, Collins, Glenfiddich, BBC, BASF. *Commissions:* private chapel for Philip Astor (Hon); 24 panel paintings and 3 stained glass windows, Migvie, Aberdeenshire. *Publications:* various publications, periodicals, etc. *Official Purchasers:* many. *Works Reproduced:* many. *Principal Works:* Currently large scale expressionist oil landscapes. *Recreations:* painting, stamp collecting, watching football, driving. *Address:* The Lost Gallery, Strathdon, Aberdeenshire AB36 8UJ. *Email:* Jean@lostgallery.co.uk *Website:* www.lostgallery.co.uk

GOODMAN, Pamela Clare, BA Hons Fine Art; City & Guilds Cert.in Teaching Adult Education. *b:* Ottery St.Mary, Devon, 13 Jun 1963. *d of:* Mr.V.Uren & Mrs. M.L.Bale. *m:* divorced. *Studied:* Winchester School of Art. *Exhib:* Exeter Cathedral, Winchester Guildhall, Bell Fine Art Gallery Winchester, numerous open studio shows. *Works in collections:* UK, Canada and USA. *Commissions:* horses, boats/marine work, and many landscape commissions. *Official Purchasers:* many restaurants and Southampton Hospital. *Works*

Reproduced: Cathedral magazine, and cards. *Misc:* demonstrations for art societies. *Address:* 5 West End Close, Winchester, Hampshire, SO22 5EW.

GOODMAN, Sheila, SWA (1995); Dip AD (Graphic Design). *Medium:* oil, acrylic, pastel. *b:* Bolton, 1949. *m:* Philip. *Studied:* High Wycombe College of Art (1966-69). *Exhib:* RA, RWA, Mall Galleries. *Works in collections:* Hunting Management Services Group Ltd., Hampshire County Council. *Works Reproduced:* prints made by Rosenstiels and Dayfold. *Signs work:* 'Sheila Goodman'. *Address:* Chapel House, Kingston, Ringwood, Hants BH24 3BJ. *Email:* info@sgart.co.uk *Website:* www.sgart.co.uk

GOODWIN, Leslie Albert, M.B.E.,RI, ROI, RWA; artist in oil, water-colour, pastel, book illustrator; Chairman, Leicester Soc. Artists. *b:* Leicester, 13 Jun 1929. *s of:* Joseph Henry Goodwin. *m:* Elizabeth Whelband. one *s.* one *d.* *Studied:* Leicester College of Art (1949-55). *Exhib:* R.A., R.W.A., R.I., P.S.; six one-man shows, Vaughan College, Leicester University; mixed shows, Leicester A.G. *Works in collections:* English Electric - Nuclear Power Division; Bristol Old Vic Co.; Leicester Royal Infirmary; various public collections; N.H.S. Founder `Asterisk' Soc. of Artists; broadcaster/art critic for B.B.C. Art Critic for 'The Leicester Mercury'. *Commissions:* several for 'Geest'. *Works Reproduced:* The Artist, Artist and Illustrators, 'The Wednesday Painter'. *Address:* The Studio, 28 Lubbesthorpe Rd., Braunstone, Leics. LE3 2XD.

GOOSEN, Frederik Johannes (Frits), V.B.K.H'sum (1981), R.S.M.A. (1990), E.K.C. (1992), K.V. Gooi & Vechtstreek (1993); artist in oil and water-colour; 1988 Award of Excellence - Mystic Seaport; 2001 Rudolph J Schaefer Award - Mystic Seaport; 2002 The Peoples Choice Award - City of Enkhuizen. *b:* Hilversum, 13 Dec 1943. *m:* M.R. Bekenkamp. two *s.* *Educ:* self-taught. *Exhib:* Great Britain, Switzerland, Norway, U.S.A., Germany, The Netherlands. *Works in collections:* Mystic Seaport Museum, C.T., and several public bldgs. in Holland. *Signs work:* "F.J. Goosen." *Address:* Waterschapslaan 14, Blaricum, Holland. *Website:* www.fritsgoosen.nl

GORALSKI, Waldemar Maria, sculptor in silver and amber, jewellery designer, architect. *b:* Lwow, 2 Jan., 1942. *s of:* Olgierd Goralski, M.Sc., engineer. *m:* Agnieszka, M.Sc. *Studied:* Faculty of Architecture and Dept. of Sculpture and Painting, Gdansk Polytechnic (1962-68). Artistic acknowledgement, Fachhochschule Köln, Dept. of Art and Design (1981). *Works in collections:* Arts Gallery Centre, University of London; Polish Culture Inst., London; Sac Freres, London; Museum Zamkowe, Malbork; Galerie Walinska, Arnhem; Galerie Konstrast, Nijmegen; Kunst-Treff Galerie, Worpswede; Old Warsaw Galleries, Alexandria, Virginia; Aleksander Galleries, St. Petersburg, Florida; Amber Gallery, Skodsborg, Copenhagen. *Signs work:* "W. Goralski" or "W.G." *Address:* Einigkeitstr. 34, D-45133 Essen. Germany.

GORDON-LEE, Michael, A.L.I. (1977); landscape architect, garden designer and calligrapher. *Medium:* works in pastel, oil, pencil, and sculptures in wood. *b:*

Harrow, 1943. widower. one *s.* one *d. Educ:* Whitehawk Boys School. *Studied:* Hammersmith College of Art and Building, Chester Art College, Liverpool, and Southern France. *Exhib:* Manchester Academy, Pastel Soc. (Mall Galleries), R.W.A., Theatr Clwyd, Mold, Cheshire Artists, Finalist Look North TV painting competition (1984), Merseyside Artists, Frodsham Arts Centre, Black Sheep Gallery, Hanover Gallery, Grosvenor Museum Chester, and in Southern France. *Works in collections:* Grosvenor Museum, Chester; and public and private collections worldwide. *Commissions:* Grosvenor Museum, Chester; Rexel Ltd.; private. *Official Purchasers:* Grosvenor Museum, Chester; Rexel Ltd. *Signs work:* "GORDON-LEE". *Address:* 2 Orchard Cottages, Eaton Rd., Tarporley, Cheshire CW6 0BP. *Email:* michael@gordon-leestudio.fsnet.co.uk

GOUGH, Paul James, M.A. (1985), Ph.D. (1991), R.W.A. (1998); artist in pastel and chalk; Dean, University of West of England, Bristol; Head of Painting, Bristol Polytechnic. *b:* Plymouth, 27 Mar 1958. *m:* Kathleen. one *s.* two *d. Studied:* Wolverhampton Polytechnic (1976-79), R.C.A. (1980-85). *Exhib:* Watermans Centre, Solomons, London; Bristol, Lancaster, Swindon, Manchester, Harlech biennale, Ottawa, Paris. *Works in collections:* Imperial War Museum, Royal Marines, Royal Artillery, Pirelli, Lord Rothermere, Canadian War Museum. *Publications:* articles and chapters in numerous academic journals. Television presenter: Art Show (BBC2 1998), Canvas (HTV 1995-99). *Signs work:* "P.J. Gough." *Address:* 136 Stackpool Rd., Southville, Bristol BS3 1NY. *Website:* www.amd.uwe.ac.uk/vortex/

GOUGH, Piers, CBE (1998); RA (2001); RIBA; AA DIP; Hon.Fellow, Queen Mary, Univ. of London (2001); D. Univ. Middlesex (1999); FRSA. *Medium:* architect. *b:* Brighton, 24 Apr 1946. *s of:* Peter & Daphne Gough. one *s. Educ:* Uppingham School. *Studied:* Architectural Association School (1965-71). *Exhib:* Luryens Exhibition (1982); Regency Galleries (2003); National Portrait Gallery; 'Saved' Exhibition, Hayward Gallery (2003). *Commissions:* Principal Buildings: Phillips West, Bayswater (1976); China Wharf (1988); The Circle, Bermondsey (1990); Craft, Design and Technology Building (1998); two boarding houses, Bryanstone School (1994); Cochrane Square, Glasgow (1994); Street-Porter House (1998), 1-10 Summer Street, Clerkenwell (1994); Crown Street Generation Project, Gorbals (1991-2004); Westbourne Grove Public Lavatories (1993); Brindley Place Cafe (1995-96); Soho Lofts (1995); Leonardo Centre (1995); Samworths Boarding House, Uppingham School (2000-01); The Glass Building, Camden (1996-99); Camden Wharf, Camden Lock (1996-2002); Green Bridge, Mile End Park (1997-2000); Westferry Studios, Isle of Dogs (1999-2000); Bankside Central (2000-02); Allen Jones Studio, Ledwell (2000-1); Site A, Edinburgh Park (2000-01); Tunnel Wharf, Rotherhithe (2001); Fulham Island (2001-02); Ladbroke Green (2002-); Queen Elizabeth Square and Crown Street Corner, Gorbals (2003-04); Steedman Street, SE17 (2006); Bling Bling Building, Liverpool (2006). *Publications:* English Extremists (1998); Shock of the Old (Ch4 TV series, 2000); CZWG Brochure (2006). *Recreations:* swimming, parties. *Clubs:* Arts, Groucho. *Signs work:* "Piers Gough". *Address:* CZWG Architects

LLP, 17 Bowling Green Lane, London EC1R 0QB. *Email:* p.gough@czwgarchitects.co.uk *Website:* www.czwgarchitects.co.uk

GOW, Neil, sculptor in wood, small and large scale (outdoor). Abstract and semi figurative. *b:* Greenford, Middx., 22 Mar 1940. *s of:* Herbert Nelson Gow (decd.). *m:* Jean Evans. one *s.* one *d. Educ:* Fitzgeorge, Malden, Kingston Technical College. *Exhib:* R.W.A., S.W.A., Amnesty International Sculptures (Bristol and London), Henry Brett Gallery, 5D Gallery, Kennys Galway, etc. *Commissions:* Monmouthshire Council (outdoor figures at Tintern and Abergavenny); various Monmouthshire schools and day centres; Ballard School; Sustrans; Wotton-under-Edge Town Council; Forestry Commission; various private individuals. *Clubs:* Glos. Soc. of Artists. *Misc:* participate in demonstration/display sculpting. Studio visits by appointment. *Address:* Brownshill Cottage, Brownshill, Stroud, Glos. GL6 8AG. *Email:* neil.gow3@virgin.net

GRAA JENSEN, Lisa, B.A. (Hons.) (1978), R.I. (1996), A.O.I. (1994); illustrator and painter in water-colour, pen and ink. *b:* Copenhagen, Denmark, 2 Mar 1953. *m:* J.A. Hendrich, M.A. one *s.* one *d. Studied:* Sir John Cass School of Art (1974-75), Camberwell School of Art (1975-78, John Lawrence). *Represented by:* Llewelyn Alexander Gallery, London; Bridgeman Art Library. *Exhib:* R.I., Mall Galleries mixed shows, C.C.A. Galleries, numerous exhbns. in South East, work available at Alresford Gallery, Hants., Llewelyn Alexander Gallery, London, Fine Art UK, Ledbury. *Works Reproduced:* Fine Art prints for Rosenstiels and C.C.A Galleries, cards for Royle, Paperhouse, Kingsmead, Royal Academy Enterprises, Medici, Cambridge University Press; Kestral Books, Hamlyn, BBC Publications, Radio Times, Heinemann Macmillan. *Recreations:* Travels with narrowboat. *Signs work:* "GRAA JENSEN." *Address:* 45 Wodeland Ave., Guildford, Surrey GU2 4JZ. *Email:* lisa@jollypix.co.uk *Website:* www.lisagraajensen.com

GRABOWSKA, Kathleen, SAF for 20 years until 1994; SWA; SOFA; bronze medal Paris Salon (1979); Silver Medal Paris Salon (1980). *Medium:* fine embroidery on silk-'needle painting'. *b:* Teddington, Middx, 10 Jan 1919. *d of:* Air Comm. D.G.Boddie. *m:* decd. one *s. Educ:* Sleaford and Kesteven High School for Girls; Twickenham County School for Girls. *Studied:* self taught. *Exhib:* SAF; Paris Salon; Enghien Monaco, New York, Montreal, Biarritz; SWA (annually), Mall Galleries; SOFA (annually), Llewelyn Alexander Gallery; in Switzerland since 1977: Basel, Avenches, Greifensee and other small galleries, solo and group exhbns. *Commissions:* ordinary people commission me to do a portrait of their dog/cat because they love them. *Principal Works:* cat and dog portraits, views. *Recreations:* gardening. *Misc:* started in art at the age of 50. *Signs work:* 'GRABOWSKA'. *Address:* Allmendstrasse 12, CH-4410 Liestal (BL), Switzerland.

GRACIA, Carmen, R.E.; etcher and engraver in colour, painter in oil. *b:* Mendoza, Argentina, 18 May 1935. *m:* E.T. Rockett (decd.). one *s. Educ:* Escuela de Bellas Artes, Mendoza, Argentina. *Studied:* L'Atelier 17, Paris, under Stanley Hayter (1960-1964), Slade, London, under Anthony Gross (1965-1966). *Exhib:* 32 solo, and 300 group exhibs. *Works in collections:* 30 in museums and public collections. *Official Purchasers:* Museums and Public Collections: London: Victoria and Albert Museum; British Museum; Slade School of Art; Dulwich Library; St Pancras Library; The Government Art Collection. Paris: La Biblioteque Nationale; Collection du Musee de la ville. Skopje: Musee d'art Contemporaine. Oslo: National Gallery. U.S.A.: Public Gallery, New York; Pan American Union Collection, Washington; Public Library, Boston; University of Alberta Print Center. South London Art Gallery. City Literary Institute. Sao Paolo: Musee d'Art Contemporaine. Worcestershire: Dudley Art Gallery. Leicester: City Art Gallery; Royal Infirmary. Lancashire: Oldham Art Gallery. Berlin: The Graphotek. Yorkshire: Wakefield Art Gallery; Scarborough Art Gallery. Wales: Newport Art Gallery. Gloucestershire: Cheltenham Art Gallery and Museum. Oxford: Ashmolean Museum. Cambridge: Fitzwilliam Museum. Buckinghamshire: County Museum. *Clubs:* Art Societies: Greenwich Printmakers Assocn.; Fellow, Royal Society of Painters Printmakers. *Signs work:* "CARmen GRAcia." *Address:* 65 Westover Rd., High Wycombe, Bucks. HP13 5HX.

GRADIDGE, Daphne, painter in water based media. *b:* Salisbury, 19 Sep., 1953. *Studied:* theatre design at Nottingham School of Art and at The Slade. *Exhib:* London, Hampshire and Dorset. *Works in collections:* private collections in England, Ireland, Australia and Norway. *Commissions:* mural paintings for the Chelsea and Westminster Hospital and other hospitals in London, Hampshire and Wiltshire. *Misc:* Member of the Art Workers Guild. *Signs work:* "DG." *Address:* Ashlands Southampton Road Landford, Salisbury Wiltshire, SP5 2EQ. *Email:* daphne.gradidge@virgin.net *Website:* www.jonathancooper.co.uk

GRAHAM, Brian, Kenneth, Frederick, inaugural Bournemouth International Festival Artist (1994); first prizewinner, Royal West of England Academy's annual exhibition (1992); painter in oil/acrylic. *b:* 26 Aug., 1945. *m:* Carol. two *s. Educ:* Poole Grammar School. *Studied:* part time at Bournemouth College of Art (1960-1962), but mainly self taught. *Exhib:* over twenty solo exhibitions, (two in Cork Street); many group shows. *Works in collections:* Dorset County Museum; Skandia Life Assurance Company; Poole Borough Council; Parnham House, Bournemouth University. *Publications:* Ochre and Ice. Brian Graham. Essay by Paul Hyland. *Misc:* Represented by Hart Gallery, Islington, Cornwall and Nottingham. *Signs work:* "Brian Graham." *Address:* Central House, Mount Pleasant Lane, Swanage, Dorset BH19 2PN.

GRAHAM, Carol, Dip.A.D.; artist in oil; Council mem. R.U.A.;. *b:* Belfast, 17 Apr., 1951. one *s.* one *d. Studied:* Belfast College of Art and Design (1969-74). *Exhib:* Ulster Museum, N.I. Arts Council, Tom Caldwell, The Engine Room, The

Guinness Hopstore Gallery, Elaine Somers Hollywood. *Works in collections:* Trinity College Dublin, National Self-portrait Collection Limerick, Ulster Television, Ulster Museum, Belfast City Council, D.o.E., N.I.E. Veridian. *Commissions:* portraits: Dr. Mary Robinson (President), James Galway (Flautist), Lord Grey (Governor N.I.), Lord Lowry, Sir Ian Frazer. *Publications:* cover, Bernard McLaverty Secrets; cover, The Blue Globe (poetry). *Clubs:* R.U.A. *Signs work:* "CAROL GRAHAM." *Address:* 1 Glenmore Terr., Lisburn, N.I. BT27 4RW.

GRAHAM, David, RP, ARCA; painter in oil. *b:* London, 20 May 1926. *m:* Luz Martha. *Studied:* Hammersmith School of Art, St. Martin's School of Art, Royal College of Art (1948-1951). *Exhib:* Retrospective at Herbert Art Gallery and Museum, Coventry - 100 Paintings of Israel (1987).One-man show Mall Galleries (1971), Bruton St. Gallery. *Works in collections:* London Museum, Barbican, Guildhall Art Gallery, Arts Council, Belgrave House Art Collection, Coca Cola Ltd, National Hospital for Neurology and Neurosurgery, etc. *Publications:* video - A Painters View. *Clubs:* Chelsea Arts. *Signs work:* "David Graham." *Address:* 1A Walton Street, London SW3 2JD. *Email:* davidgraham@davidgraham-rp.com *Website:* www.davidgraham-rp.com

GRAHAM, Peter, B.A. Hons. (1980), R.O.I. *b:* Glasgow, 17 Feb 1959. *m:* Valerie. one *s. Studied:* Glasgow School of Art (1976-80). *Exhib:* Bourne Gallery Reigate, Llewellyn Alexander Ltd, London, many mixed shows including R.S.A., R.O.I., R.S.M.A., and R.I. *Works in collections:* British Council, Nan Yang Academy, Singapore, Lord Morton, Lord Max Rayne, Lady Graham, Lady Nairn, Ernst & Young, Glasgow. *Publications:* 'An Introduction to Painting Still Life' (Apple, 2004). *Clubs:* Glasgow Art Club. *Signs work:* "Peter Graham" or "Graham." *Address:* 57 Kirklee Rd., Glasgow G12 0SS, Scotland.

GRAINGER, Chris Rowan, *Medium:* acrylic paint, oil, watercolour, drawing, sculpture. *b:* Epsom, Surrey, 17 Jan 1936. *s of:* Geoffrey Grainger. *m:* Juliet Grainger. two *s.* one *d. Educ:* Kings School, Canterbury. *Studied:* Bath Academy, Bristol Old Vic School. *Represented by:* Llewelyn Alexander Gallery, London. *Exhib:* Alwin Gallery, London, Royal Festival Hall; Llewelyn Alexander, Royal Academy, London Group, Ben Uri Gallery, Boundary Gallery, Anthony Hepworth, Cork Street Gallery. *Works in collections:* Health Trusts, LAMDA, Baha'is of Great Britain, private worldwide. *Commissions:* several private. *Publications:* "The Gate" (2006); "Baynton House" by R.H.Pearson (cover). *Works Reproduced:* Arts Review, Daily Telegraph, magazines. *Principal Works:* "Crucifixion" in St.Thomas More Church, "Misslala", "The Dawnbreakers". *Recreations:* theatre. *Signs work:* "ROWAN GRAINGER". *Address:* 3 The Old Batch, Ashley Road, Bradford-on-Avon, BA15 1TL. *Email:* chrisrgrainger@tiscali.co.uk *Website:* www.rowangrainger.com

GRANDVAL, Sophie, *Medium:* painter in oil and watercolour. *b:* Paris, 1936. *Educ:* self-taught. *Represented by:* Bernard Chauchet, 20 Brechin Place, London

SW7 4QA. *Exhib:* Galerie Lucièn Durand, Paris (1966), Galerie Delpire, Paris (1970), Olympia London (2002). *Works in collections:* Mrs. Paul Mellon, Upperville, Virginia; Mr. Oliver Hoare, London; Idries Shah, France. *Commissions:* Plan ou 'Jardin Potager du Roi a Versailles' (Mrs.Mellon). *Publications:* 'Graphis' (1966), 'Creation' No3 (Yukasu Kamekura)(1990). *Works Reproduced:* posters: 'Passé, Present, Futur', 'La Main de Fatima', 'Pissenlit'. *Recreations:* feeding wild birds. *Misc:* in 1960 hand-painted silk fabrics for Balenciaga, Givenchy, Dior. *Signs work:* Sophie Grandval. *Address:* Neuville St.Amand-Roche, Savine 63890, France.

GRANGER-TAYLOR, Nicolas, artist in oil;. *b:* London, 18 June, 1963. *Educ:* Latymer Upper School, Hammersmith. *Studied:* Kingston Polytechnic (1981-82), Bristol Polytechnic (1982-85), R.A. Schools (1987-90). *Exhib:* Royal Festival Hall (1986, 1987, 1988), N.P.G. (1987, 1990), R.A. Summer Exhbn. (1987, 1989, 1992), Cadogan Contemporary (1989, 1990); one-man shows Cadogan Contemporary (1988), Waterman Fine Art (1991, 1993). *Signs work:* "N. Granger-Taylor" or "N.G.T." *Address:* c/o Waterman Fine Art Ltd., 74a Jermyn St., London SW1Y 6NP.

GRANT, Keith Frederick, ARCA; landscape and portrait painter. *b:* Liverpool, 10 Aug 1930. *m:* Hilde Ellingsen-Grant. one (decd.) *s.* two *d. Educ:* Bootle Grammar School, Lancs. *Studied:* Willesden School of Art, Royal College of Art. *Represented by:* Portland Gallery, London; Galleri Arctandria, Oslo. *Exhib:* Fitzwilliam Museum, Cambridge; National Gallery of Iceland, Reykjavik; National Gallery of Modern Art, Edinburgh; Municipal Museum of Madrid; Hayward Gallery, London, and elsewhere. *Works in collections:* Mural/mosaics, Charing Cross Hospital, London (1979), Gateshead Metro Station (1981/83), Beaverbrook Foundation, Peter Stuyvesant Coll., Arts Council of G.B., Contemporary Art Soc., V. & A., Fitzwilliam Museum, Cambridge, Manchester City A.G., National Gallery of N.Z., Government Art Collection, London, and other public and private collections at home and abroad. *Commissions:* paintings and stained glass – Charing Cross Hospital, London (2000); 2004 winner of competition to execute a new altarpeice for Kopervik Church, Karmoy, Norway 'Triptych of The Lamb', 2005 altarpiece installed and dedicated; 2001/2002 co-inaugurated Artists and Writers programme of the British Antarctic Survey. *Works Reproduced:* 'Art in Design', London, Harper-Collins Publishers, London. *Clubs:* Garrick. *Signs work:* "Keith Grant" or "K. F. Grant." *Address:* Gamlegata P.B. 7, 3834 Gvarv, Norway. *Email:* kefreg@frisurf.no

GRANT, Marianne, NS (1977), FRSA (1975); painter in oil. *b:* St. Gallen, Switzerland, 1931. widowed. one *s.* one *d. Educ:* High School, Zürich. *Studied:* Art Colleges in Zürich and Geneva. *Exhib:* one-man shows BH Corner Gallery, Cooling Gallery, Century Galleries, Henley-on-Thames, East London Gallery, El Greco Gallery, Royal Northern College of Music, Debenhams of Romford, Austria, Germany, Switzerland. *Works in collections:* Ernst Waespe (Zürich), Standard Telephone and Cables Ltd., Arts Centre Hornchurch. *Works*

Reproduced: Fine Art Prints for 'Prints for Pleasure' and Peinture. *Clubs:* N.S., Essex Art. *Signs work:* "Marianne Grant." *Address:* Erlenwiesenstrasse 18, 8152 Glattbrugg (Zürich), Switzerland. *Email:* jagra@bluewin.ch *Website:* www.swissart.ch/marianne-grant

GRANVILLE, artist in acrylic;. *b:* Liverpool, 12 July, 1945. *Studied:* Northwich College of Art (1961-65), Southport College of Art (1980-82). *Exhib:* Over sixty exhbns. in England and Spain since 1967. *Works in collections:* Museo de la Real Academia de Bellas artes de San Fernando, Madrid. *Works Reproduced:* various exhbn. catalogues, articles and reviews; painting reproduced as cards and prints around the world. *Misc:* Work inspired by Spain and all things Spanish. *Address:* 14b Derwent Ct., Troutbeck Rd., Liverpool L18 3LF.

GRANVILLE-EDMUNDS, Peter Donald, 1st Class BA (Hons); MA Fine Art; 'Highly Commended' RBSA. *Medium:* oil, watercolour, drawing, mixed media. *b:* Hertford, 22 Sep 1931. *s of:* A.D.Edmunds & G.Edmunds. *m:* Erica M.Granville-Edmunds. one *s.* one *d. Educ:* Malven House, Herts; Cooper School, Herts. *Studied:* St.Albans School of Art (now Univ.of Hertfordshire); Cheltenham & Glos. College of Higher Education; University of Gloucestershire. *Represented by:* Design and Artists Copyright Society; The Art Group; Saatchi and Saatchi. *Exhib:* University of London; Queen Elizabeth Conference Centre, London (2000); Mall Galleries (2001, 2004); Cheltenham Open (2002, 2004); Royal West of England Academy (2005); RBSA (2005); Martins International Fine Art Gallery / Ovada Gallery, Oxford (2005); Mariners Gallery, St.Ives, Cornwall. *Works in collections:* University of London, Deutsche Bank, Writers Guild London, Glos. National Health Trust; private collections in USA, Europe and Switzerland. *Works Reproduced:* numerous catalogues. *Recreations:* influences of music and zen, calligraphy, Englishness. *Clubs:* Cheltenham Group of Artists. *Misc:* selected for Biennale de'll Arte Contemporania, Florence, Italy. *Signs work:* 'PETER D. GRANVILLE-EDMUNDS'. *Address:* The Old Stables, 156 Hewlett Road, Cheltenham GL52 6TT. *Email:* peter@artistspace.net *Website:* www.artistspace.net

GRAVETT, Guy Patrick, photographer and painter;. *b:* Wye, Kent, 2 Nov., 1919. *Educ:* Lewes County Grammar School. *Studied:* Brighton College of Art (1937-39) under Sallis Benney, Laurence Preston and Walter Bayes. *Exhib:* various. *Clubs:* Royal Ocean Racing. *Signs work:* "Gravett" or "Guy Gravett" followed by year. *Address:* Hope Lodge, 41 Hassocks Rd., Hurstpierpoint, Sussex BN6 9QL.

GRAY, Elizabeth, LRAM; self taught painter in water-colour. *b:* Scarborough, Yorks, 1928. *d of:* John W. Gray. *m:* Dr. David Trapnell. two *s. Educ:* Queen Margaret's School, Yorks. *Exhib:* one-man shows, Tryon Gallery, London; Sportsmans Edge Gallery, N.Y.; Old Amersham, Bourton-on-the-Water, etc. *Works in collections:* Nature in Art, Gloucester; The Bank of England; Leigh Yawkey Woodson Art Museum, Wausau, Wisconsin, U.S.A. *Commissions:*

Nature in Art, Gloucester, Leigh Yawkey Woodson Art Museum, Wausau, WI, U.S.A. *Publications:* The Wild and the Tame by H. Beamish (1957). *Signs work:* "Elizabeth Gray." *Address:* Wallsworth Hall, Twigworth, Gloucester GL2 9PA.

GRAY, Euan, Alexander, Alastair Salvesen Travel Scholarship (2004); Cuthbert New Young Artist Award, RGI (2003); British Institution Award Fund, RA (1996); Nat West Prize for Art Shortlist (1994, 1996); Aeneas Travel Award, RA (1995); Alexander Grahame Munro Travel Award (1995); RSA Morrison Portrait Award (1993). *Medium:* oil, watercolour, drawing, etching. *b:* Aberdeen, 13 Jun 1973. *Studied:* Slade (MFA, 1995-98); Edinburgh School of Art (BA First Class Painting and Drawing, 1991-95). *Exhib:* solo: RSA 'Journey' (2005); mixed: The Hunting Art Prizes (2004); Transmission Expo (2003); the 228th RA Summer Exhbn (1996); BP Portrait Exhbn, NPG (1994). *Misc:* BBC Radio Scotland: 'The Arts Show' (26 May 2005). *Signs work:* 'Euan Gray'. *Address:* 27 Marchbank Road, Bieldside, Aberdeen AB15 9DJ. *Email:* euan_a_gray@yahoo.co.uk

GRAY, Jane Campbell, ARCA, FMGP; stained glass artist; Liveryman, Worshipful Company of Glaziers (1983). *b:* Lincoln, 1931. *d of:* Archibald Denison Ross, M.A. *m:* Kiril Gray. two *d. Studied:* Kingston School of Art (1949-52); Royal College of Art (1952-55) under Lawrence Lee and assisted him with Coventry Cathedral nave windows (1955-58). *Exhib:* Examples of work: Uxbridge - St. Margaret's; Civic Centre entrance screen and Alphabet of Flowers in Marriage Room; Hillingdon Hospital Chapel (26 panels); St. Peter's, Martindale, Cumbria (15 windows); Pitminster, Somerset (East window, 1989); Shrewsbury Abbey (1992, 1997); Apothecaries' Hall; Glaziers Hall, London Bridge; Christchurch Priory (1999); St. Sarkis Armenian Church, London, 2000; St Nicholas, Blakeney, Norfolk (2002); St.Oswald's Oswestry (2004); St. Petroc, Inwardleigh, Devon (2005); Holy Nativity, Knowle, Bristol (2006). *Misc:* Over 160 lights in 60 churches; coats-of-arms, domestic windows. *Signs work:* "Jane Gray". *Address:* Ferry Cottage, Shrawardine, Shrewsbury SY4 1AJ.

GRAY, Leonard I.H., DA (1952), RSW (1968); John Laing (London) Landscape Painting Award (1996, 97, 98); Major Award RSW (1995); May Marshall Brown Award, RSW (1984); Stirling University Award (1981); Educational Institute of Scotland, Award (1980). *Medium:* gouache and mixed media. *b:* Dundee, Scotland, 21 Apr 1925. *s of:* Edward E.M.Gray. *m:* Alexina. one *s.* one *d. Educ:* Harris Academy, Dundee, Scotland. *Studied:* Edinburgh College of Art (1952) Post-Grad. Scholar (1952-53). *Represented by:* Roger Billcliffe Gallery, Glasgow. *Exhib:* RA London, RSA, RSW Edinburgh, Glasgow Institute, Mall Galleries London, Aberdeen Gallery, Scottish Arts Council, Edinburgh, London. *Works in collections:* H.R.H. the Duke of Edinburgh's Collection Edinburgh, Royal Scottish Academy, Edinburgh's City Gallery, Greenock Art Gallery, National Trust, Regional Authorities of Aberdeen, Edinburgh, Dundee and Highland, Heriot Watt and Aberdeen Universities, Royal Bank of Scotland, Clydesdale Bank, Royal Hospitals, Edinburgh and Aberdeen.

Publications: 'Scottish Water-colour Painting' (1979), 'Dictionary of Scottish Art' (1994 & 2006). *Official Purchasers:* see work in collections. *Signs work:* 'Leonard Gray'. *Address:* 27 Marchbank Road, Bieldside, Aberdeen, AB15 9DJ.

GRAY, Stuart Ian, lithographer, painter in water-colour; water-colour officer, NS. *b:* 19 Apr 1925. *s of:* Alfred Stephen Gray. *Educ:* Streatham Grammar School. *Exhib:* RSMA, RI, Mall Galleries, Guildhall. *Works Reproduced:* in British Marine Painting by Denys Brook-Hart. *Signs work:* "Stuart Gray." *Address:* Osborne Cottage, York Ave., E. Cowes, I.O.W. PO32 6BD.

GREAVES, Derrick Harry, ARCA (1952). *Medium:* oil, watercolour, drawing, prints, collage. *b:* Sheffield, 5 Jun 1927. *s of:* Harry Greaves, steel worker. two *s.* one *d. Educ:* apprentice signwriter (1943-48). *Studied:* R.C.A. (Carel Weight, John Minton, 1948-52); British School, Rome (1952-54). *Represented by:* James Hyman Fine Art, London. *Exhib:* Contemporary Art Soc., Venice Biennale, Pushkin Museum Moscow, John Moores, Carnegie International Pittsburgh, R.A., Mall Galleries; one-man shows: Beaux Arts, Zwemmer, Inst. of Contemporary Arts, Bear Lane Oxford, Belfast and Dublin, Whitechapel Gallery, Cranfield Inst. of Technology, Monika Kinley, City Gallery Milton Keynes, Hart Gallery London, Galerie Daniel Wahrenberger, Zurich. *Works in collections:* A.C.G.B.; Bank of Ireland, Dublin; N.Y. Public Library; Leeds, Reading, Sheffield, Southampton and Walker A.Gs.; Wesleyan University, Chicago; Tate Gallery; British Museum and worldwide. *Publications:* folios and books: Also (with Roy Fisher) 1971; Songs of Bilitis (1977); Sanscrit Love Poems (1987). *Signs work:* "Derrick Greaves". *Address:* The School, Weston Longville, Norwich, Norfolk NR9 5JU.

GREAVES, Jack, ARCA, RWA, Rome Scholar; sculptor in bronze, painter in oil; Visiting Prof. OSU. *b:* Leeds, 24 Sep 1928. *s of:* Joseph Greaves. *m:* Mildred Place. four *s. Studied:* Leeds College of Art, RCA, Gulbenkian Rome Scholar. *Exhib:* Zwemmer, RA, OSU Gallery, Bruton Gallery, Vorpal, NY and San Francisco, Gallery 200, Columbus, Ohio. Blake Gallery, York. *Works in collections:* Coventry A.G.; Bristol A.G.; Arts Council; RWA; National Revenue Corp., USA; Columbus Museum, State Saving, USA; Sirak Collection, USA; Children's Fountain Cols., Ohio, USA. *Commissions:* Naiad Fountain, Capital Sq. Columbus, Ohio; The Guardian, Police Memorial Gdn., Toledo; Christ Teaching, Cols., Ohio; Family Planning Bldg., Tucson, Arizona; Children's Fountain, Cols., Ohio, U.S.A. *Signs work:* "Greaves." *Address:* The Long House, Snainton, Scarborough, N.Yorks. YO13 9AP.

GREEN, Alfred Rozelaar, RWA (1994); Mem. Paris Salon, Comparaisons Nationale Beaux Arts; painter in oil, pastel, charcoal. *b:* London, 14 Jul 1917. *m:* Betty Marcus. three *s. Educ:* Uppingham, Cambridge (two years engineering). *Studied:* Central School of Arts and Crafts (1937, Meninsky, Roberts); Academie Julian, Paris; Atelier Marcel Gromaire (1938-39). *Exhib:* London, Paris, Brussels, The Hague, Bale, Lyon, Marseille, New York, Strasbourg, Cannes, Le Havre,

Bath, Bristol. *Works in collections:* Musee d'Art Moderne, Paris, Strasbourg, Prefecture Vaucluse, Musee d'Orange, Ashmolean, Oxford. *Commissions:* Maternity Hospital, Argentan, France. *Publications:* 40 years of Painting (Ed. Draeger, 1988). Pastels and Dessins (Stipa 2002). *Misc:* Founded and directed Anglo-French Art Centre, St. John's Wood, London. In 1946 combined art school and 'Académie Libre' with gallery showing works of artists from Paris (André Lhote, Lurcat, Germaine Richier, Saint-Saens, Couturier, Domginuez, etc.) who taught and lectured during their exhbns. Centre closed 1951. *Signs work:* "A. Rozelaar Green." *Address:* 11 Rue de Savies, 75020 Paris. France. *Email:* abrozelaargreen@gmail.com *Website:* new site coming soon

GREEN, Anthony, RA (1977), DipFA Slade (1960), Harkness Fellow (1967-69); elected Fellow of University College, London (1991); painter in oil; trustee Royal Academy 2001. *b:* Luton, 30 Sep 1939. *m:* Mary Cozens-Walker. two *d. Educ:* Highgate School, N6. *Studied:* Slade School of Fine Art. *Exhib:* over 100 one-man shows worldwide since 1962. *Works in collections:* Tate Gallery, Arts Council, museums and art galleries in USA, Japan, Brazil, etc. *Publications:* A Green Part of the World (Thames and Hudson). *Principal Works:* Resurrection - A Sculpture, RA 2003. *Signs work:* "Anthony Green," "A. Green," "Anthony," "A.G." or not at all. *Address:* 40 High St., Little Eversden, Cambs. CB23 IHE. *Website:* www.anthonygreenra.com

GREEN, David John, ROI; landscape painter in water-colour and oil;. *b:* London, 23 Feb 1935. *m:* Eileen Ann. two *s. Educ:* Goldington Rd. Secondary Modern, Bedford. *Exhib:* RI, RBA, ROI; one-man shows: London, Cambridge, Bedford. *Works in collections:* Luton Museum, Boston English Gallery. *Commissions:* undertaken. *Signs work:* "DAVID GREEN." *Address:* The Wilden Gallery, Wilden, Beds. MK44 2QH.

GREEN, Diana, *Medium:* oil, prints, pastel and etching. *b:* Warks., 17 Aug 1945. *m:* Michael Green. one *s.* one *d. Studied:* Birmingham College of Art (Graphics and Illustration). *Represented by:* Wren Gallery, Burford, Oxon. *Exhib:* various mixed exhibitions, London, since 1989, including RA Summer Exhbn (2001, 03); RWS Open; Singer and Friedlander; Discerning Eye; Pastel Society, Mall Galleries; solo shows: Islington, London (2000), Tokyo (2003), Southwell Minster, Notts (series 21 etchings'Creation and Fall', 2004), St.Alban's Cathedral, Hertfordshire (2006), Gloucester Cathedral (2008). *Works in collections:* Pilkington Collection. *Publications:* entry in 'Artists in Britain Since 1945', David Buckman; Bristol Art Dictionaries. *Misc:* 'Artist in Residence' Bourton House, Moreton-in-Marsh, Glos (2004). *Signs work:* 'DG' or 'Diana Green'. *Address:* 41 Arlington Square, Islington, London N1 7DT. *Email:* greenponny@yahoo.co.uk

GREEN, Gerald, Dip.Arch. (1978); freelance artist and architectural illustrator in water-colour, oil, acrylic. *b:* Nuneaton, 22 Jun 1947. *m:* Diana. one *s.* one *d. Educ:* King Edward VI Grammar School, Nuneaton. *Studied:* Leicester

Polytechnic. *Exhib:* Sunday Times Water-colour Exhbn., Laing, Mall Galleries, London; Glos. City Art Gallery; Wykeham Gallery, Stockbridge; Priory Gallery, Broadway, Worcs.; Granada Television; 'Not the Turner Prize', Mall Galleries, London. *Commissions:* over 1500 architectural illustration commissions undertaken for both national and international clients. *Publications:* regular contributor to Arts magazines; work featured in eight books, most recently 'Artists Essential Guide to Watercolour'. *Signs work:* 'Gerald Green'. *Address:* 211 Hinckley Rd., Nuneaton, Warwickshire CV11 6LL. *Email:* Gerald@ggarts.demon.co.uk *Website:* www.ggarts.demon.co.uk

GREEN, Lorna, BA Hons.(1982), MPhil (1991), FRBS(2001); site specific environmental sculptor; permanent and temporary projects using varied relevant materials. *b:* Manchester. *m:* David Rose F.R.C.S. (Ed.). two *d. Studied:* Manchester Polytechnic, Leeds University. *Exhib:* throughout U.K., Australia, Austria, Bosnia, China, Germany, Hungary, Ireland, Israel, Japan, Korea, New Zealand, Holland, France. *Commissions:* Leeds University; Cribb's Causeway Shopping Centre, Bristol; Kraftplatzroas, Irdning, Austria; Rochdale Partnership/Canalside S.R.B.; Changchun, China; Beer-Sheva, Israel; Monash University, Melbourne, Australia; Penticton, BC, Canada; South Gloucestershire Council; The Hamptons, Worcester Park, Surrey; Queen Elizabeth Hospital, Gateshead NHS Trust; Newall Green High School, Manchester; Wharton Junior School, Winsford, Green Heart Partnership, Herts; Windmill Hill Primary School, Runcorn; Cheshire County Council; York Art Gallery; Darwen Borough Council. *Signs work:* "Lorna Green." *Address:* Mount Pleasant Farm, 105 Moss Lane, Bramhall, Cheshire SK7 1EG. *Email:* lg@lornagreen.com *Website:* www.lornagreen.com

GREEN, Peter, O.B.E. (1988); Senior Fellow RE; Head of Post Graduate Art Teacher Training, Hornsey College of Art; Dean Faculty of Art and Design Middlesex University; Member (Council) Crafts Council of GB (1985-91); Emeritus Professor Middlesex University (Art & Design). *Medium:* relief printmaker; linocut, woodcut, paper stencil. *b:* London, 10 Jun 1934. *m:* Linda Green. one *s. Studied:* Brighton College of Art; University of London Inst. of Education. *Exhib:* solo: London Graphic Arts (1969-72); Crafts Centre of GB (63); Gallery 273 (63); National Art Gallery of Malaysia, KL (98); major group shows: Zwemmers New Editions (62, 63); London Graphics (68-72); Edinburgh Festival (67); Portfolio Gallery (81); Geffrye Museum (72); Pictures for Schools (60-80); Artmonsky Gallery (99); Gorstella Gallery (06); Bankside Gallery, RE; RA Summer Shows (94-2007); Harley Gallery (07). *Works in collections:* Welsh Arts Council, Walker Art Gallery, Bradford City A.G., Univ. of Wales, Laing A.G., South London A.G., Graves A.G., Towner A.G., Birmingham City Gallery, Cecil Higgins Museum, Bedofrd, Oldham A.G., Exeter City A.G., National A.G. Malaysia; Museum Education Depts. in Detroit, Seattle & Pittsburgh, USA. *Publications:* Creative Printmaking (Batsford, 1964); Introduction to Surface Printmaking (Batsford, 1967); Design Education, Problem Solving and Visual Experience (Batsford, 1975, 77); Working in Art Design (Batsford, 1983);

commissioning Editor, Pembridge Press Design History series (1985). *Signs work:* 'Peter Green'. *Address:* 38 De Walden House, Allitsen Road, St.John's Wood, London NW8 7BA. *Email:* plgreenart@waitrose.com

GREEN, Richard, Dip.AD (1968), MA (1970), FRSA (1988); Curator, York City Art Gallery (since 1977); previously Keeper of Fine Art, Laing Art Gallery, Newcastle upon Tyne (1971-77). *b:* 12 Oct 1946. *s of:* George William Green. *Educ:* Palmer's School, Grays. *Studied:* S.W. Essex Technical College and School of Art; Bath Academy of Art; Goldsmiths' College School of Art (1964-68) studied history of art at University of London, Courtauld Inst. of Art (1968-70). *Publications:* numerous exhbn. catalogues, articles and reviews. *Address:* c/o York City Art Gallery, Exhibition Sq., York YO1 2EW.

GREENBURY, Judith Pamela, RWA (1979); painter in oil, water-colour. *b:* Bristol, 17 Feb 1924. *d of:* Bernard Spielman. *m:* C. L. Greenbury, M.D. (decd.). three *s. Educ:* Badminton School, Westbury-on-Trym, Bristol. *Studied:* West of England College of Art (1943-46) under George Sweet, Slade School (1946-47) under Prof. Schwabe. *Exhib:* RA, RWA, RSPP, NEAC, Bear Lane Gallery, Oxford, Mall Galleries, London, Alpine Gallery, London, Phyllis Court Club, Henley-on-Thames, Gallery Piano Nobile, Holland Park, London. *Works in collections:* RWA, and many private collections. *Commissions:* many portraits of mothers and children. *Publications:* "Spey Portrait: A Memoir of Fishing and Painting on the Spey 1974-1989"; "George Sweet, Painter, Teacher and Friend"; "Piers and Seaside Towns An Artist's Journey", (published June 20 2001)."Jeanne, A Long Farewell" (June 2003). *Works Reproduced:* in all four of my books. *Recreations:* painting and gardening, previously fly-fishing. *Signs work:* "J.G." *Address:* Clarence House, 11 New St., Henley-on-Thames, Oxon. RG9 2BP.

GREENHALF, Bette, B.Sc. (Econ.) Hons. London University, M.A. Multimedia (computer); Postgraduate Printmaking; Dip. Higher Education Fine Art; artist, writer. *b:* London, 28 Dec 1932. *d of:* Archie and Maud Harmer. *m:* Tom Greenhalf (decd.). *Studied:* London University; University of the Arts, London. *Exhib:* London- Royal Academy,Festival Hall, Mall Galleries, Camden Art Centre, Chaucer Festival, Barbican, Artists for Nuclear Disarmament, Gallery of the Future, Loughborough University, Midlands Art Centre, Centre Culturel C.P.Paris, ICA, Venice Biennale, Salon des Artistes Brussels. *Works in collections:* Nelson Mandela, Tony Blair, John Major, Chaucer Heritage Trust, War Child Bosnia, Ken Livingstone, Artists for Nuclear Disarmament, Terry Waite, Tate and National Art Libraries. *Publications:* Who's Who in International Art, British Contemporary Art (1993); artist's books: Punch and Judy; Venice Biennale 1895-1995 (a socio-political history); Etchings & poems: World War I, Tiananmen Square, Chaucer, Hampstead. *Signs work:* "Bette Greenhalf." *Address:* 91 Greenhill, Hampstead High St., London NW3 5TY.

GREENHALF, Robert Ralph, RBA (1982), S.WL.A. (1981), DipAD(Graphics) (1971); artist in etching, woodcut, water-colour and oil. *b:* Haywards Heath, 28 Jun 1950. *s of:* Robert Henry Taylor Greenhalf. *m:* Sally Grace. one *s. Educ:* Haywards Heath Secondary Modern School. *Studied:* Eastbourne School of Art (1966-68), Maidstone College of Art (1968-71). *Exhib:* RA, RBA, S.WL.A., many mixed exhbns. and one-man shows London, England and Wales, Switzerland, Holland, USA, France, Spain, Germany. *Works in collections:* South East Arts, Hastings Museum, Government Art Collection. *Publications:* " Towards The Sea" (Pica Press, 1999). *Signs work:* "Robert Greenhalf." *Address:* Romney House, Saltbarn La., Playden, Rye, E. Sussex TN31 7PH.

GREENSLADE, Suzanne Lyon, BA (Psychology), MA Fine Art. *Medium:* photography. *b:* Atlanta, USA, 24 Jul 1952. *d of:* Barbara & Sam Hirsch. *m:* Malcolm Hird. four *d. Studied:* BA, Psychology-Tulane University, New Orleans, USA (1974); PostGrad Dip, Photography -South Eastern Center for the Arts, Atlanta (1985), MA Fine Art - Howard Gardens, Cardiff (1993). *Exhib:* solo exhibitions: Front Street Gallery, North Carolina, USA (1982), Watershed Media Centre, Bristol (1997), Casa Americana, Valencia, Spain (1999), Tuskegee University, Alabama, USA (2000), University of Salamanca, Spain (2001), Tulane University, New Orleands, USA (2003), Washington Gallery, Penarth, S.Wales (2004), Light House, Wolverhampton (2007). Selected group exhibitions: Univ. of Alabama, USA (1985), Oriel Mostyn (Touring, 1991), Chapter Arts Centre, Cardiff (1992), Impressions Gallery, York, UK (1993), Zelda Cheatle Gallery, London (1993), Noosa Regional Gallery, Queensland, Australia (1996), Howard Gardens Gallery, Cardiff (2006), Eisteddfod Genedlaethol Cymru, Swansea (2006). *Publications:* selected publications: 'Discovering Welshness' (photographs plus one chapter, Gomer, 1992); 'I Spy: Representations of Childhood' (14 photographs, I.B.Tauris, 1999); 'Under the Magnolias: Growing up white in the South' (text plus 85 black and white photographs, Univ. of Valencia, 2004). *Principal Works:* "My Other Mother (A Tribute to Willie"), 'Waking from the Long Sleep'. *Misc:* Taught at Swansea Institute 1986-96. Speaks Spanish, Japanese, Italian and some Welsh. *Signs work:* "S.Greenslade". *Address:* 3 Plasturton Place, Cardiff, CF11 9HP. *Email:* suzgreenslade@hotmail.com *Website:* www.suzannegreenslade.com

GREENSMITH, John Hiram, NDD (1955), ATD (1956), ARWS (1976), NEAC (1978), RWS(1983), A.RCamA (1986), RCamA (1996); painter in water-colour; former Head of Fine Art, All Saints School, Sheffield. *b:* Sheffield, 22 Apr 1932. *s of:* John Herbert Greensmith, clerk. *m:* Janet. one *s.* one (by previous marriage) *d. Educ:* De la Salle College, Sheffield. *Studied:* Sheffield College of Art. *Exhib:* RA, RWS, RBA, RCA, NEAC, MAFA. *Recreations:* bowls. *Misc:* accordion playing. *Signs work:* "John Greensmith." *Address:* 77 Whirlowdale Cres., Sheffield S7 2ND.

GREENWELL, Patricia K., B.A. (1960); artist in water-colour, acrylic, pastel;. *b:* Liverpool, 5 July, 1937. *m:* Alan. three *s. Studied:* Durham University (1956-60, Pasmore, Gowing, Stephenson, Hamilton). *Exhib:* local and regional. *Works in collections:* several in national and international private collections. *Publications:* article - Pastel Artists International. Oct/Nov 2001. *Clubs:* N.A.P.A. *Address:* 3 The Mews, Cherry Orchard, Highworth, Wilts. SN6 7TL. *Website:* www.tate-it-aint.co.uk

GREENWOOD, Eileen Constance, ARCA (Design) 1935-38 FBI. award, Pedagogic Dip. (1939), RE (1975); printmaker: etching/aquatint, mixed media computer graphic; Lecturer/Founder Principal, Sittingbourne College of Educ. (retd.). *b:* Middx., 26 May 1915. *d of:* Harold Messenger. *m:* Ernest Greenwood, ARCA, PPRWS. one *d. Educ:* Camden School for Girls, Frances Mary Buss Foundation. *Studied:* R.C.A., Courtauld Inst., Goldsmiths' College. *Exhib:* R.A., Bankside Gallery, many London and provincial galleries; four solo shows, three with husband. *Works in collections:* G.B., France, Germany, Japan, America, Australia. *Signs work:* "Eileen Greenwood" (all prints with 'cat' logo in margin). *Address:* Brushings Farm House, Broad St., nr. Hollingbourne, Kent ME17 1RB.

GREENWOOD, Ernest, P.P.R.W.S. (1976), A.R.C.A. (1931-35), F.R.S.A.; artist in oil and water-colour; Inspector of Art Educ. for K.E.C.; guest lecturer for W.F. & R.K. Swan (Hellenic) Ltd.; since 1977 on "Art Appreciation" - Art and Architecture of Greece and Rome;. *b:* Welling, Kent, 12 Feb., 1913. *s of:* Owen Charles Greenwood. *m:* Eileen C. Greenwood. one *d. Educ:* Gravesend School of Art. *Studied:* Royal College of Art, British School, Rome. *Exhib:* R.A., N.E.A.C., R.I., R.B.A., etc.; lectures and exhbns. given annually since 1985 in U.S.A. Exhbn. with wife at Tubac Arts Centre, Arizona, Nevill Gallery, Canterbury, Bankside Gallery, London (Sept., 1991), Musselwhites Gallery, Southampton; Retrospective exhbn.: 1934-97 County Gallery, Maidstone. *Works in collections:* Preston, Southend, Tate Gallery, Middlesbrough A.G., Lannards Gallery Billingshurst, Wenlock Fine Art; private collections, U.S.A., Municipal Galleries of Brighton, Hastings, Hull; "Holcaust" painting now in Ben-Uri collection, London. *Commissions:* Decorations for Judges chambers, Canterbury Crown Court. Guest at the feast of St. Catherine, St. Catherine's College, Oxford. Portraits in private collections. *Signs work:* "Ernest Greenwood." *Address:* Brushings Farm House, Broad St., nr. Hollingbourne, Kent ME17 1RB.

GREENWOOD, Maurice Arthur, R.C.A. (1996), Associats (1988); artist in water-colour and oil; art tutor; part-time lecturer, Dept. of Lifelong Learning, University College, N. Wales since 1982. *b:* Rochdale, 12 Dec 1930. *s of:* Frank and Lily Greenwood. *m:* Joan. two *s. Studied:* part-time Rochdale Art School (1946-48) (Peter Burgess Shorrock, 1960-65). *Exhib:* RCamA, and many open and one-man shows. *Works in collections:* Gwynedd Library Services; private collections in U.S.A., British Columbia, Australia, U.K. *Signs work:* "Maurice A. Greenwood, r.c.a." *Address:* Woodlands, 12 Shaftesbury Ave., Penrhyn Bay, Llandudno, N. Wales LL30 3EH.

GREENWOOD, Philip John, NDD(1965), ATC(1966), RE (1982); printmaker in etching and painter. *b:* Dolgellau, N. Wales, 20 Nov 1943. *s of:* John Edward James Greenwood, R.A.F. *m:* Valery Ratcliff (decd.), Sally Dear. four, two s- *s. Educ:* Dolgellau Grammar School. *Studied:* Harrow College of Art (1961-65), Hornsey Teachers Training College (1965-66). *Exhib:* RA, RE, Tate Gallery, RGI, 'Printmaking in Britain', Sydney; British Council Gallery, Athens; British Printmakers, Melbourne; Galerie Tendenz, Germany; J. One Fine Arts, Tokyo; Galerie Deux Tetes, Canada; 'Overseas Printmakers', Auckland, NZ; Galerie Beumont, Brussels. *Works in collections:* Tate Gallery, Arts Council, British Council, Derby Museum, Greenwich Museum, Oldham A.G., Graves A.G., Warwick Museum and A.G., Lincoln A.G. and Museum, etc. *Signs work:* "Greenwood." *Address:* 3 The Square Elham Kent CT4 6TJ. *Email:* art@philgreenwood.info *Website:* www.philgreenwood.info

GREETHAM, Robert Michael, BA (Hons) Art; MA Art and Art History); three awards/grants from Arts Council of Wales. *Medium:* photography, acrylic, mixed media. *b:* Cardiff, 7 Apr 1957. *s of:* Kathleen P.Davies (née), Stanley Greetham. *Studied:* University of Wales School of Art, Aberystwyth. *Exhib:* RA; School of Art Gallery and Museum UWA Aberystwyth; The Gate, Cardiff; Washington Gallery, Penarth; Aberystwyth Arts Centre; St.David's Hall, Cardiff; Ffotogallery, Cardiff; Christie's, London; Oriel Mostyn, Llandudno. *Works in collections:* National Library of Wales; University of Wales Aberystwyth; South Glamorgan County Council. *Commissions:* 'On the House' Chapter Arts Centre; 'Just Another Day' and 'Barrage' Ffotogallery, Cardiff. *Publications:* 'Robert Greetham Photographs 1978-1998' - UWA School of Art Press. *Signs work:* 'R.M.Greetham'. *Address:* 902a Newport Road, Rumney, Cardiff CF3 4LL. *Email:* robert.greetham@btopenworld.com

GREGORY, Annabelle, SWA (2000). *Medium:* oil, drawing, collage, pastel. *b:* Richmond, 29 Sep 1941. *m:* Robert Barry. two *s.* one *d. Educ:* Carlyle Grammar School for Girls, Chelsea. *Studied:* St.Martin's School of Art (1958-60); Camden Art Institute (Camden). *Exhib:* Oxford Art Society (1983-98); MoMA, Oxford (1991); Royal Birmingham Society of Artists (1997, 98); SWA (1998-2005). *Works in collections:* worldwide. *Principal Works:* mainly collages of botanical form, now painting large 'modern' oils of Marine Subjects and Landscapes. *Recreations:* walking, swimming, yoga. *Signs work:* 'Gregory', 'GREGORY'. *Address:* 35 Church Street, Mudbury, Devon PL21 0QR.

GREIG, Donald, RSMA (1967), Gold Medal Paris Salon (1967); painter in water-colour and oil, printmaker. *b:* London, 1916. *s of:* James Greig, Scottish water colourist. *m:* Rita Greig, RWA, ROI, NEAC. one *s. Studied:* Southend College of Art (Charles Taylor, RWS). *Exhib:* RA, RWA, RBA, NEAC, RI, RSMA, and various one-man shows. *Works in collections:* National Maritime Museum, Greenwich, Municipal Gallery, Scunthorpe. *Recreations:* angling, gardening. *Signs work:* "DONALD GREIG." *Address:* Tor Brook Studio, Woodleigh, Kingsbridge, S. Devon TQ7 4DF.

GREIG, Rita, RWA (1983), ROI(1974), NEAC1974), Silver Medal Paris Salon (1974); painter principally in oil, also water-colour and pastel, printmaker. *b:* Norwich, 6 Apr 1918. *d of:* Harry David Wimblett. *m:* Donald Greig, R.S.M.A. one *s. Educ:* Selhurst Grammar School, Ware Grammar School. *Studied:* privately - and training at Design Studio (London). *Exhib:* RA, RWA, ROI, NEAC, RBA, various one-man shows in Britain and abroad, also shared shows with husband, Donald Greig. *Works in collections:* Royal West of England Academy, Chase Manhattan Bank Collection, Bishop Otter College. *Recreations:* gardening. *Signs work:* "R.G." *Address:* Tor Brook Studio, Woodleigh, Kingsbridge, S. Devon TQ7 4DF.

GRENVILLE, Hugo Gerard, *Medium:* oil, gouache, distemper. *b:* London, 5 Aug 1958. *m:* Sophia. two *s. Educ:* p/t Chelsea and Heatherley's Schools of Art. *Represented by:* Messum's, 8 Cork Street, London W1; Wally Findlay Galleries, 124 East 57th Street, NY. *Exhib:* RBA, RI, ROI, Arts Club; seven one-man shows at Messums from 1995; one-man show 2006 in New York at Wally Findlay Galleries; one-man show 2007 in Palm Beach at Wally Findlay Galleries. *Works in collections:* Ministry of Defence; Ironmonger's (Worshipful Company of), The China Club, Hong Kong; Edinburgh City Council; the late Duke of Devonshire; The Tresco Estate. *Commissions:* War Artist, Bosnia 1995; portraits include: the late Archbishop of Canterbury, Right Rev. Lord Runcie; the late General Sir William Rous; the Countess of Verulam; Michael Chance as Orpheus at the ENO. *Publications:* regular contributor to the Artist Magazine; 'Songs of Light' with Philip Wells (Feb 2006). *Principal Works:* romantic paintings of the figure, especially the decorative studio nude; reputation as a colourist. *Recreations:* history, music, gardening. *Clubs:* Chelsea Arts Club. *Misc:* Teaches painting at The Chocolate Factory, London N16 one day a week during term-time. *Signs work:* 'Hugo Grenville' or 'H.G.'. *Address:* 157 Mount View Road, London N4 4JT. *Email:* hugo@hugogrenville.com *Website:* www.hugogrenville.com

GRETTON, Keith, travelling scholarship; Awards: London Potters Open Sculpture. *Medium:* drawing, prints, sculpture, acrylics. *b:* Rugeley, Staffs, 24 Dec 1934. *s of:* William Gretton. *m:* Penelope Warner Gretton. two *s.* two *d. Studied:* Stafford Art College, London University. *Represented by:* Skylark Galleries, London. *Exhib:* RA Summer Show; Society of Painters, Etchers and Engravers; Barbican (solo); Durham University; RBSA; West of England Academy; Cambridge Contemporary Art, Barn Gallery, Aston; regular solo exhbns in UK. *Works in collections:* Chelsea and Westminster Hospital, Homerton Hospital Trust, Lambeth Community Care, private collections worldwide. *Commissions:* founder of Battersea Contemporary Artists Art Fair from 1993-2002; commissions all private. *Official Purchasers:* Department of Trade and Industry. *Works Reproduced:* Studio Magazine, London Potters magazine No109 profile, The Independent (Oct 06), Art Review, Sunday Times, Ideal Home Building Design. *Recreations:* walking in country. *Clubs:* London Potters; (ex-Free Painters). *Signs work:* 'Keith Gretton', 'K' (in circle) or 'G' impressed on clay pieces. *Address:* 26 Honeywell Road, London SW11 6EG.

GREY, Jenni, B.A. (Hons.), M.A., Fellow, Designer Bookbinders; fine binder and book artist; part-time tutor, University of Brighton. *b:* London, 3 July, 1950. *m:* Anthony Belfield. one *d. Educ:* Bexley Grammar School. *Studied:* Brighton Polytechnic. *Exhib:* regularly since 1982 in England, Europe and America. *Works in collections:* National Poetry Library (England), Koninklijke Bibliotheek (Holland), University of Georgia and Wellesley College (U.S.A.), Les Amis de la Reliure d'Art (France), Biblioteca Wittockiana (Belgium), The British Library (England), The John Rylands Library (England), The Library of Congress (U.S.A.). *Commissions:* Winchester Cathedral (England). *Publications:* The New Bookbinder (Article 'Progress Making') 2006. *Address:* 26 St. Lukes Rd. Brighton BN2 2ZD. *Email:* jennigrey@btinternet.com *Website:* www.designerbookbinders.org.uk

GRIBBIN, Launcelot Benedict, ATD (1949); BA (Hons.) Hist. of Art (1953); painter in oil, photographer; lecturer, Victoria and Albert Museum; former principal lecturer, London College of Printing; visiting lecturer, Messrs. Sotheby's Institute; International freelance lecturer in History of Architecture and Decorative Arts. *b:* Gateshead-on-Tyne, 7 Nov 1927. *s of:* L. B. Gribbin (senior), pharmacist. *m:* Joanna Mary Satchell. two *s.* two *d. Educ:* Dartford Grammar School. *Studied:* Sidcup School of Art under Ruskin Spear, A.R.A., Robin Guthrie, William Clause; Courtauld Inst. of Art. *Exhib:* RA, NEAC, London Group, National Soc.; one-man shows, Artists' House, Manette St., etc. *Signs work:* "L. B. GRIBBIN" (written with brush). *Address:* 8 Mile House La., St. Albans, Herts. AL1 1TB.

GRICE, David, painter, sculptor, maker of constructions and mixed media artist; winner, national prizes for painting from age 6; teacher, Bradford School of Art (1971-72). *b:* Saltaire, 1 Oct 1946. *m:* Carol Ann. two *d. Studied:* Bradford School of Art (1962-66). *Exhib:* I.C.A. (1969), Angela Flowers Gallery (1970); group shows: worldwide; one-man shows: Titus Gallery, W.Yorks (1988-2000); Gallery Johanna de Poorter, Antwerp (2002-2003); S.A.G. Contemporary Art, Antwerp (2005). *Works in collections:* private, corporate and institutional collections inc. Prof. David Sharpe: Prof. Micheal Levi; Prof. Karen U Schallreuter: Prof. Paul Walton; Dr. J. M. Braganza; Peter Black plc. *Commissions:* Fine Art Developments plc, etc. *Address:* Rosier 18, B-2000 Antwerpen, Belgium. *Email:* david.grice@pandora.be *Website:* www.artbydavidgrice.com

GRICE, Sarah, PS, SEqA.; Hon. mention Paris Salon; artist in pastel and oil specializing in animals. *b:* Bootle, Cumbria, 1913. *m:* Richard Grice (decd.). *Educ:* private schools in Cumbria. *Studied:* in Paris with Roger Marx, animal sculptor (1927-29), in London (1934-37). *Exhib:* RA, RSA, Paris Salon, and six solo shows. *Signs work:* "Sarah Grice." *Address:* Well Cottage, Cottesmore, Oakham, Rutland LE15 7DH.

GRIDNEV, Valeriy, PS, ROI, ARP; prizes include: Gold Medal, USSR Academy of Arts (1990); Frank Herring Award, PS (2000, 2003); Winsor & Newton/ Daily Mail finalist prize (2004); Winsor & Newton Award, ROI (2005); The Arts Club Award, PS (2006); The Arts Club Award, RP Mall Gallery (2006); portrait painter. *b:* 1 Jan 1956. *s of:* Fedor Gridnev. *m:* Gridneva Ekaterina. one *s. Studied:* Sverdlovsk College of Art (1976-1980); St.Petersbyrg Academy of Arts (1983-90); Creative Studio St.Petersbyrg Academy of Arts. *Represented by:* John Noot Galleries; Fine Arts Commissions Ltd; FBA Mall Gallery; Cross Gate Gallery, USA; Whittington Fine Arts. *Exhib:* Mall Gallery (2000-2007), Michael Simpson Gallery (1995); Alberty Gallery (1998-2002); Arndean Gallery (2003, 2005); Langham Fine Art (2002-2007); Brian Sinfeld Gallery (2003); John Noot Galleries (2003, 2004); Cross Gate Gallery (1999-2007). *Commissions:* Henry, 7th Earl of Carnarvon; Jean Wallop, Countess of Carnarvon; Lord Porchester; Mrs.Harry Vane; Louis Frosio, leader of the Monte-carlo Orchestra; Lester Piggott; Mrs Charles Brocklebank; Mrs Sheran MacDonald-Buchanan; Mr, Mrs Compton; Mr, Mrs Whitley. *Clubs:* The Arts Club, London. *Signs work:* 'VALERIY GRIDNEV'. *Address:* Flat 4, Great Portland Street, London W1W 6QW. *Email:* fedorgridnev@yahoo.com

GRIERSON, Janet, (Deaconess); BA Hons. (Lond.) (1934), MA Lambeth (1982); painter in oil and water-colour. *b:* Dublin, 10 Apr 1913. *Educ:* Westfield College (1931-34), King's College, University of London (1934-36). *Studied:* (part time) at N. Worcs. College (1978-82), Malvern Hills College (1984-89). *Exhib:* galleries in Malvern, including one-man shows. *Signs work:* "Janet Grierson." *Address:* Flat 8 Parkview, Abbey Rd., Malvern, Worcs. WR14 3HG.

GRIFFIN, Alison Mary, RMS, SLM, BA Art and Design (1974); minature painter, and landscape and interior artist in water-colour and acrylic. *Medium:* acrylic and watercolour. *b:* Sutton Coldfield, 23 May 1953. *d of:* Charles Green (decd.). *m:* Mark Upton Yonge. one *s.* one *d. Educ:* Boldmere High School for Girls, Sutton Coldfield. *Studied:* Sutton College of Art (1969-71), Bath Academy of Art (1971-74). *Represented by:* Image Source; Francis Iles. *Exhib:* Francis Iles Gallery, Rochester, Mall Galleries, London. *Works in collections:* private collections. *Works Reproduced:* Limited Edition Prints, Rosenstiels, Medici Cards. *Recreations:* opera, classical music, swimming. *Signs work:* "Alison Griffin." *Address:* Wisteria House, 68 North St., Barming, Maidstone, Kent ME16 9HF.

GRIFFIN, David Brian, graphic designer painter in oil and water-colour, subject matter mainly nautical; Council mem. Chelsea Art Soc. since 1974, Vice-Pres. (1991-96);. *b:* Brighton, 15 Feb 1927. *m:* Kathleen Martin. one *s.* one *d. Educ:* Central School, Catford and Sayers Croft, Ewhurst. *Studied:* Camberwell, Northampton and St. Martin's Schools of Art (1940-43 under Roland Vivian Pitchforth, RA, RWS). *Exhib:* RSMA, Armed Forces, Omell Galleries, Piccadilly. *Works in collections:* Europe, USA, and Far East. Listed in "20th Century British Marine Painting". *Commissions:* include Eagle Star and British Petroleum.

Served R.A.S.C. (maritime) and R.N.V.R. *Publications:* six page contribution in 1999 Collins publication "Art Class". *Clubs:* Wapping Group of Artists, Chelsea Art Soc., Armed Forces Art Soc. *Signs work:* "David Griffin." *Address:* 19 Ross Rd., Wallington, Surrey SM6 8QN.

GRIFFITH, David Lloyd, RCamA (1996), Associate (1988); Certificate Open College (1993); Teaching experience: life drawing, RCA Conwy (1992-96) and Mostyn Gallery Llandudno (2003-), Basic art, WEA Coleg Harlech (1998-);. *Medium:* oil and watercolour. *b:* Colwyn Bay, 30 Mar 1956. *s of:* Roy Lloyd Griffith. *Educ:* Ysgol Emrys Ap Iwan, Abergele, Clwyd. *Studied:* N.E. Wales Inst. (1975-76, N.D. Mackinson, R. Hore), Open College of the Arts (1989-93, E. Williams, H. Bowcott, N. Griffiths). *Represented by:* recent work can be seen at: Y Galeri, Betws y Coed; Oriel y Bont, Aberystwyth; Kaywood Gallery Cardiff; 'Y Capel', Llangollen. *Exhib:* Rhyl Arts Centre (1997, 1999, 2004), "Land of my Fathers", Oglivy & Estil (1998); selected group shows Royal Cambrian Academy, "I Know what I like, or do I?", Kings College, Cambridge (1997), The Pure Landscape, John Davies Gallery, Stow on Wold (2001). "Moments", Denbigh Museum & Gallery (2001). Two man show at Royal Cambrian Academy, Plas Glyn y Weddw and Theatre Clwyd (2002); Llanrwst Museum (2003). National Library of Wales, Aberystwyth (2004); Y Tabernacl, Machynlleth (2005), Plas Glyn y Weddw (2005); 'Welsh Painters Past and Present', John Davies Gallery (2005); 'Wales Works', Kooywood Gallery, Cardiff (2007); selected artists - 'Gorstella Gallery', Chester (2007). *Works in collections:* Hospitals in Wales. *Misc:* interviewed for BBC 'Wales Today' in connection with RCamA 125th Anniversary (March 2007). *Signs work:* "D.L.G." *Address:* 35 Glan y Fedw, Betws Yn Rhos, Abergele, LL22 8AP. *Website:* www.davidlloydGriffith.co.uk

GRIFFITHS, David, DFA (Slade); portrait painter in oils; RCA. *b:* Liverpool, 1939. *s of:* Frederic & Muriel Griffiths. *Educ:* Pwllheli Grammar School (1951-57). *Studied:* Slade School of Fine Art (1957-61, Sir William Coldstream). *Exhib:* Royal National Eisteddfod; Retrospective exhibition, National Library of Wales (2002). *Works in collections:* American Embassy, London; Linnean Society, London; Cardiff and County Club; City Hall, Cardiff; Museum and A.G., Newport; Croydon Town Hall; House of Lords; Eton College; National Library of Wales; University of Wales, Cardiff, Swansea and Aberystwyth; Llandovery College; Trinity College; Assoc. of Anaesthetists; Speaker's House, Westminster; Liverpool University; Assoc. of Chartered Surveyors; several public and private collections throughout the country. *Publications:* 'Portraits' David Griffiths (National Library of Wales, 2002). *Signs work:* "David Griffiths." *Address:* Westville House, 49 Westville Rd., Cardiff CF23 5DF. *Email:* commissions@david-griffiths.co.uk *Website:* www.david-griffiths.co.uk

GRIFFITHS, Michael, ARE, BA(Hons.), Post Grad. Cert. in Printmaking; painter and printmaker; Principal Lecturer and course leader BA Hons Fine Art, The Arts Inst., Bournemouth; director of The Badger Press, open access

printmaking studio. *b:* London, 27 Sep 1951. two *s. Studied:* Brighton Polytechnic (1973-1977). *Exhib:* 20 solo exhibs. throughout U.K., and numerous group exhibs., U.K. and abroad. *Works in collections:* numerous private and public collections, including Ashmolean Museum, Oxford, South East Arts, University of Kent. Victoria & Albert Museum. *Clubs:* Newlyn Society of Artists: Associate, Royal Society of Painter Printmakers (ARE). *Signs work:* "Michael Griffiths" or "MG." *Address:* The Studio., Unit 4, Claylands Rd, Ind. Est., Bishops Waltham SO32 1BH. *Email:* mikegriffithsis@hotmail.com

GRIFFITHS, Michèle (Helen Françoise), MA Cantab, Diploma in Modern Social and Cultural Studies, BA Hons Fine Art: Painting, Wimbledon. *Medium:* oil. *b:* London, 8 Aug 1951. *d of:* Robert and Pierrette Hoare (school teachers). *m:* David Griffiths. *Educ:* Blackheath High School. *Studied:* Girton College Cambridge (modern languages degree), Putney School of Art (1990-92); Wimbledon School of Art (1992-95) under Michael Ginsborg and Prunella Clough. *Represented by:* Stour Gallery (Warks) www.thestourgallery.co.uk. *Exhib:* AAF, London (2004,05); Stour Gallery (2002-07); Hicks Gallery (2004, 05); Mall Galleries, selected for Discerning Eye (2003); Christie's Art for Life (2002, 2004-07); RA Summer Exhbn (1997); Art 2001 with Vertigo Gallery, Hoxton; Art 2000; Turin Art Fair and Art Brussels with James Colman Fine Art; British Art Fair, RCA (2000); and many more. *Works in collections:* works including commissions in private collections in the UK, France, USA and Japan. *Publications:* Feature article in 'Artists and Illustrators' magazine (April 2007) short editorial review in Galleries Magazine (Jul 05); article on 'The Influence of Medical Imaging' in The Lancet (Feb 1997). *Recreations:* walking, sailing, yoga, travel, literature, singing. *Misc:* interest in religions. *Signs work:* 'M.Griffiths'. *Address:* 154 Elborough Street, Southfields, London SW18 5DL. *Email:* michegriffiths@aol.com

GRIFFITHS, Tom, painter, designer and illuminator on vellum; Senior lecturer, Norwich School of Art (1942-49); chairman, Norfolk and Norwich Art Circle (1957, 1958, 1978), President (1983-);. *Educ:* City of Norwich School. *Studied:* Norwich School of Art, Heatherleys' and The Grosvenor (London). *Exhib:* RA, ROI, NS and provincial art galleries; one-man shows of townscapes (Norwich). *Works in collections:* many illuminated vellums include Loyal Address (Norwich); Freedom Scrolls for H.M. Queen Elizabeth the Queen Mother, Sir John Barbirolli (King's Lynn); the Royal Air Force and Regimental presentations and the County War Memorial Book of Remembrance, Norwich Cathedral. *Signs work:* "Tom Griffiths." *Address:* 15 Essex St., Norwich.

GRIGSBY, John Higham, NDD, ATD, ARE1973), RE (1978). *b:* Staffs., 18 Dec 1940. *Studied:* Stoke and Leicester Colleges of Art. *Exhib:* Young Contemporaries, RA, NEAC, R.WA, RWS Galleries, Mall Galleries, FBA Touring Exhbns., Woburn Abbey, Glasgow Institute, London Group, Buenos Aires Print Biennale, Bankside Gallery; solo shows: Hampstead, Exeter, Henley, Beckenham, Bedford School. *Works in collections:* Reading Museum; Whitgift

Foundation; Graves Gallery, Sheffield; Open University; National Museum of Wales; Williamson Gallery, Birkenhead; Portland State University (USA); Camden and Greenwich Councils; Hertfordshire, mid-Glamorgan and Sheffield Education Authorities; Exeter University; Bedford School; Fylde Arts Assoc; Imperial College; Fitzwilliam Museum. *Commissions:* Two murals for Trust Houses (1962); Limited edition etching for Unistrut U.K. (1978) and the P.C.C. (1982). *Official Purchasers:* University of Wales. *Signs work:* "John Grigsby." *Address:* 152a Mackenzie Rd., Beckenham BR3 4SD.

GROARKE, Michael, MA, MCSD chartered designer; BEDA Cert. (Registered European designer); wallpaper/textile/ceramics designer, painter in water-colour and oil. *b:* Manchester, Oct 1943. *m:* Prudence J. Hyde. two *s. Educ:* Manchester High School of Art. *Studied:* Calico Printers Assoc. Design School, Manchester Polytechnic Faculty of Art and Design, Rochdale College of Art. The Slade. *Exhib:* RA, RWS, RI, RCamA; design work/exhb. Britain, Europe and America. *Signs work:* "M.G." or "Michael Groarke." *Address:* Fourways, 2 Grovesnor Rd., Marple, Stockport SK6 6PR.

GROSVENOR, Stella Athalie (Mrs.), RBS, Slade Dip. Fine Art (1937); sculptor in bronze, resin, stone, wood, painter in oil. *b:* Beaconsfield. *d of:* Sidney Henderson. *m:* Hugh N. W. Grosvenor, ARIBA. *Educ:* St. Margaret's School, Hampstead. *Studied:* Slade School under Prof. Schwabe and Prof. Gerrard. *Exhib:* group shows, Society Portrait Sculptors, Hampstead Artists Council, R.A., Travers Gallery, Erica Bourne Gallery; one-man show, Foyles, London (1968). *Works in collections:* Dixons. *Publications:* Art Editor, National Trade Press; Illustrated, Caxton Publishing Co. *Clubs:* Hampstead Artists Council, R.B.S. *Signs work:* "A. Grosvenor." *Address:* 35 Flask Walk, London NW3 1HH.

GROVES, Janet B., BA (Hons). *Medium:* oil, watercolour, pastel. *b:* Birmingham, 7 Jul 1942. *m:* Reg Beach. one *s.* one *d. Educ:* OU (1984-91). *Exhib:* RA; RBSA; RWA; South West Academy. *Works in collections:* Penzance, Camborne, Liverpool, Manchester, Bristol, London; Sevenoaks, Kent; Brussels, Aix-en-Provence, Reims, Vienna, Sweden. *Clubs:* Birmingham Art Circle. *Signs work:* 'J.B.Groves'. *Address:* 19 Polwithen Road, Penzance, Cornwall TR18 4JW. *Email:* jaybea@beeb.net

GROVES, John Michael, RSMA (1977), NDD (Illustration, 1957). *Medium:* pastel, oil, pen and ink. *b:* Lewisham, London, 9 Mar 1937. *Educ:* Kilmorie Secondary School, London. *Studied:* Camberwell School of Arts and Crafts (1953-57). *Exhib:* RSMA, Mall Galleries, London. *Commissions:* five (3'x 5') historical oils for this country and abroad, commiss. by Shell. *Publications:* The Tall Ship in Art – Cassell. *Signs work:* "J. Groves." *Address:* 114 Further Green Rd., Catford, London SE6 1JQ. *Email:* john@johngroves.org *Website:* www.johngroves.org

GRUFFYDD, Pegi, BA (Hons.) (1982), ARCA(1985), Dip.RA(1986); painter/printmaker in oil, water-colour, etching, lithography. *b:* Pwllheli, N.

Wales, 28 Apr 1960. *d of:* Morris Griffiths. *Educ:* Ysgol Glan-y-Môr, Pwllheli. *Studied:* Manchester Polytechnic (1978-79), Wolverhampton Polytechnic (1979-82), R.A. Schools (1983-86). *Exhib:* R.A. Summer Exhbn. (1984-85), Royal National Eisteddfod of Wales (1980-88), Young Artists Forum, Cardiff University, Wales '83, the Welsh Group Touring Exhbn., Midwales Open, Aberystwyth, North Wales Open, Llandudno; one-man show, Theatre Gwynedd, Bangor; group show, Oriel, Bangor. *Misc:* Gallery: Oriel Glyn-y-Weddw, Llanbedrog. *Signs work:* "Pegi Gruffydd" or "P.G." *Address:* Llymgwyn Farm, Chwilog, Pwllheli, Gwynedd LL53 6HJ.

GRÜNEWALD, Eleanor Mavis, (née Wilson); NDD (Painting), ATD (Leeds); artist in oil, acryl, aquarelle; teaches art at Kronberg Art School, Germany. *b:* Stockton-on-Tees, 2 Mar 1931. *d of:* Harold Wilson. *m:* Karl-Heinz Grünewald. one *s.* two *d. Educ:* Richard Hind School, Stockton. *Studied:* Middlesbrough School of Art, Leeds College of Art. *Exhib:* Frankfurt, Wiesbaden, Marburg, Paris, Le Salon, Grand Palais des Champs-Elysees, China: Peking, Shanghai; Egypt: Cairo, Alexandria, with the Frankfurt Union of Professional Artists. *Works in collections:* Cities of Frankfurt, Wiesbaden, Marburg, Middlesbrough. *Clubs:* Berufsverband Bildender Künstler. *Signs work:* "Mavis Wilson-Grünewald." *Address:* Fahrgasse 21, 60311 Frankfurt/Main. Germany.

GUARNORI, Jacky, (nee Truelove); FSBA (1985), SLm (1986); self taught flower painter in water-colour. *b:* Surrey, 1943. *m:* Peter Truelove. two s, one step- *s.* two step- *d. Educ:* Grey Coat Hospital, London. *Exhib:* SBA; solo shows: Bromley (4), Croydon (2), Cranbrook (1), Group exhibitions: Francis Iles Fine Art, Sevenoaks Wildfowl Trust, Soc. of Limners, Samlesbury Hall, The Lake Artists, North Wales Soc.of Arts. *Works in collections:* Orpington Library, Shell U.K. *Commissions:* Shell U.K., Dr. Barnados. *Publications:. Works Reproduced:* greetings cards and calendars. *Clubs:* Ambleside Art Society. *Signs work:* "Jacky Guarnori" or "J.G." *Address:* Oak Bank, Hill Top, Windermere, Cumbria LA23 2HG. *Email:* jacpet@truelove4.wanadoo.co.uk

GUDGEON, Simon David, SWLA; ARBS; Hunting in Art Prize 2007 (International Council for Game and Wildlife Conservation). *Medium:* sculpture in bronze, drawing. *b:* Sherriff Hutton, 4 Oct 1958. *s of:* Tom & Olwen Gudgeon. *m:* Monique. *Represented by:* The Halcyon Gallery, 29 Bruton Street, London W1J 6QP. *Exhib:* SWLA (2000, 01, 02, 03, 04); Malcolm Innes Gallery, London (2000); Wykeham Gallery, Stockbridge; Nigel Stacy-Marks, Perth; The Air Gallery (2002, 03); San Diego (2003); Art Parks International, Guernsey (2004); Nature in Art, Glos (2004, 05); Art for Survival, Tryon Gallery, London (2004, 05); Birds in Art, Wisconsin, USA (2005, 06, 07); Sculpture in Paradise, Chichester Cathedral (2007); Simon Gudgeon one-man exhibition, Halcyon Gallery, London (2007). *Works in collections:* Woburn Abbey, Beds.; Amhunnsuide Castle, Isle of Harris; Matthew Gloag Ltd., Perthshire; H.R.H. Duke of Edinburgh. *Publications:* 'A Passion for Grouse' (2002); 'Woodcock,

Artists' Impressions' (2006); 'Grouse, Artists' Impressions' (2007). *Signs work:* 'Simon Gudgeon' and 'SG'. *Address:* Gills Hole Farm, Redlynch, Salisbury SP5 2JX. *Email:* sg@simongudgeon.com *Website:* www.simongudgeon.com

GUEST, Alan Sexty, artist in oil; teacher, private tutor, lecturer, autodidact; teacher, Coventry City Council. *b:* 11 Dec 1920. *s of:* Robert Sexty Guest, B.A., accountant. *m:* Kathleen Guest. two *s.* five *d. Educ:* Woodlands, nr. Doncaster. *Exhib:* Nuneaton A.G., Coventry, Chalk Farm; two paintings selected by BBC Search for an Artist; TV appearances. *Commissions:* by owner of L'escargot, now hanging in the Curragh. *Clubs:* Unicorn. *Signs work:* "A. Guest." *Address:* 19 Sharp Cl., Holbrooks, Coventry.

GUISE, Christopher John, MA, RMS; marine painter in oil on wood panels, miniaturist in oil on ivorine; formerly on staff, Hurstpierpoint College. *b:* Darjeeling, India, 19 Jun 1928. *m:* Phyllis Gibson. one *s.* one *d. Educ:* Charterhouse and Brasenose College, Oxford. *Exhib:* RMS since 1983, Brighton, Washington, NY, Boston, Toronto, Maritime and Sailing Centres. *Signs work:* "C.J. GUISE." *Address:* Carys, West Furlong La., Hurstpierpoint, W. Sussex BN6 9RH.

GUMUCHIAN, Margaret, DA (Manc.), ATD; artist in oil, gouache and lithography. *b:* Manchester, 8 Jun 1927. *d of:* Leon Gumuchian. *m:* Ian MacDonald Grant. one *d. Studied:* Regional College of Art, Manchester. *Exhib:* RA, RBA, M.AFA, SMP regional galleries, Paris, and Biarritz. *Works in collections:* School Loans Collection, Salford, Salford Art Gallery, Rutherston Loans Collection, Manchester City A.G. and various private collections, Arctophile. *Signs work:* "Mgt. Gumuchian." *Address:* Barrachnie, Aldersgreen Ave., High Lane, Stockport, Cheshire SK6 8EB.

GUNN, James Thomson, FIAL, H.IPD, DA, RI.Dipl; artist in acrylic, water-colour, gouache, mixed media and designer; Letter of Commendation from H.M. The Queen (RAF 1957); Diploma of Merit conferred by University delle Arti (1982); Highland Society of London award, RSA(1985). *b:* Gorebridge, 9 Apr 1932. *s of:* George J. T. Gunn, BSc, A.AMIEE. *m:* Mary Lang (née Linton). one *d. Educ:* Dalkeith High School. *Studied:* Edinburgh College of Art (1956), Diploma (Travelling Scholar). *Exhib:* RSA, RSW, RI, SSA, RGI, City Art Centre (1983). *Works in collections:* Royal Collection, Argyll Educ. Com.; represented in private collections. *Clubs:* I.A.L., I.P.D. *Address:* 3 Park Cres., Easthouses, Dalkeith, Midlothian EH22 4EE, Scotland.

GUNN, Linda Sue, Founding Director of the National Acrylic Painters Assoc. (USA); workshop instructor; Best Landscape Overall, The Artists and Illustrators Exhibition (London, 2000), National Watercolor Society (2004). *Medium:* watercolour, acrylic, oil, pastel. *b:* Long Beach, CA, 28 Jan 1949. *d of:* John L. and Barbara W. Stewart. two *d. Educ:* influenced by grandfather, George Drake, one of the first Disney animators. *Studied:* self-taught, through museum visits, books, workshops and direct experience. *Exhib:* Black Sheep Gallery,

Harwarden; Cornell Museum of Art and History, Florida; Cabrillo Marine Museum, California; Long Beach Museum of Art, California; Mariner's Gallery, St.Ives; Royal Birmingham Society of Artists Gallery; with NAWA, NY with International Soc. of Acrylic Painters. *Works in collections:* Cornell Museum of Art and History; Daler-Rowney, USA; Great Ormond Street Hospital; M.Graham & Co.; Trinity Hospice, CA. *Commissions:* ten paintings for children's book 'Florian's Special Gift'; set for the Fransisco Martinez Dance Co.; portraits; 7 paintings for book 'Christmas in Cedar Valley'; 7 paintings for children's book 'Flippy in Kensington Garden'. *Publications:* Florian's Special Gift, The Best of Watercolour, The Artistic Touch, Splash 6, Paper Making for the First Time, The Compiled Best of Watercolour, numerous magazines including:Russia's first art instruction magazine, X.Co.Bet, F&W Publications, International Artists' Magazine, South West Art, Splash 9. *Works Reproduced:* The Pan, Steephill, Lincolnshire, Yorkshire Cows, Happening at Windsor, Queen Mary w/ people, The Grey Ghost and Heros of WWII, The Black Pearl. *Principal Works:* The Pan, Steephill, Lincolnshire, Happening at Windsor, Friendly Village, Mother and Sargent, Yorkshire Cows, White Tower, Kings Square, York. *Recreations:* travelling in England, boating, keeping a journal/sketchbook - plein air painting. *Clubs:* NAPA, NAWA, ISAP. *Signs work:* 'Linda S.Gunn' or 'L Gunn' (works on canvas). *Address:* 5209 Hanbury Street, Long Beach, CA 90808, USA. *Email:* LINDASAnArtist@aol.com *Website:* www.lindagunn.com

GWYNNE-JONES, Emily, ARCA (1970); Mem. Contemporary Portrait Soc.; painter in oil and water-colour. *b:* 7 Jul 1948. *d of:* Allan Gwynne-Jones, D.S.O., C.B.E., RA, and Rosemary E. Allan, painter. *m:* M. Frank Beanland, painter. one *s.* two *d. Studied:* RA Schools, RCA (1966-70), NE London Polytechnic (textiles), Central School (etching) (1977-78). *Exhib:* RA (1966-90), Mayor Gallery, New Grafton Gallery, Pigeon Hole Gallery, Brotherton Gallery, Discerning Eye, Mall Galleries (1991-92), NEAC; one-man show, Michael Parkin (1977). John Player Award NPG (1987-88). *Works in collections:* RA, Nuffield Trust, National Trust, Eton College, Paintings for Hospitals, BSI. *Publications:* illustrated, Pavane for a Dead Infanta by Hugh Ross Williamson. *Signs work:* "E.G.J." or "E. Gwynne-Jones." *Address:* Metfield Lane Farm, Fressingfield, Eye, Suffolk IP21 5SD.

GYLES, Pauline Yvonne, ARMS (1981), RMS(1985), FSBA (1986); self taught miniature painter in water-colour; Hon. Sec., Royal Miniature Soc. (1987-2001) Vice President (2003); mem. Hilliard Society of Miniaturists. *b:* Bournemouth, 31 Aug 1931. *d of:* E. Stoddart Fox, FRICS, FAI. *m:* Brian Gyles. *Educ:* private schools England and Switzerland. *Exhib:* Medici, Liberty's, Llewellyn Alexander, London, Linda Blackstone, Pinner, Peter Hedley, Wareham. *Works in collections:* Russell Cotes A.G. and Museum, Bournemouth, Soc. of Apothecaries. *Signs work:* "Pauline Gyles." *Address:* 3 Old Coastguard Rd., Sandbanks, Poole, Dorset BH13 7RL.

H

HABGOOD, Yvonne Veronica, MFPS (1981); painter in oil and alkyd on canvas, pastel on paper. *b:* Lincoln, 2 Oct 1954. *d of:* Windell Oliver Walcott, RAF Civil Service retd, now CLr Conservative. *Educ:* St. John's School, Episkopi, Cyprus. *Exhib:* Mall Galleries, FPS, Loggia Gallery, NSPS (1982), Manchester Academy, Commonwealth Inst.; one-man shows: Bagazzo Gallery Marlborough, Loggia Gallery, etc. *Works in collections:* Bath Rd. Gallery, Old Town, Swindon and numerous private collections including Jamaica, Canada and Japan. *Signs work:* "Habgood." *Address:* 24 Hill Cres., Finstock, Oxon. OX7 3BS. *Email:* Yvonneartist@amserv.net

HACKMAN, David Charles, NDD, ATC, SWE. *Medium:* lino - wood engraving (previously painting). *b:* Southall, Middx, 12 Oct 1936. *s of:* Alfred Wallace Hackman. *m:* Jeanette, Rosa. one *s.* one *d. Educ:* Southall Grammar School. *Studied:* Ealing School of Art; Hornsey College of Art (Pedagogy course). *Exhib:* one man exhibition at Bignor, W.Sussex; annual SWE exhibitions and local venues, etc. *Works in collections:* Ashmolean Museum, Oxford; Hunt Institute for Botanical Documentation, Pittsburgh, USA. *Commissions:* various paintings over the years. *Publications:* personal brochures for lino and wood engraving. *Recreations:* all things practical. *Clubs:* SWE. *Signs work:* 'D.C.Hackman'. *Address:* 18 Eve Road, Isleworth, Middx., TW7 7HS.

HACKNEY, Arthur, VPRWS (1973-76), RE, ARCA; etcher; painter in oil and water-colour; Head of Dept., West Surrey College of Art and Design (retd. 1985); Mem. Fine Art Board, Council for National Academy Awards (1975-78), Hon.Ret. RWS (1996), Hon.Ret. RE (1990). *b:* Stainforth, Yorks., 13 Mar 1925. *s of:* John Thomas Hackney. *m:* Mary Hackney. two *d. Educ:* Stoke-on-Trent. *Studied:* Burslem School of Art and R.C.A. (travelling scholarship). *Exhib:* RA, RE, RWS. *Works in collections:* V&A Museum; Bradford City A.G.; Nottingham Castle A.G.; Keighley A.G.; Wakefield City A.G.; Graves A.G. (Sheffield); Wellington A.G. (N.Z.); Stoke-on-Trent A.G.; Ashmoleon. RCA. *Publications:* in 20th Century Painters and Sculptors, Who's Who. *Clubs:* Chelsea Arts. *Address:* Woodhatches, Spoil Lane, Tongham, Surrey GU10 1BP.

HACKNEY, Isla Katrina, MA Hons. (Edin.) (1985), RWS (1993); artist in water-colour, acrylic, oil, lecturer in art and visual theory. *b:* Wrotham, Kent, 6 Jun 1962. *d of:* Sheila Findlay, RWS and Alfred Hackney, RWS, ARE. *Educ:* Gads Hill Place School, Kent, and Gravesend Grammar School. *Studied:* Edinburgh College of Art (Elizabeth Ogilvie, Robert Callender, William Baillie), Edinburgh University (specialized in British art (Martin Hammer) and Scottish art (Duncan MacMillan)). *Exhib:* RWS, regularly at Bankside Gallery, London; Lynne Strover Gallery, Cambridge. *Works in collections:* Freshfields, Fleet Street, Lord & Lady Sainsbury. *Publications:* author: 'Charles Rennie Mackintosh' and 'A History of Water-colour Painting'. *Signs work:* "Isla K. Hackney." *Address:* 5 Randolph Cres., Edinburgh EH3 7TH.

WHO'S WHO IN ART

HACKNEY, Mary, ARCA, PS; painter in oil, pastel, water-colour; teacher of life painting and portrait;. *b:* Coventry, 28 Nov 1925. *d of:* Ernest William Baker. *m:* Arthur. two *d. Educ:* Sacred Heart, Coventry. *Studied:* Birmingham College of Art, RCA (1946-49). *Exhib:* RA, PS, Mall Galleries, New Ashgate, Farnham, and provinces. *Works in collections:* Leicester City (Pictures for Schools), many private collections. *Signs work:* "Mary Hackney." or "M.H." *Address:* Woodhatches, Spoil Lane, Tongham, Surrey GU10 1BP.

HADDRELL, Trevor, BA Hons (OU); SWE (2006); Candidate for RWA membership 2007; CertEd. *Medium:* painting, print-making. *b:* Rotherham, S.Yorkshire. *s of:* Albert Haddon Haddrell. *Educ:* Oakwood Technical High School, Rotherham. *Studied:* Bath Academy of Art; Open University. *Exhib:* various venues in SW including: Royal West of England Academy of Art; Theatre Collection, University of Bristol; City Museum and Art Gallery, Bristol; The Records Office, City of Bristol. *Works in collections:* Theatre Collection, University of Bristol; City Museum and Art Gallery, Bristol; Hunt Institute, Carnegie Mellon University, Pittsburgh, USA. *Commissions:* several for panoramic engravings of City of Bristol. *Publications:* 'Panoramic Bristol' (2002); 'Asparagus and Other Friends' (2005); 'Bristol and Beyond' (Redcliffe Press, 2006). *Official Purchasers:* University of Bristol; City Museum & Art Gallery Bristol; Hunt Institute, Carnegie Mellon University, Pittsburgh, USA. *Works Reproduced:* over 100 b/w relief engravings of Bristol, also 60 engravings of flowers, fruits and vegetables,. *Principal Works:* Black and White engravings up to eight feet six inches in length; watercolours. *Recreations:* Opera (listening) especially Wagner. *Clubs:* Society of Wood Engravers. *Misc:* retired teacher of Art and Design. *Signs work:* "Trevor Haddrell". *Address:* Woodwell Cottage, White Hart Steps, Clifton Wood, BS8 4TQ.

HAGGER, Henry, RIBA; Laing Landscape Competition (5 times finalist); Sunday Times/Singer & Friedlander (twice finalist); prizewinner Arts Council 'Art into Landscape' Competition (with sculptor Michael Wright). *Medium:* oil, watercolour, pastel, acrylic, printmaking. *Studied:* Hornsey School of Art; University of Newcastle-upon-Tyne; Thames Polytechnic. *Exhib:* L'Ecole des Beaux Arts, Paris; RA, RBA, PS; Whitechapel Gallery, Serpentine Gallery, Mall Galleries. *Works in collections:* Wendy Brooks and Tim Medland;private collections in Austria, Australia, Cyprus, Denmark, France, Hong Kong, India, Indonesia, Japan, Lebanon, Malaysia, Norway, Portugal, Saudi Arabia, Spain, Sweden, USA. *Commissions:* The Wine Society. *Works Reproduced:* contributing artist 'The Art of Drawing and Painting' Eaglemoss Publications Ltd. *Misc:* teaches at The Institute, Hampstead Garden Suburb, London, and privately. *Signs work:* 'HH'. *Address:* 3 Vallance Road, Alexandra Park, Wood Green, London N22 7UD. *Email:* henryhagger@yahoo.co.uk *Website:* camdenprintmakers.co.uk

HAGUE, Jonathan, NDD, ATD, Netherland State Scholarship;. *b:* Llandudno, 18 Nov., 1938. *Studied:* Liverpool College of Art (1957-63), Royal Academy of Fine Art, The Hague (1964-66). *Exhib:* one-man shows: The

Germeente Museum, The Hague; The Royal Institute Gallery, Piccadilly; sponsored John Lennon. *Signs work:* "HAGUE." *Address:* 2 Regent St., Leamington Spa, Warwicks CV32 5HW.

HAIG, George Alexander Eugenie Douglas (The Earl Haig), Associate Royal Scottish Academy; painter in oil and water-colour. *b:* London, 15 Mar 1918. *m:* (2nd) Donna Geroloma Lopez y Royo;. one *s.* two *d. Educ:* Stowe and Christ Church, Oxford. *Studied:* Camberwell School of Art (1945-47) under Victor Pasmore, other members of Euston Rd. School and privately with Paul Maze. *Exhib:* Redfern Gallery, The Scottish Gallery and elsewhere. Retrospective exhibition Scottish National Gallery of Modern Art 2003. *Works in collections:* paintings: Arts Council and Scottish National Gallery of Modern Art. *Publications:* "My father's son" (autobiography of 1st 30 years) published by Pen & Sword 2000. "Haig the Painter" (by Douglas Hall) published by Bourne Fine Art Edinburgh 2003. *Signs work:* "Haig." *Address:* Bemersyde, Melrose TD6 9DP.

HAINAULT, June, essentist painter in oil, acrylic, water-colour, printer of aquatints - movement, space, time. *d of:* Henry Lane Eno, USA. *m:* H.J. Mundy (decd.). two *s. Studied:* Regent St. Polytechnic; Heatherley School of Art. *Exhib:* solo shows: The Gallery, Cork St., London (1994), Hanover Galleries, Liverpool (1986), Fitzroy Gallery, London (1980), Carnival '75, University of Manchester (1975), Loggia Gallery (1972, 1975), Upper St. Gallery, Islington (1972, 1975), Cockpit Theatre (1970), Old Bakehouse, Sevenoaks (1970), New Town Gallery, Uckfield (1969, 1976), Lightning Mark, Rye (1967), Il Traghetto Gallery, Venice (1966), St. Martin's Gallery, London (1965), Congress Theatre, Eastbourne (1998, 1999). *Publications:* cover on book "Cultural Policy" for Council of Europe (2000). *Clubs:* F.P.S. Eastbourne Group. *Signs work:* "Hainault." *Address:* The Oast House, Five Ashes, Horleigh Green, nr. Mayfield, E. Sussex TN20 6NL.

HAINES, Nick, MA; LSIA (1974); JNC Professional Qualification; Artist and Illustrators prize NAPA (1997), Fine Art Trade Guild prize NAPA(1999), Pro Arte Prize, NAPA (2006); mem.National Advisory Group for Voluntary Arts England; artist in acrylic, oil and mixed media. *b:* Essex, 1952. *m:* Diane. two *s.* four *d. Studied:* Somerset College of Art. De Montfort University, Open University. *Represented by:* NAPA (National Acrylic Painters Association). *Exhib:* annually with NAPA, NAPA (USA), Westminster Gallery, London, Bath Fringe Festival, Mariners Gallery, St Ives, Hotbath Gallery, Bath, Black Sheep Gallery, Harwarden, Salthouse Gallery St.Ives, regularly at Millfield Summer Show, etc. *Works in collections:* many private throughout Britain and Europe, including Lord Bath, Longleat House. *Commissions:* private commissions undertaken. *Clubs:* Chairman of Northeast Somerset Arts, mem.NAPA, Bath Area Network for Artists, Old Bakery Artists. *Misc:* one grandson. *Address:* Laburnum Cottage, Little Green, Mells, Frome Som. BA11 3QW. *Email:* nick-haines@fsmail.net

HAINSWORTH, George, Slade Dip., Gulbenkian Scholar (Rome); artist in oil paint, variety of sculptural media; retired Prof. of Fine Art, Leeds Metropolitan University;. *b:* Leeds, 15 Dec., 1937. *m:* Lucy M. Rogers. one *s.* one *d. Studied:* Leeds College of Art (1955-60), Slade School of Fine Art (1960-62, William Coldstream), British School at Rome (1962-63). *Exhib:* one-man shows: Serpentine Gallery, Ikon Gallery B'ham, Spacex Gallery Exeter, Sue Rankin Gallery, Ainscough Contemporary Art, London; two-person (with Lucy): Cartwright Hall Bradford, Dean Clough Halifax, Doncaster City A.G., ongoing display at Biemen de Haas Gallery, Amsterdam. *Works in collections:* Leeds University, Hammond Suddard, Baring Investors, Provident Financial Group plc, many private collections. *Clubs:* Yorkshire Sculptors Group, Leeds Fine Art. *Signs work:* "G. Hainsworth." *Address:* Otter House, Hunsingore, nr. Wetherby, W. Yorks. LS22 5HY.

HALE, Helen Margaret, ROI, NS, SWA, FPS. *Medium:* oil (painting); marble, stone, wood, etc (sculpture). *b:* Harpenden, 18 Apr 1936. *d of:* Robert Hale. *m:* Horne Shepherd (decd.). *Educ:* St. George's School, Harpenden. *Studied:* St. Martin's School of Art and Sir John Cass School of Art. *Exhib:* group shows: London, Edinburgh, Paris, Munich. One/two person shows: Bromley, Farnham, Amersham, London. *Signs work:* "HALE." *Address:* Atheldene, Loxwood Rd., Rudgwick, Horsham, W. Sussex RH12 3DW.

HALES, Gordon Hereward, RSMA (1981), RBA, FRSA, M.Cam.; painter in water-colour, pastel and oil. *b:* Matlock, Derbys., 24 Feb 1916. *s of:* Joseph & Gertrude Annie Hales (née Graves). *m:* Margaret Lily Adams. two *d. Educ:* Avenue Road School and The Gateway School, Leicester. *Studied:* Leicester College of Art, Northampton School of Art. *Exhib:* RI, ROI, PS. *Clubs:* Wapping Group of Artists (president), London Muster of Artists (founder), The Artists Soc., and Langham Sketching Club, Armed Forces Art Soc. *Signs work:* "GORDON HALES." *Address:* 11 Rosecroft Drive, Watford, Herts. WD1 3JG.

HALFORD, Hilary, ATD(1942), AUA (1992); artist in oil, water-colour, pen and coloured pencils; lecturer in art and design, Dorset House, Oxford (1946-49); Curator, William Morris Gallery Walthamstow (1950-52), Slide Librarian, Dept. of Art History, University of Essex (1969-81);. *b:* London, 13 Apr 1920. divorced. three *s. Educ:* Tottenham County School. *Studied:* Hornsey College of Art (1935-42), Oxford University (1947-49). *Exhib:* Digby Gallery, Mercury Theatre, Colchester (1985). *Clubs:* U.A., Colchester Art Soc., Reading Guild of Artists. *Address:* 63 Lower Henley Rd., Caversham, Reading RG4 5LD.

HALL, Christopher Compton, RBA(1988), DFA (1954), RCamA (1994); De Laszlo Medal (1996); painter in oil. *b:* Slaugham, Sussex, 25 Dec 1930. *s of:* Donald John Hall. *m:* Maria Galassi. three *s. Educ:* Bedales School. *Studied:* Slade School of Fine Art (1950-54). *Represented by:* The Rona Gallery. *Exhib:* Portal Gallery, New Grafton Gallery, RA, Waterman Fine Art, Lynne Stern Assoc., Rona Gallery, Russell Gallery. *Works in collections:* London Museum,

National Library of Wales, Reading A.G., Arts Council, OUP, The Ashmolean. *Commissions:* various, mainly of buildings. *Works Reproduced:* "Young Artists of Promise" - Jack Beddington (1957), 20th Century painters and sculptors" - Frances Spalding, "London in paint" - oil paintings in the collection of the Museum of London - Mirielle Galinou & John Hayes, "The Eclipse of a great power" - Keith Robbins, "Variations in an English dialect" - Jenny Cheshire, "London in paint" - David Piper. *Misc:* Local Councillor (Liberal) 1961-67, Mayor of Newbury 1967-68. *Signs work:* "C.C. Hall." *Address:* Catherine Villa, Station Rd., Newbury, Berks. RG14 7LP. *Website:* www.christopherhall-painter.com

HALL, Dennis Henry, ARCA (1955); graphic designer and producer/publisher of Illustrated Limited Edition Books;. *b:* Caterham, 1927. *m:* Sylvia Stokeld, ARCA (decd). *Educ:* Lancing College. *Studied:* Chelsea School of Art (Brian Robb), RCA (John Lewis). Taught design: Norwich, Leeds and Oxford Schools of Art or Polytechnica. Founded and ran The Inky Parrot Press at Oxford Polytechnic (1981-87) and now runs another Inky Parrot Press. *Misc:* Books in: V. & A., Cambridge University Library, National Library of Scotland, Rijksmuseum, Columbia and Harvard Libraries, full set (44 vols.) in Brookes Oxford University Library. *Address:* The Foundry, Church Hanborough, nr. Witney, Oxon. OX29 8AB. *Website:* www.parrotpress.co.uk

HALL, Jo, BSc.(Hons) Botany (1967), PhD (1971); painter in pastel, watercolour, acrylic; freelance artist and illustrator; formerly biologist in water industry. *b:* Sidcup, Kent, 31 Jan., 1946. *m:* Geoffrey Hall. two *s. Educ:* Exeter University, Imperial College, London. *Exhib:* SGFA members and open (1996-2003), Not the Royal Academy (1997-2002), Medici Miniatures (1997-1998); solo exhib. by invitation of the European Space Agency's Fine Art Club (2001). *Works in collections:* ESA's fine art collection, Noordwijk, Holland. *Commissions:* corporate including, Southern Electric, Gardens of Woolley Hall, Assoc. Aviation Inc. (Space Division), The Creation Portfolio, a series of impressions of four galaxies; also private commissions, landscape and portrait. *Clubs:* V.P. Society of Graphic Fine Art, Assoc. of Illustrators. *Signs work:* "Jo Hall." *Address:* Morar, Altwood Close, Maidenhead, Berks. SL6 4PP. *Email:* johall@mhstudios.co.uk

HALL, Nigel John, RA (2003); M.Art RCA. *Medium:* sculptor. *b:* Bristol, 30 Aug 1943. *s of:* H.J. Hall. *m:* Manijeh (née Yadegar). *Educ:* Bristol Grammar School. *Studied:* West of England College of Art (1960-64), Royal College of Art (1964-67), Harkness Fellowship (1967-69). *Exhib:* one-man shows, Galerie Givaudan, Paris; Wilder Gallery, Los Angeles; Galerie Neuendorf, Hamburg and Cologne; Serpentine Gallery, London; Juda Rowan Gallery, London; Nishimura Gallery, Tokyo; Elkon Gallery, NY, Galerie Maeght, Paris; Galerie Mayer, Dusseldorf, Galerie Christian Scheffel, Bad homburg, Galerie Lutz und Thalmann, Zurich. *Works in collections:* Tate Gallery, V&A, Arts Council of Great Britain, National Galerie, Berlin, Dallas Museum of Fine Art, Tokyo

Metropolitan Museum, Chicago Art Institute, Kunsthaus, Zurich, Museum of Modern Art, NY. *Commissions:* Australian National Gallery, Canberra; IBM, London; Museum of Contemporary Art, Hiroshima; Clifford Chance, London; Bank for International Settlements, Basel; Bank of America, London and Paris; Said Business School, Oxford University. *Signs work:* "NIGEL HALL." *Address:* 11 Kensington Pk. Gdns., London W11 3HD.

HALL, Pauline Sophie, BSc (1938); artist in woodcut, wood engraving, linocut; ex-mem. S.WL.A.;. *b:* Birmingham, 23 Jun 1918. *d of:* Dr. E. W. Assinder. *m:* Prof. K. R. L. Hall (decd.). two (one deceased) *d. Educ:* Birmingham University, Oxford University. *Studied:* Michaelis School of Art, Cape Town (1955-60). *Exhib:* RE, S.WL.A. (Mall Galleries); one-man shows, Cape Town (1973), The Shakespeare Centre, Stratford-on-Avon (1984), Coleg, Harlech (1992). *Works in collections:* Nature in Art, Wallsworth Hall, Glos. *Signs work:* "Pauline S. Hall." *Address:* Park View Flat, Church Rd., Snitterfield, Warwickshire CV37 0LE.

HALLIDAY, Charlotte Mary Irvine, RWS (1976), NEAC (1961); topographical artist; Keeper, New English Art Club since 1989. *b:* Kensington, 5 Sep 1935. *d of:* Edward Halliday, C.B.E., PPRP, PPRBA, ARCA. *Educ:* Wester Elchies, Francis Holland. *Studied:* RASchools (1953-58). *Exhib:* RWS, RBA, NEAC etc. *Commissions:* Salisbury Cathedral, Selfridges, Lord's Pavilion, the Monument, London Clubs, City Banks and many private houses. *Publications:* Illustrations for Dictionary of Edwardian Architecture by A. Stuart Gray (1985) and co-author, with him, of "Fanlights", a visual architectural history (1990). *Signs work:* "Charlotte Halliday" or "CMIH." *Address:* 36a Abercorn Pl., London NW8 9XP.

HALLIDAY, Colin Thomas, BA (Hons) Painting. *Medium:* oils, acrylic, mixed media. *b:* Carlisle, 19 Jan 1964. *s of:* John Andrew Halliday. *m:* Anne. two *d. Educ:* Appleby Grammar School, Penrith Grammar School. *Studied:* Cumbria College of Art and Design (1987-88), University of Plymouth (Exeter Campus)(1989-92). *Represented by:* Start Space, 150 Columbia Road, London E2 7RG. *Exhib:* Dulwich Picture Gallery, Lake Artists Society Grasmere, Carnegie Arts Centre Workington, Blyth Gallery Manchester, Grey College Durham, Walk Gallery London, KAren Taylor London, Will's Art Warehouse London, Thomas Corman London, numerous art fairs in London, Glasgow, New York and Miami with Start Space, The Hayloft Gallery, Tregoning Fine Art, GX Gallery. *Works in collections:* Adrian Lester, Grey College Durham, Ashurst Morris and Crisp, Brady & Mackenzie, private collections throughout the world. *Commissions:* Rotherham NHS Foundation Trust. *Recreations:* DJ. *Signs work:* "Colin Halliday". *Address:* c/o Eduardo Sant'Anna, Start Space 150 Columbia Road, London E2 7RG. *Email:* art@st-art.biz *Website:* www.st-art.biz

HALLIDAY, Irene, DA (1952), Scholarship (1953), Travelling Scholarship (1954), RSW (1955); artist in gouache, acrylic, oil paint. *b:* Kingsmuir, Angus,

Scotland, 26 Sep 1931. *d of:* Andrew Halliday, School master. *Educ:* Arbroath High School. *Studied:* Dundee College of Art (1948-53, Alberto Morrocco, RSA, RSW). *Exhib:* 42 one-man shows, Arbroath, Dundee, Edinburgh, Manchester, Salford, New York State. *Works in collections:* art galleries of Arbroath, Bolton, Dundee, Glasgow, Greenock, Salford; education authorities of Dundee, Dunbartonshire, Edinburgh, Fife, Manchester, Wigan; Granada TV., British National Oil Co., Shell Centre, London, Manchester Ship Canal Co., Pilkingham Glass plc. St. Helens, Bowrings and Co. London. *Commissions:* Aumbry Door, St. John's Church, Moston, Manchester (1992), Reredos Wall, St. Christopher's Church, Withington, Manchester (1999), Reredos Wall, St. Chad's Church, New Moston, Manchester (2000). *Signs work:* "Halliday." *Address:* 46 Highfield Dene Rd., Didsbury, Manchester M20 2ST.

HALLOWES, Veda Nanette, *Medium:* sculptor in bronze, also some resin and ceramics teacher. *b:* Johannesburg, 16 Jan 1941. *d of:* Jo'an and Heather Couzyn. *m:* George Richard Hallowes. two *d. Educ:* Waverley Girls High School, Johannesburg. *Studied:* Wandsworth Adult Educ. under Molly Ruddle (1988-1999), Wandsworth Adult College (1992-1994); Advanced course in ceramics, Lima, Peru (1975). *Exhib:* two pieces in RA Summer Exhib. (2001); Peru, Hong Kong, Pakistan, London, Newcastle. *Works in collections:* Charing Cross Hospital, London; private collections in UK and worldwide. *Commissions:* various in UK. *Works Reproduced:* usually in editions of nine. *Principal Works:* fruits and anthropomorphic fruits. *Misc:* Has lived in England since 1971. Registered nurse and midwife, for eleven years before training as ceramicist and sculptor; co-founder: Kaleidoscope Arts. *Signs work:* 'VH' with year and number in series. *Address:* 7 Westleigh Ave., Putney, London SW15 6RF. *Email:* info@vedahallowes.co.uk *Website:* www.vedahallowes.co.uk

HALSBY, Julian, MA(Cantab.), RBA (1994), FRSA (1997); painter in oil, art historian, critic; Mem. International Assoc. of Art Critics; Critics Circle. *b:* London, 1948. *m:* Miranda Halsby, printmaker. one *s.* one *d. Studied:* Emmanuel College, Cambridge (art history). *Exhib:* RBA, NEAC, ROI, many mixed exhbns. in the UK and France, Patterson Fine Art, New Grafton, Wykeham, Century Gallery, Datchett; one-man show: Abbott and Holder (1998); Russell Gallery, Putney; Sadler Street Gallery, Wells. *Publications:* include: Scottish Watercolours 1740-1940 (Batsford, 1986), Dictionary of Scottish Painters 1600-2000 (with Paul Harris) (Canongate, 1995), Venice: The Artists' Vision (Batsford, 1990), The Art of Diana Armfield, R.A. (David & Charles, 1995); plus exhbn. catalogues and articles for "The Artist."; "A Private View" Lund Humphries (2002). *Signs work:* "Halsby." *Address:* Old Hall, 101 Newland, Sherborne, DT9 3DU.

HALSBY, Miranda, RBA (2001). *Medium:* watercolour, prints. *b:* London, 13 Apr 1948. *m:* Julian Halsby RBA. one *s.* one *d. Studied:* Kingston College of Art (1966-67); Hornsey College of Art (1967-68-left due to student sit-in); London School of Occupational Therapy (1968-71). *Exhib:* Abbott and Holder (solo, 2001, 2006); New Grafton Gallery; Russell Gallery; National Print Exhbn, Mall

Galleries; various group exhbns in London and Home Counties. *Works in collections:* work in private collections in England, France, Holland, Japan and USA. *Misc:* Partner in Highgate Gallery, dealing in 19th C. watercolours, art nouveau decorative arts, pottery and jewellery, contemporary painters (1980-88); returned to practising as an artist in 1990. *Signs work:* 'Miranda Halsby'. *Address:* Old Hall, 101 Newland, Sherborne, Dorset DT9 3DU. *Email:* halsby2000@halsby.com *Website:* www.halsby.com

HAMBLING, Maggi, O.B.E. (1995), Boise Travel award, NY (1969), Arts Council award (1977), Artist in Residence, National Gallery (1980-81); artist in oil on canvas, water-colour, drawing, sculpture in bronze and steel, printmaking;. *b:* Suffolk, 23 Oct., 1945. *d of:* Harry Hambling and Marjorie Hambling (decd.). *Studied:* Camberwell School of Art (1964-67), Slade School of Fine Art (1967-69); studied with Lett Haines and Cedric Morris (1960). *Represented by:* Marlborough Fine Art, London. *Exhib:* solo shows: National Gallery (1981), National Portrait Gallery (1983), Serpentine Gallery (1987), Arnolfini Gallery, Bristol (1988), Bernard Jacobson Gallery (1990), Yale Center for British Art (1991), Northern Centre for Contemporary Art (1993), Marlborough Fine Art (1996), National Portrait Gallery (1997), Yorkshire Sculpture Park (1997), Marlborough Fine Art, Morley College Gallery (2001), Sotheby's, Aldeburgh Festival Gallery (2003). *Works in collections:* include Tate Gallery, Whitworth A.G., ACGB, National Gallery, British Museum, NPG, Gulbenkian Foundation, Australian National Gallery, Yale Center for British Art. *Commissions:* Public statue for Oscar Wilde, London (1998). *Publications:* 'Maggi and Henrietta' Drawings of Henrietta Moraes by Maggi Hambling, with a preface by John Berger. Bloomsbury 2001. *Clubs:* Chelsea Arts. *Misc:* Jerwood Painting Prize (1995). *Signs work:* surname on back. *Address:* c/o Marlborough Fine Art, 6 Albemarle St., London W1S 4BY.

HAMILTON, Colin Reginald, MSIA General Illustration; Daily Mail 'Not the Turner Prize' Finalist (2003). *Medium:* oil, watercolour, acrylic. *b:* London, 2 Jan 1950. *m:* Christine. two *s.* *Studied:* East Ham Art School (at 16, 3-year diploma course in Graphic Deisgn, but qualified at 19 as an illustrator-had a London agent). *Exhib:* RA Summer Exhbn (2000), Whitechapel Gallery (1977), Discerning Eye (2000), AAF Battersea (2000), Llewelyn Alexander Gallery 'Not the Royal Academy Show' (2002, 03, 04, 05, 06, 07), Daily Mail 'Not the Turner Prize' (2003, 2004); group shows at the Kaleidoscope Gallery, London (2004), Beacroft Gallery (2001, 02, 03, 04, 05), Singer & Friedlander/Sunday Times Watercolour Exhibition (2006, 07). *Works in collections:* paintings requested and donated to Cancer Research UK, Art4Life auction at Christie's (2002, 03, 04, 05, 06, 07). Private collections England, Greece, Germany, USA. *Commissions:* painted and sold commissions from the age of 12. Only private commissions taken. With a small group of students produced the artwork for stage production of 'Gulliver's Travels' The Mermaid Theatre, London. *Publications:* request from 'The Artist Magazine' for an article on my work. *Works Reproduced:* Medici Card Co. *Recreations:* travel, exhibitions. *Misc:* I paint mainly landscapes but have

covered almost all subjects in my career. *Signs work:* 'Colin Hamilton', very small, right bottom corner. *Address:* 202 Collier Row Lane, Collier Row, Essex RM5 3JB. *Email:* colinhamiltonart@yahoo.co.uk

HAMILTON, Julia, BA (Hons) Fine Art Painting; BA (Hons) English Literature and Fine Art. *Medium:* photography, oil, drawing, prints. *b:* London, 27 Mar 1962. *d of:* Tom Hamilton. *Educ:* Francis Holland School, London. *Studied:* Exeter University (Fine Art & Eng. Lit, 1980-83); City & Guilds School of Art (Painting, 1999-2002). *Exhib:* Royal Academy, Sarah Myerscough, NEAC, Laing Open, New Ashgate Gallery, Gainsboroughs House, National Print Exhibition, Collyer-Bristow. *Works in collections:* Geffrye Museum. *Clubs:* ICA. *Signs work:* 'JULIA HAMILTON'. *Address:* 128 Middleton Road, London E8 4LP. *Email:* julia.hamilton3@btinternet.com

HAMILTON, Katherine, Dip. (Byam Shaw) (1974), Dip. Dance and Choreography (1977); painter in oil on canvas, pastel;. *b:* 1954. divorced. two *s. Educ:* Dartington Hall School. *Studied:* Byam School of Art (1971-74, Diana Armfield); London School of Contemporary Dance (1974-77). *Exhib:* solo shows: Christopher Hull Gallery, Sue Rankin Gallery (1993), Thackeray Gallery (1994), Chappel Galleries (1998), Chappel Gallery (2001); mixed exhbns.: Piccadilly Gallery, New Academy Gallery (1996), Chappel Gallery (1997), R.A. Summer Show (1997), Cambridge Contemporary Art (1998), Woodgates Gallery East Bergholt (1999), mixed show - Chappel Gallery (2002, 2004, 2007), Messum's (2003), Anglia Television 'Coastal Inspirations' (Apr 2006). *Commissions:* fourteen portraits (1996-97). *Publications:* British Artists – Francis Spalding, feature in Pastel International 'Artist' magazine, Artists at Walberswick, East Anglia, Interludes 1880-2000 by Richard Scott, 'Breaking Waves! Artists in Southwold, by Ian Collis (pub.2005), 'Southwold, An Earthly Paradise' by Geoffrey Munn (pub.2006). *Misc:* previously known as Kate Gault. *Signs work:* "Katherine Hamilton." *Address:* Hill House, 61 Covert Rd., Reydon, Southwold, Suffolk IP18 6QE.

HAMILTON, Susie, DipAD; BA(Hons); PhD (English Literature); George Smith Award (Univ. of London); Graham Hamilton Drawing Prize (Byam Shaw). *Medium:* oil, watercolour, acrylic, drawing, prints. *b:* London, 10 Aug 1950. *d of:* Augustine and Mollie Courtauld. *m:* Peter Hamilton. *Educ:* St.Mary's School, Calne. *Studied:* St.Martin's School of Art (1968-72); Birkbeck College, Univ.of London (1978-87); Byam Shaw School of Art (1989-92). *Represented by:* Paul Stolper Gallery, London. *Exhib:* RA Summer Show (2004); Crusaid: Art Aid, RCA (2005); St.Edmund Hall, Oxford; St.Paul's Cathedral, London; John Moores 23 (Walker, Liverpool, 2004)); Voges and Partner Gallery, Frankfurt (2005); Whitechapel Open; selected solo shows: The Hallion, Edinburgh (2005); Ferens Art Gallery, Hull (2002); A22 Projects, London (1998, 99, 2000); Church of St.Giles Cripplegate, London (2001); Babington House, Somerset (2001); Paintings and Works on Paper:The Coram Gallery, The Gallery at John Jones (1995), Galleri Trafo, Oslo (2007), and many more. *Works in collections:* The

Economist; Deutsche Bank; The Groucho Club; coll. of George Melly; Bernard Jacobson; Damien Hirst; Church of St.Giles, Cripplegate. *Commissions:* private commissions-for Hugh Pearman, John Woodman, etc. *Publications:* 'Riddled with Light': essays by Charlotte Mullins, Richard Dyer (Paul Stolper, 2006). *Works Reproduced:* 'Art Works, British & German Contemporary Art, 1960-2000' by Alistair Hicks (Deutsche Bank); 'Monoprinting', Jackie Newell (ACBlack, 2005); 'Cambridge Companion to Postmodernism', ed. Connor (CUP, 2004); in magazines and national newspapers. *Principal Works:* apocalyptic scenes of beaches and banquets with mutating figures. *Recreations:* english literature-especially poetry. *Clubs:* Groucho Club. *Misc:* drawing figures in motion - catching the life of the subject. *Signs work:* 'Susie Hamilton'. *Address:* 23 Rhondda Grove, London E3 5AP. *Email:* susie.hamilton@virgin.net *Website:* www.paulstolper.com

HAMILTON, Thomas Gottfried Louis, BA Hons.(Arch.); architect, artist in pen, pencil and water-colour. *b:* Berlin, 29 Mar 1930. *s of:* Louis Hamilton. *m:* Georgina Vera Craig. one *s.* one *d. Educ:* King's School, Canterbury; UCL. *Studied:* architecture: Bartlett School of Architecture (1949-55, Prof. A.E. Richardson). *Exhib:* private galleries. *Clubs:* The Arts, Dover St. *Signs work:* "Thomas Hamilton." *Address:* 55 Addison Ave., London W11 4QU. *Email:* Thos.hamilton@btinternet.com

HAMMICK, Tom Henry Heyman St. Vincent, B.A. (Hons.) Ist Class (1990), M.A. Printmaking; Winston Churchill Fellow (1998), Robert Frazer Award (1998); artist in painting/printmaking; Visiting lecturer, Nova Scotia College of Art;. *b:* Tidworth, 6 Sept., 1963. *m:* Martha Theis. one *s. Educ:* Camberwell School of Art (1987-92). *Works in collections:* B-Museum, Yale Center British Art, Arts Council of N.I., Deutsche Bank, Arthur Anderson, British Midland. *Publications:* "Lido" (1998) with poems by Maureen Duppy. *Clubs:* Groucho. *Address:* 10 Elwin St., London E2 7BW.

HAMMOND, Hermione, Rome Scholar (Painting, 1938). *Studied:* Chelsea Polytechnic, R.A. Schools (Dip.). *Exhib:* one-man exhbns.: Bishopsgate Institute (1956); Colnaghi's (1957); Arthur Jeffress (1961); All Hallows, London Wall (1965); New Grafton (1970); Great King St. Gallery, Edinburgh (1972); Six Portfolios, Chelsea (1973); Hartnoll & Eyre Iran & Cyprus (1978), Michael Parkin and University of Hull (1993); Michael Parkin (2000). *Works in collections:* ceiling decoration, University of London, Guildhall collection, Museum of London, Fondation Custodia, Institut Néerlandais, Paris, Fitzwilliam Museum, Hunterian A.G., Glasgow, Brymor Jones Library, University of Hull, Whitworth, Manchester. *Publications:* Oxford Almanack, Arts Review, R.I.B.A. Journal, Country Life. *Signs work:* "Hermione Hammond." *Address:* 2 Hans Studio, 43a Glebe Pl., London SW3 5JE.

HAMMOND, John Leonard, BA (Hons); mem. South West Academy of Fine and Applied Arts (Chairman of their Exhibition Committee, 2004, 2005); winner

M.Baker Award South West Academy Open (2000). *Medium:* painter in acrylics. *b:* Woodford Green, 15 Oct 1961. *m:* Dr. Kate Luck. *Educ:* Glyn Grammar School, Ewell. *Studied:* Wimbledon Art School (1978-79); Bath Academy of Art (1979-1981). *Exhib:* regular solo exhbns: John Noott Galleries, Broadway; Marine House at Beer; Montpellier Contemporary Art, Stratford-upon-Avon; mixed exhibitions: South West Academy of Fine and Applied Arts; Victoria Art Gallery (Bath Soc. of Artists); Mall Galleries (ROI); Albemarle Gallery, London; Rooksmoor 'Best of Bath'; Wykeham Gallery, Stockbridge; Cornelius Gallery, Ross-on-Wye; Carousel Gallery, Chipping Sodbury. *Works in collections:* private collections internationally. *Commissions:* Land Securities plc 'Endangered Species Project'; VFD Interiors/ Holland America Line MS. Noordam. *Publications:* 'International Artist' (2000, 2001), 'Leisure Painter' (2000, 2004), 'The Artist' (2001, 02, 03), 'Art in Devon' (2005); 'Capturing Light in Acrylics' co-author Robin Capon (pub. Batsford, 2004, pub. in Netherlands as 'Spelen met Licht in Acryl' by Cantecleer, 2004); Video/DVD 'Capturing Light in Acrylics' APV Films Ltd, 'Free Expression in Acrylics' co-author Robin Capon (pub. Batsford 2008). *Works Reproduced:* limited edition prints by John Noott Broadway Editions, and by Steam Gallery at Beer. *Recreations:* classic sports car rally/touring. *Clubs:* Morgan Sports Car Club, Morris Minor Owners Club. *Signs work:* 'J L Hammond'. *Address:* 138 Eastern Ave, Chippenham, Wilts. SN15 3XT.

HAMPTON, F. Michael, S.WL.A; wildlife artist in water-colour, scraperboard and acrylic; S.WL.A.-W.W.F.N. Fine Art award (1988). *b:* Croydon, 29 May 1937. *s of:* Francis Wilkie. one *s. Studied:* Croydon Art School. *Exhib:* RSPB, Sandy, Arnhem Gallery, Croydon, Blackheath Gallery SE3, Mall Galleries, London, Port Lympne Zoo Park, Hythe, Kent, Ringstead Gallery, Hunstanton, Cotswold Wildlife Gallery, Lechlade, Glos. *Commissions:* Mr. John Aspinall. *Works Reproduced:* three jackets of 'British Birds', two jackets of R.S.P.B. 'Birds', (1980-1983), Calendar for Sussex Fine Arts, S.WL.A. Calendars (1987, 1988), S.WL.A.-R.S.P.B. Calendar (1990, 1991, 1992), B.B.C. Wildlife Magazine (Aug. 1992). *Clubs:* S.WL.A., Croydon Art. *Signs work:* "M" and "H" with grebe's head. *Address:* 13 Sandy Way, Shirley, Croydon, Surrey CR0 8QT.

HANCERI, Dennis John, R.S.M.A. (1970); graphic designer, water-colour and gouache;. *b:* London, 7 June, 1928. *m:* Jill. one *s.* one *d. Studied:* St. Martin's School of Art. *Exhib:* one-man show, Denver, Colorado, U.S.A., Centaur Gallery, Dallas, Texas, Southport, Connecticut, U.S.A.; also shows at Mystic Seaport, Connecticut. *Clubs:* Wapping Group of Artists. *Signs work:* "Dennis John Hanceri RSMA." *Address:* 15 Cedar Mount, Mottingham Lane, Mottingham, London SE9 4RU.

HANDLEY, Paul, BA(Hons.) 1987, ATC (1991); painter in oil, lecturer; Art History lecturer, Itchen College, Soton;. *b:* Newark, Notts., 29 Jun 1964. *Studied:* Norwich School of Art (1984-87), John Wonnacott, John Lessore), Goldsmiths' College (1990-91). *Exhib:* Spectator 1st prizewinner (1992), Hunting Group,

NEAC, Discerning Eye, RP, Royal Overseas League, New Grafton Gallery, Alresford Gallery, Quantum Contemporary, Rowley Gallery London, etc. Work in private collections internationally. *Clubs:* N.E.A.C. *Signs work:* "P.H." *Address:* Brook House, 58 Upper Brook St., Winchester, Hants. SO23 8OG.

HANKEY, Christopher Dominic, BA (Hons), MA Fine Art, Postgraduate Diploma; Polish Government 10 month postgraduate scholarship. *Medium:* oil on canvas, board. *b:* Lancaster, 15 Feb 1963. one *s.* two *d. Studied:* Wolverhampton Polytechnic (1984-87), Academy of Fine Arts Krakow, Poland (1991-92), University of Wales Institute, Cardiff. *Represented by:* Will's Art Warehouse London, Innocent Fine Art Bristol, Rainyday Gallery Penzance, Pydar Gallery Truro, Tregoning Fine Art Ashbourne, International Art Consultants 'Art for Offices' London. *Publications:* Cornishman, Inside Cornwall, Arts Review, Country Home. *Works Reproduced:* Arts Review. *Recreations:* astronomy, chess, mountaineering, snowboarding. *Clubs:* Planetary Society, SETI at Home. *Signs work:* Christopher D.Hankey. *Address:* Chy Essack, Boswarthen, Newbridge, Penzance, Cornwall, TR18. *Email:* dom598@aol.com

HANLEY, James, RHA (2001); Secretary RHA (2001-); ARHA (2000); BA History of Art and English (1987), BA Fine Art Painting (1991). *b:* 8 Nov 1965. *m:* Orla Dukes. *Studied:* University College Dublin; National College of Art and Design, Dublin. *Represented by:* RHA, and Solomon Gallery, Dublin. *Exhib:* RHA; Walker Art Gallery, Liverpool; Germinations VIII Breda, Holland, and tour, Lubeck, Germany; Solo exhbns: Riverrun Gallery, Hallward Gallery & Solomon Gallery, Dublin. *Works in collections:* National Gallery of Ireland; Irish Museum of Modern Art; Arts Council of Ireland; National Self-Portrait Collection; Office of Public Works; European Parliament. *Commissions:* portraits: State portrait of Taoiseach Bertie Ahern T.D., Ronnie Delany, Olympic Gold Medallist. *Official Purchasers:* Office of Public Works, Irish Defence Forces, Royal College of Surgeons in Ireland, Allied Irish Banks. *Works Reproduced:* AN Post, Abbey Theatre, National Lottery. *Signs work:* 'HANLEY'. *Address:* 12 Leinster Avenue, North Strand, Dublin 3, Ireland. *Email:* jameshanleyrha@eircom.net *Website:* www.jameshanley.net

HANLEY, Liam Powys, self taught painter in oil on board, gouache and tempera. *b:* S. Kensington, 4 Apr 1933. *s of:* James Hanley, novelist. *m:* Hilary Hanley, etcher. one *s.* one *d. Educ:* Wrekin College, Salop. *Exhib:* Stone Gallery, Newcastle, Mermaid Theatre, Thackeray Gallery, London, RA, Abbot Hall A.G., Kendal, Phoenix Gallery, Lavenham, Suffolk, Beardsmore Gallery, London. *Publications:* The Face of Winter by James Hanley. *Official Purchasers:* National Library of Wales, Graves Art Gallery Sheffield, Abbot Hall Gallery, Kendal, Leicester, East & West Riding, Yorkshire, Lancashire, Sussex, Camden local authorities. *Recreations:* reading 20th Cent. fiction. *Signs work:* "Hanley, L." *Address:* 21 Woodsome Rd., London NW5 1RX.

HANN, Priscilla, B.A., S.Eq.A.; sculptor;. *b:* Pattingham, nr. Wolverhampton, 11 Oct., 1943. *m:* Patrick Kennedy (decd.). *Educ:* Downe House, Newbury. *Studied:* Wolverhampton College of Art (1961-65, Ron Dutton), Tyler School of Art, Philadelphia (Dean Le Clair). *Works in collections:* 'Natives of Furlong', Ringwood, Hants. *Clubs:* S.Eq.A., Friend of R.A., British Sporting Art Trust, Public Sculpture and Monuments Assoc. *Signs work:* "P. Hann." *Address:* Tetstill, Neen Sollars, Cleobury Mortimer, Worcs. DY14 9AH.

HANSCOMB, Brian, R.E. (1997); self taught artist. *Medium:* copperplate engraving, pastel and mixed media. *b:* Croxley Green, Herts., 23 Sep 1944. *m:* Jane Wilkins, née Hunt. two *d. Educ:* Rickmansworth Grammar School. *Exhib:* RA Summer Exhbn, RWA Open, RE, NEAC, Clarges Gallery, Crane Kalman Gallery, Beaux Arts Gallery; one-man shows: England and Germany; Lemon Street Gallery. *Works in collections:* G.A.C., V. & A. National Art Library, Science Museum, Royal Cornwall Museum and Art Gallery, Bodleian Library, New York Public Library. *Commissions:* Bowes & Bowes; Merivale Editions; Folio Society (On the Morning of Christ's Nativity). *Publications:* Sun, Sea and Earth (Whittington Press, 1989); Cornwall-An Interior Vision (Whittington Press, 1992); Matrix (Whittington Press, 1995); The Phoenix (Whittington Press, 2005). *Clubs:* Cyclists' Touring Club (CTC). *Misc:* cycling, walking. *Signs work:* "B. Hanscomb" or "B.H." *Address:* Tor View, Limehead, St. Breward, Bodmin, Cornwall PL30 4LU. *Email:* brian@brianhanscomb.co.uk *Website:* www.brianhanscomb.co.uk

HANSELAAR, Marcelle, RE; 'Presse Papier Award', Biennale International d'estampe, contemporain, Quebec, Canada (2003), UWA purchase prize, Originals '06, London (2006). *Medium:* oil painting, etching, lithography. *b:* Rotterdam, Holland, 23 Mar 1945. *d of:* Visser Hanselaar. *Studied:* Royal Academy of Art, The Hague, Holland (1962-64); Chelsea and Kensington College, London (B-Tech Printmaking, 2001). *Represented by:* De Queeste Art, Belgium; East West Gallery, London; Stephanie Burns Fine Art, Aus. *Exhib:* solo: East West Gallery (2001, 03, 05, 08); De Queeste Art (2004,05, 06, 07); Stephanie Burns Fine Art (2004, 06); Galerie de Buytensael, Arnhem (2003, 2008); RM Art, Essen (2003); The Millinery Works, London (1999). *Works in collections:* British Museum Prints & Drawings, London; Ashmolean Museum, Oxford; University of Wales Print Collection, Aberystwyth; Clare Hall, Cambridge; New Hall, Cambridge; Rabo Bank, London; Merrill Lynch, London; Mitsukoshi Ltd., London; AMC, Holland; Amsterdam Arts Council; Risk Publications, London; Paintings in Hospitals, London. *Publications:* 'La Petit Mort' (2005),'Notes from an Incomplete Journey' (2005), 'The weight of smoke' (2007). *Works Reproduced:* catalogues of most solo and group exhibitions. *Clubs:* Arti & Amicitae, Amsterdam;The London Group. *Misc:* taught at: Central School of Art and St.Martin's, London (1987-88); Sotheby's Educ. Inst. (1989-99); Art Dept. SW Teachers Univ., Chongqing, China (1993, 1995, 96); Sichuan Inst. of Fine Art, Chongqinq (1993, 1995, 96); Neijiang Teachers College, Sichuan (1995). *Signs work:* 'Marcelle Hanselaar'. *Address:* 58 Eccleston Sq.,

London SW1V 1PH. *Email:* maha@marcellehanselaar.com *Website:* www.marcellehanselaar.com

HARBON, Jan, SFP, SBA; Presidents Award SFP (2005), SBA (2007); Certificate Botanical Merit SBA (2006); Silver Gilt Medal RHS. *Medium:* watercolour, mixed media. *b:* London, 5 Jun 1948. *d of:* Tom & Jean Braund. *m:* Geoffrey. one *s.* one *d. Studied:* London College of Printing - Illustration. *Exhib:* Chelsea Flower Show (2004-2007); SFP, SBA, RHS Winter Shows, London; Hampton Court Palace Flower Show; Southampton City Art Gallery. *Works Reproduced:* limited edition prints. *Signs work:* 'JAN HARBON'. *Address:* Old Pastures, Passfield Road, Passfield, Liphook, Hampshire GU30 7RU. *Email:* janharbon@btinternet.com *Website:* www.janharbon.com

HARCUS, Robert, ASEA, painter in oil; first Irish artist to attain Associateship of Society of Equestrian Artists. *b:* 1 Sep 1939. *m:* Ethna. *Educ:* St. Vincent's CBS, Glasnevin. *Studied:* completely self-taught. *Exhib:* RHA, the Oireachtas, SEqA; annual solo exhibs. at Kilkenny Arts Festival since 1981; Society of Equestrian Artists, London and Newmarket; American Academy of Equine Art, Kentucky; Salon D'Arts, La Rochelle; International Salon of Fine Arts, Argeles-sur-Mer. *Works in collections:* corporate collections in Ireland and USA, including banking institutions and embassies. *Clubs:* Artists Assoc. of Ireland. *Signs work:* "Robert Harcus." *Address:* St. Endas, South Quay, Arklow, Co. Wicklow, Eire. *Email:* RobertHarcus@eircom.net

HARDAKER, Charles, ARCA (1958), NEAC (1969), RBA (1984); painter in oil and pastels; tutor in painting and drawing. *b:* Oxford, 1 May 1934. *s of:* Charles Hardaker, businessman. *m:* Annick née Pouletaud. *Educ:* Wellesbourne School, B'ham. *Studied:* B'ham College of Arts and Crafts (1949-53), RCA (1955-58). *Exhib:* RA, NEAC, RBA, RP, five one-man shows, San Francisco (2), London (3). *Works in collections:* Tate Gallery (Chantrey Bequest), Guildhall of London, National Library of Wales, Northumbria Water, BP, ICE, Townley Hall, Eire. *Signs work:* "Hardaker." *Address:* Studio 1, St. Oswald's Studios, Sedlescombe Rd., Fulham, London SW6 1RH.

HARDCASTLE, Audrey, SBA (1991); SFP (1996); Certificate of Botanical Merit, SBA (1995); St.Cuthberts Mill Award (1997). *Medium:* watercolour. *b:* 2 Aug 1934. *m:* John. two *d. Studied:* University of Southampton School of Education (Certificate in Art & Craft, and Education). *Exhib:* group: SBA, Westminster Gallery (1990); SFP (1996); The Garden Exhibition, Wales (1992); Everard Read Gallery, Johannesburg (1992); The Linnean Society (1991); The Hunt Inst. 8th International Exhbn. *Works in collections:* Hunt Institute for Botanical Documentation (Slipper Orchid). *Commissions:* various in UK. *Works Reproduced:* in 'The Origin of Plants'; 'The Art of Botanical Painting';'A History and Dictionary of British Flower Painters'; 'Collins Flower Guide'. *Signs work:* 'A Hardcastle'. *Address:* Compton, 129 Bouverie Avenue South, Salisbury, Wilts, SP2 8EA. *Email:* hard.castles@virgin.net

HARDIE, Gwen, Richard Ford award, RA (1982), Hons. Degree (1983), Daad Scholarship, W. Berlin (1984), Edward 7th British-German Foundation, W. Berlin (1986); painter in oil, sculptor in cement, plaster;. *b:* Newport, Scotland, 7 Jan 1962. *d of:* Anne Livingstone and James Hardie. *Educ:* Inverurie Academy. *Studied:* Edinburgh College of Art (1979-84, John Houston), HDK, W. Berlin (1984-85, Baselitz). *Exhib:* solo shows: Fruitmarket Gallery, Edinburgh (1987), Fischer Fine Art, London (1989), SNGMA (1990), Talbot Rice A.G., Edinburgh, Annely Juda, London (1994), Jason & Rhodes, London (1996), Peterborough Museum and Fine A.G. (1997); group shows: Vienna (1986), American tour (1989-92), Frankfurt (1993), Jason & Rhodes, New Artists: Hardie Colvin & Boyd (1995). *Works in collections:* SNGMA, Metropolitan Museum N.Y., Gulbenkian Museum Lisbon, Arts Council, etc. *Commissions:* Portrait of Jean Muir (1985). *Signs work:* "G. HARDIE" or "G.H." *Address:* c/o Jason and Rhodes, 4 New Burlington Place, London W1X 1FB.

HARDIMAN, Patsy Christine, *Medium:* oil. *b:* Amersham, Bucks, 3 Dec 1946. *d of:* George & Johanna Stevenson. *m:* Stanley. one *s. Educ:* Our Lady & St.Anselms, Middx; Paddington Polytechnic, London. *Studied:* Shaftesbury Centre, Richmond, Surrey; FE Centre, Chertsey, Surrey. *Represented by:* LondonArt.co.uk. *Exhib:* RA Summer Exhbn (2000); Llewelyn Alexander (2002/6); Christie's, London, Art for Life (2002/6); Whittlesford Gallery, Cambridge (2002/6); Arndean Gallery, London (2004). *Recreations:* writing, music, poetry. *Clubs:* Society of Catholic Artists; Christian Arts. *Signs work:* 'Patsy H'. *Address:* 17 rue de la Salle, 17240 St. Gregoire D'Ardennes, France. *Email:* patsyhardiman@aol.com *Website:* www.LondonArt.co.uk

HARDING, Alexis, BA (Hons); First Prize, John Moores 23, Walker Art Gallery (2004). *Medium:* oil and gloss paint. *b:* London, Aug 1973. *Studied:* Goldsmiths College (BA Hons) 1992-95. *Represented by:* Mummery & Schnelle, London; Rubicon Gallery, Dublin; Marella Gallery, Milan. *Exhib:* first one-person exhibition: Galerij 565, Aalst, Belgium (1997). Other solo shows include: Andrew Mummery Gallery, Rubicon Gallery Dublin, Galeria Pedro Cera - Portugal, Krohn Galerie -Basal, Marella Arte -Milan, Allerart -Bludenz, Austria (2006), Patricia Sweetow Gallery -San Francisco (2007). Since 1995, he has shown extensively in two-person and group exhibitions internationally. *Works in collections:* Arts Council of England, Bank of Spain, Irish Musum of Modern Art -Dublin, National Museums Liverpool -The Walker, Caldic -Rotterdam. *Publications:* New British Art, Chris Townsend (Thames & Hudson, p.40-48), Twisting into True (text by Martin Holman, Rubicon Gallery), John Moores 23 (Walker Art Gallery, Liverpool), Painting by the Skin of your Eyes, JJ Charlesworth (Andrew Mummery Gallery), Alexis Harding 'Unloosing Control' (text by Caoimhin Mac Giolla Leith), Shimmering Substance (Arnolfini Gallery, Bristol). *Address:* Mummery & Schnelle, 83 Great Titchfield St., London W1 6RH. *Email:* hardingalexis@hotmail.com *Website:* www.mummeryschnelle.com

HARDING, Jane Mary, SWA (1982); artist in line and water-colour. *b:* London. *d of:* Edwin Harvey, civil servant. *m:* David Harding. *Educ:* Haberdashers' Aske's Girls' School. *Studied:* Lytham St. Annes School of Art (1940-41). *Exhib:* SWA annually, Britain in Water-colour, Ealing Art Group. *Works in collections:* London Borough of Ealing Central Library and in private collections in the UK and abroad. *Publications:* editorial illustrations for Amalgamated Press, Odhams, Franey's London Diary, Grolier Press, Sunday Times, Ward Gallery. *Clubs:* Ealing Arts. *Signs work:* "Jane Harding." or jh. *Address:* Melvin House, 13 Hartington Rd., Ealing, London W13 8QL.

HARDISTY, Jan, *Medium:* photography, prints. *b:* Guildford, 23 Jan 1948. one *s. Studied:* Central School of Art, London (graphic design); self-taught photography. *Exhib:* RA Summer Show (2004); Merz Gallery, Edinburgh (2005); studio shows, London (1996, 2005). *Works in collections:* Citibank (London) Permanent Collection; international private collections; Celebrity Cruises permanent collection. *Commissions:* Conran shops, London. *Works Reproduced:* internationally by 'The Special Photographers Company Picture Library'. *Signs work:* 'Jan Hardisty'. *Address:* Flat 21 5-7 Lambolle Road London NW3 4HS. *Email:* janhardisty@btinternet.com

HARDMAN, Paul Ritson, B.Ed. *Medium:* cartoonist and illustrator, inks or computer generated colour. *b:* Liverpool, 21 Jan 1947. *m:* Mary. two *s. Educ:* De La Salle College, Liverpool; St.Mary's College, Twickenham; London Inst. of Ed. (London Univ.), studying Educational Psychology, Art, Maths. *Exhib:* many cartoon exhbns around Europe and Western Asia. *Works in collections:* FEC.O Collections. *Commissions:* for film and TV (many); Channel Four Racing. *Publications:* Daily Mirror, Sunday Mirror, Sporting Life. *Clubs:* Cartoonists Club of GB; Federation of Cartoonists Organisations; The British Cartoonists Association; Cartoonists Guild. *Signs work:* Hardman. *Address:* 37 Beach Priory Gardens, Southport, Lancs, PR8 2SA. *Email:* mail@hartoons.co.uk *Website:* www.hartoons.co.uk

HARDY, Robert, BA (Hons); MA; ATC; New Contemporaries Prizewinner (1976). *Medium:* oil, acrylic, drawing. *b:* Salford, 13 Aug 1952. *s of:* Eddie and Vera. *m:* Margaret. *Educ:* Salford Grammar School (1963-70). *Studied:* North Staffs Polytechnic (1971-74); Chelsea School of Art (1974-5); London University Institute of Education. *Represented by:* England & Co./The Sheen Gallery. *Exhib:* RA Summer exhbn (1998, 2000, 2001); Contemporary Art Fair (Art 96, 97, 98, 99); AAF (2000); Harriet Green Gallery; Sally Hunter Fine Art; Llewelyn Alexander Gallery; London Art Fair; Open Eye Gallery, Edinburgh; Cambridge Contemporary Art; Custard Factory, Birmingham; Bonhams Vision 21; Presence-St.Paul's Cathedral (2004); solo shows: Tavistock Inst. (1988), Reading Art Centre (1995), England & Co (1996/1998), Bury St.Edmunds Cathedral (1997); Ministry of Gozo, Govt. of Malta (2001); The Sheen Gallery (2005); Rudolph Steiner Centre (2006). *Works in collections:* Govt. of Malta. *Publications:* About My Work; Times of Malta; The Tablet; Church Times; Sunday Telegraph. *Works*

Reproduced: RA Summer Exhbn. Catalogue (1998); 'Presence', St.Paul's Cathedral Catalogue (2004). *Recreations:* walking, reading, praying. *Signs work:* 'R.Hardy'. *Address:* 24 Albemarle Road, East Barnet, Herts EN4 8EG. *Website:* www.roberthardyartist.co.uk

HARGAN, Joseph R., D.A. (1974), P.P.A.I. (1989); elected, Glasgow Group (1996), Stirling Smith award (1978), Cargill award (1980), Torrance award (1982), Meyer Oppenheim prize R.S.A. (1985), Hunting Group prizewinner, London (1988), Paisley Art Inst. award (1993), C.F.A.G. Award (2001); Founder Mem. and Chairman of Group 81; elected Pres. P.A.I. (1989-2001), elected P.A.I. (1996). *b:* Glasgow, 23 Jan 1952. *s of:* Patrick Joseph Hargan, postman and Elizabeth Scott. *m:* Anne Louise Clarke. two *s.* one *d. Studied:* Glasgow School of Art (1970-74, Danny Ferguson, Drummond Bone, David Donaldson). *Exhib:* R.S.A., R.G.I., R.S.W., Art Club, Group 81, R.A., P.A.I., B.W.S., S.S.A., etc. *Works in collections:* New Zealand, Brazil, U.S.A., Europe and S. America. *Clubs:* Glasgow Art. *Signs work:* "Hargan." *Address:* 40 Oakshaw St., Paisley PA1 2DD.

HARING, Noël, DES RCA (1957); Singer Friedlander/Sunday Times Prize Winner. *Medium:* watercolour. *b:* London, 11 Oct 1931. *Studied:* RCA. *Exhib:* RI; RWS; RP; RSMA; Discerning Eye; Mall Gallery; Bank Gallery; Gallery Room for Art, Cobham; Square One Gallery, London; The Gallery Virginia Water (now closed). *Signs work:* 'Noël Haring'. *Address:* 84 Weymede, Byfleet, West Byfleet, Surrey KT14 7DH. *Email:* anne.haring@ntlworld.com *Website:* www.surreyartists.co.uk

HARLEY, Alexandra, Associate Member of Royal British Society of Sculptors. *Medium:* sculpture. *b:* Essex, 13 Aug 1958. two *d. Studied:* Wimbledon School of Art (1978-82), St.Martin's School of Art (1982-84). *Exhib:* solo exhibitions: Eger Gallery, London; Chelmsford Library, Essex. Selected exhibitions: Tate Gallery, London; Royal British Society of Sculptors; Poussin Gallery, London; Horb, Germany. *Works in collections:* private. *Commissions:* Broadstairs Folkweek; Gate Theatre, London; BBC 'Charlie's Garden Army' and others. *Works Reproduced:* 'Sculpture', Jane Hill (Hodder & Stoughton, 1998). *Recreations:* traditional music. *Signs work:* "A.H." *Address:* 29 Fernholme Road, Nunhead, London SE15 3EF. *Email:* alexharley@btinternet.com *Website:* www.alexandraharley.co.uk

HARLOW, Geoff, SWLA; FSAII, ARPS. *Medium:* driftwood, metal, artists oilcolours, tinted etc. *b:* 12 Nov 1934. *m:* Dorothy. two *d. Studied:* Ealing Art School. *Exhib:* The Mall Galleries, London; Wildlife Art Gallery, Lavenham, Suffolk; Sabin Gallery, London; Pinkfoot Gallery, Cley, Norfolk; Royal Academy; Architectural Model;s, London; Royal Photographic Society, International Exhbn, Bath. *Works in collections:* The Hammerbow Group of Companies, Park Lane, London; Architectural Models; London Salon Pictorial Photography. *Commissions:* taken. *Publications:* "Drawn to the Forest", SWLA

Magazine, The Best of Norfolk, Norfolk Journal, etc. *Official Purchasers:* RSPB. *Signs work:* 'GH' (monogram). *Address:* 64 Leafield Rise, Two Mile Ash, Milton Keynes, MK8 8BX.

HARMAN, Alice, SBA; awards: RHS -Silver Gilt (2000), Silver (2000), Silver (2006). *Medium:* botanical watercolours on paper and vellum. *b:* South Africa, 1 Sep 1957. *d of:* Fredrick & Susan Milton. *m:* Peter Harman. one *s.* one *d. Educ:* Kilgraston School, Perthshire. *Studied:* self-taught. *Exhib:* RI (2003); RHS (2000, 2006); SBA (1998-2007); Chichester Open Art (1999-2001); Cow Shed Studios, Steyning; North East Open Studios, Kemnay, Inverurie. *Signs work:* 'ALICE HARMAN'. *Address:* Hammes Barn, Washington Road, Steyning, West Sussex, BN44 3DA. *Email:* peter.harman@virgin.net *Website:* www.cow-shed-studio.com

HARPER, Alison, BA (Hons) Fine Art (1985); Post Grad year (1986); Post-Diploma (Baroda, India, 1995); Norwegian Govt. Scholarship (1986); Commonwealth Scholarship (1993); Ruth Davidson Memorial Award (1998); The Prince of Wales Drawing Studio Bursary (2001); Lady Artists' Trust Award (1988). *Medium:* oil, drawing, prints. *b:* Glasgow, 25 Feb 1964. *d of:* Prof.Alexander M.Harper & Charlotte Harper. *m:* Andrew Wamae. one *s. Studied:* Glasgow School of Art (1981-85); Kunstakademie Oslo (1986); M.S.University, Baroda (1993-95); Prince of Wales Drawing Studio (2001-02). *Represented by:* Boundary Gallery, London (also known as one of 'The Glasgow Girls'). *Exhib:* selected solo & group shows: RA; RSA; NPG; Collins Gallery; Leicester City Art Gallery; Nairobi Museum; Shetland Museum; Stirling Museum; India Today Gallery, New Delhi; Iwate Arts Festival, Kyoto, Japan; National Autumn Exhbn, Oslo; City Arts Centre, Edinburgh; Compass Gallery; Sahmet, New Delhi; Cheltenham Open Drawing (prizewinner). *Works in collections:* Strathclyde University; Museum & Arts Loans Service; BBC Scotland; Glasgow School of Art. *Publications:* 'Angels Wear Silver' (Alison Harper); Sandy Moffatt Catalogue Introduction for Compass Gallery Show (1995); 'Tongues of Diamond' (Collins Gallery catalogue, 1999); 'Restoring Female Identity, Strategies by Scottish Female Artists' (dissertation). *Works Reproduced:* 'Scottish Paintings: 1837 to the Present' (William Hardie, 1990). *Principal Works:* 'Burning Woman'; 'Mother Goddess with Seven Yellow Suns'. *Misc:* ordained Buddhist, lecturer at Glasgow School of Art 1995-2001. *Address:* 47 Radbourne Crescent, London E17 3RR. *Email:* alison@alisonharper.com *Website:* www.harperart.com

HARPER, Charles, ANCA (Hons) ATC, AOSDANA, RHA; painter; head of fine art department, Limerick School of Art and Design. *b:* 30 Jul 1943. one *s.* one *d. Educ:* Crescent College, Limerick. *Studied:* Limerick School of Art, National College of Art, Dublin. *Works in collections:* Arts Council of Ireland, P. J. Carroll & Co., Irish Museum of Modern Art, Hugh Lane Municipal Gallery, San Francisco Museum of Modern Art, Limerick City Gallery of Art, University of Limerick. *Publications:* Profile: Charles Harper, Gandon Editions, 1998. *Signs*

work: "Charles Harper." *Address:* Woodstown House, Ballyvara Rd., Lisnagry, Co. Limerick, Ireland. *Email:* charlesharper600@hotmail.com

HARPER, Edward Lawrence, MA Fine Art, BA (Hons) Fine Art; UK Finalist Lexmark European Art Prize (2003). *Medium:* acrylic on canvas. *b:* Southampton, Hants, 4 Mar 1970. *s of:* Norman and Eileen Harper. *m:* Sarah Jarman. one *s.* one *d. Educ:* Merryoaks Boys, Southampton; Itchen College, Southampton. *Studied:* Goldsmiths College (1996-98), Brighton Polytechnic (1989-92). *Exhib:* solo: 'Systemax', Millais Gallery, Southampton (2005); 'Superdrive' Project Space, Northern Gallery of Contemporary Art, Sunderland(2004); Mobile Home Gallery, London (2001, 02); group shows: 'Yes, I'm a Long Way From Home' Wolverhampton Art Gallery and touring England; Espace Fauriel, St.Etienne, France (2002), Buro Friedrich, Berlin (2001), Goma, Glasgow (1999). *Works in collections:* Gun St. (213x152cm Acrylic on cotton, 2000), Tyne and Wear Museums Collection Newcastle; Sebert Road (213x152cm Acrylic on cotton, 2005), Southampton City Art Gallery. *Signs work:* "E Harper". *Address:* 35 Leighton Avenue, Leigh-on-Sea, Essex, SS9 1QB. *Email:* edharper@waitrose.com

HARRIGAN, Claire, BA Hons. (1986), RSW(1992); painter in water-colour, acrylic, gouache and pastel;. *b:* Kilmarnock, 8 Nov., 1964. *d of:* James Harrigan and Elspeth McLaren. *Educ:* Sacred Heart Academy, Girvan. *Studied:* Glasgow School of Art (1982-86, Peter Sumsion, Neil Dallas-Brown, Barbara Rae). *Exhib:* solo shows: Christopher Hull Gallery, London; Gatehouse Gallery, Glasgow; Open Eye Gallery, Edinburgh; Macaulay Gallery, Stenton; Bruton St. Gallery, London; Flying Colours Gallery, London. *Signs work:* "Claire Harrigan." *Address:* 53 King St., Crosshill, By Maybole, Ayrshire KA19 7RE. *Email:* claire.harrigan@lineone.net

HARRIS, Alfred, ARCA, FRSA; artist in acrylic and oil; Chairman (retd.), Dept. of Art & Design, University of London Inst. of Educ.; Mem. London Group;. *b:* London, 21 July, 1930. *m:* Carmel. one *s.* two *d. Studied:* Willesden School of Art (1952), RCA (1955). *Exhib:* numerous group exhbns. and 15 one-man shows in U.K. and abroad. *Works in collections:* 57 in public and corporate including: Ben Uri A.G.; Bradford University; Sweden: Dalarnas Konstnamind, Dalarnas Museum, Falun Museum, Gothenburg Hospital, Konsthallen Uppsala, Ministry of Culture, Scania Valis, Sodertalje Town Council, Uppsala Museum; G.L.C.; Leics. Educ. Authority; London University; Oxford University; R.C.A.; St. Thomas' Hospital, London; Tate Gallery; Tel Aviv Museum, Israel; Tokai Bank, Japan; Warwick University. *Commissions:* Alfred Harris "A Decade in Retrospect" by Pierre Rouue, University of London Institute of Education (1979); 12 drawings by Alfred Harris, Ben Uri Gallery (The London Jewish Museum) (1959). *Publications:* "Portrait of the Artist" edited by Sarah Fox-Pitt, Tate Gallery Publications (1989); "Modern British Painters 1900-1980" edited by Alan Windsor, Scolar Press (1992); "Dictionary of British Artists Since 1945" edited by David Buckman, Art Dictionaries Ltd (1998), The London Group, The

London Group, (2003). *Principal Works:* 3 Series: 1. Playing Cards; 2. Journey of the Dove; 3. Kite Flying. *Address:* 66-70 Camden Mews, London NW1 9BX.

HARRIS, Geoffrey, A.R.C.A. (1954); sculptor; Senior lecturer, Ravensbourne College of Art and Design (1960-86); Assistant to Leon Underwood (1954), Assistant to Henry Moore, O.M., C.H. (1957-60);. *b:* Nottingham, 1928. *s of:* C.F. Harris. *m:* Gillian Farr, M.S.I.A., textile designer. two *s. Educ:* Leeds Modern School. *Studied:* Leeds College of Art (1948-51), Royal College of Art (1951-54). *Exhib:* one-man shows: Leicester Galleries, London (1964), Queen Square Gallery, Leeds (1964). *Works in collections:* in Britain, Europe, U.S.A. *Commissions:* Baildon Primary School, Yorkshire, L.C.C. Maitland Park Housing Scheme, St. Pancras, Eurolink Industrial Centre, Sittingbourne, Kent. *Signs work:* "Harris." *Address:* 5 Queen's Rd., Faversham, Kent ME13 8RJ.

HARRIS, Jennifer Joy, N.D.D. (1955), R.W.A. (1981); etcher and painter in water-colour; display designer (1957-1965), art technician in college of education (1966-1977), and faculty of education, Bristol (1977-1978). *b:* Bristol, 8 Apr., 1935. *m:* Cyril Cave (decd.). *Educ:* Duncan House School, Clifton, Bristol. *Studied:* West of England College of Art, Bristol (1951-1955). *Exhib:* R.A., R.W.A., Nat. Exhib. of Modern British Prints, Blackpool (1979 & 1986); Internat. Mini-Print Exhib. (1997); Nat. Print Exhib., London (1997); and many other exhibs. nationwide and in Paris and New York. *Works in collections:* Print Archive, Scarborough Art Gallery. *Clubs:* member of Printmakers Council. *Signs work:* "J.J.Harris." *Address:* Berry House, Cheriton Fitzpaine, Nr. Crediton, Devon EX17 4HZ. *Website:* www.axisartists.org.uk www.rwa.org.uk

HARRIS, Jill Annfield, *Medium:* acrylic. *b:* Hereford. one *d. Studied:* Hereford School of Art; St.Martins School of Art; Chelsea School of Art. *Exhib:* Crane Kalman; New Grafton; Llewelyn Alexander; Ainscough Gallery; Chelsea Art Society exhbns, etc. *Works in collections:* internationally. *Commissions:* portraits: Edgar Bronfman Jnr.; Hume Shawcross; Philip, Lord Netherdene; Dr. Xanthe Moss; Mrs Eleanor Ruddock. *Recreations:* travel. *Clubs:* Chelsea Arts Club. *Signs work:* 'HARRIS'. *Address:* 18 Cavendish Gardens, Trouville Road, London SW4 8QW. *Email:* jillannfield@hotmail.com

HARRIS, Josephine, RWS, NEAC, FGE.; artist in water-colour, drawing and engraved glass. *d of:* P. A. Harris. *Educ:* privately. *Studied:* Plymouth College of Art (1948-52) under William Mann, A.R.C.A., gained N.D.D. *Works in collections:* Plymouth A.G, Graves A.G., Sheffield, South London A.G., I.L.E.A., K.C.C. *Misc:* Work to commission for public companies and private individuals in engraved glass. *Signs work:* "Josephine Harris" or "J.H." *Address:* Workshop No. 2, 46-52 Church Rd., Barnes, London SW13 0DO.

HARRIS, Marguerite, Fellow of Institute of Medical Laboratory Scientists (retd.); ASBA; SFP; RHS Silver Gilt Medal (2002); RHS Silver Medal (2004). *Medium:* watercolour. *b:* Winchester, 14 Oct 1941. two *s. Educ:* Winchester County High School. *Studied:* tutored 1997-2002 by Joan Osborne SBA SFP.

Exhib: SBA; SFP (Mottisfont Abbey, Hilliers Arboretum); Edinburgh Airport Gallery; Pitlochry Festival Theatre Gallery; Stages Gallery, Machynlleth. *Signs work:* 'M HARRIS' (with date in Roman numerals from 2000). *Address:* 40 Kinloch View, Blackness Road, Linlithgow, EH49 7HT. *Email:* margueriteharris@hotmail.co.uk

HARRIS, Phyllis, SWA, NDD, SGFA (Resigned), AUA; artist in water-colour and pen, lithography, linocut, school teacher (retd.);. *b:* London, 3 Aug 1925. *m:* David Harris. one *s.* one *d. Educ:* Brondesbury High School, London and Abbey School, Reading. *Studied:* Reading University School of Art, Brighton and Camberwell, Harrow School of Art (lithography). *Exhib:* SWA, Brent and Harrow, London. *Clubs:* S.W.A., Wembley Art Soc., Harrow Art Soc., U.A. *Signs work:* "Phyl Harris." *Address:* 55 Slough Lane, Kingsbury, London NW9 8YB.

HARRIS, Rosemary, MA (Hons.) History of Art; Curator, NatWest Group Art Collection;. *b:* Guildford, Surrey, 1 Dec 1962. *m:* Paul Moorhouse. *Studied:* University College, London. *Address:* Royal Bank of Scotland Group Art Collection, 12 Throgmorton Ave., London EC2N 2DL.

HARRISON, Christopher David, BA (Hons.), ATC; artist in water-colour, collage, oils; Director, Bircham Art Gallery;. *b:* Gt. Yarmouth, 21 Oct 1953. *m:* Deborah Margaret. two *s. Educ:* Bromley Grammar School, Kent, Boston Grammar School, Lincs. *Studied:* Jacob Kramer College of Art, Leeds (1973-74), Reading University (1974-78), London University Inst. of Educ. (1978-79). *Exhib:* RBA, RA, RI, RWS; many mixed exhbns. throughout England; regular one-man shows Norfolk. *Signs work:* "Christopher Harrison." *Address:* Alton House. 6 Alexandra Road, Sheringham, Norfolk NR26 8HU.

HARRISON, Claude, (Hon.)RP, ARCA; artist in oil, oil and tempera, pen and wash, etc.; primarily a painter of conversation pieces and imaginative landscapes. *b:* Leyland, Lancs., 31 Mar 1922. *s of:* Harold Harrison, engineer. *m:* Audrey Johnson, painter. one *s. Educ:* Hutton Grammar School, Lancs. *Studied:* Preston (1938-40), Liverpool (1940-41), RCA (1947-49). *Exhib:* RA, RP, RSA, RBA., etc. *Works in collections:* Harris A.G., Preston, Abbott Hall, Kendal, Lancaster City Museum, Bournemouth A.G., etc. *Publications:* The Portrait Painters' Handbook (Studio Vista, 1968); Book of Tobit (1970). *Signs work:* "CLAUDE HARRISON." *Address:* Barrow Wife, Cartmel Fell, Grange over Sands Cumbria LA11 6NZ.

HARRISON, Margot, artist in water-colour, oil;. *b:* 2 Jan 1915. *m:* George Francis Harrison, M.B.E. two *d. Educ:* Queen Anne's, Caversham. *Studied:* privately under Prescoe Holeman (1938), and Kingsley Sutton, FRSA (1965); Farnham School of Art, part-time (1966-69, John Wilkinson, ARCA). *Exhib:* Paris Salon (1972, 1973); one-man shows: Alpine Gallery (1975), Bradshaw Room FBA (1978), Mall Galleries (1974), Bradshaw Room FBA (1982), ROI, Britain in Watercolours, RBA. *Works in collections:* BP (1974), National Trust

(1980). *Signs work:* "Margot Harrison." *Address:* Stoney Cottage, The Bury, Odiham, Hants. RG29 1LY.

HARRISON, Marguerite Hazel, National Froebel Foundation Diploma in Art; artist in oil, pen and wash, and pastels. *b:* Llandudno, N. Wales, 7 Oct 1927. *d of:* Judge R. O. Roberts, d 1929. *m:* Michael Harrison (decd.). three *s.* two *d. Educ:* Royal Masonic School, Rickmansworth, Herts. *Studied:* mainly self-taught; tuition for a period under Kenneth A. Jameson. *Exhib:* RA, RCamA, Grosvenor Art Soc., Wirral Soc. of Art, National Ex. Wildlife. *Signs work:* "Marguerite Harrison". *Address:* 2 The Courtyard, Poulton Hall, Bebington, Merseyside CH63 9LN.

HARRISON, Stephanie Miriam, NDD, RMS; painter, book illustrator, graphic designer. *b:* Kings Lynn, 10 Dec 1939. *d of:* Cyril Gurr. *m:* John Harrison. *Studied:* Medway College of Art, Rochester (1955-60). *Exhib:* Westminster Gallery, Mall Galleries, The Royal Academy, Linda Blackstone Gallery, The Headcorn Gallery, Rye A.G., Kent Painter's Group and galleries throughout the U.K.; several one-woman shows. *Works in collections:* Science Museum, B.M. (Natural History), and private collections. *Publications:* Wild Flowers of Britain, Marine Life, Handbook of British Mammals, Private Life of a Country House, greetings cards. *Signs work:* "Stephanie Harrison," "S. Harrison" or "S.M.H." *Address:* Iden Cottage, Wittersham Rd., Iden, nr. Rye, E.Sussex TN31 7XB.

HARRISSON, Tim, BA (Norwich School of Art). *Medium:* sculpture in stone, prints. *b:* Quendon, 14 Jun 1952. *s of:* P.D.&E.H.Harrisson. two *s. Studied:* Hammersmith College of Art; Byam Shaw School of Art. *Represented by:* The New Centre, Salisbury. *Exhib:* Royal Academy; New Art Centre, Roche Court, Salisbury; Ulm, Germany; Russell-Coates Museum, Bournemouth; Winchester Cathedral. *Works in collections:* Southern Arts (Arts Council); Winchester Cathedral. *Commissions:* Southampton Airport; Sea Edge, Southampton City. *Publications:* 'Tim Harrisson Carved Time' by Andrew Wilson; Contemporary Art Vol.3, no.4. *Recreations:* walking. *Signs work:* 'TIM HARRISSON'. *Address:* 4 Beckford Cottages, Hindon, Salisbury, Wilts. SP3 6ED. *Email:* timharrisson@hotmail.com *Website:* www.timharrisson.co.uk

HARTAL, Paul, Ph.D.; artist and theorist, originator of Lyrical Conceptualism (1975); founder of the Centre for Art, Science and Technology; oil and acrylic paintings, works on paper, concrete poetry, various writings (fiction and non-fiction);. *b:* Hungary, 1936. *Studied:* M.A. Concordia University, Montreal; Doctoral Dissertation: The Interface Dynamics of Art and Science, Columbia Pacific University, California. *Exhib:* selected list: Musée du Luxembourg, Paris (1978), Véhicule, Montreal (1980), Montreux Centre, University of Lausanne (1983), OURS, Montreux (1990), Milan Art Centre, Italy (1993), Musée de la Poste, Paris (1994), Space Center, Houston (1994), Centre Cultural d' Alcoi, Spain (1996), Seoul International Fine Art Centre (1998), Galerie Alef, Montreal (1999), University of Oregon (2000), Lincoln Centre, New York (2001). *Works in*

collections: Museum of Civilisation, Ottawa; Musee De La Poste, Paris, and many others. *Commissions:* Seoul Olympic Games; Orbitor U.S.A.; Book and record illustrations. *Publications:* Encyclopedia of Living Artists; Olympic Catalogue, Seoul; Artists/USA, Phil., The Brush and the Compass (1988); The Kidnapping of the painter Miró (illustrated novel, 1997); articles: Leonardo, Pulsar, Contemporary Philosophy, poetry. *Misc:* Awards include: Prix de Paris; Rubens; National Library of Poetry; Poetry Canada, University of Toledo. *Signs work:* "Hartal." *Address:* 2360 Valade, Montreal, QC H4M 1N1, Canada.

HART-DAVIES, Christina Ann, BA Hons., FSBA; botanical artist and illustrator in watercolour; 4 RHS Gold medals. *b:* Shrewsbury, 1947. *Studied:* fine art, typography at Reading University (1966-70). *Exhib:* Brisbane, London, RBG. Kew, USA. *Works in collections:* Hunt Inst. Botanical Documentation, Pittsburgh; Shirley Sherwood Collection Contemp. Botanical Artists. *Signs work:* "CHRISTINA HART-DAVIES," "CH-D" (miniatures). *Address:* 31 Shaftesbury Rd., Poole, Dorset BH15 2LT. *Website:* www.christinahartdavies.co.uk

HARTILL, Brenda, RE, Dip.FA Hons. (1964); New Zealand Queen Elizabeth II Arts Council Study Award (1965-66); UK Arts Council Award in Theatre Design, seconded to Young Vic Theatre (1971). *Medium:* etchings and collographs, collage and painting. *b:* London, 27 Feb 1943. *m:* Harold Moores. one *s.* one *d. Educ:* Kings School, Ottery St. Mary; Kelston High, Auckland, NZ. *Studied:* Elam School Fine Art, NZ.; Central School of Art (theatre design, Ralph Koltai). *Represented by:* New Academy Gallery, 34 Windmill Street, London W1T 2JR. *Exhib:* RA Summer Show, RE Bankside Gallery, over 50 galleries worldwide; solo shows: New Academy Gallery and galleries in Australia, NZ, USA, Barbican Centre. *Works in collections:* Bank of England, BP, Amoco, BT. *Commissions:* Morgan Stanley, The Independent newspaper. *Publications:* Printmaking Today. Author of 'Collographs and Mixed-Media Printmaking' (pub. A&C Black). *Clubs:* Royal Society of Painter Printmakers. *Signs work:* "Brenda Hartill." *Address:* Brenda Hartill Prints, Pound House, Udimore, nr. Rye, East Sussex TN31 6BA. *Email:* brenda.hartill@gmail.com *Website:* www.brendahartill.com

HARVEY, Pat: see YALLUP, Pat,

HARVEY, Jake, DA (1972), RSA(1989); sculptor, carver of limestone/granite, and forger of iron/steel; Professor, Head of Sculpture, Edinburgh College of Art;. *b:* Yetholm, Kelso, Roxburghshire, 3 June, 1948. *m:* Penny Harvey. one *s.* two *d. Educ:* Kelso High School. *Studied:* sculpture: Edinburgh College of Art (1966-72) Postgraduate (1971-72), Travelling Scholarship to Greece (1971-72), William Gillies Bursary Research Travel in India (1989). *Exhib:* RSA, Talbot Rice A.G., City Art Centre (Edinburgh), Third Eye Gallery (Glasgow), Camden Arts Centre, Leinster Gallery, Houldsworth F.A., Art First (London), Pier Art Centre (Stromness), Aberdeen A.G., Seagate (Dundee), Maclaurin (Ayr), Stavanger (Norway), Lulea (Sweden), Kemi

(Finland), Morioka (Japan), National Museum of Scotland (Edinburgh). *Works in collections:* Scottish Arts Council, Edinburgh Museums and Galleries, University of Edinburgh, Contemporary Art Soc., Aberdeen Art Gallery, Hunterian Museum, Kulturoget, Lulea Sweden. *Commissions:* Hugh MacDiarmid Memorial, Langholm; Compaq Computers Commission, Glasgow; Newcraighall Mining Commission, Edinburgh; Poachers Tree, Maclay, Murray and Spens; Motherwell Heritage Centre; Hunterian A.G., Glasgow; Aberdeen City. *Signs work:* "Jake Harvey". *Address:* Maxton Cross, Maxton, St. Boswells, Roxburghshire TD6 0RL.

HARVEY, Michael, Winsor & Newton Prize. *Medium:* oil, drawing. *b:* Bristol, 7 Oct 1946. *s of:* adopted. *m:* Alison. three *d. Educ:* I was exposed to education, left with no qualifications at 15. *Studied:* Royal West of England Art School (Commercial Art, for two years). *Exhib:* RA Summer Exhbn; Arnolfini Gallery, Bristol; RWEA Autumn Exhbn.; 6 Chapel Row Gallery, Bath; private exhbn in London. *Works in collections:* London, Germany, Rome. *Works Reproduced:* in exhibition catalogues. *Recreations:* music, gardening, architecture, books. *Misc:* I work as a general builder/plaster and carpentry. *Signs work:* 'M.Harvey'. *Address:* Goulters Mill, Nettleton, Chippenham SN14 7LL.

HARVEY, Michael Anthony, NDD (1957), FRSA (1972), Linton prize (1973); artist in oil, pastel; journalist and art critic; mem. SGFA, Reigate Soc. of Artists, life mem. IAA (Unesco). *b:* Kew. divorced. *s of:* E.C. Harvey, solicitor. one *s. Educ:* Bryanston. *Studied:* Wimbledon School of Art (1955-57). *Exhib:* Whibley, Rutland, Fine Arts, Qantas and Connoisseur Galleries W1., Brighton Pavilion, Portsmouth Museum, and Melbourne, Oslo, Dortmund; fourteen one-man shows. *Works in collections:* Johns Hopkins University, Camden Council, E. Sussex Council. *Works Reproduced:* BBC TV, The Times, Standard, Artist. *Clubs:* Royal Society of Arts, London. *Signs work:* "Michael" or "Michael A. Harvey." *Address:* 15 Waterloo Sq., Bognor Regis, W. Sussex PO21 1TE.

HARVEY, Patricia, BA, SGFA. *Medium:* watercolour and mixed media. *b:* Isleworth, London, 18 Jun 1942. *m:* Ralph Harvey. *Studied:* Sussex University; Kingston School of Art (part-time). *Exhib:* Royal Institute of Painters in Watercolour; Brighton Festival; Menier Gallery; Arundel Festival. *Works in collections:* France, UK, Middle East, Sweden, USA. *Commissions:* EMI 'Continental Collection' (illustration); ASU Records (France), Marianne Melodie Records (France, illustration). *Publications:* Artists & Illustrators. *Recreations:* social networking. *Clubs:* Arts Centre Group. *Misc:* writer and researcher, television arts documentaires. *Signs work:* "PAT HARVEY". *Address:* 2 Britannia Quay, River Road, Littlehampton, W.Sussex, BN17 5DB. *Email:* paykayharvey@btinternet.com *Website:* www.patframes.co.uk

HASTAIRE, Claude, XXVIIIe Prix Internationale de Monte-Carlo (1994). *Medium:* painter (acryl), author, photograph. *b:* Paris, France, 24 Oct 1946. *s of:* Camille and Simone Hilaire. *m:* Edith Charlton. one *s.* one *d. Educ:* Etudes

Secondaires (Oratoriens). *Studied:* Ecole Nationale Supérieure des Beaux Arts de Paris. *Represented by:* C.Meyer (Paris); Dukan Gallery (Marseille); Zedes Gallery (Bruxelles). *Exhib:* FIAC 92 (Paris); Saga FIAC '88,'90 (Paris), Art-Paris 99; Art Jonction (95, 97, 98, 20000), Artvel (Beyrouth); Lineart (Gand, 99); Musée Goya (1990, 1993); Musée de Dunkerque (1992); La Galerie (Oslo) 1990, 1993), 'L'Embarcadere' Montceau (2004). *Works in collections:* Musée Goya, Musée Rimbaud, Musée Colette, Musée de St.Nazaire, Rank Xerox Fondation, Thomson TDI, 'La Peinture, une Pratique d'Avenir' (FW éd, 2004), 'Eves', (éd Art Estampe, 2004), 'Cri Premier, Dernier Cri' (FW éd, 2005). *Commissions:* Mosaique (Metz 1975), 'Les Maries de la Tour Eiffel "De Cocteau" Decors' (1996). *Publications:* 'Goya' Van Wilder ed. (1993), 'La Peinture Vagabonde' F.Van Wilder ed. (2002), 'La Peinture est un Roman' F.v.W. ed. (2003). *Official Purchasers:* Musee Goya (castres), Musee Rimbaud (2000), FRAC Reunion, Musee de St.Nazaire, Ville de Castres, St. Pierre, St.Denis (La Reunion). *Works Reproduced:* in 'Les Figurations' & 'Le Dessin dans l'Art' Gérard Xuriguera. *Principal Works:* 'Peintures de Bases', 'Fragments du XXe Siecle'. *Recreations:* walking beside the sea, and observing the gulls. *Clubs:* Groupe Memoires. *Misc:* drew Cape Horn at age 20 when in the Navy. *Signs work:* Hastaire. *Address:* 7 av. Marcel Proust, 14360-Trouville s/Mer France. *Email:* hastaire.h@wanadoo.fr *Website:* www.hastaire.com

HASTE, Kendra, SWLA; BA (Hons) Illustration, MA Natural History Illustration; BBC Wildlife Art Award (1999); Artists for Nature Foundation Award (1997). *Medium:* drawing, sculpture. *b:* London, 25 Jan 1971. *d of:* David Haste MA RCA. one *d. Studied:* Wimbledon School of Art (1989-90); Foundation, Camberwell College of Art (BA, 1990-93); RCA (MA, 1996-98). *Represented by:* Patrick Davies Contemporary Art. *Exhib:* solo shows: The Air Gallery, London (2003); Midlands Art Centre, Birmingham (2003); Gloucester Road Tube Station, London Underground ('Underground Safari'); also, Beaux Arts, Bath; The Burrell Collection, Glasgow; Kelvingrove Museum & AG, Glasgow; Waterloo Station; Harvey Nicholls. *Works in collections:* Eric & Jean Cass Collection; London Underground; many private collections. *Commissions:* private commissions in Europe and USA. *Publications:* work in 'Modern British Sculpture' by Guy Portelli; 'Animals -A First Art Book' (Francis Lincoln); 'Tigers - Artists for Nature in India'; 'Bleep - The Eric and Jean Cass Collection'. *Official Purchasers:* London Underground (African Elephant, currently on display at Waterloo Station, Jubilee Line Ticket Hall). *Signs work:* 'K Haste' or 'KH'. *Address:* 2 Chalk Lane, Epsom, Surrey KT18 7AR. *Email:* kendra.haste@ntlworld.co.uk *Website:* www.kendrahaste.co.uk

HASTINGS, Gerard, MA. Awards: Francis Williams Prize: Fine Art (UCW, 1981); Sir Ben Bowen-Thomas Prize: Art History (UCW, 1981); MacFarlane Walker Bursary for Painting (1984); Edward Albee Foundation Scholarship (1985); Head of History of Art Department: Brixton College (1984-91), Mander Portman Woodward College, South Kensington (1991-); painter, photographer, art collector. *Medium:* acrylic, collage, mixed media. *b.* Gateshead, 15 Jan 1960.

p. David Evans. *Exhib:* selected solo exhibitions include: 273 Gallery, London (1984), Ashawagh Hall, Long Island, New York (1985), Osborne Gallery, London (1987); The Playhouse Theatre, London (1989), The Edinburgh Festival (1990), Consort Gallery, ICL (1991), Globe Centre Gallery, Whitechapel, London (2001-2007). Selected group exhibitions since 1980 include: National Library of Wales (1980), Oriel, Cardiff (1982), Consort Gallery, Imperial College, London (1983, 1984), Printmakers Council (1985), Peter Loonam Gallery, New York (1985, 1986), Royal Overseas League (1984, 1991), ICA, London (1991, 1992), Inaugural Exhibition, MoMA, Machynlleth, Wales (1992), The Gallery, Old Burlington Street (1995), Art Forum (1996). *Works in collections:* private and public (UK, Europe, USA). *Recreations:* Opera, Ballet, Food. *Misc:* Artist-in-Residence, Salisbury Festival (collaboration with and designs for Sir Alan Bates "A Muse of Fire" (1988). Lives in London and Emilia Romagna, Italy. *Signs as:* "Hastings". *Email:* gerard_hastings@yahoo.co.uk *Website:* www.modernbritishart.net

HAUGHTON, Patrick, Cert.Ed., NSA (full member since 1996). *Medium:* acrylic painting/relief construction, drawing. *b:* Devonport, 27 Dec 1942. *s of:* Thomas Haughton. *m:* Suki (née Dullea). two *s.* one *d. Educ:* Barnstaple Grammar School, Devon. *Studied:* Exeter College of Art (1963); West of England College of Art (Bristol, 1964-67). *Represented by:* Thomsons Gallery, London; Lemon Street Gallery, Truro. *Exhib:* solo exhbns: Bakehouse Gallery, Penzance (1995); Plumbline Gallery, St.Ives (1995); Contemporary Gallery, Penzance (1996); Falmouth Art Gallery, Cornwall (1997); Atelier Gallery, Univ. of Exeter (1998); Michael Wright Fine Art, Bristol (1998, 1999, 2001); Minster Fine Art, York (2004); many group exhbns since 1996, including Newlyn Art Gallery (1998-), Thomsons City Gallery, London (2005); AAF (2004); London Art Fair (2005). *Works in collections:* collection 'La Grande Vigne' Dinan, France; St.George's Hospital, London; private collections UK, USA and South Africa. *Commissions:* set designs for Cornish Theatre Collective. *Publications:* 'Another View: Art in St.Ives' by Marion Whybrow (1996). *Works Reproduced:* '20 Years of Contemporary Art' (Falmouth Art Gallery, 2000); 'Drawing to the End of the Century' (Newlyn Society of Artists, 1996). *Recreations:* sailing, travelling, photography. *Misc:* Artist-in-Residence - Les Amis de la Grande Vigne, Dinan, France (2004). *Signs work:* 'Patrick Haughton'. *Address:* 'Elusive Cottage', 74A Lower Market Street, Penryn, Cornwall TR10 8BH. *Email:* patrick.haughton@talktalk.net *Website:* www.axisweb.org/artist/patrickhaughton

HAWDON, Paul Douglas, BA (Hons.) (1982), Dip.RA Schools, RE; painter/printmaker in oil, gouache, etching. *b:* Manchester, 13 Oct 1953. *s of:* Joseph Douglas Hawdon. *m:* Helena Earl. one *d. Educ:* Hyde County Grammar School. *Studied:* St. Martin's School of Art (1978-82), RA Schools (1982-85), Rome Scholar, British School (1988-89). *Exhib:* RE, London Group, Twelve Contemporary Figurative Artists, RA, Christie's Print prize (1985, 1990), 11th International Print Biennale, Bradford, Wrexham Print International (2001, 2003), International Print Triennial Cracow (1994). *Works in collections:*

Metropolitan Museum of Fine Art, NY. *Publications:* Printmaking Today Vol.4 No.2. *Clubs:* Chelsea Arts. *Signs work:* "Paul Hawdon" or "P.D.H." *Address:* 62 Marshall Rd., Cambridge CB1 7TY.

HAWES, Meredith William, ARCA, RWS, FRSA, ASIA; Freeman of the City of London; artist in water-colour, oil, gouache; College of Art Principal (retd.); tutor (PT), Exeter University (Extra-mural Dept.);. *b:* Thornton Heath, Surrey, 17 Apr 1905. *s of:* Walter Osborne. *m:* Margaret Charlotte. one *s.* six *d. Educ:* Selhurst Grammar School, Croydon. *Studied:* Croydon School of Art (1922-24), R.C.A. (1924-28). *Exhib:* RA, RWS, NEAC, Paris, USA and many provincial galleries. *Works Reproduced:* illustrations for John Murray, Jonathan Cape, V. & A. Museum, OUP. *Signs work:* "M.W. HAWES." *Address:* Emslake House, 2 Anderton Villas, Millbrook, Torpoint, Cornwall PL10 1DR.

HAWKEN, Anthony Wellington John, ARBS (1979), Cert. RAS Sculpture (1971); sculptor in plastics and stone, etcher. *b:* Erith, Kent, 4 Jul 1948. *s of:* Ronald Hawken, FCA., FICA. *m:* Deirdre Bew. two *s. Educ:* Northumberland Heath Secondary Modern School. *Studied:* Medway College of Art (1965-68, John Cobbett), RA Schools (1968-71, Willi Soukop). *Exhib:* Hammersmith Summer Exhbn., RBS, Chichester, Stratford upon Avon; one-man show, Blackheath Gallery. *Signs work:* "A. Hawken." *Address:* 1 Chevening Rd., Greenwich, London SE10 0LB.

HAWKES, Justin Sheridan, Byam Shaw Diploma, London Diploma, Graham Hamilton Drawing Award. *Medium:* oil, watercolour, drawing, prints. *b:* Cambridge, 7 Oct 1955. *s of:* Leo & Violet Hawkins. *m:* Laura Charles. two *d. Educ:* Foundation Cambridge Art School (1978-79). *Studied:* Byam Shaw (1979-82). *Represented by:* Lawson Gallery, Cambridge, UK. *Exhib:* Oeno Gallery, PEC Ontario, Canada (2006), Edogawa Cultural Centre, Tokyo (1990), Gallery Iseyoshi Ginza, Tokyo (1990), Bodily Gallery, Cambridge (1994), Amalgam Gallery, London (1995), Royal Watercolour Society, London (1999-2005). *Works in collections:* Suginoko Yo Chien Kindergarten, Japan. *Commissions:* Cambridge Camerata UK; Chilford Hall, Linton, UK. *Official Purchasers:* Suginoko Yo Chien Kindergarten, Japan; Edogawa Cultural Centre, Tokyo. *Works Reproduced:* Chilford Hall wine label; Camerata Concert programmes. *Recreations:* jazz, piano, cycling. *Clubs:* Polish Club, Cambridge. *Misc:* painting conservator. *Signs work:* "JUSTIN HAWKES". *Address:* 2A The Old Rectory Drive, Dry Drayton, Cambridge, CB23 8BU. *Email:* hawkes@justinhawkes.com *Website:* www.justinhawkes.com

HAWKINS, Barbara, *Medium:* ceramics, porcelian, jewellery; artist in acrylic, watercolour. *b:* Yorks., 18 Oct 1952. *m:* Michael Hawkins. two *d. Studied:* St. Albans and Bristol. *Exhib:* Port Isaac Pottery and Gallery. *Works in collections:* internationally. *Clubs:* Fellow, Craft Potters Assoc. *Signs work:* " MBH." *Address:* Port Isaac Pottery, Roscarrock Hill, Port Isaac, Cornwall PL29 3RG.

HAWKINS, Diana, NS, NAPA, FRSA; Euro-Art; (Village's Europeens d'Artistse's); work inspired by light and atmosphere; Stephen Martin Award, Best Oil; Rural/Landscape painter. *Medium:* paints in oil - acrylic. *m:* Denis Baxter, RWA, RBA. *Exhib:* RWA, RBA, SWA, "Not the Royal Academy", "A Million Brushstrokes" (annual miniature exhibition), Llewellyn Alexander Gallery London;.Bath Society of Artists. Euro-Art. Brussels - Worpswede - Ahrenshoop - Kronberg - also with National Society - Munich - Euro-Art. Barbizon, France. La Defense, Paris, 1st Euro-Art Exhibition, Christchurch, England, 1st Salon Municipal "La Roche Bernard En Quatre Saisons" Hotel de Ville, Brittany. 2003; Winchester Art Gallery - Southampton Art Gallery; St. Barbes Art Gallery; Webbs Road, Fine Art Gallery, London and Euro Art (touring) Ousterbeck, Holland. *Works in collections:* private collections in England, Germany, France, Australia, Switzerland, South Africa, America. *Commissions:* many for private individuals. *Publications:* Royal Publications); recorded artist in 'The Society of Women Artists List of Exhibitors Book 1855-1996' (4 works hung in 2004 SWA Exhibition at Mall Galleries). *Works Reproduced:* in Robert Cole's "Artists and Illustrators around the New Forest and Solent"; 'Home Interiors' magazine. *Principal Works:* landscapes & rural buildings, large skies. *Recreations:* landscape photography. *Clubs:* Royal Overseas, London, RSA House, London. *Misc:* National Trust Workshops for school children; council member, National Society; made Fellow of the Royal Society of Arts (2000). *Signs work:* 'Diana Hawkins' (and year). *Address:* Knightley House, Middle Road, Sway, Lymington, Hants., SO41 6AT. *Email:* ruralart.knightley@btinternet.com

HAWKINS, Michael, potter. *b:* 2 Aug 1950. *m:* Barbara. two *d. Studied:* Redruth School of Art, Cornwall. *Exhib:* London, Edinburgh, Bath, etc. Work in collections internationally. *Clubs:* Fellow, Craft Potters Assoc. *Signs work:* " MBH." *Address:* Port Isaac Pottery, Roscarrock Hill, Port Isaac, Cornwall PL29 3RG.

HAWKINS, Philip Dennis, FGRA; artist in oil, pencil; President, Guild of Railway Artists (1988-98). *b:* B'ham, 26 Sep 1947. *s of:* Dennis Walter Arthur Hawkins. *m:* Sonya. one *s.* one *d. Educ:* Lordswood Boys' Technical School, B'ham. *Studied:* B'ham College of Art (1964-68). *Exhib:* NRM York, Science Museum, B'ham, Festival Hall London, regularly with GRA. *Works in collections:* B'ham Post and Mail Ltd., Bristol United Press, BBC, Docklands Light Railway, European Passenger Services, Railfreight, Freightliner, Midland Metro, Royal Mail. *Publications:* Fine art prints, work featured in calendars, greetings cards, magazines, books, etc.; book: (autobiography and paintings, etc.) Tracks on Canvas (1998). Co-director, Quicksilver Publishing. *Signs work:* "Philip D. Hawkins." *Address:* 112 Chaffcombe Rd., Sheldon, Birmingham B26 3YD.

HAY, Ian, NDD (1960), ARCA (Painting 1963); awarded the Andrew J. Lloyd prize for landscape painting; artist in pastel, water-colour, etching, art lecturer; Senior Lecturer in drawing, Colchester School of Art, retired from teaching

(2000);. *b:* Harwich, 25 Jan., 1940. *s of:* the late John Hay. *m:* Teresa Sliska. two *s. Educ:* Harwich School. *Studied:* Colchester School of Art (1955-60, Hugh Cronyn), RCA (1960-63, Ruskin Spear). *Exhib:* RA Summer Exhbn, Craftsman Gallery and Minories, Colchester, Sandford Gallery, London, Phoenix Gallery, Lavenham, Wivenhoe Arts Centre, Patisserie Valerie, London SW3, Highgate Fine Art, London N6, Digby Gallery, Colchester. *Works in collections:* Doncaster City A.G., The Guildhall A.G., Graves A.G., Sheffield, Essex University, Essex County Council, Colchester Borough Council. *Commissions:* A series of paintings commissioned by Ernst & Young for their office space in Birmingham (1996). *Clubs:* Colchester Art Soc., Chairman of Select Committee. *Signs work:* "Ian Hay." *Address:* 32 Tall Trees, Mile End, Colchester, Essex CO4 5DU. *Website:* www.members.aol.com/ianhaygallery

HAYDEN, Toni, SBA (1985), FLS (1995), ASBA (1995), St. Cuthbert's Mill Award (1995), RHS medals: SGM (1981), GRM(1982), SM(1984, 1995); artist and calligrapher, graphite figure drawings, animal and flower paintings in gouache, pencil portraits; professional artist and tutor;. *b:* Woodbridge, Suffolk, 22 Aug., 1938. *m:* Anthony Hayden (divorced). two *s. Educ:* Notre Dame High School. *Studied:* Norwich School of Art (1954-55, Noel Spencer, Alan Webster). *Exhib:* Yasuda Kasai, Tokyo, RHS Westminster, SBA Mall Galleries, Hunt, USA. *Works in collections:* Hunt Inst. for Botanical Documentation, BM (NS), V&A, London University (QMC) Shirley Sherwood, John Innes Centre. *Commissions:* Specialises in magnolia paintings. *Publications:* in progress: 'How to Paint Flowers' and 'San Francisco to Go'. *Clubs:* Assoc. of Illustrators. *Signs work:* "Toni Hayden". *Address:* 6 Belvedere Pl., Norwich NR4 7PP.

HAYES, Georgia, painter in oil; shortlisted for Wollaston Prize (2000, 2003, 2006). *b:* Aberdeen, 1946. *m:* Robert. one *s.* two *d. Studied:* Tunbridge Wells, under Roy Oxlade (1977-1982). *Represented by:* HQ, Lewes. *Exhib:* Scottish Drawing Competition, Glasgow, 1987; Towner Gallery, 1991; John Moores 1993; Oriel Mostyn 1993; Flowers East, London; Harlech 94 International; Maidstone Museum 1995; Brighton Museum; Maidstone Museum 1996; Cheltenham Open Drawing 1996/97; Art First, London 2001; Royal Academy Summer Ex: 1990, 94, 96, 98-2007; Solo Exhibitions; Riviera Gallery, Hastings 1995; Harriet Green Gallery, London 1997; Maidstone Library Gallery 1999; Aberdeen Art Gallery 2000; San Francisco MOMA Artists' Gallery, USA 2002; Cafe Gallery Projects, London; Fred Spratt, San Jose, USA 2003, National Gallery Costa Rica 2006. *Works in collections:* National Gallery of Costa Rica. *Signs work:* "Georgia Hayes." *Address:* Diamonds, Bells Yew Green, E. Sussex TN3 9AX. *Email:* hayes_georgia@hotmail.com *Website:* www.georgiahayes.com

HAYNES, Alexandra, BA; artist in oil and water-colour;. *b:* 17 Mar 1966. *Educ:* New Hall, Boreham, Chelmsford, Essex. *Studied:* Shrewsbury Foundation Course, Cheltenham Art College (Michael Hollands, Leslie Prothero). *Exhib:* Mail on Sunday, Dover St. (1988), Contemporary Fine Art Gallery, Eton; one-man shows: Soloman Gallery, London (1988), Mistral Gallery, London (1989,

1990, 1991), Flying Colours Gallery, Edinburgh (1990), Bruton Street Gallery (1992). *Publications:* A Life with Food, Peter Langan by Brian Sewell. *Signs work:* "A. Haynes." *Address:* Edgcote, Banbury, Oxon. OX17 1AG.

HAYTON, Gladys, RMS, HS, SM; UEI: Union in Design, Freehand Drawing, Drawing in Light and Shade. *Medium:* watercolour, cat portraits. *b:* Poole, 20 Aug 1916. *m:* Jim Hayton. two *s.* one *d. Educ:* Oakdale School. *Studied:* Poole College of Art (1929-30). *Exhib:* RMS Mall Galleries; Westminster Hall; HS, SM; Wells; Llewelyn Alexander Gallery; Societe des Artistes en Miniature et Arts Precieux at Chateau de Bernicourt; Chettle House; Merley House. *Works in collections:* The Diploma Collection; private collections. *Publications:* '100 Years of Miniature' by Suzanne Lucas. *Official Purchasers:* Suzanne Lucas. *Works Reproduced:* 'Fred', 'Chester'. *Misc:* painted designs on Poole pottery from 1935-59. *Signs work:* 'GH'. *Address:* 19 Coventry Crescent, Poole, Dorset BH17 7HW. *Email:* ghayton@bournemouth.ac.uk

HAYWARD, Timothy John, painter in water-colour, oil and gouache; freelance illustrator (1975-2000). *b:* Weybridge, Surrey, 24 Dec 1952. *m:* Catherine. three *d. Educ:* King's College, Taunton. *Studied:* Somerset College of Art. *Represented by:* Jonathan Cooper, Park Walk Gallery. *Exhib:* solo exhibs. Park Walk Gallery, London (2001, 2003, 2005, 2007), Fine Art Fair, Olympia (2002); BADA Antiques Fair (2005, 2006, 2007); Chomé Gallery, Bath (2004); Form Art Fair, London (2007); IV Centuries of Birds, New York (2004). *Commissions:* many private. *Publications:* many natural history books and publications. *Works Reproduced:* 8 limited edition prints: see www.haywardeditions.com/ 5 limited edition prints/ Wildlife and sporting prints. *Signs work:* "Tim Hayward." *Address:* c/o Jonathan Cooper, Park Walk Gallery, 20 Park Walk, London SW10 0AQ. *Email:* mail@jonathancooper.co.uk *Website:* www.jonathancooper.co.uk

HAYWARD-HARRIS, Martin John, artist and sculptor of wildlife subjects in oil, water-colour, etchings, bronze. *b:* Reading, 28 Oct 1959. *s of:* John Stanley Harris. *Educ:* Maiden Erlegh Comprehensive. *Studied:* Berks. College of Art and Design (1978-84). *Exhib:* S.WL.A., BTO, RSPB, WTNC; one man show: Phyllis Court Club, Henley-on-Thames (1990, 1993), East African Wildlife Soc. *Works in collections:* Natural History Museum London, Zoologisk Museum, Copenhagen. *Works Reproduced:* etchings published by H.C. Dickins, auctioned at Sotheby's; Birding World; cover illustration 'In Search of Stones' M. Scott Peck, M.D. auctioned at Christie's. *Signs work:* "Martin Hayward-Harris." *Address:* 47 Clarendon Rd., Earley, Reading, Berks. RG6 1PB.

HAZLEWOOD, Robin, RI, FRSA, NDD. *Medium:* mainly watercolour and gouache. *b:* Meriden, Warks., 18 Mar 1944. *s of:* E.R.Hazlewood & N.Parker. *m:* Pauline (1st, decd), Harriett Sarah (2nd). one *s. Educ:* King Henry VIII School, Coventry. *Studied:* Coventry College of Art (1960-65); Liverpool College of Art (1965-66). *Exhib:* group shows include: Royal Academy; Mall Galleries; South

London Art Gallery; Camden Art Centre; RWS Galleries; Bankside; solo shows include: Conningsby Gallery, London; Workhouse Gallery, London; Chelsea Arts Club Gallery; RAC Gallery Pall Mall; The Little Gallery, London. *Works in collections:* private and public collections in Britain, France, Spain, Ireland, USA, Hong Kong and Australia. *Publications:* 'Introduction to Drawing' (Arcturus, 2004). *Works Reproduced:* numerous magazines relating to water colour painting. *Recreations:* reading, walking, and looking. *Clubs:* Chelsea Arts Club. *Misc:* Freedom of the City of London (1994), and the Goldsmiths' Livery Company; Head of Putney School of Art (1972-83); Head of Sir John Cass School of Art (1983-86); Vice Provost London Guildhall University (1986-95); mem. Royal Institute of Painters in Water Colours (2002). *Signs work:* 'Robin Hazlewood'. *Address:* 1 Regency Mews, London SW9 6VR. *Email:* hsg1948@aol.com

HAZZARD, Charles Walker, FRBS; BA (Hons.) Fine Art (1987), Sir Henry Doulton School of Sculpture (1988-90), Postgrad. H.Dip. Sculpture (1991); sculptor and fabricator in wood; Brother, Art Workers' Guild (1996); Sculpture Fellow, Loughborough University School of Art and Design (1996-98, 1998-99); Arts Council Awards for Individuals (2003, 2007); Elmkey Foundation Arts Award (2007). *b:* B'ham, 5 Feb 1964. *s of:* Frank Hazzard, architect. *Studied:* Cheltenham University (1984-87, Roger Luxton), Sir Henry Doulton School of Sculpture (1988-90, Colin Melbourne), City and Guilds of London (1990-91, Allen Sly). *Exhib:* national shows. *Publications:* books illustrated: Encyclopedic Techniques of Sculpture (1995); monograph: Charles Walker Hazzard, Sculpture, Structures, Drawing (pub. 2009). *Signs work:* "C.W.H." or not at all. *Address:* 6 Clydesdale Road, Droitwich. Worcs. WR9 7SA. *Email:* studio@charleswalkerhazzard.com *Website:* www.charleswalkerhazzard.com

HEADLEY, Catherine Louise, BA (Hons) Fine Art; winner The Rutland Art Prize (2004). *Medium:* oil, printmaking. *b:* Leicester, 13 Apr 1948. *d of:* Sidney W.Headley. *m:* Trevor Tanser. *Studied:* Somerset College of Art; Bath Academy of Art, Corsham. *Represented by:* Cambridge Contemporary Art, Cambridge; Leicester Print Workshop; Belgrave Gallery St.Ives, Cornwall;. *Exhib:* RA Summer Exhbn (1987, 89, 92, 94, 95, 97, 98, 2003, 06); Singer & Friedlander British Watercolour (1998); RI (1988, 90, 95, 96, 97, 98); Royal Society of Painters in Watercolour (1990, 91, 92, 95). *Signs work:* 'Headley'. *Address:* 12 Wheel Lane, Barrowden, Rutland LE15 8ER. *Email:* cathrineheadley@aol.com

HEALER, George, ARBS (1974); sculptor in clay, plaster, wood, cast aluminium, brass and bronze. *b:* 25 Sep 1936. *s of:* John Healer. *m:* Brenda Maureen Healer. one *s.* two *d. Educ:* Bullion Lane School. *Studied:* Sunderland College of Art (1952-56) under Harry Thubron, ARCA, and Robert Jewell, ARCA. *Exhib:* RA, RGI, Commonwealth Institute, Woolgate House, London, D.L.I. Durham City, Gulbenkian Gallery, Newcastle-upon-Tyne. *Works in collections:* life-size figures of John and Josiphe Bowes, Bowes Museum, Barnard Castle, Co. Durham. *Publications:* article, Aluminium for Schools for

the British Aluminium Federation. *Signs work:* "HEALER" hammered into metal with flat chisel. *Address:* 12 Melville St., Chester-le-Street, Co. Durham DH3 6JF.

HEALER, Reuben John, HND (1984); graphic designer/illustrator. *b:* Gateshead, 17 Dec 1963. *s of:* George Healer, ARBS, NDD. *Educ:* Hermitage Comprehensive. *Studied:* graphic design: New College, Durham (NDAD1980-82); Cumbria College of Art and Design (HND 1982-84). Graphic designer for: Newcastle Architecture Workshop (1984-85), Pendower Hall, EDC(1985-88), By Design, Seaham, Co. Durham (1988). *Address:* 21 Bede Terr., Chester-le-Street, Co. Durham.

HEARSON, Susan: see VOGEL, Suzi,

HEAT, Ann Olivia, Gordon Hulson award (2007) RBA; Russell Gallery award (2007) RBA. *Medium:* oil. *b:* Esher, Surrey, 30 Jul 1945. *d of:* Edward Charles Telling. *m:* Trevor Harvey Heat. *Educ:* Waynfleet, Surrey. *Studied:* The Kathleen Browne School under Kathleen Browne and her Polish husband Marian Kratochwil. *Exhib:* RA, RBA, RP, ROI, NEAC. *Clubs:* R.B.A. *Signs work:* "A.H." *Address:* Stumps Grove Farm, Whitehill La., Ockham, Ripley, Surrey GU23 6PB.

HEATH, Michael John, M.B.E (services to journalism) 2001; 'What the Papers Say' Cartoonist of the Year (1982); Glen Grant Cartoonists of the Year (1978); Pocket Cartoonist of the Year, Cartoonist Club of GB (1977). *Medium:* pen and ink. *b:* London, 13 Oct 1935. *s of:* George Henry Heath/Alice Bremner. four *d. Studied:* Brighton Art College; trained as animator, Rank Screen Services (1955). *Works in collections:* Saatchi Gallery. *Publications:* Private Eye Cartoon Library (1973, 2nd ed. 1975), Punch Cartoons of Michael Heath (1976), Book of Bores (1976), Star Bores (1979), Bores Three (1983), Love All (1982), Best of Heath (1984), Welcome to America (1985), Heath's Nineties (2000). *Works Reproduced:* weekly in The Spectator, Mail on Sunday, The Sunday Times, Private Eye. *Recreations:* walking, listening to jazz. *Clubs:* Colony Room Club. *Signs work:* Heath. *Address:* 6 Chamberlain Street, London NW1 8XB.

HEATHCOTE, Peregrine, *Medium:* oil, watercolour, charcoal, drawing, prints. *b:* UK, 10 May 1973. *m:* Louise. one *s.* one *d. Educ:* Cheam, Stonyhurst, Harrow. *Studied:* Heatherley School of Art; Florence Fine Art Academy. *Represented by:* Albemarle Gallery; RP. *Exhib:* RA, RP, RBA, Albemarle Gallery, Christie's King Street, Olympia, Guildhall, Hampton Court, Goodwood, Selective Eye. *Works in collections:* McGraw Hill. *Commissions:* Sultan of Oman; Prince Jeffrey of Brunei; Cilla Black; Julian Fellows; Captains of industry and nobility, livery companies. *Publications:* 'Art of England' (Jul 05); BBC1 documentary 'Star Portrait' (Jun 05). *Clubs:* Chelsea Arts Club. *Signs work:* 'PEREGRINE HEATHCOTE'. *Address:* 43 Cheyne Court, Royal Hospital Road, London SW3 5TS. *Email:* peregrineheathcote@hotmail.com *Website:* www.peregrineheathcote.com

HECHLE, Ann, FSSI; calligrapher in vellum, water-colour, gold leaf. *b:* 31 Dec 1939. *d of:* James Hechle, stockbroker. *Studied:* Central School of Art and Crafts (1957-60, Irene Wellington). *Exhib:* many group exhbns. *Works in collections:* Minnesota Manuscript Initiative, U.S.A., V. & A., Crafts Study Centre, Farnham, Surrey; Fitzwilliam Museum, Cambridge. *Commissions:* 19 calligraphic panels for St. Mary's Hospital, Isle of Wight. *Publications:* co-author: More than Fine Writing (Life and work of Irene Wellington). Film: In the Making (B.B.C. 1979). *Address:* The Old School, Buckland Dinham, Frome, Somerset BA11 2QR.

HEDLEY, Paul, Dip.AD (1971); artist in oil, acrylic and chalks;. *b:* 19 Dec., 1947. *m:* Dianne Flynn. *Studied:* Medway and Maidstone. *Exhib:* Priory gallery, Broadway; Thompson's Gallery, Aldeburgh & London; Walker Galleries, Harrogate; Jonathan Grant Galleries, Auckland NZ. *Works in collections:* London Borough of Camden, Queen Mary College. *Signs work:* "Paul Hedley." *Address:* 6 Powderham Cres., Exeter EX4 6DA.

HEINDORFF, Michael, MA (1977), Fellow, RCA(1988), Hon. Fellow RCA(2001); painter in oil, water-colour, pencil, print; senior tutor, R.C.A. (1980-99). *b:* Braunschweig, Germany, 26 Jun 1949. *s of:* Hans Heindorff. *m:* Monica Buferd (decd.). one *s.* one *d. Educ:* Wilhelm Gymnasium, Braunschweig. *Studied:* Braunschweig University (1970-75), RCA (1975-77, Peter de Francia, Philip Rawson). *Exhib:* Bernard Jacobson Gallery, London, New York, Los Angeles (1978-92), RA (since 1988) and others internationally. *Works in collections:* Herzog Anton Ulrich Museum, ACGB, Museum of London, Imperial War Museum; Museum of Modern Art, NY; Tate Gallery; National Gallery, Washington. *Commissions:* Imperial War Museum (1986); Designers Guild (1992). *Publications:* CD-ROM (IBM Compatible PC) of drawings (1995) and others (1996, 1998, 1999). *Clubs:* Chelsea Arts. *Signs work:* "M. HEINDORFF." *Address:* 2 Shrubland Rd., London E8 4NN. *Email:* looplight@aol.com

HELD, Julie, The Royal Watercolour Society (AMRS) elected 2003, The London Group (elected member 2002); BA (Hons.) (1981), RA Schools Postgrad. Dip. (1985); painter in oil on canvas and water-colour on paper; part-time tutor/lecturer;. *b:* 25 Mar 1958. *Studied:* Camberwell School of Art (1977-81, Philip Mathews), RA Schools (1982-85, Peter Greenham). *Exhib:* Piccadilly Gallery, Boundary Gallery, Frank Kafka Gallery (Prague), Leipzig, Hayward Gallery, Cheltenham Open Drawing Exhbns., RA Summer Shows, The Royal Watercolour Society. *Works in collections:* amongst others; Nuffield College, Oxford University, New Hall Cambridge University, Usher Gallery, LSE Open University, Ben Uri Gallery (The London Jewish Museum), Baker McKenzie Corporate. *Commissions:* 1. Chichester 750th Anniversary St Richard of Modern Time "Pilgrimage" catalogues 2. private portraits and paintings commissions. *Publications:* various book covers. *Works Reproduced:* Bridgeman Slide Library. *Signs work:* "J. HELD" or "J.H." on small works. *Address:* 48 Barrington Rd., London N8 8QS. *Email:* info@julieheld.com *Website:* www.julieheld.com

HELLEBERG, Berndt, sculptor. *b:* Stockholm, 17 Dec 1920. *s of:* Sigurd Helleberg, inspector of assurance. *m:* Margareta Kinberg. two *s.* one *d. Educ:* High School, Härnösand. *Studied:* Stockholm (1945-48), Konstfackskolan, Stockholm (1947-49), France (1950-52). Prize, The Unknown Political Prisoner, London (1953), first prize winner, competition of modern medals (Stockholm 1955), first prize winner 20,000 Sw. crowns, competition of underground station decoration (Stockholm 1960). *Exhib:* Tate Gallery, London, Stockholm, Paris, U.S.A., etc. *Works in collections:* The underground station, Hornstull, Stockholm; Cathedral Window, Baptist Church, Stockholm; several playground sculptures in Sweden; several sculptures in Stockholm and Sweden; Sculpture 9m high in Riyadh, Saudi Arabia (1981). *Signs work:* "Berndt Helleberg." *Address:* Saturnusu 7, 18450 Akersberga, Sweden.

HELLER, Rachel Pearl, painter in oil, pastel, charcoal. *b:* London, 15 Sep 1973. *Studied:* Byam Shaw School of Art, Slade, Prince's Foundation, Hammersmith and W. London College. *Exhib:* John Jones Art Centre (1997), Flowers East Gallery (1998-2000). *Works in collections:* various, private. *Signs work:* "Rachel Heller." *Address:* 53 Fitzroy Park, London N6 6JA.

HELLMAN, Louis Mario, B.Arch. (1962), M.B.E. (1993); Hon. Doc. Uni (2002), architect, designer, cartoonist, painter in acrylic, water-colour and collage. *b:* 19 Mar., 1936. *m:* Maria. one *s.* one *d. Studied:* Bartlett School of Architecture, University College, London, Ecole des Beaux Arts, Paris. *Exhib:* Architectural Assoc. (1978), Interbuild (1991-1993), Cambridge (1996), Sir John Soane's Museum (2000); Barcelona (2001), Shrewsbury (2006). *Works in collections:* RIBA Drawings Collection, V&A, London, Sir John Soane's Museum. *Publications:* Architecture for Beginners (1986), Archi-Têtes (2000), Architecture A to Z (2001). *Recreations:* music, cinema, theatre, travel. *Clubs:* Cartoonists Club of Great Britain. *Signs work:* "L Hellman." *Address:* 6 Montague Gardens, London W3 9PT. *Email:* louis.hellman@virgin.net

HEMBLEY, Stephen James, S.G.F.A.; painter in oil, water-colour, pen and ink; Founder of Shire Studios; part-time tutor;. *b:* Bournemouth, 21 July, 1957. *s of:* Reginald James Hembley. *m:* Rachel Crawford. *Educ:* Winton School. *Studied:* under George Denham at Bournemouth. *Exhib:* one-man shows: London, Telford, Shrewsbury, N.E.C. Birmingham; numerous group shows. Work in private collections worldwide. *Publications:* books illustrated for Tamarisk. *Signs work:* "S.J. HEMBLEY." *Address:* c/o Shire Studios (Telford), 25 Bishopdale, Telford, Shropshire TF3 1SA.

HEMMANT, Lynette, NDD (1958); landscape, gardens and still-life painter in oil, mixed media, black and white drawing, etching and general illustration; Director of Dedalus (Publishers);. *b:* London, 20 Sep 1938. *m:* Jüri Gabriel, literary agent. *Studied:* St. Martin's School of Art (1954-58, Roger Nicholson, Bernard Cheese, Vivian Pitchforth). *Exhib:* ROI, and various solo and mixed shows in London, Home Counties, Italy and Australia since 1984. *Commissions:*

large pieces for private clients. *Works Reproduced:* Heinemann Group, Hamish Hamilton, Random House, O.U.P., I.P.C. magazines, various US publishers, and through Art Archive photo-library. *Clubs:* SGFA. *Signs work:* "HEMMANT." *Address:* 35 Camberwell Grove, London SE5 8JA. *Website:* www.lynettehemmant.com

HEMPTON, Paul Andrew Keates, MA, RCA; artist in oil paint, water-colour, and etching; Fellow in Fine Art, University of Nottingham (1971-73). *b:* Wakefield, Yorks., 3 Oct 1946. *s of:* Revd. Canon G. B. Hempton, B.A. *m:* Margaret Helena. one *s.* two *d. Educ:* King's School, Chester. *Studied:* Goldsmiths' College School of Art (1964-68), RCA (1968-71) under Prof. Carel Weight. *Exhib:* 'British Painting ' 74, Hayward Gallery, London; 'John Moores', XI, XIII; '11th Biennale de Paris', MOMA, Paris. *Works in collections:* Arts Council, British Council, V&A, Contemporary Arts Soc., Arnolfini Trust, South West Arts, Leicester Educ. Authority, Nottingham University, Bury, A.G., Newport A.G., Wakefield A.G., Whitworth A.G., Nottingham Castle A.G., Wolverhampton A.G., Wiltshire C.C., Arthur Andersen, London. *Publications:* 'Dictionary of Twentieth Century British Painters and Sculptors', Frances Spalding. *Signs work:* "P.H." *Address:* 9 West End, Minchinhampton, Stroud, Glos. GL6 9JA.

HEMS, Margaret, FSBA, SFP; Royal Drawing Soc. (1940-43), Grenfell Medal RHS(1984-86), Founder mem. FSBA(1985); botanical artist in water-colour and pencil;. *b:* Fyfield, Essex, 1 Jan 1931. *m:* John Hems. one *s.* one *d. Educ:* Clark's College, Ilford. *Studied:* a period of art classes at Minehead (1981, Sylvia Cave), botanical illustration under Mary Grierson at Flatford. *Exhib:* SBA, HS, Westminster Gallery, Mall Galleries, galleries, West Country, East Anglia, and other mixed exhbns. in England and Wales, Denmark and Austria. *Works in collections:* private: Britain, Europe, USA, Australia. *Commissions:* wrapping paper (Medici); many private commissions. *Publications:* greetings cards for Medici and Parnassus Gallery, numerous exhbn. catalogues. Work featured in 'A History of British Flower Painters 1650-1950', 'Arte Y Botanica' and 'The Art of Botanical Painting' by Margaret Stevens. *Works Reproduced:* Limited edition prints and cards, published by the artist. *Signs work:* "M. Hems" or "M.H." joined. *Address:* Daubeney Cottage, Water St., Barrington, Somerset TA19 0JR.

HEMSLEY, George Philip, R.A. Schools cert. (1958), N.D.D. (1954), British Institution award (1958), R.A. Silver medal, Landseer Scholarship, Leverhulme Scholarship, David Murray studentships; painter in oil and water-colour; teacher. *b:* Stocksbridge, Yorks, 9 Dec 1933. *s of:* Joseph Norman Hemsley, A.M.I.Prod.E. *Educ:* Surbiton Grammar School. *Studied:* Kingston School of Art, R.A. Schools (Henry Rushbury, Peter Greenham). *Exhib:* RA, RBA, NEAC, RP, Redfern, Guildhall. *Works in collections:* Guildhall, London, Boroughs of Camden, Hackney, Kingston-upon-Thames, Weybridge Museum, Ashford Hospital, Dept. of Educ. and Science, Leicester Educ. Authority. Work loaned to Inst. of Practitioners in Advertising. *Commissions:* Camden Council, Traylens

Amusements. *Works Reproduced:* TES. *Signs work:* "Philip Hemsley." *Address:* 18 Ellis Farm Cl., Mayford, Woking, Surrey GU22 9QN.

HEMSOLL, Eileen Mary, ATD (1946), RBSA (1978); artist in thrown sculpture enamelled on earthenware, oil, oil pastels, water-colour; retd. art teacher. *b:* West Bromwich, 4 Feb 1924. *d of:* Harold Cashmore, M.D. of John Cashmore Ltd. *m:* Eric Hemsoll. one *s.* one *d. Educ:* Queen Mary's, Walsall. *Studied:* B'ham College of Art (1941-46, Eggison, Fleetwood Walker). *Exhib:* R.A., R.A. Travelling Exhbn., Local Artists, B'ham A.G., Artists for Art, R.B.S.A. Paint the City (1989), Mall Gallery Pastels Today (1994, 1995); one-man shows: Worcester College (1978), Flint Gallery, Walsall (1984), Summer Show Sally Hunters, Belgrave Sq. (1986); Retrospective: R.B.S.A. (1998), Number 9 Gallery, Brindley Place 002. *Signs work:* "Eileen Hemsoll." *Address:* 18 Mead Rise, Edgbaston, Birmingham B15 3SD.

HENDERSON, Jacqueline Kelso, Dip.AD.(1973), ATL(1974); painter in oil and pastel; tutor of equestrian art. *b:* Belfast, 29 June 1952. *m:* Eyre Maunsell (partner). one *s.* two *d. Educ:* Downe House, Newbury, Berks. *Studied:* Belfast Art College (1969-1973), Goldsmiths College, London University (1974). *Exhib:* Christies with SEA; Westminster with UA and SWA; Arts Club, Dover St., London; galleries in Britain and New York. *Works in collections:* private collections worldwide. *Signs work:* "Jackie Henderson." *Address:* Hastog Farm Studio, Church Lane, Hastog, Tring, Herts. HP23 6LU. *Email:* eyremaunsell@hotmail.com or jackie.henderson@equestrianartists.co.uk

HENOCQ, Ron, Slade Dip. (1973), San Carlos Escuela del Arte M.A. (1976); artist, Gallery Director, Cafe Gallery since 1984;. *b:* 22 Mar 1950. *Signs work:* "R.Henocq." *Address:* Cafe Gallery, Southwark Park, London SE16 2UA.

HÉNON, Sue, SBA; Owner of Art School in Germany. *Medium:* coloured pencil on coloured paper, oil on canvas, watercolour. *b:* Hayes, Middlesex, 8 Jan 1961. *d of:* Derek Bodley. *m:* Sylvain Hénon (artist). *Educ:* Dorcan Comprehensive School, Swindon. *Studied:* Open College of Arts. *Represented by:* SBA. *Exhib:* SBA, Westminster Galleries (2004-07); Exbury Gardens Five Arrows Gallery; Palmen Garten, Frankfurt; Prinz Georg's Garten, Darmstadt; Schloss Fasanerie, Fulda (Besilz-Landgraf Morritz von Hessen); Schloss and Museum Fechenbach-Dieburg; Hofgut Gallery, Reinheim. *Works in collections:* Ratskeller Hausbrauerei GMBH; Sabine Schröder SPD Party; International Women's Club, Frankfurt; Bücher Insel; Dr. Ursula Rühr, and private collections. *Commissions:* Frau A.Winkler ('The Shah's Jasmine'); Gewo Bau Russellshiem, Flower Poit Juka. *Publications:* 'Marianne's Garden'; article in 'Artists & Illustrators' (Apr 2006); featured in newspapers: Frankfurt Allegemeine; Frankfurt Rundshau, Main-Echo, Darmstadter Echo, Dieburger Anzeiger, Fuldaer Zeitung, Hünfelder Zeitung etc. *Works Reproduced:* 'Tulip';'Promises'; 'The Invitation'; 'Pretty Maids in a Row';'Ladies';'Silver Bells'. *Principal Works:* 'Tulip';'Promises';'Pretty Maids in a Row';'Peony Landscape'. *Clubs:* Reinhiem

Kunst und Kutur Verein. *Signs work:* 'SUE HÉNON SBA'. *Address:* Atelier Hénon, Mühlgasse 3, 64807 Dieburg, Germany.

HENRIQUES, Benedict James, BA Hons. Fine Art (1986-1990); painter in oil. *b:* 14 Oct., 1967. *Studied:* Newcastle -upon-Tyne University. *Exhib:* William Hardie, Glasgow; Browse and Darby, London; National Portrait Gallery (1993, 1998, 1999); Jonathan Cooper Gallery (2001). *Works in collections:* numerous. *Commissions:* assorted. *Signs work:* "B Henriques." *Address:* 160-162 Old South Lambeth Rd., London SW8 1XX. *Email:* ben.henriques@virgin.net

HENRY, Bruce Charles Reid, BD(Lond.) (1943), S.WL.A. (1982); painter in water-colour, pastel, oil, retd. school teacher. *b:* nr. Kandy, Sri Lanka, 22 Jul 1918. *s of:* G.M.R. Henry, naturalist artist. *m:* Joyce M. Henry. one *s.* one *d. Educ:* Colchester Royal Grammar School, Tettenhall College, Staffs. *Exhib:* Mall Galleries (annually), S.WL.A., Budleigh Salterton, Newport, IOW, Sladmore Gallery, London, Northern Exhbn. of Wildlife Art, Chester. *Works in collections:* Nature in Art, Gloucester. *Publications:* Author/illustrator, Highlight the Wild - The Art of the Reid Henrys (Palaquin Publishing, 1985). *Signs work:* "Bruce Henry." *Address:* 90 Broomfield Ave., Worthing, W. Sussex BN14 7SB. *Email:* b.henry996@btinternet.com

HENTALL, Maurice, FRSA (1951), SBA (1987), CBM (1997); retd. 22 years Managing Director of London Studios; part-time Art Tutor, painter in water-colour, acrylic, oil; several years Easter tutorial at Pendley Manor;. *b:* Hornsey. *m:* Nora Nelson. *Studied:* Hornsey College of Art. RAFVR from 1940, injured March 1942. Whilst convalescent official War Publication artist: encouraged by R. Stanton, Sir Alfred Munnings, Sir James Gunn. *Exhib:* RA, Mall Galleries, Westminster Central Hall, Llewellyn Alexander - portraits, wildlife, botanical, including miniatures. *Works in collections:* included in British Flower Painters History/Dictionary - copy lodged with British Museum. *Commissions:* motif Golden Jubilee of Sperry Gyroscope Co. (unveiled by Earl Mountbatten of Burma 1963). *Publications:* Royal Manor of Hanworth. *Works Reproduced:* Medici, Gordon Fraser, etc. *Clubs:* RSA. *Signs work:* "MAURICE HENTALL." *Address:* 42 The Broadway, Wheathamstead, St. Albans, Herts. AL4 8LP.

HENTHORNE, Yvonne, Professor, NDD (Painting 1965), ATC (1966), FRSA (1967), Italian Government Bursary (1969), Brazilian Government Scholarship (1971), W. German Research Grant (1974-75); constructed painting; Head of Foundation Studies Dept., Wimbledon School of Art. *b:* Wetherby, Yorks., 1942. *d of:* Leslie Henthorne. *m:* Gary Crossley, Professor, Surrey Institute. one *d. Educ:* Grey Coat Hospital, Westminster. *Studied:* London University Goldsmiths' College of Art (1961-66, Patrick Millard, Albert Irwin, Andrew Forge). *Exhib:* open, Young Contemporaries, Tate, Birmingham Festival, Midland Group Gallery, Sheffield Open National, S.W.A., R.B.A.; one-man shows, Ikon Gallery, Birmingham; Belgrade, Coventry; Laing Gallery,

Newcastle-on-Tyne. *Works in collections:* U.K., Europe, U.S.A. *Signs work:* "Yvonne Crossley." *Address:* The Chestnuts, Bishops Sutton, Hants. SO24 0AW.

HENTY-CREER, Deirdre, FRSA; Utd. Artists Council (1947-1955); FCIAD (1945); Artists of Chelsea (1961); Com. Chelsea Art Soc.; Com. Armed Forces Art Soc. *Medium:* oil. *b:* Sydney, Australia. *d of:* Capt. Reginald Creer, R.N., and Eulalie Henty. *Educ:* privately. *Exhib:* RA, ROI, RBA, NEAC, NS, UA, Towner A.G. Eastbourne, Russell-Cotes, Bournemouth, Williamson A.G. Birkenhead, and other municipal galleries, Submarine Museum, Gosport, Victory Museum, Portsmouth, etc. One-man shows, Fine Art Soc., Frost & Reed, Cooling, and Qantas Galleries, Bond St., Upper Grosvenor Gallery, Harrods, Nice XIV Olympiad Sport in Art at V&A, R.N. College, Greenwich. *Works in collections:* H.R.H. the Prince of Wales, Lord Rank, Lord Rootes, Ronald Vestey, Esq, Michael Powell, of Archer Films. *Works Reproduced:* The Artist, Cover of Studio, Medici Soc., T.A.V.R. Mag., Royal Sussex Regt. Mag., Poster for Municipality of Monaco, The Sphere, Stanton Corp., N.Y., Chrysons of California, U.S.A., Gruehen of Innsbruck. Portraits include: H.R.H. Prince Michael of Kent; Governor-Gen. of Australia, Sir John Kerr; Mayor of Kensington, Sir Malby Crofton, Bt.; Prime Minister of Malta, Dr. Borg Olivier; First Sea Lord, Sir Henry Leach, etc. *Recreations:* skiing, sub-aqua. *Clubs:* Hurlingham. *Address:* 5 St. Georges Ct., Gloucester Rd., London SW7 4QZ.

HEPPLEWHITE, Val, figurative painter in oil and printer. *Medium:* oil. *b:* Rotherham, 4 May 1938. *m:* Chris Morgan Smith. two *s.* one *d. Educ:* Oakwood High School, Rotherham. *Studied:* RWA, Bristol. *Exhib:* throughout U.K. and abroad incl. RA, RWA, WGA, SWA, SGFA. *Works in collections:* Patrick Nicholls M.P., Prof. Robin Stowell, Bruton School, Judge Joseph, Sir Matthew Thorpe. *Signs work:* "Val Hepplewhite." *Address:* The Studio, Twinneys Charlcombe Bath, BA1 8DL.

HEPWORTH, Anthony, BA Hons (1976), Central School. Post Grad Diploma Fine Art (1977). Worked at British Museum 1978-80. Since 1981 has been a dealer. Opened first gallery in Bath in 1985, specialising in 20th Century British painting and sculpture.; Fine Art dealer. *b:* Wakefield, Yorks, 30 Mar 1952. *s of:* Raymond Hepworth. *m:* Rose. one *d. Educ:* South Featherstone Secondary Modern. *Studied:* Pre-Dip & Foundation (Blackpool), BA Hons Fine Art (Bristol) and Central School Post Grad Sculpture. *Exhib:* Aqua Vella Gallery, New York (1980, sculpture). *Publications:* currently compiling Catalogue Raisonne of the works of Keith Vaughan. *Recreations:* goods food and wine, collecting tribal art. *Address:* Ivy House, Cavendish Rd, Sion Hill, Bath, BA1 2UE.

HERBERT, Albert, ARCA; painter of mainly religious or symbolic subjects in oil and etching; ex Princ. lecturer, St. Martin's School of Art;. *b:* London, 10 Sept., 1925. *m:* Jacqueline. three *d. Studied:* RCA (1949-53), British School at Rome (1953-54). *Exhib:* RA, Poetry Soc., University of California, Westminster,

Norwich, Winchester and St. Paul's Cathedrals, Castlefield Gallery, England and Co., Lancaster University, etc. *Works in collections:* Contemporary Art Soc., Coventry Training College, Methodist Educ. Com., Shell, Stoke-on-Trent A.G., Glamorgan, Herts., Notts. and Somerset C.C's. *Publications:* "Albert Herbet" retrospective (England and Co. 1999); "Albert Herbert- 50 years of Painting" (England and Co 2004). *Clubs:* Chelsea Arts. *Misc:* Agent: England and Co., London, W11. *Signs work:* "Albert Herbert." *Address:* 4 Clifton Terr., Cliftonville, Dorking RH4 2JG.

HERBERT, Barry, artist/printmaker, drawings and prints; Head of Fine Art Dept., University of Leeds (1985-92);. *b:* York, 19 Mar., 1937. *m:* Janet. one *s.* one *d. Educ:* Archbishop Holgate's School, York. *Studied:* James Graham College. *Exhib:* 39 one-man shows include: Serpentine Gallery, London (1971), Mappin Gallery, Sheffield (1972), Galerie Brechbühl, Switzerland (1972, 1976, 1979, 1982, 1984), Galerie Steinmetz, Bonn (1979, 1984, 1993, 1995), Karl-Marx-Universität, Leipzig, (1980), Gilbert Parr Gallery, London (1982), Richard Demarco Gallery (1992). *Publications:* 30 editions of prints published in Germany, Switzerland and England; "Barry Herbert - Künstler-Grafiker" (1979); "Barry Herbert" - Drawings and Etchings (1997); 'Barry Herbert- an Argosy of Beauty' (2004- Hirten Presse, Bonn/Berlin). *Signs work:* "Barry Herbert." *Address:* 43 Weetwood Lane, Leeds LS16 5NW. *Email:* barry.herbert@virgin.net

HERBST, Günther Daniel, MA Fine Art; Observer Award for New British Artists (2002); IGI Life Vita Art Now - first quarterly award, jointly with William Kentridge (1992). *Medium:* oil. *b:* Pretoria, S.Africa, 25 Apr 1963. *s of:* Mr JD & Mrs HVS Herbst. *m:* Jacqueline Anne Davies. one *s.* one *d. Studied:* Goldsmiths College, Univ.of London (2000-02); Witwatersrand Technikon, South Africa (1998-1991, National Higher Diploma Fine Art). *Exhib:* RA Summer Exhbn (2003); Loushy Art, Tel Aviv (2004); Durban National Gallery, SA (2002); Sarah Myerscough Fine Art (2002); Galerie de L'esplenade, Paris ('Un Art Contemporain d'Afrique de Sud, 1994); Linda Goodman Gallery, SA (1992). *Publications:* RA Catalogue Summer Exhbn (2003); RA Magazine no.79 (Summer 2003); Observer Magazine (8 Sep 2002). *Works Reproduced:* RA Catalogue Summer Exhbn (2003). *Signs work:* 'G.Herbst'. *Address:* 21 Burton Road, Kingston-upon-Thames, Surrey KT2 5TG. *Email:* bixie@dircon.co.uk *Website:* www.sod-and-willems

HERICKX, Geoffrey Russell, A.R.M.S., H.S.; painter in oil and water-colour; teacher, specialist in painting miniatures – all subjects;. *b:* Birmingham, 1939. *m:* Maureen. one *s.* one *d. Studied:* Birmingham College of Art (1956-58). *Exhib:* three one-man shows in Leicester, work in many private collections, annually at Royal Miniature Soc. and Hilliard Soc. exhibitions, 'Best in Exhibition' at 2000 Hilliard Soc. Exhibition. *Publications:* illustrated: Naturalist Summers. *Signs work:* "G.R. HERICKX." *Address:* 33 Ash Tree Rd., Oadby, Leicester LE2 5TE. *Email:* geoff@herickx.freeserve.co.uk

HERIZ-SMITH, Bridget, BFA (Hons.); award with commendation, History of Art (1977), prizewinner SGA. (1985); part-time tutor Clock House Studios (1979-86); Otley College; UEA; sculptor, figurative. *Medium:* bronze, stone, cement, terracotta. *b:* Hamburg, 13 Dec 1949. *d of:* Audrey Pilkington, painter. one *s*. one *d. Educ:* Framlingham Mills Grammar School. *Studied:* Goldsmiths' College, Ravensbourne College (1974-77, Eric Peskett). *Represented by:* Chappell Galleries, Essex. *Exhib:* Sculpture in Anglia (1978, 1981, 1989), R.A. Summer Show (1988, 1992), Musée Lanchelevici, Belgium, Dialogues, St Petersburg, Mercury Gallery, Discerning Eye (1997) Christchurch Mansion, Ipswich, Salthouse 06, Norfolk (2006). *Works in collections:* Women's Art, New Hall, Cambridge, Ipswich Borough Council. *Commissions:* OOCL Monument, Levington, Suffolk (stone carving); Mother and Child, Cobholm and Lichfield Resource Centre, Great Yarmouth (stone carving). *Publications:* Making the Connection (2002, ISBN 0 948252 13 8); New Hall Art Collection (2003, ISBN 0 9507108 4 9). *Clubs:* groups: Bearing 090°, ARC (Gt.Yarmouth). *Signs work:* "B.Heriz." *Address:* 145 Southtown Road, Gt Yarmouth, Norfolk, NR31 0LA. *Email:* b.herizsmith@btinternet.com *Website:* www.bridgetheriz.co.uk

HERNANDEZ, Ramon, *Medium:* chinese ink, acrylic, oil. *b:* 20 May 1959. *s of:* Ramon and Christina Hernandez. *Educ:* 1990-96- Art and Tibetan Buddhism-Djaramshala, India; 1983-87 Japanese Calligraphy and Zen Buddhism, San-Un Zenda, Kamakura, Japan; 1977-81 Eastern Philosophies and Comparative Religion, Satchidananda Centre, Connecticut, USA. *Represented by:* Bernard Chauchet. *Exhib:* Galeries Azhar, Paris (1998)Q:wi1, Perth, Australia (2001); Galerie Brun, Leglise Paris (2003), Art-London (2003), Affordable Art Fair, London and New York (2003), Kur Galeries, San Sebastian, Spain (2004). *Works in collections:* private collections in Spain, France, Australia, USA, UK. *Publications:* Madame Figaro (1999); Global Vision vol.4 (2003). *Misc:* oriental philosophies, calligraphy, professor of yoga. *Address:* 40 Quai de Jemmapes, 75010 Paris, France.

HERON, Susanna, B.A. (Hons.), F.R.S.A., Hon. F.R.I.B.A.; sculptor;. *b:* England, 22 Sep 1949. *Exhib:* solo shows since 1985 include Whitechapel A.G., Camden Arts Centre, Newlyn A.G., Mead Gallery, University of Warwick. *Works in collections:* Stedelijk Museum, Arts Council of England, V. & A., C.A.S., etc., museums in Europe, USA and Australia. *Commissions:* Major public commissions: Consilium European Union, Brussels (1995), sole British representative; front British Embassy, Dublin (1995); Shoreditch Campus, Hackney Community College (1997); Phoenix Project, Priory Place, Coventry City Council (1998-2003); Arnolfini Bristol (1999-2005); Marunouchi Building, Mitsubishi, Tokyo (2002), 'Side Street', a new pedestrian street, City Inn, Westminster (2001-2003), The Brunswick Centre London (2003-2006); 'Still Point' Metropolitan Cathedral, Liverpool (2003-2007). *Publications:* photographs/text: Shima: Island and Garden (Abson, 1992); Stills from Sculpture (Abson, 1999); 'Elements' (Mead Gallery, Warwick Arts Centre, University of

WHO'S WHO IN ART

Warwick) published 2003. *Address:* 39 Norman Gr., London E3 5EG. *Website:* www.susannaheron.com

HERRIOT, Alan B., artist/sculptor in cold cast GRP, painting in oil, acrylic and water-colour; Proprietor, Endeavour Art Studios, Edinburgh;. *b:* 20 Feb., 1952. *Studied:* Duncan of Jordanstone, Dundee (1969-74, Scott Sutherland, James Morrison). *Exhib:* Aros Centre Skye, Whisky Heritage Centre Edinburgh, Inverary Court House, Fighting Ships (Hartlepool). *Works in collections:* Miner's Monument, Newtongrange, Horse and Figure, Loanhead; 51st Highland Division Liberation Monument, Schijndel (Holland) and Perth (Scotland). *Commissions:* 'Ancient Mariner' 7' statue, Watchet, Somerset. *Publications:* The Foundling; Christmas is Coming; Travellers Tales; Broonies, Silkies and Fairies; Quest for a Kelpie. *Works Reproduced:* military prints. *Principal Works:* Highland Division Memorial. *Recreations:* music. *Signs work:* "Alan B. Herriot". *Address:* Endeavour Art Studios, 75 Trafalgar La., Leith, Edinburgh EH6 4DQ.

HESELTINE, John Robert, B. of E. Drawing (1941), B. of E. Pictorial Design T.D. (1941), scholarship, Royal College (1942); artist in oil and water-colour, portrait artist; leading name in British illustration (1950s-1970s); descendent of John Postle Hestletine, artist, famous collector, early trustee of National Gallery, a founder of R.C.A. and friend and student of James McNiell Whistler; also related to Peter Worlock, composer. *b:* Ilford, Essex, 14 Sept., 1923. *m:* Pam Masco. one *s.* one *d. Studied:* S.E. Essex College of Art (Francis Taylor, A.R.C.A., Allen Wellings, A.R.C.A.). *Exhib:* V. & A., R.W.S., R.P.S., London galleries, including David Messum and W. H. Patterson, and U.S.A. Studio and Gallery at East House Petworth. *Works in collections:* Dartmouth Naval College and Museum, Fleet Air Arm Officer's Mess,Yeovilton; private and corporate collections. *Commissions:* many portraits including H.M. Queen Elizabeth and H.R.H. Duke of York for Royal Naval Air Station, Yeovilton, officers mess, investiture of H.R.H. the Prince of Wales, Bernard Gallagher, Ryder Cup captain for Wentworth golf club. *Publications:* Odhams Press, Fleetway, I.P.C., London Times, London Standard, Harpers & Queen, Wentworth Magazine, Surrey Magazine, Twentieth Century Artists by Frances Spalding, Dictionary of British Artists since 1945 by David Buckman. *Clubs:* Wentworth. *Signs work:* "John Heseltine." *Address:* East House, East St., Petworth, W. Sussex GU28 0AB.

HEWLETT, Francis, R.W.A. (1979), D.F.A. (1955), N.D.D. (1952); painter in oil paint, also worked in polychrome ceramic (1967-76); Painter in Residence: Gregynog Hall, Powys (1977), Newlyn Soc. of Artists; Head of Painting, Falmouth (1963-81);. *b:* Bristol, 26 Sept., 1930. *m:* Elizabeth Allen. one *s.* two *d. Educ:* Fairfield Grammar School, Bristol. *Studied:* West of England College of Art (1948-52, George Sweet), Ecole des Beaux Arts, Paris (1953, Ateliers of Legeult and Brianchon), Slade School (1953-54, W. Coldstream, C. Rogers). *Exhib:* shown since 1958, Newlyn, R.W.A., R.A., Dublin, Belfast, Browse and Darby, London (1993), Falmouth, Plymouth (2000, 2001) retrospective

exhibition (painting, drawing, ceramic). *Works in collections:* Belfast, Plymouth, Leicester, Portsmouth, Southampton, Aberystwyth, Gregynog Hall, Duisburg (Germany). *Commissions:* Peter Nichols, Tom Stoppard. *Signs work:* "Francis Hewlett" or "F.H." *Address:* 21 Penwerris Terr., Falmouth, Cornwall TR11 2PA.

HEYWORTH, James Charles, L.D.A.D. distinction University of London (1982); illustrator/painter in gouache, water-colour, pen and ink, airbrush. *b:* London, 28 Feb 1956. *s of:* James Heyworth. *Educ:* Wandsworth School. *Studied:* Putney School of Art (1975), Byam Shaw School of Drawing and Painting (1976, D. Nixon), Goldsmiths' College (1979-82, Bernard Cheese). *Exhib:* Battersea Arts Centre, Ripley Arts; one-man Bury Metro Arts Assoc. *Works in collections:* private. *Clubs:* Assoc. of Illustrators. *Signs work:* "James Heyworth." *Address:* 99 Sutton Common Rd., Sutton, Surrey SM1 3HP.

HICKS, Anne Marguerite Christine, RWA, Slade Dip.; artist in oil and gouache of portraits, murals, costume design, environmental design; Adult Education Avon and Visiting Lecturer, University Architects Dept., Bristol (1976-84); RWA Prize Winner with husband of mural competition for Bristol Gas Showroom. *b:* London, 19 Jan 1928. *m:* Jerry Hicks. one *s.* one *d. Educ:* Hampstead and Minehead. *Studied:* Slade School under Profs. Schwabe and Coldstream. *Exhib:* RWA, British Women Painters Musée de l'Art Moderne, Paris (1967); two-person shows with husband: Bristol, Cardiff, Dorchester, Cannes, RWA and inaugural exhbn. for Grant/Bradley Gallery Bristol. *Works in collections:* private collections in England, France, America, New Zealand, Australia. *Commissions:* S.S. Great Britain mural (with husband) 1997; portraits in Bristol, Edinburgh; stage designs (with husband) Bristol Art Centre. *Works Reproduced:* illustrations for 'A Place for People' (co-author with husband); 'An Introduction to Portrait Painting' by Ros Cuthbert; works for RWA. *Principal Works:* mural for Bristol Univ. Pool and SSGB (with husband). *Recreations:* painting and family. *Clubs:* Bristol Civic Society. *Misc:* illustrative and written environmental work for Bristol and active campaigns. *Signs work:* "Anne Hicks." *Address:* Goldrush, Gt. George St., Bristol BS1 5QT.

HICKS, Jerry, M.B.E., ATD, RWA, Slade Dip., Judo 7th Dan; painter including portraits, murals; environmentalist; Winner of Bristol 600 Competition (1973), Queen's Jubilee Award (British Achievement), Olympic Painting prize (1984). *Medium:* oil, pastel, drawing. *b:* London, 12 Jun 1927. *s of:* Algernon Hicks, actor and Nancy Hicks. *m:* Anne Hicks (née Hayward), painter. one *s.* one *d. Educ:* Actors' Orphanage, Rishworth, Sandhurst. *Studied:* Slade under Coldstream, Freud and with Stanley Bird and Walter Bayes (Lancaster). *Exhib:* RWA annually since 1951 and two-person shows with wife; RA, RBA, King St.Gall (solo show); Mall Galleries; Bristol Art Gallery; Arnolfini, Bristol; Hanover; jointly with wife: Dorset, Cardiff, Cannes, Bristol Guild, Grant/Bradley Gall. Inaugural Exhbn, Bristol; numerous other including stage design in Bristol. *Works in collections:* RWA, Bristol University, Merchant Venturere; Britain, USA, Canada, St. Lucia, Germany, Italy, France, Australia, Japan. *Commissions:*

SS. Great Britain mural (with wife) 1997. Numerous national portraits incl. H.M. The Queen for RWA. *Publications:* 'Judo: Through the Looking Glass', 'A Place for People' (co-author with wife). *Works Reproduced:* 'An Introduction to Portrait Painting' by Ros Cuthbert; works for RWA; many catalogues. *Principal Works:* 'Supper at Emmaus'; Athelhampton, Sir Charles Frank, H,.M.Queen, Anne, Kim, Roger Bannister, Bristol 600, Paul Chadd Collection, Artists Collection, Liverpool University. *Recreations:* judo (retired), work for Bristol Civic Soc. *Clubs:* Bristol Civic Soc, Bristol Judo Kwai. *Misc:* awarded M.B.E. and M.A. for 'services to sport and the community in S.W. and City of Bristol'; organiser of national campaigns for environment, playing fields, etc. Chair: Bristol Lazi Land Use Group. *Signs work:* "Hicks." *Address:* Goldrush, Gt. George St., Bristol BS1 5QT.

HICKS, June Rhodes, B.A. (Hons.) (1956), M.A. (1960); printmaker in etching; former teacher;. *b:* Yorks., 5 June, 1935. *m:* J. Michael Hicks. two *s.* one *d. Educ:* Universities: Leeds, Belfast. *Studied:* Penzance School of Art (Bouverie Hoyton, John Tunnard, Joan Whiteford). *Exhib:* solo shows in Cornwall. *Works in collections:* galleries in Cornwall and elswhere; and in private collections. *Publications:* co-editor Ten Penwith Printmakers (1998). *Clubs:* Founder mem. Penwith Printmakers, mem. St. Ives Soc. of Artists. *Signs work:* "June Hicks." *Address:* Vingoe Cottage, Travescan Sennen, nr. Penzance, TR19 7AQ. *Email:* junehicks@trevescan.ndo.co.uk *Website:* www.trevescanstudio.com

HICKS, Nicola, M.B.E, RWA, FRBS, MA, RCA; sculptor in plaster and straw, bronze;. *b:* London, 1960. *m:* Daniel Flowers. one *s.* one *d. Studied:* Chelsea School of Art (1978-82), Royal College of Art (1982-85). *Exhib:* numerous solo exhbns. in UK and abroad. *Commissions:* monument to the Brown Dog, Battersea Park, London. *Publications:* 'Nicola Hicks' (Momentum, 1999). *Signs work:* "HICKS." *Address:* c/o Flowers East, 82 Kingsland Road, London E2 8DP.

HICKS, Philip, Dip. RAS; painter in oil, acrylic and water-colour; Past Chairman, Vice Pres. AGBI. *b:* England, 11 Oct 1928. *s of:* Brig. P. H. W. Hicks, C.B.E., D.S.O., M.C. *m:* Jill. one *s.* one *d. Educ:* Winchester College. *Studied:* Chelsea School of Art and RA Schools. *Represented by:* Messum's Fine Art, Cork Street, London W1. *Exhib:* one-man shows, Marjorie Parr, Robert Self, Hoya, New Art Centre Galleries, Gallery 10, London, Oxford Gallery, V.E.C.U. Antwerp, Engström Galleri, Stockholm; retrospective, Battersea Arts Centre, London, Bohun Gallery, Henley, 1977 British Council award, David Messum Fine Art, London, John Davies Gallery, Stow-in-the-Wold, Alpha House Gallery, Sherborne. *Works in collections:* Tate Gallery, V. & A., Contemporary Art Soc., Imperial War Museum, Nuffield Foundation, R.C.M., De Beers, Mirror Group, Wates Ltd., NatWest. Bank, B.P., APV Holdings, Chandris Shipping. *Commissions:* Wates Ltd., Control Data Corporation, Chandris Shipping. *Works Reproduced:* Imperial War Museum Catalogue of Paintings. *Clubs:* Chelsea Arts, Royal Overseas League. *Signs work:* "Philip Hicks" (often on reverse) or "HICKS." *Address:* Radcot House, Buckland Rd., Bampton, Oxon. OX18 2AA.

HICKS-JENKINS, Clive, Hon.Fellow School of Art, University of Aberystwyth (2004); Creative Wales Award, Arts Council of Wales (2002); Gulbenkian Welsh Art Prize (1999). *Medium:* acrylic, drawing, printing. *b:* Newport, Mon., 11 Jun 1951. *s of:* Trevor and Dorothy. *Educ:* Italia Conti School. *Studied:* no formal art training. *Represented by:* The Martin Tinney Gallery, Cardiff; Anthony Hepworth Fine Art, Bath. *Exhib:* Attic Gallery, Swansea (2005); Martin Tinney Gallery, Cardiff (2004); Christ Church Picture Gallery, Oxford (2004), MOMA Wales (2004); Anthony Hepworth Fine Art, Bath (2002); Brecknock Museum & Art Gallery, Brecon (2002); Newport Museum & Art Gallery (2001); New Theatre, Cardiff (1984); also RA, RWEA, National Eisteddfod of Wales, etc. *Works in collections:* MOMA Wales; Mewport Museum & Art Gallery; Contemporary Art Society for Wales; Brecknock Art Trust; National Library of Wales. *Commissions:* Artists' books for The Old Stile Press (1997-2005). *Publications:* 'The Temptations of Solitude: Paintings by Clive Hicks-Jenkins' (Cardiff, 2004); 'Clive Hicks-Jenkins: The Mare's Tale (Newport 2001). *Works Reproduced:* British Art Journal Vol3 (2004)p.68; Art Review (May 2001)p.48; Modern Painters (Summer 2001)p.104. *Signs work:* 'Hicks-Jenkins'. *Address:* Ty Isaf, Llanilar, Aberystwyth, SY23 4NP. *Email:* clive@hicks-jenkins.fsnet.co.uk *Website:* www.hicks-jenkins.com

HIGGINS, John, self taught artist in water-colour and drawing, mixed media; private tuition, tutor for H. F. Holiday Group, Peligoni Painting Holidays and others;. *b:* Carshalton, 10 July, 1934. *m:* Nicola. two *s.* *Exhib:* various exhibitions: solo exhibitions; St. Ives "In All Directions"; St. Ives Society of Artists, Penwith Gallery, St. Ives. *Works in collections:* various private buyers. *Publications:* article for Artist magazine Oct. '99 "Mixing the Media", BBC television short film on Godrevy Lighthouse, April 2000. *Clubs:* St Ives Art Club. *Signs work:* "J D Higgins." *Address:* 6 Richmond Place, St.Ives, Cornwall TR26 1JN.

HIGGINS, Nicola, artist in water-colour; private water-colour tutor, tutoring for H. F. Holiday Group, Peligoni Holidays Greece, and others;. *b:* Rustington, Sussex, 1 Mar 1943. *m:* John. one *s.* *Educ:* City and Guilds teachers certificate. *Exhib:* St. Ives Society of Artists; various exhibitions and galleries. *Works in collections:* Various private patrons. *Publications:* article for Artist magazine Dec. '99 "Adventures in Watercolour", short film for BBC Pebble Mill "Which Craft" on water-colour painting Sept. '99. *Clubs:* St. Ives Art Club. *Signs work:* "Nicola H." *Address:* 6 Richmond Place, St. Ives, Cornwall TR26 1JN.

HIGGINSON, Clifford Edward, *Medium:* oil, watercolour. *b:* Salford, 10 Mar 1939. *s of:* Albert Edward & Hilda Higginson. *m:* Vivienne Jean Higginson. three *s.* *Studied:* College of Art, Salford (1957-60), Faculty of Tech and Science, Manchester (1960-64). *Represented by:* James Collins, Vernon Gallery, Stockport. *Exhib:* in one-man shows and joint exhibitions at: Black Sheep Gallery, Hawarden; Bolton Gallery; Central Gallery, Manchester; Colin Jellicoe Gallery, Manchester; Derby City Art Gallery; Hillgate Gallery, Stockport;

Lantern Gallery, Worsley; Mariners Gallery, St.Ives, Cornwall; Newa, Liverpool; Salford Art Gallery; Swinton Art Gallery; The Calvery Gallery, Helensburgh; Tib Lane Gallery, Manchester; Torr Top Gallery, New Mills; Vernon Mill Gallery, Stockport. *Works in collections:* in Australia, Switzerland, Scotland, France and Belgium. *Commissions:* over seventy privately commissioned portraits, plus numerous other scenes, animals, etc. *Works Reproduced:* various paintings in local magazines and newspapers. *Recreations:* writing poetry, ballet, theatre, music. *Signs work:* "CLIFF HIGGINSON". *Address:* 82 Malmesbury Road, Cheadle Hulme, Cheadle, Cheshire. SK8 7QL. *Email:* cliff@artstudio.free-online.com *Website:* www.cliffhigginson.freeuk.com

HIGSON, John, M.F.P.S.; self taught sculptor in wood and ceramic, painter in water-colour and pastel. *b:* 30 Oct 1936. *s of:* Albert Edward Higson. *Educ:* Malden West County Secondary. *Exhib:* one-man shows: Bourne Hall, Ewell, Russell Studio, Wimbledon, Malden Centre, New Malden. *Address:* 22 Croxton, Burritt Rd., Kingston upon Thames, Surrey KT1 3HS.

HILL, Anthony, artist, plastician and theorist: works in industrial materials; awarded Leverhulme Fellowship, Hon. Research Fellow, Dept. Mathematics, University College, London (1971-73); currently visiting research associate (Maths. Dept. UCL). *b:* London, 23 Apr 1930. *s of:* Adrian Hill, R.B.A. *m:* Yuriko Kaetsu, ceramicist. *Educ:* Bryanston. *Studied:* St. Martin's (1947-49), Central School (1949-51). *Exhib:* Kasmin Gallery (1966, 1969, 1980); retrospective exhbn. Hayward Gallery (1983), I.C.A. (1958); Mayor Gallery (1994). *Works in collections:* Tate Gallery, V. & A., British Museum, provincial galleries; Museum of Modern Art, Grenoble, Tel Aviv and Santiago, Louisiana Museum Denmark, Gulbenkian Museum Lisbon, Stuki Museum, Lodz (Poland), Kroller-Muller (Holland). *Publications:* edited Data Directions in Art Theory and Aesthetics (Faber, 1986), Duchamp-Passim (Gordon and Breach 1995). *Works Reproduced:* in English, Continental and American publications since 1950. *Signs work:* "Anthony Hill." or "AH" (as monogram). Since 1975 has made works signed "Rem Doxford", and "Redo." *Address:* 24 Charlotte St., London W1T 2ND.

HILL, Carol Elizabeth, SWA; SFP, ARBSA; qualified teacher in Adult Education. *Medium:* oil, watercolour. *b:* Warlingham, Surrey, 23 Jul 1946. *d of:* Mr & Mrs F.C.Matthews. *m:* Michael Hill. one *s.* one *d. Educ:* St.Georges School, Hong Kong. *Studied:* oil painting and watercolours under various tutors in UK and abroad. *Represented by:* Little London Gallery, Derbyshire. *Exhib:* Westminster Gallery; Mall Galleries; Mottisford Abbey, Hampshire; in York, Hull, Harrogate, Sheffield, Nottingham, Derby, Norfolk, Lincoln and Matlock. *Commissions:* many over the years - mainly landscape, seascape and flowers. *Publications:* several articles in magazines. *Works Reproduced:* Limited Addition prints and cards. *Recreations:* gardening, walking, reading. *Clubs:* President of the Matlock Art Society. *Misc:* I also organise demonstrations, workshops and teaching sessions around the UK. *Signs work:* 'Carol Hill'. *Address:* 'Ashleigh',

Yew Tree Hill, Holloway, Matlock, Derbyshire DE4 5AR. *Email:* carolhill@mailauth.co.uk

HILL, Charles Douglas, artist in oil;. *b:* Dewsbury, W. Yorks., 16 June, 1953. *m:* Jennifer Haylett, singer. *Educ:* Dewsbury, England, and Sqaumish, Canada. *Exhib:* worldwide; and Longships Gallery, St. Ives. *Works Reproduced:* book cover (Black Swan Pub.), articles 'Cornish World', 'Inside Cornwall'. *Clubs:* St. Ives Soc. of Artists. *Address:* Longships Gallery, St.Andrew's St., St. Ives, Cornwall TR26 1AN.

HILL, Reginald H., S.G.F.A.; artist in oil, water-colour, pastel and pencil of portraits, landscapes, figure; President, Croydon Art Soc. (retired July 2003);. *b:* London, 26 Feb 1919. *m:* Jean Hill (decd.). one *s.* one *d. Educ:* Vauxhall Central School, London. *Studied:* City & Guilds Art School (1969-72, Middleton Todd, R.A., Robin Guthrie, R.P.; 1972-75, Rodney Burn, R.A.). *Exhib:* R.A., R.S.P.P., N.E.A.C., S.G.F.A. *Commissions:* Numerous. *Publications:* illustrated 'Scorched Earth' by 'Detonator' (Col. Brazier). *Clubs:* Chelsea Arts. *Misc:* Work in private collections worldwide. *Signs work:* "Reg. Hill," "R. Hill" or "R.H.H." *Address:* "Raffaello", 54 Hermitage Rd., Kenley, Surrey CR8 5EB.

HILL, Ronald James, U.A., S.G.F.A., F.S.A.I.; freelance artist in oil, water-colour, pen and ink. *b:* London, 19 Oct 1933. *s of:* James George Hill. *m:* Betty Bunn (decd.). *Educ:* Willesden Technical College. *Studied:* Heatherley's School of Art (1958-65, Jack Merriot, Patrick Larkin, Harry Riley). *Exhib:* Paris Salon (1966-69), RBA, UA; one man shows, Brent, Wantage. *Commissions:* Landscapes and architectural subjects in all media. *Signs work:* "RONN." *Address:* Orpheus Studio of Fine Art, Pound Cottage, Kingston Lisle, Wantage, Oxon. OX12 9QL.

HILL, Sonia Geraldine, painter in oil; grant to Maidenhead Art College, Berks (1955). *Medium:* oil. *b:* London, 26 Sep 1939. *d of:* John Alfred England. *m:* Major G.H.Clark (decd). *Educ:* Dorchester Abbey School, Oxon. *Studied:* Maidenhead Art College, Berks.; Zambia (pupil with Andrew Hayward). *Exhib:* RA (3 hung-3 passed between 1993 and 2000, including portrait of Quentin Crisp, which now hangs in Vancouver); Christies 'Art 4 Life' (2000-2004); Exh. Richmond Art Gallery (1999); Paris (2000). *Publications:* R.A. Illustrated (1993) Jack the Lad. *Clubs:* Friend of the RA. *Misc:* three oil portraits of celebrated artist Tracey Emin (2005). *Signs work:* "S.G. Hill." *Address:* 6a Warfield Rd., Hampton, Middx. TW12 2AY.

HILLHOUSE, David, Hon.RCamA.; BA(1969), ATD(1971), RCA (1979), AMA (1982); artist in water-colour and egg tempera. *b:* Irby, Wirral, 19 Jun 1945. *s of:* Harry Hillhouse. *m:* Paula Lane. two *s. Educ:* Birkenhead Institute. *Studied:* Laird School of Art (1964-66), Liverpool College of Art (1966-69). *Exhib:* Merseyside, Wales and Bristol, U.S.A., Germany, France. *Clubs:* Wirral Soc. of Arts, Deeside Art Group, National Acrylic Painters' Association (NAPA). *Signs*

work: "David Hillhouse." *Address:* 49 Cortsway, Greasby, Wirral CH49 2NA. *Website:* www.davidhillhouse.com

HILLI: see THOMPSON, Hilli,

HILLIER, Matthew, S.WL.A., S.A.A. (U.S.A.); wildlife artist in acrylic, pastel and water-colour; Council mem. S.WL.A.;. *b:* Slough, 7 May, 1958. *Studied:* Dyfed College of Art. *Exhib:* Christie's Wildlife Auction (1994-97), Pacific Rim Wildlife Art Expo (1994,1995) Tacoma, Vancouver, Soc. of Animal Artists (1995, 1996), Birds in Art, Wisconsin (1993, 1994, 1996), Florida Wildlife Art Expo (1997), Friends of Washington Zoo Wildlife Art Show (1996, 1997). *Commissions:* Ambleside Studio, Michigan. *Publications:* Fine Art Limited Edition prints (Millpond Press, Florida); illustrated: The Rhinocerous, a Monograph (Basilisk Press Limited Edition book). *Signs work:* "Mathew Hillier." *Address:* 166 ELMER RD., Middleton-on-Sea, W. Sussex PO22 6JA.

HILLIER, Susan Patricia, SY.Dip (Fine Art) 1969. *Medium:* water-colour, acrylic, oil, pencil, gouache, etc. *b:* Surrey, 8 Sep 1949. *d of:* Margaret and Frank Hillier. *Educ:* Mickelham Primary, Mowbray Girls School, Dorking. *Studied:* Reigate School of Art (1964-70). *Represented by:* Lander Gallery, Truro. *Exhib:* 7 solo and 20+ group exhibitions (London, Surrey, Cornwall and Lincolnshire) including Plymouth Municipal Gallery, NT, RHS, Kew Gardens, Tresco Estate. *Works in collections:* throughout the world. *Commissions:* British Rail, Tesco, McMullen's Brewery, Law Society, Police College, Scout Assoc., Royal Horticultural Society etc. *Publications:* illustrated numerous gardening books, scientific botanical publications and natural history subjects. *Official Purchasers:* see commissions. *Works Reproduced:* various magazines. *Principal Works:* drawings for 'Kew', and botanical paintings. *Recreations:* gardening, walking, cooking. *Misc:* founder member and hon. mem. Society of Botanical Artsits, RHS medallist, scientific illustrator Royal Bot. Gdns., Kew. *Signs work:* Susuan Hillier. *Address:* c/o Lander Gallery, 29 Lemon Street, Truro, Cornwall TR1 2LS.

HILLS, Jonathan Graham, MA (Cantab); Prix Italia. *Medium:* oil, drawing. *b:* London, 9 Mar 1954. *s of:* Sir Graham Hills. *m:* Lucy Makin. two *d*. *Educ:* Winchester College and Queens College, Cambridge. *Exhib:* RA Summer Exhbn (2004, 05). *Works in collections:* private, UK and overseas. *Commissions:* Abingdon School. *Clubs:* London Sketch Club. *Signs work:* 'J Hills'. *Address:* Longwall House, Penshurst, Kent TN11 8EE. *Email:* jonathanhills@mac.com *Website:* www.smartshillstudios.co.uk

HILLS, Peter Faber, N.D.D., R.A.Cert., F.R.B.S., Past Secretary of the 65 Group (Public School Art Masters); Churchill Fellow in Sculpture (1972); sculptor in clay, stone, wood; schoolmaster; Director of Art, Tonbridge School (1963-79), retd. from Tonbridge School (1988). *b:* Bearsted, Kent, 4 Dec 1925. *m:* Ann-Mary Ewart (née Macdonald). two *s*. one *d*. *Educ:* Tonbridge School. *Studied:* Bromley College of Art (1948-50), R.A. Schools (1950-55); assistant to Maurice Lambert, R.A. (1955-60), and worked for Sir Henry Rushbury, R.A., Sir

Albert Richardson, P.R.A. *Works in collections:* Skinner's Library, Tonbridge School. *Commissions:* new war memorial, Tonbridge Hight Street. *Signs work:* "HILLS." *Address:* 33 Yardley Park Rd., Tonbridge, Kent TN9 1NB.

HILTON, Bo, M.A. Print (1998), B.Sc. Biology (1984); artist in oil on canvas;. *b:* London, 9 Nov 1961. *m:* Alice. one *s.* one *d. Studied:* Brighton (1985-88). *Exhib:* Cassian de Verre Cole (1995-96), Arthur Anderson (1998). *Clubs:* N.E.A.C. *Address:* 23 St. Luke's Terr., Brighton BN2 2ZE.

HILTON, Rose Julia, A.R.C.A. *Medium:* oil and watercolour. *b:* Kent, 15 Aug 1931. *d of:* Robert Charles Phipps. *m:* widow of Roger Hilton (d.1975). two *s. Educ:* Bromley Technical School for Girls. *Studied:* Beckenham Art School (1948-53), Royal College of Art (1953-57), British School in Rome (1958-59). *Represented by:* David Messum, 8 Cork Street, London W1. *Exhib:* Huddersfield North Light Gallery (1988, '90, '93, '95, 2000, 2002), showing at Tate St. Ives January 2008 and frequently shown in RA Summer Show. *Works in collections:* Plymouth County Museum, Truro County Museum, private collections throughout UK, British Museum Collection. *Recreations:* music, singing. *Clubs:* Chelsea Arts Club. *Address:* Botallack Moor, St.Just, Cornwall, TR19 7QH. *Email:* rose.hilton@tesco.net

HINCHCLIFFE, Michael, artist in water-colour, designer. *b:* London, 25 Apr 1937. *s of:* Tom Hinchcliffe. *m:* Gillian. two *d. Educ:* St. Marylebone Grammar School. *Studied:* St. Martin's School of Art. *Exhib:* RI, UA; many one-man shows. *Works in collections:* Weybridge Museum. *Address:* 37 The Furrows, Walton on Thames, Surrey KT12 3JG.

HIND, Margaret Madeleine, R.M.S., H.S., S.Lm., M.A.S.-F., Froebel Cert.; miniaturist working mainly in water-colour with gold leaf on ivorine/vellum;. *b:* Minera, N. Wales, 9 Feb,1927. *m:* Lt. Col. J.G. Hind, O.B.E. (decd). three *d. Educ:* Woodford House School, Croydon, Coloma Froebel College (1945-48). *Studied:* art: privately under C.S. Spackman, R.B.A. (1943-45), Helen Gaudin (Washington D.C., 1976-78); started miniature painting (1986). *Exhib:* R.A., R.M.S., Llewellyn Alexander Gallery (awarded Cert. of Excellence, 1994), Medici Gallery London, Hilliard Soc., Soc. of Limners, Miniature Soc. of Florida. Awarded Historical, Mythological prize M.A.S.-F. (1995). Paints stories from Chaucer/King Arthur, etc. in the medieval manner. *Works in collections:* around the world and in private collections. *Clubs:* R.M.S., S.Lm, M.A.S.F. *Address:* 28 Shrubbs Drive, Middleton on Sea, Bognor Regis, West Sussex, PO22 7SP.

HINKS, Thomas, NDD(1951), FRSA (1981); lecturer-demonstrator, artist in water-colour, oil, acrylic; demonstrator, Daler Rowney; visiting lecturer at res. colleges and art societies. *b:* Newcastle, 26 Apr 1930. *s of:* Thomas Hinks. *m:* Vera. one *s.* one *d. Educ:* Newcastle School of Art, Stoke-on-Trent College of Art. *Studied:* under Arthur Berry. *Exhib:* 15 one-man shows in Midlands. *Works in collections:* Stoke-on-Trent City A.G., Newcastle Museum and A.G., Keele

University, W.E.A. Centre; paintings in America, Canada, Spain, Greece, France, Norway, and many private U.K. collections. *Publications:* author of New Methods and Techniques in Art - for schools. *Clubs:* Chairman, Unit Ten Art Soc., NAPA, Soc. of Staffs Artists. *Signs work:* "Tom Hinks." *Address:* Fairways, High St., Caverswall, Stoke-on-Trent, Staffs. ST11 9EF.

HINWOOD, Kay, PS, UA; painter in oil, pastel, etc. *b:* Bromley, 26 Nov 1920. *d of:* Robert Wylie, M.C., banker. *m:* (1) the late George Hinwood. (2) the late Lt. Cdr. Douglas Zeidler, R.N.V.R. one *s.* one *d. Educ:* Stratford House School, Bickley. *Studied:* first Paris, with Edouard MacAvoy, later privately with Sonia Mervyn; City and Guilds Art School, London; Kathleen Browne Studios, Chelsea under Marian Kratochwil and Kathleen Browne. *Exhib:* R.P., R.B.A., R.O.I., P.S., U.A., S.W.A., Mall Galleries. *Works in collections:* England, U.S.A., Canada, France, Spain, Australia, Holland. *Clubs:* Chelsea Arts. *Signs work:* "K. Hinwood." *Address:* 27 Edward Rd., Bromley, Kent BR1 3NG.

HIPKINS, Michael William, ARBS; N.D.D. (1964), A.T.D. (1976); artist in oil and water-colour, sculptor in alabaster and marble;. *Medium:* fine art. *b:* Blackpool, 21 June, 1942. *m:* Pauline Ashton. two *s.* one *d. Studied:* Blackpool College of Art, S.W. Hayter's Studio 17, Paris. *Represented by:* Belgravia Gallery, London; Artparks International; Sausmarez Manor, Guernsey, C.I.; Walker Galleries, Harrogate; Jo Bennett Originals, Cheshire. *Exhib:* Blackheath Gallery, The Gallery Manchester's Art House, RSA, Colours Gallery, Warstone Gallery. *Works in collections:* Grundy A.G. Blackpool, Lancaster A.G. *Commissions:* series of murals: Blackpool Zoo, several stone carving commissions. *Publications:* included in British Contemporary Art (1993). *Works Reproduced:* greetings cards and prints; Lancashire Life 2002. *Signs work:* "Michael Hipkins." *Address:* Driftwood, Ash Rd., Elswick, Preston, Lancs. PR4 3YE.

HIPKISS, Percy Randolph, RBSA (1971); freelance artist in oil, water-colour and pastel; jewellery designer. *b:* Blackheath, Birmingham, 8 Aug 1912. *s of:* William Hipkiss, woodworker. *m:* Dorothy Alice Boraston. one *s.* one *d. Educ:* at Blackheath. *Works in collections:* Dudley A.G., and in private collections throughout UK, America, Australia, Belgium. *Clubs:* past-president, Birmingham Water-colour Soc.; President, Dudley Society of Artists. *Signs work:* "Hipkiss." *Address:* 18 Lewis Rd., Oldbury, Warley, W.Mid. B68 0PW.

HIPPE, Susan Kerstin, SGFA; B.A. (Hons), Roehampton Inst. University of Surrey; progressive drawing; drawing combined with mixed media; tutor. *b:* Johannesburg, S. Africa, 28 Nov., 1966. *Educ:* schools in Denmark, Germany and France. *Studied:* art schools in France (Troyes, Le Havre, Mulhouse), and London (Roehampton Inst.). *Exhib:* solo exhibs. in London and group exhibs. in U.K., London, Paris, New York, Spain. *Works in collections:* private. *Commissions:* private. *Publications:* Painting World 2001, Wandsworth Guardian 2001, TNT Magazine 2000. *Clubs:* E.W.A.C.C., Society of Graphic Fine Art.

Signs work: "SUSAN HIPPE" or "S.H." *Address:* 29 Glimpsing Green, Erith, Kent DA18 4HA. *Email:* s-hippi@yahoo.co.uk *Website:* www.absolutearts.com/portfolio/s/susanhippe

HIRST, Barry Elliot, NDD Painting (1956), DFA (Lond.) (1958), FRSA (1989); painter; Emeritus Prof. of Fine Art, University of Sunderland;. *b:* Padstow, Cornwall, 11 Jun 1934. *m:* Sheila Mary. one *s.* two *d. Educ:* Alleyns School, Dulwich. *Studied:* Camberwell School of Art (1950-52, 1954-56), Slade School (1956-58, Keith Vaughan, Claude Rogers). *Represented by:* Mercury Gallery, London; Thos. Deans Gallery, Atlanta & Tallahassee. *Exhib:* over eighteen one-man shows, including Hanover Gallery, London (1963, 65); Central St. Gallery, Sydney, NSW (1966); Byron Gallery, NY (1968); Compass Gallery, Glasgow (1982); Mercury Gallery, London (1986-99); Latvian State Academy, Riga (1989); Vardy Gallery, Sunderland University (1994); Thos. Dean Gallery, Atlanta (2000). *Works in collections:* Contemporary Arts Soc., British Council, Sunday Times, Croydon Educ. Com., Northern Arts Assoc., Tyne & Wear Museums, University of Sunderland, Darlington Memorial Hospital, Olinda Museum Brazil, Derby Museum and A.G., H.R.H. Duchess of Kent, Latvian National Museum Riga, Latvian Academy of Art Riga, R.A.C., Sunderland and Portsmouth Newspapers, Sao Paulo Museum Brazil, B.P., A. & M. Univ. Texas, Royal Bank of Scotland. *Publications:* illustrations for poetry by: R.S.Thomas, Roy Fuller, George Barker, C.Day Lewis, Alistair Eliot, Rodney Pybus. *Clubs:* Sunderland Assoc. Football Club. *Signs work:* "BARRY HIRST" or "B.E. HIRST." *Address:* 12 Bondgate Without, Alnwick, Northumberland NE66 1PP. *Email:* profbehirst@tambylnant.fsnet.co.uk

HIRST, Derek, A.R.C.A.; artist;. *b:* Doncaster, 11 Apr., 1930. *Studied:* Doncaster School of Art (1946-48), R.C.A. (1948-51). *Exhib:* Drian Galleries (1961), Tooth's Gallery (1962-63), Stone Galleries, Newcastle upon Tyne (1962), University of Sussex (1966), Towner A.G. (1966), Angela Flowers Gallery (1970, 1972, 1975, 1979, 1984, 1987, 1989), Victorian Centre for the Arts, Melbourne, Australia (1980), Pallant House Gallery, Chichester (1987, 1991), Flowers East (1991, 1995), Flowers East at London Fields (1993, 1999), Flowers West, Santa Monica, U.S.A. (2001). *Works in collections:* Tate Gallery, V. & A., National Gallery of Canada, A.C.G.B., Contemporary Art Soc., D.O.E., Fundaçao dos Museus Regionaise de Bahia, Brazil, Bank of Ireland, Dublin, Universities of Sussex and Southampton, Art Inst. of Detroit, Brooklyn Museum, N.Y., Arizona State University, Phoenix Art Museum, etc. *Signs work:* "Derek Hirst." *Address:* 3 The Terrace, Mill La., Sidlesham, Chichester, W. Sussex PO20 7NA.

HISLOP, Helga: see CROUCH, Helga,

HITCHCOCK, Harold Raymond, FRSA (1972); Hon. Col. of State of Louisiana USA (1974); artist in water-colour and oil. *b:* London, 23 May 1914. *s of:* Thomas R. Hitchcock. *m:* Rose Hitchcock. two *s.* one *d. Studied:* Working Mens College, Camden Town (1935-36) under Percy Horton, Barnett Freedman.

Exhib: one-man shows: Hanson Gallery, New Orleans (1990), M.K. Vance Gallery, Chicago (1992), Campbell & Franks (Fine Art) Ltd. (1975), Pilkington Glass Museum (1973), Hilton Gallery (1970), Upper Grosvenor Gallery (1969), Woburn Abbey (1967), Walker Gallery (1956); retrospective shows: R.I. Galleries (1967), Philadelphia Art Alliance, U.S.A. (1982), Phillips Gallery of Fine Art, Carmel, California, U.S.A. (2001); touring exhbn. in U.S.A.: New Orleans, Huntsville, Atlanta City, Daytona Beach, Corpus Christi and Winston Salem (opened by the Duke of Bedford, 1972); R.S.A., London (1984), Gallery 106, Perrysberg, Ohio (1984), Clossons Gallery, Cincinnati (1985), Christopher Wood Gallery, London (1986), Phillips Gallery of Fine Art, Carmel Calif. (1999). *Works in collections:* V&A, Rowntree Memorial Trust, Hunterian A.G. of University of Glasgow, Lidice Memorial Museum, Czechoslovakia, Museum of Fine Art, N. Carolina, University of Louisiana, Hannema-de Stuers Foundation, Nijenhuis Castle, Netherlands, New Orleans Museum of Fine Art, Paul Mellon Collection, Yale Centre for British Art. *Publications:* Harold Hitchcock: A Romantic Symbol in Surrealism (1982) by Dr. Ian Williamson; Harold Hitchcock – 'Life in Light', Phillips Gallery of Fine Art (2000). *Address:* Hood Barton Farmhouse, Dartington, Devon TQ9 6AB.

HITCHENS, John, Painter. Compositions evolved from aerial view of landscape. *b:* Sussex, 1940. *s of:* Ivon Hitchens, painter. Grandson of Alfred Hitchens, painter. *m:* Rosalind. two *s. Educ:* Bedales School. *Studied:* Bath Academy of Art. *Exhib:* Regular London exhbns. since 1964. *Works in collections:* public and permanent collections U.K. and abroad. 1979: 52ft. mural, "A Landscape Symphony". *Signs work:* "John Hitchens." *Address:* The Old School, Byworth, Petworth, Sussex GU28 0HN. *Email:* info@johnhitchens.com *Website:* www.johnhitchens.com

HO, Dr. Kok-Hoe, D.Sc. (Hon.), PBM, MSIA, FRAIA, FRIBA, APAM, ARAS, ARPS; awarded St. Andrew's Gold (1935) and Bronze (1937); 2nd Inter-School Art gold medal (1939); architect; artist in oil and water-colour painting, pen and pencil drawing; art-photographer; president-director, Ho Kwong-Yew & Sons, Architects, Singapore; Chairman, Singapore Art Soc. (1953-70);. *b:* Singapore, 14 July, 1922. *Educ:* St. Andrew's School, Singapore. *Studied:* graduated N.S.W. College of Architecture, Sydney. *Exhib:* Sydney (1948-49); Singapore (1954-62); Kuala Lumpur (1960-62), etc. Photo salons: London (1957); La Coruna (1958); Hongkong (1958), etc. Architectural Work: National Museum, Kuala Lumpur, etc. *Publications:* Travel Sketches and Paintings, etc. *Clubs:* Royal Art Soc.; Royal Institute of Australian Architects; R.I.B.A.; Royal Photographic Soc. of Great Britain; Singapore Art Soc. *Signs work:* "Ho Kok-Hoe." *Address:* 9 Camden Park, Singapore 1129.

HOARE, Diana C., B.A. Hons.; lettering designer, calligrapher, letter carver, carving on stone and slate, calligraphy. *b:* London, 10 Feb 1956. *d of:* Reginald Hoare, picture restorer. *m:* William Taunton. one *s.* two *d. Educ:* Godolphin and Latymer; University of Kent, Canterbury. *Studied:* privately with Vernon Shearer,

Ievan Rees, Heather Child, Sam Somerville. *Exhib:* solo exhbns. in Dorset, London and B'ham. *Works in collections:* two MS. books at University of Austin, Texas. *Publications:* Advanced Calligraphy Techniques (Cassells), Everybodys Wine Guide (Quarto). *Address:* 73 Nun Street, St.Davids, Pembrokeshire SA62 6NU.

HOBART, Lady Caroline Fleur: see LEEDS, Caroline,

HOBART, John, BSc. (Lond.), RCA; self taught artist in oil and water-colour; past Vice-Pres. Royal Cambrian Academy; Fellow, University College of N. Wales, Bangor. *b:* London, 27 May 1922. *s of:* Percy John Hobart. one *s.* two *d. Educ:* St. Dunstan's College and University College, London. *Exhib:* one-man, Theatre Gwynedd; group shows, Plas Mawr, Conway, Tegfryn Gallery, Cambrian Academy, RI, N.Wales Group, Newlyn, Penwith, Kings College, Cambridge. *Works in collections:* University College of N.Wales, Bangor; private collections in USA, Canada, Australia, UK, Ireland, Holland, Germany. *Signs work:* "J. Hobart." *Address:* Buswisnan, Ludgvan, Penzance, Cornwall TR20 8BN.

HOCKIN, Julie, S.O.F.A. (1996); self taught professional artist working in water-colour, graphite and coloured pencils. Her pictures range from botanical and wildlife subjects to very detailed cat paintings and drawings; Creative Director, Hockin and Roberts Ltd, St Austell;. *b:* St. Austell, 3 Feb., 1937. one *d. Educ:* St. Austell Grammar School. *Exhib:* National Trust Cotehele, Lanhydrock, Marwell Zoological Pk. Winchester, Carlyon Bay Hotel, St. Austell, Llewellyn Alexander Gallery, London, R.M.S., H.S, Cornish Studies Centre, Redruth, Trebah Garden Gallery, Cornwall. *Misc:* Gives talks, demonstrations and teaches. *Signs work:* "Julie Hockin" or "JH" joined. *Address:* Cedar Lodge, Trevarth, Mevagissey, St. Austell, Cornwall PL26 6RX. *Email:* Jrainbowlight@aol.com *Website:* www.hockinandroberts.com

HODDER, Monroe, BA, MBA, MFA; Semi-finalist, Jerwood Painting Prize, London (2001); Art Academician, Kazakh Academy of Arts, Kazakhstan (2007). *Medium:* oil, prints. *b:* Baltimore, MD, 15 Oct 1943. *d of:* James Mumford Sawhill. *m:* R.Frederick Hodder. *Studied:* MFA, San Francisco Art Institute; MBA, Stanford University; BA, Vassar College. *Represented by:* Belgravia Gallery, Mayfair, London; Vertigo Gallery, Shoreditch, London; Havu Gallery, Denver, Colorado; Butters Gallery, Portland, Oregon; SFMOMA Artists' Gallery, San Francisco, CA. *Exhib:* Selected recent exhibitions: solo: Belgravia Gallery, Mayfair, London (2007); Toomey Tourell Gallery, San Francisco, CA (1999, 2000, 2002, 2004, 2006); Vertigo Gallery, London (2003); Cobden Club, London (1998); Maymie White Gallery, London (1997); Tengri Umai Gallery, Almaty, Kazakhstan (1997); Jan Baum Gallery, Los Angeles (1996). Selected group: Butters Gallery, Portland, Oregon (2006); Belgravia Gallery, Mayfair, London (2005); Vertigo Gallery, London (2005); San Francisco Art Fair (2003, 2004, 2005); London Art Fair (2004, 2005, 2006, 2007); Almaty International Art Biennale, Kazakhstan (2002); Lindenburgh Gallery, New York (2000);. *Works in*

collections: Tom Cruise & Katy Holmes, Linklater, Bank of America, San Jose Museum of Art, Kasteev Museum Kazakhstan, Art Museum of Palo Alto, CA; over 300 public and private collections internationally. *Publications:* several catalogues. *Official Purchasers:* The Kasteev Museum of Almaty. *Works Reproduced:* catalogues, advertisements in several art magazines. *Principal Works:* "Stairs of the Sea", "Trees of Russia", "Mysteries". *Recreations:* mountain climbing, skiing, travel. *Misc:* Art critic for several art magazines in London and Colorado; Studios in UK and US. *Address:* 50 Gordon Place, London W8 4JF. *Email:* monroe7777@aol.com *Website:* www.monroehodder.com

HODGES, Gillian Mary, SWA (1987), portrait painter in oil and pastel; SLm (1997), HS (2002) portraits and character studies in miniature, oils and water-colour; Tutor for adult education, Hants & Surrey (1976-1996). *b:* Twickenham, Middx. *d of:* Harry Leslie Snook. *m:* Peter Steer Hodges. two *s. Educ:* Richmond School of Art under Jack Fairhurst, A.R.C.A., Salisbury School of Art and Heatherley School of Art (part time). *Exhib:* SWA, various societies in S. and SW of England, Northern Ireland, RMS, HS, SLm, World Federation of Miniaturists, Tasmania 2000; World Federation of Miniaturists, Washington DC (2004), Llewelyn Alexander (Fine Paintings) Ltd. (2005, 2006, 2007). *Works in collections:* 'The Pageant' in Farnham (Surrey) Public Library; Officers' Mess QARANC, Aldershot; Inst. of Aviation Medicine, Farnborough, Regtl HQ 4/7 Dragoon Guards, York. *Works Reproduced:* QARANC - A day in the Cambridge Military Hospital (1994), The Life of Mary Queen of Scots (1998). *Signs work:* "G. M. Hodges." *Address:* 2 Abbey Mill, Church St., Bradford-on-Avon, Wilts. BA15 1HB.

HODGKINS, Barbara, sculptor in marble, bronze;. *b:* U.S.A. *Educ:* Wellesley College, Columbia University, U.S.A. *Studied:* Chelsea School of Art, London. *Works in collections:* Sculpture in corporate collections: Prudential, Bank of China, Bank of Denmark, B.P., Reynolds, Hewlett-Packer, Foote, Cone, Belding, MCL (Art and Work award 1987) and in private European, Asian and American collections. *Clubs:* Mem. Royal Soc. of British Sculptors. *Address:* 5 Hurlingham Ct., Ranelagh Gdns., London SW6 3SH.

HODGSON, Carole, F.R.B.S., H.D.F.A. (1964); sculptor in cement, bronze, wax, ceramics, lead; Professor of Sculpture, Kingston University. *b:* London, 1940. two *d. Studied:* Wimbledon School of Art (1957-62), Slade U.C.L. (1962-64). *Represented by:* Angela Flowers Gallery. *Exhib:* Angela Flowers Gallery, Flowers East, A.C.G.B., W.A.C., Wustum Museum, U.S.A., Whitefriars Museum, Coventry, New Ashgate, Farnham, Llanelli Festival, Christie's Fine Arts, Buenos Aires, Argentine, Santiago, Chile, Haggerty Museum, U.S.A., Flowers West, L.A., U.S.A., Turin Italy. *Works in collections:* Welsh Contemporary Arts, A.C.G.B., W.A.C., British Council, D.O.E., Contemporary Arts, Unilever House, Universities of Wales, London, Wisconsin U.S.A., British Medal Soc., Manpower. *Publications:* From the Sea to the Wall (Kingston U. Press), Carole Hodgson by Mary Rose Beaumont (Momentum), British Sculptors of the

Twentieth Century (Ashgate), From City to Lake (Angela Flowers), Modern British Sculpture (Schiffer Press). *Signs work:* "Carole Hodgson." *Address:* c/o James Ulph, Flowers Central, 21 Cork Street, London W1S 3LZ.

HODGSON, Kenneth Jonah, BA, GOE Dip. SW CQSW, PTA; artist in acrylic, oil and water-colour; Exec com. mem., Merseyside Arts (1985-87); Steering com. sec., Merseyside Contemporary Artists (1988-89); Hon.Vice President ISAP-USA (1985). *b:* Liverpool, 2 Aug 1936. *s of:* Jonah Hodgson. two *d. Educ:* Liverpool, Herts, Oak Hill College, London, The Open University, N.E.W.I. Wrexham Cymru, Liverpool John Moore's University. *Exhib:* RCamA., Williamson A.G.,various Liverpool and Chester galleries; collective exhbns. in Newcastle-Staffs, Ludlow, Crosby, RBSA Gallery B'ham and NAPA, USA; individual exhbns. on Merseyside and Wirral. Daylight Group - a Tate Liverpool/Metropolitan Borough of Wirral SSD Arts Project, Art Forum - MBW - SSD (1993). *Works in collections:* paintings in private and public collections in U.K. and other countries. *Clubs:* Sec., Wirral Soc. of Arts (1983-87); Founder, National Acrylic Painters' Assoc. (1985). *Signs work:* "Kenneth J. Hodgson." *Address:* N.A.P.A., 134 Rake La., Wallasey, Merseyside CH45 1JW.

HODSON, John, sculptor in stone and bronze. *b:* Oxford, 19 Aug 1945. *s of:* Frank George Hodson, toolmaker. *Educ:* Willesden R.C. *Studied:* Courtauld Inst. of Art, London. *Exhib:* one-man show Woodstock Gallery, London (1973), Paris Salon, Salon des Independants, Haas Gallery, Albemarle Gallery, Galerie Modern, Berlin, and other international exhbns. *Works in collections:* Berlin Kunst Haas. *Commissions:* Dancing Girl, Midland Bank (large bronze). *Works Reproduced:* in Modern Art Revue, Witt Library Courtauld Inst. of Art, London, The Dictionary of Artists in Britain since 1945. *Signs work:* "Hodson." *Address:* 40 Clement Cl., London NW6 7AN.

HOFFMANN, Edith, Ph.D., Munich, 1934; art historian and critic; editorial asst. Burlington Magazine (1938-46); asst. editor of the Burlington Magazine (1946-50); Lecturer, Hebrew University of Jerusalem (1960-61); art editor of the Encyclopaedia Hebraica (Jerusalem, 1953-65). *b:* 1907, Vienna. *d of:* Camill Hoffmann, author. *m:* Dr. E. Yapou (decd.). one *d. Studied:* Art History in Berlin, Vienna, Munich. *Publications:* Kokoschka: Life and Work (1947); Chagall: Water-colours (1947); contributions to the Burlington Magazine, Apollo, Art News (New York), Phoebus (Basle), Studio, Manchester Guardian, Listener, New Statesman, Twentieth Century, Neue Zürcher Zeitung, etc. *Signs work:* 'EDITH HOFFMANN' or 'EDITH YAPOU HOFFMANN'. *Address:* 52 Bethlehem Rd., 93504 Jerusalem, Israel.

HOGAN, Prof. Eileen, M.A. (R.C.A.), R.W.S.; painter;. *b:* London, 1 Mar., 1946. *m:* divorced. *Educ:* Streatham Hill and Clapham High School. *Studied:* Camberwell School of Art and Crafts (1964-67), British School of Archaeology at Athens, Royal College of Art (1971-74, Carel Weight). *Exhib:* regularly at the Fine Art Soc., numerous one-man shows in Europe and America. *Works in*

collections: V. & A., Imperial War Museum, R.A., and overseas museums and galleries. *Publications:* Under The Influence: catalogue to accompany retrospective, 1997, and numerous others. *Clubs:* Chelsea Arts, Double Crown. *Signs work:* "Eileen Hogan." *Address:* 13 Wythburen Place, London W1H 7BU.

HOLCH, Eric Sanford, artist in oil, printmaker of limited edition serigraphs. *b:* Andover, Mass., 17 Sep 1948. *s of:* Carl E. Holch and Rita S. Holch, sculptress. *m:* Elspeth R. Holch. one *s.* one *d. Educ:* Trinity-Pawling School. *Studied:* Hobart College (1969-70), mostly self taught in serigraphy, Eric Holch Gallery, Nantucket (1997-). *Exhib:* one-man shows: Geary Gallery, Connecticut (1996), Gallery 39, Osaka, Japan (1990, 1994), Martha Lincoln Gallery, Florida (1987), The Little Gallery, Nantucket (1986), D. Christian James Gallery, N.J. (1985), Portfolio Gallery, C.T. (1982-87). *Works in collections:* Champion International, Chesebrough-Ponds, E. F. Hutton, First National Bank of Boston, Merrill Lynch, Societé General, Bermuda National Gallery. *Signs work:* "Eric Holch." *Address:* 5 Pine St. Nantucket, M.A. 02554, U.S.A. *Website:* www.ericholch.com

HOLD, William Ashley, RWA: BA Hons. Fine Art; PGCE. *Medium:* oil. *b:* Cornwall, 5 Aug 1964. *Educ:* Truro School. *Studied:* Falmouth School of Art. *Exhib:* BP Portrait Award (1994,1999), Hunting Art Prizes (1996,1998), Royal Society of Portrait Painters (1995), The Discerning Eye (1999, 2002). *Works in collections:* Falmouth Art Gallery. *Commissions:* Grand Sec. General for the Freemasons (Jim Daniel), Principal of the College of St Mark & St John, Plymouth. *Publications:* How To Paint Skin Tones by James Horton (c Quarto Publishing 1993). *Recreations:* climbing, hiking, music, reading. *Address:* 5 Harbour Terrace, Falmouth, Cornwall TR11 2AN. *Email:* ashleyhold@hotmail.com *Website:* www.artincornwall.com

HOLDEN, John, Cert RA Schools (Distinction); NDD (Painting Special). *Medium:* acrylic, drawing. *b:* Medway, Kent, 24 Jun 1942. *m:* Liz. *Studied:* Medway College of A&D, Rochester (1959-63); RA Schools (1963-66); Mural dec with the late Edward Bawden, CBE,RA (1963-67). *Represented by:* Gallery Duncan Terrace, Islington; Foster Art, Rivington St. London. *Exhib:* Hunting Prizes (1998, 99, 00, 01, 03, 05); Jerwood Drawing Prize and Tour (2004, 2007); John Moore's Liverpool; Fermyn Woods Contemporary Art (2004, two-man show with Paul Mason); Witte Zaal, Ghent Belgium (two-man show); Castlefield Gallery, Manchester (1997); Liverpool University Senate House Gallery and Bury Art Gallery (1997); Dean Clough, Halifax (1996); Queens St. Gallery, Emsworth (2007). *Works in collections:* Dept. of Environment; Leicester Ed.Authority; Bury Art Gallery; Taylor Vintners; John Moore's Uni Liverpool; Gough Hotels; Fermyn Woods Contemporary Art. *Commissions:* Sabbatical Fellowship from the Vicechancellor's Office, John Moore's University, large triptych installation. *Publications:* Cat, Witte Zaal, Ghent-Nicholas Usherwood, 1998; The Guardian Guide (Feb 2004). *Works Reproduced:* RA Illustrated (1995/98); The Guardian Guide (Feb 2004); Architects Journal (Feb 2004). *Clubs:* Chelsea Arts. *Misc:* mem. London Group since 2002. *Signs work:* 'John

Holden' (on the reverse). *Address:* 61 High Street, Long Buckby, Northampton NN6 7RE. *Website:* www.numasters.com

HOLISTER, Frederick Darnton, M.A. (Cantab.) (1957), M.Arch. Harvard (1953), RIBA, Wheelwright Fellowship, Harvard (1952), Doc. U. (Buckingham) 1998; Fellow, Clare College, Cambridge; Director of Studies in Architecture, Clare College, Cambridge; University Lecturer, Department of Land Economy, Cambridge University (retd. 1994); architect in private practice; Consultant Architect to Clare College, Cambridge, Consultant Architect to University of Buckingham (retd. 1997). *b:* Coventry, 14 Aug 1927. *s of:* F.D.Holister, M.I.Mech.E. *m:* Patricia Ogilvy Reid (marriage dissolved). two *s.* two *d. Educ:* Bablake School. *Studied:* Birmingham School of Architecture under A. Douglas Jones (1944-46, 1948-51), Harvard University under Prof. Walter Gropius (1951-53). *Clubs:* Harvard Club of London. *Signs work:* "Darnton Holister." *Address:* Clare College, Cambridge CB2 1TL.

HOLLAND, Claerwen Belinda, NDD (1964); David Murray landscape studentship (1963); artist in ink, water-colour, pastel and oils; Principal's Prize Byam Shaw. *b:* Cwmdauddwr, 4 Mar 1942. *d of:* Sir Jim Sothern Holland, Bt. *Educ:* Miss Lambert's School, Queens Gdns., London. *Studied:* Byam Shaw School of Art (1960-64, Maurice de Sausmarez). *Exhib:* R.A., N.E.A.C., Bath Contemporary Art Fair (1991); one-man shows: Sue Rankin Gallery, Countryworks Gallery, Montgomeryshire, Thackeray Rankin, Thackeray Gallery. *Works in collections:* The Library, University College, Cardiff. *Commissions:* various. *Publications:* illustrations to A Year and a Day by J.L.G. Holland (Hodder and Stoughton). *Signs work:* "C.B. Holland." *Address:* Dderw, Cwmdauddwr, Rhayader, Powys LD6 5EY.

HOLLAND, Frances, H.S., S.Lm.; self taught artist in all media;. *b:* Petworth, Sussex, 22 Oct, 1939. *d of:* Lillian Holmes. one *d. Exhib:* Llewellyn Alexander, London, R.A. Summer Show (1997, 2001, 2006), R.M.S. Westminster, all local venues. Work in collections internationally, Mall Gallery. *Principal Works:* portrait Miniatures. *Clubs:* 2006 Chairman Royal Tunbridge Wells AS; from 2000 Hon Secretary Tonbridge Art Group, Hilliard Society of Limners, Royal Miniature Society. *Address:* 107 London Rd., Southborough, Kent TN4 0NA. *Email:* frans.art@virgin.net

HOLLAND, Harry, artist in oil on canvas, printmaking;. *b:* Glasgow, 11 Apr., 1941. *m:* Maureen. two *d. Educ:* Rutlish School, Merton. *Studied:* St. Martin's School of Art (1964-69). *Exhib:* extensively in Britain, France, Belgium, U.S.A.; one-man shows: Jill George Gallery (1988, 1990, 1992, 1994, 1996); retrospective travelling Britain Nov. 1991- Jan. 1993. *Works in collections:* Newport Museum and A.G., National Museum of Wales, Tate Gallery Print Coll. *Commissions:* portrait of Lord Callaghan (1990). *Publications:* Painter in Reality (1991). *Clubs:* Chelsea Arts. *Signs work:* "Harry Holland." *Address:* c/o Jill George Gallery, 38 Lexington St., London W1R 3HR.

HOLLANDS, Lesley Elizabeth, Dip AD; ATC. *Medium:* oil, watercolour. *b:* Kent, 17 Dec 1950. *m:* Peter Gooding (decd). one *s.* one *d. Studied:* Brighton College of Art; West Surrey College of Art and Design. *Exhib:* Westminster Gallery, Bankside Gallery, Mall Galleries, Southampton City Museum, Gateway-Shrewsbury, West Dean College (one-woman show). *Works in collections:* in New Zealand, USA, Belfast, Brighton, Highfield School. *Commissions:* Hughfield. *Publications:* articles for 'Leisure Painter'; contribution to 'Leisure Painter Projects Book' (Collins). *Recreations:* gardening. *Clubs:* Petersfield Art Soc.; Bramshott & Liphook Arts and Crafts Soc. *Signs work:* 'Lesley E.Hollands'. *Address:* Griggs Green Cottage, Longmoor Road, Liphook GU30 7PB. *Email:* lesleyholland@hotmail.com

HOLLEDGE, Bryan Raymond, ARCA, FRSA, AFBA; part-time lecturer, Hammersmith School of Art (1949); part-time teacher, St. Hubert's Special School, Brook Green; lecturer, London School of Printing and Graphic Arts; part-time teacher, Chelsea School of Art; graphic designer, Metal Box (1955); Head of Graphics, Swiss Co. Sulzer Bros. (1958); freelance corporate design/mural, Chelsea Arts Club (1950). *b:* Ealing, Middx., 30 Apr1919. *s of:* Raymond John Holledge, interior designer and decorator. *m:* Maria Haid. two *d. Educ:* Ealing College. *Studied:* Ealing College of Art (1937-40); H.M.F. 1940-46; Royal College of Art (1946-49). *Exhib:* painting in National Gallery Exhbn. for Young Artists, Whitechapel Gallery (1953), Arts Council U.K. tour, Mural painting, Shipping Co. and Theatres joint exhbn., London (1984); one-man show, London (1955) in assoc. with Atomic Energy Soc. Exhib. regularly at London galleries for painting/etching/wood engraving; recent exhbn. of wood engraving at Syon House, Isleworth. A Companion of Western Europe Dip., Certificate of Merit, Biographical Centre Cambridge (1998). *Publications:* poems. *Misc:* Graphic Consultant to Science (education) Company (2000), wood engraving for Country Life. *Signs work:* "Bryan R. Holledge." *Address:* 5 The Green, Feltham, Middx. TW13 4AF.

HOLLICK, Kenneth Russell, F.C.S.D.; designer;. *b:* Essex, 5 Jan., 1923. *Studied:* Central School of Arts and Crafts, London. *Works Reproduced:* trade marks, symbols, logotypes, corporate identity programmes, vehicle livery, booklets. Designs shown in books on graphic design published in Japan, Italy, Switzerland and Britain. *Address:* 4 Knighton House, 102 Manor Way, Blackheath, London SE3 9AN.

HOLLIDAY, S. J., R.B.A.; sculptor, ceramicist and muralist. *b:* Portsmouth, 10 Apr., 1955. *Studied:* Portsmouth Polytechnic & E.C.A.T. *Exhib:* Kutani Decorative Ceramics Exhib., Japan; Keramion, Keramik 25th Exhib., Frechen, Germany; European Ceramics, Germany; Westerwald Kreis Exhib., Germany; solo exhib. "Look and Like", Bern, Switzerland, Solo Exhibition Switzerland. *Works in collections:* Kaufmann Collection, Bern, Switzerland. *Signs work:* "SJH" (sculpture) and "S J Holliday" (mural). *Address:* 11 The Down,

Trowbridge, Wilts. BA14 8QN. *Email:* usram@freenet.co.uk
marus@freeuk.co.uk

HOLLOWAY, Douglas Raymond, A.R.I.B.A., R.W.A.; architect retd.; artist
in water-colour, pen and wash;. *b:* W. Hampstead, London, 25 Aug., 1923. *m:*
Marjorie Cynthia. three *s. Educ:* Haberdashers Aske's Hampstead, and Reading
School. *Studied:* Royal West of England Academy School of Architecture. *Exhib:*
R.Cam.A., various mixed and one-man exhbns. in England and Wales and New
York. *Works in collections:* R.W.A. *Commissions:* on behalf of the people of
Lancashire, Douglas Holloway presented a watercolour of the River Hodder at
Whitewell in The Forest of Bowland to H.M. The Queen on the occasion of her
Golden Jubilee visit to The Guildhall in Preston, 5th August 2002. *Signs work:*
"D.R. Holloway." *Address:* Longton Forge, 61 Liverpool Rd., Longton Preston,
Lancs. PR4 5HA.

HOLLOWAY, Edgar, R.E., R.B.A.; painter, etcher;. *b:* Doncaster, 6 May
1914. *s of:* W.H. Holloway. *m:* (1) Daisy Hawkins* (2) Jennifer Boxall. *three *s.
*one *d. Educ:* Doncaster Grammar School (1926-28). *Studied:* Slade School
(1934). *Represented by:* Wolseley Fine Arts. *Exhib:* one-man shows, London
(1931, 1934, 1979, 1993), Brighton and Oxford (1980), Doncaster (1982),
Edinburgh (1986), Abergavenny (1989), U.S.A. (1972, 1973, 1974, 1975);
retrospective Ashmolean (1991-92). Touring exhbn. at 80 (1994) National
Library of Wales, Hove A.G., Abbot Hall A.G., Kendal, Graves A.G., Sheffield
and London (Cork St.). Wolsely Fine Art W11 (1996). 'Edgar Holloway &
Friends', touring exhbn. Prints from the Thirties (1999-2001), 'Capel-y-Ffin to
Ditchling', watercolours, Ditchling, Nat. Library of Wales, Brecon, Tunbridge
Wells, Bankside Gallery, SE1 (2001-2002), 'Edgar Holloway at 90', London
(Cork Street) Wolseley Fine Arts (2005). *Works in collections:* Official purchases:
B.M., V. & A., NPG, Ashmolean, Fitzwilliam, New York Public Library,
Birmingham City A.G., Scottish Gallery of Modern Art, Scottish National Portrait
Gallery, National Museum of Wales, National Library of Wales, University
College of Wales, Oxford and Cambridge colleges, Perth (Scotland) M&AG,
Brecknock M&AG, Rensselaer County Historical Society, Troy, USA.
Commissions: USA Troy: 12 portraits & 72 watercolour drawings of industrial
archaeological subjects, portraits of Dr Kenneth Garlick, Ashmolean, Dr John
Polkinghorne, Trinity College Cambridge; John Torrance, Hertford College,
Oxford. *Publications:* "The Etchings & Engravings of Edgar Holloway" (Scolar
Press), 1996. *Official Purchasers:* see above. *Works Reproduced:* in Dictionary of
20th Century British Art (1991), British Printmakers, 1855-1955, "Edgar
Holloway and friends" (University of Wales), Aberystwyth, "Capel-y-ffin to
Ditchling" Watercolours & Drawings by Edgar Holloway (Jennifer Holloway
with SE Arts funding). *Signs work:* "Edgar Holloway." *Address:* Woodbarton,
Ditchling Common, Sussex BN6 8TP.

HOLLOWAY, Gill, BA Hons Fine Art Dunelm; University Travel
Scholarship; Tutor in Art to the Durham University Extra Mural Board (1954-67);

Head of Art & Art History, Cheltenham Ladies College (1969-88). *Medium:* oil, watercolour, drawing, prints. *b:* London, 24 Apr 1928. *d of:* Canon H.K.Luce. *m:* Ted Holloway (decd). one *s.* two *d. Educ:* Roedean School. *Studied:* Durham University (Painting and Art History). *Exhib:* one-man exhbns: Durham (1966); ICI Billingham (1967); Univ. of Hull (1967); Darlington (1968); Middlesbrough (1969); Wakefield (1969); Doncaster (1969); Woodstock, London (1971); Charlton Kings (1990); Broadway (1998); Stow-on-the-Wold (2002, 2003); Kenilworth (2004); Chipping Norton (2004); Upper Swell Gallery - major retrospective 2007. *Works in collections:* numerous public and private collections in the UK and abroad. *Commissions:* portraits and landscapes - numerous. *Publications:* author 'A Bevin Boy Remembers' (pub. 1993). Many articles and reviews for art journals and newspapers. *Recreations:* travel, studying art abroad, finding new subjects to paint. *Clubs:* teaches adults and takes groups to paint in this country (Cornwall) and abroad. *Signs work:* 'GMH'. *Address:* Henge Barn, Condicote, Cheltenham, Glos. GL54 1ES.

HOLLOWAY, Laura Ellen, S.W.A. (1994), Post.Dip.F.A. (R.A.), S.B.A. (1999); painter in water-colour and tempera;. *b:* Worcester, 1960. *d of:* Jack and Joyce Holloway. *Educ:* Worcester Girls' Grammar School. *Studied:* Glos. College of Art (1978-82), R.A. Schools (1985-88, Norman Blamey, R.A., Jane Dowling). *Exhib:* solo shows at Mason-Watts Fine Art, Warwick (1992); mixed shows in London and Birmingham. *Publications:* Medici Soc. Ltd. (greetings cards). *Signs work:* "L.H." *Address:* 404 Wyld's Lane, Worcester WR5 1EF.

HOLMES, Clyde, RCA Conway, National Diploma of Design (NDD) 1965. *Medium:* oil. *b:* Friern Barnet, London, 20 Oct 1940. *s of:* Charles Sydney Holmes. one *s.* two *d. Studied:* Hornsey College of Art, London; St.Martin's School of Art (1961-65). *Represented by:* Henry Boxer Gallery. *Exhib:* Fine Art Society, London (2002), Crane Kalman Gallery, London (2004), The Commonwealth Institute (2002), Saatchi & Saatchi, London (2000), MoMA Wales (1999), National Museum of Wales, Cardiff (1991), Victoria & Albert Museum, London (1990), York City Art Gallery (1991), Abbot Hall Art Gallery, Kendal (1994), Gashall Gallery, Birmingham (1992), Huddersfield Art Gallery (1993), Stafford Art Gallery (1993). *Works in collections:* National Library of Wales; Museum of Modern Art Wales, European Culture Centre -Cologne; private and corporate collections. *Signs work:* "C Holmes". *Address:* Cwm Hesgin, Frongoch, Bala, Gwynedd, LL23 7NU. *Email:* cwmhesgin@hotmail.com *Website:* www.clydeholmes.force9.co.uk

HOLMES, Linda Ruth, Ba (Cantab), SWE (1994). *Medium:* printmaking (wood engraving). *b:* Sutton Coldfield, Warks, 5 Jun 1950. *d of:* Mr & Mrs G.L.Kirk. *m:* David Holmes. *Educ:* Weston-super-Mare Grammar School. *Studied:* Newnham College, Cambridge, Camberwell College of Art Summer School. *Exhib:* with Society of Wood Engravers Annual Exhibitions, UK, and in USA. *Works in collections:* British Library, V & A, Penn State University, PA, USA. *Commissions:* Penn State University, PA, USA; The Whittington Press; The

Press of Appletree Alley, PA, USA. *Address:* 5 Salters Lane, Walpole, Suffolk, IP19 9BA.

HOLMES, Walter, artist/illustrator in oil, acrylic, pastel and water-colour;. *b:* Wallsend on Tyne, 21 Aug., 1936. *m:* Helen. two *s. Studied:* Newcastle University Evening School, Beamish College, Durham. *Exhib:* Gulbenkian Gallery Newcastle, Queen's Hall Hexham, Moya Bucknall Solihull, Solent Gallery Lymington, Mall Galleries London, The Art Connection, Eton. *Works in collections:* Price Waterhouse, Coopers, Bank of England. *Commissions:* Swan Hunter Shipbuilders, N.E. Shipbuilders, Northern Sinfonia, Marie Curie. *Publications:* calendars for English Estates, Newcastle Breweries, Laing Calendar Competition 2nd prize, greetings cards for Oakwood Cards and 4C, Quarto Publishing plc. *Address:* Eastern Way Farm, 4 Queensway, Darras Hall, Ponteland, Newcastle NE20 9RZ.

HOLTAM, Brenda, R.W.S., B.F.A.Hons. (1983), R.A. Schools Postgraduate Dip. (1986); painter in oil, gouache, water-colour; figurative painter of still life, interiors, portraits and landscape; Tutor in water-colour;. *b:* Whiteway, Glos., 2 Oct., 1960. *m:* Howard Vie. two *s.* one *d. Educ:* Stroud Girls' High School. *Studied:* Glos. College of Art and Design (1979, T. Murphy), Falmouth School of Art (1980-83, F. Hewlett), R.A. Schools (1983-86, Peter Greenham, C.B.E., R.A.). *Exhib:* R.A. Summer Exhbn., N.E.A.C. Annual Exhbn., R.P., R.W.S. Members Exhbn. Bankside Gallery; two-person exhbn. Cadogan Contemporary (1994). *Misc:* Elected A.R.W.S. (1987), elected to full membership (1992). *Signs work:* "Brenda Holtam" or "Holtam." *Address:* 39 Ashburnham Rd., Richmond, Surrey TW10 7NJ.

HOMES, Ronald Thomas John, D.F.C., FCSD;A.GAvA artist/industrial designer; winner of RSA industrial design bursaries (1948-49); Central School of Arts and Crafts Dip for Industrial Design. *b:* London, 3 Oct 1922. *s of:* Arthur Leopold Homes. *m:* Ione Winifred Amelia. two *d. Educ:* Willesden Technical College. *Studied:* Central School of Arts and Crafts. *Address:* 69 Linden Pk., Shaftesbury, Dorset SP7 8RN. *Email:* ronald.homes@care4free.net

HOMESHAW, Arthur Howard, R.W.A., A.T.D.; artist in water-colour, pastel, colour prints;. *b:* 27 Nov., 1933. *m:* Wendy Bennetto. two *s. Educ:* Chipping Sodbury Grammar School. *Studied:* West of England College of Art (1951-54, 1956-57). *Exhib:* R.A., R.W.A., R.E.; one-man show, Patricia Wells Gallery (1981), Exeter Arts Centre (1992). *Works in collections:* R.W.A., Bristol Educ. Com., Devon County Hall, Stoke-on-Trent Educ. Com., B.P. International, South Glamorgan Educ. Authority, Walsall Educ. Authority, Avon Schools Service, Exeter University. *Signs work:* "HOMESHAW." *Address:* Arwen, Alexandra Rd., Crediton, Devon EX17 2DH.

HONE, David, P.P.R.H.A., Hon. R.A., H.R.S.A.; ex-officio portrait and landscape painter in oil. *b:* Dublin, 1928. *s of:* Joseph M. Hone, biographer. *m:* Rosemary D'Arcy. two *s.* one *d. Educ:* St. Columba's College; Univ. College,

Dublin. *Studied:* National College of Art, Dublin (1947-50), under J. Keating and M. MacGonical. *Works in collections:* Portrait Collection, National Gallery, Dublin, Cork Municipal Gallery. *Signs work:* "D. Hone." *Address:* 4 Ailesbury Gardens, Dublin 4, Eire.

HOOD, Andrew David, BA Hons Illustration. *Medium:* acrylic. *b:* Kingston-upon-Thames, 19 Aug 1964. *s of:* John Hood. *Educ:* Stewerts Melveille College Edinburgh; Wilmslow Grammar School. *Studied:* Mid-Cheshire College of Art and Design; Stockport College; John Moores university, Liverpool. *Represented by:* Washington Gallery, Penarth; Moya Bucknall Fine Art, Birmingham. *Exhib:* RWA Autumn Show; SWA Summer Exhibition; solo shows, Washington Gallery (2000, 2002), Battersea Contemporary Art Fair, Colyer Bristow Gallery London. *Works in collections:* work held in private collections throughout the UK and abroad. *Commissions:* Wetherspoons plc; BBC; Woman's Weekly. *Works Reproduced:* works published by the Art Group, Prime Arts Ltd. *Address:* 141 Somerset Road, Knowle, Bristol BS4 2JA. *Email:* andy.hood@fineartimages.freeserve.co.uk *Website:* www.andrewhoodgallery.com

HOOKE, Robert Lowe, Jr., sculptor of figures, wild animals and birds in bronze; art dealer; investment adviser; Managing Director: Research Vision Ltd. *b:* Canton, Ohio, 12 Sep 1942. *s of:* Robert Hooke, industry executive. *Educ:* Bowdoin College, Brunswick, Maine (B.A.); Columbia University, N.Y. (M.B.A.). *Studied:* N.Y. School of Visual Arts (1973-75, Herbert Kallem). *Exhib:* one-man shows: London, Geneva, Basel, Baden-Baden, Sydney, Johannesburg, Cape Town; group shows: Paris, Zurich, Amsterdam, San Francisco. *Works in collections:* Compton Acres, Poole; Oppenheimer Collection, S. Africa. *Commissions:* various private, Bowdoin College (U.S.A). *Clubs:* Hurlingham, Royal Ocean Racing, Ascot Park Polo, Annabels. *Address:* 61 Holland Pk., London W11.

HOPE HENDERSON, Eleanora, DA, SSA, Post Grad. Scholarship, then Highest Travelling Award (1940); artist in oil. *b:* Edinburgh, 21 Jun 1917. *d of:* Major David A. Spence, farmer and land agent. *m:* David Hope Henderson. two *s. Educ:* St. George's, Edinburgh. *Studied:* Edinburgh College of Art under Sir William Gillies, Sir W. MacTaggart, Westwater, Maxwell. *Exhib:* S.S.A., R.S.A., R.A., R.P., Dumfries Art Soc., McGill Duncan Gallery and Harbour Gallery, Kircudbrightshire; one-man shows: Chelsea A.G., Kirkcudbright Harbour Gallery, Woodstock Gallery, Pittenweem A.G. Fife, Coach House, Norwich, Ropner Gallery, London. *Works in collections:* private including Germany, Portugal, Canada and America. *Recreations:* golf, Scottish country dancing. *Clubs:* Southern WESS Golf Club. *Misc:* Work in private collections. *Signs work:* "E. Hope Henderson", before marriage "BORRIE." *Address:* Achie Farm, New Galloway, Kircudbrightshire DG7 3SB.

HOPE-KING, Christopher Stewart, A.R.M.S. (1993), R.M.S. (1998), S.M. (1991), H.S. (1994), Gold Bowl Hon. mention R.M.S. (1993), Fairman Members subject miniature award (1995); miniaturist in water-colour and acrylics (paints unique duck miniatures) of still life and landscapes; R.M.S. President's Special Commendation, particular mention 2001. *b:* Leeds, Yorks., 16 Sept., 1951. *Educ:* Homefield School, Bournemouth. *Studied:* with grandfather, Hector King. *Exhib:* R.A. Summer Show, Mall Galleries, British Painters, Westminster Gallery (R.M.S.); many one-man shows. *Publications:* included in: Techniques of Miniature Painting (Sue Burton, Batsford), R.M.S. One Hundred Years (Suzanne Lucas, Lucas Art). *Signs work:* "H.K." *Address:* Staddle Cottage, 1 Mill St., Corfe Mullen, Wimborne Minster, Dorset BH21 3RQ.

HOPKINS, Clyde David F., BFA.(Hons.) (1969); painter; Professor; Head of Painting, Chelsea College of Art. *b:* Sussex, 24 Sep 1946. *s of:* Paul Hopkins, teacher and cricketer. *m:* Marilyn Hallam. *Educ:* Barrow-in-Furness, Cumbria. *Studied:* University of Reading (Claude Rogers, Terry Frost). *Exhib:* Serpentine Gallery, Hayward Gallery, Ikon Gallery, Francis Graham-Dixon Gallery, Joan Prats Gallery, NYC, USA etc. *Works in collections:* ACGB, etc. *Clubs:* Chelsea Arts. *Misc:* Studios: London and Hastings. *Signs work:* "Clyde Hopkins." *Address:* 55 Marischal Rd., London SE13 5LE.

HOPKINS, Peter, painter, teacher, writer; Dean of Men, Emeritus, New York-Phoenix School of Design; Lecturer, Art Students League of New York; grantee, American Academy and National Institute of Arts and Letters (1950); Correspondent, Christian Science Monitor. *b:* New York, 1911. *s of:* Charles R. Hopkins. *m:* Gertrude L. Beach. *Educ:* Art Students League of New York. *Works in collections:* Museum of City of New York. *Works Reproduced:* in The American Heritage History of the 1920s and 1930s; The USA, a History in Art; The Complete Book of Painting Techniques; National Museum of American Art, Smithsonian Institution. *Address:* 36 Horatio St., New York, N.Y. 10014, U.S.A.

HOPKINSON, Sian Carolyn, BA (1989). *Medium:* painter in oil. *b:* 17 Apr 1967. *Studied:* Wimbledon School of Art. *Represented by:* Rafael Valls Ltd. *Exhib:* one-man shows: John Bennett Fine Paintings, London (2000); Rafael Valls, London (2003). *Publications:* illustrations for 'The Mysterious Fayum Portraits: Faces from Ancient Egypt' by Auphrosyne Doxiadis (Thames and Hudsons, London 1995). *Signs work:* Sian Hopkinson (on the back of work). *Address:* 13 Old Ford Lane, Barnet, Hertfordshire, EN5 4QN. *Website:* www.artnet.com/rvalls.html

HORE, Richard Peter Paul, A.R.C.A. (Painting 1959, Mural Painting, Silver Medal 1960), N.D.D. (Illustration 1955), F.R.S.A. (1964), R.C.A. (Cambrian 1978); painter in gouache and mixed media. *b:* Clacton-on-Sea, 1935. *m:* Janice Hart. one *s.* one *d. Educ:* Colebaynes High School, Clacton. *Studied:* Colchester School of Art (1951-55, John O'Connor), R.C.A. (1956-60, Carel Weight, Ruskin Spear, Leonard Rosoman). *Exhib:* R.A.; Welsh Arts Council; W.A.G.,

Birkenhead; Mostyn, Llandudno; Mall Galleries; Oriel, Theatre Clwyd; Muse, Philadelphia, U.S.A. *Works in collections:* R.C.A., Cheshire County and Chester City Councils, Dept. of the Environment, various private collections. *Commissions:* Chester City Council. *Publications:* Picturesque Chester by Peter Boughton (illustrations). *Signs work:* "RICHARD HORE." *Address:* 12 Dee Fords Avenue, Chester CH3 5UP.

HORNER, Michael Julian Alistair, U.A. (1999); painter in soft pastel; Council mem. U.A.;. *b:* Amersham, Bucks., 1 July, 1975. *Educ:* Egerton-Rothesay School, Berkhamsted. *Exhib:* UA Annual - Westminster, Autumn Art Show - Sussex, Artists & Illustrators Exhibition - London, Lingfield Surrey, Penhurst Place Kent, Tunbridge Wells Art Society, Sundridge, Cowden, Kent. *Commissions:* Past include millenium map, Derwent Water from 1000ft up, takes many for portraits of animals and people, gardens. *Works Reproduced:* for publicity online. *Principal Works:* Swiss and Austrian Alpine. *Misc:* teaches and runs workshops. *Signs work:* "MICHAEL HORNER." *Address:* The Rectory, Church St., Cowden, Edenbridge, Kent TN8 7JE. *Email:* michael@galleryonthenet.com *Website:* www.galleryonthenet.com

HOROVITZ, Isabel, B.A.(Hons.) (1978), Dip.Cons. (1982); paintings conservator; freelance conservator and consultant to Royal Academy of Arts;. *b:* London, 1957. *m:* Jonathan Blake. three *s.* one *d. Educ:* St. Paul's Girls' School. *Studied:* University of London (History of Art), Courtauld Inst. of Art (Conservation of Easel Paintings). *Exhib:* Conservator for R.A. Loans Exhbns. *Publications:* contributions to various catalogues and conservation literature. *Misc:* Special interest in history, techniques and conservation of paintings on copper supports. *Address:* The Painting Conservation Studio, Belgravia Workshops, 157-163 Marlborough Rd., London N19 4NP.

HORSBRUGH, Patrick B., A.A. (Hons.) Dipl., C.D. Dipl. (London), F.A.I.A., F.C.I.P., A.P.A., F.R.G.S., F.R.S.A., F.B.I.S.; Hon. Mem. A.S.L.A.; Hon. Mem. A.S.I.D.; architect; town planner and artist in ink, water-colour, gouache, etc.; Visiting Prof. of Architecture, Universities of Nebraska and Texas; organized Texas Conference on Our Environmental Crisis (1966) and International Conference, Cities in Context; Cultural, Ethical and Natural (1968); Founder and Chairman of the Board, Environic Foundation International Inc; V.P., Channel Tunnel Assoc. (1975-91); Co-chairman, Earthday (International); Prof. Emeritus of Architecture, Former Director of Graduate Programme in Environic Design, University of Notre Dame, Indiana USA. *b:* Belfast, 21 June, 1920. *s of:* Charles B.Horsbrugh. *Educ:* Canford and A.A., School of Architecture, Dept. of Civic Design, University of London. *Studied:* Accademia Britannica, Rome (1950), Bernard Webb Scholarship. *Works in collections:* Capesthorne Hall, Cheshire. *Publications:* 'High Buildings in the United Kingdom' (1954), Texas Conference on our Environmental Crisis, (edited 1965); Bridgeport, Conneticut 1961; Pittsburgh Perceived; A Critical Review of Form, Features and Feasibilities of the Prodigious City 1963; Gunnergate Hall, Yorkshire, Record of ruins, 1947. *Clubs:*

Cosmos Club, Washington D.C. *Signs work:* "Patrick Horsbrugh." *Address:* 916 St. Vincent St., South Bend, Indiana 46617-1443, USA. *Email:* environics@aol.com

HORTON, Antony Brian, landscape painter in oil and gouache. *b:* Birmingham, 21 Aug 1933. *s of:* E.Victor Horton, M.C., J.P. *m:* Sheila Horton. three *d. Educ:* Shrewsbury School and Exeter College, Oxford. *Studied:* Cheltenham College of Art (R.S. Dent). *Exhib:* RWS, RA, David Messum Gallery, and local exhbns. *Clubs:* MCC. *Signs work:* "A. B. Horton" or "Brian Horton." *Address:* The Old Rectory, Taplow, Bucks. SL6 0ET.

HORTON, James Victor, M.A. (R.C.A.) (1974), R.B.A. (1979); Prize Winner 'Discerning Eye' (1992). *Medium:* oil, water-colour and pastel. *b:* London, 24 July, 1948. *m:* Rosalind. two *s. Studied:* Sir John Cass School of Art (1964-66), City & Guilds Art School (1966-70), Royal College of Art (1971-74). *Exhib:* widely in Britain and abroad, eleven man shows. *Works in collections:* Girton, Newnham and Trinity Colleges, Cambridge. *Commissions:* extensive portraits. *Publications:* ten books on painting and drawing; numerous articles for art magazines. Taught in art schools and summer schools in Britain and abroad. *Misc:* artist in residence to HRH Prince Charles Mt Athos. *Address:* 11 Victoria Rd., Cambridge CB4 3BW.

HORWITZ, Angela Joan, Professor; NS(1982), RAS (1983) FABS (2005); Associated Academician (Arts) Accademia Internationale Greci-Marino, Italy (1999); steward, AGBI (1985-86); Member Beaux-Arts, Cannes, South of France (1996-2007); Academical Knight, Dept. of Arts; Ordine Accademico Internazionale, Italy; Fellow of American Biographical Society; Order of the International Ambassadors; MD Eminent Fellow FABI of the American Biographical Institute; sculptress in stone, bronze, painter in oil and pastel. *b:* London, 14 Oct 1934. *d of:* M. Carson. two *s.* one *d. Educ:* Colet Court Girls' School, Rosemead Wales, Lycée Français de Londres. *Studied:* Marylebone Inst. (1978-1990), Sir John Cass College (1983-1985), Hampstead Inst. (1990-92). *Exhib:* Grand Palais, Paris (1985, 1986), R.B.A., N.S., S.W.A. (Mall Galleries), Civic Centre, Southend, City of London Polytechnic, Whitechapel, (1985), S.E.F.A.S., Guildhall, Ridley Soc., City of Westminster Arts Council, Alpine Gallery, Smiths Gallery Covent Gdn., Wintershall Gallery, nr. Guildford, The Orangery, Holland Pk. W8, Hyde Park Gallery (Winchester Cathedral, 1993), Beaux Arts, South of France (1997), Salon International du Livre et de la Presse à Genèva (1997), Miramar Hotel Beaux Arts (1998) Association Beaux Arts (1999), Antrum Gallery Bayswater (2000), Carre D'Or Gallery, Paris (2000), Association des Beaux-Arts, Cannes (2007)., Raymond Gallery, Beaux Arts (2000); Plaisterer's Hall in aid of Red Cross (2005); Gallery Saint Sauveur Le Cannet, South of France (2005); Lansdowne Club, Mayfair (2005). *Works in collections:* Sculpture in stone for Winchester Cathedral; Well Woman Centre, The United Elizabeth Garrett Anderson Hospital for Women, London; Zurich Switzerland private collection, London private collection, France. *Clubs:*

Lansdown. *Misc:* Listed Who's Who in International Art, Dictionary of International Biography, Cambridge Blue Book, Great Women of the 21st Century. *Signs work:* "A.H." or "Angela Horwitz". *Address:* 6 Wellington House, Aylmer Drive, Stanmore, Middx. HA7 3ES.

HOSKINS, Stephen, M.A. (1981), A.R.E. (1989), R.E. (1995), B.A. (Hons.) (1977); printmaker in silkscreen, lithography and drawing;. *b:* Eastleigh, Hants., 31 Aug., 1955. *m:* Barbara Munns. one *d. Educ:* Barton Peveril Grammar School. *Studied:* W. Surrey College of Art and Design (1974-77), R.C.A. (1978-81). *Exhib:* R.A., R.E., mixed exhbns. worldwide. *Works in collections:* V. & A., Tate Gallery. *Publications:* A pop-up book (53), Water-Based Screenprinting, A&C Black (2001). *Signs work:* "S. Hoskins." *Address:* 62 Monk Rd., Bishopston, Bristol BS7 8NE. *Email:* Stephen.Hoskins@uwe.ac.uk S.Hoskins@netgates.co.uk

HOUCHIN, David John, Silver Medal 2002. *Medium:* sculptor in clay and bronze. *b:* London, 20 Jun 1935. *m:* Katie. two *d. Educ:* Eastbourne College. *Studied:* Farnham School of Art (1955-57). *Clubs:* Hon. Secretary and Treasurer of Society of Portrait Sculptors, mem. Chelsea Art Society. *Address:* Farm Place, Isfield, Uckfield, E.Sussex, TN22 5TY.

HOUGH, Liz, BA (Hons) Fine Art (1988); Post Grad Dip in Painting (1991); RA Summer Exhbn Artist Under 30 Years of Age, Lanseer Scholarship. *Medium:* oil, drawing, mixed media, collage. *b:* Wolverhampton, 31 Jan 1966. *m:* James Barry. one *d. Studied:* Manchester (1985-88); RA Schools (1988-91). *Represented by:* Oliver Contemporary-Carolyn Oliver. *Exhib:* Piccadilly Gallery, Cadogan Contemporary, Offer Waterman Fine Art, RA Summer Exhbn, Belgrave Gallery (St.Ives); New Grafton Gallery. *Works in collections:* Bank of China, TSB, USA, Paintings in Hospitals, Blackwell Group, ATM New York. *Commissions:* London Contemporary Arts. *Signs work:* 'LIZ HOUGH'. *Address:* 10 Sandows Lane, St.Ives, Cornwall TR26 1QW. *Email:* lizhough@email.com *Website:* www.art-on-line.co.uk

HOUSE, Ceri Charles, artist in oil; gilding restorer;. *b:* London, 20 Mar., 1963. one *d. Educ:* St. Christopher School, Herts. *Studied:* with father, Gordon House. *Exhib:* N.P.G., B.P. Portrait awards (1994), R.A. Summer Shows (1992, 1993, 1995), RA Summer Show 2000, invited guest RA Summer Show 2001, one man show "Personal Pictures" at The Millinery Works 1999, mixed show Millinery Works 2000, 2001, 2002, 2003. *Commissions:* Numerous private commissions. *Publications:* R.A. Illustrated catalogue (1993), RA Illustrated 2000. *Address:* 109 Highbury New Park, London N5 2HG. *Email:* cerihouse@lineone.net

HOUSTON, Ian, ARCM, President, East Anglian Group of Marine Artists, Member of Guild of Norwich Painters, FRSA; Silver medal, Paris Salon, Gold medal, FNCF; artist in gouache, oil and water-colour. *b:* Gravesend, Kent, 24 Sep 1934. *s of:* Angus Houston. *m:* Angela Adams (decd.). one *s.* one *d. Educ:* St.

Lawrence College, RCM, London. *Exhib:* over 60 one-man shows UK, USA, Australia. *Works in collections:* UK and abroad. *Misc:* Official artist to "Young Endeavour"; limited edition prints, 15 signed by Premiers Thatcher and Hawke, sold to raise funds for project, 3 times solo judge for Camberwell Rotary Art Show (Melbourne, Australia). *Signs work:* "Ian Houston." *Address:* c/o Portland Gallery, 8 Bennet Street London SW1A 1RP.

HOWARD, Diana Rosemary, RA Schools Diploma; Surrey Diploma (Hons); Bronze medal Painting, RAS (1971). *Medium:* oil, watercolour, mixed media. *b:* Wallington, Surrey, 31 Mar 1947. *d of:* Cyril & Grace Howard. *m:* John Morley. one *d. Educ:* eccentric private schools. *Studied:* Sutton School of Art; Epsom and Ewell School of Art; RA Schools (1969-71). *Exhib:* RA Summer Exhbns; Piccadilly Gallery; Arnolfini Gallery; Birmingham Museum and Art Gallery; Fine Art Society, London; National Trust Exhbn, Agnews (2000); David Messum AG; Cork Brick Gallery, Suffolk. *Works in collections:* private collections. *Commissions:* mural: Epsom and Ewell Polytechnic (1969). *Publications:* 'Great Ten' poetry by Simon Rae (pub.Brotherhood of Ruralists, 1989); 'Nine Poems' poetry by Eve Machin (pub.Brotherhood of Ruralists, 1987). *Works Reproduced:* 'The Ruralists' Chistopher Martin (Academy Pub., 1991). *Principal Works:* 'Dancer in the Garden'; coll. Caroline Odgers; ruralist paintings. *Recreations:* writing, poetry, eastern mysticism. *Misc:* early member of Brotherhood of Ruralists before name change (known as Broadheath Brotherhood). *Signs work:* 'Diana Howard'. *Address:* North Green, Stoven, Beccles NR34 8DG.

HOWARD, Ghislaine Marianne, BA Hons Fine Art. *Medium:* oils, acrylics, drawings, watercolours, etchings. *b:* Eccles, nr. Manchester, 21 Jun 1953. *d of:* Martin and Maureen Dobson. *m:* Michael Howard. one *s.* one *d. Educ:* Adelphi House Grammar School, Salford. *Studied:* University of Newcastle-on-Tyne. *Represented by:* The Cynthia Corbett Gallery, 15 Claremont Lodge,The Downs, Wimbledon; Firbob and Peacock, Knutsford. *Exhib:* numerous solo and group shows in UK and abroad, including Manchester Art Gallery, The Whitworth Art Gallery, Liverpool Cathedral, Canterbury Cathedral, St. Paul's Cathedral. *Works in collections:* The Royal Collection, Manchester Art Gallery, The Whitworth Art Gallery. *Commissions:* A Shared Experience (1993), The St. Anthony Sequence (2001), The Stations of the Cross (2000), The Visitation altarpiece (2003). *Publications:* featured in various publications and articles including 'Stations of the Cross: The Captive Figure (2000). *Official Purchasers:* Her Majesty's Prison Service, Methodist Art Collection, British Medical Association, Manchester Metropolitan University. *Works Reproduced:* on website and various publications. *Principal Works:* A Shared Experience; Stations of the Cross; St. Anthony sequence; Visitation altarpiece; 365 Series. *Recreations:* making music, cooking. *Misc:* widely acclaimed as a painter of shared human experience. *Signs work:* usually signs oils and acrylics on the reverse. *Address:* The Bridge House, 1 Collier Street, Glossop, Derbyshire, SK13 8LS. *Email:* ghislaine@ghislainehoward.com *Website:* www.ghislainehoward.com

WHO'S WHO IN ART

HOWARD, Ian, M.A. (Hons.), R.S.A.; artist in acrylic, oil, mixed media, printmaking; Prof. and Principal of Edinburgh College of Art. *b:* Aberdeen, 1952. *s of:* H.G.Howard. *m:* Ruth D'Arcy. two *d. Educ:* Aberdeen Grammar School. *Studied:* Edinburgh University, Edinburgh College of Art (1970-76). *Exhib:* numerous one-man and group exhbns. *Works in collections:* SAC, ACGB, Aberdeen A.G., Dundee A.G., Hunterian A.G., City Art Centre Edinburgh, Contemporary Art Soc., Warwick University Art Centre. *Publications:* 'Ian Howard, Painting, Prints and Related Works' (Third Eye Centre Glasgow/Peacock Printmakers, Aberdeen), Heretical Diagrams (Peacock Printmakers, Aberdeen 1997). *Signs work:* "I.H." or "Ian Howard." *Address:* c/o Edinburgh College of Art, Lauriston Place, Edinburgh EH3 9DF.

HOWARD, Ken, RA (1992), Hon.RBSA (1991), RWS (1983), RWA (1981), ROI (1965), NEAC (1961); Appointed Official Artist Northern Ireland Imperial War Museum (1973-78); President, New English Art Club (1998). *b:* London, 26 Dec 1932. *s of:* Frank Howard. *m:* Dora Bertolutti. *Educ:* Kilburn Grammar School. *Studied:* Hornsey College of Art (1949-53), Royal College of Art (1955-58). *Represented by:* Richard Green, 147 New Bond St., W1S 2TS. *Exhib:* New Grafton Gallery (1971, 74, 76, 78, 81, 83, 86, 88, 90, 93, 95, 97, 99), Manya Igel Fine Art (1987-97), Richard Green (2002-07). *Publications:* 'The Paintings of Ken Howard' (David & Charles, 1992), 'Ken Howard, A Personal View' (David & Charles, 1998). *Clubs:* Chelsea Arts. *Signs work:* "Ken Howard." *Address:* 8 South Bolton Gdns., London SW5 0DH. *Website:* www.kenhoward.co.uk

HOWARD-JONES, Ray, Fine Art Dip. University of London, Slade Scholar; 1st class Hons. History of Art; painter, poet, mosaics. *b:* Lambourne, Berks., 30 May 1903. *d of:* Capt. Hubert Stanley-Howard-Jones, R.A.V.C., M.R.C.V.S. *Educ:* London Garden School. *Studied:* Slade School, University of London (1921) under Henry Tonks, Wilson Steer, Elliot-Smith (anatomy), Tancred Borenius (History of Art); Postgraduate School of Painting, Arbroath. *Works in collections:* National Museum of Wales, National Museum of S. Australia, Glynn Vivian Gallery Swansea, Contemporary Art Society, Museum and Gallery Glasgow, Imperial War Museum, Arts Council for Wales, M. of W., City Art Galleries of Aberdeen, Glasgow, Burton-on-Trent, large mosaic exterior Thomson House Cardiff and Grange Church Edinburgh. *Publications:* various contributions to The Anglo-Welsh Review. Heart of The Rock Poems 1973-92 (Rocket Press, 1993). *Signs work:* "Ray." *Address:* Studio House, 29 Ashchurch Park Villas, London W12.

HOWARTH, Constance M., B. of E. intermed. (1946), NDD(1947); winner, Vogue Cotton Design Competition 1960 designer hand painted dresses. *b:* Rochdale, Lancs., 14 May 1927. *d of:* Edward Howarth, civil servant. *Educ:* Merchant Taylors' School for Girls, Crosby; Bolton School. *Studied:* Manchester Regional College of Art. *Exhib:* Rayon Design Centre, London. *Works in collections:* V. & A. New works: mixed media abstract mirror windows,

ornamental flower trees, decoupage furniture. *Signs work:* "Constance Howarth" and "Constanza." *Address:* 2 Upper Wimpole St., London W1G 6LD.

HOWARTH, Derek, NDD (Hons); ATD; ARBS; former assistant to Henry Moore. *Medium:* sculpture. *b:* Hyde, Cheshire, 20 Aug 1939. *s of:* William and Edith Howarth. *m:* Margaret. one *s.* one *d. Studied:* Manchester College of Art and Design; Bournemouth College of Art;. *Exhib:* RA, Leicester University, Abbotsbury Gardens, Renishaw, Long Island USA, Adam Gallery Penarth, Olympia Gallery at St.Brides, Pride of the Valley Sculpture Park, 28 Cork Street, Artshed, many mixed shows. *Works in collections:* Athens Museum, Scottish Museum, Mr & Mrs J.J.Bash, 'Catchi'-Long Island USA, Mr & Mrs P.Ellwood, Mr & Mrs W Fallis USA, Mr & Mrs D.Mann. *Commissions:* Bluewater, Mr & Mrs P Ellwood, Athens Museum. *Recreations:* sculpture, sculpture, sculpture!. *Signs work:* "Howarth", with line across joining centre of 'H's'. *Address:* Colney Park House, Harper Lane, Radlett, Herts. WD7 9HG. *Email:* Howarthcolneyprk@ad.com *Website:* www.derekhowarth.co.uk

HOWELD, Cheryl, *Medium:* oil. *b:* St.Albans, 24 Jul 1944. *m:* D.J.Howeld. two *s. Educ:* Heriots Wood County Grammar School. *Studied:* Hornsey Art School, private study under Charles Hardaker, and then 4 years in Moscow with Ivan Dmitriev. *Exhib:* PS; Cox & Co., St.James; RBA; NEAC; Parkwalk Gallery; Malcolm Innes Gallery; Stephanie Knight Gallery, Knightsbridge and Fort Lauderdale; Richmond Gallery, Cork Street; Glyndebourne Opera House Gallery. *Works in collections:* numerous private collections in UK with works in America, Australia, Norway and Europe. *Commissions:* H.R.H. The Prince of Wales; private commissions. *Works Reproduced:* 'Convivium'. *Principal Works:* 'Ripples Expanding', 'Raindrop Percussion', 'Flow, Reflection, Shadow'. *Misc:* opened the Churzee Gallery in 1988 which shows artists' own work alongside the other artists. *Signs work:* 'C.Howeld'. *Address:* 33 Church Road, Wimbledon Village, London SW19 5DQ. *Email:* cheryl@howeld.com

HOWELL, David, RSMA Vice President (2003 -); self taught painter in water-colour, oil and pastel. *b:* Markyate, 14 July, 1939. *m:* Jenny. one *d. Educ:* St. Albans Grammar. *Exhib:* R.S.M.A., S.Eq.A., many mixed and one-man shows in London and the U.K., Middle East, U.S.A., Hong Kong and Japan. *Works in collections:* United Biscuits, Provident Financial, Charterhouse Bank, Albank Alsaudi Alhollandi, H.R.H. Sultan Qaboos of Oman. *Publications:* City of the Red Sea (Scorpion, 1985). *Signs work:* "David Howell." *Address:* Court Barn, High Ham, Langport, Som. TA10 9DF. *Email:* dh@davidhowell.co.uk *Website:* www.davidhowell.co.uk

HOWELLS, Suzanne, ARBSA, SWA, MFPS. *Medium:* watercolour. *b:* Birmingham, 26 Jan 1948. *d of:* Anne & James Keliher. *m:* Gareth. two *d. Educ:* Harborne Hill School, Birmingham. *Studied:* self-taught. *Represented by:* Alpha Marketing Ltd., Unit 9, Links BC, Bishops Stortford. *Exhib:* Mall Galleries: RI, NEAC; Victoria Gallery, Derby; Bowl Gallery, London; A.Frame Gallery,

Brecon; Westminster Gallery, London; Lawson Gallery, Cambridge; Quay Gallery, Guernsey; Helios Gallery, Birmingham; Templeman Gallery, Saffron Walden; Laing Exhbn, London. *Commissions:* work provided for: film 'The Queen'; TV series: Vicar of Dibley, Eastenders, Little Britain, Dangerfield, My Family. *Publications:* in Artists and Illustrators Magazine; Art of England Magazine. *Official Purchasers:* 250 galleries in the UK; Lynne Rogers MP. *Works Reproduced:* series of 150 limited edition prints. *Recreations:* gardening. *Signs work:* 'S.F.H.' or 'S.F.HOWELLS'. *Address:* 28 Bull Street, Harborne, Birmingham B17 0HH. *Email:* garyhow@hotmail.com *Website:* www.suehowells.com

HOWSON, Peter, DLitt., Honoris Causa, Strathclyde University, BA (Hons.), GSA; painter in oil. *b:* London, 27 Mar 1958. *s of:* Tom William Howson. *m:* Terry (divorced). one *d. Educ:* Prestwick Academy. *Studied:* Glasgow School of Art (1975-77 and 1979-81, Alexander Moffat). *Exhib:* widely in Europe and the USA. *Works in collections:* Tate Gallery, V. & A., Metropolitan Museum of Modern Art, NY, MoMA, NY, Oslo Museum of Modern Art, Glasgow Art Galleries. *Commissions:* Official war artist, Bosnia (1993). *Publications:* many publications, including 'Peter Howson' by Robert Heller (Momentum, 2003). *Clubs:* The Glasgow Art Club, The Caledonian Club. *Signs work:* "Howson." *Address:* c/o Flowers East, 82 Kingsland Road, London E2 0PP.

HOYLAND, John, R.A. (1983), artist; Professor of Painting, R.A. (1999); Hon. Doc. Sheffield Hallam University; Academician de San Lucia Roma. *b:* Sheffield, 12 Oct., 1934. divorced. one *s. Studied:* Sheffield College of Art (1951-56, Eric Jones), R.A. Schools (1956-60). *Exhib:* numerous exhbns. including one-man: Royal Academy of Art (1999), Marlborough New London Gallery, Whitechapel A.G., Waddington Galleries, Robert Elkon Gallery N.Y., Nicholas Wilder Gallery, Los Angeles, Andre Emmerich Gallery, N.Y., Austin Desmond Fine Art, London, also in London, Austria, Australia, Canada, Germany, Holland, Italy, Norway, Portugal, Sweden; two-man shows: Brazil, London, U.S.A.; group shows: R.A. Summer Exhbns., R.B.A. Gallery, John Moores, Liverpool, Ulster Museum, Belfast, Edinburgh Open, Chichester Natural Art, Barbican A.G., Francis Graham-Dixon Gallery, R.C.A., McLellan Galleries, Glasgow, etc., 1999 John Hoyland Retrospective Royal Academy of Art, London; John Hoyland Retrospective, Graves Art Gallery, Sheffield (2001); in 2007: Dublin, Tate St.Ives Cornwall, London Beaux arts, Nevil Keating Pictures London, Lemon Street Gallery Truro. *Commissions:* mural design for Metro, Roma, Italy (2001). *Publications:* John Hoyland (1990); John Hoyland (2006, Thames & Hudson). *Clubs:* Dover St.Arts Club, London. *Misc:* Television and radio broadcasts. *Address:* 41 Charterhouse Sq., London EC1M 6EA.

HOYLE, Jonathan Martin, BA (Hons) Fine Art, First Class Postgrad. Dip. Painting. *Medium:* painter in oil, gouache. *b:* Rochdale,10 Jul 1957. *Studied:* Gloucestershire College of Art and Design (1976-79), Royal Academy Schools (1979-82). *Represented by:* Abbott and Holder, 30 Museum Street, London,

WCIA 1LH. *Exhib:* Discerning Eye, Laing Art Exhibition. *Works in collections:* H.R.H. The Prince of Wales, St.Peter's College, Oxford. *Clubs:* RASAA. *Address:* 28A Enderby Street, Greenwich, London, SE10 9PF.

HUBBARD, Deirdre, BA (Summa cum Laude) (1957), ARBS(1981), FRBS(1999); Sohier prize (1957), Wapping Arts Trust 'Art and Work' (1987); Hon.D.Litt., Leicester University (2007); sculptor in bronze;. *b:* NYC, 28 Oct, 1935. *d of:* R.L. Hubbard, sculptor. *m:* Dr. John L. Wilson. three *s.* one *d. Educ:* Radcliffe College, Harvard University (1953-57). *Studied:* painting with Andreas Feininger (1954-55), Chelsea Art School (1957-61, sculpture with Willi Soukop and Bernard Meadows), Studio Elisabeth Frink (1963-65), Studio of Elisabeth Frink (1961-63). *Represented by:* Jonathan Clark & Co., Fine Art; McHardy Sculpture Co.; Thompsons Gallery; Garden Gallery, Red Rag. *Exhib:* RA, RBS, RWA, Essex University, Bristol Cathedral, Camden Arts Centre, National Museum of Wales, Bloomsbury Gallery, Barbican Centre, Leicester University (Leics.), Newby Hall (Yorks.), Burleigh House (Lincs.), Woburn Abbey, Chichester Cathedral, Abbotsbury Gardens. *Works in collections:* Royal Free Hospital, Inst. of Educ. London University, Towner A.G., Usher Gallery, Lincoln, Bryn Mawr College, Bryn Mawr, PA, USA, Radcliffe Inst., Cambridge, Mass., USA, Sumitomo Corporation, Tokyo, Rexam plc, Miami, Florida, USA, Leicester University (Leics.), Prudential Assurance Company London. *Publications:* "Contemporary British Sculpture" Schiffer Publishing Co. Ltd, USA. *Signs work:* "D.H." *Address:* 101 Woodsford Sq., London W14 8DT.

HUCKVALE, Iris, RMS, SBA., SM; miniaturist in oil on wood and polymin; Silver Gilt Medalist R.H.S., Certificate of Botanical Merit SBA. *b:* Northampton, 27 Sep 1930. *d of:* Herbert Leeding. *m:* John Huckvale, O.B.E. one *s.* one *d. Educ:* Northampton Grammar School for Girls. *Studied:* Nottinghamshire Evening Inst., but mainly self taught. *Exhib:* R.A., R.M.S., S.W.A., S.B.A., S.WL.A., Medici, S.M., M.A.S.-F., M.A.S.-N.J.; one-man show, Coach House Gallery, Guernsey. *Works Reproduced:* Medici greetings cards. *Address:* 4 Heath Green, Heath and Reach, Leighton Buzzard, Beds. LU7 0AB.

HUDSON, Eleanor Erlund, ARCA (1937); graphic artist, portraitist, figure subjects, water-colourist; costume designer, artistic adviser to former Brooking Ballet School of Marylebone. *b:* S. Devon. *d of:* Harold Hudson and Helen Ingeborg Olsen. *Educ:* Wentworth Hall, Surrey. *Studied:* R.C.A. (School of Engraving) under Professors Malcolm Osborne, R.A., R. S. Austin, R.A., Drawing Prize, 1936, Continuation Schol. (4th year) 1938, Travelling Schol. 1939. *Exhib:* R.A., Bankside Gallery, London and international. *Works in collections:* Boston Pub. Library, Fogg Museum, U.S.A., Imperial War Museum, London, War Artist's Advisory Comm. *Misc:* other address: Meadow House, Old Bosham, Sussex PO18 8JF. *Signs work:* "ERLUND HUDSON." *Address:* 6 Hammersmith Terr., London W6 9TS.

HUDSON, Thomas Roger Jackson, Teachers' Cert. (1951), Teachers' Dip. (1961), M.Coll.H. (1962), Mem. AWG; self employed furniture maker and designer. *b:* Bicester, Oxon., 24 Jul 1929. *s of:* Frederick Thomas John Hudson. *m:* Ragnhild Ann Schanche. one *s.* two *d. Educ:* Bicester Grammar School. *Studied:* Oxford School of Art (1947), Shoreditch College (1949-51), Camberwell School of Art (1961), Goldsmiths' College (1962). *Works in collections:* private houses, churches, schools, boardrooms. *Publications:* Wheelstocks and Ploughshares (Tabb House, 1988), Gunstocks and Dovetails (Tabb House, 2000). *Signs work:* carved into all major works (cow). *Address:* The Barn, 117 High St., Odell, Bedford MK43 7AS.

HUFTON, Susan Mary, BEd (Hons)(1980); Certificate and Diplomas in Calligraphy and Bookbinding (1983-86); Fellow of the Society of Scribes and Illuminators (FSSI)(1987). *Medium:* calligraphy, lettering, letter carving. *b:* Worcester, 1 Oct 1957. *d of:* David Kearley. *m:* Robert Hufton. two *s. Educ:* Kettering High School for Girls. *Studied:* Roehampton Institute (Southlands College 1976-80; Digby Stuart College 1983-86). *Represented by:* Ann Camp. *Exhib:* Society of Scribes & Illuminators Exhibitions, including St.Paul's Cathedral; Calligraphy exhbns at Chepstow Museum, Ditchling Museum, St.Bride's Printing Library, Wolesey Fine Arts; Crafts Council Touring Exhbn: London, Berwick, Bath, Brighton; Minneapolis Institute of Art (2005); V&A (as part of St.John's Bible team, 2006). *Works in collections:* Crafts Study Centre, Farnham. *Commissions:* British Gas, Market Research Society, West Dean College, World Methodist Council. Private commissions: St.John's Abbey Minnesota-the Saint John's Bible. *Publications:* Step-by-Step Calligraphy (Weidenfeld & Nicholson, 1995); various journals. *Works Reproduced:* in calligraphic journals and books. *Recreations:* reading, sewing, music and theatre, outdoors. *Clubs:* Society of Authors, Society of Scribes and Illuminators, Letter Exchange. *Signs work:* 'SUSAN HUFTON'. *Address:* 31 Tremadoc Road, London SW4 7NF. *Email:* sue@thehuftons.com *Website:* www.calligraphyanddesign.com

HUGHES, Christine, Dip.Ed. (1968), Dip.F.A. (1994); painter in oil, printmaker, teacher; watercolour. *b:* London, 20 Feb., 1946. *m:* D.C.C. Hughes. two *d. Educ:* Homerton College, Cambridge. *Studied:* Southampton College of Art (1989-94). *Exhib:* many mixed and solo shows in S.W. England and Cumbria. Castlegate House, Cumbria; Gallery 2, Ringwood, Hampshire. *Works in collections:* NZ, Australia and widely across Europe. *Official Purchasers:* Hampshire County Council. *Recreations:* sailing, mountain walking. *Signs work:* "C. Hughes" or H within a C. *Address:* Linmoor Cottage, Highwood, Ringwood, Hants. BH24 3LE. *Email:* cchughes@waitrose.com *Website:* www.christinehughesimages.co.uk

HUGHES, Jim, DA(1954), SGA (1972), ATC (1955), TGC (1956); artist/designer/calligrapher; former teacher of art and design, Adult Educ. Dept., University of Glasgow. *b:* Glasgow, 1934. *s of:* Janet Orr, craftswoman. *Educ:*

Ayr Academy. *Studied:* Glasgow School of Art (1950-54); Jordanhill College (1954-56) under Sam Black, DA, RSW. *Works in collections:* Glasgow Art Gallery, National Trust for Scotland, Royal Burgh of Ayr, other work in private collections throughout the world. *Publications:* Graphic Design for S.S.A.E. and Ayr Adult Educ. Booklets. Work featured in B.B.C. TV series "The Quest"(1989). *Signs work:* initials on work, name on back. *Address:* 32 Macadam Pl., Ayr KA8 0BZ.

HUGHES, Kevin Michael, B.Sc. (1969), A.L.A. (1971), R.I. (2000); Prize for Best Water-colour in 1997 Discerning Eye Exhbn., Benton/Humphries Prize in 1999 Discerning Eye; Third Prize Singer & Friedlander/Sunday Times Watercolour Competition; Ranelagh Press Award, 2006 RI Exhibition; Rowland Hilder Award, 2007 RI Exhibition; artist in water-colour, oil and pastel;. *b:* Colwyn Bay, 4 Sept., 1947. *m:* Kate Skillington. one *s.* one *d. Educ:* Reading University, Polytechnic of N. London. *Exhib:* R.I., N.E.A.C., Discerning Eye, R.W.S., R.W.A.; one-man shows: many since 1980 including several at the Alresford Gallery. *Works in collections:* Wessex Collection, Longleat. *Clubs:* Royal Institute of Painters in Watercolour. *Signs work:* "Kevin Hughes." *Address:* Edge Hill, Helscott Rd., Marhamchurch, Bude, Cornwall EX23 0JE.

HUGHES, Marcia, SWA; Awards: Princess Michael of Kent Award for Most Outstanding Watercolour in Show (SWA, 2002); finalist, 'Not The Turner Prize' (2003); Arthur Henderson Hall Award (2004 & 2005). *Medium:* watercolour. *b:* Surbiton, Surrey, 12 Dec 1943. *d of:* Ethel & Roy Beck. *m:* Fenton Hughes. two *s.* one *d. Educ:* Coombe County Girls School. *Studied:* self taught. *Exhib:* Mall Galleries: SWA, SBA, 'Not The Turner Prize'; Picturecraft, Holt, Norfolk; Savoy Hotel Gift Shop; Aberfeldy Gallery, Perthshire; Selwyn Smith Studio, Teddington; The Old Post Office, Barnes; Wadhurst, E.Sussex; Vivartis, Godalming. *Works in collections:* internationally. *Clubs:* Molesey Art Society; Teddington Riverside Artists. *Misc:* tutor in art at Richmond Adult Comm. College. *Signs work:* 'Marcia Hughes'. *Address:* 100 Shacklegate Lane, Teddington, Middx., TW11 8SH.

HUGHES, Robert, H.S. (1986), R.M.S. (1989), S.Lm. (1993); artist in oil and gouache;. *b:* London, 5 Nov., 1934. *Exhib:* R.M.S., H.S., S.Lm. *Publications:* co-author of How to Paint Miniatures. *Signs work:* "Robert Hughes" or "R. HUGHES." *Address:* Easton Barns, Easton Royal, Pewsey, Wilts. SN9 5LY.

HUGH-JONES, Philip Morrell, MA, MD, FRCP, MAS, LSC, CAS. *Medium:* all media. *b:* 22 Aug 1917. *s of:* Philip Morrell. *m:* Irene Hilary. three *s.* two *d. Educ:* Highgate School, London; King's College, Cambridge. *Studied:* self-taught, also Slade Summr School (1990, 95, 97); Hornsey Art School (1983). *Represented by:* Jane Watt. *Exhib:* Hornsey Art School (1933); Arts Council (1939); Scottish Gallery, Edinburgh (1944); Mall Gallery 'Artists of Britain' (1980); solo exhbn Ross Gallery, Eton Terrace (1998, 2000); Medical Art Society (1998-2008); Royal College of Physicians (1997-2007); 3 paintings circulated to

schools by Arts Council of GB (1939). *Publications:* all medical. *Works Reproduced:* for website. *Recreations:* mountaineering, exploration. *Clubs:* Athenaeum. *Signs work:* 'PMH-J'. *Address:* 167 Camberwell Grove, London SE5 8JS. *Email:* phj@f2s.com *Website:* www.janewatt.net

HULME, Ursula, M.B.E., NRD, FPS, BAAT; artist in oil, water-colour, pastel, felt pen and collage; textile designer; art therapist; Founder of 'Conquest' The Society for Art for the Physically Diabled People - now called Conquest Art (1979); Active Citizen Award (2004). *b:* Cottbus, 5 Mar 1917. *d of:* Dr. Karl Neumann. *m:* Ernest Hulme. *Educ:* Berlin. *Studied:* Reimann School, Berlin under Maria May. *Exhib:* one-man shows: Woodstock Gallery, London (3), Talent Store, London (1990); group shows: F.P.S., Mall Galleries, Loggia Gallery, Nimes, France, Leatherhead Theatre, Richmond Art Group, etc., Bourne Hall, Ewell (2003). *Works in collections:* Coronation Teacloth permanently exhibited in Moygashel Museum, Dungannon. *Publications:* entries in London Diary in book form from 1970-72. ABC book, and three videos on Conquest Teaching Methods produced 1988-96; book, Guide for Group Leaders, 2 videos 'Journey of Discovery' and 'The Life & Art of Ursula Hulme'. *Signs work:* "Ursula Hulme." *Address:* 3 Beverley Cl., E. Ewell, Epsom, Surrey KT17 3HB.

HUME, Robin, RGI. *Medium:* at present, clay and bronze. *b:* Airthrey Castle, Bridge of Allan, 1943. *Studied:* Glasgow School of Art. *Exhib:* The Royal Glasgow Institute of the Fine Arts; The Royal Scottish Academy of Painting, Sculpture and Architecture; Glasgow Art Club; Talbot Rice Gallery, University of Edinburgh. *Works in collections:* private collections. *Misc:* taught drawing and painting at Glasgow School of Art 1972-2003. Paid to stop 2003. *Address:* Ashpad, Kirkoswald, Ayrshire, KA19 8JB.

HUMPHREYS, David, BA (Dunelm); Thomas Penman Scholar and State Scholar at Durham University (1958-62); painter and constructor. *b:* London, 27 Oct 1937. *s of:* J.H.Ll.Humphreys. *Educ:* Battersea Grammar School and King's College, Durham University (Dept. of Fine Art). Elected mem. Royal Cam. Academy (1994). *Works in collections:* Arts Council, Leicester, Newcastle, London Universities, Ministry of the Environment, Bishop Otter College, Ashridge College, Nuffield Foundation, I.C.I., J. Sainsbury, Shell, American Express Bank (London and N.Y.), P. & O., Financial Times, H.M. the Queen Mother, H.R.H. the Prince of Wales, National Library of Wales. *Publications:* 'A Painter's Notes'(1999), A further view (2002), Heaven on Earth (2003). *Signs work:* "Humphreys." *Address:* Maudlin Hill House, Sopers La., Steyning, W. Sussex BN44 3PU.

HUMPHREYS, Ian, B.A. (Hons.); painter. *b:* St.Albans, 30 Jul 1956. *Studied:* Berkshire College of Art and Design (1973-75), Exeter College of Art and Design (1976-79). *Represented by:* Cunnamore Galleries, Eire; The Hallward Gallery, Dublin; International Art Consultants, London; Anthony Hepworth Fine Art UK. *Exhib:* numerous one man and mixed shows worldwide since 1979, Royal

Academy Summer Exhibitions, International Art Fairs, exhibits regularly. *Works in collections:* Allied Irish Bank, Bantry Hospital, Burmah Castrol, British Rail Board, Coopers & Lybrand, James Capel, Reading Museum and A.G. Tate & Lyle Sweeteners, Glaxo Smithkline, Trinity College, University of Cambridge, Pinsent and Masons, Societé Generale, Office of Public Works Eire, and numerous private collections worldwide. *Address:* Heir Island, Skibbereen, Co. Cork Eire. *Website:* www.cunnamore.com; www.hallwardgallery.com; www.anthonyhepworthfineart.com

HUMPHREYS, John Howard, ROI(1977, resigned 1992; elected Hon. Senior Mem. 1994); artist in oil; Press Officer, ROI (1978-81); Winner of Stanley Grimm Prize (1981). *b:* Bethlehem, S. Africa, 20 Oct 1929. *s of:* H.H. Humphreys. *m:* Mary Mack. one *s.* one *d. Educ:* King Edward VII School, Johannesburg. *Studied:* Heatherley's Art School (Iain Macnab), and privately under Stanley Grimm (1953-57). *Exhib:* RA, ROI, RBA, RI, RSMA, SWLA., Paris Salon, etc.; also in the USA and Japan. *Signs work:* "J. Humphreys." *Address:* 94 Kings Ave., Greenford, Middx. UB6 9DD.

HUNDLEBY, A. R., designer-packaging and graphics, artist in water-colour;. *b:* 15 Aug, 1923. *m:* Marion Smallshaw, A.T.D. one *s.* two *d. Studied:* Lincoln and Leicester. *Signs work:* "HUNDLEBY." *Address:* 35 Kelross Rd., London N5 2QS; and Hill House, Binham, Norfolk NR21 0DW. *Email:* Ahundleby@aol.com

HUNKIN, Sally Elizabeth, artist in etching, water-colour and oils, gardener; Organizer and teacher at Kew Studio; Artists Books. *Medium:* principally etching. *b:* Herts. 29 Jun., 1924. *m:* Oliver Hunkin, ex-TV producer. one *s.* one *d. Educ:* St. Mary's Calne; Dartford College. *Studied:* Richmond Adult College. *Exhib:* solo shows locally and in Suffolk and Manchester; group shows include Royal Soc. of Artist Printmakers, and RA. *Works in collections:* St. Thomas's Hospital. *Commissions:* two friezes for St. Thomas's Hospital. *Works Reproduced:* posters and cards for Kew Gdns. *Signs work:* "Sally Hunkin." *Address:* 31 Leyborne Pk. Kew, Richmond, Surrey TW9 3HB.

HUNT, Emma, B.A. (Hons.), M.A.; Sen. lecturer, Art and Design History; Course Director, Cultural Studies, Bournemouth and Poole College of Art; adviser to Southern Arts;. *b:* Bideford, 27 July, 1962. *m:* Martin. two *s. Educ:* Leicester and Birmingham. *Exhib:* curated small college exhbns. and at Russell-Cotes Museum. *Publications:* contributor to design history articles. *Signs work:* "E.F. Hunt." *Address:* Shepherds Cottage, Henfords Marsh, Warminster, Wilts. BA12 9PA.

HUNT, Geoffrey William, President RSMA; Wapping Group of Artists; marine artist and illustrator in oil and water-colour. *b:* Twickenham, 11 Mar 1948. *s of:* Eric William Hunt. *m:* Vivienne Anne Hobbs. two *s. Educ:* Hampton Grammar School. *Studied:* Kingston School of Art (1966-67), Epsom School of Art (1967-70). *Exhib:* RSMA since 1977; Mystic Seaport Gallery, USA. *Works in collections:* Royal Naval Museum, Portsmouth; R.N. Submarine Museum,

Gosport; H.M.S. Neptune, Faslane; Mariner's Museum, Newport News, USA; RSMA Diploma Collection. *Publications:* illustrated many book covers including complete series of Patrick O'Brian's Aubrey/Maturin novels; compiler: 'A Celebration of Marine Art' (Blandford, 1996); 'The Tall Ship in Art' (Blandford, 1998); 'The Marine Art of Geoff Hunt' (Conway, 2004); 'The Wapping Group of Artists' (Seafarer, 2005). *Works Reproduced:* print editions by Mystic Seaport; Richard Lucraft; Art Marine. *Recreations:* sailing. *Signs work:* "Geoff Hunt." *Address:* Dalton House, 60 Windsor Avenue, Wimbledon, London SW19 2RR.

HUNT, Georgina, DFA (Lond.); painter; mem. London Group: 1976; Major award, Greater London Arts Assoc.; 1993: 21st Century Association prize, Osaka International Triennale; 1999: Lorenzo il Magnifico Prize for Lifetime Achievement. Florence International Biennale. *b:* Reading, Berks. 15 Jun 1922. one *s.* one *d. Studied:* Slade School of Fine Art (William Coldstream) and Hunter College, New York (Prof.Robert Swain). *Exhib:* widely in the UK and internationally, including: Camden Arts Centre, The Barbican, Winchester Cathedral, Osaka International Triennale '93, Florence International Biennale '97 and '99, The Hunting Prize 1999-2005, The London Group 1992-2007 and Flowers East/Central 2001-2006, Chichester Open 2007. *Works in collections:* national and international. *Publications:* include: Guy Brett, Solo exhibition catalogue, Camden Arts Centre, London (1982); Judith Collins and Frances Spalding, '20th Century Painters and Sculptors' (1991); Mike Williams, Modern Painters (Winter 1994); David Buckman, The Dictionary of Artists in Britain since 1945 (1998), 'The London Group' edited by Jane Humphrey (The London Group 2003). *Works Reproduced:* In The London Group edited by Jane Humphrey and at www.thelondongroup.com/artists/hunt.html. *Clubs:* Chelsea Arts. *Misc:* work can be seen on the London Group website: www.thelondongroup.com/artists/hunt.html, and at the artists studio: 2 Camden Studios, Camden Street, London NW1 0LG. *Signs work:* "Georgina Hunt." or "G.H." *Address:* Flat B, 11 Burton St., London WC1H 9AQ. *Email:* georginahunt@f2s.com *Website:* www.thelondongroup.com/artists/hunt.html

HUNT, Susie, B.A. (Hons.) Fine Art (1980); artist in water-colour and mixed media, and framer;. *b:* Fareham, Hants., 18 Dec., 1957. *m:* Anthony Paul Duley. one *s.* one *d. Studied:* Canterbury College of Art (1976-77), West Surrey College of Art (1977-80). *Exhib:* many mixed and solo shows in London and Home Counties, R.W.S. Awards (1997), R.I. Open (1997, 1998, 2000), Aberdeen Artists (2001), annual Kent Painters Group charity exhibition, Art for Youth North 2003, Art for Youth London October 2003. *Works in collections:* Wallacespace - London. *Commissions:* Wallace City Training. *Clubs:* Reigate Soc. of Artists, nominated professional member Aberdeen Artists (2002). *Signs work:* "Susie Hunt." *Address:* Mill Farm, Aquhythie, Invervrie, Aberdeenshire AB51 5NY. *Email:* susiejhunt@hotmail.com

HUNTER, Alexis, Dip.F.A. (Hons. in Painting and Art History), Teaching Dip. (1971), Computer Systems Design (2000), Multimedia (2001); painter, filmaker,

photographer, writer. *b:* Auckland, N.Z., 4 Nov 1948. *d of:* Jack Carlye Hunter, industrial chemist. *m:* Baxter Mitchell, B.I.M. *Educ:* Auckland Girls Grammar. *Studied:* Elam, Auckland (Colin McCahon), Central Graphics Academy, London, (Rhys Webber). *Represented by:* White Space Gallery, Auckland, NZ, Pacart, Zurich. *Exhib:* Hayward Gallery, Whitechapel, Serpentine, Musee d'Art Moderne, Auckland City Gallery, etc. *Works in collections:* Imperial War Museum, Scottish National Gallery, Zurich Museum, Te Papa National Gallery N.Z., etc. *Commissions:* private. *Publications:* Essays on feminism and art, theory and psychoanalysis published. *Official Purchasers:* Te Papa National Gallery NZ, Auckland City Gallery, etc. *Clubs:* N.Z. Artists Assoc., S.L.A.G.S. (Soho). *Misc:* N.Z. Film Archive. *Signs work:* "Alexis Hunter." *Address:* 13 Hillier Ho., 46 Camden Sq., London NW1 9XA. *Email:* hunteralexis@hotmail.com *Website:* www.alexishunter.co.uk

HUNTER, Caroline, MA Hons History of Art; James Torrance Memorial Award 1999 most Promising Young Painter at Glasgow RGI. *Medium:* acrylic. *b:* Edinburgh, 9 Dec 1964. *d of:* James and Margaret Hunter. *m:* William Self. *Educ:* Stromness Academy, Orkney; Aberdeen University. *Studied:* History of Art. *Exhib:* five solo shows (3 with Mainhill Gallery, Ancrum; prop: Diana Bruce); over 20 mixed shows; regular contributor to RGI and RSA Shows; shortlisted for Noble Grossart Prize (1997); Laing Seascape and Landscape Competition, Mall Galleries 2002 (shortlist). *Publications:* Mainhill Gallery Exhbn. catalogue 2003. *Works Reproduced:* 'Christmas Day' print, 'Field, August' print. *Recreations:* fashion, camping. *Misc:* started painting in 1994, previously cartoon work, illustration and archaeological fieldworker. *Address:* Dunbhronaig, Carsaig, Tayvallich, Argyll PA31 8PN. *Email:* caroline@hunter339.fsnet.co.uk

HUNTER, Christa, SWA; sculptor in terracotta, porcelain, bronze resin, bronze;. *b:* Stuttgart, Germany, 18 Aug 1943. one *s.* one *d. Educ:* Ostheim Stuttgart. *Studied:* Sculpture course by Major Tugwell/Judy Cousins (1983). *Exhib:* regularly with art socs. in Berks. and Surrey, annually S.W.A. at Westminster Hall and Mall Galleries, Harrods Picture Gallery, Medici Gallery (1994), annually Surrey Sculpture Soc. Sculpture Trail Wisley, Chelsea Flower Show (1998), Art Parks International Sausmarez Manor Guernsey, Belvoir Castle (2001), Druidstone Wildlife Park (2001), Savill Garden, Borde HIll, Kingsmead Gallery Great Bookham, Century Gallery Datchet, and Affordable Art Fair with Linda Blackstone Gallery Pinner, The Gallery Virginia Water, Holme Grange Gallery Wokingham. *Works in collections:* Lincoln Joyce Fine Arts, Great Bookham; Art Parks International, Guernsey; Linda Blackstone Gallery, Pinner. *Commissions:* several private Foundry Bronze. *Signs work:* "C.H." or "Christa." *Address:* 1 Eliot Close, Camberley, Surrey GU15 1LW. *Email:* christahunter@hotmail.co.uk *Website:* www.christahunter.com

HUNTER, Elizabeth, NDD, ATD, Slade Diploma (Lond); painter and printmaker. *Medium:* oil, prints. *b:* Bristol, 8 Jun 1935. one *s. Educ:* Kingswood Grammar School. *Studied:* West of England College of Art (1951-56); Slade

School of Fine Art (1956-58, Special Commendation 1958). *Represented by:* Belgrave Gallery, St.Ives; Badcocks Gallery, Newlyn, Cornwall. *Exhib:* solo shows: Arnolfini, Bristol; Sirota Gallery, Wells; Coopers Gallery, Theatre Royal Bristol; Art Garden, Bristol; Trereife Gallery, Penzance (2007). Mixed shows: Newlyn and Penwith Societies, Cornwall, Royal Academy, RWA, Belgrave St.Ives, Badcocks Newlyn, Cube Gallery Bristol, Studio Fusion, Oxo Tower Wharf, Saltgrass, Hamps. *Recreations:* opera, gardening. *Clubs:* Newlyn Society of Artists, Penwith Society of Artists. *Address:* 5 Regent Square, Penzance, Cornwall, TR18 4BG. *Website:* www.ecrhunter.com

HUNTER, Henry Hay, U.A. (2000); artist in oil;. *b:* Beal, Northumberland, 4 Mar., 1934. *m:* Kathleen. *Educ:* St. Peter's School, York. *Studied:* Buckinghamshire College (1995-97). *Exhib:* R.D.S. (1949, 1950), U.A. (1994-2000). *Works in collections:* private: England, S. Africa, N.Z., Germany. *Publications:* Fine art prints. *Clubs:* Southwold Art Circle, Beccles Soc. of Artists. *Signs work:* "Henry Hay Hunter" or monogram of three H's. *Address:* 11 Fairmile Close, Worlingham, Beccles, Suffolk NR34 7RN.

HUNTER, Janet Claire (Jan), BA (Hons) Fine Art (2007); SWA (1997), FETC (1987), Dip. in Advertising and Design (1965); photographer, printmaker and artist in oils and water-colour, dry and acrylic media. *Medium:* digital photography, oils, watercolours. *b:* Reading, Berks., 2 July, 1946. *m:* Ian Hunter. one *s.* one *d. Studied:* Berks. College of Art, Reading (1962-65),University College for the Creative Arts, Farnham (2002-2007). *Exhib:* Mall Galleries, London; Bankside Gallery, London; Farnham Maltings; Guildford House Gallery. *Clubs:* Chertsey Arts, Guildford Art Society. *Signs work:* "Jan Hunter" and date. *Address:* Greatwood, 209 Brox Rd., Ottershaw, Surrey KT16 0RD. *Email:* janhunter1000@yahoo.co.uk *Website:* www.janhunter.com

HUNTINGTON-WHITELEY, James, B.A. (Hons.) Manchester (1985); Modern British and Contemporary Art Exhbn. Organizer;. *b:* 14 Aug., 1963. *m:* Magdalen Evans. one *s.* one *d. Address:* 38 Hopefield Ave., London NW6 6LH.

HUNTLEY, Dennis, NDD (1951), ATC (1952), FRBS (1970); sculptor in bronze, plastics, stone, wood; educationalist; Head of Sir John Cass School of Art; Governor, City of London Polytechnic. *b:* Weybridge, Surrey, 6 Dec 1929. *s of:* William Lanchbury Huntley, management executive. *m:* Gillian Huntley. one *s.* two *d. Educ:* Wallington Grammar School for Boys. *Studied:* Wimbledon School of Art (1947-51), Gerald Cooper (principal), London University Senior House (1951-52). *Exhib:* several galleries. *Works in collections:* 6 major works (4 stone, 2 wood) Guildford Cathedral, 7ft. metal fig. for L.C.C. Patronage of the Arts Scheme at Henry Thornton School, Clapham, life-sized wood fig. of Anne Boleyn, London Borough of Sutton, awarded Sir Otto Beit medal in open competition for best work, 1967, in United Kingdom and Commonwealth. *Publications:* book reviews for L.C.C. and Studio Vista and various articles for Education. *Clubs:* Arts, Chelsea Arts. *Signs work:* "D. W. Huntley" on prints and

drawings, "D. HUNTLEY" on sculptured work. *Address:* The Studio, 30 Hawthorn Rd., Sutton, Surrey.

HUNTLY, Moira Gay, A.T.C. (Lond.), P.S. (1978), R.I. (1981), R.S.M.A. (1985), R.W.A. (1995); artist in acrylic, oil, pastel, water-colour; President, Pastel Society. *b:* Motherwell, Scotland, 7 Nov 1932. *d of:* G.L.R.Watkins. *m:* Ian E. Buchanan Huntly. one *s.* two *d. Educ:* Wirral County School for Girls, Harrow Weald County School. *Studied:* Harrow School of Art (1948-53), Hornsey College of Art (1953-54). *Exhib:* Young Contemporaries, R.O.I., N.E.A.C., R.I., P.S., R.W.A., R.S.M.A., F.C.A., Pastellistes de France; numerous solo shows, Mystic Maritime Museum, U.S.A., Mercer Art Gallery, Southampton City Art Gallery. *Works in collections:* Maritime Museum, Falmouth(R.S.M.A. Coll.). *Commissions:* for international companies. *Publications:* 'Imaginative Still Life', 'Painting and Drawing Boats', 'Painting in Mixed Media', 'Learn to Paint Gouache', 'Learn to Paint Mixed Media', 'The Artist's Drawing Book', 'Learn to Draw Boats', 'Moira Huntly's Sketchbook Secrets'. *Official Purchasers:* Hampshire County Council, National Library of Wales. *Clubs:* The Arts Club, London. *Signs work:* "Moira Huntly." *Address:* "Alpha", Collin Cl., Willersey, Broadway, Worcs. WR12 7PP.

HURDLE, Robert Henry, painter; senior lecturer until 1981, Faculty of Fine Art, Bristol Polytechnic. *b:* London, 9 Aug 1918. *s of:* Arthur E. Hurdle and Flora Bensted. two *s.* one *d. Studied:* Richmond School of Art (1935-37), Camberwell School of Arts and Crafts (1946-48) under Coldstream. *Exhib:* one-man shows, University College of Swansea (1973); Albany Gallery, Cardiff (1974); New Ashgate Gallery, Farnham (1977); City A.G., Bristol (1977); Pao Sui Loong Galleries, Hong Kong Arts Centre (1978); King St. Gallery, Bristol (1982); Farnham Maltings (1983); Pelter/Sands Gallery (1988); Cleveland Bridge Gallery, Bath (1989); Retrospective exhbn. R.W.A. (1995), Robert Hurdle at 80, R.W.A. (1998), Drawings Past and Present, Rood Gallery (2002), Meetings with Trees, RWA (2003). *Works in collections:* University College, Swansea; RWA; City Art Gallery, Bristol; Bath University; Hong Kong Arts Centre; Wessex Collection, Longleat and various private collections. *Publications:* 20th Century Painters & Sculptors, Antique Collectors Club. *Signs work:* signature or seal. *Address:* 14 Oxford St., Kingsdown, Bristol BS2 8HH.

HURFORD, John Roger, *Medium:* oil, watercolour, drawing, acrylics. *b:* Chulmleigh, Devon, 8 Jun 1948. *Studied:* self-taught. *Exhib:* RCA; Plough, Torrington, Devon; Gallerie Michel-Ange, Brest, France; Burton Gallery, Bideford, Devon; Monks Withecombe, Chagford, Devon. *Commissions:* portraits (local people), theatre design (Mad and her Dad). *Publications:* illustrations in over 40 books. *Works Reproduced:* posters (1967-76); books (1974-2000). *Signs work:* 'John Hurford'. *Address:* Wixon Cottage, Chulmleigh, Devon EX18 7DS.

HURN, J. Bruce, ATD (1946), FRSA (1966), PPRBSA (President 1973); painter/designer in oils, acrylic, gouache; teacher, lecturer, examiner and HMI

(Art and Design). *b:* Spalding, 18 May 1926. *s of:* H.D.T. Hurn. *m:* June. one *s.* three *d. Educ:* King Edward's, Camp Hill, B'ham. *Studied:* Birmingham College of Art (1942-46). *Exhib:* numerous exbhns. including one-man: Universities of B'ham, Aston, Keele, Oxford, Leicester, Kent, Brunel; Compendium Gallery, B'ham and London; group shows: municipal art galleries, RBSA, RA. *Works in collections:* private, colleges, universities, schools, industrial collections in UK, private collections in USA, Europe, Australia, NZ.; permanent collections: RBSA. *Commissions:* T.C. Kemp Memorial Crucifixion, B'ham. *Publications:* Practical Biology (Dodds and Hurn). *Address:* Hawks Wing Harkwood Lane Chislehurst, Kent. BR7 5PW.

HURST, Stephanie, Dip. in illustration (1974), R.A. Dip. of advanced studies - B.A. equivalent (1984); painter in oil on board with gesso ground. *b:* Wimborne, Dorset, 3 Jul 1952. *d of:* James Hurst, Chartered architect (retd.). *Educ:* Convent of the Sacred Heart, Weymouth. *Studied:* Bournemouth and Poole College of Art (1970-71), Hornsey College of Art (1971-74), Byam Shaw School of Painting and Drawing (1976-77), R.A. Schools (1981-84). *Exhib:* R.A., Royal Festival Hall, Spirit of London Competition (awarded prize), South Bank Show, Camden Arts Centre - Druce Competition (awarded prize), Bath Contemporary Arts Fair, Elgin Fine Art, Bath, Jonathan Poole Gallery, London. *Signs work:* "S. Hurst" on back of painting. *Address:* 3 King's Ave., Muswell Hill, London N10 1PA.

HUSON, Cedric Nigel, Dip.A.D. Painting/Printmaking (1973), R.A. Schools Post. Grad. Cert. (1978). *Medium:* painting. *b:* Salop, 1 Jun 1951. *s of:* Eric & Frances Huson. *m:* Kitta Potgieter. *Educ:* Marlborough Grammar School, Wilts. *Studied:* Salisbury School of Art (1967-68), Swindon School of Art (1968-69), Winchester School of Art (1970-73), Royal Academy Schools (1975-78). *Exhib:* group shows: Piccadilly Gallery (1987-99), Lamont Gallery (1994-95), RA Summer Exhbn. (1988-94, 1997-98, 2000, 2002, 2004-07), Hunting Group Open (1989, 1990, 1994), Cleveland Bridge Gallery, Bath (1990), The London Group Open (1990, 1992, 1993), The Discerning Eye (1992, 1995, 1999, 2000, 2001), National Trust Centenary Exhbn. (1995), Everard Read Gallery, Cape Town (1997), Southwark Festival (1997), Everard Read Gallery, Johannesburg (1998), Chambers Gallery (2006), Medici Gallery (2006, 2007). *Works in collections:* Southampton City Art Gallery. *Clubs:* Royal Academy Schools, Alumni Association. *Signs work:* "Cedric Huson." *Address:* Sunnyside Croft, Overbrae, Fishrie, Nr. Turriff, Aberdeenshire AB53 5SL. *Email:* kedric@firefly.demon.co.uk

HUSSEY, Audrey, graduate in Fine Art and Theatre Design, West Country Award (1972); F.P.S. (2000), N.A.P.A. (2001); painter in acrylic, theatre design, scenic painting. *Medium:* oil, pastel, mixed media. *b:* Kent, 24 Nov., 1945. *m:* Noel Geaney. *Educ:* Maidstone Grammar School, Kent. *Studied:* St. Martin's and Chelsea, London, under Michael Browne, and Alan Cooper (1968-1972). *Represented by:* London Art. *Exhib:* various galleries in London and elsewhere. *Works in collections:* private. *Commissions:* nationally and internationally.

Recreations: interest in theosophy encompassing metaphysics, cosmology, classical music. *Signs work:* "Hussey." *Address:* 25 Brent Lea, Brentford, Middx. TW8 8JD. *Email:* healingart@msn.com

HUSSEY, John Denis, FRBS, RWA; sculptor of assemblages; principal lecturer, Director of Studies, Fine Art Dept., Bristol Polytechnic (retd. 1983). *Medium:* steel, mixed media, also paints in oils & acrylics. *b:* Slough, 26 Apr 1928. *s of:* F.W and Louisa Hussey. *m:* Katherine Hiller. two *s. Educ:* Slough Grammar School. *Studied:* Goldsmiths' College (1946-49); research Diploma in Fine Art/Sculpture at Bristol Polytechnic (1969-70). *Exhib:* RA, RWA, RBS. *Works in collections:* Tallboys, RWA. *Recreations:* golf. *Signs work:* "J. Hussey." *Address:* Sanderling, 21 Colne View, Point Clear, St. Osyth, Essex CO16 8LA.

HUSTON, John I., History's Most Significant Artist; in oil, egg tempera, pastels, sculptures, landscapes, figures, abstracts, upon canvas, wood, masonite; writer; scientist; artist; planner; Finance Innovate: Supreme Super Soul of the Universe and yourself are ready for the coming millennium(s) with the perfect calendar. *b:* Saltillo, Penn., USA, 22 Jan 1915. *s of:* Harry E. Huston, merchant & Mary Huston. three *s.* one *d. Educ:* Juniata College and University Special Studies; completely self-trained in art via Commercial Art, Industrial Art, Cinema Art, Fine Art. Work in private collection. *Publications:* Choosing You In The Millennium; The Secret of the Millennium, ready for publisher. *Misc:* listed in International Directory of Arts. *Address:* 1217 L Community Drive, Harrisburg, PA 17103, USA.

HUTCHESON, Tom, D.A. (1949) R.G.I.; artist in mixed media; principal art lecturer;. *b:* Uddingston, Lanarkshire, 13 Nov., 1922. *m:* Mary McKay. *Educ:* Motherwell. *Studied:* Glasgow School of Art (1941-49) under Hugh Adam Crawford, R.S.A., David Donaldson, R.S.A. *Exhib:* R.S.A., G.I., R.S.W., Moores; three one-man shows, Arts Council. *Works in collections:* H.M. the Queen, H.R.H. Prince Philip, Arts Council, Liverpool and Glasgow Universities, Scottish Educ. Authorities, Leeds Local Authority, Paisley A.G., Glasgow A.G., Kelvingrove, British Embassy Collection. *Clubs:* Art, Glasgow. *Signs work:* "Tom Hutcheson." *Address:* 73 Woodend Dr., Glasgow G13.

HUXLEY, Jonathan, BA (Hons); RA (Dip); Hunting Art Prizes. *Medium:* oil, watercolour, drawing, ultraviolet paint. *b:* Woking, 10 Nov 1965. *s of:* John and Patricia Huxley. *m:* Estelle Huxley. one *s. Studied:* Trent Polytechnic, Nottingham (1987-89); RA (1989-92). *Represented by:* Crane Kalman Gallery, London; Galerie Ariel Sibony, Paris. *Exhib:* Art Basil, Miami; RA Summer Exhbn; 'Sense and Sensuality' RCA; Nagoya City Art Museum, Japan; Hayashibara Museum of Art, Okayama, Japan; ICA London; Crane Kalman Gallery; FIAC Paris; Galerie Ariel Sibony, Paris. *Works in collections:* UBS Bank, Goldman Sax, Arthur Anderson, Lord Foster of Thames Bank, Swiss Embassy Washington DC, EMI, Channel 4, Met Bar London. *Commissions:* Met Bar London; UNESCO Publications, Paris; Tunnel Club, New York (for Grace

Jones' birthday party). *Publications:* The Guardian, The independent, Channel 4 website (The Ideas Factory). *Works Reproduced:* various. *Principal Works:* Saturday Night Special, Met Bar London; Red Route, collection of Norman Foster. *Clubs:* Reynolds Club (RA). *Signs work:* 'Huxley'. *Address:* 96 Raven's Way, London SE12 8HA. *Email:* jonathan@jonathanhuxley.co.uk *Website:* www.jonathanhuxley.co.uk

HUXLEY, Paul, R.A., Cert.R.A.S. (1960), Harkness Fellow (1965-67); painter in acrylic, oil, printmaking; Professor Emeritus, Royal College of Art;. *b:* London, 12 May, 1938. *m:* Susie Allen. two *s. Studied:* Harrow School of Art (1951-56, Edward Middleditch), R.A. Schools (1956-60, Peter Greenham). *Exhib:* numerous solo exhibitions, represented Britain internationally in Biennales and many major group shows. *Works in collections:* Tate Gallery, V. & A., plus various museums in the U.K., Europe, U.S.A. and Australia. *Publications:* Exhibition Road - Painters at the Royal College of Art. *Clubs:* Chelsea Arts. *Signs work:* "Paul Huxley" in bottom margin of prints and some works on paper, verso on other works on paper and all canvases. *Address:* 2 Dalling Rd., London W6 0JB. *Email:* paulhuxley@aol.com

HYATT, Derek James, A.R.C.A.; painter/writer;. *b:* Ilkley, Wharfedale, Yorkshire, 21 Feb 1931. *m:* Rosomond. one *d. Educ:* Ilkley Grammar School. *Studied:* Leeds College of Art (1948-52), Royal College of Art (1954-58). *Exhib:* London one-man shows include Austin Desmond/Gillian Jason Gallery (1987, 1989), Waddington Galleries (1974, 1977), New Art Centre (1960, 1961, 1963, 1966); group shows include John Moores, Cincinnati Bienniale, Arts Council Travelling Exhbns., and two Critics Choice exhbns., Meetings on the Moor (70 paintings), retrospective Bradford Art Gallery (Spring 2001). *Works in collections:* Museum of Modern Art, New York, Contemporary Art Soc., Carlisle, Hull, Bradford, Sheffield and Bootle Art Galleries and Nuffield Foundation. *Publications:* Edited ARK (1958); articles Modern Painters (1987-2002); Alphabet Stone (1997); "Stone Fires Liquid Clouds" The Shamaric Art of Derek Hyatt (2001). *Misc:* 1. Video "Circles on the Dark Rock" Dean Clough Gallery, Halifax(1995). 2. Video "Meetings on the Moor" 70 paintings (1hr 20mins) Bradford 2001. *Address:* Rectory Farm House, Collingham, Wetherby LS22 5AS.

HYMAN, Timothy, National Portrait Gallery Travel Award 2007. *Medium:* painter in oil, pastel and drawing, writer. *b:* Hove, 17 Apr 1946. *m:* Judith Ravenscroft. *Educ:* Charterhouse. *Studied:* Slade (1963-67). *Exhib:* Narrative Paintings (I.C.A., Arnolfini, 1979), Blond Fine Art (1981, 1983, 1985), Austin Desmond (1990), Flowers East (1994), Austin Desmond (2000, 2003, 2006). *Works in collections:* Arts Council, British Museum, Museum of London, Contemporary Art Soc., Government Art Collection, Los Angeles County Museum, etc. *Commissions:* Lincoln Cathedral, Sandown Racecourse. *Publications:* Bonnard (Thames & Hudson, 1998); Bhupen Khakhar; Carnivalesque; Stanley Spencer (Tate 2001); Sienese Painting (Thames & Hudson, 2003); British Vision (Ghent, 2007). *Recreations:* Italian Cinema, The

Novels of John Cowper Powys, Travel. *Signs work:* "T.H." *Address:* 62
Myddelton Sq., London EC1R 1XX.

I

I'ANSON, Charles, F.R.B.S. (1967), F.R.S.A. (1956), R.B.S.A. (1966), M.Sc.
(1980), O.L.J. (1981); sculptor in steel;. *b:* Birmingham, 1924. *Studied:*
Birmingham College of Art. *Exhib:* F.P.S., London Group, Commonwealth Inst.,
New Vision and Alwyn Galleries, London; "Sculpture 1971", York, etc. *Works in
collections:* Cardiff Civic Centre, Midlands Art Centre, Bristol and Leeds
Universities, Trinity and All Saint's College, Leeds; Birmingham, Bradford and
Wakefield A.G.'s, R.D.C., Walmley, Bristol, Minard Castle, Inveraray, Argyll;
R.A. Gamecock Barracks, Nuneaton; Dore School, Sheffield; Windmill Hill
School, Stourport; St. Paul's Church, Doncaster; St. Winefrid's Church, Wibsey,
Bradford, etc. *Signs work:* "I'ANSON." *Address:* April Cottage, 9 Mount Pleasant
Rd., Morcott, Oakham, Rutland LE15 9DP.

I'ANSON, Mari, artist and tutor. *Medium:* watercolour, oil, acrylic, paintings
and illustration. *b:* London, 5 Sep 1932. one *s.* one *d. Studied:* School of Science
and Art, Weston-super-Mare (1947-1950), (now Technical College); St. Martins
and Chelsea, London. *Exhib:* over 30 solo shows - St. John's, Smith Sq.,
Lauderdale House N6, Burgh House NW3, Foyles Art Gallery, Bridgwater Art
Centre, Bull Gallery, Barnet; mixed shows - Central Hall, Westminster; Swiss
Cottage Library NW3; Alexandra Palace; Lucy-Kemp-Welch Memorial Gallery,
Bushy; Bangkok Patana School, Thailand; Tavistock Centre; Chorak Pattisserie,
N2; artsdepot, North Finchley N12; St.George's Hospital, Tooting; The Picture
Factory, N12; St.Miguel de Allende, Mexico. *Works in collections:* world-wide.
Commissions: Octavia Hill Museum, Wisbech, London Borough of Barnet, The
Finchley Society, Isgara Restaurant N3; commissions for house portraits and
children's portraits. *Publications:* Artists and Illustrators, Daler Rowney Art
News, The Encyclopedia of Drawing Techniques. *Clubs:* East Finchley Open
Group of Artists; Hesketh Hubbard Art Society. *Misc:* Artist in residence at
Bangkok Patana International School four times (1994-1997), Deansbrook Junior
School, Mill Hill (1999 - 2001). *Signs work:* "Mari I'Anson" or "Mari." *Address:*
The Studio, 5 The Grove, Finchley, London N3 1QN. *Email:*
mari.artist@uwclub.net *Website:* www.mari-artist.co.uk

IBBOTSON, Pam, BA (Hons) Fine Art; PGCE; Manchester Academy of Fine
Art (MAFA) Major Award (1988), Runner Up Award (1990); National
Westminster Bank Award (1991). *Medium:* oil, watercolour, drawing. *b:*
Manchester, 26 Sep 1950. *d of:* Stanley Edmondson. one *d. Educ:* Marple Hall
Grammar School. *Studied:* Sheffield Hallam University (1987); School of Art,
Psalter Lane. *Exhib:* RA Summer Exhbn; MAFA; City Art Gallery, Manchester;
Quaker Gallery, London; Bonhams, London (Painting Today); Tatton Park (Prize
Winning Artists); Stockport Art Gallery; Mappin Art Gallery, Sheffield. *Works in
collections:* private collections. *Misc:* mem. MAFA (elected 1988). *Signs work:*

'Pam Ibbotson'. *Address:* 5 Mill Pond Avenue, New Mills, High Peak, Derbyshire SK22 4HL. *Email:* pam@ibbotson75.freeserve.co.uk *Website:* www.pamibbotson.co.uk

IBRAM, Peter B., artist in oil and water-colour; composer of jazz and classical music; Associate, Nottingham Society of Artists. *b:* Manchester, 15 Dec 1937. one *d. Educ:* Burnage Grammar School. *Exhib:* mixed shows: Chenil Gallery, London; Leslie Jones Gallery,St. Albans; Stockport A.G., Oldham A.G., Buxton A.G., Ross Gallery, Manchester; Salon des Independentes-Paris; Museum of Modern Art Wales; Nottingham; one-man show: Portico Gallery Manchester. *Works in collections:* private: America, France, Spain, Italy, Germany, Portugal, Switzerland; public: Portico Gallery, Art in Hospital, Wales, GDS Rugby, GDS Milton Keynes. *Commissions:* Portico Library, Art Gallery, Manchester; Paintings in Hospitals, Wales; GDS Rugby, GDS Milton Keynes. *Publications:* Who's Who in Art. *Clubs:* Nottingham Society of Artists. *Signs work:* "Norman Benjamin." *Address:* c/o 24 Prestwich Hills, Prestwich, Manchester M25 9PY. *Email:* pibram@hotmail.com

INCHBALD, Michael, FCSD; Architectural and Interior Designer; twice married. one *s.* one *d. Studied:* AA. *Commissions:* include: 1st Class Lounge "Queen's Room" and Library on Q.E.2, and other Liners; Ballroom, banquet areas and suites at Berkeley Hotel, Post House, Heathrow, Claridges' Penthouse, Savoy's River Room and Lincoln Room, Crown Commissioners' H.Q., Carlton House Terr., Banks of America and Trust Hanover, Player's and Plessey's H.Q. Offices, Justerini and Brooks, Boardroom etc. for Imperial Group, Law Society's Lady's Annexe, Dunhill's, Jermyn Street and Worldwide; Residential: Duc de la Rochefoucauld, Duke of St. Albans, Marquess of Ailesbury, Earls of Dartmouth and St. Aldwyn, Countess of Lonsdale, etc. *Address:* Stanley House, 10 Milner St., London SW3 2PU.

IND, John William Charles, F.R.S.A.; painter in oil, water-colour, sculptor in wood, designer, illustrator. *b:* London, 8 Oct 1927. *s of:* William Ind, engineer. *m:* Greta Bambridge-Butler. two *s. Educ:* London and Cambridge. *Studied:* in London and Oslo. *Exhib:* Royal Exchange, Madden Gallery, Barle Gallery, Harrods Gallery; one-man shows: Halford House, Newton Gallery, Kensington Ct. Gdns. *Works in collections:* Harris Bank, Barclays Bank, Hays Allan, Ind Coope, Texaco London, Taylor Hall; private collections in France, Germany, U.S.A., Britain, N.Z., Scandinavia. *Commissions:* 1994, painting commissioned for 105th Regiment, Royal Artillery. *Works Reproduced:* Starburst; Revolution; Buckland; St. David's: The Lock, Waltham Abbey; Early Morning at White Sands. *Clubs:* Somerset Society of Artists. *Signs work:* "Ind." *Address:* Atelier, Aller, Somerset, TA10 0QN.

INGLIS, Catherine Elizabeth, SWA; Founder Mem. The East Yorkshire Pastel Society; York Art Society; Professional Assoc., Promoter and Demonstrator for The Society of All Artists; Founder Member, East Riding

Artists (ERA). *Medium:* soft pastel. *b:* Yorkshire, 18 Jul 1952. *d of:* Jane & Kenneth Ainsworth. *m:* Ron Inglis. two *d. Studied:* student of Kenneth Jackson ARCA, and of Jane Parkin SWA, SEA. *Exhib:* SWA; London, Harrogate, Hull, and solo exhbns. *Works Reproduced:* limited edition Gicleè prints. *Signs work:* 'Catherine E.Inglis'. *Address:* The Old Granary, Skirpenbeck, York YO41 1HF. *Email:* cath-inglis@btinternet.co.uk *Website:* www.cath-inglis.btinternet.co.uk

INGLIS, John, P.R.S.W. (2006), R.S.W. (1984), F.S.A. (Scot.) (1983), D.A. (1974), Post. Grad. (1975), Travelling scholar (1976); painter in water-colour, oil, lecturer. *b:* Glasgow, 27 Jul 1953. *s of:* Thomas Inglis. *m:* Heather Binnie. two *s.* two *d. Educ:* Hillhead High School, Glasgow. *Studied:* Gray's School of Art, Aberdeen (1970-75, William Littlejohn, Frances Walker, Alexander Fraser). *Exhib:* R.S.A., R.S.W., R.G.I.F.A., S.S.A., Compass Gallery, Glasgow, Edinburgh, Leeds, Venice, Rome, Canada, Regensberg, Illinois, U.S.A., London. *Works in collections:* Aberdeen A.G., University of Aberdeen, Argyll and Bute Educ. Authority, Scottish Television, Inst. for Cancer Research, Aberdeen Hospitals Collection, Clackmannan District Council Collection, Royal Scottish Academy, Clackmannan College, Scottish Arts Club, Heartland College, Ill., McLean County Arts Centre, Bloomington, Ill., Scottish Arts Club, Edinburgh. *Signs work:* "John Inglis" usually on back. *Address:* 84 Burnhead Rd., Larbert, Stirlingshire FK5 4BD.

INSALL, Donald W., C.B.E., LL.D, FSA, RWA, FRIBA, FRTPI, SPDip(Hons); architect; Founder-Director, Donald Insall Assocs. (Architects and Planning Consultants), London SW1; Founder-Commissioner, English Heritage, Visiting Prof. University of Leuven, service as Consultant to City of Chester in National Pilot City Conservation Programme; Architects for post-fire Restoration of Windsor Castle; awarded the Medal of Honour (2000) by Europa Nostra; Plowden Medallist; Royal Warrant Holders Association; Harley J.McKee Award, Association for Preservation Technology International. *Medium:* architecture, watercolour. *b:* Clifton, Bristol, 7 Feb 1926. *s of:* William R Insall. *m:* Amy Elizabeth. two *s.* one *d. Studied:* RWA School of Architecture, Royal Academy School of Architecture, School of Planning and Research for Regional Development; and SPAB Lethaby Scholar. *Exhib:* RA, RWA, RIBA. *Commissions:* Council of Europe and European Commission Committees. *Publications:* The Care of Old Buildings Today (Architectural Press); 'Architectural Conservation' Encyclopaedia Britannica; Conservation in Action. *Principal Works:* post-fire restoration of Windsor Castle. *Recreations:* visiting, photographing, drawing and enjoying places. *Clubs:* Athenaeum. *Misc:* Consultancy has received over 100 Conservation and Craftmanship Awards/Commendations. *Signs work:* 'DWI' (with dots beneath letters), or 'Donald W Insall'. *Address:* 73 Kew Green, Richmond, Surrey TW9 3AH.

INSHAW, David, *Medium:* painter. *b:* Wednesfield, Staffordshire, 21 Mar 1943. *Studied:* Beckenham School of Art (1959-63); Royal Academy Schools (1963-66); French Government scholarship (1964); taught at West of England

College of Art (1966-75), Fellow Commoner in Creative Art, Trinity College Cambridge (1975-77). *Represented by:* Agnew's, Old Bond Street, London. *Exhib:* one-man shows: Arnolfini Gallery, Bristol (1969), Waddington Galleries (1975,'80, '84,'89), Wren Library, Trinity College Cambridge (1976, '77) Theo Waddington Fine Art (1995, '98), Royal Pavilion Brighton (1978), Nishimura Gallery Tokyo (1987), Annandale Gallery Sydney (1996), RWA Bristol (2003), Agnews (2005). *Works in collections:* including: Arts Council, British Council, City of Bristol Museum and Art Gallery, Dept of Environment, Sunderland Art Gallery, Devizes Museum, Tate Britain London. *Clubs:* Chelsea Arts Club. *Misc:* formed the Brotherhood of Ruralists with six other artists (1975). *Signs work:* David Inshaw. *Address:* 23 High Street, Devizes, Wilts, SN10 1AT. *Email:* davidinshaw@hotmail.com

INSOLL, Christopher, BA (Hons) Fine Art. *Medium:* oil, watercolour, drawing. *b:* London, 28 Jun 1956. *s of:* Deb and Garth Insoll. *m:* Andrea. one *s.* one *d. Educ:* Haileybury, Herts. *Studied:* Chelsea Camberwell (exchange); Falmouth School of Art. *Represented by:* New Gallery (Cornwall). *Exhib:* RA; RWA; Paris Salon; Newlyn Art Gallery; Truro City Museum; Penwith Soc.Arts; Falmouth Art Gallery. *Works in collections:* Falmouth Art Gallery. *Commissions:* various private. *Publications:* 'Paintings about Painting, Chris Insoll' by Sarah Drury; Portscatho, Portrait of a Cornish Art Colony, by Chris Insoll (pub. Halsgrove, 2006). *Works Reproduced:* widely. *Recreations:* wine, walking. *Clubs:* Chelsea Arts Club. *Signs work:* 'INSOLL' (oils); 'Chris Insoll' (drawings). *Address:* The New Gallery, Portscatho, Cornwall TR2 5HW.

INWARD, Jean Mary, M.B.B.S., M.R.C. Psych., A.U.A.; painter in oil and acrylic; psychiatrist (retired). *b:* Bromley, Kent, 9 Sep 1939. two *s.* one *d. Educ:* Guy's Hospital, London University. *Studied:* evening classes. *Exhib:* U.A, S.W.A. *Works in collections:* private. *Commissions:* private. *Clubs:* Local. *Signs work:* "Jeanie." *Address:* 5 Birchdale, Gerrards Cross, Bucks. SL9 7JA.

IRENE: see FRÖHLICH-WIENER, Irene,

IRVIN, Albert, R.A., Hon. R.W.A.; painter, printmaker; Mem. London Group. *b:* London, 21 Aug 1922. *s of:* A. H. J. Irvin. *m:* Beatrice Nicolson. two *d. Educ:* Holloway County. *Studied:* Northampton and Goldsmiths College School of Art; taught at Goldsmiths 1962-83; Honorary Fellow Goldsmiths 2002. *Exhib:* one-man shows at Gimpel Fils, London, and at galleries throughout Europe and internationally. *Works in collections:* include: Tate Gallery; Arts Council; British Council; other British and international public collections. *Commissions:* Homerton Hospital, Hackney (1987), Chelsea and Westminster Hospital (1995). *Publications:* Albert Irvin Life to Painting by Paul Moorhouse (Lund Humphries, 1998). *Clubs:* Chelsea Arts. *Address:* c/o Gimpel Fils, 30 Davies St., London W1Y 1LG.

IRVIN, Magnus, Dip.F.A. (1973), R.E. (1993); artist in woodcuts, short animated films, etching, mixed media, shoes made from bananas and ectoplasm

sculptures; founder member of London Institute of Pataphysics. *b:* London, 6 Dec 1952. one *s. Educ:* Creighton School, Muswell Hill. *Studied:* Hornsey Art College (1970), N.E.L.P. Walthamstow (1971-74). *Exhib:* Redfern Gallery, Whitechapel Open, Cleveland Drawing Biennale, Bradford Print Biennale, Ljubljana Print Biennale, Xylon Museum Germany, Art Cologne, Anthony Hancock Retrospective-Foundry Gallery, London E2 (2002). *Works in collections:* A.C.G.B., B.M., V. & A., International Centre of Graphic Art, Slovenia, Imperial War Museum. *Commissions:* Tunstall Western Bypass, Stoke on Trent - concrete aeroplanes to bypass environment. *Publications:* 'Bananas at War' and 'Chairs and Fleas' - Limited Edition Books, Daily Twit newspaper (for 25 yrs), 'Toilets and Cupboards of South America'. *Works Reproduced:* in Arts Review, Printmaking Today, Sight and Sound, Vertigo, Bizarre. *Clubs:* Tesco. *Signs work:* "M. Irvin." *Address:* City Studios, Alpha House, Tyssen Street, London E8 2ND. *Email:* magno@pig.abelgratis.com *Website:* www.magnusirvin.co.uk

IRWIN, Flavia, R.A.; artist in acrylic on canvas, mixed media on paper, tutor; Head of Decorative Arts Dept., City & Guilds of London Art School. *b:* London, 15 Dec 1916. *d of:* Clinton Irwin. *m:* Roger de Grey, K.C.V.O., P.P.R.A. two *s.* one *d. Educ:* Hawnes School, Ampthill. *Studied:* Chelsea School of Art (Graham Sutherland, Henry Moore, Robert Medley). *Exhib:* Zwemmers, London Group, R.A., Ansdell Gallery, Gallery 10 Grosvenor St., Phoenix Gallery, Curwen Gallery, Peoples Theatre, Newcastle, Arts Council Gallery, Bury St. Edmunds, Taranman Gallery, Royal Academy, Friends Room. *Works in collections:* Carlyle A.G., D.O.E., Chelsea & Westminster Hospital. *Commissions:* Daniel Galvin, George St., London. Dealers: Studio 3, 75 Leonard St., London EC2A 4QS. *Publications:* RA Magazine. *Signs work:* "Flavia Irwin" back of canvas, signed in pencil on drawings. *Address:* Camer Street, Meopham, Kent DA13 0XR.

IRWIN, Gwyther, painter: oil paint, water-colour and acrylics. *b:* Cornwall, 7 May 1931. *m:* Elizabeth. two *s.* one *d. Educ:* Bryanston. *Studied:* Central School of Art (1952-55). *Exhib:* Redfern Gallery, London; Gimpel Fils; New Art Centre. *Works in collections:* Tate Gallery, British Council, Arts Council, Contemporary Art Soc., Arts Council of N. Ireland, Calouste Gulbenkian, City Art Gallery, Bradford, Albright-Knox, Yale University, Peggy Guggenheim, Peter Stuyvesant, Government Art Collection. *Commissions:* Glaxo Group Research, Bas Relief 1965 British Petroleum. *Publications:* Edition 100 screen prints 'Super Structure' -3i Group. *Clubs:* Chelsea Arts. *Signs work:* "Gwyther Irwin." Studios in London and Cornwall. *Address:* 21 Hillbury Rd., London SW17.

ISITT, Samuel John, B.A., M.B.I.M., M.Inst.M., I.P.M.; painter in oil; retired educationist/actor. *b:* Newport, Mon., 9 Feb., 1935. *m:* Ann (divorced). three *s.* one *d. Educ:* Newport High School. *Studied:* Chelsea. *Exhib:* recent exhibs. at Mary Magdalene's Church, Oxford (1997), Oxford Playhouse (1998), Oxford University Club (2001). *Works in collections:* Drs. T. and K. Isitt, Vera Chock and others. *Commissions:* Shirley Knowlton, Hayley Bentley, Sue Walker and others.

Publications: Mary's Song, and The 7 Deadly Sins (both illustrated by Tania Holland). *Clubs:* Newport R.F.C., Royal Overseas League, Writers' Guild, U.K. Calligraphers, member of Equity (TV and Films). *Signs work:* "John Isitt." *Address:* 24 Jericho St., Oxford OX2 6BU. *Email:* taff.isitt@hot-toast.com

ISOGAI, Noboru, SBA; Certificate of Botanical Merit, SBA; Joyce Cuming Presentation Award, SBA; Silver Grenfel Medal, RHS; Judges Special Prize, Japan Seiko Art Association. *Medium:* watercolor. *b:* Gumma, Japan, 30 Jun 1935. one *s. Studied:* University of Tokyo (BA, Precision Mechanical Engineering). *Exhib:* SBA Annual Exhibition; Japan Seiko Association Exhibition. *Works in collections:* Shirley Sherwood Collection (2007). *Publications:* Arte Y Botanica SBA (Caja, Madrid); The Art of Botanical Painting (SBA, Collins); Flowers and Gardens (SBA Annual Exhbn catalogue); Hunt 11th International Exhibition of Botanical Art. *Signs work:* 'N.Isogaï'. *Address:* 6-14-1 Maebara-Higashi, Funabashi-Shi, Chiba-Ken, Japan 274-0824.

ISOM, Graham Michael, N.D.D. (1965), A.A.E.A., S.E.A.; equestrian artist;. *Medium:* oils. *b:* Kent, 5 Mar., 1945. married. one *s.* two *d. Educ:* Dartford. *Studied:* Ravensbourne College of Art (1961-65). *Represented by:* Felix Rosenstiel's Widow & Son Ltd. *Exhib:* worldwide. *Works in collections:* Kentucky Derby Museum of Racing, Churchill Downs, Louisville. *Commissions:* Household Cavalry (Officer's Mess); large calendar of 12 paintings, 12 Limited Edition equestrian beakers, several Christmas cards. *Publications:* Racing in Art/ John Fairley; numerous Limited Edition Prints. *Recreations:* garden design. *Address:* 5 Neville Pk., Baltonsborough, Som. BA6 8PY. *Email:* graham.isom@virgin.net *Website:* www.grahamisom.co.uk

IZZARD, Pamela, Dip.A.D.; artist in oil, acrylic and mixed media, etching, water-colour and pastel, and wood. *b:* London, 14 Nov 1926. *d of:* Charles G.Izzard. *m:* (1) K.Lucas. two s. one d. (decd). (2) Jack Millar (decd.) one s-son, two s-daughters. *Educ:* Old Palace School, Croydon, Torquay Grammar School. *Studied:* Beckenham, Bromley and Croydon Schools of Art. *Represented by:* Duncan Campbell. *Exhib:* R.A., London Group, N.E.A.C., R.B.A., Curwen Gallery, Linton Ct. Gallery, Ashgate Galleries and various provincial galleries. One-man shows, Ashgate Galleries, Abbot Hall, Kendal, Duncan Campbell Gallery, London, Chelsea & Westminster Hospital. Has taught in art schools in London and the provinces. *Works in collections:* local authorities and private collections in this country and abroad. *Works Reproduced:* RA Illustrated Catalogues, London Illustrated News. *Recreations:* gardening, films, reading, music. *Signs work:* "P. Izzard" or "Izzard" on back. *Address:* 10 Overhill Rd., Dulwich, London SE22 0PH.

J

JACK, Kenneth William David, M.B.E. (1982), AM(1987), RWS (1977), AWI(1955), ATD(1951), ATC(1949); Patron, Water-colour Soc. of Victoria;

Honorary Freeman of the Worshipful Company of Painter-Stainers (2003);landscape and architectural painter and printmaker in water-colour, acrylic, pastel and most drawing media, lithography, silk-screen. *b:* Melbourne, 5 Oct 1924. *s of:* Harold Jack (decd.), advertising artist for Victorian Railways. *m:* Betty Dyer. one *s.* two *d. Educ:* Melbourne High School. *Studied:* RMIT (John Rowell, Harold Freedman). *Exhib:* RWS twice annually at Bankside Gallery, Leicester Galleries (1975), Fine Art Soc. London, AWI; many one-man shows in Australia. *Works in collections:* National Galleries of all Australian capital cities; 500 works Australian War Memorial, Canberra. *Publications:* many folios and large reproductions of paintings; Kenneth Jack by L. Klepac; Kenneth Jack-World War II Paintings and Drawings (text, K.J.); Kenneth Jack by D. Dundas; The Flinders Ranges (paintings, text by K.J.); The Melbourne Book by C. Turnbull; Charm of Hobart by C. Turnbull; Queensland Paintings and Drawings, Kenneth Jack (Boolarong Press, Brisbane, 1994); Kenneth Jack - Printmaker (Beagle Press, Sydney, 1998). *Clubs:* W.S. of V. *Signs work:* "Kenneth Jack." *Address:* P.O.Box 1, 50 Linton Ct., Doreen 3754, Victoria, Australia.

JACKLIN, Bill, RA (1990), MA, RCA (1967), ARA (1989); artist in oil paintings, etching. *b:* London, 1 Jan 1943. *s of:* Harold Jacklin, M.C. *m:* (1) Lesley (divorced). (2) Janet Russo. one *d. Educ:* Walthamstow Technical College. *Studied:* Walthamstow School of Art (1962-64), RCA(1964-67, Carel Weight). *Exhib:* one-man shows, London: Nigel Greenwood (1970, 1971, 1975), Hester Van Royen Gallery (1973, 1977), Marlborough Fine Art (1980, 1983, 1988, 1992, 1995, 1997, 2000, 2002), Marlborough Gallery, N.Y. (1985, 1987, 1990, 1997, 1999, 2002, 2007), MoMA Oxford (1992), Museo de Pobo Galego, Santiago de Compostela, Spain (1993), University of Northumbria, Newcastle upon Tyne, England (1994), Hong Kong Arts Centre, Hong Kong (1995), l'Ecole de Londres Museé, Maillol, Paris (1998-99); numerous group shows. *Works in collections:* A.C.G.B., British Council, B.M., Government Arts Coll., Metropolitan Museum, NY, MoMA (NY), Museum Boymans-Van Beuningen, Rotterdam, Tampa Museum, Museum of NSW, V&A, Tate Gallery, Yale Centre for British Art. *Commissions:* by Bank of England for painting (Futures Market, London) (1988); Ivy Restaurant in London for painting (The Ivy) (1988); De Beers for Tapestry - "The Park" - 6ft. x 17ft. (1993); Metropolitan Washington Airport Authority for new terminal at Washington National Airport (1994-97); Design Architect, Cesar Pelli & Ass.; mural - "The Rink" - 6ft. x 25ft. (1997). Artist in Residence, British Council Hong Kong (1993-94). *Publications:* Monograph: Bill Jacklin by John Russell-Taylor (Phaidon Press, London, 1997); gallery catalogues and numerous articles and broadcasts. *Clubs:* Chelsea Arts. *Signs work:* "Jacklin." *Address:* Twin Beeches, 38 Catherine Street, Newport Rhode ISland 02840, USA. *Email:* billjacklin@mac.com *Website:* www.bjacklin.com

JACKSON, Ashley, F.R.S.A., U.A.; Yorkshire Arts and Entertainment Personality of the year (Yorkshire Awards 1996); Freedom of the City of London (2005); Vice President, Yorkshire Society; Yorkshire Lifetime Achievement award (Yorkshire Awards 2006); artist in water-colour; lecturer and demonstrator

in w/c throughout Britain, U.S.A., Valencia, Milan and Madrid. *b:* Penang, Malaysia, 22 Oct 1940. *s of:* Norman Valentine Jackson. *m:* Anne. two *d. Educ:* St. Joseph's, Singapore, Holyrood, Barnsley. *Studied:* Barnsley School of Art (1955-60). *Exhib:* R.I., R.B.A., R.W.S., Britain in Water-colour, U.A.; one-man shows: including Upper Grosvenor Gallery, Mall Galleries, Cartwright Hall, Bradford (1998), Armouries, Leeds (2000), etc. *Works in collections:* Royal Navy, Sir Harold Wilson, Sir Yehudi Menuhin, Lord Mason of Barnsley, Rt. Hon. Edward Heath, Yorkshire Bank, Yorkshire Television, N.C.B., Rt. Hon. John Major, Sir Bernard Ingham, President Bill Clinton, NATO HQ Brussels, Rt Hon Lord George Robertson of Port Ellen, The late L.S.Lowry. *Publications:* numerous including: autobiography "My Brush with Fortune" (Secker and Warburg, 1982); "Painting in the Open Air" (Harper Collins 1992); "A Brush with Ashley" (Boxtree 1993); "Painting in the British Isles" (Boxtree 1994);"Ashley Jackson's Yorkshire Moors – A Love Affair (Dalesman, 2000), "50 Golden Years with My Mistress and I" (Dalesman 2006) etc. Featured on Y.T.V. documentary – Some Days are Diamond; 2001 – New T.V. series "In a Different light'; 10 series of "A Brush with Ashley" Y.T.V. (1990-2001); own series on B.B.C., Channel 4, Y.T.V. Founder Mem. Yorkshire Watercolour Soc. *Address:* Ashley Jackson Galleries, 13-15 Huddersfield Rd., Holmfirth, Huddersfield HD9 2JR. *Email:* ashley@ashley-jackson.co.uk *Website:* www.ashley-jackson.co.uk

JACKSON, H. J., RE, SWE, NDD. *Medium:* full-time printmaker using lino. *b:* Kings Lynn, Norfolk, 7 Dec 1938. *s of:* D. S. B. Jackson. *m:* Maggie Jackson. one *d. Educ:* Melton Constable. *Studied:* Norwich School of Art (1954-58) printmaking under G. Wales, R.E. *Exhib:* Touring: Print Exhbns. America and United Kingdom; one-man and mixed group shows throughout East Anglia; work in Print Exhbns. in London, New York and Bombay; shows work in 'The Norwich Print Fair' each September; Hand Pressed-1953-2003, An Exhibition of Handmade Linocuts celebrating 50 Years of Printmaking, Grapevine Gallery, Norwich (2003). *Works in collections:* work selected by The Print Collector's Club (1967 and 1988); designed the 'John the Baptist Tapestry' for Worstead Church, Norfolk (1979); print to commemorate the Centenary of the Avenue Schools, Norwich (1994). *Commissions:* linocuts of 6 Norwich scenes for Hotal, Norwich (1972/3). *Publications:* work included in 'The Complete Manual of Relief Printmaking' (1988), 'Printmakers - The Directory' (2006). *Misc:* Work included in a number of public collections, and private collections worldwide; and various educational authorities. *Signs work:* "H. J. Jackson." *Address:* 12 Whitehall Rd., Norwich NR2 3EW.

JACKSON, Kurt Dominic, BA Oxon (1982); RWA. *Medium:* painter in all media, printmaker, etc. *b:* Dorset, 21 Sep 1961. *m:* Caroline. one *s.* two *d. Educ:* Francis Bacon Comprehensive, Herts. *Studied:* St.Peters College, Oxford University. *Represented by:* Messum Gallery, 8 Cork St, London WC1; Lemon St. Gallery, Truro, Cornwall. *Exhib:* numerous solo shows internationally both in public and commercial galleries since 1985. *Works in collections:* numerous municipal and private. *Publications:* 'Kurt Jackson, Cornwall and the Scillies'

(1999, White Lane Press ISBN 0953 137 015); 'The Cape' Kurt Jackson and Ronald Gaskell (2002, Truran ISBN 1 85022172 3); 'Sketchbook 2003-2004' (ISBN 1 85022190 1). *Clubs:* Newlyn Soc. of Artists; Royal West of England Academy. *Signs work:* 'Kurt J.'. *Address:* c/o Messums, 8 Cork St, London WC1. *Website:* www.kurtjackson.co.uk

JACKSON, Maz, B.A.(Hons.) (1976); artist in tempera, water-colour, drypoint, charcoal and line;. *b:* Norwich, 6 Aug., 1953. *m:* Paul Hill. two *s.* one *d. Educ:* Notre Dame High School, Norwich. *Studied:* Norwich School of Art (1972-76, Edward Middleditch). *Exhib:* dfn Gallery, Manhattan, New York; MONA Fund Raiser, Detroit; Royal Academy, London; Mall Galleries, London; Llewellyn Alexander Gallery, London; Art Connoisseur Gallery, London; Birmingham Art Centre, Hotbath Gallery, Bath, Stroud House Gallery, Stroud; Fermoy Art Centre, Kings Lynn; Primavera Gallery, Cambridge; Chimney Mill Gallery, West Stow; Thompson's Gallery, Aldeburgh, Assembly Rooms, Norwich; Gissing Hall Art Centre, Norfolk; Grapevine Gallery, Norwich. *Works in collections:* Permanent Public Archive Collection, Museum of New Art, Detroit. *Publications:* Painting World magazine. *Clubs:* S.G.F.A., E.W.A.C.C. Artworks. *Misc:* 1998 Artist in Residence at Bressingham Gardens. *Signs work:* "MAZ." *Address:* Friends House, Church Rd., East Harling, Norwich NR16 2NB. *Email:* mazjackson@aol.com

JACKSON, (Penelope) Mary, NEAC, RWS; Fine Art College Diploma. *Medium:* fine art. *b:* 15 Dec 1936. *d of:* Ronald and Dorothy Perkins. *m:* Tom Coates. one *s.* two *d. Educ:* Froebell School. Ibtock Place, Sherborne School for Girls. *Studied:* mature student Southampton and Winchester. *Exhib:* Alresford Gallery (two-person), New Grafton, Mall Galleries, Sinfield Gallery (solo), RA Summer Exhbn, Watermans (2 solo), WH Patterson, Royal West Academy, Cross Gate Gallery Kentucky (two person), Royal Watecolour Society, Bankside; Russell Gallery (solo). *Works in collections:* Lord Weymouth (Bath), Lady Getty, permanent collection 2nd Battalion REME, Garsington Opera, TH Gunnersen, Marbut Gunnersen, Melbourne, Australia. *Commissions:* worked as Artist in Residence for Glyndebourne Opera, Garsington Opera. REME commission in Fallingbostal, Germany, David Hunting family portrait. *Publications:* various articles in magazines and books, Artist Illustrator, Leisure Painter, Richard Pikesley Oils Workshop, Tom Coates Self Portraits. *Official Purchasers:* 2nd Battalion REME, Garsington Opera. *Works Reproduced:* cards by 'Rembrants Hat'. *Recreations:* theatre, opera, tennins, ski-ing, swimming. *Clubs:* Dover Street, Woodhay Tennis Club. *Address:* Bladon Studio, Hurstborne Tarrant, Hampshire. *Email:* bladonstudios@mac.com *Website:* www.newenglishartclub.co.uk

JACOB, Wendy, ARWS (2005); painter and printmaker in oil, water-colour, gouache, etching. *b:* Wigan, 1941. *m:* Robin Jacob. three *s. Educ:* North London Collegiate School. *Studied:* Hammersmith College of Art. *Exhib:* R.W.S., N.E.A.C. Open, Singer & Friedlander, R.A., Laing, Discerning Eye.

Publications: illustrated: English Bread and Yeast Cookery by Elizabeth David; North Atlantic Seafood by Alan Davidson. *Address:* 8 Ripplevale Grove, London N1 1HU.

JACOBSON, Ruth Taylor, A.M.G.P (2001), D.F.A.Lond. (1963); 1st prize, figure drawing at the Slade (1961); painter/printmaker/stained glass artist. *b:* London, 18 Aug 1941. *d of:* Dr. Henry Taylor, M.R.C.S., L.R.C.P. (decd.). *m:* U. Jacobson, F.R.C.S., M.R.C.O.G. two *s.* one *d. Studied:* Slade School of Fine Art (1959-63, Peter Brooker, Andrew Forge). *Exhib:* Agnews, Wildenstein, Royal Festival Hall, Barbican Centre; one-man shows: Camden Arts Centre, Poole Arts Centre, Zionist Confederation House, Jerusalem, Stained Glass Museum, Ely Cathedral. *Works in collections:* Panstwowe Muzeum Oswiecim Brzezinka, Poland, Yad Vashem Museum, Israel, Ben Uri Gallery, London. *Commissions:* portrait of H.M. Queen Elizabeth the Queen Mother for the Museums Association; window for new 'Stained Glass and Sacred Silver' Galleries, V&A. *Publications:* Journal of Stained Glass. *Clubs:* British Soc. of Master Glass Painters (elected Associate Member 2001). *Signs work:* "Ruth B. Jacobson." *Address:* 25 Sylvan Avenue, London NW7 2JH.

JACZYNSKA, Marysia, N.D.D. (1960), A.T.C. (1961); sculptor in wood and stone, models in clay;. *b:* Warsaw, Poland, 30 Sept., 1937. *d of:* Henryk Stanislaw Glass-Jankowski. *m:* Kazimierz Jaczynski. one *s.* one *d. Studied:* St. Martin's School of Art (1956-60, Anthony Caro), Hornsey College of Art (1960-61), Academie Julien, Paris (1963-64). *Exhib:* regularly in England; solo shows: Poland, France, England. *Works in collections:* private: England, France, Switzerland and Poland. corporate: London, England. *Commissions:* private commissions including portraits. *Publications:* see entry on axis website. *Works Reproduced:* (in bronze) 'Tears', 'Man & a Woman', 'Lullaby', 'Repose'. *Principal Works:* 'Tears', 'Silent Scream', 'Man & a Woman'. *Recreations:* reading and travelling. *Clubs:* C.A.S., A.P.A. *Signs work:* 'Marysia Jaczynska', 'M.Jaczynska'. *Address:* 27 Cascade Ave., London N10 3PT. *Email:* marysiajaczynska@hotmail.com

JAFAR, Abu, ARBS; acclaimed leading artist and Philosopher of the arts. *Medium:* visual artist and sculptor. *b:* Jhilna, Patuakhali, Bangladesh, 1968. *s of:* Muhammad Sekander Ali (decd) &Sufia Khatun. *Studied:* Institute of Fine Arts, University of Dhaka, Bangladesh (1984-89, Fine Arts, Painting & Drawing); Guildhall University, London (1989-90, Master Drawing of the human figure); Goldsmiths College, University of London (1991-92, Art and Art History); Open University (1997, Philosophy of Arts). *Exhib:* widely in the UK and abroad, including: Burghley Sculpture Garden, Stamford, Lincolnshire (2007); Asia House, London (2007); Aubourn Hall & Gardens, Lincoln (2007); Margaret Harvey Gallery, University of Hertfordshire (2006); Brick Lane Gallery, London (2006); The Brownston Gallery, Modbury, Devon (2006); Designers Week, Leeds (2006); The Sir Harold Hillier Gardens, Romsey (2006); Artshed, Herts. (2005); New London Glass, London (2005); McDowell Modern Art, London (2001);

Trafalgar Square, London (2002); The Whitechapel Open (1998); The Changing Room Gallery, London (1995); Brockhall Village, Lancashire (1996); The Concourse Gallery, Barbican Centre, London (1993); The British Council, Dhaka Bangladesh (1990), and many more. *Address:* Explosion Arts International, 22 Blackwell Road, Kings Langley, WD4 8NF. *Email:* info@abujafar.com *Website:* www.abujafar.com

JAFFE, Harold, A.S.A. (1973), F.S.V.A. (1978); artist in acrylic and mixed media; interior designer and muralist, teacher and antiquarian; certified fine arts appraiser; President, Louis Comfort Tiffany Soc.; Past President, L.I. Chapter, American Society of Appraisers; Faculty, New York University, George Washington University;. *b:* New York City, 26 Mar 1922. *s of:* Selig Jaffe. *m:* Gisèle Jaffe. one *s. Educ:* Pratt Institute, Parsons School. *Studied:* Cape Ann, Gloucester under Maxwell Starr. *Works in collections:* Denton Greens Housing Development Dr. C. MacCormick, Mr. and Mrs. S. Berman, Dr. D. Bernstein, Mr. and Mrs. A. Adler. *Works Reproduced:* Interiors Magazine, Years Work. *Signs work:* "Harold." *Address:* 5 Devon Rd., Great Neck, New York 11023, U.S.A.

JAFFE, Ilona Lola Langdorf, artist in monotype (oil), tapestries;. *b:* Krakow, Poland. *d of:* Sydonia Klausner. *Studied:* P.E. Art College, S. Africa under Joan Wright. *Exhib:* solo shows: Orchid Fine Arts, Lymington, Swanage, Berlin, Johannesburg, Munich, Boston, Freising, Cape Town Eching, Sasolburg, Rustenburg, Antwerp, Van Eck Gallery; group shows: Johannesburg, Paris, London; chosen for 'Mandela's Day', Port Elisabeth, South Africa (2005), Metropolitan Art Museum (poster from painting in their collection). *Works in collections:* King George VI A.G. and Museum, Port Elizabeth, Pretoria A.G. and Museum, Pretoria, R.A.U. Johannesburg, Dom Gymnasium, Freising, Franz Mark Gymnasium, Markt Schwaben, Germany; also private collections and institutions. *Commissions:* Prof.Dr. Maximilliane Kriegsbaum, University Bochem, Kriegsbaum, present Dean of Hamburg University,Germany (2003); St.Mary's Church, Slough (2004). *Address:* Flat 3, 5 St. Winifred's Rd., Meyrick Pk., Bournemouth BH2 6NY. *Website:* www.todres.fsnet.co.uk

JAGO, Joan E., F.R.S.A. (1989-2005), F.F.P.S. (1992), Wilfred Sirrell Award (City of Westminster Arts Council) 1989, Dip. in Creative Textiles (1985); fibre artist/paper maker. *Medium:* handmade paper. *b:* Leeds, 22 Mar 1930. *d of:* Charles E.D. Burrell. *Educ:* Aireborough Grammar School, W.Yorks. *Studied:* London College of Furniture. *Exhib:* solo shows: The Media Centre, London (2003), Marks & Spencer plc H.Q. Bldg., London (1993); two and three-artist shows in London; Liverpool Biennale (2005), London Biennale (2006) and other group shows in London, Hong Kong and the U.S.A. *Works in collections:* Wilfred Sirrell Collection. *Works Reproduced:* in 'The Crafter's Complete Guide to Collage'q (Watson-Guptill Publications, New York, 1996). *Signs work:* "Joan Jago." *Address:* 606 Nelson House, Dolphin Sq., London SW1V 3NZ. *Email:* joanjago@ntlworld.com

JAIDINGER, Judith, Fellow of the Royal Society of Painter-Printmakers/ Society of Wood Engravers. *Medium:* wood engraving, watercolour. *b:* Chicago, Illinois, USA, 10 Apr 1941. *m:* Gerald Szesko. one *d. Educ:* School of the Art Institute of Chicago, BFA (1970). *Studied:* drawing, painting, printmaking. *Represented by:* Bankside Gallery, London. *Exhib:* Taipei Fine Arts Museum, Taiwan ROC (1987), San Diego Art Institute, CA (1992), University of Hawaii at Hilo (2000), Esther Allen Greer Museum of Fine Art, OH (1999), 'Wood Engraving Here and Now', Ashmolean Museum, Oxford (1995), Muskegon Museum of Art (solo exhbn.) Michigan (2005). *Works in collections:* Purdue University, West Lafayette, IN; Ashmolean Museum, Oxford; National Museum of American History, Smithsonian Institution; Portland Art Museum, Oregon; Springfield Art Museum, MO. *Commissions:* Face to Face, Penmaen; Busyhaus Publications (1985). *Publications:* 'Lancelot and the Lord of the Distant Isles' (pub. David R.Godine, 2006). *Official Purchasers:* The State Foundation on Culture and the Arts, Honolulu, HI; Illinois State Museum, Springfield, IL. *Works Reproduced:* End Grain Contemporary Wood Engraving in North America (Barbarian Press, 1994); An Engraver's Globe by Simon Brett (Primrose Hill Press, London 2002); Relief Printmaking by Ann Westley (A & C Black, 2001). *Signs work:* 'JAIDINGER'. *Address:* 6110 N Newburg Avenue, Chicago, Illinois 60631, USA. *Email:* jaidinger@sbcglobal.net

JAKOBER, Ben, sculptor in stone, iron, bronze; winner of Miro Foundation Prize (1993). *b:* Vienna, 31 Jul 1930. *s of:* Henry Jakober. *m:* Yannick Vu, with whom he now works and signs jointly. one *s. Educ:* Mill Hill School; La Sorbonne, Paris. *Exhib:* 1982: Fundación March, Palma; 1984: Palais des Beaux Arts, Brussels; Louisiana Museum, Humlebaek; Städtische Kunsthalle, Mannheim; Museum Moderner Kunst, Vienna; 1985: Recklinghausen Museum; 1986: XLII Biennale di Venezia; 1988: Olympiad of Art, Seoul; 1990: Jeune Sculpture, Paris; 1991: MVSEV, Palma; Musée d'Art Moderne, Pully (VD); 1992: EXPO 92, Seville; 1993: Arnolfini, Bristol; Museum Moderner Kunst Stiftung Ludwig Palais Liechtenstein, Vienna; "MEDIALE", Hamburg; XLV Biennale di Venezia; 1994: Fundació Pilar i Joan Miró a Mallorca, Palma de Mallorca; 1995: Salle delle Reali Poste, Gli Uffizi, Firenze; 1996: Istituto Italiano di Cultura, Paris; Galerie Pièce Unique, Paris; XXIII Bienal International de São Paulo, Brazil; 1998: "Disidentico" Palermo, Mücsarnok Budapest; 2001: Bienal of Valencia. *Works in collections:* Museo Nacional Centro de Arte Reina Sofía, Madrid; Musée d'Art Moderne, Brussels; Museum of Modern Art, Palais Liechtenstein, Vienna; Museum of Austrian Art of the XIX and XX Centuries, Vienna; Kunsthalle Bremen; Kunsthalle, Hamburg; Musée d'Art Moderne F.A.E., Pully (VD); Colombe d'Or, St Paul de Vence; Fattoria di Celle, Pistoia; E.P.A.D., Paris; Seoul Olympic Park; Fondation Vincent Van Gogh, Arles; Fundació Pilar i Joan Miró a Mallorca, Palma de Mallorca; Gabinetto Disegni e Stampe degli Uffizi, Firenze; Museum Beelden aan Zee, Scheveningen; Ludwig Museum Budapest; Museum Fine Arts Budapest. *Signs work:* "B.J." *Address:* 205 St

Ursula St., Valletta 06, Malta. *Email:* jakobervu@kemmunet.net.mt *Website:* www.jakobervu.com

JAMES, Andrew John, RP; Carroll Foundation Award. *Medium:* oil, visual arts. *b:* Reading, Berks, 6 Aug 1969. *s of:* Dennis James. *m:* Derly Eliana. *Educ:* Battle and Langton Primary School; Claverham Community College, Battle, E.Sussex. *Studied:* self taught. *Exhib:* NEAC; RBA; NPG; RP; solo show Mall Galleries (2003). *Works in collections:* 'People's Portraits' Girton College, Cambridge; Tunbridge Wells Museum and Art Gallery. *Commissions:* BBC TV, Rolf on Art: David Dickinson. *Misc:* twin brother of Paul Henry James, visual artist, New York, USA. *Signs work:* 'A.JAMES' with date. *Address:* 108 Auckland Road, Tunbridge Wells, Kent TN1 2HT. *Email:* andrewjamesrp@yahoo.co.uk

JAMES, Donald, BSc (Honours), MA (Art); Awards: Commonwealth of Massachusetts-PE, Australia-MIE; painter, designer; exhibits internationally;. *b:* New York, 1932. *s of:* Adolph. *Educ:* San Francisco Art Institute, California School of Fine Arts, Cocoran School of Art, University of California, University of New York, University of London. *Exhib:* San Fransisco, New York, Boston, London, Paris, Vienna, Rome, Sydney, Hong Kong. *Works in collections:* worldwide. *Commissions:* cultural portraits. *Publications:* contributions to Celare Artem. *Principal Works:* wall paintings for Chapel of St. Ursula. *Clubs:* Societies: Ars Ad Summum. *Signs work:* "Don Ald," earlier "James." *Address:* The Studio, 47 Chelsea Manor St., London SW3 5RZ.

JAMES, Kim, FRSA; MA(RCA), MSc, PhD, NDD, ATC; Consultant to the French National Inst. for training psychiatric personnel, Dijon, France; Director PSI International Ltd;. *b:* Wollaston, Northants, 31 July, 1928. *s of:* Christopher James. *m:* Carole McKenzie FRSA, PhD, BA. two *d. Educ:* Wellingborough Grammar School. *Studied:* Borough Polytechnic under David Bomberg and Tom Eckersley; Royal College of Art; Brunel University, School of Applied Biology; and Division of Cybernetics; Special research field psychology of perception. *Represented by:* Alexander von Moltke, Bourne Street, Pimlico, London. *Exhib:* RA, Scottish Arts Council; Middleheim Biennale, Antwerp. *Works in collections:* Peter Owen, London; Baron Hauleville, Belgium; Sir Charles Spooner; Lloyd Grossman; The Estorick Estate, London; Bank of Brussels, Lambert, Belgium. *Commissions:* staircase wall relief, St.Mathew, Bethnal Green London (1958-59); 'Mammoth' life-size sculpture, now at Nottingham Trent University (1963-65), church ceiling decoration. *Publications:* Writings include critical essays and reviews on current theories of Perception and Philosophy (Leonardo, vols. 8, 9, 10, 11, 13, 14). *Misc:* Gallery: Grosvenor Gallery, London. *Signs work:* "Kim James." *Address:* Hickmire, Wollaston, Northants NN29 7SL. *Email:* kim@psy.co.uk

JAMES, Nicholas Philip, ROI; BA Fine Art; MA History of Art; Slade Scholarship; Trevelyan Goodall Scholarship. *Medium:* oil painting. *b:* Bromley,

Kent, 13 Nov 1948. *s of:* Fritz & Janet Wegner. *m:* Sarah Anne. three *d. Studied:* UCL (1957-66); Slade School of Art. *Represented by:* The Turner Gallery, 88 Queen Street, Exeter, EX4 3RP. *Exhib:* The Wold Gallery, Glos.; Manor House Gallery, Chipping Norton; Beaulieu Fine Art, Hants; Courcoux & Courcoux, Hants; RBA, ROI, Whittington Fine Art, Henley; regularly at Turner Gallery, Exeter. *Works in collections:* private collections in UK,Europe & USA; prints in Tate archive (Curwen Gallery gift); CD Roms and publications, media collection of The British Library. *Commissions:* The Guinness Portrait (200th Anniversary, 1981); Inch Cape plc boardroom portrait; Gutman family portrait, Versa Manos and others. *Publications:* For AN Publications (1996) with Anna Douglas - Artists Stories; for CV Publications: interviews-artists; Small Histories; Studies of Western Art, Curators and Collections. *Works Reproduced:* Moorland Views, in 'Dartmoor Artists' by Brian Le Mesurier (Hallsgrove Publishers, 2003). *Principal Works:* The Square Mile; views of the City of London 1999-2004. *Recreations:* cycling. *Misc:* Proprietor of CV Publications. Born Nicholas Philip James Wegner: name changed by deed poll 2002 to Nicholas Philip James. *Signs work:* 'PHILIP JAMES'. *Address:* Albion House, 49 Park Road, Hampton Wick, Kingston-upon-Thames, Surrey KT1 4AS. *Email:* cvpub@ision.co.uk *Website:* www.philipjamestudio.ndo.co.uk

JAMES, Roderick Morris, NDD, ATD, DAE, MA; Travelling Scholarship, Rome; International Lighting Award for design of 'Manhattan Lamp' in stainless steel (2005). *Medium:* sculptor. *b:* Torquay, 1943. *m:* divorced. two *s.* one *d. Educ:* Gloucestershire College of Art. *Studied:* Birmingham University. *Represented by:* James Fine Art. *Exhib:* Rowley Fine Art, Priory Gallery, Callaghan Fine Art, Olympia Fine Art, Chelsea 20th Century Art, Simic Fine Art USA, Cheltenham Art Gallery. *Works in collections:* numerous collections in Britain, Europe, Japan and USA. *Publications:* biography of Sculpture and Design being compiled at present. *Works Reproduced:* paintings, sculpture and design. *Principal Works:* series on dance - ballet & figurative studies. *Recreations:* squash and tennis. *Misc:* Head of Art at Cheltenham Grammar School from 1969-1979. *Signs work:* 'Ric James'. *Address:* 1 Pitville Court, Albert Rd., Cheltenham, GL52 3JA. *Email:* ric@jamesfineart.co.uk *Website:* www.jamesfineart.co.uk

JAMES, Simon, M.A.(R.C.A.) (1989); artist in oil, charcoal and printmaking;. *b:* 22 Jan., 1965. *Educ:* Northampton School for Boys. *Studied:* R.A. Schools (1984-87), R.C.A. (1987-89). *Exhib:* R.A., N.E.A.C., Marks and Spencer Young Artist award (1992), prizewinner in the 10th Cleveland International Drawing Biennale (1991), numerous exhbns. in England, U.S.A., and Berlin. *Works in collections:* Lloyd's of London, Cleveland C.C., The Foreign Office. *Signs work:* "SIMON JAMES" or "S.J." *Address:* Houseboat Clifton, Blomfield Rd., London W9 2PB.

JAMESON, Kerry, BA (Hons). *Medium:* sculpture. *b:* London, 1 Nov 1969. *Studied:* Central St.Martin's College of Art and Design. *Represented by:* Medici

Gallery; Adrian Sassoon; Snyderman-Works, USA. *Exhib:* RA; V&A; SOFA, New York; Artform, Florida, USA; The Geffrye Museum, London. *Works in collections:* David Hockney, Ronnie Wood, Russell Crowe, Valentino, Lord Rothschild, Malcolm McDowell. *Publications:* 'Ceramics: Art and Perception'; The Guardian; The Times; The Independent. *Principal Works:* ceramic and bronze animal scultpure. *Signs work:* 'Kerry Jameson BA'. *Email:* info@kerryjameson.com

JAMESON, Norma Marion, R.B.A., R.O.I., N.D.D., A.T.D., Goldsmiths' Advanced Dip.; painter, lecturer. *Medium:* works in oils and ceramics. *b:* Burslem, 18 Jan 1933. *d of:* Frank Bertram Salt. *m:* Kenneth Ambrose Jameson (decd.). *Educ:* Thistley Hough Grammar School, Stoke-on-Trent. *Studied:* Bath Academy of Art (1951-55); Liverpool University (1955-56); Goldsmiths' College (1978). *Exhib:* R.A.; various one-man shows in London and the South East. Mem. Royal Society of British Artists and The Royal Inst. of Oil Painters, Member Kent Potters Association. *Works in collections:* private in the U.K. and abroad. *Publications:* articles on drawing for "Canvas" and "Leisure Painter", "Batik for Beginners" – Studio Vista. *Works Reproduced:* by Medici, Lings and Elgin Court. *Signs work:* "Norma Jameson." *Address:* 111 Hayes Way, Beckenham, Kent BR3 6RR.

JAMIESON, Susan McDonald, painter in oil and acrylic;. *b:* Newbury, 5 Jul 1942. *m:* Andrew. two *s.* one *d. Exhib:* R.A. Summer Show, R.O.I., New English, Britain's Painters, Medici Gallery, Thomson's Gallery, Dover Street, Wykeham Gallery, Stockbridge. *Clubs:* Arts, Dover St. *Address:* Minstrel House, The Croft, Kintbury, Nr. Newbury, Berks. RG17 9TJ.

JAMILLY, Victor, painter, oil and water-colour; art gallery director. *b:* 31 May 1927. *s of:* David Jamilly. *m:* Audrey. two *s.* one *d. Educ:* Highgate and Cranleigh Schools. *Studied:* St. Martin's School of Art. *Exhib:* New English Art Club, RSBA, various group and gallery shows. *Works in collections:* Euston Gallery, London. *Signs work:* "V. Jamilly." *Address:* Wendover, 13 Hampstead Way, London NW11.

JAMISON, Paul, BAHons (1979), PGCE/ATD (1982); artist in oil and water-colour. *b:* Middlesbrough, 16 Sep 1954. *s of:* John Jamison. *Educ:* St. Mary's College, Middlesbrough. *Studied:* University of Newcastle upon Tyne (1975-79), University of Bristol (1981-82). *Exhib:* Hatton Gallery, Newcastle (1979), Alpine Gallery, London (1980, 1983), Bayswater Gallery (1987, 1989, 1991). Work in private hands throughout the world. *Signs work:* "Jamison" with year, i.e. '98. *Address:* 16 Cosway St., London NW1 5NR.

JAMMET, Lin, painter in gouache on paper, oil on canvas. *b:* 22 May 1958. *s of:* Michel Jammet, architect, and Dame Elisabeth Frink, R.A. *m:* Valerie Jammet. two *s. Educ:* French Lycée, London; C.E.G. d'Anduze, France; Millfield, Somerset. *Studied:* Chelsea School of Art (sculpture course 1976). *Exhib:* one-man shows: Beaux Arts Gallery, Bath, St. Jude's Gallery, London, Contemporary

Fine Art Gallery, Eton, Bohun Gallerie Henley, Beaux Arts Gallery, London. *Clubs:* Chelsea Arts. *Signs work:* "Lin Jammet." *Address:* Woolland House, Woolland, Blandford Forum, Dorset DT11 0EP.

JANACEK, Mirice: see MATTAROZZI DI THARASH, Mirella,

JAQUES, Norman Clifford, D.A. (Manc., 1941), M.S.I.A. (retd.); Sen. Lecturer, Manchester Polytechnic (1950-82); President, Manchester Academy of Fine Art (1984-90); Visiting Lecturer, Cleveland, U.S.A. (1979); freelance artist. *b:* 23 Apr 1922. *s of:* John Clifford Jaques. *m:* Marjorie Hovell. two *s*. *Educ:* Manchester College of Art (J. M. Holmes, P. W. Keen, 1937-42); R. M. I. Heywood Prize; Proctor Travelling Scholarship (1948) Italy, France. *Represented by:* R.P. Gossop, London (1946-89). *Exhib:* London, Manchester, Glasgow, Edinburgh, U.S.A. and Canada, etc. *Works in collections:* V. & A. Museum, M/Cr City A.G., Westminster Bank, Rochdale, Stoke, Manchester, Newcastle Education Committees, Cleveland Tric. U.S.A., etc. *Commissions:* United Steel Co., Post Office, B.B.C., British Transport, Odhams, Macmillan, etc. *Recreations:* walking and playing golf. *Clubs:* Sale Golf Club, Cheshire. *Address:* 6 Wardle Rd., Sale, Ches. M33 3BX.

JARAY, Tess, DFA (Lond., 1960), FRIBA; painter and etcher, environmental artist; Reader in Fine Art. *b:* Vienna, 31 Dec 1937. *d of:* Francis F. Jaray, M.I.Chem.E. two *d*. *Educ:* Alice Ottley School, Worcester. *Studied:* St. Martin's School of Art (1954-57), Slade School of Fine Art (1957-60). *Exhib:* solo exhbns.: Whitworth A.G., Manchester, Ashmolean Museum, Oxford, Serpentine Gallery, London. *Works in collections:* Stadtisches Museum, Leverkusen, Walker Art Gallery, Liverpool, Arts Council of Gt. Britain, Tate Gallery, Graves Art Gallery, Sheffield, Warwick University. *Commissions:* Floor for Victoria Station, London, Centenary Square, Birmingham, Cathedral Precinct pedestrianisation, Wakefield. *Signs work:* "Tess Jaray." *Address:* 29 Camden Sq., London NW1 9XA.

JARVIS, Gloria, N.D.D.; Médaille d'Argent Paris (1976); artist in oil, watercolour, pastel, ink, gouache; lecturer on historic costume and instructor in costume drawing, Polytechnic, Regent St. (1950-63). *b:* London. *m:* Raymond Smith, B.A. (1964). *Educ:* Heathfield School, Harrow; Aylesbury Grammar School. *Studied:* St. Martin's School of Art, London, under James Bateman, RA, the history of art at Florence University. *Exhib:* RA, NEAC, Leicester Galleries; one-man show, Brussels (1970-1982). *Works in collections:* Abbot Hall A.G., Kendal; Museum of the Dynasty, Brussels; International Museum of Carnival and Mask, Binche, Belgium; Museum of Dockland, U.K and private collections. *Commissions:* numerous portraits and genre paintings, Brussels and U.K. *Works Reproduced:* Macmillan, Brussels Times. Short stories; broadcast by BBC; biography and autobiography. *Clubs:* Soc. of Women Writers and Journalists. *Signs work:* "Gloria Jarvis." *Address:* Chantry Court, 38 St. Radigund's Street, Canterbury, CT1 2AA.

JASINSKI, Alfons B., RSW (1978), Latimer award RSA (1975), DA Travelling scholar (1969). *Medium:* artist in oil, acrylic, water-colour, pastel (seashore/figure/landscape/flowers/plant life). *b:* Falkirk, 1945. *s of:* Alfons B. Jasinski. *m:* Ann Conlan. one *s.* two *d. Studied:* Edinburgh College of Art (1964-68). *Exhib:* RSA, RSW, ESU, Edinburgh, M.Murray Gallery, London; Artspace, Aberdeen; RGI; Aberdeen City Art Gallery; Fair Maids, Perth; Portfolio 4, Linlithgow; Mercury, Edinburgh; Roseangle, Dundee; Pictures in Hospitals; Loomshop Gallery, Lower Largo, Scottish Gallery, Kirkcaldy A.G., Artis: Flying Colours, Stenton, Peter Potter, Haddington. *Works in collections:* S.A.C., Edinburgh Schools Collection, Aberdeen City A.G., Duke of Devonshire, P.I.H. Scotland. *Signs work:* "A. B. Jasinski." *Address:* 15 Normand Rd., Dysart, Fife KY1 2XN.

JASON, Gillian, Art Gallery Director, Gillian Jason, Modern & Contemporary Art, P.O.Box 35063, London NW1 7XQ. *b:* U.K., 30 Jun 1941. *m:* Neville. one *s.* one *d. Educ:* Dominican Convent School for Girls, Brewood. *Studied:* Royal Ballet School/London Opera Centre. *Misc:* Director of Gillian Jason Gallery, London, (1981-1994); Jason & Rhodes, London, (1994-1999); Gillian Jason, Modern and Contemporary Art (private dealer representing artists), 1999 onwards. *Address:* 40 Inverness St., London NW1 7HB. *Email:* art@gillianjason.com

JEFFERSON, Annelise, M.A. (1990); fine art painter in oil on canvas;. *b:* Pembury, 1965. *Educ:* Chichester High School. *Studied:* West Surrey College of Art and Design (Stephen Farthing), Royal Academy (Norman Adams). *Exhib:* R.A. Summer Exhbn. (1988, 1989, 1990, 1991), Bonhams: The New Generation (1990), Royal Overseas League (1990), Rubicorn Gallery, Dublin (1991), The Hunting Art Prizes finalist (U.K. and Paris, 1991), N.E.A.C., Mall Galleries (1991-92). *Works in collections:* South East Arts, Lloyds of London, Leics. C.C.; also private collections in U.K., Eire, Canada. *Address:* Maycotts Lodge, The Green, Matfield, Tonbridge, Kent TN12 7JU.

JEFFERY, Juliet, N.D.D., F.S.S.I., A.C.L.A.S., S.E.A.; President's medal S.Eq.A. (1993). *Medium:* watercolour and gouache, and calligrapher. *b:* Bognor Regis, 5 Mar 1943. *Educ:* Warren, Worthing. *Studied:* Brighton College of Art and Crafts (Dennis Flanders, R.W.S.). *Exhib:* S.Eq.A. Annual, R.W.S. Open, locally and Cumbria, S.S.I. and Portsmouth Museum. *Commissions:* specialises in illustrated and calligraphic house or animal histories (pedigrees). *Publications:* Gypsy Poems and Ballads by Lavengro; Appley Fair; Bender Tents; and A Tiny Tale. *Recreations:* gardening, old buildings, animals and my work. *Clubs:* S.Eq.A., Fellow S.S.I., Brother Artworkers Guild. *Signs work:* "Juliet Jeffery." *Address:* 23a Mill Street, Ludlow, Shropshire SY8 1BG. *Email:* julietjohn@diamond63.freeserve.co.uk

JEFFREY, Jill, A.T.D., N.D.D., A.R.B.S.A. (1996), P.S. (1997);designer (theatre) retd. 1991; Awards: Arts Council Design Award (1965), Royal

Shakespeare Theatre Design Award (1964), Pastel Society, Mall Galleries, London. *Medium:* oils, pastels, mixed media. *b:* Chesterfield, 30 July, 1940. *m:* Peter (decd.), Actor. one, one s-s *s.* one, three s-d *d. Studied:* Coventry College of Art (1957-59, David Bethel), B' ham College of Art (1959-61, Roy Abel). *Represented by:* Gallery Upstairs, Henley-in-Arden; Manor House Gallery, Chipping Norton. *Exhib:* solo shows: Solihull, Chipping Norton, also Mall Gallery, London, Stour Gallery, Shipston; National Theatre, London. *Works in collections:* U.K., Europe, U.S.A., Canada, Japan, New Zealand. *Official Purchasers:* Royal Shakespeare Theatre. *Works Reproduced:* for Royal National Theatre, London. *Recreations:* walking, swimming. *Clubs:* Fosseway Artists. *Misc:* Artist on Tour – National Theatre (1991 world tour), Artist in Residence R.S.T. Stratford Upon Avon (1993). *Address:* The Hayloft, Crockwell Street, Long Compton, Warwickshire CV36 5JN. *Email:* jilljeffrey@aol.com *Website:* www.jilljeffrey.com

JELBERT, Rebecca, BA Hons (1st Class). *Medium:* painter in acrylics and watercolour. *b:* Bristol, 30 Mar 1967. *d of:* Wendy Jelbert. *m:* Adam Walker. one *s.* two *d. Studied:* University of the West of England (1987-90); Portsmouth College of Art & Design (1985-87). *Exhib:* one-man shows: C.R.A. Gallery, St.Albans (3 shows); First Floor Gallery, Romsey; Beau Monde, Soho, London; two-man shows: Wykeham Galleries, Stockbridge; The Chettle Gallery, Dorset; mixed: Bonhams, Knightsbridge; Christie's, London; Mall Galleries, London; The Contemporary Art Group, London; The Laing Collection, Winchester; The National Art Collection Fund Exhibition, Kent, and in numerous galleries throughout the South of England in solo, two-man and mixed exhibitions. *Works in collections:* Lord Bath's 'Wessex Art Collection' at Longleat House. *Commissions:* many private. *Works Reproduced:* in 'The World's Stage' poetry book (Ginn), also shown on BBC TV. *Signs work:* "R. JELBERT". *Address:* 7 Hartington Park, Redland, Bristol, BS6 7ES. *Email:* rebecca@jelbert.com *Website:* www.rebeccajelbert.co.uk

JELBERT, Wendy, SWA, SFP; Teaching/Drama Diploma and medals; Best Painting Awards, London and provinces. *Medium:* mixed media; pen, line and wash, watercolour, acrylics, pastels, oil. *b:* Redhill, Surrey 8 Feb 1943. *m:* Paul Robinson. one *s.* four *d. Studied:* Southampton University. *Exhib:* RI, SWA, Burford, Oxford, Cornwall, St.Ives Society of Artists; 1st Floor, Romsey, Hants; Carlseen Gallery, Lymington, Hants. *Works in collections:* all over the world. *Commissions:* all over the world. *Publications:* 18 art books-Batsford, Harper Collins, Search Press, David & Charles. *Works Reproduced:* calendars, cards, prints - all over the world. *Recreations:* cycling, swimming, gardening, and looking after 12 grandchildren. *Clubs:* St.Ives Society of Artists; Marwell Wildlife Society. *Misc:* have made 7 art videos. Teacher at West Dean College (Chichester, Sussex), Denman College (Abingdon, Oxford) and locally in Lymington. *Signs work:* Wendy Jelbert. *Address:* La Palette, 25 Richmond Lane, Romsey, Hants., SO51 7LB. *Website:* www.wendyjelbert.co.uk

JELLEY, Susan Jane, SWA. *Medium:* pastel work, oil, watercolour, drawing, prints. *b:* London, 29 Jun 1945. *d of:* Mollie Marie Wright. *m:* Roger Jelley. two *s. Educ:* Fairfield Grammar, Bristol. *Studied:* Bristol College of Commerce (Business Diploma); West Surrey College of Art (Fine Art, with James Hockey). *Represented by:* C2 Gallery, Bucks (Nicki Clark); Kathi Rodgers, Arizona. *Exhib:* Federation of British Artists; PS; SWA; French Pastel Society; Paris, Limoges, Arizona; Menier Gallery, Southwark; Yvonne Arnaud Summer Festival, Guildford, Franham; Mayfair Gallery 54; AAF Battersea; C2 Bucks. *Works in collections:* Country Club, Guildford, Surrey; King Edwards School, Witley (Music Dept.);. *Commissions:* private: portrait, landscape, in Australia, America, Europe and UK. *Official Purchasers:* Country Club, Guildford, Surrey; King Edwards School, Witley (Music Dept.); Farnham Castle (CD cover). *Works Reproduced:* 'Dance'. *Principal Works:* dance, jazz, figurative. *Recreations:* travelling, reading, wines/champagnes of France. *Clubs:* The Country Club, Guildford, Surrey. *Misc:* interested in writing and languages. *Signs work:* 'Jelley'. *Address:* Normandy Hill Farm, Normandy Common Lane, Normandy, Guildford GU3 2AP. *Website:* www.suejelley.co.uk

JELLICOE, Colin, painter in oils and acrylics; art gallery director;. *b:* 1 Nov 1942. *Educ:* Heald Place School. *Studied:* Manchester Regional College of Art. *Exhib:* one-man shows: Monks Hall Museum, Eccles (1970), Stockport A.G. (1981), Salford A.G. (1981), Jellicoe Gallery (1974, 83, 84, 85, 90, 95, 00), Buxton Museum and A.G. (1997); group shows: Northern Images Manchester (1974), North West One Chenil Galleries, London (1976), North West Two National Theatre, London (1979), Contemporary Art Fair, Bath (1981, 82, 83), with Michael Goddard Royal Exchange Theatre Manchester (1985), Edinburgh Festival Fringe (1983, 84, 85), Contemporary Art Fair, London (1984, 85, 86); Open shows: Manchester Academy City A.G. (1970, 73, 75, 76, 81, 84, 85, 88, 92, 95, 2004, 05), R.A. Summer Exhbn. (1981, 2004), Discerning Eye (2000, 01); many others in Preston, Accrington, Bolton, Southsea, Wimbledon and Manchester. *Works in collections:* Granada Television, Manchester; Abbey National Didsbury; Withington Hospital, Manchester. *Recreations:* history of American West; history of American Western films; history of British and American illustrators. *Signs work:* 'Colin Jellicoe'. *Address:* 82 Portland St., Manchester M1 4QX. *Website:* www.colinjellicoe.co.uk

JENKINS, Christopher, Slade Dip. (Painting) (1957), A.T.C. (1958); Fellow C.P.A., mem. N.P.A. *Medium:* potter in thrown and glazed oxidised stoneware and wood fired domestic ware; artist in water-colour. *b:* B'ham, 1933. divorced. *s of:* Lincoln and Phyllis Jenkins,artists. one *s.* one *d. Educ:* Harrogate Grammar School. *Studied:* Harrogate School of Art (1949-52), Slade School of Fine Art (1952-54 and 1956-57), London Institute of Education (1957-58), Central School (ceramics, 1957-59). *Exhib:* V. & A., Crafts Centre, C.P.A., London, York, Scarborough, Kendal, Nottingham, Manchester, Liverpool, Tokyo, Copenhagen, Paris. *Works in collections:* North West Arts, L.E.A's: London, Leicester, Bucks.,

N. Yorks, Kirklees, Hanley, York. *Address:* 19 Towngate, Marsden, Huddersfield HD7 6DD. *Email:* chris@towngatepottery.co.uk

JENKINS, Heinke, R.B.S.A. (1967), R.B.A. (1977); printmaker in linocut, art teacher. *b:* Heilbronn, W.Germany, 2 Jul 1937. *d of:* Dr. Mayer. one *s. Educ:* Heilbronn Grammar School. *Studied:* Stuttgart Academy of Arts (Prof. Henninger), Stuttgart College of Graphic and Illustration (Prof. Leo Schobinger). *Exhib:* Germany, U.S.A., England, Printmaker of the Month, Leicester (1997), Tanner Charitable Trust Prize (1998), Colex and Tilley Prize (2000), T.N.Lawrence Couterory Print Prize (2004). *Works in collections:* Heilbronn A.G., Stuttgart A.G. *Commissions:* 1993: drawings and linocuts for B'ham University Maternity Hospital in Memory of the old Sorrento Maternity Hospital, B'ham. Now permanent display at Queen Elizabeth University Maternity Hospital, Birmingham. *Publications:* illustrated, Arts Review, 'Ambit' poetry magazine, 'Circle' poems, M. Armstrong. *Recreations:* music, walking. *Clubs:* R.B.S.A., R.B.A., Heilbronn Kunstler Bund. *Signs work:* "HEINKE." *Address:* 26 Allesley Cl., Sutton Coldfield, Birmingham B74 2NF.

JENKINS, Lawrence Fifield, RAS Cert (1972), ATC (Goldsmiths 1973). *Medium:* painter-printmaker. *b:* Sevenoaks, Kent, 7 Oct 1944. *m:* Brigitte. two *s. Studied:* Maidstone College of Art (1962-64, David Hockney, Bill Bowyer), Nottingham College of Art, Royal Academy of Art (E. Bawden). *Exhib:* RA, RP, RWS. *Works in collections:* Royal Collections, National Museum of Wales. *Commissions:* Victory Services Club, Trust House Forte, Crown Court, Maidstone. *Clubs:* RASAA. *Misc:* runs Seal Chart Etching Studio, Sevenoaks, TN15 0ES. *Address:* Seal Chart Studio, Chart Farm, Seal Chart, Sevenoaks, TN13 3QJ. *Email:* lawrence.jenkins@wanadoo.fr *Website:* www.lawrencejenkins.co.uk

JENKINS, Thomas Raymond, artist in water-colour; former Chairman Civil Public Service Artists, and Vice-President Boreham Art Circle; Mem. Islington Art Society. *b:* London, 24 Jun 1928. *m:* Margaret. one *s.* one *d. Studied:* Chelmsford, and St. Ives School of Painting under Roy Ray. *Exhib:* Council of Europe Exhbn., Strasbourg (1979, premier prize), H.S. Annual at Wells, Montelimar Festival, Barbican Arts Centre 10th Anniversary Exhbn., Llewelyn Alexander Gallery, London. *Works in collections:* private: U.S.A., Canada, Europe, N.Z., Australia, Scandinavia, Russia and Japan. *Misc:* teaches student groups, demonstrates to art clubs. *Signs work:* "Ray Jenkins". *Address:* 28 Butterfield Rd., Boreham, Chelmsford, Essex CM3 3BS.

JENNINGS, Walter Robin, artist in oil; portraits, landscape, and equestrian pictures. *Medium:* oil and watercolour. *b:* Old Hill, Staffs., 11 Mar 1927. *s of:* William Dennis Jennings. *m:* Barbara Wilkinson. *Educ:* Macefields Secondary School. *Studied:* Dudley and Staffordshire Art School, Brierley Hill School of Art, Birmingham School of Art. *Exhib:* RBSA, RWA, RCamA, Royal Institute Galleries, Utd. Soc. of Artists, NEAC, etc. extensively in GB and USA. *Works in*

collections: Allison House, Mr. H. Woodhouse; Enville Hall, Mr. and Mrs. J. Bissel; Brierley Hill A.G. *Works Reproduced:* by Royle, Medici, Solomon and Whitehead, etc. *Address:* Kestrels, Caunsall, Cookley, nr. Kidderminster, Worcs. DY11 5YJ.

JENNISON, Robert William, R.W.A., N.D.D. (1954), A.T.D. (1958); painter in oil, occasional printmaker, lecturer;. *b:* Grantham, 8 June, 1933. *m:* Angela Cook (decd). one *s.* two *d. Educ:* Grammar School, Weston super Mare. *Studied:* West of England College of Art, Bristol (1950-54, 1957-58, Paul Feiler). *Represented by:* Royal West of England Academy. *Exhib:* frequent solo and group shows since 1962: London, Wales, South-West, N. Ireland, including R.W.A., R.U.A., Milan, Italy., own gallery at Gittisham Studio W.E.F. May 2003. *Works in collections:* public and private collections in Britain, Europe, U.S.A. etc. *Publications:* featured in '50 Wessex Artists' pub. Evolver Books. *Official Purchasers:* Exeter University, RWA, 'Paintings in Hospitals'. *Recreations:* a bolt-hole in Brittany. *Signs work:* "Robert Jennison," "R. Jennison" or "R.J." *Address:* The Studio, 6 Town Farm Buildings, Gittisham, Honiton, Devon, EX14 3AL. *Website:* www.rwa.org.uk

JERVIS, Sharon, Dist. Wildlife Illustration (1978), M.A. Graphic Design (1982), M.S.I.A.D. (1980), A.R.S.M. (1996); artist in water-colour and gouache; M.D. Sharon Jervis Ltd. *Medium:* watercolour, gouache. *b:* Leicester, 5 May 1956. one *s.* one *d. Studied:* Dyfed College of Art (Wildlife Illustration), Leicester Polytechnic (now De Montfort University), MA. *Commissions:* Many varied license contacts for a variety of publishers and manufacturers in the U.K. and worldwide. My paintings are used on a diversity of products including diaries, cards, framed and limited edition prints, table top products, mugs, rugs, tapestries, pillows, trays, flags, ceramics, giftware, stationery items and fabrics. *Address:* Farndon Grange, East Farndon, Market Harborough, Leics. LE16 9SL. *Email:* sharon@sharonjervis.com *Website:* www.sharonjervis.com

JESTY, Ronald, artist in water-colour and acrylic, part-time lecturer; Pres. Somerset Soc. of Artists, elected mem. R.B.A. (1982) resigned (1990). *b:* Weymouth, Dorset, 7 May 1926. *s of:* Benjamin & Violet Jesty. *m:* Margaret Johnson. *Educ:* Weymouth Grammar School; no formal art training. *Represented by:* Newland Gallery, Sherborne, Dorset. *Exhib:* R.I., R.W.A., R.W.S., R.B.A., R.A., Singer & Friedlander/Sunday Times water-colour competition, Millfield Open; nine one-man shows. *Works in collections:* Somerset C.C. *Publications:* "Learn to Paint Seascapes" (Harper Collins, June 1996). *Works Reproduced:* Seascapes and Waterways (Rotovision SA); Painting Still Life (David & Charles); Vibrant Watercolours (Collins); Painting Workshop (Collins) etc. *Clubs:* Artists 303, Somerset Soc. of Artists. *Signs work:* "R. Jesty" and year. *Address:* 11 Pegasus Court South Street Yeovil, Somerset BA20 1ND.

JIANG HUANG, Limin, M.A.; artist in oil and water-colour, designer;. *b:* 14 Aug., 1952. *m:* Gouping Jiang. *Studied:* St. Martin's School of Art and Design.

Exhib: International Maritime Organization Art Soc., London, Arts and Science Form, Wells, America, France, Swiss, Manchester, Australia, Japan, Belgium, China. *Works in collections:* B.M., V. & A., National Galleries of Canada and Australia, Museum of Western Art, Japan, Art Modern of City of Paris, Association of China Art, Swiss Art, Japan Fan Art. *Publications:* Taiwan Art Almanas (1994, 1995), International Fan Art (1989-96), Dictionary of International Biography - 28th, Century Appreciate - Chinese Artists Works, The Radiance of Oriental-Chinese Artist in 21st Century, New Century Contemporary Artist Biography, China Contemporary Artist Works Appreciate, Dictionary of China Outstanding Artist, Dictionary of World Calligrapher-Painter 3rd edition, World Outstanding Specialists, Brilliant Accomplishment Century Light of Dawn (1999), Huaxia Chinese Outstanding Talents, China Famous Brush and Ink Artists Works Show. *Clubs:* Honorary President of China Huaihai Calligraphy & Painting Institute. *Misc:* Awarded the Gold Cup Award (2000) China, the World Gold Award (2000) Hong Kong. *Signs work:* "LIMIN J.H." *Address:* P.O. Box 4595, 9 Howick Pl., London SW1P 1AA. *Email:* liminjh@talk21.com *Website:* www.limin.com

JOEL, Alan Alfred, U.A., B.Sc., B.D.S.; portrait painter; retired dental surgeon. *Medium:* oil and pastel. *b:* Dunedin, N.Z., 27 Oct 1921. *m:* Kay Cooper. one *s.* two *d. Educ:* Kings High School, Dunedin and Otago University, N. Z. *Studied:* for fifteen years had one to one tuition with Ken Paine and Dennis Syrett. *Exhib:* Salisbury Libraries, Riverbank Gallery, Port Solent, and solo exhib. N.Z. House, London (2001). *Clubs:* London Sketch Club. *Misc:* nephew of Grace Joel, well-known professional artist, tutored by Renoir (d. 1924). *Signs work:* "Joel." *Address:* 66 St. Edmunds Church St., Salisbury, Wilts. SP1 1EQ. *Email:* alanjoel1066@btopenworld.com *Website:* www.joelpaintings.com

JOEL, Judy, self taught artist; Secretary of Association of British Naive Artists. *Medium:* gouache, acrylic, oil. *b:* Putney, London, 30 Aug 1946. *d of:* Dr. & Mrs. Reginald Glanvill. *m:* Paul. one *s.* one *d. Educ:* Villa Maria Servite Convent School, Bognor Regis. *Represented by:* own gallery: The Little Picture Gallery, Mousehole, Cornwall; Llewelyn Alexander Gallery; Webbs Gallery, London. *Exhib:* solo shows: London, Surrey, Sussex and Cornwall; Melbourne, Australia. *Works in collections:* Simon Weston, BBC, DTI. *Commissions:* BBC, Simon Weston, Nerys Hughes,Ian Lavender, Jilly Cooper, James Grout. *Publications:* featured in 'The Innocent Eye' by Marion Whybrow; many charity Christmas cards. *Works Reproduced:* several as cards, prints, limited editions. *Principal Works:* BBC, and commissions of life stories. *Recreations:* skiing, swimming. *Clubs:* Moseley Art Society. *Signs work:* "J.S Joel." and a little mouse. *Address:* Noah's Ark Studio, Abbey Pl., Mousehole, Cornwall TR19 6PQ. *Email:* littlepictures@virgin.net *Website:* www.judyjoel.com

JOHANNESON, Steven Thor, RSMA; artist of land/sea-scapes and nature in most painting mediums, but especially in water-colour; has work published including many Limited Edition Prints; Recipient of "St. Cuthbert's Mill Award",

at RSMA (1999). *Medium:* watercolour, gouache, pastel & oil. *b:* Minneapolis, Minn., 16 Jun 1948. *m:* Cynthia Joan Maurer. *Educ:* Menominee High School, Michigan; Bethel College, St. Paul, Minn. *Studied:* Heatherley School of Art, London (1970-73). *Represented by:* Stephen Jack Fine Art (www.jackfineart.com). *Exhib:* RSMA, SWLA, various mixed and one-man shows; galleries include Gallerie Marin Appledore; Arty Crafts, Wadebridge; Chagford Gallery, Dartmoor; The Hawker Gallery, Old Amersham. *Works in collections:* The Sultan of Oman. *Signs work:* "S.T. Johanneson" in vermilion. *Address:* P.O.Box 636, Yamhill, Oregon 97148, USA. *Email:* ThorshavnStudios@aol.com

JOHN, Alan, Freeman of Painter Stainers Guild, Co-founder Islington Arts Factory, Founder Director of Dance Factory Contemporary Dance Company. Designed sets for various dance companies in London. Taught painting, sculpture and contemporary dance. *b:* London, 19 Jan 1927. one *s.* two *d. Represented by:* Penwith Gallery. *Exhib:* RA, Alwin Gallery, Boundry Gallery, Woodstock Gallery, Liester Gallery, Highgate Fine Art, Penwith Gallery, Salt House Gallery, Wildenstiens, Bishop Philpotts Gallery, Contemporary Portrait Society, Cork Street, Plymouth Museum. *Works in collections:* Della Bishop Collection, Mrs. Abrahams Collection, Sweden, Australia, France, Margot Maeckelburghe Collection, Philip Groom Collection, Fergus Ahern Collection. *Official Purchasers:* Royal Academy. *Clubs:* Penwith Society. *Misc:* lectures for ILEA on painting, sculpture, creative film making. Founder of ILEA Basement Art Studios in East End. *Address:* Splatt House, Splatt Lane, Mount Hawke, Cornwall TR4 8BL.

JOHN, Samuel, BA (Lond. 1958), MBIM (1968), IPM(1960), MInst (1970), M.Inst.Ex., former Overseas Marketing Manager, Glaxo Group (1972), RLSS Inst. (1953); artist, writer, former medical student, business entrepreneur. *Medium:* oil, pastel, water-colour. *b:* Newport, Mon., 9 Feb 1935. *s of:* Col. Samuel William Isitt, and opera singer Nancy Sully. *m:* Anne Drummond-Leigh, actress. three *s.* one *d. Educ:* Newport High School; London University; Ashridge and Sundridge Management Colleges (Marketing). *Studied:* Chelsea (St. Mark and St. John College) (1955-58, P. G. Roberts, R.A.); qualified as teacher (1957). *Exhib:* Thames Gallery (1978), Chenil Galleries (1956), The Clement, Oxford (1977-79), Oxford Art Soc. (1977-78), Barclay Gallery, Chester (1980), St. Martin's, London (1983), Royal Overseas League, London (1983). *Works in collections:* St. Helen's Convent, Oxford; Blackfriars, Oxford; Mr. R. Bradon, Australia. *Commissions:* Films: (Equity Mem.) Coronation Street, Pardon the Expression, The Jewel in the Crown, The Man in Room 17, etc. *Publications:* The Sacred and The Profane (1980), The Proitiation (1980), The Act of Love (1983); awarded Koestler Prize for Verse (1980). *Clubs:* Royal Overseas, Oxford and Cambridge. *Misc:* Literary Agent: Curtis Brown, London. Theatrical: Joan Reddin, London. *Signs work:* "John." *Address:* c/o Browse Darby, 19 Cork St., London W1X 2LP.

JOHNS, Phil, elected member of Royal Society of Arts (2002); MA Fine Art; artist in water-colour and oil; Director of Art Publishing Co. *b:* Brentwood, Essex, 15 Feb 1950. *m:* Anna Louise. one *s.* two *d. Studied:* Southend Art School, Royal Wanstead School, Canterbury Christ Church University. *Exhib:* over fifteen one-man shows since 1989 worldwide. *Works in collections:* British Petroleum; Forest Healthcare Trust; Intercontinental Hotel, Park Lane. *Commissions:* numerous. *Works Reproduced:* Limited Editions. *Address:* 11 St.Jacob's Place, Canterbury, Kent CT1 3TU. *Website:* www.philjohns.com

JOHNSON, Annette, S.W.A. (1987), N.S.; painter-etcher in water-colour, oil and etching; mem. National Soc. of Painters, Sculptors and Printmakers, and Soc. of Women Artists. *Medium:* oil painting, printmaking. *b:* London, 24 Mar 1943. *m:* Alan. one *s.* one *d. Studied:* etching at Morley College; painting at Sir John Cass College of Art. *Exhib:* N.S.P.S. (1985), R.S.M.A. (1985), R.I. (1981), R.A. (1985, 2007), S.W.A. annually, N.S. annually. *Publications:* painting used in 'The Centenary Book of the Newlyn Gallery, Cornwall'. *Clubs:* The Arts Club, Dover Street. *Signs work:* "Annette Johnson." *Address:* 24 Kellerton Rd., Lee, London SE13 5RD. *Email:* annettejohnson1@btinternet.com *Website:* www.annettejohnson.co.uk

JOHNSON, Ben, MA (RCA); Hon.FRIBA; painter/sculptor collaborating with architects. *Medium:* acrylic, drawing, prints, sculpture. *b:* Llandudno, 24 Aug 1946. *s of:* Harold & Ivy. *m:* Sheila Johnson. two *s. Studied:* RCA (1965-69). *Exhib:* selected one-man shows: Wickesham Gallery/ Louis K.Meisel Gallery, New York,; Fischer Fine Art, London (1975, 84, 86, 92), Blains Fine Art, London (2002) RA (1997), Chester Beatty Museum, Dublin (2001), Edinburgh, Bradford; group shows since 1967 in UK and overseas, including: England, Scotland, Ireland, Belgium, U.S.A., Poland, Yugoslavia, Spain, Australia, France, Germany, Switzerland, Portugal, Italy. *Works in collections:* Boymans-van Beuningen Museum Rotterdam, British Council, Tate Gallery, Contemporary Art Soc., De Beers/CSO Coll., R.I.B.A., Glasgow City A.G., Whitworth Gallery Manchester, Centre Georges Pompidou Paris, V. & A., B.P., Deutsche Bank, British Museum, Guildhall, City of London, National Art Collection. *Commissions:* For last 10 years has worked exclusively to commission for both public and private collections. Millennium commission by the Khalili Family Trust:'Panorama "Jerusalem, The Eternal City"; National Museums Liverpool commission for 2008 European Capital of Culture. *Publications:* Numerous publications. *Official Purchasers:* IBM, Deutsche Bank, HSBC, National Museums of Liverpool, City of Culture Commission, BP, Special Administrative Government of Hong Kong, Cable & Wireless plc, British Steel. *Misc:* The only painter to be awarded the Fellowship of the RIBA for contributing to the public's awareness of contemporary architecture. *Signs work:* "Ben Johnson." *Address:* 4 St. Peter's Wharf, Hammersmith Terr., London W6 9UD. *Email:* benjohnson@benjohnsonartist.com *Website:* www.benjohnsonartist.com

JOHNSON, Brian Robert, R.I. (1988) Bronze Medal Award (1987), Hon. Citizen, Victoria B.C.; Graduated with distinction from The Art Center College of Design, Los Angeles, Calif. with a Bachelor of Professional Arts (1962); artist in water-colour. *b:* Victoria, B.C., Canada, 4 Apr 1932. married. two *s.* one *d. Educ:* Victoria High School, Victoria College; Art Center College of Design, Los Angeles. *Exhib:* R.I., R.B.A., A.W.S., F.C.A, C.S.P.W.C., N.W.W.S., C.S.M.A., numerous one-man and group exhbns. in Canada and U.S. *Works in collections:* Canada, U.S., Australia, U.K. and Europe. *Signs work:* "Brian R. Johnson." *Address:* 1766 Haultain St., Victoria, B.C., V8R 2L2, Canada. *Email:* brjohnsonri@shaw.ca

JOHNSON, Carl, B.A. (1971), Post grad. Ateliers 63 Holland (1973), A.T.C. (1975). *Medium:* painter in oil pastel, drypoint. *b:* Warwickshire, 5 Dec 1946. *s of:* John Johnson & Marion Drummond. two *s.* one *d. Studied:* B'ham College of Art (1964-65), Solihull Technical College (1965-68), Newport College of Art (1968-71), Ateliers 63, Haarlem, Holland (1971-73), Goldsmiths' College (1974-75). *Exhib:* RA Summer Show (1998, 1999, 2002, 2003), RWA (97, 98, 99, 00), Cuprum, Poland; Produzenten Galerie, Germany; Xtreme Art, Leicester City A.G.; National Print, Mall Galleries (99, 01, 02, 03, 05); Kunsthalle Giessen, Germany; Guildhall Gallery, Winchester (2000, 2003, 2004, 2005); University College, Winchester (05/06); National Theatre Printmakers Council, Fisherton Mill, Salisbury, Artsway, Sway, Harley Gallery; Miniature Print Exhbn (2003-07); Mini Print Cadaques Spain (2007); Art for Life, Bath (2007); Leeds City Art Gallery (2006/07). *Works in collections:* UK, Amsterdam, Germany, Austria, Australia, Poland, New York, Texas, Florida, California, S.Carolina, Gulf States. *Commissions:* many private commissions. *Recreations:* walking, weight-lifting. *Signs work:* 'Carl Johnson'. *Address:* 12 Alexandra Park, Paulton, Bristol, BS39 7QS. *Website:* www.numasters.com

JOHNSON, Colin Trever, M.A.F.A.; artist in oil, collage, water-colour and inks, principal themes: coastline, harbours, Venice, street markets, windows studio still-life. *b:* Blackpool, 11 Apr., 1942. *Studied:* Salford School of Art, Manchester College of Art. *Exhib:* one-man shows: City of London Festival, Liberty's London, Barbican Art Centre London; Derby, Oldham, Bolton, Harrogate, Salford, Scarborough, Buxton, Falmouth, Blackburn, Ayr, Bideford, Margate, Blackpool, Accrington, Ashton-under-Lyne, Stockport, Warrington, and Bury Public A.Gs.; Winchester, Manchester and Leicester Cathedrals; Salford, Manchester and Exeter Universities; Taunton, Stamford and Bridgewater Arts Centres; National Touring Exhibition (1995-97), Royal Northern College of Music, Royal Exchange Theatre. *Works in collections:* Salford, Southport, Manchester, Derby, Torquay and Worthing Public A.Gs., Exeter University, B.B.C. Artist in Residence: Manchester (1980), City of London (1984) and Wigan International Jazz (1986, 1987) Festivals. Directed Festivals of: Bolton (1979), Swinton (1973), Teignmouth (1996), St. Ives Fringe 1999-2007. *Commissions:* Granada Television, B.B.C. North West, Royal Exchange Theatre, Manchester. *Recreations:* collector of: books, tiles, jugs. *Clubs:* Manchester Academy, Morrab

Library. *Signs work:* "Colin T. Johnson." *Address:* 27 Bedford Rd., St. Ives, Cornwall TR26 1SP. *Email:* ctj.stives@amserve.com

JOHNSON, Joy Alexandra, BFA (Hons.) (1980), Higher Dip. (Lond.); artist in oils, water-colour. *b:* Hull, 26 Aug 1958. *d of:* Arnold Johnson. *Educ:* Hatfield High School, Yorks. *Studied:* Newcastle upon Tyne Polytechnic (1977-80), Slade School of Fine Art (1982-84, Lawrence Gowing). *Exhib:* Northern Young Contemporaries (1979), Sainsbury Centre (1980), Mappin Gallery Open Art (1984, 1985), R.A. Summer Exhbn. (1985), several solo exhbns. in London. Received award from Swiss based Vordemberge Gildewart Foundation (1986). *Signs work:* "J.A. Johnson." *Address:* 17 Bempton La., Bridlington, E. Yorks. YO16 5EJ.

JOHNSON, Rosalie, SWA (1991), SWLA (1990); Awards: Crown Commissioners (1991, 1994); Anthony J Lester Art Critic Award (2005). *Medium:* sculptor in clay, bronze, silver and rusty iron. *b:* South Africa, Oct 1930. *m:* widowed. one *s.* one *d. Educ:* St.Cyprian's School, South Africa. *Studied:* Putney School of Art; Manresa House, Roehampton (pottery and sculpture). *Exhib:* SWLA, Mall Galleries (1990- present); SWA, London (1991 - present); RA Summer Exhbn (1991); McGrath Gallery, Chelsea, London (1991-2003); Llewelyn Alexander Gallery, Waterloo, London (1991- present); Cricket Fine Art, Hampshire and Chelsea (1993- present); Louise Sinclair, Walton Street, London (1998-2001); Lady Daphne, Sloane Square, London (1998-2002). *Works in collections:* Dr Vivienne and Daniel Isaacson, Washington, USA; Elizabeth R.Meek, Isle of Wight, UK; Christopher and Shane Wrinch-Schulz, Cape Town, South Africa; Mr & Mrs Hugo Pratt, Hampshire; Mr & Mrs Nigel Goodhew, London;. *Commissions:* "Huberta" 7 foot hippo in pool (bronze) for Imperial Place, Capital & Counties Office Complex. *Signs work:* "ROSALIE JOHNSON". *Address:* 18 Clevedon Road, Richmond Bridge, East Twickenham, TW1 2HU.

JOHNSON, (William) Holly, Ivor Novello Award (Best Contemporary Song, 1984); Brit Award (Best Single 'Relax', 1984). *Medium:* oil, watercolour, drawing, prints, sculpture, performance, film. *b:* Liverpool, 9 Feb 1960. *s of:* Eric & Pat Johnson. *Educ:* St.Mary's Primary School; Liverpool Collegiate Grammar School. *Studied:* RCA. *Represented by:* Wolfgang Kuhle Artist Management fax: 0207 736 9212. *Exhib:* RA Summer Show (2001, 02, 03, 04, 05); RCA Secret (2000-05); The House of Holly:The Gallery, Cork Street, London (1996); Warchild, Artaid (2002); Tate, Liverpool (2000); Hanover Gallery, Liverpool - Biennial (2002); Norwich Fringe (2005). *Works in collections:* various private, including Marc Almond, Roland Orzabal, Barry Dickens. *Commissions:* illustrations for 'Details' (Condé Nasté); Kirsty MacColl 'Angel' (record Sleeve); 'Carlos' (John Brown Citrus Publishing). *Publications:* RA postcard (2001); House of Holly, catalogue (1996); A Bone in My Flute (autobiography, Random House, 1994). *Works Reproduced:* in Modern Painters, The New Statesman, Tatler, DACS. *Principal Works:* 'Waterfront' (1989); 'UK After the Rain' (2004); 'Balls of Gold and Dick of Diamond' (2005). *Recreations:* musician

and reader, poet, nocturnal activities. *Clubs:* Chelsea Arts Club, DACS, RCA Senior Common Room. *Misc:* Multi-media artist, author, poet, singer, songwriter, iconoclast, HIV Positive activist, art journalist. *Signs work:* 'Holly Johnson'. *Address:* P.O. Box 425, London SW6 3TX. *Email:* getdown@thepleasuredome.demon.co.uk *Website:* www.hollyjohnson.com

JOHNSTON, Brenda, painter in oil and scraperboard. *b:* London, 8 Dec 1930. *d of:* Walter Rumble. *m:* David Johnston. two *s.* one *d. Educ:* Rosebery Grammar School, Epsom. *Studied:* Epsom School of Art (1948-49, 1955-60) under Michael Cadman, Leslie Worth; Reigate School of Art (1961-65) under Eric Waugh. *Exhib:* R.A., R.B.A., Nimes and Avignon, Arts Council Exhbn. Midlands and East Anglia; nine one-man shows. *Works in collections:* Ryder Memorial Bequest. *Clubs:* F.P.S., Thames Valley Art, Leatherhead Art. *Signs work:* "Brenda Johnston" or "BJ." *Address:* Russells, 36 Oakfield Rd., Ashtead, Surrey KT21 2RD.

JOHNSTON, George Bonar, D.A. (Edin.), R.S.W.; artist in oil, gouache and water-colour; formerly adviser in art, Tayside Region Educ. Authority. *b:* Edinburgh, 14 Jun 1933. one *s.* one *d. Educ:* Bathgate Academy. *Studied:* Edinburgh College of Art (1951-56) under William Gillies, P.P.R.S.A., R.S.W., and Robin Philipson, P.P.R.S.A., A.R.A., R.S.W. *Exhib:* regular exhibitor R.S.A., R.S.W., R.G.I.; one-man shows: Perth, Kirkcaldy, Glasgow, Dundee; mixed shows: Edinburgh, Aberdeen, London, Paris, Toronto, New York. *Works in collections:* Glasgow, Strathclyde, Edinburgh, Dundee, London, Toronto, U.S.A., France, Australia. *Signs work:* "Johnston." *Address:* 10 Collingwood Cres., Barnhill, Dundee DD5 2SX.

JONCZYK, Prof. Dr. Leon, painter, graphic artist, art historian, author of publications about theory of art, experimental printing; Memb., National and International Academies for Arts, Sciences and Humanities, Paris, Bordeaux, Naples, Rome; JSAST, San Francisco; Prof. of Academia Polona Artium and of Polish University of London; Dean of Faculty of Fine Arts, Munich; President, Assoc. of Graphic Artists, W. Germany;. *b:* Katowice, Poland, 25 July, 1934. *Educ:* High School, Poland. *Studied:* in Poland, Netherlands, Gt. Britain. *Exhib:* Czechoslovakia, France, Italy, E. and W. Germany, Gt. Britain, Netherlands, Poland, Sweden, Switzerland, Tasmania, Turkey, Yugoslavia, U.S.A. *Works in collections:* more than 30 galleries and museums in Europe, public and private collections in Europe, Australia, U.S.A. *Publications:* illustrated monographs in different languages. *Signs work:* "L. Jonczyk." *Address:* Franz-Joseph-Str. 30/IV, 80801 München, Germany. *Email:* profdrjonczyk@aol.com *Website:* www.academia-polona-artium.de

JONES, Allen Christopher, N.D.D. (1959), A.T.D. (1960), R.A. (1984); painter, sculptor, printmaker; Trustee, British Museum (1990-99); Emeritus Trustee British Museum, ongoing; Doctor of Arts (Honoris Causa), Southampton University, 2007; Prix des Jeunes Artistes, Paris Biennale, 1961; Heitland

Foundation Prize, Colle, Germany, 1995. *b:* Southampton, 1 Sep 1937. *s of:* William & Madeline Jones. *m:* Deirdre Morrow. two *d. Studied:* Hornsey College of Art (1955-59), R.C.A. (1960-61). *Represented by:* Thomas Levy, Hamburg; Ernst Hilger, Vienna; Kaj Forsblom, Helsinki; Galleria Maggiore, Bologna. *Exhib:* since 1961 numerous museum and group shows. *Works in collections:* public museums and private collection worldwide. *Commissions:* public sculpture commissions in the U.K. and Hong Kong; private sculpture commissions in the UK, USA and Europe. *Publications:* "Figures"; "Projects"; "Allen Jones"; "Sheer Magic"; "Prints"; "Sculptures 1965-2002", "Allen Jones Works" (Royal Academy Publications, 2005). *Recreations:* gardening. *Clubs:* Chelsea Arts, Garrick, Arts Club. *Signs work:* "Allen Jones." *Address:* 41 Charterhouse Sq., London EC1M 6EA.

JONES, Aneurin M., N.D.D. (1950), A.T.D. (1955); artist in oil, acrylic, mixed media; retd. Head of Art Dept., Preseli Comprehensive School, N. Pembrokeshire;. *b:* 18 May 1930. *m:* Julie Jones. one *s.* one *d. Studied:* Swansea College of Art (Principal: Kenneth Hancock, A.R.C.A., Head of Fine Art: William Price, A.R.C.A.), Prix de Rome Scholar. *Exhib:* numerous one-man and mixed shows England and Wales. Welsh representative at the Celtic Festival, Lorient, Brittany. *Works in collections:* National Library of Wales, Aberystwyth; Welsh Arts Council; West Wales Assoc. for the Arts; Dyfed County Council; Ceredigion County Council; The Welsh Office, Cardiff. *Commissions:* three full-length studies of Welsh Archdruids for Gorsedd of Bards permanent collections; mural to commemorate 'Owain Glyndwr' the last native Prince of Wales's struggle for independence in the 13th Century. *Publications:* numerous Welsh/English periodicals, magazines and books. A comprehensive book based on the artists' work "Aneurin"- two editions are sold out. *Clubs:* lecturer for various clubs, societies and educational establishments. *Signs work:* "ANEURIN M. JONES"; 1993 onwards "ANEURIN." *Address:* Heulwen, Aberystwyth Rd., Cardigan, Ceredigion SA43 1LU.

JONES, Barry Owen, R.W.S., R.E., N.D.D.; artist in water-colour, etching/aquatint; Gallery Director. *b:* London, 11 Sep 1934. *m:* Alexandria Virginia, née Parsons. one *s.* one *d. Educ:* Friern Barnet Grammar School. *Studied:* Hornsey College of Art (1950-55). *Exhib:* R.W.S., R.E., Coach House Gallery, Guernsey, Bankside Gallery. *Works in collections:* Guernsey Museum and A.G., South London A.G. *Commissions:* National Grid Calendar (1993). *Address:* Le Chevalerie, Les Douvres Vineries, La Fosse, St. Martin, Guernsey C.I. GY4 6EF.

JONES, Doreen, SBA; B.Ed, Cert. Botanical Illustration Birmingham; RHS Gold Medal. *Medium:* watercolour. *b:* Wrexham, 17 Jan 1945. *d of:* Flora & Stan Williams. *m:* A.D.Jones. *Educ:* Grovepark Girls Grammar School. *Studied:* Bangor University. *Exhib:* Central Hall, Westminster since 2000; Royal Horticultural Society (2004, 2005); St.David's Hall, Cardiff; Oriel Gallery, Ynys Mon; various smaller galleries and exhibitions. *Works in collections:* Kew

Gardens, Lindley Library, private collections. *Commissions:* private, Wild Flowers for 'Gentleman's Tour of Countryside'. *Publications:* 'Botanical Illustration' (pub. Society of Botanical Artists). *Works Reproduced:* prints and cards. *Principal Works:* collection of rare Cotone Aster; collection of Viburnums. *Recreations:* walking, reading. *Clubs:* Chelsea Physic Garden Florigeum Society; North Wales Society Fine Arts. *Signs work:* 'DJones'. *Address:* Tophill, Maelor Court, Overton, Wrexham, LL13 0HE. *Email:* jones17maelor@tinyworld.co.uk

JONES, Edward Scott, R.C.A. (1964); artist in oil, water-colour, gouache, acrylic. *b:* Liverpool, 6 Jun 1922. *m:* Althea. one *s.* one *d. Educ:* Anfield Road Elementary School. *Studied:* Liverpool College of Art. *Exhib:* R.C.A., Williamson A.G., Bluecoat A.G., R.I., R.S.M.A. *Works in collections:* Merseyside Council Libraries, Blackpool Corp. A.G., Salford A.G., Bolton A.G., Williamson A.G., Birkenhead, also works in private collections. *Signs work:* "E. Scott Jones." *Address:* 18 The Fairway, Knotty Ash, Liverpool L12 3HS.

JONES, Geraldine M.L., Dip.A.D.(Hons.) (1972), Post Grad. Cert. R.A. Schools (1975); freelance artist and illustrator in water-colour, oil, pencil, charcoal. *b:* Ampleforth College, Yorks., 23 Nov 1949. *m:* Nigel Jones. *Educ:* The Bar Convent, York. *Studied:* Hull Regional College of Art (1969-72, John Clarke, Michael Chiltern), R.A. Schools (1972-75, Peter Greenham, Anthony Eyton). *Exhib:* York, Hull, Peterborough, Oxford, London, Norwich, Lincoln, Huddersfield. *Works in collections:* Bradford Cathedral Chapter House. *Commissions:* Bradford Cathedral. *Publications:* 'Stories from Yorkshire Monasteries' (J. & B. Spence). 'The Yorkshire Journal', 'Against the Tide', Marjorie Bourne. *Clubs:* S.G.F.A., Lincolnshire Artist Society, Royal Academy Schools Alumni Association. *Signs work:* "G. Jones." *Address:* Fleet House, Hoffleet Stow, Bicker, Boston, Lincs. PE20 3AF.

JONES, Heather Edith, H.S.; artist in water-colour, silver point, pencil; tutor (retd.); specialises in miniature portraits. *b:* Cardiff, 23 May 1930. *m:* Ivor Jones (decd.). one *s.* one *d. Studied:* Newport School of Art. *Exhib:* R.A. Summer Show, R.M.S., H.S., L.A. Gallery, Glyn Vivian Gallery, Swansea, Barbican and Pall Mall Galleries, and privately owned galleries in England, France and U.S.A. Work in private collections. *Commissions:* undertaken by request. *Publications:* illustrations for book of ghost stories, and a children's book and book cover for novel. *Signs work:* "H" and "J" joined. *Address:* 25 Spencer Gdns., Eltham, London SE9 6LX. *Email:* HeatherSJ@aol.com

JONES, Helen Coline, HS, ARMS, MAS-F; HND (Natural History illustration), 1st prize M.A.S.-F. (animal and birds category), 2nd Prize M.A.S.-F. (2001); illustrator/artist in water-colour;. *b:* Hereford, 18 Feb., 1971. *Studied:* Bournemouth and Poole College of Art and Design (1990-92). *Exhib:* HS, RMS, MAS-F, Canada, Marches Artists, international miniature exhibition Tasmania, Llewellyn Alexander Gallery, London. Work in collections internationally. *Publications:* illustrated: An Identification Guide to Dog Breeds by Don Harper.

Works Reproduced: greetings cards and wrapping paper. *Clubs:* Marches Artists. *Address:* The Croft, 96 Penn Grove Rd., Hereford HR1 1BX.

JONES, Hywel Wyn, B.A. (Hons.) 1979, M.A. (1980); sculptor. *b:* Aberystwyth, 17 Nov 1956. *Studied:* Central School of Art, Chelsea School of Art. *Signs work:* "Hywel Wyn Jones." *Address:* 37 Tregerddan Bow Street Ceredigion SY23 5AU. *Email:* HWJones@hotmail.com

JONES, Ian, B.F.A.(Hons.) (1979), M.F.A. (1982); artist; lecturer in Fine Art;. *b:* B'ham, 3 July, 1947. *m:* Carole A. Jones. two *s. Educ:* Queensbridge Secondary Modern, Moseley. *Studied:* B'ham Polytechnic School of Fine Art (1975-78, Roy Abel, Trevor Halliday), R.C.A. (1979-82, Peter de Francia). *Exhib:* regular exhbns. since 1981, group and individual shows. *Works in collections:* Britain, Europe, America. *Signs work:* "Ian Jones." *Address:* Anderson O'Day Gallery, 255 Portobello Rd., London W11 1LR.

JONES, Joan, ARBSA (1970); painter in oil and water-colour, also paper collage; painting instructor in still life, portraits, flowers and landscape. *b:* Solihull, 16 Apr 1924. married. *d of:* Leslie Woodhouse Price, M.A., M.D. one *s. Educ:* Malvern Hall, Solihull. *Studied:* Sutton Coldfield, Bourneville, Birmingham (1950-60, Dennis Greenwood, A.T.D., Alex Jackson, A.T.D., R.B.S.A.). *Exhib:* B'ham, Sutton Coldfield, Worcester, etc. *Signs work:* "Joan Jones" sloping upwards towards right hand side. *Address:* Elms Cottage, Grafton Flyford, Worcester WR7 4PG.

JONES, John Edward, R.W.A.; N.D.D. (1951), A.T.D. (1952), Dip.F.A. (Slade 1954); painter in oil, pen, etc.; University senior lecturer (retd.); Regional Director of Open College of the Arts (retd.); London University Moderator G.C.E. 'O', 'A' level and G.C.S.E. Art; Past President, Leeds Fine Art Club. *b:* Bristol, 19 Aug 1926. *s of:* Stanley Jones. *m:* Gabriela Jones. two *d. Educ:* Winterbourne Elementary; Colston's School, Stapleton. *Studied:* West of England College of Art (1942-44 (army intervened) 1948-52, George Sweet), Slade School (1952-54, Rogers, Coldstream, Wittkower). *Exhib:* R.W.A., Leeds Fine Art, etc. *Works in collections:* University of Leeds, R.W.A. *Commissions:* Communication Dept., University of Leeds. *Publications:* 'Wonders of the Stereoscope'. *Clubs:* Chelsea Arts. *Signs work:* "J.E. Jones" or "Jones" (and date). *Address:* 20 Hollin La., Leeds LS16 5LZ.

JONES, Joyce Margaret Farrall, (née Mellor); R.Cam.A.(1997); illustrator, miniature painter of portraits, animals, floral. *b:* Bangalore, India. *Studied:* Regional College of Art, Manchester (1954-57), St. Martin's School of Art (1957-59), Italy (1959-60). *Publications:* illustrated books for Longmans, University of Wales Press, Cambridge School Classics, N.W. Arts Assoc., Thames and Hudson, Encyclopedia Britannica, Nature Conservancy. *Misc:* Work purchased: by Indian Army (portraits), miniature collectors, commercial dealers in U.K., U.S.A., S. Africa, Australia. *Address:* 3 Queens Park, Colwyn Bay LL29 7BG.

JONES, Julia, RCA (elected member 2001). *b:* Darton. *m:* A. Neville Jones. two *s. Studied:* University of Wales, Aberystwyth; Bangor Technical College. *Exhib:* Royal Cambrian Academy, Conwy; RI Watercolours, London; Society of Botanical Artists, London; Royal National Eisteddfod. *Works in collections:* Hotels in Wales Art; various private collections. *Commissions:* Welsh Water Authority. *Works Reproduced:* in "1882-2002 Royal Cambrian Academy" (RCA, 2002). *Signs work:* "Julia Jones". *Address:* Rhos Cottage, Llanfaes, Beaumaris, LL58 8LR. *Email:* fjanjones@aol.com

JONES, Karen, S.Eq.A.; equine water-colourist;. *b:* 11 Aug., 1942. *d of:* Glyn Jones and Mardorie Meggitt, Sculptor. *m:* Mike Eaton. two *d. Educ:* Godolphin and Latymer. *Exhib:* R.A., England, Wales and U.S.A. *Works in collections:* England, Wales, Scotland, Ireland, U.S.A., Canada, France, Italy, Germany, Portugal, Holland, W.I., New Zealand, Spain, Australia. *Misc:* Gallery at home: open Summer. *Signs work:* "K.J.'98." *Address:* Blaenllyn, Llangolman, Clunderwen, Pembs. SA66 7XR.

JONES, Lee, self taught fine artist in acrylic;. *b:* Liverpool, 26 Aug., 1968. *m:* Denise. one *s. Exhib:* England, America, etc. *Works in collections:* England, America, Canada, Australia. *Clubs:* N.A.P.A., South Sefton Artists. *Address:* 18 College Rd., Great Crosby, Merseyside L23 0RW.

JONES, Leslie, A.R.E., A.R.C.A., D.A.(Manc.), H.R.Cam.A., Rome Scholar; painter, printmaker, illustrator; taught at Hornsey, Kingston, St. Martin's Schools of Art (1961-67); H.M.I. (1967-83); Bangor (1987-89). *b:* Tremadoc, 1934. *Studied:* Regional College of Art, Manchester (1951-55), Royal College of Art (1955-58), British School at Rome (1958-60); visitor at Belgrade Academy (1959). *Exhib:* London, Rome, U.S.A., Austria. *Works in collections:* V. & A., Arts Council, University of Oregon, University of Wales, National Library Wales, L.E.As., Church in Wales, R.C.Church. *Publications:* illustrated books for Lion & Unicorn, Longmans, University of Wales Press, Cambridge School Classics Project. *Address:* 3 Queens Park, Colwyn Bay LL29 7BG.

JONES, Lucilla Teresa, Cert.F.A. (Oxon.); painter in oil, water-colour, mixed media;. *b:* Exmouth, 30 June, 1949. divorced. one *s. Educ:* St David's Ursuline Convent, Brecon. *Studied:* Ruskin School of Fine Art and Drawing (1968-71). *Exhib:* many solo and mixed shows including Ashmolean Museum, Monaco Fine Arts Monte Carlo, Chapter Gallery Cardiff, Upton Lodge Galleries, Tetbury, Weatherall, Green & Smith, London, Osborne Studio Gallery, London, Julian Davies Gallery, San Diego, Louis C. Morten Gallery, Mexico City, Capriole Gallery, Virginia, Mall Galleries, Inst. of Contemporary Arts, Warwick Arts Trust Galleries, London, Roy Miles Gallery, London. *Works in collections:* Royal Artillery and Royal Marines, Brecknock Museum and A.G.; private collections in U.K., U.S.A., Singapore, S. Africa, Holland and Ireland including those of Prince Kais al Said and Ravi Tikoo. *Publications:* Horse Breeding in Ireland, Horses, Hounds and Hunting Horns by Dr. Colin Lewis (Allen, 1980).

Signs work: "L.T.J." or "Lucilla Jones." *Address:* Dan-y-Parc, Llandefalle, Brecon, Powys. LD3 0UN. *Email:* info@artisitlucillajones.com *Website:* www.artistlucillajones.co.uk

JONES, Lucy, B.A. 1st class B.A. Hons., Fine Art, M.A. (R.C.A.); painter in oil. *b:* 1955. *Studied:* Camberwell School of Art, R.C.A. *Exhib:* over 16 solo exhibs. at Flowers East Gallery, London, and many group exhibs. including Whitechapel Art Gallery, Camden Arts Centre, R.A., Metropolitan Museum of Art, New York. *Works in collections:* Arts Council, Deutsche Bank A.G., London, Government Art Collection, Sheffield City Art Gallery, Usher Gallery, Lincoln. *Signs work:* "Lucy Jones." *Address:* c/o Flowers East, 82 Kingsland Road, London E2 8DP. *Email:* gallery@flowerseast.com

JONES, Malcolm, H.Dip.A.D. (1973), B.A. (Hons.) (1971); artist in painting, installation, construction. *b:* Merseyside, 12 May 1949. *Studied:* Chelsea School of Art (1972-73), University of Reading (1967-71). *Exhib:* ten solo shows in London public galleries since 1980, internationally in group exhbns. since 1972. Work reviewed in Art Forum, The Architects Journal, The Times, Neue Bildende Kunst, Neues Deutschland, The Guardian, Artscribe, BBC Critics Forum, Arts Review, NRC Handelsblad, Der Tagesspiegel, Frankfurter Rundschau, Het Parool and TV Times. *Works in collections:* Bette Midler, New York. *Publications:* Tolly Cobbold Eastern Arts 4 (1983), Watercolour C21, Bankside Gallery (1999), Singer & Friedlander Exhibition, Mall Galleries (2003). *Works Reproduced:* Whitechapel Gallery Exhibtions Leaflet (March 1993); Architects Journal, Exhibtions Update (March 1997); Artscribe no.50, p.66-67; Artline (June 1984); Tolly Cobbold Eastern Arts 4, Fitzwilliam Museum, catalogue. *Address:* 64 Chisenhale Rd. London E3 5QZ. *Website:* http://www.chisenhale.co.uk/jones.html

JONES, Martyn Vaughan, BA Hons (Illustration). *Medium:* painter in acrylic, oil, mixed media. *b:* Coventry, 26 Oct 1957. *s of:* John and Jean Jones. *Educ:* Blackwood Comprehensive School (1971-75). *Studied:* Newport (Gwent) College of Art (1975-79). *Represented by:* Benjamin C.Hargreaves, Fulham, London; Washington Gallery, Penarth; Albany Gallery, Cardiff; Art Matters, Tenby. *Exhib:* Benjamin C.Hargreaves (1997-present). Group shows: Albany Gallery and Three Man Exhibition (Spring 2001); two-man show: Washington Gallery (1998, 2003), also many shows throughout South Wales. *Works in collections:* Mr Victor Spinnetti, Mr Geraint Davies (Head BBC Wales), Mr Chris Segar (tv presenter), many private. *Commissions:* sleeve cover for recording by Philip Madoc of Work of Dylan Thomas, sleeve for 'Was There a Time' (1990). *Works Reproduced:* mainly gallery promotions. *Principal Works:* 'Severn Estuary' series (ongoing project). *Misc:* currently working from narrowboat studio on the Gloucester-Sharpness canal, overlooking River Severn. *Address:* Yew Tree Cottage, Stenders, Mitcheldean, Glos, GL17 0JE. *Email:* martynvaughanjones@hotmail.com

JONES, Mary Lloyd, NDD (1955), ATD (1956); artist in water-colour and oil; Chairman, Wales Artists Development Centre Assoc.; External examiner; BA(Ed.) Art & Design, Trinity College, Carmarthen. *b:* Devil's Bridge, Ceredigion, Wales, 21 Aug 1934. *m:* John Jones. two *d. Educ:* Ardwyn Grammar School, Aberystwyth. *Studied:* Cardiff College of Art (1951-56, Eric Malthouse). *Exhib:* Montserrat Gallery, N.Y., Martin Tinney Gallery, Cardiff, Gallery of Modern Art, London, John Martin Gallery, Albemarle St., London. *Works in collections:* Tabernacle Museum of Modern Art, Wales, WAC, Crawford Museum and Gallery, Cork, Tyrone Guthrie Centre, Ireland, BBC Wales, Ceredigion CC, S4C Centre, Cardiff Arena/World Trade Centre. *Commissions:* Earth Works, Wales Garden Festival, Ebbw Vale. *Publications:* The Mountains of Wales (Univ. of Wales Press), Our Sisters Land (Univ. of Wales Press). *Clubs:* Gweled (Welsh Artists Assoc.), Water-colour Soc. Wales, R.Cam.A. *Misc:* First Prize, Wales Open Exhbn., Aberystwyth Arts Centre (1997). *Signs work:* "Mary Lloyd Jones." *Address:* c/o Martin Tinney Gallery, 18 St.Andrews Crescent, Cardiff CF10 3DD.

JONES, Megan, NDD(1956) ATD; BA (1957); artist in oil, mixed media, gouache, charcoal, conté; Arts Council of Wales travel grant, Newfoundland (1994). *b:* Neath, S. Wales, 6 Jul 1936. *m:* Derrick Jones. two *s. Studied:* Swansea College of Art (1952-57, Alfred Janes). *Exhib:* widely solo and group shows in Britain and abroad. *Works in collections:* Brecknock Museum and Gallery, Brecon; University of Newfoundland, Canada; Nippon-Sieke, Japan; County Hall, Carmarthen; Prince Philip Hospital, Llanelli; British and Continental Fuels, Belgium; Rhondda Heritage Park Gallery; Lidice Community, Czechoslovakia; University College, Swansea; Dr. Rowan Williams; Contemporary Art Society for Wales. *Commissions:* design for sculpted stone marker for Brecon Beacons Way (2005). *Publications:* Essay 'Ceri Richards' (University of Wales Press, 1999), cover 'Songs of Silence' by Patricia Barrie (Honno Press, 1999), Pastel Artists International, 'Drawn from Wales', a history of Swansea Art College; '8 Stones, 8 Artists' (Exploring the Beacons Way Art Trail). *Clubs:* The Welsh Group. *Signs work:* "Megan Jones." *Address:* 9 Heol Derwen, Ystradgynlais, S. Wales SA9 1HL.

JONES, Olwen, R.A.S. (1968), R.E. (1978), R.W.S. (1989); V.P. R.W.S. (2004 -07); painter in oil and water-colour, printmaker in relief and etching. *Medium:* watercolour painting and relief printing. *b:* London, 1 Mar 1945. *d of:* William Jones. *m:* Charles Bartlett. *Educ:* Harrow School of Art (1960-65). *Studied:* Royal Academy Schools (1965-68), engraving under Gertrude Hermes. *Exhib:* first one-man: Zaydler Gallery, London (1971). One-man: (1975) travelling exhbn to Oldham Art Gallery; Wrexham and Lewis Art centres; (1984) travelling exhbn Minories Colchester, Usher Gallery Lincoln, University of Durham, Oriel Theatre Clwyd, Anthony Dawson London; (1979, 1985, 1988, 2002, 2006) Bohun Gallery Henley; (1999) Chappel Galleries Essex; (2000) John Russell Gallery Ipswich. *Works in collections:* National Museum of Wales, Norwich Castle Museum, Reading Museum, Nuffield Foundation, Museum of London, Department of the Environment, Graves Art Gallery Shefield, Usher Art Gallery

Lincoln, Greenwich Library. *Commissions:* Set of nine mural paintings for TrustHouse Forte; Triptych for Priors Court School for Autism. *Official Purchasers:* painting for National Grid; painting for Lloyds of London. *Works Reproduced:* painting in The National Statistics 'Britain' 1998. *Recreations:* walking. *Signs work:* "Olwen Jones." *Address:* St. Andrews House, Fingringhoe, nr. Colchester, Essex CO5 7GB.

JONES, Philip Charles, painter in oil; Arts Council of Great Britain (1956-1961); Painting Prize, Eastern Open (993). *b:* London, 1 Apr 1933. *m:* Frances. two *s.* two *d. Educ:* Malvern College. *Studied:* Slade (1953-1956). *Exhib:* Grabowski, Louise Hallet, Vanessa Devereux, M. Parkin, Ainscough Contemp. Art Galleries, London, R.A. Summer Exhib. (1990-2002), Oliver Contemporary London from 2002, Lynne Strover Cambridge (2005). *Works in collections:* British Transport, Newport and Plymouth Art Galleries, Texaco Oil Co., T.V. West, CAS, NHS Hospital Trusts: Papworth, Cambridge, Norwich. *Signs work:* "Philip Jones." *Address:* Clermont Hall, Little Cressingham, Thetford, Norfolk IP25 6LY. *Email:* philip@clermonthall.com *Website:* www.philip-jones.co.uk

JONES, Robert William, NDD, ATC; painter in oil; full-time artist; former lecturer, Falmouth College of Art. *b:* Newquay, Cornwall, 22 Mar 1943. *m:* Susie Jackson. three *s.* two *d. Educ:* Tretherras School, Newquay. *Studied:* Falmouth Art School. *Exhib:* numerous throughout S. West, London, Cotswolds etc. *Works in collections:* mainly private, museums, S.W. Arts, Plymouth Museum. *Publications:* 'Robert Jones' by Jenny Pery, pub. Halsgrove Press, 'Alfred Wallis Artist & Mariner' by Robert Jones (2001), 'Reuben Chappell Pierhead Painter' by Robert Jones (2006). *Signs work:* "Robert Jones" on back or "R.J." usually in red on painting. *Address:* Bodrigey Farm, 23 Sea Lane, Hayle, Cornwall TR27 4LQ. *Email:* robertjonesfirstlightstudio@btinternet.com *Website:* www.firstlightgallery.co.uk

JONES, Rosamund, R.E., Painting N.D.D.; artist in etching, water-colour; shepherd; original work of wildlife, countryside scenes, cockerels, animals, and trout in watercolours. *b:* Harrogate, 1944. married. one *s.* three *d. Educ:* Harrogate. *Studied:* Harrogate, Leeds Colleges of Art. *Exhib:* Cartwright Hall Bradford, Edinburgh, London, Scottish Royal Academy, Royal Academy, London. *Works in collections:* Bankside Gallery, London, Printmakers Workshop, Edinburgh. *Signs work:* "Rosamund Jones." *Address:* New Bridge Farm, Birstwith, Harrogate HG3 2PN.

JONES, Royston, Dip.AD (1968), MFA (Illinois, 1971); advisor for the creative industries; Director, Pacific Stream. *b:* Wolverhampton, 15 Jan 1947. *s of:* Percy Jones. one *d. Studied:* Birmingham College of Art and Design (1965-68, John Walker, Trevor Halliday), University of Illinois (1969-71, Jerome Savage, Art Sinsebaugh, Bart Parker). *Exhib:* regularly in Britain and USA. *Address:* Pacific Stream, Liverpool Digital, Maxwell House, Edge Lane,

Liverpool L7 9NJ. *Email:* roy@pacificstream.info *Website:* www.pacificstream.info

JONES, Stanley Robert, ATD (1950), FSA.; printmaker and archaeologist. *b:* Birmingham, 9 Jun 1927. *s of:* George Jones, brewery departmental manager. two *s.* one *d. Educ:* Elementary School; Yardley Grammar School, Birmingham. *Studied:* Birmingham College of Art under Harold Smith, B. Fleetwood-Walker, A.R.A. (1942-45, 1948-50), R.A. Schools under B. Fleetwood-Walker, A.R.A., Henry Rushbury, R.A. (1950-55). *Exhib:* R.A., R.B.S.A., Printmakers' Council Venues, South Yorkshire Open. *Works in collections:* Graves Art Gallery, Sheffield. *Address:* 118 Totley Brook Rd., Sheffield S17 3QU.

JONES, Steven, Dip. in Illustration (1981); artist/illustrator in oil. *b:* Chester, 5 Apr 1959. *s of:* Peter Jones. *m:* Sian. one *s.* two *d. Educ:* Colwyn High School, Colwyn Bay. *Studied:* Wrexham College of Art (1976-81, Keith Bowen). *Exhib:* one-man show: Oriel Môn, Anglesey (1996), Penrhyn Castle, Bangor (1998). *Publications:* Specialises in figures in landscape scenes particularly beach scenes, golf scenes and views of Snowdonia. Many paintings sold through auctions in Britain including Christies, Bonhams and Chrystals. Limited Edition Prints and greetings cards sold throughout Britain and the U.S.A. *Signs work:* "Steven Jones." *Address:* The Steven Jones Gallery, The Bulkeley Hotel, Castle St., Beaumaris, Anglesey, N. Wales LL58 8AW. *Email:* steven@stevenjonesart.freeuk.com *Website:* www.stevenjonesart.freeuk.com

JONES, Trevor, N.D.D. (1953), A.T.C.(Lond.) (1954), Fellow, Designer Bookbinders, Founder Mem. and President (1983-85); artist craftsman in bookbinding; on Crafts Council Index of Selected Makers;. *b:* Wembley, 15 July, 1931. *m:* Pauline Jones. two *d. Studied:* Harrow School of Art (1947-49, 1952-53), Hornsey College of Art (1953-54). *Exhib:* Britain and internationally with Designer Bookbinders since 1956. *Works in collections:* British Library, V. & A., Royal Library Copenhagen, University of Texas, Pierpoint Morgan Library N.Y., Lilly Library Indiana, Keatley Trust Collection of 20c. British Art, Shipley A.G. Gateshead. *Publications:* articles in The New Bookbinder, Bookbinder, Crafts, Fine Print, Magnus. *Signs work:* "T.R.J." or "Trevor Jones." *Address:* 48 Burton Stone Lane, York YO30 6BU.

JONES, Trevor Grenville, N.D.D. (1965), M.A. (1968); painter/printmaker in oil, wax, ink;. *b:* 4 Feb., 1945. one *s.* one *d. Studied:* Stourbridge College of Art (1960-63), B' ham College of Art (1963-65), R.C.A. (1965-68). *Exhib:* numerous including solo shows: Flowers Graphics, London (1992, 1993), Flowers East, London (1995), Glass Mountain Gallery, Connecticut, U.S.A.; group shows: '30 Years of Printmaking' Advanced Graphics London Anniversary Show, Berkeley Sq. Gallery, London (1997), Original Print Gallery, Dublin (2000). *Works in collections:* Scottish National Gallery of Modern Art, Unilever, V. & A., B.P. Group, Johannesburg A.G. and Melbourne A.G., Office of National Statistics,

Lasmo U.K. *Address:* c/o Advanced Graphics London, B206 Faircharm, 8-12 Creekside, London SE8 3AX.

JONES, Yvonne, MA Dist.FA Painting. *b:* Holywell, N. Wales, 9 Oct 1946. *d of:* Cecil Evans. *m:* Peter M. Jones. two *s. Educ:* Holywell Grammar School. *Studied:* Liverpool College of Art, Winchester School of Art. *Exhib:* Mall Gallery, Liverpool Festival of Arts, Wrexham Arts Centre, R.A. Summer Exhbns. (1989, 1990), Portsmouth City Gallery, Doncaster City Gallery; European tour: Aspex Gallery; Quay Arts Centre; New Contemporaries 2004; Leeds Met Gallery; Winchester Gallery; Barbican Gallery. *Works in collections:* Welsh Arts Council, Merseyside Arts Trust, New Hall, Cambridge, Contemporary Women Artists; private collections: U.K. and Germany. *Address:* 84 New Forest Drive, Brockenhurst, Hants., SO42 7QW. *Email:* yvj@ntlworld.com *Website:* www.yvonnejones.net

JONES, Zebedee, B.A (Hons.) Fine Art (1992), M.A. (Hons.), Fine Art (1993); painter in oil on canvas and board. *b:* London, 12 Mar 1970. *Studied:* Norwich School of Art and Design, Chelsea College of Art and Design. *Represented by:* Hester Van Roisen. *Exhib:* Arts Council, Southampton City A.G., Leeds City A.G., Unbound at the Hayward Gallery (1994), Real Art (Southhampton 1995, Leeds City A.G. 1996); two solo exhbns. (1995, 1997), Dawese Gallery, New York (1999, 2002, 2005); Slewe Gallery, Amsterdam (1998, 2001, 2004). *Works in collections:* Southampton City Art Gallery, Leeds City Art Gallery. *Publications:* 'Affective Light' Rear Window (1994), Unbound Possibilities in Painting, Hayward Gallery (1994), From Here Exhbn. Cat., Essay by Andrew Wilson, Waddington Galleries (1995), Foundations for Fame, The London Inst. (1997), 'Zebedee Jones New Paintings' Catalogue Waddington Gallery, 1999; 'Zebedee Jones Green on Red Gallery, Dublin (1999). *Address:* 1 Albert Bridge Rd., London SW11 4PX.

JONES-ROWE, Avril, N.D.D., D.F.A.(Slade), M.F.P.S.; painter in oil and acrylic, sculptor in bronze, landscape gardener, teacher, art historian;. *b:* New Forest, Hants., 1934. *Studied:* Southampton Art College (1951-55), Sander Theatre School, Southampton (1952-54), Slade School (1955-57), Perugia University (1959). *Exhib:* group shows: Young Contemporaries, London Group, Loggia Gallery, Trends, Bloomsbury Gallery, Bougton Aluph Church, Stroud Festival; one-man shows: Bailey House, Canterbury (Artist in Residence, 1965), B'ham University (1967), St. Pancras Hospital (1975), Loggia Gallery (1987). *Signs work:* "Jones-Rowe." *Address:* 25 Station Rd, Alderholt, Fordingbridge, Hants. SP6 3AF.

JONSSON, Lars Ossian, Honorary Doctorate, Uppsala University (2002). *Medium:* watercolour, oil, graphic art. *b:* Stockholm, 22 Oct 1952. *s of:* Sven & May. *m:* Ragnhild. two *s.* two *d. Educ:* Autodidact. *Represented by:* Gerald Peters Gallery, Santa Fe, USA; Wildlife Art Gallery, Lavenham. *Exhib:* National Gallery, Stockholm; galleries and museums in Sweden, UK, France, USA etc.

Works in collections: National Museum of Wildlife Art; The Natural History Museum, Stockholm; Leigh Yawkey Woodson Art Museum. *Publications:* eleven books, including 'Birds and Light' (A&C Black, 2002). *Works Reproduced:* Audubon Magazine. *Principal Works:* works mostly with birds and their habitats. *Recreations:* music. *Misc:* leading authority in field identification of birds. *Address:* Norrgarde, Hamra, S-62010 Burgsvik Sweden. *Website:* www.larsjonsson.se

JOPE, Anne, BA Hons. (1970), ARE (1979), RE(1984), Central Postgrad. Printmaking Dip. (1981), SWE(1984), AOI (1994); painter in oil paint and watercolour, printmaker in wood engraving, woodcut and linocut, illustrator. *b:* Corfe Mullen, Dorset, 31 Jan 1945. *d of:* William John Purrington. *Studied:* Ealing Art College (1966-67), Central School of Art and Design (1967-70, 1980-81). *Exhib:* twelve one-man shows, RA, NEAC, RBA, Camden Arts Centre, Ferens AG, Graffiti, Morley Gallery, Royal Western Academy, St. David's Hall, Cardiff. *Works in collections:* Liverpool public libraries, BM, Malcolmson Collection at Hereford City AG, Ashmolean Museum, Leics. Educ. Com., NPG. *Publications:* The Song of the Reeds and Rushavenn Time, The Honey Gatherers, Animals at the Table, Nightlife Poems. *Signs work:* "Anne Jope." *Address:* 14 Millwood End, Long Hanborough, Witney, Oxon. OX29 8BX.

JORDAN, Maureen Ann, NDD, SBA. *Medium:* pastel, watercolour, acrylic. *b:* 14 Apr 1941. *Educ:* Escourt High School, Kingston upon Hull. *Studied:* Kingston upon Hull College of Art and Crafts. *Exhib:* The Royal Academy, Watercolour and Drawings Fair, Solo exhibitions in Suffolk, Pastel Society, Society of Botanical Artists, New Trends Hong Kong, Art Mart; one woman show New York, Affordable Art Fairs annual show at Llewellyn Alexander Gallery, London; various shows at Frances Iles Gallery, Rochester, also in many galleries around the country. *Works in collections:* around the world. *Publications:* art magazines, art books, greetings cards, prints and limited editions, calendars, stationery products and cards printed in the USA. *Works Reproduced:* many. *Misc:* Organizes pastel workshops and demos in Suffolk. *Address:* 43 Marlborough Road, Ipswich Suffolk IP4 5AX. *Email:* maureen.jordan@btinternet.com *Website:* www.maureenjordan.com

JOSEPH, Jane, painter, printmaker; Leverhulme Travelling Award (1965-66); Abbey Award in Painting (British School at Rome, 1991,1995). *b:* Surrey, 7 Jun 1942. *d of:* L. Joseph. *Studied:* painting: Camberwell School of Art and Crafts (1961-65, Robert Medley, E. Uglow, F. Auerbach, R. Kitaj, R.D. Lee, F. Bowling). *Exhib:* solo shows: Morley Gallery (1973, 1997, 2000), Minories, Colchester (1982), Angela Flowers (1987), Flowers East (1989, 1992), Edinburgh Printmakers (1994), Worcester City Art Gallery (2001), Victoria Art Gallery, Bath (2002), School of Art Gallery, Aberystwyth (2004). *Works in collections:* Brecknock Museum and Art Gallery, Government Art Collection, Castle Museum, Norwich, Unilever House, Imperial College, London, University of Northumbria, Chelsea and Westminster Hospital, British Museum, Paintings in

Hospitals, New Hall, Cambridge, Fitzwilliam Museum, Cambridge, Ben Uri Art Gallery, Hebrew Union College, New York, Worcester City Art Gallery, Lindley Library, London, The National Art Library (V. & A. Museum), London, Yale Center for British Art, New Haven, CT; School of Art Gallery, Aberystwyth; Birmingham City Museum & Art Gallery; The British Library, London; The Whitworth Art Gallery, Manchester. *Commissions:* Chelsea and Westminster Hospital, drawings (1994); The Folio Society, etchings to accompany "If This is a Man" and "The Truce" by Primo Levi. *Publications:* 'A Little Flora of Common Plants' with text by Mel Gooding. *Recreations:* walking, and observing life of all kinds. *Signs work:* "Jane Joseph" or "JEJ." *Address:* 6a Eynham Road, London W12 0HA. *Email:* jane_joseph2003@yahoo.co.uk

JOWETT, Jenny Ann, N.D.D. (Drawing, 1957), (Lithography, 1982), S.B.A. (Founder mem.), F.S.B.A.; botanical painter in water-colour, teacher; Tutor, Flatford Mill; President S.F.P.; RHS Gold Medals (3), Silver Gilt (4), Silver (1). *b:* 15 Mar 1936. one *s.* one *d. Educ:* Bromley High School, G.P.D.S.T. *Studied:* Studley College. *Exhib:* West Mills Newbury, Bladon Gallery, Packhouse Bath, John Magee Belfast, The Chelsea Garden London, Interiors of Ascot, Ewhurst Park Hants., Kew Gardens Gallery, Tryon Gallery London, Dr. Shirley Sherwood's Travelling Exhbn. *Works in collections:* Lindley Library, London, Hunt Inst. for Botanical Documentation Pittsburgh, U.S.A., Dr. Shirley Sherwood. *Commissions:* Chelsea Plate, Shell U.K. *Publications:* Limited edn. prints, cards, calendars; White Garden R.H.S. Plantsman, Curtis Magazine Kew. *Signs work:* "JENNY JOWETT." *Address:* West Silchester Hall, Silchester, nr. Reading, Berks. RG7 2LX.

JOYCE, Paula, botanical artist in water-colour; Founder Mem. The Society of Botanical Artists; 18 Grenfell medals-The Royal Horticultural Society. *Medium:* watercolour. *b:* Hong Kong, 1 Sep 1939. *Exhib:* solo and group shows including SBA Annual & Florum. *Works Reproduced:* greetings cards, notelets, wild flower books. *Misc:* Teaches botanical painting in East Sussex plus other venues throughout the country. *Address:* Bishopsgarth, Brede Hill, Brede, East Sussex TN31 6HH. *Email:* paulajoycesba@aol.com *Website:* www.paulajoycefsba.com

JUILLERAT, Paul, BA (Hons) Fine Art; MA. *Medium:* sculpture in stainless steel and perspex. *b:* London, 8 Mar 1962. *Studied:* Winchester School of Art, Hants (1986-89, BA), Chelsea College of Art, London (2002-03, MA). Taught at: Shrewsbury College of Art (1990-95); Hereford College of Art and Design (1991-93); Winchester School of Art (1993-2001). *Exhib:* various group and solo shows. *Works in collections:* private and corporate. *Commissions:* broad range of private, corporate and large scale commercial commissions. *Principal Works:* 'Needle Point' Worcester (2001), 'Sails' Millennium Point, Birmingham (2001). *Signs work:* "P. JUILLERAT". *Address:* 102 Wellsway, Bath, BA2 4SD. *Email:* paul@hotairdesign.com *Website:* www.hotairdesign.com

JUKES, Edith Elizabeth, FRBS, ARCA (1932), SRN (Bart's, 1945); sculptor in clay, wood, stone; teacher of sculpture, Sir John Cass School of Art, City of London Polytechnic (1946-75). *b:* Shillong, Assam, 19 Dec 1910. *d of:* Capt. Andrew Monro Jukes, M.D., I.M.S. *Educ:* Norland Pl. School, Kensington. *Studied:* R.C.A. (1928-32) under Profs. Richard Garbe, R.A., Henry Moore, and Herbert Palliser. *Exhib:* R.A., etc. *Address:* The Studio, 347 Upper Richmond Rd., London SW15 6XP.

K

KALASHNIKOV, Anatoly Ivanovich, Hon.RE (1988), Hon.SWE (1993); Russian wood engraver; Freelance designer for many Soviet publishing houses and Ministry of Communications (postal designs) 1960-80; created over 100 postage stamps and 500 commemorative envelope designs, more than 900 bookplates. *b:* Moscow, Russia, 5 Apr 1930. *s of:* Ivan & Vera Kalashnikov. *m:* (1) Iulia Borisovna 1957 (died 1980). (2) Ludmila Nikolaevna 1980 (died 1994). (3) Ludmila Ivanovna 1994. *Studied:* Moscow Art Inst. (formerly Stroganoff Art School), disciple of Academician Ivan Pavlov. *Exhib:* more than 160 solo exhbns. worldwide. Academician, International Academy of the Book and Art of the Book, Moscow (1992); Merited Artist of Russian Federation; first prizes in international bookplate design competitions: Barcelona, Budapest, Kronach (Germany), Como, Genoa, Pescara, San Vito al Tagliamento (Italy), Helsingor (Denmark), Carlisle (USA). *Works in collections:* B.M., London; Cabinet of Engraving, Biblioteque Nationale, Paris; National Museum, Prague. *Publications:* Anglo-Russian Relations (1983); War and Peace: A suite of Wood Engravings, based on the novel by Leo Tolstoy (1991); 500 Exlibrisis (1993); The Dostoyevsky Suite (1994); Omar Khayam in xylographies by A. Kalashnikov (1994); Golden Ring of Russia (1995); many other albums and suites. *Clubs:* Lions Club, Moscow. *Misc:* Leisure interest: travelling, bookplate design. *Address:* Leninsky prospect 44, Apt.124, 117334 Moscow, Russian Federation.

KALKHOF, Peter Heinz, painter, lecturer in fine art (retired 1999). *Medium:* painting / acrylic on canvas. *b:* Stassfurt, Germany 20 Dec 1933. *s of:* Heinz Kalkhof, company secretary. *m:* Jeanne The (decd.). one *s. Educ:* Germany. *Studied:* School of Arts and Crafts, Braunschweig; Academy of Fine Art, Stuttgart; Slade School of Fine Art, London; Ecole des Beaux Art, Paris (1954-62). *Exhib:* Annely Juda Fine Art (1970-79, 1990, 1997), Scottish Arts Council, Edinburgh, Glasgow, Juda-Rowan Gallery (1983), Landesmuseum Oldenburg (1988), Camden Arts Centre (1989), Galerie Rösch, Neubrunn (1993)/Karlshruhe (1994), Germany, St. Hugh's College, Oxford (1998), Galerie Planie, Reutlingen (1998), Gallery Roech, Houston/Texas (2000), Annely Juda Fine Art (2002); Gallery +1+2 Artspace, London (2004); Annely Juda Fine Art (2007). *Works in collections:* Northern Ireland Trust, Arts Council of Gt. Britain, Leics. Educ. Authority, European Parliament, Landesmuseum Oldenburg, Ostpreussen Museum, Lüneburg, University of Reading, Museo Salvatore Allende/Chile,

Imperial War Museum, London. *Commissions:* 1987 Treaty-Centre: Mural (Taylor Woodrow), Hounslow, London. *Publications:* Catalogue: Oldenburg Landesmuseum, 1988; Catalogue: Galerie Planie, 1998 Reutlingen; Catalogue: Annely Juda Fine Art, 2002 London; Catalogue: Galerie Roesch, 1994 Karlsruhe/Durlach; catalogue, Annely Juda Fine Art (2007). *Recreations:* travelling, museum visits, listening to music, reading. *Misc:* Associate Member of the British Museum; Friend of the Victoria & Albert Museum; Friend of the Royal Academy. *Signs work:* "Peter Kalkhof." *Address:* c/o Annely Juda Fine Art, 23 Dering St., London W1R 9AA. *Email:* p.kalkhof@virgin.net *Website:* www.annelyfineart.co.uk/Gallery-Artists

KALMAR, Janos, RBS; Hungarian Society of Fine and Applied Arts; Art Association of Hungarian Artists; Hungarian Sculptors Society; International Kepes Society; British Art Medal Society; Prizes and scholarships include: Derkovits Scholarship (1983-86); Biennial of FIDEM prize FIBRU (1994); Great Prize of the II. International Biennial of Contemporary Medal-Seixal (PO)(2001); Scholarship of the Hungarian Academy in Rome (2004/5). *Medium:* sculpture. *b:* Budapest, 23 Jul 1952. one *s.* one *d. Studied:* Academy of Fine Arts, Warsaw, Poland (1973-78); Academy of Fine Arts, Budapest; Paris (1983), London (1984), Switzerland (1989), India (1990). *Exhib:* Major one-man shows include: Group exhibitions include:. *Works in collections:* British Museum, City of Bath, British Art Medal Society (UK); American Numismatic Society; Graf-Zeppelin-Haus (Germany); Museum of Fine Arts, Poznan (Poland); Skironio Museum, Athens (Greece), and major museums and galleries across Hungary. *Commissions:* Public sculptures for Bath (UK), Kisoros and Fehérgyarmat (Hungary). Hauser Arnold monument, Farkasréti cemetery, Budapest (1981); Ferenc Rózsa portrait, Press Centre, Budapest (1982); Mihály Vörösmarty portrait, Bácsalmás (1983); H.H.Foundation, Germany (2000). *Publications:* include: 'Janos Halmar 1978-2003' (ISBN 963 430 773 6); 'Janos Kalmar' by Abody Rita (Könyvtáros, 1986); The Medal (1987, 1994, 1996); Mozgó Világ (1985, 1987); Art Today (1994). *Signs work:* "Janos Kalmar". *Address:* Solymarvolgyi, u.132, H-1037 Budapest, Hungary. *Email:* studio@janoskalmar.com *Website:* www.janoskalmar.com

KANDER, Nadav, *b:* Tel Aviv, 1 Dec 1961. *s of:* Jacob and Jenny Kander. *m:* Nicole Verity. one *s.* two *d. Educ:* Woodmead School, Johannesburg. *Represented by:* Burnham Niker, London (www.burnham-niker.com); Stockland Martel, NY (www.stocklandmartel.com); VPD, Paris (www.premiereheure.ph/vpd). *Assisted:* Harry de Zitter, Peter Hopkins. *Individual Shows/Exhibitions:* public collections: National Portrait Gallery, London, V & A, Tate, (Liverpool); shows: Shine Gallery, London; Acte II Gall, Paris; and in the USA, Yancey Richardson Gall, NY, Fahey Klein Gall, LA and Peter Fetterman Gall, LA. *Awards/Commissions:* advertising commissions include: Issey Miyake, Lacoste, Cartier, Levi Strauss, Nicole Farhi, Nike, Penguin Books, Piper Heidsieck, Reebok, Tag Heuer, Umbro, Absolut, Air France, Amnesty International, Big Issue, Dr.Barnardos, Heals; has also produced editorial work for Q Magazine, Dazed and Confused, Blackbook, Details, Exit, Tank, Viewpoint, Jalouse, Visionaire, Planet, Rolling Stone, Nova,

Casa do Vaticano, Observer Life Magazine and Sunday Times Magazine. Awards: National Portrait Gallery, Schweppes Prize Nomination (2003); silver and commendation, Campaign Poster Awards (2003); Terence Donovan Award, The Royal Photographic Society (2002); 3 silver awards, D & AD (1992+); 2 gold and 11 silver awards, the Assoc of Photographers (1991+); 7 awards of excellence, Communication arts (1998+); Alfred Eisenstadt award for sports photography (1999, 2000); 2 gold and 4 silver awards, The Art Director's Club of NY (1997); gold award, The Art Director's Club of Europe (1997); 2 times winner of the Pro Prize at Epica (1997, 2000),. *Publications: Monograph/Contributer:* Beauty's Nothing (2001); Nadav Kander- Night (2001). *Additional Projects:* film for Mount Sinai Hospital, NY. *Signs work:* Nadav Kander, title, date and edition. *Address:* Unit D, Imperial Works, Perren St., London NW5 3ED. *Studio Address:* Unit D, Imperial Works, Perren St, London NW5 3ED. *Email:* mail@nadavkander.com *Website:* www.nadavkander.com

KANE, Martin, B.A.(Hons.) (Edin. 1987). *Medium:* oil/canvas, pastel. *b:* Cardiff, 3 Jun 1958. *s of:* Bernard Kane, B.Ed. *m:* Sharon Goodlet. one *s. Educ:* St. Andrew's High School, Clydebank, Glasgow. *Studied:* Glasgow School of Art (1981-82), Edinburgh College of Art (1982-87, David Michie). *Exhib:* Angela Flowers Gallery (1988), Jill George Gallery (1990), Thumb Gallery, Atlanta, U.S.A. (1990), Kasen Summer Coll., N.Y.; one-man shows: Jill George Gallery (1992, 1993), Beaux Arts, London (1996), Child, Gredden, Lewis, London (2001), 'Scottish Art', Art Association, Old Lyme, Connecticut, USA (2007). *Works in collections:* Cleveland, Middlesbrough; Cleveland, Ohio; Glasgow Museums and A.Gs.; Unilever PLC; Gartmore Investments; Harry Taylor of Ashton, Kasen Summer New York, Campbell Town Museum, Scotland. *Recreations:* reading, music. *Clubs:* Glasgow Art Club. *Misc:* alt. addresses: Beaux Arts Gallery, 22 Cork St., London W1X 1HB; 47 Hawthorn Avenue, Bearsden, Galsgow, G61 3NG. *Signs work:* "Martin Kane." *Address:* Dovehill Studios, 15 East Campbell St., Glasgow G1 5DT. *Email:* martin3658@tiscali.co.uk

KANG, K.S., portrait painter in oils and sculptor;. *b:* India. *Studied:* Leicester University. *Exhib:* John Noott Galleries, Broadway. *Signs work:* "NICKS." *Address:* c/o John Noott Galleries, 58 High St., Broadway, Worcs. WR12 7DP.

KANIDINC, Salahattin, awarded High Moral Prize (1954); artist in pencil, pen, brush, ink, oil, polymer; letterer, calligrapher, designer, expert on historical writing systems (hieroglyphs to Roman alphabet) and modern letter forms; owner-creative director, Kanidinc International; and consultant designer for major corporations. *b:* Istanbul, Turkey, 12 Aug 1927. *s of:* Yahya Kanidinc. *m:* Seniha Kanidinc. two *s. Educ:* 22nd Elementary School of Uskudar, Uskudar 1st High School, Istanbul, Turkey. *Studied:* Defenbaugh School of Lettering, Minn. (1954), Zanerian College of Penmanship, Ohio (1963), State University of Iowa (1963), University of Minnesota (1964), University of California (1963-64). *Works in collections:* Peabody Inst. Library, Baltimore; W.C.C., N.Y.C.; and in

private collections. *Publications:* participant designer, Alphabet Thesaurus, Vols. 2-3. *Clubs:* S.S.I., W.C.C., International Assoc. of Master Penmen and Teachers of Handwriting, American Inst. of Graphic Arts, International Center for the Typographic Arts, National Advisory Board of the American Security Council. *Misc:* Listed in 'Who's Who' publications throughout the world. *Address:* 33-44 93rd St., Jackson Heights, New York 11372, U.S.A. *Email:* kansal@webtv.net

KANTARIS, Rachael Anna, Foundation Dip. Falmouth School of Art (1986), B.A. Hons. visual and performing arts, Brighton University (1989), M.A. Printmaking, Brighton University (1992); artist and freelance tutor in printmaking and colour etching; currently co-running Porthmeor Print Workshop, St. Ives, Cornwall; teaches regularly for schools, Newlyn Art Gallery, Tate Gallery St.Ives, and at Cornwall College on Fine Art Foundation Degree courses. *Medium:* printmaking and painting. *b:* Brisbane, Australia, 19 May 1967. *m:* Christian Guerrini. two *d. Educ:* Helston School, Cornwall. *Studied:* Falmouth School of Art (1985-1986), Brighton University degree course (1986-1989) and M.A. course (1990-1992). *Exhib:* British Council Exhib., Ayala Museum, Manila, Philippines (1997); supplies around twenty galleries in U.K; exhibits regularly at Thompson in the City Gallery, London, Affordable Art Fairs, Battersea and Bristol, Belgrave Gallery, St.Ives, Cornwall Contemporary, Penzance and others. *Works in collections:* British Council, Hong Kong and Manila; Bank of England; Allner Castle, Bonn, Germany. *Publications:* various - most recent, 'Behind the Canvas', by Sarah Brittain and Simon Cook, published by Truran (2001). *Signs work:* "Rachael Kantaris." *Address:* 1 Mount Pleasant, St. Ives, Cornwall TR26 1JW. *Email:* rachael@kantaris.com *Website:* www.kantaris.com

KAPLAN, Krystyna, Received Award of Excellence in Video Publishing for a film she directed ('Look Great, Feel Fantastic'); Certificate of Merit at the Chicago International Film Festival; nominated Best Editor at BISFA, etc. *Medium:* batik on paper, cotton & silk & textile collages ('Art Protis'). *b:* Elk, Poland, 11 Mar 1951. *d of:* Henryka & Marian Nosarzewski. *m:* Jan Kaplan, Filmmaker, photographer. *Studied:* MA Diploma at the University of Warsaw; taught by Noel Dyrenforth & Jill Denton at Kingsway College; learned 'Art Protis' at the Studio in Brno, Czech Republic. *Exhib:* solo: 1994-The Polish Cultural Centre on Prague (batiks on paper, silk, cotton & textile collage), 1995-The Art Centre in elk (batiks and collages), 2001- The Posk Gallery in London (batiks & Fashion accessories), 2002- The Pygmalion Gallery in Prague, Czech Republic (batiks on paper), 2003- The Posk Gallery ('Art Protis' collages). Group exhibitions 2004-07 with APA (Association of Polish Artists in Britain). *Publications:* 'Batik on Paper' by Krystyna Kaplan (only publication on the subject so far in the world). *Works Reproduced:* in various magazines and on the internet. *Recreations:* walking, history. *Clubs:* BAFTA. *Signs work:* "KRYSTYNA KAPLAN". Batiks on paper, signature and medieval stamp with letters KK). *Address:* 37 Lady Margaret Road, London NW5 2NH. *Email:* kkaplan@4me.pl *Website:* www.kaplan.4me.pl

KAPOOR, Anish, CBE (2003); 'Premio Duemila' award Venice Biennale (1990), Turner Prize award (1991), Hon. Fellow, London Inst. (1997); Hon. Fellowship Royal Institute of British Architecture (2001). *b:* Bombay, 1954. *Studied:* Hornsey College of Art (1973-77), Chelsea School of Art (1977-78). *Exhib:* numerous solo shows including Patrice Alexandre, Paris (1980), Lisson Gallery (1982-), W.A.G. Liverpool, Barbara Gladstone Gallery, N.Y. (1986), Tate Gallery London, Tel Aviv Museum of Art (1993), Scai The Bathhouse, Tokyo (1999), Baltic Centre for Contemporary Art (2000), Gateshead, as well as many group exhbns. from 1975 to date. *Works in collections:* Tate Gallery, London; Hirshhorn Museum and Sculpture Garden, Washington D.C.; M.O.M.A., (N.Y.); Weltkunst Foundation, Zurich; Rijksmuseum Kroller-Muller, Holland; Auckland City A.G. (N.Z.); Vancouver A.G., Canada, etc. *Publications:* many including Breaking the Mould, British Art of the 1980s and 1990s (Weltkunst Coll., London 1999), Vision - 50 years British Creativity (Thames & Hudson, 1999), etc.; numerous exhbn. catalogues. *Address:* c/o Lisson Gallery, 67 Lisson St., London NW1 5DA.

KARPINSKI, Christine Dauray, residency at Cil Rialaig Art Project, Co.Kerry, Ireland; ex-member Board of Directors, Lyme Art Association (oldest Art Assoc. in USA). *Medium:* oil. *b:* RI, USA, 24 Dec 1944. *d of:* Victor & Beatrice Dauray. *m:* Peter A.Karpinski. two *s. Studied:* Rhode Island School of Design, Providence USA; Lyme Academy, College of Fine Art, Old Lyme, CT, USA. *Represented by:* The Sylvan Gallery, Clinton, CT 06413, USA. *Exhib:* RA; Lyme Art Assoc.; Slater Museum, CT; Llewelyn Alexander; Essex Art Assoc., CT; Narrow Space Gallery, Clonmel, Ireland. *Works in collections:* permanent collection of the Florence Griswold Museum; private collections in UK, Ireland, Canada and USA. *Recreations:* celtic harpist. *Clubs:* American Harp Society. *Signs work:* 'CK'. *Address:* 183 Niantic River Road, Waterford, CT 06385 USA. *Email:* chriskarpinski@myeastern.com *Website:* www.pinneygallery.com

KAUFFMANN, C. Michael, PhD. (1957), F.B.A. (1987), F.M.A., F.S.A.; Art historian and museum curator (formerly V. & A.); Emeritus Prof. of the History of Art, and former Director; Courtauld Inst., University of London. *b:* Frankfurt a/M, 5 Feb 1931. *s of:* Arthur Kauffmann. *m:* Dorothea. two *s. Educ:* St. Paul's School; Merton College, Oxford (1950-53); Warburg Inst., London (1953-57). *Publications:* The Baths of Pozzuoli: medieval illuminations of Peter of Eboli's poem (1959); An Altarpiece of the Apocalypse (1968); V. & A. Catalogue of Foreign Paintings; British Romanesque Manuscripts 1066-1190 (1975); Catalogue of Paintings in the Wellington Museum (1982); John Varley (1984); Studies in Medieval Art (1992); Biblical Imagery in Medieval England 700-1550 (2003). *Address:* 53 Twyford Ave., London W3 9PZ.

KAVANAGH, Paul, B.Ed (1975); painter in oil on canvas; freelance lecturer at The National Gallery, London. *b:* Liverpool, 8 Jan 1947. one *d. Educ:* Nottingham University. *Studied:* Folkestone, under Fred Cuming RA (1980). *Exhib:* London, Linda Blackstone Gallery, Pinner; various galleries in UK. *Works*

in collections: in USA, Germany and France. *Commissions:* various nationally and internationally. *Official Purchasers:* Washington Green Fine Art, 44 Upper Gough Street, B'ham B1 1JL. *Works Reproduced:* as limited edition prints by Washington Green. *Signs work:* "Paul Kavanagh." *Address:* 22 Tennyson Ave. Wanstead London E11 2QN. *Email:* paulkavanagh@ntlworld.com *Website:* www.paul-kavanagh.co.uk

KAY, Janet, Dip.AD, HS, ARMS, SLm. *Medium:* watercolour, gouache. *b:* London, 4 Apr 1943. *d of:* Jack and Helen Ogilvie. *m:* John Kay. one *s.* one *d.* *Educ:* Brondesbury and Kilburn High School. *Studied:* Hornsey College of Art (1962-66). *Exhib:* Llewelyn Alexander Gallery, Mall Galleries (miniature paintings); Worthing Museum, Horsham Museum, Towner Museum (Eastbourne)(hand painted pebbles). *Works in collections:* Horsham Museum. *Recreations:* sailing, tennis, music. *Clubs:* Sussex Guild of Designers and Makers. *Misc:* for hand painted pebbles see www.thesussexguild.co.uk. *Signs work:* 'JANET KAY'. *Address:* 22 Church Road, Tarring, Worhting, W.Sussex BN13 1EU. *Email:* jan_kay@tiscali.co.uk

KAY, Nora, A.R.C.A., M.C.S.D.; decorative studio pottery, lino-cuts, book jackets; designer for Yardley's, Jenners Ltd.; teacher at St. Martin's School of Art, Newland Park College, Maltman's Green School;. *Educ:* Wycombe High School, St. Martin's School of Art, R.C.A. *Exhib:* R.B.A., N.E.A.C. *Publications:* children's books. *Works Reproduced:* general advertising work, London Transport posters, Christmas cards, book jackets. *Signs work:* "N.K." *Address:* Flat 5, Ethorpe Cres., Gerrards Cross, Bucks. SL9 8PW.

KEABLE, Karen S J, *Medium:* acrylic. *b:* Great Yarmouth, 12 May 1966. *m:* Kevin B P Keable. one *s.* one *d.* *Educ:* Great Yarmouth Grammar School. *Studied:* Grays School of Art at Robert Gordon University, Aberdeen. *Exhib:* Southwold Gallery; Thompson Gallery, Aldeburgh; Mall Galleries; Hunter Gallery, Long Melford. *Works in collections:* House of Lords Art Collection, and internationally. *Publications:* Making Waves -Artists in Southwold (2005); Acrylic Workshop II (Dorling Kindersley, 2008). *Official Purchasers:* Lord Redesdale. *Clubs:* East Anglian Group of Marine Artists. *Signs work:* 'K.S.J.KEABLE'. *Address:* Millcroft, Millfield Road, Walberswick, Suffolk, IP18 6UD. *Email:* karen@ksjkeable.co.uk *Website:* www.ksjkeable.co.uk

KEANE, John, B.A. (1976); painter in oil and mixed media on canvas, P.V.A. and mixed media on paper; Official War artist, Gulf (1991);. *b:* Herts., 12 Sep 1954. *m:* Rosemary McGowan. one *d.* *Studied:* Camberwell School of Art (1972-76). *Exhib:* twenty five one-man shows in U.K., Europe and U.S.A. since 1980. *Works in collections:* Imperial War Museum, Contemporary Art Soc., Rugby Museum, Cleveland Gallery, Harris Museum, Preston, Glasgow Museum and A.G., Aberdeem A.G., Wolverhampton Museum and A.G., Christies Corporate Collection, British Coal, Financial Times, Unilever PLC, Detroit Art Inst. *Publications:* Conflicts of Interest by Mark Lawson (Mainstream Pub. 1995).

Clubs: Groucho, Chelsea Arts. *Signs work:* "John Keane." *Address:* c/o Flowers East, 82 Kingsland Road, London E2 8DP.

KEARNEY, Joseph, D.A.Glas. (1961); painter in various media, sculptor, poet. *b:* Glasgow, 14 Sep 1939. *s of:* Joseph Kearney. *Educ:* St. Aloysius' College, Glasgow. *Studied:* Glasgow School of Art. *Exhib:* several one-man shows in Glasgow. *Works in collections:* Glasgow A.G. and Museum and in many private collections. *Commissions:* Portrait of Most Rev. J.D.Scanlan, Archbishop of Glasgow, and many other private commissions. *Clubs:* Glasgow Art. *Signs work:* "Kearney." *Address:* 97 Elmore Ave., Glasgow G44 5BH.

KEAYS, Christopher, N.D.D. (1960), R.A. Cert. (1966); elected ROI, 2001; landscape painter in oil; Alan Gourley Memorial Prize (2004). *Medium:* oil. *b:* Caterham, Surrey, 26 May 1937. *m:* Mary. two *d. Studied:* Wimbledon School of Art (1957-60, sculpture: Elisabeth Frink), Chelsea School of Art (1960-62, painting: Robert Buhler, Ruskin Spear), R.A. Schools (1962-66, Peter Greenham, Charles Mohoney). Work in collections internationally. *Exhib:* Royal Academy, Federation of British Artists, Llewelyn Alexander, etc. *Recreations:* painting. *Clubs:* Reynolds. *Address:* 21 Cope Place, Kensington, London W8 6AA. *Email:* chriskeays@hotmail.co.uk

KEELEY, Simon Phillip, MA Art in Architecture; Diploma/Degree Eq. City & Guilds of London Art School; Ray Finnis Trust Award (2003); Craftex 2000 (NAMM)(2000); Basic Heraldry Certificate-Royal College of Arms (2000); The David Ballardie Memorial Award (2000). *Medium:* stone, bronze, resin. *b:* Bolton, Lancs., 28 Dec 1962. *s of:* Christine & Christopher Keeley. *m:* Shelley Rachel Day-Keeley. one *d. Studied:* University of East London (2001-3); City & Guilds of London Art School (2001-3). *Represented by:* Garden Architecture Gallery, London (2006); Pond Gallery, London (2004-5). *Exhib:* Affordable Art Fairs: stone carving demonstrations and group exhbn with Kaleidoscope Arts (2003, 2004); National Sculpture Festival, Art Parks International Guernsey (2003); 'Art for the Park',Café with Park (2003); Basquist Selected Graduates Exhbn, Air Gallery, London (2001). *Commissions:* Heraldic Plaque for The Worshipful Company of Skinners (2000); 5 &half stone roses for Westminster Abbey (2002); Corbel Angel for Westminster Abbey (2006). *Works Reproduced:* Head of Antonio Canovas '3 Graces' (plaster, marble, 2006- measurements taken from orignal plaster of Canovas 3 Graces, Canovas Museum, Possagna, Italy). *Misc:* continually developing carving ideas, both classical and contemporary in an increasing variety of stones. Also looking to increase demonstration, exhibition and teaching opportunities. *Address:* 53 Beulah Grove, Croydon, Surrey CR0 2QW. *Email:* simon@simonkeeley.com *Website:* www.simonkeeley.com

KEIR, Sally, B.A.(Hons.) (1984), M.S.B.A. (1989), M.S.F.P. (1998); botanical artist in gouache. *b:* Guildford, 29 Sep 1938. *m:* Peter Benson. two *d. Educ:* Sydenham School, Devon. *Studied:* Hereford College of Art (1979-81), Duncan

of Jordanstone College of Art (1981-84). *Exhib:* R.H.S. gold, silver gilt and silver medals, S.B.A. (1989-97), Linnean Soc. (1990-91), Discerning Eye (1991), Del Bello Gallery, Toronto (1988-90), R.S.M. (1990), Tregaquelle (1994), S.W.A. (1991), Tryon Gallery (1998). *Works in collections:* Hunt Inst. of Botanical Art, Chicago, Shirley Sherwood Coll. *Publications:* Collin's Artists Manual, Contemporary Botanical Artists, Drawing and Painting Course. *Signs work:* "S.A.K." *Address:* "Maes Yr Haf", 8 Gorlan, Conwy LL32 8RS.

KELLY, Brendan, RP; Awards: Hunting Observer Student Prize (1991); BP Portrait Award (Commended 1992, 93, Second Prize 2001); McFarlane Painting Prize, RSA (1995); De Laszlo Prize, RP (2004); HSBC Prize, RP (2006); Changing Faces Prize, RP (2007). *Medium:* oil, watercolour, acrylic. *b:* Edinburgh, 13 May 1970. *s of:* Tom & Philomena Kelly. *m:* Kim Lansdown. *Educ:* Ampleforth College. *Studied:* Camberwell School of Art (1988-9); Slade School of Fine Art (1989-93). *Exhib:* Mall Galleries; National Portrait Gallery; Royal Society of Portrait Painters; Royal Scottish Academy; The Jerwood Space; Treasures of the National Portrait Gallery (tour in Japan). *Works in collections:* Royal Bank of Scotland; Marylebone Cricket Club; Baker and Mackenzie; High Court, Edinburgh; collection of Blair Atholl Castle; National Portrait Gallery; British Army. *Commissions:* Duke of Atholl; Sir Vivian Richards; Kate Adie; Inziman Ul Haq; the Generals of ISAF IX -Afghanistan; General David Richards. *Misc:* Head of Drawing at The Art Academy, Londonq. *Signs work:* 'KELLY'. *Address:* 149 Providence Square, London SE1 2ED. *Email:* bkellyartist@btinternet.co.uk *Website:* www.brendankellyartist.co.uk

KELLY, Deirdre, B.Ed.(Hons.) (1984), M.A. (1987), R.E.; printmaker. *b:* London, 1 May 1962. one *s. Studied:* Wimbledon School of Art. *Exhib:* B.P. International, Contemporary Art Soc., Galerie Luc Queryel, Harriet Green Gallery. *Works in collections:* Sedgewick Gp. International, Atlantis Paper Co., King's College School, Museuda Gravura, Brazil. *Commissions:* Reuters (UK) Ltd. *Works Reproduced:* Big Issue (1995), Arts Review (2000). *Signs work:* "Deirdre Kelly" or "D.K." *Address:* c/o Hardware, 162 Archway Rd., London N6 5BB. *Email:* deidrek99@yahoo.co.uk

KELLY, Fowokan George, sculptor in resins, bronze and wood; trying to recapture lost African elements through art. *b:* Kingston, Jamaica, 1 Apr., 1943. *m:* Margaret Andrews. one *d. Educ:* East Queen St. Elementary Baptist School, Kingston, Jamaica. *Studied:* self taught. *Exhib:* Brixton Art Gallery (1983), Black Art Gallery (1983), Harley Studio Museum (1997), Assoc. Portrait Sculptors (1999), R.A. (1991, 2000, 2001). *Works in collections:* London Borough of Hammersmith and Fulham, W.E.B. Du Bois Institute, Harvard University, Unilever, University of West Indies, and private collections. *Commissions:* African People's Historical Foundation, London Borough of Hammersmith and Fulham and private portraits. *Signs work:* "F G Kelly." *Address:* 20 Veda Rd., Ladywell, London SE13 7JF. *Email:* fowokan@hotmail.com

KELLY, Jane Mary, BA (Hons) History with History of Art, Advanced Dip. in Fine Art (Painting). *Medium:* oil, mixed media, drawing. *b:* London, 7 May 1956. *d of:* Ernest Francis Kelly (adopted). *Educ:* St.Peter's Collegiate School for Girls, Wolverhampton; Penderford High School. *Studied:* Stirling University; The Univ. of Sosnowiec, Poland; The Central School of Speech and Drama. *Represented by:* Stuckism International. *Exhib:* RA Summer Show (2000); Wolverhampton Art Gallery Schools Exhbn (1972); McRobert Centre, Stirling (1976); mixed show at Metropole Arts Centre, Folkestone (2000); 'West London Artists' Show, Sackville Gallery (2000); Liverpool Biennial (2004) WAG; Musee Adzac, Paris (2005); Sotheby's Action, Belfast (2006). *Works in collections:* private collections; EU, based in Luxembourg and Belfast. *Commissions:* Portraits for prisoners in Wormwood Scrubs. *Publications:* work mentioned in several magazines dealing with 'The Struggle Between Painting and Conceptualism'. *Works Reproduced:* portrait of Ken Livingstone for RA Catalogue; Liverpool paintings; portrait of Myra Hindley in numerous newspapers. *Principal Works:* 'If We Could Undo Psychosis'; 'Anne at the Beach'. *Recreations:* growing vegetables, worrying, visiting theatre, radio drama. *Clubs:* The Groucho Club, The Stuckist Painters. *Signs work:* 'JK'. *Address:* The Garden Flat, 5 Larden Road, London W3 7ST. *Email:* janekelly@dsl.pipex.com; stuckism@yahoo.co.uk

KELLY, John, BA (1985), MA.(1996); artist in oil on linen, bronze, mixed media. *b:* Bristol, 12 Apr 1965. *m:* Christina Todesco. *Studied:* Rmit University, Melbourne, Australia, (1983-85, 1992-96), Slade School of Art, London (1996-97). *Exhib:* ten one-man shows with Niagara, Melbourne, and Piccadilly Galleries, London. Work in collections internationally. *Clubs:* Colony Room, London. *Signs work:* "Klly" and year. *Address:* Reen Farm, South Reen, Union Hall, West Cork Ireland.

KELLY, Marty, Awards: Donegal County Council (2006, 2001), Arts Council of Ireland (2005). *Medium:* oil. *b:* Carndonagh, Co.Donegal, Ireland, 10 Feb 1979. *Educ:* BTEC Art & Design NWIFHEN, Ireland (1996-97). *Studied:* University Ulster, Belfast (1997-2000). *Represented by:* Blue Leaf Gallery. *Exhib:* "Postmemory", Blue Leaf Gallery, Dublin (2007), "New Paintings", Blue Leaf Gallery, Dublin (2005); "Elsewhere Chronicles", Townhouse Gallery, Belfast (2004), "Steady Gazing, Outward Looking" Townhouse Gallery, Belfast (2003); RUA, Belfast (2007), AAF London (2007, 2002-04), Iontas, Sligo, Ireland (2007), Woolf Gallery, London (2003), Steading Gallery, Kirkcudbright, Scotland (2003). *Works in collections:* Dept of Environment, N.Ireland, Irish Contemporary Arts Society, Bank of Ireland, Mandate Trade Union, Lavelle Coleman Solicitors, Wedgewood Inc, Los Angeles, USA. *Publications:* Buyers Guide to Irish Art 2008, Oxfam Calendar '07 & '08. *Signs work:* 'MK'. *Address:* Blue Leaf Gallery, 10 Marino Mart, Fairview, Dublin 3, Ireland. *Email:* info@blueleafgallery.com *Website:* www.blueleafgallery.com

KELLY, Peter J, RBA. *b:* Ilford, Essex, 11 Dec 1931. *s of:* Cyril & Christina Kelly. *m:* Brenda. two *s. Educ:* Loxford Central School. *Studied:* Central School of Art and Design. *Represented by:* John Adams Fine Art. *Exhib:* Mall Galleries, John Adams Fine Art, W.Patterson Fine Art, Bankside Gallery, Thompsons Gallery, Waterman Fine Art, Royal Academy Summer Exhbn, and many more. *Works in collections:* HSBC; ING Barings Charterhouse Securities, Ford Motor Company, Higgs and Hill, Kennedy's Solicitors. *Publications:* "How to Create Light in your Painting" (pub.New Holland); "Artist's Guide to Exeptional Colour" (pub. Quarto); "How to Paint from Photographs" (pub.New Holland Press), also in "House and Garden", "The Artist". *Recreations:* classical music. *Clubs:* Small Paintings Group. *Signs work:* "PJK". *Address:* 'The Chestnuts' The Square, Stock, Essex, CM4 9LH. *Email:* kellypeterartist@aol.com

KELLY, Victor Charles, RBSA(1983), RCA (1991); painter in water-colour, acrylic, pastel, lecturer, teacher; Past Hon. Sec. Royal Birmingham Soc. of Artists, Past Vice President RBSA. *b:* B'ham, 6 Sep 1923. *s of:* Charles Alfred Kelly. *m:* Sylvia. two *s. Educ:* B'ham Teachers Training College. *Studied:* Liverpool College of Art (1949-50). *Exhib:* RBSA, RI, Manchester Academy of Art, Chelsea Art Soc., R.C.A., Dudley Mid Art, Laing, London, New York. *Works in collections:* RBSA. *Commissions:* BBC, Levermore. Co. *Clubs:* Past Pres. B'ham Water-colour Soc., Past Pres. Easel Club, B'ham Art Circle. *Signs work:* "Victor C. Kelly." *Address:* 90 Sandringham Rd., Perry Barr, Birmingham B42 1PH. *Website:* www.victorkelly.co.uk

KELSEY, Robert, DA (Glasgow School of Art 1966-70), PAI (Diploma, Paisley Art Institute). *Medium:* oil painter of landscapes and marine subjects. *b:* Glasgow, 4 Apr 1949. *s of:* Alfred, Joseph Kelsey and Ann (nee Cook). *m:* Jean Simpson. one *d. Studied:* Glasgow School of Art; The Painting School. *Represented by:* Thompson's Galleries, London and Aldeburgh. *Exhib:* RSA, RGI, RSW, ROI, PAI; one-man shows with Thompson Gallery (1994-2004); John Martin of London (1996-2000), Walker Galleries Harrogate (2003, 2005); Corrymella Scott Gallery, Newcastle-upon-Tyne (2000, 2004). *Works in collections:* Paisley Art Gallery and Museum, The Fleming Collection; His Grace the Duke of Bedford; Lord McFarlane of Bearsden; Sir Arnold Clark. *Publications:* Artist and Illustrator Magazines; book, 'Robert Kelsey - The Artist' (pub. 2004). *Official Purchasers:* Credit Lyonnais; Scottish Friendly Assurance; Enterprise Oil. *Works Reproduced:* limited edition prints. *Recreations:* golf, classical music. *Clubs:* Glasgow Art Club. *Misc:* television documentary, BBC Breakfast (November 2004). *Signs work:* "Kelsey". *Address:* Ranfurly, 18 Newtyle Rd, Paisley, PA1 3JU. *Email:* robert@rkelsey.com *Website:* www.rkelsey.com

KELSO, James Philip, painter in acrylic. *b:* London, 6 Jul., 1934. *m:* Marianne. one *s.* one *d. Educ:* Sloane School, Chelsea. *Studied:* self taught. *Exhib:* R.A. Summer Exhibs. *Works in collections:* private collections in U.K., U.S.A., Sweden. *Signs work:* "James Kelso." *Address:* The Well House,

Christmas Common, Watlington, Oxon. OX9 5HJ. *Email:* jim@kelso.co.uk
Website: www.kelsopaintings.com

KEMPSHALL, Kim, R.B.S.A. (1985), A.R.C.A. (1960); painter/printmaker oil, acrylic, water-colour, etching, lithography;. *b:* 1934. *m:* Sylvia. one *s.* one *d.* *Studied:* Manchester College of Art (1951-55); Royal College of Art (1957-60). *Exhib:* R.A., Scottish Royal Academy, Arts Council, one-man shows. *Works in collections:* Edinburgh City Coll., Scottish Modern A.G., Aberdeen A.G., Dundee A.G., Arts Council, V. & A., Herbert A.G., Whitworth A.G., Birmingham A.G., Wolverhampton A.G., Bradford A.G., City of Lyon, City of Frankfurt, Ecole de Beaux Arts, Toulouse; many private collections worldwide. *Signs work:* "K.K." *Address:* Mere House, 49 Henley Ave., Iffley, Oxford OX4 4DJ.

KENDALL, Alice R., D.A. (Edin.), F.R.Z.S. (Scot.), F.R.S.A., P.P.S.W.A. (1977-82); artist in oil, water-colour, pen and ink, writer. *b:* N.Y.C. *d of:* James P. Kendall, LL.D., F.R.S., P.R.S.E., the late Prof. of Chemistry, Edinburgh University. *Educ:* New York and Edinburgh. *Studied:* Edinburgh under Sir Wm. Gillies, Sir Wm. MacTaggart. *Exhib:* R.A., Paris Salon, R.B.A., N.E.A.C., R.I., etc. and with the late Alice Kendall (Mother) at Cooling Galleries (1948, 1956) and Chelsea Gallery (1949). *Works in collections:* The Royal Society of Edinburgh: 1956 Official portrait of Prof. J.P. Kendall, P.R.S.E. (Father). *Publications:* children's book 'Funny Fishes'; articles and poems, many illustrated, in Punch, Poetry Review, The Artist, The Voice of Youth; Founder/ Editor - Federation of British Artists Quarterly (FBAQ) Spring 1982 to Summer 1984. *Works Reproduced:* in "The Artist". *Signs work:* "A.R. Kendall." *Address:* 35 Beaufort Gdns., London SW3 1PW.

KENDALL, Kay Thetford, R.M.S., S.W.A.; sculptor and portrait sculptor in bronze, bronze resin, and miniature sculpture;. *b:* Manchester. *Educ:* Cheadle Hulme Schools. *Studied:* Malvern College of Art; Hertfordshire College of Art and Design. *Exhib:* Mall Galleries, London; S.W.A., R.M.S.; one man shows, Welwyn Garden City, Hatfield, Knebworth, Wembley, Bishop's Stortford, Paris Salon, Galleries Italy and Switzerland. *Clubs:* R.M.S., S.W.A. *Misc:* Awards: 1st Prize for sculpture, Grolla d'oro, Venice (1981); Bidder & Borne award for sculpture R.M.S. (1986); Honourable mention Gold Bowl award RMS 1986. *Address:* The Studio, 45 Orchard Rd., Tewin, Welwyn, Herts AL6 0HL.

KENNEDY, Cecil, flower and portrait painter in oils. *b:* Leyton, Essex, 4 Feb 1905. *s of:* T.R.Kennedy, artist. *m:* Winifred Aves. one *s.* *Studied:* in London, Paris, Antwerp, Zürich. *Exhib:* RA, RSA, RHA, Doncaster, Oldham, Bradford, Southport, etc., and many London galleries; also USA and S.African galleries. Awarded Silver Medal, Paris Salon (1956) and Gold Medal, Paris Salon (1970). *Works in collections:* H.M. Queen Mary, Merthyr Tydfil Art Gallery, Rochdale Art Gallery. *Publications:* Numerous. *Address:* Manor Garden House, 135 Fishpool St., St. Albans, Herts. AL3 4R7.

KENNEDY, Keith Manning, VPSGFA; RAS Cert.; presently Webmaster and Vice President, Society of Graphic Fine Art. *Medium:* painting. *b:* Ewhurst, Surrey, 28 Aug 1941. *m:* Rosemary. *Educ:* Reigate and Redhill School of Art & Craft. *Studied:* West Sussex College of Art; Royal Academy Schools. *Exhib:* Ditchling Gallery (1968); Hove Museum of Art (1982); Towner Gallery, Eastbourne (with Eastbourne Group); Woodstock Gallery, London (1983); Brighton Festival Open Houses (2002/5); RWS Open (1989/96); Bourne Hall, Ewell (2005/6/7). *Works in collections:* Ernst & Young Private Patient Plan; private collections. *Commissions:* mural painting for Metway Electrical (1996). *Clubs:* elected Member of Sussex Watercolour Society in 2006. *Signs work:* 'K M Kennedy' or 'K M K'. *Address:* 10 Furzedene, Furze Hill, Hove, E.Sussex, BN3 1PP. *Email:* keithmkennedy@clara.co.uk *Website:* www.sgfa.org.uk

KENNEDY, Margaret, Prizewinner Carlow 'Eighse' Arts Festival; 1st & 3rd, Moyglare Stud Kildare Art Comp. (1983, 84); Highly Commended Texaco Childrens Art Comp. (1968). *Medium:* oil. *b:* Dublin, 5 May 1950. *d of:* Michael Joseph Kennedy & Josephine Agnes Kane. *Educ:* Crumlin & Tallaght National Schools. *Studied:* studied horse anatomy with Iris Kerlett, former World Champion rider. *Represented by:* Green Gallery, Dublin; Lilly Fine Art, Dunshaughlin. *Exhib:* Mall Galleries, London (2003-5); S.E.D. Exhbn, Christies, London (2002); Irish National Stud; American College Dublin (solo, 1997); Dublin Horse Show RDS (2002, 2005); SEA Exhbn, Newmarket (2005); Emo Court, NAAS Co.Kildare. *Commissions:* 'History of Tallaght Area' (South Dublin County Council, oil); 10 pictures for 'Partas' Business Enterprise Center. *Publications:* 'All Roads Lead to Tallaght', British Horse Society Christmas Catalogue (1998). *Official Purchasers:* Dublin South County Council. *Works Reproduced:* 'Gentle Giants' by British Horse Society; 'Racing Legends'; 'Arkle'. *Principal Works:* specialises in equestrian paintings in oil. *Recreations:* horse riding, writing, photography. *Clubs:* Associate Member of UAE Society of Equestrian Artists. *Misc:* author of children's book 'Mr Luggie Tatters'. *Signs work:* 'M Kennedy' (in red).

KENNEDY, Michael Peter, NDD; DFA (Slade); ADAE; MPhil; EdD; Slade Prize for Lithography (1966);. *Medium:* painting, drawing, printmaking. *b:* Dartford, 1943. *Educ:* Gravesend Grammar School. *Studied:* Bromley School of Art (1960-62); Ravensbourne College of Art and Design (1962-64); Slade School of Fine Art (1964-66); University of Wales (1973-74). *Exhib:* RA Summer Exhbn (2004, 2006); RWA Open Print Exhbn (2004);Originals 2004, 05, 06, 07; 5th & 6th British International Miniature Print Exhbn; Young Contemporaries (1966, 67). *Commissions:* Art @ the Centre, 2007. *Works Reproduced:* catalogues to: 19th-23rd Miniprint Internacional; 1°, 2° & 3o Muestra Miniprint; 5th & 6th British International Miniprint; Small Print/Big Impression. *Signs work:* 'Kennedy' or 'MK' (followed by date). *Address:* 107 Knights Croft, New Ash Green, Longfield, Kent DA3 8HY. *Email:* kennedymp@aol.com *Website:* www.michaelkennedy.org

KENNISH, Jenny, R.M.S. (1985), S.W.A., F.S.B.A.; self taught sculptress in porcelain of wild flowers and animals; school teacher; Marwell International Wildlife Art Society, winner of 'Paws' Competition (mixed media); 'Wildscape' Runner-up (2005). *Medium:* porcelain, oils, c. pencils, and mixed media. *b:* England, 11 Mar 1944. *d of:* W. J. Otway, teacher. one *s.* one *d. Educ:* Nonsuch County Grammar School for Girls; Whitelands Teacher Training College. *Studied:* Zoology, botany and art. *Exhib:* Westminster Galleries with the R.M.S., S.B.A., S.W.A. and local societies; Marwell International Wildlife Art Society National Exhibition of Wildlife Art. *Signs work:* "J.K." and "Jenny Kennish". *Address:* Kinghern, Silchester Rd., Little London, Tadley, Hants. RG26 5EX. *Email:* jenny@jkennish.com *Website:* www.jkennish.com

KENT, Colin, R.I. (1971); self taught painter in water-colour, acrylic, mixed media; Buzzacott Award; Linda Blackstone Award. *b:* 10 Feb 1934. *m:* Joan. *Educ:* Romford County Technical School; S.W. Essex Technical College and School of Art. *Exhib:* R.A., R.I., Mall Galleries, Shell House Gallery, Ledbury, Adam Gallery, Bath, London, Blackstone Gallery, Pinner, Manor House Gallery, Chipping Norton, Geneva, New York. *Works in collections:* in Britain, U.S.A., France, Germany, Finland. *Signs work:* "Colin Kent." *Address:* 64 Forest Rd., Romford, Essex RM7 8DT.

KEON, Gerald, NDD Painting (1963). *Medium:* oil, watercolour, drawing, sculpture, constructions. *b:* England, 19 Dec 1942. *Educ:* Tollington Grammar School (1954-59). *Studied:* Hornsey College of Art (1959-62); Byam Shaw School of Art (1962-63). *Exhib:* RA (2003, 2004); Discerning Eye (2003); Sunday Times Watercolour Show (2002, 2003); Francis Kyle Gallery (four one-man shows, five group shows: 1990-98); Yorkshire Artists; Leeds Polytechnic; Air Gallery, London. *Works in collections:* Arts Council; Guildhall Gallery, Corporation of London; private collections. *Works Reproduced:* Francis Kyle Catalogues; RA Catalogues. *Signs work:* 'Keon' (on reverse of work). *Address:* 28 Chelverton Road, London N19 3AY.

KERMAN, Lesley Frances, FRSA; BA Hons Fine Art. *Medium:* oil, watercolour, drawing, prints. *b:* Middx, 31 Jul 1942. *d of:* R V & P M Kerman. *m:* Graham Rich. one *s.* one *d. Studied:* University of Durham (BA Hons Fine Art); Newcastle 1960-64 (Victor Pasmore, Richard Hamilton). Taught at Newcastle College of Art, Brighton College of Art (1964-70), Exeter College of Art and Design, University of Plymouth (1970-92). *Exhib:* Young Contemporaries,1962, 1963, Gallery 273 Queen Mary College, 1985, Exe Gallery, Exeter,1992, Brewhouse, Taunton,1996, UK Etching Biennale,1998, World Print Exhibition, Slovenia, 2000, Naute Culture, Ann Lantair, Stornoway, 2002, Science Museum London, 2005, Spike Open, Spike Island, Bristol. *Commissions:* 'The Secrets of Bideford' Public sculpture, The Environment Agency; 'The Secrets of Nuneaton', SUSTRANS. 3 Ways School, Bath. *Publications:* 'The Secrets of Bideford' published by Devon County Council & Little Silver. *Official Purchasers:* Victoria & Albert Museum, London, Artist's

Books Collection. *Signs work:* "Lesley Kerman". *Address:* 13 Riverside Road, Topsham, Devon, EX3 0LR. *Email:* L.F.K@btinternet.com *Website:* www.lesleykerman.co.uk

KERN, Doreen, sculptor in bronze; Gold Medal from the Emperor Haile Selassie; consultant to B.M. Replica Dept. *Medium:* bronze. *b:* 9 Aug 1941. divorced. two *s. Educ:* Hampstead Garden Suburb Institute; studio assistant at the Morris Singer Art Bronze foundry. *Studied:* under Howard Bates, R.A. *Exhib:* Waterloo Fine Arts, Talma Gallery, Tel-Aviv, Ryder Gallery, L.A., Galerie Nichido, Tokyo, London University, Bath Festival, National Museum of Archaeology, Valletta, Malta, Design Centre, St. Paul's Cathedral, Edinburgh Festival (1995), Millennium Dome (July 2000), British Library, London. *Works in collections:* Dr Kwame Nkrumah, Guyana, Emperor Haile Selassie (Palace of Addis Ababa), Anne Frank for Anne Frank house, Amsterdam also British Library, Clint Eastwood, Ariel Sharon, Alistair McLean, Miss Bluebell, Chaim Topol. *Commissions:* all of above portraits in bronze. *Recreations:* theatre critic and features writer, lecturer. *Address:* The Studio, 38 Canons Drive, Edgware, Middx. HA8 7QT. *Email:* doreenkern@onetel.com

KERR, Janet, R.W.S. (1997); painter in water based mixed media on paper, semi abstract work mainly concerned with W. Yorkshire landscape. *b:* Hornchurch, Essex, 20 May 1947. *m:* divorced. one *d. Educ:* Palmers Girls School, Barking Regional College (Graphics). *Studied:* painting privately with Charles Bartlett P.P.R.W.S. *Exhib:* Bankside Gallery, London, and throughout Britain. *Works in collections:* Museum of Foreign Art, Japan. *Publications:* 'The Watercolour Expert' (Cassells, 2004); 'Watercolour Masters, Then and Now' (Cassells, 2005). *Recreations:* playing traditional American folk music on fiddle. *Signs work:* "JanetKerr." *Address:* 11 New Longley, Norland, Sowerby Bridge, W. Yorks. HX6 3RR. *Email:* janet.kerr@talktalk.net

KERR, Janette, PhD Fine Art (2005); Visiting Research Fellow, Bristol School of Art, Media and Design, UWE (2006); Royal West of England Academician (2003); Windle Trust Bursary (2000); David Murray Studentship Award, Royal Academy Schools (1999); Ruskin/Colle Verde Travel Bursary (1996); 1st Prize, Laing Landscape Art SW(1995). *Medium:* landscape - oil painter. *b:* London, 14 Sep 1957. one *s. Studied:* University of the West of England. *Represented by:* Adam Gallery (Bath & London); Stour Gallery (Shipston-on-Stour); Wales Workshop (Fishguard); Inspires Art (Oxford); Sadler Street Gallery (Wells). *Exhib:* 2007: Royal West of England Academy; St.Giles Street Gallery (Norwich); Hybrid (Honiton); Queens Street Gallery (Emsworthy); Bowlish Contemporary Gallery (Shepton Mallett); Alpha House Gallery (Sherborne); Art Fairs. Pre-2003: Anthony Hepworth Fine Art, (Bath); Byard Art (Cambridge); Pierrepont Fine Art (Oxford); Mullan Gallery (Belfast); Martin Tinney Gallery (Cardiff). *Works in collections:* RWA Permanent Collection; Grizedale Society; private collections: UK and abroad. *Publications:* 'Fifty Wessex Artists' (Evolver Books, 2006); 'Night & Indeterminacy: A Study of

Night in Painting' (PhD, 2005); Janette Kerr: Exhibition Catalogue (Adam Gallery, 2004); In House Twice (Wild Conversation Press, 2000); The Painter's Eye: Janette Kerr (Art Review, March 1999 1st edition); Landscape Research Journal: Representation & Indeterminacy,Two Months in Darkness (1998). *Address:* Hill House, Church Street, Coleford, Somerset BA3 5NA. *Website:* janette2.kerr@uwe.ac.uk

KERSHAW, Walter, BA Hons. Fine Art (Dunelm); mural painter and freelance artist in oil, water-colour, mosaic; occasional visiting lecturer in Environmental Art at Universities in the U.K., Brazil and W. Germany;. *b:* Rochdale, 7 Dec 1940. *s of:* Walter Kershaw. one *s.* one *d. Educ:* De la Salle College, Salford. *Studied:* Durham University (1958-62). *Exhib:* Large scale, public, external murals in Manchester, Trafford Park and N.W. Museum of Science and Industry; Norwich; Brazil, Sao Paulo and Recife. Internal murals for British Aerospace, Manchester United FC, P&O, Sarajevo International Arts Festival, Salford University, the CEGB, Hollingworth Lake Visitors Centre and Italian Consulate Manchester, Airtours cruise ship 'Sunbird'; Leonard cheshire Foundation (2003). *Works in collections:* V. & A., British Council, Arts Council, Gulbenkian Foundation, 'Cultura Inglesa', Museum of Art, São Paulo, and other public galleries in the U.K. *Works Reproduced:* Photos of murals at the Serpentine, Whitechapel and Tate galleries. *Misc:* Films: 'Terra Firma' BBC 2 (1976), 'First Graffiti Artist' (1977), 'Nationwide' (1982), '5 x 5' W. Germany (1984), 'Folio' Anglia TV (1987), Bosnia T.V. (1996). International Arts Festival. Recorded: 'Conversation Piece' with Sue MacGregor, Radio 4 (1983), 'Kaleidoscope' Radio 4 (1986). *Signs work:* "Walter Kershaw." *Address:* 193 Todmorden Rd., Littleborough, Rochdale OL15 9EG.

KETCHER, Jean, B.A.Hons. Fine Art Painting (1976); painter in oil, water-colour, etc.; art teacher, Copleston High School, Ipswich;. *b:* 6 July, 1955. *Studied:* Ipswich School of Art (1971-73), Maidstone College of Art (1973-76). *Exhib:* Halesworth Gallery, Ellingham Mill, Bungay, Corn Exchange, Ipswich. *Signs work:* "Jean Ketcher." *Address:* 46 Sandown Rd., Ipswich IP1 6RE.

KEY, Geoffrey, NDD, DA Manc. Heywood Medal, Guthrie Bond Scholarship. *Medium:* painter in oil and other media; sculptor. *b:* Manchester, 13 May, 1941. *s of:* George and Marion Key. *Educ:* High School of Art, Manchester. *Studied:* Regional College of Art, Manchester (1958-61), under Harry Rutherford, William Bailey, Ted Roocroft. *Represented by:* a number of galleries in the UK and abroad; no sole representative. *Exhib:* extensively in the UK, Europe and the Far East, most recently in Hong Kong, London and Dublin. *Works in collections:* Salford A.G., Manchester City Gallery, Bolton A.G., Granada Television, University of Manchester, Manchester Museum of Science and Industry, Victoria and Albert Museum, Wigan Metropolitan Borough, North West Arts Board, Jockey Club of Hong Kong, Society Roquefort, Mandarin Oriental,Hong Kong, Chateau de St. Ouen, Chateaux Relais, Perrier. *Publications:* G.Key: Drawings (Margin Press), Clowns (Sansom and Company), Geoffrey Key Twentieth-

Century Drawings (Sansom and Company), Dictionary of British Art (Collectors Club Press), European Painters (Clio Press), Images (Nicholson & Bass Ltd). *Official Purchasers:* see collections. *Works Reproduced:* see publications. *Recreations:* collecting African works of art. *Address:* 59 Acresfield Rd., Pendleton, Salford M6 7GE. *Email:* enquiries@geoffreykey.com *Website:* www.geoffreykey.com

KHALIL: see NORLAND (NEUSCHUL), Khalil,

KHAN, Keith Ali, BA(Hons.); sculptor in large scale exterior/interior constructions, using fabric and many people; Director, Carnival Designer. *b:* Trinidad, 4 Dec 1963. *s of:* Faiz Khan. *Educ:* King's College, Wimbledon. *Studied:* Wimbledon School of Art, Middlesex Polytechnic (Dante Leonelli), The Street, Port of Spain, Trinidad. *Exhib:* Houston International Festival, Harris Museum, Preston, Arnolfini, Bristol; one-man shows: Bluecoat Gallery, Liverpool, Greenwich Citizen Gallery; on the streets of Notting Hill, as well as numerous designs on TV and stage. *Signs work:* "Khan." *Address:* 79 Grand Drive, Raynes Pk., London SW20 9DW.

KHANNA, Balraj, MA (1962); awarded Winnifred Holtby prize by RSL (1984); painter in acrylic and oil, novelist;. *b:* 4 Oct 1939. *s of:* Amar Nath. *m:* Francine Martine. two *d*. *Educ:* Punjab University, Chandigarh. *Exhib:* fifty one-man shows including Ashmolean Museum, Oxford (1968), City A.G., Bristol (1969), Galerie Transposition, Paris (1966, 1968, 1974, 1975), Herbert Benevy Gallery, N.Y. (1971, 1972), Serpentine Gallery (1979), Richard Demarco (1986), Royal Festival Hall (1990), Arnolfini (1991). M.O.M.A. Wales (1993), Berlin and Frankfurt (1994), De La Warr Pavilion (1996), Oldham Gallery, M.A.C. Birmingham; Foster Art London (2004); Cartwright Hall Bradford (2005); Arushi Arts, Delhi (2006); Sixty Years of British Art, Hayward Gallery (2006). *Works in collections:* Arts Council; Musee d'Art Moderne, Paris; Ville de Paris; Ashmolean Museum; National Gallery of Modern Art, New Delhi; City A.G., Bristol; City A.G., Bradford; V. & A.; Calouste Gulbenkian Foundation, Lisbon; Hippodrome Theatre, Birmingham. *Commissions:* Birmingham Hippodrome safety curtain (2001), MOMA Wales Mosaic Mural (2000). *Publications:* Nation of Fools (Michael Joseph and Penguin), Sweet Chillies (Constable), Kalighat, Popular Indian Painting, 1800-1930 (Redstone Press), Krishna - The Divine Lover (South Bank Centre Publication), Art of Modern India (Thames & Hudson, 1998), Human & Divine – 2000 Years of Indian Sculpture. *Signs work:* "Khanna." *Address:* 3a Pindock Mews, London W9 2PY. *Email:* balrajkhanna@btinternet.com

KIANUSH-WALLACE, Katy, self taught professional artist and illustrator in acrylic, water-colour, pen and ink, pencil, pastel; Owner of Art Gallery and Cultural Website Art Arena; Member of the Executive Council of N.A.P.A., directed the first London exhibition of NAPA at Westminster Gallery, July/Aug. 1999. *b:* Tehran, Iran, 12 Apr 1964. *m:* Jim Wallace. *Educ:* Acton, London. *Exhib:*

over sixty solo and group shows during last eight years: Westminster Gallery; R.B.S.A. (winner, Royal Sovereign (Rembrandt) Award 1998); Victoria A.G., Bath; Black Sheep Gallery, Hawarden (winner, Daler-Rowney International Award 1999); Mariners Gallery St. Ives (Artists and Illustrators Award 2002); Handel House Gallery, Devizes; The Guildhall, Salisbury; Crosfield Hall, Romsey; Wyvern Theatre, Swindon; BBC World Service, London; National Power, Swindon, etc. Work on permanent exhbn. on Internet galleries worldwide. *Works in collections:* private collections: U.K. and abroad. *Publications:* illustrated children's poetry books, published in Iran, at age ten; covers, two books of poems, 'Closed Circuit' by Shadab Vajdi (Forest Books), and 'As Long As the Moon Shall Rise' by Ellen Moore Anderson (Holy Cow Publications). *Clubs:* NAPA, Wessex Artists. *Address:* 4 Bennett Hill Close, Wootton Bassett, Wiltshire SN4 8LR. *Website:* http://www.art-arena.com

KIDNER, Michael, BA (Cantab); paintings and constructions. *b:* Kettering, 1917. *s of:* Norman W.Kidner. *m:* Marion Frederick. *Educ:* Bedales School. *Studied:* self-taught. *Exhib:* widely. *Works in collections:* Tate Gallery, Arts Council of G.B., British Council, W.A.G., Huddersfield A.G., Manchester City A.G., Contemporary Art Soc., London, Sussex University, University of Wales, Gulbenkian Foundation, V. &. A., Museum Sztuki, Lodz, and Poznan Museum, Poland, Museum of Modern Art, N.Y., Southampton City A.G., Anios Anderson Museum, Helsinki, Norrkopings Konstmuseum, Malmo Konsthall, National Gallery, Canberra, Australia, Moderna Museet, Stockholm, Henry Moore Sculpture Trust, University of East Anglia, Norwich, England, Pfalzgalerie, Kaiserslautern, Germany. *Publications:* Elastic Membrane. *Signs work:* "Michael Kidner." *Address:* 18 Hampstead Hill Gdns., London NW3 2PL.

KIKI, John, NDD, RA Diploma. *Medium:* oil, acrylic, drawing, prints. *m:* Mary. two d. *Studied:* Camberwell Arts School; RA Schools. *Represented by:* O.K.Harris Gallery, NYC, USA; Arts Space Gallery, London; Threee Cups Gallery, Ely; St.Giles Gallery, Norwich. *Works in collections:* National Gallery of Wales; The Saatchi Collection; Gallop Finland; Siemans PLC; Chantrey Bequest; University Gallery, Liverpool; Art Esprit. *Signs work:* 'John Kiki'. *Address:* 51 Middlemarket Rd, Gt.Yarmouth, Norfolk NR30 2BZ. *Email:* johnkiki@hotmail.com *Website:* www.johnkiki.co.uk

KILLEEN, Bruce, M.A. Oxon. (1950), R.W.A. (1963), A.I.A. (1964); self taught painter in oil; formerly, senior lecturer, Colchester School of Art, tutor, R.A. Schools; Art Correspondent, The Guardian. *b:* Warwickshire, 22 Jan., 1926. *m:* (1) Angela Fry, artist/potter (died 1997) one s., two d.; (2) Julie Wroughton, A.R.C.A., R.W.A. painter. one *s.* two d. *Educ:* Merton College, Oxford. *Exhib:* one-man: Artists International Galleries, Drian Galleries, London; Minories, Colchester; Chappel Galleries, Essex; Alpha House, Sherborne; Malcolm Innes Gallery, Edinburgh; Circle Gallery, Edinburgh, An Tobar Gallery, Tobermory; mixed: R.A., R.W.A., Bruton Street Gallery, Cheltenham Group, Penwith Gallery, St. Ives, Di Rollo Gallery, Edinburgh etc. *Publications:* Arts Council Art

Films (1978-80), 'Evocations' (wood engravings and poems), with Julia Wroughton (Strathmore Publishing, London, 2007). *Signs work:* "B.A. Killeen" or "B.K." *Address:* Inniemore Lodge, Carsaig, Isle of Mull, PA70 6HD.

KIMBLE, Grace, FZS (London); PGCE-Primary (Arts); MA (Cantab) Natural Sciences(Zoology)(bursary 2005/06); SWLA Commended; Nina Mosali Prize (FPS). *Medium:* oil, acrylic, watercolour. *b:* Oxford, 5 Jul 1982. *d of:* Dr Bob Sim & Prof Edith Sim. *m:* Pete. *Studied:* Pembroke College, University of Cambridge; Inst. of Education, University of London. *Exhib:* Gasworks, Birmingham; Magdalen College, Oxford; Whitechapel Galleries, London; Gaskin & Davis, Harrow; Sarian Gallery, Pinner; The Cottons Atrium, London; Mall Galleries (SWLA); Blythe Gallery, Manchester; Bankside Gallery, London (FPS); Osterley House, London; Old Truman Brewery, London. *Works in collections:* Tottenham Hotspurs Football Club. *Commissions:* numerous business, including: The Positive Internet Co., Cafe Cocoa. *Works Reproduced:* Biodiversity: Africa; Zebras; Penguins. *Recreations:* running. *Misc:* Outreach Officer-FPS. *Address:* 1 Mead Villas, Roxeth Hill, Harrow, Middx, HA2 0JY. *Email:* grace@gracesart.co.uk *Website:* www.gracesart.co.uk

KINAHAN, Lady Coralie, USWA, UWA, RUA (resigned); artist in oil and water-colour; Lady Mayoress of Belfast (1959-62); President, Co. Antrim Red Cross (1955-67);. *b:* Surrey, 16 Sep 1924. *d of:* Capt. C. de Burgh, D.S.O., R.N. *m:* Sir Robin Kinahan. two *s.* three *d. Educ:* by 14 governesses and 4 schools. *Studied:* John Hassall, and Chelsea Schools of Art (1943-46); private portrait classes under Sonia Mervyn, A.R.A. (1946-49). *Exhib:* RA, RP, ROI, SWLA, RSA, RUA; solo exhbns. annually, Belfast, Dublin, Wexford, Galway, Bristol and London (1964-85). Exhibited in Amesbury (2005). Opened own gallery (1985) Templepatrick, exhibiting landscapes, wildlife, horses and portraits, continues now in England (near children). *Commissions:* include Lord Bishop of Durham, Rt. Hon. Humphrey and Mrs. Atkins, Rt. Hon. James Prior, General Sir Ian Freeland, Capt. Torrens-Spence, D.S.O., R.N. (H.M. Lord Lt. for Armagh), Lord Cooke of Islandreagh, Gen. Sir John and Lady Waters and many children's portraits; Army commissions for The Black Watch Regt., The Grenadier Guards, Imperial War Museum, The Royal Highland Regt., The 2nd Parachute Regt., The 9/12th Royal Lancers and the Ulster Defence Regt.; Sporting pictures for Mr. Victor McCalmont and The Master Beagler, Terence Grainger. *Publications:* historical novels: You can't shoot the English (1982), After the war, came Peace? (1987), Memoirs: Behind every great man - ? (1998). *Works Reproduced:* limited edns. 200 prints of Belfast Harbour; Patrol looking over Belfast, and others including hunting. *Recreations:* painting, travelling, nature, history. *Misc:* Husband made H.M.'s Lord Lieut. for Belfast (1985). *Signs work:* "C. de B.K." oils; "Coralie Kinahan" water-colours. *Address:* 19 Abbey Mews, Amesbury, Wilts. SP4 7EX. *Website:* www.coralie-kinahan.com

KING, Andrew Norman, B.A. (Hons.) (1978), N.S. (1984), R.O.I. (1992); David Murray Scholarship, R.A. Schools (1978); landscape and marine artist in

oil and water-colour, interested in light and atmosphere in landscape. *b:* Bedford, 8 Mar 1956. *Educ:* Barnfield College, Luton. *Studied:* Hornsey College of Art. *Exhib:* Britain in Water-colour, R.I., N.E.A.C., N.S., R.S.M.A., R.O.I., R.W.S., R.P., Laing; one-man shows, Luton, Hitchin, Linslade, Stowe, London and Aldeburgh, 'Discerning Eye' (1999). *Works in collections:* Luton Art Council, Beds. C.C., Eagle Star Offices, and in private and royal collections in Britain and abroad. Finalist, Winsor and Newton Young Artists award (1985), House of Lords (2003)(3 works). *Official Purchasers:* Luton and Beds Arts Council, House of Lords Collections 2003. *Recreations:* cycling, sailing, natural history. *Clubs:* East Anglian Group of Marine Artists. Reynolds Club (RA). *Signs work:* "Andrew King." *Address:* Pond Cottage, Long Rd., Colby, Norwich NR11 7EF. *Email:* chilli@cortj.freeserve.co.uk

KING, Christabel Frances, B.Sc.Hons.(Lond.) (1971), F.S.B.A.; Linnean Society Jill Smythies Award (1989); botanical artist in water-colour; part-time lecturer, Capel Manor College, Enfield, tutor to scholars of Margaret Mee Fellowship Program, R.B.G. Kew, since 1990. *b:* London, 11 Mar 1950. *d of:* Prof. George King Reeves Research Fellow Surrey University. *Educ:* Sherborne School for Girls. *Studied:* scientific illustration: Middlesex Polytechnic (1973-74). *Exhib:* Messrs. Agnew (1980), Kew Gdns. Gallery (1993). *Works in collections:* R.B.G. Kew, Hunt Botanical Institute, Shirley Sherwood. *Publications:* illustrations in Curtis's Botanical Magazine since 1975; also Flowering Plants of the World, ed. V.H. Heywood (Elsevier 1978); Kew Magazine Monographs: The Genus Pleione, The Genus Echinocereus, The Genus Lewisia, The Genus Galanthus, The Genus Lavandula; Africa's Mountains of the Moon by Guy Yeoman (Elm Tree Books 1989); Flowering Plants of the Falkland Islands by R.W. Woods (Falklands Conservation 2000). *Clubs:* S.B.A. (Founder mem. 1985), F.L.S. *Signs work:* "C.F.K." or "C.F. King." *Address:* 149 Fulwell Park Ave., Twickenham, Middx. TW2 5HG.

KING, Gordon Thomas, F.A.T.G. (Guild published Artist of the Year 1999-2000); artist in water-colour, oil; Chairman, F.A.T.G. Artist Com.;. *b:* London, 6 June, 1939. *m:* Mary. two *s.* one *d. Studied:* Carlton Studios, Reading University. *Exhib:* R.A. Summer Show, R.I., Halcyon Gallery (I.C.C., Birmingham), Singer & Friedlander/Sunday Times, retrospective exhibition at Halcyon Gallery (London) March 2002. *Publications:* 'Romance with Art', 'Drawn to Life'; over 60 limited edn. prints published; 3 special limited edition prints of Darcey Bussell, signed by both dancer and artist, published in aid of Alzheimer's Society. *Clubs:* Fine Art Trade Guild. *Address:* The Hollies, 21 Copthall Lane, Chalfont St. Peter, Bucks. SL9 0BY.

KING, John Gregory, S.E.A.; artist in oil, water-colour, bronze;. *b:* West Tytherley, 16 Apr 1929. *m:* Mary Rose. one *s.* one *d. Educ:* Canford School. *Studied:* briefly at Salisbury Art College. *Represented by:* The Osborne Studio Gallery, London; Ackermann and Johnson. *Exhib:* seventeen one-man shows in London. *Works in collections:* Alnwick Castle, Goodwood House, Gordon

Highlanders Museum, Perth, Royal Fusilier Museum, Tower of London, H.M. The Queen, Lord Biddulph, Duke of Northumberland, Lord Radnor. *Commissions:* Royal Tournament, Sheik Mohamod, Tattersalls, Ironmongers Co., Royal Bodyguard, Palace of Westminster, Household Cavalry, etc. *Publications:* illustrated: They Meet at 11, They Still Meet at 11, The Golden Thread, The Fox and the Orchid, Gallant Horses and Horsemen. *Official Purchasers:* Newbury Racecourse; The Palace of Westminster. *Works Reproduced:* Horse and Hound; I.P.C.Magazines; Illustrated London News. *Principal Works:* Dubai Millennium (Lifesize); H.M. The Queen Mother Lying in State. *Recreations:* hunting and shooting. *Clubs:* The Arts, The Farmers. *Signs work:* "John King." *Address:* Church Farm House, West Tytherley, Salisbury, Wilts. SP5 1LB. *Email:* mek@chfarm.freeserve.co.uk

KING, Mary, ATC (1947), SWA (1979), NS(1984), FRSA (1988); artist in mixed media, water-colour and collage; lecturer, North East Surrey College of Technology (1968-80) and Surbiton Adult Education Centre (now retired). *b:* London, 17 Oct 1926. *d of:* F.R.C. Dear. *m:* Ralph King. one *s.* three *d. Educ:* Wallington Grammar School. *Studied:* Chelsea College of Art (1946, painting, Ceri Richards; 1948-49, stained glass, Francis Spear), Central School of Arts and Crafts, London, Whitelands College, Putney. *Exhib:* Fairfield Halls, Croydon, Bourne Hall, Ewell, F.B.A., S.W.A., R.B.A., Mall Galleries, Westminster Gallery (1988-97 annually), R.A. Summer Exhbn. (1981, 1982, 2004), Bankside Gallery, RWS, London (1998, 2001, 2002, 2005, 2006), National Soc., Whiteleys Atrium (1995-98), Munich (1997), solo shows, Farnham Maltings (1983, 1985, 1987, 1990), Epsom Playhouse, Ashley Gallery, Epsom, Conway Hall, London (1984), Loggia Gallery (1983, 1984, 1986), many London exhbns. including Heifer Gallery, Islington (1990-96), Hyde Park Gallery, Fine Arts, Bond St. (1991, 1998), Bonhams Knightsbridge, Smiths Galleries, Covent Gdn. (1990-93), Windsor (1997), Alchemy Gallery, London (1999), Marketsmühle Gallery, Schwindegg, Germany. *Signs work:* "Mary King" or "M. King." *Address:* 42 Reigate Rd., Ewell, Epsom, Surrey KT17 1PX. *Website:* www.maryking.co.uk

KING, Phillip, C.B.E. (1974), P.R.A., R.A.; sculptor in steel, bronze, fibreglass; Prof. of Sculpture, Royal Academy of Art, Prof. Emeritus, Royal College of Art;. *b:* Tunis, 1934. married; one s. (decd.). *Educ:* Mill Hill School; Christ College, Cambridge. *Studied:* St. Martin's School of Art. *Exhib:* Rowan Gallery London, Richard Fergen Gallery N.Y., Venice Biennale, Whitechapel Gallery London, Kunsthalle Mannheim. *Works in collections:* Tate Gallery, M.O.M.A. (N.Y.), National Gallery of Australia, Kroller Muller Museum, New Museum of Contemporary Art Hiroshima, Yorkshire Sculpture Pk., Kunsthalle Mannheim, etc. *Publications:* The Sculpture of Phillip King by Tim Hilton. *Address:* c/o New Rowan Gallery, 25 Dover St., London W1X 3PA.

KING, Robert, RI (1970), RSMA (1985); Mem. Leicester Soc. of Artists (1960); painter in oil, water-colour; etcher and lithographer. *b:* Leicester, 28 Jun 1936. *s of:* Joseph T. King, engineer. *m:* Christine James. *Educ:* Fosse Boys'

School, Leicester. *Studied:* Leicester College of Art (1956-58). *Exhib:* one-man shows, six at Gadsby Gallery, Leicester (1970-80) and Medici Gallery (1980-89); nine with Burlington Paintings (1989-2007); annually with R.I., R.A., R.S.M.A., Leicester Soc. of Artists. *Works in collections:* Nottingham Educ. Com., Leicester Royal Infirmary, Leicester University, Fishmongers Hall London, Royal Yacht Squadron, Cowes, I.O.W. *Publications:* illustrated Denys Brook-Hart's 20th Century British Marine Painting; E.H.H.Archibald, The Dictionary of Sea Painters of Europe and America. *Signs work:* "ROBERT KING." *Address:* 2 Coastguard Cottages, Lepe, Exbury, Hants. SO45 1AD. *Website:* www.robertking.co.uk

KINGS, Tarka Huxley, M.A.; painter/printer in oil, silkscreen. *b:* London, 24 May 1961. *d of:* John Kings, literary editor, and Ann Huxley, author. *Educ:* St. Paul's Girls School. *Studied:* City and Guilds, R.A. Schools (1982-87, Peter Greenham, Norman Adams). *Exhib:* Creative Salvage (1985), R.A., Gallery 24, Phoenix Gallery, Langton Gallery, St. Paul's, Cadogan Contemporary (1988), Bill Thomson Gallery, Rebecca Hossack Gallery (1991, 1993, 1994, 1995). Asst. to Leonard Rosoman, Lambeth Palace Chapel ceiling. *Works in collections:* private collections in U.S.A. and England. Artwork for films: 'Secrets' (Dir. Phillip Savile), 'The Dream' (Dir. Con Mulgrave). *Clubs:* Congress. *Signs work:* "THK." *Address:* 35 Beethoven St., London W10.

KINGSNORTH, Jean, NDD Painting and Lithography, BA Hons History of Art, Post-Grad Diploma in Embroidery and Textiles (Goldsmiths). *Medium:* acrylic, paper-making, watercolour, drawing, prints, paintings. *b:* London, 9 Apr 1933. *d of:* Percival Fraser. *m:* Tony Kingsnorth. one *d. Educ:* Tonbridge Girls Grammar School. *Studied:* Maidstone School of Art; Courtauld Institute, Goldsmiths College. *Exhib:* RA Summer Show; Camden Arts Centre; Anderson O'Day; Drew Gallery; Brewhouse Gallery (Taunton); University of Kent; Intertext (New Zealand); Commonwealth Inst.; Helios Galerie (Calais); Piece Hall Gallery (Halifax); Battersea Contemporary Art Fair; Orleans House, Hebden Bridge, etc. *Works in collections:* private collections in Britain, France, New Zealand, Egypt, Australia. *Commissions:* Nokia; Royal Caribbean Cruise Line; Peter Millard & Ptnrs. *Publications:* 'Papermaking' by John Plowman (Apple). *Works Reproduced:* various paperpieces in John Plowman's 'Papermaking'; some catalogues. *Principal Works:* Tiryns; Argonaut Map; Summer in Mycenae (all multi-media); Winter, Colchis (painting). *Recreations:* gardening, travel, history. *Signs work:* 'JK' or 'JEAN KINGSNORTH'. *Address:* 45 Edenbridge Rd, Enfield, Middx EN1 2LW. *Email:* jeankingsnorth@hotmail.co.uk

KINGSTON, Angela Hoppe, painter; Travelling Scholarship Corsham, Bath Academy of Art. *Medium:* oil, gouache, watercolour, pastel. *b:* Mumbles, nr. Swansea, 1936. *d of:* Hubert and Lottie Hoppe. *m:* Dr. Gordon (Ph.D.). three *s.* two *d. Educ:* Llwyn y Bryn High School, Swansea. *Studied:* Bath Academy of Art, Corsham, Wilts. (1955-58, Adrian Heath, Martin Froy, William Scott). *Exhib:* solo shows: Taliesin Gallery, Swansea (2002), Mistral Gallery, London

(1992), St. David's Hall, Cardiff (1991), University College, Cardiff; group shows: W.A.C. Touring (1993-95), A.A.D.W. Cardiff Arts Festival (1988-89), S.B.A., Watercolour Society of Wales (1973-present), Welsh Group (1975-present); Vale of Glam. Artists (2003-present)Wales, France,Germany, also USA. *Works in collections:* Glynn Vivian A.G., Swansea, Cork University. *Clubs:* W.S.W., V.O.G.A.,The Welsh Group. *Signs work:* "A. Hoppe Kingston." *Address:* Monks, Dimlands Rd., Llantwit Major, Vale of Glam. CF61 1SJ, Wales. *Email:* angelakingston@monksstudio.fsnet.co.uk

KINMONT, David Bruce, Was Senior member of the University of Bristol where, in 1971, he delivered the George Hare Leonard Memorial Lecture. Visiting professorships: George Washington University, Washington D.C. (1974); universities in Beijing, Shanghai (1986), and Hebei (1989), in China; and at the University of St. Petersburg in 1990, and the Gulbenkian Museum, Lisbon (1996); oil paintings, drawings and silk screen prints; sole dealer: J. K. Contemporary, 3 Cheyne Walk, London;. *b:* Kent, 1932. *Educ:* St. John's College, Cambridge. *Exhib:* one-man shows include, Ferens City A.G., Hull (1963); City A.G., Bangor (1960); St. John's College, Cambridge (1969); Churchill College, Cambridge (1976); University of Durham (1981); University of Exeter (1986); Georges, Bristol (1987). *Address:* The Lent House, Clevedon Rd., Flax Bourton, Bristol BS48 1NQ. *Email:* andlent@btinternet.com

KINTGEN, Yanne, *Medium:* oil, sculpture. *b:* Redon, 26 Apr 1960. *m:* O. Kintgen. *Studied:* Ecole des Arts Appliques, Paris. *Represented by:* Galerie Eauvied Art (Paris); Geraldine Bauvier (Paris). *Exhib:* over 10 solo exhbns - sculpture and paintings - in France, UK, Poland. *Official Purchasers:* Mairie de Vauvesson. *Principal Works:* sculptures in bronze and cement, plaster, and oils on canvas. *Signs work:* 'Y.K.'. *Address:* 60 Av Joffre, 92420 Vaucresson, France. *Email:* yanne@kintgen.com *Website:* www.kintgen.com

KIPNISS, Robert, Elected National Academy of Design, NYC; Royal Society of Painter-Printmakers, London; artist; Honorary Doctorates: Wittenberg University, Springfield, Ohio, USA (1979), Illinois College, Jacksonville, Illinois, USA (1989). *Medium:* painter in oil, and printmaker. *b:* NYC, USA, 1 Feb 1931. *m:* Laurie Lisle. three *s.* one *d. Educ:* Wittenberg University, Ohio, USA, and University of Iowa, USA. *Studied:* self-taught. *Exhib:* Beadleston, NYC; Redfern, London; Butler Institute of American Art, Ohio, etc. *Works in collections:* The Metropolitan Museum NYC; Whitney Museum, NYC; The British Museum, London; The Fitzwilliam Museum, Cambridge, UK, Pinakotech der Moderne, Munich; Biblioteque National de Paris; Victoria and Albert Museum, London etc. *Clubs:* The Century, NYC, USA. *Address:* P.O. Box 112 Ardsley-on-Hudson, NY10503, USA. *Email:* rkipniss@msn.com

KIRBY, Michael, MFPS; fine art restorer, artist in oil. *b:* Farnham Common, Bucks., 30 Dec 1949. married. *s of:* H.Kirby, M.I.Nuc.E., LRSH. two *s.* two *d. Studied:* High Wycombe School of Art (1967-71) under G. G. Palmer, Romeo Di

Girolamo, RBA, Eric Smith, RBA, RWS, Henry Trivick, RBA. *Exhib:* RBA, Open Salon, FPS, HUAS. *Signs work:* "M. Kirby." *Address:* 30 Sycamore Rise, Bracknell, Berks. RG12 3BU.

KIRCHNER, Celina, printmaker, draftsman; 13 national and international awards, grants and distinctions. *Medium:* linocut, drawing. *b:* Krzyzowce, Poland, 22 Apr 1970. *m:* Adam Kirchner. one *d. Educ:* Fine Arts College in Bielsko-Biala, Poland. *Studied:* Academy of Fine Arts in Cracow, Graphic Faculty in Katowice. *Exhib:* 6 solo and over 70 group exhibitions in Poland and abroad, International Biennial and Triennials in Canada, Belgium, Bosnia and Hecegovina,Spain, Estonia, Germany, Bulgaria, Finland, Macedonia, Portugal, Romania, Slovenia and UK. *Works in collections:* 'Centro Torrente Ballester' - Ferrol, Spain; Museum Karkonoskie, Jelenia Gora, Poland; Collegium Europaeum Gnesnense Library, Gniezno, Poland; Museum of Teveto area - Tetevo, Macedonia; Art Summer Collection - Tallin, Estonia. *Clubs:* mem. Polish Artists Association. *Address:* ul. Szeroka 23/1a, 40 231 Katowice, Poland. *Email:* ckirchner@poczta.onetel.pl

KIRK, Barry, N.D.D. (1954), A.R.C.A. (1959), F.R.S.A. (1989); Travelling scholarship R.C.A. (1959); painter, draughtsman; Canterbury College of Art 1959-1988 (Vice-Principal 1974-87, Principal 1987-88); thereafter full-time art practice. *Medium:* oils, watercolour. *b:* Deal, Kent, 17 Feb 1933. *s of:* Dr.Dudley Kirk, MB, ChB. *m:* Pleasance Kirk, A.R.C.A., M.S.D.C. two *s. Educ:* Westminster School. *Studied:* Canterbury College of Art (1950-54), R.C.A. (1956-59). *Represented by:* Francis Kyle Gallery, W1. *Exhib:* R.A., Francis Kyle Gallery; one-man shows, Alwin Gallery, etc. *Works in collections:* V. & A., Kent C.C., Canterbury C.C., Glasgow C.C. *Works Reproduced:* 'Etching', Julian Trevelyan (Studio); 'The Lair of the Leopard', Francis Kyle Gallery (Third Millennium Publishing). *Signs work:* "Barry Kirk." *Address:* 13 High St., Bridge, Canterbury, Kent CT4 5JY.

KIRK, Douglas William, painter in oil and water-colour; lecturer, City of London Polytechnic (1976-89). *b:* Edinburgh, 22 Feb 1949. *s of:* Robert Kirk. two *s.* two *d. Educ:* George Heriot's School, Edinburgh. *Studied:* Duncan of Jordanstone College of Art, Dundee (1967-71), Royal College of Art, London (1971-74). *Exhib:* SSA., Compass Gallery, Glasgow, Fine Art Soc., 57 Gallery, Edinburgh, Fruit Market Gallery, Edinburgh, Leonie Jonleigh Gallery, Guildford, Kunsthaudlung Jouiskeit, Stuttgart. *Works in collections:* Carlisle Museum and Gallery. *Signs work:* "douglas kirk." *Address:* 170 South Madison Avenue #12 Pasadena, CA 91101-2559 USA. *Email:* dw_kirk@hotmail.com

KIRK, Robert Joseph, B.A. (1973), M.Sc. (1978), N.A.P.A. (1988); painter in acrylic and pastel;. *b:* Walsall, 7 Jan., 1932. *m:* Sheila M. two *d. Studied:* Walsall and Stafford Schools of Art (1955, Angus Macauley, David Bethel). *Exhib:* N.A.P.A. Annual, (1989-1993). *Clubs:* N.A.P.A., Ludlow Art Soc. *Misc:* Digital images and graphic design for internet. *Signs work:* "Robert Kirk."

Address: West Fortune, Ashford Carbonell, Ludlow, Salop. SY8 4DB. *Email:* robertkirk@rkstudio.demon.co.uk *Website:* www.robertkirk.co.uk

KIRKMAN, Susan, BSc Physics; no recognised qualifications in art. *Medium:* oil, pastel, etching. *b:* London, 13 Jan 1931. *d of:* Eleanor and Robert Downes. *m:* John Kirkman. *Educ:* Open College of the Arts; Filton College, Bristol (etching), and private tutor Robin Child. *Exhib:* National Print exhbns, Pastel Society, Discerning Eye, Royal West of England Academy, South West Academy, Victoria Gallery Bath, Wine Street Gallery Devizes, and many more. *Works in collections:* Textile Council, Welsh School of Architecture, private collections UK, USA, France, Holland, Germany. *Signs work:* S.K. (paintings), S. Kirkman (prints). *Address:* Witcha Cottage, Ramsbury, Wilts, SN8 2HQ.

KIRKPATRICK, Aidan, LTCL, FRSA; Goldsmiths' Travel Award (1976). *Medium:* pen and watercolour, oils, etching. *b:* Norwich, 13 Mar 1932. *m:* Frances Mary. two *s.* two *d. Educ:* Ulverston Grammar School, Glasgow School of Art. *Studied:* St.Benedicts Abbey, Fort Augustus. *Exhib:* RBA, RI, RSMA, Hesketh Hubbard, EAGMA (Mall Galleries); in Belgium at Ghent and Bruges (Oude Huis Longville). *Works in collections:* worldwide. *Commissions:* numerous. *Official Purchasers:* Barclays Bank, Local Government. *Recreations:* Chamber music playing (violin), and sailing. *Clubs:* East Anglian Group of Marine Artists (20 yrs Chairman). *Signs work:* 'AIDAN KIRKPATRICK'. *Address:* Aidan Kirkpatrick Studio, Langley Forge, Langley, Norwich NR14 6BW. *Email:* kirkpatricks@langleyforge.wanadoo.co.uk

KIRKWOOD, John Sutherland, artist, mixed media, photography and etching. *b:* Edinburgh, 6 Apr 1947. *s of:* J. E. Kirkwood. *m:* Ines Santy. *Educ:* George Watson College, Edinburgh. *Studied:* Dundee College of Art. *Exhib:* one-man shows: 57 Art Gallery, Edinburgh Printmakers Workshop, A.I.R. Gallery, Talbot Rice Art Centre, Demarco Gallery, "Scottish Art Now". *Works in collections:* S.A.C. Loan, Hunterian Museum, University of Glasgow, Scottish Museum of Modern Art, Imperial War Museum, Edinburgh City Arts Centre. *Publications:* Contemporary Paintings in Scotland (1995) - Bill Hare. *Signs work:* "J. S. Kirkwood." *Address:* 15 Leopold Pl., Edinburgh EH7 5LB.

KISSEL, Gernot, *Medium:* oil on canvas and paper, lithographies; woodcuts, drawings. *b:* Worms/Rh., Germany, 18 Apr 1939. *m:* Sonja. *Studied:* engineering, architecture. *Represented by:* Vera Schuhmacher Fine Art, 6 Beresford Avenue, Twickenham, TW1 2PY 0208 744 0056. *Exhib:* in England since 1997 (solo shows 1997, 1999, 2001,2003, 2004); all over the continent since 1983 including Switzerland, Holland, France, Belgium, Luxembourg, Germany, Austria, Art Basel, Art Miami, Art London. *Works in collections:* Glasgow Museum; Museum of Bagnoles/Seze, France; Kunsthalle Ettlingen, Germany. *Publications:* book "Frauen"; many exhibition catalogues. *Works Reproduced:* lithographies, woodcuts. *Principal Works:* paintings of figures (women); landscapes, still lifes. *Signs work:* 'Kissel'. *Address:* c/o Vera Schuhmacher, Fine Art Representative, 6

Beresford Avenue, Twickenham, TW1 2PY. *Email:* veraschuhmacher@aol.com *Website:* www.veraandkisselart.co.uk

KITSON, Linda Francis, B.A. (1967), M.A., R.C.A. (1970); official war artist, Falkland Islands Task Force (1982); artist/tutor; Pres. Army Arts and Crafts Soc. (1983). *b:* London, 17 Feb 1945. *m:* Hon. Barnaby Howard (1996). *Educ:* Tortingdon Pk., nr. Arundel, Sussex. *Studied:* St. Martin's School of Art (1965-67), R.C.A. (1967-70). *Exhib:* Workshop Gallery, Illustrators A.G., Imperial War Museum (Falkland's War Exhbn. U.K. tour), National Theatre, R.A. *Works in collections:* Imperial War Museum, Fleet Air Arm Museum. *Publications:* Picnic (Jill Norman); The Falklands War, a Visual Diary (Mitchell Beazley); The Plague; Sun, Wind, Sand and Stars (Folio Soc.). *Clubs:* Chelsea Arts, Dover St, Arts Club. *Signs work:* "Linda Kitson." *Address:* Flat 3, 25 Onslow Sq., London SW7 3NJ.

KITTS, Barry Edward Lyndon, NDD (1964), FRSA(1972); landscape painter and writer on art; visiting lecturer at Central St. Martin's College of Art and Design. *b:* Bath, 18 Oct 1943. *s of:* George Edward Kitts. *Educ:* Sutton East County Secondary School (Surrey Special Art Course under George Mackley, M.B.E., RE). *Studied:* Kingston School of Art (1959-61) under J.D.Binns, ARCA, D.A Pavey, ARCA, Wimbledon School of Art (1961-64) under Gerald Cooper, ARCA. *Exhib:* NEAC, RBA, Wessex Artists' Exhbn. *Publications:* Co-author of a Graphic Design Sourcebook (1987). *Signs work:* "Barry Kitts." *Address:* 500 Kingston Rd., London SW20 8DT.

KITZLEN, Member SNSP, Paris; Charter member, Association of Lifecasters International, 2000-; sculpteur/plasticien: moulage, ciment fondu, plaster, bronze. *Represented by:* Galabia. *Exhib:* Palais Episcopal, Belley, France - but most work commissioned privately. *Works in collections:* private: England, France. *Publications:* 'Féminèite'(2003, 2005: ISBN 2-914078-01-3), 'Curves' (in preparation). *Works Reproduced:* in 'Sculpteurs & Plasticiens du 21e siècle (2004) ISBN 2-7515943-1-3. *Clubs:* Farmers' London. *Address:* B.P.3, F-01350 Culoz, France. *Website:* www.kitzlen.com

KLEIN, Anita, B.A.Hons. (1983), M.A. (1985), R.E. (1991); Elected President of Royal Soc. of Painter Printmakers 2003; painter/printmaker in drypoint, woodcut, oil on board. *Medium:* oil on board, drypoint, woodcut. *b:* Sydney, Australia, 14 Feb 1960. *d of:* Prof. A.G. Klein. *m:* Nigel Swift. two *d.* *Educ:* Hampstead School. *Studied:* Chelsea School of Art (1978-79), Slade School of Fine Art (1979-83, Mick Moon, Paula Rego; 1983-85, Barto dos Santos). *Represented by:* Boundary Gallery, London, Advanced Graphics London. *Exhib:* I.C.A., Hayward, R.I., Blond Fine Art; one-man shows: Creaser Gallery, Leigh Gallery, Tall House Gallery, Wilson Hale; Cambridge Contemporary Art, Beaux Arts, Bath, C.C.A. Oxford, Boundary Gallery, London (main dealer), Advanced Graphics, London. *Works in collections:* A.C.G.B., R.E., Ashmolean Museum, University of Wales. *Publications:* "20 Years of Printmaking" catalogue published by Advanced Graphics 2002. *Clubs:* Chelsea

Arts Club. *Address:* 82 Tressillian Rd., London SE4 1YD. *Email:* anita@anitaklein.com *Website:* www.anitaklein.com

KNAPP-FISHER, John, R.C.A. (1992); painter;. *b:* London, 2 Aug 1931. *s of:* Prof. A.B. Knapp-Fisher, F.R.I.B.A. *m:* Sheila Basset (divorced). one *s.* one *d. Educ:* Eastbourne College. *Studied:* Maidstone College of Art (1951-53), Designer in Theatre. *Exhib:* extensively, England and Wales. *Works in collections:* National Museum of Wales, National Library of Wales, Tenby Museum, Beecroft A.G., Haverfordwest Museum, prize winning panel, Withybush Hospital Haverfordwest, Contemporary Art Soc. for Wales, major private collections worldwide. *Publications:* many Welsh publications. Featured on Welsh radio and television; wrote and illustrated John Knapp-Fisher's Pembrokeshire (Senecio Press, 1995, 2nd edition 2003). *Recreations:* boating. *Signs work:* "John Knapp-Fisher." *Address:* Trevigan Cottage, Croesgoch, Haverfordwest, Pembrokeshire SA62 5JP.

KNEALE, Bryan, RA Rome Scholar; sculptor in steel and all metals, wood, etc.; Mem. CNAA Fine Arts Panel, Royal College of Art, Professor of Sculpture, Royal Academy (1980-83), Head of Sculpture RCA (1985-90), Professor of Drawing (1990), Chairman ASG. *b:* Douglas, I.O.M., 19 Jun 1930. *s of:* W.T.Kneale, newspaper editor. *m:* Doreen Kneale. one *s.* one *d. Educ:* Douglas High School. *Studied:* Douglas School of Art (1947) under W. H. Whitehead; RA Schools (1948-52) under Philip Connard, Henry Rushbury. *Exhib:* John Moores, Art d'aujourd'hui, Paris, Battersea Park, Whitechapel Retrospective, Cardiff, Leics. Educ. Com., Whitechapel, City of London, Peter Stuyvesant, Southampton, British Sculptors, R.A. Holland Park, Royal Exchange Sculpt., Hayward Gallery, R.A., London Group, Redfern Gallery, New Art Centre. *Works in collections:* Tate, Arts Council, C.A.S., W.A.G., Fitzwilliam Museum, B.M., City Art Galleries of Manchester, Birmingham, Sheffield, Bradford, Wakefield, Leicester, York and Middlesbrough, Sao Paulo, Brazil, Museum of Modern Art, N.Y., National Galleries of N.Z., Queensland and S. Australia, Manx Museum and A.G., Abbot Hall Gallery, Cumberland, Beaverbrook Foundation, Frederickton, Bochum Museum, W. Germany, Bahia Museum, Brazil. *Clubs:* Chelsea Arts. *Signs work:* "BRYAN KNEALE" (die stamp), "Bryan Kneale" (drawings, etc.). *Address:* 10a Muswell Rd., London N10 2BG.

KNEALE, William, Henry (Bill), DipAD, ATD, NAPA; Winner of Clwyd, North Wales and Oswestry Opens, NAPA International Louisiana-Col Art America Award. *Medium:* acrylic paint, figurative impressions of people, places visited, landscapes and shorelines. *b:* Crewe, 19 Nov 1945. *s of:* Charles Henry Kneale. *m:* Dilys. one (Dylan) *s.* one (Lowri) *d. Studied:* Flint School of Art, Manchester and Liverpool Universities, studying art, industrial design and art education. *Exhib:* solo: Telford Town Centre, Theatre Clwyd, Royal Pavilion Llangollen, and Rhyl Arts Centre Group: NAPA Opens in Durham, St.Ives and Black Sheep Hawarden, Glasgow Art Exposure Gallery; Red Bill Gallery Deeside. *Works in collections:* private collections Wales, England and Sri Lanka.

Principal Works: winning Open paintings: Pant March, Llandudno Promenaders, Barmouth, Barmouth Boats. *Recreations:* protecting wildlife as an RSPB field teacher. *Clubs:* NAPA. *Misc:* enjoys the versatility of acrylics in spray, knife and brushwork. *Signs work:* 'W.H.Kneale'. *Address:* Silverdale, Lloc, Holywell, Flintshire, CH8 8QX. *Website:* www.billkneale.co.uk

KNIGHT, Clifford (Edgar Levi), FRSA, PVPUA, AFAS; painter in oil, water-colour and mixed media, lecturer/demonstrator;. *b:* Kempston, Beds., 8 Mar 1930. *s of:* the late H.R. Knight. *m:* Sherri. three s- *s.* two s- *d. Educ:* Kempston Secondary Modern School. *Studied:* under William Twybel, ARCA (1948-54), LCC Central School (1955-57, William Roberts, Merlyn Evans, Paul Hogarth, S.R. Badmin). *Exhib:* UA, NEAC; one-man shows, Upper St. Gallery (1973), Carlton House Terr. (1983), Bedford, Luton, Letchworth, Northampton, Retford, Wellingborough, Welwyn Garden City, Abbotsholme School, Bedford School. *Works in collections:* Northampton, Luton and Letchworth A.Gs, Crown Commissioners, Texas Instruments, Beds. CC; private collections: USA, S.Africa, Paris, Canada. *Commissions:* Bedford, USA, Paris, London. *Works Reproduced:* Leisure Painter; London Today, TV. *Recreations:* looking at churches. *Misc:* studio address: Roe Farm, Cogenhoe, Northants, NN7 1LL. *Signs work:* "Clifford Knight." *Address:* 8 Wood Street, Wellingborough, Northants NN8 2AN.

KNIGHT, David Spencer, BA Fine Art; Best Painting, 9th Annual Xmas Exhibition, St.David's Hall. *Medium:* oil, drawing, sculpture. *b:* Essex, 2 Mar 1965. *s of:* John Knight. *Educ:* Comp. *Studied:* University of Wales, Cardiff (1993-96). *Represented by:* Albany Gallery, Cardiff; Denise Yapp Fine Art, Monmouth. *Exhib:* Albany Gallery, Oriel Tri Penarth, Denise Yapp Gallery, Bay Art Gallery, Cardiff, St.David's Hall Cardiff, Campden Gallery, Glos., Wiseman Gallery, Oxford. *Commissions:* private, portraits. *Signs work:* "D.KNIGHT". *Address:* 16 Larch House, Hollybush Est., Whitchurch, Cardiff, CF14 7EA.

KNIGHT, Geraldine, National Diploma, Sculpture; RA Schools Cert.; Prix de Rome Sculpture. *Medium:* sculpture, casting in bronze, figurative, mostly animals. *b:* Horsham, Sussex, 8 Nov 1933. *d of:* Mr & Mrs Knight. *m:* Mark Churchill. *Educ:* Horsham High School for Girls. *Studied:* RA Schools; in Italy. *Represented by:* Sladmore Gllery, Bruton Place, London W1. *Exhib:* RA; Discerning Eye (exhbn. work chosen by W.Packer, also Prince of Wales); West of England Academy; Holly Snapp Gallery, Venice and others. *Works in collections:* worldwide. *Commissions:* mostly private. *Recreations:* travel, and visiting museums. *Clubs:* Chelsea Arts Club, Reynolds Club, RA Schools. *Misc:* overseas address: 595 Guidecca, Venice, Italy. *Signs work:* 'Geraldine Knight'. *Address:* The Studio, Overford Farm, Wyham, Oxford OX2 8QN. *Email:* geraldine.knight@appleinter.net *Website:* www.geraldineknight.com

KNIGHT, Sophie, RWS(1992), ARWS (1990), BA(Hons.) Fine Art (1986), Post Grad. Dip. (1989); Ian Tragarthen Jenkins award (1986), David Murray

Scholarship (1988), Erik Kennington award (1989), Hunting Group Student prize (1989), RWS award (1989); painter in water-colour and acrylic. *b:* London, 20 Mar 1965. *d of:* Terence Knight, art director/painter. *Educ:* The New School, Kings Langley. *Studied:* Herts. School of Art, St.Albans (1982), Camberwell School of Art and Design (1983-86), RA Schools (1986-89). *Exhib:* numerous exhbns. including R.A. Summer Exhbn. (1988), R.W.S. Bankside Gallery S.E.1 (1988), Mall Galleries (1989), Whitechapel Open (1994); solo shows include Cadogan Contemporary (1991, 2000), Waterman Fine Arts (1993), The Unicorn Gallery, London S.W.10, Reutlingnen Gallery, Germany (1996). *Works in collections:* B.M., The House of Lords, The New Parliamentary Building W1, T.S.B. Bank. *Signs work:* "Sophie Knight." *Address:* 36 Ivinghoe Rd., Bushey, Herts., London WD2 3SW.

KNOWLER, Ann Patricia, SWA (1993); artist in oil and soft pastels; past member of SWA Council. *b:* Pinner, 3 Jun 1940. *m:* Jonathan Knowler. one *s.* one *d. Educ:* Northwood Secondary Modern School. *Studied:* F.E. classes and privately under Claude Murrills. *Exhib:* SWA Westminster Gallery. *Works in collections:* several private collections both in UK and abroad. *Commissions:* Artists' Impression-Ventnor Haven, commissioned by Mr. R.G. McInnes for IOW Council. *Publications:* 'Leisure Painter', and limited edition books: '50 Years Along the Undercliffe' of the IOW, by Robin McInnes, 'The Book of the Isle of Wight Coast'. *Clubs:* Weald of Sussex Art, The Adventurers Art, Assoc. of Sussex Artists. *Signs work:* "Ann Knowler." *Address:* Sundown, 7 Western Rd., Newick, E. Sussex BN8 4LE. *Email:* ann.knowler@talk21.com

KNOX, Jack, R.S.A. (1979), R.G.I. (1981), R.S.W. (1987), Hon. R.I.A.S. (1997), D.Litt (2004); painter in oil; Head of Painting, Glasgow School of Art (1981-92);. *b:* Kirkintilloch, 1936. *s of:* Alexander Knox, tailor. *m:* Margaret. one *s.* one *d. Educ:* Lenzie Academy. *Studied:* Glasgow School of Art (1952-58, William and Mary Armour). *Exhib:* one-man shows: Scottish Gallery (1966, 1989), Demarco Gallery, Edinburgh (1969), Serpentine, London (1971), Glasgow School of Art (1982), Retrospective (1983), Glasgow A.Gs. (1990), Open Eye Gallery, Edinburgh (1991), Festival Exhbn., Open Eye Gallery, Edinburgh (1993, 1999, 2003). *Works in collections:* Scottish National Gallery of Modern Art, Manchester City A.G., Scottish National Portrait Gallery, Glasgow A.Gs., Arts Council, Otis Art Inst., Los Angeles. *Publications:* The Scottish Bestiary by George Mackay Brown (Charles Booth-Olibborn/Paragon Press, 1986), Lapotiniere and Friends by David and Hilary Brown (Century Editions/Random Century Group Ltd., 1990). *Signs work:* "Jack Knox." *Address:* 66 Seafield Road, Broughty Ferry, Dundee DD5 3AQ.

KNOX, Liz, Diploma of Art (DA Edin. 1971), Diploma of Paisley Art Inst. (PAI, 2005); Winner of Aspect Prize (2003), University of Paisley Award (2006), The Bessie Scott Award (2004), Blytheswood Gouache GSWA (2007). *Medium:* gouache, oil, watercolour drawing. *b:* Glasgow, 20 Jan 1945. *m:* Peter Whittle. two *s. Educ:* Glasgow and Paisley. *Studied:* Edinburgh College of Art (graduated

1971). *Represented by:* Duncan Campbell Fine Art, London; The Edinburgh Gallery, Edinburgh. *Exhib:* House of Scientists, St.Petersburg, Russia; Contemporary Fine Art, Eton; Medici Gallery, London; Roger Billcliffe, Glasgow; Royal Glasgow Institute of the Fine Arts; Paisley Art Institute; Visual Arts Scotland; Walker Gallery, Harrogate; Duncan Campbell, London; The Edinburgh Gallery; Thompsons, Aldeburgh; Glasgow Art Club. *Works in collections:* Paisley Museum & Art Galleries; The Royal Bank of Scotland, Edinburgh; Aspect Capital Ltd., London; ARA Interior Architectural Design, London; Biggart Baillie, Solicitors, Glasgow. *Works Reproduced:* Limited Edition Prints - Studio Sixty, Glasgow. *Clubs:* Glasgow Art Club. *Misc:* at present, President of Paisley Art Institute; lecturer in Fine Art in Further Education (1983-2003). *Signs work:* "L Knox". *Address:* Jesmond, High Street, Neilston, Glasgow, G78 3HS. *Email:* lizknox1@ntlworld.com *Website:* www.lizknox.com

KOCH, C.-Clarissa, AROI (2006). *Medium:* painter (oils and classical drawing media). *b:* Austria, 13 Oct 1972. *Studied:* initially self-taught, 1997 UCL Medical School Anatomy for Artists, 1997-1999 Florence Academy of Art, Italy, 2001-2004 Summer Student with Nerdrum, Norway. *Exhib:* W H Patterson Fine Arts, London; Whittingdon Fine Art, Henley; Jonathan Cooper's Park Walk Gallery, London (solo and mixed); Solomon Gallery, Dublin; Anderson Fine Arts, Georgia; Panorama Museum, Germany; Palazzo Corsini, Florence. *Works in collections:* private/corporate. *Publications:* "Realism Revisited", catalogue, Panorama Museum, Germany (2003); "Tretyakov Gallery Magazine", Russia (02/2004); "Malenwie die Alten Meister", Die Salzburgerin, Austria (7/8, 2003). *Clubs:* Arts Club - Dover Street. *Signs work:* "CCK" as monogram with Roman numerals, or "C.- CLARISSA KOCH". *Address:* Unit 142, Battersea Business Centre, 99-109 Lavender Hill, London SW11 5QL. *Email:* cck_clarissa@hotmail.com *Website:* www.c-clarissakoch.com

KOJIMA, Yuriko, SBA; President of 'Atelier Bleuet' China Painting Club; Special Art Teacher of High School National Diploma 2006 SGM (RHS). *Medium:* water colour, china painting and instructor. *b:* 19 Apr 1949. *m:* Nobuo Kojima. one *s.* one *d. Studied:* Ekota Western Art Institute, Okura China Painting School; National Tokyo Liberal Arts University. *Exhib:* Nakayama Gallery (1999-2002); The Banquet of Flora (2000, 2002, 2004); SOGEI (2002); SBA (2003, 2004, 2006, 2007); Orpa Gallery (2003); RHS Lily Convention (2004); RHS Show (2006). *Publications:* The New Collection of Helleborus (Illust.); Christ Rose Gallery (Illust.); Musashin Rose Society's Quarterly Magazines (cover and column, 2000-2001); Ibaraki Rose Society's magazine (cover). *Principal Works:* Research and painting of Helleborus Species in Europe, Lilium. *Recreations:* gardening, reading, cinema, VTR. *Misc:* Volunteer of Hino City Rose and Hellebore Garden; Director of Japan Christmas Rose Society. *Signs work:* 'YURIKO'. *Address:* 20-17-2 Matsuyaga, Hachioji-shi, Tokyo 192-0354, Japan. *Email:* kojima@ttv.ne.jp

KOLAKOWSKI, Matthew Edmund Czeslaw, B.A. (1978), M.A. (1979); artist/painter in oil, sculptor mixed media; Foundation tutor, Woolwich College, and Central St. Martin's; visiting lecturer, Ravensbourne College;. *b:* Ruislip, Middx., 12 Mar., 1956. divorced. one *s. Educ:* Douay Martyrs School, Ickenham. *Studied:* Watford School of Art (Michael Werner, Peter Schmidt, Charles Harrison), Ravensbourne College of Art (Brian Fielding, Victor Kwell, Kit Twyford), Chelsea School of Art (Anthony Wishaw, Ian Stevenson). *Exhib:* London Group since 1989; one-man show: Duncan Campbell Gallery (1993, 1995), Mid Pennine Art Centre (1997). *Clubs:* London Group (Vice-Pres. since 1996), elected President (1998). *Signs work:* "M" in circle or triangle. *Address:* Brightside Studios, 9 Dartford St., London SE17 3UQ.

KONDRACKI, Henry Andrew, artist in oil on canvas;. *b:* Edinburgh, 13 Feb 1953. *s of:* Pavel Kondracki. *m:* Sara. three *s. Educ:* Bellevue School, Edinburgh. *Studied:* Slade School of Fine Art (Ron Bowen, Jeffrey Camp, Jock McFadyen, Patrick George). *Exhib:* Vanessa Deveureux Gallery (1987, 1989), William Jackson Gallery (1991, 1994), Flowers East Gallery (1995, 1996, 1998, 2001), Flowers West Gallery, California (1998, 2000), Royal Academy Summer Exhibition (1989, 1990, 1993, 1994, 2000, 2001). *Works in collections:* British Council, A.C.G.B., Guildhall, London, Granada Foundation, Manchester, University College London, Manchester A.G., City Art Centre, Edinburgh, Glasgow Museums. *Publications:* Contemporary Scottish Painting by Bill Hare, Paint by Jeffrey Camp. *Signs work:* "H. Kondracki." *Address:* 20 Marchmont Cres., Edinburgh EH9 1HL.

KOPEL, Harold, F.R.O.I. (Hon. Treasurer, 1984-94); painter in oil, acrylic and pastel; art master, lecturer, Further Education I.L.E.A. *b:* Newcastle upon Tyne. *Educ:* Rutherford Grammar School, Newcastle; University College, London. *Studied:* Central School of Arts, London. *Exhib:* several one-man shows, numerous mixed shows including R.A., R.B.A., N.E.A.C., R.W.A., Paris Salon (Silver medal), Barcelona biennial, R.G.I., Contemporary Art International, Olympia (1989), many private galleries; Cornelissen prize. *Works in collections:* University College, London, Nuffield Foundation, I.L.E.A. *Signs work:* "Kopel." *Address:* c/o Mrs E.Dewey 47 Birnbeck Court, 85a Finchley Road, London NW11 6BB.

KORALEK, Paul George, C.B.E., R.A., R.I.B.A., F.R.I.A.I., A.A.Dipl. (Hons); architect; Director, Ahrends Burton and Koralek. *Medium:* architecture. *b:* 7 Apr 1933. *s of:* Ernest Koralek (decd.). *m:* Jennifer Chadwick. one *s.* two *d. Educ:* Aldenham. *Studied:* architecture: Architectural Assoc. *Exhib:* Heinz Gallery, R.I.B.A. (1982), R.A. Summer Show (annually since 1987). *Publications:* Monograph "Ahrends Burton and Koralek". "Collaborations. The Architecture of ABK". *Address:* Unit 1, 7 Chalcot Rd., London NW1 8LH. *Email:* abk@abklondon.com *Website:* www.abk.co.uk

KOSTER, David, D.F.A. (Lond.), N.D.D., A.T.D., S.WL.A.; printmaker and painter. *b:* London, 5 Nov 1926. *s of:* Rowland Koster. *m:* Katherine Macrae. one *d. Educ:* Clayesmore. *Studied:* Slade School. *Works in collections:* Aberdeen City A.G., Royal Ulster Museum, Belfast, Berliner Graphothek, U.C.L., Dept. of Environment, All Soul's College, Oxford, Hokin Gallery, U.S.A., Hamilton Public Library, Canada, University New South Wales, S. London Gallery, Towner A.G., Eastbourne, numerous County Council and Educ. Com. Collections, Ministry of Agriculture, S.W.A.N. Governemt Art Collection. Private collections in Europe, USA, Canada, Australia. *Publications:* Wood engraved illustrations 'Down to Earth', drawings 'Fellow Mortals'. *Signs work:* "David Koster." *Address:* 5 East Cliff Gdns., Folkestone, Kent CT19 6AR.

KOWAL POST, Christine, RCamA (2005); BA (Joint Hons); prizewinner, John Moore's Liverpool. *Medium:* sculpture: polychromed woodcarvings. *b:* Nigeria, 31 Dec 1951. *d of:* Jan Kowal O.B.E., Pamela Dunroe. *m:* Rory Post. *Educ:* Brigidine Convent, Denbigh. *Studied:* University College of Wales, Aberystwyth; Accademia Delle Belle Arti, Florence. *Exhib:* widely in Britain and abroad, including RA; Walker Art Gallery, Liverpool; Manchester and Brighton City Art Galleries; Tate Liverpool; Kiss Untergroeningen and Stadtmuseum, Beckum, Germany. *Works in collections:* Walker Art Gallery, Liverpool; Williamson Art Gallery, Birkenhead; Manchester City Art Gallery; Liverpool University; Villa Merkel Esslingen. *Commissions:* Ashworth Hospital, Merseyside; Galn Clwyd NHS Trust; Wrexham Maelor NHS Trust; Broomfield Hospital, Essex. *Publications:* catalogues of solo and group exhbns. *Signs work:* 'C.Kowal Post'. *Email:* ckowalpost@talk21.com *Website:* www.christinekowalpost.com

KOWALSKY, Elaine Gloria, Dip. of Art, M.A.; artist in relief, litho, ceramics; Henry Moore Fellow in Printmaking, Leeds Polytechnic. *b:* Winnipeg, Manitoba, 24 Sep 1948. *d of:* Rosemary A. Kowalsky, abstract painter. *m:* Elton Bash, painter. *Educ:* Charleswood Collegiate, Winnipeg. *Studied:* University of Manitoba, St. Martin's School of Art, Brighton Polytechnic; M.A. Visual Theory University of East London. *Exhib:* R.A., and numerous one-man shows. *Works in collections:* V. & A., Birmingham A.G., Worcester A.G., Leeds A.G., Manchester A.G., Canada Council Art Bank, University of Manitoba, National Gallery of Australia, Smithsonian Inst. *Commissions:* banners, Dover Castle. *Publications:* Wood engraving and the Woodcut in Britain c.1890-1990, J. Hamilton (Barrie & Jenkins Ltd. 1994). *Signs work:* "Elaine Kowalsky." *Address:* 27 Aberavon Rd., London E3 5AR.

KOZARZEWSKA, Magda, LCAD (1977), SIAD (1977), B.A.Hons. (1981); artist in oil, charcoal, pencil. *b:* Warsaw, 7 Oct 1952. *d of:* Zbigniew Kozarzewski. *m:* Jonathan Goldberg. one *s. Educ:* Grammar School, Warsaw. *Studied:* Chelsea School of Art (1974-77), Slade School of Fine Art (1977-81, Prof. Sir L. Gowing, Patrick George, Euan Uglow). *Exhib:* solo shows: Polish Cultural Inst. (1975), Sue Rankin Gallery (1988), Thackeray Gallery (1991);

major retrospective, Polish Cultural Inst. (1991), Thackery Gallery (1993), Duncan Campbell Fine Art (1995, 1997), Konrad Bayer Gallery, Munich (1996); group shows: Hayward Gallery (1982), N.P.G. (1986), Zacheta Gallery, Warsaw (1991), R.A. (1995), Konrad Bayer Gallery, Munich (1995), Polish Cultural Inst., London (1996). *Works in collections:* U.K., Europe, U.S.A., Canada, S. Africa. *Signs work:* "M.K." or "Kozarzewska." *Address:* 15 Woodlands Ave., New Malden, Surrey KT3 3UL.

KREYMANN, Ute-Marie, MA Fine Art. *Medium:* mixed media, installation, drawing, prints, sculpture. *b:* Leipzig, 24 May 1958. *m:* John Seaton. *Studied:* Middlesex University (BA (Hons) Interior Design 1989-90, transferred to BA(Hons) Fine Art 1990-93); University of East London (MA Fine Art, 1989). *Represented by:* Wiebke Morgan Gallery, 6 Cyprus Street, London E2, www.wiebkemorgan. *Exhib:* solo: Wiebke Morgan Gallery 'On the Point of Comprehension' (2003); Spitalfields Festival,St.Leonards Church, London (2002); Map Gallery, London (2000); Hyattsfield Park (1996); Galerie Unwahr, Berlin, Hackney Empire, London (1995). Group: Wiebke Morgan Gallery (2007), Avivson Gallery, Paris (2000), Hackney Empire Theatre (2000), St.Pancras Chambers, London (1998); National Trust, Sutton House (1998), Waterman's Art Gallery (1997), Mall Gallery, London (1996), Open Window Gallery, London (1994), London Public Transport Bus 73 & 38 (1994). *Works in collections:* private. *Commissions:* private. *Publications:* 'Time Out' December 2002, preview by Martin Herbert; The Ladies Smoking Room catalogue, essay by Tom McCarthy (1998). *Official Purchasers:* Hurlingham & Chelsea School (2004, porcelain mobile); Winton School, London (1999, Outdoor sculpture, permanent). *Misc:* 1991-1997 'Art & Place' Founding Member, initiation of projects of environmental and cultural issue, formed after 1989 Landscape & Sculpture Symposium, Manchester. *Signs work:* "UTE KREYMAN". *Address:* 90 Lynmouth Road, London E17 8AQ. *Email:* ute.kreymann@talk21.com

KRUT, Ansel Jonathan, MA (1986), BFA (1982); painter in oil; awarded Rome prize (1987). *b:* Cape Town, 1959. *s of:* Dr. Louis Harold Krut. *m:* Felicity Powell. two *d. Studied:* University of the Witwatersrand (1979-82), R.C.A. (1983-86). *Exhib:* R.A., John Moores, London Group, Cité des Arts, Paris; one-man shows Fischer Fine Art (1989, 1990), Gillian Jason Gallery (1994), Jason and Rhodes Gallery (1995, 1996). *Works in collections:* Arts Council London, British Council, Government Art Collection, Harris Museum of Art Preston, Mercer A.G. Harrogate, Ben Uri Collection, Johannesburg A.G. *Signs work:* "A. Krut." *Address:* Jason and Rhodes Gallery, 4 New Burlington Pl., London W1X 1FB.

KUBECKI-PEARCE, Terence Peter, DipAD. *Medium:* oil, acrylic, drawing, prints (etchings). *b:* Chingford, Essex, 11 Nov 1947. *s of:* Mary Kubecki & Harry Pearce. *m:* Cherry Storer. two *s.* two *d. Educ:* McEntee School, Walthamstow. *Studied:* Walthamstow School of Art: Painting (main), Printmaking/Lino (secondary); Camden Evening Inst (now Westminster Kingsway College, 1993,

studied etching with Peter Freeth). *Exhib:* RA Summer Exhbn (1991, 93, 94, 97, 98, 2000, 01, 04, 07); RWA (1994, 95, 97, 98, 2000, 01, 02, 03, 05, 06); National Print Exhbn. (1995, 2002, 03, 04); Discerning Eye (1997, 2001, 03, 04, 05, 06); NEAC (1998, 2001, 02); Hunting Prize (RCA, 1999, 2000, 01, 04, 05); RWA Print Open (1997, 2004); Originals (2006); Laing Landscape Exhbn (2001, 02); one-man show Beecroft Gallery, Westcliff-on-Sea, plus many other exhibitions, most recently of prints. *Recreations:* astronomy and optics. *Clubs:* invited to join 12PM (East Anglian Print Makers Group) 1999, joined Camden Print Makers (2004). *Misc:* continued painting after art school, taught in secondary school for a while then turned to making and selling astronomical reflecting telescopes; since 1994 has concentrated on exhibiting prints and developing etching style. *Signs work:* 'Terence Pearce' (paintings); 'Terry Kubecki (prints); 'TKP' (drawings/sketches). *Address:* 66 Barrett Rd., Walthamstow, London E17 9ET. *Email:* enquiries@terrykubecki.co.uk *Website:* www.terrykubecki.co.uk

KUELL, Victor John, ARCA (1950), Hon. Mem. London Group (elected 1980, Honorarium 1998); RCA Awards: Perspective Drawing Prize; Air Malta Award, 1st International Biennale, Malta. *Medium:* artist in acrylics and water-colour. *b:* Andover, Hants, 28 Aug 1924. *s of:* Ernest Hector & Clarissa Kuell. *m:* Margaret. one *s.* one *d. Educ:* Simon Langton, Canterbury. *Studied:* Bromley School of Art (1938-42), R.C.A. (1947-50). *Exhib:* London Group (1977-2005), R.A. (1987-2003), Galerie Espace Laser, Paris (1990), Galerie Metropolis, Geneva (1985), Société de l'Art Contemporain, Paris (1984), International Biennale of Malta (Award winner, 1995), Galerie Carre D'Or Paris (2000), The Green Space, Dulwich, London; Centre Culturel Christiane Peugeot (Paris, 2005). *Works in collections:* James Capel, N.Y., Mitsui London. *Publications:* Les Editions Art et Image du Monde, The London Group- Visual Arts from 1913. *Signs work:* "Vic Kuell." *Address:* 45 Hever Rd., Edenbridge, Kent TN8 5DH. *Email:* mkuell@zoom.co.uk

KUHFELD, Peter, B.A., N.E.A.C.; artist in oil, pencil and charcoal. *b:* Glos., 4 Mar 1952. *m:* Cathryn Showan, artist. two *d. Educ:* Gateway School, Leicester. *Studied:* Leicester College of Art (1972-76), R.A. Schools (1977-80, Peter Greenham, Norman Blamey). *Exhib:* R.A., N.E.A.C., R.P., R.B.A., R.W.A., N.P.G., Windsor Castle, Hampton Court Palace, Accademia Italiana, New Grafton Gallery, Agnews, W.H. Patterson, Christie's, Fine Art Soc., National Gallery of Wales, Cardiff, Brian Sinfield Fine Art, Petley Fine Art; Crossgate Gallery, Kentucky; Everard Read Fine Art, Johannesburg, South Africa. *Works in collections:* H.M. The Queen, H.R.H. Prince of Wales, Baring Bros., Lazards, Cable and Wireless, Hammerson Group, National Trust, Elizabeth Greenshield Foundation, Hambros, Mercury Asset Management, Sabanci Bank. *Signs work:* "Kuhfeld." *Address:* The Corner House, Upper Bridge St., Wye, Kent TN25 5AW.

KUO, Nancy, director, choreographer, dancer, actress, designer, authoress, art critic and painter, gold medallist; visiting lecturer to universities, art colleges, art

societies, women's societies, clubs and museums. *b:* Shanghai, China. *m:* Guy Davis, DA(Edin.). *Studied:* western painting in Hanzhou National Art Academy and Shanghai Art Academy, traditional Chinese painting under Chen Shu-ren, a founder of the Lingnan School. *Exhib:* in China, Hong Kong, Gambia, Burma, Afghanistan, France, Norway, Argentina and England. *Works in collections:* private collections all over the world, National Museums of Burma and National Museum of Ethology, Leyden. *Publications:* author of "Chinese Paper-cut Pictures", "The Sky is Singing", "Dream Valley", "Rolling and Folding", etc., catalogue, "Arts from China". Work repro.: numerous newspapers and journals of various countries; contributions: poems, essays, plays, art reviews, etc. in Chinese and English to newspapers and journals in China, Hong Kong, Burma, Afghanistan, Italy and England; scripts for B.B.C. Radio; T.V. apperances: I.T.V., B.B.C., France T.V., Monte Carlo T.V. and China T.V. Fellow International P.E.N.; mem. of International Assoc. of Art Critics, International Assoc. of Art, and British Actors' Equity; Director of Chinese Arts Inst.; Adviser to the Chinese writers in Britain, Adviser to the Hainan Poetry Soc., Adviser to the Qing Yuan City Government on Culture and Arts. *Signs work:* "Nancy" in Chinese. *Address:* No.1 Block, 5th Fl.(Post Box 5) Riverside Residence, Bei Jiang Yi Road, New Town, Qing Yuan City, Guang Dong, P.R. ChinaPostcode 511515.

KURTZ, Peter Felix Magnus von, MA, BA (Hons), FRSA. *Medium:* photography, installation, multimedia, paint. *b:* Berlin, 15 Mar 1969. *Studied:* University of Lancaster. *Represented by:* Highgrove Fine Arts, London. *Exhib:* UK, Germany, Australia, USA. *Works in collections:* UK, Germany, Switzerland, Australia, USA. *Commissions:* private collectors. *Publications:* (books, magazines, internet) including: Skin Two, Marquis, EPS, 'A' Magazine, Secret Fetish Photo Anthology, Bloody & Dishonour (Satanic Sluts), Arena. *Clubs:* Fine Art Trade Guild. *Signs work:* 'Peter Felix Kurtz', 'Peter Kurtz', 'Kurtz', 'PFK'. *Address:* Highgrove Fine Arts, PO Box 22894, London NW9 6ZE. *Email:* pfkproductions@yahoo.com *Website:* www.fetishfoto.co.uk

KYNOCH, Kathryn Marie, R.G.I. (1994); artist in oil and pastel;. *b:* Portobello, Midlothian, 18 Aug., 1941. *m:* Michael Andrew Tribe. *Studied:* Glasgow School of Art (1959-64). *Exhib:* R.G.I., R.S.A., S.S.A. *Works in collections:* Glasgow A.G's, Kelvingrove, Hunterian Art Gallery, Glasgow University, Dover House, Whitehall; private collection in Britain and U.S.A. *Commissions:* include R.S.A. Music and Drama, Glasgow, Edinburgh, Stirling, Strathclyde and Leicester Universities. *Clubs:* Glasgow Art. *Address:* 35 Kelvinside Gdns., Glasgow G20 6BG.

KYRIAKIDES, Yvonne, MPhil (RCA); BA (Hons) Fine Art; Saatchi & Saatchi Prize for Painting. *Medium:* drawing, prints, photography, text. *b:* London, 25 Oct 1950. *d of:* Nicholas Christopher Kyriakides. one *s.* one *d.* *Studied:* University of Nottingham (English); Goldsmith's College, London (Fine Art); RCA (Painting). *Exhib:* RA; ICA London; Whitechapel Gallery; Eagle Gallery; Drawing Research Centre, RCA; Queen's Theatre, London;

Peterborough Museum and Art Gallery; Sainsbury Centre for Visual Arts, UEA; Cheltenham & Gloucester College; University of Lincs. & Humberside, Hull; Kunstlerwerstatt Barnhofwestend, Berlin; Sharjah Biennale, UAE. *Works in collections:* RCA; St.Anne's College, Univ. of Oxford; Peterborough Museum; Annenberg Rare Book & Manuscript Library, PA, USA. *Publications:* 'My Czech Grandmother. A Story' imprint by ImageWord in collaboration with EMH Arts, London. Commentary for 'Media, Culture and Society' Vol 27 No3. *Principal Works:* drawing series 'Heads' and 'Rivers'; Complicite Sketchbook project; Artist books. *Recreations:* swimming, sailing, choral singing, cinema, theatre. *Misc:* member of IAGS with conference profile; drawing collaboration with Theatre de Complicite's 'Streets of Crocodiles' and 'Mnemonic'. *Address:* St.John's College, University of Oxford, OX1 3JP. *Email:* y.kyriakides@blueyonder.co.uk

L

LABAN, Keith Maurice, Surrey Dip. (1970); artist in water-colour; Sir Alec Issigonis Prize for Art (1969);. *b:* London, 22 May 1949. *m:* Vivienne Jane Laban (née Ferne). *Studied:* Reigate College of Art (1996-70). *Exhib:* mixed exhbns. London, U.K., Holland. *Signs work:* "Laban." *Address:* 2 Bolsover Grove, Merstham, Redhill, Surrey RH1 3NU.

LACKNER, Suzanne O., FZSL, FFPS; sculptor in marble, onyx, alabaster, soapstone, portland stone, etc. and recently bronze and wood. *b:* Berlin, 10 Feb 1908. widow. *d of:* Richard Chotzen, banker. one *d. Educ:* Berlin Technical University (architecture), in France since 1933. *Studied:* Camden Main Institute. *Exhib:* Camden Institute (1975), Camden Arts Centre (1976), City of Westminster Arts Council (1976), Burgh House (1992), Loggia Gallery (1999, 2001). *Works in collections:* England, France, Germany, U.S.A., Japan. *Address:* 49 Eton Hall, Eton College Rd., London NW3 2DR.

LAGADEC, Jean, Brevet-Mart. *Medium:* acrylic and sculptured paper. *b:* Paris, 12 May 1941. *s of:* Francois & Ruth Lagadec. two *s.* one *d. Educ:* Niveau Brevet. *Studied:* College Jean-Saures. *Represented by:* Quayside Gallery. *Exhib:* worldwide. *Works in collections:* private and corporate (Regency, Genesis, etc.) in Africa, Europe, Australia and USA. *Commissions:* private and corporate. *Publications:* Art East; Sticks, etc. *Works Reproduced:* in magazines and newspapers. *Principal Works:* Salomé; Discobolus; Kouros; Ophelia. *Recreations:* martial arts; travelling. *Misc:* autodidact. *Signs work:* 'Jean Lagadec'. *Address:* 87 High Street, Ramsey, Cambs. PE26 1BZ. *Email:* j.lagadec@talktalk.net

LAGO, Darren, B.A. (Fine Art), M.A. (Fine Art); sculptor in installation and object based artworks; Tutor, Kingsway College, London;. *b:* 22 Sept., 1965. *Educ:* King Edward VI School, Lichfield. *Studied:* Portsmouth University (Don Hopes), Chelsea School of Art and Design (Shelagh Cluett). *Exhib:* New

Contemporary I.C.A. London, Annely Juda Gallery. *Works in collections:* Annely Juda Fine Art Gallery, Unilever House, Unilever plc. *Address:* 23b Lonsdale Rd., London NW6 6RA.

LAI, William Sui Khee, RMN; Special Distinction at International Art Biennale, Malta (1999); Prizewinner, International Amateur Art Exhbn, London (1976) The Artist; Short-listed from 10,000 entries for Art from the Heart (News of the World)(1992). *Medium:* oil, watercolour, sculpture, drawing, gouache, chinese ink, acrylics, pastel, mixed media. *b:* Singapore, 14 Sep 1941. *s of:* Lai Chek Meng & Lim Kim Hoon. *m:* Maria Encina Gomez Robles. two *s. Educ:* St.Andrew's, Singapore. *Studied:* self-taught; evening classes (Adult Education). *Exhib:* RA (1993, 2001); Ann Bellion Gallery (1994, 1995); Malta International Biennale (1995, 97, 99); Library/Museum Surrey 3-man Show (1996); Nanyang Academy, Singapore, solo show (1997); Oriental City, London (2001); group shows: AOI, Mall Galleries (1998, 99, 2000, 2007); Goldmark Gallery, Leics. (2002); The Gallery, Cork St., London (2002, 03); Galleriat Art, Kirkcudbright, Scotland (2003); Brave Destiny: Williamsburg Historical Art Centre, NY (2003); Diego Victoria Fine Art, Miami, USA (2003); Lauderdale House, Highgate, London (2004); Obsidian Art Centre, Bucks (2005); Riva Museum, Italy (2005); solo exhbn, paintings and sculptures, Windsor St.Gallery, Chertsey, Surrey (2006);. *Works in collections:* private in UK, USA, Peru, Spain, Norway, Singapore. *Commissions:* none taken. *Publications:* RA Catalogues (1993, 2001); Malta International Biennale catalogues (1995, 97, 99); Malta Biennale Dictionary, Malta Biennale Book 1 (2001); Inscape, AOI (2005). *Principal Works:* Nude Candle Dance; Rehearsal; Shepherdess; Head (Sculpture). *Recreations:* walks, reading, swimming, chess, travels. *Clubs:* Society:Art of Imagination (AOI). *Signs work:* 'William Lai', 'W.Lai'. *Address:* 276 Woodham Lane, New Haw, Addlestone, Surrey KT15 3NT. *Email:* william_suikhee_lai@yahoo.co.uk

LAIN, Graham E.W., SGFA; retired architectural technician and self taught artist in water-colour, pen and ink. *b:* Wymondham, Norfolk, 18 Sep 1938. *m:* Betty. one s-son *s.* one; one s-daughter *d. Exhib:* one-man shows biennially. *Signs work:* "G.L." *Address:* Nesbit Cottage, 2 Granary Loke, Spooner Row, Wymondham, Norfolk NR18 9JW.

LAING, Gerald, NDD (1964), FRBS (1994); artist: figurative (Pop) painting (1962-65), highly finished abstract painting/sculpture (1966-69), abstract 3-dimensional sculpture in the landscape (1970-72), formal figurative sculpture (1973-82), figurative sculpture (1983-to date), returned to painting with a group of anti-Iraq War images (exhb. Edinburgh, Cambridge, New York, Paris, 2004-2005); Commissioner, Royal Fine Art Commission for Scotland. *b:* Newcastle-upon-Tyne, 11 Feb 1936. five *s.* one *d. Educ:* Berkhamsted School. *Studied:* St. Martin's School of Art. *Represented by:* Fine Art Society; Hazlitt Holland Hibbert; Sims Reed, London; OContemporary, Brighton. *Exhib:* more than 40 one-man shows worldwide. Major retrospectives: Scottish National Gallery of

Modern Art (1971), Fruitmarket Gallery, Edinburgh (1993). *Works in collections:* National Gallery, Tate Gallery, V&A, NPG, SNGMA, SNPG, MOMA, NY, Whitney Museum, NY, Smithsonian, Washington DC, and many others worldwide. *Commissions:* 'Callanish' Glasgow, 'Fountain of Sabrina' Bristol, 'Wise and Foolish Virgins', 'Axis Mundi', 'Conan Doyle Memorial' Edinburgh and 'Ten Dragons', Bank Underground Station, 'Sam Wanamaker', Globe Theatre, Southwark, London, 'Four Rugby Players' Twickenham, 'Sir Paul Getty', National Gallery, London, 'Batsman', M.C.C. Lord's Ground, London, 'Falcon Square Mercat Cross', Inverness. *Publications:* Kinkell: The Reconstruction of a Scottish Castle. *Works Reproduced:* in all books and catalogues of major exhibitions of UK Pop Art. Other works widely reproduced in catalogues, magazines and newspapers. See website for more details. *Clubs:* Chelsea Arts, Academy. *Signs work:* "Gerald Laing." *Address:* Kinkell Castle, Ross-shire IV7 8AT, Scotland. *Email:* kinkell@btinternet.com *Website:* www.geraldlaing.com

LAING, Gordon James, ISO, PhD., MSc; painter in acrylic and oils (or crayon, chalk, pastels for small sketches). *b:* Oldham Lancs, 12 Jan 1923. divorced. one *s. Educ:* Eltham College and Oldham Hulme Grammar School, Manchester University, Sussex University and London University. *Exhib:* RA, Paris Salon, International Centre in Washington, also Hong Kong and New York. *Signs work:* signs on canvas on rear of painting, and sometimes on front also. *Address:* Senlac House, 42 York Way, Fort George, St. Peter Port, Guernsey, GY1.

LAKE, C. Elisabeth Matheson, R.M.S. (1989), F.H.S. (1982-95); miniature painter in water-colour (interiors). *b:* Norwich, 12 Apr 1939. *d of:* James Matheson Fleming, M.R.C.S., L.R.C.P. *m:* Geoffrey N. Lake. one *s.* three *d. Studied:* West of England College of Art (1957-60). *Exhib:* H.S. (1982-95), R.A. Summer Exhbn. (1986), R.M.S. (1984-), many N. American and Canadian exhbns. (1985-89). *Works in collections:* England, N. America and Europe. *Publications:* Books, magazines. *Address:* White Cottage Hollow Marsh, Farrington Gurney, Somerset BS39 6TX.

LAKEY, Antony William Albert, BA (Hons) Fine Art, Painting. *Medium:* photography and film, oils, drawing. *b:* Elgin, Scotland, 11 May 1981. *s of:* Michael & Elisabeth Lakey. *Studied:* Northbrook College of Art and Design (2000-2003), Maidenhead College of Art and Design (1999-2000). *Exhib:* 2006: RSA Building, Edinburgh, SSA Group Show; Threshold Artspace, Perth, Group Film Show; Glasgow Film Theatre, Glasgow; Cameo Cinema, Edinburgh; Peacock Visual Arts, Aberdeen. 2005: Bistro du Sud, Glasgow; Transmission Gallery, Glasgow; Kazoo Club, Bar Fly, Glasgow. *Works in collections:* private collections of Oxford University Air Squadron, The Beales family, Henley-on-Thames, Clive Hemsley. *Commissions:* Oxford University Air Squadron, the Beales family, Clive Hemsley, the Corcoran family. *Publications:* The Henley Standard, The Worthing Herald. *Principal Works:* "I Think. ." (2003), "Madison"

(2004), Film. *Signs work:* "LAKEY". *Address:* 2/2, 70 Landressy Pl., Bridgeton, Glasgow G40 1HF. *Email:* awalakey@hotmail.com *Website:* www.myspace.com/Antony_Lakey

LALLY, Richard, painter in oil, pastel and water-colour. *b:* London, 2 Oct 1928. *s of:* A. R. Lally. *Educ:* Brixton College of Building and Architecture (1942-45). *Studied:* Hammersmith School of Art (1955-59, Leon Underwood, Dennis Gilbert). *Exhib:* one-man shows, Real Club Nautico, Tenerife (1961), Manolette Gallery, Richmond (1977); R.O.I., N.S., U.A., S.WL.A. *Works in collections:* private collections in Rio de Janeiro, Scotland, Zurich, England, USA, Isle of Man. *Commissions:* Many private. *Signs work:* "LALLY." *Address:* Strathcroy Studio, Drumbeg, Lairg, Sutherland, Scotland IV27 4NG. *Email:* r.lally558@btinternet.com

LAMAN, Amanda Karen Kirkland, Dip SLm, MCMI. *Medium:* miniatures & silhouettes, oil, watercolour. *b:* Newcastle, 23 Oct 1951. *d of:* A.C.K.Laman, Naval Commander. *Studied:* private tuition. *Exhib:* RA Summer Exhbn (1996, 97, 2001, 2006); Mall Galleries; Gallery 47; Chichester, Preston, Leeds, Kent, Aberdeen, Japan, Tasmania, Washington USA. *Works in collections:* private collections UK and overseas. *Commissions:* commissions undertaken. *Principal Works:* still life and animal portraiture. *Recreations:* ceramic repair, gardening. *Address:* 2a Callow Street, Chelsea, London SW3 6BE.

LAMB, Elspeth, DA (Glas.) (1973), HDipAD (Manc.) (1974), ARSA (1990); lecturer/printmaker in printmaking, papermaking, drawing; Lecturer in drawing and painting, Edinburgh College of Art. *b:* Glasgow, 28 Mar 1951. *d of:* John Cunningham Lamb, accountant. *Educ:* Kings Pk. Senior Secondary School, Glasgow. *Studied:* Glasgow School of Art (Philip Reeves), Manchester Polytechnic, The Tamarind Inst. of Lithography, University of New Mexico, U.S.A. (Lynn Allen). *Exhib:* Mercury Gallery (1988, 1990), Conservative Management (1990), Marlborough Graphics (1991), Glasgow Print Studio (1990). *Works in collections:* S.A.C., British Council, Japanese Consular Coll., Perth A.G., Glasgow A.G., City Arts. *Address:* Bon a Tirer Editions, 15 E. Campbell St., Glasgow G1 1DG.

LAMB, Thomas, BA Fine Art Painting, MA Fine Art Drawing; Sainsbury Scholarship Painting and Sculpture (2001-2003, BSR). *Medium:* painter. *b:* Lincolnshire, 4 Apr 1978. *s of:* Michael and Anne Lamb. *m:* Yuki Abe. *Studied:* Wimbledon School of Art, London (1997-2001). *Exhib:* British School at Rome (2003); Braccio di Carlo Magno, Piazza San Pietro, Vatican City (2002), Lethaby Gallery, London (1999), Fukuoka Asian Art Museum, Japan (2005), Hyogo Prefectural Museum of Art, Japan (2005), Estorick Collection of Modern Art (2006). *Works in collections:* private collections. *Publications:* The British School at Rome Fine Arts (2001-02, 2002-03), Accademia di Bella Arti 'O' Europa (2002), 'Renascence' Hyogo International Competition of Painting

(2005), Yomiuri Times (13 May 2005). *Address:* Rose Cottage, Belleau, Lincolnshire, LN13 0BW. *Email:* lamb_thomas@hotmail.com

LAMBERT, Colin Joseph, sculptor in bronze and stone. *b:* Guantanamo Bay, Cuba, 17 Jan 1948. *s of:* Virgil Mangus-Colorado, American Indian poet. *m:* Catherine Finn. *Studied:* Chouinard Art Inst., Los Angeles (1966-68); apprenticed with Karl Gomez in Amsterdam (1980-83). *Works in collections:* Stamford Forum, Stamford, Conn.; London United Bldg., London; Renaissance Vineyard and Winery, Calif.; Warminster Market Centre, Warminster, Wilts. *Address:* Flint Barn Studio, West End, nr. Essendon, Hatfield, Herts. AL9 5RQ.

LAMBIRTH, Alan, R.B.A. (1986), R.A. Gold medal (1982), R.A. Schools Advanced Dip. (1983), Higher Surrey Dip. A.D. (1980), De Laszlo medal awarded by R.B.A. (1991); artist in oil, pastel, gouache and water-colour, ink. *b:* Cuckfield, 19 Feb., 1959. *s of:* Ivor Edward & Joyce Lambirth. *Educ:* Hazelwick School, Crawley. *Studied:* W. Sussex College of Design (1975-77), Epsom School of Art (1977-80, Peter Peterson), R.A. Schools (1980-83, Peter Greenham, R.A.). *Exhib:* R.A., R.B.A., N.E.A.C., Soc. of Landscape Painters; one-man shows: Odette Gilbert Gallery (1984, 1986), Solomon Gallery (1988), Sheila Harrison Fine Art (1989, 1991), Enid Lawson Gallery (1997); four-man show: Hallam Gallery (1990). *Signs work:* 'Alan Lambirth' or 'ALAN LAMBIRTH'. *Address:* 22 Brushwood Rd., Roffey, Horsham, W. Sussex RH12 4PE.

LAMONT, Ian James, painter in oil. *b:* Streatham Vale, 16 May 1964. *s of:* John Lamont, scenic artist. *Educ:* Nork Pk. School; N.E. Surrey College of Technology; Sutton College of Liberal Arts. *Studied:* Kingston Polytechnic School of Art and Design; also portrait painting under Ronald Benham, NEAC, RBA (1982-86). *Exhib:* RA, NEAC, RBA, ROI (Winsor and Newton Young Artist award finalist 1983-88), Royal Portrait Soc., Lynn Painter-Stainers Prize (Exhibition), National Portrait Gallery (BP Award Finalist). *Works in collections:* United Racecourses. *Signs work:* "Ian Lamont." or "Lamont". *Address:* 25 Woodgavil, Banstead, Surrey SM7 1AA.

LAMPUTT, Norman Howard, NDD (1965). *Medium:* oil, watercolour, drawing. *b:* Much Wenlock, 7 Mar 1943. *s of:* Gordon & Kathleen. *Educ:* Wenlock Edge School. *Studied:* Shrewsbury School of Art (1961-65). *Represented by:* Twenty Twenty, Much Wenlock. *Exhib:* widely throughout the UK. *Works in collections:* private collections in the UK, USA and Europe. *Signs work:* "N.H.LAMPUTT". *Address:* Flat 5, Lower Bromdon Farm, Wheathill, Burwaton, Bridgnorth, WV16 6QT. *Email:* lamputt755@btinternet.com

LANCASTER, John Maurice, N.D.D., M.Phil., Ph.D., F.S.A.E.D.; painter, calligrapher, heraldic artist, author. *Medium:* watercolour, oil, acrylic, gold, heraldic colours, vellum. *b:* Wigan, 29 May 1930. *m:* Janet Lancaster. *Studied:* Leeds College of Art (1946-51), advanced painting with Victor Pasmore. *Exhib:* sixteen one-man shows in the UK and USA including: Leicester, Nottingham,

London, Keele, Bristol, Decatur, U.S.A., Columbus, U.S.A., Thatcher, Az., U.S.A., Cheltenham, Stowe, Wadhurst; group shows: R.W.A., R.B.A., Hesketh Hubbard, Mod. Art in Yorkshire, W. Riding Artists, John Noott 20th C. Gallery, Kenulf Galleries, Bristol, and other galleries. *Works in collections:* world-wide. *Commissions:* private, public bodies, City of London institutions, the Church. *Publications:* 16 books. Visiting Prof. and Visiting Artist U.S.A. *Recreations:* golf. *Clubs:* Naval and Military, S.H.A. Liveryman and Court Member Worshipful Company of Gardeners, Freeman City of London. *Signs work:* "John Lancaster." *Address:* 10 Walnut Cl., Cheltenham, Glos. GL52 3AG. *Email:* johnmlanc@aol.com

LANDAU, David, M.D. (1978), M.A. (1980); Editor, Print Quarterly; Trustee: National Gallery Trust and N.A.C.F., The Courtauld Institute; Treasurer, Venice in Peril Fund. *b:* 22 Apr 1950. *m:* Marie-Rose Kahane. one *s.* one *d. Publications:* Georg Pencz (1978); Federica Galli (1982); The Renaissance Print (with P.Parshall) (1994). *Address:* 51 Kelso Place London W8 5QQ.

LANDERS, Linda Anne, B.A.(Hons.) (1986), R.E.; Mall Galleries prize for Printmaking (2001). *Medium:* wood engraving, printmaking, handmade books, oils, watercolour, film, theatre, performance, writing. *b:* Herts., 27 Dec 1959. *d of:* Harry Landers (Engineer - Concorde). two *s. Studied:* Central St.Martin's School of Art; Desmond Jones Mime and Physical Theatre, Laban Dance Centre. *Exhib:* 'Fine Press' book fairs and exhibitions; RA Summer show; Saatchi & Saatchi; Icehouse Gallery. *Works in collections:* British Art Library, V. & A., Ashmolean Museum, R.C.A., Musuem Van Het Boek, Netherlands, University of California L.A., University of Plymouth, USA collections, Longleat House Library, Library of Congress, Washington DC. *Commissions:* wood engraving (Circle Press) and Delos and Redlake Press. *Publications:* published seventeen Limited Edn. artists books under imprints: Spoon Print Press and 'Merlin's Grail'. *Official Purchasers:* Lord Bath. *Signs work:* "Linda Anne Landers" Signature varies according to size of work. *Address:* 1st Floor, 68 Elsham Road, London W14 8HD. *Email:* lindalanders87@hotmail.com *Website:* www.lindalanders.co.uk

LANE, Christopher Owin, BA Fine Art; MA Fine Art. *Medium:* oil. *b:* London, 24 Apr 1977. *s of:* Chris & Patricia Lane. *Studied:* Barnet College (1995); Northbrook College, Worthing (1996-99); University of Wisconsin (1998); University of East London (2001-02). *Exhib:* with 'SAFE' Studios, Spitalfields Gallery (2001, 02, 04, 05, including solo show in 2002); O2 Brasserie, Bethnal Green Road (2003); St.Martins Church, Plaistow (2003, 2004); Spitalfields Community Festival and Eco Fun Fair (2005). *Works in collections:* St. Martin's Church, Plaistow (painting of 'St.Martin Clothing the Beggar', blessed in 2003, now on permanent display). *Publications:* Christian Arts Journal (Winter, 2003), review. *Recreations:* sport, music, art. *Misc:* travelled extensively in Italy during degree courses. Volunteer for Crisis, working

in the Skylight building helping homeless people with their art. *Address:* 9 Prospect Place, Tottenham, London N17.

LANE, Jason, Royal West of England Academician (2004); Year of the Artist Award (2000); Morris Singer Bronze Casting Award (1998). *Medium:* reclaimed steel (sculptor). *b:* Leamington Spa, 28 Oct 1970. *Studied:* Hereford College of Art and Design (1989-90), Exeter Faculty of Art and Design (1990-93); Dublin NCAD (1991). *Exhib:* RWA, Spike Island, Bristol; Workshop Wales Gallery; Jokelson Gallery, Dunkirk; Honiton Arts Festival; The Thelma Hulbert Gallery, Honiton; Hot Bath Gallery, Bath; Contemporary Arts Society, Festival Hall. *Works in collections:* Royal West of England Academy. *Commissions:* St.Pauls Gateway Sculpture (2007); Art Car for Art Car Parade, Manchester (2007); Guard Dog for Blake Castle Estate (2005); Sustrans Residency-Dewsbury Cycle track (2000); solid fuel vending machine for Crest Homes (2002); Red Bull ship (2004). *Principal Works:* Human hamster wheel; mechanical rocking horse; mechanical drawing machine. *Signs work:* 'Lane'. *Address:* 18 The Yard, Mina Road, St.Werburghs, Bristol, BS2 9YR. *Email:* jason.lane@zen.co.uk *Website:* www.jasonlane.org.uk

LANE-DAVIES, Hugh John, Dip. Arch. (Dist. in Thesis) R.I.B.A. (1951); architect/artist in water-colour. *b:* Ramsgate, 20 Dec 1927. *m:* Wendy Isabel (née Pierce). one *s. Educ:* King's College, Taunton. *Studied:* architecture at University of Westminster. *Exhib:* numerous exhbns. in London and Home Counties, including R.I.B.A., Cider House Gallery Bletchingley, Llewellyn Alexander Fine Art, Bourne Gallery Reigate, World of Drawings and Water-colours, London, Fine Art and Antiques Fair, London. *Works in collections:* private and corporate collections world wide, including Tokai bank of Japan, I.B.M., Price Waterhouse, Trafalgar House, W.S. Atkins and others. *Works Reproduced:* Christmas cards, calendars and limited edition prints. *Signs work:* "H.L.D." *Address:* White Rose Cottage, White Hill, Bletchingley, Surrey RH1 4QT. *Email:* lane_davies@tiscali.co.uk

LANG, Wharton, R.S.M.A. (1948), now Hon. Mem., F.R.S.A. (1983); sculptor in wood; ex Mem. S.WL.A.;. *b:* Oberammergau, Bavaria, 13 Jun 1925. *s of:* Faust Lang, wood sculptor. *m:* Ingrid. *Educ:* Newquay Grammar School. *Studied:* Leonard Fuller School of Painting (1946) and privately under Faust Lang (1946-49). *Works in collections:* Ulster Museum, Belfast, R.S.M.A. Diploma Collection, National Maritime Museum, Greenwich, Carving in Relief 'Castle of Mey' presented to H.M. Queen Mother (1967). *Signs work:* "W. LANG," "Wharton Lang". *Address:* Fauna Studio, Mount Zion, St. Ives, Cornwall TR26 3HA.

LANGFORD, Martin James, RE. *Medium:* mezzotint, etching. *b:* Kingston upon Thames, 2 June, 1970. *m:* Therese Langford. one *s.* one *d. Studied:* University of Plymouth (B.A. (Hons.) Fine Art 1993); Post Grad. Advanced Printmaking, Central St. Martin's College of Art (David Gluck, R.E.). *Exhib:*

annually at Originals, Affordable Art Fair and Urban Art. *Works in collections:* For Art's Sake, Ealing, W. London; Will's Art Warehouse, Barnes, London; Cupola Gallery, Sheffield; Bankside Gallery, London; South Bank Printmakers, Gabriel's Wharf, London. *Publications:* Selected for Best of International Printmaking book, whole page coverage (Rockport Publishers, U.S.A., 1997); featured in 'Printmaking Today' (Into the Labyrinth' article July 07). *Works Reproduced:* none. *Address:* 2 Norfolk House, The Farmlands, Northolt, Middx. UB5 5EU. *Email:* martinlangford70@hotmail.com *Website:* www.martinlangford.com

LANGHORN, Doreen M., SWA; Awards: Highly Commended RBSA (2004); Harper Collins Prize (1993); Daler Rowney Prize at SWA, Mall Galleries (2006). *Medium:* pastel, watercolour, drawing. *b:* Evesham, Worcs., 23 Mar 1946. *d of:* John Bennett Martin. *m:* John A. Langhorn. one *s. Educ:* Southend-on-Sea Grammar School for Girls. *Studied:* entirely self-taught, but has particularly studied the works of Ruskin Spear and Lucien Freud. *Exhib:* RWA; RSMA; RBSA; SWA; Salon International de la Peinture a L'Eau, Tregastel, France. *Works in collections:* UK, USA, Sweden, Australia. *Publications:* in The Artist Magazine. *Clubs:* Stratford-upon-Avon Art Society; Chipping Camden Art Society. *Misc:* specialises in painting people - not just formal portraits, but undertaking daily activities of life. In particular enjoys painting children. *Signs work:* 'DML' or 'D.Langhorn'. *Address:* 17 Hawthorn Way, Shipston-on-Stour, Warks CV36 4FD. *Email:* jodo@talktalk.net

LANGLEY, Siddy, blown glass;. *b:* Withnell, Lancs., 2 Feb., 1955. *m:* Michael Crane. one *d. Studied:* Apprenticed to Peter Layton at London Glassblowing Workshop (1979-81). *Exhib:* Rosengalerie, Amsterdam; 'Glaskunst aus Grossbritannien' Lucerne and Frankfurt; Broadfield House Glass Museum, Dudley; Coleridge of Piccadilly, London and Edinburgh; Musée des Beaux Arts, Rouen; Kringel Gallery, Switzerland; Museu de Arte de São Paulo, Brazil; Neville Pundole Gallery, Canterbury, etc. *Works in collections:* Musée du Verre, Liege, Belgium and Sars Poteries, France; Turner Glass Collection, Sheffield; Norwich Castle Museum; B'ham Museum and A.G.; Leics. Collection for Schools and Colleges; The Glass Museum, Ebeltoft, Denmark. *Commissions:* font for Methodist Church, Winchester. *Signs work:* "Siddy Langley" and year. *Address:* The Longhouse, Plymtree, nr. Cullompton, Devon EX15 2JW. *Email:* mail@siddy.com

LARGE, George Charles, R.I. (1986), A.T.C., R.B.A. (1997); artist in oil and water-colour; Awards: Winsor Newton Award, R.I. Singer Friedlander/Sunday Times, Llewellyn Alexander Award R.I. St. Cuthbert's Mill Paper Award. *b:* London, 20 Jan 1936. *m:* Pamela Parkinson-Large. one s-s two *s.* one s-d one *d. Educ:* Downhills Central School, Tottenham. *Studied:* Hornsey College of Art (1958-63, Maurice de Sausmarez, John Titchell, Alfred Daniels). *Exhib:* R.I., R.B.A., S.W.E.; one-man shows, Mall Galleries, National Gallery Malta, Duncan Campbel Fine Arts, Melitensia A.G., Malta, Llewellyn Alexander, Goldmark

Gallery. *Works in collections:* Ralli Foundation, British Rail, National Gallery Malta, British Consulate Malta, Cranfield Inst., I.C.I. *Commissions:* Chesterfield Corporation murals. *Publications:* illustrated, Laughter in the Kitchen, and various magazines, Taste of History, Food of the Knights of Malta, Pamela Parkinson-Large; The Cartographer, David Mackenzie. *Signs work:* "LARGE 98." *Address:* Affric Cottage, 33 South View, Uppingham, Rutland LE15 9TU. *Email:* george_largo@btopenworld.com

LARMONT, Eric, N.D.D., A.T.C.; painter in oil, etcher; part-time art lecturer; Prizes and awards: Reeves Bi-centenary Premier Award (1966); Second Non-purchase Prize, Northern Painters Exhibition (1966). *Medium:* oil painting, printmaking & metal sculpture. *b:* South Shields, 27 Sep 1943. *Studied:* Sunderland College of Art (1963-65); Goldsmiths' School of Art (1965-66), Post-grad. Belgian Scholarship (1968-69). *Exhib:* one-man shows, London: 273 Gallery (1969), Scribes Cellar (1978), Holsworthy Gallery (1981), Galerie Blankenese, Hamburg (1983), Pump House Gallery, London (1997); two-man show, Jonathan Poole Gallery (1986); 3 man show; Studio Gallery, London (1999); Putney School of Art (one-man, 2004). *Works in collections:* Carlisle Corporation; private collections: various. *Address:* 20 Rainville Rd., London W6 9HA.

LARUSDOTTIR, Karolina, R.E., R.W.S., N.E.A.C.; painter in oil and water-colour, etcher and printmaker;. *b:* Reykjavik, Iceland, 12 Mar 1944. *Studied:* Ruskin School of Art, Oxford University and Barking College of Art. *Exhib:* Bankside Gallery, R.E., R.A., R.B.A.; one-man shows: Kjarvalsstadir Reykjavik (1982, 1986), Gallerie Gammelstrand, Kobenhagen, Gallery 10 (1984, 1987, 1991), Cambridge Contemporary Art (from 1994), John Brandler Galleries, Brentwood. *Works in collections:* Cartwright Hall Musuem, Bradford; The Vatican Collection, Rome; Nelson Atkin Museum, Kansas City, U.S.A.; British Musuem, London; Ashmolean Museum, Oxford; Fitzwilliam Museum, Cambridge; Pompidou Museum, Paris. *Misc:* Prizes: The Dicks and Greenbury Award, Bankside Gallery (1989). Special award: Premio Internazionale Biella per l'incisione, Italy. *Signs work:* "LARUSDOTTIR." *Address:* 38 Longworth Ave., St. Andrews Park, Chesterton Cambridge CB4 1GU.

LAST, Bob, NDD, MSIAD, PS. *Medium:* all mediums. *b:* Surrey, 1932. *s of:* Victor Last. *m:* Miriam. two *d. Studied:* Sutton School of Art. *Exhib:* Mall Galleries, AAF Battersea, Linda Blackstone Gallery. *Works in collections:* private only. *Commissions:* 1973 St.Mary Magdalene Church, Cowden, Kent (sculpture). *Publications:* 'The Artist' (Jan 2003); 'Artist & Illustrators' (June 2006); 'Artist & Illustrators' (July 2007). *Clubs:* Pastel Society. *Address:* 27 Tate Road, Sutton, Surrey, SM1 2SY. *Website:* www.thepastelsociety.org.uk

LAST, Joanne, GRSM, ARCM. *Medium:* oil, watercolour, mixed media & pastel. *b:* Sutton, Surrey, 29 Apr 1962. *d of:* Bob Last. *Studied:* Royal College of Music (1980-84)*; Putney School of Art (1990-92). *Represented by:* Bernard

Chauchet, Thirteen Langton Street. *Exhib:* Thirteen Langton Street Gallery; Pastel Society, Mall Galleries; Royal Institute of Painters in Watercolour, Mall Galleries; Royal Acedemy of Arts Summer Exhibition. *Works in collections:* private/corporate. *Commissions:* Sandy Lane Hotel, Barbados; Carlton Tower Hotel, Knightsbridge; Churchill Hotel, London. *Works Reproduced:* 'Tuscan Landscape' - Ikea, worldwide. *Misc:* also known as Jo Last. *Originally trained as Classical pianist. *Signs work:* "J. LAST". *Address:* 32 Wavertree Court, Streatham Hill, London SW2 4TN. *Email:* jo@joannelast.co.uk *Website:* www.joannelast.co.uk

LATHAM, Rebecca, SAA (US), MASF, MPSGS, CPA, HS; Awards: Most Popular Exhibit (HS); Best Work by a Young Artist (MASF); Best of Show (BSM); Second in Show (MPSGS). *Medium:* watercolour. *b:* Cincinnati, USA, 1979. *s of:* Ted & Karen Latham. *Studied:* Beartooth School of Art, and private study. *Represented by:* Decoys and Wildlife Gallery (NJ); Galleries West Fine Art (WY), Whistle Pik Galleries (TX), Moosehorn Gallery. *Exhib:* Smithsonian Museum (Washington DC); Thomas Gilcrease Museum (Tulsa, OK), James Ford Bell Museum (Minneapolis,MN); Wildlife Experience Museum (Parker, CO), NEWA, Marwell Wildlife Art Society, TWASI. *Works in collections:* MASF Permanent Collection; Butler Museum of American Art. *Commissions:* Harvard University (USA); Butler Museum of American Art (USA). *Works Reproduced:* Yes (Giclee). *Clubs:* TWASI, MIWAS. *Misc:* mother and sister are also accomplished artists. *Signs work:* 'REBECCA LATHAM'. *Address:* 11203 Saint Croix TR.S. Hastings, MN 55033, USA. *Email:* rebecca@lathamstudios.com *Website:* www.lathamstudios.com

LAUBIN, Carl David, B.Arch. *Medium:* oil. *b:* New York, 8 Dec 1947. *s of:* Alfred & Lillian Laubin. *m:* Christine Creighton-Laubin. one *s.* two *d. Studied:* Cornell University College of Art, Architecture & Planning. *Represented by:* Plus One Plus Two Galleries. *Exhib:* RA; Centre Pompidou; Musée d'Aquitaine; Frankfurt Architecture Museum;Museum of London; V&A; Sotheby's Johannesburg; Petworth; Christie's; Thomas Agnew. *Works in collections:* Museum of London, Castle Howard, Linklaters, National Trust, London Borough of Richmond, Anglo-American Corp. *Commissions:* Castle Howard, Royal Opera House, Royal Armouries, National Trust, Centre Pomidou, Duchy of Cornwall. *Official Purchasers:* Museum of London; London Borough of Richmond; Grosvenor Museum, Chester. *Works Reproduced:* 'A Vision of Britain', 'London in Paint: Paintings in the Collection of the Museum of London'. *Principal Works:* 'Hawksmoor', 'Canary Wharf', 'Si Monumentum Requiris'. *Recreations:* gardening. *Signs work:* 'Laubin' or 'CL'. *Address:* 74 Lancaster Road, Hitchin, Herts SG5 1PE. *Email:* carl@carllaubin.com *Website:* www.carllaubin.com

LAUCHLAN, Anya, M.A., F.F.P.S.; painter/illustrator in oil, acrylic, watercolour;. *b:* 6 Apr 1948. *m:* Peter Rolland Lauchlan. one *s.* two *d. Studied:* Pushkin Museum of Fine Art, and Moscow Polygraphic - Art and Design (1963-75, Basov, Goncharov, Chazanov, Burdjelian). *Represented by:* Atelier Art

International, NY, USA. *Exhib:* Loggia Gallery, Westminster, Leighton House Museum, Menier Gallery, Garden of Eden and various commercial London galleries. *Works in collections:* work in private collections internationally. *Commissions:* Painting scenes from English National Ballet (1998-2000). *Publications:* illustrator of more than 50 books. *Works Reproduced:* "Blue Mountain", "Dance of Spring", "Villa Christina", "Le Buffon", "Golden Roses", "Delphiniums", "White & Gold", "Black Unicorn". *Clubs:* F.P.S. *Signs work:* "Anya Lauchlan," "A. Lauchlan" or "Anya" and dated. *Address:* The Studio, 2 Grovehill Rd., Redhill, Surrey RH1 6PJ. *Email:* rolland.art@btopenworld.com *Website:* www.Rolland-Fine-Art.com

LAW Enid: see CHAUVIN, Enid,

LAWRENCE, Gordon Robert, Dip.A.D. (1951), Teacher's Cert. (1952), 1st Class Hons. Rome Accademia de Belle Arte (1962), M.Ed. Liverpool (1975), Ph.D. (1979); painter/sculptor in acrylic, water-colour, stone;. *b:* Glasgow, 1930. divorced. three *s. Educ:* Hillhead High School, Glasgow. *Studied:* Glasgow School of Art, Accademia de Belle Arte, Rome. *Exhib:* Britain, France, Germany, Spain, Ireland and U.S.A. *Address:* Camboulit, 46100 Figeac, France.

LAWRENCE, John Wilfred, RE, SWE; winner, Francis Williams Book Illustration award (twice), New York Times Certificate Of Excellence; freelance illustrator in wood engraving and water-colour; part time lecturer, Camberwell School of Art (1960-93); external assessor, Bristol College of Art, Exeter College of Art, Duncan of Jordanstone College of Art, Brighton College of Art, Edinburgh College of Art; Kingston School of Art (various appointments between 1978-94); Visiting Professor in illustration at the London Inst.; part-time lecturer MA Childrens' Book Illustration, Anglia Ruskin University. *Medium:* wood engraving, pen and watercolour. *b:* Hastings, 15 Sep 1933. *s of:* Wilfred James Lawrence and Audrey Constance (née) Thomas. *m:* Myra. two *d. Educ:* Salesian College, Oxford. *Studied:* Hastings School of Art (1951-53),and Central School of Art and Design (1955-57). *Exhib:* RE, SWE, Royal Society of Painter Printmakers. *Works in collections:* V. & A., Ashmolean Museum, National Museum of Wales, several provincial galleries, and in several collections in U.S.A. *Commissions:* book illustraions with many publishers, also ephemeral work in advertising and design. *Publications:* over 150 books, including recently 'The Once and Future King' by T.H.White (Folio Soc.); 'Lyra's Oxford' by Philip Pullman (David Ficking Books); 'This Little Chick' by J.L. (Walker Books); 'Tiny's Big Adventure' by Martin Waddell (Walker Books). *Recreations:* piano. *Clubs:* AWG (Master, 1990), SWE, Double Crown. *Signs work:* "John Lawrence." *Address:* 6 Worts Causeway, Cambridge CBI 8RL.

LAWRENCE, Peter Alfred, Dip.Ad. (Bristol, 1973), SWE (1998), ARE (2003); winner SWE Prize at National Print Exhibition, Open Printmaking Prize at NPE, Rachel Reckitt Prize for UK Wood Engraver (2003); Printmaking Today Prize at RE Annual Exhibition (2007); Managing Director Oxford Designers and

Illustrators. *Medium:* wood engraving and other printmaking. *b:* Hornchurch, Essex, 30 Aug 1951. *s of:* Mr & Mrs A Lawrence. *m:* Cathryn. two *s. Studied:* Bristol Polytechnic, Faculty of Art and Design. *Exhib:* Society of Wood Engravers and in group shows. One-man exhbn. at Henman's, Oxford (1999), The Little Gallery, Oxford (2005). *Works in collections:* Ashmolean Museum, Oxford, private collections. *Publications:* featured in 'An Engraver's Globe' (Primrose Hill Press, 2002), Printmakers- The Directory (A&C Black 2006). *Clubs:* Society of Wood Engravers, Royal Society of Painter-Printmakers, Oxford Art Society, Oxford Printmakers Co-operative. *Address:* 48 Lonsdale Road, Oxford, OX2 7EP. *Email:* pete@odi-design.co.uk/ www.woodengravers.co.uk *Website:* the-art-works.co.uk

LAWRENCE, Tory, winner Spink Prize for Painting (1996); Royal Bath & West Soc. (1997); finalist Spink Prize for Painting (1998); finalist Hunting Art Prize (2000, 2001); winner, Drawing for All, Gainsborough's House Museum (2002). *Medium:* oil, watercolour, drawing, prints. *b:* London, 2 Apr 1940. *d of:* John & Nancy Dennistoun. *m:* div. one *s.* one *d. Educ:* East Haddon Hall School, Northants. *Studied:* Morley College, Westminster (painting and printmaking). *Represented by:* various galleries. *Exhib:* Royal Academy. *Works in collections:* Abacus Electronic Holdings Ltd; All Saints Church, Oaksey, Wilts; Chelsea & Westminster Hospital; de Wiersse Collection, Holland; work in many private collections in UK, USA, Australia and Europe. *Commissions:* Mrs.A.Boulton; Mrs.Simon Burne; Mr M.Bradstock; Sir Edward Cazalet; The late Duke of Devonshire; Mrs.Peter Gatacre; Sir Mark Palmer; Lady Reay; Mr.Martin Scott; Riding for the Disabled. *Publications:* Artist's Manual (Harper Collins, 1995). *Works Reproduced:* Artists & Illustrators; Galleries Magazine; Modern Painters; The Spectator; The Week. *Recreations:* gardening, cooking, travelling. *Signs work:* 'Tory Lawrence' (with date), sometimes 'TL' (with date). *Address:* White House Rendham Saxmundham Suffolk IP17 2AZ. *Email:* tory@torylawrence.com *Website:* www.torylawrence.com

LAWRENSON, Diane M., R.C.A. (2000), A.S.W.A. (2004); S.W.A (2006); sculptor in bronze, resin; SWA Peter Hambro Sculpture Award (2004). *b:* Liverpool, 5 Sep 1946. *m:* Kevin A.Howley. two *s.* one, two s-daughters *d. Educ:* Keighley College. *Studied:* West Yorkshire. *Exhib:* Royal Cambrian Academy, various. *Signs work:* "LAWRENSON." *Address:* Barker House, Winton, Kirkby Stephen, Cumbria CA17 4HS.

LAWSON, Gillian, painter in water-colour and oil, printmaker in etching. *b:* 6 May 1936. married. *d of:* Oliver Massingham, director. one *s.* two *d. Educ:* Parliament Hill Grammar School. *Studied:* Camden Institute (silkscreen printing, Ingrid Greenfield), Camden Art Centre (1971-75, etching, Dorothea Wight). *Exhib:* Cape Town, S.A., Georgetown, Washington, U.S.A., R.A., Halesworth Gallery, Burgh House, Hampstead, The Ice House, Holland Park, Hinton Gallery, nr. Horley, Ninth British International Print Biennale. *Signs work:* "Gillian Lawson." *Address:* 7 Oak Hill Way, Hampstead, London NW3 7LR.

LAWSON, Simon Nicholas, B.A. Hons. (1985), R.A. Post Grad. Dip. (1998); winner, Curwen Print Prize for best non-digital print (RA Summer Exhbn, 2005). *Medium:* oil, watercolour, etching. *b:* Waltham, Lincs., 2 Aug 1964. *s of:* David Lawson, graphic designer. one *d. Educ:* Waltham Toll Bar Comprehensive. *Studied:* Grimsby School of Art (1980-82, Peter Todd), Wimbledon School of Art (1982-85, Bernard Cohen), R.A. Schools (1985-88, Norman Adams). *Represented by:* Print (vb.n)- 8 Huguenot Place, Wandsworth, SW18 2EN. *Exhib:* Royal Festival Hall (1986), Mall Galleries (1986, 2004, 2005), RA (1987-92, 1998-2007). *Works in collections:* Royal Caribbean Cruise Line, Cabinet Office. *Commissions:* Cabinet Rooms Admiralty Arch. *Works Reproduced:* Royal Academy Summer Exhibition Illustrated Catalogue 2000, 04, 06; Printmaking Today Vol 16 no.2 Summer. *Recreations:* jazz musician. *Signs work:* "S. Lawson." *Address:* Flat One, 20 Allfarthing Lane, Wandsworth, London SW18 2PQ. *Email:* simon_ann.lawson@virgin.net

LAWSON, Sonia, RA, RWS, Hon RWA, RCA, MA(1st) (1959); artist in oil, water-colour, etching; visitor RA Schools. *b:* Wensleydale, Yorks., 2 Jun 1934. *d of:* Fred Lawson and Muriel Metcalfe, artists. *m:* Charles Congo. one *d. Studied:* Royal College of Art (1956-59, Prof. Carel Weight), Post-graduate year (1959-60), Travelling Scholarship, France. *Exhib:* solo exhibitions, retrospective tour, Leicester Polytechnic, Mappin Gallery Sheffield, Ferens Hull, Cartwright Bradford, Central Gallery Milton Keynes (1982-83); selected solo exhbns. Kirklees (1985), Manchester (1987), Wakefield (1988), Bradford (1989), London, Boundary Gallery (1989, 1995, 1998, 2000-2003, 2005), retrospective, Dean Clough Gallery (1966-96), Halifax, Stafford 1999R.W.A. Bristol (2000), Vertigo Gallery, London 2002, Aylesbury Museum and Gallery (2006); mixed shows, New York, Fragments against Ruin tour, China, British Council tour, Arts Council, Tolly Cobbald, John Moores, Edinburgh, R.A. London, Haywards Annual London, Subjective Eye, Midland Group Nottingham. *Works in collections:* Arts Council, Sheffield, Carlisle, Belfast, Bradford, Middlesbrough, Bolton, Harrogate, Rochdale, Wakefield and Huddersfield A.G.'s, Open University, M. of W., Leeds University, R.C.A., Nuffield, Cranfield, Imperial War Museum, R.A., Vatican, Chatsworth, RWA Bristol. *Commissions:* Imperial War Museum (1984), Lambeth Palace/Vatican (1989). *Publications:* Modern Painters, Summer '96; Art Review, July '96, Galleries Mag Nov 2003, 2005, 2006. *Clubs:* Overseas League. Arts. *Signs work:* "S. Lawson," "Sonia Lawson" or "Lawson." *Address:* c/o Royal Academy of Arts, Piccadilly, London W1V 0DS. *Email:* art@sonialawson.co.uk *Website:* www.sonialawson.co.uk

LAWSON-BAKER, Auriol, muralist, sculptor in bronze; Director, L.B.P. Sculpture and Design; owner "Scene Inside" Mural Co.;. *b:* 7 Sept., 1963. *m:* Neil Lawson-Baker. one *s. Educ:* Ditcham Park, Petersfield, Hants. *Exhib:* R.A., sculpture project managed throughout U.K. and Europe including Houses of Parliament Arts Com.; London International Financial Futures Exchange; British Gas plc., etc. *Signs work:* "A. Lawson-Baker." *Address:* Graingers, West Ashling, W. Sussex PO18 8DN.

LAWSON-BAKER, Dr. Neil, M.B., B.S. (Lond.), B.D.S., L.D.S. (Lond.), L.D.S., R.C.S. (Eng.); dental surgeon and sculptor in bronze; Director, L.B.P. Sculpture and Design. *b:* Watford, 8 Nov 1938. *m:* divorced. one *s. Educ:* Merchant Taylors and London University. *Exhib:* one-man shows: Watermans Gallery, London (1991); abstract paintings: The Arts Club, Dover Street, London W1 (June 2005). *Commissions:* Sterling House, Albert Bridge, London, SW11; Entrance and trading floor at London International Financial Futures Exchange; British Gas plc, 7 metre bronze flame, Reading and Loughborough; Entrance Hall, 1 Parliament Street, London SW1; Entrance Gibran Library, Beirut University, Lebanon; Inauguration Sculpture for Channel Tunnel, Eurotunnel plc; Magna Carta Fountain, Runnymead Borough Council, Egham; 14 metre Keris, National Stadium, Kuala Lumpur, Malaysia. *Publications:* Visual Times, a private Journal of sculpture. *Clubs:* Arts, R.A.C. *Signs work:* "Neil Lawson-Baker." *Address:* Graingers, West Ashling, W. Sussex PO18 8DN.

LAYCOCK, Allan Bracewell, A.T.D. (1951), F.S.A.I. (1975), R.W.A. (1986); landscape painter in acrylic, in situ; lecturer in graphics and illustration. *b:* Sutton-in-Craven, 4 Jun 1928. *Educ:* Keighley Grammar School. *Studied:* Keighley School of Art (1945-46, 1948-50), Sheffield College of Art (1950-51), Norwich School of Art (1951). *Exhib:* one-man and group shows in eastern and S.W. England. Work in private collections in U.K. and overseas. *Signs work:* "Allan Laycock." *Address:* Tararua, Broad St., Hartpury, Glos. GL19 3BN.

LAYZELL, Peter, B.A.(Hons.) Fine Art; artist in oil; Head of Foundation in Art at Blackpool College (2004-). *b:* Hitchin, Herts., 1962. *m:* Jean Palmer. one *s.* one *d. Studied:* Mander College, Bedford and Coventry Polytechnic (1981-84). *Represented by:* Portal Gallery, London. *Exhib:* R.A. Summer Exhbn. from 1986-'00 (prizewinner, 1990); various group exhbns. in London, Solo shows every two years at Portal Gallery, London. *Works in collections:* Morgan Grenfell, St. Martin's College, Lancaster, Warrington Arts Council. *Signs work:* "P. Layzell" on reverse. *Address:* 72 Vale Rd., Lancaster LA1 2JL.

LAZAROV, Peter Petkov, *Medium:* graphic art, wood engraving, woodcut, lithography. *b:* Plovdiv, Bulgaria, 22 Dec 1958. one *s. Educ:* University of Veliko Tarnovo, Bulgaria (1976-80). *Works in collections:* British Museum, Rijksmuseum Amsterdam, National Gallery Sofia Bulgaria. *Commissions:* Ex Libris, book illustrations, Fine Press Books. *Publications:* Het Labyrinth in Zwart en Wit (1991), Endgrain Three by Barbarian PPES (2003); Shoji; Rubbing Roads (2003-2004). *Principal Works:* Footprint (1988), Mimicry (1993), Quadratic Rhapsody (2001), Night Hunger (2004-5). *Misc:* owner of Pepel Press. *Address:* Zilverlaan 127, 9743 RG Groningen, Holland. *Email:* p.lazarov@hetnet.nl *Website:* www.lazarov.nl

LEACH, Mark Alan, P.S. (1994), Honorary Treasurer; self taught artist in pastel, charcoal, acrylic. *b:* Bromley, Kent, 10 Apr 1952. *m:* Gabrielle Janice. three *s. Educ:* Dulwich College; Bromley Grammar School. *Represented by:*

Blackheath Gallery, London. *Exhib:* P.S., Mall Galleries, various one-man and mixed shows London and U.K. *Publications:* 'Raw Colour with Pastels' Batsford (2006). *Signs work:* "Mark LEACH". *Address:* The White House, Pannel Lane, Pett, Hastings, E. Sussex TN35 4JB. *Email:* mark@markleach.net *Website:* www.markleach.net

LEACH, Ursula Mary, R.E., B.A. (Hons.) (1992); printmaker/painter in etching and oil paint. *b:* Woking, 14 May 1947. *m:* John Leach (separated). one *s.* one *d. Studied:* Winchester, Wimbledon and Farnham Schools of Art. *Exhib:* Attendi, London W4, Mall Galleries, London, Redfern, London, Southampton City A.G., Oliver Contemporary, London, Dorset County Museum, Arflex, Osaka & Tokyo, Japan. *Works in collections:* Diploma Collection, Ashmolean, Oxford, Royal Hospitals N.H.S.Trust, Dorset County Hospital; The Curwen Archive. *Commissions:* Worthing Hospital Postgraduate Medical Centre, Artsreach. *Works Reproduced:* review: Contemporary Art Vol. 2. No.3., Art on Paper Fair catalogue (1999), Flight over Cranborne Chase ISBN 0-86080-426-7, Bournemouth University Catalogue 1999-2005, Growing Concerns - Touring Show Catalogue; Collagraphs and Mixed-Media Printmaking (ISBN 0-780713-6296-0); Elemental Insight Touring Show catalogue reviews, Galleries Magazine May 2006, The Week 29.4.06; The Printmakers Directory (ISBN 0-7136-7387-7); 50 Wessex Artists (ISBN 978-0955-450306). *Signs work:* "U.Leach." *Address:* 14 The Square, Cranborne, Dorset BH21 5PR. *Email:* ursulaleach@hotmail.com

LEAPER, Landreth Francis, R.W.A.; self taught artist in water-colour and mixed media;. *b:* Horsham, 22 Dec., 1947. *s of:* Landreth E Leaper, Author. *Exhib:* numerous in South and S. West England. *Signs work:* "LEAPER" or "L. LEAPER" or double LL within a circle, sometimes above the year. *Address:* 28 Gerald Rd., Ashton, Bristol BS3 2DN.

LE BAS, Rachel Ann, R.E., N.E.A.C.; Mem. A.W.G., Somerset Guild of Craftsmen; painter, line-engraver, etc. *b:* 9 Apr 1923. *d of:* Capt. R. S. Le Bas, Somerset Light Infantry (retd.). *Educ:* W. Heath School, Sevenoaks. *Studied:* City and Guilds of London Art School (A.R. Middleton Todd, R.A., R.W.S., R.E., N.E.A.C.). *Exhib:* R.A., N.E.A.C., R.E., etc. *Works in collections:* Ashmolean Museum, Exeter Museum, Southampton Civic Centre, R.A. Graphics. *Commissions:* Bishop of Bath & Wells; Royal Academy Graphics. *Clubs:* Arts, Dover St. *Signs work:* "R. A. LE BAS." *Address:* Winsford, nr. Minehead, Som. TA24 7JE.

LE BRETON PARKER, G, BA (Hons). *Medium:* oil, prints, sculpture. *Studied:* Warwick University; Central St.Martins. *Exhib:* RA; Smith's Galleries; Covent Garden; Printmakers' Council; London Print Studio; Christie's. *Works in collections:* UK, USA, E.Europe, Canada, France, Italy. *Signs work:* 'G.Le Breton Parker'. *Address:* 23 Birchington Road, London N8 8HP.

LE BROCQUY, Louis, H.R.H.A. (1983), F.C.S.D. (1960), Hon. Litt.D., Dublin (1962), Hon. Ll.D. National University of Ireland (1988), Hon. Ph.D.

Dublin City University (1998), Chevalier de la Légion d'Honneur (1975), Officier, l'Ordre des Arts et des Lettres (1996); Officier de l'Ordre Couronne Belge, 2001; Hon. D. Univ., Queen's University, Belfast 2002. *b:* Nov., 1916. *s of:* Albert le Brocquy. *m:* Anne Madden le Brocquy. two *s.* one *d. Studied:* self taught. *Exhib:* Gimpel Fils (London, N.Y.), Galerie Jeanne Bucher (Paris), Taylor (Dublin), Agnews (London). Retrospective exhbns.: Municipal Gallery of Modern Art, Dublin (1966, 1978), Ulster Museum, Belfast (1967, 1987), Fondation Maeght, St. Paul (1973), Arts Council, Belfast (1975, 1978), Musée d'Art Moderne, Paris (1976), New York State Museum (1981), Palais des Beaux Arts, Charleroi (1982), Festival Centre, Adelaide (1988), Westpac, National Gallery of Victoria, Melbourne (1988), Museum of Contemporary Art, Brisbane (1988), Musée Picasso, Antibes (1989), Museum of Modern Art, Kamakura (1991), Itami Museum of Art, Osaki (1991), City Museum of Contemporary Art, Hiroshima (1991), Irish Museum of Modern Art, Dublin (1996), Chateau Musée de Tours (1997), Municipal Gallery of Modern Art, Ljubljana (1998), Museum of Modern Art, Oaxaca (2000). *Works in collections:* National Gallery, Ireland; Irish Museum of Modern Art; Hugh Lane Municipal, Dublin; Ulster Museum, Belfast; Foundation Maeght, St. Paul; Crawford Municipal, Cork; Musee d'Art Moderne, Paris; Konsthaus, Zurich; Guggenheim, New York; Hirshhorn, Washington; Musee Picasso, Antibes; National Gallery, Dublin; Tate Gallery, London; etc. *Signs work:* 'LE BROCQUY'. *Address:* c/o Gimpel Fils, 30 Davies St., London W1Y 1LG. *Email:* info@le-brocquy.com *Website:* www.le-brocquy.com

LE BROCQUY, Melanie, HRHA; Taylor scholarship (1938, 1939); California gold medal of the R.D.S. (1939); member of Aosdana(1981). *Medium:* sculpture in bronze. *b:* Dublin, 1919. *d of:* Albert & Sybil Le Brocquy. *m:* the late Professor F.S. Stewart, T.C.D. (Dublin University). two *s.* two *d. Studied:* National College of Art, Dublin; Ecole des Beaux Arts, Geneva; Royal Academy School of Art, Dublin. *Represented by:* Taylor Galleries, Dublin. *Exhib:* R.H.A. (1938, 1939, 1941, 1974, 1982-2005); joint exhib. with her brother Louis Le Brocquy (1942); I.L.A. (1943, 1965, 1967, 1971); Biennale Christlicher, Salzburg (1962); 'Melanie Le Brocquy/William Scott (1973); (prints) Dawson Gallery, Dublin; Solo exhibitions, or retrospectives, Taylor Galleries, Dublin (1986), Bell Gallery, Belfast (1989), Austin Desmond Fine Art, London (1990), Taylor Galleries (1991), Bell Gallery (1992); also, bust of Oscar Wilde purchased for T.C.D. (1996), the American College, Dublin, for Oscar Wilde House (1997), Magdalen College, Oxford (1997) and the Irish Embassy in Washington D.C. (2000). *Works in collections:* Arts Council; Hugh Lane Municipal Gallery; Allied Irish Bank; Aer Riantha; National Self-Portrait collection; 'St. Patrick' (1941), installed in St. Patrick's Cathedral (2001); portrait of Oscar Wilde, Magdalen College, Oxford. *Commissions:* "The Arts Reflected", eight small sculptures commissioned by the Bank of Ireland for the Art Show Awards (1990). *Publications:* weekly illustrations for gardening articles in the Irish Times, (from 1980 to 1988). Large catalogue for retrospective in R.H.A. (1999). *Recreations:* reading, theatre,

garden. *Signs work:* "M le B." *Address:* 29 Waltham Terrace Blackrock Co.Dublin Eire.

LE BRUN, Christopher Mark, Dip. F.A. Slade (1974), M.A. Chelsea (1975), R.A. (1996); painter, printmaker, sculptor; Trustee National Gallery (1996 - 2003), Trustee Tate Gallery (1990-95), Trustee Dulwich Picture Gallery (2000-2005), Trustee Prince of Wales's Drawing School (2003-), Professor of Drawing, R.A. (2000). *b:* Portsmouth, 20 Dec 1951. *m:* Charlotte Verity. two *s.* one *d. Studied:* Slade School of Fine Art, Chelsea School of Art. *Exhib:* numerous mixed exhbs., one-man shows worldwide since 1978. *Works in collections:* Tate, V. & A., B.M., M.O.M.A. New York, Arts Council, Fitzwilliam Museum, Courtauld, Oslo, Sydney, Yale, S.N.G.M.A., Edinburgh, Whitworth, Southampton, etc. *Commissions:* The Parables, Liverpool Cathedral (1996), Portrait of George Steiner, National Portrait Gallery. *Publications:* 'Christopher Le Brun' Booth-Clibborn Editions (2001); 'Christopher le Brun Fifty Etchings' Paragon Press (1991). *Clubs:* Chelsea Arts, The Arts Club. *Address:* 8 Love Walk, London SE5 8AD. *Website:* www.christopherlebrun.co.uk

LEDER, Carolyn, M.A. (1968); Curator, Old Speech Room Gallery, Harrow School (1989-); Trustee, Stanley Spencer Gallery, Cookham (1978-90, 2004-); formerly Lecturer in History of Art, University of London, Dept. of Extra-Mural Studies (1972-88). *b:* Melbourne, 5 Mar 1945. *d of:* Harold Beck, violincellist. *m:* Professor Malcolm Leder. two *s. Studied:* Courtauld Inst. of Art, University of London. *Publications:* book, Stanley Spencer: The Astor Collection (1976); articles; numerous catalogues on English watercolourists including 'Watercolours at Harrow' (2007), and key figures in British Art. Historical Adviser, BBC 2 Television, 'Stanley', drama-documentary on Stanley Spencer (1988). Specialist commentator in Stanley Spencer Gallery's video 'Stanley Spencer: A Painter in Heaven' (1996). Article 'Old Speech Room Gallery' in 'Harrow: Portrait of an English School' (2004). *Address:* The Steps, Hill Close, Harrow on the Hill, Middx. HA1 3PQ.

LEDGER, Janet, Hon. Citizen of Dallas; painter in oil of landscapes, townscapes, beach scenes. *Medium:* oil on board - acrylic on board. *b:* Northampton, 22 Jul 1931. *m:* H.E. Clements (decd.). two *d. Studied:* Northampton School of Art. *Exhib:* Dallas Texas, R.A. Summer Show, Mall Galleries, S.W.A., Century Gallery, Henley, Medici Gallery, London, Edwin Pollard Gallery, Linda Blackstone Gallery since 1985, 9 Solo Exhibitions 1985-2003 with Linda Blackstone Gallery. *Works in collections:* H.R.H. Princess Margaret, Tate Gallery, National Westminster Bank, Marks & Spencer Plc, National Coal Board, McDonalds Plc. *Works Reproduced:* Sunday Times colour supplement Editions of 250; ' Nuns on the Beach (eating Candifloss)'; 'Waves'. *Address:* c/o Linda Blackstone Gallery, Old Slaughterhouse, R/O 13 High St., Pinner, Middx. HA5 5QQ.

LEE, Christine Mary, B.A. (Hons.) Fine Arts, Sculpture (1981); sculptor in various medias; Artistic Director, Ragley Hall Sculpture Park, Warwickshire (1994-95), Artistic Director, Westonbirt Arboretum Sculpture Park, Glos. (1996);. *b:* Bucks. *m:* Douglas May. one *s.* one *d. Studied:* privately under Ulrica Seaton-Lloyd, Oxford; Banbury Art College (1977-78); St. Martin's School of Art (1978-81); Central School of Art (1981-83, painting and drawing: Cecil Collins). *Exhib:* Spain, U.S.A., U.K., Channel Islands. Work in collections worldwide. *Commissions:* numerous including 17 ft. fountain, Stratford-upon-Avon, inaugurated by H.M. The Queen. *Clubs:* F.P.S., Fountain Soc. *Signs work:* "Lee." *Address:* Beechwood House, High Bickington, Devon EX3 9BQ.

LEE, Debbie, 1st Class BA(Hons), Glasgow; Post Baccaluareatte, Chicago; MA, RCA; Commonwealth Universities Research Scholar (India); Sir William Gillies Bursary (RSA). *Medium:* drawing and painting. *b:* Leicester, 15 Jun 1967. *m:* Paul Jefferis. one *s. Studied:* Glasgow School of Art (1989); Art Institute of Chicago (1990); Royal College of Art (1992). *Exhib:* Boundary Gallery, London (1997, 2002); Institute of Psychiatry (2004); Budapest Art Expo, Hungary (1994); Cafe Gallery, London (2002); Opus Gallery, Nicosia (1993); Collins Gallery, Glasgow (1999); Gallery 2, Chicago (1990); Peacock Gallery, Aberdeen (1995, 2002); Jerwood Drawing (2002); City Gallery, Leicester (1993, 99); Royal Overseas League (1998). *Works in collections:* British Library, RSA, Aberdeen Library, Indian Center for Public Relations, Aberdeen Royal Infirmary. *Commissions:* Aberdeen Royal Infirmary (mural); St.Mary's of Rotherhithe (Stations of the Cross). *Publications:* 'Tongues of Diamonds' (Collins Gallery catalogue). *Works Reproduced:* in the following catalogues: Jerwood Drawings (2002); Royal Overseas League (1998); Fine Art Society (1998). *Principal Works:* drawings and paintings. *Recreations:* etching. *Clubs:* Bermondsey Artists' Group. *Signs work:* 'DEBBIE LEE'. *Address:* 29 Admiral Street, Deptford, London SE8 4HZ. *Email:* pauljefferis@ntlworld.com

LEE, Rern, painter in oil colour. *b:* Jakarta, Indonesia, 19 Sep 1938. *s of:* Lee Man-Fong and Li Mu-Lan. *m:* Siew Pui-Sam. two *d. Educ:* Singapore and Jakarta. *Studied:* Nanyang Academy of Fine Arts, Singapore. Trainee for several years in father's studio, then travelled and worked in England, France, Italy, Holland, Germany and Singapore (1969-72); Australia and New Zealand (1976); U.S.A. and Canada (1981). *Exhib:* one-man shows: Singapore (1970) and Jakarta (1980), etc. *Works in collections:* Nanyang University Museum, Singapore; Indonesia Palace Museum, Jakarta; The Asia and Pacific Museum, Warsaw, etc. *Misc:* Awards: Academic of Italy with Gold Medal; International Parliament U.S.A. Gold Medal of Merit; conferred Honorary Prize with Memorial Medal of Golden Centaur 1982; Diploma of Honoris Causa "Master of Painting" from the International Seminar of Modern and Contemporary Art and Diploma of Merit from Italian University of Arts. *Signs work:* "R. Lee." *Address:* Jalan Gedong 11-A, Jakarta Barat, Indonesia.

LEE, Sara Charlotte, BA (Hons); National Eisteddfod Highly Commended (1993), TWAS Bronze medal (1999). *Medium:* painter in acrylic and watercolour, printmaker. *b:* Harwell, 31 Dec 1969. *Studied:* Gwent College of Higher Education, CCTA, Huddersfield University. *Exhib:* WWF Search for an Environmental Sculptor (1992), Welsh National Eisteddfod (1993), BP Portrait Award (1999), TWASI (1997-2006), Hilliard Society (2002-4, 2006), SWLA (2003), NAPA (2003-6), RMS (2003, 2005), Falmouth Art Gallery (2004, 2006), SWA (2005-7), The Welsh Artist of the Year (2005), SOFA (2006), MIWAS (2006). *Works in collections:* private collections. *Commissions:* private commissions. *Clubs:* NAPA, TWASI, MIWAS. *Signs work:* 'Sara C.Lee' or 'S L'. *Address:* 17 The Cleave, Harwell, Oxon, OX11 0EL.

LEE, Sidney Edward, graphic artist and painter in oil and charcoal/chalks. *b:* London, 22 Nov 1925. *m:* Amy Gwendoline Aston (decd.). *Studied:* Harrow School of Art, Willesden School of Art. *Exhib:* R.W.A., R.O.I., R.S.M.A., Guildhall and Mall Galleries London; International Boat Show Earl's Court, London; Royal West of England Academy, Bristol; Norway Gallery and Mariners Gallery, St. Ives; exhib. marine paintings regularly with the R.S.M.A. (1979-85) - see 20th Century British Marine Painting by Denys Brook-Hart. Recent work includes charcoal and conté drawings of the Cornish landscape. *Clubs:* St. Ives Soc. of Artists. *Misc:* Also had a long career as a Graphic Artist with London Agencies and Television companies. *Signs work:* 'Sidney Lee'. *Address:* Rose Lea, Rose Hill, Marazion, Cornwall TR17 0HB. *Website:* www.StIvesSocietyofArtists.com

LEE, Terry Glyn, D.F.A. (Lond.), 1957; artist in oil. *b:* Sheffield, 28 Oct 1932. *s of:* G. W. Lee. four *s. Educ:* King Edward VII School, Sheffield. *Studied:* Sheffield College of Art; Slade School of Fine Art (1955-58); Sir William Coldstream. *Exhib:* New Art Centre, Agnews, Piccadilly Gallery, Wildenstein, R.A., Van Rijn Maastricht, Bühler Gallery Stuttgart. *Works in collections:* Liverpool Art Gallery, Ferens Art Gallery, Hull, Coventry Art Gallery, Oldham Art Gallery, The Arts Council, Financial Times, Contemporary Art Soc., Sheffield Art Galleries, Duke of Devonshire, Government Art Collection. *Signs work:* "Terry Lee." *Address:* Calton Houses, Calton Lees, Beeley, nr. Matlock, Derbyshire DE4 2NX.

LEECH, Raymond Ian, R.S.M.A. (1986), L.S.I.A.D. (1969); mem. E.Anglian Group of Marine Artists; landscape and seascape painter in oil and water-colour; partner in a design group, Pencil Point Studio. *b:* Gt.Yarmouth, 1949. *s of:* Gordon William Leech (decd.). *Educ:* Edward Worledge School, Alderman Leach High School. *Studied:* Gt.Yarmouth College of Art and Design (1965-69). *Exhib:* R.S.M.A., Hunting Group, Mystic U.S.A., Assembly Rooms Norwich, Ladygate Gallery, and other provincial galleries. *Works in collections:* National Maritime Museum, The Sheik of Oman, Mystic Maritime Gallery U.S.A., etc. *Publications:* represented in Tonal Painting (Quarto). *Address:* 1 The Staithe, Oulton Broad, Lowestoft, Suffolk.

LEEDS, Caroline (Lady Hobart), portrait and landscape painter in oil, water-colour, pastel, silverpoint and conté;. *b:* Jersey, C.I., 17 May, 1931. *m:* Lt. Comdr. Sir Robert Hobart, Bt. (decd.). *Studied:* under Bernard Adams, R.P., R.O.I., and Philip Lambe, R.P. *Exhib:* over forty exhbns. in London, Paris, New York, Zurich and Palm Beach including Wildenstein London, Galerie M.B. Paris, Sotheby Zurich. *Works in collections:* Moët and Chandon, Epernay, Citi Bank, Lord and Lady Montagu of Beaulieu, The Royal Hospital Chelsea. *Commissions:* H.R.H. Prince Andrew, The Duke and Duchess of Bedford, Christine Mrs. Henry Ford, Sir John Nicholson, Bt. former Commodore of the Royal Yacht Squadron, I.O.W. *Clubs:* Arts Club Dover St., Royal Yacht Squadron, I.O.W. *Signs work:* "Leeds." *Address:* Flat 14, 42 Egerton Gdns., London SW3 2BZ.

LEES, Caroline, AFAS; CAS. *Medium:* watercolour interiors; oil landscapes; egg tempera/gold leaf. *b:* Shropshire, 14 Apr 1940. *d of:* John H.Everall. *m:* Brian Musson Lees. two *d. Studied:* Corcoran Gallery School of Art, Washington DC(1982/84); Slade School of Art (Master Classes). *Represented by:* Rafael Valls Ltd, SW1Y 6QB. *Exhib:* Ebury Galleries (1995); Atlantic Gallery, Washington DC (1983, 84); Mathaf Gallery, Knightsbridge (1986, 92, 98, 2000); Henry Brett, Stow-on-the-Wold (1988, 89); RSMA, Mall Galleries (1992); Watermans (1992); Laing Art Group (1996); RA Summer Exhbn (1995, 97, 2005); Rafael Valls Ltd (2001, 2003-06); Indar Pasricha Fine Arts (2005). *Works in collections:* National Trust; Adam Co. Bank; St.Catherine's Monastry, Sinai, Egypt. *Commissions:* F&CO: watercolour for presentation to H.R.H. The Prince of Wales. *Publications:* Watercolours of Shropshire; The Way of Life (Icons). *Works Reproduced:* Garsington Opera Company; Stacy International 'Oman Today'. *Signs work:* 'C LEES'. *Address:* 14 Ringmer Avenue, London SW6 5LW. *Email:* caroline_lees@talk21.com *Website:* www.caroline-lees.com

LEES, Irene, SWA (2007); BA (Hons) Drawing and Applied Art (2005); Martini Prize, Cheltenham Art Festival (2006); Cliff Moss Memorial Award (2005); shortlisted, Jerwood Drawing Prize (2005-06). *Medium:* pen and ink, and drawings in all media. *b:* Oldham, 11 Feb 1943. *d of:* Irene Leghorn. *m:* Harry. three *s.* one *d. Studied:* UWE, Bristol (2002-05). *Exhib:* RWA Bristol (2003, 2006); Iguana Gallery, Stroud (2003); RWA (2004); Octagon Visual Arts Centre (Draw Group)(2004); Stroud House Gallery (2005); Sherwell Gallery, Plymouth; London Art Fair; SWA, Mall Galleries (2006); Smithfield Gallery, London (2006); Full Circle, London (2006-07); Holt Gallery, Norfolk (SWA, 2006); Foyer Gallery, UWE, Bristol (2002-06); Wells Gallery, St.Ives (2007). *Commissions:* for private collections in Spain & Australia. *Signs work:* 'Irene Lees'. *Address:* 5 Bos Vean, The Lizard, Helston, Cornwall TR12 7RU. *Email:* irene17lees@aol.com

LEES, Stewart Marshall, D.A. (Edin.) (1952), R.O.I. (1987), R.S.W. (1992), R.W.S. (1991);. *b:* Auchtertool, Fife, 15 Jan., 1926. *Educ:* Edinburgh College of Art (1947-52). *Exhib:* R.A. Summer Exhbn., Royal Scottish Academy, R.S.W., R.W.S., and privately. *Works in collections:* Glenrothes New Town, Liverpool

Educ. Com., Fife Educ. Com., University of Glasgow, University of Nottingham, Nuffield Foundation, Imperial Tobacco Co., Sheffield City A.G., Leverhulme Foundation, Scottish Arts Council, Esso Ltd., Leeds Educ. Com. *Clubs:* Arts, London. *Signs work:* "Stewart Lees." *Address:* Southlands, Arlington Drive, Mapperley Pk., Nottingham NG3 5EN.

LEES, Susan Jane, artist in gouache, acrylic, pastel, batik, oil; Wildlife illustrator at Bristol Zoo since 1995. *b:* Bristol, 23 June, 1961. *Educ:* Hengrove Comp. Bristol. *Studied:* Glos. College of Art and Design (1980-82). *Exhib:* Soc. of Amateur Artists, Soc. of Women Artists, British Soc. of Painters, The Wildlife Art Soc., and local exhbns, National Exhbn. of Wildlife Art. Christies & Sotheby's Wildlife Art Auction. *Clubs:* Soc. of Amateur Artists '93, Wildlife Art Soc. '94, Soc. of Women Artists '95-'96, British Soc. of Painters '94-'95, Whitchurch Art Club '92. *Signs work:* "Susan Jane." *Address:* 163 Avonvale Rd., Redfield, Bristol BS5 9RY.

LEESON, Geoffrey Glynne, NDD, BA. *Medium:* acrylic on canvas, oil, watercolour, drawing, prints. *b:* Sutton, Surrey, 20 Mar 1942. *s of:* G.W.J.Leeson. *m:* Kay. two *s. Educ:* London Nautical School (1952-58). *Studied:* Camberwell School of Arts and Crafts (1958-62, painting and printmaking). *Represented by:* Peter Weaver. *Exhib:* solo exhibitions: Scunthorpe Art Gallery (1964), Canaletto Gallery, London (1980), Gallery 21, Tonbridge, Kent (1982), Tunbridge Wells Art Gallery (1990), Ripley Arts Centre, Bromley, Kent (2006, 2007). *Works in collections:* private and corporate. *Commissions:* private and corporate. *Misc:* Known as Geoff Leeson. Taught Art in various schools to include Winterton Comp, Scunthorpe, Oakwood Park Grammar, Maidstone, currently The Priory, Orpington. *Signs work:* on prints "GEOFFREY LEESON", on paintings "LEESON". *Address:* 256 Downham Way, Bromley, Kent, BR1 5NS. *Email:* leeson@wobblybridge.co.uk *Website:* www.wobblybridge.co.uk

LEGG, Owen, FFPS, MBBS; printmaker and artist in oil on board, lino-cut prints, abstract constructions. *b:* London, 1 Aug 1935. *Educ:* Alleyns School, Dulwich; Guy's Hospital, London. *Studied:* Tunbridge Wells Adult Education Centre. *Exhib:* York University, Tunbridge Wells Library, Loggia Gallery, St Martin-in-the-Fields, Oxford, Newcastle -USA, ICA London. *Works in collections:* Greenwich Library; Graphotek, Berlin; Columbia University, NY. *Publications:* Cut in the Chalk, Rubaiyyat of Omar Khayaam; The Garden by V. Sackville West (1989), On First Seeing Iceland (1992), Christmas letters from a Friend (1997), Advice to a Young Explorer (1999), Egily Head Ransom (2001), Battle of Maldon (2003), The Gardens of Stowe (2006). *Recreations:* gardening. *Clubs:* Secretary to Free Painters & Sculptors. *Signs work:* "Owen Legg." *Address:* Woodcraft Press, 152 Hadlow Rd., Tonbridge, Kent TN9 1PB. *Email:* owen@legg152.freeserve.co.uk

LE GRICE, Jeremy Day, B.A. Slade; painter in oil; Award Scholarships: Atelierhaus, Worpswede, Bremen (1994/5), Atelierhaus, Bremerhaven (1997/8).

Medium: oil. *b:* Penzance, 17 Sep 1936. *s of:* Andrew Le Grice. *m:* Lyn. two *s.* two *d. Educ:* Eton College. *Studied:* Guildford College of Art, Slade School, London University. *Represented by:* Cadogan Contemporary, 87 Old Brompton Rd, SW7 3LD. *Exhib:* one man shows since 1962 including Penwith Gallery St.Ives (1965, 1990, 1996, 2000), Cadogan Contemporary (1989, 1992, 1995, 1999), Lemon Street Gallery, Truro (2000), Badcocks Gallery Newlyn (2001), Eton College Gallery (2003); selected group shows: Hunting Prize, RCA; Royal Academy, London Group, Young Contemporaries, West of England Academy; Royal Cornwall Museum, Truro, etc. *Works in collections:* Nuffield Foundation, Birmingham University, Plymouth Museum, Gloucester CC, Cornwall CC. *Publications:* 'Catching the Wave' by Tom Cross (1999) etc. *Works Reproduced:* various art magazines. *Clubs:* Penwith Soc., St. Ives, Newlyn Soc. of Artists. *Signs work:* "Jeremy Le Grice." *Address:* Flower Loft Studio, Trereife, Penzance, Cornwall TR20 8TJ. *Email:* jeremy@blue-earth.co.uk

LEIGH, David Roy, M.A.(Oxon.) (1972), F.S.B.A. (1986); botanical artist in water-colour; former official artist to the Orchid Com. of the R.H.S.;. *b:* Leeds, 2 June, 1945. *m:* Vaila Mary Eastabrook. one *s.* one *d. Educ:* City of Leicester Boys' School, and Oxford University (Worcester College). *Exhib:* S.B.A. at Mall Galleries, R.H.S. *Publications:* illustrated Aroids (Century, 1988), author: Orchids (Cassell, 1990), Growing Your Own Orchids (Salamander) 1982, Field Guide To Wild Flowers (Collins 1989). *Recreations:* golf. *Signs work:* "David R. Leigh" or more often "D.R.L." with year. *Address:* West Hill House, Plush, Dorset DT2 7RQ.

LEIGH, Michelle Beverly, BA (1st Class) Hons, Fine Art, Painting, MA Painting; British Academy Major State Studentship Award (1986-88). *Medium:* oil, watercolour, prints. *b:* Manchester, 20 Apr 1964. *Studied:* Manchester Polytechnic (1982-3), Medlock Fine Art Centre (1983-6), University of Newcastle upon Tyne (1986-88). *Represented by:* Wendy J Levy Contemporary Art, Manchester. *Exhib:* Wendy J Levy Contemporary Art, Manchester (2001, 03, 05, 06), The New Grafton Gallery, London (2005), Firbob & Peacock Contemporary Art (2002, 03), The Whitworth Art Gallery, Manchester (2000), Liverpool Biennial (1999), Reynolds Fine Art, London, Castlefield Art Galelry, Manchester (1991, 99), Salford Museum & Art Gallery, Manchester Academy of Fine Arts (1991), Ben Uri Gallery (1988). *Works in collections:* Rutherstones Loan Collection, Manchester City Art Gallery, Manchester Airport, Harvard University. *Commissions:* Robert J Duncan. *Publications:* 'A Colourful Canvas' 12 Women Artists in the North West, by Wendy J Levy & Judy Rose. *Official Purchasers:* Manchester City Art Galleries, British Midland (for Manchester Airport). *Recreations:* languages, travelling, walking, writing. *Misc:* Draws upon two cultures: her Jewish background, and modern life. *Signs work:* "M. LEIGH". *Address:* 229 Hulme St., Hulme, Manchester, M15 5EF. *Email:* michellebleigh@hotmail.com

LEK, Karel, M.B.E., RCA, ATD; artist in oil, water-colour and graphic media. *b:* Antwerp, 7 Jun 1929. married. *s of:* Hendrick Lek, artist. one *s.* one *d. Studied:* Liverpool College of Art. *Exhib:* National Museum for Wales, R.A., R.C.A., Cardiff, Albany Gallery, Cardiff, Arts Council, Bangor Gallery, Mostyn Gallery, Llandudno, Retrospective (1994) Oriel Ynys Môn, Anglesey, Breknock Museum Brecon (1997); Retrospective RCA (2004); Retrospective: Plas-Glyn-y-Weddw, Llanbedrog, Pwllheli (Nov 2005). *Works in collections:* University Coll. of N. Wales, Contemporary Art Soc. for Wales, National Library of Wales, Anglesey C.C. Welsh Collection, Michael Forte Collection, Breknock Museum, Brecon. *Official Purchasers:* Nat.Library of Wales: 7 works, 2 sketch books (2005). *Misc:* Documentaries: "Prime Time" HTV (9 May & 9 Oct. 1994), "My Story" BBC2W (19 June 2007). *Address:* Studio House, Beaumaris, Anglesey LL58 8EE.

LEMAIRE, Angela Jacqueline, DipAD (1967). *Medium:* mixed media, gouache, oil, watercolour, drawing, prints. *b:* Burnham, Bucks., 27 Sep 1944. one *s. Educ:* Presbytyrian Ladies College, Sydney, Australia. *Studied:* Chelsea School of Art (1963); Camberwell School of Arts and Crafts (1964-67); Morley College, South London (1968-69). *Exhib:* solo shows: Open Eye Gallery, Edinburgh (1977); Stadia Graphics, Sydney, Australia (1975); Edinburgh Music School (1993); Grey College, Durham (Retrospective Prints, 2001). Group: various including - 16 Woodengravers, Collingwood, Durham (19820; Society of Wood Engravers; Association of Applied Arts, Scotland (1997-98); Biennales (Ex Libris) in Europe. *Works in collections:* various - including Museo del Ex libris, San Paulo di Jesi, Museo Communale Arte e Informazione, Ancona, Italy; many private collections. *Commissions:* Ian Hamilton-Finlay, The Folio Society, Scottish Borders Council, and others. *Publications:* Artists books, and 4 books with The Old Stile Press (2001-2007). *Official Purchasers:* The National Library of Scotland; The Nat. Library of Wales; Swathmore Library, Pennsylvania, USA; Armstrong-Browning Library, Texas, USA; Eton College Library, and others. *Works Reproduced:* "Forty Five Wood Engravers" (Whittington Press); "An Engravers Globe" (Primrose Hill Press, 2002); "International Contemporary Bookplates" (Portugal, 2007); "Scottish Bookplates" (Bookplate Society, Brian North Lee, 2007), and others. *Principal Works:* 4 books with Old Stile Press, and "A Christmas Sequence: Chosen by Benjamin Britten from Chester Mystery Cycle: Intro Dr. Andrew Plant" (over 80 images - woodcuts - for this book). *Signs work:* "A.Lemaire" on prints and drawings, "AL" on paintings. *Address:* The Studio, The Friars, Jedburgh, Roxburghshire, Scotland, TD8 6BN. *Email:* angelamaire2004@yahoo.co.uk *Website:* www.angelalemaire.co.uk

LEMAN, Martin, RBA; artist in oil; former graphic design teacher, Hornsey College of Art (1961-77). *b:* London, 25 Apr 1934. *s of:* Arthur Leman. *m:* Jill. *Educ:* Royal Masonic School. *Studied:* Worthing School of Art, and Central School of Arts and Crafts. *Exhib:* RA Summer Exhbns (1980-2005); Discerning Eye; Chris Beetles; Royal Festival Hall; Walker Art Gallery, Liverpool; Galerie Contemporaine, Geneva; International Primitive Art Exhbn, Zagreb, Yugoslavia, etc. selected solo shows: Portal Gallery, London (1971, 74, 98); Rona Gallery,

London (1999, 2001, 2002, 2004); Wren Gallery, Burford (1999, 2001). *Commissions:* many cat portraits. *Publications:* twenty-four books, mainly cat paintings. *Clubs:* Royal Society of British Artists. *Signs work:* "Leman." *Address:* 1 Malvern Terr., London N1 1HR.

LE MARCHANT, Sir Francis, Bt., Cert RAS, Bilan de Paris silver medal; landscape and portrait painter/ farmer. *Medium:* painter in oils/watercolours. *b:* Hungerton, 6 Oct 1939. *Educ:* Gordonstoun. *Studied:* art Byam Shaw School, Royal Academy Schools. *Exhib:* Agnews, Roy Miles Fine Art, Sally Hunter Fine Art, Museum of Arts and Science Evansville USA, ING Bank (sponsored by Barings Asset Management). *Works in collections:* Government Art Collection, Financial Times, Evansville Museum of Arts and Science, Barings Asset Management, University of Evansville. *Commissions:* portraits-watercolours/drawings for the Wine Society, private portrait and landscape, houses. *Official Purchasers:* Government Art Collection. *Works Reproduced:* two works on website. *Recreations:* Music, Reading. *Clubs:* Savile Club. *Signs work:* 'Le M', or 'Le Marchant'. *Address:* Hungerton Hall, Grantham, Lincs. NG32 1AJ. *Website:* www.francislemarchant.com

LENAGHAN, Brenda, RSW (1984). *Medium:* oil and watercolour. *b:* 10 May 1941. one *s. Studied:* Glasgow School of Art Dip (1963). *Exhib:* RSA, RA, RSW, RGI; Peter Potter McCauley Gallery; Caltac Gallery, Gerber, Glasgow; William Hardie, Glasgow; Duncan Campbell, London; Christopher Hall, London; Open Eye (Edinburgh); Edin Gallery; Rendezvous, Aberdeen; Richard Hagen, Japan. *Works in collections:* private in USA, Japan, Scandinavia, Australia. *Commissions:* portraits. *Recreations:* painting furniture. *Signs work:* 'Brenda Lenaghan'. *Address:* 'Clouds', 3, The Green, Tyninghame, East Lothian, EH42 1XL. *Email:* clouds@talktalk.net

LENEY, Sheila, S.B.A. (1987); floral artist in water-colour and embroidery. *b:* London, 23 Nov 1930. *d of:* William W. Davis, insurance surveyor. *m:* Edward W. Leney (decd.). two *s.* one *d. Educ:* St. Helen's School, Streatham. *Studied:* Croydon School of Art (1947-49), Epsom A.E.C. (1982). *Exhib:* Mall Galleries; Outwood Gallery, Surrey; Linnean Soc.; Lannards Gallery, Sussex; Westminster Gallery, Knapp Gallery, London; McEwan Gallery, Scotland; work in private collections. *Publications:* greetings cards for Medici Soc. *Signs work:* "Sheila Leney." *Address:* Invermene, 107 Newton Wood Rd., Ashtead, Surrey KT21 1NW.

LENG-SMITH, Barbara, Hon. Mention, Paris Salon, Silver Medal, Paris Salon; portrait painter in oil, water-colour and pastel specialising in children. *b:* Isle of Man, 7 Mar 1922. *d of:* E. Gibson Teare. *m:* Ralph Leng-Smith. one *s.* four *d. Educ:* Sheffield. *Studied:* Manchester under Harry Rutherford. *Exhib:* one-man show: Tib Lane Gallery, Manchester; Royal Society of Portrait Painters, London; Paris Salon; R.S.A., Edinburgh, The Churchill Gallery, Knutsford, Cheshire.

Commissions: numerous. *Recreations:* iyengar yoga. *Signs work:* "Leng-Smith." *Address:* Miramar, Arthog Rd., Hale, Altrincham, Cheshire WA15 0LS.

LENNON, Stephen, F.I.G.A. (1995), B.W.S. (1994), Y.W.S. (1997); artist in water-colour and mixed media;. *b:* Burnley, Lancs., 10 Mar., 1953. *m:* Laila (née Wesenlund). one *s.* one *d. Studied:* mostly self taught, life classes in Burnley in the 1970's. *Exhib:* Laing Finalist (1989); one-man show: Bradford University (1990); mixed shows: Mercer Harrogate, Ginnel Manchester, Salford City A.G., Chantry House Gallery, Ripley, many private collections. *Commissions:* eight paintings for the Marquess of Hartington. *Works Reproduced:* BWS catalogue (1997), articles in the Yorkshire Journal. *Clubs:* Yorkshire Water-colour Soc., Leeds Fine Art Club. *Signs work:* "Stephen Lennon." *Address:* 24 Ickornshaw, Cowling, nr. Keighley, W. Yorks. BD22 0DE. *Email:* ste@stephenlennon.co.uk *Website:* www.stephenlennon.co.uk

LEONARD, (Douglas) Michael, painter and illustrator. *b:* Bangalore, India, 25 Jun 1933. *s of:* Maj. D. G. R. Leonard, IXth Jat Regt. *Educ:* Stonyhurst College. *Studied:* St. Martin's School of Art (1954-57). Worked as an illustrator from 1957-72 and subsequently as a painter. *Exhib:* one-man shows: Fischer Fine Art London (1974, 1977, 1980, 1983, 1988), Harriet Griffin, New York (1977), Gemeentemuseum, Arnhem (1977-78) (retrospective), Artsite, Bath (1989) (retrospective), Jonathan Edwards College, Yale University (2007) (Retrospective), Stiebel Modern New York (1992), Thomas Gibson Fine Art, London (1993, 1997, 2004), Forum Gallery, New York (1999); mixed shows: "Realismus und Realitat" Darmstadt (1975), John Moores, Liverpool (1976, 1978), "The Craft of Art" Walker A.G. (1979), "Nudes" Angela Flowers, London (1979/80), "The Real British", Fischer Fine Art (1981), "Contemporary British Painters", Museo Municipal, Madrid (1983), "Self Portrait: A Contemporary View", Artsite, Bath (1987), "In Human Terms", Stiebel Modern, New York (1991), 'Its Still Life', Forum Gallery, New York (1998), 'Between Earth and Heaven', Museum of Modern Art, Ostend (2001), "Artists of the Ideal-New Classicism", Palazzo Forti, Verona (2002). *Works in collections:* The Boymans Van Beuningen Museum Rotterdam, De Beer/C.S.O., N.P.G., V. & A., Fitzwilliam Museum Cambridge, Ferens A.G., Hull, Arnot Art Museum, Elmira, N.Y. *Commissions:* Painted H.M. Queen Elizabeth II for Readers Digest (1986) now in N.P.G. *Signs work:* "Leonard" or "ML." *Address:* 3 Kensington Hall Gdns., Beaumont Ave., London W14 9LS.

LEONARD, Patrick, A.R.H.A. (1942), H.R.H.A. (1980); painter in oil and pastel. *b:* Rush, C. Dublin, 11 Oct 1918. *m:* Doreen. two *d. Educ:* O'Connell Schools, Dublin. *Studied:* Metropolitan School of Art, Dublin, under John Keating R.H.A. and Maurice MacGonigal R.H.A. *Exhib:* R,H.A. (1941-2003), solo exhibs. in Dublin, Irish Art in U.S.A. and Canada. *Works in collections:* Hugh Lane Gallery, Dublin; Cork Municipal Gallery, Waterford; Wexford Corporation Galleries. *Publications:* Exhib. catalogue, Gorry Gallery, Dublin (1990). *Official Purchasers:* Thomas Haverty Trust, Dublin, Gibson Bequest,

Cork. *Signs work:* "P. Leonard" or "P. LEONARD." *Address:* 19 Dublin Rd., Skerries, Co. Dublin, Eire.

LESTER, James Richard, NDD (1955), SBA (1986). SWAc (2004); artist in water-colour, oil, pastel. *b:* Dover, 18 Dec 1932. one *s.* three *d. Studied:* Dover School of Art (1951-53), Canterbury College of Art (1953-55). *Exhib:* RA, RWA, RBA, RI, SBA, SWAc.; one-man show: Tenterden and Otterton. *Works in collections:* many private collections. *Commissions:* accepted for portraits, landscapes and figurework. *Publications:* co-author and illlustrator: 'Painting the Secret World of Nature'. *Clubs:* Society of Botanical Artists, South West Academy of Arts (SWAc). *Signs work:* "James Lester." *Address:* Rydon Farm, Ottery St., Otterton, Devon EX9 7HW. *Email:* jim,pessers@btinternet.com *Website:* www.james-lester.com

LETTS, John Barry, sculptor in clay for casting in bronze. *b:* Birmingham, 20 Aug 1930. *s of:* Joseph Omer Letts, graphic designer. *m:* Patricia Letts. two *s.* one *d. Educ:* Sharman Cross Senior School, Birmingham. *Studied:* Birmingham College of Art (1945-49) under William Bloye. *Exhib:* London, Birmingham, Nuneaton, Solihull, Stratford-upon-Avon, Stoke-on-Trent. *Works in collections:* Nuneaton and Stratford-upon-Avon galleries. *Commissions:* one and a half times life-size statue of George Eliot (authoress) for Nuneaton Town Centre (1985); 1994: portrait bust of H.M. The Queen, unveiled by Her Majesty 8 Dec. 1995, commissioned by Warwickshire Health Authority. *Signs work:* "John Letts." *Address:* 160 Tilehouse, Green Lane, Knowle, Solihull, W. Midlands B93 9EJ. *Website:* www.lettssculptures.co.uk

LEVEE, John, B.A., Grand Prix, Academie Julian (1951); prizes in California Watercolor Ass. Annual (155-56); Biennal de Paris (1959); Purchase Award, Commonwealth of Virginia Biannual (1966); Ford Fellowship, Tamarind Workshop (1969); Grand Prix, Woolmark Foundation, Paris (1974-75); painter in oil, gouache, crayon; visiting Professor of Art, University of Illinois (1965), N.Y. University (1967-68), University Southern Calif. (1970-72). *b:* Los Angeles, 10 Apr., 1924. *Educ:* University Calif., New School for Social Research, N.Y. *Studied:* New School; Academie Julian, Paris (Grand Prix 1952). *Exhib:* one man shows: Andre Emmerich Gallery, N.Y. (1957-59, 1962, 1966); Gimpel Fils, London (1958, 1960, 1966); Galerie de France (1961-62, 1964, 1969); Nora Gallery, Jerusalem (1963); Moose Gallery, Toronto (1963); Kantor Gallery, Los Angeles (1956); Esther Robles Gallery, Los Angeles (1961, 1963, 1965); Felix Landau Gallery, Los Angeles (1957); Margo Leavin Gallery, Los Angeles (1970); Henry Mayer Gallery, Lausanne, Switzerland (1971), Liatowitch Gallery, Basle, Switzerland (1972); Galerie La Tortue, Paris (1975); Galerie Roquefeuil, Paris (1996); Galerie Callu Merite, Paris (1990); Galerie 1900-2000, Paris 1997; Galerie Reynolds, Paris (2001); Hanna Fine Arts, London (2003); Galerie Helene Lamargue (2004). *Works in collections:* Kunst Museum, Basel; Smith College Museum, Massachusetts; Museum of Modern Art, New York; New York Public Library; Stedelijk Museum, Amsterdam; Carnegie Institute, Pittsburgh;

Cincinnati Museum, Ohio; Musee du Havre, France; Whitney Museum, New York; Fogg Museum, University of Harvard; Museum Haifa, Israel; Museum of Los Angeles; Yale University Museum; Santa Barbara Museum; Museum of Modern Art, Djakarta; The Tower Art Gallery, Eastbourne, England; Baltimore Museum; Dallas Museum of Contemporary Art; Oberlin College Museum; Columbus Gallery of Fine Arts, Columbus, Ohio; Phoenix Art Museum, Phoenix, Arizona; Allentown Art Museum, Allentown, Penn.; Des Moins Art Museum; Washington University Museum, St. Louis, Mo.; Honolulu Academy of Arts; Corcoran Gallery, Washington DC; Walker Art Centre, Minneapolis; Virginia Museum of Fine Arts; Guggenheim Museum, New York; University of Arizona Museum; Musee de Tel Aviv, Israel; Oklahoma Art Center, Oklahoma City; Power Gallery of Contemporary Art, University of Sydney; University Museum, University of California, Berkeley; Palm Springs Museum, Palm Springs, California; Musee Municipale, Blanc-Mesnil, France; Joseph Hirshhorn Museum, Washington DC; New Washington Gallery of Modern Art, Washington DC; Musee Municipal Toulouse, France. *Publications:* 16 Painters of Young, School of Paris, Abstract Art, Dictionary of Abstract Art, Concise History of Modern Art, L'École de Paris 1945-1965 Harambourg. *Signs work:* "Levee." or "J.L." plus date. *Address:* 119 rue Notre Dame des Champs, Paris 75006, France. *Website:* google my name

LEVEN, Marian, D.A. (1966), R.S.W. (1993), R.S.A. (elect, 2005); artist in water-colour, acrylic; Winner, Noble Grossart/ Scotland on Sunday Painting Prize (1997). *b:* Edinburgh, 25 Mar 1944. *m:* Will MacLean. two *s.* one *d. Educ:* Bell-Baxter, Cupar, Fife. *Studied:* Gray's School of Art, Aberdeen (1962-66). *Exhib:* R.S.A., R.S.W., R.G.I., Aberdeen Artists. *Works in collections:* Arts in Fife, Paintings in Hospitals, Lillie Gallery, Milngavie, Kirkcaldy Museum and A.G., University of Dundee Fine Art Collection. *Signs work:* "Marian Leven." *Address:* Bellevue, 18 Dougall St., Tayport, Fife DD6 9JD.

LEVENE, Ben, A.R.A. (1975), R.A. (1986); painter (genre) in oils, water-colours; Curator, Royal Academy Schools (1995-98). *b:* London, 23 Dec 1938. *s of:* Mark and Charlotte Levene. *m:* Susan. one *s. Studied:* Slade School of Fine Art (1956-61), Boise Scholarship (1961-62). *Exhib:* regularly at R.A., and Browse and Darby Gallery, London; work in many private and public collections. *Commissions:* several landscape commissions especially "tree portraits" Lydham Oak (1997), Mulberry Tree, Lindsay House (1998) and Bucklebury Acacia (2002-3). *Publications:* 'Oils Masterclass' by Sally Bulgin. *Signs work:* Usually signed on back; since 1975 with monogram "B.L." *Address:* c/o The Royal Academy, Burlington House, Piccadilly, London W1V 0DS.

LEVERITT, Thomas Michael James, MA (Hons) Cantab.; Carroll Award for Portraiture (2000). *Medium:* oils and acrylics. *b:* Glasgow, 16 Jan 1976. *s of:* T C M Leveritt, Esq. *Educ:* Peterhouse, Cambridge. *Studied:* self-taught. *Represented by:* Sara Stewart Fine Art, 107 Walton St., London. *Exhib:* BP Exhbn. (2000, 2001); RP (1999, 2000, 2001); ROI (1998, 2003). *Works in collections:*

Somerville College, Oxford. *Commissions:* Simon Thurley; Lord and Lady Northbrook; Rt.Hon. John S. Gummer; Dean and Christi Jernigan. *Signs work:* leveritt. *Address:* 17a South Audley St., London W1K 2NT. *Email:* thomas@leveritt.com *Website:* www.leveritt.com

LEVI, Edgar: see KNIGHT, Clifford,

LEVI, Judy Julia Miriam, MBBS, DPH; Medical Art Society Prize x 3. *Medium:* watercolour, oil. *b:* London, 26 Jun 1930. *d of:* David Levi MS FRCS, Vera Hemmens (journalist, first woman lobby correspondent in House of Commons). three *s.* one *d. Educ:* Northwood College, St. Mary's Hospital Medical School. *Studied:* Josh Partridge (watercolour), Robin Child, Lydgate Research Centre, Wiltshire. *Exhib:* Medical Art Society, Royal College of Physicians, Highgate Gallery, Rosvik Gallery. *Works in collections:* Northwick Park Hospital. *Recreations:* family, painting, gardening. *Address:* 103 Swains Lane, London N6 6PJ. *Email:* judlevi.b@btinternet.com

LEVINE, Shirley Blossom, BA, MA; awards include 'Best in Show-Contemporary Painting, NAPA UK St.Ives (2003), University of Judaism 'Author-Artist', 'Woman of the Year' (honored with playwright Neil Simon). *Medium:* subjects in various media range from ancient cultures to cosmic abstractions. *b:* San Francisco. *d of:* Jean and Mildred Blum. one *s.* one *d. Studied:* University of California; workshoprs USC, UCLA, Otis-Parsons, Art Center School California; Art Students League NY, New Mexico and Mexico City. *Exhib:* solo: Los Angeles City Hall, Thinking Eye, Heritage, Skirball Museum LA, USC; galleries: Ludmilla Raczynski NY, Matsuzaki Tokyo, Engel Jerusalem; group: Hawarden, Wales; Durham Castle, Windsor, Royal Society of Artists Brimingham; California Museum Science and Industry; various venues throughout US, Japan, Israel and Mexico. *Works in collections:* Kyoto Museum of Fine Art, Japan; Skirball Museum, Los Angeles; American President Lines; Mauser Corporation, Germany; Mogi Industries, Japan. *Clubs:* NAPA UK/USA, International Association of Experimental Artists, Women Painters West, National Association of Painters in Casein/Acrylic. *Signs work:* Shirley Levine. *Address:* 1201 Laurel Way, Beverly Hills, California 90210, USA.

LEWIS, Ann, R.C.A., B.A.; artist/illustrator in gouache, water-colour, mixed media, pencil, ink; printmaker: linocutting, etching. *b:* St. Asaph, N. Wales, 29 Aug 1962. *Studied:* Exeter College of Art and Design (1985-88). *Exhib:* Royal Cambrian Academy - Conwy, W.A.C., National Library of Wales, Mostyn Gallery, Wales Open, Clwyd Open, Mercier Gallery, Albany Gallery - Cardiff, Tegfryn Gallery - Anglesey, Hanover Galleries - Liverpool, Royal Exchange Theatre - Manchester, Plas Glyn y Weddw-Llyn. *Works in collections:* National Library of Wales. *Publications:* books illustrated: eight children's books, one collection of poetry, numerous illustrations for published articles. *Signs work:* "Ann Lewis." *Address:* 6 Well St. 2, Gerlan, Bethesda, Gwynedd LL57 3TW. *Email:* ann@annlewis.co.uk *Website:* www.annlewis.co.uk

WHO'S WHO IN ART

LEWIS, Charles Walter Edward, A.R.C.A., F.R.B.S., A.W.G., Royal Exhibition and Continuation Scholarship (1946); sculptor in stone and wood; Head of Sculpture, Kingston College of Art (1947-78). *b:* Southsea, 18 Jul 1916. *s of:* Charles A. Lewis. *m:* Margaret Parkinson. two *s.* one *d. Educ:* Portsmouth Southern Secondary School. *Studied:* Portsmouth College of Art (1932-36), Royal College of Art, under Prof. Richard Garbe (1936-39). *Exhib:* retrospective, Weston Press Gallery, New York (1983). *Commissions:* sculpture commissioned by the Ministry of Public Building and Works, The G.L.C. and several private architects. *Address:* 4 Ancien Chemin D'Agel, 11120 Bize-Minervois, France. *Email:* charles.lewis@wanadoo.fr

LEWIS, Christopher Conrad Strafford, RCA, NDD(1950), ATD(1951), RCA (1964); sculptor in clay, woodcarver and printmaker; lecturer in art history & drawing, Chester School of Art, visiting lecturer - North Wales, Liverpool. *b:* Woodford, Essex, 15 Jul 1922. *s of:* Dr.J.B.S.Lewis MD. *m:* Marjory Rae. two *s.* three *d. Educ:* Epsom College, Royal Signals 1942-46. *Studied:* Ealing (1946-1950) under Tom Bayley, Hornsey (1951). *Represented by:* Royal Cambrian Academy. *Exhib:* Chester, Liverpool, London, St. Albans, Amsterdam, Wales. *Works in collections:* many private collections. *Commissions:* various, including Chester Canoe Club, Queens School, British Legion. *Publications:* Songs of William Shakespeare. *Recreations:* Modern Art, travelling, watching rugby and cricket matches, literature. *Clubs:* Royal Society Art Education (Retired Member). *Signs work:* "CONRAD LEWIS." *Address:* Appletrees, 19 Fish St., Redbourn, Herts. AL3 7LP.

LEWIS, Cynthia, ASWA (2007); DipHE Art & Design. *Medium:* Sculpture: animals and birds in bronze and stone carvings. *b:* Finchley, 14 Sep 1937. three *s. Educ:* henrietta Barnet School; Clarks College. *Studied:* Camden School of Art; NE London Poly (now University); The Institute School of Art. *Exhib:* SWA (2000, 2002, 2005, 2007); Wildlife Society (2005, 2007); Chelsea Art Society (2007); The Institute Annual Show (1994-2002, 2004-2007). *Recreations:* reading, making patchwork quilts, 3D decoupage. *Signs work:* 'C.L.', or 'C.LEWIS', or 'CL' (monogram). *Address:* 15 Kenver Avenue, Finchley, London N12 0PG. *Email:* cynthialewis@sculptures.demon.co.uk

LEWIS, Dennis, R.W.A. (1979), F.C.S.D. (1986); artist in oil, acrylic, watercolour; Design Group Chairman (retd.). *b:* Bristol, 2 Apr 1928. *s of:* Francis George Henry Lewis. *m:* Irene Margaret. one *s.* two *d. Educ:* F.A.S. Bristol. *Studied:* No. 3 Army College (1948, Mervyn Levy), West of England College of Art (1948-52). President, Bristol Savages (1972, 1979, 1989). *Signs work:* "Dennis Lewis." *Address:* 4 Oatley House, Cote Lane, Bristol BS9 3TN.

LEWIS, Jane, Dip AD (1974), Slade School (1977); Artist in Residence Kent Opera (1985); Slade Prize 1977; Henry Moore Fellowship in Drawing (1992-93); Arts Development Grant from Arts Council England (2006-08). *Medium:* oil on canvas, pastel, conte crayon (earlier work in etching and watercolour). *b:* London,

23 Feb 1953. *Educ:* Hornsey College of Art (1970-74); Slade School (1975-77). *Represented by:* Portal Gallery, 15 New Cavendish Street, London W1G 9UB. *Exhib:* solo: Royal Museum Canterbury; Gardner Centre, Brighton; Portsmouth City Museum; Ramsgate Library Gallery, Marcus & Marcus Amsterdam; Cartwright Hall, Bradford; Collins Gallery, Glasgow; Rye Art Gallery, Sussex; UCL Strang Print Room; Portal Gallery, LondonGallery II, University of Bradford. Selected group shows: Curwen Gallery London, Fitzwilliam Museum Cambridge, Hunting Group Mall Galleries, NPG London, Mercer Gallery Harrogate, Palais Royal Paris, Arnolfini Gallery, Bristol. *Works in collections:* UCL, Unilever plc, South East Arts, Manchester City Art Galleries, Trinity Arts Centre Tunbridge Wells, Leicester School and Colleges Collection, Royal Museum and Art Gallery Canterbury, Provident Financial Art Collection, Sheffield University Fine Art Society, Brown's Hotel London, also many private collections. *Commissions:* South East Arts, Etchings of Kent Opera (1985); Kent Opera 20th Anniversary, watercolours; portrait of Andrew Shore (singer) as Falstaff at ENO; several private commissions. *Publications:* 'Women's Images of Men' ICA (1980), 'Pandora's Box' ed. Calvert, Morgan & Katz (1984), SE Arts Annual Report 'Fashioning a Future' (1986); 'Extending the Medium', The Artist (1988); 'Jane Lewis' Cartwright Hall Bradford (1991); Nouveau Magazine, Amsterdam (1993); Portal Gallery Publications (1994-2008); 'Still Life with a Twist' Artists & Illustrators (2005); 'Masking Reality', Anne Ellis/Uptown Magazine (2005). *Works Reproduced:* Mslexia Magazine (Faber & Faber); Bloodaxe Books; The Sciences magazine; Univers des Arts (Paris); Obsession Publishing; have published limited edition Seri Graphs; Christie's Contemporary Art. *Signs work:* "Jane Lewis". *Address:* 29 Gledhow Wood Close, Leeds, LS8 1PN. *Email:* jlew_art@yahoo.co.uk *Website:* www.janelewisartist.com

LEWIS, Jane, BA Hons (Fine Art). *Medium:* oil, watercolour, drawing. *b:* Bedfordshire, 3 Oct 1951. *d of:* Marjorie & Sylfanus Lewis. two *s. Educ:* University College of Wales (Aberystwyth). *Exhib:* RA; NEAC; Fry Gallery, Saffron Walden; Mall Galleries; The Wall, Ely; solo exhbns: (Andrew) D'Arcy Gallery, Ipswich; widely exhibited in East Anglia and UK. *Publications:* included in: 'Artists at Walberswick' by Richard Scott (2002). *Works Reproduced:* East Anglian Daily Times; Suffolk Journal. *Clubs:* Hollyfarm Studio. *Signs work:* 'JLewis'. *Address:* 12-14 Swan Street, Boxford, Sudbury, Suffolk CO10 5NZ. *Email:* jalewis@mac.com

LEWIS, John, A.K.C., B.Sc. (1950), ex F.L.S., M.F.P.S. (1974), Dip.V.A. (Lond.) (1980); phanerogamic taxonomist, poet and amateur artist in oil; recently International Conifer Registrar. *b:* Chingford, 25 Nov 1921. *s of:* A. H. C. Lewis, bank clerk. *Educ:* City of London School, Kings College, London. *Studied:* Richmond Adult College and Field Studies Council. *Exhib:* F.P.S. and privately. *Publications:* numerous scientific papers and one poem. *Signs work:* uses ideogram, a rhomboid with two verticals included. *Address:* Applefield, North Street, South Petherton, Somerset TA13 5DA.

LEWIS, Roger, Leslie, President: The Society of Graphic Fine Art (SGFA) since 2006. Tutor in Fine Art at the Ripley Arts Centre, Bromley, Kent, since 2001 (part-time), 'Signature' member of the United Kingdom Coloured Pencil Society (UKCPS); Awarded 'Annie Longley' Award, 2005, Pastel Society Exhibition. *Medium:* oil, watercolour, drawing, scraperboard etching. *b:* Strood, Kent, 2 Sep 1939. *s of:* Winifred and Leslie Lewis. *m:* Elaine, Lilian. one *s.* one *d. Educ:* Rochester (Kent) Technical College, Rochester Art College. *Studied:* Sutton and Cheam School of Art (5 year full-time National Diploma course, 1954-59, NDD). *Represented by:* self. *Exhib:* Group show Lauderdale House, Islington, London (1999/2000). Solo exhibition, The Ripley Arts Centre, Bromley (2001). Group Exhibition: Hotbath Gallery, Bath (2001/2/3). Group Show at Gallery 27 Cork Street, London (2004). Exhibitor with Chelsea Art Society (2001), Pastel Society at Mall Galleries (2004/5/6). Group show at Menier Gallery, London (2005/6/7/). Has exhibited with the Croydon Art Society since 1998. *Works in collections:* works in private collections worldwide. *Commissions:* portraiture. *Publications:* work featured in "Painting World" magazine (2000). *Works Reproduced:* Pastel painting: "Windfall at Sunrise" featured in "International Artist" book "How Did You Paint That?". *Principal Works:* pastel paintings, scraperboard drawings, coloured pencil works. *Recreations:* photography, art lectures/critiques at art society meetings. *Misc:* writes features and demonstrations for the art press. *Signs work:* "ROGER LEWIS". *Address:* 27 Lorne Avenue, Croydon, Surrey, CR0 7RQ. *Email:* rogerlewissgfa@tiscali.co.uk *Website:* www.sgfa.org.uk

LEWIS, Sanchia, Cert. Printmaking and Cert. Advanced Printmaking (Distinction 1982);1st prize Portobello Open Exhib. (1993), Marlborough Gallery Prize,National Open Print Exhib. (1994); etcher and painter in oil, pastel, pigment stick. *b:* London, 31 Mar 1960. *m:* Jeremy Youngs. *Studied:* City and Guilds School of Art, London. *Exhib:* Honor Oak Gallery, London; Westbourne Gallery, London; Cambridge Contemporary Art, Cambrisge; Castle Gallery, Inverness; Serena Hall Gallery, Southwold, Suffolk; RA Summer Exhbn (2006); Originals 05 & 06, Mall Gallery, London; Affordable Art Fair, Battersea (2000-04); Art on Paper Fair, RCA (2001-02). *Publications:* The Art World Directory (pub.Art Review, 2002-). *Works Reproduced:* in Dictionary of International Biography, International Biographical Centre, Cambridge. *Signs work:* "Sanchia Lewis." *Address:* 50 Cheltenham Rd., Peckham Rye, London SE15 3AQ. *Email:* sanchia@sanchialewis.co.uk *Website:* www.sanchialewis.co.uk

LEWIS, Stephen, B.F.A.(Hons.); sculptor in steel;. *b:* 11 Jan., 1959. *Educ:* Deyes High School, Maghull, Merseyside. *Studied:* Southport College of Art (1976-77), Manchester Polytechnic (1977-80), Jan van Eyck Academie, Maastricht, The Netherlands. *Exhib:* New Contemporaries, I.C.I. London (1979), Kunst Europa, Germany (1991); one-man shows: Francis Graham-Dixon Gallery (1988, 1990, 1993), Holden Gallery, Manchester (1990). *Signs work:* "Stephen Lewis." *Address:* 76 Royal Hill, Greenwich, London SE10 8RT.

LEWTHWAITE, Paul Frank, ARBS. *Medium:* Sculpture. *b:* Douglas, Isle of Man, 10 Dec 1969. *s of:* Frank Charles & Edith Patricia. *m:* Sarah. *Educ:* Ballakermeen High School, Douglas. *Studied:* Isle of Man College of Further Education (1989-90); University of Sunderland (1990-93). *Represented by:* Transplant (Live) Norway; Nela Alberca Galeria, Madrid. *Exhib:* solo and group shows including venues in UK, New York, Madrid, Barcelona, Bergen and Vienna. *Works in collections:* Geldards Art at the ARC, Nottingham. *Commissions:* Wrightington Hospital, Wigan; Chesterfields Magistrates Court; Greenfields Arts Centre; UMIST, Manchester; Warwickshire College. *Principal Works:* The Generation of Possibilities (1999); A System of Support and Balance (2004). *Recreations:* music, film, literature, sport. *Signs work:* 'Lewthwaite' (and date). *Address:* 80 Melton Road, West Bridgford, Nottingham, NG2 7NF. *Email:* info@paullewthwaite.com *Website:* www.paullewthwaite.com

LEYDEN, John Michael, hon. mem., S.A. Assoc. of Draughtsmen; cartoonist in black and white; artist in water-colour and etching; staff cartoonist, Daily News, since 1939; S.A. Cartoonist of the Year (1981); awarded Papal Cross, "Pro Pontifice et Ecclesia" (1986). *b:* Grangemouth, Scotland, 21 Nov 1908. *s of:* Patrick Joseph Leyden. *m:* Annabel Eugenie Wishart. one *s.* three *d. Educ:* St. Aloysius College, Glasgow. *Studied:* Durban School of Art, Heatherley's, Central Schools of Arts and Crafts. *Exhib:* Natal Soc. of Artists, Durban Art Gallery (one-man shows). *Works in collections:* Africana Museum, Johannesburg, Durban A.G. and University of Natal (cartoons and caricatures). *Publications:* thirteen books of cartoons. *Clubs:* Patron, Natal Motorcyle and Car Club. *Address:* 233 Nicholson Rd., Durban, Natal, South Africa.

LEYSHON-JONES, Steffan, B.A. Hons. Graphic Design with Illustration (1997); visual designer; Laing National Under 25 winner 2001; photographer, artist and graphic designer. *Medium:* photo montage; oil & ink. *b:* Slough, 3 Aug 1975. *Educ:* Windsor Boys. *Studied:* Degree, Bath College of Higher Education; Central, St. Martin's, (Foundation). *Exhib:* Laing, Mall Galleries, (2000, 2001); Cabaret Voltaire, Edna Galleria, Buenos Aires (2003); Print Room, London (2000-); Cafe Corridor, Hong Kong (2004), Islington Art & Design Fair, London; West Wing Arts Centre, Berkshire; People's Bookstore, Hong Kong; various smaller exhibs. *Works in collections:* Beckford's Tower Trust, Bath, Great Western Trains, Raleigh International Chile. *Commissions:* Beckford's Tower Trust, Bath, Raleigh International Expedition artist, Chile (2002), Bath and West, www.bleep43.com. *Publications:* 'Words' -bilingual poetry and photography collaboration, with poet Ana Lema, Buenos Aires (pub. 2007, UK and Argentina); Raleigh International Calendar 2003 (Chile); Lantigua.com.ar. *Clubs:* Professional Photographers File, BANA. *Misc:* web gallery: www.untitled.co.uk. *Signs work:* "S L Jones." *Address:* 7 Colenorton Cres., Eton Wick, Windsor, SL4 6NW. *Email:* colenort@dircon.co.uk *Website:* www.urbandecoy.co.uk

LIDZEY, John, BA (1975), MSCD (1970), FRSA (1980); Daler Rowney Award, Royal Watercolour Society Open Exhibition, 1990; Kaupthing Singer &

Friedlander/Sunday Times Watercolour Competition Prizewinner,1992; artist in watercolour; formerly Senior lecturer Typographic Design, Camberwell School of Art;. *b:* London, 1935. *m:* Elsie. one *s.* one *d. Studied:* Camberwell School of Art, Hornsey College of Art - part time. *Exhib:* one-man shows, London: The Barbican Gallery, The Medici Gallery, The Heifer Gallery; one-man shows: John Russell Gallery, Ipswich; Burford Gallery, Burford, Oxon.; Linda Blackstone Gallery, Pinner, Middx. Work in collections worldwide. *Works in collections:* Europe, U.S.A., Australia. *Publications:* 'Water-colour Workshop', and 'Paint Light in Water-colour' (Harper Collins) plus two associated videos; 'Mix Your own Water-colours' (Apple Press); regular contributor to Artist magazine. *Address:* 1 London Road, Harleston, Norfolk IP20 9BH. *Email:* john@lidzey.co.uk *Website:* www.johnlidzey.co.uk

LIGHTFOOT, Katharine Lucy, BA Hons Fine Art. *Medium:* oil on canvas. *b:* Launceston, Cornwall, 24 May 1972. *d of:* Mr & Mrs D Lightfoot. *m:* Mark Hildyard. *Educ:* Kingsbridge School, Devon. *Studied:* Plymouth College of Art and Design (1989-91), University of Plymouth, Exeter Faculty (1992-95). *Exhib:* Arndean Gallery, Cork St., London; Lemon Street Gallery, Truro; Smithfield Gallery, London; Lenox Gallery, Fulham, London; Chomè Gallery, Bath. *Official Purchasers:* 505. *Works Reproduced:* 590. *Signs work:* "K.Lightfoot". *Address:* 3 Granary Mews, Parliament St., Crediton, Devon, EX17 2BJ. *Email:* footlightkat@aol.com *Website:* www.lightfootart.com

LIJN, Liliane, Honorary Degree of Doctor of Letters, University of Warwick (2005); International Fellowship, Arts Council of England (2005). *Medium:* sculpture, video. *b:* New York, 22 Dec 1939. *d of:* Herman Segall & Helena Kustanowicz. two *s.* one *d. Studied:* École du Louvre Sorbonne, Paris. *Exhib:* has exhibited extensively worldwide, both solo and group exhibitions. *Works in collections:* British Museum, London; Tate Gallery, London; Musée de la Ville de Paris, France; MoMA, New York; Chicago Institute, USA; V&A, London; Bibliotheque National, Paris; Museum of Fine Arts, Bern (Switzerland); Glasgow Museum; Museum of NSW (Australia); City Art Gallery, Manchester; Henry Moore Foundation, Leeds. *Commissions:* many commissions across UK. *Publications:* 'Liliane Lijn: Works 1959-80' (2005); 'Light and Memory' (2002); 'Powergame' (2004); 'Her Mother's Voice' (1996); 'Six Throws of the Oracular Keys' (1982); 'Crossing Map' (1982). *Recreations:* cooking, walking, gardeing, travelling. *Misc:* films: 'Look A Doll! My Mother's Story' (1999); 'What is the Sound of One Hand Clapping?' (1975). *Signs work:* 'LILIANE LIJN'. *Address:* 28 Camden Square, London NW1 9XA. *Email:* liliane@lilianelijn.com *Website:* www.lilianelijn.com

LILLFORD, Ralph, Ph.D., A.R.C.A., N.D.D.; Professor of Fine Art, Richmond University (1983-98). *Medium:* drawing and painting. *b:* Doncaster, 6 Nov 1932. *s of:* W & W Lillford. two *s.* three *d. Studied:* Doncaster Coll. of Art & R.C.A. *Exhib:* Houses of Parliament, European Parliament, Science Museum, St. Lawrence University, U.S.A., Schick Gallery, Saratoga, U.S.A., Channel

Tunnel Exhbn., Universities of Bradford, Durham, Brunel and Imperial College. Retrospective Exhbn. Doncaster (1972-92). *Works in collections:* R.C.A., R.A., B.M., V. & A., Nat. Science Museum, Nat. Army Museum, Pushkin, Moscow, State Heritage, St. Petersburg, Dunedin, N.Z., Imperial War Museum; private collections in China, Japan, Australia, Sweden, Holland, France, Spain, Hungary. *Commissions:* 'Crucifixion' mural, Mudgereeba Church, Queensland, Australia; Melbourne Gold Cup (oil); portraits of: David Doyle, O.M., Gary Neihl, O.M., MP; Gary Baildon, Mayor, Gold Coast; Donald Jackson, ATC, MVO; Clara Rodriguez, concert pianist; David Helfgott, concert pianist. *Publications:* unpublished PhD thesis 'A Method of Establishing the Sequence of Printing William Hogarth's Hudibras Prints'. *Works Reproduced:* in catalogues. *Principal Works:* National Army Museum, Chelsea, London. *Misc:* Taught: Richmond University (1983-98), Barnes Boys School, Slough College of FE, and in U.S.A., Russia, Holland, France, Italy, Aborigine Centres in Australia; sons: Pascal, Martyn; daughters: Elsa, Liana, Maia. *Address:* 47 Creffield Rd., Ealing, London W5 3RR. *Email:* ralphlillford@hotmail.com

LILLINGSTON, Joyce Olive Mary, (Mrs.Kastner); National Certificate of Art; ARMS(1972), HSF(1983); artist in water-colour and acrylic. *Medium:* watercolour, oil, acrylic, tempera, linocuts. *b:* India, 11 Mar 1922. *d of:* Lt.Col. Edward Lillingston. *m:* Prof. Leslie James Kastner (decd.). *Educ:* St.Swithins School, Winchester. *Studied:* Byam Shaw School (B. Thomas, P. Greenham, B. Dunstan), Exeter Art School. *Exhib:* Walker Gallery (1959), Eastbourne Art Soc., R.A. (1950, 1965); Michelham Priory (solo show)(1966), Royal Portrait Society, Mall Galleries, RMS Westminster Hall, HSF Wells Town Hall, Marine Artists, six one-man shows and many mixed shows. *Works in collections:* many in private collections. *Commissions:* five miniature portrait commissions (1997, 1998(x2), 1999, 2000), miniature commissions of adults, children, dogs, cats, yachts. *Works Reproduced:* several landscapes on postcards. *Recreations:* riding, gardening. *Clubs:* Campden Hill, Eastbourne Art Soc. *Address:* Moor Cottage, Belstone, Okehampton EX20 1QZ.

LIMBREY, John Nigel Stephens, N.D.D. (1953), M.C.S.D. (1969); Freeman of the Worshipful Company of Goldsmiths, City of London; silversmith and product designer; artist in water-colour and oil; landscape, architectural and marine subjects. *b:* Hatfield, 2 Feb 1933. *Educ:* King Edward's School, B'ham. *Studied:* B'ham College of Art (1949-53). *Exhib:* R.I., R.W.S., R.S.M.A. *Works in collections:* worldwide. *Signs work:* "Limbrey." *Address:* Silk Mill Cottage, Chipping Campden, Glos. GL55 6DS. *Website:* www.fossewayartists.com

LIN, Hsiao-Mei, BA (1994), MA (1997); Crabtree & Evelyn Scholarship, Taipei City Museum of Fine Arts, Taiwan; Tony Smith Landscape Prize; David Murray Landscape Scholarship; Winsor & Newton Young Artist Award. *Medium:* painter in oil. *b:* Taiwan, 7 Oct 1971. *Educ:* Royal Academy Schools of Art, London(Norman Adam); University of Brighton; Fu Hsin School of Arts, Taipei, Taiwan. *Exhib:* solo shows: Adam Gallery, London, (1999, 2000, 2002, 2004,

2006, 2008), University of Oxford St.Anne's College (1999), Bohun Gallery, Henley, Oxon (2002) etc. Group shows: Arts Fair, London (1997-2007), Artfair 20th Century, New York (2002, 2006), Artfair Palm Beach, Miami USA (2003), art4life, Christie's (2002-03), Singer and Freidlander (2002), Royal Academy Summer Shows and many more in UK and abroad since 1988. *Works in collections:* USA, UK, Europe and Far East, corporate and private. *Publications:* Art Review '97, Autumn RA Magazine. *Clubs:* RASA (Royal Academy Schools Alumni). *Address:* Flat 4, 29 Pleshey Road, London N7 0RA. *Email:* lin.hm@hotmail.com *Website:* www.hmlin.co.uk

LINDGREN, Carl Edwin, M.Ed., Ed.S., F.C.P., D.Ed., F.R.S.A., F.R.A.S., F.Coll.P. (Essex), A.S.I.I.P.C. (New Delhi); Faulknerian landscape photographer, art historian, antiquarian. *b:* 20 Nov 1949. *s of:* Carl and Ruby K. (Corder). *Educ:* University of Mississippi, College of Preceptors (Essex), U.N.I.S.A. *Exhib:* Center for Faulkner Studies, Center for the Study of Southern Culture, The Cossett Gallery, Northwest College Art Gallery, The University of Mississippi, India Intl. Photographic Council (New Delhi), Manipur University Museum, etc. *Publications:* over 200. *Signs work:* "C.E. Lindgren." *Address:* 10431-Hwy 51, Courtland, MS. 38620, U.S.A. *Email:* celindgren@panda.com

LINDSAY, Rosemary, S.B.A.; botanical illustrator in water-colour, pen and ink. *b:* Croydon, 22 Jun 1939. *s of:* Douglas & Georgina Gough. *m:* Crawford Lindsay. one *s.* one *d. Educ:* Croydon High School. *Studied:* Kingston School of Art (1957-60, architecture: Eric Brown), Morley College (botanical illustration: Margaret Merrett). *Exhib:* S.B.A. yearly, British Council Travelling Exhbn., Morley College, Horniman Museum, Battle Gallery, The Other Dulwich Picture Gallery, Limpsfield Gallery, Art in Action at Waterperry, Oriel Ynys Môn Anglesey, Everard Read, Johannesburg, S.A., Pashley Manor, many private collections. *Works in collections:* Archive of the Florilegium Society of The Chelsea Physic Garden; many private. *Commissions:* RHS. *Publications:* illustrations in R.H.S. Journals and Herb Soc. Journals. *Works Reproduced:* cards and prints published by Aria Cards. *Recreations:* music, reading, travel, gardening, galleries. *Signs work:* "Rosemary Lindsay." *Address:* 5 Burbage Rd., London SE24 9HJ.

LINDSLEY, Kathleen Margaret, BA Hons Fine Art (1976). *Medium:* wood engraving. *b:* Gibraltar, 26 Jul 1951. *d of:* Richard Harford Lindsley. *m:* Nicholas Carter. one *s.* one *d. Educ:* Burford Grammar. *Studied:* Newcastle-upon-Tyne Polytechnic. Introduced to wood engraving by Leo Wyatt. *Represented by:* self. *Exhib:* London, Oxford, York, Leeds, Halifax, Kendal, Edinburgh, Glasgow, Inverness, Orkney. *Works in collections:* V & A. *Commissions:* illustration, design, bookplates, architecture. Private press work: Perpetua, Black Pennel, Partick, Wild Hawthorn. *Publications:* Collins Love Poems, Folio Golden Treasury, An Engravers Globe. *Clubs:* Society of Wood Engravers. *Address:* Raven Press Gallery, Colbost, Dunvegan, Isle of Skye, IV55 8ZS. *Email:* raven@kathleenlindsley.co.uk *Website:* www.kathleenlindsley.co.uk

LINES, John, RSMA; Awards: Museum of Modern Art, Wales (1st Prize); RBSA Daler Rowney winner (three times); RSMA (1st Prize); Wellingboro Arts Festival (1st Prize). *Medium:* oil. *b:* Rugby, 3 Aug 1938. *s of:* Mr & Mrs E E Lines. *Educ:* Rugby College. *Studied:* York Art School. *Represented by:* RSMA, RBSA, Red Rag Gallery; Tyler/White Gallery, USA. *Works in collections:* P&O Ships; Fisher Everard Ships; Rugby Council; Nuneaton Council; Birmingham Civic Society. *Publications:* RSMA Marine Art; Millers Art Guide 2003. *Recreations:* cycling, walking. *Clubs:* Rugby Arts Soc., Kineton Arts Soc. *Signs work:* 'J.W. Lines'. *Address:* 12 Wesley Road, Hillmorton, Rugby, CV21 4PG.

LINFIELD, John Leslie, R.W.S. (1988), N.E.A.C. (1982), A.R.C.A. (1953); painter in oil and water-colour;. *b:* Carshalton Beeches, Surrey, 5 Jan., 1930. *Educ:* Sutton County School. *Studied:* Wimbledon School of Art, R.C.A. *Exhib:* R.A., R.B.A., R.P., N.E.A.C.; one-man shows, Trafford Gallery (1961, 1963), Ditchling Gallery (1964, 1965), Halifax House, Oxford (1972), Waterman Fine Art (1991), "Venice in Peril" W.H. Patterson since 1992. *Commissions:* Spink & Sons Ltd., Milton Abbey School, Dorset, Hove Museum and A.G., John Dickinson Ltd., Winsor and Newton Ltd. *Signs work:* "JOHN LINFIELD." *Address:* The Old Armoury, Court Barton, Crewkerne, Somerset TA18 7HP.

LIPTON, Laurie, BA Fine Art (Hons). *Medium:* drawing. *b:* New York, 11 Nov 1953. *Studied:* Carnegie-Mellon University, Pittsburgh, USA. *Represented by:* Henry Boxer Gallery, Copro Nason, Los Angeles; Strychnin Gallery (New York, Berlin, London), TAG Gallery, Nashville, USA; Cabinodd, Holland. *Exhib:* recent selected solo shows: Espacio para el Arte, Madrid (2007), Micaela Gallery, San Francisco (2006); mixed shows include: Strychnin Gallery, New York (2007), American Visionary Art Museum, Baltimore (2006, 2007), Giger Museum, Zurich (2006), East West Gallery, London (2005), Casa-Decor, Valencia (2004), Orleans House Gallery, Twickenham (2004). *Commissions:* Illuminated manuscripts include: "Splendor Solis", "Mutus Liber" and "Atalanta Fugiens" (for Bibliotheca Philosphica Hermetica, Amsterdam). *Publications:* Juxtapoz Magazine, Du Fantastique Au Visionaire, Metamorphosis ("50 Contemporary Surreal, Fantastic and Visionary Artists"), The Art and Meaning of Women's Altars. *Works Reproduced:* in many lit. magazines and art magazines. *Signs work:* "LLipton". *Address:* 12 Steeple Court, Coventry Road, London E1 5QZ. *Email:* laurielipton@yahoo.co.uk *Website:* www.laurielipton.com

LISTER, Caroline Nicola Josephine, B.A.Hons. (1980), A.R.B.A.; painter and printmaker; printmaking tutor, Guildford College of Art (1980); Director and tutor, Tyger, Tyger Printmaking, Cambridge (Intaglio Printmaking Workshop); Steering Group mem. Cambridgeshire Regional College (1989);. *b:* Cambridge, 30 Mar 1958. *d of:* Brian Lister, designer of Lister-Jaguar racing car. *Educ:* Perse School, Cambridge. *Studied:* Cambs. College of Arts and Technology (1976-77), W. Surrey College of Art and Design (1977-80). *Exhib:* R.B.A., R.E., R.I., P.S., R.W.S., S.W.A., C.D.S. *Misc:* studio: Tyger, Tyger Printmaking, Studio One, 37

City Rd., Cambridge CB1 1DP. *Signs work:* "Nicola Lister." *Address:* 79 St. Philips Rd., Cambridge CB1 3DA.

LITTLER, Ken, landscape and seascape painter in pastel. *b:* Liverpool, 15 Aug 1925. *Exhib:* Sarah Samuels Fine Paintings, Chester; Waterman Fine Art, London; Burford Gallery, Cotswolds; Datchet Gallery, Windsor, as guest of the Pastel Soc. *Works in collections:* England, Japan, Australia, U.S.A., Saudi Arabia. *Signs work:* "K. Littler." *Address:* 172 Booker Ave., Liverpool L18 9TB.

LLOYD, Reginald James, R.I.; self taught artist in water-colour, oil, acrylic. *b:* Hereford, 21 Dec 1926. *m:* (1) Diana van Klaveren (decd.) (2) Louise MacMillan. three *s.* four *d. Educ:* Dawlish Boys and County Senior School. *Exhib:* 'Portrait of the Artist' Tate Gallery, etc. *Works in collections:* Tate Gallery, V. & A., National Maritime Museum, Hatton Gallery Newcastle, Burton Gallery Bideford. *Publications:* illustrated: What is the Truth by Ted Hughes, The Cat and the Cuckoo by Ted Hughes, The Mermaid's Purse by Ted Hughes. *Signs work:* "R.J. LLOYD," "R.J.L." or "R.J. Lloyd." *Address:* Iffield, North Rd., Bideford, Devon EX39 2NW.

LLOYD-JONES, Pamela, Dip.Art Ed. (Sydney) 1968, B.A. Fine Art (Sydney); artist in mixed media and acrylic; specialising in portraiture. *b:* Australia, 4 Jan 1947. one *s.* one *d. Exhib:* Australia, France, Canada, USA, Great Britain. *Signs work:* "P. Lloyd-Jones." *Address:* 7 Roman Close, Acton, London W3 8HE. *Email:* pamelalloydjones@hotmail.com *Website:* www.pamelalloydjones.com

LLYWELYN HALL, Dan, BA (Hons); Sunday Times Artist of the Year 2003. *Medium:* oil, watercolour, drawing, prints. *b:* Cardiff, 18 Aug 1980. *s of:* Bridget & Timothy Hall. *Studied:* Cardiff UWIC (Wales)- Foundation Diploma; University of Westminster, Harrow Campus (BA (Hons) Illustration)). *Represented by:* Roman Black Gallery, London; Washington Gallery, Wales. *Exhib:* Roman Black Gallery, London (2007); Washington Gallery, Wales (2005, 2004), Martin Tinney (2005), The Art Shop (2005), Brecknock Museum, London Art Fair (2007, 2006), Wales Millennium Centre (2006), Albemarle Gallery (2005), Mall Galleries (2006, 2003), St.Davis's Hall (2006, 2004), The Albany Gallery (2004). *Works in collections:* MoMA Wales (Tabernacle Collection), Newport Museum and Gallery, Tenby Museum and Gallery, Houses of Parliament, BT Corporate Collection, Barclays Bank. *Publications:* Matter of Time catalogue, Culture magazine (Times, Sept 2003), Western Mail (numerous). *Principal Works:* Sunday Times, 'Ship Hotel de Splash', 'Fan Hir', 'The Palace of Westminster as a Party Goes By'. *Signs work:* "DLH" or "Dan Llywelyn Hall". *Address:* 22 Stanley Road, South Harrow, Middx., HA2 8AZ. *Email:* danllywelynhall@yahoo.co.uk *Website:* www.danllywelynhall.co.uk

LOBANOV-ROSTOVSKY, Princess Roxane, S.W.A.; water-colourist sculptor in alabaster, marble. *b:* Athens, 3 Oct 1932. *d of:* R. Bibica-Rosetti, Greek Ambassador. two *s.* one *d. Educ:* St. George's Ascot, Pretoria Girls High

WHO'S WHO IN ART

School. *Studied:* Carlton University, Ottawa; Brighton Polytechnic (Norma Weller, Norman Clarke, R.W.S.). *Exhib:* numerous exhbns. R.I., R.W.S., R.O.I., R.S.M.A., S.W.A.; one-man shows: The Grange, Rottingdean (1987), Art Gallery, Kettering. *Works in collections:* in U.S.A., Austria, U.K., France, Italy, UK, India. *Commissions:* Dream of Gerontius for P. Foss Esq., Standing Stones for B. White Esq. *Publications:* mentioned in D.Rook-Hart 20th C. Marine Painting. *Works Reproduced:* limited edition prints of all watercolours. *Principal Works:* Dream of Gerontius, Othello, Ophelia, Prince Ieor. *Recreations:* Opera, Classical Music, Sailing, Climbing. *Signs work:* "R. Lobanov-Rostovsky." *Address:* Swallowdale, 67 Woodruff Ave., Hove, E. Sussex BN3 6PJ.

LOCKHART, David, RSW (1969), DA(Edin.) (1944), EIS Purchase Award (1984); artist in acrylics, oil and water-colour. *b:* Leven, Fife, 4 Nov 1922. *s of:* Thomas Lockhart, miner. *m:* Jean Lockhart. one *s.* two *d. Educ:* Beath High School, Cowdenbeath (1934-40). *Studied:* Edinburgh College of Art (1940-46). *Exhib:* Carnegie Dunfermline Trust Festival of Arts (1972), Byre Theatre (St. Andrews) (1996), Richmond Hill Gallery (1997), Billcliffe Gallery Glasgow (1997), 'Loomshop' Gallery, Lower Largo Fife (1988), 'Frames' Gallery Perth (1994); one-man show: Opening of Byre Theatre, St. Andrew's (June 2001), 'Frames' Gallery, Perth (2006). *Works in collections:* Scottish Committee of the Arts Council, W. Riding of Yorkshire Educ. Authority, Carnegie Dunfermline Trust, Fife County Council, Dunbartonshire Educ. Authority, Harry Cruden Coll. (Pitlochry Festival Theatre), E.I.S. award, R.S.W. (1984). *Commissions:* 19 x 12ft. mural "Many Mansions" Benarty Primary School, Fife (1963); commemorative painting – Moss Moran Pit Disaster 1901; Private collections: Germany, Scotland, America. *Publications:* 'Unforgotten' (Autobiography 2007). *Recreations:* traditional fiddle (TMSA). *Signs work:* "David Lockhart" (paintings). *Address:* 138 Cocklaw Street Kelty Fife KY4 0DH. *Email:* jlockhart11@btinternet.com *Website:* RSW Lockhart

LOCKWOOD, Arthur, RBSA (1994); RBA (2001); NDD (1954); ARCA (1959); ARWS (2006). *Medium:* watercolour. *b:* Birmingham, 27 May 1934. *s of:* Frank T.Lockwood. *m:* Gillian Newing. two *s. Studied:* Birmingham College of Art; RCA. *Exhib:* RBA, Mall Galleries; RBSA, RBSA Galleries, Birmingham; RWS Bankside Gallery. *Works in collections:* Walsall Museum & Art Gallery; National Coal Mining Museum; Birmingham Museum and Art Gallery; Museum of Richmond. *Publications:* 'Change in the Midlands' (2007). *Signs work:* 'Arthur Lockwood' or 'AL'. *Address:* Kingswood Hollow, Mill Lane, Lapworth B94 6HT.

LODGE, Jean, R.E., B.A. (Miami), M.A. (Oxon.); painter/printmaker; Emeritus Fellow of New College, Oxford. *Medium:* colour woodcuts, collages. *b:* U.S.A., 1941. *d of:* Cora Stier Lodge. *Educ:* Miami University, Ohio, Oxford University. *Studied:* Beaux Arts de Paris, Atelier 17 with S.W. Hayter. *Exhib:* solo shows: Europe, Japan, India, Argentina, Venezuela, U.S.A., etc.; numerous international print shows. *Works in collections:* Museums in Europe and N. and

S. America; Galerie Schweitzer, Luxembourg; Broughton House Gallery, Cambridge; Bankside Gallery, London. *Address:* 52 Granville Ct., Cheney Lane, Headington, Oxford OX3 0HS.

LOFTHOUSE, Hermione Thornton, NS; painter in water-colour, oil and pastel; tutor, Moor Park College (1968-82); Master Classes for Richmond-upon-Thames Arts Council (1982, 1983), Adult Educ.;UA (1975-2002), VP Ridley Art Soc. *b:* Chelsea. *d of:* Prof. Charles Thornton Lofthouse, musician. *m:* F.H. Lockyer. three *s. Educ:* St. Paul's Girls' School. *Studied:* Heatherleys' (1946-50) under Iain Macnab, Académie Julian and La Grande Chaumière (1950); cert. History of Art, Courtauld Inst. *Exhib:* Paris, Germany, N.Z. Academy, Bombay Museum, W.A.G., Artists of Chelsea, R.B.A., R.O.I., etc.; eleven solo shows, Upper St. Gallery, Mall Galleries, Ice House - Holland Park, Surrey Univ. *Works in collections:* Richmond Parish Charity Lands, R.A.M., Surrey Univ., Guildford House Museum etc. *Publications:* The Art of Drawing and Painting. *Signs work:* "H. Thornton Lofthouse." *Address:* 48 Compton Way, Farnham, Surrey GU10 1QU. *Email:* htl@amserve.com

LOGAN, Andrew, Dip.Arch.(Oxon.); sculptor in glass. *Medium:* glass. *b:* Witney, 11 Oct 1945. *s of:* William Harold Logan. *Educ:* Lord Williams' Grammar School; Burford Grammar School. *Studied:* architecture: Oxford School of Architecture (1964-70). *Exhib:* ICA (1970), Whitechapel AG, Beverly Hills, LA, Ebury Gallery, Space Gallery, Faerie Fair, Norfolk, Crafts Council, Sandbeck Hall, Yorks., Sculpture Pk., Portland Bill, Commonwealth Inst., German Film Museum, Frankfurt, Hotel Meridian, Singapore, Botanical Gdns., Rome, Angela Flowers (Ireland) Inc., Flowers East (1991), Old Library, Cardiff (1991); first one-man show: New Art Centre, London (1973); retrospective: Museum of Modern Art, Oxford (1991), 'The Happy Heart show', Manchester City Art Galleries (1995), Moscow Art Fair (1996), 'Reflections of the Heart' Show, Monterrey, Mexico (1997), 'Love' AVAM Baltimore, USA, 'Magic Moments' Ruthin, British Figurative Art, Flowers East, 'Britain in Russia', Ekaterinburg, Russia (1998), 'Universe of Smiles' Expo 2000, Hanover, Germany; 'Glittering Glass' Cheltenham Museum (2000); Summer Exhibition RA (2001); Alternative Miss World Film Show, Norwich (2002); 'Universe of Smiles', Flowers West, LA (2003). *Works in collections:* Andrew Logan's Museum of Sculpture, Berriew, Powys; NPG; Australian Gallery of National Art; Arts Council of Britain; Warner Bros UK; Costume Inst.; MoMA, New York; Curzon Tussaud, London; Cleveland Jewellery Collection, Middlesbrough; Museo de Vidrio, Mexico; HM Queen Elizabeth the Queen Mother; Brian Eno; Derek Jarman; Julie Christie; Zandra Rhodes; Elton John. *Commissions:* Dudley Council; Cheltenham Art Museum; P&O; American Visionary Art Museum, Baltimore USA. *Principal Works:* 'Alternative Miss World' 1972, 1975, 1978, 1981, 1985, 1986, 1991, 1995, 1998 and 2004. *Signs work:* Andrew Logan. *Address:* The Glasshouse, Melior Pl. London SE1 3SZ. *Email:* andrewl@andrewlogan.com *Website:* www.andrewlogan.com

LOIZOU, Renos, painter in oil on canvas, oil on paper and board. *b:* Cyprus, 24 Jan 1948. *s of:* Andreas Loizou, tailor. *m:* Susan. one *s.* two *d. Educ:* Shrubbery School, Cambridge. *Studied:* Cambridge School of Art (1963-66, Alec Heath). *Exhib:* Kettles Yard, Cambridge (1974, 1981), I.C.A. (1975), Orangerie, Cologne (1976), Peterborough Museum of Art (1982), Christopher Hull Gallery, London (1982, 1985, 1987, 1989, 1991), Fine Art Soc. (1990), Fitzwilliam Museum, Cambridge (1990); many mixed shows and overseas exhbns. *Works in collections:* Kettles Yard, Fitzwilliam College, Gonville and Caius College, Magdalene College, Cambridge, M. of E. Cyprus, Arts Council Denmark, University of Surrey, B.P. Coll., Baring Bros., W.H. Smith plc. *Publications:* book cover, Voices of Czechoslovak Socialists. *Clubs:* Chelsea Arts, National Arts N.Y. *Signs work:* "Renos Loizou." *Address:* Girton Gate, Cambridge CB3 0LH.

LOKEN, Julia, SBA. *Medium:* watercolour. *b:* Worthing, 28 Oct 1939. *d of:* John & Norah Petty. *m:* James. one *s.* one *d. Educ:* Faringdon Grammar School. *Studied:* self-taught. *Exhib:* solo: Oxford area, 18 exhibitions (1982-2006); Geneva, Switzerland (1986, 1990, 1995, 1999); Dijon, France (1990); Gerald Peters Gallery, Santa Fe, USA (2005, 2007). *Works in collections:* in Switzerland, France, England, USA. *Commissions:* Sultan of Oman, 2005. *Recreations:* gardening, walking, travel. *Clubs:* Eynsham Arts Group. *Signs work:* 'Julia Loken'. *Address:* Myrtle Cottage, Tanner's Lane, Eynsham, Oxon, OX29 4HJ. *Email:* julia@loken.co.uk *Website:* www.loken.co.uk

LOKER, John Keith, D.A. Graphic Design (1958), A.R.C.A. Fine Art (1963); painter in oil;. *b:* Leeds, 15 Sept., 1938. *m:* Emily Mayer, sculptor. two *s. Studied:* Bradford Regional College of Art (1954-58), Royal College of Art (1960-63). *Exhib:* over 30 one-man exhbns. in U.K. and abroad. *Works in collections:* Tate, Arts Council, Power Inst., etc. *Commissions:* Watmough Holding, Bradford, Essex General Hospital, I.T.N. Building (Norman Foster). *Clubs:* Chelsea Arts. *Signs work:* "John Loker," occasionally "J.L." *Address:* Union Workhouse, Guilt Cross, Kenninghall, Norfolk NR16 2LJ.

LONG, Denny Jane, RWA; MA, DipAD, BEd, ATD, NSA (Newlyn Society of Artists) Penwith Printmakers. *Medium:* acrylic & collage, drawing, prints, installation. *b:* Bristol, 4 Nov 1948. *d of:* Harold & Linda Johnston. *m:* Richard Long (1969-98). two *d. Educ:* Redland High School, Bristol. *Studied:* West of England College of Art (now UWE)(1963-67, DipAD Ceramics); Falmouth College of Art (MA Fine Art, 1996-2001). *Represented by:* Wescotts Gallery, St.Ives. *Exhib:* RA, RWA, Penwith Gallery St.Ives, Plymouth Arts Centre, Spacex Exeter, Watershed Media Centre Bristol, Bristol Museum and Art Gallery, DeptfordX, Porthminster Gallery St.Ives, Falmouth Art Gallery and Arts Centre, Mid Cornwall Gallery, Chipping Campden Gallery, St. Ives Society of Artists, St. Ives Arts Club. *Works in collections:* Wilhemina Barns-Graham, Sandra Blow. *Publications:* 'The Leach Pottery, St.Ives, and the Influence of Bernard Leach' (2005). *Principal Works:* 'The Fabrics of Life' (1996); 'Original?' (1996);

'Evidence' (2000); 'Rawhide' (2005). *Recreations:* travel, gardening, vegan cooking, dog walking. *Misc:* zen buddhist and UK representative of the Tibetan Buddhist Nuns Project. *Signs work:* japanese seal: DEN-É. *Address:* Lower Tregerthen, Zennor, St.Ives, Cornwall TR26 3BP. *Email:* djdenzen@hotmail.com

LONG, Gary Nigel, MA by Research (ADF (Manc). *Medium:* mixed media, oil, drawing. *b:* Birmingham, 10 Feb 1945. *s of:* Nigel and Irene Long. *m:* Patricia Ann Long. one *d. Educ:* Hodge Hill School, Birmingham. *Studied:* Birmingham College of Art, Margaret Street (1962-65), Manchester College of Art (School of Advanced Study, 1969). *Represented by:* Penhaven Gallery, St.Ives. *Exhib:* Society of Illustrators, E 63rd Manhattan; Webbs Road Gallery, Battersea, London; Map Works Gallery, Cornwall; Stour Gallery, Shipston-on-Stour; extensively in England, New England and British Columbia. *Commissions:* six paintings for Queen Mary II cruise liner; numerous landscape and portrait commissions. *Publications:* "The Essence". *Official Purchasers:* Slate Valley Museum, Granville, NY; Granite Museum, Barre, Vermont. *Works Reproduced:* short run from 6 paintings on Queen Mary II. *Recreations:* modern jazz, St.Ives, Jazz Club. *Clubs:* member, Society of Illustrators, New York, USA. *Misc:* part-time lecturer, Falmouth College of Art. Featured in BBC Countryfile, painting around St.Ives. *Signs work:* "Gary Long" or "Long". *Address:* 3 Restcot, Tyringham Road, Lelant, St.Ives, Cornwall, TR26 3LJ. *Email:* garylong3@aol.com *Website:* www.garylongart.com

LONG, John Cecil, B.A. Slade (1988), Higher Dip. Slade (1990), Artist in Res., Byam Shaw (1990-1991), A.R.H.A. (1995); painter in oil; lecturer at N.C.A.D., Dublin (1994-1995), lecturer at Canterbury, Christchurch University (1998 -). *b:* Portadown, N. Ireland, 30 Aug., 1964. *Educ:* St. Patrick's Boys Academy, Dungannon. *Studied:* Slade School of Fine Art (1984-1990) under Euan Uglow. *Exhib:* European Modern Art, Dublin (1993); Twentieth Century British Art Fair, London (1996); Theo Waddington Fine Art, London (1998); Jorgensen Fine Art, Dublin (1999, 2003); London Contemporary Art Fair (2001). *Works in collections:* Haverty Trust, Allied Irish Bank. *Publications:* exhib. catalogue, Jorgensen Fine Art (1999, 2003), 'British Art' (Southbank Publishing, 2006), prints and posters. *Signs work:* "LONG". *Address:* c/o Jorgensen Fine Art, 29 Molesworth St., Dublin 2, Eire.

LONGUEVILLE, James, PS (1983), RBSA (1989); landscape painter in oil, pastel and water-colour; lecturer and demonstrator. *b:* Waverton, Chester, 22 Sep 1942. *s of:* Charles Longueville Willding-Jones, B.A. *m:* Elizabeth Mary Smith. two *s.* one *d. Educ:* Sedbergh School, Cumbria. *Exhib:* ROI, PS, RI, RCA, RBSA, galleries in UK, Eire, Australia, Canada. *Signs work:* "James Longueville." *Address:* The Studio, Shocklach, Malpas, Cheshire SY14 7BW.

LOPEZ-REY, Jose, Ph.D. (Madrid, 1935); Doctor of Humane Letters (honorary, Southern Methodist University, 1979); art historian; Prof. Emeritus, New York University; Prize, Elie Faure, Paris, 1981;. *b:* Madrid, 14 May, 1905. *s*

of: Leocadio Lopez Arrojo, M.D. *m:* Justa Arroyo López-Rey. *Educ:* Universities of Madrid, Florence, and Vienna. *Publications:* Antonio del Pollaiuolo y el fin del Quattrocento; Realismo é impresionismo en las artes figurativas españolas del siglo XIX; Goya y el mundo a su alrededor; Goya's Caprichos; Beauty, Reason and Caricature; A Cycle of Cycle of Goya's Drawings: The Expression of Truth and Liberty; Velázquez: A Catalogue Raisonné of his oeuvre; Velázquez' Work and World; Velázquez: The artist as a maker. With a catalogue raisonné of his extant works (1979);. *Misc:* Vélasquez, artiste et créateur. Avec un catalogue raisonné de son oeuvre intégral (1981); Views and Reflections on Murillo (1987). *Address:* Callejón Sierra,3, 28120 Ciudad Sto. Domingo (Madrid), Spain.

LOUDON, Irvine Stewart Lees, A.R.E. (1995) R.E. (1999), B.M.B.Ch. (1951), D.M.(Oxon.) (1973), D.R.C.O.G. (1961), F.R.C.G.P. (1976); medical practitioner, medical historian, artist in etching and drawing; Annual Purchase Prize by 'Paintings in Hospitals' at Annual Exhibition by RE, Bankside Gallery (2005). *b:* Cardiff, 1 Aug 1924. *m:* Jean Loudon. two *s.* three *d. Educ:* Dauntseys School, Oxford University. *Studied:* Oxford Printmakers Co-operative (1983). *Exhib:* mixed shows with Oxford Art Soc., Oxford Printmakers Co-operative, Bankside Gallery, London; one-man shows in Oxford and London. *Works in collections:* Ashmolean Museum, Oxford. *Publications:* Medical Care and the General Practitioner 1750-1850 (O.U.P. 1986), Death in Childbirth (O.U.P. 1992), Western Medicine: An Illustrated History (O.U.P. 1997), The Tragedy of Childbed Fever (OUP 2000). *Clubs:* Oxford Art Soc., Royal Society of Painters - Printmakers (member of council). *Address:* The Mill House, Locks Lane, Wantage, Oxon. OX12 9EH.

LOVELL, Margaret, DipFA (Slade, 1962), FRBS (1973), RWA (1972); sculptor in bronze, marble, slate. *b:* Bristol, Mar 1939. *m:* Edward. two *s.* two *d. Studied:* West of England College of Art, Bristol, Slade School of Fine Art, Academy of Fine Art, Florence (Italian Scholarship 1962-63), Greek Government Scholarship (1965-66). *Represented by:* Katherine House Gallery, Marlborough; Porthminster Gallery, St. Ives. *Exhib:* City Art Gall., Bristol, RA, Marjorie Parr Gall., London (4 one-man shows); one-man shows inc. Park Square Gall., Leeds, Fermoy A.G., King's Lynn, Univ. of Bath, Bruton Gall., Somerset; 1st retrospective Plymouth City A.G. (1972), McHardy Sculpture Co. London, Bruton St. Gallery, London; Sausmarez Sculpture Park, Guernsey; Minster Art Gallery, York; Red Rag Group, Stow-on-the-Wold, R.W.A. *Works in collections:* public & private collections in UK, Europe and USA. *Commissions:* Barclays Bank, Bristol; Grafham Water, Hunts, Cadbury Heath School, Gloucestershire. *Signs work:* "M. Lovell." *Address:* 26 Victoria Road, Hanham, Bristol BS15 3QH. *Email:* mlsculpt@onetel.com *Website:* www.margaretlovell.co.uk

LOW, Bet, ARSA, RSW, RGI, Hon. D.Litt. Glasgow University; artist in oil and water-colour. *b:* Gourock, Renfrewshire, 27 Dec 1924. *d of:* John Low, engineer, tea planter. *Educ:* Greenock Academy. *Studied:* Glasgow School of Art. *Exhib:* regularly at Royal Scottish Academy, Water-colour Soc., Royal Glasgow

Inst., Fine Art Soc., and widely in U.K. and Europe. Retrospective exhbn. 1945-'85, Third Eye Centre, Glasgow (1985), retrospective exhbn. Art Club (1999). *Works in collections:* Scottish Arts Council, Glasgow, Aberdeen, Abbot Hall, Hunterian, Lillie, Perth, Waterford A.G.'s, Fife and Dunbarton Educ. Authorities, Glasgow and Strathclyde Universities, Cruden Collection, Britoil, Clyde Shipping Co., Clydesdale Bank, Flemings, London. *Clubs:* Glasgow Art. *Signs work:* "LOW." *Address:* 53 Kelvinside Gdns., Glasgow G20 6BQ.

LOWE, Adam, M.F.A. (Oxon.), M.A. (R.C.A.); artist in oil, printmaking;. *b:* Oxford, 18 Feb., 1959. *m:* Yuka. *Studied:* Ruskin School of Drawing, Oxford; R.C.A. (Peter de Francia). *Exhib:* regularly at Pomeroy Purdy Gallery, also exhbns. in England and America. Commissioned work in Japan. *Works in collections:* Contemporary Art Soc., Atkinson A.G. *Publications:* A Resurgence in Contemporary Painting (Alistair Hicks, Phaidon 1989). *Signs work:* "ADAM LOWE." *Address:* Reeds Wharf, Mill St., London SE1.

LOWE, Ian, M.A., Hon.R.E, (1975); Museum Curator, Ashmolean Museum (1962-87). *b:* London, 18 Apr 1935. *m:* Mary Howard. *Educ:* Oriel College, Oxford. Laurence Binyon prize (1958). *Publications:* author: The Etchings of Wilfred Fairclough (1990), Writings: obituaries (20) in The Independent, reviews in Print Quarterly. *Address:* Spring Ford, Newton Reigny, Penrith, Cumbria CA11 0AY.

LOWE, Peter, *Medium:* reliefs, drawing, prints, sculpture. *b:* London 17 Jun 1938. *m:* Tessa. one *s.* one *d. Studied:* Goldsmiths (1954-60). *Exhib:* see website. *Works in collections:* Arts Council, London; V&A; Musée de Grenoble; Museo de Arte Moderno, Fundacion Soto, Cuidad Bollvar, Venezuela; University of East Anglia; National Museum Warsaw; Peter Stuyvesant Foundation Amsterdam; Kemin Kaupunki Taidesmuseo, Kemi, Finland; Stedelijk Museum, Schiedam; Alvar Alto Foundation, Pino Torinesi, Turin; Museum of Modern Art, Zagreb; Commanderie Sint Jan, Nijmegen; Museum of Art, Chelm, Poland; Tate Britain; Southampton City Art Gallery; Modriaanhuis, Amersfoort, Wurzburg; Henry Moore Institute, Leeds; also see website. *Publications:* 'Notes on Plus Minus. A Dialogue with Colin Jones', Structure 6/1 ed Joost Baljeu, Amsterdam (1963); 'Thoughts on Construction' Structure 6/2 ed Joost Baljeu, Amsterdam(1964); 'Statements' Systems catalogue, Whitechapel Art Gallery, Arts Council (1972); 'Engelse en Nederlandse Rationale Tekeningen' De Volle Maan Gallery, Delft, Netherlands (1976); 'Notes on Horizontal Relief Construction' Constructive Context. Arts Council (1979); 'Un pas vers la composition Sereille dans la peinture de Theo van Doesburg, Ed.S.Lemoine. Philippe Sers, Paris (1990); 'Notes on Exhibited Drawings' Peter Lowe Serial Drawings, Clare Hall Gallery, Cambridge (1994); 'Concrete Art, some pros, some cons' KunstKonkret 6. Saarbrücken Ed.S.Rompza & J.Enzweiler (1999); 'On Construction' KunstKonkret 6. Saarbrücken Ed.S.Rompza & J.Enzweiler (2002); 'A Missing Force', KunstKonkret 9. Saarbrücken Ed.S.Rompza & J.Enzweiler (2003); ' Mary Martin as Teacher' KunstKonkret 10. Saarbrücken Ed.S.Rompza &

J.Enzweiler (2004); 'Atelierportrait' KunstKonkret 11. Saarbrücken Ed.S.Rompza & J.Enzweiler (2006). *Official Purchasers:* see website. *Clubs:* The London Group; 'Systems Group'. *Signs work:* "Peter Lowe". *Address:* 27 Lanercost Road, London SW2 3DP. *Email:* peterloweuk@yahoo.com *Website:* www.peterllowe.plus.com

LOWRY, Peter William, R.B.A.; painter in water-colour. *b:* London, 28 Oct., 1914. *m:* Sandra. one *d. Educ:* Highgate, London. *Studied:* St. Martin's School of Art, London. *Exhib:* Batsford; tours of annual exhibs. R.A., R.B.A. *Clubs:* The Reform Club. *Signs work:* "Peter Lowry." *Address:* 36 Nower Road, Dorking, Surrey RH4 3DJ.

LUCAS, Suzanne, M.B.E.; F.L.S., Médaille de la France Libre, R.H.S. Gold Medal (1975, 1976, 1977, 1978, 1979, 1980, 1982, 1983, 1984, 1985, 1986, 1987, 1988); painter and miniaturist in water-colour; President, Royal Society of Miniature Painters, Sculptors and Gravers; Founder-President, Society of Botanical Artists; Vice President, Dorset Arts and Crafts Soc.; Hon. Mem. Women Artists Soc.; Hon Mem. Miniature Artists of America and Miniature Art Soc. of Florida; Hon. Director American Society of Botanical Artists, Winner R.M.S. Gold Bowl (2000);. *Medium:* watercolour. *b:* Calcutta, 10 Sep 1915. *d of:* S/Ldr. Alfred Craven, B.Sc.Eng. 1st Cl., M.I.Mech.E., M.I.E.E. and Lydia J.W.Craven (nee Beeby). *m:* Admiral Louis Lucas, C.B.E., Commander Legion of Honour. *Educ:* Roedean School, Edinburgh University; Munich and Grenoble Universities; Berlin School of Art with Professor Schmidt. *Exhib:* R.A., Paris Salon, R.I.; one-man shows in London: Cooling Galleries (1954), Sladmore Gallery (1973), Mall Galleries (1975, 1979), Liberty's (1977), Royal Society of Miniature Painters Sculptors and Gravers annual exhibitions and one-man show (2000), Society of Botanical Artists annual exhbn one-man (2000); Sponsored first World Exhibition of Miniature Art. *Publications:* author and illustrator of large art volume "In Praise of Toadstools" Vol. 1 (1992) and Vol. 2 (1997), a botanical work; author and editor of highest quality art book "The Royal Society of Miniature Painters, Sculptors and Gravers - One Hundred Years" the official celebratory volume. *Recreations:* mountain walking and climbing, world travel, gardening, botanical research, wildlife observation. *Clubs:* Royal Automobile, Overseas League, Cercle Militaire Paris. *Signs work:* 'Suzanne Lucas'. *Address:* Ladymead, Manor Rd., Mere, Wilts. BA12 6HQ.

LUKE, John, National Diploma in Design; Higher Diploma in Design Education. *Medium:* oil, drawing, prints. *b:* Co.Durham, 12 May 1944. *s of:* the late John Luke. *m:* June Luke. one *s.* one *d. Studied:* Sunderland College of Art (1960-64, NDD); Sunderland University (1990, Dip. Design Ed.). *Exhib:* group exhbns: Seaton Holme Gallery, Easington; Hartlepool Art Gallery; across UK. *Works in collections:* throughout UK. *Commissions:* private and business in UK and Spain, including portrait of retiring Lifeboat Coxwain; created visuals for Top Shop's catwalk, Oxford Street, London, Ipswich Town Football Stadium, and refurbishment of the British Telecom Tower (1999). *Publications:* featured in

'Shafts of Light' mining painting publication by R.McManners & Gillian Wales. *Official Purchasers:* Peterlee Tertiary College (2 mining paintings); several offical purchases. *Works Reproduced:* limited edition prints mining theme, sold in DCC libraries. *Principal Works:* large mining paintings. *Misc:* taught at Hartlepool College of Art (1964-80); Head of Faculty of Exp. Arts, County Durham School until 2002. *Signs work:* 'John Luke'. *Address:* Neptuno 1623 Poli D17, Camposol Golf, Mazarron 30879, Murcia, Spain. *Email:* juneluke@msn.com *Website:* www.johnlukepaintings.com

LUKIC, Jelena, BA (Hons) Sculpture 1st (1987), RA Post Grad RA DipHE (1990); Contemporary View Postgraduate winner, (1990), 'The Hunting Group' Student Prize (1990), Landseer Scholarship (1990), Commonwealth Scholarship Belgrad Univ. (1990), Andre Dunoyer de Segonzac travelling schol. (1990), Bolton House Trust award (1988). *Medium:* painter in oil. *b:* Peterborough, 4 Apr 1962. *m:* Seamus More. one *s.* one *d. Studied:* Cambridge College Art and Technology (1982-83), Sheffield City Polytechnic (1983-87), RAS (1987-90). *Exhib:* RA Summer Show (1989, '90, 2000, '01), art4life (2002), various London and regional galleries in UK. *Clubs:* RASAA. *Address:* 3 Clare Court, Thaxted, Essex CM6 2RN. *Email:* jelenalukic@hotmail.com *Website:* www.homunculus.co.uk/jelena/

LUMLEY, Alexandra Mary, B.A. (Hons.) 1980, A.R.B.A. (1997); painter in water-colour, pastel, acrylic, collage; principal lecturer, Central Saint Martins College of Art and Design. *b:* Essex, 15 Aug 1958. *d of:* Robert Lumley & Priscilla Sidgwick. *m:* Philip White. one *d. Studied:* Camberwell College of Art (1977-80). *Exhib:* regularly at New Grafton Gallery since 1984, and in many group shows nationally. *Works in collections:* Herts. C.C., University of the Arts, London. *Works Reproduced:* in 'A Private View: David Wolfers and the New Grafton Gallery' (Julian Halsby Lund Humphries 2002). *Signs work:* "Alex Lumley" (occasionally "A. Lumley or "A.M.L."). *Address:* 9 Tabard St., London SE1 4LA. *Email:* lumley.white@virgin.net

LUMLEY, Thomas Henry, The Prince of Wales Drawing School Prize, Royal Society of Portrait Painters Annual Show. *Medium:* oil, drawing. *b:* Sheffield, 6 Feb 1980. *s of:* The Earl of Scarbrough. *Studied:* Charles Cecil Studios, Florence (1999-2003). *Exhib:* Royal Society of Portrait Painters (2006, 2007); solo exhibition at Ramsay, Pimlico Road, London. *Works in collections:* private. *Commissions:* private portrait commissions. *Clubs:* Chelsea Arts Club, Blacks. *Signs work:* "THL". *Address:* 14 Offley Road, London SW9 0LS. *Email:* tom@thomaslumley.com *Website:* www.thomaslumley.com

LUNCH, John, C.B.E. (1975), V.R.D. (1965), F.C.A. (1946), F.R.S.A. (1976); artist in water-colour and oil; retd. Director General, Port of London Authority; Hon. Art Adviser to R.N.L.I. (1981-99); Life V.P. R.N.L.I. (1994). *b:* Eastbourne, 11 Nov 1919. *s of:* Percy Valentine Lunch. *m:* (1st) Joyce Barbara Clerke (decd.). two s. (2nd) Fiona Charis Elizabeth Fleck. *Educ:* Roborough School, Eastbourne.

Exhib: Mall Galleries. *Works in collections:* R.N.L.I. Collection (180 Years of Lifeboat History). *Clubs:* Army and Navy. *Signs work:* "John Lunch." *Address:* Martins, East Ashling, Chichester, W. Sussex PO18 9AX.

LUPTON, Lewis F., preacher, writer, historian, painter in oil and water-colour;. *b:* London, 18 July, 1909. *Studied:* Sheffield College of Arts (1923-30). Practised commercial art in Strand advertising agency before the war. Freelance since 1940. Exhibition designer during and just after the war. Many paintings in the R.A. at this period. Then turned to the illustration of Christian literature. Numerous exhibitions of own, and wife's work held in recent years. Publisher under the Olive Tree imprint of own History of the Geneva Bible (25 vols.) and other related literature. *Address:* 2 Milnthorpe Rd., London W4 3DX.

LUSTY, Elfrieda, ARBS (2005); Chelsea Arts Council Prize (2003); Chelsea Arts Society Prize (1997). *Medium:* steel - applied resin. *b:* Vienna, 11 Jun 1925. *d of:* Hans & Anna Salzer. *m:* Gordon. two *s.* one *d. Educ:* Twickenham High School; Birkbeck College, London. *Studied:* St.Martins School, London; Kensington & Chelsea College; Richmond College of Art; Vienna. *Exhib:* Mall Galleries (2006); Battersea Affordable Art Fair (2006); Trinity Arts Guild (1998-2007); Chelsea Art Society (1990-2007); Ealing Art Society (1995-99); one-man exhbn Trinity Church, Sloane Square (2006). *Works in collections:* mainly private collections. *Commissions:* Holy Trinity, Sloane Street; many private commissions. *Works Reproduced:* collagraphs. *Principal Works:* steel abstract sculptures based on operas. *Recreations:* opera, tennis. *Clubs:* Ealing Art Society. *Signs work:* LUSTY (with L running below name, on sculptures), 'Elfrieda Lusty (paintings). *Address:* Holland House, 62 Castlebar Road, Ealing, London W5 2DD. *Email:* elfrieda.art@virgin.net

LYDBURY, Jane Sarah, BA Hons English Literature, BA Hons Illustration; wood engraver and illustrator in black and white, and watercolour. *b:* London, 11 Aug 1953. *m:* divorced. two *d. Educ:* Newnham College, University of Cambridge, Camberwell School of Art (1978-81). *Represented by:* regularly with Greenwich Printmakers, and Society of Wood Engravers. *Commissions:* occasional private press commissions. Has illustrated for Folio Society, OUP, BBC Publications, Simon and Schuster etc. *Publications:* Goodnight Stories (Piccolo), The Oxford Book of Christmas Poems (with others) OUP; Ghostly Companions (Methuen); A Book of Christmas Carols (Simon & Schuster); The Norse Myths (Folio Society); This Solid Globe (Camberwell Press) etc. *Signs work:* Jane Lydbury. *Address:* 101 Humber Road, London SE3 7LW. *Email:* janelydbury@hotmail.com *Website:* www.janelydbury.com

LYDIATE, Avril Ann, *Medium:* oil, watercolour, drawing. *b:* Beckenham, Kent, 5 May 1945. *d of:* Audrey & Frederick Lydiate. *m:* Derek Osborne. one *s.* one *d. Educ:* Henrietta Barnet, London; Stoke Girls School, Coventry. *Studied:* Coventry College of Art; St.Martin's School of Art. *Exhib:* RA; Coventry Art Gallery; Rugby Art Gallery; Ashbarn, Hampshire; Look Gallery, York; Portal

Gallery, London; Peephole Gallery, Long Buckby, Northants. *Commissions:* many. *Misc:* I describe my work as rural fantasy. *Signs work:* 'A.Lydiate'. *Address:* 16 Well Hill Close, Crick, Northants NN6 7TB. *Email:* avril@lydiate1.fsnet.co.uk *Website:* www.avrillydiate.co.uk

LYELL: see ROBINSON, Peter Lyell,

LYFORD, Rosina, Founder Member 'Group Nine Plus' (1973). Prize winner of GLC Spirit of London Competition (1983). *Medium:* acrylic, mixed media, pastel, print. *b:* London, 11 May 1936. two *s. Studied:* I left school at fifteen, and was sponsored by J Lyons to study Fine Art with Adrian Heath, Hammersmith (1952-54). Studied at Chelsea School of Art (1957-58). *Exhib:* Selected solo & group exhibitions: 1969: Richmond Hill Gallery, 'Young Contemporary Artists' showed paintings on Bayswater Road. 1972: 'Art goes to Industry'. 1973: 'Chennel Gallery' London. 1974: Caracas, Venezuela. 1975: Seen Gallery, London. 1976: Bauhouse 2', Connecticut, USA. 1979: 'New York Women in Communication', TWA, New York. 1981: Caracas, Venezuela. 1982: Major exhibition Gallery Hormansben, Oslo; RA Summer Show; 1994: Major Exhibition Kunst-Invest. 2002: Webersters Gallery, Surrey. 2007: Robert Philip Gallery, Surrey. *Works in collections:* private collections worldwide. *Commissions:* Lithographs for Gallery Kunst-Invest., Norway. *Works Reproduced:* Posters, prints, cards, film of work in progress. *Recreations:* Theatre, friends, books, walking, garden and music. *Misc:* History is included in the Archives of the National Gallery of Women in Art, Washington DC. Degree course in Jungian psychology. One of sixteen poets to be selected for the Dillon Book Prize. Backpacked alone around Australia. *Signs work:* "Lyford". *Address:* 14 Hamhaugh Island, Shepperton, Middx., TW17 9LP. *Email:* art@rosinalyford.com *Website:* www.rosinalyford.com

LYNCH, James, Greenshield Foundation Award (1983), Pimms Prize, R.A. (1986), Spectator prizewinner (1993). *Medium:* painter in egg tempera. *b:* Hitchin, 12 Jul 1956. *s of:* Ronald Lynch, A.T.D. *m:* Kate (nee Armstrong). two *s.* one *d. Educ:* Devizes School. *Exhib:* R.A., R.W.S., Portal, Bath Festival Art Fairs; one-man shows: Linfields, Bradford-on-Avon (1982-83), Nevill, Bath (1984), Odette Gilbert, London (1988), Maas Gallery, London (1991, 1993, 1995, 1997, 1999, 2001, 2003). *Works in collections:* Longleat House, Chatsworth House, National Trust, Foundation for Art. *Publications:* illustrated "Wind in the Willows" (Folio Soc., 1995). *Recreations:* paragliding and motorcycling. *Signs work:* "J. Lynch." *Address:* Four Chimneys, High Ham, Langport, Som. TA10 9BB. *Email:* james@lynchmail.fsnet.co.uk *Website:* www.james-lynch.co.uk

LYNCH, Kate Mary, (née ARMSTRONG); B.A. Hons. History of Art, Essex University (1975), PGCE / ATD Bristol University (1976), Post Grad. Diploma in Fine Art, University of West of England (1992) art teacher; member of Royal West of England Academy (RWA). *Medium:* oil, pastel. *b:* London, 17 Aug 1949. *d of:* John & Patricia Armstrong. *m:* James Lynch. two *s.* one *d. Educ:* St. Mary's

Grammar School, Northwood Hills, Middx. *Studied:* University of Essex, Bristol University, and University of West of England. *Exhib:* Beaux Arts, Bath (1993, 1996, 1998); Alpha House, Sherborne, (1998, 2000, 2005); Touring Exhibition "Willow" (2003) to Brewhouse, Taunton; Somerset Rural Life Museum; Norfolk Rural Life Museum; Platform Gallery, Clitheroe; Somerset Art Weeks (2000, 2002, 2004, 2006). *Works in collections:* Wessex Collection, Somerset Museums Collection; Talboys Collection, Royal West of England Academy; St.George's Hospital, London. *Publications:* Willow - paintings, drawings and voices ISBN 0-9544394-0-6. *Signs work:* "K. Lynch" or "Kate Lynch." *Address:* Four Chimneys, High Ham, Langport, Somerset TA10 9BB. *Email:* kate.lynch@virgin.net *Website:* www.katelynch.co.uk

LYWOOD, Sally, FPS; BA Art & Design; ATC; Runner-up, Nina Hosali Award (2007). *Medium:* pastel, charcoal, watercolour, acrylic, collage. *b:* Exmouth, 7 Mar 1950. *d of:* John & Pamela Lywood. one *s. Studied:* Newton Abbott College of Art; Loughborough College of Art; Leeds Polytechnic. *Represented by:* various galleries in Norway (Rogaland). *Exhib:* National Museum, Raratonga, Cook Islands (1998); one woman show, Fotland Mill, Rogaland (2000); group exhbns: Rogaland (2001-07); Painted Penguin Gallery, Caldbeck, Cumbria (2003); Nordic Pastel Forum, Falkenburg, Sweden (2006); Bankside Gallery, Hopton St., London (2007); Osterley House, London (2007). *Works in collections:* private collections in Britain, USA, Australia, Norway, Denmark and Cook Islands. *Commissions:* Stavanger County Council, Norway; British School, Stavanger, Norway;. *Publications:* Norwegian Flower Book. *Official Purchasers:* Stavanger Town Council, Stavanger, Norway. *Principal Works:* portraits, nudes, abstract paintings. *Recreations:* walking, dancing, reading. *Signs work:* 'S.Lywood'. *Address:* c/o Deer Park, Caldbeck, Cumbria, CA7 8EW. *Email:* lywood@c2i.net

M

MABBUTT, Mary, BA (Hons) Loughborough College Art and Design, RAS PostGrad Cert.; part-time lecturer; TSWA National Art Competition; John Moores Exhbn (1995); Major Award South West Arts. *Medium:* painter. *b:* Luton, 2 May 1951. *m:* Joe Coates. one *s.* one *d. Studied:* Luton School of Art, Loughborough College of Art and Design, Royal Academy Schools. *Exhib:* solo shows: Paton Gallery, New Grafton Gallery, Newlyn Gallery. *Works in collections:* Metropolitan Museum of Art, New York; Arts Council, London; Coopers and Lybrand, Unilever, Bankers' Trust, Usher Gallery, Lincoln, Pentland Industries, Robert and Susan Summer, New York, Slaughter and May. *Works Reproduced:* The New British Painting: Phaidon. *Clubs:* RASAA. *Address:* 6 Wood Lane, Falmouth, Cornwall, TR11 4RF. *Email:* marymabbutt@btconnect.com

MAC ARTHUR, Paula, post-Grad Diploma RA Schools. *b:* Enfield, 13 Mar 1967. *m:* Matthew Ashby. two *s. Studied:* Royal Academy Schools (1990-93),

Loughborough College of Art and Design (1987-90). *Exhib:* Whitworth Young Contemporaries, John Player Portrait Award (1st prize), Royal Academy Summer Exhbn., John Moore's Exhibition. *Works in collections:* National Portrait Gallery. *Commissions:* Frederick Sanger (biochemist) for NPG, Baroness von Oppenheim, and President RICS, etc. *Clubs:* RASAA. *Address:* 83 Shrubland Rd, London E8 4NH.

McADAM CLARK, Caroline, RBA; MA Hons Fine Art; painter in oil, gouache, printmaking; co-Director, Piers Feetham Gallery. *b:* London, 18 Jan., 1947. *m:* Piers Feetham. one *s.* one *d. Studied:* MA at Edinburgh College of Art, Edinburgh University (1965-70). *Exhib:* Thackeray Gallery, Highgate Fine Art, Lena Boyle Fine Art, Chappell Galleries, various UK art fairs and Piers Feetham Gallery. *Works in collections:* private: France, UK, USA. *Commissions:* illustrator of "Three Fairy Tales" by Oscar Wilde (pub. The Winged Lion, 1995). *Publications:* co-author with P. Feetham 'The Art of Framing' (1997). *Official Purchasers:* West Deutches Landesbank; Archant Group; Firmdale Hotels. *Works Reproduced:* 'Covehithe' oil on paper, illustrated in 'Making Waves' by Ian Collins (pub.Black Dog Books, 2006). *Recreations:* sailing. *Clubs:* Chelsea Arts. *Signs work:* "McAdam Clark." *Address:* 49 Larkhall Rise, London SW4 6HT. *Email:* cmcadamclark@hotmail.com *Website:* www.mcadamclark.com

McADAM FREUD, Jane, MA(1995), FRBS(1994), Freedom of the City of London (1991). *Medium:* conceptual sculptor - multi media. *b:* London, 24 Feb., 1958. *d of:* Lucian Freud. *m:* Peter Henson. two s- *s. Studied:* Central School of Art (1978-81), Scoula De l'Arte Della Medaglia, Rome Scholarship(1986-89), RCA (1993-95). *Exhib:* Beverley Knowles Fine Art (2006), Freud Museum (2006), Adele Boag Fine Art, Adelaide, Australia (2006), Museum Novojicinska, Pribor, Czech Republic (2007), Harrow Museum (2007). *Works in collections:* V&A, BM, Berlin State Museum, Rijksmuseum, Leiden, Goldsmiths' Hall, National Museum of Ireland, Pulitzer Foundation USA, Fitzwilliam Museum, Royal Mint Museum, Ashmolean Museum, National Gallery Archives, Yorkshire Museum, HRH Queen Elizabeth. *Commissions:* recent: J.P. Getty, All Souls College, Simmons Gallery, Oxford University Sheldon Medal, Munton Medallion. *Publications:* Sculpture: On the Edge; Forms of Relief La Medailles (1995), Resonating: The Medal (2000), RA Casting Course - The Medal (2003), Modern British Sculpture by Guy Portelli, 'Relative Relations 2007', 'Inside Out' Paper for Oxford University. *Signs work:* "J.Mc.A.F." or "J. McA. Freud." *Address:* 4 Elm Close, North Harrow, Middlesex HA2 7BT. *Email:* mail@janemcadamfreud.com *Website:* www.janemcadamfreud.com

MACALPINE, Jean, BA Fine Art (1976). *Medium:* hand toned photographs. *b:* Ribble Valley, Lancs., 1953. *m:* Kenneth Draper, R.A. *Studied:* Bristol College of Art (1973-76), Camberwell College of Art (1976-77). *Exhib:* R.A. Summer Show; Hart Gallery, London; Flowers East, London; Leeds University Art Gallery; Europ'Art, Geneva; Art London; Clifton Studio NY, USA; Bridport Art Centre, Dorset; On Line Gallery, Southampton; Cleveland Bridge Gallery, Bath.

Works in collections: ICI London; Leicestershire Education Authority; Welsh museums and schools. *Commissions:* West Dorset General Hospital. *Publications:* Jean Macalpine: 'Intervals in Light' by Mary Rose Beaumont (Hart Gallery). *Signs work:* photographs signed on back "JEAN MACALPINE." *Address:* Carrer Gran 55a, 07720 Es Castell, Menorca, Spain. *Email:* drapermacalpine@terra.es *Website:* www.jeanmacalpine.com

MACARA, Andrew, R.B.A. (1983), N.E.A.C. (1984); self taught figurative painter in oil. *b:* Ashbourne, Derbyshire, 4 Apr 1944. *m:* Ann. two *s. Educ:* Derby College of Technology. *Exhib:* New Academy Gallery, London, Contemporary Fine Art Gallery, Eton, Fosse Gallery, Stow-on-the-Wold. *Works in collections:* Derby Museum and A.G. *Commissions:* Palace of Westminster (Paintings for Members Dining Room). *Signs work:* "Andrew Macara." *Address:* Aberfoyle, 32 Farley Rd., Derby DE23 6BX. *Email:* macara@ntlworld.com *Website:* www.picasaweb.google.com/andrewmacara

MACARRÓN, Ricardo, RP(1962); 1st prize National Fine Art Exhbn. (1962), Prize Direction of Fine Art (1954); artist in oil of figures, dead nature, landscapes, portraits. *b:* Madrid, 9 Apr 1926. *s of:* Juan Macarron, art dealer. *m:* Alicia. two *d. Studied:* Fine Art School of San Fernando, Madrid (1942); scholarship to study in France by French Institute (1950). *Works in collections:* Contemporary Art Museum, Madrid, University of Oslo, National Gallery (Cape Town), Güell Foundation (Barcelona), and several private collections. *Address:* Augustin de Bethencourt 5, Madrid 3, Spain.

McARTHUR, Christine Louise, R.S.W. (1995), R.G.I. (1990), artist in oil, acrylic, watercolour and collage; Hon. Sec. Royal Glasgow Institute of the Fine Arts (2000-2002); Awards: Travelling Bursary (1975 & 1976); SAC (1980 & 2004); Glasgow Soc. of Women Artists Trust Fund Award & GSWA Lauder Award; RGI NS MacFarlane Award; Alexander Munro Award RSW. *b:* Kirkintilloch, 14 Mar 1953. *m:* divorced.m.Roger Billcliffe (2004). two *d. Educ:* Lenzie Academy, Glasgow. *Studied:* Glasgow School of Art (1971-1976). *Exhib:* several, principally with Fine Art Society, Glasgow; Gertsev Gallery, Moscow; Roger Billclifte Gallery, Glasgow; John Martin, London. *Works in collections:* Royal Bank of Scotland, Clydesdale Bank, John Lewis Partnership, Amerada Hess, Scottish Nuclear plc, Caledonian University, Macfarlane Group, Allied Distillers, Argyll Group plc, Craig Capital, University of Strathclyde. *Commissions:* murals for John Lewis Partnership, Glasgow and Peter Jones, London. *Clubs:* Western Baths Club. *Misc:* Also working from a studio in St. Ives, Cornwall. *Signs work:* "Christine McArthur." *Address:* Glen Rowan, Shore Road, Cove, Argyll & Bute G84 0NU. *Email:* clm@rbfa.demon.co.uk

MacARTHUR, Ronald Malcolm, RSW 1982), DA Painting (1937); painter in water-colour and oil; Principal teacher of Art, Portobello High School, Edinburgh (1952-79). *b:* Edinburgh, 1914. *s of:* Charles MacArthur. *m:* Dorothy Stephenson. *Educ:* Royal High School of Edinburgh. *Studied:* Edinburgh College of Art

(1933-37, William Allison, R.S.A., David Foggie, R.S.A., William MacTaggart, R.S.A.). *Exhib:* R.S.W. (1948-60 and 1976 onwards). *Works in collections:* Lothian Schools Collection, Strathclyde Schools Collection, and private collections. *Signs work:* "Ronald MacArthur, r.s.w." *Address:* Morden, 1 Duddingston Rd., Edinburgh EH15 1ND.

MACARTHUR, Susan, Fellow of Society of Designer Craftsmen. *Medium:* drawing, textiles, acrylic painting. *b:* Eastbourne, 4 Sep 1952. *d of:* Anthony and Pauline Fishenden. *m:* James D.Macarthur. *Studied:* Laguna Beach School of Art; California State Long Beach University (US: B.A General Art; Associated Arts Degree). *Exhib:* Mall Galleries, London; Affordable Art Fair, Battersea; Star Gallery, Lewes; Byard Art, Cambridge; Linda Blackstone, Pinner; Art in Action, Waterperry; Brighton Art Fair; Bournemouth University Atrium Gallery; Artspace, Henley; Contemporary Textile Fair; Landmark Arts Centre. *Commissions:* private and business. *Publications:* 'L'aura di Giorgio de Chirico' Klaus Podoll; various textile magazines. *Signs work:* 'SMacarthur'. *Address:* Bena Cottage, South Street, Broad Chalke, Wilts. SP5 5DH. *Email:* susanmacarthur@btinternet.com *Website:* www.susanmacarthur.co.uk

MACCABE, Gladys, M.B.E., HROI, M.A.(Honoris Causa), FRSA; Founder and Past-Pres. Ulster Society of Women Artists; Academician with gold medal Italian Academy; Diploma of Merit, University of Arts, Parma; Hon. Academician, Royal Ulster Academy; Hon. Mem. Ulster Water-colour Soc.; Hon. Mem. Ulster Soc. of Miniaturists, Mem. Water-colour Soc. of Ireland; painter in oil and water-colour and various other media; art lecturer, writer and broadcaster; pianoforte soloist. *b:* Randalstown, N. Ireland. *d of:* George Chalmers, army officer and artist. *m:* Max Maccabe. two *s. Educ:* Brookvale Collegiate School, Ulster College of Art, France and Italy. *Exhib:* London, Dublin, U.S.A., Canada, Belfast, Scotland, France, etc. *Works in collections:* Irish National Self-portrait Collection, Limerick University (3 works), Imperial War Museum, Ulster Museum, Arts Council of Northern Ireland, The Queen's University, Belfast, Ulster Office, London, Longford County Library, Thomas Haverty Trust, County Dublin Educ. Authority, B.B.C., Cyril Cusack, Esq., Miss Beatrice Lillie, Lady Wakehurst, the late Adlai Stevenson, Esq., Dr. James White, Director, National Gallery of Ireland, B.B.C. (N.I.), Royal Ulster Academy, Crawford Municipal A. G, Cork. *Commissions:* numerous. *Publications:* Many important publications; T.V. programmes at home and abroad. *Signs work:* "GLADYS MACCABE." *Address:* 1a Church Rd., Newtownbreda, Belfast BT8 7AL.

McCANN, Brian, BA Sculpture (1980), MA (RCA) (1983), Stanley Picker Fellowship(1983), Prix de Rome Scholar (1986); Stanley Picker Gallery Sculpture Commission (1988), Tate Gallery Fellowship (First), Tate Gallery Liverpool (1990), British School at Rome Selection Committee (1991-96), Wollaston Award Nomination RA (2000),Kingston University London, MA Film Studies (2004, Distinction), Senior Lecturer Kingston University, Visiting Lecturer Royal Academy Schools, Royal College of Art. *Medium:* drawing, print,

sculpture, painting, video, film, text. *b:* Glasgow, 2 Jul 1955. *s of:* William McCann. *Studied:* Duncan of Jordanstone, Dundee (1977-80), RCA (1980-83), Stanley Picker Fellow, Kingston University, London (1984), British School at Rome (1984-86). *Exhib:* Tom Bendham Collector UK Travelling Exhibition, Waldorf Hotel London, RAC Club London (20070, Mairie D Espelette, Pays Basque (2006), St.Galmier, France (2004), Pilgrim Gallery, London, Pride of the Valley Sculpture Park Surrey (2003), Chichester Sculpture Festival (2002), British Museum, London, Michigan University USA (2000), 100 Park Lane London, Stanley Picker Gallery London (1998), and many others in UK and Europe. *Works in collections:* Arts Council of Great Britain, British School at Rome, Contemporary Arts Society, British Museum, Dundee University Fine Art Collection, Stanley Picker Gallery Fellows Collection; private collections worldwide. *Commissions:* Stanley Picker Gallery Sculpture Commission, London. *Publications:* 'Sojourn' poetry (1980), 'Harpers & Queens' (1986), 'Plumage of Recognition' (1991), many catalogues. *Signs work:* "Brian McCann." *Address:* 98 High Street, Hampton Wick, Richmond Upon Thames KT1 4DQ. *Email:* brian_can@tiscali.co.uk *Website:* numasters.com; www.tate.org.uk/liverpool; www.kingston.ac.uk/picker/fellowships

McCARTER, Keith, D.A.(Edin.) (1960), F.S.I.A. (1968), F.R.S.A. (1969), A.R.B.S. (1991); Sir Otto Beit Medal (RBS, 1992). *Medium:* sculptor in bronze, stainless steel, concrete. *b:* Edinburgh, 15 Mar 1936. *s of:* Peter McCarter. *m:* Brenda Schofield. one *s.* one *d. Educ:* Royal High School, Edinburgh. *Studied:* Edinburgh College of Art (1956-60, Eric Schilsky, Helen Turner). *Represented by:* Open Eye Gallery, Edinburgh. *Exhib:* R.A., Monaco, Burleighfield Gallery, Alwin Gallery, Berkeley Sq. Gallery, Blains Fine Art. *Works in collections:* Numerous countries worldwide. *Commissions:* many public sited sculptures in U.K., U.S.A., Europe, Africa. *Signs work:* "McCarter"; small works. *Address:* 10 Coopersknowe Crescent, Galashiels, Scotland TD1 2DS. *Email:* keith@keith-mccarter.com *Website:* www.keith-mccarter.com

McCARTHY, Peter, *Medium:* acrylic, oils, watercolours. *b:* Westcliff-on-Sea, Essex, 30 Aug 1955. *Studied:* Suffolk College; Colchester School of Art. *Represented by:* The John Russell Gallery, Ipswich. *Exhib:* The John Russell Gallery, Ipswich (1997-2007), White Space Gallery, London (2005-2006), The Nevill Gallery, Canterbury (2000-2003), Galerie Not, London (1986), The Mall Galleries, London (1985). *Commissions:* a few. *Clubs:* Ipswich Art Society. *Signs work:* "McCarthy". *Address:* 35 Orford Street, Ipswich, Suffolk, IP1 3PE. *Email:* P.McCarthy1@ntlworld.com *Website:* www.pmcart.co.uk

McCARTNEY, Jamie, BA (Fine Art)(1991); Erotic Signature Prize (2006); The Kyoto Prize, Art Car Parade (2007). *Medium:* sculpture. *b:* Marylebone, London 9 Oct 1971. *Educ:* Westminster School. *Studied:* London College of Printing (Art Foundation, 1986); Hartford Art School, Connecticut (-1991). *Represented by:* JAG Gallery, Brighton; Gallery Kaleidoscope, London; Sheridan Russell Gallery, London; Garden Architecture, London. *Exhib:* Recent

exhibitions: AMORA, London(Academy of Sex and Relationships); Body of Work, Lewes (group show, 2007); Peter Jones, London (2007); Arts Club, Mayfair (2007); JAG Gallery, Brighton (2007); Unitarian Church, Brighton (group show, 2007). *Publications:* The World's Greatest Erotic Art of Today Vols I & II. *Official Purchasers:* Public: steel sculpture, Runnymeade Council, Egham, Surrey (1999); Art Car Parade, Blackpool (2007); AMORA: seven sculptures commissioned 2006/2007. *Principal Works:* The Impossibility of Passion (2007). *Address:* Brighton, UK. *Email:* jamie@jamiemccartney.com *Website:* www.jamiemccartney.com

McCAUSLAND, Christine, BA (Fine Art), RASC (Post Graduate in Painting). *Medium:* oil, drawing, prints. *b:* Scotland, 17 Feb 1944. *Educ:* Harrogate School of Art (1969-70) Pre-Diploma (Award for Drawing). *Studied:* Camberwell School of Arts and Crafts BA (Commendation in Art History) under Anthony Eyton and Francis Hoyland (1970-73), Royal Academy Schools (Prize for Draughtsmanship, 1973-76) under John Lessore and Michael Salaman. *Exhib:* Kelvingrove Art Galleries & Museum, Glasgow; 'New Voices' Gowdoc Gallery, Glasgow; Festival Club 'Celtic Images', Edinburgh; Festival Hall, Grafton Gallery, Alexandra Palace, Royal Academy, South London Art Gallery, Pall Mall Gallery, etc. *Works in collections:* Royal Livery Company of Painters and Stainers, private collections. *Recreations:* listening to Radio 3. *Signs work:* "CHRISTINE MCCAUSLAND" on prints and drawings. Sometimes on back of paintings. *Address:* 88 Clarendon Road, London W11 2HR.

McCLURE, Daphne Quintrell, *Medium:* acrylic, gouache. *b:* Helston. *m:* George McClure. one *s.* one *d. Studied:* Hornsey College, Central School, London. *Exhib:* Thompsons, Cadogan, Archeus, London galleries. Penwith Gallery, St.Ives. *Works in collections:* Newlyn Gallery Cornwall, Germany, Australia, America. *Publications:* monograph -1997 'A Cornish Journey from Porthleven to Penzance'. *Address:* 17 St. Mary's Tce, Penzance, Cornwall, TR18 4DZ.

McCOMB, Leonard William, R.A., R.E. (1993), Slade Dip. (1960); artist-painter, sculptor, printmaker; visiting teacher: R.A. Schools;. *b:* Glasgow, 3 Aug., 1930. *m:* Barbara Elenora. *Studied:* Manchester School of Art (Harry Suttcliffe), Slade School (Sir William Coldstream, Prof. A.H. Gerrard). Removed Golden Man sculpture - Lincoln Cathedral Travelling Exhbn. *Works in collections:* Tate Gallery, Arts Council Collection, V. & A., B.M., Towner A.G., Belfast A.G., B'ham, Manchester, Sheffield, Swindon and Worcester city galleries. *Commissions:* commemorative plaque bronze gold leaf Brookes University, Oxford (1993); tapestry 'Fishes and Invertebrates in the Sea' Boots plc (1994). *Publications:* Arts Council Catalogue (1983), Painting from the South Catalogue (1989), Catalogue Drawings and Paintings, Browse and Darby Gallery (1993), Gillian Jason Gallery; Video Film Arts Council 'Flow of Life' (1983). *Signs work:* "McCOMB" and "L.M" within circle and date. *Address:* 6 St. Saviours Rd., Brixton Hill, London SW2 5HD.

McCOMBS, John, N.D.D., R.O.I., R.B.A., F.R.S.A., M.A.F.A.; landscape and figure artist in oil. *b:* Manchester, 28 Dec 1943. *s of:* John McCombs (Snr). *Educ:* Manchester High School of Art (1957-62). *Studied:* St. Martin's School of Art (1962-67) under F. Gore, Reynolds, Kossoff. *Exhib:* R.A., Mall Galleries, Manchester City A.G., Saddleworth Museum, John McCombs Gallery. R.A. Scholarship and 'College prize' St. Martin's (1966); Stanley Grimm prize R.O.I. (1990); 'People's prize' Manchester Academy (1991), Alan Gourley Memorial Award ROI (2001). *Works in collections:* Manchester, Salford, Oldham A.G's, Saddleworth Museum. *Publications:* articles for 'Leisure Painter' 'International Artist' magazines. *Clubs:* R.O.I., R.B.A., M.A.F.A. *Signs work:* "J. McCombs," sometimes "J.Mc." *Address:* 12 King St., Delph, Oldham OL3 5DQ. *Website:* www.johnmccombs.co.uk

MACCORMAC, Sir Richard Cornelius, Kt 2001: C.B.E. 1994; R.A. 1993; PPRIBA; Chairman, MacCormac Jamieson Prichard Ltd (incorporated in 2002), formerly a partnership since 1972; President, Royal Institute of British Architects, 1991-93; Taught in Dept. of Arch., Cambridge Uni. (1969-75 and 1979-81), Univ. Lectr. (1976-77); Studio Tutor, LSE (1998). Visiting Professor: Univ. of Edinburgh,Dept of Architecture(1982-85); Hull Univ. (1998-99). Dir. Spitalfields Workspace (1981-); Chm., Good Design in Housing Awards, RIBA London Region (1977); Mem., Royal Fine Art Commn (1983-93); Comr, English Heritage (1995-98). Royal Academy: Chairman: Architecture Committee (1997-); Exhibitions Cttee (1998-); Council (1998-); Advisor: British Council (1993-); Urban Task Force (1998-); Pres., London Forum of Amenity and Civic Soc. (1997-); Trustee, Greenwich Foundation for RNC (1998-2002); FRSA 1982. *b:* 3 Sep 1938. *s of:* the late Henry MacCormac, CBE, MD, FRCP and Marion Maud, d. of B.C.Broomhall, FRCS. *m:* 1964, Susan Karin Landen (separated in 1983). one s. (and one s. decd) *s. Educ:* Westminster School. *Studied:* Trinity College, Cambridge (BA 1962); University College London (MA 1965). RIBA 1967. Served RN 1957-59. Proj. Archt, London Borough of Merton, 1967-69; estabd private practice 1969. *Publications:* articles in Architectural Review and Architects Journal. *Principal Works:* major works include: Cable & Wireless Coll., Coventry (Royal Fine Art Comm/Sunday Times Bldg of the Year Award, 1994); Garden Quadrangle, St John's Coll., Oxford (Ind. On Sunday Bldg of the Year Award, 1994); Bowra Building, Wadham Coll., Oxford; Burrell's Fields, Trinity College, Cambridge; (RIBA Regional Award 1997, Civic Trust Award 1997); Ruskin Library, Lancaster Univ. (Ind. On Sunday Bldg of the Year Award, 1996; RFAC/BSkyB Bldg of the Year, Universities Winner, 1998; Millennium Products status awarded by the Design Council 1999); Southwark Stn, Jubilee Line Extension (Millennium Bldg of the Year Award, RFAC Trust/BSkyB 2000); Wellcome Wing, Science Mus. (Celebrating Construction Achievement, Regional Award for Greater London 2000). *Recreations:* sailing, music, reading. *Address:* MacCormac, Jamieson, Prichard Architects, 9 Heneage Street, London, E1 5LJ. *Website:* www.mjparchitects.co.uk

McCOY, Josie, MA Fine Art, BA Fine Art; Woo Charitable Foundation Arts Bursary (2002), Royal West of England Academy Open Painting Exhbn, commended (2001), 1st Prize The Centre of Attention Painting Prize (2001). *Medium:* oil on canvas. *b:* Plymouth, Devon, 14 Nov 1969. *d of:* Keith and Janet McCoy. *Studied:* Central St.Martins, Solihull College, & Plymouth College of Art and Design. *Exhib:* solo exhbns: DF Arte Contemporanea, Santiago de Compostela, Eyestorm Gallery, Milan and London, Notting Hill Arts Club, London, Centre of Attention, London; and group shows including Metropole Galleries, Folkestone, The Fieldgate Gallery, London and BP Portrait Award (2000-04), NPG. *Works in collections:* BBC, Collection of University of Wales, Jeremy Mogford Collection, The Borchard Collection of British Self-Portraits in the 20th Century, The Centre of Attention Permanent Collection. *Publications:* The Guardian, Art Review, Time Out, Metro, Art Monthly, Dazed and Confused, Tema Celeste Contemporary Art. *Principal Works:* series: Eastenders, The Royle Family, The Beauty series. *Signs work:* Josie McCoy. *Address:* Trenhorne Cottage, Trenhorne, Congdons Shope, Launceston, Cornwall PL15 7PN. *Email:* josie@josiemccoy.co.uk *Website:* www.josiemccoy.co.uk

McCRUM, Bridget, sculptor in stone, bronze-abstracted figurative. *b:* Yorks., 27 Apr 1934. *d of:* Patrick Bain. *m:* Robert McCrum. three *d. Studied:* painting at Farnham (1951-55, Musjynski; 1980-82 stone carving). *Exhib:* solo shows: St James Cavalier, Malta, Vanessa Deneveux, Phoenix, Plymouth School of Architecture, Dartington Hall Gdns., Wattis Fine Art, Hong Kong, Messums Fine Art; mixed shows: R.A., R.S.A., R.W.A., New Art Centre at Roche Court, Bohun, Deans Court, University of Surrey, Chelsea Harbour, Plymouth Museum, Concerts Gallery, Sculpture at Goodwood. *Works in collections:* Frink, Golden Door Foundation, National Trust, Charterhouse Bank, Lismore Castle, Priors Court School, Spencer Stuart, Tresco. *Commissions:* Hambledon Church, Dittisham; The Homewood, Greenway, Coleton Fishacre, University of Surrey. *Publications:* 'Touch & Time- The Sculpture & Drawings of Bridget McCrum' by Ann Elliot; The Art of Priors Court School; Modern British Sculpture by Guy Portelli. *Clubs:* R.B.S. *Signs work:* "Bridget McCrum" or "McC." *Address:* Hamblyns Coombe, Dittisham, Dartmouth, Devon TQ6 0HE.

McCULLOCH, Ian, D.A. (1957), S.S.A. (1964), A.R.S.A. (1989), R.S.A. (2005); painter, printmaker; Fine Art Fellow, Strathclyde University (1994-); winner of Glasgow International Concert Hall Mural Competition (1989/90). *b:* Glasgow, 4 Mar 1935. *m:* Margery Palmer. two *s. Educ:* Glasgow School of Art (1953-57). *Exhib:* solo exhbns.: Royal Scottish Academy, Edinburgh (2007)Peacock Printmakers, Aberdeen (1995), Aberdeen A.G. (1992), Aberystwyth A.C. (1991), Camden A.C. (1986); group exhbns.: New North, Tate Gallery Liverpool (1990), Leabhar Mòr and tour Glasgow(2001/2), The Drawn Figure, University of N.S.W., Australia (2001); Leabhar Mor - book, exhibition and tour, Stornoway, Isle of Lewis (2002/03). *Works in collections:* Saatchi Collection, Glasgow A.G., Dundee A.G., Edinburgh City A.G., Pallant House A.G., Chichester, Perth A.G., Stirling A.G., R.S.A. Collections, Glasgow,

Strathclyde and Liverpool Universities. *Commissions:* mural for Italian Centre, Glasgow (1989). *Publications:* The Artist in his World (Argyll, 1998). *Signs work:* "Ian McCulloch." *Address:* 51 Victoria Rd., Lenzie, Glasgow G66 5AP. *Website:* www.s-s-a.org/html/featart/mcculloc/index.htm

McCULLOUGH, George, M.S.Exc., hons. M. of E. dipl.; artist in oil, water-colour, gouache, pastel; Founder and Tutor, Donegal School of Landscape Painting, Dunfanaghy, Co. Donegal, Rep. of Ireland;. *b:* Belfast, 2 Oct., 1922. married. two *d. Educ:* Belfast College of Technology and Belfast College of Art (1940-47). *Studied:* as above. *Exhib:* R.U.A., United Nations, N.Y., Oriel Gallery, Dublin, Cambridge Gallery, Dublin, Eaton Gallery, Toronto, Flowerfield Art Centre, Portstewart, Yonge Gallery, Chicago, Bell Gallery, Belfast. *Address:* 20 Joanmount Drive, Carrs Glen, Belfast BT14 6PB.

McCURRY, Steve, *b:* Philadelphia, PA, 23 Apr 1950. *s of:* Doris and Eugene McCurry. *Educ:* College of Arts and Architecture: Pennsylvania State University. *Studied:* BA in Cinematography and History. *Represented by:* Magnum. *Individual Shows/Exhibitions:* Tibet House, NYC (2003); 'Face of Asia' George Eastman House, Rochester, NY (2003); Arthur Ross Gallery, U of Penn (2003); John Hopkins Univ., Baltimore (2003). *Awards/Commissions:* Magazine Photographer of the Year, National Press Photographer Assoc. (1984); Robert Capa Gold Medal for best Photog. Reporting from Abroad (1980); Oliver Rebbot Memorial Award (1986, 1992), World Press Photographer of the Year (1992). *Principal Published Pieces:* The Imperial Way (1985); Monsoon (1988); Portraits (1999); South South East (2000); Sanctuary (2002); Path to Buddha: Tibetan Pilgrimage (2003). *Publications: Monograph/Contributor:* Arms Against Fury (Magnum, 2002), 9.11.01 (Magnum, 2001), 11.09.01, Palazzo delle Esposizion Roma (2001), Our Turning World (Magnum (2000). *Specialist Area:* documentary. *Equipment Used:* Nikon F100. *Additional Projects:* NY Film Festival 'Gold' for Documentary 'Afghan Found'. *Misc:* also see: www.pdonline.com/legends/mccurry. *Address:* 2 Fifth Ave #9H, New York, NY 10011 USA. *Studio Address:* 2 Fifth Ave, NY, NY (#9H) 10011, USA. *Email:* stevemccurry@aol.com *Website:* www.stevemccurry.com

MACDONALD, Alan, B.A. (Hons.) Fine Art 1984, Post Dip. (1985); painter in oil on linen and board;. *b:* Malawi, 1962. *s of:* Donald & Margaret Macdonald. *m:* Carolynda. one *s. Studied:* Duncan of Jordanstone College of Art, Dundee; Cyprus College of Art, Paphos. *Exhib:* 1987: Stirling Biennale, Scotland; 1992: 'Far Horizons' Kyoto, Japan; 1995: Hunting Group prizes competition exhbn. RCA London; 2000-07: England and Co., London; Caldwell Snyder Galleries, New York & San Francisco; Smelik & Stokking Galleries, Netherlands; Galerie Rademakers, Netherlands; Stewart Gallery, Boise, Idaho, USA; PM Gallery, Ealing, London. *Works in collections:* EMI, Old Mutual, Leeds Education, Kailey Hong Kong. *Signs work:* "Alan Macdonald" and dated on back. *Address:* 46 High Street, Carnoustie, Angus, DD7 6AH. *Email:* alanmacd@globalnet.co.uk *Website:* www.alanmacdonald.net

MacDONALD, Alastair James Henderson, R.M.S., M.A.S.F., F.R.S.A., H.U.A.; Gold Bowl Hon. Men. (1991, 1992, 1993, 1998); Llewellyn Alexander Masters Award (1995); miniature painter; Hon. Treas. R.M.S. (1981-2004). *b:* Tighnabruaich, Argyll, 5 Jul 1934. *s of:* Angus Graham MacDonald, licensed master grocer. *m:* Juliet Anne Mead. two *s.* three *d. Educ:* Pope Street School, New Eltham. *Studied:* Woolwich Polytechnic School of Art and Crafts. *Exhib:* R.M.S., U.A., M.A.S.F., Miniature World Exhibitions I and II. *Address:* 63 Somers Rd., North Mymms, Herts. AL9 7PT.

MACDONALD, Allan Sween, GP Culloden General Practice; BA (Hons) Degree in Drawing and Painting. *Medium:* oil, drawing. *b:* Inverness, 13 Nov 1965. *s of:* Iain MacDonald. *m:* Zena MacDonald. *Studied:* Edinburgh College of Art, Edinburgh (1983-87). *Exhib:* Duncan Campbell Gallery, London; Lennox Gallery, London; Kilmorack Gallery, Inverness; Brown's Fine Art, Tain. *Publications:* 'As Others See Us' - Scottish Portrait Show. *Recreations:* playing fiddle, song writing. *Signs work:* "A MacDonald". *Address:* 24 Caulfield Gardens, Cradgehall, Inverness-shire, IV2 5GE. *Email:* macdonald_art@yahoo.co.uk *Website:* www.allanmacdonald.co.uk

MACDONALD, Robert James, M.A., R.C.A. (1976-1979), Dip. L.C.S.A.D. (1982); printmaker and painter in oil, acrylic, water-colour; trained as a journalist before studying art; prizewinner Singer and Friedlander Watercolour Exhibs. (1994 & 1998); First Prize, Winsor & Newton Award, RWS, 21st Century Exhbn (2005). *b:* Spilsby, Lincs., 1935. *m:* Annie Merrill. two *d. Educ:* Te Awamutu College, N.Z. *Studied:* R.C.A. (1976-1979), London Central School of Art (Special Advanced Printmaking Studies 1981-1983). *Exhib:* exhibits widely in Wales and London. *Works in collections:* V. & A. Print Collection, Ferens Gallery, Hull, Brecknock Museum and Art Gallery, Contemporary Art Society for Wales. *Commissions:* private. *Publications:* author and illustrator 'The Fifth Wind' (Bloomsbury 1989); illustrator 'Where Many Shipwrack' (John Donnes Poems), Old Stile Press (2004). *Clubs:* Welsh Group, and Watercolour Society of Wales. *Signs work:* "Macdonald" or "Macd" on early pictures. *Address:* Abersefin House, Penpont, Brecon, Powys LD3 8EU. *Email:* Abersefin@aol.com

McDOWELL, Leo, B.A.Hons., C.Ed., R.I.; Winsor and Newton R.I. award Mall Galleries (1990); self taught artist in water and acrylic colour; Council Mem. R.I.;. *b:* 19 Jan., 1937. *Educ:* Keighley Grammar School; Manchester University; Innsbruck University; Cambridge University. *Studied:* Modern Languages, History of Art. *Exhib:* Shell House Gallery, Ledbury, Blackstone Gallery, Pinner, Albemarle Gallery, London, The British Gallery, Los Gatos, Calif., La Difference Gallery, Dinslaken, Germany, Lisette Alibert Gallery, Paris. *Works in collections:* H.R.H. The Prince of Wales, Hertfordshire C.C., Reuters. *Signs work:* "Leo McDowell." *Address:* Craigleith, Hanbury La., Essendon, Hatfield, Herts. AL9 6AY.

McDOWELL, Phyllis Ann Graham, NDD (1958), ATD (1959). *Medium:* oil, watercolour, drawing, prints. *b:* Kent, 19 Mar 1937. *d of:* Thomas Holder. one *s.* three *d. Educ:* Chislehurst Grammar. *Studied:* Bromley College of Art (1953-58), Brighton Art Teachers' Training College (1958-59). *Exhib:* 'Retrospective 1953-2007' solo exhibition, The Grand, Folkestone (2007); RA Summer Exhibition; Royal Institute of Painters in Watercolour, Mall Galleries; Society of Botanical Artists, Westminster Galleries. *Works in collections:* British Council - Ghana, Zambia; Africa Centre - Covent Garden. *Commissions:* Saga Rose cruise Liner; postage stamp, Ghana. *Publications:* 'Acrylics Workshop' (Dorling & Kindersley, 2006); 'Just Lay it On' instructional videos and DVDs. *Works Reproduced:* Leisure Painter, Kent Life, 'Watercolour Workshop' (D&K). *Misc:* Founder Member of Folkestone Artists' Cooperative. Monthly article on art in 'Folkestone Herald'. *Signs work:* "Phyllis McDowell". *Address:* 8 Myrtle Road, Folkestone, Kent, CT19 6EE. *Email:* phyllismcd@macunlimited.net *Website:* www.phyllismcdowell.com

McENTAGART, Brett, B.A. (1961), M.F.A. (1963), R.H.A. (1980), W.C.S.I. (1974); artist in oil, water-colour, etching, pastel; Head of Printmaking, National College of Art and Design, Dublin (1990-2000); Board Mem. National Gallery of Ireland (1993-1996); Council Mem. Royal Hibernian Academy. *b:* Dublin, 27 May 1939. *m:* Miriam O'Hara. two *s.* one *d. Educ:* St. Columba's College, Rathfarnham, Dublin. *Studied:* Dartmouth College, N.H., U.S.A., University of Colorado, U.S.A., Salzburg Academy, Austria. *Exhib:* R.H.A., W.C.S.I., R.W.A., R.U.A.; one-man shows Dublin. *Works in collections:* Board of Works Dublin, H.E.A. Dublin, W.C.S.I. Collection, Limerick, National Self Portrait Collection, Limerick, Haverty Trust, Dublin. *Publications:* covers for: 'Blooms' - Joyce anthology, 'At Europe's La Terrasse' by Gerard Duffy. *Works Reproduced:* RHA catalogues, Whites Auction catalogues. *Recreations:* golf, swimming, skiing. *Clubs:* Honorary Life Member, Ski Club of Ireland; Ballaghadereen Golf Club. *Misc:* alt. address: St. Columba's College, Rathfarnham, Dublin. *Signs work:* "B.McE." or "BMcEntagart". *Address:* 5 Sandycove Ave. West, Sandycove, Co. Dublin, Eire. *Email:* brettmac@eireom.net

McEWAN, Angus Maywood, RSW; BA (hons) Fine Art; Post Gras. Fine Art (Commended); Post Grad Secondary Educ. (Distinction). Awards: RSA- Diana King/Scottish Gallery Prize (2002); Glasgow Art Club Fellowship RSW (2001); Alexander Graham Muro Award RSW (1999); Alasdair Sauzen Award (RSA)(1996); Elizabeth Greenshields (1987, 1990); The John Blockley Prize (RI)(2004); 2nd Prize, Kaupthing Singer & Friedlander Watercolour Competition (2007). *Medium:* oils, acrylics, water-colour and mixed media, on canvas, board or paper. *b:* Dundee, Scotland, 19 Jul 1963. *s of:* Neil and Doreen McEwan. *m:* Wendy Ann Bell McEwan. three *s. Educ:* Carnoustie High School, Kirkton High School, Dundee College -Graphics/Illustration. *Studied:* Duncan of Jordanstone College of Art, Scotland. *Represented by:* Thompson's, London; Open Eye, Edinburgh; Jerdan Gallery, Crail; Queen's Gallery, Dundee; Frames Gallery, Perth. *Exhib:* Thompson's of Marylebone, London; Open Eye Gallery,

Edinburgh; Shire Pottery, Northumberland; Bilcliffe Fine Art, Glasgow; Jerdan Gallery, Crail; RSA (Royal Scottish Academy); RGI (Royal Glasgow Institute), RSW (Royal Scottish Society of Painters in Watercolours); Blyhtswood Gallery, Glasgow; Queen's Gallery, Dundee; Frames Gallery, Perth. *Works in collections:* Duncan of Jordanstone College of Art; Dundee Art Galleries and Museums; Dundee City Council Chambers; Paintings in Hospitals; RSA Collection; Qatar Royal Family; Ernst & Young. *Commissions:* Lord Provost Dundee; portrait commission; Qatar commission; Dundee Leisure Centre mural, etc. Many private commissions. *Publications:* International Artist Magazine; Who's Who Scotland; RSW Catalogue; RGI; Brit Art Directory; Books: The Watercolour Skies and Clouds Techniques of 23 International Artists; 100 Ways to Paint Still-Life and Florals; 100 Ways to Paint Seascapes, Rivers and Lakes. *Official Purchasers:* Perth Royal Infirmary; Lord Bonomy; Historical Scotland; Scottish Enterprise; Scottish Equitable. *Recreations:* art, galleries, photography, walking, travelling abroad, children. *Clubs:* Glasgow Art Club, RSW. *Misc:* part-time lecturer, Dundee College. Elected mem. Royal Scottish Society of Painters in Watercolours (RSW) (1995); Elected mem. Visual Arts Scotland (VAS) (2002); elected Associate Member of the International Guild of Realism (USA, 2005). *Signs work:* Angus McEwan. *Address:* 7 Glenleven Drive, Wormit, Newport-on-Tay, Fife, DD6 8NA. *Email:* art@angusmcewan.com *Website:* www.angusmcewan.com

McEWAN REID, Marjorie, SWA (1994); MA (1942), BA (Oxon.) Hons. Zoology (1939), Dip.Ed. (1940); winner, Seifas Cup (1991); immunologist in medical research (retd.);artist in oil. *b:* Uckfield, Sussex, 5 Nov 1917. *d of:* Edward William Little, B. Sc. one *s.* one *d. Educ:* Talbot Heath, Bournemouth; Somerville College, Oxford. *Studied:* Bletchingley AEI (1977-80, Arthur Easton, ROI, NS), Elmers End Art Centre (1992-97) and at Edinburgh College of Art (1994, George Donald); also privately (1980-86) with the late Edmond Perini, (1987-97) with Richard Walker, SGFA, UA and (1996-2003) with Jean Hammond, Tollers Design Centre, Old Coulsdon ongoing. *Exhib:* SWA, FPS, UA; many mixed shows; three two-man shows with husband. *Clubs:* SWA,The Croydon, Old Coulsdon Art Soc. *Address:* 21 Byron Ave., Coulsdon, Surrey CR5 2JS.

McEWEN, Elizabeth Alexandra, N.D.D. (1960), A.T.D. (1961), U.S.W.A. (1980), U.W.S., R.U.A. (1990), S.B.A. (1987); R.U.A. Gold medallist (1991). *Medium:* water-colour, gouache and acrylic. *b:* Belfast, 13 Dec 1937. *m:* James A. Nelson. *Educ:* Belfast Royal Academy. *Studied:* Belfast College of Art (1956-60), Reading University (1960-61). *Exhib:* many mixed and solo shows throughout N. Ireland, S.B.A. London, Laing London. *Works in collections:* Royal Ulster Academy, National Self Portrait Collection, Limerick University, Dept. of Finance, Stormont. *Signs work:* "E.A. McEwen." *Address:* APT 2, 31A Kings Road, Belfast BT5 6PS.

MacEWEN, Penelope, Chairman FPS (2006- present); BA Fine Art (Oxon) 1986; MA (Hons) Oxon, 1991; PGCE; PGDip (Psy). *Medium:* mixed media, oils. *b:* 8 Jul 1965. one *d. Educ:* Bryanston School, Dorset (Art Bursary); Queen Elizabeth's School, Dorset (1979-83). *Studied:* St.Hugh's College, Oxford. *Represented by:* Free Painters and Sculptors (FPS). *Exhib:* mixed shows: Hambledon Gallery (1979-80); Chichester, Norwich (Touring, 1987, 1988); Bournemouth Museum (1989); Braodgate, London (1990); Osterley House (2003, 04, 07); The Cotton's Atrium (2004, 2006); Blythe Gallery, Manchester (2006); Bankside Gallery (2007); solo shows: St.Hugh's College (1985); San Felicecirceo; Soriano Nelcimino, Italy (1988); shared shows: The Commonwealth Institute (2006). *Works in collections:* private collections in Italy and UK; displayed 'Crucifixion' stained glass in St.James's, Piccadilly, London. *Commissions:* only private works - portraits, murals. *Publications:* unpublished - 'Reptiles from Around the World', children, educational. *Official Purchasers:* Dame Elizabeth Frink (from Hambledon Gallery, 1980). *Principal Works:* cycle called 'Journey'. *Recreations:* classical music; member of British Psychological Society. *Misc:* rubs creative visualisation workshops for children and over 60s. *Signs work:* 'P.MACEWEN'. *Address:* 35 Seaton Gardens, Ruislip, Middx., HA4 0BA. *Email:* athens@athens.plus.com *Website:* www.FreepaintersandSculptors.co.uk

MACEY, Julian Bernard, R.M.S. (1995); retired Divisional Youth and Community Officer; self taught artist in oils, water-colour, pastel, pencil; Hon. Life Mem. (1991) and President Gt.Yarmouth and District Soc. of Artists (1994-);. *b:* Minehead, Som., 13 Apr., 1920. widower. one *s. Educ:* Duke of York's Royal Military School, Dover. *Exhib:* Westminster and Mall Galleries with R.M.S.; Tasmania and Washington D.C. in the World exhibitions of Miniature Art. *Works in collections:* Gt. Yarmouth and District Soc. of Artists. *Publications:* R.M.S. Centenary Book "One Hundred Years". *Signs work:* J. B. MACEY or J. B. Macey. *Address:* 119 Beccles Rd., Bradwell, Gt. Yarmouth, Norfolk NR31 8AB.

MACEY, Leo, C.B.E. (1979), H.S. (1988); picture restorer, painter of miniatures in oil on ivorine and board; painter of oleographs. *b:* Minehead, 23 Feb 1922. *s of:* William Henry Macey. two *s.* one *d. Educ:* English Military School, Cairo and D.Y.R.M.S. *Studied:* Frobisher School of Painting (1964-66, Lucy Frobisher). *Exhib:* R.W.A., H.S., Armed Forces Art Soc. *Works in collections:* Sultan of Negri Sembilan, Malaysia and others. *Clubs:* Professional/Businessmen, Warminster. *Address:* 56 Upper Marsh Rd., Warminster, Wilts. BA12 9PN.

McFADYEN, Jock, B.A., M.A.; artist in oil on canvas; Arts Council Film Award (1978); Arts Council Major Award (1979); Prizewinner, John Moore's 17 (1981). *Medium:* painting. *b:* Paisley, 18 Sept 1950. *s of:* James McFadyen & Margaret Owen. *m:* (1) Carol (divorced)(2)Susie Honeyman. two *s.* one *d. Educ:* Renfrew High School. *Studied:* Chelsea School of Art (BA 1973-76, MA 1976-

77, Anne Rees Mogg, Ron Bowen, Ian Stephenson). *Represented by:* The Grey Gallery, www.thegreygallery.com. *Exhib:* 36 one-man shows including Blond Fine Art, Imperial War Museum, William Jackson Gallery, Camden Arts Centre, Talbot Rice, Agnew's (2001), Rude Wercs (2005). *Works in collections:* 32 public collections including British Council, Imperial War Museum, Kunsthalle Hamburg, National Gallery, V. & A., Tate Gallery. *Commissions:* Artist-in-Residence The National Gallery (1981). Designed sets and costumes for Sir Kenneth McMillan's last ballet 'The Judas Tree', Royal Ballet, Royal Opera House, Covent Gdn. (1992). *Publications:* 'Jock McFadyen – A Book about a Painter' monograph by David Cohen, published by Lund Humphries (2001). 12 Exhibition Catalogues. *Works Reproduced:* Art magazines, covers for Penguin, Bloodaxe, Museum Cards, etc. *Principal Works:* large urban landscapes. *Clubs:* Vintage Japanese Motorcycle. *Signs work:* "Jock McFadyen". *Address:* 15 Victoria Park Square, Bethnal Green, London E2 9PB. *Email:* info@jockmcfadyen.com *Website:* www.jockmcfadyen.com

McFALL, David, R.A.; sculptor in stone and bronze. *b:* Glasgow, 1919. *s of:* David McFall, civil servant. *m:* Alexandra Dane, actress. one *s.* one *d. Educ:* English Martyrs, Spark Hill. *Studied:* Birmingham, R.C.A. and Lambeth. *Works in collections:* Bullcalf (Tate), Churchill (Burlington House), Balfour (House of Commons), Vaughan Williams (National Portrait Gallery), Lord Attlee (Imperial War Museum), bronze study of Prince Charles (Buckingham Palace), Oedipus and Jocasta (W. Norwood Library), Pocahontas, Sir Godfrey Allen (bust) in crypt of St. Paul's Cathedral, 'Son of Man', Canterbury Cathedral. *Address:* 9 Fulham Park Gdns., London SW6 4JX.

MacFARLANE, Sheila Margaret, D.A. (Edin.) 1964; artist, printmaker and engraver; lecturer in printmaking, Duncan of Jordanstone College of Art, Dundee (1970-76); founder and director, Printmakers Workshop at Kirkton of Craig (1976-90). *b:* Aberdeen, 2 May 1943. *d of:* Alexander Stewart MacFarlane. one *d. Studied:* Edinburgh College of Art; Atelier 17 Paris. *Exhib:* 'Tangleha to Bars Nab' touring exhbn. (1999-2004); 'The Finella Prints' Welsh Museum Modern Art (2005-6). *Works in collections:* national and private collections in U.K. and private collections Overseas. Previously worked with children with special needs and now as a freelance artist. *Commissions:* 6th Bradford International Prints Exhibition. *Official Purchasers:* include: Kelvingrove Art Gallery, Glasgow; Arts Council of GB; Scottish National Gallery of Modern Art. *Signs work:* "Sheila M. MacFarlane." *Address:* 1 Tangleha', St. Cyrus, Montrose DD10 0DQ.

McGOOKIN, Colin Trevor, B.A. (Hons.), A.R.U.A.; Artist in Residence, Down Lisburn Trust. *Medium:* acrylic, oil, collage, assemblage. *b:* Belfast, 4 Jun 1958. *m:* Punam. one *s.* one *d. Educ:* Belfast. *Studied:* Belfast College of Art (now Univ. of Ulster). *Represented by:* Engine Room Gallery, Belfast. *Exhib:* U.K., Ireland, Europe, N.America. *Works in collections:* Ireland, U.K., U.S.A. *Commissions:* local councils, Ireland. *Publications:* 'Beyond the Partitions', 'From Tradition into the Light', 'Works on Paper', 'Glimpse', 'Thinking Long'.

Official Purchasers: Arts Council of N.Ireland. *Works Reproduced:* 'Thinking Long' by Liam Kelly (Gandon Editions). *Signs work:* 'C.T.McGookin' (with year, e.g. '05). *Address:* 28 Belmont Ave., Belfast BT4 3DD Northern Ireland. *Email:* colin.mcgookin@ntlworld.com *Website:* www.colinmcgookin.com

MacGREGOR, David Roy, MA(Cantab). 1948, FSA, FRHist.S.; retired architect, ship draughtsman, author, artist in oil, water-colour and pen. *b:* Fulham, 1925. *s of:* Lt.-Col. W. W. MacGregor, D.S.O. *m:* Patricia M.A.P. Gilpin. *Educ:* Eton and Trinity College, Cambridge. *Studied:* under Julius Olsson, R.A., R.O.I. and Cdr. G. F. Bradshaw, R.S.M.A. *Exhib:* R.O.I., N.E.A.C., R.B.A., R.S.M.A.; one-man shows: Woodstock Gallery, London (1974), Digby Gallery, Mercury Theatre, Colchester (1976), Old Butchers Bookshop, Cley (1994). *Publications:* illustrations to his own books. *Signs work:* "D. R. MacGregor." *Address:* 12 Upper Oldfield Park, Bath BA2 3JZ.

McGREGOR, Lynn Barbara, RSW, SSA, VAS; BA (Hons) degree in Drawing and Painting (1984-88), Post-Graduate Diploma in Painting and Printmaking (1989); Awards: Mabel McKinley Art Prize, Royal Glasgow Inst., McLellan Galleries (1999), Eli Lilly Purchase Prize (1996), Scottish Society of Women Artists Special Award, Scottish Arts Club Award (1991). *Medium:* painter in acrylic. *b:* Pittenweem, Fife, Scotland, 21 Aug 1959. *m:* Michael Faulkner. *Educ:* Waid Academy, Fife, Scotland; Telford College of FE, Edinburgh, Scotland. *Studied:* Edinburgh College of Art. *Exhib:* The Scottish Gallery, Edinburgh; Thompsons, Marylebone, London; David Curzon Gallery, London; Stenton Gallery, Haddington; Wren Gallery, Burford, Oxfordshire. *Works in collections:* Robert Fleming Holdings Ltd., London; Eli Lilly Industries, Surrey; Morrison Construction; Bank of Scotland; Edinburgh College of Art; Project Planning Int., N.Ireland. Various private collections in Britain and abroad. *Clubs:* mem. RSW; Prof. mem. SSA & VAS. *Misc:* currently living and working on otherwise uninhabited island on Strangford Lough, N.Ireland. *Address:* 35 Farranfad Rd, Downpatrick, Co. Down, NI BT30 8NH. *Email:* lynnmcgregor@elite.com *Website:* www.lynnmcgregor.co.uk

McGREGOR, Mhairi Patricia, RSW, BA (Hons) Fine Art. *Medium:* oil and watercolour painting. *b:* Paisley, 10 Sep 1971. *d of:* Alastair and Marilyn McGregor. *m:* Graham Batin. one *s.* one *d. Studied:* Glasgow School of Art, under J.D.Robertson and Barbara Rae (1989-1993). *Represented by:* Roger Billcliffe Gallery, Glasgow; Thompson's Gallery, London. *Exhib:* 11 solo shows (1993-2005). *Works in collections:* Fleming Collection, London, John Rae Collection, Scotland. *Clubs:* Royal Scottish Society of Painters in Watercolour. *Address:* 33 Park Gardens, Kilbarchan, PA10 2LR.

MacGREGOR, Moira, Diploma Drawing and Painting (1954); awarded Travelling Scholarship (1954). *Medium:* oil, watercolour. *b:* Dundee, 7 Dec 1931. *m:* John McConnell. one *s.* one *d. Educ:* Harris Academy, Dundee. *Studied:* Dundee College of Art (Alberto Morrocco Head of the Painting School). *Exhib:*

RA Summer Exhbns; RWS Open Exhbns; Singer & Friedlander/Sunday Times Watercolour; NEAC; RBA; RI; mixed shows: Cadogan Gallery, London (Spring 1984); solo show: Pentagram Gallery, London (1998, 2003). *Works in collections:* set of 12 silk screen prints of fruit bought by Chelsea & Westminster Hospital Arts Programme (1996). *Works Reproduced:* RA Summer Exhbn postcard (1987); Unicef cards (2). *Signs work:* 'MM'. *Address:* 12 Orme Court, London W2 4RL. *Email:* studio_macgregor@yahoo.co.uk

MacGREGOR, (Robert) Neil, M.A., Ll.B.; Director, British Museum 2002-present, Director National Gallery 1987-2002, Editor Burlington Magazine 1981-86, lecturer in art history and architecture at the University of Reading and the Courtauld Institute 1975-1981. *b:* 16 June, 1946. *Educ:* New College, Oxford: BA French and German (1967); University of Edinburgh: Law (1970); Courtauld Institute of Art: MA History of Art (1975). *Publications:* 'Seeing Salvation: Images of Christian Art' (2002); 'Britain's Paintings' (2003). *Signs work:* "Neil MacGregor." *Address:* Director The British Museum Great Russell Street London WC1B 3DG.

McGUIGAN, Bernard, RBS; British Interior Design Association Gold Medal 2006. *Medium:* sculpture. *b:* Essex, 16 May 1956. *s of:* Mr & Mrs T F McGuigan. *Studied:* self taught. *Represented by:* Lucy B Campbell Fine Art, London W8. *Exhib:* Art London (2004-06); RA Summer Exhibition; Bruton Stret Gallery; Art Dublin; Hanal Purschar Sculpture Garden; Art for Offices; Langham Fine Art; Manchester Art House; Bohun Gallery. *Works in collections:* Bank of India; Crest Nicholson Properties; Lady Lewington. *Commissions:* Sir Sydney & Lady Lipworth; Cambridge Housing Association; Sir Christopher Ondaatje. *Publications:* Modern British Sculpture; Evening Standard; House and Garden. *Recreations:* reading, walking. *Signs work:* "BMc". *Address:* The Annexe, 1B Lady Margaret, London NW5 2NE. *Email:* bernardmcguigan@yahoo.co.uk *Website:* www.bernard-mcguigan.co.uk

McGUINNESS, Michael, R.W.S. (1993); painter in water-colour and oil; Senior typographic and book designer with Readers Digest and, subsequently, Art Editor of The Independent and The Independent on Sunday (1986-91);. *b:* Essex, 20 Mar., 1935. *Studied:* S.E. Essex Technical College (illustration and typography, Harry Eccleston, O.B.E.), Royal Academy Schools (painting, Fleetwood Walker, R.A.), Walthamstow School of Art (Stuart Ray). *Publications:* The Encyclopaedia of Water-colour Techniques (two paintings), Einstein for Beginners (illustration), Jung for Beginners (illustration). *Clubs:* Wynken de Worde Soc. *Signs work:* "McG." *Address:* 4 Denmark Rd., London W13 8RG.

MACINNES, Jock, RGI; DA in Art and Design, Post Graduate (Highly Commended); Cargill Award (RGI); Scottish Amicable Award (RGI). *Medium:* oil on gesso panel. *b:* 23 Aug 1943. *s of:* John Allan MacInnes. *m:* Elspeth Stirling MacInnes. one *d. Educ:* Alloa Academy. *Studied:* Glasgow School of Art. *Exhib:* Portland Gallery, London; Thompsons Gallery, London; Richmondhill Gallery;

Open Eye Gallery, Edinburgh; Roger Billcliffe Gallery, Glasgow; Redrag Gallery, Stow-on-the-Wold; Lemon St. Gallery, Truro. *Works in collections:* Dick Institute, Kilmarnock; Paisley Art Institute; Strathclyde University; Glasgow University; Royal Bank of Scotland; Misys Plc; Dumbartonshire Education Authorities; Robert Fleming Holdings; Nationwide Building Society; Scottish Amicable; Royal Bank of Scotland, Sweden. *Works Reproduced:* prints: The Art Group, London; Studio Sixty Six, Glasgow. *Signs work:* 'JM'. *Address:* Tawthorn Smiddy, Nr. Kilmarnock, Scotland KA3 6HU. *Email:* jaamrgi@btinternet.com

McINTOSH, Iain, ARSA; sculptor. *b:* Peterhead, 4 Jan 1945. *s of:* James McIntosh, cabinet maker. *m:* Freida. two *d. Educ:* Peterhead Academy. *Studied:* Gray's School of Art (1962-67). *Signs work:* "I.M." plus year. *Address:* 53 Kilrymont Rd., St. Andrews, Fife, Scotland KY16 8DQ.

McINTYRE, Donald, RI, RCA; landscape painter in acrylic, oil and water-colour. *b:* Yorkshire, 1923. *s of:* Dr. Donald McDonald McIntyre. *m:* Lauren Lindee. *Educ:* Scarborough College, Skipton Grammar School. *Studied:* studio of James Wright, R.S.W. *Works in collections:* H.R.H. Duke of Edinburgh, National Library of Wales, Welsh Arts Council, Robert Fleming Holdings plc, Birkenhead A.G., Newport (Gwent) A.G., Merthyr Tydfil Gallery, Welsh Contemporary Art Soc., Atkinson Art Gallery, Southport, St. Andrew's University. *Address:* 3 Waen-y-Pandy, Tregarth, Bangor, Gwynedd LL57 4RB.

McINTYRE, Fiona Mary Elspeth, BA Hons (painting, drawing), Postgrad. (European Fine Art), Diploma Printmaking, Diploma Art Foundation. *b:* Nairobi, Kenya, 7 Apr 1963. *d of:* Archibald Duncan Ogilvie McIntyre. *Educ:* Winchester School of Art, Grafikskolan Forum Sweden. *Studied:* painting, drawing, anatomy, then printmaking specialising in copper etching. *Represented by:* The Rope Store, Studio Gallery, Nailsworth. *Exhib:* The Hot Bath Gallery, Bath; The Rope Store Studio Gallery, Nailsworth; Royal West of England Academy, Bristol; Victoria Art Gallery, Bath; Camden Fine Art, Bath; Lund Konstmuseum, Bakfikan, Sweden; The Mall Galleries, London; Gallery Fis, Norway; Roseum Forum Galleriet, Sweden. *Works in collections:* Fjarhitin Geothermal Engineers, Iceland; Hoganes Art Museum, Sweden. *Commissions:* public art for Malmo General Hosptial, Sweden. *Publications:* Devon Today, Somerset Life, Bath Chronicle, Sydvenska Dagbladet. *Official Purchasers:* 5 paintings sold at Lotts Road Auction, Chelsea, London. *Works Reproduced:* 'Crouching Figure' drypoint included in catalogue of Southern Swedish Artists (1991). *Principal Works:* 'Premonition' (mixed media on canvas, 1989), 'Burning' (series of 6 uniqie etchings, 1993), 'Indian Series' (acrylics on canvas, 2003). *Recreations:* music, travel, yoga, reading, walking. *Misc:* describes work as an expression of emotion, associations, memories of travels and a search for the truth in the human condition. *Signs work:* Fiona McIntyre. *Address:* 5 Mill Cottage, Ampney Crucis, Cirencester, Glos., GL7 5RS. *Email:* fiona@mcintyredesigns.co.uk

MACKAY, Jane Elizabeth, MB.BS (London) 1970. *Medium:* watercolour, oil, mixed media, silkscreen prints. *b:* London, 2 Oct 1947. *d of:* Barry Sloan Mackay. *Educ:* Perse School for Girls, Cambridge (1958-65). *Studied:* King's College, London & Westminster Medical School (1965-70), art courses at West Dean College, Slade, Camberwell. *Represented by:* Art Contact. *Exhib:* solo shows include: Salisbury, Aldeburgh, Dulwich festivals; Wigmore Hall, Royal Northern College of Music; St.John's, Smith Square. Mixed shows include: Florence Biennale (2003), Art on Paper, Watercolours and Drawings Fair, Affordable Art Fair. *Works in collections:* Women's Art Collection, New Hall, Cambridge. *Commissions:* paintings of classical music for leading performers; stained glass design, illustrations for books and CDs. *Publications:* 'De La Bible' by Danielle Nairac (illustrations); CD cover designs for Hyperion, Collins Classics, Vasari Singers; Synesthesia by Robertson & Sagiv (cover). *Works Reproduced:* many works in press articles and on websites. *Principal Works:* 'Britten Series' paintings - approx. 200 works. *Recreations:* choral singing, oboe, wildlife. *Clubs:* member of the Bach Choir since 1967. *Misc:* Jane Mackay is a synaesthete. Much of her art is based around images of classical music as seen in her mind's eye. *Address:* 60 Cambria Road, London SE5 9AS. *Email:* janemackay@btinternet.com *Website:* http://www.soundingart.com

MACKAY CLARK, Deirdre, NDD; Pimms Prize for Drawing RA (1985); painter in oil, mixed media; tutor. *b:* Ilford, 18 Sep 1937. *d of:* David Mackay Edward, restorer, carver. *m:* John Clark. three *s.* one *d. Educ:* Copthall Grammar. *Studied:* Hornsey College of Art (1954-59, Alfred Daniels, Colin Sorensen). *Exhib:* Minories, Colchester, RA Summer Exhbns., RWS, RI, MoMA (Wales), Old School Gallery, Bleddfa, H'Art 2003. Work in private and business collections. Designed/painted ceramics (1977-82). *Works in collections:* Sir William Crawshay. *Publications:* Artists Cards (1984), RA Pubs. (1985), card and print; book jackets (1988), range of Fine Art cards and prints (1989-90). *Misc:* Family ran BOURLETS -1965. *Signs work:* "D.M." or "Deirdre Mackay." *Address:* Brierley Cottage, Brierley, Leominster, Herefordshire HR6 0NT.

McKEAN, Lorne (Miss), FRBS; sculptor; silver medal for sculpture combined with architecture; Feodora Gleichen and Leverhulme Scholarships;. *b:* 16 Apr 1939. *m:* Edwin Russell, FRBS. two *d. Exhib:* four one-man shows, London W1. *Works in collections:* Portrait sculptures include: the late Marquess of Salisbury, Hatfield House; H.R.H. Prince Philip on polo pony 'Portano', H.M. The Queen's personal Silver Wedding gift to her husband; the late Prince William of Gloucester, Kensington Palace; Earl of Lichfield for BBC programme 'Portrait'; Prince Charles on 'Pans Folly'. Public works: A.A. Milne public memorial of bear cub at London Zoo; Shearwaters, Shearwater House, Richmond Green; Girl and Swan 17 ft. bronze in Reading; 'Galoubet' French show jumping stallion; H.M. The Queen, Drapers Hall; Flight 27 Feet Bronze, City Square Leeds; half-lifesize bronze HRH Duke of Edinburgh on Portano at Guards Polo Club. *Clubs:* Guards Polo Club. *Signs work:* "Lorne McKean." *Address:*

Lethendry, Polecat Valley, Hindhead, Surrey GU26 6BE. *Website:* www.polosculpture.co.uk

McKECHNIE, Christine, NDD; Royal Academy of Art Special Award (1983); SGFA Award (2005); Awards for All (2001, for Maze Project). *Medium:* paper collage. *b:* Bursledon, 7 Jan 1943. *m:* Ian James McKechnie. one *s.* one *d. Studied:* Southampton School of Art; Kingston School of Art. *Exhib:* RA Summer Show; Royal College of Art; Anna Mel Chadwick, New Kings Road; Bury Walk Gallery, Modern Gallery, Goodge Place; The Market Cross Gallery, Bury St.Edmunds; SGFA, Mall Galleries, NEAC, Thompson Gallery; Chelsea Arts Club, Artworks, Bury St.Edmunds; Suffolk Open Studios. *Commissions:* too many to list. *Publications:* Paper Collage (Search Press); articles - The Artist - Leisure Painter. *Works Reproduced:* 'A Celebration of Autumn' (David Adam), prints (Pauntley Press). *Principal Works:* Lake District, Italy, Morocco. *Recreations:* opera, gardening, walking, working. *Clubs:* Chelsea Arts Club. *Signs work:* "C Mc Kechnie". *Address:* Cornerways, Southolt, Eye, Suffolk, IP23 7QJ. *Email:* christinemckechnie@suffolkonline.net *Website:* www.christinemckechnie.co.uk

McKELLAR, Robert, painter in oil and acrylic specialising in abstract and still life with a predominant interest in colour; nine years teaching experience. *b:* Gravesend, 2 Jul 1945. one *s. Studied:* Medway College of Art, Camberwell School of Art. *Represented by:* Northcote Gallery, 110 Northcote Rd., London SW11. *Exhib:* RA, Hong Kong, London, Singapore, Los Angeles. The Netherlands, New York, Spain. *Commissions:* British Consulate. *Signs work:* "R. McKellar." *Address:* Apt 1043, La Herradura 18697, Granada, Spain. *Email:* info@robert-mckellar.com *Website:* www.robert-mckellar.com

McKENNA, John Anthony, ARBS. *Medium:* sculpture, drawing. *b:* Manchester, 18 Jan 1964. *m:* Claire Suzanne. two *s.* one *d. Educ:* Royal Grammar School, Worcester; The Victorian Institute, Worcester. *Studied:* Sir Henry Doulton School of Sculpture (1987-990); Middlesex Polytechnic (1984-85). *Exhib:* various in UK, including London, Birmingham, Glasgow, Channel Islands. *Works in collections:* States of New Jersey, Cunard, Sainsbury, Tesco, Pepsi Fritolay, MEPC, Centro, Ibstock, Warwickshire CC, Leeds City, Haringey BC, Wolverhampton MBC, Havant BC. *Commissions:* numerous public ar commissions including bronze statues and relief artworks throughout the United Kingdom commissioned by local government and ocrporate bodies. *Official Purchasers:* The Crown Estate. *Principal Works:* The Colossus of Brownhills (12+m high); Jersey Cattle Group (St.Helier); The Knight of the Vale (Castlevale); Queen Mary 2 bronze relief panel (7m sq). *Recreations:* kite flying, bronze founding. *Misc:* sculptor specialising in large scale public art projects in fabricated steel and casting bronze statues, and smaller gallery artworks at his studio foundry. *Signs work:* 'JMC' or 'JOHN MCKENNA SCULPTOR'. *Address:* High McGowaston, Turberry, Ayrshire, KA26 9JT. *Email:* johnmckthesculptor@mac.com *Website:* www.johnmckenna.co.uk

McKENNA, Laurence, artist in oil, water-colour, pastel and pencil. *b:* 20 Nov 1927. *s of:* Charles J. McKenna. *m:* Carmel Beattie. two *s.* one *d. Educ:* St. Kevin's, Belfast. *Studied:* 1965-68 under John Luke, R.U.A. *Exhib:* Belfast, Dublin, Cork, London, U.S.A. *Works in collections:* private collections: Ireland, Gt. Britain, Italy, U.S.A. *Works Reproduced:* Revue Moderne, Paris (drawing, 1947), Sunday Independent, Dublin (drawing, 1956), Irish News (drawing, 1958), Ulster Illustrated (drawing, 1958), Sunday Independent (drawing, 1965), Ulster Tatler (pastel, Jan'01). *Signs work:* "LAURENCE McKENNA." *Address:* 23 Grangeville Gdns., Belfast BT10 0HJ.

McKENZIE, Mo, ASWA; Teaching Diploma (TMHA); Management Diploma (DMS); Cert. in Fina Art (HNC); Diploma in Fine Art (HND). *Medium:* oil on board/canvas; acrylic. *b:* Amersham, Bucks, 1 Jun 1943. *s of:* Anthony Athol Cathcart. *m:* William. *Educ:* Vauxhall Manor School for Girls (1956-61). *Studied:* Brighton College of Art & Craft (1961-63); University of E.London (1992-94). *Exhib:* The Islington Art Circle (1982-83); Royal Festival Hall, London (1961); Eastern Open Exhbn, King's Lynn (1998); Mall Galleries, London (annually since 2001); Beecroft Art Gallery, Essex (annually since 2000); solo exhbns locally at Queens Theatre, Hornchurch, The Fairkytes Arts Centre, Essex. *Official Purchasers:* Bachorski Gallery, Essex. *Recreations:* Mosaic design, piano, garden. *Clubs:* British Assoc. for Modern Mosaic (BAMM); Havering Mosaic Workshop Assoc. (HMWA). *Signs work:* 'McK'. *Address:* 134 Slewins Lane, Hornchurch, Essex, RM11 2BU. *Email:* mo.mck@virgin.net *Website:* www.mckenziepictures.co.uk

McKENZIE SMITH, Ian, O.B.E., D.A., P.R.S.A., Hon. R.A., Hon. R.H.A., Hon. R.U.A., H.R.W.A., P.P.R.S.W., R.G.I., LL.D. (Aberdeen University, 1991), D.Art (Robert Gordon University 2000), F.R.S.A., F.R.S.E., F.S.S., F.M.A., F.S.A. Scot; artist in oil and water-colour; Commissioner, Museums and Galleries Commission; Trustee, National Galleries of Scotland. *b:* Montrose, 3 Aug 1935. *s of:* James McKenzie Smith. *m:* Mary Rodger Fotheringham. two *s.* one *d. Educ:* Robert Gordon's College, Aberdeen. *Studied:* Gray's School of Art (1953-59) under Ian Fleming and R. Henderson Blyth; Hospitalfield College of Art, Arbroath (1958 and 1959). *Exhib:* Royal Scottish Academy, Royal Academy, Fine Art Soc., Royal Glasgow Inst., Scottish Gallery, Ingleby Gallery, Open Eye Gallery. *Works in collections:* Scottish National Gallery of Modern Art, Scottish Arts Council, Abbot Hall Gallery, Kendal, Aberdeen A.G., Glasgow A.G., City Arts Centre, Edinburgh, Perth A.G., Royal Scottish Academy, Arts Council of Northern Ireland, Contemporary Art Soc., IBM, Robert Fleming Holdings, Deutsche Bank. *Clubs:* Royal Northern, Scottish Arts, Caledonian, Royal Overseas League. *Signs work:* normally unsigned, labelled on reverse. *Address:* Heron House, Montrose, Angus DD10 9TJ. *Email:* ian.mckenziesmith@btinternet.com

MACKEOWN, James Martin, B.A. (Open Univ.); painter in oil, acrylic, water-colour and pastel. *b:* London, 3 Nov 1961. *m:* Marie Lestang. two *s.* four

d. Educ: left school at 14, painting full time since. *Exhib:* first one-man show (1977); one-man shows in London, Paris, Rouen, Belfast and Dublin. Permanently shown: Galerie Rollin, Galerie Alfa, Galerie Colette Dubois, West Wales Art Centre, Bell Gallery, Solomon Gallery, Bircham Gallery, Arlesford Gallery. *Works in collections:* National Self Portrait Collection, Ireland; Welsh National Library; Welsh Arts Society. *Commissions:* Colas Foundation. *Signs work:* "James MacKeown." *Address:* 45 Chemin de L'Etoile, 76111 Vattetot sur Mer, France. *Email:* mackeown@wanadoo.fr

MacKEOWN, Martin Graham Clarke, D.A. (Edin.) (1952); painter in oil;. *b:* Belfast, 14 May, 1931. *m:* Ann Carr. four *s.* two *d. Educ:* Campbell College, Belfast. *Studied:* Belfast College of Art (1948-50), Edinburgh College of Art (1950-52). *Exhib:* numerous. *Works in collections:* National Self-Portrait Collection of Ireland, Clare College Cambridge, Arts Council (N. Ireland), Ulster Television. *Publications:* illustrated several, including ten of his wife's cookery books, e.g. 'Ann Carr's Recipe Collection' (1987). *Signs work:* "M. MacKeown." *Address:* Manor House, Itteringham, Norfolk NR11 7AF.

MCKERRELL, John, Diploma in Art (Ed.Coll.Art) Post Grad (Highly Commended); Helen Rose Travelling Scholarship (Ed.Coll.Art) to Paris; Abbott & Holder Award, RWS (2002); RWS Council Award (1996); Alexander Stone Foundation Award RGI (1988); Tregastelle International Watercolour Award (France, 2000), Daler Rowney Award, RWS (2007). *Medium:* watercolour. *b:* Falkirk, 12 Jan 1947. *s of:* William McKerrell. *Educ:* Marr College, Troon. *Studied:* Edinburgh College of Art, Jordanhill College of Education. *Represented by:* self and DACS. *Exhib:* Royal Scottish Academy, Royal Glasgow Institute of the Fine Arts, Royal Scottish Society of Painters in Watercolour, Scottish Society of Artists, Royal Watercolour Society, Royal Insititute of Painters in Watercolour, Sunday Times/Singer Friedlander Comp., many mixed shows at the Maclaurin Art Galleries, Rozelle, Ayr. *Works in collections:* F.Dahl (Roald household). *Clubs:* DACS (Designer and Artist's Copyright Society). *Address:* c/o Summers, 36 Main Street, Symington, Ayrshire KA1 5QF.

McKIVRAGAN, Terrence Bernard, R.I., N.D.D.; artist in water-colour, acrylic and oils. *b:* Wallasey, 22 Jul 1929. two *s. Educ:* Wallasey Grammar School. *Studied:* Wimbledon School of Art (1947-51). *Exhib:* R.I. annually, Laing, Hunting Group, R.A. Summer Show, Singer & Friedlander/Sunday Times, N.E.A.C., R.B.A., R.S.M.A; galleries: Llewellyn Alexander, Shell House Ledbury, Manor House Chipping Norton, Alresford Hants., K.D. Fine Art, Guildford, Rowley, Winchester, Peninsula USA, Little Picture, Mousehole. *Commissions:* Baltic Exchange, Daily Express, Samsung, British Medical Assoc., Abbey National, Deutsch Financial, R.A.C. Pall Mall. *Publications:* Acrylic Masterclass - 9 featured artists, Paint Seascapes & Waterways - 14 artists; Watercolour Skies and Cloud Techniques -23 International artists; Watercolour Innovations - 8 artists. *Clubs:* Chelsea Art Soc. *Address:* The Old Pottery Bldg.,

Down Lane, Compton, Guildford, Surrey GU3 1DQ. *Email:* studio@terrymckivragan.co.uk *Website:* www.terrymckivragan.co.uk

McLACHLAN, Edward Rolland, Cartoonist of the Year (4 times). *Medium:* ink and wash. *b:* Leicester, 22 Apr 1940. *m:* Shirley Ann. one *s.* three *d. Educ:* Humberstone Village Junior School, Wyggeston Grammar. *Studied:* Leicester College of Art. *Represented by:* Folio; Oxford Designers and Illustrators; Cartoon Stock; Tony Cuthbert Productions. *Exhib:* Chris Beetles Gallery; London Cartoon Gallery. *Works in collections:* Chris Beetles Gallery; London Cartoon Gallery. *Commissions:* publishers: Methuen, Macmillan, Profile, Pearson, John Wiley; too many Ad agencies to mention. *Publications:* Punch, Private Eye, Spectator, Saga Magazine, European Lawyer, IFG Financial, Oldie, Property Week, Economist, Roof, Big Issue. *Recreations:* weight training, cycling, gardening, pubs. *Signs work:* McLachlan. *Address:* 3 Spinney View, Coverside Road, Great Glen, Leics, LE8 9EP. *Email:* mail@edmachlachlan.co.uk *Website:* www.edmclachlan.co.uk

McLAREN, Sally, RE. *Medium:* painting, etching, drawing. *b:* London, 21 Sep 1936. *Educ:* Langford Grove, Sussex. *Studied:* Ruskin School of Art, Oxford University (1956-59), Central School of Art, London (1959-61), French Government Scholarship: Atelier 17, Paris (1961, S.W.Hayter). *Exhib:* worldwide including U.S.A., Europe, Russia, S.Korea and S.America and the R.A.; solo shows: Bear Lane Gallery, Oxford (1964), Hambledon Gallery, Blandford Forum (1971, 1993), Wessex Craft Centre (1980), Salisbury Festival, Cranborne Gallery (1995), Edwin Young, Salisbury (1996), 107 Workshop, Shaw, nr. Bath (1997), Wilts Heritage Museum, Devizes, Bankside Gallery London annually. *Works in collections:* N.Y. Public Library, S.A.C., Ashmolean, Fitzwilliam and Devizes Museums, Scarborough Museum and A.G., Edwin Young Collection, Skopje Museum of Modern Art, Macedonia, Greenwich Library, Musee Russe en Exile, Montgeron, France, Bradford City Council, Huddersfield Gallery, Universities of Glasgow, Oxford and Fordham (N.Y.), Reed College, Oregon, Cabo Frio Print Collection, Brazil, Olivetti, J. Walter Thompson, City of Norwich Museum. Prizewinner, Mini Print Exhbn., Orense, Spain. *Commissions:* P. & O. Oriana, National Grid, Printmakers Council Print Club, Print Collectors Club, etc. *Publications:* Printmakers Journal (1989), Water-colours, Drawings and Prints Magazine (1992), Printmaking Today (1996). Featured Artist, Art for Sale in The Guardian; 50 Wessex Artists (2007); Printmakers Directory. *Official Purchasers:* Government Art Collection; New York Public Library; Devizes Museum; Olivetti; J Walter Thomson; City of Norwich Museum; Edwin Young Collection; Paintings for Hospitals. *Recreations:* sailing, walking, theatre, gardening. *Clubs:* Arts Club, Dover Street. *Signs work:* "Sally McLaren" or "McLaren." *Address:* Steeple Close, Milton, East Knoyle, Salisbury, SP3 6BG. *Email:* sally@sallymclaren.com

MACLAURIN, W. Patricia, Annie Longley Award, Pastel Society (2002); Dover St.Arts Club Award MAS (2005). *Medium:* oil and pastel. *b:* Christchurch, NZ, 10 Oct 1933. *m:* James. two *s.* two *d. Educ:* Convent of the Sacred Heart,

Timaru, NZ. *Studied:* Canterbury College School of Art, Christchurch, NZ. *Exhib:* RA Summer Exhbns, Royal Society of Portrait Painters, New English Art Club, Pastel Society, Royal Institute of Oil Painters, Discerning Eye, New Grafton Gallery, Llewelyn Alexander. solo: Sadlers Wells, Lyric Hammersmith and others. *Commissions:* various families. *Works Reproduced:* TSB Lloyds. *Principal Works:* portraits, figurative works. *Recreations:* music, dance. *Clubs:* Arts Club, Dover St. *Signs work:* Maclaurin. *Address:* 6 Burnside Close, Twickenham, TW1 1ET. *Email:* pat.maclaurin@blueyonder.co.uk

McLEAN, John, self taught painter in acrylic. *b:* Liverpool, 10 Jan 1939. *s of:* Talbert McLean. *m:* Janet. *Educ:* Reform Street School, Kirriemuir. *Studied:* St. Andrews University; Courtauld Institute. *Exhib:* over thirty-five solo shows worldwide. *Works in collections:* Tate Gallery, Scottish National Museum of Modern Art, Fitzwilliam Museum, Hunterian Collection, Glasgow University, Swindon, Southampton, Dundee,Glasgow, Edinburgh City and Whitworth Art Galleries. *Commissions:* Edinburgh University; Hairmyres Hospital, East Kilbride; Scottish Equitable H.Q. *Publications:* Scottish Art, by Duncan MacMillan (1990); Art Crazy Nation by Matthew Collings (2001). *Official Purchasers:* Arts Council of Great Britain, Scottish Arts Council, British Council, Department of Envirornment, Scottish Parliament, British Embassy, Moscow, Royal Jamaican Academy. *Signs work:* "John McLean" or "J.M." *Address:* 704 Mountjoy House Barbican London EC2Y 8BP.

McLEAN, Mary, R.M.S. (1994), H.S. (1990); miniature painter in water-colour; Gold Bowl Hon. Mention (1997); Llewellyn Alexander Award (2000). *b:* Farnborough, Kent, 1944. *m:* John S. McLean. two *s.* one *d. Educ:* Marion Vian School, Beckenham. *Studied:* privately with Ronald Jesty, A.R.B.A. *Exhib:* R.A., R.M.S., Llewellyn Alexander (Fine Arts), The Market Cross Gallery, Sturminster Newton, Dorset, Japan and U.S.A., Lannards Gallery, Billingshurst, Sussex, Hilliard Soc. Work in private collections. *Publications:* front cover illustration for specialist poultry magazine, Artist and Leisure Painter magazines, Royal Miniature Society, 100 years book. *Signs work:* "Mary McLean." *Address:* 35 Old Station Gdns., Ashvale, Henstridge, Templecombe, Som. BA8 0PU. *Email:* marysmclean@btinternet.com *Website:* www.paintingsinminiature.com

MACLEAN, William J., D.A., R.S.A., R.G.I., R.S.W.; Professor, fine art, Dundee College, Univ. of Dundee. *b:* Inverness, 12 Oct 1941. *s of:* John Maclean, master mariner. *m:* Marian Leven. two *s.* one *d. Educ:* Inverness Royal Academy, H.M.S. Conway, N. Wales. *Studied:* Grays School of Art, Aberdeen (1961-66); British School at Rome (1966). *Exhib:* one-man shows: Edinburgh, New 57 Gallery, Richard Demarco Gallery, R.H.W. London; group shows: Scottish Arts Council, Art First, London, 3rd Eye Gallery. *Works in collections:* Aberdeen A.G., Scottish Arts Council, Contemporary Art Society, Scottish National Gallery of Modern Art, Hull A.G., Fitzwilliam Museum, Cambridge, B.M. *Signs work:* "W. J. Maclean." *Address:* 18 Dougall St., Tayport, Fife DD6 9JD, Scotland.

MacLENNAN, Alastair MacKay, M.F.A. (1968), D.A. (1965); intermedia artist in mixed media installations, actuations, time-based work, conceptual orientation; Prof. of Fine Art, University of Ulster (1992-); Lifetime Achievement Award from TRACE, Cardiff Art in Time, Cardiff. *b:* Blairatholl, Scotland, 3 Feb 1943. *s of:* Christopher MacLennan. *Educ:* Perth Academy, Scotland. *Studied:* School of the Art Institute of Chicago, U.S.A. (1966-68), Duncan of Jordanstone College of Art, Dundee, Scotland (1960-65). *Exhib:* national and international festivals of performative and time-based work throughout America, Canada, Britain, E. and W. Europe, Asia. *Works in collections:* British Arts Council; private collections in Britain, America, Canada, Germany, Switzerland and Poland. *Commissions:* Representing Ireland at the Venice Biennale (1997), with 'Body of (D) earth'. *Publications:* reviews and interviews in art publications and periodicals. *Misc:* MacLennan has lived in Belfast since 1975. He is known for long, durational performances, and performance/installations, or 'actuations'. From the seminal work 'Days and Nights' (1981), a 144 hour non-stop actuation, to 'No Nemesis' (2000), his Zen-informed practice has been constant. His concerns include ethics, aesthetics, religious/political bigotry, inclusive tolerance, oppositional or consensus means of political/social improvement, death, decay, new life and mutation, transformation. An enthusiastic and influential artist and educator, he has exhibited extensively nationally and internationally. In 1989 he joined the innovative European performance art group, Black Market International. *Address:* c/o University of Ulster, School of Art and Design, York St., Belfast BT15 1ED, N. Ireland. *Email:* a.maclennan@ulster.ac.uk *Website:* http://www.vads.ahds.ac.uk/collections/maclennan

MACLEOD, Duncan, D.A. (1974), R.S.W. (1980); artist in mixed media, water-colour, school teacher; S.A.C. Lecturers Panel;. *b:* Glasgow, 5 Apr., 1952. *m:* Maretta Macleod, artist (divorced). one *s.* one *d. Educ:* Clydebank High School. *Studied:* Glasgow School of Art (1970-74, David Donaldson). *Exhib:* R.S.A., R.S.W., R.G.I., and many mixed and one-man shows in Britain. *Works in collections:* U.K., U.S.A., France, Sweden, and the Far East. *Signs work:* "Duncan Macleod." *Address:* 13 Miltonhill, Milton, By Dumlarton.

MCLEOD, Ian, DA (Edin), RSW, FFCS; tutor in Life Drawing and Painting, Glenrothes College of Further Education. *Medium:* painter in acrylics on board. *b:* Port, Glasgow, 27 Jun 1939. *m:* Mary Rintoul. one *s.* one *d. Educ:* Burntisland Primary/Secondary School, Kirkcaldy High School. *Studied:* Edinburgh College of Art 1961-65; Regent Road Institute for Adult Education; Moray House College, Edinburgh. *Exhib:* 10 solo exhibitions; 3 two-person exhbns.; 56 group exhbns. *Works in collections:* Aberdeen University; Maclean Art Gallery, Greenock; Hamilton City Art Gallery, Ontario; IBM; The Arts in Fife, Fife Council; Edinburgh City Council; Dunfermline Museums and Art Galleries; private collections in the UK, France, Germany and USA. *Commissions:* portraits, drawings, photography for books and videos. *Publications:* Sottish Realism, Alan Bold; The Eye in the Wind: Contemporary Scottish Painting since 1945, Edward Gage; Glasgow League of Artists Yearbook 1978; Roots in the

'80s', Emilio Coia, Stan Bell, Duncan MacMillan, Jim Waugh; Dictionary of Scottish Art and Architecture, Peter McEwan; The Paintings of Stephen Campbell, Duncan MacMillan; Scottish Art in the 20th Century, Duncan MacMillan. *Official Purchasers:* see work in collections. *Recreations:* reading, walking, music. *Clubs:* Scottish Arts Club, RSW. *Address:* 33 Craigkennochie Terrace, Burntisland, Fife, Scotland, KY3 9EN.

MACLUSKY, Hector John, Slade Dip. (London); painter; illustrator; lecturer, Stevenage College; art master, Highgate School (1948-50). *b:* Glasgow, 20 Jan 1923. *s of:* W. B. McLusky, M.C. *Educ:* Roundhay and Warwick Schools. *Studied:* Leeds College of Art (1939-40) and Slade School (1945-48). *Exhib:* R.A., R.B.A., London and provinces, Barbican Foyer Exhbn., The Face of Bond (1996). *Works in collections:* America and Australia. *Publications:* freelance cartoonist and illustrator for Press and television. *Signs work:* "John McLusky." *Address:* Hollybush Studio, Baines Lane, Datchworth, Herts. SG3 6RA.

MACMARTIN, John Rayment, D.A., F.R.S.A.; Diploma of Merit, Italy; D.M.D.A.; F.S.A.(Scot.); Industrial Design Consultant and Architectural Designer; Director (Tackle & Guns); artist in oils; inventor. *b:* Glasgow, 3 Oct 1925; Creamola Kid (1936-37). *m:* Evelyn Margaret Lindsay Macmartin, embroideress. two *s.* one *d. Educ:* Allan Glen's School, Glasgow. *Studied:* Glasgow School of Art (A past president of the Graduate Association). *Exhib:* oil paintings - Product design, Scottish Inventions of the year - (finalist). *Works in collections:* throughout the world. Structural Building MODULE, designed after a visit to Pompeii; invited to Leningrad, Moscow (1985), U.S.A. (1987), China (1988), Florida (1988), France (1989, 1994) and Norway (1991). National Trust for Scotland: V.P., Lanarkshire (1992-99), Probus Mem. (1992-99). Scottish Core of Retired Executives. *Address:* Rosebank, 2 Markethill Rd., East Mains, East Kilbride G74 4AA.

MACMIADHACHÁIN, Pádraig, R.W.A.(resigned 1996); artist, Travelling Prize to Moscow (1957), winner, Laing National Painting Competition (1991), winner Daler Rowney award in Royal West of England Academy (1992), Polish Govt. to Poland (1961). *b:* Downpatrick, Ireland, 2 Mar., 1929. *m:* Hazel McCool. two children. divorced. m Ann Slacke. one child. divorced. m Charlotte Kockelberg (T.A. Charlotte Kienitz). divorced. m Bonnie Brown, painter. divorced. m Jane Hobday, painter. *Educ:* Bangor Grammar School; Portora Royal School, Enniskillen. *Studied:* Belfast College of Art (1944-48), National College of Art, Dublin (1948-49), Academy of Art, Krakow, Poland (1960-61). *Exhib:* one-man: Belfast, Dublin, London, Madrid, Krakow, Seattle, Los Angeles, Vancouver, Las Palmas; group shows: R.A., R.W.A., R.U.A., Gorky Park, Moscow, Irish Exhbn. Living Art, Discerning Eye, Thompson Gallery, Crane Kalman, Cadogan Contemporary City Gallery - all London, Penwith Soc. of Art, St. Ives. *Works in collections:* in many private and public collections throughout the world, among them Hertford College, Oxford; Sussex University; The Bank of China; Irish Allied Bank; West Merchant Bank; Office of Public Works,

Ireland; Dept. of Finance & Personnel, Govt. of N. Ireland. *Publications:* three collections of poems. *Misc:* Works always in New Academy Gallery, 34 Windmill Street, London; New Craftsman, St.Ives; Belgrave Gallery, St.Ives; Molesworth Gallery, Dublin, and Mullan Gallery, Belfast. *Signs work:* Work always in New Academy Gallery, 34 Windmill St., London, New Craftsman, St. Ives and The Molesworth Gallery, Dublin. *Address:* Wharf House Studio, 4 Commercial Lane, Swanage, Dorset BH19 1DE.

McMULLEN, Sue, DipAD; PG Cert. of RAS; PG Cert of Educ.; painter in oil and draughtsperson in pen and ink; lecturer at Salisbury College of Art (1974-1982); RA Schools Turner Gold Medal for Painting; freelance artist. *b:* Yorks., 7 Oct 1948. *d of:* Patrick McMullen. *m:* Andrew. one *s.* one *d. Educ:* Kingston-upon-Hull High School for Arts and Crafts. *Studied:* Hornsey; Loughborough College of Art; Royal Academy of Arts Schools; The Victoria University of Manchester. *Exhib:* 50+ solo/mixed exhibitions since 1996, including RP (Mall Galleries 2003, 04), RSMA (2004) Art 4 Life, Christie's, Burlington Fine Art, The Athenaeum, Loggia Gallery, London; RA Summer Exhibs.; Upstream Galleries, London; Cathedral Church of St. Nicholas, Newcastle; Ferens Art Gallery, Hull; Crook, Co. Durham; Art Exhib. Grenville Court, Burnham, Bucks, The Westminster Gallery, London. *Works in collections:* slide collection Staffordshire University; private collections UK, USA, Australasia, Netherlands, Switzerland. *Commissions:* Cedric Messina (B.B.C. producer), Sq. Ldr. Revd. Davies, Dr. R. Langford, John Curtis (structural engineer), Christopher Seward. *Publications:* images for Thea P. Hilcox, Inspirational Art Books pub. Ava/Rotovision (2001), reviews and interviews in art publications and various newspapers. *Official Purchasers:* Cambridge Education Authority. *Clubs:* R.A.S.A.A. *Signs work:* "Sue Mc." and "Sue McMullen". *Address:* 36 Whenby Grove, Huntington, York YO31 9DS. *Email:* sue-mcmullen@hotmail.com *Website:* www.suemcmullen.com

McNAUGHTON, Rachel Patricia, *Medium:* watercolour and pastel. *b:* 26 May 1952. *d of:* Mr & Mrs R.J.Wilson. *m:* Robert McNaughton. one *s.* one *d. Educ:* Leeds Girls High School, Eaton Hall Coll. of Ed. *Studied:* English Theatre Arts. *Exhib:* widely in Yorkshire and N.England; 1 solo show Harlow Carr (Harrogate), 5 solo shows at Wetherby (Yorks). *Publications:* 'Putting Colour into Watercolour' instructional video; 'From Flower to Watercolour' instructional video. *Works Reproduced:* cards & prints by Claughton Images, Wellington Place, Harewood Road, Leeds, www.claughtonphotography.co.uk. *Clubs:* mem. Yorkshire Watercolour Society, Leeds Fine Art Club. *Misc:* tutor for RHS -watercolours; runs own classes/workshops in watercolour and pastel; Professional Associate of S.A.A. (Society for All Artists). *Address:* Stonethwaite, Scarsdale Ridge, Bardsey, Leeds, LS17 9BP. *Email:* rachelm@artbyrachel.co.uk *Website:* www.artbyrachel.co.uk/ www.minigalleryworld.com/Rachel_McNaughton

McNIVEN, Peter Alister, French Govt.Scholarship Cité International des Arts (Paris) (1986); NPG Portrait Award prizewinner. *Medium:* oil, watercolour, drawing. *b:* Edinburgh, 28 Feb 1952. *m:* Helen (BA Fashion, Kingston). two *s.* one *d. Educ:* George Watson's College, Edinburgh. *Studied:* Liverpool Coll. Art; Manchester School of Art. *Exhib:* RA, RP, NEAC, RCA, NPG; Hayward Gallery (British Drawing); various commercial galleries London, South East, Edinburgh, Brittany. *Works in collections:* Queen's Collection, Windsor (O.M drawing); Imperial War Museum (8 portrait drawings); private collections. *Commissions:* Margaret Thatcher; John Nott for Imperial War Museum; Sir George Edwards O.M.; numerous private portrait. *Publications:* First Arts and Crafts with Helen McNiven (Four Art Books for Children). *Principal Works:* portrait, landscape and still life. *Recreations:* music, cooking, art history France/Italy. *Misc:* Director of Art, Cranleigh School, Surrey. *Signs work:* on back 'McNiven', oil & title & date. *Address:* Old Yew Cottage, Horseshoe Lane, Cranleigh, GU6 8QF. *Email:* pamcn@cranleigh.org

McPAKE, John A., NDD, ATD, RE, P.MAFA; painter/printmaker working in acrylic painting and etching. *b:* Lancs., 1943. *s of:* Nicholas McPake. *m:* Anne Genner Crawford M.A.F.A. *Educ:* St. Anselm's College, Birkenhead. *Studied:* Wallasey School of Art and Crafts (1961-65), Liverpool Polytechnic (1965-66), Birmingham Polytechnic (1966-67), Leeds Polytechnic (1977-78). *Exhib:* various group shows including RE's Bankside Gallery, RA Summer shows, Seoul Print Biennale (1986, 1988), MAFA, various one and two person shows, including "Two Artists" at St.George's Chapel, Windsor Castle; Central Art Gallery, Ashton Under Lyne, and The Portico Library and Gallery, Manchester. *Works in collections:* Bankside Gallery (RE's); Colin Jellicoe Gallery, Manchester; various public and private collections in the U.K. and abroad, including Westcote Bell, Highfalls, New York. *Commissions:* various, including commemorative etching for "Wakefield in the '80's", Print Collector's Club, Commemorative Print, Leeds Art Fair. *Signs work:* "John A. McPake." *Address:* 21 Ingbirchworth Rd., Thurlstone, nr. Sheffield S36 9QN. *Email:* john.mcpake@talktalk.net

MACPHAIL, Ian S., F.I.P.R.; artist in typography and print design; European Co-Ordinator, International Fund for Animal Welfare and editor; asst. music controller, E.N.S.A., specializing in publicity; asst. music director, Arts Council of Gt. Britain, responsible for all printing and publicity design;. *b:* Aberdeen, 11 Mar., 1922. *m:* Michal Hambourg. one *s.* one *d. Educ:* Aberdeen Grammar School. *Studied:* with Charles W. Hemmingway. *Exhib:* Exhbns. of posters, Council of Industrial Design. *Publications:* You and the Orchestra (McDonald & Evans), editor and designer of Dexion News, Good Company and The Griffith Graph, designed literature for the first world conference on gifted children (1975). *Works Reproduced:* in British Printer. *Clubs:* Savile. *Signs work:* "Ian Mac. Phail." *Address:* 35 Boundary Rd., St. John's Wood, London NW8 0JE.

WHO'S WHO IN ART

MACPHERSON, Hamish, A.R.B.S.; sculptor; teacher, Central School of Arts and Crafts, London (1948-52), Sir John Cass School of Art, London (1948-53). *b:* Hartlepool, 20 Feb 1915. *Educ:* New Zealand. *Studied:* Elam School of Art, Auckland, N.Z. (1930-32), Central School of Arts and Crafts, London (1934-39). *Exhib:* one-man exhbns., Picture Hire, Ltd., London (1938), Chelsea Gallery, London (1947), Apollinaire Gallery, London (1950, 1952), Alwin Gallery, London (1968), London Group, N.S., New York, Paris, the Colonies and provinces; work for Festival of Britain (1951). *Signs work:* "Hamish Macpherson." *Address:* Casa Mia, Mitchel Troy Common, Monmouth, Gwent NP5 4JB.

MACQUEEN, Charles Thomas Keane, D.A. (1962), R.G.I. (1985), R.S.W. (1984); painter in water-colour, acrylic and oil; lecturer in Art Education at Moray House Inst. of Educ. - retired. *b:* Glasgow, 23 Feb., 1940. *m:* Christine Woodside R.S.W., R.G.I., (partner). two *d. Educ:* St. Aloysius College. *Studied:* Glasgow School of Art. *Exhib:* numerous exhibs. including R.S.A., R.S.W., R.G.I. *Works in collections:* Royal Scottish Academy, Paisley Museum and Art Gallery, The Royal Bank of Scotland. *Commissions:* two murals for the new Cunard liner, Queen Victoria. *Clubs:* Scottish Arts club. *Signs work:* "MACQUEEN." *Address:* Tower View, 1 Back Dykes, Auchtermuchty, Fife KY14 7AB.

McRAE, Jennifer, NEAC; BA (1st class hons), Higher Diploma Post Grad. Painting/ Fine Art; Awards: Hunting Art Prizewinner (1st, 1998; 2nd 1992; Regional 2001), Singer & Friedlander (2nd, 2001 & 2002) etc. *Medium:* painter. *b:* 29 Jan 1959. *d of:* Evelyn & Douglas McRae. *m:* David McLean. one *d. Educ:* North Berwick High School. *Studied:* Grays School of Art. *Exhib:* solo: Anthony Hepworth Gallery, Bath (1992, 1994), Open Eye, Edinburgh (1993, 1996), Beaux Arts Bath (1997, 2001, 2003), Scottish Gallery (2000), Scottish Arts Club (2002); Bohun Gallery (2002); Group: Royal Scottish Academy, Edinburgh (1993), National Portrait Gallery (1995, 1996, 1998), Singer & Friedlander, Mall Galleries (1998, 2001, 2002), Discerning Eye, Mall Galleries (2002), National Print Exhibition, Mall Galleries (2003). Also Cricket Hill Assoc. NYC, USA, Aberdeen Art Gallery, Mall Galleries, Contemporary Art Fairs, London, etc. *Works in collections:* Scottish National Portrait Gallery, National Portrait Gallery, Aberdeen Art Gallery, Reading Museum, Clare Hall, Cambridge. *Publications:* Self Portraits by Women, NPG London. *Official Purchasers:* Dame Gillian Beer (Clare Hall Cambridge), Alan Caiger Smith (Reading Museum), Thelma Holt (NPG), Robin Jenkins, (SNPG), Tom Fleming (SNPG, drawing), Paul Anderson (Aberdeen Art Gallery) Michael Frayne (NPG) and many more. *Works Reproduced:* 'Double Exposure' repro. in 'Mirror Mirror'. *Principal Works:* Thelma Holt, portrait (NPG), Robin Jenkins (SNPG), Paul Anderson (Aberdeen Art Gallery), 'Double Exposure', self portrait, Alan Caiger Smith (Reading Museum). *Recreations:* printmaking, running, socialising, travelling, theatre, reading. *Clubs:* Scottish Arts Club, Glasgow Arts Club, Chelsea Arts Club. *Misc:* awarded a scholarship place on the Drawing Year, The Prince's Foundation

(2002-3), member of Edinburgh Printmakers since 1993. *Address:* 68 Sudbourne Road, London SW2 5AH. *Email:* MCRAE597@aol.com

MACRAE, Tom, *Medium:* oil, watercolour, drawing, sculpture. *b:* Rhodesia, 31 Mar 1959. one *s.* one *d. Studied:* Northwich School of Art; Stockport School of Art. *Represented by:* Theo Waddington, and self. *Exhib:* RA Summer Exhbns; Hunting Art Prize; Discerning Eye; Jerwood. *Works in collections:* Ericsson, Baker Tilly, Ruan Milborrow Collection, Robertsons. *Works Reproduced:* Royal Academy Summer Exhibition Catalogue (full page). *Recreations:* guitars, automobilia. *Signs work:* 'Tom Macrae'. *Address:* 7 Edwards College, South Cerney, Cirencester GL7 5TR.

McSLOY, Jane A.C., BA (Hons), MA, HS, SOFA (Assoc.). *Medium:* w/c on ivorine, w/c and gold leaf on vellum (miniatures). *b:* Leicester, 1962. *d of:* W. and R.F.McSloy. *Educ:* BA (English and History of Art) 1981-4 University College, London University; MA (Mediaeval Studies) 1992-4 Birkbeck College, London University; Montefiascone (medieval pigments) 2000. *Exhib:* London; Peterborough City Art Gallery; King's Lynn; Chichester; Wells; Tasmania; Austen Texas. *Works in collections:* University of Austen Texas (illumination to illustrate Gerard Hopkins' poem). *Commissions:* D & S Hughes, N. Bate, H. Lushington, D. Bromilow. *Publications:* Hopkins Quarterly. *Principal Works:* heavily detailed feline subjects and mediaeval illumination using gold and traditional materials. *Recreations:* running (1990 London Marathon), researching Victorian Papier Mache. *Misc:* works as gilder/ furniture restorer; teaches widely, including Geffrye Museum and Victoria and Albert Museum. *Signs work:* J McS. *Address:* Studio 2F Cockpit Workshops, Cockpit Yard, Northington St., London WC1N 2NP. *Email:* jmcsloy@britishlibrary.net

MacSWEENEY Dale Louisiana; see PRING MacSWEENEY, Dale Louisiana,

McWILLIAMS, Simon, RUA; BA (Hons) Fine Art; PgDip.RAS; Guinness Award RA; British Institute Award for Painting; award winner at RA, RUA and RHA, major award NI Arts Council. *Medium:* oil, drawing, prints. *b:* Belfast. one *d. Studied:* University of Ulster; RA Schools, London. *Represented by:* Solomon Gallery, Dublin. *Exhib:* Solomon Gallery; Art Space Gallery, London; RA; RUA; RHA; Cavehill Gallery; Hunting Art Prizes; John Martin Gallery, London; Katzen Gallery, Washington DC. *Works in collections:* Arts Council NI; Guinness Plc; Ulster Museum; Queen's University; University of Ulster; AIB Bank; Ulster Television; The Haverty Trust; ESB, Irish Permanent; NI Govt. *Commissions:* ESB Ireland; National Self-Portrait Collection, Ireland; Centrum Kunstlicht in de Kunst (Eindhoven); UNISON for NI. *Publications:* "Best Paintings" John Martin Gallery, London. *Official Purchasers:* Arts Council NI; Guinness; Ulster Museum; as collections. *Works Reproduced:* Ulster Museum; Allied Irish Banks; Bank of Ireland; Solomon Gallery. *Principal Works:* 'Church' (Ulster Museum); 'Greyhound Track' (Allied Irish Bank); 'Scaffolding'. *Recreations:* amateur

engineer. *Clubs:* The Reynolds Club. *Signs work:* 'Simon McWilliams'. *Address:* 4 Grasmere Gardens, Belfast BT15 5EG N.Ireland. *Website:* www.simonmcwilliams.com

MADDISON, Eileen, N.D.D. (1955), A.T.D. (1956), S.B.A. (1998); botanical artist in water-colour;. *b:* Lancs., 22 Aug., 1934. *m:* Colin Maddison. one *s.* two *d. Studied:* Central School of Art (1953-55), Liverpool College of Art (1955-56). *Exhib:* S.B.A., Westminster Gallery, Guildford House Gallery, American Daffodil Soc., Pashley Manor, work in private collections internationally. *Signs work:* "Eileen Maddison" or "E.M." *Address:* Cedar Cottage, Cedar Rd., Woking, Surrey GU22 0JJ.

MADDISON, John Michael, B.A. (1974), Ph.D. (1978), F.S.A. (1991); painter in oil, distemper, gouache; former architectural adviser to Victorian Soc. (1979-81), and Historic Buildings Representative, National Trust East Anglia (1981-92);. *b:* St. Andrews, Fife, 17 Nov., 1952. *m:* Jane Kennedy. two *s. Studied:* University of Manchester. *Exhib:* R.A., R.I., many mixed exhbns. and one-man shows in London, Norfolk, Cambridge, Salisbury, Stockbridge, Ripley and Bury St. Edmunds. *Commissions:* distemper panels for National Trust restaurant Felbrigg Hall; reredos for Bishop Alcock's Chapel at Ely Cathedral. *Publications:* articles and books on medieval architecture and books on country houses. *Signs work:* "JM" or "John Maddison". *Address:* 88 St. Mary's St., Ely, Cambs. CB7 4HH.

MADDISON, Robert, SGFA (1985), MENSA. (1987); painter in water-colour, pastel, graphite. *b:* Newcastle upon Tyne, 6 May 1946. *s of:* Robert Maddison. *m:* Elizabeth Finch. one *s.* one *d. Educ:* Heaton Grammar School. *Studied:* Newcastle College of Art (1962-64, John Crisp), Manchester College of Art (1964-65). *Exhib:* S.G.F.A., N.S.; numerous one-man shows. *Works in collections:* Durham University; numerous private collections including H.R.H. The Prince of Wales. *Publications:* The Northern Pennines - An Artist's Impressions; articles; television broadcasts, "The Artist", "International Artist". *Clubs:* Society of Graphic Fine Arts, UK Coloured Pencil Society. *Misc:* Artist in residence "Prudhoe Community Arts", Artist in Residence "Newcastle Opera House". *Signs work:* "R. Maddison." *Address:* Spring Cottage Studio, Dovespool, Allenheads, Northumberland NE47 9HQ. *Email:* rmaddison@supanet.com *Website:* www.maddisonstudios.com

MADDOX, Ronald, PRI, Hon. RWS, Hon. RBA, FCSD, FRSA.; illustrator, consultant Designer, artist in water-colour, line, gouache, specialising in architecture and landscape; Design Council Award (1973); Isle of Man Europa stamps Prix de l'Art Philatelique (1987); Winsor & Newton RI. Award (1981,1991); finalist Hunting Group Art Prizes (1980-81-83); RI Rowland Hilder Award (1996, 2000); Elected President RI (1989) re-elected (1994,1999, 2004), Governor FBA (1989-2002). *b:* Purley, Surrey, 5 Oct 1930. *s of:* H. G. Maddox. *m:* (1st) Camilla Farrin. 1958 (decd. 1995); two s. (2nd) Diana Goodwin (1997).

two *s*. *Studied:* St Albans School of Art, Hertfordshire College of Art and Design, London College of Printing and Graphic Arts. Design/Art Direction 1951-61, freelance from 1962. *Exhib:* RA, RI, RBA, Bankside Galleries- national and provincial exhbns., one-man shows. *Works in collections:* Britain, USA, Canada, Germany. Designer -British Commemorative stamps (1972/78/84/89);. *Publications:* national and international publications. *Clubs:* AGBI Council/Hon.Secretary; The Arts Club. *Signs work:* "RONALD MADDOX." *Address:* Herons, 21 New Rd., Digswell, Welwyn, Herts. AL6 0AQ.

MADERSON, Arthur Karl, NDD (1964); painter in oil, pastel, acrylic and water-colour. *b:* London, 27 Dec 1942. three *s*. three *d. Educ:* Battersea County Comprehensive. *Studied:* Camberwell School of Art (1960-64, Robert Medley). *Represented by:* The James Gallery, Dublin; The Taylor Gallery, Belfast; The Lavitt Gallery, Cork. *Exhib:* regularly at RWA (Cornelissen prizewinner 1986), RA, RHA (Abbey Studio prizewinner 1992), viewing of recent work at the Artists Studio Gallery, Derriheen House, by appointment. *Works in collections:* Europe and abroad. *Works Reproduced:* contributor to many journals and art publications including The Artist. Mem. Cork Arts Soc. *Recreations:* chess, revolutionary Marxism. *Clubs:* "Old Brixtonian". *Signs work:* "A.K. Maderson," or "A.K.M" on picture and reverse. *Address:* Derriheen House, Cappoquin, Waterford, Eire. *Email:* maderson@gofree.indigo.ie

MAECKELBERGHE, Margo Oates, artist. *Medium:* painter. *b:* Penzance, Cornwall. *d of:* Mr. & Mrs. E.O.Try. *m:* Dr. one *s*. one *d. Educ:* Penzance Grammar School. *Studied:* Penzance School of Art, Bath Academy of Art, Corsham. *Represented by:* various galleries. *Exhib:* London Group, Leicester Galleries, Penwith Gallery, Newlyn Gallery, Plymouth City Art Gallery and Museum, Peter Hyde Fine Arts, London (1968), Ewaston Gallery, Durham University, Edinburgh University, Exeter University, Festival Exhbns. Aldeburgh, Black Swan Gallery, Frome, Kunsthalle Munich, Kursaal Ostend, etc. *Works in collections:* significant representation in private and public collections in Britain and throughout the world. *Publications:* 'The Timeless Land' Denys Val Baker; 'St.Ives Revisited' Peter Davies; 'St.Ives, Portrait of an Art Colony' Marian Whybrow; 'Catching the Wave' Tom Cross; 'Behind the Canvas' S.Cook, S.Britain, etc. *Official Purchasers:* Contemporary Art Society, V. & A. Museum, Plymouth Museum and City Art Gallery, Toronto University, Exeter University, Durham University, Kunst Museum, Berlin, British Council, Cornwall Collection, Devon County Council, etc. *Recreations:* reading, exploring!. *Clubs:* Chelsea Arts, Chairman Penwith Society of Artists, Newlyn Society of Artists. *Misc:* elected Bard of Cornish Gorsedd 1997. *Signs work:* Maeckelberghe. *Address:* 'Roscadghill' Penzance, Cornwall, TR20 8TD.

MAER, Stephen, FSDC; Chairman of Soc. of Designer Craftsman, Designer Jewellers Group: Founder-Member and Chairman (1980-83, 1992-95), Crafts Council, Index; designer jeweller. *b:* London, 1933. *s of:* Mitchel Maer. *m:* Janet Eddington. two *d. Educ:* Clayesmore School. *Studied:* jewellery design at R.C.A.

under Prof. R. Goodden. *Exhib:* group shows: British Crafts Centre, R.S.A., Design Centre, Goldsmiths Hall, Barbican Centre, Chelsea Crafts Fair, Mall Galleries. *Signs work:* "SM" (hallmark). *Address:* 18 Yerbury Rd., London N19 4RJ. *Email:* stephen.maer@btinternet.com

MAGIS, Pascal, Dip. National des Beaux Arts (1976); abstract artist in acrylic and oil and tapestry designer. *b:* Aurillac, France, 1 Apr 1955. *m:* Lilou Magis. *Educ:* Ecole St. Joseph de Sarlat, France. *Studied:* Ecole Nationale des Arts Decoratifs de Limoges, France. *Exhib:* Wimbledon Fine Art, Galerie Lewis Guy, Holland, Galerie Inuit, Denmark, Galerie Briand, France. *Works in collections:* Glaxo Smith Kline, Rabo Bank, A.M.B. Amro. *Commissions:* R.A. Christoforides collection. *Address:* c/o Wimbledon Fine Art, 41 Church Rd., Wimbledon Village, London SW19 5DQ. *Email:* magis.art@wanadoo.france

MAHON, Phyllis Josephine, BA Hons (1976); H.Dip.Fine Art (1977); Arts Council Northern Ireland Award (1977); Arts Council East Midlands Award (2004). *Medium:* painting, stonecarving. *b:* Omagh, Co.Tyrone, NI. *d of:* Joseph & Alice Mahon. *m:* (1977-92) Brian Campbell; (2000) Robert Willmington. 2 s.,2 s- s. 1 d., 1 s- d. *Educ:* Mt.Carmel Grammar School, Strabane (1965-71). *Studied:* Belfast College of Art (1971-6). *Exhib:* solo exhbns: UK and Irish galleries including Belfast, Chester, Dublin, London, Taunton, Worcester, Mount Berry College-Georgia,USA; group exhbns include: RA Summer Show; Curwen gallery; England & Co.; Fung Ping Shan Museum, Hong Kong. *Works in collections:* Arts Council N.Ireland; Belfast Telegraph; UTV; Bedfordshire & Somerset Councils; private collections worldwide. *Commissions:* private commissions: Finland, Germany, Japan, USA, UK. *Publications:* editorial illustrations; wrote and illustrated 'Goddesses for the Millennium' (1999). *Works Reproduced:* Lontano CD 'Music from Northern Ireland' (2004); Rouge Press Portfolio (1986); Arts Council Editioned Prints (1989). *Principal Works:* Pietas (1987); River of Time (1989); Catching the Precious (1994). *Recreations:* reading, travelling. *Signs work:* 'Phyllis Mahon'. *Address:* The Studio, Joll's Lane, Greetham, Horncastle LN9 6NT. *Email:* phyllis.mahon@googlemail.com *Website:* www.jolls.co.uk

MAI, Jinyao: see MAK, Kum Siew,

MAK, Kum Siew, (Mai, Jinyao), A.R.C.A. (1967); full-time artist in Chinese and Western media. *b:* Singapore, 21 Apr 1940. two *s. Educ:* Singapore. *Studied:* St. Martin's School of Art (1961-64) under Frederick Gore, R.C.A. (1964-67) under Carel Weight. *Exhib:* R.A., I.C.A., R.C.A., Serpentine Gallery, Tate Gallery, Whitechapel Gallery. *Works in collections:* Tate Gallery, London; National Gallery, Singapore; Museum of Modern Art, Hyogo, Japan; Arts Council of G.B. *Publications:* Talking Pictures, The Best of Friends. *Address:* Derrylehard, Ballydehob, Co. Cork, Eire.

MAKEPEACE, John, O.B.E. (1988), F.C.S.D., F.I.Mgt., F.R.S.A.; designer and furniture maker since 1961; Founder and Director: The Parnham Trust (1977-

2000);. *b:* 6 July, 1939. *m:* 1983 Jennie Moores. two *s. Works in collections:* Cardiff; Fitzwilliam; Leeds; Frankfurt; Art Institute, Chicago; Lewis Collection, Richmond,Va.; V. & A.; Royal Museum of Scotland. *Commissions:* Furniture commissions for Nuffield Foundation; Post Office; Royal Society of Arts; Boots plc; Banque Generale du Luxembourg. *Publications:* "A Spirit of Adventure in Craft and Design" by Jeremy Myerson. *Clubs:* The Athenaeum, London. *Misc:* Study/Consultancy Tours: Scandinavia; N.America; W.Africa; Australia and Japan. Featured in numerous books, articles and films internationally. *Address:* Farrs House, Beaminster, Dorset DT8 3NB.

MAKLOUF, Raphael, sculptor in bronze; painter;. *b:* Jerusalem, 10 Dec., 1937. *Studied:* Camberwell School of Art (1953-58) under Dr. Karel Vogel. *Works in collections:* Life-size bronze bust of H.M. Queen Elizabeth II for Royal Society of Arts, John Adam St., London (1986); life-size bronze bust of General Sir John Mogg for Army Benevolent Fund (1987); Tower of London; Carnegie Hall, N.Y., etc. New portrait effigy of H.M. The Queen on all U.K. coinage from 1985; bronze of H.M. The Queen, National Theatre; 15 Stations of the Cross, for Brentwood Cathedral (architect Quinlan Terry). *Address:* 3 St. Helena Terr., Richmond, Surrey TW9 1NR.

MALCOLM, Bronwen, BA Hons. Fine Art; painter in oil. *b:* London, 31 Jul 1963. *m:* Stephen Ackhurst. one *s.* one *d. Studied:* Wimbledon School of Art (1981-1982), St. Martins School of Art (1982-1985) under Eileen Cooper and Albert Herbert. *Exhib:* Discerning Eye; RA Summer Show; Crickethill NYC, NY, USA; Thackery Gallery; Gallery 286, London. *Works in collections:* Unilever. *Commissions:* Merrill Lynch, U.K. *Publications:* Arts Review, (Oct. 1987, Dec. 1988), Company, (Jan. 1989), Soloarte 1st issue. *Works Reproduced:* RA Summer Show 2001 catalogue, Soloarte magazine 1st issue. *Clubs:* Chelsea Arts, Alberg Ski Club. *Address:* 19 Crescent Grove London SW4 7AF. *Email:* bronny@ackhurst.com *Website:* www.bronwenmalcolm.com

MALCOLMSON, Joe, artist in oil and gold leaf, water-colour. *b:* Lanarkshire, 28 Jun 1932. *m:* Joyce Franklin. *Studied:* Medway College of Art (1959-61). *Exhib:* R.A., R.W.S., R.I., R.O.I., N.E.A.C., N.S. *Signs work:* "J.L. MALCOLMSON." *Address:* The Cottage, Woodland Way, Kingswood, Surrey KT20 6NU. *Email:* joymalcolmson@tiscali.co.uk

MALENOIR, Mary, R.E. (1984); R.A. Schools Dip. (1964), Rome Scholar in Engraving (1965-67); artist in mixed media. *b:* Surrey, 29 Jul 1940. *m:* Michael Fairclough, artist. two *d. Studied:* Kingston School of Art (1957-61), R.A. Schools (1961-64), S.W. Hayter's Atelier 17, Paris (1967). *Exhib:* Prizewinner in:- P.M.C. National Print Competition (1987), Hunting Group Competition (1987), Humberside Printmaking Competition (1987), Bankside Gallery Open Print Competition (1989), Arts Club Prize (1998), R.A. Summer Exhbn. *Works in collections:* Ashmolean Museum, Ipswich Museum, Graves A.G. Sheffield, Stephanie Shirley Collection, Prior's Court. *Signs work:* "MALENOIR." or

"m.m." *Address:* Tilford Green Cottages, Tilford, Farnham, Surrey GU10 2BU. *Email:* info@malenoir.co.uk *Website:* www.malenoir.co.uk

MALI, Yashwant, RBS; General Diploma in Fine Art; Gold Medal, Bombay Art Society. *Medium:* mixed media. *b:* Mumbai, India 20 Oct 1934. *Studied:* JJ School, Bombay (1956); St.Martin's School, London (1962). *Represented by:* Mr Tolleck Winner. *Exhib:* India, Paris, Italy, London, Manchester, Oxford, Brighton; 110 group shows, most recent Coningsby Gallery, London (2006); 25 solo shows inc. James Colman, London. *Works in collections:* Air India, Godreg, Mrs.Profulla Dahamukar. *Publications:* Art Review, Art News, Time Out, Christie's London. *Works Reproduced:* Brain-wave from JJ (Times Review, 1996). *Principal Works:* Pencil Yard (2005); After Dali (1998). *Clubs:* Watemans Art Centre, Brentford; Whitechapel Gallery; Richmond Art Soc.; Friends of the RA. *Signs work:* 'Mali'. *Address:* 13 Crestwood Way, Hounslow Heath, Middlesex, TW4 5EQ. *Email:* maliart2000@yahoo.co.uk *Website:* www.Maliart2000.co.uk

MALIN, Suzi, Slade Post. Grad. (1975); painter in tempera. *d of:* Michael Malin, textile designer. *m:* David Hames. one *s.* one *d. Educ:* Badminton, Bristol. *Studied:* Slade School of Art (1969-75, John Aldridge, R.A.). *Exhib:* one-man shows, J.P.L. Fine Arts, London (1977), Achim Moeller, London (1978), Coe Kerr, N.Y. (1978), Galerie d'Eendt, Amsterdam (1983), Gimpel Fils, London (1982). *Works in collections:* N.P.G.; Raby Castle; Gt. Hall, Christchurch, Oxford; Hull University; East Anglia University; Midland Bank. *Commissions:* Lord Home, Alistair Morton, Queen of Greece, Elton John. *Clubs:* Chelsea Arts. *Signs work:* "S. Malin." *Address:* The Meeting Hall, 158a Mill La., London NW6.

MALLIN-DAVIES, Joanna, ARBS; BA Ceramic Design. *Medium:* bronze, clay, misc. *b:* Llwynypia, S.Wales, 2 Dec 1965. *Studied:* South Glamorgan Inst. HE, Howard Gardens, Cardiff. *Represented by:* DBS, Dawlish Society of Sculptors. *Exhib:* Thompson's Galleries (2001- present); Hannah Peschar (1991-93); Mandarin Oriental Fine Art, Hong Kong (1994-2003); Broomhill Art Park (1997- present); Morsø Kunstforening, Denmark (1999), Badcock's Gallery, Cornwall, Open Eye Gallery, Edinburgh (1996-2005). *Works in collections:* Aberystwyth Arts Centre, Broomhill Art Park, Devon, Kirsten Kjaers Museum, Denmark. *Commissions:* Brockhall Village Estate, Lancashire. *Publications:* Encyclopedia of British 20th Century Sculpture; Metamorfoser (Danish Landar Publication). *Official Purchasers:* Welsh Arts Council. *Recreations:* yoga, films, books. *Signs work:* "J-D", "JM-D". *Address:* c/o 31 High Street, Addlestone, Surrey, KT15 1TT. *Email:* Joanna@mallin-davies.com *Website:* www.mallin-davies.com

MALTMAN, Philip John, BA Hons Fine Art. *Medium:* oil, watercolour, drawing, prints. *b:* Irvine, Scotland, 9 Mar 1950. *m:* Stephanie. two *s. Educ:* Carrick Academy, Kingsdale School. *Studied:* Hornsey College of Art (1968); Ravensbourne College of Art (1968-71). *Exhib:* Angela Flowers; Bernard

Jacobson; London Group; Cheltenham Open Drawing; John Moores Contemporary Painting; Contemporary Art Society; RA Summer Exhbn; 'MAL' Birmingham; Glasgow Print Studio; Bede Gallery, Jarrow; Piers Feetham, London; Hunting Group Art Prizes. *Works in collections:* in USA, Switzerland, Austria, UK. *Commissions:* private and business. *Recreations:* books, beach, garden. *Misc:* on-going work with Katy English on 'My Shore-Your Horizon'; 1996-joint exhibition, 'Beginning and Ending on the Shore'. *Signs work:* 'Philip Maltman'. *Address:* The Mount, 23 Thurlow Park Road, London SE21 8JP. *Email:* philip.maltman@btinternet.com *Website:* www.numasters.com; www.maybole.org/photogalleries

MANCHOT, Melanie, M.A. Fine Art (Photography) (1992); artist/part-time lecturer/photographer; works with video, photography and film. *b:* Germany, 7 Jul 1966. *Studied:* Royal College of Art (1990-92). *Represented by:* FRED, London. *Exhib:* England and abroad, regularly, solo and group shows. Most recent: 52nd Biennale, Italy. *Works in collections:* Saatchi, National Art Collection, The Mead Gallery Collection, University of Warwickshire, DG Bank Collections, Germany, Portland Museum, USA, Staedtische Galerie Wolfsburg, Germany, Unilever Collection, London. *Publications:* Moscow Girls, Haus an Waldsee, Berlin; Love is a Stranger, Prestel Verlag; Look at You Loving Me, Friedrich Reinhardt Verlag, Zurich. *Address:* 33 Dunloe St., London E2 8JR. *Email:* mel@melaniemanchot.net

MANDL, Anita, RWA (1978), FRBS (1980), PhD (1951), DSc (1960); sculptress, formerly University Reader, Medical School, Birmingham; carvings in wood and stone (alabaster, soapstone); also bronzes from carvings cast exclusively by Pangolin Editions. *b:* Prague, 17 May 1926. *d of:* Dr.B.Mandl. *m:* Dr. Denys Jennings (decd.). *Studied:* part-time at Birmingham College of Art. *Exhib:* RA, RWA, RSMA, Curwen-New Academy Gallery, Alresford Gallery, Falle Fine Arts, Brian Sinfield Gallery, Wykeham Gallery, Gallery Pangolin, Martin's Gallery, Moncrieff-Bray Gallery, Red Rag Gallery, Quest Gallery. *Works in collections:* Ulster Museum; Royal West of England Academy; National Maritime Museum. *Commissions:* Zoological Society of London. *Signs work:* Mostly unsigned. (Highly polished carvings are marred by signature). Bronzes marked A.M. *Address:* 21 Northview Rd., Budleigh Salterton, Devon EX9 6BZ. *Email:* anitama@onetel.com

MANIE, Ann Elizabeth, Dip Fine Art, MA; Lowes Dickinson Scholarship (1982); Debenhams Golden Jubilee Prize (2002); John & Elizabeth Smith 'New Discovery Prize', Discerning Eye (2006). *Medium:* mixed media in paper collage and acrylic, prints (landscape and still life). *b:* Bromley, Kent, 19 Jan 1954. *m:* Barry John Manie. *Studied:* City & Guilds of London Art School, Kingston College. *Exhib:* RA Summer Exhbn (1988, 93, 97, 2003, 2007); Pumphouse Gallery, London (1996, solo exhbn); Waterman Fine Art Ltd., London (1993-2001); Medici Gallery, London (1996); CCA Galleries (1997), SWI Gallery (2006), Discerning Eye (2005, 2006), SWA (2006), RSMA (2006), Langham Fine

Art Autumn Exhibition (2007), Chritie's Cancer Research Appeal Exhibition (2007); various other group exhbns incl., Business Design Centre; Wills Gallery, St.Ives; Salthouse Gallery, St.Ives. *Works in collections:* private and business. *Commissions:* private and business. *Clubs:* Penwith Society of Artists; Freeman of the Worshipful Company of Painter-Stainers. *Misc:* Teaching Certificate (FAETC); Collage workshops with children and adults; wall murals. *Signs work:* 'A.M.'. *Address:* 25 Surrey Lane, Battersea, London SW11 3PA. *Email:* manies@ntlworld.com

MANLEY, Jim, A.R.U.A.; Patron's prize, E.V.A. Limerick (1984), Elmwood, Belfast Smallworks (1997) Painting Prize, Iontas (1999), RUA, Ross' Watercolour Prize (2005); painter in water-colour, pastel, collage. *b:* St. Helen's, 1934. *m:* Margaret. three *s. Educ:* West Park Grammar School, St. Helen's; De La Salle College, Middleton. *Exhib:* over twenty exhbns. in Ireland and England, including London Gallery, Duncan Campbell Fine Arts, Dublin, Solomon Gallery. *Works in collections:* Abbot Hall Kendal, U.T.V. Belfast, Walker Liverpool, Bank of Ireland Dublin. *Clubs:* United Arts, Dublin. *Signs work:* "J. Manley." *Address:* Coastguard Cottages, Killough, Downpatrick, Co. Down BT30 7QS, N. Ireland.

MANN, Alex, painter of 'visual-sound' (music) - portraits, landscapes, castles, homes;. *b:* Ayr, Scotland, 26 Feb., 1923. *s of:* Charles and Doretheu Mann. *m:* Joyce. four *d. Studied:* Sidcup School of Art, Fine Art (paintings and sculpture). *Exhib:* London, Birmingham, Edinburgh, Germany, U.S.A., Work in collections worldwide. *Commissions:* worldwide. *Signs work:* "Alex Mann." *Address:* Alastrean House Tarland Aboyne, Aberdeenshire AB34 4TA.

MANN, Caryl J., S.W.A. (1994), N.D.D. (1960); artist in water-colour, pastel, acrylic;. *b:* London, 31 Mar., 1938. *m:* Christopher Mann. one *s. Educ:* Eastbourne High School. *Studied:* Eastbourne School of Art (1956-60). *Exhib:* S.W.A. annually since 1991, David Curzon Gallery since 1988; various mixed and solo shows in Sussex. *Signs work:* "C. Mann." *Address:* Six Birches, Upper Hartfield, Hartfield, E. Sussex TN7 4DT.

MANN, Sargy, H.N.D. Mech. (1958), N.D.D. (1964); landscape painter. *b:* Hythe, Kent, 29 May 1937. *m:* Frances Carey. two *s.* two *d. Educ:* Dartington. *Studied:* Camberwell School of Arts and Crafts (1960-64, Frank Auerbach, Euan Uglow, Dick Lee) (1967, Francis Hoyland). *Exhib:* R.A., Hayward Annual (1983), London Group, International Drawing Biennale; one-man shows, Salisbury Festival of Arts, Cadogan Contemporary. *Works in collections:* Arts Council of G.B., Contemporary Art Soc., Cleveland C.C. *Publications:* Drawings by Bonnard (Arts Council, 1984), Pierre Bonnard Drawings (J.P.L. Fine Art, 1981), Pierre Bonnard Drawings Vols. 1-2 (J.P.L. Fine Art, 1987), Raoul Dufy (J.P.L. Fine Art, 1987), Pierre Bonnard (Nottingham Castle Museum, 1984), Introduction Past and Present (Arts Council, 1987), Bonnard Drawings (John Murray J.P.L. Fine Arts, 1991), Introduction to Bonnard at Lebosquet Southbank

WHO'S WHO IN ART

Centre (1994, co-curator). *Signs work:* "Sargy Mann" or "Sargy." *Address:* Lawn Meadow, Bridge St., Bungay, Suffolk.

MANNES-ABBOTT, Sheila, FSBA (1986); Fellow, The Linnaen Society(2000); RHS Grenfell Silver Gilt Medal (1974, 1978); RHS Gold Medal (1997, 1999); SBA Medalife Award (1990); SBA Joyce Cuming Award for Botanical Excellence (1998). *Medium:* water colour. *m:* Edward Frewin. two *s.* one *d. Studied:* Ealing School of Art (awarded scholarship aged 13). *Exhib:* solo: Bohun Gallery, Henley-on-Thames; Furneaux Gallery, London; Noel Gregory Gallery, Bucks.; Reading Fine Art Gallery; group: Mall Galleries; Westminster Gallery; Tryon Gallery; Hunt Inst., Pittsburgh, USA; RA, RHS, RWS, RMS, SBA. *Works in collections:* Shirley Sherwood, Sir Hugh Beach; Berkshire County Council; Hunt Inst. for Botanical Documentation, USA; numerous private collections, worldwide. *Commissions:* Artlines; Athena Int.; BBC; BCA; Boots Co. Ltd.; Coalport; Coates Leisure Group; Franklin Mint; Friends of the Earth; National Trust; RNLI; Royal Kendal; Royal Society for Nature Conservation; Waddingtons; Werldwide Fund for Nature. *Works Reproduced:* in 'Four Seasons' by Mannes-Abbott and Phil Drabble (1981); 'Contemporary Botanical Masterworks - A Passion for Plants' by Shirley Sherwood; 'Arte y Botanica'; A Book of Irises (Antique Collector's Club, 2008); A Book of Orchids (Antique Collector's Club, 2008). *Recreations:* painting, drawing, reading, gardening. *Signs work:* 'Sheila Mannes-Abbott'. *Address:* Almyr House, Goviers Lane, Watchet, Somerset, TA23 0ER. *Email:* sheilafrewin@hotmail.com *Website:* www.botanicalartist.co.uk

MANNING, Julia, BA (Hons) Fine Art. *Medium:* artist/printmaker. *b:* London, 8 Dec 1952. *d of:* Tom and Irene Manning. two *d. Educ:* Notting Hill and Ealing High School. *Studied:* Bath Academy of Art, Corsham, Wilts (1970-74). *Exhib:* 11 solo shows; many mixed shows. *Works in collections:* Lord Bath, Longleat House; Palace of Westminster (House of Lords); British Embassy Collection, Paris; Aberystwyth University Print Collection. *Commissions:* many for painted tapestries, murals and trompe l'oeil throughout UK, Europe and USA (1984-2000). *Official Purchasers:* House of Lords, British Embassy Paris. *Principal Works:* etchings, collographs and limited edition relief prints. *Recreations:* gardening. *Clubs:* Devon Guild of Craftsmen. *Misc:* 'Makers'- Taunton (Gallery Co-operative) Somerset Printmakers. *Signs work:* "Julia Manning". *Address:* 2 Rosebank, Queen St., Keinton Mandeville, Somerset, TA11 6EQ. *Email:* julia@juliamanning.co.uk *Website:* www.juliamanning.co.uk

MANNOCCI, Lino, BA, MA. *Medium:* oil, drawing, prints. *b:* Viareggio (Italy), 13 Apr 1945. *s of:* Oreste Mannocci. two *s.* one *d. Studied:* Camberwell School of Art; Slade (UCL). *Represented by:* Art First, London; Galleria Ceribelli, Bergamo, Italy. *Exhib:* over thirty solo exhbns since 1981 worldwide, most recently, Art First, New York (2001); Art First, London (1999, 2000, 2005); Mercurio Arte Contemporanea, Viareggio (2002); Galleria Ceribelli, Bergamo (2004); Museo H.C.Andersen, Rome (2005); over thirty mixed shows since 1982

across Europe. *Publications:* Catalogue Raisonné of Claude Lorraine (Yale U.P., 1988). *Official Purchasers:* British Museum; Jewish Museum, Vevey; Ludwighaffen Museum, etc. *Address:* 119 Elgin Avenue, London W9 2NR. *Email:* lino.mannocci@virgin.net

MANOUK: see BAGHJIAN, Manouk,

MANSER, Michael John, C.B.E., R.A., P.P.R.I.B.A., R.W.A. Dip.Arch., Hon. F.R.A.I.C.; architect; Chairman, Manser Assoc.;. *b:* 23 Mar., 1929. *m:* José Manser, journalist. one *s.* one *d. Educ:* Polytechnic Regent St. School of Architecture (now Westminster University). *Exhib:* R.A., R.W.A., Japan, Hong Kong, U.S.A., Singapore, Canada, Italy. *Publications:* Planning Your Kitchen, co-author with wife José Manser (C.I.D.); part author: Psychiatry in the Elderly (O.U.P.), House Builder Reference Book (Newnes), The Nature of Architecture (Routledge), Innovative Trends in Psychogeriatrics (Karger, Switzerland). *Clubs:* Brooks's. *Signs work:* "Michael Manser." *Address:* Bridge Studios, Hammersmith Bridge, London W6 9DA.

MANTLE, Ruth, SGFA (1984), CFA (Oxon.) (1949); artist in pencil, ink, water-colour of buildings and botanical subjects; illustrator and teacher of drawing. *b:* Newbury, Berks., 27 Aug 1925. *d of:* Kenneth Baines. *m:* Ian Mantle, M.A. two *s.* one *d. Educ:* St. Catherine's School, Bramley, Surrey. *Studied:* Ruskin School of Drawing, Oxford (1946-50, Albert Rutherston, Percy Horton; History of Art, Sir Kenneth Clark). *Exhib:* S.G.F.A. Annual, provincial exhbns. Work mainly in private collections, in Britain and abroad. *Publications:* illustrated, The Necklace Villages, Cambridge Itself, My Cambridge (Robson Books). *Clubs:* S.G.F.A., Shropshire Art Soc., Ludlow Art Soc., The Marches Artists. *Signs work:* "Ruth Mantle." *Address:* 35 Central Ave., Church Stretton, Shropshire SY6 6EF.

MANUEL, Sylvia, artist in water-colour, acrylic, pastel; tutor;. *b:* London. *Exhib:* England, France, Jersey C.I. *Commissions:* B.B.C., etc. *Signs work:* "Sylvia Manuel" or "S. Manuel." *Address:* Wall Cottage, Leicester Sq., Penshurst, Kent TN11 8BJ.

MARA, Pam, M.C.S.D. (1970), N.D.D. (1958), F.F.P.S. (1997); illustrator, designer, painter, printmaker in oil, pastel, acrylic, water-colour, lithography. *b:* London, 12 May 1928. *d of:* Harold Faulkner Mara, F.I.B.D. *Educ:* Henrietta Barnett School, London. *Studied:* Willesden School of Art, Central School of Art. *Exhib:* mixed shows: Mall Galleries, Barbican, National Theatre, Bloomsbury Gallery, Loggia Gallery, St. Martin in the Fields Gallery, Royal Festival Hall, Holland Park Orangery, Menier Gallery. Solo Exhibition: Royal Commonwealth Society. *Publications:* illustrated over 100 books, work published in England, America, several European countries, W. Africa, Near and Far East, South Africa and Australasia. *Signs work:* "Pam Mara." *Address:* 5 Gloucester St., London SW1V 2DB.

MARAIS, (Mary Rachel Brown), Mem. Visual Artist and Gallery Assoc.; self taught artist in oil. *b:* New York City, 24 Sep 1921. *Educ:* New York University. Lived in Paris several years and painted warm, charming nostalgic scenes of Paris completely capturing the ambiance in a very personal style. *Exhib:* Paris, New York, Switzerland; Centre d'Art Contemporain, Paris (1984); Galerie Chantepierre Auboune, Switzerland; Soho-20 Gallery, 545 Broadway, New York (2000); seen on NYC Channel 13 TV (1979, 1980). *Works in collections:* Jean Aberbach, Theodora Settele, Hugo Perls, Dr. M. Reder, Jacques Bellini. *Signs work:* "Marais." *Address:* 33 W. 67th St., New York, N.Y. 10023, USA.

MARDEL-FERREIRA, Elizabeth Gilchrist, painter in acrylic, ink and wash, printmaker. *b:* Nottingham, 5 May 1931. *d of:* John G. McMeeking, C.B.E., J.P., lace manufacturer. *m:* Joseph Charles Mardel-Ferreira. one *s.* two *d. Educ:* Headington School, Oxford. *Studied:* Nottingham College of Art (1949-53). *Exhib:* R.A. (1978); S.W.A. Work in private collections. *Publications:* Illustrations for Warblington Church guide. *Signs work:* "E. Mardel" or "Elizabeth G. Mardel.'. *Address:* 15 Warblington Ave., Havant, Hants. PO9 2SD.

MAREK, Jerzy, self taught primitive painter in oil. *b:* Poland, 22 Apr 1925. *m:* Margaret Baird. one *s. Exhib:* Portal and Grosvenor Galleries, London, also in a number of International and Arts Council Exhbns. for primitive painters. *Works in collections:* Bolton City A.G., Abbott Hall Museum, Kendal, Lancaster City Museum, Glasgow Gallery of Modern Art, Sydney Janis Coll., N.Y., Salford City Art Gallery, Manchester City Art Gallery. *Publications:* Naive Kunst by Ida Niggli, The Rona Guide to the World of Naive Art, Twentieth Century British Naive and Primitive Artists by E. Lister and S. Williams, A World of Their Own by J and M Leman; many postcards. *Signs work:* "J. Marek." *Address:* 7 Pittville St., Portobello, Edinburgh EH15 2BZ.

MARGRIE, Victor, C.B.E., F.C.S.D.; potter; Associate Editor, Studio Pottery (1993-2000), Ceramics in Society (2000-2005); Visiting Prof. University of Westminster (1992-96); Director, Crafts Council (1977-84); Mem. Advisory Council, V&A Museum (1979-84)Mem. of Board of Studies in Fine Art, University of London (1989-1994); Mem. UK National Commission for UNESCO (1984-85); Fine Art Advisory Committee British Council (1983-86). *b:* London, 29 Dec 1929. *Works in collections:* V. & A., Ashmolean and private collections. *Publications:* contributed to: Oxford Dictionary of Decorative Arts (1975); Europaischt Keramik Seit (1950, 1979); Lucie Rie (1981); contrib. specialist publications and museum catalogues. *Address:* Bowlders, Doccombe, Moretonhampstead, Devon TQ13 8SS.

MARINKOV, Sasa (Alexandra), Fellow of Royal Society of Painter Printmakers (RE); Awards: GLC, South Bank Picture Show, RA Summer Show (twice), Ministry of Transport, London Arts Board, British Council; artist in printmaking, lecturer, teacher, sculpture in schools. *Medium:* printmaking. *b:* Belgrade, Yugoslavia, 12 Jan 1949. *d of:* Dr. C.B. Marinkov and Mary Lishman.

m: Michael Jones. one *d. Studied:* Fine Art: Leeds University, PGCE London University, Advanced Dip. Printmaking: Central St. Martin's. *Exhib:* Biennales: Cleveland, Bradford, Brazil, Korea, Spain, Xylon 13, Whitechapel and Riverside Open, London Group, Kunsthaus Zug, Prints from Wood (Arts Council), Royal Academy, RE, SWE, one-man shows. *Works in collections:* Leeds,London & Cambridge Universities; Brazil; Skopje; London and Winchester Hospital; British Rail Freight; Bank of China; Winchester Hospital; Dept. of Transport; Arts Council/South Bank Centre; Ashmolean. *Commissions:* 1992 British Railways Board; 1990 Winchester Hospital. *Publications:* 2001 "Sasa Marinkov's picture book", Quince Tree Press. *Works Reproduced:* 1990-98 Royal Academy Summer Show catalogue; 1994 "Wood engraving and the woodcut in Britain c 1890-1990", James Hamilton; 2001 "Handmade prints", A. Desmet, J. Anderson; "Relief printmaking", A Westley; "Printmaking for Beginners", J. Hobart; 2006 "The Printmakers Directory", www.axisartists.org.uk. *Misc:.* Signs *work:* "S. Marinkov." *Address:* Woodcut, Riverside, Twickenham TW1 3DJ. *Email:* sasamarinkov@hotmail.co.uk

MARJ: see BOND, Marj,

MARKEY, Danny, R.W.A.; painter. *b:* Falmouth, 9 June, 1965. *Educ:* Falmouth School. *Studied:* Falmouth School of Art and Camberwell School of Art. *Exhib:* Redfern Gallery, London Group, R. A., R.W.A., South Bank Picture Show (First Prize) Discerning Eye, Newlyn Gallery, Royal Overseas League, Charleston Farmhouse Sussex. *Works in collections:* various private and Old Jail House Museum and Gallery, Texas. *Signs work:* "Danny Markey." *Address:* c/o Redfern Gallery, 20 Cork St., London W1X 2HL. *Email:* art@redfern-gallery.com *Website:* www.redfern-gallery.com

MARKS, Laura Anne Celia, Greenshields Foundation award (1982, 1983); artist in oil, water-colour and pencil. *b:* Toronto, Canada, 1954. *d of:* Benjamin Marks, chemical engineer. *Educ:* Forest Hill Collegiate, Toronto. *Studied:* Central Technical School, The Three Schools of Art, Art's Sake, and Ontario College of Art (1971-80, Paul Young). *Exhib:* one-man shows: Evans Gallery, Toronto (1973), Prince Arthur Gallery, Toronto (1980), October Gallery, London (1982), Alberta House, London (1982), Gallery Gabor, Toronto (1984), International Exhbn., Monte-Carlo (1985), John Denham Gallery, London (1991). *Works in collections:* Ontario House, London. *Signs work:* "MARKS." *Address:* 26 West End La., London NW6.

MARLIN, Brigid, Founded the Society for Art of Imagination. Awards: International Art Appreciation Award for Outstanding Contribution to the Arts, USA (1988); International Painting Competition, Dublin, Ireland (1988); Upper Street Gallery Sculpture Competition, London (1990). *Medium:* oil, watercolour, drawing, prints. *b:* Washington DC, 16 Jan 1936. *d of:* Mr E.R.Marlin & Hilda Van Stockum. three *s. Studied:* National College of Art, Dublin; Andre L'Hote Studio Centre d'Art Sacre, Paris; Art Students League, New York. *Represented*

by: The Gouden Phoenix Gallery, Holland. *Exhib:* Selected exhibitions: Mall Galleries (1998, 1999, 2000, 2007), The Gallery in Cork Street (2002, 2003), Brave Destiny, Brooklyn, New York (2003), Diego Gallery, Miami, Florida (2004), SAI European Tour (2004), HR Giger's Castle Museum and Art Gallery (2006); works exhibited in Museums and Art Galleries worldwide. *Commissions:* portraits: the Dalai Lama, the late Queen Mother, Lord Longford, Gertrude Crain (Crain's Communications), Cardinal George of Chicago, Admiral Paulsen (American Navy), Princess Mata'aho (hier to the throne of Tonga), J G Ballard, Cecil Lewis (founder of the BBC). *Publications:* Author: 'From East to West' (pub. Collins 'Fount' Books, 1989); 'Paintings in the Mische Technique'. *Official Purchasers:* National Portrait Gallery, London; House of Lords Art Collection, London. *Works Reproduced:* many. *Principal Works:* portraits and fantastic art. *Signs work:* "Brigid Marlin". *Address:* 28 Castle Hill, Berkhampsted, Herts., HP4 1HE. *Email:* brigmarlin@aol.com *Website:* www.brigidmarlin.com

MARR, Leslie, MA (1947); painter and draftsman in oil, water-colour, etc.; Secretary, Borough Group (1947-50). *b:* Durham, 14 Aug 1922. *s of:* Col. J. Lynn Marr, O.B.E., TD. *m:* Maureen Marr. two *d. Educ:* Shrewsbury, Pembroke Coll. Cambridge. *Studied:* Borough Polytechnic under David Bomberg. *Represented by:* Piano Nobile Fine Paintings, 129 Portland Rd., London W11 4LW. *Exhib:* one-man shows: Everyman Gallery, Drian Galleries, Laing A.G., Newcastle upon Tyne, Woodstock Gallery, Maddermarket Norwich, Fermoy Gallery, Kings Lynn, "Bomberg and the Family" exhbn. Ben Uri Gallery (The London Jewish Museum), London, Catto Gallery, London; major retrospective, Durham City, 'Piano Nobile' London, Mercer Art Gallery Harrogate, Northumbria University Gallery, Newcastle-upon-Tyne. *Works in collections:* Laing A.G., Newcastle upon Tyne, University of Haifa, Graves A.G., Sheffield, St.Mary Abbots Hospital, London, Mercer Art Gallery Harrogate, Pallant House, Chichester. *Publications:* From My Point of View (photographs)(Acorn Editions 1979), 2 albums of piano solos (Seresta Music). *Official Purchasers:* Laing AG Newcastle-on-Tyne, Graves AG Sheffield, Mercer AG Harrogate. *Works Reproduced:* Jarrold's Calendar of Norfolk Artists (2004). *Signs work:* 'Marr'. *Address:* Blandings Cottage, Mill Street, Gimingham, Norfolk NR11 8AB. *Email:* mandl.marr@btinternet.com

MARRIOTT, Michael, F.R.B.S. (1974), N.D.D. (1960); sculptor in stainless steel, glass, G.R.P., stone, clay, plaster, bronze;. *b:* London, 3 May, 1940. *Educ:* Latymer Foundation and Christopher Wren Secondary. *Studied:* St. Martin's School of Art (1956-60, Elizabeth Frink, Anthony Caro, Edward Paolozzi). *Exhib:* one-man shows: Cockpit Theatre, London (1971), Alwin Gallery, London (1976); two-man show: Europa Gallery, Surrey (1978); group exhbns.: annually all over U.K. since 1960, Margam Park, S. Wales, Barbican Centre, Hannah Peschar Gallery, Surrey; also in U.S.A. and Europe. *Works in collections:* I.B.M. Cosham, Hunting Engineering Bedford, Heron House London, Crown House London. *Address:* 16 Seymour Rd., London SW18 5JA.

MARSHALL, Dunbar: see MARSHALL MALAGOLA, Dunbar,

MARSHALL, Joan, S.W.A. (1994); equestrian and portrait artist in oils;. *b:* Yorks., 8 Jan 1931. *Studied:* Hull Art School. *Exhib:* S.W.A., S.Eq.A. *Signs work:* "Joan Marshall." *Address:* The Studio, Treskerby Lodge, Treskerby, Redruth, Cornwall TR16 5AG.

MARSHALL, John, landscape painter in water-colour;. *b:* Colchester. *Educ:* Rugby School. *Studied:* pupil of Cedric John Kennedy (1898-1968). *Exhib:* British Art Centre, New York, Leicester Galleries, London; one-man exhbns.: Leicester Galleries WC2 (1956-59-62), Anthony Reed's Gallery W1 (1981). *Works in collections:* Wadsworth Atheneum, U.S.A., Columbia Museum of Art, U.S.A., Norwich Castle Museum, Hull Education Committee. *Publications:* Cedric Kennedy memorial Catalogue and Monograph (1969 and 1972). *Works Reproduced:* in The Studio (July, 1956, Feb., 1960); monographs: Arts Review (June, 1956), The Studio (Feb., 1960). *Signs work:* "John (J) Marshall." *Address:* 41 Campden Hill Rd., London W8.

MARSHALL, Maria Heléne, BAHons. (1986); sculptor in steel, stone, wood and canvas. *b:* India, 14 Feb 1964. married. *d of:* Samuel Marshall. *Educ:* Millfield School, Somerset, Ardingly College, Sussex. *Studied:* Chelsea Foundation (1982), Wimbledon School of Art (1986, Glyn Williams), Ecole des Beaux Arts, Geneva. *Exhib:* Gallerie Eric Frank (Geneva, Chicago, Basel); one-man shows: Odette Gilbert Gallery (London and Madrid), Crucral Gallery. Public sculpture 'Goddess' Princes Ct., Brompton Rd. *Signs work:* "Maria Marshall." *Address:* The Workshops, 23 Theatre St., London SW11.

MARSHALL, Richard, P.S. (1983); painter in oil, pastel, gouache, part-time lecturer; demonstrator. *b:* Goring, Sussex, 29 Jan 1943. *s of:* Phillip James Marshall. two *d. Educ:* West Sussex College of Art. *Studied:* under William Cartledge, R.I., R.S.M.A. (1969-72), Gyula Sajo (1973-89), former Professor of Applied Art, Budapest Academy, Hungary. *Exhib:* internationally; mixed shows, France, London and Sussex; one-man show, Croydon and Littlehampton; two-man show, Arundel and Worthing. *Works in collections:* U.K., Europe and North America. *Publications:* Pastel Artist International, Leisure Painter. *Clubs:* Worthing Atelier Art Group. *Signs work:* "R. Marshall." *Address:* 17 Harsfold Cl., Rustington, W. Sussex BN16 2QQ.

MARSHALL, Steven, B.A. Hons. Fine Art; painter in oil and enamels on glass. *b:* Dover, 10 Apr., 1967. *m:* Michèle. *Educ:* Kings School, Wessex. *Studied:* Wolverhampton University. *Exhib:* Future Famous, London; Modern Art and Modernisms, London; View of the New, London; Contemporary Art Soc.; R.A. *Works in collections:* Ernst and Young, Unilever, Eversheds, Manorca Services. *Publications:* co producer of film for Picasso Pictures, 'In Flight', Readers Digest Award (1990). *Signs work:* "S.M." or "Steven Marshall." *Address:* c/o Wimbledon Fine Art, 41 Church Rd., Wimbledon Village, London SW19 5DQ. *Email:* stevenmarshall@virgin.net

MARSHALL MALAGOLA, Dunbar, R.B.A.; painter; mem. Salon d'Automne, Paris; former Sec.-General International Assoc. of Art, UNESCO;. *b:* Florence, 1918. *m:* Daphne Chart. *Studied:* Westminster and Chelsea Schools of Art under Gertler, Meninsky, Robt. Medley, Ceri Richards. *Exhib:* one-man shows, Grabowski, London (1961, 1964), UNESCO House (1985), Prévôt Gallery, Paris IV (1986, 1989). *Works in collections:* Museums of Contemporary Art: Skoplje and Bihac (former) Yugoslavia; Lodz, Poland; Baghdad, Iraq; Pori, Finland; Academy Savignano, Italy; University of Liverpool; Japan Artists' Centre, Tokyo; Imperial War Museum, Lambeth. *Signs work:* "D M" or "Marshall Malagola." *Address:* 14 Cross Hayes, Malmesbury, Wilts. SN16 9BG.

MARTIN, Barry John, Intermediate exam. Arts & Crafts (1963), N.D.D. Painting (1965), Post Dip. (1966), Post Grad. (1967); painter, sculptor, draughtsman, printmaker, acrylic, stainless steel, bronze, electricity, charcoal; former lecturer numerous colleges. *b:* Amersham, Bucks., 20 Feb 1943. *m:* Sarah Anne. one *d. Studied:* University of London Goldsmiths' College (1961-66), St. Martin's School of Art (1966-67). *Exhib:* one-man shows: Arts Council, Serpentine Gallery (1970), Richard Demarco Gallery (1971), Newcastle upon Tyne Polytechnic A.G. (1977), Goya Gallery, Zaragosa, Spain (1980), 'Look - Reflections on Structure and Meaning' Olympia (1999), Riverside Studios (2000), Gallery Rigo, Citta-Nova, Croatia (2003), 'Zest Gallery' London (2004), Inaugural Exhibition 'The Drawing Gallery' (2004)etc.; group shows: Northern Young Contemporaries, Whitworth A.G. (1965), Young Contemporaries, London (1966), Manifestation of Light - Light Artist's, Bromsgrove Festival, B'ham (1968), Gelsen Kirchen Museum, Berlin (1969), Onnasch Gallery, Berlin (1970), A.C.G.B. Hayward Gallery Kinetics (1970), I.C.A. Electric Theatre (1971), Arts Council, Spectrum, Alexandra Palace (1972), Harlow, Essex Movements (1973), 12 British Painters, Arts Council and British Council Exhbn. for Iceland (1977), Beaux Art Gallery, Brussels (1995), Mus. of Modern Art, Paris (2000), Tate Gallery 'New Acquisitions' (2000), Royal Academy Summer Show (2003), 'The Art of Chess', Somerset House, London (2003), S.O.F.A., Chicago Art Exhbn., International (2004). *Works in collections:* numerous public and private including Science Museum, Tate Gallery, N.P.G., B.M., A.C.G.B., Mus. of Modern Art, Paris, Government Art Collection, Deutsche Bank, Victoria & Albert Museum. *Commissions:* Howard Staunton Memorial, Kensal Green Cemetery; Mr. Resistor, New King's Rd. London; English Heritage (2005). *Publications:* Light and Movement (1985); Comp. with Red, Mondrian (1986); Chess for Absolute Beginners, with Keene; The 'G' Spot, Lord Burlington (1998); '.. au pied de la lettre' (2001); 'Meaning, Movement' (2003) 'The English Grand Tour'. *Recreations:* chess. *Clubs:* A.R.B.S., Chelsea Arts Club, R.A.C., Pall Mall. *Misc:* Studio: South Lodge, Chiswick House Grounds, Chiswick, London W4 2RP. *Address:* 98 Cole Park Rd., Twickenham, Middx. TW1 1JA. *Email:* bsjmartin@btinternet.com *Website:* www.barrymartin.co.uk

MARTIN, Blandine, BA Hons Interior Design & Architecture. *Medium:* painter & sculptor. *b:* Aix-en-Pce France, 21 Mar 1970. *d of:* Yann Martin

(painter) & Danielle Martin. one *s.* one *d. Studied:* Metropolitan University, London. *Exhib:* Hype Gallery, Brick Lane (2004), Serena Hall Gallery, Southwold, Suffolk (2006), Battersea Art Fair (2007) Solo exhibitions: The Euro Art Gallery, London (2004); National Theatre, London (2005); Lewisham Art House, London (2006); Gallery Le Panier, Marseilles, France (2004, 2006). *Misc:* earned a permanent spot with the Cherwell Theatre Company, Stratford upon Avon, designing posters. *Signs work:* "BLANDINE MARTIN". *Address:* 46b Clarendon Gardens, Ilford, Essex, IG1 3JW. *Email:* blandinemartin@hotmail.com *Website:* www.blandinemartin.com

MARTIN, David McLeod, RSW, RGI, DA (Glasgow) (1948), Hon. Professional Mem. SSA (1949), Past Vice-Pres. RSW; David Cargill Award (RGI, 1995), Special Award of Merit, Robert Coloquhoun Memorial Art Prize exhbn., Kilmarnock (1974); Prizewinner, Friends of the Smith Art Gallery, Stirling (1981); May Marshall Brown Award, RSW Exhbn. (1984); Mabel McKinlay Award, RGI (1990); Prizewinner, Laing Exhbn., Mall Gallery, London (1990, 1993); RSW Council Award (2003). *b:* Glasgow, 30 Dec 1922. *s of:* Allan McLeod Martin. *m:* Isobel A.F. Smith (decd.). four *s. Educ:* Glasgow. *Studied:* Glasgow School of Art, 1940-42 (RAF1943-46), 1946-48. *Exhib:* RA (1984), Bath Contemporary Art Fair (1987), numerous group shows; one-man shows in Glasgow, Edinburgh, Perth, Greenock, Stone Gallery, Newcastle and London. featured artist, Perth Festival (1999), Perth Museum & Art Gallery Retrospective; 'Themes & Variations', John Martin of London (2000), Rhythm & Hues, John Martin (2004); solo show Roger Billcliffe (2005), with Carlo Rossi (2007), Miami Art Fair (1996), Art International New York (1998). *Works in collections:* Work in numerous public and private collections. *Signs work:* "DAVID M. MARTIN." *Address:* The Old Schoolhouse, 53 Gilmour St., Eaglesham, Glasgow G76 0LG.

MARTIN, Jean B, RSW; DA (Glasgow School of Art); PGTC (Aberdeen College of Education). *Medium:* mixed media; watercolour. *b:* 5 Aug 1947. *d of:* Henry Campbell. *m:* John Martin. one *s.* one *d. Represented by:* Flying Colours, London. *Exhib:* Gatehouse Gallery, Glasgow (1997, 2001); Flying Colours, Edinburgh (1991, 94, 98); Flying Colours Gallery, London (2005); Queens Gallery, Dundee (2002, 2005); Frames Gallery, Perth (2007). *Works in collections:* McManus Galleries, Dundee; private collections UK, USA, Australia. *Commissions:* private portrait commissions. *Publications:* Structure and Expression for Flowers in Watercolour, ISBN 1 9219834 22 5. *Works Reproduced:* in 'International Artist' magazine. *Signs work:* 'Jean B Martin'. *Address:* Alma Cottage, 4 Queen Street, Tayport, Fife DD6 9NS. *Email:* jeanmartin@mail2artist.com

MARTIN, Jenny, MA (Hons) Fine Art; MFA; The Aspect Prize (runner-up, 2005); Fenton Arts Trust Award (2005); Russell Trust Award (2005); Outstanding Print Award, Univ. of Aberystwyth, Nat.Print Exhbn (2003); Frank Herring Award RI (2002); John Kinross Scholarship (RSA, 1997); DM Hall Painting

Prize (1997); Andrew Grant Bequest Awards (1994, 96); James Torrance Award (RGI 2006); The RE Prize (Originals 07). *Medium:* mixed media and printmaking. *b:* Dundee, 23 Sep 1973. *d of:* John & Jean Martin. *m:* Stephen Long. one *s. Educ:* Madras College, St.Andrews. *Studied:* University of Edinburgh; Edinburgh College of Art. *Represented by:* Ewan Mundy Fine Art, Glasgow. *Exhib:* RA (2000, 04, 05), RSA (1999-2000), RI (2001-05), RSW (1995-2003), NEAC (2001, 03), RBA (2000, 05), Discerning Eye (2002, 03) W21 Bankside Gallery (2003, 05); Leith Gallery, Edinburgh; Mall Galleries, etc.; solo exhbns include: Ewan Mundy Fine Art, Glasgow (2004), University of Aberystwyth (2006), Edinburgh Printmakers Workshop (2007). *Works in collections:* RSA; Edinburgh College of Art; University of Wales; Royal Bank of Scotland; Paintings in Hospitals. *Publications:* 'Crucial Colour', The Artist Magazine ((Dec 2004); 'Artist Masterclass', The Artist Magazine ((Sep 2003); fully illustrated catalogue, Ewan Mundy Fine Art (2004). *Misc:* professional member and Council member Visual Arts, Scotland; lecturer at Leith School of Art, Edinburgh; Board Member, Edinburgh Printmakers Workshop. *Address:* 7 Esplenade Terrace, Edinburgh EH15 2ES. *Email:* jmartin9@tiscali.co.uk

MARTIN, John, RBA, BA(Hons.), RA Post Dip. (1983); painter in oil, gouache and water-colour. *b:* London, 25 Jan 1957. *s of:* Robert Albert Martin, gardener. *Educ:* Houndsfield School, London. *Studied:* Exeter College of Art (Micheal Garton, Alexander MacNeish), R.A. Schools (Peter Greenham). *Exhib:* numerous one-man shows in England; mixed shows in France and Canada. *Works in collections:* Norfolk County Collection, Art in Hospital Fund. *Signs work:* "J.M." *Address:* 70 Florence Rd., Brighton BN1 6DJ.

MARTIN, John Scott, NDD (1963). *Medium:* painter, marine artist. *b:* Nottonghamshire, 5 Mar 1943. *m:* Hilary. one *s.* one *d. Studied:* Nottingham College of Art (1959-63). *Represented by:* Image by Design hugh@ibd-licencing.co.uk. *Exhib:* RBSA, RSMA, RWA, PS. *Works in collections:* RBSA. *Commissions:* National Trust; English Nature. *Signs work:* "JSM" or "JOHN SCOTT MARTIN". *Address:* Millbank, Mill Lane, Aston Cantlow, Henley-in-Arden B95 6JP.

MARTIN, Marie-Louise, D.F.A. (1982), B.F.A. (1983); artist printmaker in etching; Director, Black Church Print Studio, Dublin;. *Medium:* etching. *b:* Dublin, 29 Mar., 1960. *Studied:* National College of Art, Dublin (1978-83). *Exhib:* R.A. (1987, 1988), R.H.A. (1985-07), R.U.A. (1987-06), An tÓireachtas (1984-02), E.V.A. (1984, 1986, 1988); print exhbns. in Ireland, England, Japan, America, Germany, Spain, Taiwan; exchange print exhbns. to China, Finland, Cuba. Print prizewinner R.H.A. (1989), RUA (2001, 2003). *Works in collections:* B.P. Oil (Brussels); Kilkenny Castle; Guinness Peat Aviation; National Self portrait Coll.; Contemporary Arts Soc.; Office of Public Works; Stormont Castle, Belfast; Microsoft. *Clubs:* United Arts, Dublin. *Address:* 9 Estate Cottages, Shelbourne Rd., Dublin 4. Ireland. *Email:* mlmartin.printmaker@gmail.com

MARTIN, Mary Grace, Dip AD (1972); Post Grad. (Painting) RAS (1975); Bard of Cornish Gorsedd; professional painter, landscape and seascape, garden and still-life artist. *Medium:* oil and watercolour. *b:* St.Dominic, 24 May 1951. *Educ:* Callington Grammar. *Studied:* West of England College of Art, Bristol; Gloucester College of Art, Cheltenham; Royal Academy Schools under Peter Greenham. *Exhib:* London, Bristol, Cornwall, etc. Numerous one-man shows. *Works in collections:* National Trust; National Maritime Museum, Greenwich; Plymouth City Museum; Hotel de Ville, Lorient, France. *Publications:* 'A Wayward Genius', Lodenek Press (1978). Illustrated 'Burcombes Queenies and Colloggetts' by Virginia Spiers (1996); 'Olives, Lavender and Vineyards' by Mary Martin and Virginia Spiers (2002) West Brendon; documentary film made for BBC1 'Daffodils, Bullions and Steam' (1984), 'Look Stranger' series. *Recreations:* collection and maintainence of West Country apple and cherry trees. *Clubs:* RASAA. *Signs work:* "Mary Martin". *Address:* Ash Barn, Bury, Callington, Cornwall, PL17 8BP. *Website:* www.marymartin.eu

MARTIN, Misty, Gerry Lenfest Award for American Art, Salmagundi Club NY; People's Choice, NAPA UK, Black Sheep gallery N.Wales; Best International Artist NAPA UK. *Medium:* acrylic, casein, watercolour. *b:* Tulsa, Oklahoma, 23 July 1963. *d of:* Gary Scott Sr. *m:* Alvin Dean. one *d. Studied:* self-taught. *Represented by:* M A Doran Gallery, Tulsa, Oklahoma; G Michael Gallery online:www.gmichaelgallery.com. *Exhib:* NAPA Westminster Gallery, London (1999), Black Sheep Gallery, Hawarden (1999), Royal Birmingham Society of Artists, Birmingham, England (1998), National Society of Painters in Acrylic and Casein, Salmagundi Club, New York (2002), Gilcrease Museum, Tulsa Oklahoma (2002), Leigh Yawkey Woodson Art Museum Wausau, Wisconsin (2003), Realism 2002, Parkersburg WV (2002). *Works in collections:* Tate Gallery Archives, London; Royal Archives, London; Sisters of Mercy, St.Louis MO, Hotsprings AR, State Farm Insurance, Tyler TX, Bank One, Rapides Bank LA, USA. *Publications:* Southwest Art Sep 2003, American Artists Mag. Nov 2003, Art and Illustration mag. Daler-Rowney (fall 1999), Artist Magazine Calendar (2004), Artist Magazine (Dec 2003). *Works Reproduced:* The Natchitoches Hope Chest, Taking Time to Smell the Flowers, Time in Texas Stone, All Roads Lead from Rome. *Principal Works:* The Ohio Club, Old World Illumination, Colours in the Quarter. *Clubs:* NAPA (UK and USA), National Oil and Acrylic Painters Soc., National Society of Painters in Acrylic and Casein. *Misc:* Signature Artist NAPA USA & UK, Ambassador USA; Signature Artist/ Board of Trustees NOAPS USA; Signature Artist Guild. *Signs work:* Misty Martin NAPA NOAPS. *Address:* 28317 NE 138th Pl, Duvall, Washington 98019, USA. *Email:* mistyNAPA@hotmail.com *Website:* www.mistymartin.com

MARTIN, Nicholas Gerard, BA(Hons.) (1980); artist in oil-stained acrylics, paper collage and paper mosaics, mural mosaics; educational project artist, Glyndbourne Touring Opera (1987): music and composition for four part choirs. *b:* Edinburgh, 5 Jul 1957. *s of:* James Martin. *m:* Marion Brandis. two *s. Educ:* Edinburgh Academy. *Studied:* Edinburgh College of Art (1975-80, Ian Davidson).

Exhib: R.S.A., Traverse Theatre, Gardner Art Centre, Brighton Polytechnic A.G., Royal Pavilion A.G., Brighton, Dryden St. Gallery, Horsham Arts Centre, Royal Festival Hall A.G., Ramsgate Library Gallery, Booth Natural History Museum, Brighton, Mason's Law Firm, Sussex Watercolour Society, Ditchling. *Works in collections:* S.E. Arts, Royal Pavilion A.G., Forestry Commission, Edinburgh, Royal Festival Hall, Towner A.G., mosaic mural for Channel Tunnel, Ashford Library (1990), Herne Bay Sea Front Mosaic Fountain (1993), Govan Shipyard Mural, Glasgow (1993), Queen Elizabeth Queen Mother Hospital Mural (1996), Maps for Rochester City Council, University of Surrey Roehampton, Mosaics 2002-3. *Recreations:* Music Certificate Sussex University. *Misc:* Educational residencies with: Glyndebourne Touring Opera, Destafford School, Hextable School, Spinney School; programme convenor for 'Art for Public Space' degree course at University of Roehampton, Surrey. Since 1999, has combined composition for voices with visual art. *Signs work:* "Nicholas Martin." *Address:* 2 Baron's Walk Lewes E.Sussex BN7 1EX. *Email:* n.martin@roehampton.ac.uk

MARTINA, Toni, B.A. (Hons.) (1978), Prix de Rome scholar (1987), R.E. (elected 1992); many prizes and awards including 1st prize Dept. of Transport National Art Competition (1992), Christie's Contemporary Art award at R.A. (1987), N.Y. National Academy of Design Summer Exhbn. (1986), Lloyds Bank Printmakers award at R.A. (1986), prize, London Print Fair, Air Gallery London (1997), Birgit Skiold Prize (2003). *Medium:* painter/printmaker. *b:* London, 7 Mar 1956. *m:* Tessa. one *s.* one *d. Studied:* Harrow College of Art (1974-75), Kingston Polytechnic (1975-78), Central School of Art (1986). *Exhib:* Europe and the U.K. including R.A. Summer Show, R.E., Rome, New York, Florida, Czech Republic, India. *Works in collections:* Cambridge libraries, Plymouth Museum, Rochdale Museum, Oldham Museum, Dept. of Transport, Museum of London, The London Hospital, Ashmolean Museum, New York Public Library, US Airways. *Publications:* "Citybites" (TNT Publications). *Signs work:* "T. Martina." *Address:* 85 Harold Road, Hastings, East Sussex TN25 5NJ.

MARTINEAU, Luke, 1st class Joint Honours, BA, English and French, Oxon. *Medium:* oil. *b:* London, 27 Mar 1970. *s of:* Elizabeth and David Martineau. *m:* Bella Taylor. one *d. Educ:* Eton College, Magdalen College, Oxford. *Studied:* Heatherleys. *Represented by:* Panter and Hall Ltd, London. *Exhib:* Royal Society of Portrait Painters, NEAC, Hunting Art Prize, Laing Competition. *Works in collections:* Eton College, Magdalen College, Marquess of Anglesey, Buckinghamshire County Council. *Commissions:* Portraits of: Lord Wilberforce, Liz Gloster QC, Brig. the Lord Vivian. *Publications:* 'The View' (published privately). *Recreations:* writing and performing songs in own band, skiing, tennis. *Signs work:* Luke Martineau or L M. *Address:* c/o Panter and Hall Ltd, 9 Shepherd Market, London W1J 7PF. *Email:* enquiries@panterandhall.co.uk *Website:* www.panterandhall.co.uk

MARTINEAU, Luke, Garrick/Milne Portrait Prize, Runner-Up (2003). *Medium:* oils, acrylic. *b:* 27 Mar 1970. *m:* Bella Taylor. one *s.* one *d. Educ:* Eton

College; Magdalen College, Oxford. *Studied:* Heatherley School of Fine Art. *Represented by:* Panter and Hall, London W1J 7PF. *Exhib:* Royal Society of Portrait Painters, Mall Galleries (1997-2005); Chelsea Art Society (2000-2007); Panter and Hall (2001, 02, 04, 06, 08); Thompson's Gallery, Dover Street (1997, 99). *Works in collections:* Middle Temple, Oundle School, Eton College, Magdalen College, Clifton College. *Recreations:* my children; writing pop songs. *Clubs:* Chelsea Art Society. *Address:* 77 Pennard Road, London W12 8DW. *Email:* luke@lukemartineau.com *Website:* www.lukemartineau.com

MASCO, Pam, artist in oil and water-colour, mixed media;. *b:* Springfield, Mass., 19 Mar., 1953. *m:* John Heseltine. *Studied:* School of the Boston Museum of Fine Art, U.S.A. (Grad. Dip.) 1976. *Exhib:* Clarendon Gallery, London (1986), David Messum, London (1990), R.B.A. (1992), R.W.S. (1992), Sunday Times Singer & Friedlander Water-colour (1992), W.H. Patterson, London. Studio and Gallery at East House, Petworth., U.S. galleries. *Works in collections:* private and corporate collections; other collections Wentworth Club, Barings Bank. *Commissions:* portrait painting commissions. *Publications:* Dictionary of British Artists Since 1945 by David Buckman. *Signs work:* "P. MASCO." *Address:* East House, East St., Petworth W. Sussex GU28 0AB. *Email:* pm.hestletinemasco@virgin.net

MASON, Cyril Harry, M.C.S.D. (1966), F.C.S.D. (1979), M.S.T.D. (1966), A.R.B.S.A. (1983), R.B.S.A. (1986); landscape and marine painter in water-colour and oil; chartered designer. *b:* Halesowen, Worcs., 30 May 1928. *m:* Barbara Hill. one *s.* one *d. Educ:* Halesowen Grammar School. *Exhib:* R.I., R.W.S., R.S.M.A., R.B.S.A., R.C.A., R.W.A., Clarges Gallery and Llewellyn Alexander, London and Midland galleries. *Works in collections:* Wyre Forest (Kidderminster), Wychavon, Marks & Spencer. *Clubs:* B'ham Water-colour Soc. *Signs work:* until 1986 "Mason"; after 1986 "Cyril H. Mason." *Address:* Bank Cottage, Shenstone, Kidderminster, Worcs. DY10 4DS.

MASON, Michael, A.T.D., D.A. (Manc.) (1956), Fellow in Sculpture British School at Rome (1976), F.R.B.S. (1992); sculptor in ceramics/bronze; former PR/lecturer sculpture, Manchester University;. *b:* Lancs., 1 June, 1935. *m:* Barbara. one *s.* one *d. Studied:* Manchester College of Art, British School, Rome. *Exhib:* Whitworth A.G., Serpentine Gallery, Yorkshire Sculpture Park. *Works in collections:* V. & A., A.C.G.B., Zagreb A.G., A.V.A.F. Caracas. *Commissions:* Manchester Business School, Hackney Empire. *Publications:* Art International, Ceramic Review. *Signs work:* "Michael Mason" or "M.M." in rectangle. *Address:* 89 Park Rd., Hale, Altrincham, Ches. WA15 9LE.

MASON, Richard, sculptor of constructions in metals, wood and perspex, painter in oil and acrylic;. *b:* Ipswich, 20 June, 1931. *Educ:* Ipswich Grammar School. *Exhib:* one-man show: Woodbridge A.G. (1967); regular exhib. with Ipswich Art Club and Felixstowe Art Group. *Clubs:* Ipswich Art, Felixstowe Art

Group. *Signs work:* "Richard Mason." *Address:* Upland Gate, 39 Bishops Hill, Ipswich 1P3 8EW.

MASSEY, Carole Margaret, Dip. A.D; painter/illustrator in acrylic, water-colour, pastel, pencil; art tutor;. *b:* Hertford, 8 Jan., 1948. *m:* Eric. one *s.* one *d. Educ:* Welwyn Garden City Grammar School, Leicester School of Art. *Studied:* St.Albans (John Brunsden), Leicester School of Art (Edward Bawden, David Howells). *Exhib:* Cambridge, London, Hong Kong, Bury St Edmunds. *Commissions:* portraits - people, animals. *Publications:* books – Water-soluble Pencils (Search Press); video – Water-colour Pencils (Teaching Art), Figures in watercolour (Search Press). *Official Purchasers:* Born Free Foundation. *Principal Works:* Rolf Harris, Joanna Lumley portraits. *Clubs:* N.A.P.A., P.A.S.A.A., Bury Art Society. *Signs work:* "CAROLE MASSEY." *Address:* Fyletts Barn, The Green, Hawstead, Bury St Edmunds, Suffolk IP29 5NP. *Email:* carole@massey-art.fslyc.co.uk

MASSON, Linda, DA, Post Grad Dip.; Travelling Scholarships (2). *Medium:* sculpture, mainly ceramic. *b:* Aberdeen, 27 Jul 1948. *Studied:* Gray's School of Art. *Represented by:* Riverside Gallery, Stonehaven. *Exhib:* Riverside Gallery; Heinzel Gallery, Tolquhon, Aberdeen; RSA, Edinburgh; RGI, Glasgow; Mall Galleries, London; Braemar; Inverurie. *Works in collections:* Royal College of Physicians and Surgeons, Glasgow. *Commissions:* various, private. *Signs work:* 'L Masson'. *Address:* 30a Skateron Road, Newtonhill, Aberdeenshire AB39 3PT.

MASTER, Jean, R.O.I. (1987); painter in oil and acrylic. *b:* London, 25 Feb 1934, married. two *s.* one *d. Educ:* St. Joan of Arc Convent, Rickmansworth, Herts. *Studied:* St. Martin's School of Art (Kenneth Martin), also in Hamburg under Prof. Karl Kluth. *Exhib:* Royal Academy, London, Royal West of England, Bristol, Mall Galleries London, solo exhibition Edinburgh and many other mixed exhibitions. *Address:* 16 Hillside Rd., Redcliffe Bay, Portishead, N. Somerset BS20 8EW.

MATANIA, Franco, UA, SGFA, SEA; First prize 'Talens' award Mall Galleries (1984), Soc. Equestrian Art prize for drawing (1986, 1988), United Soc. of Artists award (1993); artist in all media. *b:* Naples, 1922 (British subject 1935). *s of:* Mario Matania, business executive. *Educ:* Salesian College. *Studied:* at studio of artist relative, the late Fortunino Matania, R.I. (Chevalier): distinguished artist (Imperial War Museum: Benizet, etc.); student apprentice 1947-55. *Exhib:* mixed shows, R.I., R.O.I., N.S., P.S., U.A., S.G.A., S.G.F.A., S.E.A.; one-man shows, Campbell and Franks Fine Art, Bajazzo Gallery, Marlborough, Alpine Gallery, Guild Fine Arts; (abroad 1980's), Galleria Maitani, Orvieto, Italy, Galleria Treves, Milan, Italy, Galleria Alandaluz, Granada, Spain, Tanisia Gallery, N.Y. Galleria Toison, Madrid. *Works in collections:* Centro Hogar, Granada, Knight Inc. Conference Centre, Boston, Industria Marmo Design of Italy. *Address:* Little Venice Studio, 20 Clarendon Gdns., Maida Vale, London W9 1AZ.

MATHESON, Andrew Kenneth Mackenzie, DA, RBSA, Cert. Ed.; artist/potter and teacher works mainly in stoneware/porcelain - from, Rose House Pottery, 13 Tamworth St., Lichfield, Staffs.; thrown or handbuilt pieces reduction fired to 1280oC. *b:* Edinburgh, 22 Jul 1949. *s of:* Farquhar Mackenzie Matheson, accountant. *Educ:* Riland Bedford High School, Sutton Coldfield. *Studied:* Madeley College of Education (1968-71), Grays School of Art, Aberdeen (1974-79), Dip. in Art (1978), postgrad. Dip. in Art (1979). *Exhib:* in Scotland and England. *Works in collections:* RBSA, permanent collection, Grays School of Art, Aberdeen, North Ayrshire Museum, work in various private collections in UK and abroad. *Official Purchasers:* in 2000, work purchased by HRH, Prince of Wales. *Clubs:* Mem. of: RBSA (& Hon Treasurer), B'ham Art Circle, Midland Potters Association (Vice Chairman). *Signs work:* "Andrew K.M. Matheson". *Address:* 7 Driffold, Sutton Coldfield, W. Midlands B73 6HE.

MATHEWS, Alister, B.Sc,; botanical painter in water-colour. *b:* Prestbury, 25 Feb 1939. *m:* Carl Mathews, Ph.D. one *s.* one *d. Educ:* James Allen's Girls' School, Dulwich; University of Wales. *Exhib:* S.B.A., S.W.A., Malcolm Innes; solo show: Hitchin Museum, Westminster Gallery annually, National Gallery of Wales, Linnaean Society, Piccadilly, London, Durham Museum, Hunt Institute for Botanical AA & Illustration 8th International Exhibition. *Works in collections:* Hunt Inst. for Botanical Illustration, Carnegie Mellon University, Pittsburg, Shirley Sherwood Collection, National Museum and Gallery of Wales, Cardiff. *Recreations:* gardening. *Signs work:* "Alister Mathews." *Address:* 4 Bramshott Close, London Rd., Hitchin, Herts. SG4 9EP.

MATHEWS, Binny, Elizabeth Greenshield Foundation Award (1989); painter in oil, specialising in portraiture, tutor;. *b:* Dorset, 25 June, 1960. *m:* Stuart Martin, architect. two *s. Studied:* Bournemouth and Poole College of Art (1977-78), West Surrey College of Art (1978-81), Brighton Polytechnic (1981-82). *Exhib:* N.E.A.C., Hunting Award, R.P., Mall Galleries, N.P.G. (1981, 1982 1985, 1988, 1990, 1993), R.A., etc., numerous one-woman shows in the provinces and London. *Works in collections:* La Sainte Union College, Southampton; National Trust, Castle Drogo; Seagrams; British Gas; Carpenters Hall; American Embassy. *Clubs:* Chelsea Arts. *Signs work:* "Binny Mathews." *Address:* 13 Crescent Pl., Brompton Rd., London SW3 2EA. *Website:* www.hereasel.com

MATSUNAGA, Rui, BA Fine Art Painting(1999), MA Fine Art Painting (2002); Lexmark European Painting Prize finalist (2003), May Cristea Award for Painting (2002), Royal Academy Schools of Art Fellow (2002-3), Landseer Award (2001). *Medium:* oils. *b:* Japan, 17 Oct 1968. *d of:* Masahiro Matsunaga. *m:* Gordon Cheung. *Educ:* Central St.Martin's. *Studied:* RA Schools. *Exhib:* Lexmark European Prize (2003), Kyoto Art Centre (2003), Studio J, Osaka, Japan (2003), Michael Goedhuis Gallery, London (2002). *Works in collections:* Museum of Senegallia, Italy; London Institute, London. *Address:* 6 Beverley Hyrst, Addiscombe Road, Croydon, CR0 6SL. *Email:* rui.matsunaga@ukonline.co.uk

MATTAROZZI DI THARASH, Mirella (Mirice Janàcêk), artist-painter, fine arts professor, writer; Diploma, Istituto Belle Arti di Bologna, Accademia di Belle Arti di Bologna. *b:* Bologna. *d of:* Adelmo. *Exhib:* Italy, Europe, South America. *Works in collections:* museums, Palazzo Vecchio, Firenze, Castello Sforzesco, Milano, Museo S. Matteo, Pisa, etc. Associate of Incisori d'Italia (I.D.IT.), Ex Libristi d'Italia (E.L.D.IT.). *Publications:* Il Comanducci, Annuario Internazionale di Belle Arti (Berlin), Guida all'arte Italiana, Who's Who in Europe, ed. Feniks, etc., Knight of the Tommaso da Vico Order; Academician of the Accademia dei 500, Rome. Lady-in-waiting of the Corporazione Internazionale della Stella Croce d'Argento (C.I.S.C.A.) dei Cavalieri del Bene. *Address:* via Sigismondo no33, Cattolica Forlì, Italy.

MATTHEWS, Anton, R.C.A., (1960) N.D.D., A.T.D., artist in oil; Head of Art School(retired). *b:* 5 Dec., 1925. *m:* Janet. three *s. Studied:* Cheltenham College of Art, University of Reading. *Exhib:* R.A., R.B.A., R.W.A., R.C.A., and many mixed exhbns. and one-man shows. *Works in collections:* Pictures for Schools and Welsh Arts Council. *Signs work:* "Anton Matthews" or "AM". *Address:* 8 Elizabeth Way, Chard, Som. TA20 1BY.

MATTHEWS, Les, MA Art (RCA), BA Hons (1st); Galleries Magazine prizewinner, Andrew Brownsword Award. *Medium:* oil painting cityscapes. *b:* 19 Apr 1946. *s of:* Reg and Violet Matthews. *m:* Anthea Matthews. one *s.* one *d. Studied:* Gloucestershire College of Art, Royal College of Art; student restorer National Gallery London. *Represented by:* Alan Morgan. *Exhib:* numerous mixed shows including RA, RWA, Athena, Saunders & Bockingford, Sunday Times, Bath Society of Artists, Laing, etc.; Shared and one-man shows: Will's Art Warehouse London, Clifton Gallery Bristol, Europe, Middle East. *Works in collections:* MO, MA, Canberra Australia; many private and public collections including museums, National Trust and universities, H.R.H. Prince Michael of Kent KCVO. *Commissions:* Open University, Hawkwood College, etc. *Publications:* Oxford University Press, Transworld Corgi, Galleries Magazine, RWA publications. *Works Reproduced:* various range of paintings in print form. *Principal Works:* American, European and Far East cityscapes. *Recreations:* travel and wine, intense interest in European Art History. *Clubs:* Bath Society of Artists. *Signs work:* Les Matthews. *Address:* 16 Streamside, Clevedon, North Somerset, BS21 6YL. *Email:* les@lesmatthews.co.uk *Website:* www.lesmatthews.co.uk

MATTHEWS, Sally, BA Hons. *Medium:* sculpture and drawing. *b:* Tamworth, 30 Dec 1964. *m:* Richard Harris (sculptor). one *s.* one *d. Studied:* Loughborough College of Art 1983-86. *Represented by:* The Cass Foundation (Sculpture at Goodwood). *Exhib:* Tullie Hse Carlisle, Oriel Mostyn Gallery Touring Exhbn., Peggy Guggenheim Collection Venice with sculpture at Goodwood, Collins Gallery Glasgow, Robert Sanderson Cork Street. *Works in collections:* Prudential Corp. London, Shipley Art Gallery Gateshead, National Museum of Wales, Contemporary Arts Society of Wales, Brecknock Museum and Art Gallery.

Commissions: Grizedale Forest, Gateshead Riverside, Sustrans, Cardiff Bay, Arte Sella Italy, Bialowieza Poland. *Publications:* 'With Animals', 'Sentient Beings',& 'Gathering'. *Address:* The Castle, Rhosgoch, Builth Wells, Powys, LD2 3JU. *Email:* 2sculptors@freeuk.com *Website:* www.sallymatthews.co.uk

MATTHEWS, Sharyn Susan, SWA; self taught artist in water-colour, acrylic, gouache, oil. *b:* Bristol, 13 Jan 1951. *d of:* Ralph Valentine-Daines, stonemason. one *s.* one *d. Exhib:* numerous one-man shows at home and abroad, including Mall Galleries. Work permanently on show Park Lane Fine Arts, Ashtead, Surrey. *Signs work:* "Sharyn Matthews." *Address:* 19 Longdown La. North, Ewell, Surrey KT17 3HY.

MATTHEWS, Zara, M.A., R.C.A. (1999); painter in oil, artist printmaker, digital artist. *b:* London, 6 Jun 1960. *Educ:* St Paul's Girls School, Hammersmith, London. *Studied:* Goldsmiths College (1979-1980), Kingston Polytechnic (1980-1983), Royal College of Art (1997-1999). *Exhib:* Flowers East (1991), Eagle Gallery, London (1992, 1996, 2001), Harewood House, Leeds (1996), Kunst Zurich (2004). *Works in collections:* D.L.A. Art Collection, British Land, R.C.A. Print Archive, V. & A. Print Collection, British Museum. Private collections in Switzerland, Italy and Great Britain. *Principal Works:* 'Self Portrait: 1st Edition' (1999), 'Fold' (2001), 'State of Play ' (2004). *Signs work:* "Zara Matthews." *Address:* 73-75 Cressy Court, London E1 3JQ. *Email:* zaram@talk21.com

MAUGY, Sandrine, SFP; MA; CertHE Community Work; Cert.Botanical Illustration; awards: Hillier Legacy Award (SFP, 2003); Silver Medal (RHS, 2004); Popular Choice Runner Up (SFP, 2004); Miggy & Gordon Bath Award for Oil Painting, Runner Up (SFP 2005, 2007); Certificate of Botanical Merit (SBA 2007). *Medium:* watercolour, oil. *b:* Rouen, France, 1969. *Studied:* University of Caen, France. *Exhib:* Mottisfont Abbey, Hampshire; Westminster Gallery, London; Southampton City Art Gallery; The Sandra Whitman Gallery, San Francisco, USA; RHS Hall, London. *Works in collections:* internationally. *Commissions:* Roy Lancaster. *Publications:* Artists & Illustrators Magazine (since 2006). *Recreations:* ballet, gardening. *Signs work:* 'SANDRINE MAUGY'. *Address:* Southampton. *Email:* sandrine@sandrinemaugy.co.uk *Website:* www.sandrinemaugy.com

MAY, Elsie D., *Educ:* Sydney, London, Tunbridge Wells. *Exhib:* Sydney, Melbourne, Bristol, London, Tunbridge Wells, East Grinstead, Cranbrook. *Works in collections:* Australia, USA, UK, Canada, Japan, Netherlands and Switzerland. *Publications:* 'Community Paediatrics' (1981), 'Our Guardian Angels' (2001), 'Sophie and her Star (2003). *Recreations:* walking, theatre, music, yoga. *Address:* 13 Forge Rd, Tunbridge Wells, Kent, TN4 0EU. *Email:* edangel@waitrose.com *Website:* www.elsiemay.com

MAY, Joanna, *Medium:* liquid acrylic through an airbrush, and gouache, also works in oil. Paints wildlife subjects (specialising hare). *b:* Tonbridge, 22 May 1965. *d of:* Mr & Mrs Peter Cowne. three *d. Studied:* 2 years technical illustration

Bournemouth College, 2 years further study General Illustration Falmouth College graduating 1991. *Represented by:* Joannah May Gallery opened 2001 continual display of painting and prints. *Exhib:* Christie's Contemporary Art Auction (2001), Westminster Gallery Society of Women Artists (2002/3), Readers Digest Exhbn (1991), AOI Exhbn (1990), Gallery One Barnes (solo show 'The Call of the Wild', 2005), Christie's St.James (2004/05/06) Charity Auction Cancer Research; Brian Sinfield Gallery, Burford (2001, and solo show 2006). *Commissions:* paintings commissioned by Raymond Blanc for the Lemongrass Suite at Hotel Le Manoir de Quat'Saison (2007). *Works Reproduced:* by Animal World Magazine (2 yrs), Kingfisher Books. *Misc:* also published under name Joanne Cowne. Life and Works featured on BBC's Spring Watch series (June 2006). Invited to speak about work on BBC's Radio Wiltshire (2005/06). *Address:* Studio Gallery, 4 Old Hughenden Yard, High Street, Marlborough, Wilts, SN8 1LT. *Email:* joanna@joannamay.com *Website:* www.joannamay.com

MAYER, Charlotte, ARCA(1952), FRBS(1980); RBS Silver Medal (1991). *Medium:* sculpture in bronze and steel. *b:* Prague, 4 Jan 1929. *d of:* Frederick Mayer. *m:* Geoffrey Salmon. one *s.* two *d. Studied:* Goldsmiths' College School of Art (1945-49, Wilson Parker and Roberts Jones), RCA (1949-52, Frank Dobson). *Represented by:* Gallery Pangolin 004(0) 1453 886527; Garden Gallery 01794 301144. *Exhib:* RA, RWA, V&A.; Selected Galleries: Belgrave, Pangolin, Sladmore, Berkeley Sq., Bohun, Sculpture at Goodwood, Garden Gallery Hants; Hannah Peschar Sculpture Garden; New Academy; Cass Sculpture Foundation. *Works in collections:* Wadham College Oxford; The Wirral Autistic Society; Basingstoke and N. Hants. Health Authority; Cement and Concrete Assoc.; British Petroleum; Banque Paribas; Bledlow Manor; J C Decaux, France; St.Ethelburgas Centre for Reconciliation and Peace; Cass Sculpture Foundation. *Commissions:* Tree of Life, North London Hospice; Ascent, Barbican, City of London; Journey 2 Nene College, Northants.; Wind and Fire, Marylebone Gate, London; Sea Circle, Liverpool; 'Moon Arch', Prior's Court School, Berkshire. *Publications:* The Mystery of Creation, Lealman and Robinson; Patronage and Practice, Tate Gallery Liverpool; Liverpool Seen, Peter Davis; The Alchemy of Sculpture, Tony Birks, The Art of Prior's Court School, Ann Elliott; Sculpture at Goodwood by Ann Elliott; 'Modern British Sculpture',Guy Portelli. *Recreations:* friends. *Signs work:* "C.M." or "Mayer." *Address:* 6 Bloomfield Rd., Highgate, London N6 4ET. *Email:* charlottemayer@talktalk.net

MAYES, Emerson, B.A. Hons., Graphic Arts, Leeds Metropolitan University (1994); painter/printmaker and draughtsman of British landscapes. *b:* Harrogate, N. Yorks., 22 May 1972. *Educ:* St. Aidans C. of E. High School, Harrogate. *Studied:* Harrogate College, Leeds Metropolitan University. *Exhib:* N.E.A.C., Discerning Eye, Laing Landscape prize, numerous solo exhibs. including London and Edinburgh, represented by Gascoigne Gallery, Harrogate. *Works in collections:* N. Yorks. County Council, Harrogate Borough Council, Provident Financial Plc and numerous private collections. *Signs work:* "Emerson Mayes."

Address: 5 Cliff View Terrace, Galsshouses, Harrogate, N.Yorks HG3 5QU. *Email:* emerson@mayes100.fsnet.co.uk *Website:* www.emersonmayes.co.uk

MAZ: see JACKSON, Maz,

MAZZOLI, Dino (Leopoldo), artist in oil and water-colour. *b:* Terni, Italy, 10 May 1935. *s of:* Gino Mazzoli, artist. one *s.* one *d. Educ:* Oriani College, Rome. *Studied:* Villa Massimo, Rome (1953-54, Renato Guttuso), Villa Medici, Rome (1954-56), Eastbourne College of Art, and with Dorothy Swain, R.C.A. *Exhib:* Don Orione, Farnesina, Rome, Heathfield A.G., E. Grinstead Autumn Show, Towner Museum and A.G., Eastbourne, Brighton Museum and A.G., Star Gallery, Lewes, Blackheath Gallery, London; also in Dusseldorf, Germany, St. Laurent en Grandvaux, France, Birmingham, Alabama U.S.A., etc. *Works in collections:* La Charbonniere, St. Laurent en Grandvaux 39150 France. *Signs work:* "D. Mazzoli." *Address:* 33 Cavalry Cres., Eastbourne, E. Sussex BN20 8PE.

MEACHER, Neil, NDD (1955), ARCA (1960), R.I. (1981); artist and teacher in inkline and water-colour; visiting Professor in Illustration, Buckinghamshire Chilterns University College. *b:* Sandwich, Kent, 20 Dec 1934. *s of:* Reginald John Meacher, architect. *m:* Margaret Joyce. one *s.* one *d. Educ:* Sir Roger Manwood's Grammar School. *Studied:* Canterbury College of Art (1951-55), R.C.A. (1957-60, Humphrey Spender, Julian Trevelyan, Alistair Grant, Edward Ardizzone). *Exhib:* Shell Gallery, Mall Galleries, Campion Gallery, Alresford Gallery, Linda Blackstone Gallery, Medici Gallery, Walker Galleries, Anthony Campion Gallery. Work in numerous private collections. *Works in collections:* Mr & Mrs John Senter, Dulwich, Mr & Mrs Grahan Naill, Rye. *Publications:* joint author 'Mastering Water-colour' (Batsford, 1994). *Clubs:* Royal Inst. of Painters in Water-colour. *Signs work:* "NEIL MEACHER." *Address:* Warehouse Studio, Apartment No. 2, The Corn Exchange, Strand Quay, Rye, E.Sussex TN31 7DB.

MEADOWS, Anthony William, A.R.M.S. (1984); self taught painter and illustrator in oil, wood engraving;. *b:* Aldershot, 28 Aug., 1957. *m:* Dawn Hardy (jeweller). *Educ:* Fanshawe School, Ware. *Exhib:* R.A., R.I., R.M.S. and several one-man shows. *Works in collections:* Hertford Museum. *Signs work:* "A. W. Meadows". *Address:* 27 Victoria Rd., Oswestry, Salop. SY11 2HT.

MEDHURST, Doreen, R.M.S. (1993), S.B.A. (1989), S.W.A. (1989); Llewelyn Alexander Gallery Master Award Commendation of Excellence- six paintings 'Scenes of Rye' (April 2002), single miniature 'Haymaking' (April 2001); self taught painter in acrylic and oil. *b:* London, 5 Aug 1929. *d of:* Sydney Holmes. *m:* Cyril Medhurst. two *s. Educ:* Sydenham High School. *Exhib:* R.M.S., S.B.A., S.W.A., Llewelyn Alexander Gallery, Alfriston Gallery, Elan Art Centre, Limpsfield Gallery, Cherry Creek Gallery, Oxted, Florum Exhibition, Sevenoaks, and several one-man shows. *Publications:* Greetings cards, Lings, "Penshurst, Kent". *Signs work:* "D. Medhurst." *Address:* 45 Blenheim Rd., Orpington, Kent BR6 9BQ. *Email:* d.medhurst@tiscali.co.uk

MEDWAY, Sarah, BA (Hons). *Medium:* abstract painter in oil, watercolour, drawing, prints. *b:* Seaton Carew, Co.Durham, 9 Jul 1955. *d of:* Michael Hilborne-Clarke. one *s. Studied:* after early career as ladies' shoe designer 'Sarah Medway Couture Shoes, Piccadilly & Knightsbridge': Chelsea School of Art, Byam Shaw School of Art (1991-94); ICA London (Modern Art Studies-Distinction). *Represented by:* Vertigo Gallery, Hoxton, London. *Exhib:* since 1994, 15 solo exhbns in London (Vertigo) and Milan (Vertigo), Thailand (Chateau de Bangkok) Bangkok, Magdeburg, Frankfurt and Heidelberg, Germany; over 100 group exhbns in the UK and abroad including RA Summer Exhbns; Vertigo Gallery London; Flowers East and Central, London; Tate Britain; South London Gallery; Bloomberg Space, London; Gallery Seven, Hong Kong; Schwetzingen Castle, Germany; Forum Galerie, Usingen; Stephen Lacey Gallery, London. *Works in collections:* numerous corporate collections, and public collections including Nord LB, Germany; Municipal Hospital, Brunswick, Germany; St.Thomas' Hospital; Paintings in Hospitals. *Commissions:* private commissions in UK, Thailand, New York, Belgium, Germany, Italy & Spain. *Works Reproduced:* in catalogues UK and Italy, and Catalogue Triangle Artists Workshop, New York. *Recreations:* theatre, opera, dance, walking, poetry and Shakespeare. *Clubs:* Groucho Club, London; Chelsea Arts Club, London; Annabels, London. *Signs work:* 'S.Medway' (back of canvas). *Address:* 509 Union Wharf, 23 Wenlock Road, London N1 7TD. *Email:* medwayart@aol.com *Website:* www.medwayart.com

MEEK, Elizabeth R., PPSWA, PRMS, HS, FRSA; portrait artist; Past President of Society of Women Artists (2000-2005); President Royal Society of Miniature Painters Sculptors & Gravers (2005-); Patron of The Society of Limners; Awards: winner, RMS Gold Memorial Bowl (1995); The Bell Award (1992, 1997) (best portrait in exhbn.); HS(1993, 1994) (best in exhbn. twice); RMS(1992, 1994) (runner-up for Gold Memorial Bowl, twice); RMS(1993) Gold Bowl hon. mention, The Mundy Sovereign Award (1995, 1999, 2004), Best Set RMS(1999), RMS (2002) Presidents Special Commendation, The Peter Charles Booth memorial Award (RMS, 2005), Daler Rowney Choice Award (2006); Barbara Tate Award for Best Oil, SWA (2004). *b:* London, 7 May, 1953. *d of:* Anthony J.Lester AICA, FRSA. two *d. Educ:* Beaconsfield High School. *Exhib:* RMS, Hunting/Observer, Mall Galleries, Smith Gallery, Yorks., L'Espace Pierre Cardin, Paris, British Painters, Barbican Centre, SWA, HS, Llewellyn Alexander Gallery, RA Summer Exhbn., Royal Portrait Society, Chelsea Art Society; one-woman show in Valletta, Malta, Africa '97 London, Soc. of French Miniature Artists, France, Jersey Arts Centre, Australia & others. *Works in collections:* National Museum of Fine Art, Valletta, Malta; H.R.H. The Prince of Wales; H.R.H. Princess Michael of Kent; The Clockmakers Museum. *Publications:* 'The Techniques of Painting Miniatures' by Sue Burton; '100 Years of Miniatures' by Suzanne Lucas. *Clubs:* Fellow Royal Society Arts. *Signs work:* "E.R. Meek." *Address:* Chine Lodge, 11 Eastcliff Road, Shanklin, Isle of Wight PO37 6AA. *Email:* elizabethmeek@msn.com *Website:* www.elizabethmeek.com

MEEKS, Sheila Mary, BA Honours Degree in Fine Art (1977), Post Graduate Certificate in Education (1981), Picker Travel Scholarship (to visit New York, 1977), Royal Bank of Scotland Award, Manchester Academy Show (1996). *Medium:* oil, watercolour, drawing. *b:* Stalybridge, 15 Mar 1955. one *s*. *Educ:* Harrytown Convent School, Romily, Cheshire; Foundation Course, Tameside College, Lancashire. *Studied:* Kingston University, Surrey (1974-77), Cyprus College of Art (1979), Manchester University (1981). *Represented by:* Wendy J Levy Gallery, Manchester. *Exhib:* British Council, Nicosia, Cyprus; Castlefield Gallery, Manchester; 20thC British Art Fair (RCA); Chelsea Art Fair; Discerning Eye Exhibition, Mall Galleries, London; Cornerhouse 10th Anniversary Exhibition, Manchester; Royal Academy of Fine Arts Summer Show; Wendy J Levy Fine Art, Manchester; New Grafton Gallery, Barnes, London; Firbob & Peacock, Knutsford, Cheshire. *Works in collections:* Rutherston Collection, Manchester Art Gallery; Readers Digest Corporate Collection, New York. *Publications:* A Colourful Canvas - Twelve Women Artists in the North West (pub. Wendy J Levy Contemporary Art Ltd.). *Works Reproduced:* White Jug/Black Boats, Yellow Road to the City (reproduced by Blink Red). *Principal Works:* "Valley at Dusk" (2006, oil on board, 4ft x 2ft). Generally, landscapes and still life paintings in oil or watercolour. *Recreations:* walking, yoga, rading, galleries. *Misc:* Member of Manchester Artists Studio Association. *Signs work:* "S M Meeks". *Address:* 26 Chamberlain Road, Heyrod, Stalybridge, Cheshire, SK15 3BR. *Email:* sheilameeks@fsmail.net

MEHTA, Sharda, Post Grad Fine Art. *Medium:* etching, collagraph, oil, watercolour, drawing, prints. *b:* Tanzania, 12 Jun 1937. *d of:* B.N.Uohara. *m:* A.K.Mehta. *Studied:* Byam Shaw School of Art. *Exhib:* many exhibitions in London UK including RA Summer Exhbn., also in France. *Clubs:* Alumni Association. *Signs work:* 'S.Mehta'. *Address:* 4 Fitzroy Close, Highgate, London N6 6JT. *Email:* Amehta2431@aol.com

MEISELAS, Susan C., Awards: MacArthur Fellowship (1992); Hasselblad Foundation (1994); Cornell Capa Award (2005). *Medium:* photography. *b:* Baltimore, USA, 21 Jun 1948. *d of:* Dr. Leonard Meiselas. *m:* Richard P. Rogers. *Studied:* BA: Sarah Lawrence College, EdM:Harvard Graduate School of Education. *Represented by:* Magnum Photos since 1976. *Exhib:* Rose Gallery, LA; Stephen Daiter Gallery, Chicago; Cohenamador Gallery, NYC. *Works in collections:* Whitney Museum of American Art, New York; Hasselblad Centre, Sweden; George Eastman House, Rochester, New York, etc. *Commissions:* CCB, Lisbon, Portugal; CAM, Madris, Spain. *Publications:* Carnival Strippers (2003); Nicaragua (1981); Kurdistan: In the Shadow of History (1997); Pandora's Box (2001); Encounters with the Dani (2003). *Works Reproduced:* New York Times, Geo Magazine, Time Magazine. *Individual Shows/Exhibitions:* one-woman exhbns include: FOAM, Amsterdam (2003), Whitney Museum of American Art (2000), Leica Gallery, New York/Art Institute of Chicago (1990); Camerawork, London (1982); Group exhbns include: Museum of Modern Art Oxford (2002), Nederlands Foto Instituut, Rotterdam (2001), New Museum, New York (2000),

Centre Georges Pompidou, Paris (1996), International Center of Photography, NYC (1989), Museum for Photographic Arts, San Diego, USA (1984). *Awards/Commissions:* Awards include: Rockefeller Foundation, Multi-Media Fellowship (1995), Hasselblad Foundation Prize (1994), MacArthur Fellowship (1992), Photojournalist of the Year, ASMP (1982). *Publications: Monograph/Contributer:* monographs: Encounters with Dani (Steidl/ICP, 2003); Pandora's Box (Magnum Editions, 2001); Kurdistan: In the Shadow of History (Random House, 1997);Nicaragua, June 1978-July 1979 (Pantheon, 1981); Carnival Strippers (Straus & Giroux, 1976, reprint Steidl/Whitney, 2003). *Specialist Area:* documentary. *Equipment Used:* Leica, Canon, Hasselblad. *Additional Projects:* Voyages, directed by M.Karlin, writing and photography by Meiselas produced for Channel 4, England; Pictures from a Revolution, co-directed and co-produced with A.Guzzetti & R P Rogers, 1991 (distributed by Kino International); Living at risk, co-directed and co-produced with A.Guzzetti & R P Rogers, 1985 (distributed by New Yorker Films). *Misc:* teaching: 1975, Faculty, Centre for Understanding Media (New School for Social Research, NY); 1974-5, Artist-in-Residence, South Carolina Arts Commission & Mississippi Arts Commission (teaching photography and animation film in rural communities); 1972-4, Photographic Consultant (Community Resources Inst.). Academic positions held: Globalization Fellow in Human Rights, University of Chicago (1999); Visiting Lecturer, Harvard University, Carpenter Center (1998); Graduate Seminar Instructor, Cal Arts, Los Angeles (1992); Gahan Fellow, Harvard University, Carpenter Center (1991); Faculty, Berkeley School of Journalism (2001-2007); Professor of Photographic Studies, Leiden University, The Netherlands (2005-). *Signs work:* 'SCMeiselas'. *Address:* 256 Mott Street, NYC 10012, USA. *Studio Address:* 256 Mott St, NY. *Email:* smeiselas@earthlink.net *Website:* www.susanmeiselas.com

MELAMED-ADAMS, Alicia, U.A. (1965), Gold medallist, Academie Italia belle arti el Lavore (1981), Art in Edinburgh (1984), Gallery Internationale, Paris (1984); artist in oil. *b:* Borystaw, Poland, 26 Sept., 1927. married. *d of:* Jzydore Goldschlag, oil mining engineer. one *s. Studied:* St. Martin's School of Art (1960-63); Academie Chaumiere, Paris; Sir John Cass College of Art. *Exhib:* Foyles A.G., R.B.A., Augustine Gallery, Flower Paintings of Today, Flower Paintings of the World, 100 Years of British Drawing, Galerie Solombo, Paris (1987-89), Crypt Gallery, London, R.A. (1988), Hunting Group, Mermaid Theatre (1991), Real Art Gallery (1992), Intaglio Gallery, Manchester (1993), Crocodile Gallery (1993), Leicester City Gallery (1993), Laudersdale House (1994)Oxo Tower (2005), Louderdale House (2005); two artists, two views, Bird and Davis Ltd. (1996); Sackville Gallery mixed (1996, 1997), Artbook Chelsea Harbour mixed (1998), one-woman show (1998), Patron, Exh. Ark T Centre Oxford, Patron, Bishop Harris of Oxford, Holocaust exhibition, St. Luke's Church, Holloway, London (27 Jan.); mixed pottery exbn. Morley College Art Gallery (2001), 2002/3 painters, 3 sculptures, the Gallery in Cork St., Feb. 2003 one woman show, Sheffield University; The Art of Holocaust Survivor, Etz Haim Gallery

Norwood (2004); Sheridan Russel Gallery London; The Art of Love, Arndean Gallery (2004); Oxo Tower Gallery, The Art of Love (2005); retrospective exhibition Lauderdale House (2007). *Works in collections:* Brazil, Paris, London; permanent collection, Ben Uri. *Publications:* British Contemporary Art (1993), Editions Arts et Image du Monde (1989), Britt Art 2000, The Cambridge Blue Book (2005). *Official Purchasers:* Ben Uri Museum. *Signs work:* "Alicia Melamed." *Address:* 17 Edmunds Walk, London N2 0HU.

MELLAND, Sylvia, RE; painter-etcher. *b:* Altrincham. *d of:* Brian Melland, M.D., M.B. (Lond.). *m:* Brian Mertian Melland. one *s. Educ:* Altrincham Grammar School. *Studied:* Manchester College of Art, Byam Shaw, London, Euston Road, Central School (Graphics). *Exhib:* one-man shows, Wertheim and Jackson's Galleries, Manchester, Zwemmer Gallery, London, Galleria S. Stefano, Venice, Galerie Maurice Bridel, Lausanne, Galerie Bürdeke, Zürich, Agi Katz Fine Art, London. *Works in collections:* Rutherston Collection, S. London A.G., N.Y. Library, Leeds A.G., Brighton Museum, Coventry Educ. Council, Twickenham Educ. Council, Greenwich Library, Ferens A.G., Hull, V. & A., R.A. (Stott Foundation), Talmuseum des Münstertals, Switzerland, New Hall College, Cambridge and in private collections here and abroad. *Signs work:* prints, "Sylvia Melland," oils, "S.M." *Address:* 68 Bedford Gdns., London W8.

MELLOR, Mary, LL.B., A.K.C. (1961), Called to Bar (1962), B.A. Graphics (1984); artist in oil and mixed media; teacher. *b:* Swansea, 1939. *d of:* David M. Clement, C.B.E., F.C.A. *m:* His Hon. Judge David Mellor. two *d. Educ:* King's College, London, Inner Temple. *Studied:* Norwich School of Art and Design (1979-84). *Exhib:* Norwich Castle Museum, Advice Arcade Gallery etc. King's Lynn Eastern Open, Figurative Painting Prize (1996), Mall Galleries, N.E.A.C. (1998), New York Expo. (1999), Sheringham Little Theatre (1999); solo exhbn. Bergh Apton Sculpture Trail, Norfolk (3-Dimensional work). *Signs work:* "Mary Mellor." *Address:* The Old Hall, Mulbarton, Norwich NR14 8JS.

MELLOR, Pamela, FRSA; painter in oil, writer; Hon. Sec., Chelsea Art Society (1971-1978); Com., Armed Forces Art Society;. *Medium:* oil. *b:* Sydney, Australia. *d of:* Capt. R. C. F. Creer, R.N. retd. and Eulalie Henty. *m:* Lt.Col. Gerard Mellor, Royal Signals, retd. *Educ:* at home and abroad. *Exhib:* UA, RWS, RMS, Artists of Chelsea, Chelsea Art Soc., Leighton House, Ridley Art Soc., Armed Forces Art Soc., Dowmunt Gallery, Qantas Gallery. *Works in collections:* H.R.H. The Prince of Wales, The Agent General of NSW, The Agent General of Queensland and other private collections. *Publications:* author, The Mystery of X5 (pub. William Kimber). *Official Purchasers:* H.R.H. The Prince of Wales. *Clubs:* Huntingham Club. *Signs work:* "Pam Mellor." *Address:* 44 Stanford Rd., Kensington, London W8 5PZ.

MELVIN, Johanna Helga, BA Hons; Painting of the Month, Russell & Chappel. *Medium:* acrylic and cutout work, watercolour, drawing. *b:* London, 12 Jul 1951. *d of:* Ellen Sömme & John P.Dennis. *m:* Rod Melvin. three *s. Educ:*

Convent of Our Lady; Convent of St.Agnes and St.Michael. *Studied:* Sir John Cass Faculty of Fine Art, London. *Exhib:* RA; Contemporary Art Society; Mall Galleries; Flowers East Gallery; Spitz Gallery; RCA; The Groucho Club; Stenersen Museum, Oslo; The Barbican; Whitechapel Library; Dover Street Arts Club. *Works in collections:* John Cass Faculty of Fine Art Print Collection; Groucho Club Collection, Colony Room. *Commissions:* Marie Lloyd Wing, Hackney Empire Theatre. *Publications:* Arty Magazine. *Clubs:* The Groucho Club. *Misc:* appointed Limited Editions Assistant at the Whitechapel Gallery, London (2006). *Signs work:* 'Johanna Melvin'. *Address:* 20 St.Barnabas Road, Walthamstow, London E17 8JY. *Email:* johanna_melvin@hotmail.com *Website:* www.johannamelvin.com

MENDEL, Renée, sculptor and potter. *b:* Elmshorn, 22 Sep 1908. *d of:* Oscar Mendel, leather merchant. *Educ:* Lichtwark School, Hamburg; universities of Berlin, Frankfurt, Paris. *Studied:* Berlin under Ernest de Fiori, Paris under Pablo Gargallo. *Exhib:* Salon d'automne, Paris, R.A., Hertford House; one-man show at Royal Copenhagen Porcelain Co., 6 Bond St., Heal & Son Exhbn. Sculpture for the Home, Camden Arts Centre, Royal Exchange (1977). *Works in collections:* sculpture (wood carving) of James Joyce, National Portrait Gallery. *Commissions:* Dm. H. Winsley-Stolz, S.P. (bronze portrait 1989). *Works Reproduced:* in The Studio, Evening Standard, Semaine à Paris, Artistes d'aujourd'hui, Hampstead and Highgate Express and News, Hornsey Journal. Sculpture of 'Beatles' sold by Sotheby's (21 May 81), Sculpture of James Joyce, N.P.G. (Feb. 1987). *Signs work:* "Renée Mendel." *Address:* 27 Onslow Gdns., London N10 3JT.

MENDELOW, Anne, artist in oil and pastel; gallery owner promoting Scottish artists;. *b:* Johannesburg, 1 Apr., 1947. divorced. two *s.* one *d. Educ:* in S.Africa. *Exhib:* R.G.I., S.A.A.C., and galleries in Edinburgh and Glasgow. *Works in collections:* private galleries in Edinburgh and Glasgow. *Signs work:* "Anne Mendelow." *Address:* Park Cottage, The Gatehouse Gallery, Rouken Glen Rd., Glasgow G46 7UG.

MENDOZA, Edwin, portrait painter, landscape and still life paintings in the Impressionist/Expressionist styles, Matisse, Derain, Bonnard, Jawlenski, member of Federation of British Artists F.B.A. *b:* Alexandria, Egypt. *m:* Katherina. two *d. Studied:* Fontainbleu, France and St. Martin's School of Art. *Exhib:* in Spain, France, England, USA and Canada. *Works in collections:* clients in USA, France, Malaysia, Switzerland, Canada. *Signs work:* "Mendoza". *Address:* 38 Whittington Court, Aylmer Road, London N2 0BT. *Email:* edwinmendoza_painting@yahoo.co.uk *Website:* www.mendoart.co.uk

MENDOZA, June, A.O., O.B.E., RP, ROI, SWA (Hon. Mem.); portrait painter. *b:* Melbourne, Australia; musician parents. *m:* Keith Mackrell. one *s.* three *d. Educ:* Lauriston Girls' School, Australia. *Studied:* St. Martin's School of Art. *Exhib:* various galleries internationally, esp. London. *Works in collections:*

government; H.M. Forces; industry; commerce; medicine; academic and legal professions; theatre; sport, and private collections internationally. Portraits include: H.M. The Queen; H.R.H. Prince Charles; H.R.H. Princess of Wales; H.M. Queen Mother; Baroness (Margaret) Thatcher; Sir John Major; Prime Ministers of Australia and Fiji; Presidents of Philippines and Iceland; series of musicians inc. Sutherland, Solti, Menuhin, Colin Davis, Tippett. Group portraits include: House of Commons in Session; Council of Royal College of Surgeons; House of Representatives, Canberra. Hon. D.Litt. Bath University; Hon.D.Litt. Loughborough University; A.O.(Australia); lectures; T.V, also Hon. Doctor of Open Univ. *Recreations:* music, theatre, travel. *Signs work:* "MENDOZA". *Address:* 34 Inner Pk. Rd., London SW19 6DD. *Website:* www.junemendoza.co.uk

MENZIES, Gordon William, DA; Josef Sekalski Award for Printmaking; Head of Pottery Dept., Community Centre, Edinburgh; established Iona Gallery and Pottery, 1982 (Workshop/Gallery) with own ceramics, engravings, landscapes; specialising in paintings of Iona- Early 20th Century to Contemporary. *Medium:* etching, ceramics, watercolour, pastel. *b:* Motherwell, Scotland, 9 Jan 1950. *s of:* David M. Menzies, storekeeper. *m:* Fiona Menzies. one *s. Educ:* Dalziel High School, Motherwell. *Studied:* Duncan of Jordanstone College of Art, Dundee (1969-73) under Sheila Green, Ron Stenberg; Atelier 17, Paris (1974) under S. W. Hayter. *Exhib:* Edinburgh, Printmakers Workshop, Compass Gallery, Glasgow, Montpelier Art Institute, France, RSA, SSA, Edinburgh, City Art Centre, Edinburgh, many others within Edinburgh and surrounding area; Dundas St. Gallery, Edinburgh: 100 years of Iona Paintings (2002), Hebridean Odyssey (2003), Iona & The West (2004), An Eye for Iona (2006). *Publications:* books illustrated mainly within Children's Educational area. *Address:* Lorne Cottage, Isle of Iona, Argyll PA76 6SJ. *Email:* menzies@ionagallery.com *Website:* www.ionagallery.com

MEO de, P. (Pamela Synge): see DE MEO, P. (Pamela Synge),

MEREDITH, Julian Nelson, artist and printmaker. *b:* Bath, 4 Mar 1952. *s of:* Bernard Nelson Meredith, MA, ARIBA. *m:* Jane. three *d. Educ:* Clifton College. *Studied:* Exeter College of Art (1972, 1974). *Exhib:* R.A. Summer Exhbn. (1989), Henry Brett Galleries (1989), Natural History Museum London (1995), Cartwright Hall (1993), Mead Gallery (1984). *Works in collections:* V. & A. Museum, London, Birmingham University, Teesside Airport, Deutsche Bank. *Commissions:* R.V.I. Hospital Newcastle, Ross-on-Wye Hospital. *Signs work:* "J.Meredith." *Address:* Avondale House, Polmont, Falkirk FK2 0YF.

MEREDITH, Norman, ARCA; illustrator; tutor University of Aberystwyth (1935) and St. Martin's School of Art; war service M. of A.P. (Farnborough). *s of:* Jane Ann Meredith. *m:* Violet Mary Brant. *Studied:* Liverpool College of Art and R.C.A.; travelling scholar. *Exhib:* frequently at Chris Beetles Gallery, London SW1, since 1984. *Works in collections:* H.R.H. The Duke of Gloucester, etc.

Textiles for Moygashel, Crowson Fabrics; designs for Metal Box Co., greetings cards, gift wraps, nursery pictures for Brunott of Holland; nursery china. *Works Reproduced:* in Punch, Tatler, Bystander; books illus. most British publishers, strip cartoonist. *Misc:* Hobbies: Recording piano music, photography, travel, (two world tours). *Signs work:* "NORMAN MEREDITH." *Address:* The Elders, Epsom Rd., Ewell, Surrey KT17 1JT.

MERRILLS, David, NDD, ATD, DAE, RCA (Royal Cambrian Academy, 1997). *b:* Rotherham, Yorks, 9 Feb 1933. *s of:* Gilbert Merrills. *m:* Rona. two *s.* *Studied:* Rotherham/Sheffield/Cardiff Colleges of Art (1973). *Represented by:* Royal Cambrian Academy. *Exhib:* throughout North Wales: Denbigh, Rhyl, Llanbedwrog, Theatre Clwyd Mold, Llangollen; St.David's Cardiff. *Works in collections:* in France, Australia, America, UK. *Address:* Ty Isaf, Bodfari, Denbigh, Denbighshire LL16 4DD.

MERRYLEES, Andrew, R.S.A., B.Arch., Dip. T.P., R.I.B.A., F.R.I.A.S., F.C.S.D., F.R.S.A., hon. Prof. of Arch. University of Dundee; architect, Hypostyle Architects. *b:* 13 Oct., 1933. *m:* Maie. two *s.* one *d.* *Studied:* Glasgow. *Commissions:* University Bldgs. at Edinburgh, Heriot-Watt, Dublin, Liverpool, Newcastle and Aston, Birmingham, Scottish H.Q. for Automobile Association, sorting office for Post Office, National Library of Scotland, British Golf Museum at St. Andrews, Motherwell Heritage Centre, and Dundee Science Centre. *Clubs:* Scottish Arts. *Misc:* Awards: Student Senior Prize, Student Life Drawing Prize, R.I.B.A. Bronze Medal, Saltire Award, Civic Trust Award, Art in Architecture Award, R.S.A. Gold Medal, Concrete Award, Sconul Award. *Address:* 204 Bonkle Rd., Newmaws, Lanarkshire ML2 9AA. *Email:* amer@hypostyle.co.uk

MERTON, John Ralph, M.B.E. (1942); Mil. Legion of Merit USA (1945); painter. *b:* London, 7 May 1913. *s of:* Sir Thomas Merton, K.B.E., F.R.S. *m:* 1939 Viola Penelope von Bernd. two (and one decd.) *d. Educ:* Eton; Balliol Coll. Oxford. Served War of 1939-45 (MBE); Air Photo reconnaissance research, Lieut-Col. 1944. *Studied:* Ruskin Art School, Oxford; Legion of Merit, USA. *Works in collections:* The National Portrait Gallery, Buckingham Palace, Jane Dalkeith in Duke of Buccleash's Dramlanrig Collection. This is the only picture in living memory which was given an A award by theRoyal Academy (meaning that the selection committee were unanimous), distinguished by not being elected Royal Academician. *Publications:* A Journey Through an Artist's Life Part 1 - Part 2. *Principal Works:* Lord & Lady Rounsey with Broadlands reflected in 18th century mirror between them (refused by the RA). *Recreations:* music, making things, underwater photography. *Clubs:* Savile Club, 69 Brook Street, London. *Misc:* Works include Mrs Daphne Wall (1948); The Artist's daughter Sarah (1949); altar piece (1952); The Countess of Dalkeith (1958); A Myth of Delos (1959); Clarissa (1960); Mrs Julian Sheffield (1970); Sir Charles Evans (1973); Iona Duchess of Argyll (1982); Sir David Piper (1985, N.P.G.); H.R.H. The Princess of Wales in Cardiff City Hall (1987); Professor James Meade, Nobel Prize Winner (1987); H.M. The Queen (1989) as head of the Order of Merit; Head

Master of Eton (1990); Triple portrait of The Duke of Grafton for the National Portrait Gallery (1992); Paul Nitze (1992). *Signs work:* 'John Merton', 'JOHN MERTON'. *Address:* Pound House, Oare, nr. Marlborough, Wilts. SN8 4JA.

MESSER, Peter John Easton, Chichester Art Prize (1997). *Medium:* tempera. *b:* Brighton, E.Sussex, 28 Feb 1954. *s of:* John & Patricia Messer. *m:* Margaret Pethick. two (s-) *s. Educ:* Purley County Grammar School; Lewes Priory School. *Studied:* Brighton Polytechnic Faculty of Art and Design (now Univ. of Brighton). *Exhib:* RA; NEAC; Hunting Prizes; Garrick Milne; Star Gallery, Lewes. *Works in collections:* University of Brighton; House of Lords. *Commissions:* various mural commissions for East Sussex Hospitals; 'The Book of Sussex Revelations'-12 paintings for handmade book. *Publications:* 'The Book fo Sussex Revelations' (published to accompany the above). *Official Purchasers:* House of Lords; University of Brighton. *Recreations:* playing guitar, growing vegetables. *Clubs:* Commercial Square Bonfire Society (CSBS). *Signs work:* 'Peter Messer'. *Address:* 5 Market Lane, Lewes, E.Sussex BN7 2NT. *Email:* peterpaint@btinternet.com

MICAH, Lisa, M.F.P.S. (1989), N.A.P.A. prize (1988); artist in acrylics; Council mem. Cambridge Drawing Soc. (1988-91), Consultant, Galeries d'Attente, London (1989-91). *m:* M.J. Chapman. four *d. Educ:* in Europe and Africa. *Exhib:* solo-shows: Cambridge (1987, 1988), London (1991), Lyon (1992, 1993, 1994), Château du Cingle (1994), Aix-le-Bains (1998), Belleg (2003), Geneva (WTO, 2004). Artiste invitée d'honneur, St.Galmier (1996). Invitée, Festival du Nu (Le Corbier, 2005). *Works in collections:* private: Austria, Belgium, England, Finland, France, Germany and Switzerland; public: England, France, United States. *Publications:* 'Who will Station the Ox there? The Imanna Series (2002) ISBN 2-914078-00-5; 'Féminéité' (2003, 2005) ISBN 2-914078-01-3; 'Lisa Micah peint Inanna' (DVD, 2004). *Principal Works:* The Inner Workings Series (1998), The Moving Parts Series (1994-9), The Towards Femininity Series (1999-2000), The Inanna Series (2002). *Clubs:* Farmers' London. *Signs work:* "L. Micah". *Address:* B.P.3, F-01350 Culoz, France. *Website:* www.LisaMicah.com

MICHAEL, Colin, BA (Hons), NS; D&AD Award (1986); National Society Commended (2002); Winner Aya Broughton Award (2004). *Medium:* oil on canvas. *b:* Bulawayo, 6 Nov 1959. *s of:* Eric Alfred Fuller. *m:* Sophie Debusscher-Fuller. *Educ:* Churchill School, Westerham. *Studied:* Ravensbourne College of Art (1977-81); Slade Post-graduate (1993-99). *Represented by:* londonart.co.uk. *Exhib:* Gallery 47, London (solo, 1994, 95, 97, 98); Candid Arts (1998, 99); Gallery 17, Beckenham (1998-2007); Blackheath Gallery (2004, 2006); RA Summer Exhbn (selected 1994); Oxo Tower (2005); The Art Connection, Eton (2005); Stark Gallery (2005); Picture Room, Dulwich (2005-07). *Works in collections:* private collections- Karen Squibb-Williams (Barrister), Viscount Francois Dumonteil-Lagreze, Andrew Scott (Architect). *Commissions:* BP, Canon, Matra-Marconi, Amdahl, Midland Bank, Bromley Arts Council,

Dulwich Life magazine. *Official Purchasers:* Bromley Council, Spa Beckenham. *Clubs:* Friends of the Royal Academy, SEOS (2000-07), National Society (Council member 2002-08), Arts Club London (selected 1994). *Signs work:* 'Colin Michael'. *Address:* 161 Village Way, Beckenham, Kent, BR3 3NL. *Email:* colinmichael@btconnect.com *Website:* www.londonart.co.uk

MICHIE, Alastair Milne, RWA, FRBS, Hon. D. Arts. *Medium:* painter in acrylic and mixed media, sculptor in bronze. *b:* St. Omer, France, 9 Dec 1921. *s of:* James Michie. *m:* (1) Hazel Greenham (decd) three d. (2) Sally Gaye. one s. one d. *Educ:* France; Hawick High School, Scotland. *Studied:* Edinburgh University. *Exhib:* in Europe, North and South America, Middle and Far East. *Works in collections:* MoMA, São Paulo; Robert Fleming Holdings; MoMA, Rio de Janeiro; BP International; Mitsui Banks; British Aerospace; RWA; City A.G. Cleveland, etc. *Commissions:* numerous private and public commissions, British Aerospace, etc. *Publications:* 'Re-inventing the Landscape' by Vivienne Light; 'Art in Poole and Dorset' by Peter Davies. *Official Purchasers:* 'Endeavour' (British Aerospace); Eagle Star, Bournemouth University, Bristol University, etc. *Signs work:* 'Alastair Michie'. *Address:* The Manor House, Wareham, Dorset BH20 4LR.

MICHIE, David Alan Redpath, O.B.E. (1997); painter; Prof. Emeritus, Heriot Watt University (1991); Head, School of Drawing and Painting, Edinburgh College of Art (1982-90). *b:* St. Raphael, Var, France, 30 Nov 1928. *s of:* James Michie. *m:* Eileen Michie. two *d. Educ:* Hawick High School. *Studied:* painting: Edinburgh College of Art (1946-1953), Italy (1953-1954). *Exhib:* one-man shows, Mercury Gallery, London (1967, 1969, 1971, 1974, 1980, 1983, 1992, 1996, 1999), Mercury Gallery, Edinburgh (1986), Lothian Region Chambers (1977), The Scottish Gallery, Edinburgh (1980, 1994, 1998, 2003), Kasteel de Hooge Vuursche, Netherlands (1991). *Works in collections:* H.M. The Queen, Scottish National Gallery of Modern Art, Royal Scottish Academy, Royal West of England Academy, Fleming Collection. *Signs work:* "David Michie." *Address:* 17 Gilmour Rd., Edinburgh EH16 5NS.

MICHNA-NOWAK, Krysia Danuta, BA.Gen. London University (1970), Post Grad. Cert. Ed. London University (1973), John West prize, Letchworth (2000); art education officer, Sheffield Art Galleries (1975-1987), exhibs. organiser, Salama Caro Gallery, Cork St., (1987-1988), art consultant, Northern General Hospital, Sheffield (1992-1994). *Medium:* mixed media. *b:* Halesworth, 18 Mar 1948. *d of:* Wladyslaw Jan Nowak and Henrietta Michna. *Educ:* Ealing College, and Garnett College, London University. *Studied:* with Prof. Bohusz-Szyszko (1967-1970), Marek Zulawski (1972-1973), Felix Topolski (1972-1973). *Exhib:* 1999 - Posk Gallery, Hammersmth, solo exhibs., Air Gallery, Dover St., London (2000); Letchworth Museum (2000), Thomas Plunkett Fine Art, St. Albans (2000); Seven Springs Gallery, Ashwell (2000); St. Raphael Gallery, London (2001), Courtyard Arts Centre (2001), Hitchin Muesum (2002, 2007), The Old Laundry Gallery, Wimpole Hall (2002), Stevenage Arts Centre, Boxfield

Gallery (2003), Chapel Gallery, Riseley, Beds (2005), Art Amis - Little Wymondley, Herts Open Studio (2005/06/07), Sheridan Russell Gallery, London (2005/06), Letchworth Arts Centre (2007). *Works in collections:* Worksop Town Hall, Greys College, Durham, Sikorski Museum London, Nottingham County Council Collection, Hertfordshire Education Centre, Hitchin Museum. *Commissions:* 1993 three paintings for Northern General Hospital, Sheffield, 1981 "Planet of the Towers" illustrated children's educational reader - Sheffield, 1972 murals "Swinging London" Regent School of Languages, Oxford St., W1. *Publications:* illustrated 'The Planet of the Towers', Sheffield (1981), 1979 Oficyna Poetow, No. 1, 1980 Poland - No. 5, 2002 Hertfordshire Life magazine, 'The Artist' 2004. *Works Reproduced:* 1979 "Inscape" The Journal of The British Assoc. of Art Therapists Vol 3 No. 2. *Clubs:* Printmakers Council, Polish Assoc. of Artists, Herts. Visual Arts Forum, Artists Network, Bedfordshire. *Misc:* 2000 John West Award, The Place Arts Centre, Letchworth; 1987 2nd prize, Dulux Community Awards - murals for Hallamshire Hospital, Sheffield. *Signs work:* "Krysia D. Michna-Nowak." *Address:* 309 Wedon Way, Bygrave, Nr. Baldock, Herts. SG7 5DX.

MICKLEWRIGHT, Robert Flavell, D.F.A. (London), R.W.S.; illustrator, painter in oil, water-colour;. *b:* Staffordshire, 1923. *Studied:* Wimbledon School of Art (1947-49), Slade School (1949-52). *Exhib:* regular exhibitor in London, provinces and U.S.A. *Works in collections:* pictures in public and private collections. *Publications:* illustrated numerous books. Work reproduced in the following reference books: Artists of a Certain Line (Bodley Head), Designing a Book Jacket (Studio), Designers in Britain, 5, 6, 7 (Andre Deutsch), Drawing for Radio Times (Bodley Head), Illustrators at Work (Studio), Royal Academy Illustrated, Underground Art (Studio Vista), Dictionary of 20th Century British Book Illustrators (Antique Collectors Club). *Address:* Mount Hill, Mogador, Tadworth, Surrey KT20 7HZ.

MIDDLETON, Michael, ARE (1981), RE (1986), DipAD (1971), HDA.(1974); lecturer/painter/printmaker in oil, water-colour, etching, woodcut; teaches printmaking, art history, Colchester Inst. School of Art and Design. *b:* Louth, Lincs., 25 Jun 1950. *s of:* Roy Middleton. four *s. Educ:* Heron Wood, Aldershot. *Studied:* Farnham School of Art (1966-68), Sheffield Polytechnic (1968-71), Chelsea School of Art (1973-74). *Exhib:* R.A., R.E., and several one-man shows. *Works in collections:* Harlow Town Corp., R.E., Ashmolean Museum Oxford, Fitzwilliam Museum Cambridge. *Commissions:* Print Collectors Club. *Signs work:* "M. Middleton." *Address:* 104 Maldon Rd., Colchester, Essex CO3 3AP. *Email:* mike.middleton@btinternet.com

MIDDLETON, Michael Humfrey, C.B.E., Hon.FRIBA, Hon. FLI.; Assistant Editor/Editor of Picture Post (1949-53); Lilliput (1953-54); House and Garden (1955-57); Deputy Director, the Civic Trust (1957-69), Director (1969-86); art critic, Spectator (1946-56). *b:* London, 1 Dec 1917. *s of:* Humfrey Middleton. *m:* Julie Harrison. one *s.* two *d. Educ:* King's School, Canterbury. *Studied:*

Heatherley's. *Publications:* Group Practice in Design; Man Made the Town; Cities in Transition; contributor to many periodicals, etc., on art, design and environment. *Address:* 84 Sirdar Rd., London W11 4EG.

MIDDLETON, Nicholas, *Medium:* oil. *b:* London, 10 Mar 1975. *s of:* Mike Middleton. *Educ:* Wanstead High School. *Studied:* London Guildhall University; Winchester School of Art. *Exhib:* RA Summer Exhbns (2000, 01, 02, 05); BP Portrait Award (2004, 05); John Moores 23, Walker Art Gallery (2004); Discerning Eye 2004, The Mall Galleries; Defining the Times, Milton Keynes Gallery (2000). *Commissions:* numerous paintings for Royal Caribbean Cruise Liners 'Eagle' series (1998-2003). *Works Reproduced:* John Moores 23 Exhibition Catalogue (2004); BP Portrait Award Catalogue (2004 & 05). *Signs work:* infrequently as possible. *Address:* 53 Montague Road, Hackney, London E8 2HN.

MIDDLETON, Renée, S.G.F.A., S.B.A., S.W.A.; Rexel prizewinner (1984), Rotring prizewinner (1994); artist in pen and ink specialising in natural forms of stipple and/or line;. *b:* 19 Mar., 1920. married. one *s.* one *d. Educ:* Old Palace School for Girls, Croydon. *Exhib:* R.B.A., S.W.A., S.G.F.A., S.B.A., 'Flowers and Gardens' Mall Galleries and Central Hall, Westminster; three-man show, Fairfield Halls, Croydon. *Clubs:* S.G.F.A., S.B.A., S.W.A., local Sussex Socs. *Address:* Merryhill Corner, Thakeham, W. Sussex RH20 3HB.

MIDGLEY, Julia, R.E. (2005), A.R.E. (2001), Dip.A.D. (1969); mem.: P.M.C., Manchester Academy of Fine Arts (Vice President, 1994-96); Reader, Liverpool John Moores University;. *b:* 1948. *m:* J. Godfrey. two *s. Studied:* Northwich School of Art and Design (1965-66), Manchester College of Art and Design (1966-69). *Exhib:* Manchester Academy annually since 1979, R.A. (1983, 1986, 1987, 1997, 2005), R.E. (1987, 1990), Business A.G's. (1981, 1982, 1983, 1985), New Academy (1987-94), Chelsea Arts Club, P.M.C. Exhbns. (1984-97); Bankside Gallery, London, annually since 2001. *Works in collections:* national, international, public and private. *Commissions:* corporate and public. *Publications:* 'Drawn from Experience', 'Granada Sketchbook', 'Blackpool Pleasure Beach - A Palette of Life', 'Amphitheatre' (2005). *Recreations:* tennis. *Clubs:* Chelsea Arts. *Signs work:* "Julia Midgley." *Address:* 79 School Lane, Hartford, Ches. CW8 IPG. *Email:* julia@juliamidgley.co.uk *Website:* www.juliamidgley.co.uk

MIERS, Christopher John Penrose, RBA (1986); artist in oil, water-colour and tempera; Secretary, The Arts Club (1986-90); Trustee, The Water-colour Foundation (1988-91); Trustee, RBA (1999-2005). *b:* 26 Sep 1941. *s of:* Lt. Col. P.R.P. Miers, RA. *m:* (1) 1967 Judith Hoare. one s. one d.; (2) 1993 Liza Thynne. *Educ:* Wellington College and R.M.A. Sandhurst. *Exhib:* R.A., R.B.A., N.E.A.C., The Minories, Colchester (1964), Ansdell Gallery, Kensington (1967, 1968), Fortescue Swann, Brompton Rd. (1976), C.D. Soar & Son, Launceston Pl. (1986, 1988), Sally Hunter Fine Art (1990, 1993, 1995), Mall Galleries (1991), Jerram

Gallery (1994, 1996), Grosvenor House (1996), Tryon & Swann Gallery (1998), Rafael Valls Ltd (2000, 2002, 2004, 2006). *Works in collections:* Imperial War Museum, House of Commons, Sultan of Oman. *Clubs:* Arts, Chelsea Arts, Fadeaways. *Signs work:* "C. MIERS." *Address:* 114 Bishop's Mans., Bishop's Park Rd., Fulham, London SW6 6DY. *Website:* www.christopher-miers.co.uk

MILES, Arran Elizabeth, B.A. (Hons.) 1973; artist in charcoal, pastel and inks (drawings). *b:* Southampton, 28 Mar 1951. *m:* Steve Tapper. one *s.* one *d.* *Studied:* Leicester School of Art (1969-70), St. Martin's School of Art (1970-73). *Exhib:* regularly with Jelly Leg'd Chicken, Reading; Wine Street Gallery Devizes; S.W.A. West-minster Gallery; Marlborough Festival Open Studios; Newbury Open Studios; Corn Exchange, Newbury; Mosaic Gallery, Buxton; Mall Galleries, London. *Works Reproduced:* greetings cards, postcards, life drawings at Pennyhill Park Hotel, Bagshot. *Signs work:* "AEMiles". *Address:* 5 Forge Cottages, Froxfield, Marlborough, Wilts. SN8 3LE. *Email:* arranmiles28@yahoo.co.uk

MILES, June, R.W.A., Slade diploma for Drawing; painter in oil. *b:* London, 4 Jul 1924. *m:* Paul Mount, sculptor. one *s.* two *d. Educ:* Portsmouth High School. *Studied:* Slade, under Prof. Randolph Schwabe (1941-1943), West of England College of Art (1945-1947). *Represented by:* Cornwall Contemporary, Penzance; 'Great Atlantic' St.Just and Falmouth. *Works in collections:* Nuffield Foundation for paintings in hospitals, Plymouth City Art Gallery, Bristol City Art Gallery, Sussex Education Committee, R.W.A. *Clubs:* Penwith Society; Royal West of England Academy. *Signs work:* "June Miles" on back of paintings. *Address:* Nancherrow Studio, St. Just, Penzance, Cornwall TR19 7LA.

MILLER, Colin James, ARBS. *Medium:* sculpture in marble, stone, bronze, olive wood; oil, drawing. *b:* Simla, India, 9 Oct 1943. *s of:* Bunty Miller (painter). *m:* Diana. one *s.* one *d. Educ:* Nautical College, Pangbourne. *Studied:* self-taught. *Exhib:* one-man: Lasson Gallery; Kunsthandel Ina Broerse, Amsterdam; British Council, Athens (1979-81); Phoenix Gallery, Lavenham, Suffolk (1988); Gallery Bonneland Odder Denmark (1994, 2000). Group: RA Summer Exhbn (1973, '74, '82); Le Salon Societe des Artists Francais, Paris; Gallery Madison 90, New York (1985). *Works in collections:* The Froehlich Foundation, and many private collections around the world. *Commissions:* Property Partnerships plc; Allied Lyons; Norwich Union; Wyndham Investments; Jersey Museum; Bedford Maternity and Paediatric Hospital. *Publications:* Oakham School, Rutland. *Recreations:* diving, travelling. *Signs work:* 'COLIN MILLER'. *Address:* Sea Grass, Saxlingham Road, Blakeney, Holt, Norfolk NR25 7PB. *Email:* colin@colin-miller.co.uk *Website:* www.colin-miller.co.uk

MILLER, David, R.B.A. (1994), N.D.D. (1958); artist in oil; I.L.E.A. Head of Dept. for Art in A.E.I. (1971-87). *b:* Belfast, 25 Feb 1931. divorced. one *s.* one *d. Educ:* Trinity College, Glenalmond, Perthshire. *Studied:* Polytechnic School of Art, Regent St. London (1954-60, Norman Blamey, R.A., Sir Lawrence Gowing

C.B.E., R.A.). *Exhib:* R.A., R.B.A., R.P., New Soc. of Portrait Painters, and other mixed exhbns. *Works in collections:* private collections. *Commissions:* many portrait commissions. *Signs work:* "DAVID MILLER." *Address:* First Floor Flat, 76 Auckland Hill, West Norwood, London SE27 9QQ. *Email:* dmillerrba@aol.com

MILLER, Ingrid, printmaker, painter in etching, drypoint, oil, acrylic, watercolour. *b:* Copenhagen, 1940. *d of:* William Tougaard. *m:* R.G. Miller, printmaker. *Educ:* Copenhagen University. *Studied:* Malmö Printmaking School. *Exhib:* R.A., R.S.A., Mall Galleries, Leighton House Gallery, Guildhall Gallery, R.A. Copenhagen, National Museum Gdansk, Wainö Aaltonen Museum Finland, Liljevalchs Stockholm, Print Triennales Malmö and Gothenburg. International Print Biennales: Cracow, Ljubljana, Rockford, Horgen, Cadaques, Varna, Maastrich, Biella, Berlin, Fredrikstad; Museums: Kalmar, Eksjö, Kristianstad, Vetlanda, Växjö. *Works in collections:* Cabo Frio, Brazil; Swedish States Arts Council; Kalmar Museum. *Clubs:* Swedish and Danish Federations of Printmakers, G.S., D.G. and K.R.O., S.K., K.K.S., F.S.K., Grant Swedish State. *Signs work:* "Ingrid Miller." *Address:* Bolmen, 34194 Ljungby, Sweden.

MILLER, Michael John, John Laing Calendar Award. *Medium:* oil, watercolour, acrylic. *b:* Kingston, 14 Nov 1940. *s of:* Leonard Miller. *m:* Sheila Mary (Lawlor). one *s.* one *d. Studied:* Epsom School of Art; St.Martin's, London. *Exhib:* Royal Academy; Mall Galleries; NEAC; Royal Society of Oil Painters; John Neville Gallery, Canterbury. *Works in collections:* John Laing (private collection). *Commissions:* Cricket mural-Royal Marsden Hospital, Surrey. *Publications:* RA Summer Exhbn Catalogue. *Official Purchasers:* John Laing (calendar). *Works Reproduced:* RA; Surrey Life Magazine. *Recreations:* musician: banjo and guitar player; magician. *Signs work:* 'M.Miller'. *Address:* 22 Court Farm Avenue, Ewell, Surrey KT19 0HF.

MILLER, Ronald George, printmaker, painter in etching, mezzotint, engraving, acrylic; sculptor in wood. *b:* London, 1938. *s of:* George Frederick Miller. *m:* Ingrid, printmaker. *Educ:* Haverstock Hill Secondary School. *Studied:* Ingrid Miller's Print Workshop, Ljungby, Sweden. *Exhib:* R.A., R.S.A. Edinburgh, International Print Biennales in Ljubljana, Krakow, Grenoble, Cadaques, Varna, Biella, Maastrich, Majdanek, Frechen, Berlin, Fredrikstad; museums in Kristianstad Vetlanda, Kalmar, Växjö, Liljevalchs, 4th National Exhbn. of British Prints, Grundy Gallery, Blackpool. *Works in collections:* Majdanek Museum Poland, Museums in Växjö, Vetlanda, Swedish Arts Council. *Clubs:* Federation of Swedish Printmakers, G.S., K.R.O., S.K., Grant Swedish State. *Signs work:* "Ronald Miller." *Address:* Bolmen, 34194 Ljungby, Sweden.

MILLER, Rosemary, SWA; winner, Anthony J Lester Art Critic Award (SWA, 2005); winner, Derwent Artist Award (2005, 2007). *Medium:* watercolour. *b:* Leicester. *m:* Colin John Miller. one *s.* one *d. Educ:* Ranelagh Grammar School, Bracknell. *Studied:* self taught. *Exhib:* RSMA, RI, SWA. *Works in collections:*

internationally. *Clubs:* Maritime Art Group. *Signs work:* 'Rosemary Miller'. *Address:* 1 Pilgrims Cottages, Wood Lane, Sale, Farnham, GU10 1HS. *Email:* rosemarym-art@tiscali.co.uk

MILLER, Shannon, Rural career awards (1999), Cosmopolitan Woman of the Year award, National Acrylic Painters Assoc. member. *b:* Redruth, Cornwall, 20 May 1963. *d of:* Patricia Slee and Francis Miller. *Educ:* Queen Elizabeth College, Crediton, Devon. *Studied:* Art history, Egyptology (1982-86), Art in Rural Areas programme (Gambia, 2002). *Represented by:* Womens Rural Workshop; Keith Duncan; Royal Agricultural Society; President of Grasslands Assoc., John Vincent MA, National Farmers Union. *Exhib:* Radar Galleries Washington USA, 17 exhbns 'Quo Vadis' Phillipines (resident artist); Blue Pineapple, Florida; Queen's Theatre Barnstaple; Burton Gallery Devon; St Ives Tate, Cornwall; works on 2 year tour for Royal Agricultural Society 'Celebration of the Farmyard'. *Works in collections:* of Rebecca Bernt (Germany), Elsa Bennatar (London). *Commissions:* National Farmers Union and Royal Agricultural College; Heatherleigh and Torrington Town Councils. *Publications:* 'Celebration of the Farmyard' (2001). *Official Purchasers:* Noel Edmunds, the Le Bons, Jean Lethbridge, National Botanical Society, Tracy Merrifield, Women's Rural Workshop. *Works Reproduced:* 'The Farmyard', 'Charolais Bull'. *Principal Works:* 'The Diner', 'The Hand that Feeds'. *Recreations:* 'Sotto' reworked, as 'Yr Place or mine' 2000, 'Everything we Ever Done'. *Clubs:* Bacardi Club, Toddiport Torrington, Country Club UK, St.James Club London. *Signs work:* S F Miller. *Address:* Loft Studios, Limers Hill, Torrington, Devon, EX38 8AX. *Website:* www.shanmiller.com

MILLINGTON, Terence, painter/printmaker in oil, water-colour, etching. *b:* B'ham, 20 Oct 1942. *s of:* George Millington. *m:* Patricia. one *s. Educ:* Moseley Secondary School of Art. *Studied:* painting: B'ham College of Art (1958-63), and printmaking at Manchester College of Art (1965-66). *Exhib:* many group and one-man exhbns. throughout Europe and the U.S.A. *Works in collections:* various private and public including Tate Gallery, and V. & A. *Commissions:* Royal Mail stamp commission 1997 (100th Anniversary of sub post offices). *Publications:* Editions of etchings regularly published by C.C.A. London and Behr-Thyssen Ltd. New York. *Signs work:* "Terence Millington." *Address:* 'Oakridge', Plymouth Rd., Kingsbridge, Devon TQ7 1AT. *Website:* www.terencemillington.net

MILLIS, Susan M., S.W.A. (1987), S.E.A. (1995), A.R.M.S. (1997), M.A.S.F. (1998); B.A. Hons First Class 2002; pyrographic artist specializing in wildlife, equestrian and pictorial subjects on hand turned wooden paper-weights, pomanders, plaques, jewellery, paper and blowtorch fire paintings, also works in other media. *b:* Tidworth, Hants., 14 Nov 1953. *d of:* Major W.G. Lemon, A.R.C.M. psm, R.E. (decd.). *m:* Gareth Hughes Millis. one *s.* one *d. Studied:* De Montfort University Lincoln, conservation and restoration; PhD student 2005-at BCUC. *Exhib:* R.M.S., S.W.A., S.E.A., M.A.S.F. annually. Work in private

collections worldwide. *Publications:* A Burning Art (Popular Crafts, May 1989); Pyrography: A Guide (SSCR Journal, Nov.2004). *Clubs:* Fellow of the Royal Society for the encouragement of Arts Manufacturers and Commerce, member of Institute for Conservation of Historic and Artistic works. *Signs work:* "S.M. Millis,". *Address:* 26 Doglands Farm, Newtoft, Market Rasen Lincs. LN8 3NG. *Email:* smmillis@hotmail.com

MILLMORE, Mark Alexander, R.E., B.A. (Hons.) Fine Art; artist in etching, painter in oil and water-colour - computer art. *b:* Shanklin, I.O.W., 13 Jan 1956. *Studied:* Falmouth School of Art (1977-80, Prof. Lionel Miskin). *Exhib:* C.C.A. Galleries, and around the U.K. (1990-95); mixed shows: Japan, U.S.A., Sweden, Taiwan, Australia, Spain, Canada, Kenya and the U.K. *Works in collections:* Ashmolean Museum, Habikino City Hall Japan, Crown Court, Bristol, Victoria A.G. Bath, Kanagawa Prefectural Gallery Japan, Auburn University Contemporary Art Collection U.S.A., International Centre for Wildlife Art Gloucester. *Publications:* 1990: 'Working with Etching' Artists& Illustrators Magazine; 1992: 'Ideas for Images' The Magazine for The International Collector of Water-colours, Drawings & Prints; 1996: 'Medi8or Magic' Pc Answers, 'Birds, Beasts & Fish' Multimedia Cd Rom, 'From Paint to Pixels' Pc Answers; 1997 & 98: Monthly column in Web Masters (Paragon Publishing); Editor of 'Printworks Magazine', Mark Millmore's Ancient Egypt, www.discoveringegypt.com. *Works Reproduced:* 2001-Discovering Ancient Egypt CD ROM; 2003-The Ancient Egyptian Print Studio. *Clubs:* Fellow, Royal Soc. of Painter-Printmakers. *Misc:* Theatre designer: Stinkfoot, a comic opera by Vivian Stanshall (Bristol 1985, London 1988); Rawlinson Dogends, starring Vivian Stanshall (London 1991), Global Art Director for Microgystics Inc (2000), Director for Eyelid Productions Ltd (2002). *Signs work:* "Millmore." *Address:* Turvey House, Coldwells Road, Holmer, Hereford HR1 1LH. *Email:* mark@markmillmore.com *Website:* www.eyelidproductions.co.uk

MILLNER, Etienne Henry de la Fargue, F.R.B.S.; Vice President, S.P.S. *Medium:* figurative sculptor in plaster and clay for bronze. *b:* Penang, Malaysia, 15 Jan 1954. *m:* Mary Castle. one *s.* two *d. Educ:* Stowe School. *Studied:* Goldsmiths' College (Ivor Roberts-Jones, C.B.E., R.A.), R.A. Schools. *Represented by:* Fine Art Commissions Ltd, Portraits, Inc., Commission A Portrait, & Cadogan Contemporary. *Exhib:* R.A. Summer Shows (1979, 1982, 1984, 1985, 1986, 1988), N.P.G. 'New Faces' (1987), 'Art for Sale' Whiteleys (1992), Chelsea Harbour (1993), Cadogan Gallery Summer Show (1993); one-man show Cadogan Contemporary (1994). S.P.S. Annual Exhbn. (1995-2007), People's Portraits (April 2000 - July 2001). *Works in collections:* N.P.G., Wellington College, Harris Manchester College, Oxford, Goodwood House, Longford Castle, Holdenby House, Daily Mail Newspapers, Chester Music, The Museum of Negev, Beersheva Israel, Ealing Borough Council. *Commissions:* Field Marshal Sir Claude Auchinleck for Wellington College (1992), Capt. Charles Harris, M.C., Statue for Harris Manchester College, Oxford (1997), Rumer Godden (1996), Lord Thurlow (1996), Sir Derek Alun-Jones (1997), Lord

Settrington (1999), Count Jules Dembinski (2000), Oliver Mould (2002), Mr Garry Weston, Lord Balfour of Inchrye, Lord Allenby, The family of Viscount Folkestone, the children of the Garthwaite family. *Publications:* Editor, Society of Portrait Sculptor's Annual Exhibtion Catalogue. *Official Purchasers:* Trustees of The National Portrait Gallery, British Embassy, Tel Aviv. *Principal Works:* Charles Harris, M.C. at Harris Manchester College, Oxford; Lord Allenby (Museum of Negev, Israel). *Clubs:* Chelsea Arts. *Address:* 5 Priory Grove, London SW8 2PD. *Email:* etienne.millner@btinternet.com *Website:* www.portrait-sculpture.org Etienne Millner

MILLS, Clive, BAHons. (1987); painter in oil on canvas. *b:* Shoreham, Sussex, 7 Mar 1964. *s of:* G.Mills, builder. *Educ:* Portslade College. *Studied:* Brighton Polytechnic (1984-87), R.A. Schools (1987-90). *Exhib:* Mall Galleries (group show 1988; Post Grad. show 1989), R.A. Summer Exhbn. (1989). *Works in collections:* South East Arts and private collections including Switzerland. *Signs work:* "Clive Mills." *Address:* 22 Easthill Drive, Portslade, Brighton, E. Sussex BN4 2FO.

MILLS, Glynis, BA (Illustration), SEA. *Medium:* oil, watercolour, drawing, prints, sculpture, china trophies, etchings, woodcut. *b:* Tadcaster, 12 Aug 1952. *d of:* Iorwerth Lloyd Mills. *Educ:* Tadcaster Grammar School. *Studied:* York College of Art (Foundation); Leicester Polytechnic (BA). *Exhib:* Tyron Gallery, Mall Galleries, local galleries. *Works in collections:* UK, USA, France, Spain. *Commissions:* too many to list. *Works Reproduced:* various equestrian paintings as cards. *Principal Works:* equestrian and hound paintings. *Recreations:* dressage to high level; listed judge; keen gardener. *Clubs:* British Dressage. *Signs work:* 'G.Mills'. *Address:* 41 Wharfedale Crescent, Tadcaster, N.Yorks LS24 9JH. *Email:* glynismills@btinternet.com *Website:* www.equestrianartists.co.uk

MILLS, John W., ARCA, FRBS; sculptor in bronze; Hon.MA, UCN. *b:* London, 4 Mar 1933. *s of:* William Samuel Mills. *m:* Josephine Demarne. one *s.* one *d. Educ:* Bec School, Tooting. *Studied:* Hammersmith School of Art (1947-54), R.C.A. (1956-60, John Skeaping). *Exhib:* Arts Council, R.A., Alwin Gallery London, Simsar Gallery Michigan, Vilas F.A. Letchworth, Herts. *Works in collections:* Wellcome Foundation, Chicago Inst. of Fine Art, University of Cambridge, University of Michigan, Orient Express, City of London, British Museum. *Commissions:* Memorials to William Blake and National Firefighter, plus various Royal Mint coins and medals. *Publications:* 8 books on sculpture techniques, recent - Encyclopedia of Sculpture Technique. *Clubs:* Chelsea Arts. *Signs work:* "John W. Mills." *Address:* Hinxworth Pl., Hinxworth, Baldock, Herts. SG7 5HB.

MILLS, Teresa Ann, ARBS; BA (Hons) Mixed Media Arts; Millennium Award, Champions for Change (2003); Awards for All (2004, 2006); Norwich County Council Award (1999); Texaco Award (1998). *Medium:* sculpture, drawing, film/conceptual/installation. *b:* Hitchin, Herts, 12 Apr 1948. *m:*

divorced. one *s*. one *d*. *Educ:* West Thames College (1990-91). *Studied:* Art Foundation, Sir John Cass (1991-2); University of Westminster (1993-96); work palcements with Antony Gormley, and the late Helen Chadwick. *Exhib:* selected exhibitions: Mall Galleries (1996); Brixton Art Gallery (2002); RBS Annual Open (2003); Art house, Hants (2004); UEL Docklands (2006); Kowalsky Gallery, Great Sutton St. (2007-08); solo show, West Reservoir Stoke Newington (2003). *Publications:* Essays by: Kathy Fawcett, Rachael Fijalkowska, Martin Holman, Dr.Emmanuel Minne; Westminster Alumni (1998). *Recreations:* High soprano singer. *Misc:* Founder of Artram Arts Organisation; held workshops since 2000. *Signs work:* "Teresa Mills". *Address:* 23A Chesholm Road, Stoke Newington, London N16 0DP. *Email:* teddygalore@hotmail.com *Website:* www.teresamills.com

MILLWARD, Michael, MA, AMA; museum curator; Curator and Museum Manager, Blackburn Museum and Art Gallery. *b:* Oldham, 9 Nov 1944. *m:* Dorothy. one *s*. one *d*. *Educ:* King George V Grammar School, Southport; St. John's College, Cambridge. *Publications:* Victorian Townscape (with Brian Coe) 1974. *Address:* Blackburn Museum and Art Gallery, Museum St., Blackburn, Lancs. BB1 7AJ.

MILNE, Judith Erica, N.D.D. (1965), A.T.D. (1966); painter of botanical, landscape and garden scenes in water-colour; writer; tutor. *Medium:* watercolour, pen, ink & wash. *b:* Malvern, 30 Oct., 1943. *d of:* E.G. Knight, head teacher. *m:* J.A.S. Milne. one *s*. one *d*. *Educ:* St. Mary's Convent, Worcester. *Studied:* B'ham College of Art and Crafts. *Exhib:* London and various galleries in British Isles. *Works in collections:* nationally and internationally. *Commissions:* taken. *Publications:* Flowers in Water-colour (B.T. Batsford); Wildflowers in Water-colour (B. T. Batsford, 1995); greetings cards and prints, regular articles for Leisure Painter magazine. *Works Reproduced:* many landscapes and florals. *Clubs:* Chairman Society of Floral Painters, President Woodley & Earley Arts Group. *Misc:* School Governor. *Signs work:* "Judith Milne." *Address:* 20 Colemansmoor Rd., Woodley, Reading RG5 4DL. *Email:* tony.milne@ntlworld.com *Website:* www.miart.org.uk

MINERS, Neil, artist in oil, water-colour. *b:* Redruth, Cornwall, 19 Jun 1931. *s of:* Charles Arthur Miners. *m:* Wendy Noak. two *d*. *Studied:* Falmouth School of Art under Jack Chalker (1948) drawing only. *Exhib:* R.I., R.O.I., and Britain in Water-colours; one-man shows and various in Cornwall. *Works in collections:* R.N.L.I., Trinity House and H.R.H. Prince Charles. Official designs and medals, illustrated book and Flags for Tall Ships start from Falmouth (1966). *Address:* 6 Chy Nampara Trevethan Rd., Falmouth, Cornwall TR11 2AH.

MIRECKI, Wladyslaw, painter in water-colour; co-Proprietor of Chappel Galleries;. *b:* Chelmsford, 1956. *m:* Edna Church, née Battye. *Educ:* Kingston Polytechnic (B.Sc. Applied Sciences, 1975-78). *Exhib:* N.E.A.C. (1988), Epping Forest District Museum 'Artists in Essex' (1989), Southend-on-Sea 31st Open

(1989), Foyles A.G. (1991), Dept. of Transport Art Competition (1992), Deuxième Salon Biennale de L'Aquarell, Hirson, France (1992), Singer & Friedlander/Sunday Times Water-colour Competition (1997), Beecroft A.G. Open (1997); solo shows: Chappel Galleries (1990, 1996, 1998, 1999, 2003), Nanjing, China, Jiangsu Art Museum (1999). *Works in collections:* Essex C.C., Ipswich Museum and Art Gallery, Chelmsford Museum and Art Gallery, Dept. of Culture, Jiangsu, Jiangsu Art Museum, PR China. *Publications:* Jiangsu Art Monthly Feb 2000, Artists & Illustators magazine April 2000, "A Walk in the Country" pub. June 2003 by Cahapell galleries, monograph. *Signs work:* "Mirecki." *Address:* 15 Colchester Rd., Chappel, Essex CO6 2DE.

MISHIO, Hideharu, *Medium:* copper engraving, wood engraving, drawings. *b:* Saga, 31 Apr 1956. *m:* Tomoko Mishio. *Educ:* 1982 finished Print-making Course, Graduate School of Fine Arts, Tokyo National University; 1980 graduated Tokyo Zokei University (Art and Design); 1983 finished Post-Graduate in Tokyo National University. *Studied:* Vienna National University of Fine Arts (as overseas art researcher of the Agency of Cultural Affairs), 1998-9. *Represented by:* An illusion picture. *Exhib:* one-man show Shirota Gallery (1985), International Biennial Print Exhbn (1991), five-man show Wood-engraving (Osaka, 1996), Art du Japan (France, 1997), Aomori Print Grand Prize Exhbn (1998), four-man show of Japanese Woodprint (Kleinegalerie, Wien, Austria, 1999), also in UK etc. *Works in collections:* Tokyo National UN, Tochigi Prefecture Museum, etc. *Clubs:* Japan Print Assocaition. *Address:* 11-21-304 Ogino, Yokosuka-shi, Kanagawa 240-0102, Japan.

MISTRY, Dhruva, R.A., M.A. (1981), M.S. University, M.A. (R.C.A. 1983), F.R.B.S. (1993); artist in Residence, Kettle's Yard, Cambridge (1984-85); sculptor in plaster, bronze, stone; Prof. of Sculpture, Faculty of Fine Arts, M.S. University of Baroda (1999);. *b:* Kanjari (Gujarat) India, 1 Jan., 1957. *Exhib:* over 15 one-man shows worldwide, U.K., India, Japan. *Works in collections:* Tate Gallery, National Museum of Wales, Fukuoka Art Museum, British Council, etc. *Publications:* exhbn. catalogues: Kettle's Yard (1985), Nigel Greenwood Gallery (1990), Fukuoka Art Museum (1994). *Signs work:* "Dhruva Mistry" or "D.M." *Address:* c/o Royal Academy, Burlington House, Piccadilly, London W1V 0DS.

MITCHELL, Brian, R.S.M.A.; painter in oil, water-colour, acrylic. *b:* St. Ives, Cornwall, 12 Oct 1937. *s of:* Edward Matthew and Lily Mitchell. *m:* Marion. one *s. Educ:* Penzance Grammar School. *Studied:* Penzance (1958-60, Bouverie Hoyton), Falmouth (1960-62), Inst. of Educ. London University (1962-63). *Exhib:* R.W.A., R.W.S., R.I., R.B.A., R.S.M.A., Grand Prix International de la Peinture a l'Eau, (2002). *Signs work:* "MITCHELL." *Address:* Chy-an-Garth Porthrepta Rd., Carbis Bay, St. Ives, Cornwall TR26 2NZ. *Email:* bmitchellrsma@onetel.com

MITCHELL, Enid G. D., F.R.B.S.; Dip.A.D. (Ceramics), Visual Arts Diploma, London University; Ghilchrist Prize; sculptor of portraits and figures

cast in bronze, cement and resin, art ceramics in porcelain and stoneware. *b:* London. *d of:* R. J. Mitchell, B.A. Hons., Lond., J.P. one *s.* two *d. Educ:* Lady Eleanor Holles School, Hampton, Middx. *Studied:* Ealing School of Art (sculpture tutors, Tom Bailey and Robert Thomas, A.R.C.A.), Chelsea School of Art (ceramics). *Exhib:* RBS London and regional shows; one man shows London and Bristol; RWA Bristol. *Works in collections:* Leamington Spa, Islip Manor and Drayton Green Primary Schools and private collections: England, Holland, Israel, Denmark, U.S.A., etc. *Commissions:* Memorial Park Lagos, Nigeria; portrait heads small figures and relief portraits, ceramics, etc. *Recreations:* drawing, horticulture. *Clubs:* Royal Society of British Sculptors. *Signs work:* "MITCHELL" or "Enid G. D. Mitchell." *Address:* 'Medmenham 2', 32 Stanier St., Swindon, Wilts. SN1 5QX.

MITCHELL, Gordon Kinlay, Dip.Art (Edin.), awarded Post.Dip. Scholarship and Travelling Scholarship; surrealist artist in water-colour, acrylic, oil; full-time professional artist;. *b:* Edinburgh, 16 Nov., 1952. *m:* Catriona A.C. Mitchell. one *s.* one *d. Studied:* Edinburgh College of Art (Sir Robin Philipson, David Michie). *Exhib:* many major exhbns. in the British Isles; one-man shows, Henderson Gallery, Edinburgh (1978, 1981), Open Eye Gallery, Edinburgh (1992), Roger Billcliffe Fine Art, Glasgow (1993). *Works in collections:* Scottish Arts Council, Kansas City Art Inst., Educational Inst. for Scotland, Old City A.G., Jerusalem, Paisley Art Inst., Teachers Whiskey, Scottish Brewers, Alliance & Leicester Bldg. Soc. *Signs work:* "Gordon K. Mitchell." *Address:* 10 Argyll Terr., Haymarket, Edinburgh EH11 2BR.

MITCHELL, Janet Elizabeth, BA Hons Fine Art (Reading Univ. 1964). *Medium:* assemblages in recycled beach plastic and wood; collages using fabric, paper and wax; woodcuts and etchings. *b:* Yorkshire, 2 Jun 1942. *m:* David. one *s.* two *d. Educ:* Reading University, School of the Museum of Fine Art, Boston USA. *Studied:* assemblage with Jesseca Ferguson USA, painting with Claude Rogers and Terry Frost. *Represented by:* artspaces. *Exhib:* Royal Academy, Mall Galleries, Society of Wood Engravers, Orleans House Twickenham, Riverside Gallery Richmond, Boston, Cambridge, Albany USA, Braintree Museum, Essex, Sherborne House Dorset, Turnpike Gallery Manchester, Brighton University Gallery, Thelma Hulbert Gallery Honiton. *Works in collections:* UK, Europe, Australia, USA. *Publications:* Printmaking Today. *Official Purchasers:* Boston University, Print Club of Albany USA, Braintree Museum, Essex, UK. *Works Reproduced:* cover of 'Network'. *Misc:* Board Member, Devon Artist Network. *Address:* Leechwell Cottage, Leechwell Street, Totnes, Devon, TQ9 5SY. *Email:* janet@artifex.freeserve.co.uk *Website:* www.artspaces.co.uk

MITCHELL, John, R.S.W., Mem. S.S.A.; lecturer and writer; works in all media;. *b:* Glasgow, 21 Dec., 1937. *m:* Isabel. two *s.* one *d. Educ:* Glasgow Academy, Royal High School. *Studied:* Edinburgh College of Art, The Open University. *Exhib:* Royal Scottish Academy, Royal Scottish Soc. of Painters in Water-colours, Royal Glasgow Fine Arts Inst., Soc. of Scottish Artists, many one

person and group exhbns. *Works in collections:* Fife Council. *Publications:* illustrated: 'Scottish Hill and Mountain Names', 'The Bothy Brew', 'The Cairngorms Scene and Unseen'. *Signs work:* "John Mitchell." *Address:* West Gowanbrae, 4 The Temple, Lower Largo, Fife KY8 6JH.

MITCHELL, S. M., PPSPS, FRBS, ARCA, NDD; sculptor in clay, wood, stone, fibreglass, resins, concrete, bronze. *b:* Farnham, 24 Nov 1926. *d of:* Flight Lt. L. J. Mitchell. *m:* Charles Bone, artist. two *s. Educ:* Seager House School, Farnham G.G.S. *Studied:* Farnham School of Art (1946), under Charles Vyes, Guildford School of Art (1947), under Willi Soukop, RA, Royal College of Art (1948-51), under Frank Dobson, RA, John Skeaping, RA, Edward Folkard, FRBS. *Exhib:* RA, SPS, NEAC, WIA, Ashgate Gallery, Furneaux Gallery, Canaletto Gallery, Chenil Gallery; 20 one-man exhbns., Medici Gallery, Ashgate Gallery, Gainsborough's House, University of Surrey, Guildford House, Malta, G.C., 1, Majorca, Spain, Pasadena, USA, Mall Gallery, The Gallery Cork Street, Canterbury Cathedral, Worcester Cathedral. *Works in collections:* France, Spain, Malta, Australia, Hong Kong, America. *Commissions:* portrait commissions in bronze, terracotta. Recent portraits: H.R.H The Duchess of Kent, Sebastian Coe, Robert Bolt, Sarah Miles, Sir Edward Tuckwell, Sir George Edwards, and over 300 bronze portrait sculptures. *Publications:* World Who's Who of Women; House and Garden; Who's Who in Art; Clay Models and Stone Carving; Occaisions; Debrett's 'People of Surrey'; Telegraph, Mail and Times supplements; Surrey Today; Vogue. *Works Reproduced:* life size madonna, Ireland. *Principal Works:* pilgrim statue, Walsingham; statue Madonna and Child, Colombia, South America. *Recreations:* piano. *Misc:* Two 9ft. sculptures for Majorca Legend of Chertsey, forecourt of Thorn PLC, bronze 11ft. high, etc. Designer: ceramic sculpture, including Royal Worcester Porcelain. Elected first woman president Society of Portrait Sculptors (1977). *Signs work:* "S. Mitchell." sometimes (B) after signature. *Address:* Winters Farm, Puttenham, nr. Guildford, Surrey GU3 1AR.

MITCHELL, Shuna Patricia, *Medium:* oil, watercolour, pen and ink. *b:* Bedford, 16 Dec 1959. *d of:* Gordon Hinchcliff & Agnes Patricia Mitchell. *Educ:* Bedford High School. *Studied:* Slade School of Fine Art. *Represented by:* Barbara Vanderbilt, Nantucket, USA. *Exhib:* RA Summer Exhbn.; Hohenberger Gallery, Houston, USA (2005); Leicestershire County Schools; Bedford School Solo, 1998; Scottish Arts Club, Edinburgh (solo show, 2006). *Works in collections:* UK, USA, Paraguay, China. *Recreations:* outdoors, riding, travel. *Clubs:* Chelsea Arts Club. *Signs work:* 'Shuna'. *Address:* 33-34 Devonshire Street, London W1G 6PY. *Email:* shoosal@shoosal.com *Website:* www.shoosal.com

MOCKFORD, Harold, self taught artist in oil. *b:* 25 Jan 1932. *Exhib:* one-man shows: Towner A.G. (1970, 1987), Hove Museum (1980, 1985), Thackeray Gallery, London (1978); R.A. Summer Exhbns., London Group, Newport (Gwent) A.G. (1995), Star Gallery, Lewes (1999, 2000, 2002, 2005). *Works in collections:* Tate Gallery, Chantry Bequest, Towner Gallery, Hove Museum of

Art, Government Art Collection. *Signs work:* "H. Mockford" on back of board. *Address:* 45 Hillcrest Rd., Newhaven BN9 9EE.

MOFFAT, Alexander, O.B.E., RSA. *Medium:* painting. *b:* Dunfermline, 23 Mar 1943. *Studied:* Edinburgh College of Art (1960-64). *Exhib:* Royal Scottish Academy; Open Eye Gallery, Edinburgh. *Works in collections:* Scottish National Portrait Gallery; Scottish National Gallery of Modern Art; Yale Cneter for British Art, Newhaven, USA. *Commissions:* portraits of: Hugh MacDiarmid (Scottish Arts Council), Muriel Spark (Scottish National Portrait Gallery). *Publications:* Seven Poets, Third Eye Centre, Glasgow. *Works Reproduced:* "Scottish Art" by Murdo MacDonald (Thames & Hudson). *Principal Works:* Poet's Pub (Scottish National Portrait Gallery). *Clubs:* The Glasgow Art Club. *Signs work:* "MOFFAT". *Address:* 20 Haddington Place, Edinburgh, EH7 4AF. *Email:* sandysmoffat@btinternet.com

MOGER, Jill, S.W.A. (2001), S.WL.A. (1999); ceramic sculptor (wildlife) in stoneware, porcelain clay; Council mem. S.WL.A. (1999), Hon Sec. SWLA (2004-); editor SWLA bi-annual newsletter (2000-2007); Awards: SWA President's and Vice President's Award 2001 (Best in Exbn.); Anthony J. Lester Art Critic Award (SWA, 2006). *b:* London, 10 Aug 1946. *m:* Dr. Philip Moger. two *s.* two *d. Educ:* Ursuline High School, Ilford, and Saffron Walden County High. *Exhib:* SWA, Llewellyn Alexander, 'Nature in Art' Wallsworth Hall, Wildlife A.G. Lavenham, S.WL.A., Slimbridge WWT, Bonham's "Art of Living World", Singapore, Yorkshire Sculpture Park; many mixed and two solo exhbns;. *Works in collections:* Stoke on Trent City Museum and A.G., Nature in Art Museum, Wallsworth Hall, Gloucester. *Commissions:* Leeds Playhouse, Yorkshire Museum of Farming. *Publications:* included in 'Drawn to the Forest' by Robert Burton and the S.W.L.A. *Signs work:* "Jill Moger" (and date) etched into clay. *Address:* The Studio, 75 Millfield Lane, Nether Poppleton, York YO26 6NA. *Email:* jill_moger@hotmail.com

MOLLOY, Sylvia, M.A.; painter in oil and other media. *b:* 27 Mar 1914. *d of:* James Leyden. *m:* Patrick Molloy. two *s. Educ:* Durham, M.A. (English and Art). *Studied:* Johannesburg College of Art (1949-52). *Exhib:* R.A., R.B.A., R.O.I., S.W.A., W.S.; solo shows, six in London, Letchworth, Hitchin, Lavenham; retrospective: 27 Cork St., London (Sept. 1998). *Works in collections:* stained glass in Johannesburg and Pretoria, paintings in East London, Bloemfontein, Pretoria; U.K.: Letchworth A.G., Sax House, Heritage Foundation. *Commissions:* Archbishop Edinburgh, other portraits. *Publications:* autobiography 'Burma Bride' (1995) illustrated with own pictures. *Clubs:* N.S., F.P.S. (Fellow). *Misc:* Entry in Dictionary of S. African Painters and Sculptors. *Signs work:* "Sylvia Molloy." *Address:* 41 Field Lane, Letchworth, Herts. SG6 3LD.

MONCHER-DUNKLEY, Anthea, SBA, SFP; scientific illustrator (botanical and geological) in oil; University illustrator/cartographer and muralist and botanical painter;. *b:* Isle of Wight, 10 Oct 1945. *Educ:* private school. *Studied:*

Southampton College of art (part-time). *Exhib:* commissioned paintings: Dept. of Geology, Southampton University, and educational establishments; commissioned work in private collections: Egypt, Japan, India, Syria, USA, France and Australia. *Commissions:* private collections worldwide. *Publications:* scientific journals. *Signs work:* "Anthea Moncher Dunkley". *Address:* 'Trees', Hamstead Road, Cranmore, IOW PO41 0XP.

MONROE, Chuck, BA (Hons) Fine Art. *Medium:* oil, watercolour, drawing, objects. *b:* Frankfurt, 16 Sep 1950. *Educ:* Grammar School (Ancient Languages). *Studied:* Academy of Arts, Kassel (Fine Art). *Represented by:* Gallery Kaleidoscope, London. *Exhib:* in Hamburg, Munich, Frankfurt, Paris, London; RA Summer Show (2000); Llewelyn Alexander; Westbourne Gallery; Affordable Art Fair (2002, 03, 04, 05, 06, 07); Art for Life, Christie's; Art for All, Portsmouth. *Publications:* Richmond Magazine (2002); Arts & Crafts Magazine (2002). *Works Reproduced:* Marilyn in Art (Roger Taylor, 2006). *Signs work:* 'Chuck Monroe', '-Monroe'. *Address:* 26 Albany Road, London E17 8DA. *Website:* www.monroe-art.com

MONTAGUE, Lucile Christine, LCAD (1974); Byam Shaw Diploma. *b:* London, 9 May 1950. *d of:* Gen.Sir Allan Taylor, K.B.E., M.C. one *s. Educ:* Fyling Hall School, Yorks. *Studied:* Plymouth College of Art (1967-69), Byam Shaw School of Art (1971-74). *Exhib:* Pastel Society, Royal West of England Academy, R.A., Whitechapel Open, London Group, Spirit of London, South Bank Show, Thumb Gallery; group shows: Artsquare, London, kon Gallery touring, 'Ways of Telling' Mostyn Gallery, Llandudno, 'Subjective City' touring, 'Witnesses and Dreamers' touring; 'A Century of Art' Herbert Museum, Coventry; one-man shows, Mario Fletcher Gallery, London; Clayton Gallery, Newcastle; The Studio Gallery, London; Riverside Studios, London; Signatures Gallery, London (2005); Pastels Today (2005). *Works in collections:* Bankers Trust, Coopers and Lybrand, Herbert Museum and A.G., Coventry Museum and Art Gallery. *Signs work:* "L.C. Montague." *Address:* 47 Hargrave Pk., London N19 5JW. *Email:* lucearts@hotmail.com *Website:* www.axisartists.org.uk

MONTANÉ, Roger, painter in oil; Prix Bethouard (1948); President, Groupe 109 (1982);. *b:* Bordeaux, 21 Feb., 1916. married. two *s. Educ:* Toulouse. *Studied:* self-taught. *Exhib:* Chicago (1964), New York (1965), Musée de Toulon (1965). *Works in collections:* Musée d'Art Moderne (Paris), Musées de la Ville (Paris), de St. Denis (Paris), de Toulouse, d'Albi, Ishibashi (Tokyo), Groupe International d'Art Figuratif (Japan, 1960), Exposition Particulière la Maison de La Pensée Française, Paris (1961), Aberdeen Museum and Art Gall., Musées de Valence, de Rodez, de Sete, de Bagnols s/Cèze, Wellington Museum (N.Z.), de Grenoble. President, Salon d'Automne (1966-68), Musées de Narbonne, Prague, du Sport (Paris). *Address:* 33 rue Charcot, Paris 13. France.

MONTGOMERY, Iona Allison Eleanor, BFA(Hons) (1987), Post.Grad. DFA (1988), RSW (1991); numerous awards including Alexander Graham Munro

travel award, Lauder Award, Sir William Gillies Award. *Medium:* painting and printmaking. *b:* Glasgow, 14 Apr 1965. *d of:* Hamish Montgomery, artist. *Educ:* Boclair Academy, Bearsden, Glasgow. *Studied:* Glasgow School of Art, Tamarind Inst., Albuquerque, U.S.A. *Exhib:* one-man shows including Galerie Seghaier, Vienna, State University of West Georgia USA, Ancrum Gallery, Edinburgh Gallery, Lillie Art Gallery, various group shows including RSA, RSW, RGI, GPS, Consument Art, also USA, Europe, USSR, and Japan. *Works in collections:* Lillie Art Gallery, Milngavie, BBC, Hilton Hotels, etc. *Clubs:* RSW, GPS, GSWA, SAC. *Misc:* Various teaching including part-time lecturer Edinburgh College of Art. *Signs work:* "Iona A.E. Montgomery." *Address:* 171a Maryhill Rd., Flat 2/3, Glasgow G20 7XL.

MONTGOMERY, James Alexander, artist in water-colour, pen and ink, oil; Leader of Complex of Rehabilitation Units, including Art Therapy. *b:* Glasgow, 3 Oct 1928. *s of:* James Montgomery. *m:* Isabelle, artist. two *s.* one *d. Educ:* Woodside School, Glasgow. *Studied:* Glasgow School of Art (David Donaldson, Edward Powell), apprenticed to industrial artist. *Exhib:* Columbus City Museum, U.S.A., Carrollton Nova Lomason A.G., Atlanta. *Clubs:* Glasgow Art. *Signs work:* "Hamish Montgomery." *Address:* 13 Avon Ave., Bearsden, Glasgow G61 2PS.

MONTGOMERY, Kate, B.F.A. (Oxon.) 1988, M.A. Fine Art (1992); painter in casein;. *b:* Wokingham, 5 Nov.,1965. *m:* Jonathan Warner. two *d. Educ:* Oxford High School for Girls. *Studied:* Ruskin School of Drawing and Fine Art (1985-88), R.C.A. (1990-92, Prof. Keith Critchlow). *Exhib:* Cadogan Contemporary London, Piccadilly Gallery London, R.A. Summer Show, The Discerning Eye. *Works in collections:* internationally including H.R.H. The Prince of Wales. *Publications:* illustrations for children's book 'Razia, Queen of India' (Hood Hood Books). *Clubs:* London Group. *Signs work:* "Kate Montgomery" on back of work. *Address:* 18 Farm Rd., Hove, East Sussex BN3 1FB. *Email:* kate@3-w.net

MOOD, Kenneth, B.A. (Hons,); artist/writer, actor (equity member). *b:* Gateshead, 24 Nov 1950. *m:* Margaret. one *s.* one *d. Educ:* Gateshead. *Studied:* Sunderland Art College. *Exhib:* Mail Art shows worldwide. *Works in collections:* Arts Council, Whitney Museum (N.Y.), sixty-five U.K. art galleries and museums; 100 Pastel Portraits at Gateshead Baltic International Art Gallery; Drawings at San Francisco Art Gallery and Museum USA. *Address:* 1 Burns Cres., Swalwell, Tyne and Wear NE16 3JE.

MOODY, Catherine Olive, PS (1958), SPS (2001),RBSA (1965); ATD (1944), Exhbn. Scholarship RCA (1941); Head of School of Art, Malvern Hills College (1962-80); President, Malvern Art Club, Editorial Consultant, Leisure Painter periodical. *Medium:* Painter in oil and pastel, writer, designer. *b:* London, 27 Nov 1920. *d of:* Victor Moody, A.R.C.A. and May Olive Willoughby. *Educ:* Stroud High and Thornbank Schools. *Studied:* Malvern School of Art (1935-41,

Victor Moody), Royal College Art (1941,Gilbert Spencer RA), Birmingham College of Art (1944, Fleetwood-Walker RA). *Exhib:* RA, PS, RP, London Exhibition. *Works in collections:* Worcester City A.G., British Rail Archives, Blackburn Art Gallery. *Publications:* Silhouette of Malvern (1953); Painter's Workshop (Batsford, 1983); Leisure Painter; Elgar Journal; art periodicals. *Clubs:* Malvern Art. *Misc:* In charge of Bauhaus Study Natural Form, Manchester Municipal School of Art (1944-47). Mounted Underpainting Project Blackburn Gallery 2003, Kidderminster Art Gallery 2004, Elgar Birthplace 2005. The Big Draw 2004. *Signs work:* "C.O. MOODY" or "C.M." *Address:* 'Lorne Lodge', 1 Sling La., Malvern, Worcs. WR14 2TU.

MOON, Liz, BA./MA Oxon. (Engineering) 1964, SWA (1987); painter in acrylic, water-colour; Artist Residency, John Innes Centre, Norwich (1997-98), Downing College Cambridge (1999-2000), St Hugh's College Oxford (2002). *b:* India, 4 Oct 1941. *d of:* Lt.-Col. L. Montague-Jones. *Educ:* Sherborne Girls' School; St. Hugh's College, Oxford; Redlands College, Bristol. *Studied:* San Francisco Art Inst. *Exhib:* R.S.M.A., R.W.A., R.B.A., R.I.; solo shows: Barbican Level 5 West, Royal Opera House, Covent Gdn., John Russell Gallery, Ipswich, and Clare Hall, Cambridge. "Liz Moon paints the world she knows with amused intensity. Her everyday scenes of people in action are infused with energy and humour.". *Works in collections:* John Innes Centre, Norwich; Downing College and Clare Hall, Cambridge, St Hugh's College Oxford. *Commissions:* Private Commissions, Parties, Weddings, playing music and sport. *Publications:* article in The Artist (1987). *Address:* 21 Bermuda Terr., Cambridge CB4 3LD.

MOON, Michael, First prize, John Moores Liverpool Exhbn. (1980), print award, Gulbenkian (1984); painter in mixed media. *b:* Edinburgh, 9 Nov 1937. *s of:* Donald Moon, Lt.Col. *m:* Anjum Moon. two *s. Educ:* Shoreham Grammar School, Sussex. *Studied:* Chelsea School of Art (1958-62), R.C.A. (1963). *Exhib:* one-man shows in U.K., Australia and U.S.A. including Tate Gallery (1976); numerous group exhbns. worldwide. *Works in collections:* Tate Gallery, Arts Council, Saatchi Collection, provincial and overseas. *Signs work:* "Mick Moon." *Address:* 10 Bowood Rd., London SW11 6PE.

MOON, Tennant, A.R.C.A. (1936), F.S.E.A.D., F.R.S.A., Principal, Cumbria College of Art and Design (1957-78); Principal, Gravesend School of Art and Crafts (1949-57); Lecturer, Leicester College of Art (1946-49); President, National Society for Art Education (1972-73); Chairman, Association of Art Institutions (1976-77); Chairman, Standing Advisory Committee for Art & Design, Associated Examining Board (1970-86). *b:* Penarth, Vale of Glamorgan, 12 Nov 1914. *m:* (1) Barbara Ovenden (decd.). one s. one d.; (2) Joan Whiting. *Studied:* Cardiff School of Art, Royal College of Art under Sir William Rothenstein and Gilbert Spencer. *Exhib:* R.A., Leicester Galleries, National Museum of Wales, South Wales Group, Newport (Gwent) A.G., Leicester A.G., etc. *Works in collections:* Cumbria Educ. Com. and private collections. *Clubs:*

The New (Cheltenham). *Signs work:* "TENNANT MOON." *Address:* The Penthouse, 18 Winchester House, Malvern Road, Cheltenham GL50 2NN.

MOONEY, Eddie, HRHA. *Medium:* oil paintings, mixed media, drawings, pastels, etc. *b:* 31 Jul 1940. *Studied:* National College of Art, Dublin, Ireland. *Represented by:* Royal Hibernian Academy. *Exhib:* all major exhibitions in Ireland. *Works in collections:* most important collections in Ireland. *Official Purchasers:* publicised in most art publications in Ireland. *Signs work:* 'Ed. Mooney'. *Address:* 18 Waterloo Road, Ballsbridge, Dublin 4.

MOORE, Bridget, RAS.Dip., RBA, NEAC, Greenshield Foundation (1985); painter in oil, gouache and mixed media. *b:* Whitstable, 2 Aug 1960. *d of:* Keith Charles Moore. *m:* Alistair Milne. one *s.* one *d. Educ:* The Sir William Nottidge School, Whitstable. *Studied:* Medway College of Design, Epsom School of Art, R.A. Schools. *Exhib:* RA, RBA, NEAC, numerous mixed shows, London; Enid Lawson Gallery, Neville Gallery, Cedar House Gallery, Red Biddy Gallery, Milne & Moller, Business Art Gallery, New Academy Gallery, Red Rag Gallery. *Clubs:* Reynolds. *Signs work:* "BRIDGET MOORE" on back. *Address:* 17 Heath Rise, Westcott, Dorking, Surrey RH4 3NN.

MOORE, Cleland Randolph, BA, MFA; Artist in Residence Royal Academy of Arts 'Starr Scholar'. *Medium:* oil. *b:* Richmond, Virginia, USA, 28 Sep 1964. *s of:* John Williamson Moore III. *m:* Mark Patrick Murray-Threipland. one *s.* one *d. Studied:* College of Charleston, SC, USA (1987, BA); School of Visual Arts, New York, USA (1995, MFA); RA Schools (1996-98). *Exhib:* RA Summer Exhbn (1998, 2001); Visual Arts Gallery, New York (1995); City Gallery/ Halsey Gallery, Charleston, South Carolina (1993). *Works in collections:* Linklaters; Paines. *Works Reproduced:* Summer Academy Illustrated (2001) (curated by Peter Blake). *Clubs:* Alumni Assoc. RA. *Signs work:* 'Cleland R.Moore'. *Address:* 7 Pier Head, Wapping, London E1W 1PN. *Email:* cleland@freeola.com *Website:* www.clelandmoore.co.uk

MOORE, Gabrielle Kaye, Chadwyck Healey Painting Prize (1981); Rodney Burn Drawing Prize (1981); Richard Ford Travel (1983); Wimbledon Centenary poster (1986). *Medium:* oil, etching, sculpting. *b:* Worcs, 6 Feb 1949. *m:* David Lewis- Architect. *Educ:* Manor House Convent, London. *Studied:* Byam Shaw; City & Guilds of London Art School; RA Schools. *Exhib:* Contemporary Artists in Camden (1981); NPG BP Portrait Awards (1981,1982); NEAC (1981, 2001); Agnews (1983); RPPS (1984); one-man show Spink & Son (1991); Charleston Sussex (1992); 'Making a Mark' Mall Galleries (1993); RWEA (1995); Glyndebourne Opera (1999, 2002, 2007); frequently at the RA Summer Exhbn; many one-man and mixed exhbns. *Works in collections:* Lloyds of London. *Commissions:* Zamana Gallery, London; Museum of Jerusalem; Alhambra, Grenada; Glyndebourne -six aquatints. *Recreations:* raising chickens. *Misc:* taught life drawing and trompe l'oeil painting under Roger de Grey at City & Guilds Art School for fourteen years. *Signs work:* 'G.M.' 'Gaby Moore'. *Address:*

1 Poundfield Cottages, Chalvington, E.Sussex BN27 3TG. *Email:* gaby@macdream.net *Website:* www.gabymoore.co.uk

MOORE, Gerald John, N.D.D. (1958), A.T.C., A.T.D. (Manc.) (1959), B.A.(Hons.Theol.) (1969), F.R.S.A. (1985); traditional painter in water-colour and oil: landscapes, animals, birds, buildings, historical genre and portraits. *Medium:* oil and watercolour. *b:* Ratby, Leics., 21 Aug 1938. *s of:* Gilbert Moore. *Educ:* Broom Leys School, Leics. *Studied:* Loughborough (1955-58), Manchester Regional College of Art (1958-59), University of Exeter (Theology 1966-69; History of Art 1974-75). *Exhib:* Teignmouth, Tiverton, Taunton, Widecombe-in-the-Moor, Braunton, Bournemouth, Salisbury and Bristol. *Works in collections:* Private Collections in Australia, Italy, France. Sweden, Germany and Britain. *Works Reproduced:* Harvest Time at Plush, Dorsetshire, Afternoon: Double Lock Inn on the Exeter Canal. *Principal Works:* Portrait: Boy with violin, oil on canvas 36" x 28". *Misc:* Work may be seen at my home during Somerset Art Weeks and at other times by Appointment. *Signs work:* "G.J.M." or "G.J. MOORE." *Address:* Lower Huntham Farm, Stoke St. Gregory, Taunton, Som. TA3 6EY.

MOORE, Heather Ruth, ex S.B.A.; botanical painter in water-colour and oil; now Hon. Lay Mem. S.B.A.;. *b:* Scarborough, 9 May, 1925. *m:* James K.L. (decd.). three *s. Studied:* Scarborough School of Art (1939-41), A.E.C. Tunbridge Wells (Maurice Weidman). *Exhib:* Mall Galleries, Westminster Gallery, Camden Arts Centre, Linnean Soc., Burlington House, etc. *Signs work:* "H.R. MOORE" (initials H.R. linked). *Address:* 2 Newlands, Langton Green, Tunbridge Wells, Kent TN3 0BU.

MOORE, Jean Marigold, R.M.S. (1993); Hon. Mention R.M.S. (1995); painter in oil and water-colour, writer;. *b:* Valletta, Malta, 24 Nov., 1928. divorced. three *s. Educ:* privately. *Studied:* Lowestoft School of Art. *Exhib:* Mall, Westminster and Llewellyn Alexander Galleries; also in Brussels at the American Embassy; solo shows in Sussex. *Signs work:* "J.M. MOORE" (oils), "J.M.M." (water-colours and miniatures). Also painted under Dunbar (maiden name) and Seabrook (1st married name). *Address:* 17 Garrod House, 12 Charles Rd., St. Leonards, Sussex TN38 0QD.

MOORE, Ken, painter in oil; director, Commonwealth Biennale of Abstract Art London (1963). *b:* Melbourne, Australia, 16 May 1923. *s of:* Albert Moore, teacher of painting Geelong School. *Studied:* St. Martin's School of Art under Derrick Greaves, Kenneth Martin, Russell Hall. *Works in collections:* New Britten Museum, Connecticut, Phoenix Art Museum Arizona, Cedar Rapids Art Museum, Iowa, Keppe Gallery, Denmark, Lynam Allen Museum, Connecticut, Finch College Museum, N.Y., Tweed Gallery, Minneapolis, Witchita University, Kansas, Bertrand Russell Foundation, The Australian Ballet, University of Sydney, University of Melbourne, University of New England Armidale, H.R.H. Princess Margaret, King George VI and Queen Elizabeth Foundation, Windsor,

The American Legation Museum, Tangier. *Signs work:* "Ken Moore." *Address:* 33 Vicarage Court Vicarage Gate London W8 4ME.

MOORE, Sally, B.A, Fine Art (1984), M.A. Fine Art (1987); Welsh Artist of the Year (2005)prizewinner, Discerning Eye, Mall Galleries, London (1996), Abbey Memorial Scholarship at British School in Rome (1992-1993), Residency at Delfina Studios Trust (1988-1990), Prizewinner, National Eisteddfod of Wales (1994); painter in oil, self-employed artist. *b:* Barry, S. Wales, 7 Apr 1962. *Studied:* South Glamorgan Institute, Cardiff (1980-1981), Ruskin School of Drawing and Fine Art (1981-1984), City of Birmingham Polytechnic (1986-1987). *Exhib:* solo exhibs. include Martin Tinney Gallery (1995, 1997, 2000, 2003, 2005), Long and Ryle Art International, London (1991); group exhibs. include R.A. Summer Exhib. (2000, 2001), Art London with Martin Tinney Gallery (1994-2005). *Works in collections:* National Museum of Wales, Cardiff; National Library of Wales; Newport Museum and Art Galleries, Wales; Contemporary Art Society U.K.; Contemporary Art Society, Wales; Sunderland Art Gallery; South East Wales Art Association; St.John's College, Oxford; private collections worldwide. *Signs work:* "Sally Moore." *Address:* c/o Martin Tinney Gallery, 18 St. Andrew's Crescent, Cardiff CF10 3DD. *Email:* mtg@artwales.com *Website:* www.artwales.com

MOORE, Tom, *Medium:* oil. *b:* Sunderland, 5 May 1951. *s of:* Stanley Moore/ Eileen Pitt. *m:* Linda Maddison. *Educ:* Bede Grammar School, Sunderland. *Studied:* Northumbria University at Newcastle-upon-Tyne; Newcastle-upon-Tyne University. *Exhib:* Chatton Gallery, Northumberland; Globe Gallery, North Tyneside; VANE, Newcastle; New British Artists-AAF London; Art London (2004, 2005); Sheridan Russell, London; solo exhbns: Customs House, South Shields; Henshelwood Gallery, Newcastle; Red Box Gallery, Newcastle. *Works in collections:* Herwood Collection. *Commissions:* private and business UK. *Publications:* 'Finding A Language' (catalogue, Red Box Gallery); 'Brief Encounters' (catalogue, Henshelwood Gallery). *Signs work:* 'TOM MOORE' on verso. *Address:* 33 Clayton Road, Jesmond, Newcastle-upon-Tyne NE2 4QR.

MORAN, Carolyne Sandra Anne, Dip. A.D., A.T.C. (Fine Art); formerly head of Art: Queensmount Bournemouth, and Knighton House, Durweston; C21 First Prize Award (2005). *Medium:* gouache, oil, watercolour. *b:* Trowbridge, Wilts., 27 Dec 1946. *d of:* John Henry Parsons O.B.E., FRCVS. *m:* James. two *s*. *Educ:* Bruton School for Girls, Sunny Hill, Bruton, Somerset. *Studied:* Bournemouth College of Art, Exeter College of Art, Cardiff Post. Grad. College of Art Educ. *Exhib:* 1989 onwards: RWS, C21, Bankside Gallery, London (Open), RI, Mall Galleries, London (Open), Jerram Gallery, Salisbury, Four Seasons Gallery, Wimborne. *Commissions:* Sir Michael and Lady Angus; Sir Edward and Lady Hulse (Breamore House, Fordingbridge). *Publications:* The Encyclopedia of Water-colour Techniques-Painting Solutions; Houses and Buildings Texture; How to Paint It, How To Draw It, Painting and Drawing Magazine; Water-colour Still Life, The Art of Drawing and Painting, A

Compendium of Water-colour Techniques; 'Step by Step' Paintings for Dorling Kindersley Publications/ Eaglemoss Publications; The Watercolour Artist Bible; images taken from works for greetings cards. *Works Reproduced:* The Artist Magazine. *Signs work:* 'Carolyne Moran'. *Address:* Cleohill Cottage, 27 Blandford Rd., Corfe Mullen, Wimborne, Dorset BH21 3HD. *Email:* carolyne@carolynemoran.com *Website:* www.carolynemoran.com

MORENO, Michel, *Medium:* oil, watercolour, drawing, sculpture. *b:* St.Etienne du Rouvray, 26 Nov 1945. *s of:* Jules Moreno. *m:* Christiane. *Studied:* Ecole d'Arte Technique, Paris. *Exhib:* Galerie Morel Blenheim (1973); Galerie de Lucia (1974); Galerie Miromesnil (1994). *Works in collections:* Petit Palais, Genève. *Publications:* Benezit, Mayer, Annual des Arte, Artprice. *Official Purchasers:* Ville de Paris. *Works Reproduced:* catalogues. *Principal Works:* Parabole de la vie (1991). *Recreations:* marathon. *Signs work:* 'Michel Moreno'. *Address:* 11 Mont Thabor, Paris 75001, France. *Email:* renogaou@free.fr

MORESCHI, Maria, ABA, FPS; art teacher, portrait artist in oil, pastel and water-colour; art teacher The American School, Cobham. *b:* Florence, 18 Jul 1949. married. *d of:* Galliano Taddey, Col. in The King's Cavalry. one *s.* two *d. Educ:* SS. Ma. Annunziata. *Studied:* Academia delle Belle Arti; taught portraiture by Annigoni in Florence. *Exhib:* America, Italy, Holland, England, Paris. *Works in collections:* La Loggia, Oxshott, Walton, Epsom, Studio 54 Cobham, The Investment Gallery, private collections: Galerie Jacques, Galerie L'Oeil de Boeue, Galleria St Croce, Il Nerone, La Cantina, Turelli, Il Toro, La Studente, Vallerini. *Commissions:* private portraits. *Publications:* in the process of illustrating an animal and wildlife drawing book. *Official Purchasers:* ACS. *Recreations:* travel, cooking, theatre, photography, animals, music, hiking. *Clubs:* Epsom, Oxshott, Walton, Mosley, Cobham, London, Ferndown, Ringwood. *Signs work:* "M. Moreschi." *Address:* A.C.S. Middle School, Heywood, Portsmouth Rd., Cobham, Surrey.

MORETON, Nicolas, B.A.(Hons.) (1985), A.R.B.S. (1995). *Medium:* fine art sculptor in English stones, bronze, pencil drawing. *b:* Watford, Herts., 22 Oct 1961. *s of:* Cecil Peter Moreton, Ph.F., F.R.I.C.S., F.C.B.S.I. *m:* Julie Rose Bills. one *s. Educ:* Weston Favell Upper School, Northampton. *Studied:* Nene College, Northampton (1981-82, Frank Cryer), Wolverhampton Polytechnic (1982-85, John Paddison, R.C.A.). *Exhib:* The Discerning Eye; Young Sculptors, Beaux Arts; British Art Fair ('95-2001); Conversation, Milton Keynes Gallery; Sherborne Festival; one-man shows: Mall Galleries (1989, 1991), Lamont Gallery (1992), Hunt Jennings (1993), Goldmark Gallery (1995, 1997, 1999), Peter Gwyther Gallery (2001), Longleat House (2002), Hutson Gallery (2004), 'Transition', national tour (2004-2006). *Commissions:* Double public commission, Milton Keynes (1995), Millenium Sculpture, University College Northampton (2001), Cefn Henllan, Monmouthshire (2005). *Signs work:* drawing "Nicolas Moreton". *Address:* 4 West Lodge Cottages, London Rd., Courteenhall, Northampton NN7 2QA. *Website:* www.nicholasmoreton.com

MOREY de MORAND, C., FRGS; LG; BSc. PHm (Hons); Dip (Hons) Painting & Printmaking; QEII Arts Council of New Zealand Grant (1973); Greater London Arts Grant (1979); Arts Council GB (1980); Elephant Trust Grant (1983); Europe Prize for Painting, Ostend (Bronze Medal, 1986); British Council Grant (1988); Leighton Foundation, Alberta Canada (1991); Arts Council England Award (2006). *Medium:* resolutely abstract contemporary painter in acrylic and watercolour; drawing, prints. *b:* Paris, France. *d of:* Jean-Louis Morey de Morand & Natalie Sikevich. *m:* James Corcoran. one *s.* one *d.* *Studied:* University of Toronto; University of Manawatu, Wellington. *Represented by:* Palette Contemporary, Albuquerque, New Mexico, USA. *Exhib:* extensively in Britain and abroad, including: Solo Exhbn, Milchhof, Berlin (2007),Solo Exhbn, Spinach, London (2005), Hunting Prize Exhbn, RCA (2001, 05), Palette Contemporary, Albuquerque, NM, USA (2005); RA Summer Exhbn (2000,01, 04); two-artist exhbn: Owen Taylor Gallery, Castle Park, Warwick (2004); London Group (2000, 04); Flowers East (2003); Denizli City Art Centre, Turkey (1998); Museo Municipal de la Ciudad de Orense, Spain (1997); New Labour Exhbn, Riverside Studios, London (1996); Discerning Eye (1996); major retrospective Dean Clough Gallery (2002). *Works in collections:* British Railways Board, London; Denizli City Museum, Turkey; National Gallery, Wellington, NZ; Robert McDougall Art Gallery, Christchurch, NZ; Museo Municipal de la Ciudad de Orense, Spain; Kharkov State Museum, Ukraine; Karelian State Museum, Petrozavodsk, Karelia, Russia; Civic Gallery, Pomorie, Bulgaria; Society of Artists, Graphics Base, Burgas, Bulgaria; New Hall College, Cambridge; represented in public and private collections in Britain and worldwide. *Commissions:* include carpeting and notice boards; entrance lobby Time Out building; Light Boxes entrance art installation, Steedman Street Building. *Publications:* Register of Artists and Craftsmen-London Art and Architecture (1987), Moscow TV (1988, 89, 90); Art Monthly (no.56, 66); Studio International, vol 195; 'Oskar Nitzchke, Architect' (1991); plus many others worldwide. *Address:* 61d Oxford Gardens, London W10 5UJ. *Email:* colettemoreydemorand@yahoo.co.uk *Website:* www.cmoreydemorand.co.uk

MORGAN, Geri, painter in oil; part time teacher at Hornsey College of Art (1958-1968), Camberwell College of Art (1962-1970), Principal of Byam Shaw School of Art (1970-1991). *b:* London, 19 Mar 1926. three *d. Educ:* The Bec School, Tooting, London. *Studied:* St. Martin's School of Art (1944), Camberwell School of Art (1948-1951). *Exhib:* R.A. Summer Exhibs. regularly since mid 1960s; recent solo exhibs., Duncan Campbell Gallery (1998, 1999), Collins and Hastie (2002). *Works in collections:* private collections in U.K., U.S.A., and Canada. *Commissions:* portrait of President of Institution of Civil Engineers (1991). *Publications:* 'Getting it Right' William Packer, Collins and Hastie (2002). *Clubs:* Chelsea Arts. *Signs work:* "GERI MORGAN" on verso. *Address:* 7 Mildmay Grove North, London N1 4RH.

MORGAN, Glyn, *Medium:* painter in oil, water-colour, collage. *b:* Pontypridd, 16 Jul 1926. *s of:* H I Morgan. *m:* Jean Bullworthy. *Educ:* Pontypridd

Grammar School. *Studied:* Cardiff School of Art (1942-44, Ceri Richards), Camberwell School of Art (1947), East Anglian School (1944-82, Cedric Morris). *Exhib:* one-man shows: Gilbert Parr, London (1978, 1980), Alwin, London (1982, 1983), Richard Demarco Gallery, Edinburgh (1973), Minories, Colchester (1971, 1981), Archway Gallery, Houston, Texas, Chappel Gallery, Essex (1991, 1996, 2001, 2006), Rhondda Heritage Park, Y Tabernacl, Wales (1997), John Russell Gallery, Ipswich (1998); organised 'The Benton End Circle' exhbn. of work by pupils of Cedric Morris and Lett Haines, Bury St. Edmunds Gallery (1985), 'Glyn Morgan at Eighty' National Library of Wales (2006). *Works in collections:* Auckland and Brisbane A.G's, Derbyshire, Monmouthshire, Oxford and West Riding Educ. Coms., Welsh Arts Council, Contemporary Art Soc. for Wales, Ipswich Borough Museum and A.G., Newport Museum and A.G., National Museum of Wales, Brecknock Museum, Nat. Library of Wales, Glynn Vivian Art Gallery, Swansea. *Publications:* 'A Vision of Landscape', The Art of Glyn Morgan (Chappel Galleries), 'Glyn Morgan at Eighty', John Sansom. *Signs work:* "MORGAN." *Address:* Hunters, 120 High St., Hadleigh, Suffolk IP7 5EL.

MORGAN, Helena Frances, Dip. in Textiles (1985), F.F.P.S. (1997), L.C.G.I. (1992); fibre artist; Gold Medal, Hungary. *b:* Mountain Ash, Mid Glam., 11 Feb 1938. *m:* Hugh. one *s.* two *d. Educ:* Mountain Ash Grammar School. *Studied:* Glos.College of Art (1957-61); Regent St. Polytechnic (1963-64); London College of Furniture (1983-85). *Exhib:* group shows in France, Hong Kong, Hungary, London, and throughout Britain. Work in private collections. *Signs work:* "Helena Morgan." *Address:* Lansbury, 51a High St., Langford, Beds. SG18 9RU. *Email:* hugh@hmorgan.fsnet.co.uk

MORGAN, Howard James, M.F.A., R.P.; painter in oil, water-colour, casein. *b:* 21 Apr 1949. *s of:* Thomas James Morgan, teacher. *m:* Susan Ann (divorced). two *s.* one *d. Educ:* Fairfax High School. *Studied:* Newcastle-upon-Tyne University (Ralph Holland, Charles Leonard Evetts). *Exhib:* Anthony Mould, Claridges, Agnews, Richmond Gallery, Eaton Gallery, Sarah Stewart, Messums. *Works in collections:* N.P.G. *Commissions:* numerous Royal and private commissions. *Clubs:* Chelsea Arts, Beefsteak. *Misc:* (studio) 4011/2 Wandsworth Rd., London SW8. *Signs work:* roman numerals of month, followed by arabic year and surname, i.e. "MORGAN II 98." *Address:* 12 Rectory Grove, Clapham, London SW4.

MORGAN, Jennifer Frances, N.D.D. (1962), A.R.S.M.A.; freelance artist-painter, mostly in oil/gouache, specializing in marine painting, ships, sailing craft, etc. *Medium:* oils/gouache. *b:* Woolwich, London, 22 Jun 1942. *Studied:* Camberwell School of Art (1960-64, Robert Medley). *Exhib:* throughout U.K. and overseas,including Ferens Gallery, Hull; National Maritime Museum, Falmouth; Royal Cornwall Polytechnic Society, Falmouth; solo shows: Grimsby (1995), Waterman Fine Art, London (1998), Coach House Gallery, Guernsey (2004); also shows regularly at Mall Galleries, London, and work sold regularly through Gallerie Marin, Appledore, Devon; Kendall's Fine Art, Cowes, Isle of

Wight. *Works in collections:* private collections overseas and UK. *Commissions:* many private commissions over years, including works in Australia, Switzerland, Ireland, USA and major oil corporation. *Publications:* catalogues, book illustrations, calendar publications, Ltd. Ed. prints.Sotheby's Catalogues. *Clubs:* R.S.M.A., elected Associate (1996). *Address:* The Nest, Highgate Lane, Sutton-on-sea, nr. Mablethorpe, Lincs. LN12 2LH. *Email:* jenny.morgan15@btinternet.com

MORGAN, Mark Andrew, BA (Hons) Fine Art/Sculpture (2003); HND Fine Art (Distinctions, 2001); Salon Culinaire de Londres, Hotel Olympia Silver Medal (1996)/Cert.Merit (1998). *Medium:* sculpture, drawing, prints. *b:* Kensington, London, 21 Apr 1965. *s of:* David Richard Morgan, Dublin. *m:* Ann Morgan. one *s.* one *d. Educ:* Lampton Secondary School, Middx (1982); Brighton Tech. Coll. (1985). *Studied:* Northbrook College, W.Sussex (1997-2003). *Exhib:* RA Summer Show (2001); Worthing Artists & Makers Festival (2004, 05); 'Fresh Art' Fair, Battersea (2003); Northbrook College (2000, 2003); Worthing Museum & Gallery Open Art Comp. (1991); Salon Culinaire, Earls Court Olympia (1986, 96, 98); Royal Hibernian Academy, Dublin, Summer Show (2006). *Works in collections:* permanent siting of Sculpture, Devils Dyke, Sussex (National Trust, 2000). *Works Reproduced:* works photographed for British Airways Flight Magazine (1986). *Principal Works:* 'Earth Egg (A Glimmer of Hope)' selected for Sonia Lawson's Summer Show Gallery, RA (2001), 'Seed from the Tree of Life', RHA Dublin 2006. *Misc:* calligraphy work selected for presentation to H.R.H. The Queen Mother (1980). *Signs work:* 'M.A.Morgan'. *Address:* 13 Wenban Road, Worthing, W.Sussex BN11 1HY. *Email:* markasculptor@hotmail.com *Website:* www.artcatz.biz

MORGAN, Michael, M.Phil., D.Litt., HonLL.D., FRSA, RI, SWAc; Past Chairman Board of Trustees, Founding Academician and Trustee Laureate; South West Academy of Fine and Applied Arts; Member Royal Institute of Painters in Watercolours; Founding Trustee, American International University in London; former Chairman, Richmond Foundation and Trustee; Prospera Language Institute, Shizuoka-Shi, Japan; Former Principal: Froebel Institute, and Trustee Emeritus, New England College, New Hampshire, U.S.A.; President, Honiton Art Society; Trustee Emeritus, Richmond University; winner RI medal (1998), Rowland Hilder Award for landscape painting (2001). *Medium:* water-colour. *b:* 2 Jun 1928. *m:* Jill. two *s. Studied:* Exeter University and University of Southampton. *Represented by:* Marine House at Beer. *Exhib:* RI, RWS, RCA, SWAc; Marine House at Beer. *Works in collections:* RI, The Arts Club Collection, Somerset County Council, Richmond University. Work in private collections internationally. *Publications:* featured or illustrated in 'The Artist' magazine (1992, 1993), 'Art Review' (1999), 'Contemporary Art' (1997/98, 2007/08) (Allan & Bertram Ltd.), 'Galleries' (2000), 'International Artist', Elladrent (2001/02/03/05), 'Dartmoor Artists' Brian le Messurier, Halsgrove (2002), 'Painting in Watercolour' Eaglemoss International (2002), 'Capturing Texture' Michael Warr, Quarto Books (2002), 'Composition' Eaglemoss International

(2003), Artists and Illustrators (2005/06), Leisure Painter (2005), 'Art in Devon' (2005/06/07); 'Michael Morgan RI' by Michael Morgan (Halsgrove, 2004, Second Ed. 2006), 'Watercolour Innovations' J Simmonds (Harper Collins, 2005). *Clubs:* The Arts Club, Dover St. W1. *Signs work:* "Michael Morgan." *Address:* Valley House, Churchill, Axminster, Devon EX13 7LZ. *Website:* www.marinehouseatbeer.co.uk

MORGAN, Ronald, R.B.A. (1984), R.O.I. (1984); draughtsman, painter in water-colour, black and white, oil and pastel, illustrator, teacher; Mem. Chelsea Art Soc.; winner of numerous awards for painting. *b:* Landywood, Staffs., 28 Feb 1936. *s of:* J. Morgan. *Educ:* Landywood Junior School, Great Wyrley Secondary School, Staffs. *Studied:* Walsall School of Art (1951-53). *Exhib:* R.A., R.I., R.B.A., N.E.A.C., S.G.A., R.W.A., R.B.S.A., R.S.M.A., R.O.I., Paris Salon, Britain in Water-colours and touring exhbns., etc. *Works in collections:* London Boroughs of Islington, and Tower Hamlets, Graves A.G., Sheffield, Sultan of Oman. *Works Reproduced:* in Leisure Painter, La Revue Moderne (Paris, 1963, 1965), Royal Academy Illustrated. *Signs work:* "R. MORGAN. 1990." *Address:* 8 Marina Ct., Alfred St., Bow, London E3 2BH.

MORGAN, Tina, S.W.A., L.S.I.A.D. S.W.A.; painter in oil; art director (1973-1983); Awards: Silver Award, Cannes Film Festival (1980), Campaign Press Award (1980), two awards London Designers and Art Directors Assoc. Gold Award, Cannes (1981), Irish Advertising Award, British Television Award (1982); Winsor and Newton Prize (2003); Daler Rowney Award (2005). *b:* Linton, Devon, 9 Jan 1952. *m:* Roger. three *s. Studied:* Cornwall College of Art and Design. *Exhib:* R.W.A., R.S.M.A., R.B.A., S.W.A., Southwest Academy, Discerning Eye, Exeter University; solo exhibs. at Albemarle Gallery, Walker Galleries, First Sight Gallery, Marine House at Beer Gallery, Priory Gallery, Fowey River Gallery, Sarah Samuels Fine Art. *Works in collections:* national and international. *Commissions:* MBNA Bank, Madrid Branch. *Publications:* Leisure Painter Magazine 2002, International Artist Magazine 2004. *Signs work:* "Tina Morgan." *Address:* Woodside, Farringdon, Exeter, Devon EX5 2JA. *Email:* ART@eclipse.co.uk

MORLEY, John, SWE; wood engraver and painter in oil and pastel. *b:* Beckenham, Kent, 12 Sep 1942. *m:* Diana. one *d. Studied:* Beckenham Art School, Ravensbourne College of Art, RA Schools. *Exhib:* RA Summer Exhibs. (1962-2007), Piccadilly Gallery (1977-2003), Brotherhood of Ruralists, International Art Fair, Basle, Cologne, Dusseldorf, London. *Works in collections:* Museum of Modern Art, Wales, Arts Council of Great Britain, Ashmolean Museum, Glasgow City Art Gallery, National Trust, V&A Museum, British Museum. *Publications:* numerous. *Official Purchasers:* see above. *Clubs:* Soc. of Wood Engravers, Art Workers Guild. *Signs work:* "John Morley." *Address:* North Green Only, Stoven, Beccles, Norfolk NR34 8DG. *Website:* www.johnmorley.info

MORPETH, Vivienne Helen Bland, (née Totty); B.A. Hons. Fine Art (1984), A.M.A. (Art) (1990); curator/fine art; Fine Arts Officer, Middlesbrough Art Gallery (1985-88), Exhbns. Officer, Scunthorpe Museum (1989-92), County Arts and Museums Officer, Cleveland C.C. (1992-95), freelance curator (1995-). *b:* Edinburgh, 16 Feb 1962. *d of:* Alan Bland Totty, M.B.E., B.A. *Educ:* The Rudolph Steiner School, Edinburgh. *Studied:* history of art and architecture: University of E. Anglia, Norwich (1981-84). *Exhib:* curated numerous exhbns. at Middlesbrough A.G. and Scunthorpe Museums, local, national, international art and artists tours. *Publications:* exhbn. catalogues. *Address:* 28 Westfield Rd., Barton-upon-Humber, South Humberside DN18 5AB.

MORREAU, Jacqueline Carol, artist in oil; Prof. of Art, Regent's College, London; lecturer, Royal College of Art. *b:* Wisconsin, U.S.A., 18 Oct 1929. *m:* Patrick Morreau. two *s.* two *d. Educ:* Chouinard Art Inst., L.A.; Jepson Art Inst., L.A., (Rico Lebrun); University of California Medical School, San Francisco. *Exhib:* one-person shows: Odette Gilbert (1989, 1990), Art Space, London (1986, 1988), Ferens A.G. (1997), retrospective, one person Ferens A.G., Hull (1988); group shows: Museum of Modern Art, Oxford, 'Women's Images of Men' I.C.A. London and tour, Rochdale A.G., Lamont Gallery, London (1997), Cleveland Drawing Biennial (1996), Cheltenham Drawing Show (1997, 1999, 2000), Reflections in Water 2003, Morley College, London. *Works in collections:* A.C.G.B., B.M., V. & A., Open University, Nuffield College Oxford, City Art Galleries, Hull, Rochdale A.G., Cleveland A.G., New Hall College, Cambridge. *Publications:* Women's Images of Men with Sarah Kent (1985, 1989), Bibliography Jacqueline Morreau, Drawings and Graphics (1985), From the Interior (Kingston U. Press, 1997), Themes and Variations (Artemis Press, 1996), Print series, U. of Northumbria (1999), illustrations, Odysseus Poems (Cargo Press). *Official Purchasers:* Frances Cory - Prints and Drawings Collection, British Museum, has bought drawings and complete portfolio of Disclosing Eros (12 prints). *Works Reproduced:* too many to list. *Signs work:* "J. Morreau." *Address:* 40 Church Cres., London N10 3NE. *Website:* www.morreaux.co.uk

MORRELL, Peter John, N.D.D. (Painting, 1956), A.R.C.A. (Painting, 1959), Rome Scholar in Painting (1959), R.W.S. (1973), Mem. London Group (1990); Arts Council Prize (1959); painter in oil and water-colour, lecturer. *b:* Newton Abbot, 28 Feb 1931. divorced. *s of:* Arthur Markham, M.A. one *s.* one *d. Educ:* Worthing High School for Boys. *Studied:* Kingston-upon-Thames College of Art (1952-56), R.C.A. (1956-59, Ruskin Spear, Carel Weight, John Minton, Colin Hayes). *Exhib:* R.A., John Moores, Grabowski Gallery, New Art Centre, London Group, Beaux Arts Gallery, Arnolfini Gallery, Six Young Painters, Gimpel Fils, R.W.S., Arts Council Touring Exhbns., Gallery Appunto Rome; RWA Bristol. *Works in collections:* Arts Council, L.C.C., Charterhouse Boys' School, Science Museum. *Commissions:* P. & O. Shipping. *Publications:* 'Face to Face' (pub. Piano Noblile), 'The Watercolour Expert' (pub.RWS). *Signs work:* "MORRELL." *Address:* 19 Tremeadow Terrace, Hayle, Cornwall TR27 4AF.

MORRIS, Anthony, RP, NDD(1958), RAS(1961), NEAC (1995); painter/illustrator in oil and water-colour. *b:* Oxford, 2 Aug 1938. *s of:* Francis Morris. *m:* Aileen. *Studied:* Oxford School of Art, R.A. Schools (Peter Greenham). *Exhib:* R.A., R.P., Medici Gallery. *Works in collections:* Bodleian Library, Open University, King's College Hospital. *Publications:* B.B.C. and major publishers. *Signs work:* "MORRIS." *Address:* Church House, Cloduck, Longtown, Herefordshire HR2 0NY.

MORRIS, Caroline Nova, Dip. in Fashion; fashion designer. *b:* Dewsbury, 31 Oct 1965. *d of:* Graham Teasdill, museum and art gallery curator. *m:* Christopher Thomas Morris. two *s. Educ:* Stourfield and Beaufort Schools, Bournemouth, and the School of Fashion, Bournemouth and Poole College of Art and Design. Practices as Caroline Nova Fashions. *Address:* 99 Carbery Ave., Southbourne, Bournemouth BH6 3LP.

MORRIS, Elizabeth, NDD (1953), ATC (1955), Coley & Tiley Prize RBSA (1999). *Medium:* oils, prints, etchings. *b:* Bristol, 20 Jul 1932. *d of:* Captain George Villar RN. *m:* Bill Morris FRIBA. one *s.* two *d. Educ:* St.Stephens College, Broadstairsq. *Studied:* Southern College of Art, Bournemouth (1949-53), Goldsmiths College (1954-55), Central School (1953-54, part-time), Morley College (1975-77, part-time). *Exhib:* RA 'Originals', Mall Galleries, The Barbican, National Theatre, Eastern Open. Solo shows: Bircham Gallery, Holt (2001), John Russell, Ipswich (2004), Haylett's, Maldon (2004, 2006), Univ. of Essex (2004). *Works in collections:* Chelsea and Westminster Hospital; Colchester Castle; 'Graphotek' Berlin; House of Lords; various LEA Collections. *Commissions:* 2 editions of etchings commissioned for the P&O cruiser 'Oriana' (1993); mural, Langley Primary School (1956). *Publications:* illustrations for: 'Oysters & Ale' by Heather Howard; 'Barbeque Cookers' by Maggie Black. *Official Purchasers:* etchings for House of Lords; Ministry of Defence; Chelsea and Westminster Hospital. *Recreations:* boating, gardening, and DIY on island home in West Cork. *Misc:* Featured in Anglia TV series 'Coastal Inspirations' (2006). Founder Member of Greenwich Printmakers Association & Chair for 2 years. Member from 1979-2002. *Signs work:* "Elizabeth Morris" (prints), "E.M." (oil paintings). *Address:* Stone House, 112 Coast Road, Mersea Island, Essex, CO5 8NA. *Email:* liz@elizabethmorrisprints.co.uk *Website:* www.elizabethmorrisprints.co.uk

MORRIS, John, Mem., Water-colour Soc. of Wales; painter in water-colour. *b:* Deiniolen, N. Wales, 27 Sep 1922. *s of:* Robert Morris, boot and shoe retailer. *m:* Eluned Mary. one *s.* one *d. Educ:* Brynrefail County School, Bangor Normal College. *Studied:* Bangor Normal (1955-57, H. Douglas Williams), Press Art School, London (1958-60, Percy V. Bradshaw). *Exhib:* Williamson A.G. Birkenhead, Oriel Theatre Clwyd Mold, Wrexham Arts Centre, Albany Gallery Cardiff, R.I., N.S., Royal National Eisteddfod of Wales, Water-colour Soc. of Wales. *Works in collections:* Royal Welsh Agricultural Soc., National Library of Wales, Midland Bank Ltd., Burnley Building Soc., Clwyd C.C., Shotton Paper

Co. *Publications:* Newid Aelwyd, Newid Bro. *Signs work:* "John Morris." *Address:* Elidir, 46 Bryn Awelon, Yr Wyddgrug (Mold), Clwyd CH7 1LU, N. Wales.

MORRIS, John Meirion, N.D.D. (1959), A.T.D. (1961), M.Phil. (1989), R.C.A. (2000), Glyndwr Award (2001); sculptor in bronze; lecturer at University of Kumasi, Ghana (1966-1967), Aberystwyth University (1968-1981), Bangor University (1985-1990), author. *b:* Wales, 14 Mar., 1936. *m:* Gwawr. two *s.* one *d. Educ:* Bala Boys Grammar School. *Studied:* Liverpool College of Art (1955-1961), University College of North Wales, Bangor (1985-1990). *Exhib:* Piccadilly Gallery, Cork St., London, National Museum Galleries of Wales, Cardiff (1999), Glynn Vivian Art Gallery, Swansea (2000); solo exhibs. Y Tebernacl Museum of Modern Art, Wales (2000), Bangor Museum and Art Gallery, Wales (2001), solo exhibition at the Royal Cambrian Academy (2005). *Works in collections:* eight bronze portrait heads at the National Library of Wales, Aberystwyth - 'Gwenallt', Marion Eames, T. Llew Jones, Nestawyn Jones, Prof. Peter Abbs, Gerallt Lloyd Owen, Lord Hooson, Ann Catrin Evans; portrait head of Prof. Jac L. Williams at University of Wales, Aberystwyth;. *Commissions:* five panels to commemorate Sir O. M. Edwards at Village Hall, Llanwwcallyn, Gwynedd; a bronze cauldron for Celtica, Machynlleth, Powys; a bronze maquette of 'Rhiannon' for Dr Roy Evans, Narberth, Pembroke,; memorial bust of the Celtic scholar Edward Lhwyd at Aberystwyth; designed a cross to commemorate R. S. Thomas the poet at Porthmadog Church. *Publications:* The Celtic Vision (2003); Y. Weledigaeth Geltaidd (2002). *Principal Works:* Maoliette of the Tryweryn Monument. *Signs work:* "J.M.M." *Address:* Griolen, Erwnant, Brynrefail, Caernarfon, Gwynedd LL55 3PB.

MORRIS, Mali, BA, MFA; Awards: Lorne, Daiwa, Arts Council, British Council, research awards, Prizewinner Creekside Open 2007. *Medium:* acrylic, canvas, paper. *b:* North Wales, 1945. *Studied:* University of Newcastle upon Tyne (1963-68), University of Reading (1968-70). *Exhib:* 25 solo shows since 1979, including Ikon Gallery, Serpentine Gallery, Saoh Gallery, Tokyo, Robert Steele Gallery, New York, and Poussin Gallery, London (2008); many group shows worldwide. *Works in collections:* A.C.G.B., British Council, Contemporary Arts Soc., Eastern Arts Assoc., Government Art Collection, Lloyds of London, Whitworth Gallery, Manchester, etc. and many private collections. *Publications:* Mali Morris ('92) (text by Stuart Bradshaw) ISBN 1 873215 606; Mali Morris ('94) (text by Martha Kapos) ISBN 1 899535 004; Mali Morris ('02) (text by David Ryan) ISBN 0 905634 543. *Signs work:* "Mali Morris." *Address:* Apt Studios, Harold Wharf, 6 Creekside, London SE8 4SA. *Email:* malimorris@talktalk.net *Website:* www.malimorris.co.uk

MORRIS, Nigel William, B.Des (Hons), Cert.Ed. *Medium:* oil, acrylic, mixed, watercolour. *b:* Wirral, 24 Oct 1957. *s of:* R W Morris. *Studied:* Liverpool Hope University. *Exhib:* Mall Galleries, Manchester Aerospace Museum, Bury Art Gallery, Mariners Gallery, DLI Gallery Durham, Westminster Gallery,

Carisbrooke Gallery, Royal Cambrian Academy, Grosvenor Museum and Gallery, Williamson Art Gallery, RAF Cosford Aerospace Museum, Red Bill Gallery, Deeside, Obsidian Gallery, Buckinghamshire. *Works in collections:* Chester Grosvenor Museum and Gallery; many private collections. *Commissions:* British Aerospace. *Official Purchasers:* Chester City Council. *Clubs:* Deeside Art Group. *Misc:* mem. Wirral Society of Arts, NAPA, Associate of GAvA. *Signs work:* Nigel W.Morris. *Address:* 1 Headington Road, Saughall, Massie, Wirral, CH49 4GG.

MORRIS, Stanley William, M.Ed. (1976), A.T.D. (1951), A.R.B.S.A., M.F.P.S.;. *b:* 1922. *Studied:* Birmingham College of Art, University of Manchester. *Exhib:* Paris Salon, R.O.I., N.E.A.C., U.A.S., R.B.S.A., Birmingham University, Keele University. *Works in collections:* Midlands Arts Centre, wood carving for Prince of Wales Regt., Leeds Permanent Building Soc., Alexander Ross. *Address:* Bromley Cottage, Ashbrook La., Abbots Bromley, Staffs. WS15 3DW.

MORRIS-JONES, Muriel (Moo), (nee TURNER); R.D.S. Hons.; no formal art education; City & Guilds 'Post graduate' painting prize, prizes for watercolours, drawings and prints; U.S.A.; portrait painting; in oils. *b:* London, 4 Nov 1928. one *s.* one *d. Exhib:* U.S.A. (1963-69), Belgium, London. *Works in collections:* U.S.A., Belgium. *Commissions:* bronze bust of Princess Diana at Gt. Ormond Street Hospital. Intellectual Property, patents granted U.S.A. and U.K. *Publications:* cartoons 'Women Draw 84' and Sunday Times; 'Science and Public Affairs' (Christmas 1999). *Signs work:* early work: "MURIEL TURNER," now "M. Morris-Jones." *Address:* 26 Old Gloucester St., Bloomsbury, London WC1N 3AF. *Email:* moosideas@hotmail.com

MORRISON, James, R.S.A., R.S.W., D.Univ., D.A.; painter in oil and watercolour; paints extensively in the High Arctic, France. *b:* Glasgow, 11 Apr 1932, married. one *s.* one *d. Educ:* Hillhead High School, Glasgow School of Art. *Represented by:* The Scottish Gallery, 16 Dundas St., Edinburgh EH3 6HZ tel: 0131 558 1200. *Exhib:* Edinburgh, London, Glasgow, New York, Toronto, Florence, Dusseldorf, The Hague, Johannesburg, Tokyo, Hong Kong, Dublin. *Works in collections:* Glasgow, Dundee and Aberdeen Art galleries, Arts Council, Argyll, Dundee and Edinburgh Educ. Committees, Glasgow, Edinburgh, Strathclyde and Stirling Universities, H.R.H. the Duke of Edinburgh, Dept. of the Environment, various embassies, Kingsway Technical College, Vaughan College, Leicester, Municipality of the Hague, Earls of Dalhousie, Moray, Airlie, Robert Fleming, Merchant Bankers, BBC, Grampian Television, General Accident, Scottish Amicable, Life Assoc. of Scotland; Banks: Royal, Scotland, Clydesdale, T.S.B. *Commissions:* numerous private and public. *Publications:* author, Aff the Squerr; Paris in Winter. *Works Reproduced:* From Balgove, 1996; Montrose, 1995. *Misc:* Chamber Music Group. *Signs work:* "Morrison" and date. *Address:* Craigview House, Usan, Montrose, Angus DD10 9SD.

MORROCCO, Jack Bernard, DA (1974) Post Diploma (Highly Commended)(1975); Farquhar Reid Travelling Scholarship (1975). *Medium:* oil, watercolour. *b:* Edinburgh, 27 May 1953. *s of:* Valentino Morrocco ARIBA & Rozelle Morrocco, artist. *m:* Fiona Morrocco. one *s.* one *d. Educ:* Madras College, St.Andrews. *Studied:* Duncan of Jordanstone College of Art, Dundee. *Exhib:* solo exhbns: Thompson's Gallery, London; Richmond Hill Gallery, London; Leith Gallery, Edinburgh; Henshelwood Gallery, Newcastle; Broadway Modern, Cotswolds; Solo Gallery, Edinburgh; Rendezvous Gallery, Aberdeen; Eduardo Alessandro Gallery, Dundee; Open Eye Gallery, Edinburgh; group exhbns include: RSA, RGI, Compass Gallery, Glasgow; 6 Scottish Colourists, St.Andrews; Falle Fine Art, Jersey; Forbes Gallery, New York; Gallerie Azur, St.Paul de Vence; CFAG, Eton. *Works Reproduced:* various signed editions by 'Rosenstiels'. *Signs work:* 'MORROCCO'. *Address:* Cairnie House, By Colinsburgh, Fife, Scotland KY9 1JX. *Email:* jack@jackmorrocco.com *Website:* www.jackmorrocco.com

MORROCCO, Leon, D.A., (Edin.), A.R.S.A., R.G.I.; painter in oil and mixed media. *b:* Edinburgh, 4 Apr 1942. *m:* Jean Elizabeth Selby. two *s. Educ:* Harris Academy, Dundee. *Studied:* Duncan of Jordanstone College of Art, Dundee (1960, Alberto Morrocco, R.S.A.), Slade School of Fine Art (1960-61, Sir William Coldstream), Edinburgh College of Art (1961-65, Sir Robin Philipson, R.S.A.). *Represented by:* John Martin Galleries, London; Open Eye Gallery, Edinburgh. *Exhib:* 20 one-man shows since 1966, Scotland, London, Melbourne, Sydney. *Works in collections:* U.S.A., Britain, Australia, etc. *Commissions:* mural, John Lewis Partnership, Glasgow (2000); 3 paintings aboard P&O's 'Arcadia' (2004). *Publications:* 'Journeys and Observations' monograph (1999). *Clubs:* Chelsea Arts. *Signs work:* "Leon Morrocco." *Address:* c/o Royal Scottish Academy, The Mound, Edinburgh EH2 2EL.

MORROW, Elizabeth Eleanor, DA (Belfast, 1954), USWA (1961), UWS (1967); housewife, painter in water-colour; Hon. Sec. Ulster Soc. of Women Artists. *b:* Enniskillen, Co. Fermanagh, 14 Apr 1926. *m:* T.A. Morrow (decd.). one *s.* two *d. Educ:* Enniskillen Collegiate Grammar School. *Studied:* Belfast College of Art. *Exhib:* R.I., R.U.A., U.S.W.A., U.W.S., S.WL.A. *Clubs:* U.S.W.A., U.W.S. *Address:* 33 Kensington Gardens South, Belfast BT5 6NN, Northern Ireland.

MORSE, Colin Benjamin Scale, Dip.A.D. (1982); illustrator in water-colour and mixed media. *b:* Pembrokeshire, 6 Aug 1942. *m:* Joan, Ellen. one s-son *s.* two s-daughters *d. Educ:* Haverfordwest Grammar School. *Studied:* Dyfed College of Art, Carmarthen (1978-82); work on display in various commercial galleries throughout U.K. *Publications:* limited edition prints – images of the coast, countryside and people of Wales. *Signs work:* "Colin Morse". *Address:* Beudy Bach Penfeidr, Castlemorris Haverfordwest Pembrokeshire, SA62 5EN. *Website:* www.bestofruralwales.co.uk / www.welshpictures.co.uk

WHO'S WHO IN ART

MORSMAN, Phil, Northern Arts Awards 1986, 87, 89, 92, 97; Oppenheim-Downes 1989; Cumbria Visual Arts Award 1996; Eden Arts Bursary 1996; Cultural Business Award 2000. *Medium:* acrylic, gouache, mixed media, prints. *b:* London, 30 Jan 1946. *m:* Jean. two *d. Studied:* Epsom School of Art (1962-63), Wimbledon School of Art (1963-65), Sheffield College of Art (1965-67). *Exhib:* Abbot Hall Gallery, Kendal; Northern Centre for Contemporary Art, Sunderland; Salt House Gallery, St.Ives; Collins Gallery, Glasgow; The View, Liverpool; Broughton House Gallery, Cambridge; Lady Margaret Hall, Oxford; Storey Gallery, Lancaster; Tullie House, Carlisle; McLellan Galleries, Glasgow; RFH, London; Lamec, Vicenza, Italy; Irma Stern Museum, Capetown. *Works in collections:* Tullie House Museum, Carlisle; Penrith Museum, Fitzwilliam Museum (prints), Darlington Borough Council, North Tyneside Council, Cumbria County Council, Durham City Council, Cumberland Infirmary, Lancaster Royal Infirmary, University of Newcastle-upon-Tyne, Marriott Hotel Group. *Signs work:* "MORSMAN". *Address:* St.Michaels, Bongate, Appleby, Cumbria, CA16 6UR. *Email:* philmorsman@beeb.net

MORTIMER, Justin Roger, B.A. Fine Art (1992); painter in oil. *b:* U.K., 6 Apr., 1970. *Educ:* Wells Cathedral School. *Studied:* Slade School (1988-1992). *Exhib:* solo exhibs., Beaux Arts, Bath (1993), Blue Gallery, London (1995, 1997, 1998), Lefevre Contemporary (2000). *Works in collections:* National Portrait Gallery, NatWest Collection, Henley River & Rowing Museum, Royal Collection, R.S.A. *Commissions:* portraits of Harold Pinter (N.P.G. 1992), David Bowie & Iman (1994), H.M. The Queen Elizabeth (R.S.A. 1998), Lord Chamberlain (Airlie, R.C.A. 1998), Steve Redgrave (1998). *Signs work:* "J Mortimer." *Address:* 165 Victoria Rd., London NW6 6TE. *Email:* justinmortimer@hotmail.com

MORTIMER, Martin Christopher Fortescue, Consultant, Delomosne & Son Ltd. Specialist in English Porcelain, English and Irish Glass, particularly English glass lighting fittings, and articles on these subjects in various art journals. *b:* London, 4 Jul 1928. *s of:* George Mortimer (British Aluminium Co.). *m:* Sara Ann Proctor. *Educ:* Shrewsbury School. *Publications:* author, The English Glass Chandelier (Antique Collectors' Club, 2000). *Address:* Court Close, North Wraxall, Chippenham, Wiltshire SN14 7AD.

MORTON, Cavendish, R.I., R.O.I., Hon. S.G.A., Hon. N.S.; painter of landscape, marine, in oil, water-colour, black and white; Vice Pres., Gainsborough's House Society, Vice-Pres., Norfolk Contemporary Arts Society; Past Chairman, Isle of Wight Council for the Arts, Vice-Pres., Isle of Wight Art Society. *b:* Edinburgh, 17 Feb 1911. *s of:* Cavendish Morton. *m:* Rosemary Britten. one *s.* two *d. Exhib:* R.A., R.B.A., U.S.A., Canada, Australia, Bermuda; one-man shows: London, York University, Norwich, King's Lynn, Sudbury, Ipswich, Aldeburgh, Henley, Portsmouth. *Works in collections:* B.M., Norwich Castle Museum, Wolverhampton A.G., Contemporary Arts Society, Eastern Arts Assoc., I.O.W. Cultural Services, Glasgow City A.G., Royal Naval Museum,

Gustav Holst Museum, National Trust. *Commissions:* Review of The Cumberland Fleet, Royal Thames Yacht Club. *Publications:* illustrations for Dorothy Hammond Innes' Occasions (Michael Joseph, 1972), What Lands are These (Collins, 1981), and The Bembridge Redwings, David Swinstead (1997). *Signs work:* "CAVENDISH MORTON." *Address:* 6 Fairhaven Cl., Bembridge, I.O.W. PO35 5SX.

MORTON, Gina, RMS, HS, SLm; Awards: RMS Gold Memorial Bowl (2005); Llewelyn Alexander Subject Miniature Award (RMS, 2003), SLm 'Chairman's Choice' (2004); Llewelyn Alexander Masters Award (2005); RMS Group Award (2005); Mary Scott-Kestin Award (HS, 2005); Peter Charles Booth Memorial Award (RMS, 2006); winner, 'Saunders Waterford Postcard Competition' (2006). *Medium:* watercolour. *b:* Darlington, 26 Apr 1951. *Educ:* Branksome School, Darlington. *Exhib:* solo exhbns: County Durham and North Yorkshire; group exhbns: Mall Galleries, Llewelyn Alexander Gallery, and others. *Works in collections:* Darlington Borough Council. *Principal Works:* traditional loose watercolours and detailed miniatures. *Clubs:* Hon.Sec. Darlington Society of Arts (1977-2007). *Signs work:* 'G MORTON'. *Address:* 37 Westbourne Grove, Darlington, Co.Durham, DL3 8HT. *Website:* www.ga-morton.co.uk

MOSELEY, Austin Frank, R.B.S.A. (1988), C.A.S. (1987), C.Eng.M.I.Mech.E. (1958); painter in oil, ink, pastel, charcoal. *b:* Tividale, Staffs., 25 Apr 1930. *s of:* Frank Moseley, engineering tool maker. *m:* Sylvia. two *s. Educ:* Dudley Technical College. *Studied:* Dudley School of Art. *Exhib:* R.B.S.A., Chelsea Arts Soc., Dudley Mid. Art, Llewellyn Alexander (London), John Noott (Broadway), R.O.I. *Works in collections:* Dudley Metropolitan County Borough, R.B.S.A, and many private and commercial collections. *Signs work:* "Austin Moseley." or "AM". *Address:* 24 Raglan Cl., Sedgley, Dudley, W. Midlands DY3 3NH.

MOSELEY, Malcolm, B.A. (1969), M.A. (1973); painter. *Medium:* mixed media on canvas and paper. *b:* Birmingham, 2 Feb 1947. *m:* Christine. one *s.* one *d. Studied:* Birmingham College of Art (1965), Winchester School of Art (1966-69), Central School of Art (1969-70), R.C.A. (1970-73). *Exhib:* R.A., R.S.W., London Group, Mall Galleries, Barbican, Eastern Open, New English, Laing Landscape, Suffolk Group. *Works in collections:* Ipswich Museums, P. & O., McDonalds, Hammersmith and Fulham Council, private collections. *Clubs:* Ipswich Art Soc., Suffolk Group. *Signs work:* "M.M." *Address:* 133 Norwich Rd., Ipswich, Suffolk IP1 2PP.

MOTT, Miranda J M, S.W.E. (1996). *Medium:* oil, acrylic and watercolour, etching, lino, wood engraving, intaglio and relief prints, artist's books. *b:* London, 6 Jul 1934. *d of:* Helga and Tom Mott. *m:* John Hoskyns. two *s.* one *d. Educ:* Eothen, Caterham, Surrey. *Studied:* Byam Shaw; Royal Academy Schools. *Exhib:* Royal Academy, Portrait Painters, Society of Wood Engravers, Barbican,

National Theatre, sixteen solo exhibitions, numerous group exhibitions in UK and abroad. *Works in collections:* public and private collections in UK, Germany, USA, South Africa. *Commissions:* portraits and murals, various others and publishers. *Publications:* book illustration for Faber, Michael Joseph, MacMillan, Folio Society, Penguin. *Works Reproduced:* as above. *Recreations:* writing, gardening. *Clubs:* Chelsea Arts. *Misc:* Gainsborough's House Print Workshop (Chairman 1979-82), Printmakers Council (1981-6), 12PM (twelve printmakers)(1996), Gainsborough Printmakers (1979). *Address:* Windrush, Great Waldingfield, Sudbury, Suffolk, CO10 0RZ. *Email:* mj_mott@compuserve.com *Website:* www.mjmott.co.uk

MOUNT, Paul Morrow, RWA; ARCA (1948); sculptor. *b:* Newton Abbot, 8 Jun 1922. *s of:* Ernest Mount BSc. *m:* June Miles. one *s.* one *d. Educ:* Newton Abbot Grammar School. *Studied:* RCA (1940-1941 & 1946-1948) under Gilbert Spencer, Percy Horton. *Exhib:* Architectural Assoc., Drian Gallery, Whibley Gallery, South West Arts, Marlborough, New Art Centre, Beaux Arts Gallery, Penwith Gallery, Falmouth Art Gallery, Thompsons Gallery, Gallerie Ruf, Munich. *Works in collections:* Hyde and Fermi, USA, Dept. of Environment, Stanley Picker Trust, Cornwall County, Exeter University. *Commissions:* Swiss Embassy; Chase Manhattan Bank; Tafawa Balewa Sq., Lagos, Nigeria; Ibadan University, Cocoa House, Ibadan; Cabinet Offices, Accra; British Steel, York House, Bristol; C.W.S., Falmouth. *Publications:* Agnes Holbrook, under pseudonym, Andrew Morrow, Minerva Press (2001), A Ticket to the Garden, under own name Nancherrow Studio Productions (2004) A Rustle of Dry Leaves (2007) Nancherrow Studio Productions. *Clubs:* Penwith Society. *Signs work:* "Paul Mount." *Address:* Nancherrow Studio, St. Just, Penzance, Cornwall TR19 7LA.

MOUNTFORD, Derylie Anne, B.A. Hons, S.W.A. (1988); artist in pencil, etching, oil and water-colour. *b:* London, 17 Jun 1943. *d of:* Alfred Hobson, F.R.C.S. *m:* Malcolm Mountford, B.A.(Oxon.). two *s. Educ:* Montessori, Wimbledon. *Studied:* Byam Shaw School of Art (1960-62, Peter Greenham, Bernard Dunstan), St. Martin's School of Art (1963), University of Brighton (B.A. Hons. History of Design, 1998). *Exhib:* R.A., R.B.A., R.M.S., S.W.A., N.S.P.S., C.D.S.; one-man shows: Japan (1986, 1988), Lyric Theatre, Hammersmith (1990), Cambridge (1988); group shows: Cambridge, Ely, Saffron Walden, Salisbury, London, Sussex, etc., Brighton Festival, Sussex Open. *Works in collections:* Addenbrookes Hospital Trust. *Commissions:* various. *Signs work:* "Derylie Mountford" (etchings), "D. Mountford" (paintings). *Address:* 3 Belle Vue Gdns., Brighton, Sussex BN2 2AA. *Email:* derrymountford@hotmail.com

MOWAT, Jane Catherine, B.A. (Hons.) History of Art, P.G.C.E. (Art); artist/printmaker in woodcuts. *b:* Stamford, Lincs., 5 Apr 1956. one *s.* one *d. Studied:* Courtauld Inst. of Art - Art History (1975-78, Anita Brookner, George Zarnecki). *Exhib:* many Open Exhbns. in South West, including RWEA and Spike Island in Bristol, Royal Academy, Curwen Gallery, Air Gallery, National Print at

Mall Galleries in London. *Commissions:* Screen for Russell-Cotes Museum, Bournemouth; carving for Hestercombe Gardens (National Trust), Taunton, Somerset; prints for Musgrove Park Hospital, Taunton. *Publications:* illustrated: You and Your Child's Behaviour (Birmingham and Redditch Health Authority, 1984). *Clubs:* Somerset Printmakers, Hurstone Studios, Swiss Artists UK. *Signs work:* "Jane Mowat." *Address:* 5 Palmerston Rd., Taunton Somerset TA1 1ES. *Email:* janemowat@eclipse.co.uk

MOXLEY, Ann Barbara, (nee Scampton); RWA, FRIBA; chartered architect. *Medium:* pen and ink, watercolours, oils. *b:* Shanghai, 2 Feb 1933. *m:* Ray Moxley. three *d. Studied:* Royal West of England Academy School of Architecture. *Exhib:* annual exhibits at RWA Bristol. *Works in collections:* mainly private. *Signs work:* "ANN SCAMPTON","A.S." or "A. Scampton." *Address:* March House, Cargreen, Cornwall, PL12 6PA.

MOXLEY, Ray, F.R.I.B.A., R.W.A., Hon. F.(W.Eng.). *b:* 28 Jun 1923. *s of:* Rev. H.R. Moxley. *m:* Ann. one *s.* two *d. Educ:* Caterham. *Studied:* architecture: Oxford (1940-42 and 1946-49). *Exhib:* R.W.A. annual 1960 onwards, A.C.A. Salons at the Royal Academy (1982, 1984, 1986). *Commissions:* architect of Chelsea Harbour and Excel Exhibition Centre, London; Vice-president R.I.B.A. (1971-74), Chairman A.C.A. (1974-76). *Publications:* Building Construction (Batsford), Fee Negotiations (A.P.), Architects Eye (G.P.C.), Building Management by Professionals (Butterworth). *Recreations:* sailing. *Clubs:* Royal West of England Yacht Club, Cargreen Yacht Club Cornwall, RIBA, ACA, WCCA. *Signs work:* "Ray Moxley." *Address:* 10 The Belvedere, Chelsea Harbour, London SW10 0XA.

MOXLEY, Susan, Diploma in Fine Art, Postgraduate Printmaking. *Medium:* oil, drawing, prints and stained glass. *b:* South Africa, 17 May 1955. *d of:* Peter Moxley. *m:* Korky Paul. one *s.* one *d. Educ:* matriculation. *Studied:* Durban School of Art, South Africa (1974-77); Croydon College of Art (1978-79). *Exhib:* mixed and private, Print Show Barbican, Mall Galleries, Affordable Art Fair. *Commissions:* Stained glass panel for Reading Museum of Rural Life, SSI Philip & James School Oxford. *Official Purchasers:* Art in Hospitals, Foreign Office. *Signs work:* "Susan Moxley". *Address:* 43 Oakthorpe Road, Summertown, Oxford, OX2 7BD. *Website:* www.susanmoxley.co.uk

MUIR, Jane, artist, in mosaic, etching and water-colour. *b:* 11 Apr 1929. *d of:* H. Pinches, M.D. *m:* A. W. E. Muir. two *s. Educ:* Rye St. Antony School. *Studied:* Oxford University, Teesside College of Art. M.A. Oxon (1950), Dip. Architectural Decoration (1969), F.C.S.D. (1974). *Exhib:* numerous. Founder Mem. International Assoc. of Contemporary Mosaic Artists, U.K. exhibitor Ravenna (1980), Trier (1984), Louvain (1986), Tokyo (1994), Alexandria (1996), Exeter (1999), Touring Anglo-Italian Mosaic Exhbn. (2000). Patron, British Assoc. for Modern Mosaic, 'Sounding Image', Buckinghamshire Art Gallery (2003); 'Soundings', St.Anne's College Oxford (2005). *Works in collections:*

Public: Oxon County Museum, Buckinghamshire County Museum, Glynn Vivian A.G., Open University, St. Anne's College, Oxford; Ruskin Gallery, Sheffield; Corning Museum, U.S.A. Major Commissions: St. Anne's College Oxford; Open University; Princes Sq., Glasgow; Longmarket, Canterbury; Becket's Well, Northampton; Doha, Arabian Gulf. *Commissions:* numerous. *Publications:* videos: 'Mosaic as Art', 'New Directions in Mosaic'. *Clubs:* Art Workers' Guild; Guild of St.George. *Signs work:* "Muir." *Address:* Butcher's Orchard, Weston Turville, Aylesbury, Bucks. HP22 5RL. *Website:* www.artworkersguild.org

MUIRDEN, Philip, David Murray Student, NDD, ATD; Lecturer, Mansfield College of Art (1965-72), Senior lecturer, Newport College of Art (1975-);. *b:* Milford Haven, 23 Oct 1932. one *s. Educ:* Haverfordwest Grammar School. *Studied:* Cardiff College of Art, Cardiff University. *Represented by:* Agents: Janet Martin, GPF Gallery, Newport, Gwent; www.seapicturesgallery.com. *Exhib:* RA (5 yrs.), Sunday Times Water-colour of the Year (3 yrs.), Hunting Group - Britain in Water-colour; one-man shows include Newport Gallery (2); Welsh Drawing Biennale (2). *Works in collections:* Arts Council of Wales, Contemporary Art Soc., Mold Council, Newport Museum, Newport Council S.Glam., International Drawing Biennale 1999, one man show Newport, Gwent 2003. *Publications:* Poems; TV BBC Wales, and Swap Shop National BBC; articles for Art News and Review; films: River Patrol S4C 2000, 30 minute film Nigerian TV 2003. *Clubs:* The Welsh Group. *Signs work:* "PHILIP MUIRDEN" or "MUIRDEN." *Address:* 6 Lower Hill St., Hakin, Milford Haven SA73 3LP.

MULCAHY, Bruce, Associate, Royal Society of Marine Artists (2005); BA (Hons) Fine Art; Hamer Award (1991); Sykes Award (1995, 1997, 2000); Laing Competition Guests Award (1995, 1997); Calder Graphics Prize (2003). *Medium:* painter in gouache, oil, acrylic and watercolour. *b:* Dewsbury, 1955. *Educ:* Wheelwright Grammar School, Dewsbury. *Studied:* University of Newcastle-upon-Tyne (1974-78) Fine Art (Prof. Kenneth Rowntree). *Represented by:* Pybus Fine Arts, Whitby; Top Pictures, Hull. *Exhib:* Mall Galleries, London; Singer and Friedlander/Sunday Times Watercolour Competition; Manchester Academy of Fine Arts; many group and one-man shows in UK. *Works in collections:* work in many private collections in UK and fourteen other countries to date. *Clubs:* Fylingdales Group of Artists; Huddersfield Art Society; Dewsbury Art Group. *Misc:* part-time lecturer in Art, Dewsbury College. *Signs work:* 'B. MULCAHY' (and date). *Address:* 44 Barber Walk, Eightlands, Dewsbury, W Yorks, WF13 2PN.

MULES, Joanna Mary, B.Ed. (1977), A.R.U.A. (1990). *Medium:* pencil, pastel, printmaking, water-colour. *b:* Hants., 4 Sep 1949. *m:* Marcus Patton. three *s. Educ:* Elmhurst Ballet School, Camberley, Surrey (1957-63), Londonderry High School (1963-66). *Studied:* Belfast College of Art and Design (1966-68); Stranmillis College of Education, Belfast (1973-77). *Exhib:* Bell Gallery, Arts Club, Queen's University Common Room, Belfast. *Works in collections:* D.O.E., but mainly private collections. *Commissions:* National Self-portrait Collection,

Limerick, portraits, landscapes. *Publications:* covers for Gape Row, Night of the Big Wind (1st and 2nd Edition). *Works Reproduced:* RUA catalogues; History of RUA. *Recreations:* singing in opera, reading, gardening. *Clubs:* R.U.A. *Address:* Ingledene, Sans Souci Park, Belfast BT9 5QZ. *Email:* joanna.patton@virgin.net

MULLEN, Kay, S.W.A. (1993), S.B.A. (1995), A.R.M.S. (1998); self taught painter in water-colour gouache, pastel and mixed media; Winner of Alexander Gallery Award, S.W.A. (1999). *b:* Mottingham, Kent, 3 Sep 1959. one *d. Educ:* Nonsuch High School for Girls, Cheam, Surrey. *Studied:* City and Guilds, - teaching of adults in further education. *Exhib:* S.W.A., S.B.A. and R.M.S. at Westminster Central Halls, many mixed exhbns. *Commissions:* numerous for private collections. *Works Reproduced:* Medici, The Paper House Group and Quatro Publishing. *Signs work:* 'K.Mullen'. *Address:* 1b Parkhurst, Epsom, Surrey KT19 8QZ.

MULLETT, Vivien, A.R.M.S. (1992), H.S. (1990), B.A. Fine Art (1974); artist in water-colour, graphic designer;. *b:* Oxford, 1952. *Educ:* Milham Ford School, Oxford. *Studied:* Reading University (1970-74). *Exhib:* R.A. Summer Show, R.M.S., H.S., M.A.S.-F. *Publications:* illustrated The Night Watchman - collection of stories. *Signs work:* "VM." *Address:* 111 Penwith Rd., Earlsfield, London SW18 4PY.

MULLINGS, Pam, freelance artist of British wildlife in gouache;. *b:* Littlehampton, 18 Jan., 1940. *m:* Maurice. one *s.* one *d. Exhib:* London and West Country. *Clubs:* H.S., A.R.M.S. *Signs work:* "Pam Mullings." *Address:* 'Rough Close', 13 Park Lane, Seend Cleeve, Melksham SN12 6PT.

MULLINS, Edwin Brandt, B.A., M.A. (Hons.) Oxford University (1957); writer and film-maker, mainly on art subjects. *b:* London, 1933. *s of:* Claud Mullins. *m:* Gillian Brydone (d. 1982). one s. two d.; Anne Kelleher (1984). one *s.* two *d. Educ:* Midhurst Grammar School and Oxford University. *Publications:* numerous books and over 200 television films. *Address:* 25 The Crescent, Barnes, London SW13 0NN.

MULROY, Alison, ASWA, SWA Committe Member; Winsor & Newton Young Artist Award (SWA, 2006). *Medium:* oil on canvas. *b:* Aylesbury, Bucks, 23 Oct 1978. *Studied:* self taught. *Exhib:* Mall Galleries. *Signs work:* 'A J Mulroy'. *Address:* Flat 4, 145A Balham Hill, London SW12 9LD. *Email:* alison_mulroy@yahoo.co.uk *Website:* www.alisonmulroy.com

MUMBERSON, Stephen Leonard, R.E. (1995), M.A. (1981), B.A. (Hons.) (1977); Reader in Fine Art Printmaking; Grand Prize Winner International Cartoon Contest China (2005); Special Prize Winner Bird 05 China. *Medium:* printer/ painter/ sculptor. *b:* Beaconsfield, 16 Feb 1955. *Educ:* Secondary Modern School, Bucks. *Studied:* Brighton Polytechnic (1977-78), R.C.A. (1978-81, Prof. Grant, Prof.Chris. Orr), Cité des Arts, Paris (1980). *Exhib:* R.E., Bankside London, Art Now London, P.M.C. *Works in collections:* V. & A., U.S.A., Japan,

S.America, Europe, Canada, Zambia, Zimbabwe. *Recreations:* travel. *Signs work:* "Stephen Mumberson" or "S. Mumberson." *Address:* APVC-School of Arts, Middlesex University, Cat Hill, Barnet, Herts. BN4 8HT. *Email:* s.mumberson@mdx.ac.uk

MUNDY, William Percy, R.M.S., M.A.A., M.A.S.F., H.S.; self taught artist in water-colour and oil, miniaturist, portrait and Trompe l'oeil painter; Awarded "Exhibit of the Year" at 1980 and 1982 R.A. Summer Exhbns; Silver medal, Paris Salon (1982); Gold Memorial Bowl, R.M.S. (1986); Bell Award (1987); Best of Show M.A.S.F. (U.S.A.) (1997); Bell Award (1996, 2000); Best of Show H.S. (2001); Best Portrait MASF (USA)(2004). *b:* Wokingham, 30 Oct 1936. *s of:* P. W. Mundy. *Educ:* Forest School, Berks. *Exhib:* R.A., R.M.S., R.P. *Works in collections:* H.M. The Queen; H.R.H. The Duke of Edinburgh; H.M. King Bhumipol Aduladej of Thailand; The Yang di Pertuan Agong of Malaysia; H.R.H. The Sultan of Johor; H.R.H. The Sultan of Oman; V. & A., London; Cincinatti Museum of Art, U.S.A. *Publications:* 'Portrait Miniatures'. *Recreations:* boating, photography. *Clubs:* Tanglin, Singapore; Phyllis Court, Henley. *Signs work:* "W. P. Mundy." *Address:* 2 Marsh Mills, Wargrave Rd., Henley-on-Thames, Oxon. RG9 3JD. *Email:* WPMundy@aol.com *Website:* www.billmundy.co.uk

MUNSLOW, Angela E., H.N.C., Grad.R.I.C., B.Ed.Hons.; sculptor in bronze, resin, terracotta, ceramic, cement and plaster, glass; figurative painter in oil, water-colour and pastel. *b:* Sandbach, Ches. *m:* Peter. two *s. Educ:* Ravenscroft Hall School, Cheshire; N.Staffs. Polytechnic (now Staffs. University); Crewe and Alsager C.H.E. (now Manchester University). *Studied:* sculpture: Sir Henry Doulton School of Sculpture. *Exhib:* Expo '92 Seville; group shows: St. Martin in the Fields, Mall Galleries, Westminster Gallery, and galleries in the North-West and Midland regions. *Works in collections:* Royal Doulton Museum, Stoke-on-Trent, Stapeley Water Gdns., Nantwich Ches., The Gallery; private collections. *Commissions:* 'Harmony' (Stapeley Water Gdns.); 'Heredities'; Garden Sculpture - a series of fairies (Tile House Statuettes). Private commissions. *Clubs:* S.W.A., Soc. of Staffordshire Artists. *Signs work:* "A.E. Munslow". *Address:* Mayfield Studio, 65 Station Rd., Alsager, Stoke-on-Trent ST7 2PD.

MURISON, Neil, A.T.D. (1951), R.W.A. (1979); painter in oil and acrylic; Head, Dept. of Foundation Studies, Bristol Polytechnic (1961-87); previously art master, Queen Elizabeth's Hospital, Bristol (1952-61). *b:* Bath, 10 Oct 1930. *s of:* William Murison, M.P.S., Ph.C. *m:* (1) Valerie Elizabeth John. one s. one d.; (2) Sheila May Tilling (1985). *Educ:* Bristol Grammar School. *Studied:* West of England College of Art (1946-51). *Works in collections:* Nuffield, Wills Tobacco Co., Bank of America, Skopje Modern Art Museum, Yugoslavia, Trumans Breweries, Bridgwater Public Library, Bristol, Devon, Leeds, Herts., Hull, Leics., Liverpool, Surrey and West Riding of Yorks, Educ. Authorities, The Fleming Collection. *Clubs:* Bath Society of Artists; Preisdent, Clevedon Arts Club. *Signs work:* "Murison." *Address:* The Grange, 53 High Street, Wick, S.Glos BS30 5QQ.

MURPHY, Richard, B.A. (Hons.), Dip.Arch., F.R.S.A., F.R.I.A.S., A.R.S.A., R.I.B.A.; architect; recipient of 14 R.I.B.A. awards. *b:* Cheshire, 24 Apr 1955. *Educ:* Newcastle and Edinburgh Universities. *Commissions:* Fruitmarket Gallery; Dundee Contemporary Arts; Stirling Tolbooth Arts Centre; John Muir Visitor Centre, Dunbar; The Eastgate Theatre, Peerles; Galeri Enterprise Centre, Caernarfon; New Medical Centre, The University of East London. *Publications:* The Works of Richard Murphy Architects (1977), two books on Carlo Scarpa; Richard Murphy Architects - Ten Years of Practice. *Signs work:* "Richard Murphy." *Address:* Richard Murphy Architects Ltd. The Breakfast Mission, 15 Old Fishmarket Close, Edinburgh EH1 1RW. *Email:* mail@richardmurphyarchitects.com *Website:* www.richardmurphyarchitects.com

MURRAY, Dawson Robertson, DA (1965); Post-grad (1966); RSW (1988); RGI (1995); Head of Art and Design, Boclair Academy (1976-94); President, Glasgow Group of Artists (1990-94); Vice President, RSW (1993-96); painter in water-colour, acrylic, etching; atmospheric abstractions of garden themes. *b:* Glasgow, 25 Jun 1944. *s of:* Dawson Murray, engineer and gardener. *m:* Liz Murray. two *d. Studied:* Glasgow School of Art (1961-66), L'Accademia delle Belle Arti, Venice (1966). *Exhib:* Solo shows: 1999 Roger Billcliffe Gallery, Glasgow; 1997 Nancy Smillie Gallery, Glasgow; 1990 Richard Demarco Gallery, Edinburgh, 2006 Pittenweem Festival, Invited Artist. Group shows: 2007 Scottish Printmaking, Glasgow Print Studio, 2005/6 Mini Print International tour, 2003 Sanctuary/Amnesty, Gallery of Modern Art, Glasgow; 2002 "Beyond Conflict", European Parliament, Brussels: 2000 "Beuys in Scotland", Matthew Gallery, Edinburgh School of Architecture; 1999 Maritime Museum, Vittoria, Malta; 1998 Lord Provost's Prize, Gallery of Modern Art, Glasgow; 1994 Encuentro Acuarela, Santa Cruz, Canaries. *Works in collections:* McManus Galleries Dundee; BBC Scotland; SAC. *Commissions:* Buchanan Galleries, Glasgow. *Signs work:* "Dawson Murray." *Address:* The Old Post Office, Kilmany, Cupar, Fife KY15 4PT.

MURRAY, Donald, BA, DA; artist and designer in calligraphy, water-colour and pastel; Head of Art, Robert Gordon's College, Aberdeen. *b:* Edinburgh, 1940. *m:* Mary F. Low. two *s. Educ:* George Heriot's School, Edinburgh. *Studied:* Edinburgh College of Art (1958-63). *Exhib:* R.S.W., S.S.A., Pitlochry Festival Theatre, Aberdeen Artists' Society. *Works in collections:* Edinburgh District Council, Heriot-Watt University, Moray House College of Education, Edinburgh Merchant Company. *Commissions:* Illuminated scrolls and miscellaneous formal calligraphy: Aberdeen City Council; Orkney Islands Council. *Publications:* illustrated Growing up in the Church, Christian Symbols, Ancient and Modern. *Signs work:* "Donald Murray." *Address:* Manorlea, Commerce St., Insch, Aberdeenshire AB52 6JB.

MURRAY, Howard, NDD; Cert RA Schools; RA Bronze Medal; David Murray Prizes. *Medium:* oil, sculpture. *b:* London, 23 Mar 1937. *m:* Gillian Mary. two *s. Educ:* Academic Art School; Walthamstow School of Art. *Studied:* RA

Schools. *Exhib:* RA; Burlington Fine Art Gallery. *Recreations:* photography. *Clubs:* The East India Club; The Thunderers Dining Club. *Misc:* worked extensively in theatre and film; Founder Member of the Props and Sets company MDM. *Address:* 11 The Crescent, Independent Place, London E8 2HE. *Email:* howardmurraydalston.m@ukonline.co.uk

MURRAY, Liz, D.A. (1965), S.S.A. (1991), R.S.W. (1992); painter in mixed media - collage including stitched and moulded paper;. *b:* Aberdeen, 21 May 1943. *m:* Dawson Murray. two *d. Studied:* Duncan of Jordanstone College of Art, Dundee (1961-65). *Exhib:* regularly at R.S.A., R.S.W., S.S.A., R.G.I., S.A.A.C.; work featured in many touring exhbns. in Scotland, and selected for group exhbns. in Italy, Poland, Germany, Bosnia and Canaries. *Works in collections:* Scottish Arts Council, Renfrewshire Educ. Authority, Lanarkshire Educ. Authority, Hamilton District Libraries, City Art Space, plc., Angus Council. *Signs work:* "Eliz Murray." or "E.M." *Address:* The Old Post Office, Kilmany, Cupar, Fife, KY15 4PT. *Email:* liz@kilmany.plus.com

MUSGRAVE, Barbara, NDD; sculptress specialising in portraiture and animals; painter in oil. *b:* London 1937. *d of:* Reginald Taylor, solicitor. *m:* Peter Musgrave. one *s.* two *d. Educ:* Maltman's Green, Gerrards Cross. *Studied:* Regent St. Polytechnic (1955-59) under Mr. Deeley. *Exhib:* Harrow Art Soc., Mall Galleries, Compass Theatre, Ickenham, Smiths Covent Garden, Cow Byre Ruislip. *Signs work:* "B. Musgrave" or "B.M." *Address:* 25 Bury Street, Ruislip, Middx. HA4 7SX.

MUSGRAVE, Olivia Mirabel, BA in Sculpture. *Medium:* bronze sculpture. *b:* Dublin, 30 Nov 1958. *d of:* Richard and Lady Musgrave. *m:* John Gardiner. *Educ:* Newtown School, Waterford, Ireland. *Studied:* City and Guilds of London Art School. *Represented by:* John Martin of London, 38 Albemarle St., London W1X 3FB; Jorgensen Fine Art, 29 Molesworth Street, Dublin 2; Everard Read Gallery, 6 Jellicoe Ave, Rosebank, Johannesburg, S.Africa. *Exhib:* Royal Academy, (1992, 94), Royal Hibernian Academy, Dublin (1997, 02), Discerning Eye, Mall Galleries (1989, 2002), John Martin of London, Christopher Hull Gallery, Jorgensen Fine Art Dublin. *Works in collections:* Boots plc, The National Bank of Greece, The National Self-Portrait Collection of Ireland, Oxford University, Irish Guide Dogs for the Blind. *Commissions:* Oxford University, Irish Guide Dogs, Boots plc. *Principal Works:* Life-size Ox for Oxford University; life-size figure and dog for Irish Guide Dogs. *Recreations:* antique collecting, tapestry. *Clubs:* Chelsea Arts Club. *Signs work:* Musgrave. *Address:* Flat 1, 163 Sussex Gardens, London W2 2RH. *Email:* olivia@oliviamusgrave.com *Website:* www.jmlondon.com

MUSGRAVE, Sally Ann, Dip AD Fine Art; Slade Higher Dip. in Fine Art; Arts Council Award; Boise travelling scholarship. *Medium:* oil, drawing, prints, objects (gesso wood). *b:* Hampstead, London, 1959. *Studied:* Central School of Art; Slade School of Art; University of London. *Represented by:* Kapil Jariwala

Gallery, New Burlington St., London W1. *Exhib:* RA Summer Show (2004); 'Modern Tantra', New Burlington Street; 'British Abstract Art' LA, USA; Flowers West; Flowers Central. *Works in collections:* private and public. *Publications:* catalogue; 'Surface' by Stephen Bann. *Signs work:* 'Sally Musgrave'. *Address:* 12a Approach Road, London E2 9LY. *Website:* www.kapiljariwalagallery.co.uk

MUSKER, Alison Awdry Chalmers, Royal Watercolour Society (2000, elected Council Member 2006), Chelsea Art Society (1980), Small Paintings Group (2000); Agnes Reeve Award (1989 & 1991); won the William-Powlett prize; award International Watercolour Biennale, Mexico. *Medium:* watercolour and gouache. *b:* Southampton, 9 Sep 1938. *d of:* Sophie Alexandra James. *m:* Roger. one *s.* two *d. Educ:* Sherborne. *Studied:* in Paris, under Jacqueline Groag and Edward Wesson. *Exhib:* solo exhbns. include: Richmond Gallery in Cork Street, King Street Gallery, St.James's, Brotherton Gallery, Walton Street and Royal Geographical Soc., London; group exhibs. RA, RWS, RI, NEAC, Singer and Friedlander. *Works in collections:* The Late Elizabeth, Queen Mother; H.R.H. The Prince of Wales, Peter Boizot, Martin Vandersteen and others. Collections abroad. *Publications:* Artist's Manual (Collins); Creative Watercolour Techniques (Collins); Light and Color Techniques in Watercolour (North Light Books, Ohio); The Watercolour Expert / Watercolour Masters(Cassell). *Works Reproduced:* 'Music In Country Churches' charity. *Signs work:* "A.C.Musker." *Address:* Rose Cottage, Beech Hill, Reading RG7 2AZ.

MUSZYNSKI, Leszek Tadeusz, DA (Edin.); artist in oil, pastel, water-colour, drawing, lithograph; Retd. Head of Painting School, West Surrey College of Art and Design. *b:* Poland, 19 Apr 1923. *s of:* Alexander Muszynski. *m:* Patricia. one *s. Educ:* in Poland. *Studied:* Edinburgh College of Art (W. Gillies, J. Maxwell, W. MacTaggart); Travelling Scholarship to Paris, Florence, Arezzo, Assisi. *Exhib:* R.S.A. Edinburgh; one-man shows: London, Edinburgh, Copenhagen, Basle, Dallas, Texas, Warsaw, Cracow, Poznan. *Works in collections:* V. & A., N.P.G., L.C.C., National Museum, Poland, Museum of Art, Dallas, Texas, Museum, Durban, S. Africa. *Address:* West Wing, Bramshott Ct., Liphook GU30 7RG.

MYERS, Bernard, NDD (1951), ARCA (1954), Hon.FRCA, Hon. Prof. RCA.; painter in oil, water-colour, oil pastel, printmaker; taught at various London art schools and RCA; Visiting Prof., Indian Inst. of Technology, New Delhi (1968-72), Prof., Brunel University (1980-85). *b:* London, 22 Apr 1925. *s of:* D.N. Myers. *m:* Pamela Blanche Fildes. *Studied:* St. Martin's (1947-49), Camberwell School of Art (1949-51), R.C.A. (1951-54). *Signs work:* "B. Myers", "B.M." or "MYERS". *Address:* 5 St. Peter's Wharf, Hammersmith Terr., London W6 9UD.

MYERS, Chris, RBA; BA (DipAD Hons). *Medium:* watercolour. *b:* London, 5 Oct 1949. *m:* Lynda Jane Myers. two *s.* one *d. Educ:* William Morris School, Walthamstow. *Studied:* Maidstone College of Art. *Exhib:* RI, RWS, RBA, Kent

Painters Group, Singer & Friedlander/Sunday Times Competition; Gascoigne Gallery (Harrogate), Curwen Gallery, Goodwood Revival/Festival of Speed. *Publications:* feature articles in 'The Artist' (June 2004); 'Octane' (Dec 2005); Classic and Sports Car (Oct 2004). *Recreations:* music/ guitar. *Clubs:* Royal Society of British Artists. *Signs work:* "CHRIS MYERS". *Address:* Woodside Cottage, Wadhurst Road, Frant, Tunbridge Wells, TN3 9EH. *Email:* chris.Frant@virgin.net *Website:* www.chrismyersart.com

MYERS, Mark Richard, B.A.(Hons.), R.S.M.A. (1975), President R.S.M.A. (1993-1998), A.S.M.A. (1978), Fellow, A.S.M.A. (1979); marine artist. *Medium:* watercolours, oils, acrylics, inks, lithography, etching. *b:* San Mateo, Calif., USA, 19 Nov 1945. *s of:* Jackson Sandine Myers, airline pilot. *m:* Peternella Bouquet. one *s.* two *d. Educ:* Pomona College, Calif. *Exhib:* R.S.M.A., A.S.M.A., New York, London, Seattle. *Works in collections:* National Maritime Museum, Greenwich, San Francisco Maritime Museum, N. Devon Maritime Museum. *Publications:* various maritime books illustrated. *Signs work:* "Mark Myers," "Mark Richard Myers" or "Myers." *Address:* The Old Forge, Woolley, Bude, Cornwall EX23 9PP.

MYERSCOUGH, Ishbel, BA, Post Dip. & Distinction; painter in oil. *b:* London, 5 Nov 1968. *m:* Cormac Alexander. *Educ:* Highbury Hill High School, City of London Girls School. *Studied:* Glasgow School of Art (1987-1991), Slade (1993-1995). *Exhib:* three solo exhibs., Anthony Mould Contemporary, London (1992, 1996, 2001), BP Portrait Award, National Portrait Gallery (1990, 1991, 1992, 1993, 1995); various group exhibs. including Flowers East and National Portrait Gallery. *Works in collections:* Natwest Bank, Christies, National Portrait Gallery, MCC. *Commissions:* Helen Mirren for National Portrait Gallery, Graham Gooch for MCC, private and public paintings and portraits. *Publications:* catalogues for solo exhibs., 'British Sporting Heroes', National Portrait Gallery, 'British Figurative Art Part 1', Flowers East, 'Die Kraft Der Builder', Berlin, 'Treasures from the National Portrait Gallery,' Japan. *Signs work:* "I M" or "I Myerscough" on verso. *Address:* 81B St. Peter's St., London N1 8JR.

MYERSON, Ingrid, B.A., M.B.A. (1986), U.A.;. *Medium:* sculptor in bronze, stone, stainless steel, perspex, marble. *b:* 30 Jun 1960. two *s.* one *d. Studied:* University of Witwatersrand, Hampstead Institute. *Exhib:* Business Design Centre, Mall Galleries, Westminster Gallery, Expo Geneva, Les Hirondelles Geneva, McHardy Sculpture Gallery, London, Cato Gallery, London, Affordable Art Fair, Phillips Ltd, London. *Commissions:* private and business: England, Switzerland, S. Africa, U.S.A., Australia. *Clubs:* U.A. *Signs work:* "IMyerson". *Address:* 22 Maresfield Gardens, Hampstead, London NW3 5SX. *Email:* ingrid@ingridmyerson.com

MYLES, Noel, Artist in Residence for ITN (1995/6),Shaftesbury PLC (1995), Rowe & Mann (1994); 1984 London Group Prizewinner; 1987 National Museum Photography Film & TV Prizewinner; 2007 Discerning Eye Prizewinner.

Medium: fine photography; platinum printing. *b:* London, 19 Oct 1947. *Studied:* Hornsey and Walthamstow Schools of Art (1966-70). *Represented by:* Chappel Galleries; Art Contact; Byard Art. *Exhib:* RA Summer Exhbn (1989, 90, 92, 93, 99, 2000, 01, 03); Contemporary Art Society (2002, 03); Inside Space (2002, 03); Discerning Eye (2007); Royal Photographic Society (1995-6), and extensively in Europe, UK and Japan. Selected solo exhbns: NPG (1986); The Gallery in Cork Street (1995); Gainsborough's House (1999), L'Oeil Ecoute, Limoges (1995,1999); Zelda Cheatle Gallery (2001); Stephanie Hoppen Gallery (2003);. *Works in collections:* Stonehart Publications; Contemporary Arts Society; Sir William Halcrow & Ptnrs; Paintings in Hospitals; Dept. of the Environment; National Westminster Bank; Paintings in Churches; V&A (etching, cyanotype); Rank Xerox; Camden Council; St.Thomas' Hospital; MORI; Rowe & Maw; Bradstocks; L'Oeil Ecoute, Limoges; Fondation D'Art Contemporain du Limousin; V&A; Platinum Printa; Roche Pharmaceuticals; Coutts Bank; Bostick & Sullivan. *Commissions:* NPG (1986); MORI (1987); Rowe & Maw (1988/9, 1994); Shaftesbury Plc (1995); ITN (1995, 96); Nationale Woningraad, Netherlands (1997-8), Roche Pharmaceuticals (2007),etc. *Official Purchasers:* Contemporary Art Soc.; V&A (2); Fondation D'Art Contemporain, Limousin; Dept. of Environment. *Works Reproduced:* reviews: Sing Tao Daily; The Observer (full page colour); Daily Telegraph; Daily Express; Evening Standard; British Journal of Photography; Amateur Photographer (5 page feature); Artists & Illustrators; Creative Review; Independent on Sunday (double page colour); The Times; Boardroom; The Lawyer; Siyu Times (front cover Feb.1996, feature Mar 1996); Foto, Germany. *Address:* 51 Newton Croft, Sudbury, CO10 2RW. *Email:* noelmylesphoto@hotmail.co.uk

MYLIUS (MASSIE), (Frances) Jill, Dip Art (Edin, 1959), Teachers Cert (1970), BA Hons (1983); Prize for Painting, GLC 'Spirit of London' (1983). *Medium:* oil, watercolour, drawing, prints, etching. *b:* Coventry, 27 Nov 1938. *d of:* Charles & Ellen Sweetman. *m:* Peter Massie. two *s. Educ:* St.Michael's Convent, Stoneleigh; Croft School, Stratford-on-Avon; Abbotsford School, Kenilworth. *Studied:* Edinburgh College of Art (1955-59), Sidney Webb, London (1968-70), Birkbeck College (1979-83). Etching: Morley College/Central School of Art; Falmouth School of Art. *Exhib:* RA (1975-81); Royal Society of Watercolours, Mall Galleries (2005); Pool on the Park, Southwark (2006); one woman shows: Scottish Art Council, Edinburgh (1975,2004); Dryden St., London (1979), Senior Common Room, Bristol (1982) and many more. *Works in collections:* Fine Art Dept., Seoul National University, South Korea; Scottish Arts Council (etchings); private collections. *Publications:* review of Anish Kapoor's etchings for Camberwell Society magazine. *Works Reproduced:* painting in The Guardian (1993). *Principal Works:* paintings of family and friends, sacred art, own book. *Recreations:* reading, writing, walking, talking, drinking, music, making books. *Clubs:* Birkbeck Poetry Workshop. *Misc:* involved in Birkbeck Poetry workshop, and regularly writes poetry. Previous married name, retained

for art, 'Mylius'. *Signs work:* "Jill Mylius" (Massie). *Address:* 85 Camberwell Grove, London SE5 8JE.

MYNOTT, Gerald P., F.S.S.I.; landscape artist, printmaker and calligrapher. *Medium:* oil, watercolour, pastel. *b:* London, 2 Mar 1957. *s of:* Derek Mynott, R.B.A., N.E.A.C., and Patricia Mynott, artist. *Studied:* Reigate College of Art; College of Arms, London; Vienna Kunstlerhaus, Austria. *Exhib:* Francis Kyle Gallery, London, continuously from 1980, New York (1984), Bath Festival (1983), Arts Club, London (1987)' Lincoln Centre, New York (1991), Hong Kong (1992), National Theatre (2001), 'Discerning Eye' Mall Gallery, London (2002). *Works in collections:* V. & A., Tate Gallery (Curwen Archive), The Savoy Group, Chevening Estate, U.S.A., Tokyo. Lloyds Printmakers Award (1981), King's Foundation, London, St Catherines, Oxford. *Commissions:* Antony Lambton 'The Lunette' Cetinale, Italy, 1989. *Works Reproduced:* in The Times, The Observer, Tatler, Radio Times, Weidenfeld and Nicolson, Penguin Books, V&A Publications, The Field, BBC, OUP. *Clubs:* Arts. *Signs work:* Gerald Mynott. *Address:* 3 Belgrave House, 157 Marine Parade, Brighton, Sussex.

MYNOTT, Katherine S., B.A.; illustrator/printmaker in gouache, line and lino. *b:* London, 1962. *d of:* Derek Mynott, N.E.A.C., and Patricia Mynott, artist. one *s*. *Studied:* Heatherley School of Art, Central School of Art and St. Martin's School of Art. *Works Reproduced:* in Vogue, Radio Times, Daily Telegraph, Tatler, Harpers and Queen, B.B.C., Palace Pictures, Cosmopolitan, Time Out, Over 21, 19, The Observer, The Listener, I.P.C., New Society, Economist, etc. *Signs work:* "K. Mynott." *Address:* 23 Mount Park Rd., London W5.

MYNOTT, Lawrence, MA (RCA), AOI; portrait painter, illustrator in watercolour, oil, line and gouache; lecturer and art writer. *b:* London, 1954. *s of:* Derek Mynott, NEAC, and Patricia Mynott, artist. *Studied:* Chelsea School of Art (1972-76), Royal College of Art (1976-79). *Exhib:* R.A., European Illustrators, Folio Soc., Thames Television; two one-man shows of portraits at Cale Art, Chelsea. *Works in collections:* N.P.G., National Gallery of Wales, Hull A.G., Arts Council. Awarded D. & A.D. silver award (1985). Lecturer at V. & A., 'The Sitwells as Patrons', Neo-Romanticism, The Rococo Revival. *Works Reproduced:* in Radio Times, Vogue, Tatler, Harpers and Queen, The Observer, Penguin Books, Macmillans, Hamish Hamilton, etc. *Clubs:* Chelsea Arts. *Signs work:* "Lawrence Mynott," "Mynott" or monogram "L.M." *Address:* c/o "The Organisation", 69 Caledonian Rd., London N1.

MYNOTT, Patricia, film designer, illustrator and natural history artist working in water-colour, line and gouache;. *b:* London, 30 Apr 1927. *m:* Derek Mynott, N.E.A.C. (d. 1994). two *s*. one *d. Educ:* Dominican Convent, Chingford. *Studied:* S.W. Essex School of Art. Films: National Screen Service, National Savings, Film Producers Guild. *Represented by:* "Images de la Nature" 2003; L. Arnott Gall, Tangier. *Publications:* illustrated, Marine Life of the Caribbean, Guide to the Seashore, Beaches and Beachcombing, Folklore of Fossils, The

Curious Lore of Malta's Fossil Sharks Teeth, Edible Seaweeds; children's books: Encyclopedias, Educational Teaching Alphabet. Publishers: Blackies, Readers Digest, Paul Hamlyn, Michael Joseph, Macdonalds, Pitmans, Sacketts. *Recreations:* Music. *Signs work:* "Patricia Mynott" or "Barton." *Address:* Garden Flat, 130A Marine Parade, Brighton, Sussex BN2 1DE.

N

NAGL, Hazel Anna, R.S.W. (1988), R.G.I. (2000); painter in mixed media of still life and landscape, mainly Scottish gardens. *b:* Glasgow, 2 Nov 1953. *m:* Geoff Keanie. one d. *Educ:* North Kelvinside Senior Secondary School. *Studied:* Glasgow School of Art under Donaldson, Robertson, Shanks. *Exhib:* R.S.W., R.G.I., R.S.A. Thomsons, London, Roger Billcliff; solo exhibs, Open Eye, Stenton, G.A.C. *Works in collections:* Royal Bank of Scotland, Glasgow University, Fleming Collection, Arthur Anderson, Scottish and Newcastle Breweries. *Clubs:* Glasgow Art Club. *Signs work:* "NAGL." *Address:* Lawmarnock House, 2 Troon Drive, Bridge of Weir, Renfrewshire PA11 3HF.

NALECZ, Halima, FFPS; Dip. U.S.B. (Wilno), Dame Chevalier d'Honneur (18 May, 1957); Bronze Medal, Europe prize for painting, Kursaal, Ostend,Belgium (1969, 1971); painter in oils and mixed media; Founder and Director of Drian Galleries, London. *b:* Wilno, Poland, 2 Feb 1917. *d of:* Antoni Kzrywicz-Nowohonski, landowner. *m:* Zygmunt Nalecz, writer. *Educ:* Lycée, Wilno. *Studied:* under Professor Roube, Professor Szyszko-Bohusz, Professor Zahorska, and in Paris under H. J. Closon. *Exhib:* most municipal and public galleries in England, and W.I.A.C., A.I.A., Free Painters and Sculptors, London Group, Salon de Réalités Nouvelle, Galerie Collette Allendy, Salon des Divergences, Galerie Creuze (Paris); one-man exhbns. at Walker Galleries, London (1956), New Vision Centre, London (1957, 1959), Ewan Phillips, London (1967), County Town Gallery, Lewes (1967), Drian Galleries, London (1968-69), R.A. Summer Exhbn. (1967, 1968, 1969), S.S.W.A., Edinburgh. *Works in collections:* Britain, France, Spain, Italy, Germany, Australia, U.S.A., Sweden, Nuffield Foundation, London, National Gallery of Israel, Bezalel, Jerusalem, National Museum in Warsaw, Gdansk, Poznan. *Works Reproduced:* Quadrum, Apollo, Arts Review, Art and Artists, Wiadomosci, Art International, etc.; prefaces to catalogues by Denis Bowen and Pierre Rouve. *Clubs:* A.I.A., W.I.A.C., Hampstead Artists Association, Free Painters and Sculptors, Polish Hearth. *Misc:* Paintings featured in film, The Millionairess. *Address:* 7 Porchester Pl., Marble Arch, London W2 2BT.

NAPP, David, Dip. C.S.D., Elizabeth Greenshields Foundation award (1986, 1990); artist in chalk, pastel, oil and water-colour; sessional lecturer, Kent Inst. of Art and Design;. *b:* London, 5 Mar., 1964. *Educ:* Queen Elizabeth's School, Faversham. *Studied:* Canterbury College of Art (1981-85). *Exhib:* Bourne Gallery, Reigate (1987-), Art London (1989, 1990, 1991), Walker Galleries, R.W.S., R.B.A., P.S., Napier Gallery Jersey. *Publications:* illustrations:

Encyclopaedia of Pastel Techniques (Headline); Colour: How to see it, how to paint it; How to Paint Trees, Flowers and Foliage; Pastels Workshop. *Signs work:* "David Napp" and date. *Address:* Windmill Cottage, Mill La., Barham, Canterbury, Kent CT4 6HH.

NAPPER, Helen, BA (1980), MFA (1983), PGCE (1985); painter in oil on board. *b:* Wivenhoe, 29 Mar 1958. *d of:* Peter Napper. *Educ:* Friends School, Saffron Walden; Colchester County High School for Girls. *Studied:* Colchester Art School, Wimbledon Art School (Maggi Hambling, Colin Cina), Reading University (Adrian Heath, Terry Frost), London University Central School of Art (Norman Ackroyd, Bernard Cheese). *Exhib:* Sue Rankin Gallery (1989-91), L.A. Contemporary Art Fair (1989, 1990), Olympia Art, London (1990, 1991) with Sue Rankin Gallery, Tatistcheff and Co., N.Y. and L.A. (1992, 1993). *Works in collections:* Citicorp Bank, London. *Signs work:* "Helen Napper." *Address:* 5 Castle Hill, Orford, Suffolk.

NASH, David, O.B.E. (2004), R.A. (1999), B.A. (Hons.) Fine Art (1967); artist/sculptor in wood; Hon. Doc. Kingston University; Research Fellow, University of Northumbria;. *b:* Esher, Surrey, 14 Nov 1945. *m:* Claire Langdown. two *s. Studied:* Kingston College of Art Foundation Course (1963-64), Brighton College of Art (1964-65, painting), Kingston College of Art (1965-67, sculpture), Chelsea College of Art (1969-70, post-grad.). *Exhib:* Forest of Dean, Sculpture Trail, Walker Art Centre, Minneapolis, U.S.A., Nagoya City Museum, Japan, Guggenheim Museum, N.Y., Muhka Antwerp, Kröller Müller Museum, Holland. *Works in collections:* Tate Gallery, London, Guggenheim Museum N.Y., British Council. *Commissions:* 'Eighteen Thousand Tides' Eastbourne, public sculpture (1996), 'Divided Oaks' and 'Turning Pines' (planted sculptures) Ottorlo, Netherlands (1985), 'Seven Vessels' Cincinnatti. *Publications:* The Sculpture of David Nash by Julian Andrews; Forms into Time (with essay by Marina Warner); Black and Light (essay by Dr. Judith Collins), 'Pyramids Rise, Spheres Turn, Cubes Stay Still' (essay Ian Barker). *Address:* Capel Rhiw, Blaenau Ffestiniog, Gwynedd LL41 3NT.

NASH, Elizabeth, DipAD, B.Ed. *Medium:* mixed media, textiles, prints. *b:* London, 4 Nov 1947. *d of:* Richard & Joan Nash. *m:* Michael Shearman. *Educ:* St.Michael's Petworth. *Studied:* West Sussex College of Art (1965-66), West of England College of Art (1966-69), Redland College. *Represented by:* The First Gallery, Southampton. *Exhib:* various galleries, incl. Basingstoke, Bath, Bristol, Dorchester, Glasgow, Farnham, Frome, Gloucester, Guernsey, London, Salisbury, Winchester. RWA Autumn Exhbirions, Bristol; National Open Print, London; Society of Wildlife Artists, London; Yewtree 2006 Salisbury. *Works in collections:* Artcare, Salisbury District Hospital. *Commissions:* 'In Praise of Trees' Salisbury Festival 2002 - 2 silk hangings for Cathedral; Newbury Spring Festival 2003 - 14 silk hangings for St.Nicholas Church, Newbury. *Works Reproduced:* 'In Praise of Trees' (2002), Art in Nature, Search Press (1996). *Recreations:* plays flute, member of 'Musica Rustica' ensemble. *Misc:*

Community Art, Silk Paintings and Print Projects for Artcare. Broughton Banners, Millennium Project. Projects for 'The Making' and 'Making Space'. *Signs work:* "ELIZABETH NASH". *Address:* Greystones, Vicarage Road, Tisbury, Wilts, SP3 6HY. *Email:* elizabethnash@mshearman.wanadoo.co.uk *Website:* www.elizabethnash.co.uk

NASH, Tom, ATD, RCA.; artist in oil, PVA, gouache, collage, murals in retroreflective plastics, etc.; awarded Geoffrey Crawshay Memorial Travelling Scholarship; West Wales Association for the Arts, Research Award. *b:* Ammanford, 17 Apr 1931. *s of:* William Nash. *m:* Enid Williams. two *d. Educ:* Llandeilo. *Studied:* Swansea, Paris, Provence. *Exhib:* one-man and mixed exhibitions in London, provinces, Washington, D.C., Argentine, Toronto, Japan. *Works in collections:* National Museum of Wales, Nuffield Foundation, Arts Council, Clare, Churchill, Pembroke Colleges, Cambridge, various county collections, Caerleon College, Glynn Vivian Art Gallery, Swansea, Steel Company of Wales, C.A.S., Caiman Museum, Argentina, Wadham College, Oxford, University of Wales, India Rubber Co., Macco Corp., California, Brasenose College, Oxford, Trinity College, 3M United Kingdom Limited, University of Bradford, Church of Wales Collection, I.T.V., British Petroleum Co., B.B.C., National Library of Wales, Conservetoire Darius Milhaud, Aix en Provence; private collections in Britain, France, Germany, U.S.A., Canada, New Zealand. *Commissions:* 3M U.K. Ltd., B.B.C., University of Bradford, Brecon Jazz Festival, P.T.P. Ltd., S.W. Police Authority, Prestige Hotels, Cardiff Festival, Brasenose College Oxford. *Publications:* I.T.V. biographical films, B.B.C. biographical films, national and international publications, 3M/UK/France publications. *Clubs:* Brecon. *Signs work:* "Tom Nash." *Address:* Clydfan, Llandeilo, Wales SA19 6HY.

NASON, Kristine, SEqA, SWA; painter in water-colour, draughtsman in graphite pencil; portrait painter, equestrian artist, illustrator, tutor. *b:* Matlock, Derbyshire. *d of:* Denis Nason and Anna Oswell-Jones. *m:* L.B.Giwa. one *s.* one *d. Educ:* Basingstoke High School. *Studied:* Portsmouth College of Art and Design. *Exhib:* London, Toronto; Society of Equestrian Artists, SWA, Mall Galleries; and various group exhibs. and galleries throughout U.K. *Works in collections:* private collections worldwide. *Commissions:* U.K. and international clients. *Clubs:* S.A.A. Professional Associate. *Signs work:* "Kristine Nason." *Address:* 1 Savory Walk, Foxley Fields, Binfield, Berks. RG42 4LP. *Email:* kristinenason@btinternet.com *Website:* www.axisweb.org/artist/kristinenason

NEAL, Arthur Richard, Dip.A.D.; painter/printmaker in oil, water-colour and etching;. *b:* Chatham, 15 Mar., 1951. *m:* Jane. one *s.* one *d. Educ:* Reeds School. *Studied:* Camberwell School of Art. *Exhib:* R.A. Summer Shows, Cadogan Contemporary. *Publications:* Illustrated Poems of Edward Thomas. *Clubs:* N.E.A.C. *Signs work:* "ARN" or "ARNEAL" or not at all. *Address:* 32 Duke St., Deal, Kent CT14 6DT.

NEAL, Charles William, B.Sc. Hons. (1980); Contemporary British Impressimist painter. *Medium:* painter in oil. *b:* Carshalton, 27 Nov 1951. *m:* Susan Ann. one *s. Educ:* Highview High School/City of London University. *Studied:* initially private tuition with Malcolm Domingo and Francis Lane-Mason; later self taught to perfect style and technique. *Exhib:* Omell Gallery (1982); R.B.A.: Omell Gallery (1983), Godalming Gallery (1984), Harrods Picture Gallery (1985); annual, national, international exhbns.: Campbell's of London and Astley House Fine Art, Glos., The Jersey Gallery at Osterley Park with the National Trust (1996, 2000); Museum of Garden History, London (1994); The Royal Horticultural Hall in support of the RHS (1998); The River and Rowing Museum (2006); The Museum in Docklands, London (2006). *Works in collections:* one royal and many private and commercial collections both national and international. *Misc:* Gallery affiliation: Campbell's, 1-5 Exhibition Rd, London SW7 2HE; Astley House Fine Art, Moreton-in-Marsh, Glos., GL56 0LL; Wally Findlay Galleries International Inc, Palm Beach, New York. *Signs work:* C. Neal." *Address:* Woodside Cottage, 4 Cotswold Park, Woodmancote, Cirencester, Glos. GL7 7EL.

NEAL, James, A.R.C.A. (1939); artist. *b:* Islington, 18 Jan 1918. *s of:* James Abram Neal. *m:* Doreen Barnes. two *s.* one *d. Educ:* St. John Evangelist. *Studied:* St. Martin's School of Art; R.C.A. *Exhib:* R.A., R.S.A., N.E.A.C., London Group, Redfern Galleries; one-man shows Trafford Gallery, Wildensteins, etc. *Works in collections:* Nottingham A.G., Wakefield A.G., Ferens A.G., Hull, Beverley A.G., Graves A.G., Sheffield, London County Council, Hull Educ. Com., W. Riding Educ. Com., East Riding Educ. Com., Derbyshire Educ. Com., Durham Educ. Com., etc. *Signs work:* "James Neal." *Address:* 205 Victoria Ave., Hull, N. Humberside HU5 3EF.

NEAL, Trevor, self taught artist in all media. *b:* York, 15 Oct 1947. *s of:* Reginald and Anne Neal. *m:* Sharon. one *d. Exhib:* Graves A.G. (1972-75, 1977), White Rose Gallery Bradford (1974), R.A. (1975, 1980, 1981, 1992), Art Centre St. Petersburg, U.S.A. (1980, 1982), Anderson Marsh Galleries St. Petersburg (1983), Ginnel Gallery Manchester (1988), Evander Preston Gallery St. Petersburg (1988, 1989, 1991), S. Yorks. Open Cooper A.G. Barnsley (1989), Ferens A.G., Hull (1995, 1996, 1997), Roy Miles, London (1994, 1995), Art Miami, Florida (1998), Leighton House, London (2001), Not The Turner Prize (2003), Mall Galleries London; Cooper Gallery, Barnsley: Retrospective, 2004. *Works in collections:* U.K., U.S.A., France, Germany, Israel. *Commissions:* U.K., U.S.A., Germany, Italy. *Publications:* "Dreams" (The Bridgewater Book Co., 1996). *Clubs:* Soc. of Tempera Painters. *Address:* Fossdale Towers, 23 Fossdale Rd., Sheffield S7 2DA. *Email:* painter@trevorneal.co.uk *Website:* www.trevorneal.co.uk

NEALE, John, self taught landscape and seascape painter in oil and water-colour;. *b:* 13 Sept., 1944. divorced. two *s.* two *d. Studied:* self taught, but privately helped by Edward Seago. *Exhib:* Omell Galleries, Quantas Galleries,

Frost and Reed, Bristol, John Noott, Broadway, Chime Gallery, N.Y., etc. *Works in collections:* in Europe and U.S.A. *Signs work:* "John Neale." *Address:* Maple Leaf House, 59 Maidenhead Rd., Stratford-on-Avon CV37 6XU.

NEASOM, Norman, R.W.S. (1978), R.B.S.A. (1947), Hon.Stratford-on-Avon S.A.S. (1976); artist in water-colour and gouache; retd. art master; 2 Priddy Awards through the RBSA. *b:* Parish of Tardebigge, 7 Nov 1915. *s of:* Arthur Neasom, farmer. *m:* Jessie Mary (d.1994). two *d. Educ:* Redditch County High. *Studied:* Birmingham College of Art (1931-35, Harold H. Holden, Michael Fletcher, Fleetwood Walker, R.A., W.F. Colley, H. Sands). *Exhib:* R.A. (1970, 1974, 1976), R.W.S., R.B.S.A., Stratford Art Soc., Mall Galleries, Chris Beetles Ltd, Ryder St, St. James, London; two World War Two paintings exhibited in recent WWII Exhibition Birmingham City Art Gallery. *Works in collections:* West Midland Arts Council and various private collections; John Hughes collection at Forde Mill, Redditch. *Official Purchasers:* Birmingham City Art Collection. *Works Reproduced:* articles for Leisure Painter, covers for Reader's Digest, illustrations for many local history books. *Recreations:* sailing. *Clubs:* Redditch Sailing (founder). *Signs work:* "N. NEASOM" and date. *Address:* 95 Bromfield Rd., Redditch, Worcs. B97 4PN.

NEEDHAM, Timothy, BA (Hons); R.a.t.h. Dip AT; various awards. *Medium:* oil, watercolour, drawing, printmaking. *b:* Doncaster, 28 Feb 1961. *s of:* Arther and Joan Needham. *m:* Helen Claire Needham. two *s.* one *d. Studied:* Winchester School of Art (1982); Sheffield University (1986). *Exhib:* RA (2003, 05); various regional, including Adze Gallery, York; New Ashgate Gallery, Farnham. *Works in collections:* various UK and abroad (private). *Recreations:* travel. *Signs work:* 'T.Needham', 'TN', 'Tim Needham'. *Address:* Chadwell, 15 Caistor Road, Barton on Humberside, Lincs. DN18 6AH.

NEILAND, Brendan, R.A. (1992), Dip.A.D. (1966), M.A. (1969), Silver Medal R.C.A. (1969); painter in acrylic on canvas, printmaker in silkscreen, lithography; Prof. of Painting, University of Brighton (1996); Visiting Prof., Loughborough University (1998); Keeper, Royal Academy of Arts (1998), resigned Keepership 2004), ex-RA (2005). *b:* Lichfield, 23 Oct 1941. *m:* Hilary. two *d. Educ:* St. Philip's G.S., B'ham; St. Augustine's Seminary, Ireland. *Studied:* B'ham College of Art (1962-66, William Gear, John Walker, Ivor Abrahams), R.C.A. (1966-69, Carel Weight, Roger de Grey). *Represented by:* Redfern Gallery; Turlej Gallery, Poland. *Exhib:* Angela Flowers Gallery, Fischer Fine Art, Redfern Gallery. *Works in collections:* Tate Gallery, V. & A., British Council, Arts Council. *Commissions:* National Bank of Dubai (1997), Rolls Royce Engines, Pidemco Singapore. *Publications:* "Brendan Neiland on Reflection" (Motivate Publishing, Oct. 1997). *Clubs:* Chelsea Arts. *Misc:* alternative address: Crepe, La Greve sur Mignon, Courcon 17170, France. *Signs work:* "Brendan Neiland" on all prints and paper work; "NEILAND" stencilled onto back of canvas on stretcher. *Address:* 2 Granard Rd., London SW12 8UL. *Email:* neilands@talktalk.net *Website:* www.brendanneiland.com

NEILL, Errol James, LL.B. (Lond.), Paris Salon: Silver Medallist (1980), Gold Medallist (1981); solicitor; artist in oil and pastel. *b:* Doune, Perthshire, 15 Aug 1941. *s of:* James Francis Neill. *m:* Audrey Bradbury. one *s.* two *d. Educ:* Christ Church, Preston. *Exhib:* R.B.A., R.O.I., R.S.M.A., N.E.A.C., U.A., S.E.A., Lancashire Art, Société des Artistes Francais, Paris, Deauville, N.Y., Melbourne, Australia. *Works in collections:* Britain, France, Eire, U.S.A., S. America. *Publications:* Travelling the Turf 1987 to 1992. *Clubs:* Law Soc. Art Group. *Signs work:* "ERROL NEILL." *Address:* Bridge House, 217 Chapel La., New Longton, Preston, Lancs. PR4 4AD.

NEILL, William Andrew Knight, Dip.A.D. (Fine Art) Leeds (1966), A.T.C. Goldsmiths' (1967), S.WL.A. (1990); wildlife and landscape artist in water-colour;. *b:* Middlewich, Ches., 22 Aug., 1943. *Educ:* Sandbach School. *Studied:* Leeds College of Art, Goldsmiths' College. *Exhib:* annually with S.WL.A., Kranenburg & Fowler Fine Arts, Oban, Taigh Chearasbhagh, Lochmaddy. *Works in collections:* Nature in Art, Wallsworth Hall. *Commissions:* Scottish Natural Heritage, and The Western Isles Health Board. *Publications:* illustrations in: British Birds, Scottish Birds, etc.; illustrated, Scottish Wildlife Trust, Discovery Book of Western Isles. *Address:* Rannachan, Askernish, SouthUist., Western Isles HS8 5SY. *Email:* bill_neill@hotmail.com

NELLENS, Roger, painter in oil on canvas. *b:* Liege, Belgium, 11 May 1937. *s of:* Gustave Nellens. one *s.* two *d. Educ:* College St. Michel et St. Louis, Brussels, and London Academy; autodidact. *Works in collections:* Collection de l'Etat Belge; Musée d'Ostende; Collection de la Flandre Occidentale, Bruges; Museum Boymans-van Beuningen, Rotterdam; Musée d'Art et d'Industrie, St. Etienne France; CNAC, Paris; McCrory Corp., N.Y.; Tate Gallery, London; Musée d'Art Moderne, Brussels; The Menil Foundation, Houston; Centre Pompidou, Paris. *Signs work:* on the back. *Address:* Fort St. Pol, Zoutelaan, 280, 8300 Knokke-Heist, Belgium.

NELSON, Kathleen, R.M.S. (1984), H.S.F. (1982); Hon. Men. Gold Memorial Bowl award R.M.S. (1985, 1994), Drummond award R.M.S. (1984), Llewellyn Alexander subject miniature award R.M.S. (1996); Llewellyn Alexander Masters award (1997), Presidents award Hilliard Soc. (1998); wildlife, natural history artist in water-colour and oil;. *b:* Durham City, 12 Mar., 1956. *Educ:* Durham Wearside. *Exhib:* R.M.S., H.S., Medici Gallery, Llewellyn Alexander Gallery; solo shows: Darlington A.G., Durham A.G. *Works in collections:* Darlington A.G., Diploma Collection, R.M.S. *Publications:* chapter with illustrations, The Techniques of Painting Miniatures by S. Burton (B.T. Batsford Ltd., 1995). *Signs work:* "Kathleen Nelson." *Address:* 18 Beverley Gdns., Chester-le-Street, Co. Durham DH3 3NB.

NESBITT, Mark Alexander, MA (Distinction) Visual Communication through Cartooning; Awards: Guardian Cartoon Competition (1985), Botswana Press Trust Award (1990). *Medium:* pen and ink, finished on AppleMac and

delivered by email. *b:* Dublin, Ireland, 1 May 1961. *Studied:* Trinity College Dublin (1980-5), University of Central England (1995-6). *Exhib:* since 1994 at international cartoon festivals and exhibitions in Rathdrum (Ireland), Holland, France, Scotland, Turkey and the UK. *Works in collections:* private and corporate collections. *Commissions:* The Financial Times, The Daily Telegraph, The Press Association, The Times Higher Education Supplement, The Evening Standard, The Irish Times, The Sunday Business Post, and many others. *Publications:* see commissions. *Works Reproduced:* Children's Picture Book 'The Toy That Got Away' ISBN 0 222 77451 5 (2000). *Clubs:* BCA, PCO, PCS, CCGB. *Misc:* works as cartoonist and caricaturist principally for the national press in UK and Ireland. *Signs work:* 'Luke Warm'. *Address:* Greencroft, Hartland, Devon, EX39 6AE. *Email:* lukewarm@autografix.com *Website:* www.autografix.com

NEUENSCHWANDER, James Brody, Ph.D., M.Phil., A.B.; calligrapher, lettering artist, graphic designer;. *b:* Houston, Texas, 8 Sept., 1958. *Educ:* Princeton University, Courtauld Inst. *Studied:* Roehampton Inst. under Ann Camp. *Exhib:* Princeton University Library, Museum of Fine Arts, Houston, Gallerie Comptoir des Ecritures Paris, Torre di Malta, Padua, Vizo Gallery, Brussels. *Works in collections:* Princeton University, Westminster Cathedral. *Publications:* Modern German Calligraphy - Special issue of Letter Exchange Magazine; Letterwork - Creative Letterforms for Graphic Design (Phaidon, London 1993). Collaborated with Director Peter Greenaway on several films, including Prospero's Books, The Baby of Mâcon and The Pillow Book. *Signs work:* "Brody Neuenschwander." *Address:* Spinolarei 2, 8000 Bruges, Belgium.

NEVE, Margaret, painter in oil on wood panels. *b:* Wolverhampton, 29 Mar 1929. *d of:* John Neve, solicitor. *m:* James Sutton. two *s. Educ:* privately. *Studied:* Birmingham College of Art (1946-49), R.A. Schools (1949-55, B. Fleetwood Walker). *Represented by:* Robert Sandelson, 5 Cork Street, London W1S 3NY. *Exhib:* Hamilton Gallery (1967), Marjorie Parr Gallery (1976), Gilbert Parr Gallery (1977, 1979), New Grafton Gallery (1981), Montpelier Studio (1987, 1990, 1994), Montpelier Sandelson Gallery (1998), St.John the Baptist Church, Burford (2001),Robert Sandelson Gallery (2002,2006). *Works in collections:* Birmingham City Art Gallery; private collections in England and abroad. Hull, West Riding, Hertfordshire, Derbyshire & Glamorgan Local Authorities; Pictures for Hospitals Scheme. *Publications:* monograph: Margaret Neve (Montpelier Sandelson, 1998). *Works Reproduced:* Sister Wendy Beckett on Art and The Sacred Rider Books. Images of Earth and Spirit (2003) Resurgence Art Anthology. *Signs work:* "M. Neve." *Address:* 18 Greville Pl., London NW6 5JH.

NEVETZ: see COX, Stephen B.,

NEVIA: see ROGERS, Joseph Shepperd,

NEW, Terry, FRBS (1996); DipAD; MA; RCA; Jack Goldhill Prize for Sculpture, RA (1992, 2002). *Medium:* sculpture, drawing, prints. *b:* Prest, 6 Oct 1945. *s of:* John New. three *d. Studied:* Wimbledon School of Art (1963-65);

Hornsey College of Art (1965-68); RCA (1968-71). *Exhib:* RA Summer Show (1987-05); RWA (2003); RBS(2003); Air Gallery; group shows in Australia, UAE, Italy, France, Switzerland, and across UK; selected solo shows: Serpentine Gallery (1974); Studio Exhbn, Tabernacle Street (1982, 85); Windsor Workshop, London (1996); GEC Building (1998). *Works in collections:* The Art Gallery of Western Australia; Visual Arts Board of Australia; Freemantle AG, W.Australia; Artbank, Australia; Merck, Sharp & Dohme, UK; Sharjah Art Museum. *Commissions:* St.Peter's Hospital, Chertsey; WAIT, Western Australia; Intasun, Bromley; Robert Nabarro, Whitchurch; Day, Leigh and Co., UK; Keith Benham. *Publications:* 'Modern British Sculpture' by Guy Portelli. *Works Reproduced:* 'Germinations II', 'Unfold', 'Nidus', 'Flayed Landscape II', 'Undercurrents II', 'Lunar Manouevres', 'Moya', 'Fetter', 'Spinifex Spectrum'. *Recreations:* gardening, chess, reading, swimming. *Misc:* Head of Sculpture at RA Schools since 1986; Head of Fine Art at RA Schools since 2001. *Address:* 74 Florence Road, Newcross, London SE14 6QL. *Email:* terry.new@royalacademy.org.uk

NEWBERRY, Angela, ARCA; Vogue Talent Contest; Earthwatch Art Fellowship. *Medium:* prints. *b:* Surrey, 17 Oct 1934. three *s.* one *d. Studied:* Kingston/Wimbledon Schools of Art, RCA (1953-57). *Represented by:* Joshua McLelland Print Room, Melbourne; Solander Gallery; Framed Gal. Darwin; *Exhib:* solo: Rebecca Hossack, London; Royal Exchange, Manchester; Valerie Cohen, Sydney; Joshua McLelland, Melbourne; Framed Gallery, Darwin; Print Biennale Ljubljana, Yugoslavia; Bahpa Varna, Bulgaria; group shows: RA, RWA, RSMA; SWLA; National Print Open; Print Fairs, Hamburg, Bremen, USA, London, Paris etc. *Works in collections:* Manchester City Art Gallery; St.Mary's Hospital Collection; MoD; Royal Veterinary College; Gulbenkian Trust; St.Thomas' Hospital. *Commissions:* Sunday Express newspapers; Ian Sinnamon Collection; Scafa Modern Art, NY. *Publications:* Printmaking Today; Australian Artist Magazine; Arts Review; Bridgeman Art Library. *Official Purchasers:* House of Lords; MoD; Customs House, Darwin; Hospitals; Libraries. *Works Reproduced:* Wentworth Wooden Jigsaws; publishers USA/Australia. *Principal Works:* limited edition artist made relief prints on handmade paper from Nepal, India and Japan. *Misc:* international artist, studios England and Australia. *Signs work:* 'Angela Newberry'. *Address:* Old Forge House, 4 Cannon Street, Lydd, Romney Marsh TN29 9AS. *Email:* angela_newberry@yahoo.co.uk *Website:* www.angela-newberry.co.uk

NEWBERRY, John Coverdale, RWS(1995), B.A. Dunelm (1960), M.A.Oxon. (1989); Water-colour Foundation prize RWS.Open (1990); painter of landscapes in water-colour and figure compositions in oil; tutor, Ruskin School of Drawing, Oxford (1963-89);. *b:* Horsham, 8 May 1934. *s of:* G.W.Newberry, MA. *Educ:* Kingswood School, Bath; School of Architecture, Cambridge. *Studied:* King's College, Newcastle upon Tyne (1957-60, Lawrence Gowing, Victor Pasmore). *Exhib:* RWS, OAS, RA, RI, NEAC, Singer & Friedlander, numerous one-man shows mostly in Oxford: Ashmolean (1978), Chris Beetles (1990, 1991), Duncan Campbell (1993, 1994, 1996, 1998, 2001, 2003, 2005,

2007), Christ Church Picture Gallery, Oxford (2002), Sadler Street Gallery, Wells (2007). *Signs work:* "Newberry." *Address:* 2 Churchway Close, Curry Rivel, Langport, Somerset TA10 0ED.

NEWCOMB, Tessa, B.A. (Hons.) Fine Art 1976; painter in oil. *b:* Suffolk, 20 May 1955. *d of:* Mary Newcomb. one *s.* one *d. Studied:* Bath Academy of Art (1973-76), Wimbledon School of Art (1977). *Exhib:* Royal Academy,Crane Kalman, Cadogan Contemporaries, Lena Boyle, Mercury Gallery, London, many regional galleries. *Works in collections:* Bradford Metropolitan Museum, Whitworth Art Gallery, Manchester; The Chelsea & Westminster Hospital Collection; Archant, Norwich. *Commissions:* many commissions for paintings, ceramics and furniture. *Publications:* jacket illustrations for Julia Blackburn's 'Daisy in the Desert' (Secker & Warburg, 1994),and 'The Emperor's Last Island' Minerva Paperback edn., 1994; 'South Facing Slope' by Carla Carlisle (Snakehead Press, 2001); 'Walberswick' by Richard Scott (Art Dictionaries Ltd., 2002); 'Line Dancing' ed. Peter Tolhurst (Black Dog Books, 2003); 'Canns Down Cards - five images; 'What's Cooking' 50 booklets, hand printed styrofoam prints for Aldeburgh Foundation. *Works Reproduced:* Lithographs and etchings made with Curwin Press and Cawfold Gallery. *Clubs:* Small Paintings Group. *Signs work:* "TN" joined. *Address:* Driftwood, Back Rd., Wenhaston, Halesworth, Suffolk IP19 9EB. *Email:* tessanewcomb@hotmail.co.uk

NEWELL, Robert Alan, B.A.Hons. (1977). M.A. (1984), P.G.C.E. Art (1981), PhD (2005); artist in water-colour, oil, drawing, lecturer; Associate lecturer, in Fine Art, Swansea Inst H.E. *b:* 4 Dec 1952. *m:* Eileen Valerie Newell. *Studied:* Wimbledon School of Art (1973-77), University of Reading, School of Educ. (1980-81), Goldsmiths' College (1982-84), Swansea Institute of Higher Education (1999-2005). *Exhib:* R.A. Summer Show, Royal Cambrian Academy, Glynn Vivian A.G., other galleries in Wales, London, Dusseldorf, etc. *Works in collections:* Brecknock Museum and Art Gallery. *Official Purchasers:* Brecknock Museum and Art Gallery. *Address:* Bryneira, Talley Road, Llandeilo Carmarthenshire SA19 7HS.

NEWLAND, Anne, Edwin Abbey Major Scholarship (1938);. *b:* Wilts., 11 Jan., 1913. *Educ:* Byam Shaw Art School (1934-38). *Address:* 4 Vaughan Rd., London SE5 9NZ.

NEWNHAM (CHILES), Annie, NDD; Cert RAS; Alma-Tadema Scholarship; 1st, 2nd, 3rd Armitage Prize; Silver Medal, Bronze Medal (2), Leverhulme Scholarship. *Medium:* illustration, oil, watercolour, drawing, gouache and wax. *b:* London, 23 Jul 1933. *m:* Richard Newnham. one *s. Educ:* Lady Eleanor Holles School, Hampton. *Studied:* Twickenham School of Art; Wimbledon School of Art; RA Schools. *Represented by:* Fosse Galelry, Stow-on-the Wold, Gloucestershire. *Exhib:* RA Summer Exhbn; Royal West of England Academy; CCA Gallery, Oxford. *Works in collections:* Bodleian Library; British Library. *Works Reproduced:* illustrations for Folio Society; private presses.

Recreations: walking, looking. *Clubs:* RASAA; Oxford Art Society. *Signs work:* 'AN', 'Annie Newnham'. *Address:* 2 Railway Court, Eynsham, Witney, Oxon OX29 4NY. *Email:* art@annienewnham.co.uk *Website:* www.annienewnham.co.uk

NEWSOME, Peter Martin, Batchelor of Technology, PhD, ARBS, MSDC; RBA Surdival Memorial Award (2007). *Medium:* sculpture. *b:* Isleworth, Middx, 25 Feb 1943. *s of:* Henry Albert Newsome. *m:* Christine. three *s. Educ:* Little Ealing School; Acton Tech. College (1948-61). *Studied:* Brunel University (1961-5 BTech, 1972-5 PhD); Sutton College Liberal Arts (1970 - present). *Represented by:* Cynthia Corbett Gallery. *Exhib:* Mall Gallery, London; DFN Gallery, New York; International Sculpture Exhibition, Guernsey; RBS, London; Cynthia Corbett Gallery. *Works in collections:* various private collections in UK and USA. *Commissions:* for Hilton Hotels, Peter Gabriel, Leasing Group, Watersheds, Roffey Park. *Publications:* 'Peter Newsome - Sculptures in Glass' (hardcover, 26 pages, pub. 2006). *Principal Works:* "If"; "In Concert Series". *Recreations:* oil painting, dog. *Misc:* since 1993 specialised in constructivist glass sculpture, exploring light and form. *Signs work:* "PETER NEWSOME". *Address:* The Limes, 20A York Road, Cheam, Surrey, SM2 6HH. *Email:* Peter@Newsome.com *Website:* www.peter.newsome.com

NEWSOME, Victor George, artist in egg tempera;. *b:* Leeds, 16 June, 1935. one *s.* one *d. Studied:* Leeds School of Art, British School at Rome. *Exhib:* A. d'Offay, Anne Berthoud, Marlborough Fine Art, Grosvenor Gallery. *Works in collections:* Arts Council, Contemporary Arts Soc., British Council, Ferens Art Gallery, Whitworth Art Gallery. *Address:* 4 Elizabeth Mews, London NW3 4TL.

NEWTON, Joanna Dawson, Dip. in Art (1982); artist in oil on canvas, charcoal drawing. *b:* Oxford, 24 Apr 1958. *d of:* Dr. G. F. Newton. *Educ:* Headington School, Oxford. *Studied:* Byam Shaw School of Art (1979-82, P. Gopal-Chowdhuny, N. Volley). *Exhib:* Whitechapel Open, N.P.G., John Player award, R.A. Summer Exhbn., Picture Brokers Exhbn. *Clubs:* Chelsea Arts. *Signs work:* "Joanna D. Newton." *Address:* 60 St. Dionis Rd., Fulham, London SW6.

NEWTON, William Alexander, sculptor, specialising in lost wax casting in bronze and silver, mainly animals; creator of The Derby Trophies, Epsom (1998-2007). *b:* Alford, Somerset. *m:* Sharon. one *s.* one *d. Represented by:* Jonathan Cooper, Park Walk Gallery. *Exhib:* solo exhibs. at Park Walk Gallery (1995, 1997, 2000), and other group exhibs. *Signs work:* "Newton" or "W. Newton." *Address:* The Rosary, West Hill, Wincanton, Somerset BA9 9BY.

NEWTON-DAVIES, Diana Elizabeth: see WHITESIDE, Diana Elizabeth Hamilton,

NG, Kiow Ngor, Dip.F.A. (1989); artist in painting and printmaking. *b:* Singapore, 6 Apr 1963. *Studied:* Nan Yang Academy of Fine Arts (1986-89),

Slade School of Fine Art (1991-93). *Exhib:* London Group (1992), R.A. Summer Show (1992, 1993). *Address:* 9a Kang Choo Bin Rd., Singapore 1954.

NGUYEN, Tân-Phuoc, Mem. Confédération Internationale des Associations des Experts et du Conseils auprès du Conseil Economique et Social de l'Onu Cidadec.; Président Asia-Africa Museum (fondé en 1961); Président de la Chambre Internationale de Commerce Vietnam-Suisse; art expert on Asiatic archaeology and Africa Art, specialised in the founding of Fine Art Collections and Muséums, historian, writer. *b:* Saigon, S.Vietnam,11 Oct 1932. *s of:* Thierry & Florian Nguyen. *m:* Hélène Gerber. two *s. Educ:* Saigon, S. Vietnam, and Paris. *Studied:* l'Institut Hautes, Etudes Indochinoises, and Ecole du Louvre. *Represented by:* Asia-Africa Museum, 30 Grande Rue, CH-1204-Geneve. Tel: 4122 311 71 90. *Publications:* Archéologie asiatique, Netzuke, La Culture de Ban-Chiang (Siam) 7.000-5.000 ans, Fouilles archéologiques à Ban-Chiang. Conférencier invité à Davos Symposium (from 1985 during 10 years) by W.E.F. *Recreations:* tennis, golf. *Clubs:* Musée d'Ethnographie, Musée des Collections Baur-Duret, Union Internationale des Experts, Croix Rouge Suisse, Intérêt de Genève, Kiwanis International, Président, Asia-Africa Museum (GVA) (1993), Chevalier du Tastevin, Expert membre C.I.D.A.D.E.C., O.N.U., Tennis Club Geneva. *Misc:* President Asia-Africa Museum: expose en permanence ses collections d'antiquites selectionees de grande qualite, 30 Grand Rue, CH-1204-Geneve. Tel:4122 311 71 90, Fax: 4122 735 89 04. *Address:* 30 Grand Rue, Genève 1204, Switzerland.

NICE, Derek Vernon, NDD Painting and Ceramics; ATD Teacher Training; Postgraduate Design. *Medium:* oil, sculpture. *b:* London, 25 May 1933. *s of:* Emily & Robert Nice. *m:* Mary Nice. one *s.* one *d. Educ:* Municipal College, Southend, Essex. *Studied:* Southend School of Art; Central School of Art; London University Inst. of Education. *Exhib:* group exhbns: Victoria Art Gallery, Bath; solo shows: Fermoy Arts Centre, Kings Lynn; Kings School, Worcester; Chelsea and Westminster Hospital; Piers Feetham Gallery, London and Aldeburgh; Yew Tree Gallery, Cornwall; St.James Centre for Creativity, Valletta, Malta; The Cut, Halesworth, Suffolk; Sladers Yard, West Bay, Bridport, Dorset. *Publications:* catalogues (various); Derek Nice Images (1997/2007). *Official Purchasers:* Shirley Conran O.B.E.; Chelsea Westminster Hospital. *Works Reproduced:* Bridgeman Library. *Principal Works:* Viking Longship Sculpture for Tusenfryd Park, Oslo. *Recreations:* travel, films and music (various). *Clubs:* Babington House; Soho House. *Misc:* particular interest in marine archaeology and associated historical graffiti. *Signs work:* 'D.N.', 'Derek Nice'. *Address:* Manor Cottage, Hassage, Faulkland, Bath BA3 5XG. *Email:* nices@maltanet.net *Website:* www.dereknice.com

NICHOLAS, Peter, N.D.D. (1956), A.R.C.A. (1962), F.R.B.S. (1993); sculptor in stone, bronze, G.R.P. *b:* Tredegar, S. Wales, 5 Jul 1934. *m:* Marjorie (decd.). one s. two d.; m Annie. one *s.* two *d. Educ:* Ebbw Vale County Grammar School. *Studied:* Cardiff College of Art (1951-56, Frank Roper, Geof Milsom),

R.C.A. (1958-61, John Skeaping). *Exhib:* Jonathan Poole Fine Art. *Works in collections:* U.K., Europe, U.S.A. *Commissions:* 1990-2000 include: The Celtic Manor Hotel, Cwmbran New Town, Rotheram Met. Bor. Council, Merthyr Tydfil, Royal Caribbean Cruise Line, Aberystwyth, Mountain Ash, Porthcawl Town. *Publications:* Art in Architecture an Architects Choice (Eugene Rosenberg), The Encyclopedia of Sculpture Techniques (John Mills), Teaching Art in Wales (Alan Torjussen), Debrett's People of Today, Wales Video Gallery. *Signs work:* "P.W. NICHOLAS." *Address:* Craig-y-Don, Horton, Gower, W. Glam. SA3 1LB.

NICHOLLS, Paul Edward, Diploma in Art and Design (Dip. AD), ATC (Art Teachers' Cert). *Medium:* acrylic, water-colour, pastels. *b:* Colchester, Essex, 1 Apr 1948. *s of:* Robert James Nicholls, architect and surveyor. *m:* Jennifer. nine *s.* one *d. Educ:* Epsom College of Art 1966-67, Portsmouth College of Art (1967-69), Brighton College of Art, Dept. Ed. Studies (1969-70). *Studied:* Painting and Ceramics. *Represented by:* Lander Gallery, Lemon Street, Truro. *Exhib:* Newlyn, St.Ives, Birmingham, Taunton, Pont Aven, Torquay, Wadebridge, Truro, RWA Bristol, Guildford. *Works in collections:* UK, Israel, Ireland, USA, France. *Commissions:* Mural: Our Lady of Lourdes R.C.Church, Portmouth, Redruth Operatic HQ, Leedstown Village Hall, private swimming pool, Truro, and two primary school (library projects). *Publications:* Drawing Towards the End of a Century (Newlyn Society); Paintings in Public Ownership Cornwall and Isles of Scilly; 100 Years in Newlyn. *Official Purchasers:* see mural projects, also Royal Cornwall Museum. *Works Reproduced:* history books and covers, cartoonist. *Principal Works:* Action figures (surf paintings), landscape and still life. *Clubs:* Newlyn Society of Artists (1973-). *Signs work:* "P.Nicholls". *Address:* South Barn, Mithian, St.Agnes, Cornwall, TR5 0QH. *Email:* south_barn@yahoo.co.uk *Website:* www.paulnichollsartwork.com

NICHOLS, Patricia Mary, R.M.S., S.W.A.; portrait painter in miniature and full-size portrait drawings in sanguine, chalk; Mem. Royal Society of Miniature Painters; and Soc. of Women Artists; teaches miniature painting at the West Norfolk Art Centre. *d of:* W/Cdr. E. T. Carpenter, A.F.C., R.A.F. *m:* Dr. F.D.P.Shaw. one *s.* one *d. Educ:* innumerable private schools. *Studied:* Central School of Arts and Crafts London. *Exhib:* R.I., Mall Galleries, Westminster Gallery and many others. *Commissions:* has undertaken many important, including royal, commissions. *Works Reproduced:* in The Artist, Illustrated county magazines and newspapers. 'R.M.S. One Hundred Years'. *Signs work:* "Patricia Nichols." *Address:* Sealand, Wodehouse Rd., Old Hunstanton, Norfolk PE36 6JD.

NICKOLLS, Deborah, BA (Hons) First Class: Fine Art; MA Fine Art (RAS). *Medium:* acrylic. *b:* Watford, 31 Aug 1976. *m:* Joe Fletcher. *Educ:* Aylesbury High School. *Studied:* Central St.Martins College of Art and Design; RA Schools. *Exhib:* RA Exhbns; New Academy Gallery (solo show); 'Earth Songs' A.T.Kearney; Paton Gallery; Rebecca Hossack Gallery; East 73rd Gallery; The Barbican Centre; Royal Festival Hall; Sotheby's Auction Shows: Tel Aviv and

Chicago. *Works in collections:* London Institute; private collections. *Commissions:* private. *Recreations:* mountain walking, rock-climbing, independent travel. *Misc:* works based on rock-forms and other elements of the landscape, predominantly paintings in acrylic. *Signs work:* 'D Nickolls', 'Deborah Nickolls'. *Address:* 20 Lound Street, Kendal, Cumbria LA9 7EA. *Email:* info@deborahnickolls.com *Website:* www.deborahnickolls.com

NICKS: see KANG, K.S.,

NIEKERK, Sarah Compton Van: see VAN NIEKERK, Sarah Compton,

NINNES, Lesley Marian, H.N.C. Art And Design (Illustration); painter in alkyds - fast drying oils; member of Art Space Gallery co-operative, St. Ives. *b:* Redruth, Cornwall, 7 Dec 1953. two *d. Educ:* St. Ives School. *Studied:* Cornwall College. *Exhib:* group exhibs. Cornwall, Devon and France. *Works in collections:* private collections in U.K. and abroad. *Commissions:* 'Porthmeor Rock Pools' 24"x36", private sale; 'Opposite Attraction 3', 'St.Ives - Sand, Sea and Sky'. *Publications:* colour illus. for 'The Endemic Plants of St. Helena' and pen and ink illus. for F.A.O. pub. on Inland Fisheries, pen and ink illustrations for series of Distance Learning Work Books. *Clubs:* St. Ives Arts Club, Penwith Soc. of Artists - assoc. member. *Signs work:* "L.esley Ninnes." *Address:* 8 St. Johns Walk, St. Ives, Cornwall TR26 2JJ. *Email:* ninnes@btinternet.com

NOAD, Julie Ann, B.A. Hons. Fine Art (1978); painter in oil; figurative painter of interiors and views through windows preoccupied by light and colour. *b:* Essex, 29 Oct 1955. one *s. Studied:* Camberwell School of Art (1975-1978), under Antony Eyton R.A. *Exhib:* N.E.A.C., S.W.A., Mall Galleries; John Russell Gallery, Chappel Galleries, South London Gallery. *Works in collections:* private collections, U.K., Europe, America. *Publications:* illustrations for Agenda, P.N. Review. *Signs work:* "J Noad." *Address:* Turkey Hall, Metfield, Suffolk IP20 0JX.

NOAD, Timothy Martin, MA, BA (Hons) in History of Art (London), Herald Painter at HM College of Arms, London; HSDAD (Higher Surrey Diploma in Art and Design), FSSI, FCLAS. *Medium:* Heraldry and Calligraphy in gouache and watercolour on vellum, miniatures and illumination. *b:* 3 Jul 1966. *m:* Alice Clark. one *d. Educ:* Bishop Ramsey C of E School, Ruislip. *Studied:* Reigate School of Art and Design: calligraphy, heraldry and illumination (1986). *Exhib:* Llewelyn Alexander Gallery (best miniature in show) (1996), RMS Annual Exhibition, various exhbns with SSI and CLAS; Bedlam Gallery, Brunel University (2001), Art in Action (1995-7). *Commissions:* College of Arms, Chapel Royal St.James Palace (ceiling panels), Royal Mint (Jubilee medal and Gold sovereign), Brunel University, Northern Ireland Assembly. *Publications:* The Art of Illuminated Letters, Mastering Calligraphy. *Works Reproduced:* British Library Companion to Calligraphy, Illumination and Heraldry (2001). *Recreations:* concerts, exhibitions, travel, gardening. *Signs work:* T.Noad, Tim

Noad, Timothy Noad. *Address:* 2 Gibson Road, Ickenham, Uxbridge, Middlesex, UB10 8EN. *Email:* teanoad@aol.com

NOAKES, Michael, PPROI, RP, CPS, HonNS, HonUA, Cert. RAS, NDD; landscape and portrait painter (subjects include the Queen, other members royal family, the Pope, Margaret Thatcher, Bill Clinton,etc.); Chairman (1971) Contemporary Portrait Society; Pres. Royal Institute of Oil Painters (1972-78); art critic (1964-68), BBC Television. *b:* Brighton, 28 Oct 1933. *m:* Dr.Vivien Noakes FRSL. two *s.* one *d. Educ:* Downside. *Studied:* Reigate School of Art and R.A. Schools. *Exhib:* RA, ROI, RP, RBA, NS, etc. *Works in collections:* The Queen, The Prince of Wales, BM., National Portrait Gallery, etc. *Commissions:* London portrait sittings can be held at North Gate, Prince Albert Road, NW8, overlooking Regent's Park. *Publications:* A Professional Approach to Oil Painting (Pitmans, 1968); The Daily Life of The Queen: an Artist's Diary (illustrated)(Ebury Press, 2007). *Recreations:* idling. *Clubs:* Garrick. *Signs work:* "Michael Noakes," with date underneath. *Address:* Eaton Heights, Eaton Road, Malvern, Worcs. WR14 4PE. *Email:* mail@michael-noakes.co.uk *Website:* www.michael-noakes.co.uk

NOBLE, Guy, BDA; LCAD; National Portrait Award; Singer & Freidlander/Sunday Times Watercolour Competition. *Medium:* oil, watercolour, drawing, prints. *b:* Kent, 1959. *s of:* Reginald Noble. *m:* Nicola. two *s. Educ:* Byam Shaw School of Art. *Represented by:* Peter Müller (GR) Germany; Joao Ferreira Gallery, Cape Town, S.Africa; Gallery Miralli, Viterbo, Italy. *Exhib:* NPG; John Moores Liverpool; Whitechapel Gallery; Chisenhale; Manchester City Art Galleries; Raw Space, London. *Works in collections:* numerous corporate and private collections in UK and abroad. *Commissions:* BAA, Clyde Petroleum, Christopher Firmstone, numerous corporate and private commissions. *Publications:* has written for 'Art Review'-Professor Stephen Bann - The True Vine; 16 minute video by Bill Long 'Victims'. *Works Reproduced:* widely. *Recreations:* sailing/skiing. *Signs work:* 'Guy Noble'. *Address:* 66 Hornsey Lane, Highgate, London N6 5LU. *Email:* guy@guynoble.com *Website:* www.guynoble.com

NOBLE, Jean, BA Hons (Fashion & Textile Design); RSA Design Competition Winner; Abstract Painting Award, Hertford Art Soc. (2002); Lady Laming Award for Abstract Art (2007). *Medium:* acrylic, oil, mixed media. *m:* John. two *s. Educ:* Kingston Polytechnic. *Studied:* Loughborough College of Art; Central St.Martins (short courses). *Exhib:* RA Summer Exhbn (2005, 2006); RI, Mall Galleries (2002-2007); Discerning Eye; SWA; RWS 21st Century Open, Bankside; many regional across UK. *Works in collections:* private collections. *Commissions:* private, in UK and abroad. *Publications:* websites - various. *Works Reproduced:* postcards, notelets and posters. *Principal Works:* abstract paintings. *Recreations:* garden, theatre. *Clubs:* Chelsea Art Society. *Signs work:* 'JNoble'. *Address:* Brooklands, Clavering, Saffron Walden, Essex, CB11 4QW. *Email:* Jeannoble@nobledesigns.co.uk *Website:* www.jeannoble.com

NOELLE: see SIMPSON, Noelle,

NOOTT, Edward John, BA, RBSA (2001); painter in oil. *b:* W. Midlands, 4 Oct 1965. *s of:* John Noott, Fine Art Dealer. *m:* Denise Cardone. one *s.* one *d. Educ:* Cheltenham College. *Studied:* Gloucestershire College of Art, Cheltenham, Trent Polytechnic College, Nottingham, State University of N.Y. *Exhib:* John Noott Galleries, RBSA, ROI, RWA. *Works in collections:* University of Wales. *Works Reproduced:* by The Art Group, Robertson Collection. *Signs work:* "Edward Noott." *Address:* Dickens House, 20 High Street, Broadway Worcs. WR12 7DT.

NORBURY, Ian, B.A. (1979); sculptor in wood, metal, semi precious stones. *b:* Sheffield, 21 Aug 1948. *s of:* Kenneth Peter Norbury. *m:* Betty Ann. two *s.* one *d. Educ:* Andover Grammar; St. Paul's College, Cheltenham. *Studied:* St. Paul's College, Cheltenham (Harold Sayer, R.E., R.W.A., A.R.C.A.). *Exhib:* annual one-man, annual Juried Exhibition 'Celebration of Craftsmanship & Design'. *Works in collections:* Tower of London, Fine Art Museum of the South of Mobile, U.S.A., Nature in Art, many private collections. *Publications:* Techniques of Creative Woodcarving, Projects for Creative Woodcarving, Relief Woodcarving and Lettering, Fundamentals of Figure Carving, Carving Facial Expressions, Carving Classic Female Faces, Carving Classic Female Figures, The Art of Ian Norbury. *Signs work:* "IAN NORBURY," "I. NORBURY" or "I.N." *Address:* Ballycommare, Tournafulla, Co. Limerick, Eire.

NORLAND (NEUSCHUL), Khalil, M.A. Physics (Oxon.); artist-painter in mixed media. *b:* Aussig (Usti), Czechoslovakia, 25 Mar 1934. *s of:* Ernest Neuschul-Norland, artist-painter. *m:* Layla Shamash (decd.). three *s. Educ:* Merton College, Oxford. *Studied:* Ruskin College of Art, Oxford (1953-57), Slade School of Art London University (1959-60). *Exhib:* Artist House, Jerusalem (1959), Woodstock Gallery, London (1961), Gallerie Lambert, Paris (1964), Camden Arts Centre, London (1987), Queen Elizabeth House, Oxford (1987), Loggia Gallery, London (1988), Haus am Lützowplatz, Berlin (1991), Linacre College, Oxford (2006). *Address:* 25 Southmoor Rd., Oxford OX2 6RF. *Email:* khalilnorland@gmail.com

NORMAN, Barbara, Paris Salon bronze medal (1975), silver medal (1976); glass engraver in diamond point, flexible drive drill. *b:* London. *d of:* Augustus Arthur Norman. *Studied:* Stanhope Institute and glass engraving at Morley College under Mary Stevens. *Exhib:* Bourne Hall, Ewell, New Ashgate Gallery, Farnham, Florida Gulf Coast Art Center, Clearwater, Florida, Tampa Bay Art Center, Florida. *Publications:* Engraving and Decorating Glass (David and Charles 1972, McGraw Hill, U.S.A. 1972); Glass Engraving (David and Charles 1981, ARCO, U.S.A. 1981, A. H. & A. W. Reed, Australia 1981). *Signs work:* "Barbara Norman." *Address:* 9 Downs Lodge Court, Church St., Epsom, Surrey KT17 4QG.

NORMAN, Michael Radford, R.S.M.A. (1975); artist/model maker, in pen and water-colour, often of river and coastal scenes. *b:* Ipswich, 20 Aug., 1933. *s of:* Frank Norman, builder. two *d. Educ:* Woodbridge School. *Studied:* Bournemouth School of Art, Regent St. Polytechnic. *Exhib:* R.I., R.S.M.A.; one-man shows, Colchester, Ipswich, Norwich, London. *Works in collections:* water-colour at D.o.E. *Commissions:* numerous. *Publications:* illustrated, The Suffolk Essex Border by John Salmon. *Signs work:* "Michael Norman" usually in black ink. *Address:* The Studio, Woolverstone, Ipswich, Suffolk IP9 1AX.

NORMAN, Richard, D.A. (1978), R.S.W. (1994); Cargill award R.G.I. (1991), Travelling Scholarship, Venice (1995); artist in water-colour and oil; teacher;. *b:* Glasgow, 15 June, 1956. *Studied:* Glasgow School of Art (1974-78, Dr. David Donaldson, James Robertson, Leon Morrocco). *Exhib:* regularly at R.G.I., R.S.A. and R.S.W.; one-man shows 1990-92: Kelly Gallery, Glasgow, Blythswood Gallery, Glasgow. One-man shows: Artbank, Glasgow 1995, Glasgow Art Club 1999, Theatre Royal Glasgow 2002, Glasgow Film Theatre 2003; various galleries in England, France, Netherlands, Hong Kong. *Principal Works:* 'Preparation Time', 'Baksheesh'. *Recreations:* travel, classical music, history. *Clubs:* Glasgow Art. *Signs work:* "Richard Norman." *Address:* 185 Bath St., Glasgow G2 4HU.

NORMAN-McCULLOUGH, Juliette, Inter. NDD, RA Cert; 'Assemblage Award' Dallas Texas (1993), Main St National Fine Art Award Texas (1993), Artist-in-Residence S.E.Wales Arts Assoc. UK (1984), Artist in Industry West Midlands Arts Assoc. UK (1983), Landseer Silver Medal Royal Academy Schools; art lecturer/teacher. *Medium:* painter, oil, mixed media. *b:* Lincolnshire, 10 Jun 1945. one *s.* one *d. Studied:* Royal Academy of Art, Byam Shaw School, Camberwell School of Art. *Represented by:* Alan Barnes Fine Art, Dallas, Texas, USA. *Exhib:* many solo and group shows UK and USA, most recent in Japan and Italy. *Publications:* New Art International (2003). *Misc:* alternative address: c/o 52 Maxwell Park, Dalbeattie, Kircudbrightshire, Scotland, DG5 4LS. *Signs work:* 'J McCullough' or 'J.N.Mc' or 'J.Mc'. *Address:* 3432 High Bluff Drive, Dallas, Texas 75234 USA. *Email:* pierodella@earthlink.net

NORRIS, David, Cert. RAS, FRBS; sculptor in bronze; Vice-Pres. Royal Soc. of British Sculptors; Awarded the Sir Otto Beit Medal. *b:* São Paulo, Brazil, 26 Sep 1940. *s of:* Sir Alfred Norris, K.B.E. *m:* Carol. three *d. Educ:* Millfield. *Studied:* Guildford School of Art and RA Schools. *Exhib:* RA, Mall Galleries, Royal Mint. *Works in collections:* 'Women and Doves' Stevenage Town Park; 'Britannia' for the Falklands Monument; 'Mother and Child' Portland Hospital; Sir Barnes Wallis, RAF Museum Hendon; 'Spindrift' 3.5m. high stainless steel spiral with bronze gulls for P&O liner Royal Princess; two life-size bronzes for Royal Caribbean Cruise Line; group of 'flying flamingos', Arndale Centre, Luton; bronze portrait of Maria Callas for the Royal Opera House, London; bronze relief portrait of General Sir David Fraser, Grenadier Guards; bronze 'Birds of Prey' for the Middle East. *Commissions:* Life-size figures of Presidents

Lincoln and Washington for Star Cruises. *Clubs:* RASSA. *Signs work:* "David Norris." *Address:* 15 Danemere Street, London SW15 1LT. *Website:* www.davidnorris.co.uk

NORRIS, Linda, B.A. (Hons.) Visual Art (1982); artist in mixed media;. *b:* Chichester, 22 June, 1960. *m:* Denbeigh Vaughan. one *d. Studied:* U.C.W. Aberystwyth. *Exhib:* selected: 1998: New Academy Gallery, London, Martin Tinney Gallery, Cardiff; 1999: Attic Gallery, Swansea, Six Chapel Row Gallery, Bath; 2000: New Academy Gallery, London; 2000-2001: Adam Gallery, Bath; ongoing galleries in artist's home. *Works in collections:* Chevron U.K., General Medical Council. *Commissions:* Llandough Hospital, Penarth, Urdd Llangrannog. *Address:* The Manse, Trefgarn Owen, Haverfordwest SA62 6NE. *Email:* linda@linda-norris.com *Website:* www.linda-norris.com

NORRS, David, Cert RAS, FRBS; sculptor. *Medium:* sculpture-bronze and stainless steel. *b:* Sao Paulo, 26 Sep 1940. *m:* Carol. three *d. Educ:* Millfield School. *Studied:* Royal Academy Schools (1963-66). *Exhib:* RA Summer Exhbn, and many provincial galleries. *Commissions:* P & O, Rolal Caribbean Cruises, North Devon DC, Crawley BC, Jaguar. *Clubs:* RASAA. *Address:* 15 Danemere Street, London SW15 1LT.

NOSWORTHY, Ann Louise, N.D.D. (1952), A.T.D. (1953); painter in oil, gouache, pastel and charcoal. *b:* Stonehaven, Scotland, 24 Aug 1929. *d of:* Col. J. M. Savege, R.A.M.C. *m:* T. C. Nosworthy. one *s. Exhib:* one-man shows: Redcar, Yorks. (1968), Castle de Vide, Portugal (1966), Egton Surgery, Whitby (2005). *Works in collections:* Municipal Art Gallery, Port Allegre, Portugal. *Signs work:* "A. L. Nosworthy." *Address:* Brackengarth, Lealholm, Whitby, Yorks. YO21 2AE.

NOT, Philip James, self taught artist in oil; proprietor of Galerie Not;. *b:* 28 Feb., 1938. *m:* Violet Vidot 'Une Belle Seychelleoise'. one *s.* two *d. Educ:* Holloway Grammar School. *Works in collections:* Etablisement de Reu (Arras, France), Lloyds Bank Plc. (Hampstead Village Branch). *Misc:* Noted for legal still life and local West Hampstead and Hampstead landscapes. *Signs work:* "P.J. Not" or "PJN". *Address:* 37 Narcissus Road, West Hampstead, London NW6 1TL.

NOYES, Margot, N.D.D. (1960); painter in oil. *b:* London, 17 Aug 1939; divorced. *d of:* Frederick Henry Noyes and Margaret Jane Noyes. one *s.* one *d. Educ:* Fulham County Grammar School. *Studied:* Camberwell School of Arts and Crafts (1956-60, Robert Medley, Anthony Eyton, Richard Lee, Michael Salaman, Richard Eurich, Henry Inlander). *Exhib:* Many solo shows and mixed shows nationwide and overseas. *Publications:* 'Camberwell School of Arts & Crafts - Its Students & Teachers 1943-1960' by Geoff Hassel; 'Artists at Walberswick- East Anglian Interludes 1880-2000' by Richard Scott. *Misc:* A founder member of the Suffolk Group. *Signs work:* "M. Noyes," very small works initials only.

Address: 51 London Rd., Halesworth, Suffolk IP19 8LS. *Website:* www.thesuffolkgroup.co.uk

O

O'AIVAZIAN, Edman, painter in oil, water-colour and acrylic; designer. *b:* Tehran, 10 Aug., 1932. *m:* Thelma. two *s. Educ:* Tehran, Rome and London. *Exhib:* since 1948; Tehran, Venice (Biennale), New York, Boston, Jeddah, Yerevan, London - R.O.I., R.S.M.A., N.E.A.C.; prizes - 1st prize Iranian Contemp. Artists (1956), 1st prize Iranian Ministry of Culture Competition (1958), George Grimm prize R.O.I. (1998), Windsor and Newton Award R.O.I. (2000). *Works in collections:* Museums - San Lazaro, Venice; Aram Khachaturian, Yerevan; Aivazovski, Crimea; Armenian National Gallery, Yerevan; Modern Art, Yerevan. Private collections - Saudi Arabia, Oman, Tehran. *Commissions:* Boston, New York, Los Angeles, London; portraits for Saudi Royals, and Sultan Qaboos, Oman; Murals in Armenian churches; calligraphy and design of Grand Mosque, Riyadh; mural for Jeddah airport; designs for King Fahed Int. Airport Mosque; mosaic design for Sultan Qaboos Mosque, Muscat; mural for Nat. Museum, Riyadh. *Publications:* illus. Armenian Village (1984), Portraits of Poets (1970); Poems of Toumanian (1970); Komitas (1998). *Clubs:* A.R.O.I.; Wapping Group of Artists. *Misc:* 2001 design of Armenian exhibition, British Library. *Signs work:* "EDMAN." *Address:* 61a Fulham High St., London SW6 3JJ. *Email:* edman@lineone.net

OATES, Bennett, painter in oils, specialising in flowers and landscape; President, Guild of Norwich Painters. *b:* London, 1 Jan 1928. *s of:* Joseph Bennett Oates, FPE. *m:* Phyllis Mary, Art Historian and Designer A.R.C.A. two *d. Educ:* Raynes Park Grammar School. *Studied:* Wimbledon School of Art (1943-46, Gerald Cooper), R.C.A. (1948-51, Robin Darwin and Ruskin Spear). *Exhib:* three Continents. *Works in collections:* Stacy-Marks Gallery. *Clubs:* City Club, Norwich. *Signs work:* "Bennett Oates." *Address:* The Grange, Little Plumstead, Norwich NR13 5DJ.

OATHAM, Richard, BSc (Chemistry). *Medium:* oil, watercolour, prints. *b:* Ruislip, Middx, 21 Aug 1942. *s of:* Robert Oatham. *m:* Catherine Oatham. *Studied:* Reading University. *Exhib:* RA Summer Exhbn; Orleans Gallery, Twickenham. *Works in collections:* etchings: London Borough of Richmond upon Thames. *Recreations:* golf, bridge, walking, reading, gardening. *Signs work:* 'Richard Oatham'. *Address:* 58 Marina Place, Hampton Wick, Kingston-upon-Thames, Surrey, KT1 4BH. *Email:* oatham@hotmail.com

O'CARROLL, John Patrick, South West Arts Dip., graduated distiction, painting. *Medium:* art and design. *b:* Bedfordshire, 17 Mar 1958. *s of:* Shirley Finch, John F.O'Carroll. *Educ:* Treviglas, Newquay; Tretheris, Newquay. *Studied:* Cornwall College of Art and Design. *Represented by:* Galerie Nanky de Vreeze, Amsterdam; Galerie le Besset, St.Jeure de Andaure, France; Galerie

Krijger & Katwijk, Amsterdam; Galerie Pimm van der Donk, Hamburg; Padstow Gallery, Cornwall. *Exhib:* Holly Solomon, NYC (1985); Galerie Charlotte Daneel, Amsterdam (1994-97); L'Atelier, Alexandria, Egypt (1995); Pulitzer Gallery, Amsterdam; British Council, Cairo, Egypt (1996); Contempo, Rotterdam (1996); Kunst RAI, Amsterdam (1984-2003); Art Fare, Rotterdam; PBS, Houston, Texas; Akzo Nobel, Arnhem, NL.(1997); British Embassy, Cairo (2001); Galerie Le Besset/parc de scultures, France (2003); Galerie Pimm van der Donk, Hamburg (2004); Kunst RAI Hamburg (2004, 2005); International Biennale, Alexandria Library, Egypt (2005); 'Groen en Haut', Haarlem, Netherlands (2005). *Works in collections:* Pulitzer Art Collection, Amsterdam; Royal Collection, The Hague, Akzo-Nobel Art Collection, Arnhem, NCM Headquarters, Cardiff. Private collections worldwide. *Commissions:* Akzo-Nobel- Garden of Time and Desert Poems. *Publications:* Proof of Principle (Akzo Nobel)(2003), illustrations for Island of Blessed by Harry Thurston (Cairo Times), Ai Ahram Weekly, De Welt. *Official Purchasers:* The Royal Collection, Den Hague, Pulitzer Art Collection, Amsterdam, AMC, Amsterdam, NCM Headquarters, Cardiff. *Principal Works:* NCM Cardiff, Desert Tracks; Akzo Nobel Garden of Time and Desert Poem. *Recreations:* archaeological illustrator, travel and fieldwork. *Clubs:* Dakhleh Oasis Project, Egypt. *Misc:* studios in Egypt, Amsterdam, Cornwall. Abstractions of place, landscape, time and space. *Address:* 3A Parnell Court, Padstow, Cornwall, PL28 8BH. *Email:* johnankh@hotmail.com *Website:* www.johnocarroll.co.uk

OCEAN, Humphrey, RA (2004); winner Imperial Tobacco Award (1982); visiting Professor in Painting and Drawing, Camberwell College of Art 2002-2008; Hon. Fellowship KIAD 2002. *b:* Pulborough, 22 Jun 1951. *s of:* Capt. M.E. Butler-Bowdon, O.B.E., R.N. *m:* Miranda Argyle. two *d. Educ:* Ampleforth. *Studied:* Tunbridge Wells Art School (1967-69), Brighton College of Art (1969-70), Canterbury College of Art (1970-73). *Exhib:* RA, Haus der Kunst Munich, British Council; one-man shows: NPG (1984), Ferens A.G. Hull (1987), Whitechapel A.G.,and Tate Gallery, Liverpool (1991), Whitworth A.G., Manchester, Ormeau Baths Gallery, Belfast (1997-98), 'Painter's Eye' NPG (1999), Dulwich Picture Gallery (2003). *Works in collections:* NPG, Imperial War Museum, Ferens A.G., Scottish NPG, V&A Museum, Royal Library, South London Gallery Collection, Wolverhampton A.G., National Maritime Museum, Bruges-Zeebrugge Port Authority; British Council; Christ Church, Oxford; The Whitworth Art Gallery, University of Manchester. *Publications:* The Ocean View (Plexus 1982), Big Mouth (Fourth Estate 1990, and Brown Trout, San Francisco 1994), 'Zeebrugge' (M.B.Z. Belgium 2002). *Address:* 22 Marmora Rd., London SE22 0RX.

OCKENDEN, John Richard, B.Ed. (Hons.) (1978); artist in water-colour and acrylic; Vice Chairman, Deeside Art Group;. *b:* Cheltenham, 6 Aug., 1946. one *d. Educ:* Alsager C.H.E., Chester C.H.E. *Exhib:* one-man shows: Theatr Clwyd Gallery since 1988; many mixed shows in England and Wales, including

International Spring Fair, N.E.C. B'ham. *Publications:* limited editions. *Signs work:* "John R. Ockenden." *Address:* 29 Marksway, Pensby, Wirral L61 9PB.

O'CONNELL, Richard Marcus, Dip. A.D. (Hons.) Norwich (1969), Cert. F.A. (Oxon. 1972); figurative painter in oil, acrylic, water-colour, poet. *b:* Mumbles, Swansea, 19 Jul 1947. two *d. Educ:* Swansea College of Art (1965-66), Ruskin School of Drawing, Norwich School of Art (1966-69), University of Oxford (1971-72). *Exhib:* one-man shows: Marlborough Fine Art, London (1974), St. David's Hall, Cardiff (1989, 1996), National Museum of Wales, Turner House, Penarth (1994), Washington Gallery, Penarth (2001, 2002, 2006). *Works in collections:* Balliol College-Oxford University, National Museum of Wales, Cardiff, Vale of Glamorgan Council, Barry. *Publications:* poetry book: 'Cardiff, my Cardiff' (Inika Press, Penarth, 1997); 'I Remember Swansea' (1999). *Clubs:* Vale of Glamorgan Artists. *Signs work:* "Richard O'Connell." *Address:* 26 Coronation Terrace, Penarth, Vale of Glamorgan, Wales CF64 1HN.

O'CONNOR, Marcel, B.A. (Hons.) Fine Art; artist/teacher in oil and wax encaustic painting;. *b:* Lurgan, Co. Armagh, 19 Nov., 1958. *Educ:* St. Michael's High School, Lurgan. *Studied:* Liverpool Polytechnic (1977-78), Brighton Polytechnic (1978-81), Cyprus College of Art (1983-84). *Exhib:* Scotland, Ireland, England, Cyprus, Hungary, Germany. *Works in collections:* City Arts Centre, Edinburgh. *Publications:* catalogues: 'Boundaries' in Edinburgh and Belfast; 4 Artists in Hungary; 'Europe 24' in Hungary; 'Europe 24 no.2' in Germany, bookcover artwork 'Scotland and Ulster'. *Signs work:* "Marcel O'Connor." *Address:* W.A.S.P.S. Studios (115), Patriothall, Stockbridge, Edinburgh.

O'CONNOR, Martin Simon, BA Hons (1973-76); RA Post Grad (1977-80); C & G of London Inst.- Adv. masonry distns (1992); C & G Art School- Dip. in Conservation & Rest. (1993-95); conservator. *Medium:* sculptor in stone, wood, plaster, bronze, etc. Draughtsman (mixed media on paper and canvas). *b:* London, 2 Jan 1953. *m:* divorced. Angelica Bornhausen (prima ballerina). one *s. Educ:* Salvatorian College, Harrow Weald, London. *Studied:* Harrow School of Art (1972-73), Canterbury College of Art (1973-76), RA Schools (1977-80). *Exhib:* Maidstone, Falmouth, Canterbury, RA Dip. Gallery. Germany: Freiburg, Kassel, Hamburg. *Works in collections:* all private. *Commissions:* all private. *Publications:* appears in The Dictionary of Artists in Britain since 1945. *Clubs:* Reynolds Club (RA). *Signs work:* "M.O'CONNOR". *Address:* 10 Woodcroft Ave, Mill Hill, London NW7 2AG.

ODDY, Mercy, S.W.A., H.S.; Seascape painter in water-colour, miniaturist; Council Mem. Soc. of Women Artists, Mem. Hilliard Soc. of Miniaturists, Sec. Christchurch Arts Guild. *b:* Southsea. *d of:* William Kingston. *m:* David Oddy. two *d. Exhib:* Solo show: Red House Museum and A.G., Christchurch, Dorset. Recent showings in London include Llewellyn Alexander, The Mall and Westminster Central Hall. *Works in collections:* internationally. *Clubs:*

Christchurch Arts Guild, Romsey Art Group. *Signs work:* "Mercy Oddy" larger works; "M.O." miniatures. *Address:* 1 Lyme Cres., Highcliffe, Dorset BH23 5BJ.

O'DONOGHUE, Declan, M.C.S.D. (1986), F.S.C-D. (1991), M.Inst.P.I. (1991), M.S.D.I. (1991); designer and furniture maker in wood, metal, stone, glass; Director, Wilcogold Ltd. (1985), Adviser, Connemara West plc. (1992), Partner, S.F. Furniture (1980), Principal visiting tutor, Furn. Coll. Letterfrack (1988). *b:* Cork, 18 Oct 1960. *m:* Fiona Mary Curry. two *d. Educ:* St. Vincent's College, Castleknock, Dublin. *Studied:* Parnham College (1978-80, R. Ingham). *Exhib:* National Theatre, Barbican, Camden Arts Centre, Mall Galleries, Bath Festival, Kilkenny Design Dublin, British Crafts Centre, British Crafts, Cheltenham; ORGATEC, Cologne; Bonhams, London: Create Cork. *Commissions:* National Gallery, Dublin, Guildhall, London. *Publications:* numerous exhbn. catalogues, articles, book features, B.B.C. (1981), H.T.V. (1992-93). Freeman City of London (1994), Liveryman Worshipful Co. of Furn. Makers (1994), Furniture for 21st Century (Norbury); Celebration of Excellence (WCFM). *Clubs:* Royal Cork Yacht, Exe Sailing Club. *Address:* Street Farm, Acton Turville, Badminton, Glos. GL9 1HH. *Email:* declan@sffurniture.co.uk *Website:* www.sffurniture.co.uk

O'FARRELL, Bartholomew Patrick, B.Ed.Hons. (Wales), Dip.A.D.; landscape painter; Lecturer in Illustration, Faculty of Art, W.G.I.H.E., Swansea (1981-85). *Medium:* acrylic and water-colour. *b:* Ogilvie, Mid-Glamorgan, 11 Aug 1941. *Educ:* Caerphilly Grammar School. *Studied:* Cardiff College of Art (1959-62), Polytechnic of Wales, Barry (1974-78). *Exhib:* Cornwall and S. Wales; annual one-man shows in Cornwall from 1986 onwards at Trelowarren, Helston Folk Museum, Camborne School of Mines Museum and Gallery, St. Austell Arts Centre, Falmouth A.G.; selected: National Museum of Wales, Albany Gallery, Cardiff; Celtic Art, Falmouth; Manor House Fine Arts; 3 Spires, Truro; Royal Cornwall Museum, Truro. *Works in collections:* National Library of Wales, Lloyds TSB Bank plc. *Works Reproduced:* in The Encyclopedia of Acrylic Techniques; The Best of Acrylic Painting; Inspirational Portraits; Encyclopedia of Water-colour Landscape Painting; Water, How to paint it; Acrylic School; The Acrylic Artists Bible. *Recreations:* dowsing. *Signs work:* "Bart O'Farrell." *Address:* Treleague Farm, St. Keverne, Helston, Cornwall TR12 6PQ.

OFFEN, John, BA(Hons.); designer and author; partner Ken Moore Design Associates. *b:* 15 Mar 1951. *s of:* Raymond Offen. *Educ:* University of Exeter. Positions held: British Council, UNESCO, Attache, British Embassy, Tunis. *Publications:* A History of Irish Lace, Thoroughbred Style. *Address:* Flat 17, 11 Holland Park Avenue London W11 3RL.

OGDEN, Catherine, A.R.B.S.A. (1992), R.M.S. (1993), S.W.A. (1988); miniature seascape painter, flower pastelist; acrylic landscapes. *b:* London, 10 Apr 1951. *Educ:* Plashet Secondary Modern, Kingsway College. *Exhib:* R.M.S., S.W.A., R.I., R.B.S.A., R.W.S., Mid 'Art' 86 Dudley, Laing Art collection

competition, John Noott Gallery, Llewellyn Alexander Gallery. *Signs work:* "C. Ogden." *Address:* Forge House, Brimfield, Ludlow, Shropshire SY8 4NG.

OGILVY, Susan Pamela, R.H.S. Silver Gilt Medal (1995), R.H.S. Gold Medal (1997); botanical illustrator. *Medium:* water colour, pen and ink, pencil. *b:* Bromley, Kent, 22 Mar 1948. *m:* A.R.W. Ogilvy. three *s. Educ:* Park School, Yeovil and St. Loyes School of Occupational Therapy, Exeter. *Studied:* Luton School of Art. *Exhib:* six solo exhibs. at Park Walk Gallery and group exhibs. at Tryon Gallery and R.H.S. *Works in collections:* Dr. Shirley Sherwood. *Commissions:* national. *Signs work:* "Susan Ogilvy" or a monogram of an S within an O. *Address:* Orchard End, East Lambrook, South Petherton Somerset TA13 5HN. *Email:* spogilvy@hotmail.com

O'GORMAN, Linda Helen, B.A. Hons., graphics/illustration; artist and framer in monoprint and mixed media. *b:* Woodend, Staffs., 8 July, 1948. *m:* Tom O'Gorman. one *s.* four *d. Studied:* Gwent College of Art, Nuneaton School of Art and Bath Spa University. *Exhib:* Royal West of England Autumn open, Cheltenham open, Battersea Art Fair, Bath Society of Artists, Atrium Gallery Spring show, Society of Graphic Fine Artists, Bath Visual Arts Exhibition. *Clubs:* member Bath Area Network of Artists, Society of Graphic Fine Artists. *Signs work:* "L H O'Gorman." *Address:* 2 Beech View, Bath BA2 6DX. *Email:* lindaogorman@hotmail.com

O'HARA, D. Patrick, F.L.S.; botanical sculptor (original works in porcelain, engraving and enamelling on crystal); botanical water-colours. *b:* Windsor, 17 Jun 1936. *m:* Anna O'Hara, landscape painter. one *s.* one *d. Educ:* Haileybury and Reading University. *Studied:* Malvern Art School (1969-71). *Exhib:* Cartier, N.Y. (1972), Tryon and Moorland Gallery (1973), Chicago Flower Show (1975), Wexford Festival (1976), Victor Zelli (1978), R.H.S. (1979), Bank of Ireland (1980), Meister Gallery, Zurich (1980, 1981), Chester Beatty Library, Dublin (1984), United Nations (1984), EXPO, Osaka (1990), Royal Bot. Gdns. (1994), Huntington, California (1998), Ulster Museum, Belfast (2001),National Botanical Gardens, Dublin (2002), Fota House, Cork (2004). *Works in collections:* Lewis Ginter Botanical Gdn., Richmond, Va.; Flagler Museum, Florida; Jones Museum, Maine; International Museum of Wildlife Art, Gloucester; Chicago Horticultural Soc.; Gloucester City Museum; Adachi Inst., Tokyo; Smithkline Beecham Corp., Sumitomo Group; Jefferson Smurfit Foundation; Molecular Nature Ltd., National Museum of Ireland; American Museum of Ceramic Art, Pomona, CA; California Academy of Sciences; H.R.H. Prince Charles; National Bank of Dubai. *Commissions:* ongoing commission: collection of watercolours of California wildflowers for Santa Barbara Botanic Garden. *Publications:* 'Botanical Sculpture - A Lifesaving Alternative' (Biological Collections & Diversity, Linnean Soc/Westbury). *Signs work:* "Patrick O'Hara." *Address:* Manor House, Currabinny, Carrigaline, Co. Cork, Eire. *Email:* patrick@oharasculpture.com *Website:* www.oharasculpture.com

OHL, Gabrielle, painter in oil, inks, stained glass;. *b:* Diego-Suarez, Malagsy. *Studied:* Paris Academie Julian (1949-50), Madrid Beaux Arts (1950-51), Melbourne Technical College of Arts (1951-53), Paris. *Exhib:* Paris salons: Independents, Marine, Automne, Femmes Peintres; Maison de l'Alsace Germany, U.S.A. One-man shows, Paris, Belgium, London, Italy, Malaya, Korea, Kuwait, Luxemburg, Sardinia, La Coupole, Paris, Stasburg, Rosheim, Barr, Alsace, MDIAC, Paris. *Misc:* Awards: Medaglia "Nuova Critica Europea" Italy (1969); Gold Medal, Paternoster Academy, London (1971), Palmes d'or, Paris-Critique (1977), Gold Medal, Baden Baden (1981), Bronze Medal, New York (1983), Gold Medal, Milan (1989), Prix Special, Nouvelle Figurtion, MDIAC. Paris (1995). *Address:* 10 Rue des Halles, Paris 75001. France.

OLDFIELD, Joy M., ATD (1943); painter, sculptor and potter in oil, pastel, charcoal, clay and stone. *b:* Hampstead, 5 Jul 1920. *d of:* Reginald Royston Course, FDS, RCS. *m:* John Oldfield (decd.). one (decd) *s.* two *d. Educ:* Camden School for Girls. *Studied:* Westminster and Central Schools of Art (1938-40, K. Jamieson, R. Millard), Regent St. Polytechnic Art School (1940-42, S. Tresillian), Hornsey School of Art (1943). *Exhib:* RP, SWA; one-man show, Watatu Gallery, Nairobi (1980), Castle Park Frodsham (1994), and locally in Northwich. *Works in collections:* England, Scotland, Ireland and Kenya. *Signs work:* "Joy M. Oldfield." *Address:* 38 Townbridge Court, Castle St., Northwich Ches. CW8 1BG.

OLIN, Leon, N.D.D. (1962), A.T.D. (1963); artist and illustrator in oil, water-colour, line drawing; Resident Artist and co-Proprietor, Gallery One, Fishguard, Pembrokeshire. *b:* 28 May, 1939. *m:* Sylvia Gainsford. *Studied:* Leicester and Brighton Colleges of Art (D.P. Carrington). *Exhib:* Numerous. *Works in collections:* Portsmouth Civic Gallery, Kallis Foundation, Beverly Hills. *Commissions:* numerous. *Publications:* Pembrokeshire Architecture (Rosedale Pub.), Wildlife of St. James' Park (Brick by Brick L.H.A.G.), Food from the Countryside, Where have all the Cowslips gone, Out of This World (Bishopsgate Press), The Country Kitchen (Bell and Hyman). *Works Reproduced:* Limited edition prints by Buckingham Fine Art Publishers Ltd. *Signs work:* "LEON OLIN." *Address:* Fron Haul, Rhos-y-Caerau, Goodwick, Pembrokeshire SA64 0LB. *Website:* www.LeonOlin.com

OLINER, Sheila, *Medium:* oil/canvas, drawing, etching. *b:* London. one *s.* two *d. Studied:* Slade and City & Guilds. Printmaking - Dorothea Wight Studio Prints. *Represented by:* Penwith Gallery, St.Ives; Plumbline Gallery, St.Ives; Willshane Gallery, St.Ives. *Exhib:* solo: London, St.Ives, Tokyo, Hiroshima, Osaka. *Works in collections:* private collections. *Publications:* 'Artists in their Workplace', '22 Painters' (M.Whybrow), 'Art and Artists-Contemporary Cornwall' (Tom Cross), 'Drawing Towards the End of the Century' -NSA 'Art NSA 2002', 'St.Ives 1975-2005 Art Colony in Transition' (Peter Davies, 2007). *Recreations:* walking, reading, music. *Clubs:* Penwith Society. *Address:*

Studio 7, Penwith Galleries, Porthmeor Rd, St.Ives TR26. *Email:* sheilaoliner@yahoo.co.uk *Website:* http://www.org/artist/sheilaoliner

OLIVER, Dawn Nicola, H.S. (1999), M.A.S.-F. (1999); artist in water-colour, art tutor;. *b:* High Wycombe, 14 Apr 1959. *Exhib:* R.M.S. Westminster, H.S. Wells, M.A.S.-F., Royal Soc. of Painters in Watercolour, Mall Galleries, etc. Work in collections internationally. *Clubs:* Chilterns Art Group. *Address:* 20 Elmhurst Road, Aylesbury Bucks. HP20 2EA. *Email:* dawnoliver2@hotmail.com

OLIVER, Kenneth Herbert, RWS, RE, ARCA, RWA; etcher, lithographer, artist in water-colour; taught at Gloucestershire College of Arts and Technology, Cheltenham. *b:* Norwich, 7 Feb 1923. *s of:* Herbert B. Oliver (artist) & Ellen Oliver. *m:* Joyce Margaret Beaumont, ARCA, RWA (decd.). three *d. Educ:* King Edward VI Grammar School, Norwich. *Studied:* Norwich School of Art and R.C.A. *Exhib:* RWS, RWA, RA, RE, provincial galleries and abroad. *Works in collections:* Royal West of England Academy, Bristol, Cheltenham A.G. *Publications:* represented in the RWS book 'The Watercolour Expert' (pub. Cassell Illustrated). *Signs work:* "KENNETH H. OLIVER." *Address:* Green Banks, Blakewell Mead, Painswick, Stroud, Glos. GL6 6UR.

ONIANS, Richard (Dick) Lathbury, M.A.(Cantab.), A.R.B.S. (1989); City and Guilds Art School Cert. of Merit (1968); lecturer; Senior Carving Tutor, City and Guilds of London Art School; President of the City & Guilds Institute's Award for Teaching (2003). *Medium:* sculptor in wood and stone. *b:* Chalfont St. Giles, 19 May 1940. *s of:* Prof. R.B. Onians, M.A., Ph.D. *m:* Frances Clare Critchley. *Educ:* Merchant Taylors' School, Northwood; Trinity College, Cambridge. *Studied:* City and Guilds of London Art School (1966-68). *Exhib:* Mall Galleries, Marjorie Parr Gallery, Century Galleries, Henley-on-Thames, Galleria Renata, Chicago, Clementi House Gallery, Edith Grove Gallery, Bow House Gallery, London. *Commissions:* 'The Family' outdoor wood sculpture for S.Oxhey, Watford, 2001. *Publications:* Essential Woodcarving Techniques: (G.M.C. Publications Ltd., 1997); Carving The Human Figure: (G.M.C. Publications Ltd., 2001). *Signs work:* "R.L.O." *Address:* Woodside, Commonwood, King's Langley, Herts. WD4 9BA. *Email:* dick.onians@talk21.com

OOZEERALLY, Barbara, B.A. Hons. Architecture; botanical artist in water-colour. *b:* Poland, 18 Dec 1953. *m:* Shahood. one *s. Educ:* Warsaw Politechnik. *Exhib:* S.B.A., S.F.P., R.H.S., Chelsea Flower Show, United States Boatanica Gardens in Washington, New York Horticultural Society, Kirstenbosh Botanica Garden in Cape Town, Hunt Institute of Botanical Documentation (Pittsburgh, USA). *Works in collections:* Dr Shirley Sherwood, U.K., and Mrs Barbara Macklowe, New York, Lindley Library Collection (RHS), Hunt Institute of Botanical Documentation (Pittsburgh, USA). *Publications:* book to be pub. 2003. *Works Reproduced:* 'A Passion for Plants' Dr. Shirley Sherwood. *Signs work:* "B

Oozeerally." *Address:* 45 Manor Close, London NW9 9HD. *Email:* barbara@barbaraoozeerally.co.uk *Website:* www.barbaraoozeerally.co.uk

ORAM, Ann Alexandra, B.A.(Hons.) 1980, Post Grad. Dip. in Fine Art (1981), RSW (1986); painter in water-colour, mixed media and oil. *b:* London, 3 May 1956. *d of:* Thomas Alexander Oram. *m:* David Cemery. one *s*. *Educ:* Grantown Grammar School, Inverness Royal Academy. *Studied:* Edinburgh College of Art/Heriot Watt University (1976-82). *Exhib:* one-man shows include: Thackeray Gallery, Scottish Gallery, Portland Gallery, Loomshop and Macauley Gallery; group shows: R.S.A., R.S.W., R.G.I., R.A., Stowell's Trophy, Royal Overseas League, Compass Gallery - New Generation, Corrymelia Scott, Duncan Miller Fine Art, Roger Billcliffe, S.T.V. Student Show. Air Fairs Bath, London, Manchester, New York. *Works in collections:* Britain and abroad. *Signs work:* "Ann Oram." *Address:* 10 West Court, Ravelston House Park, Edinburgh EH4 3NP.

ORCHARD, Colin, RBA (2007). *Medium:* oil. *b:* Ewell, Surrey, 7 Jul 1935. *s of:* Thomas Seth Orchard. *m:* Celia Mary. two *s*. two *d*. *Educ:* state education (Secondary Modern). *Studied:* self-taught. Full-time painter since 1990; typographer/graphic designer 1952-90. *Represented by:* Penhaven Gallery; New Grafton Gallery. *Exhib:* Royal Academy Summer Exhibitions (1993-98 inclusive), New Grafton Gallery, David Messum, Brian Sinfield, Walker Galleries, Ainscough, Rowley, City Gallery, Thompson's, Langham Fine Art, Hagen Aria, Penhaven (St.Ives); Medici Gallery RBA Annual Exhbns (2006/07). *Works in collections:* Falmouth Art Gallery. *Commissions:* 1957-75, produced humorous illustrations for 'The Times', Shell, ICI, WHSmith, RTZ, Sony and many leading publications. *Publications:* Dictionary of Artists in Britain since 1945; St.Ives 1883-1993-Portrait of an Art Colony, by Marion Whybrow; designer and co-publisher with Janet Axten 'Gasworks to Gallery- Story of St.Ives'; co-author of 'Art About St.Ives' with Cyril Gilbert and Roy Ray. *Recreations:* classical music, opera, films (cinema). *Signs work:* monogram of 'C' inside 'O'. *Address:* Manor House, Ayr, St.Ives, Cornwall, TR26 1DU. *Email:* cocostives@btinternet.com

O'REILLY, Faith, N.D.D., Dip. R.A., A.T.C.; oil and water-colourist. *b:* Boston, Mass., U.S.A., 6 Aug., 1938. *d of:* Eileen O'Reilly. *Educ:* in U.S.A. and England. *Studied:* Berkshire College of Art, Royal Academy Schools, Hornsey and University of London. *Exhib:* group and solo shows: Midland Group Gallery; 273 Gallery, London; shows in Universities, Surrey, Sussex, Montpellier, Paris and Dieppe. *Works in collections:* U.S.A., France, Australia, Singapore, Britain. *Commissions:* 'Roman' Mosaic, Moorgate, London. *Publications:* Snoopy's Guide to Computors, Btn. Poly, Mag. *Clubs:* N.A.A., Reynolds Club, R.A. London. *Misc:* Helped to found Stanley Spencer Gallery, Cookham, Berkshire. Studios: Le Vernet, Zamalou les Bains, 34240 France; Kemptown, Brighton BN2 2EB. *Signs work:* "F.O.R." and "Faith O'Reilly." Returned to "O'Reilly" from

adoptive name "Gibbon" in 1975. *Address:* 13 Walpole Terr., Kemptown, Brighton, Sussex BN2 2EB.

O'REILLY, Joseph, 1st Class Hons, Fine Art; Awards: Hunting Art Prize; Edward Oldham Prize, Manchester Academy. *b:* Yorkshire, 1957. *Educ:* Batley School of Art and Design. *Studied:* Sheffield Polytechnic of Art and Design. *Represented by:* Bruton Gallery Ltd., and others. *Exhib:* Discerning Eye, Mall Galleries, London; RCA; Olympia; Hunting Art Prize, RCA; public galleries in Dean Clough, Leeds, Bradford, Liverpool, Huddersfield, Halifax, Manchester; France and Holland. *Works in collections:* Boston, USA; Calderdale Art Gallery; Kirklees Art Gallery; Duke of Devonshire; private collections, UK & USA. *Principal Works:* Still Life. *Signs work:* "Joseph O'Reilly". *Address:* c/o Bruton Gallery Ltd., P O Box 145, Holmfirth, Yorks, HD9 1YU.

O'REILLY, Oran, MA (RCA). *Medium:* digital media, drawing, prints. *b:* Stockport, 27 Jun 1975. *Studied:* RCA (1999-2001). *Represented by:* Keith Talent Gallery, London; Toomey-Tourel, San Francisco. *Exhib:* Cynthia Broan Gallery, New York (2005); Keith Talent Gallery, London (2003-05); Toomey-Tourel Gallery, San Francisco (2003); RA Summer Show (2003, 2005); Nickle Arts Museum, Calgary (2002). *Works in collections:* Thomas Dane (London); Royal College of Art; University of Lincoln. *Publications:* Miser and Now Magazine 'Eighty six Occurences'. *Signs work:* 'Oran O'Reilly'. *Address:* c/o Keith Talent Gallery, 2-4 Tudor Road, London E9 7SN. *Email:* mail@oranoreilly.co.uk *Website:* www.oranoreilly.co.uk

O'REILLY, Richard, F.P.S.; artist in oil, water-colour, ink, wood;. *b:* London, 11 May, 1932. *m:* P. Turner. two *s.* one *d. Educ:* Avondale School, Cheadle Heath, Ches. *Studied:* under William Redgrave, sculptor-draughtsman 'One to One'. *Exhib:* Guildhall London, Ragley Hall, Foyles's King's College, Vienna 9th International, P.S., Tattershall Castle, Cambridge Union, University of Essex, House of Commons, B.A.C., St. Martin-in-the-Fields, London. *Works in collections:* Loggia Gallery, The Investment Gallery, Paris, Berlin, Vienna, N.Y. *Works Reproduced:* Arts Review. *Signs work:* "O'Reilly." *Address:* 12 Acanthus Rd., Battersea, London SW11 5TY.

ORGAN, Robert, D.F.A. (Lond.), R.W.A.; painter in oil, water-colour, sometimes tempera; Arts Council Award (2005). *b:* Hutton, Som., 27 Jan 1933. *s of:* Edward Organ, architect. *m:* Valerie Barden. one *s.* three *d. Studied:* West of England College of Art, Slade School. *Exhib:* Beaux Arts, Bath (1983-95), Browse & Darby (1981-2007), R.W.A. (1995). *Works in collections:* Brighton and Hove A.G., Exeter Royal Albert Museum, Devon Educ. Com., Cornwall Educ. Com., R.W.A. Collection, Somerset C.C., S.W.A. Collection, Universities: Edinburgh, Exeter, Reading, Dorset County Hospital, Dorchester, Hereford County Hospital; Godolphin House, Cornwall. *Publications:* By the Look of Things (biography) Jenny Pery, Redcliffe Press 2003; various articles, art and

architectural journals. *Signs work:* "Robert Organ" usually on back. *Address:* Lower Ridge, Wambrook, Chard, Som. TA20 3ES.

ORMELL, Christopher Peter, FRSA; FIMA; BLitt; MA. *Medium:* watercolour and acrylic. *b:* Coventry, 24 Dec 1929. *s of:* Dr. R.L.Wormell. *m:* (1) Iris Bennett (1958-90); (2) Sheila Rosemary Richards (1995 -). one *d. Educ:* King Henry VIII School, Coventry (1938-48) (Senior Painting Prize 1946, 47). *Studied:* Magdalen College, Oxford. *Exhib:* RA Summer Exhbn (2003); Blackheath Conservatoire (2002-07); Blackheath Art Society (2005, 2006). *Publications:* 'After Descartes' (Ingleside-Ashby, 2000). *Official Purchasers:* painting in RA Summer Exhbn 2003 sold. *Principal Works:* Madrid from the Viaduct (2002); Landscape Peak District (2003); A Visitor from the Past, Broadstairs (2005). *Recreations:* writing, walking. *Clubs:* Royal Overseas League. *Misc:* painting was my favourite activity at school. It was suggested that I should go to Slade School of Art, however, I chose an academic career. Since 2002 I have returned to painting. *Signs work:* 'Chris Ormell'. *Address:* 3 Ingleside Grove, Blackheath, London SE3 7PH. *Email:* chrisormell@compuserve.com

ORR, Chris, M.A. (1967), R.A. (1995); artist in painting, etching, lithography; Professor of Printmaking, Royal College of Art. *b:* London, 8 Apr 1943. *m:* Catherine Terris. one *s.* one *d. Educ:* Beckenham & Penge Grammar School. *Studied:* R.C.A. (1964-67). *Exhib:* R.A. Summer Exhbn.; one-man shows: London, America, Australia, France, Japan, Canada, Jill George Gallery, London. *Works in collections:* V. & A., British Council, Arts Council, Science Museum, Royal Academy of Arts, Government Art Collection, British Museum. *Publications:* John Ruskin (1976), Arthur (1977), Many Mansions (1990), The Small Titanic (1994), Happy Days (1999), Semi-Antics (2001), The Disguise Factory (2003). *Clubs:* Chelsea Arts Club. *Signs work:* "Chris Orr." *Address:* 5 Anhalt Road, Battersea, London SW11 4NZ. *Email:* chrisorr@aol.com *Website:* www.chrisorr-ra.com

ORR, James, Royal College of Surgeons and Physicians award R.G.I. (1997); artist in acrylic. *b:* Glasgow, 29 Jun 1961. *m:* the late Elizabeth Inglis. one *d. Studied:* part time, Glasgow School of Art (1970-78). *Exhib:* R.S.A., R.G.I., R.W.A., P.A.I. *Works in collections:* Royal College of Surgeons and Physicians, London and Glasgow; H.R.H. The Duke of Edinburgh; Ayr Civic Collection. *Signs work:* "Orr." *Address:* 36 Gray St., Prestwick, Ayrshire KA9 1LX.

ORWIN, Carol, SWA, SSS, CAS; Falle Fine Art Bronze Award. *Medium:* sculptor. *b:* Herts, 8 Dec 1950. *d of:* Cyril William Orwin. one *s. Studied:* High Wycombe School of Art; St.Martins School of Art. *Represented by:* Leslie Frontl. *Exhib:* Mall Galleries; SWA; RHS Wisley Borde Hill Savill Garden, Painshill Park, Petworth; Polesden Lacey, Chelsea; Fire Iron Gallery. *Works in collections:* in Israel, America, Canada, Australia, New Zealand, Europe. *Commissions:* University of Surrey. *Signs work:* 'Carol Orwin'. *Address:* 26 Barrack Road,

Guildford, Surrey, GU2 9RU. *Email:* orwin@sculpture50.fsnet.co.uk *Website:* www.orwinsculptures.com

OSBORNE, Dennis Henry, N.D.D., Hon.R.U.A.; painter in oil, retd. teacher of art. *b:* 23 Dec 1919. *m:* Maureen. one *d. Studied:* Heatherley School of Art (1946), Camberwell School of Art (1946-50, Pasmore, Coldstream, Minton, Monnington). *Exhib:* many including N.E.A.C. (1950), R.A., Hamilton A.G. Canada (1954, 1956, 1957), O.S.A. Toronto Gallery, Queen's University Belfast, R.H.A. Dublin, Royal Academy, London (1952), Brooklyn Museum, New York – 20th Biennial International (1959); one-man shows: Ulster Arts Council (C.E.M.A.) (1962, 1968), Jorgensen Fine Art Dublin, Molesworthy Gallery, Dublin (2001); self portrait – Haverly Trust Award, etc. *Works in collections:* Hamilton A.G., Canada; National Self-portrait Collection, Limerick; UTV Belfast; Linen Centre and Museum, Lisburn, etc. *Publications:* Dictionary of Canadian Artist Vol.5, Dictionary of British Artists by Grant McWaters, 1900-1950, Dictionary of Royal Academy Exhibitors, 1905-1970, Camberwell School of Art - Teachers and Students by Geoff Hassell, etc. *Signs work:* "D.H. OSBORNE." *Address:* 12 South Street Mews South Street, Newtownards, Co. Down BT23 4LB.

OSBORNE, Roy, Turner Medal of Colour Group GB (2003); MA (Lond.)(1994), BA (Hons)(1970). *Medium:* painter in oil, acrylic, watercolour; author, educator. *b:* Bristol, 15 Jul 1948. *Studied:* Inst. of Education (1992-94), Brighton Polytechnic (1966-71). *Exhib:* UK frequently and USA (since 1970). *Works in collections:* Brighton and Hove Museums, RCA (London), 30 private collections (UK and abroad). *Publications:* Color Influencing Form (2004), Books on Colour 1500-2000 (2004), From Prism to Paintbox (exhbn. cat. 1989), Lights and Pigments (1980), and contributions to Colour and Humanism (Pavey, 2003), The Color Compendium (Hope, 1989). *Official Purchasers:* University of Newcastle (2002). *Principal Works:* West Pier series, Bends series, Heraldic series. *Recreations:* writing, music. *Clubs:* Society of Authors, Colour Group GB. *Misc:* lectured at 150 art schools worldwide (1978-2003). *Signs work:* Osborne f. year. *Address:* 17 Hepplestone Close, London SW15 5DE. *Email:* art.school@virgin.net *Website:* www.coloracademy.co.uk

OSBORNE, Stuart John, A.R.C.A., A.T.D.; sculptor, models portraits, figures and animals; stone and wood carver. *b:* Weston-s-Mare, Som. *s of:* H. T. Osborne. *m:* Margaret Cole, A.T.D., portrait and animal painter. one *d. Educ:* Kingsholme School, Weston-s-Mare. *Studied:* Bristol College of Art, and Royal College of Art, London. *Exhib:* Galerie Salammbo, Paris, Vallombreuse, Biarritz, International, New York, Geneva, Tate, Kulfurgeschichtliches Museum, Osnabruck. *Works in collections:* public and private, including portraits and animals. *Publications:* in 'Cambridge Blue Book'. *Signs work:* "S.J. Osborne." *Address:* 64 Burton Manor Rd., Stafford ST17 9PR.

OSLER, Anthony, *Medium:* watercolour, gouache, occasionally oil. *b:* Ipswich, 5 Jan 1938. two *d. Educ:* Northgate Grammar School, Ipswich; Royal Agricultural College, Cirencester. *Studied:* Southampton University. *Represented by:* Francis Iles, Rochester; Peter Hedley Gallery, Wareham; The Southwold Gallery. *Exhib:* Mall Galleries (with EAGMA, four times; with RSMA twice); currently: Francis Iles, Rochester; Peter Hedley Gallery, Wareham; The Southwold Gallery; Snape Maltings Gallery, Suffolk; Thoresby Exhibition Centre, Nottinghamshire; one-man shows include: Ipswich, Maldon, Bury St.Edmunds, Galerie Atlantide (Paris); numerous mixed exhibitions. *Works in collections:* work in private collections worldwide. *Commissions:* many commissions for yachts and tradition craft. *Publications:* Yachts and Yachting Illustrations (1970s); author of book about a sailing barge skipper "Whe're Yer For" (Chaffcutter Books, 2006). *Works Reproduced:* Yachting Magazines (see above); The Artist. *Recreations:* yachting (own boat). *Misc:* Founder Member (1979) and Chairman, East Anglian Group of Marine Artists. *Signs work:* "ANTHONY OSLER". *Address:* Cambria Cottage, 20 The Street, North Lopham, Diss, Norfolk, IP22 2NB. *Email:* oslers@camcot.fsnet.co.uk

OSMOND, Edward, A.T.D., M.S.I.A., Carnegie Award; artist in oils, wash, line, illustrations, commercial drawing and book design;. *m:* C. M. ("Laurie") Osmond, sc. and painter. *Signs work:* in full, block caps. *Address:* Downland Cottage, Lullington Cl., Seaford, E. Sussex BN25 4JH.

OTTEY, Piers Ronald Edward Campbell, B.A.(Hons.); painter in oil on canvas and panel, lecturer. *b:* London, 27 Sep 1955. *s of:* Ronald Harry Ottey, F.S.C.A. *m:* divorced. two *s.* one *d. Educ:* King's College School, Wimbledon. *Studied:* Chelsea School of Art (1974-78, the late Patrick Symons, Myles Murphy). *Exhib:* R.A., Bath Contemporary Arts Fair, London, Sussex, Paris; one-man shows: Brighton (1988), Midhurst (1991), Stansted House (1994), Seaford College (1994), The Mill Studio, Sussex (1996, 2003, 2004, 2005), Bates Gallery, London (1996, 1998), Sheridan Russell Gallery, London (2000, 2001), Weil am Rhein, Germany (2006), West Stoke House (2006). *Works in collections:* Exxon UK, National Health Service Trust, Worthing Museum, Pallant House Gallery, Bath University. England, France, Denmark, Canada. *Commissions:* Grant Thornton, Chichester Hospital. *Publications:* Exhibit 'A' Magazine, 4 page feature (2000), Norbert Lynton Essay (2000). *Signs work:* "Ottey." *Address:* The Mill Studio Newhouse Farm Barns Ford Lane, Arundel, W. Sussex BN18 0EF. *Website:* www.piersottey.co.uk

OULTON, Therese, B.A. Hons. (Fine Art), M.A. (R.C.A.); painter in oil. *b:* Shrewsbury, Salop, 20 Apr 1953. *m:* Peter Gidal. *Studied:* St. Martin's and Royal College of Art. *Represented by:* Marlborough Fine Art, London. *Exhib:* fifteen solo exhibs. since 1984 in London, New York, Los Angeles, Vienna, Berlin, Munich, Museum of Modern Art, Oxford etc., as well as group exhibs. Venice Biennale, Turner Prize at The Tate, Mellon Centre, Yale, Stockholm etc. *Works in collections:* Tate, Metropolitan, National Gallery of Australia, Harris Museum,

Museum of Fine Art, Boston, British Museum, Leeds City Art Museum, V. &. A., St. Louis Art Museum, Missouri, Broadgate, Hoffman Collection, Berlin etc. *Publications:* monograph catalogues include Marlborough, London, Andrew Benjamin in 'Journal of Philosophy and the Visual Arts', Stuart Morgan's essay and interview in 'What the Butler Saw', Angela Moorjani's chapter in 'Loss and Lestness' etc. *Signs work:* "Therese Oulton." *Address:* 28 1/2 Lansdowne Crescent London W11 2NS. *Email:* thereseoulton@btinternet.com

OUTRAM, Steven, RBA. *Medium:* pastel, oil, drawing. *b:* Kent, 22 Jul 1953. *Studied:* Medway College of Art (1969-73). *Represented by:* Fairfax Gallery; Island Fine Arts; Linda Blackstone Gallery; John Allen Fine Art; Red Rag Gallery; Martins Gallery, Cheltenham. *Exhib:* solo: Seen Galleries, London (1979, 1981, 1983, 1985); King Street Gallery, London (1986); Gloucester City Museum and AG (1992); group shows inc. New York Art Expo, Seen Galleries Seattle, The Private Collector Cork & Dublin; Mall Galleries; NEAC; ROI; PS; RBA; Christie's Contemporary Arts, Bath & Cambridge; Liverpool Royal Liver Building; Glasgow Kelvingrove Museum & AG. *Clubs:* The Arts Club, Dover St., W1. *Signs work:* 'Outram'. *Address:* Mission Hall, Forge Hill, Lydbrook, Glos GL17 9QS.

OVERTON, Alan, artist in acrylic. *b:* Salisbury, Wilts., 27 Nov 1946. *m:* Petula. one, Melissa *d. Educ:* St. Thomas' School, Salisbury. *Exhib:* R.A. Summer Show, R.W.A., Royal Bath and West Show, N.A.P.A. (The Artist award Wales, 1999), S.W. Academy of Fine and Applied Arts, Exeter, Oexmann Art Awards Competitions, Devizes (3rd prize 1992), Black Swan Arts Open Painting Competitions, Frome, Bath Society of Artists Open Exhibition. *Works in collections:* Lord Bath, many private collections. *Clubs:* N.A.P.A., Frome Art Soc. *Signs work:* "A. Overton." *Address:* 26 Lynfield Rd., Frome, Som. BA11 4JB.

OWEN, Don, NDD, ATC, RBA, WSW. *Medium:* oils (landscape and portrait), wood and PVC engraving, drawings (pencil and other media), watercolours. *b:* Wales, 7 Dec 1929. *s of:* Jonn Owen. *m:* Janet. *Educ:* Llandiloes Grammar School. *Studied:* Swansea College of Art. *Exhib:* RWS, RMA, NEAC, RA, RI, RE Originals Exhbn (1990-2005 inc.), RBA (1995-2007 inc.), SWLA. *Works in collections:* internationally. *Commissions:* various portraits in oil and pencil, landscapes, etc. *Signs work:* 'DON OWEN'. *Address:* 97, Saunders Way, Derwen Fawr, Swansea, SA2 8BH.

OWEN, Glynis, BA (Fine Art) (1966), ATC (1967), FRBS (1990); sculptor in stone, bronze, glass and printmaker; mem. of Printmakers Council. *b:* Gravesend, Kent, 22 May 1945. *d of:* Henry Joseph Collins Jones, company director. *m:* Robert John Owen. two *s.* one *d. Educ:* Portsmouth High School, GPDST. *Studied:* Portsmouth College of Art (1962-66), Goldsmiths' College (1966-67). *Represented by:* Royal Society of British Sculptors. *Exhib:* RIBA (1991), Glyndebourne Festival Opera (1996), Millennium Exhbn., Artmonsky Arts

(1999), Charlotte Street Gallery, London (2003), R.A.Summer Exhibition (2003), AAF New York (2003), Gallery K (2005), Hampstead, London, Printroom, London (2007). *Works in collections:* Alton College, Hants. purchased by Hants. Architects Dept.; Stevenage Town Centre, life-size family group, commissioned by Stevenage Development Corp.; Portrait of Jacqueline du Pre for Music Bldg. St. Hilda's College, Oxford; Tate Modern, Resource. *Commissions:* national: Teaching Awards Trophy established by Lord Puttnam C.B.E. (2000), Relief Sculpture for Stafford (2003), John Downton Awards for Young Artists (2003), Covent Garden Commemorative Bronze Relief Sculpture (2004-06), Empress State Building, London (2007). *Publications:* Carving Techniques by Glynis Beecroft (Batsford 1976), Casting Techniques by Glynis Beecroft (Batsford 1979). *Official Purchasers:* Tate Modern. *Works Reproduced:* Open Air Sculpture in Britain, W.J.Strachan, Zwemmer, Tate Gallery. *Signs work:* "Glynis Owen." *Address:* The Studio, 52 Pilgrim's Lane, Hampstead, London NW3 1SN. *Email:* glynisowen@talk21.com *Website:* www.glynisowensculptor.co.uk

OWEN, Muriel Sylvia, NDD, ATD, SWA, FRSA; painter in water-colour, lecturer; Head of Art and Deputy Principal, Dixon and Wolfe, Tutors, London SW1 (1969-82); Vice-Pres., Soc. of Women Artists; runs painting holidays worldwide – under the name "Muriel Owen Painting Holidays". *Medium:* mainly watercolour. *b:* Welwyn Garden City. *d of:* Arthur Tremlett Cuss. *m:* Edward Eardley Owen, M.A. three s. by previous marriage. *Educ:* Welwyn Garden City Grammar School. *Studied:* St. Albans School of Art (1946-50 under Gwen White and Christopher Sanders, R.P., R.A.), London University (1951). *Exhib:* R.I., S.W.A., U.A., Llewellyn Alexander Gallery, London; ten one-man shows, London, Fairfield Halls, Croydon, Yarmouth Castle, I.O.W. official galleries, Italy, permanent exhibition at Osborne House, Isle of Wight. *Works in collections:* 38 paintings English Heritage, I.O.W. Arts Council, Bank of England, Queen Elizabeth Military Hospital, Woolwich, Atomic Energy Commission, London. *Commissions:* English Heritage. *Publications:* 'Artist in Residence' (new book of Painting). *Official Purchasers:* Bank of England, English Heritage. *Works Reproduced:* St. Paul's, Westminster, floral, (Henry Ling), calendars and 32 cards (IoW County Press), series of 4 art teaching videos, articles in major newspapers. *Principal Works:* Westminster Cathedral, Bank of England, Guildhall, etc. *Signs work:* "Muriel Owen." *Address:* Briarwood House, Church Hill, Totland, I.O.W. PO39 0EU. *Email:* muriel@po39eu.freeserve.co.uk

OXENBURY, Helen Gillian, illustrator/writer in water-colour; Kate Greenaway medal (1969), Smarties award (1989), Boston Globe award, Kurt Maschler award (1985);. *b:* 2 June, 1938. *m:* John M. Burningham. one *s.* two *d. Studied:* Ipswich School of Art and Central School of Arts and Crafts, London. *Publications:* illustrated: The Three Little Wolves and the Big Bad Pig (1993), Farmer Duck (1991), We're Going on a Bear Hunt (1989), Alice's Adventures in Wonderland (1999), Franny B.Kranny (2001), Big Momma Makes the World (2002). *Signs work:* "Helen Oxenbury." *Address:* c/o Walker Books, 87 Vauxhall Walk, London SE11 5HJ.

OXLADE, Roy, M.A., R.C.A.; painter. *b:* 1929. *s of:* William Oxlade, engineer. *m:* Rose Wylie. one *s.* two *d. Studied:* Bromley College of Art and with David Bomberg. *Represented by:* Art Space Gallery, London. *Exhib:* Young Contemporaries (1952-54), Borough Bottega Group (1954, 1955), Winnipeg Biennial (1st prize drawing, 1960), John Moores (1963, 1991), Hayward Annual (1982), Norwich Gallery 'Rocks and Flesh' (1985), Cleveland International (1989), Norwich Gallery, 'EAST' (1991, 1994), Velan, Turin (2000); one person shows: Vancouver A.G. (1963), New Metropole, Folkestone (1983), AIR Gallery (1983), Odette Gilbert Gallery (1985, 1987, 1988), Gardner Centre, University of Sussex (1990), Reed's Wharf Gallery, London (1993), Art Space Gallery, London (2001, 2004); two person show: Wrexham & Aberystwyth Arts Centres (1999). Korn/Ferry R.A. Picture of the Year (1997). *Works in collections:* South East Arts, Railtrack London, Deal Dallas, University College Oxford, J.C.R. *Publications:* David Bomberg (R.C.A. Papers 3 1981). *Clubs:* Chelsea Arts Club. *Address:* Forge Cottage, Newnham, Kent, ME9 0LQ.

OXLEY, Valerie Mary, Cert.Ed. (1969), A.N.E.A. (1983), S.B.A. (1987); self taught botanical illustrator in pencil, water-colour, pen and ink; Tutor, botanical illustration, A.E.C. *b:* Manchester, 26 Sep 1947. *m:* Michael Oxley, M.Sc., C.Eng. one *d. Educ:* Abbeydale Girls' Grammar School, Sheffield; Hereford College of Educ. *Exhib:* S.B.A., R.H.S., Linnean Soc., Portico Gallery, Manchester, Durham A.G., Museum of Garden History, London. *Works in collections:* The Florilegium Society at Sheffield Botanical Gardens Archive. *Publications:* Art Editor 'Wild Flowers of the Peak District' published by the Hallamshire Press, Sheffield. *Clubs:* Vice President, Northern Soc. of Botanical Art, Chairman: The Florilegium Society at Sheffield Botanical Gardens. *Signs work:* "Valerie Oxley." *Address:* Brookside, Firbeck, Worksop, Notts. S81 8JZ.

P

PACE, Shirley, sculptor and artist in bronze, charcoal, pen and ink, conté, monochrome, representational. *b:* Worthing, Sussex, 16 Feb 1933. *d of:* Arthur Blasdale, musician, writer, artist. *m:* Roy Pace. two *d. Educ:* Worthing Convent. *Studied:* Worthing School of Art (1948-51). *Exhib:* Mall Galleries, Alwin Gallery, many provincial and overseas galleries. *Works in collections:* Life and a quarter dray-horse, London; private collections: Britain, U.S.A., Bermuda, New Zealand, Australia, Hong Kong. *Commissions:* bronze works from life of specific horses. *Works Reproduced:* most, in limited editions. *Clubs:* Chichester Art Soc. *Misc:* specialising in dynamic power of movement. *Signs work:* "Shirley Pace." *Address:* Quinnings Barn, Mill Road, West Ashling, Chichester, W.Sussex PO18 8EA.

PACKARD, Gilian E., Des.RCA (1962), FSDC (1963), FRSA(1975), FCSD (1977); first woman freeman of Goldsmiths' Company by special grant (1971); designer of jewellery in gold, platinum, silver and stones; Senior Lecturer, Sir John Cass Dept. of Arts, Design and Manufacture, London Guildhall University.

b: Newcastle upon Tyne, 16 Mar 1938. *d of:* John L. Packard. *Educ:* Claremont School, Esher. *Studied:* Kingston-upon-Thames School of Art (1955-58), Central School of Arts and Crafts (1959), Royal College of Art (1959-62). *Works in collections:* Goldsmiths Hall, De Beers, V. & A. *Signs work:* "G.E.P." within oval, (Hallmark). *Address:* 8.2 Stirling Ct., 3 Marshall St., London W1V 1LQ.

PACKER, Neil Martin, SIAD; DipAD. *Medium:* watercolour, drawing. *b:* Sutton Coldfield, 7 Aug 1961. *s of:* Judith & John Packer. one *s.* *Studied:* Colchester School of Art (1977-81). *Represented by:* Hugo Wienberg, 32 Place St.George, Paris. *Exhib:* Royal Academy; Portal gallery, London; Medici Gallery, London; Chris Beetles; British Museum; British Library. *Works in collections:* several hundred in The Hoffman Collection, Atlanta, Georgia, USA; many in private collections in the UK. *Commissions:* Atlanta Historic Society, numerous private and commercial commissions. *Publications:* various advertising campaigns in UK/USA; wide variety of books including eight for the Folio Society. *Works Reproduced:* several prints reproduced by Cheyne Walk Publications as well as many illustrated books. *Recreations:* walking, drinking, opera. *Clubs:* Brave Club. *Signs work:* 'Neil Packer'. *Address:* 55 Miles Buildings, Penfold Place, Edgware Road, London NW1 6RG. *Email:* arvokimchi@yahoo.co.uk

PACKER, William John, N.D.D. (Painting), N.E.A.C.,Hon. F.R.C.A., Hon. R.B.A.; painter in oil and water-colour; Art Critic, The Financial Times (since 1974). *b:* Birmingham, 19 Aug 1940. *s of:* Rex Packer. *m:* Clare Winn. three *d.* *Educ:* Windsor Grammar School; Wimbledon School of Art (1959-63), Brighton College of Art (1963-64). *Represented by:* Piers Feetham Gallery. *Exhib:* R.A.; solo shows at Piers Feetham Gallery (1996, 2001, 2004), two-man show (with William Feaver)(2005); group exhbns.: Angela Flowers, Cadogan Contemporary, Ian Potts (2007), and many other galleries. *Works in collections:* private collections. *Publications:* The Art of Vogue Covers (Octopus, 1980), Fashion Drawing in Vogue (Thames & Hudson, 1983), Henry Moore (with Gemma Levine) (Weidenfeld & Nicolson, 1985); John Houston (Lund Humphries, 2003), Tai-Shan Schierenberg (Flowers East, 2005). *Clubs:* Chelsea Arts, The Academy, Garrick. *Signs work:* "W.P." or "W. PACKER." *Address:* 60 Trinity Gardens, Brixton, London SW9 8DR.

PACKHAM, John Leslie (Les), M.B.E. *Medium:* watercolour, oil, acrylic. *b:* Keighley, 9 Feb 1945. *m:* Judith. one *s.* one *d.* *Studied:* self-taught. *Exhib:* Mall Galleries, London; House of Commons; University Womens' Club, London; Ferens, Hull; Mercer, Harrogate; Smith Galleries, Winston-Salem NC, USA. *Works in collections:* National Trust; Barnsley M.D. Council; Halifax BS (HBOS), Arla. *Commissions:* National Trust; Archant Life Magazines; 'Emmerdale', Yorkshire TV. *Publications:* Yorkshire Life Magazine, Dalesman Magazine, Judges Calendars, Yorkshire Ridings Magazine. *Recreations:* motorcycling. *Clubs:* Fylingdales Group of Artists. *Signs work:* 'P A C K H A M'.

Address: Holly House, 104 Lennox Drive, Wakefield, W.Yorks, WF2 8LF. *Email:* les.packham@btinternet.com *Website:* www.lespackham.co.uk

PAES, Rui, M.A., R.C.A. (1988), Dip. E.S.B.A.P. (1976-81); painter in oil and water-based media;. *b:* Pemba, Mozambique, 13 July, 1957. *m:* divorced. one *s.* *Educ:* Escola de Belas Artes do Porto, Portugal (1976-81), Royal College of Art, London (1986-88); Calouste Gulbenkian Scholarship (1986-1988) and the Beal Foundation Grant. *Exhib:* England, Germany, Portugal and Spain. *Works in collections:* Museu de Arte Moderna, Oporto, Portugal, The Beal collection, U.S.A., the Royal College of Art Permanent collection; John Studzinski; Durazzo Pallavicini, Genoa; Madonna. *Commissions:* Mural painting in Egypt, England, France, Germany, Norway, Portugal, Lebanon and Italy. *Publications:* illustrations for "..do tempo inutil" by Gloria de Sant'anna (1975); illustrations for 'Lotsa de Casha' by Madonna (2005). *Clubs:* Chelsea Arts. *Address:* Studio 4, 381 King's Road, London SW10 0LP. *Email:* paes.rui@gmail.com

PAGE, Charles, R.I. (1988), M.S.I.A. (1955); painter, illustrator and graphic designer in water-colour, acrylic, mixed media, collage;. *b:* Leighton Buzzard, 17 Apr., 1910. *m:* (1) Jessie Stevens (decd.). (2) Beryl Sheaves (decd.). one *s. Educ:* Luton Grammar School. *Studied:* Central School of Art and Crafts (1928-29). *Exhib:* R.I., R.W.S., R.S.A., R.B.S.A. and several provincial galleries. First recipient of Rowland Hilder Award at R.I. (1994). *Works in collections:* Luton A.G., Letchworth A.G. *Signs work:* "Charles Page." *Address:* 13 Carisbrooke Rd., Harpenden, Herts. AL5 5QS.

PAGE, Dione, RWA; RWA Watercolour Award (1983, 1988); Essex Open Exhibition Award (1994, 1995); East of England Art Exhibitions Award (1995, 1996); Graphic Designer, Adult Education Art Tutor. *Medium:* mixed media- wax pastels, gouache and lumograph pencil 8B. *b:* London, 10 Jul 1930. *m:* Nelson Blowers. two *s.* one *d. Studied:* Colchester School of Art. *Exhib:* RA; RWA (1984-present); Fermoy Gallery, Kings Lynn; Heffer Gallery, Cambridge; Fishguard/ Cardiff, South Wales; Aldeburgh Festival; Merrick Gallery; Patricia Wells Gallery, Bristol; 5D Gallery, Chepstow; Clifton Gallery, Bristol; John Russell Gallery, Ipswich; Hayletts, Colchester, Maldon; The Minories, Colchester; Chappel Galleries, Essex. *Publications:* The Artist (Nov '04). *Official Purchasers:* National Library of Wales; Nuffield Foundation; Guiness plc; Waterworks, Bristol; Essex County Council; Chelmsford and Essex Museum; Suffolk Education Committee; Glamorgan Education Committee; Faculty of Design, Bristol; The Minories, Colchester. *Recreations:* gardening, travelling, collecting ceramics. *Signs work:* 'D Page R.W.A.'. *Address:* Dale Brow, Thorpe Road, Weeley, Clacton, CO16 9JL.

PAGE, Warren Lee, UK finalist, Lexmark European Art Prize (2003). *Medium:* acrylic on aluminium; acrylic on canvas. *b:* Shoeburyness, Essex, 5 Mar 1979. *Studied:* self-taught. *Exhib:* Lexmark European Art Prize, Eyestorm Gallery, London (2003). *Principal Works:* Angelina on Mars; Second Coming

Advent Calendar (series); Read My Lips (series). *Signs work:* WLP (on reverse). *Address:* 80a Southwold Crescent, Benfleet, Essex. *Email:* warren@pagenw.fsnet.co.uk

PAGE-ROBERTS, James, painter in oil, sculptor, artist in black and white, and writer. *b:* Silchester, 5 Feb 1925. *m:* Margaretha Klees. two *s. Educ:* Wellington College, and Taft, U.S.A. *Studied:* Central School of Arts and Crafts. *Exhib:* one-man shows at Galerie de Seine, Reid Gallery, Kintetsu Gallery, Osaka, Qantas Gallery, Cambridge. *Works in collections:* National Art Collection. *Publications:* Writer of over 700 articles on vines and wines, and author/illustrator of 14 books on vines, wines, cooking, docklands, household management and travel. *Clubs:* MCC. *Misc:* paintings sold Christie's 2006 - £28,000. *Signs work:* "P R" and "PAGE-ROBERTS." *Address:* 37 St. Peter's Grove, London W6 9AY.

PAINE, Ken, P.S., S.P.F.; portrait artist in pastel, oil, water-colour; Master Pastellist of France. *b:* 2 Nov 1926. one *s.* two *d. Studied:* Worked with R.Q. Dunlop, R.A.; studied at Twickenham College of Art. *Exhib:* annually P.S., R.P., R.O.I., R.I. at Mall Galleries London, R.W.A., widely exhib. in and around London, U.S.A., France, Canada, Germany; solo exhbns. include Llewellyn Alexander Gallery, London; Edward Day Gallery, Ontario, Canada, Holburne Museum of Art, Bath; L'Abbaye de Flaran, nr.Toulouse, France. *Commissions:* many which include Sir David Atkinson Air Marshal, Trevor McDonald broadcaster. *Publications:* (Biography) "Ken Paine - His Life and Work" by Michael Simonow. *Works Reproduced:* television programme 'Ken Paine, Painting Faces'. *Signs work:* "PAINE." *Address:* 8 Spring Gdns., E. Molesey, Surrey KT8 0JA.

PALMER, Brian, BA (Hons) Fine Art. *Medium:* painter in oil and watercolours; printmaker. *b:* Dublin, Eire, 1929. *m:* Brenda(decd). one *s.* two *d. Studied:* Sir John Cass (1991-93) Middlesex University (1993-94), University of Herts (1994-98). *Represented by:* New British Artists. *Exhib:* RA Summer Exhbn (1996, 1998); New British Artists; Wills Art Warehouse; Small Print Beinnale; Reform Club; New Ashgate Gallery, etc. *Works in collections:* University of Herts, Tavistock Insititute, Big Green Door Ltd., New Solutions Ltd. *Publications:* illustrations to 'There's a Small Hotel' by Nicky Heyward. *Clubs:* Tripod. *Address:* Studio 307c, The Chocolate Factory, Wood Green, London N22 6XJ.

PALMER, Jean C., B.A. (Hons.) Fine Art; painter in oil; part-time Tutor - Adult College, Lancaster. *b:* Southport, 1961. *m:* Peter Layzell. one *s.* one *d. Studied:* Southport College of Art (1977-79), University of Central Lancs. (1979-82). *Exhib:* R.A. Summer Shows (1992-99), Society of Women Artists, Mall Galleries, London (2007); various North West and London exhbns. *Works in collections:* Manchester City A.G., NatWest Coll., Warrington Arts Council,

Jerwood Foundation. *Signs work:* "J.Palmer" on reverse. *Address:* 72 Vale Rd., Lancaster LA1 2JL.

PALMER, Joan Dowthwaite, First recipient of the Hilda Ball Award, South London Artists Group. *Medium:* sculpture, specializing in portraiture, in ceramics, bronze-resin and bronze. *b:* Barrow-in-Furness. *d of:* Herbert D Parker & Maude Sharpe. *m:* Raymond Palmer, writer. *Educ:* Barrow-in-Furness Grammar School, Cumbria. *Studied:* Muriel Painter, ARCA; John Ravera, PPRBS, SRSA; Angela Connor. *Exhib:* Royal Academy of Arts; Society of Portrait Sculptors; Discerning Eye; Mall Galleries; W.H.Patterson Fine Arts, Albemarle Street, London; Dulwich Picture Gallery; County Hall, London; Woodlands Art Gallery; South London Art Gallery; Public works: Carlisle Cathedral; John Rylands Library, Manchester University; Millom Library, Cumbria; St.Barnabas' Church, Bexhill-on-Sea; Tollgate Hotel, Gravesend; Churchill Theatre, Bromley, Kent; Hall Place, Bexley, Kent. *Works in collections:* The Rt. Hon. Margaret Hodge, MBE, MP; Joan Hurst; Manfred Mann. *Commissions:* Lakeland Poet Norman Nicholson, QM, OBE, for Millom Town Council, Cumbria, and private commissions. *Works Reproduced:* Daily Telegraph, The Guardian, Church Times, South London Press, North West Evening Mail, Kentish Times, Art for Pleasure, and exhibition catalogues. *Signs work:* 'J.D.Palmer' or 'JP' (as monogram). *Address:* 1 Lyme Farm Road, London SE12 8JE. *Email:* joanpalmer@f2s.com *Website:* www.joanpalmer.com

PALMER, John Frederick, RWA.(1991); Cornelissen prize RWA annual exhbn. (1985); graphic designer; artist in oil, water-colour, gouache; PP, Bristol Savages. *b:* Bristol, 11 Aug 1939. *s of:* Robert Palmer. *Educ:* Carlton Park, Bristol. *Studied:* West of England College of Art (1955-56, J. Arnold). *Exhib:* Bristol Artists, Arnolfini, R.W.A., Mall Gallery, First Sight. *Works in collections:* Bristol Savages, Leeds Bldg. Soc., NatWest Assurance, British Aerospace, Atomic Energy Authority, Wessex Collection, Block Busters, International Duty Free, private collectors. *Publications:* Drawing & Sketching (1993), Watercolour Landscape (1994). *Clubs:* Bristol Savages. *Signs work:* "J.F. Palmer." *Address:* 18 Haverstock Rd., Knowle, Bristol BS4 2BZ.

PALMER, Juliette, RBA (2001), NDD(1950), ATD(1951); painter in watercolour, illustrator, author; Finalist in Hunting, Singer & Friedlander/Sunday Times National Art Competitions, prizewinner Laing Painting Competition (1996); travel prize RWS (1996); St.Cuthberts Mill Prize, Royal West of England Academy (2000). *b:* Romford, 18 May 1930. *d of:* Sidney Bernard Woolley. *m:* Dennis Palmer BSc (Eng), DIC MICE. one *d. Educ:* Brentwood County High School. *Studied:* S.E. Essex School of Art (1946-50, Alan Wellings, William Stobbs, Bernard Carolan). *Exhib:* RA, RBA, RI, NEAC, RWS, RWA; group gallery shows, Philadelphia, USA, Sheffield, Windsor, Henley, Barnes, Bloomsbury; one-man shows, S. Australia, Tokyo, Cambridge, Chipping Norton, Cookham. *Works in collections:* Barking Library, Leicestershire Educ. Com. *Commissions:* numerous house portraits. *Publications:* 60 children's books

illustrated; author/illustrator, 6 children's picture/information books (Macmillan). *Works Reproduced:* magazines: Artists & Illustrators, International Artist; books: 'A Complete Watercolour Course' by Michael Whittlesea; 'Encyclopedia of Watercolour Techniques' by Hazel Harrison; 'Watercolour Techniques of 23 International Artists' by International Artist magazine. *Clubs:* Hon. Bucks Art Society. *Signs work:* "Juliette Palmer." *Address:* Melmott Lodge, The Pound, Cookham, Maidenhead, Berks. SL6 9QD. *Website:* www.the-rba.org.uk

PALMER, Margaret, A.T.D., P.S., N.S.; portrait painter in oil and pastel, animal and genre painter, book illustrator. *b:* London, 10 Sep 1922. *d of:* R.E.A.Palmer. *m:* R.G.W. Garrett. two *d. Studied:* Hornsey School of Art (1938-39), Salisbury School of Art (1939-41), Bournemouth College of Art (1941-42). *Exhib:* R.P., R.O.I., etc.; one-man shows in London, Guildford, Farnham, Leatherhead, works in worldwide collections. *Commissions:* Lord Howell, Lord Nugent, Sir David Rowe-Ham, Sir Richard Nichols, Sir Greville Spratt, Mother Teresa, Sandy Gall, Susan Hampshire, etc. *Publications:* written and illustrated, Honeypot and Buzz; also illustrated books published by Harrap, Heinemann, etc. *Signs work:* "Margaret Palmer." *Address:* Robins Oak, Wonersh Common Rd, Wonersh, Guildford, Surrey GU5 0PR.

PALTENGHI, Julian Celeste, B.F.A.; Winner 1993 Hunting/Observer art prizes: Travel award - Australia; painter in oil, sculptor in plaster and bronze. *b:* London, 28 Aug 1955. *s of:* David Celeste, ballet dancer/film director. *m:* Angela. one *d. Educ:* Stowe, Bucks. *Studied:* Cambridge (1976-77), Loughborough College of Art (1978-81). *Exhib:* 'Critic's Choice' Clare Henry: Cooling Gallery, Beaux Arts Galleries, London and Bath, Swiss Artists in Britain: October Galleries, Stephen Bartley, Chelsea, Camden Annual, G.L.C. Spirit of London Festival Hall, Centre Georges Pompidou, Paris, Royal West of England Academy, (purchased by) Christie's Cooperate Collection, Cassian de Vere Cole 'Paintings from Zanzibar'. *Clubs:* Chelsea Arts, Colony Rooms. *Signs work:* "PALTENGHI." *Address:* Tudor Cottage Burrington Shropshire SY8 2HT.

PANCHAL, Shanti, 1st prize winner Singer and Friedlander/Sunday Times Watercolour Competition (2001);M.A. Bombay (1977), Byam Shaw, London (1980); painter; resident artist, Harris Museum, Preston, British Museum (1994). *b:* Mesar, India. three *s. Studied:* Byam Shaw, London. *Exhib:* over 25 solo exhibs. in U.K. and abroad. *Works in collections:* Arts Council, British Museum, Birmingham Museum, Walker Art Gallery, Liverpool. *Commissions:* Imperial War Museum (1989), De Beers (1996), B.Arunkumar, Mumbai (2006). *Publications:* exhib. catalogues, 'Earthen Shades', Cartwright Hall, Bradford; Castlefield Gallery, Manchester (1998); 'Windows of the Soul', Angel Row Gallery, Nottingham (1997); 'Private Myths', Pitshanger Manor Museum and Gallery, London (2000), 'A Personal Journey' British Council, Jehangir Art Gallery and Cymroza Art Gallery, Mumbai (2003), 'Rigard and Ritual', Ben Uri Gallery, London Jewish Museum (2007). *Signs work:* "Shanti Panchal" or in

Gujarati. *Address:* 11a Graham Road Harrow, Middx. HA3 5RP. *Email:* shantipanchal@yahoo.co.uk *Website:* www.shantipanchal.com

PANCHERI, Robert, ARBS, Dip. (1977); sculptor in wood and stone. *b:* Bromsgrove, 22 Jun 1916. *s of:* Celestino Pancheri, wood carver. *m:* Bridget Milligan. two *s.* two *d. Educ:* Bromsgrove School. *Studied:* Birmingham School of Art (1934-39, William Bloye). *Works in collections:* statues: Winwick Lancs; Great Malvern Priory; Franciscan Friary, Chester; St. Peter's Church, Swinton, Manchester; sculpture panel, Sheldon Fire Station. *Signs work:* "R. Pancheri" lower case letters. *Address:* 12 Finstall Rd., Bromsgrove B60 2DZ.

PANKHURST, Alvin Ernest, Diploma Graphic Design (Hons); Benson & Hedges Art Award Winner (1974). *Medium:* oil, silk screen art, prints. *b:* New Zealand, 16 Nov 1949. *m:* Ephra. two *s. Studied:* Wellington School of Design. *Represented by:* Real Gallery, Auckland, NZ (Director). *Exhib:* RA Summer Exhbn; Apunto Gallery, Amsterdam; Real Gallery, Auckland, NZ; public galleries throughout NZ. *Works in collections:* London University; Te Papa National Art Gallery; Christchurch, Dunedin and Southland Public Art Galleries. *Commissions:* Equestrian Hotel, Christchurch; Fox Glacier Hotel, Westland National Park (50 paintings). *Publications:* 100 New Zealand Paintings; Art New Zealand Today. *Official Purchasers:* Parliament Buildings, Wellington: Te Papa, Dunedin, Southland Public Art Gallery. *Works Reproduced:* Treasures of the Dunedin Public Art Gallery. *Principal Works:* NZ Art - A Modern Perspective. *Signs work:* 'Alvin Pankhurst'. *Address:* 78 Gurney Court Road, St.Albans, Herts AL1 4RJ. *Email:* alvin@pankhurst.co.nz *Website:* www.alvinpankhurst.com

PANNETT, Denis Richard Dalton, GAvA; Hon. Freeman Painter Stainers Company; Winner, Hawker Siddeley Trophy (five times, for aviation art); Awarded The Order of Merit for Fine Art in Brazil. *Medium:* watercolour and oils. *b:* Hove, Sussex, 7 Sep 1939. *s of:* Major M R D Pannett & Juliet Pannett M.B.E. (portrait painter). *m:* Valerie. one *s.* two *d. Educ:* Uppingham School, Rutland. *Studied:* taught by my mother, Juliet Pannett MBE. *Exhib:* RI, RSMA, City of London Art Exhbn.; Guild of Aviation Artists; Painter Stainers Company; Wapping Group; Singer & Friedlander/Sunday Times Watercolour Competition; plus many private exhibitions including Hong Kong & USA. *Commissions:* The official Christmas cards for Sandringham, St.George's Chapel Windsor, St.Paul's Cathedral and Canterbury Cathedral. *Works Reproduced:* illustrations and covers for many books, calendars and cards; over 300 prints of golf courses. *Principal Works:* mainly landscape, marine, aviation and golf. *Recreations:* tennis, collecting militaria. *Clubs:* GAvA; Wapping Group; Past President of Arun Society; Chairman of Chiltern Painters. *Signs work:* 'Denis Pannett'. *Address:* 1 Woodlands Drive, Beaconsfield, Bucks HP9 1JY. *Email:* info@denispannett.co.uk *Website:* www.denispannett.co.uk

PAPADOPOLOUS, George, MA, Glass & Ceramics; Bombay Sapphire Prize (Short-listed). *b:* Cyprus, 28 Oct 1969. *s of:* R E Nos. *Studied:* RCA (1997-99).

Exhib: The Hub, Sleaford (2006); 50 Bank Street, Canary Wharf (solo, 2006); Gallery in Cork Street (solo, 2004); 'Rosenthal: New Routes, New Destinations', Frankfurt, Milan; many others in UK and abroad. *Works in collections:* British Airways Art Collection. *Commissions:* Cunard - MV Queen Victoria (2004); Vima Dance Studio, San Francisco (2005); Pied à Terre Restaurant (2006). *Publications:* 'Lamination', George Papadopolous (A&C Black, 2004). *Principal Works:* Architectural Glass Art. *Address:* 31 Tower Gardens Road, London N17 7PS. *Email:* george@yorgosglass.com *Website:* www.yorgosglass.com

PARDUE, Prudence, NDD (Painting); ATD; College Painting and Drawing Prizes. *Medium:* oil, drawing. *b:* Witney, Oxon, 1940. *m:* widow. one *s. Studied:* Oxford School of Art, Cardiff College of Art, RA Schools London; pupil of Evelyn Dunbar, war artist. *Exhib:* RA Summer Exhbn; NEAC Mall Galleries; The Gallery, Cork Street; Merriscourt Gallery, Oxon; Central Gallery, Oxford; Oxford University Said Business School Gallery; The Northwall, Oxford. *Misc:* worked as a textile designer for Manchester Studios and textile firm 'Cohn Hall Marx' New York; freelance illustrator for Pergammon Press; Head of Art, Mandeville School, Bucks; painting tutor (part-time) College of Education, Oxford; Prue Pardue Painting and Pictorial Composition Classes for ex-Art Graduates, Oxford; tutor, Meridian TV programme 'Summer Painting'. *Address:* 12 Russell Court, Woodstock Road, Oxford OX2 6JH. *Email:* prupardue@tiscali.co.uk

PARFITT, David Granville, ARCA, NEAC; David Murray Landscape Award 1963, Anstruther Award 1964, RCA Life Painting Prize 1964, J.Milner Kite Award 1966, Hugh Dunn Memorial Award 1966, Abbey Minor Scholarship 1966. *Medium:* oil painting, watercolours, drawing. *b:* Pontypool, Gwent 13 Jan 1943. *s of:* Sidney Parfitt. *m:* Sara Paton MA, FSA. one *d. Educ:* Abersychan Grammar School 1954-55, Monmouth School 1955-59. *Studied:* Newport College of Art 1959-63, Royal College of Art 1963-66 1st Class Hons Painting; Art History. *Exhib:* RA Summer Exhbns (1991-2003), NEAC (1997-2006), Royal Society of Portrait Painters (1998-2007), Discerning Eye (1996, 1999). *Works in collections:* private collections worldwide. *Commissions:* many commissions, mostly portraits. *Works Reproduced:* catalogues: Discerning Eye (1996), New English at Sotheby's (2002), The View (2003). The Artists Magazine (2003, Feb.), Artists' Kew (2006). *Recreations:* gardening, jazz piano. *Clubs:* Chelsea Arts Club. *Misc:* Senior Tutor, Royal Academy Schools (1987-90). *Address:* 20 Strand on the Green London W4 3PH. *Website:* www.newenglishartclub.co.uk

PARFITT, James Roderick, BA (2nd class Hons), RAS Post Grad Cert; PGCE Bretton Hall, Leeds University; RHS General Cert. in Hort.; landscape and portrait painter. *Medium:* painting. *b:* 5 Aug 1951. *Educ:* King's School, Ely. *Studied:* Walthamstow Polytechnic, St.Martin's School of Art, Royal Academy Schools. *Represented by:* Gallery 44, Lauderdale House. *Exhib:* Edith Grove Galleries, Trinity Arts and Crafts Guild. *Clubs:* RASAA, London Sketch Club, CAS, Trinity Arts and Crafts Guild. *Misc:* also studied etching. *Address:* 45c Roland Gardens, London SW7 3PQ.

PARFITT, Margaret, C.B.E. (1980), J.P.S.R.N., S.W.A.; sculptor in wood and metal. *b:* Romford, 23 Oct 1920. *d of:* Ion Victor Cummings, F.C.A. *m:* Dr. Ronald Parfitt. two *d. Educ:* Brentwood County High School; St.Mary's Hospital W2. *Studied:* Croydon Art College part-time, tutor Don Smith. *Exhib:* Sun Lounge, Fairfield (1991), Outwood Gallery (1988-90), Soc. of Women Artists, Bromley Library, Kingsmead Gallery Great Bookham, Paolo Francis Gallery Croydon, Barren and Barren Gallery Croydon. *Works in collections:* in Japan. *Signs work:* "Margaret Parfitt' or "M.P." joined. *Address:* The White House, 165 Shirley Church Rd., Shirley, Croydon CR0 5AJ.

PARISI, Francesco, Professor at Rome University of Fine Arts, teaching wood engraving. *Medium:* wood engraver and painter. *b:* Roma, 20 May 1972. *s of:* Umberto Parisi. *m:* Agnese Sferrazza. *Studied:* Academy of Fine Arts Rome. *Represented by:* Galleria Russo, Rome; Galleria Scalzi, Latina; Galleria Gonnelli, Florence; Caelum Gallery, New York;. *Exhib:* Rome, Florence, Cagliari, Napoli, Paris, London, New York. *Works in collections:* Galleria Comunale D'Arte Moderna di Cagliari, Galleria Comunale D'Arte Moderna di Latina; Statliche Graphische Samlung Huenchen, Bibliotheque Nationale de France, Paris; Royal Museum of Fine Art, Antwerp. *Commissions:* wood engraving by the City Council of Rome and Florence. *Publications:* C.F.Carli: Francesco Parisi-L'Ombra di Dioniso; Guido Giuffre: Francesco Parisi Xilografia; Emanuele Bardazzi: Francesco Parisi Xilografie; Fabio Benzi: Francesco Parisi paesaggi e simboli; Maria Teresa Benedetti & Arianna Mercanti: Francesco Parisi l'opera xilografica; Francesco Parisi Drawings 2001-2005;. *Principal Works:* Hymn to Pan (Triptych); Passo di Toro (Triptych); Estasi; Abysmos. *Address:* Via Casilina 102, 00182 Roma, Italy. *Email:* parisi_francesco@hotmail.com

PARKER, Constance-Anne, A.T.D., F.R.B.S.; Lecturer, Archivist and Travelling Exhbns. Organiser, Royal Academy (1986-), Librarian, Royal Academy of Arts (1974-86), Assistant Librarian (1958-74); Landseer Scholar, Sir David Murray Scholarship, Leverhulme Scholarship; painter in oil, sculptor in wood and clay;. *b:* London, 19 Oct., 1921. *Educ:* privately. *Studied:* Polytechnic School of Art and Royal Academy Schools (four silver and three bronze medals). *Exhib:* R.A., London galleries and provinces. *Publications:* Mr. Stubbs the Horse Painter (1971), Royal Academy Cookbook (1981), Stubbs Art Animals, Anatomy (1984). *Clubs:* Reynolds. *Address:* 1 Melrose Rd., Barnes, London SW13 9LG.

PARKER, Gill, S.Eq.A. (1987); winner President's Medal S.Eq.A. (1992); sculptress in bronze. *b:* Amesbury. *Educ:* South Wilts. Grammar School. *Studied:* self-taught. *Exhib:* solo shows: Sladmore Gallery, London (1984, 1987, 1989), S.Eq.A. (1984-96), National Horse Racing Museum, Newmarket (1991), Chute Standen (1992), Robert Bowman Ltd, London (Dec. 1999, June 2000), Kevin Anderson Gallery, Los Angeles (Nov. 2000), Robert Bowman Ltd., London (Nov. 2002). *Works in collections:* National Horse Racing Museum, Newmarket, World Wildlife Art Museum, Jackson Hole, Wyoming. *Commissions:* Habibti, Mrs.Moss, Precocious, Rainbow Quest, Sir Wattie, Dancing Brave, Middleroad,

Motivator (Lifesize) Ascot Racecourse. *Recreations:* breeding and showing American quarter horses. *Signs work:* "G. Parker" or "Gill Parker." *Address:* Mill Lodge, Mill Lane, Lowbands, Redmarley, Glos. GL19 3SH. *Email:* bronze@gillparker.com *Website:* www.gillparker.com

PARKER, Walter F., A.R.C.A., M.S.I.A.D., A.T.D., F.R.S.A.; Principal, Hartlepool College of Art (1953-78); War Service in Middle East as F/Lieut. in R.A.F.; senior posts held at Preston and Hastings Schools of Art; since retirement in 1978 takes a number of regular painting schools in Britain specialising in water-colours and printmaking. *b:* Carlisle, 11 May 1914. *m:* Joy E. Turk, contralto, Guildhall School of Music (d. 1996). *Educ:* Carlisle Grammar School (1922-30). *Studied:* Carlisle Art School (1930-35), Royal College of Art (1935-38), Courtauld Inst. (1938-39). *Clubs:* Pres., Lake Artists' Soc. and Life mem. (1996). *Signs work:* "Walter F. Parker." *Address:* 19 The Cliff, Seaton Carew, Hartlepool TS25 1AP.

PARKIN, Ione, Royal West of England Academician; BA (Hons). *Medium:* painting and printmaking. *b:* Henley-on-Thames, 19 Oct 1965. *m:* David Madison Metcalfe. two *s*. *Studied:* Winchester School of Art (1985-88). *Represented by:* Cube Gallery, Bristol; Byard Art, Cambridge; Adam Gallery, Bath; Original Print Gallery, Dublin;. *Exhib:* Art First, Cork St (1995/96/98); Adam Gallery (2006); Northcote Gallery, Chelsea (2005); Rosenberg & Kaufman, New York (1998); Gomez Gallery, USA (1998); Stour Gallery, Warwickshire (2004/05/07); Crane Kalman (1996/97); RWA (2001/03/04/06); Anthony Hepworth Fine Art (1993/95); exhibited extensively since 1991. *Works in collections:* Taylor Vinters Solicitors (Cambridge); Reuters HQ (London); Duchas Heritage Service; Premier Steel; Caceis Financial Services; Kindle Banking Systems; Knightsley Ltd.; Alliance Corporate Ireland plc (Dublin); Vera Forsyth Chartered Architects; G&D Services, Bath; RWA (Bristol); West Wiltshire Primary Care Trust; Mullis & Peake, Essex. *Publications:* 'Collecting Original Prints' Rosemary Simmons (A&C Black, London, 2005); 'Fred Cuming RA & Ione Parkin RWA' (Adam Gallery, 2006); '50 Wessex Artists' (Evolver, 2006); Exhibition catalogue, Six Chapel Row, Bath (2004). *Clubs:* Bath Area Network for Artists (BANA). *Signs work:* 'Ione Parkin RWA'. *Address:* 15 Kensington Gardens, Bath, BA1 6LH. *Email:* ione@ioneparkin.fsnet.co.uk *Website:* www.ioneparkin.co.uk

PARKIN, Jane Maureen, S.Eq.A., S.W.A.; numerous awards with S.Eq.A. *Medium:* oil and pastel. *b:* Sheffield, 29 Aug 1936. *m:* Frank. one *d. Educ:* Wath Grammar School, S. Yorks. *Studied:* mainly self taught with five years tuition by P.K.C. Jackson, A.R.C.A. *Exhib:* S.Eq.A., Mall Galleries, Westminster Gallery, Christie's, Carisbrooke Gallery, every year since 1997 with the Society of Women Artists at Westminster Gallery, American Academy of Equine Art, Kentucky. *Publications:* Limited edn. prints and Open prints by Rosensteils London/New York. *Signs work:* "Jane M. Parkin." *Address:* 103/109 Main St., Haworth, Keighley, W. Yorks. BD22 8DP. *Email:* frank.parkin@totalise.co.uk

PARKIN, Michael Robert, art dealer; chairman/managing director, Michael Parkin Fine Art Ltd. *b:* London, 1 Dec 1931. *s of:* Frank Robert Parkin. *m:* Diana Mary Frances. three *d. Educ:* Mill Hill and St. George's Schools; Magdalen College, Oxford. *Exhib:* at Michael Parkin Gallery, 11 Motcomb St., SW1. Cover British Art 1850-1950, have included The Cafe Royalists, Four for Whistler, The Fitzrovians, Claude Flight, A Salute to Marcel Boulestin and J. E. Láboureur, Jean Cocteau, Cecil Beaton Memorial Exhbn., Artists of the Yellow Book, Nina Hamnett, Walter Sickert, Walter Greaves, Rex Whistler and Stephen Tennant, Walter Bayes, Jaques Emile Blanche, Artists of Corsham - a Celebration, Sylvia Gosse, Therese Lessore, the 7 & 5 Society, Paul Stevenson and John Pawle, Hermione Hammond, Gwyneth Johnstone, Roland Collins, Philip Jones, Damian O'Brien. *Publications:* Old Chelsea (Newson, London 1975), Louis Wain's Cats (Thames & Hudson, London 1983), Louis Wain's Edwardian Cats (Thames & Hudson, New York 1983); in preparation: Modern British Art 1860-1960; Walter Greaves. *Clubs:* Beefsteak, Norfolk, B.A.F.T.A., Chelsea Arts, Garrick. *Address:* Gunton Hall, Hanworth, Norfolk NR11 7HL.

PARKINSON, Gerald, painter in oil, gouache and water-colour. *b:* Shipley, Yorks., 5 Nov 1926. *s of:* Edward Parkinson. *m:* Sylvia Mary. one *s. Educ:* Woodhouse Grove School, nr. Leeds. *Studied:* Bradford College of Art (1951-54). *Exhib:* R.A., West of England Academy, John Moores, Sussex Artists, Yorks. Artists, S.E.A.; one-man shows: London, Bologna, Stockholm, Brighton, York, Bristol, Monte Carlo, Lewes, Bradford, Hove, Tunbridge Wells. *Works in collections:* Glasgow, Brighton, Leicestershire C.C., L.C.C., Surrey C.C., West Riding C.C. *Commissions:* Mural for NatWest Bank. *Signs work:* "Gerald Parkinson." *Address:* The Gate House, Wootton Manor, Nr. Polegate, East Sussex BN26 5RY. *Email:* sales@conceptengland.freeserve.co.uk

PARKINSON, Richard Henry, Dip. A/D (1967); painter in oil on canvas/board, restorer, critic, designer, frame maker; Prop./M.D. The Studio, tutor for Pitman's Correspondence Courses since 1967, judge at Royal College for Parkinson/Henderson Prize since 1988, and Cheltenham Correspondence College. *b:* Epsom, 23 Mar 1947. *s of:* Freddy Parkinson (decd.) art director and publisher, Principal, Heatherleys Art School. *m:* Susan Sanders. one *s.* one *d. Educ:* Ewell Castle, Epsom. *Studied:* Folkestone School of Art (1963-67), Heatherleys School of Art (1968-71). *Exhib:* R.A.1967Resigned: nothing to do with RA since 2000; Wye, Henley, Wimbledon, R.W.A., Mall Galleries, R.B.A., Stockbridge, etc. *Works in collections:* Woolworth Holdings, various Boardrooms. *Commissions:* portraits various, restorer to Canterbury Cathedral. *Publications:* Introductory Art (Pitman), Mounting Water-colours (The Artist). *Recreations:* Tutor for Cheltenham College since 1970. *Clubs:* Life mem. Chelsea Arts. *Misc:* City of Canterbury Councillor, Past Sheriff (2004-2005); alternative address: The Studio, 7 rue de la Valee, 62770 Willeman, Pres Hesdin, France. *Signs work:* "R.H.P." or "Richard Parkinson." *Address:* Restorer's House No. 3 Best Lane, Canterbury, Kent CT1 2JB. *Email:* richard.parkinson@canterbury.gov.uk

PARR, Elizabeth, painter in water-colour and oil; paints the Lake District, Cornwall and teddy bears. *b:* Horsham, W. Sussex. *m:* Douglas Ashley (1999), (previously widowed in 1996). one *s.* two *d. Educ:* St Christophers, Horsham. *Studied:* Horsham School of Art and I.C.S. under Patrick Barclay. *Exhib:* eighteen solo exhibs. in Cornwall and The Cotswolds; group exhibs. at Mall Galleries and Westminster Galleries, London; work accepted by "Britain's Painters" for four consecutive years. *Works in collections:* various national and international collections incl. St Ives Gallery. *Publications:* greeting cards and prints. *Signs work:* "Elizabeth Parr." *Address:* The Beach House, Coverack, Nr. Helston, Cornwall TR12 6TE.

PARR, Martin, *b:* Epsom, Surrey, 23 May 1952. *s of:* Donald and Joyce Parr. *m:* Susan P. Mitchell. one *d. Educ:* Manchester Polytechnic 1973 1st Creative Diploma. *Represented by:* Magnum; Rochet Gallery, London. *Exhib:* Retrospective Barbican Centre (2002) and subsequent tour. *Works in collections:* 30 x public collections. *Publications:* Last Resort (1986); Common Sense (1999); Martin Parr (Phaidon, 2002), & 32 others. *Individual Shows/Exhibitions:* The Photographers Gallery (1977, 81, 82, 87, 95); Whitechapel Art Gallery (1978); Haywards Gallery (1979); Serpentine Gallery (1986); National Centre of Photography, Paris (1987, 95); RA (1989); RPS (1989), Janet Borden Gallery, NY (1991, 92, 96); National Museum of Photography, Bradford (1998); Barbican Gallery (2002); Kunsthal Netherlands (2003); Reina Sofia, Madrid (2003). Work in permanent collections include V & A Museum, MOMA NY, Walker Art Gallery. *Awards/Commissions:* Arts Council of GB Photography Award 1975, 76, 79. *Publications: Monograph/Contributer:* Bad Weather (1982), A Fair Day (with Ian Walker, 1984), The Last Resort: photgraphs of New Brighton (1986, 2nd ed. 1998); jtly: The Actual Boot: the photographic postcard 1900-1920 (1986), The Cost of Living (1989), Signs of the Times (1992), Home and Abroad (1993), From A to B (1994), Small World (1995), West Bay (1997), Flowers (1999), Common Sense (1999), Boring Postcards (1999), Auto Portrait (2000), Think of England (2000); Martin Parr by Val Williams (2002). *Additional Projects:* Signs of the Times/Mosaic with Nicholas Barker (1992). *Recreations:* working!. *Clubs:* Clifton Poker. *Address:* 63 Gee Street, London EC1V 3RS. *Website:* www.martinparr.com

PARROTT, Denis William, N.D.D.(Painting) (1953), A.T.C. (1958), Ph.D. (1993), Fulbright Scholar, U.S.A. (1970-71), F.R.S.A. (1977), F.S.A.E. (1980); painter, printmaker; lecturer, University of Northampton. *b:* Dewsbury, Yorks., 22 Mar 1931. *s of:* Ernest and Edith Parrott. *m:* Kathleen Hendry. one *s. Educ:* Dewsbury Technical College. *Studied:* Dewsbury and Batley School of Art (1948-51), Camberwell School of Art (1951-53), Leeds College of Art (1957-58). *Exhib:* R.A., Mall Gallery, U.S.A., Centre International d'Art Contemporain de Paris and Galerie Salammbo, Paris. *Works in collections:* England, Europe and U.S.A. *Publications:* author for Schools Council. *Signs work:* "Denis W. Parrott." *Address:* 37 Bowling Green Rd., Kettering, Northants. NN15 7QN.

PARRY, David, S.WL.A., NDD, CSD. *Medium:* watercolour, oil, pencil. *b:* Liverpool, 23 Jun 1942. *m:* Patricia Parry. *Educ:* in Tunbridge Wells. *Studied:* Tunbridge Wells School of Art, Central School of Art, London. *Exhib:* Mall Galleries, Walton Street Gallery; one-man shows, Brasted, Kent, Lanhydrock House, Cornwall PL22 0JN. *Commissions:* many bird paintings for The Sultan of Oman and other private collectors. *Publications:* Bird and animal books for Salmon Publications. *Works Reproduced:* limited edition prints. *Principal Works:* paintings and drawings of African Wildlife. *Recreations:* birding, sailing. *Clubs:* RFYC (Official Artist). *Signs work:* "David Parry." *Address:* The Old School, Milton Lilbourne, Pewsey, Wilts, SN9 5LQ.

PARRY, Leigh, M.A. (1946), P.S. (1966), P.P.S. (1983-88), R.B.A. (1988), P.S. (Canada) (1987), S.E.A. (1983); painter in pastel, oil and water-colour of equestrian subjects, landscapes, buildings, etc.; Cuneo Medal, Soc. of Equestrian Artists; St.Cuthbert Mill (RBA). *b:* London, 12 Apr 1919. married. two *d. Educ:* Uppingham; Pembroke College, Cambridge. *Studied:* St. Martin's School of Art (1945). *Exhib:* R.A., Paris Salon, New Grafton, Nat.Gal. Canada, R.B.A., N.E.A.C., P.S.; one-man shows, Canada and London. *Works in collections:* Kesteven C.C., Essex C.C., Lincolnshire museums, Midland Bank. *Commissions:* many equestrian including British Horse Society, and Duke of Devonshire. *Publications:* illustrated Climbing and equestrian publications. *Recreations:* drawing. *Signs work:* "Leigh Parry." *Address:* Studio 6, 6 Wharf Rd., Stamford, Lincs. PE9 2DU.

PARSONS, Denis Alva, M.B.E. (1993); sculptor in wood, stone and bronze. *b:* Polesworth, Warwickshire, 14 Nov 1934. one *s.* one *d. Educ:* Tamworth Secondary Modern; apprenticeship to R. Bridgemen Ltd. (1950-55); Birmingham College of Art (1953-55, part-time). *Misc:* Work in various churches and public buildings. *Address:* Alderways, Fosseway La., Pipe Hill, Lichfield, Staffs. WS13 8JX.

PARSONS, Gwendolene Frances Joy, FRSA (1976), SWLA (1966); painter in watercolour, pastel, oil; tutor on Galleo sketching party holidays for 30 years. *b:* Bollington, 9 Jul 1913. *m:* W.N.T. Parsons, ARIBA (decd.). *Educ:* privately. *Studied:* Frome School of Art, Bridgwater Art School, Somerset. *Exhib:* annually in Mall Galleries, ans SWLA; solo exhibs: Red House Museum, Christchurch; Diss, Norfolk; Madison, USA. *Works in collections:* Russell Cotes Museum, Bournemouth, Ulster Museum, Belfast. *Commissions:* 40ft mural for Birdland, Bourton-on-the-Water (1969). *Publications:* 'Flower Painting' (F.Warne), 'Wildlife Painting' (Batsford), 'Days Out in Dorset', 'Days Out in Hampshire', (Thornhill Press), 'Holiday Painting and Wildlife Tales' (Natula Publications), Days Out in Dorset (reprint by Natula Publications). *Official Purchasers:* Ulster Museum, Belfast. *Clubs:* Bournemouth Arts, Lymington Palette Club, Southbourne Art Soc. (president for 14 years, now retired). *Signs work:* "Joy Parsons." *Address:* 3 Willow Pl., Bridge St., Christchurch, Dorset BH23 1ED.

PARTINGTON, Peter Norman, N.D.D., A.T.C., S.WL.A.; painter in watercolour, oil, drypoint etching, art lecturer; Com. mem. S.WL.A.;. *b:* Cambridge, 29 Sep 1941. *m:* Josephine. two *s.* one *d. Educ:* Poole Grammar School. *Studied:* Bournemouth College of Art and Design (1960-66), Middlesex Polytechnic (1967-68). *Exhib:* various galleries in London including Tryon Gallery, Glos., Wilts. *Works in collections:* Nature in Art Museum. *Publications:* illustrations, 'Down the River' H.E. Bates (Gollancz 1987), 'Painting Birds in Watercolour' (Collins 1989), 'A Floating World' own poetry and illustration, 'Learn to Draw' 'Birds', 'Wildlife', 'Farm Animals' (Harper Collins, 1998). *Signs work:* "Peter Partington." *Address:* The Hall, Kettlebaston, Suffolk IP7 7QA.

PARTRIDGE, John Arthur, antique dealer; Chairman, Partridge Fine Arts PLC; Com. *b:* London, 6 July, 1929. married. *s of:* Claude A. Partridge. two *s.* one *d. Educ:* Elstree and Harrow. *Address:* 144-146 New Bond St., London W1J 2PF.

PARTRIDGE, Josh, NDD Painting; Slade Diploma Painting; Corsham Travelling Scholarship to Paris (1961). *Medium:* watercolour and gouache. *b:* Malmesbury, 18 Jun 1942. *s of:* Graham & Rhoda Partridge. *Educ:* Dartington Hall School. *Studied:* Bath Academy, Corsham (under Howard Hodgekins, 1959-63); Post Graduate, Slade School of Art (1963-65); studied Woodblock Printing in Kyoto, Japan (1966-67). *Exhib:* selcted solo shows: Curwen Gallery, London (1985, 1988); Gallerie Maggie Bettini, Amsterrdam (1986); Cadogan Gallery, London (1988); West Wales Arts Centre, Fishguard (1995, 1998, 2003); MoMA Wales Machynlleth (May 2006); recent group shows: Beaux Arts Bath (2006). *Works in collections:* British Museum, Paintings for Hospitals, Welsh Contemporary Art Society, Montreal Visual Arts Centre, West Wales Arts Society, GLC, University of London. *Recreations:* Tai Chi, textile design. *Signs work:* 'Josh Partridge'. *Address:* Long Dean Cottages, Castle Combe, Chippenham, Wilts. SN14 7EX.

PASCOE, Jane, BA(Hons.) Fine Art (1977), ATC(1978), RWA (1988); painter/sculptor/printmaker, teacher (Head of Art Dept.). *b:* Bristol, 9 May 1955. *d of:* Ernest Pascoe, DFA (Lond.), FRBS, RWA. one *s. Educ:* The Redmaids School, Bristol (Bristol Foundation Scholarship 1966-73). *Studied:* Bristol Polytechnic Faculty of Art and Design, Dept. of Fine Art (1974-77), Brighton Polytechnic School of Art Education (1977-78). *Exhib:* R.W.A., Eye Gallery, Bristol, Parkin Fine Art, Mall Galleries, London, Salisbury Arts Centre, Swindon Museum and A.G., Victoria Gallery, Beaux Arts Gallery Bath. *Works in collections:* R.W.A., Avon County Art Collection, Cheltenham and Gloucester Bldg. Soc. Art Collection. *Signs work:* "Jane Pascoe." *Address:* Honeysuckle Cottage Charmus Rd, Old Calmore Old Calmore Southampton SO40 2RG.

PASKETT, David, V.P.R.W.S. (2007), R.W.S. (2001), B.A. (1966), A.T.D. (1967), Queens Award (1965); resident artist, Pitt Rivers Museum, Oxford (1993). *Medium:* watercolour, oil, tempera. *b:* Potters Bar, 3 Jun 1944. *m:* Sally.

two *d. Educ:* Mountgrace Comprehensive School, Potters Bar. *Studied:* Hornsey and Exeter Colleges of Art, teacher training at Liverpool College of Art. *Exhib:* Singer Friedlander Sunday Times Watercolour Competiition (1992-2001), prizewinner (1992); Hunting Observer Competition, R.W.A.; Pitt Rivers Museum; Oxford University (1993); Pastel Society (1994); R.W.S. open prizewinner (1994, 1999); Catto Gallery (1997), Bankside Gallery (2001-2007), Kew Gardens (2006), Watercolour & Drawings Fair, Burlington House (2004-07), New Grafton Gallery (2007), Picture This Gallery, Hong Kong (2006, 07). *Works in collections:* Philip Morris, Kerry International, Honeywell, Shell, World Bank, Chase Manhattan, Jardines, Freshfields. *Commissions:* H.R.H. The Queen Mother's 100th Birthday Celebration, Hong Kong Jockey Club, Lord and Lady Wilson, Hong Kong Tourist Assoc., Time Life, Chinese University of Hong Kong. *Publications:* book: 'A Vision of China, The Paintings of David Paskett', boxed silk bound book, pub. Hutchison Whampoa. *Official Purchasers:* Hutchison Whampoa UK, Standard Chartered Bank, Shanghai. *Misc:* 1986 to present day, paintings inspired by annual visits to China. *Signs work:* "PASKETT." *Address:* 50 Bickerton Rd., Headington, Oxford OX3 7LS. *Email:* info@davidpaskett.co.uk *Website:* www.davidpaskett.co.uk

PASMORE, Wendy, painter; teacher of painting at Sunderland College of Art, (1955-58), and at Leeds College of Art (1958-67). *b:* Dublin, 1915. *d of:* J. Lloyd Blood. *m:* Victor Pasmore (decd.). one *s.* one *d. Educ:* privately. *Studied:* art: privately. Mem. London Group. *Works in collections:* Tate Gallery, Arts Council, Leeds Education Committee. *Clubs:* Arts. *Address:* Dar Gamri, Gudja 2TN, Malta.

PASS, Derek Percy, artist in ceramic enamels, water-colour; ceramic artist, Royal Doulton (retd.). *b:* Newcastle, Staffs., 19 Apr 1929. *s of:* Frank Pass. *m:* Doreen Odell. two *d. Educ:* Knutton Elementary School; Burslem School of Art. *Studied:* Stoke-on-Trent College of Art (1942) under Gordon Forsyth, R.I. and Reginald Haggar, R.I. *Exhib:* Trends, Britain in Water-colours, N.S. *Signs work:* "Derek Pass," "D. Pass" (ceramic). *Address:* 12 Thirlmere Pl., Clayton, Newcastle, Staffs. ST5 3QJ.

PASS, Donald James, N.D.D., R.A.S.; portrait and landscape painter in oil, pastel and water-colour; noted for works of a visionary nature;. *b:* Congleton, Ches., 9 Sep 1930. *s of:* Arthur James Pass, master builder. *m:* Anne Jacqueline Whitelegge. two *s.* three *d. Educ:* Macclesfield Kings School. *Studied:* Macclesfield School of Art, Stoke-on-Trent Regional College of Art, R.A. Schools (silver medal). *Exhib:* Drian Gallery - New Art Centre, Premio Lissone, Milan, Royal Soc. Portrait Painters, Royal Inst. Painters in Water-colours, Royal Water-colour Soc., Soc. of Art of the Imagination (1999) First Prize at Mall Galleries, also in 2000 adjudicator, 2001 Outsider Art Exhibition, New York, The Attic Gallery, Nashville, Tennessee, Art of Imagination Cork Street London 2002-3, New York 2002-07, Orleans House, Private Worlds Exhibition London 2001. *Works in collections:* Gdansk National Museum, Poland, Stoke-on-Trent A.G.,

Yorkshire Educ. Com., Gallery of Contemporary Art Skopje, Yugoslavia, Gallery of Art Lissone, Milan, University of Keele, Church of St. Mary the Virgin, Elmley Castle, Worcs., Graves A.G., Sheffield, Sir John Rothenstein, American Museum of Visionary Art, Baltimore, U.S.A., H.R.H. Duke of Edinburgh, Prince Edward (1991, 2001). *Commissions:* portraits: Sir Compton Mackenzie, Brigadier Sir Alex Stanier, Bt., D.S.O., M.C., Lt. Col. Sir John Miller, G.C.V.O., D.S.O., M.C. *Publications:* Apollo Magazine article by Sir John Rothenstein, Quarto Press, work included in Encyclopedia of Water-colour Techniques, Raw Vision Magazine and others, Art Visionary Australia Time Out 2001. *Works Reproduced:* Quarto Press Raw Vision, New Statesmen. *Recreations:* birds and wildlife. *Clubs:* Reynolds. *Misc:* Dealer, Henry Boxer, Henry Boxer Gallery, 98 Stuart Court, Richmond, London; Dance Theatre Production 'Awakenings' based on Pass's visionary paintings, music composed by Marcus Davidson, performances in Norwich Cathedral and Dorchester Abbey, Oxon. *Signs work:* "D. Pass" or "DONALD PASS". *Address:* 2 Green Lane Lodge, Old Rd., Wheatley, Oxford OX33 1NY.

PATERSON, Donald M., D.A.; artist in water-colour, teacher; elected Mem. Royal Scottish Soc. of Painters in Water-colour;. *b:* Kyleakin, Isle of Skye, 28 Nov., 1950. *m:* Alexandra. two *s. Educ:* Portree High School. *Studied:* Glasgow School of Art (1969-73). *Exhib:* one-man show: Fair Maids Gallery, Perth; mixed shows: 'Artists under 30' Third Eye Centre, Glasgow, Glasgow Herald Exhbn. Collins Gallery, Strathclyde University, R.S.A. Annual, G.I. Annual. *Signs work:* "D.M. Paterson." *Address:* Blaven, Torr Rd., Bridge of Weir, Renfrewshire PA11 3BE.

PATERSON, Michael Hugh Orr, B.A., F.R.S.A., F.M.A.; art restorer; freelance lecturer and archivist; trainee, City A.G., Birmingham (1953-54); asst., City A.G., Hereford (1954-55); asst.-in-charge, Municipal A.G., Oldham (1956); asst. keeper, City A.G., Leicester (1957-58); Curator, Russell-Cotes A.G. and Museums, Bournemouth (1958-66); Curator of Art, London Borough of Enfield (1966-81); Hon. Curator, Thomas Coram Foundation for Children to 1995; volunteer lecturer, National Trust. *b:* London, 7 Dec 1927. *s of:* G. E. Paterson. *m:* Maureen Robinson. *Educ:* Kirkcudbright Academy; Cranleigh School; Manchester and Edinburgh Universities. *Address:* 24 Adamsrill Cl., Enfield, Middx. EN1 2BP.

PATON, Anne Elizabeth, London Diploma in Art and Design. *Medium:* oil, watercolour, drawing, prints, sculpture, mixed media. *b:* Sussex, 29 Oct 1944. *d of:* Christopher Paton. *Educ:* St.Agnes & St.Michaels' School, East Grinstead, Sussex. *Studied:* Chelsea School of Art (1975-78). *Exhib:* NEAC, RA Summer Exhbn., Leighton House, Peter Pears Gallery, Chappell Galleries; solo exhbns: Chappel Galleries, 2007; The Studio, Walberswick annually since 1992; Shape Maltings. *Works in collections:* London Borough of Kensington and Chelsea; Guinness; private collections worldwide. *Commissions:* for architects and private collectors. *Publications:* 'Artists at Walberswick 1880-2000'; Artists &

Illustrators Magazine, 'Artists in Britain since 1945' David Buckman (2006). *Works Reproduced:* Richard Scott's book: 'Artists at Walberswick 1880-2000'. *Recreations:* listening to opera, playing the paino, travelling, interior design. *Signs work:* 'Anne Paton'. *Address:* 5 The Terrace, Main Street, Walberswick, Suffolk IP18 6TZ. *Email:* annpannie@tiscali.co.uk

PATTERSON, Janet, Slade Dip., Churchill Fellow (1987), M.A. (1993); painter/printmaker, art lecturer; Vice President, London Group (1991-92), Vice Chairman, Chelsea Arts Club (1996-97); Awards: French Government Scholarship (1964), R.W.S. award (1984), Winston Churchill Travel award (1987), Norwegian Travel Scholarship (1989), major prizewinner Hunting Art Prizes (2000). *b:* 13 Feb 1941. *d of:* John & Agnes Patterson. one *s.* one *d. Studied:* Slade School of Fine Art (1960-64, Patrick George, Harold Cohen). *Represented by:* Workhouse Gallery (2001); Pilgrim Gallery (2003); The Walk Gallery (2002). *Exhib:* 'Natural Elements' University Sussex tour (1999), 'Dreamtime' Talbot Rice, Edinburgh (1988), London Group, R.A., R.A.C.Club, Deutsche Bank, Cliffod Chance. *Works in collections:* Scottish Arts Council, Unilever, Texaco, I.C.I., NatWest, Ciba-Geigy, Coopers & Lybrand, Astra Zeneca, etc. *Commissions:* Dresdner Kleinwort Benson (2000). *Publications:* 'Dreamtime' catalogue (1988); Britart Directory (2001); The London Group (2003). *Clubs:* Chelsea Arts. *Signs work:* "J.P." *Address:* Studio 1, 71 Stepney Green, London E1 3LE. *Email:* janetpatterson_arts@hotmail.com *Website:* www.janetpatterson.co.uk

PATTERSON, Linda, B.A.Hons., S.B.A., S.F.P., Dip. Eur. Hum. (Open) 1999; painter in pastel, oil, acrylic, teacher, lecturer; Chairman, Christchurch and District Arts Council; President, Christchurch Arts Guild. *b:* London, 3 Dec 1942. *m:* David. one *s.* one *d. Studied:* London and Bournemouth. *Exhib:* Westminster Central Hall, London, Bournemouth, Christchurch, Salisbury, Romsey, Sofiero Castle, Sweden (1998), Société Jersiaise, Jersey (1999), St. Lo, France. Work in collections internationally. *Works Reproduced:* cards for Medici; published in 'Pastel Artist International' magazine; published works in "How to Create Light in your Paintings" by Tony Paul. *Clubs:* Soc. of Botanical Artists, Soc. of Floral Painters, Christchurch Arts Guild, Romsey Art Group, Wessex Artists, Southbourne Art Society. *Signs work:* "L. PATTERSON." *Address:* 22 Heatherlea Rd., Southbourne, Dorset BH6 3HN. *Email:* lindapatterson@hotmail.com

PATTON, Marcus, O.B.E., B.Sc., Dip.Arch., A.R.U.A.; architect/illustrator in ink, water-colour, screen printing; Trustee of 'In You We Trust' (artists' residency), and past chairman Belfast Print Workshop. *b:* Enniskillen, Co. Fermanagh, 23 Aug 1948. *m:* Joanna Mules. three *s. Exhib:* various. *Works in collections:* B.B.C., Arts Council of N. Ireland, Ulster Television, Belfast City Council, Down Museum, etc. *Commissions:* B.B.C., U.T.V., etc. numerous posters. *Publications:* 'Ireland', 'Scotland', 'South West Ireland', 'Bugs, Bites and Bowels' (all Cadogan Press), etc. *Works Reproduced:* in 'The Opera Hat of Sir Hamilton Harty' (Grand Piano Press, 2003). *Clubs:* Tonk's. *Signs work:*

signature usually hidden in a maze of lines. *Address:* Ingledene, Sans Souci Park, Belfast BT9 5BZ. *Website:* www.operahat.co.uk

PAUL, Celia Magdalen, R.E.; B.A. 1st. Hons. Fine Art (1981); painter in oil and etcher. *b:* Trivandrum, India, 11 Nov 1959. one *s. Educ:* Edgehill College, Bideford, Devon. *Studied:* Slade School (1976-1981) under Prof. Lawrence Gowing. *Represented by:* Marlborough Fine Art, London. *Exhib:* Bernard Jacobson (1986), Marlborough Fine Art (1991, 1995 & 1999), Israel Museum (Bacon to Bevan) (1991), Musée Maillol, Paris (1998), Charlottenborg, Copenhagen (2003), Abbot Hall Kendal (2004), Graves Art Gallery, Sheffield (2005). *Works in collections:* Saatchi Collection, British Museum, Metropolitan Museum, New York, Fitzwilliam Museum, Cambridge, Abbot Hall, Kendal; Carlsburg Foundation, Denmark; V&A; Yale Center for British Art, Newhaven. *Publications:* School of London - Alistair Hicks, Marlborough Fine Art catalogues; Rowan Williams: Modern Painters (Summer 2004); William Feaver: Abbott Hall Catalogue (2004); Catherine Lampert: Graves Catalogue (2005). *Signs work:* "Celia Paul." *Address:* 50 Great Russell St., London WC1B 3BA.

PAUL, John, President, London Sketch Club (1999, 2000); Treasurer, Small Paintings Group. *Medium:* oil. *b:* Chelsea, London 19 Jan 1940. *m:* Beatrix. two *s.* one *d. Educ:* Henry Compton Boys School (1951-56). *Studied:* Camberwell School of Art (1956-59). *Exhib:* Piers Feetham Gallery (1996-2007); Mall Gallery (1992, 94); St.James Gallery (2003); Park Lane Fine Arts (2006/7); Hamstead Gallery (2004); The Cinema Gallery (2006); Bartley Drew (1999); Carlyle Gallery (1994); Duncan Miller Fine Arts (2006); Hawker Gallery (2002); Red Leaf Gallery (2007). *Works in collections:* private collections in the UK and Continental Europe; The Stiefsohn Trust, Austria. *Commissions:* Daiichi Jitsugyo Co Ltd, Tokyo; H.Genthner, Commerzbank Frankfurt; James Dingeman QC; London Borough of Hammersmith & Fulham. *Publications:* The Art Pack (aimed at people with disabilities, LBHF, MENCAP, SHAPE). *Clubs:* Small Paintings Group, Artists and Potters, Chelsea Art Society, London Sketch Club, Chelsea Arts Club. *Signs work:* 'JOHN PAUL'. *Address:* 65 Shorrolds Road, Fulham, London SW6 7TU. *Email:* ja.paul@btinternet.com

PAUL, Sylvia, *Medium:* oil, acrylic, collage, pastel, mixed media. *b:* Maldon, Essex, 11 Aug 1956. *m:* Geoffrey Alan Catchpole. two *s. Studied:* Colchester School of Art, Hockeril Collge of Education. *Exhib:* PS, SWA, ROI, Laing Landscape Exhibition. *Works in collections:* internationally. *Clubs:* East Anglian Group of Marine Artists. *Signs work:* 'SYLVIA PAUL'. *Address:* Shobita's Ship, 21 Empire Road, Dovercourt, Harwich, CO12 3QA. *Email:* sylvialouisepaul@hotmail.com *Website:* www.sylviapaul.com

PAVEY, Don, FRSA, ARCA; director, Micro Academy producing art education videos and computer art software; author; lecturer in design and colour; a founder of the National Art Education Archive (Leeds Univ.). Freedom of the City of London (July, 1987). *Publications:* The Artist Colourmen's Story (about

Winsor & Newton's Museum of Colour, 1985), Color (Knapp Press, Los Angeles, 1980), Art-based Games (Methuen, 1979), Methuen Handbook of Colour and Colour Dictionary (Methuen, 1961, 1967, 1978). Mem., Colour Group (Great Britain) - awarded the Isaac Newton Medal for researches into the psychology and history of colour (1997). On Colour (translation of Thylesius 1528)(Universal 2003), Colour and Humanism (Universal 2003), ProMICAD system for empowerment (Lifetime Careers, Trowbridge 2003). *Address:* Studio House, 30 Wayside, Sheen, London SW14 7LN. *Email:* studio@coloracademy.co.uk *Website:* www.coloracademy.co.uk

PAVITT, Diane, H.S., S.Lm.; self taught painter of miniatures specialising in portraiture in water-colour on ivorine/polymin. *b:* Brighton, 31 May 1954. *m:* John. one *s.* one *d. Exhib:* R.M.S., S.A.M.A.P., Hilliard & Limners Societies, World Federation of Miniaturists, several galleries etc. Work in collections internationally. *Commissions:* taken. *Publications:* Editor of The Hilliard Society Newsletter. *Address:* 'Le Mas des Restanques', 521 Avenue des Sources, 06370 Mouans Sartoux, France. *Email:* diane-pavitt@club-internet.fr *Website:* included in art-in-miniature.org

PAVLENKO, Sergei, potrait artist. *Medium:* oil, drawing. *b:* St.Petersburg, Russia, 26 Oct 1953. *m:* Tatiana Radko. one *s.* one *d. Studied:* Painting Dept. of the Academy of Fine Arts, St.Petersburg (6 years). *Represented by:* Fine Arts Commissions, London; Andreeva Gallery, Santa Fe, NM, USA. *Exhib:* solo shows: Russian Embassy, London (2004); British Embassy, Moscow (2004); group exhbns: RA Summer Show(1996, 97), RP(1992-2007), ROI (1989, 93, 2006), Discerning Eye, Mall Galleries, Art London, Andean Gallery, RWA, Los Angeles Art Expo, Kertesz Gallery San Francisco. *Works in collections:* H.R.H.the Prince of Wales; H.R.H. Prince of Hanover; Prince Nikolas Romanoff; Lee Bass; Drapers Company; Brown University, Cambridge University, Cazenove Group plc, plus many others worldwide. *Commissions:* many distinguished names worldwide; Worhsipful Company of Drapers: portrait of H.M.Queen Elizabeth II (2000); Royal Military Academy, Sandhurst: The Royal Family Group Portrait (The Queen, Prince Philip, Prince Charles, Duchess of Cornwall, Prince William, Prince Harry). *Works Reproduced:* postage stamp of the Queen's Portrait; The Guardian; Daily Mail; The Telegraph; The Times, and all British main newspapers; Hello Magazine; many in Russia; a film on Channel 4 about Sergei and his portraits. *Principal Works:* portrait of H.M.The Queen, Duke of Marlborough, Michael Stone, Hawila children; Group portrait of the Royal Family at Sandhurst Military Academy. *Recreations:* tennis. *Clubs:* Chelsea Arts Club. *Signs work:* 'Sergei Pavlenko'. *Address:* 51 Heathwood Gardens, London SE7 8ES. *Email:* sergei@spavlenko.demon.co.uk *Website:* www.spavlenko.demon.co.uk

PAYNE, David, NDD, ATC (1954); painter in oil and water-colour (triptychs); formerly senior lecturer in painting, Bedford College of Educ. *b:* Dover, 29 Jul 1928. *m:* Iris. one *s.* one *d. Studied:* Canterbury, Farnham and Brighton Colleges

of Art until 1954, R.A. Schools (1980-81) (Guest student/Peter Greenham). *Exhib:* RA (23 Summer exhbns, 35 paintings hung), Singer & Friedlander, NEAC, RWS, Portal Gallery, Laing Gallery, Ellingham Mill, Ash Barn Gallery, Sotheby's; The Gallery, Wellingborough, New Ashgate Gallery, Farnham, Discerning Eye. *Works in collections:* Beds. Educ. Loan Service, Bedford Hospital Trust (two paintings), University of Central England Archive 'David Payne Collection' Childrens Work; and private collections. *Publications:* reviews, ITV (1982), BBC2 (1983), Academy Illustrated (1983, 1984, 1991), Royal Academy Exhibitors (1971-89); RA German TV film (ARD, 1999). *Clubs:* Reynolds (RASA). *Signs work:* "David Payne." *Address:* 25 Willmers Cl., Bedford MK41 8DX.

PAYNE, Margaret A., N.D.D. (1959), A.T.C. (1960), B.A.(Hons.) History of Art (1981), M.A. (Art Educ.) (1983), R.E. (1975); graphic artist including computer graphics, painter in oil, etcher; Currently researching children's learning in N.C. Art at KS1 & 2. *b:* Southampton, 14 Apr 1937. *d of:* G. E. B. Payne, M.D., D.P.H. *Educ:* St. Helen's School, Northwood, Middx. *Studied:* Harrow School of Art (1955-59), Goldsmiths' College (1959-60). *Exhib:* R.A., R.E., Paris Salon, Society of Women Artists, Young Contemporaries, R.I. *Works in collections:* Sheffield and Nottinghamshire C.C., Pictures for Schools circulation. *Publications:* in Journal of Art and Design Education (1993), Froebelian Principles and the Art National Curriculum. *Address:* 11a Wallorton Gdns., London SW14 8DX.

PAYNE, Tom, BA (Hons) Ceramics. *Medium:* ceramics, high grog crank. *b:* Camberwell, 24 Apr 1978. *s of:* Alasdair and Elizabeth Payne. *Studied:* KIAD Rochester (Kent Institute of Art and Design). *Represented by:* Start Space, 150 Columbia Road, London E2 7RG. *Exhib:* UK (London, Surrey, Eton, Glasgow, Winchester, Birmingham), Ireland. *Works in collections:* of Greg Dyke, and private collections in UK, Ireland and USA. *Works Reproduced:* figurative works up to lifesize. *Principal Works:* small figurines, smoke fired, and larger stone carving inspired pieces. *Signs work:* monogram of 'TP'. *Address:* c/o Eduardo Sant'Anna, Start Space, 150 Columbia Road, London E2 7RG. *Email:* contact@st-art.biz *Website:* www.st-art.biz

PAYNTER, Hilary, NDD (1964), ATC (1965), MA (Psych.Ed., 1982), ARE (1984), MSc (1988), FRSA (1986); wood engraver; Chairman SWE. *b:* Dunfermline, 16 Jun 1943. *d of:* Comdr. E.V.K. Paynter, R.N. *m:* Gerry Bradley. one *s.* one *d. Studied:* Portsmouth College of Art (Gerry Tucker). *Exhib:* SWE, RE, Xylon, Switzerland. *Works in collections:* Hereford, Birmingham, Portsmouth and Durham City AGs, Ashmolean Museum, V&A, Fitzwilliam Museum; Laing Art Gallery. *Commissions:* Newcastle-upon-Tyne Central Station Station Metro mural. *Publications:* Fragments from the Satyricon (1999), The Story of Poetry (1992), Legal London Engraved (1998), The Engraver's Cut (1996), Goblin Market (2003). *Signs work:* "Hilary Paynter."

Address: Torridge House, Torridge Hill, Bideford, Devon EX39 2AZ. *Email:* hilarypaynter@yahoo.com

PAYNTON, Colin Frank: see SEE-PAYNTON, Colin Frank,

PEACOCK, Carlos (Charles Hanbury), BA(Cantab.); writer and art critic. *b:* 6 Oct 1909. *s of:* W. E. Peacock, M.D. *m:* Cynthia Howell. *Educ:* Uppingham and Cambridge. *Exhib:* Arranged: Constable Exhbn. at Aldeburgh Festival (1948), Pre-Raphaelite Exhbn. at Bournemouth (1951). *Publications:* Painters and Writers (Tate Gallery), co-author (with John Rothenstein) of essay on Tate Gallery in The Nations Pictures (Chatto and Windus, 1951), John Constable (John Baker Ltd.), Samuel Palmer (John Baker Ltd.), Richard Parkes Bonington (Barrie & Jenkins). *Address:* 26 Brompton Sq., London SW3 2AD.

PEARCE, Antony, B.A. (Exeter) (1963), F.R.S.A. (1990), A.N.S. (1991); teacher/full time artist in water-colour and acrylic since 1980;. *b:* Leigh, Essex, 21 July, 1933. *Educ:* Mayfield College, Sussex. *Studied:* self taught, but inspired principally by Rowland Hilder and Edward Seago. *Exhib:* Edwin Pollard Gallery, Wimbledon (annually), numerous one-man shows. *Publications:* by Sharpe's, Castlebar Graphics, Kingsmead Publications. *Clubs:* R.S.A. *Signs work:* "Antony Pearce." *Address:* 16 Sandra House, Hansler Gr., E. Molesey, Surrey KT8 9JL.

PEARCE, John Allan, Cavaliere of the Italian Order of Merit; First Chairman and Vice-Pres., Turner Society; painter in oils; retd. solicitor. *Medium:* oil. *b:* Sidcup, Kent, 21 Oct 1912. *s of:* J.W.E. Pearce, M.A. *m:* Raffaella Baione. two *s.* *Educ:* Charterhouse and B.N.C. Oxon. *Studied:* with Giorgio de Chirico and privately. *Exhib:* R.A., N.E.A.C., R.B.A., R.O.I., Chelsea Art Soc., etc. *Clubs:* Travellers. *Signs work:* "A.P." *Address:* 32 Brompton Sq., London SW3 2AE.

PEARSON, Bruce Edward, B.A. Fine Art (1973), S.WL.A. (1978);printmaker, and painter in water-colour and oil; President, Soc. of Wildlife Artists (1994-2004); GMAC Commercial Mortgage Europe Art Award (2005). *b:* Newmarket, Suffolk, 20 Sep 1950. *m:* Sara Oldfield. two *d.* *Studied:* pre-Dip.: Gt. Yarmouth College of Art and Design (1969-70); BA Fine Art: Leicester Polytechnic (1970-73). *Exhib:* many solo exhbns. in U.K., and group shows in U.S.A., Holland; Ministère de L'Environment, France; Natural History Museum, London. *Commissions:* Sultan of Oman, Natural History Museum, Royal Caribbean Cruise Line. *Publications:* chapter with illustrations in 20th Century Wildlife Artists, Nick Hammond (Croom Helm, 1981); author and illustrator: An Artist on Migration (Harper Collins, 1991). Author and illustrator: In a New Light (Wildlife Art Gallery 2003). *Recreations:* playing music (guitar) in jazz/funk band. *Signs work:* "B.P." (on some illustrative work), "BRUCE PEARSON" (on all other work). *Address:* The Old Plough, Caxton Rd., Great Gransden, Sandy, Beds. SG19 3BE. *Email:* bep@brucepearson.net *Website:* www.brucepearson.net

PEARSON, James E., artist in oil, clay, bronze; William Boyd Andrews, Best of Show, 1961; Gold Keys, 1951, 1954, 1956; Scholastic Art Awards, Carnegie

Institute; art instructor, Woodstock, Comm. High School, Woodstock, Illinois, U.S.A.; Bachelor of Science in Education (1961), Master of Science in Education (1962), Master of Fine Art (1964). *b:* Woodstock, Illinois, U.S.A., 12 Dec 1939. *s of:* John C. Pearson. *Educ:* McHenry Community High School, McHenry, Illinois; Northern Illinois University, Dekalb, Illinois. *Studied:* Northern Illinois University, Dekalb, Illinois. *Works in collections:* Northern Illinois University; over 100 private collections (company and individual). *Publications:* McHenry County, 1832-1968. *Address:* 5117 Barnard Mill Rd., Ringwood, Illinois, 60072, USA.

PEARSON, Yvette L., B.A.Hons.; freelance graphic designer in oil and water-colour, fashion designer; visiting lecturer, South Devon College of Art and Design;. *b:* 16 May, 1962. *Studied:* South Devon College and Ravensbourne College of Art and Communication (1985). *Exhib:* South Devon. *Misc:* Work manufactured: Kirtle, Jester Dress. *Address:* 22 Central Ave., Paignton, S. Devon.

PEART, Tony, B.A. (Hons.) (1983), M.A. (1986); painter in oil; associate lecturer, Cumbria College of Art and Design;. *b:* Darlington, 23 June, 1961. *m:* Sharyn Brown. one *d. Educ:* Eastbourne School. *Studied:* Cheltenham College of Art, Leeds Polytechnic, Newcastle Polytechnic. *Exhib:* Piccadilly Gallery (1988-). *Works in collections:* Carlisle A.G., Darlington A.G., Government Painting Coll., Rank Xerox, Newcastle University, Northern Arts. *Signs work:* "Tony Peart" always on reverse. *Address:* 4 Beanley Ave., Lemington, Newcastle upon Tyne NE15 8SP.

PEBWORTH, Pam, RWA; Certificate of Education; Diploma in Visual Arts. *Medium:* wood engraving. *b:* Altrincham, 28 Jan 1931. *Educ:* Withington Girls' School, Manchester (1942-47). *Studied:* Bath Academy of Art (1951-54). *Exhib:* Royal West of England Academy, Bristol; South West Academy of Fine and Applied Arts, Exeter; Society of Wood Engravers. *Works in collections:* Royal Albert Memorial Museum, Exeter; Tiverton and Mid-Devon Museum, Tiverton;. *Commissions:* Brook Gallery, Budleigh Salterton. *Publications:* examples of work included in Simon Brett's 'Engravers two (1992)/ Engravers' Globe (1992); Hilary Paynter's 'Engraved Gardens (2001); 'Art in Devon' magazine no.5 Summer 2006 (article by Hilary Paynter about wood engraving, entitled 'Touch Wood' with my work of that title illustrating it); 'Devon Life' magazine (article by Jenny Pery 'World within World', a short biography illustrated with nine of my wood engravings). *Address:* Dovetail, Lower Town, Sampford Peverell, Tiverton, Devon, EX16 7EG.

PECKHAM, Barry Arthur, S.E.A. (1984), R.O.I.; Awards: Royle prize (1984), Cuneo medal (1989), Crossgate Gallery award (1989), Pastel award (1990), Champagne Mumm Marine Artist (1990), Cuneo medal 2002; landscape, marine and equestrian artist in oil, water-colour, pastel, etching. *b:* New Forest, Hants., 30 Dec 1945. *s of:* Harold Arthur & Doris Joan Peckham. *m:* Sarah Peckham. three *d. Educ:* Bartley School. *Studied:* Southampton College of Art.

Exhib: R.A., R.I., R.O.I., P.S., R.S.M.A., S.E.A., N.E.A.C., Royal West of England Academy. *Works in collections:* Royal Marines, Poole. *Publications:* Barry Peckham's New Forest (Barry Peckham-paintings and text, Barry Miles-text), pub. Halsgrove 2001; Seasons of the Forest (paintings and text by Barry Peckham) pub. Red Post Books 2005. *Signs work:* "B.A. PECKHAM." *Address:* Fletchwood Cottage, 15 Busketts Way, Ashurst, Southampton, Hants. SO40 7AE.

PEGLITSIS, Nicolas, painter in oil, water-colour, pastel; awards: (1990, 1993) Beecroft Gallery Trustees Award for best painting in Essex open exhib., by public vote, (1993) short listed for the Bank of Cyprus (London) Ltd. Art Award, (2001) awarded prize for Best Landscape, Essex Open exhib. *b:* Larnaka, Cyprus, 9 Oct 1938. *m:* Jacqueline Taylor. two *d. Educ:* Southend High School. *Studied:* Goldsmith's College, London. *Exhib:* RA; RWS; Minories, Colchester; Beecroft Gallery, Westcliff; Crome Gallery, Norwich; Furneaux Gallery, London; Chartwell Gallery, Southend; Melford Fine Arts, Suffolk. *Works in collections:* private collections in UK, USA, Canada, Australia, New Zealand, Germany, Denmark, Holland, France, Spain, Cyprus; public collections, Municipal Gallery, Larnaka, Cyprus. *Commissions:* many private commissions, various subjects, important commission for The Moneo Company, Tokyo, Japan. *Publications:* Monograph: 'As John Constable Saw it'. *Signs work:* "Peglitsis" with date. *Address:* 25 Bridgwater Drive, Westcliff-on-Sea, Essex SS0 0DJ. *Email:* nicolas.peglitsis@btinternet.com *Website:* www.nicolaspeglitsis.com

PELHAM, Mary Catherine, SWA. *Medium:* watercolour, pastel, collage. *b:* Harrow, 30 Sep 1936. *d of:* Alan & Florence Henderson. *m:* Rodney Pelham. one *s.* two *d. Educ:* North London Collegiate School (1948-54). *Studied:* Maria Grey College, London University (1954-57). *Exhib:* SWA; RSMA (1994-); Mall Galleries; Central Hall Westminster; St.Breock Gallery, Wadebridge, Cornwall; Cowes, Isle of Wight; John Lewis, London; Holt, Norfolk; Bristol. *Commissions:* Northwood Prep School; Merchant Taylors School. *Works Reproduced:* Medici greeting cards. *Recreations:* yoga and badminton. *Misc:* taught art at Northwood Prep School for 25 years; marine subjects of particular interest. *Signs work:* 'Mary Pelham'. *Address:* 4 Chester Road, Northwood, Middx HA6 1BQ.

PELL, Robert Leslie, N.D.D. (Painting) (1948), F.R.S.A. (1968); painter in oil and gouache and lecturer. *b:* Northampton, 24 Nov 1928. *s of:* Harry Pell. *m:* Pamela Crake. one *s.* one *d. Educ:* Technical High School, Northampton. *Studied:* Northampton School of Art and Camberwell School of Art and Crafts. *Exhib:* R.C.A. Galleries, R.B.A., Foyle's Gallery, Canaletto Gallery, Leicester Gallery (Artists of Fame and Promise), Piccadilly Gallery, Bear Lane Gallery, Oxford. *Works in collections:* University College and Balliol College, Oxford, Leicestershire, Reading, Surrey and Northumberland Education Committees, The John Lewis Organisation, Northampton Art Gallery, Coventry City Art Gallery, private collections in England, America, Finland, Canada and Australia. *Works Reproduced:* in La Revue Moderne, Art Review, The Artist, The Oxford Magazine, The Studio. *Clubs:* Royal Society of Arts. *Signs work:* "Pell" (written

in italic script). *Address:* The Studio House, 141 High St., Brackley, Northants. NN13 7BN.

PELLING, John Arthur, A.R.C.A.; painter in oil on canvas; clergyman, Church of England. *b:* Hove, 9 Aug 1930. divorced. *s of:* Arthur Robert Pelling. four *s. Educ:* Brighton, Hove and Sussex Grammar School. *Studied:* Brighton College of Art (1946-49) and Royal College of Art (1951-55), Chichester Theological College (1955-58). *Exhib:* nine one-man shows: London, Sussex University, Manchester, and including two latest exhbns., Air Gallery, Dover St., London. 'The Splitting Image' - Dilemma of Women as Priests (1998) and 'Double Exposure' (2001). *Works in collections:* National Collection of Modern Art, Gdansk, Poland, Nuffield Foundation, Vittorio 'de Sica private collection, Italy. 14 'Stations of the Cross', The Church of St. Thomas, Hanwell, London. At present full time painter in France and London. *Commissions:* 'Annunciation' Altar Piece for Lady Chapel, St Gabriel's, Acton, London. *Clubs:* Chelsea Arts. *Signs work:* "PELLING" (on paintings), "John Pelling" (on drawings). *Address:* 44 Redcliffe Rd., London SW10 9NJ.

PELLY, Frances, R.S.A., D.A.; sculptor in wood, stone, clay, paper. *b:* Edinburgh, 1947. *d of:* Russell Steele Pelly, forester. *Educ:* Morrisons Academy, Crieff. *Studied:* Duncan of Jordanstone, Dundee (1965-71, Scott Sutherland, Alistair Smart). *Exhib:* R.S.A., S.S.A., R.G.I.; solo shows: 'Nousts', travelling exhbn. in Highland Region and Norway (1992-93), St. Magnus Festival, Orkney; Shetland and Norway in 2003; Scottish Lettercutters, Edinburgh (2004) & Perthshire (2007). *Works in collections:* Fine Art Soc., Scottish Arts Council, Dundee, BBC Glasgow, Perth, Orkney, Aberdeen, Royal Concerthall Glasgow, Banff, City Halls Glasgow and Fort William, Edinburgh, Kirkwall. *Commissions:* North Inch Perth, Orkney Art Soc., Parcelforce Glasgow, Mobil North Sea Banff, Strathclyde Regional Council Glasgow, Highland Regional Council Fort William, Orkney Arts Soc., Kirkwall, Museum of Scotland, Edinburgh. *Signs work:* Never signs work. *Address:* Quoyblackie, Rendall, Orkney KW17 2HA.

PELZ, Peter, M.A. (Cantab.) (1968); artist in oil, tempera, water-colour, drawing and etching;. *b:* Oxford, 18 Sept., 1945. *Educ:* King's College, Cambridge. *Studied:* Wigan, Lancs. (1957-63, Theodore Major). *Exhib:* Rebecca Hossack Gallery, London. *Works in collections:* on commission (chief works): triptych at St. James's, Piccadilly; mural at St. Peter's, Morden. *Publications:* Prayer for the Day (Cairns). *Signs work:* "Peter Pelz" and date. *Address:* 28 Victoria Rd., Cirencester, Glos. GL7 1ES.

PEMBERTON, Christopher Henry, MA (1948); landscape, portrait and still life painter and draughtsman in oil, pencil, pen, water-colour and gouache; Head of Foundation Studies, Camberwell School of Art (1982-85; taught at Camberwell 1958-85). *b:* London, 14 Mar 1923. *s of:* Richard Pemberton, H.M.I. *m:* Hester Riddell. four *s.* one *d. Educ:* Eton College, Christ Church Oxford. *Studied:* Camberwell School of Art (1948-50, Claude Rogers). *Exhib:* one-man

shows: Woodlands, Blackheath (1977), Bury St. Edmunds A.G. (1977), Wells Centre, Norfolk (1987), Quay Theatre, Sudbury (1988), Gainborough's House (1989), Cadogan Contemporary (1989, 1992), Swaffham Prior Festival (1998), Chappel Galleries, Essex (2001). *Works in collections:* Newnham College, Cambridge; Christ Church, Oxford; private collections. *Commissions:* various, portraits. *Publications:* Gasquet's Cézanne- a translation (Thames & Hudson, 1991). *Signs work:* "C. Pemberton." *Address:* Place Farmhouse, Bardwell, Bury St. Edmunds, Suffolk IP31 1AQ.

PENDERED, Susan Marjorie Anne, M.C.S.P., R.I. (1983); painter in water based medium; Winner of the Winsor & Newton R.I. Award (1988). *b:* London, 15 Jun 1925. *d of:* Robert Kenrick-Cornish-Bowden. *m:* John H. Pendered, G.P., M.B.E., M.B., B.S. (decd). one *s.* two *d. Educ:* Lillesden School for Girls, Hawkhurst, Kent. *Studied:* part-time at Brighton Polytechnic (1975-82, Norma Weller). *Exhib:* Mall Galleries, R.I., R.A. Summer Exhbn., R.W.A., Bristol, participated in travelling exhbn. to Vancouver, Canada and Seattle, U.S.A. (1986). *Works in collections:* work purchased by Hertford Education Authority. *Clubs:* Sussex Water-colour Soc., Attic Club Ditchling, Assocn. of Sussex Artists. *Signs work:* "S. Pendered." *Address:* Littleway, West Furlong La., Hurstpierpoint, W. Sussex BN6 9RH.

PENDERY, Carroll, S.W.A. (1997); artist in pastel, water-colour, oil. *b:* Leicester, 30 Dec 1935. *m:* Terence Pendery, B.Sc. two *s. Educ:* Gateway Girls School, Leicester. *Exhib:* by selection in Yorkshire, Birmingham, Peterborough, Leicestershire, Norfolk and London. *Recreations:* gardening. *Clubs:* Founder Member Leicester Pastel Society, Kirby Bellans Art Group. *Signs work:* "C. Pendery" or "Carroll Pendery." *Address:* 134 Station Rd., Cropston, Leicester LE7 7HE.

PENKETH SIMPSON, Barbara, FRSA, RMS, PSWA; Mundy Sovereign portrait award (1989), RMS President's Special Commendation (1996), RMS Gold Memorial Bowl (1997), RMS Presidents Special commendation (1999); Hon.Sec. RMS (2002-), elected President SWA (2005); self taught artist and miniaturist, larger oils and portraiture. *Medium:* oil. *b:* Crewe, Ches. *d of:* George & Gwendoline Penketh. *m:* F.W. Simpson. one *s.* one *d. Exhib:* HS, SWA, RMS. *Works in collections:* Britain and abroad. *Publications:* featured on flyer for, and included in Royal Society of Miniature Painters, Sculptors and Gravers '100 Years of Miniatures', Artists & Illustrators Magazine (A&I). *Address:* The Cottage, 22 St. Agnes Road, Conwy, LL32 8RY. *Email:* bsimpson1@btinternet.com

PEPYS, Rhoda Gertrude, N.A.T.C. (South Africa); artist, portrait painter, tutor;. *b:* Port Elizabeth, 12 Mar 1914 (née Kussel). *m:* Prof. Jack Pepys (1938). two children. *Educ:* Collegiate, School of Arts and Crafts, Port Elizabeth; Silver Medal (1934). *Exhib:* one-man shows: S.A.; Italy; Paris (1962); London: Hampstead Art Cellar (1963), Barbican (1982), Studio 36 (1967-89); U.S.A.:

Washington (1985); group shows in London: R.A. Summer Exhbn. (1966, 1989), Images of Italy (1987-89), Israel Paintings (1988). *Commissions:* Univ. of London, Portrait of (1) Prof. G. Scadding (1974); (2) Prof. Jack Pepys (1979). *Clubs:* Accademia Italia. *Misc:* Awards: Academie International de Lutèce, Paris, Silver Medal, (1978); Accademia Italia, Gold Medal (1980); Centauro D'Oro (1982). *Signs work:* "Pepys" and "Rhoda Pepys." *Address:* 34 Ferncroft Ave., London NW3 7PE.

PEPYS, Sandra, B.A. (Hons.) London University; artist, art historian, exhibition curator. *Medium:* oil, watercolour. *b:* Cape Town, 1942. one *s.* one *d. Educ:* South Hampstead, S.O.A.S., University of London. *Studied:* Slade School of Art, also studied with Ruszkowski. *Exhib:* Solo shows include: London: Hampstead Art Cellar (1962, 1973-76), Studio 36 (annually from 1966-76), Duncan Campbell (1994, 1996, 1998, 2000); Paris: Galerie Tedesco (1962); Italy: Sperlonga (1962, 1965, 1999); group shows: London: Society of Landscape Painters, annually from 1989 at W.H. Patterson and Duncan Miller Fine Arts. "Venice in Peril", annually from 1992 at W.H. Patterson. "Images of Italy", Accademia Italiana, London. Arts Club Dover St. Florentine Artists Assoc. Soc. of Landscape Painters Rotunda Gallery Hong Kong (1995). R.A. Summer Exhbn. (frequently from 1973 to present). *Works in collections:* University of London, Municipality of Jerusalem, Brown Forman, Yeo Valley Organic. *Commissions:* mural paintings, London University (1966), British Railways (1967). Portraits include: Professor Sir Ernst Gombrich, O.M., Lady Alexander Fleming, Dr. Arnold Miles F.C.C.P., F.A.C.P, Vineyards and Vintners Fattoria Castellina Capraia. *Publications:* Contributor: Artists and Illustrators Magazine, The Art of Drawing and Painting, Former Editor: Arts Club Journal, Dover Street Arts Club. *Works Reproduced:* The Art of Painting and Drawing. *Clubs:* Chelsea Arts Club. *Misc:* Founder and Chairman, Society of Landscape Painters; Founder and Vice President, Small Painters Group; 1st Prize University of London Exhbn. (1966); Co-ordinator Soil Association Arts Project. *Signs work:* "Sandra Pepys." *Address:* 36 Ferncroft Ave., London NW3 7PE.

PERKINS, Marion, FRSA; MIL (London, 1963); SBA (2001); Sennelier Watercolour Award (2005); Certificate of Botanical Merit (2007); Director of Society of Botanical Artists (2006). *Medium:* watercolours, gouache, egg tempera, lithography. *b:* London, 25 Feb 1943. *m:* Carl. two *d. Educ:* Wembley County Grammar School. *Studied:* Regent Street Polytechnic; Harrow School of Art; St.Albans College of Art; Chelsea Physic Garden. *Exhib:* Westminster Gallery (1999-2002, 2004-07); RA Summer Exhbn (1975); several venues in the Home Counties. *Works in collections:* private collections in the UK and Australia. *Commissions:* mostly landscape, private collectors. *Publications:* entries in 'The Art of Botanical Painting' (Collins, 2004); 'The Botanical Palette' (Collins, 2007). *Works Reproduced:* Christmas and greeting cards, self-published. *Principal Works:* rosa 'Crazy for You'; cover for SBA Catalogue and publicity. *Recreations:* music, gardening, writing. *Misc:* Artist in Residence, National Trust, Brancaster Millennium Centre. *Signs work:* 'Marion Perkins'. *Address:* Thatched

Cottage, Mill End, Hambleden, Henley-on-Thames, Oxon, RG9 3BL. *Email:* marionperkinswatercolours@msn.com *Website:* www.soc-botanical-artists.org

PERKINS, Stuart M.G., R.M.S. (1991), M.A.A. (1990), A.T.D., N.D.D. 1st Class Hons.(1956), M.P.S.G., M.A.S.-F.; landscape miniaturist in water-colour and gouache with occasional still life; trained as a sculptor, and practised as a Studio Potter (1976-85);. *b:* Leicester, 4 July, 1935. *s of:* Frederick G. Perkins & Audrey H.Harris. *m:* Joan Chatterley, A.T.D. three *d. Educ:* Alderman Newton Boys G.S., Leicester. *Studied:* Leicester College of Art (1952-56, Albert Pountney). *Exhib:* R.M.S., R.W.A., R.W.S. Summer Show, W.A.C.; many mixed exhbns. in England and Wales, miniature exhbns. in U.K., Canada, U.S.A., Australia and Japan. *Works in collections:* M.A.S.-F., M.P.S.G.& Washington. Works mainly held in private collections in Canada, France, U.S.A. *Signs work:* "S. PERKINS, r.m.s, m.a.a.," (dated), "Stuart Perkins." *Address:* The Old School, Scowles, Coleford, Glos. GL16 8QT. *Email:* sperkins@freeuk.com

PERRIN, Brian, A.R.C.A., Rome Scholar (1954); painter/etcher; Head of Printmaking Dept., Wimbledon School of Art (1964-97); Mem. C.N.A.A. Fine Art Board (1978-90). *b:* 19 Aug 1932. *s of:* Charles Perrin. *m:* Jane Lisle. two *s. Educ:* Whitgift Middle School. *Studied:* Croydon School of Art (1948-51), R.C.A. (1951-54). *Exhib:* extensively in Europe and U.S.A., including international print Biennales. *Works in collections:* Library of Congress, Washington, V. & A., Arts Council, British Council; Museums of Art: Metropolitan N.Y., Perth, Jerusalem, Boston, Cincinatti, Glasgow, Ashmolean Museum Oxford, British Government Art Collection. *Signs work:* "Brian Perrin." *Address:* 293 Kings Rd., Kingston-upon-Thames, Surrey KT2 5JJ.

PERRIN, Sally Jane, *Medium:* usually water-colour. *b:* Hoddesdon, 1964. *m:* Graham Russell Perrin. one *s.* one *d. Exhib:* Westminster Gallery with S.B.A. annually, Mall Galleries with R.S.M.A., Medici; solo show: Tudor House Gallery, Aldeburgh. *Works Reproduced:* greetings cards for RHS. *Address:* 25 The Roundings, Hertford Heath, Herts. SG13 7PX. *Email:* sally-jane.perrin@virgin.net *Website:* www.soc-botanical-artists.org

PERRY, Jeffrey, N.D.D., A.T.D., N.A.P.A. *Medium:* all. *b:* West Bromwich, 10 Jan 1935. *m:* Sylvia. *Studied:* B'ham College of Art (Bernard Fleetwood-Walker). *Works in collections:* private: England, Wales, Ireland, U.S.A., Canada, France. *Clubs:* Fosseway Artists, R.B.S.A., Helios, N.A.P.A. *Signs work:* "PERRY." *Address:* 90 Badgers Lane, Broadway, Worcs. WR12 7QW.

PERRY, Robert, NDD, ATD, RBSA. Elected Member, Royal Birmingham Society of Artists. Honorary Citizen of the town of Albert (Somme, France). *Medium:* oil, watercolour, drawing. *b:* Brierley Hill, W.Midlands, 15 Jul 1944. *s of:* Ernie Parry. two *s.* one *d. Educ:* Stourbridge Secondary Art School (1957-59). *Studied:* Stourbridge College of Art (NDD, 1959-64), Birmingham University (ATD, 1964-65). *Represented by:* RBSA Gallery, Birmingham; Artifex Gallery, Sutton Coldfield; No.9 The Gallery, Birmingham. *Exhib:* Numerous mixed

exhibitions. Solo Exhibitions (UK): Wolverhampton Art Gallery, Birmingham City Art Gallery, Blackburn Art Gallery, Stockport Art Gallery, Durham City Art Gallery and DLI Museum, RBSA Gallery. Solo Exhibitions (Europe); Galeria Afinsa Almirante (Madrid), Volksbank Halle, Alzey (Rheinland Pfalz), Espace Culturel, Albert (France), Centre Mondial de la Paix (Verdun), Council of Europe (Strasbourg). *Works in collections:* Wolverhampton Art Gallery, Birmingham City Art Gallery, and various private collections. *Commissions:* various, but not normal practice. *Publications:* Booklet "Artists' Diary. Painting in the Somme Battlefields". Various articles, Art Review, Le Figaro. *Principal Works:* General 'on the spot' landscapes throughout Europe, but also in battlefields of the two World Wars, including the Somme, Verdun, Flanders, Normandy, Auschwitz, Oradour-sur-Glane. *Recreations:* cycling and motorcycling. *Misc:* Strong commitment to Internationalism and Education. Offers a comprehensive "Exhibition and Lecture Service" ro Art Galleries, Museums, Universities, schools, and other institutions of Education and Culture. *Signs work:* "ROBERT PERRY". *Address:* 39 Wordsley Green, Stourbridge, West Midlands, DY8 5BN. *Email:* robertperry.artist@btinternet.com *Website:* www.robertperry-artist.co.uk

PERRY, Roy, RI (1978); painter in oil, water-colour and acrylic; awarded RI Medal (1978), RI Council (1979). *b:* Liverpool, 1935. *s of:* Sydney Perry, chartered accountant. *m:* Sallie Charlton. one *s.* one *d. Educ:* John Lyon School, Harrow and Southampton University. *Exhib:* R.A., R.I., R.B.A., R.S.M.A., etc.; one-man shows, Oxford, Guildford, London, Henley and Cambridge. *Works in collections:* many large business corporations; The Fleet Air Arm Museum; H.R.H. The Duke of Edinburgh and other private collections throughout the world. *Works Reproduced:* Lithographs, New York, Industrial Reviews and Laings Calendar. *Signs work:* "Roy Perry." *Address:* The Mill House, Donhead St. Mary, Shaftesbury, Dorset SP7 9DS.

PERRY, Simon Peter George, BSc; MSc; PhD. *Medium:* oil, pastel, drawing. *b:* Mousehole, Cornwall, 26 May 1950. *s of:* Raymond Perry (forester) and Biddy Picard (artist). *m:* Margaret Cook. *Educ:* Penzance Grammar School. *Studied:* University of Newcastle; University of Sheffield. *Represented by:* Wren Gallery, Burford; Sandpiper Gallery, Mousehole, Cornwall. *Exhib:* solo shows: Penzance Arts Club; Sandpiper Gallery, Mousehole; Bartley Drey, London; Wren Gallery, Burford, and others; group shows: Royal Academy Summer Show; City Gallery, London; Bartley Drey, London; Llewelyn Alexander (2); Walker Gallery, Devon (2); Russell Gallery, London; Sandpiper Gallery, Mousehole(2) and many others. *Works in collections:* work in private collections in UK, France and USA. *Recreations:* reading, music, travel. *Clubs:* Penzance Arts Club. *Signs work:* 'Peter Perry' or 'P.P.'. *Address:* Stile Cottage, Trevithal, Paul, Penzance, Cornwall TR19 6UQ. *Email:* peter@peterperry.com *Website:* www.peterperry.com

PERRYMAN, Margot, M.A.; painter; tutor at Goldsmiths, Portsmouth, Ravensbourne, and Winchester Colleges of Art (1967-1974); By-Fellowship - Churchill College, Cambridge University (2002-2003). *b:* Plymouth, 26 Mar

1938. *m:* Luc Delfanne. three *s. Studied:* Harrow School of Art and The Slade. *Exhib:* numerous solo and group exhibs. *Works in collections:* Tate Gallery, Arts Council G.B., Govt. Art Collection U.K., B.B.C., Leicestershire County Education Authority, Moller Centre, Cambs., Fitzwilliam Museum, Cambs.; Cambridge University; University of Natal, S.Africa. *Commissions:* various private commissions. Franciscan International Study Centre - Chapel, Canterbury. *Works Reproduced:* Tate Women Artists (2004). *Signs work:* "Perryman." (on reverse of canvases). *Address:* 26 Leighville Dr., Herne Bay, Kent CT6 8UJ. *Email:* margot.perryman@virgin.net

PESKETT, Tessa, BA (Hons.) Fine Art (1979), PGCE (1982), H.Postgrad.Dip.Painting (1992), ROI (1994); Chadwick Healey prize for painting (1992), Anne LeClerc Fowle medal (1993); artist in oil, charcoal. *b:* Three Bridges, Sussex, 25 Apr 1957. *m:* Nigel Cox. *Educ:* Beaumont School, St. Albans. *Studied:* Reading University (1975-79), City & Guilds of London Art School (1992). *Exhib:* RA Summer Shows, RBA, ROI, Linda Blackstone Gallery, Mall Galleries, Trinity A.G. Arundel, Parkview, Bristol, Laing Art Competition, London (1994-97), Atrium Gallery, Bournemouth University, solo show (1996), Albemarle Gallery, London (1996-97), Paris (1996), New York (NYAD 2000), Four Seasons Gallery, Wimborne (2001, 2003), Discerning Eye Mall Galleries 2002, ROI Annual Exhibition Mall Galleries 2002, The Gallery Upstairs (Henley-in-Arden) 2003, The Orange Tree Galerie, Seillans. *Commissions:* numerous. *Publications:* Positive Health, Dorset Magazine, Living France. *Misc:* Has own studio and gallery in Var region of Southern France (see website). *Signs work:* "Tessa D. Peskett" and "T.P." *Address:* The Orange Tree, Route de Bargemon, 83440 Seillans, France. *Email:* tessapeskett@hotmail.com *Website:* www.theorangetreegalerie.com

PETERSEN, David Thomas, N.D.D (1965), A.T.C. Lond. (1966), R.C.A.; sculptor; Head of Sculpture, Harrow School of Art (1967-1970), lecturer in Fine Art (1972-1974), senior lecturer in Fine Art (1974-1978), head of Sculpture and 3D, Dyfed College of Art (1978-1982); now full time sculptor; director of First Internat. Festival of Iron, Cardiff (1989); visiting prof. at Makina Inst., St. Petersburg; visiting lecturer to World Congress in Aachen, Germany, ABANA conference, Birmingham, Alabama, and to Penland, North Carolina, U.S.A. *b:* Cardiff, 25 Feb., 1944. *m:* Bronwen. three *s.* one *d. Educ:* Taunton School. *Studied:* Newport College of Art (1961-1965), London University, Inst. of Educ. (1965-1966). *Exhib:* numerous from 1963 onwards. *Works in collections:* Dyfed County Council, Cardiff City Council, London Borough of Harrow. *Commissions:* Cardiff City Council H.Q. building (1989), Mametz Wood Dragon, Somme, France (1987), Trinity College (1990), Millennium Beacon for Wales (2000). *Clubs:* past chairman of B.A.B.A. *Signs work:* "David Petersen." *Address:* Efail Y Tyddyn, San Clêr, Sir Gaerfyrddin SA33 4EJ. *Email:* davidtpetersen@aol.com

PETERSON, Peter Charles, N.D.D., V.P.R.B.A. (1988), R.B.A. (1978); mem. Landscape Soc. (1989), Vice Chairman, Soc. of Landscape Painters; Daler Rowney Prize (1983), First Prize (1988), De Laszlo medal (1994); artist in oil, water-colour and gouache; lecturer, Visual Research Dept. Chesterfield College of Art; senior lecturer, Fine Art Dept. Epsom College of Art; visiting lecturer, Falmouth College of Art (1986);. two *d. Studied:* Hornsey College of Art. *Exhib:* R.A. Summer Exhbn. since 1968, R.B.A. since 1978, Falmouth A.G., Hallam Gallery, N.E.A.C., Crossgate Gallery, U.S.A.; one-man shows, Portal Gallery, Highgate, Southwell-Brown Gallery, Richmond, Gt.Yarmouth Museum; group shows, Odette Gilbert Gallery (1983-84), Southwell-Brown Gallery, Richmond, Alexander Gallery London. *Clubs:* Dover Street Arts Club, Penzance Arts Club. *Signs work:* "Peter Peterson." *Address:* Waratah House, 11 The Praze, Penryn, Cornwall TR10 8DH.

PETHERS, Ian Peter Andrew, SBA(1989), RMS(2006), HS; Winner of Llewelyn Alexander Masters Award 2003. *Medium:* watercolour, oil, ink & wash, botanical, marine, architectural, still life inc. miniatures. *b:* London, 23 Jan 1956. *m:* Marylou. *Educ:* Langley County School, Slough. *Studied:* at school under Thomas McCabe (1967-73), Marlow Community College under Jenny Riley (1983-1986). *Exhib:* SBA Westminster Gallery since 1987, RMS Westminster Gallery since 1999, Llewelyn Alexander Gallery, Waterloo since 2002. Various one-man shows. Hilliard Society, Wells; Mall Galleries, London. *Commissions:* 2 murals in Callington, Cornwall. *Works Reproduced:* greetings cards; illustrated Travel Guides by Kingsley Media (1996-99), jacket cover designs for various publishers, wrote and illustrated 'Visions of Glastonbury', Bossiney Books (2001). *Signs work:* "Ian Pethers." *Address:* Glenrock Studio, Drakewalls, Gunnislake, Cornwall PL18 9EE. *Website:* www.glenrockstudio.co.uk

PETLEY, Roy, self taught. *Medium:* oil, watercolours, pastels, pencil. *b:* Grantham, Lincs, 3 Apr 1951. *s of:* Ernest Petley. one *s. Studied:* Brighton School of Art. *Represented by:* Petley Fine Art; David Messum Gallery; Petley Fine Art (Monte Carlo). *Exhib:* Bell Gallery, Belfast (1968), Liberty's Gallery London (1970), Heals Gallery London (1972-85), Open Air Art Show, Green Park London (1973), Crome Gallery, Norwich (1975), Travelling Show, East Anglian Marine Artists (1978-80), Century Gallery, Henley-on-Thames (1979-86, 2001), Fine Art Trade Guild Gallery (1987-89), David Messum (1993-95, 97-01), Jorgensen Fine Art, Dublin (1995-2002), and extensively in UK and abroad. *Works in collections:* Her Late Majesty Queen Elizabeth the Queen Mother, H.R.H. the Duke of Edinburgh, H.R.H. The Prince of Wales, H.R.H. The Duchess of Kent, Her Grace the Duchess of Norfolk, Sultan of Brunei, Durban Museum, Ulster Museum, The High Lane Municipal Gallery, Dublin, Harvard University, Lord Hanson, Frederick Forsyth, Mr. & Mrs. RK Black, Susan George, Timothy Dalton, Philip and Dorothy Solomon, Michael Jaye. *Commissions:* Her Late Majesty Queen Elizabeth the Queen Mother, Duchess of Kent, Duchess of Norfolk, The Salbanchi family, Lord Hanson. *Publications:* Roy Petley by Brian Sewell. *Principal Works:* oil paintings in the figurative manner, portraiture

(landscape), beach scenes and the nude. *Recreations:* chess, classical music. *Signs work:* Roy Petley. *Address:* 9 Cork Street, London W1S 3LL. *Email:* info@petleyfineart.com *Website:* www.petleyfineart.com

PETTERSON, Melvyn Lawrence, N.E.A.C., R.E. (1991), B.A. (1986); painter/printmaker in oil, etching, water-colour; partner, Artichoke Print Workshop. *b:* Cleethorpes, 7 Jul 1947. *m:* Glynis. one, Sara *d. Educ:* Cleethorpes-Beacon Hill Sec. Modern. *Studied:* Grimsby Art School (Peter Todd, Alf Ludlam, Nev Tipper), Camberwell School of Art (Graham Giles, Francis Hoyland, Anthony Eyton, R.A., Ben Levene, R.A.). *Exhib:* R.A., N.E.A.C., R.O.I., Bankside Gallery, museums and galleries in U.S.A., France, Russia, China, Spain, Sweden, Finland, Mont Carlo. *Works in collections:* Oxford, Leicester, galleries in U.S.A. *Publications:* British Painters/Sculptors, Painting and Drawing, Art Review, Drawing and Painting the Landscape (Collins-Brown). *Signs work:* "M.L. Petterson" or "M.L.P." *Address:* c/o Artichoke Unit 51 245a Coldharbour Lane London SE9 8RR.

PETZSCH, Helmut Franz Günther, D.A. (Edin.) 1951; F.S.A. Scot.; painter in oil and water-colour. *b:* Berlin, 13 Dec 1920. *s of:* Max Leberecht Petzsch. *m:* Catherine Oag Craigie. one *s.* two *d. Educ:* Hamburg and London. *Studied:* Edinburgh College of Art (1947-51). *Exhib:* R.S.A., S.S.A., '57 Gallery, Edinburgh. *Publications:* author of Architecture in Scotland (Longman). *Signs work:* "Helmut Petzsch." *Address:* 32 Canaan Lane, Edinburgh EH10 4SU.

PEVERALL, Adrienne, B.Ed., Dip. A.D.; printmaker of etchings and monoprint landscapes; ceramics tutor (1979-1982). *b:* London, 15 Oct 1939. *m:* Ronald Peverall. two *s. Educ:* Southgate Grammar School. *Studied:* King Alfred's College, Winchester (1974-1978), Falmouth College of Art (1990-1992). *Exhib:* annual group exhibs. with Penwith Printmakers, St. Ives Society, Falmouth Art Gallery. *Publications:* 'Ten Penwith Printmakers' (pub. Penwith Printmakers). *Signs work:* "A Peverall." *Address:* Kerrow Lodge, Bosullow, Penzance, Cornwall TR20 8NR. *Website:* www.penwithprintmakers.co.uk

PHILIP, Jackie, BA (Hons), MA; Italian gov. Scholarship, Andre de Sezonaz Scholarship, British Institute Award, Mary Amour Award, RSA Hospitalfield Residency, Russel Trust Award, VAS; John Cunningham Award RGI; artist/lecturer. *b:* Edinburgh, 3 Jan 1961. *Studied:* Gray's School of Art, Aberdeen, Wimbledon School of Art, Royal Academy Schools, London. *Exhib:* UK, Caribbean, Hong Kong, Australasia. *Works in collections:* corporate and private. *Clubs:* RASAA, VAS, RGI, PAI. *Address:* 5 Great King Street, Edinburgh, EH3 6QW. *Email:* philipjackie@hotmail.com

PHILIPPS, Nicola Jane, artist in oil. *b:* London, 27 Aug 1964. *Studied:* City & Guilds; apprentice to Studio Cecil Graves, Florence (1986-88). *Exhib:* Malcolm Innes Gallery (3) including solo shows (1995, 1997); Arndean Gallery (solo, 2001, 2003, 2004); BP Portrait Exhbn, NPG (2005); Garrick Club: Garrick/Milne Exhbn. *Commissions:* Scottish and Newcastle Breweries, The

Irish Guards, Freemasons Hall, Grocers Livery Company, Ken Follett (author), Baltic Exchange, Lord Mayor 1999. *Clubs:* Chelsea Arts Club. *Signs work:* "Nicola J. Philipps." *Address:* c/o Fine Art Commission Ltd., 79 Walton St., London SW3 2HP.

PHILLIPS, Aubrey, R.W.A., P.S.; Gold Medal, Paris Salon (1966); artist in pastel, water-colour and oil, teacher;. *b:* Astley, Worcs., 18 June, 1920. *m:* Doris Kirk. three *s. Studied:* Stourbridge School of Art (E. M. Dinkel), Kidderminster School of Art (W. E. Daly, C. J. Lavenstein). *Exhib:* F.B.A. Galleries, National Library of Wales, City A.G's of Worcester, Hereford and Gloucester. *Works in collections:* Worcester A.G., Worcester County Museum. *Publications:* Two works on pastel and one on water-colour publ. by Search Press. *Works Reproduced:* in Leisure Painter and Artist, Batsford. *Signs work:* "Aubrey R. Phillips." *Address:* 16 Carlton Rd., Malvern, Worcs. WR14 1HH.

PHILLIPS, Francis Douglas, painter and illustrator in water-colour, oil, acrylic, pastel, ink. *b:* Dundee, 19 Dec 1926. *s of:* James Phillips, engineer. *m:* Margaret Parkinson. one *d. Educ:* Dundee. *Studied:* Dundee College of Art (J. Milne Purvis). *Exhib:* R.S.A., R.S.W., R.G.I., R.I.; 'Grampian' T.V. appearances (Feb. and July 1987, Aug 1991) 'Tayside Artist'. Radio Tay broadcast 1995. *Works in collections:* National Trust for Scotland, English Speaking Union, Northern College of Educ., Aberdeenshire Health Board, Glasgow Port Authority; private collections worldwide. *Works Reproduced:* Limited Edn. Prints; illustrated over 100 books; covers on British and French Reader's Digest, The Artist Magazine, International Artist Magazine, Scots Magazine March 2001, Artists and Illustrators Magazine Feb 2007; Over 1160 covers for People's Friend magazine. *Signs work:* "Phillips." *Address:* 278 Strathmore Ave., Dundee DD3 6SJ.

PHILLIPS, John Edward, NDD (Sculpture) 1958, ATC (Lond.) 1961; full-time sculptor and Artist in Residence. *b:* Ealing, London, 28 June, 1937. *s of:* William Francis Phillips. *m:* Valerie Maughan. one *s.* one *d. Educ:* Ealing College. *Studied:* Ealing School of Art (1953-58), Hornsey College of Art (1960-61). *Exhib:* various galleries, art centres, libraries, schools in London, Southern England and France. *Works in collections:* Hillingdon Civic Centre, Uxbridge Library and various schools in the London area, Bucks., Herts. and Oxford. *Signs work:* "John Phillips." *Address:* Lanhael, Hedgerley Hill, Hedgerley, nr. Slough SL2 3RW.

PHILLIPS, Karen E, SGFA; artist in pencil - graphite and colour, pastel, photography and tattoo art; wildlife, portraits and fantasy; Karisma prize for drawing, Born Free Foundation Auctions. *b:* Bromley, Kent, 7 Sep 1966. *Studied:* self taught from life and nature. *Exhib:* SWLA, SGFA, Wildlife Art Soc., and various exhibs. throughout UK. *Works in collections:* private collections in UK, USA, and Australia. *Commissions:* nationally and internationally. *Publications:*

Absolute Press. *Clubs:* B.F.P. *Signs work:* 'K E Phillips." *Address:* 1 Brambleacres Cl., Sutton, Surrey SM2 6NJ.

PHILLIPS, Karen Erica, DATEC (1982), BAHons. (1985), MFA (1987); painter in oil, ink, charcoal, acrylic. *b:* Kidderminster, 1 Nov 1962. *d of:* Alan Neville Phillips, NDD, SDAS. *Educ:* Franche Middle School, Kidderminster; Ilfracombe Comprehensive. *Studied:* North Devon College (1979-82, Robin Wiggins), Bristol Polytechnic (1982-85, Ernest Pascoe), Newcastle University (1985-87, Norman Adams). *Exhib:* New Theatre Gallery, Barnstaple (shared exhbn. with father), Zetland Studios, Bristol, Burton A.G., Bideford, Jigsaw, Barnstaple, Long Gallery, Newcastle, R.W.A., R.A., Vicarage Cottage Gallery, North Shields. *Signs work:* "K. Phillips." *Address:* 6 Laburnum Ct., Guidepost, Northumberland.

PHILLIPS, Rex, Cdr.R.N. (retd.); marine and landscape artist in oil and water-colour. *b:* March, Cambs., 19 Jul 1931. *m:* Shirley Chadwick. one *s.* two *d. Educ:* Nautical College, Pangbourne. *Exhib:* R.S.M.A., A.F.A.S., and various one-man shows. *Works in collections:* Royal Naval, Royal Marines and Fleet Air Arm Museums, London and provincial galleries; private collections in U.K. and abroad, naval ships and establishments, R.N.L.I. and other institutions. *Signs work:* "Rex Phillips." *Address:* 15 Westbourne Ave., Emsworth, Hants. PO10 7QT. *Email:* rex.phillips7@ntlworld.com *Website:* www.rex-phillips.co.uk

PHILLIPS, Tom, C.B.E., RA(1988), RE, MA (Oxon), NDD; artist in oil, water-colour, book productions, television director (A TV Dante, etc.). *b:* London, 25 May 1937. *m:* Fiona Maddocks, 1995. *Educ:* St. Catherine's, Oxford. *Studied:* Camberwell School of Art (Frank Auerbach). *Exhib:* Royal Academy of Arts, Yale Centre for British Art, Victoria & Albert Museum. *Works in collections:* Tate Gallery, B.M., V&A, Moma, N.Y., etc. Gallery (Graphics) www.57talfourd.com. *Publications:* A Humument (etc.). *Clubs:* S.C.C.C., Groucho. *Signs work:* "Tom Phillips." *Address:* 57 Talfourd Rd., London SE15 5NN. *Email:* tom@tomphillips.co.uk *Website:* www.tomphillips.co.uk

PHIPPS, Howard, BA(Hons.) Fine Art (1975), RWA (1979), SWE(1985); wood engraver, painter and illustrator; Landscape Engraving Award (National Print Exhbn, London: 2003, 2004); Christie's Contemporary Print Award, RA Summer Exhbn (1985). *b:* Colwyn Bay, 1954. *s of:* Eric and Margaret Phipps. *Studied:* Fine Art, Cheltenham Art College (1971-75), Brighton Polytechnic (1975-76). *Exhib:* RWA, SWE, also at R.A. Summer Exhbns.; one-man exhbns. include Dorset County Museum (1993, 1998, 2004), Salisbury Museum (1993), Victoria Gallery, Bath (1994, 2001), Cassian de Vere Cole Fine Art, London (1996), featured in '20th Century Wood Engraving' Exeter Museums Touring Exhbn (1996/7) Cheltenham Art Gallery (1997), Lymington Museum (2001), Playhouse Gallery, Salisbury (2001, 2007), Bircham Gallery (2006). *Works in collections:* Cheltenham, Salisbury, Exeter and Dorset County museums, Royal West of England Academy, Hunt Institute, USA. *Publications:* illustrated books

for: Bloomsbury, Century, Perdix, Folio Soc., Fleece Press, and Whittington Press who published the artist's own books: Interiors (1985), Further Interiors (1991), and Ebble Valley (2007). *Works Reproduced:* two catalogues of work - 1996 and 2003 (the latter still in print); 'An Engraver's Globe' (S.Brett, 2001). *Address:* Hilfield, Homington Rd., Coombe Bissett, Salisbury SP5 4ND.

PHIPPS, Jemma Louise Rose, *Medium:* oil (mainly portraits), drawing. *b:* Edinburgh, 21 Jul 1977. *d of:* Susan Crawford. *m:* Dr.William Fenton. *Educ:* Sherborne School for Girls, Dorset. *Studied:* Charles Cecil Studios, Florence, Italy (1995-1999). *Exhib:* Summerleaze Gallery, Wiltshire (2003), Mall Galleries (2003, 2006). *Commissions:* H.M. The Queen, H.R.H. Prince of Wales, Duke of Devonshire, Lord Rothermere, H.H. Prince Khalid Abdullah. *Recreations:* travel, walking my dog, galleries, churches, Italy. *Signs work:* "Jemma Phipps". *Address:* Studio 2P, Cooper House, 2 Michael Road, London SW6 2AD. *Email:* jlrphipps@hotmail.co.uk *Website:* www.jemmaphipps.com

PICARD, Bridget Margaret, painter in oil; tutor, Badminton School, Bristol (1942-1943), Penzance Art School (1960s); started Mousehole Pottery with husband, stoneware sculptures. *Medium:* oil paint, acrylic, mixed media, clay. *b:* Chesterfield, 26 June, 1922. *m:* Bill Picard, pottery teacher. one *s.* three *d. Educ:* Chesterfield. *Studied:* Chesterfield Art School (1936-1939), Slade School, under Swarb and Rutherford (1939-1941). *Exhib:* galleries countrywide, mainly West Country. *Works in collections:* Tyne and Weir Civic Centre. Many private collections nationally and internationally. *Publications:* Biddy Picard - A Life's Work. *Works Reproduced:* prints and cards. *Clubs:* Newlyn Society of Artists. *Signs work:* "Biddy Picard." *Address:* Trungle Byre, Trungle, Paul, Penzance, Cornwall TR19 6UG.

PICHÉ, Roland, 1st Class N.D.D., A.R.C.A., F.R.B.S., Medal for Work of Distinction, R.C.A.; many awards since 1961, most recent;y: The Julian Trevelyan Award for Prints, 'Originals' (2007); sculptor in resin, fibreglass, stainless steel, stone and bronze; lecturer in sculpture; Principal Lecturer, Canterbury College of Art;. *b:* London, 21 Nov., 1938. one *s.* two *d. Educ:* Romsey College, Embley Park, Hants. *Studied:* Hornsey College of Art (Mr. C. Anderson, A.R.C.A., 1956-60), Royal College of Art (Mr. B. Meadows, A.R.C.A., 1960-64). *Exhib:* Recent Exhibitions: Sculpture in the Garden, Botanic Garden, Leicester(solo, 2006), RA Summer Exhbn (1994-98), 'Originals' Print Exhibition, Mall Galleries (2007), Bridehall Garden Exhibition, Herts (2007), Chichester 'Sculpture in Paradise' (2007), Arts Council Collection 'Sculpture at McLaren Technology Centre, Working, Surrey (2007-08). *Works in collections:* The Arts Council of Great Britain and Wales, São Paulo Museum, Gothenburg Museum, Sweden, National Gallery of Western Australia, MoMA New York, Aberdeen Scotland, Nene College, Northampton, and many more. *Commissions:* two sculptures for Lovells, Paris (2004). *Publications:* Private View (B. Robertson and T. Armstrong-Jones), Dada, Surrealism (W. S. Rubin). *Address:* Victoria Studios, Tollesbury, Essex CM9 8RG. *Website:* www.rolandpiche.com

PICK, Wayne Erich, National Diploma in Graphic Design (Distinctions: drawing, sculpture, printing). *b:* Johannesburg, South Africa, 6 Dec 1970. *s of:* Wolfgang and Nadalina Pick. *m:* Kin Pick (writer). one *d. Educ:* Edenvale High School, johannesburg (1984-88) Bronze medal: Painting (highest distinction). *Studied:* Witwatersrand Technicon, Johannesburg (1989-91). *Represented by:* Start Space, 150 Columbia Road, London E2 7RG. *Exhib:* London, New York, Miami, Chicago. *Works in collections:* Price (Waterhouse) Forbes, Anchor, Presidential Medical, Display Concepts International, University of the Witwatersrand, African Eagle Insurance; Private collections in the UK, USA, South Africa, Germany. *Principal Works:* 'Somebody Else's Boy', 'Getting Some Colour'. *Signs work:* 'Pick'. *Address:* c/o Eduardo Sant'Anna, Start Space, 150 Columbia Road, London E2 7RG. *Email:* contact@st-art.biz *Website:* www.st-art.biz

PICKEN, Mollie, N.D.D. (1963), A.T.C. (1964); freelance artist in illustration, embroidery and fabric collage;. *b:* 13 Oct 1940. *Studied:* Goldsmiths' College School of Art (1959-64) under Constance Howard and Betty Swanwick. *Works in collections:* Education Authorities, Sibford Village Panels (1999 community project). *Publications:* Illustrated books by Constance Howard; collaborated with Christine Bloxham to produce Love and Marriage (Pub. date: Feb. 1990). Art work for Oxfordshire Museum Services, Embroiderers Guild. *Clubs:* S.D.C.; Embroiderers' Guild, Assoc. of Illustrators. *Address:* The Old Post Office, Sibford Gower, Banbury, Oxon. OX15 5RT.

PICKERING, J. Robin H., BA (Hons); First Prize, Thelma Hulbert Gallery Open Exhbn (2005). *Medium:* pastel, oil. *b:* Exeter, 5 Oct 1945. *s of:* Major Jim Pickering, Royal Warks. Regiment. two *s. Educ:* St.Lawrence College (Ramsgate), Queen's College (Taunton); Exeter University (1964-68). *Studied:* self-taught. *Exhib:* South West Academy; Pastel Society; AAF; solo shows: Hyde Park Gallery, Plymouth (1997-2005); Exeter University (1995-2002); Inspires Gallery, Oxford (2004); Rostra Gallery (1995, 1999); La Lanterne Magique (2003); Troubadour Gallery, Manchester (2007); Rhapsody House Gallery, Tunbridge Wells (2007); mixed/group shows: Art Connection,Eton; Bohemia Galleries; The Gallery, Dorchester; Llewelyn Alexander; Marine House at Beer; No.5 Gallery; Red Rag Gallery. *Works in collections:* University of Exeter permanent collection; private collections in the UK, USA and Australia. *Commissions:* private and business. *Works Reproduced:* signed limited editions: Solomon & Whitehead; Buckingham Fine Art. *Misc:* specialises in Venice, Tuscany, The South West Coast. *Signs work:* monogram R with reverse P. *Address:* 1 Tipton Lodge, Tipton St.John, Sidmouth, Devon EX10 0AW. *Email:* robin_pickering@hotmail.com *Website:* www.robinpickering.co.uk

PICKING, John, N.D.D. (1960), D.A. Edin. (1962), A.T.D. (1966); painter and lecturer; Mem. Manchester Academy; ex Senior Lecturer in Fine Art, Manchester Polytechnic;. *Studied:* Wigan School of Art, 1956-60 (Governors Medal); Edinburgh College of Art, 1960-63 (Postgrad. Scholarship); Scholarship

to Spain 1963-64; Goldsmiths' College, London, 1965-66. *Exhib:* Scottish Gallery, Edinburgh, Colin Jellicoe Gallery, Manchester, Mercury Gallery, London, La Barcaccia galleries in Rome, Naples, Palermo etc.; since 1989 exclusive with Telemarket (Brescia) with galleries in Milan, Rome, Bologna etc.; many group exhibitions including Royal Academy, London and Galleria Borghese, Rome. *Works in collections:* Salford and Manchester Universities, Edinburgh Corp., Palermo Museo Regionale, private collections over the world. Work reflects interest in mixing painting languages, mythology, geology. Since 1979 painting full-time. Studios in Brescia and Sicily. *Address:* c/o Colin Jellicoe Gallery, 82 Portland St., Manchester M1 4QX.

PIDOUX, Janet Anne, S.W.A. (1992), S.O.F.A. (1997). *Medium:* pastel. *b:* High Wycombe, Bucks., 2 Sep 1950. *m:* Derek. one *s.* one *d. Educ:* Wellesbourne. *Exhib:* S.W.A., S.W.L.A., P.S., S.O.F.A. *Works in collections:* private collections: England, America and Canada. *Works Reproduced:* greetings cards, limited edition prints, Cat World publication. *Signs work:* "JANET PIDOUX." *Address:* The Laurels, 97 Hazlemere Road, Penn, Bucks. HP10 8AF. *Email:* janetpidoux@mac.com

PIERCY, Rob, R.C.A.; painter in water-colour and mixed media. *b:* Porthmadog, Wales, 22 Jan., 1946. *m:* Enid. three *s. Studied:* Bangor under Selwyn Jones. *Exhib:* regularly in Singer and Friedlander/Sunday Times Watercolour; shortlisted in Garrick Milne Art Prize (2000), Wales Artist of the Year 2002. *Signs work:* "Rob Piercy." *Address:* Rob Piercy Gallery, Porthmadog, Gwynedd LL49 9BT. *Email:* gallery@robpiercy.com *Website:* www.robpiercy.com

PIERCY, Sioban, M.A., National Dip.; painter, printmaker, lecturer in Fine Art, Galway and Mayo Inst. of Technology. *b:* Rutland, 6 Jan 1957. *m:* Gerard O'Brien. *Studied:* Ravensbourne College of Art, Kent; Crawford College of Art, Cork; Royal College of Art. *Exhib:* International Print exhbns. Norway, Brazil, Germany, Poland, Slovina, Japan, Spain, Taiwan; numerous including one and two person shows in Ireland and UK. *Works in collections:* private and public: UK, USA and Ireland. *Publications:* 'Profile 4 - Sioban Piercy' (Gandon Edns., 1997). *Clubs:* Artists Assoc. of Ireland. *Signs work:* "SIOBAN PIERCY." *Address:* Rahard, Athenry, Co. Galway, Eire. *Email:* spgob@eircom.net

PIERSE, Simon, RWS (2003); BA (London, 1979); MA (Essex, 1992). *Medium:* painter in oils and watercolour. *b:* 18 Sep 1956. *m:* Alison Hall. one *d. Educ:* Haberdashers' Aske's School, Hatcham. *Studied:* Slade School of Fine Art (1975-9); Essex University (1991-2). *Exhib:* RA, RWS, RI; Singer Friedlander/Sunday Times Competition; Barbican Art Centre; Commonwealth Institute; Oxford Gallery; National Library of Wales; ICIA Mumbai; MOMA Wales; Treeline Gallery, Michigan. *Works in collections:* Slade School of Art, London University, La Trobe University Melbourne. *Publications:* The Watercolour Expert (Cassell Illustrated, 2004); Watercolour Masters Then and

Now Cassell Illustrated, 2006-with other RWS members); Artists of the Alpine Club (Ernest Press/Alpine Club, 2007). *Clubs:* Alpine Club. *Signs work:* 'PIERSE'. *Address:* Highfields, Brynymor Road, Aberystwyth, SY23 2HX. *Email:* srp@aber.ac.uk *Website:* www.simonpierse.co.uk

PIERSON, Rosalind, landscape miniaturist in water-colour. *b:* Tavistock, Devon, 14 Sep 1954. *d of:* L.G. Pierson, M.A. *Educ:* St. Audries School, West Quantoxhead, Som. *Studied:* Ruskin School of Drawing and Fine Art (John Newberry). *Exhib:* R.A., Paris Salon, Silver Medal (1978), Gold Medal (1981); R.M.S. Drummond Award (1987), Twice Hon. Mention for Gold Bowl; Bilan de l'Art Contemporain, New York (1982), Silver Medal; Florida Miniature Art Society (1996), Best in Exhibition; Hilliard Soc. of Miniaturists, Co-founder (1981); M.A.A.; M.P.S.G. Washington D.C.; M.A.S.F. *Works in collections:* Miniature Art Soc., Florida, Hilliard Soc. of Miniaturists, Wells, Som. *Signs work:* "R. Pierson." *Address:* Brangwyn House, Kilworthy Hill, Tavistock, Devon PL19 0EP.

PIESOWOCKI, Leon, painter and printmaker in oil, water-colour and silkscreen; Prizewinner: International Print Biennale (Bradford, 1968; Krakow, 1972; Copernice & Sapense, 2nd prize and distinction; Fridrikstad/Norway, 1974, distinction). *b:* Poznan, Poland, 9 Dec 1925. two *d. Studied:* painting: Academy in Rome (1946-47), graphics: Sir John Cass College of Art, London (1949-52). *Exhib:* International Biennale of Graphis, Bradford, Krakow Poland, Frechen Germany, Biella Italy, Fredrikstad Norway; Gorner & Millard Gallery, London; Compendium Gallery, Birmingham; Crest (France) Espace Liberte. *Works in collections:* V. & A., Nuffield Foundation, National Museum Warsaw, Stedelijk Museum Netherlands, Boymans van Beunigen Netherlands, Arts Council, British Council, Dudley Museum and A.G., Northampton Central Museum, National Museum Poznan. *Publications:* 'Modern Prints' by Pat Gilmour (Studio Vista, 1970); Life & Work of Leon Piesowocki, by Krzysztof Kittel (University of Torun, 2004). *Clubs:* International Prizewinners Club, Krakow, ex-mem. Printmakers Council. *Address:* 26160 Manas, La Begude de Mazene, France. *Website:* www.leonpiesowocki.net

PIKE, Septimus: see WATTS, Michael Gorse,

PIKE, Celia, SWA, HS, SFA; BA; artist in gouache and oil. *b:* Surrey, 24 May, 1952. *m:* Richard Morris. two *s. Studied:* Central College of Art and Design, St. Martin's School of Art, RA Schools post.grad. *Exhib:* RA, Whitechapel, Mall Galleries. Work in collections internationally. *Works Reproduced:* prints, calendars, greetings cards. *Signs work:* "CELIA PIKE." *Address:* 51 Estcourt Rd., Woodside, London SE25 4SE.

PIKE, Jonathan, B.A. (1971); painter in water-colour and oil. *b:* Leatherhead, 17 Jan 1949. two *d. Studied:* Central School of Art and Design, Falmouth School of Art. *Exhib:* one-man shows: London; mixed shows: throughout England and U.S.A. *Commissions:* Oxford University Press, The Clothworkers' Company.

Signs work: "JONATHAN PIKE." *Address:* 26 Manor Lane Terr., London SE13 5QL. *Email:* jonathan,pike@hotmail.co.uk *Website:* www.jonathanpike-paintings.blogspot.com

PIKE, Mark Walter, painter in oil, water-colour and acrylic. *b:* Wilts., 22 Sep 1938. *m:* Lesley-Jean. *Exhib:* worldwide. *Works in collections:* private and corporate: worldwide. *Commissions:* best known for development of "Dark 2" dual reality paintings. *Clubs:* N.A.A., Fine Art Guild, N.A.P.A. *Signs work:* "MARK PIKE," "PIKE", "M.P." or "P". *Address:* Langley Studio, Rake, Liss, Hants. GU33 7JL.

PIKESLEY, Richard Leslie, NEAC, Dip.AD (1973), ATC (1974); finalist, Hunting Group Prize (1981 and 1989), winner, E.F. Hutton Prize (1987), W.H. Patterson Prize (1988); painter in oil and water-colour. *b:* London, 8 Jan 1951. *s of:* Leonard Leslie Pikesley. *m:* Susan Margaret Stone. *Studied:* Harrow School of Art (1969-70), Canterbury College of Art (1970-73). *Exhib:* R.A., R.O.I., R.W.A., R.I.; one-man shows include New Grafton Gallery London (1990), Linfield Gallery, Bradford-on-Avon (1986), St. James's Gallery, Bath Festival (1986). *Clubs:* N.E.A.C. *Signs work:* "Richard Pikesley." *Address:* Middlehill Farm, Marrowbone Lane, Bothenhampton, Bridport, Dorset.

PILKINGTON, Ruth Jane, R.O.I. (1976), H.S.W.A. (1985); painter in oil. *b:* Manchester, 2 May, 1924. *d of:* Sir Leonard Behrens. *m:* Eric W. L. Pilkington (decd). one (decd) *s.* one (decd) *d. Educ:* Ladybarn House School, Manchester and Maltman's Green, Gerrard's Cross. *Studied:* Johannesburg Technical College (1947-48), Macclesfield C.F.E. (1962-65). *Exhib:* R.B.A., R.O.I., Paris Salon, Manchester Academy, etc., other group exhbns., one-man show in Channel Islands (1976). *Works in collections:* Barreau A.G., Société Jersiaise, Jersey States. *Signs work:* "Ruth J. Pilkington." *Address:* 97 Rose Mews, L'Hermitage Gardens, St.Peter, Jersey JE3 7HF, C.I.

PILLOW, Lorna Mary Carol, A.R.C.A.; Sir Frank Warner Memorial Medal; freelance textile, exhibition and graphic designer; taught, Croydon and Berkshire Colleges of Art; senior lecturer, West Surrey College of Art and Design (retd.). *b:* Cork, Eire. widow of Peter John Palmer. *d of:* W. Farquhar Pillow. one *s. Educ:* Wolverhampton and Leeds. *Studied:* Leeds, Hull and the Royal Colleges of Art. *Exhib:* Beverley Art Gallery, Ferens Art Gallery, Guildhall, R.W.S. Galleries, Mall Galleries, London, W.S.C.A.D. Gallery, Farnham, R.S.A. Travelling Exhibition, Design Centre, London. *Publications:* International Textiles; illustrated Geography of Flowering Plants. *Signs work:* "Lorna Pillow." *Address:* 33 Havelock Rd., Maidenhead, Berks. SL6 5BJ.

PIMLOTT, Geoffrey, ARWS (2006); MA Fine Art, Painting (2004); FFPS (1997); Cert Ed. (FE, 1975); SY Dip AD (1968); Nina Hosali Award (2nd Prize, 1991); Rome Study Bursary (1992); RWS Award (2005). *Medium:* watercolour, acrylic, oil, metallic and spray paints, graphite and charcoal, block printing. *b:* Croydon, 1 Jul 1946. *s of:* Norman Pimlott. *m:* Lorraine. one *s.* two *d. Educ:* John

Newnham Secondary Selective; John Ruskin Grammar School. *Studied:* Reigate School of Art and Design (1965-8); Wimbledon School of Art (2001-4). *Represented by:* RWS. *Exhib:* Thorndyke Theatre Gallery (1972); Garnett College Foyer (1975); Arts 38 Gallery, London (1976-79); Herriot Watt Theatre, Edinburgh (1980); Centre Gallery, Bletchingley (1981, 1996); Harlequin Theatre, Redhill (1987); Loggia Gallery, London (1997, 99, 2000); The Bettie Morton Gallery (2001, 2002); MA Show, Wimbledon School of Art (2004); Bankside Gallery (RWS, 2005-7); plus numerous mixed shows, UK. *Works in collections:* RWS Diploma Collection; private collections in England, USA, Canada, South Africa. *Works Reproduced:* in 'The Encyclopedias of Acrylic and Drawing Techniques (Quarto Books); The Acrylic Artists' Bible (Chartwell Books); Artist Magazine article (Mar 07). *Principal Works:* watercolours of extreme abstraction of the visual experience. *Recreations:* world travel, folk music, gardening. *Misc:* taught in Further & Secondary Education to 2007; taught in Papue New Guinea (1984-6). *Signs work:* 'PIMLOTT'. *Address:* 61, rue de l'Hermitage, Le Parcq 62770, France. *Email:* geoff@pimlott.info *Website:* www.geoffrey@pimlott.info:

PINCUS, Helen Frances, B.A. Hons. (1982), M.F.P.S. (1984), M.S.D.C. (1993), Adult Educ. Dip. (1979); fibre and textile artist, designer, embroiderer in fibres, yarns, aluminium mesh, wood, piano wire and pure silk; freelance lecturer, writer and musician;. *b:* London, 22 Oct 1938. *Educ:* Haberdashers' Aske's Acton Girls' School; Arts Educational Schools. *Studied:* Nottingham University; Loughborough College of Art and Design. *Exhib:* numerous one-man shows and mixed exhbns. both in the U.K. and abroad including Commonwealth Inst. A.G., Cork St. Fine Arts, Leighton House, Savaria Muzeum (Hungary), Galeria Bellas Artes (Spain), University of Surrey, Loggia Gallery, Contemporary Arts (Hong Kong), Hampton Court Palace, Guild Gallery, Bloomsbury Gallery, Vincent A.G. (Australia), Cecilia Colman Gallery, Metro Toronto Convention Centre (Canada), Del Bello A.G. (Canada), Strathclyde University, Barbican Centre, The Rotunda Gallery Hong Kong, dfn Gall., Manhattan N.Y.C., Tidedancers, Easton, Md. U.S.A., Mall Galleries, Sheridan Russell Gallery, London. *Works in collections:* Savaria Muzeum, Hungary, Embroiderers' Guild Collection, Hampton Court Palace, The World Bank, U.S.A. *Clubs:* F.P.S., Soc. of Designer Craftsmen, The Colour Group (G.B.), Embroiderers' Guild, Cornwall Crafts Assoc., New Embroidery Group, Registered with the Crafts Council. *Signs work:* occasionally embroiders initials and year. *Address:* MoonGates, 9 Castle Heights, Tintagel, N. Cornwall PL34 0ED.

PINE, Diana, Assoc. Sussex Artists (1974, Hon. Sec. 1978-83); artist in water-colour, pastel and oil; documentary film director, Crown Film Unit, Wessex, etc. BBC; part-time teacher, Mole Valley AEC and Day Centre. *b:* London. *d of:* Charles F. R. and E. M. Gubbins. *Educ:* Jersey, France, London, P.N.E.U. *Studied:* Regent St. Polytechnic (1936-37) under Clifford Ellis, Chelsea Art School under H. S. Williamson, Central School; apprentice Edward Carrick for Art Direction, Films (-1940), Ernest Savage, Aubrey Sykes (1968-75). *Exhib:* R.I., P.S., S.W.A. (1976-86), Assoc. Sussex Artists, Horsham, Barns Green,

Dorking Group. *Signs work:* "D. Pine." *Address:* 2 Lodge Close, North Holmwood, Dorking, Surrey RH5 4JU.

PINKETT, Neil Anthony, SIAD (Society of Industrial Artists and Designers). *Medium:* oil. *b:* Penzance, 27 Jan 1958. *s of:* Mr. & Mrs. J.B.Pinkett. *m:* divorced. one *d. Educ:* as designer and illustrator. *Studied:* Cornwall College. *Exhib:* many galleries including: Great Atlantic Mapworks Gallery, St.Just, Cornwall; Beside the Wave Gallery, Falmouth; Thompson's Gallery, London; Innocent Fine Art, Bristol; Lemon Street Gallery, Truro. *Works in collections:* many. *Commissions:* one of several artists asked to provide work for ocean liner Queen Mary II. *Publications:* small books of collected paintings. *Official Purchasers:* limited edition prints produced through Great Atlantic Mapworks Gallery, St.Just. *Address:* 18 Belgravia Street, Penzance, Cornwall, TR18 2BJ. *Email:* neilpinkett@blue-earth.co.uk

PINKNEY, Richard, N.D.D., A.T.D.; painter, sculptor and printmaker in oil, acrylic, gouache, intaglio, etc.; teacher, Ipswich, Colchester and St. Martin's Schools of Art, and Kingsway College; Director, Lady Lodge Arts Centre, Peterborough, Open College of the Arts. *b:* 22 July, 1938. *m:* Judith Foster, A.R.C.A. two *s. Educ:* Ipswich School. *Studied:* Ipswich Civic College, School of Art; West of England College of Art, Bristol. *Exhib:* solo shows: A.I.A. Gallery, London; Traverse Theatre, Edinburgh; Paperback Bookshop, Edinburgh; St. Martin's Schools of Art, London; Lady Lodge Arts Centre, Peterborough; Manor School of Ballet, Edinburgh; University College Suffolk; Christchurch Mansion, Ipswich; Sans Walk Gallery, London; Gainsborough's House, Sudbury; group shows: graphics and mailart widely, U.K., Europe, U.S.A., Japan, S. America. *Works in collections:* Tate Gallery, V. & A., B.M.; public and private collections U.K. and worldwide. *Publications:* Circle, Tetrad, Trivia & Bad Presses. *Clubs:* Suffolk Group, Ipswich Arts Soc. *Signs work:* "R.P.," "R. Pinkney," "Richard Pinkney." *Address:* 10 The Street, Bramford, Ipswich, Suffolk IP8 4EA. *Email:* arpyarpy@aol.com

PINSKY, Michael, Doctorate in Fine Art, M.A.(R.C.A.), B.A. (Hons.) Fine Art (1991); artist in photography, sculpture, site-specific installation. *b:* Scotland, 24 Nov 1967. *Educ:* James Gillespies High School. *Studied:* Manchester Polytechnic (1987-88), Brighton Polytechnic (1988-91, Bill Beach), R.C.A. (1993-95), University of East London (1998-2001). *Exhib:* one-man shows: Collective Gallery Edinburgh, The Warehouse Amsterdam, Open Eye Gallery Liverpool, Viewpoint Gallery Manchester,Quay Arts Centre, I.O.W., Gatwick Airport, Metropole A.G. Folkestone, Dean Clough A.G. Halifax, Towner A.G. Eastbourne, Photofusion, London, Duncan of Jordanstone A.G. Dundee, Delfina London, Bonnington Gallery Nottingham, Leeds City A.G., Watershed, Cymar, Wiemar, Germany, Economist Gallery, London, East London Gallery; group shows worldwide, including I.C.A. London, Cornerhouse, Manchester, Armory Centre of the Arts, Los Angeles, Contemporary Art Forum, Canada, Rotterdam International Architectural Biennale; CCC, Tours, France; Le Parvis, France.

Commissions: British Waterways, Nexus, Commissions East, NHS, Arts Council England, Sustrans. *Publications:* Transparent Room, Catalogue, pub. Skelton-Forster ISBN 09525098 14; Pinsky Projections, catalogue (pub. Chelmsford Council ISBN 095185 63 16). *Address:* 47 Earlsferry Way, London N1 0D2. *Email:* michael@michaelpinsky.com *Website:* www.michaelpinsky.com

PIOTTI, Vittorio, Dip. of Artistic Maturity, Art-Liceum, Carrara (1967), Knighthood of Italian Republic (Cav.) (1978), RWA (1983); Major Alpini Parachutists; sculptor in iron. *b:* Brescia, Italy, 5 Mar 1935. *s of:* Mario Piotti, bookkeeper, bank director. *m:* Andreina. one *s.* one *d.* *Studied:* Art Liceum of Venezia; Art-Liceum of Carrara. *Exhib:* (1967-93): Brescia, Trento, Padova, Vicenza, Mantova, Cremona, Bari, Pavia, Biarritz and Parigi (France), Venezia, Pompeii, Cassino, Bolzano, Verona, Bergamo, Torino, Bristol (England), Genova, Monaco and Mainz (Germany). *Works in collections:* in Italy, Libya, France, England, Germany. Public monuments: in Italy and Germany, etc. *Signs work:* "V. PIOTTI" or "Vittopiotti." *Address:* via Columbaia 17, 25050 Rodengo, Saiano, Brescia, Italy.

PIPER, John S., have painted and exhibited since mid 1960s. Paintings are always in oil and either on canvas or board. Images based on the Cornish Landscape, in particular that of West Penwith. *b:* Salisbury, 27 Aug 1946. *Exhib:* major one-man shows in recent years: St.Ives (Penwith Gallery), London (Northcote Gallery), Antwerp (Capela Arte Falco). *Clubs:* Penwith Society, Newlyn Society of Artists. *Address:* Mowhay, Trebehor, St.Levan, Penzance TR19 6LY.

PIPER, Raymond Francis Richard, FLS (1974), M. Univ. (2000), HRUA (2002), HRHA(1999), UWS(Hon. 1975); portrait painter, draughtsman, botanical illustrator. *Medium:* pencil, pastel, oil, water-colour. *b:* London, 6 Apr 1923. *Educ:* Belfast High School. *Studied:* Belfast College of Technology. *Exhib:* R.W.S. Galleries London, R.H.S. London, Ulster Museum, Dublin, British Museum Dept. of Natural History etc. *Works in collections:* Arts Council of Northern Ireland, Ulster Museum, Royal College of Physicians, London, St. Columb's College, Derry, Irish National Portrait Collection, etc. *Commissions:* As professional portrait painter sitters have included Sir Adrian Boult, Lord Justice MacDermott, Lord Brookeborough and Sir Brian Faulkner (past Prime Ministers of Northern Ireland) several Lords Mayor of London and Belfast including Sir Frederick Hoare and Sir Bernard Waley-Cohen, and Sir Cuthbert Ackroyd, etc. *Publications:* at least 22, mainly on Ireland and botanical works, Shakespeare, etc. *Official Purchasers:* Royal College of Physicians, Ulster Museum. *Works Reproduced:* portraits, journals, 22 books etc. *Recreations:* botany, archaeology, drawing. *Clubs:* Ulster Arts, United Arts (Dublin), The Irish Club (London). *Address:* 11c Notting Hill, Malone Rd., Belfast BT9 5NS.

PITFIELD, Thomas Baron, NRD, Hon.FRMCM; artist in water-colour, reed-pen, lino-cut, lettering; composer; art master. *b:* Bolton, Lancs., 5 Apr 1903. *s of:*

Thomas Baron Pitfield. *m:* Alice Maud Astbury. *Educ:* Bolton and Manchester. *Studied:* Municipal School of Art, Bolton (apprenticed in Engineer's drawing-office). *Exhib:* R.A., Northern Academy of Fine Arts, and various one-man exhbns. *Publications:* Junior Course in Art Teaching, Senior Course in Art Teaching, The Poetry of Trees, Bowdon and "Limusicks" (40 limericks), (texts, script, illustrations), Recording a Region (drawings and hand-lettered script), and a large number of musical compositions; autobiographies: A Cotton Town Boyhood, No Song, No Supper, A Song after Supper. *Works Reproduced:* in Artist, Countryman, and other periodicals, calendars, etc. C.D. issued by R.N.C.M., of chamber music and songs. *Address:* Lesser Thorns, 21 East Downs Rd., Bowdon, Ches.WA14 2LG.

PITMAN, Primrose Vera, SGA (1953), LRAM, Gold Medal for Design; painter in water-colour, commercial artist in pencil; etcher. *d of:* James L. Pitman. *Educ:* St. Hilda's School. *Studied:* Royal Albert Memorial School of Art under Burman Morrall and James Sparks. *Exhib:* R.W.A. and provincial galleries. *Works in collections:* Royal Albert Memorial Museum, City of Exeter. *Publications:. Works Reproduced:* of pencil drawing of Exeter Cathedral for Preservation Fund organized by Mayor of Exeter. Etchings and pencil drawings in This Jewel Remains (1942). *Clubs:* Exeter Art Soc., Kenn Group. *Signs work:* "Primrose V. Pitman." *Address:* Marlands, 4 Victoria Park Rd., Exeter.

PITTAWAY, Neil John, RWS, RE, RAP, G.DIP, MA, BA (Hons). *Medium:* painter and printmaker. *b:* Wakefield, Yorks, 14 Aug 1973. *Studied:* RA Schools(Norman Adams, 1998-2001), University of Bradford (1996-98), Gloucestershire University (1992-96). *Exhib:* nationally and internationally including India, Italy, and throughout UK. *Works in collections:* Ashmolean Museum, British Museum, V & A, St. Paul's Cathedral, Guild Hall (London), Gloucestershire University, DH Lawrence Museum (Nottingham), Dover Street Arts Club London. *Commissions:* DH Lawrence Museum (painting). *Publications:* drawings for 'London in Poetry and Prose' ed. Anna Adams, Enitharm Press, London, 2003. *Clubs:* hon. artist mem. Dover Street Arts Club, London. *Misc:* featured in Channel 5 TV 'Great Artists' series. *Address:* 1 Glenfields, Netherton, Wakefield, WF4 4SH. *Email:* njpittaway@hotmail.com

PLATT, Eric Warhurst, A.R.C.A., Silver Medallist (1940); artist in line and wash, water-colour, etching, graphic design, and creative cut card relief; Vice Principal Doncaster College of Art; Head of Design, Doncaster M.Inst. of H.E. (retd. July 1980). *b:* Cudworth, Yorks., 2 May 1915. *s of:* John R. Platt, A.V.C.M. *m:* Mary Elizabeth. one *s.* one *d. Educ:* Wakefield and Doncaster School of Art. *Studied:* R.C.A. under Malcolm Osborne, R.A., and Robert Austin, R.A. (1937-40). *Exhib:* R.A., Brighton, West Riding Artists exhbn., Yorkshire Artists exhbn., Doncaster A.G., Feren's Gallery, Hull, Graves Gallery, Sheffield, Liverpool, and Williamson A.G. Birkenhead. *Works in collections:* National Coal Mining Museum of England. *Signs work:* "Eric Platt." *Address:* 18 Warren Hey, Spital, Wirral CH63 9LF.

PLATT, Theo, BA (Hons). *Medium:* oil, watercolour, egg tempera, drawing. *b:* York, 26 Aug 1960. *s of:* Russell Platt, ARCA & Margaret Mackay, ARCA. *m:* Louise. one *s. Studied:* York College of Art (1979-80), St.Martin's School of Art (1980-83). *Exhib:* National Portrait Gallery, Royal Society of Portrait Painters. One-man shows: Jon Wylder Gallery, Belgravia (1996); Air Gallery, Mayfair (2000, 2004); The Gallery in Cork Street (2008). *Works in collections:* Stirling Castle, National Hospital of Neurology, Inner Temple. *Commissions:* portraits: H.R.H. The Princess of Wales; H.R.H. The Countess of Wessex; Chief of Defence Staff, Sir Jock Stirrup; James Garfunkel. *Signs work:* "THEO PLATT". *Address:* 1 Prout Grove, London NW10 1PU. *Email:* theoplatt@hotmail.com *Website:* www.theoplatt.com

PLINCKE, J. Richard, RI, NWS (USA), SFCA; 1997 St Cuthberts Watercolour Prize, Royal West of England Academy; 2000 AIM International Exhibition Award, Vancouver; 2002 L.Blackstone RI Prize for Most Innovative Work; 2004 Allan Edwards Award 'Painting on the Edge' Exhbn, Federation of Canadian Artists. *Medium:* water-colour and mixed media; work includes designs for tapestries. *b:* Woldingham, Surrey, 1928. *s of:* John Plincke. *m:* Rosemary D. Ball. two *d. Educ:* Stowe, Bucks. *Studied:* art: Southampton Inst. of Higher Educ., gaining Higher Cert. (Distinction); architecture: Architectural Assoc. School of Architecture, London. *Exhib:* RA, RWA, RI, RSMA; Manor House Gallery, Chipping Norton; Linda Blackstone Gallery, Pinner; Rowley Gallery, Winchester; Fine Art UK, Ledbury; also USA, Canada, France and Jersey. *Works in collections:* Work included in a number of private collections. *Publications:* 'Watercolour Innovations' by Jackie Simmonds (Harper Collins). *Signs work:* "R.P." *Address:* The Studio, 2 St. Thomas Mews, Winchester, Hants. SO23 9HG.

PLOWMAN, Christopher Charles, B.A. Fine Art (1973), M.A. Printmaking (1976); artist in printmaking (etching) and sculpture (steel);. *b:* Fareham, 16 Sep 1952. *m:* Annie. one *s.* one *d. Studied:* Wolverhampton Polytechnic (1970-73), R.C.A. (1973-76). *Exhib:* Flowers East (1995), Jill George Gallery, London (1998). *Works in collections:* Tate Gallery, V. & A., British Museum. *Commissions:* Legal and General, Coca-Cola Schweppes, Maidstone Hospital, Derby City Council. *Address:* The Old Farmhouse, Cooks Lane, Lockerley, nr. Romsey, Hants. SO51 0JE. *Email:* chrisplow@aol.com *Website:* www.chrisplowman.co.uk

PLUME, Anita Frances, B.A. Hons, Fine Art (1993-2000); painter in oil, water-colour, acrylic, pastel. *b:* 11 May 1947. *m:* David. one *d. Educ:* Glendale Grammar School, N. London. *Studied:* Falmouth College of Arts. *Exhib:* Mariners Gallery, St. Ives; Norway Gallery, St. Ives Soc. of Artists.; Vitreous Contemporary Gallery, Mitchell Hill, Truro, Estuary Estates, Trebetherick. *Clubs:* St.Ives Society of Artists, Porthmeor Group St.Ives. *Misc:* regular attendee of the St.Ives School of Painting. *Signs work:* "Anita Plume" or "AP." *Address:* 3 Sarah's Meadow, Padstow, Cornwall PL28 8LX. *Email:* dplume9705@aol.com

PLUMLEY, Richard Harry, interior designer, painter in oil, water-colour and gouache, early sculpture, stage and theatre design, consultant; co-Director, Personal Choice Interiors;. *b:* Harrow, Middx., 5 Mar., 1944. *m:* Snezana Nikolic. one *s.* one *d. Educ:* Orange Hill, Edgware. *Studied:* Harrow College of Art (1962). *Exhib:* one-man shows: George St. London (1969, 1972), Isle of Man (1994); mixed shows: Windsor (1976), Douglas (1984), artfulhand (2000) Casteltown (2006); retrospective exhbn. (1998). *Works in collections:* London, Chicago, Spain, Isle of Man, Gallery artfulhand I.o.Man, private and corporate collections. *Commissions:* Interiors Avon Castle, Ringwood, Creek Peel. *Publications:* Manx Life, Isle of Man Examiner and Courier. *Principal Works:* London River Studies, People & Places, Venice, Set Designs. *Clubs:* Legion Players, Dramatic Personae. *Misc:* Recent return to stage design and painting on large scale. *Signs work:* "R.H. Plumley" or "R.P." or monogram with year. *Address:* Seaforth House, 4 Crown St., Peel, I.O.M. IM5 1AJ. *Email:* plumleyr@hotmail.com

PLUMMER, Brian, painter in acrylic and water-colour relief. *b:* London, 1934. *Studied:* Hornsey College of Art, R.A. Schools. *Exhib:* R.A., Expo Montreal, Barcelona Bienal (prizewinner), Toronto, Abbot Hall, Kendal, Lucy Milton, Galerie van Hulsen, Amsterdam, Rex Irwin Sydney, Sloane St. Gallery, Audun Gallery, Macquarie Galleries, Sydney, Gallerie St. Pierre, Bordeaux, Piano Nobile, London, Minster Fine Art, York. *Works in collections:* D.O.E., St. Thomas' Hospital, Power Collection Sydney, Ministero Cultura Madrid, Mobil Oil Co., Lancaster University, Abbot Hall, Kendal. Armidale N.S.W. *Commissions:* mural: London Office, Western Asset, Pasadena, U.S.A. *Publications:* Brian Plummer - Landscape & Perception, text by Norbert Lynton & Susan King (University of Westminster). *Signs work:* "BRIAN PLUMMER" on acrylics, hand written on water-colours. *Address:* 89 Palmerston Rd., London N22 8QS.

POCKLEY, Jenepher Ruth, BA (Hons) Fine Art; PG Dip Fine Art. *Medium:* oil. *b:* Felsted, Essex, 26 Mar 1972. *d of:* Tom and Jane Pockley. *m:* Nicholas Archer. one *s.* one *d. Educ:* Chelsford County High School for Girls. *Studied:* Kent Institute of Art and Design at Canterbury; RA Schools. *Represented by:* Sarah Myerscough Fine Art, london. *Exhib:* Royal Academy of Arts; Sarah Myerscough Fine Art; Gibsone Jessop Gallery, Toronto, Canada. *Commissions:* various private commissions, London, Scotland and UK. *Publications:* article in 'The Independent'. *Signs work:* 'J.Pockley'. *Address:* High Meadow, Friarshill, Guestling, E.Sussex TN35 4EP. *Email:* jennypockley@hotmail.com

POCOCK, Heather, BA (Hons) (1976), ATC (1978). *Medium:* oil, acrylic, mixed media. *b:* London, 5 May 1954. *Studied:* St.Albans and Sheffield Colleges of Art (1972-76), University of London (1977-78), British Council Travelling Bursary Italy (1978). *Represented by:* Francis Kyle Gallery (since 1994). *Exhib:* Malcolm Innes Gallery, Edinburgh; Royal Glasgow Institute; Royal Scottish Academy, Edinburgh; Royal Academy, London; Francis Kyle Gallery, London -

group shows, and one person shows 1998 & 2002. *Works in collections:* private and corporate. *Publications:* Arts Review 1999 (Art & Artists in Argyll and Bute). *Signs work:* "Heather Pocock" (on back of painting). *Address:* c/o Francis Kyle Gallery, 9 Maddox Street, London W1S 2QE. *Email:* info@franciskylegallery.com *Website:* www.franciskylegallery.com

POLAINE, Peter David, NDD, FCSD, FRSA. *Medium:* painter in oil, printmaker and stained glass artist. *b:* London, 30 Apr 1937. *m:* Betty. two *s. Educ:* Harlow College. *Studied:* Walthamstow School of Art (1954-1959). *Represented by:* Sudbourne Park Printmakers (member). *Exhib:* RA, and other London and East Anglian galleries. *Commissions:* private worldwide. *Signs work:* "PETER POLAINE" or monogram or both. *Address:* Gardener's Cottage, Broke Hall Park, Nacton, Suffolk IP10 0ET. *Email:* peter@polaine.com *Website:* www.polaine.com/peter

POLLARD, Elke Kairies, NDD Northampton School of Art, Diamond Award 2002 Best Fine Artist. *Medium:* drawing and painting, murals. *b:* Bielefeld, Germany, 16 Feb 1942. *d of:* Mr & Mrs B C Addis. *m:* the late Malcolm Pollard. two *s. Educ:* Osningschule, Berengaria Cyprus. *Studied:* Northampton School of Art under Henry Bird, P.Cubitt, T.Hughes. *Exhib:* solo exhibitions: New Hall, Cambridge, Derngate Foyer Gallery,Northampton, Bedford School, Royal Theatre, Northampton; Best of British, Kuwait. *Works in collections:* Royal Theatre, Spirit of the Theatre, New Hall College Cambridge (self-portrait) etc. *Commissions:* portraits include Mayor of Northampton, Lord and Lady Ednam, David Essex, Alan Lamb, Steve Waugh, Michael Holding, Chairman of Derngate Trust, Gerard Naprous (horseman), plus military personnel, actor and rock star portraits; murals: three for The Racecourse Pavilion, Northampton; ceiling of Mayor's Parlour, Northampton Town Hall, one ceilings for private client; landscapes and flower painting. *Publications:* various newspapers, magazines, journals, books (including Who's Who in Art since 1945 by David Buckman). *Official Purchasers:* commissions for institutions e.g. Kings College Choir School, Spratton Hall School. *Works Reproduced:* postcards of New Hall Cambridge, Darwin College,Northamptonshire scenes and pavillion murals. *Principal Works:* autobiographical paintings in oil or acrylic. *Recreations:* diarist, love of open spaces, meeting and drawing people. *Clubs:* Northampton Town & Country Arts Society. *Misc:* life-long partner and muse to artists/sculptor Malcolm Pollard. *Address:* 42 East Park Parade, Northampton, NN1 4LA. *Email:* art@newhall.cam.ac.uk

POLLARD, Michael Vincent, Dip. A.D. (1970), S.B.A. (1988); freelance artist, designer and model maker in oils, acrylics, water-colour, gouache and crayon; visiting tutor to junior and secondary schools. *b:* Cambridge, 6 May 1948. *s of:* Vincent Samuel Pollard. *Educ:* Harpur Secondary School, Bedford. *Studied:* Luton School of Art (1966-70). *Exhib:* Westminster Gallery, London, 'Flora', Sevenoaks, Rackhams, Birmingham and New York. Work in private collections worldwide. *Commissions:* over 200 postage stamps designed for

British Crown colonies and dependencies, worldwide. *Publications:* books illustrated: Fairytales and romance. *Works Reproduced:* greetings cards, jigsaw puzzles and calendars. *Recreations:* gardening. *Clubs:* Hasselblad Forum. *Misc:* Architectural models, sculpture, photography. *Signs work:* 'Michael Pollard' or 'M.V.P.'. *Address:* Tara House, Dychurch Lane, Bozeat, Northants. NN29 7JP.

POLLOCK, Sir George F., Bt., M.A. (Cantab.), Hon. F.R.P.S., Hon. P.A.G.B., F.R.S.A., E.F.I.A.P., M.P.A.G.B.; artist-photographer, a-v producer; past President, Royal Photographic Society. *b:* Paris, 13 Aug 1928. *s of:* Sir John Pollock, Bt., Officer Legion of Honour (etc.). one *s.* two *d. Educ:* Eton College and Trinity College, Cambridge. *Exhib:* numerous. *Works in collections:* British Council, R.P.S., National Gallery of Victoria, Musée de Photographie, Bièvres, Towner A.G., Eastbourne, Texas University, University of Surrey. *Commissions:* murals for Lloyds Bank, British Petroleum, Metals Research. *Publications:* numerous articles on photography; "The Limits of Photography" - Prizewining essay. *Signs work:* "George F. Pollock." *Address:* 83 Minster Way, Bath BA2 6RL.

POMEROY-MATTHEWS, Barbara, awarded place at Bittan College of Art (1940s). *Medium:* watercolour, drawing. *b:* Warwickshire, 21 Mar 1930. *m:* Vincent. one *s. Educ:* private, Warwickshire and Oxfordshire. *Studied:* Bittan College of Art (1945-47). *Exhib:* mainly West Country (45 years). *Works in collections:* private. *Commissions:* private commissions - Holland, Germany, USA, Canada, Columbia, England, etc. *Principal Works:* Birds, butterflies, waterfowl, flora, or the Moor. *Clubs:* Tavistock Group of Artists (in existence for 52 years). *Misc:* Resided in Cornwall for 40 years, and since 1988 has lived on Dartmoor. *Signs work:* "Barbara Pomeroy-Matthews". *Address:* 'Horndon Cottage', Horndon, Peter Tavy, Tavistock, Devon PL19 9RQ.

PONSONBY, Caroline Christine, BA Hons. *Medium:* oil. *b:* Scarborough, 29 Nov 1953. *d of:* Brigadier W.M.Ponsonby. *m:* John F.Molony. two *d. Educ:* Sherborne School for Girls, Dorset. *Studied:* Thames Polytechnic, Woolwich (1974-76). *Exhib:* Eastern Open (2000); RBA (2000); W.H.Patterson (2001-03); Albemarle Gallery (2001); Eaton Gallery (2004); Llewelyn Alexander (2004-07); NEAC (2006); Fairfax Gallery, Burnham Market (2007). *Works in collections:* Korn/Ferry International; The Late Lord Alexander of Weedon; Anthony Mould Esq. *Signs work:* "Caroline Ponsonby". *Address:* Clematis Cottage, 30 St.Ann's Lane, Godmanchester, PE29 2JE. *Email:* caroline.molony@talk21.com

POOLE, David James, RP (1969), ARCA; artist; President, Royal Soc. of Portrait Painters (1983-91); Senior lecturer in Painting and Drawing, Wimbledon School of Art (1962-77). *b:* 5 Jun 1931. *s of:* Thomas Herbert Poole. *m:* Iris Mary Toomer. three *s. Educ:* Stoneleigh Secondary School. *Studied:* Wimbledon School of Art, R.C.A. *Exhib:* one-man shows: Zurich and London. Portraits include: H.M. The Queen, H.R.H. The Duke of Edinburgh, H.M. The Queen Mother, H.R.H. Prince Charles, H.R.H. Princess Anne, H.R.H. Princess Margaret,

Earl Mountbatten of Burma and The Duke of Kent; also distinguished members of govt., industry, commerce, medicine, the academic and legal professions. *Works in collections:* H.M. The Queen and H.R.H. The Duke of Edinburgh; and in Australia, S. Africa, Bermuda, France, W. Germany, Switzerland, Saudi Arabia, U.S.A. *Address:* Trinity Flint Barn, Weston Lane, Weston, Petersfield, Hants. GU32 3NN.

POOLE, Greg, B.Sc. Zoology (1983); Mem. S.WL.A.; artist/illustrator in printmaking and collage;. *b:* Bristol, 26 Oct, 1960. *Studied:* Foundation Course, Manchester Polytechnic (1989-90). *Exhib:* many mixed exhbns., annually with S.WL.A. *Works in collections:* Nature in Art Museums, Glos. Many private collections. *Publications:* At present working on a book for Editions Gallimard based on the Cote d'Azur. *Works Reproduced:* Book covers for Blackwells, CUP and Reed International, many magazine illustrations. *Misc:* Participant in Artists for Nature Foundation Projects on the Loire Estuary, France, and Bandavgarh, India. Recent Residences in France, Ireland and Barbados,. *Address:* 1 Eagle Tap, Eagle Lane, Kingscliffe, nr. Peterborough PE8 6XD. *Email:* greg.poole@virgin.net *Website:* http://homepage.virgin.net/greg.poole

POOLE, Jonathan, City & Guilds Diploma (Sculpture); exhibition organiser and designer; sculptor; wildlife artist. *b:* London, 20 Sep 1947. *s of:* Rozelle & Harold Poole. *m:* Virginia. two *s.* one *d. Educ:* Kings School, Ely. *Studied:* Hertford College of Design; City and Guilds Sculpture School, London. *Represented by:* many galleries worldwide. *Exhib:* Royal Academy, London; Dubai (many exhbns); Brian Sinfield Gallery; AJW, LA; Bermuda; many exhbns worldwide. *Works in collections:* many private collections throughout the world. *Commissions:* Mr & Mrs Michel, Jersey; many private commissions (portrait). *Recreations:* fishing, shooting. *Clubs:* Sloane Club, London. *Signs work:* 'Jonathan Poole'. *Address:* Compton Cassey House, nr. Withington, Cheltenham, Glos. GL54 4DE. *Email:* jonathan@jonathanpoole.demon.co.uk *Website:* www.jonathanpoole.co.uk

POOLEY, Vanessa, FRBS; BA Hons; PG Dip. *Medium:* sculpture. *b:* Norwich, 7 May 1958. *d of:* Mr W.B. & E.M.Pooley. *m:* Tobias Arnup. two *s. Studied:* Norwich School of Art (1977/8, 1978/81); City and Guilds of London Art School (1982/3). *Represented by:* Bircham Contemporary Artists. *Exhib:* RA Summer Show (2002); Bircham Contemporary Art, Norfolk (1999, 2002, 2004); Chelsea Flower Show (2004); Thompsons Gallery, London (2002); Keele Gallery, Keele University (2001); ART '92, '94,'95,'97,'98, 2001; City AG, London (2000); Aldeburgh Festival (1997); The Castle Art Show, Norwich (1995); solo show:The Orangery, Holland Park, London (1994); RCA (1993); Beaux Arts Gallery, Bath; Discerning Eye; Sotheby's; Art Fair, Ghent, Belgium; and many others in UK. *Works Reproduced:* various books. *Recreations:* masters swimming. *Signs work:* 'VMP'. *Address:* 9 The Crescent, Norwich, Norfolk, NR2 1SA. *Email:* vanessapooley@onetel.com *Website:* www.vanessapooley.com

POPE, Perpetua, D.A. (Edin.) 1947; painter in oil; lecturer in visual arts, Moray House College of Education (1968-73). *b:* Solihull, Warwicks., 29 May 1916. *d of:* John Robert Pope. *Educ:* Albyn School, Aberdeen. *Studied:* Edinburgh College of Art under W. G. Gillies, John Maxwell, Leonard Rosoman. *Exhib:* one-man shows: Scottish Gallery, Stenton Gallery, Edinburgh; mixed shows: R.A., R.S.A., S.S.A., S.S.W.A., Aberdeen Artists, Stirling Gallery, Open Eye Gallery. *Works in collections:* H.R.H. The Duke of Edinburgh, Scottish Arts Council, Nuffield Trust, Argyll County Council, Robert Fleming Plc., Royal Bank of Scotland; works in private collections Britain, U.S.A. and France. *Signs work:* "Perpetua Pope." *Address:* 27 Dean St., Edinburgh EH4 1LN.

PORTELLI, Guy Anthony, FRBS, RBA; UBS Sculpture Award; Scott, Goodman, Harris Award; Elizabeth Frink School Award; sculptor; specialises in large corporate commissions. *Medium:* bronze, mosaic, stainless steel and glass. *b:* Durban, S. Africa, 13 June, 1957. one *d. Educ:* Hugh Christie School, Tonbridge. *Studied:* Medway College of Art (1974-1978). *Represented by:* Robert Bowman Modern, Bill Clarke, Manchester. *Exhib:* various in U.K., London, Manchester, Edinburgh, Guernsey & USA. *Works in collections:* Porsche Collection, Paris, Ringo Starr. *Commissions:* Sainsburys, Eagle Gates, Guernsey, Commomwealth Inst., London Pavillion, Piccadilly, Trafford Park, Manchester, Rowland Hill Monument. *Publications:* 'Modern British Sculpture'. *Signs work:* "Guy Portelli" and date. *Address:* The Studio, 125 St. Mary's Rd., Tonbridge, Kent TN9 2NL. *Email:* guyportelli@hotmail.com *Website:* www.portelli.sculptor.co.uk

PORTSMOUTH, Delia, painter of landscapes, portraits, flowers, birds, wildlife in oils. *b:* Mottram, Ches., 6 Aug 1939. *d of:* Edward Ford, farmer. *m:* A. C. Portsmouth. four *d. Educ:* Hyde and Bala Grammar Schools. *Studied:* self taught. *Exhib:* R.O.I., Hesketh Hubbard, Flower Painters' Summer Salon; one-man shows: Chester, Lampeter, Bala, Brantwood, St. Davids, Usher Gallery, Lincoln, Public Gallery, Oldham. *Works in collections:* National Library of Wales, National Museum of Wales, Liverpool Corp. and numerous private collections worldwide. *Clubs:* founder member, Modern Millais Association. *Signs work:* "Delia Portsmouth." *Address:* 14 Saffron Park, Kingsbridge, Devon TQ7 1RL.

PORWOL, Steven, painter in water-colour on paper; specializes in natural history painting, predominantly birds. *b:* Ilford, London, 14 Feb 1973. *Educ:* Ilford County High Grammar School. *Studied:* self taught. *Represented by:* Jonathan Cooper, Park Walker Gallery: jonathancooper.co.uk. *Exhib:* Singer and Friedlander Watercolour Exhib., Art and Antiques Fair, Olympia (2001-2003), Park Walk Gallery (2001-2003), Natural History Museum, Vienna (2001). *Commissions:* numerous in U.K. and Europe. *Signs work:* "Steven Porwol" or "S.Porwol." *Address:* c/o Jonathan Cooper, 20 Park Walk, London SW10 0AQ. *Email:* mail@jonathancooper.co.uk

POTTER, David, *Medium:* oil, pastel, acrylic, collage. *b:* Hillingdon, 28 Jun 1939. *s of:* F.S. & G.O. Potter. three *d. Educ:* St. Clement Danes Grammar School, London. *Studied:* bibliography and librarianship, Ealing. *Exhib:* Alpha Gallery, Swanage; Bettles Gallery, Ringwood; Blue Lias Gallery, Lyme Regis; Allsop Gallery, Bridport; John Davies Gallery, Stow-on-the-Wold. *Works in collections:* UK, Europe, USA. *Recreations:* painting. *Address:* 37 Gallwey Road, Weymouth, Dorset, DT4 9AJ. *Email:* davidpotter@no46.fslife.co.uk

POTTER, George, RHA (2006); BFA Rhode Island School of Design (1962); Fulbright Fellowship, Berlin (1967-68) and many other awards. *Medium:* oil, drawing. *b:* Washington DC, USA, 28 Jan 1941. *s of:* George Potter Sr. *Studied:* Rhode Island School of Design; Hochschule fur Bildende Kunst, Berlin (1968-71). *Represented by:* Taylor Galleries, 16 Kildare Street, Dublin 2. *Exhib:* solo shows at Taylor Galleries since 1982;Project Arts Centre (1973), Tom Caldwell Gallery, Dublin (1976, 78); United Arts Club, Dublin (1974, 75, 77, 79, 80, 81); many group shows including RHA Annual since 1990, United Arts Club, Dublin (1975-83); across Ireland, in USA and Germany. *Works in collections:* in Ireland, England, France, Italy, Germany, Philippines, USA; some Irish collections include: Trinity College Dublin, Bank of Ireland Dublin, St.Patrick's Hospital Dublin, GPA Group Shannon, Imperial Hotel Cork, Nissan (Ireland). *Commissions:* many commissioned portraits over the years. *Publications:* The Irish Times (reviews and profiles since 1973); The Sunday Independent (numerous profiles). *Official Purchasers:* Bank of Ireland, Trinity College, Jury's Hotel Group, St.Patricks Hospital, GPA Group, Shannon, Nissan (Ireland), Office of Public Works. *Works Reproduced:* Art in Ireland (1982). *Recreations:* walking, antiques, cooking. *Clubs:* ex-United Arts Club. *Misc:* moved to Dublin (1971); part-time lecturer NCAD (1975-2000); served in US Army Germany (1963-65). *Signs work:* 'Potter'. *Address:* 2 Clarinda Manor, Clarinda Park East, Dun Laoghaire, Co.Dublin Ireland.

POTTINGER, Frank, D.A. Sculpture (1963), R.S.A. (1991); sculptor in bronze, stone, wood, clay. *b:* Edinburgh, 1 Oct 1932. *s of:* William Pottinger, stone mason. *m:* Dr. Norah Smith, 1991. one s-s. two s-d. *Educ:* Boroughmuir School. *Studied:* Edinburgh College of Art (1958-63). *Exhib:* Richard Demarco Gallery, Yorkshire Sculpture Park, Landmark Scottish Sculpture Trust, Camden Arts Centre, Pier Arts Centre Orkney, Kildrummy Castle, S.S.W. Open, Royal Scottish Academy. *Works in collections:* Heriot Watt University, Hunterian Museum, I.B.M., Scottish Development Agency, Leeds Educ. Authority, Scottish Arts Council, Paisley Museum; Eurodos Parkas, Lithuania; private collections, U.K. and abroad. *Commissions:* L.A.S.M.O., The Woodland Trust, Motherwell District Council, Ellon Development, Aberdeenshire, Dundee University, Royal Mail, Western Isles Health Board, Scottish Parliament. *Address:* 30/5 Elbe St., Edinburgh EH6 7HW.

POTTS, David, FBSP (1999), NAPA, winner of British Society of Painters 'Old Masters Award' (2001). *Medium:* oil, acrylic. *b:* Maltby, South Yorkshire, 13

Apr 1945. *s of:* John Reginal Potts. *m:* Patricia. two *s. Educ:* Rotherham, South Yorks. *Studied:* self-taught. *Exhib:* widely throughout Midlands and North of England, and with Societies inc. Royal Birmingham Society of Artists (RBSA). *Works in collections:* work in many private collections in UK, Europe and Australasia. *Clubs:* British Society of Painters (fellow), NAPA (full member). *Signs work:* "Potts" or monogram "DP" (works on paper). *Address:* 20 Packington Road, Doncaster, S Yorks, DN4 6TZ. *Email:* pottshq@tiscali.co.uk

POTTS, Ian N., NDD, RAS Cert.; artist in water-colour; retd. Dept. Head, School of Art, University of Brighton. *b:* 11 Apr 1936. *m:* Helen B. Bewick. one *s.* two *d. Studied:* Sunderland College of Art (1956-59), R.A. Schools (1959-63, H. Rushbury). *Exhib:* Barbican London, RA Summer Show, Brighton Museum, Amalgam Art London, Coombes Gallery London, SCR Bath, Centro Modigliani, Florence. *Works in collections:* V&A, Arts Council, British Council, Towner A.G. Eastbourne, University of Kent, The Aldrich Collection at the University of Brighton. *Commissions:* Brighton Festival, Daystar, Contemporary Sundials, Windsor Castle, St. George's House. *Publications:* Water-colours and Landscapes (Bridgewater Press). *Works Reproduced:* Royal Academy Summer Exhibition. *Address:* 12 Southdown Ave., Lewes, Sussex BN7 1EL.

POTTS, Kenneth Arthur, ARBS (1988), Dip.AD, BA (1972), CIC. (1969); sculptor in bronze, stoneware, terracotta and fine porcelain. *b:* Macclesfield, 16 Mar 1949. *s of:* Reginald Potts. *m:* Anne. one *s.* one *d. Educ:* Stockport C.F.E. (1966). *Studied:* Stafford College of Art (1969), Stoke-on-Trent College of Art (1972). *Exhib:* R.A. Summer Show, Festival Hall, Sladmore Gallery, Art Expo N.Y., R.B.S. West of England Academy, Tokyo, Hakone Sculpture Park and Museum, Japan, etc. *Works in collections:* Dyson Perrins Museum, Raphael Djanogly Trust. *Commissions:* Bronze statue, Sir Edward Elgar, Worcester; bronze statue, A.E. Housman, Bromsgrove; mosaic panels, Holy Trinity, Sutton Coldfield; "Spitfire" mural, Longton, Stoke on Trent; Cassidy Memorial, Tamside Metropolitan Borough; Hogg Memorial, Edinburgh, Duke of Wellington, Equestrian sculpture; The Craftsman sculpture, Poole; Bull Entry sculpture & Worcester Black Pear Tree sculpture, Crown Estate, Worcester; bronze statue, Sir Douglas Bader, Goodwood. *Signs work:* "Kenneth Potts." *Address:* Langholme House, 50 Albert Road North, Malvern, Worcestershire WR14 2TL. *Email:* potts@clater.demon.co.uk

POUNTNEY, Monica, (née Brailey); S.E.I.F.A.S. Cup for Oils (1976); freelance artist in oil, water-colour, acrylic, pastel, etc.;. *b:* London. *m:* D. H. Pountney. one *s. Studied:* Hammersmith School of Arts and Crafts (Carel Weight and Ruskin Spear), Central School (John Farleigh). *Exhib:* Federation of British Artists, U.A., S.W.A., R.I., N.S., and various mixed exhbns. *Works in collections:* landscapes in London, Moscow and U.S.A. *Commissions:* various. *Works Reproduced:* books illustrated for Heinemann, Blackie and others. *Clubs:* U.A., L.A.G., Essex A.C. *Signs work:* "M.P." or full name. *Address:* 3 Thickwood House, Bedford Rd., S. Woodford, London E18 2AH.

POVER, Lesley, RBA; sculptor (largely figurative and portraiture) in bronze, plaster, cement;. *b:* Plymouth, 1 Apr 1950. two *s. Educ:* Devonport High, St. John's, Singapore. *Studied:* New College of Speech and Drama. *Exhib:* numerous provincial galleries, Woodlands, R.A., Mall Galleries, Islington Art Fair. *Works in collections:* life-sized bronze Lambeth Palace; Pegasus & Boy, Mervyn Peake Library, Eltham College; various private collections. *Commissions:* Eric Liddell Sports Centre, Edinburgh University; Life-sized statue of Nelson sited on the Thames at Greenwich. *Signs work:* "L. Pover" or "Pover." *Address:* 34 Guibal Road, Lee, London SE12 9LX. *Email:* lesleypover@lesleypover.com *Website:* www.lesleypover.com; www.bronze-icous.com

POVEY, Edward, B.Ed. (1978), RCA. *Medium:* artist in oil,and bronze. *b:* London, 1 May 1951. *s of:* Edward Povey. two *s. Educ:* Crown Woods Comprehensive School, Eltham. *Studied:* Eastbourne College of Art and Design (1972-73), University of Wales (1974-78, Selwyn Jones). *Represented by:* Hanson Gallery, New Orleans; Kooywood Gallery, Cardiff. *Exhib:* Martin Tinney Gallery, Cardiff; Jan de Maere Galleries, Brussels; Gallery Gerard, The Hague; Midtown Payson Galleries, N.Y.; Hanson Gallery, New Orleans and San Francisco. *Works in collections:* University of Wales at Bangor, Laguna Gloria Museum in Austin, Texas, The National Library of Wales, Aberystwyth, Wales; National Museum of Wales, Cardiff, Wales; Glynn Vivien Art Museum, Swansea, Wales; J.P.Morgan Inc., New York; Goldman Sachs, London; Anglesey Museum of Art Collection, Wales; Mastercard Europe, Belgium; Procter and Gamble, Venezuela, 3M Art Collection, USA. *Publications:* chapters and photographs in: Painting The Town by Cooper and Sargent (Phaidon Press 1979), Wales on Canvas by Hywel Harries (Lolfa Press 1983), Gwynedd by Ian Skidmore (Robert Hale 1987), The University of Wales (1839-1939) by J. Gwynn Williams (University of Wales Press 1997). *Signs work:* "Edward Povey" or "Povey." *Address:* The Studio, Meirion Rd., Bangor, Gwynedd LL5 2BY. *Email:* artist@edwardpovey.com *Website:* www.edwardpovey.com

POWELL, Christopher Alan, LL.B. (1957), B.A. (2000); former journalist; painter mainly in oil with occasional water-colour and tempera of landscapes, seascapes, city scenes, still life and flower studies; former sub-editor on The Times (1968-92). *b:* Newcastle upon Tyne, 11 Jul 1935. *s of:* Alan Powell, consulting engineer. *Educ:* Queen Elizabeth Grammar, Hexham. *Studied:* part time at City Literary Inst., London (Cecil Collins). Studied Law at King's College, Newcastle upon Tyne, Arts with Open University. *Exhib:* Mall Galleries, Leighton House, various art societies in London. *Works in collections:* U.K., U.S.A., Japan. *Signs work:* "C.A. POWELL." *Address:* Flat A7, Sloane Ave. Mans., Chelsea, London SW3 3JF. *Email:* powell7st@aol.com

POWELL, Roy Owen, N.D.D. (1956), A.T.D. (1959); landscape figure and still life artist in oil on canvas, charcoal and pencil drawings; retd. art teacher. *b:* Chepstow, 3 Dec 1934. *s of:* Ivor Powell, primitive painter (decd.). *Educ:* Monmouth School and West Mon School, Pontypool. *Studied:* Cardiff College of

Art (1952-56, Eric Malthouse, J.C. Tarr). *Exhib:* National Gallery of Wales, 1996 (with the work of my father - 1906-85 - a primitive painter); one-man shows: Brecknock Museum (1994), International Pavilion, Llangollen, Washington Gallery, Theatre Brecheiniog; various group shows in England, Wales and Scotland including Celtic Vision. *Works in collections:* Brecknock Museum, National Library of Wales, private collections. *Publications:* articles for 'Planet' magazine. *Official Purchasers:* Contemporary Art Society for Wales. *Works Reproduced:* 'Planet' front covers. *Clubs:* The Welsh Group. *Signs work:* "R.O. Powell." *Address:* 10 Mill St., Brecon, Powys LD3 9BD.

PRAED, Michael, NDD, ATD. *Medium:* oils, mixed media. *b:* 29 Nov 1941. one *s.* two *d. Educ:* Falmouth and Brighton Colleges of Art. *Studied:* etching and engraving, oil painting two and three dimensional. *Represented by:* Praed Gallery, Marazion, Penzance, Cornwall TR17 0AR. *Exhib:* Cornwall: Praed Gallery, Marazion; Penwith Society; London: mixed exhbns. and one-man; Brittany, S.France, Holland, Germany, Sweden. *Works in collections:* United Nations, New York. *Commissions:* many private. *Publications:* Cornish Magazine and TV programmes, recently Grenadas 'Landscapes'. *Works Reproduced:* Twenty Paintings. *Principal Works:* Large Semi-abstract Cornish Cliff Scenes. *Recreations:* photography, gardening, bowls. *Clubs:* Bowls Club. *Signs work:* MJ Praed. *Address:* 2 Bon Villas, Newlyn, Penzance, Cornwall. *Website:* www.michaelpraed.co.uk

PRENTICE, David, landscape painter; co-founder/director, Ikon Gallery, B'ham. (1964-71); taught at College of Art, B'ham (1968-86), Ruskin, Oxford (1986-87), U.C.E., Birmingham and Fine Art B.A., Trent Polytechnic (1986-93); Winner of the Singer & Friedlander/Sunday Times water-colour prize (1990, 1996, 1999, 2007). *b:* 4 July, 1936. *s of:* H.G. Prentice (decd.). *m:* Dinah Prentice. four *d. Educ:* Moseley School of Art, B'ham. *Studied:* B'ham College of Art and Crafts. *Represented by:* Cowleigh Gallery, Malvern and John Davies Gallery, Moreton-in-the-Marsh, Glos. *Exhib:* Serpentine, Betty Parsons, NY; Gainsborough's House, Suffolk; Art First, London; John Davies Gallery; Modern British Artists, London; Lemon Street Gallery, Truro. *Works in collections:* M.O.M.A., N.Y., Albright Knox, Buffalo, House of Commons, Arts Council, Art Institute of Chicago, Ashmolean Museum. *Commissions:* Oxford Almanack 2001, Fired Earth/Art First 2004. *Publications:* British Art: A Walk Round the Rusty Pier, by Julian Freeman (2006). *Signs work:* "David Prentice." *Address:* Ashdown Villa, 9 Hanley Terr., Malvern, Wells, Worcs. WR14 4PF. *Email:* dinah.prentice@virgin.net

PRENTICE, Dinah, NDD (1956), ATD (1957), textile artist. *b:* Beckenham, Kent, 9 Sep 1935. *m:* David Prentice. four *d. Educ:* Haberdashers Askes, Wyggeston G.S., Leicester. *Studied:* Birmingham College of Art, Royal Academy Schools. *Exhib:* Objects of Our Time, Crafts Council London & New York (1996-8); Revelation, London (touring), 7 MOMA Kyoto Japan (1997-8); Take 4, Whitworth (touring) (1998); Ikon 40th Anniversary Exhibition (2004); solo:

Worcester Museum (2002). *Works in collections:* private and public including V & A, Shipley Art Gallery. *Clubs:* RASAA. *Misc:* co-founded Ikon Gallery Birmingham (1963). *Signs work:* 'DINAH PRENTICE'. *Address:* 9 Hanley Terrace, Malvern, Wells Worcs, WR14 4PF. *Email:* dinah.prentice@virgin.net

PRESLEY-ROY, Michael Roy, ATC(1970) Reading University, DAE(1976) London University; professional artist (drawing, painting) landscapes, religious themes, flower-pieces, abstract motifs. *b:* London, 20 Apr 1928. *Educ:* Upton Grammar, Berks (1939-44). *Studied:* Newland Park College (1967-70), Post Grad Centre, Hornsey College of Art (1973-76). *Exhib:* Reading A.G., Southampton Civic A.G. *Works in collections:* private and public, U.K. and abroad. *Publications:* Author: "The Rôle of the Art Teacher" (1976); "The Art Lark" (1992). Profile p.182 "International Panorama of Contemporary Art" (Verona, Italy 1998); p.61 "British Contemporary Art" (Gagliardi, London 1993); "Dictionary of International Biography" (Cambridge, 2008), pps 214/215 "2000 Outstanding Artists & Designers of the 20th Century" (Cambridge, I.B.C., 2001); Biopic in "Cambridge Blue Book" (2008). *Works Reproduced:* 'Art Lark' monoprint series (from original works by Michael Roy). *Principal Works:* oil paintings: 'Flight of Holy Family', Allington Castle, Kent; 'Mary Magdalene', Crowmarsh Church, Oxon; 'Carisbrooke Halt', Castle Museum, Carisbrooke, IoW; 'Road to Calvary' (1967), Parish Church, Windsor, Berkshire; 'Crucifixion', 'Madonna and Child Jesus' (1970), 'Sailing into New Millennium, 2000AD', Gosport Parish Church of Holy Trinity, Hants. *Recreations:* writing poetry, published UK and USA. *Signs work:* "Michael Roy" with symbol of small spider and date. *Address:* "La Palette" 110 Anns Hill Road Gosport, Hants. PO12 3JZ.

PRESS, Eugène, RSPA (Road Safety) Art Award (1950); Best Art on Gospel Music Album (1980). *Medium:* oil, watercolour, drawing. *b:* Sutton-on -Trent, 14 Jan 1936. *s of:* Thomas James Press. *m:* Jo (Joan). three *d. Studied:* part-time, London; St.Martins Central and Northampton; privately under Graham Sutherland, James Fitton, influence of Charles Mahoney. *Exhib:* Royal Academy; Woodstock Gallery; Brixton; Clapham; Sevenoaks; Folkestone; Tunbridge Wells. *Works in collections:* private: London, Bath and throughout Britain, Italy, France, Canada, USA. *Commissions:* mural at Borough Green; Turner Society: portrait of Turner; Thames Wildlife and Plants; Thames Dockland Old Buildings Record; National Gallery, 1982 Extension Proposal; Turner's Birthplace Trust-New Building Proposal. *Works Reproduced:* Art Magazines, News Print, journals, cards, prints, books. *Recreations:* music, art and antiquities. *Signs work:* 'Eugène Press' or 'EP'. *Address:* Old Pond House, Forest Way, Tunbridge Wells, Kent TN2 5HA.

PREST, Harry, Albert, Le Bealle, A.R.I.B.A. (1948-1966 - resigned); painter in oil and watercolour; specialises in paintings of coastal scenery of Cornwall. *b:* Nr Shrewsbury, 25 Oct 1914. *m:* Lily Hillage (decd.). two *s. Educ:* Shrewsbury Priory County School for boys. *Studied:* mainly self taught. *Exhib:* St Ives

Society of Artists and various other galleries in England. *Works in collections:* numerous private collections in Britain, Europe and U.S.A. *Publications:* entry in Millers Picture Price Guide 2002. *Clubs:* St Ives Society of Artists. *Signs work:* "HARRY PREST." *Address:* 6, Northfield Drive, Truro, Cornwall TR1 2BS.

PREST, Kathy, Best Visual Artist (London Art, Art of Love, Oxo Tower); Best Figurative Artist (SWA, Mall Galleries); Sculpture Award (Chelsea Art Society). *Medium:* clay, plaster, bronze, stainless steel. *b:* London. *d of:* Mr & Mrs Wall. one *s.* two *d. Represented by:* Art Movement, Arkhangel Gallery. *Exhib:* McHandy's, Affordable Art Fair, Art London, Christie's, Richmond Riverside Gallery, RSBA, Anderson Gallery, SW Academy of Fine Art; Mall Galleries. *Works in collections:* private collections. *Commissions:* Mayfair Properties (2005); Intuitive Systems (2001); private commissions. *Works Reproduced:* in 'Artist & Illustrators Magazine' (Sept 07); Hertfordshire Magazine (2001). *Principal Works:* figurative sculpture, contemporary and classical. *Misc:* Register of Sculptors, RBS. *Signs work:* 'Kp' or 'Kathy Prest'. *Address:* 145 St.Albans Road, Barnet, Herts, EN5 4LD. *Email:* kathy@kathyprest.co.uk *Website:* www.kathyprest.co.uk

PRESTON-GODDARD, John, Professional painter. *Medium:* oil, watercolour, gouache. *b:* Liverpool, 5 May 1928. *m:* Kathleen Preston-Goddard, art gallery owner. *Educ:* private. *Studied:* Croydon College of Art 1946-50. *Exhib:* foremost London galleries, Moscow and Croydon. *Works in collections:* Britain, U.S.A., Europe, Australia, Japan and S.Africa. *Commissions:* numerous and ongoing. *Publications:* numerous. *Official Purchasers:* Oxford University, Leicester Education Authority, Surrey EA. *Principal Works:* located in Surrey UK and Arkansas US. *Signs work:* "PRESTON GODDARD." *Address:* Studio House, Selborne Rd., Croydon CR0 5JQ.

PRETSELL, Peter, DA (Edin.); artist in printmaking, painting; lecturer in printmaking, Nene College, Northampton; lecturer, Edinburgh College of Art (1985); Head of Printmaking, ECA(1999). *b:* Edinburgh, 25 Sep 1942. *s of:* William Pretsell. *m:* Philomena Pretsell. three *s. Educ:* George Heriots School, Edinburgh. *Studied:* Edinburgh College of Art (1960-65). *Exhib:* New 57 Gallery, Printmakers Workshop, S.S.A. and Fruitmarket Gallery (Edinburgh), Northampton, Birmingham, Newcastle, Kettering, Bedford, Thumb Gallery, London, Bradford Print Biennale prizewinner, Humberside Print Competition prizewinner. *Works in collections:* V. & A., Scottish Arts Council, Edinburgh Corp., Hull, Northampton A.G. *Signs work:* "Pretsell." *Address:* c/o Edinburgh College of Art, Edinburgh EH3 5QD.

PRICE, Christopher Francis, BA Hons Hull University. *Medium:* Black & white illustration and cartoons. *b:* Birmingham, 17 Aug 1947. *s of:* Rex Price and Anne Grogan (of Tipperary). *m:* Delisia Howard. one *s. Studied:* The Design Studio, Cadbury Bros, Bourneville (1964-5), Hull University (1966-69). *Represented by:* Gisele Kearley, 16 Chilton Street, London W1. *Exhib:* (Mel

Calmans) Workshop Gallery, Lambs Conduit St. (one-man show, 1973), South Bank Picture Show (1991), Salon des Arts (1998), Smiths Gallery, Covent Garden (1987), Libby Edwards Gallery, Sydney, Australia (2006). *Works in collections:* Brighton Museum and Art Gallery (portrait of Barbara Hulaniki and Steven Fitzimon), Maxwells, Covent Garden, The Rank Organisation (Jumpin Jaks Clubs, 1997). *Commissions:* BBC, Observer, Sunday Times, Daily Mail, Financial Times, Radio Times, etc. *Publications:* most newspapers and magazines, many books and publications - 30 years of freelance illustration - Erotic Review, Harpers Bazaar, TES, OUP, Harper Collins, Pan Picador, Heinemann, Hamish Hamilton etc. etc. *Works Reproduced:* Association of Illustrators 10th Annual, AKJ Erotica, Harpers Bazaar Big Red Book. Annual: in Biba, Sin Biba, Boogie Woogie Book. *Recreations:* publishing, music, cabaret, poetry, theatre (passions not recreations). *Clubs:* London Sketch Club, Dilke St, Chelsea. *Misc:* regularly performs in clubs and festivals as Hazard Arts Theatre. *Signs work:* "CHRIS PRICE" (sometimes with Delisia Howard). *Address:* The New House, 46 Marlborough Place, St.John's Wood, London NW8 0PL. *Email:* priceart@solutions-inc.co.uk *Website:* www.BibaBook.com

PRICE, Harry, NDD, ATD, MA, RI; RI Award (2005); Winsor & Newton Award, Patchings Open (2003, 2005). *Medium:* watercolour, oil, acrylic. *b:* Kington, Herefordshire, 1933. *s of:* I.W & M.E Price. *m:* Yvonne. one *s.* one *d. Educ:* Kington Grammar School, Herefordshire. *Studied:* Hereford College of Art; West of England College of Art, Bristol; Middlesex University. *Represented by:* Linda Blackstone Gallery, Pinner; Broadway Modern, Worcs. *Exhib:* Univision Gallery, Newcastle; RWA; RI; Mall Galleries; AAF London; Watercolour and Drawing Fair, Park Lane Hotel, London; Chichester Open,; Broadway Modern, Worcs; Linda Blackstone, Pinner; Fine Art UK, Ledbury. *Works in collections:* private collections in England, USA and Australia. *Publications:* International Artist (Feb/Mar 2007). *Signs work:* 'Harry Price'. *Address:* 49 Station Road, Balsall Common, Coventry CV7 7FN. *Email:* harry@49rowan.freeserve.co.uk

PRICE, Stephen Jon, M.A., F.M.A.; Head of Museums and Art Gallery, Bristol;. *b:* Birmingham, 15 Feb 1949. *Educ:* University of Exeter 1967-70 (B.A.). *Studied:* University of Birmingham 1970-71 (M.A.) History and Archaeology. *Publications:* various on museums and visitor attractions. *Address:* City of Bristol Museum and Art Gallery, Queen's Rd., Bristol BS8 1RL.

PRICE, Trevor, RE, BAHons; artist/printmaker; Printmaking Today Award (1997); Julian Trevelyan Outstanding Printmaking Award (2002). *b:* Cornwall, 18 Jul 1966. *Studied:* Falmouth School of Art (1984-85), Winchester School of Art (1985-88). *Exhib:* regular solo shows including: Cambridge Contemporary Arts, Original Print Gallery Dublin, Biscuit Factory Newcastle, etc. numerous group shows including: National Print Exhibition and Royal Academy of Arts Summer Exhibition. *Works in collections:* Bank of England, Yale University, U.S.A., University of Wales. *Commissions:* various including P&O, Marriott Hotels, John

Lewis plc. etc. *Signs work:* "Trevor Price." *Address:* 23 Blue Anchor Lane, London SE16 3UL. *Email:* trevor@trevorprice.co.uk *Website:* www.trevorprice.co.uk

PRIESTNER, Stephen Miles, artist in oil, pastel, water-colour, collages; sign-writer, life-guard, film projectionist. *b:* Altrincham, Ches., 1 May 1954. *s of:* Arthur Priestner. *m:* Ann (nee Warburton). *Educ:* Dodoma School, Tanzania (1959-61), Ellesmere College, Salop. (1967-70), Blackpool College of Art (1971-72), Manchester Polytechnic (1972-74). *Studied:* École des Beaux Arts, Paris (1978, B. Neiland). *Exhib:* Olympian Arts, London (1993), Salford Museum (1988), New York City, Art Competition Winner (1994), Nice, Milan, Stockholm, Venice, Barcelona (1998). *Works in collections:* Ghent Museum, Belgium; M.O.M.A., New York (prints); Musée d'Art Moderne, Paris; Bradford Art Gallery, Tate Gallery. *Works Reproduced:* The Artist, Apollo Magazine, New York Post (review), Contemporary Art, N.Y., etc.; book: New Art International, N.Y., Art News, Art Monthly, Modern Painters. *Signs work:* "Stephen M. Priestner." *Address:* 20 Sandpiper Drive Stockport, Cheshire SK3 8UL.

PRING MacSWEENEY, Dale Louisiana, Dip.A.D. *Medium:* oil on linen and water-colour on paper;. *b:* London, 17 Apr 1949. *d of:* Percy Pring. *m:* divorced Dr.D.MacSweeney. *Educ:* Burlington Grammar, W. London; Greycourt School, Ham, Surrey, Kingston School of Art. *Studied:* Wimbledon School of Art (1966), Waltham Forest College (1967-70). *Represented by:* Jorgensen, Dublin; Thompson's UK. *Exhib:* RA, NEAC, Piccadilly Gallery, London; Hammer Galleries, NY; Montgomery Gallery, San Francisco; Gerald Peters Gallery, Santa Fe, New Mexico; Riverside Museum, Calif.; Louis Newman Galleries, Beverly Hills; Thompson's Galleries, UK; Jorgensen Fine Art, Dublin. *Works in collections:* H.M. Ministry of Arts, London; Chelsea Arts Club, London; Dallas Museum of Art, Texas; D'Management Milan; Inland Revenue and Customs and Excise U.K., private collectors. *Commissions:* Princess Cruise Lines; private galleries; private collectors. *Publications:* American Artists Magazine; Art Scene USA; Galleries UK. *Principal Works:* Interiors and Still Life. *Recreations:* music, concerts mainly classical and operas; dancing; cooking. *Clubs:* Chelsea Arts. *Signs work:* "Dale Pring MacSweeney" or "DPMac S". *Address:* 2 Benhall Lodge, Benhall, Saxmundham, Suffolk IP17 1JD. *Email:* dale.macsweeney@onetel.com

PRITCHARD, Marion Ruth, SWA (1987), SOFA (1994); painter and illustrator in oil and water-colour. *b:* London, 10 Nov 1934. *d of:* Albert Henry Latter. *m:* Ronald Pritchard. two *s.* one *d. Educ:* Minchenden Grammar School. *Studied:* Hornsey College of Art and Crafts (1951-56, graphic design). *Exhib:* RA, RBA, RI, ROI, SWA, SWLA, SGA, SBA, RMS, SOFA; mixed exhbns. throughout London; Discerning Eye (2005). *Works Reproduced:* greetings cards and calendars for Medici, Royle, Bucentaur, Camden Graphics, Hallmark. *Signs work:* "Marion Pritchard." *Address:* 50 Arnos Grove, Southgate, London N14 7AR.

PROCTER, Alison, *Medium:* oil and watercolour. *b:* Hertford, 17 Dec 1935. *d of:* Dr M & Dr M E Thomson. *m:* Tony. one *s.* one *d. Educ:* Westcliff (weston-Super-Mare). *Studied:* no formal training. *Exhib:* SBA, North Somerset Art, various local exhibitions. *Works in collections:* private collections in the UK, Japan, and Holland. *Publications:* two books on making flowers in sugarcraft: 'Flowers for Cakes', 'Simplifying Sugar Flowers'. *Works Reproduced:* by Woodmansterne card and notelets. *Recreations:* painting, family and gardening. *Clubs:* Clevedon Art Club. *Signs work:* 'ALISON PROCTER' or 'ALISON M.PROCTER', on oils: 'A.P.'. *Address:* Treelands, Hillside Road, Bleadon, Weston-Super-Mare, N.Somerset, BS24 0AA. *Email:* tony.procter@tesco.net

PROCTER, Brenda, BA (Hons) Fine Art, 1970, PGCE Art Education, 1971. *Medium:* mixed media, oil, watercolour, drawing, prints. *b:* Manchester, 9 Jun 1948. *m:* John W. Procter. two *d. Studied:* Dept. of Fine Art, University of Newcastle-upon-Tyne (1966-70), Dept. of Education, University of Newcastle-upon-Tyne (1970-71). *Represented by:* Colin Jellicoe Gallery, Portland Street, Manchester 1. *Exhib:* Haworth Art Gallery, Accrington; Laing Art Gallery, Newcastle; Hatton Gallery, Newcastle; Robert Burns Centre, Dumfries (one-man); Old Well Theatre, Moffat; Portfolio Gallery, Lincolnshire (one-man); Public Library, Lockerbie; Lockerbie Ice Rink (Millennium Festival); Gracefield Arts Centre, Dumfries; Colin Jellicoe Gallery, Manchester. *Works in collections:* private collections. *Recreations:* reading, music. *Misc:* I am intrigued by metamorphasis and the beauty of the covering over and assimilation by nature of rejected man-made objects. My works grows by accretion in the same way. "Things made by iron and handled by steel are born dead, they are shrouds, they soak life out of us till after a long time, when they are old and have steeped in our life, they begin to be soothed and soothing: then we throw them away" D.H.Lawrence. *Signs work:* "BRENDA PROCTER". *Address:* Gilmartin, Waterbeck, Lockerbie, DG11 3HL. *Email:* procterjb@btinternet.com

PROCTER, Marjorie, (née PALMER); A.T.D. (1940); artist in water-colour, pencil and wash; art teacher, Ealing School of Art (1943-74); art teacher, Liverpool Inst. for Boys (1941-43). *b:* Birmingham, 17 Feb 1918. *d of:* W. H. Palmer, B.A. (Cantab.), M.I.Chem.E., F.R.I.C. *m:* Kenneth Procter, painter (decd.). *Educ:* Wade Deacon Grammar School, Widnes. *Studied:* Liverpool City School of Art (1935-40). *Exhib:* R.A., R.I., R.B.A., Nat. Soc., United Soc. of Artists, S.M.A., S.W.A., R.I. Summer Salon, Britain in Water-colour. *Signs work:* "Marjorie Procter," either written or in block capitals. *Address:* Spring Cottage, Woonton, Almeley, Herefordshire HR3 6QL.

PROUD, Alastair Colm, artist in oil and water-colour, specialising in wildlife and landscape. *b:* Dublin, Rep. of Ireland, 2 Oct 1954. *m:* Jill Paula. one *s.* one *d. Educ:* St.Andrews College, Dublin. *Studied:* West Wales School of Art. *Exhib:* 'Birds in Art' Leigh Yawkey Museum of Art, U.S.A., Mall Galleries, London, Combridge Fine Art, Dublin. *Works in collections:* Sultan of Oman. *Publications:* illustrator: Birds of Prey of British Isles; Wildfowl of British Isles and North West

Europe. *Clubs:* S.WL.A. *Address:* Plas Bach, Newchurch, Carmarthen, Carms. SA33 6EJ, S. Wales.

PROWSE, Alexander Reginald, P.S. *Medium:* artist, illustrator in acrylic, oil, watercolour and pastel. *b:* London, 23 Jun 1949. *m:* Janet Prowse. *Studied:* Harrow School of Art (Christopher Sanders, R.A.). *Exhib:* one-man shows: London, Mexico, Venezuela; N.E.A.C., P.S., R.S.M.A., R.P., R.I., R.M.S., R.W.A.- Christie's. *Works in collections:* Lord & Lady Sainsbury, Hotel de Ville, Paris, Sadlers Wells Theatre, Chaitanya Jyoti Museum, India. *Publications:* illustrator: Love All Serve All; book covers for Gerald Durrell and Jennings series. *Official Purchasers:* Linbury Trust. *Signs work:* "Alex Prowse." *Address:* 25 Bitham Mill Court, Westbury, Wiltshire, BA13 3DB. *Email:* alex@alexprowse.com *Website:* www.alexprowse.com

PRYSE: see SPENCER PRYSE, Tessa,

PUGH, Tim, RCA; awarded 'Creative Connections' Grant by the Arts Council of Wales for personal research (2004); awarded travel grants to Tasmania (2000) and Switzerland (2005) for Environmental Art residencies, by Arts Council of Wales. *Medium:* drawing, environmental art and mixed media. *b:* 10 Dec 1965. *s of:* Christopher Alan Pugh. *Studied:* Wrexham and Edinburgh College of Art: OND, HND, BA (Hons) Ceramics. *Exhib:* 125th Summer Exhibition at the RCA in Conwy (2007); Welsh National Eisteddfod, Felinheli, Gwynedd (2005); Muhlberg, Germany; Summer Show, Galerie Wandlebar, Gstaad, Switzerland; Botanical Gardens of Wales, Carmarthen (2003); Lorient, Brittany, France; Hobart, Tasmania (1999), and many other venues. *Works in collections:* private collections in the UK and worldwide. *Commissions:* 'Storyteller's Seat' for schools in Conwy, North Wales; large outdoor sculpture for Alyn Waters Country Park. *Publications:* many gallery catalogues. *Misc:* Secretary for the Royal Cambrian Academy/ North Wales. *Signs work:* 'Tim Pugh'. *Address:* 61 Mancot Way, Mancot, Deeside, Flintshire CH5 2AW. *Website:* www.timpugh.co.uk

PULLAN, Tessa, S.Eq.A. (1988), F.R.B.S. (2001); sculptor in wood, clay, stone, bronze. *b:* London, 20 Dec 1953. married. one *s.* one *d. Educ:* Tudor Hall. *Studied:* apprenticeship with John Skeaping, R.A. (1971-74), City & Guilds of London Art School (1974-77, James Butler), R.A. Schools (1977-80, Willi Soukop, R.A.). *Exhib:* R.A. Summer Shows, Cork St. Fine Arts, Ackermann (London and N.Y.), S.Eq.A., Christies, London Contemporary Art Fair, Bruton St. Gallery, etc.; solo shows: Quinton Green Fine Arts, London, John Hunt Gallery, Frank T. Sabin, London. *Works in collections:* N.P.G., National Horse Racing Museum, Newmarket, Yale Center for British Art, Clare College, Cambridge, Virginia Museum of Fine Art, Paul Mellon Center for Studies in British Art, Virginia Historical Soc., Fitzwilliam Museum. *Signs work:* "Tessa Pullan". *Address:* Granby House, Kings Lane, Barrowden, Rutland LE15 8EF. *Email:* tessapullan@btinternet.com *Website:* www.tessapullen.co.uk

PULLÉE, Michael Edward, Des.R.C.A., F.C.S.D., N.E.A.C., F.R.S.A.; artist in oil, designer and educational consultant; former H.M. Inspector of Schools. *Medium:* oil. *b:* London, 8 Sep 1936. *s of:* Edward and Margaret Pullee. *m:* Sheila Mary Threadgill. two *d. Educ:* Bootham School, York. *Studied:* Leeds College of Art (1955-57), R.C.A. (1959-62). *Exhib:* New English Annual, Pattersons, R.A. Summer Exhbn., Bankside, Lloyds TSB Private Banking, Alresford Gallery, Sheen Gallery, Cedar House Gallery, Cross Gate Gallery (Kentucky USA). *Works in collections:* various private. *Works Reproduced:* in 'The New English' by Kenneth McConkey (Royal Academy Publications). *Clubs:* N.E.A.C. *Signs work:* "Michael E. Pullée." *Address:* White Gables, 48 Wray Common Rd., Reigate, Surrey RH2 0ND.

PULLEN, William, MA (Hons) 1st Class; 1st Prize, Hunting Art Prizes, 1987; John Kinross Scholarship, RSA (1984). *Medium:* egg tempera, oil, watercolour. *b:* Alton, Hants., 17 Feb 1961. *s of:* Brian Pullen. *m:* Brenda. one *s. Educ:* Midhurst Grammar School, W.Sussex. *Studied:* University of Edinburgh; Edinburgh College of Art (1979-84). *Represented by:* Russell Gallery, Putney, London. *Exhib:* RA, Christie's, RCA, Piccadilly Gallery, RP, RBA, Belgrave Gallery, St.Ives, Beatrice Royal Gallery Eastleigh, and others in Scotland, England and France. *Works in collections:* Edinburgh College of Art. *Commissions:* painter of architectural landscape subjects, occasional portrait, including commissions. *Recreations:* garden design. *Signs work:* 'W.P.' or 'William Pullen'. *Address:* 6 The Mead, Petersfield, Hants. GU32 3LG.

PURNELL, John, Ph.D., M.A., B.A.Hons., F.R.G.S., F.R.S.A., F.B.P.A., A.R.P.S., A.B.I.P.P., L.C.G.I., M.Ph.E.; art and photography tutor, University researcher. *b:* Birmingham, 8 Jan 1954. *Studied:* Bournville College of Art and Design; Cardiff Inst. of Higher Education; University of Wales Institute, Cardiff. *Clubs:* Mensa. *Signs work:* "John Purnell". *Address:* Flat 3, 4 West Luton Place, Adamsdown, Cardiff CF24 0EW.

PURSER, Keith, *Medium:* oil, collage, gouache, watercolour, pastel, woodcut, 3D. *b:* Bromley, Kent, 20 Jun 1944. *s of:* Eric Purser, Doris Tidy. *m:* Mhaire McLean. one *s.* one *d. Studied:* Sidcup School of Art (1960-62, Graphic Design). *Represented by:* Jonathan Clark Ltd., 18 Park Walk, London SW10 0AQ. *Exhib:* frequent one-man exhbns Jonathan Clark from 1989; numerous group exhbns. *Works in collections:* corporate and private. *Publications:* 20th Century Painters and Sculptors by Francis Spalding, Jonathan Clark Exhibition catalogues. *Recreations:* music. *Address:* c/o Jonathan Clark Fine Art, 18 Park Walk, London SW10 0AQ. *Email:* jclark@jc-art.com *Website:* www.jc-art.com

PUTMAN, Salliann, B.A. (Hons.) Fine Art, R.W.S., N.E.A.C.; painter in oil and water-colour. *b:* London, 20 Apr 1937. *m:* Michael. one *s.* one *d. Studied:* West Surrey College of Art and Design, Farnham (1988-93). *Exhib:* one and two-man shows: London, Windsor, Stockbridge; R.A., Mall Galleries, N.E.A.C., R.B.A., R.O.I., R.I., P.S., Bankside Gallery, W. H. Pattersons Gallery, New

Grafton Gallery. *Signs work:* water-colours: "Salliann Putman," oils: "S.P." *Address:* 3 Pinecote Drive, Sunningdale, Berks. SL5 9PS. *Email:* salliann_putman@onetel.net.uk

PYBUS, Michelle Christine, *Medium:* oil, watercolour. *b:* Whitby, 3 May 1954. *d of:* William & Patricia. *m:* none (divorced). *Educ:* Whitby Primary and Secondary Schools; York Technical College. *Studied:* self-taught. *Represented by:* Pybus Fine Arts, Whitby. *Exhib:* Royal Academy; Royal Institute of Oil Painters; Royal Society of Marine Artists; Henley Regatta; Eton College. *Works Reproduced:* Millers Picture Price Guide. *Principal Works:* marine oils. *Recreations:* travel. *Clubs:* The Fyling Dales Group of Artists. *Misc:* Previously known as PYBUS, Michael Christopher (changed gender in 2006). opened own gallery in Whitby in 1998 selling own work, other British artists' work and antique paintings. Paints in Australia, New Zealand, Far East and throughout Europe. Radio broadcasts for BBC Cleveland. *Signs work:* 'M.C.Pybus'. *Address:* 1 Newlands Avenue, Whitby, N.Yorkshire YO21 3DX. *Email:* enquiries@mpybusfinearts.co.uk *Website:* www.mpybusfinearts.co.uk

PYE, Chris, MCA. *Medium:* woodcarver. *b:* Co. Durham, 24 Jan 1952. two *s. Address:* Linden, Brilley, Whitney-on-Wye, Hereford, HR3 6JZ. *Email:* chris@chrispye-woodcarving.com *Website:* www.chrispye-woodcarving.com

PYE, Patrick, Mem. of Aosdána and R.H.A.; NCAD; DPhil (Hon.Causa, Maynooth)(2005); painter in tempera and oil, stained glass artist, etcher - an artist of the sacred theme. *b:* Winchester,10 Apr 1929. *s of:* Dorothy & Edmund Pye. *m:* Noirin Kennedy. two *d. Educ:* St. Columba's College, Dublin 14. *Studied:* National College of Art, Dublin (1951-54), Jan van Eyck Akad., Maastricht (1957-58). *Represented by:* Jorgensen Fine Art, Molesworth St., D2. *Exhib:* many one-man shows, (Jorgensen Fine Art); Dublin, R.H.A. Annual (since 1990), Retrospective: Triptychs & Related Works, March 1997 at R.H.A.Gallery, Ely Pl., Dublin2 (catalogue available), Major Works Exhibition: Oct 2003, Jorgensen Fine Art; Irish Living Art (1960s-1980s); David Hendricks Gallery, Dublin (pre-1980). *Works in collections:* Ulster Museum; Hyde Lane Municipal Gallery; Crawford, Cork. *Commissions:* Stations of the Cross, Killarney; Wall Hanging, The Transfiguration, Maynooth University and church commissions throughout Ireland including St.Thomas More, and Dulwich. *Publications:* author: Apples and Angels; The Time Gatherer (on El Greco) publ. by Veritas (1981) & Four Courts Press (1991) respectively. *Official Purchasers:* Municipal Hugh Lane Gallery, Parnell Sq.; Crawford Gallery, Cork; St.Thomas' University, St.Paul, MN, USA. *Works Reproduced:* Allied Irish Bank Coll.; Bank of Ireland Coll; various catalogues. *Principal Works:* 'The Glory Fortold', 'Theologian in his Garden', 'Transfiguration' (Maynooth), 'Woman and Serpent' (Bank of Ireland HQ, 1982). *Recreations:* singing in my bath. *Misc:* converted to Roman Catholicism (1963); accepts William Blake's valuation of imagination in processes of art, and Coleridge's distinction between fantasy and imagination;

second cousin of William Pye, sculptor. *Signs work:* "P.Pye" and "TI". *Address:* Piperstown, Tallaght, Dublin 24, Eire.

PYE, William, A.R.C.A., F.R.B.S., Hon.F.R.I.B.A.; sculptor. *b:* 16 Jul 1938. *s of:* Sir David Pye, M.A., Sc.D., F.R.S., C.B. *m:* Susan. one *s.* two *d. Educ:* Charterhouse. *Studied:* Wimbledon School of Art (1958-61) under Freda Skinner, R.C.A. Sculpture School (1961) under Prof. B. Meadows. *Works in collections:* Arts Council, Museum of Modern Art, N.Y., Contemporary Art Soc., Szépmúvészeti Muzeum, Budapest, National Museum of Wales, National Portrait Gallery, London. *Commissions:* Water Wall, British Pavilion Expo '92, Seville; Slipstream and Jetstream, Gatwick Airport; Chalice, London WC1; Cristos, St. Christopher's Place, London; Derby Cascade; British Embassy Oman; Antony House, Cornwall; Cader Idris, Central Sq., Cardiff; Aquarena, Millennium Sq. Bristol; Jubilee Fountain, Lincoln's Inn, London; Charybdis, Seaham Hall, Sunderland; eight water sculptures for Serpent Garden, Alnwick, Northumberland; Mount Parnitha, Greece; Three water sculptures for Marinsky Concert Hall, St.Petersburg. *Recreations:* playing the flute. *Clubs:* Chelsea Arts Club. *Signs work:* 'William Pye' or 'W.Pye'. *Address:* 43 Hambalt Rd., Clapham, London SW4 9EQ. *Website:* www.williampye.com

PYNE, Doris Grace, A.T.D. (1934), oil painting cert., Slade School; freelance artist in water-colour, art teacher. *b:* Wealdstone, 8 Oct 1910. *d of:* John Herman Binder, O.B.E., A.R.C.S. *Studied:* Hornsey School of Art (1930-34, Norman Janes, A.R.C.A., R.E., Douglas Percy Bliss, M.A.), Slade School (Randolph Schwabe). *Exhib:* one-man show, Salon des Nations, Paris (1984), Mall Galleries, London (1982); Norwich (1967, 1969, 1972, 1978), Park Gallery, Chislehurst (1973), Aldeburgh (1974), International Art Centre, London (1975), frequent exhib. R.I., Graphic Artists, Mall Galleries. *Clubs:* F.B.A., Bromley Art Soc. *Signs work:* "PYNE." *Address:* 32 Clarendon Way, Marlings Pk., Chislehurst, Kent BR7 6RF.

PYNE, Kenneth John, CCGB Cartoonist of the Year (1981); Strip Cartoonist of the Year, Cartoonist Art Trust Awards (2001); Caricaturist of the Year, Cartoonist Art Trust Awards (2006); several international awards. *b:* London, 30 Apr 1951. *s of:* John and Maud Pyne. *Studied:* Holloway County School, London. *Exhib:* Burgh House, Hampstead; Cartoonist Gallery, London; Barbican Centre, London; Cartoon Museum, London. *Works in collections:* V & A, British Museum, Cartoon Art Trust, Brunswick Centre, Salon International du Pessin et d'Humour, Switzerland, Cartoon Museum, London. *Commissions:* The Times, Private Eye, Punch, The Independent, The People, London Evening Standard, The Observer, Hampstead and Highgate Express, The Guardian. *Publications:* The Oldie, Reader's Digest, Which?, Sunday Times, Today, Marketing Week, Stern etc., plus 30 books. *Works Reproduced:* see commissions and publications. *Recreations:* walking, drawing, drinking and reading. *Clubs:* British Cartoonist Association. *Signs work:* 'Ken Pyne'. *Address:* 15 Well Walk, Hampstead

Village, London NW3 1BY. *Email:* pyne9@hotmail.com *Website:* www.kenpyne.com

PYTEL, Walenty, NDD(1961), ARBS; Crown Estates Award, SWLA, Mall Galleries; Coventry Design Award 2001 Conservation area -bridge - 'Wings over Water'. *Medium:* bronze and mild steel. *b:* Poland, 10 Feb 1941. *m:* Janet Mary. one *s.* one *d. Studied:* Hereford College of Art (1956-61). *Exhib:* Mitukoshi Gallery, Tokyo (1988), Marbella (1985), U.S.A., Germany, France, Jersey, S.WL.A. Mall Galleries (award winner 1988), Solihull Fine Art Exhibitions (1983-1991), Artparks (2002, 2003), Nature in Art, Twigworth, Glos., Arts and Gems, Dubai, Birds in Art-The RSPB Centenary Exhbn. *Works in collections:* Hereford, Worcester and Stockport County Library and Art Galleries; J. Bamford,Uttoxeter (JCB), Mr & Mrs G Linzon (Bacardi); Rodda Film Productions; Sir Edward Du Cann; Patrick Cooke-Athelhampton; Lord & Lady Leigh-Stoneleigh Abbey; Ron Hickman-Jersey; Mr & Mrs S Yorke-Brookes. *Commissions:* Silver Jubilee Fountain, New Palace Yard Westminster, B'ham International Airport, J.C.B. Uttoxeter, Gracemount Developments Ltd. Royal Caribbean Cruiseline; Lloyds Bank Trophy; Lloyds of London; Colin Grazier Memorial, Tamworth; 10 Millenium Planet Walk Sculptures-Tamworth Borough Council, bronze War Memorial-Ludlow branch of British Legion, H.P.Bulmer, Hereford; Yamazaki Mazak -Europe Corporation. *Publications:* London Art and Antiques Guide (1991), Debrett's Distinguished People of Today (1988-2007), Into the New Iron Age (Amina Chatwin 1995). *Works Reproduced:* bronze limited editions. *Recreations:* shooting, fishing and sailing. *Clubs:* The Fountain Society. *Signs work:* "WALENTY PYTEL," "W. Pytel" or "W.P." *Address:* Hartleton, Bromsash, Ross-on-Wye HR9 7SB. *Email:* info@wyebridge.com *Website:* www.wyebridge.com

Q

QUANTRILL, David James, artist in most media. *b:* Lowestoft, 11 Jul 1938. *m:* Angela. one *s.* one *d. Studied:* Lowestoft College (part-time). *Represented by:* various galleries East Anglia. *Exhib:* since 1985 Mall Galleries London, Gainsborough's House, Fermoy Centre. *Works in collections:* Norwich Castle; private collections U.K., U.S.A., Europe. *Commissions:* James Paget Healthcare Trust. *Signs work:* "Quantrill." *Address:* 18 Carlton Sq., Lowestoft, Suffolk NR33 8JL.

QUEMBY, Sigrid, Slade Dip.Fine Art; Nettleship Prize (1964); Boise Travelling Scholarship (1964-5); prizewinner, Open Exhibition, Mall Galleries (2001). *Medium:* painter/printmaker, textile designer, oil, watercolour, drawing. *b:* London, 8 Jan 1942. *d of:* Arthur and Maryann Quemby. *Studied:* Ealing School of Art (1958-62); Slade School of Fine Art (1962-64). *Exhib:* RA; V&A; Mall Galleries; The Morley Gallery; Bankside Gallery, London; Pryzmat Gallery, Krakow; Morandi Museum, Bologna. *Commissions:* Heals; Fidelis; Bernard Wardle; Sanderson's Textiles. *Publications:* Treasury of Embroidery Designs

(pub. Bell & Hyman, 1985). *Works Reproduced:* 20th Century Pattern Design-Textile and Wallpaper Pioneers (pub. Mitchell Beazley, 2001); Stone Lithography (pub.A&CBlack, 2001). *Misc:* teacher of printmaking, Ealing School of Art (1965-73), Wimbledon School of Art (1972-2002). *Signs work:* 'S.Quemby'. *Address:* 32 Bushwood Road, Kew Gardens, Surrey TW9 3BQ. *Email:* sigrid.q.@tesco.net

QUIGLEY, Thomas Antony Gerard, *Medium:* acrylic (collage), oil, watercolour, drawing, sculpture, collage. *b:* Cregan, Armagh, N.Ireland, Dec 1935. *s of:* Peter and Theresa Quigley (nee Murphy). *Educ:* Killkerley. *Studied:* Technical School, Dundalk, Ireland (painting and drawing); mostly self-taught, including picture conservation and restoration. *Represented by:* Mary Quigley, Newtown, Ballegan, Dundalk, County Louth, Ireland. *Exhib:* RA Summer Exhbn; invited painter, Discerning Eye, Mall Galleries;Art for Life, Cancer UK at Christie's; Hammersmith Open; The Atrium, Hammersmith Town Hall. *Works in collections:* private collections in England, Ireland and USA including the collections of Sir Peter Blake, Noel Sheridan, Jean Kenney Smith, Victoria Chaplin, Willie Nelson, President Clinton, Professor Eileen Joyce. *Publications:* Bare Facts Fulham Gazette. *Principal Works:* 'Latter Day Aesthete'; 'Pingo Corner' series. *Clubs:* RA Friends Membership. *Misc:* Artist in Residence, Atrium Festival (2006); invited to curate and exhibit at Hammersmith & Fulham Festival, 2006, by Mayor Charlie Treloggan. Exhibition opened by Sir Peter Blake and Deputy Mayor Michael Cartwright. *Signs work:* 'Tom Quigley'. *Address:* 3 River Side Gardens, Hammersmith, London W6 9LE.

QUIGLEY, Vlad, artist and portraitist in monochrome, linear, Art Nouveau; Pop Art; Baroque; works in collaboration with celebrity Hollywood supermodels, Playboy models, porn stars, Hollywood actresses, Page 3 models, Gothic and Fetish models. *Studied:* Southampton Inst. of Art and Design, Northbrook College, Joe Orlando (E.C. Comics). *Exhib:* Pop Art Nouveau portraits of Viola D'Amour, Fairfield Halls, Vampyria, Hippodrome, Big Draw, Alfresco, Vampire Viola, Frogpond, The 100 (100 years of comic art), A.D. 2000, Shock, Anglo-French Aubrey Beardsley Centenary. *Commissions:* private portraits for clients, models, actresses, model agencies. Book illustrations, Pop Art exhbns. *Publications:* too numerous to list. *Address:* c/o 276a Lower Addiscombe Rd., Croydon, Surrey CR0 7AE. *Email:* vlad.quigley@virgin.net *Website:* www.vladquigley.com

QUINN, Máire Catherine, B.A. Hons Fine Art (1984); National Portrait Gallery award finalist (1988), R.W.S. Elizabeth Scott Moore prize winner (2001); artist in oil, water-colour, printmaking, sculpture, textile. *b:* Armagh City, N. Ireland, 4 Aug., 1961. *Studied:* University of Ulster. *Exhib:* N.P.G., Whitechapel Gallery, South London Gallery, Bankside Gallery, Museum of London, plus solo and group exhibs. in U.K. and abroad. *Commissions:* private, national and international. *Signs work:* "Máire Quinn." *Address:* Eliot Lodge, 295 Hither Green Lane, London SE13 6TH.

QUINN, Mary P., (née McLAUGHGLIN) Hons. sculpture (1986); sculptor in bronze portrait busts and statues. *b:* Co. Down, N.I., 26 May 1943. three *d. Educ:* St. Dominic's High School, Belfast. *Studied:* Richmond Adult College (1982-89). *Exhib:* many group shows since 1985. *Works in collections:* many bronze busts and statues in Ireland, England and U.S.A. including life-size statue of John Wesley in Virginia Wesleyan College, Virginia, U.S.A. *Commissions:* Frank Sinatra, Frankie Dettori (bronze busts). *Clubs:* F.P.S., S.C.A. *Signs work:* "Mary Quinn." *Address:* 1 Exeter Rd., Hanworth, Feltham, Middx. TW13 5PE. *Email:* mary@maryquinnsculptor.com *Website:* www.maryquinnsculptor.com

QUIRKE, Michael Patrick, Fine Arts Diploma. *Medium:* oil, acrylic and pastel on canvas, board, paper. *b:* Hampstead, London, 19 Apr 1946. *s of:* David Quirke. *m:* Geraldine. two *s. Educ:* St.James', London. *Studied:* St. Martin's School of Art, and with Maurice Feild (Prof. Art at Slade). *Represented by:* Simpson Fine Art, London; Highgate Fine Art, London; Webb's Gallery. *Exhib:* New York, Spain, Germany, France, Italy. Since 1982: 14 one-man shows and 12 group shows. *Works in collections:* Paul Hillman Collection; private collections all over the world. *Commissions:* Spar Group plc; Marks and Spencer Group plc. *Publications:* British Artists from 1945. *Principal Works:* London scenes, fairgrounds and musicians. *Recreations:* music. *Clubs:* St.Ives Art Club, President of Arts Club 2000-2002. *Signs work:* "M.Q." (in red paint). *Address:* 'Half Moon Gallery', 12 St.Andrew's St., St.Ives, Cornwall, TR26 1AH.

R

RACZKO, Julian Henryk, Dip. Eng. (Warsaw, 1963); artist; Prof. of Art, Warsaw Academy of Fine Arts. *b:* Warsaw, 2 Jan 1936. *s of:* Waclaw Raczko. *m:* Malena Raczko, architect. two *d. Educ:* Warsaw Technical University. *Studied:* voluntary basis at Warsaw Academy of Fine Art (1963-65, Prof. Alexander Kobzdej). *Exhib:* one-man shows: Poland, Denmark, Norway, Sweden, France, Germany, C.K. Norwid art critics award 1980. *Works in collections:* National Museums of Warsaw, Wroclaw, Poznan, Cracow,Gdansk Arts Museum Lodz, galleries of Chelm, Bydogoszcz, National Gallery of Arts, Washington, Museum of Modern Art, Hünfeld, Van Reekum Museum of Apeldoorn, Fyns Kunstmuseum, Odense, Museum Bochum, Bochum. *Signs work:* "Julian H. Raczko." *Address:* J. Bruna 34 m 35, 02-594 Warsaw, Poland.

RAE, Barbara, C.B.E., R.A., R.S.A., R.S.W., R.G.I.; D.Arts, Napier University Edinburgh (1999), Hon. Fellowship, Royal College of Art, London (2003), D.Litt. University of Aberdeen (2003); painter and printmaker. *b:* Falkirk, Scotland, 10 Dec 1943. one *s. Educ:* Morrisons Academy, Crieff. *Studied:* Edinburgh College of Art. *Exhib:* recent solo exhibs., Art First, London (1994, 1996, 1997, 1999, 2001, 2002), Waxlander Gallery, Santa Fe, U.S.A. (1996), Bohun Gallery, Henley-on-Thames (1996), Galleri Galtung, Oslo (1998), The Scottish Gallery, Edinburgh (2000, 2003, 2004); recent group exhibs., Eigse '94, Carlow Arts Festival, Ireland (1994), Hunting Group Awards, London and Wales

(1994-1996), A Scottish Renaissance, Rotunda Gallery, Hong Kong (1996), R.A. Summer Exhibs. (1997-1999); Travelog, Glasgow Print Studio (2003); Graphic Studio Gallery, Dublin (2003); Tom Caldwell Gallery, Belfast (2004); Manningtree Gallery (2004); The Adam Gallery, Bath (2005); Jorgensen Fine Art, Dublin (2005). *Works in collections:* public collections include, Aberdeen Art Gallery, Birmingham City Art Gallery, British Museum, City Arts Centre, Edinburgh, Contemporary Arts Soc., London, Derby Museum and Art Gallery, Dundee Art Gallery, Glasgow Museum and Art Gallery, Hunterian Art Gallery, Glasgow, Museum of Art for Woman, Washington, U.S.A., Perth Art Gallery and Museum, Scottish National Gallery of Modern Art, Edinburgh, Scottish Office, Edinburgh, University of Edinburgh, Whitworth Art Gallery, Manchester, Stirling University, University of York, Birmingham Art Gallery, New College Cambridge. *Clubs:* Glasgow Art Club. *Signs work:* "Barbara Rae." *Address:* 11 Circus Lane, Edinburgh, EH3 6SU. *Email:* barbararaera@aol.com *Website:* www.barbararae.com

RAE, Fiona, painting;. *b:* Hong Kong, 10 Oct 1963. *Studied:* Croydon College of Art (1983-84), Goldsmiths' College, London (1984-87). *Exhib:* selected solo shows 1999: Luhring Augustine Gallery, N.Y., Komji Ogura Gallery, Nagoya; 1997: Saatchi Gallery, London (with Gary Hume), British School at Rome; 1996: Contemporary Fine Arts, Berlin; 1993-94: Inst. of Contemporary Arts, London; 1992: Kunsthalle Basel, Basel; 1991: Waddington Galleries, London; 1990: Third Eye Centre, Glasgow. *Works in collections:* includes Tate Gallery, London; Arts Council; Walker A.G., Liverpool; Muse Departemental de Rochechouart, Haute-Vienne; Hamburger Bahnhof, Berlin; Sintra Museum of Modern Art, Portugal. *Works Reproduced:* numerous exhbn. catalogues, articles, reviews. *Address:* Luhring Augustine Gallery, 531 West 24th St., New York, N.Y. 10011, U.S.A.

RAE, John, H.S., formerly R.I.B.A. & R.T.P.I.; works in mixed media, often in combination with PVA, and also makes screen and mono prints, and draws in conté and pencil. Subjects include landscape, plants and trees, buildings, people, and life paintings. Formerly a lecturer in Architecture at University College London, the Architectural Association, and at Hornsey College of Art. He has travelled and painted in Australasia, Africa, and the New World;. *b:* Exeter, 1931. *Educ:* Blundells. *Studied:* University College London. *Exhib:* Royal Academy, Royal West of England Academy, Libby Edwards Gallery and Greenhill Galleries (Australia), Statements Gallery and Wine Country Gallery (New Zealand), and various miniature societies world-wide. *Publications:* Sketch Book of the World (ISBN 0-9524557-0-6); William Lyons-Wilson 1892-1981 (ISBN 0-9524557-1-4); The Hedgers (ISBN 0-9524557-2-2, hand-coloured hardback, ISBN 0-9524557-3-0, black and white paperback). *Signs work:* "John Rae." *Address:* 14 Orchard St., St. Albans, Herts. AL3 4HL.

RAE, Robin, ARCA (1953). *Medium:* oil, prints, sculpture. *b:* London, 24 Nov 1928. *m:* Catherine. two *d. Educ:* Colet Court, Peter Symonds' Winchester. *Studied:* Ealing School of Art (1945-48); Royal College of Art (1949-1953).

Exhib: RA, RSA, London Group, Liverpool Academy. 2 one-man shows at Little Gallery, Piccadilly (1949-50); one-man show at Dorset County Museum (1995). Group or two-man exhibitions at: Ashmolean Museum, Oxford; Aitken Dott, Edinburgh; Bridport Art Centre; Belgrave Gallery; Camden Gallery; Old Warehouse Gallery, Dorchester; Thomas Henry Fine Art, Nantucket, USA. Retrospective Exhibition: Sladers Yard, West Bay, Dorset (2008). *Works in collections:* Walker Art Gallery, Liverpool; many private collections. *Publications:* amongst many, 'Re-inventing the Landscape', Vivian Light. *Official Purchasers:* Pictures for Schools. *Works Reproduced:* 'Liverpool Seen' by Peter Davies. *Misc:* Taught at Edinburgh College of Art and Liverpool College of Art. *Signs work:* "Robin Rae". *Address:* 4 Tunis Terrace, Bradpole, Bridport, Dorset DT6 3ET. *Email:* kate@tunis.fsnet.co.uk *Website:* www.robinraepaintings.co.uk

RAEBURN, Kenneth Alexander, D.A.(Edin.) (1966); Post Grad. Scholarship (1966-67). *Medium:* figurative sculptor (preferred medium is wood), works in a range of materials. *b:* Haddington, E. Lothian, 9 Jun 1942. *s of:* Francis James Raeburn. *m:* Helen Raeburn. one *s.* one *d. Educ:* Trinity Academy, Edinburgh. *Studied:* School of Sculpture, Edinburgh College of Art under Eric Schilsky. *Exhib:* R.S.A., S.S.A., various group exhbns. in Scotland, Salon des Nations Exhbn., Paris (1983); one-man show, Metropolis Galerie d'Art, Geneva (1985). *Works in collections:* having undertaken public and private commissions, the sculptor now concentrates on free-standing figures (up to life-size). *Misc:* "I have always drawn inspiration from the human figure, concentrating on a certain stillness, rather than gesture or excessive movement. The content of the work is intensely personal: the human figure 'Out of Time'". *Signs work:* "Raeburn." *Address:* Edingreine, Middle Terrace, Kingussie, Inverness-shire PH21 1EY. *Email:* helen.raeburn@hotmail.co.uk

RAGGETT, Mark Andrew, BA Fine Art. *Medium:* acrylic/ mixed media, watercolour, drawing. *b:* Pembrokeshire, 4 Dec 1953. *s of:* Jean & Paul Raggett. two *s. Educ:* Haverfordwest Grammar School. *Studied:* Reading University. *Represented by:* ARC Prints, London; West Wales Art Centre, Fishguard. *Exhib:* RA Summer Exhbns (1999, 2005); Fountain Gallery, Llandeilo; National Eisteddfod Exhbn; Stow Gallery, Shipston on Stour; East West Gallery, London; Arc Prints, London; West Wales Art Centre, Fishguard. *Signs work:* 'MR'. *Address:* 4 Wallingford Avenue, London W10 6QB. *Email:* markraggett@aol.com

RAMOS, Theodore S.de P., RAS Dip. (1954); RAS Silver Medal. *Medium:* oil. *b:* Oporto (Portugal), 30 Oct 1928. *m:* Julia. four (one decd.) *s. Educ:* Colegio Araújo Lima. *Studied:* Royal Academy Schools (1949-54). *Exhib:* Royal Academy of Arts, Royal Society of Portrait Painters, Portraits, Inc. (New York), Chatsworth Collection, The Guards Museum. *Works in collections:* National Portrait Gallery (Anita Leslie, Lord Thorneycroft), RoyaL Academy of Arts, Government House, Western Australia, The Guards Museum, Chatsworth,

Valderrama Golf Club, Louisiana University, several other institutions. *Commissions:* numerous Royal and civil commissions including 'The Transfiguration'- a mural painted for number 20 St.James' Square (a famous Robert Adam house). *Publications:* illustrated for Penguin Books: 'Monumental Brasses' by Sir James Mann; 'Chinese Art' (two vols.) by William Willetts, etc. *Works Reproduced:* H.M. The Queen, H.R.H. The Duke of Edinburgh, H.R.H. Prince Charles, H.M. Queen Elizabeth the Queen Mother, The Grand Duke of Luxembourg, The Duke of Devonshire, group portraits of The Irish Guards, 'The Transfiguration'. *Clubs:* East India Club, Marylebone Cricket Club, Reynolds Club. *Misc:* Freedom and Livery of the Worshipful Company of Painter-Stainers, and the Worshipful Company of Founders. *Signs work:* Ramos. *Address:* Studio 3, Chelsea Farm House, Milmans St., London SW10 0DA.

RAMSAY, Alexander, Dip. A.D. (Hons.), 1968, H.D.A. (1969); artist in oil paint and drawing media; Senior lecturer in Fine Art, Central/St. Martin's School of Art;. *b:* London, 23 Mar., 1947. *m:* Tricia Gillman. two *s.* one *d. Studied:* Chelsea School of Art (1964-69). *Exhib:* one-man shows: Hatton Gallery Newcastle, Newcastle Polytechnic Gallery, Creaser Gallery London, Castlefield Gallery Manchester, South Square Gallery Bradford. *Clubs:* London Group. *Signs work:* "Alex Ramsay." *Address:* 149 Algernon Rd., London SE13 7AP.

RAMSBOTHAM, Meredith, BA (1965). *Medium:* oil, watercolour. *b:* Haifa, Palestine, 30 Oct 1943. *d of:* Brian & Kay Jones. *m:* Oliver. three *s. Educ:* Cranborne Chase School. *Studied:* The Slade (1961-65). *Represented by:* Madeleine Ponsonby, Sally Hunter, Piers Feetham. *Exhib:* New Art Centre, London; Sally Hunter Fine Art, Halkin Arcade, London; Piers Feetham Gallery, London; Minories, Ipswich; Parkin Gallery, London; The Playhouse, Salisbury; Contemporary Arts Fair, London; Ken Spelmans, York. *Works in collections:* Courtalds Collection, Arts Council of Great Britain, New College Oxford, Pilkington Glass Collection, IBM Collection, University of Melbourne. *Commissions:* Lord Rothschild. *Publications:* entry in 'Dictionary of Artists in Britain since 1945', David Buckman. *Signs work:* "MEREDITH RAMSBOTHAM". *Address:* 7 Museum Chambers, Bury Place, London WC1A 2LD. *Email:* meredithramsbotham@yahoo.co.uk *Website:* www.meredithramsbotham.com

RANASINGHE, Tissa, FRCA (1991); Dip. Tropical Agriculture (1946); Dip. Painting (1952); Dip.Sculpture (1958); Awarded first Unesco Scholarship allocated to Sri Lanka (1958); 'Bunka Prize, '98' (Japan/Sri Lanka Friendship Cultural Fund (1998); 7th Sao Paolo Biennale 'Honourable Mention Plaque for bronze 'Brazil'. *Medium:* sculpture. *b:* Sri Lanka, 2 Nov 1925. *m:* Sally Anne. one *s.* one *d. Studied:* Government College of Fine Arts, Colombo, Sri Lanka; Chelsea School of Arts; RCA (bronze casting). *Exhib:* RA Summer Exhbn (since 1955 and 1974, 75, 81, 88, 89, 90,1998); Sao Paolo Biennale (7th, 9th); 43 Group Exhbn, Royal Festival Hall (1964, 85, 87); Expo '67, Montreal Canada; solo exhbns: Lionel Wendt Gallery, Colombo, Sri Lanka (1959, 1971, 1994); RSBA;

SPS; plus many galleries and exhbns in UK and worldwide. *Works in collections:* Government of Sri Lanka; MOMA, Sweden; London CC Art Collection; private collections in Sri Lanka, Germany, UK, Greece, USA, France, and Australia. *Commissions:* bronze panel for International Court of Justice, The Hague; Professor Gananath Obeyeskere, Princeton, USA; bronze statues for Sri Lankan Government; many private and corporate commissions. *Official Purchasers:* Govt. of Sri Lanka; former London CC; Museum, Malmo, Sweden. *Recreations:* reading, travel. *Signs work:* 'Tissa'. *Address:* 7 Woodlands Rd, Isleworth, Middx TW7 6NR.

RAND, Keith John, BA Hons(1981), ARSA(1996), RSA (2006); sculptor in wood including site-specific land-based works. *b:* Germany (British nationality), 25 Oct 1956. *Educ:* Woodroffe School, Lyme Regis, Dorset. *Studied:* Winchester School of Art (1979-1981). *Represented by:* Sculpture at Goodwood; John Martin, London. *Exhib:* solo exhibs. in U.K. since 1982, Royal Scottish Academy, Royal Glasgow Institute, Salisbury Cathedral, Guggenheim, Venice, Steven Lacey Gallery, London, John Martin, London Group exhbns in Europe and Japan. *Works in collections:* Aberdeen Art Gallery, Obihiro Internat. Building, Japan, Canary Wharf, London, Grizedale Forest, Cumbria, private collections Europe, U.S.A. and Japan. *Commissions:* public - UK and Japan. *Publications:* exhib. catalogues, works 1987-1992. Shape of the Century, 100 years of British Sculpture (2 vols), 1999, In Praise of Trees, 2002, Keith Rand, The Space Between, 2002, Keith Rand New Carvings, 2005. *Official Purchasers:* Scottish Arts Council, Forest Enterprise, Woodland Trust, Sustrans. *Principal Works:* Blooming Box, The Passage, Two Poles, Original Form, Silent Figures, Senser. *Recreations:* walking, cycling. *Signs work:* "KR" or "RAND." *Address:* 4 East Woodyates, Salisbury, Wilts SP5 5QZ. *Email:* annette.ratuszniak@btinternet.com

RANDALL, Carl, B.A, Hons. in Fine Art (Slade School, M.A. in Drawing (The Princes Drawing School) R.B.A; painter in oil, and water-colour, sculptor in wood and mixed media, draughtsman in pencil and charcoal. *b:* South Shields, 26 Jul 1975. *Studied:* Slade School of Fine Art, University College, London (1995-99), The Princes Drawing School, The Princes Foundation, London (2002-03). *Exhib:* National Portrait Gallery, Royal Academy of Arts, Mall Galleries, London. *Works in collections:* Singer and Friedlander Bank, Railtrack Plc., Forbes Finances Ltd. *Misc:* Prizes and awards: John Adams Fine Art Award, The Mall Galleries, London; 1st prize, 1998 Singer and Friedlander Water-colour Competition; 2nd prize, William Coldstream Painting Competition, The Slade School of Art; The Slade School of Art Travel Scholarship. *Signs work:* "CARL RANDALL." *Address:* 22 Ryton Court, South Shields, Tyne and Wear NE33 4HS. *Email:* info@carlrandall.com *Website:* www.carlrandall.com

RANDALL, Edward Mark, graphic designer, painter in oil, pastel, water-colour. *b:* Coventry, 24 Feb 1921. *s of:* A.G.E. Randall. *m:* Marjory. two *s.* one *d.* *Educ:* Coventry Technical College. *Studied:* Coventry Art School, Hornsey and

Central Schools. *Works in collections:* Marks and Spencer, Plessey Co. private collection, R.C.M. Printing Group. *Signs work:* "Mark Randall." *Address:* B7 Argyll House, Seaforth Rd., Westcliff-on-Sea, Essex SS0 7SH.

RANDALL-PAGE, Peter, B.A. (Hons.) 1977, Hon. Doctorate of Arts, University of Plymouth (1999); sculptor; Research Fellow in Visual Performance at Dartington College of Art (2002-05). *b:* Rochford, Essex, 2 Jul 1954. *m:* Charlotte Eve Randall-Page. one *s.* one *d. Studied:* Bath Academy of Arts (1973-77). *Exhib:* 'Sculpture and Drawings 1980-1992' Leeds City A.G. (1992), 'In Mind of Botany' R.B.G. Kew (1996), 'Nature of the Beast', Nottingham, Sheffield and Eastbourne (2001), Gwangju Biennale, Korea (2004). *Works in collections:* Tate Gallery, British Museum, etc. *Commissions:* National Trust (1995), L.D.D.C. London (1996), Hunters Sq. Edinburgh (1996), Sculpture at Goodwood (2000,2003), Dartington Trust (2005), Said Business School, Oxford (2005), Eden Project (2006). *Publications:* Peter Randall-Page: Sculpture and Drawings 1977-1992; Granite Song (1999), Nature of the Beast (2001). *Address:* P.O. Box 5, Drewsteignton, Exeter, Devon EX6 6YG. *Email:* contact@peterrandall-page.com *Website:* www.peterrandall-page.com

RANDLE, Susan Ann, Dip.H.E.; painter, muralist and graphic artist in oil, water-colour, gouache, pen and ink. *b:* Portsmouth, 16 Jun 1936. *d of:* Harry Wilson, director. *m:* Dave Randle, writer. one *s.* one *d. Educ:* Dominican Convent, Harare, Zimbabwe. *Studied:* Dartington College of Art, Totnes (1978-80, Chris Crickmay, John Gridley). *Exhib:* Carlos Gallery, London, Arnolfini, Bristol; one-man show: Bruyas Gallery, Torquay, Wrotham Art Festival, Salon des Paintres-Ile de Re, France; South East Open Studios. *Clubs:* Forge Arts, Romney Marsh Art Society. Weald of Kent Art Group, Folkestone Art Co-operative. *Signs work:* "Sue Randle." *Address:* 26 High Street, Lydd, Romney Marsh, Kent. *Email:* suerandle@aol.com

RANK-BROADLEY, Ian, H.D.F.A. (Lond.) (1976), Boise scholar (1976), F.R.B.S. (1994), A.W.G. (1995); sculptor. *b:* Walton-on-Thames, 4 Sep 1952. *s of:* John Kenneth Broadley. *m:* Hazel Rank. one *s.* one *d. Studied:* Epsom School of Art (1970-74, Bruce McLean), Slade School of Fine Art (1974-76, Reg Butler). *Works in collections:* British Museum, Fitzwilliam Museum, Cambridge, Staatliche Museen, Berlin, Rijksmuseum, Leiden, N.P.G. London, Royal Swedish Coin Cabinet, Royal Mint, Goldsmiths' Hall, London, H.M. The Queen Mother. *Commissions:* effigy of H.M. The Queen on U.K coinage from 1998, new effigy of H.M. Queen for Golden Jubilee crown & medal; King George VI and Queen Elizabeth Diamond Stakes Trophy (2005); Armed Forces Memorial (2005). *Recreations:* rowing. *Clubs:* Gloucester Rowing Club. *Misc:* Freeman of the Goldsmiths' Company; Granted Freedom of City of London (1996). *Address:* Stanfields, Kingscourt La., Rodborough, Stroud, Glos. GL5 3QR. *Email:* irb@ianrank-broadley.co.uk *Website:* www.ianrank-broadley.co.uk

RANKIN, Stella, Diploma (Goldsmiths); painter in oil. *b:* London, 7 Jan 1915. widow. one *d. Studied:* St. Martin's, London (1956-58), Goldsmiths' College of Art (1958-61, Kenneth Martin). *Represented by:* Mrs.Lesley Brett, 32 The Pippins, Glemsford, nr.Sudbury. *Exhib:* RA (1985, 1992); Royal Festival Hall, (Education Through Art), Guildhall, London; Barbican (FPS); Suffolk Gallery, Trafalgar Square; Corn Exchange, Saffron Walden; White Hart, Braintree; The Guardian "Art for Sale", Christie's (Imperial Cancer Research), London; Beecroft Gallery, Westcliff-on-Sea; The London Group; Artists International, London WC1; Market Cross Gallery, Bury St.Edmunds; Galerie Internationale, NY; The Crypt, St.Martin-in-the-fields, London. Solo Exhibitions since 1957, include: Oriel Gallery, Aberystwyth (1976), Loggia Gallery, London (1973); Halesworth Gallery, Suffolk (1984); Chappel Gallery (1989, 1991). *Works in collections:* Chelmsford Museum; and private collections. *Publications:* British Artists Since 1945; The Public Catalogue Foundation (a national inventory of oil paintings which are in public ownership, based in National Gallery, London). *Signs work:* "Stella Rankin" or "S.R." *Address:* The Red House, Meadow Lane, Sudbury, Suffolk CO10 2TD.

RASMUSSEN, Roy, F.F.P.S. (1961); sculptor in hand beaten and welded aluminium; Co-Director, Woodstock Gallery, London (1958-67); Director, Loggia Gallery, London (1984 to 2001). *b:* London, 29 Apr 1919. *Exhib:* British Council, Berlin (1961); Réalités Nouvelles, Paris (1966); John Whibley Gallery, Cork St., London (1968-77); New Directions 1999, Loggia Gallery, London; F.P.S. exhbns. (1957-99); and many London galleries, including one-man shows. *Works in collections:* Towner Gallery and Museum, Eastbourne, Paris, Berlin and U.S.A. *Publications:* The Free Painters and Sculptors 1952-1992 (author). *Signs work:* "RASMUSSEN." *Address:* 123 Canterbury Rd., N. Harrow, Middx. HA1 4PA.

RAVEN, Shane, *Medium:* limewood. *b:* Farnborough, 14 Oct 1959. *s of:* James & Kathleen Raven. *m:* Alexandra L. Raven. three *d. Exhib:* Battersea Fine Arts and Antiques Fair; Fergus Cochrane Antiques, Kings Rd., Chelsea; Old World Antiques, Kings Rd, Chelsea. *Works in collections:* Guild of Master Carpenters; Throgmorton Ave; Shepperton Studios; Susan Schrieburg Interior Designs. *Commissions:* Susan Schrieburg, Valerie Foster, Shepperton Studios, Maggie Charpentier. *Publications:* Sunday Telegraph, Apollo, Home & Gardens, Country Life, Wood Carving Magazine. *Principal Works:* Augustus Panel, English Country Gardens. *Clubs:* Assoc. Mem. Guild of Master Carpenters. *Signs work:* "S. Raven". *Address:* 16 Thorndon Close, Orpington, Kent, BR5 2SJ. *Email:* corvuscarvings@hotmail.co.uk

RAVERA, John, P.P.R.B.S., F.R.S.A.; President, R.B.S. (1988-90); sculptor in clay. *b:* Surrey, 27 Feb 1941. *m:* Daphne (1838-2002). one *s. Studied:* Camberwell School of Art (1954-62). *Exhib:* R.A. (1975, 1976), Alwin Gallery (1977), Woodlands (1977), Bexleyheath (1985), Haywards Heath (1985), Johannesburg S.A. (1995), Chris Beatles Gallery (1996). *Commissions:* Major

commissions: Academy of Arts Hong Kong (1982), Morgan's Walk London (1983), London Dockland Development, bronze bust (1986), Bayswater London, bronze group of children (1987), Barbican London, bronze group dolphins (1989), Elstree London, stainless steel abstract (1989), Tokyo (1994), Maidenhead (1996), Reading (1996), bronze, Tokyo (1994), Bexleyheath, William Morris bust (1997), Bracknall 9" ABS, Staines 8ft ABS, 7ft bronze nr. Stratford-on-Avon (2002), Geronimo (2003), bronze life and 1/4, 7ft bronze Einstein nr. Stratford-on-Avon (2004). *Signs work:* "John E. Ravera." *Address:* Studio, 82 Latham Rd., Bexleyheath, Kent DAG 7NQ.

RAWLINGS, Raymond, commercial artist in water-colour (retd.);. *b:* Windsor, 26 Apr., 1934. *m:* Frances. three *d. Studied:* apprenticed to major art studio (London) producing artwork for major multi national companies (1951). *Exhib:* Oxford, R.W.A. Work in collections worldwide. *Clubs:* Oxford Art Soc. *Address:* 1 Chestnut Close, Fawley, nr. Wantage, Oxon. OX12 9YW. *Email:* ray.rawlings@tiscali.co.uk

RAWLINS, Janet, N.D.D. (Illustration), A.T.D., book illustration, fabric collage, gouache, water-colour. *b:* Horsforth, Leeds, 3 May 1931. *d of:* E. J. Rawlins. *m:* John G. Leyland, F.C.A. one *s. Educ:* Gt. Moreton Hall, Ches. *Studied:* Leeds College of Art. *Exhib:* R.A., northern galleries. *Works in collections:* Bradford, Harrogate and Batley Art Galleries, Leeds, Huddersfield, West Riding, Leicester and Essex Education Committees, Leeds Permanent Building Society, I.W.S., N.C.B., I.C.I. *Publications:* children's books by William Mayne and Jane Gardam; compiled and illustrated A Dales Countryside Cookbook (1993). *Signs work:* "Janet Rawlins." *Address:* Unicorn House Bainbridge Via Leyburn N. Yorks. DL8 3EH.

RAY: see HOWARD-JONES, Ray,

RAY, Karen, painter in oil, water-colour, pencil, coloured pencil, lecturer;. *b:* Queensland, Australia, 8 Dec., 1931. *m:* Stuart Ray (decd.). three *s. Studied:* Walthamstow School of Art (Stuart Ray, John Tichell, Fred Cuming); R.A. Schools (Peter Greenham). *Exhib:* many times in the R.A. Summer Exhbn. *Signs work:* "K. Ray." *Address:* 91 Mountview Rd., London N4 4JA.

RAYMENT, Brenda, A.R.M.S. (1991); artist in oil on ivorine. *b:* Paddock Wood, Kent, 5 May 1951. *m:* Laurence Rayment. one *s.* one *d. Educ:* Kidbrooke School. *Studied:* Bexley A.E.C. (1980-90, Barry Shiraishi, R.M.S.). *Exhib:* S.W.A., R.M.S. *Address:* Willow Cottage, Main Street, Northiam, E.Sussex TN31 6LE.

RAYNER, Desmond, L.G.S.M.; self taught artist in gouache, charcoal, pencil, oil; literary agent, writer, actor. *b:* London, 31 Oct 1928. *m:* Claire Rayner. two *s.* one *d. Educ:* theatre: Guildhall School of Music and Drama. *Exhib:* Heals, London; Embankment Gallery, Tattershall Castle, London; Grays, Mayfair; Talent Store, Belgravia; October Gallery, U.S.A.; Mall Galleries, London; Seven

Dials Gallery, London; Barbican Centre, London; Wylma Wayne Fine Art, London; Building Centre, London; Charisma Gallery, Harrow, Galerie Profils, Collioure, France etc. *Works in collections:* U.S.A., Canada, Australia, U.K. *Publications:* The Dawlish Season, The Husband (novels). *Misc:* Work can be viewed by appointment at own address below. *Signs work:* "RAYNER." *Address:* Holly Wood House, Roxborough Ave., Harrow-on-the-Hill, Middx. HA1 3BU.

RAYNOR, Trevor Samuel, former Mem. Associé, Société des Artistes Français (1977)(resigned); textile designer, artist in oil and water-colour and floral subjects in gouache. *b:* Oldham, 13 May 1929. *s of:* William Ernest Raynor, produce merchant. *m:* Margaret Joyce Marwood. one *s. Educ:* Werneth Council School. *Studied:* Oldham School of Art (1942-45), Manchester School of Art (1945-49). *Exhib:* Paris Salon (1975, 1976, 1977); one-man shows, Salford City A.G., Swinton Memorial A.G. Work in private collections. *Works Reproduced:* prints of floral work. *Signs work:* "RAYNOR" or "T.S. RAYNOR." *Address:* 1 Hollin Cres., Greenfield, Oldham OL3 7LW.

READ, Sue, RI (1985), NDD.(1963), ATD (1964); artist in water-colour. *b:* Slough, 1941. *d of:* John Melia (decd.). *m:* Robert Read (divorced). three *s. Educ:* Aylesbury Grammar School. *Studied:* High Wycombe School of Art (1959-63), Royal West of England College of Art (1963-64). *Exhib:* Mall Galleries, RA Summer Exhbn., RWS, NEAC, Linda Blackstone Gallery. *Publications:* International Artist Magazine; Artists & Illustrators; Watercolour: A Step-by-Step Guide, by Angela Gair. *Signs work:* "S.R." *Address:* Vine Cottage, Chackmore, Buckingham MK18 5JF. *Email:* susanread41@btinternet.com

READING, Peter William, M.S.I.A. (1957); painter in oil, acrylic, pastel, water-colour and etcher; design consultant, (retired 1990). *b:* London, 3 Aug., 1933. *m:* Doreen Rita. two *d. Educ:* Edmonton County Grammar School. *Studied:* Hornsey and London School of Printing (part time). *Exhib:* London, Henley-on-Thames, Bournemouth, Gloucester, Plymouth, Penzance, St. Ives, Brest, France, Minneapolis, U.S.A.; two solo exhibs. annually, Mariners Gallery, St. Ives. *Works in collections:* various private collections in U.K. and U.S.A., and St. Ives Gallery. *Clubs:* St. Ives Soc. of Artists. *Signs work:* "Peter Reading" and date. *Address:* 5 Higher Tamar Terr., Gunnislake, Cornwall PL18 9LP. *Email:* enq@peter-reading.co.uk *Website:* www.peter-reading.com

REAL, Jacqueline, FFPS (1992); contemporary painter in acrylic, collage and mixed media. *b:* Zürich, 5 Oct 1931. *d of:* Fred Berger, architect. *m:* Christopher Butler. one *s.* one *d. Studied:* in Zürich (1975-78), Academy of Modern Art, Masterclass, Salzburg (1979), Painting Course in Meran (1980). *Represented by:* International Art Consultants, London, Gallery One, London, Artizan Editions, Hove, Penhaven Gallery, St. Ives, Galerie Elfi Bohrer, Bonstetten (Zürich), Galerie Ruth Schwarzer, Illnau (Zürich), Galleria Borgo, Ascona (CH). *Exhib:* solo and group shows: Switzerland, England, U.S.A. and Germany. *Works in collections:* Switzerland, England, U.S.A., Germany, including Oerlikon

Contraves, Zürich, Mark Rich Switzerland, Union Bank of Switzerland Zürich and London, Zürich Insurance, Credit Swiss Bank Zürich, British Government, Johnson & Johnson, Tokai Bank, Bank of Austria, Crown Court Truro. *Publications:* New Visions, St. Ives Painters. *Clubs:* F.P.S., Soc. of Swiss Painters, Sculptors and Architects, Eastbourne Group of Artists. *Signs work:* "J. Real." *Address:* 7 Bath Court, Kings Esplanade, Hove BN3 2WP.

REDDICK, Peter, D.F.A. (Slade, 1951), R.E. Hon. Retd., R.W.A.; printmaker and wood-engraver, freelance illustrator. *b:* Essex, 5 Jun1924. widower. two *s.* one *d. Studied:* Slade School of Fine Art (1948-51); Gregynog Arts Fellow (1970-80). *Exhib:* SWE. *Works in collections:* V&A; National Library of Wales Aberystwyth. *Works Reproduced:* Folio Society Publications. *Signs work:* "Peter Reddick." *Address:* 18 Hartington Park, Bristol BS6 7ES. *Email:* reddickpeter@waitrose.com

REDEMER, Roberta, 2nd Prize, Eli Lilly "Oncology on Canvas" (2006, World-wide Comeptition, now on tour world-wide). *Medium:* acrylic, pastel, charcoal, watercolour, drawing. *b:* London, 30 Jan 1937. *d of:* Robert Mortimer. one *s. Educ:* Tiffins Girls School, Kingston. *Studied:* Kingston School of Art. *Exhib:* annually at Wokingham & District Art Group Exhibition, Berkshire; "Paws" Exhibition, Hertfordshire. *Works in collections:* various trading establishments in Bracknell, Berks.; private. *Works Reproduced:* copies of works on canvas in The Ambassador Hotel, 12 Upper Woburn Place, London WC1H 0HX. *Recreations:* bridge, gardening. *Clubs:* Wokingham & District Art Group; Great Hollands Art Group. *Signs work:* "BREDEMER". *Address:* 54 Wheatley, Great Hollands, Bracknell, Berks., RG12 8UG. *Email:* roberta.redemer@ntlworld.com *Website:* www.bracknellartgallery.org.uk

REDFERN, June, D.A. (1972); prizewinner, Scottish Young Contemporaries; Artist in Residence, National Gallery (1985); painter in oil and water-colour. *b:* St. Andrews, Fife, 16 Jun 1951. one *d. Educ:* Dunfermline High School, Fife. *Studied:* Edinburgh College of Art (1968-73, Robin Philipson, David Michie, Elizabeth Blackadder, John Houston). *Exhib:* many throughout Britain and U.S.A. including National Gallery, London (1985). *Works in collections:* S.N.G.M.A., National Gallery London, B.B.C. Television, Robert Fleming plc, Arthur Andersen, Texaco, Hiscox Holdings, etc. *Commissions:* many private; corporate: Scottish Equitable. *Recreations:* opera. *Signs work:* "June Redfern" on reverse of oils only. *Address:* 12 Lawley St., London E5 0RJ. *Website:* www.juneredfern.com

REDINGTON, Simon, B.A. (Fine Art), Postgrad.Dip. in Art Therapy, Cert. of Advanced Printmaking; artist/printmaker in etching, woodcuts, letterpress, painting, mixed media;. *b:* London, 28 Sept., 1958. *Educ:* Pimlico School. *Studied:* Goldsmiths' College, Hertfordshire College of Art, Central St. Martin's College of Art. *Exhib:* N.P.G., R.A. Summer Show, Slaughterhouse Gallery, Southbank Picture Show, Royal Festival Hall, Bankside Gallery. *Works in*

collections: V. & A., Theatre Museum, Ashmolean Museum, N.Y. Public Library, Harvard University, Yale Center for British Art, Museum of London, Newberry Library, Chicago. *Commissions:* Peter O'Toole as Jeffery Bernard, Shaftesbury Theatre, London. *Publications:* see website. *Clubs:* R.E. *Signs work:* "S. Redington." *Address:* 149 Archway Rd., London N6 5BL. *Website:* www.kamikazepress.com

REDVERS, John Stephen, (formerly PIGGINS, John Redvers Stephen, changed 1979), Slade Dip. (1948), P.S. (1984); portrait painter in pastel, oil. *b:* Birmingham, 18 Jul 1928. *s of:* Major Charles Redvers Piggins, RAOC. *m:* Mary Pennel. one *s.* two *d. Educ:* Solihull School, Warwickshire. *Studied:* Slade School of Art (1945-48, Prof. Randolph Schwabe), Ruskin School of Art, Oxford (1950, Prof. Albert Rutherston). *Exhib:* R.P., P.S., Hopetoun House, W. Lothian (1977); one-man show, Chakrabongse Palace, Bangkok (1962). *Signs work:* "JOHN REDVERS" or "REDVERS" ("J.R.S. Piggins" or "John Piggins" pre 1979). *Address:* Tweenhills, Hartpury, Gloucester GL19 3BG.

REES, Darren, B.Sc. (Hons.) (1983), S.WL.A. (1985); self taught artist in water-colour of natural history particularly birds;. *b:* Andover, Hants., 15 Mar., 1961. *m:* Gwynneth Jane Rees (Kenny). one *s.* one *d. Educ:* Southampton University. *Exhib:* S.W.L.A., Artists for Nature Foundation, Holland, Sweden, Poland, U.S.A. *Works in collections:* Lloyds, Les Ecrins National Park, Leigh Yawkey Museum Wisconsin, Stirling Council. *Commissions:* Awards: B.B.C., R.S.P.B., Lloyds. *Publications:* Bird Impressions, Portrait of Wildlife on a Hill Farm, Birds by Character. *Misc:* Awards: R.S.P.B. Fine Art Award, Natural World Award, Young European Bird Artist Award. *Signs work:* "Darren Rees" or "DR". *Address:* New East Frew, Thornhill, Stirling FK8 3QX.

REES-DAVIES, Kay, A.L.C.M. (1976), S.B.A. (1994), R.H.S. Silver-Gilt Medal (1993); Cert. Botanical Merit, S.B.A. (1994 and 2003); R.H.S. Gold Medals (1996, 1998, 2003); freelance botanical artist;. *b:* Brighton, 17 Jun 1936. *m:* John Rees-Davies. one *s.* one *d. Educ:* Bretton Hall College (1954-56), courses in Botanical Art, Adult Study Centre, Gwynedd (1988-89). *Exhib:* several solo and joint exhbns. in Wales; S.B.A., London; R.H.S.; Waterman Fine Art, London; Gordon-Craig Gallery; North Wales Society of Fine Art. *Works in collections:* R.H.S. Lindley Library; Hunt Inst. for Botanical Documentation, Carnegie Mellon University, Pittsburgh U.S.A.; Library, R.B.G., Kew; Shirley Sherwood Collection; Chelsea Physic Garden Florilegium; Highgrove Florilegium. *Publications:* illustrated 'Plantas Endemicas e Avores Indigenas de Cabo Verde (1995); 'Contemporary Botanical Artists' Shirley Sherwood Collection (1996); 'Fine Botanical Paintings' – Gordon Craig Gallery (2000).; 'Arte y Botanica' SBA (2002); 'The Art of Botanical Painting' SBA (2004); 'Flower Painting from the Apothecaries' Garden', Andrew Brown (2005), 'The Botanical Palette' (2007). *Signs work:* 'Kay Rees-Davies'. *Address:* 6 Balmoral, The Promenade, Llanfairfechan, N.Wales LL33 0BU. *Email:* kayreesdavies@botartbalmoral.freeserve.co.uk

REESON, Warren, Christopher, RAS (Painting) 1988; Winsor & Newton Award for Painting, RA (1986); artist/illustrator. *Medium:* painter in acrylic, watercolour. *b:* Plymouth, Devon, 23 Jan 1966. *m:* Judith Ann. one- Charlotte Rose *d. Educ:* Bemrose School, Derby, UK. *Studied:* University of Derby (1984-85), Royal Academy Schools, London (1985-88). *Exhib:* RA, Green Lane Gallery, Derby (1980, 1986), St. Michaels Gallery, Derby (1986), City Museum and Art Gallery, Derby (1982, 83, 84), Kelowna Art Gallery, BC, Canada; various nationally. *Works in collections:* De Laszlo Collection, London, and private. *Commissions:* portraits, murals, private commissions. *Clubs:* RASAA. *Address:* 419 Cadder Avenue, Kelowna V1Y 5N2, British Columbia, Canada.

REEVE, Marion José, N.D.D. (1953), M.F.P.S. (1968); landscape painter in oil, acrylic and gouache; retd. civil servant, Building Research Establishment. *b:* Watford, 26 Sep 1926. *d of:* Richard John Reeve. *m:* Albert Edward Butcher (decd.). *Educ:* St. Joan of Arc Convent, Rickmansworth. *Studied:* Watford College of Technology, School of Art (1947-53) under Alexander Sutherland, M.A. *Exhib:* one-man show: Loggia Gallery (1974), Young Contemporaries (1954), F.P.S. Annual and Travelling exhbns. at Kings Lynn Festival, South of France, etc. *Works in collections:* St. Michael and All Angels Church, Watford (Stations of the Cross), also design for Christ in Majesty. *Recreations:* photography. *Clubs:* Watford and Bushey Art Soc. *Signs work:* "M. Reeve" and date. *Address:* 10 Kelmscott Cres., Watford, Herts. WD18 0NG.

REEVE, Michael John, NDD (1959); Wedgewood Scholarship (1955, 1957). *Medium:* oil, watercolour, drawing, prints, sculpture. *b:* Kensington, 22 Apr 1939. *s of:* R.D.H.Reeve, Art Director. *m:* Liliane. two *d. Studied:* Camberwell School of Art, London (1952-59). *Represented by:* Michael Parkin Fine Art. *Exhib:* London. *Works in collections:* private. *Recreations:* art, design, music. *Misc:* Brother of Geoffrey R Reeve ARCA. *Signs work:* "MICHAEL REEVE" or "MJR". *Address:* c/o Michael Parkin Fine Art, Studio 4 Sedding Street, 1-6 Sloan Square, London SW1.

REEVES, Philip Thomas Langford, A.R.C.A. (1954), R.E. (1963), R.S.W. (1959), A.R.S.A. (1971), R.S.A. (1976), R.G.I. (1981); painter-etcher. *b:* Cheltenham, 7 Jul 1931. *s of:* Herbert John Reeves, printer. *m:* Christine MacLaren (decd.). one *d. Educ:* Naunton Park Senior Secondary School, Cheltenham. *Studied:* Cheltenham School of Art (1945-49), Royal College of Art (1951-54). *Represented by:* Fine Art Society, London, Open Eye Gallery, Edinburgh, Glasgow Print Studio, Glasgow, Cyril Gerber Fine Art, Glasgow, Hughson Gallery, Glasgow. *Works in collections:* Arts Council of Gt. Britain, V. & A., Contemporary Art Soc., Gallery of Modern Art, Edinburgh, Glasgow A.G., Glasgow University Print Collection, Aberdeen A.G., Paisley A.G., Milngavie A.G., Dundee A.G., Edinburgh University, Stirling University, Dept. of the Environment, British Government Art Collection, Edinburgh City Art Collection;The Fleming-Wyfold Art Foundation; Royal Scottish Academy. *Signs work:* "Philip Reeves." *Address:* 13 Hamilton Drive, Glasgow G12 8DN.

REGO, Paula, F.R.C.A.; painter in various mediums; D. Litt. (Honoris Causa) University of St. Andrews, Scotland, and University of East Anglia;. *b:* Lisbon, Portugal, 26 Jan., 1935. *m:* Victor Willing (decd.). one *s.* two *d. Educ:* St. Julian's, Portugal. *Studied:* Slade School of Fine Art. *Works in collections:* Gulbenkian Foundation, Lisbon; National Gallery, London; Tate Gallery, London; Saatchi Collection, London. *Commissions:* National Gallery, Sainsbury Wing Brasserie, mural. *Publications:* Paula Rego by John McEwen (Phaidon Press), Peter Pan (Folio Soc.), Nursery Rhymes (Thames & Hudson), Pendle Witches (Enitharmon Press). *Address:* c/o Marlborough Fine Art, 6 Albemarle St., London W1X 4BY.

REID, Paul John, M.A. (Hons.) Fine Art: painter in oil. *b:* Perth, 21 Apr 1975. *m:* Heather Reid. *Studied:* Duncan of Jordanstone College of Art, Dundee (1994-98). *Exhib:* Rendezvous Gallery, Aberdeen; Scottish Gallery, Edinburgh; 108 Fine Art, Harrogate. *Works in collections:* Flemings of London, Perth Museum and Art Gallery, Duke and Duchess of Roxburgh, H.R.H. The Prince of Wales. *Publications:* Art Tomorrow-Edward Lucie Smith-Terrail, Paris (2002); A History of Scottish Art-Selina Skipwith/Bill Smith- Merrel, London (2003). *Signs work:* "REID." *Address:* 6 Ash Grove, Scone, Perth PH2 6NU.

REID, Sir Norman Robert, Kt. (1970), D.A. (Edin., 1937), D.Litt., F.M.A., F.I.I.C., joined Tate Gallery, 1946; appointed Director, 1964; Chairman, British Council Fine Arts Committee; Fellow and Vice-Chairman, International Institute for Conservation of Historic and Artistic Works; Member, British National Cttee. of I.C.O.M.; Mem. Culture Adv. Cttee.; President, Council of the Rome Centre. *b:* London, 27 Dec 1915. *s of:* Edward Reid. *m:* Jean Bertram. one *s.* one *d. Educ:* Wilson's Grammar School. *Studied:* Goldsmiths' College, Edinburgh College of Art (1933-38) and Edinburgh University. *Works in collections:* paintings in Tate Gallery, S.N.G.M.A. and the Government Art Collection. *Clubs:* Arts. *Signs work:* "Reid." *Address:* 50 Brabourne Rise, Beckenham BR3 6SH.

REILLY, Kevin Patrick, FIGA (1994); painter in oil, water-colour and pastel; tutor, lecturer, founder of Hermes Galleries; studied humanities, Open University (1979-1984). *b:* Lancs., 1949. *m:* Diane. one *s.* one *d. Educ:* Sts. John Fisher and Thomas More, Lancs. *Studied:* Wirral Art College (1978) under Philip Smith. *Exhib:* I.G.A., British Soc. Oil Painters, Watercolour, Pastels, Liverpool Academy; solo exhibs. Laing, Manchester, and in Cumbria, Liverpool, Wirral, Ireland, Portico Manchester (solo)(2002), Midland Museum, Texas USA (2002), Liverpool Academy, Spectacular (2003), Glasgow (2003), Liverpool University Gallery (2003), Liverpool Artists Club (2003), Royal Cambrian Academy Open (2005). *Works in collections:* various private collections in U.K., Eire, U.S.A., Australia, Spain, Italy. *Commissions:* National and international, Artist and Illustrator Magazine, Wet Day in Dublin, (Feb. 1996), various articles in M.A.M. magazine 2002-3. *Publications:* magazine articles, national and international, Hermes publications, prints, gift cards, postcards, limited editions, Cheshire Life. *Clubs:* Liver Sketching Club 1989. *Signs work:* "Kevin Reilly." *Address:* 6 Cromarty Rd., Wallasey, Wirral, Merseyside CH44 2BH.

REILLY-DEAS, Anne, business studies, qualified for "Mensa"; self taught artist in oil, water-colour, pastel, mixed media; accounting executive; Eclipse Award 2004, Woman of the Year 2004/2005 USA, Woman of Achievement Award 2005 USA. *b:* Mullingar, 28 Nov 1950. *m:* Arthur Deas, scientist (divorced). *Educ:* Loreto, Bloomfield, Rosse, Christie Colleges. *Exhib:* Tullynally Castle, R.H.A., Westmeath County Library, Alliance Francaise, Longford Library, Granard Library, Caley House, Orchard House, Allen Manor, Cheltenham Show, selected for New York Prestige Artists Debut 2000, National Irish Bank, dfn Gallery N.Y., Christie Wild Int., Florida, Athlone Agricultural Show, invited to exhibit: Irish Council Against Blood Sport Exhbn., Art US Exhbn., International Lions Club Art Auction, Townley Hall, Art Horizons NY, International Artexpo NY, International Artexpo San Fransisco, Art 54 Gallery NY, Special Olympics World Games Art Exhbn., 'Greenville' Castle Pollard, Mullingar Arts Centre, Rogallery NY. *Works in collections:* private collections. *Publications:* Who's Who in Art UK, Dictionary of International Biography UK, Great Women of 21st Century USA, Contemporary Who's Who of Professionals USA, European City Guide Spain, Cambridge Blue Book UK. *Works Reproduced:* catalogues, articles, exhbns. *Misc:* Member ABI Professional Womens Advisory Board USA. *Signs work:* "Anne Deas", "Reilly-Deas." *Address:* "Greenville", Dublin Rd., Castlepollard, Co. Westmeath, Eire. *Email:* reilly-deas@o2imail.ie

REIS, Klari, BA; MFA; Associate Research Fellowship, City and Guild of London Art School; Signpost New Graduate Competition. *Medium:* mixed media painting. *b:* Denver, USA, 4 Oct 1977. *d of:* Ron and Barbara Reis. *Educ:* Masters in Painting. *Studied:* City and Guilds of London Art School; University of California at Davis. *Represented by:* Cynthia Corbett Gallery; Beverley Knowles Fine Art; Steps Gallery, Florence Fine Art, Themes and Variations. *Exhib:* solo shows in London and Bristol; group shows:AAF New York/Bristol; ArtLondon; Cynthia Corbett Gallery, London; in the USA, UK, Italy and Spain. *Works in collections:* many international collections. *Commissions:* public: Standard Life, 10 Piccadilly,London; Matt Roberts Center, 16 Berkeley Street, London; The Guardian; The Independent; Financial Times Magazine; A-N Magazine; RA Magazine. *Signs work:* 'Klari Reis'. *Email:* klarireis@hotmail.com *Website:* www.klarireis.com

REITER, Laura, B.A. (Hons.) (1986), M.A. (1989), R.E. (1989); painter in oil, acrylic and water-colour, printmaker mainly in silkscreen/linocut; teacher/lecturer. *b:* London, 25 Aug 1950. *m:* Steve Reiter. three *d. Educ:* Brondesbury and Kilburn High School. *Studied:* Kingston School of Art (1983-86), Wimbledon School of Art (1986-89), Middlesex University. *Exhib:* Bankside Gallery, Barbican, London, Manchester Royal Exchange Theatre Gallery, Brunel University Gallery. *Publications:* 'Learn to Paint Abstracts' (Harper Collins, 2006); article, 'The Artist Magazine' (Oct. 1995). *Signs work:* "Laura Reiter." *Address:* 5 Norman Crescent, Pinner, Middx. HA5 3QQ. *Email:* laura.reiter@virgin.net

RELF, James Alan, *Medium:* oil, drawing, prints. *b:* Carlisle, Cumbria, 15 May 1982. *Studied:* De Montfort University (2000-01), Lincoln School of Art (2002-04); mainly self-taught. *Represented by:* The City Art House, Lincoln. *Exhib:* The City Art House, Lincoln (2006, 2007 - group shows), Gallery on the Strait (2004, 2005, 2006 - group shows), The Burrows Gallery (2007 - solo exhibition), Spencer Arts (2007 - group show), British Contemporary Art, Hong Kong (2008 - group show). *Works in collections:* private/corporate. *Commissions:* private/corporate. *Publications:* Art of England, Bailgate Independant, Lincolnshire Pride, Licolnshire Echo, The Journal. *Works Reproduced:* some as limited edition prints. *Signs work:* "JR" or "JRELF". *Address:* 14 Coningsby Crescent, Lincoln, LN4 2JL. *Email:* jamesrelf@hotmail.com

RELFE, Elizabeth Anne Harvey (Liz): see SEWARD RELFE, Elizabeth Anne Harvey (Liz),

RELTON, Maxine, RWA; BA Hons 1st Class Sculpture; MA Sculpture; Richard Briganshaw Prize, Sculpture (London, 1975); F&L Warren Award, Farnham (1989); UWE Drawing Prize, RWA (2000); Tibbatts Associates Prize, RBSA (2004). *Medium:* works on paper (drawings, paintings, prints). *b:* Weybridge, Surrey. *Educ:* Shute School, Devon. *Studied:* Camberwell College of Art (1971-75), Slade (1975-77). *Represented by:* Maxine Relton Studio Gallery, Gloucestershire. *Exhib:* Whitechapel Gallery; Genie de la Bastille, Paris; National Museum of Women in the Arts, Washington DC; RWA; RA Summer Exhbn; Hunting/Observer, Mall Galleries; RBSA; SWE; Llewelyn Alexander Gallery; London Print W'shop; Art-in-Action; Off Centre Gallery, Bristol; Royal National Theatre, London; Guest Artist Glos. Guild of Craftsmen; Arnolfini Gallery; Spike Island, Bristol; SBA; Victoria Art Gallery, Bath; Greenwich Arts Festival, London; Solo touring show of West Africa. *Works in collections:* RWA Permanent Collection. *Commissions:* TV documentary 'Frieze Frame' (1997). *Works Reproduced:* 'Relief Printmaking' (AC Black); 'The Spirit of Trees' by F. Hagenaden (Gaia International Journal, 1990). *Misc:* Visiting Lecturer, numerous US Universities (1990-2001). *Signs work:* 'M Relton'. *Address:* 5 The Street, Horsley, Stroud, GL6 0PU. *Email:* maxine.relton@tiscali.co.uk *Website:* www.maxinerelton.com

REMFRY, David, M.B.E.; RWS; painter in oil and water-colour. *b:* Sussex, 30 Jul 1942. *Studied:* Hull College of Art (1959-64). *Exhib:* solo shows: Mercury, London (1978/80/82/84/86/88/90/92/94/97), Edinburgh (1983), New Grafton Gallery (1973), Editions Graphiques (1974), Old Fire Engine House, Ely (1975/77/79/81/83/86/90/92/94), Ferens A.G., Hull (1975, 2005), New Art Centre, Folkestone (1976), Ankrum Gallery, Los Angeles (1980/81/83/85/87), Bohun Gallery, Henley (1978/81/83/85/87/89/91/93/96), Galerie de Beerenburght, Holland (1979/80/83/86), Middlesbrough A.G. (1981), Zack Shuster Gallery, Florida (1986/88/90), Margaret Lipworth Fine Art, Florida (1992/93/97), N.P.G. (1992), Portal Gallery, Bremen, Germany (1993/95),

Tatistcheff Gallery, N.Y. (1996), Elaine Baker Gallery, Florida (1999, 2002), Boca Raton Museum of Art (1999, 2002), Neuhoff Gallery, N.Y. (1999, 2001, 2004), PSI Contemporary Art Center, Museum & Modern Art NY Affiliate (2001). *Works in collections:* N.P.G., V. & A., Middlesbrough A.G., Minneapolis Museum of Art, U.S.A., Swarthmore College, Pennsylvania, U.S.A., Museo Rayo, Colombia, South America, Boca Raton Museum of Art, Florida, U.S.A., Royal Collection, England, Whitworth Art Gallery, Manchester, Contemporary Art Society, Butler Institute of American Art, Fitzwilliam Museum Cambridge. *Clubs:* Chelsea Arts, Groucho, Colony, Soho House. *Signs work:* "David Remfry." *Address:* 19 Palace Gate, London W8 5LS. *Email:* info@davidremfry.com *Website:* www.davidremfry.com

RENTON, Joan Forrest, D.A., R.S.W.; painter and teacher in oil, water-colour and mixed media;. *b:* 1935. *m:* Professor R. S. Renton. two *s.* one *d. Educ:* Dumfries Academy and Hawick High School. *Studied:* Edinburgh College of Art, Post.Dip. Travelling Scholarship. *Works in collections:* H.R.H. the Duke of Edinburgh, Yorkshire Educ. Dept., Scottish Hospitals, Lothian Region Collection, Royal College of Physicians, Paintings in Hospitals and Jean Watson Trust; private collections in Europe, U.K., U.S.A. and N.Z. *Signs work:* "Joan Renton." *Address:* Holmcroft, 4 Tweeddale Ave., Gifford, E. Lothian EH41 4QN.

RENTON, Margaret Mary, prizewinner, Artist Magazine (1976); finalist Laing Landscape Competition. *Medium:* oil. *b:* Ireland, 6 Nov 1931. one *s. Educ:* Convent education. *Studied:* Maynooth, Ireland; Epsom School of Art (1973-76). *Exhib:* RA (1977, 78, 81, 82, 84, 86, 2001); NEAC, RBA; ROI, RWA, RHA,; Stock Exchange, London; Paris (awarded Diploma, 1979); Spirit of London, Festival Hall; Walker Gallery, Camden Town; Pictures for Schools; National Museum of Wales; Gloucester Museum. *Works in collections:* in Europe, USA, Japan, Canada, Australia; solo exhbns: The New Gallery, Sutton; Art Centre, Christ Hospital, Horsham (1979). *Commissions:* The Histon Gallery, Cambridge; Bourne Hallewell, private commissions. *Publications:* local newspapers, magazines. *Official Purchasers:* Canadian Ambassador. *Works Reproduced:* 'The Signal Box, Epsom, Surrey'. *Recreations:* reading, gardening, walking, entertaining friends, visiting galleries. *Clubs:* trained nurse. *Signs work:* 'M Renton'. *Address:* 12 Dirdene Gdns, Epsom, Surrey KT17 4AX.

REYNOLDS, Graham, C.V.O. (2000), O.B.E. (1984), B.A. (1935), F.B.A. (1993); keeper, Dept. of Prints and Drawings, and Paintings, V. & A. (1959-74); hon. keeper of Portrait Miniatures, Fitzwilliam Museum (1994-). *b:* 10 Jan 1914. *s of:* Arthur T. Reynolds. *m:* Daphne Reynolds née Dent (decd.), painter and engraver. *Educ:* Highgate School and Queens' College, Cambridge. *Publications:* Twentieth-century Drawings (1946), Nicholas Hilliard and Isaac Oliver (1947) 2nd edition (1971), English Portrait Miniatures (1952) 2nd edition (1988), Painters of the Victorian Scene (1953), The Constable Collection, Victoria and Albert Museum (1960) 2nd edition (1973), Constable, the Natural Painter (1965), Victorian Painting (1966) 2nd edition (1987), Turner (1969), A Concise History

of Water-colours (1971), Portrait Miniatures, Wallace Collection (1980), Constable's England (1983), The Later Paintings and Drawings of John Constable (1984), awarded Mitchell Prize (1984), English Watercolours (1988), The Early Paintings and Drawings of John Constable (1996), European Miniatures in the Metropolitan Museum of Art (1996), (with K. Baetjer), Sixteenth and Seventeenth Century Miniatures in Collection of H.M. The Queen (1999). *Clubs:* Athenaeum. *Address:* The Old Manse, Bradfield St. George, Bury St. Edmunds Suffolk IP30 0AZ.

REYNOLDS, Michael, Rome Scholarship in Engraving; twice Winner of the Christopher Ondaatje Prize for Portraiture. *b:* Brighton,30 Aug 1933. *m:* decd. *Studied:* Varndean and Brighton Art College. *Represented by:* Peter C.F.Borsboom, Oude Boor 6, 9922 PL Westeremden, The Netherlands. *Exhib:* usual places. *Works in collections:* Windsor Castle (The Queen's Collection, The Royal Library); National Portrait Gallery, London. *Commissions:* portraits. *Official Purchasers:* Windsor Castle. *Recreations:* reading, music, cooking. *Signs work:* 'Reynolds'. *Address:* Rademarkt 29-3, 9711 CT Groningen, Holland. *Email:* amaborsboom@planet.nl *Website:* see website of Royal Portrait Society; also Gallery Vieleers:www.vieleers.nl

REYNOLDS, Vicki, B.A.(Hons.) (1976), Dip.RAS(1979); British Inst. award (1978), Richard Ford scholarship (1980), S.J. Solomon silver medal for painting (1979); prizewinner, The Spirit of London; Louise Band Drawing Prize; Landseer Scholarship; Fred Elwell Award. *Medium:* oil, oil pastels, water-colour, charcoal, glass. *b:* Portsmouth, 8 Jun 1946. *d of:* Cyril William Mitchell. *m:* Terry New. *Educ:* Paulsgrove and Southsea Schools, Portsmouth. *Studied:* Goldsmiths' College (1972-76, John Thompson), R.A. Schools (1976-79, Peter Greenham). *Exhib:* Stowells Trophy, New Contemporaries, Three College Show, R.A. Summer Exhbn., Vortex Gallery; group shows, R.A., The London Group, Gallery 10, Royal Overseas League, South Bank Picture Show, Cadogan Contemporary Gallery, Highgate Gallery, The Hunting Group. *Works in collections:* Paintings for Hospitals collection, Arthur Anderson collection. *Signs work:* "V.R." *Address:* 4 Whidborne Cl., St. John's Vale, London SE8 4DL.

RHIND, Margaret Scott, DA, RSW; Shell Award in Aberdeen Artists' Exhibtion. *Medium:* watercolour and oil. *b:* Strichen, Aberdeenshire, 23 Feb 1935. *d of:* John H. Taylor. *m:* David Gordon Rhind. oner *s.* one *d. Educ:* Fraserburgh Academy, Aberdeenshire. *Studied:* Gray's School of Art, Robert Gordon's College (now Univ.) Aberdeen: sculpture and drawing - specialisation within four year course. *Exhib:* regularly, annually, in RSW, RSA, RGI exhibitions, and in several galleries throughout Scotland: The Edinburgh Gallery, John Green Fine Art, Glasgow & Tolquhon Gallery, Tarves, Aberdeenshire; solo exhibitions: Randolph Gallery, Edinburgh (1997), The River Room, Pitlochry Theatre, Pitlochry (2003). *Works in collections:* several private collections. *Commissions:* private commissions. *Recreations:* curling, bridge, walking and gardening. *Clubs:* Aberfeldy Breadalbane. *Signs work:* Margaret S. Rhind.

Address: Rannoch Lea, Taybridge Road, Aberfeldy, Perthshire, Scotland, PH15 2BH.

RHOADES, Peter G., C.F.A.Oxon. (1958), N.D.D. Painting (1959), M.A. Cardiff (1992), R.E. (1989); artist/lecturer in printmaking, drawing, photography; Tutor in Art, Christ Church College, Oxford, Visiting Tutor in Drawing, Ruskin School of Drawing, University of Oxford, Lecturer, Abingdon College. *b:* Watford, 6 May, 1938. *m:* Jane Harrison. one *s.* three *d. Educ:* Bryanston School. *Studied:* Ruskin School of Drawing (1955-59, Percy Horton), Central School of Art and Crafts (1960-61, William Turnbull, Alan Davie), Cardiff Inst. of Higher Educ. (1990-92, John Gingell). *Exhib:* periodic one-man shows, numerous selected exhbns. in Britain, Europe and U.S.A. *Works in collections:* Ashmolean Museum Oxford, John Radcliffe Hospital Oxford, Art in Hospitals, The Museum, Trondheim, Norway. *Signs work:* "PETER RHOADES" or "P.G.R." *Address:* Seven Stars, Spurt St., Cuddington, Aylesbury, Bucks. HP18 0BB.

RHYS-JAMES, Shani, M.B.E. (2006); RCamA; BA.Hons.; Hunting/Observer first prize (1993), Gold medal, Eisteddfod (1992), BP Portrait prize (1994), BBC Wales Visual Artist of the Year (1994); Jerwood Painting Prize (2003); Creative Wales Award (2006); Glyndwr Award (2007); Hon.Fellowship, UWIC (2007). *Medium:* oil on linen, canvas, gesso board, automata, metal, cloth, wood. *b:* Melbourne, Australia, 2 May 1953. *d of:* Harold Marcus Rhys-James. *m:* Stephen West, artist and curator. two *s. Educ:* Parliament Hill Girls' School. *Studied:* Loughborough (1972-73), St. Martin's (1973-76, Freddie Gore, Jennifer Durrant, Gillian Ayres, Albert Herbert, John Hoyland). *Represented by:* Martin Tinney Gallery, Cardiff; Connaught Brown Gallery, London (Anthony Brown). *Exhib:* mixed shows: Disclosures, Touring to Barcelona, Reclaiming the Madonna, Intimate Portraits Glyn Vivian, In the Looking Glass, Usher, Jerwood Painting Prize, London, The Black Cot (2004), Discerning Eye (2004); solo shows: Blood Ties Touring(1993), Beaux Arts Bath (1992), Martin Tinney, Cardiff(1993-2005) Facing the Self, Mostyn Llandudno, touring (1997), Stephen Lacey London (2000), Kunstlerhaus, Dortmund, Germany; Aberystwyth Art Centre and Tour (2005), Automata -Towards Addiction, Tactile Bosch, Cardiff (2007). *Works in collections:* National Museum of Wales, Newport Museum, Contemporary Art Soc., Glyn Vivian, Swansea, B.B.C., Lincoln Museum, Birmingham Museum and Art Gallery, Wolverhampton Museum & Art Gallery, National Library of Wales, MoMA Glasgow, Arts Council of England, New Hall College, Cambridge. *Commissions:* 'Disclosures' from Mostyn & National Museum of Wales; Fettered Past, Birmingham MAC Art Centre. *Publications:* Art Today by Edward Lucie-Smith(Phaidon); Facing the Self, Welsh Artists Talking,Tony Curtis; The Black Cot (Gomer Press, 2003); Imagining the Imagination (Gomer Press, 2005), Cassandra's Rant (2007), many exhibition catalogues. *Official Purchasers:* see work in collections, also Usher Gallery, Lincoln, National Library Aber., BBC Wales, Contemporary Art Society of Wales. *Works Reproduced:* many catalogues and books. *Principal Works:* 'The Red Self Portrait', 'Caught in a Mirror', 'The Boards', 'Stare', 'She Seized the

Tablecloth with both Hands', 'The Blackcot', 'The Pink Room', 'Yellow Dress/Black Top'. *Signs work:* "Shani Rhys-James." *Address:* Dolpebyll, Llangadfan, Powys SY21 0PU, Wales. *Email:* shanirhysjames@btinternet.com *Website:* look under Shani Rhys-James

RICE, Brian Wilfrid, NDD, ATC; Arnolfini Open (1963); Westward TV Print Prize (1971); Millfield Open (2003), Evolver Prize (2007). *Medium:* mixed media, collage, oil, drawing, prints. *b:* Yeovil, Somerset, 12 Aug 1936. *s of:* Wilfrid Harry Rice. *Educ:* Yeovil Grammar School. *Studied:* Yeovil School of Art; Goldsmiths College; London University. *Represented by:* Belgrave Gallery, St.Ives; New St.Gallery, Plymouth; Somerville Gallery, Plymouth; Westbrook Gallery, London. *Exhib:* NVC London (1964, 65); London Arts Gallery, Detroit (1968); Verona, Padja, Milan (1970); Clytie Jessop, London (1970); Paperpoint Gallery, London (1979); touring exhbn. Bridgwater, Torrington, Plymouth univ. (1997); Retrospective (2001-2003); Messum's, London (2001); Atkinson Gallery, Millfield, Som.(2003), Atrium Gallery, Univ.of Bournemouth (2004); Bridport Art Centre (2006); Westbrook Gallery, London (2007). *Works in collections:* Tate Gallery, V&A, British Council, Government Art Collection, twenty-five public collections in USA, thirty in UK. *Publications:* 'The English Sunrise' (1972); 'A Pictorial History of Santa Claus' (1995). *Official Purchasers:* The British Council Collection; Tate Gallery Coll.; Plymouth City Art Gallery; Somerset Health Authority. *Works Reproduced:* 'Modern and Contemporary Prints' (Phoebe Phillips, 2004); 'Printmaking' (Harvey Daniels, Hamlyn, 1971);'Collecting Original Prints' (Rosemary Simmons, 2005); 'Fifty Wessex Artists' Evolver Book (2007). *Recreations:* archaeology, music. *Misc:* work used in films: 'Morgan, a Suitable Case for Treatment'; 'The Candidate'; 'The Touchables'. *Signs work:* 'Brian Rice' or 'RICE'. *Address:* New House, Hewood, Chard, Somerset TA20 4NP. *Email:* brian-rice@tiscali.co.uk

RICE, Cecil, B.A. (Hons.) Fine Art (1983), P.G.C.E. (1989); artist in watercolour and oil;. *b:* Nottingham, 3 Mar., 1961. *m:* Linda. one *s. Studied:* Brighton College of Art (1979-83). *Exhib:* Brighton, London, Suffolk, Norfolk; one-man shows: Red Pot Gallery London, Clairmonte Galleries Brighton, Ropner Gallery, London. Work in collections internationally. *Works Reproduced:* fine art screen prints (Chapel Green Prints). *Address:* 14 Granville Rd., Hove, E. Sussex BN3 1TG.

RICE, Elizabeth Helen, R.H.S. Gold Medal; botanical painter in watercolour; illustrator. *b:* Canterbury, 4 Apr 1947. *d of:* Patrick Arthur Rice, F.R.S.A., farmer retd. *Educ:* Ashford School, Kent. *Studied:* Exeter College of Art (1963-65), bursary to study wallpaper design with Arthur Sanderson & Sons (1965-70). *Exhib:* Mall Galleries, Medici Gallery, Pawsey & Payne, St. James's, Jersey Wildlife Preservation Trust, C.I., McEwan Gallery, Scotland, Hunt Institute, USA, etc. *Works in collections:* H.R.H. The Princess of Wales, Hunt Institute for Botanical Documentation USA, Bridgeman Art Library. *Commissions:* Sultan of Oman, Sissinghurst Castle Kent, Medici Society, etc. *Publications:* contributor to

Collins Fieldguide to Crops of Britain and Europe, Reader's Digest Fieldguide to Butterflies, Collins Gem Guide to Herbs, etc. *Signs work:* "Elizabeth H. Rice." *Address:* Flat F 22 Bassett Road London W10 6JJ.

RICH, Andrea, bronze medal 'Salon Nationale des Artistes Animaliers' France; Award of Excellence Witter Museum. *Medium:* woodcut. *b:* Racine, Wi, USA, 31 Oct 1954. *d of:* Kenneth and Joan Groenke. *m:* Donald. one *d. Educ:* BS University of Wisconsin, Whitewater. *Studied:* art education. *Represented by:* Williams Gallery West 40680 Hwy 41, Oakhurst, CA 93644; Wildlife Art Gallery, Phoenix House, 97 High St, Favenham, Suffolk, CO10 9PZ. *Exhib:* extensively in US and Europe, including Birds in Art, Leigh Yawkey Woodson Art Museum, Society of Animal Artists, NY. *Works in collections:* Nature in Art, Wallsworth Hall, Gloucester, UK, Fine Arts Museums of San Francisco. *Commissions:* International Wildlife Federation, Vienna. *Publications:* Best of Wildlife Art (North Light Books, 1999), Woodcuts of Andrea Rich (Many Names Press, 1997). *Official Purchasers:* Leigh Yawkey Woodson Art Museum. *Clubs:* Society of Animal Artists NY, Society of Wildlife Artists, London, Calif. Society of Printmakers. *Address:* 706 Western Drive, Santa Cruz, CA95060, USA. *Email:* darich@prodigy.net *Website:* andrearich.com

RICH, Graham Denton, BA Hons, PGCE (Distinction), MA. *Medium:* mixed media. *b:* Kingswood, Surrey, 23 Feb 1945. *s of:* L.A & B.E Rich. *m:* Lesley Kerman. one *s.* one *d. Studied:* Foundation (Bursary Award), BA Hons, Exeter College of Art (1963/1967), PGCE, Bristol University (Distinction, 1967/1968), MA Exeter University (Distinction 1987/89). *Represented by:* The Fine Art Society, 148 New Bond Street, London W1S 2JT. *Exhib:* Artist with Gordon Hepworth Fine Art (1990-2006), 'The Sea, The Sea' Ingleby Gallery, Edinburgh (1999), 'Ian Hamilton Finlay and Friends' Pittenwheem (2002), 'Time and Tide' Margaret Mellis and Graham Rich, The Hub, Ingleby Gallery, 'Greenwaters' Pier Gallery, Stromness, Orkney (1998), 'Beyond Stereotypes' Tibilisi, Georgia (2005), 'Spike Open', Spike Island, Bristol (2005), Vannabe Museum, Endhoven (2006), Cairn Gallery, Nailsworth (1998-91, 1996, 97, 99). Artist with the Fine Art Society 2006. 'Monochrome 1' 2006, 'Private Keep Out' 2007, 'Monochromed 2' 2007. *Works in collections:* Victoria and Albert Museum. *Publications:* "Green Waters" ed. Alec Finlay (pub. Morning Star). *Works Reproduced:* "Two Painters", works by Alfred Wallis and James Dixon, Irish Museum of Modern Art, Merrell Holberton. *Signs work:* "GRAHAM RICH", "GRAHAM D. RICH" or boat. *Address:* 13, Riverside Road, Topsham, Devon EX3 0LR. *Email:* graham.d.rich@btinternet.com *Website:* www.faslondon.com

RICHARD, Gabriel-Georges, Graduate of the National Fine Arts School of Paris (engraving, 1974); many awards and medals from official exhbns in France, Belguim, Sweden. *Medium:* oil, sculpture, drawing, prints. *b:* Cellé, France, 2 Feb 1945. *s of:* Louis Richard (Shoeing Smith). *Educ:* Technical College. *Studied:* Vendôme, Paris. *Exhib:* RA Summer Exhbn (1999); Haus Greiffenhorst, Krefeld, Germany (1995, 2001); St.Jacques Chapel, Vendôme, France (annually);

Grand Palais Official Exhbns, Paris, France (1977-87); most representative exhbns. *Works in collections:* private collections in France, England, Germany (engravings and sculptures). *Commissions:* Garden Festival of Chaumont, Loire, Amboise (2002); Cherisay (2000); Vendôme (2000); Libercourt (2004), and private. *Principal Works:* 3 maquettes of imaginary architectures; Donkey of Cherisay City; engraving 'Reconciliation'. *Recreations:* sculptures. *Clubs:* Association CAC41; Association des Artistes de la Vallee du Loir. *Signs work:* 'R' (sculptures, paintings and drawings); 'Richard.' (engravings). *Address:* Le Pont Cellé France. *Website:* www.artotheque-valdeloire.com

RICHARDS, E. Margaret, (née Turner); exhbn. scholarship R.C.A. (1940), Drawing prize (1943), A.R.C.A. (Painting) (1943), M.F.P.S. (1976); artist in oil and water-colour;. *b:* Kingston, Surrey, 29 Dec., 1918. *m:* E. M. Richards, LL.B. three *s.* one *d. Educ:* St. Paul's Convent, Teddington. *Studied:* Kingston School of Art (1935) under Reginald Brill, R.C.A. (1939-40) under Gilbert Spencer. *Exhib:* R.A., R.O.I., London Group, R.B.A., N.E.A.C., Trends. *Clubs:* F.P.S. *Signs work:* "E. Margaret Richards" on back, sometimes "Peggy E. M. Turner." *Address:* 3 Cheapside, Horsell, Woking GU21 4JG.

RICHARDS, Patricia, N.D.D.; freelance display artist, art tutor with Adult Educ. including art for the handicapped, pre-school toddlers and paper sculpture for primary school children; diversional therapist for the elderly (retired), Clare House Nursing Home, Walton, Surrey; artist in oil, water-colour, pencil and pen work; demonstrator of varied crafts; private art tutor for the over 60's. *b:* New Malden, Surrey, 9 Nov 1935. divorced. *d of:* Harold Richards. one *s.* one *d. Educ:* Wimbledon County Grammar School. *Studied:* Kingston Art School (1950-55, Reginald Brill). *Exhib:* Graphic Artists (1984), Heritage '84 (National Trust), R.A. (1984), Mall Galleries, Festival Hall, London, Guildford House, Blaydon Gallery, Parkshot Gallery, Richmond, Garden Gallery, Kew, Boathouse Gallery, Walton; one-man show, Trends (F.P.S.) and Esher. Work in private collections. *Misc:* therapist in Arts & Crafts for Parkinson's Disease and Stroke people, WASP; manicurist for Clare House Nursing Home, Walton, Surrey. *Signs work:* "P. Richards" or "P.RICHARDS." *Address:* 39 Woodlands, Meadowlands Pk., Weybridge Rd., Addlestone, Surrey KT15 2RQ.

RICHARDSON, Barbara E., BA(Hons), RBA (1996); elected member of Small Paintings Group (2006); de Laszlo Medal Winner at RBA (2008). *Medium:* oils, watercolour/gouache. *b:* 29 Jun 1944. two *s. Studied:* Chelsea School of Art (1975-79). *Exhib:* NPG Portrait Competition, RA, NEAC, London Group Open, Discerning Eye, ROI, RP, RBA, RWS, Singer & Friedlander/Sunday Times. *Signs work:* "B.R." (oils), "Barbara Richardson" (water-colours). *Address:* 71 Engadine St London SW18 5BZ.

RICHARDSON, Geoffrey Philip, landscape artist in oil, water-colour, etching, drypoint. *b:* Woodbridge, 15 Apr 1928. *s of:* Philip John Richardson, cabinet maker. *Educ:* Woodbridge Elementary School. *Studied:* Ipswich School

of Art (1942-46) under A. Ward, ARCA, A W Bellis, ARCA, Miss E. Wood, ARCA. *Exhib:* RI, NS, Summer Salon; one-man shows, Haste Gallery, Ipswich, Deben Gallery, Woodbridge; and various group shows. *Works in collections:* England, America, Germany, Turkey, New Zealand. Drypoint prints in permanent collection Woodbridge Museum. *Signs work:* "G. Richardson", followed by date and monogram, paintings, and "G" engraved in etchings and drypoint. *Address:* 21 Old Barrack Rd., Woodbridge, Suffolk, IP12 4ET.

RICHARDSON, Ilana, Dip. A.D. (1968); painter in water-colour and oils, screen printer. *b:* Haifa, Israel, 1946. *m:* Crispin Ellison. two *d. Studied:* Betzalel Academy of Art, Jerusalem (1963-67), Hornsey College of Art (1967-68). *Exhib:* C.C.A. Galleries London, Oxford, Bath, Window Gallery Brighton, R.A., Catto Gallery, Tidal Wave Gallery, Hereford, Brighton Festival, and many exhbns. abroad. *Commissions:* St. John's College, Oxford; McDonalds International; Taylor's Port, Portugal; Crofts, Portugal; many private commissions. *Publications:* participated as artist in The New Guide to Screen Printing by Brad Faine. Prints published by C.C.A. since 1982 printed at Coriander Studio London. Posters published by the art group and Ikea. Gicleé prints published by the Artist. *Signs work:* "Ilana Richardson." *Address:* 175 Ramsden Rd., London SW12 8RF. *Email:* art@ilana-richardson.com *Website:* www.ilana-richardson.com

RICHARDSON, Philip David, B.A. (Hons.) 1974 (Painting). *Medium:* oil and watercolour. *b:* Harpenden, 11 Oct 1951. *Studied:* St. Albans School of Art (1970-71), Liverpool College of Art (1971-74). *Exhib:* recent solo shows include: Highgate Fine Art, London (1999, 2001, 2003, 2005), Enid Lawson Gallery, London (1999, 2001, 2002, 2004), The Cottage Gallery, Huntingdon (1998, 2001); has particpated in group shows at all the above galleries plus: Francis Iles Gallery Rochester, Patisserie Valerie London, Star Gallery Lewes, New Grafton Gallery London, Rowley Gallery London, Whittlesford Gallery Cambridge, etc. *Address:* Amery, Theobalds, Hawkhurst, Kent TN18 4AJ.

RICHARDSON, Ray, B.A. (Hons.) 1987; artist in oil and printmaking. *b:* London, 3 Nov 1964. *m:* Gila. two *s. Studied:* St. Martin's School of Art (1983-84), Goldsmiths' College (1984-87). *Exhib:* Boycott Gallery, Brussels (1989, 1992, 1995, 1998, 2000, 2001, 2002, 2005), Galerie 31, Lille (1990), Gallery Aoyama, Tokyo (1999, 2002), Galerie Alain Blondel, Paris (1994, 1996, 1998, 2000, 2003), Beaux Arts, London (1994, 1996, 1999), Mendenhall/Sobieski Gallery, L.A. (1998, 2005), Gallery Fabien Fryns, Marbella (2002, 2004), Advanced Graphics, London (2002, 2004, 2006), New Arts Gallery Connecticut USA (2005), Gallery 11 London (2006). *Works in collections:* de Beers, J.P Morgan, N.P.G. London, Kasen-Summer, N.Y., Tama University, Tokyo, R.C.A. London, V. & A. Museum, London, Ashmolean Museum Oxford, Arnold Collection Connecticut. *Commissions:* Sir Matt Busby (commemoration sculpture), Lennox Lewis (portrait), paintings for the R.S.C. *Publications:* Ray Richardson: 'One Man on a Trip', 'Oil on Canvas', 'British Figurative Painting', 'British Sporting Heroes'; TV: Oil on Canvas (BBC2), Titian National Gallery

Films, Sampled LWT; radio: Radio 3 Artists on Music, BBC London various interviews. *Official Purchasers:* Telegraph Magazine. *Clubs:* Royal Brussels British F.C., Old Roan F.C., King Vic F.C., Old Tennisonians FC. *Signs work:* "RAY RICHARDSON." *Address:* 58 The Hall London SE3 9BG. *Website:* www.rayrichardson.co.uk

RICHES, Lizzie, *Medium:* oil and pastel. *b:* London, 1950. one *s.* one *d. Educ:* Chingford Grammar School. *Studied:* Camberwell School of Art. *Represented by:* Portal Gallery, 15 New Cavendish Street, London W1G 9UB. *Exhib:* Chicago, Paris, Holland, Germany, London. *Works in collections:* P & O, Sainsbury, Prudential, Accenture. *Commissions:* London Underground, Leopold Joseph, Websters Publishing. *Works Reproduced:* Livre de Poche (France), Garsington Opera, London Underground. *Recreations:* wine, books, travel, friends. *Signs work:* Lizzie Riches. *Address:* Fairhurst Gallery, Bedford Street, Norwich, NR2 1AR.

RICHMOND, Donald Edward, NDD, painting (1952), ATC, London (1953); painter and theatrical designer; hon. treas. (1952), hon. adviser (1953), Young Contemporaries; senior lecturer in stage design, West Midlands College (since 1966). *b:* Ilford, Essex, 13 Aug 1929. *s of:* H. J. Richmond. *Educ:* Ilford County High School. *Studied:* S.W. Essex Technical College and School of Art (1946-48 and 1950-52), Brighton College of Art (1952-53). *Exhib:* Young Contemporaries, R.B.A. galleries (1952-53). *Misc:* Designer: Tower Theatre, N.1 (1956-61); English première Goyescas (Granados), Morley College (1965-66). *Signs work:* "DON RICHMOND." *Address:* Portsea House, 3 Sea Lane Cl., E. Preston, W. Sussex BN16 1NQ.

RICHMOND, Miles Peter, *Medium:* oil, watercolour, drawing. *b:* Isleworth, Middx., 19 Dec 1922. *s of:* George William Richmond. *m:* 1.Susanna Richmond, 2. Miranda Sullivan. four *s.* two *d. Educ:* Thames Valley School, Twickenham; Kingston School of Art. *Studied:* Borough Polytechnic (now London University of the South Bank) with David Bomberg (1946-51). *Represented by:* Robin Katz Fine Art. *Exhib:* Borough Group; London Group; Morley Gallery; Middlesbrough Art Gallery; Darlington Art Centre; Palacio Mondragon, Ronda, Spain; Convento Santo Domingo, Ronda, Spain. *Works in collections:* Harry Hurst, Penn., USA; Pat Barnes, Chicago; Sarah Rose, London; Gavin & Kay Lockhart, Scotland. *Official Purchasers:* London University of the South Bank. *Principal Works:* 'Resurrection' 1947, 'Duino' 1948, 'Studio' 1969-70, 'London from South Bank' 1998-9. *Recreations:* walking. *Signs work:* "Miles Richmond" and "Miles". *Address:* 15 Albert Street, Middlesbrough, TS1 3PA. *Email:* milesrichmond@googlemail.com *Website:* www.milesrichmond.co.uk

RICHMOND, Robin, B.A., M.A.; artist in water-colour, pastel, mixed media, oil; writer and broadcaster. *b:* Philadelphia, USA, 7 Nov 1951. *d of:* Patricia Cooper Richmond, M.A. *m:* Dr. James Hampton. one *s.* one *d. Educ:* St. George's English School, Rome. *Studied:* Chelsea School of Art (1969-74). *Exhib:*

(selected) Mercury Gallery (1989, 1990, 1992), Barbican Centre (1992); group shows: (selected) Cleveland Biennale (1990), Southwestern Arts, Dallas (1993), etc. *Works in collections:* San Francisco Fine Art Museum, Middlesbrough A.G., M.O.M.A. (N.Y.). *Publications:* (selected) illustrated: The Magic Flute (Faber); author: Michelangelo and the Creation of the Sistine Chapel (Barrie and Jenkins, 1992), Introducing Michelangelo (Little Brown, 1992), Story in a Picture, Vols. I, II (Ideals, 1992, 1993), Frida Kahlo in Mexico (Pomegranate, 1993). *Signs work:* "Robin Richmond." *Address:* c/o Rebecca Hossack Gallery, 35 Windmill St., London W1.

RIDLER, Valerie, ASWA. *Medium:* mixed media and oil. *b:* Bristol, 29 Oct 1940. *m:* Mr C Ridler. one *s.* two *d. Studied:* Bath College of Art. *Exhib:* Mall Galleries, London; Bath College of Art; The Guild, Bristol. *Clubs:* South Cotswold Art Society (Chairlady); Thornbury Art Society; Winterbourne Art Society. *Signs work:* 'VAL RIDLER'. *Address:* 10 Mill Close, Frampton Cotterell, South Gloucestershire, BS36 2RJ.

RIDLEY, Annabel, Member, Chelsea Art Society; Craft Member Guild of Glass Engravers; mem. Army Arts Society. *Medium:* oil and watercolour; diamond point and drill glass engraving. *b:* London, 27 Aug 1940. *m:* Adam. one *s.* two *d. Educ:* Hatherop Castle. *Studied:* South Thames College. *Exhib:* Cork Street; Mall Galleries; Sotheby's; NEAC. *Works in collections:* H.R.H. Prince of Wales; H.R.H. Duchess of York. *Commissions:* BBC; RICS; Sultanate of Oman; British Council, Yemen. *Recreations:* tennis, swimming. *Address:* 29 Richmond Hill, Richmond, Surrey, TW10 6RE. *Email:* a.ridley@btinternet.com

RIDLEY, Martin Friedrich, H.N.D.; artist and wildlife illustrator;. *b:* Liverpool, 9 Aug., 1967. *Educ:* Calday Grange Grammar School, Wirral. *Studied:* Carmarthenshire College of Technology and Art (1985-88). *Exhib:* 'Birds in Art' Leigh Yawkey Woodson Art Museum, Wausau, Wisconsin, U.S.A., Nigel Stacy-Marks Gallery, Perth, Scotland, The Wildlife A.G, Lavenham, Suffolk, S.WL.A., 'Wild in de Natur' Enschede, Holland, Theatre in the Forest, The Grizedale Soc. Cumbria, St. Helier Gallery, Jersey, John Noott Galleries, Carousel Gallery, 'Nature in Art' Wallsworth Hall, Glos. *Publications:* The Best of Wildlife Art (North-light Books, 1997). *Signs work:* "Martin Ridley." *Address:* c/o John Noott Galleries, 14 Cotswold Ct., Broadway, Worcs. WR12 7AA.

RIDLEY, Philip, BA(Hons.); artist in oil and charcoal. *b:* London, 29 Dec 1962. *Educ:* St. Martin's School of Art. *Exhib:* The Vinegar Blossoms. *Signs work:* "Philip Ridley." *Address:* c/o Lamont Gallery, 65 Roman Rd., Bethnal Green, London E2 0GN.

RIDLEY, Virginia, *Medium:* oil. *b:* London, 13 May 1933. *d of:* Count Cosimo de Bosdari. *m:* Simon Ridley. one *s.* two *d. Educ:* private and at Arts Educational School as a dancer. *Studied:* Heatherley Art School (life drawing, 1950s). *Exhib:* RA Summer Exhbn (several times); Mall Galleries; Wykeham Gallery; Barnes Gall.; Scotland, Jersey, etc. and regularly in Rye. *Works in*

collections: private collections. *Commissions:* many oils of children. *Works Reproduced:* for Medici. *Recreations:* gardening, tapestry, tennis, bridge. *Signs work:* 'V.Ridley'. *Address:* Oxney House, Wittersham, Tenterden, Kent TN30 7ED.

RIGDEN, Geoffrey, NDD(1963), ARCA (1966); painter/sculptor in acrylic, oil, canvas, wood; visiting artist, Cyprus College of Art. *b:* Cheltenham, 22 Jul 1943. *s of:* John S. Rigden. *Educ:* King's School, Gloucester, Grammar School, Weston-super-Mare. *Studied:* Somerset College of Art, Taunton (1960-63, Terence Murphy), R.C.A. (1963-66). *Exhib:* John Moores Liverpool (prize, 1965), Tolly Cobbold (prize, 1977), Hayward Annual (1980-82); one-man shows: Francis Graham-Dixon Gallery (1988, 1990, 1993, 1995). *Works in collections:* Arts Council, Contemporary Art Soc., Eastern Arts Assoc. *Signs work:* "Rigden." *Address:* c/o Francis Graham-Dixon Gallery, 17 Gt. Sutton St., London EC1V 0DN.

RIGGS, Clive, BA (Hons) ASGFA (2003), PGCE. *Medium:* oils, watercolour, pencil, relief and intaglio print. *b:* Bournemouth, 19 Aug 1964. *s of:* Mr & Mrs F Riggs. *Educ:* The King's School, Ely. *Studied:* Duncan of Jordanstone College of Art and Design (1995-99). *Exhib:* The Leith Gallery, Edinburgh (1999, 2000, 2001); Compass Gallery, Glasgow (1999); Cambridge Open Studios (2005, 06); Society of Graphic Fine Art (2003, 04, 07). *Works in collections:* private collections UK; University of Dundee. *Misc:* Professional Associate for the Society for All Artists. *Signs work:* "CLIVE RIGGS". *Address:* 12 Station Road, Swaffham Prior, Cambridge, CB25 0LG. *Email:* clive.riggs@talk21.com *Website:* www.saa.co.uk/art/cliveriggs

RILEY, Bridget, C.B.E. (1972), A.R.C.A.; 1st English painter to win the major Painting Prize at Venice Biennale (1968); painter;. *b:* London, 1931. *Studied:* Goldsmiths' College of Art; Royal College of Art. *Works in collections:* Arts Council, Tate Gallery, V. & A., British Council, Museum of Modern Art, New York, Albright Knox Gallery, Buffalo, Gulbenkian Foundation, Art Gallery of Victoria, Melbourne, Stuyvesant Foundation, Chicago Institute, Whitworth A.G., Manchester, Power Gallery of Contemporary Art, Sydney, Walker A.G., Liverpool, Dept. of the Environment, Fitzwilliam Museum, Cambridge, Scottish National Gallery of Modern Art, Edinburgh, Ulster Museum, Belfast, Museum Boymans van Beuningen, Rotterdam, Stedilijk Museum, Amsterdam, Ohara Museum, Okayama-Ken, National Gallery of Australia, Canberra. *Address:* Karsten Schubert Ltd., 41-42 Foley St., London W1P 7LD.

RIMMINGTON, Eric, artist in oil and charcoal;. *b:* Portsmouth, 14 Jun 1926. one *d. Studied:* Slade School of Fine Art. *Exhib:* many mixed exhbns. in public and private galleries since 1963, R.A., Mercury Gallery (1983-99), Bohun Gallery, Henley-on-Thames (1999-present), Millinery Works Gallery, London (2000-present). *Works in collections:* Bradford City A.G., Gulbenkian Foundation, Scarborough A.G., Museum of London, Imperial War Museum,

Reading Museum. *Signs work:* "E.R." "Eric Rimmington" or not at all. *Address:* C/o Bohun Gallery, 15 Reading Road, Henley-on-Thames, Oxon, RG9 1AB.

RISOE, Paul Schjelderup, Dip. A.D. (Painting) (1968), A.T.C. (1972); painter in acrylic on board, work based on landscape. *b:* Calcutta, 19 Mar 1945. *m:* Clare Perry. two *s.* one *d. Educ:* Christ College, Brecon. *Studied:* Epsom (1963-65, Leslie Worth), Chelsea (1965-68, Brian Young, Jeremy Moon). *Exhib:* Young Contemporaries, R.A.; one-man shows, London, Middlesbrough, Newbury; various mixed exhbns. *Works in collections:* B.P. International, Leicester Educ. Authority etc. *Signs work:* "Paul Risoe." *Address:* 3 Tower Hill Court, Kingsclere, Newbury, Berks. RG20 5SS.

RITCHIE, Ian, C.B.E.(2000); Diploma Arch (dist), RIBA, FRSA, Hon D Litt; RA (1998); Academie d'Architecture Silver Medal; Professor of Architecture RA Schools. *Medium:* etching, stainless steel sculptures, light sculptures. *b:* Hove, 24 Jun 1947. *s of:* Christopher Charles Ritchie. one *s. Educ:* Varndean G.S. *Studied:* Liverpool and London (Univ. Westminster). *Exhib:* Royal Academy; Reina Sofia Museum of Modern Art (Cars); Lodz Municipal Art Gallery; numerous UK and overseas exhibitions since 1970, most recently: Ian Ritchie Architects, Terrasson-La-Villedieu, France (2000); Jubilee Line Extension, Municipal Art Society of New York (2001); Deutsches Architektur Museum, Frankfurt (2002); Venice Biennale (2004); Urban Space by Design, City Hall, London (2005). *Commissions:* The Spire, Dublin; Alba de Milano sculpture, Milan; 'S' Seat and Turville Sun. *Publications:* several books published since 1994, as well as being a major contributor to many other books on architecture. Most recent include: 'The Spire', Ian Ritchie Architects (Categorical Books, 2004), 'The RSC Courtyard Theatre' (Categorical Books, 2007), 'The Leipzig Book of Drawing (RA, 2007). *Recreations:* writing, reading, thinking. *Clubs:* Arts. *Signs work:* "Ian Ritchie". *Address:* 14 Garford Street, London E14 8JG. *Email:* ian@rvdbvr.co.uk *Website:* www.ianritchiearchitects.co.uk

RITCHIE, Paul Stephen, Dip.A.D. (1972); painter, etcher and intaglio printmaker; formerly ran Manchester Etching Workshop; formerly ran, Two Rivers Paper Co. (1984-88). *b:* Chatham, 29 Oct 1948. *Educ:* Taunton School. *Studied:* Somerset College of Art, Manchester College of Art and Design (Norman Adams, Brendan Neiland), Croydon College of Art. *Exhib:* R.A., R.S.A., S.A.C., M.A.F.A., Whitworth A.G. *Works in collections:* Arts Council, S.A.C., Johnsonian, S.N.G.M.A., Hunterian, Aberdeen A.G., Salford A.G., Bradford A.G., Oldham A.G., Rochdale A.G. *Publications:* in conjunction with V. & A. and B.M.: facsimile edition of William Blake's Songs of Innocence and of Experience (1983). *Signs work:* "Paul Ritchie." *Address:* 14A Edinburgh Rd., South Queensferry, West Lothian EH30 9HR.

RITMAN, Lieke, Interior Design Diploma. *Medium:* mixed media painting on board. *b:* Holland, 23 Apr 1942. *Educ:* Royal Melbourne Institute of Technology Australia. *Studied:* Interior Design (5 year course). *Exhib:* DeMarco Edinburgh,

Marjorie Park London, Dublin, Shipston-on-Stour, Penwith Gallery, St.Ives, New Craftsman St.Ives, Plumbline Gallery, St.Ives, Penzance, Truro, Brittany. *Recreations:* walking, cycling, foreign travel. *Clubs:* Penwith Society of Arts (mem.). *Address:* 6 Bowling Green Terrace, St.Ives, Cornwall, TR26 1JS. *Email:* lieke.ritman@tesco.net

RIZVI, Jacqueline Lesley, RBA (1992), RWS (1986), ARWS (1983), NEAC (1982), DipAD (1966); painter. *b:* Dewsbury, Yorks., 25 Jun 1944. *d of:* Fred Haigh Sterry, F.C.A., A.A.C.C.A. *m:* Syed Muzaffar Rizvi. one *d. Educ:* Whitley Bay Grammar School. *Studied:* The Polytechnic, Regent St. (1962-63), Chelsea School of Art (1963-66, Patrick Symons, R.A., Norman Blamey, R.A.). *Exhib:* R.A., R.I., R.S.M.A., N.E.A.C., R.W.S., R.B.A., I.C.A.F.; Bath Festival; London Chamber of Commerce; Sothebys; World of Watercolours, Park Lane; Lineart, Ghent; 20th Century British Art Fair; Minton Fine Art Toronto; Ruthven Gallery, Ohio; Glyndebourne; The Upstairs Gallery, R.A.; New Grafton Gallery; The New Academy Gallery; Agnews, National Trust Foundation for Art; Fosse Gallery; Patterson Gallery; Milne and Moller; Tokyo; St. James' Art Group; The Arts Club; The Hague; Castle Museum, Norwich; Catto Gallery; Waterman Fine Art; Exchange Quay, Manchester; Visions of Venice; S.A.V.E., The Heart of the City; Duncan Miller; Albany Gallery, Cardiff; Malcolm Innes, Edinburgh; Bilbao; Seville; Barcelona; Gorstella Gallery, Chester; City Gallery; Duncan Cambell; Thompsons Gallery; Whittington Gallery, Amersham; Discerning Eye; County Gallery, Maidstone; Piers Feetham; Mexico City; Crown Estates Millenium, New Academy/Curwen; Vaila Fine Art, Shetland; Royal Cornwall Museum; six one-man shows: The Sallyport Tower, Newcastle-upon-Tyne, Cale Art, Chelsea, New Grafton Gallery, The Upstairs Gallery, R.A., The New Academy Gallery. *Works in collections:* murals for The Medical School, St. Mary's Hospital, Paddington; London Underground Ltd., London Clubs Ltd., Shell, Amoco, Davy Corporation. *Commissions:* three murals for The Medical School, St. Mary's Hospital, Paddington; London Underground Ltd.; London Clubs Ltd. *Clubs:* The Arts, Dover Street. *Signs work:* "J.L.R." and year. *Address:* 24 Sunny Gardens Rd., Hendon, London NW4 1RX.

ROBARDS, Audrey, RDS.Hons.; freelance artist in water-colour, oil, collage. *b:* B'ham, 1924. *d of:* W.R. Peck, publisher. *m:* Jack Robards. two *s.* one *d. Educ:* Park House School, Malvern. *Studied:* B'ham College of Art (Alex Jackson), Sutton Coldfield College of Art (Dennis Greenwood), Bournville College of Art (Alex Jackson). *Exhib:* numerous one-man shows in the Midlands. *Works in collections:* hotels, boardrooms, theatres in G.B. and various European venues. *Clubs:* Stratford on Avon Art Soc., Sutton Coldfield Soc. of Arts, Worcs. Soc. of Arts. *Signs work:* "Audrey Robards." *Address:* Ivy Cottage, Main St., Wick Pershore, Worcs. WR10 3NU.

ROBBINS, Richard, Hon.RBA; MA Oxon; Hon. Professor Middlesex University. *Medium:* oil, watercolour, drawing, prints, sculpture. *b:* London, 12 Jul 1927. *s of:* Lionel & Iris (Lord & Lady Robbins). *m:* Brenda. two *s. Educ:*

Dauntsey's School; New College Oxford. *Studied:* Goldsmiths, Ruskins, Slade. *Represented by:* Highgate Fine Art (Noel Oddy); Leicester Galleries (Peter Nahum); Robert Travers; Piano Nobile. *Exhib:* solo shows in London, Tokyo, Singapore; many mixed shows including: John Moore's, RA, RBA. *Works in collections:* many private collections in UK, USA, Japan, Australia, France, Spain. *Commissions:* life-size family group (bronze)- Golfer; 6-figure 'Ruck', 14-figure Line-Out (bronze). *Publications:* 'Moment' (isbn 0951 340107); Collection of Poems, Flowers, Blossoms, Seasons (isbn 0951 340123). *Official Purchasers:* paintings and sculpture, Stirling University & LSE. *Principal Works:* sculptures: 'Dance' (bronze-19 figures); 'Grief' (aluminium, 13 figures); 'Steam Room' (aluminium, 12 figures); 'Lovers'; Family Group 1 & 2; 'Ruck, Line Out'; paintings: 'The Sea, Beach & Sky, Lyme Regis; Flowers, Fields, Lovers; over 150 etchings. *Recreations:* golf, gardening. *Clubs:* Hampstead. *Misc:* since 1960 taught at Belmont School, Camberwell School of Art, Hornsey (Hon.Prof. and Head of Fine Art 1990-93). *Signs work:* 'Richard Robbins'. *Address:* 20 Muswell Avenue, London N10 2EQ.

ROBERT, Mary, MA RCA(1985), BA (1973); photographer /artist in photographic and mixed media; Professor of Lens Media at Richmond International University, London; Tutor in Photography, Royal College of Art. *b:* Atlanta, Georgia, 11 Dec 1951. *d of:* R.R. Robert, Engineers. *m:* Dr.John Dickerson. *Educ:* Miami University, Oxford, Ohio; University of Akron, Akron, Ohio; R.C.A., London. *Exhib:* U.S.A., U.K., France, Japan, Mexico. *Works in collections:* Bibliothéque Nationale, Paris, N.P.G. London, Indianapolis Museum, U.S.A., and private collections in U.S.A., Britain, Europe, Asia. *Commissions:* several especially in the area of classical music and portraiture. *Signs work:* "Mary Robert." *Address:* 47 Creffield Rd., London W5 3RR. *Email:* robertm@richmond.ac.uk

ROBERTS, Gladys Gregory, R.C.A.; artist in oil and acrylic. *b:* Rhyl. *d of:* C. Wesley Haslam, surveyor. *m:* Prof. E. J. Roberts, M.A., M.Sc. (decd.). one *d.* *Educ:* Pendre Private School, Prestatyn. *Studied:* Bangor Technical College (1959-63). *Exhib:* Royal Cambrian Academy of Art, Tegfryn Gall., Menai Bridge, Anglesey. *Signs work:* "G. Roberts." *Address:* "Bryn Llinos", Victoria Drive, Bangor LL57 2EY.

ROBERTS, Marguerite Hazel: see HARRISON, Marguerite Hazel,

ROBERTS, Phyllis Kathleen, ROI (1961); Paris Salon Silver Medal (1959) and Gold Medal (1964); portrait and landscape painter in oil, and sculptor. *b:* London, 11 Jun 1916. *d of:* Ernest Hart Aspden. *m:* A. Gwynne Roberts, F.C.I.I. (decd.). *Educ:* Clifton College, London. *Studied:* Hornsey College of Art. *Exhib:* R.A., Paris Salon, R.O.I., N.E.A.C., R.B.A., R.P., Contemporary Portrait Society, and principal provincial municipal art galleries, etc. *Works in collections:* British Isles, France, Portugal, Spain, etc. *Publications:* articles in Leisure Painter, etc.

Address: c/o Mrs. D.Esmonde-White, 19 Davenport Road, Felpham, Bognor Regis, PO22 7JR.

ROBERTS, Richard Travers, BA Hons Fine Art Sculpture. *Medium:* sculpture. *b:* Little Horwood, Bucks, 11 Oct 1956. *s of:* Keith Roberts & Betty (nee) Travers. *Educ:* St.Martins, Northwood, Middlesex; Zambia, South Africa; Royal Latin School, Bucks. *Studied:* Norwich School of Art. *Represented by:* Turner Fine Arts; UK Fine Arts. *Exhib:* Mall Galleries, Bruton Street Gallery; Sheridan Russell Gallery, London; Artifex, Birmingham; Wildlife Art Gallery, Lavenham; Walsall New Art Gallery; Brian Sinfield Gallery, Burford; The Mayne Gallery, Kingsbridge; On the Wildside Gallery, Gt. Malvern; Gloucestershire Guild of Craftsmen. *Commissions:* private commissions in the UK including portraits. *Works Reproduced:* primarily birds and animals in bronze, also portraits. *Principal Works:* Series of male figures. *Recreations:* walking, bird watching, swimming, classical music, opera. *Clubs:* GOC (Gay Outdoor Club). *Signs work:* RTR. *Address:* 52 Buchanan Road, Walsall, W.Midlands WS4 2EN. *Email:* richard.roberts1@homecall.co.uk *Website:* www.richardrobertsbronzes.com

ROBERTSON, Anderson Bain, D.A. (1955), A.T.C. (1956), B.A.Hons. (1982); painter in oil and water-colour; formerly Principal Art Master, Prestwick Academy. *b:* Bristol, 22 Oct 1929. *s of:* Mungo Robertson. *m:* Mary M.M. Christie (decd.). two *s. Educ:* Ardrossan Academy, Ayrshire. *Studied:* Gray's School of Art, Aberdeen (1951-52, Robert Sivell), Glasgow School of Art (1952-55, 1981-82, David A. Donaldson, William Armour, Jack Knox). *Exhib:* R.S.A., R.S.W., R.G.I., S.S.A., R.P., V.A.S., R.I. *Works in collections:* Many private collections. *Clubs:* Glasgow Art. *Misc:* Elected professional member of Visual Arts Scotland (1996). *Signs work:* "Anderson B. Robertson." *Address:* "Window Rock", Sandy Beach, Innellan, Argyll PA23 7TR. *Email:* kiowa@dsl.pipex.com

ROBERTSON, Barbara Janette, D.A. (1970), S.S.A. (1974), Lily MacDougall, S.S.W.A. (1975); printmaker in linoprint, part-time lecturer. *Medium:* linocut. *b:* Broughty Ferry, Dundee, 16 Aug 1945. *d of:* James Fleming Robertson, inn-keeper. *Educ:* Blairgowrie High School. *Studied:* Duncan of Jordanstone College of Art, Dundee (1965-71) under Ron Stenberg, Josef Sekalski. *Exhib:* Aberdeen Art Centre, Print Exchange, Galerie Tendenz; Contributor R.S.A. (1973-75), Prints in Folios of Compass Gallery, Glasgow, Glasgow Print Workshop, Strathearn Gallery Crieff. *Works in collections:* Leeds, Aberdeen, Glasgow, Stirling, Angus. *Publications:* illustrated The Cuckoo's Nest by Carl McDougall; The Oath Takers, Sea Green Ribbons, by Naomi Mitchison. *Clubs:* Artists Lunch. *Signs work:* "Barbara Robertson." *Address:* 10 The Row, Douglastown, Forfar DD8 1TL, Scotland.

ROBERTSON, Seonaid Mairi, Dip. in Design and Crafts, Edinburgh (1935), A.T.D., Postgrad. Dip. in Psychology, London University (1947); educator, lecturer, craftswoman; fellow of Edinburgh College of Art (1944-47),

Founder/Mem. and senior lecturer, Bretton Hall (1948-54), Senior Research Fellow in Educ., Leeds University (1954-57), Deputy Head A.T.C. Goldsmiths' College, London (retd.). *b:* Perth, Scotland, 1912. *d of:* Theodore Robertson. *Educ:* Edinburgh University and College of Art. Visiting Prof. or Lecturer in seven U.S.A. Universities, and in Brazil, Canada and Germany. Founder/Mem. W.C.C., I.N.S.E.A., British Soc. of Aesthetics. *Exhib:* London, Manchester, Edinburgh, U.S.A. and Brazil. *Publications:* Creative Crafts in Education, Rosegarden and Labyrinth, Dyes from Plants, Using Natural Materials, articles in Craftsman Potter, Studio Potter, Parabola, etc. *Signs work:* "S.M.R." *Address:* Alterra, 1935 South Federal Highway, Boynton Beach, Florida 33435. USA.

ROBERTSON, Sheila Macleod, R.S.M.A., Former Mem. St. Ives Society of Artists; artist in oil, water-colour. *b:* London, 1927. *d of:* A. L. Robertson, chartered accountant. *Educ:* St. Michael's School, Leigh-on-Sea. *Studied:* Watford Art School, Central School of Arts and Crafts. *Exhib:* R.O.I., R.S.M.A., S.W.A. and St. Ives. *Works in collections:* R.S.M.A. Diploma Collection. *Signs work:* "S. M. ROBERTSON". *Address:* Flat 7, 1 Pentland Drive, Edinburgh EH10 6PU.

ROBINSON, Barbara, Prize for Portrait, Marlborough Fine Art, Prize and Medal, City of Monaco/Medal, City of Rodez; painter in oil, gouache, pencil. *b:* London, 7 Mar 1928. *d of:* Major William Lloyd Jones, D.S.O. *m:* Walter Robinson (decd.). two *s. Educ:* Lycée Français du Royaume Uni, Kensington High School. *Studied:* Slade and Ruskin Schools (1943-45, Prof. Randolph Schwabe), Ruskin School of Drawing (1945-47, Albert Rutherston. *Exhib:* New Art Centre, London (1959-83), French, Swiss and American Galleries (1975-94), Nîmes (1987), Sommières (1994), Bruton St. Gallery, London (1999, 2000). *Works in collections:* Contemporary Art Soc. London; City Halls Monaco, Sommières, Rodez and Pamiers; Museums of La Rochelle, Frontignan, Nimes, St. Annes College, Oxford, BP, Shell, The Daily Express, North Sea Oil Corp., St. Hilda's College, Oxford, Students Union London Univ., Girton College, Cambridge, British Library, Society of Performing Arts, National Gallery Western Australia. *Publications:* Lumières du Barbara Robinson by Geneviève Conte (1985), D'Autres Lumières du Barbara Robinson by Marc Moulin (1997), Let There Be Light! Que La Lumiere Soit!. *Recreations:* sudoku. *Signs work:* 'Barbara Robinson'. *Address:* 30260 Vic-le-Fesq (Gard), France. *Email:* robarbara@wanadoo.fr *Website:* www.barbararobinsonpaintings.com

ROBINSON, Dr. Hilary, BA(Hons) (1979), MA(RCA)(1987) PhD, FRSA; lecturer, writer, artist; Dean, College of Fine Arts, Carnegie Mellon University Pittsburgh (2005-); previously senior lecturer, research co-ordinator, University of Ulster;. *b:* UK, 25 Jun 1956. *m:* Alastair MacLennan. *Educ:* John Mason School, Abingdon. *Studied:* University of Newcastle upon Tyne (1975-79, Prof. Kenneth Rowntree), R.C.A. (1985-87, Prof. Christopher Frayling). *Exhib:* U.K., Italy, Hungary. *Publications:* author: Feminism-Art-Theory 1968-2000 (Blackwells, 2001), Visibly Female: Feminism and Art Today (Camden Press

1987, Universe (N.Y.) 1988), The Rough Guide to Venice (1989, 1993); many catalogue essays including: Mothers, Ikon Gallery, Birmingham (1990), Sounding the Depths, I.M.M.A., Dublin (1992), Louise Bourgeois, M.O.M.A. Oxford (1996); Editor, Alba (1990-92). *Address:* Dean, College of Fine Arts, Carnegie Mellon University, 5000 Forbes Avenue, Pittsburgh, PA 15213, USA.

ROBINSON, Gillian, M.A. (1984), Ph.D. (1989); Isis Gallery award best contemporary work, Artists in Essex award winner; painter in mixed media; senior lecturer in art;. *b:* 30 June, 1944. *m:* John Robinson. three *s.* one *d. Studied:* University of London. *Exhib:* Bloomsbury Gallery London, Elizabeth Soderberg Gallery Israel, Sabae Contemporary Art Centre, Japan, Residence Gallery, Herzliya, Israel, R.A.Summer Exhibition, London. *Works in collections:* Epping Forest Museum, Archive of the Karelian Republic Art Museum, Petravodska, Russia; and private collections. *Publications:* Sketchbooks: Explore and Store (Hodder & Stoughton, 1995). *Signs work:* "Gillian Robinson." *Address:* Coolmore Lodge, High St., Thorpe-le-Soken, Essex CO16 0EG.

ROBINSON, Ivor, M.B.E., artist-bookbinder; Hon. Fellow of Oxford Brookes University, Hon.Fellow of Designer Bookbinders (Fellow 1955-2003, President 1968-73). *b:* 28 Oct 1924. *m:* Olive Trask one d. one s. *Educ:* Malmesbury Park School, Bournemouth. *Studied:* Bournemouth Art School(1939-42, Eric Burdett). Royal Navy (1942-45). Lectureships: Salisbury School of Art (1946-52), London School of Printing and Graphic Arts (1953-58), Oxford Polytechnic (1959-89). *Exhib:* major one-person shows: Hantverket, Stockholm (1963); Galleria del bel Libro, Ascona (1969); two person show: Prescote Gallery, Cropredy with Hilary Robinson showing Works on Paper (1981); one hundred and three group exhbns. (1951-2002). *Works in collections:* British Royal collections, British Library, V&A, Bodleian Library, Crafts Council; Keatley Trust,;Danish Royal Library; Royal Library, The Hague; Swedish Royal Library; Röhsska Museum, Gothenburg; and major private collections in Great Britain and overseas. *Misc:* Awards: Triple Medallist, Prix Paul Bonet, Switzerland (1971). *Signs work:* "IR" and year. *Address:* Trindles, Holton, Oxford OX33 1PZ.

ROBINSON, Jim, F.B.S.P. (1988); line artist (printing industry) in acrylic, pencil, scaperboard. *b:* Leeds, 12 Apr 1928. *m:* Anne. one *s.* one *d. Studied:* Leeds College of Art (1941-43). *Exhib:* Yorkshire Artists Ilkley, Yorkshire Itinerants, numerous venues throughout Yorkshire. *Commissions:* various. *Clubs:* Horsforth Arts Soc. *Address:* 33 Grove Farm Cl., Cookridge, Leeds LS16 6DA.

ROBINSON, Kay, BA (Hons), MAFA, AFAS; Fine Art Degree, John Moores University; Wirral Metropolitan Print Fellowship Award (1998-99). *Medium:* fine art printer-painter. *b:* Warrington, 18 Mar 1945. *d of:* John & Priscilla I Robinson. *Educ:* Warrington Collegiate. *Studied:* Wirral Metropolitan College. *Represented by:* Comme Ca Art Ltd., Manchester; Indigo Art Ltd., Liverpool. *Exhib:* AFAS, Mall Galleries (2003, 04, 07); NS (1999-2004); RA Summer Exhbn (2000); National Print, Mall Galleries (2000); Christie-Wild International NYAD 2000,

dfn Gallery, New York; MAFA (2001, 02, 04); Printmakers Council, Falmouth (1999, 2000); Mercury Music Prize (Finalist), Mayfair, London (1997); Discerning Eye, Mall Galleries (2006); Cancer Research, Christie's, London (2002-05, 07); Chester CC Artists, Sens, France (1999); Senigallia, Italy (2005); Museum am Burghof, Lorrach, Germany (2006). *Works in collections:* Manchester Art Galleries Patrons Loan Collection; Warrington Museum and Art Gallery. *Clubs:* Cheshire Artists Network. *Signs work:* "K ROBINSON". *Address:* 15 Parkland Close, Appleton Thorn, Warrington, WA4 4RH. *Email:* kayrobinson_925@fsmail.com *Website:* www.chester.gov.uk

ROBINSON, Leslie Ernest, B.A. (Hons.) 1968, Post Grad. (1969); painter in water-colour, acrylic, pen and ink; Artists' Manager, Art Exhbn. Promoter;. *b:* Consett, Co. Durham, 3 Sep 1947. *m:* Jill Robinson. *Studied:* Sunderland College of Art and Design, Manchester University. *Exhib:* numerous worldwide. *Works in collections:* U.K., Europe, Australia and Gulf States. *Publications:* wrote, photographed and published 'The Materials of the Artist' - a visual 15 series course. *Clubs:* Falmouth Arts Soc., Royal Cornwall Polytechnic Soc. *Address:* Lemon Court, Carclew, Perranarworthal, Truro, Cornwall TR3 7PB. *Email:* lescornwallart@aol.com

ROBINSON, Peter Lyell, B.A.(Hons.) (Geog. Geol.); sculptor in clay, plaster, bronze, stone. *b:* Melbourne, Australia, 12 Apr 1962. *m:* Kate MacNab. two *s.* one *d. Educ:* King's School, Bruton. *Studied:* Durham University. Apprenticed to sculptor John Robinson (1987-90). *Exhib:* London: Alwin Gallery, Harrods F.A. Gallery, McHardy Sculpture Co., Art Scene; Arlesford Gallery Hants., Beaver Galleries, Australia, McHardy Sculpture Company at Butler's Wharf, The Garden Door at Ladbroke Sq., Alwin Gallery at Tunbridge Wells. *Signs work:* "LYELL." *Address:* Lower Huxham Farm, East Pennard, Somerset BA4 6RS.

ROBINSON, Sonia, NSA (1977), RSMA (1979), SWA.(1990), Past Chairman of St. Ives Soc. of Artists; paints in oil, water-colour and gouache. *b:* Stockport, 24 May, 1927. *d of:* Philip Robinson, C.B.E., company director. *Educ:* Glasgow High School; Manchester High School; Copthall School, Mill Hill, London. *Studied:* Manchester School of Art (1943-45), Hornsey Art School (1945-47). *Exhib:* London: R.S.M.A., R.I., Singer and Friedlander (Mall Galleries), S.W.A. (Westminster Galleries), Orangery, Holland Park, St. Katharine's Dock, Thackeray Gallery, R.A. Summer Exhbn. and Heals, shared R.S.M.A. exhbns. at Century Gallery, Datchet, Bruton St. Gallery London, Guildford House Gallery, Guildford. Solo show at Coach House Gallery, Guernsey and the Mariners' Gallery, St. Ives (1990-94 and 1996). Exhibits regularly at the St. Ives Soc. of Artists Norway Gallery, Lyonesse Gallery, Lands End, and the Passmore Edwards Gallery, Newlyn Cornwall. Exhbns. abroad: Mystic Maritime Gallery, Connecticut, U.S.A., Prouds, Sydney, Australia, Vancouver, Canada and Pont Aven, France. *Publications:* A Celebration of Marine Art (Fifty Years of the Royal Society of Marine Artists), and Marine Painting by James Taylor. *Signs*

work: "SR" on oils; "Sonia Robinson" on gouaches and water-colours. *Address:* 3 Paul La., Mousehole, Penzance, Cornwall TR19 6TR.

ROBINSON, Virginia Susanne Douglas, artist in pastel, oil, acrylic. *b:* London, 27 Jul 1933. *d of:* Douglas Stannus Gray, R.P. *m:* Lowther. *Educ:* privately. *Studied:* Brighton College of Art, R.A.S. *Exhib:* R.A., Bradford, York, Cheltenham, Gottingen, Annecy. *Signs work:* "Virginia S.D. Robinson." *Address:* 49 The Green, Southwick, Brighton BN42 4FY.

ROBINSON, Wayne, B.A.Hons, Fine Art (1981), M.A., Fine Print (1991); painter, printmaker-woodcut; lecturer, St. Helens College of Art. *Medium:* painter printmaker. *b:* Peterborough, 19 May 1959. *m:* Amy. one *d.* *Studied:* Cambridge College of Art, Loughborough College of Art and Design, Manchester Metropolitan University. *Exhib:* widely throughout Britain and Europe. *Works in collections:* Malta, USA, Germany, Poland, GB, Cyprus, France. *Signs work:* "W Robinson." *Address:* 254 Dentons Green Lane, St. Helens, Merseyside WA10 6RY. *Email:* wayne.robinson@talk21.com *Website:* www.waynejrobinson.com

ROBOZ, Zsuzsi, mem. Pastel Society, Fellow of Royal Society of Arts. *Medium:* painter in oils, acrylics, pencil, charcoal and pastel, photo collage. *b:* Budapest. married. *Studied:* Regent St. Polytechnic, R.A. under Peter Greenham, and in Florence under Annigoni. *Represented by:* Messum's, Cork St., London. *Exhib:* solo shows include 'Revudeville' at Theatre Museum (1978) at V. & A., London, Lincoln Centre N.Y. (1989), David Messum, Cork St. (1995, 1997, 1999, 2000, 2002, 2005). *Works in collections:* Museum of Fine Arts, Budapest, National Portrait Gallery, Tate Gallery, V. & A., Royal Festival Hall, London, Bradford Museum, Graves A.G., Sheffield, Cambridge University. *Publications:* Women and Men's Daughters, Chichester 10 - Portrait of a Decade, British Ballet To-day, British Art Now with E. Lucie-Smith (1993); 'Roboz, A Painter's Paradox' by John Russell Taylor (2005). *Clubs:* Chelsea Arts, Arts Club, Dover St. *Signs work:* "Roboz." *Address:* The Studio, 76 Eccleston Sq. Mews, London SW1V 19N.

ROBSON, Hugh Mather, artist in oil, gouache, pen and ink;. *b:* Hinckley, Leics., 28 June, 1929. *m:* Barbara Ann Mills. four *d.* *Educ:* Hinckley Grammar School. *Studied:* Fine art: St. Martin's School of Art (1945-49, William Craig, Russell Hall); Slade School of Art (1949-53, Lucien Freud, Sam Carter, tutor). *Exhib:* Arthur Jeffress, Trafford Gallery, Windsor Fine Arts, King St. Gallery, Mallets at Bourdon House, Colefax and Fowler, Nina Campbell's and Stephanie Hoppens Gallery. Murals include Crockfords, Park Lane Hotel, Belfry Club, Capital Hotel, 45 Park Lane, Croix des Gardes and many private houses. Visuals of gardens for Peter Coats; visuals of interiors for Interior decorators including John Siddley, Nina Campbell and Colefax and Fowler. Fabric designs for Nina Campbell. Bookplates, letterheads and tile designs. A series of Genre Singerie water-colours (96 to date), also a series of 20 military pansy figures (signed EWL). *Publications:* articles in House and Garden, Country Life, Connaissance

des Arts, World of Interiors, Harpers, Southern Accents, etc. *Signs work:* "Hugh Robson." or "H. M. Robson." *Address:* 47 Loraine Rd., London N7 6HB.

ROCHE, Helen, D.A. (Edin.); painter in acrylic and mixed media; theme of work includes abstract and semi abstractions based on natural and man made objects. *b:* Limavady, Co. Derry, 23 Mar 1945. *m:* Laurence Roche, D.A. (Edin.). *Studied:* Edinburgh College of Art (1963-67). *Exhib:* R.S.A., R.W.A., S.S.A., R.S.W., S.S.W.A., and numerous other exhbns. *Works in collections:* private collections in Britain and abroad. *Signs work:* "Helen R." *Address:* 67 Valley View Rd., Stroud, Glos. GL5 1HW. *Email:* helen@hroche.orangehome.co.uk

ROCHE, Joan, RAS; lecturer. *Medium:* oil, watercolour, acrylic, mixed media. one *s.* one *d. Studied:* Royal Academy Schools. *Exhib:* Modigliani Centre, Florence (2002), Discerning Eye (2001). *Works in collections:* private collections. *Publications:* Footprint-animals, insects, flowers, trees, illustrations. *Clubs:* RASAA. *Address:* 12 Grand Union Walk, Kentish Town Road, Camden, London NW1 9LF. *Email:* joan@roche.demon.co.uk

ROCHE, Laurence, NDD, DA(Edin.), GRA, HonGRA, PPGRA. *Medium:* oil and acrylic (marine, landscape, industrial subjects, etc.). *b:* Goodwick, Pembs., 1 May 1944. *m:* Helen Roche, D.A.(Edin.). *Educ:* Fishguard County Secondary School. *Studied:* Swansea College of Art (1961-65), Edinburgh College of Art (1965-68, Postgrad. scholarship); Moray House College of Educ., Edinburgh (1969-70). *Exhib:* Many group and one-man exhbns. *Works in collections:* in U.K. and abroad, corporate and private. *Commissions:* several for the steel and construction industry - the latter being for Sir Robert McAlpine (Civil Engineers). *Recreations:* walking-standing,staring,observing-painting. *Signs work:* "Laurence Roche." *Address:* 67 Valley View Rd., Stroud, Glos. GL5 1HW. *Email:* helen@hroche.orangehome.co.uk

RÖDER, Endre Zoltán Eugene, painter in oil on canvas and acrylic on paper; formerly art gallery educ. officer, senior lecturer (Art History). *b:* Budapest, 17 Aug 1933. *s of:* Pál Röder, journalist (decd.). *m:* Carole. one *s. Educ:* St. John's College, Southsea. *Studied:* School of Art, Malta; College of Art, Portsmouth; Sheffield College of Art (1956-60, W.S. Taylor, Eric Jones). *Exhib:* R.O.I., various Open Shows (provinces), but generally in private galleries in England, Scotland, U.S.A. and France. *Works in collections:* Sheffield City A.Gs., Sheffield University, etc. *Signs work:* "RÖDER." *Address:* 50 Clifford Rd., Sheffield S11 9AQ.

RODGER, Willie, RSA (2006), ARSA(1989), RGI(1994); artist in lino and woodcuts; Hon. Degree of Doctor of the University of Stirling (1999); Saltire Awards for Art in Architecture (1984-87). *b:* Kirkintilloch, 3 Mar 1930. *s of:* Robert Gilmour Rodger, pawnbroker. *m:* Anne Henry, illustrator. two *s.* two *d. Educ:* Lenzie Academy. *Studied:* Glasgow School of Art (1948-53, Lennox Paterson). *Exhib:* many one-man since 1964, also group in U.K. and abroad, including RSA, RA, SSA, RGIFA, Glasgow Group, 'In Between the Lines'

retrospective, Collins Gallery, Glasgow (1986); now exhibits mainly 'The Open Eye Gallery' Edinburgh, transparencies of paintings, Bridgeman Art Library, London. *Works in collections:* V&A, SAC, numerous public collections in UK. *Commissions:* Enamel mural, Exhibition Station, Glasgow, (Scot Rail, 1987); illustrations and mural, Dallas DHU Distillery, Forres (Historic Scotland, 1987-88); designs, stained glass windows, St. Mary's Parish Church, Kirkintilloch (1987-93); street banners, 200th Anniversary, Union St., Aberdeen (1994), edition of linocut prints P & O Ferries (2000), linocut illustrations "Finding Alba', Scottish Television (2000). *Publications:* Scottish Historical Playing Cards (1975); illustrated, The Field of Thistles (1983); Willie Rodger, Open Eye Gallery, Edinburgh (1996, 2000); Willie Winkie, Strathpride Universality Ltd., Glasgow (1997); Willie Rodger 'On the Other Hand' Open Eye Gallery, Edin. 2003; Lino and Woodcut Prints accompanying book of poems-'The Colour of Black and White' by Liz Lochhead, 2003. *Misc:* Artist in Residence, University of Sussex (1971). *Signs work:* "Willie Rodger." *Address:* Stenton, 16 Bellevue Rd., Kirkintilloch G66 1AP.

RODGERS, Harry Stewart, painter in acrylic, pastel. *b:* Stamford, 18 Jul 1920. *s of:* Charles E. Rodgers, CMBHI. *m:* Pamela Codd (decd.). *Educ:* Stamford School. *Studied:* with Ian Macnab (1951-52). *Exhib:* Boston, Stamford, London, Dublin. *Works in collections:* Lincolnshire Arts. *Clubs:* R.A.F.A. *Signs work:* "H.S. Rodgers" or "Roger." *Address:* 1 Tinwell Rd., Stamford, Lincs. PE9 2QQ.

RODULFO, Peter, Barony of Fulwood Award (2003). *Medium:* oil, watercolour, drawing, prints, sculpture. *b:* Washington DC, USA, 6 Feb 1958. *s of:* Monty & Mary Rodulfo. one *d. Educ:* Glebe House, Hunstanton; Framlingham College, Suffolk. *Studied:* Norwich School of Art (1975-79). *Exhib:* RA; Hong Kong Museum; Norwich Museum; Margaret Fisher Gallery, London; diverse galleries in Switzerland, Asia, Miami USA, New York USA, London, Brazil, Venezuela. *Works in collections:* Norfolk Museums Service Collection. *Commissions:* Lloyds 'Lutine' commission. *Works Reproduced:* in forthcoming publication 'Eyes of the Soul: An International Overview of Imaginative Art' by Prof. Philip Rubinov. *Signs work:* 'Rodulfo' also sometimes monogram 'R'. *Address:* 95 Connaught Road, Norwich, Norfolk NR2 3BS. *Email:* peterrodulfo@aol.com *Website:* www.peterrodulfo.com

ROGERS, Carol Ann, U.A. (2003); artist and tutor, water-colourist and printmaker, clay sculptor. *Medium:* watercolour/mixed media/acrylic/clay. *b:* Enfield, 12 Dec 1944. *m:* Dennis. one *s. Studied:* West Herts. College, Harrow Arts Centre. *Exhib:* U.A. regularly, London and Herts. *Works in collections:* in France, Germany and Switzerland. *Commissions:* 'St. Mary's Parish Church, Watford' for Mayor of Watford as gift for twin town of Mainz, Germany, 2003; 'Almshouses, Watford' for twin town of Pesaro, Italy, 2003. *Publications:* 'Optima', 'Hertfordshire Countryside' (magazines). *Official Purchasers:* Mayor of Watford for Watford Council. *Principal Works:* painting / sculpting.

Recreations: photography, gardening, bird watching, walking. *Clubs:* U.A., Herts. Visual Arts Forum, Watford Area Arts Forum, Society for All Artists, Radlett Art Society. *Misc:* demonstrator to art societies. *Signs work:* C A Rogers. *Address:* Oxhey Hall Cottage, Hampermill Lane, Oxhey, Watford, Herts. WD19 4NU. *Website:* www.hvaf.org.uk/gallery/rogers or www.saa.co.uk/art/rogers

ROGERS, John Boydell, M.A.; Welsh National Eisteddfod First prize (1980), Hunting Art prizes (1995), Arts Council of Wales Travel grant (1995); painter acrylic and oil; retd. teacher Goldsmiths' College (1987);. *b:* Leigh, Lancs., 13 Sep 1934. *m:* Johanna Willson. three *s.* one *d. Educ:* Hyde County Grammar School. *Studied:* Bretton Hall, University of Birmingham, University of London, Goldsmiths' College. *Exhib:* Arnolfini (1962-63), Camden Arts Centre (1980), Sheffield City Gallery Mappin (1977), Glyn Vivian Gallery, Swansea (1997), Barbican Arts Centre (1996), Islington International Arts Fair '95, Kafe Gallery, Verteillac, 24320 France (2000, 2002). *Works in collections:* Museum of Modern Art, Wales, private collections in U.S.A., Europe, S.E. Asia. *Misc:* Glider and power pilot. *Signs work:* "J.B. Rogers" back of painting, "J.B.R." and date on front of drawings. *Address:* Laborie 24320 Champagne et Fontaine France.

ROGERS, John Rowland, painter, mainly landscapes, in water-colour and oil; Art Com., WAC, Mem. WCSW. *b:* Cardiff, 28 May 1939. married. *s of:* Ronald Edwin Rogers. three *s. Studied:* Cardiff (John Roberts, Phil Jennings, David Tinker). *Exhib:* R.S.M.A., I.C.A., W.A.C. (touring); Pascoe Gallery, Winnipeg; Mostyn Gallery, Wales; 'Journey in Morocco' (1983), Cardiff; Edwin Pollard Gallery, London; John Rogers' Retrospective (touring) (1991); Royal Society of Arts, London (1999). Solo exhibition 'From Africa to Iceland', National Library of Wales (Spring 2008). *Works in collections:* Haverfordwest County Museum, West Wales Arts, W.A.C., Museum and A.G., Newport, Gwent, National Library of Wales, Aberystwyth, Contemporary Art Soc. for Wales, The Museum of Modern Art, Wales. *Publications:* 'Magic Islands', Gomer Press 2002, BBC Wales, 'From Africa to Iceland', John Rogers, with an essay by Alistair Crawford (hardback, Gomer Press, 2007). *Signs work:* "John Rogers." *Address:* Peter's Lane, St. Davids, Pembrokeshire, Wales, SA62 6NT. *Website:* www.johnrogersartist.co.uk

ROGERS, Joseph Shepperd (Nevia), BA(1967), MFA(1969), Instructor, Corcoran School of Art, Columbia Inst. of Art (1970-72), MPSGS(Jamieson Award, 1982). *Medium:* oil and collage. *b:* Washington, D.C., 10 Mar 1943. *s of:* the late James Webb Rogers, LL.B., developer, and Anna Phillips Clarke Rogers. *Educ:* Longfellow School for Boys, Bethesda, Md. *Studied:* Corcoran School of Art, D.C., Greensboro College, N.C., (Irene Cullis, U.N.C.G., M.F.A., Gilbert Carpenter, Peter Agostini, Stephen Antonakos), American University (Dr. Turak). *Represented by:* Tamsin de Lee, Ruckersville, VA. *Exhib:* Berryville VA (2007). *Works in collections:* University of Maryland, "Maryland Collection", main altar collage, Chapel, Bishop Dennis J. O'Connell School, Arlington, Va.; Gauntt

Collection, Washington DC. *Address:* Bealls Pleasure, P.O. Box 1268, Landover, Md., USA.

ROGERS, Lord Richard George (Rogers of Riverside), Baron 1996 (Life Peer), Kt.1991; M.Arch., R.I.B.A.; Richard Rogers Partnership, Rogers P.A. Technical and Science Centre; Piano and Rogers, France;. *b:* 23 July, 1933. *m:* Ruth Elias (1973). three *s. Educ:* Architectural Assoc. (graduate, Dip.); Yale Univ. (Fulbright, Edward D. Stone, and Yale Scholar, M.Arch), R.I.B.A. Chairman, Tate Gallery (1984); Royal Gold Medal for Architecture (1985); Royal Academician; Hon. Fellow Royal Academy of the Hague; Hon. Fellow American Institute of Architects; Saarinen Professor Yale University (1985); Mem. United Nations Architects Committee; IBM Fellow; Mem. R.I.B.A. Council; Visiting Lecturer/Professor: U.C.L.A., Princeton, Harvard, Berkeley, Cornell U.S.A., McGill Canada, Hong Kong University, Aachen Germany, Cambridge University England. Winner of internat. competition from 680 entries for Centre Pompidou (1 million sq. ft. in Paris for Min. of Culture) (1977); winner of Lloyd's internat. competition for 600,000 sq. ft. Headquarters in City of London (1978). Projects include: Music res. centre for Pierre Boulez and Min. of Cultural Affairs, Paris (1977); B. & B. Factory, Como, Italy (1972); P.A. Science Lab. Princeton, U.S.A. (1984); Urban Conservation, Florence Italy (1984); HQ Wellcome Pharmaceuticals Esher U.K. (1984); Cummins/Fleetguard factory, Quimper, France (1980); Electronics Factory for Reliance Controls Ltd., Swindon U.K. (1967); P.A. Technology Centre, Phases 1, 2 and 3, near Cambridge U.K. (1975); Inmos semi-conductor manufg. facilit, Newport, S. Wales (1982). Prizes: include: Fin. Times Indust. Arch. Award for Most Outstanding Indust. Bldg. 1967, (Reliance Controls, Swindon), and 1976 (Patscentre) and 1983 (Inmos); Auguste Perret Prize, Internat. Union of Architects (1978), Premier Europeo Umberto Biancamano (1979), Royal Institute of British Architects Research Award (1970), Royal Institute of British Architects Commendations (1976), British Steel Structural Design Award (1975, 1982), Eurostructpress Award (1983), Architectural Design Awards (1964, 1965, 1968). Subject of BBC documentary, Building for Change (1980). *Publications:* incl. contribs. to Architectural Design, Global Arch. and Arch. and Urbanism. Monograph. G.A. Beaubourg. *Address:* (offices and studios) Thames Wharf, Rainville Rd., London W6 9HA.

ROGERSON, Joyce, F.R.S.A. (1998); R.M.S. (1986); S.W.A. (1986), wildlife artist and miniaturist in water-colour, for miniatures vellum; Vice Pres. S.W.A. (1997-2005); RMS Group of Paintings Award (2003). *b:* Yorkshire. *m:* Ronald Rogerson, A.M.R.Ae.S., I.Eng.Cei., retd. aeronautical engineer. one *s.* one *d. Educ:* Mayfield Girls School, Walton-on-Thames. *Studied:* art: Chertsey Trust. *Exhib:* R.M.S., S.W.A., H.S., M.A.S.-F. (U.S.A.), G.M.A.S. (U.S.A.), U.S.M. (Ulster), Mall Galleries, Westminster Gallery, Medici Gallery, Llewellyn Alexander Gallery, Soc. of Wildlife Art of the Nations. *Commissions:* worldwide, and designs for greetings cards. *Publications:* Included in: Technique of Painting Miniatures, Royal Miniature Society 100 Years, Magic of Miniatures. *Works Reproduced:* 'Swallow', 'Barn Owl', 6 miniatures. *Signs work:* "Joyce

Rogerson.", "JOYCE ROGERSON". *Address:* 84 Cobham Rd., Fetcham, Surrey KT22 9JS.

ROMER, Caroline Eve, Byam Shaw Dip. (Painting); painter in oil, water-colour, etching. *b:* Braughing, Herts., 25 Sep 1955. *d of:* Mark L.R. Romer, barrister-at-law. *m:* David Marzo. three *d. Educ:* Ware Grammar School for Girls. *Studied:* Cambridge Polytechnic (1972-73), Byam Shaw School of Art (1974-76). *Exhib:* R.A., R.B.A., N.E.A.C.; one-man shows, Brotherton Gallery (2), Prades Festival, Thackeray Gallery (1989, 1991, 1993), Lineart, Belgium, 20th Century British Art Fair, France, Spain, Lennox Gallery, London (2001, 2003). *Signs work:* "C.E. Romer." *Address:* Casa Moline, Escalarre, Esterri de Aneu, Prov. de Lerida, Spain. *Email:* carolinamarzo@navegalia.com

ROMER, Philippa Maynard, portrait painter in oil;. *b:* Hitchin, Herts. *d of:* Maynard Tomson, M.C., F.R.I.C.S. *Studied:* Cambridge School of Art and R.A. Schools. *Exhib:* R.A., R.P., R.B.A., N.E.A.C. *Clubs:* RASA. *Signs work:* "Philippa Romer." *Address:* North End Farm, Littlebury, Saffron Walden, Essex CB11 4TW.

RONALDSON, David Bruce, BA(Hons), PGCE; NADFAS Lecturer, OCA Tutor; freelance art historian. *Medium:* oil, water-colour and egg tempera. *b:* Felsted, 20 Jan 1950. *m:* Dorothy Ronaldson. *Studied:* Newcastle University. *Works in collections:* UK, Europe, USA. *Signs work:* 'Bruce Ronaldson'. *Address:* 4 Sandhills, Wethersfield, Braintree Essex CM7 4AG.

RONN: see HILL, Ronald James,

ROONEY, Michael John, RA.(1991), RE(2001), NDD.(1964), ARCA, MA (1967); painter in gouache, water-colour, tempera, oil; printmaking in etching, collographs, drypoint, monoprint. *b:* Epsom, 1944. *s of:* John Rooney, steel fixer (decd.). *m:* (1) Patricia Anne (decd.); one s. one d. (2) Alexandra. one s. *Educ:* Sutton School of Art (1959-62), Wimbledon School of Art (1962-64), RCA (1964-67), British School at Rome (1967-68; Rome Scholar). *Exhib:* Royal Academy, Mercury Gallery (London), Portal Gallery (London), Arts Council Touring 'Fragments against Ruins' (1981), 'Headhunters' (1984), 'After Ausschwitz' (London, Manchester, Sunderland, Dresden, 1995), De Vreeze Gallery (Amsterdam), Seasons Gallery (The Hague). Ten years retrospective 1980-1990 (Folkestone, Eastbourne, Hastings). Art Fairs: Chicago, New York, Basle, London, Bath, Galerie Franziskanergasse (Salzburg, 1999), Broderick Gallery, Portland (Oregon, U.S.) (1999/2001). *Works in collections:* Hove Museum, Towner (Eastbourne), Rye A.G., University of Aston, Museo Ralli (Uruguay), De Beers (London), Bolton Museum, Ambro Bank (Amsterdam), Tullie House (Carlisle). *Commissions:* 'Annunciation' (mosaic, Franciscan Basilica, Nazareth, 1968), Gulbenkian Foundation Printmakers' Award (1984), Financial Times centenary (1988), 'Brick Lane' (London Underground Poster, 1991), 'Aesop's Fables' (tapestry for T.S.B. HQ in Birmingham, 1991). *Publications:* Country Life - P. Kitchen 'A Vision for Europe' (1991). *Clubs:*

Chelsea Arts. *Misc:* Artist in Residence, Towner Art Gallery, Eastbourne (1984), Korn Ferry Premium Award (R.A., 1990). *Signs work:* "M.R." joined, from 1996. *Address:* The Old Sorting House, 19 Alder Rd., Mortlake, London SW14 8ER. *Email:* mick.rooney@ukgateway.net

ROOT, Malcolm Trevor, self taught, GRA. *Medium:* oil, drawing, prints. *b:* Colchester, 12 Sep 1950. *s of:* George and Barbara Root. *m:* Marilyn. two *d. Educ:* Halstead Secondary School. *Studied:* Printing College, NEETC, Colchester. *Exhib:* Grimes House Gallery, Moreton-in-the-Marsh, Gloucestershire; Bressingham Steam Museum, Guild of Railway Artists (various). *Works in collections:* Colchester Castle Museum, H.R.H.The Duke of Edinburgh (Royal Train), Shanes Castle, Antrim. *Commissions:* various including BT Phone Book covers. *Publications:* 4 books (colour, each containing 60+ full page images. *Works Reproduced:* various as prints, cards, collectors plates, calendars, etc. *Principal Works:* Painting of Halstead town commissioned for Millennium. *Recreations:* local history, cycling, watching football. *Clubs:* CAMRA (Real Ale). *Signs work:* "R.+". *Address:* 38 Churchill Avenue, Halstead, Essex, CO9 2BE. *Email:* meryl_malc@hotmail.com

ROOUM, Denise, ARMS; BA. *Medium:* oil, watercolour, drawing. *b:* Bradford, 26 Dec 1929. *d of:* Fred Rooum and Sarah Taylor Rooum. *m:* Brian John Vale. two *d. Educ:* Hanson Girls High School, Bradford; Darlington Training College. *Studied:* evening classes Bradford and Canterbury, mostly self-taught. *Exhib:* Royal Academy; Leeds Art Gallery; Sheffield Art Gallery; most Yorkshire galleries; Cartwright Hall, Bradford. *Works in collections:* Middlesborough Art Gallery, Keighley Cliff Castle, many private collections. *Publications:* 'Stories of the Stars'; 'Hurdy Gurdy Figurines'. *Clubs:* Bradford Arts Club. *Signs work:* 'Denise R.' or 'Denise Rooum' or 'Denise Rooum Vale'. *Address:* Westmoorside, 90 Smith Lane, Daisy Hill, Bradford BD9 6DQ.

ROPER, Geoffrey John, painter in oils and water-colours, illustrator. *b:* Nottingham, 30 Jul 1942. *s of:* Tom Roper, O.B.E., political agent. *Educ:* Nottingham Sec. Art School. *Studied:* Nottingham College of Art (1958-60); Edinburgh College of Art (1960-63) under Sir Robin Philipson, P.R.S.A. *Exhib:* William St. Gallery, Edinburgh (1964, 1965, 1966), Silver Coin Gallery, Harrogate (1965, 1966),Douglas Foulis Gallery, Edinburgh (1967), Middlesbrough Civic A.G. (1968), King St. Gallery, Dublin (1967-8), David Letham, Edinburgh (1967, 1968, 1969), Great King St. Gallery, Edinburgh (1970, 1971, 1972),Fine Art Society (1972, 1974, 1975, 1977, 1980, 1988), Teesside A.G. (1972), Paullencroix des Garges, Cannes (1979), Figurehead Gallery, Edinburgh (1992), Murray Motor Co., Edinburgh (1994), Loomshop Gallery (1997), Open Eye Gallery, Edinburgh (1995, 1997-99, 2001-03). *Works in collections:* works in public and private collections throughout Europe. *Publications:* illustrated books, poems - Sydney Goodsir-Smith; Stanley. R. Green; Suburn of Belsen; mainstream pub. 'Destiny's Daughter; Newhall House,

illustrations; McDonald Press, 100 life paintings. *Address:* Whinstane Cottage, Pumpherstone Farm, Mid Calder, Scotland EH53 0HR.

ROPER, June Morgan, mural painter in oil and acrylic. *b:* Kirkaldy, Fife, 7 Jun 1940. *m:* Geoffrey John Roper. *Studied:* Edinburgh College of Art (1958-62, Sir Robin Philipson, Sir William Gillies, John Maxwell). *Exhib:* Douglas & Foulis, Torrance Gallery, Loomshop Gallery, Kilbarchan Gallery, The Edinburgh Gallery. *Commissions:* A. Fletcher of Saltoun, Travel Scotland Ltd., H. Cathie, Sangster Distillers Jamaica, Dr. Melvin of Edinburgh, Mr. & Mrs. D. Workman of Edinburgh, Hunter Carson Co. Ltd., Torphichen, M. Ladzow, W. Lothian, Mr & Mrs J Duncan, Edinburgh. *Address:* Whinstane Cottage, Pumpherston Farm, Mid Calder, Scotland EH 53 0HR.

ROSCINI, Count M., F.R.S.A. (1967), M.F.P.S. (1985), B.A. (1960); sculptor in bronze;. *b:* Rome, 22 Dec 1933. *m:* divorced. one *d. Educ:* Rome and Cambridge University. *Studied:* Accademia dell'Art Rome. *Exhib:* Hamilton Gallery, Drian Gallery, Loggia Gallery, Salon de Provence, Grenoble, Tevere Expo Rome. *Works in collections:* Morristown N.J., Manilla, Lambeth Palace. *Publications:* Sounds of the Cross by David Owen. *Signs work:* "Roscini." *Address:* 19a Annandale Rd., Greenwich, London SE10 0DD.

ROSE, Christopher Andrew, SWLA; Biology B.Sc. Hons. (1981); artist in acrylic and oils;. *b:* Uganda, 27 Aug., 1959. *m:* Elaine Smith. *Educ:* Rydens County Secondary School, Hersham, Surrey; Nottingham University. *Exhib:* Wildlife A.G., Lavenham, annually at Society of Wildlife Artists, London; many mixed exhbns. in UK, France, Holland, Spain, USA, Japan, Singapore. *Publications:* Swallows and Martins of the World (Christopher Helm, 1989), Complete Book of British Birds (RSPB and AA, 1988), Handbook of the Birds of the World (Lynx Edicions), In A Natural Light-The Wildlife of Chris Rose (Langford Press, 2005); and many other publications. *Signs work:* "Chris Rose." *Address:* 6 Whitelee Cottages, Newtown St.Boswells, Melrose, Scotland TD6 0SH.

ROSE, Diana Cecilia, MFPS (1976); artist in oil. *b:* Chiswick, 12 Jun 1921. *d of:* H. V. Base. *m:* Donald Rose. *Educ:* Lourdes Mount Convent, Ealing and Westcliff High School for Girls, Westcliff-on-Sea. *Studied:* Southend-on-Sea Art School (1948-60 part-time) under Leo Hardy; St. Martin's Art School (1946-47) under A. Ziegler. *Exhib:* Whitechapel A.G., Mall Galleries, Trends, Barbican A.G., Beecroft A.G., Southend-on-Sea. *Works in collections:* Britain, U.S.A. and Sweden. *Address:* 19b Cliff Parade, Leigh-on-Sea, Essex SS9 1AS.

ROSE, Jean Melville, artist/painter in water-colour and powdered colour; retired art teacher;. *b:* 29 Apr., 1929. married. two *s. Studied:* Bath Academy of Art, Corsham (Kenneth Garlick, William Scott, Peter Potworowski, Clifford Ellis, Kenneth Armitage). *Exhib:* Portal Gallery, London, Woodstock Gallery, London, Ancrum Gallery, Los Angeles, (three shows) and may others. *Works in collections:* H.S. Ede Kettles Yard permanent collection, Cambridge.

Commissions: Fresco through Country Works Gallery, Montgomery, Wales. *Clubs:* Cambridge Soc. of Painters and Sculptors. *Signs work:* "JEAN ROSE." *Address:* 1 Wingfield House, Wingfield, Trowbridge, Wilts. BA14 9LF.

ROSE, Tim Simon, BA Hons Fine Art. *Medium:* oil, watercolour. *b:* London, 8 Mar 1953. *Studied:* Watford School of Art (1971-72); Sheffield Polytechnic (1972-75). *Represented by:* Ingleby Gallery, Derbyshire. *Exhib:* Royal Watercolour Society Open; Royal Institute of Watercolourists Open; Ingleby Gallery, Gallery 93 Derby, St Pauls Cathedral (2000) and many group shows. *Works in collections:* Barclays Bank, Marks & Clerk, Institute of Economic Affairs. *Commissions:* portrait of Headquarters of Barclays Bank Plc, London Patent Office. *Publications:* International Artist magazine. *Works Reproduced:* cards and prints, Solomon & Whitehead, Royal Doulton. *Principal Works:* Architectural studies of cathedrals. *Recreations:* music, good food and good company. *Signs work:* "Tim Rose". *Address:* 17 Plymouth Road, Sheffield, South Yorks., S7 2DE. *Email:* tim@timrose.co.uk *Website:* www.timrose.co.uk

ROSEMAN, Stanley, BFA (1967), MFA (1972); painter, engraver, draughtsman and sculptor in oil, drypoint, engraving, chalk, pen and ink, bronze. *b:* Brookline, Mass., 4 Sep 1945. *s of:* Bernard Roseman. *Studied:* The Cooper Union for the Advancement of Science and Art, NYC (1965-67), Pratt Inst., NYC (1970-72). *Exhib:* (among others) N.Y.C., Zurich, Vienna, Oxford, Dublin, London, Bordeaux, Philadelphia, New Haven, Brussels, Washington, Paris. *Works in collections:* (among others) British Museum; V. & A.; Ashmolean; National Gallery of Art, Washington D.C.; Los Angeles County Museum of Art; California Palace of the Legion of Honor, San Francisco; Bibliothèque Nationale, Paris; Musée des Beaux-Arts, Lille; Musée des Beaux-Arts, Rouen; Musée d'Art Moderne, Strasbourg; Musée des Beaux-Arts, Bordeaux; Musée Ingres, Montauban; Musée d'Art Moderne, Brussels; Teylers Museum, Haarlem; Prentenkabinet der Rijksuniversiteit, Leyden; Museum of Modern Art, Rio de Janeiro; National Museum of Wales, Cardiff; National Gallery of Ireland, Dublin; Vatican Museum, Vatican City; Staatliche Graphische Sammlung, Munich; Museum of Fine Art, Budapest; Israel Museum, Jerusalem; Albertina, Vienna; China Museum of Fine Arts, Beijing; H.M. The Queen. *Publications:* Stanley Roseman and the Dance-Drawings from the Paris Opera (Ronald Davis, Paris, 1996); Stanley Roseman - Dessins sur la Dance à la Opéra de Paris (Bibliothèque Nationale de France, Paris, 1996). *Address:* 4, rue de la Liberation, 55120 Clermont (Meuse) France. *Email:* stanleyroseman@wanadoo.fr

ROSEN, Hilary, B.A. (1976), M.A. (1980); painter in water-colour; part-time art lecturer;. *b:* London, 3 Sept., 1953. married. one *s.* one *d. Educ:* J.F.S. Comprehensive School, London. *Studied:* Trent Polytechnic (1973-76, Derek Carruthers), R.C.A. (1978-80, Peter de Francia). *Exhib:* solo shows: Royal National Theatre, Galerie Rose Hamburg, Strausberg Galerie Berlin, Galerie Fischinger Stuttgart; mixed shows: R.A., Singer and Friedlander, Arthur Andersen, Boundary Gallery, London. *Works in collections:* Neville Burston

Coll., Zeiss, Hamburg, Imperial College; private and public collections in Munich, Hamburg, New York, Paris, Arthur Andersen, B.T., British Gas, Liberty, Brown Part Works Publisher, Brompton Hospital. *Publications:* Dorling Kindersely: Water-colour Still Lives. *Clubs:* Chelsea Arts. *Signs work:* "H. Rosen." *Address:* Chisenhale Studios, 64-84 Chisenhale Rd., London E3.

ROSKELL, Susan Kim, SWA (1998); BA Hons in Furniture Design. *Medium:* prints, acrylic on canvas. *b:* Preston, Lancs, 5 Apr 1960. *d of:* George and Ann Roskell. *Studied:* W.R.Tuson College, Preston; Harris Art College, Preston; Nottingham Polytechnic. *Represented by:* Picturecraft Gallery, Holt, Norfolk; Art-Amis Gallery, Herts. *Exhib:* SWA Annual Exhbns at Mall Galleries, London; Aubergé du lac Restaurant, Herts; Sheene Mill, Cambs.; Redcoats Restaurant, Herts. *Works in collections:* many private collections including Mr.David Jackson. *Clubs:* Hertford Art Society. *Misc:* paintings are in modern impressionistic style with a particular love of man-made structures within nature. *Signs work:* 'KIM ROSKELL'. *Address:* 2 Cheapside Cottages, Anstey, Buntingford, Herts SG9 0BL. *Email:* kimroskell@aol.com

ROSMAR: see BOOTH, Rosa-Maria,

ROSOMAN, Leonard, O.B.E. (1981), A.R.A. (1960), R.A. (1970); artist and teacher; teacher of illustration, Camberwell School of Art; teacher of mural decoration, Edinburgh College of Art; tutor at the Royal College of Art, London. *b:* Hampstead, London, 27 Oct 1913. *s of:* Henry Rosoman. *m:* Roxanne. *Educ:* Deacons School, Peterborough. *Studied:* King Edward VII School of Art, Durham University; Central School of Arts and Crafts; R.A. Schools. *Exhib:* Fine Art Society, Roland, Browse & Delbanco, Leicester Galleries, Leger Gallery, St. George's Gallery, Sheffield, Bradford, Edinburgh, Dublin, and provincial galleries, and Lincoln Center, N.Y., State University of New York at Albany. *Works in collections:* Tate Gallery, London, Nat. Portrait Gallery, London, Royal Academy, London, Aberdeen A.G., Royal College of Art, London, Bradford City A.G., Leeds Art Gallery. *Commissions:* murals: vaulted ceiling, Lambeth Palace Chapel, Royal Academy Restaurant, London. *Publications:* Mad Meg, Pieter Breughel; illustrated: Old Testament, Exodus (O.U.P); Aldous Huxley's Brave New World, and Point Counterpoint; Thomas Mann's Buddenbrooks; Evelyn Waugh's Brideshead Revisited (all Folio Soc.), Magic Mountain, Thomas Mann (Folio Soc.). *Principal Works:* Korat Cat, painting, Key West. *Recreations:* classical music. *Clubs:* Chelsea Arts. *Signs work:* "Leonard Rosoman." *Address:* 7 Pembroke Studios, Pembroke Gdns., London W8 6HX.

ROSS, Alastair Robertson, C.St.J., FRBS, RSA, RGI; sculptor; DA (1965), Post-grad. (1966), FRSA (1966), FSA Scot. (1971), ARBS (1968), FRBS (1975), ARSA (1980), Mem. of Council, SSA (1972-75), Scottish Mem. of Council, RBS (1972-92), Vice Pres., RBS (1988-90), Hon. FRIAS (1992), Mem. of Council, Royal Scottish Academy (1998-2000); Hon. Doctorate of Arts (University of Abertay Dundee, 2003), RGI (2004), RSA (2005); Awards: Dickson Prize (1962),

Holokrome Award (1962), S.E.D. Travelling Scholarship (1963), R.S.A. Chalmers Bursary (1964), R.S.A. Carnegie Travelling Scholarship (1965), Duncan of Drumfork Scholarship (1965), S.E.D. Post-grad. Scholarship (1965-66), bronze and silver medallist Paris SalonGillies Award of RSA (1989); Sir Otto Beit Medal of RBS (1989); Freeman of the City of London (1989); Librarian, RSA (2005-). *b:* Perth, Scotland, 8 Aug 1941. *s of:* Alastair J. Ross, FSA Scot. *m:* Kathryn Wilson. one *d. Educ:* St. Mary's Episcopal School, Dunblane, McLaren High School, Callander. *Studied:* Duncan of Jordanstone College of Art, Dundee. *Works in collections:* numerous collections in this country and abroad. *Clubs:* Puffins, Edinburgh. *Address:* Ravenscourt, 28 Albany Terr., Dundee DD3 6HS.

ROSS, Annie, BA Fine Art (Slade), MA Fine Art (Slade), MA Royal College of Art. *Medium:* mixed media including glass. *b:* Brimingham, 29 Jul 1951. *d of:* Solange & Charles Ross. one *s. Studied:* Slade School of Fine Art (1975-1980), Royal College of Art (1980-). *Exhib:* see website. *Works in collections:* Arts Council Collections, private collections. *Commissions:* glass commissions - Margate Hospital; public glass works nationally and internationally. *Official Purchasers:* Arts Council of Great Britain. *Misc:* Teaching - lecturer at KIAD (now University College for the Creative Arts). *Signs work:* "AR" (previously "ARD"). *Address:* 19 Wordsworth Road, Maidstone, Kent, ME14 2HH. *Email:* info@annieross.com *Website:* www.annieross.com

ROSS, John, MA (RCA); US Bicentennial Fellowship (1978-79); Sunday Times Illustration Award, First Prize (1974); Berger Painting Award (1975); BAFTA Nomination, Best Animated Film category (1998). *Medium:* oil, drawing, prints. *b:* Leicester, 27 May 1949. *m:* Anne Dalley, landscape architect. two *s. Studied:* Northampton School of Art (1967-69); Leeds Fine Art (1969-72); RCA (1972-75). *Exhib:* 18 solo exhbns in Britain, France, Germany, Malta and USA,inc. 'The New Fossils' J. Walter Thomson (1975); 'Watch Out Son, This is Cougar Country' UCLA Gallery, California (1978); 'Skating on Thin Ice', Norwich Gallery (1995); 'Dog Years' Volksbank Gallery, Tubingen, Germany (2001); group shows: British Painting and Drawing, Angela Flowers (1972); Leeds Kids Rule, ICA (1973). *Works in collections:* including V&A, Imperial War Museum, Leeds City Art Gallery, Leicester City Museum, Vancouver City Museum, J.Walter Thompson, the late Sir Stephen Spender, the late Elizabeth Frank. *Commissions:* The Times, Sunday Times, Guardian, New York Times, Het Parool, Aardman Animation, Frankfurter Allgemeiner, Jackdaw, Royal Corp. of Transport, etc. *Publications:* Monogram: Words and Pictures-or As Quiet as and Eeel in a Barrel of Tripe' (Arcturus Pub., 1996); The Biggin Hill Frescoes (Lion & Unicorn Press, 1975). *Works Reproduced:* creative review - article 'Class Struggle' Oct 1996. *Recreations:* the politics of the environment and lobbyist, cartoonist, etc. *Misc:* a graphic artist who now concentrates on oil painting. Has worked as an illustrator, cartoonist, scriptwriter and educationalist. *Signs work:* 'Ross'. *Address:* Gloom Hall, 44 Beaumont Park Road,

Huddersfield, W.Yorks HD4 5JS. *Email:* annedalley.la@virgin.net *Website:* www.axisweb.org/artist/johnross

ROSS, Michèlle, SBA(1987), BA(1985) Illustration and Applied Drawing; freelance illustrator/artist in water-colour;. *b:* Morpeth, Northumberland, 9 Mar 1964. *Educ:* Hustler Comprehensive, Middlesbrough. *Studied:* Cleveland College of Art (1980-82), Harrow School of Art (1982-85). *Exhib:* solo show: Talent Store Gallery, Belgravia, London (1988), S.B.A. Open Exhibitions, The Mall Galleries, London, Westminster Halls, London, The Dover Prize, Darlington, Co. Durham. *Works Reproduced:* illustrated numerous books for adults and children, including Dorling Kindersley Eye-Witness Guides, greetings cards, calendars, posters and packaging. *Recreations:* playing a Celtic harp, walking. *Signs work:* "Michèlle Ross." *Address:* c/o The Conifers, Moorsholm, Saltburn-by-the-Sea, Cleveland TS12 3JH. *Website:* http:.mysite.wanadoo-members.co.uk/MichelleRoss

ROSSER, Jennifer C., BA Hons (Fine Art Painting) 1973; art tutor, partner in printing business, home educator; artist. *Medium:* oil, watercolour, mixed media, photography, video, sound. *b:* Reading, Berkshire, 28 Aug 1950. *m:* A.P.Hill. two *d. Educ:* Alfred Sutton School. *Studied:* Falmouth School of Art, Royal Academy Schools. *Exhib:* mixed: ICA Mall Galleries, RA Schools, Centro Modigliani Florence. *Publications:* Calligraphy for Juniper Press. *Clubs:* RASAA. *Address:* 25 Lark Hill Rise, Winchester, SO22 4LX. *Email:* jenniferrosser@yahoo.co.uk

ROSSER, John, N.D.D. (1952); painter. *b:* London, 8 Jun 1931. *s of:* Edward John Rosser. *m:* Margaret Rosser. *Studied:* Regent St. Polytechnic and Watford School of Art (1947-52) under A. J. B. Sutherland. *Exhib:* R.A., R.B.A., N.E.A.C., R.I., Young Contemporaries, Medici Gallery, Compton Gallery, Windsor, Neville Gallery, Sandford Gallery, Paris Salon; one-man shows: Brian Sinfield Gallery, Burford (1987), Hallam Gallery, SW14 (1989); finalist in the Hunting Group art prizes (1981); Chelsea Library (1992), Radisson Hotel, Brussels (1997). *Works in collections:* Watford Museum, Goodwood House. *Works Reproduced:* print: 'One Day by the River' (Sloane Graphics); Elgin Court, Simon and Schuster, Australia, Foyles Books, Rosenstiels, Medici, Reader's Digest Publications. *Clubs:* tennis. *Misc:* National Service: army 1952-54. *Signs work:* capital R. *Address:* 4 Beachview, 91 Banks Rd., Sandbanks, Poole, Dorset BH13 7QQ.

ROSSETTI, Mary Christina, SWE. *Medium:* oil, pastel, drawing, prints. *b:* Kingsbridge, S.Devon, 8 Oct 1946. *d of:* Oliver & Cicely Rossetti. *m:* Lionel Rutterford. two *d. Studied:* self taught with occasional assistance. *Exhib:* SWE Annual (Touring) Exhbns (1998, 2002-07); '500 Cats Exhbn' (2002); South Africa (2003); also small exhbns in Somerset, Dorset and Univ. of Surrey in 1990s. *Commissions:* private commissions for wood engravings, pastel and oil paintings. *Publications:* SWE Catalogue (2003). *Recreations:* sketching etc., reading, gardening, visiting exhibitions, listening to classical music, walking. *Signs work:* 'MCR', 'MRR' (Mary Christina Rossetti, Mary Rossetti Rutterford).

Address: The Red House, Waterloo Lane, Stourton Caundle, Sturminster Newton DT10 2JF. *Email:* rossetti@rutterford.eclipse.co.uk

ROSSI, Carlo, RGI (1973); RSW (1978). *Medium:* mixed media, oils, watercolour. *b:* Johnstone, Scotland, 13 Feb 1921. *s of:* Domenico Rossi. *m:* widower. two *s.* *Studied:* Glasgow School of Art; Florence, Venice, Italy. *Represented by:* Glasgow Art Gallery. *Exhib:* Compass Gallery, Glasgow; The Open Eye Gallery, Edinburgh; Roger Billcliffe Fine Art, Glasgow; Marlebora Gallery, London; RSA; RGI. *Works in collections:* private collections at home and abroad; Glasgow Art Galleries. *Publications:* works mentioned in various art publications including Scottish Water-colour Painting, Scottish Art and Artists. *Works Reproduced:* various art publications. *Principal Works:* Italian landscapes, still lifes, abstractions. *Recreations:* music, classical. *Signs work:* "Carlo Rossi". *Address:* 34 Garthland Drive, Glasgow, G31 2RD.

ROSSIE, Kay, Dip.F.A., A.Dip., F.F.P.S.; abstract painter/sculptor in acrylic, water-colour, oil, wood, metal constructions. *b:* Porthcawl, 1940. one *s.* *Studied:* Croydon College of Art (1983-86), one year advanced sculpture (1986-87). *Exhib:* one-man show, Loggia Gallery, London; many mixed exhbns. of painting and sculpture, including Trends, Phillips, G.E.C. Management College, Business Design Centre, Royal Society of Birmingham Artists, N.Y.A.D. 2000 Manhattan, New York; Cotton's Atrium, City of London; Blythe Gallery, Manchester; Bankside Gallery, London; Osterley Park House Gallery, London. *Works in collections:* Croydon College, Price Waterhouse. *Commissions:* Kenetic Sculpture for First Light Ltd. *Publications:* included in international biographies, and The Cambridge Blue Book. *Clubs:* F.P.S., London, Reigate Soc. of Artists, Dorking Soc. of Artists. *Signs work:* "Kay Rossie." *Address:* 12 Brokes Cres., Reigate, Surrey RH2 9PS.

ROWAN, David Paul, RBA (1979), RA. Schools Post. Grad. Cert. (1972-75), Dip.AD (Painting, 1969-72); artist in acrylic. *b:* Colne, Lancs., 28 Apr 1950. *s of:* William Rowan, careers officer. *Studied:* Maidstone College of Art (1969-72, D. Winfield, R.B.A., W. Bowyer, R.A.), R.A. Schools (1972-75, P. Greenham, C.B.E., R.A., Margaret Green, John Holden). *Exhib:* R.B.A., Mid-Pennine Arts, Colne. *Works in collections:* F. Kobler, London; A. Whalley, Windsor. *Signs work:* "DAVID ROWAN" or "D.P. Rowan." *Address:* 1 Sandown Rd., London SE25 4XD.

ROWBOTHAM, Mark A., Dip.A.D., P.S. (1992); painter in oil and pastels; Mem. Pastel Soc., winner Patterson Award;. *b:* Sarawak, Borneo, 1959. *m:* Sherree E. Valentine-Daines. one *s.* two *d.* *Studied:* Epsom School of Art (1977-81). *Exhib:* R.B.A., R.O.I., R.W.S., R.P., N.E.A.C., P.S. *Signs work:* "M.A.R." *Address:* St.Michael's House, Dell Close, Mickleham, Dorking, Surrey RH5 6EE.

ROWLAND, Dawn, F.R.B.S.; sculptor in stone and bronze; member R.B.S. and M.A.F.A. *b:* London, 24 Sep 1944. *m:* Prof. Malcolm Rowland. two *d.* *Educ:* Orange Hill Girls' Grammar School. *Exhib:* Chelsea Harbour Sculpture (1993),

Chichester Festival (1994), Konishi Gallery Kyoto, R.A. Summer Show, Salford A.G., Hannah Peschar Sculpture Garden, Air Gallery, London (2000), Newby Hall Sculpture Park, Renishaw Sculpture Garden. *Commissions:* Nicola Horlick. *Signs work:* "DAWN" in semicircle with date under. *Address:* The Pines, 39 Bramhall Park Rd., Bramhall, Stockport, Ches. SK7 3NN. *Email:* sculpture@dawnrowland.com *Website:* www.dawnrowland.com/ www.dawnrowland.co.uk

ROWLAND, Robert John, SNR Dip. Art & Design. *Medium:* oil, watercolour, acrylic. *b:* Chesterfield, 17 Sep 1946. *m:* Althea. *Studied:* Nottingham College of Art (1963); Gloucester College of Art & Technology (1980, 1982). *Exhib:* various galleries UK, and with Gloucestershire Society of Artists, and Guild of Railway Artists. *Works in collections:* private and corporate. *Commissions:* private and corporate. *Recreations:* plays trumpet - jazz. *Misc:* Themes of work include: 19c and early 20c Social History, Industrial Heritage and Landscape. *Signs work:* "ROB ROWLAND". *Address:* 54 Henry Road, Gloucester, GL1 3DY.

ROWLETT, George Goldie, *Medium:* painter of land and seascapes, portrait and figure in oil. *b:* Troon, Ayrshire, 29 June, 1941. *m:* Marion Sneller. two *s. Educ:* De Aston Grammar, Market Rasen. *Studied:* Grimsby School of Art (1960-62), Camberwell School of Art (1962-65), R.A. Schools (1965-68). *Represented by:* Michael Richardson Contemporary Art. *Exhib:* one-man shows: Grimsby Museum (1962), Greenwich Theatre Gallery (1975), Woodlands Gallery (1982), Zur Torkel Zehn, Konstanz (1985, 1986, 1987, 1991), D.M. Gallery (1987), Everard Read Gallery, Johannesburg (1987, 1988, 1990, 1992), Smith-Jariwala Gallery (1989), Cleveland Bridge Gallery, Bath (1989), Albemarle Gallery (1990, 1992, 1995), Art Space Gallery (1993,'95,'97,'99, 2001,'03,'05), Belloc Lowndes, Chicago (1995), Grant Fine Art, Newcastle, N. Ireland (1996), Abergavenny (2005), Maidstone & Rochester Galleries (2002), Canterbury Christchurch University (2000); mixed shows: R.A., Whitechapel Open, Cleveland Drawing Biennale, N.P.G., Hayward Annual 'A Singular Vision', Hunting Group, Spirit of London, South Bank Picture Show, London Group, Druce-Constable, Zur Torkel Zehn, Read Stremmel San Antonio, Everard Read, Architectural Arts Co. Dallas, Elizabeth Gordon Durban, Cleveland Bridge, Albemarle, Henry Wyndam, National Trust Centenary - Christies, Grant Fine Art, Belloc Lowndes, Art Space Gallery, Chicago Art Fair, Glasgow Art Fair, Discerning Eye, Canterbury Museum. *Works in collections:* Grimsby Museum, Northern Arts, Cleveland Museum Service, Nuffield Foundation, Baring Bros., Manny Davidson Discretionary Trust, Equitable Real Estate Investment, Atlanta, Ga., Kelmac Group, Price Forbes Ltd., Auto & General Ltd., Innovative Marketing Ltd., Ken Solomon Ltd., African Salt Works Ltd., Weedon Minerals, Anglo American Ltd., A.G. Diamond Cutters, Mesquite Investments, Philip Loot's Assoc., Stephen Fauke Interiors, Altron Ltd., Charles Glass Soc., Rose Gardens Ltd., Nedfin Bank Ltd., Momentum Components, Grinrod Unicorn Group Ltd., Voicevale Ltd.; Hiscox plc; Prudential Corporate plc; Berardo

Foundation, Lisbon; Medway Council; British Council. *Misc:* Gallery: Art Space Gallery, 84 St. Peter's St, London N1 8JS. *Signs work:* "George Rowlett." *Address:* 23 Farrins Rents, London SE16 1NF.

ROWSELL, Joyce, (née Gwyther); History of Art Degree (London). Membership of the following Societies: Royal Society of Miniature Painters, Sculptors & Gravers; Miniature Artists of America; Miniature Art Society of Florida; Hilliard Society Founder Member; Miniature Painters Sculptors and Gravers Washington DC; Cider Painters of America; New Mexico Miniature Art Society; Holds 66 International Awards for Miniature Painting. *Medium:* oil. *b:* S. Wales, 20 Nov 1928. *d of:* Bill and Floss Gwyther. *m:* Geoffrey N. Rowsell. two *s. Educ:* Coborn School, Bow; Bishop Fox's School, Taunton. *Studied:* Courtauld Inst. *Represented by:* Llewelyn Alexander Gallery, London; Alexander Gallery, Bristol; Elford Fine Art, Tavistock; Figura Gallery, Windsor; Francesca Anderson Fine Art, Lexington Mass. *Exhib:* London, Wells, Bristol, Tavistock, Exeter, Windsor, Bath, Birmingham (in UK); New York, Philadelphia, New Mexico, New Jersey, North Carolina, Oregon, Alabama. Also in Tasmania. *Works in collections:* In the Permanent Collections of: Hilliard Society, Miniature Art Society of Florida, Dutch Foundation of Miniature Art, Miniature Artists of America. Private collections. *Commissions:* portraits of people, houses, events. *Works Reproduced:* Somerset Magazine, May 2001; West Country Life, June 16th 2001; The Artist Magazine, Nov 2001; 'Countryman' Magazine April 2005; book jacket designs, illustrations, limited edition prints. *Principal Works:* miniature oils. *Clubs:* Somerset Art Weeks; Ten Parishes Fesival. *Signs work:* "Joyce Rowsell" or "JR". *Address:* Spring Grove Farm, Milverton, Som. TA4 1NW. *Email:* joyce@rowsell.net *Website:* www.spring-grove-gallery.com

ROWSON, Hugh Thomas, B.A., D.A., R.S.W.; artist in water-colour, acrylic, printmaking; former Educ. Officer, Aberdeen A.G.; former V.P., Aberdeen Artists Soc., mem. Peacock Visual Arts, Aberdeen, mem. Royal Scottish Soc. of Painters in Water-colour, Edinburgh (since 1980). *b:* Aberdeen, 4 Aug 1946. *m:* Lesley. two *s. Studied:* Grays School of Art, The Robert Gordon University (1965-70, Alexander Fraser, Ian Fleming), Aberdeen College of Education (1970-71), Open University (1972-76). *Exhib:* RSW Annual Exhibitions (2002-07), Aberdeen University, Aberdeen Arts Centre, Peacock Printmakers (1997), Riverside Gallery, Stonehaven (1999, 2007), Queens Road Gallery, Aberdeen (2000). *Works in collections:* Grampian Hospitals Art Trust, Gray's School of Art, Aberdeen, private collections. *Publications:* Children's Guide to Aberdeen Art Gallery. *Signs work:* "Hugh T. Rowson" or "H.T.R." *Address:* 276 Union Grove, (Ground Floor Flat East), Aberdeen, AB10 6TQ.

ROWSON, Martin George Edmund, MA (Cantab) 1983; Cartoon Arts Trust Political Cartoonist of the Year (2000, 2003); Political Cartoon Society Cartoon of the Year (2002). *b:* London, 15 Feb 1959. *s of:* K E K Rowson. *m:* Anna Clarke. one *s.* one *d. Educ:* Merchant Taylors', Northwood; Pembroke College, Cambridge; no formal artistic training. *Exhib:* Gekoski's Bookshop and Gallery

(1996); Politico's Bookshop aqnd Gallery (1998, 2000, 2002); Tate Britain (2001, 2003). *Works in collections:* British Museum; Saatchi Collection; countless private collections. *Commissions:* regularly from newspapers and periodicals, including The Guardian, The Times, Daily Mirror, Independent on Sunday, Scotsman, etc., etc. *Publications:* 'Scenes from the Lives of Great Socialists' (Grapheme 1983); 'Lower than Vermin: An Anatomy of Thatcher's Britain' (Arrow 1986); 'The Waste Land' (Penguin 1990); 'The Nodland Express' (Macmillan 1994); 'Imperial Exits' (Macmillan 1995);'Tristram Shandy' (Picador 1996); 'The Sweet Smell of Psychosis' (with Will Self, Bloomsbury 1996); 'Purple Homicide' (with John Sweeney 1997). *Recreations:* zoo administration. *Clubs:* Chelsea Arts Club, Soho House, Zoological Club, British Cartoonists' Association (Chairman). *Misc:* Vice-President and Council member of Zoological Society of London; appointed first 'Cartoonist Laureate' for London by Ken Livingstone. *Signs work:* Martin Rowson. *Address:* 46 Vicars Hill, London SE13 7JL. *Email:* ye46@dial.pipex.com

ROXBY, Brian, R.O.I. (1993); painter in oil, acrylic and water-colour. *b:* 25 Oct 1934. *s of:* Thomas Roxby (decd.). *m:* Christina Mary (decd.); Iris Irene. one *s.* two *d. Educ:* St. Cuthbert's Grammar School, Newcastle upon Tyne. *Studied:* Sunderland College of Art (1951-55, Harry Thubron), R.C.A. (1955-58, Leonard Rosoman, Robert Buhler). *Exhib:* R.B.A., N.E.A.C., R.I., R.O.I., Contemporary British Painters, Wildenstein (1958); one-man shows: Queen's Hall Gallery, Hexham (1988), Trevelyan College, Durham (1989), Zillah Bell, Thirsk (1998), Gallery 5 Lincoln (2001), Hawker Gallery, Amersham (2002, 2004). *Works in collections:* National Gallery of Wales and Government Art Collection. *Signs work:* "B. Roxby." *Address:* The Chestnuts, 21 High St., Walcott, Lincoln LN4 3SN. *Email:* broxby@ukonline.co.uk

ROY, Michael (Michael Roy Presley Roy): see PRESLEY-ROY, Michael Roy,

ROZELAAR GREEN, Alfred: see GREEN, Alfred Rozelaar,

RUBIRA, Sue (Susan Debra), BA (1st Class Hons), MA (RCA) Royal College of Art; Winner, Daily Mail 'Portrait of the Queen' Competition (2006), Second Prize, Sunday Times/Singer & Friedlander Watercolour competition (2006);1st Prize, Daler Rowney, RWS 21st Century Open Exhibtion (2007); Anthony J.Lester Art Critic Award, SWA Annual Exhibition (2007). *Medium:* oil, watercolour, drawing. *b:* Brentwood, Essex, 10 May 1959. *m:* Carlos. two *s.* one *d. Studied:* Banbury School of Art (1976-77); University of West of England (1977-80); Royal College of Art, London (1980-83). *Represented by:* Roman Black Gallery. *Exhib:* RP, ROI, RWS, Mall Galleries, London Art Fair (2007), Foyer Gallery, Southampton City art Gallery (solo, 2006), 'The Slave Market Gallery', Lagos, Portugal (1983-94), Folio Society (1981-83) and others. *Works in collections:* New Hall Art Collection, Cambridge University (on loan); "Geoff" Singer & Friedlander (Kaupthing) Collection. *Commissions:* 'Engraving' for

Granada Televisions' 'Jewel in the Crown (1982), work for BBC QED programme 'Shroud of Jesus: Fact or Fake?' (1982). *Publications:* 'Under Bright Wings' (illustrations for paperback). *Works Reproduced:* 'Urgent' postcard. *Signs work:* "S. RUBIRA" or "S.R." (hidden on some portraits). *Address:* 2 Pretoria Road, Hedge End, Southampton, Hants, SO30 0BS. *Email:* info@suerubira.co.uk *Website:* www.suerubira.co.uk

RUDD, Bob, B.A. (1973), R.I. (1995); painter in water-colour and oil. *b:* Ipswich, Suffolk, 18 Jan 1944. *m:* Jennifer Cuff. two *s.* *Studied:* Ipswich Art School (1960-63), Bath Academy of Art (1969-73, Adrian Heath). *Exhib:* R.A., R.I., R.W.A. and many mixed exhbns. and one-man shows in London and Edinburgh. *Works in collections:* 15 works in the permanent collection of the Houses of Parliament. *Address:* 38 The Causeway, Chippenham, Wilts. SN15 3DB. *Email:* bob.rudd@virgin.net *Website:* www.bobrudd.com

RUDDUCK, Ron, FFPS (1990), Mem. SSS (1997), LRBS (1999), ARBS; sculptor in steel, copper and bronze. *b:* 1 Apr 1932. *m:* Annette. two *d.* *Educ:* Chiswick School. *Studied:* Richmond and Kingston Colleges, Middlesex Polytechnic. *Exhib:* 'Age of Shakespeare' British Council, Athawes Gallery W. London, Loggia Gallery W1, R.S.B.A., Boxfield Gallery, Stevenage, Bettina Fine Art, London. *Works in collections:* F.P.S., London, Belfast U.S.A. *Address:* 53 Axbridge, Forest Park, Bracknell, Berks. RG12 0XB. *Email:* ronald.ruddock@ntlworld.com *Website:* www.rbs.org.uk/ www.sculpturesales.fsnet.co.uk

RUDDY, Austin, NDD. *Medium:* oil, watercolour, drawing, prints, etching. *b:* Harrogate, Yorks, 13 May 1942. *s of:* Austin Ruddy & Edith Smith. *m:* Stephanie Jane Percy-Ruddy. two *s.* one *d.* *Studied:* Harrow School of Art. *Represented by:* Zillah Bell (Thirsk); Godfrey & Watt (Harrogate). *Exhib:* RA Summer Exhbn; Royal Watercolour Society; Royal Institute of Watercolour Painters; John Laing Landscape; Harrogate Open; Ripon International Festival; various galleries in North of England. *Works in collections:* mainly private collections in Europe, Australia, N.America. *Commissions:* taken. *Recreations:* Art History, walking, archery. *Misc:* formerly Senior Designer BBC Television, retd. 1990 to take up painting full-time. *Signs work:* 'A.RUDDY' or 'RUDDY' or 'AUSTIN RUDDY' or 'AR' (A and R joined). *Address:* Yorebank Studio, Mickley, Ripon, N.Yorks HG4 3JE. *Website:* c/o www.art-connections.org.uk

RUFFING, A. E., professional artist in water-colour. *b:* Brooklyn, NY. *d of:* J. P. Frampton, architectural engineer. *m:* George Ruffing. one *d.* *Educ:* Cornell University, Drexel Institute of Technology. *Studied:* under John Pike (1964). *Works in collections:* Metropolitan Museum of Art, Smithsonian Institute, Library of Congress, Brooklyn Museum, Harvard University, Institute of Early American History and Culture, Albany Institute of History and Art, Atwater Kent Museum, Johnston Historical Museum, N.Y. Historical Society. *Signs work:* "A. E. Ruffing." *Address:* 1200-206 New World Circle, Raleigh, NC 27615, USA.

RUNAGALL, Alan Trevor, R.S.M.A., marine artist in water-colour; worked for thirty five years with Port of London Authority in India and Tilbury Docks; St.Cuthberts Mill Watercolour Award-RSMA Exhbn. 2002. *b:* Rochford, Essex, 26 May 1941. *m:* Carol. two *d. Educ:* Southend High School. *Studied:* self taught. *Exhib:* various solo and group exhibs. throughout UK and USA. *Works in collections:* Southend Museums Service, various shipping companies. *Commissions:* Port of London Authority, Port of Tilbury London Ltd. *Works Reproduced:* (1) A Celebration of Marine Art - 60 Years of the Royal Society of Marine Artists (2005 ed.); (2) The Wapping Group of Artists - 60 Years of Painting by the Thames. *Clubs:* Wapping Group of Artists., East Anglian Group of Marine Artists. *Signs work:* "Alan Runagall." *Address:* 7 Albany Rd., Rayleigh, SS6 8TE. *Email:* alan.runagall@tesco.net

RUNAYKER, Irene, N.D.D. (1958); painter in acrylic;. *b:* London, 11 May 1937. *m:* decd. two *s. Educ:* Sarah Bonnell Grammar School, London. *Studied:* Camberwell School of Art (1954-58), Drawing with Merlyn Evans, Central School (1960-61). *Exhib:* Towner AG, Eastbourne; Brighton Art Fair; Bonhams Auction NNAH, Britart Gallery, W1; Art in Health, Eastbourne DGH; Thebe's Gallery, Lewes; NYAD2K Show, British Artists in New York(2000), Sussex Open '98; Brighton AG; Standard Cable & Wireless plc (1996/7); Musee Jeu de Paume, Albert, France; Stadtiches Museum, Gelsenkirchen, Germany (curated by Anne-Lise Knorr); London Borough of Camden 'Abstraction and Allusion' University of East London; Morley College Gallery, SE1 'Laithwaites Gyroscopes'; curator: 'Sources of Humanity' Show, Conway Hall WC1; Portobello Fitness Centre 'Art & Sport', London W11; 4 Over 50, Thebe's Gallery, Lewes. *Works in collections:* London Borough of Camden Permanent Collection; University of Technology, Sydney, Australia; Our Lady of Dolours, London; Hallfield School, London. Private collections Australia, Barbados, Belgium, Canada, Cuba, Mexico, South Africa, Europe and USA. *Publications:* ref. in: Camberwell Students and Teachers 1943-1960 (by Geoff Hassell (pub.Antique Collectors, Woodbridge, 1995), Edgell Rickword by Charles Hobday (Carcarnet Press); Femmes Artists International, Paris (interview with Laurence Morechand); 'Dictionary of International Biography (Cambridge); Blue Book, International Biography (Cambridge); 'East' magazine interview with Adam Lloyd-Monaghan. *Official Purchasers:* London Borough of Camden. *Works Reproduced:* Camberwell School, it's Students and Tutors; Good Looking Sussex; 'East' magazine March and September 2005; Artwave video, Lewes (1998); brochure: Education Through Art (professional development programme, 1999). *Clubs:* IAA; INIVA; FWA. *Misc:* Electro Studio, St. Leonards on Sea, E.Sussex; niece of Frank Runacres, RA (1904-1974); Talks: Artists Talk, Claremont, Hastings (Brit. Sociology Assoc. Conf.); 'Nomadic Lines in Becoming a Woman Artist' (University of E.London). *Signs work:* "Runayker"; before 1982 "Runacre." *Address:* 1/68 Terminus Road Eastbourne BN21 3LX. *Email:* runayker@aol.com *Website:* www.irenerunayker.com

RUNSWICK, Eddie, Director of Community and Leisure Services, Borough of Blackburn;. *Address:* Town Hall, Blackburn BB1 7DY.

RUSH, Maureen Elizabeth, freelance artist in water-colour and pastel; Adult Educ. teacher; mem. Yorkshire Water-colour Soc.;. *b:* Surrey, 1938. *m:* Christopher John Rush. three *s. Educ:* Roseberry County Grammar School, Epsom. *Studied:* primarily self taught, influenced by Edward Wesson and the English Water-colour Impressionist School. *Exhib:* many joint and solo shows. *Works in collections:* Royal Tunbridge Wells A.G. *Signs work:* "Maureen Rush." *Address:* Weaver's Cottage, 3 New Row, Birstwith, Harrogate, N.Yorks. HG3 2NH.

RUSHBURY, Julia, Royal Academy Gold Medallist (1950), Landseer prize for Painting (1950), Edward Stott travelling scholarship. *Medium:* oil, watercolour, tempera, pencil. *b:* Stoke-by-Nayland, Suffolk, 8 Oct 1930. *d of:* Sir Henry Rushbury, RA. four *s. Educ:* Langford Grove School, Maldon, Essex. *Studied:* Chelsea School of Art; Royal Academy Schools (1948-51); studied fresco painting in Italy. *Exhib:* RA Summer Exhbns., British and Arts Council exhbns., Young Contemporaries, Redfern Gallery, Southover Gallery, AIA Gallery. *Works in collections:* private collections. *Commissions:* major mural projects at Lewes: for Asa Briggs; Mrs. Stewart-Roberts; Lord Lieutenant of East Sussex; mural panels at: St.Augustine's Church, Scaynes Hill, Sussex, The Old Bridge, Huntingdon, Cambs. The Hon. Julian Fane, Anthony Smith, President of Magdalene College, Oxford. *Publications:* article on murals 'Word of Interiors' 1988; Architectur & Wohnen 1992. *Principal Works:* mural commissions as above. *Recreations:* walking, talking. *Clubs:* RASAA. *Address:* 39A Southover High Street, Lewes, Sussex, BN7 1HX.

RUSHMER, Gordon, landscape and war artist. *Medium:* oils and water-colours. *b:* Petersfield, 12 Jul 1946. *s of:* George Rushmer. *m:* Shirley Ann Holland. one *s.* one *d. Educ:* Petersfield School. *Studied:* Farnham School of Art (1962-67). *Exhib:* Furneaux Gallery, Edwin Pollard Gallery, Ceri Richards Gallery, R.I., Ashbarn Gallery, New Ashgate Gallery, Peter Hedley Gallery, Dragon St. Gallery, Gallery East, N.Y., David Curzon Gallery, Francis Iles Gallery, Weald & Downland Museum, Royal Marines Museum, Mariniers Museum Rotterdam, Lincoln Joyce Fine Art, Oriel Ynys Mon, Wykeham Gallery, Albany Gallery, 'A Decade of Conflict'-Hampshire Museums, Allen Gallery. *Works in collections:* Her Majesty The Queen, Royal Logistics Corps, Special Boat Service, National Library of Wales, I.C.I., Nelson Mandela, Royal Marines, Royal Netherlands Marine Corps., H.M. Foreign and Commonwealth Office, Princess of Wales' Royal Regiment, Royal Marines Museum, Mariniers Museum, House of Lords, Japanese Govt. *Commissions:* British Embassy Warsaw, Series on Conflicts in Bosnia, Cambodia, Kosovo, Eritrea, Afghanistan 2002 & 2007,and Iraq, Palace of Westminster. *Publications:* Art Business News U.S.A., Artists and Illustrators Magazine, Globe and Laurel, Korps Mariniers Magazine, Hampshire the County Magazine. *Works Reproduced:* Felix Rosensteils, Hamlyn

Group, Champaign Publishing. *Recreations:* cycling, hill walking. *Clubs:* East Anglian Group of Marine Artists. *Signs work:* "Gordon Rushmer." *Address:* 2 Sherwood Cl., Liss Forest, Hants. GU33 7BT. *Email:* gordonrushmer@btinternet.com *Website:* www.gordonrushmer.com

RUSHTON, James, A.R.C.A., R.W.S., N.E.A.C.; artist in oil and water-colours; principal lecturer (retd.). *b:* Newcastle-u-Lyme, 15 Jan 1928. widower. one *s.* one *d. Studied:* Burlem School of Art; Royal College of Art. *Exhib:* R.A. R.W.S. and N.E.A.C. annual exhbns. Work in private collections. *Works in collections:* portraits: Dr. Derek Ferrington, Mrs. Bette Pyatt, Mrs J. Barrow, The Earl of Belmore. *Publications:* illustrations for, Maxwells Ghost, On a Shoe String to Coorg, Archaeology Publications (Quality Book Club, London). *Signs work:* "J Rushton." *Address:* 17 Gower St., Newcastle-u-Lyme, Staffs. ST5 1JQ.

RUSPOLI, Francesco Mario Robert, Silver Medal, Rome & Villeneuve (1985), Silver Medal, French Institute (1986), Eugene Fromentin Award (1987), Gold Medal, French Institute (1988), Knight of the Art, Italy (1998), Bronze Medal, Paris (1991); theatre designer of set and costumes. *Medium:* oil and watercolour. *b:* Paris, 11 Dec 1958. *Studied:* Central St. Martin, London. *Represented by:* Roberto Gagliardi, Gagliardi Gallery, 509 Kings Road, Chelsea, London SW10 0TX, www.gagliardi.org. *Exhib:* America and Europe. *Works in collections:* Gauguin Museum, Tahiti, French Polynesia; International Museum of Cupramontana, Italy; Museum of Art of Chianciano, Italy. *Publications:* Exhibit A Magazine, The Observer Magazine, Absolut Magazine, Contemporary Famous Artists (Masters of Today -World of Magazine). *Works Reproduced:* 'Rimo' designs as rugs; Digital ceramics as Tiles; 'Silent Gliss' as blinds and sliding panels for windows. *Signs work:* "Ruspoli." *Address:* 54 Chestnut Gr., London SW12 8JJ. *Email:* francesco.ruspoli@virgin.net *Website:* www.francesco-ruspoli.com

RUSSELL, Caroline, B.A. (Hons.) 1989, A.R.B.S.; sculptor, work cast in foundry bronze and bronze resin. *b:* London,12 Jun 1968. *m:* Howard Granville. one *s.* one *d. Studied:* privately under Patricia Finch, F.R.B.S. *Exhib:* Air Gallery, Gallery 27 London. *Works in collections:* various private collections. *Commissions:* large sculpture - Lehmann Communications plc. Entrance Hall. *Signs work:* "C. RUSSELL." *Address:* Russell Sculptures, 50 The Drive, Edgware, Middx. HA8 8PT. *Email:* caroline@russellsculptures.com *Website:* www.russellsculptures.com

RUSSELL, Christine Gillian, S.W.A.; self taught professional artist specialising in pastel still life and other subject matter; SWA President & Vice-Presidents Award (2003). *Medium:* pastel, oils, watercolour. *b:* London, 4 Apr 1952. *m:* Sidney Stephen Russell. one *s.* one *d. Educ:* Tollington Park School, London. *Exhib:* S.W.A., U.A., P.S., R.B.S.A.; Bourne Gallery, Reigate, Alexander Gallery, Bristol, John Noott Galleries, Broadway, Century Gallery, Datchet, Royall Gallery, Tunbridge Wells, Thornbury Castle, South Glos., Webbs

Country Gallery, Battersea; Artifex Gallery, Sutton Coldfield; Peter Hedley Gallery, Dorset; Llewelyn Alexander, London; Figura Gallery, Windsor; Fine Art UK, Ledbury. *Works in collections:* private collections. *Commissions:* private commissions. *Publications:* entry in S.W.A. Exhibitors 1855-1996, work illustrated in 'Masterstrokes: Pastel' and 'Painting Great Pictures from Photographs', 'International Artist' Magazine, 'Pastel Artist International' magazine and 'The Artist's Sketchbook', 'The Collins Artist's Sketchbook'. *Works Reproduced:* 3 limited edition, 5 open edition prints; greetings cards. *Misc:* Tutors painting holidays: Spain, Italy, UK, Morocco (2008), Marlborough College Summer School. Workshops: own studio and Art Societies. *Signs work:* "C.G. Russell" (originals) "Christine Russell" (prints). *Address:* The Laurels Studio, Stone, Nr.Berkeley, Glos GL13 9LD. *Email:* christinerussell@ukonline.co.uk *Website:* www.art-christinerussell.co.uk

RUSSELL, Edwin John Cumming, F.R.B.S., Cert. R.A.S., R.A. Gold Medal for sculpture; Sir Otto Beit Medal for sculpture (1991); sculptor in bronze, stone, wood;. *b:* Heathfield, 4 May, 1939. *m:* Lorne McKean, sculptor. two *d. Studied:* Brighton College of Art and Crafts (1955-59), Royal Academy Schools (1959-63). *Works in collections:* Crucifix, and St. Michael, St. Paul's Cathedral; Bishop, Wells Cathedral; Dolphin Sundial, Greenwich; Sundials for Oman University and Dubai Parliament Sq.; Mad Hatters Tea Party, Warrington; Lion and Lamb, best shopping centre (1987); Alice and White Rabbit, Guildford; Panda, W.W.F., H.Q.; Forecourt Sculpture, Rank Xerox U.K., H.Q. *Signs work:* "E.R." *Address:* Lethendry, Hindhead, Surrey GU26 6BE.

RUSSELL, Jim, R.B.A.; painter and illustrator in oil and water-colour;. *b:* Walsall, Staffs., 30 June, 1933. *m:* Becky. one *s.* one *d. Educ:* Royal School, Wolverhampton. *Studied:* Birmingham College of Art. *Exhib:* RA, John Moores, RBA, FBA, Bankside, Laing, Singer & Friedlander, Hunting, etc.; one-man shows: Amalgam, Drian London, Alpha House Sherborne, Boxfield Stevenage. *Works in collections:* Liverpool University, various L.E.A.'s. *Commissions:* various theatre rehearsal drawings, Wine Soc. *Works Reproduced:* Radio Times, Punch, newspapers, theatres, etc. *Address:* 10 Milton Rd., London SE24 0NP.

RUSSELL, Kathleen Barbara, D.A.Edin. (1962); one time Membre Associé Société des Artistes Français;. *Medium:* artist in oil, pastel, gouache and water-colour. *b:* Edinburgh, 1940. *d of:* John Sandilands Russell and Margaret Murray Russell. *m:* John Caskey. *Educ:* The Mary Erskine School for Girls. *Studied:* Edinburgh College of Art (1958-63) under Sir Wm. Gillies, R.A., R.S.A. and Sir Robin Philipson, P.R.S.A. *Exhib:* one-man shows since 1965. *Works in collections:* Watson Coll., Edinburgh Corp. Schools Coll., Nuffield Collection, Durham University, Kings College, London, Royal Botanic Gardens, Kew. Private collections. *Commissions:* several private. *Publications:* illustrated 'Magnus the Orkney Cat'. *Works Reproduced:* 'Under African Skies'. *Recreations:* gardening, entertaining, writing- blank verse and childrens tales.

Signs work: "Kathleen Russell" or "K. Russell" or "K." *Address:* Smithy Cottage, Kilberry by Tarbert Argyll PA29 6YD.

RUSSELL, Pat, FSSI, FCLAS; textile artist in fabric collage, lettering artist, calligrapher. *b:* Wembley, 17 Aug 1919. *d of:* Herbert Cooch. *m:* Birrell Russell. one *s.* one *d. Educ:* Farnborough Hill. *Studied:* Chelsea College of Art under M. C. Oliver. *Exhib:* Oxford Gallery and various group exhbns. *Works in collections:* V. & A., Oxford City and County Museum, Reading Museum. *Publications:* Lettering for Embroidery (Batsford); Decorative Alphabets Throughout the Ages (Bestseller Publications). *Signs work:* "Pat Russell." *Address:* 48 East Saint Helen's St., Abingdon OX14 5EB.

RUST, Graham Redgrave, artist (muralist, illustrator and botanical painter) in water-colour and water-based paints; Artist-in-Residence, Woodberry Forest School, Virginia (1967-1968). *b:* Hatfield, 17 Feb 1942. *Studied:* Polytechnic School of Art, Regent St. (1958-60), Central School of Arts and Crafts (1960-61), under Sir Lawrence Gowing, and Norman Blamey, R.A., National Academy of Art, N.Y. (1962). *Exhib:* First exhib. R.A. (1965), over 27 one-man exhbns. since 1964. *Commissions:* Private mural commissions in various country houses in England. Largest work, the South staircase, Ragley Hall, Warwickshire for the Marquess of Hertford (1969-83). Public mural commission, The Theatre, Chipping Norton, Oxon. (1996), The Theatre, Espelkamp, Germany (2002) with Rui Paes. *Publications:* The Painted House (1988), Decorative Designs (1996), Needlepoint Designs (1998), The Painted Ceiling (2001), Revisiting the Painted House (2005). *Clubs:* Brooks's; Art Workers Guild. *Signs work:* "GRAHAM RUST" or "G.R. Rust." *Address:* The Old Rectory, Somerton, Suffolk, IP29 4ND.

RUTHERFORD, Iain, MA, DipAD, ATC. *Medium:* oil, watercolour, oil and soft pastel, gouache, acrylic, prints. *b:* Hitchin, Herts, 28 Jun 1953. *s of:* George (John) Rutherford. one *d. Educ:* Rainham, Kent, New Milton, Hants (comprehensives); Southampton Technical College. *Studied:* Winchester School of Art (1970-71); GoldsmithsCollege (1971-74)(1976-77)(1978-80). *Represented by:* Harlequin Gallery, London www.studio-pots.com. *Exhib:* one-person exhbns: Art Space Gallery, London (1986); L'Artiste Assoiffé Restaurant, London (1993); Harlequin Gallery, London (2002, 04); Group exhbns: ICA; Heatherly Gallery; City of London University; Camden Arts Centre; Whitechapel Open; Leicester Exhibition for Schools and Colleges; Air Gallery; Greenwich Citizens Gallery; Woodlands Gallery; The Gallery at Architecture Ltd.;Barbican Centre; RCA; RA Summer Exhbn; Berkeley Square Gallery; Business Design Centre; Tudor Barn Art Gallery; Harlequin Gallery; The French House Soho; Belgrave Gallery, St.Ives; 'Sharing a View' exhbns (including the late Denis Bowen) at Huddersfield Art Gallery; Derby Museum and Art Gallery; Quarr Gallery, Swanage, Dorset; APT Gallery, London; Burton Art Gallery and Museum, Bideford, Devon; Dimbola Lodge Museum (Julia Margaret Cameron Trust), Isle of Wight. *Works in collections:* The Leicester Collection for Schools and Colleges; Huddersfield Art Gallery; Dimbola Lodge Museum (Julia Margaret

Cameron Trust), Isle of Wight; many private collections in UK and abroad. *Publications:* Directory of Artists, Space Open Studios (London, 1975); Hampstead and Highgate Express; The Hill Magazine; The Guardian; Dictionary of Artists in Britain since 1945; St.Ives Times and Echo, and Hayle Times; The Huddersfield Daily Examiner; Derby Evening Telegraph; 'Sharing a View' catalogues; 'St.Ives 1975-2005, Art Colony in Transition' by Peter Davies. *Works Reproduced:* Directory of Artists, Space Open Studios (London, 1975); The Hill Magazine; Derby Evening Telegraph; 'Sharing a View' Catalogues. *Signs work:* 'Iain Rutherford'. *Address:* 83 Riverdale Road, Plumstead, London SE18 1PD. *Email:* iain@iainrutherford.com *Website:* www.iainrutherford.com

RUTT, Loraine, BA (Hons) Ceramics, HND Surveying and Cartography; Winston Churchill Memorial Trust Travelling Fellowship (1996). *Medium:* ceramics. *b:* Wimbledon, 29 Aug 1962. *m:* Stephen Tomkinson. *Educ:* Maidstone Girls' Grammar School. *Studied:* Central St.Martins (1990), Southbank University (1983). *Represented by:* Start Space, 150 Columbia Road, London E2 7RG. *Exhib:* Michael Simpson Fine Art, London; Ice House Holland Park (2 solo exhbns); Gainsboroughs House, Suffolk; Mall Galleries, London; A.T.Kearney, London; USA: New York, Miami. *Works in collections:* NHS Trust South London and Maudsley, Wooden Spoon House Panels, private collections in the UK and USA. *Commissions:* Bellenden Map Terrace: Bellenden Renewal Scheme, London; Fred Clarke Memorial Map of Jersey: Le Masuriers, Jersey. *Publications:* 'Porcelain' Caroline Whyman (Batsford, 1994). *Principal Works:* ceramics, wall panels. *Clubs:* Society of Designer Craftsmen. *Misc:* research studio ceramics in public art and architecture. *Signs work:* Loraine Rutt. *Address:* c/o Eduardo Sant'Anna, Start Space 150 Columbia Road, London E2 7RG. *Email:* contact@st-art.biz *Website:* www.st-art.biz

RUTTER & BENNETT, Christopher & Evelyn, CR: MA, Dip, ARBS; EB: MA (RCA), BA, ARBS. *Medium:* sculpture, mixed media, drawing. *b:* CR: Catterick, 15 Sep 1961; EB; Gosport, 27 Dec 1964. one *s. Educ:* CR: Maidstone, Wimbledon, City & Guilds of London, East London Uni. Architecture School; EB: Portsmouth, Worthing, Winchester, Royal College of Art. *Represented by:* 'Sculpture at Goodwood'; 'Rollo Contemporary Art'; 'Plan Art'. *Exhib:* 'Sculpture at Goodwood', De Lawarr Pavilion, Bexhill; Rochester City Art Gallery; Rollo Contemporary Art, London; Aspex Gallery, Portsmouth; Turner Contemporary, Margate. *Works in collections:* Sculpture at Goodwood, Dame Stephanie Shirley. *Commissions:* Sculpture at Goodwood; Royal Caribbean Cruises; Chichester, Hastings and Swindon hospitals; Lovells Developers. *Publications:* British Sculptors of the 20th Century; Ten Years of Sculpture at Goodwood. *Misc:* Christopher Rutter and Evelyn Bennett have worked in partnership for 15 years. *Signs work:* 'rb'. *Address:* 2 Queens Road, Faversham, Kent, ME13 8RJ. *Email:* rutterandbennett@yahoo.com

RYAN, John Gerald Christopher, Creator "Captain Pugwash" "Sir Prancelot" "Lettice Leefe-The Greenest Girl in School", "Herris Throod, Extra

Special Agent" and various other children's cartoon characters; freelance artist, illustrator, writer and cartoon film-maker. *Medium:* pen, ink, watercolour. *b:* Edinburgh, 4 Mar 1921. *s of:* Sir Andrew Ryan, diplomat. *m:* Priscilla. one *s.* two *d. Educ:* Ampleforth College. *Studied:* Regent St. Polytechnic. *Represented by:* Jane Gregory Agency. *Exhib:* R.A. *Works in collections:* various. *Commissions:* Catholic Herald - weekly cartoon. *Works Reproduced:* internationally in various magazines and picture-books. Cartoonist 'Catholic Herald' since 1967. *Clubs:* Royal Society of Artists. *Signs work:* "JOHN RYAN." *Address:* Gungarden Lodge, The Gungardens, Rye, E. Sussex TN31 7HH.

RYAN, Thomas, K.C.H.S. (Knight Commander Equestrian Order of the Holy Sepulchre of Jerusalem); K.L.J. (Knight Hospitalier Order of St.Lazarus of Jerusalem); P.P.R.H.A., D.Litt., A.N.C.A.D., Hon.R.A., Hon.R.S.A.; painter in oil, water-colour, pastel, red chalk, coin, postage stamp and medal designer; President, United Arts Club, Dublin, and Limerick Art Soc.; Council mem. Stamp Design Com. An Post; Freeman of Limerick. *b:* Limerick, Ireland, 16 Sep 1929. *s of:* John and Mary Ryan (nee Ryan). *m:* Mary Joyce. four *s.* two *d. Educ:* Christian Brothers School, Limerick. *Studied:* Limerick School of Art (Richard Butcher, A.R.C.A.), National College of Art, Dublin (Seän Keating, Maurice McGonigle). *Exhib:* many one-man and mixed shows in Ireland, G.B., Ukraine, U.S.A., Latvia. *Works in collections:* Mostly portrait and figure subjects: National Gallery of Ireland, President of Ireland official residence, Cardinal's residence Armagh, European Court, E.E.C. Brussels, St. Patrick's College, Maynooth, Kings Inns, Dublin, Royal College of Surgeons, Trinity College Dublin, University College, Dublin, University College, Galway, Limerick University, Dublin Castle, Leinster House (Dáil Eireann), National University of Ireland, Royal Hibernian Academy, Archbishop of Cashel, McKee Barracks (Chiefs of Staff), Government Buildings (Taoiseachs Office), Pro-Cathedral, Christ Church Cathedral, N.C.E.A.; Office Public Works, Pontificial Irish College, Rome, Episcopal Residence, Limerick, Derry, Irish Management Institute, Irish Embassies abroad. *Commissions:* 2002-2003: Hon. Mr. Justice Ronan Keane, Chief Justice, His Eminence, Desmond, Cardinal Connell, Archbishop of Dublin; for National Gallery, Dr. Ken Whittakee. *Official Purchasers:* see above. *Principal Works:* 'The Crucifixion', 'Flight of the Earls', 'GPO 1916'. *Clubs:* Arts Dublin, Friendly Brothers of St. Patrick, Dublin. *Signs work:* "Thomas Ryan." *Address:* Robertstown Lodge, Robertstown, Ashbourne, Co. Meath, Eire.

RYDER, Betty Pamela Dorothy, landscape painter in oil on canvas and board. *Medium:* oil. *b:* London, 5 Jan 1924. *d of:* D.S.R. Ryder, OBE. *m:* P.B.H. Furlong, D.F.C., F.R.I.C.S. two *s.* one *d. Educ:* L.M.S., Parsons Green. *Studied:* Epsom School of Art - mature student (1969-75, John Morley). *Exhib:* N.E.A.C., R.B.A., R.A., Lincoln Joyce, Bookham, David Curzon Gallery, Church Rd., Wimbledon. *Signs work:* "B. Ryder." *Address:* 22 Lansdowne Rd., Wimbledon, London SW20 8AW.

RYDER, Susan, RP (1992), NEAC (1980), NDD (1964), David Murray Travel scholarship (1964); NEAC Critics prize (1990, 1993), Barney Wilkinson prize (1990), Alexon Portrait Competition (1991); painter in oil and water-colour. *b:* Windsor, 14 Mar 1944. *d of:* Capt. Robert Ryder, R.N., V.C. *m:* Martin Bates. one *s.* one *d. Studied:* Byam Shaw School of Painting (1960-64, Maurice de Sausmarez, A.R.A., Bernard Dunstan, R.A.). *Exhib:* R.A., Portrait Painters, N.E.A.C.; one-man shows, Haste Gallery, Ipswich (2), W.H. Patterson, Albemarle St., W1. (1989, 1995, 1999). *Works in collections:* "Miss Pears 1984" Pears Collection, several at Allen and Overy, and James Capel Co. Ltd., Royal Automobile Club. *Commissions:* H.R.H. The Princess of Wales (1982); H.M. The Queen (1997). *Misc:* Vice President R.P. 2002-. *Signs work:* "Ryder." *Address:* 17 Queen's Gate Place, London SW7 5NY. *Email:* paintings@susanryder.co.uk

RYLAND, Christopher, BA Fine Art (1972), ATC(1975), SBA(1995); Winner of SBA President's Award 2001, St.Cuthbert's Mill Award 2007; artist specialising in flower painting in water-colour, also runs art courses from his studio. *b:* Eastbourne, Sussex, 2 Feb 1951. *m:* Pamela Ryland. *Studied:* Goldsmiths' College School of Art, University of London. *Exhib:* The Barbican, London, Antony Dawson Fine Art, London, Medici Galleries, London, R.B.A., Mall Galleries, London, recently two solo exhbns. at John Russell Gallery, Ipswich, Exhibitions John Russell Gallery, Ipswich (Jul 2003, Feb 2006). *Commissions:* Wedgewood, Royal Doulton. *Publications:* articles in Country Life, International Artist. *Signs work:* "Ryland" or "RYLAND." *Address:* 35 Gainsborough St., Sudbury, Suffolk CO10 2EU.

S

SADDINGTON, Donald William, N.A.P.A.; painter in oil, pastel, water-colour, acrylic, specialising in landscape and marine; Tutor in Art Workshops. *b:* Dartford, 31 Aug 1935. *s of:* William S. Saddington. *m:* Vivienne Crouch (decd.). one *s.* one *d. Educ:* Wordsworth Secondary. *Studied:* London College of Printing and Graphic Arts (1950-55), Cricklade College, Andover. *Exhib:* R.I., P.S., R.W.S., R.W.A., R.B.S.A., City A.G., Southampton, Wykeham Galleries, Stockbridge, Westminster Gallery, International Water-colour Exhbn., Tregastel, France and the DFN Gallery, New York, USA. *Signs work:* "D. Saddington." *Address:* 85 Highlands Rd., Andover, Hants. SP10 2PZ. *Email:* don@donsaddington.co.uk *Website:* www.donsaddington.co.uk

SAHAI, Virendra, O.B.E., Dip.T.P., R.I.B.A.; painter in oil and water-colours, and illustrator. *b:* Shahjehanpur, India, 25 Jun 1933. *s of:* Girwar Sahai. *m:* Ingrid Clara Marie. one *s. Educ:* trained as an architect and townplanner. *Studied:* painting: Central School of Art, London. *Exhib:* one-man shows: New Vision Centre and Biggins Gallery, London (1961), Commonwealth Institute, London (1966), Galerie Suzanne de Coninck, Paris (1967), Bear Lane Gallery, Oxford (1967), Horizon Gallery, London (1991); group and mixed exhbns.: Redfern Gallery, London, Commonwealth Biennale of Abstract Art (1961-67), Kettle's

Yard, Cambridge (1996), Reading Museum, Bradford Museum, Brighton Museum, Beaune Gallery, Paris, Cambridge Book and Print Gallery, Wimpole Hall, Cambridge (2003) and others. *Works in collections:* Bradford Museum, Councils for Art Education, Leicester, Oxford and Cambridge University; private collections in England, Nigeria, U.S.A., Canada, Germany, Hong Kong and Spain. *Publications:* Guardian, Art International, Discovering an Historic City - Cambridge. *Misc:* represented India at Commonwealth Biennales. *Address:* 39 New Rd., Barton, Cambs. CB3 7AY.

ST. JOHN ROSSE, Nicholas David, figurative artist in oil, pencil, pastel, gouache, tempera; twice Elizabeth Greenshields Foundation. *b:* London, 18 Sep 1945. *m:* Chantale. two *s. Educ:* University College School. *Studied:* under Pietro Annigoni, Florence, and at the Scuola del Nudo of the Florence Academy, early 60's. *Exhib:* regular one-man shows and group shows London, nationwide and the Continent. *Works in collections:* E. Greenshields Foundation, Montreal, Britannia Royal Navy College, Dartmouth, Lord St.Levan, St. Michael's Mount. *Commissions:* portrait/figure, religious, houses. *Publications:* series of illustrated articles on egg tempera painting 'Artist' magazine (1980). *Works Reproduced:* privately and by leading publishers. *Recreations:* plays clarinet. *Signs work:* "N. St. John Rosse." *Address:* St. Adwen, Trethevy, Tintagel, Cornwall PL34 0BE. *Email:* nicholas@nstjohnrosse.com *Website:* www.nstjohnrosse.com

SALAMAN, Christopher, artist in oil, bronze and resin bronze. *b:* Dorking, 4 Nov 1939. married. *s of:* Easton Salaman, ARIBA. one *s. Educ:* Bedales School. *Studied:* Camberwell School of Art and Crafts under Karel Vogel. *Exhib:* Woodstock Gallery, Upper Street Gallery, Mall Galleries, Margaret Fisher Gallery. *Signs work:* "Christopher Salaman." *Address:* West Park Lodge, High Ongar, Essex.

SALMON, Martin, illustrator in watercolour and gouache; designer (Advertising). *b:* Barnehurst, Kent, 19 Apr 1950. *m:* Janice. *Educ:* Dartford Technical School. *Exhib:* Lincoln Joyce Gallery, Limpsfield Watercolours, Westcott Gallery, Bourne Gallery, Linda Blackstone Gallery. *Works in collections:* Hong Kong, N.Z., Italy, N. America, Switzerland, Kuwait, Spain, etc. *Works Reproduced:* Greeting cards, tablemats, etc. *Signs work:* "Martin Salmon." *Address:* Dome Hill, Caterham, Surrey CR3 6EE.

SALMOND, Ronald, A.T.D. (1938), S.G.A. (1967); wood engraver, etcher, painter, etc.; Head of Art Dept., Preston Manor High School, Wembley (retd.). *b:* Hornsey, 30 Dec 1912. *s of:* Ralph M. Salmond. *m:* Mary. one *s. Educ:* Tollington Grammar School. *Studied:* Hornsey College of Art (printmaking under Norman Janes). *Exhib:* R.A., R.E., R.B.A. *Works in collections:* South London A.G., Ashmolean Museum. *Signs work:* "Ronald Salmond." *Address:* 13 Treve Ave., Harrow, Middx. HA1 4AL.

SALTER, Anthony, graphic designer and printmaker in etching. *b:* London, 2 Mar 1949. *Studied:* Goldsmiths' College School of Art (1966-69). *Exhib:* R.A.,

R.S.P.E.E., P.M.C. *Works in collections:* Rank Zerox, London Borough of Greenwich. *Signs work:* "ANTHONY SALTER." *Address:* 34 Lizban St., London SE3 8SS.

SALTER, Rebecca, B.A. Art and Design; artist in acrylic on canvas, works on paper, woodcut prints;. *b:* Sussex, 24 Feb., 1955. *m:* Geoffrey Winston. *Educ:* Bristol Polytechnic (1974-77). *Exhib:* extensively in Britain and Japan; solo shows: Jill George Gallery (1994, 1996), New York (1997). *Works in collections:* Tate Gallery, British Museum, Portland Museum and San Francisco Museums of Modern Art, Library of Congress, Washington, British Council. *Publications:* Exhibition catalogue (1996, 1998, 1999). *Signs work:* "REBECCA SALTER." *Address:* c/o Jill George Gallery, 38 Lexington St., London W1R 3HR.

SALTZMAN, William, B.S. Education, University of Minnesota (1940); easel and mural painter, designer, teacher; Prof. Emeritus, Macalester College (since 1984); Director-resident artist, Rochester Art Centre, Rochester, Minn. (1948-63), Freelance Studio, Minneapolis, Minn. (since 1963); Prof. of Art, Macalester College, St. Paul, Minn. (since 1966); currently painting and designing stained glass and sheet copper sculpture reliefs for many architectural commissions; exhibiting paintings widely coast to coast; (3) I.F.R.A.A. National awards; Regional/National awards. *b:* Mpls., Minn., 9 Jul 1916. *s of:* Jacob Saltzman. *m:* Muriel. one *s.* two *d. Educ:* University of Minnesota; Art Students League, N.Y.C. *Studied:* as above. *Misc:. Address:* Studio: 5916 Walnut Drive, Edina, Minn. 55436-1750. USA.

SAMUEL, Alison, Cert.Ed., BSc. (Hons) Psych. (Open). *Medium:* oils, acrylics. Works on canvas or board, framed and unframed. *b:* Leamington Spa, 17 Dec 1951. *m:* Philip. two *s. Educ:* Truro High School (1960-70), Bedford College of PE (1970-73), Open University (1996-2000). *Studied:* Physical Education and Art (dissertation on Printing). *Represented by:* Lander Gallery, Truro; Children's Royal Academy, London. *Exhib:* Market St. Mews Gallery, Trelowarren, Lander Gallery, Wavelength Gallery, Crantock Forge Gallery, Falmouth Arts Centre. Prints and cards at Navigator Gallery, Ottakars, Glivian Gallery, Gallery Tresco, Round House and Capstan Gallery,. *Commissions:* A.Scales, H.Mulcahy, P.Christian (N.Z.). *Principal Works:* seascapes (Scilly Isles) and wave forms, enlarged plant forms, abstract work. *Recreations:* sailing, walking. *Address:* Bithek House, Budock Vean Lane, Mawnan Smith, Falmouth, Cornwall, TR11 5LH. *Email:* alisam5@aol.com *Website:* www.silverwellfineart.com

SAMUELSON, Becky, A.S.W.A., H.S., U.A.; marine and landscape artist in pastel and gouache; teacher, Adult Educ. I.O.W. *b:* Oxon, 13 Jul 1959. *m:* Colin. one *s.* one *d. Educ:* self taught. *Exhib:* London (various), Kendall's Fine Art Cowes, Turnpike Gallery Petersfield, Bembridge Gallery I.O.W., H.S., Century Gallery, Datchet, Alexander Gallery, Bristol. *Works in collections:* private. *Commissions:* marine and landscape paintings in pastel, acrylic and gouache. *Works Reproduced:* greetings cards, prints for

WHO'S WHO IN ART

Shanklin Chine, Sailing Clubs, Appuldurcombe House, Priory Hotel, calendar and local cards, prints through 'Art Marketing'. *Recreations:* sailing, gardening. *Clubs:* Bembridge Sailing Club, Brading Haven Yacht Club. *Signs work:* "B. SAMUELSON." *Address:* Kempsford, Hilbre Rd., St. Helens, Ryde, I.O.W. PO33 1TJ. *Email:* becky@beckysamuelsonfinearts.co.uk *Website:* www.beckysamuelsonfinearts.co.uk

SANDERS, Rosanne Diana, S.B.A.; botanical painter in water-colour and printmaker; five R.H.S. gold medals, R.A. miniature award. *b:* Stoke Poges, Bucks., 21 June, 1944. one *s. Educ:* Roedean. *Studied:* High Wycombe College of Art. *Represented by:* Jonathan Cooper, London. *Exhib:* Hunt Institute, U.S.A., S.B.A., Westminster, Tryon & Swann Gallery, London, R.H.S., Devon Guild, and various galleries in Britain; solo exhib., Hortus, London, Jonathan Cooper, Park Walk Gallery. *Works in collections:* Dr. Shirley Sherwood, V. & A. Museum, First National Bank, Johannesburg, S. Africa. *Commissions:* stamps - commemorative plates for H.M. Queen Elizabeth and the Queen Mother. *Publications:* The English Apple, Phaidon Press; Portrait of a Country Garden, Aurum Press; Painting The Secret Life of Nature, Search Press; A Little Book of Old Roses, Appletree Press; The Art of Making Wine, Aurum Press. *Signs work:* "RS" and on prints "Rosie Sanders." *Address:* c/o Jonathan Cooper, Park Walk Gallery, 20 Park Walk, London SW10 0AQ. *Email:* info@rosiesanders.com *Website:* www.rosiesanders.com

SANDERS, Susan Mary, D.F.A. (1968), R.A. Schools Post Grad. Cert. (1971); painter in oil, water-colour, pencil, chalk and gouache; Partner, The Studio, Wye Art Gallery. *b:* Haslemere, 11 Aug 1946. *d of:* Air Commodore P.J. Sanders, D.F.C. *m:* Richard Henry Parkinson. one *s.* one *d. Educ:* St. Mary's School, Baldslow Hastings. *Studied:* Byam Shaw School (1964-68), R.A. Schools (1968-71). *Exhib:* R.A. Summer Exhbn. (1971-98), R.W.A., (1983-88), Mall Galleries (1986-89), Bath, Bristol, Stockbridge, etc. *Works in collections:* Merchant Navy Pensions London, B.& Q. Southampton, and various boardrooms and offices. *Works Reproduced:* Whatmans Ltd. Calendar (1989), advertising of B.& Q. Southampton. *Clubs:* Reynolds, R.A. Schools. *Signs work:* "S. Sanders," "Susan Sanders," or "S.S." *Address:* Restorers House 3 Best Lane, Canterbury, Kent CT1 2JB. *Email:* richard.parkinson@canterbury.gov.uk

SANDERSON, C. J., 1st Prize Corfu Landscapes (1967); Dip. d'Honneur Salon International Biarritz (1974); artist in oil, acrylic, water-colour, pastel, gouache, pencil, etching, Indian ink, stone, clay and wood. *b:* London, 18 Aug 1949. *s of:* James Comber Sanderson, printer. *Educ:* Millfield. *Studied:* Byam Shaw School of Art (1967-71) under Maurice de Saumarez and Ruskin Spear, R.A. *Exhib:* one-man shows: Woodstock Gallery (1974), Gallery Vallombreuse (1974), Gallery Mouffe (1974), Drian Gallery (1979); mixed shows: John Neville (1974), Ashgate Gallery (1973, 1974), Paris Salon (1974), R.A. (1970, 1972, 1973, 1983-86, 2006), Wylma Wayne Gallery (1983), Roy Miles Gallery (1995), Grosvenor Gallery (1995), Bruton St. Gallery (1995), Highgate Fine Art (1999),

Cornelius Gallery (1999-2001), Finalot Fine Art (2001), Guildford House Gallery (2007); Galerie Tamenega, Paris, and 2 websites: artdirectukltd and finalotgal and other mixed shows London and abroad. *Works in collections:* D. J. Redwood White, Warsaw Art Gallery Poland, London, and Paris. *Publications:* 1995 Critics Choice Sunday Telegraph, Arts Review, La Revue Moderne. *Official Purchasers:* Warsaw Art Gallery (1980); Guildhall Gallery (2005). *Recreations:* gardening, music, cooking. *Clubs:* The Organ, The Arts Club. *Signs work:* "C.J. Sanderson." *Address:* 7 Gordon Pl., London W8 4JD.

SANDERSON, Roger, N.D.D. (1951), S.G.F.A. (1985-96), A.O.I. (1980), S.C.A. (1986); painter in water-colour, illustrator, designer (landscapes, figurative, humorous); Senior tutor, Linguaphone Institute's Paris School of Art (1982-94). *b:* London, 23 Nov 1923. *s of:* Herbert Arthur Sanderson, banker. *m:* Hilde Kokorz. one *s.* three *d. Educ:* Dulwich College. *Studied:* Croydon and Epsom Art Schools (Barbara Jones, Michael Cadman, Leslie Worth, Ray Evans). *Exhib:* R.I., R.W.S. Open, R.B.A., P.S., U.A., etc. H.W. Peel prizewinner - drawing S.G.F.A. (1992). Private and corporate collections. *Publications:* illustrations for leading publishers. *Signs work:* "ROGER SANDERSON". *Address:* Bucklers Lodge, St. Ives, Ringwood, Hants. BH24 2NY.

SANDLE, Michael Leonard, RA, FRBS, DFA(Lond.); artist in water-colour and ink, sculptor in bronze; Prof. at The Academy for Visual Arts, Karlsruhe, W. Germany. *b:* Weymouth, 18 Ma 1936. divorced. *s of:* Charles Edward Sandle, C.P.O., R.N. *m:* Demelza Spargo, 1988. one *s. Educ:* Douglas High School. *Studied:* Douglas School of Art, I.O.M. (1951-54), Slade School of Fine Art (1956-59). *Exhib:* group: Young Contemporaries (1957-59), Grabowski Gallery, London (1964, 1966), British Sculptors '72, R.A. (1972), Hayward Annual (1978), Träume vom Frieden, Recklinghausen (1982), etc.; one-man: Drian Gallery (1963), Haus am Lützowplatz, Berlin (1975), Allen Gallery, Vancouver (1975), Fischer Fine Art (1981, 1985), Wilhelm Lehmbruck Museum (1984), Whitechapel (1988), Württembergischer Kunstverein, Stuttgart (1989), Ernst Museum, Budapest (1990), etc. *Works in collections:* Arts Council, British Council, B.M., Imperial War Museum, Leics. A.G., Leics. Educ. Authority, Metropolitan Museum, N.Y., Museum des 20. Jahrhunderts, Vienna, Neuberger Museum of Modern Art, U.S.A., Neue Sammlung, Munich, National-Galerie, Warsaw, Preston Art Museum, Tate Gallery, V. & A., W. German Government, etc. *Signs work:* "Michael Sandle." *Address:* 22a Avonmore Road London W14 8RR.

SANDWITH, Noelle, artist in line (particularly people), water-colour, oil, egg tempera, acrylic, pastel, etching. *b:* 1927. *Educ:* Carshalton House, Surrey. *Studied:* Kingston-on-Thames, Croydon and Heatherley's. *Exhib:* RA, RBA, SWA, Brighton A.G., Waldorf Astoria, New York; one-man show: Foyle's Art Gallery. *Works in collections:* Royal Naval College, Greenwich, Starr Commonwealth, Albion, Michigan, USA, Royal Free Hospital, London, Auckland Inst. and Museum, NZ, National Museum of Australia, British

Museum, London. *Commissions:* Edith Wertheimer Memorial, Royal Free Hospital. *Works Reproduced:* The Times, Sydney Morning Herald, R.A. Illustrated, Revue Moderne, Frost & Reed, etc. *Signs work:* "Noelle Sandwith." *Address:* Howard House, 8 Vicarage Way, Gerrards Cross, Bucks SL9 8AT.

SANFORD, Sheila, RI, RMS, MAA, HS; water-colour artist, miniaturist. *b:* Singapore, 1922. *d of:* A. E. Thornley Jones, shipping agent. *m:* Roy Sanford. three *s. Educ:* Brentwood School, Southport. *Studied:* St. Martin's School of Art. *Exhib:* Llewellyn Alexander (Fine Paintings) Ltd.; MAS-F; RI; RMS; HS; RA Summer Exhbn. *Works in collections:* Miniature Art Society - Florida, Llewellyn Alexander (Fine Paintings) Ltd., Miniature Artists of America, Royal Miniature Society. *Signs work:* "Sheila Sanford." *Address:* Sheepwash Cottage, Uploders, Bridport, Dorset DT6 4PH. *Email:* sheepwashart@gmail.com *Website:* www.sheila-sanford.com

SANIN, Fanny, Prizes: VIII November Salon Prize, Monterrey, Mexico (1963); Selected in open competition among 1500 artists working in the UK to participate in the I Edinburgh Open 100 (1967); Medellin Award, II Coltejer Art Biennial, Medellin, Colombia (1970); represented Colombia, XV International Sao Paulo Biennial, Brazil (1979); Canadian Club Award (1985); Colombia Award in Art (1993); Colombia External Excellence Award, Miami (2006). *Medium:* acrylic, watercolour. *b:* Bogotá, Colombia, 30 Nov 1938. *m:* Mayer Sasson. *Studied:* Degree in Fine Arts, University of the Andes, Bogotá, Colombia (1956-60); Graduate studies in printmaking and art history, University of Illinois (1962-3); Studies in Printmaking at the Chelsea School of Art and Central School of Art, London (1968-9). *Represented by:* Latin Collector Art Gallery, New York; Andrea Marquit Fine Arts, Boston; Alonso Garcés Galería, Bogotá. *Exhib:* selected one-person shows: Modern Art Gallery, Monterrey, Mexico (1964), Lake House Gallery, National University, Mexico City (1965); Museum of Modern Art, Bogotá, Colombia (1965); Museum of Fine Arts, Caracas, Venezuela; AIA Gallery, London; Panamerican Union Gallery (OAS), Washington, DC (1969); National Institute of Culture and Fine Arts, Caracas, Venezuela (1972); Phoenix Gallery, New York (1977, 80, 82); MoMA, Mexico City, Mexico (1979); Garcés Velasquez Gallery, Bogotá, Colombia (1979, 86, 94); Retrospective Exhibition, MoMA, Bogotá (1987); Greater Lafayette Museum of Art, Lafayette, Indiana (1990); InterAmerican Art Gallery, Miami-Dade Community College, Miami, FL (1991); Antioquia Museum, Medellín, Colombia (1996); Color and Symmetry - Retrospective Exhibition 1987-1999, Luis Angel Arango Library, Bogotá, Colombia (2000); Gomez Gallery, Baltimore (2003); National Arts Club, New York (2003); Latin Collector Art Center, New York (2004); Retrospective Exhibition, Colombian Embassy, Washington DC; selected group shows: Summer Exhbn., RBA, London (1968); Brooklyn Museum, New York (1975); British Council, Bogotá, Colombia (1976); School of Fine Arts, Paris, France (1983); Centro Cultural Conde Duque, Madrid, Spain (1984); MoMA, Bogotá (travelling exhbn: Imperial; Palace, Rio de Janeiro, Brazil; Sao Paulo Cultural Center, Sao Paulo, Brazil); Italian-American Institute, Rome, Italy; Centro

Cultural Avianca, Barranquilla, Colombia (1985-6); National Museum of Fine Arts, La Habana, Cuba (1986); Art Museum of the Americas, Washington DC (1992); Interamerican Bank for Development, Hamburg, Germany (1993); Milwaukee Art Museum, Milwaukee, WI (travelling exhbn: Phoenix Art Museum, Phoenix, AZ; Denver Art Museum; Museo de las Americas, Denver; National Museum of Women in the Arts, Washington, DC; Center for Fine Arts, Miami - 1995-6); Sainsbury Centre for Visual Arts, University of East Anglia, Norwich (2004); MoMA, Bogota (2007). *Works in collections:* including: University of Essex Collection of Latin American Art, Colchester; New Orleans Museum of Art, New Orleans, LA; National Museum of Women in the Arts, Washington, DC; Museum of Modern Art, Mexico City, Mexico; Museum of Modern Art, Bogotá, Colombia; Museum of Art, Warsaw, Poland; Museum of Art of the Americas, Washington, DC; Museum of Art of the National University, Bogotá, Colombia; Museum of Contemporary Art, Bogotá; Museum of Art, Monterrey, Mexico; Museum of Abstract Art Manuel Felguerez, Zacatecas, Mexico; Inter-American Bank, Washington, DC; Luis Angel Arango Library, Bogotá, Colombia; Minnesota Museum of Art, St.Paul, MN; Everson Museum of Art, Syracuse, NY; Gallery of Latinamerican Art, Cracovia, Poland; Biblioteque Nationale, Paris, France; Chemical Bank Collection, New York, NY; Colgate University, Hamilton, NY. *Commissions:* set for play "A Clear Midnight from Walt Whitman's Leaves of Grass", Americas Society, New York. *Works Reproduced:* in books: 'L'Art Abstrait 1945/1970, Vol IV', Ragon, Michel & Michel Seuphor (Maeght Editeur, Paris, France, 1974); 'Women Artists in America II' Collins, J. (University of Tennessee, Chatanooga, TN, 1975); 'Historia del Arte Colombiano', Rubiano, Germán (Salvat Editores, Bogota, 1976); 'Cien Años de Arte Colombiano', Serrano, Eduardo (Museo de Arte Moderno, Bogotá, 1985); 'Arte de América Latina 1900-1980', Traba, Maria (Interamerican Bank, Washington, DC, 1994); 'North American Women Artists of the Twentieth Century: A Biographical Dictionary' (reproduced on the cover), Heller, Jules & Heller, Nancy G. (Garland Publishing, New York/London, 1995); 'Latin American Women Artists of the United States', Henkes, Robert (McFarland & Co., Jefferson, North Carolina, 1999); 'Women Artists', Barlow, Margaret (Hugh Lauter Levin Associates, 1999); St.James Guide to Hispanic Artists', Riggs, Thomas (ed.), (St.James Press, Farmington Hills, MI, 2002); 'Why a Painting is like a Pizza - A Guide to Understanding and Enjoying Modern Art', Heller, Nancy G. (Princeton University Press, Princeton, NJ, 2002). *Clubs:* National Arts Club, New York. *Signs work:* "Fanny Sanin". *Address:* 345 E.86th St., Apt. 17C, New York, NY 10028, USA. *Email:* sassonm@coned.com *Website:* www.lablaa.org/blaavirtual/todaslasartes/sanin/indice.htm www.colarte.com/colarte/conspintores.asp?idartista=525 www.latincollector.com/artists/index.php?lang=en

SANN, Tin Tin, Council Member of United Society of Artists. *Medium:* oil, watercolour, batik (one of the 1st Burmese artists to create and exhibit batik paintings in Burma, 1975). *b:* Thayet Myo, Myamar, 20 Oct 1944. *d of:* Dr Ba

Khet and Daw May Yu. *m:* Dr. M.Salman Raschid. *Educ:* BSc (Hons) 1966, MSc 1974, ADSC 2000. *Studied:* Rangoon Arts and Science University, Martran College (Marketing and Communications). Painting: under U Lun Gwye and Dr. Sun Myint (State School of Fine Arts); sculpture: U Soe Tint (State School of Fine Arts Rangoon); Chinese watercolours under U Lawsan. *Represented by:* Art on the Hill Gallery, Bushey, Herts; Wine Street Gallery, Devizes, Wiltshire. *Exhib:* since 1968 has participated in more than 50 exhibitions in Burma; (1981-82) Cambridge, Mass. USA, four one-person shows including one at Harvard Law School; regularly exhibited at BBC Art Society Annual Exhbn. since 1983; 1986 one-person show in London (sponsored by Alliance and Leicester Building Society; 2003, 142nd Society of Women Artists Annual Exhbn.; 2003, 'Breaking the Waves' Wine Street Gallery, Devizes; many London Exhbns., United Society of Artists since 2003. *Works in collections:* Rangoon Arts and Science University, UNESCO, Paris, private collections all over the world-Burma, Nepal, UK, USA, Germany, Norway, Australia, Russia. *Commissions:* 3R Exhibtion in Myanmar (Burma) early '70s, private commissions for portraits, landscapes and seascapes. *Official Purchasers:* Rangoon Arts and Science University, UNESCO during 3R Exhbn. in Burma. *Recreations:* going to art exhbns, concerts, theatre, opera, pilates, gym, swimming, walking. *Clubs:* BBC Art Club and Life Style Club, UA. *Misc:* one of the pioneers of Young Avant-Garde Art Movement in Burma (Myanmar). *Signs work:* Tin Tin Sann. *Address:* 15 Hillfield Mansions, Hampstead, London NW3 4ZR. *Email:* tin-tin-sann@bbc.co.uk *Website:* www.tin-tin-sann.narod.ru

SANZ-PASTOR Fz. de PIÉROLA, Consuelo, Doctor of History; Chairman of I.C.O.M. National Committee (1981-84); Mem. Hispanic Society of America (since1959); Directora Museo Cerralbo (1942-86); Inspectora Museos Bellas Artes (1963-69); Chairman of Sup. Council of Museums (1980-82); Mem., Trustees the Prado Museum (1980-85); Directora Honoraria Museo Cerralbo (since 1986). *b:* Madrid. *Publications:* Guia Museo Cerralbo (4th ed. 1981), Catálogos Exposiciones A. Berruguete (1960), San Pablo en el Arte (1963), Francisco de Zurbarán (1964), Museos y Colecciones de España (5th ed. 1990), Guia Museo Casas Reales (Rep. Dominicana 1976), Museo Cerralbo: Catálogo de Dibujos (1976). *Address:* Juan Hurtado de Mendoza 9-28036 Madrid Spain.

SAPIEHA, Christine, S.W.A., A.P.A.; painter in acrylic, portraits, sculpture; therapist;. *b:* Vienna, 5 May, 1934. *m:* Adam Fremantle. two *s. Educ:* The Brearley, N.Y.C., Georgetown University, Washington D.C. *Studied:* Abbott School of Art, Washington D.C. (1951-52), Parsons School of Design, N.Y.C. (1952-56). *Exhib:* Mall Galleries, Spirit of London, R.A. Summer Show, Francis Kyle, Stable Gallery, Ice House, Bush House, Beach Thomas Gallery, Burford, Gallery East, N.Y., Westminster Gallery. *Works in collections:* Sheldon Weisfeld, Brownsville, Tex., W.A.S.L. *Publications:* illustrated science and fiction for children, local press. *Address:* 20 Macduff Rd., Battersea, London SW11 4DA.

SAPP, Prudence Eugenie, (née Williams); School Cert. with Hons. in Art and English (1945); painter in oil. *b:* London, 11 Mar 1928. *m:* Reginald Walter. *Educ:* Wycombe Abbey; Benenden School, Kent; English School of Languages, Chateau d'Oex, Switzerland. *Studied:* C.F.E. Bognor Regis (1964), portraiture at Epsom A.E.C. (1974, Reg Sapp). *Exhib:* one-man shows: Hyde Park Gallery (1992, 1993); two-man shows: Barnes Gallery, SW13 (1994, 1995); Mall Galleries since 1974; R.A. Summer Exhbn. (1987, 1992-95, 2004, 2005), Llewelyn Alexander Autumn Exhibitions (2000, 2001, 2003). *Works in collections:* America, Sweden, Japan. *Commissions:* portraits undertaken. *Clubs:* Chelsea Art Soc. *Signs work:* "Prue Sapp." *Address:* 19 Waterer Gdns., Tadworth, Surrey KT20 5PB.

SAUMAREZ SMITH, Romilly, Fellow of Designer Bookbinders; bookbinder;. *b:* London, 10 Feb., 1954. *m:* Charles Saumarez Smith. two *s.* *Studied:* Camberwell School of Art and Crafts (1975-78). *Exhib:* many bookbinding exhbns. since 1982. *Works in collections:* Crafts Council, V. & A., N.Y. Public Library, H.R.C., Austin Texas, British Museum. *Publications:* reviews and articles for Crafts Magazine. *Address:* 13 Newell St., Limehouse, London E14 7HP.

SAUNDERS, Jutta Gabrielle, Slade Dip.; painter in oil and water-colour, portrait sculptor; tutor. *b:* 10 Jul 1929. *d of:* Felix Callman, L.D.S., R.C.S. *m:* Vernon Saunders. one *s.* one *d.* *Educ:* The Hall School, Somerset, St. Maurs, Weybridge. *Studied:* Kingston School of Art (1945-48), Slade School of Fine Art (1948-51) under William Coldstream, John Piper; sculpture under F.E. McWilliam. *Exhib:* R.A., R.W.A., Leicester, London and provincial galleries. *Works in collections:* in England, U.S.A., Brazil, Germany, France, Sweden and Canada. *Commissions:* National Trust, and portraits. *Official Purchasers:* Elmbridge Museum, Weybridge. *Signs work:* "J.S." or "J.G.S." or "J. Saunders." *Address:* Flint House, Oatlands Mere, Weybridge, Surrey KT13 9PD.

SAVAGE, Judith, L.D.A.D.; artist in oil on canvas;. *b:* Sydney, Australia. one *s. Educ:* Australia. *Studied:* Interior Design and Decoration and Mural Design, Chelsea College of Art (1977-80). *Exhib:* London: Loggia Gallery, Leighton House, C.W.A.C., etc. *Misc:* Specialises in colour: therapeutic, psychological, symbolic aspects. Studies in art therapy, psychology, sociology (1991-92). Guest Lecturer Chelsea College of Art. Currently working St. Bernards Psychiatric Hospital, Ealing. *Signs work:* "J. Savage." *Address:* 32 Mansell Rd., The Vale, London W3 7QH.

SAVAGE, Nicolette Jane, SWA; Society of Feline Artists; NDD; ATC. *Medium:* ceramics, watercolour, drawing, prints. *b:* London, 2 Feb 1943. *d of:* Ernest Savage PVPPS (decd). *m:* Tom Jaffray. *Educ:* Plaistow Grammar School. *Studied:* Goldsmiths College, School of Art (1961-66); Guildhall School fo Music and Drama (Opera Singing)(1970-72). *Exhib:* etchings and paintings: RA Summer Exhbn (2003, 04, 05); SWA; Assoc. of Sussex Artists; Llewelyn

Alexander; Peter Hedley Gallery; annual one-man show Bromley; ceramics: Chelsea Flower Show; Petworth House; Bettles Gallery. *Works in collections:* many private collections inc. Lord Sterling; Herb Adler (USA). *Commissions:* private commissions of etchings, paintings and garden ceramics. *Works Reproduced:* greeting card designs, Woodmansterne; RA postcard (2004). *Principal Works:* 'First Flight', etching ed. 150 (sold entire edition RA 2004). *Recreations:* gardening, singing, animal welfare. *Misc:* Head of Art Dept., Blackheath High School (1966-70); Bromley Adult Education tutor in printmaking and pottery (1972-99). *Signs work:* 'Nicolette Savage'. *Address:* 145 Goodhart Way, West Wickham, Kent BR4 0EU. *Email:* nicolettesavage@aol.com

SAVIC, Nikola Ritterman, BA Fine Art; MA Fine Art; Award: Atkinson Gallery, Somerset (selected as one of best 30 Post-graduates in Fine Art from all UK Universities). *Medium:* acrylic on canvas. *b:* Belgrade, Serbia, 19 Feb 1973. *s of:* Voin Savic (composer), M.Ruza Savic (architect). *m:* Tanja Savic (shoe designer). one *s. Studied:* Belgrade Academy of Art (1992-97); Central St.Martins College of Art & Design (1998-99). *Represented by:* Flora Fairburn, London; Gallery Zvono, Belgrade; Stephen Mahoney, London; Rollo Contemporary Art, London. *Exhib:* RA Summer Exhbn (2004); Contemporary Art Society 'Art Futures' (2003, 2004, 2005); Museum of Modern Art, Belgrade (2005); Contemporary Art Auction, Marine Stewardship, Billingsgate Market, London (Damien Hirst, Tracy Emin, Cathy Demonchioux, etc.); October Salon, Belgrade; Gallery Zvono, Belgrade;. *Works in collections:* MoMA, Belgrade; The Bank of America, London; European Diamonds plc, London; private collections London, Moscow, Cologne. *Publications:* many catalogues and newspaper reviews in UK and abroad. *Works Reproduced:* Soen Magazine, Tokyo; Royal Summer Exhibition Illustrated, London; The Times, Play Supplement; MoMA Belgrade Catalogue; Politika Newspapers, Belgrade; Blic Newspapers, Belgrade; Independent Newspapers. *Clubs:* Chelsea Art Club. *Signs work:* 'NIKOLA VOIN SAVIC'. *Address:* Flat 3, 71 Haverstock Hill, London NW3 4SL. *Email:* rittermansavic@hotmail.com

SAWYER, David James, RBA (2004); Daler Rowney Award, RBA (2005); Katherine William-Powlett Memorial Award for Watercolour, Chelsea Arts Society (1997); Education Purchase Prize awarded, RBA (2006). *Medium:* oil, watercolour, drawing. *b:* London, 19 Jul 1961. *s of:* James & Cynthia Sawyer. *Studied:* Canterbury College of Art. *Represented by:* Panter & Hall, The Wykeham Gallery, Thompson's Gallery; Crossgate Gallery, Kentucky, USA; Denise Yapp, Contemporary Art, Monmouth; Jeremy Barlow Fine Art, Norfolk. *Exhib:* solo exhbns: Panter & Hall (2001-07); Thompsons Gallery, Aldeburgh (2004, 2007); The Wykeham Gallery, Stockbridge (2002); The Ashdown Gallery, Sussex (1998); Gallery Forty-Seven (1994, 95, 97); Primrose Hill Gallery (1996); selected group exhbns: RBA (2003, 04, 05); RI (1996, 97, 99, 2000, 01); NEAC (2003, 04); RSMA (2004); Mall Galleries; Sadler Street Gallery (2003-05); W.H.Patterson Fine Art Ltd. (1999-2007); Hesketh Hubbard Art Society (2001); The Wykeham Gallery (1998, 2001, 03, 05, 06). *Works in collections:* private

collections worldwide. *Commissions:* 3 oil paintings for the State Rooms of the Cunard Liner 'Queen Mary II' (26 limited edition prints of each painting, 2003); "Skylines for Baordrooms", views from the 8th floor of the Friedfrank building, City Rd, London EC1 (2006-07). *Publications:* Artists and Illustrators Magazine (March 1998, May 1998, Oct 2000). *Recreations:* interior and garden designing. *Misc:* also resides at: 1 Rue du Pont, St.Lizier 09190, Ariege, France; modern British Impressionist. *Signs work:* 'David Sawyer', 'D.Sawyer', 'DJS'. *Address:* 10 Corsehill St., London SW16 6NF.

SAWYERS, David Robert, A.T.C. (1964), A.R.E. (1964), M.A. (1983); topographical draughtsman in pen and ink with water-colour washes. *b:* Brighton, 29 Apr 1941. married. one *s.* one *d. Educ:* Varndean Grammar School, Brighton. *Studied:* Brighton College of Arts and Crafts (1959-64), University of Sussex (1982-83). *Exhib:* Gardner Centre, Bankside Gallery, Corn Exchange and Gallery, Brighton Museum and Library. *Works in collections:* held by Leoframes, 70 North Rd., Brighton. *Recreations:* all year round sea bathing. *Signs work:* "D.R. Sawyers." *Address:* 34 Kensington Place, Brighton BN1 4EJ.

SAYERS, Brian, B.A. (1978); painter in oil on canvas;. *b:* Bromley, Kent, 3 Oct., 1954. one *d. Educ:* St Olave's Grammar School, Kent. *Studied:* Slade School of Fine Art (1974-78, Jeffery Camp, Patrick George). *Exhib:* R.A., N.P.G., Long & Ryle, Hohental & Littler, Munich, Discerning Eye, Mall Galleries (1st Prize). *Signs work:* "Brian Sayers" on reverse. *Address:* 27a Walterton Rd., London W9 3PE.

SAYLE, Norman Alexander, ATD (Goldsmiths), BA (Open), RI; winner of RI medal at Mall Galleries, 1st prize and three times winner of 3rd prize Singer & Friedlander Watercolour Competition at Mall Galleries. *Medium:* mainly watercolour. *b:* Douglas, Isle of Man, 13 Dec 1926. *s of:* Alexander & Mona Sayle. *m:* Rosemary. one decd. *s Educ:* Douglas High School; Isle of Man Art School; U.of L. Goldsmiths' School of Art. *Studied:* NDD Illustration (special level), ATD. *Exhib:* RI, RWS, Singer & Friedlander, Discerning Eye, Richard Hagen (Worcs.), IoM National Heritage. *Works in collections:* IoM National Heritage, private collections. *Commissions:* private. *Publications:* 'Artist & Illustrators' magazine, 'Watercolour' magazine. *Address:* 56 King Edward Road, Onchan, Isle of Man, IM3 2AT.

SCALES, Terry, National Diploma Fine Art; Arts Council Award (1972, 1983); Lottery Awards (2000, 2005). *Medium:* oil, watercolour, drawing. *b:* Rotherhithe, London, 16 Nov 1932. *s of:* Sidney Jacob Scales & Elizabeth Driscoll. one *s.* one *d. Educ:* Sir Walter Trevelian, Seaton, Devon until 1945. *Studied:* Camberwell School of Art (1946-52). *Represented by:* various London galleries throughout career. Currently Harlequin Gallery, Greenwich. *Exhib:* RA (1976, 83, 84, 85); London Group (1960, 64); Scottish Arts Council Travelling Show (1972); Ikon Gallery, B'ham (1976); Arts Council South Bank Show (1987); Belgrave Gallery, Camberwell Artists (1988); Austin Desmond Fine Art

(1989); Michael Parkin Gallery (1995, 96); major retrospective, City of London Guildhall Art Gallery (2003). *Works in collections:* South London Gallery, The Guildhall Art Gallery, London Boroughs of Southwark and Lambeth; The Landmark Trust. *Commissions:* National Maritime Museum, The Civil Service, Tate & Lyle, Scruttons plc, London Borough of Southwark, and many private commissions. *Publications:* 'Bermondsey Boys' (1999); 'Visions of Greenwich Reach' (2000). *Official Purchasers:* City of London Guildhall Art Gallery; Civil Service; London Borough of Southwark. *Works Reproduced:* The Countryman Magazine (1972); BBC1 TV Royal Academy Review (1984); The London Magazine (1995); British Satellite News, profile (Guildhall Exhbn, 2003). *Recreations:* classical music, jazz. *Misc:* publication of three books: 'Bermondsey Boys', 'Visions of Greenwich Reach', 'To Seaton With Love' commissioned by the Axe Vale Heritage Association. *Signs work:* 'Terence Scales'. *Address:* 12 Prior Street, Greenwich, London SE10 8SF.

SCHAVERIEN, Pat, B.A, Hons. in Fine Art (1974), Slade Higher Dip. in F.A. (1976); printmaker in etchings-collographs and linocuts;. *b:* London, 12 Oct., 1951. *m:* Charles Frydman. *Educ:* Middlesex Polytechnic (1970-74). *Studied:* Slade School of Fine Art (1974-76). *Exhib:* R.A. Summer Exhbns. and mixed shows. *Works in collections:* V. & A., Museum of London, British Council, Guildhall Library, City of London. *Commissions:* The site of Bracken House, London, by the Museum of London, Henderson Assoc. Bldg., Broadgate, London. *Address:* 12 Frognal Lane, London NW3 7DU.

SCHETNEV, Leonid, SWE (2006); Artists Union of Russia (1982); Awards: The Sign on the Ministry of the Russian Federation "For Achievements in Culture" (2002). *b:* Sokol, Vologda, 1942. one *s.* two *d. Studied:* Graphic Arts Faculty, Kostroma Pedagogical Institute (graduated 1981). *Exhib:* A participant of numerous national and foreign exhibitions, about ten solo, the most recent being Vologda (1997), and the Museum of Bookplate, Moscow (1999). Participated in the International Ex Libris Congresses in Austria (1980), St.Petersburg (1998), USA (2000), Denmark (2002). *Works in collections:* many in State museums and picture galleries, also in private collections around the world. *Works Reproduced:* Has created more than 400 bookplates, 80 easel engravings, and over 30 complimentary postcards. *Address:* P O Box 30 Vologda, 160000, Russia. *Email:* leonschet@yandex.ru *Website:* www.cultinfo.ru/schetnev

SCHILDERMAN, Pamela, FPS; First Prize '15 Anniversary Show' Cupola Art Galelry (2006); prizewinner, 'Re-Worked Exhbn', Oriel Washington Gallery (2006); prizewinner, '3-D Show', Surface Gallery (2005). *Medium:* painting, drawing, installation. *b:* 4 Feb 1982. *d of:* Theo Schilderman. *Studied:* Goldsmiths University (BA Hons, 2004); Princethorpe College (1998-2000); Warwickshire College (2000-01). *Exhib:* St. Martins Church, Birmingham, St.Andrews Church Rugby (2007); St.Pancras Church Crypt (2004, 2007); Red Gallery (2006); Bankside Gallery (2007); Cupola Art Gallery (2006); RSA (2006); Bury Art Gallery (2006); Surface Gallery (2005, 2006); Oriel Washington

Gallery (2006); Qube (2005); Shrewsbury Museum & A.G. (2005); Stroud House Gallery (2005); Artworks-MK (2005); Crescent Art Gallery (2005); Rugby Art Gallery (2004); Mall Galleries (2004); The Atkinson Art Gallery (2004). *Publications:* SSA 109th Annual Exhibition 2006 (Woods of Perth Ltd.); 'The Art of Recycling' (Washington Gallery Education publication, Dalton Printers, 2006); The Discerning Eye Exhbn (2004). *Works Reproduced:* 'Punctum', 'Allusions', 'Miniatures 30', 'Void'. *Principal Works:* 'Bula Matari', 'Almas','Oculto', 'Punctum', 'Allusions'. *Signs work:* 'PAMELA SCHILDERMAN'. *Address:* 3 Main Street, Clifton-upon-Dunsmore, Rugby, CV23 0BH. *Email:* pamela.schilderman@btinternet.com *Website:* www.pamelaschilderman.com

SCHLEE, Anne H., P.P.N.S.; artist in water-colour, acrylic, ink; Cert. Fine Art (1972); Hon. Officer, National Soc. Painters, Sculptors and Printmakers. *b:* Shanghai, China, 6 Sep 1931. *d of:* the late Anker B. Henningsen. *m:* Charles A. Schlee. three *d. Educ:* Katharine Branson School, California. *Studied:* International School (1962-65, Chinese art: Chow Chian-Chui), Famous Artists' School (1970-72, Charles Reid, John Pellew, Joseph Laskar, Ray Peese). *Exhib:* Hong Kong, N.S., Chelsea Art Soc., Ridley Art Soc., Women Painters of Washington, Rogue Gallery and Art Center. *Works in collections:* Guildford House Museum and Gallery, University of W.A. Medical Centre – permanent art collection; private collections in U.S.A., Canada, Australia, U.K., etc. *Official Purchasers:* Guildford House Museum and Gallery, University of W.A. Medical Centre. *Works Reproduced:* Best of Water-colour Series - Textures (Rockport). *Clubs:* N.S., W.P.W. *Signs work:* "Anschlee." *Address:* 6554 Monte Vista Drive N.E., Bainbridge Island, W.A. 98110, USA.

SCHLEE, Nick, M.A. (Oxon.). *Medium:* painter in oil. *b:* 17 Jul 1931. *m:* Ann Acheson Schlee. one *s.* three *d. Educ:* Rugby School (1942-47), Oxford (1952-55). *Studied:* Evening Classes, Art Students League New York, Central School London, Morley College, Putney Art School, Slade. *Exhib:* one-man, Flying Colours Gallery, Edinburgh (1992), Barbican Centre, University of Liverpool (1994), Christchurch Picture Gallery, Oxford (1996, 2003), Gallery 27, London (1998, 2000, 2002, 2004, River and Rowing Museum (2002). *Works in collections:* Guildhall Art Gallery, London; Swindon Art Gallery, Reading Art Gallery, River and Rowing Museum, Henley; Southampton City Art Gallery, Liverpool University, Wessex Collection, Longleat. *Address:* Galvey, Upper Basildon, Reading RG8 8LU. *Website:* www.nickschlee.co.uk

SCHOFIELD, David Owain, BA (Hons); Latimer Award, Royal Scottish Academy; N.S.Macfarlane Award; The David Cargill Award; James Torrance Award (all RGI). *Medium:* oil. *b:* Wrexham, 12 Jan 1972. *s of:* Gerry Schofield & Mary Rogers. one *d. Educ:* Nairn Academy. *Studied:* Duncan of Jordanstone College of Art Dundee (1989-93). *Exhib:* various group shows: RGI, RSA; solo shows: Henshelwood Gallery, Newcastle; Open Eye Gallery, Edinburgh; Rendezvous Gallery, Aberdeen. *Works in collections:* private collections. *Commissions:* private. *Signs work:* 'D.S.' or 'D.Schofield'.

Address: 85 Beach Crescent, Broughty Ferry, Angus DD5 2BG. *Email:* tigercalmdown@hotmail.com *Website:* www.david-schofield.com

SCHOFIELD, Roy Malcolm, N.D.D. (1953), M.S.I.A. (1973), G.R.A. (1986); illustrator in pen, ink and wash, painter in watercolour and mixed media; art director, Field Enterprises Educational Corp. (1962-1967), tutor, Sutton College of Liberal Arts (1979-1983). *b:* Huddersfield, 8 Jul 1933. *m:* Dorothy. one *s. Educ:* Hillhouse School. *Studied:* Huddersfield School of Art (1948-1953). *Publications:* illustrator and designer of many books for Brockhampton Press, Holmes McDougal, Edward Arnold, Macdonald, Ginn & Co., Cornelsen, Berlin, and own imprint, 'Travel About Books' for children. *Signs work:* "Roy Schofield." *Address:* 39 Northey Ave., Cheam, Surrey SM2 7HS. *Email:* roy@schofield39.Wanadoo.co.uk

SCHOFIELD, Sara Anne, F.S.B.A. (1986); R.H.S. Gold medal (1987, 1991); artist, primarily botanical, also animals, birds, landscape, seascape, still-life. *Medium:* water-colour, chromacolour, pastel. *b:* London, 21 May 1937. *d of:* artists, Sara & Francis Sutton. *m:* John Schofield. one *s.* one *d. Educ:* Ashford County Grammar School. *Studied:* Twickenham College of Art. *Exhib:* solo shows: London (3); solo and group shows: R.W.S., R.B.A., R.I., S.B.A. and around the UK regularly. *Works in collections:* Hunt Inst. of Botanical Documentation; Carnegie Mellon University, Pittsburgh; The Shirley Sherwood Collection of Contemporary Botanical Artists, and many private collections worldwide. *Commissions:* numerous series of collectors plates, several of them Royal commemoratives. *Publications:* 'The Artist' magazine. *Works Reproduced:* in books of collections, reference, and in Society of Botanical Artists; Fine Art prints and cards. *Clubs:* Founder mem. S.B.A. *Signs work:* "SARA ANNE SCHOFIELD" or "S.A.S." *Address:* 40 Grove Wood Hill, Coulsdon, Surrey CR5 2EL.

SCHWARTZ, Bernice Rochelle, Silver Medal, Grand Palais, Paris (1985). *Medium:* sculpture, cast bronze, drawing, prints. *b:* Zambia, Africa. *Studied:* Art Students League, New York; Accademia de Belle Arte, Rome; Michaelis School of Art, Cape Town, SA; Open Studio, Toronto, Canada. *Works in collections:* Library of Congress; Texaco; Esso. *Address:* 21 Howland Avenue, Toronto, Ontario M5R 3BZ Canada.

SCOTT, Celia Maxwell, BSc (Hons); DipArch (Lon), RIBA, AIA, FRSA. *Medium:* sculpture: bronze, iron, plaster, oil paint. *b:* Bristol, 5 Apr 1947. *d of:* John Moffatt Cuthbert Scott. *m:* Prof. Robert Millar Maxwell. *Educ:* Cambridgeshire High School for Girls. *Studied:* Corsham, Bath Academy of Art, Bartlett School of Architecture, UCL. *Exhib:* Royal Academy, London; John Nichols Gallery, New York; Museum of Modern Art, Ostend, Belgium, and others. *Works in collections:* H.R.H. The Prince of Wales; Scottish National Portrait Gallery; Dean Gallery, Edinburgh; National Trust for Scotland, 28 Charlotte Square; British Library. *Commissions:* portraits: by Mies van der Rohe

School Aachen, of Mies; by Charle Jencks of Sir Eduardo Paolozzi as Vulcan; Sir James Stirling; Prof. Sir Colin St.John Wilson; Sir Terry Farrell; Richard Meier; Peter Eisenman; John Miller; Edward Jones; Michael Graves; Leon Krier, David Attenborough and others. *Publications:* 'Between Earth and Heaven' (PMMK Ostend, Belgium, catalogue), Celia Scott (Black Dog Publishing, forthcoming). *Official Purchasers:* Scottish National Portrait Gallery. *Works Reproduced:* illustrated: Scottish National Portrait Gallery website. *Principal Works:* portraits of Sir James Stirling, Sir Eduardo Paolozzi, Sir Terry Farrell, Leon Krier, David Attenborough. *Recreations:* architecture, walking, swimming, travel. *Signs work:* 'Celia Scott' or 'Celia Maxwell Scott'. *Address:* 3 Mall Studios, Tasker Road, London NW3 2YS. *Email:* mail@celiascott.com *Website:* www.celiascott.com

SCOTT, Dafila Kathleen, S.WL.A. (1991), M.A. (1975), Ph.D. (1978); painter. *Medium:* oil, water-colour, pastel, acrylic. *b:* London, 9 Jun 1952. *m:* Tim Clutton-Brock. one *s.* one *d. Educ:* Badminton School, Millfield School, Oxford University, Cambridge University. *Studied:* in the studios of Peter Scott (during childhood), Thomas Newbolt and Robin Child. *Publications:* illustrated 'Antarctica: A Guide to the Wildlife' by Tony Soper (Bradt Publications, 1994). *Signs work:* "Dafila Scott" or "DKS." *Address:* White Roses, The Hythe, Reach, Cambs. CB5 0JQ. *Email:* dafilascott@yahoo.co.uk

SCOTT, I. Borg, Associate, Société des Artistes Français, F.R.S.A.; artist in oil and sanguine chalk;. *b:* 4 Feb., 1940. *Studied:* under Leonard Boden, R.P., and F. Wyatt, V.P.S.W.A., R.M.S. *Exhib:* Salon des Artistes, France; Salon Sony, Osaka, Japan; European Art, Auckland, N.Z.; Roy Miles, London; group shows: Westminster Gallery; Gagliardi Gallery, etc. *Signs work:* "I. Borg Scott." *Address:* 8 Colinwood, Colinwood Rd., Farnham Common, Berks. SL2 3LN.

SCOTT, Jac, ARBS; BA (Hons) Design Crafts. *Medium:* sculpture. *b:* Bournemouth, 12 May 1959. *m:* Michael Slaney. two *s. Studied:* University of Cumbria (1991-96). *Represented by:* Beverly Knowles Fine Art; Lowood Gallery. *Exhib:* throughout UK including: Commonwealth Institute, London (1995); Whitworth Art Gallery, Manchester (1995); Museum for Textiles, Edinburgh City Arts Centre (1999); Bankfield Museum, Halifax (2001); Oxo Peugeut Design Awards (Shortlisted, 2001); V&A Museum (2002-3); Sheffield Millennium Galleries (2004); Royal Hospital (2006); Brewery Arts Centre, Kendal (2006); Customs House, Sheffield (2007). *Works in collections:* Bowes Museum, Tullie House Museum. *Commissions:* Feather Brooksbank (corporate); Designed for Dales (public); Bowes Museum; Tullie House Museum. *Publications:* Artist author of 'Textile Perspectives in Mixed-Media Sculpture' (Crowood Press, 2003). *Misc:* visiting lecturer at various universities. *Signs work:* 'Jac Scott'. *Address:* Studio, Swallow Cottage, Broughton Beck, Ulverston, Cumbria, LA12 7PR. *Email:* studio@jacscott.com *Website:* www.jacscott.com

SCOTT, Judy, N.D.D. (1961), C.S.D. (1962); winner of R.W.S. Abbott & Holder Travel Prize (1993), National Print Exhibition, St. Cuthbert's Mill Prize

WHO'S WHO IN ART

(2001) and Eastern Open Print Prize (2005). *Medium:* figurative painter in gouache and oils, printmaker. *b:* Herts., 7 Nov 1939. *Educ:* Longdene, Chidingstone, and St. Christophers, Letchworth. *Studied:* Maidstone College of Art (1956-58, Dick Lee), Central School of Arts and Crafts (1958-62), mid 80's, Dick Lee. *Exhib:* solo shows: Abbott & Holder, and Cadogan Gallery, London; Bircham Gallery, Norfolk; selected mixed shows: New Grafton, N.E.A.C., R.P., R.I., R.W.S., Garrick-Milne and National Print Exhibition. *Commissions:* portrait paintings and theatre prints for 'Open Stage' Company, and actors/performers. *Works Reproduced:* FPBA/Clarion Press: Alphabet Book Competition (2002 supplement). *Signs work:* "J. Scott." *Address:* 4 Church Cottage, Bale, Fakenham, Norfolk NR21 0QZ.

SCOTT, Richard Ridsdale, National Diploma in Design (Sculpture). *Medium:* oil. *b:* Bromley, Kent, 5 May 1938. *s of:* Eric & Marjorie Scott. *m:* Lesley Scott. two *d. Educ:* Cranbrook School, Kent. *Studied:* Lowestoft School of Art (1954-56, Intermediate), Camberwell School of Art & Crafts (NDD, 1956-58), (post-NDD year 1960-61). *Exhib:* solo: Chappel Galleries, Essex (1999, 2007); Ipswich Borough Council, Christchurch Mansion (2002). Mixed: RA (1984); Suffolk Group (since formation in 1991); NEAC (most years since 1992). *Works in collections:* Ipswich Borough Council Museums and Galleries. *Commissions:* many private commissions. *Publications:* Author of "Artists at Walberswick: East Anglian Interludes 1880-2000" (Art Dictionaries Ltd., 2002); "The Walberswick Enigma" (Ipswich Borough Council Museums and Galleries, 1994); Contributing author: "Southwold: Portraits of an English Seaside Town" (Phillimore, 1999), "Painting at the Edge" (Sansom, 2005). *Works Reproduced:* in: 'Making Waves', Ian Collins (Black Dog Books, 2005), 'Southwold: An Earthly Paradise' by Geoffrey Munn (Antique Collectors Club), 'Artists at Walberswick' (see above). *Recreations:* writing. *Clubs:* Founder Member, The Suffolk Group, Life Member, Ipswich Art Society. *Signs work:* "R.R.SCOTT". *Address:* Samphire Cottage, The Green, Walberswick, Suffolk, IP18 6TX. *Website:* www.thesuffolkgroup.co.uk

SCOTT, Sally, painter in oil, pastel, drawing and lithography, glass engraver in sandblasting and engraving on flat architectural glass; Partnership with David Peace, Peace and Scott (1986-2002). *b:* London, 28 Jan 1939. *d of:* Sir Hilary Scott. *m:* Tony Guy, graphic designer (decd.). one *s.* one *d. Educ:* Benenden School, Kent. *Studied:* Croydon College of Art (1957-59), R.A. Schools (1959-62). *Works in collections:* glass work in Norwich, Leicester, Llandaff, St. Albans Cathedrals, Westminster Abbey, Lancaster, Sheffield, Oxford and Cambridge Universities, Birmingham Museum; private collections in France and England. *Publications:* contributed to Drawing, Seeing and Observing by Ian Simpson (1992), co-author, Engraved Glass in Architecture (Peace and Scott, 1995). Included in 'Modern and Contemporary Prints' by Phoebe Phillips and Tom Robb. *Clubs:* A.W.G., Fellow, Guild of Glass Engravers. *Signs work:* "Sally Scott." *Address:* The Cottage, Cambalt Rd., London SW15 6EW. *Email:* sallyscott.guy@btopenworld.com

SCOTT BOLTON, Tim, *Medium:* oil, watercolour. *b:* Shrewsbury, 29 Mar 1947. *m:* Patricia Scott Bolton. one *s.* three *d. Educ:* Bromsgrove, London University. *Studied:* Heatherley. *Represented by:* Summerleaze Gallery. *Exhib:* Tryon Gallery; Summerleaze Gallery; Malcolm Innes Gallery; Mathaf Gallery. *Works in collections:* National Trust, Richard Branson, Sultan of Oman, H.R.H. The Prince of Wales. *Commissions:* H.M.The Queen, the late Duke of Devonshire, Duke of Wellington. *Works Reproduced:* Whitbread Calendar of Trees. *Recreations:* travel, history. *Clubs:* Chelsea Arts Club. *Misc:* teaches and takes art tours to India and Romania, helps run the Summerleaze Gallery; artist-in-residence Garsington Opera (2004). *Signs work:* 'Tim Scott Bolton'. *Address:* Summerleaze House, East Knoyle, Salisbury, Wiltshire SP3 6BY.

SCOTT-KESTIN, Colin, SEqA (2003); painter in oil, water-colour and gouache of landscapes, equestrian and other animal subjects; Commendation of Excellence, Llewelyn Alexander Fine Art (1995, 2001); Honourable Mention in Oil, Miniature Art Society of Florida (2002). *b:* 14 Jan 1921. *m:* Mary Widdows. *Educ:* St. Giles School, St. Leonards-on-Sea. *Studied:* Beckenham School of Art (1938-39, Henry Carr, R.P.). *Exhib:* R.M.S., H.S., S.Eq.A., M.A.S.-F., Llewellyn Alexander (Fine Art), where awarded a Commendation of Excellence (1995, 2001). Regular exhibitor at above and occasionally at local exhibitions. *Works in collections:* war sketches, Royal Signals Museum, Blandford. *Commissions:* for equestrian painting. *Works Reproduced:* by The Medici Society. *Clubs:* Civil Service Club. *Misc:* R.M.S. (2005, retired); H.S. (2004, retired); MASF (2003 retired). *Signs work:* "C. SCOTT-KESTIN." *Address:* Strapp Cottage, Skillgate La., Chiselborough, Som. TA14 6TP.

SCOTT-MILLER, Melissa Emma, B.A. Hons., R.P.; painter in oil. *b:* London, 17 Jul 1959. one *s.* one *d. Educ:* Queens College, London. *Studied:* Slade School of Fine Art (1977-1981). *Exhib:* Albemarle Gallery (1989), Grosvenor Gallery (1995), Mark Jason Fine Art (2002), Oakham Gallery (2004). *Works in collections:* the late Stanley Kubrick, David Gray, Sir Simon Rattle. *Signs work:* "Melissa Scott-Miller." *Address:* Flat G, 5 Lonsdale Sq., London N1 1EN.

SCOTT-TAGGART, Elizabeth Mary Josephine, F.P.S.; N.D.D.; previously sculptor working mainly as wood-carver, now calligrapher and illustrator. *b:* nr. Croydon, 10 Oct 1927. *Educ:* Old Palace School, Croydon. *Studied:* Central School of Arts and Crafts, and St. Martin's, London (1945-49). *Exhib:* R.A.; group shows: R.B.A., Trends at Mall Galleries, Loggia Gallery, Wooburn and Cookham Festivals; one-man shows at Century Galleries, Henley-on-Thames. *Signs work:* "est." *Address:* 96 Gregories Rd., Beaconsfield, Bucks. HP9 1HL. *Website:* www.elizabethscotttaggart.co.uk

SCOULLER, Glen, DA (1972), RGI (1989), RSW (1997); artist in oil and water-colour. *b:* Glasgow, 24 Apr 1950. *s of:* Thomas & Mary Scouller. *m:* Carol Alison Marsh. two *d. Educ:* Garthamlock Secondary, Glasgow. *Studied:* Glasgow

School of Art (1968-73, David Donaldson). *Exhib:* solo shows: John D. Kelly Gallery, Glasgow (1977), The Scottish Gallery, Edinburgh (1980), Fine Art Soc., Glasgow (1985, 1988), Harbour Arts Centre, Irvine (1986), Fine Art Soc., Edinburgh (1989), Portland Gallery, London (1989, 1992, 1994, 1998), Macauley Gallery, Stenton (1990, 1993, 1996), French Inst., Edinburgh (1990), Open Eye Gallery, Edinburgh (1992, 1994, 1997, 2000, 2002), Roger Billcliffe Fine Art, Glasgow (1992, 1995, 1998, 2003), Everard Read Gallery, Johannesburg (1997, 2001), Corrymella Scott Gallery, Newcastle upon Tyne (1999), Everard Read Gallery, Capetown (2000), Lemon Street Gallery, Truro (2002), The John Davies Gallery, Stow-on-the-Wold (2004); Red Box Gallery, Newcastle-upon-Tyne (2005), Henshelwood Gallery (2005). Regular exhibitor: Royal Scottish Academy, Edinburgh, RGI, RSW. *Works in collections:* Works in numerous private and corporate collections worldwide. *Publications:* Italian Sketchbook/W. Gordon Smith; Who's Who in Scotland (1999), Kilmarnock/J.A.Mackay (1992); Dictionary of Art in Britain since 1945/D.Buckman; The Dictionary of Scottish Painters 1600 to the Present (1998). *Clubs:* Glasgow Art. *Signs work:* "SCOULLER." *Address:* East Loudoun Hill Farm, Darvel, Ayrshire KA17 0LU. *Email:* glen.scouller@btinternet.com

SCOULLER, Kim, Awarded Anna Miller Trust Scholarship (2007); Winner of The Aspect Prize (2005). *Medium:* oil, drawing. *b:* Glasgow, 1980. *d of:* Glen Scouller, Artist. *Studied:* Duncan of Jordanstone College of Art, Dundee (1999-2003); MA in Drawing, Prince's Drawing School, London (2007-2008). *Exhib:* BP Portrait Award, NPG (2003), Royal Institute of Oil Painters, Mall Galleries, London (2003), Aspect Prize Exhibition, Thompson's Gallery (2005), Royal Society of Portrait Painters, Mall Galleries (2005), Paisley Art Institute (2004-2007). *Works in collections:* Aspect Capital, London; Clyde Property, Glasgow. *Commissions:* several private portrait commissions. *Signs work:* "K SCOULLER". *Address:* East Loudoun, Hill Farm, Darvel, Ayrshire, Scotland, KA17 0LU. *Email:* kim.scouller@btinternet.com *Website:* www.kimscouller.com

SCOULLER, Lara, BA Hons Fine Art; RSA Landscape Painting Prize (2006); RSA John Kinross Scholarship (2006). *Medium:* painter in pastels and water-based media. *b:* Glasgow, 28 Nov 1983. *d of:* Glen Scouller RSW, RGI. *Educ:* Loudon Academy (1996-2001). *Studied:* Duncan of Jordanstone, Dundee (2002-2006). *Exhib:* Artistri Online Gallery, www.artistri.co.uk; 2006: RSA Edinburgh, Wade Gallery Elie, RSA Student Exhibition. 2007: Lemond Gallery, The Wade Gallery. *Works in collections:* RSA, Edinburgh. *Publications:* Royal Scottish Academy, John Kinross Scholars. *Signs work:* "Lara Scouller". *Address:* East Loudon Hill Farm, Darvel, Ayrshire, KA17 0LU. *Email:* lara.scouller@btinternet.com *Website:* www.larascouller.com

SCRIVENER, Tony (Anthony Graham Roux), BA (Hons) Open First Class. *Medium:* mixed media, oil. *b:* London, 3 Jan 1944. *s of:* Kenneth & Stella Scrivener. *m:* Eleanor Margaret. one *s.* one *d. Educ:* Carshalton Technical College. *Studied:* Bournemouth and Poole College of Art. *Exhib:* regularly at

Royal Academy Summer Exhbn; widely in London and throughout the UK. *Recreations:* reading, travel. *Clubs:* International Ambassador Club. *Misc:* began painting after business career, professionally since 1993. *Signs work:* 'TONY SCRIVENER'. *Address:* 'Crandel', 28 Beaufoys Avenue, Ferndown, Dorset BH22 9RH. *Email:* tony@scrivenerart.com

SCROPE-HOWE, Pat, F.R.G.S., Sociétaire of Société des Artistes Indépendants Paris (1973); Sociétaire of Artistes Français Le Salon Paris (1975); painter in oil, pastel, acrylic, water-colour; sculptor in cire perdue and GRP/bronze. *b:* London, 27 Jan 1926. widow. two *s. Studied:* Torbay Art School (1958-59), Saskatchewan Art Council (1959-60), Bourneville Art School (1961-62), Manchester Fine Arts (1963-69), Florence, Rome and Venice. Also travelled and painted in France, U.S.A., Spain, Egypt, Far East, South America and the Caribbean. Studied under Harry Rutherford (pupil of Sickert) for portraiture and studies in pastel and oils, Terry McGlynn for abstract and experimental art, Ian McDonald Grant for History of Art, life and composition. *Exhib:* Paris: Salon des Nations (1984), Grand Palais (Indépendants and Artistes Français) since 1973; provinces: Salford Open (1964), Withington, Liverpool Open (bi-annual), Colin Jellicoe Gallery, Manchester College; London: R.S.M.A. Boat Show and National Tour (1969-73). Painting rented via R.S.M.A. for a Polaris Submarine which went under North and South Poles (1973); London International Open, S.W.A. and their National Tour (1972), Laing Competition (1975), Hesketh Hubbard Soc., U.A., Long Gallery, Isleworth (solo show), Royal Horticultural Art Exhbn., Festival of Paintings and Graphic Art (1972); Ireland: Kilkenny (solo show), Dunmore East, Waterford (Studio, permanent solo show). *Works in collections:* Canada, Australia, Gt. Britain, Ireland and the continent. *Misc:* Has appeared on CKBI TV (Canada) to talk on art. *Signs work:* "Pat Scrope-Howe." *Address:* Maudwill, Flat 3, 9 Barton Terr., Dawlish, Devon EX7 9QH.

SCRYMGEOUR WEDDERBURN, Janet, F.R.B.S. (1980), R.S.A. Ottillie Helen Wallace Scholarship (1972), R.S.A. Benno Schotz Prize (1973), Paris Salon bronze medal, silver medal; sculptor in clay and bronze, stained glass window designer;. *b:* Winchester, 14 Aug 1941. *d of:* Lt. Col. the Hon. David Scrymgeour Wedderburn, D.S.O. *m:* Mervyn Fox-Pitt. one *s.* two *d. Educ:* Kilgraston, Convent of the Sacred Heart, Bridge of Earn, Perthshire. *Studied:* with Alastair Ross, F.R.B.S. (1970-71). *Exhib:* R.S.A. (1971-76, sculpture); Paris Salon (1972, 1973, sculpture). *Works in collections:* East Window of the Episcopal Church of St. James the Great, Cupar, Fife; West Window the Chapel Royal, Falkland Palace; Meditation Window Bedale Church, Yorks.; Victory and Freedom Windows, R.A.F. Leuchars, St. Paul's Church (1993), Sir Nicholas Fairbairn, M.P. (Scottish National Portrait Gallery), (posthumous) The Marquis of Bute, National Museum of Scotland. *Commissions:* St. Columba 1997 (Diocese of Dunkeld), Admiral Lord Duncan, 1997 (Camperdown Trust), Dundee Sea Gate (seven foot high), The Cosmic Christ (crucifix 8ft.) Carnoustie (1998), The Stobhall Madonna (6ft. bronze) Stobhall, Perthshire (1998), The Annunciation (3ft. bronze figures) (1999), Dancing Girl (4ft bronze) Stobhall

(2002), Skipping Girl (4ft Bronze), Easter Dunboy (2000), stained glass doors St.Mathews RC Church, Auchtermuchty (2004). *Principal Works:* The Stations of the Cross, Aberfeldy Perthshire (2005). *Clubs:* Boisdale. *Signs work:* "J.S.W." *Address:* Grange Scrymgeour, Cupar, Fife. KY15 4QH.

SCULL, Paul Harvey, B.A.Hons. (1975), H.D.F.A. (1978), R.E. (1986), M.Ed. (1988); artist; Senior Lecturer in fine art, University of Wolverhampton;. *b:* London, 21 Jun 1953. *m:* Dawn. *Educ:* Kimbolton School, Cambs. *Studied:* Northampton School of Art (1971-72), Maidstone College of Art (1972-75), Slade School of Fine Art (1976-78), University of Wales, Cardiff (1984-88). *Exhib:* Whitworth A.G., Manchester; Museum of Modern Art, Wales; Manchester City A.G.; University of Keele Gallery; Taipei Museum of Fine Art, Taiwan. *Works in collections:* Rank Xerox; Oxigen Foundation, Hungary; Xantos Janos Museum, Gyor; Mappin A.G., Sheffield; H.M.K. (Fine Arts) New York; West Midlands Arts. *Signs work:* "Paul Scull." *Address:* Fair View, Brockhampton, Hereford HR1 4SQ.

SCULLARD, Susan Diane, S.W.E., B.A. (Hons.), M.A.; freelance illustrator in wood engraving, pen and ink, water-colour. *b:* Chatham, 20 Apr 1958. *m:* Jeremy Duncombe. one *s. Educ:* Chatham Grammar School. *Studied:* Camberwell School of Art (John Lawrence), R.C.A. (Yvonne Skargon). *Exhib:* regularly with SWE, RA Summer Show (1999), New Ashgate Gallery Farnham, Open Eye Gallery Edinburgh, Craft Gallery Cranbrook, Watergate St. Gallery Chester, Tidal Wave Gallery Hereford, Art in Action Gallery Waterperry nr. Oxford, West End House Gallery, Smarden, Crooked House Gallery, Lavenham, Turtle Fine Art, Rye. *Publications:* illustrations for Folio Soc. books, Canterbury Tales, Shakespeare, The Lives of the Later Caesars; children's books: The Great Round the World Balloon Race, and Miss Fanshawe and the Great Dragon Adventure, Freya and the Magic Cloak by Nanna Aida Svensden (USA only), The Nutcracker pop-up book with Nick Denchfield. *Signs work:* "Sue Scullard." *Address:* Beech Hill Cottage, Glassenbury Rd., Cranbrook, Kent TN17 2QJ. *Email:* sue@suescullard.co.uk *Website:* www.suescullard.co.uk

SCULLION, Anthony Kevin, B.A. Hons., Painting; painter in oil: Garrick-Milne Prize 2005 (2nd Prize). *b:* East Kilbride, 3 Jun 1967. *m:* Fiona Stewart. *Educ:* St. Bride's High School, East Kilbride. *Studied:* Glasgow School of Art (1988-1992). *Exhib:* solo and group exhibs. in S. Africa (1995-1998), solo exhib., Flying Colours Gallery, London (2000, 2002). *Signs work:* "A S" on verso. *Address:* c/o Flying Colours Gallery, 6 Burnsall St., London SW3 3ST. *Email:* art@flyingcoloursgallery.com

SEAGER, Harry Abram, A.T.D. (Birm., 1955); sculptor in glass and mixed media, cast and constructed metals; Senior Lecturer, College of Art, Stourbridge, W. Midlands. *b:* Birmingham, 9 May 1931. *s of:* Maurice Seager. *m:* Marie. one *s.* one *d. Educ:* Holly Lodge Grammar School, Smethwick, Warley, W. Midlands. *Studied:* College of Art, Birmingham. *Exhib:* Gimpel Fils London, Rotterdamse

Kunstkring, Camden Art Centre, Fondation Maeght, S. France, Middleheim Park Antwerp, Perth, Economist Bldg London; Retrospective Broadfield House Glass Museum, W.Midlands. *Works in collections:* City Art Gallery, Leeds, C.A.S., London, Joseph H. Hirshorne Coll., U.S.A., D.O.E. London, V. & A., W. Midlands Arts; private collections in Canada, U.K., U.S.A., Holland, Italy, Broadfield House Glass Museum. *Commissions:* London Hilton Park Lane, Hilton, Mauritius, 'Arcadia' P&O, AJEX Memorial Alrewas National Memorial Park. *Publications:* Open Air Sculpture in Britain, W. Strachan Tate Gallery (A. Zwemmer Ltd); International Modern Glass, Geoffrey Beard Barrie & Jenkins, London; Public Sculpture of Birmingham, George Noszlopy, Liverpool University Press. *Address:* 1 Baylie St., Stourbridge, W.Midlands DY8 1AZ. *Email:* info@harry seagersculptor.com *Website:* www.harryseagersculptor.com

SEAL, Norman, painter in oil, ink, water-colour, calligrapher. *b:* Warsop, Notts., 26 Feb 1921. *s of:* George Seal. one *s.* one *d. Educ:* Mansfield Technical College. *Studied:* Mansfield College of Art (1963). *Exhib:* Nottingham Castle (1965), Fermoy, Kings Lynn (1978), Hudson Gallery, Wisbech (1978), Assembly House, Norwich (1978, 1990), Municipal Gallery, Mansfield (1981), Angles Theatre, Wisbech (1988), Central Library, Cambridge (1988). *Clubs:* Cambridge Arts Forum. *Signs work:* "N. Seal". *Address:* 15 Westfield Rd., Wisbech, Cambs. PE13 3EU.

SEARLE, Ronald, C.B.E., RDI, AGI; Légion d'honneur (France). *b:* Cambridge, 3 Mar 1920. *Studied:* Cambridge School of Art (1936-39). *Exhib:* Leicester Galleries (1948, 1950, 1954 and 1957); Kraushaar Galleries, New York (1959); Bianchini Gallery, New York (1963); Kunsthalle, Bremen (1965); Wilhelm-Busch Museum, Hanover (1965, 1976, 2001); Wolfgang Gurlitt Museum, Linz, Austria (1966); Galerie La Pochade, Paris (1966, 1967, 1968, 1969, 1971, 1976); Galerie Carmen Cassé, Paris (1975, 1977), Galerie Gurlitt, Munich (1967, 1969, 1970, 1971 and 1973); retrospectives: Bibliothèque Nationale, Paris (1973), Prussian National Gallery (1976), etc. *Works in collections:* V & A, B.M., Imperial War Museum, Tate Gallery; Bibliothèque Nationale, Paris; WilhelmBusch Museum, Hannover; Museum of Fine Arts, San Fransisco; Staatliche Museum, Berlin; Cooper-Hewitt Museum, New York, etc. *Publications:* Ronald Searle: a biography, by Russell Davies, 1990. *Clubs:* Garrick. *Address:* Sayle Literary Agency 1 Petersfield, Cambridge CB1 1BB. *Email:* rachel@sayleliteraryagency.com

SEDDON, Joyce, SWA (1988). *Medium:* oil: small still-life subjects on wood panels. *b:* Horwich, 26 Dec 1933. *m:* Dr. G.B.Seddon M.B.ChB., D.A. one *s.* two *d. Studied:* self-taught. *Exhib:* RA Summer Exhbns (1977, 79, 82, 84, 87, 92, 2006); SWA since 1988; RBSA; Toronto International Exhibition, Canada; Birmingham and Midland Medical Art Society; galleries in London, Stratford-upon-Avon, and Ledbury. *Signs work:* 'J.Seddon'. *Address:* Goose Green Cottage, 61 High Street, Barrington, Cambridge CB22 7QX.

SEDDON, Richard Harding, P.R.W.S., A.R.C.A., Ph.D.; painter in oil and water-colour, and writer on art;. *Educ:* King Edward VII School and Reading University. *Studied:* Sheffield College of Art (1932-36); Royal College of Art (1936-39). *Exhib:* R.A., R.W.S. *Works in collections:* H.M. The Queen, V. & A., Imperial War Museum, Sheffield, Leeds, Derby, Southport, Reading, Philadelphia (U.S.A), Neufchatel (France). *Publications:* The Academic Technique of Oil Painting (1960), A Hand Uplifted (War Artist Memoirs) (1963), Art Collecting for Amateurs (1965), A Dictionary of Art Terms (1982) (with K. Reynolds), The Artist's Studio Book (1983); art criticism in The Guardian and most art journals; London art critic of Birmingham Post (1961-70); of Yorkshire Post since 1974. *Address:* 6 Arlesey Cl., London SW15 2EX.

SEDLECKA, Irene, FRBS; SPS; Prize of the City of Prague (1953), State Prize of Czechoslovakia (1953). *Medium:* sculpture. *b:* Czech Republic, 7 Sep 1928. *Works in collections:* private collections in the UK, USA, Germany and the Czech Republic; life-size statues of Sir Arthur Conan Doyle and Sherlock Holmes (for publisher Felix Dennis). *Commissions:* commissioned portraits include: Lord Lichfield, Bobby Charlton CBE, Donald Sinden, Lord Laurence Olivier, Magnus Magnusson, Lord Chilver (for Granfield Institute of Technology), Sir Frank Whittle (for Institute of Mechanical Engineers), Duncan Goodhew, Paul Eddington, Nigel Hawthorn, Jackie Stewart OBE, Kenneth Kendall, Nicholas Parsons, Raymond Baxter, Richard Briers, Kenneth Williams, David Bellamy, Gordon Kay, Ken Dodd, Andrew Gardner, Jimmy Edwards, Ted Moult, William Lyne (for Wigmore Hall), Peter Brown (for British Academy), Vernon Ellis (for English National Opera) and many others. Most recent public work monument to Freddie Mercury in Montreux and Beau Brummell in London. *Official Purchasers:* public works include monument to the victims of Fascism at Velke Mezirici in Moravia, Julius Fucik in Pilsen and relief on public buildings in Prague. *Address:* 4 The Green, Sutton Courtenay, Oxfordshire. OX14 4AE.

SEELEY, Eric Charles, BA Hons (1973), Cert RAS (1976), ATC (1977); British Inst. Fund Award in Fine Art, Armitage Prize (silver medal) for painting, Landseer Prize (bronze medal) for painting, Arthur Hacker Prize (silver medal) for portrait painting, Laing Art Show winner (1977, 1993). *Medium:* painter, printmaker; oil watercolour, drawing. *b:* Luton, 2 Dec 1951. one *d. Studied:* Luton School of Art (1968-1970), Kingston Polytechnic (1970-1973), RA Schools (1973-1976), under Ruskin Spear, David Tindle, Gertrude Hermes, Peter Greenham, London University, Goldsmiths (1976-1977). *Exhib:* RA, John Player Awards, National Gallery, Marryat Gallery, Leighton House, Famagusta, Cyprus, Cambridge Contemporary Arts, Centro Modigliani, Florence, Russell Gallery, Martins Gallery, Burlington Fine Art, Eagle Gallery Bedford. *Works in collections:* Cecil Higgins Art Gallery, Bedford; Bedford BC; Bedford Art Loan Collection; private collections home and abroad. *Publications:* illustrations for 'Sketches of Academe; by Trevor Whittock; cover illustration 'The Interpreter's House' (2000); 'Face to Face', Artists & Illustrators (Dec 2000). *Works Reproduced:* Royal Academy Illustrated (1979, 1990). *Clubs:* (Reynolds Club)

RA, RASAA. *Signs work:* "Eric Seeley" and year. *Address:* 4 Irwin Rd., Bedford, Beds. MK40 3UL. *Email:* sukitely@treemail.fsnet.co.uk *Website:* www.rasalumni.org

SEE-PAYNTON, Colin Frank, R.C.A. (1993), R.E. (1986), S.WL.A. (1986), S.W.E. (1984), A.R.E. (1983); painter, etcher and engraver in water-colour, etching and wood engraving. *b:* 8 Jul 1946. *s of:* Frederick Paynton. *m:* Susie See (decd). *Educ:* Bedford. *Studied:* Northampton School of Art (1963-65, Henry Bird). *Represented by:* Bankside Gallery, London. *Exhib:* R.A., R.E., R.W.S., S.W.E., S.WL.A. *Works in collections:* V & A, London, Ashmolean Museum Oxford, Beecroft A.G., Southend, Bedford C.C., Fremantle Museum, Australia, National Museum of Wales, National Library of Wales, S.W.A.N., and others. *Publications:* illustrations in many private press and commercial publications, The Incisive Eye - Colin See-Paynton Wood Engravings 1980-1996 (Scolar Press, 1996), Of a Feather (Gwasg Gregynog, 2007), Of a Feather -An Avian Alphabet (National Library of Wales, 2007). *Recreations:* walking and working. *Address:* Oerle Hall, Berriew, Powys, Wales SY21 8QX. *Email:* info@see-paynton.co.uk *Website:* www.see-paynton.co.uk

SEGELMAN, Frances Rosaline, FRSA; ARBS; Liveryman of the Painters-Stainer's Company. *Medium:* sculpture in terracotta, bronze and polished steel; prints, oil, drawing. *b:* Leeds, Yorkshire, 10 Feb 1949. *d of:* Sonia & Stanley Segelman. one *s.* one *d. Educ:* Gateways High School, Harewood, Yorkshire. *Exhib:* Harewood House, Yorkshire (1986), Leeds Art Fair (1986), Walkers Art Gallery, Harrogate (1987), Burgh House, Hampstead (1997), Painters' Hall (1998, 1999, 2004, 2006), Coutts Bank, The Strand (1998), House of Commons (2002), Chelsea Arts Society (2002), Fine Arts Gallery, Bond Street (2005). *Commissions:* HM The Queen, Duke of Edinburgh (Buckingham Palace), Ronald Walker (Australia), Arnold Ziff, OBE (Merrion Centre, Leeds), Billy Bremner (Leeds Utd FC), Raymond Burton (Jewish Museum, Camden), Jack Petchey OBE (in hotels and The Tourism Board, Algarve); also many other commissions of well known people. *Publications:* in numerous magazines and newspapers throughout career. *Official Purchasers:* many. *Works Reproduced:* Limited Editions of various sculptures reproduced for clients and for sale. *Principal Works:* H.M.The Queen (unveiled 2007); Duke of Edinburgh, Buckingham Palace; Billy Bremner (at Leeds Utd. FC). *Signs work:* "FRANCES SEGELMAN". *Address:* 5 The Pierhead, Wapping, London E1W 9PN. *Email:* jpfspier@aol.com *Website:* www.segelman.com

SEGRAVE, Lydia, *Medium:* sculpture in bronze. *b:* London, 10 Jun 1945. *d of:* Edmond & Desirée Segrave. *m:* Dr I M D Little. one *s.* one *d. Studied:* Maidstone College of Art. *Works in collections:* private collections and sculpture parks. *Works Reproduced:* Edition number is usually seven per sculpture. *Signs work:* monogram of "LS" with edition no. *Address:* Hedgerows, Pyrton, Watlington, Oxon, OX49 5AP. *Email:* lydiasegrave@hotmail.com *Website:* www.lydiasegrave.com

SEIJO, Armando, *Medium:* oil on board, watercolour on paper. *b:* Spain, Sep 1971. *Studied:* University of Seville 'Santa Isabel de Hungria' (91-96), Central St.Martins (1996), Chelsea School of Arts (1996-7). *Represented by:* Start Space, 150 Columbia Road,London E2 7RG. *Exhib:* BP Portrait Award (NPG), Royal Society of Portrait Painters, Glasgow, Aberdeen, Bristol, London; Miami, USA; Sevilla, Utrera, Spain. *Works in collections:* several private and corporate collections in UK and abroad. *Commissions:* private. *Signs work:* seijo. *Address:* c/o Eduardo Sant'Anna, Start Space, 150 Columbia Road, London E2 7RG. *Email:* contact@st-art.biz *Website:* www.st-art.biz

SELBIE, Rosy, artist in oil, water-colour, pastel. *b:* Wales. *m:* Robert, civil engineer. one *s.* one *d. Educ:* Birtwhistles, London SW1. *Studied:* Sir John Cass Foundation, Whitechapel. *Exhib:* solo shows: Knapp Gallery, Burghclere Manor, Picton Castle; numerous mixed shows including Mall Galleries, dfn Gallery, Broadway, Manhattan, New York, U.S.A. *Works in collections:* many private collections. *Publications:* Southern Arts Visual Art Index. *Clubs:* Sloane. *Signs work:* "Selbie." *Address:* Fellowes Cottage, 35 Hurstbourne Priors, Whitchurch, Hants. RG28 7SE. *Email:* rosy@selbie.co.uk *Website:* www.selbie.co.uk

SELBY, William, RBA (1989), RWS (1992), ROI (1982), NEAC(1994), RSW (1998); Prizes: Christina Leger award R.O.I. (1985, 1987), Chris Beetle award (1986), L. Cornelissen & Son award R.O.I. (1988), Le Clerc Fowle medal R.O.I. (1994), Granada award, Mancaster Academy N.S. (1995), Macfarlane award R.G.I. (1995), Llewellyn Alexander award N.E.A.C. (1995), Menena Joy Schwabe Memorial Award (2004); painter. *b:* Fitzwilliam, nr. Pontefract, Yorks., 26 Dec 1933. *s of:* Henry Selby, miner. *m:* Mary. *Educ:* Fitzwilliam Secondary Modern. *Exhib:* RA Summer Exhbns. from 1972; solo shows: Adam Gallery, Bath (1995, 1997, 1999, 2001, 2003, 2005), Thomsons Gallery, Dover St., London (1997, 1999), City Gallery (1998, 2000, 2002), Thompsons Marylebone Gallery (2003, 2005). *Works in collections:* Mapin Gallery, Sheffield. *Clubs:* Leeds Fine Art. *Signs work:* "SELBY" or "WILLIAM SELBY." *Address:* 2 Broad Steps, Middle Street, Brixham, S. Devon TQ5 8EW.

SELL, Richard, A.T.D. (1949); artist in lithography, water-colour, drawing; Vice Pres. Cambridge Drawing Soc. *b:* Berkhamsted, 26 Jan 1922. *s of:* F.R. Sell, Prof. of English, Mysore Educ. Service. *m:* Jean Bryant. one *s.* one *d. Educ:* Berkhamsted School. *Studied:* Chelsea School of Art (Brian Robb, Morland Lewis, Harold Jones, Ceri Richards, Ella Griffin). *Exhib:* one-man shows: Old Fire Engine House Ely, Heffer Gallery Cambridge, Trumpington Gallery Cambridge; R.A. Summer Shows, National Exhbn. Prints and Drawings R.I. Gallery (1964), E. Anglian Art Today R.I. Gallery (1969), Mall Prints (1971, 1972, 1973), Art in Business, Arthur Young, Cambridge (1987, 1988), Anglesey Abbey, Cambridge (July 2001),'4 from vintage'22', Conservatory Gallery Cambridge (2002), Whittlesford Gallery (July 2003). *Commissions:* portrait drawings for several Cambridge colleges; lithographs for Lloyd's Register of Shipping, Emmanuel College Cambridge, Pembroke College Cambridge, St.

Catharine's College, Cambridge, large water-colour of the Octagon, Ely Cathedral, commissioned by the Dean & Chapter to be presented to the Lord Lieutenant of the County on his retirement (2002). *Official Purchasers:* Manchester Education Committee, Gt. Yarmouth ditto, Addenbrookes Hospital Kettles Yard Loan Collection, Eastern Arts Association, Cambridgeshire Central Libraries. *Recreations:* previously gliding. *Signs work:* "Richard Sell 1998." *Address:* 22 Station Rd., Fulbourn, Cambridge CB1 5ES.

SELWAY, John Henry, artist in mixed media; lecturer. *b:* Askern, Yorks., 11 Jul 1938. *m:* Margaret. one *s.* one *d. Studied:* Abertyleri Technical School, Newport School of Art, RCA. *Exhib:* one-man shows: Roland, Browse & Delbanco, Browse Darby, Christopher Hull, Jeffrie Museum. *Works in collections:* ACGB, Welsh Arts Council, National Museum Wales, Leeds City A.G., Ferens Gallery Hull, Glynn Vivian, Johannesburg A.G., Nuffield Foundation, de Beers; private: USA, GB, USSR, Europe. *Address:* Park View, Roseheyworth Rd., Abertyleri, Blaenau, Gwent NP3 1SB.

SELWYN, William, R.C.A.; artist in water-colour, mixed media;. *b:* 4 Dec 1933. *m:* Mary Ann Jones. one *s.* one *d. Educ:* Bangor Normal College. *Works in collections:* National Library of Wales, Gwynedd C.C., Anglesey C.C., University of N. Wales, Bangor. *Misc:* Award: Welsh Artist of the Year (2001). *Address:* Bron Eryri, Aelygarth, Caernarfon, Gwynedd LL55 1HA.

SEMMENS, Jennifer Anne, B.A.(Hons.) (1986). *Medium:* mixed media on paper, and oil painting on board/canvas. *b:* Penzance, 12 Jan 1964. *d of:* Peter Semmens. *m:* Roger Asbury. one *s.* two *d. Educ:* in Penzance, Cornwall. *Studied:* Falmouth School of Art (1982-83), Gloucestershire College of Arts and Technology, Cheltenham (1983-86). *Exhib:* Alpha Gallery, Sherborne; Candover Gallery, Alresford; Penwith Gallery and New Craftsman, St. Ives; Rainyday Gallery, Penzance. *Works in collections:* George & Ann Dannatt, Truro School. *Publications:* 'Twenty-Two Painters (who happen to be women) St. Ives' by Marion Whybrow; 'Drawing Towards the End of the Century' by Newlyn Society of Artists. *Clubs:* Penwith Soc. of Artists. *Signs work:* "J. Semmens." *Address:* Higher Barn, Bone Farm, Bone Valley, Heamoor, Penzance, Cornwall TR20 8UJ. *Email:* higherbarn@tiscali.co.uk

SEMPLE, Patricia Frances, SSA (1980), RSW (1987); painter of expressionist landscape in water-colour, ink, oil, charcoal; tutor, Open College of the Arts. *b:* Kintyre, Argyll, 3 Jul 1939. *d of:* Neil Thompson Semple, merchant naval officer. *Educ:* Lasswade Grammar. *Studied:* Edinburgh College of Art (1958-63), post. grad. (1963-64). *Exhib:* Stirling Gallery, Art Space Aberdeen, Edinburgh University, Aberdeen University, Dundee College of Art, Open Eye Gallery Edinburgh, regularly with R.S.A., S.S.A., R.S.W.; group shows: Glasgow Group, Scottish Gallery, Compass Gallery, Arts Council Travelling Exhbn. Scotland and Yugoslavia. *Works in collections:* S.A.C., Aberdeen A.G., B.B.C., Globus, Gateway Inc. N.Y., Educ. Inst. of Scotland, Grampian TV, Aberdeen

Hospitals, Shell U.K. *Signs work:* "Pat Semple." *Address:* Tigh-Nan-Uiseagan, By Drumnadrochit, Inverness-shire.

SENFT, Nadin, A.R.B.S. (1980), City and Guilds D.F.A. (1968); Award: First Prize Winner W. Mid. Arts Open Exhibition (1999); sculptor in bronze, stone, wood, perspex and stainless steel. *b:* London, 8 Mar 1932. *d of:* Basil Andreanoff, B.Sc. *m:* Dr. Paul Senft (decd.). *Educ:* St. Mary's Abbey, London; Eversley, Lymington, Hants. *Studied:* Leicester College of Art; City and Guilds of London College of Art, Kennington. *Exhib:* R.A., Alwin Gallery, Royal Exchange, Jordan Gallery, Annely Juda Fine A.G., Hertford Museum, Sutton College of Art, Natalie Stern Gallery, Richard Demarco Gallery, Edinburgh, Scone Palace, Perth, Herbert Museum and A.G. Coventry, Aim Gallery, Milton Keynes, Nature in Art, Glos., Broomhill Sculpture Gardens, Barnstaple, Devon, Art Lounge, Birmnigham, steel sculpture, Druidstone Wildlife Park, Blean, Kent, Artparks International, Guernsey, C.I. *Works in collections:* Nature in Art Museum, Twigworth, Glos., and private collections worldwide. *Commissions:* 'St. George and the Dragon', St. George's Centre, Preston; 'Seated Bronze Figures' Guildhall Sq., Portsmouth; Royal Inst. of Chartered Surveyors Trophy (sculpture of Logo in perspex for annual presentation); The Fasson Trophy (6 aluminium sculptures); Bronze Crucifixion, St. Gregory's, Tredington; Madonna and Child, painted wood carving, St. George's, Brailes, steel sculpture fountain, Alveston, Warks. *Publications:* Sixteen Stories as they Happend by Michael Bullock. *Signs work:* "Nadin Senft". *Address:* Willowbrook, Cotswold Cl., Tredington, Warwicks. CV36 4NR. *Website:* Axis Leeds Univ. - www.axisartists.org.uk

SENIOR, Bryan, painter of figures, streets, landscape, still-life in oils and acrylic; Prizes include: G.L.C. 'Spirit of London'; Druce Competition. *b:* Bolton, 10 Jun 1935. *Exhib:* one-man shows include: Crane Kalman Gallery, London (1965, 1968, 1971), Demarco, Edinburgh (1970, 1973), Vaccarino, Florence (1968, 1970, 1975), Pucker-Safrai, Boston, U.S.A. (1968), Bolton A.G. (1961), Fieldborne Galleries, London (1972), Ashgate Gallery, Farnham (1973), Exeter Museum (1974), Exeter University (1975), Galleria Acropoli, Milan (1976), Lad Lane Gallery, Dublin (1977), Architectural Assoc., London (1982), Hampstead Museum (1983), Manor House, Finchley (1989), Tricycle Gallery, London (1990), Tunbridge Wells Museum (1998, 2000), Sevenoaks Library Gallery (2004), Trinity Gallery, Tunbridge Wells (2007). *Address:* 134 Upper Grosvenor Rd., Tunbridge Wells, Kent TN1 2EX. *Website:* www.axisweb.org/artist/bryansenior

SEPPLE, Rosa, RI; The Herring Award (RI, 2003); The Elizabeth Scott-Moore Award (RWS, 2003); Debra Manifold Award (RI, 2004); Daler-Rowney Award (RWS, 2003, 2005); Freshfields Brackaus Deringer Award (RWS 2006). *Medium:* watercolour, mixed media. *b:* London, 7 Sep 1951. *d of:* James & Luciana Wright. *m:* Ted. two *s. Educ:* Collegio S.Liberale, TV, Venezia, Italy. *Studied:* St.Angela's Convent, London. *Represented by:* Linda Blackstone Gallery, Pinner; Enid Lawson Gallery, London; Albany Gallery, Cardiff; Sheen

Gallery, London; Fine Art UK, Ledbury; David Curzon Gallery, London; Blackheath Gallery, London; Orange Street Gallery, Uppingham; St.Giles Street Gallery, Norwich. *Exhib:* Mall Galleries; Linda Blackstone Gallery; Bankside Gallery (RWS); RCA; Sheen Gallery; Shell House; David Curzon Gallery; Blackheath Gallery; Singer & Friedlander/Sunday Times; Enid Lawson Gallery; Albany Gallery; Fine Art UK; Orange Street. *Works in collections:* private collections in UK, Italy, France, India and USA. *Commissions:* J.D.Wetherspoons. *Signs work:* 'Rosa Sepple'. *Address:* 33 Hacton Lane, Hornchurch, Essex RM12 6PH. *Email:* tedsepple@clara.co.uk

SERGEANT, Emma, BA Fine Art. *b:* 9 Dec 1959. *d of:* Sir Patrick Sergeant. *m:* Count Adam Zamoyski. *Educ:* Channing (1965-76), Camden School for Girls (1976-78), Holmes Road Institute(1978), Camberwell Foundation (1978-79). *Studied:* Slade (1979-83). *Represented by:* The Fine Art Society (1996-2003, next show November 2004). *Exhib:* Agnews (1984-96), Fine Art Society, The New House Gallery New York (1996), Brian Sinfield (2002) (Oxfordshire), Green and Stone Chelsea, The Prince's Foundation, The Royal Hibernian, Dublin. *Works in collections:* The Queen's Collection, Prince Charles, Duke of York, Earl of Radnor, Viscount Folkestone, Sting and Trudie Styler, National Portrait Gallery, Lord Olivier, Lord David Cecil and Sir Christopher Cockerell. *Commissions:* Paul Dacre, Sir Rocco Forte, Michael Portillo. *Publications:* 'Dottie's Diary' (illustrated and written by Emma Sergeant, pub. Harper Collins). *Principal Works:* every picture feels like a principal work. *Recreations:* polo. *Signs work:* 'ES'. *Address:* 12 Avenue Studios, Sydney Close, London SW3 6HW. *Email:* emma@emmasergeant.com *Website:* www.emmasergeant.com

SEROTA, Sir Nicholas Andrew, Director, Tate (since 1988); Hon. Fellow, Queen Mary and Westfield College; Univ. of London (1988), HonDArts, London Guildhall (1990), HonDLitt. City University (1990), HonFRIBA(1992), HonDLitt. Plymouth University (1993), HonDLitt. Keele University (1994), Hon. Fel. Goldsmiths (1994), HonDLitt. South Bank University (1996), Sen. Fel. RCA(1996), HonDUniv.,University of Surrey (Wimbledon School of Art, 1997), HonDLitt. Exeter (2000), HonDLitt. London Institute (2001), Hon.Fellow Christ's College, Cambridge (2001). Regional Art Officer and Exhbn. Organiser, Arts Council of GB (1970-73); Director, Museum of Modern Art, Oxford (1973-76); Director, Whitechapel A.G. (1976-88). Mem., Fine Art Advisory Com., British Council (1976-), Chairman 1992; Trustee, Public Art Development Trust (1983-87); Trustee, Architecture Foundation (1992-99). Selector 'A New Spirit in Painting', RA (1981), Carnegie International, Carnegie Museum of Art, Pittsburgh (1985,1988); Commissioner, Commission for Architecture and the Built Environment (1999-2006); Member, Olympic Delivery Authority (2006). *b:* 27 Apr 1946. *s of:* Stanley & Beatrice Serota. *m:* Angela Mary Beveridge (marr. diss. 1995); two d. m Teresa Gleadowe (1997). *Educ:* Haberdashers' Askes School, Hampstead and Elstree; Christ's College, Cambridge (B.A.). *Studied:* Courtauld Inst. of Art, London (M.A.). *Publications:* Experience or

Interpretation: The Dilemma of Museums of Modern Art 1996 (Neurath Lecture, National Gallery, 1996). *Address:* Tate, Millbank, London SW1P 4RG.

SETCH, Terry, D.F.A. (Lond., 1959); painter. *b:* London, 11 Mar 1936. *s of:* Frank Arthur Setch, welder. *m:* Dianne Shaw. one *d. Educ:* Sutton and Cheam School. *Studied:* Sutton School of Art (1950-54), Slade School of Fine Art (1956-60). *Works in collections:* Tate Gallery, Arts Council of G.B., Welsh Arts Council, Aberystwyth University, Contemporary Arts Soc. of Wales, V. & A., University College, London, Gallery of Modern Art, Lodz, Poland, Swansea University, British Council, National Museum of Wales, Contemporary Arts Soc., Coleg Harlech, Wakefield City A.G., Glynn Vivian Museum and A.G., Northampton A.G., Rugby Borough Council, Leicestershire Educ. Authority, Cardiff C.C., Glamorgan Educ. Authority, Normal College Bangor. *Commissions:* National Museum and Galleries of Wales, painting for the restaurant, Cardiff. *Publications:* New Work by Terry Setch, pub. Welsh Arts Council, National Museum of Wales, Camden Arts Centre (1992); Terry Setch a Retrospective, pub. University of Wales Institute, Cardiff (2001). *Clubs:* Chelsea Arts, London. *Signs work:* "Terry Setch." *Address:* 111 Plymouth Rd., Penarth, Vale of Glamorgan CF64 5DF, S. Wales.

SETFORD, Derek Lawrence, Diploma of Fine Art (London), Art Teachers Certificate. *Medium:* oils, gouache, wood-engraving, etching. *b:* Liverpool, 1 Mar 1936. *s of:* Harry and Catherine Setford. *m:* Eirlys. two *d. Educ:* Leeds College of Art, Slade School of Fine Art. *Studied:* drawing, painting, print-making. *Exhib:* Manchester Academy, Society of Wood Engravers Annual Exhbns, Society of Botanical Artists Open Exhbns. *Recreations:* the countryside, gardening. *Clubs:* Society of Wood Engravers. *Address:* 1 Oakbank Drive, Sharples, Bolton, Lancs, BL1 7DG.

SEWARD, Prue, A.R.C.A., Hon. Retd. A.R.E., R.W.S., Rome Scholar, Dip. in Paper Conservation; artist in pen and ink, water-colour, etching and lithography, and ceramics. *b:* London, 1926. *Studied:* Royal College of Art, Camberwell School of Art and Crafts (Conservation of Prints and Drawings). *Exhib:* R.A., Bankside Gallery, Curwen Gallery, Barbican, London, Flitcroft Gallery, London, Oliver Contemporary, London, Fine Art Society (ceramics). *Works in collections:* Mr. & Mrs. A. Walsh, Mr & Mrs Mark Mason and Bankside Gallery, Mrs. Paul Anthony, Gaynor Thompson, Robert Cooper. *Publications:* children's books, cookery books, Radio Times. *Signs work:* "P. Seward" or "Prue Seward." *Address:* 30 Sekforde St., London EC1R 0HH.

SEWARD RELFE, Elizabeth Anne Harvey (Liz), S.F.P. (2000), S.W.A. (1993), F.E.T.C. (1980); painter in water-colour and pastel, teacher; lecturer in drawing, water-colour and mixed media: Surrey Adult and Continuing Educ. Service (retired). *b:* Harrow, Middx., 21 Dec 1943. *m:* Gerald (Gerry) Seward. two *d. Educ:* Paddington and Maida Vale High School for Girls. *Studied:* with John Kingsley Sutton (1972-75), Edward Wesson (1977-82). *Exhib:* S.W.A.,

S.F.P., numerous mixed and solo shows in London and around United Kingdom. *Works in collections:* Surrey Heath Museum. *Publications:* five teaching videos; The Artists' Sketch Book, 'Watercolour Plus'; regular contributor to 'The Artist Magazine'. *Signs work:* "Liz Seward Relfe" or "L.S.R." *Address:* 12 Riverside Ave., Lightwater, Surrey GU18 5RU. *Email:* liz@sewardart.co.uk *Website:* www.sewardart.co.uk

SEWELL, Peggy Joan Kearton, M.F.P.S. (1986); painter of landscapes and flowers in oil on canvas; Freeman of the Worshipful Company of Painter-Stainers, London. *b:* London, 18 Dec 1920. *d of:* Albert E. Chandler, Director. *m:* Robert H. Sewell, Ch.M., F.R.C.S. two *d. Educ:* Manchester High School, and Merchant Venturers College, Bristol. *Studied:* Croydon Art College and privately with Richard Walker, N.D.D., A.T.D. *Exhib:* Guildhall London, Royal Exchange, Fairfield Halls Croydon, Loggia Gallery, London and Painters Hall, London. *Works in collections:* in the U.K., Ireland, Spain and France. *Recreations:* travel, gardening. *Clubs:* Croydon Art Soc., Purley Art Group. *Signs work:* "Joan Sewell." *Address:* 4 Bayards, Warlingham, Surrey CR6 9BP. *Website:* www.croydonartsociety.org.uk

SEXTON, Anthony John, (known as John Sexton); NDD Special Level, MA Fine Art, Churchill Fellowship. *Medium:* drawing, prints, sculpture, digital imaging. *b:* London, 16 Feb 1944. *m:* Ute Kreyman. *Educ:* Woolverston Hall, Suffolk. *Studied:* Hammersmith College of Art (1962-67); Goldsmiths College (1980-82). *Exhib:* solo shows: 'Transit London Durchreise', Berlin (1995); Janus Avivson, London (1991, 1995); Gymnasium Project Space, Goldsmiths College (1989); Mario Flecha, London (1989), Artworks Space, London (1986). Selected Group exhibitions: Millennium Monument, Paris (2000); Whitechapel Open (1996); 'On Site', Abbey St., London (1992); 'Attention au Vide', Nantes (1990); 'Threee London Artists', New York (1987). *Works in collections:* Henry Moore Foundation; Victoria and Albert Museum; various private collections. *Publications:* 'Reports of Worldwide Visual Diseases', Hausmeister. *Misc:* Taught at City Lit, London (1981-2006). *Signs work:* "JOHN SEXTON". *Address:* 90 Lynmouth Road, Walthamstow, London E17 8AQ. *Email:* john@johnsexton.myzen.co.uk *Website:* www.jsexton.eu

SEYMOUR, Jack, N.D.D. (1954), Ad.Cert.Ed. (1962); painter of landscapes, interiors and portraits in oil, pencil and water-colour. *b:* London, 23 Apr 1928. *s of:* Clive Seymour. one *s.* two *d. Educ:* Southall Technical School. *Studied:* Harrow School of Art (1948-52, C. Sanders, T. Ward), Gloucester College of Art (1952-54, R.S.G. Dent), St. Paul's College, Cheltenham (1960-62, H.W. Sayer). *Exhib:* R.B.A., R.P., R.A., R.W.A.; one-man show, Stroud, Gloucs.; provincial galleries, travelling exhbns. and abroad. *Works in collections:* Britain and abroad. *Works Reproduced:* RA Illustrated, An Introduction to Painting Portraits. *Signs work:* "SEYMOUR" and year. *Address:* 3 Holeground, School Hill, Wookey Hole, Som. BA5 1BU.

SHACKLETON, Keith Hope, Past President RSMA & SWLA.; LL.D. (Birmingham); oil painter, writer, naturalist, TV. *Medium:* oil. *b:* Weybridge, 16 Jan 1923. *s of:* W.S.Shackleton. *m:* Jacqueline Tate. two *s.* one (d. May 2003) *d. Educ:* Grimwade House,Melbourne, Australia; Oundle, UK. *Exhib:* RSMA, SWLA, RA. *Works in collections:* RSMA Maritime Museum, Greenwich, Birkenhead, Belfast A.G., LYW Art Museum Wisconsin, USA. *Commissions:* Royal Marines; Shell; BP; Whitbread. *Publications:* Wake, Tidelines, Wild Animals in Britain, Ship in the Wilderness, Wildlife and Wilderness, Keith Shackleton: An Autobiography in Paintings, Shakewell Afloat. *Works Reproduced:* limited edition prints by Millpond Press Inc., Florida. *Recreations:* field work. *Clubs:* Itchenor Sailing Club, Royal Geographical Society. *Address:* New Barton, Top Parts, Littlebredy, Dorchester, Dorset, DT2 9HX.

SHAKESPEARE, Francesca, muralist in London for 15 years before becoming full-time painter. *Medium:* gouache, fresco techniques, oil, watercolour, drawing. *b:* Oxford, 20 Aug 1961. *m:* Christopher Shakespeare. one *s.* two *d. Studied:* Exeter University/College of Art; Rome and Florence (fine art and Italian). *Represented by:* The New Grafton Gallery, London. *Exhib:* Discerning Eye (2001); Oxford Arts Society; Merriscourt Gallery; Rowley Gallery. *Commissions:* US Naval Headquarters. *Principal Works:* conceived and produced "Spoon Race", a collective work of art to celebrate 1000 Years of Oxfordshire, at Modern Art Oxford (Sept 2007), www.spoonrace.co.uk. *Address:* 1 Oakthorpe Road, Oxford OX2 7BD. *Email:* francesca@francescashakespeare.com *Website:* www.francescashakespeare.com

SHANKS, Duncan Faichney, DA, ARSA(1972), RGI (1983), RSW (1987), RSA (1990); artist in oil; Provost's prize for contemporary art (GOMA) 1996. *b:* Airdrie, 30 Aug 1937. *s of:* Duncan Faichney, D.A. *m:* Una Brown Gordon. *Studied:* Glasgow School of Art. *Exhib:* Art Spectrum, Contemporary Art from Scotland (1981-82), Five Glasgow Painters, Scottish Painting - Toulouse, About Landscape - Edinburgh Festival, Scottish Painting - Rio de Janeiro, Ten Scottish Painters - London, Scottish Painting - Wales, Bath, Basle, London Art Fairs; one-man shows: Stirling University, Scottish Gallery, Fine Art Soc. - Glasgow and Edinburgh, Talbot Rice Gallery, Edinburgh (cat.), Crawford Centre, St. Andrews, Maclaurin Gallery, Ayr, Glasgow A.G. (1990), Touring Exhbn. Wales (1991-92) (Cat.), Billcliffe Fine Art (1992, 2006), Scottish Gallery (1997, 2000, 2004, 2007), London (2002). *Works in collections:* A.C.G.B., Scottish Art Council, Glasgow, Dundee and Swansea A.Gs., Hunterian Museum, Edinburgh University, City Art Centre, Edinburgh, Lillie A.G., Government Art Collection, Scottish TV., 'Talking Pictures', STV film. *Recreations:* music. *Signs work:* "SHANKS." *Address:* Davingill House, Crossford By Carluke, Clyde Valley ML8 5RA.

SHANKS, Una Brown, D.A. (Textiles) (1962), R.S.W. (1988); Awards: Alexander Stone R.G.I. (1990, 1991), Betty Davies R.S.W. (1993); artist in watercolour, pen and ink. *b:* Hartwood, 9 Jun 1940. *d of:* Lawrence Gordon. *m:* D.F. Shanks. *Educ:* Wishaw High School. *Studied:* Glasgow School of Art (1958-62).

Exhib: Scottish Artists Shop (1987), Fine Art Soc. (1988, 1989, 1993). *Signs work:* "Una B. Shanks." *Address:* Davingill House, Crossford By Carluke, Clyde Valley ML8 5RA.

SHARP, Elizabeth, SEqA (1988), ASEA (1984), SWA (1986), BHSAI (1969); artist in oil and acrylic, China and silk painting, also sculptor specializing in golfing, animal and equestrian subjects, presentation items and trophies, in hand painted porcelain. *b:* 7 Jan 1947. *d of:* H.S. Sharp (decd.). *Educ:* Kesteven and Grantham Girls' High School. *Studied:* Leicester College of Art and Design (1965-66), Stoke Rochford College (1966-70). *Represented by:* Stanton Graphics, and Artworks. *Exhib:* regularly with S.E.A. and S.W.A. in London; occasionally one-man shows, Napier Gallery, St. Helier, Jersey, Newmarket, Melton Mowbray, Mkt. Harborough, Cheltenham Sporting Gallery @ Tetbury. *Works in collections:* sculpture in Victoria Centre, Sydney, Australia; Flying Horse Centre, Nottingham; Reindeer Court, Worcester. Numerous private collections internationally, Duke of Rutland. *Commissions:* Lords Cricket Club, Hunt committees, societies, corporations. *Publications:* Osprey Historical Books. *Works Reproduced:* numerous prints and cards, and limited edition prints. *Clubs:* B.C.P.A.A., British Horse Soc., SWA, SEA. *Misc:* Breeds American Morgan horses, avid golfer. *Signs work:* "Elizabeth Sharp." *Address:* Stanton Court, Denton, Grantham, Lincs. NG32 1JT. *Email:* stantongraphics@btinternet.com *Website:* www.stantongraphics.co.uk

SHAVE, Terry, B.A.(Hons.), H.D.F.A. (Slade); artist in oil, acrylic on canvas, etching; lecturer; Head of Painting, Staffordshire Polytechnic; Professor of Fine Art (1998);. *b:* 8 June, 1952. *m:* Helena. three *s.* one *d. Studied:* Loughborough College of Art (1972-75), Slade School of Fine Art (1975-77). *Exhib:* Anderson O'Day Gallery, John Moores Liverpool Exhbn. (Prizewinner), Ikon Gallery Birmingham, City Gallery Stoke. *Works in collections:* A.C.G.B., Unilever, B'ham City Museum and A.G., Stoke Museum and A.G. *Signs work:* "Terry Shave." *Address:* 19 Park Ave., Wolstanton, Staffs. ST5 8AY.

SHAW, Andrew Stuart Dunlap, BSc Architecture; DipArch; James Clerk Maxwell Prize for Science. *Medium:* architectural design, drawing, prints. *b:* Edinburgh, 2 Dec 1977. *s of:* Drs TRD & MPL Shaw. *Educ:* The Edinburgh Academy. *Studied:* The Bartlett School of Architecture; University College London. *Represented by:* Clarke Mulder Purdie Public Relations. *Exhib:* RA, London; Beyond Media, Florence; Biennale, Rotterdam; Venice Biennale; University of Technology, Tokyo. *Works in collections:* The Cooper Foundation. *Commissions:* Aberdeen Futures. *Principal Works:* Casa Lenta; The Hiker. *Recreations:* film, music, sky-diving, whisky. *Clubs:* The Duck Fund Club (President). *Signs work:* 'Andy Shaw'. *Address:* 16 Wigmore Place London W1U 2LX. *Email:* andyabides@mac.com *Website:* www.oio.nu

SHAW, Barbara Nancy, R.H.S. Gold medallist (1980), Grenfell medals (1976, 1977); botanical artist in water-colour. *b:* Dartmouth, Devon, 28 Sep 1922.

WHO'S WHO IN ART

m: Denis Latimer, surgeon (decd.). three *s.* one *d. Educ:* Fairview College and Hampton Court School. *Studied:* Dartington (for a time). *Exhib:* Chagford Galleries (1977), Thompson Gallery, Aldborough and London, etc. *Works in collections:* U.K., U.S.A., Germany, Japan. *Commissions:* several national collections and others. *Publications:* author and illustrator: The Book of Primroses (David & Charles 1991), illustrations in The Plantsman, illustrator: Foliage and Form by Phillipa Rakusen, and others. *Recreations:* tapestry work, gardening. *Clubs:* S.B.A., S.M. *Address:* Tan Cottage, West Lane, Cononley, nr. Skipton, N. Yorks. BD20 8NL.

SHAW, Sax Roland, D.A. (Edin.), F.M.G.P.; former Head of Stained Glass Dept., Edinburgh College of Art (retd. 1984); works in tapestry, stained glass, mural decoration, water-colour paintings;. *b:* Huddersfield, 5 Dec., 1916. *s of:* Roland Wilfred Shaw. *m:* Mary. two *s. Educ:* Almondbury Grammar School. *Studied:* Huddersfield, Edinburgh, Paris. *Works in collections:* private and public buildings in Edinburgh, London, New York, San Francisco, Iceland. At present working on windows and tapestries for the Marquis of Bute. *Signs work:* "Shaw." *Address:* 25 Howe St., Edinburgh EH3 6TF.

SHAW, Tim, 1st Class Honours Degree: Sculpture (Fine Art); Distinction Award: Foundation Diploma; Awards include: The Kenneth Armitage Fellowship (2006); The Mullan Prize (RUA, 2005); First Prize, Millfield Open (2003); prizewinner, Discerning Eye (1997). *Medium:* sculpture, installations. *b:* Belfast, 7 Aug 1964. *Educ:* Manchester Polytechnic (1984-85). *Studied:* Falmouth School of Art (1985-89). *Represented by:* Goldfish Fine Art. *Exhib:* solo shows: Albemarle Gallery (1992), Duncan Campbell (1995, 1997), Falmouth Art Gallery (1999), Truro Cathedral (2005), Goldfish Fine Art (2006, 2007); selected group exhibitions: London Art Fair ((2005, 2006), Discerning Eye (1997), Lemon Street Gallery, Truro (2000-2004), SWA Open (2003, 2004), many more across UK. *Works in collections:* David Roberts; Eden Project; Delfina Andalucia. *Commissions:* Eden Project, Cornwall; portrait bust Seamus Heaney, and other private commissions. *Principal Works:* The Middle World (1989-95); La Corrida - Dreams in Red (1996-9); The Rites of Dionysus (2000-4). *Recreations:* cattle herding and karate. *Clubs:* Newlyn Society of Artists. *Address:* 22a Avonmore Road, London W14 8RR. *Email:* timshawsculptor@btinternet.com *Website:* www.timshawsculptor.com

SHEARD, Rosalind Elizabeth Allaway, (nee MOIR); A.R.M.S., H.S., A.U.A.; artist in oil and water-colour; Daler Rowney Choice Award (2005). *b:* Penzance, 9 Sep 1940. *m:* Michael (decd). two *s.* one *d. Educ:* Chiswick County Grammar School. *Studied:* Webber Douglas Academy of Dramatic Art. *Exhib:* R.A., Medici Gallery, Llewellyn Alexander Gallery; 'Discerning Eye' Mall Galleries; R.M.S., H.S., S.W.A., U.A., S.Lm., Chichester, Tunbridge Wells, Leeds, Aberdeen, London, Inside Art Gallery, Ryde, Kendalls Fine Arts, Cowes, Alchemist Gallery, Yarmouth, Ryde Gallery, Saltgrass Gallery, Lymington. *Commissions:* Quay Arts, Newport, IOW -postcard. Various private. *Clubs:*

894

I.O.W. Art Club, A.P.K. Group. *Signs work:* "ROS SHEARD." *Address:* c/o The Sea Chest, 9 Westfield Park, Ryde, I.O.W. PO33 3AB. *Email:* rossheard@btinternet.com *Website:* www.londonart.co.uk

SHEATH, Janet, R.M.S. (1998), S.W.A. (1995), H.S. (1992); self taught artist in miniatures, water-colour, dry mediums and egg tempera; Llewelyn Alexander Masters Award (2001); Fairman Members' Subject Miniature Award, RMS (2001). *b:* Portsmouth, 1952. *m:* Robert J.C. Sheath. two *d. Educ:* Cowplain Secondary Modern School for Girls. *Exhib:* R.A., R.M.S., S.W.A., S.B.A., H.S., Llewellyn Alexander, Medici, Fine Art UK. *Signs work:* "Janet Sheath" or "J. SHEATH." *Address:* 4 Cupressus Ave., Winford, Sandown, I.O.W. PO36 0LA.

SHELBOURNE, Anita, RHA (2002); Diploma History of Eurpoean Painting; painter in oil, water-colour, acrylic, mixed media; Art Flight, Irish Arts Council Aer Lingus Travel Award, De Veres Award for a Work of Distinction, R.H.A., Oireachtas, Landscape Award. *b:* 17 Jul 1948. *Educ:* Holy Faith Convent, Dublin. *Studied:* Trinity College, Dublin. *Represented by:* Royal Hibernian Academy, Gallagher Gallery, 15 Ely Place, Dublin 2, Eire. *Exhib:* solo: Solomon Gallery (1987), Pantheon Gallery (1993), Ashford Gallery, RHA Gallagher Gallery (2000). Group: RHA, Oireachtas, Pyms Gallery London (1997), Art for Omagh (1998), Ashford Gallery, RHA Gallagher Gallery (1999-2002), Wexford Festival (1999-2002), RHA Gala Show (2002) etc. *Works in collections:* Irish Arts Council, Irish Embassies, Greece and Japan, Bank of Ireland, Ulster Bank, Trinity College, Dublin, Jefferson Smurfit Group, University College, Dublin, Embassy of The Republic of Korea, Haverty Trust, Norma Smurfitt Collection and collections in Milan, Rome, Sardinia. *Publications:* Irish Woman Artists, Dorothy Walker (1987), The Female Vision, Brian Fallon (1990), Irish Arts Review Year Book (1998). *Recreations:* music, theatre, poetry. *Clubs:* United Arts Club. *Signs work:* "ANITA SHELBOURNE." *Address:* 76 Willowfield, Park Ave., Sandymount, Dublin 4, Eire.

SHELLEY, John David, NDD 1957. *Medium:* oil. *b:* Margate, 23 Feb 1938. *s of:* W.E.G. & M.Shelley. *Educ:* Sutton East County Sec. *Studied:* Wimbledon School of Art (1953-58); Slade School of Art (1958). *Exhib:* RA Summer Exhbn (1968-1980, 1988, 1992). One-man shows: Trafford Gallery (1970-75). Tate Gallery 'Art of the Garden' (2004). *Works in collections:* Tate Britain, Contemporary Art Society. Private collections in England, America. *Works Reproduced:* Tate Diary 2005. *Signs work:* "JOHN SHELLEY". *Address:* 16 Warren Park, Warlingham, Surrey, CR6 9LD.

SHELLIM, Maurice Arthur, MRCS, LRCP. *Medium:* watercolour, oil, acrylic. *b:* Shanghai, 12 Feb 1915. *s of:* Arthur Joseph Shellim. *Studied:* Guy's Hospital, St. Thomas' St. London SE1. Qualified Apr 1939. *Exhib:* one-man exhbns: Sheridan Russell Gallery, London (1998,-99, 2001-2003), C.D.Soar Gallery (1995-6), Charlotte Lampard Gallery, London (1989, 91, 92), Academy of Fine Arts, Calcutta (1969, 70). Selected Group exhbns: New Grafton Gallery

London (1998), Medical Art Society (1986-90), Academy of Fine Arts Calcutta (1955, 62, 65). *Publications:* 'About Maurice Shellim's Paintings' by George Manfred (London, 2002). *Address:* 76 Boydell Court, St.John's Wood Park, London NW8 6NG. *Website:* www.mauriceshellim.me.uk

SHEPHARD, Rupert, Hon. A. L'Accademia Fiorentina; R.P., N.E.A.C.; painter, graphic artist; Slade Dipl.; lecturer, Central School, St. Martin's School of Art (1945-48); Professor of Art, University of Cape Town (1948-63);. *b:* 12 Feb., 1909. *m:* 1st, Lorna Wilmott (decd., 1962). one s. two d. 2nd, Nicolette Devas (1965). *Exhib:* one-man: Calmann Gall. (1939), Agnews (1962, 1980), Upper Grosvenor Gall. (1966, 1970), Kunsthalle, Bielefeld, Germany (1973), Collectors Gall., Johannesburg (1975), Patrick Seale Gall. (1975, 1979), Sally Hunter Gall. (1985, 1987, 1989, 1991), National Museum of Wales, Parkin Gallery (1977), Cape Town (seven) and Johannesburg (three) (1949-63); general: London: R.A., R.P., etc.; Venice Biennale (1958), São Paulo Bienal (1957), Ljubljana Biennale (1955, 1957, 1959, 1961). *Works in collections:* C.E.M.A. British Museum, War Artists, National Portrait Gall., National Museum of Wales, South African National Gall., Johannesburg Municipal Gall. *Publications:* illustrated: Capescapes (1954), Passing Scene (1966). *Address:* 68 Limerston St., London SW10 0HJ.

SHEPHERD, David, O.B.E. (1979), F.R.S.A. (1986), F.R.G.S. (1988); artist;. *b:* 25 Apr 1931. *s of:* Raymond Oxley Shepherd. *m:* Avril Gaywood. four *d.* *Educ:* Stowe. *Studied:* under Robin Goodwin (1950-1953); started career as aviation artist, founder member of Guild of Aviation Artists; many worldwide trips for aviation and military paintings for Services; began specializing in African wildlife subjects (1960). *Exhib:* R.A., R.P.; one man exhbns. London (1962, 1965, 1971, 1978, 1999), Johannesburg (1966, 1969), New York (1967). *Works in collections:* 15ft reredos of Christ for Army Garrison Church, Bordon, Hants (1964). Portraits: H.E. Dr Kenneth Kaunda, President of Zambia (1967), H.M. The Queen Mother (1969), H.E. Sheikh Zaid of Abu Dhabi (1970). *Publications:* Artist in Africa (1967), The Man who Loves Giants (1975), Paintings of Africa and India (1978), A Brush with Steam (1983), David Shepherd: The Man and his Paintings (1985), An Artist in Conservation (1992), David Shepherd, My Painting Life (1995). *Misc:* In 1984 David founded The David Shepherd Conservation Foundation, a registered charity, to raise funds and awareness for endangered animals. Awards: Order of Golden Ark by H.R.H. Prince Bernhard of The Netherlands (1973), Hon.D.F.A.Pratt Inst. N.Y. (1971), Hon. Doctor of Science, Hatfield Polytechnic (1990), Member of Honour, World Wildlife Fund (1979), Order of British Empire (1979), Officer (Brother) of the Order of St. John (1996). Life story subject of BBC TV documentary "The Man Who Loves Giants" (1971), Harlech TV documentary, "Elephants and Engines", etc. Auctioned five wildlife paintings in U.S.A. in 1971 and raised funds for Bell Jet Ranger Helicopter for anti-poaching work in Zambia, in return President Kaunda presented an 1896 steam locomotive, its return to Britain subject of BBC TV documentary "Last Train to Mulobezi" (1974); painted "Tiger Fire" 1973,

raised £127,500 for Operation Tiger (1973). Purchased two mainline steam locomotives 92203 Black Prince, and 75029 The Green Knight (1967) and founded The East Somerset Steam Railway, Cranmore, Somerset, a registered charity and fully operational steam railway. Videos: The Man who Loves Giants: The Most Dangerous Animal; Behind the Scenes, In Search of Wildlife I and II. Ambition: to drive Black Prince into Waterloo Station. Recreations: driving steam locomotives and raising money for wildlife. *Address:* Brooklands Farm, Hammerwood, East Grinstead, West Sussex RH19 3QA.

SHEPHERD, Eve, ARBS, SPS; Commendation for Tiranti Prize, & Pangolin Prize for Best Newcomer (2002). *Medium:* bronze, silver and resin sculpture. *b:* Sheffield, 12 May 1976. *Studied:* Chelsea College of Art and Design. *Exhib:* Sotheby's Artlink 2001, New York; Face Portrait Awards, Cork St., London (2002, 04, 06); Blake Gallery, York (ongoing); The Biscuit Factory, Newcastle (ongoing); The Hatton Gallery, Newcastle (2006); The Calder Gallery, Hebdonbridge (ongoing). *Works in collections:* private collections. *Commissions:* private portrait commissions; Sheffield Woustead Woodlands; Stephen Hawking, Cambridge University. *Principal Works:* "Stephen Hawking", "Dignified", "Silent Circle". *Signs work:* "E.SHEPHERD". *Address:* 46 Downland Road, Woodingdean, Brighton, E.Sussex, BN2 6DJ. *Email:* info@eveshepherd.com *Website:* www.eveshepherd.com

SHEPHERD, Gerald, F.F.P.S. (1990); painter and graphic artist in oil, acrylic, ink and pencils; sculptor in metal & found materials. *b:* 17 Feb 1955. *m:* June Taylor. one s-d. *Exhib:* solo and group exhbns. in London and south of England, including Loggia Gallery, London. *Works in collections:* Surrey University, Stevenage Art and Leisure Centre; private collections. *Publications:* edited, Ion Exchange Magazine; Editor, FPS Newsletter. *Recreations:* wildlife conservation and gardening. *Clubs:* Founded: Ionist Art Group, Modern Wiltshire Artists & Artists for Animals. *Misc:* Coined terms 'Ionist' and 'Meditative Process Art'. *Signs work:* usually "G.S." occasionally "GERALD SHEPHERD"; signature often incorporated into composition. *Address:* 56 Mylen Rd., Andover, Hants. SP10 3HG. *Email:* geraldshepherd@ionistart.com *Website:* www.ionistart.com/ www.ionistart.co.uk

SHEPHERD, Philip, R.W.S. (1977); Gold medal Paris Salon (1976); artist in water-colour, oil, wood engraving;. *b:* London, 4 May, 1927. two d. *Studied:* Harrow College of Arts and Crafts (1941-45), Birmingham College of Arts and Crafts (1948-50). *Exhib:* R.W.S. *Works in collections:* Fitzwilliam Museum Cambridge, Whitworth A.G. Manchester (wood engravings). *Signs work:* "Philip Shepherd, R.W.S." *Address:* 52 Aston Cantlow Rd., Wilmcote, Stratford-upon-Avon, Warwickshire CV37 9XZ.

SHEPHERD, Valerie Mary, SWA (1987), Cert.AD; graphic artist, sculptor and printmaker, paints in water-colour, oil and mixed media. *b:* Orpington, Kent, 5 Feb 1941. *d of:* John Freed, consulting electrical engineer. *m:* Norman

Shepherd, dental surgeon. one *s.* two *d. Educ:* St. Philomena's Convent. *Studied:* Gyula Sajo Atelier; Brighton Polytechnic. *Clubs:* S.W.A., W. Sussex Art, Arun Art Soc., Assoc. of Sussex Artists. *Signs work:* "Valerie Shepherd." *Address:* Bacon Hall, Poling, nr. Arundel, Sussex BN18 9PU.

SHEPPARD, Liz, Intermediate in Arts Crafts (1953), NDD Painting (1955), ATD (Lond. 1956), Scholarship Pratt bequest (1956, to Italy); painter, printmaker in etching. *b:* Tonbridge, 20 Dec 1933. *d of:* D O Pearce. *m:* Clive Sheppard, sculptor (decd.). two *s.* one *d. Educ:* St. Albans Girls Grammar School. *Studied:* St. Albans School of Art (1950-52), St. Martin's College of Art (1952-55), London University Institute (1955-56). *Exhib:* Digswell House, Bear Lane Gallery, Oxford, City Gallery, Milton Keynes, R.A. Summer Exhbn. (1977, 1978), Cartoon (1978), Wavendon Festival (1979), Margaret Fischer (1980), Bedford School (1990), Leighton Buzzard Arts Centre (1990), Milton Keynes Exhbn. Gallery (1991), Bromham Mill Gallery, Bedford (1992), Art in Milton Keynes (1993), New Studio Gallery Olney (2001). *Works in collections:* H.R.H. The Princess Margaret; John Dankworth and Cleo Laine; The Open University; Milton Keynes Development Corp.; M.K. Hospital; Anglian Water, Huntingdon; Bedford Art Loan Collection; Bedfordshire Library; Leicester Royal Infirmary; Ernst and Young, etc. *Publications:* writes for Printmaking Today since 1994. *Clubs:* Friends of Royal Academy. *Misc:* Millenium Artist in Residence, Woburn Schools Cluster (2001). *Signs work:* "Liz Sheppard." *Address:* 6 Leighton St., Woburn, Milton Keynes MK17 9PJ.

SHEPPARD, Maurice, P.P.R.W.S., N.E.A.C., M.A. (R.C.A.), Dip.A.D.; professional painter in oil and water-colour. *b:* Llangwm, Pembrokeshire, 25 Feb 1947. *s of:* the late W. E. & F.H. Sheppard. *Educ:* Haverfordwest Grammar School. *Studied:* Loughborough College of Art; Kingston College of Art under Alfred Heyworth; R.C.A. under Hamilton-Fraser, Buhler, Spear, Weight. *Exhib:* London and abroad. *Works in collections:* V. & A., National Museum of Wales, Cardiff, B'ham Museum and A.G., B.M., National Library of Wales, Aberystwyth, Tullie House, Carlisle. *Commissions:* 'The Golden Valley' image for 'Shadowlands' movie: Lord Attenborough. *Publications:* Old Water-colour Soc. Club Annual Vol. 59. *Signs work:* "Maurice Sheppard." *Address:* 33 St. Martin's Pk., Crow Hill, Haverfordwest, Pembrokeshire SA61 2HP, Wales. *Email:* sheppardpprws@hotmail.com

SHEPPERSON, Patricia Ann, artist in pastel and oils, wildlife, still life and landscape; recent works in water-colour. *b:* London, 2 Oct 1929. *d of:* Robert and Doris Apps. *m:* Desmond Vereker. one *s.* one *d. Educ:* Holy Trinity Convent, Bromley. *Studied:* Heatherley School of Art (1959-62, Patrick Larking, R.O.I.), Sir John Cass School of Art (1963-67), studied drama at Guildhall School of Music and Drama (1946-49). *Exhib:* one-man shows, London, Norwich and The Hague, mixed exhbns., R.A., Mall Galleries. *Works in collections:* U.K. and abroad. *Recreations:* piano, needlepoint. *Clubs:* U3A Norwich. *Signs work:*

"Patricia Shepperson." *Address:* 2 Grange Rd., Norwich, Norfolk NR2 3NH. *Email:* patriciasheppers@aol.com

SHERLOCK, Siriol Ann, BAHons. (1977), SBA (1988); Former President, Society of Floral Painters; RHS Gold Medal (1993, 1994, 1995, 1999); textile designer, water-colour painter, botanical artist. *b:* Nantwich, 28 Aug 1954. *d of:* Dr. Alexander Cattanach. *m:* Stephen Paul Sherlock. two *d. Educ:* Fernhill Manor School; Brockenhurst College. *Studied:* Winchester School of Art (1973-77). *Exhib:* many galleries in south of England, The Hillier Gdns. and Arboretum (1990, 1993, 1996), Kew Gdns. Gallery (1992), Sweden (1998), Jersey (1999). *Works in collections:* The Hunt Inst., Pittsburgh, U.S.A., The Hillier Gdns. and Arboretum, Romsey, The Royal Horticultural Soc, The Shirley Sherwood Collection. *Commissions:* R.H.S. 'Chelsea Flower Show Plate' (1999). *Publications:* Exploring Flowers in Water-colour by Siriol Sherlock (B.T. Batsford, 1998), Botanical Illustration by Siriol Sherlock (B.T. Batsford, 2004). *Works Reproduced:* in The Kew Magazine, The New Plantsman, Contemporary Botanical Artists. *Signs work:* "Siriol Sherlock." *Address:* Woodside, Embley Lane, East Wellow, Romsey, Hants. SO51 6DN.

SHETLAND, Ilric, Hornsey Dip.; painter. *b:* London, 24 Oct., 1946. *s of:* John Preston. *Educ:* Forest Hill Comprehensive School. *Studied:* Hornsey College of Art (1966-69), Goldsmiths' College of Art. *Represented by:* Thomas Corman Arts. *Exhib:* International Cultural Centre, Antwerp, Gamstyl, Brussels, Basle, Serpentine Gallery, London, Treadwell Gallery, London, Patrick Seale Gallery, London, Angela Flowers, RA Hunting Prize. *Publications:* The Male Nude by Edward Lucie Smith. *Clubs:* Space Studios Arts Service Grants Ltd. *Signs work:* "Ilric Shetland." *Address:* 76a Lauriston Rd., London E9 7HA.

SHIELDS, Christopher Ronald, Dip.A.D. (1973); artist in water-colour, gouache,acrylic and oils. *b:* Sale, Ches., 7 Jun 1954. divorced. *s of:* Ronald Brian Shields, A.M.I.P. one *d. Studied:* Northwich College of Art and Design (1970-73). *Exhib:* Warrington Museum and A.G. (1983, 1986, 1989, 1992), Wildfowl Trust Martin Mere (1985), Towneley Hall A.G. and Museum, Burnley (1988), Stockport A.G. (1991), The Art House, Shanghai, China (2003), Stock Exchange, Shanghai, China (2004); Shanghai International Art Fair (2003), plus several other one-man shows in private art galleries throughout Gt. Britain. *Works in collections:* Trafford Borough Council's Art Archives, City of Wakefield Educ. Resource Service Collection, Shanghai Insect Museum. *Publications:* published in Gt. Britain, Europe, N. America and Japan. Illustrated over 100 books including Collins Guide - Seashore of Britain and Europe, Collins New Generation Guide - Wild Flowers, Collins Gem Guide - Pond Life, Tracks and Signs of the Birds of Britain and Europe (A & C Black Publishing); City Birds(A & C Black Publishing); plus commissions for BBC publications, the RSPB and the Field Studies Council. *Signs work:* "Chris Shields" - always includes moth or butterfly in every work. *Address:* 2 Bramble Walk, Sale, Ches. M33 5LL. *Email:* chris@chris-shields.com *Website:* www.chris-shields.com

SHIELDS, Mark, B.A. (1985), P.G.C.E. (1989), A.R.U.A.; painter in acrylic, oils and water-colour. *b:* Co. Down, N. Ireland, 22 Feb 1963. *Educ:* Regent House School, Newtownards, Co. Down. *Studied:* University of Ulster (1981-1985 & 1988-1989). *Exhib:* R.A., R.I., R.O.I., N.P.G., Florence Biennale; 'Inhabitants of the Dream Courtyard','Pilgrimage', and 'Paintings and Drawings' Grosvenor Gallery, London; Art Basel. *Works in collections:* National Gallery of Ireland, Ulster Museum, Arts Council for Northern Ireland, National Self-Portrait Collection of Ireland. *Commissions:* portrait of Prince Charles for Royal Gurkha Regiment. *Signs work:* "MS" monogram. *Address:* c/o Grosvenor Gallery 21 Ryder Street, London SW1Y 6PX. *Email:* art@grosvenorgallery.com *Website:* www.grosvenorgallery.com

SHIPSIDES, Frank, M.A.; painter in oil and water-colour, specialising in marine painting; President, Bristol Savages (1974-75);. *b:* Mansfield, Notts., 20 Sep 1908. *m:* Phyllis. one *s.* one *d. Educ:* King Edward School, Mansfield. *Studied:* Mansfield College of Art (1923) under Buxton; Nottingham College of Art (1925) under Else. *Exhib:* Alexander Gallery, Bristol 8. Ten one-man exhibitions. *Works in collections:* Bristol Maritime Heritage Centre "Visit of H.M. The Queen", Bristol Council House, H.M.S. Bristol paintings 1653-1983. *Publications:* Frank Shipsides Bristol; Somerset Harbours; Bristol Impressions; Original Graphic - Days of Steam & Sail; Bristol: Portrait of a City; Bristol: Maritime City, Shipsides Bristol (2001), Shipsides-Slow Boat to Bristol (2002). *Works Reproduced:* a number of limited edition prints-Alexander Gallery. *Clubs:* Bristol Savages (Pres. 1983-84). *Address:* 5 Florence Pk., Bristol BS6 7LS.

SHIRAISHI, Barry Toshio, teacher (painting and sculpture);Vice Pres. Royal Soc. of Miniature Painters, Sculptors and Gravers;. *b:* Woolwich, London, 5 May, 1938. *m:* Colleen Powell. two *s.* three *d. Studied:* Woolwich Polytechnic School of Arts (1950-54, Heber Matthews). *Exhib:* Geneva, Frankfurt, Paris and London. *Works in collections:* Franklin Mint Museum, Philadelphia. *Commissions:* Channel Tunnel Products and Franklin Mint. *Address:* 34 Paget Rise, Plumstead, London SE18 3QQ.

SHIRLEY, Rachel, B.A.Hons. (1986); animal, landscape and figures in oil; Daler Rowney art prizewinner (Spring 1995 and Autumn 1998), winner of Best Professional Abstract Painting in the S.A.A. Competition (2001). *b:* Nuneaton, 26 May 1965. *d of:* Sidney Raymond Shirley. one *s.* one *d. Studied:* N. Warwickshire College of Art, Nuneaton (1981-83), Kingston Polytechnic School of Fine Art (1983-86). *Exhib:* one-man shows: Museum and A.G., Nuneaton (1987), Hinckley Municipal A.G., Leics. (1988), Whitmoors Fine A.G., Leics. (1989); group shows: Hurlingham Gallery, London, Warwick University, Twycross Zoo Gallery, Leics. *Works in collections:* Midland private collections. *Commissions:* Cow Parade, London (2002), Cow Parade, Manchester (2002). *Publications:* 'Oil Paintings from your Garden'; 'Oil Paintings from the Landscape' (Guild of Master Craftsman Publications). *Works Reproduced:* Rosenstiels Fine Art Ltd., The Guild of Master Craftsmen Publications Ltd. *Signs work:* "Rachel Shirley."

Address: 65 Gipsy Lane, Whitestone, Nuneaton, Warwickshire CV11 4SH. *Website:* www.rachelsgallery.fsnet.co.uk

SHIRLEY, Sidney Raymond, Médaille d'Argent (Paris Salon, 1981); still life artist in oil. *b:* Coventry, 27 Nov 1930. *s of:* the late Horace James Shirley. *m:* Sylvia Denise Elizabeth. six *d. Studied:* privately. *Represented by:* Claire Galleries, Birmingham. *Exhib:* one-man shows, Museum and A.G., Nuneaton (1968, 1974, 1982, 1993); group shows, R.A., N.E.A.C., R.B.A., R.O.I., R.B.S.A., New King's Rd., and 20th Century Galleries, London. *Works in collections:* Australia, N.Z., France, Austria, U.K. *Publications:* Brimstone Design and Print, Nuneaton, Warwickshire. *Works Reproduced:* R.A. Illustrated, La Revue Moderne, Le Monde, etc. Work reviewed BBC-CWR (1993). *Clubs:* Membre Associé, Société des Artistes Français, Founder mem, Bedworth Civic and Arts Soc. (1969). *Signs work:* "R. SHIRLEY" or "R.S". *Address:* 65 Gipsy Lane, Whitestone, Nuneaton, Warwickshire CV11 4SH.

SHIRLEY SMITH, Richard Francis, Slade Diploma. *Medium:* wood engraving, acrylic painting, mural decorations. *b:* Hampstead, 1935. three *s.* one *d. Educ:* Harrow School, Slade School of Fine Art. *Studied:* Rome (1961-62). *Exhib:* over 25 solo shows including: Aldeburgh Festival, Holburne Museum, Bath, The Maas Gallery, Chris Beetles Gallery. a 50th birthday Retrospective at the Ashmolean Museum, Oxford. *Works in collections:* Harrow School, Sir Roy Strong, Ashmolean Museum Print Room (hold all the engravings). *Commissions:* illustrations: The Limited Editions Club of New York, The Folio Society, OUP, Fabers, etc.; murals: Grey's Court, Princes Gate, Kensington Palace Gdns, The Kindersley Centre, etc. *Publications:* The Wood Engravings of Richard Shirley Smith (Silent Books, 1992); Richard Shirley Smith, The Paintings & Collages (John Murray, 2002); The Bookplates of Richard Shirley Smith (The Fleece Press, 2005). *Recreations:* music. *Misc:* Photographic expeditions to the villas of Veneto (1970), The Roman Baroque (1972), and Antiquities of Asia Minor (1996). *Signs work:* 'Richard Shirley Smith'. *Address:* Studio House, Elcot Lane, Marlborough, Wilts, SN8 2BA. *Website:* www.richardshirleysmith.co.uk

SHIRREFF, Jack Robert, N.D.D., A.T.D., A.R.E.; artist in intaglio; Lecturer, Bath Academy of Art (1965-85); Director of 107 Workshop; Currently engaged in producing and publishing work by Howard Hodgkin, Joe Tilson, Jim Dine, Oleg Kudryashov, David Inshaw, Gillian Ayres, Patrick Hughes, Mark Vaux, Tony Fry, Tony Eyton, Craig Aitcheson, Michael Heindorff, Tom Hopkins, William Kendridge. *b:* Sri Lanka, 11 Jul 1943. *m:* Patricia. *Educ:* Sutton Valence. *Studied:* Brighton Polytechnic. *Publications:* S.W. Hayter: Eluard; S.W. Hayter: Death of Hektor; produced The Way We Live Now: Hodgkin/Sonntag; 'Evermore' (Hodgkin/Barnes). *Recreations:* flying: aerobatics. *Signs work:* "J. Shirreff." *Address:* 107 Workshop, The Courtyard, Bath Rd., Shaw, nr. Melksham, Wilts. SN12 8EF.

SHOA, Nahem, RSPP winner Carol Foundation, Mall Galleries (1992), BP National Portrait award NPG (1993), Elizabeth Greenshield award (1994). *Medium:* oil on canvas. *b:* 4 Oct 1968. *Educ:* Holland Park Comprehensive. *Studied:* London College of Printing (1987-88), BA, Manchester School of Art (1988-91). *Exhib:* R.A. Summer Show (1992, 1993), Discerning Eye (1992), The Sacred Body, James Colman Fine Art (1996), Modern British Show, RCA (1996,1997), Art 98-99 Business Design Centre. One-man shows: Montpelier Sunlesom's, London (1999); Walton Gallery, London (2002). 'Youth Culture' Plymouth City Museum and Art Gallery (2004); 'Giant Heads' (2004), 'Uncompromising Study' (2006) Hartlepool City Art Gallery; 'Facing Yourself' Bury City Art Gallery (2006)'We Are Here' (2005), 'True to Life' (2007) The Herbert, Coventry (2007). *Works in collections:* regional galleries, Hartlepool, Bury, Plymouth, Kew Gardens. *Commissions:* Peter Mandelson, MP, Dr. Mary Cowling, Lady Kate Douglas, Lord Queensbury. *Publications:* The Amazing Aventures of Nahem Shoa, Montpelier Sandleson (1999). *Signs work:* "N. Shoa." *Address:* 69 Princes Sq., London W2 4NY. *Email:* nahem.shoa@virgin.net *Website:* http://www.nahemshoa.co.uk

SHORE, Jack, A.T.D. (1943); artist in collage, acrylics and drawing in various media; President, Royal Cambrian Academy of Art (1976-82);. *b:* Ramsbottom, Lancs., 17 Jul 1922. *s of:* Frank Shore. *m:* Olive Brenda Shore. one *s.* one *d. Educ:* Haslingden Grammar School. *Studied:* Accrington and Manchester Schools of Art (1938-43, S. V. Lindoe, John M. Holmes). *Exhib:* R.Cam.A.; one-man shows, Theatre Clwyd, N. Wales (1979), R.Cam.A., Conwy (1980), Oriel Gallery, Bangor (1984). *Works in collections:* Bury A.G., and University College, N. Wales; private collections U.S.A., G.B. *Signs work:* "J. Shore." or "J.S." *Address:* 11 St. George's Cres., Queen's Pk., Chester CH4 7AR.

SHORES, Margot, painter in oil and acrylic; lecturer in painting, University of Newcastle upon Tyne (1985-90); visiting lecturer, R.A. Schools (1987-88);. *b:* 1961. *Exhib:* 'Young Masters' Solomon Gallery (1985), R.A. Summer Show (1986-87), Cleveland Drawing Biennale (1989). *Signs work:* "Margot Shores." *Address:* 70 On the Hill, Old Whittington, Chesterfield, Derbyshire S41 9HA.

SHORT, Andy M., BA (Hons) Painting (1977). *Medium:* acrylic, watercolour, oil, pencil, etc. *b:* London, 10 Nov 1954. *m:* Bernadette. one *s.* two *d. Educ:* Blackpool and Loughborough Colleges of Art. *Represented by:* Sandpiper Gallery, NAPA. *Exhib:* numerous individual and group exhbns including Daybook Exhibition and Tour, Cleveland International Drawing and Biennial Show, John Moores Liverpool Exhibition, RA Summer Show, NAPA-Birmingham Society of Artists. *Works in collections:* Jones Art Ltd, Leics CC, Blackpool Borough Council. *Publications:* exhbn catalogus: Cleveland International Drawing Biennial; John Moores 10. Natural History Southport. *Works Reproduced:* Art Review. *Clubs:* NAPA (1990). *Address:* 14 Leyburn Avenue, Norbreck, Blackpool, FY2 9AQ.

SHORT, Susan, MA Fine Art (print); First Prize, The Bread & Roses Competition (2004); KR Burt Paper Prizes (1999, 2000). *Medium:* installation, painting, drawing, prints. *b:* Yeovil, 10 Sep 1955. *Studied:* Wimbledon School of Art (Univ. of Surrey); London College of Printing; Goldsmiths College. *Represented by:* Southbank Printmakers Gallery, London SE1 9PP. *Exhib:* RA (2002, 04); 5th British International Miniature Print Exhbn. (2003-05); Mall Galleries; Chamber of Commerce and Industry; John Moore's; Morley Gallery, SE1; Beldam Gallery, Brunel Univ.; Riverside Studios, W6; The Tannery, SE1; BHF Bank, Queen St., London. *Works in collections:* BP/AMACO, private collections. *Publications:* 2004 'Printmaking Today Magazine', Summer, Vol 13 no.2; 'The Instant Printmaker' by Melvyn Petterson & Colin Gale (pub.Chrysalis, 2003); 'Screen Printing: The Complete Water-based System' by Robert Adam & Carol Robertson (pub. Tahmes & Hudson). *Works Reproduced:* 'Canary Wharf, E14' (woodcut, reproduced on postcard). *Signs work:* 'S.Short'. *Address:* 38 Abbey Gardens, London W6 8QR. *Email:* sushouk@yahoo.co.uk *Website:* www.southbank-printmakers.com

SHORTHOUSE, G. Sydney, PVPRMS, MAA, MAS-F, HS, FID (1969-83); retd. Company Director; artist in water-colour, mainly miniature portraiture; Display and Advertising Manager, Leicester Corp., Area Design Manager, E. Midlands Gas Board, Design Director, City Design and City Leather Companies; Awards: Hon. men. (1988, 1989, 1991, 1994, 1995, 1996) RMS Gold Bowl award; 1st International Portrait award Washington DC (1989); 2nd International Portrait award Florida (1990); Best In Exhbn. (1987), Bell award (1989) Hilliard Soc.; Suzanne Lucas award (1985); Mundy Sovereign Awards R.M.S. (1991); Excellence in all Entries award and 1st International Portrait award Florida (1995). *b:* Whitwick, Leics., 1925. married. *s of:* Alfred John Murby-Shorthouse, general manager. one *s.* one *d. Educ:* Hugglescote School. *Exhib:* RMS, Hilliard Soc., Florida and Washington DC. *Commissions:* The Garter Principal King of Arms, Lady Hilda Swan, The Governor of Anguilla, The Lord Provost of Perth, Scotland, The Pro-Chancellor of Edith Cowan University, W. Australia, Anastasia, Baroness Peter Hatvany. *Publications:* RMS - One Hundred Years; The Techniques of Painting Miniatures; The Magic of Miniatures. *Address:* The Barn, Main St., Wilson, Derbyshire DE73 1AD.

SHOWELL, Billy, BA; SBA; Certificate of Botanical Merit, SBA (2002-04, 2006-07); Silver Gilt RHS. *Medium:* watercolour and oil. *b:* 7 Aug 1966. *m:* Simon. two *s. Studied:* St.Martins School of Art; Epsom Art School (Diploma and BA in Fashion Design and Illustration). *Exhib:* Westminster Central Hall; Mall Galleries; Tunbridge Wells Art Gallery; Cranbrook Art Show; Linda Blackstone Gallery; Jersey; Isle of Wight; Lincoln Art. *Works in collections:* UK and internationally. *Commissions:* Mr L Rothschild; Mr & Mrs N Moore. *Publications:* Watercolour Flower Portraits (Search Press); The Art of Botanical Illustration by Margaret Stevens. *Works Reproduced:* images sold for cards. *Recreations:* cartoon/portraits. *Misc:* private classes ongoing. *Signs work:* 'Billy

Showell'. *Address:* 41 Bayham Road, Tunbridge Wells, Kent, TN2 5HU. *Email:* billyshowell@aol.com *Website:* www.billyshowell.co.uk

SHRAGER, Ann Jessica, N.E.A.C. (1975); artist in oil and water-colour; Arts Club Prize (2001); Travel Prize (2004). *b:* London, 9 Jan 1948. *m:* Martin Anderson. two *s. Studied:* Byam Shaw (1967-70, Maurice De Saumarez), R.A. (1970-73, Peter Greenham). *Represented by:* Manya Igel, Claudia Wolfers, Rowley Gallery. *Exhib:* mixed: R.A., N.E.A.C., New Grafton, Erica Bourne, British Art at Auction, Bilan de L'Art Contemporian, Paris; one-man: Michael Parkin (1976, 1978, 1979, 1996), New Grafton Gallery (2004, 2005), Olympia, James Huntington-Whiteley; two-man show: New Grafton Gallery (April 2002). *Works in collections:* Sir Brinsley Ford, Mitsubishi Japan, De Beers. *Publications:* book cover design for Remember Your Gramer! (Winged Lion Publishers). *Clubs:* Arts Club. *Signs work:* "A.J.S." *Address:* 3 Maids of Honour Row, The Green, Richmond, Surrey TW9 1NY.

SHUKMAN, Barbara Benita, Jacox Students Painting Prize, Edmonton, Canada (1968), John Radcliffe Purchase Prize, Oxford (1983); painter in acrylic on paper and canvas, and inks on silk, and printmaker, etchings, etc.;. *b:* London, 25 Nov 1934. *d of:* Denys King-Farlow, M.B.E. *m:* (1) Harold Jacobs. one s. two d. (2) Harold Shukman. *Educ:* USA primary schools; Queen's College, London. *Studied:* University Saskatchewan, Regina, Canada (1963-65), University Alberta, Edmonton, Canada (1966-70). *Exhib:* group shows: Canada, UK, Spain; solo shows: UK, USA. *Works in collections:* USA: Solomon Guggenheim Museum, NY; Georgia Museum of Art; New Orleans Museum. Turkey: Sheraton Voyager, Antalya. Barbados: Sandy Lane Hotel. UK: Sedgwick Group; British and Commonwealth; Sarm Film Studios; Bain and Co.; Jardine and Co.; Strutt and Parker; Chartwell Land: Christiana Bank; Booz Allen, (all London). John Radcliffe Hospital Oxford. *Signs work:* "Barbara Shukman." *Address:* 11 Cunliffe Cl., Oxford OX2 7BJ.

SHURROCK, Christopher, ATD (Dist.); Art Advisor, University Settlement, Bristol, Cardiff College of Art, Foundation Dept. 1962-91 (Senior Lecturer/Director). Consultant Art and Design. *Medium:* painting, sculpture, print, constructions. *b:* Bristol, 1939. *Studied:* painting: West of England College of Art Bristol, Postgraduate Cardiff. *Exhib:* since 1966 internationally. One-man shows 'Some Small Works', Old Hall Gallery, Cowbridge (1994), 'Cabinet' (2007). *Works in collections:* National Gallery of Slovakia, Bratislava, National Museum/Gallery of Wales, University of Wales, CASW, Bristol Art Gallery, etc. *Publications:* 'Do You Feel Surrounded by Things.' (1974); Studio International (June, 1966) D'Ars Agency N36-37 (1967), Art and Artists (Jan. 1969), Art in Britain, 1969-70 (Dent), Studio International 991/2 (1981), Art in Wales 1850-1980. *Clubs:* member: 56 Group Wales; Royal West of England Academy. *Address:* 9 Min-y-Nant, Rhiwbina, Cardiff CF14 6JR.

SHUTT, David Richard Walter, BA 1st Class Hons Fine Art; HDip (Post Grad); mem. London Group. *Medium:* oil, watercolour, drawing, prints. *b:* West Kirby, UK, 30 Jan 1945. *s of:* Arthur Shutt. one *d. Studied:* graduate and postgraduate study in painting, Leeds University, Slade School of Art UCL. *Represented by:* Kapil Jariwala Gallery (UK); Jill Yakas Gallery (Greece). *Exhib:* UK, USA, Greece, Ireland, Italy. *Works in collections:* Leeds University; Arts Council of Wales; museums on Merseyside; Emmanuel College Cambridge; private: USA, Australia, Japan & UK. *Commissions:* not accepted. *Publications:* 'David Shutt, A Retrospective (Andrew Lambirth, 1999 ISBN 1 898 669 21 X); 'David Shutt, The Greek Paintings' (Kapil Jariwala, 2002, ISBN 1 899 253 114); 'David Shutt, Sacred Sites' (Augustine Zenakos, 2005, ISBN 1 898 669 23 6). *Official Purchasers:* as in collections. *Works Reproduced:* various newspapers, catalogues (solo and group exhbns), magazines. *Misc:* mem. London Group. *Signs work:* 'David RW Shutt'. *Address:* c/o Kapil Jariwala Gallery, 2 Talfourd Place, London SE15 5NW. *Email:* shuttdavid@yahoo.co.uk *Website:* www.shuttpaintings.com

SIDERY, Vera Ethel, painter in pastel and oil. *b:* 3 Aug 1916. *d of:* Charles Chapman. *m:* Albert Sidery (decd.). two *s.* two *d. Educ:* Tottenham High School. *Studied:* with Leonard and Margaret Boden. *Exhib:* P.S., Mall Galleries, London; one-man show, Broomfield Museum, Southgate. *Signs work:* "V.E. Sidery." *Address:* 8 Roedean Cl., Enfield EN3 5QR.

SIDOLI, Dawn Frances, RWA (1987), NEAC (1990); Awards: NEAC: Critic's Prize (1988, 2004), Drawing Prize (2000); 1st Prize Winner: Laing National Painting Competition (1988); Teacher's Cert. (1956); Finalist, Laing '85, '86; Hunting Group '86, '87, '89, Inveresk, Singer and Friedlander w/col. Comp., Laing National First Prize '88, RWA Artistic Excellence Award 2003. *Medium:* oils, prints. *b:* Gosport, Hants., 24 Nov 1933. *d of:* Patrick Thompson, accountant. *m:* Frank Sidoli. two *s.* one *d. Educ:* Wigton High School, Cumbria; Notre Dame Convent, Northampton. *Studied:* Northampton Art School (1949-52). *Exhib:* RA from 1977-2006, Regularly: RWA, NEAC; Discerning Eye Comp. (1997, 2002). Mixed exhbn: Red Rag Gallery, Stow-on-the-Wold; NEAC Mall Galleries; Rowley Cont.Art, London; Lynne Strover, Cambridge; solo exhbns: New Gallery, RWA (Bristol 2000, 2004). *Works in collections:* RWA, West Glamorgan CC, Cardiff School of Economics (Schools Art, Avon, Cardiff, Salisbury), Hewlett Packard. *Clubs:* Clifton Arts. *Signs work:* "Dawn Sidoli" or "SIDOLI." *Address:* Grafton Lodge Battery Lane Portishead Bristol BS20 7JD. *Website:* RWA & NEAC

SIEVEWRIGHT, Dionne Lesley, B.Des (Hons) Illustration and Printmaking degree; Livewire Young Business Award, Crighton Bequest-Travel Scholarship. *Medium:* painter and illustrator in mixed media, watercolour and printmaker. *b:* Perth, Scotland, 24 Jul 1973. *d of:* Alan and Lesley Abel. *Educ:* Perth Grammar School. *Studied:* Duncan of Jordanstone, Dundee University, Scotland (graduated 1997). *Exhib:* Clifton Gallery, Bristol (2003); Leith Gallery, Edinburgh (2003);

The Art Shop, Abergavenny (2001-08); Broadway Modern (2003); The Strathearn Gallery, Crieff (1997, 2003), D.Art, Dartmouth (2003-08); The Albany Gallery, Cardiff (2005, 06); The Waterford Gallery, Manchester (2005-08); Scottish Art Portfolio (2003-08). *Commissions:* Woodmansternes, Hallmark, Ling Design, Carlton, Gibsons, Marks & Spencer, Waitrose, Barnardo's, Tesco, and for private clients. *Signs work:* 'Dionne Sievewright', or 'DS'. *Address:* 'Dunvegan' Wern-y-Cwrt', nr. Raglan, Monmouthshire, NP15 2JG. *Email:* dionne@sievewright.freeserve.co.uk *Website:* www.dionesievewright.co.uk

SILBER, Evelyn Ann, Ph.D.(Cantab.), M.A.(Cantab.), M.A. (University of Pennsylvania), F.M.A.; art historian and museum curator; Director, Leeds Museums and Galleries (1995-2001); Director, Hunterian Museum and Art Gallery, University of Glasgow (2001-6); Chairman, Charles Rennie Mackintosh Society; heritage and museums consultant; lecturer. *b:* Welwyn Garden City, 22 May 1949. *d of:* Martin Silber, M.Sc. *Educ:* Hatfield Girls' Grammar School. *Studied:* history of art: New Hall, Cambridge (1968-72), University of Pennsylvania (1972-73), Clare Hall, Cambridge (1975-78). *Exhib:* organised: Jacob Epstein, Sculpture and Drawings, Leeds City A.G., and Whitechapel A.G. (1987). *Publications:* The Sculpture of Jacob Epstein (Phaidon, 1986), Gaudier - Brzeska: Life and Art (Thames and Hudson, 1996); catalogues, articles, lectures. *Clubs:* Royal Overseas League. *Address:* Hon.Prof.Research Fellow, Dept. of Art History, University of Glasgow, Glasgow G12 8QQ. *Email:* easilber2249@yahoo.co.uk

SILLMAN, Norman H., A.R.C.A., F.R.B.S.; sculptor, coin and medal designer, Royal Mint; Fine Art Dept. (retd.), Nottingham Polytechnic. *b:* 4 May, 1921. *m:* Gillian M. one *d. Educ:* Pyramid Hill, Australia. *Studied:* Blackheath Art School, Royal College of Art. *Exhib:* R.A., R.B.A., London Group, Midland Group, Arts Council "Sculpture in the Home" Exhbn., R.C.A. Open Air Exhbn. and others; medals exhib. in Europe and U.S.A. *Works in collections:* B.M., Derby Educ. Coll., Kelham Hall, Notts. Designed R.I.B.A. Awards (1990), British coins: £2 (1986), four £1 (1994), various overseas and private British. *Commissions:* sculpture 16ft. Staythorpe Power Station, Notts., several schools and various. *Publications:* articles, Saeculum (1981), Tubingen; Jour. Indian Anthrop. Soc. (1983). *Signs work:* "N. Sillman." *Address:* 33 Church St., Eye, Suffolk IP23 7BD.

SILVERMAN, Lisa Nicole, B.A. (Hons.) 1991, P.G.C.E. (1997); painter in oil and acrylic, printmaker, art teacher;. *b:* London, 26 June, 1968. *Studied:* Exeter College of Art (1987-91), Ecole des Beaux Arts, Toulouse (1989-90). *Exhib:* London: Mall Galleries, Barbican Centre, Battersea Arts Centre, Suburb Gallery, Railings Gallery, International A.G., Smith's Galleries, Ben Uri Gallery (The London Jewish Museum), Business Design Centre. *Works in collections:* Apthorp Fund for Young Artists. *Address:* 2 Danescroft, 21 Torrington Park, London N12 9AG.

SILVERTON, Norma, MA, NS, HND, FETC; artist/printmaker in etching, lithograph, silkscreen, 2D and 3D. *Medium:* printmaking/sculpture. *b:* Birmingham, 1941. married. one *s.* two *d. Educ:* in Birmingham. *Studied:* Byam Shaw School of Art, Camberwell College of Art (MA). *Exhib:* solo shows: Tel Aviv, Israel and London; and continually in group shows in U.K. and abroad. Curated print exhbns. between U.K., Israel and Germany. *Works in collections:* Scarborough Municipal A.G., Ben Uri Museum Collection. *Commissions:* private commissions. *Publications:* Eye Music - a collection of nine lithographs, Unspoken Poems - a collection of ten etchings. *Clubs:* Printmakers Council, N.S.P.S. *Signs work:* "Norma Silverton." *Address:* 13 Linden Lea, London N2 0RF. *Email:* nsilverton@hotmail.com

SIMCOCK, Jack, *Medium:* painter in oils. *b:* Biddulph, Staffs., 6 Jun 1929. one *s.* one *d. Exhib:* over 50 one-man shows, England and abroad. Work in many public art galleries and private collections at home and abroad. Major retrospective, Potteries Museum and Art Gallery (2001). *Publications:* Simcock, Mow Cop, autobiography (1975), Midnight Till Three, volume of poems (1975). *Signs work:* "SIMCOCK." *Address:* 13 Primitive St., Mow Cop, Stoke-on-Trent ST7 3NH.

SIMMONDS, Colin Dennis, NDD, ARBSA. *Medium:* oil, watercolour, pastel, drawing. *b:* Birmingham, 25 Oct 1940. *s of:* Charles & Lilian Simmonds. two *s. Educ:* Moseley School of Art (1953-56). *Studied:* Birmingham Collge of Art (1956-60); Birmingham School of Art Education (1973-74). *Represented by:* Broadway Modern; Montpellier Gallery, Cheltenham. *Exhib:* The Europe Salon, Brussels; The John Moores Exhibition, Liverpool; The Hurlingham Gallery, London; Royal Society of Portrait Painters; Royal West of England Academy; Royal Institute of Oil Painters; Royal Birmingham Society of Artists; The John Davies, Stow-on-the-Wold. *Works in collections:* Arts Council, Worcester University; numerous private collections in Germany, France, America, New Zealand. *Commissions:* various portrait and landscape commissions. *Official Purchasers:* West Midland Arts Council. *Signs work:* "CDSimmonds". *Address:* Nethercourt, Stoke Lacy, Herefordshire, HR7 4HJ. *Email:* colin.nethercourt@virgin.net

SIMMONDS, Jackie, H.N.D.; artist in pastel and all other media; First Prize 'Art in Nature' (1992), Pastel Society Award (1989). *b:* Oxford, 27 Dec 1944. *m:* Geoffrey Simmonds. two *d. Educ:* Preston Manor Grammar. *Studied:* Harrow School of Art (1978-82). *Exhib:* P.S., R.I., R.W.A., R.S.B.A., R.W.E.A., B.P.S., Britain's Painters (1992), several one-man exhbns in London; numerous UK galleries inc. Kelvingrove Museum, Glasgow; Art Expo, NY, USA; Smart Gallery, Florida. *Works in collections:* Guernsey Museum, Middlesex Hospital, Chesterfield Hospital, Bristol. *Publications:* Pastels Workshop (Harper Collins, 1994), Pastels Workbook (David & Charles), Learn to Paint Gardens (Harper Collins), You Can Sketch (Harper Collins), 6 videos for 'Teaching Art', Watercolour Innovations (Collins, 2005). *Works Reproduced:* many works

reproduced as prints and sold world-wide. *Misc:* signature member of The Pastel Society of America. *Signs work:* "Jackie Simmonds.PSA". *Address:* 23 Linksway, Northwood, Middx. HA6 2XA. *Email:* jackiesimmonds@aol.com *Website:* www.jackiesimmond.co.uk

SIMMONS, Fay, NDD (1959), Cert.RA (1963), Leverhulme Scholarship (1963), ARBS (1976); sculptor in bronze or gesso composition with mixed media; VSO Business/Social Development, Uganda. *b:* New Zealand, 12 Jul 1938. *d of:* Eric Simmons, MRCVS. *m:* Sean Mullaney (decd.). *Educ:* Stella Maris Convent, Bideford. *Studied:* Bideford School of Art; Hammersmith College of Art; R.A. Schools. *Exhib:* R.A., Nicholas Treadwell Gallery, A.I.A., Alec Mann Birmingham, XVIII Gallery Knightsbridge, Jersey, Guernsey, Gallery Oste Hamburg, New York, Washington. *Clubs:* R.B.S. *Misc:* First woman awarded the President's Prize for Sculpture, R.A. Schools (1963). *Signs work:* "F.S." *Address:* 54 Coburg Cl., Greencoat Pl., London SW1P 1DP.

SIMMONS, Rosemary, N.D.D. (1955), Hon. R.E. (1990); artist in relief printmaking, water-colour; writer; Founder Editor, Printmaking Today, now retired as editor. *b:* Brighton, 19 Oct 1932. *d of:* Alys & Donald Simmons. *m:* Anthony Christie, M.A., F.S.A. (decd). *Studied:* Chelsea School of Art (1951-55). *Exhib:* International Gdn. Festival (1984), Museum of Gdn. History (1985), St. John's, Smith Sq. (1987). *Works in collections:* Tate Gallery print collection. *Publications:* Collecting Original Prints (1980), Complete Manual of Relief Printmaking with Katie Clemson (1988), Dictionary of Printmaking Terms (2002), Collecting and Understanding Original Prints (2005). *Signs work:* "Simmons." *Address:* 12 Greendown Place, Combe Down, Bath BA2 5DD. *Email:* rosyprint@care4free.net

SIMONDS, Gillian Betty, NDD (1956); artist in acrylic. *b:* London, 8 Jun 1935. *m:* Brian Simonds. one *d. Educ:* Henley Grammar School. *Studied:* Folkestone and Dover Art Schools (1952-54), Canterbury College of Art (1954-56), Folkestone Arts Centre (1979-85, Beryl Bell). *Exhib:* Shepway Show, Folkestone; with NAPA: Newcastle-under-Lyme, Ludlow, RBSA Gallery B'ham, Westminster Gallery, London, Durham Art Gallery, Rooksmoor Gallery, Bath, Mariners Gallery, St. Ives, two-man exhbn, The Nevill Gallery, Canterbury; one-man exhbn: Shaftesbury Arts Centre. *Commissions:* Mr. A. Hobbs, Mrs. M. Eason. *Publications:* illustrated: From My Reading to Yours (Prometheus Trust), pencil drawings; 'One Pair of Boots' by Tony Hobbs (Logaston Press 2000), pen & ink drawings. *Clubs:* N.A.P.A. *Signs work:* "Simonds." *Address:* 8 Home Farm, Iwerne Minster, Blandford Forum, DT11 8LB.

SIMPSON, Alan John, R.S.M.A.; marine and landscape artist in oil, water-colour, pastel;. *b:* Basingstoke, 22 Jul 1941. *s of:* Arthur James Simpson. *m:* Denise. two *s. Studied:* informal training at College of Art, Bournemouth. *Exhib:* R.S.M.A., R.O.I., R.I., Britain in Water-colour, Mystic, Seaport, U.S.A., Linda Blackstone Gallery, Lincoln Joyce Fine Art, Kendalls Fine Art, Peter Hedley

Gallery. *Signs work:* "Alan Simpson." *Address:* 24 Waltham Rd., Bournemouth BH7 6PE. *Email:* alansimpsonrsma@lineone.net

SIMPSON, Cathy, BA(Hons), ARBSA, RMS, HS; freelance illustrator in water-colour and gouache; PG Cert; PG Diploma. *b:* Kingston on Hull, 15 Nov 1959. *Educ:* Christ's Hospital Girls' School, Hertford; Leicester University; Birmingham University. *Studied:* Central St. Martin's School of Art, Swindon College/University of Bath. *Exhib:* RI, SWLA, SWA, SBA, RMS, HS, RBSA, MAS-F, MAS-G, SAMAP. *Signs work:* 'with monogram'. *Address:* 23 The Dock, Catshill, Bromsgrove, Worcs. B61 0NJ. *Email:* casartist@ukonline.co.uk

SIMPSON, Ian, A.R.C.A. (1958); Abbey Travelling Scholar (1958); freelance artist-writer in oil, acrylic and drawing media; Principal, St. Martin's School of Art (1972); Assistant Rector, The London Institute, Head of School, St. Martin's School of Art (1986-88); Course Director, Open College of the Arts (1997-99), Consultant (1999-). *b:* Loughborough, Leics., 12 Nov 1933. *m:* Birgitta Simpson. two *s.* one *d. Educ:* Bede Grammar School, Sunderland. *Studied:* Sunderland College of Art (1950-53); Royal College of Art (1955-58). *Exhib:* R.A. since 1956; solo exhbn.: Durham, Cambridge, Blandford, Dorset, Chappel, Essex. *Works in collections:* Glasgow City A.G., Nuffield Foundation, Hull Education Authority, Northumberland Education Authority, London Borough of Camden. *Publications:* Eyeline (B.B.C.), Picture Making (B.B.C.) Drawing: Seeing and Observation (Van Nostrand Reinhold) 3rd Revised Edn. (A. & C. Black 1992), Ian Simpson's Guide to Painting and Composition (Warnes), Painters Progress (Allen Lane) re-published as "Practical Art School" (Tiger Books 1995), The Encyclopedia of Drawing Techniques (Headline), The Challenge of Landscape Painting (Collins 1990), The New Guide to Illustration (Chartwell Books 1990), Anatomy of Humans (Studio Editions 1991), Collins Complete Painting Course (Harper Collins 1993), Collins Complete Drawing Course (Harper Collins 1994). T.V. Programmes written and presented: Eyeline (B.B.C. 1968), Picture Making (B.B.C. 1972), Reading the Signs (B.B.C. 1976). *Clubs:* Suffolk Group. *Signs work:* "Simpson." *Address:* 20a The Paddocks, Bures, Suffolk, CO8 5DF.

SIMPSON, Leslie, F.R.S.A. (1985); portrait artist in oil and water-colour working to commission on all subjects; Director, Soc. of Miniaturists, British Water-colour Soc., British Soc. of Painters; Founder, Yorkshire Artists Exhbn. (1981); Principal, International Guild of Artists; inventor of 'Whimseycollie' collection of humorous paintings. *b:* Horsforth, 28 May 1930. *s of:* Sidney Arthur Simpson (decd.). *m:* Margaret. one *s. Educ:* Bridlington School. *Studied:* Hull College of Art. *Works in collections:* portrait of the full Wakefield City Council (1974); portraits of the Lady Lord Mayors of Leeds, Bradford, Sheffield and London; 'The Winning Throw' portrait of Tessa Sanderson, Los Angeles Olympics (1984). Descendant of James Simpson (1791-1864) leading non-conformist architect in the North, and John Simpson official portrait artist to Queen Donna Marie II of Portugal (1837). *Signs work:* "Leslie Simpson."

Address: Briargate, 2 The Brambles, Victoria Drive, Ilkley, W.Yorks. LS29 9DH. *Email:* info@britpaint.co.uk *Website:* www.britpaint.co.uk/www.britpaint.com

SIMPSON, Noelle, painter, colourist of joyous landscapes, nudes, interiors and portraits in oil on canvas, original limited edition prints. *b:* Auckland, N.Z., 10 Aug 1950. *d of:* Noel Simpson, racehorse breeder. one *d. Educ:* Chatelard, Switzerland; Moreton Hall, Shropshire. *Studied:* under Philip Sutton, R.A., and Frederick Deane, R.P. (1985), Van Wieringen, Bali (1986-90). *Exhib:* J. Weston Gallery, London (1985), Symon Gallery, Bali (1987), Bowmoore Gallery, London (1991), Hilton International, Bali (1992), Gagliardi Gallery, London (1992, 1994), Pacific Rim Gallery, San Diego (1993), Los Angeles (1995-97), Auckland, N.Z. (1998-99). *Works in collections:* Agung Rai Museum, Bali. *Publications:* Then Till Now - Noelle Simpson. *Address:* 18 Cottesmore Gdns., London W8 5PR.

SIMS, Anna, Southampton Institute of Higher Education Certificate in Painting (1986). *Medium:* oil, watercolour, drawing. *b:* Ringwood, Hants, 29 Mar 1953. two *s. Studied:* Southampton College of Fine Art, part-time, but mainly self-taught. *Represented by:* The Hunter Simmons Gallery, Westbourne, Bournemouth. *Exhib:* RA (2000); Llewelyn Alexander; Royal Society of Painters in Watercolours; Mall Galleries; 'Not the Turner Prize' (2003). *Works in collections:* Margaret Ziegler. *Commissions:* portrait, pastel: Mrs Lawrie McMenemy; Dr. Adam Sawyer and his three children. *Publications:* International Artist Magazine (article, Sept 2005); 100 Ways to Paint People and Figures (pub. by International Artist). *Works Reproduced:* 'Untitled Lady', 'Waldolf Castle' published by the above. *Clubs:* CAD Arts, Christchurch, Dorset. *Signs work:* 'Anna Sims'. *Address:* 25 Millhams Street, Christchurch, Dorset BH23 1DN. *Email:* anna@annasims.co.uk/anna.sims@ntlworld.com *Website:* www.annasims.co.uk

SIMS, Ronald Ivan, Gloucestershire College of Art Fellowship, RA Schools MA (Post Grad); NDD Painting; Hayward Gallery Prizewinner. *Medium:* acrylic paintings, drawing, prints, sculpture. *b:* Burnham-on-Crouch, Essex, 25 May 1944. *s of:* Frank & Irene Sims. *m:* Wendy Cruickshank. two *d. Studied:* RA Schools; Manchester College of Art; Colchester Art School. *Represented by:* Chappel Galleries, Colchester, Essex. *Exhib:* RA Summer Shows(1972, 73, 74, 75, 99); Chappel Galleries; Burlington Fine Art; Christie's Piccadilly; Hayward Gallery, Young Contemporaries (RA); Mall Galleries; National Print Exhbn; Art4Life, extensively in UK. *Works in collections:* Chappel Galleries; Colchester School of Art; Portsmouth College of Education; GLC London. *Commissions:* murals for Ancoats School, Manchester (18'x4'), Essex churches, altar panels (Russian Orthodox Church, Manchester), private commissions. *Publications:* 'British Artists since 1945' (Buckman); 'A Brush with Words' (Border Poets); 'Roderic Barrett' (Buckman). *Official Purchasers:* 'King'-Colchester School of Art; 'Puffer Fish' - Chappel Gallery. *Works Reproduced:* in RA Illustrated; Connoisseur Magazine; National Print Exhbn; Anglia TV. *Principal Works:*

'Mickey Mouse with Hands in Pockets'; 'Female Auto Hairstyle'; 'Pregnant Dog and Moon; 'French Racing Cyclist Head'. *Recreations:* sailing, walking, badminton, Italian holidays. *Clubs:* 12PM (Printmakers); RASA; Gainsborough House Print Workshop; Colchester Art Society. *Misc:* art criticism for 'a-n Magazine'; Art Expo column for Essex County Standard newspaper. *Signs work:* 'R.I.Sims' (generally on reverse of works for hard-edge painting style) e.g. R.I.Sims '05. *Address:* 'Bugle Cottage' 123, Tilkey Road, Coggeshall, Essex CO6 1QN. *Email:* simscruick@arts123.fsnet.co.uk

SINCLAIR, David Mackenzie, RSW (2001) elected to Council (2002); Post Diploma Glasgow School of Art (Highly Commended), DA. *Medium:* painting oil/ watercolour; printing craft (etching and wood engraving). *b:* Glasgow, 9 Oct 1937. *s of:* David Sinclair and Jessie McLennan. *m:* Anitra Rushbrook. two *s.* *Educ:* Allan Glen's School, Glasgow. *Studied:* Glasgow School of Art. *Represented by:* Ewan Mundy Fine Art (Glasgow); Randolph Gallery (Edinburgh); Tom Dean's Gallery (Atlanta, USA). *Exhib:* London: Duncan Campbell, Piano Nobile, Mall Galleries, Islington Art Fairs; Edinburgh: Bourne Fine Art, Open Eye, Randolph, RSA, RSW, Printmakers; Glasgow: Ewan Mundy, Gerber, Compass, Kelly Gallery, Art Fairs, RGI; Tom Dean's, Atlanta, USA. *Works in collections:* Paintings in Hospitals Scheme, Scotland; Gracefield Art Centre, Dumfriesshire; Hunterian Collection Glasgow; various private collections Britain/USA. *Commissions:* various private commissions. *Official Purchasers:* Paintings in Hospitals, Gracefield Art Centre, Hunterian Collection, Royal Bank of Scotland. *Works Reproduced:* winning portrait for Morrison Portrait Award RSA (1997). *Address:* Rosebank, Paxton, Berwick-on-Tweed, TD15 1TE. *Email:* anitrasinclair@onetel.com

SINCLAIR, Elizabeth, N.D.D. (1954), A.T.D. (1958) Visual Arts Dip.(1969), Dip. in History of Art (1972); painter in oil, pastel, acrylic and water-colour. *b:* Glasgow, 18 Jan 1933. *d of:* Surgeon Captain, A.D. Sinclair, M.B., Ch.B., F.F.A., R.C.S. *Educ:* 'Wings', Charlton Pk., Wilts. *Studied:* Plymouth School of Art, Bath Academy of Art, London University. *Exhib:* one-man shows: Hong Kong, Italy; group shows: Hong Kong, Germany, Plymouth, London, Reigate, etc., Surrey Open Studios. *Works in collections:* Plymouth A.G. *Clubs:* Reigate Soc. of Artists, North Weald Group, Free Painters and Sculptors. *Signs work:* "E. Sinclair." *Address:* 10 Cockshot Hill, Reigate, Surrey RH2 8AE.

SINCLAIR, Helen, B.F.A.(Hons.) (1976); sculptor in cast stone and metal. *b:* S.Wales, 27 Feb 1954. *d of:* Noël Sinclair, electrical engineer. *m:* Terry Ryall, sculptor. *Educ:* Llanelli Girls' Grammar School. *Studied:* Dyfed School of Art, Wimbledon School of Art (1973-76, Peter Startup, Jim Turner). *Exhib:* Online Gallery, Southampton, Fairfax Gallery, Tunbridge Wells, Fairfax Gallery, Chelsea & Norfolk; Garden Architecture, Fulham; Hannah Peschar Sculpture Garden, Surrey. *Works in collections:* Bultarbo Estate, Sweden, Gary Rhodes. *Commissions:* Trophy for W. Wales Tec Management Awards; Wall Reliefs, Castle Square, Swansea; Award Trophy for Shelter Cymru; 'Mother & Child' for

churchyard, All Saints, Fulham; circle of figures for St.Mary's Hospital, Chichester; seated figure for 'Rhodes 24' restaurant. *Misc:* half-hour TV programme in 'Jigsaw' Arts Series (Aug 2003). *Signs work:* "Helen Sinclair" or "H.S." *Address:* Rhossili Farmhouse, Rhossili, Gower, Swansea SA3 1PL. *Email:* helen@sculptureculture.co.uk

SINCLAIR, N. T., M.A., F.M.A.; Senior Curator;. *Address:* Museum and Art Gallery, Borough Rd., Sunderland SR1 1PP.

SINNOTT, Kevin, MA (RCA); artist in oil on canvas;. *b:* Wales, 1947. *m:* Susan. three *s.* one *d. Studied:* Cardiff College of Art (1967-68), Gloucester College of Art (1968-71), R.C.A. (1971-74). *Exhib:* one-man shows: Ikon Gallery (1980), Blond Fine Art (1982, 1984), Chapter Arts Centre, Cardiff (1984), Bernard Jacobson Gallery (1986, 1987, 1988, 1990), Flowers East (1992, 1994, 1996), Caldwell/Snyder N.Y. (2000, 2001, 2002), Martin Tinney, (2001, 2003). *Works in collections:* British Council, B.M., A.C.G.B., R.C.A., Whitworth Manchester, Wolverhampton City Gallery, Unilever, Deutsche Bank A.G. London, Metropolitan Museum of Art, N.Y., National Museum of Wales, Ashmolean, Oxford. *Clubs:* Chelsea Arts. *Signs work:* initials right hand corner. *Address:* Ty'r Santes Fair, Pont-y-Rhyl, Bridgend CF32 8LJ. *Email:* mail@kevinsinnott.co.uk *Website:* kevinsinnott.co.uk

SITWELL, Pauline, S.W.E., R.A.S.A.A. Dip. (1937), L.I.S.T.D., F.R.G.S.; painter, printer, poet and lecturer; oil, water-colour, wood engraving, lithography, etc. *b:* Malta, 5 Oct 1916. *d of:* Group Captain William George Sitwell. *Educ:* full stage training and young career. *Studied:* St. John's Wood School of Art (1930), Royal Academy Schools of Art (1933-37). *Exhib:* S.W.E., R.S.M.A., and Mall Prints tour of G.B., etc.; Laureat Paris Salon de Printemps, Auribeau s/Siagne, France (1988); one-man show sponsored by Westminster City Council, many others. *Works in collections:* works in seven countries. *Commissions:* many and various. *Publications:* Green Song; Train Journey to Deal and other Poems (Outposts, 1981). *Clubs:* Royal Academy, Reynolds (Hon. Treasurer, retd. after 20 years), SIAC, BSCG, SWE, RASAA, FRGS, CAS. *Signs work:* "Pauline Sitwell". *Address:* 46 Porchester Rd., Bayswater, London W2 6ET.

SKARGON, Yvonne, *Medium:* wood engraving, botanical watercolours. *b:* Dovercourt, 1 May 1931. *m:* John Commander. *Educ:* Colchester School of Art (Blair Hughs Stanton, John O'Connor). *Studied:* wood engraving and design. *Exhib:* Society of Wood Engravers, numerous mixed exhibitions, International Exhibition of Botanical Art and Illustration, Pittsburgh. *Works in collections:* V & A, Hunt Institute for Botanical Documentation, Pittsburgh. *Commissions:* many books for most major publishers, Royal Mail Commemorative Stamps, Roses (1991). *Publications:* Author/Compiler/Illustrator: The Importance of Being Oscar (1988); Lily and Hodge & Dr. Johnson (1991); A Garden of My Own (1996); Concatenation (2000); Watermarks (2003). *Address:* 44 Prentice Street, Lavenham, Suffolk, CO10 9RD.

SKEA, Janet, RI (2002); BFA (1968); RI Members Award (2004); RI Arts Club Award (2006). *Medium:* water-colour, tempera and oils. *b:* Johannesburg, S.Africa, 15 Sep 1947. *Educ:* Parktown Girls' High, Johannesburg. *Studied:* Stellenbosch University (1965-68, Prof. Otto Schröder). *Exhib:* widely in the UK. London: Mall Galleries (RI, Singer and Friedlander, Discerning Eye and others); Manya Igel Fine Arts; Honor Oak; Linda Blackstone; West Country: Little Gallery, Mousehole; Waterside, St.Ives; RWA; Martins, Cheltenham; Red Rag and Noott, Broadway. Also: Langhams, Suffolk; Lincoln Joyce, Great Bookham; Look, Helmsley. Abroad: Annual Tregastel International Watercolour Exhibition (Talenz Prize, 1996); Solos: Museum of Garden History (1985), Heifer (1994), Southwark Festival (1995), Dick the Dog, Penzance (2001, 2002). *Works in collections:* Hertfordshire CC. *Publications:* Artists and Illustrators (January 1996, March 2002). *Works Reproduced:* 'Watercolour Workshop' (Harper Collins, 1995). *Signs work:* "Janet Skea" dated on reverse. *Address:* Le Bourg, St. Front la Riviere, 24300 France.

SKILLINGTON, Nancy: see TALBOT, Nancy Wilfreda Hewitt,

SKINNER, John, B.A. (Hons.) Fine Art (Painting); artist in oil painting;. *b:* Kent, 19 Aug 1953. *m:* Mary Skinner. one *s. Educ:* Brighton Polytechnic (1973-76). *Address:* 31 Quai Docteur Scheydt, 34200 Sete, France.

SLASKI, Peter, Dip Arch; FRIBA; DipTP London; Building Diploma. *Medium:* watercolours, oils, acrylic, pastels. *b:* 28 Jun 1925. *s of:* C.Slaski. one *s.* one *d. Studied:* Regent Street Polytechnic. *Represented by:* Chelsea Art Society; Langham Sketching Club. *Exhib:* Chelsea Art Society; Langham Sketching Club; FAAS (Architects Artists Society); My Studio; Polish Cultural Society; France (Forces); Hurlingham Club. *Commissions:* portraits, landscapes. *Principal Works:* landscapes. *Recreations:* painting, reading, music, theatre. *Clubs:* Hurlingham Tennis. *Signs work:* 'Peter Slaski'. *Address:* 18 Homefield Road, London SW19 4QF.

SLATER, Paul, MA; many and various design awards; D&AD Glenfiddich, National Library Illustration Award. *Medium:* acrylic, oil, drawing, prints. *b:* Burnley, Lancs.,7 Aug 1953. *s of:* Clayton & Marie Slater. *m:* Sophie. one *d. Studied:* Burnley College of Art (1969-71); Royal College of Art (1975-78). *Exhib:* regular one-man shows (annually) London and Florida, USA. *Commissions:* illustrated 'The Times' Saturday Magazine 'Restaurant Review' since 1990; work regularly appears in 'Radio Times' and 'The Week'. *Clubs:* The United Arts Club, Dublin; patron AOI. *Signs work:* 'P.SLATER'. *Address:* 22 Partridge Close, Chesham, Bucks HP5 3LH. *Email:* paulslater@btinternet.com *Website:* www.paulslaterbugle.com

SLATER, Richard, N.D.D. Illustration (1950), A.T.D. (1951), N.D.D. Painting/Lithography (1954), R.I. (1999); printmaker and painter in oils and water-colour; formerly principal lecturer, College of S.M. & S.J., Chelsea and Plymouth (1960-1980); 1st prize S.W. Open Figurative Art Comp. (1991), R.I.

medal (1992), Kingsmead/Rowland Hilder Prize (2003). *b:* Tottenham, London, 2 Jan 1927. *m:* Mavis. three *d. Educ:* Tottenham Grammar School. *Studied:* Hornsey School of Art (1943-1945, 1948-1954). *Exhib:* R.A., R.S.M.A., R.I., first solo exhib. at Whibley Gallery (1974), art centres in Plymouth and Cornwall, various galleries in S.W. and S. England. *Publications:* illustrations for Cambridge Univ. Press, lithographic editions for Consolidated Fine Arts, New York. *Clubs:* assoc. member St Ives Soc. of Artists. *Signs work:* "R E Slater R.I." *Address:* The Barn, Ducky Lane, Landrake, Saltash, Cornwall PL12 5DL.

SLICER, Sheila Mary, A.R.M.S. (1978); first prize M.A.S.-F. (1983, 1986, 1992); President, A.S.M.A. (Vic.); freelance miniature portraitist in water-colour; miniature restorer, lecturer. *b:* Yorks., 26 Sep 1930. *m:* Robert Slicer. two *d. Educ:* Bradford Girls Grammar School. *Studied:* Bradford Regional College of Art (1946-49). *Exhib:* R.M.S., M.A.S.-F., Andorra, Yorks. Water-colour Soc., Brighouse and Bradford Art Clubs, Victoria, New South Wales, Queensland and Tasmania, Australia, Hilliard Soc., Royal Pastel Soc. and Sweden. *Works in collections:* England, Bermuda, Florida, Australia, Hong Kong, Andorra, America, Japan. *Clubs:* R.M.S., M.A.S.-F., H.S., M.A.A., Victoria, N.S.W. and Queensland Miniature Socs., Australia, Tasmania. *Signs work:* "Sheila M. Slicer." *Address:* 16 Marna St Healesville Victoria 3777 Australia. *Email:* sslicer@bigpond.net.au

SLOAN, Bob, R.U.A., D.A., A.T.D.; Mont Kavanagh award (1983), R.U.A. medals: Silver (1983), gold (1988, 1999); sculptor in mixed media; Lecturer in Fine Art, University of Ulster;. *b:* Belfast, 10 Apr 1940. *m:* Veronica. one *s.* one *d. Studied:* Belfast College of Art (1959-63), Central Schools, London (1963-64). *Exhib:* Belfast, London, Liverpool, Dublin, N.Y., Kassel Germany. *Works in collections:* Ulster Museum, N.I. Arts Council, Arts Council of Ireland, National Self-Portrait Collection; private collections in Ireland, England, America. *Commissions:* Northern Bank, Strabane District Council, N.I. Tourist Board, Belfast Newsletter, Diocese of Derry, N.I. Housing Executive. *Signs work:* "R.W. Sloan". *Address:* 58 Upper Mealough Rd., Belfast BT8 8LR, Northern Ireland.

SLOAN, Victor, M.B.E., DA, FRPS, ATC, RUA, FRSA; visual artist/lecturer - photography, video, printmaking, painting and drawing; Awards: British Council, Arts Council of N.Ireland, Dept. of Foreign Affairs (Ireland), An Chomhairle Ealaion, Arts Council of Ireland, Culture Ireland, Gold Medal Print Award and Connor Prize (R.U.A.);. *b:* Dungannon, Co. Tyrone, 16 Jul 1945. *m:* Katherine Joyce Sloan (nee McCrum). two *s. Studied:* Belfast and Leeds Colleges of Art - Fine Art Painting (1963-69). *Exhib:* Exhibited widely throughout Europe, North America, South America and Asia. *Works in collections:* Imperial War Museum; National Photographic Archives; Dublin City University; Arts Council; National Self-Portrait Collection of Ireland; North West Arts Trust; British Telecommunications; National Museum of Photography, Film and Television; Ulster Museum; also public and private collections in U.S.A., Canada, Europe, Australia, Asia. *Publications:* 'Marking the North - The Work of Victor Sloan'

(England); 'Walls' (Northern Ireland); 'Borne Sulinowo' (Poland); 'Stadium' (Germany); 'Acts of Faith' (Ireland); 'Victor Sloan: Selected Works 1980-2000' (Northern Ireland)., 'Victor Sloan: Walk (Germany); 'Luxus' (Northern Ireland). *Signs work:* "VICTOR SLOAN." *Address:* Rosedale House, 10 Church Rd., Portadown, Co. Armagh BT63 5HT. *Email:* mail@victorsloan.co.uk *Website:* www.victorsloan.co.uk

SLOGA, Alison, Diploma (BA equivalent) in Communication Design and Fine Art (1984), Post Grad. Fine Art Painting (C & G. of London Art School, 1998); TDF Award for excellence in Art Direction and Design (1984), New Grafton Gallery Travel Scholarship for Painting (1998), City and Guilds of London Art School Prize for Gilding and Decorated Surfaces (1998). *Medium:* oil on canvas, oil on linen, mixed media on canvas/paper. *b:* Toronto, Canada, 29 Sep 1961. *d of:* Anthony and Elise Sloga. *m:* Lennart Hergel. one *s.* one *d. Educ:* Ontario College of Art (1980-84); City and Guilds of London Art School (1996-98); RCA (1996). *Represented by:* New Grafton Gallery, 49 Church St., Barnes, London SW13 9HH. *Exhib:* Royal Watercolour Society (1990); Quantum Contemporary Art (1997, 1998),New Grafton Gallery (1999, 2000, 2001,2002, 2003). *Works in collections:* Royal Institute of International Affairs, City and Guilds Institute, Dept. for Employment and Education, Mark Anthony Group Inc., B.C.Canada, Mission Hill Vineyards, B.C.Canada. *Commissions:* London Contemporary Art, Royal Caribbean International, Mission Hill Vineyards, B.C.Canada. *Publications:* 'A Private View- David Wolfers and the New Grafton Gallery'. *Principal Works:* Hyde Park War Memorial, Battersea Power Station, Lloyds Insurance Building -oil on canvas. *Address:* April Cottage, Farnham Lane, Haslemere, Surrey, GU27 1EU. *Email:* alison@alisonsloga.com *Website:* www.alisonsloga.com

SLOSS, Sheila, ARE; Chairman, Printmakers Council; teaches at London College of Communication (LCC). *Medium:* printmaking. *b:* Herts., 4 Jun 1950. *Studied:* Chelsea School of Art (PG, 1974); Portsmouth DipAD Fine Art (1973); RCA Post Experience Programme (2002). *Exhib:* Originals 07, Mall Galleries (Jury mem. 04); Bankside Gallery RE; Brit.International Mini Prints (Jury 06); MAAPS Int. Print, Canada - one of six UK representatives; RCA Portfolio (2002); Ofcom Building SE1; Printmakers Gallery, W5; many Printmakers shows. *Works in collections:* private collections. *Works Reproduced:* RE Printmakers Directory; 'Etching Guide' by Alan Smith. *Recreations:* B&W photography. *Signs work:* 'SHEILA M.SLOSS' ('S.M.SLOSS' on miniatures). *Address:* c/o Printmakers Council, Ground Floor, 23 Blue Anchor Lane, London SE16 3UL. *Email:* s.sloss@lcc.arts.ac.uk

SLOWE, Vikki, R.E.; printmaker. *b:* London, 24 May 1947. *d of:* David Ross. *m:* Martin Slowe. two *d. Educ:* Camden School for Girls. *Studied:* London College of Fashion; Camden Arts Centre. *Exhib:* R.A., R.E., Japan & U.S.A. *Works in collections:* Smithsonian Inst., Washington, Tel Aviv Museum, Israel,

Ashmolean Museum, Oxford. *Signs work:* "Vikki Slowe." *Address:* 35 Ornan Rd., London NW3 4QD.

SMAIL, Elizabeth Ann, F.L.S. (1991), F.S.B.A. (1985); Cert. of Botanical Merit (S.B.A. Exhbn. 1993 & 2000); botanical artist; Personnel Officer, Council Mem. (Ex-officio), Soc. of Botanical Artists (1988-95). *Medium:* watercolour. *b:* Ross-on-Wye, 5 Mar 1942. *d of:* Robert and Joan Ollis. *m:* Norman Smail. *Educ:* Ross-on-Wye. *Studied:* Hereford College of Art (1958-62). *Exhib:* Mall Galleries (1986, 1987), Westminster Gallery (annually since 1988), Hereford Museum and A.G. (1991), Kent Painters Group since 1992, Sevenoaks Reserve annually since 1994; 21 other centres worldwide since 1984. *Works in collections:* Hunt Inst. of Botanical Documentation, Pittsburg; Marine Soc., London; private collections throughout the world. *Commissions:* Wildfowl and Wetlands Trust (designs for stationery and giftware). *Publications:* contributions to 'Arte y Botanica (Banco de Madrid); Encyclopedia of Flower Painting Techniques; The Art of Botanical Painting. *Works Reproduced:* illustrations for articles in various publications; designs for reproduction on greetings cards and ceramics. *Recreations:* music, cinema, dandelions. *Misc:* teaches botanical illustration at centres in Kent and Dorset; tutor/assessor for SBA Distant Learning Diploma Course. *Signs work:* "Elizabeth Smail." *Address:* 25 Walton Rd., Tonbridge, Kent TN10 4EF.

SMAIL, Janice Ann, U.A.; Council mem. U.A. (1995-98), Teacher's Cert. (1962), C. & G. Fashion (1980); painter in oil, pastel, and water-colour. *b:* Bury St. Edmunds, Suffolk, 23 Feb 1939. *m:* Peter. one *s.* one *d. Educ:* Whitelands College, Putney. *Studied:* University of London Inst. of Educ., Reigate College of Art. *Exhib:* Westminster Gallery, London with U.A.; solo shows: Surrey and Cambs. Whittelsford Gallery, Cambs., Castle Gallery, Rothesay, Isle of Bute. *Works in collections:* internationally. *Clubs:* U.A., Cambridge Drawing Society. *Signs work:* "Jan Smail." *Address:* Woodlands, 24 North Rd., Whittlesford, Cambs CB2 4NZ.

SMART, Jeffrey, painter in oil, gouache and watercolour, pen and ink;. *b:* Adelaide, S. Aus., 26 Jul 1921. *s of:* Francis I. Smart. *Educ:* Pulteney Grammar School, Adelaide. *Studied:* S.A. School of Arts, Adelaide (1940), Grand Chaumiere (1948) under McEvoy, Academie Montmartre (1949) under Fernand Leger. *Exhib:* Whitechapel (1962), Tate Gallery (1963); one-man shows: Redfern Gallery (1967, 1979, 1982), Galleria 88 Rome (1968), Leicester Galleries (1970), Australian Galleries, Sydnet (1978, 1990, 1995, 1999, 2002), Philip Bacon Gallery (1992, 1996, 2000), Retrospective Exhibition, Art Gallery of NSW (1999). *Works in collections:* National Galleries of Sydney, Melbourne, Adelaide and Perth, Mertz Coll., Corcoran Gallery, Washington, Yale University, Von Thyssen Coll., Lugano, De Beers Coll., 20th Century Art, London. *Publications:* Art International (May, 1968), Present Day Australian Art (Ure Smith), Masterpieces of Australian Art (1970), 200 Years of Australian Art (1971), The Moderns (Phaidon Press, 1976), Jeffrey Smart (S. McGrath, Art International Vol. XXI/I, 1977), Jeffrey Smart (David Malouf, Art International, Nov. 1982); Jeffrey

Smart by Peter Quartermaine (Gryphon Press, 1983). Documentary film BBC "Omnibus" (1984), 'Not Quite Straight', memoir, pub. Heineman 1996, film documentary 'Smart's Labyrinth', Featherstone Productions 1995, Retrospective Catalogue of Art Gallery NSW 1999, 'Jeffrey Smart' by John McDonald, Craftsman, 1990. *Recreations:* piano playing. *Signs work:* "Jeffrey Smart." *Address:* c/o Redfern Gallery, Cork St., London.

SMITH, Barry Edward Jervis, B.A.; artist/illustrator in water-colour. *b:* Sydney, Australia, 27 Apr., 1943. *Educ:* Coburg High School; University of Melbourne (1961-66). *Exhib:* group shows in London; one-man shows: Nantes, Edinburgh, Sweden and Australia. *Publications:* written and illustrated 15children's books. *Signs work:* "B. Smith", "B.E.J.Smith" or "Barry Smith." *Address:* P.O. Box 846, London E8 1ER. *Email:* barryejsmith@btinternet.com *Website:* www.barryejsmithart.co.uk

SMITH, Basil, C.B.M. (2000), F.S.B.A. (1985), M.G.M.A. (1992); freelance artist in water-colour and acrylic. *b:* Hove, 13 Mar 1925. *m:* Mavis Grant. three *s.* one *d. Educ:* Xaverian College, Brighton. *Studied:* Brighton College of Art and Crafts (1940-42, 1946-48, Charles Knight). *Exhib:* R.I., Mall Galleries, Sussex Artists, Wildlife Artists, Westminster Gallery, Donnington, Limerock U.S.A., The Booth Museum of Natural History, Botanical Artists. *Commissions:* Veteran Car Paintings. *Publications:* illustrated: The Principles of Gardening, The Good Cook, Vegetables, Graham Hill's Motoring Racing Book, Food from your Garden. Over 400 paintings of flora and fauna, all types of transport through the ages for American First Day Covers, Veteran Cars fot London/Brighton programmes, stamps. *Official Purchasers:* Royal Automobile Club. *Works Reproduced:* greetings cards for Camden Graphics. *Signs work:* "BASIL". *Address:* 53 Davigdor Rd., Hove, E. Sussex BN3 1RA.

SMITH, C. Philip, M.B.E. (for services to art)(2000); ARCA (1st Class) (1954), MDE (1970), Fellow and Past President (1977-79) Designer Bookbinders; Presidium of Honour (Czech) (1989); several international Gold, Silver Medals; book artist, bookbinder, painter, author, inventor (Patents: maril, lap-back book-structure); Editor, The New Bookbinder (1980-95); British Museum team Florence flood 1966-67. *b:* Southport, Merseyside, 10 Jun 1928. *m:* Dorothy M. Weighill, artist. three *s. Educ:* Ackworth School, Yorks. *Studied:* Southport School of Art (1949-51), RCA (1951-54, Roger Powell); Sydney Cockerell bindery (1957-61). *Represented by:* British Library National Sound Archive, Life Story Collection (2004). *Exhib:* several solo UK and abroad, over 150 book-art, binding exhbns. UK, USA, France, Germany, Holland, Belgium, Luxembourg, Spain, Norway, Czechoslovakia, S. America, Canada, Japan, S. Africa, etc.; painting exhbns. include John Moores, RBA, etc. *Works in collections:* V& A, BM (BL), Royal Collection, Bibliothèque Historique, Paris, Royal Library Holland, and other major public collections UK, USA, Spain and around the world. *Publications:* The Lord of the Rings and Other Bookbindings, (1970); New Directions in Bookbinding (London and N.Y. 1975); The Book: Art

& Object (1982); Book Art: Concept and Making, in prep.; numerous exhbn. catalogues, articles and reviews internationally. *Official Purchasers:* Man Booker Prize Author's Presentation Bindings, 1991- present. *Principal Works:* book-walls: notably for Lord of the Rings, Vesalius: Dehumani.Corporis.Fabrica (BL), Macbeth (BL), King Lear (USA), 5-vol English Bible (V&A). *Clubs:* Designer Bookbinders, Meister der Einbandkunst, Canadian G. of B.B.A., Soc. of Bookbinders, Center for Book Arts, N.Y., Hon. Fellow Soc. of Czech Bookbinders. *Signs work:* "Philip Smith." *Address:* The Book House, Yatton Keynell, Wilts. SN14 7BH. *Email:* philipsmithbookart@tiscali.co.uk

SMITH, Caryl, S.B.A. (1997); mainly self taught artist, mostly flowers and gardens;. *Medium:* pastel and water-colour. *b:* Wiltshire, 21 Oct 1943. *m:* V. J. Smith. two *s. Exhib:* galleries in the Cotswolds, Wiltshire and Sussex. *Publications:* greetings cards. *Clubs:* SFP. *Signs work:* paintings "CARYL." *Address:* 16 Elm Avenue, East Peston, W. Sussex, BN16 1HJ. *Email:* carylsmith@onetel.com

SMITH, Colin Hilton, B.A.(Hons.), M.A.(R.C.A.); Harkness Fellow (Yale University), Royal Overseas League joint first prizewinner; painter in oil on canvas, acrylic etc. on paper; associate lecturer, Loughborough University;. *b:* Harpenden, Herts., 21 Feb 1953. divorced. *s of:* Reginald Walter Smith, headmaster. one *s. Educ:* Hitchin Boys Grammar School. *Studied:* St. Albans School of Art (1971-72), Falmouth School of Art (1972-75), R.C.A. (1975-79), Yale (1983-85). *Exhib:* solo shows: Adair Margo Gallery, El Paso, Texas U.S.A. (1999), Musikpaviljongen, Grenadjarstaden, Örebro, Sweden (1999), British Council Art Centre, Buenos Aires (1998), 6 Chapel Row Contemporary Arts, Bath (1998), VIP Lounge, Virgin Airways, Heathrow Airport (1997), Galleri M, Stockholm (1997), Arte.X.Arte, Buenos Aires (1996), Wilmer, Cutler and Pickering, Berlin (1995), University of Northumbria Gallery, Newcastle-upon-Tyne (1995), Chelsea Arts Club, London (1995), Galleri M, Stockholm (1995), Big Paintings for the Barbican, London (1993), Gallery Three Zero. N.Y. (1993), Kunst Europa, Kunstverein Freiburg, Germany (1991), Anderson O'Day Gallery (1991), Ruth Siegal, N.Y. (1986), Art Iteinera '83, Volterra, Italy (1983), Nicola Jacobs Gallery, London (1982, 1984, 1987, 1989). *Works in collections:* Tate Gallery, London, British Council, Buenos Aires, NatWest Group, London, Royal Palm Hotel, Phoenix, Arizona, Scottish Equitable, Edinburgh, Museum of Modern Art, Tel Aviv (Herrmann's Bequest), Virgin Communications, London, Wilmer, Cutler and Pickering, Berlin, BML Corporate Management, Frankfurt, Arthur Anderson, Newcastle, Amerivox Scandinavia, Stockholm, Duke and Duchess of Westminster, Coopers Lybrand, London, Hunting Group Plc., British Airways, Kettering A.G. and Museum, Kettering, Arthur Andersen, London, EMI Worldwide, London, British Standards Inst., London, Pearl Development, London, Contemporary Art Soc., London, Pepsi Cola, London, Prudential Holborn, London, A.C.G.B., Unilever, London, Royal College of Art, London. *Clubs:* Chelsea Arts. *Signs work:* "Colin Smith." *Address:* 27 Orsman Rd., London N1 5RA.

SMITH, David Henry, M.Art, R.C.A. (1971), Hugh Dunn Plaque (1971); artist in oil and water-colour;. *b:* Cleethorpes, 29 Oct 1947. *s of:* Henry Smith. *m:* Irena Ewa Flynn. *Educ:* Elliston Secondary Modern School, Cleethorpes. *Studied:* Grimsby School of Art (1965-68); R.C.A. (1968-71). *Exhib:* one-man shows, New Art Centre, London (1970-72), Fischer Fine Art, London (1974, 1976, 1978, 1981), Vienna (1976), W. Germany (1976), Sweden (1979). *Works in collections:* Arts Council, Contemporary Art Soc. *Signs work:* "D. H. Smith." *Address:* Hall Lodge, Holton-cum-Beckering, Wragby, Lincoln.

SMITH, Edward John Milton, A.T.D. (1952), N.D.D. 2nd Cl. Hons. (1951), F.S.A.E.; artist in lettering, writing and illumination; Principal Lecturer, Subject Leader (Art) P.G.C.E. Course, Leeds Polytechnic 1963-85 (now retd.); art teacher, West Monmouth School, Pontypool (1952-62); visiting lecturer, Newport College of Art (1954-62); President N.S.A.E. (1972);. *b:* Stonehouse, Glos., 3 May 1922. *s of:* Edward Milton Smith. *m:* Doreen. one *s.* two *d. Educ:* Central School, Stroud, Glos. *Studied:* Stroud School of Art (1936-38), Gloucester College of Art (1939-40), Leeds College of Art (1946-52). *Address:* Glevum, 30 Burnham Rd., Garforth, Leeds, Yorks. LS25 1LA.

SMITH, Elizabeth Anne, RSMA. *Medium:* pastel. *b:* 1950. *Studied:* Winchester School of Art; Bournemouth and Poole College of Art. *Exhib:* RSMA, PS, RBSA. *Commissions:* BASF; National Power; BP; South Tees Health Authority. *Signs work:* 'Elizabeth A.Smith'. *Address:* Still Point, Cross Lane, Ingleby Arncliffe, North Allerton, N.Yorks DL6 3ND.

SMITH, Graham, NDD; Samuel Jones Post Graduate Award (1961-62); Committee Member, Printmakers Council. *Medium:* drawing, prints, artists books. *b:* Exeter, 4 Feb 1941. *s of:* F.C. Smith & Jane Coakley. *m:* Susanna King. two *s.* one *d. Educ:* Roan Grammar School (1952-57). *Studied:* Camberwell School of Arts & Crafts (1957-61). *Exhib:* Print shown: 'Originals 05', Mall Galleries; Lessedra Mini Print Exhibition (2003, 04, 05); Major Show of Prints, Stark Gallery (2005); Exhibitor, Artists Books Show, ICA (2006); Prints exhibited with Printmakers Council group in various venues, also, Morley Gallery, Swiss Cottage Library, James Hockey Gallery; touring exhibition throughout UK (2008). *Works in collections:* various private collections. *Publications:* illustrated article, "Mangle to Printing Press", Printmaking Today (2004). *Works Reproduced:* Linocut print in 'Showcase' feature, 'Computer Arts Projects' (Feb 2007). *Signs work:* "G.F.SMITH". *Address:* 51 Murillo Street, London SE13 5QG. *Email:* gs.prints@virgin.net *Website:* www.art.abelgratis.co.uk

SMITH, Gregor, R.S.W., D.A. (1966), Post-grad. scholarship (1967); artist in oil and water-colour. *b:* Renton, Dunbartonshire, 15 Jul 1944. *s of:* Rev. Henry Smith, M.A. (decd.). *m:* Elizabeth. *Educ:* Wishaw High School. *Studied:* Edinburgh College of Art (1962-67). *Exhib:* R.S.A., R.S.W., R.I., Compass Gallery, Glasgow, numerous group and one-man shows. *Works in collections:*

H.R.H. The Duke of Edinburgh, S.A.C., numerous educ. authorities and district councils. *Signs work:* "Gregor Smith." *Address:* 'Waveney' Argyll Rd Kilcreggan, Helensburgh, Dunbartonshire G84 0JR.

SMITH, Ivor Stanley, M.A., LL.D., R.I.B.A., A.A. Dip.; consultant architect; educational consultant, Professor Emeritus. *b:* Leigh-on-Sea, Essex. *s of:* H.S. Smith, M.A. *m:* Audrey. one *s.* three *d. Studied:* Southend School of Art; Bartlett, Cambridge; A.A. Schools of Architecture. *Signs work:* "Ivor Smith." *Address:* 28 Victoria Park, Cambridge, CB4 3EL.

SMITH, Jack, artist in oil. *b:* Sheffield, 18 Jun 1928. *s of:* John Edward Smith. *m:* Susan. *Educ:* Nether Edge Grammar School. *Studied:* R.C.A. (1949-52). *Exhib:* twenty-eight one-man shows in England. *Works in collections:* Tate Gallery, Arts Council, Berlin Internatioal Gallery, Guggenheim Museum, Gottenburg Museum, British Council, Government Art Collection. *Publications:* Jack Smith, A Painter in Pursuit of Marvels, text Prof: Norbert Lynton. *Signs work:* "Jack Smith" or "Jacksmith." *Address:* 29 Seafield Rd., Hove, Sussex BN3 2TP.

SMITH, Jesse, B.A. (Hons.) 1988, Postgrad. Dip. (1992); artist in mixed media, visiting lecturer;. *b:* London, 5 Aug., 1966. *m:* Sharon Purves. one *d. Studied:* Norwich School of Art (1985-88), R.A. Schools (1989-92). *Exhib:* solo shows: One Gallery, Brick Lane, London (1999), Ozten Zeki Gallery, Walton St. London (1997-98); group shows: Bow Wow, Holland Pk. (1999), Clink St. Gallery, London Bridge (1999), R.A. Summer Show (1999), Studio 3 Gallery, Old St. London (1995-98). *Address:* 67 Whipps Cross Rd., Leytonstone, London E11 1NJ.

SMITH, Joan, M.A. (Hons.) (1987), Postgrad. Dip. in Painting (1988), M.F.A. (1989); artist in acrylic, oil and mixed media on canvas and paper, lithography; Lecturer in Drawing and Painting, Edinburgh College of Art;. *b:* Dundee, 28 June, 1964. *Educ:* Monifieth High School, Dundee. *Studied:* Edinburgh University (1982-87, Prof. Fernie), Edinburgh College of Art (1982-89, Prof. David Michie). *Exhib:* solo shows: Collective Gallery, Edinburgh (1992), Crawford Art Centre, St. Andrews (1993); many group shows, Pier Art Centre, Orkney (1994), Christopher Boyd Gallery, Galasheils (1995). *Works in collections:* R.S.A., Edinburgh College of Art, Edinburgh City Art Centre, Heriot Watt University, Glasgow Museums and Art Galleries. *Publications:* Drawing Comparisons (1997). *Signs work:* "Joan Smith." *Address:* 14 Coillesdene Gdns., Edinburgh EH15 2JS.

SMITH, Jonathan, DA; PGCE (A&D); Alexander Barker Award (1979). *Medium:* oil, acrylic, mixed media,drawing. *b:* Aberdeen, 16 Feb 1958. *s of:* D J Smith DA; J B Smith DA. *m:* Catherine Smith BSc Hon, MA Dist. two *s. Educ:* Ellon Academy, Aberdeen; Nicolson Inst., Stornoway. *Studied:* Grays School of Art, Aberdeen (1976-80). *Represented by:* The Barry Keene Gallery, Henley-on-Thames; HQ Gallery, Lewes, East Sussex. *Exhib:* RBA (2006); Barry Keene

Gallery; Fairfax Gallery Tunbridge Wells; RA (2004); RCA (2005); Lewes Contemporary Art; AAF London; Brighton Festival (various); Maltby Contemporary Art, Winchester; Henley Festival 2007. *Works in collections:* private collections UK, USA, Europe and Far East. *Official Purchasers:* East Sussex CC; Art and Museum Service; Art for Hospitals. *Principal Works:* 'Old Boat' (exhib. RA 2004); 'Boat Shed, St.Ives' (RCA, 2005), 'Hebridean Beach' (RBA Henley 2007). *Recreations:* music, walking. *Clubs:* NSEAD. *Misc:* Head of School, Creative Arts, Varndean College, Brighton. *Signs work:* 'Jonathan Smith'. *Address:* 24 South Way, Lewes, East Sussex BN7 1LU. *Email:* jsmithart@tesco.net

SMITH, Keir, B.A. Fine Art (1973); artist and teacher. *b:* Gravesend, Kent, 1950. *m:* Clare. *Studied:* University of Newcastle upon Tyne (1969-73), postgraduate study, Chelsea School of Art (1973-75). *Exhib:* selected solo shows: 'Mark/Meaning' A.I.R. Gallery, London (1977); 'Like Nimrod's Tower' Acme Gallery, London (1980); 'Sailing Ancient Seas' Ceolfrith Gallery and Ikon Gallery (1982); 'Navigator' Rochdale A.G. and nautical tour (1984); 'The Dreaming Track' Laing Gallery, Newcastle upon Tyne and Wolverhampton A.G. (1989); 'Flint Sepulchre' Mead Gallery and Bury St. Edmunds A.G. (1994); 'Ognissanti' Concourse Gallery, Barbican Centre (1998), Enclosed Garden, Lincoln Cathedral (2001). *Commissions:* 'The Iron Road' Forest of Dean (1986); 'The Way of Clouds' Usher Gallery, Lincoln (1990); 'From the Dark Cave' Henrietta House, London (1992); 'Stefano' - Enabled by Sculpture at Goodwood (1997). *Publications:* 'Ognissanti. Essays by Keir Smith, William Furlong and Ann Elliott' (1998); 'Towards the Eremitani'. Essay by Keir Smith (2000); 'Enclosed Garden'. Essay by Keir Smith (2001). All titles available on request from above address. *Address:* 19 Florence Rd., New Cross, London SE14 6TW.

SMITH, Ken, *Medium:* sculpture and printmaking. *b:* Manchester, 1944. *Educ:* Carpentry apprenticeship. *Studied:* Walthamstow College of Art; Bristol College of Art. *Represented by:* Bruton Gallery Ltd., and others. *Exhib:* Royal Academy, London; Royal West of England Acedemy; Manchester City Art Gallery; Cardiff City Art Gallery; Leighton House, London; Cork Street, London; Bath. Bristol, Leeds, etc. *Works in collections:* University of Vienna; Phillips Collections; private collections. *Commissions:* Large Scale commission in Majorca (2003). *Principal Works:* Stone carved figures and groups. *Address:* c/o Bruton Gallery, P O Box 145, Holmfirth, Yorks., HD9 1YU.

SMITH, Leo Illesley Gibbons, P.U.A.; Pres. United Society of Artists, past mem. of Executive Council, Federation of British Artists, past Vice-Pres. Soc. of Graphic Fine Arts, past Pres. Herts. Visual Arts Forum; painter in water-colour, pastel, acrylic, landscape, portrait, works of the imagination; Art Director in publishing and advertising, illustrator, typographer; latterly art editorial, Radio Times. *b:* Cobham, Surrey. *s of:* Cecil Arthur Smith, engineer, and Ethel Illesley Smith. *m:* Constance Hilda (decd.). one *d. Educ:* Queen Elizabeth's Grammar School Kingston. *Studied:* Hornsey College of Art (1945-49). *Exhib:* Mall

Galleries, R.B.A., R.I., R.P., P.S., N.E.A.C., R.W.S.; several one-man shows. *Works in collections:* Ealing Educ. Com. *Publications:* U.A. News and Views. *Signs work:* "Leo Gibbons Smith" or "L.I.G.S." *Address:* 207 Sunnybank Rd., Potters Bar, Herts. EN6 2NH.

SMITH, Liz, S.F.P. (1996), H.S. (1998); artist in water-colour, oil, acrylic. *b:* Romsey, Hants., 13 Sep 1927. *m:* Colin Smith. two *s. Studied:* Adult Education (Robert Palmer, R.O.I., R.B.A.). *Exhib:* S.F.P. at Castle Sofiero, Sweden; Societé Jersaise, St. Helier, Jersey; and Mottisfont Abbey, Hampshire; H.S.: Mall Galleries and Wells, Somerset; also exhibited at Castle Bosjokloster, Sweden, and Geras, Austria, St. David's Hall, Cardiff; "Spirit of the Garden" open exhibition at Salisbury Museum, Wilts, award winner (oil landscape) Dorchester Open Exhibition. *Publications:* greetings cards. *Clubs:* Boscombe Art Circle. *Signs work:* 'LIZ SMITH'. *Address:* 26 Herbert Ave., Parkstone, Dorset BH12 4EE.

SMITH, Marion, BA Hons, ARSA (1998), RSA (2005); 2003 Thyne Scholarship, English Speaking Union; 2000 Sir William Gillies Bequest, RSA. *Medium:* visual artist, mainly sculpture in stone, wood, metal, mixed media, coloured sheet acrylic. *b:* St. Andrews, 14 Feb 1969. *Studied:* Grays School of Art, Aberdeen (1987-1991). *Exhib:* solo exhib: Patriothall Gallery, Edinburgh (2005), Bonhoga Gallery, Shetland (2004), Crawford Arts Centre, St. Andrews (1997); Group Exhibitions: Iwate Art Festival, Japan (1998); Scandex, Stavanger, Norway (1995); Lulea, Sweden; Kemi, Finland. *Commissions:* Keith, Morayshire (2006), North Atlantic Fisheries College, Scalloway, Shetland (2002), Southampton, Manor Quay (2002), La Selle en Cogles, Brittany, France (2002), Hamilton Town Centre, South Lanarkshire (2000), House for an Art Lover, Bellahouston Park, Glasgow (1999); Gyle Shopping Centre, Edinburgh (1994), Tyrebagger Forest, Aberdeen (1994), Haddo Arts Trust, Tarves, Aberdeenshire (1994). *Signs work:* "Marion W Smith." *Address:* Royal Scottish Academy, The Mound, Edinburgh, RH2 2EL.

SMITH, Peter Macdonald, Fine Arts Hons Degree. *Medium:* oil, pastel, pencil; oil paintings, seascapes worked mostly out in front of the subject or from drawings and memory, also abstracts in oil plus acrylic collages. *b:* Hinckley, Leics, 6 Oct 1945. *s of:* Joan and Harry Smith. *Educ:* Secondary Modern, Hinckley, Leics. *Studied:* Falmouth College of Art. *Exhib:* Newlyn Society of Artists, Penwith Society of Artists, various St.Ives galleries, plus gallery mixed shows in Bristol, Cheltenham, Basingstoke, Cambridge and Mall Galleries, London, 'Webbs Road Fine Art', Battersea, London. *Publications:* 'Drawings to the End of the Century', 'Newlyn Society of Artists'. *Recreations:* gardening, sailing, listening to music, collecting contemporary works. *Clubs:* Sailing Club, St.Mary's. *Misc:* love ceramics which I also made at college- I buy other peoples now. *Signs work:* Peter Smith. *Address:* The Bungalow, Rocky Hill, St.Mary's, Isles of Scilly, TR21 0NE. *Website:* www.petermacdonaldsmith.co.uk

SMITH, Peter William, D.F.C.; artist in oils and water-colour. *b:* New Malden, Surrey, 3 Jul 1920. *s of:* A. W. Smith. *Educ:* Whitgift, Croydon. *Studied:* Reigate Art School. *Exhib:* East Sussex Art Club, Hastings (1947 and 1948), International Amateur Art (1969). *Signs work:* "Peter Smith." *Address:* Dean Cottage, Blanks Lane, Newdigate, Surrey RH5 5ED.

SMITH, Richard Michael, B.A. (Hons.) (1993); winner, Carroll Foundation award (R.P.); painter in oil on canvas, pastel, pencil. *b:* Warlingham, Surrey, 15 Jun 1957. three *s.* one *d. Educ:* Caterham School. *Studied:* Coventry Art School (1977-80, Colin Saxton, Harry Weinberger), and in studio of John Ward, R.A. *Exhib:* R.A. Summer Exhbns., R.P., Brian Sinfield Gallery, Burford, Portland Gallery, London, David Messum Gallery, London. *Works in collections:* G.L.C. *Commissions:* Dr. Robert Runcie, Past Archbishop of Canterbury; Lord Plumb, Past President of European Parliament; Mr. Justice Owen; Mr. John Fenwick. *Signs work:* "Richard Smith," "R.S." or "R.M.S." *Address:* Flat 5, Stangrave Hall, Godstone, Surrey RH9 8NB. *Email:* richardsmith.gallery@btinternet.co.uk *Website:* www.richardsmith.gallery.btinternet.co.uk

SMITH, Rita, B.A. (Hons.) (1978), H.D.F.A. (Lond.) (1980); Winner of The Guinness Award for best first-time exhibitor at Royal Academy of Art Summer Exhibition, 1993; artist in water-colour, oil and etching. *b:* London, 9 Mar 1946. two *s. Educ:* Collingwood School for Girls. *Studied:* Camberwell School of Art (1974-78), Slade School of Fine Art (1978-80), Boise Travelling Scholarship (1980). *Represented by:* Art Mill Gallery, Plymouth. *Exhib:* The Townmill Galleries, Lyme Regis; Thelma Hulbert Gallery, Honiton; Chapel Gallery, Saltram House, Devon; Plymouth Arts Centre; University of Surrey; Royal Academy of Arts Summer Exhibition (1993, 1997, 1998, 2003); Singer and Friedlander/Sunday Times Watercolour Competition (1995, 1997, 1998, 2000); SW Academy Open (2001-2005). *Works in collections:* National Trust, Guinness plc, University College London, University of Surrey. *Signs work:* "RITA SMITH." *Address:* 1 Gnaton Terr., Albaston, nr. Gunnislake, Cornwall PL18 9AG. *Email:* smithandarcher@aol.com *Website:* www.ritasmith.org.uk

SMITH, Ronald F, RGI (1999); David Cargill Award (RGI, 1997); John Cunningham Award (RGI, 2001). *Medium:* oil on canvas. *b:* Glasgow, 11 Apr 1946. *Educ:* Hillhead High School. *Studied:* Glasgow School of Art: graduated in Drawing and Painting (1969). *Exhib:* RGI; RSA (Festival Exhbn); Ainscough Contemporary Art, London; Portland Gallery; Thompson's Gallery, London; Edgar Modern International Art, Bath; Lemon Street Gallery, Truro. *Works in collections:* internationally. *Commissions:* Cunard: Queen Mary II. *Official Purchasers:* Glasgow City Council; Leeds Education Authority; Lanarkshire Education Authority. *Recreations:* squash; eating. *Clubs:* Glasgow Art Club. *Signs work:* 'SMITH' (on paintings): 'RONALD F SMITH' (on back). *Address:* c/o Glasgow Art Club, 185 Bath Street, Glasgow G2 4HU. *Email:* ronaldfrank@smith8034.fsnet.co.uk *Website:* gallery websites

SMITH, Simon, ARBS; Member, Master Carvers Association; Graduate, City & Guilds Institute; Member, Art Workers Guild. *Medium:* stone, marble, clay, brick. *b:* 18 Nov 1964. *s of:* Jeremy & Mary Smith. *Studied:* City and Guilds of London Art School, London. *Commissions:* public and private commissions. *Principal Works:* statue of Sir Hans Sloane, Duke of York Square, London; Cherubs and Cartouche, VCS School, London. *Signs work:* "SIMON SMITH". *Address:* Unit 3, Fishers Court, Besson Street, London SE14 5AS. *Email:* stonecarving@simonsmith.plus.com *Website:* www.simonsmith.plus.com

SMITH, Stan, R.W.S.; painter/draughtsman; Hon. Life President, London Group; former Head of Fine Art, Ruskin School, University of Oxford; Fellow, Linacre College, Oxford (1981); Chairman, Chelsea Arts Club (1994);. *b:* Hull, 1929. *Exhib:* widely in U.K. and abroad. Work in national, corporate and private collections worldwide. Prizewinner: R.A. and Hunting Group. *Publications:* include books, articles and videos on art and art theory. Consultant on magazines, TV and radio programmes. *Clubs:* The Arts Club, Chelsea Arts, Grouchos. *Address:* 1 Brunswick Cl., Twickenham, Middx. TW2 5ND.

SNOW, Graham, Dip.A.D. (1968), H.Dip. (1972); Mombusho scholar, Japan (1974-77), Artist in Residence, Cambridge University (1977-81); artist in oil and water-colour;. *b:* Exeter, 28 Oct., 1948. *Educ:* Colfox School, Dorset. *Studied:* Bournemouth College of Art (1966-68), Hornsey College of Art (1968-70), Slade School of Fine Art (1970-72). *Exhib:* one-man shows in London, New York and Tokyo. *Works in collections:* Arts Council, Chase Manhattan Bank, Texaco, etc. *Signs work:* "G. SNOW." *Address:* c/o Grob Gallery, 20 Dering St., London W1R 9AA.

SNOWDEN, Hilda Mary, BA (Hons.) Open University, FIAL; artist in pastels, oils, water-colour, embroidery, sculpture. *b:* Bradford, 13 Apr 1910. *d of:* James Snowden, textile manager. *Educ:* Grange Upper School, Hillcroft College, Surbiton. *Studied:* Regional College of Art, Bradford, Positano Art Workshop, Italy. *Exhib:* London, Bradford, Harrogate, Ilkley. *Publications:* author and illustrator, Dalesman (Nov. 1985); Under Stag's Fell - A History of Simonstone-Wensleydale (1989); author, Bradford Antiquary (1987). *Address:* Flat I, Victoria Mans., Dawson St., Thackley, Bradford BD10 8LH.

SOAR, John Richardson, M.A. (1966), B.Sc. (1952), A.R.M.S. (1996), H.S. (1989); landscape painter in pastel (from miniature to large size pastel paintings); Principal, Swindon Technical College and School of Art (retd. 1984); Inspector of Further Education for Essex C.C. (1965-70). *b:* London, 30 May 1927. *s of:* John C. Soar (decd.). *m:* Miriam Theresa. one *s.* one *d. Educ:* West Ham Municipal College; King's College, London. *Exhib:* U.A. (annually), Westminster Gallery; Hilliard Soc. of Miniaturists (annually), Wells; R.M.S. Westminster Gallery (annually); World Exhbn. of Miniatures (1995); regular contributor to Medici Gallery and Llewellyn Alexander Gallery, London. *Works in collections:* mostly in West of England, U.S.A., Canada and various European countries.

Clubs: Guild of Wiltshire Artists (President). *Signs work:* "JOHN SOAR." *Address:* 81 Chestnut Springs, Lydiard Millicent, Swindon, Wilts. SN5 3NB.

SOBIEN, Inka, (aka STEVEN, Inka); Grand Prix Humanitaire de France avec Medaille d'Argent (1977), La Palme D'or, Belgo-Hispanique (1977); artist; lecturer, Hornsey College of Art and Central Academy of Film, Art and Drama, London (1963-66), St. Martin's School of Art (1963-67). *b:* 25 Feb 1939. *d of:* Prof. Sobieniewski Zdzislaw. *m:* Stewart Steven (decd). one *s. Studied:* St. Martin's School of Art (1959-63). *Exhib:* one-man shows: Upper St. Gallery, London (1974), Gallerie Raymond Duncan, Paris (1975), New Jersey (1975), Ligoa Duncan, N.Y. (1975), Philadelphia (1975), Florida (1976), Festival International de Peinture et d'Art Graphico-Plastique de St. Germain-des-Pres, Paris (1976), Scribes Writers' Club, London (1978), Little Palace, Warsaw (1979), B.W.A. Gallery, Cracow (1979), Avant Garde Gallery, Wroclaw (1979), Barbican Centre (1985), Budapest (1985), Camden Arts Centre (1989); mixed shows: Grande Palais Paris; London: Marjorie Parr Gallery, Gallery XVIII, Annely Juda Fine Art, Leinster Fine Art, Salomon Gallery, Inka's Extravaganza ('97, '98, 2001), 'Inka's Story' Cork Street Gallery, London (2003). *Works in collections:* National Museum, Warsaw and Cracow, Museum of Modern Art, Budapest. *Signs work:* "Inka Sobien." *Address:* 15 Charlwood House, Strand Drive, Kew, Surrey, TW9 4DP. *Email:* inkasteven@btinternet.com

SOLOWAY, Louise Joanne, BA Fine Art; Baroda Scholarship. *Medium:* watercolour, drawing. *b:* London 27 Feb 1962. *d of:* Audrey & Alan Soloway. *m:* Reynold Chan. one *s. Studied:* Bath Academy of Fine Art, Corsham; Harrow College of FE. *Exhib:* Whitechapel Open; BP Portrait Awards; Museum of London Transport; exhbn. of drawings at Spitalfields Health Centre (sponsored by Whitechapel Gal.); Hillside Gallery, Edinburgh; Gallery 7, Hong Kong; China Club, Hong Kong. *Works in collections:* British Council, Bombay; Timothy Hyman; Homerton Hospital; Hackney Museum of London Transport; Whitechapel Library; Airport Authority Hong Kong. *Commissions:* London International Financial Futures Exchange; Oxford House Community Centre; Salomon Brothers Hong Kong Chek Lapkok Airport; Smithkline Beecham; Royal Bank of Scotland. *Address:* c/o Derwent Cottage, 1060 High Road, Whetstone, London N20 0QP. *Email:* lou_@hotmail.com

SOREL, Agathe, R.W.S., R.E., Churchill Fellow (1967), Fellow, Printmakers Council; printmaker, sculptor, lecturer. *Medium:* sculpture, prints, watercolours, artist's books. *b:* Budapest, 1935. *m:* G. Sitkey. one *s. Studied:* Academy of Fine Art, and Academy of Applied Art, Budapest; Camberwell School of Art and Crafts; Atelier 17, Paris. *Exhib:* one-man shows: Curwen Gallery, London, Arleigh Gallery, San Francisco, Philadelphia Print Club, Camden Arts Centre, O.U.P., Robertson Gallery, Ottawa, Mälargalleriet, Stockholm, Sculpture at Paul Kõvesdy Gallery, N.Y., Galerie Geiger Kornwestheim, Germany, Städtische Galerie Filderstadt, Germany; retrospective exhbn. Herbert Read Gallery, Canterbury, Highgate Fine Art, Galerie La Hune, Paris, Bankside Gallery,

London; Retrospective, Cartwright Hall Museum & Art Gallery, Bradford, ICA Mumbai, The Nehru Centre, London, LG Gallery London. *Works in collections:* in 33 major museums including B.M., Tate Gallery, Los Angeles Museum of Art, Philadelphia Museum of Art, Chicago Art Inst., National Gallery, Washington. *Publications:* illustrated: Jean Genet, Le Balcon, 'Catalana Blanca' in collaboration with Lorand Gaspar; 'The Book of Sand' in collaboration with David Gascoyne, Text Messages (2007). *Official Purchasers:* DCMS Government Art Collections, British Library, British Museum. *Works Reproduced:* Printmaking Today, Print Quarterly, Art & Metier du Livre, The Tamarind Papers. *Signs work:* "Agathe Sorel." *Address:* Dorrell Hall, 43 London Rd., London SE23 3TY. *Email:* agathe@sorel.eclipse.co.uk *Website:* www.agathesorel.co.uk

SORRELL, Julia, BA, Post-Grad RA Schools; artist/ tutor. *Medium:* painter in all media. *b:* Westcliff-on-Sea, 4 Aug 1955. *m:* Ian Sanders. two *s. Studied:* Southend College of Art (1972-73); Goldsmiths College (1973-76); RA Schools (1978-81). *Exhib:* RA Summer Exhbns, New Grafton Gallery, RBA, NEAC, Singer & Friedlander, RWS Open Shows, National Portrait Gallery, Maas Gallery (one-woman show), various exhbns nationwide. *Works in collections:* Chelmsford Museum and Art Gallery, Reading Museum Schools Service, National Portrait Gallery, Beecroft Art Gallery, Prof. Philip Rieff, Pennsylvania, various UK, USA and Europe. *Commissions:* Baron Ramsay of Canterbury, National Portrait Gallery, portrait commissions. *Clubs:* RASAA. *Misc:* keen to uphold the importance of drawing. *Address:* Manor Farm, Wash Lane, Snetterton, Norfolk, NR16 2LG. *Email:* wildplant@i12.com *Website:* www.juliasorrell.i12.com

SORRELL, Richard, PRWS; DipAD (1969), RA Schools Post. Grad. Cert. (1972), RWS (1978), RBA (1989), NEAC (1995); President, the Royal Watercolour Society. *Medium:* oil, water-colour and acrylic. *b:* Thundersley, Essex, 24 Sep 1948. *s of:* Alan and Elizabeth Sorrell, artists. *m:* Doreen Burke (divorced). two *s. Educ:* Eton House School, Thorpe Bay, Essex. *Studied:* Walthamstow Art School (1965-66), Kingston College of Art (1966-69), RA Schools (1969-72). *Exhib:* RA, RWS, NEAC, Bourne Gallery, Reigate, Agnews, Leamington Art Gallery, Galleries Sternberg, Chicago, Russell Gallery. *Works in collections:* V & A, Museum of London, National Trust. *Publications:* The Artist, Country Life. *Clubs:* Art Workers Guild. *Signs work:* "Richard Sorrell." *Address:* Spindlewood, High St., Kintbury, Berks RG17 9TN. *Email:* SorrellR@aol.com *Website:* www.richardsorrell.co.uk

SOUBIRAN-HALL, Alix, Batchelor of Political Science. *Medium:* acrylics, oil. *b:* Suresnes, France, 25 May 1974. *d of:* Monique Moullet & Jose Soubiran. *m:* Sean C.Soubiran-Hall. *Studied:* Academic art studies, decorative painting: Institut d'Etudes Politiques de Lyon, France; ESAG: Ecole Superieure des Arts Graphique, Pairs, France; Cepiade: Centre Pictural des Arts Decoratife, Boulogne, France. *Exhib:* RA Summer Exhbns, London; Avalon Gallery/

MOMA, Orlando, Florida; Covivant Gallery, Tampa, Florida;. *Works in collections:* 'Our Fabulous Babysitter', E.Rubinfield Collection (private coll.). *Publications:* BBC News, St.Pete Times, Orlando Leisure, House Beautiful (UK), Figaro Madame (France). *Recreations:* belly dancing, DJ. *Clubs:* Independant. *Signs work:* 'Alix Soubiran-Hall'. *Address:* 620 Delaney Park Dr., Orlando, FL 32806, USA. *Email:* alix_simopath@hotmail.com *Website:* www.alixsoubiran-hall.com

SOULAGES, Pierre, painter;. *b:* Rodez, France, 24 Dec 1919. *s of:* Amans Soulages. *m:* Colette Llaurens. *Exhib:* one-man shows in Museums of Hannover, Zurich, Essen, De Hagen (1960-61), Copenhagen (1963), Houston (1966), Paris (1967, 1979), Buffalo, Pittsburgh, Montréal (1968), Mexico, Caracas, Rio de Janeiro, Sao Paulo (1975-76), Liège et Salzburg (1980), Tokyo (1984), Kassel, Valencia, Nantes (1989), Séoul, Pekin, Taipei (1994), Paris, Montréal, Sao Paulo (1996), Hamburg, Zaragoza (1997), St.Petersburg, Moscow (2001), Munster, Copenhagen (2006). *Works in collections:* Centre G. Pompidou, Paris, Museum of Modern Art, Guggenheim Museum, N.Y., National Gallery, Washington, National Gallery of Australia, Canberra, Museo de Arte Moderna, Sao-Paulo, Tate Gallery, London, etc. *Address:* 18 rue des Trois-Portes, 75005 Paris, France. *Email:* pierre-soulages@wanadoo.fr

SOUTHEY, Marilyn Silvia April, *Medium:* oil, watercolour, drawing, prints. *b:* Zambia (N.Rhodesia) 17 Apr 1942. *d of:* Douglas & Sylvia MacKendrick. *m:* Verner Southey. one *s.* one *d. Educ:* Chaplin School, Gwelo, Zimbabwe (S.Rhodesia). *Studied:* Hornsey College of Art; Regent St. Polytechnic. *Exhib:* ROI, RWS, RI, RA Summer Exhbn; National Print Exhbn 'Originals '05'; Zimbabwe National Gallery; in France, and in International Print exhibitions. *Works in collections:* Royal Free Hospital; private collections. *Recreations:* gardening, reading, film, ballroom dancing. *Clubs:* PMC; HAC. *Signs work:* 'Marilyn Southey'. *Address:* Flat 10, Southgrove House, South Grove, Highgate, London N6 6LP. *Email:* marilynsouthey@aol.com

SOWDEN, Trevor, NDD, Adv.Dip.Ceramics (Goldsmiths); Taught in Newham, London (1957-92), finally as Head of Faculty of Design and Technology, Snr.Assessor MREB (1983-87). *Medium:* relief printmaking, small sculpture, painting. *b:* Cardiff, 7 Apr 1933. *s of:* Reginald & Muriel Sowden. *m:* Madeleine Chabloz. one *s. Educ:* Hereford High School; Cathays High School, Cardiff. *Studied:* Cardiff College of Art (1950-54); Royal Navy (1954-56); University of Wales (1956-57); Goldsmiths (1979-80). *Represented by:* Bircham Gallery, Holt; Gainsborough's House, Sudbury; Seapictures Gallery. *Exhib:* Mall Galleries, London; Mandell's Gallery, Norwich; Westcliffe Gallery, Sheringham; Gainsborough's House, Sudbury; Rooksmoor Gallery, Bath; Peter Hedley Gallery, Wareham. *Works in collections:* Palace of Westminster; private collections in Europe and America. *Commissions:* numerous private commissions for sculpture, paintings and illustrations. *Official Purchasers:* Palace of Westminster Print Collection. *Recreations:* reading and working. *Clubs:* Member

and ex-Chair, Gainsborough's House Printmakers; Elected Member and Secretary, East Anglian Group of Marine Artists. *Address:* 10 Harefield, Long Melford, Sudbury, Suffolk CO10 9DE. *Email:* tbsowden@btinternet.com

SPACKMAN, Sarah, B.A. (1981); painter in oil, water-colour, gouache, charcoal. *b:* Reading, Berks., 19 Feb 1958. *Educ:* Abbey School, Reading. *Studied:* Byam Shaw School of Art (1977-78), Camberwell School of Art (1979-81). *Represented by:* Solomon Gallery, Dublin; New Ashgate Gallery, Farnham. *Exhib:* Austin Desmond Fine Art, Cadogan Contemporary, New Ashgate Gallery, Farnham, Solomon Gallery, Dublin, Mitchell Gallery, Toronto, Canada. *Works in collections:* Contemporary Art Collection, Allied Irish Bank, many private collections worldwide. *Commissions:* portraits, landscapes and still lives. *Publications:* Millers Guide; c20 Painters and Sculptors, ed. Frances Spalding. *Works Reproduced:* several paintings as posters and cards by The Art Group. *Signs work:* "S.S." *Address:* 12 Henley St., Oxford OX4 1ER. *Email:* spackmansarah@hotmail.com

SPAFFORD, Iola Margaret, DFA 1953), RCA (1984), mem. MAFA.; artist in oil, pen and ink, water-colour, etching. *b:* Cambridge, 24 Aug 1930. *d of:* B.L. Hallward, MA. *m:* George Spafford (decd). one *s.* one *d. Educ:* Queen Anne's, Caversham. *Studied:* Bristol Art School (1947), Nottingham Art School (1948-50), Slade School of Fine Art (1950-54). *Exhib:* 8 one-man shows, Tib Lane Gallery, Manchester; Tegfryn Art Gallery, Menai Bridge, Anglesey; Snape Art Gallery, Suffolk. *Works in collections:* Manchester A.G. (Rutherston Collection), Salford A.G., and many private collections here and abroad. *Recreations:* music, travel. *Signs work:* "Iola Spafford." *Address:* 57 Hawthorn La., Wilmslow, Ches. SK9 5DQ.

SPARE, Richard, John, BA. *Medium:* glass, prints. *b:* Chelmsford, Essex, 16 Apr 1951. *s of:* Charles & Phyllis Spare. *m:* Kay Greendale. two *s. Educ:* Billericay School. *Studied:* Thurrock Technical College (Foundation); Maidstone School of Art (BA). *Exhib:* frequent exhibitor at RA Summer Exhbn; invited exhibitor 'Discerning Eye', Mall Galleries; 'The Art on Paper Fair', RCA; National Print Exhbn; has exhibited widely throughout Japan, Australia, and UK. Solo shows in: Tokyo, Fukuoka, Osaka, Yokohama, Hiroshima, Matsuyama, Nara (Japan), Melbourne, London. *Works in collections:* Trevelyan College, University of Durham. *Works Reproduced:* by The Art Group; 'Etching, A Guide to Traditional Techniques' (Alan Smith, pub. Crowood); 'Galerie d'Amour' (John Powls), Canns Down Press. *Recreations:* travel, visiting museums. *Signs work:* 'Richard Spare'. *Address:* 72 Ravensbourne Park, London SE6 4XZ. *Email:* kayart@globalnet.co.uk *Website:* www.richardspare-kayspare.com

SPELLER, Michael Phillip, *Medium:* sculpture. *b:* Romford, Essex, 20 Feb 1958. *s of:* Keith & Olive Speller. *m:* Sarah Speller. one *s. Studied:* Chelsea School of Art. *Exhib:* Langham Fine Art, Kings Road Gallery, Woolff Gallery, Biscuit Factory, Art London, Affordable Art Fair, Garden Architecture, Barn

Galleries, London Art Fair, Cambridge Contemporary Art, The Gallery Cork Street, Art Space. *Works in collections:* private and public, UK and worldwide. *Commissions:* "Equity" - Newham Health Authority; Loch Lomond Golf Club. *Publications:* "At Home with Art" Tiddy Rowan Quadrille. *Principal Works:* Supportive Brothers; Family Tree; Secure; Balance; Commitment. *Signs work:* "MS" or "MICHAEL SPELLER". *Address:* 42 Beaconsfield Road, Blackheath, London SE3 7LZ. *Email:* speller@sculpture2000.fsnet.co.uk *Website:* www.spellersculptures.com

SPENCE, Leslie James Arthur, painter in oil. *b:* Wallasea, 30 Sep 1934. *m:* Mary. two *s.* one *d. Educ:* Leeds. *Studied:* under Prof. George McTaque. *Exhib:* R.S.M.A., R.B.A., Royal Society, Birmingham Artists; solo exhibs. throughout U.K. *Works in collections:* Westward T.V., Rowntrees of York. *Commissions:* R.N. Devonport, Norwegian Royal Navy, Rowntrees of York, Arndale Developments, Royal Marines, Plymouth Sound Radio, Leeds Regional Hospital Board, Chandos Records, Kunstanstalten May A.G., Germany, Lloyds Bank plc. *Publications:* reproductions published by Northern Editions, Solomon and Whitehead and others. *Clubs:* St. Ives Soc. of Artists, ECSofA. *Signs work:* "L J A Spence." *Address:* Clifton Farmhouse, Landulph, Saltash, E. Cornwall PL12 6QG.

SPENCER, Charles Samuel, lecturer and art critic; Former editor: Art and Artists, and Editions Alecto Collectors Club; former art critic London Daily Mail, New York Times European Edition. *b:* London, 26 Aug 1920. *Publications:* author: Erté (1970); A Decade of Print Making (1973); Leon Bakst (1973), enlarged and revised (1995); Cecil Beaton (1975), enlarged and revised (1995); The World of Serge Diaghilev (1974); editor: The Aesthetic Movement (1973); The World of Flo Ziegfeld (1974); Alecto Monographs on Kenneth Armitage, Colin Lanceley, Tom Phillips, Achilles Droungas, Ed Meneely, Harald Becker, Paulo Legnaghi, Igino Legnaghi; Dear Charliko - Memoirs of an English Art Critic in Greece (2005). *Recreations:* reading, cooking, travelling, opera, theatre. *Clubs:* Lansdowne Club, London. *Address:* 24a Ashworth Rd., London W9 1JY.

SPENCER, Claire, N.D.D. (1958), A.R.C.A. (1963), A.T.D. (1973), R.B.S.A. (1980), P.S. (1985); painter in oil, water-colour and pastel. *b:* Kingsbury, Middx., 17 May 1937. one *s. Educ:* Harrow County School for Girls. *Studied:* Hornsey College of Art (1954-58), R.C.A. (1960-63), Accademia di Belle Arti, Perugia (1966). Numerous individual and group exhbns. *Represented by:* Bridgeman Art Library for reproduction. *Exhib:* Major Retrospective, RBSA Galleries (2007). *Works in collections:* Nuffield Collection, West Midlands Arts Collection. *Publications:* contributor to The Artist Magazine, A Life with a View (Retrospective catalogue 2007). *Signs work:* "Claire Spencer". *Address:* 10 Sandbourne Drive, Bewdley, Worcs. DY12 1BN. *Email:* cpostins@gotadsl.co.uk

SPENCER, Gwen, N.S.; painter in oil, pastel and water-colour; Hon. Sec., National Soc. of Painters, Sculptors and Printmakers (Full mem. since 1980). *b:*

Argentine, 2 Oct 1927. *d of:* Edwin Arthur Conran, engineer. *m:* Christopher Spencer, F.C.A. two *s.* one *d. Educ:* St. Hilda's College, Buenos Aires. *Studied:* Atelier Josse, Buenos Aires, and Putney School of Art. *Exhib:* N.S., R.O.I., P.S., Ridley Soc., County Hall Westminster; Pump House, Battersea; Medici Gallery; Central Gallery, Great Yarmouth; Chelmsford Museum; Poole Art Centre; The Versicherungskammer, Bayern-Munich, and others. *Works in collections:* U.K., N. and S. America, Italy, Holland, Denmark, India and Australia. *Works Reproduced:* Medici Soc. *Misc:* member: Thames Valley Arts Society, Richmond Art Society. *Signs work:* "Gwen Spencer" or "G. Spencer." *Address:* 122 Copse Hill, Wimbledon, London SW20 0NL.

SPENCER, Liam David, B.A.; artist in oil paint. *b:* Burnley, 16 Apr 1964. *m:* Heather Walker. two *s. Educ:* Manchester Polytechnic (1983-86). *Represented by:* Philips Contemporary Art, Manchester, Wendy Levy Contemporary Art, Manchester. *Exhib:* touring exhbns."Windows on the City" (1996-97), "The Mancunian Way" (1997-98), "Urban Panoramas" (2000) – The Lowry, Salford; "Manchester to Shanghai" (2006), Manchester Art Gallery. *Works in collections:* Towneley Hall A.G. and Museum, Burnley, Manchester City A.G., Readers Digest, N.Y. *Commissions:* Price Waterhouse, Manchester, Arthur Andersen, Addleshaw, Booth & Co., Eversheds. *Publications:* 'Article of Faith' Richard Kendal Art Review (Oct. 1996), 'Landscape Next Door' Laura Gascoigne Artists and Illustrators (Sept. 1997), 'Urban Panoramas' David Sweet (2000), 'Liam Spencer - Painting from Life' (pub. Wendy J.Levy, Contemporary Art Ltd., 2004). *Recreations:* fly fishing, music. *Signs work:* paintings signed on reverse with monogram. *Address:* Higher Bridge Clough Farm, Coal Pit Lane, Waterfoot, Rossendale BB4 9SB. *Email:* liam@liamspencer.demon.co.uk *Website:* www.liamspencer-art.co.uk

SPENCER, Sarah, BA (Hons.) (1988), Post. Dip.RA.Schools (1991); painter in oil, charcoal, pastel; part-time lecturer, Canterbury College. *b:* Sevenoaks, 26 Sep 1965. *Educ:* Tonbridge Grammar School, West Kent College of FE. *Studied:* Camberwell School of Art and Crafts (1985-88), RA Schools (1988-91). *Exhib:* solo shows: New Grafton Gallery, Waterman's Fine Art; many mixed shows. *Works in collections:* West Wales Arts Council. *Signs work:* full signature on reverse of works, sometimes "S.S." on front. *Address:* 9 Cromwell Road, Whitstable, Kent CT5 1NW.

SPENCER PRYSE, Tessa, R.B.A. (1986); painter of portraits, landscapes and interiors in oil, water-colour, lithography. *b:* Highcliff on Sea, 28 Sep 1939. *d of:* Capt. Gerald Spencer Pryse, artist and lithographer. *m:* E.D.A. Cameron. one *s.* one *d. Educ:* France and Switzerland. *Studied:* Byam Shaw School of Art (1960-64, Peter Greenham, Bernard Dunstan). *Exhib:* R.A., R.P., R.B.A., N.E.A.C., R.S.A., R.W.S.; one-man shows: Phoenix Gallery, Lavenham, Hayletts Gallery, Colchester, Alpine Gallery, London, John Russell, Ipswich, Arthur Andersen, London, Llewellyn Alexander, London, Davies and Tooth, London, Wykeham

Gallery, Stockbridge. *Works in collections:* Essex Museum. *Signs work:* "PRYSE." *Address:* 12 Alma St., Wivenhoe, Colchester, Essex CO7 9DL.

SPENDLOVE, Gerald Hugh, A.T.D. (Dist.) (1954), F.S.D.C. (1972); designer- craftsman in calligraphy, lettering and ceramics; formerly Head of Ceramics, Herts. College of Art, St. Albans; Chairman, Soc. of Designer-Craftsmen (1979-81). *b:* Derby, 1929. *s of:* Horace Albert Spendlove. *m:* Valerie Spendlove. one *s.* three *d. Educ:* Salisbury School of Art (1949-51), L.C.C. Central School of Art (1951-53), N.D.D. Pottery and Calligraphy: Inst. of Education, London University (1953-54). *Exhib:* Nottingham, Southampton, Bath, York, St. Albans, London, Winchester. *Works in collections:* H.M. the Queen, Herts. C.C., Australia, France; private collections in U.S.A., France, Norway, Germany, Nigeria, U.K. *Commissions:* calligrpahy, ceramics, hand produced, all forms of lettering; stoneware and porcelain. *Signs work:* "G. H. Spendlove", stamp GHS in square. *Address:* The Sycamores, New Rd., Swanmore, Hants. SO32 2PE.

SPRAKES, John, ROI, RBA; Andrew Grant scholarship, D.A. (Edin.) post grad.; Prizewinner, Singer Friedlander/Sunday Times water-colour (1992), Manchester Academy (prize 85), Barclays Bank award (1986, 1991), P/P award (1989), The Le Clerc Fowle Gold Medal (ROI). *Medium:* oils, acrylic and watercolour. *b:* 17 Oct 1936. *s of:* T.B. Sprakes. *m:* Barbara Ann. three *s. Studied:* Doncaster College of Art, Edinburgh College of Art (1954-57). *Exhib:* RA; group and one-man shows. Work in public and private collections. Agent in London, J. Corless, Blackheath Gallery. *Works in collections:* Manchester City Art Gallery, UBS Collection, Singer Friedlander. *Works Reproduced:* several images reproduced in Books and Art magazine. *Clubs:* Mem. of The Manchester Academy. *Signs work:* "John Sprakes" or "J. Sprakes." *Address:* 39 Douglas Rd., Long Eaton, Notts NG10 4BH.

SPRINGS, John, American Society of Illustrators. *Medium:* ink, oil on canvas, acrylic. *b:* Leeds, Yorkshire 6 Feb 1960. *Educ:* Moorlands School, Leeds; Lawnswood School, Leeds. *Studied:* Park Lane College of Further Education. *Exhib:* Sally Hunter Gallery, Motcomb Street (1993); Rebecca Hossack Gallery, London (1998); Cartoon Gallery, London (1995). *Works in collections:* V & A, Chelsea Arts Club, Travellers' Club, private collections. *Commissions:* book illustrations, magazines (UK and USA). *Publications:* 'The Isles of the Sea' (Collins, 1983), The Spectator, Telegraph etc. *Official Purchasers:* private portraiture. *Recreations:* bodybuilding, motor sport. *Clubs:* Chelsea Arts Club, Travellers' Club, Savage Club. *Signs work:* Springs. *Address:* 53/55 Dovehouse Street, London SW3 6JY. *Email:* john.springs@ft.com

SPROULE, Lin, DES RCA; 1st & Silver Medal. *Medium:* goldwork, sculpture, oil, drawing. *b:* Oxford, 26 Feb 1942. *d of:* Donald Sproule, physicist & Elizabeth Irving Watson, artist. one *s.* one *d. Educ:* Monkton Wylde School, Dorset. *Studied:* Colchester School of Art, Central School of Arts & Crafts; Royal

College of Art; Slade School of Fine Art. *Represented by:* David Thomas, 65 Pimlico Road, London SW1W 8NE. *Exhib:* RA Summer Exhbns; Bear Lane Gallery, Oxford; Arnolfini Gallery, Bristol; V&A; Goldsmiths Hall, London and New York; Metropolitan Museum, New York, USA; Oxford Art Society. *Works in collections:* Goldsmiths Hall, London; Norman Parkinson; Noma Copley, New York, USA; John Aspinal. *Commissions:* Norman Parkinson: to make gold tiara for Princess Anne to be photographed in for her 21st birthday celebrations; Norman Parkinson: Gold tiara for his wife Wendell; Michael Severne: Gold grass stem and pomegranate pill box. *Publications:* 'Treasures of the 20th Century'. *Official Purchasers:* Goldsmiths Hall. *Recreations:* work, friends, food, dancing, sun, reading, film, music. *Signs work:* 'Lin Sproule' or 'LS'. *Address:* 8 Castle Street, Totnes, Devon TQ9 5NU. *Email:* lin.sproule@virgin.net

SQUIRE, Geoffrey, R.S.A. (2005), D.F.A. (Lond.) 1948, A.R.S.A. (1977), R.G.I. (1980), R.S.W. (1983); painter in oil, acrylic, water-colour, pastel; retd. senior lecturer, Glasgow School of Art (1988), Governor (1988-91). *b:* Yorks., 21 Feb 1923. *s of:* Norman Squire. *m:* Jeanmarie (decd.). one *s.* one *d. Studied:* Leeds College of Art (1939-41); Slade School of Art, Oxford (1941-42), London (1946-48, Randolph Schwabe). *Exhib:* Yorks., Glasgow, Fife, Edinburgh, London, Hamburg. *Works in collections:* Glasgow A.G., Greenock A.G., Paisley A.G., Jordanhill College of Educ., Royal Scottish Academy, Royal and Ancient Golf Club, New College, Edinburgh, Royal Hospital, Edinburgh, Court of the Lord Lyon, King of Arms, H.R.H. The Princess D. Maria Cristina, Duchess of Bragança, Advocates Library, Parliament House, Edinburgh. *Commissions:* portraits: Sir Henry Wood, Sheriff W.Hook, Dame Margot Hook, The Very Reverent Professor T.Torrance, Sir M.Innes, Lord Lyon, King of Arms, Lord Kincraig, G. Way Baron of Plean. *Signs work:* "SQUIRE." *Address:* 1/9 Ocean Way, Edinburgh, EH6 7DG.

STABELL, Waldemar Christian, painter in oil, wax drawings. *b:* Hillsborough, N.B., Canada, 1913. *s of:* Lorentz Stabell, shipowner (1865-1933), and Laura Edna (b Forbes Edgett, 1890-1968). *m:* Margit Baugstö. one *s.* one *d. Educ:* Canada, Norway. *Studied:* Scandinavia, Anglo-French Art Centre, London, Brighton College of Art (etching). *Exhib:* first one-man show in London (1947), St. George's Gallery; several one-man shows and mixed exhibitions. *Publications:* Edvard Munch and Eva Mudocci; Bernt Tunold 1877-1977; Phillip King - En Engelsk Billedhugger (1969); British Artists at the Voss Summer School of Fine Arts. *Works Reproduced:* in Studio, Canada's Weekly, Contact Book, Arts Review, London. Founder of the Voss School of Fine Arts (1964) Voss, Norway. *Signs work:* "Stabell." *Address:* c/o Christian Stabell, Os & Fusa Posten Postboks 272, 5201 Oslo, Norway.

STACK, Sharon Rachel, BTEC Cert. in Fine Arts. *Medium:* mixed media, oil, watercolour, drawing, prints. *b:* Penbury, Kent, 28 May 1973. *d of:* Sander & Bill Stack. *Studied:* Coleg Ceredigion (2005-2007). *Exhib:* Aberystwyth Arts Centre, Cambrian Arts Society. *Works in collections:* private collections in Wales and

England. *Commissions:* private. *Principal Works:* semi abstract, and abstract. *Recreations:* fashion and interior designer. *Clubs:* Cambrian Arts Society. *Signs work:* "S.Stack". *Address:* c/o Maes-y-Deri, Caibyn, Lampeter, Ceredigion, SA48 7ND. *Email:* www.sstack@hotmail.com

STAFFORD, C. Carolyn, C.P.S., S.G.F.A., P.M.C., N.S., A.U.A., N.D.D., D.A. (Manc.) (1955), Dip. Fine Art (1957); painter in oil and water-colour, printmaker in etching, woodcut, lino; tutor. *b:* Bolton, 9 Aug 1935. *d of:* Stanley & Elizabeth Stafford. *m:* Gordon Clough, broadcaster (decd.). one *s.* three *d.* *Educ:* Bolton School Girls Division. *Studied:* Bolton School of Art, Manchester College of Art (Ralph Downing, Ian Grant), Slade School of Fine Art (William Coldstream, Claude Rogers, Anthony Gross), Esmond Scholar British Inst. in Paris, etching with S.W. Hayter (1957-58). *Exhib:* John Moores, Liverpool, R.A., Bankside Open Prints, London Group, Arts Council tours, R.I., R.B.A., Printmakers Council, Malta, Art Olympia, Pump House, Contemporary Portrait Soc., Northern School (Pelter-Sands and touring exhbn.), Lvov, New Academy Gallery, Paris, Universities of Bristol, Cambridge, London, Oxford and Surrey (1980-90), Tel Aviv, Ben Uri Gallery, Curwen, F.P.S., Munich, North-South Printmakers Barbican, Yehudi Menuhin School, National Society (2007). *Works in collections:* Slade School, D.O.E., Bolton School (Girls Div.), Bolton A.G., Lvov A.G., Landau A.G., Scarborough A.G. *Commissions:* paintings for cruise ship "Musica" (2006). *Publications:* Arts Review, A Northern School (Peter Davies). *Works Reproduced:* UCL & Slade Catalogue Foundation (2007); Government Art Collection (2008). *Signs work:* "Carolyn Stafford," "Carolyn Stafford Clough" or "C. STAFFORD." *Address:* 52 Ellerton Rd., London SW18 3NN.

STAFFORD, Simeon, *Medium:* oil, plaster, wood, bronze. *b:* Dukinfield, 1 Jul 1956. *Represented by:* Oliver Contemporary, 17 Bellevue Road, London; Badcocks, The Strand, Newlyn, Cornwall; Rob Whittle Gallry, Birmingham. *Exhib:* Oliver Contemporary, London (2003, 2005, 2006, 2007); Sancreed House Sculpture Garden, Cornwall (2005); Shire Hall Museum, Bodmin, Cornwall (2005, 2006); Falmouth Art Gallery & Museum, Cornwall (2006); Musée de l'Art en Marche, Hauterives, nr.Lyon, France (2006); Badcocks, Newlyn, Cornwall (2006, 2007); Morley Contemporary Gallery, Torpoint, Cornwall (2006, 2007, retrospective 2008). *Works in collections:* H.M.The Queen. *Publications:* St.Ives-Art Colony in Transition, by Peter Davies (pub. 2007). *Address:* Bolloggus Cottage, Long Rock, Penzance, Cornwall TR20 9TT.

STAGE, Ruth, B.A. Hons., P.G. Dip. N.E.A.C.; painter in egg tempera. *b:* 8 Jan., 1969. *m:* Benet Spencer (painter). *Educ:* Blakeston Comprehensive. *Studied:* Newcastle University, R.A. Schools. *Exhib:* 4 solo exhibs., New Grafton Gallery. *Works in collections:* A T Kearney, Charing Cross Hospital, Durham University, Hiscox Plc. *Commissions:* Chevron U.K. Calendar. *Clubs:* NEAC. *Signs work:* "R Stage." *Address:* 13a Wyneham Rd., London SE24 9NT.

STAHL, Andrew, Slade H.D.F.A.; painter in oil, water-colour, acrylic; head of undergraduate painting, Slade School of Fine Art. *b:* London, 4 Jul 1954. *m:* Kumiko Tsuna. one *s.* three *d. Studied:* Slade School of Fine Art. *Exhib:* many one-man and group shows in U.K. and abroad. *Works in collections:* Arts Council, British Council, British Museum, Contemporary Arts Soc., City Museum Peterborough, Leics. Educ. Authority, Metropolitan Museum of Art, New York. *Misc:* Ex Rome Scholar and Wingate Scholar. *Signs work:* back of work usually "ANDREW STAHL" or "A. STAHL." *Address:* 1 Old Oak Rd., London W3 7HN.

STAINTON, Frances: see EASTON, Frances,

STALLARD, Michael James, ARBS; NDD; ATD; Cert.Ed. *Medium:* sculpture: carving in marble. *b:* Stourport-on-Severn, 20 Nov 1944. two *d. Educ:* Adams Grammar School, Newport, Salop. *Studied:* High Wycombe College of Art; Camberwell School of Arts and Crafts 1963-65; Bristol School of Art Education (West of England College of Art/Bristol University). *Exhib:* RA (1985-1996); Festival of London Sculpture Exhbn, Alexandra Palace; New Academy Gallery; Ewan Phillips Gallery. *Works in collections:* H.R.H.Sultan of Brunei; many private collections in Britain and the USA. *Commissions:* Hiram Walker International; Wapping Arts Trust; Homerton Hospital; Sun Life of Canada. *Publications:* founder of 'The Art and Design Directory' (pub. AVEC Designs Ltd., 1991). *Principal Works:* 'Scribble' (1993); 'Random One' (1988); 'Sidestep' (1995); 'Around Zero' (1988). *Recreations:* drawing in pencil and charcoal. *Misc:* member of Spike Island Artists Studios (1986-98). See 'British Sculptors of the 20th Century' by Alan Winsor (Ashgate Pubs.). *Signs work:* marble sculpture not signed. *Address:* 5 South Road, Redland, Bristol BS6 6QP. *Email:* mike.stallard@blueyonder.co.uk

STANDAERT, Dora, *Medium:* ceramics, sculpture. *b:* Antwerp, Belgium, 2 Feb 1944. *d of:* Achilles Standaert & Isabel Deroeck. *m:* Paul Gelissen. one *s. Studied:* Royal Academy, Antwerp. *Exhib:* various exhbns in Belgium, Holland and Paris. *Works in collections:* private collections in Belgium, Holland, USA, Australia. *Works Reproduced:* in several catalogues. *Recreations:* exhibitions, gardening, expressive dancing, tango, theatre, film. *Address:* Herentalsebaan 1, Ranst, Belgium 2520. *Email:* hayloft@skynet.be

STANDEN, Peter, D.A. (Edin.); works in oil, acrylic, etching: subjects allegorical, subtle humour, imaginary future ruins, merpeople and cats; Mem. Edinburgh Printmakers Workshop; Scottish Art Council Awards incl. 'Artist in Industry' Ferranti plc (1987). *b:* Carshalton, 3 Apr 1936. *s of:* Charles Standen and Isabel (née) Ogier. *m:* Helen. one *s.* one *d. Educ:* Epping Secondary. *Studied:* Nottingham College of Art (1954-56), Edinburgh College of Art (1956-59). *Exhib:* one-man shows: 'Up the Nile' Commonwealth Inst., Edinburgh (1965), 'Paintings' New 57 Gallery, Edinburgh (1977), 'Mr. Cat' Traverse Theatre Club, Edinburgh (1985), 'Looking Back to the Future' P.M.W. Edinburgh (1988); group

shows: 'Art into Landscape' I and III Serpentine Gallery, London (1974, 1979), '5 Scottish Printmakers' selected by Peter Fuller, P.M.W. Edinburgh Festival (1983), 'Ljubljana Biennial' Yugoslavia (1987). *Works in collections:* H.M. The Queen, Windsor Castle, Hamilton A.G., Ontario, City of Edinburgh, Moray House College Edinburgh, Eastern General Hospital Edinburgh, The University of Edinburgh, Royal Bank of Scotland. *Publications:* etchings included in "Edinburgh Suite" (1992) and "The Sea, the Sea" portfolios (Pub. by E.P.M.W., Edinburgh). *Signs work:* prints: "P. Standen" (pencil signature); paintings: "P. STANDEN." *Address:* 5 Lee Cres., Portobello, Edinburgh EH15 1LW. *Email:* peterstanden@edinburghetchings.com *Website:* www.edinburghetchings.com

STAPLETON, Rose, WCSI (Watercolour Society of Ireland); BA Fine Art; James Adams Salesrooms Award (RHA), NCAD College Prize, Fergus O'Ryan Memorial Prize (RHA). *Medium:* painter in oils, watercolour; printmaking. *b:* Dublin, 27 Oct 1951. *d of:* Frank Stapleton. *m:* John C. Brobbel, RBA. three *s. Studied:* National College of Art and Design, Dublin (1995-99). *Represented by:* Jorgensen Fine Art, Dublin; McBride Gallery, Co.Kerry. *Exhib:* Jorgensen Fine Art, Dublin; Lavit Gallery, Cork; Petley Fine Art, London; Wren Gallery, London; Royal Ulster Academy, Belfast; Royal Hibernian Academy Annual Exhibition; Royal Hibernian Academy Banquet Exhibition, Dublin. *Works in collections:* AXA Insurance; Bank of Ireland; Bank of Montreal; Maynooth College, Co.Kildare, Ireland; O'Flaherty Holdings; United Arts Club, Dublin; Watercolour Society of Ireland Collection (at University of Limerick, Ireland). *Publications:* 'Thought Lines' (2000). *Signs work:* "ROSE STAPLETON" since 1997, "ROSE CONNOLLY" prior to 1997. *Address:* 14, Lansdowne Park, Ballsbridge, Dublin 4 Eire. *Email:* rosemaryannestapleton@yahoo.com

STARK, Christine Anne, BA Hons (painting). *Medium:* mixed media (painting). *b:* Derby, 3 Dec 1962. *Studied:* Chelsea College of Art. *Exhib:* RA Summer Exhbn; Contemporary Art Society (Art Future), London; The New Ashgate Gallery, Farnham; RCA. *Works in collections:* many private collections. *Recreations:* travel, cinema, theatre, golf. *Address:* Basement Flat, 9 Dartmouth Park Road, London NW5 1SU. *Email:* starkbat@hotmail.com

STARR, Marion, artist in oil. *b:* Hitchin, Herts., 19 Apr 1937. *d of:* Walter Starr. *m:* Christopher Fielder. two *d. Educ:* various Grammar Schools in U.K. and abroad. *Studied:* Chinese brush painting and the Sogetsu School discipline of flower arrangement while in the Far East. *Exhib:* R.A. Summer Exhbn. (since 1979), R.W.A., R.O.I., R.B.A., N.E.A.C., Laing, Spirit of London, Rye Soc. of Artists, Chichester City of Culture Open Art Exhbn., 'A Celebration of the Romney Marsh' at Sassoon Gallery, Folkestone and Marsh Gallery, New Romney; New Grafton Gallery, Easton Rooms and Stormont Studio, Rye, Neville Gallery, Canterbury, Attendi Gallery, Chiswick, Anna-Mei Chadwick Gallery, Fulham, Talents Fine Arts, Malton. *Misc:* Major winner, Laing Landscape Painting competition (1994). *Signs work:* "M.S." or "Marion Starr." *Address:* 23 Military Rd., Rye, E. Sussex TN31 7NX.

STAUVERS, Feliks, R.V.D.S. Arts Academy School (Riga, Latvia); Diploma of Merit, University of Art, Italy; artist in oil, water-colour, dry pigments, restorer, art historian, lecturer in Art and Old Master Paintings. *b:* Riga, Latvia, 22 Apr 1926. *s of:* C. Stauvers, farmer. *m:* M. E. Stauvers. two *s. Educ:* Latvia. *Studied:* Riga Government Arts Academy School (1939-44) under, Prof. Brumel, Dr. V. Luans, Daluns Paks, R.V.D.S. *Exhib:* Nuneaton, Coventry, London, Paris. *Works in collections:* Nuneaton Museum A.G., Riga Government A.G., Latvia, Coventry Museum/A.G. *Commissions:* portraits - for private collections. *Official Purchasers:* over 150 oil paintings. *Clubs:* Former Associate of I.I.C. London. *Signs work:* "Feliks Stauvers." *Address:* 83 Windmill Rd., Exhall, Coventry CV7 9GP. *Email:* felikssstauvers@talktalk.net *Website:* www.felikssstauvers.co.uk

STEAD, David Thomas Kirby, BA(Hons.); artist in oil on canvas, and watercolour;. *b:* Ripon, Yorks., 14 Apr 1959. *m:* Rebecca Susan. one *s.* three *d. Studied:* Harrogate and Wimbledon. *Exhib:* Ariel Centre, Devon, Henry Brett Gallery, Stow, Coves Quay Gallery Salcombe, Thompson Gal. Stow., Art Co. Leeds, etc. Work in collections internationally. *Works in collections:* UK, America, Europe, Far East. *Commissions:* album covers for 'Just Music' records. *Address:* 34 Kirkgate, Ripon, HG4 1PB.

STEADMAN, Ralph Idris, Hon D.Litt. University of Kent (1995); Kent Institute of Art and Design Fellowship Award (1993); many national and international awards from 1973, including WHSmith Award for Best Book (1987), BBC Design Award for Postage Stamps (1987), Illustrator of the Year from American Institute of Graphic Arts (1979). *Medium:* social/political drawings, books. *b:* Wallasey, Cheshire, 15 May 1936. *s of:* Lionel Raphael and Gwendoline Steadman. *m:* Anna. two *s.* three *d. Educ:* Abergele Grammar School, North Wales. *Studied:* London College of Printing and Graphic Arts. *Represented by:* Sobel Weber Associates Inc. *Exhib:* many group and individual exhbns from 1984-2001 in UK, Germany, Italy, USA, Bulgaria, Turkey. *Commissions:* publications: The Observer, The Guardian, The Telegraph, The Independent, New York Times, LA Times, Punch, Private Eye, Radio Times, Rolling Stone, Esquire, GQ, The New Statesman, etc.; theatre design: Royal Opera House, Everyman Liverpool, Queen Elizabeth Hall London etc.; television includes 'Harry Enfield's Guide to the Opera' (opening credits), Men Behaving Badly, USA (titles); commercial: Oddbins, Sony, etc., etc. *Publications:* over fifty books written and illustrated, both for adults and children. *Works Reproduced:* limited edition prints and posters (see website). *Clubs:* Chelsea Arts. *Address:* c/o Sobel Weber Associates, 146 East 19th Street, NY 10003, New York, USA. *Website:* www.ralphsteadman.com

STEEL, Hilary, B.A. Hons. (1985), Dip. Arch. (1988); draughtsman in pen and pencil; freelance architectural illustrator; specialises in architectural elevational drawings. *b:* Carshalton, 17 Mar 1964. *m:* Adrian Odey. one *s. Studied:* Brighton University School of Architecture. *Exhib:* R.A. Summer Exhib. (2000-2001), RA Summer Exhbn prize runner-up (2002). *Commissions:* Medici

Gallery Cards (2001). *Principal Works:* Kensington Trio, Big Ben, St. Pancras Details. *Signs work:* "Hilary Steel." *Address:* 132 Lower Church Rd., Burgess Hill, W. Sussex RH15 9AB. *Email:* h.steel@btclick.com

STEELE-PERKINS, Christopher Horace, *b:* Burma, 28 Jul 1947. *s of:* Alfred and Mary. *m:* Miyako Yamada. two *s. Educ:* Christ's Hospital. *Studied:* Newcastle-upon-Tyne Univ. (BSc.Hons. Psychology). Photography self-taught. *Represented by:* Magnum Photos. *Exhib:* Barbican, London; Hayward Gallery, London; Pompidou Centre, Paris; ICP New York; Tate Britain. *Works in collections:* V&A, NPG, Tokyo Fuji Art Museum, Side Gallery. *Individual Shows/Exhibitions:* FNAC France (1990), Hong Kong Festival (1993), PGI, Tokyo (1999), Perpignan, France (1992, 1999), Side Gallery UK (2000), Mt.Fuji -8 UK galleries (2002), Granship, Japan (2002), 292 Gallery, New York (2003). *Awards/Commissions:* Oskar Barnak Award, Tom Hopkinson Award (1988), Robert Capa Gold Medal (1989), Sasakawa Foundation (1999), World Press Award (2000). *Principal Published Pieces:* The Teds (1979, reprinted 2003), About 70 Photographs (1980), Beirut: Frontline Story (1983), The Pleasure Principle (1989), Afghanistan (2000), Fuji (2002), Echoes (2003), Northern Exposures, Tokyo Love Hello, Survivial Programmes. *Publications: Monograph/Contributer:* In Our Time (Magnum), The Photo Book (Phaidon), Magnum Degrees. *Specialist Area:* documentary. *Equipment Used:* 35mm and medium format cameras. *Additional Projects:* films: Dying for Publicity (BBC 1994), Afghan Taliban (Netherlands TV 1995). *Recreations:* squash, music, gardening, walking. *Misc:* Visiting Professor, Moshishino Art University (2000). *Address:* 49 St. Francis Rd, London SE22 8DE. *Email:* chrissteeleperkins@hotmail.com *Website:* www.chrissteeleperkins.com

STEPHENS, Ian, N.D.D. (1961), R.E. (1984), S.W.E. (1984) (Chairman 1992-95); artist in wood engraving, water-colours. *b:* Gt. Linford, Bucks., 19 May 1940. *s of:* the late A.B. Stephens. *m:* Valerie. two *s. Educ:* Wolverton Technical School. *Studied:* Northampton School of Art (1956-61). *Exhib:* R.E. (1975 onwards), Fremantle, Jeune Gravure Contemporaine, Paris, Humberside (1985); one-man show Daventry (1989, 1993), British Miniature Print International, Bristol (1989, 1997), Cadaqués (1991, onwards), National Print Exhibition, London (1996-2001), Aylesbury (2001), Harlech (2000), Society of Wood Engravers (1984 onwards). *Works in collections:* Northants C.C., Notts. C.C., Surrey C.C., Warwicks. Museums, Kettering B.C., Daventry D.C., Fremantle Arts Centre, Ashmolean Museum Oxford, Northampton Central Museum and A.G, Adogi Cadaqués. *Publications:* The Engravers Cut, Primrose Academy (2001). *Works Reproduced:* The Engravers Globe (ed. Simon Brett), Primrose Hill Press Ltd. (2002). *Recreations:* walking, music, reading, natural history. *Signs work:* "I. Stephens" or "Ian Stephens." *Address:* 46 Yardley Drive, Northampton NN2 8PE.

STEPHENS, Nicholas Anthony, N.D.D. (1960), A.R.C.A. (1963), Harkness Fellowship, U.S.A. (1963-65), Arts Council Major award (1977), A.R.B.S.

(1981); sculptor in bronze; Principal Lecturer in Fine Art, Glos. College of Art and Technology; visiting teaching: U.C. Davis, California (1971), Victoria College, Prahran, Australia (1983);. *b:* Nottingham, 6 Jun 1939. *s of:* R.S. Stephens. *m:* Jenifer Beesley (divorced 1984). two *s. Educ:* Nottingham High School. *Studied:* Central School (Wm. Turnbull), R.C.A. (1960-63, Lord Queensbury), Pratt Inst., N.Y. (1964), San Francisco Art Inst. (1965, James Melchert). *Exhib:* Davis Cal. (1971), S.W. Arts (1978), The State of Clay (1978-80), R.A. (1980, 1981, 1983, 1984), R.B.S. Scone Palace (1983), Park Gallery Cheltenham (1982, 1985), St. Donat's Castle, Wales (1983), Nicholas Tredwell Gallery (1985), Air Gallery, Harkness Arts (1985), St. David's Hall, Cardiff (1988). *Signs work:* "N.A. STEPHENS." *Address:* The Red House, Bredon, Tewkesbury, Glos. GL20 7LM.

STEPHENSON, Christine Frances, N.D.D. (1957), A.T.D. (1958), S.B.A. (1997), R.H.S. Silver Medal (1996), Gold Medal (1997), Cert. of Botanical Merit S.B.A. (1999); botanical artist in water-colour. *b:* Winchester, 3 Apr 1937. *m:* Jack Stephenson, artist. two *s. Educ:* St. Swithun's School, Winchester. *Studied:* Bournemouth College of Art (1953-58); University of London Goldsmiths College (1984). *Exhib:* Capel Manor Gallery, Enfield (1993); Thompson's Gallery, Aldeburgh, Suffolk (1994); Royal Horticultural Society, London (1995, 96); Society of Botanical Artists (1993-99); Open Studios Galleries, Suffolk (1997, 98); Lucy B. Campbell Gallery, London (1996-2005); Gordon Craig Gallery, Knightsbridge (1999); Chelsea Flower Show (2000); The Hunt Institute of Botanical Documentation, Pittsbugh, USA (2000); Hindlesham Hall Gallery, Suffolk (2001, 04); Scanlons Court Museum, Poole, Dorset (2004); Cobbold and Judd, Hindlesham Hall, Suffolk (2001-); Julia Gooch Pictures, Aldeburgh, Suffolk (2004-). *Works in collections:* Hunt Institute for Botanical Documentation, Pittsburgh, U.S.A, and private collections worldwide. *Commissions:* taken. *Publications:* "Woottens of Wenhaston" Handbook 1994-2004; Country Living magazine (May 2004); Detuin Exclusif (March 2004). *Works Reproduced:* 'Pauntley Prints'. *Signs work:* "C.F.S." *Address:* 3 Causeway Cottages, Middleton, nr. Saxmundham, Suffolk IP17 3NH. *Email:* christine@paintingsofplants.com *Website:* www.paintingsofplants.com

STEPHENSON, Jack, BA Fine Art; Post Graduate Diploma. *Medium:* oil, drawing. *b:* Lincolnshire, 27 May 1945. *s of:* Ernest and Felicity. *m:* Christine Frances. two *s.* one *d. Educ:* East Ham Grammar School. *Studied:* Walthamstow School of Art (1963-64); Hornsey College of Art (1964-67, BA Fine Art); Goldsmiths' (1983-84, P.G.Dip). *Exhib:* Royal Academy Summer Exhibition; Peter Pears Gallery, Aldeburgh; Buckenham House Gallery; Aldeburgh Gallery. *Works in collections:* private collections. *Commissions:* Christ's Hospital (portrait of Headmaster, with two senior Grecians); Bancroft's School (portrait of Headmaster, with two senior Grecians). *Publications:* Dictionary of Artists 1945 to Present. *Clubs:* President of Southwold Art Society; Treasurer of Suffolk Group. *Misc:* Committee Member, Blythe Valley Chamber Music Society. *Signs work:* "J.Stephenson". *Address:* 3 Causeway Cottages, Middleton,

Saxmundham, IP17 3NH. *Email:* jackstephenson@metronet.co.uk *Website:* www.portraitsfromlife.co.uk

STERN, Catharni Clara, ATD, NDD, Feodora Gliechen Award; Assistant sculptor Bournemouth College of Art, Life modelling and wood-carving St.Martins School of Art, Sculptor Southend School of Art, Further Education College Chelmsford. *Medium:* wax, bronze, stone, terracotta. *b:* Southsea, Hants, 22 Aug 1925. *d of:* Ernest Hamilton Stern. *Educ:* Edgbaston High School, Chelmsford High School, Chelmsford School of Art, RA Schools, London University Institute of Education. *Studied:* sculpture at Chelmsford School of Art, Regent Street Polytechnic, RA Schools (Maurice Lambert), Huxley Jones. *Exhib:* John Whibley Gallery (five one-man shows), Alwyn Gallery, RA Summer Exhibitions, Minories, Colchester, Callard Galleries Chicago USA, Southend Municipal Gallery, Walker Gallery Liverpool. *Works in collections:* National Museum of Wales, Stanley Picker Trust Richmond, Hertfordshire Education Authority, First Site Colchester (was the Minories). *Commissions:* Mosaic panel Chelmsford, mosaic panel Eastern Electricity Chelmsford, Black Madonna Willisden, Madonna Truro Cathedral, Madonna Totnes Parish Church, Racing Group British Racing School, Happy Valley Hong Kong, Race Horses, Tokio Race Course, Racehorses, Crucifixion Feltham Prison Chapel, St.Francis Guy Harding Gardens Chelmsford, St.Francis Langford Parish Church, Edward Bright Wager, Kingsmead, Maldon, Essex. *Recreations:* wildlife conservation, walking, bird watching. *Clubs:* RASAA. *Address:* 11 Chelmer Terrace, Maldon, Essex, CM9 5HT.

STETTLER, Michael, D.Sc.; art historian; architect; Director of Bernese Historical Museum from 1948 to 1961; Director Abegg Foundation (1961-77); P. Helvetia Foundation (1965-71);. *b:* Berne, 1 Jan 1913. *s of:* Wilhelm Stettler de Graffenried, architect. *m:* Barbara von Albertini. four d. *Educ:* Berne. *Studied:* ˙ Zürich Inst. of Technology and University under J. Zemp and H. Wölfflin, and at Rome. *Publications:* Das Rathaus zu Bern (1942), Inventory of Historical Monuments of Canton Aargau (Vol. I, 1948, Vol. II, 1953); Swiss Stained Glass of the 14th Century (English Edition, 1949); Of Old Berne (1957); Rat der Alten (1962); Bernerlob (1964), Neues Bernerlob (1967); Aare, Bär und Sterne (1972); Machs na (1981); Ortbühler Skizzenbuch (1982); A la Rencontre de Berne (1984); Sulgenbach (1992), Lehrer und Freunde (1997). *Address:* Ortbühl, CH-3612 Steffisburg, Switzerland.

STEVENS, Chris, B.F.A. (Hons.); artist in oil;. *b:* Basingstoke, 1956. *Studied:* University of Reading (1974-78). *Exhib:* one-man shows: U.K., London and Holland; group shows: London, Germany and U.S.A; shows with Sue Williams, London. *Works in collections:* National Gallery of Wales. *Address:* Space Studios, Deborah House, Retreat Pl., London E9.

STEVENS, Helen M., S.W.A. (1989); artist in pure silk hand embroidery, writer;. *b:* Belmont, Surrey, 2 Oct., 1959. *m:* Brian Rayner. *Educ:* Bury St.

Edmunds County Grammar School. *Exhib:* S.W.A., Soc. of Wildlife Art in Nature; numerous solo shows every two years. *Works in collections:* Palace of Westminster. *Publications:* author and illustrator: 'The Embroiderers Countryside', 'The Embroiderers Country Album'; 'The Timeless Art of Embroidery' and 'The Myth and Magic of Embroidery' (David & Charles). *Signs work:* "Helen M. Stevens." *Address:* 3 The Green, Flempton, Bury St. Edmunds, Suffolk IP28 6EL.

STEVENS, Margaret Cecilie, PSBA (2005-), VPSBA (1997- 2005); RHS Silver Gilt Lindley medal (1989), Gold (1990), Cert. Botanical Merit, SBA (1998); freelance botanical and miniature artist in water-colour; Adult Class Tutor at two ARCA Colleges; Course Director: Distance Learning Diploma Course (DLDC) in Botanical Painting (2004-); joint Editor 'Arte y Botanica' (2001); contributor to 'Botanical Gardens - A Living History' (2007). *b:* Brixham, Devon, 14 Oct 1937. *m:* Derek Stevens (decd.). *Educ:* Dartmouth Grammar School. *Exhib:* solo shows: Penrhyn Castle, National Trust; mixed exhibitions: SBA, Westminster, Llewellyn Alexander Gallery, RMS - all regularly. *Works in collections:* Hunt Inst. for Botanical Documentation, Pittsburgh; numerous private collections worldwide. *Commissions:* large collection of old roses for private buyer, Fine Art prints, greetings cards, etc., Chelsea plate (1993, Franklin Mint), Royal British Legion plates (Bradford Exchange). *Publications:* 'An Introduction to Drawing Flowers' (1994), 'The Art of Botanical Painting' (2004), 'The Botanical Palette' (2007). *Works Reproduced:* 'RHS New Dictionary of Gardening (Paphiopedilums) 1992; A History of British Flower Painters 1650-1950 (2006). *Recreations:* reading, music, opera and ballet. Friend of Covent Garden. *Clubs:* Founder mem. SBA. *Signs work:* "Margaret Stevens". *Address:* 1 Hen Gapel, Gerlan, Bethesda, Gwynedd LL57 3ST. *Email:* maggs.stevens@tiscali.co.uk

STEVENS, Meg, B.A. (Hons.) Fine Art, M.A. Art History, elected Royal Cambrian Academician, 1996. *Medium:* landscape painter in oil, gouache, pen and ink wash. *b:* Leeds, 8 Feb 1931. *m:* Roger Stevens. two *d. Studied:* Reading University. *Exhib:* Royal Cambrian Academy (members annual show), St. David's Hall, Cardiff, Oriels Ynys Mon, R.S.P.B., Nature in Art. Has toured four N.F.S. travelling shows annually in support of habitat conservation: 'Grass' (old common); 'Flowerscapes, 'Trees' and 'Towpath'. *Works in collections:* Nature in Art, Gloucester, private collectors. *Publications:* own booklets (two) with reproductions of work on each page. *Signs work:* "Meg Stevens." *Address:* Bridge House, Llanfrynach, Brecon, Powys LD3 7BQ.

STEVENSON, David John, painter in egg tempera and oil. *b:* Leicester, 26 Nov 1956. *s of:* Samuel Stevenson. *m:* Alison Wilkins. two *s. Educ:* Guthlaxton College, Leicester. *Exhib:* RA; Leicester Museum; Loseby Gallery, Leicester; Tettenhall Gallery; City Gallery, Leicester; Gallery 3, Leicester. *Signs work:* "D. Stevenson." *Address:* High Brinks, 107 Lubenham Hill, Market Harborough, Leics., LE16 9DG. *Email:* stevenson@highbrinks.fsnet.co.uk

STEVENSON, Richard Lee, printmaker, intaglio, relief printing, oils. *b:* Penzance, 9 Apr 1955. *Studied:* Falmouth School of Art, North Staffs. University, Penzance School of Art (Sue Lewington). *Exhib:* R.W.A. Mall Galleries, Victoria Galleries, Bath, The St. Ives Society of Artists, The Cornwall Crafts Association, The Great Atlantic Map Works Galleries. *Commissions:* Linocut cover design for the 18th International Celtic Film And Television Festival catalogue. *Publications:* Ten Penwith Printmakers (1998). *Clubs:* St. Ives Soc. of Artists, Cornwall Crafts Assoc., Penwith Printmakers. *Signs work:* "Lee Stevenson." *Address:* Little Trevarrack, Brandy Lane, Rosudgeon, Penzance, Cornwall TR20 9QB. *Email:* lee@littletrev.fsnet.co.uk

STEWART, Barbara Jean, R.W.A., P.S., R.B.S.A.; painter in oil, mixed media and pastel; archivist Pastel Soc. *b:* York, 18 Nov 1929. *m:* Rae Stewart (decd.). three *d. Studied:* Leeds College of Education, but mainly self taught. *Exhib:* mixed shows countrywide. *Works in collections:* R.W.A. *Address:* 29 Meadowcourt Rd., Oadby, Leics. LE2 2PD.

STEWART, Hannah, 2000 Alec Tiranti Prize for Young Portrait Sculptors; 1999 Manchester Academy of Fine Arts Major Award; 1998 Second Prize Sefton Open Exhibition. *Medium:* sculpts in clay and casts in bronze. *b:* Horsham, 19 Jan 1976. *m:* Dr.Simon Stewart. *Studied:* City & Guilds of London Art School, Kennington, London. *Commissions:* many private commissions, also 3m long bronze Iguanodon, Southwater (Miller Construction & Horsham District Council); human-sized bronze of 'The St. Leonards Forest Dragon' (Horsham in Bloom Committee). *Signs work:* "Hannah Stewart". *Email:* hannah@hannahstewartsculpture.co.uk *Website:* www.hannahstewartsculpture.co.uk

STEWART, Laurie Leon, (aka de SWARTE). *Medium:* painter in oil, watercolour, and pastel and Art Dealer. More recently Photography. *b:* Stepney Green, East London, 15 Apr 1926. one *s. Educ:* West Norwood and various elementary schools. *Studied:* Sir John Cass, Toynbee and St Martins (under Bainbridge Copnall, Paul Drury and Kenneth Martin). *Represented by:* Laurie Stewart Fine Art. *Exhib:* Free Painters Society, Mount Street Gallery, Hamlet Gallery, Plus Ultra Gallery, New York. *Works in collections:* many private collections. *Address:* 36 Church Lane, London N2 8DT. *Email:* Lstew181072@aol.com *Website:* www.artonlinelimited.com

STEYN, Carole, sculptor, painter, pastellist and engraver - abstract, pop art and figurative. *Medium:* oils, watercolour, pastels, etchings drypoint, aquatint and arte povera media. *b:* Manchester, 20 Sep 1938. two *s. Educ:* Wycombe Abbey. *Studied:* Académie Julian, Paris (1954), St. Martin's School of Art (1955-57). *Represented by:* Noel Oddy, Highgate Fine Art, N1; Richard Chapman, Sheridan Russell Gallery, W1. *Exhib:* eight solo shows: Drian Galleries (1971, 1975, 1981 (First Retrospective Exhbn.), 1985), Jablonsky Galleries, London (1987), Galerie Harounoff, London (1991); 30+ group shows: all in London (1968-97);

Lauderdale House (1997), Sheridan Russell Gallery (-2005); current mixed exhibitions in London, Harlequin Gallery, London SE10. *Works in collections:* National Museum, Warsaw, Poland (Nalecz Collection), Sheffield City Museum, National Museum, Gdansk, Poland, Ben Uri Collection, National Gallery of Art, Bosnia, Herzogovina. *Commissions:* British Telecom (1985). *Works Reproduced:* Catalogue of Art Auction for Medical Foundation (victims of torture); in Apollo "The Select Few" (1975), Arts Review (1975, 1981); Radio broadcast BBC (1971), Open House (1975) and BBC Manchester (1985). Television BBC1 (1971) and BBC2 (1989), inclusion of brochures, letters and photographs in both archive and library of Tate Britain; The Feminine Eye by Halina Nalecz; Bonhams Catalogue; British Contemporary Art; le Benezit (1999). *Signs work:* "C. Steyn." *Address:* c/o The Director, Noel Oddy Highgate Fine Art 26 Highgate High Street London N6 5JG.

STIEGER, Jacqueline, FRSA (1986); Royal Scottish Academy Award(1959); 1st Prize, Revival of the Medal, Paris (1974); Freeman of the Worshipful Company of Goldsmiths (1985); 1st Prize Medal Design, Goldsmiths Crafts Council (2000). *Medium:* sculpture, jewellery, medals - lost wax technique, casting, bronze and precious metals. *b:* London, 26 Jan 1936. *d of:* H. J. Stieger, F.R.Ae.S. *m:* Alfred Gruber. two s- *s. Educ:* Bedales, Hants; The Mount School, York. *Studied:* Edinburgh College of Art (1952-58) under W. Gillies. *Exhib:* Goldsmiths' Hall, Galerie Riehentor, Basel. *Works in collections:* Eidgenosische Kunstkommission, Bern Ch; Museum of Medallic Art, Cracow, Poland; Goldsmiths' Hall Collection; B.M. *Commissions:* Plaque to commemorate Second World War, The Reform Club, London (1995), Bronze Sculpture, St. Clare's Oxford (1997); Bronze font, St.Martins in the Bullring, Birmingham (2000); Bronze cross, Scots Kink, Paris (2003); Medallion, University of Edinburgh Benefactors (2005). *Signs work:* "J. Stieger." *Address:* Welton Garth, Welton, N. Humberside HU15 1NB. *Email:* ja@gruberstieger.karoo.co.uk

STILLMAN, John, *Medium:* oil, pencil, watercolour. *b:* Carshalton, 6 Jun 1968. *Studied:* self-taught artist. *Represented by:* Lincoln Joyce Fine Art, Great Bookham, Surrey. *Exhib:* RSMA, ROI, RA. *Works in collections:* London Borough of Sutton. *Clubs:* Croydon Arts Society, Chelsea Arts Society. *Signs work:* 'JOHN STILLMAN'. *Address:* 196 Stanley Park Road, Carshalton, Surrey, SM5 3JP. *Email:* j.stillman@lycos.com *Website:* www.johnstillman.co.uk

STJERNWARD, Philippa, BA Hons; Dupree Painting Award for a Woman Artist, Royal Academy. *Medium:* oil, mixed media on canvas board. *b:* Kenya, 7 Jun 1952. *Studied:* St.Martins College of Art; Ravensbourne College of Art. *Represented by:* Art First, Cork Street. *Exhib:* Royal Academy; Diorama; Barbacan; Stephen Lacey; Reeds Wharf Gallery; London Group; Art First. *Works in collections:* many private collections. *Recreations:* travel, reading, exhibitions, cinema, gardening. *Address:* 181b Lavender Hill, London SW11 5TE. *Email:* philippastjernward@yahoo.co.uk

STOBART, Jane, Honorary Fellow, Royal Society of Painter-Printmakers; artist printmaker; lecturer at Goldsmiths' College; Mem., Wynkyn de Worde Soc. *b:* S. Shields, Tyne and Wear, 10 Nov 1949. *d of:* Robert William & Edith Stobart. *m:* Mustafa Sidki. *Educ:* S.E. Essex Technical School, Dagenham. *Studied:* Hornsey College, Central School and University of East London. *Represented by:* www.newmasters.com; Bankside Gallery. *Exhib:* Royal Academy, Gainsborough's House, Bradford Print Biennale, Manhatten Graphics Center, N.Y., Barbican. *Works in collections:* Ashmolean Museum, Museum of London, Smithsonian Inst., U.S.A., Fitzwilliam Museum. *Commissions:* National Grid (1995), Smithsonian Inst., U.S.A. (1996), Florence Nightingale Health Centre, Harlow (1997). *Publications:* 'Printmaking for Beginners' (A&C Black), 'Drawing Matters (A&C Black). *Address:* 47 Potter St., Harlow, Essex CM17 9AE. *Email:* jstobart.printmaker@virgin.net

STOCK, Andrew Nicholas, RE, PSWL.A.; Richard Richardson award for bird illustration (1980); PJC award for individual merit (1990), prizewinner in Natural World fine art awards (1989, 1990), runner-up in BBC World Magazine's Wildlife Artist of the Year (1991); Bird Illustrator of the Year (1995); Council mem. S.WL.A. (1992-94), secretary (1995-2004), President (2004-); Governor F.B.A. (1997-2003), Council Member RE (2003-2005); self taught painter in water-colour, etching, oil, pen and ink. *b:* Rinteln, W. Germany, 25 Mar 1960. *s of:* Lt. Col. Peter William Stock, M.B.E., M.A. *m:* Melanie Vass (divorced 1995). one *d. Educ:* Sherborne School, Dorset. *Exhib:* S.WL.A., Tyron Gallery, Royal Academy, etc.; one-man shows: Malcolm Innes Gallery, London (4), Alpine Club Gallery, London (2), Gallery in Cork St., London (1), The Mall Galleries (5), Edinburgh and Cerne Abbas, Dorset (2). *Works in collections:* 29 Commando R.A., The Sultan of Oman, RACAL. *Commissions:* MAFF, RSPB. *Publications:* illustrated Driven Game Shooting by D. Bingham (Unwin Hyman, 1989). *Signs work:* "Andrew Stock." *Address:* The Old School House, Ryme Intrinseca, Sherborne, Dorset DT9 6JX. *Email:* AndrewNStock@aol.com *Website:* www.andrewstock.co.uk

STOCKHAM, Alfred Francis, A.R.C.A. (1966), Rome Scholar (1967), Granada Arts Fellow (1968), R.W.A. (1992); painter in oil. *b:* London, 1 Jan 1933. *m:* Catherine Bellohoubek. *Studied:* Camberwell School of Art (1960-63, Robert Medley), R.C.A. (1963-66, C. Weight), Rome Scholar (1966-67). *Exhib:* Il Capittello, Rome, Munster, Germany, Arts Fair, New York, R.A., R.W.A. *Works in collections:* Bradford City Museum, Bristol City Museum, G.L.C., M. of W., Arts Council (N.I.), York City A.G. *Signs work:* "A.S." front; "Alfred Stockham" back. *Address:* 75 Woodhill Rd., Portishead, Bristol BS20 9HA.

STOCKHAUS, Eva H. M., R.E.; artist in wood-engraving; Mem. Swedish Printmakers' Assoc.; Mem. British Soc. of Wood Engravers; Hon. Retd. Mem. Royal Soc. of Painter-Printmakers. *b:* Gothenburg, Sweden, 4 Apr 1919. *d of:* Hugo Lindegrén, engineer. *m:* Bengt Stockhaus. one *s.* one *d. Educ:* Stockholm University; art studies Stockholm and London. *Works in collections:* V. & A.,

London; National Museum, Stockholm; Nasjonalgalleriet, Oslo; New York Public Library; Graphische Sammlung Albertina, Vienna; various museums Scandinavia etc. Recipient artist's grant of the Swedish State (1975, 1976). *Signs work:* "Eva Stockhaus." *Address:* Pontonjärgatan 16, 11237 Stockholm, Sweden.

STOCKWELL, Susan, RBS; MA RCA, BA (Hons). *Medium:* sculpture, installation, drawing, film. *b:* Manchester, 19 Aug 1962. *d of:* Peter & Peggy Stockwell. *m:* Mr.Michael Roberts. *Studied:* Royal College of Art (1991-93, MA Fine Art/Sculpture); Sheffield Hallam University (1985-88, BA (Hons) Fine Art/Sculpture). *Exhib:* selected solo exhibitions: Battersea Art Centre (1997), Thomas Korzelius Fine Art, New York (2000), V&A (2001), The Gallery at The Art Institute, Bournemouth (2005), Studio Caparrelli, London (2002, 2005), Shenghua Art Centre, Nanjing, China (2006), 20/21 Visual Art Centre, Scunthorpe (2006); Canary Wharf (2007) Group exhibitions across UK and in USA, including 2-person show Patrick Heide Fine Arts Projects (2007), 198 Gallery, London. *Works in collections:* V&A, London; Binghampton Museum, New York; Karole Vail Collection, New York; Finesilver Gallery, San Antonio, Texas; Studio Caparrelli, London; Shenghua Art Centre, China; Seeds of Peace, charity, USA; various private in UK, USA, Saudi Arabia, Europe. *Publications:* Crafts Magazine (2006), catalogue, 20/21 Visual Art Centre, Scunthorpe. *Works Reproduced:* in The Guardian, Scunthorpe Telegraph. *Recreations:* up and coming projects and shows. *Misc:* 'Visiting Arts' residency - Taipei, Taiwan (Sept-Dec 2007). *Address:* 44 Effra Parade, London SW2 1PZ. *Email:* susanstockwell@fsmail.net *Website:* www.susanstockwell.co.uk

STODDART, Tom, *b:* Morpeth, 28 Nov 1953. *s of:* Tommy and Kathleen. *Educ:* University of Life. *Represented by:* Independent Photographers Group, London, UK (Founder Member). *Individual Shows/Exhibitions:* Edge of Madness, Royal Festival Hall, London (also shown at Royal Photographic Society and Oeksnehallen, Copenhagen); Sarajevo Retrospective, Perpignan Festival of Photojournalism; River Blindness, Alchemy Gallery London; Night of British Photography, Zurich, Switzerland; Lest We Forget, Aids in Africa, Stavager Museum, Norway. *Awards/Commissions:* Poy World Understanding Award, Larry Burrows Award for Outstanding Photojournalism during 2003 Iraq Conflict, several World Press Photo Awards, Poy Canon Photo-essay Award, twice Nikon Photographer of the YEar, three times Nikon Feature Photographer of the Year; commissioned extensively by international magazines and publications. *Principal Published Pieces:* books: Sarajevo (Motta Press, Italy), Edge of Madness (Royal Festival Hall), Road to Victory (Bookman). *Publications: Monograph/Contributer:* work appears extensively in international magazines such as Time, Newsweek, Sunday Times magazine, Observer, Stern, Life, etc. *Specialist Area:* documentary; photojournalism. *Equipment Used:* Leica. *Recreations:* watching Newcastle United, music, film, sport. *Address:* IPG, Zetland House, 109 Clifton Street, London EC2A 4LD. *Email:* tom@tomstoddart.com *Website:* www.tomstoddart.com

STOKER, Richard, J.P. (1995-03), FRAM (1973); artist in oils, pen, pencil; film actor, composer, author; Treasurer, RAM Guild; BACS. *b:* Castleford, Yorks., 8 Nov 1938. *m:* Dr. Gillian Stoker. *Studied:* Huddersfield Art School(now University) under Sugden and Napier (1954-58), privately under H.R.M. Irving (1958-59);Paris with Nadia Boulanger (1962-63). *Exhib:* Lawrence House, Lewisham Soc. of Arts(1992), Tudor Barn, Eltham (1990), Blackheath Art Soc.(1989, 1990, 1991), Lewisham Festival (1990, 1992). Work in private collections. *Works in collections:* Royal Naval College. *Publications:* Open Window - Open Door (Regency); Words Without Music (Outposts, 1971); Tanglewood (novel) (Merlin); Diva (novel) (Minerva); Collected Short Stories (Minerva, 1997). *Official Purchasers:* Trinity College, London. *Works Reproduced:* on many CD covers. *Clubs:* The Garrick, Blackheath Art Soc. (1988), Lewisham Arts Soc. (1990), elected to International PEN (1996), Founder mem. Atlantic Council (1993), Euro-Atlantic Group (1993), RSL(1997). *Misc:* Portrait painted by John Bratby, RA (1983). Treasurer, Lewisham Arts Festival (1990, 1992). Nominated: 'Man of the Year 1997' by the American Biographical Soc., three Editors Awards: National Library USA. *Signs work:* Richard Stoker. *Address:* 38 Lee Rd., Blackheath, London SE3 9RU. *Email:* richardstoker@yahoo.co.uk *Website:* www.richardstoker.co.uk

STOKES, Tina Yvette, SWA (2004); BA Hons Sculpture (1984); Post Graduate in Publishing (1985); Picture Restoration (1987); President & Vice President Award (SWA) for Best Art Work (2005); Winsor & Newton First Prize (SWA) 2007. *Medium:* oil, acrylic. *b:* Willenhall, 8 Feb 1964. *d of:* George, Henry Stokes. *Studied:* Walsall College of Art (1980); Exeter College of Art and Design (1981-85); Billington - Picture Restoration. *Represented by:* Marine House at Beer, Devon. *Exhib:* International AAF London, Bristol, Bath, Dublin, Edinburgh (2000-07); SWA Westminster Hall, Mall Galleries (2001-07); Marine House at Beer (2000-07); South West Academy (2005); Webbs Fine Art, London (2004-07). *Works in collections:* private collections worldwide (Hong Kong, Canada, USA, Germany, France, Belgium, etc.). *Commissions:* Netherton Hall, Honiton, Devon; Palace of Westminster. *Publications:* Country Life, Devon Life, Devon Today, and catalogues. *Official Purchasers:* Princess Michael of Kent. *Works Reproduced:* series of limited edition prints (limited to 150). *Recreations:* travel. *Clubs:* Branscombe, Emouth, Seaton. *Misc:* paintings predominantly marine landscape of a calm impressionistic nature, with an expansive use of sky and water. *Signs work:* 'Tina Stokes'. *Address:* Watch House, Quay Lane, Lympstone Devon, EX8 5HA. *Email:* teestokes@yahoo.co.uk

STOKES, Vincent, B.A. (Hons.) Photography and Semiotics; designer/photographer; art director;. *b:* 9 Jan 1964. *s of:* Vincent Stokes. *Studied:* London College of Printing (1986-89, Ann Williams, Peter Osborn). *Exhib:* Camera Work U.K., Camera Work San Francisco, Photographers Gallery, Arnolfini Bristol, New Orleans, Buffalo, Vancouver, N.Y. *Address:* 14 Beckley House, Hamlets Way, London E3 4SZ.

STOKOE, Michael Arthur, NDD (1957); painter; ex-senior lecturer, Ravensbourne College of Design. *b:* London, 30 Sep 1933. *s of:* Dr. Neville Stokoe, M.A. *m:* Gillian Stacey. one *s.* one *d. Educ:* King's School, Bruton. *Studied:* St. Martin's School of Art (1953-57). *Exhib:* RA, RBA, ROI, RSOPP, Young Contemporaries, Arts Council, Belfast, Piccadilly Gallery, Arnolfini Gallery, Hamilton Gallery, John Moores, New Gallery, Belfast etc.; one-man shows: Temple Gallery, Drian Galleries, Bear Lane Gallery, Nottingham City A.G., Oxford Gallery, Anna Mei Chadwick Gallery, Zella Gallery. *Works in collections:* Arts Council of N. Ireland, V. & A., W.A.G., Ferens A.G., Hull, Leeds City A.G., I.C.I., etc., and 20 educational authorities. Bibliotheque National. *Publications:* prints with editions Alecto, Collectors Guild, Anely Juda Fine Art. *Recreations:* sailing. *Signs work:* "STOKOE." *Address:* The Bough House, 43-45 High Street, Robertsbridge, TN32 5AL.

STONES, Anthony, F.R.B.S. (1992), President the Society of Portrait Sculptors (1998-2004), FRSA; sculptor in clay for bronze; Visiting Professor: Tsinghua University, Beijing, China & Nanjing University, Nanjing, China 2004-2008. *b:* Glossop, Derby., 8 Feb 1934. *s of:* Arnold Stones, dyer. *m:* Lily Feng-Stones. *Educ:* St. Bede's College, Manchester. *Studied:* Manchester Regional College of Art (1950-51), Auckland Teacher's College 1959-61. *Works in collections:* bronze portrait heads: John Piper in Reading City Art Gallery; Prof. Dorothy Hodgkin, O.M., Somerville College, Oxford; Sir Ronald Syme, O.M. and Sir Isaiah Berlin, O.M., Wolfson College, Oxford; Liam Ó Flaherty, National Gallery of Ireland; Sean Ó Faolin, Irish Writers Museum, Dublin, John Wain C.B.E., Philip Larkin & Seamus Heaney at St. John's College Oxford; Sir S.Y.Chung, The University of Science & Technology, Hong Kong; Bruce Mason, Downstage Theatre, Wellington, New Zealand; Han Meilin, sculptor, private coll. Beijing. *Commissions:* commemorative bronze figures: The Hon. Peter Fraser, Wellington, N.Z.; Lord Freyberg, V.C., Auckland, N.Z.; Jean Batten, Auckland International Airport; Victorian Navvy (1992), Gerrards Cross Railway Station; Seven Pacific Explorers for New Zealand Pavilion Expo 92 Seville; Captain James Cook, Gisborne, New Zealand (1994); The Pioneer Wine Maker, Waitakere City, New Zealand (1995); equestrian statue of "Bonnie Prince Charlie", Derby (1995); Captain James Cook, National Maritime Museum, Greenwich (1997); Blair 'Paddy' Mayne, Newtownards, Northern Ireland (1997); 'King' and 'Queen', 'Orpheus and Eurydice', four bronze statuettes for Royal Caribbean Cruise Line A/S (1997), John Northwood, Merry Hill Birmingham, Abel Tasman, Nelson, New Zealand, Arthur Brooke, Manchester, The Emperor Nerva, equestrian statue, Gloucester, Prince Potemkin, equestrian statue, private collection UK: 'The Young Shakespeare' 2004, 'Migrant Family Group' 2005 Nelson, NZ, 'Michelangelo', Nanjing Museum, China, 'Prof. Tu Chang Wang', China Meteorological Administration HQ, Beijing, China; 'Brunel', Brunel University UK (2006); 'Gustav Holst', Cheltenham, UK (2007). *Publications:* edited: Celebration (Penguin Books, 1984); wrote and illustrated: Bill and the Ghost of Grimley Grange (Wolfhound Press, 1988; Puffin Books, 1994), Bill and

the Maze at Grimley Grange (Wolfhound Press, 1990); 'Venus and Cupid': a relief carving by Michelangelo? papers of The British School at Rome Vol. LXI (1993). *Clubs:* Commonwealth. *Signs work:* "Anthony Stones." *Address:* 2 Kent Place Lechlade-on-Thames GL7 3AW. *Email:* fengstones@hotmail.com *Website:* www.sculptor.co.nz

STONES, Thomas Fiendley, O.B.E. (1981), B.A. (Admin.), F.M.A.;. *b:* Astley, Lancs., 25 Jul 1920. *s of:* Thomas Stones and Agnes Fiendley Stones. *m:* Elizabeth Mackie (decd.). one *d. Educ:* Leigh Grammar School and Manchester University. *Studied:* Served R.A.F. (1941-46); Keeper of the Rutherston Collection, Manchester City Art Galleries (1946-52); Keeper of Modern European Dept. and Print Dept., Royal Ontario Museum of Archæology, Toronto; special lecturer in art and archæology, University of Toronto (1953-54); British Council, Fine Arts Dept., Fine Arts Officer, Paris; Cultural Attaché, British Embassy, Budapest; etc. *Address:* c/o National Westminster Bank, P.O. Box 2162, 20 Dean St., London W1A 1SX.

STONYER, Andrew Allan, R.W.A., R.B.S.; B.A. (1966), A.A. Dip. Arch. (1974), Ph.D. (1978); sculptor; Prof. in Fine Art, University of Gloucestershire. *b:* Sibbertoft, Leics., 11 Oct 1944. *m:* Linda. one *s.* one *d. Studied:* Northampton School of Art (1960-63), Loughborough College of Art and Design (1963-67), Architectural Assoc. (1970-72), Leicester Polytechnic/Slade School of Fine Art (1975-78). *Exhib:* R.A., Ikon Gallery, Cairn Gallery, Barbican Centre, Art 45 and Terre des Hommes, Montreal. *Works in collections:* Ottawa, Hague, Leicester, etc. *Commissions:* Leicester City Council, Cheltenham Racecourse, Ottawa City Council, Laval - Montreal, Newcastle Metro, Cumberland Infirmary, Gloucester Docks, etc. *Publications:* Leonardo Vol.18.No.3, The Structurist No.27/28. *Clubs:* Chelsea Arts. *Address:* Eastmead, Watery Lane, Newent, Glos. GL18 1QA.

STOREY, Terence, P.P.R.S.M.A., RBSA, F.R.S.A.; marine and landscape artist in oils and water-colour. *b:* Sunderland, 17 Apr 1923. *Educ:* Sunderland Art School and Derby College of Art. *Exhib:* N.S., R.B.A., R.S.M.A., R.O.I., N.E.A.C.,S.WL.A. and R.B.S.A. *Works in collections:* H.R.H. the Prince of Wales, R.S.M.A. Diploma Collection, Derby A.G., The Picture collection of the Port of London Authority, and private collections in U.S.A., Canada, Australia, New Zealand, Germany and the U.K. *Commissions:* Sultan of Oman, The Royal Eagles Club, The Royal Burnham Yacht Club, The Forth Ports - Tall Ships Gathering - Leith. *Works Reproduced:* Rolls-Royce Ltd., Medici Soc., Royles, Winsor and Newtons, 20th Century British Marine Art, Square Rigged Sailing Ships, Marine Painting, A Celebration of Marine Art, International Artist Mag.,and numerous shipping lines. *Address:* Merlewood, 6 Queensway, Derby DE22 3BE.

STOREY, Warren, Hon.R.W.A. (2002), R.W.A. (1957), V.P.R.W.A. (1988-Mar.93), A.T.D. (1950), Brit. Inst. Scholarship (1948); painter, general and

ecclesiastical designer, mural artist; Head of Weston-super-Mare School of Art (1958-84); extra mural art history lecturer, Bristol University. *b:* S. Shields, 19 Aug 1924. *s of:* Joseph Storey. *m:* Lilian Evans. five *d. Educ:* S. Shields High School. *Studied:* S. Shields School of Art under Ernest Gill, A.R.C.A. (1941-44), and Regent St. Polytechnic School under Wm. Matthews and Norman Blamey (1947-50). *Exhib:* R.A., R.B.A., R.W.A., etc. *Works in collections:* R.W.A., St. Monica Home, Bristol, Somerset C.C., Walsall, Casa Piccolo Valletta, Weston-super-Mare Museum, Weston-super-Mare General Hospital. *Commissions:* Harvey's Sherry Bristol, various churches, Windwhistle Junior School mural, private portraits. *Publications:* contributor to Leisure Painter since 1987. *Works Reproduced:* Leisure Painters, John Noot Gallery. *Recreations:* music. *Clubs:* RWA, Cheltenham Music Soc. *Signs work:* "Storey" and date. *Address:* 14 Leighton Cres., Weston-super-Mare BS24 9JL.

STORK, Mary, B.A., Slade Dip.; painter in pastels; figure painter. *b:* Portsmouth, 5 Sep 1938. *d of:* J.W.Stork. one *s.* three *d. Educ:* Beadales, The Hall School. *Studied:* West of England College of Art, under Paul Feiler (1955), The Slade, London University, under Frank Auerbach, Keith Vaughan (1958). *Exhib:* David Messum, Cork St., Thompsons, Dover St., and many others. *Clubs:* Newlyn Soc. of Artists, Penwith Soc. of Artists. *Signs work:* "Stork." *Address:* 19 St. Mary's Terr., Penzance, Cornwall TR18 4DZ. *Email:* artmarystork@supernet.com

STRAFFORD, Judy, artist in oil and water-colour. *b:* Hove, 6 Mar 1932. *m:* Thomas Strafford (Earl of Strafford). one *s.* two *d. Studied:* Brighton College of Art. *Exhib:* solo and group shows: London, Paris, New Dehli, Alresford, Bristol, etc. Work in collections internationally. *Works in collections:* private. *Publications:* illustrated: The Green Home by Karen Christensen. Wrote and illustrated 'An Indian Journal', 'Pig Tales' etc. *Works Reproduced:* 1993 Good Hotel Guide, greetings cards, Limited Edn. prints. *Recreations:* travelling, gardening, cooking, wine. *Clubs:* Chelsea Arts. *Misc:* Workshops in water-colour, oil and mixed media in England, Italy, Spain, Turkey & Canada. *Signs work:* 'Judy Strafford'. *Address:* Apple Tree Cottage, Easton, Winchester, Hants SO21 1EF. *Email:* painting@judystrafford.co.uk *Website:* www.judystrafford.co.uk

STRANG, Michael, DipAD (Hons). *Medium:* oil, watercolour, drawing. *b:* Datchet, 24 Oct 1942. *s of:* Christopher John & Margaret Ann Strang. four *d. Educ:* Surrey and Windsor, Berks. *Studied:* Wimbledon School of Art (1968-70); Camberwell School of Art (1970-73). *Represented by:* Cry of Gulls Gall., Fowey; Oriel Pen y Fan Gall., Brecon; Elder Fine Art, North Carolina; Great Atlantic Galls, St.Just, Falmouth, Monmouth;. *Exhib:* RA; Tate St.Ives (over 50 works shown 1995); Medici, Bond St.; St.Martins-in-the-Fields Church, London; Curr St. Galls., London; Brecknock Museum, Wales; George Frederick Watts Museum & Gallery; Truro Museum, Cornwall; Chelsea Arts Club; Frost & Reed, Bristol; Cornwall Education Coll.; Thomsons Gall., London; Chomé, Bath; Guardian Exh Gall., USA, and many others. *Works in collections:* Penlee House Museum,

Penzance; C&G Building Society Collection; Brecknock Museum Coll.; Cornwall County Educ. Coll.; Mandells, Norwich; USA galleries. *Commissions:* many commissions including Bryan Forbes, Nanette Newman, Frank Muir, a number of portrait commissions. *Publications:* Guardian, Arts Review, Western Morning News, Cornishmen, etc. *Official Purchasers:* Brecknock Museum, Wales. *Principal Works:* recent retrospective Brecknock Museum 'The Welsh Collection', unique coll. of Llanelly Hill Brynmawr in 1970s-last mining years in Valleys, 3 works bought for collection; works sold at Christie's. *Clubs:* Chelsea Arts Club. *Misc:* painting of St.Martins-in-the-Fields, Trafalgar Square, London 'Easter Symphony' in the church to help promote £34 million restoration project. Documentary film being made. Studio at: 299 Stroude Road, Virginia Water, Surrey, GU25 4DE. *Signs work:* 'M J Strang'. *Address:* 1, Ridgeo Mill, Gulval, nr.Penzance, Cornwall TR18 3BX. *Email:* michaeljstrang@tiscali.co.uk *Website:* www.michaelstrang.com

STRANGELOVE, Nikolas Alexander, BA (Hons); Awards: Creative Skills; Arts Council; Kodak Bursary; University of London Laurel; Guardian/NUS Photographer of the Year; Finalist, Guardian/Penguin Book Cover; Finalist, Seeds of Change/Observer. *Medium:* photography. *b:* London, 9 Apr 1970. *Studied:* University of Westminster; Northbrook College of Technology. *Represented by:* Michael Wood Fine Art, Plymouth; New British Artists, Bedford; Heading West Gallery, Cornwall. *Exhib:* Festival Internazionale Di Roma, Italy; Oxo Tower Gallery, London; Newlyn Society of Artists, Cornwall; Orleans House Gallery, Twickenham; Falmouth Art Gallery, Cornwall; Stark Gallery, Canterbury, Kent; Mariners Gallery, St.Ives, Cornwall; Penlee House, Cornwall. *Works in collections:* The National Portrait Gallery. *Commissions:* British Journal of Photography, BBC, William Morris PR Agency, Art & Antiques (USA), The Progressive (USA), Shots Magazine (USA), Prima Records, Tate Enterprises Ltd., Kneehigh Theatre. *Principal Works:* B&W/colour hand printed photography. *Clubs:* Newlyn Society of Arts. *Misc:* Selected for: Discerning Eye, Mall Galleries, & Festival Internazionale Di Roma, Italy. *Signs work:* "NIK STRANGELOVE". *Address:* The Old Custom House, 53 Chapel Street, Penzance, Cornwall, TR18 4AF. *Email:* nik.strangelove@virgin.net *Website:* www.studiostrangelove.com

STREVENS, Bridget Julia, MA (Cantab., 1979); artist and illustrator in oil, water-colour, line, and digital pen. *b:* Ongar, Essex, 24 Sep 1956. *d of:* John Strevens, painter. *m:* (1) Stephen Romer. one s. (2) Michael Finch. one d. one *s.* one *d. Educ:* King's College, Cambridge University. *Studied:* Ecole Nationale Superieure des Beaux Arts, Paris. *Exhib:* London, Paris, Society of Illustrators, New York. *Works in collections:* Epping Forest District Museum. *Publications:* 'Toto's Travels' (Little, Brown & Co.),'Kiss, Kiss!' (Little Hare, Simon & Schuster US, Bayard, France), The Big Book for Little Hands (Tate UK, Harper Collins US). *Signs work:* "B. Strevens" or "Biddy Strevens." or B.Strevens.Marzo. *Address:* 59 Rue de Meaux, 60300 Senlis, France. *Email:* b@bridgetstrevens.com *Website:* www.bridgetstrevens.com

STRINGER, Simon Kenneth, MA Royal Academy Schools (1985); Vice-President of Royal Society of British Sculptors. *Medium:* sculptor. *b:* Bovey Tracey, 3 Feb 1960. *m:* Barbara. one *d. Studied:* Royal Academy. *Exhib:* various one-man and group shows from 1985. *Works in collections:* Tate Modern Education Department. *Commissions:* Hackney Council, Gloucester City Council, Foulton Group Ellesmere Port. *Clubs:* Royal Society of British Sculptors, RASAA. *Address:* Rear Studio, 24 Englefield Rd, London N1 4ET. *Email:* stringer@dial.pipex.com

STRONG, Sir Roy, Ph.D. Fellow Ferens (1976), Prof. of Fine Art (1972), Hon.D.Litt. (Leeds) (1983), Hon.D.Litt. (Keele) (1984); writer and historian; Director, Victoria and Albert Museum (till Dec. 1987); Fellow, Royal Society of Literature (1999). *b:* London, 23 Aug 1935. *s of:* G.E.C. Strong. *m:* Dr. Julia Trevelyan Oman (1971). *Educ:* Edmonton County Grammar School; Queen Mary College, London; Warburg Inst., London. *Commissions:* Occasionally acts as garden consultant. In this capacity he has designed and aided H.R.H. Prince of Wales, Gianni Versace and Sir Elton John with their gardens. *Publications:* author: Portraits of Queen Elizabeth I (1963), Holbein - Henry VIII (1967), Tudor - Jacobean Portraits (1969), The English Icon: English - Jacobean Portraiture (1969), Van Dyck: Charles on Horseback (1972), Splendour at Court: Renaissance Spectacle - the Theatre of Power (1973), Nicholas Hilliard (1975), The Cult of Elizabeth: Elizabethan Portraiture - Pageantry (1977), And When Did You Last See Your Father? (1978), The Renaissance Garden in England (1979), Britannia Triumphans: Inigo Jones, Rubens and Whitehall Palace (1980), The English Renaissance Miniature (1983), Art - Power (1984), Strong Points (1985), Henry, Prince of Wales - England's Lost Renaissance (1986), Creating Small Gardens (1986), Gloriana, Portraits of Queen Elizabeth I (1987), A Small Garden Designer's Handbook (1987), Cecil Beaton, The Royal Portraits (1988), Creating Small Formal Gardens (1989), Small Period Gardens (1992), A Celebration of Gardens (1992), Successful Small Gardens (1994), A Country Life (1994), William Larkin (1994), The Tudor and Stuart Monarchy, I, Tudor, II, Elizabethan (1995), III, Stuart (1996), The Story of Britain (1996), The Roy Strong Diaries 1967-1987 (1997), The Spirit of Britain (1999), Garden Party (2000), The Artist and the Garden (2000), Ornament in the Small Garden (2001), Feast, A History of Grand Eating (2002), The Laskett, The Story of a Garden (2003), Passions Past and Present (2005), Coronation (2005); 'A Little History of the English Church' (2007); other books jointly with Julia Trevelyan Oman, J.A. van Dorsten, Stephen Orgel, Colin Ford and J. Murrell; contributor to numerous books and learned journals. *Clubs:* Garrick. *Misc:* Serving or has served on numerous public committees including:Chevening House, the Council of the Royal College of Art, Fine Arts Advisory Committee of the British Council, Arts Council and South Bank Board. In 2000 became High Bailiff and Searcher of the Sanctuary of Westminster Abbey, one of the institution's two great lay offices. *Address:* The Laskett, Much Birch, Herefordshire HR2 8HZ.

STUART, Gordon Thomas, RCA(2000), WSW(1995); painter in oil, water-colour and draughtsman; lecturer, Heatherleys School of Art, Dyfed College of Art (1975-1982); artist in residence, UK Year of Literature (1995), artist in residence, Dylan Thomas Centre (since 1996); Second Prize, Welsh Painter of the Year (2005). *b:* Toronto, Canada, 30 May 1924. *m:* Mair Jenkins. *Educ:* Toronto Schools (1931-1946). *Studied:* Central Technical College, Toronto, Ontario College of Art, St. Martin's, London, University of London. *Exhib:* numerous, Toronto, Vancouver, England, Wales. National Library of Wales, Aberystwyth honoured artist with exhibition on his 80th birthday; St.David's Centre Cardiff, 2005: 30 portraits by artist for 50 Years Cardiff as Capital celebration. *Works in collections:* H.R.H. Prince of Wales, Contemporary Art Soc., Wales, Canadian High Commission, London, National Portrait Gallery, Ontario College of Art, Buffalo University, New York, National Library of Wales, Glynn Vivian Art Gallery, Swansea. *Publications:* Dylan Thomas Trail, illustration, Dylan the Bard, Sinclair, illustration. *Works Reproduced:* numerous. *Recreations:* music, books. *Signs work:* "Gordon Stuart." *Address:* 15 Richmond Rd., Uplands, Swansea, W. Glamorgan SA2 0RB. *Email:* mairgordon@ntlworld.com

STUART, Kiel, A.P.S.; artist in papier mache, mixed media and fibre, writer; Editor, Poetry Bone. *b:* NYC, 1951. *m:* Howard Austerlitz. *Studied:* Suny New Paltz, Suny Stony Brook. *Exhib:* Lynn Kottler Galleries, N.Y.C.; Gallery II RSVP, Virginia; Artforum, Mills Pond House, N.Y.; Myths, Music and Magic, East End Arts Council, N.Y.; Gallery North, Setauket, N.Y. *Works in collections:* National Museum of Women's Art, Washington DC. *Works Reproduced:* cover, Island Women Anthology (N.S.W.W.A. Press). *Address:* 12 Skylark Ln., Stony Brook, NY 11790, USA.

STUART-SMITH, Susanna J., B.Mus., Dip.Ecol., Gold medal (R.H.S.); botanical artist in water-colour, pencil, ink; freelance botanical illustrator working at R.B.G. Kew; experienced in fieldwork abroad (Oman), orchid illustration; botanical illustration tutor. *b:* B'ham, 26 May 1943. *m:* Richard Clymo, ecologist. *Educ:* Universities of London, Cambridge, Kent. *Studied:* trained: R.B.G. Edinburgh (1984), R.B.G. Kew (1993). *Exhib:* R.H.S. London; R.B.G. Edinburgh; R.B.G. Kew; Linnean Soc. London; Hunt Inst., U.S.A.; World Orchid Conference, Glasgow. *Works in collections:* R.B.G. Edinburgh, R.B.G. Kew. *Publications:* illustrated: 'Plants of Dhofar, Southern Region of Oman', Miller and Morris (Sultanate of Oman 1988); 'The New R.H.S. Dictionary of Gardening' (Macmillan Press Ref. Books 1992); 'The Orchids of Belize' (1996), 'Orchids of Bhutan', 'Orchids of Borneo'; reference books and scientific publications. *Signs work:* "Susanna Stuart-Smith" or "S.S.S." *Address:* 49 High St., Robertsbridge, E. Sussex TN32 5AL.

STUBBS, Constance, A.R.C.A.; painter and etcher in collage and acrylic;. *b:* Cheltenham, 6 Aug., 1927. *m:* Harold Yates. two *s.* one *d. Studied:* Cheltenham School of Art, Royal College of Art (1949-51, Carel Weight, Ruskin Spear, John Minton, Barnett Freedman). *Exhib:* mixed shows: R.A., Hayward, Mall Galleries,

C.P.S., S.C.A., Print Biennale-Berlin, Cracow and Rijeka; solo shows: Anglo Hellenic League Athens, John Russell Ipswich, Chappel Essex, Market Cross and St. Johns St., Bury St. Edmunds, Oxford Gallery, Chelmsford Festival. *Works in collections:* the late Princess Marina, Christchurch Mansions Ipswich, Unilever, Prudential, Sir Hugh Casson, Courtauld Private Collection, etc. *Signs work:* "C. STUBBS." *Address:* The Willows, Bell Corner, Pakenham, Suffolk IP31 2JT.

STUBBS, Michael, BA (Hons) Fine Art, MA (Fine Art), Phd (Fine Art); Lexmark European Art Prize (UK finalist); Celeste Art Prize. *Medium:* current medium: oil based mixed media on MDF. *b:* Rustington, West Sussex, 1 Sep 1961. *Studied:* West Sussex College of Art and Design (1978-79), Bath Academy of Art (1984-87), Goldsmiths College (1988-90, 1999-03). *Represented by:* Marella Gallery, Milan; Hollenbach Gallery, Stuttgart; Petrarce/Baro Cruz Gallery, Sao Paulo. *Exhib:* solo: Nicola Jacobs Gallery (1991); Bipasha Ghosh, London (1993); Curtain Road Arts, London (1995); Lotta Hammer Gallery, London (1996); Concourse Gallery, Byam Shaw School of Art (1997); Duncan Cargill Gallery, London (1998); Entwistle Gallery, London (2002); Marella Contemporary Art, Milan (2005); Hollenbach Gallery, Stuttgart (2006); Barocruz Gallery, Sao Paulo (2007); Group shows from 1990 at many museums and galleries worldwide, including RA, RCA, New Voices, British Painting (1993-97); John Hansard Gallery, Southampton (1996); The Cornerhouse, Manchester (1996); Centro Britanico Barzsiliero, Sao Paulo, Brazil (2002);Mead Gallery, University of Warwick (2002); Northern Gallery of Contemporary Art, Sunderland (2002); Museum Horsbruich, Leverkusen (2003); John Moores 24:Walker Art Gallery, Liverpool (2006);. *Works in collections:* British Council, Gibraltar Bank, Kreditanstalt fur Wiederaufbau; BHP Oils, Texas Pacific, Marsh, Slough Estates and numerous international private and corporate. *Works Reproduced:* Exhibition Catalogues, Art Magazine, national newspapers. *Signs work:* 'Michael Stubbs'. *Address:* 16 Wrexham Road, Bow, London E3 2TJ. *Email:* momentum@dircon.co.uk *Website:* www.michaelstubbs.org

STUBLEY, Trevor Hugh, D.A. (Edin.) (1951), R.P. (1974) Vice-President (1994-99), R.S.W. (1990), R.B.A. (1991), R.W.S. (1995); painter; Prizes: Hunting Group (1986), Singer & Friedlander (1990). *b:* Leeds, 27 Mar 1932. *s of:* Frank Stubley. *m:* Valerie Churm. four *s. Studied:* Leeds College of Art (1947-49); Edinburgh College of Art (1949-53). *Exhib:* Edinburgh, London. *Works in collections:* N.P.G., M.of.D., I.E.E., Palace of Westminster, British Library, Windsor Castle, six Oxford Colleges, Art Galleries: Doncaster, Harrogate, Huddersfield, Hull, Leeds, Lincoln, Manchester, Sheffield, Wakefield, nine University collections. *Commissions:* H.M. The Queen (1986), Lord Hailsham of Marylebone (1992). *Publications:* illustrated over 400 children's books. *Signs work:* "Stubley." *Address:* Trevor Stubley Gallery, Greenfield Rd., Holmfirth, nr. Huddersfield HD7 2XQ. *Website:* www.trevorstubleygallery.co.uk

STULTIENS, Jeff, Dip.A.D. (1966), R.P. (1990); First Prize - The Portrait Award, National Portrait Gallery (1985); Hon. Sec. R.S.P.P.; Senior Lecturer at

Hertfordshire College of Art and Design (1974-1987); painter in oil;. *b:* Blackpool, 12 Sep 1944. *s of:* Thomas Stultiens. *m:* Catherine Knowelden. *Educ:* Hutton and Tiffin Schools. *Studied:* Kingston School of Art under Alfred Heyworth and Camberwell School of Art under Robert Medley R.A. (1961-1966). *Exhib:* John Player Portrait Award - N.P.G., British Portraiture 1980-85, Drawings for All, R.S.P.P., Hunting/Observer, Nikkei Exhbn. - Tokyo, The Portrait Award 1980-89. *Works in collections:* N.P.G., Merton and Oriel Colleges - Oxford, National Heart and Lung Inst., R.N.L.I., Royal Medical Foundation, R.A.M. Many other public and private commissions. *Signs work:* "Stultiens." *Address:* 26 St. George's Cl., Toddington, Beds. LU5 6AT.

STUMMEL, Henning Friedrich, Dip-Ing.Architect, RIBA, RIBA Award, RIBA Housing Award. *Medium:* architecture. *b:* Frankfurt, 9 Jun 1966. one *d. Educ:* Deutsche Schule, London; Rokeby Prep; Gutenberg Gymnasium, Wiesbaden. *Studied:* TH.Darmstadt; ETH Zurich; worked with N.Foster (1993), and D.Chipperfield (1993-2000). *Exhib:* RA Summer Exhbn; RIBA. *Principal Works:* extension to Georgian townhouse, Marylebone; Mews house, Alba Place, Notting Hill. *Address:* 6 Shouldham Street, London W1H 5FH. *Email:* mail@henningstummelarchitects.co.uk *Website:* www.henningstummelarchitects.co.uk

STYLES, (Elizabeth) Caroline, DipAD, PG Cert. *Medium:* pastels, oil, drawing. *b:* Paulton, Bristol, 27 Nov 1947. *s of:* Harry & Betty Styles. two *s.* two *d. Educ:* King Edward's School, Witley, Surrey. *Studied:* Chelsea School of Art (1965-72); Royal Academy Schools (1969-72). *Exhib:* Grabowski Gallery, Bowmoore Gallery, Whitechapel Open, Space Open, Fish Island Events, Burlington Fine Art, Arts Unwrapped, Royal Academy Summer Exhibitions. *Works in collections:* private collections. *Commissions:* portraits and landscapes for private clients. *Works Reproduced:* 2006 RA Summer Exhibition Catalogue. *Principal Works:* 'Still Dying', series of still lives depicting roadside flower shrines. *Recreations:* gardens, concerts, theatre. *Clubs:* Chelsea Arts Club. *Misc:* taught at The Working Men's College, Mornington Crescent, and various adult colleges and secondary schools. *Signs work:* "Caroline Styles" or "CS". *Address:* 14 Byron Road, London E10 5DT. *Email:* caroline_styles@hotmail.com *Website:* www.carolinestyles.com

SULLIVAN, Benjamin Christian, RP, NEAC; BA (Hons) degree in Painting (2000). *Medium:* painter in oil and printmaker. *b:* Grimsby, 10 May 1977. *Educ:* Priestlands School, Lymington. *Studied:* Edinburgh College of Art (1997-2000). *Exhib:* Royal Academy, Royal Scottish Academy, National Portriat Gallery, Mall Galleries, etc. *Works in collections:* Royal Scottish Academy, Edinburgh; Parliament House Portraits, Edinburgh; University College, Oxford; Girton College, Cambridge; Institute of Civil Engineers, London. *Commissions:* Faculty of Advocates, private commissions. *Clubs:* NEAC, RP. *Address:* 8 Duddery Road, Havershill, Suffolk, CB9 8EA. *Email:* benjaminsullivanrp@yahoo.com *Website:* www.benjaminsullivan.com

SULLIVAN, Jason, B.A. (1979); painter in oil. *b:* Poole, Dorset, 31 Mar 1958. *s of:* Michael Sullivan. *m:* Una. one *s. Educ:* Queen Elizabeth Grammar School, Horncastle, Lincolnshire. *Studied:* Grimsby College of Art (1974-76, Mr. Todd), Sheffield College of Art (1976-79, Mr. Peacock). Numerous exhbns. *Address:* 19 Meersbrook Pk. Rd., Sheffield, S. Yorks.

SULLIVAN, Wendy, poet, painter; Winner: Brixton Open. *b:* London, 18 May 1938. *Educ:* Notre Dame High School, Battersea; attended Sir John Cass and Goldsmiths' Colleges; life drawing Leonard McComb, R.A.; anatomy Prof. Pegington, F.R.S. (U.C.H.). *Exhib:* R.A. Summer Shows, Galerie Dagmar, Portobello Opens, South Bank Show, Tamsins, Satay, Cooltans, Paperworks IV, Brixton Gallery, Le Creole, The Carrot Cafe, W. Norwood Library, First Sight Gallery, Bristol, The Ritzy, Brixton Library, Z Bar, The Village Hall, Brixton, Brixton Open, Jacaranda, Brixton, Destination Brixton, Bettie Morton Gallery, Dulwich Art Fair, Pullens Restaurant. *Works in collections:* on loan/and collections: Galerie Dagmar, Breast Screening Clinic Camberwell, St, John's Church, Brixton, Lambeth Archives, Movement for Justice, St.Marks Centre, Deptford. *Publications:* poetry: small presses 1964-2001; art reviews; 'Wendy Sullivan' webpages. *Misc:* Artist-in-Residence, A.S.C. Studios, Brixton (2000/2001). *Signs work:* "Wendy Sullivan". *Address:* 127 Crescent La., London SW4 8EA. *Email:* draw2day@hotmail.co.uk

SUMMERS, Rosalind, SEqA; SWA; DA; Daler-Rowney Award (SWA, 2003); Winsor & Newton Award, (SAA, 1998); SAA Artist of the Year (Best Professional, 1998); SAA International Art Event (Best Professional, 2000); SCF Art Competition Winner (1998); WSPA Art Competition Winner (Scotland, 2000). *Medium:* oil, watercolour, pastel. *b:* Irvine, Ayrshire, 2 Apr 1951. *d of:* Charles Summers (ex-Provost of Troon). *Educ:* Marr College, Troon. *Studied:* The Glasgow School of Art; Jordanhill College of Education, Glasgow. *Exhib:* Scotland: The Maclaurin Galleries, Ayr; The House for an Art Lover, Glasgow; RSAMD, Glasgow; The Aberdona Gallery, Alloa; The Dick Institute, Kilmarnock; England: Carisbrooke Gallery, London; Christie's; Westminster Gallery; Mall Galleries; Heath Gallery, Ascot; Century Fine Art, Datchet; Obsidian Art, Bucks; USA: Arlington Park. *Commissions:* Scottish Television (portrait of a stallion for King Hussein's daughter); Mr.James E.Patch's racehorse 'Killycally' (USA) winning at Arlington Park; Ayr Gold Cup Runner 'Ho Leng'. *Works Reproduced:* The Medici Society; The British Horse Society; KB Fine Art. *Principal Works:* equestrian artist specialising in action studies. *Recreations:* ex-horse trials competitor, breeds own horses. *Clubs:* Federation of British Artists (member). *Misc:* teacher of art and design, Prestwick Academy (Ayrshire) (1973-). *Signs work:* 'Rosalind Summers'. *Address:* 36 Main Street, Symington, Ayrshire KA1 5QF.

SUMSION, Peter Whitton, A.R.C.A. (1955); painter in oil and printmaker in relief and mono prints, drawing, lecturer; Lecturer, Glasgow School of Art (retd. 1995). *b:* Gloucester, 23 Aug 1930. *s of:* Dr. H. W. Sumsion, C.B.E., composer

and cathedral organist. *m:* Sarah Noble. two *s.* two *d. Educ:* St. George's Choir School, Windsor, St. Thomas' Choir School, New York City, Rendcomb College, Glos. *Studied:* Cheltenham School of Art (1949), Chelsea School of Art (1950-52), R.C.A. (1952-55, Carel Weight, John Minton, Robert Buhler). *Exhib:* one-man, Drawing Schools Gallery, Eton College (1960, 1978), Bury St. Edmunds Gallery; group shows, R.P., R.G.I. *Works in collections:* Brewhouse Gallery, Eton College. *Signs work:* "Peter Sumsion." *Address:* Bachie Bhan House, Cairndow, Argyll PA26 8BE.

SURREY, Kit, Dip.AD (Theatre design, 1968); theatre designer and artist in several media, mainly pastel and charcoal drawing; Winner of Drawing Prize, SGFA (2002, 2003, 2005, 2006). *b:* B'ham, 23 Jun 1946. *m:* Meg Surrey (née Grealey). one *s.* one *d. Educ:* Tauntons Grammar School, Southampton. *Studied:* Southampton College of Art (1963-65), Wimbledon School of Art (1965-68). *Exhib:* RA Summer Exhbn. (1993, 2002), International Drawing Biennale Cleveland (1991), Cheltenham International Open (1994), S. W. Academy of Fine Art (2000-03), Soc. of British Theatre Designers (1976, 1978, 1983, 1999, 2003), International Organisation of Scenographers, Berlin (1981), Moscow (1982). *Works in collections:* RSC Coll., Stratford, The Alpine Club, London,many private collections. *Publications:* included in British Theatre Design - The Modern Age, 'Time & Space', Design for Performance 1995-1999. *Recreations:* mountain walking and climbing. *Clubs:* mem. Society of British Theatre Designers; mem. Society of Graphic Fine Art; Assoc. Mem., The Alpine Club. *Signs work:* "KIT SURREY" or not at all. *Address:* Rock Cottage, Balls Farm Rd., Alphington, Exeter, Devon EX2 9HZ. *Email:* kit.surrey@btinternet.com

SURRIDGE, Mark Steven, BA Hons Graphic Design (1984); painter in oil; part-time lecturer at Falmouth College of Art; prizewinner Hunting Art Prizes (2001). *Medium:* mixed media; oil. *b:* Walthamstow, 6 Aug 1963. *s of:* Terrance & Joyce Surridge. *m:* Lisa Wright. two *s. Studied:* Maidstone College of Art (1981-1984). *Represented by:* Beardsmore Gallery; The New Millennium Gallery. *Exhib:* Beardsmore Gallery, solo exhib. (2000, 2003, 2005), New Millennium Gallery, St. Ives, solo exhib. (2001, 2004, 2006), many open exhibs.; Hunting Art Prizes, prizewinner (2001), Royal Overseas League (1995 & 1998), Newlyn Art Gallery; Merriscourt Gallery, Oxon; London Art Fair; Glyndebourne Festival Opera; RA Summer Exhbn; 20/21 British Art Fair; Art London; Cornish Art in the Nineties; Beatrice Royal; West of England Academy; 'Art Now', Tate Gallery St.Ives (2007). *Commissions:* three editions of lithographic prints for Club Quarter, London (2000, 2004), and two editions of lithographic prints New York. *Publications:* Guardian 'Living on the Edge'; exhibition catalogues; Grand Designs Magazine. *Recreations:* walking, cycling, guitar, nature, building. *Clubs:* Newlyn Soc. of Artists. *Signs work:* "Mark Surridge". *Address:* Chapel House, Crelly, Helston, Cornwall TR13 0EY. *Email:* marksurridge@googlemail.com

SUTHERLAND, Carol Ann, BAHons. (1973); artist in water based mixed media oil. *b:* Greenock, Scotland, 16 Mar 1952. *d of:* James Sutherland. three *s.*

Educ: St. Columba School for Girls, Kilmacolm, Renfrewshire. *Studied:* Glasgow School of Art (1969-73, Donaldson, Goudie, Grant, Robertson). *Exhib:* Mercury Gallery. *Works in collections:* McNay Museum, San Antonio, Tex., Middlesbrough A.G., Paintings in Hospitals. *Publications:* Leafy and Adam at the Seaside (handmade artist's book). *Signs work:* "Carol Ann Sutherland" or "C.A.S." *Address:* c/o Mercury Gallery, 26 Cork St., London W1X 1HB.

SUTTON, Jilly Bazeley, SRN, BA, ARBS. *Medium:* sculpture- mainly wood, some cast in bronze. *b:* Whitminster, Glos., 3 Mar 1948. *d of:* Bonham & Phylis Bazeley. *m:* Peter Sutton, Architect. two *s.* one *d. Educ:* Malvern Girls College; Westminster Hospital; Exeter College of Art. *Studied:* Exeter University (1988). *Represented by:* Rebecca Hossack Gallery, London. *Exhib:* Rebecca Hossack Gallery, London; Bourne Fine Art, Edinburgh; Holly Snapp Gallery, Venice; Galerie het Vifde Huis, Antwerp, Belgium; Coombe Gallery, Devon; various sculpture gardens. *Works in collections:* National Portrait Gallery, London; Museum of Liverpool Life, Liverpool. *Commissions:* portrait of Poet Laureate; Swan Centre, Leatherhead; P&O Cruise Ship 'Ventura'; Bulgari family; Mary Wesley; Nicholas Evans; HSP Architects, and many more. *Publications:* Modern British Sculpture by Guy Portelli; many magazines and broadsheets. *Works Reproduced:* many wood carvings are cast in bronze, including bronze of Andrew Motion for Portsmouth Grammar School. *Principal Works:* wooden portrait of Andrew Motion, Poet Laureate, for NPG in 2000. *Recreations:* rowing on River Dart. *Clubs:* Chelsea Arts Club. *Misc:* known for large grain bleached wooden heads. *Signs work:* 'JS' on wooden sculpture. *Address:* Whitestone Farmhouse, Cornworthy, Totnes, Devon TQ9 7HF. *Email:* info@jillysutton.com *Website:* www.jillysutton.com

SUTTON, Linda Olive, M.A. (R.C.A.) (1974); painter in oil on canvas, etching, water-colour, books; Double Painting Prize, Winchester School of Art (1968); prizewinner, Royal Festival Hall (1979, 80, 81); prizewinner, NPG (1982); prizewinner, RA (1987). *b:* Southend-on-Sea, 14 Dec 1947. *Educ:* Southend College of Technology. *Studied:* Winchester School of Art (1967-70), Royal College of Art (1971-74). *Exhib:* one-man shows, Galerij de Zwarte Panter, Antwerp; Bedford House Gallery, London; L'Agrifoglio, Milan; World's End Gallery, London; Ikon Gallery, Birmingham; Chenil Gallery, London; Royal Festival Hall, London; Stephen Bartley Gallery, London (1986); Beecroft Gallery, Westcliff-on-Sea (1987); Christopher Hull Gallery (1988); Jersey Arts Centre (1988); Beaux Arts, Bath (1988); Austin/Desmond, Bloomsbury (1989); Isis Gallery, Essex (1993); Lamont Gallery, London (1993); Pump House Gallery, Battersea Park (1994); Sutton House (National Trust) (1994); Chappel Galleries, Essex (1995, 2003); Bromham Mill, Beds. (1995); Piers Feetham Gallery, London (1995, 2002); Lamont Gallery, London (1996); John Bloxham, Fine Art (1996); Emscote Lawn, Warwick (1996); Six Chapel Row, Bath (1997); Fosse Gallery, Stow-on-the-Wold (1998); Workhouse Gallery, Chelsea (2000, 2001). *Works in collections:* Royal Academy of Arts, Chantrey Bequest for Tate, Sainsbury's Collection. *Commissions:* 100 murals commissioned by Royal

College of Art (1972). *Publications:* Limited Edition of etchings and poems in collaboration with Brian Patten (1996), Limited Edition Books of paintings and text of Shakespeare's "The Tempest" (1999), Ovid's Metamorphoses I and II (2000, 2001). *Recreations:* reading, opera, wine. *Clubs:* Chelsea Arts. *Signs work:* "Linda Sutton." *Address:* 192 Battersea Bridge Rd., London SW11 3AE.

SUTTON, Philip, R.A. (1976); artist in oil and water-colour. *b:* Poole, Dorset, 20 Oct 1928. *s of:* Louis & Ann Sutton. *m:* Heather. one *s.* three *d. Studied:* The Slade School of Fine Art. *Exhib:* Roland, Browse & Delbanco (1954-79), Australia, S. Africa and U.S.A., Berkeley Square Gallery, London, Piano Nobile, London. *Works in collections:* Tate Gallery, etc. *Commissions:* Post Office, stamps design. *Signs work:* "Philip Sutton." *Address:* 3 Morfa Terr., Manorbier, Tenby, Pembrokeshire SA70 7TH.

SWAIN, Dorothy Louisa, artist in oil; private art teacher. *b:* Wimbledon, 21 July, 1922. *d of:* Robert May, journalist. *m:* A.C. Swain. two *s.* two *d. Educ:* Wimbledon College of Art. *Studied:* Royal College of Art (Charles Mahony, Gilbert and Stanley Spencer, Paul and John Nash). *Exhib:* R.A., R.C.A., Russell Cotes Gallery. *Works in collections:* Premier Gallery, Eastbourne. *Signs work:* "D.L. Swain." *Address:* Hawthorn, West St., Mayfield, E. Sussex TN20 6DR.

SWALE, Suzan Georgina, Dip. A.D. (Hons.) 1969, M.A. (R.C.A.) Painting (1972); Artists Union (1983), I.A.A. (U.K.) (1979-86), London Group - mem. Working Party and Selection Com. (1984), R.C.A. Soc. (1993) artist/lecturer in paint, photo media, text, print, performance; Lecturer, Central/St. Martin's School of Art (1992-2002); Tutor, Morley College; Workshop Tutor, V&A Museum; Tutor, Open College of Arts. *b:* Nottingham, 30 Apr 1946. *m:* Robert Coward. one *s.* one *d. Studied:* Pre-Dip. Derby (1965-66), Bristol Polytechnic (1966-69), RCA (1969-72). *Represented by:* Jill Yakas Gallery, 16 Spartis Kifissia, Athens. *Exhib:* 'A Catalogue of Fear' retrospective Gardner Arts Centre, Brighton (1998); Grabowski Collection, Sztuki Muzeum, Lodz, Poland- 'Swinging London' Exhibition (2007)exhibits widely solo and group shows. *Works in collections:* public and private, UK and abroad. *Publications:* 'A Catalogue of Fear' Collective Works - Suzan Swale ISBN 09533977 01. *Works Reproduced:* catalogue 'Swinging London' Sztuki Museum 2007. *Signs work:* "Suzan Swale." *Address:* 217 Brecknock Rd., Tufnell Park, London N19 5AA. *Email:* susanswale@hotmail.co.uk *Website:* www.thelondongroup.com

SWAN, Ann, S.B.A., S.G.F.A.; R.H.S. Silver-gilt medal (1990), Gold medal (1991, 1993, 1997), Joint Gold (1999); botanical artist in pencil, coloured pencil, oil pastel, water-colour, drypoint engraving;. *b:* England, 7 Apr., 1949. *Educ:* Gravesend Grammar School for Girls. *Studied:* Manchester College of Art and Design. *Exhib:* R.H.S. Hampton Ct. International Flower Show (1990, 1991, 1994-97), S.B.A. (1991, 1992, 1994-97), R.H.S. (1990, 1991, 1993, 1997), Century Gallery Henley (1991), Lyric Theatre Hammersmith (1992), R.B.G., Kew (1994), Hunt Inst. of Botanical Documentation, Pittsburgh, U.S.A. (1996),

R.H.S. Chelsea Flower Show (1998-99). *Works in collections:* The Shirley Sherwood Collection, National Collection of Lycastes, Beckenham, Kent. *Works Reproduced:* limited edns. prints, and greetings cards. *Signs work:* "Ann Swan." *Address:* 55 Railway Rd., Teddington, Middx. TW11 8SD. *Email:* ann@annswan.co.uk *Website:* www.annswan.co.uk

SWAN, Martin, BA (Hons) Philosophy; RSMA. *Medium:* oil, watercolour, drawing. *b:* Newport, Isle of Wight, 14 Apr 1951. *s of:* Mr & Mrs E.N Swan. *m:* Melanie. *Educ:* Carisbrooke Grammar School (Newport, IoW); University College of Wales (Aberystwyth). *Studied:* self-taught. *Exhib:* Mall Galleries (RSMA); National Maritime Museum (RSMA); Portsmouth Cathedral (RSMA); Jonathan Grant Gallery, Auckland, New Zealand; St.David's Hall, Cardiff (RSMA); Les Artistes et la Mer, St.Malo; various local galleries. *Works in collections:* Isle of Wight Archive; RSMA Archive; various private collection. *Official Purchasers:* Healing Arts. *Works Reproduced:* limited ed. Marine Paintings reproduced 2005 (Artists Harbour, Portsmouth). *Recreations:* walking, reading, music, food, drink, rugby, cricket. *Signs work:* 'Martin Swan'. *Address:* 124 Carisbrooke Road, Newport, Isle of Wight PO30 1DF. *Email:* martinswan@ntlworld.com

SWAN, Peter John, RWA, NDD, ATD,. *Medium:* painter in oil. *b:* London, 28 Sep 1936. *s of:* John Thomas Swan. *m:* Janet. two *s.* three *d. Educ:* Dr. Morgan's Grammar School, Bridgewater, Somerset 1947-53. *Studied:* Somerset College of Art, Taunton 1953-55; St. Martin's School of Art, London 1955-57 NDD Painting; Institute of London University 1958-59 ATD. *Exhib:* solo: Arnolfini Gallery, Bristol 1961, 62, 66; Barrow Court 1979; Group: AIA Galleries, London, John Moore's Liverpool, Ben Lane Gallery, Oxford, RWA Bristol. *Works in collections:* private collections in England, Jersey CI, Australia, America, France, Abu Dhabi DAE. *Commissions:* two murals for Yateley Comprehensive School, Hampshire. *Clubs:* RWA. *Misc:* retired full-time lecturer Faculty of Fine Art, Bristol Polytechnic. *Signs work:* Peter Swan. *Address:* 23 Cornwallis Crescent, Clifton, Bristol, BS8 4PJ.

SWANBOROUGH, Patsy & Janet, both studied Illustration at Medway College of Design, Rochester, Kent (both 1st Class passes). Patsy mem. Society of Feline Artists. *Medium:* watercolour, drawing, prints, soft sculpture, egg tempera, acrylics. *b:* Maidstone, Kent. *d of:* Pam & Alan Swanborough. *Studied:* Medway College of Design (1972-76). *Represented by:* Rosehill Studio, St.Mary's, Isles of Scilly. *Exhib:* 'Cats in Windows' exhibited at RA Summer Exhibitions (1992, 1993, 2000)- the only living twins to have exhibited in the same year. Have been exhibiting since 1977, including Llewelyn Alexander (SOFA-Patsy only). *Works in collections:* private collections. *Commissions:* Roy Mitchell; Robert Dorrien-Smith; The Isles of Scilly Tourism Association; Jeremy Mills (for BBC TV); Michael Galsworthy. *Publications:* latest series of 'Cats in Windows' published by Hockin & Roberts Ltd; 'Cats in Windows' Calendar 2006 by Judges Ltd. *Works Reproduced:* available as prints, giftware from our gallery

or by mail order. *Clubs:* SOFA. *Address:* The Swanborough Twins, Gallery, Rosehill Studio, Rosehill, St.Mary's, Isles of Scilly, Cornwall TR21 0NE. *Email:* patsyjanet.swanborough@yahoo.co.uk *Website:* www.rosehillstudio.co.uk

SWANN, Marilyn, Fellow of Free Painters and Sculptors; painter; Women's Art Library, Fulham. *Medium:* water-colour, oils, acrylic. *b:* Kent, 16 Apr 1932. *d of:* H.H. Whiddett and C.W. Swann. *Studied:* Woolwich Poly. (1945-50), Central, Chelsea and Sidcup (evenings and Adult Education). *Exhib:* Trends (Mall, Wieghouse, Barbican, Bloomsbury Galleries, etc.), F.P.S. shows since 1973, St. Martin's Crypt, Trafalgar Sq.; solo shows, Brangwyn Studio (1976/7), Univ. of Surrey, Old Bull, Barnet (1978), Loggia Gallery (1984), Holland Park Orangery (1987), Hall Place and various other venues in Bexley and Cheltenham. *Works in collections:* Univ. of Surrey, Wilfred Sirrel Collection, Westminster Arts Council, Queen Mary's Hospital, Sidcup. *Official Purchasers:* Westminster Arts Council. *Recreations:* writing, and studying history. *Clubs:* CPS Artists. *Signs work:* "SWANN." *Address:* Cheltenham GL52 2JJ.

SWEENEY, Deborah, BA Hons Fine Art; PGCE. *Medium:* oil, watercolour, drawing, prints. *b:* Halifax, W.Yorks., 18 Jun 1956. one *d. Educ:* Highlands Grammar, Halifax. *Studied:* Sheffield Polytechnic College of Art; Bretton Hall. *Represented by:* Bull Yard Gallery, Southwell, Notts. *Exhib:* Royal Academy Summer Exhbns (2003, 2004, 2005); Mappin Art Gallery, Sheffield; Sheffield Colourists (2002). *Commissions:* various. *Works Reproduced:* some works available as prints. *Misc:* established 'The Westhorpe School of Art' in 1997, teaches young people and adults. *Signs work:* 'Deborah Sweeney'. *Address:* Long Barn, Westhorpe, Southwell NG25 0NG. *Email:* deborah@westhorpeart.demon.co.uk

SWEENEY, Kevin Michael, *Medium:* sculpture. *b:* Maldon, Essex, 28 Jan 1965. *s of:* Michael & Jackie Sweeney. *m:* divorced. one *s.* one *d. Studied:* studied spraying at all levels since leaving school, including water born, electro c static, 2pack. *Exhib:* RA Summer Exhibition (first two pieces)(2007), Flitch Gallery, Gt.Dunmow. *Works in collections:* private and corporate. *Commissions:* waiting list. *Publications:* Royal Academy Illustrated 2007 (Summer Exhibition). *Works Reproduced:* none. *Misc:* Spent 3 years at E15 Acting School. *Signs work:* initials: 'K.M.S". *Address:* 5a White Street, Gt. Dunmow, Essex, CM6 1BD. *Email:* kevin@sweeney.org.uk *Website:* www.abstractsculptures.co.uk

SWEENEY, Maureen, NSPS; MNS; BA Hons (Fine Art); PGCE; Anya Broughton Award, NSPS (Best Painting, 2005); Robertson Award for Best Figurative Painting (1974). *b:* London. *d of:* Patrick & Anne Sweeney. *m:* Christopher Lewis Ruffley. one *s.* one *d. Educ:* Notredame High School for Girls. *Studied:* Wimbledon School of Art (1973-77); Roehampton University. *Represented by:* Southbank Printmakers, Gabriels Wharf, Lambeth, London. *Exhib:* RA Summer Exhbn; RWS; NEAC; Llewelyn Alexander (2002-07); Salon de Graphique; Curwen Gallery; Natural History Museum; Southbank

Printmakers, London; Oxo Gallery, London; Menier Chocolate Factory, London; Business Design Centre, Islington; Paris, Germany, Norway & Russia. *Works in collections:* private and public, home and abroad. *Commissions:* private commissions for portraits, landscapes and seascapes. *Official Purchasers:* Kunstverein, Landau, Germany; Merton Local Authority. *Recreations:* travel, reading, theatre. *Clubs:* Southbank Printmakers. *Signs work:* 'Sweeney'. *Address:* 13 Burntwood Grange Road, Wandsworth, London SW18 3JY. *Email:* mosweeney2003@yahoo.co.uk

SWETCHARNIK, Sara Morris, Fulbright Fellow, Spain (1987-88, 1988-89); painter, sculptor. *b:* Shelby, N. Carolina, 1955. *d of:* William Morris. *m:* William Swetcharnik. *Studied:* Art Students League, N.Y.; Schuler School of Fine Art, Baltimore, Maryland. *Represented by:* Swetcharnik Art Studio (by appointment). *Exhib:* Arts in Embassies, Honduras (1997-98). Residency Fellowship, Virginia Center for Creative Arts, Sweet Briar, Virginia (1990, 2003); Workshop instructor, Landon School, Washington D.C. (1991-96); Artist's Residency Fellowship, American Numismatic Assoc. Conference, The American Numismatic Museum, Colorado Springs, (1994). *Clubs:* Fulbright Assoc., Delaplaine Visual Art. *Signs work:* "Sara Morris Swetcharnik." *Address:* Swetcharnik Art Studio 7044 Woodville Rd., Mt. Airy, Maryland 21771-7934, U.S.A. *Email:* sara@swetcharnik.com *Website:* www.swetcharnik.com

SWETCHARNIK, William Norton, P.S.A., Fulbright Fellow: Spain (1987-89), Honduras (1994-95), Yaddo Foundation (1987), Cintas Foundation (1985), Millay Colony for the Arts Fellowship (1983), Stacey Foundation (1983); painter in oil, pastel, tempera, encaustic. *b:* Philadelphia, Pennsylvania, 1951. *s of:* Charles Jacob Swetcharnik. *m:* Sara Morris. *Educ:* Sandy Spring Friends School, Maryland. *Studied:* Rhode Island School of Design, University of California, New York Art Students League. *Represented by:* Swetcharnik Art Studio (by appointment). *Exhib:* Springville (Utah) Museum of Art, Butler Inst. of American Art, Youngstown, Ohio, Washington County (Maryland) Museum of Art, National Arts Club, N.Y.C., Hermitage Museum, Norfolk, Virginia. *Signs work:* "Wm. Swetcharnik." *Address:* Swetcharnik Art Studio 7044 Woodville Rd., Mt. Airy, Maryland 21771-7934, U.S.A. *Email:* william@swetcharnik.com *Website:* www.swetcharnik.com

SWINGLER, Brian Victor, NDD, ATD, RBSA (1986); artist in water-colour and acrylics; part time teacher at Birmingham, Hereford and Worcester. *b:* Birmingham, 8 July, 1939. divorced. *s of:* Ernest Swingler. two *s. Educ:* Yardley Grammar School. *Studied:* Birmingham Art School (1962-65, Gilbert Mason, Roy Abell). *Exhib:* mainly at Potter Clarke Gallery, St. Ives, also at Compendium Gallery, Ombersley Gallery, R.B.S.A., Timaeus Gallery, Helios Gallery, Cedric Chivers Gallery, Pictures, Henry-Brett Gallery, Richard Hagen Gallery, New Gallery, Moseley Gallery, Bankside, Frames, Noott Gallery. *Works in collections:* R.B.S.A. Gallery. *Commissions:* many public and private portrait commissions. *Works Reproduced:* Artist Magazine and Leisure Painter. *Clubs:* V.P.R.B.S.A.

Signs work: "B.V. Swingler." *Address:* 17 Beverley Rd., Rubery, Birmingham B45 9JG.

SYKES, Barbara, BA (Hons.) Fine Art (1993); painter in water based paint on paper, and charcoal; textile designer (1962-75). *b:* Doncaster, 4 Mar 1944. *d of:* Richard and Ada Johnson. *m:* Jeffrey Howard Sykes. two *s.* one *d. Studied:* Bretton Hall, University of Leeds (1990-93, Tom Wood), Bradford College, MA Printmaking (2003-2005). *Represented by:* Tregonning Fine Art, Derby; Gascoigne, Harrogate; Artifex Birmingham, etc. *Exhib:* Mall Galleries, RA Summer Show, Discerning Eye; RWA; Djanogley Gallery (Nottingham University), Logos London, Dean Clough, Halifax, Huddersfield Art Gallery, Peterborough Museum and Gallery, Bury Art Gallery, DFN New York, North West House Brussels, Bradford University, Hastings Museum and Art Gallery, Cleveland Gallery Middlesborough, Derby Art Gallery, Djangoly Gallery. Nottingham Univ.,etc. *Works in collections:* Studio: Dean Clough, Halifax, Provident Financial Group, Bretton Hall. Private collections: UK, USA, France, Slovenia. *Commissions:* private commissions. *Works Reproduced:* magazines, cards, etc. *Principal Works:* 'Concerning Senses'; 'Intergenerational'; 'Human Condition'. *Recreations:* reading, gardening, jazz. *Clubs:* M.A.F.A. *Misc:* studio holder at Dean Clough Galleries, Halifax. *Signs work:* "Barbara Sykes" (on request.). *Address:* The Hollows, Shore Edge, Shaw, Oldham, Lancs. OL2 8LJ. *Email:* barbarasykes@supanet.com *Website:* www.barbarasykes.com

SYKES, Sandy, BA Hons. (1966), MA (1987); Awards: Bank of Canada Prize, Trois Rivier International, Quebec (2005), The Lorne Award Scholarship, UCL (2003), Major funding award Arts Council England East; printmaker, painter and maker of artists books;. *b:* Yorkshire, 13 Mar 1944. *m:* Martin Appleson. *Studied:* Leeds Metropolitan University (1962-66), Middlesex University (1966-67), Wimbledon College of Art (1984-87). *Exhib:* recent solo shows: Manhattan Graphic Centre, N.Y. (2002), 'Manhattan Transfer' London Print Studio (1998), Crossley Gallery Dean Clough (1995), Brahm Gallery, Leeds (1995), Pentonville Gallery (1988), Creaser Gallery (1988), Hardware Gallery (1988, 1991, 1995, 1997), Wakefield A.G. (1988-89); many group shows in Britain, America, Russia and Europe. *Works in collections:* Tate Britain, M.O.M.A. N.Y., Metropolitan Museum of Art N.Y., British Arts Council, V. & A., Merrill Lynch, Yale University, U.S.A, Nagasawa Art Park, Japan, etc. *Commissions:* Oxfam (1992), B.B.C. (1990), etc.,; residencies include: Senigallia, Italy (1991); Manhattan Graphic Centre, N.Y. (1998); Nagasawa, Japan (2001). *Publications:* Lament for Ignacio Sanchez Mejias by Federico Garcia Lorca; 'Paradise is Always Where You've Been' (1999) ISBN 1902111002; 'The Dante Series' catalogue (1997) ISBN 190211001. *Official Purchasers:* National Arts Collection Fund, Ashmolean Museum, Oxford, etc. See collections. *Clubs:* Chelsea Arts. *Misc:* Represented in video 'Etching' Brighton University; 'The Wood Engraving and Woodcut in Britain 1890 to 1990,' by James Hamilton; Digital Data Bases 'Art View', New York and 'Axis', 'The Best of Printmaking: An International Collection.' Residencies: Manhattan Graphic Center NY (2000), Nagasawa Art

Park, Japan (2001). *Signs work:* "Sandy Sykes." *Address:* 12 Kirkley Rd., London SW19 3AY. *Email:* sandy@sandysykes.co.uk *Website:* www.sandysykes.co.uk

SYKES, Thelma Kathryn, BA Hons(1962), SWLA(2001). *Medium:* artist printmaker, linocut and woodcut. *b:* Heckmondwike, Yorks., 29 Apr 1940. *Educ:* Durham University. *Represented by:* Birdscapes Gallery, Manor Farm Barns, Glandford, Holt, NR25 7JP; Pinkfoot Gallery, High Street, Cley-next-the-Sea, Norfolk, NR25 7RB. *Exhib:* SWLA, Mall Galleries, London, Royal National Theatre (2001), Soc. of Wood Engravers, Internat. Festival of Printmaking, Chong Qing, China (2000), English Nature Touring Exhbn (2004-2005). *Works in collections:* Nature in Art, Wallsworth Hall, Gloucester; Contemporary Art Collection, Grosvenor Museum, Chester, Powergen, Bristol University. *Publications:* European Atlas of Breeding Birds, Academic Press (1997), Birdwatchers Yearbook (1985-1996), New Atlas of Breeding Birds, and many publications for British Trust for Ornithology. *Signs work:* "Thelma K Sykes' or book illustrations, "TKS." *Address:* Blue Neb Studios, 18 Newcroft, Saughall, Chester CH1 6EL. *Email:* thelmasykes@tiscali.co.uk

SYLVESTER, Diana, RWA (1986), ROI; artist in oil; Ex. Wilts. County Council part-time lecturer; ex. Sec. Bath Soc. of Artists; Vice President, Bath Society of Artists. *Medium:* oil paint. *b:* Bath, Som., 16 Mar 1924. *d of:* Edgar King, solicitor. *m:* Robin Sylvester. three *s.* one *d. Educ:* Bath High School. *Studied:* Chippenham Technical College, Corsham and Bristol Polytechnic. *Represented by:* RWA, BSA. *Exhib:* RA, RWA, ROI, BSA, London etc. *Works in collections:* R.W.A., Bristol Schools Art Service. *Clubs:* Bath Soc. of Artists, Bruton Art Society. *Signs work:* "DIANA SYLVESTER." *Address:* Upper Farm, South Wraxall, nr. Bradford-on-Avon, Wilts. BA15 2RJ.

SYMINGTON, Christy Mary, ARBS; Board Member, Royal British Society of Sculptors (2003-07); Merit Award for Sculpture. *Medium:* sculpture. *b:* Northampton, 10 Nov 1962. *m:* José Antonio 'Tontxi' Vasquez. two s- *d. Educ:* Wycombe Abbey School, Bucks. *Studied:* Atelier des Beaux Arts, Paris, France (1996-7); New York Studio School, NYC, USA (1997-2001); Byam Shaw School of Art, University of the Arts, London (2001-02). *Exhib:* Society of Portrait Sculptors (2002, 04, 07); University of Leicester "Sculpture in the Garden" (2005, 06); RWA (2003, 04); USA: National Arts Club, New York (Paul Manship Award, 2001); The Great American Women's Sculpture Park, New York (2001); Taller Boricua, New York (2001); Angel Orensanz Foundation Center for the Arts, New York (1999). *Works in collections:* Angel Orensanz Foundation, New York. *Misc:* originator of Sculpture Bridge Park across the River Thames. *Signs work:* "Christy" (with paw mark). *Address:* 23 Brockley Grove, London SE4 1QX. *Email:* christysym@aol.com *Website:* www.christysymington.com

SYMONDS, Ken, N.D.D., P.S.; artist in pastel, oil, water-colour;. *b:* 18 Jan 1927. *m:* Jane. one *s.* one *d. Educ:* Euclid St. Grammar School, Swindon. *Studied:*

Regent St. Polytechnic, London (1948-52, Norman Blamey, R.A.). *Exhib:* regularly in Cornwall, Mall Galleries, Europe, U.S.A. *Works in collections:* Government Collection, Plymouth C.C., Guernsey, etc. *Publications:* 'Around the Penwith'. *Official Purchasers:* Exeter University (portrait of Vice-Chancellor), 'Catching the Wave' by Tom Cross. *Signs work:* "Symonds." *Address:* St. Andrew's Studio, Fore St., Newlyn, Cornwall TR18 5LD.

SYMONDS, Peter John, B.A.; painter in oil of landscape architectural and marine subjects;. *Medium:* oil on canvas. *b:* Woking, 15 Jan 1964. *m:* Vanessa. one *s.* one *d. Studied:* Leicester University. *Exhib:* Bourne Gallery, Reigate; Clifton Gallery, Clifton; Beckstones nr. Penrith; four solo shows S.E. England, mixed shows nationwide. *Commissions:* Lloyds Bldg. London, numerous private commissions home and abroad. *Works Reproduced:* Limited Edn. prints (Solomon & Whitehead). *Recreations:* trekking, sport, travel. *Signs work:* "Peter Symonds." *Address:* Magpies, Vicarage Lane, Send, Woking, Surrey GU23 7JN.

SYNGE, Pamela: see de MEO, P.,

SYVERSON, Judith, RMS. *Medium:* traditional miniature paintings in oil and acrylic. *b:* Merrill, Wisconsin, 20 Sep 1944. *m:* Richard F.Syverson. one *s.* two *d. Educ:* BS Wisconsin State University, River Falls. *Studied:* Sergei Bongart School of Painting/Marke Ogle/Joe Abbreccia/Jean Hamilton/Joan Willies RMS. *Exhib:* London, UK; USA: Colorado, California, Florida, Montana, Minnesota, Washington DC-Smithsonian, Connecticut, Wyoming. *Works in collections:* corporate and private individuals worldwide. *Commissions:* corporate and private individuals across the US. *Publications:* 'Royal Society of Miniature Painters, Sculptors and Gravers: One Hundred Years' (pub. 1995). *Works Reproduced:* 'Story Time'; 'The Eccles Farm'; 'Mountain Homestead'; 'High Mountain Monarch'; 'The Ol' Dortch Place'. *Recreations:* gardening, hiking the mountains of the North-West. *Clubs:* Montana Professional Artists Assoc.; Royal Miniature Society,London. *Misc:* noted for her delicate portrayal in miniature of a wide range of subjects. Inspired by her great-grandparents' stories of ranching in Montana, she especially enjoys portraying homesteads of the West. Many of her pieces are documented with stories. *Signs work:* 'Judith Syverson RMS'. *Address:* 136 Lake Hills Drive, Bigfork, Montana 59911 USA. *Website:* www.MontanaProfessionalArtistsAssoc.com

T

TABB, Barrington Moore, R.W.A. (1999); self taught painter in oil. *b:* Almondsbury, Glos., 25 Apr 1934. *m:* Grace Pearn. two *d. Educ:* All Saints School, Bristol. *Represented by:* Cube Gallery, Bristol; Anthony Hepworth Fine Art, Bath. *Exhib:* Olympia Fair, London (4 yrs.), Wimbledon Gallery (1980), Christopher Hull Gallery (1982), Neville Gallery, Bath (1986), Cleveland Bridge Gallery (1990), Black Swan Gallery, Frome (1997), R.W.A. (1998 onwards), Cube Gallery, Bristol (2002-2007), St. David's Hall Cardiff (2002), Albany

Gallery Cardiff (2002), Rob Whittle Gallery (2002), Gormleys Gallery (Belfast, 2007). *Works in collections:* 14 paintings Wessex Collection Longleat House. *Publications:* 'Pictures' with forewords by Anthony Hepworth and Charles Hall; 'Passion for Paint' by Jonathan Bennington. *Recreations:* painting!. *Signs work:* "B.M.T.", "Barrington M Tabb", or "BT." *Address:* 10 Frys Hill, Brislington, Bristol BS4 4JW.

TABER, A. Lincoln, artist;. *b:* Colchester, 1970. *Studied:* City and Guilds School of Art (1989-92). *Exhib:* R.A. Summer Show, New Grafton Gallery. *Commissions:* murals, portraits. *Clubs:* Chelsea Arts. *Address:* 6 Hermes House, Arodene Rd., London SW2.

TABER, Jacqueline, artist and picture restorer. *Medium:* oil. *b:* London, 1 Sep 1946. *m:* the late A. Lincoln Taber, painter. one *s*. *Educ:* Heathfield School; Paris (one year). *Studied:* Florence (Signorina Simi), Gabinetto del Restauro, Uffizi Museum. *Represented by:* Russell Gallery; Geedon Gallery. *Exhib:* RA Summer Exhbn (1999-2006), RBA (2005, 2007), New Grafton Gallery, Discerning Eye (2000, 2003, 2006), Hayletts Gallery (two solo exhbns), Lennox Gallery, Russell Gallery, Mall Galleries. *Commissions:* 'Tulips'. *Publications:* A Bit of Trompe - The Art of Lincoln Taber. *Principal Works:* 'Still Lives'. *Recreations:* reading, painting, projects. *Clubs:* Chelsea Arts, Colchester Art Society, Art Workers Guild. *Signs work:* 'J.A.Taber'. *Address:* Jaggers, Fingringhoe, Colchester, Essex CO5 7DN. *Email:* jataber@aol.com

TAHERIAN, Christine, SWA; a number of awards from art societies. *Medium:* oil, acrylic, mixed media. *b:* Cardiff, 14 Dec 1960. *m:* Dr.Alireza Taherian. two *s*. one *d*. *Exhib:* SWA, ROI; Yvonne Arnaud; Guildford & Woking Art Society. *Works in collections:* internationally. *Principal Works:* Impressionism. *Clubs:* Guildford Art Society, Woking Art Society. *Signs work:* 'C.TAHERIAN'. *Address:* Gralyn, Sylvan Close, Woking, Surrey, GU22 7UD. *Email:* artctt@aol.com *Website:* www.society-women-artists.org.uk

TAIT, Renny, painter;. *b:* Perth, Scotland, 27 June, 1965. *m:* Valerie Anderson. one *d*. *Studied:* Edinburgh College of Art, Royal College of Art. *Exhib:* regularly with Flowers East, London. *Signs work:* "Renny J. Tait" on back of painting. *Address:* 26a Lygon Rd., Edinburgh EH16 5QA.

TAIT, Wendy Ann, SFP, SBA; water-colour artist and demonstrator;. *Medium:* watercolour, oils, acrylic. *b:* Derby, 19 Apr 1939. *d of:* W.G. Kirk. *m:* H.D.L. Tait (decd). two *s*. two *d*. *Studied:* Joseph Wright School of Art, Derby (1952-55), Adult Educ. (1974-78, Roy Berry). *Exhib:* Derbyshire and Westminster, London galleries. Residential courses and Dayschools, Midlands and Yorkshire area. *Commissions:* 'Autumn Flowers' (1999), 'Winter Flowers' (2003), 'Summer Flowers' (2007),Government of Jersey Philatelic Bureau. *Works Reproduced:* greetings cards by Robertson Collection; book 'Watercolour Flowers' (Search Press), 'Watercolour Wild Flowers' (Search Press), 'Ready to Paint' (Search Press). *Clubs:* Amber Art Group, Belper Art Group. *Signs work:* "W.A. Tait."

Address: Harwen, 1 Chevin Rd., Duffield, Derbys. DE56 4DS. *Email:* wendytait@gmail.com *Website:* www.wendytait.com

TAJIRI, Shinkichi, William and Noma Copley Award for sculpture (1959); John Hay Whithey Found. Opp. Fellowship (1960); Mainichi Shibum Prize, Tokyo Biennale (1963); sculptor in bronze and brass; Prof. of Sculpture, Hochschule für Bildende Kunste, W. Berlin (retd. 1989);. *b:* Los Angeles, 7 Dec 1923. *m:* Ferdi (decd.). two d. m Suzanne Van Der Kapellen (1976). *Educ:* Los Angeles. *Studied:* under Donald Hord, San Diego (1948-51); O. Zadkine and F. Leger, Paris. *Works in collections:* Stedelijk Museum, Amsterdam, Gemeente Museum, Den Haag, Modern Museum, Stockholm, Town of Arnhem, Holland, Museum of Modern Art, N.Y., etc. *Address:* Kasteel Scheres, 5991 NC Baarlo, Limburg, Holland.

TAKEDA, Fumiko, B.A. (1989), M.A. Hons. (1991); artist in etching; lecturer since 1992, Tokyo Y.M.C.A. Inst. of Design; lecturer since 1999, Tokyo University of Fine Art and Music. *b:* 26 July, 1963. *Studied:* Tokyo University of Fine Art and Music (1985-89), The Graduate School of Tokyo University of Fine Art and Music (1989-91). *Exhib:* over seventeen solo exhbns. since 1990, R.A. (1997), The 2nd and 3rd Sappro International Print Biennial Exhbn. (1993, 1995), The 23rd International Biennial of Graphic Arts in Ljubljana, Slovenija (1999). *Works in collections:* Tokyo University of Fine Art and Music. *Signs work:* "Takeda, F." *Address:* 2-10-21, Takagi-cho, Kokubunji-shi, Tokyo 185-0036, Japan. *Email:* pajaco@dream.com *Website:* http://homepage1.nifty.com/miuraarts

TALBOT, Nancy Wilfreda Hewitt, D.A. (Lond.) (1948); painter in oil and stage designer; consultant, Talbot Film Productions; teacher of painting for Hampshire (1950-66). *b:* Coventry, 31 Aug 1925. *d of:* Wilfred John Skillington, lawyer. *m:* Major Leon Talbot. *Educ:* Leamington High School, Leamington Spa. *Studied:* Ruskin Drawing School, Oxford (1945) (Albert Rutherston), Slade School, London (1945-48) (Randolph Schwabe, Vladimir Polunin). *Exhib:* first one-man show, Alfred Herbert Gallery, Coventry (1965). *Works in collections:* mural and portrait commissions, privately owned. *Signs work:* "Nancy Talbot" or "Nancy Skillington." *Address:* Greensleeves, Avon Castle, Ringwood, Hants. BH24 2BE.

TALBOT KELLY, Chloë Elizabeth, M.C.S.D. (1968), S.WL.A. (1964), M.B.O.U. (1960); freelance bird artist/illustrator in water-colour, gouache and black and white. *b:* Hampstead, 15 Jul 1927. *d of:* the late Major R. B. Talbot Kelly (Richard Barrett), M.B.E., M.C., S.WL.A. one *s. Educ:* St. George's School for Girls, Convent of the Sacred Heart; adviser, father and Bird Room, B.M.N.H. *Exhib:* S.WL.A. and provincial galleries in U.K., Australia and Canada. *Commissions:* various. *Works Reproduced:* Field Guides to Birds N.Z, Seychelles, Fiji, Tonga and Samoa; contributor to New Dictionary of Birds, African Handbook of Birds, Collins Handguide to Birds of New Zealand, etc.

WHO'S WHO IN ART

Clubs: British Ornithologists; Leicestershire and Rutland Ornithological Society. *Signs work:* "C.E. Talbot Kelly" semi printed in paint or written, or initials only. *Address:* 22 St. Philip's Rd., Leicester LE5 5TQ. *Email:* cetk@btinternet.com

TALKS, David, Received Gold Medal in Rouen (2001) for services to French culture (own exhibitions, plus arranging exhibitions for English artists in Rouen, and French artists in Norwich); Former mem. Coventry and Warwickshire Society of Artists; Past President, Rugby and District Art Society; President, Norfolk and Norwich Art Circle (2007-09); East Anglian Group of Marine Artists Committee Member. *Medium:* watercolour. *b:* Wimbledon, 10 Nov 1937. *m:* Audrey. four *s. Educ:* Mercers School, London (1946-56); Worcester College, Oxford (1958-63); MA (French and Russian); M.Litt (French); Civil Service Commission Interpretership Qualification in Russian (1958). *Exhib:* RI (1988-92, 94, 95); RSMA (1992); EAGMA, Mall Galleries (1998, 2000, '02, '04, '06); Thompson's Gallery, London (1996); Westcliffe Gallery, Sheringham (1997, '99, 2001, '03); Peter Hedley Gallery, Wareham (2002, '04, '07); Mandell's Gallery, Norwich (2006); La Galerie Lespinasse, Rouen (1998-2007 - one-man shows annually); Crome Gallery, Norwich (1998-, occasional one-man shows). *Commissions:* Norwich Cathedral, Norwich School, Rugby School, plus many private commissions. *Recreations:* walking and watching. *Misc:* Reserve Decoration (and Clasp) for service as Lieutenant-Commander in the Royal Navy Reserve (1958-1986). *Signs work:* 'DAVID TALKS'. *Address:* 20, The Close, Norwich, NR1 4DZ.

TAMPLIN, Heather, M.F.P.S. (1984); artist in oil, computer generated images, land art installations in response to the North Norfolk landscape. *b:* Caterham, 4 Aug 1950. one *s.* one *d. Studied:* Wimbledon College of Art (1967). *Exhib:* Loggia Gallery and Barbican with F.P.S., Mall Galleries, Fermoy Centre, King's Lynn; one-man shows locally, dfn Gallery, Broadway, N.Y., C.21, Mundesley, Burlington Lodge Gallery, Sheringham, The Forum, Norwich, Battersea Contemporary Art Fair. *Commissions:* A series of 34, computer generated/manipulated images, to project during performances of Alison Burns choral work "The Raven" with words by Tony Bonning. Sound and Light Installation, Nova Commission, funded by 'Awards for All'. *Misc:* Founder Member -North Norfolk Organisation for Visual Artists (NOVA). *Signs work:* "H. TAMPLIN." *Address:* Orchard House, The Green, Aldborough, Norfolk NR11 7AA. *Email:* h.tamplin@btinternet.com

TANDY, Bonita Marilyn, BA Fine Art, Painting & Printmaking. *Medium:* oil, watercolour, drawing. *b:* London 9 Mar 1946. *d of:* Herbert Mortimer Lewis. *m:* divorced. one *s. Studied:* Camberwell School of Art (1963-68). *Exhib:* RA Summer Shows, Whitechapel Open, Royal Overseas League, Mall Galleries, Cardiff Museum, Trinity Art, Woodlands Gallery, Lynn Stern Associates, Llewelyn Alexander; Southwark Open, Battersea Contemporary Art, Zella Gallery, Highgate Fine Art, British Society of Graduate Artists. *Works in collections:* Paintings in Hospitals. *Signs work:* 'BT'. *Address:* 56 Upland Road,

East Dulwich, London SE22 0DB. *Email:* bonnietandy@hotmail.com *Website:* www.theinternetartshop.com

TANG, George, Associate, Society of Botanical Artists. *Medium:* rice paper / silk. *b.* Hong Kong, 30 Aug 1948. *m.* Dr. Wai Yuk Chun Veronica. 3 *s. Educ:* Lai Ching Art Institute (1957-66), University of Hong Kong (1968-71), B.Soc. Sc., Solicitor of England and Wales (1978). *Exhib:* Hong Kong, London, Toronto, Singapore, Kuong Dong (China). *Commissions:* Hong Kong Post: Hong Kong stamps "Flowers of Hong Kong" (2008). *Publications:* The Artworks of George Tang (2005). *Official Purchasers:* Hong Kong Post (Hong Kong Government SAR). *Recreations:* calligraphy. *Signs as:* "Tang Kwok Wing". *Address:* 43 Stubbs Road, D1 3/F, Evergreen Villa, Hong Kong. *Email:* gkwtang@hotmail.com *Website:* www.georgetang.com.hk

TARRANT, Olwen, FROI (only woman to have been President of ROI, 1999-2003); oil painter, sculptor, lecturer. *b:* Newport, South Wales,1927. *d of:* the late Thomas Lewes, Merchant Navy officer. *m:* John Tarrant, retired BBC and Fleet St. journalist and author. *Educ:* Newport High School. *Studied:* Sir John Cass School of Art. *Exhib:* ROI (Llewellyn Alexander Gallery award, 1997, Alan Gourlay Memorial award, 1998, Cornelissen Prize, 1987) and RBA, and in numerous galleries throughout England. *Works in collections:* London Polytechnic, Warburg, the late Sir Charles Wheeler, PPRA, etc. *Works Reproduced:* Art text books, cards, calendars, other books. Articles: The Artist, Leisure Painter, Artists and Illustrators, International Artist, many national magazines. *Signs work:* "Olwen Tarrant." *Address:* High Ridge, 4 Yew Tree Lane, Upper Welland, Malvern, Worcs. WR14 4LJ. *Email:* olwentarrant@tiscali.co.uk *Website:* www.olwentarrant.co.uk

TARRANT, Peter Rex, F.N.D.D.; artist in oil and mixed media. *b:* Shropshire, 1943. *Educ:* Morville School. *Studied:* Shrewsbury Art School. *Works in collections:* Birmingham City Museum and A.G. *Address:* 10 Lower Bromdon, Wheathill, Burwarton, nr. Bridgnorth, Salop. WV16 6QT.

TARRANT, Terence Richard, FRCOphth. (Hon); MSC (Hon); F.M.A.A.; medical artist; ophthalmic artist Theodore Hamblin Ltd. (1945-48); ophthalmic artist Queen Alexandra's Military Hospital, Millbank (1948-50); medical artist at Inst. of Ophthalmology, London (1950-84). *b:* London, 7 Jan 1930. *s of:* R. J. Tarrant. *m:* Susan. one *s.* two *d. Educ:* London. *Studied:* Camberwell School of Arts and Crafts. *Works in collections:* Moorfields Eye Hospital. *Publications:* Stallard's Eye Surgery, Roper-Hall; Clinical Ophthalmology, J.J. Kanski; System of Ophthalmology, Duke-Elder; Management of Vitreoretinal Disease, Chignell and Wong; Contact Lens Complications, N. Efron. *Signs work:* "TARRANT" with tops of the Ts joined. *Address:* 'Woodlands', Rectory Lane, Child Okeford, Blandford Forum, Dorset DT11 8DT.

TARRAWAY, Mary, BSc Special Botany, PGCE, SBA, SFP; RHS Silver-gilt medallist Grenfell range; self taught artist in water-colour, ink, etching with

aquatint, miniatures; retd. Deputy Head, Parkstone Grammar School, Poole, and teacher of 'A' level biology; Member Dorset Natural History and Archaeological Soc.; Life mem. Dorset Wildlife Trust; Council Member of SBA; Committee Member SFP; Member South West Society of Botanical Artists. *b:* Wimborne, Dorset, 29 Mar 1928. *m:* Harold George Tarraway (decd). *Educ:* Westwing School for Girls, Ryde, IOW. *Studied:* Southampton University (1945-50). *Exhib:* SBA Westminster Gallery (1991-07), RHS London (1991-05), Britain's Painters, '91 winner of Osborne & Butler award Best Flower Painting; solo shows: Hillier's Gdns. Romsey, Dorset County Museum (4), 8th International Exhbn. Hunt Inst. USA (1995). Exhibitions at Exbury Gardens (Four Seasons Invited Artists, 2006, 07, 08). *Works in collections:* Hunt Inst. for Botanical Documentation, Pittsburgh, Shirley Sherwood Collection of Contemporary Botanical Art, and private collections worldwide. *Works Reproduced:* Wild Flower greetings cards. *Recreations:* gardening, sailing, travelling and painting, teaching workshops in Wild Flower painting. *Clubs:* Parkstone YC, Royal Motor YC. *Signs work:* "Mary Tarraway." *Address:* 6 Pearce Ave., Parkstone, Poole, Dorset BH14 8EQ.

TATE, Barbara, P.S.W.A., R.M.S., F.S.B.A., F.R.S.A., I.A.A., Ass. Société des Artistes Français; Silver Medal, Paris Salon (1968); Gold Medal, Paris Salon (1969); Prix Marie Puisoye (1971); Special Mention Palme d'or des Beaux-Arts, Monte Carlo (1972); Laureat Grand Prix de la Côte d'Azur (1972); painter in oil; President, Society of Women Artists (1985-2000), Hon. President, Society of Women Artists; Hon. Prof. Thames Valley University;. *b:* Uxbridge, Middlesex. *m:* James Tate, also a painter. one *d. Educ:* Dormers Wells School, Southall. *Studied:* Ealing School of Art (1940-45, under T. E. Lightfoot, A.R.C.A., T. Bayley, A.R.C.A., J. E. Nicholls, A.R.C.A.) and Wigan Art School (1945-46). 1957-58, under Peter Coker, R.A., A.R.C.A. *Exhib:* BBC2 Television, Royal Academy, Royal Society of Portrait Painters, Royal Institute of Oil Painters, Royal Society of British Artists, New English Art Club, National Society, Royal Society of Miniature Painters, Sculptors and Gravers, United Society of Artists, Society of Women Artists, Hesketh Hubbard Art Society, Royal Institute, Free Painters and Sculptors, R.W.S. Galleries' Flower Painting Exhbn., Chenil Galleries, Chelsea, Paris Salon, Salon Terres Latines, Salon du Comparaisons, Ville Eternal, Rome, Nice, Monte Carlo, Royal Festival Hall. *Works Reproduced:* The Green Shawl, Clematis, Nasturtiums, Golden Girl, Marigolds, King's Pawn, Moon Goddess, Josephine, Marigold, Daisy, Scabious, Poppy, as prints for hanging, published by Solomon & Whitehead, London, and Marigold published by Felix Rosenstiel's Widow and Son. *Signs work:* Some work done in collaboration with husband. *Address:* Willow House, Ealing Green, London W5 5EN.

TAULBUT, John Maurice, R.W.A.; Jack Goldhill award for sculpture R.A. (1987); sculptor in stone, wood and bronze, teacher;. *b:* Gosport, 19 Jan 1934. *s of:* Patrick John Taulbut (decd.). *m:* Janet Marian Rickards. three *s. Educ:* Portsmouth College of Art, Highbury Technical College. *Studied:* Eaton Hall

College of Educ., Retford. *Exhib:* RA, RBA, RWA, S.WL.A., RSMA., Sotheby's, Southampton A.G., Swindon A.G., Oxford Soc., Cheltenham Soc., 3D Gallery, Bristol, Rooksmoor Gallery, Bath, Ceri Richards Gallery, Swansea, Ash Barn, Petersfield, Swansea Arts Workshop, Barry Keene Gallery, Henley on Thames, The McHardy Sculpture Co. *Works in collections:* Royal West of England Academy, Grand Pavilion, Porthcawl, and private collections. *Commissions:* Madonna and Child, Parish Church, Llansteffan; bronze plaque, St.Anthony's Well, Llansteffan; major conch form, St.Anthony's Well, Llansteffan. *Signs work:* "John Taulbut." *Address:* 40 Crawte Ave., Holbury, Southampton SO45 2GQ. *Email:* taulbut9@aol.com

TAUNTON, Adrian, MA (Cantab). *Medium:* watercolour, oil, some pastel/gouache. *b:* Norwich, 9 Mar 1939. *s of:* John Taunton. *m:* Juliet Taunton. one *s.* one *d. Educ:* Norwich School, Gonville & Caius College, Cambridge. *Exhib:* Mall Galleries (RI, RSMA, EAGMA); Thompson's Gallery, Aldeburgh/London; The City Gallery, London; Century Gallery, Henley-on-Thames; Mandell's Gallery, Norwich; Westcliffe Gallery, Sheringham; Peter Hedley Gallery, Wareham; Hunter Gallery, Long Melford. *Works in collections:* Mr.S.B.Witt, Richmond, Virginia, USA. *Recreations:* music, sailing, good food. *Clubs:* East Anglian Group of Marine Artists; Bracaster Staithe Sailing Club. *Signs work:* 'Adrian Taunton'. *Address:* The Old Barn House, Kelling, Holt, NR25 7EF.

TAYLOR, Alan, N.D.D. (1954), A.R.C.A. (1957); artist in water-colour, gouache, ink, chalks; T.V. Designer/Art Director; retd. from T.V., painting full time, now producing computer art and writing novels. *b:* India, 5 June, 1930. s-s of Vladimir Shibayev, Prof. of Languages, Delhi University. *m:* Rachel Taylor. *Studied:* R.C.A. (Prof. John Skeaping, Leon Underwood). *Exhib:* one-man shows: three in Wales, one in Holland; mixed shows: Wales, England, France, Holland and U.S.A.; one-man show in computer art: Newport (Nov., 1997). *Works in collections:* University of Wales, Bangor, University of Wales, Cardiff, B.B.C., Welsh Tourist Board. *Commissions:* Computer landscape and portrait commissions (private), computer images for T.V. Channel S4C.; designed book covers for the last two years: see website. *Publications:* illustrated Song of the Harp (Christopher Davies); illustrations for B.B.C. T.V. and H.T.V. Listed in Welsh Arts Council and Axis slide libraries, published novel 2001 'One Day as a Tiger' set in India – published by Authors on Line. *Address:* 75 Preston Ave., Newport, S. Wales NP20 4JD. *Email:* a.taylor6@ntlworld.com *Website:* www.supercovers.co.uk

TAYLOR, Alan, BA(Hons)(1973), ATC(1974); painter in acrylic. *b:* Wembley, Middx., 1942. *s of:* John and Constance Taylor. *m:* Josephine. one *d. Educ:* Hornchurch Grammar School. *Studied:* Colchester School of Art (1963-65, drawing: John Nash), Stourbridge College of Art (1965-68 and 1972-73), University of Sussex Art Teachers' Certificate (1973-74). *Represented by:* http://www.ArtWanted.com/alantaylor. *Exhib:* Midland Young Contemporaries

(1966-67), London, Trends in Modern Art (1966), Corning Museum, N.Y. (1968), numerous mixed and one-man shows Birmingham, London, Colchester, Wivenhoe, Exeter, Chudleigh, Sidmouth, Normandy. *Works in collections:* U.K., Europe, Middle East, Australia, U.S.A. Works mainly to commission. *Signs work:* "ALAN TAYLOR." *Address:* La Chapelle, Foulognes, 14240 Caumont L'Evente, Calvados, Normandie, France. *Email:* alan@2cv-france.com *Website:* www.paintingstore.net

TAYLOR, Anita, BA (Hons), MA (RCA), RWA (Academician); Professor University of Surrey/Wimbledon School of Art; Hunting Art Prize (2000); Hunting Art Prize (Drawing)(1999); Cheltenham Open Drawing (1999); Malvern Award, Drawing (1993). *Medium:* oil, drawing. *b:* Cheshire, 3 Dec 1961. *m:* Paul Thomas MA (RCA), RWA. *Studied:* Gloucestershire College of Art (1981-84); Royal College of Art (1985-87). *Exhib:* Agnew's, London (2007); The Drawing Gallery, London (2004); Mall Galleries, London; NAS Sydney, Australia; Sherborne House, Dorset; Artsway, Hampshire; NCCA, Sunderland; Durham Museum and Art Gallery; Berkeley Square Gallery, London; RWA, Bristol; Lanchester Gallery, Coventry; Kunstlerhaus, Gottingen, Germany. *Works in collections:* V&A, London; Jerwood Foundation, London/Oxford; RWA; NAS, Australia; Universities of Gloucestershire/ Sunderland; Leicestershire Collection; Leeds Education. *Commissions:* Project Director, Jerwood Drawing Prize (1994-present). *Publications:* Drawing, Cassell Illustrated (2003); Jerwood Drawing Prize Catalogues (2001-2007); Drawing Breath (2007). *Works Reproduced:* Drawing, Cassell Illustrated; Hunting Art Prize: 25 Years. *Signs work:* 'Taylor' and year completed. *Address:* Old Methodist Chapel, The Street, Leonard Stanley, GL10 3NR. *Email:* a.p.taylor@wimbledon.arts.ac.uk

TAYLOR, James Spencer, A.R.C.A. (1948), B.Sc.(Econ.) (Hons.) (1951), F.R.S.A., M.M.A.F.A.; painter; lecturer, Bolton College of Art (1948-79). *b:* Burnley, 7 May 1921. *s of:* Harry Taylor. *m:* Joyce B. Haffner. one *s.* one *d.* *Studied:* Burnley School of Art (1935-40), Slade School of Fine Art (1940-41), Royal College of Art (1945-48). *Exhib:* Red Rose Guild of Craftsmen, Crafts Centre of Gt. Britain, Society of Designer Craftsmen, Arts Council Touring, R.A., R.W.S., R.B.A., R.I., V. & A., C. of I.D., and others. *Works in collections:* Towneley Hall A.G., Burnley; Bolton A.G. Executed many commissions in UK and abroad. *Publications:* 'Noel H. Leaver, A.R.C.A.' biography, published 1983. *Works Reproduced:* 'Decorative Art', Studio Annuals, 'Form' (Sweden) magazines, and others. *Signs work:* "JT" (books, 1948-70), "J. S. Taylor" or "JST" (paintings). *Address:* 7 Leaverholme Cl., Cliviger, Burnley, Lancs. BB10 4TT.

TAYLOR, Jane Winifred, ARCA (1946), RWS (1988), RBA (1988); artist in gouache, private tutor. *b:* Sheffield, 20 Jun 1925. *d of:* Wilmot Taylor. *m:* Leslie Worth. one *s.* three *d.* *Educ:* Sheffield High School G.P.D.S.T. *Studied:* Sheffield College of Art (1941-43, Eric Jones), R.C.A. (1943-46, Gilbert Spencer). *Exhib:* R.B.A., R.W.S., R.A., Linfield Gallery, Jon Leigh Gallery, and others. *Works in*

collections: Graves A.G. Sheffield, and various Educ. authorities, several private collections. *Publications:* magazine articles on drawing and painting. *Signs work:* "Jane Taylor." *Address:* 11 Burgh Heath Rd., Epsom, Surrey KT17 4LW.

TAYLOR, Joan D., ATD (1946); textile designer and printer and painter; instructor in printed textiles, Laird School of Art, Birkenhead (1946-67). *d of:* George H. Taylor, company director. *Educ:* St. Edmund's College, Liverpool. *Studied:* Liverpool College of Art. *Exhib:* R.A., N.E.A.C., Liverpool Academy of Arts, Bluecoat Display Centre, Liverpool. *Signs work:* paintings: "J. D. Taylor." *Address:* 79 Grosvenor Rd., Birkenhead L43 1UD.

TAYLOR, John Russell, B.A.(Cantab.1956), M.A.(Cantab.1959); writer; Art Critic, The Times since 1978. *b:* Dover, 19 Jun 1935. *s of:* Arthur Russell Taylor. *Educ:* Jesus College, Cambridge; Courtauld Inst. of Art, London. *Publications:* The Art Nouveau Book in Britain; The Art Dealers; Impressionism; Edward Wolfe; Bernard Meninsky; Impressionist Dreams; Ricardo Cinalli; Muriel Pemberton; Claude Monet: Impressions of France; Bill Jacklin; The Sun is God: The Life and Work of Cyril Mann; Roberto Bernardi; Peter Coker, RA; Philip Sutton, Printmaker; Roboz; Adrian George: Luxe, Calme et Volupté; The Art of Michael Parkes; Carl Laubin: Paintings; Jeremy Ramsey, etc. *Signs work:* "JOHN RUSSELL TAYLOR". *Address:* The Times, 1 Pennington St., London E1 9XN.

TAYLOR, Krista Louise, BTEC Dip G.AD, MCSD. *Medium:* painter. *b:* Lancashire, 2 Feb 1967. *d of:* Mr & Mrs G Taylor. *m:* Rob Maynard. two *s. Educ:* Falmouth College of Arts. *Exhib:* Great Atlantic Gallery, Falmouth. *Works Reproduced:* Wisdom of the Psyche series, Goddess series, Lifelines series, Swanpool series. *Principal Works:* current 2005: Swanpool series. *Signs work:* Krista Taylor. *Address:* 34 Wood Lane, Falmouth, Cornwall. *Email:* krista@kristataylor.com *Website:* www.kristataylor.com

TAYLOR, Martin, B.A.(Hons.) (1975), A.T.D. (1976); Awards: Chris Beetles Open Exhbn. (1988), Jeffrey Archer Award RWS (1989); artist, etcher. *Medium:* water-colour, pencil, oil. *b:* Hayes, Middx., 10 May 1954. *m:* Marianne Read. one *s.* one *d. Studied:* Ealing School of Art, Wimbledon School of Art, Goldsmiths' College. *Represented by:* Catto Gallery, 100 Heath Street, Hampstead, London. *Exhib:* Bankside Gallery (1986-2002), Contemporary British Water-colours (1983-93), Mercury Gallery, Cork St., Catto Gallery, Hampstead, London, Edwin Pollard Gallery, Wimbledon, Linda Blackstone Gallery Pinner, Savage Fine Art, Northampton, R.A. Exhbns. (1982, 1985), Singer & Friedlander/Sunday Times water-colour exhbns. (1987-97), RWS Open Exhibitions (1986-2002), Wold Galleries, Bourton, Glos., World of W/C Fair, Park Lane (1990-2002), Chris Beetles Gallery, London (1991, 1993), Compton Cassey Gallery, Glos. (1996). *Works in collections:* The Prudential, The Fuller Collection. *Publications:* contributor to: Encyclopaedia of Water-colour Techniques (Quarto), Buildings (Quarto), Acrylics Masterclass (Quarto), Encyclopaedia of Drawing Techniques (Quarto); articles in The Artist magazine; Watercolour Artists Bible (Quarto).

Signs work: "Martin Taylor." *Address:* 13 St. Georges Ave., Northampton NN2 6JA. *Email:* martintaylorartist@hotmail.com *Website:* www.martintaylor.org

TAYLOR, Michael John, Dip.Arch. (1953), ARIBA (1955), PVPSGFA; architectural illustrator in water-colour, gouache, linocuts;. *b:* Scarborough, 22 Sep 1930. *s of:* H.S.P. Taylor, artist. *m:* Molly Crowther, textile artist. one *s.* one *d. Educ:* Scarborough Boys High School. *Studied:* Leeds College of Art, School of Architecture (1948-53). *Exhib:* RA, RI, RSMA, SGFA, UA, "Not the RA" Llewellyn Alexander Gallery, Laing, Singer and Friedlander and Hunting competitions; one-man shows: Bath, Canterbury, Harrogate, Russell Gallery Putney. *Works in collections:* RAC Pall Mall, Hertfordshire C.C. Museums Service, private collections France and USA. *Commissions:* Aoke Soletanche (Jubilee Line Extension), RAC Pall Mall. *Publications:* book jackets for Foyle, Hodder and Stoughton. *Signs work:* "Michael J. Taylor". *Address:* 4 Sewell Ave., Wokingham, Berks. RG41 1NS.

TAYLOR, Michael Ryan, RP (2001), B.A.Hons.(Lond.); Awards:Changing Faces Prize (winner 2002), Holburne Contemporary Portrait Prize (winner 2002), Royal West of England Academy Lark Trust Award (2005), NPG John Player Award (1983). *Medium:* oil. *b:* Worthing, 17 Feb 1952. *s of:* Patrick Taylor. *m:* Caroline. one *s.* one *d. Educ:* Worthing High School for Boys. *Studied:* Goldsmiths' School of Art (1970-73). *Represented by:* Waterhouse & Dodd, London. *Exhib:* Morley Gallery, NPG John Player Award (winner 1983), Millfield Open (winner 1989), Hunting Group Art Prize (3rd prize 1989), RA, Worthing Art Gallery, Quay Arts Centre, IOW, Beaux Arts, Bath, and Beaux Arts, London (1993, 1997), Royal Society of Portrait Painters; Waterhouse & Dodd, London (2006). *Works in collections:* NPG, Christchurch Hall, Oxford, Robinson College, Cambridge, Holburne Museum of Art, Bath, House of Lords, Westminster, Scheringa Museum, Netherlands. *Commissions:* Julian Bream (NPG,1984); P D James (NPG,1996), Sir John Tavener (NPG, 2001), Andy Sheppard (Holburne Museum of Art, 2003), Lord Falconer - Lord Chancellor (House of Lords, 2007). *Address:* 1 Upper St., Child Okeford, Blandford Forum, Dorset DT11 8EF. *Email:* michael@mrtaylor.co.uk *Website:* www.mrtaylor.co.uk

TAYLOR, Pam, A.R.B.S. (1980), S.P.S. (1975); Chelmsford Borough Council Civic Award for services to the Arts (1998). *Medium:* sculptor in bronze. *b:* Pontypridd, 13 May 1929. *d of:* the late W.G. Archer. *m:* Peter William Taylor. two *s. Educ:* South Shields and Wick High Schools. *Studied:* Sir John Cass College School of Art (1947-50). *Exhib:* Mall Galleries, Guildhall, Royal Exchange. *Works in collections:* Principal works: R.A.F. and Allied Air Forces WW2 Monument, Plymouth Hoe; R.A.F.,Battle of Britain and Bomber Command Museums, Hendon; Shakespeareplatz, Berlin; Colgate-Palmolive Head Office; Bancrofts School; Georgetown Guyana; bronze bust of Shakespeare in Shakespeare's Globe Theatre, London; R.A.F. North Coates Strike Wing Memorial; Hordle Walhampton School – child figures, Garden of Heroes, Dorsington. *Commissions:* All the above were commissions as well as numerous

portrait commissions. *Clubs:* Royal Soc. of British Sculptors, Society of Portrait Sculptors. *Signs work:* "Pam Taylor". *Address:* Merrydown, 88 Haltwhistle Rd., S. Woodham Ferrers, Chelmsford, Essex CM3 5ZF.

TAYLOR, Sean, Hons.D.F.A. (1982), M.A.F.A. (1983), F.F.A. (1989); sculptor in mixed media; Course Director, Sculpture and Combined Media, Limerick School of Art and Design, Ireland; mem. Sculptors Society of Ireland. *b:* Cork, 16 Aug 1959. partner. *m:* Annette Moloney. one *d. Educ:* Presentation Brothers College, Cork. *Studied:* Crawford College of Art and Design, Cork (1979-82), University of Ulster, Belfast, N.I. (1982-83), Kunstenacademie, Rotterdam (1988-89). *Exhib:* 29 one-man shows since 1983 worldwide. *Works in collections:* museums in Poland, Ireland, Mexico;. *Commissions:* in Glasgow and Ireland. *Publications:* 34 catalogues; 5 CD, CD Rom's: Bliain le Baisteach, Coisir an Tsionann; articles for Circa Art Magazine. *Misc:* Work on: axis website (UK) http://www. Imu.ac.uk/ces/axis, also www.the-artists.org. *Signs work:* "Sean Taylor." *Address:* The Old School Brackile, Pallasgreen Co. Limerick, Rep. of Ireland. *Email:* seantaylor@eircom.net *Website:* www.softday.ie

TAYLOR, Mrs. M.:, see BRIDGE, Muriel Elisabeth.,

TAYLOR, Newton:, see TAYLOR, William Henry.,

TAYLOR, W. S., A.R.C.A., M.Phil.; painter; editor of Manuals Series for Thames and Hudson Ltd.; Dean of Faculty, Sheffield Polytechnic (1972-75)(now Sheffield Hallam University). *b:* Sheffield, 26 Sep 1920. *s of:* W. Taylor. *m:* Audrey Wallis. one *d. Educ:* City Grammar School, Sheffield. *Studied:* Sheffield College of Art and R.C.A. (1939-43). *Exhib:* R.A., etc. *Works in collections:* various. *Publications:* Catalogue of Burne-Jones Exhbn., Sheffield City Art Galleries (1971). *Address:* Lower Manaton, South Hill, Callington, Cornwall PL17 7LW.

TAYLOR, Wendy Ann, C.B.E. (1988); sculptor; Mem. Royal Fine Art Commission (1981-99); Specialist Adviser, Com. for Arts Design (1988-91); Mem. Advisory Group P.C.F.C. (1989-90); F.Z.S. (1989-); Mem. Design Advisory Panel, London Docklands Development Corp. (1989-'98); Trustee, L.A.M.A. (1993-), F.Q.M.W. (1993-), F.R.B.S. (1994-) Council Mem. (1999-2000); F.R.S.A. (2004-). *b:* 29 Jul 1945. *d of:* Edward Philip Taylor and Lilian Maude Wright. *m:* 1982, Bruce Robertson. one *s. Educ:* St. Martin's School of Art, L.D.A.D. (1st Dist.). *Exhib:* twelve one-man shows: (1970-2005); over 100 group exhbns. (1964-82). *Works in collections:* G.B., U.S.A., Eire, N.Z., Germany, Sweden, Qatar, Switzerland, Seychelles. *Commissions:* Major commissions: over seventy throughout the U.K. *Publications:* 'Wendy Taylor' monograph by Edward Lucie-Smith (1992). *Address:* 73 Bow Rd., London E3 2AN. *Email:* Wendy-Taylor@fsmail.net *Website:* www.wendytaylorsculpture.co.uk

TAYLOR, William Henry (Newton Taylor), A.R.C.A. (1934), A.R.E. (1957), Free Studentship (1932), Prix-de-Rome Finalist in Engraving (1935); artist in oil (portrait and landscape), water-colours, etching and engraving on metal and wood; Head (retd.) School of Art, Amersham; lecturer, demonstrator, critic. *b:* Normanton, Yorks., 31 Aug 1911. *s of:* James Taylor. *m:* Elsie May Newton (decd.). three s. m. Monica Newton Taylor. *Educ:* Normanton Boys' Grammar School, Yorks. *Studied:* Wakefield School of Art; Leeds School of Art; R.C.A. *Exhib:* Yorks. Artists Soc., Bucks. Art Soc., R.P.E., R.B.A., R.A. *Signs work:* "NEWTON TAYLOR" in two lines. *Address:* Newstone Bungalow, Bovingdon Green, Marlow, Bucks. SL7 2JL.

TAYLOR WILSON, Joanne, M.A. Fine Art (Edin. 1977), A.T.C. Goldsmiths' College (1978), R.A. Schools Post. Grad. Cert. (1981), Elizabeth Greenshields Scholarship (1981-82); still life, landscape and portrait painter in oil and water-colour; Mem. of Manchester Academy of Arts (1985). *b:* Bolton, Lancs., 12 Sep 1953. *d of:* James Spencer Taylor, A.R.C.A. *m:* Ivan Wilson, R.I.B.A. one *s.* one *d. Educ:* Canon Slade Grammar School, Bolton. *Studied:* Edinburgh College of Art (1972-77), R.A. Schools (1978-81, Peter Greenham, R.A.). *Exhib:* Royal Scottish Academy (1975, 1987), R.A. (1979, 1980, 1982, 1983, 1986, 1987), R.B.A. (1980), Manchester Academy (1979-83, 1985-97), Manchester; one-man show, Bolton A.G. (1979), Howarth A.G., Accrington (1991), Towneley Hall, Burnley (1999). *Works in collections:* Bolton A.G., West Midlands College of Education, Howarth Art Gallery, Accrington. *Signs work:* "J. TAYLOR WILSON" or "J.T.W." *Address:* 4 Beechwood Ave., Clitheroe, Lancs. BB7 1EZ.

TEASDILL, Graham, F.R.S.A., F.R.N.S., F.Z.S., F.M.A.; Museum and Art Gallery Curator (retd.); Assistant at Ilkley (1950-55), Leeds (1955-56) and Huddersfield (1956-60); Assistant Curator, Cheltenham (1960-62); Curator, Batley (1962-66), Russell-Cotes A.G. and Museum, Bournemouth (1966-88). President, Yorkshire Federation of Museums (1966-67); South-Eastern Federation (1969-70); Chairman, Museum Committee of the Bournemouth Natural Science Society (2005). *b:* Horsforth, 5 Oct 1935. *s of:* late Clifford Humphrey Teasdill, bank official, of Guiseley. *m:* Nova Ann Pickersgill of Horsforth, 22 July, 1960. one *s.* two (see Morris, Caroline Nova; Andrews, Pauline Ann) *d. Educ:* Ilkley Grammar School. *Publications:* museum guides, exhibition handbooks, magazine articles. *Address:* 99 Carbery Ave., Southbourne, Bournemouth BH6 3LP.

TEBBS, Margaret, Freelance botanical illustrator in ink and water-colour; freelance artist: R.B.G. Kew, Natural History Museum, New Plantsman, etc. *b:* 5 Sep 1948. *Educ:* Manor School, Ruislip. *Studied:* Ealing College of Art. *Exhib:* Westminster Gallery, London, Everard Read Gallery, South Africa. *Publications:* numerous illustrations for Kew Bulletin, Flora of Arabia, B.S.B.I. Publications, Wild Flowers of Europe (New Holland), Flora Zambesiaca, Flora of Bhutan, Flora of Egypt. *Signs work:* "M. Tebbs." *Address:* c/o Royal Botanic Gdns, Kew, Richmond, Surrey TW9 3AB.

TENGBERG, Violet, City of Gothenburg award for cultural achievement (1966), Bronze Medal, Europe Prize for painting (1971), Ostende, Belgium; Accademico Tiberino, Rome, Il Premio Adelaide Ristori, Rome (1984); City of Gothenburg Hon. Award (1987); Swedish Artists Foundation (1995); artist in oil and graphic work, and enamels on iron; poet, has published poetry books, 'Vision of the World Egg' (1996, 1997), 'Poetish Inspiration' (1999), 'Studies and Whisperings' (2004), 'Microcosmos - Macrocosmos' A book of oil and enamel paintings with 180 colour ill. and poem. *b:* Munktorp, Sweden, 21 Feb 1920. *s of:* A. Englund, master builder. *m:* J G A Tengberg, DHS (decd). one *s.* one *d. Educ:* Dipl. Academy of Fine Arts, "Valand" (1958-63), BA in Art History, Gothenburg University (1997). Religoin, Science and History, Gothenburg University. *Exhib:* 19 one-man shows, Stockholm, Helsinki, London, Brussels, Paris, Rome, Viterbo, etc.; nearly 200 group shows all over Europe; Riksutställningar travelling exhbn.; 2nd Enamel Triennial, Trondheim, Norway (1993); group exhbn.: Enamel Artists from the Northern Countries, Kecskemet (1993); Szegred, Budapest, Hungary; Vienna, Austria; Germany (1994); 3rd International and enamel ausstellung, Coburg, Germany (1995). Official invite to exhibit in India, New Delhi and The Government Museum of Chandigarh (1997). *Works in collections:* Museums and official collections in Sweden including: Modern Art Museum, Stockholm, Kalmar Art Museum; Institut Tessin, Paris; Musée de Pau and Musée de Caen, France; Bibliothèque Nationale, Paris; Musée Vatican, Italy; Tate Gallery, London; Museo Nationale, Gdansk, Poland; Galleria Nationale, Varsavia, Poland; Museo di Viterbo, Italy; National Gallery of Modern Art, New Delhi, The Government Museum of Chandigarh, India, Dos Ehamil Museum, Coburg, Germany. *Publications:* Swedish Art Lexicon, part V, Allhem; Enciclopedia Universale "SEDA" della Pittura Moderna, Milano, etc. (colour ill.); "Violet Tengberg - Paintings, drawings, graphics and poems" (1982) in three languages and with 45 colour reproductions; Creative Mysticism - a Psychological Study of Violet Tengberg's religious visions and artistic creations by Prof. Antoon Geels (University of Lund, 1989). Essays by (Prof.) J.P. Hodin, Teddy Brunius (Prof. art History, University of Copenhagen) and Benkt-Erik Benktson (Prof. University of Gothenburg); Violet Tengberg: paper on William Blake's poem "The Tygor" of "Songs of Innocence and of Experience" (Gothenburg University of Art Dept. 1994), M.A. paper on William Blake's "World of Ideas" (1997). *Clubs:* A.I.A., W.I.A.C., F.P.S., K.R.O. *Signs work:* "VT," "Violet Tengberg." *Address:* Götabergsgatan 22, 41134 Gothenburg, Sweden.

TERRY, John Quinlan, FRIBA(1962); architect, artist in pen and ink, water-colour, linocut. *b:* London, 24 Jul 1937. *s of:* Philip Terry, solicitor. *m:* Christine. one *s.* four *d. Educ:* Bryanston School. *Studied:* architecture: Architectural Assoc., London. *Exhib:* R.A. Summer Show since 1962, Biennale in Venice (1980), San Francisco (1982), Paris (1981), Real Architecture Building Centre (1987); one-man shows: Rye A.G. (1980), Architectural Design (1981), Anthony

Mould Gallery (1986), Judd St. Gallery (1987), Vision of Europe, Bologna (1992). *Address:* Old Exchange, Dedham, Colchester, Essex CO7 6HA.

TESKEY, Donald, RHA (2003); awards from Arts Council of Ireland, EV&A Limerick, ESB, RHA, Vermont Studio Centre. *Medium:* oil, acrylic, drawing. *b:* Co.Limerick, Ireland, 1956. one *s.* one *d. Educ:* Diploma in Fine Art. *Studied:* Limerick School of Art and Design. *Represented by:* Rubicon Gallery, Dublin; Art First, London. *Exhib:* Rubicon Gallery, Dublin (1993, 95, 97, 99, 2001, 04, 05); Art First, London (1998, 2000, 2002); also in Canada, USA, Germany, Finland, UK and in group and curated shows. *Works in collections:* Arts Council of Ireland, Bank of Ireland, Allied Irish Bank, Barings Assett Management London, Contemporary Irish Art Society. *Commissions:* The Electricity Supply Board (ESB); Irish Agricultural Wholesalers Society (IAWS); Crampton Builders. *Publications:* 'Profile: Donald Teskey' (Gandon Editions, pub. 2005). *Address:* c/o Rubicon Gallery, 10 St.Stephens Green, Dublin 2, Eire. *Email:* donaldteskey@eircom.net

THICKE, Thelma Gwendoline, N.D.D., A.T.D., Dip. H.E., M.F.P.S.; dealer in fine art, restorer and painter in oil and water-colour; principal: Thicke Gallery, and Swansea Antique Club; retd. lecturer, Faculty of Art and Design, W. Glamorgan Inst. of Higher Educ., Swansea, also Swansea University, Faculty of Educ. *b:* 20 Aug 1921. *Educ:* St. Leonards-on-Sea. *Studied:* Hastings School of Art (Vincent Lines), West of England College of Art, Bristol University, B'ham University (1966-67). *Exhib:* R.A., R.B.A., N.E.A.C., F.P.S., R.W.S. *Clubs:* Royal Overseas League, L.A.P.A.D.A. *Misc:* Valuations and restoration of oils, water-colours and prints. *Signs work:* "T.G. Thicke." *Address:* 24 Masefield Way Parc Beck Sketty, Swansea SA2 9FF.

THISTLETHWAITE, Ann, NDD painting; artist, landscape painter in oil, pastel and charcoal. *b:* Birmingham, 22 Oct 1944. *d of:* C E D Thistlethwaite, dental surgeon. *Educ:* Edgbaston Church of England College. *Studied:* Birmingham College of Art and Design (1961-66) under Gilbert Mason and Mr. Francis. *Exhib:* one-man shows: London, Birmingham, Worcester, Tunbridge Wells, Malvern, R.B.A., R.O.I., R.S.M.A., P.S., Contemporary Art. (Royal Overseas Commonwealth Art 1st Prize (1969) presented to H.M. the Queen). *Works in collections:* J. M. Beaul, Michigan. *Recreations:* loves countryside, wild flowers, birdsong, wildlife. *Signs work:* "Ann Thistlethwaite." *Address:* 4 King George Ave., Droitwich, Worcs. WR9 7BP.

THOMAS, David Arthur, B.A. (1972), P.G.C.E. (1982); artist in oil and acrylic; retd. teacher;. *b:* Croydon, 30 Apr 1928. *s of:* Arthur Thomas, M.I.M.E. *Educ:* Wallington County Grammar School. *Studied:* Croydon Polytechnic (1949-53), Farnborough Technical College (1962), Roehampton Adult Inst. (1982). *Exhib:* Compass Theatre Co., Sheffield; several one-man shows. *Clubs:* F.P.S. *Signs work:* "D. THOMAS." *Address:* 21 Baileys Rd., Southsea, Hants. PO5 1EA.

THOMAS, Glynn David Laurie, L.S.I.A. (1967), R.E. (1975); freelance artist in etching; taught printmaking, Ipswich Art School (1967-79);. *b:* Cambridge, 7 Apr 1946. *m:* Pearl. two *s. Studied:* Cambridge College of Art (1962-67). *Exhib:* mixed and one-man shows incl. R.A., National Print Exhbn. Pall Mall Gal., Barbican, and Cambridge Contemporary Art, John Russell, Ipswich, Printworks, Colchester, Royal Exchange, Manchester, Lyric, Hammersmith, Aldephi, New York, Toronto, Hong Kong, Birhcam Gallery, Snape Maltings. *Works in collections:* Museum of London, Ashmolean and Ipswich Museum. *Commissions:* Christies Contemporary Art. *Publications:* Victorian Cambridge, Illustrated Journal of Nepal. *Address:* Lodge Cottage, Bluegate Lane, Capel St. Mary, Ipswich IP9 2JX. *Email:* studio@glynnthomas.com *Website:* www.glynnthomas.com

THOMAS, Jean, Dip.A.D. Fine Art (Bristol, 1974); painter/printmaker in oil on canvas;. *b:* Haverfordwest, 1950. *m:* Paul Preston, goldsmith. one *s.* one *d. Educ:* Taskers, Haverfordwest. *Studied:* Newport College of Art (1969-71), Bristol Polytechnic (1971-74). *Exhib:* Welsh National Eisteddfod, R.S.P.P., R.S.B.A., R.S.P.M., Galerie d'Or Hamburg, Fountain Fine Art Llandeilo, Manor House Cardiff; and numerous exhbns. G.B.H., Germany, Austria. *Commissions:* portraits for: Earl of Halifax, Lady Brooksbank, Judge Haworth, plus commissions for Christie's, and Northallerton Council for Duke and Duchess of York. Recently worked on large mural and now flag/banner sculpture. *Address:* The Old Smithy, Llandeilo, Haverfordwest, Pembrokeshire SA62 6LD.

THOMAS, Margaret, RWA, RBA (1947), NEAC (1951); De Lazlo Medal (RBA, 1971); Hunting Group Award (Oil Painting of the Year, 1981). *Medium:* oil. *b:* London 26 Sep 1916. *d of:* Francis Stewart Thomas & Grace Whetherley. *Educ:* private. *Studied:* Slade School (1936-38), R.A. Schools under Thomas Mannington and Ernest Jackson (1938-39). *Exhib:* RA (since 1943), RWA, and RSA; one-man exhbns. include Leicester Galleries (1949 and 1950); Aitkin Dott's Edinburgh (1952, 1955 and 1966); Canaletto Gallery (1961); Howard Roberts, Cardiff (1963); Minories, Colchester (1964); Queen's University, Belfast (1967); Mall Galleries (1972); Octagon, Belfast (1973); Scottish Gallery, Edinburgh (1982); Sally Hunter Gallery, London (1988, 1991, 1995, 1998); Royal West of England Academy (1992); Messum's Gallery, London (Sept. 2001, Dec 2003). *Works in collections:* H.R.H. Duke of Edinburgh; Chantrey Bequest; Arts Council; Tate Britain; Exeter College, Oxford; Min. of Educ.; Min. of Works; Paisley, Hull and Carlisle Art Galleries; G.L.C.; Edinburgh City Corporation; Steel Company of Wales; Financial Times; Nuffield Foundation Trust; Scottish National Orchestra; Robert Fleming; Lloyds of London;Warburg Group. *Commissions:* National Library of Wales (portrait of Sir Kyffin Williams R.A.). *Works Reproduced:* in 'Country Life', 'Eastern Daily Press'. *Recreations:* dogs, gardens, antiques. *Address:* Ellingham Mill, Bungay, Suffolk NR35 2EP.

THOMAS, Norma Marion, BA (1980), NSAM, Cert. in Art; artist in oil, water-colours, restoration. *b:* Hawarden, Ches., 9 Jan 1922. *d of:* Alfred

Robinson, chief marine engineer. *m:* Leslie Gurwin Thomas, A.T.D. (decd.). three *s. Educ:* Hawarden Grammar School; Normal College, Bangor. *Studied:* Liverpool School of Art, Goldsmiths' and Hornsey College of Art. Art mistress in Liverpool, Wisbech and Wirral Grammar School. Own studio and exhbn. gallery. Paintings in Gt. Britain and abroad. *Signs work:* "Norma M. Thomas." *Address:* Old School Studio, Blaenporth, Cardigan SA43 2AP.

THOMAS, Robert John Roydon, A.R.C.A. (1952), Otto Beit Medal R.B.S. (1963), R.B.S. Silver Medal (1966); sculptor in bronze, stone; Past-President, Society Portrait Sculptors; Past V.P.R.B.S.;. *b:* Cwmparc, Treorchy, Rhondda, Glam., 1 Aug., 1926. *m:* Mary Gardiner, Des. R.C.A. two *s.* one *d. Educ:* Pentre Grammar School, Rhondda. *Studied:* Cardiff College of Art (1947-49), R.C.A. (1949-52). *Exhib:* R.A. and various London galleries. *Works in collections:* Sculptures at Coalville, Leics., Birmingham City Centre, Blackburn Town Centre, Ealing Broadway Centre, London, Cardiff, Swansea, Rhondda; portraits include, H.R.H. Princess Diana, Viscount Tonypandy, Lord Parry, Lord Chalfont, Aneurin Bevan, Cliff Morgan, Sir Geraint Evans, Sir Julian Hodge, Dame Gwyneth Jones, Gwyn Thomas, Ryan, Carwyn James. *Signs work:* "Robert Thomas sculptor." *Address:* Villa Seren, 23 Park Rd., Barry, Vale of Glam. CF62 6NW.

THOMAS, Robin, SGFA; Cert.Ed.; Certificate of Fine Art; The Coghill Prize for Landscape Painting, Oxford (1973). *Medium:* oils, watercolour, bodycolour. *b:* Nuneaton, 8 Jul 1948. *m:* Pamela. one *s.* one *d. Educ:* Yallet Hall, Staffs; Whittlebury School, Northants. *Studied:* The Ruskin School of Drawing, Oxford (1973); Glos.College of Art (1967). *Exhib:* Ashmolean Museum, Oxford (1973); Museum of Modern Art, Oxford (1973); Bodleian Library, Oxford - London (with SGFA) from 2001; also Bath, Cheltenham, South Molton, Dartington, Totnes, Widecombe and other South Devon galleries. *Works in collections:* international collections, private British collections; National Trust; Lord Lichfield Collection; Royal Navy. *Commissions:* The Wordsworth Trust; The National Trust; private and corporate commissions, Midas Construction. *Publications:* prints and cards. *Official Purchasers:* The National Trust; Wordsworth Trust; Royal Navy. *Works Reproduced:* over 50 NT properties - prints, notecards, postcards. *Principal Works:* English cottages (watercolour); Genre landscapes (oils). *Recreations:* music, country pursuits, gardens. *Misc:* presently runs classes, clubs, holidays etc. (private and local authority) for artists. *Signs work:* "R.D.Thomas". *Address:* 'Mynwy', 25 Biltor Road, Ipplepen, Newton Abbott, Devon, TQ12 5QL.

THOMAS, Shanti, artist in oil, pastel and charcoal, teacher; Artist in Residence, Gatwick Airport (1993);. *b:* London, 3 Dec., 1949. *Studied:* School of Signa Simi (1965), Academy of Fine Arts, Florence (1965-67), Camberwell School of Art and Crafts (1971-73, Sargy Mann). *Exhib:* Commonwealth Inst. (1987), Ikon touring (1984, 1989), Whitechapel Open (1987, 1989), Athena Arts Award Open, Barbican (1987), 'Critical Realism' Nottingham, Camden Arts Centre (1988), 'Black Art, Plotting the Course' Oldham (1988), 'The Artist

Abroad' Usher Gallery, Lincoln (1989). *Works in collections:* A.C.G.B., Leicester Schools, and private collections. *Publications:* Birthday Book, Women's Artist Diary (1988), catalogues, Critical Realism, Black Art, The Artist Abroad, etc. *Signs work:* "Shanti Thomas." *Address:* 18 Cornwall Rd., London N4 4PH.

THOMPSON, Christopher, P.G.Dip. Painting, RA Schools 1997; The Noel Spencer Award for Painting, Norwich School of Art (1994), George Isted Prize for Portrait Painting, RA Schools (1996), Armitage Prize for Painting, RA Schools (1997), Villiers David Prize, shortlisted (2003). *Medium:* painter in oil on canvas. *b:* Grimsby, 4 Aug 1969. one *s. Studied:* Grimsby School of Art (1988-90), Norwich School of Art (1991-94), Royal Academy Schools (1994-97). *Represented by:* Albemarle Gallery. *Exhib:* over 30 solo and mixed exhibitions in UK and abroad since 1993, including: RA Summer Exhbn (1996, 1997), Royal Society of Portrait Painters, Mall Galleries (1999, 2002), BP Portrait Award, NPG (2002), Young Contemporaries, Albemarle Gallery (2002, 2003) DFN Gallery New York (2002), Eleanor Ettinger Gallery, New York (2005). *Works in collections:* National Portrait Gallery, London. *Signs work:* 'C.Thompson'. *Address:* 17 Crystal Drive, Peterborough, Cambridgeshire, PE2 9RJ.

THOMPSON, George, P.S.; ATD, NDD. *Medium:* oils, watercolours, pastels and acrylics. *b:* Wigan, Lancs, 26 Jul 1934. *s of:* George and Annie Thompson. *Educ:* Chester College School. *Studied:* Chester School of Art (1950-54), Liverpool College of Art (1955). *Exhib:* one-man shows: Chester (annually), Melbourne Australia, Vancouver Canada, Tokyo Japan (on two occasions). Mixed shows: Pastel Society, Mall Galleries, Solomon Gallery Dublin, Wirral Society of Arts; Retrospective Exhibition, Williamson Gallery, Birkenhead (2004). *Works in collections:* Duchy of Lancaster, Bank of Scotland, Williamson Art Gallery and Museum, Wirral; Grosvenor Museum, Chester. *Publications:* regular articles in national artists magazine publications. *Official Purchasers:* see work in collections. *Works Reproduced:* 16 limited edition prints (Brentwood Gallery), International Artist and International Pastel Artist. *Misc:* has made three instructional videos in Watercolour Painting and Pastel Painting, sold nationally. *Signs work:* 'George Thompson'. *Address:* 2 Hilbre Court, South Parade, West Kirby, Wirral, CH48 3JU.

THOMPSON, Hilli, B.A.Hons. (1967), M.Phil. (1971), P.G.C.E. (1977); artist/botanical illustrator in linocut, etching, pen, pastel, acrylic, stained glass;. *b:* London, 3 Apr 1946. *Educ:* Brondesbury and Kilburn Grammar School; Universities of Newcastle (1964-67), Ulster (1968-71), Leeds (1976-77). *Exhib:* frequently at botanical socs. of British Isles, S.B.A.; solo shows: Ipswich/E. Anglia. *Works in collections:* Norwich City Museum. *Publications:* The New Flora of British Isles by C.A. Stale (C.U.P.). *Recreations:* music, gardening. *Signs work:* "Hilli." *Address:* 42 Dover Rd., Ipswich, Suffolk IP3 8JQ.

THOMPSON, Kathleen M., BA Hons Fine Art; MA Fine Art; BA Hons Philosophy; David Murray Award, RA; South East Arts Research Grant. *Medium:*

painting and drawing, oil. *b:* London, 26 Jun 1948. *d of:* Charles Thompson & Myra Love. *m:* Brian Watterson. *Educ:* Blackwell County, Harrow, London. *Studied:* Harrow School of Art; Sheffield College of Art; Chelsea School of Art; London University Birkbeck College. *Exhib:* RA Summer Exhbns; Cheltenham Art Gallery (2002); 8th Mostyn Open, Llandudno, Wales (1997); 'City of Journeys', London (1997); Maidstone Museum & Art Gallery (1996), EAST Norwich etc. *Works in collections:* Department of the Environment, London; Kings College, London University; Kings College Hospital; private collections England, France, New Zealand. *Publications:* exhibition catalogues. *Works Reproduced:* 'Empedocles', 'Zoogony', 'Yellow Car', 'Carrie'. *Principal Works:* paintings and drawings. *Misc:* from 1986 taught painting Summer Schools (and p/t in term-time) at Tunbridge Wells Adult Education Centre with Brian Watterson, Rose Wylie and Roy Oxlade. *Signs work:* 'K.T.' or 'Kathleen Thompson'. *Address:* 3 Haynes Cottages, High Street, Brasted, Westerham, Kent TN16 1HS. *Email:* kmtartist@hotmail.com

THOMPSON, Kevin Barry, Professional East Anglian landscape and marine artist since 1989. *Medium:* oil, acrylic, water-colour. *b:* Dorking, Surrey, 11 Mar 1950. *s of:* Brian P. Thompson & Hilda M.Goff. *m:* Vanessa Jane. one, Spencer *s.* one, Carrie *d. Educ:* Roman Hill School, Lowestoft; studied general design at Lowestoft College (1985-87). *Studied:* self taught artist. *Exhib:* R.O.I., R.S.M.A., Mall Galleries, London; one-man shows: Assembly House, Norwich (1982), Reades Gallery, Aldeburgh (1986), Conservative Hall, Southwold (1989), Toll House Gallery, Gt. Yarmouth (1991, 2003, 2004, 2005, 2006), Ferini Gallery, Lowestoft (2002). *Works in collections:* Many works are held in private collections, both in Gt. Britain and abroad. *Clubs:* Norfolk and Norwich Art Circle (NNAC), Oulton Broad Art Circle (OBAC), East Anglian Group of Marine Artists (EAGMA). *Signs work:* "KEVIN.B. THOMPSON." or "K.B.THOMPSON". *Address:* 24 Pound Farm Drive, Lowestoft, Suffolk NR32 4RQ.

THOMPSON, Liam, B.A. Hons. (1978); self employed artist in water-colour and oil; Adult Educ. tutor, creative studies curriculum leader;. *b:* Larne, Co. Antrim, 20 Nov., 1956. *Educ:* Campbell College, Belfast. *Studied:* Newcastle College of Art and Design (1974-75), Chelsea School of Art (1975-78), City and Guilds of London Art School (1978-79, Peter Coker, R.A.). *Exhib:* RA Summer Shows (1983-97). *Works in collections:* National Trust, UTV Collection. *Commissions:* National Trust, Storm Damage at Nymans, Sussex, Mount Stewart House, Co. Down. *Works Reproduced:* Leisure Painter Magazine (1990-97). *Signs work:* water-colours and oils: signed on back. *Address:* Stone Cottage, Hogbens Hill, Selling, Faversham, Kent ME13 9QU.

THOMSON, Diana, (née Golding); B.A., F.R.B.S.; sculptor in bronze, terracotta, wood, resin. *b:* Manchester, 1939. *m:* Alexander Thomson, B.S.C., Cinematographer. one *d. Educ:* Cheltenham Ladies' College. *Studied:* Kingston Polytechnic Sculpture Dept. (1976-79). *Exhib:* R.A., R.W.A., New College,

Oxford, Margam Park, S. Wales, and various group shows including "Free Range" Simmons Gallery, London WC1. *Commissions:* 'Woking Market' bronze plaque 7'3" x 4'6" at Network House, Bradfield Cl., Woking; 'Father and Child' bronze over life-size at Central House, off New St., Basingstoke; 'The Swanmaster' 7' bronze at Fairfield Ave., Staines; 'The Hurdler' bronze life-size, at APC International, The Lodge, Harmondsworth, Middx.; 'The Inheritors' bronze life-size group; 'Portrait of Yvonne de Galais and her daughter' life-size group; 'The Bargemaster' 7' bronze at Data-General Tower, Brentford, Middx.; 'Portrait of D.H. Lawrence' bronze life-size, at Nottingham University; 'The First Cinematographer' bronze life-size homage to William Friese-Greene, sited at Shepperton Studios, Middx.; Pinewood Studios, Bucks; Panavision U.K. Ltd., Greenford, Middx.; and Panavision, L.A., Calif., U.S.A.; Bronze homage to DH Lawrence at Nottingham Castle Museum and Art Gallery (2007). *Signs work:* "D.C. Thomson" or "D.C.T." and the year. *Address:* The Summerhouse, 64 Mincing La., Chobham, Surrey GU24 8RT.

THOMSON, George L., D.A. (Edin.), S.S.A., F.S.S.I.; calligrapher; principal art teacher (retd.);. *b:* Edinburgh, 15 Dec., 1916. *Studied:* Edinburgh College of Art (1932-37). *Publications:* Better Handwriting (Puffin, 1954), Traditional Scottish Recipes (1976), New Better Handwriting (1977), Scribe (1978), Christmas Recipes (1980), Rubber Stamps (1982), Traditional Irish Recipes (1983), (Canongate), Dear Sir, (1984), The Calligraphy Work Book (1985), The Calligrapher's Book of Letters (1990) (Thorsons), The Art of Calligraphy (1987, Treasure Press), My Life as a Scribe (Canongate, 1988), others in preparation. *Signs work:* "George L. Thomson." *Address:* The White Cottage, Balgrie Bank, Bonnybank, by Leven KY8 5SL.

THOMSON, Harry Ross, Diploma of Art (Edinburgh) Graphics; over 30 International Cartoon Prizes and Awards. *Medium:* cartoonist. *b:* Hawick, 5 Oct 1938. *m:* Glenda Charnley. one *s.* one *d. Educ:* George Watson's College, Edinburgh. *Studied:* Edinburgh College of Art. *Exhib:* Ankara, Turkey (2002), Zenum, Subotica, Novi Sad, Serbia (2003). *Publications:* How to Draw and Sell Cartoons (Apple Press). *Clubs:* FECO. *Signs work:* 'roSS'. *Address:* 'Portus', Haywards Heath Road, Balcombe, Sussex, RH17 6PG. *Website:* www.rosstoons.com

THORESBY, Valerie Cecilia, second year MA Painting, Wimbledon. *Medium:* acrylic, oil, watercolour, drawing. *b:* Suffolk, 3 Feb 1941. *d of:* June Vyvyan. *m:* Henry Thoresby. two *s. Studied:* Byam Shaw School of Art; Wimbledon School of Art; Cecil Collins City Lit. (1982-84). *Represented by:* Wills Art Warehouse, London SW15 1LY. *Exhib:* Royal College of Art; New Grafton Gallery; RA Summer Exhbn; Art League of Daytona, USA; Jacksonville Watercolour Society (USA). *Works in collections:* Royal Museum, Canterbury; De Beers, London; Merrill Lynch, Florida. *Commissions:* Nicholas Byam Shaw. *Signs work:* 'Valerie C. Thoresby'. *Address:* 6 Granville Road,

Walmer, Kent CT14 7LU. *Email:* studio@valeriethoresby.co.uk *Website:* www.valeriethoresby.co.uk

THORNBERY, Mary, painter in oil. *b:* Bredhurst, Kent, 23 May 1921. *m:* Michael Dobson, F.R.A.M. one *s.* 1 s- *d. Studied:* painting: London, Florence, Rome. *Exhib:* R.A., London Group, New English Art Club. *Works in collections:* West of England Academy, Bristol B8; Imperial War Museum, London SE1; West Wales General Hospital, Carmarthen, SA31. *Official Purchasers:* West of England Academy, Bristol. *Signs work:* "MARY THORNBERY." *Address:* 20 Hafan Tywi, The Parade, Carmarthen, S. Wales SA31 1LW.

THORNE, Trevor John, *Medium:* painter of townscape and marine subjects as well as figures in historical sporting costume in watercolour, gouache, pen and ink, and pastel. *b:* Southampton, 8 May 1961. *m:* Marriam. *Educ:* Wyvern School, Hampshire. *Studied:* engineering at Southampton College of Technology 1977-81, and Politics and Economics at the Open University. *Exhib:* London and provincial shows including the Wykeham Galleries, Peter Hedley Gallery, Century Gallery, Dragon Gallery, WH Patterson Ltd.,James Purdey & Son Ltd., Whitgift Gallery and The Phoenix Gallery. *Commissions:* various private commissions. *Recreations:* walking, reading and listening to music. *Signs work:* "T J Thorne" or "Trevor Thorne". *Address:* 4 Masefield Close, Eastleigh, Hants, SO50 9EH. *Email:* trevor.thorne@virgin.net

THORNTON, Leslie, A.R.C.A. (1951). *Medium:* sculpture. *b:* Skipton, 1925. *Studied:* Leeds College of Art (1945-48), R.C.A. (1948-51). *Exhib:* One-man shows, Gimpels Fils (1957, 1960, 1969); Retrospective, Manchester (1981); I.C.A. (1955); Berne (1955); British Council Young Sculptors Exhbn. (Germany, 1955-56), Sweden (1956-57); São Paolo Biennal (1957); Holland Park (1957); C.A.S. Religious Theme Exhbn., Tate Gallery; British Embassy, Brussels (1958); Middelheim Biennial, Antwerp (1959); Royal Academy (1974, 76, 78, 79, 1987); 100 Years Sculpture, Leeds (2004). *Works in collections:* Museum of Modern Art, New York; Arts Council of Gt. Britain; Leeds Art Gallery; Felton Bequest, Australia; Albright Museum; Fogg Art Gallery; National Gallery of Scotland; Peggy Guggenheim, Venice; private: U.K., Europe, U.S.A. and S. America. *Commissions:* Daily Mirror Building; Crucifix: St.Louis Priory Missouri, and St. Ignatious College, London. *Address:* Stable Cottage, Chatsworth Pl., Harrogate HG1 5HR.

THORNTON, Pat, RBS (1993); BA Fine Art, Postgraduate Printmaking, Postgraduate Sculpture; British Airports Sculpture Competition Finalist (1991); John Moores Foundation Sculpture Bursary (1992). *b:* Wallasey, 18 Aug 1968. *m:* Oliver Bevan. two *s.* three *d. Studied:* Brighton Polytechnic, St.Martins. *Exhib:* Solo exhibitions: Southern Arts Touring Exhbn (1988), Centre 181 Gallery, Hammersmith (1990); Milton Keynes Exhibition Gallery (1990), Stamford Arts Centre (1991), Mansfield Museum and Art Gallery (1991), Cooper Gallery, Barnsley (1992), Sue Williams Gallery, London (1993), The Woodlands Gallery,

London (1993), Myles Meehan Gallery, Darlington (1997), Galerie La Geste, Uzes, France (2003); Group exhibitions since 1981 across the UK, including: The London Group, Beatrice Royal Gallery, The Oxford Gallery, and the Affordable Art Fair, Battersea Park (1999-2006). *Works in collections:* South London Gallery Print Collection, Electra Investment Trust Plc, Trace Computers Ltd, National Museum of Photography, Film and Television, Wolverhampton Museum and Art Gallery, Birmingham Museum and Art Gallery. *Publications:* work selected for the Winsor & Newton supplement in The Guardian. *Official Purchasers:* Bradford (sculpture). *Address:* 9 rue Grande Bourgade, Uzes 30700, France. *Email:* art@patthornton.net *Website:* www.patthornton.net

THORPE, Hilary, B.A. (Hons.) Woven Textiles; marine and landscape painter in acrylic. *b:* Elsecar, Yorks., 9 Apr 1959. *Studied:* West Surrey College of Art and Design. *Exhib:* solo shows: Cowes, Camelford and London. *Works in collections:* Cowes Maritime Museum. *Commissions:* marine paintings: various locations UK, Bermuda. *Works Reproduced:* several limited edition prints available. *Misc:* Hilary Thorpe paints primarily 'on location'. *Address:* 58 Nelson Drive, Cowes, I.O.W. PO31 8QY. *Email:* hilary@hilarythorpe.co.uk *Website:* www.hilarythorpe.co.uk

THURGOOD, Gwyneth, N.D.D. (1958), A.T.D. (1959), F.N.S.E.A.D. (1970); Woman of Achievement 2007 Award; artist/teacher in painting, etching, stained glass. *b:* Swansea, 2 Apr 1938. *m:* Anthony Thurgood. one *s. Educ:* Neath Girls' Grammar School. *Studied:* Swansea College of Art, B'ham College of Art. *Exhib:* nine solo shows: art/science (1987-2001) including B.A. Meeting (1993), Science Museum, London (1995); Annual Exhibition of Microscopy, Natural History Museum, London, various including 2005, 2006, 2007 (sciart images). *Works in collections:* Universities of Surrey, Manchester, Kent and Warwick, Maidstone Hospital. *Commissions:* University of Warwick. *Publications:* illustrated: papers - three international journals, catalogues; Meridian Television The Gallery (1994, 1995), Meridian Tonight, interview (1997); included in: Dictionary of International Biography 32nd Ed. (2004); The Cambridge Blue Book (2005); Woman of the Year 2006, Great Women of the 21st Century 2007, Great Minds of the 21st Century 2005/6 Edition, American Biographical Institute. *Official Purchasers:* University of Warwick. *Works Reproduced:* in journals. *Principal Works:* Images invisible to the naked eye - micro crystals, etc. *Recreations:* tennis, badminton. *Clubs:* Quekett Microscopical. *Signs work:* "Gwyneth Thurgood" or "Thurgood." *Address:* Serengeti, Pilgrims Way, Harrietsham, Maidstone, Kent ME17 1BT. *Email:* gwyneth.thurgood@tesco.net *Website:* www.micro-art.co.uk

THURSBY, Peter, PPRWA, FRBS, Hon.D.Art; 1987 awarded RBS Silver Medal; sculptor in bronze, stainless steel & sterling silver. *b:* Salisbury, 23 Dec 1930. *s of:* Major and Mrs. L.A. Thursby. *m:* Maureen Suzanne Aspden. *Educ:* Bishop Wordsworth's School, Salisbury. *Studied:* West of England College of Art, Bristol and Exeter College of Art. *Exhib:* solo shows: Arnolfini Gallery; A.I.A.

Gallery; Plymouth City A.G. (2); Marjorie Parr Gallery (3); Westward TV Studios, Plymouth; Northampton Museum and A.G.; Royal Albert Museum and A.G., Exeter (2); University of Sheffield; Haymarket Theatre, Leicester; Nottingham Playhouse; University of Exeter; Alwin Gallery; R.W.A. Bristol, Bruton St. Gallery London (2). Salisbury Museum and Art Gallery (2003), Guernsey Museum (2005), Townmill Gallery, Dorset (2006), Dorset County Museum (2008). *Works in collections:* Arnolfini Gallery; A.T.E.I. London; Gloucester Regt.; Plymouth City A.G.; R.W.A. Bristol; University of Exeter; Westminster College Oxford; National Guard of Saudi Arabia; Newcastle College of Arts and Technology; Wates Built Homes Ltd.; Exeter Museum & Art Gallery; Temple – Japan; President, Royal West of England Academy, Bristol (1995-2000), Salisbury Museum and Art Gallery. *Commissions:* Croydon, Exeter, Dallas and New York State, U.S.A., Harrow, London (2), Plymstock, Tunbridge Wells, Uxbridge, Berlin. *Publications:* "Peter Thursby" by Vivienne Light (Canterton Press). *Clubs:* Chelsea Arts. *Signs work:* "P.T." *Address:* Oakley House, 28 Oakley Close, Pinhoe, Exeter, EX1 3SB. *Email:* mo.thursby@btinternet.com *Website:* www.peterthursbysculptor.co.uk

THYNN, Alexander (7th Marquess of Bath), B.A., M.A.(Oxon.); painter in oil, novelist. *b:* London, 6 May 1932. *s of:* Henry Thynne (6th Marquess of Bath). *m:* Anna Gael. one *s.* one *d. Educ:* Eton and Christchurch, Oxford. *Studied:* Paris: Grande Chaumiere (Henri Goetz), Academie Julian (Andre Planson), Academie Ranson (Roger Chastel). *Works in collections:* murals at Longleat House. *Publications:* Lord Weymouth's Murals by Alexander Thynn; novels, The Carry-Cot (W. H. Allen 1972), The King is Dead (Longleat Press 1976), Pillars of the Establishment (Hutchinson 1981), The New World Order of Alexander Thynn (Starhaven 2000), Strictly Private (an autobiography). *Address:* Longleat House, Warminster, Wilts. BA12 7NN. *Email:* lordbath@btinternet.com *Website:* www.lordbath.co.uk

TIDNAM, Nicholas Rye, RBA (2001), NDD (1961); painter in oil and water-colour, illustrator, lecturer; visiting lecturer, Kent Institute of Art & Design;. *b:* Oadby, Leics., 13 May 1941. *s of:* Albert Arthur Tidnam. *m:* Ruth Murray. one *s.* one *d. Educ:* Kings Park, Eltham. *Studied:* Camberwell School of Art (1957-61)(Michael Rothenstein R.A., Frank Martin, Henry Inlander, Richard Lee, Bernard Dunstan R.A., Peter Weaver R.I.), RBA. *Exhib:* Mercury Gallery, London, RA, NEAC, RBA, Drew Gallery, Canterbury, The Peter Hedley Gallery, Wareham, The Fry Gallery, Saffron Walden, ROI, Laing Landscape and Seascape, Teriade Museum, Greece; All India Fine Arts, New Delhi; Randolph Gallery, Edinburgh; The Scottish Arts Club, Edinburgh. *Works in collections:* Unilever, Leics., Notts. and W. Riding Educ. authorities and numerous private collections in UK., USA, France, Germany, Greece, India. *Works Reproduced:* magazine illustrations, and book 'Oils and Acrylics' (Cassell). *Clubs:* Savage, The London Sketch Club. *Signs work:* "Nick Tidnam" or "N.T." *Address:* 16 Roebuck Rd., Rochester, Kent ME1 1UD. *Email:* nicktidman@hotmail.com *Website:* www.tidnam.com

TIERNEY, James Richard Patrick, Dip.A.D.(1966), Postgrad. Dip. in Printmaking (1967); artist in all painting and printmaking media; principal lecturer;. *b:* Newcastle upon Tyne, 23 May, 1945. *m:* Janet Rosemary. one *d. Educ:* The Royal Grammar School, Newcastle. *Studied:* Sunderland Polytechnic (1961-66, David Gormley), Brighton Polytechnic (1966-67, Jennifer Dickson). *Address:* Maple Cottage, Holt End La., Bentworth, Nr. Alton, Hampshire GU34 5LF.

TIERNEY, Robert, D.A.Dip. (1956); International artist, Cos.; recipient of Royal Society Bursary Award (1958); textile designer/graphics, etc.; artist in water-colour, oil, design colours; début U.K. and Paris (1958); since 1958 annually engaged by numerous companies throughout three continents;. *b:* Plymouth, 9 Aug 1936. *s of:* Hilda Tierney. *Studied:* Plymouth College of Art (Joan Lee, A.T.D.), Central School, London (1956-58, Alan Reynolds). *Exhib:* from 1959, London Design Centre, Paris, Vienna, Italy, Australia, Sweden, Denmark, U.S.A., Canada, Munchen, Switzerland; five tours of Japan (1977-81), U.S.A. tour (1981), exhbns. in European, USA, Far East cities (1982, 1983, 1984, 1985), Target Gallery, London (April 2003). *Works in collections:* Boston Museum of Fine Arts (1981), honoured by five works accepted by V. & A. Museum (1986), etc., and private collections. *Signs work:* "Tierney" or "Robert Tierney." *Address:* Club Cottage, 31 Church St., Modbury PL21 0QR.

TIERNEY, Sadie, MA, RCA (1997); Basil Alkazzi Travel Award (1996); Printmakers Council Award (1997); The Abraham and Lillian Rosenberg Foundation (1997); Arts Council England Grants for Individuals Awards (2006, 2007). *Medium:* acrylic, watercolour, drawing, prints, film. *b:* London, 4 Oct 1971. *d of:* John & Ingrid Tierney. *Studied:* Newcastle University (1990-4); RCA (1995-7). *Exhib:* Flowers East, Flowers Ireland, Eton College, Oxford Gallery, Rivington Gallery, Clifford Chance, RCA, Christie's, Peterborough Museum and Art Gallery, 39, Rabley Contemporary Drawing Centre; ICA, Millais Gallery, Transition, Aspex Galelry. *Works in collections:* Sir Michael Hopkins, Albert Irvin, Roger Evans, Eton College, Clifford Chance, Baker & MacKenzie. *Commissions:* Chichester Harbour Conservancy; RCA. *Works Reproduced:* Sunday Times, Basil H.Alkazzi Foundation Catalogue. *Signs work:* 'Sadie Tierney'. *Address:* 37 Hunter Road, Southsea PO4 9AU. *Email:* sadie.tierney@ntlworld.com *Website:* www.sadietierney.co.uk

TIFFIN, Sheila, self-taught. *Medium:* oil on canvas/board. *b:* Essex, 11 Feb 1952. *Studied:* self-taught. *Represented by:* Tony Sanders. *Exhib:* Royal Portrait Society's Exhibition at the Mall Galleries; John Noot; Tony Sanders, Penzance. *Address:* 28 Union Street, Camborne, Cornwall, TR14 8HG.

TIHOV, Yanko, BA Printmaking and Fine Arts; Robertson Award ROI at Mall Galleries (2004); Ex Libris Award, Argentina (2001), and others; Printmaking Manager for Cornelissen & Son, London. *Medium:* oil, prints. *b:* Burgas, Bulgaria, 30 Aug 1977. *s of:* Georgy Tihov. *Studied:* National Art Academy,

Sofia. *Exhib:* ROI (2004); PS (2004); RA Summer Exhbn (2003); RP (2003); Mall Galleries; Ex Libris, Ville d'issy, les Molineaux, France (2001); 21st Mini Print Biennial, Cadaques, Spain (2001). *Works in collections:* Biblioteca Comunale di Lomazzo, Italy; Rotary Club Acqui Terme, Italy; Internationale Ex Libris Center, Sint-Niklas, Belgium. *Commissions:* The Culture Society in Buenos Aires for Ex Libris: small print of 'Gral.S.Martin' Argentina. *Publications:* UK Press; 'Kensington News'; The Mill Magazine, London. *Signs work:* Yanko Tihor (in cyrmic or latin). *Address:* 81 Wadloes Road, Cambridge CB5 8PF. *Email:* yankotihov@hotmail.co.uk

TILL, Michael John, S.G.F.A.; artist in graphic, engraving, etching, pastel; Insurance Broker;. *b:* Sri Lanka, 23 Mar., 1939. *m:* Kathleen Margaret. one s. (decd.). two d. *Educ:* St. George's College, Weybridge. *Studied:* City and Guilds (1970-72 part-time). *Exhib:* S.G.F.A. *Clubs:* Bosham S.C., R.C.Y.C., Royal London Y.C. *Address:* 57 Southway, Carshalton Beeches, Surrey SM5 4HP.

TILLEY, Nicola Jane, (nee FISHER); painter in watercolour; tutor and demonstrator. *b:* Ismailia, Egypt, 31 Jan 1956. *d of:* Peter Fisher. *m:* Peter George. two: Robin, Roo *s.* one: Rosie *d. Educ:* Maidstone Grammar School for Girls. *Studied:* Penzance Art School, under Colin Scott. *Exhib:* various in Cornwall, Exeter, Mall Galleries, London, St. Ives Soc. of Artists, South West Academy of Fine and Applied Arts, Exeter (2002, 2003). *Works in collections:* many private collections at home and abroad. *Commissions:* National Trust, Godolphin Estate-front cover illustration for guide. *Publications:* articles in Artists and Illustrators magazine (Sept. 2001, Aug 2002). *Clubs:* St. Ives Soc. of Artists. *Signs work:* "Nicola Tilley." *Address:* Evergreen Cott., Townshend, Hayle, Cornwall TR27 6AQ.

TILLING, Robert, M.B.E. (2006), R.I. (1985); painter in water-colours and acrylic; lectures include Tate Gallery and Exeter University; awarded R.I. Medal (1985); prizewinner, International Drawing Biennale (1989); R.I. Members Award (1995); Watercolour Award-RWA (2004). *b:* Bristol,29 Sep 1944. *m:* Thelma, NDD. two d. *Educ:* Bristol; studied art, architecture and education Bristol and Exeter. *Represented by:* Studio 18, Jersey. *Exhib:* one-man exhbns. include London, Bristol, Exeter, Southampton, Guernsey, and Jersey; various mixed exhbns. include the R.A., R.W.S., Barbican Centre (1988). *Works in collections:* include Lodz Museum, Poland and the States of Jersey, Cleveland Museum. *Publications:* illustrations to 'Twenty One Poems', by Charles Causley C.B.E., (Cellandine Press); various reviews/criticism on jazz and blues in many magazines. *Signs work:* "Robert Tilling." *Address:* Paul Mill, La Rosiere, St. Saviour, Jersey JE2 7HF.

TILLYER, William, artist in acrylic on canvas and panel, water-colour, print; French Government Scholarship (1962); Artist in Residence, Melbourne University (1981-82). *b:* Middlesbrough, 25 Sep 1938. *m:* Judith. one *s.* one *d. Studied:* Slade School of Fine Art (1960-62, William Coldstream, Anthony

Gross), Atelier 17, Paris (1962, gravure under William Hayter). *Exhib:* one-man shows: Bernard Jacobson Gallery (1978-80, 1983, 1984, 1987, 1989, 1991), Wildenstein & Co. (1991, 1994), Andre Emmerich, N.Y. (1994), Whitworth A.G., Manchester (1996). *Works in collections:* V. & A., A.C.G.B., Tate Gallery, M.O.M.A. (N.Y.). *Publications:* illustrations for A Rebours by J.K. Huysmans, 'William Tillyer: Against the Grain' monograph by Prof. Norbert Lynton, published October 2000 by 21 Publishing, 'Hardware Variations on a Theme of Encounter' by W. Tillyer (2002), pub. 21. *Signs work:* surname on back. *Address:* c/o Bernard Jacobson Gallery, 6 Cork Street, London W1S 3EE. *Email:* William@Tillyer.com *Website:* www.jacobsongallery.com/ www.tillyer.com

TILMOUTH, Sheila, Dip.A.D. (Hons.), A.T.C. *Medium:* oil on gesso panel: non toxic print. *b:* London, 25 Sep 1949. two *s.* one *d. Educ:* Latymer Grammar School, London. *Studied:* Hornsey College of Art (1969-72, Jack Smith, Nigel Hall, Norman Stevens), Byam Shaw School (1974-75, Bill Jacklin), Finnish Academy, Helsinki (1973). *Exhib:* R.A. Summer Exhbn., Alresford Gallery, Hants., Resident Dean Clough Artist; Soil Association Exhibitions including tour from Low Luckens Organic Farm. Residency, Cumbria as broadcast on Radio 4 and BBC1 (Shared Earth with Dylan Winters, and Countryfile with John Craven). *Works in collections:* Calder Museums, Halifax Courts. *Commissions:* Samaritans. *Publications:* Limited Edn. prints (Buckingham Fine Arts, and Contemporary Arts Group). *Signs work:* "ST 2002" "ST 2004". *Address:* 2 Bethel Terrace Hebden Bridge, W. Yorks. HX7 8HT. *Email:* sheila@sheilatilmouth.co.uk

TILSON, Joe, painter, sculptor. *b:* London, 24 Aug 1928. *s of:* Frederick A.E. Tilson. *m:* Joslyn. one *s.* two *d. Studied:* St. Martin's School of Art (1949-52), R.C.A. (1952-55), Accademia Britannica Rome 1955-57. *Exhib:* Venice Biennale (1964), Marlborough Gallery (1960-77), since 1977 Waddington Galleries, internationally since 1961. *Works in collections:* major museums in Gt. Britain, U.S.A., Italy, S. America, Australia, Germany, Holland, Denmark, Belgium, N.Z., etc. *Signs work:* "Joe Tilson." *Address:* 93 Bourne St., London SW1W 8HF.

TIMMIS, Rosemarie, Diploma in Drawing and Painting Byam Shaw. *Medium:* oil, drawing. *b:* Staffordshire, 9 Feb 1946. *d of:* A.M Timmis. *Educ:* Lowther College. *Studied:* Byam Shaw School of Art. *Exhib:* RA Summer Exhbn, Royal Society of Portrait Painters, Society of Women Painters. *Works in collections:* Harrow School, The Admiralty, Sweden, Sir Tim Rice, Lady Antonia Fraser. *Commissions:* H.M.Sultan of Oman, Lord Butler of Brockwell, Lord Guthrie of Craigie Bank, family of William Cash MP. *Signs work:* Rosemarie Timmis. *Address:* 9 Douro Place, London W8 5PH. *Website:* www.rosemarietimmis.co.uk

TINDLE, David, RA (1979), Hon.FRCA (1984), MA (Oxon.) (1985); painter in egg tempera; Ruskin Master of Drawing, University of Oxford (1985-87), Hon. Fellow at St. Edmund Hall, Oxford; Hon.RBSA. *b:* Huddersfield, 29 Apr 1932.

Studied: Coventry School of Art (1945-47). *Represented by:* Redfern Gallery, Cork St., London. *Exhib:* Fischer Fine Art since 1985, Piccadilly Gallery (1954-83), Galerie XX, Hamburg (1974, 1977, 1980), Redfern Gallery (1994). *Works in collections:* Tate Gallery, Manchester City Art Gallery, Wakefield, Coventry & Whitworth Art Galleries, Bradford, Huddersfield, RA, NPG, London Museum, Government Art Collection. *Clubs:* Arts Club, Dover St. *Signs work:* "David Tindle" or "D.T." *Address:* Via C.Barsotti 194, S.Maria del Guidice, 55058 Lucca, Italy.

TINGLE, Michael, BA Fine Art. *Medium:* acrylic, relief sculpture, drawing. *b:* Skegness, 12 Oct 1954. *s of:* Peter Tingle. *m:* Val. three *d. Studied:* Bath Academy of Art, Corsham (1973-76). *Represented by:* Devon Guild of Craftsmen. *Exhib:* one-man shows: inc. Heffer Gallery, Cambridge; Printworks, Colchester; Gainsboroughs House Museum, Sudbury; Market Cross Gallery, Bury St.Edmunds, Suffolk; mixed shows include: Royal Academy; North House Gallery, Manningtree; Allen Art Gallery, Singapore; Devon Guild Summer Shows, Bovey Tracey; Black Swan, Frome. *Works in collections:* Met. Office, Exeter; Christchurch Mansion, Ipswich; Manor House Museum, Bury St.Edmunds. *Publications:* 'Drawings from the Attic' (Nosuch Press, 2005). *Works Reproduced:* 'Elemental Insight' catalogue; 4th and 5th British International Miniature Print Catalogue; Wrexham Print International Catalogue. *Recreations:* walking (between country pubs). *Signs work:* 'M.Tingle' or 'MT' (monogram). *Address:* 29 Applegarth Road, Newton Abbott, Devon TQ12 1RP. *Website:* www.miketinglepaintings.com

TINSLEY, Francis, M.A. (1971); lecturer, painter in oil, etching, woodcut; Sen. lecturer, Camberwell College of Arts;. *b:* Liverpool, 30 Mar., 1947. *m:* Jennifer. *Studied:* Camberwell College of Arts (1967-70), Chelsea College of Art (1970-71). *Exhib:* one-man and mixed shows in London. *Works in collections:* Flyde Museum, Blackpool, Hereford Museum, and Liverpool. *Publications:* Practical Printmaking. *Clubs:* Chelsea Arts. *Signs work:* "FRANCIS TINSLEY." *Address:* 28 Ewell Court Ave, Epsom Surrey KT19 0DZ.

TIPPETT, Jane, freelance artist in water-colour, tempera, also lithography, and teacher. *b:* London, 25 Feb 1949. *d of:* George Thomas Tippett. *Studied:* Gloucestershire College of Art and Design, R.A. Schools (1977-80). Artist in Residence, Oundle School (1980-82). *Exhib:* R.A. Summer Exhbn. (1978-90), Agnew's Albermarle St. Gallery (1982), Church St. Gallery, Saffron Walden (1983, 1984, 1986); 14 lithographs made at the Curwen Studio. *Signs work:* "Jt." *Address:* 11 Cantelupe Rd., Haslingfield, Cambridge CB3 7LU.

TISDALL, Hans, painter and designer;. *b:* 1910. *Exhib:* London, Paris, Rome, Brussels, Germany, Spain, Switzerland. *Commissions:* murals, tapestries. *Address:* 7 Brunel House, 105 Cheyne Walk, London SW10 0DF.

TITCOMBE, Cedric Anthony, N.D.D. (1962); painter and screen-printer in charcoal, oil, screen prints;. *b:* Gloucester, 11 Dec., 1940. divorced. two *s.* two *d.*

Educ: Crypt Grammar School, Gloucester. *Studied:* Gloucester College of Art (1959-63, James Tucker, John Whiskerd, Gordon Ward). *Exhib:* R.A., R.W.A., and numerous mixed shows. *Works in collections:* Trevor Barnes, etc. *Signs work:* "TITCOMBE." *Address:* 72 Priory Rd., Gloucester GL1 2RF.

TITHERLEY, Hazel M., R.C.A. (1985), A.T.C., A.T.D.(Manc.); painter in oil, acrylic and water-colour. *b:* Little Singleton, Lancs., 4 Mar 1935. *d of:* Tom C. Burgoyne. *m:* Philip Titherley, F.R.I.B.A., M.R.T.P.I. (decd.). one *s. Educ:* Queen Mary School, Lytham. *Studied:* Blackpool School of Art (1953-58), Manchester Regional College of Art (1958-59). *Exhib:* over 30 solo, many open and groups shows. Exhibits with Royal Cambrian Academy, New English 7, North West Design Collective, & New Longton Artists. *Works in collections:* Salford A.G. and private collections in Europe, U.S.A., and Far East. *Clubs:* Founded New Longton Artists (1969). *Signs work:* "Hazel Titherley." *Address:* Woodside, Woodside Ave., New Longton, Preston, Lancs. PR4 4YD.

TO, Frank, MA Fine Art; BA (Hons) Fine Art Painting and Drawing. *b:* Falkirk, 10 Mar 1982. *Studied:* Duncan of Jordanstone Art College; University of Huddersfield. *Represented by:* Witmer Fine Art, New York City, USA. *Exhib:* Albemarle Gallery, London (2007); Queens Gallery, Dundee (2006-07); Beaux Arts Gallery, Bath (2006); Modern Artist Gallery, Pangbourne (2007); Mansfield Park Gallery, Glasgow (2006); Leith Gallery, Edinburgh (2006); Gallery 23, Glasgow (2006); Gascoigne Gallery, Harrogate (2002, 2003); Fairfax Gallery, London (2005-07). *Works in collections:* Patrick Stewart O.B.E. *Commissions:* Louise Chapman, Texas, USA. *Signs work:* 'FRANK TO'. *Address:* Studio 200, WASPS Factory, 77 Hanson Street, Glasgow, G31 2HF. *Email:* frank_to_artist@hotmail.com

TOBOLEWSKI, Marek, BA (Hons) Painting; awards: Pollock-Krasner Foundation, USA (1989); 1st Prize, 'East Midlands Artist of the Year' Printing Section (1993) Smiths Wallers, London. *Medium:* oil, watercolour, drawing, prints. *b:* Bishops Stortford, 16 Aug 1964. *s of:* Helena & Mieczyslaw Tobolewski. *m:* Beatrice. one *s.* one *d. Studied:* Brighton Polytechnic (1986). *Exhib:* 11 solo exhbns in UK and abroad, inc. Angel Row Gallery; Galerie Oz, Paris (1991, 92, 94); selected group exhbns: RA Summer Exhbn (2000); Silverstein Gallery, NY, USA (1995); Air Gallery, London (1996); Angel Row Gallery, Nottingham (2004). *Works in collections:* Warwick Arts Trust, London; Nottingham City Council; Nottingham Trent University; Nottingham Law School; Eversheds Solicitors UK HQ; Pharmaceuticals Profiles UK HQ. *Commissions:* Derby Dance Centre (1997); Nottingham City Council (2001). *Works Reproduced:* exhibtion catalogues Angel Row Gallery (1994, 2004). *Signs work:* 'M. TOBOLEWSKI'. *Address:* 16 Drummond Road, Ilkeston, Derbyshire DE7 5HA. *Email:* marek.tobolewski@ntlworld.com

TODD, Daphne Jane, O.B.E. (2001), RP (1985), NEAC (1984), FRSA (1997), Hon.SWA(1996), HDFA(Lond.) (1971); awards: 2nd prize John Player

award (1983), GLC prize (1984), 1st prize Hunting Group (1984), Ondaatje prize for Portraiture & Gold Medal of Royal Soc. of Portrait Painters (2001); painter in oil on panel; Hon.Sec.RP (1990-91); Director of Studies, Heatherley School of Art, Chelsea (1980-86); President R.P. (1994-2000); Governor, Heatherley School of Art (1986-); Governor, Federation of British Art (1995-2000); one of few women admitted to the Livery, Worshipful Co. of Painter Stainers (Hon.Liveryman, 2004); Freedom, City of London (1997), Hon. Doctorate of Arts, DMU (1998). *b:* York, 27 Mar 1947. *d of:* Frank Todd. *m:* Lt.Col. P.R.T. Driscoll. one *d. Educ:* Simon Langton Grammar School, Canterbury. *Studied:* Slade School (1965-71). *Represented by:* Messum's Gallery, 8 Cork Street, London; Royal Society of Portrait Painters. *Exhib:* RA, RP, NEAC, Patterson Gallery; Retrospective Morley Gallery (1989). *Works in collections:* Chantrey Bequest; University College, London; Royal Holloway A.G. and Museum; HQ Irish Guards; Pembroke College, Cambridge; Lady Margaret Hall, Oxford; St. David's University; NPG; St. Catharine's College, Cambridge; Science Museum; De Montfort University; NUMAST; Institution of Civil Engineers; Bishop's Palace, Hereford; University College, Oxford; Science Museum; National Portrait Gallery; Windsor Castle. *Commissions:* incl.: H.R.H. The Grand Duke of Luxembourg, K.G.; Dame Janet Baker, D.B.E.; Spike Milligan, Hon. C.B.E.; Lord Sainsbury, Lord Sharman, Tom Stoppard. *Publications:* occasional articles in The Artist. *Clubs:* Chelsea Arts, The Arts. *Signs work:* "D. Todd." *Address:* Salters Green Farm, Mayfield, E. Sussex TN20 6NP. *Email:* Daphne.todd@freenet.org.uk

TODD, James Gilbert, M.A. (1965), M.F.A. (1970), R.E. (1997); visiting art residencies: China (1984), Russia (1985), Lithuania (1997), Slovakia and Austria (1998); artist in painting and wood relief printmaking; Prof. Emeritus of Art and Humanities, University of Montana. *Medium:* painting and printmaking. *b:* Minneapolis, Minn., 12 Oct 1937. *s of:* James and Doris Todd. *m:* Julia Katherina Brozio. three *s. Educ:* Chicago Art Inst., College of Great Falls (1958-63), University of Montana (1964-70, Rudy Antio, Donald Bunse, James Dew). *Represented by:* Armstrong-Prior Inc.; Royal Society of Painter-Printmakers; Society of Wood-Engravers. *Exhib:* North and South America, England, Europe, Russia, Asia, Canada. *Works in collections:* U.S.A., England, Europe, Asia, Canada. *Commissions:* murals: 1970, '73, '76- Newman Center; Univ. of MT.; AmerFed. of Labor. *Publications:* numerous articles on artists and art theory, and four books illustrated. *Official Purchasers:* Honolulu Academy of Art; Gonzaga Univ.; Missoula Museum of Art; Rendsburg Sparkasse; Yellowstone Art Center. *Works Reproduced:* 'Berlin Wall'; 'Angel over Berlin'; 'Pool Sharks'; 'Easter at Hussman's'; 'Evacuation of Phnom Penh'; 'Brother Terry'; 'Julia and Seamus'. *Recreations:* martial arts, billiard, reading, walking. *Clubs:* Society of Wood Engravers, Royal Society of Painter-Printmakers, Phi Kappa Phi. *Signs work:* "James G. Todd", "JR" or "TODD." *Address:* 6917 Siesta Drive, Missoula, Montana 59802, USA. *Email:* masuria@mtwi.net

TODD, Peter William, ARCA (1949); artist in oil; Head of Grimsby School of Art (1956-86). *Medium:* oil, drawing, sculpture. *b:* Sheffield, 13 May 1921. *s of:* William James Todd, physicist. *Educ:* J.A.D., Sheffield. *Studied:* Sheffield College of Art, Royal College of Art (1946-49). *Exhib:* RA, London Group, RBA, NEAC, New Grafton Gallery. *Official Purchasers:* Sculpture, Grimsby Central Library. *Clubs:* Caterpillar. *Signs work:* "Peter Todd." *Address:* School House, Walesby, nr. Market Rasen, Lincs. LN8 3UW.

TODD WARMOTH, Pip, BA(Hons.), MA; artist in oil. *b:* 5 Oct 1962. *Educ:* Caistor Grammar School. *Studied:* Grimsby, Camberwell, RA Schools. *Exhib:* Catto Gallery, New Grafton, Bellock-Lowndes, Chicago, Albemarle, LKF Gallery, Hong Kong, China Club, Hong Kong, CAC; group shows: RA, Bonhams, Ice Gallery, NY. *Works in collections:* Franklin Trust, Kingston Lacey, Montecute - National Trust, London Transport, Standard Chartered Bank, Abn Ambro, H.R.H. Prince of Wales. *Commissions:* poster for London Underground, Crown Trust. *Works Reproduced:* Country Life, House and Garden, Evening Standard, South China Morning Post, Hong Kong Standard, Artist Illustrators, Art Review. *Clubs:* Dover St. Arts, Chelsea Arts. *Misc:* B.B.C. Breakfast Show, H.K. Radio 4 and 5, C.B.S., News International. *Signs work:* "Pip T.W." *Address:* 396 Brixton Rd., London SW9 7AW.

TOLLEY, Sheila, RWA (Royal West of England Academy); artist in all media; Twice winner of the Cornelissen Prize for Painting. *b:* Birmingham, 28 Jun 1939. *d of:* Ernest Saville Atkins. *Educ:* Richard C. Thomas School for Girls, Staffs. *Studied:* Bournemouth and Poole College of Art (1972-74, Edward Darcy Lister, R.C.A.). *Exhib:* RA Summer Exhbns. (1978-2004), RWA (1976-2005). *Works in collections:* UK and abroad. *Signs work:* "sheila tolley". *Address:* Flat 16 Hollybush House, 3 Wollstonecraft Rd., Boscombe Manor, Bournemouth, Dorset BH5 1JQ.

TOLSON, Roger Nicholas, BA, MA; painter in oil; Head, Dept. of Art, Imperial War Museum. *b:* Sheffield, 2 Dec 1958. *s of:* James Eric Tolson, M.A. (decd.). three *d. Educ:* King Edward VII School, Sheffield; Oriel College, Oxford; Birkbeck College, London. *Studied:* Sir John Cass College of Art (1986-90). *Exhib:* RA Summer Show (1986-87), Hunting Group (1987), Whitechapel Open (1988, 1989, 1992), NEAC (1988); one-man show: Cadogan Contemporary (1990). *Address:* 51 Albion Rd., London N16 9PP.

TOLSTOY, Carolinda, *Medium:* faience, lustre, gold, ceramic, semi-precious stones and rubies; 'Brush Embroidery' acrylic on silk; oil, acrylic, art rock, gold, marble dust, metal leaf on canvas; acrylic on suede and Mongolian pig skins; acrylic, bricks and wood. *b:* London. two *s.* one *d. Studied:* Sir John Cass School of Art (apprentice, Chelsea Pottery). *Represented by:* George Renwick, London; Thomas Goode, London; Primavera, Cambridge; Tom Caldwell, Belfast; Barzina, Palm Beach; Dar al Funoon, Kuwait. *Exhib:* Brunei Gallery, Alexander Coats Gallery, National Geographical Society, Hellenic Centre, London; London-

Syrian Cultural Centre, Paris-The Hannah Paeschar Sculpture Garden, Ockley. *Works in collections:* The Watts Gallery, Compton-School of Oriental and African Studies, London University. *Publications:* Carolinda Tolstoy Ceramics by Ernst J. Grube (ABI); Sources of Inspiration by Caroline Genders (A&C Black); Three Journeys in the Levant by Shusha Guppy (Starcrest); The Golden Age of Persian Art by Sheila Canby (British Museum Press), Dream Homes by Andreas Einsiedel (Merrell), Arabesque by Claudia Rhoden (Michael Joseph). *Clubs:* The Chelsea Arts Club, London; The Arts Club, London (Honorary Member). *Misc:* Masterclass/Artist in Residence: V&A Museum, Camberwell School of Art, Royal College of Art, St.Martin's School of Art, National Gallery-London, Watts Gallery, Compton Capetown Potters Society. *Address:* 8 Orlando Road, London SW4 0LF. *Email:* carolinda@carolinda-tolstoy.co.uk *Website:* www.carolinda-tolstoy.co.uk

TOMALIN, Peter John, R.I.B.A. Dip.Arch. (Leics. 1964), F.S.A.I. (1978), U.A. (1978); first prize in B.B.C. Christmas painting competition (1977); self employed architectural illustrator and water-colour artist. *b:* Kettering, 18 Oct 1937. *s of:* Sidney Tomalin. *m:* Marjorie Elizabeth. two *s. Educ:* Kettering Technical College, Leicester School of Architecture. *Studied:* Northampton School of Art (1976-79, Peter Atkin, Frank Cryer). *Exhib:* Mall Galleries, U.A., R.I., Grosvenor Gallery, Hitchin, Northampton A.G. *Clubs:* Northampton Town and County Art Soc., S.A.I. *Signs work:* "Peter Tomalin." *Address:* 170 Sywell Rd., Overstone, Northampton NN6 0AG.

TOMBS, Sarah Jane, B.A. (Hons.) 1983, M.A. (R.C.A.) 1987; sculptor in welded steel, stone; Sculpture Fellow, Keele University;. *b:* Herts., 17 Nov., 1961. *Studied:* Wimbledon School of Art (1981-83, Glynn Williams), Chelsea School of Art (1983-84), R.C.A. (1984-87). *Exhib:* Cannizaro Pk. Wimbledon (1981-84), Christopher Hull Gallery, Berkeley Sq. Gallery, Mall Galleries, Margam Pk. Glamorgan, R.C.A., Keele University, etc. *Works in collections:* Government Art Collection, Christie's Contemporary Collection, Linklater & Paines. *Commissions:* 'The Man at the Fire' National Gdn. Festival, Stoke on Trent and British Steel (1986); 'Sailing by Stars' Basingstoke Railway Station (1990); 'Breath of Life' Hammersmith Hospital (1993); 'Beths Arch' Black Country Route, Wolverhampton (1996), etc. *Address:* 80a Nightingale Lane, Balham, London SW12 8NR.

TOMLINSON, Greta, Dip. F.A., N.A.P.A.; Awards: Daler Rowney, Chris Beetles, Jo Aicheson, St.Cuthberts Mill (1st Prize, RWS). *Medium:* water-colour, acrylic, oil, mixed media. *b:* Burnley, 30 Jan 1927. *m:* Richard Edwards (decd.). one *d. Educ:* privately. *Studied:* Burnley School of Art (Harold Thornton), Slade School, Oxford and London (Prof. Schwabe). *Exhib:* regularly with R.I., R.W.S., R.W.E. and London Galleries. *Works in collections:* Southport A.G. *Commissions:* Hamilton Barnes, Interiors, private. *Publications:* Eagle Magazine for Boys, 'Dan Dare' (1950-54). *Works Reproduced:* fine art prints, cards, USA. *Recreations:* travel. *Clubs:* Farnham Art Soc. *Signs work:* "G. TOMLINSON." or

"Greta Tomlinson". *Address:* South Dunrozel, Farnham Lane, Haslemere, Surrey GU27 1HD.

TOMS, Peter Edward, ARSMA(1997), RMS(1995), ARMS (1991), HS(1991); marine and landscape painter, principal designer, British Aerospace, to 1982; full time painter since then. *b:* Hayes, Middx., 28 May 1940. *s of:* Edward James Toms, athlete. *m:* Patricia Mary Toms. five *s.* two *d. Educ:* Mellow Lane School, Hayes. *Studied:* engineering and design: Southall Technical College (1956-63). *Exhib:* RSMA, RI, RMS, RBA, NS, UA, numerous London and provincial one-man and other exhbns. including Alpine Club, Century, Edwin Pollard, Oliver Swann, Omell, Skipwith, Solent and Wykeham Galleries. *Works in collections:* P&O "SS Canberra", Royal Hampshire Regt., Royal Navy (HMS "Osprey"), NV Amev Group (Utrecht), HM Land Registry, Astrid Trust and many other corporate and private collections. *Publications:* biographical notes in: RMS. Centenary Book '100 Years', 'Celebration of Marine Art (Sixty Years of the RSMA)'. *Clubs:* Dorchester (past President 1991-98). *Signs work:* "Peter Toms." *Address:* 20 Egdon Glen, Crossways, Dorchester, Dorset DT2 8BQ.

TONG, Belinda Josephine, VPSWA; painter in oil, pastel, water-colour and acrylic. *b:* Woodford, Essex, 7 Sep 1937. *m:* Bernard Tong. two *s.* one *d. Educ:* Loughton County High School for Girls, Havering College. *Studied:* Open College of the Arts. *Represented by:* Peter Hedley Gallery, Wareham, Dorset. *Exhib:* ROI, SBA, SWA, Essex Art Club, local galleries and societies. *Works in collections:* private collections in UK and abroad. *Commissions:* animal portraits in pastel, houses and gardens. *Recreations:* Golf - President Essex Ladies County Golf Association. *Signs work:* "B. Tong" (oil, acrylic), "Belinda Tong" (watercolour and pastel). *Address:* 57 Theydon Grove Epping Essex CM16 4PX.

TONKS, John, A.T.D., F.R.B.S., V.P.R.B.S.; freelance sculptor in stone, wood, terracotta, bronze; part-time lecturer, Birmingham University; V.P., Royal Soc. of British Sculptors (1990-91). *b:* Dudley, Worcs., 14 Aug 1927. *s of:* John Henry Tonks. *m:* Sylvia Irene. one *s.* one *d. Educ:* Dudley Grammar School. *Studied:* Wolverhampton and B'ham Colleges of Art specialising in sculpture (William Bloy, Albert Willetts, Tom Wright). *Exhib:* one-man shows: University of B'ham (1974, 1984), Ombersley Gallery, Worcs. (1983), Helios Gallery, B'ham (1984); V.B. Gallery, St. Louis, U.S.A. (1981), Poole Willis Gallery, N.Y. (1983), Liverpool International Gdn. Festival (1984), Gardens of New College, Oxford (1988), Garden Festival, Wales (1992). *Commissions:* Alexandre Hospital, Redditch; Pendrell Hall, Stafford; Gretna Green; B'ham Botanical Gdns. *Signs work:* "J.T." joined. *Address:* Downshill Cottage, Comhampton, Stourport-on-Severn, Worcs. DY13 9ST.

TOOP, Bill, RI (1979), MCSD (1971); artist and illustrator in water-colour, line and wash, line, with own gallery in Broadmayne, Dorchester. *b:* Bere Regis, Dorset, 27 May 1943. *m:* Elizabeth Thurstans. one *s.* one *d. Educ:* Weymouth Grammar School, Blandford Grammar School. *Studied:* Bath Academy of Art

(1961-63, Robyn Denny, Howard Hodgkin), Southampton College of Art (1964-66, Peter Folkes), Bristol Polytechnic Art Faculty (1967-68, Derek Crowe). *Exhib:* RI, RWA, numerous one-man shows. *Works in collections:* The Sultan of Oman, Northern Telecom, British Gas, Whitbread Inns, Coutts & Co., The Sedgwick Group, NFU Mutual and Avon Insurance, Royal School of Signals, Atomic Energy Authority, Inst. of Directors, etc. *Publications:* illustrated Portrait of Wiltshire (Pamela Street), National Gardens Scheme Handbook, etc. *Signs work:* "Bill Toop." *Address:* Bill Toop Gallery & Studios, Easter Cottage, 5 Knighton Lane, Broadmayne, Dorchester Dorset DT2 8EZ. *Email:* william.toop1@virgin.net *Website:* www.billtoop.com

TOPHAM, John, F.P.S., I.A.A., Assoc. Internationale des Arts Plastiques; painter. *b:* Hampstead, London. *m:* Hazel Grimsey, painter. two *s*. *Studied:* Melbourne, Australia; Harrow and Ealing Schools of Art. *Exhib:* R.W.A., R.B.A., F.P.S., R.S.B.A., U.A., H.A.C., Camden Art Centre, Allsop Gallery, Anglo-French Exhbn., Poole Art Centre, Seldown Gallery, Hambledon Gallery, Archer Gallery, Minstrel Gallery, Colne Group, Parkway Gallery, Questers Gallery, Swiss Cottage Library, Olympus Gallery, Upton House Gallery, Poole Art Centre Open Exhbn. *Works in collections:* Nuffield Foundation, Camden Council; private collections in U.K. and U.S.A. *Clubs:* F.P.S., life mem. I.A.A., Assoc. Internationale des Arts Plastiques. *Signs work:* "Topham." *Address:* Holmstoke, West Milton, Bridport, Dorset DT6 3SJ.

TOVEY, David Charles Wilson, BA (1999), MA (1976); Solicitor (1979), since 1999 working as independent art historian specialising in Cornish art; author, curator for various exhibitions including 'A Newlyner from St.Ives- W H Y Titcomb' (Penzance 2003), 'Creating a Splash-the St.Ives Society of Artists 1927-52' (2003-4), 'Pioneers of St.Ives Art' (Penzance 2008), Pre-Colony St.Ives Art (Tate Gallery, St.Ives 2008), also Penzance, Lincoln, Doncaster, Hereford, Sunderland, Newport; NADFAS lecturer. *b:* Bristol, 4 Jul 1953. *s of:* Gordon Tovey, founder of Tockington Manor School. *m:* Sherry. *Educ:* Clifton College Bristol (1967-71); Pembroke College, Oxford (MA in Jurisprudence 1976). *Studied:* University of Warwick (BA in History of Art, 1999). *Publications:* George Bradshaw and the St.Ives Society of Artists (2000); W.H.Y.Titcomb: A Newlyner from St.Ives (2003); W.H.Y.Titcomb: Bristol, Venice and the Continental Tours (2003); Creating a Splash: The St.Ives Society of Artists:the first 25 years "1927-52" (2003); Early St.Ives Art - A History (2008). *Recreations:* walking and photography. *Address:* Mill Avon House, 11.13 Millbank, Tewkesbury, Glos GL20 5SD. *Email:* tovey@millavon.fsnet.co.uk

TOVEY, Robert Lawton, A.T.D. (1947); painter in oil. *b:* Birmingham, 3 Apr 1924. *s of:* Edward Francis Tovey. *m:* Annette Suzanne Hubler. *Educ:* The George Dixon Grammar School, Birmingham. *Studied:* Birmingham College of Art under B. Fleetwood-Walker (1939-43, 1946-47). *Exhib:* R.B.S.A., R.B.A., A.I.A., N.E.A.C., R.O.I., R.W.A., one-man shows, Geneva (1957, 1962, 1964, 1980, 1981, 1982, 1983, 1984, 1985, 1995), Baden (1973, 1976), Nyon (1978, 1985).

Works in collections: Musée d'Art et d'Histoire, Geneva; Dudley A.G.; oil painting, The Red Scarf, for above (1953). *Signs work:* "R. L. TOVEY." *Address:* 2 Place de L'Octroi, 1227 Carouge, Geneva, Switzerland.

TOWELL, Larry, *b:* Chatham, Ontario, Canada 23 Aug 1953. *s of:* Earl. *m:* Ann Marie. three *s.* one *d. Educ:* Bachelor of Fine Arts (Hons). *Studied:* York University. *Represented by:* Magnum Photos. *Individual Shows/Exhibitions:* The Caixa Forum, Barcelona, Spain (2003), Perpignan Photo Festival, France (2000, '01), National Portrait Gallery, Edinburgh (2001), The Leica Gallery, New York USA (1997, 2001), Stephen Bulger Gallery, Toronto, Canada (1996, 97, 2001), Zelda Cheatle Gallery, London (19960, also broadly in Europe and North America. Group shows: The Photographer's Gallery, London (2003), Catherine Edelman Gallery, Chicago, USA (2003), National Arts Club, New York, USA (1997, 2002), World Press Photo Exhibition (international tour)(1993, 94, 95), International Centre of Photography (ICP) NYC (1993). *Awards/Commissions:* World Press Foundation Awards (1993, '94, 2003), Henri Cartier Bresson Award (2003), Roloff Beny Book Award (1999, 2002), Pictures of the Year Awards (1994, '96, '98, '99), Alfred Eisenstadt Award (Portraiture)(1998). *Principal Published Pieces:* Magazine, Rolling Stone, Aperture, New York Times, Paris Match, Max (Germany), Photo Italia (Italy). *Publications: Monograph/Contributer:* monographs: The World From My Front Porch, Trolley (Italy), Textual (France) (2004); The Memmonites (Phaidon Press UK, France,2000); Then Palestine, (Aperture USA, Marval France,1999); El Salvador (W W Norton/Doubletake Books, Dunvegan, ON,1997); House on Ninth Street (Cormorant Books, Dunvegan ON, 1994); The Prison Poems of Ho Chi Minh (Cormorant Books, Dunvegan, ON, 1992); Somoza's Last Stand (Williams-Wallace Publishers, Stratford, ON,1990); Gifts of War (Coach House Press, Toronto, ON, 1988); Burning Cadillacs (Black Moss Press, Windsor, ON,1983); selected group books: Aperture at 50 (Aperture 2002), The Best of 2002 (American Photography, USA, 2002); Magnum O (Phaidon UK 1999), Israel 50 Years (Aperture USA, 1998), Flesh and Blood: Photographer's Images of their own Families (The Picture Project, New York USA, 1992). *Specialist Area:* documentary. *Signs work:* various. *Address:* RRI, Bothwell, ON, Canada. *Email:* larrytowell@yahoo.com

TOWNSEND, Storm Diana, N.D.D. (Sculpture) (1960), A.T.C. (1962); Resident Fellowships: Siswa Lokantara Fdn, Indonesia (1960-61), Huntington Hartford Fdn, Calif. (1963), Wurlitzer Fdn. Taos, NM, USA (1964); sculptor. *Medium:* plastilina, plaster, wax to fibreglass, concrete and bronze. *b:* London, 31 Aug 1937. *d of:* Douglas & Winifred Townsend. *Educ:* Sacred Heart Convent, Hammersmith, London (1947-55). *Studied:* London University, Goldsmiths' College (1955-60, Harold S. Parker, Ivor Roberts-Jones). *Exhib:* throughout U.S.A., inc. LA, New York, Santa Fe. *Works in collections:* Museum of New Mexico, Santa Fe and the City of Albuquerque, public works, many private collections. *Commissions:* over life-size bronze "To Serve and Protect" commissioned by City of Albuquerque and others, N.M. (1984); "Bronze

Trophy" for P.G.A. 'Charlie Pride International Senior Golf Classic' Albuquerque (1987); Three figure bronze 'Tres Culturas del Rio Grande' commissioned by Sunwest Bank, Albuquerque, N.M. (1988). *Publications:* many and various articles and interviews in local and national publications. *Official Purchasers:* many. *Misc:* sculpture instructor: The College of Santa Fe, NM (1974-75), University of Albuquerque, NM (1976-83), University of New Mexico in Albuquerque (1980-93); Associate sculptor, Alcazar Corp., Albuquerque (1988-99); contract sculptor: New Mexico Museum of Natural History (1987-1991). *Signs work:* "STORM." *Address:* P.O. Box 1165, Corrales, New Mexico 87048, U.S.A.

TOWSEY, Mary, TD; Stock Exchange Award (1971-72); SBA Honourable Mention, Exhibit of the Year, Alton 1984; Josephine Majella Award, Petersfield 1986; Best Collection of Work 'Ville d'Epone' 2000; landscape artist, oils. *b:* Epsom, 24 Jul 1936. *d of:* G.T.N. Prideaux & Mrs.F.D.Prideaux. three *d. Studied:* Goldsmiths' College University of London (1955-57), Epsom College of Art (1960-67). *Exhib:* Wintershall Gallery Bramley, Hallam Gallery London, Edwin Pollard Gallery, Ebury Gallery London, Wykeham Gallery London, Jonleigh Gallery Wonersh, Llewellyn Alexander Gallery, London, Galerie de Vétheuil, France, R.B.A., R.O.I., N.E.A.C., R.W.S., S.W.A., S.B.A. B.B.C.2 television series 'Painters', winner - Best Collection Paintings "Au Bout du Monde" Épone, France. *Works in collections:* Marie de Vétheuil - France, Government Art Collection. *Commissions:* The Great Hall, King's College, Wimbledon, private collections. *Publications:* 'Mary Towsey - Vétheuil and other Passions. *Works Reproduced:* Ropley Station, Kings College Wimbledon. *Recreations:* gardening, interior decoration, reading. *Misc:* TV demonstration BBC2 "Painters". *Signs work:* "Mary Towsey." *Address:* Ambelor, Lands End La., Lindford, Hants. GU35 0SS. *Email:* mary.towsey@btopenworld.com *Website:* www.marytowsey.com

TRANT, Carolyn, DFA(Lond.) (1973);David Murray Landscape Scholarship; artists books under imprint 'Parvenu Press'; First Prize for 'Gawain', Soc. of Bookbinders competition for the complete book; Chichester Prize for Painting (2001). *Medium:* painter-printmaker. *b:* Middx., 29 Oct 1950. *d of:* Brian Trant, musician. two *s.* one *d. Educ:* North London Collegiate School. *Studied:* Slade School of Fine Art (1969-73). *Exhib:* New Grafton Gallery, Brighton Festival, London Artists Bookfair - ICA, RA Summer Shows, Oxford Fine Press Fair, West Dean College, St.Brides Printing Library. *Works in collections:* RA, National Art Library (V&A). *Commissions:* ESCC/SE Arts commission: 'Rituals and Relics' - Earthworks on the Downs, National Theatre - poster 'Blood Wedding' (Lorca). *Publications:* Art for Life: Biography of Peggy Angus (Incline Press 2004). *Official Purchasers:* Library Collections across USA, British Library-Modern British Collection. *Works Reproduced:* Illustration Magazine - Spring 2006. *Principal Works:* Gawain, Lorca's Sonnets of Dark Love, The Garden of Earthly Delights, Beauty and the Beast, Winterreise, The Falcon Bride, Bluebeards

Castle. *Signs work:* "Carolyn Trant". *Address:* 17 St. Anne's Cres., Lewes, E. Sussex BN7 1SB.

TRATT, Richard, S.WL.A. (1981), S.B.A. (1987); painter in oil; First prize winner of national competition - 'Nature in Art'. *b:* Enfield, 19 Oct 1953. *s of:* Robert Tratt. *m:* Hilary Wastnage. two *d. Educ:* Crewe Grammar School. *Studied:* Northwich College of Art (1970-72), Dartington College of Arts (1972-74). *Exhib:* R.A., Mall Galleries, Robert Perera Fine Arts, Alresford Gallery, New Forest Fine Art, Peter Hedley Gallery, Isetan Gallery, Tokyo; twenty seven one-man shows. *Works in collections:* Nature-in-Art, Royal Palace of Oman. *Works Reproduced:* Reynard Fine Art, Royles, McDonald, Rosenstiel's, Langford Press. *Signs work:* "Richard Tratt." *Address:* 10 Sharpley Cl., Fordingbridge, Hants. SP6 1LG. *Email:* abctratt@aol.com *Website:* www.richardtratt.co.uk

TRAYHORNE, Rex, R.M.S. (1988); artist in water-colour and gouache; art teacher, demonstrator and writer; exhbns. organiser, Wessex Artists Exhbns. *Medium:* watercolour. *b:* 13 Oct 1931. *m:* Geraldine. two s. (one s-s), two d. (one s-d). one *s.* one *d. Educ:* Newbury Grammar School. *Studied:* Reading College (1958). *Exhib:* R.I., R.M.S., R.W.S., local art societies, Wessex Artists Exhbns., etc. *Works in collections:* Lord Romsey (now known as Lord Brabourne). *Publications:* 'Adventure into Watercolour' (an instructional video). *Clubs:* Romsey Art Group, Ringwood Art Soc. *Signs work:* "Rex Trayhorne" R.M.S. *Address:* Stable House Studio, Newton Lane, Romsey, Hants. SO51 8GZ. *Email:* rextrayhorne@btinternet.com *Website:* www.rextrayhorne.co.uk

TRAYNOR, Mary, J.P.; artist in pen and ink, water-colour and mixed media. *b:* 23 Mar 1934. *m:* Brian Traynor (decd.). one *s.* two *d. Educ:* Walthamstow Hall, Sevenoaks. *Studied:* Birmingham College of Art and Crafts, Theatre Design: Findlay James, Roy Mason. *Represented by:* Washington Gallery, Penarth. *Exhib:* National Museum of Wales, Welsh National Eisteddfod; one-man: Welsh Industrial and Maritime Museum (1988), St. David's Hall, Cardiff (1990, 2005), Manor House Fine Arts, Cardiff (1997), Washington Gallery, Penarth (2001, 2004), Hanover Hall Arts Centre (2005). *Works in collections:* National Museum of Wales, Cardiff Magistrates, Professional Offices, County of Cardiff, Gwent Health Authority, University of Wales, St. James's Palace, private. *Commissions:* public and private inc. C.A.D.W., University of Wales, Cardiff, Welsh Development Agency, and private companies. *Publications:* illustrated: Wales Tourist Board, Western Mail, National Museum of Wales, Cardiff City Council, C.A.D.W.; book: "Temples of Faith: Cardiff's Places of Worship" (2001). *Clubs:* The Victorian Soc., Cardiff Architectural Heritage Soc., Cardiff Civic Soc. *Signs work:* "Mary Traynor." *Address:* 72a Kimberly Rd., Penylan, Cardiff CF23 5DN.

TREANOR, Frances, P.S. (1978), A.T.C. (1967), N.D.D. (1966); L'Artiste Assoifee awards winner (1975), Diplome d'Honneur, Salon d'Antony, France (1975), George Rowney award (1982), Frank Herring award (merit) (1984), Conté (U.K.) award (1986), Government Print Purchase (1987); 'Woman of the

Year 2006' (nominated by ABI). *b:* Penzance, Cornwall. *d of:* George Treanor, musician. *m:* (1) Frank Elliott, (2) Anthony Taylor (divorced). one *d. Educ:* Assumption Convent, Kensington; Sacred Heart Convent, Hammersmith. *Studied:* Goldsmiths' College (1962-66), Hornsey College of Art (1966-67). *Exhib:* London, Paris, Yugoslavia, Berlin. Stage set design commission 'As You Like It' O.U.D.S. Summer Tour (Japan, U.S.A., U.K.) 1988. *Commissions:* Broomfield Hospital NHS Trust 2002; Royal Parks Greenwich First Artist-in-Residence (2005-06). *Publications:* Vibrant Flower Painting (David & Charles). *Clubs:* London Press Club. *Signs work:* "Treanor" or "F.T." *Address:* 121 Royal Hill, London SE10 8SS. *Website:* www.francestreanor.com

TREE, Michael Lambert, portrait painter, etcher, draughtsman and illustrator;. *b:* New York, 5 Dec 1921. *m:* Lady Anne Tree. two *d. Educ:* Eton. *Studied:* Slade School of Fine Art. *Exhib:* Hochmann Gallery, N.Y. (1982), Fine Arts, London (1984), St. Jame's Gallery (1989), Lumley Cazalet (1995). *Publications:* illustrations to Summoned by Bells by John Betjeman (1960). *Clubs:* White's. *Signs work:* "M. Tree." *Address:* 29 Radnor Walk, London SW3.

TRELEAVEN, Richard Barrie, S.WL.A. (founder member), M.B.O.U.; artist in oil on canvas and board, alkyd, gouache, and graphite drawings, specialises in painting birds of prey; company director of family business. *b:* London, 16 Jul 1920. *s of:* G. L. Treleaven. *m:* Margery (decd.). *Educ:* Dulwich College (1932-36). *Studied:* under G. E. Lodge. *Exhib:* S.WL.A. Art Exhbns. Bureau, Moorland Gallery, etc.; one-man show, Bude (1953), Launceston (1973, 1980). *Works in collections:* many private collections. *Commissions:* Hawk portraits and falconry scenes including book covers. *Publications:* Peregrine (1977); author and illustrator 'In Pursuit of the Peregrine' (Tiercel Press, 1998); and ornithological journals. *Clubs:* British Falconers. *Signs work:* "R. B. Treleaven." *Address:* Blue Wings, South Petherwin, Launceston, Cornwall PL15 7JD.

TRELOAR, Janet Quintrell, MA Oxford, ARWS, FRGS. *Medium:* watercolour and work on paper, oil on board. *b:* 12 Feb 1940. *d of:* Arthur and Doris Treloar. *m:* John Hale-White. two *s.* two *d. Educ:* David Manzur Atelier, Bogota. *Studied:* Burleighfield House, High Wycombe with Patrick Reyntiens; Stavanger with Stanislas Dombronsky. *Represented by:* Royal Watercolour Society; Square One Gallery; Celia Purcell Contemporary; Webb's Gallery; Benjamin Hargreaves; Richard Demarco (Edinburgh). *Exhib:* solo: Piers Feetham Gallery; Square One Gallery; Russina Embassy; Galitzine Library, St.Petersburg; Chelsea Arts Club; Trereife House, Penzance; British Council, Dubrovnic; Groups: Bankside Gallery (RWS); RA Summer Exhbn.; Royal West of England Academy; Laing Competition; Nine Elms Group; Chelsea Art Society; Society of Russian Watercolour Painters. *Works in collections:* Kunstforening Bergen; Stavanger, Norway; Richard Demarco Foundation, Edinburgh; RWS Archive; Malta Art Archives; Zagreb Museum. *Commissions:* private commissions in UK; Viyella UK; Croatian Embassy; Russian Embassy. *Publications:* Catalogues: The

Romanesque Arch in Europe; Russia's Hero Cities; Defending the Countryside. Illustrated articles in: Watercolour Masters Then and Now (RWS, 2006); St.Ives Revisited, 1975-2005, by Peter Davies (2007); The Artist (magazine, March 2005). *Official Purchasers:* Croatian Embassy, London; Lipik Town Hall, Croatia; Rogaland Kommune, Norway; Bergen Kunstforening, Dubrovnik City. *Principal Works:* series on Romanesque Arch in Europe: Russia's Hero Cities. *Recreations:* looking, walking, thinking, cinema. *Clubs:* Chelsea Arts Club. *Misc:* Eleanor of Aquitaine; Pilgrimage to Santiago de Compostela. *Signs work:* "J.Q.TRELOAR". *Address:* 48 Thorne Rd, London SW8 2BY. *Email:* hale.treloar@homechoice.co.uk *Website:* www.janetqtreloar.com

TREMLETT, Phillippa Mary, HS(1994), RMS (2002), Llewellyn Alexander award HS (1998); self taught miniaturist following a stroke in 1988. *Medium:* watercolour on vellum. *b:* London, 21 Sep 1947. *m:* Peter Ian (decd). *Educ:* London. *Studied:* dress-making and design at Risinghill Comprehensive (1962-64). *Exhib:* annually RMS and HS, London and Wells. *Works in collections:* private: London, Home Counties, Jersey, USA, E. Anglia, NZ. *Commissions:* from £250. *Recreations:* reading, dogs, computers, all music genres, writing short stories. Practising Christian. *Clubs:* Human Writes. *Misc:* teaches miniature painting, lectures and talks with demonstrations. *Signs work:* monogram. *Address:* 4 Paddock Cl., Ropsley, Grantham, Lincs. NG33 4BJ. *Email:* phillippa.tremlett@btopenworld.com

TRESS, David, painter in mixed media, graphite, acrylic. *b:* London, 11 Apr 1955. *Educ:* Latymer Upper School, Hammersmith. *Studied:* Harrow College of Art (1972-73), Trent Polytechnic, Nottingham (1973-76). *Exhib:* regularly in Wales, England, Ireland. *Works in collections:* National Museum of Wales, National Library of Wales, C.A.S.W., Glynn Vivian Art Gallery, Guildhall Art Gallery, London. *Commissions:* Royal Mail, one of their millennium stamps (1999). *Publications:* Exhbn. catalogues: Boundary Gallery, London, West Wales Arts Centre, Brian Sinfield Gallery. Monograph: 'David Tress', Gomer Press, 2003. *Signs work:* "David Tress." *Address:* c/o West Wales Arts Centre 16 West Street Fishguard Pembrokeshire SA65 9AE.

TREVENA, Shirley, R.I. (1994); self taught artist in water-colour;. *b:* London, 11 Sept., 1934. *m:* Michael Pickerill. *Educ:* Drayton Manor Grammar School, Middx. *Exhib:* R.I. Mall Galleries, R.W.S. Bank St. Gallery, Nicholas Bowlby Gallery, Tunbridge Wells. *Publications:* numerous articles and reviews; examples of work in several books on water-colour painting and drawing. *Signs work:* "S. Trevena." *Address:* Flat 3, 4 Medina Villas, Hove, E.Sussex, BN3 2JR.

TRINDER, Wendy, FSBA (founder member); SWA; BSc (Botany) and PG Cert. in Education. *Medium:* acrylic, watercolour, drawing, prints. *b:* Oswestry, Shropshire, 12 Sep 1942. *m:* Peter Trinder. one *s.* one *d. Educ:* Twickenham County Grammar School (1954-61). *Studied:* University of Hull (1961-65). No formal art training. *Exhib:* SBA, SWA; regular exhbns at Urchfont Manor

College, Devizes; galleries across UK. *Commissions:* Bishopsgate School, Englefield Green, Surrey; Guards Polo Club, Windsor Great Park. *Publications:* illustrated 'Teddy Bear Quotations', 'Teddy Lovers Address Book', 'Teddy Bears - A Celebration' (Exley Publications, 1990). *Works Reproduced:* limited edition prints: 'Pottering at Urchfont' (2000); 'Roses' (2007); 'Back Door Step' (2007); greeting card (Woodmansterne Ltd.). *Clubs:* Virginia Water Art Society; Sunningdale Art Society. *Signs work:* 'Wendy Trinder' (watercolours); monogram on acrylics and drawings. *Address:* 5 Canada Rise, Market Lavington, Devizes SN10 4AD. *Email:* wendytrinder@waitrose.com

TROITZKY, Nina, M.A. Fine Art, B.A. Hons; painter, installations & mixed media. *d of:* Rev. Nicanor Troitzky, Archimanderite, Russian Orthodox Church in Exile. *m:* Philip Richardson. *Studied:* The City Lit London, London Guildhall University, University College Chichester, and Brighton University. *Exhib:* R.O.I., Mall Galleries, London Contemporary Art Fair, British Painters, Discerning Eye, Llewellyn Alexander, London, Chelsea Arts Club, S.W.A.N. Sydney, Australia, Mountbatten Gallery, Portsmouth, University College Chichester, Brighton University Gallery, Hotbath Gallery Bath, Stroud Gallery, Phoenix Gallery Brighton, Cheltenham & Gloucester Open and many provincial and European galleries, selected Exhbn. 1999 in Dostoyevsky Museum, St. Petersburg, Russia. *Works in collections:* V. & A. Museum, London, St. Richard's Hospital, Chichester, California State University of Long Beach, U.S.A., University College, Chichester. *Works Reproduced:* Medici card. *Clubs:* Chelsea Arts. *Misc:* Mem. of 'Catalyst' Women, Arts and Science Group, Artel Studio Trust, East & West Cultural Artists Club. *Signs work:* "N.T." *Address:* 10 Henty Gardens, Chichester, W. Sussex PO19 3DL.

TROTH, Miriam, B.A. Hons. (1983); fine artist. *Medium:* mixed media. *b:* Edgbaston, 1 Oct 1951. *Studied:* W. Surrey College of Art (1980-83). *Exhib:* Barbican, British Commonwealth Inst., Swansea A.G., Coleridge Piccadilly, Bristol A.G., R.A., Bankside, Royal Soc. of Artists, Salisbury Museum, Windsor Arts Centre, Christchurch Museum, Bournemouth University, London Contemporary Art, Waterloo Gallery, Brunei Gallery, CCA Glasgow, Study Gallery Poole, Southampton AG, CBK Leiden, Spandow G. Berlin, National Trust, Artsway, Pallant House. *Works in collections:* London, Sydney, Detroit, Frankfurt, Wiltshire C.C., Bournemouth C.C. *Commissions:* Russell Cotes Museum, Bournemouth. *Official Purchasers:* Wiltshire C.C., Bournemouth C.C. *Signs work:* "Miriam Troth." *Address:* Flat 31, Overcombe Court 22 St. John's Road Boscombe Spa Village Bournemouth BH5 1EW. *Website:* www.axisweb.org/artist/miriamtroth

TROWELL, Jonathan Ernest Laverick, N.D.D. (1959), R.A.S.Dip. (1962), F.R.S.A. (1983), N.E.A.C. (1986); painter in oil, pastel and water-colour;. *b:* Easington Village, Co. Durham, 1938. *m:* Dorothea May Howard. *Educ:* Robert Richardson School. *Studied:* Sunderland College of Art, R.A. Schools. *Exhib:* New Bauhaus Cologne, Young Contemporaries, John Moores, R.A., Lee Nordnes

N.Y., Bilan de Contemporain Paris, R.B.A., N.E.A.C.; one-man shows, Brod Gallery London, Century Gallery, Culham College Oxford, Richard Stone-Reeves New York, Osborne Gallery London, Stern Galleries Australia. *Works in collections:* Bank of Japan; Culham College, Oxford; de Beers (Diamond Co.); Oriental Diamond Co.; Ciba-Geigy; Imperial College of Science; R.C.A.; B.P. *Clubs:* Chelsea Arts. *Signs work:* "TROWELL." *Address:* Carr Farm, Old Buckenham, Attleborough, Norfolk NR17 1NN.

TRUZZI-FRANCONI, Jane, B.A. (1977); Angeloni prize (1979), Discerning Eye prize (1990); sculptor in bronze; Supervisor, Fiorini Fine Art Foundry;. *b:* London, 26 July, 1955. one *d. Educ:* Sydenham School. *Studied:* Goldsmiths' College of Art (1973-74), Ravensbourne College of Art (1974-77), R.C.A. (1978-79). *Exhib:* R.A., Mall Galleries, many mixed shows in London, E. Anglia, Kent and Surrey. *Signs work:* "J.E.T.F." *Address:* 4 Wolsey Cottages, Strickland Manor Hill, Yoxford, Suffolk IP17 3JE.

TUBB, Stephen David, *Medium:* pastel, oils, drawing, prints. *b.* Chippenham, 7 Jun 1959. *s.* of: AA Tubb & D M Cornwell. *Studied:* self-taught. *Exhib:* Various. *Work in Collections:* British Racing Drivers Club, Silverstone. Various private in USA, UK and Australia. *Works reproduced:* prints. *Principal works:* motoring, motorcycle, portrait. *Recreations:* motorcycling. *Signs work as:* "Steve Tubb", "Stephen Tubb", or "Tubb". *Address:* 86 New Road, Wootton Bassett, Swindon, SN4 7AW. *Email:* steve.tubb7@btinternet.com *Website:* www.tubbart.co.uk

TUCKER, Patricia Rosa, (née Madden); N.D.D. (1950), A.T.D. (1951); oil and water-colour painter, art teacher; Past Chairman, Bromley Art Soc.; Visual Arts Officer, Bromley Arts Council (1970-87); Sec. Chelsea Open Air Art Exhbn. (1967-87). *b:* London, 2 Jan 1927. *d of:* Michael and Rosa Madden. *m:* L. Tucker. two *s.* one *d. Educ:* Mayfield, Putney, St. Catherines, Swindon. *Studied:* Swindon School of Art, West of England College of Art. *Exhib:* R.A., Bankside, Mall, etc.; one-man shows, London, Blackheath, Greenwich, Bromley, Chelsea, Gloucester and Denmark. *Works in collections:* Bromley, Gloucestershire, Kensington and Chelsea, Swindon. *Commissions:* portraiture, architectural landscapes, floral work. *Publications:* illustrations, Parenting Plus. *Clubs:* Croydon, Blackheath, Bromley, S.E.F.A.S. *Signs work:* "Patricia Tucker." *Address:* 5 Bromley Ave., Bromley, Kent BR1 4BG.

TUDGAY, Norman, A.T.D. (1949); painter in oil; formerly head of dept., Medway College of Art, principal, Bournemouth and Poole College of Art and Design. *b:* Nantyglo, Wales, 21 Apr 1925. one *s.* two *d. Educ:* Bishop Gore Grammar School, Swansea. *Studied:* Swansea College of Art (1940-1943 and 1947-1952), Guildford College of Art (1953-1956). *Exhib:* recently at Collyer-Bristow Gallery, London, Heseltine-Masco Gallery, Petworth. *Works in collections:* emulsion drawings, Gernsheim Collection, the Harry Ransom Centre, Austin, University of Texas. Paintings, private collections UK, France, Holland. *Publications:* Review: Gernsheim's Concise History of Phtography

1965. *Signs work:* "TUDGAY." *Address:* The Lodge, 11 Chaddesley Wood Rd., Poole, Dorset BH13 7PN. *Email:* tudgayart@aol.com

TUFF, Richard, BA Hons (Textile Design). *Medium:* gouache. *b:* Cheshire, 3 Dec 1965. *s of:* Mr & Mrs Tuff. *m:* Sara Tuff. one *d. Educ:* Winchester School of Art (1985-88). *Studied:* textile design. *Represented by:* Beside the Wave Gallery, CCA Galleries. *Exhib:* Royal West of England Society of Art (1990-92), various. *Publications:* silkscreen prints published regularly from 1992 (CCA Galleries). *Works Reproduced:* approx. 20 images over 12 years (Art Group). *Signs work:* Richard Tuff (lower case letters). *Address:* Wrinklers Wood, Mithian Downs, St.Agnes, Cornwall, TR5 0PZ.

TULLY, Joyce Mary, U.A. (1978); artist in oil and water-colour, teacher; speaker at local societies; teaches calligraphy and exhibits examples of work. *b:* Wooler, Northumberland. *d of:* Walter Tully. *Educ:* Duchess Grammar School, Alnwick. *Studied:* Hammersmith Art College (part-time) and private tuition with Mr. Harold Workman, R.O.I., R.B.A., R.S.M.A. *Exhib:* Paris Salon, R.O.I., R.B.A., Chelsea Artists, N.S., U.A., Ridley Soc. and in Australia, British Painting in 1979, Paxton House, Berwickshire, participates in Northumberland Art Tour. *Works in collections:* Copeland Castle, and private collections in England, Europe and America. *Publications:* entry in Marshall Hall's 'The Artists of Northumbria'. *Signs work:* "J. M. Tully." *Address:* Kia-ora, 26 Tenter Hill, Wooler, Northumberland NE71 6DG.

TURNBULL, Alan, BA (Hons) Fine Art (1977), MA (1978); painter in oil, printmaker (etching), lecturer; Boise Scholar; numerous Arts Council Awards. *b:* Co. Durham, 3 Oct 1954. *Studied:* Newcastle University, Chelsea School of Art. *Exhib:* selected one-man shows: North House Gallery (2007); Hatton Gallery (2007); Vladimir Nabokov Museum, St.Petersburg (2005); Liteyny Studios, St Petersburg (2003); York City Art Gallery (2001); Marlowe Centre, Canterbury; State Theatre Dresden, Cathedrals of Durham, Ripon, Newcastle, Norwich. Selected group shows: RA London, Scottish Royal Academy, Society of Scottish Artists Edinburgh, Canterbury Museum, 7th Mostyn Open, Compass Gallery Glasgow, Mappin Art Gallery Sheffield, Ketterer Kunst Hamburg, Museum of Fine Arts Ekaterinberg. *Works in collections:* City of Dresden, London University, Northern Arts, Nabokov Museum St.Petersburg, Harvard University, Arts Council England, Woodland Trust; private collections worldwide. *Publications:* 'Etchings after Van Gogh' Liteyny Print, St. Petersburg. *Works Reproduced:* RA Summer Exhibition Catalogues 2001/2004, 'Aspects of Drawing', Canterbury Museum, 'Waterlog' Literary Journal, Autumn 2001. *Signs work:* "Alan Turnbull." *Address:* The Cottage, Moor Rd., Bellerby, Leyburn, N.Yorks. DL8 5QX. *Email:* turnbull.fineart@virgin.net

TURNBULL, Andrew, Fellowship Royal Academy Schools (2002-05); MA (RCA) Printmaking (2000-02); First Class Honours Fine Art: Printmaking, Loughborough University; The Tim Mara Printmaking Award. *Medium:* prints. *b:*

Hastings, 12 May 1978. *Studied:* HCAT, Loughborough University, Royal Academy Schools, Royal College of Art. *Exhib:* solo shows: RA (2005); New Academy Gallery, London (2004); Case-1 Gallery, London (2004); many group exhbns inc. Workplace Art, London (2004), RA Summer Exhbn (2003, 04); Metropolis, Mark Jason Gallery, London (2002). *Works in collections:* V&A; Churchills College, Cambridge; RCA; Loughborough University; many private collections. *Commissions:* Cable & Wireless (Red Lion Square, London, 2005); R3 (London, 2003). *Principal Works:* 'Water Arch' (2004); 'Canary Construct' (2004); 'Middle Town' (2003). *Signs work:* 'A.Turnbull'. *Website:* www.akturnbull.com

TURNBULL, William, sculptor and painter;. *b:* Dundee, 11 Jan., 1922. *m:* Kim Lim. two *s*. *Studied:* Slade School of Fine Art (1946-48). *Exhib:* I.C.A. (1957), Waddington Galleries (1967, 1969, 1970, 1976, 1978, 1981, 1985, 1987, 1991, 1998), Tate Gallery (1973); one-man and major group shows worldwide. *Works in collections:* Arts Council, Tate Gallery, Scottish National Gallery of Modern Art; numerous provincial and overseas collections. *Address:* c/o Waddington Galleries, 11 Cork St., London W1X 1PD.

TURNER, Peggy E. M.: see RICHARDS, E. Margaret,

TURNER, Alan, Image Liberation Front (ILF). *b:* Farnham, Surrey, 2 Feb 1942. *s of:* Helen & Harold Turner. *m:* Janet Barbara. one *s*. two *d*. *Studied:* Hornsey School of Art (1962-65); Camden Institute (1965-70). *Represented by:* England & Co. *Exhib:* London Group, Tolly Cobbold, Eastern Art National Exhibition, Discerning Eye, Alternative Arts, England & Co., Haringey Arts Council, Aberystwyth Printmaker, Cambria Arts. *Works in collections:* various private international. *Publications:* Leonardo, Pergamon Press. *Misc:* It is the duty of the artist to engage with the issues of the day. *Signs work:* "ALAN TURNER". *Address:* Penarth, Pennant, Llanon, Ceredigion, SY23 5JP.

TURNER, Anthony Hugh, RBS; BA (Hons) Social Studies. *Medium:* sculpture: stone and bronze. *b:* Nairobi, Kenya, 20 Apr 1959. *s of:* Pilly Turner. one *s*. one *d*. *Educ:* Marlborough College (1971-76). *Studied:* Exeter University (1977-80); 4 year apprenticeship with Peter Randall-Page. *Represented by:* Messums, London; New Millennium Gallery, St.Ives. *Works in collections:* mainly private. *Commissions:* mainly private, also post seating for Barratt's Homes and East Cumbria Countryside Project; gatepost finials for Asthall Manor, Oxfordshire. *Address:* Burnt Cottage, Lower Ashton, Exeter, Devon EX6 7QW. *Email:* at@anthonyturner.net *Website:* www.anthonyturner.net

TURNER, Cyril B., M.P.S.G. (1985), M.A.A. (1988), I.G.M.A. (Fellow Fine Art 1994), W.F.M. (1998); Fine Art master miniaturist in most categories including illuminated miniatures; Order of International Ambassadors (O.I.A 2005); Founder Member of the American Order of Excellence (F.A.O.E. 2005); Awards: 128 miniature paintings have won awards; awarded ABI 'Man of the Year 2004'; ABI World Medal of Freedom (2005); United Cultural Convention of

the USA 2005 International Peace Prize; 2005 American Medal of Honour; inventor of Lumitex, an acid free, ultra-violet proof substitute for ivory as a miniature base; introduced cold enamel as a medium for miniature paintings;. *Medium:* miniaturist in oils, cold enamel, soft pastel, gouache, acrylic, egg tempera, water-colour, pigmented inks, silverpoint. *b:* Aldeby, Norfolk, 10 Sep 1929. *Educ:* Beccles Area School. *Exhib:* one-man exhibs.: Museum Galleries Gt. Yarmouth. Many other U.K. one-man miniature shows. Group: R.A., Salon des Nations Paris, many U.S.A. International Miniature Shows, others Jersey, Canada, France, Bermuda, Ulster, Sweden, Bangladesh, Japan, S. Africa, Australia, Germany, Belgium, Smithsonian Institution Washington DC. *Works in collections:* Private, corporate, university, college, national and state libraries, miniature paintings and miniature books in permanent, heritage or special collections throughout the world. *Publications:* author: Painting Miniatures in Acrylics (1990), miniature section of Painting in Acrylics (English, Danish and French edns. 1991). Author Publisher: 'Painting Original Fine Art Miniatures' - informative series books 1 to 13. Limited editions of minature books; 2 limited edns of miniature paintings (1997); Collecting Contemporary Original Fine Art Miniature Paintings (1998); Tasmania 2000 Turner Miniature Collections (2000); Miniature Artists of America Turner 2000 (2000); Clearwater Florida Turner Miniature Collections (2001); Original Fine Art Miniature Paintings with Words 2002 (2002); Old English Apples-The Turner Brothers-Aldeby Norfolk (2003); Collections of Original Fine Art Miniature Paintings 2004 (2004); East Norfolk and East Suffolk Old English Apples (2004); Bringing You Love for the New Year (2005); East Anglian Old English Apples (2005); East Anglian Old English Apples (2006); Best of Show Original Miniature Paintings 2002 (2006); Tasmania 2008 Turner School Collection (2007); 2008 Turner Collection (2008); 2008 Tasmania Collection (2008). *Works Reproduced:* Actual size reproduction of miniature painting for stamp issued by the Swiss publishers of Who's Who in International Art in recognition of his art and artistic activities, copies of this stamp deposited in postal museums by the publishers. *Principal Works:* ongoing principal work 'The Turner Miniature Painting Collection of Old Apple Varieties', now in it's fifth year with over 250 paintings completed. *Clubs:* Who's Who Art Club International. *Misc:* Founder of the Turner School of Miniature Painting promoted by Original Fine Art Miniature Paintings, website and miniature books. *Signs work:* "C.B. Turner." *Address:* 6 Gablehurst Ct., Long Lane, Bradwell, Gt. Yarmouth, Norfolk NR31 7DS. *Email:* tsofmp@fsmail.net *Website:* http://miniaturepaintings.mysite.orange.co.uk

TURNER, Derek, Xeron Painting Competition First Prize; East/West Contemporary Art Online Competition. *Medium:* acrylic. *b:* London, 27 Aug 1934. *Studied:* Beckenham School of Art (National Diploma in Design). *Exhib:* Gallery Circus Circus, Osaka, Japan; Gallery Le Deco, Paris; Stanley Picker Gallery, Kingston upon Thames; Mariners Gallery St.Ives; Bankside Gallery, London; A la Galerie E-Space, Paris; Battersea Arts Centre, London; Royal Society of Arts, London; Menier Gallery, London; Rooksmoor Gallery, Bath.

Works in collections: Hounslow & Spetthorne Trust; Hillingdon Hospital; West Middlesex Hospital. *Address:* 45 Templemere, Oatlands Drive, Weybridge, Surrey, KT13 9PA. *Email:* turnerjdg@aol.com

TURNER, Helen Louise, BA Hons. *Medium:* oil, watercolour, acrylic, mixed media, drawing, prints. *b:* Bromley, 23 Jun 1964. *Studied:* Canterbury College of Art (1982-86). *Represented by:* HQ Gallery, Lewes, East Sussex. *Exhib:* one person shows: HQ Gallery, Lewes (2008), 'Artist of the Day', Flowers Central, Cork Street (2006), Trinity Arts Centre, Tunbridge Wells (2005), Rochester Art Gallery (2005). Group exhibitions: Olympia Art Fair (2004), John Moores 22 The Walker Art Gallery, Liverpool Biennale (2002), Sussex Arts Club, Brighton (1997), Brighton Museum and Art Gallery (1994), Smiths Gallery, Covent Garden, London (1992). *Works in collections:* private and corporate. *Signs work:* "H Turner". *Address:* 14 Castle Ditch Lane, Lewes, East Sussex, BN7 1YJ.

TURNER, Helen Margaret Fordyce, (née REID); DA Edin.; Daler-Rowney Painting Award (MAFA, 2000); Still Life Award (RI, 2003); Bessie Scott Award (2006) Paisley Art Institute Annual Open Exhbn. *Medium:* oil, watercolour. *b:* Torphins, Aberdeenshire, 21 Apr 1950. *d of:* William Reid. *m:* Clive D.R.Turner. two *s. Educ:* Ross High School, Tranent, East Lothian. *Studied:* Edinburgh College of Art (1967-71); Moray House College of Education (Edin.)(1971-72). *Represented by:* Walker Gallery, Harrogate. *Exhib:* in open exhbns with: RBSA; MAFA; RSA; RSW; RGI; RWS; Royal Institute of Painters in Watercolour; Singer & Friedlander/Sunday Times Watercolour Competition; Lake Artist Society Annual Exhbns; various gallery mixed exhbns. *Publications:* feature in 'The Lake Artists Society-A Centenary Celebration' (pub.2004). *Works Reproduced:* RWS/RGI catalogues. *Principal Works:* still life, landscape. *Clubs:* elected member Lake Artists Society. *Signs work:* 'H.M.F.TURNER'. *Address:* 4 Yeats Close, Kendal, Cumbria LA9 5HY.

TURNER, Jacquie, B.A.; painting in mixed media on paper;. *b:* 27 Mar., 1959. *m:* Nigel Wheeler. three *s.* one *d. Educ:* Rickmansworth School, Herts. *Studied:* Winchester School of Art (1979-81). *Exhib:* Linda Blackstone Gallery, Pinner, Middlesex. *Works in collections:* Leics. Coll. for schools and colleges, Norsk Hydro Oslo, Adam Bank London, Shangri La Hong Kong. *Publications:* The Encyclopaedia of Acrylic Techniques by Hazel Harrison (Headline), How to Capture Movement in Your Paintings by Julia Cassels (Northlight Books), Artists Manual (Collins), Mixed Media Pocket Palette by Ian Sidaway (Northlight Books), Israel at 50 (Linda Blackstone Gallery). *Signs work:* "Jacquie Turner." *Address:* Fairview House, Chinnor Rd., Bledlow Ridge, Bucks. HP14 4AJ. *Email:* jacquieturner@talk21.com *Website:* www.jacquieturner.com

TURNER, Lynette, Hons.B.Sc. (Zoology, 1968), H.N.D.D. (Graphic design, 1970); printmaker in coloured etchings using zinc. *b:* London, 28 May 1945. *d of:* Engineer Rear-Admiral A. Turner. *Educ:* Hall School, Wincanton, Som., Manchester University. *Studied:* Brighton Art School (1963), City and Guilds Art

School (1969, etching), Manchester Art School. *Exhib:* Century Gallery, Henley (1976), Margaret Fisher Gallery (1976), R.A. (1977), S.E. London Art Group, Y.M.C.A., Gt. Russell St., WC1. (1983), R.A. Summer Show (1987), December 1989 exhbn. in Crypt of St. Martin-in-the-Fields, (etchings and water-colours), writing and illustrating comic strip adventures. *Clubs:* Falmouth's Royal Cornwall Polytechnic Soc. *Signs work:* "Lynette Turner." *Address:* Pendynas, Minnie Pl., Falmouth, Cornwall TR11 3NN.

TURNER, Martin William, N.D.D. (1961), R.O.I. (1974), N.S. (1975); painter in oil, acrylic and water-colour, printmaker;. *b:* Reading, 3 Oct 1940. *s of:* William Alexander Turner. *Educ:* Gravesend Technical School. *Studied:* Medway College of Art under David Graham, C. Stanley Hayes. *Exhib:* R.A., R.O.I., R.B.A., N.S., R.S.M.A., R.E. *Works in collections:* Abbot Hall Gallery, Swansea University, Cardiff Museum, Glamorgan Educ. Com., Liverpool A.G. *Works Reproduced:* articles for Leisure Painter. *Clubs:* RI, NSPS, Hampstead Artists' Council. *Signs work:* "Martin Turner." *Address:* 24 Marshall Rd., Rainham, Kent ME8 0AP.

TURNER, Nicholas James, RWA (2003); BA Hons Fine Art. *Medium:* oil. *b:* London, 23 Jun 1972. *Studied:* UWE, Bristol. *Exhib:* solo shows: RWA (2003, 2007); Thompson's London (2004); Parkview Paintings (1998, 2000); group exhbns: Redrag Gallery, Cotswolds; Musee Beaux Arts, Bordeaux, France (1998); RWA Autumn Shows since 1994; Art Ireland, Manchester Fair (2006), Rowley Contemporary (2007). *Works in collections:* RWA Permanent Collection; Marquess of Bath; Law Society. *Commissions:* Unite Plc. *Works Reproduced:* Rembrandt's Hat; Signature series art cards; 'Pictures in an Academy' (Redcliffe Press). *Principal Works:* landscapes Bristol and hillsides of Spain (imaginary and observed). *Recreations:* jazz drummer. *Misc:* intimate semi-romantic oil on cardboard panels of small scale, elements of pointilism and post-impressionism. *Signs work:* 'Nicholas Turner'. *Address:* 2 Algiers Street, Windmill Hill, Bristol BS3 4LP. *Email:* nicknak4654@hotmail.com

TURNER, Prudence, freelance artist in oil on canvas; Scottish landscape painter specifically since 1966; plus portraiture, seascapes and dream-fantasies. *b:* 15 Mar., 1930. *d of:* Brigadier Charles Ernest Windle, O.B.E., M.C. *Studied:* in India, Egypt, France and England, learning from artists already famous. Nationally recognized in England in 1934. Fine Art Publication copyrights purchased from 1967 onwards by well-established publishers and given international circulation, including limited editions of signed prints. *Works in collections:* U.K., and Overseas. *Commissions:* Professional: constant, including royalty. *Signs work:* "Prudence Turner." *Address:* 49 Romulus Ct., Justin Cl., Brentford Dock Marina, Brentford, Middx. TW8 8QW.

TURNER, Silvie, publisher, writer, artist, curator, book/internet based projects;. *b:* 19 Oct., 1946. two *d. Studied:* Corsham (1965-68), University of Brighton (Post grad., 1968-70). Work in permanent collections worldwide.

Publications: about 25 on various print, paper, book subjects. *Clubs:* Chelsea Arts. *Signs work:* "Silvie Turner." *Address:* 204 St. Albans Ave., London W4 5JU.

TURNER, William Ralph, RCA; artist in oil and water-colour. *b:* Chorlton-on-Medlock, 30 Apr 1920. *s of:* Ralph Matthew Turner. *m:* Anne Grant (decd.). one *d. Studied:* Derby College of Art (1945). *Exhib:* R.B.A., R.I., R.C.A., O'Mell Galleries London, Christopher Cole Galleries, Henley-on-Thames, Pitcairn Galleries, Knutsford, Boundary Gallery, London. *Works in collections:* Manchester Educ. Com., Stockport A.G., Saab (Manchester) Ltd.; private collections in New York, Los Angeles, Kenya, Portugal, Switzerland, Zaire. *Publications:* Cheshire Life Magazine. *Signs work:* "William Turner". *Address:* (studio) Renrut, 23 Gill Bent Rd., Cheadle Hulme, Cheadle, Ches.

TURPIN, Louis, Dip.Ad.(Hons.) Fine Art (1971); painter in oil on canvas; South East Arts Major Award. *b:* 25 Apr 1947. *s of:* Digby Denis Turpin, film director. *m:* Davida Smith. two *s. Educ:* Alleyns, Dulwich; Sunbury Grammar School, Sunbury-on-Thames. *Studied:* Guildford School of Art (1967-68), Falmouth Art School (1968-71). *Exhib:* Beaux Arts, Bath, N.P.G., Bohun Gallery, Henley-on-Thames, Rye A.G., R.A., R.S.P.P., Rona Gallery, London, Fosse Gallery, Stow-on-the-Wold. *Works in collections:* Rye A.G., South East Arts, Towner A.G., Bath University, John Radcliffe Hospital, Oxford, Nat.West Bank, Dame Stephanie Shirley Collection, Sir Paul MaCartney, Dr. Bolling Feild, Fred Olsen. *Commissions:* Miss Pears, Bedruthan Steps Hotel, Priors Court School. *Publications:* The Painted Garden by Huxley, The Art of Priors Court School. *Clubs:* Rye Soc. of Artists. *Signs work:* "Louis Turpin." *Address:* 19 Udimore Rd., Rye, E. Sussex TN31 7DS. *Email:* louisturpinartist@hotmail.com *Website:* www.louisturpin.com

TUTE, George William, N.D.D. Illustration, N.D.D. Painting, R.A.Cert., M.A. (R.C.A.), R.E., R.W.A.; Landseer and David Murray Scholarships, silver and bronze medals for Drawing and Mural Painting; artist in oil, water-colour, printmaking; freelance graphic designer, wood engraving. *Medium:* oil, watercolour, wood engraving. *m:* Iris Stoltenberg-Lerche. two *s. Studied:* Blackpool School of Art (1951-54); Royal Academy Schools (1954-59); Regent St.Polytechnic (part-time, 1954-56); Royal College of Art (1981-88); Central Schools (part-time, 1959-60), Courtauld Institute (part-time, 1956-57); Royal West of England Academy. *Exhib:* R.A., R.W.A., R.E.; private and public galleries. Exhibits prints and paintings, book illustration and general illustration for commissions, wood engraved illustrations and autographic prints. *Works in collections:* private. *Commissions:* advertising, book illustration. *Publications:* various illustrated: Shakespeare, Rob Roy, The Monk, The Professor, Chris Marlow, etc. *Official Purchasers:* Royal West of England Academy, etc. *Works Reproduced:* RWA, website C.V. *Principal Works:* oil paintings of landscape, figures, autographic prints. Freelance graphic designer. *Recreations:* travel, gardening, collecting 20th century English paintings and engravings. *Clubs:* Society of Wood Engravers (former chairman). *Misc:* lecturer York School of Art

(1961-63), ret. principal lecturer Graphic Design Univ. of W. of England (1963-85). *Signs work:* "G. W. Tute." *Address:* 46 Eastfield, Westbury-on-Trym, Bristol BS9 4BE. *Email:* georgetute@onetel.net *Website:* www.georgetute.com

TUTTIETT, Dora, NDD; David Murray Award RA; RA Cert.; Tutor Fine Art. *Medium:* painter in oil. *b:* Bromley, Kent, 29 Nov 1935. *Educ:* Charterhouse Secondary Modern, Chelsfield, Kent. *Studied:* Bromley College of Art, Royal Academy, Goldsmiths College of Art. *Exhib:* RA, RA West of England, Mall Galleries, Burlington Fine Arts, Bedales, etc. 18 one-man shows. *Works in collections:* Los Angeles, Holland, Scotland, England. *Commissions:* Holland and Scotland, and Bromley portrait. *Publications:* Golden Hands Illustrator, British Medical Association, Illustrations Bristol University Biochemical Dept. Medical Artist. *Clubs:* RA Alumni Association Club; BAS, Blackheath A.S., Bromley A.S.; Bexley Arts Council; Bromley Arts Council. *Address:* 63a Queensway, Petts Wood, Kent, BR5 1DQ. *Website:* www.dorat.yourprivatespace.com/ www.axisartists.org.uk

TWEED, Jill, F.R.B.S., Slade B.A.; sculptor in bronze. *b:* U.K., 7 Dec., 1931. *m:* Philip Hicks. one *s.* one *d. Studied:* Slade School of Art (F. E. McWilliam). *Represented by:* Messums, Cork St., London. *Exhib:* London, Caen, France, Dorset, Gloucesteshire, New York USA. *Works in collections:* H.M. The Queen; Corps of the Royal Military Police, Chichester; Royal Engineers, Mill Hill, London; Austin Reed Ltd., London; Picker Collection, Kingston-upon-Thames, Guernsey Museum C.I. Numerous private collectors. *Commissions:* Large public sculptures commissioned by: Hampshire C.C.; Amec U.K. Ltd., London; Conseil Regionale de Normandie, Caen, France; K.C.C.; Oxon. C.C.; Gosport D.C.; Herts. C.C.; Kent C.C., Millennium Sculpture, Ware, Herts, Cirencester Shopping Centre, Glos. *Signs work:* "Jill Tweed." *Address:* Royal Society of British Sculptors, 108 Old Brompton Rd., London SW7 3RA.

TYDEMAN, Naomi, RI (2004); B.Ed. (Hons.); Welsh Artist of the Year - Watercolour Award; self taught water-colourist, gallery owner. *b:* Taiping, Malaysia, 5 Jun 1957. *Studied:* Trinity College, Carmarthen. *Exhib:* R.I., W.S.W. *Works in collections:* Tenby Museum. *Publications:* several watercolour instruction books. *Clubs:* W.S.W. *Signs work:* "Naomi Tydeman." *Address:* 60 Bevelin Hall, Saundersfoot, Pembrokeshire SA69 9PQ.

TYLER, Carol, BA Fine Art, MA Fine Art; Emma Phipps Award MA Studies, two awards Yorkshire Arts. *Medium:* oil, drawing, mixed media. *b:* Sunderland, 4 Jan 1941. one *s. Studied:* Wolverhampton Polytechnic (BA, 1983-86); Birmingham Insitute Art & Design (MA, 1989/90). *Exhib:* Wills Art Warehouse, London (2001-07), Stroud House Gallery, Stroud, Glos (2004), Ronald Pile Gallery, Ely (2006), Zillah Bell Gallery, Thirsk, N.Yorks (2007), Artco, Leeds (2005-07). *Works in collections:* private. *Commissions:* Grizedale Forest Residency, workshops and exhibitions in hospitals at Birmingham and Dudley. *Publications:* Grizedale catalogue (1995) "Natural Order", Wills Art Warehouse

catalogues 2000-06. *Recreations:* walking, archaeology. *Misc:* currently invloved in restoration of old Mill. *Signs work:* "CAROL TYLER". *Address:* Greystones, Burtersett, Hawes, N.Yorks, DL8 3PH. *Email:* caroltyler@onetel.com *Website:* www.axisweb.org/artist/caroltyler

TYLER, Neil, CAS; Daler Rowney Art Paper Prize (1999). *Medium:* oil, watercolour. *b:* London, 14 Jun 1945. *s of:* James Tyler. *m:* Catherine Rhoda Tyler (nee Pethybridge). *Studied:* 1966-72, tutored in Life Drawing and Portraiture by Haydn Mackey (1881-1979). *Represented by:* Hang:Ups Ltd, NW8 6JN; The Spa Galleries, TN2 5TN. *Exhib:* CAS (1973-4, 1992 onwards); Paris Salon (1974-5); ROI (1971,88,89); A Taste of Brighton at Dieppe Town Hall (1992); Chateau Derchigny-Graincourt (1994); Envermeu Town Hall (1994, 2002); Sussex Open, Brighton (2003). *Works in collections:* internationally. *Commissions:* various townscapes in Normandy; landscapes and still life in UK. *Works Reproduced:* The Daler Rowney Art Paper (1999). *Principal Works:* recycling wine bottles. *Recreations:* Chelsea Art Society. *Signs work:* 'NEIL TYLER', 'N.TYLER'. *Address:* 16 Westbourne Park, Scarborough, Yorkshire YO12 4AT.

TYSON, Rowell Edward Daniel, A.R.C.A., R.B.A.; painter in oil, water- colour and pastel. *b:* London, 5 Jan 1926. *s of:* Rowell Tyson, engineer. *m:* (1) Kathleen. one s. (2) Monica. *Studied:* Tunbridge Wells School of Art, Beckenham School of Art, Royal College of Art (1946-1950), fourth year scholarship (1949- 1950). Senior Mem of Royal Soc. of British Artists. *Exhib:* R.A., R.S.A., R.B.A., R.O.I., R.S.M.A., London and provincial galleries, touring exhbns., and Nevill Galleries, Canterbury. *Works in collections:* include Leo-Burnett, Miles Laboratories, Shell, Lopex, Leicester Educ. Com., Carlisle City A.G., K.C.C., Paxus, Sumicorp Finance Ltd., Merrill Lynch, Arthur Andersen & Co., Qatar National Bank, Inst. of Directors. *Publications:* included in '20th Century British Marine Painting' by Denys Brook-Hart. *Signs work:* "ROWELL TYSON." *Address:* 29 Fisher St., Sandwich, Kent CT13 9EJ.

TYSON EDWARDS, Marian, DFA; sculptor in bronze, cement fondu, terracotta. *b:* Manchester, 2 Oct 1937. *d of:* Henry Tyson Edwards, civil servant. *m:* John T. Sharples. one *s.* one *d. Studied:* Liverpool College of Art and High Wycombe College of Art. *Exhib:* Mall Galleries, galleries in Henley, Birmingham, Chalfont, etc. *Works in collections:* Windsor and Eton Fine Art. *Signs work:* "M. Tyson Edwards." *Address:* Wispington House, Worster Rd., Cookham, Berks. SL6 9JG.

U

UGLOW, Euan, painter in oil; First Prize John Moores (1972); awarded Austin Abbey Premiere Scholarship; artist Trustee, National Gallery, London; teacher at Slade School of Art; Fellow, London Institute;. *b:* London, 10 Mar 1932. *s of:* E. W. Uglow, company accountant. *Educ:* Strand Grammar School for Boys. *Studied:* Camberwell School of Art and Slade School. *Exhib:* Beaux Arts

Gallery, London (1961), Gardner Centre, Sussex University, Brighton (1969), Whitechapel A.G. (1974), Browse & Darby, London (1977, 1983, 1989, 1991, 1997, 1999), Salander O'Reilly, N.Y. (1993). *Works in collections:* Tate Gallery, Arts Council, Glasgow Art Gallery, Southampton Art Gallery, South Australia National Gallery, Liverpool University, Ferens A.G., Hull, Government Art Collection, Metropolitan Museum of Art, N.Y., British Council, London, British Museum, London. *Publications:* 'Euan Uglow' (Browse & Darby, 1998). *Clubs:* Garrick. *Misc:* Gallery & Agent: Browse & Darby, Cork St., W1. *Signs work:* "Euan Uglow." *Address:* 11 Turnchapel Mews, Cedars Rd., London SW4 0PX.

UHT, John, R.I. (1976); painter in oil and water-colour, sculptor in bronze, marble, wood, lead sheet; Buzzacott Award RI (2002); Frank Herring & Sons Award, RI (2004). *Medium:* watercolour. *b:* Dayton, Ohio, 30 Aug 1924. *s of:* E. J. Uht, occupational therapist. *m:* Jill Gould. two *s.* one *d. Educ:* Danville High School, Illinois. *Studied:* University of Illinois Fine and Applied Arts College (1943-47, Marvin Martin, John Kennedy) and Ishmu Naguchi (1948). *Exhib:* Art, U.S.A. (1958), Reading Museum (1970), Edwin Pollard Gallery, Barry M. Keene Gallery, R.A., R.I., Shell House Gallery, Hereford; Peter Hedley Gallery, Dorset; Lincoln Joyce Gallery, Surrey. *Works in collections:* R.A. (bronze), Nelson Rockefeller (bronze). *Clubs:* R.I. *Signs work:* painting, "JOHN UHT," sculpture, "UHT." *Address:* 44 Dorchester Rd., Weymouth, Dorset DT4 7JZ.

UNDERWOOD, George, painter in oil, water-colour, acrylic. *b:* Bromley, Kent, 5 Feb 1947. *m:* Birgit. one *s.* one *d. Educ:* Bromley Technical High School. *Studied:* Beckenham Art School (1963), Ravensbourne College of Art (1964-1965). *Represented by:* The Portal Gallery, 15 New Cavendish Street, London W1G 9UB. *Exhib:* solo exhib., About Face, London (1997), group exhibs. in Japan, Copenhagen, Spain, U.K., R.A. Summer Exhibs. (1998 & 2001). *Works in collections:* David Bowie Collection (15 works). *Commissions:* Helena Bonham Carter, David Bowie, Mike Leigh (Topsy-Turvy film poster 1999). *Publications:* illustrated many book covers, authors include, Julian Barnes, John Fowles, William Styron, Russell Hoban. *Signs work:* "george underwood." *Address:* 90 Priory Rd., Hornsey, London N8 7EY. *Email:* underwoodgeorge@hotmail.com *Website:* www.georgeunderwood.com

UNDERWOOD, Keith Alfred, Leverhulme Research Award in Fine Art (France, 1957-58); realist painter in oil and water-colour; sculptor, restorer, designer. *b:* Portsmouth, 21 Jun 1934. *s of:* the late A. T. Underwood, B.E.M., late R.E. *Educ:* Monmouth School (1946-53). *Studied:* Newport College of Art (1953-57) under the late Tom Rathmell, A.R.C.A, and the late Hubert Dalwood; West of England College of Art (1960-61), Diploma in Education. *Exhib:* Welsh Arts Council, Pictures for Schools, British Art for Moscow, Young Contemporaries, Mall Galleries, Chepstow locale. *Works in collections:* Margaret Cleyton Memorial restoration (St. Mary's, Chepstow 1984), Onitsha Cathedral, Nigeria (portrait bronze 1985), Earl of Worcester armorial sculpture (Chepstow Town Gate 1988); large historical mural, Drill Hall, Chepstow, and town map

(1991); Caldicot town map (1994); twelve stained glass cartoons for windows in SS. Richard and Alexander, Bootle (1994); paintings in private collections: U.K., U.S.A., Australia, S. Africa and Netherlands, Portskewett & Sudbrook Map 2002. *Recreations:* local history. *Clubs:* Monmouthshire Antiquarian Association. *Misc:* since 1983 involved in heraldic, set and prop design for the pageants and son et lumiere productions of the Chepstow Biennial Festival in Chepstow Castle and Tintern Abbey; costume/prop design Usk Castle Pageant (2005). *Signs work:* "KAU" until c1974, "K. Underwood" and "Keith Underwood" thereafter. *Address:* 1 Madocke Rd., Sedbury, nr. Chepstow, Monmouthshire NP16 7AY.

UNWIN, Bren, RE, NSA; BA (Hons) Fine Art; MA (Research) Fine Art; Gewn May award, RE. *Medium:* printmaking, film, paint. *b:* Kent, 1 Sep 1956. *d of:* Leslie Hall. *m:* Stephen Unwin. two *s. Educ:* Presdales Girls School, Ware. *Studied:* University of Hertfordshire. *Represented by:* Cornwall Contemporary Gallery, Great Atlantic Galleries. *Exhib:* Newlyn Art Gallery, Cornwall; Bankside Gallery, London; Lemon St. Gallery, Truro; Mall Galleries, London; Gallery Tresco, Isles of Scilly. *Works in collections:* Ashmolean Museum; various private collections. *Publications:* 'Bren Unwin' ISBN 1 898543 860. *Principal Works:* films: 'Lime', 'Length'; prints: Palimpsest Seies. *Recreations:* walking, reading, growing vegetables. *Signs work:* 'Unwin'. *Address:* 24 Bosorne Road, St.Just in Penwith, Penzance, Cornwall, TR19 7JJ. *Email:* brenunwin@btopenworld.com *Website:* www.brenunwin.com

UPSON, (Rosalie) Anne, NDD, RMS, NAAT, PGCA Phys. *Medium:* oil, watercolour, enamel on copper. *b:* Wigan, 20 Apr 1938. *d of:* Rev.E.A.Marsh. *m:* Peter Norman Upson. one *s.* one *d. Educ:* Slope Hall (St.Ives, Huntingdon); Maidstone Tech. for Girls. *Studied:* Maidstone Art College. *Exhib:* Royal Miniature Society. *Works in collections:* Royal Miniature Collection. *Commissions:* special commission animals on enamel. *Recreations:* equine, canine. *Misc:* animal physiotherapist for 25 years. *Signs work:* 'RA Upson', 'A', 'R.Anne Upson' and monogram. *Address:* 1 New Barn Cottages, Loughborough Lane, Lyminge, Folkestone CT18 8DG.

UPTON, Mark Lundy, *Medium:* oil, watercolour, drawing, prints. *b:* Marlborough, 9 Dec 1964. *s of:* Roger Upton. *Studied:* St.John's, Marlborough; Swindon College of Art. *Exhib:* The Osborne Studio Gallery, London; Mathaf Gallery, London; Rocham Gallery, Jeddah, Saudi Arabia; The Park Grosvenor Gallery, London; William Marler Gallery, Cirencester; The Gallery, Cirencester; The McEwan Gallery, Aberdeenshire; The Lee Gallery, Cork, Ireland. *Works in collections:* The Late Queen Elizabeth the Queen Mother; most of the Middle Eastern Royal families. *Commissions:* Injured Jockeys Fund; Spinal Injuries Association; British Horseracing Board; Countryside Alliance; Fahad Bin Sultan Falconry Centre, Riyadh. *Recreations:* falconry, hunting, racing. *Signs work:* 'M.L.UPTON'. *Address:* Plough Cottage, Bath Road, Marlborough Wilts SN8 1PT. *Email:* mark@markupton.com *Website:* www.markupton.com

URQUHART, Anne, MA, RCA. *Medium:* painting/ oil. *b:* Chorley, Lancs, 29 Ocy 1962. *Educ:* Royal College of Art. *Represented by:* Benjamin C. Hargreaves Contemporary Art, 90 Kenyon Street, Fulham, London SW6 6LB. *Exhib:* British Consulate, New York USA (2002), Montserrat Gallery (2002), 'Works on Paper' Royal College of Art (2002). *Works in collections:* Karen Burke USA; Stephenson Harwood London; Shannon Smith USA; British Airports Authority. *Clubs:* Chelsea Arts Club. *Address:* 147a Bermondsey Street, London SE1 3UW. *Email:* anne@home147a.demon.co.uk *Website:* www.nonsafety.co.uk/pauk.html

UTERMOHLEN, William C., painter;. *b:* Philadelphia, Pa., 1933. *Studied:* Pennsylvania Academy of Fine Art, Philadelphia; Ruskin School of Drawing, Oxford. *Exhib:* one-man shows: Traverse Theatre Gallery, Edinburgh Festival (1963), Bonfiglioli Gallery, Oxford (1965, 1967), Nordness Gallery, N.Y. (1967), Marlborough New London Gallery (1969), Galerie d'Eendt, Amsterdam (1970, 1971), Mead Art Museum, Amherst College, Amherst, Massachusetts (1974). Visiting artist, Amherst College (1972-74). Mural, Liberal Jewish Synagogue, St. Johns Wood, London (1981); mural, Royal Free Hospital, Hampstead (1985). *Publications:* illustrated, Ten war poems by Wilfred Owen (1995). *Signs work:* "Utermohlen." *Address:* 35 Blomfield Rd., London W9 2PF.

V

VAHEY, Lorna, BA Fine Art (1967); narrative and autobiographical painter. *Medium:* oil, watercolour, usually very small scale. *b:* Pett, Sussex, 22 Apr 1946. *d of:* Fred & Zoe Vahey (artists). two *d. Educ:* Rye Grammar School. *Studied:* Brighton College of Arts and Crafts(1962-1967). *Exhib:* RA, RSA, NEAC, HQ, Lewes; Red Biddy, Shalford; Stratton Gallery, Hastings; Cross Gate Gallery, Kentucky, USA; Alex Gerrard, Chichester Open, Brighton Museum, Hastings Museum, Rye Art Gallery. *Works in collections:* Hastings Museum, private collections. *Recreations:* more work. *Clubs:* Hastings Against War. *Signs work:* "L. VAHEY." *Address:* 145 Emmanuel Rd, Hastings, E. Sussex TN34 3LE. *Email:* lvahey@hotmail.com *Website:* www.hastingsarts.net

VAIZEY, Marina (Lady Vaizey), B.A. Radcliffe, M.A. (Cantab.); Art Critic, Sunday Times (1974-91); Editor, N.A.C.F. (1991-94), Editorial Consultant, N.A.C.F. (1994-98); Art Critic, Financial Times (1970-74); Past Trustee, National Museums and Galleries on Merseyside, Imperial War Museum, South Bank Centre, trustee London Open House, Geffrye Museum, National Army Museum. *b:* New York City, 16 Jan 1938. *m:* Lord Vaizey (decd. 1984). two *s.* one *d. Publications:* 100 Masterpieces of Art (1979); Andrew Wyeth (1980); Artist as Photographer (1982); Peter Blake (1985); Christo (1990); Christiane Kubrick (1990); organised Critic's Choice, Tooth's (1974); Painter as Photographer, Arts Council (1982-85); Shining Through (Crafts Council, 1995), Sutton Taylor (1999), Art the Critics Choice (1999); Women Collectors (1999); The British Museum Smile (2002). *Address:* 24 Heathfield Terr., Chiswick, London W4 4JE.

VALENTINE, Barbara, N.D.D. (Illustration), RMS, HS, MAS-F, SLM; miniaturist in oil and water-colour, art tutor; many international and national awards. *b:* London, 1943. *m:* Louis Dodd, marine artist (decd.). one *s*. one *d*. *Studied:* Goldsmiths' College (1960-64, Betty Swanwick). *Exhib:* R.A. Summer Exhbns (1989-99),; RMS; annual miniature shows at Medici and Llewellyn Alexander Galleries. *Works in collections:* private collections internationally. *Publications:* featured in 'How to Paint Miniatures', 'Miniature Painting', etc. *Works Reproduced:* articles in art magazines, books on miniatures, fine art prints. *Recreations:* rose growing. *Clubs:* R.M.S., M.A.S.-F. *Misc:* teaches adult education leisure classes, and puts on two or three exhbns a year of her students work. *Signs work:* "B.V." *Address:* Mountfield Pk. Farmhouse, Mountfield, Robertsbridge, E.Sussex TN32 5LE. *Email:* barbara.valentine@virgin.net

VALENTINE, Dennis Robert, N.D.D.(1953), A.T.D. (1956); professional artist in oil, pen and ink, charcoal, water-colour. *b:* Leicester, 12 Jan 1935. *s of:* Robert and Olive Valentine. *m:* Anne Valentine. two *s*. two *d*. *Studied:* Leicester College of Art (D.W.P. Carrington), Plymouth College of Art. *Exhib:* Lincolnshire Artist Soc. regularly since 1966, Spectrum (Arts Council) 1971, Corby Glen Gallery, Lincs.: one-man show (1999): John Laing Art Competition Mall Galleries (1989), Singer and Friedlander/Sunday Times W/c competition (2002). *Works in collections:* private collections. *Commissions:* portrait of Miss Butcher, one-time principal of Bishop Grosseteste College, Lincoln (1990). *Clubs:* Lincolnshire Artists Soc. *Address:* Wheelwright Barn, 6 East Rd., Navenby, Lincoln LN5 0EP.

VALENTINE-DAINES, Sherree E., Dip. A.D., U.A. (1983), S.W.A.; painter in oil. *b:* Effingham, 1956. *d of:* Rose & Ralph Valentine-Daines, master builder and stone mason. *m:* Mark Alun Rowbotham. two *s*. three *d*. *Studied:* Epsom School of Art and Design (1976-80, Leslie Worth, Peter Petersen). *Exhib:* R.B.A., R.A., Tate Gallery, R.O.I., R.W.S., R.P., Royal Overseas League, N.E.A.C., U.A., P.S., Olympic Games Exhbn., Royal Festival Hall, Barbican, Laing Landscape, N.S.P.S. *Commissions:* include Test Cricket, 5 Nations Rugby, Royal Ascot, Henley Royal Regatta. *Signs work:* "S.E.V.D." *Address:* Park Lane Fine Arts, 102 The Street, Ashtead, Surrey KT21 1AW. *Email:* lorna@parklanefinearts.com *Website:* www.parklanefinearts.co.uk

VANDER HEUL, Yvonne Christine, BA Fine Art; Daily and Sunday Telegraph 'Best Display of British Fashion' (National and London Trophy, 1962). *Medium:* mixed media, oil, watercolour, drawing. *b:* South Africa, 8 Sep 1939. *d of:* Winnefred Griffiths & Piet Vander Heul. *Studied:* Hammersmith College of Art and Building (1965); Regent St.Polytechnic (sculpture, 1961-65); University of Cape Town (1980). *Exhib:* RA Summer Exhbn (1997); Royal College of Music (1998); London South African Embassy (1993); Art of Africa, Knightsbridge (1993); Fox Theatre, Atlanta, Georgia, USA (1990); World Congress Centre (1990); 'Art Scene' Cape Town (1985); Nico Malan Opera House foyer, Cape Town (1983); Museo Nationale Bellas Artes, Rio de Janeiro, Brazil (1982).

Commissions: Swiss Embassy, London (1999); private commissions. *Publications:* 'Dictionary of Art and Artists' ed. Esmé Berman (Everaad Reed Gallery, S.Africa, 1980). *Official Purchasers:* RA Summer Exhbn work sold £1200. *Works Reproduced:* in Chelsea Festival Program (1997-2005). *Principal Works:* ballet, swimming, orchestral. *Recreations:* swimming, dance, russian ballet, travel, international venues. *Clubs:* Chelsea Trinity Arts and Crafts Guild. *Misc:* all work produced en situ, during performance, e.g. Covent Garden Opera House, Cadogan Hall Chelsea, Royal Festival Hall. *Signs work:* 'Y.Vander Heul', sometimes 'Yvonne Vander Heul'. *Address:* 49 Draycott Place, Flat 3, London SW3 3DB. *Email:* heul39@yahoo.co.uk *Website:* www.drawingwaterworks.net

van DOORSSELAERE, Joyce, *Medium:* oil, watercolour, drawing. one *d.* *Educ:* Royal Navy School, Regents Park Central, Sondes Place County Secondary, Surrey (left with A's in Art, English and Maths, B's History and Geography). *Studied:* City Literary Institute (St.Martins in the Fields)(1962); Pitmans College (1950s). *Exhib:* Royal Academy (1997, 2001, 2006); The Mall; 'Not the Royal Academy'; New York Gallery (2001); Art for Life, St.James' (2002); New Gallery, Store St,.WC1. *Works in collections:* Jordanian Royal Palace Collection; Michel Grunberg, architect; Peter Letts; Lady Margaret Thatcher; Great Ormond Street Hospital, etc. *Recreations:* cycling, reading, writing, music, theatre, film world. *Signs work:* 'Joyce van Doorsselaere'. *Address:* 11 High Street, West Moseley, Surrey KT8 2NA.

VAN DUYN, Jeroen, SWE. *Medium:* wood engraving, linocut, watercolour. *b:* The Hague, Holland, 31 May 1952. *Studied:* Vrije Akademie, Psychopolis, The Hague (1969-73). *Exhib:* Galerie Edison, The Hague; since 1989 regular contributions to the SWE Annual Exhibition; The Line Gallery, Linlithgow. *Works in collections:* Roberto Peccolo, Livorno, Italy. *Commissions:* illustrations for 'Tien Verzen Voor Een Doode', Avalon Pers Woubrugge. *Publications:* 3 volumes of privately printed linocut illustrated poetry. *Works Reproduced:* Engravers III; An Engravers Globe. *Signs work:* 'JEROEN VAN DUYN'. *Address:* Coffray, Flety 58170 France.

VANGO, David, self taught artist in oil and mixed media; early work mostly perceptual reductionism. Since 1994 large metamorphic abstract constructions; recent work: creating a convincing, deceptive sensation of 3D real space and form on a 2D surface: Illusionism. *b:* London, 18 Feb 1950. one *s. Studied:* private studies Witt Library, and galleries and museums U.K. and abroad. *Exhib:* 6 one-man shows: Vidal Gallery, Barcelona; Picture Workshop; Gallery Three, City Art House, Lincoln; Loggia Gallery; 23 group shows, including: F.P.S. Gagliardi Gallery, Kings Rd.; Paxhaven Studio; Foresters Court; Black Horse Chambers, Sam Scorer Gallery, Drury Lane, Gallery on the Strait, Lincoln; Artworld at the NEC; Manchester Art Show, IMEX. *Works in collections:* Japan, France, Spain, Germany, Italy, Australia, America, etc. *Commissions:* Large abstract construction (Nicron 1) for number, 10. (Lincoln), portrait Colin McFarlane (actor). *Publications:* contributor to British Contemporary Art (1993), The

BritArt Directory (2000), Dictionary of International Biography (IBC, Cambridge, 2004). *Address:* 68 Alexander Terr., Lincoln LN1 1JE. *Email:* rosie.ritchie@btinternet.com

VAN INGEN, Jennifer Anne, NDD (1962). *Medium:* acrylic, mixed media, oil, drawing. *b:* Wormley, nr.Witley, Surrey, 12 Mar 1942. *d of:* Mr & Mrs C.L.Vincent. *m:* John. one *s.* one *d. Educ:* Convent of the Sacred Heart, Barnes. *Studied:* Ealing School of Art. *Represented by:* The Bruton Street Gallery, London. *Exhib:* RA Summer Exhbn (1996); RBA, RGI, NEAC, RSA, The Bruton Street Gallery (1997, 2001 solo/1998, 1999, 2002 mixed); Drian Galleries, London (1969-88); Black Swan Arts, Frome, Somerset (solo, 2003); Sue Rankin Gallery, London (1993); 238 Gallery, Dorking, Surrey (2995, 2006 mixed exhibition). *Commissions:* The Royal Caribbean Cruise Lines (1997, London Contemporary Art). *Publications:* The Artist Magazine, article on mixed media (1993, 2001). *Works Reproduced:* The Artist Magazine. *Recreations:* music, theatre, swimming. *Clubs:* National Art Fund, NADFAS, Kingston, Surrey. *Signs work:* 'Mrs Jenny Van Ingen'. *Address:* 131 Ember Lane, Esher, Surrey KT10 8EH. *Email:* johnvaningen@tiscali.co.uk

VAN NIEKERK, Sarah Compton, RE (1976), SWE (1974), RWA (1992), HonRBSA; wood engraver; Tutor, City and Guilds of London Art School (1978-2000), RA Schools (1976-86), West Dean College; Awards: Royal Bath & West Soc. Show (1992, 1995), Cornellissen Award, SWE Prize etc. *Medium:* wood engraving. *b:* London, 16 Jan 1934. *d of:* D.J. Hall, writer. *m:* Chris van Niekerk. one *s.* two *d. Educ:* Bedales. *Studied:* Central School of Art, Slade School of Fine Art. *Exhib:* RA, Bankside Gallery, USA, 20 one and 19 two-man exhbns, Artmonsky Arts, Royal Cambrian Academy, Victoria Gallery, National Print, etc. *Works in collections:* V. & A., Fitzwilliam, Ashmolean, National Museum of Wales, National Library of Wales, UCLA, USSR, Fremantle Arts Centre, Graves, Hereford Museum. *Commissions:* illustrator for: Folio Soc., Gregynog, OUP, Readers Digest, Pavilion, Virago, Rider. *Publications:* The Engraver's Cut. Sarah van Niekerk (Primrose Academy Press). *Recreations:* gardening, reading, cooking. *Signs work:* "Sarah van Niekerk" in pencil. *Address:* Priding House, Saul, Glos. GL2 7LG.

VAN ROSSEM, Ru, Knight of the Order of the Netherlands Lion (2003); Hon. Mem., Academy of Fine Arts, Florence; Premio Milano (1988); Euro-medal in gold, Bonn; Gold Medal Biennale, Perugia; M.A.I. International Graphic Prize, Biennales Gorizia, Italy, Malbork, Poland; Head of Graphic Department, Tilburg Academy of Fine Art, Holland. *b:* Amsterdam, 19 Mar 1924. *s of:* Karl van Rossem. *m:* 1st Miriam Pollock (decd.); two s. one d. 2nd Marianne van Dieren, one s. *Educ:* Rijksmuseumschool of Fine Art; Grammar School, Zaandam. *Exhib:* most European countries and U.S.A. *Works in collections:* Rijksmuseum and Municipal Museum, Amsterdam, Boymans Museum, Rotterdam, Bibliothèque Nationale, Paris, Museum of Modern Art, New York, National Museum, Cracow, Cincinnati Museum, etc. *Commissions:* sculpture for St. John's Cathedral, 's

Hertogenbosch, sculpture for the town of Schyndel. *Publications:* biography written by Frans Duister (1977, 1994), biography by Joep Monnikendam (2001). *Signs work:* "Ru Van Rossem." *Address:* Burg, Vonk de Bothstr. 54, 5037NL Tilburg, Holland.

VAN STOCKUM, Hilda, H.R.H.A. (1989); painter in oil. *b:* Rotterdam, Holland, 9 Feb 1908. *m:* Spike Marlin (decd.). two *s.* four *d. Educ:* Ryks-Academy, Amsterdam. *Studied:* Dublin School of Art, André L'Hote, Paris. *Exhib:* regularly at R.H.A., Dublin. *Works in collections:* National Gallery, Dublin. *Publications:* 24 childrens books written and illustrated, including A Day on Skates, and The Winged Watchman. *Signs work:* "HvS." *Address:* 8 Castle Hill, Berkhamstead, Herts. HP4 1HE.

van ZWANENBERG, Miki, NDD Hornsley College of Art (1966) Fine Art; previously Production Designer in film, tv and theatre (1968-97), Cannes Film Festival (1989) for 'Distant Voices/Still Lives' by Terence Davies. *Medium:* painting and sculpture. *b:* London, 23 May 1945. *d of:* Claude Kahn and Andree Weiss. *m:* William van Zwanenberg. two *s. Educ:* Woodhouse Grammar School, London. *Studied:* Motley Design School (1968). *Represented by:* since 1997: Andrew Coningsby Gallery; as a painter: Benjamin Hargreaves. *Exhib:* New Business Academy, London (group, 1998, sculpture 2004), Coningsby Gallery (1998, 2001, 2002), The Engineer (2000, 2003), Leo Burnett Gallery (2001), Affordable Art Fair (Benjamin Hargreaves, 2002-06), Andrew Coningsby (painting and sculpture,2004); Love British Art 20/21 Catherine Hodgekinson (2004); Norwich University Hospital (2005); Works on Paper 2005, Tricycle Theatre Gallery; Form (Benjamin Hargreaves, 2006). *Works in collections:* portraits: Vanessa (as Hecuba) & Corin (as Tynan) Redgrave in performance-Theatre Museum (2006). *Commissions:* mural (Graeme Garden, 1998); sculpture (Ruth Nissim, 2000); garden sculpture commissioned by Peter Bramley (2005). *Recreations:* travel. *Address:* 12 Georges' Mansions, Causton Street, London SW1P 4RZ. *Email:* mikivz@hotmail.com

VARELA, Armando, Gold MEdal, ENBA (1960); French Government Scholarship (1963); First Prize National Award of Sculpture, Peru (1963); Malta Biennale Award (1999). *Medium:* sculptor. *b:* Lima, Peru, 2 Oct 1933. *s of:* Alberto Varela. *m:* Maria Varela. two *s. Educ:* ENBA (Escuela Nacional de Bellas Artes) Peru (1952-60). *Studied:* L'Ecole de Beaux Arts, Paris (1963-64); St.Martin's School of Art, London (1972-73). *Exhib:* National Society (2000-07); Instituto de Arte Contemporaneo, Lima, Peru; Museo de Arte, Lima, Peru; Tesoros Del Peru, Mexico; Galeria Lirdlay, Argentina; Festival of London, Barnet Borough Arts, Brent Arts Council; The Stables Gallery; RA Summer Exhbn; Espace Latino American Paris; Contemporary Art Medals, British Art Medal Soc. London; Shamballa Gallery, Copenhagen. *Works in collections:* Museo De La Nacion, Lima, Peru; Burghley Sculpture Garden; The Pride of the Valley Sculpture Park; private collections internationally. *Commissions:* Collection of Latin American Art, University of Essex (2004). *Misc:* paintings, drawing, and

ceramic. *Signs work:* 'Armando Varela'. *Address:* 151 Elmstead Avenue, Wembley Park, Middlesex, HA9 8NU. *Email:* varela@maria35fsnet.co.uk *Website:* www.armandovarela.net

VAUGHN-JAMES, Martin, Howard, Drawing Prize, Salon Marcel Pouvreau (1982), Painting Prize, Institut de France (1987). *Medium:* painting, drawing, writing. *b:* Bristol, UK, 5 Dec 1943. *s of:* C H James & K F Stevens. *m:* Sarah McCoy. *Educ:* Corby Grammar School, UK; North Sydney Boys' High, Sydney, Australia. *Studied:* National Art School of Australia, East Sydney (1961-64). *Represented by:* Zedes Gallery, Brussels; Galerie Dukan, Marseille; Christian Meyer, Paris. *Exhib:* 35 one-man shows principally in Paris, Brussels, Cologne. Art Gallery of Ontario (1975). Group exhbns: Institut de France, Salon de Montrouse, Stedelijk Museum Delft, Centre Ampidou, Paris. *Works in collections:* France, Belgium, Netherlands, Germany, UK, USA, Australia, Canada, Spain. Art Fairs: Strasbourg, Gent, Art Paris, Nimes etc. *Publications:* 6 visual novels, 4 catalogues, 2 novels. *Official Purchasers:* Fonds National D'Art Contemporain, Paris (1986), CNBDI, Angouléme (manuscript of 'The Cage')(1999). *Clubs:* Groupe Mémoire, Paris. *Misc:* born in England, lived in Sydney, Australia, Toronto and Montreal, Canada, Paris, Brussels. Travelled in USA, Mexico, Central America, Europe. *Address:* 7 Place Morichar, 1060 Brussels, Belgium.

VEALE, Anthony McKenzie, self taught painter in oil and acrylic, sculptor (surrealist and figurative work) in bronze, wood, marble and stone; also abstract painting and minimalist work. *b:* Tonbridge, 20 Oct 1941. *m:* Susan. one *s.* two *d. Educ:* Sevenoaks School. *Exhib:* Tryon Gallery (1979), 20th Century Gallery (1985), Mall Galleries (1992). Permanent exhbn. of bronzes in sculpture garden at Buckstone House. *Publications:* cartoon illustrations: 'Hippo, Potta and Muss' (Chatto, Boyd & Oliver U.K., 1969), 'A Lemon Yellow Elephant called Trunk' (Harvey House Inc. U.S.A., 1970), 'The Orchard': A Novel (Snowball Press, ISBN 0-9547733-1-4)(paperback - Imprint Academic ISBN 1-845-400585). *Principal Works:* please refer to website. *Clubs:* Star Cross Dining Club. *Signs work:* "Tony Veale," "Anthony Veale" or "A.V." *Address:* Buckstone House, Upton Hellions, Crediton, Devon EX17 4AE. *Email:* aveale@buckstone.eclipse.co.uk *Website:* www.tonyveale.com

VERITY, Charlotte Eleanor, DipFA (1977); Slade Prize; Fellowship Bath Academy of Art; Boise Travelling Scholarship, Italy. *Medium:* still life; landscape; portrait; artist in oil on canvas, watercolour, monoprint, etching. *b:* Germany, 1 Jun 1954. *d of:* Hugh B.Verity. *m:* Christopher Le Brun, RA. two *s.* one *d. Educ:* Downe House. *Studied:* Slade School of Fine Art UCL (1973-77), studied under William Coldstream, Lawrence Gowing, Euan Uglow, Patrick George, Noel Foster. *Represented by:* Browse & Darby. *Exhib:* solo shows: Anne Berthoud Gallery (1984, 1988, 1990), Browse & Darby (1998,2002, 2007); John Moores, Liverpool (1980, 87); Harris Museum, Preston (1985); L.A.Lower Gallery, USA (1988); many mixed shows including RA Summer Exhbn (1999,

2007); Singer & Friedlander Watercolour Competition (1993); Discerning Eye (2003); Tate Modern (2005). *Works in collections:* Arts Council; East of England Arts (Wingfield Arts); Deutsche Bank; Electra Investment; Paintings in Hospitals; Stanhope Proerties; Tate Modern Education Dept.; UCL, CAS, San Diego MOCA, Westminster School. *Publications:* illustrated catalogues 1990,1998 and 2002 to solo shows, catalogues for 'Still Life, A New Life', RA Summer Show, Discerning Eye, PCF Catalogue for UCL Collection, Deutsche Bank Collection. *Works Reproduced:* Exhibition catalogues 1990; 1998; 2002; 2007. *Misc:* since 2001 taught at The Prince's Drawing School, London. *Signs work:* "Verity." *Address:* 8 Love Walk, London SE5 8AD. *Email:* charlotte.verity@mac.com

VERITY, Colin, A.R.I.B.A. (1965), R.S.M.A. (1975); architect, artist in oil, water-colour and gouache; retd. principal architect, Humberside C.C., Pres., Hornsea Art Soc., Mem. Fylingdales Group of Artists. *b:* Darwen, Lancs., 7 Mar 1924. *s of:* Thomas Verity. *m:* (1)Stella Elizabeth Smale(d. 2000- one s., three, d.); (2) Sonya Josephine Raven Ainley (m. 2003). *Educ:* Malet Lambert High School, Hull. *Studied:* Hull School of Architecture. *Exhib:* R.S.M.A. London; Mystic Maritime Gallery, Connecticut, U.S.A.; Francis Iles Gallery, Rochester; Ferens Gallery, Hull; Pannett Gallery, Whitby; Retrospective, Hull Maritime Museum (2003). *Works in collections:* National Maritime Museum, Greenwich, Sultanate of Oman, DFDS, Ben Line, Harrison Line, P&O Line, Maritime Museum, Hull, Kassos Steam Nav. Co., - 17 countries. *Commissions:* Numerous shipping cos., Lloyds and private. *Publications:* 'A Glance Astern' (Hutton Press, 2003). *Official Purchasers:* H.R.H. Duke of Gloucester, Sultan of Oman, John Betjeman, etc. *Signs work:* "Colin Verity." *Address:* Melsa House, Meaux, Beverley, E. Yorks. HU17 9SS.

VERNON-CRYER, Joan, ARCA, RWS (1970); painter in water-colour. *b:* Blackburn, 21 Mar 1911. *d of:* Harold Cryer. *m:* W. Fairclough. one *s.* one *d.* *Educ:* Blackburn High School and Blackburn Technical College. *Studied:* Royal College of Art (Painting School). *Exhib:* Hunting Group Competition, Mall Galleries (1990), Sunday Times Water-colour Exhbn., Mall Galleries, Glasgow Cultural Year (1990), The Art of the Garden, Victoria A.G., Bath and North-East Somerset (1997). *Works Reproduced:* in Old Water-colour Society's volumes, Visions of Venice (Michael Spender, 1990); Water-colour Drawings and Artists Magazine (1991); La Exposicion Internacional de Acuarela (1992, 1995). *Signs work:* "Joan Vernon-Cryer." *Address:* 12 Manorgate Rd., Kingston-upon-Thames, Surrey KT2 7AL.

VERRALL, Nicholas Andrew, NDD (1965); artist in oil, pastel, water-colour, etching and litho;. *b:* Northampton, 4 Jan 1945. *s of:* R.E. Verrall, civil servant. one *s.* one *d.* *Studied:* Northampton College of Art (1960-65). Full-time artist since 1970. Prizes: R.W.S. Barcham Green Prize for Water-colour, Royal Horticultural Grenfell Medal, R.A. Committee Prize from B.A.T. *Exhib:* RA, RWS, RE, RBA, RP, and NEAC; mixed shows: Tryon Gallery, RA Upstairs

Gallery, Abbott & Holder, Gallery 10; one-man shows: Upper Grosvenor, Langton Gallery Chelsea, Catto Gallery, Hampstead, Art Obsession Inc., Tokyo, and Brian Sinfield, Oxfordshire. *Works in collections:* City of London, B.A.T. Coll., Crown Life, Painshill Park Trust, Coys of Kensington. Private collections in Britain, France, America and Japan. *Publications:* 'Colour and Light in Oils' by Nicholas Verrell, 'Painting Still Life' by Peter Graham; entry in 'Forty Years at Curwen Studios'. *Signs work:* "Nicholas Verrall." *Address:* The Orchard, Ivy La., Woking, Surrey GU22 7BY.

VIEIRA DA SILVA DALL'ORTO, Lucy, Bronze Medal Hon Mention (II) Researches; Gold Medal (II) Great Brazil Award of Visual Arts; The Presidents Award (NAPA); Best Contemporary Painting (Golden Art Materials); Highly Commended Contemporary Painting (Pro Arte). *Medium:* mixed media. *b:* Vitoria City, 10 Oct 1940. *d of:* Luis Alvez & Lacy V.da Silva. *m:* Elmo Luis C.Dall'Orto. one *s.* two *d. Studied:* Graduate in Neo-Latins Letters and Arts, Federal University Course on Specialization; Masters Degree in History of The Paintings of Brazil in 20th Century (Modernism). *Exhib:* several solo and group exhibitions in Brazil. *Works in collections:* Alliance Francaise; Space Law Court; Federal University. *Publications:* Arts and Letters;Capixabas (catalogue); review 'Voce'. *Official Purchasers:* 'Auctions'. *Principal Works:* series 'Piscis' and 'Archetypes'. *Clubs:* 'Lions' Vitoria. *Signs work:* "Lucy Vieira da Silva Dall'Orto" or "Lucy Dal'Orto". *Address:* Rua Jose Teixeira 890, Sta. Lucia-Vitoria, State Espirito Santo, CEP 29055-310, Brazil. *Email:* lucydalorto@globo.com *Website:* www.lucydalorto.kit.net

VILLAS, Patrick, *Medium:* sculptures in bronze, paintings oil on canvas. *b:* Antwerp, 27 Jan 1961. *Educ:* Academy of Fine Arts Hoboken, Antwerp. *Studied:* drawing and painting, Autodidactic Studies at Zoos in Belgium and France. *Represented by:* Plus Galleries, Wolstraat 25-29, 2000 Antwerp; Verlat Gallery, Verlatstraat 3, 2000 Antwerp. *Exhib:* solo exhbns since 1990 mainly in Belgium, Holland and France, as well as: Rafael Valls Ltd., London (2004); selected group exhbns: Art London (2002, 2005), Olympia Spring Fair (2003), BADA Fair/Grosvenor House, Rafael Valls Ltd. (2004), plus extensively in Europe. *Works in collections:* Royal Museum of Zoology (Antwerp), private collections all over the world. *Commissions:* Royal Museum of Zoology (Antwerp), Fidem Belgium/Promotion de la Medaille. *Publications:* Van der Haegen, E. 'Patrick Vollas Catalogue', Antwerp (2003), Plus Galleries, The Digital @rt Labyrinth. *Official Purchasers:* Royal Museum of Zoology (Antwerp). *Misc:* co-founder of Art-Prom (1991); co-founder of Salon d'Artistes (1993). *Signs work:* 'Villas'. *Address:* Verlatstraat 3, 2000 Antwerp, Belgium.

VINCENT, Michael John, Cert.Ed. (Dist.) 1973, B.Ed. (Hons.) 1974, M.A. (1979), Dip. Ed. (1983); landscape and seascape artist in gouache and oil, pencil and ink. *b:* Bury St. Edmunds, Suffolk, 9 Feb 1949. *m:* Kaisa (decd.). one *d. Studied:* Chelsea School of Art (1968-69), London University (1970-74), Inst. of Educ. (1977-79). *Exhib:* throughout U.K., Finland, N.Z. Work in collections

worldwide. *Official Purchasers:* Somerset County Council; H.M.S. Somerset (Royal Navy). *Works Reproduced:* The Guardian, T.E.S., Artist and Illustrators Magazine, Countryman, The Somerset Magazine. *Clubs:* U.A. *Signs work:* "M. VINCENT." *Address:* 79 Northload Street, Glastonbury, Somerset BA6 9JR. *Email:* artvincent@onetel.com

VINE, Edward, landscape/still life artist in acrylic, water-colour, oil, pastel. *b:* Weymouth, Dorset, 10 May 1943. *Exhib:* regular one-man shows at Peter Hedley Gallery, Wareham, Dorset; exhibits with Royal Society of Marine Artists at the Mall Galleries, London. *Publications:* 'Edward Vine's Dorset', 120 colour reproductions in hardback, published by Halsgrove, Tiverton, Devon. ISBN 84114 1992 (2002). *Misc:* Artist-in-Residence at "Max Gate", Thomas Hardy's Dorchester home now owned by the National Trust. *Signs work:* "Edward Vine." *Address:* 90 Easton St., Portland, Dorset DT5 IBT.

VISOCCHI, Michael, RSA; BA (Hons) Fine Art -Sculpture. *Medium:* sculpture and photography. *b:* UK, 10 May 1977. *Studied:* Glasgow School of Art (1997-2001). *Exhib:* Royal Scottish Academy, Edinburgh; Peacock Visual Arts, Aberdeen; The Dick Institute, Kilmarnock. *Works in collections:* Royal Scottish Academy; Italian Cultural Institute; Glasgow Art Galleries and Museums; Art in Healthcare. *Commissions:* Clackmannanshire Council; The Merchants House of Glasgow; The Saltire Society; Channel 4; BBC TV. *Signs work:* 'MICHAEL VISOCCHI' OR 'VISOCCHI'. *Address:* c/o Royal Scottish Academy, The Mound, Edinburgh, EH2 2EL. *Email:* michael@michaelvisocchi.com *Website:* www.michaelvisocchi.com

VLITOS, Roger, BA English with Hons; Dip AD Art & Design. *Medium:* watercolour, drawing, prints, photography. *b:* New York, 15 Dec 1950. *s of:* Prof.A.J.Vlitos. *Studied:* Central School of Art and Design, Hornsey School of Art and Design, Bristol University, Greenwich University. *Exhib:* New York, London, Bristol, Cardiff, Swansea, Venice, Athens, Bath, Swindon. *Works in collections:* National Trust, English Heritage. *Commissions:* Thorn/EMI: The Seasons (film), HTV, National Maritime Museum, British Museum, Natural History Museum. *Publications:* contributed to over 90 books and magazines worldwide. *Works Reproduced:* extensively. *Principal Works:* This Foreign Land (Travelling Exhibition); Reflections of Venice (Travelling Exhibition). *Recreations:* walking, reading, films, travel. *Signs work:* "R.G.Vlitos". *Address:* 110 High Street, Avebury, Wilts, SN8 1RF. *Email:* rogervlitos@hotmail.com

VOGEL, Paul, Sidney, BA Hons. *Medium:* textile design-wovens. *b:* London, 6 May 1966. *s of:* Peter & Juliette Vogel. *m:* Samatha Denny Hodson. three *s.* *Educ:* Mill Hill School; Foundation at Harrow College. *Studied:* Nottingham Trent University. *Represented by:* Antony Brown, Los Angeles, USA. *Exhib:* most major textile exhibitions: Indigo, Paris; Surtex, NYC; Directions, NYC; Heimtex, Frankfurt, Germany. *Works in collections:* US Clients: Abercrombie & Fitch; Calvin Klein; Donna Karran; Kate Spade; Martha Stewart; Old Navy; Gap;

Ralph Lauren; Stussy; Victoria's Secret; UK: Oasis, M&S, Mothercare; Timberland; Levi Strauss UK; Missioni; Warehouse; Monsoon; Top Shop; Debenhams; East; Liberty; Ted Baker. *Commissions:* Uniqco, Japan; Timberland, UK; Alfred Dunhill; Levi Strauss; Boden; Warren Noronita. *Publications:* Vogue, Elle, Hello, OK Magazine, Sunday Express Magazine. *Misc:* lecturer at Royal College of Art, Central St.Martins, Winchester School of Art, Nottingham Trent University. *Address:* Packway Farm, Halesworth Road, Chediston, Suffolk IP19 0AE. *Email:* paul@paulvogel.com *Website:* www.paulvogel.com

VOGEL, Suzi, S.B.A., S.W.A.; self taught botanical and landscape artist in oil on panel;. *b:* Kent, 1950. one *s. Exhib:* regularly with S.B.A. and S.W.A. Suzi Vogel paints to celebrate the beauty of the natural world. She belongs to a long established Kentish family of passionate writers, gardeners and horticulturalists. Now living and working in Dorset and working only in oils, she uses the finest traditional methods and materials, following in the footsteps of the Dutch and French masters of the sixteenth and seventeenth centuries. Her paintings combine the classically decorative with the botanically accurate and are appreciated and collected by connoisseurs of fine representational oil painting. *Publications:* example of work, picture and caption on page nine of "Drawing Flowers" by Margaret Stevens. *Address:* Flat 1, 22 Victoria Grove, Bridport, Dorset DT6 3AA.

VOJDAEVA, Olga Alexseevna, artist in acrylic and oil;. *b:* Crimea, Kerch, U.S.S.R., May 1972. *m:* Nathaniel James Giles. *Studied:* Art School, St, Petersburg (1983-88). *Exhib:* Beechfield House, Corsham, The Gallery Cirencester, Royal Inst. of Artists Birmingham, The Highgate Gallery, London (1999), Westminster Gallery, London (1999). *Works in collections:* Lord Bath, Longleat House. *Commissions:* Gleeson Homes, Pizza Hut (U.K.) Ltd. *Clubs:* N.AP.A. *Signs work:* "Olga Vojdaeva." *Address:* 29a Bath Rd., Wootton Bassett, Wilts. SN4 7DF.

VOLLER, Peter Robert, painter in oils, acrylic polymer, painted wood and paper collage. *b:* Fleet, Hants., 26 Sep 1943. *m:* Tessa Philpot. two *s.* one *d. Studied:* Farnham School of Art. *Exhib:* mostly in London, including R.A., Discerning Eye, and nationally. *Works in collections:* America, Australia, Germany, Hong Kong and UK. *Signs work:* "Voller" or "Peter Voller." *Address:* 53 The Street, Wrecclesham, Farnham, Surrey GU10 4QS.

VON STROPP, *Medium:* oil, watercolour, drawing. *b:* London, 1962. *m:* Fiona. *Represented by:* Henry Boxer Gallery. *Exhib:* American Visionary Art Museum, Baltimore; Orleans House Gallery, Twickenham; Collection de L'Art Brut, Lausanne; Whitechapel Art Gallery, London; England and Co., London; New York Outside Art Fair (1999-2006). *Works in collections:* American Visionary Art Museum (Baltimore), Collection de l'Art Brut (Lausanne), Outsider Archive (London). *Official Purchasers:* Bethlem Royal Museum Collection 'Oestrum' (1980, acrylic on board). *Works Reproduced:* Whitechapel Art Gallery 'Inner Worlds Outside'. *Principal Works:* 'Vision' (c.1982),

'Transvextion' (1979, mixed media on board). *Misc:* self taught visionary artist. *Signs work:* "VON STRÖPP". *Address:* 98 Stuart Court, Richmond Hill, TW10 6RJ. *Website:* www.outsiderart.co.uk

VON STUMM, Johannes, FRBS; Treasurer RBS. *Medium:* sculpture. *b:* Munich, Germany, 27 Jul 1959. *m:* Carolyn. one *s.* one *d. Educ:* Ettal, Benedictine Monastery; OVM Gymnasium, Munich. *Studied:* Academy of Fine Arts, Munich. *Represented by:* Robert Bowman Modern. *Exhib:* RBS (2003); Cass Sculpture Foundation (2004); RA (2005); German Embassy, London (2005); Hannah Peschar Sculpture Garden (2006); Robert Bowman Modern Gallery (2007). *Commissions:* 'Couple' Vale of the White Horse District for Grove; 'Couple in Conversation' for the town of Newbury. *Publications:* Johannes von Stumm (2000, ISBN 0 95303 43 48); Modern British Sculpture (2005, ISBN 0-7643-2111-0). *Signs work:* "Johannes von Stumm". *Address:* Wellhill House, South Fawley, Wantage OX12 9NL. *Email:* vonstumm@aol.com *Website:* www.vonstumm.com

von HARTMANN, Sylvia, DA (Edin.) (1965), Post.Dip (1966), RSW (1983); artist in wax. *b:* Hamburg, Germany, 8 Dec 1942. *d of:* Wolf von Hartmann, merchant. *m:* Hamish Dewar. one *s.* one *d. Educ:* Walddoerfer Schule, Hamburg-Volksdorf. *Studied:* Werkkunstschule, Hamburg (1961-63), Edinburgh College of Art (1963-66), Royal College of Art, London. *Exhib:* R.A., R.S.A. Edinburgh, R.S.W., R.G.I.F.A., The Scottish Gallery, Edinburgh, National Trust of Scotland, Grosvenor Gallery, London, Open Eye Gallery, Edinburgh, etc. *Works in collections:* Scottish Arts Council, Scottish National Gallery of Modern Art, City of Edinburgh Art Collection, Dundee Museum and Art Galleries, National Westminster Bank, Edinburgh, The Royal Infirmary, Edinburgh, H.M. The Queen, St. John's Hospital, Livingstone. *Publications:* Living Light, Books II and III (Holmes McDougall), The Scots Magazine (June, 1984), The Green Book Press Ltd., Bath, Botanical Illustrations in: Sales, F. & Hedge, I.C. 2003, Apiaceae (Umbelliferae) in: Flore de Madagascar et des Comores 157 Museum National d'Histoire Naturelle, Paris. *Signs work:* "Sylvia von Hartmann." *Address:* Rhododendron House, 5 Whitehorse Cl., Canongate, Edinburgh EH8 8BU.

VOROBYEV, Alexander, RWS. *Medium:* oil, acrylics, mixed media. *b:* 63 Lyham Road,. *s of:* Leonid Vorobyev. *m:* Oksana Vorobyev. one *s. Studied:* Almaty Art College (Almaty, Kazakhstan). *Represented by:* Bankside Gallery. *Exhib:* Bankside Gallery; The Mall Galleries; White Knights Gallery; Michael Wood Fine Art Gallery; Modern Art Gallery (moscow); Paul Costello Art & Fashion Charity Show (London). *Official Purchasers:* Victoria & Albert Museum. *Works Reproduced:* in 'Royal Watercolour Society Masters- Then and Now'. *Principal Works:* 'Red Drummer', 'Construction of a Dream', 'The City of Jerusalem'. *Signs work:* 'Alexander Vorobyev'. *Address:* 3 Ashby Mews, Clapham Park, London SW2 5EP. *Email:* alexander_vorobyev@yahoo.co.uk *Website:* www.alexandervorobyev.com

W

WADDELL, Heather, M.A. St. Andrews (1972), D.F.A. (1976), Cert. Ed. London (1977); author, artist, art critic;. *Medium:* paintings, etchings, drawings, photography (b & w). *b:* Scotland, 1950. *Studied:* Byam Shaw School of Art, London (1972-76); St. Andrews University (1968-72). *Exhib:* N.S.W. House A.G., (1980), ACME Studio (1977-80), Battersea Arts Centre (1979), Morley Gallery (1984). *Works in collections:* National Portrait Gallery 20th Century Collection (photo portraits of David Hockney, and others). *Publications:* Articles on art: Artnews, Art and Australia, The Artist, Art Monthly, Glasgow Herald (1978-94), London correspondent, Vie des Arts (1979-89), The Independent, The European (arts editor, 1990-'91), The Times; author/photographer: London Art and Artists Guide (11th edn. 2009); The London Art World 1979-99 (2000); co-author, The Artists Directory (3rd edn. 1988); photographer: Glasgow Arts Guide; N.P.G. 20th C. Collection; contributor: London Encyclopaedia (Macmillan), Henri Goetz (1986), Time Out Publications (1987-92), L'Ecosse (1988), Londres (1997), Edns. Autrement, Paris. *Clubs:* IAA (1978-84), AICA (1980-). *Signs work:* 'Heather Waddell'. *Address:* 27 Holland Park Ave., London W11 3RW. *Email:* hw.artlondon@virgin.net *Website:* www.hwlondonartandartistsguide.com

WADDINGTON, Geri, DFA (Slade), SWE. *Medium:* wood engraver. *b:* Chatham, Kent, 20 Sep 1953. *Studied:* Slade School of Fine Art (1972-76). *Exhib:* solo shows: Nuneaton Museum and Art Gallery, Skylark Studios, Cambs., University of Leicester, Alfred East Gallery, Kettering; group shows include: Society of Wood Engravers, National Print Exhibition, Peterborough Museum, Eastern Open, Leicester Print Workshop, Hebden Bridge Arts Festival. *Works in collections:* Georgetown University Library, Washington DC, Bristol City Museum and Art Gallery, Hunt Institute for Botanical Documentation, Pittsburgh. *Commissions:* Bristol City Museum and Art Gallery; The Edward Thomas Society. *Publications:* illustrated books: "The Five Senses" (Incline Press 1999), Hans Andersen's "The Storks" (Ken Ferguson, 2002), "My Father Made Toys" (Incline Press, 2006), "Aeroplane" (Oundle Festival of Literature Press, 2007). *Works Reproduced:* 'Engraved Gardens' (2001), 'An Engraver's Globe' (2002), both by Primrose Hill Press, "Two by Two" (Society of Wood Engravers 2004). *Clubs:* Society of Wood Engravers (General Secretary). *Address:* The Old Governor's House, Norman Cross, Peterborough, Northants, PE7 3TR. *Email:* g.waddington@dial.pipex.com *Website:* www.geraldinewaddington.com

WADE, Jonathan Armigel, M.A. St. Andrews (1983); painter in oil and water-colour; mentioned in despatches (1991) - British Army, Captain RHF. *b:* Virginia, U.S.A., 12 May 1960. *m:* Marie-Louise Maze. one *s.* one *d. Educ:* Lancing. *Exhib:* Paris Salon (1991), Cognac (1991, 1992), Clarges Gallery, London (1993, 1994, 1996, 2000, 2004), Sutton, Sussex (1995), Haddo House, Aberdeenshire (1995), Grimsby (1996, 1997), Arundel (1997), Alchemy Gallery, London (1998), Glasgow (1998), Elsham Hall (2004), Lincoln (2006), Sherwin Gallery (2007). *Works in collections:* National Army Museum (over 120 sketches

and paintings of Gulf Campaign, Bosnia and Northern Ireland), R.M.A. Sandhurst (water-colours), Gen. Norman Schwarzkopf (Gulf), H.R.H. Duke of York (gift), and many private. *Commissions:* 104 completed including a Bosnian triptych for A. & N. Club. Commissioned to paint in Iraq 2004. *Works Reproduced:* many works reproduced as prints and cards. *Recreations:* shooting, playing accordion and violin, fishing. *Misc:* painted in India (1979), Pakistan (1982 and 1993), Turkey (1980 and 1983), Bosnia (1994), Iraq (2004). *Signs work:* "JONATHAN WADE," "J. Wade," J.A. Wade" or "Armigel Wade." *Address:* Walk House Walk Lane Irby, N.E.Lincs DN37 7JU. *Website:* www.jonathanwade.co.uk

WAKEFIELD, Nicole, R.Cam.A.; B.A. (Hons.) Fine Art (1983), P.G.C.E. (1991); artist in oil, pastel, acrylic, clay; teacher. *b:* Manchester, 27 Oct 1960. *Studied:* Wolverhampton (1980-83), Blackburn (1979-80). *Exhib:* R. Cam. A., and locally. *Clubs:* local mountain clubs, drama groups. *Signs work:* "Nicole." *Address:* 2 Tan y Bonc, Valley Rd., Llanfairfechan, Conwy LL33 0ET. *Email:* nicolewakefield@btinternet.com

WALCH, Kenneth Charles Crosby, N.D.D. (1955); artist in oil, garden design; former A.E. art tutor with I.L.E.A. Hounslow, Bognor. *Medium:* oil, mainly. *b:* Wimbledon, 16 Sep 1927. *m:* Olive Winifred (decd.). *Educ:* Bradfield College. *Studied:* National Gallery Art School, Melbourne (1952-53, Murray Griffin), St. Martin's School of Art (1953-55, Bateson Mason, F. Gore). *Exhib:* Belgium (Hof de Bist), London, Germany (Unna), Hong Kong (Nishiki), Dublin; John Batten Gallery, Hong Kong. *Works in collections:* Hof de Bist, Antwerp, Chichester Centre of Arts; private collections in U.K., Europe, America, Australia, Quaker International Centre, Byng Place, London, Nuffield Hospital, Chichester, St. Winifreds Hospice, Chichester. *Works Reproduced:* drawing of Rothesay Church N.B.-End Papers, Hong Kong Dairy, The Milky Way. *Principal Works:* 4 Views from Pallant House; Historical Time Chart. *Recreations:* essays and letters. *Clubs:* Chichester Centre of Arts, Friends of Pallant Ho. *Signs work:* in block letters with pencil into wet paint, or scratched. *Address:* 193 Oving Rd., Chichester, W. Sussex PO19 4ER.

WALDRON, Dylan Thomas, B.A.Hons. Art & Design. *Medium:* artist in egg tempera, acrylic, pencil, oil and water-colour. *b:* Newcastle-under-Lyme, 21 Aug 1953. *s of:* the late Jack L. Waldron, sculptor and lecturer in fine art. *m:* Susan Dorothy Ann Waldron. *Educ:* King Edward VI Grammar School, Stourbridge. *Studied:* Stourbridge College of Art (1971-72), Wolverhampton Polytechnic, Faculty of Art and Design (1972-76). *Represented by:* Goldmark Gallery / Artifex Contemporary Arts. *Exhib:* R.A. Summer Exhbn. (1983-2005), Piccadilly Gallery, Cork St., London (1981-96), Mall Galleries, London (1988-2003). *Works in collections:* West Midlands Arts, Basildon Arts Trust. Private collections worldwide. *Publications:* Buckman Directory of British Artists Since 1945. *Recreations:* country walking, running, cycling, gardening, music. *Clubs:* Leicester Soc. of Artists. *Signs work:* "Dylan Waldron" paintings initialled

"D.W." *Address:* 2 Hallaton Rd., Slawston, nr. Market Harborough, Leics. LE16 7UA. *Website:* www.dylanwaldronartist.co.uk

WALES, Patricia Ann, S.W.A. (1995), S.F.P. (1997); artist in water-colour - flower paintings;. *b:* Hamilton, Ontario, 27 Feb 1933. *m:* Graham Wales. two *s.* *Exhib:* London, Paris, Sweden and Wessex Region. *Works in collections:* paintings in private collections in Australia, Americas and Western Europe. *Works Reproduced:* greetings cards. *Clubs:* Lymington Art Group, Lyndhurst Art Group, Lymington Palette. *Address:* Willowbank, Widden Close, Sway, Hants. SO41 6AX.

WALKER, Edward Donald, marine artist, publisher; owner, Sumar Publications. *Medium:* oils, watercolour. *b:* 2 Aug 1937. *s of:* A.E. Walker, ship constructor. *m:* Susan. one *s.* one *d. Educ:* Warbreck School, Liverpool. *Studied:* Liverpool College of Art (1950-56). *Exhib:* R.S.M.A., Paris Salon, Talbot Gallery, Ethos Gallery, Lancs., Harrods London, Fulmar Gallery, N. Wales, McEwan Gallery, Ballater, Scotland and galleries throughout U.S.A. *Works in collections:* Liverpool Museum; private and public collections worldwide. *Commissions:* from Cunard Steamship co., Royal Mail, Museum Science and Industry Chicago USA, Merseyside Maritime Museum. Official Artist for RMS Titanic Touring Artefacts Exhbn. *Publications:* "Sea Liverpool". *Official Purchasers:* Cunard. *Signs work:* "E.D. Walker." *Address:* 1 Richmond Grove, Lydiate, Merseyside L31 0BL. *Email:* Ed-walker@sumarpubl.fsnet.co.uk *Website:* www.edwalkermarine.com

WALKER, Leigh Diane, BA (1st Class Hons), MFA; Royal Scottish Academy Latimer Award (2006), The Derwent Award (2005), Hope Scott Trust Award (2005), Andrew Grant Bequest (2004), Ken Cowley Award (1999), Australian Sunday Mail Commended (1998), Great Universal Stores Award (1998), Macallan Award (1997). *Medium:* acrylics, drawing, prints. *b:* Irvine, Scotland, 23 Sep 1974. *d of:* William & Elise Walker. *m:* Roger Scott Barnes. one *d. Studied:* Edinburgh College of Art (1993-97, 2004-06), Ecole des Beaux Arts, Strasbourg (1996). *Exhib:* Contemporary Scottish Art, The Chambers Gallery, London (2006); RSA 180th Annual Exhibition (2006); Atkinson Gallery, Somerset (2006); RSA Open (2004, 2005); Society of Graphic Fine Art (2005, 2006); Singer & Friedlander/Sunday Times Watercolour Competition (2005); Edinburgh College of Art Degree Show (1997, 2005, 2006); RSA Student Exhibition (1996, 2005); 'Fromage et Frottage', Evolution House, Edinburgh (2005); Talbot Rice Gallery, University of Edinburgh (2004); Manchester Academy of Fine Arts (2004); Philips Gallery, Manchester (2003, 2004); Orleans House Gallery, Twickenham (2004); 'Art London 2003'; BP Portrait Award (2000, 2001); The Scottish Gallery, Edinburgh (2002); Compass Gallery (2002/2003), Scottish Portrait Exhibition, RSA (1997); Affordable Art Fair, New York (2002). *Works in collections:* Scottish Equitable, South Ayrshire Council, Livingstone, Batnes & Cunninghame Construction. *Commissions:* South Ayrshire Council; Philips Gallery, Manchester; Satow, Edinburgh; MacDonnel/De Laszlo,

London; Simmons, London. *Official Purchasers:* Scottish Equitable, South Ayrshire Council. *Principal Works:* 'The Brides' acrylic on canvas; 'Bye' acrylic on canvas, landscape diptych. *Recreations:* walking, reading, yoga. *Signs work:* "LEIGH D.WALKER". *Address:* 39 Letham Rise, Dalgety Bay, Fife, Scotland, KY11 9FW. *Email:* leighdwalker@hotmail.com

WALKER, Richard Ian Bentham, NDD (1947), ATD (1949); Mem. United Soc. of Artists, Armed Forces Art Soc., Soc. of Graphic Fine Arts; portrait and landscape painter; teacher of oil painting, Croydon Art School (1948-53). *b:* Croydon, 18 Mar 1925. *s of:* Norman Walker, I.C.S. *Educ:* Canford School, Dorset; Queen's College, Oxford; Founder's Prize, Royal Drawing Soc. (1938). *Studied:* Croydon School of Art (1945-48), London University (1949), Slade School (1949). *Exhib:* RA, RP, RBA, ROI, Paris Salon, Imperial Institute, etc.; one-man shows, Oxford, Croydon, Mall Galleries (1978), Alpine Galleries (1981). *Works in collections:* Portraits of: Dr. Herbert Howells for Royal College of Music (1972); A. K. Chesterton (1973); Sir Reginald Wilson for the Brompton Hospital; Sir Thomas Holmes Sellors for the Middlesex Hospital; C.B. Canning (1989), John Hardie (1990), Ian Wallace (1991), all for Canford School; Sir William Penney, Reading A.G. (1953); London panorama, Museum of London (1978); Croydon Landscape (1939), for the Croydon Collection; Museum of Ness, Lewis; Kjarval Museum, Reykjavik. *Publications:* drawings of Stokowski, Havergal Brian, Edmund Rubgra, etc., published Triad Press, London (1971-73); illustrations to C. Palmer's biography of Herbert Howells (1993). *Works Reproduced:* London Panorama, Museum of London. *Recreations:* music, travel. *Signs work:* "RICHARD WALKER". *Address:* 15 Dean's Close Croydon CR0 5PU.

WALKER, Roy, A.R.E. (1975); painter/etcher; Director, Print Workshop, Penwith Society of Arts, St. Ives, Cornwall. *b:* Welling, Kent, 25 Aug 1936. *s of:* Edwin James Walker. *m:* Margaret Anne Walker. two *s.* one *d. Studied:* Gravesend School of Art (1951-52), Regent St. Polytechnic (1952-54); Central School of Art (1957-60). *Exhib:* one-man shows: Camel Gallery, Wadebridge, Orion Gallery, Penzance, Plymouth Art Centre; three-man show: Marlborough Graphics; joint shows: Penwith Society of Arts, Wills Lane Gallery, St. Ives, Newlyn Gallery. *Works in collections:* Print Room, V. & A. *Misc:* Studio: 6 Porthmeor Studios, Back Rd. West, St. Ives. *Signs work:* "Roy Walker." *Address:* Warwick House, Sea View Terr., St. Ives, Cornwall.

WALKER, Sandra, R.I.; artist in water-colour. *b:* Washington D.C., U.S.A. two *s.* one *d. Exhib:* many mixed and one-man shows: Singer & Friendlander (1st Prize); R.I., R.W.S., R.B.A., Galerie Mensch, Hamburg; Bourne Gallery; Mall Galleries; Watermans, London; Gallery Henoch, N.Y., U.S.A., Franz Bader Gallery, Wash.D.C., Corcoran Gallery, Wash.D.C., Smithsonian Inst., Wash.D.C., National Geographic, Wash.D.C., Tregastel Salon International de la Peinture a l'Eau, France, Curzon Gallery, Wimbledon. *Works in collections:* John Le Carré, Senator Edward M.Kennedy, Senator George McGovern, Wall St. Journal;

National Geographic Soc., Washington DC, Baroness Thatcher. *Commissions:* Baroness Thatcher: print of Parliament. *Publications:* work illustrated in: "Water-colour Step by Step" (Harper Collins, 1993), "How to Draw and Paint Texture" (Harper Collins, 1993), "Collins Complete Painting Course" (Harper Collins, 1993), "Shapes and Edges" (Sandstone Books, 1996), "Houses and Buildings" (Cassells Press, 1991). *Clubs:* Arts Club, London. *Misc:* Designer of President's Medal of Freedom honouring Simon Weisenthal (U.S. Mint). *Address:* 39 Stewkley Rd., Wing, Leighton Buzzard, Beds. LU7 0NJ.

WALKLIN, Carol, ARCA (1953), RE (1986); graphic artist and printmaker. *Medium:* wood and lino-cuts - etching. *b:* 10 Jun 1930. *m:* Colin, ARCA, co-Director 'Mullet Press'; tutor-lecturer in printmaking. *Studied:* Beckenham School of Art and Royal College of Art (Graphic Design). *Exhib:* widely in UK including Bankside Gallery and Mall Galleries, London, Royal Academy Summer Exhibition. *Works in collections:* National Portrait Gallery, London; U.K., U.S.A. and Europe. *Commissions:* BBC T.V. 'Jackanory', Post Office U.K. (stamp designs and air letters). *Clubs:* Senior Fellow, Royal Soc. of Painter-Printmakers. *Signs work:* "Walklin." *Address:* 2 Thornton Dene, Beckenham, Kent BR3 3ND.

WALLACE, Donald Ian Mackenzie, SWLA: GCE:A (Art), B.A. (Economics, Law), Cantab.; artist in pencil, ink, gouache; author. *b:* Gt. Yarmouth, 14 Dec 1933. *m:* Wendy. three *d. Educ:* Loretto School; Clare College, Cambridge. *Exhib:* SWLA (annually). *Commissions:* several annually; roughs supplied free. *Publications:* Birds of the Western Palearctic (Field Characters, plates); six other books, including 'Beguiled by Birds' (2004); many papers. *Recreations:* natural history; wilderness. *Signs work:* "dim wallace." *Address:* Mount Pleasant Farm, Main Rd., Anslow, Burton-on-Trent, E. Staffs. DE13 9QE. *Email:* dimwit@talktalk.net

WALLER, Jonathan Neil, B.A. (Hons.), M.A. (Painting). *Medium:* mixed media. *b:* Stratford upon Avon, 16 Apr 1956. two *d. Studied:* Nene College, Northampton (1979-80), Coventry (Lanchester) Polytechnic (1980-83), Chelsea School of Art (1984-85). *Exhib:* one-man shows: Paton Gallery, London (1986, 1988), Flowers East, London (1990, 1992, 1993, 1994), New End Gallery, London (1997), Axiom, Cheltenham (1998),Lancaster Gallery, Coventry (2003), Jonathan Waller's True Adventures, National Maritime Museum, Cornwall (2005), touring to Arlington Gallery, London (2006); group shows: 1984: New Contemporaries, I.C.A. London, Midland View 3 (major prizewinner), 1988: London, Glasgow, N.Y., Metropolitan Museum, N.Y., New British Painting, Cincinnati (touring), 1991: Kunst Europa, Karlsruhe, Germany. *Works in collections:* Tate Gallery, London; Metropolitan Museum, N.Y. *Commissions:* Art on the Underground (1994), Heathrow Airport (1995). *Publications:* Jonathan Waller (Flowers East, 1990); Jonathan Waller's True Adventures (NMMC, 2005). *Signs work:* "J.W.2001." *Address:* 35 Campbell Road,

Walthamstow, London E17 6RR. *Email:* j.waller@coventry.ac.uk *Website:* www.geocites.com/jonathanwalleruk

WALLER, Margaret Mary, FIAL (1958, mem. of Council), ATD, Mem. Liverpool Academy (1953); painter in oils, portrait, landscape, and decorative church work in gold leaf, also water-colour and egg tempera. *b:* Yorks., 13 Nov 1916. *d of:* Arthur Basset Waller. *m:* Stephen Bryant, 1989. *Educ:* Friary Convent School (Venice), Belvedere School (Liverpool). *Studied:* Liverpool College of Art (1934-37) and R.A. Schools (1937-39). *Exhib:* R.A., S.W.A., R.P., Paris Salon, Funchal, Madeira (1992); executed Altar-piece for the Chapel of St. John, Guernsey (1960); also large decorative panels for St. Stephen's Church (1964). Invited to U.S.A. (1986) to give exhbn. of water-colours. Commissioned to paint in St. Malo, France (1993). *Clubs:* Sandon Studios Soc. (Liverpool), Reynolds (London). *Misc:* alternative address: Mayfield Studio, Sark. *Signs work:* "MARGARET WALLER." *Address:* Les Sauterelles, St. Jacques, Guernsey GY1 1SW.

WALLIS, Linda Joyce, S.W.A. (1994), S.B.A., (1999); artist in oil. *b:* 20 Sep 1940. *m:* Howard. one *s.* two *d. Studied:* largely self taught, local evening class, and Verrochio Art Centre, Casole d'Elsa. *Exhib:* Guildhall, Royal Exchange, Westminster Gallery, Mall Galleries and many provincial galleries. *Works in collections:* America, Canada, Japan. *Works Reproduced:* CD covers, Limited Edn. prints, Medici cards. *Clubs:* Epsom and Ewell Art Group, Croydon Art Soc., Carshalton and Wallington, Oxshott. *Signs work:* "WALLIS." *Address:* 25 Langton Ave., Ewell, Surrey KT17 1LD. *Email:* lindawallisart@yahoo.co.uk

WALPOLE, Josephine Ailsa, artist specialising in flower painting and botanical illustration. *b:* Cockfield, Suffolk, 27 Apr 1927. *d of:* Joseph James Horn. *m:* Derek Walpole. one *s. Educ:* East Anglian School for Girls, Bury St. Edmunds; Notre Dame High School, Norwich. *Studied:* privately under Stuart Somerville. *Exhib:* London and East Anglia. *Publications:* 'Anna' Memorial, Biography of Anna Zinkeisen; Biography of Leonard Squirrell, R.W.S., R.E.; Leonard Squirrell, Etchings and Engravings; Life and Work of Martin Kidner; Vernon Ward (Biography); 'Roses in a Suffolk Garden'; 'Leonard Squirrell- the Best of the Norwich School?';Leonard Squirrell, the Museum Collection'; 'Art and Artists of the Norwich School'; Kenneth Webb - A Life in Colour; History and Dictionary of British Flower Painting. *Signs work:* "J. Walpole." *Address:* St.Augustine's, 8 Kingston Farm Road, Woodbridge, Suffolk IP12 4BD.

WALTER, Stephen, MA RCA Fine Art Print, Jerwood Drawing Prize (2nd)(2004); Tim Mara Charitable Trust (RCA)(2001); Daler Rowney Drawing Prize (RCA)(2001). *Medium:* drawing, prints, photography and painting. *b:* London, 7 Oct 1975. *Educ:* Queen Elizabeth's Boys School, Barnet. *Studied:* Middlesex University; Manchester Met. University; RCA. *Exhib:* selected shows: RA Summer Exhbn (2005); Foster Art Summer Show (2005); The Lab, San Francisco, USA (2005); solo shows: Vertigo Gallery, The Drawing Gallery. *Works*

in collections: The British Museum, Deutsche Bank (London), The Houses of Parliament Museums; Trussardi Foundation (Milan). *Commissions:* Queen Elizabeth's School for Boys, Barnet. *Publications:* RA Summer Exhibition Illustrated Catalogue (2005); Jerwood Drawing Prize Catalogue (2004). *Works Reproduced:* RA Summer Exhibition Illustrated Catalogue (2005). *Principal Works:* Throw Away After Use (A London Town), 2002-2004. *Recreations:* music (guitar, DJ-ing), golf, football. *Signs work:* 'Stephen Walter'. *Address:* 144 Brooke Road, Stoke Newington, London N16 7RR. *Email:* contact@stephenwalter.net *Website:* www.stephenwalter.net

WALTERS, Kate, B.A. (Hons.) Fine Art. *Medium:* drawings. *b:* London, 23 May, 1958. one *s. Studied:* Brighton College of Art (1978-81), Falmouth College of Art (1966-2000). *Exhib:* I.C.A., Raw Art, Millfield, Laing, Beatrice Royal, Goldfish Fine Art, Discerning Eye, Jerwood Drawing Prize, Sefton Open. *Works in collections:* private: U.K. and Europe. *Publications:* several catalogues. *Clubs:* Penzance Arts; member Newlyn Society of Artists. *Address:* 6 Tremenheere Road, Penzance, Cornwall, TR18 2AH. *Email:* kate.horse@tiscali.co.uk *Website:* www.katewalters.co.uk

WALTON, Barbara Louise, MFA (Hons.) (1981), Post.Grad. Dip. Painting and Drawing (1982); painter in oil and acrylic paint on canvas and paper. *b:* Bishop Auckland, 30 Dec 1955. *d of:* Martin and Mavis Walton, teachers. *m:* Dursun Cilingir, doctor. *Educ:* Queen Anne Grammar School. *Studied:* Edinburgh University/College of Art (Elizabeth Blackadder, David Michie). *Exhib:* York University (1982), Gloucester College of Art (1983), Paisley Art Inst. drawing competition (1987), N.P.G. portrait competition (1987, 1989), Mall Galleries Open (1989); solo shows: Mercury Gallery (1988, 1993), Grape Lane Gallery, York (1989); regular exhib. with Mercury Gallery since 1986. *Signs work:* "B.L. Walton". *Address:* 31 St. John's Rd., Exeter EX1 2HR.

WALTON, John, D.F.A. (Lond. 1949), R.P. (1976); portrait painter in oil and tempera; Principal, Heatherley School of Fine Art, London; Governor, Federation of British Artists, Mem., Royal Soc of Portrait Painters. *b:* Birkenhead, 5 Dec 1925. *s of:* Eric Walton. *m:* (1) Annette d'Exéa. two *s.* one *d.* (2) Alice Low. *Educ:* Birkenhead School, Edge Grove School, Aldenham School. *Studied:* Ruskin School of Fine Art (1944-45, Albert Rutherston), Slade School of Fine Art (1945-49, Randolph Schwabe). *Exhib:* R.A., R.P., Paris Salon (Hon. mention), Academie des Beaux Arts, Institut de France. *Clubs:* Chelsea Arts. *Signs work:* "John Walton." *Address:* 30 Park Rd., Radlett, Herts. WD7 8EQ.

WANG, Elizabeth, FSBA (1987); Founder mem. Soc. of Botanical Artists, Medalife Art award (1990); artist in water-colour, oil, pencil, writer. *b:* Slough, 24 Aug 1942. *m:* M.K. Wang. two *s.* one *d. Educ:* Dr. Challoner's Grammar School, Amersham. *Studied:* part-time at St. Albans College of Art. *Exhib:* FBA Mall Galleries; mixed shows: still-life and botanical works: SBA, RA, RI, Fine Art (Solihull); solo shows: recent religious works: Harpenden, Westminster

Cathedral, Bar Convent Museum, York, St. Paul's Conference Rooms, Westminster, The French Church, London (Leicester Square). *Works in collections:* numerous private collections. *Commissions:* numerous private commissions until approx. 1993 when I decided only to do my own themes, and to halt all sales. *Publications:* illustrated: The Way of the Cross (Collins Liturgical 1988); written and illustrated: Teachings in Prayer, Vols. 1-4 (Radiant Light, 1999), My Priests are Sacred (Radiant Light, 1999), How to Pray (Radiant Light, 1999), Falling in Love (Radiant Light, 1999), The Wonder of the Christian Story (Radiant Light, 2001), The Majesty of the Mass (Radiant Light, 2000), The Glory of the Holy Trinity (Radiant Light, 2001), The Mass Through the Eyes of Christ (Radiant Light, 2003), The Purpose of the Priesthood (Radiant Light, 2005). *Works Reproduced:* by The Bridgeman Art Library, USA. *Principal Works:* The Mass Paintings. *Signs work:* "Wang" or "E.W." *Address:* 25 Rothamsted Ave., Harpenden, Herts. AL5 2DN. *Email:* mail@radiantlight.org.uk *Website:* www.radiantlight.org.uk

WANLESS, Tom, NDD(1957), DAE(1970), M.Ed.(1974), ROI (1996), RBA (1997); Prizes: Cornelissen Award (ROI,1994), Charles Pears Award (RSMA,1994), Roberson Award (ROI,1996), Sir William Ramsay Award (RBA 2002/2006); artist/printmaker in oil, water-colour and etching. *b:* Philadelphia, Co. Durham, 19 Jul 1929. *m:* Marjorie. one *d. Studied:* Bede College (1946-48), Sunderland College of Art (1952-57), Bristol University (1970-74, post graduate). *Exhib:* regular exhibitor in London and regional galleries; one-man/group shows: Zillah Bell Gallery (Thirsk); Russell Gallery (London); Nevill Gallery (Canterbury); Blake Gallery (York); Red Rag Gallery (Stow). *Works in collections:* U.K., Europe, N. America and Australia. *Publications:* illustrated educational books for Collins, Schofield & Sims, and Harraps (1958-89). Featured artist in 'The Artist' (1997), 'International Artist' (2005). *Official Purchasers:* Provident Financial plc, MBNA, Paintings in Hospitals, Brighton West Pier Trust; Scarborough Art Gallery; Leeds City Council. *Signs work:* "T. Wanless." *Address:* 41 Badgerwood Glade, Wetherby, W. Yorks. LS22 7XR. *Email:* t.b.wanless@btinternet.com *Website:* www.t.b.wanless.btinternet.co.uk

WARD, Eric Thomas, *Medium:* oil, watercolour, drawing, prints. *b:* St.Ives, Cornwall, 20 Nov 1945. *s of:* Tom Ward. *m:* Karen Ward. two *s. Educ:* Hayle Grammar School, Cornwall. *Studied:* St.Ives School of Painting (1986-90). *Represented by:* New Gallery, Portscatho, Cornwall. *Exhib:* solo: Waterside Gallery (2006), Coves Quay Gallery, Salcombe (2003-6), Fowey River Gallery (2004), Belgrave Gallery, St.Ives (2004), Glasshouse Gallery, Truro (2002), Out of the Blue, Marazion (2001), Tregony Gallery (1999), The One Below Gallery, London (1998), Mid Cornwall Galleries, St.Austell (1997), Sims Gallery, St.Ives (1994), Hallam Gallery, London (1989). Mixed exhibitions across UK and Europe. *Works in collections:* Penlee House Museum, Penzance; Grey College, Durham University; Westfield Grant Maintained School. *Commissions:* numerous. *Publications:* "Eric Ward, St.Ives from His Studio and Beyond" (Halsgrove Press, 2003). *Clubs:* Chelsea Arts Club, London. *Misc:* Joined RNLI

as St.Ives Lifeboatman in 1964, promoted to Coxwain in 1989, retired after 34 years of service in 2000. *Signs work:* "ERIC WARD". *Address:* 5 Ocean View Terrace, St.Ives, Cornwall, TR26 1RQ. *Email:* wardthp@aol.com *Website:* www.ericward.org

WARD, Gordon, D.F.A. Lond., R.W.A.; artist in all mediums; formerly Head of Painting, Gloucestershire College of Arts and Technology. *b:* N. Walsham, Norfolk, 1932. *s of:* William Ward. *m:* Maureen Liddell. one *s.* two *d. Educ:* Paston Grammar School, N. Walsham, Norfolk. *Studied:* Norwich School of Art (1949-53), Slade School of U.C.L. (1955-57). *Works in collections:* Royal West of England Academy, Robert Fleming Holdings, The Royal Bank of Scotland, Prudential Assurance and various private collections in Europe, America and Australia. *Signs work:* "GORDON WARD" and date. *Address:* Prospect House, Oakridge Lynch, Stroud, Glos. GL6 7NZ.

WARD, Michael Lawrence, ist Class Hons Fine Art Painting, HDFA Lond. *Medium:* mixed media, oil. *b:* Barrow-in-Furness, 9 Feb 1952. *s of:* Clifford and Marjorie. two *s.* one *d. Studied:* Manchester Polytechnic, Ravensbourne, Slade School. *Exhib:* Oriel Cardiff, Battersea Arts Centre, Fitzwilliam Museum Cambridge; White Space, London; Leeds City Gallery; Talbot Rice, Edinburgh; MoMA Oxford; Royal Academy, London; Walker Liverpool. *Works in collections:* Weisman Foundation Los Angeles, USA; Simkin Estate, San Diego; Science Museum, London. *Works Reproduced:* Pandemonium; Bandits. *Recreations:* horse racing, snooker, physics. *Signs work:* 'M.Ward' or monogram. *Address:* 121 Tooting Bec Road, London SW17 8BW. *Email:* artistfidelis@hotmail.com *Website:* www.pbase.com/deadlinearts/mikeward

WARD, Nicholas, Dip.A.D. (1971), R.A. Schools (1974), R.E. (1992); artist and printmaker in etching, pencil, pen, watercolour. *b:* Gt. Yarmouth, 10 Jan 1950. *m:* Elizabeth Somerville. one *s. Educ:* Lowestoft County Grammar School. *Studied:* Lowestoft School of Art (1967-68), St. Martin's School of Art (1968-71, Alan Cooper, James Stroudley), R.A. Schools (1971-74, Denis Lucas, Peter Greenham. *Exhib:* R.A. Summer Shows (1982, 1984-87, 1990, 1994), R.E. Annual (1988-2003), British Miniature Print (1989, 1994, 1997), Bradford Print Biennale (1990), National Print Exhbn. (1995-2003); one-man shows 1974-97. Triennale Mondiale D'Estampes Petit Format (1994). *Works in collections:* Norfolk Museums, Ipswich Museum, British Railways Board. *Commissions:* BP Petroleum Development Ltd. (1987, 88, 89), Print Collectors Club (1991), National Grid (1994). *Works Reproduced:* drawings regularly published in classic car and motorcycle magazines. *Signs work:* "N. Ward." *Address:* 38 Bulmer La., Winterton-on-Sea, Gt. Yarmouth, Norfolk NR29 4AF.

WARDEN, Peter Campbell, ARBA (1982), RBA (1994), DA (1976), Post. Dip. (1977); award, Robert Colquhoun (1976); 1st prize Devon and Cornwall Figurative Art competition (1992); painter in oil, water-colour, pen, pencil. *b:* Vancouver, Canada, 19 Mar 1950. *s of:* Jack & Doreen Warden. one *d. Educ:*

Lancing College. *Studied:* Glasgow School of Art (1972-77). *Exhib:* RA, RBA, RSA, RGI, RSW, NEAC, RWA, RBSA; one-man shows: Malaga, Marbella, Dumfries, Sterts. *Works in collections:* Kilmarnock and Loudon D.C.; Sociedad Economica, Malaga. *Works Reproduced:* various art magazines, books on techniques. *Signs work:* "Peter C. Warden" and date. *Address:* 62 St.Anne's Drive, Llantwit Fardre, Pontypridd, Mid Glam., CF38 2PD. *Email:* peterwardenpear@yahoo.com

WARMAN, Oliver Byrne, R.B.A., R.O.I.; painter in oil of landscapes, houses, gardens, boats, cattle; Chief Executive, Federation of British Artists; Director, Arts News Agency (1983-92);. *b:* London, 10 June, 1932. Former regular officer Welsh Guards. *Educ:* Stowe, Exeter University, Royal Military College of Science, Staff College Camberley, Balliol College, Oxford. *Studied:* Exeter University. *Exhib:* R.A., R.B.A., R.W.A., N.E.A.C., R.S.M.A., R.O.I. *Works in collections:* Lancaster House, all major Banks, Sultan of Oman, Emir of Kuwait, American Embassy. *Publications:* Royal Society of Portrait Painters (joint, 1984), Arnhem, 1944 (1971), Omaha 1944 (2003). *Official Purchasers:* most members of the Royal Family, all the clearing banks, Crown Prince of Persia, AGA, US Ambassador etc. *Clubs:* Cavalry and Guards, Chelsea Arts, Royal Cornwall Yacht. *Signs work:* "O.B.W." or "Oliver Warman." *Address:* Barn Cottage, Spring Farm House, Hanwell, Banbury OX17 1HN. *Email:* oliverwarman@aol.com

WARMAN, Sylvia (Mrs.), Ass. des A. Francais; portrait sculptor and painter; Wells Prize in Fine Art Reading University (1952); Owen Ridley Prize in Fine Art Reading University (1954); Bronze Medal (Sculpture) Paris Salon (1969); Silver Medal (Sculpture) Paris Salon (1973); Gold Medal Accademia Italia (1981); Hon. Sec. National Society Painters, Sculptors Printmakers (1978-83) Vice-President (1984/5). *b:* St. Leonards on Sea, Sussex. *m:* J. Royce Warman. three *d. Studied:* Reading University (1947-54). *Exhib:* various including R.A., London, and West of England R.A., five times Paris Salon. *Commissions:* various. *Address:* 1 Chester St., Caversham, Reading RG4 8JH.

WARNER, Robert, artist in oil and water-colour. *b:* Colchester, 14 Sep 1947. *s of:* Harold. *Studied:* Colchester Art School (1964-71, John Nash, Peter Coker). *Exhib:* ROI, NEAC, RI, RA Summer Exhbn (1974-84, 1986, 1988, 1991, 1992, 1993, 2000, 2001), Athena Art Awards (1987), Hunting Group (1988), Sunday Times W/c Exhbns. (1988, 1990, 1996-99), Laing Art Competition (1990, 1991,1994, 1996), Discerning Eye (2003) Mall Galleries, prizewinner 32nd Essex Open 35th best water-colour; one-man shows: Minories, Colchester (1973), Mercury Theatre (1972, 1980, 1985), Chappel Gallery, Essex (2000). *Works in collections:* Epping Museum, private collections in Britain and America. *Works Reproduced:* RA Illustrated (1980, 1988, 2000). *Clubs:* Colchester Art. Soc. *Signs work:* "R. Warner." *Address:* St. Elmer, Queens Rd., W. Bergholt, Colchester, Essex CO6 3HE.

WARNES, Robin, B.A.(Hons), R.A. Schools Cert. (Postgrad.); painter in oil, charcoal, pastel, acrylic, pencil; David Murray Studentship, Turner Gold medal for Landscape Painting (1980), regional prizewinner, Laing Landscape Exhbn. (1990); Artist in Residence, Ipswich Museums and Galleries (1989-90). *b:* Ipswich, 13 Mar 1952. *m:* Vanessa. two *s.* one *d. Studied:* Ipswich School of Art (1972-74, Colin Moss), Canterbury College of Art (1974-77, Tom Watt), R.A. Schools (Peter Greenham, C.B.E., R.A.). *Exhib:* R.A., Federation of British Artists, Laing Landscape, John Russell Gallery Ipswich, Cadogan Gallery London, Chappel Gallery Colchester. *Works in collections:* Ipswich Borough Council, Suffolk C.C. *Commissions:* Richard Ellis Drawing commission. *Clubs:* Royal Academy Schools, Alumini Association. *Signs work:* "R. Warnes" or "R.W." *Address:* 77 Rosehill Rd., Ipswich, Suffolk IP3 8ET. *Email:* robin@rwarnes.freeserve.co.uk

WARREN, Barbara, RHA (1989), Aosdana (1990); Certificate for South Kensington Drawing Exams, honours in all subjects (1941), Diploma in History of European Painting-Trinity College, Dublin (1955). *Medium:* oil painting, pastel, lithography, etching, and gouache studies. *b:* Dublin, 28 Aug 1925. *d of:* John Warren. *m:* William Carron, ARHA. one *d. Studied:* National College of Art, Dublin, Regent St. Polytechnic, London (with Norman Blaney, RA). Also in 1950s studied over a period of time with Andre L'Hote in Paris. *Represented by:* RHA, Taylor Galleries, 16 Dawson Street, Dublin. *Exhib:* solo: Dublin Painters Gallery (two shows, 1950s), Dawson Gallery, Dublin (1957, 1976, 1982, 1992), Taylor Galleries Dublin (3 shows). Many group shows in Ireland, England and Scotland. *Works in collections:* Ulster Museum, Irish Museum of Modern Art (Gordon Lambert Collection), Royal Bank of Scotland, National Self-Portrait Collection Limerick University, Haverty Trust, Boyle Civic Collection, Co. Roscommon. *Commissions:* Mosaic: St. Philip & St. James Church, Mt. Merrion, Black Rock, Co. Dublin. *Publications:* Royal Hibernian Academy Dublin 2002, A Retrospective with essay by Dr. Julian Campbell (catalogue). *Works Reproduced:* Art of the State Exhibition, New Direction 1970-85 (Office of Public Works, 1998); Florence Biennale Italy Certificate and Medal (catalogue, 1999). *Recreations:* reading, gardening, photography. *Clubs:* RHA. *Misc:* over many years I have returned to work in the West of Ireland - all landscape studies. *Signs work:* 'B.Warren'. *Address:* Matakana, Gray's Lane, Howth, Co.Dublin, Eire.

WARREN, Michael John, N.D.D. (1958), S.WL.A. (1971);. *b:* Wolverhampton, 26 Oct 1938. *s of:* Herbert Leslie Warren. *m:* Kathryne. one *s.* one *d. Educ:* Wolverhampton Grammar School. *Studied:* Wolverhampton College of Art (1954-58). *Exhib:* (recent): Wildlife Art Gallery, Lavenham, Suffolk, (1998/2001/ 2003); Auditorium Sa Maniga, Cala Millor, Mallorca (2000), Conservatoire du Patrimoine Naturel de Savoie, Le Prieure, Le-Bourget-du-Lac, France (2001), Casa da Cultura, Alpera, Albacete, Spain (2001), WWT London Wetland Centre (2002), Artists for Nature Foundation, Holland. *Works in collections:* Nature in Art. *Commissions:* 1985-87 Unicover Corporation U.S.A.,

paintings from 50 States; 1990-92 Unicover / Ducks Unlimited U.S.A., 50 paintings North American Wildfowl; Tarmac Calendar 1995-2001; work for R.S.P.B. *Publications:* 1984: 'Shorelines', Hodder & Stoughton, London & Times Books, N.Y.; 1998: 'Field Sketches', Arlequin Press, Chelmsford, England; 1999: 'Langford Lowfields 1989-99', Arlequin Press, Chelmsford, England; 2001: 'Le Lac du Bourget' Gallimard, Conservatoire du Littoral, Paris, France. *Clubs:* Nottinghamshire Birdwatchers (President); Society of Wildlife Artists (treasurer). *Misc:* postage stamp designs: waterbirds – British Post Office (1980); Native & migratory birds, Republic of Marshall Islands (1990-92); conservation stamp designs: National Audubon Society, U.S.A. (1984-1997, 2001); U.K. Habitat Stamp (1996). *Signs work:* "warren" (paintings), "Michael Warren" (prints). *Address:* The Laurels, The Green, Winthorpe, Notts. NG24 2NR. *Email:* mike.warren.birdart@care4free.net *Website:* www.mikewarren.co.uk

WARREN, Vaughan, BA Hons 1st Class Fine Art, Royal Academy Schools, MA Postgraduate Diploma Fine Art, Royal Academy Schools. *b:* Watford, Herts, 22 Jan 1959. *s of:* Frank and Grace Warren. *m:* Dr. Sandra Warren (divorced). *Educ:* English Lit./ Art A'level, Grange Park Boys School. *Studied:* Royal Academy Schools, Piccadilly, London (1978-84). *Represented by:* Burlington Fine Art, London, Padstow Contemporary Art Gallery and Camelford Gallery, Cornwall. *Exhib:* National Portrait Gallery, RA, Royal Overseas League, Royal Festival Hall, Cork Street Galleries, various exhbns in London and Cornwall. *Works in collections:* Fort Worth, Texas. Private collections in Finland. *Commissions:* undertaken, various private portrait commissions. *Publications:* 'Found' Painting. A Statement of Intent (2002); 'Fragmentations of Light' (2005). *Works Reproduced:* A Marazion Moment (Melanie) (2003), limited edition print. *Principal Works:* Empty Harbour (2002), Grand Slipway (2002), Fragmentations of Light Series (2005). *Recreations:* teaching and surfing. *Misc:* Co-created The Penzance Art Gallery, 1 East Terrace, Penzance, Cornwall, TR18 2TD. *Address:* The Penzance Art Gallery, 1 East Terrace, Penzance Cornwall TR18 5HU. *Email:* pzartgallery@btconnect.com *Website:* www.thepenzanceartgallery.com

WASIM, L., painter in oil and water-colours; nominated as an "Academic of Italy with Gold Medal" and Gold Plaque "Premio d'Italia 1986"; awarded Golden Centaur 1982 Prize with Gold Medal; and International Parliament U.S.A. Gold Medal of Merit; conferred Honoris Causa diploma "Master of Painting" from Salsomaggiore International Seminar of Modern and Contemporary Art, and Diploma of Merit from Italian University of Arts; Institute of Art Contemporer at Milano conferred the Great Gold Medal with the Institute's emblem in 24 carat gold on brass with box and relative certificate of merit for "Premio Milano 1988"; 20th Century Award Medal Achievement '96 from International Biographical Centre Cambridge, England;. *b:* Bandung, Java, 9 May 1929. *m:* Alisma Sudja. one *s.* one *d. Studied:* Graduated from The Central Academy of Arts, Beijing (1956). Instructor of Shanxi Provincial College of Fine Arts, Xian (1956-59). Court painter in Indonesian Presidential Palaces, Jakarta and Bogor (1961-67).

Study tour in Asia and Europe (1975-80); participated several art exhbns. in Indonesia and Europe. *Works in collections:* Indonesian Palaces Museums, Jakarta and Bogor; The Asia and Pacific Museum, Warsaw, etc. *Signs work:* "L. Wasim". *Address:* J1 Tanah Sereal V no. 6, Jakarta Barat 11210, Indonesia.

WATERFIELD, Ken, S.WL.A. (1972); landscape and wildlife artist in oil and acrylics; 'Natural World' Wildlife Art Award (oils, 1995, 1998); Accademia Nazionale D'Arte Antica e Modena -Culture (2000) for 'Lifetime Achievement'. *b:* Watford, 7 Nov 1927. *s of:* George Waterfield. *m:* Enid. two *s.* two *d. Studied:* Watford School of Art (1940-43). *Exhib:* Mall Galleries, Medici, Guildhall London, Southern Regional Galleries; major one-man show, Winchester City Gallery (1979), 'Nature in Art' Gloucester (2000), Rome Biennale exhibitor (2001), Blacksheep Gallery, Hawarden (2001), Culture 2000 exhibitor, 2nd International Animals in Contemporary Art at Turin, Barcelona and London (2002-03), Pierrepoint Gallery, Bridport Dorset -Retrospective (2005). *Works in collections:* Oxford C.C., King Alfred's College, Winchester, 'Nature in Art', Wallsworth Hall, Twigworth, Gloucester. *Commissions:* Oystercatchers @ E.Quantoxhead. *Works Reproduced:* Tiger Rag I; Fisher King; illus. profiles, RSPB Magazine 'Birds' (Autumn, 1978); Oxford Mail (28 Oct., 1976); Entry Dictionary of International Biography (1999), Dorset Art Weeks Dictionary (2002), Dorset Life (Oct 2005). *Principal Works:* Nine Day Wonders; Pond; Green Man; River Osprey; Fisher King. *Signs work:* "Waterfield." Later work displays strong abstract characteristics. *Address:* Plaintiles, Uploders, Bridport, Dorset DT6 4NU.

WATERS, Linda Mercedes, HS; BA Hons (1977). *Medium:* painter, illustrator and designer in water-colour, pen and ink, oils, wood engraving. *b:* Monmouthshire, 10 Nov 1955. *d of:* H. Ivor Waters, local historian and poet. *Educ:* Chepstow School. *Studied:* Gwent C.H.E. Faculty of Art and Design, Newport (now University of Wales, Newport)(1974-77). *Exhib:* Royal West of England Academy, Medici Gallery, Oriel Cardiff, Llewellyn Alexander Gallery, Hilliard Society, etc. *Works in collections:* historic reconstructions of Chepstow in Chepstow Museum; many private collections. *Publications:* many books and magazines illustrated, particularly botanical, natural history and history. *Recreations:* gardening, local history. *Clubs:* Hilliard Society of Miniaturists. *Signs work:* "Linda Waters" or "L. Waters." *Address:* 41 Hardwick Ave., Chepstow, Monmouthshire NP16 5DS.

WATKINS, Frances Jane Grierson (Peggy), oil, water-colour, pencil artist; jewellery; speciality, pencil portraiture; instructor silverwork and jewellery Hereford College of Art (1957-72). *b:* 24 Jul 1919. *d of:* the late Thomas Vaughan Milligan, A.R.C.A. *m:* Rev. Alfred Felix Maceroni Watkins. one (decd.) *s.* one *d. Educ:* Elms School. *Studied:* Herefordshire School of Art and Crafts; Birmingham School of Jewellery. *Exhib:* R.A., R.S.A., R.B.A., R.W.A., R.B.S.A., National Eisteddfod, Herefordshire Arts and Crafts. *Works in collections:* Hereford A.G.; Lady Hawkins Grammar School; Agric. Exec. Com.;

Hereford City Art Gallery; Hereford RDC (badge of office). *Commissions:* oil portrait of Mayor of Hereford, silver vase, Burghill Church, various jewellery. *Signs work:* "PEGGY WATKINS." *Address:* Leylines, 26 Southbank Rd., Hereford HR1 2TJ.

WATSON, Alfred Colin, BA(Hons) Fine Art; Ireland Fund of Great Britain Award; Don Niccolo D'Ardio Carracciolo Medal and Award; De Veres Award; RUA Most Popular Painting Award. *Medium:* oil, drawing. *b:* Belfast, 28 Jun 1966. *s of:* Lorenzo & Mary Watson. *Studied:* University of Ulster (1984-88). *Represented by:* Pyms Gallery, Mayfair, London. *Exhib:* solo exhbns: Pyms Gallery, London; mixed: National Portrait Gallery, London; RA; RHA; Discerning Eye, Mall Galleries; Gallery Revel, New York, USA; Ava Gallery, N.Ireland; Albemarle Gallery, London. *Works in collections:* Royal Geographical Society, London; Northern Ireland Office; Arts Council of Northern Ireland; National Self-Portrait Collection of Ireland. *Publications:* exhibition catalogues; Modern Masters (2005); Works on Paper 1800-Present Day (2005). *Recreations:* travel. *Signs work:* 'CW' or 'C.WATSON'. *Address:* 34 Cherryvale Gardens, Belfast, N.Ireland BT5 6PQ. *Email:* alfredcolinwatson@hotmail.com

WATSON, Arthur James, RSA, DA; sculptor/printmaker; Senior Lecturer Fine Art, Duncan of Jordanstone College of Art and Design, University of Dundee; The Highland Society Prize (2001), Edinburgh; The Chicago Prize (2004). *b:* Aberdeen, 24 Jun 1951. *Educ:* Aberdeen Grammar School. *Studied:* Grays School of Art, Aberdeen (1969-74). *Exhib:* Venice Biennale (1990), New Directions, Sarajevo (1988), 'Singing for Dead Singers' 5 Exhbns, Aberdeen (2000), Leaving Jericho, Chicago (2003), Art on the Borders of Art, Venice & Wroclaw (2003). *Works in collections:* Aberdeen A.G. and Museum, Arts Council of England. *Commissions:* University of Aberdeen, Monklands District Council, Sabhal Morostaig, Skye, Cairngorm Mountain. *Publications:* Singing for Dead Singers (Aberdeen City Council); Leaving Jericho (John David Mooney Foundation, Chicago). *Signs work:* 'A.J.Watson'. *Address:* 30 Marine Parade, Dundee, DD1 3BN.

WATSON, Heather, R.M.S. (1999), H.S. (1989); miniaturist painter in watercolour. *b:* Coventry, 10 Mar 1939. *m:* William James Egerton Smith. *Educ:* Stoke Park School, Coventry. *Exhib:* R.A., R.M.S., Llewellyn Alexander (Fine Arts) Ltd., Medici Gallery, London, Linda Blackstone Gallery, Pinner, Hilliard Exhbns. Wells; solo shows: Dorset and N. Yorks, Nunnington Hall, National Trust Property, N. Yorks, Talents Gallery, Malton, N.Yorks; Box of Delights Gallery, Thirsk, N.Yorks. *Address:* Dale Cottage, Dale End, Kirkbymoorside, N. Yorks. YO62 6EQ.

WATSON, Howard, abstract painter. *Medium:* oil on canvas and soft pastel. *b:* 13 Oct 1930. *m:* Patricia. one *s.* two *d. Educ:* Grammar School. *Studied:* Coventry School of Art. *Exhib:* Plumbline Gallery St. Ives, Penwith Gallery, St. Ives, Number Nine The Gallery, Brindley Place, Birmingham

(www.numberninethegallery.com). *Works in collections:* South Warwickshire Hospital Trust, Stratford-on-Avon & Warwick Hospitals; County Library, Warwick. *Commissions:* BMW Group Financial Services, Pizza Express Albangate, Charlotte St. London, Maidenhead, New Delhi, Walton-on-Thames,Cambridge, British Telecom HQ London. *Official Purchasers:* Art Consultants. *Principal Works:* Radiant Abstraction, multi-forms, minimalism. *Recreations:* music, cycling, swimming, cinema. *Clubs:* Penwith Soc. of Arts (Associate), St.Ives, Cornwall. *Signs work:* "Howard Watson" and initials on verso. *Address:* Vincent Lodge, Percy St., Stratford on Avon CV37 6SL.

WATSON, Janet, RWA. *Medium:* oil and mixed media painting. *b:* Harrogate, 12 Feb 1953. *m:* Peter. one *s.* one *d. Exhib:* RWA; Crane Kalman, London; Schoolhouse Gallery, Bath; Black Swan Guild, Frome. *Works in collections:* private and corporate. *Signs work:* 'Janet Watson' or 'J.W.'. *Address:* 50 Devonshire Bldgs, Bath, BA2 4SU.

WATSON, Thomas Jude (Tomas), BA (Hons) Fine Art (1994), 3rd prize Stoves Exhibition (1991), Robert Ross Scholarship (1994), Greek Govt. Scholarship (1994-96), Gavin Graham Gallery award (1997), BP Portrait Award (1998). *Medium:* oil on canvas, charcoal etc. *b:* Shoreham-by-Sea, Sussex, 6 Jun 1971. *m:* Ornella Mammoliti. *Studied:* Slade School of Fine Art (1990-94). *Represented by:* Jill George Gallery, Soho, London. *Exhib:* solo exhbns in London and Greece; group exhbns in USA, Canada, UK, Greece. *Works in collections:* National Portrait Gallery, Clare College Cambridge, University College London. *Commissions:* portrait of John Fowles for NPG, portrait of Bob Hepple (Master of Clare College, Cambridge). *Publications:* exhib. catalogue - 'Shadow and Light' 2003- intro. by John Russell Taylor; 'Aspects' 2005-intro. by Jane Carter. *Address:* Stenies Village, Andros, Greece. *Website:* www.jillgeorgegallery.co.uk

WATSON-GANDY, Basia, B.A.Hons., S.W.A., I.P.A., Grollo d'Ora Silver Medal (1980), Gold Medal (1981); painter on china, porcelain and ceramics using glazes, lustres, goldwork; lecturer and researcher in the Industry; lecturer. Founder Com. mem. and past president, B.C.P.A.A. Commissioned work in private collections throughout the world;. *Publications:* many magazine articles; appearances on TV and radio. *Clubs:* S.W.A., Confraternity of Polish Artists, Virginia Water Art Soc. *Address:* Squirrel Court Studio, Hare La., Little Kingshill, Gt. Missenden, Bucks. HP16 0EF.

WATSON STEWART, Lady Avril Veronica, (nee GIBB); D.G.S.J. (1997), FRSA (1969), Hon.FBID (1979), Hon.M.Aust.S.C. (1983); artist/calligrapher/lettering designer on vellum, glass, metals, stone; worldwide lecturer with humour; The Gilbert Inner Award (Glasgow School of Art). *b:* Glasgow. *m:* Sir James Watson Stewart, Bt. (decd. 1988). *Educ:* Glasgow High School for Girls, Glasgow and West of Scotland College of Commerce (now University of Strathclyde). *Studied:* Glasgow School of Art (1950, Prof. Colin

Horsmann). *Exhib:* California, Norfolk, Va., St. Andrews, Dunfermline, Greenock A.G., National Library of Scotland, Australia. *Works in collections:* V&A, Paul Getty, Royal Family, Glasgow School of Art Archive, and private collections. *Commissions:* glass doors in churches, all forms of architectural lettering or illuminated panels, calligraphy heraldry worldwide. *Recreations:* caring for sick and injuredbirds. Known as Bird Woman of area. *Misc:* Lecturer aboard 'Royal Princess', 'QE2', and for GMC London. Now confined to travelling in Scotland. Lectures: 'Illuminating Thoughts by a Designing Woman', 'A Calligrapher Goes West' (own art in USA), 'The Birds and The Bees' (Illuminated Mss. and own contemporary designs, i.e. from monks to modern. 11th Year as Hon. President 'Variations', 50 members of Choral Society, Largs; Donating Lecturer 15 medical societies and Drogowan Hospice, etc., etc. *Signs work:* owl followed by maiden name. *Address:* 36 Brisbane Road, Largs, Ayrshire, Scotland, KA30 8NH.

WATT, Gilbert, D.A. (1946), A.R.B.S. (1982), Landseer bronze medal; Cert. of Merit (R.A. 1952), Prix de Rome (1952); sculptor in clay, stone, steel, wood. *b:* Aberdeen, 19 Sep 1918. *s of:* James Watt, master blacksmith. *m:* Irene Mae. *Studied:* Gray's School of Art, Aberdeen, under T.B. Huxley-Jones; R.A. Schools under Maurice Lambert; British School at Rome. *Exhib:* R.A.; R.S.A.; Rome; Leicester Galleries; Royal Festival Hall; Arts Council Travelling Exhbn.; G.I.; Aberdeen A.G.; Scone Palace; Shakespeare Birthplace Trust Exhbn.; Taliesin Art Centre, Swansea University; one-man show, Inverurie, Aberdeenshire. *Works in collections:* Britain, America, W. Germany. *Signs work:* "Gilbert Watt." *Address:* Riverside, 4 Ellon Rd., Bridge of Don, Aberdeen AB2 8EA.

WATT, James, RGI (2002), SSA (1965); DA Drawing and Painting (1954); Royal Bank of Scotland Award RGI (1997). *Medium:* oil painting. *b:* Port Glasgow, 17 Nov 1931. *s of:* Alexander Watt. *m:* Nancy Sinclair. one *s.* three *d. Educ:* Greenock. *Studied:* Glasgow School of Art (1950-54). *Represented by:* Cyril Gerber Fine Art, Glasgow; Leith Gallery, Edinburgh. *Exhib:* RSA, RGI, SSA, RSMA, Greenock Art Gallery, Aberdeen Art Gallery, Perth Art Gallery, Strathclyde University, Paisley Art Gallery, Leith Gallery, Cyril Gerber Fine Art, AIA Gallery, T.R.Annan Gallery, Scottish Gallery Hong Kong, Torshavn Smidjanilitluvik. *Works in collections:* H.M.The Queen, H.R.H. The Princess Royal, H.R.H. Prince Phillip; Scottish Arts Council; BBC, Clydeport, IBM, Yarrow Shipbuilders Ltd., Royal Bank of Scotland, United Distillers, WD & HO Wills; Danish Embassy Ivory Coast, Clyde Shipping Co., Britoil, GEM Shipping Co., Greenock Art Gallery, Scottish Education Authorities. *Publications:* The Artist, Scots Magazine, Scottish Field, Maritime Life and Traditions,. *Works Reproduced:* 'The Clyde' Canniesburn Hospital, Glasgow. *Principal Works:* Industrial shipping on River Clyde; landscape. *Recreations:* nature study, sailing, angling, travel. *Clubs:* Glasgow Art Club. *Misc:* Founder Member, Glasgow Group (1957). *Signs work:* "Watt". *Address:* 5 Boathouse Drive, Largs, Ayrshire, KA30 8NX.

WHO'S WHO IN ART

WATTS, Brenda Mary, N.D.D. (1951), Cert. in Educ. (1973), S.B.A. (1998), C.B.M. (2002); Joyce Cummings Award (1999), G.M. (2001); botanical artist in water-colour, retd. teacher. *b:* Ilford, Essex, 29 Jul 1932. *m:* Michael Watts. two *s. Educ:* S.E. Essex (1948-51). *Exhib:* annually SBA and RHS, Pashley Manor, Florum. *Works in collections:* Dr. Shirley Sherwood and Lindley Library. *Commissions:* private. *Signs work:* "B.W." in a lozenge. *Address:* Barrohill, Horsell Rise, Woking, Surrey GU21 4AY.

WATTS, Joan Alwyn, Hon.A.R.M.S.; portrait miniatures and water-colour landscapes. *b:* Birmingham, 19 Dec 1921. *d of:* J. Lineker, sales manager. *m:* Ronald O. Watts. one *s.* one *d. Educ:* Birmingham College of Art. *Exhib:* Birmingham Soc. of Artists, Royal Miniature Soc., Paris Salon, various exhbns. in America and Australia; permanent exhbn. Art Bureau, London. *Publications:* The Royal Miniature Society 100 Years (a portrait min. requested for this publication). *Address:* Dial Cottage, Bannut Tree La., Bridstow, nr. Ross-on-Wye, Herefords. HR9 6AJ.

WATTS, Michael Gorse, (otherwise PIKE, Septimus - cartoonist), A.R.I.B.A. (1965), M.F.P.S. (1989); artist, cartoonist, illustrator, in ink, acrylic, water-colour. *b:* Stepney, London, 3 Dec 1934. *s of:* the late George Watts, O.B.E. *m:* Meg Wattson Dean. three s. one d. by first marriage. *Educ:* St. Edward's School. *Studied:* Oxford School of Technology and Art (1951-54), S.W. Essex School of Art (1960-62). *Exhib:* Group, solo, etc., in Gt. Britain and the U.S.A. Work in private collections at home and on four continents. *Commissions:* pair of Trompe l'Oeil doorways in 14th century house, Shropshire, portraits, book illustrations, church furniture design. *Works Reproduced:* numerous articles, cartoons and illustrations. *Clubs:* Free Painters and Sculptors, Chichester, ELAND. *Address:* 27 Sutherland St., London SW1V 4JU. *Email:* megwump@btinternet.com

WATTS, Mrs. Dorothy, SWA (1952), Mem. Federation of British Artists; artist in water-colour; early years, fashion designer for London and Northern papers. *b:* London, 3 Apr 1905. *d of:* S.C.Ravenshoe. *m:* A. Gordon Watts, LL.B., solicitor. *Studied:* Brighton College of Arts under J. Morgan Rendle, R.I., R.B.A. *Exhib:* R.A., R.I., R.B.A., S.W.A., Britain in Water-colours and provincial galleries. *Works in collections:* Hove Art Collection. *Works Reproduced:* in Londoner's England, various Christmas cards and in newspapers, London and provincial. *Clubs:* S.W.A. *Address:* Southwoods, 65 Surrenden Rd., Brighton, Sussex BN1 6PQ.

WATTS, Richard, LLb Barrister, BVSc, MRCVS, HS. *Medium:* watercolour portraits and caricatures, and animation. *b:* Birmingham, UK, 17 Mar 1955. *s of:* George & Nora Watts. *m:* Joanne. two *s.* two *d. Educ:* King Edwards School, Birmingham. *Studied:* Birmingham University, Liverpool University. *Exhib:* HS; Birmingham Botanical Gardens. *Signs work:* 'RICHARD WATTS'. *Address:* 16 Hollister Drive, Harborne, Birmingham, B32 3XG. *Email:* richardwatts21@hotmail.com

WATTS, Terry, RBA; awards: Buzzacott Defries Memorial Prize, RI (2007); Guest Prize, Laing Landscape Competition (2002); First Prize, City Airport Competition (2002, 2003). *Medium:* acrylic. *b:* London, 4 Aug 1946. *s of:* KE & G Watts. *m:* Jennifer Watts (née Precious). *Studied:* Camberwell School of Art, Hammersmith College of Art, Open University. *Exhib:* Sunday Times Watercolour Competition; Discerning Eye; galleries: Beaux Art (Bath), Bell (Winchester), Blackheath, Bloxham, Hunter, John Noott, Francis Iles, Llewelyn Alexander, Redleaf, Piers Feetham, Stark, Mall - RSMA, RI, RBA, plus many other London and provincial galleries. *Works in collections:* Wiltshire County Council, Transco Plc. *Commissions:* London Docklands Development Corporation; Soviet Weekly; L.B. of Merton; Aldeburgh Festival. *Publications:* Pratique des Arts, Spring 2006, My Room, Quistgard, Anderson et al. *Works Reproduced:* B;ackheath Guide: n paradoxa. *Signs work:* "TW" (or monogram of TW). *Address:* 8 Rainton Road, Charlton, London SE7 7QZ.

WATTSON DEAN, Meg, HS, MAS-F, MPSG, SLM, GGE; specialist in miniatures and glass engraving; artist/sculptor. *b:* Luton, 11 Nov 1929. *m:* Michael Watts. one *s.* one *d. Educ:* Bedford High School. *Studied:* Rolle College, Exmouth (1968-70). *Exhib:* with RMS (1989-2004), Hilliard Soc., 'A Million Brushstrokes' at Llewellyn Alexander Gallery, Florida & Washington Miniature Art Socs. (1991-2005), Guild of Glass Engravers, Westminster Arts Council, 3rd World Exhibition Fine Art in Miniature, Smithsonian Institute, Washington DC (2004); 4th World Miniature Art Exhibition (Australia 2008); one-person exhibitions Oxmarket Centre of Arts, Chichester. *Works in collections:* Chelsea and Westminster Hospital, private collections U.K., U.S.A. and Australia. *Commissions:* Millennium window Edmond Church. *Clubs:* Guild of Glass Engravers. *Signs work:* cipher of MWD, W and D attached to base of M either side, or "Meg Wattson Dean". *Address:* 27 Sutherland St., London SW1V 4JU. *Email:* megwattsondean@btinternet.com

WAUGH, Eric, A.R.C.A. (1953), R.I. (1990); artist in water-colour. *b:* London, 15 Dec 1929. two *s.* two *d. Studied:* Croydon School of Art (1946-50), R.C.A. (1950-53). *Exhib:* Ashgate Gallery, Farnham (1965-67), Geffrye Museum (1968), Roland, Browse & Delbanco (1971), Arte Benimarco, Spain (1980), Galeria de Arte Denia, Spain (1981), Galeria de Arte Javea, Spain (1982), R.A., R.I., R.B.A., London Group, Sport in the Fine Arts, Madrid. *Works in collections:* Mexico, U.S.A., Australia, Spain, U.K. *Commissions:* 100ft x 7ft mural- tactile for West of England School for the Partially Sighted. *Publications:* articles written for various magazines; Painting in Acrylics - A Correspondence Course (Pitmans). *Signs work:* "Eric Waugh." *Address:* Pen-an-Vrea, Leeches, St. Kew Highway, Bodmin, Cornwall PL30 3EG.

WAUTERS, Jef, artist (painter). *b:* B9910 Mariakerke, 26 Feb 1927. *m:* Denise D'hooge. one *s.* one *d. Studied:* Sup. Inst. St. Lucas and Academy of Fine Arts, Ghent. *Exhib:* numerous one-man and group exhbns. *Works in collections:* New York, Chicago, San Francisco, Los Angeles, Paris, München, Brussels,

Rome, Bern, The Haegue e.o. Diff. museums. *Publications:* Palet (300 numb. ex.), "Paris-Roma" sketch-book, (500 numbered ex.), Jef Wauters by J. Murez, Jef Wauters (Ed. Aro, Roma) by G. Selvaggi, Jef Wauters (ed. Arben Press Switzerland). *Address:* 7 Rode Beukendreef, 9831 St. Martens Latem, Belgium. *Email:* info@jefwauters.be *Website:* www.jefwauters.be

WEALLEANS, Jon, MA (RCA) Distinction; FRCA; FCSD. *Medium:* oil, watercolour. *b:* Yorkshire, 10 Feb 1946. *m:* Natalie Gibson. *Studied:* Royal College of Art (1967-70). *Represented by:* Francis Kyle Gallery, Maddox St, London W1. *Exhib:* Royal Academy Summer Shows; Francis Kyle Gallery. *Works in collections:* all private. *Recreations:* architecture and design. *Misc:* consultant to: Kemp Muir Wealleans Architects and Designers, 247-249 Cromwell Road, London SW5 9GA. *Signs work:* JW (monogram within circle). *Address:* 9 Grange Walk, London SE1 3DT.

WEAVER, Felicity, N.D.D. City & Guilds; printmaker in etching and drawing. *b:* Leeds, 11 Feb 1930. *m:* Peter Weaver. one *d. Exhib:* B'ham Museum and A.G., Greenwich Printmakers Gallery, LWT Terrace Gallery; group shows: R.E., R.W.A., R.B.S.A, R.P., RBA, Curwen Gallery, Barbican, C.P.S., P.S., etc., also Moscow, Paris, Landau, Belize, Belfast, 54 The Gallery. *Works in collections:* B'ham Museum and A.G., Scarborough Archives, Victoria and Albert Museum, Lewisham Council, and private collections in England, Germany, America and Australia. *Clubs:* P.M.C., G.P.A. *Signs work:* "FELICITY WEAVER." *Address:* 36 Cator Rd., London SE26 5DS.

WEAVER, Peter Malcolm, RI, RBA, ARBS, Slade Dip.; painter in watercolour, sculptor in mixed media; Founder mem. Printmakers Council; teacher of drawing and lithography: Camberwell School of Art and Crafts (1957-87). *b:* London, 10 Jun 1927. *s of:* P.R.Weaver. *m:* Felicity Rachel. one *d. Studied:* St. Martin's School of Art and Camberwell Schools of Art, Slade School of Fine Art, UCL. *Represented by:* Mall Gallery. *Exhib:* galleries: Grosvenor Gallery, Nicholas Treadwell, Sloane St., Ikon, Primavera Gallery, Alresford Gallery, ICA, Whitechapel Gallery, Shell House Gallery, Manor House Gallery; Open exhbns.: RA, RWS, RBA, RWA, NEAC, RI, PMC, London Group, Birmingham Museums and Art Gallery, 54 The Gallery. *Works in collections:* V&A, Birmingham Museum and AG, also private collections in UK, Japan, Sweden and America. *Commissions:* garden architecture-sculpture, Tatsumo, Japan. *Publications:* The Technique of Lithography; Printmaking - A Medium for Basic Design. *Works Reproduced:* 'The Artist' Magazine; 'British Sculpture' by Guy Portelli. *Clubs:* The Arts Club, Dover St. *Signs work:* "P. WEAVER, RI, RBA". *Address:* 36 Cator Rd., London SE26 5DS.

WEBB, Barbara, etcher; teacher for I.L.E.A. *b:* London, 18 Dec 1933. *m:* T.R. Webb. one *d. Educ:* South Hampstead High School. *Studied:* Cass School, Whitechapel, London, Corcoran School of Art, Washington, D.C., U.S.A. *Represented by:* Camden Printmakers co.uk. *Exhib:* R.A. Summer Exhbns, St.

John's Smith Sq., Print Exhbn Mall Gallery; Contemporary Art Fair. *Works in collections:* Government Art Collection, Camden Council. *Commissions:* etchings of wedding ceremony. *Signs work:* "Barbara Webb." *Address:* 39b Rosslyn Hill, London NW3 5UJ.

WEBB, Elizabeth, A.R.C.M., (1953), G.R.S.M. (London) (1955); artist in oil on canvas or board; music teacher;. *b:* Fakenham, 7 Sept., 1931. *m:* (1) Frank Rayer (decd.). (2) Graham Webb (decd.). two *s. Educ:* The Park School, Yeovil; Royal College of Music, London. *Studied:* Evening Classes with Mary Bairds (1989-93). *Exhib:* R.A., Paris Salon, Meridian International Center, Washington, Sui Loung Gallery, Hong Kong. *Signs work:* "Elizabeth Webb". *Address:* La Guelle, Guelles Rd., St. Peter Port, Guernsey, C.I. GY1 2DE.

WEBB, Gwendoline E., RAS Cert (1954), London University Extra-Mural Diploma History of Art (1975); picture conservator (retired), painter. *Medium:* painter in oil, some watercolour. *b:* Bromley, Kent, 8 Jul 1929. *Educ:* Kingston School of Art, NDD Painting 1949. *Studied:* Royal Academy Schools 1950-54. *Exhib:* RA Summer Exhibitions, NEAC, Society of Women Artists, Lord Mayors Art Award Exhibition, SEA Pictures for Schools. Shared: Fairfield Halls, Croydon; Old Bankhouse Watlington; Phoenix Gallery, Lavenham; Century Galleries, Sonning. *Works in collections:* private collections and SEA Schools. *Commissions:* portraits (private). *Publications:* Encyclopedia Britannica, section on picture conservation. *Recreations:* visiting exhibitions, National Trust, etc. *Clubs:* RASAA. *Signs work:* 'GW'. *Address:* 7 Parkfields, Shirley, Surrey, CRO 8DH.

WEBB, Kenneth, N.D.D., A.T.D.Hons., N.S., F.R.S.A., R.W.A.; artist in oil and acrylic; Head of Painting School, Ulster College of Art (1953-60);. *b:* London, 21 Jan 1927. *s of:* William George Webb and Mabel Melissa Webb. *m:* Joan Burch. two *s.* two *d. Educ:* Bristol Grammar School; Lydney Grammar School and School of Art. *Studied:* Gloucester College of Art and University College, Swansea. *Exhib:* one-man shows 1954 to 1994: Verhoff Washington D.C., Arts Council Belfast, Walker Galleries London, Toronto, San Francisco, Ritchie Hendricks Dublin, Kenny Galleries, Alexander Gallery Bristol, Geneva, Solomon, James Gallery, etc. *Publications:* Kenneth Webb (Shenval Press, London), Profile of an Artist by Thomas Kenny (1990), 'A Life in Colour' (Antique Collectors Club, UK, 2003), British Flower Painters 1650-1950 (two entries), also video 'A Life in Colour'. *Works Reproduced:* landscape prints, Paul Hamlyn, Prints for Pleasure, and Quality Prints. *Clubs:* Bel-Air Equestrian Club. *Signs work:* figurative work: "Kenneth Webb," non figurative work: "Webb." *Address:* Portland House, Chagford, Devon TQ13 8AR.

WEBB, Sarah Ann, B.A.(Hons.) (1978), S.W.A. (1994); Best of Show (1987) and Athena award (1992) Central South Art competition (U.S.A.); artist in oil. *b:* Nashville, TN, 19 Feb 1948. *m:* Gary A. Webb, attorney. *Educ:* University of Tennessee. *Studied:* University of Tennessee and Vanderbilt University. *Exhib:*

regular exhib. S.W.A. and Central South Art competition (U.S.A.), winner American Artists National Art competition, Grand Central Gallery (N.Y. 1985), Tennessee All State competition, numerous national and international group and solo shows; P.B.S. Television (U.S.A. 1994, 1995), Radio (U.S.A. 1985), Nashville Arts Comn (USA, 1994); Belmont Univ. (USA 1999). *Works in collections:* corporate and private collections worldwide. *Publications:* Who's Who in American Art. *Signs work:* "Sarah Webb." *Address:* P.O. Box 50134, Nashville, TN 37205, USA. *Website:* www.sarahwebb.com

WEBBER, Angela Mary, SCA; painter and maker of religious images, writer on and tutor of animal painting; founder and secretary, SSSA. *b:* London, 4 Jan., 1931. *d of:* Ambrose Webber, shipping merchant. *m:* Russell Arlen Bedingfield, art and antiques collector. *Studied:* Hull College of Art (1949-52). *Exhib:* O'Mell Gallery (1976), Solange de la Bruyere Gallery, Saratoga Springs, U.S.A. (1976-77), S.E.A. (1981), N.S. (1980), N.E.A.C. (1983). *Works in collections:* Martin S. Vickers, Stella A. Walker, Miss Wiesenthall, U.S.A. *Commissions:* various. *Works Reproduced:* The Webber Prints, Quartilles International, etc. *Signs work:* "A. M. WEBBER." *Address:* 2 Marina Cottage, Willingdon Lane, Jevington, Polegate, Sussex BN26 5QH.

WEBSTER, John Morrison, RSMA (2001); marine and landscape painter in oil, pastel, water-colour; 40 years in Royal Navy; Chairman, Armed Forces Art Society (1990-96), mem. Board of Governors FBA (2002-). *b:* Sri Lanka, 3 Nov 1932. *m:* (decd). two *d. Studied:* No formal art training. *Exhib:* one-man shows: Art Gallery of Nova Scotia (1976), London since 1980, Tryon and Swann, Cork St. (1996, 1999), Tryon, Bury St. (2002, 2004, 2007); NEAC, ROI, RI, RSMA, Alresford Gallery, Alresford; Wykeham Gallery, Stockbridge. *Works in collections:* H.M. The Queen, H.R.H.The Prince of Wales, Corporation of Trinity House, Naval establishments, HM Ships, and private collections in Canada, Australia, New Zealand, Holland, France, U.K. *Commissions:* Royal Cruising Club, Trinity House, many private. *Works Reproduced:* numerous. *Principal Works:* 'HMY Britannia on Decommissioning Day' Collection, H.M. The Queen; 'International Fleet Review 2005' Collection, Trinity House; 'Silver Jubilee Fleet Review 1977' Diploma Collection RSMA. *Signs work:* "JOHN WEBSTER." *Address:* Old School House, Soberton, Southampton SO32 3PF. *Website:* www.johnwebster.org.uk

WEBSTER, John Robert, A.T.C., D.A.E.; W.A.C. travel grant to Ireland (1991); artist in etching, printmaking, gouache; senior lecturer, St. Mary's College, Bangor, N. Wales (1968-75); Dip. in Art Educ., Leeds University Inst. (1975-76); Lecturer in Art Educ., U.C.N.W. Bangor (1977-89); part-time Curator, U.C.N.W. Art Gallery (1982-). *b:* Bridlington, E. Yorks., 22 May 1934. *s of:* Joe Webster, commercial traveller. *m:* Dorothy Lloyd Webster. one *s.* four *d. Educ:* Leeds G.S. *Studied:* Leeds College of Art (1951-55-57). *Exhib:* Mold, Conway (1969-), National Eisteddfod Llangefni (1983), Cardiff, Aberystwyth Open (from 1986), Birkenhead (1986), Anglesey Eisteddfod (1986), etc. *Works in collections:*

Schools Museum, Cardiff, D.O.E., National Library, Aberystwyth. *Address:* Tyn' Cae, Paradwys, Bodorgan, Anglesey, Gwynedd LL62 5PF.

WEBSTER, Norman, R.W.S., R.E., A.R.C.A.; painter etcher;. *b:* Southend-on-Sea, 6 May 1924. *s of:* George W. Webster. *m:* Joan W. Simpson, A.R.C.A. three *s. Educ:* Dover Grammar School; Tunbridge Wells School of Art (1940-43, E. Owen Jennings, R.W.S.); Royal Navy (1943-46); R.C.A. School of Engraving (1946-49, Malcolm Osborne, C.B.E., R.A., Robert Austin, R.A.). *Studied:* School of Engraving, Royal College of Art (1946-49). *Exhib:* Painter Etchers, R.W.S., R.A., Yorkshire Artists at Leeds, Bradford, Wakefield and Hull City A.G.'s, with Yorkshire Printmakers in Britain, U.S.A., Israel and Canada. *Works in collections:* Ashmolean Museum; Salford University; Leeds City A.G. and Arts Council of G.B. *Signs work:* "Norman Webster." *Address:* 48 The Drive, Cross Gates, Leeds LS15 8EP.

WEEKS, John Lawrence Macdonald, L.R.M.S. (1984), A.R.M.S. (1987), F.N.C.M. (1984); artist in oil and water-colour; private music teacher and organist. *b:* Chelmsford, 28 Apr 1954. *Educ:* Moulsham High School, Chelmsford. *Studied:* Colchester Inst. of H.E. (1973-74, John Buhler). *Exhib:* R.M.S. annual, Medici Gallery and one-man shows. *Signs work:* name followed by date and device. *Address:* 49, Prescott, Hanworth, Bracknell, Berks. RG12 7RE.

WEERDMEESTER, Neil Jackson, B.A. (Hons.) Fine Art (1986), M.A. Fine Art (1994); artist in painting and photography;. *b:* London, 21 Feb., 1960. one *d. Studied:* Dartington College; Reading University; Winchester School of Art. *Exhib:* London, Barcelona, Antwerp. *Clubs:* London Group. *Address:* Lower Flat, 5 Gilmore Rd., London SE13 5AD. *Email:* neilweerdmeester@hotmail.com

WEGMULLER, Ann, BA (Hons) Fine Art, RSW, RWS; Freshfields Bruckhaus Deringer Prize, Bankside Gallery (2002), Scottish Arts Club Award, RSW (1996), Macdonald Orr Ltd. Purchase Prize SAAC(1994), James Torrence Memorial Award, RGI (1989). *Medium:* oil, gouache and watercolour. *b:* Gourock, Inverclyde, 3 May 1941. *d of:* William Bayne Paton & Isabella Forbes Paterson. *m:* Alfred Wegmuller. one *s. Educ:* Greenock Academy, Renfrewshire, Scotland. *Studied:* Duncan of Jordanstone College of Art Dundee (1981-85). *Represented by:* Bankside Gallery, London; Gallery Heinzel, Aberdeen; Lost Gallery, Strathdon, Aberdeenshire. *Exhib:* Royal Scottish Academy, Royal Glasgow Institute, Aberdeen Artists Society, Royal Scottish Society Painters in Watercolour; Gallery Woll & Brandshof, Cullemborg, Holland. Solo and group shows Scotland, England, Holland, Switzerland. *Works in collections:* Mobile North Sea Ltd. Aberdeen, Delaitte & Touche, Aberdeen, various private collections worldwide. *Publications:* 'The Watercolour Expert' (RWS, Cassell Illustrated); Watercolour Masters Then and Now (RSW, Cassell). *Works Reproduced:* Lallans magazine, Chapman magazine. *Recreations:* reading, poetry, Scottish Country Dancing. *Clubs:* Aberdeen Artist Society (Professional

Member). *Misc:* lived for ten years in Zurich, Switzerland (1961-71). *Signs work:* 'Ann Wegmuller'. *Address:* Kirk House Main Road Aberuthven, Perthshire PH3 1HE Scotland.

WEGNER, Fritz James, M.C.S.D., Mem. Art Workers' Guild; freelance artist, retired lecturer, St. Martin's School of Art. *b:* Vienna, 15 Sep 1924. *m:* Janet Wegner. two *s.* one *d. Studied:* St. Martin's School of Art. *Represented by:* John Huddy of Olympia Fine Art. *Works in collections:* private. *Works Reproduced:* bookjackets and illustrations for British, American and Continental publishers; cover designs and illustrations for magazines; educational publications; G.P.O. Christmas and Anniversaries sets of stamps. Examples of work reproduced in several manuals on illustration. *Clubs:* Chelsea Arts, Double Crown Club. *Signs work:* "Wegner." *Address:* 14 Swains Lane, London N6 6QS.

WEIL, Hanna, N.D.D. (1943); painter in oil, water-colour, gouache; tutor, Hammersmith School of Arts and Crafts (1945-48); St. Martin's School of Art (1945-87). *b:* Munich, 19 May 1921. *d of:* Ernest Weil, Ph.D. one *d. Educ:* North London Collegiate School. *Studied:* St. Martin's School of Art (1940-43). *Exhib:* R.A., Leicester Galleries, Liverpool, Brighton, London Transport (posters), Pro Arte Kasper Gallery, Switzerland, Arthur Jeffress (Pictures) Ltd., 4 galleries Munich, Portal Gallery, Elaine Benson Gallery, U.S.A., Perrins Gallery, Hampstead. *Works in collections:* Thyssen, Sir Basil Spence. *Commissions:* Still Life - Claus Hansmann, Munich. *Works Reproduced:* Amalgamated Press, The Queen, Art News and Review, The Studio, The Artist; postcards, calendars, prints of paintings, two posters: London Transport. *Recreations:* theatre, opera. *Signs work:* "H. Weil." *Address:* 34 Christchurch Hill, London NW3 1JL.

WEINBERGER, Harry, artist in oil and all kinds of drawing. *b:* Berlin, 7 Apr 1924. one *d. Educ:* Continent and England. *Studied:* Chelsea School of Art under Ceri Richards, and privately with Martin Bloch. *Represented by:* Duncan Campbell Fine Art, 15 Thackeray St., Kensington Sq., London. *Exhib:* 36 one-man shows, including sixteen in London, one in Berlin and three in Stuttgart; Retrospective at Royal Pump Rooms Art Gallery, Leamington Spa. *Works in collections:* Ben Uri Gallery London; Herbert Art Gallery and Museum, Coventry; Royal Pump Rooms Art Gallery, Leamington Spa. *Signs work:* "HW." *Address:* 28 Church Hill, Leamington Spa, Warks. CV32 5AY.

WEISS, Edna, Sheila, (Née ROSE); Landseer Scholar, Royal Academy of Arts, silver and bronze medals, portrait painter, and writer of letters to newspapers. *Medium:* painter in oils. *b:* London, 10 Dec 1927. *m:* Willard Weiss. one *d. Educ:* Skinners' Company School. *Studied:* St.Martins, Royal Academy Schools (1946-51). *Exhib:* RP & RA. *Works in collections:* private collections and Arts Club. *Commissions:* private collections. *Works Reproduced:* in 'Daily Telegraph' and 'Builders' Magazine'. *Recreations:* gardening, swimming, tennis. *Clubs:* Arts Club, RASAA. *Misc:* worked in animation film studio of Halas &

Batchelor; fax no.: 0208-455-0788. *Address:* 3 Maurice Walk, London NW11 6JX.

WELCH, Robert Joseph, B.A. (1979), M.A. (1981); painter in oil and acrylic on canvas;. *b:* 22 Feb 1956. *s of:* V.R. Welch. *Educ:* Regis Comprehensive, Wolverhampton. *Studied:* Hull C.H.E. (1976-79, John Clarke), Manchester Polytechnic (1980-81, David Sweet). *Exhib:* Castlefield Gallery, Manchester, Showroom Gallery, London, Winchester School of Art, Mall Galleries; one-man shows: Patricia Brown, Dulwich, Smith-Jariwala, London. *Signs work:* "Welch, R.J.W." *Address:* 4a Husbourne House, Chilton Grove, London SE8 5DZ.

WELCH, Rosemary Sarah, S.W.A., A.A.E.A.; artist in oil and pastel. *b:* 24 May 1943. *m:* Anthony Crockford. *Educ:* private school Bournemouth, American High School, N.Y. *Studied:* St. Ives School of Painting (Leonard Fuller, R.A., R.O.I.). *Exhib:* Belfast, Mall Galleries, Omells, John Davies, St. Ives Soc. of Artists, American Academy Equine Art. *Works in collections:* Russell-Cotes Museum, Bournemouth. *Recreations:* riding, walking. *Signs work:* "Rosemary Sarah Welch." *Address:* Cherries, Crabbswood Lane Tiptoe Lymington, Hants SO41 6EQ.

WELLINGS, Tricia, self taught artist in gouache, charcoal and ink and gouache;. *b:* Guildford, 20 Mar., 1959. *Educ:* Horsham High School. *Exhib:* Painters Hall, London EC2, Mall Galleries, London SW1, Edith Grove Gallery, London SW10, Wattis Fine Art, Hong Kong, Ramsay Galleries, Honolulu, Hawaii, Ropner Gallery, London SW6, Bartley Drey Gallery, London SW3. *Works in collections:* U.S.A., Australia, Mexico, U.K., Hong Kong, Ireland (Eire). *Clubs:* The Nine Elms Group of Artists. *Signs work:* "T. Wellings." *Address:* 5a Pentland Gdns., Wandsworth, London SW18 2AN.

WELLS, Peter, Dip.Soc. (Lond.) (1970), M.F.P.S. (1987); painter in oil, poet. *b:* London, 12 Jan 1919. *s of:* Herbert Percy Wells (decd.). *m:* (1) Elisabeth Van der Meulen (decd.). (2) Gillian Anne Hayes-Newington. one *d. Educ:* privately, and Universities of London and Manchester. *Studied:* Hornsey School of Art - part-time (1952-54, J.D. Cast). *Exhib:* Hornsey Artists (1953), Ellingham Mill Art Soc. (1981), The Crest Gallery, London (1982), Minsky's Gallery, London (1982), Wells Arts Centre, Norfolk (1982), Loggia Gallery (1988), Fermoy Gallery, King's Lynn (Eastern Open Competition 1992), School House Gallery, Wighton, Norfolk (1991-). *Publications:* The One Time Press - illustrated edns. (see website). *Clubs:* P.E.N. *Address:* Model Farm, Linstead Magna, Halesworth, Suffolk IP19 0DT. *Website:* www.onetimepress.com

WELTMAN, Boris, Nature micro miniaturist, draughtsman, cartographer, stylus; painter, water-colour;. *b:* London, 29 Nov., 1921. *m:* Phyllis Joyce. *Educ:* Chatham House, Ramsgate; Folkestone College Diploma; art and light craft. *Exhib:* R.A., R.I., R.M.S., S.M. *Works in collections:* Work in private and national collections worldwide. *Commissions:* Warburg Inst. London, and U.S.A. Universities, Rep. British Art, Tokyo Exhbn. (1977). *Publications:* educational

books. *Signs work:* on back of micro miniature drawings and paintings. *Address:* St. Luke's, The Drove, Monkton, Ramsgate CT12 4JP.

WELTON, Peter, B.A.; artist in water-colour; Emeritus Prof. of Fine Art, De Montfort University, Leicester. *b:* Barnetby, Lincs., 15 Mar 1933. *m:* Liza. two *s.* *Studied:* King's College, Newcastle (Gowing, Pasmore and Hamilton). *Exhib:* Keele University (1997), Laing Gallery, Newcastle, Bar Convent Museum, York, Buxton Art Gallery, Jersey Arts Centre, Unicorn Gallery, London, The Royal Academy. *Works in collections:* Wimbledon 1997 "The New No. 1 Court", H.M. The Queen "Moored Boat" (1992), Peter Ogden: "The Jethou Suite" (1997), National Art Archive (London Transport), The Duke of Gloucester "Kimbolton School", Lady Conyngham "Udaipur 2001". *Publications:* "See What I Mean" with John Morgan (Edward Arnold, London, 1986), "Paint in Water-colour" (Patchings Farm, Nottingham). *Works Reproduced:* in Illustrated London News, The Artists Magazine; "Peter Welton's Sketch Diary 1999". *Misc:* Video "Peter Welton's Way with Water-colour" (1997). *Signs work:* "Peter Welton." *Address:* Orchard Cottage, Arnesby, Leics. LE8 5WG. *Email:* peter@peterwelton.com *Website:* www.peterwelton.com

WERGE-HARTLEY, Alan, N.D.D. (Leeds) 1952, A.T.D.; painter in oil, pen and wash of marine landscapes, lecturer; senior lecturer Dept. of Education, Portsmouth Polytechnic (1962-90). *b:* Leeds, 1931. *m:* Jeanne Werge-Hartley. two *d. Studied:* Leeds College of Art (1947-53) under Maurice de Sausmarez and E. E. Pullée; Hornsey College of Art (1972-73) (sabbatical). *Exhib:* in group exhbns. and one-man shows in Hampshire from 1962. *Works in collections:* Portsmouth City Gallery and numerous private collections in England and abroad. *Address:* 5 Maisemore Gdns., Emsworth, Hants. PO10 7JU. *Email:* alan@werge.go-plus.net

WERGE-HARTLEY, Jeanne, N.D.D., F.S.D.C., F.R.S.A.; designer/jeweller/goldsmith; Founder Mem., Chairman, Designer Jewellers Group; Vice-President and past Chairman, Soc. of Designer Craftsmen, member of the Association for Contemporary Jewellery. *b:* Leeds, 26 Aug 1931. *d of:* Edgar Vauvelle. *m:* Alan Werge-Hartley. two *d. Educ:* Leeds Girls' High School. *Studied:* Leeds College of Art (1948-52). *Exhib:* nationally and internationally. *Works in collections:* City of Portsmouth University, Portsmouth County Council, private collections in U.K. and abroad. *Commissions:* U.K., U.S.A., Europe, New Zealand, Japan. Freeman of the Worshipful Company of Goldsmiths and the City of London (1986). Included on Craft Council Index and BBC Domesday Project. *Publications:* 'Enamelling on Precious Metals'. *Address:* 5 Maisemore Gdns., Emsworth, Hants. PO10 7JU. *Email:* jeanne@werge.go-plus.net

WERNER, Max, B.A., M.A.; printmaker in etching, acrylic, pencil on paper;. *b:* Ghent, Belgium, 17 Oct., 1955. *m:* Shireen. two *d. Educ:* College de la Berlière (Belgium). *Studied:* Byam Shaw School of Art (1979-82, Winn Jones, Chris Crabtree, John Lewis), Slade School of Fine Art (1983-85, B. dos Santos). *Exhib:*

mixed and one-man shows in U.K., Belgium, France, Portugal, Switzerland, Germany, Ireland, Pakistan, Taiwan, Argentina. *Commissions:* collaborated with B. dos Santos to the decoration of the "Enter Campos" underground station, Lisbon, and to an etched limestone panel for the Nyombashi station, Tokyo. *Signs work:* "M. Werner." *Address:* Grenada 774, Acassuso 1641, Prov. de Buenos Aires, Argentina.

WESSELMAN, Frans, R.E. (1986); painter, etcher, stained glass artist;. *b:* The Hague, Holland, 1953. one *s. Studied:* printmaking and photography at Groningen College of Art (1976-78). Work concerned with the human figure, emotions and interactions. Sometimes literary sources (Shakespeare) are a starting point, from where my paintings develop into valid graphic, pictorial statements with strong colours and compositions. *Exhib:* R.E., R.A., R.W.S., R.W.A., and widely in the U.K., Holland, Ireland, Germany. *Works in collections:* Fitzwilliam, Ashmolean Museum; private collections in U.S.A., Japan, Australia. *Commissions:* limited edition print for Shropshire County Council, limited edition print for Galerie Inkt., Holland, commissions of paintings for private collectors. *Address:* 5 Green Mount, Cunnery Rd., Church Stretton SY6 6AQ.

WESSELOW, Eric, M.A., M.F.A., Prix de Rome, R.C.A., S.C.A., F.R.S.A.; past Pres. Independent Art Assoc. and Quebec Soc. for Educ. through Art; painter, artist in water-colour, acrylic, chalk and glass (patented system of coloured glass lamination), of portraits, landscapes, abstracts; teacher, linguist. *b:* Marienburg, Germany, 12 Sep 1911. *m:* Thea. one *s.* one *d. Educ:* Academy of Fine Arts, Koenigsberg. *Studied:* Philology, University Koenigsberg. *Exhib:* one-man shows: Montreal Museum of Fine Arts; Waddington Gallery, Montreal; N.Y. State University, Plattsburgh; Inaugural Exhbn. Eaton A.G., Montreal; Robertson Galleries, Ottawa; Toronto Dominion Centre; Ontario Assoc. of Architects, Toronto, etc. Represented in numerous national and international art exhbns. *Works in collections:* architectural laminated coloured glass relief windows and screens: Montreal Airport Dorval; Hospital Dortmund, W. Germany; Sanctuaries Congregation Beth-El, Montreal; Temple Emanu-El-Beth Sholom, Montreal; Temple Sinai, Toronto; Humbervalley United Church, Toronto; St. Dunstan of Canterbury Anglican Church, West Hill, Ontario; Baptistery Church of the Resurrection, Valois, Quebec. *Publications:* Sparks, illustrated own aphorisms (1980); New Sparks (1985 and 1992). *Signs work:* "Wesselow" or "W" followed by date or year. *Address:* 5032 Victoria Ave., Montreal, Quebec, Canada H3W 2N3.

WEST, Steve, Dip.A.D. (1969), R.A.S. Higher Cert. (1972), Prix de Rome (1972), A.R.B.S. (1992); sculptor in bronze, and a variety of media;. *b:* Warrington, 6 Apr., 1948. *m:* Jenny. one *s.* one *d. Studied:* Liverpool College of Art and Design (1965-69), R.A. Schools (1969-72, Willi Soukop). *Represented by:* Plus Fine Art Limited, 161/163 Seymour Place, London W1H 4PS. *Exhib:* Crescent Gallery Scarborough, Oldknows Gallery Nottingham, Lanchester Gallery Coventry, Tabor Gallery Canterbury, Woodlands Gallery Blackheath,

Prediger Schwabisch Gmund, Hart Gallery London, Derby Museum and Art Gallery, Doncaster Museum and Art Gallery, Buckenham Galleries Southwold, Wolverhampton Art Gallery. *Signs work:* "Steve West." *Address:* 17 Swift St., Barnsley, S. Yorks. S75 2SN.

WESTLEY, Ann, sculptor and printmaker; Gulbenkian Rome Scholarship in Sculpture (1970-71), Gulbenkian National Printmaking Prize (1982). *b:* Kettering, 5 Mar 1948. *Studied:* Northampton School of Art (1965-67), Bristol Polytechnic (1967-70). *Exhib:* Serpentine Gallery (1976), Out of Print, South Hill Arts Centre, Bracknell (1983), British Miniature Print Biennale (1990), A New Generation of British Printmakers, Xylon Museum, Germany (1992), Royal Society of Birmingham Artists (2002). *Works in collections:* Gulbenkian Foundation, Ashmolean Museum, Fredrikstaad Museum Norway. *Commissions:* Mural of four wood panels for Great Notley Community Centre commissioned by Countryside Properties and Braintree District Council (1997), 'Unity', iron and corten steel, public sculpture, Great Notley, Essex. *Publications:* Relief Printmaking (pub. A. & C. Black, 2001). *Signs work:* "Ann Westley." *Address:* Calle Alhondiga 5 Cutar Malaga 29718 Spain.

WESTON, David J., BA (Hons.) Fine Art, RMS, BWS, HS, BSM, MASF, MPSG, FRSA; seascape and landscape painter in water-colour; miniaturist. *b:* 21 Sep 1936. *m:* Ann. two *s.* one *d. Studied:* St. Albans School of Art and Design (University of Hertfordshire). *Exhib:* one-man shows: Clare Hall Cambridge, Grosvenor Gallery, Old Fire Engine House Ely and Conservatory Gallery. Has exhibited at New Academy, Llewellyn Alexander and Medici galleries; with UA, RMS, RSMA, RBA, RI, NEAC and HS at Mall and Westminster Galleries, also with BWS and BSM at Ilkley. Overseas with MAS-F, MPGS and WFH. *Signs work:* "DAVID J. WESTON" or "D.J.W." (miniatures and small works). *Address:* Little Glebe, 11 Longcroft Ave., Harpenden, Herts. AL5 2RD. *Email:* david.weston3@ntlworld.com *Website:* www.artisticactivities.co.uk

WESTWOOD, John, A.R.C.A. (1948); graphic designer; Head of Typographic Design, later Director of Graphic Design, at Her Majesty's Stationery Office, London (1960-1978);. *b:* Bromley, 26 Sep 1919. *s of:* W. H. Westwood. *m:* Margaret Wadsworth. two *s. Educ:* Bromley County Grammar School. *Studied:* Bromley College of Art (1936-39) and R.C.A. (1940 and 1947-48). *Exhib:* South Bank (1951). *Commissions:* Binding designs for The Folio Society. *Publications:* articles on graphic design; International Meccanoman; printing trade press, etc. *Address:* The Malt House, Church La., Streatley, Reading RG8 9HT.

WHALLEY, Ann Penelope, N.D.D., A.T.D., A.T.C., S.W.A.; artist in oils, water-colour, acrylic and pastel; tutor and organiser for painting holidays abroad. *b:* Yorks., 1 Apr 1933. *d of:* Dr G.M. Mayhall, M.D., F.R.C.S. *m:* Theo Whalley, N.D.D., A.T.D., A.T.C. four *s. Educ:* Pontefract Girls' High School. *Studied:* Leeds College of Art (1950-55, Mr. Pullé). *Exhib:* one-man shows: Albany

Gallery, Cardiff, Fountain Gallery Llandeilo, Library Hall, Haverfordwest annually since 1981, Workshop, Wales (1983), Bloomfield Hall (1986), Coachhouse (1987), Henry Thomas Gallery, Carmarthen, Patricia Wells Gallery (1987), Art Matters, Tenby; group shows: St. Ives Gallery (1984),B.W.S. (1986), Laing Comp. (1987), S.W.A. (1987), R.I. (1986), Albany Gallery, Cardiff, Century Gallery, Henley-on-Thames, Bromley Gallery, Kent, Fountain Gallery, Llandeilo, Wold Gallery, Bourton on the Water. *Publications:* illustrated, About Pembrokeshire; author, Painting under a Blue Sky; author, Painting Water in Water-colour (Batsfords); articles for Artist and Illustrator, and Leisure Painter. *Recreations:* gardening, travel, teaching abroad. *Signs work:* "Ann Whalley." *Address:* Haroldston House, Haverfordwest, Pembs. SA61 1UH.

WHEELER, Colin, S.G.F.A. (1986); graphic artist, illustrator and cartographer in ink, pencil and pastel. *b:* Amersham, Bucks., 4 Jul 1946. *s of:* Arthur Wheeler, retd. industrial engineer. *Educ:* Alleyne's Grammar School, Stevenage. *Studied:* privately. *Exhib:* S.G.F.A., various one-man shows including Fermoy Gallery, King's Lynn, Lion Yard, Cambridge, Theatre Royal, Norwich, Denington Gallery, Stevenage. *Works in collections:* B.Ae., Stevenage and N. Herts. Museum. *Commissions:* 'Discover Hertford'; Stevenage Museum, Stevenage Borough Council. *Publications:* travel and tourist brochures. *Clubs:* Artists' Co-operative. *Signs work:* "Colin Wheeler." *Address:* 39 Plash Drive, Stevenage SG1 1LN.

WHEELER, Sir H. Anthony, Kt. (1988), O.B.E. (1973), P.P.R.S.A., P.P.R.I.A.S., F.R.I.B.A., M.R.T.P.I. (rtd.), B.Arch. (Strath.), Hon. R.A., Hon. R.G.I., Hon. R.B.S., Hon. Doc.Des., Robert Gordon's Inst. of Technology, P.R.I.A.S. (1973-75), P.R.S.A. (1983-90), Hon. Pres. Saltire Soc. (1995); architect and planner, Consultant, Wheeler & Sproson, Edinburgh and Kirkcaldy since 1986 when ceased to be senior partner; mem. of the Royal Fine Art Commission for Scotland (1967-85); trustee of the Scottish Civic Trust (1970-83). *b:* Stranraer, Scotland, 7 Nov 1919. *m:* Dorothy Jean Wheeler. one *d. Studied:* architecture: Glasgow School of Architecture under Prof. W. J. Smith, and Glasgow School of Art; graduated 1948; John Keppie Scholar, Rowand Anderson Studentship R.I.A.S. (1948); R.I.B.A. Grissell Gold Medallist (1948); R.I.B.A. Neale Bursar (1949); 22 Saltire Awards and Commendations for Housing and Reconstruction; 12 Civic Trust Awards and Commendations. *Exhib:* R.S.A., R.A., R.G.I., S.S.A.A. *Clubs:* Scottish Arts, New Club. *Signs work:* "H. A. Wheeler." *Address:* South Inverleith Manor, 31/6 Kinnear Rd., Edinburgh EH3 5PG.

WHEELER-HOPKINSON, John Samuel, S.G.A. (1983); graphic artist in pen and ink, pencil and colour wash. *b:* Prestatyn, N. Wales, 1 Mar 1941. *m:* Claire Follett. two *d. Educ:* Grammar School, Colne, and King's College, London. *Exhib:* Mall Galleries, London. *Signs work:* "J.W-H." and date as ideogram. *Address:* LeBourg, 03500 Lafeline, France.

WHELAN, Diana, ARBS (1992). *Medium:* sculpture: bronze, resin, terracotta. *b:* Sussex, 9 Jul 1931. *d of:* James Drawbell (Editor) & Marjorie Drawbell (FRBS). *m:* 1: Dennis Whelan; 2: Peter Held. three *d. Educ:* Bedales. *Studied:* Goldsmiths' College School of Art (1950-53); Adult Education Colleges. *Exhib:* Artparks International; RBS; SPS; SWA; RBA; two-sculptor show in Orangery, Holland Park, London. *Works in collections:* UK, USA, Italy, Holland, Germany, Switzerland, Portugal. *Commissions:* St.Thomas' Hospital; Keele University; Heinrich Stahl Housing Association; Albourne Church Sussex. *Clubs:* Chelsea Art Society. *Signs work:* 'WHELAN'. *Address:* 13 Princedale Road, London W11 4NW.

WHIDBORNE, Timothy Charles Plunket, artist in oil, tempera, sanguine, lithography, sculptor;. *b:* Hughenden, Bucks., 25 Jul 1927. *s of:* Charles Whidborne. *m:* Wendy. *Educ:* Stowe School. *Studied:* St. Martin's Art School (1944), with Mervyn Peake, Chelsea (1945) and Pietro Annigoni, Florence (1949). *Exhib:* R.A., R.P., S.P.S., etc.; Kent Painters Group, East Kent Art Society; one-man show: Upper Grosvenor Galleries (1969). *Works in collections:* portrait of H.M. The Queen, H.Q. Irish Guards, London; St. Katherine of Alexandria, Worshipful Company of Haberdashers, London; H.M. The Queen Mother, the Inspection of the In-Pensioners Founder's Day at the Royal Hospital, Chelsea, 1991; The Duke of Devonshire, Proprietor of Pratt's Club, 1994; collection of the late Sir Paul Getty, K.B.E. and Lady Getty; St. Jude, 2000 Pheasantry Studios. *Publications:* various poems illustrated. *Clubs:* Chelsea Arts. *Signs work:* "T. Whidborne" or "T.W." *Address:* The Studio, 30 Albert Rd., Deal, Kent CT14 9RE.

WHISHAW, Anthony, R.A., R.W.A., A.R.C.A. (1955), Travelling Scholarship, R.C.A., Spanish Government Scholarship, Abbey Premier Scholarship (1982), Lorne Scholarship (1982-83), John Moores minor prize. *b:* 22 May 1930. *Exhib:* one-man shows: Madrid (1956), Roland, Browse and Delbanco (1960, 1961, 1963, 1965, 1968), I.C.A. (1971), New Art Centre (1972), Hoya (1974), Nicola Jacobs (1981, 1983, 1984), Mappin A.G. (1985), Barbican Centre (1994). *Works in collections:* National Gallery, Melbourne, Australia, Seattle Museum, Arts Council, Coventry Museum, Leicester Museum, Chantrey Bequest, Bolton A.G., Bayer Pharm., Western Australia A.G., Museo de Bahia, Brazil, Power A.G., European Parliament, Ferens A.G., Tate Gallery, Graves A.G. Sheffield. *Address:* 7a Albert Pl., Victoria Rd., London W8 5PD. *Email:* anthony.whishaw@btinternet.com *Website:* www.anthonywhishaw.com

WHISKERD, Jennifer, BA Hons. Fine Art Painting; travel illustrator, Central Asia, Armenia, Syria, Eastern Europe, Islamic Africa. *b:* Gloucester, 23 Mar 1962. *d of:* John Whiskerd, artist. *Exhib:* international and national. Work in public and private collections. Fine Art tutor. *Commissions:* Gulfoil, Terrapin International. *Signs work:* "J.H. Whiskerd." *Address:* 2 Pittville Lawn, Cheltenham, Glos. GL52 2BD.

WHITAKER, Rita Elizabeth, RMS, HS, MAS-F, MPSGS, MAA; Top awards, Royal Miniature Soc., Llewellyn Alexander Gallery, London, and Florida Miniature Art Soc. in America; Awards: Llewelyn Alexander Master Award, RMS Group Award, Fairman Subject Award; professional artist. *Medium:* stoving enamel on copper. *b:* 3 Sep 1936. *d of:* Mr & Mrs W.J.Pedley. *m:* C.J.Field. two *s. Educ:* Sion Convent, Worthing. *Studied:* Worthing Art College; Regent St. Polytechnic under Stuart Tresilian. *Exhib:* Royal Miniature Soc., R.A., Medici's, Hilliard Soc.,Llewelyn Alexander, Assoc. of Sussex Artists, Miniature Art Soc. of Florida and various galleries throughout England, Wales and USA. *Works in collections:* Royal Miniature Soc., Baltic Exchange, London, and Carningli Centre, Newport, Pembrokeshire, Florida Miniature Society; private collections throughout the world. *Commissions:* Baltic Exchange. *Works Reproduced:* Medici cards. *Recreations:* gardening, walking, sketching and croquet. *Clubs:* Sidmouth Croquet Club. *Signs work:* "R. E. Whitaker." *Address:* 7 Connaught Close, Sidmouth, Devon, EX10 8TU.

WHITAKER, Vivien, ARBS, FPS; MSc BA Art & Design (First Class). *Medium:* directly carving the last of the English alabaster. *Represented by:* Tregoning Gallery, Derby; Buckenham Galleries, Southwold. *Exhib:* Bankside Gallery, London (2007); Studio Voltaire, London (2007); RBS (2007). *Works in collections:* private collections of: Dr.V.James; J & A Kellie. *Publications:* 'Cultivating Self Development' (CIPD, 1996), co-author David Megginson; 'Continuing Professional Development' (CIPD, 2007), co-author David Megginson. *Misc:* Vivien uses art to assist people to discover their dreams and make plans to achieve their potential. *Address:* 16 Rutland Terrace, Barlow, Dronfield, S18 7SS. *Email:* enquiries@vivienwhitaker.co.uk *Website:* www.vivienwhitaker.co.uk

WHITCOMBE, Susan Anne Clare, painter in oil and water-colour of equestrian portraits and landscapes. *b:* London, 17 Jun 1957. *d of:* Philip Whitcombe. two *s. Educ:* N. Foreland Lodge, Hants. *Studied:* Heatherley School of Fine Art (John Walton, Bernard Hailstone). *Exhib:* SEA., NEAC (2004, 2005, 2006); one-man shows: London (1981, 1988, 1993), Tokyo (1985, 1987), Melbourne (1982). *Signs work:* "S. WHITCOMBE". *Address:* Redwood Cottage, West Meon, Hants. GU32 1JU.

WHITE, David, Des.R.C.A. (1959); potter, producing individual porcelain pots for sale in most of the leading galleries throughout the country; Joint Winner of the Duke of Edinburgh's Prize for Elegant Design (1960). *b:* Margate, Kent, 27 Jun 1934. *s of:* C. H. P. White (decd.). *m:* (1962) Diana Groves. one *s.* one *d. Studied:* Thanet School of Art (1950-54) and Royal College of Art (1956-59). Accepted as Full mem. Craftsmen Potters' Assoc. (Apr. 1991). *Address:* 4 Callis Court Rd., Broadstairs, Kent CT10 3AE.

WHITE, Helen Elizabeth, R.M.S. (2002), H.S.D.A.D. (1986), H.S. (1996), M.A. (2007); calligrapher, illuminator and miniaturist in gouache and gold;. *b:*

Amersham, 26 July, 1965. *Educ:* Chesham High School. *Studied:* Reigate School of Art and Design (1984-86), The Prince's School of Traditional Arts (2005-2007). *Exhib:* annually since 1996: Llewellyn Alexander Gallery - A Million Brushstrokes, R.M.S. and H.S.; R.A. Summer Show (1997). *Signs work:* "H.W." sometimes "H.E.W." *Address:* 115 Vale Rd., Chesham, Bucks. HP5 3HP.

WHITE, John Norman, N.D.D. (1951); painter, illustrator, oil, gouache, and water-colour;. *b:* Chipperfield, Herts., 27 Mar 1932. *s of:* John Eugene White. *m:* Irene White, potter. two *s. Educ:* Belmont Senior Modern School. *Studied:* Harrow School of Art (1945-51). *Exhib:* R.A., Young Contemporaries. *Works in collections:* Municipal collection Borken Germany. *Signs work:* "JOHN - WHITE." *Address:* Northwood Lodge, Bullockstone Rd., Herne, Herne Bay, Kent CT6 7NR. *Email:* john.nwhite@btopenworld.com

WHITE, Judith Hannah Christine, BA Hons (Cant.). *Medium:* watercolour, drawing, printmaking; specializing in the figure. *b:* Eastry, Kent, 2 Feb 1945. *d of:* Rev. Gordon White. *m:* Mark Osborne, MA, MSIAD, FRSA. *Educ:* Stroud High School for Girls, Stroud. *Studied:* Cheltenham College of Art (1962-4); Canterbury College of Art (1964-8). *Exhib:* RA Summer Exhbn (2004, 2005, 2007); Morley Gallery, London (2003, 2005, 2007); Jerwood Open Drawing Exhbn, Cheltenham, Berlin, Geneva (1999, 2000); Pastel Society Centenary Exhbn (1999); Highgate Gallery, London (2006). *Signs work:* 'JUDY WHITE'. *Address:* 84 Bonneville Gardens, London SW4 9LE. *Email:* whitejudy@btinternet.com

WHITE, Karyn, BA (Hons) Art. *Medium:* painter/printmaker. *b:* Australia, 16 Aug 1956. *d of:* John & Patricia White. one *d. Educ:* Melbourne State College, Victoria Australia (Fine Art/Craft). *Represented by:* Benjamin Hargreaves, London SW6. *Exhib:* Gryphon Gallery, Australia; Camberwell Press, London; Square Gallery, London; Business Art Gallery, London; Roar Gallery, Australia; Republique Gallery, Australia; Contemporary Art Fairs, Islington (91-95), Benjamin Hargreaves, Lennox Gallery London. *Works in collections:* private collections. *Commissions:* World Wildlife Fund Portfolio, Camberwell Press. *Works Reproduced:* exhibition catalogues. *Recreations:* music, opera, horseriding, cooking. *Signs work:* 'KWhite'. *Address:* 58 Shacklewell Lane, London E8 2EY.

WHITE, Laura, B.A.(Hons.); sculptor in stone, wood and bronze;. *b:* Worcester, 10 Mar., 1968. *Educ:* Alice Ottley School, Worcester. *Studied:* Worcester Art College, Loughborough College of Art and Design. *Exhib:* various mixed and solo shows in U.K. *Works in collections:* Art Scene London, Gallery Shurini London. *Signs work:* "LAURA WHITE" or not at all. *Address:* Flat B, 4 Corporation Oaks, Woodborough Rd., Nottingham NG3 4JY.

WHITE, Lucy Annette, painter in egg tempera, oil, with prelim. sketches in conté crayon; modernist, landscapes, people, nature, usually combined, including design styles of 1950s. *b:* Perth, Australia, 29 Oct 1960. *Educ:* Perth Technical

College. *Studied:* self taught. *Signs work:* "LAW." *Address:* Room 11, Everton Court, Milford Rd., Everton, Hants. SO41 0JG. *Website:* www.cornwallhumanists.org.uk

WHITE, Mary, A.T.D.; prizes include the Staatspreis fur das Lunsthandwerk, Rheinland-Pfalz; ceramic artist and calligrapher; Rheinland-Pfalz Staatspreis (1982);. *b:* Croesyceiliog, Wales, 1926 née Rollinson. *m:* Charles White, artist. *Studied:* St. Julian's High School; Newport Art College; Hammersmith Art College; London University Goldsmiths' College of Art. *Exhib:* Many exhibitions in USA, UK, Germany, France, Holland, Belgium, Italy. *Works in collections:* British Museums: V.&.A., Fitzwilliam Cambridge, Newport, Cardiff, Winchester, Bristol, Norwich Castle, Swindon; Collections: Bath Study Centre, Leicester Educ. Authority, Aberystwyth Univ., Welsh Arts Council; U.S.A.: Pennsylvania State Museum; Museums in Germany: Kunstgewerbemuseum Köln, Veste Coburg, Westerwald, Berlin, Keramion, Deidesheim, Stuttgart, Mainz, Darmstadt, Hamburg-Kunstgewerbemuseum. Many private collections. *Official Purchasers:* Ceramic Museum, Berlin; Gutenberg Museum, Mainz, etc. *Works Reproduced:* many books and magazines including Ceramic Review, Letter Arts Review, German Keramik Magazines; work in many books in G.B., Germany, France, Belgium and U.S.A. 'Letters on Clay' A & C Black, London (2003). *Recreations:* gardening. *Clubs:* Fellow C.P.A., Fellow S.S.I, Deutscher Handwerkskammer, Fellow C.L.A.S., Letter Exchange. *Address:* Zimmerplatzweg 6, 55599 Wonsheim, Germany. *Email:* mary.white@t-online.de

WHITE, Michael B., painter in oil, water-colour; also etcher, serigrapher, lithographer; unique monoprints, trichoprints, bronze, charcoal, pastel. *b:* Hythe, Kent, 2 Jul 1958. *Educ:* Sevenoaks School, Kent. *Studied:* Hastings College of Art and Design (1972-1974), Ravensbourne College of Art and Design (1974-1976), Brighton Polytechnic (1979-1981). *Exhib:* various including, R.A. Summer Exhib., B.P. National Portrait Gallery, Internat. Contemporary Arts Fair, Bath Arts Festival, N.E.A.C., Not the Royal Academy, London Group, Hildt Gallery, Chicago, Printmakers Council, national open prize winner, Hunting Group, Singer & Friedlander. *Works in collections:* Foundation Wood, Fontenay, France; Stena, Oslo, Norway; Hildt Corpn., Chicago; Kidd Collection; New Zealand. *Commissions:* Eyre Estate, J.&J. Allen, Cochrane Co., Dewars. *Recreations:* big game, fishing, vintage motorbikes and travelling. *Clubs:* Chelsea Arts, RNC, RAYC, Blue Bird. *Signs work:* "M B White"or "M B W." *Address:* 143 Old Church St., London SW3 6EB. *Email:* m.b.white@artcreative.com

WHITE, Philippa, *Medium:* watercolour. *b:* Aberdeen, Scotland, 18 Jun 1944. two *s. Educ:* Lycée Francais, London & Ancaster House, Sussex. *Studied:* largely self-taught, studied briefly in Paris and Chelsea. *Exhib:* Chelsea Art Society (2001-); Art Westminster (2002); St.Martin's-in-the-Field Gallery. *Commissions:* private. *Recreations:* sailing; skiing. *Clubs:* Itchenor Sailing Club. *Signs work:*

"Philippa White". *Address:* No 4, 36 Buckingham Gate, London SW1E 6PR. *Email:* philippa_white@hotmail.com *Website:* www.chelseaartsociety.org.uk

WHITE, Robert Edward, BA (Hons) Fine Art, Post Grad Diploma, Royal Academy Schools; BBC4/Meritcafe Trust Award (2002), Greenshields Foundation, Lucie Morison Prize ROSL. *Medium:* oils on canvas, prints, watercolour, mixed media. *b:* Westminster, London, 17 Oct 1963. *s of:* Mr E T and Mrs A M White. *m:* Susannah Beasley-Murray. one d. *Educ:* Royal Academy Schools, Norwich School of Art, Medway College of Art and Design. *Studied:* Fine Art (painting). *Exhib:* Lexmark Art Prize, Eyestorm Gallery, London; Neuropop A & D Gallery, London; Hunting Group, Royal College of Art, solo shows at Royal Overseas League, London and Edinburgh; BP Portrait Award, National Portrait Gallery, Discerning Eye, Mall Galleries, London Art Fairs Art 98 and Art 97, Business Design Centre, London; The Collection - Lawrence Graham, London (2006); One Love -The Lowry, Manchester (2006-7). *Works in collections:* Royal Overseas League, London; Scottish Equitable, Edinburgh; Paintings in Hospitals, London; Prudential Corporate Collection; Norwich School of Art. *Commissions:* Sir Geoffrey Ellerton, Royal Overseas League, The Prudential Collection. *Publications:* The First Harlech Biennale (ISBN 0 9524147911). *Works Reproduced:* Arts Review, The Guardian, The Times, The Sunday Telegraph, RA Magazine; The Observer. *Recreations:* cooking, travelling. *Misc:* Travel Scholarship to Barcelona (Norwich School of Art, 1985). *Signs work:* Robert White. *Address:* 26 Shaftesbury Road, London E7 8PD. *Email:* robert@obertwhite.info *Website:* www.robertwhite.info

WHITEFORD, Joan, N.D.D. (1963), A.T.D. (1964); artist in etching and wood engraving. *b:* St. John, Cornwall, 5 May 1942. *d of:* Francis Kinsmund Doidge. *m:* David Whiteford. *Educ:* Grammar School, Tavistock, Devon. *Studied:* Plymouth College of Art (1958-63, William Mann, Jeff. Clements), Bournemouth College of Art (1963-64). *Exhib:* R.A., R.E., N.S., S.W.A., N.E.A.C., R.I., Mall Print. *Signs work:* "J. Whiteford." *Address:* Meadowside, Cockwells, Penzance, Cornwall TR20 8DB.

WHITEFORD, Kate, Dip.A.D. (1973), Dip.F.A. (1976) History of Art; Sargant Fellow, British School at Rome (1993-94); artist in oil on gesso, also land drawings;. *b:* Glasgow, 9 Mar., 1952. *m:* Alex Graham. *Educ:* Glasgow High School. *Studied:* Glasgow School of Art (1969-73), Glasgow University (1974-76, History of Art, Prof. Martin Kemp). *Exhib:* Institute of Contemporary Art (1983), Riverside Studios (1986), Whitechapel A.G. (1988), Glasgow Museum and A.G. (1990). *Works in collections:* Tate Gallery, British Council, C.A.S., A.C.G.B., National Gallery of Modern Art Edinburgh, S.A.C., Glasgow Museum and A.G. *Publications:* artists books published by Whitechapel A.G. (1988), Tetra Press and Advanced Graphics (1992), Cairn Gallery (1992), Sitelines (1992), Graeme Murray Gallery (1992). *Signs work:* "Whiteford" or "Kate Whiteford." *Address:* c/o Frith St. Gallery, 60 Frith St., London W1V 5TA.

WHO'S WHO IN ART

WHITEHEAD, Steve, twice won the Wales Open. *b:* 1960. *m:* Paula Zimmerman. *Studied:* UCW Aberystwyth. *Represented by:* Panter & Hall, London. *Exhib:* Panter & Hall, London. *Works in collections:* Contemporary Art Society of Wales; Prudential Corporate Collection; The Royal Bank of Scotland. *Signs work:* 'Steve Whitehead' (on reverse only). *Address:* c/o Panter & Hall, 9 Shepherd Market, Mayfair, London W1J 7PF. *Email:* enquiries@panterandhall.com *Website:* www.panterandhall.com

WHITELEY, Alfred, A.R.C.A. (1952); Arts Council major award (1977); painter in oil, water-colour, lithography. *b:* Chesterfield, 18 Nov 1928. *s of:* Alfred Whiteley, butcher. *m:* Ottoline Reynolds. one *s.* one *d. Educ:* Tapton House, Chesterfield. *Studied:* Chesterfield School of Art (1945-47), R.C.A. (1949-52). *Exhib:* RA, Odette Gilbert Gallery; one-man shows Odette Gilbert, Vorpal Gallery, NY and Pride Gallery, The Pieter Breughal Gallery, Amsterdam. *Works in collections:* UK, USA, Germany, Switzerland, The Netherlands. *Works Reproduced:* in The Times, Sunday Times, Art Line, etc. *Signs work:* "Alfred Whiteley." *Address:* Fairfield, Mogador Rd., Tadworth, Surrey KT20 7EW.

WHITE-OAKES, Sue, M.C.S.D.; metal sculptor in copper and bronze. *Medium:* sculpture. *b:* 26 May 1939. *m:* Roger Oakes. two *s. Educ:* St. Martin's High School, London. *Studied:* Central School of Art. *Represented by:* The Lost Gallery, Aldachuie, Strathdon, Aberdeenshire, AB36 8UJ. *Exhib:* Edinburgh, Glasgow, St. Andrews, London, Scottish Borders, Aberdeenshire and Ireland. *Works in collections:* many private collections. *Commissions:* not taken. *Publications:* articles: Craftsman Magazine and The Scotsman colour supplement. *Recreations:* archaeology, photography. *Clubs:* C.S.D., FSA (Scot.). *Signs work:* "Sue White-Oakes." *Address:* Tarfhaugh Farmhouse, West Linton, Peeblesshire EH46 7BS.

WHITESIDE, Diana Elizabeth Hamilton, (formerly Newton-Davies); miniature painter in water-colour. *b:* London, 13 Jan 1942. *d of:* the late Borras Noel Hamilton Whiteside, M.P. *m:* John Newton Davies (1964-87). two *d. Educ:* Lycée Français de Londres, Glendower School, Sydenham House, Devon. *Studied:* Simi's and L'Accademia delle Belle Arti, Florence (1959-60), Camberwell School of Art (1961-62). *Exhib:* R.A., R.M.S., R.H.S., Tate Gallery, Mall Galleries, Anna-Mei Chadwick's, Westminster Gallery, Medici Gallery. *Commissions:* animal portraits. *Signs work:* "19 D.E.N.D. 85" (or relevant year pre 1987); "19 D.E.H.W. 99" (or relevant year from 1987). *Address:* Chapel Lands, Chailey, nr. Lewes, Sussex BN8 4DD.

WHITFORD, Christopher, artist in water-colour and acrylic;. *b:* Malvern, Worcs., 18 Feb., 1952. *m:* Filippa. two *d. Studied:* Malvern. *Exhib:* R.M.S., John Noott, Broadway. *Signs work:* "C. Whitford" or "C.W." *Address:* c/o John Noott Twentieth Century, 14 Cotswold Ct., Broadway, Worcs. WR12 7DP.

WHITFORD, Filippa, artist in water-colour;. *b:* Italy, 22 Jan., 1951. *m:* Christopher Whitford. two *d. Exhib:* R.M.S, R.W.S., John Noott, Broadway.

Signs work: "Filippa Whitford." *Address:* c/o John Noott Twentieth Century, 14 Cotswold Ct., Broadway, Worcs. WR12 7DP.

WHITING, David Geoffrey, BA (Hons); AICA (International Association of Art Critics); FRSA; art critic, writer and curator; Appointments: Trustee of the Anthony Shaw Collection, London (2001); External Examiner, BA Ceramics, University of Wales Institute, Cardiff (2002-05); Awards Examiner Dip HE Ceramics, City Lit. (London Metropolitan University)2004-08; Editorial Board, 'Interpreting Ceramics' Electronic Journal (2004). *b:* Bromsgrove, 14 Feb 1963. *s of:* Geoffrey Whiting, artist potter. *Studied:* Oxford Brookes University (1982-85). *Publications:* numerous publications and exhibition catalogues. Writes regularly for 'Crafts' Magazine (London), and 'Ceramics; Art and Perception' (Australia), also obituaries for 'The Guardian'; contributor 'Oxford Dictionary of National Biography '(OUP); contributor 'Redaktion Allegemaines Kunstlerlexicon, Leipzig'. *Recreations:* poetry, architecture, and the countryside. *Misc:* Exhibitions curated include: 'Pandora's Box and the Tradition of Clay' Crafts Council, London (1995); 'Ewen Henderson Paintings' London Institute Gallery (2001); 'Constructed Clay' Galerie Besson, London (2003); 'Functional Form Now' Galerie Besson, London (2005); Annie Turner 'River' RBSA Gallery, Birmingham (2007). *Address:* Crossways, Hampton Lovett, Droitwich Spa, Worcs. WR9 0LU.

WHITTAKER, Lucianna, BA; MA; Shortlisted for Visual Arts Prize, Brighton Festival Fringe (2006). *Medium:* oil. *b:* Aldershot, 22 Dec 1979. *m:* Ben Whittaker. *Studied:* University of Brighton (2002-2003, MA Cultural and Critical Theory); Bath Spa University (1998-2001 BA Fine Art Painting). *Exhib:* Friese Green Gallery, Brighton Media Centre; Friends Meeting House, Brighton; Open Houses, Brighton & Hove; Art in Mind, Hoxton, London; Universities of Brighton and Bath. *Principal Works:* The New Sublime: Be Found, Believe, Be Held, Behold (2m x 1.4m oil paintings, 2006-07). *Clubs:* Founding Member of 'See This' (2005-06). *Signs work:* "LUCIANNA WHITTAKER". *Address:* 10 Chatham Place, Brighton, BN1 3TP. *Email:* info@luciannawhittaker.com *Website:* www.luciannawhittaker.com

WHITTEN, B. Janice E., Dip.Bact. (1960), F.R.S.H. (1990); bacteriologist and freelance artist in oil. *b:* Middx., 15 Jul 1937. *m:* Don Whitten, designer (decd.). two *d. Educ:* Torquay Girls' Grammar School, Greenford Grammar School. *Studied:* Regent St., Chelsea, Harrow School of Art. *Exhib:* R.I. Gallery, mixed exhbns., Devon County Show, Royal Bath and West, Thelma Hulbert Gallery. *Publications:* illustrated: Modern Cereal Chemistry; Countryside Commission: The East Devon Way; Science of Bread; catalogues, articles. *Signs work:* capital W supporting initials. *Address:* 1 Boundary Park, Seaton, E. Devon EX12 2UN.

WHITTEN, Jonathan Philip, B.A. Hons. (1977), P.G.C.E. (1978); teacher and potter in ceramic; Head of Art, Sir James Smith's School, Camelford;

Chairman: Cornwall Ceramics and Glass Group. *b:* Eastbourne, 23 Sep 1954. *s of:* Philip Whitten, A.R.C.A. *m:* Sally Bowler. two *s. Educ:* Eastbourne Grammar School. *Studied:* Eastbourne College of Art and Design (1972-73, Geoffrey Flint, A.R.C.A.), University of E. Anglia (1974-77, Prof. Andrew Martindale), University of London (1977-78, William Newland); apprentice potter to Michael Leach (1978-79) and Roger Cockram (1980-81). *Exhib:* Brewhouse Gallery, Taunton (1979), Devon Guild of Craftsmen (1981), Leics. Guild of Craftsmen (1983-87), Cornwall (1990-05), etc. *Address:* Hale Farmhouse, St. Kew, Bodmin, Cornwall PL30 3HE. *Email:* whitten@stkew.eclipse.co.uk *Website:* www.stkewpottery.co.uk

WHITTEN, Miranda M.A., B.Sc.(Hons.) (1994), Ph.D. (2001), M.R.S.H. (1994), F.R.S.A. (1998), MI Biol, C. Biol (2001); biologist, artist/illustrator in acrylic, pencil, ink; nature artist commissioned by E. Devon District Council; Post-Doctoral research assistant (immunology); Member of Guild of Natural Science Illustrators (2006). *b:* London, 25 Sep 1972. *Educ:* Colyton Grammar School; Aston University; Swansea University. *Exhib:* mixed shows: Christie's, Devon County Show, Bath and West, Thelma Hulbert Gallery. *Publications:* illustrated: Countryside Commission: The East Devon Way; Nature in East Devon; Elefriends Recipe Book; catalogues, posterwork. *Signs work:* "M. Whitten." *Address:* 1 Boundary Park, Seaton, E. Devon EX12 2UN. *Email:* mwhitten@vegemail.com

WHITTEN, Philip John, A.R.C.A. (1949), F.R.S.A. (1952); armiger painter in oil; teacher, London University Inst. of Educ. (1968); senior lecturer; examiner, Cambridge and London University Insts. of Educ. (retd.). *b:* Leyton, Essex, 19 Jun1922. *s of:* Albert Edward Whitten, engineer. four *s.* one *d. Educ:* Bishopshalt, Hillingdon. *Studied:* Hornsey College of Art (1937-40), R.C.A. (1946-49). *Exhib:* R.B.A., Dowmunt Gallery, Bond St., Towner Gallery, Cecil Higgins; Bedford, Shoreditch Colleges, private galleries in Weybridge, Walton and Eastbourne areas. *Works in collections:* Towner Gallery, Brunel University. Work sold by Christie's and Sotheby's. *Signs work:* "Philip Whitten." *Address:* 10 Beechwood Cres., Eastbourne BN20 8AE.

WHITTEN-LOCKE, Helena M.J., freelance artist in pen and ink, water-colour; scientific proof reader. *b:* London, 9 Oct 1970. *m:* Tony Locke. one *s.* one *d. Educ:* Colyton Grammar School. *Exhib:* mixed shows: Devon County Show, Royal Bath and West; exhbn. designer: The Business Shop Agency. *Commissions:* sign writing, various house and pub exteriors in pen and ink. *Publications:* illustrated: Countryside Commission: The East Devon Way; catalogues, articles, posterwork. *Signs work:* "H.W.," "H.L." or "H. LOCKE." *Address:* 'The Rosary', Godford Cross, Awliscombe, E. Devon EX14 3PP.

WHITTINGHAM, Dr. Selby, B.A. (1964), M.A., Ph.D. (1975); art historian; founded Turner Soc. 1975 (Hon. Sec. 1975-76, 1980-84; Vice Chairman 1984-85); and Watteau Soc. 1984 (Sec. General and Editor); and J.M.W. Turner, R.A.

(Co-Editor), 1988; and Donor Watch, 1995. *b:* Batu Gajah, Malaya, 8 Aug 1941. *s of:* H.R. Oppenheim, F.C.A. *m:* Joanna Dodds. *Educ:* Shrewsbury School; Universities of Oxford and Manchester. *Publications:* An Historical Account of the Will of J.M.W. Turner, R.A. (1989, 1996); The Fallacy of Mediocrity: The Need for a Proper Turner Gallery (1992); World Directory of Artists' Museums (1995). *Address:* Turner House, 153 Cromwell Rd., London SW5 0TQ.

WHITTLE, Janet, SBA, SWA, SFP, CBM; Teaching Cert.; Founder Pres. Award SBA; Chairman's Trophy SFP. *Medium:* watercolour. *b:* 22 Apr 1948. *m:* Barry. two *s. Studied:* self-taught. *Exhib:* Westminster Galleries; Mall Galleries; Mottisfort Abbey; various. *Works in collections:* Australia, Sweden, USA. *Publications:* Painting Flowers and Plants; Janet Whittle's Watercolour Flowers; Draw and Sketch Landscapes. *Works Reproduced:* De Montfort Fine Art; Solomon & Whitehead. *Signs work:* 'JANET WHITTLE SBA SWA SFP'. *Address:* 5 Manor Road, Barrowby, Grantham, Lincs NG32 1BB. *Email:* janet@janetwhittle.co.uk *Website:* www.janetwhittle.co.uk

WHITTLESEA, Michael, R.W.S. (1985), N.E.A.C.; painter; prizewinner, Singer Friedlander/Sunday Times Water-colour Competition. *b:* London, 6 Jun 1938. *s of:* Sydney Charles Whittlesea. *m:* Jill. *Studied:* Harrow School of Art. *Publications:* The Complete Watercolour Course (1987). *Clubs:* Chelsea Arts. *Signs work:* "Michael Whittlesea." *Address:* 98 Defoe House, Barbican., London EC2Y 8ND. *Email:* whittlesea@waitrose.com

WHITTON, Judi, B.Sc. (Hons.) Physics (1966), M.Sc., Radiobiology (1967); painter in water-colour, teacher and demonstrator in water-colour; President, Palette Club. *b:* St. Helens, 24 Nov 1944. *m:* Peter. three *d. Exhib:* solo shows: Painswick Town Hall (1995-00, 2005), St. George's Church, Upper Cam (1994, 1998). Work in collections internationally. *Publications:* Book of Paintings (1999); Limited Edn. prints for Radio Times. Regular contributor to 'The Artist' magazine, including in 'The Artists Problem Solver' (watercolour), pub. Collins (2003), author of 'Loosen Up Your Watercolours' (Collins, 2005). *Clubs:* Fosseway Artists, Thornbury Art, Tetbury Art, Palette Club. *Misc:* apperaed on BBC1 'Countryfile', painting Upper Cam Church (Sept, 2005). *Address:* Street Farm, Upper Cam, Dursley, Glos. GL11 5PG. *Email:* judi@watercolour.co.uk *Website:* www.watercolour.co.uk

WIGGINS, Toby, RP; BA Hons Fine Art, Royal Academy Diploma in Painting, BP Travel Award 2006, Changing Faces Award 2005, Princes Drawing Prize 2005. *Medium:* oil, watercolour, drawing, prints. *b:* Swanage, Dorset, 29 Mar 1972. *s of:* Wendy & Tim Wiggins. *Studied:* RA Schools (1996-99); Falmouth College of Art (1991-94). *Represented by:* Royal Society of Portrait Painters. *Exhib:* BP Portrait Award, National Portrait Gallery, Royal Society of Portrait Painters, Mall Galleries, RA Summer Exhbn, Jerwood Drawing Prize, Royal West of England Academy, New Englisg Art Club, Discerning Eye. *Works in collections:* Somerset County Council, Falmouth College of Art, University of

Wales, and numerous private. *Publications:* Times Magazine (Saturday 9th June 2007). *Clubs:* Poole Printmakers. *Signs work:* "TMW". *Address:* Flat 6, 20 Burlington Road, Swanage, Dorset, BH19 1LS. *Email:* tobywiggins@hotmail.com *Website:* www.tobywiggins.co.uk

WILD, David Paul, D.F.A. Slade (1955), Abbey Major Scholarship to Rome (1955); artist in oil and water-colour; Founder Chairman, Friends of the Weavers Triangle. *b:* Burnley, 14 Apr 1931. *s of:* Benjamin Wild. *Educ:* Burnley Grammar School. *Studied:* Burnley School of Art; Slade School of Fine Art; Academia Britannica, Rome. *Exhib:* extensively in the north of England since 1957; Woodstock Gallery (1965), John Moores (1965, 1970), R.A. (1972-74), Arts Council 'Drawings of People' Serpentine Gallery. *Works in collections:* Manchester City A.G., Rutherston Coll., Granada TV, Arts Council of G.B., Walker A.G., Liverpool. *Principal Works:* 'Landscape' Walker A.G.; 'Landscape' Towweley Hall, Burnley. *Signs work:* "D. Wild." *Address:* 66 Rosehill Rd., Burnley BB11 2QX.

WILDE, Louis Walter, PhD, MA, DAE, ATC, NDD, SGFA; ex-Principal, Halifax School of Art; Goldsmiths Travel Award (1964). *Medium:* painter in oil and acrylic. *b:* London, 14 Mar 1921. *m:* Janet Wilde. one *s.* one *d. Educ:* The Millbank School, Westminster. *Studied:* Leeds College of Art (1951-55, Tom Watt, Gavin Stuart), Leeds University (1955-56 and 1969-70), B'ham Polytechnic (1977-78), privately under Impressionist painter George Dafters. *Exhib:* Chiltern Gallery, London; New Art Centre, Chelsea; Seven Dials Gallery, London; Edinburgh Festival; Manchester Academy; Arts Council Show with Pasmore, Moore, Riley; Piece Hall Gallery, Halifax; Contemporary British Art touring U.S.A./Canada; Lane Gallery, Bradford; City A.G. Bradford. *Works in collections:* Bradford City Art Galleries, International Shakespeare Globe Centre, Bradford City Football Club. *Publications:* contributor to: Systems Art Enquiry Two (B'ham Polytechnic), Index of British Studies in Art Education (Allison). *Clubs:* S.G.F.A. *Signs work:* "Louis Wilde," "L.W.W.," "L. Wilde" or "Louis." *Address:* 60 Park Lane, Baildon, Shipley, W. Yorks. BD17 7LQ.

WILDE-LATHAM, H.V., EAWLS Award, Nairobi (1991); specialised in African subjects 1988-2001. *Medium:* oil, acrylic, on canvas, landscape/wildlife. *b:* Worcester, 15 Apr 1931. *Educ:* Worcester High School. *Studied:* Victoria Institute Worcester (Harry Adams, RA), evening classes. *Represented by:* Galerie Kornye West, Fort Worth, Texas, USA. *Exhib:* Mall Galleries, London (1989); Whaletail Exhbn. Niarobi (1991); Harrods Gallery, London; First Texas Council of Campfire (1998-03); CISAC (2002); DACS Exhbn, Lyttleton Gallery Malvern; many provincial galleries since 1969. *Works in collections:* 'The Adoption' Oserian Dev. Co. Kenya, and private collections internationally. *Commissions:* 'After the Rain', Ludlow (2000), Millennium Trust Fund (2003). *Publications:* exhibition catalogues, 'Campfire' USA. *Works Reproduced:* 'After the Rain' Ludlow (2000), Mill Trust Fund; 'Elephants in the City of Ghosts' (1987). *Recreations:* research into lost knowledge, walking. *Clubs:* EVP Soc.,

DH Soc., EAWLS, DACS. *Signs work:* 'wilde-latham'. *Address:* 2A Church Street, Ludlow, Shropshire, SY8 1AP.

WILES, Gillian, A.R.B.S., I.B.H.S.,mem. Royal Soc. of British Sculptors; sculptor/painter/illustrator. *d of:* Dr.G.G. Wiles. *m:* Dr. Robin Catchpole. *Educ:* Royal Veterinary College, London. *Studied:* Cape Town University, and Heatherley, London. *Exhib:* one-man shows: Sladmore, London, John Pence, San Francisco, The Collector, Johannesburg; exhib. at Tryon, London, R.B.S., Denis Hotz, London, Sportsmen's Edge, N.Y., Collector's Covey, Dallas. *Works in collections:* bronze sculptures: Genesee Museum, N.Y.S., Toyota, Nikon, Anglo-American, many international private collections. *Commissions:* many, international. *Works Reproduced:* art gallery catalogues. *Signs work:* "Gill Wiles." *Address:* 9 Sterndale Close Girton Cambridge CB3 0PR.

WILHIDE, Carol Louise, BA (Hons), PGCE. *Medium:* prints. *b:* 12 Sep 1959. *Studied:* Brighton Polytechnic (Art & Design Foundation 1978-79); Newcastle Polytechnic (BA Hons Graphic Design, 1980-83); London Institute of Education, London University (PGCE). *Exhib:* solo shows: Floral Hall (1991), Gallery 47 (1993), Grey's Inn (2000); mixed: (1983) St.Martins School of Art; (1986) Tricycle Theatre; (1987) Summer Exhibition Royal Academy; (1987) National Theatre Southbank D&AD; (1993) Piers Fleetham Gallery; (1994) Liberty Print Room; (1997) Chalk Farm Gallery; (1997) Abbott & Holder; (1997) Southwark Arts Festival; (1999) Greenwich Village. *Misc:* also known as CAROL JUSTIN (married name). *Signs work:* prints: using maiden name "CAROL WILHIDE". *Address:* 7 Seymour Road, London N3 2NG. *Email:* caroljustin@hotmail.com

WILKES, Lynne, BA Hons Fine Art/English (1969); Dip. Advanced Fine Art (Distinction, 1997). *Medium:* mixed media. *b:* Leeds, 23 Mar 1948. *m:* Adrian. two *s.* one *d. Studied:* Leeds University under Quentin Bell and Sir Lawrence Gowing; Bournemouth Arts Institute. *Exhib:* Royal Academy; RWEA; NEAC; Mall Galleries; Alpha Gallery, Dorset; Bettles Gallery, Hampshire; Thompsons Gallery, London/Stow-on-the-Wold; Cambridge Contemporary Art; Leith Gallery, Edinburgh; Firbob and Peacock, Cheshire; Study Gallery, Poole. *Works in collections:* RNLI Headquarters, Poole; other private collections here and abroad; Art Loan Collection (2003 & 2007); Bournemouth University. *Commissions:* several small private commissions. *Publications:* 'Fifty Wessex Artists' (Evolver Books), 'Ex Chaos' (Renscombe Press). *Clubs:* Bournemouth Art Club. *Signs work:* 'Lynne Wilkes'. *Address:* Shoal House, 48 Pearce Ave, Lilliput, Poole, Dorset BH14 8EH. *Email:* adrwilkes@aol.com

WILKINS, William Powell, A.R.C.A.; artist in oil, lecturer and consultant;. *b:* Kersey, Suffolk, 4 Apr., 1938. *m:* Lynne Brantly. two *d. Educ:* Malvern College. *Studied:* Swansea and Royal College of Art. *Exhib:* London, New York, San Francisco, Swansea. *Works in collections:* National Museum of Wales, Glynn

Vivian Museum Swansea, Hirshorn Museum Washington D.C. *Address:* c/o Piccadilly Gallery, 16a Cork St., London W1X 1PF.

WILKINSON, John Charles, R.B.A., certificate in Decoration (University College London), certificate Royal Academy Schools;; artist in oil, water-colour, pastel, and all drawing mediums. *b:* Barnes, London, 20 July, 1929. *m:* Sarah Goodwin, artist. one *s.* one *d. Educ:* Bradfield College; University College, London. *Studied:* Decoration, Bartlett School of Architecture (1949-52). Drawing and Painting:R.A. Schools (1954-59). *Exhib:* two one-man shows, numerous mixed exhbns. *Works in collections:* UK, France, Italy, Germany, Switzerland, Greece, Australia, Japan, USA. *Commissions:* portrait, figure and decorative arts compositions. *Principal Works:* portrait, figure and landscape. *Recreations:* reading (classical novels), Artists biographical data. *Signs work:* "J.C.W." and on back of work signs full name. *Address:* Orchard House, Alderholt Rd., Sandleheath, Fordingbridge, Hampshire SP6 1PT.

WILKINSON-CLEMENTSON, William Henry, R.E., A.R.C.A., F.I.A.L. (1946), Ph.D. (1980); line engraver and painter; Head of Dept. Engraving, City and Guilds of London Art School. *b:* Bath, 27 Aug 1921. *s of:* H. R. Wilkinson, A.R.C.A., Head, Bath School of Art. *m:* Lady Margaret Ewer. one *d. Educ:* Winchester. *Studied:* Royal College of Art under Malcolm Osborne and Robert Austin, Heidelberg and Lindau, Germany, Fiorenza, Italy. *Exhib:* R.A., H.C.Dickens (Bloxham, nr. Banbury), and 5 countries. *Works in collections:* Holland, Switzerland, Italy and America. *Commissions:* consistent. *Clubs:* Chelsea Arts, Aviemore, Scotland, Swiss Alpine. *Signs work:* "HENRY WILKINSON." *Address:* Crane Cottage, Tatsfield, Westerham, Kent TN16 2JT.

WILKS, Paul John, NDD (1961), RASC (1965); researcher and lecturer Visual Perception and Comparative media; University of London C.I.T. (1975-91). *Medium:* painter in oil, draughtsman. *b:* York, 12 Aug 1941. *m:* Kay. two *s. Educ:* Danesmead School, York. *Studied:* York School of Art (1956-61), Royal Academy Painting Schools (1961-65). *Works in collections:* University of Birmingham, City University, Kettering Art Gallery, Municipa Gallery Brazilia. *Clubs:* RASAA. *Address:* 10 Peak Hill, Forest Hill, London SE26 4LR.

WILLAN, Maeve, BA Hons; NS; Hesketh Hubbard Art Society 'Best Figurative Painting Prize' Mall Galleries (2007); N.S. 'The Aya Broughton Painting Prize' Highly Commended (2001). *Medium:* figurative painter mainly oil, also watercolour and pastel. *b:* Ireland. *m:* Peter James Willan, Hon RCM. *Educ:* Salesian Convent School, Limerick, Ireland. *Studied:* Limerick School of Art (1963-68), Slade School of Art masterclasses (1989-2002) and Open University Degree in Art History. *Exhib:* Group Exhbns: Mall Galleries Reopening Celebration (2007); RA Private Event (2000); Regularly in London/home counties with NS, Hesketh Hubbard Art Society and Richmond Art Society. Other group exhibitions have included Trinity Arts and Crafts Guild, and Galsworthy Group. Galleries include Mall, Westminster, Menier, Whiteleys and

Osterley House. *Signs work:* "Maeve Willan". *Address:* 7 The Green, Richmond, Surrey, TW9 1PL. *Email:* willan829@btinternet.con

WILLIAMS, Alex, N.D.D., A.T.D.; artist in oil on canvas. *b:* Reading, 22 Jul 1942. *s of:* Sqn. Ldr. Albert George Williams. *m:* Celia. one *s.* two *d. Educ:* St. Peter's School, Cambs. *Studied:* St. Martin's School of Art (1962-66, Frdk. Gore, Peter Blake, Peter de Francia, David Tindle). *Exhib:* Helen Greenberg Gallery, Los Angeles (1977, 1982), Retrospective Hereford City Museum (1987), Fosse Gallery Stow on the Wold, D'Arcy Fine Art Cheltenham. *Works in collections:* National Library of Wales, National Trust, Hurst Newspapers, Los Angeles International Airport, Hereford, Brecon and Worcester City Museums; public and private collections in the U.S.A., Australia and the UK. *Commissions:* designed flags, passports etc. for The Independent Kingdom of Hay (1977), numerous country house portraits, restaurant designs and many book illustrations. *Publications:* illustrated The Bird who Couldn't Fly (Hodder & Stoughton, 1988), many prints and reproductions, greetings cards and book covers. Over 100 fine bone china designs distributed worldwide. *Recreations:* boating and pond yachts. *Signs work:* "Alex Williams '98." now signs 'AW'o5'. *Address:* 13 St.Philip's Street, Leckhampton, Cheltenham, Glos. GL50 2BP. *Email:* alexwilliams@beeb.net *Website:* www.alexwilliams.net

WILLIAMS, Angela Elizabeth, S.G.F.A.; artist in drawing, water-colour, oil; college tutor. *b:* Belfast, 15 Jul., 1948. *m:* John Shelley (partner). *Studied:* Wimbledon School of Art. *Exhib:* London and U.K. including R.A. Summer Exhib., S.B.A., S.G.F.A., N.E.A.C. Drawing Scholar (2000). *Works in collections:* U.K. and abroad. *Publications:* magazine articles, greetings cards, limited edition prints. *Signs work:* "A E Williams." *Address:* 16 Warren Park, Warlingham, Surrey CR6 9LD. *Email:* angelawilliams@ukgateway.net

WILLIAMS, Annie, RWS (2007), RE (2007); ARWS (2003); ARE (2005); City and Guilds Diploma in Fine Art; Chris Beetles Prize (1984); Collins & Brown Award (1996); Abbot and Holder Travel Award (1998); Baker Tilly Award (2001); The Artist Magazine Award (RBA exhbn, 2004), Purcell Paper Award, Originals 06 (Mall Galleries). *b:* London, 6 May 1942. *d of:* Ivor Williams. *m:* Ron Bayliss. one *s.* one *d. Educ:* Elm Tree House, Llandaff; Our Lady's Convent, Cardiff. *Studied:* City & Guilds (1966-69). *Represented by:* Bankside Gallery, 48 Hopton Street, London SE1. *Exhib:* Royal Academy Summer Exhbns; RWS Opens at Bankside Gallery; Original Print Exhbns; Discerning Eye/Singer & Friedlander/The Laing (Mall Galleries); Whitechapel Gallery, and many small galleries around the country. *Works in collections:* private collections in UK, USA and Japan. *Works Reproduced:* in books, magazines, posters and cards, the most recent being 'The Watercolour Expert' for the RWS. *Recreations:* walking, DIY. *Misc:* exhibited and demonstrated etching at Art in Action (2003, 2005); taught silk screen printing at Islington Inst. evening classes (1984-86); works as a printmaker and in watercolour. *Address:* 31 Ellington Street, London N7 8PN. *Email:* annie@baylissnet.freeserve.co.uk

WILLIAMS, Antony Mack, Still Life Prize, Discerning Eye (1998); Carroll Award (1991, 1995); Arts Club Prize (2004); Ondaatje Prize (1995). *Medium:* egg tempera. *b:* Kingston-upon-Thames, 23 Jun 1964. *s of:* Mrs Jean Williams. *Studied:* North West Surrey College of Art; Portsmouth University. *Exhib:* solo exhbns: Albemarle Gallery, London (1997); Sala Parés, Barcelona (1999); Messum Gallery, London (2000); Galeria Leandro Navarro, Madrid (2001), Petley Fine Art, London (2004). *Works in collections:* National Portrait Gallery; Royal Society of Portrait Painters, The Queen;s College, Oxford. *Commissions:* H.R.H. The Queen, Sir Alan Budd, Amartya Sen. *Publications:* The School of London and their Friends: The Collection of Elaine and Melvin Merians (Herlin Press); The Portrait Now: The 21st Century (NPG Publications). *Recreations:* swimming, walking. *Signs work:* 'Antony Williams'. *Address:* The Cottage, 8E Windsor Street, Chertsey KT16 8AS.

WILLIAMS, Charles, B.A. (Hons.) (1989), M.A. (R.A.S.) (1992); Prize for Anatomical Drawing (1991), Creswick Prize, Silver Medal for Painting, British institute Fund Award, Landseer Scholarship and Richard Ford Award for Study in Spain (1992), Countess Driscoll-Spalietti Watercolour Prize (1993), Bursary from SEArts and NEAC/Marks and Spencer Young Artists (2nd prize 1994), Travel Bursary, ROSL (1995), Sir Ernst Cassel Education Fund Prize, ROSL (1997), 'The Real Turner Prize' (2000, 02). *Medium:* oil painter. *b:* Evanston, Ill., U.S.A., 16 Mar 1965. *Studied:* Maidstone College of Art (1986-89, Mike Upton, Peter Morrell, John Titchell), R.A. Schools (1989-92, Norman Adams, Mick Rooney, Roderic Barrett, David Parfitt). *Exhib:* Star Gallery Lewes, Coombs Contemporary, C.A.S., Mercury Gallery, NEAC, RA, ROSL, NPG, Beaux Arts, Bath, The Bakersfield Museum of Art, California (2004), Cadogan Contemporary. *Works in collections:* HSBC, TVS, Chevron UK, KIAD, British High Commission in Nairobi, Hammersmith Hospital Trust, Lily Savage, British Design Council, Alan Howarth MP and many private collections. *Publications:* Art Review (Sept., 1999). *Clubs:* Reynold's, NEAC (Executive Committee since 1998), Stuckists, Governor of The Federation of British Artists (2004), Barbican Arts Group. *Signs work:* "C.W." or "VERSO." *Address:* 21 Warneford St. London E9 7NG. *Email:* swiftcharles2002@yahoo.co.uk

WILLIAMS, Emrys, BA Fine Art (1980); painter in acrylic and oil; Lecturer in art and design, Coleg Menai, Bangor. *b:* Liverpool, 18 Jan 1958. one *s. Studied:* Slade School of Fine Art (1976-80). *Exhib:* Benjamin Rhodes Gallery (1989, 1991, 1994), touring shows: 'Sunny Spells' Oriel Mostyn, Llandudno (1995), 'Various Fictions' Collins Gallery, Glasgow (1998). *Works in collections:* Metropolitan Museum of Art, N.Y., Arts Council of England, Government Art Collection. *Commissions:* National Museum of Wales. *Address:* 47 Cecil St., Cardiff CF2 1NW.

WILLIAMS, Glynn, sculptor in stone and bronze; Prof. of Sculpture, R.C.A., Head of the School of Fine Art. *b:* Shrewsbury, 30 Mar 1939. *s of:* Idris & Muriel Williams (decd). *m:* Heather (divorced). two *d. Studied:* Wolverhampton College

of Art (1955-60, 1960-61 Post Dip.); Rome Scholarship in Sculpture (1961-63). *Exhib:* one-man shows: including Blond Fine A.G. (1982), Bernard Jacobson Gallery (1985, 1986, 1988, 1991, 1994, 2000), Artsite Gallery, Bath (1987), Retrospective exhbn. at Margam Park, S. Wales (1992), Atkinson Gallery, Millfield (1997). *Works in collections:* A.C.G.B., Hakone Open Air Museum, Japan, V. & A., Tate Gallery, N.P.G. *Commissions:* Henry Purcell Memorial, City of Westminster (1996), "Gateways of Hands", Chelsea Harbour, memorial to Lloyd George to stand in Parliament Square commencing 2007. *Recreations:* music, cooking, crosswords. *Clubs:* Chelsea Arts. *Signs work:* "G.W." *Address:* c/o Bernard Jacobson Gallery, 14a Clifford St., London W15 4JX. *Email:* glynn.williams@rca.ac.uk *Website:* www.glynnwilliams.co.uk

WILLIAMS, Graham Richard, ARBS (2001), SWE (1982). *Medium:* sculptor in metal and stone. *b:* Bromley, Kent, 21 Feb 1940. *m:* Nina. one *s.* one *d. Educ:* Beckenham Grammar School. *Studied:* Day release from Grammar School to Beckenham Art School, also in evenings. *Represented by:* Annely Juda Fine Art, 23 Dering Street, London W1S 1AW. *Exhib:* One man shows: West End House Gallery, Smarden (2006), Konstruktiv Tendens, Stockholm (1998, 2001), Annely Juda Fine Art, London (1995, 2000, 2004), Sassen Galerie, Berlin (1992), Galerie Walzinger, Saarlouis (1991), Alex Gerard Fine Art, Battle (1985). *Works in collections:* private and corporate. *Commissions:* all private. *Publications:* illustrated exhibition catalogues. Has written several essays on Naum Gabo. *Works Reproduced:* Roxtec 1990-2000 pub. Roxtec International AB (2000), 40 Nudes, pub. Silent Books (1988), Engraver Two pub. Silent Books (1992). *Clubs:* Society of Wood Engravers, Brother of the Art Workers Guild, Chairman of the Trustees of the Gabo Trust for Sculpture Conservation. *Address:* Weavers Cot, Cot Lane, Biddenden, Kent, TN27 8JB. *Email:* grw@grahamwilliams.co.uk *Website:* www.grahamwilliams.co.uk

WILLIAMS, Jacqueline E. E., N.E.A.C.; B.A. (Hons.) (1985), Advanced Dip. (R.A.) (1988); artist in oil. *b:* Lincoln, 2 Nov 1962. *Educ:* Downlands School, Hassocks. *Studied:* Glos. College of Arts and Technology (1982-85), R.A. Schools (1985-88). *Exhib:* New Grafton Gallery, Barnes; solo show: Brian Sinfield Gallery; mixed shows: N.E.A.C., R.W.A., R.A., Adam Gallery, Bath. *Works in collections:* Cheltenham and Gloucester Bldg. Soc. H.Q., Contemporary Arts Soc. for Wales. *Clubs:* C.G.A. *Signs work:* "J.W." *Address:* Garden Flat, 73 Bath Rd., Cheltenham, Glos. GL53 7LH. *Website:* www.jacquelinewilliams.co.uk

WILLIAMS, Jane Harker, 1993 Saunders Waterford Prize at Royal Watercolour Society Open exhbn. *Medium:* watercolour, acrylic, drawing. *b:* Monxton, Hants., 28 Sep 1942. *d of:* Capt. & Mrs. John Smallwood. *m:* Charles Williams. one *s.* one *d. Studied:* Coventry School of Art; Birmingham Institute of Art and Design. *Exhib:* Manor House Gallery, Chipping Norton; The Whibley Gallery, Worthing; Castle Gallery, Kenilworth; Park View Gallery, Edgbaston; Open exhbns: RI, RWS, RBSA, Coventry, Cheltenham, Leamington. *Works in collections:* private collections in Australia, Singapore, France, USA.

Commissions: Warwick School Recital Room (2004). *Signs work:* 'JW'. *Address:* 17 Binswood Avenue, Leamington Spa, Warwickshire CV32 5SE.

WILLIAMS, John, NDD, ATC. *Medium:* photography. *b:* Bury St.Edmunds, 17 May 1941. *s of:* George Barnacle Calvert. two *d. Educ:* Silver Jubilee Secondary School for Boys. *Studied:* Cambridge School of Art (1956-61), University of South Wales (1969-70), Leeds and Leicester Polytechnics p/t MPhil (1974-76, not completed). *Exhib:* extensively in UK and Europe, including solo show for London Undergrounds 'Platform for Art' (82 portraits) Piccadilly Circus (2003); Jelly-Legged Chicken Gallery, Reading (2004); 20/21 Gallery Scunthorpe (2005); Royal Photographic Society International Touring Exhbn (2004/5); Peter Piers Gallery/Sudbury Quay, Bury St.Edmunds (2005); Brighton Art Fair (2005); Brighton Photo Biennial Fringe (2006); Hellenic Photographic Society (2006); Suffolk Open (2006); Christopher Gull Brighton (2006); East London Photo-Feast (2006); Bow Arts East London (2007); Ickworth Round House, National Trust (2007); Simultaneous Portraits at National Stroke Headquarters London and Edinburgh Scotland (2007); Et.Cetera Gallery, London (2007); Islington Photography and Design Fair (2007). *Recreations:* have sailed a board for 20 years, then took up skate boarding. *Clubs:* F6 foto-group. *Signs work:* 3djon.com. *Address:* 92 Kings Road, Bury St.Edmunds, Suffolk IP33 3DT. *Email:* info@freeformphoto.co.uk *Website:* www.freeformphoto.co.uk

WILLIAMS, Michael Antony Ellis, BA Modern History. *Medium:* watercolour, pen and ink, graphite. *b:* Patna, India, 11 Nov 1936. two *s. Studied:* University College, Oxford. *Exhib:* London Group; John Moores, Liverpool; RA Summer Exhbn; Singer & Friedlander/Sunday Times Watercolour Comp.; 56 Group Wales, inc. exhbns in Prague and Bratislava; Christie's, London (National Trust Centenary); MoMA Dublin; Austin Desmond Fine Art (solo shows 1988, 1991); Aegean Centre, Paros, Greece; Bay Art, Cardiff; Silk Top Hat, Ludlow. *Commissions:* many private commissions for landscape. *Publications:* Francis Spalding: Dictionary of British Art, Vol.6, 20th century; David Buckman: Dictionary of Artists in Britain since 1945. *Recreations:* some writing, e.g. catalogue introductions. *Misc:* extensive teaching career. *Signs work:* 'MAEW'. *Address:* The Hawthorns, Middle Road, Thrupp, Stroud, Glos. GL5 2DL. *Email:* maewilliams2005@yahoo.co.uk

WILLIAMS, Nicholas Charles, figurative painter in oil on canvas. *b:* U.K., 1961. *Studied:* Richmond College (1977-79). *Represented by:* Artonomy. *Exhib:* Brian Sewell's A Critic's Choice, Cooling Gallery, London; The Spectator Awards, Christie's, London; Hunting/Observer Awards, Mall Galleries, London; Bayer art prize, London; Garrick Milne Exhibition, London; winner of the Hunting art prize (2001); Royal Cornwall Museum; Russell-Cotes Museum and Gallery. *Works in collections:* Hunting plc, Bluestone, Bournemouth Central Library. *Works Reproduced:* cover of Steven Berkoff's Collected Plays, volume one. *Principal Works:* Searching III, Adoration of the Sea, Desideratum.

Recreations: surfing. *Signs work:* "Nicholas Charles Williams." *Address:* Old Lifeboat Station, Towan Headland, Newquay, Cornwall TR7 1HS.

WILLIAMS, Simon, SBA; Silver Gilt Medal (RHS); Certificate of Botanical Merit (SBA, 2001, 2003). *Medium:* gouache, watercolour, black and white line work. *b:* Poole, 26 Nov 1979. *s of:* Rona & Roger Williams. two *s. Studied:* The Arts Institute, Bournemouth (1996-2000, HND in Natural History Illustration). *Exhib:* SBA Annual Exhbn; RHS shows for Botanical Art; National Orchid Show. *Works in collections:* internationally. *Commissions:* private commissions and illustration work undertaken. *Publications:* Gouache Painting Step-by-Step chapter 'The Art of Botanical Painting'. *Works Reproduced:* in 'The Art of Botanical Painting'. *Address:* S.W.Illustrations, 17 Gussage Road, Parkstone, Poole, Dorset, BH12 4BZ. *Email:* simon@swillustrations.com *Website:* www.swillustrations.com

WILLIAMS, Sue, MA (Oxon); SBA; Fellow Chelsea Physic Garden Florilegium Society; RHS Silver Gilt Medal (2006). *Medium:* botanical watercolours. *b:* Murree, Pakistan, 10 May 1942. *d of:* AM & MJ Dent. *m:* Martin John. two *s. Studied:* St.Hughs College, Oxford (Modern Languages). *Exhib:* Harare Botancial Gardens (1998); Adam Art Gallery, Wellington, NZ (1999); RHS; SBA; Sevenoaks Kent Painters Group; Tasmania. *Works in collections:* The Girdlers Company; Chelsea Physic Garden; Pitcairn Philatelic Bureau. *Commissions:* Definitive Stamp Issue (2000); botanical, Pitcairn and stamp designs of shells and beekeeping (1991-2001). *Publications:* 'Flower Painting from the Apothecaries' Garden' (Andrew Brown). *Signs work:* 'Sue J Williams' or 'SJW'. *Address:* Russet House, Lughorse Lane, Yalding, Kent ME18 6EG.

WILLIAMS, Susan, R.A. Schools Dip.; artist in oil and water-colour. *b:* Lichfield, Staffs., 23 Jul 1944. *m:* Ben Levene. one *s. Educ:* Lichfield Central School. *Studied:* Stafford Art School, Byam Shaw School, R.A. Schools. *Exhib:* regularly at R.A. Summer Exhbn., Spirit of London (prizewinner), Ogle Gallery, Cheltenham, Hintlesham Hall Pictures, Ipswich, The Gallery Southwark Park, Bermondsey, Duncan Campbell Gallery, Waterman Gallery, London. Work in private collections. *Recreations:* gardening, cooking. *Signs work:* "S.W." *Address:* 26 Netherby Rd., London SE23 3AN.

WILLIAMS-ELLIS, Bronwyn Mary, R.C.A. (2001), B.A. (1973), M.A. (1983). *Medium:* drawing and colour in 2D ceramics, sculpture, tiles; also on paper; ceramicist. *b:* 20 Jan 1953. *Studied:* Cardiff College of Art (1971-1973), S.G.I.H.E., Cardiff (1982-1983), M.A. *Exhib:* regularly, including, 1000 Years of Tiles (1991-1993), Ceramic Series, Aberwsytwyth Arts Centre, Tremayne Applied Arts, St. Ives, Oriel Plas Gly-y-Weddw, Royal Cambrian Academy, Victoria Art Gallery, Bath. *Works in collections:* Aberwsytwyth Arts Centre, private collections. *Commissions:* majority tile work. *Publications:* work appears in Decorating With Tiles, Elizabeth Hilliard; Ceramics and Print, Paul Scott; Practical Solutions for Potters, Gill Bliss; 20th Century Decorative British Tiles,

C.Blanchett. *Signs work:* "B W-Ellis", "BRON" or "B W-E." *Address:* Mill Farm, Woolley, Bath, BA1 8AP. *Website:* www.handmade-tiles.co.uk

WILLIAMS-ELLIS, David Hugo Martyn, R.C.A. (1993), A.R.B.S. (1992); sculptor in clay for bronze and terracotta;. *b:* Ireland, 6 Apr., 1959. *m:* Serena Stapleton. two s. two d. (one decd.). *Educ:* Headfort School, Ireland; Stowe School. *Studied:* in Florence (1977-78, Signorina Nerina Simi), Carrara (1979-80), Sir John Cass (1981-83). *Represented by:* Robert Bowman Gallery, London. *Exhib:* London, Belfast, Paris, U.S.A., Japan, Argentina, South Africa. Many portrait busts and figures in private and public collections. *Clubs:* Chelsea Arts. *Signs work:* "D.W.E." dated with signet ring eagle on larger pieces. *Address:* Lazonby Manor, Lazonby, Penrith, Cumbria CA10 1BA. *Email:* david@dwe.com *Website:* www.DWE.com

WILLIES, Joan, RMS (1976) (Eng.), MAA (1995) (USA), HS (Eng.), Mem. Florida (Hon.mem.), Washington and Georgia Miniature Art Socs., USA; painter in oils, alkyds and water-colours, specialising in miniatures. *b:* Bristol, England, 23 Dec 1929. *d of:* B. Cornish, Royal Marines. *m:* Mark Willies. three *s. Educ:* Bristol Commercial College, art studies under private tutors. *Exhib:* R.M.S., R.I., S.W.A., U.A., H.S. (Eng.), U.S.A., Australia, Spain, Germany, Canada, Japan, Tiffanys, U.S.A.; permanent exhbn. Bilmar Hotel, Treasure Island, Florida. *Publications:* The Artist's Workbook 1 and 2; illustrated children's books, St. Francis of Assisi (worldwide prints) I.G.M.A. prints Ohio. Writer of articles, artist magazines; author, 'Miniature Painting techniques and applications' (pub. Watson & Guptil, N.Y. June 1995; English distributors Phaidon Press, London). *Misc:* Awards: numerous U.K. and U.S.A. Teacher: Workshops internationally and private groups at Joan Cornish Willies Studio, 1726 St. Croix Drive, Clearwater, Florida 34619. *Signs work:* "Joan Willies," or "Joan Cornish Willies, R.M.S., M.A.A., H.S." *Address:* P.O. Box 7659, Clearwater, Florida 34619, U.S.A.

WILLIS, Lucy, RWA (1993); BP Portrait Award. *Medium:* water-colour, oil, printmaking. *b:* 15 Dec 1954. *m:* Anthony Anderson. one *s.* one *d. Educ:* Badminton School, Bristol. *Studied:* Ruskin School of Drawing and Fine Art, Oxford (1972-75). *Represented by:* Curwen & New Academy Gallery, London W1. *Exhib:* eight solo shows at Chris Beetles, London since 1986; RA, RWA, NPG, BP Portrait award (1st prize 1992), Mall Galleries, RWS, RE, Curwen Gallery, London: five solo shows (2000-2006). *Works in collections:* NPG, RWA. *Commissions:* 'Year of the Artist' murals in Portland Prison (2000); NPG, oil portrait of Lord & Lady Longford (1993). *Publications:* 'Light, How to See it, How to Paint it'; 'Excursions in the Real World' by William Trevor (illustrations); Light in Water-colour (1997); Travels with Watercolour (2003). *Official Purchasers:* Exeter Health Care Arts, National Portrait Gallery, RWA. *Works Reproduced:* numerous works as prints and cards. *Principal Works:* 'Her Majesty's Pleasure' (oil on canvas, BP Portrait Award, 1992). *Signs work:* "Lucy Willis." *Address:* Moorland House, Burrowbridge, Bridgwater, Som. TA7 0RG. *Website:* www.lucywillis.com

WILLIS, Victor, M.A. Fine Art (1985); artist in oil;. *b:* London, 2 Aug., 1934. *m:* Mary. two *d. Educ:* Dulwich College. *Studied:* Camberwell College of Art (1974), City & Guilds (1978), Goldsmiths' College (1985). *Works in collections:* London and abroad. *Commissions:* Swan Hellenic, British Rail, Anna Bornholt Assoc. *Publications:* articles illustrated: 'The Thames at Night', 'Light on Landscape'. *Clubs:* Chelsea Arts. *Signs work:* "Victor Willis." *Address:* Studio: Unit 8, Shakespeare Business Centre, 245 Coldharbour Lane, London SW9 8RR.

WILLS, Richard Allin, N.D.D., A.U.A.; painter in oil and water-colour, etc.; art tutor; visiting lecturer. *b:* Monmouth, 11 Sep 1939. *s of:* W.L.J. Wills. *m:* Vera Elizabeth. one *s.* two *d. Educ:* King Henry VIII Grammar, Abergavenny. *Studied:* Newport College of Art (1956-61, Thomas Rathmell). *Exhib:* R.A., R.W.A., Welsh Young Contemporaries, R.S.P.P., U.A., W.C.S.W., P.S., R.W.S., R.I. *Works in collections:* British Steel Corp., Welsh Div. British Steel, Rank Xerox, Lloyds TSB, International Rugby Board, Electronic Art, National Museum of Wales, University of Wales. *Commissions:* Welsh Office, Whitehall; Guildhall School of Music, London; Polytechnic of Wales; Yamazaki Mazak Europe; Royal Monmouthshire Royal Engineers; Royal Regiment of Wales Contemporary Art Society. *Publications:* Colllins: Complete Drawing Course, Watercolour Workshop; Headline: Encyclopedia of W/C Techniques. *Signs work:* "Richard A. Wills." *Address:* The Studio, Mansard House, Vine Acre, Monmouth, Gwent NP25 3HW.

WILSON, Eleanor Mavis: see GRÜNEWALD, Eleanor Mavis,

WILSON, Arnold, M.A., F.S.A., F.M.A.; former Chairman of Trustees, Holburne of Menstrie Museum, Bath, and serves on numerous other Coms.; formerly Director, City Art Gallery, Bristol. *b:* Dulwich, 1932. twice married. two *d.* by first marriage. *s of:* Robert Arthur Wilson, artist. *Educ:* Selwyn College, Cambridge, and Courtauld Inst. of Art. *Publications:* author: Dictionary of British Marine Painters (3 eds.); Dictionary of British Military Painters; Exploring Museums: South West England; numerous articles for Burlington Magazine, Apollo, Connoisseur, Country Life, etc. *Clubs:* Bristol Savages. *Address:* St. Winifred's Well Cottage Winifred's Lane Bath BA1 5SE.

WILSON, Arthur, artist in mixed media; ex-Vice President, London Group. *b:* London, 31 Dec 1927. *m:* Ivy. three *s.* two *d. Studied:* Chelsea School of Art. *Exhib:* solo and mixed shows. Venues include:Arnolfini, Royal Academy Diploma Gallery, Camden Arts Centre, Barbican, ICA, Whitechapel. *Works in collections:* Bristol City Art Gallery, Hounslow Picture Scheme, private collections. *Publications:* The Guardian, Arts Review, Art International, The Observer, Directory of Marine Artists, Mathematics and Modern Art. *Works Reproduced:* The London Group Visual Arts from 1913 (pub. London Group 2003). *Signs work:* "ARTHUR WILSON." *Address:* 22 Wingate Rd., Hammersmith, London W6 0UR. *Email:* info@arthurwilson.co.uk *Website:* www.arthurwilson.co.uk

WILSON, Chris, B.A.(Hons.) (1982), M.A. (1985); artist in oil and collage;. *b:* Belfast, 27 Dec., 1959. *m:* Cindy Friers. one *s. Educ:* Belfast Royal Academy. *Studied:* Brighton College of Art (1979-82), University of Ulster (1984-85). *Exhib:* 'Shocks to the System' A.C.G.B. (1991), 'On the Balcony of the Nation' touring U.S.A. (1991-92), 'Shadows of Light' one-man touring Romania (1992), Bulgaria (1993). *Works in collections:* A.C.G.B., Arts Council of Ireland, Aer Rianta Dublin, Queens University Belfast; private collections in Ireland, England, Germany, U.S.A. *Signs work:* "CHRIS WILSON" or "C. WILSON" with date. *Address:* 44 Victoria Rd., Bangor, Co. Down BT20 5EX.

WILSON, David, B.A. (Hons)(Open)(2000); painter in oil, acrylic, water-colour, gouache, etching, linocut. *b:* Gillingham, Kent, 23 May 1936. *s of:* Jack Wilson, R.N. *m:* Sheila. two *s.* two *d. Educ:* Sir Joseph Williamson's Mathematical School, Rochester; Joint Services School of Linguists. *Studied:* Heatherley's (Evening classes 1976-77, Terry Shave). *Exhib:* R.A., R.B.A., Royal National Eisteddfod, R.W.A., The Discerning Eye, N.E.A.C., S.G.A., R.Cam.A., F.P.S., and elsewhere in U.K., France and Ireland. *Works in collections:* National Library of Wales, Aberystwyth. *Signs work:* "David Wilson Bridell." *Address:* Treleddyn Isaf, Bridell, Cardigan SA43 3DQ. *Email:* david@david-wilson.net *Website:* www.david-wilson.net

WILSON, Douglas, R.C.A., D.F.A., F.R.S.A.; painter in oil and water-colour. *b:* 8 Nov 1936. *s of:* George William Wilson. *m:* Heather Hildersley Brown. one *s. Studied:* Oxford University (1959-62, Percy Horton, Richard Naish, Geoffrey Rhodes). *Represented by:* Highgate Fine Art, London. *Exhib:* R.A., R.B.A., R.O.I., R.Cam.A., Vis Art I (prizewinner), Edinburgh Festival, National Library of Wales, New Grafton Gallery, Piccadilly Gallery, Thackeray Gallery, Jablonski Gallery, Waterman Fine Art, St. James's, London; one-man shows: Bluecoat Gallery, Williamson A.G. (1981, 1983), King St. Galleries, St. James's (1983, 1986, 1991), Metropolis International Galerie d'Art Geneva (1985), Phoenix Gallery, Lavenham (1987, 1989), Phoenix Gallery, Kingston upon Thames (1987), Anthony Dawson Artists at the Barbican (1987, 1990), Outwood Gallery (1987), Newburgh St. Gallery (1988), Highgate Fine Art, London (2001, 2004), Distinguished Landscapes 1 (2003). *Works in collections:* Lord Wandsworth College, Williamson A.G, Shire Hall Gallery, Stafford, numerous collections in Britain and abroad. *Publications:* author, 'Wirral Visions'. *Official Purchasers:* Williamson AG, Staffordshire Arts and Museums Service. *Works Reproduced:* The Public Catalogue Foundation - The National Inventory of Oil Paintings in Public Ownership. *Signs work:* "Douglas Wilson." *Address:* 123 Masons Pl., Newport, Salop. TF10 7JX. *Website:* www.oddyart.com

WILSON, Helen, B.A. (F.A.) 1995 (Uni.S.A.); painter in oils; administrator at Somerset Art Week Ltd.;. *b:* Surrey, 1 Sept., 1948. *m:* Mua Wilson. two *s. Studied:* City and Guilds of London Art School (1987-88), University of South Africa (1990-95). *Exhib:* solo show at National Art Gallery of Namibia (1996), S.B.A. (1997), Brewhouse Theatre and Arts Centre, Taunton (1999). *Works in*

collections: Telecoms Namibia. *Publications:* article in "De Arte" (1994). *Clubs:* Greenpeace. *Signs work:* "HW" joined. *Address:* Orchard Cottage, Hare Lane, Buckland St Mary, Chard, Somerset TA20 3JS. *Email:* helen@orchardstudio.freeserve.co.uk

WILSON, Helen Frances, D.A. (1975), R.G.I. (1984), R.S.W. (1998), P.A.I. (2005); artist in oil, water-colour, mixed media. *b:* Paisley, Scotland, 25 Jul 1954. one d. *Educ:* John Neilson High School, Paisley. *Studied:* Glasgow School of Art (1971-76); Hospitalfield (1973). *Exhib:* R.G.I., R.S.A., R.S.W., etc. and various galleries in Britain and U.S.A. *Works in collections:* Glasgow A.G., Kelvingrove; Scottish Arts Council; Royal College of Physicians, Edinburgh; Paisley A.G. *Commissions:* portraits: Royal College of Ophthalmologists, Royal College of Physicians, Garrick Club, London, etc. also private commissions. *Address:* 1 Partickhill Rd., Glasgow G11 5BL.

WILSON, Lorna Yvette, B.A. Hons. (1989), Dip.F.A.- R.A. Schools (1992); artist in oil and gouache;. *b:* Jamaica, 6 July, 1967. *Studied:* Kingston University (1986-89, Derek Hirst), R.A. Schools (1989-92, Prof. Norman Adams, R.A.). *Exhib:* many mixed exhbns. in London. Currently doing series of prints for C.C.A. Galleries. *Address:* 8 Petherick House, 79 Stanley Rd., Hounslow, Middx. TW3 1YU.

WILSON, Peter Reid, D.A.; artist in oil paint on canvas. *b:* Glasgow, 4 Sep 1940. married. one *s.* one *d. Studied:* Glasgow School of Art (1960-64). *Works in collections:* Contemporary Arts Soc., A.C.G.B., S.A.C., Sheffield City A.G., Ferens A.G. Hull, Nottingham Castle Museum and A.G., Leicester Museum and A.G., Glasgow A.G., Kelvingrove, Stoke-on-Trent Museum and A.G., Kettles Yard, Cambridge, Museum of Modern Art, Glasgow, Loyola Marymount University, Los Angeles. *Publications:* Peter Wilson - Paintings 1979-1985 (Third Eye, Glasgow, 1985), Dacapo - Drawings (Arc Publications, 1989). *Clubs:* Chelsea Arts. *Signs work:* c within a circle "Peter Wilson" and date. *Address:* 5 The Square, South Luffenham, Oakham, Rutland LE15 8NS. *Email:* peewee.wilson@virgin.net

WILSON, Susan Ahipara, BFA, DipRA Schools; Richard Ford Award to Spain (1986); Italian Government Borso di Studio (1985); British School at Rome (Abbey Award) 1993; artist in oil on canvas;. *b:* Dunedin, N.Z. *d of:* Rev. C.R. Wilson, BA. *Studied:* Camberwell School of Art (1978-82), R.A. Schools (1982-85). *Represented by:* Browse & Darby, 19 Cork Street, London W1. *Exhib:* 2000, 2005. *Works in collections:* National Trust, H.R.H. The Prince of Wales, Usher Gallery, Rochdale A.G., Auckland Museum, Contemporary Art Soc., Tauranga Art Gallery (NZ), Aigantigue Art Gallery (NZ), Bishop Suter Gallery, Nelson (NZ), etc. *Commissions:* portrait of Baroness Helena Kennedy Q.C. for Oxford Brookes Univ. *Publications:* illustrated: Katherine Mansfield's Short Stories (Folio Soc., 2000), Balancing Acts (Virago), Gillett: The Mind and Its Discontents (O.U.P., 1999), Catalogues to Touring Shows (co-curator),

Reclaiming the Madonna (1993) and In the Looking Glass (1997 - Usher Gallery Publications). *Official Purchasers:* Usher Gallery, Lincoln; Rochdale Art Gallery and Museum; Contemporary Art Society; National Trust. *Address:* 16 Balliol Rd., London W10 6LX. *Website:* www.susanwilsonartist.com

WILSON, Timothy Hugh, M.A., M.Phil., F.S.A. (1989), Hon.R.E. (1991), Fellow of Balliol (1990); Keeper of Western Art, Ashmolean Museum, Oxford (since 1990);. *b:* Godalming, 8 Apr., 1950. *m:* Jane Lott. two *s.* one *d. Educ:* Winchester College; Mercersburg Academy, U.S.A.; Corpus Christi College, Oxford; Warburg Inst. (London University); Dept. of Museum Studies (University of Leicester). *Publications:* books and articles chiefly on Italian maiolica and Renaissance applied arts. *Address:* Balliol College, Oxford OX1 3BJ.

WILSON, Vincent John, A.T.D., Mem. Penwith Soc. of Arts, Devon Guild of Craftsmen (prints); painter and etcher;. *b:* Mold, Flintshire, 24 Nov 1933. *s of:* J. Wilson. *m:* Sheila Richards. one *d. Educ:* Alun Grammar School, Mold. *Studied:* Chester School of Art (1950-54), Liverpool College of Art (1954-55). *Exhib:* R.A., R.W.A., R.C.A., Piccadilly, Thackeray, Gagliardi, Penwith Galleries, Celle, W. Germany, Welsh Arts Council (1958, 1974, 1981), Cornwall Now (Sussex 1986), Cornwall in the Eighties (Chichester 1987); one-man shows: Exeter University (1966), Newlyn (1971, 1972, 1980), Plymouth (1979), Taunton (1981), Guernsey (1990), St. Ives (1992), St. Ives Artists (Dublin, 1998), four-man exhibition, Minster Fine Art, York (2005). *Works in collections:* Plymouth A.G., Devon C.C., Surrey Educ. Com., Royal Cambrian Academy, Celle, British Foreign and Commonwealth Office (etchings), V & A Museum (prints). *Recreations:* music (singing). *Signs work:* "V. Wilson." *Address:* 3 Drakefield Drive, Saltash, Cornwall PL12 6BU.

WILTON, Andrew, MA, FSA, FRSA, Hon.RWS; museum curator; Keeper of British Art, Tate Gallery (1989-1998); Keeper and Senior Research Fellow, Tate Gallery (1998-2002); Visiting Research Fellow, Tate Gallery (2003-); Curator, Turner Collection, Clore Gallery (1985-89), Curator of Prints and Drawings, Yale Center for British Art (1976-80), Asst. Keeper, Dept. of Prints and Drawings, British Museum (1967-76, 1981-84). *b:* Farnham, Surrey, 7 Feb 1942. *Educ:* Dulwich College; Trinity College, Cambridge. *Publications:* British Watercolours 1750-1850 (1977); The Life and Work of J.M.W. Turner (1979); Turner and the Sublime (1980); Turner in his Time (1987) and numerous exhbn. catalogues, articles and reviews. *Clubs:* Athenaeum, Chelsea Arts Club. *Address:* Tate Gallery, London SW1P 4RG.

WINDSOR, Alan, B.A. (Lond.), Dip.F.A. (Lond.), N.D.D., D.A.(Manc.); artist and writer; art historian; Senior Lecturer, Reading University. *b:* Fleetwood, Lancs., 10 Jul 1931. *s of:* Major G. V. Windsor, M.C., M.B.E. *m:* Elfriede Windsor. one *s.* two *d. Educ:* Audenshaw Grammar School. *Studied:* Regional College of Art, Manchester (1949-54); Slade School, University College (1954-

56); Universities of Paris and Aix (1956-57); Courtauld Institute, London University (1967-69). *Exhib:* Young Contemporaries, London Group, Gimpel Fils, Roland, Browse & Delbanco, Pollock, Toronto, New Ashgate, Farnham. *Publications:* Peter Behrens, 1868-1940, Architect and Designer (Architectural Press, 1981); Handbook of Modern British Painting, 1900-1980 (Scolar Press, 1992). *Clubs:* Architectural Association. *Signs work:* "A. Windsor." *Address:* 2 Wykeham Rd., Farnham, Surrey GU9 7JR.

WINER, Zalmon, RBA (1984); painter in oil, pastel, acrylic, water-colour; designer, etcher and lithographer. *b:* Gateshead, Co. Durham, 21 Nov 1934. married. *s of:* Louis Winer. one *s.* two *d. Educ:* Gateshead Grammar School. *Studied:* art and architecture at Durham University; etching at Central School of Art and Design. *Exhib:* R.A., R.B.A., P.S., U.A., N.S., Ben Uri Gallery (The London Jewish Museum), C.P.S., Safrai Gallery, Jerusalem, Discerning Eye Exhbn. at Mall Galleries (1990), etc. *Works in collections:* Shipley A.G., Oundle Public School Gallery. *Publications:* illustrated Haggadah for the Exilarchs Foundation. *Address:* 53 Shirehall Park, London NW4 2QN.

WINKELMAN, Joseph William, B.A. (1964), C.F.A. (1971), R.E. (1982), R.W.A. (1989), Hon. R.W.S. (1996); Prizes: International Print Shows: Spain '82, Korea '82, New York '98, Connecticut 2001 & 2003; artist and printmaker; Past President, Royal Soc. of Painter-Printmakers; Artist-in-Residence, St.John's College, Oxford (2004). *Medium:* etching. *b:* Keokuk, Iowa, U.S.A., 20 Sep 1941. *s of:* George Winkelman, B.A. *m:* Harriet Lowell Belin. two *d. Educ:* University of the South, University of Pennsylvania, University of Oxford. *Studied:* University of Oxford, Ruskin School of Drawing (1968-71). *Exhib:* New Grafton Gallery, Royal Academy, Bohun Gallery, Lumley Cazalet Gallery, Graffiti Gallery, Anthony Dawson, Oxford Gallery, M.o.M.A. Oxford, Matsuya Ginza, Tokyo, Space Gallery, Seoul, Connecticut Graphic Arts Centre, Taller Galeria Fort, Barcelona. *Works in collections:* Ashmolean Museum, Hereford Museum, Usher Gallery, Victoria & Albert Museum, Graves A.G., Bowes Museum, The Museum of London, The Royal Collection, Fitzwilliam Museum, National Museum of Wales, Science Museum London, The Royal Collection, Tate Gallery. *Commissions:* Balliol College, Oxford, St. Antony's College, Oxford, Christ Church, Oxford, Lady Berlin, St.John's College, Oxford; Keeper of the Royal Collection. *Official Purchasers:* Lord Sainsbury. *Signs work:* "J. W. Winkelman." *Address:* The Hermitage, 69 Old High St., Headington, Oxford OX3 9HT. *Email:* winkelman@ukgateway.net

WINNER, Tolleck, ARBS. *Medium:* steel, bronze, aluminium, brass, copper, glass, hot and cold resins, stone, granite, marble, wood, textile. *b:* Russia, 30 Jul 1959. *m:* Angela. two *s.* one *d. Exhib:* solo: Diorama Gallery (2003), Charity Fair, Business Design Centre(2003), Fresh Art (2003),Alon Zakaim Gallery Cork Street, London (2007); group:The Art Engine Gallery (2004), ICI, Manchester Square, London (2004/5), Beldam Gallery Brunel University (2005), Brunei Gallery Russell Square London (2005), Millais Gallery, Southampton University

(2006), Alon Zakaim Gallery Cork Street, London (2006, 2007); DAC'S London (2007); ArtParks International, Guernsey (2007). *Works in collections:* Private Hands (Charity Fair, London), Octavia Housing and Care (Miranda House) Holland Park; Jerusalem Museum; Peterborough Sculpture Park; collections across the UK, Europe and the Middle East. *Clubs:* Designer and Artist Copyright Society. *Signs work:* Tolleck Winner. *Address:* 31 Fencepiece Road, Barkingside, Ilford, Essex, IG6 2LY. *Email:* atwinner@ntlworld.com *Website:* www.tolleck.com/ www.tolleckwinner.com

WINSTANLEY, Roy, Cert. Ed. (Hons.) 1961, B.A. (Hons.) 1973, Dip. (1986); painter in water-colour, acrylic, oil, mixed media;. *b:* Wakefield, 31 Mar., 1940. *m:* Jean. two *s. Studied:* Westminster College, Oxford (1959-61), University of Leek (1970-73), Goldsmiths' College (1986). *Exhib:* R.I., R.W.S., John Laing Landscape, Images of Dorset, Poole, Honiton Festival, Thomas Hardy Conference Dorchester, Twin Tracks Bridport, Modern British Painting Exeter, Battersea Contemporary Art Fair. *Works in collections:* Sheffield City A.G. *Commissions:* series of paintings: Capital Interiors, London for a Royal Villa in Rabat, Morocco (1998); water-colours: The Constable Wing of Colchester General Hospital (1998). *Signs work:* "Winstanley." *Address:* Fig Tree Cottage, Preston, Weymouth, Dorset DT3 6DD.

WINTER, Faith, FRBS, Feodora Gleichen Sculpture Award, FRBS, Silver Medal Open Award (1984), Bronze, William Crabtree Memorial Award (1993), Bronze; sculptor in stone, wood, and bronze. *b:* Richmond, Surrey, 1927. *d of:* J.F.Ashe, architect. *m:* Col. F.M.S. Winter, M.B.E., FRSA. two *s.* one *d. Educ:* Oak Hall. *Studied:* Guildford and Chelsea Schools of Art. *Exhib:* RA, RBA, RWS, Glasgow Academy of Fine Art, Covent Garden and elsewhere in the UK; International Centre of Contemporary Art, Paris; Malaysia and Singapore. *Works in collections:* Earl of Mansfield, Scone Palace. Sir Reresby & Lady Penelope, Renishaw Hall etc. *Commissions:* include: "The Soldiers" Catterick Camp; "Compassion" Hambro Foundation; Falklands Islands Memorial relief; The Mysteries of the Rosary, Church of Our Lady Queen of Peace, East Sheen; John Ray statue, Braintree; Air Chief Marshal Lord Dowding and Marshal of the Royal Air Force Sir Arthur "Bomber" Harris statues, The Strand, London; Lennard standing figure 'The Spirit of Youth', Ontario, Canada; Salters' Hall Coat-of-arms, London; Archbishop George Abbot, Guildford; H.R.H. The Princess Royal, The President of Kenya, Jeffrey Archer, Maria Callas and the late Kamal Jumblatt; David Devant, Magic Circle; memorial relief Mulberry Harbour, Arromanches, Normandy; General Sikorski, Portland Place, London; Sir Frank Whittle (1½ life size, Coventry 2007). *Signs work:* "Faith Winter" (formerly "Faith Ashe."). *Address:* Venzers Studio, Venzers Yard, The Street, Puttenham, Guildford, Surrey GU3 1AU. *Email:* Faith@FaithWinter.co.uk *Website:* www.FaithWinter.co.uk

WINTERINGHAM, Claude Richard Graham, Dip. Arch., F.R.I.B.A., R.B.S.A.; Architect; R.N.V.R. Fleet Air Arm Lt. (1941-46), chairman, Solihull Round Table (1956-57), founder mem. and vice chairman, Solihull Civic Soc.

(1958-62), president, B'ham Architecture Assoc. (1971-72); chairman, Sir Barry Jackson Trust (1982-96), Trustee (1996-); Awards: Mason Court Civic Trust (1969), Lichfield City Hall, Civic Soc. Commendation (1976), Lench's Close, Moseley, D.O.E. Housing Design (1983), B'ham Repertory Theatre Architecture (1972). *b:* Louth, Lincs., 2 Mar 1923. *s of:* Francis Winteringham, M.B.E. (decd.). *m:* Lesley Patricia. two *s.* one *d. Clubs:* Royal Naval Sailing Association, R.I.B.A. Sailing, Edgbaston Priory. *Address:* 7 Sir Harry's Rd., Edgbaston, Birmingham B15 2UY.

WISE, Gillian, artist, architectonic reliefs and paintings. *b:* London, 1936. one *s. Educ:* Wimbledon School of Art (1953-57); post-graduate, Repin Inst., Leningrad (1969-70); Unesco Fellowship, Prague (1968); Fellow, C.A.V.S (M.I.T.) 1981-82; Research Fellow, Open University, U.K. (1983). Awards: A.C.G.B. (1976); Research Grant, International Communication Agency (1981); Graham Foundation, Chicago (1983). *Represented by:* see website. *Exhib:* London, Paris, Chicago, Liverpool, Japan, Germany, Finland. *Works in collections:* Tate Gallery (London and Liverpool), V. & A., British Council, Contemporary Arts Society, University of E. Anglia, D.O.E., Amos Andersonin Taidemuseo (Helsinki), Unilever, Gulbenkian Foundation (Lisbon), Henry Moore Foundation. *Commissions:* Steel wall relief: Nottingham University Hospital (1975); Relief panel in wood: Unilever House (1982); painting/relief: Barbican Centre (1983); three wall relief: Open University (1984). *Publications:* currently: transcriptions of life-story for British Library National Sound Archives: "Artists Lives". *Works Reproduced:* in 'English Constructed Art' by Alastair Grieve (Yale Univ. Press, 2005). *Principal Works:* Barbican murals placed under English Heritage protection (2004). *Clubs:* M.I.T. Club of France, Hon.Life mem. ICA London. *Signs work:* "Gillian Wise." *Address:* 3 Passage Rauch, BP 37, Paris 75011, France. *Email:* alexander.wise@wanadoo.fr *Website:* www.gillianwise.com

WISHART, Michael, painter, writer; Knight of St. Lazarus; nominated Academician of Italy with gold medal (1980);. *b:* London, 12 June, 1928. *s of:* E. E. Wishart. *m:* 1950, Anne, d of Sir James Dunn, Bt. one *s. Studied:* Academie Julian, Paris (1948). *Exhib:* one-man shows: Archer Gallery (1944), Redfern Gallery (1956, 1958, 1960), Leicester Galleries (1963, 1967, 1969, 1973), portrait of Rudolf Nureyev, Royal Academy (1968), Arts Council "Six Young Painters" (1957), Contemporary Art Society "Recent Acquisitions" Whitechapel Gallery (1968), Morley Gallery (1969); retrospective exhbn., "Paintings 1964-76" David Paul Gallery, Chichester (1976); Parkin Gallery (1985); R.A. Summer Exbhn. (1980, 1985, 1988, 1989, 1990); group shows: Parkin Gallery (1985-95). *Works in collections:* Arts Council, C.A.S., Garman Ryan Collection, Walsall. *Works Reproduced:* in Apollo, Burlington Magazine, Studio International, The Book of Joy, The Observer, Arts Review, Dance and Dancers, La Revue Moderne, Art and Literature, "High Diver" (autobiography), 1977. *Clubs:* Travellers', Chelsea Arts. *Signs work:* "Michael Wishart."

WISHART, Sylvia, D.A. Aberdeen, R.S.A. (2005); painter in oil; lecturer in Fine Art, Gray's School of Art, Robert Gordon University, Aberdeen. *b:* Stromness, Orkney, 11 Feb 1936. *d of:* Elsie & James Wishart. *Educ:* Stromness Academy, Orkney. *Studied:* Gray's School of Art. *Exhib:* R.A., R. Scot. Academy, Pier Arts Centre, Orkney, Peacock Printmakers, Aberdeen, 21 Years of the Compass Gallery, Glasgow, Scottish Art in the 20th Century, Royal W. of E., Bristol, various solo exhibs. *Works in collections:* Arts Council of Gt. Britain, The Scottish Arts Council, Contemporary Arts Society, London, Royal Scottish Academy, Aberdeen Art Gallery. *Publications:* Catalogue 1987-92, Pier Arts Centre, Looking North, West and South. *Signs work:* late work unsigned. *Address:* Heathery Braes, Stromness, Orkney KW16 3JP.

WISZNIEWSKI, Adrian, painter, sculptor, interior designer. *b:* Glasgow, 31 Mar., 1958. *m:* Diane. two *s.* one *d. Studied:* Mackintosh School of Architecture, Glasgow School of Art. *Works in collections:* Tate, M.O.M.A., New York, Setegaya, Tokyo. *Commissions:* Liverpool Cathedral. *Publications:* exhib. catalogues and historical books. *Signs work:* "A. Wiszniewski." *Address:* Calder House, Main St., Lochwinnoch, Renfrewshire PA12 4AH. *Email:* awiszniewski@btclick.com

WITHINGTON, Roger, Dip.A.D. (Graphics) (1966), A.T.D. (1967), A.R.E. (hon. retd.); artist/designer at Bank of England (1983-93), designed new series of banknotes known as Series E. *Medium:* pencil, watercolour, etching. *b:* Prestwich, 4 Oct 1943. *m:* Rose-Marie Edna Cobley. one *s.* one *d. Educ:* Barry Grammar/Technical School, S. Glam. *Studied:* Cardiff College of Art (1962-63, etching: Philip Jennings, A.R.E.), Newport (Gwent) College of Art (1963-66, illustration: John Wright). *Exhib:* R.E. Galleries, Bankside Galleries. *Publications:* designed/part author series of booklets to accompany new banknotes. Limited Editions of prints from selected pieces of artwork for series E banknotes issued 1990-94; limited edition print of St. Paul's Cathedral and Thames Riverside that featured on reverse of £50D note issued in 1981. *Signs work:* "R. Withington" or "R.W." *Address:* Hedge-Rose, Goodleigh, Barnstaple, N.Devon EX32 7NP.

WITHROW, William John, Honour B.A., Art and Archaeology (1950), Art Specialist, O.C.E. (1951), B.Ed. (1955), M.Ed. (1958), M.A. (1965); Director Emeritus, Art Gallery of Ontario; Member: Order of Canada (1980), Fellow, Canadian Museums Assoc. (1985), Canadian Art Museums Directors Organisation, American Assoc. of Museums, Assoc. of Art Museum Directors, Canadian National Com. for I.C.O.M., Art Advisory Com., University Club of Toronto. *b:* Toronto, 30 Sep 1926. *s of:* W. F. Withrow. *m:* June Roselea Van Ostrom. three *s.* one *d. Educ:* University of Toronto. *Studied:* University of Toronto (1946-65, Professor Peter Brieger, Professor Stephen Vickers). *Commissions:* Ricard/Withrow report on National Museums, Canada. *Publications:* Sorel Etrog Sculpture, Contemporary Canadian Painting. *Clubs:*

University Club of Toronto, Highland Yacht. *Address:* 7 Malabar Pl., Don Mills, Ontario M3B 1A4. Canada.

WNEK-WEBB, Ewa, N.D.D.; artist;. *b:* Przemysl, Poland, 7 Jan 1940. *m:* Michael Robert Webb. two *s.* one *d. Studied:* St. Martin's School of Art (1958-61), Regent St. Polytechnic School of Art, and Chelsea College of Art (1961-63), London College of Printing. *Exhib:* R.O.I., U.A., S.W.A. Mall Galleries, R.A. Summer Show; solo shows: Gallery 47 London, Terrace Gallery Worthing, Ropner Gallery London, Heifer Gallery London, St. Rafael Gallery London, Thomson Gallery-Aldborough, Suffolk, Hunter Gallery, Long Melford, Suffolk, Chase Gallery, Wadebridge, Cornwall, National Physical Laboratories, Teddington. *Clubs:* Assoc. of Polish Artists in G.B., Teddington Artists. *Address:* 8 King Edward's Gr., Teddington, Middx. TW11 9LU. *Email:* ewawebb@connectfree.co.uk *Website:* www.wnek-webb.co.uk

WOLKERS, Joan Elizabeth Margaret, N.D.D. (Painting, 1948), Abbey Scholarship (1949), R.A. Silver Medals (1951, 52, 53); Diploma of Association of Occupational Therapists; retd. teacher. *Medium:* oils. *b:* Tunbridge Wells, 28 Aug 1928. *d of:* M. E. Ransome. *m:* G.L. Wolkers (decd.). one *s. Educ:* Lawnside, Malvern. *Studied:* Malvern School of Art under Victor Hume Moody (1945-50) and R.A. Schools under Henry Rushbury, Fleetwood Walker and William Dring (1950-54); Royal Academy, Amsterdam (1954-58). *Exhib:* R.A., R.B.S.A., R.P., N.E.A.C., Brighton A.G., Worcester A.G., Malvern Art Club, Kenn Group, Exeter. Specialises in portraiture. *Commissions:* portraits. *Signs work:* "J.E.M. Wolkers." *Address:* 37 Powderham Cres., Exeter EX4 6BZ.

WOLSTENHOLME, Jonathan, artist/illustrator in water-colour, oil, pen and ink;. *b:* London, 22 Nov., 1950. *m:* Margaret. one *s.* one *d. Educ:* Purley Grammar School. *Studied:* Croydon College of Art (1969-72). *Exhib:* several one-man shows in London, others in Paris, Brussels and New York. *Works in collections:* private and corporate collections internationally. *Commissions:* many. *Misc:* Gallery affiliation: Campbell's of Walton St. Ltd., 1-5 Exhibition Rd, London SW7 2HE. *Signs work:* "Jonathan Wolstenholme." *Address:* c/o Campbell's of Walton St. Ltd., 164 Walton St., London SW3 2JL.

WOLVERSON, Margaret Elizabeth, NDD, ATD, elected ARMS (1977); painter of living landscape, portraits and miniatures (in oils); formerly lectured Hornsea Inst. of Further Education and Stourbridge College of Art. *b:* 1937. *d of:* Charles Lloynes Smith. *m:* 1961. one s. (div. 1985); m 1987, S. Jones-Robinson. *Studied:* Dudley School of Art, Wolverhampton College of Art, Leicester College of Art. *Exhib:* R.M.S., Mall Galleries, Cheltenham Group, Britain's Painters; one-man show Dean Heritage Centre, Workshop Gallery, Chepstow, Taurus Gallery (1999). *Works in collections:* East Riding Collection for Schools, Ferens A.G.; private collections in U.K., U.S.A. *Commissions:* numerous. *Clubs:* Forest Artists Network, Hon. Mem. Hornsea Art Society, Glos, Guild of Weavers, Spinners and Dyers. *Misc:* Hand spun, dyed and woven, felted, or knitted-tapestries, bags,

clothes to own design. *Address:* Sunny Bank, Pope's Hill, Newnham-on-Severn, Glos. GL14 1JX.

WOLVERSON, Martin, F.R.B.S. (1971), F.R.S.A. (1976); R.B.S. Silver medal (1971), Trident Television Fine Art Fellow (1977-78), Fulbright Prof. Kansas City Art Inst. (1985); sculptor in wood, stone, metal, lecturer;. *b:* Wolverhampton, 26 May 1939. *s of:* Cyril Wolverson, accountant. *m:* (1) Margaret Smith; one s. (2) Sandra Tipper. *Educ:* Wednesbury Boys High School. *Studied:* Wolverhampton School of Art (1956-60, Tom Wright, John Paddison), Goldsmiths' College, London University (1960-61). *Exhib:* widely in the North, London and in the U.S.A. *Works in collections:* Ferens A.G., Hull, Usher A.G., Lincoln, Yorkshire Television, N.C.B., Ecclesiastic Insurance Co. Ltd., Lincolnshire and Humberside Arts, Humberside C.C., Leeds City A.G., and numerous private collections. *Commissions:* National Coal Board-Safety Trophy, for the Nation's safest mine; Caedmon School, Whitby- 'Caedmon Cross'; St. Mary's Church, Whitby -'Altar Cross'; Hull Maternity Hospital, Hull- bronze relief to celebrate its centenary; Tivoli House, Hull- bronze portrait head and installation commemorating 'Old Mother Riley' (Arthur Lucan); Presentation 'Aussohnung' a collage presented to Klever Cathedral as an act of reconciliation for war damage between Whitby and Klever. *Recreations:* jazz piano. *Signs work:* "M. Wolverson." *Address:* Alexandra Lodge Mount Pleasant East, Robin Hoods Bay, Whitby, N. Yorks. YO22 4RF.

WONNACOTT, John Henry, C.B.E.; Slade Dip. (1962); Hon. RP. *b:* London, 1940. *s of:* John Alfred Wonnacott, A.R.I.B.A. *m:* Anne Rozalie Wesolowska, B.Sc. one *s.* two *d. Educ:* University College School. *Studied:* Slade School (1958-63). *Exhib:* Hayward (1974), R.A. Jubilee (1952-77), Marlborough (1981), Marlborough, N.Y. (1983), Tate Gallery (1984), The Foudation Veranneman (1986-87), The Pursuit of the Real, Barbican (1990); one-man shows, Minories, Colchester (1972), Rochdale (1978); touring, Marlborough (1980-81, 1985, 1988), Scottish National Portrait Gallery (1986-87), Agnews (93, 97, 2000), Hirschl & Alder, N.Y. (2000), N.P.G. (2000), N.M.M. (2001). *Works in collections:* Nat. Art Collection, Arts Council, Rochdale A.G., Norwich Castle Museum, Tate Gallery, Scottish National Portrait Gallery, N.M.M., I.W.M., Met. Mus. York, Brit. Council. *Commissions:* Sir Adam Thomson (N.P.G.), Rt. Hon. John Major (N.P.G.), Lord Lewin (Nat. Mar. Mus.), Royal Family (2000). *Official Purchasers:* Arts Council, Tate, NMM, IWM, Norwich, Ipswich, British Council, SNPG, NPG, Gov. Art Coll., House of Commons. *Signs work:* "C.B.E." *Address:* 5 Cliff Gdns., Leigh-on-Sea, Essex.

WOOD, Annette (Mrs.): see GARDNER, Annette,

WOOD, Andy, Dip.A.D. (1970), A.R.B.A. (1980), R.I. (1981), R.B.A. (1999); painter in acrylic, oil and water-colour. *b:* Porlock, Som., 1947. *s of:* H.E. Wood. *m:* Katrina Wood. one *s.* two (one decd.) *d. Educ:* schools in Walton-on-Thames, Hersham and Dorking. *Studied:* Croydon and Newport Colleges of Art (1965-70).

Exhib: R.I., R.B.A., Thackeray Gallery, etc. *Works in collections:* Sultan of Oman; Duke University, N.C., U.S.A.; Central Carolina Bank, N.C., U.S.A.; Lyme Regis Museum. *Commissions:* Sultan of Oman; British Telecom; Southern Gas. *Publications:* Dictionary of 20th Century British Painters, Sculptors and other artists (Antique Collectors Club Ltd). *Clubs:* Chelsea Arts. *Signs work:* "Andy Wood" or "A. Wood." *Address:* Rafters, Old Brick Yard, Rye, E.Sussex TN31 7EE. *Email:* andy@andywoodgallery.com *Website:* www.andywoodgallery.com

WOOD, Christopher Malcolm Fayrer, RSW, SSA, VAS/Glasgow Art Club Fellowship (2005); BA Hons (Edinburgh); James Torrance Memorial Award (RGI, 1993); Nancy Graham Memorial Award (1994); The Scottish Arts Club Award (SAAC, 1994); The Armour Award (RGI, 1994); SSWA Special Award for Painting (1997). *Medium:* oils, acrylics, mixed media. *b:* Leeds, 9 Jul 1962. *s of:* Sheila & Dr.Eric A M Wood. *m:* Jane. one *s.* one *d. Educ:* George Watsons Boys College, James Gillespies High School (both Edinburgh). *Studied:* Edinburgh College of Art (1980-84). *Represented by:* The Scottish Gallery, Edinburgh. *Exhib:* RSA, RGI, RSW, SSA, SAAC, VAS, The Scottish Gallery, The Manor House Gallery, Thompson's Gallery, The Hart Gallery, The Richmond Hill Gallery. *Works in collections:* Bank of Scotland, United Distillers, Edinburgh University, The Demarco European Foundation, Macroberts Solicitors, Premier Property Group. *Commissions:* Andrew Radford for the 'Blue Bar Cafe'; Strathvale House, Grand Cayman. *Publications:* The Glasgow Art Club Fellowship Exhibtion Catalogue ISBN 0 9554121 0 2. *Signs work:* 'Wood'. *Address:* Port Lodge, 7 High Street, Dunbar, EH42 1EN. *Email:* mail@christopherwood.co.uk *Website:* www.christopherwood.co.uk

WOOD, Christopher Paul, B.A.Hons. (1984), M.A. (1986); painter in oil on canvas. *b:* Leeds, 10 Jun 1961. *s of:* Peter Liddle Wood. *m:* Simone Abel. two *d. Educ:* Leeds. *Studied:* Jacob Kramer School of Art (1980-81), Leeds Polytechnic (1981-84), Chelsea School of Art (1985-86). *Exhib:* one-man shows: Oldham City A.G. (1986), Sue Williams Gallery, London (1989, 1990, 1992, 1994), Rebecca Hossack Gallery, London (1996, 1997, 1999), Newark Park, Glos. (1998); retrospective exhibition Mercer Gallery Harrogate (1999), Michael Carr Gallery, Sydney Australia (2000), Picidilly Gallery (2002); mixed shows include Festival Hall (1986), New Contemporaries (1986), New Generation (1991), Hunting Prize (2000) R.C.A. *Publications:* 'Echo Moment' Mercer Gallery (1999). *Signs work:* full signature on back of canvas; initialled on front of paintings - "C.P.W." and date. *Address:* 1 Norfok Pl., Chapel Allerton, Leeds LS7 4PT.

WOOD, Duncan, B.A. Hons. Fine Art, P.G.C.E., Art and Design Education, M.A. Fine Art; Artist in Residence: National Trust (1997-99); visiting tutor in Fine Art London University (2000-01). *Medium:* oil, water-colour, charcoal/chalk;. *b:* London, 14 Nov 1960. *s of:* Mr E.C. and Mrs. M.A. Wood. *Educ:* Brockhurst School, Berks., Kingham Hill School, Oxfordshire. *Studied:*

Gloucestershire College of Art (1980-81), Sheffield College of Art (1981-84), The Institute of Education, London University (1996-97),City & Guilds of London Art School, (2001-03). *Exhib:* R.C.A., R.A., City art galleries: Sheffield, Glasgow, Nottingham; galleries: Cardiff, Edinburgh, Birkenhead, London, Fosse Gallery, Stow-on-the-Wold; also exhib. at 'Discerning Eye Exhbns.' (work chosen by Glynn Williams, Prof. of Fine Art at R.C.A. 1992, and by Sir Brinsley Ford former Chairman of National Art Collections Fund 1991, William Packer, art critic Financial Times, and Martin Gayford, writer and art critic of the Daily Telegraph and Modern Painters 1996), National Trust (1997-99). *Works in collections:* London, throughout the U.K. and in the U.S.A., Germany and Japan; public collections: The Finnish Embassy, Sheffield University, The Duke of Devonshire and the Trustees of the Chatsworth House Settlement. *Clubs:* N.E.A.C. (1991), mem. Com., N.E.A.C. School of Drawing (1995-). *Misc:* delivered lectures on 'The Understanding of Contemporary Art' at 'The Affordable Art Fair' London (1999). *Signs work:* "Duncan Wood." *Address:* York House Baslow, Derbyshire DE45 1RY.

WOOD, Gerald Stanley Kent, M.B.I.A.T. (1968), M.S.A.I. (1977), F.E.T.C. (1978); artist and architectural illustrator in pencil, ink, water-colour, gouache and tempera, perspectivist, architectural technologist, tutor, lecturer. *b:* Cambridge, 29 Oct 1923. *s of:* Harry Stanley Wood. *Educ:* Perse Preparatory School, Cambridge, Elmers Grammar School, Old Bletchley, Bucks. *Studied:* under H. J. Sylvester Stannard, R.B.A. (1934-39). *Exhib:* R.A., R.B.A., R.I., R.M.S., N.E.A.C., U.A., N.S., S.B.A., S.G.A., P.S., Contemporary British Watercolours, Pictures for Schools, Britain in Water-colours, Britain's Painters, Lord Mayor's Art Award, Hesketh Hubbard Art Soc., Chelsea Art Soc., Open Salon, Luton Museum. *Works in collections:* Theatre Royal, Haymarket, National Westminster Bank Theatre Museum; private collections: England, Wales, Australia, Canada, Germany, Saudi Arabia. *Address:* 21 Salisbury Rd., Luton, Beds. LU1 5AP.

WOOD, Juliet Anne, Slade Diploma in Fine Art. *Medium:* painter in oil. *b:* London, 4 Jun 1939. *d of:* Dr.Paul Wood OBE. *m:* Simon Brett. three *s.* two *d.* *Educ:* Arts Educational Schools, London and Tring. *Studied:* St.Albans School of Art (1955-7), Slade School of Fine Art (1957-60), British School in Rome (1960-61). *Represented by:* New Grafton Portrait Centre. *Exhib:* RA, Swindon Museum, RP, New Grafton Gallery. *Works in collections:* Scottish National Portrait Gallery; Royal Society of Edinburgh; Stirling University,Heriot Watt University; St.Cross and Hertford Colleges, Oxford. *Commissions:* portraits include: Sir Michael Atiyah, Sir Peter Ramsbotham, Lord Balfour of Burleigh, Sir Walter Bodmer, Judge Monier Williams, and numerous public and private commissions. *Official Purchasers:* British Cardiac Society, Dr. Paul Wood, O.B.E. *Works Reproduced:* Rosalind Cuthbert -An Introduction to Painting Portraits (Leo in Red, Emily Brett). *Recreations:* gardening, music, dancing. *Misc:* Lecturer in Fine Art, Swindon College 1978-95. *Signs work:* Juliet Wood, or J Wood.

WHO'S WHO IN ART

Address: 12 Blowhorn Street, Marlborough, Wilts, SN8 1BT. *Email:* juliet@julietwood.co.uk *Website:* www.julietwood.co.uk

WOOD, Nigel, Dip. (wildlife illustration) 1984; painter in oil and pastel;. *b:* Reading, 26 Dec., 1960. one *s.* one *d. Studied:* Dyfed College of Art (1980-84). *Exhib:* solo and group shows including N.P.G., R.C.A., Aberdeen A.G., Glyn Vivian Gallery, Ceri Richards Gallery, Mall Galleries, Martin Tinney Gallery, Oriel Myrddin, Fountain Fine Art and Edith Grove Gallery. *Works in collections:* Carmarthenshire County Collection. *Signs work:* "NIGEL WOOD." *Address:* Ty Dderwen, Maesycrugiau, Pencader, Carms. SA39 9LY.

WOOD, Tom, painter in oil, printmaker, lecturer; Hon. Fellow, Sheffield Hallam University (1989). *b:* Dar es Salaam, Tanzania, 1955. *m:* Elaine Barraclough. three *d. Studied:* Batley School of Art (1975), Sheffield School of Art (1976-78). *Exhib:* solo shows: Huddersfield A.G., Leeds City A.G., Schloss Cappengberg, Kreissunna, Germany, Hart Gallery London and Nottingham. *Works in collections:* H.R.H. The Prince of Wales, N.P.G., Yale University, Provident Financial Group. *Commissions:* portraits: Arthur Haigh and W.T. Oliver (1984); H.R.H. The Prince of Wales (1987); Alan Bennett (1990); Prof. Lord Winston for the National Gallery (1999). *Publications:* Man and Measure - The Painting of Tom Wood by Duncan Robinson (Hart Gallery Pub.). *Misc:* Studio: Dean Clough, Halifax. *Signs work:* "TOM WOOD." *Address:* 4 Westfield Ave., Lightcliffe, Halifax, W. Yorks HX3 8AP.

WOODCOCK, John, ARCA (Graphic Design). *b:* Cudworth, Yorks, 27 Aug 1924. one *s. Educ:* Barnsley Holgate Grammar School; Calligraphy, Design and Engraving at Barnsley School of Art. *Studied:* Royal College of Art. *Exhib:* various exhbns in UK and abroad of Calligraphy, Painting and Printmaking (esp. Wood-Engraving). *Works in collections:* Walters Art Gallery and Museum, Baltimore; Boston Public Library; Houghton Library, Harvard; Harrison Collection, San Fransisco Library; Edward Johnston Foundation; Ditchling Museum (numerous examples). *Commissions:* RAF Books of Remembrance, St. Clement Dane's Church (part); Logo for Millennium Commission; Design of 'The Book of Ruth', Gwasg Gregynog, Newtown, Powys. *Publications:* A Book of Formal Scripts (with Stan Knight), A & C Black. *Works Reproduced:* in many books on calligraphy and lettering. *Address:* Husky Hall, Kerry, Newtown, Powys, SY16 4PQ.

WOODFINE, Sarah, BA; Post Graduate RA Schools; Jerwood Drawing Prize (Winner, 2004); Gold Medal, Royal Academy Schools (1985). *Medium:* drawing, prints. *b:* Poole, Dorset, 27 Sep 1968. *d of:* Alan Woodfine (photographer). *Studied:* Sir John Moores University (BA Sculpture, 1989-91); RA Schools (Postgraduate, 1992-95). *Represented by:* Danielle Arnaud Contemporary Art. *Exhib:* Compton Verney, Sheffield Millennium Gallery, Middlesbrough Art Gallery (MIMA), Maritime Museum Portsmouth, Museum of Garden History; in Norway: Galleri F15, Ha Gamle Prestegard, Haugersund Art Museum; Outline,

Amsterdam. *Works in collections:* Middlesbrough Art Gallery; Ha Gamle Prestegard (Norway). *Publications:* 'The Drawing Book' (Sarah Simblet); 'Drawing' (Paul Thomas & Anita Taylor). *Misc:* only works in monotone (pencil on paper and lithographs). *Signs work:* 'Sarah Woodfine' (always on back of works). *Address:* Flat D, 23 Gloucester Street, London SW1V 2DB. *Email:* sarah.woodfine@virgin.net *Website:* www.daniellearnaud.com

WOODFORD, David, N.D.D., A.T.C. with distinction, Cert. R.A.S.; painter in oil and water-colour; Royal Cambrian Academician. *b:* Rawmarsh, Yorks., 1 May 1938. *m:* June. two *s. Educ:* Lancing College. *Studied:* West Sussex College of Art (1955-59), Leeds College of Art (1959-60), Royal Academy Schools (1965-68). He lives by his painting. *Works in collections:* British Arts Council; Welsh Arts Council; National Museum of Wales; National Library of Wales. *Signs work:* "David Woodford." *Address:* Ffrancon House, Ty'n-Y-Maes, Bethesda, Bangor, Gwynedd LL57 3LX.

WOODROW, Bill (William Robert), RA (2002); finalist Turner Prize (1986); winner Anne Gerber Award, Seattle (1988). *Medium:* sculpture, drawing, prints. *b:* near Henley-on-Thames, 1 Nov 1948. *m:* Pauline Rowley. one *s.* one *d. Educ:* Barton Peveril Grammar School, Eastleigh, Hants. *Studied:* Winchester School of Art, Winchester; St.Martin's School of Art; Chelsea School of Art. *Represented by:* Waddington Galleries, Cork Street, London. *Exhib:* since 1972, 70 plus solo exhbns in UK, Europe, Australia, N.America, including: Duveen Galleries,Tate Gallery; 'Regardless of History' for the fourth plinth, Trafalgar Square; London/Mappin Art Gallery, Sheffield; Glynn Vivian Art Gallery, Swansea; many group exhbns around the world. *Works in collections:* Arts Council of England, British Council, British Library, BM, Imperial War Museum, Government Art Collection, Tate Gallery, Cecil Higgins AG & Museum, Scottish National Gallery of Modern Art, Leeds City Art Galleries, Henry Moore Inst., Southampton AG, University of Warwick; major museums and art galleries worldwide. *Commissions:* 'Regardless of History' for the fourth plinth, Trafalgar Square. *Publications:* Bill Woodrow, Sculpture 1980-86 (Fruitmarket Gallery, Edinburgh, catalogue); A Quiet Revolution-British Sculpture since 1965 (Thames & Hudson, 1987); Bill Woodrow, About This Axis, Drawings 1990-95 (Camden Arts Centre, 1995); Fools Gold (Tate Gallery, 1996); Sculptures 1981-1997 (Mestne Galerija, Ljubljana, Slovenia (1997). *Misc:* trustee of the Tate Gallery 1996-2001; trustee of the Imperial War Museum (2003-); governor of the University of the Arts London (2003-). *Email:* bill@billwoodrow.com *Website:* www.billwoodrow.com

WOODS, Brian, DipAD (Hons), MAFA, shared 1st Prize Painting (Manchester Academy, 1986); Edward Oldham Trust Bursary (Venice, 1995 and 2001); Siemens Figure Painting Award (1997). *Medium:* acrylic, watercolour, drawing, prints. *b:* Loughborough, 22 Mar 1938. *s of:* C.L.& E Woods. *m:* June M.Woods. one *s.* one *d. Educ:* Loughborough College School (1949-54). *Studied:* Loughborough College of Art (1963-67). *Represented by:* Tib Lane Gallery, Manchester; Wendy Levy Gallery, Didsbury, Manchester. *Exhib:* solo exhbns:

Rochdale Art Gallery, Bury Art Gallery (x2), Portico Gallery, Manchester; mixed exhbns: RA Summer Exbhns; Singer & Friedlander/Sunday Times Competition (2003-07); Manchester Academy Annual Open Exhbns; Contemporary British Watercolours, Bankside Gallery, London; British Print Open Exhbn; West of England Academy; House of Commons, London with Rochdale Sculptors Group. *Works in collections:* Manchester City Art Gallery, Bury Art Gallery, Rochdale Art Gallery. *Commissions:* Wetherspoons. *Official Purchasers:* Manchester, Bury and Rochdale Art Galleries; Wetherspoons. *Recreations:* things Italian. *Clubs:* elected member MAFA (1989); member of Rochdale Sculptors Group (late 60s early 70s). *Misc:* lecturer (drawing and painting) Rochdale College of Art, then Hopwood Hall College (1967-92); occasional host on SAGA painting holidays (1996-2005). *Signs work:* 'Brian Woods' or 'BW'. *Address:* 3 Seymour Grove, Rochdale, Lancs. OL16 4RB.

WOODS, Grace Mary, ARCA; artist in black and white and pastel, and weaving. *b:* Ilford, Essex, 25 Feb 1909. *d of:* Charles J. Kaye. *m:* Sidney W. Woods, ARCA (decd.). two *s.* three *d. Educ:* Ursuline Convent, Forest Gate, E7. *Studied:* West Ham Art School and Royal College of Art in Design and Engraving Schools. *Exhib:* R.A. and other London galleries. *Misc:* Work purchased by private collectors. *Signs work:* "Mary Woods." *Address:* 157 Warren Rd., Chelsfield, Orpington, Kent BR6 6ES.

WOODS, Michael John, DFA Slade Diploma in Fine Art. *Medium:* ceramics, designer, oil, watercolour, drawing, prints. *b:* Norwich, 6 Dec 1933. *s of:* Reginald Woods M.B.E. *m:* Jacqueline. one *s.* two *d. Educ:* Norwich School under John Marshall. *Studied:* Norwich School of Art under Noel Spencer; Slade School of Fine Art under Sir William Coldstream; Farnham School of Art (Ceramics) under Paul Barron. *Exhib:* RA, London galleries, Manchester, Norfolk, Surrey and Sussex; ceramics: British Crafts Centre. *Works in collections:* Nuffield Foundation; The National Trust; City of Norwich Castle Museum; numerous private collections in UK, USA and Australia. *Commissions:* The Bishop of Norwich; academic portraits; Memorial at Dachau for The International Committee; Historic Map for the Godalming Trust; illustrator of ten books; Ceramic Fountain for RHS Chelsea. *Publications:* nine books on the process of drawing and painting for Batsford Press and Dryad Press. *Official Purchasers:* City of Norwich. *Works Reproduced:* 20 books; articles for art magazines. *Recreations:* walking, sailing. *Misc:* taught at Charterhouse from 1957, Director of Art 1970-94. *Signs work:* 'MICHAEL WOODS'. *Address:* 2 Alan Road, King Street, Norwich NR1 2BX. *Website:* www.michaelwoods.me.uk

WOODSIDE, Christine A., D.A. (1968), Post Dip. (1969), RSW(1993), RGI (1999); artist in water-colour and mixed media;. *b:* Aberdeen, 24 Apr 1946. one *s.* one *d. Educ:* Aberdeen High School for Girls. *Studied:* Gray's School of Art, Aberdeen (1964-69, Ian Fleming, Robert Henderson Blythe). *Exhib:* numerous including RSA, RSW, RGI. *Works in collections:* Saltire Soc., RSA, Perth Museum. *Commissions:* 2 paintings for Queen Victoria Cunard Liner. *Clubs:* The

Scottish Arts Club. *Signs work:* "Woodside". *Address:* Tower View, 1 Back Dykes, Auchtermuchty, Fife KY14 7AB. *Email:* christinewoodside@hotmail.com

WOODWARD, Justine, HS (1998); MASF, SLM. *Medium:* watercolour, pastels and oil, specialising in miniatures. *b:* Beckenham, 23 Feb 1944. divorced. one *s.* one *d. Educ:* Columbia University. *Studied:* self-taught. *Exhib:* RMS, Hilliard Society, Miniature Art Society of Florida. *Commissions:* completed several commissions of children. *Publications:* Leisure Painters article. *Recreations:* gardening, reading. *Clubs:* art societies; Runnymede, Virginia Water. *Address:* Fauns Glen, The Friary, Old Windsor, Berks. SL4 2NR. *Email:* jwofow@onetel.net.uk *Website:* http://www.starhub.net.sq/jascough

WOOLF-NELLIST, Meg, B.A., A.T.D., F.S.D.C; awarded Exhibition, R.C.A. (1949); formerly lecturer in art, Rachel McMillan College of Educ., Director, Bermuda Art Assoc. School (1950-52); artist in stone, wood, calligrapher. *b:* Isle of Thanet, 10 Dec 1923. *d of:* Dr. E. A. Woolf, D.Litt. *m:* Anthony Nellist (decd.). one *s.* three *d. Educ:* Couvent des Oiseaux. *Studied:* Ravensbourne College of Art, Brighton College of Art (1939-42). *Exhib:* Roland, Browse and Delbanco, A.I.A., R.B.A., R.A., V. & A., Russell Cotes, Hove A.G. (one-man, 1948); with Designer Craftsmen (1968-69), Hornchurch A.G. (1986, 1987, 1989, 1991, 1993, 1994, 1998, 1999), Oxford Scribes (2000). *Works in collections:* Canada, U.S.A., Germany, Australia. *Works Reproduced:* Studio. *Address:* 84 Front Lane, Cranham, Essex RM14 1XW.

WORMELL, Christopher, Graphics Prize, Bologna for 'An Alphabet of Animals' International Children's Book Fair (1991); Bronze Medal, Smarties Award, for 'Two Frogs'(2003); New York Times Book Review - Best Illustrated Children's Book for 'Teeth, Tails and Tentacles'. *Medium:* wood engraving, lino cut, watercolour, commercial artist. *b:* Gainsborough, Lincs., 1 Sep 1955. *s of:* John Wormell (now L.J.W.Linsey). *m:* Mary Carroll. one *s.* two *d. Represented by:* The Artworks, 40 Frith Street, London W1D 5LN(Illustration Agency). *Exhib:* many shows in UK and US. *Works in collections:* Victoria and Albert Museum. *Commissions:* numerous since 1983. *Publications:* many children's picture books. *Works Reproduced:* all work is for reproduction. *Address:* 34 Brownlow Rd, New Southgate, London N11 2DE. *Email:* chriswormell@blueyonder.co.uk

WORSDALE, John Dennis, painter in water-colour, oil; tutor and art soc. demonstrator. *b:* Southend, Essex, 18 Apr., 1930. *m:* Ann. one *s.* two *d. Educ:* Southend High School for Boys. *Studied:* Southend Art School and privately. *Exhib:* R.I., R.O.I., R.S.M.A., Britain in Watercolours, galleries in London and elsewhere; four solo exhibs. *Works in collections:* private collections in Europe, U.S.A., Australia, S.Korea, Morocco. *Publications:* greetings cards and calendars. *Clubs:* Wapping Group of Artists. *Signs work:* "JOHN WORSDALE." *Address:* 11 Central Close, Benfleet, Essex SS7 2NU.

WORTH, Leslie Charles, A.R.C.A. (Lond.) (1946), R.B.A. (1951), R.W.S. (1967), N.E.A.C. (2001); prizewinner Hallmark International Art Award, New York (1955); painter in water-colour and oil; Past President, R.W.S. *b:* Bideford, Devon, 6 Jun 1923. *m:* Jane Taylor. one *s.* three *d. Educ:* St. Budeaux School, Plymouth. *Studied:* Plymouth School of Art (1938-39, 1942-43), Bideford School of Art (1940-42), Royal College of Art (1943-46). *Exhib:* Agnews, Mercury Gallery, Wildenstein, W.H. Patterson Fine Art. Several mural commissions, National Trust Commissions. *Works in collections:* R.A., National Gallery of New Zealand, Aberdeen, Birmingham, Brighton, Burton (Bideford), Rochdale, Southport and Wakefield Art Galleries, Whitworth A.G. (Manchester University), Eton College, West Riding of Yorks. Educ. Authority, G.L.C., Admiralty; private collections: H.M. Queen Elizabeth, Queen Mother, H.R.H. The Prince of Wales and several private collections. *Publications:* The Practice of Watercolour Painting (Pitmans and Watson Guptil, 1977, Search Press 1980); 'The Paintings of Leslie Worth' by Michael Spender(pub. David & Charles,1995); magazine articles. *Recreations:* music, gardening, literature. *Signs work:* "Leslie Worth." *Address:* 11 Burgh Heath Rd., Epsom, Surrey KT17 4LW.

WORTH, Philip, M.A., LL.B., Hon. Sec. F.P.S.; self taught artist in acrylic. *b:* Gillingham, 23 Jun 1933. *s of:* Lloyd Worth, Major (R.E.). *m:* Jennifer Louise. two *d. Educ:* Royal High School, Edinburgh, Edinburgh University. *Exhib:* many one-man and group shows throughout U.K. since 1984. *Signs work:* "P. WORTH." *Address:* The White House, 282 St. John's Rd., Boxmoor, Hemel Hempstead, Herts. HP1 1QG.

WOUDA, Marjan Petra, ARBS, BA (Hons.) Fine Art (1987), MA Fine Art/Sculpture (1988); sculptor in clay/bronze. *b:* Aduard, The Netherlands, 20 Feb 1960. *m:* Immy Deshmukh. two *s.* one *d. Studied:* N.E. London Polytechnic, Manchester Polytechnic. *Represented by:* Curwen Gallery, London; Kunsthandel Pieter Breughel, Amsterdam; Firbob & Peacock, Knutsford, Cheshire; Broomhill, Barnstaple, Devon; Pride of the Valley Sculpture Park, Farnham, Surrey. *Exhib:* Art Fair, Islington, London (1997, 1998) Affordable Art Fair, London (2003), Edinburgh Festival (2005). *Works in collections:* Provident Financial Head Office, Bradford, Bury Art Gallery and Museum, Blackburn Museum and Art Gallery, and private collection of Felix Dennis, publisher. *Commissions:* London Dockland Development Corp.; Groundwork Trust, Wigan; Arcades Shopping Centre, Ashton-under-Lyne: major bronze sculpture at centre of development; drawings for British Consulate, Hong Kong, River Lune Millenium Park, Lancashire, Mustique, West Indies (first public sculpture on island). *Clubs:* R.B.S., M.A.F.A., R.Cam.A. *Signs work:* "Marjan" or "M.W." joined. *Address:* Whitehall, Queen's Rd., Darwen, Lancashire BB3 2LN. *Email:* marjan.wouda@lineone.net *Website:* www.marjanwouda.co.uk

WOUDHUYSEN, Alice, NDD, ATD. *Medium:* oil. *b:* Bath, Somerset, 13 Jul 1926. *d of:* C.M.Roberts. *m:* Lewis Wuodhuysen. two *s. Educ:* Wycombe Abbey School; St.Mary's, Calne. *Studied:* Bath School of Art. *Exhib:* RA Summer

Exhbn (1998); King Street Galleries, St.James's, London; Llewelyn Alexander Gallery; The Portal Gallery, London; Blackheath Galleries; Millinery Works, Islington. *Works in collections:* numerous private collections. *Works Reproduced:* cards for Medici Society, Hallmark; prints for Collingbourne Fine Arts. *Signs work:* 'Alice Woudhuysen'. *Address:* 40 Murray Road, Wimbledon, London SW19 4PE.

WRAGG, John, R.A., A.R.C.A., R.I.S.; sculptor. *b:* York, 20 Oct., 1937. one *s. Studied:* York School of Art (1954-56), Royal College of Art (1956-60). Awards: Sainsbury Award (1960), Winner of Sainsbury Sculpture Competition (1966), Arts Council (1977), Chantrey Bequest (1981). *Exhib:* solo shows: (1963-97), include; Hanover Gallery, Gallerie Alexandre Iolas Paris, York Festival, Devizes Museum Gallery, L'Art Abstrait London, Monumental '96 Belguim; Courcoux, etc.; group shows (1959-93): Bradford A.G., Gimpel Hanover Galerie Zurich, L'Art Vivant, Bath Festival Gallery, Quinton Green Fine Art London, Connaught Brown, etc. *Works in collections:* Sainsbury Centre, University of E. Anglia; Israel Museum, Jerusalem; Tate Gallery, London; A.C.G.B.; Arts Council of N.I.; Contemporary Art Soc.; Wellington A.G., N.Z.; National Gallery of Modern Art, Edinburgh. *Publications:* Neue Dimensionen der Plastic (Undo Kutterman), British Sculpture in the 20th Century (1981), etc. *Address:* 6 Castle Lane, Devizes, Wilts. SN10 1HJ. *Email:* johnwragg.ra@virgin.net

WRAITH, Robert, R.P.; painter in oil, water-colour, drawing, etching. *b:* London, 11 Dec 1952. *m:* Tina. one *s.* two *d. Educ:* Stowe. *Studied:* Florence (Pietro Annigoni). *Exhib:* twenty one-man shows, also N.P.G., R.A., R.P., etc. *Works in collections:* H.M. The Queen, H.R.H. The Prince of Wales, Chatsworth, The Vatican, M.C.C., National Trust, Oxford University, fresco in the Church of Ponte Buggianese, Italy, etc. *Commissions:* Many portrait commissions, including H.M. The Queen, The Duke and Duchess of Devonshire. *Misc:* Invited by H.R.H. The Prince of Wales to accompany him on his visit to South Africa as travelling artist, 1997. *Signs work:* "WRAITH" or "Robbie Wraith." *Address:* The Old School House, The Green, Holton, Oxon. OX33 1PS. *Email:* robbie@robbiewraith.com *Website:* www.robbiewraith.com

WRAY, Peter, R.E. (1991), M.A. (1992), P.G.Dip.A.D. (1984), Cert.Ed. (1972); artist in printmaking/painting; Senior lecturer in Printmaking, University College of Ripon and York St. John (1987-2001);. *b:* Sedgefield, Co. Durham, 27 Oct., 1950. two *d. Educ:* St. Mary's School, Darlington. *Studied:* St. Mary's College, Strawberry Hill, Twickenham (1969-72), Goldsmiths' College (1983-84, John Rogers, Peter Mackarrell), Leeds Polytechnic (1990-92, Geoff Teasdale). *Exhib:* R.E., International Print Biennale, New Academy Gallery, Curwen Gallery, etc. *Works in collections:* Price-Waterhouse, Sainsbury, Intel U.K., St. Thomas's Hospital, Bank of England. *Clubs:* Royal Society of Painter/Printmakers (R.E.). *Signs work:* "P. Wray." *Address:* The Old School, 62 York Rd., Acomb, York YO24 4NW.

WRIGHT, Anne, N.D.D., R.A.Dip.; portrait painter in oil and pastel; Mem. Chelsea Art Soc., and The Small Paintings Group. *b:* Nottingham, 28 Mar 1935. *m:* Henry Brett. two *d. Studied:* Nottingham College of Art (1952-54), R.A. Schools (1954-59, Peter Greenham). *Represented by:* commissionaportrait.com. *Exhib:* Coach House Gallery, Guernsey, Carlyle Gallery, London, Piers Feetham Gallery, London; Llewelyn Alexander Gallery, London; Russell Gallery, London. *Works in collections:* Candie Museum, Guernsey. *Commissions:* murals: McAlpine and General Dental Council. *Clubs:* Chelsea Arts. *Signs work:* "A" above"W". *Address:* 55 Englewood Rd., London SW12 9PB.

WRIGHT, Bert, PPRSMA, FRSA; Past President, Royal Society of Marine Artists; President, Wapping Group of Artists; President Ealing Art Group; Prizewinner Sunday Times/Singer Friedlander Water-colour competition; marine and landscape painter of contemporary subjects, plein air painter on location worldwide, also paints architectural subjects. *Medium:* watercolour, oils. *b:* 1930. *m:* Marjorie Wright. one *s.* TWO *d. Studied:* Nottingham College of Art. *Represented by:* Mall Galleries, London; Frances Iles Galleries, Rochester. *Exhib:* RA, and regularly at major galleries in the London area and in the USA. One-man show, Mall Galleries (2005). Audience with Her Majesty the Queen and Duke of Edinburgh (2005). *Works in collections:* UK, USA, Far East and the Middle East. *Commissions:* New York Yacht Club, Sultan of Oman, Daily Express, Standard Chartered Bank, British American Tobacco, Mullard Electronics, Beecham Group, Lloyds, Allied Dunbar, P&O. *Publications:* listed in '20th Century Marine Art', articles for 'Artist' magazine. *Recreations:* music (piano). *Clubs:* Arts Club. *Address:* 19 Carew Rd., Ealing, London W13 9QL. *Email:* bert.wright@virgin.net *Website:* www.bertwright.com

WRIGHT, Bill, RSW (1974), RGI (1990), PAI (1996); painter in water-colour and acrylic; President, Scottish Artists' Benevolent Soc. *b:* Glasgow, 1 Sep 1931. *m:* Annie. three *d. Studied:* Glasgow School of Art. *Exhib:* many solo and national exhbns. *Works in collections:* several public collections including H.R.H. The Duke of Edinburgh. *Clubs:* Glasgow Art. *Address:* Old Lagalgarve Cottage, Bellochantuy, Argyll PA28 6QE.

WRIGHT, Brian Howell, ARCA; Chelsea Diploma of Painting. *Medium:* oil, watercolour, drawing. *b:* London, 8 Feb 1937. *m:* Julia Chandler (decd). one *s.* one *d. Studied:* Chelsea College of Art under Edward Middleditch, Derek Greaves, Jack Smith (1956-60); RCA under Carel Weight, Roger de Grey, Julian Trevelyan (1960-63). *Exhib:* London, Japan. *Works in collections:* in UK, USA, Canada, Belgium, Poland. *Commissions:* paintings, sundials, mechanical clocks. *Misc:* demonstrator and organiser painting section 'Art in Action'. *Signs work:* 'WRIGHT'. *Address:* Bakers Cottage, The Green, Pirbright, Surrey GU24 0JE. *Email:* bhowellwright@aol.com

WRIGHT, David, ASGFA, LSIAD, MSTD; City & Guilds Teaching Qualification. *Medium:* all media. *b:* Woking, 17 Jan 1948. *m:* Ginny. two *s.*

Studied: Croydon College of Art (1965-69). *Represented by:* Lincoln Joyce Fine Art. *Works in collections:* internationally. *Publications:* appears in "How to Paint from Photographs" by Tony Paul; articles, Artist Magazine. *Clubs:* North Weald Art Group, Mole Valley Sketch Club. *Signs work:* "David Wright". *Address:* Greengates, Longfield Road, Dorking, Surrey, RH4 3DE. *Email:* david.wright-art@virgin.net *Website:* www.davidwright-artist.co.uk

WRIGHT, Gordon Butler, F.B.S. Comm., F.Inst.C., Mem. International Association of Artists; professional artist in oils;. *b:* Darlington, Co. Durham, 2 Apr 1925. *s of:* Reginald Wright. *m:* Joan. *Educ:* Gladstone School, Darlington and Kings College, Newcastle. *Studied:* Chichester College of Art (1943-44) followed by two periods of study in Amsterdam and The Hague. Influenced by the Dutch Romantic School. *Exhib:* Galerie Montmartre, Paris, Grosvenor Gallery and Portal Gallery, London, Trinity Art Gallery, Wareham, Whitgift Galleries, London, Recorded in the National Maritime Museum, Greenwich. *Publications:* The Collector's Guide to Paintings as an Investment. *Signs work:* "G. B. Wright." *Address:* 123 Wetherby Rd., Harrogate, Yorks.

WRIGHT, Lisa, B.A. Hons 1st Class (1987), M.A. Fine Art (1993); 1st prize winner Hunting Art Prize (2003); shortlisted for Sovreign European Art Prize (2006); part-time lecturer, Falmouth College of Art. *Medium:* oil. *b:* Kent, 3 Jan1965. *m:* Mark Surridge. two *s. Studied:* Maidstone College of Art (1983-1987), R.A. Schools (1990-1993). *Represented by:* Beardsmore Gallery. *Exhib:* Beardsmore Gallery, London solo exhibs. (1999, 2001, 2003, 2005, 2007), Lemon Street Gallery, Truro, Cornwall solo exhibs. (2003, 2006), regularly at R.A. Summer exhibs. and Newlyn Gallery; Tate Gallery St.Ives (2007), Hunting Art Prizes (2000), Royal Overseas League (1993, 1994, 1996), Cheltenham Drawing Open (2000), Contemporary Arts Soc., N.E.A.C. (prizes 1994, 1996), national and international group exhibs. *Works in collections:* Unilever, Guinness, B.U.P.A., Astra Zeneca, and in private collections worldwide. *Commissions:* Artist-in-Residance with Royal Shakespeare Company (2006-2008). *Publications:* catalogues for solo exhibs. (1999, 2001, 2003, 2005, 2006, 2007). *Clubs:* Newlyn Soc. of Artists. *Signs work:* "Lisa Wright." *Address:* Chapel House, Crelly, Helston, Cornwall TR13 0EY. *Email:* lisa.surridge@googlemail.com

WRIGHT, Liz, BA Art and Design. *Medium:* oil, watercolour, drawing, prints. *b:* Wembley, London, 14 Dec 1950. *d of:* George Wright. *Educ:* St.Bernards Convent School. *Studied:* St.Martins College of Art (1968-69); West of England College of Art (1969-72, under David Inshaw and Alfred Stockham). *Exhib:* in UK and USA. *Works in collections:* Wessex Collection, Lord Bath, Longleat, Wiltshire. *Publications:* illustrations 'Chocolate' (Pavillion Books). *Works Reproduced:* many with the Bridgeman Art Library; book covers, CD covers, cards, prints. *Recreations:* walking, swimming. *Clubs:* Chelsea Arts Club. *Signs work:* 'Liz Wright'. *Address:* 8 Higher Lane, Portland, Dorset DT5 1AT. *Email:* lizonportland@btinternet.com *Website:* www.wrightfineart.co.uk

WRIGHT, Roy, PS; NDD (Post Dip); RA Summer Exhibition Drawing Prize (2001); Cross Gate Gallery Award, Kentucky USA (1999); Willie Hoffmann-Guth Award (PS, 2002); 'Arcadia in the City' Exhibition Award (2002). *Medium:* charcoal, watercolour. *b:* Hornsea, E.Yorks, 4 Jul 1945. *s of:* Ken & Olive Wright. *m:* Jennifer. one *s.* one *d. Educ:* Hornsea Secondary School. *Studied:* Hull College of Art (1961-66). *Represented by:* Henry Boxer Gallery; Roman Black Gallery, Rebecca Hossack Gallery. *Exhib:* RA Summer Exhbns; Cheltenham Open Drawing; Hunting Art Prizes; 20/21 British Art Fair; Pastel Society; Art London; Singer & Friedlander Watercolour; Affordable Art Fair; Laing Landscape; Roman Black Gallery; Henry Boxer Gallery; Messum's; London Art Fair; NEAC; AA Fair NYC; Art on Paper Fair. *Works in collections:* The Open University; Liberty Syndication; Harrogate Borough Arts Council; Richmond & Twickenham Arts Council. *Commissions:* private and business: cityscapes and landscape. *Publications:* The Times T2 2004; London Topographical Society (2002); Anglo-Spanish Society Review (2001); catalogues: RA Summer Exhibition catalogues(2001, 04); 20/21 British Art Fair catalogues; AAF (2002) / Books: "The View" (2003), "Artists' Kew" (2006). *Signs work:* 'Roy Wright' or 'Wright'. *Address:* 4 Rosemont Road, Richmond, Surrey TW10 6QL. *Email:* roywrightart@hotmail.com *Website:* www.henryboxergallery.com

WRIGHT, Sally Diane, SBA; artist in water-colour and pencil. *b:* London, 21 Oct 1952. *m:* Robert Wright. one *s.* one *d. Exhib:* Westminster Gallery, London, Brighton Festival. *Publications:* work published by Medici. *Address:* Holly Cottage Elven Lane, East Dean, E. Sussex BN20 0LG.

WRIGHT, Stuart Pearson R., B.A. Fine Art (1999); painter in oil, printmaker, sculptor; B.P. Portrait Award (1998-Travel Award Winner, 1999, 2000, 2001-First Prize Winner), Hunting Art Prizes (1998, 2000, 2001), Garrick / Milne Prize (2000-Third Prize, 2005 -First Prize), Winsor and Newton Millenium Comp. (2000), Singer and Friedlander Sunday Times, Watercolour Comp. (1998, 1999-Third Prize, 2004-First Prize). *b:* Northampton, 11 Oct., 1975. *Studied:* Slade School of Fine Art (1995-1999), Drawing Year, Prince's Foundation (2002-03). *Exhib:* see awards, also Jerwood Space (2004), ICA (2005). *Works in collections:* National Portrait Gallery, British Academy, Ashmolean Oxford, Garrick Club, University of Aberystwyth, Rhode Island School of Design Museum US, Aberdeen Art Gallery, House of Commons. *Commissions:* John Hurt, Adam Cooper, The Six Presidents of the British Academy, Prince Philip, Diane Abbott MP, Mike Leigh (director), front cover for 'The League of Gentlemen' Script Book for BBC, J K Rowling -NPG. *Works Reproduced:* front cover for 'The League of Gentlemen' Script Book for BBC. *Principal Works:* Middlesbrough, Eastbourne Pier, Gallus Gallus with still life and presidents, John Hurt portrait, J K Rowling portrait. *Recreations:* fencing, tango dancing. *Signs work:* "SPW". *Email:* stuart@thesaveloyfactory.com *Website:* www.thesaveloyfactory.com

WRIGHT, Valerie Margaret, B.Ed.Hons. (1977), SWA(1986), SBA (1987); landscape, botanical and wildlife painter in water-colour. *b:* Manchester, 6 Jan 1934. *d of:* Sydney Wainwright Musgrove. *m:* Norman Wright. one *s.* two *d. Educ:* Peterborough High School, Hendon Polytechnic, Coloma College of Educ. London University. *Studied:* Coloma College (Constance Stubbs, Norma Jameson). *Exhib:* RI, SWA, SBA, Portico Gallery, Manchester, Manchester Academy, BWS. Gorstella Gallery; one-man shows: Chester, Warrington, Bolton Octagon Theatre, Frodsham Arts Centre, Norton Priory. *Signs work:* "Valerie Wright." *Address:* Appletree Cottage, 55 Rushgreen Rd., Lymm, Ches. WA13 9PS.

WROUGHTON, Julia, N.D.D. (1957), A.R.C.A. (1960), R.W.A. (1963); painter in oil and water-colour; Principal, Inniemore School of Painting (1967-1999). *b:* Bridge of Allan, Stirlingshire, 24 Oct 1934. *d of:* Robert Lewis Wroughton, Controller of Customs, Zanzibar. *m:* Alastair Macdonald (decd.). Bruce Killeen M.A., R.W.A. one *s.* three *d. Educ:* Beacon School, Bridge of Allan. *Studied:* Colchester School of Art (1953-57) under John O'Connor, Hugh Cronyn, Royal College of Art (1957-60) under Carel Weight, R.A., Colin Hayes, R.A. and Roger de Grey. *Exhib:* R.A., R.W.A., one-man show: Torrance Gallery, Edinburgh, Glengorm Castle, Isle of Mull, Malcolm Innes Gallery, Edinburgh, Alpha House Gallery, Sherborne, The Circle Gallery, Edinburgh. *Works in collections:* Royal West of England Academy, Nuffield Foundation, Mrs. Nelson, Glengorm Castle, Marquess of Bath, Longleat. *Publications:* Evocations - Wood Engravings and Poems, by Julia Wroughton and Bruce Killeen ISBN 978-0955088-2-8. *Signs work:* "Julia Wroughton," "J. W." *Address:* Inniemore Lodge, Carsaig, Isle of Mull PA70 6HP.

WU, Ching-Hsia, artist; paintress in water-colour and poetess; Prof. Shanghai Academy of Fine Arts, Prof. Shanghai Normal University; Vancouver Golden Jubilee Chinese Carnival Honorary Prize, Canada (1936). *b:* Changchow, China, 11 Feb 1910. *Educ:* at home and studied art under father. *Exhib:* Shanghai, Nanking, Peking, Rome, Jakarta, Surabaya, Singapore, Helsinki, Tokyo, Hong Kong, Osaka, Paris, Stockholm, Canton, etc. *Works in collections:* Shanghai Art Gallery; Katesan House, Jakarta; etc. *Publications:* Select Work of Wu Qing-Xia. *Clubs:* China Art Society, Shanghai, Accademico d'Europa. *Signs work:* "WU Ching-Hsia," (Wu Qing-Xia). *Address:* 301/3, Lane 785, Ju Lu Road, Shanghai (China).

WUNDERLICH, Paul, painter in oil, gouache, lithography; sculptor. *b:* Eberswalde, 10 Mar 1927. *s of:* Horst Wunderlich, pilot. *m:* Karin Székessy, photographer. two *d. Educ:* Berlin High School. *Studied:* Academy Hamburg. *Exhib:* all over Europe, United States, Japan, S. Africa and Australia. *Works in collections:* museums in Europe, U.S.A. and Japan. *Publications:* Paul Wunderlich (Denoel, Paris 1972), Lithografien 1959-73 (Office du Livre, Fribourg Suisse), Monographie 1978 (Filipacchi Paris), Monographie (1955-80), Huber, Offenbach, Homo Sum 1978 (Piper, Munich), Bilder zu Manet (Cotta,

Germany 1978), Skulpturen and Objecte I and II, Huber, Offenbach, Germany. *Signs work:* "Paul Wunderlich." *Address:* Haynstr. 2. D-20249, Hamburg Germany. *Email:* paul@wunderlich.org

WYATT, Arthur Leonard, T.D. (art pottery), F.F.P.S.; artist in acrylics, mixed media; art teacher (1950-82). *b:* London, 6 Dec 1922. *s of:* A.A. Wyatt. *m:* Margaret Sybil Lucy. two *s. Educ:* West Ham Grammar School. *Studied:* Hornsey School of Art (1950's). *Exhib:* 22 one-man shows in U.K., America, Germany, Norway, S. Africa; numerous group shows with F.P.S.; invited exhibitor (11 works) 49th World Sci-Fi Convention, Brighton (1987); Astro-Physics Dept., Queen Mary College, London; F.P.S. Fellows exhbn. at Loggia Gallery (1996), F.P.S. group exhbn. '5 Decades' at Loggia Gallery (1996), F.P.S. Selected at R.B.S.A. (1996). *Works in collections:* Pennsylvania Museum of Modern Art, City A.G. Lichfield, Gateshead Municipal Collection, Save and Prosper, Head Office. *Publications:* Illustrated five rambling books (Essex, Herts.). *Clubs:* F.P.S. *Signs work:* "WYATT." *Address:* 1 Kenwood Gdns., Gants Hill, Ilford, Essex IG2 6YH.

WYATT, Joyce (Mrs Derek Wraith), RMS, VPSWA, Hon.UA, FRSA; Prix Rowland and Mention Honorable (Paris Salon, 1963); Médaille D'Argent (Paris Salon, 1965); Médaille D'Or (Paris Salon, 1969); Member of La Société des Artistes Français (1969); portrait painter in oil, water-colour, etc. *b:* London. *d of:* Francis W. Wyatt, company director. *m:* Dr. Derek Greenway Wraith. one *s.* one *d. Exhib:* R.A., R.P., R.M.S., R.B.A., Société des Artistes Français, U.A., S.W.A., etc.; one-man shows: Federation British Artists, Edinburgh Festival Exhbn., Rutland Sq., Edinburgh, La Galerie Mouffe, Paris. *Works in collections:* Fresco (Christ Consoling the Women) Italy; St. Andrew's Church, Totteridge (The Nativity). *Commissions:* include portraits for H.R.H Prince Michael of Kent. *Signs work:* "WYATT." *Address:* Archgate, North Stoke, nr. Wallingford, OX10 6BL.

WYER, Annraoi, B.A. Hons. Fine Art (1986), Dip. Design Hons. (1985); Greenshield Foundation award, Montreal (1988), President's Gold medal (1987); Prof. of Art, Blackrock College; painter, printmaker, illustrator. *Medium:* print. *b:* Dublin, 7 Sep 1963. *s of:* Henry A. Wyer. *m:* Sheila. one *s. Educ:* Blackrock College. *Studied:* National College of Art and Design, Dublin, Dublin Inst. of Technology (1981-84, Alice Hanratty, Patrick Graham). *Exhib:* Ljubljana (1987, 1989), Varna (1989, 1991), Taipei (1988), various national exhbns. Work in corporate and private collections. *Works in collections:* national and international. *Publications:* 'Blackrock College 1860-1995'. *Clubs:* Assoc. of Artists in Ireland, Black Church Print Studio. *Signs work:* "Annraoi Wyer." *Address:* 3 Ardmore Wood, Herbert Rd., Bray Co., Wicklow, Eire.

WYLES, June, B.A. (Hons.) Fine Art, M.A. Printmaking; painter/printmaker in oil, charcoal - landscape and the human form; lecturer of art, Berkshire College of Art and Design;. *b:* Berks., 1955. *Studied:* St. Martin's School of Art. *Exhib:*

one-man shows: Dusseldörf, London. *Signs work:* "June Wyles." *Address:* 14a Eldon Rd., Reading, Berks. RG1 4DL.

WYLIE, Rose Forrest, MA, RCA; Dupree Award (R.A. 1999); painter. *b:* 14 Oct 1934. *d of:* Alexander Forrest Wylie, O.B.E., Director of Ordnance, India. *Studied:* Folkestone and Dover School of Art, R.C.A. *Exhib:* Hayward Annual (1982), Odette Gilbert Gallery 'Women and Water' (1988), John Moores (1991), R.A. Summer Exhbn. (1992, 1993, 1997-2005), Towner Gallery 'Interiors' (1993), Norwich EAST Int.(1994, 2004, 2007), Seattle Art Fair (1996), Cheltenham Open Drawing (1996, 1998,2000), Jerwood Painting Prize (1997), Velan, Turin (2000), Jerwood Gallery, London (2000) 'Give & Take' CAS purchases, Essor Gallery'Pizza Express Prospects' (2002), Cheltenham Museum & Gallery 'As It Seems' (2002); Pearl, London, 'Reverse Engineering' (2002), Mostyn Open 13 (2003); two person shows: Odette Gilbert Gallery (1988), Towner Gallery (1994), Rutherford College UKC (2004); one-person shows: Reed's Wharf Gallery, London (1995), Abbotsbury Studios (1998), Stephen Lacey Gallery, London (1999), UNION, London (2006). *Works in collections:* Deal Collection, Dallas; Railtrack, London; Arts Council of England; University College, Oxford J.C.R.; York City Art Gallery; Norwich Gallery; Royal Colelge of Art, print coll. *Publications:* 'Twink & Ivy, and Other Paintings' (2004); Some Drawings 1987-2005. *Address:* Forge Cottage, Newnham, Sittingbourne, ME9 0LQ.

WYNNE, Althea, ARCA (1960), FRBS (1994). *Medium:* fired clay, plaster, bronze. *b:* Bedford, 6 Oct 1936. *d of:* Group Capt. F.R. Wynne, M.B.E. *m:* Antony Barrington-Brown. one *s.* two *d. Educ:* North Foreland Lodge School. *Studied:* Farnham Art School, Hammersmith College, R.C.A. *Exhib:* Henley Arts Festival (1994), Margam Sculpture Pk. (1991), Tower Bridge Plaza (1995), Winchester Cathedral (1997), Shape of the Century (1999) ArtParks, Guernsey (2005). *Works in collections:* 3 horses 1.5 x L/size, bronze, Mincing Lane EC1; Family of goats L/size bronze, Barnard's Wharf Rotherhithe; "The Family" group L/size, Walsall Maternity Hospital; "White Horses" L/size resin, QE2 liner; "Chalk Columns" 9m obelisk, Bluewater. *Principal Works:* all the above. *Recreations:* riding, sailing, gardening. *Signs work:* 'Althea Wynne'. *Address:* Mizmaze, 26c Upton Lovell, Warminster, Wilts. BA12 0JW. *Email:* althea.wynne@btinternet.com *Website:* www.althea-wynne-sculptor.com

Y

YALLUP, Pat, RWA; Dip.Ad.S.A. (1956), S.I.A.D., A.T.D. (1963); artist in water-colour (landscapes and abstracts), oil (portraits); Pat Yallup Studio/Gallery, Llandogo, Gwent, (teacher own School). *b:* Johannesburg, S. Africa, 29 Sep 1929. *d of:* Hugh Astley Treadwell, accountant. *m:* R. W. Yallup. three *s. Studied:* Witwatersrand, Johannesburg; Byam Shaw School (portraiture). *Exhib:* 35 one-man shows, six in London (1984-94). *Works in collections:* Expressionist Abstracts, S. Africa, Canada, Germany, America, Australia and New Zealand.

Commissions: many portraits, landscapes and places. *Publications:* "Creative Imagination". *Works Reproduced:* Calendars, Limited Prints, Postcards, Gift Cards. *Clubs:* Wye Valley Art Society. *Signs work:* "Pat Yallup" (water-colours and abstracts). *Address:* Gallery House, Llandogo, nr. Monmouth, Monmouthshire NP25 4TJ. *Email:* patyallup-artist@yahoo.co.uk *Website:* www.patyallup.com

YARDLEY, Bruce Christopher, A.R.O.I. (2000); painter in oil. *b:* Reigate, Surrey, 18 Jul 1962. *m:* Caroline Rosier. *Educ:* Reigate Grammar School, Bristol University, Worcester College, Oxford. *Exhib:* R.O.I., biannual solo exhibs. at various galleries in U.K. *Signs work:* "Bruce Yardley." *Address:* 22 Somers Rd., Reigate, Surrey RH2 9DZ.

YARDLEY, John Keith, R.I.(1990); painter, particularly interior and street subjects, in oil and water-colour; Water-colour Foundation prize R.I. (1990), and various individual gallery prizes at RI Annual Exhbns. *b:* Beverley, Yorks., 11 Mar 1933. *s of:* R.E. Yardley. *m:* Brenda. two *s.* one *d. Educ:* Hastings Grammar School. *Exhib:* R.I., R.W.S., N.E.A.C., numerous one-man shows. *Works in collections:* Merrill Lynch, C.T. Bowring, A.P.V., and private collections. *Publications:* Water-colour - A Personal View; The Art of John Yardley by R. Ranson; Water-colour Impressionists by R. Ranson; John Yardley by Susanne Haines; videos: 'Sunlight in Water-colour', 'Water-colour in Venice' and 'Variety in Water-colour'. *Signs work:* "John Yardley" in script. *Address:* 5 Evesham Rd., Reigate, Surrey RH2 9DF.

YASMIN, Robina, BA Hons, Postgraduate (Commended). *Medium:* oil on canvas. *b:* Sanwell, Pakistan, 17 Sep 1968. *d of:* Mr & Mrs Rashid. *m:* Jan Morgan. one *s. Studied:* Birmingham Institute of Art and Design; Glasgow School of Art. *Represented by:* Ingo Fincke Gallery, 24 Battersea Rise, London SW11. *Exhib:* Ingo Fincke Gallery, London; Fairfax Gallery, Tunbridge Wells; New Designers BDC, Tiley House Carlisle; Worcester Art Gallery; Birmingham Museum and Art Gallery; Paperleaf Art Fair, Affordable Art Fair, Chelsea Art Fair, Art Ireland, Glasgow Art Fair, Art 2003 Islington, Contemporary Fine Art Gallery, Eton. *Works in collections:* private collections. *Commissions:* numerous private. *Publications:* Art Review, Living etc., SW Magazine, The Index, Living South. *Misc:* subjects constantly changing, currently studying giraffes, reflections, swimmers, people. *Signs work:* R.Yasmin. *Address:* Kira Fincke, Ingo Fincke Gallery, 24 Battersea Rise, London SW11 1EE.

YATES, Alan, ARBS, FSCD, Cert.Ed., FRSA; sculptor in cast bronze. *b:* Bishop Auckland, 30 Nov 1947. *Educ:* Leeholme School; Bishop Auckland Grammar School. *Studied:* Bede College, Durham University (1966-69). *Exhib:* RA, RSA, RGI, RWA, Paris Salon, Durham University, York, Grantham, Darlington, Perth, Newcastle Polytechnic, Edinburgh, S. Shields, Swansea University, Stratford, Northern Open Touring Exhbn., Chelsea Harbour, Manchester Academy, Mall Galleries London, Kowalsky Gallery London.

Commissions: St. James' Youth Centre, Coundon; Grey College, Durham University. *Publications:* entries in: 'Artists in Britain since 1945' by David Buckman; 'Artists of Northumbria' by Marshall Hall. *Signs work:* "A. YATES." *Address:* Leaside, Frosterley, Bishop Auckland, Co. Durham DL13 2RH. *Email:* enquiries@sculpturestudio-alanyates.com *Website:* www.alanyates-sculpture.com

YATES, Anthony, RBSA (2002); RBA (2005); major awards: Kate Fryer Award, RBSA (2002); Davison Award, RBA (2005); TNT Award, RBSA Prize Exhibition (2005). *Medium:* oil. *b:* Birmingham, 18 Sep 1957. *s of:* Clifford and Lily Yates. *m:* Janice Yates (nee Mills). one *d. Studied:* Bourneville College of Art. *Represented by:* Fosse Gallery Fine Art, Stow-on-the-Wold, Gloucestershire. *Exhib:* Driffold (1998, 99); Anderson (1999); Park View (1999, 2000, 2001); Galerie "De Herkening" Amsterdam, Holland (1999); Cowleigh (2001); The Stables, Birmingham (2002); Ombersley (2003, 04); Chomé, Bath (2005); Claire Galleries (2006); Fosse Gallery (2006, 07); Society Exhibitions: RBSA (1995-2007); RWA (1996, 97, 2004); Pastel Society (1998); NEAC (2004); RBA (2003-07). *Works in collections:* RBSA Permanent Collection. *Commissions:* private commissions only. *Publications:* featured in "Miller's Pictures Price Guide 2003", and "West Midlands Public Foundation Catalogue 2007". *Principal Works:* 'Nude on an Orange Bedspread'; 'Flats Overlooking Houses'. *Clubs:* Birmingham Art Circle. *Misc:* type of work: figurative, domestic size. Everyday local scenes from sketches made on spot. *Signs work:* "A.Yates". *Address:* 495 Harborne Park Road, Harborne, Birmingham, B17 0PS.

YATES, Jack, Lecturer at Camden Arts Centre (24 years), and at Hornsey College of Art (1 year), retired. *Medium:* oil, watercolour, drawing, prints, collages, photo-montages, paper-cuts, cliché verre, lino-cuts, mono-types, watercolour on linen. *b:* Sheffield, 16 Dec 1923. *m:* Hanne. one *s.* one *d. Studied:* Sheffield College of Arts & Crafts. *Exhib:* RA Summer Show (1963); selected one-man shows: Camden Arts Centre (1970-77, 1980, 85, 88), Rotunda Gallery, Hampstead (1971), Quai Gallery, Sudbury (1988), Gallery MC2 Mannheim Germany (1995); Wabe Gallery, London (1988, 90, 96, 98); many mixed exhbns. since 1963 in UK and abroad. *Works in collections:* private collections in Great Britain and abroad. *Publications:* 'Creating in Collage' (Studio Vista, 1976); Editor of 'Kaleidoscope' Magazine 1-8; book: 'Collage' by Jack & Hanne Yates (Otto Maier, Germany, 1981); 'Figure Painting in Watercolour' (Search Press, 1983); illustrations in 'Drawing for Pleasure' (Search Press, 1983); featured in 'Life Drawing Class' by Diana Constance (pub. Century, USA); Editor of 'Fragments' magazine (1995-2005). *Recreations:* editor of 'Fragments' magazine(art work and poetry # 1-27, last issue). *Misc:* paper-cut frieze of 82 segments 1983-2000, theme: childhood in Sheffield and episodes in later life. *Signs work:* 'Jack Yates'. *Address:* 13 Lindfield Gardens, London NW3 6PX. *Email:* pcwhy@hotmail.com

YATES, Jeremy, RCA (Royal Cambrian Academy). *Medium:* watercolour, acrylic, oils (landscape and figure). *b:* Wolverhampton, 14 Mar 1947. *m:* Christine (decd). two *s. Educ:* Brewood Grammar School, Staffordshire. *Studied:* Stafford (1963-65); Brighton College of Art (1965-68); Chelsea School of Art (1968-69). *Exhib:* Summer Shows: RI & RWS; Royal Cambrian Academy of Art. *Works in collections:* variuos private collections- UK, Canada, Moscow, University of Wales, Bangor. *Publications:* author of 'Frank Brangwyn RA (1967-1956)': The Bangor Collection (2006). *Misc:* Tutor with Univ. Wales Bangor & WEA/Coleg Harlech; Yale Center for British Art, Research Fellowship (1994). *Signs work:* 'Yates'. *Address:* Y Fron, Cilfodan, Bethesda, Gwynedd LL57 3SL. *Email:* jslyates@tiscali.co.uk

YATES, Kate (Katherine), MA, MB, BChir. *Medium:* oil, drawing. *b:* New York, 11 Nov 1937. *m:* Dr.Michael Yates. one *s.* one *d. Studied:* JR College New York State (Harry Guggenheimer); Accademia dei Belle Arte, Florence, Italy (Primo Conti); Art Students League, NYC (Julian Levy, Harry Sternberg:graphics/Robert Hale: life drawing/anatomy). *Exhib:* RA, NEAC, CAS (group shows); London, Dakha, France (solo shows). *Works in collections:* many private collections in England, USA, France, Italy, Bangladesh. *Commissions:* (NYC) murals, portraits. *Works Reproduced:* Bridgeman Library. *Recreations:* skiing, golf, tennis for sport, theatre, food. *Clubs:* Arts Club, Dover Street, London. *Misc:* observes passing moments in life with a lean towards caricature. *Signs work:* 'Kate Yates'. *Address:* 25 Bloomfield Terrace, London SW1W 8PQ. *Email:* kate4michael@aol.com

YATES, Marie, B.A.Hons (1971); artist. *b:* Lancashire, 9 Aug 1940. *Studied:* Manchester and Hornsey. *Exhib:* Arts Council, British Council, Arnolfini. *Works in collections:* Arts Council, Arnolfini Trust, Cornwall Educ. Com., Plymouth City A.G. *Publications:* A Re-Evaluation of a Proposed Publication (1978). *Signs work:* "Marie Yates." *Address:* 17 Victoria Rd., London N22.

YEOMAN, Martin, R.P., N.E.A.C.; artist in oil, pencil, pen and ink, silver point, pastel, etching, clay. *b:* Egham Hythe, 21 Jul 1953. *s of:* Arthur John Yeoman. *m:* Anne Louise. one *s. Studied:* R.A. Schools (Peter Greenham). *Exhib:* Agnews, New Grafton Gallery, R.A., N.P.G., Mallett, Waterman Fine Art, Hampton Court Palace, National Gallery, Yemen. *Works in collections:* H.M The Queen, H.R.H. The Prince of Wales, N.P.G., Sir Brinsley Ford, National Trust, Barings Bank. *Commissions:* The Queen's Grandchildren; The Royal Household. *Publications:* National Trust Foundation for Art, catalogue; British Council, catalogue; Ford Collection (The Walpole Soc.); illustrated: Yemen Travels in Dictionary Land by T. MacIntosh Smith. *Clubs:* R.P., N.E.A.C. *Signs work:* "Yeoman." *Address:* 101 West Street, Warminster, Wilts. BA12 8JZ.

YHAP, Laetitia, D.F.A.(Lond.) (1965); artist. *b:* St. Albans, 1 May 1941. *d of:* Dr. L.N. Yhap. one *s. Educ:* Fulham County Grammar School. *Studied:* Camberwell School of Art (1958-62, Euan Uglow, Frank Auerbach), Slade

School of Fine Art (1963-65, Harold Cohen, Anthony Green). *Exhib:* solo shows, Piccadilly Gallery (1968-73), Serpentine Gallery (1979), Air Gallery (1984), 'Life at the Edge' Charleston Farmhouse (1993); 'The Business of the Beach' 1988-89 Touring show organised by Laing A.G., Newcastle-upon-Tyne, 'Bound by the Sea', The Berwick Gymnasium (1994), Maritime Counterpoint (1996), Boundary Gallery, London, 'Being in the Picture' A Retrospective (2002), Piers Feetham Gallery, London. *Works in collections:* Tate Gallery, Unilever House, Hove A.G., Hastings Museum, Rugby Museum, Portsmouth City A.G., British Council, Contemporary Art Soc., New Hall Cambridge, S. East Arts Coll., University College London, Walker A.G., Liverpool, Nuffield Foundation, D.O.E., Arthur Anderson Coll., Yorkshire, Leicestershire Educ. *Recreations:* badminton, concert going. *Signs work:* "Laetitia Yhap."

YOSHIMOTO, Eiko, P.S., S.W.A., S.B.A., S.P.F.; artist in pastel, conte, charcoal, oil. *b:* Japan, 5 Jul 1937. *Educ:* Notre Dame Sacred Heart School, Japan; Diploma from Drama School of Toho Film Company, Tokyo. *Studied:* City & Guilds of London Art School (part-time, 1994-96, Eric Morby), École de Société des Pastellistes de France (Jean Pierre Merat). *Exhib:* P.S. (1986-), S.B.A. (1986-), S.W.A. (1987-), Glyndebourne Opera House (1989, 1991), R.A. (1993, 1994, 1997), N.E.A.C. (1986-), Royal Opera House (1992); solo shows: S.P.F. Paris (1992, 1993, 1995, 1996, 1997). *Signs work:* "Eiko Yoshimoto." *Address:* "Hermitage Lodge", The Hermitage, Richmond, Surrey TW10 6SH.

YOUNG, Dr. Joseph L., F.I.A.L.; pioneer of reintegration of art in architecture; creator of over 50 cultural landmarks for civic, educational and religious structures throughout America, including works in mosaic, metal, wood, stained glass, concrete, granite, etc.; author of 2 books on mosaics published by Reinhold, N.Y. (1957-63); guest lecturer and artist-in-residence at numerous institutions of higher learning in U.S.A. and Europe. *b:* Pittsburgh, Pa., 27 Nov 1919. *m:* Millicent E. Young. two children. *Educ:* Westminster College, New Wilmington, PA. *Studied:* Boston Museum School of Fine Arts; American Academy of Art, Rome. *Signs work:* "J. Young." *Address:* Art in Architecture, 79171/2 W. Norton Ave., Los Angeles, CA 90046, U.S.A.

YOUNG, Emily, *Medium:* stone. *b:* London, 13 Mar 1951. *d of:* Lord & Lady Kennet. one *s. Educ:* varied. *Studied:* Chelsea School of Art, St.Martins School of Art, Stonybrook University, NY, USA. *Represented by:* Fine Art Society. *Exhib:* R.A., London; Thackeray Gallery, Fine Art Society, Berkeley Square Gallery, Ingleby Gallery, Royal Botanical Gdns Kew, and many others. *Works in collections:* worldwide. *Commissions:* La Defense Paris, London St.Pauls Churchyard, Gateshead (public), numerous private commissions. *Publications:* Emily Young (Ingleby Gallery, 2003); 'Time in the Stone' (Tacit Hill Editions, 2007). *Principal Works:* Wounded Angel I, Royal Botanical Gdns Kew; Golden Angel, Gateshead; 5 Angels for St. Paul's Churchyard; Lunar Disc, Salisbury Cathedral. *Recreations:* singing. *Clubs:* Chelsea Arts Club, Academy Club, Frontline Club, Electric House. *Signs work:* 'Emily Young', but does not

normally sign. *Address:* 47 Blenheim Cres. London W11 2EF. *Email:* info@emilyyoung.com *Website:* www.emilyyoung.com

YOUNGER, Elspeth Chalmers, D.A. (1957), Post Dip. (1958); embroiderer, painter in inks, water-colour, gouache. *b:* Paisley. *d of:* William Younger. *m:* John Gardiner Crawford. one *s.* one *d. Educ:* Camphill Secondary School, Paisley. *Studied:* Glasgow School of Art (1953-58, Kathleen Whyte); National Wool Textile Award (1957), Travelling Scholarship, Paris (1958). *Exhib:* solo shows: 57 Gallery, Edinburgh (1965), Lane Gallery, Bradford (1965), Civic Arts Centre, Aberdeen (1969, 1971), University of Aberdeen (1971), Cornerstone Gallery, Dunblane (1983, 1984, 1988, 1989), Haddo House, Aberdeen (1988), McEwan & Ritchie Fine Art, Dundee (1990), Tolquhon Gallery, Tarves (1992), Cottage Gallery, Newtyle (1993, 1995, 1997, 1999); group shows include Glasgow School of Art, S.A.C., S.S.A., Scottish Gallery, R.S.W., etc. *Works in collections:* Aberdeenshire Educ. Authority, Tayside Educ. Authority, North British Hotel, Dundee A.G., and private collections throughout Britain, and Norway, Holland, Germany, France, Australia, Canada, U.S.A. *Publications:* in various publications, and in "20th Century Embroidery in Gt. Britain", Vols. 2, 3, 4, by Constance Howard. *Signs work:* "ELSPETH YOUNGER" and date, embroidery unsigned, label on reverse. *Address:* 34 Strachan St., Arbroath, Angus DD11 1UA, Scotland.

YOUNGMAN, Erica, HS; HND in Natural History and Technical Illustration; 'Honorable Mention' (HS, 2004). *Medium:* watercolour. *b:* Skelmersdale, 27 Sep 1972. *m:* Mark. *Studied:* Bournemouth and Poole College of Art and Design. *Exhib:* Mall Galleries (1994); The Town Hall, Wells, Somerset; HS. *Works in collections:* Fine Art of all sizes, and miniature fine art; landscapes, floral, animal portraits, human portraits (large and miniature). *Publications:* book illustrations for Dorling Kindersley, and OUP. *Works Reproduced:* many as greeting cards. *Signs work:* 'E.Youngman'. *Address:* 15 Cutlers Place, Colehill, Wimborne, Dorset BH21 2HN. *Email:* ericayoungman5@yahoo.co.uk

YOUNSON, Sydna, BA (Hons) Painting; City & Guilds Calligraphy; Artist-in-Residence, St.John-at-Hackney (1991-95). *Medium:* oil, watercolour. *b:* London, 5 Jan 1968. *d of:* George & Sylvia Younson. *Studied:* Central St.Martins College of Art & Design. *Represented by:* Beverley Knowles Fine Art. *Exhib:* selected exhbns: Beverley Knowles Fine Art (Bedole Gallery, Bevington Street, Art London, Affordable Art Fair); Discerning Eye (Mall Galleries); Fordham Gallery (1999-); Paul Smith Flagship Store; Roger Evans College; Hat on Wall; Transition Gallery; Quantum Contemporary Art; Tabernacle; Lethaby; Smiths; Ing Bank; solo shows at Fordham, Lyndons Fine Art, Antics. *Works in collections:* various private collections worldwide. *Commissions:* Topshop; Topman. *Works Reproduced:* 'World of Interiors'; 'London Evening Standard'. *Address:* Unit 3X Cooper House, 2 Michael Road, London SW6 2AD. *Email:* sydna@younson.com *Website:* www.younson.com

YULE, (Duncan) Ainslie, D.A. (1963); sculptor/teacher; Head of Sculpture, Kingston University 1982- (Reader 1987-). *b:* North Berwick, 1941. *s of:* Edward Campbell Yule & Elizabeth Morgan Yule. *m:* (1) Patricia Carlos (m dissolved). one d. (2) 1982, Mary Johnson. *Educ:* Edinburgh College of Art. *Exhib:* regular solo and group exhbns. including Whitechapel A.G. (1973), Gubbio Biennale (1973), Silver Jubilee Exhbn. Battersea Park (1977), Fruitmarket Gallery and travelling (1977-79), Angela Flowers (1986-99), Scottish Gallery (1989-91), Talbot Rice (1999). *Works in collections:* include Aberdeen A.G., A.C.G.B., Dundee A.G., Leeds City A.G., S.A.C. University of Leeds, Gregory Fellow (1974-75). *Clubs:* Chelsea Arts. *Signs work:* "Ainslie Yule." *Address:* 11 Chiswick Staithe, Hartington Rd., London W4 3TP.

Z

ZACRON, NDD Painting (Special Level), RA School Diploma; founder member of the Psychedelic Surrealist Movement (late '60s), and of 'The New Visionaries' school (1978). *Medium:* multi-media artist, photography, poetry, journalism, writing. *b:* Surrey, 29 Sep 1943. *Studied:* Studio 35, Surbiton (1957-60), Kingston College of Art (1961-64), Royal Academy Schools (1964-67). Lectured in Visual Studies at Leeds College of Art (1967-70). *Represented by:* Number Nine the Gallery, Birmingham; The Grapevine Gallery, Norwich; The Lantern Gallery, S.Norfolk; BBC Radio Norfolk. *Exhib:* Royal Academy, Leeds College of Art, widely throughout the UK including East Anglia, the Midlands and London West End galleries, Also travelling exhibitions in the USA; recent one-man shows include: 'Art is Human Ecology', BBC Norwich; 'Zacron Past and Present', The Warehouse, Lowestoft; 'Zacron at the Grapevine Gallery', Norwich. Permanent exhibition at the Lantern Gallery. *Works in collections:* include: Christie's Contemporary Art, Ordnance Survey, Halifax Pemanent Collection, V&A Museum, extensive private collections worldwide. *Commissions:* Brian Epstein, Leyland Cars, Alginate Industries, Led Zeppelin, Fancy the Supergroup, Legs & Co., Whatman Paper, Daler Rowney, Longford and Hill, Mo Faster, numerous private commissions. *Publications:* Graphics World, Graphics, Creative Review, The Artists' & Illustrators Magazine., New Visionaries' (pub. Zacron Studios), East Anglian Daily Times, Eastern Daily Press; hundreds of articles and reviews. *Official Purchasers:* Led Zeppelin III album cover (1970). *Principal Works:* 'Between Heaven and Earth' (fine art print, Ordnance Survey, 1978); 'A Window on London' (painting & collage, 1964); Media Exposure -300 works; 250 works for Daler Rowney-Media Research; Reflections of Paris (2007). *Recreations:* Astronomy, Ancient History, ancient language, extra-terrestrial research, arts collecting. expanding arts and film libraries. *Clubs:* Chelsea Arts Club, Royal Academy ex-students. *Misc:* Widely regarded as an ambassador for the arts, campaigning for freedom in the arts, art as human ecology and as a humanity in education. Zacron combats elitism and insularity in post-modernism. He supports the right of all to their legacy of historic knowledge and their right of access to all skills and processes -

established and progressive. Regular contributor to BBC Radio Norfolk and other regional media networks. *Signs work:* "Zacron". *Email:* enquire@zacron.com *Website:* www.zacron.com

ZALMON: see WINER, Zalmon,

ZAO, Wou Ki, Commandeur de la Légion d'Honneur; Commandeur de Mérite National; painter. *b:* Pekin, 13 Feb 1921. *m:* Francoise Marquet. *Studied:* Ecole Nationale de Beaux Arts at Hang Tcheou (1935-41). Professor of Drawing, Ecole Nationale de Beaux Arts at Hang Tcheou (1941-47). *Works in collections:* in Germany, England, Austria, Belgium, Brazil, Canada, Switzerland, U.S.A., France, China, Taiwan, Hong Kong, Israel, Italy, Japan, Luxembourg, etc. Praemium Imperiale Lauréat (peinture) 1994, Japan. *Address:* 19 bis, Rue Jonquoy, 75014 Paris, France.

ZELIN, Linda, SWA, SGFA; awards for painting and sculpture at various exhibitions. *Medium:* oil, watercolour, acrylic, sculpture. *b:* London, 1 Sep 1940. *d of:* Rose & Harry Alton. *m:* Bernard Zelin. two *s. Educ:* Hendon County. *Studied:* Harrow College of Further Education (painting); Hampstead Institute (sculpture). *Exhib:* Mall Galleries; Westminster Gallery; John Noot Gallery; Linda Blackstone Gallery; Russell Sheriden Gallery. *Works in collections:* in Spain and USA. *Clubs:* Pinner Sketch Club, Stanmore Art Society, Law Society Art Group, Harrow Art Society. *Signs work:* 'L.Z.', 'L'. *Address:* 42 Batchworth Lane, Northwood, Middx HA6 3DT.

ZENIN, Eugene, PhD degree, professional painter, graphic designer and book illustrator; gold medal of the University of St.Petersburg. *Medium:* painting, oil on canvas. *b:* Khodjent, USSR, 27 Nov 1946. *s of:* Emilia and Mikhael Zenin. *m:* divorced. one *d. Educ:* PhD degree University of St.Petersburg, Russia; State Art School, Tashkent, USSR. *Represented by:* Artistic Licence Gallery, London NW3 3AJ. *Exhib:* many solo and group exhibitions in Denmark, France, England, USA, Russia. *Publications:* 'Angels My Beloved', (pub.A Seraphim Book, Copenhagen 2002); V.Sosnora 'Ajojib Parvoz', 'Sovet Uzbekistoni Sanati' Nr.8.1985 p.17-18; S.Spirikhin 'From Here to Eternity', 'Young Generation' Nr.2 (44) 1990 p.26-27; Affordable Art Fair catalogue, London, October 2003, and 17 other catalogues; 'Dansk kunst 96', 'Danst kunst 99', Forlaget Soeren Fogtdal, 1996 p.67, 1999 p.72; Dictionary of International Biography, 32nd Edition, Cambridge, 2005/06. *Works Reproduced:* in the book 'Angels My Beloved'; 2 articles in magazines,27 articles in newspapers, 42 postcards (pub. 'Go-Card'), also in the Affordable Art Fair catalogue 2003, and 17 other catalogues. *Principal Works:* 'The Annunciation' (75x110cm) 1996; Madonna and Child (128x85cm) 1996. *Signs work:* 'eZenin'. *Address:* Tuborgvej 236, 2400 Copenhagen NV, Denmark. *Email:* ezenin@sol.dk *Website:* www.zenin.dk

ZIAR, Elizabeth Rosemary, painter. *b:* St. Ives, Cornwall. *d of:* Charles and Grace Rowe. *m:* Ian Ziar, L.D.S., R.C.S. one *s. Educ:* West Cornwall School for Girls (art mistress Miss M.E. Parkins of "Newlyn School"); Penzance School of

Art (1936-41 James Lias, 1945 Bouverie Hoyton); Leonard Fuller (1945). *Exhib:* over 30 solo shows in Britain, France and Italy with usual complement of mixed international expositions, e.g. Paris Salon, Monaco, Biarritz (Dip. d'Honneur 1973), Juan-les-Pins (premier award Coupe d'Antibes 1979), R.I., R.B.S.A., S.W.A., U.A., Hesketh Hubbard, etc. *Publications:* 'Good Morrow, Brother'. *Signs work:* "ZIAR" or with monogram; occasionally: "E. R. ZIAR" or "E.R.Z." *Address:* Trevidren, Penzance TR18 2AY.

ZIZOLA, Francesco, *b:* Rome, 20 Dec 1962. *s of:* Giancarlo. *Educ:* University of Rome, Anthropology Dept. (1981-82). *Represented by:* Magnum Photos. *Individual Shows/Exhibitions:* Heirs of 2000/ Unicef, Palazzo delle Espusizioni, Rome e Arengario di Palazzo Reale, Milan (1996-7), Fait et Cause, Paris (1999), NRW Forum, Dusseldorf (2000), 'Les Choix d'Henri Cartier Bresson', Paris (2003). *Awards/Commissions:* 5 times awarded the World Press Photo including 'World Press Photo of the Year (1997); Visa D'Or magazine (1996), PoY (1998, 1997). *Principal Published Pieces:* Etat D'Enfances, Photopoches Series (Mathan, 1999), Sei Storie di Bambini (Contrasto, 1997), Ruas (Group Abele Editions, 1994). *Publications: Monograph/Contributer:* Arms Against Fury -Afghanistan, Magnum Photographers (Powerhouse Books, 2002), Within Reach: Hope for the Global Aids Epidemic (Umbrage, 2002), A Day in the Life in Africa (pub. Group West, 2002). *Specialist Area:* documentary. *Equipment Used:* Leica M6/7; Nikon D1000, D1X. *Address:* Via A.Grandi, 14 Rome 00185, Italy. *Studio Address:* Magnum Photos France: rue Hegesippe Moreau 19, 75018 Paris. *Email:* francesco@zizola.com *Website:* www.zizola.com

ZWOLINSKA-BRZESKI, Teresa, Chartered Architect, Royal Institute of British Architects, NS, SWA, SFP, FRSA, Charles Morris Award. *Medium:* acrylic. *b:* Poland, 17 Jun 1934. *d of:* Konstancia Zwolinska. *m:* Zygmuni Brzeski. *Educ:* Iran, Lebanon and England. *Studied:* at Bournemouth College of Art, Architectural Association School, Brixton School of Building. *Exhib:* one-man exhbns: Krakow and Warszawa, Polish Cultural Inst. London, TZB Southbourne Gallery; mixed exhbns: Priory House Art Gallery, Red House Museum, St.Barbe Museum, Mottisfont Abbey, Sofiero Castle, Westminster Gallery, Highcliffe Castle, Lewes Gallery, Isle of Wight, Jersey, Austria, RWA Bristol, Bankside, Mall Galelries, Sir Harold Hillier Gardens. *Works in collections:* Canada, Austria, Poland, Spain, USA, England, NZ. *Publications:* Who's Who in Art and Antiques, Dorset Art Weeks guides, Dziehnik Polski, The Sticks, Daily Echo, Who's Who Polonia, book: How to Paint from Photographs, SWA catalogue. *Works Reproduced:* poster for Southbourne in Bloom, greeting cards, calendars NZ/UK, book by T.Paul. *Recreations:* photography, classical music. *Clubs:* RHS, Amici di Verdi, CAG, HAF, SAS. *Misc:* practised architecture in London, now devotes her time to painting. *Address:* TZB Southbourne Gallery, 2 Carbery Row, Southbourne Road, Bournemouth, BH6 3QR. *Website:* www.theartshopper.com

ZYW, Aleksander, painter. *b:* Lida, Poland, 29 Aug 1905. *s of:* J. S. Zyw. *m:* Leslie Goddard. two *s. Studied:* in Warsaw, Athens, Rome and Paris. *Exhib:* Warsaw, Paris, Basle, Milan, London, Edinburgh. *Works in collections:* State Collection of Poland, National Gallery of Poland, Union of Polish Painters, Tate Gallery, Glasgow Art Gallery, Arts Council of Scotland, University of Edinburgh, Scottish National Gallery of Modern Art, Rhodes National Gallery, Salisbury, Carnegie Trust. *Signs work:* "Zyw." *Address:* Bell's Brae House, Dean Village, Edinburgh EH4 3BJ.

WHO'S WHO IN ART

APPENDIX I

OBITUARY

1992
LEYGUE, Louis b.25 Aug 1905, d.1992

1994
JANES, Violeta d. 2 Feb 1994

1995
COOLIDGE, John b.16 Dec 1913, d.1995
FINLAY, Ian C.B.E., HRSA d.1995

1996
WILKINSON, Ronald Scotthorn d.1996

1997
INGHAM, George Bryan ARCA b.11 Jun 1936, d.22 Sep 1997

1998
CHAO, Shao-an M.B.E. b.6 Mar 1905, d. Jan 1998
GILMORE, Sidney b.3 Jun 1923, d.1998
PRICE, E.Jessop SWA d.1998

2000
BECK, Stuart RSMA b.18 Jun 1903, d.2000
HENRI, Adrian b.1932, d.21 Dec 2000
McCLOY, William Ashby b.2 Jan 1913, d.2000

2001
JOLL, Evelyn b.6 Feb 1925, d.2001
LEHMANN, Olga SGFA, NS, FRSA b.1912, d.2001

2002
SHEPHEARD, Sir Peter Faulkner Kt., C.B.E., PRIBA, b.1913, d.2002
SOUZA, F.N. b.12 Apr 1924, d.28 Mar 2002
WILLIAMS, Joan Barbara Price ARCA, RE, RWS, d.2002

2003
CLEMENTS, Keith b.19 May 1931, d.27 Nov 2003
DINKEL KEET, Emmy Gerarda Mary RWA b.5 Sep 1908, d. 2003
POWELL, John ARCA b.27 Aug 1911, d. Oct 2003
TEMPEST, Victor b.23 Mar 1913, d.2003

WHO'S WHO IN ART

2004

BARRIE, Mardi RSW b.25 Apr 1931, d.25 Jun 2004

BRIDGEMAN, John ARCA, FRBS b. 2 Feb 1916, d. 29 Dec 2004

HEINE, Harry RSMA, b.24 Jul 1928, d. Sept 2004

MAITLAND, Moira RSW b.20 Jun 1936, d. 2004

RAYNER, Martin ARSA b.21 Nov 1946, d. 2004/05

SCOTT, Irene Mary RSW, SSA b. 31 Dec 1942, d. 26 Nov 2004

TAVENER, Robert, RE b.6 Jul 1920, d.Jul 2004

YOUNGER, Alan Christopher Wyrill b.13 Mar 1933, d.2004

2005

BLACKBURN, Mavis RCA b. 29 Oct 1923, d.18 Nov 2005

BUSBY, George Cecil RBSA, FRSA b.2 Feb 1926, d. Nov 2005

CHEN, Chi b.2 May 1912, d.2005

GINGER, Phyllis Ethel RWS b.19 Oct 1907, d.3 May 2005

HAMILTON, Richard James b. 15 Mar 1970, d.2005

HARLE, Dennis F. SWLA b.26 May 1920, d. 2005

HEINDEL, Robert b.1 Oct 1938, d.3 Jul 2005

HILL, Francis b. 11 Sep 1917, d.25 Sep 2005

LIDDELL, John b.6 Jul 1924, d.11 Dec 2005

LOCHHEAD, Thomas b.28 Nov 1917, d.2005

OXLEY, Ursula Frances b.4 May 1918, d.24 Nov 2005

PORTEOUS WOOD, James RSW b. 12 Sep 1919, d. 19 Apr 2005

ROBINSON, Basil William FBA, FSA b.20 Jun 1912, d.29 Dec 2005

2006

ADAMS, (Dorothea Christina) Margaret, Hon RMS b.17 Feb 1918, d.2006

ADDYMAN, John, ARCA, b. 1929, d. Jul 2006

ARTHUR, Harry H.Gascoign b.30 Jun 1920, d.19 Apr 2006

BLOW, Sandra RA, HonFRCA d.22 Aug 2006

BOSTOCK, James Edward RE b.11 Jun 1917, d.26 May 2006

BOWEN, Denis ARCA, AICA b.5 Apr 1921, d.22 Mar 2006

COTTINGHAM, Grenville George RSMA, RBA b.16 Apr 1943, d.Feb 2006

DEAN, John H.W. RMS, SM, FRSA, FSOA b.25 Mar 1930, d.2006

DREISER, Peter M.B.E. b.11 Jun 1936, d.2006

FLETCHER, Alan ARCA, MFA b.27 Sep 1931, d.21 Sep 2006

GOAMAN, Sylvia d. 3 Aug 2006

HARRIS, Lyndon Goodwin RI, RSW, RWA, b.25 Jul 1928, d.Jun 2006

IBBETT, Vera HRMS, FSSI, b.30 May 1929, d.2006

JARMAN, Anne Nesta HonRMS, d.2006

LANCASTER, Brian Christy RSMA, FRSA, GRA, b.3 Aug 1931, d.2006

LAWRENCE, Mary R. b. 17 Jun 1922, d.Aug 2006

LITTLEJOHN, William RSW, RSA, RGI b. 16 Apr 1929, d. 5 Sep 2006

MILLAR, Jack Ernest ARCA, RBA, NEAC b. 28 Nov 1921, d. 2 Nov 2006

MORRIS, James Shepherd RSA, MLA, FRIAS, ARIBA b. 22 Aug 1931, d.16 Aug 2006

WHO'S WHO IN ART

ROSS-CRAIG, Stella FLS, b.19 Mar 1906, d.6 Feb 2006
SCOTT, Colin Gale b.22 Aug 1941, d.27 Sep 2006
SUMMERS, Leslie John FFPS b.2 Nov 1919, d.6 Aug 2006
TAYLOR, Joyce Barbara b.6 Aug 1921, d.15 May 2006
TAYLOR, Kate Dornberger b.26 Jul 1926, d.2006
VICARY, Richard Henry, RE, RWA, b.8 Jul 1918, d.8 Aug 2006
WILLIAMS, Sir Kyffin O.B.E., RA, b.1918, d.1 Sep 2006
YOUNG, Florence RMS, SWA b.19 Nov 1919, d.2006

2007
BALFOUR, Maria b. 27 Jun 1934, d.29 Jul 2007
BROCKWAY, Michael NEAC, b.11 Apr 1919, d.Jan 2007
CAMPBELL, Alexander Buchanan, PPRIAS, RSA, FRIBA b.14 Jun 1914, d.13 May 2007
COPNALL, John b.16 Feb 1928, d.9 Jun 2007
CROWTHER, (Deryck) Stephen ARCA, RBA b. 23 Aug 1922, d. 26 May 2007
EAVES, John b. 10 Nov 1929, d.29 Mar 2007
FAIRS, Tom NEAC, ARCA b. 3 Oct 1925, d.15 Mar 2007
GARDNER, Derek George Montague Hon.VPRSMA, b.13 Feb 1914, d.11 Feb 2007
GOBLE, Anthony Barton b. Oct 1943, d.13 Apr 2007
JOBSON, Patrick b. 5 Sep 1919, d.29 Jan 2007
KEANY, Brian James RSW b. 16 Jan 1945, d.9 Feb 2007
LA FONTAINE, Thomas Sherwood b.21 Dec 1915, d.3 Aug 2007
MILLAR, Sir Oliver Nicholas G.C.V.O., FBA, FSA b.26 Apr 1923, d.10 May 2007
MONTES, Fernando, b.14 Aug 1930, d.17 Jan 2007
PEARCE, Bryan b.25 Jul 1929, d.11 Jan 2007
PILKINGTON, (Richard) Godfrey b.8 Nov 1918, d. 8 Jul 2007
PRENDERGAST, Peter RWA, RCA b.27 Oct 1946, d.14 Jan 2007
PRIEST, Charles Robert DPA b.26 Jun 1910, d. 20 Sep 2007
ROBERTSON, Richard Ross FRBS, RSA b.1914, d.3 May 2007
SIMPSON, E.Charles d. 10 Jul 2007
WARD, John VPRP, RA, NEAC, Hon RWS b. 10 Oct 1917, d.14 Jun 2007
WHITAKER, David Malcolm RWS b.1938, d.15 Mar 2007

OTHER
CLYNE, Henry Horne b. 5 Mar 1930, d.
LILLEY, Geoffrey Ivan b.1 May 1930, d.
ROWAN, Evadné Harris MCSD, AIA d.
STEWART, John Dunlop MSIA, NRD b.3 Sep 1921, d.

APPENDIX II

QUALIFICATIONS AND
GENERAL ABBREVIATIONS

In using this list of abbreviations care should be taken to split up any compound abbreviation into its constituent parts, e.g., "F.R.S." should be broken into "F." and "R.S.," the equivalents of these letters being found under "F." and "R.S." respectively. Also in this and future editions, abbreviations may be more commonly found without punctuation between letters (i.e. F.R.S. will become FRS).

A.	Associate; Associate-Engraver (of Royal Academy).
AA	Architectural Association; Automobile Association.
AAA	Allied Artists of America; Australian Academy of Art.
AADW	Association of Artists/Designers in Wales(disbanded).
AAEA	American Academy of Equine Art.
AAH	Association of Art Historians.
AAI	Association of Art Institutions.
AAL	Academy of Art and Literature.
AAPL	American Artists Professional League.
AAS	Aberdeen Art Society.
AB	Art's Bachelor (American).
ABIRA	American Biographical Institute Research Association.
ABPR	Association of British Picture Restorers.
ACA	Association of Consultant Architects; Atlanta College of Art.
ACAVA	Association for Cultural Advancement through Visual Art
ACGB	Arts Council of Great Britain.
ACTC	Art Class Teacher's Certificate.
ACW	Art Council of Wales (formerly WAC).
AD	Anno Domini.
ADAE	Advanced Diploma in Art Education.
ADB	Associate of the Drama Board.
ADC	Aide-de-camp.
ADG	Architect Diplome par le Gouvernement.
ADMS	Assistant Director of Medical Services.
AEC	Adult Education Centre.
AFAS	Armed Forces Art Society
AFIAP	Artiste, Fédération Internationale de l'Art Photographique.
AG	Art Gallery.
AGBI	Artists' General Benevolent Institution.
AGI	Artistes Graphiques Internationales.
AGMS	Art Gallery and Museum Services.
AGPA	Artes Graficas de Pan America.
AGPP	Academia Gentium Pro Pace.

AI	Auctioneers' Institute.
AIA	Academy of Irish Art; American Institute of Architecture.
AIAL	Association of International Institute of Art and Letters.
AI Archts.(Scot.).	Association of the Incorporation of Architects in Scotland.
AICA	Association Internationale des Critiques d'Art.
AID	American Institute of Decorators.
AIID	American Institute of Interior Design.
AKC	Associate, King's College.
AM	Air Ministry; Member of Order of Australia.
AMA	Associate of the Museums Association.
AMC	Art Masters' Certificate.
AMIP	Associate Member, Institute of Plumbing.
AMTC	Art Masters' Teaching Certificate.
ANA	American National Academy.
AO	Officer, Order of Australia
AOC	Artists of Chelsea.
AOI	Association of Illustrators.
AOSDANA	Aosdana is an affiliation of artists engaged in literature, music and visual arts in Ireland.
APA	Association of Polish Artists.
APS	American Portrait Society.
ARCA	Associate of the Royal College of Art.
Ariz.	Arizona.
ARWA	Associate of the Royal West of England Academy.
ASA	American Society of Artists Inc.
ASBA	American Society of Botanical Artists.
ASG	Air Services Grants.
ASLA	American Society of Landscape Architects.
ASMA(Q).	Australian Society for Miniature Art (Queensland).
Assoc.	Association.
Asst.	Assistant.
ASTMS	Association of Scientific, Technical and Managerial Staff.
ATC	Art Teachers' Certificate.
ATD	Art Teachers' Diploma.
AUC	Anno Urbis Conditæ (from the foundation of the city).
AVAW	Association of Visual Artists in Wales.
Ave.	Avenue.
AWG	Art Workers' Guild.
AWI	Australian Water-colour Institute.
b.	born.
BA	Bachelor of Arts; British Airways.
BAAT	British Association of Art Therapists.
BAC	British Aircraft Corporation.
BADA	British Antique Dealers' Association.
BAe.	British Aerospace.

B-AS	Britain-Australia Society.
Batt.	Battalion.
BBC	British Broadcasting Corporation.
BC	Before Christ.
BCC	British Craft Centre.
B.Chrom.	Bachelor of Chromatics.
BCL	Bachelor of Civil Law.
BD	Bachelor of Divinity.
BEA	British European Airways.
B.Ed	Bachelor of Education; Board of Education.
BEDA	Bureau of European Designers' Association.
Beds.	Bedfordshire.
BEF	British Expeditionary Force.
BENA	British Empire Naturalist Association.
Berks.	Berkshire.
BFA	Batchelor of Fine Arts.
B'ham.	Birmingham.
BHP	Broken Hill Priority Ltd.
BHSAI	British Horse Society Assistant Instructor.
BIAT	British Institute of Architectural Technicians.
BIF	British Industries Fair.
BIIA	British Institute of Industrial Art.
BIID	British Institute of Interior Design.
BIM	(see I.Mgt.).
BIPP	British Institute of Professional Photography.
BIS	British Interplanetary Society.
BL	Barrister-at-Law.
Bldg.	Building.
BLitt.	Bachelor of Letters.
Blvd.	Boulevard.
BM	British Museum.
BOAC	British Overseas Airways Corporation.
B.of E	Board of Education.
BOU	British Ornithologists' Union.
BPD	British Society of Posters Designers.
BPS	British Psychological Society; Birmingham Pastel Society.
BRC	British Refugee Council.
Bros.	Brothers.
BSC	British Society of Cinematographers.
BSc.	Bachelor of Science.
BSI	British Standards Institution.
BSMGP	British Society of Master Glass Painters.
BSocSc	Bachelor of Social Science.
Bt.	Baronet.
BTA	British Travel Association.

Bucks.	Buckinghamshire.
BWS	British Water-colour Society.
C.	Central.
c.	century.
CAC	Chertsey Art Club.
Caerns.	Caernarvonshire.
Calif.	California.
Cambs.	Cambridge; Cambridgeshire.
Capt.	Captain.
CA.	Cathcart Art Society.
CAST	Centre for Art, Science and Technology.
CASW	Contemporary Art Society for Wales.
Cav.	Cavalière (Knight).
CAVS.	Center for Advanced Visual Studies.
CB	Companion of the Bath.
C.B.E.	Commander Order of the British Empire.
CC	County Council; County Councillor.
CCH	Cacique Crown of Honour.
CDS	Cambridge Drawing Society.
CEMA	Council for the Encouragement of Music and Arts.
CERN	Centre for European Nuclear Research.
Cert.	Certificate.
CertAD.	Certificate in Art and Design.
CertFA	Certificate in Fine Art.
Certs.	Certificates.
CFE	College of Further Education.
CGA	Cheltenham Group of Artists.
Chas.	Chambers.
ChB	Bachelor of Surgery.
CHE	College of Higher Education.
CI	Channel Isles.
CIAD	Central Institute for Art and Design.
CIE	Companion of the Order of the Indian Empire.
CIHA	Comité Internationale de l'Histoire de l'Art.
CIS	Institute of Chartered Secretaries and Administrators.
Cl.	Close.
CLAS	Calligraphy and Lettering Art Society.
CM	Master of Surgery.
CMG.	Companion of St. Michael and St. George.
CNAA	Council for National Academic Awards (disbanded).
Co.	Company; County.
c/o	care of.
COID.	Council of Industrial Design.
Col.	Colonel.
Com.	Committee; Common.

Comdr.	Commander.
Conn.	Connecticut.
Cons. & Rest.	Conservation and Restoration
Corp.	Corporation.
Cos.	Companies.
CP	College of Preceptors.
CPA	Craft Potters Association.
CPR	Canadian Pacific Railway.
CPS	Contemporary Portrait Society.
Cres.	Crescent.
CS	Chemical Society; Conchological Society of Great Britain and Ireland.
CSD	The Chartered Society of Designers (formerly Society of Industrial Artists and Designers).
CSI	Companion of the Order of the Star of India.
CSMA	Cornish Society of Marine Artists.
CSP	Chartered Society of Physiotherapists.
CT	Connecticut.
Ct.	Court.
Cttee.	Committee.
CUP	Cambridge University Press.
C.V.O.	Commander of the Royal Victorian Order.
CWAC	City of Westminster Arts Council.
d.	daughter.
DA	Diploma of Art; Diploma of Edinburgh College of Art; Doctor of Arts.
DACS	Design and Artists Copyright Society
DAE	Diploma in Art Education.
D.B.E.	Dame Grand Cross Order of the British Empire.
DC	District of Columbia.
DCL	Doctor of Civil Law.
D.C.M.	Distinguished Conduct Medal.
DD	Doctor of Divinity.
decd.	deceased.
Dept.	Department.
Des.	RCA Designer of the Royal College of Art.
DFA	Diploma of Fine Art.
DFAstrol.S.	Diploma of the Faculty of Astrological Studies.
DIA	Design and Industries Association.
DipAD	Diploma in Art and Design.
DipFA	Diploma in Fine Art.
DipHE	Diploma in Higher Education.
DL	Deputy Lieutenant.
DLitt.	Doctor of Letters.
DNB	Dictionary of National Biography.

DOE	Department of the Environment.
DPM	Diploma in Psychological Medicine.
Dr.	Doctor.
DRCOG	Diploma of Royal College of Obstetricians and Gynaecologists.
DS	Dental Surgery; Dental Surgeon.
DSc	Doctor of Science.
DSLU	Association of the Slovene plastic artists.
DSO	Companion of the Distinguished Service Order.
DStJ	Dame of Honour, Order of St. John of Jerusalem.
E.	East.
EAGMA	East Anglian Group of Marine Artists.
ECIA	European Committee of Interior Architects.
Educ.	Educated; Education.
EEC	European Economic Community.
EIS	Educational Institute of Scotland.
EMF	European Management Foundation.
ES	Entomological Society.
Esq.	Esquire.
etc.	etcetera.
Exam.	Examination.
Exhbn.	Exhibition.
Exhib.	Exhibited.
F.	Fellow; Foreign Member; Founder Member
(F)	Founder Member (usually following Society inits.)
FATG	Fine Art Trade Guild.
FBA	Fellow of the British Academy.
FBSComm.	Fellow of the British Society of Commerce.
FCA	Federation of Canadian Artists.
FCBSI	Fellow of the Chartered Building Societies Institute.
FECO	Federation of Cartoon Organisations
FETC	Further Education Teacher's Certificate.
FFS	Fellow of the Franklin Society.
FGA	Fellow of the Gemmological Association.
FGCL	Fellow, Goldsmiths' College, London.
FGE	Fellow of the Guild of Glass Engravers.
FIAL	Fellow of the International Institute of Arts and Letters.
FInstC	Fellow of the Institute of Commerce.
FISA	International Federation of Works of Art.
Fla.	Florida.
FLS	Fellow, Linnean Society of London.
FMA	Fellow, Museums Association.
FNCF	Federation Nationale de la Culture Française.
FPE	Fellow, Philosophical Enquiry.
FPS	Free Painters and Sculptors.
FSI	Fellow of the Surveyors' Institute.

FSP	Fellow of Sheffield Polytechnic.
FSS	Federation of Scottish Sculptors.
Ft.	Feet; Foot.
FTDA	Fellow of the Theatrical Designers and Craftsmen's Association.
Ga.	Georgia.
G.B.E.	Knight Grand Cross Order of the British Empire.
G.C.B.	Knight Grand Cross of the Bath.
G.C.M.G	Knight Grand Cross of St. Michael and St. George.
G.C.S.I.	Knight Grand Commander of the Star of India.
g-d.	grand-daughter.
Gdn.	Garden.
Gdns.	Gardens.
GESM	Group for Educational Services in Museums.
GI	Royal Glasgow Institute of Fine Arts.
GLC	Guild of Lettering Craftsmen; Greater London Council.
Glos.	Gloucestershire.
GMAS	Miniature Art Society of Georgia.
GMC	Guild of Memorial Craftsmen.
GNVQ	General National Vocational Qualification
Govt.	Government.
GPDST	Girls' Public Day School Trust.
GPFireE	Graduate Institution of Fire Engineers.
GPO	General Post Office.
GPS	Glasgow Printmaking Society.
Gr.	Grove.
GRA	Guild of Railway Artists.
g-s.	grandson.
GS	Geological Society.
GSA	Glasgow School of Art.
GSWA	Glasgow Society of Women Artists.
Gt.	Great.
Hon. D'Art-	Honorary Doctorate of Art
H.	Hon. Member.
HAC	Hampstead Artists Council.
Hants.	Hampshire.
HDFA	Higher Diploma in Fine Art.
HDipAD	Higher Diploma in Art and Design.
Herts.	Hertfordshire.
HFRA	Hon. Foreign Academician.
HLI	Highland Light Infantry.
H.M.	His Majesty; Her Majesty.
HMI	H.M. Inspector of Schools.
HMSO	Her Majesty's Stationery Office.
HND	Higher National Diploma
H.R.H.	His Royal Highness; Her Royal Highness.

HS	Hilliard Society.
HSA	Hampstead Society of Artists.
HSS	History of Science Society (American).
Hunts.	Huntingdonshire.
IAA	International Association of Art.
IAAS	Incorporated Association of Architects and Surveyors.
IAASBA	International Associate, American Society of Botanical Artists.
IAeE	Institute of Aeronautical Engineers.
IAL	International Institute of Arts and Letters.
IArb.	Institute of Arbitrators.
IAS	Incorporated Association of Surveyors; Irish Art Society.
IBA	International Biographical Association.
IBD	Institute of British Decorators and Interior Designers.
IBIA	Institute of British Industrial Art.
IC	Institute of Chemistry.
ICA	Institute of Contemporary Arts.
ICE	Institute of Civil Engineers.
ICOGRADA.	International Council of Graphic Design Association.
ICOM	International Council of Museums.
ICOMOS	International Council of Monuments and Sites.
ICS	Indian Civil Service.
ICSID	International Council of Societies of Industrial Design.
ID	Institute of Directors; Institute of Decorators.
IED	Institution of Engineer Designers.
IEE	Institute of Electrical Engineers.
IELA	Irish Exhibition of Living Art.
IFA	Incorporated Faculty of Arts.
IFAW	International Fund for Animal Welfare.
IFI	International Federation of Interior Architects/Designers.
IFS	Irish Free State.
IGA	International Guild of Artists.
IGB	Brazilian Institute of Genealogy.
IIC	International Institute for Conservation of Paintings.
ILEA	Inner London Education Authority.
ILGA	Institute of Local Government Administration.
Ill.	Illinois.
IMBI	Institute of Medical and Biological Illustration.
IMCE	Institute of Mechanical and Civil Engineers.
IME	Institute of Mechanical Engineers; Institute of Engineers.
I.Mgt.	Institute of Management (formerly British Institute of Management).
IMM	Institute of Mining and Metallurgy.
Imp.	Printer (Imprimerie, Imp).
INA	Institute of Naval Architects.
Inst.	Institute; Institution.

IOM	Isle of Man.
IOW	Isle of Wight.
IPA	Portuguese Institute of Archaeology.
IPAT	International Porcelain Artist Teachers.
IPD	Institute of Professional Designers.
IPG	Independent Painters Group; Industrial Painters Group.
IPI	Institute of Patentees and Inventors.
IPM	Institute of Personnel Management.
IS	International Society of Sculptors, Painters and Gravers.
ISCA	International Society of Catholic Artists.
ISLFD	Incorporated Society of London Fashion Designers.
ISMP	International Society of Marine Painters.
ISO	Imperial Service Order.
ISTD	Imperial Society of Teachers of Dancing.
ITAC	Imperial Three Arts Club.
ITD	Institute of Training and Development.
IWS	International Wool Secretariat.
IWSP	Institute of Work Study Practitioners.
JHAMI.	Johns Hopkins University Association of Medical Illustrations.
JI	Institute of Journalists.
JP	Justice of the Peace.
KAAG	Kirkles Art Action Group.
K.B.E.	Knight Commander Order of the British Empire.
KC	King's Counsel.
K.C.B.	Knight Commander of the Bath.
KCC	Kent County Council.
K.C.M.G.	Knight Commander of St. Michael and St. George.
K.C.S.G.	Knight Commander of St. Gregory the Great.
K.C.S.I.	Knight Commander of the Star of India.
K.C.V.O.	Knight Commander of the Royal Victorian Order.
K.G.	Knight of the Order of the Garter.
KIAD	Kent Institute of Art and Design.
Kt.	Knight.
L.	Licentiate.
La.	Louisiana; Lane.
LA	Library Association; Los Angeles.
LAA	Liverpool Academy of Arts.
LAMDA	London Academy of Music and Dramatic Art.
Lancs.	Lancashire.
LAW	Liverpool Artists Workshop.
LC	Legislative Council.
LCAD	London Certificate in Art and Design.
LCC	London County Council.
LDAD	London Diploma of Art and Design.
LDS	Licentiate in Dental Surgery.

Leics.	Leicestershire.
LG	Life Guards.
LGSM	Licentiate, Guildhall School of Music and Drama.
LI	Landscape Institute.
Lieut.	Lieutenant.
LIFA	Licentiate of International Faculty of Arts.
Lincs.	Lincolnshire.
LISTD	Licentiate of the Imperial Society of Teachers of Dancing.
LLA	Lady Literate in Arts.
LL.B.	Bachelor of Laws.
LL.D.	Doctor of Laws.
LL.M.	Master of Laws.
LPTB	London Passenger Transport Board.
LS	Linnean Society.
LSA	Licentiate of the Society of Apothecaries.
LSIA	Licentiate of the Society of Industrial Artists.
LSU	Louisiana State University.
Ltd.	Limited.
M.	Member; Ministry; Monsieur.
m.	married; metre.
MA	Master of Arts.
MA.	Massachusetts.
MAA	Medical Artists' Association; Miniature Artists of America.
MAFA	Manchester Academy of Fine Arts.
MAI	Master of Fine Arts International.
Mans.	Mansions.
MAS-F	Miniature Art Society/Florida.
MAS-NJ	Miniature Art Society/New Jersey.
MAS-W	Miniature Art Society/Washington.
Mass.	Massachusetts.
MB	Bachelor of Medicine.
M.B.E.	Member of the Order of the British Empire.
M.C.	Military Cross.
MChrom.	Master of Chromatics.
MD	Doctor of Medicine; Managing Director.
MDE	Mitglieder - Meister der Einbandkunst.
Mem.	Member.
men.	mention.
Messrs. M	essieurs.
MFA	Master of Fine Art.
MGP	Master Glass Painters.
Mich.	Michigan.
Middx.	Middlesex.
Minn.	Minnesota.
MInstM	Member, Institute of Marketing.

MInstPkg.	Member, Institute of Packaging.
MIT	Massachusetts Institute of Technology.
MIWAS	Marwell International Wildlife Art Society
ML	Licentiate in Medicine.
MLitt	Master of Letters.
Mme.	Madame.
Mo.	Missouri.
MoD	Ministry of Defence.
MofE	Ministry of Education.
MofH	Ministry of Health.
MOI	Ministry of Information.
MofS	Ministry of Supply
MofW	Ministry of Works.
MOMA	Museum of Modern Art.
Mon.	Monmouthshire.
MPSG DC	Miniature Painters, Sculptors and Gravers Society of Washington
MS	Society of Miniaturists; Motor Ship.
MS.	Manuscript.
MSc.	Master of Science.
MSM	Meritorious Service Medal.
MSocSc	Master of Social Science.
MSS.	Manuscripts.
M-SSE	Multi-Sensory Sculpture Exhibitions.
M.V.O.	Member of the Royal Victorian Order.
N.	North.
NA	National Academy of Design (New York).
NAA	National Artists Association.
NACF	National Art Collection Fund.
NADFAS	National Association of Decorative and Fine Arts Societies.
NAMM	National Association of Master Masons.
NAPA	National Acrylic Painters' Association.
NAWA	National Association of Women Artists (USA)
NB	North Britain.
NBA	North British Academy.
NBL	National Book League.
NC	North Carolina.
NCAC	New Chertsey Art Club.
NCB	National Coal Board.
NCDAD	National Council for Diplomas in Art and Design.
NCR	National Cash Register.
NDD	National Diploma in Design.
NEAC	New English Art Club.
NEC	National Executive Committee.
NECA	National Exhibition of Children's Art.

NFT	National Film Theatre.
NFU	National Froebel Union/ National Farmers Union
NGA	National Gallery of Australia.
NH	New Hampshire.
NI	Northern Ireland.
NJ	New Jersey.
NM	New Mexico.
NMGM	National Museums and Galleries on Merseyside.
No.	Number.
Notts.	Nottinghamshire.
NottsSA.	Nottingham Society of Artists.
NP	Notary Public.
NPG	National Portrait Gallery.
NPS	National Portrait Society.
nr.	near
NRD	National Registered Designer.
NS	National Society.
NSA	New Society of Artists; Natal Society of Artists; Newlyn Society of Artists.
NSAE	National Society for Art Education.
NSMP	National Society of Mural Painters.
NSPS	National Society of Painters, Sculptors and Printmakers.
NSW	New South Wales.
NUM	National Union of Mineworkers.
NUMAST	National Union of Marine, Aviation and Shipping Transport Officers.
NUT	National Union of Teachers.
NWAB	North West Art Board.
NY	New York.
NYS	New York State.
NZ	New Zealand.
O	Ohio.
OAS	Oxford Society of Artists.
O.B.E.	Officer, Order of the British Empire.
OC	Order of Canada (Officer).
OCR	Officer of the Crown of Romania.
OCS	Oriental Ceramic Society.
ODACA	Original Doll Artist Council of America.
ODF	Ouvrier de France
OHMS	On Her Majesty's Service.
Okla.	Oklahoma.
OLJ	Officer Companion of Order of St. Lazarus of Jerusalem.
O.Ont.	Order of Ontario.
OS	Optical Society.
OSA	Ontario Society of Arts.

OSB	Order of St. Benedict.
O.St.J.	Officer of the Most Venerable Order of the Hospital of St. John of Jerusalem.
OUDS	Oxford University Dramatic Society.
OUP	Oxford University Press.
OWS	Old Water-colour Society (defunct).
Oxon.	Oxford/Oxfordshire
P.	President.
PAI	Paisley Art Institute.
PASI	Professor Associate of the Surveyor's Institution.
PC	Privy Councillor.
PCFC	Polytechnics and Colleges Funding Council.
PEN	Poets, Playwrights, Editors, Essayists, Novelists Club.
Penn.	Pennsylvania.
PGCE	Post Graduate Certificate of Education.
PhB	Bachelor of Philosophy.
PhD	Doctor of Philosophy.
Phil.	Philosophy.
PI	Portrait Institute.
PIH	Pictures in Hospitals.
Pk.	Park.
Pl.	Place.
PMC	Personnel Management Centre.
P&O	Peninsular and Oriental Steam Navigation Co., Ltd.
Pres.	President.
Princ.	Principal/Principle
Prof.	Professor.
PS	Pastel Society.
QC	Queen's Counsel.
QEH	Queen Elizabeth's Hospital School.
QMW	Queen Mary and Westfield College, London.
RA	Royal Academician; Royal Academy.
RAA	Runnymede Association of Arts.
RAAS	Royal Amateur Art Society.
RAC	Royal Automobile Club.
RAE	Royal Aircraft Establishment.
RAF	Royal Air Force.
RAI	Royal Anthropological Institute.
RAM	Royal Academy of Music.
RAMC	Royal Army Medical Corps.
RAS	Royal Astronomical Society; Royal Asiatic Society; Richmond Art Society; Ridley Art Society.
RBA	Royal Society of British Artists.
RBC	Royal British Colonial Society of Artists.
RBG	Royal Botanic Gardens.

RBS	Royal Society of British Sculptors.
RBSA	Royal Birmingham Society of Artists.
RCA	Royal College of Art; Royal Canadian Academy; Royal Cambrian Academician.
RCamA	Royal Cambrian Academy.
RCGP	Royal College of General Practitioners.
RCI	Royal Colonial Institute.
RCM	Royal College of Music.
RCN	Royal College of Nursing.
RCO	Royal College of Organists.
RCOG	Royal College of Obstetricians and Gynaecologists.
RCP	Royal College of Physicians.
RCS	Royal College of Surgeons.
RCSE	Royal College of Surgeons, Edinburgh.
RDI	Royal Designer of Industry.
RDS	Royal Drawing Society.
RE	Royal Society of Painter-Printmakers (formerly Royal Society of Painter-Etchers and Engravers); Royal Engineers.
Regt.	Regiment.
Retd.	Retired.
Rev.	Reverend.
RFA	Royal Field Artillery.
RGA	Royal Garrison Artillery.
RGI	Royal Glasgow Institute.
RGIFA	Royal Glasgow Insitute of Fine Art.
RGS	Royal Geographical Society; Royal Graphic Society.
RHA	Royal Hibernian Academy.
RHS	Royal Horticultural Society.
RHistS	Royal Historical Society.
RI	Royal Institute of Painters in Water-colours.
RIA	Royal Irish Academy.
RIAI	Royal Institute of Architects in Ireland.
RIAS	Royal Institute of Architects in Scotland.
RIBA	Royal Institute of British Architects.
RIC	Royal Institute of Chemistry.
RICS	Royal Institution of Chartered Surveyors.
Rly.	Railway.
Rlys.	Railways.
RM	Royal Marines.
RMA	Royal Military Academy.
RMIT	Royal Melbourne Institute of Technology.
RMS	Royal Society of Miniature Painters.
RN	Royal Navy.
RNCM	Royal Northern College of Music.
RNIB	Royal National Institute for the Blind.

RNLI	Royal National Lifeboat Institution.
RNR	Royal Naval Reserve.
RNVR	Royal Naval Volunteer Reserve.
ROI	Royal Institute of Oil Painters.
RP	Royal Society of Portrait Painters and Member.
RPS	Royal Photographic Society.
RS	Royal Society.
RSA	Royal Scottish Academy; Royal Society of Arts.
RSAI	Royal Society of Antiquaries of Ireland.
RSE	Royal Society of Edinburgh.
RSFSR	Russian Soviet Federative Socialist Republic.
RSGS	Royal Scottish Geographical Society.
RSL	Royal Society of Literature.
RSMA	Royal Society of Marine Arts.
RoSPA	Royal Society for the Prevention of Accidents.
RSPB	Royal Society for the Protection of Birds.
RST	Royal Society of Teachers.
RSW	Royal Scottish Water-colour Society or Royal Scottish Society of Painters in Water-colours.
Rt.	Right.
RTPI	Royal Town Planning Institute.
RTYC	Royal Thames Yachting Club.
RUA	Royal Ulster Academy of Painting, Sculpture and Architecture; Royal Ulster Academician.
RWA	Royal West of England Academician; Royal West of England Academy.
RWS	Royal Water-Colour Society (formerly Royal Society of Painters in Water-colours).
S.	South.
s.	son; sons.
SA	Society of Antiquaries; Society of Apothecaries.
SAA	Society of Aviation Artists.
SAA	(US) Society of Animal Artists
SAAC	Society of Scottish Artists and Artist Craftsmen (renamed 'Visual Arts Scotland').
SABA	Scottish Artists' Benevolent Association.
SAC	Scottish Arts Council.
SAE	Society of American Etchers; Society of Automobile Engineers (American).
SAF	Société des Artistes Français.
SAGA	Society of American Graphic Artists.
SAI	Scottish Arts Institute; Society of Architectural Illustrators.
SAII	Society of Architectural and Industrial Illustrators.
Salop.	Shropshire.
SAM	National Society of Art Masters.

SAP	Society of Artist Printmakers.
SBA	Society of Botanical Artists.
SBSt.J	Serving Brothers of the Order of St. John of Jerusalem.
SC	Senefelder Club; South Carolina.
Sc.	Sculptor.
s-d.	step daughter.
SDC	Society of Designer Craftsmen and Craft Centre (formerly Arts and Crafts Exhibition Society).
SEA	Society for Education in Art; Society of Equestrian Artists (see SEqA).
Sec.	Secretary.
SEFAS	South Eastern Federation of Art Societies.
SEqA	Society of Equestrian Artists (formerly S.E.A.).
SFP	Society of Floral Painters.
SGA	Society of Graphic Art.
SGE	Society of Glass Engravers.
SGFA	Society of Graphic Fine Art (formerly Society of Graphic Art).
SGP	Society of Graver Printers.
SGT	Society of Glass Technology.
SI	Surveyors' Institute.
SIAC	Société Internationale des Artistes Chretiens.
SIAD	(see C.S.D.)
SID	Society of Industrial Designers of U.S.A.; Mem. Swedish Industrial Designers.
SIPE	Societe Internationale de Psychopathologie de l'Expression, Paris.
SKM	South Kensington Museum.
SLm.	Society of Limners.
SM	Society of Miniaturists.
SMOM	Knight of Magisterial Grace of the Sovereign Military Order of Malta.
SMP	Society of Mural Painters.
SNAD	Society of Numismatic Artists and Designers.
SNGMA	Scottish National Gallery of Modern Art.
SNPG	Scottish National Portrait Gallery.
Soc.	Société; Society.
Socs.	Societies.
SOFA	Society of Feline Artists.
Som.	Somerset.
South. S.A.	Southern Society of Artists.
SP	Société Internationale de Philogie, Sciences et Beaux Arts.
SPAB	Society for the Protection of Ancient Buildings.
SPCK	Society for the Promotion of Christian Knowledge.
SPDA	Society of Present-Day Artists.
SPE	International Society of Philosophical Enquiry.

SPF	Société des Pastellistes de France.
SPS	Society of Portrait Sculptors.
SPSAS	Swiss Society of Painters, Sculptors and Architects.
Sq.	Square.
s-s.	step son.
SS	Royal Statistical Society.
SSA	Society of Scottish Artists.
SSC	Solicitor to the Supreme Court (in Scotland).
SSI	Society of Scribes and Illuminators.
SSMCE	Society of Sculptors Medal and Coin Engravers.
SSN	Societaire de la Société Nationale des Beaux Arts.
SSS	Surrey Sculpture Society.
SSSA	Society of Sussex Sporting Artists.
SSWA	Scottish Society of Women Artists.
St.	Saint; Street.
Staffs.	Staffordshire.
STC	Sydney Technical College.
STD	Society of Typographical Designers.
SWA	Society of Women Artists.
SWAc	South West Academy of Fine and Applied Art Academician
SWAN	Society for Wildlife Art of the Nations.
SWAS	Society of Women Artists of Scotland.
SWE	Society of Wood Engravers.
SWLA	Society of Wildlife Artists.
T&T	Trinidad and Tobago.
TCD	Trinity College, Dublin.
TCM	Trinity College of Music.
TCTA	Teaching Certificate for Teachers of Art.
TD	Territorial Decoration; Teacher's Diploma.
Terr.	Terrace.
TES	Times Educational Supplement.
Tex.	Texas.
TGC	Teacher's General Certificate.
TLS	Times Literary Supplement.
TMP	Tamarind Master Printer of Lithography (NM, USA)
TN.	Tennessee.
TPI	Town Planning Institute.
TR.H.	Their Royal Highnesses.
TSB	Trustee Savings Bank.
TWASI	The Wildlife Art Society International
U.	Unionist.
UA	United Society of Artists.
UAE	United Arab Emirates.
UCH	University College Hospital.
UCL	University College, London.

ULUJ	Union of the plastic artists of Yugoslavia.
USA	United States of America.
USM	Ulster Society of Miniaturists.
USSR	Union of Soviet Socialist Republics.
USWA	Ulster Society of Women Artists.
UWA	Ulster Women Artists.
UWP	University of Wales Press.
UWS	Ulster Water-colour Society.
V.	Vice.
v.	versus.
V&A	Victoria and Albert Museum.
Va.	Virginia.
VAD	Voluntary Aid Detachment.
VC	Victoria Cross.
VD	Volunteer Officers' Decoration; Victorian Decoration.
Vol.	Volume.
VP	Vice-President.
VRD	Volunteer Reserve Decoration.
W.	West.
WA	Western Australia/Washington
WAC	Welsh Arts Council (see A.C.W.).
WAG	Walker Art Gallery.
WASCE	World Art Science and Cultural Exchanges.
WCC	World Crafts Council.
WCSI	Water-colour Society of Ireland.
WSW	Water-colour Society of Wales.
WEA	Workers' Educational Association.
WERP	Wood Engravers and Relief Printers.
WGA	Wapping Group of Artists
WGIHE	West Glamorgan Institute of Higher Education.
WIAA	Women's International Arts Association.
WIAC	Women's International Art Club.
WIAS	Women's International Art Society.
Wilts.	Wiltshire.
Wis.	Wisconsin.
Worcs.	Worcestershire.
WPW	Women Painters of Washington.
WSofV	Water-colour Society of Victoria.
WWF	World Wildlife Fund.
YAE	Yorkshire Artists' Exhibition.
YM(W)CA	Young Men's (Women's) Christian Association.
Yorks.	Yorkshire.
YWDA	Yiewsley and West Drayton Arts Council.
YWS	Yorkshire Water-colour Society.
ZS	Zoological Society.

NOTES

NOTES

NOTES

NOTES